The Grove Encyclopedia
of Materials and Techniques in Art

The Grove Encyclopedia of

Materials and
Techniques in Art

Edited by

GERALD W. R. WARD

OXFORD
UNIVERSITY PRESS

2008

OXFORD
UNIVERSITY PRESS

Oxford University Press, Inc., publishes works that further
Oxford University's objective of excellence
in research, scholarship, and education.

Oxford New York

Auckland Cape Town Dar es Salaam Hong Kong Karachi
Kuala Lumpur Madrid Melbourne Mexico City Nairobi
New Delhi Shanghai Taipei Toronto

With offices in

Argentina Austria Brazil Chile Czech Republic France Greece
Guatemala Hungary Italy Japan Poland Portugal Singapore
South Korea Switzerland Thailand Turkey Ukraine Vietnam

Copyright © 2008 by Oxford University Press

Published by Oxford University Press, Inc.
198 Madison Avenue, New York, NY 10016
www.oup.com

Oxford is a registered trademark of Oxford University Press

The Library of Congress Cataloging-in-Publication Data

The Grove encyclopedia of materials and techniques in art / edited by Gerald W.R. Ward.
p. cm.
Includes bibliographical references and index.
ISBN 978-0-19-531391-8 (alk. paper)
1. Artists' materials—Encyclopedias.
2. Art—Technique—Encyclopedias.
I. Ward, Gerald W. R.
II. Title: Encyclopedia of materials and techniques in art.
N8510.G76 2008
702.8–dc22
2008002486

1 3 5 7 9 8 6 4 2

Printed in the United States of America
on acid-free paper

Contents

v

Introduction

The object stands at the very point where the structures and properties of matter resulting from forces between atoms are in visible interaction with man's ideas and purposes. An artist's work preserves a record of both—one in the outer form and decoration, the other in the texture and color and fine contours that result from the interplay of atomic, molecular, and crystalline forces.

Cyril Stanley Smith, *A Search for Structure* (1981)[1]

Art is created by humans using techniques to transform materials into objects that have the capacity to stir the emotions and challenge the intellect. Rich sources of aesthetic joy, art objects are also tangible artifacts of memory and, when analyzed and interpreted, provide abundant information about the lives and work of their makers and owners. Much of what we know about prehistoric peoples and non-literate cultures, for example, is necessarily derived from the close study of the technical and artistic qualities of the artefacts they produced and left behind. The same is true for works created in historic and contemporary times, as these nonverbal forms of communication nevertheless speak volumes about their creators and consumers. They, too, are reflections of ideas and aspirations and emotions, all made manifest through the manipulation of materials.

For millennia, craft apprentices were instructed by their masters in the 'art and mystery' of a specific skill, which principally meant that they were to be taught the techniques, generally carefully guarded, necessary to work the materials of their given trade. A profound understanding of the properties of their chosen material—pigment, canvas, paper, fibre, glass, clay, silver, pewter, iron, wood, leather, or anything else—was fundamental to the practice of their craft. This attitude survived through to the Arts and Crafts Movement at the turn of the 20th century, when it was still believed that materials and techniques were inextricably interlinked. As one British author put it in the early 20th century, 'The one guiding principle of all true craftsmanship is this: the forms used in design should express naturally and simply the properties of the particular material employed'.[2] Today, many artists consciously create works that stand in opposition to the traditional qualities of a given material. The contemporary American artist Hank Murta Adams, for example, consciously rejects the traditional, seductively beautiful qualities of glass to create his monumental, yet ghostly and haunting, massive heads. Yet even in such a case, the artist can only achieve his goals through an appreciation of the capabilities of his or her chosen material.

The need of artists to understand materials and their incessant drive to find new ways to manipulate them is not just a matter of interest to the art historian, however. These needs have been central to the development of what we call civilization. The great MIT metallurgist, Cyril Stanley Smith, observed, 'Historians of science … commonly overlook the fact that thoughtful intimate awareness of the properties of matter first occurred in the minds of people seeking effects to be used decoratively'.[3] The desire for new forms of art, in Smith's view, has driven advances in endless facets of technological and scientific life: 'Neither art nor history can be understood without paying attention to the role of technology; and technology cannot be understood without history and art'.[4] Works of art exist in three dimensions, consisting of one or more materials and created using one or more techniques. An understanding of these manifold materials and diverse techniques, while essential for those who create works of art, is no less central to the concerns of art historians, curators, archaeologists, conservators, collectors, dealers and others, such as the growing number of students of material life. This book is aimed at providing an introduction, to varying degrees of depth—often quite considerable depth—to the enormous range of materials and methods used to create works of art from ancient times to the 21st century and, in many cases, to the various techniques used to examine and conserve them by conservators and others. While many books are devoted to a single material or a single craft, few—if any—offer the comprehensive treatment offered here.

It is thus our hope that this book will be of use to everyone interested in understanding works of art, especially those who wish to comprehend them as more than studies in iconography or part of a biography. As the art historian Henri Focillon noted, 'the observation of technical phenomena not only guarantees a certain controllable objectivity [to the studies of an historian] but affords an entrance into the very heart of the problem, *by presenting it to us in the same terms and from the same point of view as it is presented to the artist*'.[5] The study of 'technical phenomena' is also a central plank in the platform of connoisseurship—of separating the old from the new, the original from the reproduction, the restored from the pristine—as well as in determining the traditional subjective aesthetic-value gradations of 'good, better, and best'.

It should be noted immediately that, in this book, the modern, artificial distinction between the so-called fine arts and the so-called crafts is not recognized. In this attitude we follow the lead of the German medieval

monk, possibly Roger of Helmarshausen, who, writing in the 12th century under the pen name Theophilus, compiled one of the first, if not the very first, practical manuals on creating works of art. Theophilus devoted chapters to painting, glasswork, and metalwork—the principal ecclesiastical arts of his time—and many of his detailed instructions, although spiced with occasional bits of medieval folklore, remain valuable today.[6] This Grove Encyclopedia, while including painting and sculpture in depth, also includes lengthy discussions of silversmithing and other metalwork, ceramic production, glassmaking, textile creation, woodworking and many other topics pertaining to three-dimensional objects ranging from a humble earthenware pot to the most magnificent cathedral or skyscraper.

The articles included here have been drawn from *The Dictionary of Art* (1996, ed. Jane Turner) as well as from its successor, Grove Art Online. The lengthy versions prepared originally for the published and online texts have been edited to retain their focus on materials and techniques, while eliminating completely, or in large part, sections on the history and usage. In condensing the entries, I have tended to retain detailed historical information regarding some of the lesser-known materials and techniques. In the case of better-known areas of art, which possess their own vast historical literature, my editing has been more aggressive. In nearly every case, the chronologically arranged bibliography appended to the entry has been updated with selected titles appearing in the last decade. Several articles were prepared especially for this volume to cover topics of emerging importance.

Even a work as large as this book, however, cannot be completely comprehensive. Moreover, no encyclopedia entry can fully describe the complex subjects included in this volume. Nearly any craftsmen will tell you that he or she learns something new about their craft on a regular basis. As the old aphorism goes, 'The life so short, the art so long to learn'. Thus the researcher should use this book primarily as an initial introduction to each of the topics covered. The field of conservation, in particular, is a fluid area in which new treatments and tools are being developed on a daily basis. The information on conservation presented within the various entries should be regarded as a basic starting point, and readers are advised to seek specialized information before embarking on any unusual conservation treatments.

In the final analysis, materials and techniques have been, and remain, inextricably intertwined in their ongoing use by artists to create a bewildering yet fascinating assortment of objects over time. It is our hope that this book will suggest the variety and versatility of artists' abilities to seize the opportunities provided by the raw stuff of the physical world, to take advantage of that 'interplay of atomic, molecular, and crystalline forces', in order to fashion the transcendent works of art that enrich and transform our lives.

GWRW
Portsmouth, New Hampshire
August 2008

[1] Cyril Stanley Smith: *A Search for Structure: Selected Essays on Science, Art, and History* (Cambridge and London, 1981), p. 327

[2] H. Wilson: *Silverwork and Jewellery: A Text-Book for Students and Workers in Metal* (1902, London, 2/1931), p. 29

[3] Smith: *A Search for Structure*, p. 327

[4] Smith: *A Search for Structure*, p. 331

[5] Henry Focillon: *The Life of Forms in Art*, trans. C. B. Hogan and G. Kubler (New York, 1948; *R* 1992), p. 103

[6] Theophilus: *De diversis artibus* (?1110–40); Eng. trans. by C. R. Dodwell as *The Diverse Arts* (London, 1961)

Acknowledgements

Several years ago, Christine Kuan, Senior Editor of Grove Art Online/Grove Dictionaries of Art at Oxford University Press, invited me to undertake this project. I am most grateful to Christine for her willingness to entrust me with this massive job, for her enthusiasm and guidance along the way, and for her patience as it moved to completion. I first came into contact with Christine through *The Grove Encyclopedia of Decorative Arts*, edited by Gordon Campbell. Professor Campbell's work on that two-volume publication was an inspiration, and I have tried to emulate his high standards here.

Many other talented people at Oxford University Press helped bring this project to completion, including Jane Woolley; Kei Chan; Sara Lieber; Stephen Wagley; Martin Coleman and the whole production team.

Christine assembled a talented team of consultants to assure the quality of this book. Clare Hills-Nova, History of Art Librarian, The Sackler Library, Oxford University, tirelessly compiled updated bibliographies for nearly every entry included here with lightning speed, demonstrating a command of the literature of art history that is awe-inspiring to an amateur bibliographer such as myself. Rebecca A. Rushfield, a consultant specializing in research, writing and editing in the field of art conservation, cheerfully coordinated the demanding job of selecting and obtaining images for a book that could be almost infinitely illustrated. Rebecca also read over the various conservation sections included in many entries and made numerous valuable suggestions for updating and improvements. The enormous manuscript was copy edited with incredible speed and tremendous capability by Gillian Northcott. Gillian also improved the final product through the judicious insertion and deletion of entries as the project neared its conclusion. Although many people contributed to this book, the efforts of Clare, Rebecca and Gillian were central to any success that we may have achieved. Although our contact was almost entirely through the ether of intercontinental e-mail, I am delighted to have made three new friends.

All of us who worked on this project are enormously indebted to the many scholars—listed individually at the end of this volume—whose articles for *The Grove Dictionary of Art* form the basis for this book. In nearly every case their work has been abridged, and occasionally reformulated, but the scholarship that they brought to their given subjects is truly impressive. Whatever value this book may have is due to their exemplary work. Jeffrey Martin, Research Fellow at the Hirshhorn Museum and Sculpture Garden of the Smithsonian Institution, contributed new entries under tight deadlines for several topics in new media and we are grateful to him for his assistance.

Many colleagues at the Museum of Fine Arts, Boston, were of assistance along the way, often without their knowing it. My colleagues in the Department of the Art of the Americas, including Elliot Bostwick Davis, Kelly H. L'Ecuyer, Julie Muñiz, Nonie Gadsden and Dennis Carr, were helpful in many ways. Erin Schleigh, Susan Ward, Heather Porter and many other members of the staff were also helpful. CAMEO (Conservation and Art Materials Encyclopedia Online), a searchable information centre developed by the MFA's conservators, available at www.mfa.org, was a very useful resource in editing this book. I am also grateful to the staff of the MFA library and the Portsmouth Athenaeum for their assistance. As this book was in progress, Ron and Anita Wornick of California provided me with an opportunity to prepare an essay on the diverse materials and innovative techniques used by the artists represented in their collection of 20th- and 21st-century craft, and that experience informed my work on this project.

In all my professional activities, I am indebted to Jonathan L. Fairbanks, the Katharine Lane Weems Curator Emeritus of American Decorative Arts and Sculpture at the Museum of Fine Arts, Boston. Jonathan, a talented painter himself, comes from a long line of distinguished artists. He is also a Fellow of the American Institute for Conservation, a rare distinction for a curator. In his teaching and writing, Jonathan always emphasizes the importance of understanding an artist's or craftsman's methods and materials in order to fully understand a given work of art, whether it be a painting, a sculpture, or an example of furniture, silver, glass, ceramic, or other decorative arts. As his student, and later his associate curator, I am fortunate to have had many opportunities to learn first-hand from Jonathan, through his lectures, demonstrations and wise counsel. I am hopeful that he will find this book a useful tool for current and future generations of students devoted to the study of works of art, a field of inquiry that he himself has done so much to enrich.

In all that I do, I am indebted to my wife, Barbara McLean Ward, for her encouragement, patience and support. In projects such as this, her sage (and frank) editorial advice and scholarly insights are always invaluable.

GWRW
Portsmouth, New Hampshire
August 2008

ix

Abbreviations

AD	Anno Domini	e.g.	*exempli gratia* (for example)	
Add.	Additional	Eng.	English	
AL	Alabama	esp.	especially	
a.m.	ante meridiem (before noon)	est.	established	
Aug	August	etc	*etcetera* (and so on)	
Austral.	Australian	exh.	exhibition	
AZ	Arizona	facs.	facsimile	
B	Bartsch (catalogue of Old Master prints)	Feb	February	
		ff	following pages	
b	born	fig; figs	figure(s) (illustration)	
BC	Before Christ	*fl*	*floruit* (he/she flourished)	
Berks	Berkshire	FL	Florida	
BP	Before Present	Flem.	Flemish	
Bros	Brothers	fol.; fols	folio(s)	
Bucks	Buckinghamshire	Fr.	French	
Burm.	Burmese	ft	foot, feet	
C	Celsius	g	gram(s)	
c.	*circa* (about)	Ger.	German	
CA	California	Glos	Gloucestershire	
Cambs	Cambridgeshire	Gr.	Greek	
cat.	catalogue	h.	height	
chap., chaps	chapter(s)	Herts	Hertfordshire	
Chin.	Chinese	IA	Iowa	
Cie	Compagnie (French)	i.e.	*id est* (that is)	
Co.	Company; County	IL	Illinois	
Cod.	Codex	illus.	illustrated, illustration	
Col.	Colonel	Inc.	Incorporated	
cont.	continued	incl.	including	
Corp.	Corporation	Indon.	Indonesian	
CT	Connecticut	intro.	introduced by, introduction	
d	died	It.	Italian	
DC	District of Columbia (USA)	Jan	January	
DE	Delaware	Jap.	Japanese	
Dec	December	jr	junior	
Dept	Department	KG	Knight of the Garter	
Derbys	Derbyshire	kg	kilogram	
destr.	destroyed	km	kilometre	
Devon	Devonshire	kN	kilonewton	
diam.	diameter	Kor.	Korean	
diss.	dissertation	KS	Kansas	
Dr	Doctor	KY	Kentucky	
Dut.	Dutch	£	libra, librae (pound, pounds sterling)	
E.	East			
ed, eds	editors(s), edited by	l.	length	
edn	edition	LA	Louisiana	

xi

Lancs	Lancashire		PVA	polyvinyl acetate
Lat.	Latin		PVC	polyvinyl chloride
lb	pound weight		R	reprint
Leics	Leicestershire		r	recto
Lincs	Lincolnshire		*reg*	*regit* (ruled)
Lt-Col.	Lieutenant-Colonel		repr.	reprinted
Ltd	Limited		rest.	restored
m	metre(s)		rev.	revised
MA	Massachusetts		Rev.	Reverend
MD	Maryland		RH	relative humidity
ME	Maine		RI	Rhode Island
mg	milligram(s)		S	San, Santa, Santo, Sant',
MI	Michigan			São (Saint)
Mid. Eng.	Middle English		S.	South
Misc.	Miscellaneous		Salop	Shropshire
mm	millimetre(s)		Sept	September
MN	Minnesota		SJ	Societas Jesu (Society of Jesus)
MO	Missouri		Skt	Sanskrit
MS., MSS	manuscript(s)		Sp.	Spanish
Mt	Mount		sq.	square
N.	North		SS	Saints
n	refractive index of		St	Saint, Sankt, Sint
	a medium		Staffs	Staffordshire
NC	North Carolina		Ste	Sainte
ND	North Dakota		suppl.	supplement(s), supplementary
n.d.	no date		TN	Tennessee
NH	New Hampshire		trans.	translation
NJ	New Jersey		TV	television
NM	New Mexico		TX	Texas
nm	nanometre (10^9 metre)		UK	United Kingdom of Great
Northants	Northamptonshire			Britain and Northern Ireland
no, nos	number(s)		UNESCO	United Nations Educational,
Notts	Nottinghamshire			Scientific and Cultural
Nov	November			Organization
n.p.	no place (of publication)		unpubd	unpublished
nr	near		US	United States
n.s.	new series		USA	United States of America
NT	National Trust		USSR	Union of Soviet Socialist
NY	New York			Republics
Oct	October		*v*	verso
OH	Ohio		VA	Virginia
Ont.	Ontario		V&A	Victoria and Albert Museum
OR	Oregon		vol, vols	volume(s)
p., pp.	page(s)		VT	Vermont
PA	Pennsylvania		W.	West
Pers.	Persian		WA	Washington
PhD	Doctor of Philosophy		Warwicks	Warwickshire
pl.	plate, plural		WI	Wisconsin
pls	plates		Wilts	Wiltshire
p.m.	post meridiem (after noon)		Worcs	Worcestershire
pubd	published		Yorks	Yorkshire
pubn	publication			

A Note on the Use of the Encyclopedia

Abbreviations used in this encyclopedia are listed on pp. xi.

Alphabetization of headings, which are distinguished in bold typeface, vis letter by letter up to the first comma (ignoring spaces, hyphens, accents and any parenthesized or bracketed matter); the same principal applies thereafter.

Authors of every article are included in the Contributors list on pp. 787.

Bibliographies are arranged chronologically (within section, where divided) by order of year first publication and, within years, alphabetically by authors' names.

Cross-references are distinguished by the use of small capital letters, with a large capital to indicate the initial letter of the entry to which the reader is directed; for example: 'Metalcut was superseded by RELIEF ETCHING…' means that the entry is alphabetized under 'E'.

Illustration Acknowledgements

We are grateful to all those who granted permission to reproduce copyright illustrative material and to those contributors who supplied photographs or helped us to obtain them. All copyright information can be found in the credit line contained in the caption accompanying each image. Where illustrations have been taken from books, publication details are also provided in the captions. Every effort has been made to contact copyright holders and to credit them appropriately; we apologize to anyone who may have been omitted from the acknowledgements or cited incorrectly. Any error brought to our attention will be corrected in subsequent editions. Line drawings have been obtained and/or modified from *The Dictionary of Art* (1996) © Oxford University Press.

The Grove Encyclopedia of
Materials and Techniques in Art

A

Acrylic painting. Although 'acrylic' has become a generic term for any synthetic paint medium, acrylics are a specific type of manmade polymer that has become standard in the commercial paint industry as well as widely used by artists from the mid-20th century; most synthetic paint media in contemporary artistic use are based on acrylic emulsions. Acrylics are thermoplastic, have great optical clarity and excellent light stability, good adhesion and elasticity and resist ultraviolet and chemical degradation. Their unique surface properties, transparency and brilliance of colour, together with the possibilities they offer for indeterminacy, immediacy, randomness and the ability to rework immediately and to achieve extremely thin or thick surfaces, are qualities that have been exploited fully by such painting movements as Abstract Expressionism in the 1950s, and, subsequently, colour field painting, hard-edge painting and Pop art.

See also PAINT, §§I and II; POLYMER COLOUR; and PLASTIC, §2(ii).

1. HISTORY AND USES. Acrylics were first prepared in 1880 as acrylate by Otto Rohm (1876–1939). He patented it in 1915, and its suggested use was as a substitute for drying oils in industrial paints and lacquers. Polymethyl methacrylate, a rigid form of acrylic, was first marketed in Germany in 1927, but large-scale production of it in the form of Plexiglass (Perspex) began in 1936 in the USA, where acryloid—an acrylic resin surface coating—was first marketed in 1931. Thus the early development of acrylics was for industrial purposes. In the 1920s, however, the Mexican muralists experimented with synthetic media developed for industrial use, including pyroxylin (nitrocellulose) automobile lacquers and ethyl silicate (an organic/silicon compound) when looking for a durable material for outdoor use (*see* WALL PAINTING, §I, 4(iv)). In 1936 David Alfaro Siqueiros (1896–1975) held an experimental workshop in New York City, where artists, among them Jackson Pollock (1912–56), experimented with the latest synthetics and paints, trying new methods of application such as spray-guns. Subsequently Siqueiros used pyroxylin for *Echo of a Scream* (1937; New York, Museum of Modern Art) and for *Portrait of the Bourgeoisie* (1939) in the stairwell of the Electricians' Union Building in Mexico City; and from the late 1940s Jackson Pollock

used a pyroxylin lacquer tradenamed Duco in many of his works (e.g. *Number 2, 1949*; Utica, NY, Munson–Williams–Proctor Institute). The disadvantage of Duco and lacquer-based paints, however, is their toxic solvent base which may be damaging to the artist's health.

The alkyd resins (a type of polyester) were discovered in 1902 and marketed as Glyptal from 1926. Many Works Progress Administration (WPA) artists experimented with alkyd-based paints in the 1930s. (In the late 20th century they have been used to manufacture artists' paints that have faster drying properties and a higher gloss than oil paints; *see* PAINT, §I). In 1946 Bocour Artists Colours Inc. first marketed Magna, an oil-like painting medium comprising acrylic resin (n-butyl methacrylate) dissolved in an organic solvent, which could be thinned with turpentine or mineral spirits and combined with oil paints. Magna colours were used in the 1950s by Morris Louis (1912–62), Helen Frankenthaler (*b* 1928) and later by Roy Lichtenstein (1923–97) (e.g. *Whaam!*, 1963; London, Tate). They were also used extensively by Mark Rothko (1903–70), who employed them to originate a form of colour field painting that strongly resembled the effect of watercolour stain.

After World War II the vinyl polymers—polyvinyl acetate (PVA) and polyvinyl chloride (PVC)—superseded the alkyd-based paints in industrial use but were never widely used by artists. Acrylics and vinyls were developed simultaneously, but the former superseded the latter because of their extensive handling and colour properties. There was a major breakthrough in the 1950s with the introduction of aqueous emulsion acrylics or latex paints. In 1953 Rohm and Haas Co. introduced Rhoplex, the first acrylic emulsion specially designed for paint. Rhoplex resists ageing, is exceptionally fast drying and has good adhesion and intermixing properties, including a tolerance for a wide variety of pigments; it is also alkaline, non-yellowing and resistant to ultraviolet and most mild acids. It has become the base for all contemporary artists' acrylic emulsions and was instrumental in the development of hard-edge painting, colour field painting and stain painting. Notable exponents of acrylic painting in the USA include Helen Frankenthaler (e.g. *Cape (Provincetown), 1964*; Melbourne, National Gallery of Victoria), Kenneth Noland (*b* 1924) (e.g. *Trans West*, 1965; Amsterdam,

Stedelijk Museum), Morris Louis, Sam Francis (1923–94), Jules Olitski (1922–2007), who used a spray-gun to create subtle variations of colour, and Larry Poons (*b* 1937), who at first used acrylics to produce dot Op art paintings and later poured layers of acrylic into one another to create a heavy, craggy surface.

Acrylic painting was an integral part of Pop art, where its adhesive qualities and brilliant colour were exploited in such collage paintings as *Got a Girl* (1960–61; Manchester, University of Manchester, Whitworth Art Gallery) by Peter Blake (*b* 1932). By the mid-1970s there had been a thorough investigation of acrylic painting media, in particular thickeners, gels, dispersants (to ensure uniform pigment dispersion), wetting agents and preservatives to prevent bacterial contamination through water or other additives (see Painting medium). Acrylic paint could be used in a wider variety of techniques than oil paint and with much more primitive tools, for example brooms and razors, as it tends to retain the integrity of the colour with manipulation. Such techniques as pouring, splashing, blowing and adding other materials to the paint made the entire painting process more fluid and accelerated painterly experimentation from the mid-1970s. In the late 1970s and early 1980s fluorescent colours (Day-glo paints) became popular but proved ephemeral as the dyes fade in a few years. They were used by Frank Stella (*b* 1936) in such paintings as *Darajerd III* (1967; Washington, DC, Hirshhorn Museum and Sculpture Gallery). More recently, painters such as Paula Rego (*b* 1935) have abandoned oil in favour of acrylic, partly because of its quick drying properties but also because of an aversion to the smell of turpentine.

2. Properties. The properties of acrylic paints include durability, good flexibility and brushing properties, and a range of transparent to opaque covering qualities. The advantages include ease of use, quick drying time, easy mixture with other media and with elements to create body and texture (e.g. sand, plaster, twigs, diatomaceous earth, glitter, modelling paste and spackling paste). Their good adhesive qualities allow the medium to be used as a glue in collage and permit much more flexibility than the brittle surface of an oil painting. They can be thinned with water or with an acrylic base painting medium such as gloss, matt, or gel, without becoming granulated. In hard-edge, colour field and stain painting, acrylic paint (unlike oil paint) produces no halo and is therefore ideal for the fresh watercolour effect and matt surface of these styles. Alternatively, acrylic may be thickened with additives to make a 'stiffer' paint that can be used to imitate oil techniques. Other advantages include easy cleaning (soap and water as opposed to thinner and soap and water with oils) and the absence of hazardous (or simply unpleasant) fumes. Large amounts of acrylic mixed colour may be combined with water, or medium or texture, and stored in a tightly closed container for long periods of time for later use.

Acrylics can be used with wax or oil crayons in a resist technique or mixed with chalk, which will partially resist and partially blend with the acrylic, causing unpredictable results, a combination used in situations where the artist wishes to work with little control of the medium for 'fresh' results. These methods are too new to permit proper assessment for longevity and colourfastness by conservators, however, and for conservation purposes the artist should employ only the family of acrylic paints and gels developed for artists' use; it is also helpful if all the materials used, along with brand names, are recorded on the reverse of the support. Although conservators discourage the use of oil over an acrylic underpainting as a more rapid way of building a painting, suggesting that mixtures of oils and acrylics are probably not permanent, many artists do use acrylic in combination with oils for underpainting (*see* Ground). Acrylic paint can be glazed over with oils, allowing the saturated acrylic colour to 'glow' through. This method has been employed by photorealist artists such as Richard Estes (*b* 1932) and Audrey Flack (*b* 1931). As acrylic paint is easily soluble in relatively weak solvents, acrylic paintings should not be varnished with a traditional varnish; even 'Soluvar' varnish, formulated specifically to address this problem, is not safe in all cases. Acrylic is useful in multimedia art objects such as painted sculpture, ceramics or wood because, if a medium other than water is used, acrylic paint does not sink into the material or damage it as oil would.

Acrylics can be used with multiple supports of varying texture as they are not abrasive or deleterious to either raw canvas or paper. Rigid supports, such as Masonite, can be used and are preferable for thickly applied paint or a heavily laden mixed-media work. The high flexibility of acrylics makes them particularly suitable for use on fabrics, as the fabric can be stretched and pulled without cracking the paint; it also enables their use with heavy texturizing elements and allows scraping, scratching and modelling into the surface.

H. T. Neher: 'Acrylic Resins', *Industrial and Engineering Chemistry*, xxviii (1936), pp. 267–71

'Methacrylate Resins', *Industrial and Engineering Chemistry*, xxviii (1936), pp. 1160–63

R. L. Wakeman: *The Chemistry of Commercial Plastics* (New York, 1947)

G. Allyn: *Basic Concepts of Acrylic Resin Emulsion Technology* (Philadelphia, 1956)

A. Duca: *Polymer Tempera Handbook* (Somerville, MA, 1956)

J. Gutierrez: *From Fresco to Plastics, New Materials for Easel and Mural Painting* (Ottawa, 1956)

B. Chaet: *Artists at Work* (New York, 1960)

A. M. Reed: *The Mexican Muralists* (New York, 1960) *Amer. Artist* (1962–77) [technical page]

J. Charlot: *The Mexican Mural Renaissance, 1920–25* (New Haven, 1963)

L. N. Jensen: *Synthetic Painting Media* (Englewood Cliffs, NJ, 1964)

C. R. Martens: *Emulsions and Water-soluble Paints and Coatings* (New York, 1964)

J. Gutierrez and N. Roukes: *Painting with Acrylics* (New York, 1965)

R. O. Woody: Painting with Synthetic Media (1965)

J. A. Brydson: *Plastics Materials* (London and New Jersey, 1966/*R* London, 1975)

R. J. Gettens and 4. 5. Stout: *Painting Materials* (Dover, 1966)

A. Rodriguez: *A History of Mexican Mural Painting* (London, 1969)

R. Mayer: *The Artists' Handbook* (New York, 1970, rev. 5/1991)

R. O. Woody: *Polymer Painting* (New York, *c.* 1970)

R. Kay: *The Painter's Guide to Studio Methods and Materials* (New York, 1972)

C. R. Martens: *Technology of Paints, Varnishes and Lacquers* (New York, 1974)

B. Chaet: *An Artist's Notebook: Materials and Techniques* (London and New Jersey, 1979)

R. Mayer: 'The Alkyd Generation', *American Artist* (1979)

E.-G. Güse and others, eds: *Pierre Alechinsky: Zwischen den Zeilen* (Gerd Hatje, 1993)

J. Harten: *Siqueiros, Pollock: Pollock, Siqueiros* (Düsseldorf, 1995)

Scottish Society for Conservation and Restoration, 2nd Conference: Resins Ancient and Modern: Edinburgh, 1995

P. Ball: *Made to Measure:New Materials for the 21st Century* (Princeton, 1997)

D. Rochfort: *Mexican Muralists: Orozco, Rivera, Siqueiros* (San Francisco, 1998)

K. Varnedoe: *Jackson Pollock* (New York, 1998)

P. Karmel: *Jackson Pollock: Interviews, Articles, and Reviews* (New York, 1999)

J. Crook and T. Learner: *The Impact of Modern Paints* (New York, 2000)

M. Wagner: *Das Material der Kunst: Eine andere Geschichte der Moderne* (Munich, 2001)

T. Hoppe: *Acrylmalerei: Die künstlerischen Techniken* (Leipzig, 2/2002)

T. van Oosten, Y. Shashoua and F. Waentig, eds: *Plastics in Art: History, Technology, Preservation* (Munich, 2002)

M. Wagner, D. Rübel and S. Hackenschmidt, eds: *Lexikon des künstlerischen Materials: Werkstoffe der modernen Kunst von Abfall bis Zinn* (Munich, 2002)

T. J. S. Learner: *Analysis of Modern Paintings* (Los Angeles, 2005)

R. Tauchid: *The New Acrylics: Complete Guide to the New Generation of Acrylic Paints* (New York, 2005)

A. Fuga: *Artists' Techniques and Materials* (Los Angeles, 2006)

Adhesives. Substances used to bond two surfaces. The surfaces may consist of the same material, as when mending a broken object, or of different materials, for example a collage. When applied to pigments the adhesive is called a Fixative, when applied to a crumbling solid a Consolidant.

1. Types. 2. Uses

1. Types. The earliest adhesives used in the making of works of art and decorative objects were such natural products as proteins, resins, juices of plants, waxes and fats. In the 20th century the development of synthetic polymer adhesives has made it possible to join any two materials.

(i) Natural.

(a) Animal-derived adhesives. 'Glue' is a general term for adhesives based on gelatin, that is degraded collagen (the major connective protein in animals). Skin and bone waste products are the most generally used source of collagen but yield contaminated products, for example glue made from tannery waste is likely to contain both metal and organic tanning agents and be of low quality. Purer forms of collagen provide better products, for example the swim-bladders of fish, especially sturgeon, yield isinglass, while parchment yields parchment glue. The glue is made by slow cooking of the source-material in water, then clarifying the resulting solution and concentrating or drying the gelatin. Mammal-derived glues are soluble only in hot water, while fish glues dissolve to form liquids at room temperature. Skin glues tend to be stronger than other types. Terms such as 'rabbit-skin glue' (Europe) and 'deer-skin glue' (Japan) do not now define the source-material but indicate the grade. Casein, a protein obtained from milk, can be converted to very strong adhesive by mixing with lime (calcium hydroxide) suspension; the calcium cross-links the protein to form a strong, water-resistant film. Albumin, a protein derived from egg white or blood, has been used in the same way as casein or by hot pressing to denature and cross-link the molecules while drying the adhesive to a film. All proteins are susceptible to bacterial attack in damp conditions. Two other animal-derived adhesives are beeswax (see Wax) and shellac (*see* Resin, §1).

(b) Plant-derived adhesives. Starch pastes are some of the oldest adhesives. Starch occurs in roots or seeds as granules, which can be separated and purified by milling. Pastes can be made from the purified starch or the crude flour, which contain proteins and oils. The granules must be heated in water to break down their structure and dissolve the starch. Starch occurs in two main forms: branched amylopectin and straight-chained amylose. The amylopectin is soluble in cold water, but an amylose solution will gel or precipitate on standing. The composition and proportions of the two components in different starches determine the resultant working and adhesive properties of the paste. Starch is a polysaccharide and can be degraded to make semi-synthetic gums. In Mexico, after the Spanish conquest of 1519, Christian 'stalk' sculptures were constructed from plant stems, held together by the mucilage extracted from an orchid root (*Sobralia citrina*). The alginates obtained by heating seaweeds in water are a different class of polysaccharide. Polysaccharides are susceptible to fungal attack in damp conditions. Tree exudations, resins such as rosin, dammar and rubber, and Gum, such as gum arabic, are also used in adhesives.

(c) Mineral-derived adhesives. The major natural mineral adhesive is bitumen, a mixture of solid and semi-solid hydrocarbons derived from crude oil; it is soluble in solvents but was mostly applied molten.

Hydrocarbon waxes purified from bitumen can be classified as micro-crystalline (branched molecules) and paraffin (straight chain molecules) waxes (*see* PIGMENT, §IV, 2).

(ii) Synthetic.

(a) Solvents. Materials that dissolve in organic solvents can be stuck by applying the appropriate SOLVENT to the surfaces to be joined. The material will then swell or even dissolve, and when the surfaces are pressed together the molecules of one surface will merge with those of the other, leaving a strong bond once the solvent has evaporated. The strength of the bond depends primarily on the polarity of the materials: if the materials are of identical polarity the surfaces will merge completely and it is hardly appropriate to speak of a glued joint. If, however, different materials are joined, polarity and solubility will have a crucial influence on the final result—for example, in the bonding of polymethyl methacrylate (Perspex) with toluene.

(b) Polymer solutions. The most frequently used adhesives are made by dissolving polymers in a highly volatile solvent. In this way the polymer can be applied as a liquid film. The solvent evaporates, leaving a polymer film that bonds the two surfaces. Because the evaporation is accompanied by a reduction of volume, air bubbles may appear between the adhesive and the surface to which it is applied. This will weaken the adhesion. The bonding is chiefly brought about by electrostatic attractions and by the mechanical adhesion of the glue to the irregularities of the surface. In order to get the highest possible concentration of solid material, low-molecular polymers are used. In many cases the temperature at which these polymers will turn into glass lies below room temperature, which may cause problems with cohesion. Typical adhesives of this kind are contact adhesives such as polyvinyl acetate (PVA), nitrocellulose and chloroprene.

(c) Dispersants. A high-molecular substance (i.e. one with a high relative molecular mass) can be combined with a larger volume of solid material and given lower viscosity by using dispersants. This means that the monomer is dispersed in a non-solvent. After polymerization the viscosity of the mixture is determined primarily by the size of the polymers and no longer by their molecular volume. Water is invariably the vehicle used for these glues so that the adhesion is mostly of a mechanical nature. Nevertheless they contain another 40% to 50% water, which has to evaporate after the surfaces have been pressed together. This means that they are suitable only for joining porous materials. Typical adhesives of this kind include white-wood glues and acrylate dispersants.

(d) Heat sealing. Thermoplastics can sometimes be used as adhesives without the need for a solvent.

The solid polymer is applied between two surfaces and then heated to above its melting point. When liquid, the polymer flows into the irregularities of the surfaces to be joined and holds these together mechanically once it has solidified again. Because melted polymers have a high viscosity and surface tension it may be difficult to achieve good adhesion. This can be remedied by using a mixture of high-molecular and low-molecular polymers: when heated the low-molecular polymer will melt and the high-molecular polymer will then dissolve in it. After solidification the low-molecular polymer secures adhesion and the high-molecular polymer cohesion. A typical example of this type of adhesive is polyvinyl acetate (PVA).

(e) Reactive adhesives. Liquid substances consisting of monomers and pre-polymerized monomers can be polymerized into thermosetting or thermoplastic polymers after they have been applied between two surfaces. Because this involves no evaporation of solvents, and shrinkage tends to be limited with polymerization, good adhesion can be achieved. By adjusting the viscosity of the basic liquid it is possible to join smooth as well as rough surfaces. Typical adhesives are epoxy resins and polyesters.

See also PLASTIC, §I, and RESIN, §2.

2. USES.

(i) Natural adhesives. All the water-soluble adhesives (glue, albumin, starch and alginates) have been used more or less interchangeably in lightweight, non-critical applications. Glue is an excellent adhesive for wood, and its use in furniture production has been documented from the earliest records over 3000 years ago (*see* WOOD, §III, and MARQUETRY, §1). The solution is applied hot to warmed surfaces and the parts are closed quickly. A join that can be handled forms rapidly by the cooling and jelling of the glue, which dries to create a joint frequently stronger than the wood itself, although over time, and particularly in damp conditions, the join deteriorates. This defect ensures that gluing wood is reversible and that the process has as a result been retained as the major technique in conservation of both structural and decorative repairs. Glue is the binding agent in GESSO, a coating used as a ground for painting and gilding since antiquity. Glue has long been used for sizing fibres for textiles and paper (*see* SIZE). The drying of glue from a jelly causes considerable shrinkage, and glass can be decorated by glue etching in which the surface is pulled off in the required design and texture by the shrinking film (*see* GLASS, §III). Glue is widely used as a paper adhesive, for instance in COLLAGE, paper tapes and cardboard. Shrinkage damages objects by detaching surfaces or disturbing shapes, and the gradual delamination of ageing ephemeral paper objects is a considerable problem (*see* PAPER, §VI). Both parchment glue and egg white have been used traditionally as the adhesive for gold leaf (*see* GILDING, §I, 1(i)).

Casein adhesives have similarly been used for millennia, primarily for wood where some water resistance was required. Until the late 20th century much plywood was constructed using casein. Beeswax was used as a medium in encaustic painting (*see* ENCAUSTIC PAINTING, §1), and shellac is widely used as a heat-set adhesive for photographs but may prove impossible to detach. Starch pastes are the traditional adhesives for paper and generally facilitate conservation (*see* PAPER, §VI). Resin and bitumen have been used since antiquity as adhesives and waterproofing agents for masonry constructions. Genesis (11:3) states that bitumen was employed as a mortar and adhesive in the construction of the Tower of Babel. Molten sulphur, which sets to a rigid solid, holds interlocking parts together, in a similar fashion to the use of molten lead for securing iron clamps in stonework, and has been used both for constructing and repairing ceramics. The technique was used as porcelain increasingly became more sculptural; such as the Sèvres centrepiece presented to the Duke of Wellington.

(ii) Synthetic adhesives. With the development of synthetic adhesives it is now possible to join any two materials. Two major factors are the choice of the right type of glue—one that is adapted to the chemical composition of the materials to be joined—and the preparatory treatment of the surfaces. The actual adhesion of the glue and the surface to be bonded takes place at a molecular level, and every alteration in the surface condition, no matter how small, has an influence on the final result. Metal surfaces, for example, may be covered with a thin layer of grease or rust, or with inhibitors, used to prevent corrosion during storage, which change the surface structure. Plastic surfaces may be contaminated with the remains of stripping agents or by the diffusion of softeners. Any surface to be bonded should therefore be degreased with a suitable solvent. In order to improve the mechanical aspects of the adhesion the surface may be roughened with sandpaper or a sandblaster, by etching with acids or alkalis, or by means of a bombardment of ions or electric discharge. Immediately after the preparatory treatment the surfaces must be covered with a film of glue to avoid new corrosion or the deposition of contaminants.

The physical characteristics of commercial glues can be adapted to specific needs, bearing in mind the following basic principles. In order to avoid the evaporation of solvents and to slow down chemical reactions, adhesives are best stored at a low temperature. Before use, however, they must be brought up to room temperature in their sealed container, as opening the container at a low temperature causes condensation of water on the adhesive. The viscosity of adhesives dissolved in organic solvents can be reduced by adding quick solvents. Slow-evaporating solvents will sometimes improve the penetration and can increase the flexibility of the glued joint for a long time. In the case of soluble adhesives both surfaces are covered with a thin film of glue. Before

pressing the surfaces together time should be allowed for most of the solvent to evaporate, thus achieving almost instant bonding. The optimal adhesive power, however, will not occur until after several hours or days, depending on the nature of the solvents and the porosity of the materials joined. The viscosity of dispersants can be either increased or reduced. It is increased by adding small quantities of water-soluble polymers (carboxymethyl cellulose, polyvinyl alcohol) of an aromatic hydrocarbon (toluene, xylene) or of an acrylic acid dispersant. To improve the moistness of the surfaces to be joined, small quantities of tensioactive substances may be added. These are also necessary when fillers (sawdust, stone dust, pigments) are added to dispersants in order to fill bigger gaps or to colour the glued joint. Dispersants contain a high proportion of water, which makes them suitable only for joining porous materials.

A slightly raised temperature can help to accelerate the evaporation of water or solvents. When using reactive adhesives (epoxys, polyesters) it is important to measure the various components carefully before mixing them. In the case of polyesters an increased quantity of initiator will influence the setting time. With epoxy resins, however, the setting time is influenced not by the mixture but by the chemical composition of the hardener. Because of the reaction mechanism, an incorrect mixture will in this case invariably result in weaker adhesion. The adhesive powers of reactive glues can be strongly increased by using linking agents. These are products that combine various reactive groups in one molecule (vinyl and epoxy materials). One of the reactive groups will react chemically with the surface to be bonded while the other will react with the adhesive. Pressure-sensitive adhesives are used to join close-fitting surfaces quite rapidly. The glue consists of a highly reactive monomer (cyanoacrylate), which is stabilized with an acid. When the adhesive is spread out over a large surface the acid is neutralized and the glue polymerizes instantly. Because the inhibitor is destroyed at the contact surface only, and because the monomer is highly liquid, these adhesives are suitable only for joining tightly fitting, non-porous materials.

(iii) Conservation. In conservation it is never the intention to bring about an adhesion that is stronger than the original materials; thus when a glued joint is exposed to pressure or stretched or bent, the bond must break first to avoid damage to the original. Another fundamental rule is the principle of reversibility; when choosing an adhesive it is again necessary to be able to break the seal without damaging the original. This may cause problems, especially when liquid glue flows into porous surfaces. The choice of adhesive for a specific conservation task depends primarily on the object to be treated. Further information on the use of adhesives in the conservation of a specific material will be found in the relevant section of that article.

A. Lucas and J. R. Harris: *Ancient Egyptian Materials and Industries* (London, 1962)

H. Lee and K. Neville: *Epoxy Resins* (London, 1967)

J. T. Martin: *Adhesion and Adhesives* (Amsterdam, 1967)

B. Parkyn, F. Lamb and B. V. Clifton: *Polyesters* (New York, 1967)

C. V. Cagle: *Adhesive Bonding: Techniques and Application* (New York, 1968)

Hoechst, ed.: *Manuel sur la Mowilith* (Frankfurt, 1970)

J. Shields: *Adhesives Handbook* (London, 1970)

J. F. Kohlwey: *Kunststoffen* [Artificial materials] (Amsterdam, 1971)

W. J. Roff and J. R. Scott: *Fibres, Film, Plastics and Rubbers* (London, 1971)

E. De Witte and M. Goessens-Landries: 'The Use of Synthetic Resins in Conservation: An Annotated Bibliography, 1932–1974', *Art and Archeology Technical Abstracts*, xiii/2 (1976), suppl., pp. 279–354

N. S. Brommelle and G. Thomson: *Science and Technology in the Service of Conservation* (London, 1982)

Science for Conservators Book 3: Adhesives and Coatings, Crafts Council Conservation Science Teaching Series, ed. H. Wilks (London, 1983)

Adhesives and Consolidants, Paris Congress 1984, Reprints, International Institute for Conservation of Historical and Artistic Works [IIC]

P. Mora, L. Mora and P. Philippot: *Conservation of Wall Paintings* (London, 1984)

L. Masschelein-Kleiner: *Ancient Binding Media, Varnishes and Adhesives*, International Centre for the Study of the Preservation and Restoration of Cultural Property, Rome (ICCROM), Technical Notes Series (Rome, 1985, 2/1995)

R. J. Koestler: *Assessment of the Susceptibility to Biodeterioration of Selected Polymers and Resins* (Los Angeles, 1988)

Preprints of the Scottish Society for Conservation and Restoration: Modern Organic Materials: Edinburgh, 1988

C. V. Horie: *Materials for Conservation: Organic Consolidants, Adhesives and Coatings* (London, 1990, Boston, 2/1992)

C. Selwitz: *Epoxy Resins in Stone Conservation* (Los Angeles, 1992)

H. H. Ellis: 'The Shifting Function of Artists' Fixative', *Journal of the American Institute for Conservation*, xxxv/3 (Fall–Winter 1996), pp. 239–54

A. Harmssen, ed.: *Firnis: Material, Ästhetik, Geschichte* (Brunswick, 1999)

J. H. Townsend and others, eds: *Conservation Science 2002* (London, 2003)

A. Marrion, ed.: *The Chemistry and Physics of Coatings* (London, 2/2004)

T. Learner: *Analysis of Modern Paints* (Los Angeles, 2005)

C. McCabe: *Coatings on Photographs: Materials, Techniques, and Conservation* (Washington DC, 2005)

G. Wheeler: *Alkoxysilanes and the Consolidation of Stone* (Los Angeles, 2005)

Adobe. See BRICK, §I, 1(i).

Airbrush. Hand-held painting instrument, of about the same size as or slightly larger than a pen, that delivers paint in a controlled spray. It is connected to a supply of compressed air by a flexible hose and draws paint from an integral reservoir or attached cup. Depending on the sophistication of the model, the user may control the supply of air and paint and the spray pattern in varying degrees. Additional effects are achieved by a form of stencilling, using special masking film or other means of temporary protection of the artwork. An airbrush may be used with any paint if it is sufficiently thinned and contains pigment particles that are suitably fine. Dyes are also employed. Versions of several media exist that are specifically intended for airbrush application.

The first airbrush was patented in 1893 by Charles L. Burdick, an American living in Britain. It was manufactured by the Fountain Brush Co. and was called an 'aerograph'. Burdick eventually became friends with Dr Alan De Vilbiss, who *c.* 1890 had invented a system for applying medicines without using a swab; in 1931 the two men combined their inventions to create the airbrush as it is now known. Several designs have since developed, offering different technical features.

The airbrush is mainly a designers' and illustrators' tool, used to enhance photographic images by retouching and for realistic illustrations where photography would be unsuitable or impracticable. It has also been adopted for other purposes, for example for hand-painting textiles and for custom-car decoration. Typically, airbrush art features smooth, sharp images and exceptionally subtle gradations of tone and colour. It is therefore well-suited to Photorealism. The airbrush need not be used exclusively and may be employed just for particular effects. The illustrations of George Petty (1894–1975) and Alberto Vargas (or Varga; 1896–1982), both of whom worked in the USA in the 1930s and 1940s (on *Esquire* magazine), provide early examples of airbrush art.

T. J. Carroll: *A Manual of Airbrush Technique* (n.p., 1941)

J. Renau: *Tecnica aerografica: La brocha de aire* (Mexico, 1946)

J. R. Podracky: *Photographic Retouching and Air-brush Techniques* (Englewood Cliffs, 1980)

Airbrush Art in Japan, 4 vols (Tokyo, 1984)

P. Owen and J. Sutcliffe: *The Manual of Airbrushing* (London, 1986)

J. Stephenson: *Graphic Design, Materials and Equipment* (London, 1987), pp. 41–9

P. Bridgewater, B. Lewis and B. Breckon: *Design: Graphics, Illustration, Airbrushing* (Secaucus, 1988)

T. K. Karsai: *The Airbrush in Architectural Illustration* (New York, 1988)

P. Owen and J. Rollason: *The Complete Manual of Airbrushing* (New York, 1988)

Alabaster. Term used to describe two types of stone, one of gypsum and one of limestone. 'True' alabaster is hydrated calcium sulphate, a finely fibrous form of gypsum. It occurs as nodular masses with a felted, fibrous microstructure, variably intermixed with streaks of red or green clay. Deposits of economic size accumulate as precipitated salts in evaporating saline lakes in arid areas. The variety satin spar occurs in vein-like form with the fibres in regular parallel arrangement, giving the mass a silk-like lustre.

Alabaster is slightly soluble in water and therefore not suitable for outdoor works; it is very soft and readily cut and polished with the simplest tools. (see fig.). It provides an excellent surface for painting and gilding, without priming being necessary. Geologically ancient deposits provided material for sculptors, although gypsum continues to form in suitable environments in the Middle East, the USA and elsewhere. European sources exploited for decoration since the Middle Ages are present in England (S. Derbys and Staffs), France (Paris), Spain (e.g. nr Mérida) and Italy (nr Volterra and Castellina), while German deposits have given material since the 18th century. More recently alabaster from the USA and the former USSR has been used.

The second type is the stone that was referred to as alabaster by Theophrastus and Herodotus and that is now known as calcite alabaster, onyx-marble, Egyptian alabaster or Oriental alabaster (although alabaster is still used as a synonym in the eastern Mediterranean area). Onyx-marble is a stalagmitic limestone marked with patterns of swirling bands of cream and brown. It was an admired decorative stone in the Ancient Near East and the Mediterranean region (see colour pl. I, fig. 1). The early authors named stone types from their outward appearance, rather than their chemical or mineralogical composition, and 'alabaster' was used for stone of any composition that showed large-scale banding similar to that of the Egyptian alabaster or onyx-marble. During the Middle Ages in Western Europe, where useful deposits of stalagmitic limestone are rare, other material of similar appearance was named as, and used in place of, the rare stone, then available only as salvage from Roman ruins. At this time, English alabaster, a massive, fine-grained, translucent form of gypsum, became famous as a material for finely carved tomb figures and altar furnishings. Later mineralogists retained this use of the term, and it is in this sense that it is currently generally understood. In addition to its use as a sculptural medium, true alabaster is used crushed for mineral white or terra alba and as a filler in paint and paper. Plaster of Paris, Keene's cement and Parian cement are prepared from calcined gypsum (see STUCCO AND PLASTERWORK, §2).

R. Webster: *Gems: Their Sources, Descriptions and Identification*, 2 vols (London, 1962, rev. Oxford, 5/1994)

W. A. Deer, R. A. Howie and J. Zussman: *Non-silicates*, v of *The Rock-forming Minerals*, 5 vols (London, 1962–3, 2/1978)

R. Gnoli: *Marmora Romana* (Rome, 1971)

F. G. Dimes: 'Alabaster: Soft Option for Sculptors', *Stone Industries*, xiv/6 (July–Aug 1979), pp. 21–3

Alabaster row of ibexes, l. 200 mm, Yemen, 4th–3rd century BC (Vienna, Kunsthistorisches Museum); photo credit: Erich Lessing/ Art Resource, NY

N. Jopek: *Studien zur deutschen Alabasterplastik des 15. Jahrhunderts* (Worms, 1988)

L. A. Diaz Rodriguez: 'El alabastro: Un enigmático mineral industrial ornamental: Criterios para su reconocimiento', *Boletin del Museo arqueológico nacional de Madrid*, ix.1–2 (1991), pp. 101–12

J. Blair, ed.: *English Medieval Industries: Craftsmen, Techniques, Products* (London, 1991)

C. García and others: *El retablo mayor de la Catedral de Huesca: Restauración 1996* (Saragossa, 1996)

M. Trusted: *Spanish Sculpture: Catalogue of the Post-medieval Spanish Sculpture in Wood, Terracotta, Alabaster, Marble, Stone, Lead and Jet in the Victoria and Albert Museum* (London, 1996)

C. Prigent: *Les sculptures anglaises d'albâtre: Musée national du Moyen Age* (Paris, 1998)

L. Flavigny and C. Jablonski-Chaveau: *D'Angleterre en Normandie: Sculptures d'albâtre du Moyen Age* (Rouen, 1998)

J. Quaegebeur: *La naine et le bouquetin, ou, L'énigme de la barque en albâtre de Toutankhmamon* (Louvain, 1999)

F. Cheetham: *Alabaster Images of Medieval England* (Woodbridge, 2003)

Aluminium. Silvery white metal. The third most abundant element in the earth's crust (after oxygen and silicon), aluminium is found only in the form of its compounds, such as alumina or aluminium oxide. Its name is derived from *alumen*, the Latin name for alum, and in the 18th century the French word *alumine* was proposed for the oxide of the metal, then undiscovered. The name aluminium was adopted in the early 19th century and is used world-wide except in the USA, where the spelling is aluminum, and in Italy where *alluminio* is used. Following the discovery of processes for separating the metal from the oxide, at first experimentally in 1825, then commercially in 1854 and industrially in 1886–8, aluminium rapidly came to be valued as an adaptable material with both functional and decorative properties. Thus in addition to being used in engineering, transport, industrial design and household products, it was also widely adopted in architecture, sculpture and the decorative arts.

1. Properties. 2. History and uses

1. PROPERTIES. Aluminium is produced by smelting after the extraction of alumina from bauxite, a reddish-brown ore first mined in 1816 at Les Baux in France. The metal is ductile, non-magnetic and can be shaped by stamping, drawing, spinning, forging and extrusion, and it can be rolled into sheets and foil. It can be cast by all known foundry methods and joined by soldering, brazing, welding, adhesive bonding and by such mechanical methods as riveting and bolting. In the late 20th century a 'superplastic aluminium' was developed, which, when heated, acts like plastic and can be blown into a mould with compressed air to produce intricate shapes. The particular advantages of aluminium are its light weight, workability and versatility; its strength when alloyed with other metals; its heat reflectivity and electrical conductivity; and its resistance to corrosion. Aluminium can be mechanically buffed and textured, chemically cleaned, etched and brightened, with finishes ranging

from dull to mirror. The main method of finishing is anodizing, an electrolytic process by which the metal is coated with a hard, protective layer of oxide, enhancing its corrosion resistance. Colour can be introduced into this layer by means of dyes, producing a characteristic effect quite unlike paint or lacquer finishes. Typical colours of anodized aluminium include silver, gold, bronze, grey and dead black, which is highly resistant to fading. Other applied finishes include organic coatings, the most durable being porcelain enamel. In the early 1970s powder colour coatings were introduced and proved to be highly resistant to impact and corrosion. The attraction of aluminium as an alternative casting material lies in its natural silvery white colour (see fig.), which is one of the only finishes not obtainable through the patination of bronze.

See also METAL.

E. Dorre and others: *Alumina: Processing, Properties and Applications* (Berlin and New York, 1984)

F. King: *Aluminum and its Alloys* (Chichester, NY, 1987)

R. G. King: *Surface Treatment and Finishing of Aluminium* (Oxford, 1988)

C. J. Smithells: *Smithells Metals Reference Book* (Oxford and Boston, 7/1992)

R. E. Smallman and R. J. Bishop: *Metals and Materials: Science, Processes, Applications* (Oxford and Boston, 1995)

C. Kammer, ed.: *Fundamentals and Materials* (1999), i of *Aluminium Handbook* (Düsseldorf, 1999)

2. HISTORY AND USES.

(i) Architecture. From its first recorded architectural use (1884) as a cast pyramidal cap for the Washington Monument, aluminium was initially employed mainly for such utilitarian elements as doors, windows and roofing components, and for elements of constructional and mechanical systems that were often concealed. It also served as an economical substitute for other metals. The key to the history of its use in architecture lies in the development of the Modern Movement and its adoption of such technologies as industrial production, skeletal frame construction and the non-load-bearing curtain wall: aluminium is eminently suited to the mass-production of lightweight rigid composite panels incorporating insulation. Aluminium began to receive greater recognition

J. Peter, ed.: *Aluminum in Modern Architecture*, 2 vols (Louisville, KY, 1956)

J. Peter, ed.: *An International Review of Aluminum in Modern Architecture*, 2 vols (Louisville, KY, 1958–60)

C. Davies: *High Tech Architecture* (New York, 1988)

B. Bognar: *The New Japanese Architecture* (New York, 1990)

S. Werner, T. Schleper and M. Tauch: *Aluminium: Das Metall der Moderne: Gestalt, Gebrauch, Geschichte* (Cologne, 1991)

J. Lane: *Aluminium in Building* (Aldershot and Brookfield, 1992)

L.W. Zahner: *Architectural Metals: A Guide to Selection, Specification, and Performance* (New York, 1995)

J. Dwight: *Aluminium Design and Construction* (London and New York, 1999)

H. Wilquin: *Aluminium Architecture: Construction and Details* (Boston, 2001)

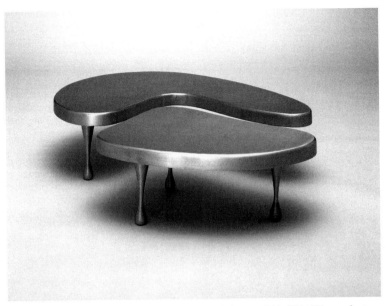

Cast aluminium *Nesting Coffee Table* by Frederick Kiesler, top 241×864×635 mm, bottom 241×559×413 mm, 1935–8 (New York, Museum of Modern Art, gift of Carlo M. Grossman and Josie G. Lindau in memory of their parents Isobel and Isidore Grossman (109.1996 a-b.)); photo © Museum of Modern Art/Licensed by SCALA/Art Resource, NY

(ii) Sculpture. The use of aluminium in sculpture has evolved in parallel with the availability of different forms of the material as dictated by the demands of industry, particularly the construction industry. As a result the immense variety of sheets, plates, tubes, rods, structural sections, extruded shapes and different alloys that developed for mundane purposes have all been used in some way to make sculpture. The first use of aluminium in sculpture was in the Shaftesbury Monument, a statue of *Eros* cast in 1892 and erected in Piccadilly Circus, London. As aluminium became more widely available in such forms as wire, rod and sheet, it became a part of the material vocabulary of the new sculpture developing in Russia at the beginning of the 20th century. Vladimir Tatlin (1885–1953), for example, used aluminium with iron and zinc in his seminal Constructivist piece, *Corner Relief* (1915; destr.). Artists working in constructed sculpture subsequently relied heavily on steel due to its ease of use, ready availability and comparative cheapness. Aluminium was more often used in its cast form wherever light weight was required, as in the large *Christ in Majesty* (1954) in Llandaff Cathedral by Jacob Epstein (1880–1959) and the wall sculpture (1962) for John Lewis, London by Barbara Hepworth (1903–75). The particular colour and nature of aluminium were emphasized in the *Head as a Still Life* (1942; estate of the artist) by David Smith (1906–65) and in *Towards a New Laocoon* (1963; London, British Council) by Eduardo Paolozzi (1924–2005), who was also the first artist to use paint on cast aluminium.

Aluminium was often used by the Minimalists in the late 1960s and early 1970s, as it was ideally suited to the manufactured perfection required by their large, simple forms. Donald Judd (1928–94) used the precision of flat sheet in *Untitled, Aluminium and Glass* (1965; London, Saatchi Collection) and Sol LeWitt (1928–2007) used it as a substrate for impeccable white stove enamel in *Serial Project 1 (A,B,C,D)* (1966; London, Saatchi Collection). Exploiting the strength and lightness of structural sections, Kenneth Snelson (*b* 1927) used anodized aluminium tubes for *Needle Tower* (1968; Washington, DC, Hirschhorn Museum and Sculpture Gallery and version in Otterlo, Rijksmuseum Kröller-Müller) and in England Nigel Hall (*b* 1943) used very thin, internally wired tubes for his delicate wall pieces. In the mid-1970s American artists produced kinetic sculptures using brightly polished aluminium in conjunction with neon tubes, glass, lasers, television screens and computers. Notable in this field were Takis (*b* 1925), Otto Piene (*b* 1928) and Julio Le Parc (*b* 1928). The first artists to explore the use of aluminium for its specific material qualities as finished surface rather than as a substrate for paintwork were Donald Judd (1928–94), Carl André (*b* 1935), who used 25 one-metre squares of bare aluminium plates for *Aluminium Square* (1968; New York, Museum of Modern Art), and Frank Stella (*b* 1936), whose aluminium honeycomb panel constructions were etched and inscribed, abraded and partially painted. In Japan in the 1970s Morio Shinoda (*b* 1931) perfected the treatment of unpainted aluminium in his exquisite machine-like constructions, notably *Tension and Compression* (1972; Humlebæk, Louisiana Museum of Modern Art).

The use of anodizing as a colouring method rather than just an added corrosion protection was first used as early as 1969 by Judd and was still being explored in the late 20th century by sculptors, notably Karl Schantz (*b* 1944) and Barbara Brown (*b* 1958). Unlike steel, aluminium became readily available in plate form of considerable thickness, enabling sculptors to carve directly into large blocks of the material using machine-shop techniques, as with *Relic* (1989; London, Eagle Star private collection) by Mark Firth (*b* 1952). Cast aluminium became popular once again in the 1980s and 1990s and was used for example by Jürgen Goertz (*b* 1939) in his surreal figurations and in a spectacular installation by Arnaldo Pomodoro (*b* 1926) at the 1988 Venice Biennale. Contemporary uses of aluminium in art were explored in 1989 in *Artluminium*, an international exhibition held in Montreal, Canada. It showed that whereas the metal had traditionally been considered by sculptors merely as an alternative to steel, to be employed where corrosion or weight was a factor, its own particular expressive characteristics were still being explored.

D. Davis: *Art and the Future* (London, 1973)

W. Rotzler: *Constructive Concepts* (Zurich, 1977)

P. Schjeldahl, ed.: *Art of our Time*, London, Saatchi Collection cat. (London, 1984)

K. W. Jensen, ed.: *Louisiana: The Collection*, Humlebæk, Louisiana Museum of Modern Art cat. (Copenhagen, 1986)

E. Lucie-Smith: *Sculpture since 1945* (London, 1987)

A. M. Hammacher: *Modern Sculpture: Tradition and Innovation* (New York, 1988)

M. G. Gervasoni, ed.: *43rd Venice Biennale* (exh. cat., Venice, 1988)

D. Wheeler: *Art since Mid Century* (New York, 1991)

(iii) Decorative arts. From the 1920s and 1930s aluminium was widely used for industrial design, household products and interior features, due to its lightness and durability. At the Bauhaus in the 1920s aluminium was used experimentally in fabrics, and Marianne Brandt (1893–1983) and others incorporated it into lighting fixtures. Aluminium staircase railings and light fixtures were used in the De La Warr Pavilion, Bexhill-on-Sea (1936), by Serge Chermayeff (1900–96) and Erich Mendelsohn (1887–1957). During this period it was particularly favoured by American designers, for example Donald Deskey (1894–1989) (e.g. furniture and lamps in the Radio City Music Hall, New York, 1932) and Russel Wright (1904–76). It was cast and wrought for ornamental gates, lift and radiator grilles and has been used for jewellery making. The stacking chair (1938) by Hans Coray (1906–91) was mass-produced for parks and gardens, the seat and back being formed of a single piece of aluminium. After World War II such designers as Ernest Race (1913–64) used aluminium for furniture, due to timber shortages. Eero Saarinen (1910–61) used aluminium as the base of his fibreglass tulip chair (1956–7) produced by Knoll. Aluminium has enjoyed a continuous and widespread popularity for the production of kitchen utensils, although it was slowly superseded in the late 20th century by stainless steel and plastics.

L. Aitchison: *A History of Metals* (London, 1960)

J. McAslan and T. McAslan: 'Restoring a Modernist Masterpiece' [the De La Warr Pavilion], *English Heritage Conservation Bulletin*, xxvii (Nov 1995), pp. 5–7

S. Nichols: *Aluminum by Design* (Pittsburgh, 2000)

P. Noever: *Donald Judd: Architecture* (Ostfildern-Ruit, 2003)

Amber. Fossilized, water-insoluble RESIN, 20–120 million years old, which exuded from giant coniferous trees and became buried below them.

1. MATERIAL AND SOURCES. Amber is amorphous, of resinous lustre and usually found in small pieces: irregular lumps, grains, drops and stalactites. It feels warm, is lightweight and porous and may fluoresce naturally under daylight, especially when freshly extracted. Inclusions of organic matter—insects, crustacea (some now extinct), flora, bark etc.—resulted from these being trapped in the liquid resin as it flowed downwards. When in contact with atmospheric air, its surface becomes oxidized and forms a crust. Transparent, opaque (due to an abundance of tiny bubbles) or osseous, it is commonly yellow to honey-coloured (see colour pl. I, fig. 2), but approximately 250 different colour varieties including white and black are known, the rarest being red, blue and green. On lengthy exposure to air, golden-yellow amber slowly darkens to red. Green amber is thought to have formed in marshy areas through inclusions of decaying organic material. When burnt or rubbed vigorously amber emits a resinous pine aroma, and friction causes it to produce static sufficient to pick up small particles of paper. It is soft and carves easily but can be brittle, and skill is required to prevent fracturing. It tends to craze when subjected to sustained and extreme heat. Imitations include Chinese dyed sheep's horn and such plastic substitutes as phenolic resin. Amber has been confused with the fossil resins copal, dammar and kauri gum, of more recent date.

The major source of amber in Europe is from the Baltic, where it was formed during the Eocene period. In the Ice Age the geological stratum containing amber, known as Blue Earth, was carried by glaciers and rivers to parts of northern Europe. Some remained on what became the Baltic Sea bed, especially around Kaliningrad and Gdańsk. Until the 19th century, when organized digging, dredging and mining began, all Baltic amber was gathered from the beach or loosened from the sea bed with nets or pronged forks. It was still sought at the end of the 20th century, but the amount collected was comparatively small. It is also deposited along the shores of eastern England and the Netherlands and in Romania along the Carpathian Mountains, where the earliest found piece dates from the Palaeolithic era. 'Simetite' amber from the River Simeto in Sicily, known for its

fluorescence and colour range, is $c.$ 25 million years old and extremely rare. Amber has been found in 20 states in the USA, frequently associated with coal beds; New Jersey amber is $c.$ 100 million years old. Mexican amber occurs in calcareous sandstones and siltstones and in river and stream deposits. The Dominican Republic yields mainly golden-coloured amber with blue fluorescence that is rich in inclusions. Burmite, the major Asian trading amber from Upper Burma, is 38–54 million years old and is mined from pits in the jungle floor.

2. WORKING AND POLISHING METHODS. The basic working process consists of removing any outer crust, generally by scraping, then sawing away surplus pieces. Shaping and carving is done with scrapers, files and graving tools. Prior to the advent of metals, amber objects were crudely shaped by means of sandstones or other gritty stones serving as saws or files. Wood with sand could be used for smoothing surfaces, and a paste of wood ashes or chalk smeared on a piece of wood and rubbed on to the surface imparted a polish. A pointed stick revolved against the amber with an abrasive of fine sand was probably used for drilling holes. With bronze and then iron implements, more sophisticated work was achieved, but the methods for shaping, smoothing and polishing remained essentially unchanged, and as late as the 17th century amber was still worked with traditional tools. In the 18th century a spinning wheel was adapted into a crude lathe for turning objects, which were shaped with the aid of a piece of broken glass held against the amber. Industrialization reintroduced lathes and drills (which had been used by the Romans), but hand methods persisted with various saws, files, graving tools, sandpapers and such polishing compounds as tripoli, aluminium oxide and rouge; power-driven lapidary equipment used at slow speeds prevents shattering or melting. In the late 20th century the majority of amber from northern Europe was heated and clarified and underwent block-pressing processes; this made the cutting or moulding of beads or cubes, of uniform colour and composition, efficient for large-scale manufacture. Much of this adulterated amber was produced in Poland and Germany.

W. A. Buffum: *The Tears of the Heliades, or Amber as a Gem* (London, 1898)

G. C. Williamson: *The Book of Amber* (London, 1932)

E. Borglund and J. Flanensgaard: *Working in Plastic, Bone, Amber and Horn* (New York, 1968)

Z. Zalewska: *Amber in Poland* (Warsaw, 1974)

J. Grabowska: *Amber in Polish History* (Edinburgh, 1978)

P. C. Rice: *Amber: The Golden Gem of the Ages* (New York, 1980)

W. Baer: 'Ein Bernsteinstuhl für Kaiser Leopold I: Ein Geschenk des Kurfürsten Friedrich Wilhelm von Brandenburg', *Jahrbuch der kunsthistorischen Sammlungen in Wien*, lxxviii (1982), pp. 91–138

H. Fraquet: *Amber from the Dominican Republic* (London, 1982)

M. Trusted: *Catalogue of European Ambers in the Victoria and Albert Museum* (London, 1985)

H. Fraquet: *Amber* (London, 1987)

K. Beck: *Amber in Prehistoric Britain* (Oxford, 1991)

K. B. Anderson, J. C. Crelling, eds: *Amber, Resinite, and Fossil Resins* (Washington, DC, 1995)

M. Bora: *Lungo la via dell'ambra: Apporti altoadriatici alla romanizzazione dei territori del Medio Danubio (I sec. a.C.–I sec. d.C.)* (Udine, 1996)

D. Grimaldi: *Amber: Window to the Past* (New York, 1996)

V. I. Kulakov: *The Amber Lands in the Time of the Roman Empire* (Oxford, 2005)

Antler. See HORN AND ANTLER.

Appliqué. Technique of decorating textiles with motifs cut from one material, which are attached or 'applied' to another with embroidery stitches (see TEXTILE, §III, 2).

D. Blum and others: 'Nineteenth-century Appliqué Quilts' [with catalogue]', *Bulletin: Philadelphia Museum of Art.,* lxxxv (Fall 1989), pp. 3–45

M. Singer and M. Spyrou: *Textile Arts: Multicultural Traditions* (Philadelphia, 1990)

K. Kirihata: *Ayako Miyawaki, the Art of Japanese Appliqué* (Tokyo, 1991)

Aquatint. Term used to describe either the intaglio process or the print made by etching a plate through a special etching ground composed of particles of resin. During the confused early history of the technique, the term *manière de lavis* was used. However, this led to a misleading broad definition that included any printmaking process emulating the effect of a flat wash. The strict definition above is now generally preferred.

See also PRINTS, §III, 2.

1. Materials and techniques. 2. Technical history.

1. MATERIALS AND TECHNIQUES. After stopping-out (with varnish) areas that are to remain white, the image is formed by applying the aquatint ground of resin (or a substitute of asphalt, bitumen or pitch) using one of two methods. The first is to allow the resin to settle on the plate as a dry dust, usually by inserting the plate at the bottom of a box in which the dust has previously been shaken. The plate is then heated so that each separate grain of the dust-ground melts and adheres to the metal. The second method is to dissolve the resin or asphalt in alcohol (or equivalent distillate); this spirit-ground is then poured over the plate. The alcohol evaporates, leaving a thin film of resin, which cracks in the final stages of drying.

The plate is then immersed in acid, which etches the metal in the gaps around the grains of resin, thus forming a very fine crazed pattern of etched lines. Like an ordinary line ETCHING, the ground is then cleaned off the plate, to which ink is applied. The ink penetrates the etched depressions, and when the plate is printed, it creates a very fine network of lines that gives the effect of a soft grain or wash. The process produces areas of only a single tone, but the

density of the tone varies depending on how finely the dust was ground and how thickly it covered the plate. Because it cannot produce lines, the process is often combined with etching.

Gradations of tone for modelling forms can be achieved by using different densities of ground on the same plate, by burnishing the aquatint after it has been etched or by etching some areas of the plate longer than others to give a darker tone (either by tilting the plate out of the acid or by successively stopping-out areas with varnish). Another method of drawing an aquatint, more suited to making an artist's print, is called LIFT-GROUND ETCHING (or sugar-lift etching). In this the artist draws directly on the plate with a brush using a sugar solution, which swells when immersed in warm water and lifts the varnish to leave the brushed design as exposed metal; an aquatint ground is then applied in the usual way (or it can be applied to the whole plate before the sugar solution is brushed on), but it will affect the plate only in the exposed areas. When etched and printed, this gives the effect of a brush drawing.

Aquatints can be printed in colour in two ways: different coloured inks can be applied to the plate à la poupée (i.e. with a rag stump or 'dolly'), or a separate plate can be made for each colour and the several plates aligned for printing by a system of registration pins. Colour can also be added to aquatints by hand with considerable success due to the affinity between aquatint tone and watercolour washes (see colour pl. I, fig. 3).

2. TECHNICAL HISTORY.

(i) Experiments and prototypes, c. 1650–c. 1760. (ii) Development, c. 1760–c. 1800. (iii) Subsequent use, c. 1800 and after.

(i) Experiments and prototypes, c. 1650–c. 1760. The first known resin-ground aquatints were made by Jan van de Velde IV (1610–86) in the Netherlands in the 1650s, at the same time as Ludwig von Siegen (1609–?80) was developing another tonal intaglio process, the MEZZOTINT. The process, however, did not catch on, and these isolated experiments seem to have had no successors until the aquatint was reinvented in France in the mid-18th century, stimulated by the search for better tonal printmaking processes in response to the demand for reproductions of drawings. Various processes then invented were grouped under the term manière de lavis and have since been mistaken for aquatint proper. In certain early examples it is impossible to discern whether an aquatint ground was used.

In the early 1720s reproductions of drawings were made using mezzotint and wooden tone blocks by Elisha Kirkall (1685–1742). These were followed by facsimiles that used etching and wooden tone blocks, most notably the first volume of the Cabinet Crozat (1729) by the Comte de Caylus (1692–1765), and the Imitations of Drawings (1732, 1736) by Arthur Pond (1701–58) and Charles Knapton (1700–60). Pond also invented the method called CRAYON MANNER, which used a roulette through an etching ground to reproduce the effect of chalk drawings. But crayon manner became widely established only after it was re-invented by Jean-Charles François (1717–69) in 1757 in France, where it was more suited to the taste for chalk drawings among artists and collectors. Many 18th-century prints, including the celebrated colour prints of Jean-François Janinet (1752–1814) and Philibert-Louis Debucourt (1755–1832) (which were initially called manière de lavis and have also been called aquatints), are actually refinements of the crayon manner method. They were made using a vast array of special stippling tools and roulettes through an etching ground, or directly to the plate (as in mezzotint), to build up a patchwork of dots that imitated the manner of a wash.

Several artists, including Paul Sandby (1731–1809) in England c. 1750 and François in France in 1758, experimented with the distinct but related tonal process of lavis (open-bite etching), which consisted of brushing pure acid directly on to the plate. This technique had been in limited use in the 17th century, for instance by Stefano della Bella (1610–64), but in the 18th century attempts were made to make lavis more controllable. The method invented by the Nuremberg engraver Johann Adam Schweikart (1722–87) used an acidic paste that could be brushed on to the plate in a more controlled fashion than pure lavis, etching the plate in irregular patterns similar to those produced by etching through an aquatint ground. Schweikart's technique was used from the late 1750s onwards by a school of engravers in Florence to make facsimiles of drawings, most notably in the Disegni originali d'eccellenti pittori esistenti nella R. Galleria di Firenze (Florence, c. 1766) of Andrea Scacciati (1725–71) and Stefano Mulinari (c. 1741–c. 1790).

(ii) Development, c. 1760–c. 1800. The first prints to be made in France with an actual aquatint ground were probably those made in 1761–2 by François-Philippe Charpentier (1734–1817) and his Swedish pupil Per Gustaf Floding (1731–91). An examination of the prints suggests the application of a very fine aquatint ground to the whole plate and the subsequent use of stopping-out varnish to define the areas of shading. Floding returned to Sweden in 1764 and made no more prints in this manner. Charpentier continued to use the method between 1763 and 1766, including a large number of plates for the second edition of the Cabinet Crozat (1763), and then again in 1778–9. The next group of aquatints was made probably in 1766 by the Abbé de Saint-Non (1727–91), who learnt it from somebody else (presumably Floding or Charpentier) and was sworn to secrecy. Whereas Charpentier was restricted by the need to draw negatively with a stopping-out varnish, Saint-Non must have made use of some equivalent to lift-ground, which enabled him to brush his design positively on the plate.

Although preceded by Charpentier and Saint-Non, the artist usually credited with the invention of the resin-ground aquatint process is Jean-Baptiste

Le Prince (1734–81). In 1769, after experimenting with various methods of achieving tone, including drypoint hatching, *lavis* and uncontrolled resin tone, he arrived independently at a highly individual method of aquatint. After the outlines were etched, he covered the plate with a new ground, then brushed his design with a special solvent ink that weakened the ground so that it could be wiped off. The patches of exposed metal plate were then brushed with a sticky solution of soap and sugar on to which pulverized resin was shaken from a silk bag held above the plate. The resin was held by the sticky solution until it was fused to the plate by heating. The plate was then etched in the normal way. The process could be repeated many times, and sometimes stopping-out varnish was also used. The considerable success of Le Prince's aquatints was due to the freedom of drawing that resulted from the positive brush process. His method found no real followers in France, perhaps because the wash drawings it was best suited to reproducing were not popular there. The most extraordinary aquatints produced by a Frenchman in the last decade of the 18th century were actually made in Sweden by Louis-Jean Desprez (1743–1804).

The first British aquatint artist was Peter Perez Burdett (*fl c.* 1770–73), who exhibited his first aquatints in 1772. His technique varied from the French methods, suggesting that he developed it himself. He drew by brushing acid on to an aquatint ground, using stopping-out varnish merely to define large areas of flat tone. Other early aquatints were made in England by François-Xavier Vispré (*c.* 1730–after 1789) in 1774, Francis Jukes (1745–1812) in 1775, Philippe Jacques de Loutherbourg (1740–1812) in 1776, James Barry (1741–1806), whose long series of aquatints began in 1776, and Thomas Gainsborough (1727–88), who used the process by 1780. The most important early aquatint artist in Britain was Paul Sandby, who made his first prints in the medium in 1774 and published them in the *Twelve Views in South Wales* (1775). Sandby himself introduced significant developments to the aquatint process. He was the inventor of the spirit-ground, which he laid over the entire surface of the plate. He then brushed his design on to the ground with a sugar solution and laid a coat of varnish over the top. The varnish lifted off when the plate was immersed in water. This is the basic lift-ground technique, which was subsequently preferred to Le Prince's more complicated method, itself brought to Britain by Robert Adam (1728–92) when it was first made public in 1782. Although the spirit-ground became popular, since the end of the 18th century most aquatint artists have preferred the dust-ground.

Britain has the strongest tradition of aquatinting because the technique was ideally suited to the reproduction of late 18th-century British watercolours, usually made up of outlines and flat washes. In some cases a specialist aquatint artist would add aquatint to the lines etched by another printmaker. Most of these prints were topographical and many illustrated the series of colour-plate books published in large numbers throughout this period, such as the three-volume *Microcosm of London* (London, 1808–11). After 1780 aquatint was often combined with etching in satirical caricatures. Thomas Rowlandson (1756/7–1827) was a notable exponent in both fields.

In the last 30 years of the 18th century the technique of resin-ground aquatint spread rapidly to most European countries. Although it is not clear how the information was disseminated, it is likely that it stemmed from France. The earliest practitioners in Germany worked at the Leipzig academy. They were the architect Johann-Friedrich-Karl Dauthe (1749–1816) in 1770, Ernst Gottlob (1744–89) in 1772, Johann Gottlieb Prestel (1744–89) and Maria Prestel (1747–94) in 1775. In Italy the only notable 18th-century practitioner was Giovanni David (1743–90); his *Divers portraits à l'eau-forte* were published in 1775, although the aquatint may have been added later.

(iii) Subsequent use, c. 1800 and after. The invention of lithography in the final years of the 18th century produced a technique better suited to the reproduction of certain types of drawings, particularly those in ink and chalk. Aquatint thus began to lose its status as a reproductive medium everywhere except Britain, where watercolour imitations continued to be produced in the first half of the 19th century. Aquatinted plates wore out too quickly for a wide commercial application, especially in comparison with steel-engraving and lithography, and by the second or third decade of the 19th century lithography was also more popular as an original printmaking medium. That aquatint survived at all as an artist's medium has much to do with the inspiration of Francisco de Goya (1746–1828), who used it with etching for most of his print series: the *Caprichos* (1799), the *Disasters of War* (*c.* 1810–20), the *Tauromaguia* (1816) and the *Disparates* (1820). It is not known how Goya learnt the basic technique displayed in his earliest aquatints (1778), but it has been suggested that he was inspired by Giovanni David. Goya developed his range of techniques to include acid washes and the extensive use of burnishing. One plate, *The Colossus* (*c.* 1812), is one of the few in the history of printmaking to be made entirely in burnished aquatint. Goya's aquatints are unparalleled in their expressive strength. Few other aquatints have used chiaroscuro to such dramatic effect. In the *Disasters of War* even the substandard plates available to Goya in wartime were exploited to produce aquatints of technical imperfection but profound power.

The influence of Goya's aquatints was most strongly felt in 19th-century France, first in the work of Eugène Delacroix (1798–1863), particularly in *The Blacksmith* (1833), and later in the work of Edouard Manet (1832–83). Towards the end of the 19th century aquatint again became more widely used when its delicacy was exploited for Impressionistic and then Symbolist purposes. Edgar Degas (1834–1917) used it for its flat tonal properties, while it was the more subtle atmospheric

effects that appealed to Camille Pissarro (1830–1903). In Germany Max Klinger (1857–1920) was the most effective exponent of aquatint. In 1891 Mary Cassatt (1844–1926) made a set of ten colour-printed aquatints 'in imitation of Japanese prints' which exploited the medium's potential for the effect of delicate flat washes. Partly in response to the popularity of colour lithographs, around 1900 several other artists made colour aquatints, some of the best and most sophisticated being those by Jacques Villon (1875–1963). At the same time the growing school of professional reproductive engravers in France also started to use colour aquatint. The plates could be steel-faced to print a large edition.

In the 20th century aquatint has been either used for its painterly properties or subsumed in mixed method prints. Georges Rouault (1871–1958) started to rework photogravures for which he made drawings in 1916, but it was only in the mid-1930s that the printer Roger Lacourière (d 1967) showed him how colour might be added to his prints by means of aquatint plates. Lacourière actually made the colour plates in the same way as he did when making a reproduction of a watercolour. Rouault simply drew the black plates, usually in lift-ground etching. It was also Lacourière who in 1936 introduced aquatint to Pablo Picasso (1881–1973), who used it for the last of the *Vollard Suite* (assembled 1937, but offered for sale only in 1950) and a number of subsequent prints. Picasso also favoured lift-ground, which he used with dust-ground resin and also with *lavis* (or open-bite etching as it became known in the 20th century). In 1938–9 Picasso attempted colour-printed aquatints of his companion, the Surrealist artist Dora Maar (1909–97).

Picasso's use of aquatint can be related both to the expressive tradition deriving from Goya and to the narrative use of the technique, for it has been employed to a large extent in 20th-century book illustration (many of Rouault's colour aquatints, for example, were book illustrations). David Hockney (*b* 1937), some of whose earliest and most impressive prints used aquatint, employed it to great effect in his *Illustrations for Six Fairy Tales from the Brothers Grimm* (1969). The flat wash properties exploited in these prints also led to the increased use of the medium by abstract artists in the 1970s. The most subtle aquatints ever made are those of the North American Minimalist artists Robert Mangold (*b* 1937), whose flat geometric shapes are enlivened only by the texture of the aquatint, and Robert Ryman (*b* 1930), whose white aquatints depend for their variety solely on the density of the ink and its edges. At the opposite extreme, artists such as Gerhard Richter (*b* 1932) have used aquatint to modify photo-engravings of the real world. Aquatint has also been used in commercial photomechanical printmaking, particularly in photogravure.

P. Deleschamps: *Des mordants, des vernis et des planches dans l'art du graveur:Traité complet de la gravure* (Paris, 1836)

T. H. Fielding: *The Art of Engraving, with the Various Modes of Operation* (London, 1841)

S. T. Prideaux: *Aquatint Engraving: A Chapter in the History of Book Illustration* (London, 1909)

A. M. Hind: 'Notes on the History of Soft-ground Etching and Aquatint', *Print Collector's Quarterly*, viii (1921), pp. 397–401

B. F. Morrow: *The Art of Aquatint* (New York, 1935)

A. Griffiths: *Prints and Printmaking* (London, 1980)

E. Rebel: *Faksimile und Mimesis* (Mittenwald, 1981)

B. Gascoigne: *How to Identify Prints* (London, 1986)

A. Griffiths: 'Notes on Early Aquatint in England and France', *Print Quarterly*, iv (1987), pp. 255–70

C. MacKay: 'An Experiment to Follow the Spirit Aquatint Methods of Paul Sandby', *Print Quarterly*, iv (1987), pp. 271–3

M. A. Fusco: *L'acquatinta e le tecniche di resa tonale* ([Rome], 1989)

L. Nadeau: *Encyclopedia of Printing, Photographic, and Photomechanical Processes: A Comprehensive Reference to Reproduction Technologies, Containing Invaluable Information on Over 1500 Processes*, 2 vols (Fredericton, 1989–90)

A. Stijnman: 'Jan van de Velde IV and the Invention of Aquatint', *Print Quarterly*, viii (1991), pp. 153–63

A. Griffiths: *Prints and Printmaking: An Introduction to the History and Techniques* (London, 1996)

C. Wiebel: *Aquatinta oder 'Die Kunst mit dem Pinsel in Kupfer zu stechen': Das druckgraphische Verfahren von seinen Anfaengen bis Goya* (Munich, 2007)

Architectural conservation and restoration. The stabilization, repair or reconstruction of buildings of historic, cultural or architectural significance. The history of building conservation is beset with ideological and aesthetic problems, including whether it should be practised at all and, if so, to what extent restoration should supervene in the original structure. Modern conservation principles, as set out in the Venice Charter (1964; *see* §3 below), are based on specific alternative approaches. Preservation involves minimal intervention, ensuring the stabilization and maintenance of remains in their existing state and retarding further deterioration. Restoration involves returning the fabric to a known earlier state of greater significance by removing accretions or by reassembling existing components, but without the introduction of new material. Reconstruction involves returning the fabric as nearly as possible to a known earlier state and is distinguished by the introduction of materials— new or old—to the fabric. Architectural conservation may include any of these approaches or a combination of more than one, as well as the adaptation or modification of a building to suit proposed new and compatible uses.

The following survey discusses the historical development of largely Western attitudes towards architectural conservation, which culminated in the above principles. In other areas of the world, such as East Asia, restoration involving the incorporation of materials into older fabric and even replacement are regarded as valid ways of dealing with wear and damage. Information on the technical conservation of specific materials, for example

brick, concrete, stone and wood, may be found in the relevant articles on such materials. For information on the general principles and techniques of conservation of other art forms *see* CONSERVATION AND RESTORATION.

1. Before *c.* 1800. 2. *c.* 1800–*c.* 1900. 3. After *c.* 1900.

1. BEFORE *c.* 1800. The desire to preserve significant monuments from the past is not an invariable concomitant of high civilization. Ancient Egyptian kings, while anxious to keep their own funerary chambers intact, had little compunction in defacing the buildings of their predecessors for political reasons, or in adapting them to serve other purposes. Greek monuments were sedulously preserved by the emperors Augustus (*reg* 30 BC–AD 14) and Hadrian (*reg* AD 117–38), while, after the fall of the Western Empire, Flavius Magnus Aurelius Cassiodorus acted as custodian of ancient monuments to Theodoric the Great, the Ostrogothic ruler of Italy (*reg* 493–526). Charlemagne appointed Einhard (*c.* AD 770–837) superintendent of public buildings. During the Middle Ages, however, theatres, baths and tombs in Rome were adapted as fortifications by rival aristocratic families, such as the Savelli, who took over the Theatre of Marcellus (13–11 BC) in 1150. More than 140 of these structures were damaged in 1257 by the senator Brancaleone degli Andalò (*d* 1258) in a drive against nobles' towers, with consequent injury to the underlying monuments.

The continuing deterioration of the remains of Classical antiquity proved a source of anguish to the early humanists, most notably Petrarch (1304–74), who protested to Cola di Rienzo (1313–54) in 1347 against the destruction of buildings and the export of art treasures. A similar outlook is evinced by Raphael (1483–1520) at the pinnacle of the High Renaissance. In a celebrated letter (1519) to Pope Leo X (*reg* 1513–21), who had appointed him Romanarum Antiquitatum Praeses, Raphael deplored the current state of the remains of antiquity, as compared with the descriptions of them in the ancient authors. He urged the Pope to protect them, the Forum Romanum in particular, and to attempt a reconstruction, either in fact or at least on paper. Despite Raphael's plea, the spolia—ancient building material—continued to be used as a quarry, and not just the spolia. The Temple of Vesta in the Forum Romanum was still in a fair state of preservation at the end of the 15th century; it was destroyed by Michelangelo (1475–1564) and his successors, who used the materials, in whole blocks or burnt for lime, to build St Peter's. As late as 1624 Gianlorenzo Bernini (1598–1680), at the behest of Urban VIII (*reg* 1623–44), stripped the original cladding from the portico beams of the Pantheon to provide bronze for the baldacchino in St Peter's.

A proclamation issued in 1666 by the Swedish regents for the protection of all the country's monuments was the harbinger of a fundamental change in attitude to the restoration of historic architecture that began to develop in the 18th century. Great care was taken at Orléans Cathedral to ensure that the rebuilding work conformed with the prevailing Flamboyant style. The study of Classical antiquity was given strong impetus by the discoveries from 1738 at Pompeii and Herculaneum, by the four volumes of *Antiquities of Athens* (London, 1762–1816) by James Stuart (1713–88) and Nicholas Revett (1720–1804), which describe the city's surviving Classical buildings, and by the *Geschichte der Kunst des Altertums* (Dresden, 1764) by Johann Joachim Winckelmann (1717–68). In England the *Gentleman's Magazine* started to issue warnings from the early 1790s, notably in many articles by John Carter (1748–1817), about the destruction of medieval buildings. Various European administrations began to legislate for the conservation of antiquities, but a setback came with the French Revolution. In 1792 the Legislative Assembly ordained 'the destruction of all monuments of a kind to recall the memory of feudalism, and the obliteration of everything liable to revive the remembrance of despotic rule'. A number of valuable monuments were lost or damaged in consequence, as they were in China almost two centuries later during the Cultural Revolution, at its most frenzied in the years 1966–8, when the Red Guards pursued an identical policy.

2. *c.* 1800–*c.* 1900. The first complete official scheme for the care of monuments was formulated in a decree (1818) issued by Ludwig I, Grand Duke of Hesse-Darmstadt (*reg* 1806–30). This required the compilation of a graphic survey of the duchy's historical buildings. Thereafter no alterations or demolitions were to be permitted without prior notification to a Higher College of Building, and schemes for repair and preservation had to be submitted for official approval. Ludwig's decree was given wider publicity in *Denkmäler der deutscher Baukunst* (Darmstadt, 1815–51) by his court architect Georg Moller (1784–1852). In this form it was seen by and undoubtedly influenced Arcisse de Caumont (1801–73), who was agitating for a government grant for the protection of ancient monuments in France and the setting up of a Historical Monuments Commission. His allies included Victor Hugo (1802–85), whose manifesto *Guerre aux Démolisseurs* (1825) urged the protection and rescue of medieval monuments. The campaign was successful. In 1830 the Ministry of the Interior voted funds for the care of ancient monuments, a practice continued ever since. The Commission des Monuments Historiques was set up in 1837 and elaborated a method of listing monuments of national importance as the basis for a system of protection, conservation and research. Other European states followed and the foundations were laid for many of the historic monuments' services in operation throughout the world.

The establishment of official provision for conservation coincided with the emergence of a new ethic of restoration. In the 15th century the Colosseum (completed AD 80) had served as a travertine quarry

from which stones were robbed to build the Palazzo Venezia (begun 1455), the Cancelleria (*c.* 1483–1514) and later St Peter's. When Pope Leo XII (*reg* 1823–9) ordered the outer wall of the amphitheatre's west end to be shored up in 1825 to save it from collapse, strong brick buttresses were built. No attempt was made to imitate the original structure, and the material used was completely different from that employed in antiquity. A different approach was adopted, however, for the repair of the Arch of Titus (AD 81) at the eastern end of the Forum Romanum. When it was freed in 1819–21 from its medieval encumbrances in the Torre Cartularia, it was found to require lateral support. This was supplied to a design by Giuseppe Valadier (1762–1839), who extrapolated side panels and outer pairs of Corinthian columns by analogy with other more completely preserved arches. Valadier left the shafts of the new columns unfluted, however, and simplified the capitals, establishing a compromise between a restoration that sought to imitate the missing parts exactly, albeit conjecturally, and one that aimed to consolidate, like the Colosseum buttress, without reinstating the unity of the structure. At the same time, it had been determined that the medieval fortress of the Frangipani family, into which the arch had been incorporated, had to be dismantled and removed. A historic townscape that showed the working of time and society on architecture was thereby destroyed in favour of restoring a Classical monument, which was then exposed without its ancient context.

The first explicit theory of restoration was formulated by Eugène-Emmanuel Viollet-le-Duc (1814–79), who worked for the new Commission des Monuments Historiques in France from 1840. In the eighth volume of his *Dictionnaire raisonné de l'architecture française du XIe au XVIe siècle* (Paris, 1854–8) he expressed the view that to restore a building was not to repair or rebuild it, but to re-establish it in its original state. The resultant work would then conform as closely as possible to its ideal prototype. In pursuance of this doctrine he reconstructed in a uniform style buildings that had developed by accretion over the centuries, retaining forms he thought typical and altering others to conform with them by stylistic analogy. Major restorations in this spirit were effected at Ste Madeleine (1840–59), Vézelay, St Sernin (from 1860), Toulouse, and Clermont-Ferrand Cathedral (from 1862), where a new Rayonnant west front was supplied. His pupils took these doctrines to the logical extremes. Erveuf proposed erecting spires on the twin towers of Notre-Dame, Paris, and removing the decoration (1708–25) of the choir. Other followers replaced the Flamboyant balustrades of Amiens Cathedral with parts copied from Chartres. At Angoulême Cathedral, a scheme for simple conservation (1842) grew into a major project, directed by Paul Abadie (1812–84) from 1849 to 1880, involving a new pitched roof, which required new gables to support it. 'No risks of interpretation or of creating lost portions are involved', Abadie wrote in 1862, but the west front's present appearance features a gable with five stepped windows, flanked by twin-light belfries surmounted by conical spires, which is purely a work of Abadie's invention superimposed on an early 12th-century elevation. Even less compunction was displayed in dealing with post-medieval features. Simon-Claude Constant-Dufeux (1801–71) swept away the entire Renaissance façade of St Laurent, Paris, and replaced it with a Flamboyant design (1863–6) of his own.

Viollet-le-Duc's theory of restoration found a sympathetic response in England among the members of the Cambridge Camden Society, which had been founded in 1839 for the study of ecclesiology. They were intimately concerned with questions of church restoration, which they classified as destructive, conservative or eclectic. Destructive restoration would preserve nothing of the original building; conservative would keep everything down to the Tudor period; while eclectic, the Society's choice, would sometimes restore, sometimes remodel. 'To restore,' the *Ecclesiologist* declared, 'is to revive the original appearance … lost by decay, accident or ill-judged alteration' (i, 1842, p. 70), although such action, it was later admitted, might in fact produce an ideal state that the building had never enjoyed in the first instance.

Much work in this spirit is attributable to George Gilbert Scott I (1811–78), who, although he maintained in *A Plea for the Faithful Restoration of our Ancient Churches* (London, 1850) that 'as a general rule it is highly desirable to preserve those vestiges of the growth and history of buildings which are indicated by the various styles and irregularities of its parts', in practice acted quite differently. His tendency was to reconstruct in a uniform style a medieval church that exhibited work of different epochs, sometimes on the evidence of a single surviving early feature. Most notoriously, he pulled down the whole east end of Christ Church Cathedral, Oxford, and rebuilt it (1870–76) in the Norman style. The work of Scott and his school provoked an early reaction from John Ruskin (1819–1900), who in *The Seven Lamps of Architecture* (London, 1849) declared unequivocally that 'it is impossible, as impossible as to raise the dead, to restore anything that has ever been great or beautiful in architecture'. Ruskin's attitude influenced the Society of Antiquaries of London, which urged at the Council meeting of 1 May 1855 that 'no restoration should ever be attempted, otherwise than … in the sense of preservation from further injuries'.

Notwithstanding these objections, the tide of inventive restoration flowed unabated. It was helped by the critical research into the nature of Gothic architecture that was evoked by the Gothic Revival and by the confidence that the new knowledge inspired in architects. It culminated in the completion, after a hiatus of 300 years, of Cologne Cathedral (1842–80) to designs by Ernst Friedrich Zwirner (1802–61), an extraordinary episode in which nationalism battled with scholarship in a manner reminiscent of the Greek and Roman controversy that existed at the time of Giovanni Battista Piranesi (1720–78). Few amenders of the mistakes and mishaps

of ancient buildings exceeded the boldness of Josef Mocker (1835–99). Among many other works, not least those at Prague Cathedral, he reconstructed Křivoklát Castle (from 1882) in the Jagiellonian style and undid the Renaissance remodelling (1587–96) of Karltejn Castle by Gothicizing it again (1887–94). Finally, in 1889 he gave the early 14th-century castle at Konopiště its present admired appearance.

It was the prospect of Scott intervening in similar fashion at Tewkesbury Abbey that led William Morris (1834–96) to found the Society for the Protection of Ancient Buildings (SPAB) in 1877 and write its manifesto. This urged all who might be responsible for the upkeep of historic buildings 'to put Protection in place of Restoration', and in the work of maintenance only to employ 'such means as are obviously meant for support or covering, and show no pretence of other art'. The extreme reserve of this outlook took some time to attract support, but ultimately its diffusion was widespread and long-lasting: its traces may be observed in such dicta as that of Camillo Boito (1836–1914): 'It is better to consolidate than to repair, better to repair than to restore' (*Questioni pratiche di belle arti*, Milan, 1893).

3. AFTER *c.* 1900.The influence of the Society for the Protection of Ancient Buildings (*see* §2 above) remained strong in Great Britain in the early 20th century and its advice was sought by government departments. Many great monuments were restored in conformity with SPAB practice, including Fountains Abbey and Dover Castle. Similarly, the Deutscher Werkbund, founded by Hermann Muthesius (1861–1927) in 1907, combined a thorough study of historic buildings with the wish to revive standards of craftsmanship. In 1908 the Royal Commission on Historical Monuments was established in England (with similar bodies in Scotland and Wales) to provide inventories of ancient monuments and historic buildings dated before 1714, a date that has been progressively advanced. Major works of historical architecture in Belgium and France destroyed during World War I were generally restored in faithful imitation of the original design. At Arras, for example, the historic core of which was reduced to rubble by German artillery, the squares were restored in the 1930s by Pierre Paquet (1875–1959). The scale of the damage was obviously beyond the scope of restrained SPAB-type interventions. The alternative would have been what Ruskin called the 'necessity of destruction'. 'Accept it as such', he had written, 'pull the building down, throw its stones into neglected corners, make ballast of them, or mortar if you will' (*The Seven Lamps of Architecture*). But the death of buildings as contemplated by Ruskin was occasioned by irreversible decay, not apocalyptic bombardment. At all events, no government was prepared to abandon its nation's heritage for the sake of conservational purism. Where, on the other hand, damage, or its threat, was occasioned by the inroads of decay, greater reserve was still displayed. In particular, where ancient façade

sculpture began to show signs of dilapidation, the tendency was to put it indoors and substitute simplified replacements, instead of pastiche re-creations of ancient statuary, in the manner of Viollet-le-Duc.

In the USA the restoration of colonial Williamsburg was initiated in 1926 when John D. Rockefeller (1874–1960) bought 173 acres of the town with the intention of restoring it to its layout and appearance in 1775. Existing, run-down buildings were subsequently restored and those that were in ruins or completely built over were reconstructed, the latter involving the removal of several hundred 19th- and 20th-century buildings. An unusual feature of the exercise was the archaeological and archival research put into each property, with the foundations of each house being excavated before rebuilding. By the end of the 20th century more than 100 major buildings had been restored, 50 of which were reconstructions. The authenticity of the whole is as careful as a mixture of old and new can be, much enhanced by mature trees and gardens. It is the yardstick by which other similar museums are judged, although few can boast original house plots on the scale of Williamsburg.

After World War II many countries took stock of their losses and chose various paths. In England, Coventry Cathedral, at the heart of a city centre almost totally demolished in November 1940, was left as a consolidated ruin beside the new cathedral (1954–62) designed by Basil Spence (1907–76) and surrounded by shops and offices. The precise restoration of the destroyed centre of Warsaw owed more to sentiment than any idea of conservation. In Cologne, a voluntary tithe was collected from the citizens and almost every church destroyed by bombing was reconstructed with painstaking accuracy over a period of nearly half a century, each reconstruction publicly accounted for with photographs and drawings placed at the entrance. This campaign was helped through the application of photogrammetry, by which measured drawings of elevations are produced from photographs.

Loss or damage through fire, for example at Hampton Court, near London, and York Minster in 1984 and at Windsor Castle in 1992, flood, as at Florence in 1966, and earthquake, such as struck Tuscania in Latium in 1971, has led to the growth of international establishments to coordinate work during such disasters, to study techniques and to teach them; the best-known of these is the International Centre for the Study of Preservation and Restoration of Cultural Property (ICCROM) in Rome. International funding and advice for World Heritage Sites is provided through the United Nations Educational, Scientific and Cultural Organization (UNESCO). In the 1960s, for example, a series of Egyptian temples in the Upper Nile region was moved above the flood level behind the Aswan Dam, the construction of which was then considered essential to the feeding of the nation. Here the rock-cut temples built at Abu Simbel by Ramesses II (*reg c.* 1279–*c.* 1213 BC) were cut away from the living rock in blocks and reassembled.

By the mid-1990s, however, the temples of the complex were at a second crisis, suffering from severe wind erosion. World funds and advice have also been used for all the 5th-century BC buildings on the Acropolis in Athens. The Parthenon, Propylaia and Erechtheion were all built of Pentelic marble, the exact placing of every feature, the pattern of light and shade, and the quality of each piece of sculpture having been the subject of intense consideration during their construction. The explosion of gunpowder stored in the Propylaia (1645) and the Parthenon (1687), and further erosion owing to time, visitors, deteriorating iron ties and pollution have, however, severely altered the view. Repairs and reconstructions have involved years of discussion and extensive computer studies to determine the original place of each major stone. At the Parthenon indeed, as at the prehistoric sites of Lascaux and Stonehenge, visitors may no longer approach or touch the monument, to avoid abrasion.

Anastylosis, the resurrection of monuments at sites where the fallen pieces have remained close to their original position, has been seen as the simplest form of repair, especially for Classical temples. The drums used by Greek and Roman builders to make up large columns were pinned together at their centres by wooden blocks and iron pins that rotted over time. Hundreds of sites are littered with the collapsed but comprehensible remains of temples, agora, fora—and indeed whole towns—not only in Greece and Rome but also in Tunisia, Turkey, Israel and France (see fig.). The opportunity to study preserved sites throughout the Greek and Roman empires has greatly enhanced understanding of the quality of architecture of the Classical world and the structures chosen for reconstruction are no longer confined to temples. Anastylosis, however, is not always aesthetically pleasing. If stones are unevenly worn from the time they were collapsed, resurrection could be unstable. If the deficit is made up in artificial materials rather than matching stone, the effect tends to be honest but ugly. There also remains a risk of incorrect reconstruction. In Rome, the Arch of Titus is generally considered to be a successful anastylosis but the Arch of Constantine (AD 315) is marred by obtrusive infill. Anastylosis is widely accepted as ethical provided that a full visual record is kept showing the state of the building before and after restoration, and that only insertions or other action that can be reversed without harming the fabric is taken.

Leptis Magna, Severan basilica, dedicated AD 216 (Los Angeles, CA, Getty Conservation Institute); photo © The J. Paul Getty Trust, all rights reserved

The ethics of restoration, including anastylosis, were debated in 1964 at the International Congress for Conservation in Venice. A summary of the ideas raised was published as the Venice Charter, and the International Council on Monuments and Sites (ICOMOS) was established to promote its principles. The Venice Charter has been accepted by many countries but has no legal standing and has received widely varying interpretations. Its principles are most applicable to archaeological sites and are not always suited to buildings in use. Where a building is of great antiquity or unique, total preservation is the aim. No-one today would require the Tower of London, for example, to meet modern building regulations, although European Community Health and Safety regulations are applied. Most buildings, however, need to be in use to guarantee their conservation. Social change has caused vast numbers of important buildings to become redundant or face ideological opposition. In countries under Communist rule, for example, some churches were maintained as historic buildings but their care was not always paramount and their contents were sometimes gathered in museums, lost or stolen. Wooden churches were particularly vulnerable. In Muslim countries, conversion into mosques has guaranteed the maintenance of some buildings, such as SS Sergios and Bakchos in Istanbul, but lack of finance and interest has threatened many churches, especially in rural areas.

The decline of the Church's wealth and support has led to large numbers of churches becoming redundant: in England, for example, there were 16,500 Anglican churches in 1968, but within 20 years, 147 had been declared redundant. To prevent wholesale demolition, many were converted into music and theatre workshops, old people's day centres, bookshops, libraries or heritage centres. Uses that require an open space can be compatible, but some schemes preserve only the outer appearance of the building and carve up the interior. The extra floors and rooms that were inserted when the imposing SS Thomas and Swithun (1845–6), Winchester, designed by E. W. Elmslie (fl 1843–72), was converted to house the Hampshire County Records Office did little for either church or record. Social and economic change has also altered the circumstances for the maintenance of other types of buildings. Manor houses, châteaux and palazzi were built to be run by armies of servants who lived on the premises. By the end of the 20th century few individuals, aristocratic or otherwise, were able to devote their lives to such properties. A select few are maintained by the state or by public trusts. Some became schools, agricultural colleges, sports clubs and hotels, but the necessary adaptive treatment is rarely in keeping. In 1977 there was public outcry when the 7th Earl of Rosebery allowed the contents of Mentmore House (1852–4, by Joseph Paxton (1803–65) and George Henry Stokes (1826–74)) to be sold at auction, but no legislation existed in Britain to deal with assemblages of furniture and paintings that belong to the architecture.

In the urban environment economic growth creates pressure for change and demolition. In the 1950s and 1960s bombed areas were redeveloped and there was expansion into green-field areas, but from the 1970s the increasing demands of traffic, changes in manufacturing requirements and even the marketing of vegetables have sometimes led to inner city decay and congestion. In France, the Loi Malraux (1962), named after André Malraux, the then minister of cultural affairs, introduced the concept of conservation areas (secteurs sauvegardés), where city districts or entire historic villages would be surveyed and their reinstatement systematically planned. This would be financed by a mixture of state grants, loans and private investment. The areas selected, such as the Marais district in Paris and much of the city of Chartres, have subsequently been magnificently cared for regardless of the owners' wishes. Although France has sometimes been accused of being too selective in the areas conserved, its standards are high.

In England and Wales the Civic Amenities Act (1967), which was clearly inspired by the French initiative, required local authorities to designate Conservation Areas. The aim was to recognize that the value of a street or square is created not only by its individual buildings of quality, but also by the attention to scale and the care taken with the minor properties, spaces and street furniture. Chester, Bath, Chichester and York were selected for pilot studies that helped develop ways of funding and organizing repairs in buildings with multiple occupancy, such as the Circus (1754–8), by John Wood I (1704–54) in Bath or the Rows in Chester. The Edinburgh New Town Conservation Committee, faced with similar problems, formed an agency to inspect their terraces quinquennially and has protected the ability to pay with insurance policies. Some of the schemes promoted under French and British legislation have been accused of 'gentrification', pushing out old people and small shops from the Marais or York city centre and attracting rich tenants who can afford to maintain the properties. A similar charge is often laid against the conversion of market buildings. In Boston, MA, the businesses that operated around Faneuil Hall Market (Faneuil Hall, 1742; additional rows, 1824–6, by Alexander Parris (1780–1850); rest. by Benjamin Thompson Associates) were moved away from their 18th- and 19th-century arcades and replaced by cafes and expensive shops. Similarly, in 1974 the fruit and vegetable market (1828–30, by Charles Fowler (1792–1867)) in Covent Garden, London, and the Piece Hall (1775–9, by Thomas Bradley), the former cloth hall in Halifax, W. Yorks, were abandoned, restored with care and converted into successful commercial ventures.

Imaginative conversions of dock warehouses abound, saving magnificent buildings with a variety of uses. The scheme in 1980 to convert St Katharine Docks in London, built by Philip Hardwick (1792–1870) in 1827–9, into luxury apartments and a hotel was followed by numerous other projects, including the neighbouring Tobacco Dock

(1811–14, by David Asher Alexander and John Rennie (1761–1821)), now a shopping centre. In Liverpool, Albert Dock (1839–45), built by Jesse Hartley (1780–1860), has been turned into a recreation area with museums, an art gallery, a TV station, shops, boating pools and apartments. In Amsterdam, 84 warehouses built between 1708 and 1829 were converted into council apartments above offices and shops. Copenhagen Docks, built in the late 18th century and largely disused by the 1970s, became hotels, condominiums, a conference centre and an exhibition centre for architecture.

The difference between adaptive reuse and the careful preservation of every stone in a cathedral or castle has been frequently debated. 'Façadism', in which only the street frontage is preserved in the belief that only the façade is in the public domain, has allowed much of value to be demolished through misattribution. The practice of facing medieval timber-framed buildings with fire-resistant brickwork has often disguised the structures' true origins, such as in several buildings in Salisbury, Wilts, which were listed as 19th-century, but which proved to be well-preserved timber-framed merchants' houses erected between the 14th and 17th centuries and which were saved largely because representatives from the Royal Commission on Historical Monuments pleaded their case.

The destruction of vast areas in two world wars encouraged a comprehensive approach to redevelopment. Even after the loss of many precious town centres, there continued to be arguments based on the premise that any buildings could be demolished provided that a substitute of sufficiently high quality was proposed. This argument was hotly refuted by conservationists on the grounds that there will never be another 18th- or 19th-century building and therefore the stock is always dwindling. Until the 1970s penalties for the demolition of a protected building were derisory, especially when compared with the cost of land in expensive city-centre locations. European Architectural Heritage Year in 1974 did much to influence public awareness. Craft skills that had been endangered by large-scale, post-war building booms made a modest revival, and the manufacture of specialist products in clay, ironmongery and lead has been resumed. Some types of building stone became rare, however, and France set up an international stone supplies organization to fill the need.

It has sometimes been difficult to ensure that old and new buildings in historic cities are compatible. In Jerusalem, for example, all buildings must be stone-clad, requiring vast quantities of stone for its skyscrapers. In Bath, height restrictions reduce the demand, and correctly coloured stone substitutes are permitted in many situations. No height restrictions were imposed in Boston, MA, and several key buildings, including the King's Chapel (1750, by Peter Harrison (1716–75)) and the Old State House (1713), are dwarfed by skyscrapers. In Chicago, however, the Loop area, close to the Stock Exchange, with buildings by H. H. Richardson (1838–86), Louis Sullivan (1856–1924) and Frank Lloyd Wright (1867–1959),

was protected by transferring 'air rights': skyscrapers were forbidden within the historic core, and in exchange the city authorities allowed extra storeys outside the protected area. Recognition of the earlier skyline's value can be expensive, as for example at Philadelphia, where surroundings were not protected at first, but there was a change of heart in the 1970s and tall buildings were demolished at great cost.

Whole districts of smaller houses abandoned as unfit or unwanted have been reconditioned by both public and private means. The National Trust for Scotland bought a number of neglected villages, including Culross, Fife, restored them and leased the properties. Historic Hill, Newport, RI, has been similarly restored. Trinity, an area of 17th-century weavers' houses in Frome, Somerset, was condemned for demolition in the early 1970s but was reprieved and restored after a prolonged campaign (Pearce). Tall terraces of stone tenements in the Gorbals of Glasgow were saved by careful reuse of open space between the rows. Smaller terraces ripe for redevelopment were 'enveloped', given new roofs, identical kitchens and bathrooms in the 1980s. At this level the conservation gain is small, but it demonstrates a preference for rehabilitation rather than the construction of new tower blocks.

Architectural conservation in the late 20th century has drawn on a wide range of attitudes and techniques. At its most sophisticated it has supported such projects as the floating of York Minster's central tower on self-adjusting hydraulic jacks. This may be contrasted with controversial schemes to move timber-framed buildings to museums or other locations to aid development.

G. B. Cavalcaselle: *Sulla conservazione dei monumenti ed oggetti di belle arti* (Turin, 1863)

E. Viollet-le-Duc: *On Restoration* (London, 1875)

C. Boito: *I restauratori* (Florence, 1884)

C. Boito: 'I nostri vecchi monumenti: Conservare o restaurare?', *Nuova antologia*, (1 June 1886), pp. 480–506); Fr. trans. as *Conserver ou restaurer: Les dilemmes du patrimoine* (Besançon, 2000)

A. Riegl: *Der moderne Denkmalcultus* (Vienna, 1903); Eng. trans. as 'The Modern Cult of Monuments: Its Essence and its Development', *Historical and Philosophical Issues in the Conservation of Cultural Heritage*, eds N. S. Price and others (Los Angeles, 1996)

G. B. Brown: *The Care of Ancient Monuments: An Account of Legislative and Other Measures Adopted in European Countries for Protecting Ancient Monuments and Objects and Scenes of Natural Beauty, and for Preserving the Aspect of Historical Cities* (Cambridge, 1905)

P. Léon: *Les Monuments historiques: Conservation, restauration* (Paris, 1917)

G. Giovannoni: *Il restauro dei monumenti* (Rome, [1946?])

La ricostruzione del patrimonio artistico italiano (Rome, 1950)

P. Léon: *La Vie des monuments français: Destruction, restauration* (Paris, 1951)

C. Pedretti: *A Chronology of Leonardo da Vinci's Architectural Studies after 1500* (Paris, 1962) [contains Raphael's letter to Pope Leo X on the architecture of ancient Rome]

C. Brandi: *Teoria del restauro* (Turin, 1963, rev. 2/1977); Eng. trans. as *Theory of Restoration* (Rome, 2005)

A. Ciborowski: *Warsaw: A City Destroyed and Rebuilt* (Warsaw, 1964)

F. Mielke: *Fremdenverkehr, Altstadt und Denkmalpflege* (Bonn, 1971)

Il monumento per l'uomo: Atti del II congresso internazionale di restauro: Venezia, 1964 (Padua, 1972)

J. Harvey: *Conservation of Buildings* (London, 1972)

Architects' Journal (May 1974) [special issue on tourism and conservation]

J. Fawcett: *The Future of the Past: Attitudes to Conservation, 1174–1974* (London, 1976)

S. T. Madsen: *Restoration and Anti-restoration: A Study of English Restoration Philosophy* (Oslo, 1976)

New Life for Old Churches (London, 1977)

D. Hodges: *The Care and Conservation of Georgian Houses* (Edinburgh, 1978)

E. R. Chamberlin: *Preserving the Past* (London, 1979)

Das Baudenkmal: Zu Denkmalschutz und Denkmalpflege: Mit deutschem, französischem und englischem Index (Tübingen, 1981)

M. W. Thompson: *Ruins: Their Preservation and Display* (London, 1981)

G. Torraca: *Porous Building Materials—Materials Science for Architectural Conservation* (Rome, 2/1982)

B. M. Fielden: *Conservation of Historic Buildings* (London, 1982, rev. Amsterdam and Boston, 3/2003)

N. Huse: *Denkmalpflege: Deutsche Texte aus drei Jahrhunderten* (Munich, 1984)

P. Bianchina: *Illustrated Dictionary of Building Materials and Techniques: An Invaluable Sourcebook of the Tools, Terms, Materials, and Techniques Used by Building Professionals* (Blue Ridge Summit, PA, 1986, rev. 2/1993)

D. Pearce: *Conservation Today* (London, 1989)

P. Panza: *Antichità e restauro nell'Italia del Settecento: Dal ripristino alla conservazione delle opere d'arte* (Rome, 1990)

W. Denslagen: *Architectural Restoration in Western Eruope: Controversy and Continuity* (Amsterdam, 1994)

L. Réau: *Histoire du vandalisme: Les monuments détruits de l'art français* (Laffont, 1994)

K. E. Larsen: *Architectural Preservation in Japan* (Trondheim, 1994)

J. L. Bacharach, ed.: *The Restoration and Conservation of Islamic Monuments in Egypt* (Cairo, 1995)

E. Bacher, ed.: *Kunstwerk oder Denkmal? Alois Riegls Schriften zur Denkmalplege* (Cologne, 1995)

S. Bergeon: 'Pietro Palmaroli e I fondamenti del restauro moderno', *Archeopiceno*, iii/10 (1995) pp. 5–10

I. Ordieres Díez: *Historia de la restauración monumental en España (1835–1936)* (Madrid, 1995)

S. Scarrocchia: *Alois Riegl: Teoria e prassi della conservazione dei monumenti: Antologia di scritti, discorsi, rapporti 1898–1905* (Bologna, 1995)

W. Bucher, ed.: *Dictionary of Building Preservation* (New York, 1996)

A. K. Seshadri: *Conservation of Monuments in India* (Delhi, 1997)

J. Jokilehto: *A History of Architectural Conservation* (Boston, 1999)

K. D. Murphy: *Memory and Modernity: Viollet-le-Duc at Vézelay* (University Park, PA, 2000)

A. M. Racheli: *Restauro a Roma: 1870–2000* (Venice, 2/2000)

F. Choay, ed.: *La conférence d'Athènes: Sur la conservation artistique et historique des monuments (1931)* (2002)

C. Bellanca: *Antonio Munoz: La politica di tutela dei monumenti di Roma durante il Governatorato* (Rome, 2003)

C. Henrichsen: *Historische Holzarchitektur in Japan: Statische Ertüchtigung und Reparatur* (Stuttgart, 2003)

S. P. Schreiber: 'Yin Yu Tang: A Chinese Home', *Curator*, xlvii/4 (Oct 2004), pp. 450–55

P. D. Siegenthaler: *Looking to the Past, Looking to the Future: The Localization of Japanese Historic Preservation, 1950–1975* (PhD thesis, Austin, TX, University of Texas, 2004)

G. Lai, M. Demas and N. Agnew: 'Valuing the Past in China: The Seminal Influence of Liang Sicheng on Heritage Conservation', *Orientations*, xxxv/2 (March 2004), pp. 82–9

C. Miele, ed.: *From William Morris: Building Conservation and the Arts and Crafts Cult of Authenticity, 1877–1939* (New Haven, 2005)

P. Mortensen, ed.: *Bayt al-'Aqqad: The History and Restoration of a House in Old Damascus* (Aarhus, 2005)

Arriccio [*arricciato*; It.: 'wrinkle']. In a FRESCO, the rough coat of plaster on which the preliminary composition sketch or *sinopia* is drawn.

Artificial leather. See LEATHER, IMITATION.

Artificial stone. Material most commonly used as a cheaper alternative to stone. Occasionally, its special properties make it a preferred but more expensive choice to stone. In its simplest form, artificial stone is an ashlar covering for buildings (e.g. 18th-century terraced houses by John Nash (1752–1835)). It is found in its most sophisticated form as the component of numerous 19th-century terracotta or cement-based sculptures.

1. MATERIALS AND TECHNIQUES. The earliest and simplest form of artificial stone is the lime-and-gypsum plaster used to decorate the walls of Egyptian tombs. These facings were predominantly of gypsum plaster lined and painted to simulate the texture of stone. In ancient Rome, renders (first coats of plaster) had a similar design and purpose, although they were applied to a wider variety of buildings. The incorporation of lime, pozzolana, additives of volcanic ash, sherds of pottery and brick dust strengthened the mortars and gave them greater durability. The renders were often painted to increase the illusion that actual stone was used. In 16th- and 17th-century Italy, recipes for stucco included marble dusts, lime and glue to aid in the imitation of stone and to ensure the strength of the mix. In the 18th century the interiors of Neo-classical buildings often featured stuccowork modelled to appear carved, and were coated with a light blue-grey overpaint to enhance the appearance of artificial stone, as seen for example in reliefs (*c.* 1764) by Thomas Carter (*d* 1795) in the Pantheon (1754) at Stourhead, Wilts by Henry Flitcroft (1697–1769).

With the arrival of the Industrial Revolution and the increasing market for durable architectural decoration and statuary, recipes for harder and more dense artificial stone were created. In 1767 Daniel Pincot showed specimens of artificial stone at the Free

Society of Artists Exhibition, London, and Eleanor Coade (1733–1821) set up her manufacture in Lambeth, London, in 1769. Both produced stone far superior in strength and durability to white marble or ordinary rock stone. Strictly a terracotta material, the highly successful recipe and manufacturing technique for Coade stone was never published; neither Pincot nor Coade took out a patent. When analysed, Coade stone revealed a predominance of clay, silica and grog of flint and feldspar fired at high temperatures over a long period. As with most terracotta pieces produced from moulds, elements were interchangeable from one composition to the next. John Sealy (1749–1813) became Coade's partner, and later William Croggon (*fl* 1814–35) took over as manager. Other companies that manufactured artificial stone in Britain were run by Blashfield and John Doulton (1793–1873). Cement-based artificial stones, though not as sharply defined, weather well in the climate of Britain and have the appearance of natural stone. Pulham stone and Haddon stone, produced in the 19th century, are composed mainly of cement and aggregate cast and were used to make garden ornaments and statuary of great durability.

See also STUCCO AND PLASTERWORK.

2. USES. In ancient times artificial stone was widely used as a facing for houses and monuments when quarried stone was not easily available. In the 3rd and 4th centuries BC towns of the Roman Empire contained buildings built predominantly of brick with concrete walls faced with stucco polished to 'shine like marble'. Emperor Augustus (*reg* 30 BC–AD 14) boasted that he found 'Rome of brick and left it in marble' (Suetonius: *Augustus*). SCAGLIOLA, a type of imitation marble or pietra dura, was popular from the 16th century and was used for table-tops and as a moulding on walls and door panels. In the 17th and 18th centuries it was especially used as part of the design of monasteries in Italy.

In the 18th and 19th centuries Neo-classical façades of buildings were cheaply and quickly built with renders lined to look like stone entablatures, this having been made possible at the time by means of various formulae for the manufacture of cement. Prince Albert had Osborne House (begun 1845), Isle of Wight, inexpensively constructed with the latest of building technology: the house is faced with artificial stone. In the UK the demand for a more durable type of sculpture and ornament for out of doors frequently led to artificial stone being chosen as a preferred material. In the 19th century approximately 25 British manufactories produced artificial stone for statuary and garden ornaments. The fashion for Neo-classical façades and gardens, combined with existing skilled building technology, resulted in the manufacture of cast ornament of the highest standard. The most successful producer of artificial stone ornament was the Coade Artificial Stone Manufactory (*see* §1 above). Between 1769 and 1843 the company, through a combination of suitably fine mixtures of terracotta and the best contemporary craftsmanship,

produced Coade stone, which is as resilient today as it was in the 18th and 19th centuries.

G. E. Bessey: 'The Maintenance and Repair of Regency Painted Stucco Finishes', *Royal Institute of British Architects Journal*, n.s. 2, lvii/4 (1950), pp. 143–5

Proceedings of the International Symposium, The Conservation of Stone, I: Bologna, 1975

A. Kelly: *Mrs Coade's Stone* (Hanley Swan, 1990)

J. P. S. Davis: *Antique Garden Ornament: 300 Years of Creativity, Artists, Manufacturers and Materials* (Woodbridge, 1991)

M. Koller: 'The Use of Artificial Stone in the Late Middle Ages: A Survey of the Development of Casting Techniques', *Technologia Artist: Yearbook of the Archives of Historical Art Technology* (Prague), iv (1996), pp. 66–9

R. Grilli: 'La bottega della pietra artificiale: Materiali, strumenti e tecniche tradizionali', *Architettura e materiali del novecento: Conservazione, restauro, manutenzione: Atti del Convegno di studi, Bressanone, 13–16 luglio 2004.*, pp. 483–92

J. Kearney: 'Cast Stone's Trials of Authenticity: How Labor and Modernism Conspired to Kill a Nascent Materials Industry', *Future Anterior: Journal of Historic Preservation History, Theory and Criticism*, i/1 (Spring 2004), pp. 83–9

Audiotape. See MAGNETIC TAPE.

Automatism. Term appropriated by the Surrealists from physiology and psychiatry and later applied to techniques of spontaneous writing, drawing and painting. In physiology, automatism denotes automatic actions and involuntary processes that are not under conscious control, such as breathing; the term also refers to the performance of an act without conscious thought, a reflex. Psychological automatism is the result of a dissociation between behaviour and consciousness. Familiarity and long usage allow actions to become automatic so that they are performed with a minimum of thought and deliberation. Pathological automatism, also the consequence of dissociative states, ensues from psychological conflict, drugs or trance states; automatism may also be manifested in sensory hallucinations.

During the late 19th century Pierre Janet (1859–1947), a French psychiatrist, treated mental disorders with hypnosis, as did other practitioners of dynamic psychiatry. In particular, he studied the automatic behaviour of mediums to determine the degree to which the subconscious interacts with the conscious during a trance. A medium, while in a self-induced trance, performs spontaneous physical acts with no conscious control. Psychiatry suggests that their apparent messages from a spirit world may actually be subliminal thoughts or feelings, released and given free expression.

While psychiatry considers automatism reflexive and constricting, the Surrealists believed it was a higher form of behaviour. For them, automatism could express the creative force of what they believed was the unconscious in art. Automatism was the cornerstone of Surrealism. André Breton (1896–1966) defined Surrealism in his *Manifeste du surréalisme* (1924) as 'psychic automatism in its pure state'. This automatism was 'dictated by thought, in the absence of any

control exercised by reason, exempt from any aesthetic or moral concern'. Breton's formulation of automatism borrowed ideas from the practices of mediums and from dynamic psychiatry, which emphasized the interplay among conscious and unconscious forces in directing behaviour. Although related to Sigmund Freud's free association, the automatism of the Surrealists required only one person and was written rather than spoken. Automatic writing served as the Surrealists' first technique for tapping what they believed to be the unconscious; subsequently, hypnotic trances and dream narration provided other routes to the unknown.

Automatism in the visual arts can arise from manual techniques that involve chance in the creation of the work (*frottage* (taking rubbings from textured surfaces), *grattage* (rubbing and scraping off layers of paint), decalcomania (applying paint to paper and then folding the paper or pressing it against another surface to create a mirror image)) or from psychological experiences (hallucination, intoxication, hypnotic trance, dream narration). The automatic drawings of André Masson (1896–1987), such as *Furious Suns* (1925; New York, Museum of Modern Art), paintings by Joan Miró (1893–1983) from the mid-1920s and *frottages* by Max Ernst (1891–1976) are examples.

By the mid-1940s the American painters known as the Abstract Expressionists (in particular 'Action Painters') had adopted automatic methods in their work. Influenced by Surrealism, these artists introduced the appearance of automatism even when their pictures were deeply deliberated. They included Arshile Gorky (1904–48), Jackson Pollock (1912–56), Franz Kline (1910–62) and Willem de Kooning (1904–97). Between 1946 and 1951 Les Automatistes, a group of Canadian Surrealist painters, painted in a technique based on automatic writing. In post-war Europe, the artists grouped under the label Tachism produced paintings with swiftly registered, calligraphic signs and broad brushstrokes, which had the spontaneity associated with automatism.

H. Ellenberger: *The Discovery of the Unconscious* (New York, 1970)

J. Gibson: 'Surrealism before Freud; Dynamic Psychiatry's "Simple Recording Instrument"', *Art Journal* [New York], xlvi/1 (1987), pp. 56–60

I. Dervaux: 'Surrealism and Abstract Expressionism: From Psychic to Plastic Automatism', *Surrealism USA* (exh. cat. by I. Dervaux; New York, National Academy Museum; Phoenix, AZ, Art Museum; 2005)

Aux trois crayons [Fr.: 'with three chalks']. Term applied to a drawing in black, red and white chalks, often carried out on tinted paper; the technique was particularly employed by Antoine Watteau (1684–1721), among others, in the early part of the 18th century. The variant terms *aux deux crayons* (black and red chalks) and *aux quatre crayons* (black, white and two shades of red chalk) are occasionally also used.

Avant-garde film. See EXPERIMENTAL FILM.

B

Bamboo. Common name given to members of the variety *Bambuseae* of the grass family (*Gramineae*), found mainly in tropical and sub-tropical regions. Some 76 genera and over 1000 species have been described; one of the smallest is *Arundinaria pygmaeus*, which grows to *c.* 300–400 mm in height; the largest, the Himalayan *Bambusa gigantea*, can reach 30 m in height, with a diameter of 300 mm. Bamboo is an extremely versatile material that has a wide variety of uses in Africa, Asia and South America, including construction, food preparation and service, medicine, arms and armour, basketry, furniture making and paper making. Bamboo has long been associated with the arts in East Asia, where it is both the raw material for the implements of calligraphers and painters and a popular theme in literati ink-painting. As a decorative motif, it is ubiquitous, being found on lacquerware, metalwork and ceramics.

1. TECHNIQUES AND TOOLS. The hollow stems, or culms, of the bamboo plant divide at the internode to form cylindrical, boxlike structures. The canes can be split longitudinally into pliable, even lengths, seasoned bamboo being used except in basketwork. Unseasoned bamboo is easier to work than dried or soaked material, and it has the added advantage for basketwork of shrinking slightly as it dries. The tools required for basketwork include a sharp knife or shears for trimming, a bodkin for opening holes in tight weaves to insert new canes, and a beater or commander to settle horizontal lines. For most other uses, bamboo must be seasoned, and woodworking tools—saws, drills, rasps and hammers—are required to work with the dried and hardened material. Conventional woodworking joints are used, e.g. butt, tenon, mortice and mitre joints; these must be modified to compensate for the hollowness of bamboo. For joining sections of bamboo lengthwise, wooden dowels are glued inside joints and are then drilled and pinned with pegs. When a butt joint is employed, the end of the stud is filed to match the profile of the cross-piece. Joints are often reinforced by binding with split bamboo. Bamboo may be shaped by heating and bending over a form.

2. USES. In parts of Africa, India, China and South-east Asia, entire houses are made of bamboo; in areas where wood or other materials are used for the main construction, bamboo may be used for certain functional features or to provide a decorative element. The Toraja of Sulawesi in Indonesia roof their rice barns with bamboo shingles, and traditional houses throughout Indonesia are often thatched with cuscus grass fixed to horizontal bamboo ledgers. In Japan bamboo is used in the construction of traditional buildings such as teahouses, particularly gutters, spouts, balcony rails, interior panelling and the trusses for thatched roofs. Bamboo is still used throughout East Asia for constructing bridges, except in Japan; even there it is used for decorative garden bridges. Fences and enclosures of all kinds are made of bamboo. The Japanese produce a wide variety of decorative garden fences made of woven bamboo. Barely modified canes are used as water conduits for garden and farm use.

One of the most common and widespread uses of bamboo is for making containers. These come in two forms: those made from a segment or segments of a cane, retaining the internodal septum to form a bottom, as in the brushpots of East Asia, and baskets made from woven canes (*see* BASKETWORK). Bamboo is carved into decorative and functional objects, ranging from pipes in Vietnam to *netsuke* in Japan. The Toba Batak of northern Sumatra use bamboo containers decorated with incised texts of divination, spells and magic formulae in Batak language and script, and with geometric designs. The Toraja and other South-east Asian groups decorate containers similarly with incised geometric patterns accentuated with pigment. These containers are sometimes fitted with carved hardwood stoppers bound with intricately woven rattan bands and mounted with carved horn or wood hangers.

The flexibility of bamboo makes it an ideal material for bows, which can be made from simple, split and shaped poles, such as those used in New Guinea, or complex laminates, such as Japanese *kyūdō* ('way of the bow', traditional Japanese archery) bows. Arrows and quivers are also made of bamboo. Bamboo clappers, rattles, slit gongs and Jews' harps are made in several parts of Asia. The *angklung* is a rattle found only in West Java, Indonesia. It is composed of two bamboo tubes in a bamboo frame, which emit a single note when shaken. The most common instrument made from bamboo is the pipe or flute, an example of which is the multi-piped mouth organ. The double

Bamboo woven vest, from south-west China, 20th century (private collection); photo © François Guenet/Art Resource, NY

clarinet is found in countries as far apart as Brazil, among the Dayak people of Borneo and India. Bamboo flutes, end blown (known in Japan as *shakuhachi*) and side blown (Chin. *dizi*; Jap. *fuye*) are found in many regions. Before the invention of paper, books were made of bamboo tablets and silk; bamboo is also used as a raw material for making paper. Other common uses include equipment for sports and games (e.g. polo sticks, mahjong sets) and shipbuilding (e.g. masts, spars and other fittings, as well as whole rafts) and even for clothing (see fig.). Bamboo furniture is common virtually throughout the world.

Annotated Bibliography on Bamboo, Forest Research Institute (Dehra Dun, India, 1960)

F. A. McClure: *The Bamboos: A Fresh Perspective* (Cambridge, MA, 1966)

G. R. G. Worcester: *Sail and Sweep in China* (London, 1966)

B. Hickman: *Japanese Craft Materials and their Application* (London, 1977)

K. Ueda, R. Austin and D. Levy: *Bamboo* (Tokyo, 1981)

D. Farrelly: *The Book of Bamboo* (San Francisco, 1984)

I. Tadashi and Y. Mitsukuni, eds: *Wood and Bamboo* (1992), v of *The Traditional Crafts of Japan* (Tokyo, 1992)

N. M. Bess: *Bamboo in Japan* (Tokyo, 2001)

M. McArthur: *The Arts of Asia: Materials, Techniques, Styles* (London, 2005)

Basketwork. Artefacts of more or less rigid construction produced by the interlacing of linear materials (see fig. 1). Basketwork is of considerable antiquity (dating from at least 8000 BC in Egypt and Peru) and in one form or other has been practised almost everywhere in the world.

1. Materials. 2. Techniques. 3. Uses.

1. MATERIALS. Basketry materials vary according to the environment of the basketmaker: the wood, bark, roots, shoots, stems, leaves and fibre of hundreds of trees and plants can be used. With few exceptions, these materials take time to find, select, gather and prepare. Many require pounding, stripping, splitting, gauging, drying, dyeing, bleaching or soaking before they can be used. The acquisition and preparation of materials often takes longer than the actual making of the basket.

Many of the baskets of northern and western Europe are made from rods of osier or basket willow. In North America splint baskets are made from split ash, oak, maple and hickory in the east; cedar bark, spruce root and grasses are the traditional materials on the north-west coast. Californian baskets are made from willow and hazel shoots, conifer roots, ferns, sedges and rushes; in the south-west, sumac, willow and cotton-wood shoots, yucca leaves and beargrass are commonly found. In Central and South America palm leaves and various types of cane and bamboo are employed. Pandanus and the fronds of the coconut palm are used throughout the Pacific, while the Maoris employ New Zealand flax (*Phormium tenax*). In South and South-east Asia cane and bamboo are the preferred materials. African basketmakers employ palm leaves, raffia, cane and grasses; sparto grass is used extensively in North Africa and southern Spain.

Many other materials, including reeds, rushes, straws and vines, can also be employed in basket construction; unusual examples include the baskets made of cloves in Ambon in the Moluccas and of rice grains in eastern India. To make the former, cloves are placed side by side in rows, their heads pointing in alternate directions. Two threads are then sewn through each row of cloves to make it rigid. The rigid rows are placed together to form the desired shape and joined with occasional stitches. Borders and details are formed with strings of cloves threaded

1. Various items of basketwork: lidded box, made by Kuba peoples, Congo (Zaïre); back apron (*negbe*), made by Mangbetu peoples, Congo (Zaïre); lidded basket, made by Tutsi peoples, Burundi; nested baskets, made by Tusyan peoples, Burkina Faso (Washington, DC, National Museum of African Art); photo credit: Aldo Tutino/Art Resource, NY

end to end. For the latter, rice grains are placed side by side in rows, each row sandwiched between two slender cane splints to which the grains are securely lashed with thread. The rigid rows are then overlapped within a cane framework to make a rigid structure.

Decoration may be added to baskets in the form of painting (e.g. in Australia), feathers and beads (e.g. in California), cowrie shells (Nigeria) or strips of leather (East Africa). In South Sumatra ceremonial food baskets are sometimes coated inside and out with layers of black or red lacquer with an underlayer of gold leaf. Recent developments include baskets made of coloured plastic-coated telephone wire (southern Africa) and metal wire (the Tohono O'Odham people of southern Arizona).

2. TECHNIQUES. While basketmakers and scholars are in general accord regarding the concepts of basketmaking, no universal set of terms has been agreed upon. The following is a guide to the basic techniques, more than one of which may be combined in the same basket.

Stake and strand baskets are woven in much the same way as textiles, but without the aid of a loom. The warp and weft, which may be of different materials and widths, are interlaced at right angles to produce a fabric. The warp elements remain passive, while the weft passes actively over and under them, one row at a time. Many European willow baskets are of stake and strand construction, and the technique is found in many other parts of the world, particularly in Asia and the Americas.

Twined baskets are woven using two or more wefts at once, crossing over each other at intervals between the warps. In the simplest form of twining, two wefts cross between each warp; in wrapped twining, one weft remains passive, while the other binds it to the warps. There are particularly fine twined basketry traditions in California, on the north-west coast of North America and in Australia. Twining is found on openwork fish-traps in many parts of the world.

Plaited baskets are made with two or more sets of elements, usually all of the same material and width; there is no distinction between warp and weft, all elements being equally active. The use of three sets of elements results in a hexagonal lattice. Plaiting with palm fronds can produce a variety of interesting shapes, as seen in the baskets of the Amazon rain forest and Polynesia.

Twill effects can be produced on woven, twined and plaited baskets by passing elements over and under particular combinations of the opposing set (e.g. over two, under two) and shifting each successive row to the left or right to produce a diagonal pattern. The twilled baskets of Sarawak, Malaysia and the Amazon are particularly fine.

Rib baskets, which tend to be oval in shape, are woven over a rigid framework. They seem to be of European origin and are also made in south-eastern North America and in the West Indies (see fig. 2).

2. Basketwork using willow reeds shown in *Aunt Cord Ritchie and Family, Hindman, Kentucky*, platinum print by Doris Ulmann, 200×152 mm, *c.* 1932–4 (Los Angeles, CA, J. Paul Getty Museum); photo credit: The J. Paul Getty Museum

Coiled baskets are made by a sewing process, built up spirally from the centre of the base. The two elements involved are the foundation—one or more rods or a bundle—and the sewing material, which simultaneously binds the foundation and stitches the coils together). The related technique of looping, more widely used for bags and nets, does not involve a foundation; a row of loops is first created around a holding thread, and subsequent rows link into the previous row. Coiled baskets were made in ancient Egypt and have a long history in the rest of Africa, the Middle East and the Americas; they are also made in India and the Pacific. The early tradition of coiled basketry in northern Europe (e.g. in Iceland, Scandinavia and the Orkney, Shetland and Faroe islands) has few exponents in the 21st century.

3. Uses. Baskets have a multitude of functions, one of the most obvious being transport. Burden baskets are used universally for collecting firewood, gathering food and taking produce to market. Such baskets might be balanced on the head, as in Guatemala, slung on each end of a pole, as in China and Japan, carried by means of a tump-line round the forehead, as in South America, or hung on the arm, as with European market baskets. Basketwork cages transport live birds, pack-animals carry panniers, mothers shoulder baby-baskets, and children take books to school in basketry satchels. The basket is an indispensable accessory for the cyclist. Nor is basketwork restricted to land transport: the coracle is a floating basket, and balloon passengers have always travelled by basket.

Baskets are also closely connected with food. They are used for sowing, harvesting, winnowing and storing grain. Many special designs are used for catching and transporting different kinds of fish; traps, for example those made by the Akawaio

Indians of Guyana, have an internal structure that allows fish to swim in easily but not to escape. In the Amazon region a whole range of baskets is needed to process poisonous bitter manioc into nutritious cassava flour and bread. In Japan baskets are used as ventilated containers for cooked rice. On the west coast of North America finely made baskets were used to hold liquids; cooking was done by dropping hot stones into baskets of soup or stew. Baskets are used all over the world to serve and protect all kinds of food.

Basketwork clothing takes the form of shoes, hats and rain-shields. Basketwork used for defence includes the body armour of Kiribati in Micronesia and the shields used by the ancient Romans, by many African tribes and by the Nagas of Nagaland in north-eastern India. Basketry is used to make blowpipe dart quivers and spear grips in tropical South America; it was also used for gun emplacements in Europe until the early 19th century and for shell-cases until World War I. Baskets have often been used ceremonially to hold shamanic equipment and medicines; they also form the basis of many masks (e.g. the female crest masks of the Jukun of Nigeria) and are used in dances. They may be given to people on special occasions, such as weddings, or buried or burnt with their owners after death.

Baskets can take the form of clothes chests, trinket boxes, sewing baskets, tobacco-pouches, purses, fans, toys, laundry baskets, magazine racks, wastepaper baskets, lampshades, coffee-tables and plant-pots. Although mass-produced containers have superseded some baskets, new shapes are developing constantly, both in response to the tourist and craft markets and as contemporary basketry takes on a more sculptural dimension.

See also FIBRE ART.

E. Rossbach: *Baskets as Textile Art* (London, 1973)

D. Wright: *The Complete Book of Baskets and Basketry* (London, 1977/R 1983)

J. L. Larsen: *Interlacing: The Elemental Fabric* (Tokyo, New York and San Francisco, 1979)

K. Kudo: *Japanese Bamboo Baskets* (Tokyo, New York and San Francisco, 1980)

D. M. Guss: *To Weave and Sing: Art, Symbol and Narrative in the South American Rain Forest* (Berkeley, 1989)

W. Arbeit: *Baskets in Polynesia* (Honolulu, 1990)

L. Mowat, H. Morphy and P. Dransart, eds: *Basketmakers: Meaning and Form in Native American Baskets*, Pitt Rivers Museum, Monograph 5 (Oxford, 1992)

N. Odegaard: 'Basketry: An Introduction to Materials, Techniques and Conservation', *American Indian Art*, xxiv/3 (Summer 1999), pp. 34–43

W. Wendrich: *The World According to Basketry: An Ethnoarchaeological Interpretation of Basketry Production in Egypt* (Leiden, 1999)

B. Sentance: *Basketry: A World Guide to Traditional Techniques* (London, 2001); as *Art of the Basket: Traditional Basketry from Around the World* (New York, 2001)

M. Butcher: *Contemporary International Basketmaking* (London, 2004)

Bas relief [low relief; It. *basso-relievo*]. Term for carving, embossing or casting that protrudes only moderately from the background plane (*see* RELIEF SCULPTURE).

Batik. Resist dyeing technique. Patterns are created on cloth (usually undyed cotton or silk) by painting, printing or stencilling designs in wax, rice or cassava paste, mud or some other dye-resistant substance on to those areas intended to retain their original colour after dyeing. Further patterns and colours can be introduced by altering or adding to the resist areas before re-dyeing. Finally, the resist media are removed by rubbing or washing. Delicate lines within the patterns, where the resist substance has cracked and allowed the dye to seep in, are characteristic of the technique.

The term batik is thought to derive from the Malay *tik*, to drip or drop, but exactly where and when the technique was first practised is uncertain; it seems likely that the principle was discovered independently in several different areas. The earliest known batiks (London, Victoria and Albert Museum, nos 1552–1899 and 1103–1900; Basle, Museum für Völkerkunde), dated to the 5th–6th century AD, were excavated in Egypt and included a linen cloth with white patterns showing biblical scenes on a blue background (Bühler). Indigo blue was the commonest early dye: it is especially suitable for batik as the indigo dye process does not involve heat, which might destroy the resist. Cotton fragments dated to the 12th–16th centuries excavated at al-Fustat, Cairo, may have been imported from India, where batik is believed to have flourished from the 5th century AD. Although no Indian examples have survived from that time, 6th–7th-century AD frescoes at Ajanta, Maharashtra, show garments decorated with batik-type patterns, suggesting contemporary knowledge of the technique. Indian batik (New Delhi, National Museum) export has been documented since the 17th century, and painted, stamped and woodblock-printed cotton and silk resist textiles continue to be produced in the subcontinent (Udaipur, Batik Art Research and Training Institute).

Excavations in Central Asia at Loulan and Kucha in Xinjiang have yielded many examples of batik textiles (Beijing, Historical Museum; Guizhou, Batik Art Academy), mainly dated to the 7th–11th centuries. Some silk batiks may have been imported to China, but local production is suggested by the patterned garments shown in wall paintings at Kucha Oasis. The oldest examples of Japanese wax resist textiles (*rōkechi*) are in the Shōsōin repository of imperial treasures, Nara, and belong to the Nara period (AD 710–94). They include silk screens representing trees, mountains and animals on glowing yellow, green, red or dark-blue backgrounds. These designs appear to have been painted free-hand, but other textiles (Tokyo, National Museum; Osaka, National Museum of Ethnology) suggest resist application by stamping, block-printing or stencilling. Some wax and rice paste resist textiles are still produced in Japan (Kyoto, Juraku

International Textile Centre). There is also a long and continuous tradition of batik production among the Miao (Hmong) hill peoples of southern China and northern Thailand, who draw geometric patterns with wax on to hemp and cotton using a pen. This practise probably predates the flourishing silk batik trade of the Tang period (AD 618–907), through which batik textiles and techniques could have spread to other parts of the world.

However, the best-known batiks are produced in South-east Asia, chiefly in Indonesia. Batik-like patterns are represented on the walls of the Loro Longgrang Temple at Prambanan (c. AD 800) and also in sculpture. There is an ancient tradition of rice paste resist batik cotton cloth (*kain simbut*) in West Java (Yogyakarta, Batik Research Centre) and the Toraja region of Sulawesi. Wax batik, especially in Java, was perfected by the Indonesian invention of the wax applicator (*chanting*): this consists of a bamboo handle attached to a small brass container for hot wax, which is applied to the cloth through a curved spout. The batik artist, usually a woman, uses a number of *chantings* with spouts of different diameters, which allow her to draw, free-hand, an immense variety of patterns: mythical or geometric, or derived from plants, animals or clouds. The design is usually drawn on both sides of the cloth to ensure complete exclusion of the dye. Natural dyes used include the different shades of indigo blue, yellow (rare), red and brown. As the demand for Indonesian batik increased in the 19th century, metal stamps (*caps*) came into use for applying the hot wax to the cloth more speedily. The *cap*, which is usually operated by men, consists of thin, shaped copper strips fastened together with pins soldered on to a metal base with a handle on the reverse side. The repetitive *cap* batik print is less valued than batik *tulis* (writing) drawn with a *chanting*. Both techniques are also practised in Malaysia, especially Kelantan. In the mid-19th century a number of Dutch factories developed a mechanical process for reproducing Indonesian batiks.

In Africa, resist dyeing (e.g. London, British Museum, Department of Ethnography; Lagos, National Museum) is an ancient tradition that is still practised, with the main centres of production in West Africa, in Nigeria, Senegal, Sierra Leone and the Gambia. Cassava and rice paste, applied with palm fronds, brushes, sticks, woodblocks or stencils, were originally used, but in the late 20th century hand-painted wax batiks depicting African scenes and motifs became popular. In Senegal, the Soninke people cover the whole cloth with rice paste, which is then combed to form line patterns into which the dye can penetrate. In Mali the Bamana people practise a discharge-dye method called *bogolanfini*: the cloth is initially coloured with a yellow dye before passing through several processes, involving the application of designs using mud and caustic soap, to produce eventually a light-coloured design on a dark background (Picton and Mack). Batik methods have spread to many parts of the world. The best-known centres that continue to flourish are found in

Indonesia, Malaysia, India and Africa. While traditional designs are still made, the 20th-century trend is to follow contemporary fashion in design and home decoration, often using synthetic rather than natural dyes, to achieve a wide colour range. Individual artists and designers in the older established centres and elsewhere, including Europe, have discovered in batik methods a new creative medium of expression.

See also TEXTILE, §III, 1(ii)(b).

G. P. Rouffaer and H. H. Juynboll: *Die Batik-Kunst in Niederländisch-Indien und ihre Geschichte* (Utrecht, 1914)

J. Marzuki, N. Tirtaamidjaja and B. R. C. O. G. Anderson: *Batik, Pola and Tjorak: Pattern and Motif* (Jakarta, 1966)

A. Bühler: *Ikat, Batik, Plangi*, 3 vols (Basle, 1972)

J. L. Larsen, with A. Bühler, B. Solyom and G. Solyom: *The Dyer's Art* (New York, 1976)

J. Picton and J. Mack: *African Textiles* (London, 1979/R 1989)

S. Fraser-Lu: *Indonesian Batik* (Singapore, 1986)

N. Dyrendorth: *The Techniques of Batik* (London, 1988)

M. Hitchcock: *Indonesian Textiles* (London, 1991)

J. Gillow: *Traditional Indonesian Textiles* (London, 1992)

R. Heringa and H. C. Veldhuisen: *Fabric of Enchantment: Batik from the North Coast of Java* (Los Angeles, 1996)

K. J. Saunders: *Contemporary Tie and Dye Textiles of Indonesia* (Kuala Lumpar, 1997)

F. Kerlogue: *Batik: Design, Style & History* (London, 2004)

Beadwork. Decorative assembly of beads, usually incorporated into a piece of weaving, netting or knitting or sewn on to a ground. At its simplest, beadwork is just a string of beads, but the term is generally applied to more elaborate constructions.

1. Materials and techniques. 2. History and uses.

1. MATERIALS AND TECHNIQUES. Beads are made from a vast range of natural and manmade materials: metals, including gold and silver, stones, whether hard, soft or gemstone, ivory, amber, shells, pearls and coral, bones and seed pods, glass and faience (see colour pl. II, fig. 3). The beads may be fashioned in a simple, even crude, manner, or be intricately worked and decorated. There are many techniques for constructing beadwork (Orchard, 1929; Clabburn, 1980). Bead fabric can be woven on an ordinary loom, but with the weft, on which the beads are threaded, just laid across the warps and secured (with a bead between each pair of warps) by the same weft passing in reverse direction below the warps and through the holes in the beads. Alternatively, it is 'woven' from an upper thread with 'warps' hanging down vertically, on which the beads are strung. Non-woven bead fabric is made by using detached buttonhole or simple loop stitches to thread the beads into a mesh, which may be spaced either widely or densely, as in French *sablé* (Fr.: 'covered with sand') work (*see* §2(iii) below). To obtain a good three-dimensional shape the beads can be worked around a mould which may or may not be removed later. In knitting or crocheting, the beads are threaded on to the yarn and worked into the fabric at the appropriate point.

When beads are applied to fabric or leather they may be sewn on singly (spot stitch) or several at a time. In 'lazy stitch', for example, several beads are strung together and secured only by a stitch at either end; this can be repeated in regular rows to cover a field with beads, as in an Orang Bukit coat. In couching, the beads are threaded on to a string that is secured by stitches at intervals from the underside, while in tambourwork (a quick method, used in Europe from the late 18th century) the beads are held in a chain-stitch. Beads can also be used in canvaswork, alone or with other yarns. The Cornely or Bonnaz machine has been used for commercial beading since the late 1890s.

It is not always necessary to have a ground fabric. Beads can be strung on to wire, which is then formed into a stiff, free-standing construction; or on to a thread that is later wound around a rigid core. Fringes and tassels are threaded and tied. The thread may be an indicator of origin. Sinew thread, used by the Plains Indians of North America or the Bantu of southern and eastern Africa, points to a hunting or pastoral economy, as does the use of leather thonging. Raffia thread shows that the beadwork comes from a country such as the Democratic Republic of Congo (formerly Zaïre), where raffia is much used. Handspun cotton thread may indicate South America or West Africa. Machine-spun thread is universally found.

2. HISTORY AND USES. Primitive beads are known from the advent of *Homo sapiens* 40,000 years ago. Few examples exist from this early date, but they appear in numbers from the Upper Palaeolithic period (38,000–8000 BC). The first beads were simply grooved pebbles, bones, teeth etc, but by 16,000 BC abrasives and bow-drills were being used to form and drill beads from other materials. From the beginning beads had talismanic and symbolic connotations, which have continued to this day. These, and the desirability and rarity of particular materials, meant that beads were highly valued, and there is clear archaeological evidence that they have been traded since the earliest times. It is probable, for example, that etched cornelian beads were being exported from the Indus Valley to Sumer as early as 2500 BC.

From the mid-15th century AD beads were used as currency, either singly or in strings, by explorers, traders and missionaries. In pre-industrial societies beads were painstakingly handmade from such materials as stone, shell, wood and metal, so glass and other imported beads constituted an exchange medium that was highly valued for its rarity and novelty; at the same time it cost the foreign supplier little and was a means of getting trade goods cheaply. Venice, the chief source of glass trade beads in the Western world, supplied them strung on cotton threads, bunched according to number, or, in the case of the small 'seed' beads, by weight, hence the alternative name of 'pound' beads. These beads went by the shipload to Africa and the Americas to be traded for ivory, slaves, furs and other commodities.

Wampum is a form of currency beadwork. It was made and used in eastern North America as an exchange medium between Native American groups of the coastal and interior regions, as well as Europeans. Traditional wampum beads are 7 mm long by 3–4 mm in diameter and are made of the hard quahog seashell (*Mercenaria mercenaria*), which has a purple interior. These beads seem to have been produced after the arrival of the Europeans, when iron awls became available; before that, wampum beads were made of wood. Purple beads were more valued than white, which might also have been made from conch shells. Wampum came in currency strings, in jewellery or threaded into belts.

Beadwork was sometimes used as a form of communication. The design on a wampum belt, for example, could encode a message or ratify a treaty, and the beadwork 'love-letters' of the Zulu used colour symbolism and bead-stringing order to convey messages from a girl to her betrothed. Generally, however, beadwork has been used for personal adornment, ceremonial and talismanic purposes and, in Europe, for craftwork and various objects.

(i) Personal adornment. In this context beadwork may be found in jewellery or in clothing. Almost any part of the body can be ornamented, and there is hardly any part of the world where such ornamentation has not occurred. The first-known examples date from *c.* 28,000 BC and include shell, stone and ivory. Later jet, amber, cornelian, lapis lazuli and gold were utilized. Beadwork often reflects the status of the wearer, distinguishing him or her as of royal or noble blood, of the priesthood, or as a headman. Elaborate bead ornaments worn by deceased royalty have been found, for example, in ancient sites in the Middle East, Egypt and Mesoamerica (e.g. the bead cloak of Queen Pu-abi from the Royal Cemetery at Ur, 2500 BC; Philadelphia, PA, University of Pennsylvania, University Museum; and the pectoral from the grave of Tutankhamun, *c.* 1323 BC; Cairo, Egyptian Museum). Beadwork may also indicate the age and personal circumstances of the wearer. Among women, unmarried girls, brides, young mothers, senior wives and widows may all wear different bead ornaments to show their position, especially at weddings and special occasions. In the Americas, Africa and much of Asia, beadwork is also a sign of tribal identity.

Beadwork for personal adornment is seen most notably among the Plains Indians of North America, who wore beaded leather garments and moccasins, and in eastern and southern Africa, where the pastoral tribes in particular use beaded leather aprons, cloaks and blankets to indicate a woman's age and identity. Further examples include the Native Americans of Guyana, who also wear beaded pubic aprons; the Greenland Eskimos, who wear beadmesh shoulder capes over their fur clothing; and the tribeswomen of Mongolia and Thailand, whose headdresses include rich assemblies of coral, amber and turquoise beads.

In Europe jet and imitation jet beads were lavishly applied to mourning and other day clothes during the later 19th century; a wider range of beads was used for evening dresses, particularly *c.* 1900. After the more severe styles of the 1910s, beads and sequins again dominated evening dresses in the 1920s, and solidly beaded handbags and garments retained their popularity into the 1930s.

(ii) Ceremonial and talismanic uses. The bead cloak from Ur is one of many instances in which beadwork is used to identify and set apart those in high position, often royalty and court officials. Royal burials in Mesoamerica have been similarly identified by the presence of fine jade necklaces, and in Egypt the bead ornaments in royal burials included protective gold amulets. Beaded child's garments found in the tomb of Tutankhamun confirm that beadwork was not restricted to a funerary context. Although evidence is scant, it is likely that beadwork collars were worn by both sexes on such ceremonial occasions as banquets; high-ranking ladies also wore elaborate beaded overdresses on top of their simple, everyday linen shifts. A king, his family and court might wear elaborate beadwork; late 20th-century examples include the *oba* of Benin, Nigeria, with his coral bead headdress, collars and tunic, and the king of the Kuba of the Congo (Zaïre), whose state costume, covered with beads and cowrie shells, weighs 84 kg, comprises almost 50 elements and takes hours to put on. The priesthood in a tribal society is often marked out by its beaded regalia; examples include the Ifa diviners among the Yoruba of Nigeria and the Xhosa diviners of South Africa, who wear white bead ornaments signifying purity. In Tibet the tantric priests wore aprons made of beads fashioned from human bones as a reminder of the transience of earthly life.

Through the ages grave goods have included beadwork: for instance, the shell and stone beads used by the Indus Valley civilization of the Indian subcontinent; the jet necklaces in Neolithic European burials; and the ancient Egyptian mummy shrouds, made of a network of blue faience beads or of amulets (gods' faces and scarabs) in white, black, blue and terracotta disk beads. Anglo-Saxon graves contained strings of beads with amber from the Baltic and mosaic beads from the eastern Mediterranean, showing how beads were traded over great distances. From the Chimú culture (*c.* AD 1200–*c.* 1470) of Peru come pectoral collars made of small disk beads strung on cotton with a mosaic-like design in pink and red *Spondylus* shells, other white shells and greenstone. In France and Germany, during the 19th and 20th centuries up to *c.* 1950, funeral wreaths were made of beads strung on wire and shaped into flowers and crosses (e.g. white beads from Paris, Père-Lachaise Cemetery; Santa Fe, NM, Museum of International Folk Art).

Weddings are an occasion of celebration and display. In Saurashtra, western India, a woman's dowry may include friezes to hang above the doorway and square hangings made of mesh-sewn seed beads. The bridegroom might wear a beaded bridal sash and pouch and receive a beadwork *parchese* gaming board. Among the Straits Chinese of Malaysia during the 19th century, women of good family spent much of their time threading or embroidering ornaments with minuscule glass beads for use as decorations for the wedding bed or as room-hangings or table-covers. Elsewhere, the dowry necklace may include beadwork: of coral, as in Italy, Romania and Poland, where the red colour is thought to bring good luck and fertility; of heirloom or amber beads, as in parts of Africa; or of silver, turquoise and lapis lazuli, along with silver coins, as in Asia. Brides among the Iraqw of Tanzania, the Maasai of Kenya and the Ndebele of South Africa may wear beautiful beaded wedding skirts and other finery. Ornaments in the form of long, beaded, conical hanging baskets decorate the wedding house in Ethiopia, and a Kamba bride from Kenya serves her husband his first meal in a specially beaded gourd, which later becomes a house ornament.

Beadwork may single out individuals who are important to the community, especially babies. The Plains Indians of North America and some Dayak peoples of Sarawak make elaborately beaded baby-carriers to protect the infant during its first vulnerable months of life; in Africa a pregnant Zulu woman may wear as a 'maternity apron' a beaded skin, which later becomes the baby's carrying-skin; a string of beads on a baby's neck may include a charm against infant sicknesses. Also, among many African peoples, a beaded doll is a charm to ensure pregnancy or cure sterility.

(iii) Craftwork and other uses. Beadwork in Europe dates back at least to the medieval period, when glass beads, coral and pearls were used for embroidery. In the 17th century it flourished in England, where young ladies were expected to complete a series of needlework projects that often included beadwork. These could take the form of pictures, gloves, purses and, occasionally, jewellery boxes, with the beads embroidered in spot stitch on to a satin ground. Elaborate baskets were made entirely of beads threaded on to wire. In the 18th century the finest beadwork, *sablé* work, was made in Paris in professional workshops, using tiny, densely worked glass beads. It was made into such small, luxurious items as parasol handles, purses, needlecases, perfume bottles and boxes, using designs taken from contemporary engravings. One particular collection of this beadwork, in the Museum of Fine Arts, Boston, MA, includes a design reflecting the craze for ballooning that took place in the 1780s and 1790s.

Professional beadwork continued into the 19th century, particularly in Germany where there was a home-based industry in beaded bags and purses dating back to the 17th century. Professional patterns were used, and the beads (larger than those used for *sablé* work) were obtained from Bohemia. There was also a fashion for beaded caps, knitted or crocheted with very fine yarn and tiny beads. In the middle of

the century, however, there was a surge in craftwork, and beading became a favourite pastime; in England this was encouraged by the abolition in 1845 of the excise duty on glass, which had included beads. A number of magazines published patterns for beadwork, the most popular items being purses to be knitted, netted or crocheted. Beads were often used to highlight Berlin woolwork, a highly fashionable, rather garish form of canvaswork, which was made up into a variety of household objects (firescreens, cushion-covers, pipecases, slippers etc). In the early 20th century, from *c.* 1913 to the 1920s, 'Indian' beadwork strips, made on table looms from printed patterns, were popular for decorative wristbands and belts.

W. C. Orchard: *Beads and Beadwork of the American Indians*, Contributions from the Museum of the American Indian, Heye Foundation, xi (New York, 1929, rev. 1975)

L. Salmon: 'Ballooning: Accessories after the Fact', *Dress*, ii (1976), pp. 1–9

P. Clabburn: *Beadwork* (Princes Risborough, 1980)

V. Foster: *Bags and Purses* (London, 1982)

L. von Wilkens: '"Baderleins geschnür und geschling" über Perlenarbeiten im 17. und 18. Jahrhundert', *Kunst und Antiquitäten* (1982), pp. 58–63

M. Carey: *Beads and Beadwork of East and South Africa* (Princes Risborough, 1986)

L. S. Dubin: *The History of Beads from 30,000 BC to the Present* (London, 1987)

Wing Meng Ho: *Straits Chinese Beadwork and Embroidery* (Singapore, 1987)

J. Mack, ed.: *Ethnic Jewellery* (London, 1988)

L. D. Sciana and J. B. Eicher, eds: *Beads and Bead Makers: Gender, Material Culture, and Meaning* (Oxford, 1998)

L. S. Dubin: *North American Indian Jewelry and Adornment: From Prehistory to the Present* (New York, 1999)

M. M. Wright: *Ethnographic Beadwork: Aspects of Manufacture, Use and Conservation* (London, 2001)

P. Francis: *Asia's Maritime Bead Trade: 300 BC to the Present* (Honolulu, 2002)

C. Crabtree and P. Stallebrass: *Beadwork: A World Guide*

J. W. Lankton: *A Bead Timeline: A Resource for Identification, Classification and Dating* (Washinton, DC, 2003)

Ben Day dots [Benday prints]. Manufactured transparent celluloid sheets of tints consisting of dots or a variety of patterns used widely in blockmaking and lithography to add texture, shading and detail to artwork and designs. The name derives from Benjamin Day (1836–1916), a printer from New Jersey, USA, who was the first to patent and sell 'shading mediums' in 1879. They have been used, for example, by Roy Lichtenstein (1923–97) in his Pop art enlarged cartoon strip images.

Bistre. Warm brown, transparent pigment obtained by boiling the soot from a wood fire. It may also have been produced by burning resin or peat. Its history is uncertain, as references to the use of soot, even if they imply a brown colouring rather than a black, are often too vague to be associated with bistre. As well as being used as a watercolour, bistre tended to be used alone as a monochrome wash, and its name is associated with the shading of drawings in that way; however, the extent of its use is unclear because Van Dyck brown, Cologne earth, sepia and various inks all produce effects that are difficult to differentiate from bistre. It was listed by name in the 17th century by Sir Théodore Turquet de Mayerne (London, British Library, MSS Sloane 1990 and 2052), although it was not mentioned with any frequency in England until the following century, when watercolour methods began to develop. Around the beginning of the 19th century it was eclipsed by sepia.

See also DRAWING, §III, INK, §I, 1(ii)(a), and PIGMENT, §IV.

R. D. Harley: *Artists' Pigments, c. 1600–1835: A Study in English Documentary Sources* (London, 1970, rev. 2/2001)

R. L. Feller, ed.: *Artists' Pigments: A Handbook of their History and Characteristics* (Washington, DC, 1986)

Bite. Printmaking term used to describe the chemical action of acid etching or 'eating' into a metal plate. Back-biting describes the irregular and sideways action of acid on an etched line (*see also* ETCHING and FOUL-BITING).

Bitumen. Dark brown solution of asphalt, a naturally occurring petroleum residue, dissolved in oil or turpentine and used as a brown oil paint from the 17th century to the 19th. It shows undesirable characteristics on ageing, as it never completely dries and, when applied in thick films, forms a network of broad cracks resembling an alligator's skin, revealing the ground colour below. The use of bitumen is evident in many paintings by Joshua Reynolds (1723–92) and his contemporaries.

Bladder colours. Ready-mixed oil paints, prepared commercially and contained in a bladder of animal membrane. The bladder was pierced and resealed with a tack of metal or bone, and the paint remained usable for several months. Bladder colours were available from the mid-17th century until the 1840s, when they were superseded by metallic tubes.

Blanching of paint. Cloudy discoloration of an oil paint film caused by the breakdown of the binding medium or the pigment. The effect may occur within the film or on the surface below the varnish. Blanching is the result, among other things, of the action of moisture and heat (e.g. during lining), the action of solvents during cleaning or the chemical instability of certain pigments in oil.

Bleed (i). Term used in printing to describe that part of an image that extends beyond the intended edge or trimline of a page. An illustration that is 'bled-off' has no margin.

Bleed (ii). Seeping and spreading of one colour into another. Bleeding occurs with watercolour washes, when two colours are applied next to each other. In other forms of painting, bleeding can take place

when an under layer of paint seeps through to the upper surface. It is in order to prevent this phenomenon that pigments used in oil painting must be insoluble in oil.

Blender. Flared brush, often of badger hair, used dry, with a vertical stippling action, to blend two areas of freshly applied oil paint.

Blind-blocked [blind-stamped; blind-tooled]. Method in which a design on a block (or die or tool) is impressed into a surface without the use of any ink (see BOOKBINDING, EMBOSSING and LEATHER).

Blister. Raised area of paint that has become detached from the ground or support due to faulty technique or to unfavourable environmental conditions, such as extremes of humidity. Blistering, also known as cleavage, may develop into flaking and the loss of paint fragments.

Block. In printing, a solid material, usually wood (rather than a metal plate), which can be engraved or cut and used to print on to a surface.

Bloom. Misty surface coating that occurs on certain oil paintings with natural resin varnish films, especially of mastic. It diminishes the transparency of the varnish but can be removed in water. Bloom is apparently the result of atmospheric pollution. It is no longer a major problem, owing to the widespread use of synthetic varnishes.

Blot drawing. Technique described by Alexander Cozens (1717–86) in his book *A New Method for Assisting the Invention in Drawing Original Compositions of Landscapes* (1786), whereby a blot or accidental mark can be developed and incorporated into a composition. Cozens's title may have been inspired by the description by Leonardo da Vinci (1452–1519) of a method of 'quickening the spirit of invention' by observing in damp walls and stones 'strange landscapes', 'figures in violent action', 'expressions of faces' and 'an infinity of things'.

See also AUTOMATISM.

Blue-and-white ceramic. Category of ceramics defined by the use, on a white surface, of blue derived from cobalt oxide, the most powerful of the colouring oxides in tinting strength. Depending on its concentration, colours range from a pale blue to a near blue-black. Cobalt produces good colours on all ceramic bodies, from low-fired earthenwares to high-fired porcelains (see CERAMICS, §I, 4). It was used as a colourant on figures found in Egyptian tombs of the 5th Dynasty (c. 2465–c. 2325 BC), and glass beads coloured with cobalt and dating to c. 2250 BC have been discovered in north-west Iran. Its use in ceramic glazes is datable to 1200 BC from tomb objects found in Ethiopia, Mycenae and Tiryns, which probably originated in Egypt or Phoenicia. Persian and Syrian potters used cobalt on

earthenwares for several centuries before they introduced it to China, where it was first used as an underglaze colour on earthenware during the Tang period (AD 618–907) and then later on porcelain.

1. Islamic world. 2. East Asia. 3. The West.

1. ISLAMIC WORLD. The opaque white, tin-glazed earthenware that originated in Mesopotamia during the 9th century AD or early 10th should be considered the first blue and white. The technique was later introduced into Europe during the Arab conquests of North Africa and Spain. Merchants from Persia (now Iran) established communities on the coast and in the large cities of China, so it is logical that they would have had an effect on the production of ceramics and constituted one of the earliest and largest markets for Chinese blue-and-white decorated porcelains (*see* §2(i) below); blue-and-white porcelain was first really appreciated in the Middle East, which was unable to produce its own high-fired ceramic due to the lack of appropriate materials and techniques. Illustrations in Persian books of the 15th century occasionally show large numbers of Chinese blue-and-white wares, which attest to their popularity in Persia, as do the existing collections at the Topkapı Palace Museum in Istanbul (10,358 pieces from the Yuan to the Qing dynasty) and the Ardabil Shrine in Ardabil, Iran, which was dedicated in 1611 to Shaykh Safi and holds 1162 pieces dating from the 14th to 16th centuries.

In the Ottoman empire, a general indebtedness to Chinese blue-and-white porcelains is visible in the hexagonal tiles decorating the mosque of Murad I (1436) in Edirne or the ceramic vessels attributed to the reign of Mehmed I (*reg* 1444–81). By the 1520s close imitations of Chinese blue-and-white wares were produced at Iznik in western Anatolia. They were copied from porcelains the Ottomans had acquired as booty at Tabriz in 1514 and at Damascus and Cairo in 1517. These copies incorporated Chinese shapes influenced by 15th-century designs and such motifs as the lotus, peony, dragon and phoenix (*see also* TILE, colour pl. XV, fig. 2).

In Kashan and Meshhed the use of cobalt on pottery produced a smeared effect, which was minimalized with the use of a black outline. This technique was used during the 17th century at the kilns in Kirman, which produced blue-and-white pottery decorated with dragons and flowers closely imitating Chinese wares.

The Safavid monarch 'Abbas I (*reg* 1588–1629) is said to have brought Chinese potters and great quantities of Ming wares to his capital in Isfahan, from where the Chinese influence filtered throughout the pottery industry. 'Kubachi' wares, made in the 17th century and named after the small town in the Russian republic of Dagestan where they were found, were directly inspired by Chinese porcelains. They are decorated in blue without the black outline frequently found on other Persian wares. 'Kubachi' wares were frequently decorated with pagodas and

high hills, imitating 17th-century Chinese porcelain (*see* §2(i) below), and were marketed in Europe but not in quantity. One of the motivating factors in the production of Chinese-style wares was the placing of orders by the Dutch in an effort to fill the void caused by the destruction of kilns in China at the fall of the Ming dynasty (1644). Records from the Dutch East India Company show that these blue-and-white wares were shipped from Gombroon (Bandar Abbas; now Bandar Khomeini) in the Persian Gulf nearly every year between 1652 and 1682.

2. EAST ASIA.

(i) China. The introduction of blue and white represents 'the most revolutionary technical and decorative innovation of the Mongol regime in China, if not in the whole of Chinese ceramic history' (Medley, 1969). Initially the cobalt oxide for making blue and white was imported from Persia, probably from the Kashan area and possibly in a cake form, which was ground into a powder. The cobalt was called *wu ming yu* ('nameless rarity'), *sunibo* ('Sumatra') or *hui hui qing* ('Muhammadan blue'). Local Chinese cobalt was at first difficult to obtain, and what was available invariably contained too much manganese, which blackened the colour; a refined form of cobalt from Chinese sources was not perfected until *c.* 1520.

It is uncertain when the systematic production of blue-and-white wares began in China. Three porcelain figures decorated in underglaze blue were excavated in 1978 from a tomb dated 1276 at Hangzhou in Zhejiang Province, but the first blue-and-white wares appear to have been made during the early 14th century; of more than 18,000 pieces of ceramics found in 1975 on a Sinan shipwreck of 1323, there were no blue-and-white wares. The first dated blue-and-white porcelains are the David Vases, two temple vases inscribed and dated to 1351 (London, University of London, School of Oriental and African Studies, Percival David Foundation of Chinese Art). The mastery of the blue-and-white decoration on these vessels indicates that the use of cobalt was well understood by this date.

Large-scale production of good-quality blue and white began *c.* 1328 and became well established in Jingdezhen, Jiangsu Province. The Mongol rulers of the Yuan dynasty (1279–1368) had a particular predilection for monochromatic whitewares; there were some blue-and-white porcelains used in temples and for burials, but only one piece has been found at the site of the Yuan capital, Dadu (now Beijing). Blue and white was considered vulgar by the Chinese literati and was therefore mostly exported: the Mongol rulers were chiefly interested in this ware as a means of raising revenues.

Large dishes, derived from Islamic metalwork or glass forms, comprised the major export from China to the Middle East in the 13th and 14th centuries (*see* §1 above). Wares were densely decorated with designs based on the mathematical complexity of decorative schemes found in Islamic architecture, a Near-Eastern aesthetic alien to the Chinese. The few 14th-century blue-and-white wares made for the Chinese markets are decorated with scenes from Yuan plays and such motifs from the established Chinese repertory as clouds, dragons, prunus and pine trees, phoenix birds, waves and lappets; these designs were, however, framed by forms and elements derived from the Near East.

An edict of 1368 by the Ming Hongwu emperor (*reg* 1368–98) disrupted trade routes, and with the loss of the Islamic market the exportation of blue-and-white wares temporarily ceased. The subsequent loss of Islamic influence led to the production of more wares decorated with underglaze red, which Hongwu preferred. When blue-and-white wares were produced in this period the cobalt used was a mixture of Persian—of which supplies were scarce—and native sources, which contained iron impurities and therefore lacked the clarity and depth of the later blue-and-white wares of the Yuan dynasty; the hues ranged from a pale silver to a dark grey-blue.

In 1403 the Yongle emperor (*reg* 1403–24) sent diplomatic missions overseas for trade; these were described by Feixian and Ma Huan, the latter a translator to Zheng He, the Muslim eunuch who commanded the naval expedition for the emperor. Ma Huan listed 'blue porcelain' as one of the products traded and reported that it was popular in Dai Viet (now Vietnam), Java, Sri Lanka and Dhofar (now the province of Zufār, Oman). He also included comments on Jingdezhen blue and white as highly valued in foreign countries.

During the Xuande reign period (1426–35) imperial interest in blue-and-white wares increased, and the palace placed large orders for it. This period is considered the apogee in the development of blue-and-white wares. The *Ming shu* (official history of the Ming dynasty) records that in 1426, 1430, 1433 and 1434 Muhammadan blue was brought as tribute from Sumatra. One of the results of the use of cobalt at this time is known as the 'heaped and piled' effect, where the cobalt occasionally burnt black through the glaze. The period is also noted for the subtle, pitted surface of its wares, which was known as 'orange peel', and a more exuberant style of decoration. The exact sources for the motifs then found on blue-and-white porcelains is not fully understood, although they ultimately derive from traditional scroll paintings, reflecting scholarly interest in ornamental rocks and gardens.

During the Chenghua reign period (1465–87) the execution of motifs outlined and filled in with blue became more refined and delicate. The purity of the porcelain body and the fineness of potting became highly important. During the reign of the Zhengde emperor (*reg* 1506–21) there were major changes in the production of blue-and-white wares, among which was the beginning of the use of purely local cobalt, which was only occasionally mixed with imported cobalt.

Between 1573 and 1661, during the last four imperial reigns of the Ming dynasty and the first of the Qing,

there was a style of blue-and-white porcelain produced first for the South-east Asian market and later exported to Europe; it is generally identified by its thinness, brittle edges, pale and uneven blue colouring and decoration of divided panels with a central scene and is known as 'kraak' ware (see §3(iii) below). The forms and decorations also followed those used for the local and South-east Asian market, but these were modified to suit the tastes of the new European market.

Artistic vitality was rekindled during what is termed the Transitional period (1620–83). With a lack of direction from the imperial kilns in Jingdezhen, which were destroyed during civil disturbances in 1673 and 1675, the decorators painted motifs taken from popular poetry, myth, history and paintings. Jars decorated with the 'prunus on cracked ice' motif, sometimes called the 'Hawthorn' pattern, were one of the most popular and enduring forms and decorations of this period related to the production of blue-and-white wares.

The kilns at Jingdezhen were rebuilt in the 1680s. By the Kangxi reign period (1662–1722), the cobalt had become a clear and translucent blue, sometimes running to a bright violet under a thick glaze, which prompted the descriptive phrase 'violets in milk'. Trade was re-established with the European market, and the production of 'Chinese Imari' was introduced, a combination of underglaze blue with overglaze iron-red and gilding, a palette borrowed from the Japanese.

Wares produced during the reign of the Yongzheng emperor (reg 1723–35) imitated early blue-and-white Ming. Although he preferred wares decorated with polychrome enamels, Yongzheng's son, Qianlong (reg 1736–96), did retain a reverence for earlier wares, which led to an imitation of the 'heaped and piled' effect of the Xuande reign period. It had been the introduction of opaque, overglaze enamels of a palette called famille rose during the reign of Qianlong's grandfather that led to the decline of interest in blue-and-white wares. The production of blue-and-white wares, however, never completely ceased, especially for the export market.

In the mid-18th century a renewed interest in blue-and-white wares of Western manufacture occurred with the introduction of transfer-printing (see §3(v) below). The development in the West of less expensive porcelain and pottery led to the decline of Chinese porcelain exportations. Nevertheless, blue-and-white wares remained an important trade commodity for Europe and America during the 18th and 19th centuries. Nineteenth-century blue-and-white wares, which were popular then and have remained so with 21st-century collectors, include patterns with such names as 'Fitzhugh', 'Nanking' and 'Canton'. Chinese hand-painted blue-and-white wares continued to be produced until the 1930s.

(ii) Korea. The gift to King Sejong by the Chinese Ming Xuande emperor (reg 1426–36) in 1428 is the first recorded instance of Chinese blue-and-white wares being introduced into Korea. By 1456 Korean potters were reproducing Chinese wine cups in hwa chagi (blue and white). Cobalt was, however, extremely difficult to find, and in 1461 its use was limited by decree; porcelain decorated with cobalt was to be used only by the warrior class and only for wine vessels, a strict control that lasted for about 100 years. The first official reference to blue-and-white wares is in the Sejo sillok, or annals of King Sejo's reign (1455–68), which states that in 1464 cobalt was discovered near the southern coastline of Korea. In 1469 prizes were offered for further discoveries of cobalt. No other references to sources of Korean cobalt exist, and the only mentions of cobalt in official records are complaints about the expense and difficulty of obtaining it. A Korean publication of 1591 states that Muhammadan blue was priced at 'double that of gold'.

The Japanese invasions of 1592 and 1597 destroyed the Korean potteries. Little, if any, blue and white was produced from this period until c. 1618. When production resumed, the style had changed from a direct imitation of Chinese originals to a wholly Korean style reflecting the aesthetics of restraint and simplicity; the scarcity of cobalt played into this. The standard form of decoration consists of floral or scenic designs within a circular or polygonal frame. The blue-and-white ware produced during this period was much appreciated and was collected by the Japanese tea masters.

Official potteries were established in 1718 at the Punwon kilns in Kwangju district, south-east of Seoul. The production of blue-and-white wares was confined to these potteries, which sold their surplus implements for the writing-table to scholars and artists. As late as 1754 restrictions concerning the use of cobalt existed, although production continued in a much diminished artistic mode until 1883, when the state subsidy was terminated.

(iii) Japan. From the 16th to the 17th century three types of Chinese blue-and-white porcelains had been brought into Japan by independent Japanese merchants, as well as by Portuguese, Dutch and Chinese merchants: ko-sometsuke (old blue and white), tenkei (named after the Tianqi emperor, reg 1621–8) and shonsui (refined, mid-17th-century, blue-and-white porcelain ordered by tea masters). When Japanese traders were restricted by an edict in 1633 from trading with China, the Dutch, Portuguese and Chinese continued to supply them with blue-and-white porcelains.

The end of the Ming dynasty (1644) resulted in—among other calamities—the destruction of kilns and the disruption of trade between China and Europe. The Japanese were called upon to supply the orders from the Western traders, which they did as early as the 1640s by producing porcelain in imitation of blue-and-white 'kraak'. The Dutch East India Company records first mention their importation into Japan of 'porcelain paint' (cobalt) in 1650, and they began exporting enormous quantities of blue-and-white wares from Japan. The first ship

loaded with Japanese porcelain (2200 gallipots) for the Western market left Nagasaki in 1653 for Batavia (now Jakarta) on Java. This was the start of a short-lived but world-wide trade of Japanese porcelain, not only to the Netherlands but through the Dutch to India, Persia, Sri Lanka, Siam (Thailand), Vietnam and other parts of South-east Asia. Among the most notable blue-and-white exports of the second half of the 17th century are apothecary bottles bearing monograms within wreaths, and flatware with the VOC (Verenigde Oostindische Compagnie) monogram. Tall, cylindrical vases (known as *rolwagens*), jugs and tankards, all decorated with blue, Chinese-style motifs, were also common.

The re-establishment of the kilns in China during the 1680s led to the decline of the ceramic industry in Japan. The Dutch returned to their sources in China, which were better equipped to provide cheaper ceramics in larger quantities. Japanese blue-and-white porcelain, however, continued to be made on a limited scale throughout the 18th and 19th centuries, especially at Hirado.

3. THE WEST.

(i) Portugal, Spain and Mexico. The Portuguese were the first Europeans to arrive in China by sea (1517) and to begin direct trade with China. They were the major exporters of Chinese blue-and-white wares throughout the 16th century and were therefore the first Europeans to be directly influenced by these porcelains. By the 1520s shipments of mostly blue-and-white porcelain to Portugal amounted to between 40,000 and 60,000 pieces, many of which were re-exported to the Netherlands. One outstanding example of the mania for Chinese blue and white is the Santos Palácio (now the French Embassy) in Lisbon: in what an inventory of 1704 calls the 'Casa das Porçolanas', a pyramidal ceiling was covered with 261 Chinese blue-and-white dishes and plates dating from the 16th century to the early 17th.

Portuguese imitations of Chinese blue-and-white wares are not well documented until the 1580s, when Chinese blue-and-white 'kraak' was the most imitated ware in the production of tin-glazed earthenware; even then they reflected an inevitable leaning towards Islamic, Italian, Spanish and Flemish styles. At first the products were direct copies of the Chinese, although by the 1650s the styles became increasingly European and by the 1680s tin-glazed wares were far more European in style, with only the most oblique references to China. Blue decoration was used on such Western forms as *albarelli* (drug jars) rather than on Chinese forms.

Although Spain ruled Portugal from 1580 to 1640, different ceramic traditions existed in each territory. Blue-and-white decorated ceramics were not as influential in Spain as they were in Portugal. The first influences came through the blue-and-white tin-glazed wares made by the Arabs, whose caliphates extended through most of the Iberian Peninsula. Imitations of Chinese blue-and-white wares did,

however, occur, at Talavera de la Reina and Puente del Arzobispo. Familiar late Ming designs, especially those on 'kraak' ware, were the favoured motifs. By the late 17th century and the early 18th blue and white had been replaced by polychrome decoration.

Mexican tin-glazed earthenware reflects the influence of the Spanish Conquest (1519–21) and of Spain's trade with China. Spanish galleons sailed from Manila in the Philippines to Acapulco on the Pacific coast. Wares were carried across Mexico to Puebla (if not sent to Mexico City) and then to Veracruz on the Gulf of Mexico, from where they were shipped across the Atlantic to Seville. The presence of Chinese blue-and-white wares in Puebla exerted an influence that, when mixed with native pottery styles, produced an exuberant Mexican version of Chinese blue and white. Potters were first working in Puebla between 1550 and 1570, at about which time native potters were being retrained by friar–potters from Talavera de la Reina; Pueblan pottery of this style is known as Talavera de Puebla. The Ordenanzas (est. 1653) stipulated that 'in making the fine wares the colouring should be in imitation of the Chinese ware, very blue, finished in the same style and with blue relief work, and on this style of pottery there should be painted black dots and grounds in colours'. The speciality of Pueblan potters was large, Chinese-style, blue-and-white jars decorated with landscapes, birds, deer or flowers painted in an ebullient manner.

(ii) Italy. Because of Venice's early efforts in maritime trade, the importation of silk and other luxuries from Asia made Italy a viable location for the introduction of Chinese porcelain to the European Continent. In 1461 the Sultan of Egypt presented 20 pieces of Chinese blue-and-white porcelain to Doge Pasquale Malipiero (*reg* 1457–62) of Venice and later even more to Lorenzo the Magnificent (*reg* 1469–92) in Florence. Francesco I, Grand Duke of Tuscany (*reg* 1574–87), was the first to develop a close replica of Chinese porcelain; a soft-paste porcelain was made in his court workshops (est. *c.* 1565) in Florence *c.* 1575 using clay from Vicenza, which contained some kaolin. Only 57 pieces are recorded and all are decorated with blue winding stems and coiled foliage resembling similar decoration on Chinese porcelain of the 15th and 16th centuries. Similar Chinese motifs had already been used on Italian maiolica in a style known as *alla porcellana*. At the end of the 16th century Italian potters dispersed the technique of maiolica production, including the blue-and-white palette, throughout Europe.

(iii) The Netherlands. The Dutch established their own East India Company in 1602, after Philip II, King of Spain, closed Lisbon to the Dutch. In the same year the Dutch captured two Portuguese ships (*carracks*) containing approximately 200,000 pieces of Chinese export porcelain (hence the name 'kraak' ware). In 1609 the Dutch were granted permission to establish a trading post at Hirado in Japan, and in July 1610 the first ship arrived in the Netherlands from Japan

carrying Chinese blue-and-white porcelains, which had previously been brought by Portuguese ships. In 1636, 259,000 pieces of 'kraak' were shipped from Batavia, and the passion for blue-and-white wares in the Netherlands was thus established.

From the second quarter of the 17th century the declining Delft breweries became the site for a pottery industry where tin-glazed earthenware was produced in such profusion that the name of the town has become synonymous with its product, Delftware. The enormous quantities of Chinese blue-and-white wares imported by the Dutch East India Company affected the local ceramics industry to the extent that at first they directly copied the imported blue-and-white porcelain and only later introduced Dutch motifs and designs. In the Netherlands wares were covered with a clear lead glaze to resemble more closely the finish of the Chinese porcelains. Plates, chargers, ewers and tiles were decorated with designs in cobalt in the Chinese style. The Dutch East India Company records show requests for Delftwares by Japanese warlords and wealthy merchants from 1634 until 1668, when Japanese sumptuary laws prohibited the importation of foreign pottery. These wares were thought to be especially suitable for the tea ceremony, and a set of small, irregularly shaped dishes (*mukozuke*) for this ceremony, made in Delft and decorated by Frederik van Frytom (1632–1702), has been found in Japan.

(iv) Germany. Centres for the production of tin-glazed wares were established at Hamburg, Frankfurt am Main and Jannau in the late 17th century in order to compete with Dutch imports. The first fine earthenware factory established in Frankfurt am Main in 1666 was influenced by Chinese blue-and-white wares, either directly or through the Dutch wares. As with the Dutch tin-glazed wares, these were covered with a clear lead glaze.

Under the auspices of Frederick-Augustus I, Elector of Saxony (*reg* 1694–1733) (later Augustus II, King of Poland; known as Augustus the Strong), a method of imitating Yixing ware, called *Jaspis Porzellan*, was discovered at Meissen in 1706–7, and a hard-paste 'true' porcelain, using kaolin from Colditz, was made from 1710. By March 1720 David Köhler (*d* 1723) and Johann Gottfried Mehlhoun had discovered a method of decorating the white ground in blue enamels at Meissen (see colour pl. II, fig. 2), and examples were exhibited that year at Leipzig and Naumberg. The technique, however, was lost after Köhler's death and was not rediscovered until some years later. The *Zweibelmuster* ('blue onion' pattern), a highly stylized pattern derived from the Chinese, was originally introduced at Meissen on tableware *c.* 1735 and continued to be popular into the 21st century.

(v) England. Early examples of Chinese blue-and-white wares in Britain suggest that blue and white was rare in the 16th century: William Cecil, Lord Burghley (1520–98), Lord Treasurer to Elizabeth I,

owned a blue-and-white Wan li dish with silver-gilt mounts, and another dating to between 1580 and 1600 was a gift from the Queen to her godchild Thomas Walsingham.

After the accession of William III to the English throne in 1688, the stylistic influences from the Dutch court were strong and included the extensive use of blue and white, especially in interior design. The display of blue-and-white wares became one of the primary styles of interior decoration, mainly through the work of the Huguenot Daniel Marot I (1661–1752), who had worked for Queen Mary II in the Netherlands.

This passion for blue and white naturally led to its being imitated by English potters producing tin-glazed earthenwares, especially at the London potteries of Southwark and Lambeth. In the 18th century the production of tin-glazed wares—mostly tablewares—was centred in Bristol and Liverpool. Soft-paste porcelain was first produced at the Cheslea Porcelain Factory in London *c.* 1745. Other porcelain factories were established in England, including the Bow Porcelain Factory in London's East End, which, after 1749, specialized in the production of blue-and-white wares decorated with chinoiseries. Not until the New Hall Factory in New Hall, Staffs, was established in 1781 were blue-and-white hard-paste porcelains produced in quantity. By 1800 Josiah Spode II (1755–1827) had perfected bone-china at Stoke-on-Trent, Staffs, making blue-and-white ware less expensive and thus available to a wider public.

In the 1750s transfer-printing was introduced at such factories as Worcester; the designs from an engraved copper plate were transferred with tissue paper on to the ceramic object. One of the most ubiquitous patterns in this category of ceramic ware is the so-called 'Willow' pattern. 'Flow blue', a category of transfer-printed blue and white, was an early 19th-century development that, by firing in an atmosphere containing volatile chlorides, created a soft appearance resulting from the diffusion of the pigment into the glaze.

(vi) France. The production of blue-and-white wares first began in France when Chinese-style faience was produced at Nevers. Made between 1650 and 1680, typical pottery of this type is decorated with a deep-blue ground and yellow and orange motifs; it was erroneously known as *bleu persan*. It was imitated at Rouen as well as in the Netherlands and England. The French East India Company was established in 1664, after which many French ceramics reflected an increased interest in Chinese wares. From *c.* 1700 factories in Normandy began to produce blue-and-white faience in the *style rayonnant*, identified by blue lacy borders sometimes accented by red, yellow and green. A similar style was developed at the factory of Pierre Clérissy (1651–1728) in Moustiers in southern France.

T. Volker: *Porcelain and the Dutch East India Company* (Leiden, 1954)

T. Volker: *The Japanese Porcelain Trade of the Dutch East India Company after 1683* (Leiden, 1959)

G. St. G. M. Gompertz: *Korean Pottery and Porcelain of the Yi Period* (London, 1968)

M. Medley: *The Chinese Potter* (Oxford, 1969)

M. Yoshida: *In Search of Persian Pottery* (New York, 1972)

D. Macintosh: *Chinese Blue and White Porcelain* (Newton Abbot, 1977, rev. Woodbridge, 3/1994)

M. Lerner: *Blue and White: Early Japanese Export Ware* (New York, 1978)

C. J. A. Jörg: *Internations in Ceramics: Oriental Porcelain and Delftware* (Hong Kong, 1984)

D. Lion-Goldschmidt: 'Les Porcelaines chinoises du palais de Santos', *Arts asiatiques*, xxxix (1984), pp. 5–72

S. Little: *Chinese Ceramics of the Transitional Period, 1620–1683* (New York, 1984)

Blue and White: *Chinese Porcelain and Its Impact on the Western World* (exh. cat. by J. Carswell; Chicago, IL, University of Chicago, Smart Gallery, 1985)

N. Atasoy and J. Raby: *Iznik: The Pottery of Ottoman Turkey* (London, 1989)

M. Rinaldi: *Kraak Porcelain* (London, 1989)

Ma Xigui, ed.: *Qinghua mingci* [Blue and white porcelain], iii of *Beauty of Ceramics* (Taipei, 1993)

B. V. Harrisson: *Later Ceramics in South-east Asia, Sixteenth to Twentieth Centuries* (Kuala Lumpur, New York and Oxford, 1995)

R. Scott and J. Guy: *South East Asia & China: Art, Interaction & Commerce* (London, 1995)

Zhongguo lidai qinghua huadian: renwu dongwu juan [Paintings on blue and white porcelain: people and animals], 2 vols (Hangzhou, 1996)

L. Gotuaco, R. C. Tan and A. L. Diem: *Chinese and Vietnamese Blue and White Wares Found in the Philippines* (Makati City, 1997)

C. J. A. Jörg: Chinese *Ceramics in the Collection of the Rijksmuseum, Amsterdam: The Ming and Qing Dynasties* (London, 1997)

J. Carswell: *Iznik Pottery* (London, 1998)

M. S. van Aken-Fehmers: *Delfts aardewerk: Geschiedenis van een national product* (Zwolle and The Hague, 1999–2001)

J. Carswell: *Blue & White: Chinese Porcelain around the World* (London, 2000)

J. Loughman and J. M. Montias: *Public and Private Spaces: Works of Art in Seventeenth-century Dutch Houses* (Zwolle, 2000)

P. Scott: *Painted Clay: Graphic Arts and the Ceramic Surface* (New York, 2000)

E. Stober: *'La maladie de la porcelaine': East Asian Porcelain in the Collection of Augustus the Strong* (Leipzig, 2001)

E. Berguelt, M. Jonker and A. Wiechmann, eds: *Schatten in Delft: Burgers Verzamelen 1600–1750* (Zwolle, 2002)

Y. Crowe: Persia and China: *Safavid Blue and White Ceramics in the Victoria & Albert Museum, 1501–1738* ([Switzerland] 2002)

L. Chabanne and C. Shimizu: *L'odyssée de la porcelaine chinoise: Collections du Musée national de la céramique, Sèvres, et du Musée national Adrien Duboché, Limoges* (Paris, 2003)

E. B. Schaap: *Delft Ceramics at the Philadelphia Museum of Art* (Philadelphia, 2003)

A. Turner: Glazes: *Materials, Recipes and Techniques: A Collection of Articles from Ceramics Monthly* (Westerville, OH, 2004)

Blueprint. *See under* PHOTOGRAPHY, §I, 2.

Board. Flat panel on which paper may be rested during drawing or painting, on which a painting or drawing may actually be executed (*see also* PANEL PAINTING), or on or with which a completed artwork is mounted. In these uses the board is of thin, rigid material such as natural wood or, more probably, processed and reconstituted wood or of a substance similar to or evolved from paper. Before *c.* 1700 artists were often depicted resting their work on a stout folder, but drawing boards are shown in use in the *Drawing Academy* (Palacio Granja de San Ildefonso) by Michel-Ange Houasse (1680–1730), and a variant form with legs appears in *Time and Death* (1814; San Marino, CA, Huntington Library and Art Gallery) by Thomas Rowlandson (1756/7–1827). Since the 19th century, the commercial production of various types of boards has increased the range of potential supports. Millboard, a stiff card of pulp or paper sheets pasted together, frequently used in book covers and sometimes heavily impregnated with size, was used for oil sketching by J. M. W. Turner (1775–1851) and for several nude studies by William Etty (1787–1849). Cardboard, a packaging material related to millboard, was used extensively by Henri de Toulouse-Lautrec (1864–1901) and features in the work of several artists active *c.* 1900, notably Pierre Bonnard (1867–1947) and Edouard Vuillard (1868–1940). By 1900 Academy Board (pasteboard or millboard primed with a white ground) had become popular as an inexpensive support, and it evolved during the 20th century into a range of commercial painting boards that are either embossed in imitation of canvas or covered with a thin layer of primed cloth or primed and embossed paper; these are known as canvas boards or panels.

Various artists' papers are also mounted on boards to give them increased stability or to permit a specialized application (e.g. strippable airbrush board). More robust types of board, including hardboard (Masonite), chipboard (particle board), blockboard (lumber-core plywood), plywood and fibreboard, are made from wood or wood pulp. These sheet materials have significant practical advantages over natural wood, but none is specifically intended for artistic use. As their suitability is dependent upon the exact specification and mode of employment, they have been exploited with various degrees of wisdom by painters at both amateur and professional level. Potential problems are well illustrated by the case of mount board (matt board), used to mount and display works on paper within their frames. Made from wood pulp, with various chemicals involved in its manufacture, it has proved to be self-destructive and to harm the artwork it houses; in consequence, the specification of such boards has been altered to take account of their art-related use. Museum board, conservation board and acid-free board are products now supplied as mount board with the necessary archival qualities.

See also PAPER, §VI, and SUPPORT, §§1 and 2.

J. Laurila and A. Hattari: *Paper and Board Dictionary: Theory, Manufacture, and Products* ([Finland], 1986)

J. Stephenson: *Graphic Design: Materials and Equipment* (London, 1987)

J. Stephenson: *The Materials and Techniques of Painting* (London, 1989)

S. Fairbrass: *Learn to Frame* (London, 1990)

C. F. Baker, ed.: *Products of Papermaking*, 3 vols (Leatherhead, 1993)

P. Bower: 'The Vivid Surface: Blake's Use of Paper and Board', *William Blake: The Painter at Work*, ed. J. H. Townsend (Princeton, 2003)

Bole. Fine red clay tinted with iron oxides to a red or yellow colour. When mixed with size, it is used as a base for gilding, since it takes a fine polish when burnished. It was widely employed on panel paintings up to the mid-15th century and is still used for picture frames. The red colour is often visible below worn areas of gilding. White bole is a synonym for kaolin or china clay.

Bone. The material that forms the skeletons of the higher animals. It consists of an organic portion composed mainly of the fibrous protein collagen and an inorganic portion formed by crystals of hydroxyapatite, a complex of tricalcium and calcium hydroxide. (For the identification of bone, *see* Technical examination, §VIII, 8.) The combination of these two substances forms a material that is light and strong, especially longitudinally. It is fairly flexible and possessed of reasonable cross-sectional strength. It is readily available as a by-product of butchery and is easily worked with simple tools. It can be sawn, scraped, carved, filed and glued. The size and structure of even the largest bones tend to limit their utility to small objects. These artefacts tend to be utilitarian in nature, though they may be decorated to some extent, and bone was often used to adorn objects made from other materials. Bone has sometimes been used as a cheap substitute for ivory, but it cannot be so finely worked, and the grain is more prominent. For tools it was often the preferred material because of its greater strength in small sections.

Objects made from bone are among the earliest known artefacts made by man, and broken, worked and whole utilized animal bones are common on the sites of Stone Age occupation. The utility of even unmodified bone splinters and fragments is readily apparent. Numerous unworked bone fragments (*c.* 500,000–450,000 BC) were found in association with the remains of *Homo erectus* at Zhoukoudian, the home of Peking Man (*Sinanthropus*), located southwest of Beijing, China. Bone fragments and pendants (*c.* 30,000–20,000 BC) were also discovered together with the remains of *Homo sapiens sapiens* at the same site. Elsewhere, by the later Palaeolithic era spear throwers and bone tools, mainly simple points, harpoon heads and fish-hooks, were being carefully worked, polished and embellished with engraved ornament. Notable finds have been made in France, at Les Eyzies and La Madeleine in the Dordogne region, and in Britain at Starr Carr, S. Yorks, a Mesolithic site. Zoomorphic carvings have been found at Vogelherd in Germany, and anthropomorphic and zoomorphic figurines occur in the Brno

area of the Czech Republic. In Russia notable finds have been made at Kostyonki and Sunghir.

Later, the cultures of ancient Egypt, Mesopotamia and associated West Asian areas used bone as a decorative inlay on such wooden objects as furniture and boxes. They also used it to make sewing awls, spatulas, knife-handles and game-pieces, as well as more decorative objects, for example perfume bottles and cosmetic pallets. Ivory seems to have been the preferred material for all of the above, bone generally being a lower-quality substitute.

The Greco-Roman civilizations used bone in a similar manner, but metals gradually replaced bone for awls, needles, spatulas and similar objects. By *c.* 500 BC finely carved articulated dolls were being produced, alongside others made from only slightly modified portions of long bone.

In ancient East Asia similar small utilitarian objects were produced. Spatulas, chisels, harpoons, arrowheads, hairpins and needles (5th–4th millennium BC) were excavated in China at the Neolithic village site of Banpo, in Henan Province. Finds at the Shangperiod (*c.* 1600–*c.* 1100 BC) site of Zhengzhou included arrowheads, knives and a piece of cut ox bone, the last being a left-over of bone-carvers' work. By the 2nd millennium BC ox scapulae were being used for divination. In more recent times bone was used in China instead of ivory for cosmetic pots, brush handles and scroll roller ends. Bone gamepieces were used for mahjong in China and *go* in Japan. Since the late 18th century bone has been used as an inlay for furniture, notably in Japan, China and parts of South-east Asia, and as carved relief inlay on lacquerwares, lacquer screens and plaques, where it is often stained red, green or brown; it was frequently used for export pieces. Jewellery and small ornamental items are still made from bone in China in the absence of ivory.

In India, Nepal and West Asia bone continues to be used as an inlay for furniture and in the production of small figurines. Throughout the late 18th, 19th and early 20th centuries Indian craftsmen produced bone chess sets. In Tibet, parts of Nepal and those areas of China in which Tibetan Lamaist Buddhism was practised, human bones were used for such Buddhist ritual objects as drums, begging-bowls and cups, which were made from crania. Sets of monks' beads were made from epiphyses carved to resemble the human skull.

In North America bone is known to have been worked from the 5th millennium BC. Until the late 20th century the local people continued to use it much as their ancestors did, fashioning harpoon heads from long bones, sled runners from walrus ribs and snow shovels from various scapulae and larger whale bones, as well as a multitude of small, everyday objects. The Plains and Woodland tribes of North America appear to have used bone in much the same way as other pre-industrial societies (see fig.).

In Mesoamerica the use of bone dates from the Pleistocene period (10,000–8,000 BC), when the material was used for tools and musical instruments.

Carved bone-handled sewing awl, iron, from the Native North American Plains region (London, British Museum); photo credit: Werner Forman/Art Resource, NY

The first known example of a ritual piece from this area is the sacrum of a fossilid llama (c. 8000 BC; Mexico City, Museo Nacional Antropología) worked to represent the head of a coyote. However, most extant bonework from this region dates from the 10th century AD onwards. In the 14th century, for example, the Aztecs made bone rattles, rasps and perforators for ritual bloodletting; they also used human skulls, overlaying them with turquoise mosaic work. In Central America most bonework is Maya in origin. Numerous tools and ritual objects have been found at pre-Classic (c. 2000 BC–c. AD 250) and Classic sites (c. AD 250–c. 900), and it is clear that the Maya, like the Aztec, attached particular significance to human bones.

In the Pacific, bone usage is limited to a few neck ornaments of whalebone and bird-leg bones from Hawaii, Tonga and Fiji, whalebone breast plates from Tonga and Fiji and whalebone meri and flutes from human femurs made by the New Zealand Maoris. The peoples of Papua New Guinea make daggers, arrowheads and nose and hair ornaments from cassowary and pig bones. Australian Aborigines use a magically charged 'pointing bone' to curse enemies.

In Sub-Saharan Africa the use of bone has been similarly limited. It is occasionally found in body ornaments; long bones are used for drumsticks, and ritual trumpets were made from human femurs decorated with mandibles by the Asante of Ghana; and various other African groups made bone spoons, votive masks and small zoomorphic carvings.

In Britain and elsewhere in Europe the use of bone was common up to the medieval period and peaked between 1820 and 1920, when a wide variety of artefacts, both decorative and utilitarian, was produced, ranging from the needleworker's crochet hook and the bookbinder and shoemaker's rubber to intricate miniature models of sailing ships and furniture.

See also SCRIMSHAW.

G. B. Hughes: *Living Crafts* (London, 1953)

R. J. Forbes: *Studies in Ancient Technology*, iii (Leiden, 1955)

J. P. Weinman and H. Sicher: *Bone and Bones* (St Louis, 1955)

J. F. Hayward: *English Cutlery of the 16th to 18th Centuries* (London, 1957)

R. C. Bell: *Board and Table Games from Many Civilisations* (London, 1960)

I. A. Crawford: 'Whalebone Artefacts', *Scottish Studies*, xi (1967), pp. 88–91

N. K. Sanders: *Prehistoric Art in Europe*, Pelican History of Art (Harmondsworth, 1968, 2/1985), pp. figs 34–6

J. D. Currey: 'The Mechanical Properties of Bone', *Clinical Orthopaedics*, lxxiii (1970), pp. 210–31

H. Wichmann and S. Wichmann: *The Story of Chesspieces from Antiquity to Modern Times* (London, 1970)

R. E. Chaplin: *The Study of Animal Bones from Archaeological Sites* (London, 1971)

B. Halstead and J. Middleton: *Bare Bones: An Exploration in Art and Science* (Edinburgh, 1972)

A. MacGregor: *Bone, Antler, Ivory and Horn: The Technology of Skeletal Materials since the Roman Period* (London, 1985)

P. McComb: *Upper Palaeolithic Osseous Artifacts from Britain and Belgium: An Inventory and Technological Description* (Oxford, 1989)

O. Krzyszkowska: *Ivory and Related Materials: An Illustrated Guide* (London, 1990)

L. Martini, ed.: *Oggetti in avoiro e osso nel Museo nazionale di Ravenna* (Ravenna, 1993)

M. T. Gibson: *The Liverpool Ivories: Late Antique and Medieval Ivories and Bone Carving in Liverpool Museum and the Walker Art Gallery* ([Liverpool], 1994)

A. St Clair: *Carving as Craft: Palatine East and the Greco-Roman Bone and Ivory Carving Tradition* (Baltimore, 2003)

D. Gaborit-Chopin: *Ivoires médiévaux: Ve–Xve siècle*, Paris, Musée du Louvre (Paris, 2003)

I. Riddler, ed.: *Materials of Manufacture: The Choice of Materials in the Working of Bone in Northern and Central Europe during the First Millenium* (Oxford, 2003)

J. F. De Mouthe: *Natural Materials: Sources, Properties, Materials* (Oxford, 2006)

Bookbinding. Cover of a book and process of creating and attaching it by hand. This article is concerned with the Western tradition of bookbinding. Mechanization of the various binding processes started in the 1820s, radically changing the traditional processes and turning the craft into an industry;

handbinding continued in the late 20th century, but only as a small part of the luxury and collectors market.

 I. Materials and techniques. II. Decoration. III. Conservation.

I. Materials and techniques. Binding materials and the ways in which they have been deployed have varied over the centuries. The material on which a text is written or printed and its intended use have influenced the binding structure, as have economic and social circumstances. In the West the most important development in the history of the book before the age of printing was the change from roll to codex (*see* CODICOLOGY), which by the end of the 4th century AD had become the preferred format. The codex consists of sections of folded leaves (gatherings), sewn through the fold of each section and protected by some form of cover. Binding materials may be divided into structural or support materials and covering materials. Structural or support materials are those that hold the leaves of the book together and form the structure of the binding. Covering materials cover this structure and form the book cover itself; they provide the ground for decoration (*see* §II below).

 1. Structural. 2. Covering.

 1. STRUCTURAL. The structure of a binding comprises sewing thread and supports, boards, adhesives, end-bands and strengtheners (e.g. end-leaves and paste-downs, spine linings and joints); all these can be made of a variety of materials.

 (i) Sewing thread and supports. (ii) Boards. (iii) Spines. (iv) End-bands. (v) Strengtheners.

(i) Sewing thread and supports. The sections or gatherings of Insular codices are linked together by a chain stitch, sewn through the fold of each gathering; the sewing thread may also be used to attach the boards to the textblock. An early Insular codex, the St Cuthbert Gospel of St John (*c.* AD 698; Stonyhurst, on deposit at London, British Library, Loan MS. 74), is sewn in this way: a chain stitch links the gatherings and the boards have been sewn on. There is also evidence that early codices could be held together by some form of sewing around the spine. Unsupported sewing through the fold persisted for certain types of bindings. Stitching through holes stabbed in the inner margins of the text leaves occurs from the last two decades of the 16th century.

Sewing on supports with a herring-bone stitch occurs as early as the 8th century. In Carolingian bindings flax or hemp cords were used for sewing supports. Sewing on a sewing frame may have been introduced during the 10th century, and sewing on supports remained the most common type of sewing in western Europe. From the second half of the 11th century tawed leather thongs, split across the width of the spine and sewn round in a variety of patterns

(herring-bone, figure-of-eight, spiral, wrapped-round), were commonly used and continued to be used until the early 16th century. Tanned leather thongs were also used and cords were reintroduced in the 15th century. Thinner and single tawed and tanned thongs came into use during the 16th century, when parchment is also found as a sewing support. The number of sewing supports varied considerably, depending on the size of the textblock, but also on local traditions and on date. For example three sewing supports were usual for small books in Italy in the 16th century, while five were commonly used in England. Fewer supports were used for cheaper work. The thread could be of hemp, thin cord, linen, cotton or silk.

Thongs or cords could be used raised (lying on top of the backs of the gatherings) or recessed (lying in grooves cut or sawn into the backs of the gatherings). Recessed cords and thongs, producing a flat spine, were introduced during the 16th century and became common in France from the mid-16th century and in England from the late 16th century or the early 17th. Italian, Spanish and French bindings of the 16th century were sometimes sewn on flat (parchment) supports and the compartments between the supports were lined to form flat spines. Recessed cords were commonly used in France until *c.* 1650 and in England up to *c.* 1710. They were reintroduced at the end of the 18th century. Sewing on recessed cords saved time as the sewing thread could be passed over the cord instead of being wrapped around it. Later, recessed cords were combined with hollow spines (in France from *c.* 1770, in England from *c.* 1800, becoming widespread during the 1820s) to make the book open more easily. In the 19th century sewing on tapes made of canvas or linen came into use.

In the mid-16th century sewing took a variety of new forms. Instead of every thong or cord being circled by the sewing thread, every other cord could be bypassed, or two or more gatherings could be sewn at the same time. Quantity and economy forced binders to find ever quicker and ever cheaper methods of sewing. Sewing two gatherings at a time was widely used in retail binding in France in the last four decades of the 16th century and elsewhere early in the 17th century, but sewing three, four or even six gatherings at a time is not unknown. Overcasting, the practice of sewing single sheets together to make up gatherings that can then be sewn on to tapes, is found at the end of the 19th century and during the 20th, and earlier for volumes of plates or maps.

Decorative false bands (i.e. stuck-on cords, not proper sewing supports) are found in Italy and France in the 16th century. Many Italian bindings show alternating raised sewing supports and thin false bands. In France (as early as the late 1530s) there were bindings with three raised sewing supports and two false bands. Alternating double cords and false single bands are also occasionally found in Germany from the 1550s. False bands became increasingly common in inexpensive work, and by

the 18th century bindings sewn on recessed cords were given false bands for decorative purposes. In England in the 18th century false bands were used in pairs, but from the 1760s onwards smooth spines came back in fashion.

(ii) Boards. Not all bindings have solid boards. The structure and shape of the binding depend to a large extent on its function and on the way it is stored. When books were stored flat or on sloping shelves or lecterns there was less need for a fixed and rigid structure than when, from the mid-15th century, books were stored on shelves. Limp and semi-limp parchment bindings occur throughout the Middle Ages. Limp structures were frequently used for account-books and stationery bindings but also, from the 16th century onwards, as temporary bindings (in parchment or paper) or for inexpensive retail bindings. Paper wrappers were used for pamphlets and other thin publications, but paper was also used as a temporary cover for properly sewn books that could then later be bound in leather or parchment-covered boards. Books in limp parchment bindings (without boards) could be made firmer by sewing through rigid plates of horn, wood or stiff leather. Sometimes metal rods were incorporated in the sewing of limp parchment bindings of the 16th century.

The boards of the earliest codices were made of papyrus or wood. Anglo-Saxon, Carolingian and later medieval boards are usually made of wood. Oak, beech, box, birch and poplar were all used. Scaleboard or scaboard, very thin wooden boards, were already in use for cheap work in the 16th century. The thickness of wooden boards depended on the size and weight of the book, and the boards could be shaped (cushioned, chamfered, bevelled) in a variety of ways. Italian boards were normally bevelled only on the inside, while German boards were bevelled on the inside and outside. German boards were frequently partly bevelled, leaving the full thickness at the corners and at the fore-edge where the clasps would be fitted. Boards were also bevelled at the spine edge to accommodate the joints. Thick wooden boards were used well into the 17th century and in Germany well into the 18th. Thin wooden boards were used in America at the end of the 18th century and in the 19th. Wooden boards were occasionally used, especially in England but also in Germany, in the 19th century.

There are examples of leather boards in the 13th and 15th centuries, but these are rare. Boards made of sheets of parchment (sometimes from parchment manuscripts) pasted together were also sometimes used. In Europe, from the mid-15th century sheets of paper, often wastepaper, were pasted together to make boards, first in Italy but also elsewhere, and during the 16th century these pasteboards became more and more common. Couched laminated boards, made by pressing together sheets of paper straight from the papermaker's vat, were also used and were common in France from the 1530s. Pulpboard, made of pulped paper or paper shavings, was much used in

England. Later in the 17th century pasteboard was replaced by rope-fibre millboard—at least for fine bindings—although pasteboard remained in use for inexpensive work until late in the 18th century. Rope-fibre millboard was made from rope fibres in a paper mill; it was particularly popular for better quality work in England in the 18th century. Strawboard appeared after the middle of the 19th century and had become the usual material by the 1880s.

Boards had to be cut to size. The amount by which the board extends beyond the textblock varied over the centuries. Early medieval boards were cut flush with the leaves of the book. Slight 'squares' (extension of the board beyond the leaves) emerged during the 15th century, now often only visible (because of shrinking of the boards) at head and tail; squares all round were widespread from the 16th century onwards. Board attachments also vary, depending on date and region. In Insular codices the boards were sewn on with the textblock. In Carolingian bindings the cord sewing supports enter the board through holes in the edge and are anchored in a loop. In Romanesque bindings the tawed leather thongs also enter through holes in the board, come out into a groove, re-enter the boards and are fastened with pegs or wedges. A great many different patterns have been found, largely on bindings in post-Conquest England: thongs entering the wood in a tunnel, emerging on the inside or on the outside of the board and being fastened with a peg; or thongs lying in grooves on the outside of the board, passing through holes and then lying in grooves on the inside of the board and being pegged. During the 13th century the thongs were sometimes taken over the outside of the board, then pulled through holes and pegged on the inside. The length and angle of the grooves can vary considerably. Sharply angled grooves forming triangles have been found in Anglo-Saxon bindings. Post-Conquest bindings appear to have grooves and tunnels of varying length perpendicular to the back edge of the board. During the 15th century the thongs were often brought over the outside of the boards, entered through holes and laid in grooves on the inside of the boards, secured by square or round pegs.

Single thongs were laced in using similar patterns, through holes punched or cut into pasteboards, often through two holes, either straight or at an angle. Lacing in through three holes appears to be characteristically French. In the late 16th century and the 17th not all thongs or cords were laced in. Books sewn on tapes were attached to the covers by inserting the tapes into split boards. There are medieval bindings where the leaves are held to the (limp) covers with tackets (short thongs), and limp and semi-limp bindings could be sewn through the fold of the gatherings with a longstitch. Covers could also be attached by the spine linings and the paste-downs, using adhesives. Case bindings, where the binding case (covers and spine) was made separately, were introduced in the mid-to-late 1820s (earlier in Germany); the textblock was attached to the case with adhesive and held firm by linings and paste-downs.

(iii) Spines. In bindings with boards, the shape of the spine is influenced by the shape of the boards, as well as by the thickness of the leaves (parchment, paper) and by the thickness or amount of sewing thread. The flat spine is a characteristic feature of Insular and Carolingian bindings. The rounding of the spine appeared as early as the 13th century and was the result of the swelling caused by the sewing thread in the centre fold of the gatherings: the wooden boards, shaped or bevelled on the side nearest the leaves, pressed the backs of the gatherings into a gently rounded shape.

The flat spine survived in Italy until *c.* 1510–20, but elsewhere a rounded spine had become the most common form by the beginning of the 16th century. Later in the century the shaping of the spine was assisted by knocking the backs of the gatherings with a hammer (backing). The shape of the rounded spine varies. For example the use of thin sewing thread in France in the mid-16th century produced gently rounded spines. In England in the 16th and 17th centuries spines are smoothly rounded in shape. By the end of the 18th century more heavily shouldered, half-elliptical spines were introduced. At the beginning of the 19th century spines became flat once again and by *c.* 1820 hollow spines were in widespread use. Later in the 19th century very heavily rounded, glued-up and stiff spines became fashionable; they were strong but difficult to open. Against this trend T. J. Cobden-Sanderson (1840–1922) introduced flat, barely rounded spines.

(iv) End-bands. End-bands draw the boards to the spine and prevent the boards from swivelling. There is little evidence of the materials of Insular end-bands. The spine leather of the Stonyhurst Gospels is turned over at head and tail and sewn through with a white thread that was tied down in the middle of each gathering; a blue thread that was worked with it is passed through the leather only. After the introduction of sewing on supports, the end-bands usually consisted of tawed or tanned leather thongs, or cores, laced into the boards, usually at an angle. End-bands were sewn, usually with white thread, sometimes also with a coloured thread, over the thongs or cores and tied down in the centre of each gathering. In the 12th century and the early 13th end-bands were often combined with semi-circular (or other-shaped) tabs, an extension of the spine leather or of the spine lining. They were sometimes lined with textile or stiffened by sewing them to the spine lining. The tabs were frequently sewn around the perimeter with coloured thread.

There are German and Netherlandish examples of complex plaited end-bands, while in the 15th and 16th centuries in Germany, Holland and England the spine leather is turned over the end-bands and sewn through. Already from the 13th or 14th century there is evidence of secondary, decorative sewing in coloured threads over the primary (structural) sewing. During the 16th century end-bands gradually lost their structural function and became purely decorative. They were no longer tied down in the centre of each gathering and were seldom laced into the boards.

End-band cores consisted of thongs, rolled leather, rope or cords, split lengths of cane (especially in England), flat strips or rolled pieces of parchment or rolled paper. The secondary, decorative sewing was almost always of coloured silk thread. At the end of the 15th century in Germany there were stuck-on end-bands, strips of tawed leather, folded over a core and sewn after they had been stuck on to the backs of the gatherings. The ends were either laced into or stuck on to the boards. (An early plaited German stuck-on end-band may date from the end of the 15th century.) These early stuck-on end-bands, also found in England in the late 16th century and the 17th and sometimes made of parchment, were not an economy measure, unlike the false end-bands of the late 18th and 19th centuries, which were manufactured separately and stuck on as a purely decorative device.

(v) Strengtheners. These were added to the basic structure of a binding to give it greater strength and to help maintain its shape. The principal materials for end-leaves are parchment, paper, either plain or decorated, and sometimes silk or leather. During the first few centuries of the codex, end-leaves consisted simply of two or four parchment leaves folded and sewn with the text leaves. When paper became the customary material for books (late 15th century), parchment end-leaves (still much in use in Italy and France in the 16th century) were gradually replaced with paper and were often strengthened at the fold with a strip of parchment (frequently a piece of manuscript waste). The use both of manuscript waste and of printed waste for end-leaves and paste-downs is not uncommon. For example parchment manuscript paste-downs are found in Oxford bindings of the end of the 15th century and throughout the 16th. A single leaf, folded, sewn through the fold and leaving a stub; a folded sheet, sewn through the fold forming two end-leaves, one of which could be pasted down; and multiple folded sheets are all found. Plain white paper was most commonly used during the 16th and 17th centuries, and for fine binding marbled paper was used from the end of the 16th century. Marbled end-leaves also appear in retail binding, more often in France and Holland, less frequently in Italy, Spain and England. In France in the 17th century books contain marbled paper paste-downs and plain white paper end-leaves. Marbled paper for end-leaves became more common during the 18th and 19th centuries, while for fine bindings other kinds of decorated paper were also used, such as paste paper (usually in German bindings), block-printed papers (in French, Italian and Dutch bindings) and embossed papers (most frequently in German bindings, often in Scottish bindings of the 18th century and, rarely, in English bindings). All these were first commonly used in the 18th century, reaching their peak of popularity during the first quarter of the century, and were less frequently employed during the 19th century. Marbled (or other decorated) paper and plain

white paper could be pasted together after sewing to provide extra strength and hide the sewing thread.

Extra strength was sometimes provided by a leather joint, used as early as the 17th century in France but more often during the 18th century, especially in England. Thin leather joints could also be purely decorative. Cloth joints were in use in England at least as early as the 1840s. Leather *doublures* (linings) provided both extra strength and room for decoration. The earliest-known English leather *doublure* dates from *c.* 1550. *Doublures* were not much used in England until *c.* 1750, but they were popular for fine bindings in France during the 17th and 18th centuries. Silk or paper *doublures*, purely ornamental, are found in the 18th and 19th centuries. Spines, too, were reinforced in a variety of ways. Lining material (of parchment, thin leather, textile or paper) was used to hold the shape of the spine. In Italy, and also in Germany and France, spine liners were cut from single pieces of parchment so as to leave space for the sewing supports. The panels between the sewing supports could be lined separately. Spine linings could be glued or pasted into place or, occasionally, stabbed through with a bodkin. Sometimes only selected spine panels were lined. Spine liners could be used to reinforce the joints but were by no means always employed to do this.

2. COVERING. Materials used to cover a binding include leather, parchment, paper, textile, straw, metal, ivory (or whalebone), wood, tortoiseshell, plaster of Paris and Perspex. Among these the most commonly used are leather, parchment, paper and, from the third decade of the 19th century, cloth. Leather and parchment are made of the skin of a variety of animals with different cell structures and different patterns of hair growth: goat, sheep, pig and calf are most frequently used, but leather made of deer, shark, seal and a variety of mammals, even human skin, has been used. Once cleaned, animal skins can be tawed or tanned (for the discussion of these processes *see* LEATHER, §2(i)). Parchment is made from animal skins that have been washed, soaked in lime water, stretched on a frame, scraped and dried under tension (for further discussion *see* PARCHMENT, §1).

Goatskin and sheepskin had been used in Egypt in the 4th and 5th centuries. The few Insular bindings that survive are also made of goatskin. Tawed skins, sometimes dyed pink, were most commonly used in Europe from the 12th century, alongside brown tanned calf during the 12th and 13th centuries. Parchment, calf, hide, pigskin, sealskin and chamois leather were all in use during the Middle Ages. Tawed pigskin was popular in Germany in the 15th, 16th and 17th centuries; tawed sheepskin and tawed calf were both frequently used. Tanned calf and sheep were used more frequently from the 15th century onwards and could be dyed or stained. Sprinkled calf was used from the 17th century; stained and marbled calf were common throughout the 18th century, especially in England. Diced calf (from a more mature animal),

called Russia, came into use early in the 18th century and became more popular later in the century. Reversed calf was also used, especially in England and especially for law books and stationery bindings.

Shagreen or sharkskin was in use in the 17th and 18th centuries, frequently found on almanacks or on prayerbooks. During the later Middle Ages tanned goatskin seems to have disappeared from use in Europe; it was reintroduced from the Middle East into Italy early in the 15th century. It remained a popular leather, especially for the more expensive bindings, and was tanned and dyed in a variety of colours. Marbled goatskin was used in France in the 1540s. Goatskins used in England were imported through Turkey, while goatskins from Morocco were not introduced there until the 1720s. Straight-grain morocco, an artificially grained goatskin, became popular in the 1770s. Limp and semi-limp parchment bindings were used on account-books at least as early as the 14th century and probably considerably earlier. Limp parchment bindings are found in Italy in the 16th century, and they became more widely used for inexpensive work throughout the 16th and early 17th centuries. Limp parchment remained in use in Italy and Spain until the 18th century. Parchment over boards is found in the second half of the 16th century in France, and it became common in Holland in the 17th century. It was also employed in England, even for fine work, in the 18th and 19th centuries and was frequently used in Italy in the 18th century.

Textile and embroidered bindings were already produced in the 14th century (possibly earlier) and became popular at the end of the 16th century and during the 17th. Such bindings continued in the 18th century, when canvas came into use for cheap books (especially school books). Bookbinders' cloth was introduced in the early 1820s, and both cloth and buckram were the most frequently used covering materials during the period following the mechanization of the various binding processes. (For the discussion of other, rarer, cover materials *see* §II below.)

To cover the boards and spine, leather was usually pasted and moulded over them; some kinds of parchment bindings were not pasted. Most 12th-century bindings had a chemise: a loose over-cover of leather or textile, with envelope pockets for the boards to slip into, sewn at the top and bottom of the covers and with flaps or skirts to wrap around the book. They were often held to the covers by bosses and by a long strap with a strap pull and a clasp that fitted over a pin protruding from the outer face of the opposite cover. In order to hold the leather to the covers and the spine, the binding was tied up with ropes or cords, either only at head and tail on smooth spines (in France) or at each spine band. The edges of the leather were turned in and pasted down. There are various methods of dealing with the accumulation of the leather at the corners, such as cutting off the corner or cutting a gap so that the edges when folded over would meet, cutting the corners so that they overlapped, or cutting the leather to leave a tongue. Many other methods have been used.

Straps, clasps and ties were employed to fasten the binding and to keep the book shut. Already on 10th-century German bindings clasps are found hinging on the lower cover. It appears that as a rule French and English clasps hinged on the upper cover and fastened on the lower cover, while in Germany and the Netherlands clasps fastened on the upper cover. Four pairs of clasps are common on Italian bindings. Metal bosses served to keep the bindings from rubbing on the surface of the lectern or sloping shelf. Chains to fasten the book to a reading desk or to rods above or below the shelves were used from the 14th to the 18th centuries.

G. Pollard: 'Changes in the Style of Bookbinding, 1530–1830', *The Library*, 5th ser., xi (1956), pp. 71–94

B. C. Middleton: *A History of English Craft Bookbinding Technique* (London, 1978)

G. Pollard and E. Potter: *Early Bookbinding Manuals* (Oxford, 1984)

C. H. Roberts and T. C. Skeat: *The Birth of the Codex* (London, 1987)

F. A. Schmidt-Künsemüller: *Bibliographie zur Geschichte der Einbandkunst* (Wiesbaden, 1987) [bibliog. to 1985]

J. A. Szirmai: 'Old Bookbinding Techniques and Their Significance for Book Restoration', *7th Internationale Arbeitsgemeinschaft der Archiv- Bibliotheks- und Graphikrestauratoren Congress: Uppsala, 1991*

B. van Regemorter: *Binding Structures in the Middle Ages*, Eng. trans. ed. J. Greenfield (Brussels and London, 1992)

M. Foot: *Studies in the History of Bookbinding* (Aldershot, 1993)

R. Devauchelle: *La relieur: Recherches historiques, techniques et biographiques sur la reliure française* (Paris, 1995)

A. A. Watson: *Hand Bookbinding: A Manual of Instruction* (New York, 1996)

J. Greenfield: *ABC of Bookbinding* (New Castle, DE, 1998)

M. Lock: *Bookbinding Materials and Techniques, 1700–1920* (Toronto, 2003)

M. Foot: *Bookbinders at Work: Their Roles and Methods* (London, 2006)

II. Decoration. Decorated bindings form only a small percentage of all books bound. They are collectors' items, presentation copies produced by top craftsmen, rather than the protective covers of books for daily and constant use. Bindings may be decorated in numerous ways, with metalwork, jewels, enamel, ivory, carved or painted wood, embroidery, painting, staining, stencilling, onlaying or inlaying with pieces of material in contrasting texture and/or colour, moulding or sculpting. The most widespread method of decorating leather bindings is by impressing them with engraved brass tools, either cold (obtaining a 'blind' impression) or heated through gold leaf (*see* LEATHER, §2(ii), and GILDING, §II, 5).

1. Covers. 2. Fasteners and leaf edges.

1. COVERS.

(i) Before c. 1400. The most extravagant medieval bindings are of precious metals or ivory and are usually found on liturgical books. Silver or silver gilt covers were engraved or show relief or filigree work, with or without precious stones or hardstones. Repoussé or separately cast figures often represent Christ, the Virgin, the four Evangelists or saints. Carved ivory book covers were modelled on Late Antique diptychs. They too show saints or scenes from the Old and New Testaments. Book covers were sometimes enamelled, particularly from Limoges between *c.* 1180 and *c.* 1230. In Siena painted wooden covers (*biccherne*) were used to protect and adorn the local tax accounts from the 13th century to the 18th. The earliest surviving embroidered binding, made in England, covers the early 14th-century Felbrigge Psalter (London, BL, MS. C.17.b.11). The upper cover shows the *Annunciation* and the lower cover the *Crucifixion*. Textile and embroidered bindings continued to be popular in England during the following centuries, especially for religious books. They were less common in Holland, France, Spain and Italy.

Very few medieval European decorated leather bindings are known. The earliest surviving European decorated binding, that on the Stonyhurst Gospel, was produced in England. It probably dates from the end of the 7th century and is covered in red–brown goatskin, decorated with a different design on each cover. The upper cover has an embossed floral design, surrounded by incised lines filled with coloured paint; the lower cover has a much simpler incised step design, also showing traces of colour. During the 12th and early 13th centuries blind-tooled Romanesque bindings were produced in France, England, Germany and Austria. Several show stamps or tools depicting biblical subjects side by side with figures from Classical antiquity and mythology, monsters, dragons, birds and other animals. The tools are large and their motifs bear strong resemblance to those found on Romanesque stone-carvings. They are usually arranged in circles, rows or concentric panels.

(ii) c. 1400–c. 1700. The monastic reforms on the Continent early in the 15th century contributed to a revival in book production, and the invention of printing gave a substantial boost to the book trade. An increase in the output of decorated leather bindings followed. In Germany, France and Italy and a little later in Spain, a large number of leather bindings decorated with small hand tools used in blind were produced, mainly in monasteries. Interlacing strapwork, effected with very few small rope or knot tools, were popular in Italy and Spain in the second half of the 15th century and persisted well into the 16th. In France small animal, bird, insect and floral tools were used in vertical strips.

The earliest 15th-century English blind-tooled bindings were made in London. Other early centres were Oxford, Canterbury, possibly Salisbury, Winchester and, a little later, Cambridge. Small engraved tools showing animals, birds, stylized flowers, roundels, squares, triangles, monsters and fleurs-de-lis abound. Two designs, widely used on both sides of the Channel, show a frame of intersecting

lines around a diamond and a saltire, or lines dividing the centre into smaller diamond-shaped and triangular compartments. Designs formed by arranging the tools in rows are frequently found in Oxford and sometimes in London, as well as in France. The influences of continental binding and tool design on English bookbinding of the last quarter of the 15th century and the first half of the 16th is marked. Rolls (engraved brass wheels) were introduced at the very end of the 15th century, while panels (engraved or, more probably, cast blocks) had been used in the Netherlands as early as the second half of the 13th century. They came into frequent use during the late 15th century and the early 16th, and are most commonly found in the Netherlands and England, but also in France and Germany. A technique that used a knife or other sharp instrument to draw a design into the leather or to cut or carve the leather away, leaving the decoration to stand out against the cut-away, sometimes punched, background, was popular in German-speaking countries between the end of the 14th and the beginning of the 16th centuries. Many of these cut-leather ('Lederschnitt') bindings have pictorial designs.

The technique of impressing heated brass tools through gold leaf into the leather is of Islamic origin. Gold-tooled bindings were made in Morocco from the 13th century and the practice was well established by the second half of the 14th century in the Mamluk empire and Iran. Gold-tooling reached Italy early in the 15th century, where by the third quarter of the century it was widely known. The technique came to Spain by the end of the 15th century and was used in Hungary, on bindings for Matthias Corvinus (reg 1458–90). Early in the 16th century gold-tooled bindings were produced in France. The best-known French binding collector of the 16th century, Jean Grolier (1479–1565), acquired his earliest bindings in Milan, but the pride of his collection was bound in Paris between 1520 and 1565. In France the binding trade was divided into forwarders (binders) and finishers (decorators) and it is frequently difficult to attribute French bindings purely on the basis of their finishing tools, the more so as the person who was paid for the bindings may well have been a bookseller or stationer who ordered rather than made them. The most stunning gold-tooled bindings were produced in Paris during the reign of Henry II (reg 1547–59), using a wide variety of designs showing linear frames, arabesques, or interlacing strapwork combined with solid, open and hatched tools. In the 1540s, 1550s and 1560s many famous collectors had their books bound in Paris, for example Thomas Mahieu (fl 1536–72) and the Englishman Thomas Wotton (1521–86). Thin pieces of onlaid leather in contrasting colour were combined with gold-tooling to produce the finest bindings of the period.

The technique of gold tooling came to England from France, the earliest example dating from 1519 (Oxford, Bodleian Library, MS. Bodley 523). For the next ten years it was still largely an experimental technique, but from c. 1530 many fine gold-tooled bindings were produced, most of which show French or Italian influence. Gold-tooling was also practised in the Netherlands and in Poland. German binders continued tooling in blind, often on white-tawed pigskin, well beyond the mid-16th century. They also used rolls and panels longer than their colleagues in other countries and employed them either in blind or with low quality gold during the second half of the century. Italy continued to produce fine bindings. The bibliophiles Apollonio Filareto (fl 1537–50) and Giovanni Battista Grimaldi (c. 1524–c. 1612) used their own medallion-shaped devices. Bindings with plaquettes modelled on antique coins or Classical intaglios and cameos were a typical Italian phenomenon, but they are also found in France, and to a lesser degree in England and Germany. During the reign of Elizabeth I (reg 1558–1603) fine gold-tooled bindings were made in England, the designs of many of which show French influence. Interlacing ribbons, combined with solid and hatched tools, as well as designs showing large corner and centre pieces prevailed. The latter continued to flourish during the reign of James I (reg 1603–25). The Dudley Binder (fl 1558), the Morocco Binder (fl 1571), the Initial Binder (fl 1562–3), Jean de Planche (fl 1567–80), the McDurnan Gospels Binder (fl 1566) and the private bindery of Matthew Parker (1504–75), Archbishop of Canterbury, among others, all produced first-rate work in London.

In France during the second half of the 16th century interlace developed into the fanfare style. Echoes of this style are found in Holland and England in the 17th and 18th centuries and in Italy and Germany in the 18th. In France, later in the 17th century, this style developed into mosaic designs, when the compartments were frequently made of inlays or onlays of contrasting colours and filled with small dotted tools. At the end of the 16th century and during the 17th other designs that covered the whole of the boards in a regular way were also popular in France and a little later in Holland; they were effected by a sprinkling of small tools, sometimes as the background of a central arms block, or with drawer-handle tools and fleurons. The habit of sprinkling the covers with small tools was still current in England during the reign of Charles I (reg 1625–49). In the 1630s and 1640s dotted or pointillé tools became fashionable in France; they were much used in Holland later in the 17th century and continued in the 18th; they occur in Italy in the later part of the 17th century; and they first appeared in Cambridge in the 1640s and 1650s, soon to become one of the typical features of English Restoration binding. Characteristic designs, either circular or formed of concentric panels, and made with small tools, were prevalent in Cambridge in the first half of the 17th century.

Corner and centre designs, formed by whole or quarter fan shapes, were fashionable in Italy in the 1640s; they also occurred in Spain in the 17th century. The movement towards the use of smaller pointillé tools and polychrome leather onlays in England started early in the 1650s and developed into the splendours of the golden age of English bookbinding,

the period following the restoration to the throne of Charles II. The cottage roof design, typical of the Restoration binding, remained in use until the early 18th century.

(iii) After c. 1700. During the first decade of the 18th century, the Geometrical Compartment Binder introduced some new designs to replace the cottage-roof style or 'all-over' designs of his predecessors and contemporaries; a number of his bindings recall the French fanfare style. The library founded by Robert Harley, Earl of Oxford (1661–1724), gave its name to a design formed by roll-tooled borders and a diamond-shaped centrepiece, built up of small tools. Developed by Thomas Elliott and Christopher Chapman (both *fl* 1719–25) for the Harleian Library, it persisted well into the 1760s in London and Cambridge. Bindings decorated with emblematic tools were made for Thomas Hollis (1720–74) and Jonas Hanway (1712–86) from the 1750s till the 1780s and are also found on Masonic bindings of the second half of the 18th century. Neo-classical bindings were designed by James Stuart (1713–88) and Robert Adam (1728–92) in the early 1760s.

In the second half of the 18th century numerous German binders immigrated to England and ran the fine binding trade in London. Native English binders working during the latter part of the 18th century include Roger Payne (*fl* 1757–97), who was an outstanding finisher and employed finely cut tools to comparatively simple designs, and the firm of Edwards of Halifax, best known for parchment bindings with scenes painted on the transparent under-surface and for so-called Etruscan bindings. Parchment bindings painted on the top surface were made in Italy in the 18th century and also in Hungary and Germany.

Very fine bindings were produced in Dublin in the 18th century with characteristic white onlays (made of paper, parchment or thin leather) and floral or fan tooling. During the 18th century in France two binding styles prevailed. One achieving a lace effect with the help of small tools (dentelle), the other using onlays and inlays to form colourful, often floral or pictorial, mosaics. The best known Paris binders of this period were Derome, Monnier and Padeloup. Pictorial designs are also found in Germany, Austria and Italy, often tooled or blocked but sometimes painted or made of onlaid straw. Decorated paper bindings, already produced in Italy and Germany in the 16th century, became more popular during the 18th, especially on pamphlets, and survived well into the 19th century when they gradually lost their artistic merit. Printed woodblocks, marbling, coloured paste and embossed metal plates were all employed. Printed and painted silk bindings are found in France, Italy and the Netherlands in the 19th century, especially on almanacs.

During the first half of the 19th century a number of different styles were current: Neo-classical designs, simple panel designs, sometimes combined with elaborately tooled *doublures*, more complex designs

effected with small tools, and designs making use of thick (sometimes double) boards with sunk panels, tooled and blocked in blind and gold. In the late 1820s, the process of embossing bindings was introduced in France and Germany, but it was soon practised in England where embossed designs often depicted cathedrals, although floral and chinoiserie designs were not uncommon. Painted parchment persisted, but black moulded papier mâché on a metal frame, often in elaborate Gothic designs, was also used. During the second half of the century pastiches of earlier periods were in vogue, both in France and in England. Breaking away from these traditional designs, Marius Michel and others produced bindings in Art Nouveau designs (see fig.), while T. J. Cobden-Sanderson (1840–1922) designed his own (frequently floral) tools and used them in a variety of ways, always with great taste and restraint. He gave rise to the amateur school of English bookbinding which has dominated binding design in the 20th century both in the UK and in the USA.

Throughout the 20th century, but especially since World War II, binding design reached remarkable standards in France and in England, although interesting work is also produced in Germany, Holland, the USA, and Japan. Styles have become more individual and designs tend to be determined by the book they embellish rather than by tradition. A wide variety of materials such as metal, stone, Perspex and plastics have taken the place of or are combined with the more traditional leathers, parchment, paper or cloth. In some cases it is hard to draw the line between bookbindings and sculpture.

2. FASTENERS AND LEAF EDGES. Straps, clasps or ties, necessary to keep books shut, also offer scope for decoration. Medieval luxury bindings tend to have elaborate, often jewelled clasps. Finely chased, engraved, or otherwise decorated clasps occurred from the 12th century onwards and elaborately ornamented clasps are frequently found on textile bindings of the 15th and 16th centuries, as well as on leather work, or—in the 17th and 18th centuries—on tortoiseshell or as part of chased or repoussé metal covers, especially in Holland and Germany. Clasps were often combined with metal bosses or with metal corner and centre pieces and these are a typical feature of German bindings of the 15th century and later.

Decorated leaf edges may be stained, painted, marbled, sprinkled, gilt, or gilt and gauffered. Coloured edges seem to be as old as the codex itself and purple edges have been found on a 4th-century book. Edges painted with decorative designs are found at least as early as the 10th century. Marbled edges are most frequently found on 17th and 18th century books. Edge gilding started in Italy in the second half of the 15th century and gilt edges, sometimes also gauffered (decorated with heated finishing tools), were widespread from the 1530s in Italy, France, Spain, Holland and a little later in England, Germany and Scandinavia. The peak of elaboration, when paint was combined with gilding

Stamped binding design by Aubrey Beardsley, of Sir Thomas Malory's *Le Morte Darthur* [sic], cloth, 1893 (Vienna, Österreichische Nationalbibliothek); photo credit: Erich Lessing/ Art Resource, NY

and gauffering, was reached during the second half of the 16th century, and continued in Holland, Germany and Scandinavia in the 17th and 18th centuries.

Stained edges are more common on retail bindings but are also found on finer work, especially in Germany and Holland, while sprinkled edges occur on English books of the 18th century and continued to be popular. The painting of designs underneath the gold of the edges dates back in England to the 1650s and was common during the Restoration Period. This practice continued in England during the first half of the 18th century and was much employed by Edwards of Halifax in the 1780s; it was still carried on in the first three decades of the 19th century and was revived early in the 20th century.

L. Gruel: *Manuel historique et bibliographique de l'amateur de reliures*, 2 vols (Paris, 1887, 1905)

E. Thoinan: *Les Relieurs français, 1500–1800* (Paris, 1893)

H. Loubier: *Der Bucheinband von seinen Anfängen bis zum Ende des 18. Jahrhunderts* (Leipzig, 1926)

E. P. Goldschmidt: *Gothic and Renaissance Bookbindings*, 2 vols (London, 1928)

G. D. Hobson: *English Bindings before 1500* (Cambridge, 1929)

F. Hueso Rolland: *Exposición de encuadernaciones españolas* (Madrid, 1934)

H. Thomas: *Early Spanish Bookbindings* (London, 1939)

G. D. Hobson: *English Bindings in the Library of J. R. Abbey* (London, 1940)

E. Kyriss: *Verzierte gothische Einbände im alten deutschen Sprachgebiet* (Stuttgart, 1951)

L.-M. Michon: *La Reliure française* (Paris, 1951)

J. B. Oldham: *English Blind-stamped Bindings* (Cambridge, 1952)

L.-M. Michon: *Les Reliures mosaïquées du XVIIIe siècle* (Paris, 1956)

H. M. Nixon: *Broxbourne Library: Styles and Designs of Bookbinding* (London, 1956)

J. B. Oldham: *Blind Panels of English Binders* (Cambridge, 1958)

R. Devauchelle: *La Reliure en France de ses origines à nos jours*, 3 vols (Paris, 1959–61)

T. de Marinis: *La legatura artistica in Italia*, 3 vols (Florence, 1960)

G. Pollard: 'The Construction of English 12th-century Bindings', *The Library*, n. s. 4, xxvii (1962), pp. 1–22

H. M. Nixon: *Bookbindings from the Library of Jean Grolier* (London, 1965)

H. M. Nixon: *Sixteenth-century Gold-tooled Bookbindings in the Pierpont Morgan Library* (New York, 1971)

H. M. Nixon: *Restoration Bookbindings* (London, 1974)

A. R. A. Hobson: *Apollo and Pegasus* (Amsterdam, 1975)

G. Pollard: 'Some Anglo-Saxon Bookbindings', *Book Collector*, xxiv (1975), pp. 130–59

J. Storm van Leeuwen: *De achttiende eeuwse Haagse boekband* [18th-century bookbinding] (The Hague, 1976)

H. M. Nixon: *Five Centuries of English Bookbinding* (London, 1978)

M. M. Foot: *The Henry Davis Gift*, 2 vols (London, 1978, 1983)

P. Needham: *Five Centuries of Bookbindings, 400–1600* (New York and London, 1979)

A. R. A. Hobson: *Humanists and Bookbinders* (Cambridge, 1989)

H. M. Nixon and M. M. Foot: *The History of Decorated Bookbinding in England* (Oxford, 1992)

J. Raby: *Turkish Bookbinding in the 15th Century: The Foundation of an Ottoman Court Style* (London, 1993)

S. Caron: *Livres en broderie: Reliures françaises du Moyen Age à nos jours* (Paris, 1995)

P. Ward: *Contemporary Designer Bookbinders: An Illustrated Dictionary* (Cambridge, 1995)

J. McDonnell: *Five Hundred Years of the Art of the Book in Ireland: 1500 to the Present* (Dublin, 1997)

M. Foot: *The History of Bookbinding as a Mirror of Society* (London, 1998)

N. R. Ker: *Fragments of Medieval Manuscripts Pastedowns in Oxford Bindings: With a Survey of Medieval Binding c. 1515–1620* (Oxford, 2000)

R. M. Rouse: *Manuscripts and their Makers: Commercial Book Producers in Medieval Paris, 1200–1599* (Turnhout, 2000)

T. Conroy: *Bookbinders' Finishing Tool Makers, 1780–1965* (New Castle, DE, 2002)

E. King: *Victorian Decorated Trade Bindings, 1830–1880: A Descriptive Bibliography* (London, 2003)

M. Lock: *Bookbinding Materials and Techniques, 1700–1920* (Toronto, 2003)

S. Bennett: *Trade Bookbinding in the British Isles, 1660–1800* (New Castle, DE, and London, 2004)

E. Holzenberg: *Lasting Impressions: The Grolier Club Library* (New York, 2004)

D. Pearson: *English Bookbinding Styles, 1450–1800: A Handbook* (London and New Castle, DE, 2005)

J. van den Leeuwen: *Dutch Decorated Bookbinding in the Eighteenth Century* ('t Goy-Houten, 2006)

R. Minsky: *American Decorated Publishers' Bindings, 1872–1929* (Stockport, NY, 2006)

III. Conservation. The basic concept of book conservation is to preserve the true nature of the book and to ensure that none of the bibliographic evidence is lost. It was and still is usual practice for books to be rebound, especially if the original binding was plain, dirty and worn as many early bindings often are. The practice of rebinding early books in a contemporary style is the cause of an enormous loss to the student of the history of bibliography; a more acceptable practice is for books to be kept as close to their original state as possible. Apart from rebinding, books may become damaged in a number of different ways and have to be repaired if they are to survive in a usable condition. Although the processes of conservation are easy to learn, the diagnosis and prescription of the correct treatment requires experience and a good knowledge of the history and structure of books and bindings.

Books covered in vellum, especially those in limp vellum, are usually able to resist the ravages of time provided they are kept away from excessive heat and moisture. Vellum covers without clasps tend to warp and lift away from the book. This problem can be overcome by expertly relaxing and flattening the vellum thereby returning the covers to their original position.

Most of the damage to leather bindings occurs at the back or spine or the corners of the board covers. Under normal storage conditions the spine is the area of the cover most exposed, and the hinge or joint where the boards meet the spine becomes either broken or seriously weakened by repeated flexing as the book is opened and closed. Invariably the cause is over-thinned and poor quality leather. One of the tasks most frequently undertaken by the book conservator is that of reinforcing or replacing the spine or joints of a binding. The usual method is to place a layer of new leather over the spine and joints of a book in an operation known as rebacking. The original spine is removed by carefully cutting underneath the leather with a specially designed knife and lifting it from the spine. The leather on the sides along the outer joints is lifted by making an incision at a shallow angle parallel to the joints. The leather turn-ins and end-papers at the inside of the head and tail ends of the boards are also lifted. A new piece of matching leather is cut to size, stained with aniline dyes to match the exact colour of the original and pared to the correct thickness. The new leather is coated with adhesive, centred on the back of the book and drawn-on and moulded over the spine, and the original spine is reattached in position. Damaged, worn, cracked and broken corners are repaired by lifting the original leather cover, turn-ins and end-papers away from the corners of the boards and inserting and moulding a new piece of matching leather underneath the area of damage. Providing the matching of the leather and colour is successful and the repairs are sound, they should be undetectable and will not disturb the aesthetic harmony of the binding.

Publishers' edition bindings in paper and cloth, first introduced in the early 19th century, are not constructed to last and quickly show signs of wear. They become damaged at the joints along the edge of the spine. The conservator's task is to restore the binding to its original state without disturbing the cover decoration. This is usually achieved by attaching a strip of matching material underneath the cover to reinforce the weakness at the spine. The main cause of decay of modern books is acid paper. In the late 20th century processes for the deacidification of paper were successfully developed (*see* PAPER, §VI).

Much can be done to slow down the speed of deterioration of bindings. It is important that the books are stored on uncrowded shelves to permit a free circulation of air and to enable a book to be removed without damage. They should be kept in a

constant temperature away from sources of heat such as radiators and fires. Bindings that are liable to damage by handling, especially those in paper wrappers, should be stored in a protective container made from acid-free board.

B. C. Middleton: *A History of English Craft Bookbinding Technique* (London, 1963, rev. 1978)

B. C. Middleton: *The Restoration of Leather Bindings* (Chicago, 1972, rev. New Castle, DE., and London, 3/1998)

A. D. Baynes-Cope: *Caring for Books and Documents* (London, 1981, rev. 1989)

J. Greenfield: *Care of Fine Books* (New York, 1988)

A. W. Johnson: *A Practical Guide to Book Repair and Conservation* (London, 1988)

P. Culot: 'La Bibliotheca Wittockiana, un musée de la reliure decorée', *Rev. Belge Archéol. & Hist. A.*, lxvi (1997), pp. 211–15

D. Helliwell: *The Repair and Binding of Old Chinese Books* (Princeton, 1998)

B. M. Haines: *Surface Coatings for Binding Leathers* (Northampton, 2002)

C. Clarkson: *Limp Vellum Binding and its Potential as a Conservation Type Structure for the Rebinding of Early Printed Books* (Oxford, 2005)

M. Kite: *Conservation of Leather and Related Materials* (London and Boston, 2006)

L. S. Young: *Bookbinding and Conservation by Hand: A Working Guide* (New Castle, DE, 1995)

Boucharde [bush hammer]. Mallet studded with V-shaped indentations used in sculpture to wear down the surface of the stone or material.

Bozzetto [*Abbozzo*; It.: 'sketch']. Rough, preliminary version of a composition. The term bozzetto is used for the initial outline, drawing or underpainting of a picture and for the roughly shaped piece of material approximating the finished form of a sculpture.

See also OIL SKETCH and MODELLO.

Brass. The alloy of copper and zinc. The alloy of copper and tin is bronze, while alloys with both zinc and tin are known as gunmetals. Many of the alloys that are described as bronze are in fact brass; for a discussion of the origins and usage of these terms *see* BRONZE.

E. R. Caley: *Orichalcum and Related Ancient Alloys*, American Numismatic Society Publication, no. 151 (New York, 1964)

P. T. Craddock, ed.: *2000 Years of Zinc and Brass*, British Museum Occasional Papers, no. 50 (London, 1990, rev. New Castle, DE and London, 3/1998)

I. Properties. These depend very much on the zinc content, which gives a wide range of alloys. The properties of certain alloys will be considered here in order of ascending zinc content. For further technical information the reader should consult the publications of the Copper Development Association in Britain or of the corresponding group elsewhere.

Many copper alloys, including bronzes, have a small percentage of zinc as a deoxidizer. It scours out any dissolved oxygen in the metal and reduces gas porosity in the subsequent casting. For example, the alloy commonly used for sculpture in North American foundries contains 5% zinc with 90–95% copper, 3–4% silicon and 1% manganese; it is extremely malleable and pours very smoothly since it oxidizes less than traditional alloys. Brasses with *c.* 10–15% zinc are known as gilding metal, not so much because they are suitable for gilding but because they resemble gold in colour. These alloys have always been popular for costume jewellery and decorative metalwork, from the time of the Romans to the 18th century, when a variety known as pinchbeck was used, and right up to the present day. They are very ductile, and as the zinc content increases they become stronger but more brittle, hence the cracks seen on many thin-walled brass vessels.

The alloy with *c.* 25–35% zinc, known as red or common brass, is perhaps the most common. It has excellent all-round properties, being easy to cast, machine and work. It is especially suited to such industrial processes as spinning and extrusion. The bright golden-yellow colour is attractive, and this, coupled with the relative cheapness of the alloy, has ensured its usage for a wide range of objects and fittings.

Brass with *c.* 40% zinc, known as yellow or Muntz metal, is widely used for castings and sometimes for hot working. Alloys with more zinc than this tend to be brittle and impossible to work, but some 19th-century castings have up to 50% zinc. This made a cheaper alloy, because the zinc was so much less expensive than the copper, but the metal is rather grey and unattractive as well as brittle. For bidri, an alloy containing *c.* 90–98% zinc, *see* §II below.

All brasses tend to lose zinc as they weather, a process known as dezincification. This can often be seen on old brass, where the use of household cleaners over many years has selectively removed the zinc, leaving pinkish areas of almost pure copper on the surface.

Both brass and gunmetal may contain some lead, in which case they should be termed leaded brass or gunmetal. The lead improves their casting properties by lowering the melting temperature and rendering the molten alloy more fluid.

II. Production. Brass is by far the most common copper alloy, but in comparison with bronze its history is relatively short. Bronze was first used in the late 4th millennium BC (*see* BRONZE, §II, 1), while brass only rose to prominence in the late 1st millennium BC; indeed, it was probably the last major alloy to be discovered before the Industrial Revolution. The reason for the late arrival of brass is the great volatility of zinc. At the temperature necessary to smelt zinc from its ores, zinc is a gas. In simple shaft furnaces other metals will collect in the bottom as dense, molten droplets to form an ingot, but zinc simply vaporises and goes up the flue, to be lost as smoke. Thus, metallic zinc was not produced until the development of special furnaces incorporating distillation apparatus to condense the metal away from contact with air. Such furnaces were first developed in India *c.* AD 1000

(*see* §3 below). Brass was in use, however, long before zinc itself was known. This apparent anomaly arose because early brass was made directly from copper metal and zinc ore. Comments by Pliny the elder (AD 23/4–79) suggest that some early brasses were produced simply by smelting a mixed copper–zinc ore, but his text is unclear; this account of brass will start with an assessment of the possibilities of a 'natural brass'.

1. 'NATURAL BRASS' AND EARLY PRODUCTION METHODS. Pliny implied that brass (*aurichalcum*) had once been produced naturally from a special ore found on Cyprus but that the source had been exhausted, and an artificial *aurichalcum* had to be made by mixing copper with zinc ore. By the time that Pliny was writing, in the 1st century AD, brass had been made by the latter process for some time, so the natural *aurichalcum* could well be hearsay. However, 'natural brasses' are certainly possible: some Pre-Columbian copper-alloy artefacts from Argentina have been shown to contain several percent zinc, and experiments in China have demonstrated that alloys of copper and zinc can be produced by a primitive smelting process using a mixture of copper and zinc ores. More significantly, a few copper alloys containing some zinc have been excavated from sites in the Near and Middle East dating from the end of the 2nd millennium BC and beginning of the 1st. Assyrian records from this period mention, in addition to ordinary copper, a special 'copper of the mountain' that was highly prized. This could be synonymous with the contemporary Greek material *oreikhalkos*, which also meant 'copper of the mountain' and later came to refer to brass. Possibly 'copper of the mountain' was a natural brass produced from a zinc-rich copper ore, a contention that is supported by some of the bronze bowls discovered at the ancient Assyrian palace of Nimrud, which have been found to contain several percent zinc.

There are numerous Greek references to *oreikhalkos* from the 7th century BC, and they all speak of the metal as an exotic and highly prized material. Indeed, Plato in the *Critias* placed the value of *oreikhalkos* between that of gold and silver. Initially, *oreikhalkos* may have been produced as a natural alloy by co-smelting mixed ores, but there is one extraordinarily early reference to the production of brass from copper and zinc metals. This was made by the geographer Theopompos in the 4th century BC and recorded by Strabo in his *Geography*: 'There is a stone near Andeira which yields iron when burnt. After being treated in a furnace with a certain earth it yields drops of false silver. This, added to copper, forms the so-called mixture which some call *oreikhalkos*.' (Caley, p. 18)

The place in question is almost certainly the mine of Balia Maden, which lies near the site of ancient Andeira in north-west Turkey. The mine has a long history, producing silver from a mixed lead–zinc–iron-pyrites ore that was rich in such other metals as arsenic and antimony, as well as silver. These ores are quite common, but they are difficult to smelt with only simple technology. The Greeks may have used a method similar to that recorded by Georgius Agricola in his description of the German mines at Rammelsberg in the 16th century AD. According to Agricola, drops of metallic zinc condensed on the flue walls during the smelting, though most of the zinc would have been lost up the flue. The German miners called this metallic zinc 'false silver' and used it to produce a superior brass. They also scraped off the zinc oxide that formed in considerable quantities on the walls of the furnace and mixed it with charcoal and finely divided copper to make brass, heating it in a closed crucible to a temperature of about 1000°C. The charcoal reduced the zinc oxide to zinc vapour, which could not escape from the closed crucible but instead was absorbed into the exposed surfaces of the copper to form brass directly.

It is almost certain that a process similar to this first took place at Balia Maden or at some other mine near by, because this is the region in which brass first became common, and by the beginning of the 1st century BC local coins of low denomination were regularly being produced in brass (*see* §III, 1 below). It would have been obvious that *oreikhalkos* could be made from the zinc oxide as well as from the drops of 'false silver', and from there it would have been a short step to use zinc ores by themselves. Thus, the direct method of producing brass from copper and zinc ore in a crucible, known as the cementation process, was born. The process survived with only minor changes until the mid-19th century.

2. THE CEMENTATION PROCESS. Most of the zinc ores in the Middle East are sulphidic, so before they could be used in the cementation process they had to be converted to the oxide. This operation, which was first described by Dioskurides in the 1st century AD, was one of sublimation and gave a very pure product, which can be seen in the composition of brasses from the Middle East. It remained in use through the medieval period and was described in the 13th century by Marco Polo (1254–1324), who saw it in operation in Kirman: 'They take a vein of earth that is suited for the purpose and heap it in a furnace with a blazing fire above which is an iron grid. The fumes and vapour given off by this earth and trapped by the grid constitute *tutty* [zinc oxide].' (Latham, p. 39).

In Europe the zinc ore calamine (Amer.: smithsonite) was much more common. This is the carbonate, and it could be used without the elaborate pretreatment necessary for the sulphidic ores. An excellent and very detailed description of brass production in 12th-century Europe (see fig. 1) was given by Theophilus (Dodwell, pp. 123–4):

Put in the furnace three, or four, or five [crucibles]—as many as the furnace can take—and surround them with coals [charcoal]. When they are hot, take the calamine … which has been finely ground with coal, put some in each crucible—about a sixth full—top it up with copper

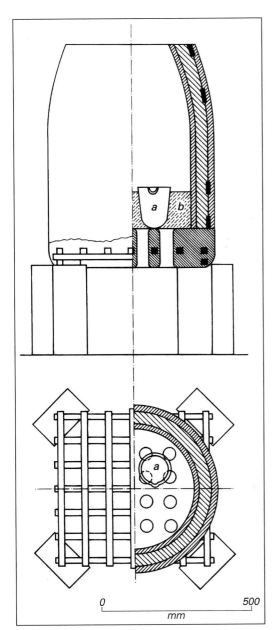

1. Section through a brass cementation furnace, based on a description given in the 12th century by Theophilus

and cover with coals…. When the copper has completely melted, take a thin iron rod … and carefully stir so that the calamine is mixed with the copper. Then … put calamine in all of them as before, fill up with copper and cover with coals. When it has been completely melted again, stir it again with great care, and, taking one crucible off with the tongs, pour it all out in the trenches dug in the ground and return the crucible to its place.

Subsequent accounts of the process include such texts as the *Pirotechnia* of Vannuccio Biringucci (1480–1539), the *Beschreibung allerfürnemsten mineralischen Ertzt Berckwercksarten…* (1580) of Lazarus Ercker (*c.* 1530–*c.* 1594), *L'Art de convertir le cuivre rouge en cuivre jaune* (1766) by Col. Galon and H. L. Duhamel du Monceau (1700–82), and the *Encyclopédie of Denis Diderot* (1713–84). The last contemporary description of the cementation process was given by J. Percy in his *Metallurgy* of 1860, in which he described the old process as practised in Wales in the 1790s and said that it had been carried on in Birmingham until recently and that some cementation furnaces might still be operating.

The reason for the decline of the cementation process in Europe through the first half of the 19th century was the growing prevalence of speltering. Although the cementation process was in some ways more efficient, since the brass was made directly from the zinc ore instead of from the metal, it was very difficult to control the amount of zinc in the alloy and impossible to make high-zinc brasses containing more than *c.* 30% zinc. Another disadvantage with European cementation brass was that it usually contained undesirable impurities derived from the ore, particularly lead and iron.

3. Speltering. In this process superior brass is made by mixing copper and metallic zinc together. Speltering seems to have developed in the Indian subcontinent, where brass has a long history, certainly going back to the late 1st millennium BC. At first Indian brasses were made by the cementation process, and some of the early literature seems to refer to this, describing, for example, how zinc ore added to copper in a crucible will turn it golden. However, various Indian scientific and alchemic writings suggest that metallic zinc was known over 2000 years ago, and quite detailed descriptions of the speltering process survive from *c.* AD 1000.

Recent excavations at Zawar, near Udaipur in Rajasthan, where zinc production on an industrial scale was in full swing by the 12th century, have uncovered the intact remains of medieval furnaces and retorts. The zinc ore was sphalerite, which was first roasted to remove the sulphur and then powdered and made into small balls, with charcoal and sticky organic materials as a binder. Contemporary scientific treatises, for example the *Rasaratnasamuccaya*, give lists of the ingredients to be added: 'Zinc ore is to be powdered with lac, treacle, white mustard, the myrobalans, natron and borax, and the mixture boiled with milk and ghee and made into balls. These are to be enclosed in a retort and heated strongly.' (Ray, p. 171)

The ingredients sound a little fanciful, perhaps more appropriate to the laboratory than to the commercial enterprise that flourished at Zawar, but the principle is sound enough, and examination of the retort contents has confirmed that it was made of a network of small balls fused together. It is impossible to say what material was used as the binding agent, as it would have burnt

out, but in the 19th century cow dung was used in copper smelting. The *Rasaratnasamuccaya* says that when the balls had been loaded into the retorts (described as being shaped like an aubergine), a condenser was sealed in place, terminating in a long, thin clay tube (see fig. 2). This is exactly what has been found at Zawar, where in addition a stick was pushed through the contents. When the retort was heated the organics burnt off, but the rest of the charge began to fuse, thus preserving the open structure. This was essential if the reducing gases were to circulate freely and the forming zinc vapour escape to the central channel left by the now-charred stick. The text describes the process whereby the inverted crucibles or retorts were placed in the hot upper chamber and the zinc collected in a cool chamber beneath: 'A vessel filled with water is to be placed inside a *koṣṭhī* apparatus [furnace] and a perforated plate placed over it; a crucible charged as described above is to be fixed in an inverted position over the plate and strongly heated by means of jujube wood charcoal.' (Ray, p. 172)

The site at Zawar is made up of huge mounds containing millions of spent retorts, and in some places the ancient *koṣṭhī* lie buried. One example, dating from the 14th century, has been excavated with the retorts still in place from the last firing. Thirty-six retorts had been placed in a 6×6 arrangement in each furnace. The excavated block was made up of a row of 7 furnaces shaped like truncated pyramids, each with 36 retorts, and thus a total of no less than 252 retorts were fired simultaneously. The zinc would condense in the necks of the clay condensers and drip into receiving vessels below. A furnace block such as this would probably have been capable of producing 25–50 kg per day, and it is assumed that many such blocks would have been operational. It is estimated that somewhere in the region of about 50,000–100,000 tonnes of zinc were produced at the site during its operational life,

which lasted until the early 19th century, and that most of this would have been used for brass production.

The early history of brass in China is not well researched. The first references to zinc date from the late 15th century and the early 16th, when it was described as 'superior tin' or 'poor lead'. Despite the latter name, it was much valued because it could be mixed with copper to produce brass superior to that produced by the old cementation process. The process of zinc-making is illustrated in the *Tian gong kai wu* ('The workings of heaven revealed'; 1637) by Song Yingxing (see fig. 3) and seems very similar to that practised in south-west China in the late 20th century. It is based on the principle of the Mongolian still, with an internal condenser in the form of a saucer (see fig. 4). The charge of zinc ore and powdered coal is placed in the retort, and about 36 retorts are stacked together in trough-shaped furnaces. The retorts are fired open for several hours to calcine the ore, and then the collecting saucers are added and loose fitting lids put on the retort tops. The zinc vapour begins to condense on the underside of the lids and drips back down into the saucers. As in India, most of the zinc was used to make brass. Zinc and

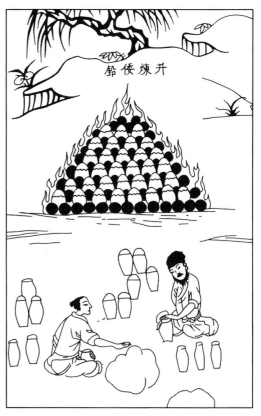

3. Zinc smelting in China in the 17th century; woodcut from Song Yingxing: *Tian gong kai wu* ['The workings of heaven revealed'], 1637

2. Simplified section through one of the zinc-smelting furnaces at Zawar, Rajasthan

0 mm 400

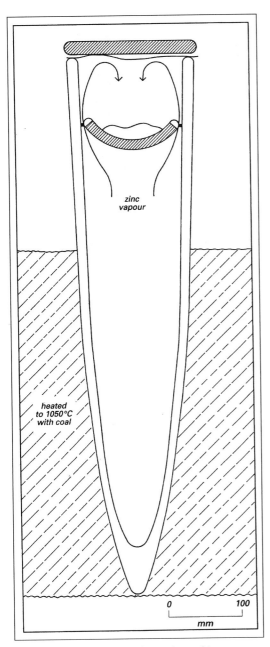

4. Simplified section through a Chinese zinc-smelting retort

zinc vapour

heated to 1050°C with coal

0 100

mm

costume jewellery. A number of special alloys were developed, among them pinchbeck (*see* §I above), the success of which lay in the use of zinc metal. Industrial production of zinc began in Bristol in the 1740s, when William Champion (1709–89), a prominent local brass-maker, developed a process of zinc smelting by downward distillation. The principle was identical to that used in the Indian process, but on a much larger scale. The charge of zinc ore and charcoal was placed in six very large retorts in a furnace, the iron necks of the retorts protruding down through the furnace floor into the cool chamber, where the zinc was collected in vessels of water. The furnace itself was an adaptation of those used by the local Nailsea glass-makers, a good and quite typical example of technical cross-fertilization. Champion's ambitious spirit was perhaps better suited to technical innovation than to business: his industrial empire outran his resources, and he was declared bankrupt. However, the brasses produced by his process were highly satisfactory. It was said of James Emerson (*b* 1739), a former employee of Champion who set up his own business: 'His brass is … more malleable, more beautiful, and of a colour more resembling gold than ordinary brass is. It is quite free from knots or hard places, arising from iron, to which other brass is subject, and this quality, as it respects the magnetic needle, renders it of great importance in making compasses.' (R. Watson, *Chemical Essays*, London, 1784, pp. 47–8, reported in Day, 1973, p. 124)

The downward distillation process, or the 'English process' as it came to be known, was taken up by a few local brass-makers but without great success, since it was too expensive for utilitarian goods. It was rapidly superseded by other developments in Europe, particularly in Silesia and Belgium. In the Belgian (or Dony) process, developed by Jean-Jacques Daniel Dony (1759–1819) in the early 19th century (Ladeuze, De Jonghe and Pauquet, 1991, pp. 15–34), some hundreds of retorts were fired together in double horizontal banks. This method became one of the standard means of zinc production around the world, but from the beginning of the 20th century zinc began to be made electrolytically, and this now accounts for the majority of the world's production.

Pliny: *Natural History*, XXXIV, ii

Dioskurides: *Materia medica*; Eng. trans. by J. Goodyer (1655), ed. R. T. Gunter (Oxford, 1934), p. 234

Theophilus [Rugerus]: *De diversis artibus* (?1110–40); Eng. trans. by C. R. Dodwell as *The Diverse Arts* (London, 1961), pp. 123–4

V. Biringucci: *De la pirotechnia …* (Venice, 1540); Eng. trans. by C. S. Smith and M. T. Gnudi as *The Pirotechnia of Vannuccio Biringucci* (New York, 1942), pp. 70–76

G. Agricola: *De re metallica* (Basel, 1556; Eng. trans., London, 1912), p. 234

L. Ercker: *Beschreibung allerfürnemsten mineralischen Ertzt Berckwercksarten …* (Frankfurt am Main, 1580); Eng. trans. by A. G. Sisco and C. S. Smith as *Lazarus Ercker's Treatise on Ores and Assaying* (Chicago, 1951), pp. 254–8

brass production grew rapidly into a large-scale industry, and by the beginning of the 17th century China was exporting considerable quantities of zinc to Europe.

In Europe some quality brass had been made from the 17th century, using the metallic zinc imported from the East or that collected from the flues of such smelters as those at Rammelsberg. It was used for making scientific instruments and

Col. Galon and H. L. Duhamel du Monceau: *L'Art de convertir le cuivre rouge en cuivre jaune* (Paris, 1766); Eng. trans. by A. P. Woolrich and A. den Ouden as *Galon and Duhamel du Monceau: The Art of Converting Red, or Rosette, Copper into Brass* (Eindhoven, n.d.)

D. Diderot and J. Le Rond d'Alembert: *Métallurgie, Calamine*, vi of *Encyclopédie* (Paris, 1768)

J. Percy: *Metallurgy: Fuels, Fireclays, Copper, Zinc and Brass* (London, 1861)

P. Ray: *History of Chemistry in Ancient and Medieval India* (Calcutta, 1956)

R. E. Latham: *The Travels of Marco Polo* (London, 1958)

E-tu Zen Sun and Shiuo-chuan Sun: *T'ien-kung k'ai-wa: Chinese Technology in the 17th Century* (Philadelphia, 1966)

J. Day: *Bristol Brass* (Newton Abbot, 1973)

R. Halleux: 'L'Orichalque antique', *L'Antiquité classique*, xlii (1973), pp. 64–81

J. Needham: *Science and Civilisation in China*, v/ii (Cambridge, 1974)

A. R. Gonzalez: 'Pre-Columbian Metallurgy of Northwest Argentina', *Pre-Columbian Metallurgy of South America*, ed. E. P. Benson (Washington, DC, 1979), pp. 132–202

P. T. Craddock, A. M. Burnett and K. Preston: 'Hellenistic Copper-base Coinage and the Origins of Brass', *Scientific Studies in Numismatics*, ed. W. A. Oddy, British Museum Occasional Papers, no. 18 (London, 1980), pp. 53–64

P. T. Craddock: 'Report on the Composition of Metal Tools and Weapons from Ayia Paraskevi, Vounous, and Evereti, Cyprus', appendix to E. Peltenberg: *Cypriot Antiquities in the Birmingham Museum and Art Gallery* (Birmingham, 1981), pp. 77–8

Sun Shuyun and Han Rubin: 'Zhongguo zaoqi tongqi de chubu yanjiu' [A preliminary study of early Chinese copper and bronze artefacts], *Kaogu xuebao*, iii (1981), pp. 287–302 [Eng. abstract p. 302]

C. F. A. Schaeffer-Forrer, U. Zwicker and K. Nigge: 'Untersuchungen an metallischen Werkstoffen und Schlacken aus dem Berich von Urgarit', *Mikrochimica Acta*, i (Vienna, 1982), pp. 35–61

P. T. Craddock: 'The Early History of Zinc', *Endeavour*, xi (1987), pp. 183–91

M. J. Hughes and others: 'The Evidence of Scientific Analysis: A Case Study of the Nimrud Bowls', *Bronzeworking Centres of Western Asia*, ed. J. Curtis (London, 1988), pp. 311–16

F. Ladeuze, L. De Jonghe and F. Pauquet: 'Vielle-Montaigne, l'exploitation minière et la métallurgie du zinc dans l'ancien duché de Limbourg', *Bulletin trimestriel du Crédit communal de Belgique*, clxxviii (1991), pp. 15–34

R. Hughes and M. Rowe: *The Colouring, Bronzing and Patination of Metals: A Manual for Fine Metalworkers, Sculptors and Designers: Cast Bronze, Cast Brass, Copper and Copper-plate, Gilding Metal, Sheet Yellow Brass, Silver and Silver-plate* (London, 1991)

Weirong Zhou: 'The Emergence and Development of Brass-smelting Techniques in China', *Kinzoku Hakubutsukan kiyō*, xxxiv (2001), pp. 87–99

N. Eniosova and V. Murashova: 'Manufacturing Techniques of Belt and Harness Fittings of the 10th century AD' *Journal of Archaeological Science*, xxvi/8 (1999), pp. 1093–1100

P. Hammer: 'Zur Gruppierung von Kupferlegierungen: Der Terminus "Aes" bei Plinius', *Metalla: Forschungsberichte des Deutschen Bergbau Museums*, vii/1 (2000), pp. 23–32

K.M. Linduff, H. Rubin and S. Shuyun: *The Beginnings of Metallurgy in China* (Lewiston, NY, 2000)

J.-M. Welter: 'The Zinc Content of Brass: A Chronological Indicator?', *Technè: La science au service de l'histoire de l'art et des civilisations*, xviii (2003), pp. 27–36

J. Riederer: '10,000 Jahre Kupfer und Kupferlegierungen: die Erschliessung ihrer Entwicklung durch chemische Analysen', *Restauro*, cx/6 (2004), pp. 394–400

III. Uses.

1. Ancient world. 2. Indian subcontinent. 3. Islamic lands. 4. China. 5. Europe.

1. ANCIENT WORLD. The production of brass on an industrial scale began in the late 1st millennium BC, almost certainly somewhere between Greece and India, using the cementation process of reacting zinc ore with copper metal (*see* §II, 1 above). It is likely that the first brasses came from this region, but little analytical work has been done on copper alloys of such relevant civilizations as the Achaemenid Persians (7th–4th centuries BC) or the Mauryans of north India (4th–2nd centuries BC) or of the Hellenistic states that sprang up in the wake of Alexander the Great's short-lived empire of the 4th century BC. Some isolated examples have been found, and there is a little documentary evidence in the *Inscriptiones graecae* in the form of lists of offerings made at Greek temples. From the 4th century BC these differentiate between objects made of brass (*oreikhalkos*) and those of bronze or copper (*khalkos*).

The first regular series of surviving brasses that have so far been identified are some of the coins of Mithridates VI, who ruled much of Asia Minor between 121 BC and 63 BC. The brass coins all contain *c.* 20% zinc, made by the cementation process, and they commence *c.* 100 BC. The coins were minted in north-western Asia Minor, at Bithynia and Phrygia, whence there is other evidence of an early interest in brass and even in zinc. The copper-base coins in this series include both bronze and brass, and there was a conscious selection of alloy for particular types. This practice continued in the region for the next half-century or so, down to the reform of the Eastern coinage undertaken by Augustus when he became emperor in 27 BC. The *Caesar Augustus* coins were then made of brass and the *aes* of copper. This process seems to have been a trial run for the great central coin reform of 23 BC, when large numbers of copper-base coins were minted in Rome, including the *dupondii* and *sestertii* of brass and the *aes* of copper, clearly based on the preceding *Caesar Ausgustus* coinage. Thus, the coins of Mithridates VI seem to be directly ancestral to the reformed coins of the Roman Empire itself. The *dupondii* and *sestertii* were minted in enormous numbers and, from the 18th century, were known by numismatists as the 'first brass' series; they probably represent the first large-scale use of brass anywhere.

The coins made over the first 50 years of the Roman Empire usually contain *c.* 20–28% zinc with very little tin or lead; they were almost certainly made of cementation brass. However, after the mid-1st

century AD the zinc content declines, and there is a corresponding rise in the lead and tin content, which suggests that scrap metal was being added to the brass. The decline in zinc content continued until, by the end of the 2nd century, none of the coins of the central mints could be described as being of brass at all. This led Caley to claim that the secret of brass-making had been lost, but in fact the situation was more complex. It seems that during the last years of the Republic and the early years of the Empire the use of brass was concentrated in coinage, military fittings and such decorative metalwork as brooches and fibulae, but otherwise bronze was still prevalent. Indeed, it is no exaggeration to state that most military fittings were of brass and, what is more, of undiluted, high-zinc brass straight from the cementation crucible. The contemporary civilian decorative metalwork tended to be made from a diluted brass with rather less zinc but some tin and lead. This suggests that in the early Imperial period, at least, there could have been an Imperial monopoly on the production of brass. In general, during the Roman Empire c. 20–30% of copper alloys contained significant amounts of zinc, with no sign of the fall off suggested by Caley. However, bronze remained the prevalent alloy and was used almost exclusively for some types of art metalwork, for example statues and mirrors.

2. INDIAN SUBCONTINENT. Brasses have been found among the metalwork excavated at Taxila, in Pakistan, a city that rose to prominence as a trading centre in the last centuries of the 1st millennium BC, after Alexander's campaigns had opened up contact and commerce between the Mediterranean and the East. Many of the metal vessels found at Taxila are local brass copies of Greek types, whereas the originals would have been of bronze. Unfortunately, metalwork from other major urban sites of the same period has not been analyzed. From the Gupta period (4th–5th century AD) copper-alloy statuettes of deities etc were produced in quantity in north India, and analysis has shown that these are almost all of brass. This tradition of image-making in brass continued all over north India and Tibet until the mid-20th century; it still flourished in Nepal in the late 20th century. In south India, where trade contacts with the rich tin sources of South-east Asia were much stronger, statuettes continued to be made exclusively of bronze up to about the 15th century.

Not only did India have a precocious use of brass, but the technology was very advanced, and zinc metal was being produced on an industrial scale from c. AD 1000 (see §II, 3 above), enabling superior brass to be made by speltering copper and zinc metals. Enormous quantities of metal must have been used on vessels alone, since they have always been of brass in India.

A distinctive and uniquely Indian material is bidri (see fig. 5). This is an alloy containing c. 90% zinc and 5% copper. Vessels and a whole range of decorative metalwork are cast from the dull grey metal, then inlaid in silver with intricate floral patterns and

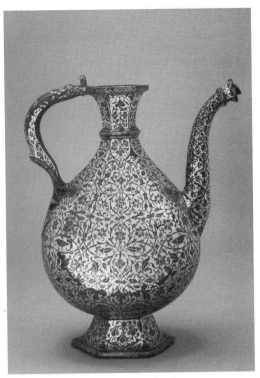

5. Brass bidri-ware ewer, inlaid with silver, h. 285 mm, from India, Deccan, mid-17th century (London, Victoria and Albert Museum); photo credit: Victoria and Albert Museum, London/Art Resource, NY

arabesques before being dipped in a hot solution of salt, nitre and ammonium chloride, which gives the base metal an attractive matt black patination. Bidri has been made in Muslim areas throughout the subcontinent, including the town of Bidar in the Deccan, from which it takes its name and whence it is supposed to have originated in the 15th century.

3. ISLAMIC LANDS. Islamic writers, for example Abu'l-Qasim Kashani, writing c. 1300, listed all tin sources as being well outside the Islamic world. The unavailability of tin in the Islamic world is reflected in the copper alloys, which are almost exclusively of brass (though they are often described as bronze), with the exceptions of mirrors and certain special high-tin bronzes (see BRONZE, §II, 6). On technical grounds Islamic metalwork can be divided into two groups: the cast metalwork that tends to be of brass, with c. 10% zinc and similar amounts of lead and a little tin, and the thinner pieces made from sheet brass that tend to have c. 20% zinc and only traces of other metals. The sheet metalwork was generally shaped by hammering, but by the 13th century some vessels were formed by spinning. Islamic brassware was often richly decorated by chasing, emphasized by bitumen, and inlaid with silver or, more rarely, with gold. From the 16th century brass became less popular for everyday use and was replaced by tinned copper.

4. CHINA. The evidence for the history of brass in China is sparse, but it seems that the alloy sprang to prominence very quickly *c.* 1500. This assumption is based on analyses of the coinage, which was of bronze until the late 15th century, when there was a change to brass; contemporary records speak of making the coinage from copper and a 'new' tin, almost certainly metallic zinc. Caution should be exercised here: a similar study of British coinage would suggest that the use of brass did not start until the 1930s with the minting of the brass threepenny bit. However, analyses of copper alloys of the Song (960–1279) and Ming (1368–1644) periods suggest that bronze remained the usual alloy, at least for art metalwork. From the 16th century brass replaced bronze almost completely. The technology and indeed the basic design of the ritual vessels and statuettes remained much the same, and the difference between the colour of the earlier, heavily leaded bronzes and the golden, high-zinc brass would have been nullified by the dark varnish or patination that almost invariably covers the later metalwork.

5. EUROPE. In the West the watershed between the general use of bronze and that of brass seems to have come with the fall of the Western Empire in the 5th century AD. Virtually all the sources of tin on which the Middle East and the Mediterranean relied were in the north-west of the Empire, so the loss of the tin-producing provinces of Britannia, Hispania and Pannonia must have severely curtailed production and supply. Analyses of Coptic metalwork, for example, show that by the 6th and 7th centuries AD brass had already largely replaced bronze; by the time industry had recovered in medieval Europe, brass was the prevalent copper alloy. Zinc ores are quite abundant over much of the earth's surface, including the Middle East, whereas tin is rare. The account by Stephanos of Alexandria in the 7th century AD of tin being brought to Egypt from Cornwall after miraculous voyages only serves to emphasize its rarity.

When Europe emerged from the Dark Ages brass was already prevalent. Analyses of some specific issues of base silver coins from Saxon England have shown that they were debased with brass of regular composition, and it is calculated that the smiths would have needed about ten tonnes of brass, which suggests they had access to freshly smelted metal. The chief areas of production lay in northern Italy, southern Germany and Flanders, and it is believed that the 12th-century writer Theophilus, whose work *De diversis artibus* contains a detailed description of brass-making and working (*see* §II, 2 above), was a German. There is increasing evidence that the calamine zinc deposits at Stolberg, near Aachen, were exploited in Roman times, and it seems probable that this industry survived the barbarian onslaught of the 4th and 5th centuries, joined later by La Calamine (Kelmis, now in Belgium).

By the time of Charlemagne (*reg* AD 742–814) the brass industry was capable of producing major items of considerable artistic and technical sophistication,

for example the doors of the Palatine Chapel, Aachen, and of the cathedrals of Hildesheim and Mainz, together with crosses, fonts and other major ecclesiastical fittings. In the medieval period the industry was centred in such small towns as Dinant (hence the term dinanderie to describe medieval decorative brasswares) and Huy on the river Meuse, and in other centres throughout the Meuse Valley. The workshops in these towns produced a wide range of cast and hammered domestic vessels but are especially renowned for the church fittings, for example memorial brasses and lecterns, which once adorned the churches of all Christendom but, after centuries of strife and neglect, survive chiefly in England. Another centre developed in the late medieval period at Nuremberg, utilizing the metal deposits at Rammelsberg and other mines in the Harz Mountains. This seems to have produced smaller, more domestic wares but on a very large scale. Documents from the early 16th century list enormous quantities of brassware shipped out to West Africa, with thousands of brass vessels being sent to individual trading stations. This trade demonstrates that brass production was now a major and increasingly international industry. The rise of the British brass industry dates from the end of the 17th century. Bristol was the first substantial centre and always specialized in sheet metalwork, including all manner of pots and pans. Much of the trade was for export.

The earlier centres, for example Bristol and Stolberg, favoured traditional water-powered hammers to fashion their wares, but as the Industrial Revolution gathered momentum such innovations as the fly press, for mass production of simple pressed metalwork such as brass buttons, and steam-powered lathe were introduced elsewhere, for example at Birmingham, which already specialized in cast brass.

In the past 500 years to the end of the 20th century brass was the predominant copper alloy owing to its attractive appearance, relative cheapness and ease of working. Although for utilitarian purposes it came to be largely replaced by enamelled iron or aluminium, it continued to be used for sculpture and decorative items.

J. Tavenor-Perry: *Dinanderie: A History and Description of Medieval Art Work in Copper, Brass and Bronze* (London, 1910)

F. S. Taylor: 'The Alchemical Works of Stephanos of Alexandria', *Ambix*, i (1938), pp. 116–39

J. Marshall: *Taxila* (Cambridge, 1951)

O. Werner: *Spektraanalytische und metallurgische Untersuchungen an indischen Bronzen* (Leiden, 1972)

J. W. Allan: *Persian Metal Technology, 700–1300 AD* (London, 1979)

A. M. Burnett, P. T. Craddock and K. Preston: 'New Light on the Origin of *Orichalcum*', *Proceedings of the 9th International Congress of Numismatics: Berne, 1979*, vi, pp. 263–8

P. T. Craddock: 'The Copper Alloys of the Medieval Islamic World', *World Archaeology*, xi (1979), pp. 68–79

H. Dannheimer: 'Zur Herkunft der 'koptischen' Bronzegefässe der Merowingerzeit', *Bayerische Vorgeschichtsblätter*, xliv (1979), pp. 123–47

G. R. Gilmore and D. M. Metcalf: 'The Alloy of the North-umbrian Coinage of the Mid-ninth Century', *Metallurgy in Numismatics*, ed. D. M. Metcalf and W. A. Oddy (London, 1980), pp. 88–93

W. A. Oddy and W. Zwalf, eds: *Aspects of Tibetan Metallurgy* (London, 1981)

U. von Schroeder: *Indo-Tibetan Bronzes* (Hong Kong, 1981)

E. W. Herbert: *The Red Gold of Africa* (Whitewater, WI, 1984)

P. T. Craddock: 'Three Thousand Years of Copper Alloys', *Application of Science in the Examination of Works of Art*, ed. P. England and B. van Zelst, v (Boston, 1985), pp. 59–67

P. T. Craddock and J. Lambert: 'The Composition of the Trap-pings', appendix to I. Jenkins: 'A Group of Silvered-bronze Horse-trappings from Xanten (Castra Vetera)', *Britannia*, xvi (1985), pp. 141–64

M. de Ruette: 'Etude technologique de la fonderie de laiton au moyen âge dans les Pays-Bas méridionaux et la principauté de Liège', *Revue des archéologues et historiens d'art de Louvain*, xix (1986), pp. 338–60

S. G. Bowman, M. R. Cowell and J. Cribb: '2000 Years of Coin-age in China', *Journal of the Historical Metallurgy Society*, xxiii (1989), pp. 25–30

S. Fraser-Lu: *Burmese Crafts: Past and Present* (Kuala Lumpur and New York, 1994)

R. Gentle and R. Field: *Domestic Metalwork, 1640–1920* (Woodbridge, 1994)

D. R. Hook and D. R. M. Gaimster, eds: *Trade and Discovery: The Scientific Study of Artefacts from Post-Medieval Europe and Beyond* (London, 1995)

D. L. Fennimore: *Metalwork in Early America: Copper and Its Alloys from the Winterthur Collection* (Winterthur, DE, 1996)

F. Kurzer: 'Samuel Parkes' Lost Analyses of Roman Imperial Brass Coins', *Historical Metallurgy*, xxxi/2 (1997), pp. 47–53

J. Riederer: 'Der Beitrag der Metallanalyse zur Bestimmung römischer Bronzestatuettenwerkstätten', *Kölner Jahrbuch*, xxxiii (2001), pp. 575–83

Weirong Zhou: 'The Emergence and Development of Brass-smelting Techniques in China', *Kinzoku Hakubutsukan kiyō*, xxxiv (2001), pp. 87–99

T. Stanley, M. Rosser-Owen and S. Vernoit: *Palace and Mosque: Islamic Art From the Middle East* (London and Washington, DC, 2004)

Brayer. Hand roller of rubber or gelatin used for applying ink to relief printing blocks (*see* PRINTS, §III, 1) or occasionally for the direct application of paint or ink to a surface.

Brick. Small, regular-sized unit, usually of clay but also of calcium silicate (sand and lime) or concrete, used as a building material.

I. Materials and techniques. II. Conservation.

I. Materials and techniques. Raw materials for bricks are widespread; the method of manufacture is determined by the physical and chemical properties of the clay and by economic circumstances. Calcium silicate bricks are made of a damp mixture of sand with 10% hydrated lime, formed in a powerful press and steamed in an autoclave for several hours. Concrete bricks (*see* CONCRETE, §II, 1) are made from a Portland cement and sand mixture cast in moulds.

In the most common format the length is approxi-mately twice the width and three or four times the depth. The size and weight of a brick are such that the bricklayer can pick it up in one hand, although sizes have varied over the centuries. Square blocks and thin, tile-like bricks have also been used. Bricks are used either in massive load-bearing structures or as a thin cladding to other materials in a structural frame (*see* MASONRY). The earliest use of brick was in areas where timber and stone were not readily available, and walls, arches, vaults and domes were all developed in brick. The ancient Romans sometimes used brick as a permanent formwork for concrete structures. Brickwork reinforced with iron bars or strips first appeared in the early 19th century. The structural strength of brickwork is achieved by laying in mortar and bonding so that all the vertical joints are staggered (*see* §3(i) below). Brick is especially desirable as a facing material, and an acceptable prod-uct can be made by methods as primitive or sophisti-cated as the market demands.

1. Manufacture. 2. Finishing. 3. Bricklaying.

1. MANUFACTURE.

(i) Adobe. Adobe bricks are always handmade under primitive conditions: there are no adobe brick facto-ries. The clay is mixed with chopped straw and water, trodden and then worked with a hoe to form a paste suitable for moulding. It is left for at least a day before use to improve workability. An open-bottomed wooden mould is first wetted to stop the clay sticking, placed on flat ground covered with sand or straw and filled with clay. This is struck off level, the mould lifted off, wetted and placed alongside for moulding the next brick. The process of drying the rows of bricks is speeded up by setting them on edge when stiff enough to handle. Broken bricks can be soaked down and reused. The dimensions of adobe bricks are often twice those of fired clay ones.

(ii) Fired. Fired bricks can be made by hand or machine. The amount of mechanization in the manufacturing processes of clay winning, preparation, moulding, drying and firing can vary considerably; clays that are unsuitable for hand processing may often be used for mechanized manufacture. Clay winning and prepara-tion by hand have been virtually superseded in indus-trialized countries. The clay is dug by mechanical excavators, including the shale-planer for hard clays, and may be stored in stockpiles to allow different seams of clay to be mixed and for winter frosts to break down hard lumps.

During preparation such undesirable materials as flints and limestone, which calcine on firing and slake on exposure to moisture, damaging the brick, are eliminated and other materials added to give the required characteristics. The latter may include sand to reduce plasticity and shrinkage, barium carbonate to stop efflorescence and metallic oxides for colour-ing (e.g. manganese dioxide for browns and greys). The materials are ground in a pan-mill and mixed

with sufficient water for moulding. Soft and plastic clays are finally kneaded in a pug-mill (an arrangement of knives in a cylindrical tub, which may be positioned vertically or horizontally, depending on the type of machine) before moulding. Traditionally the clay for the yellow 'London Stocks' was reduced to a slurry in a wash-mill and mixed with chalk slurry before drying out in settling ponds. It was mixed with fuel and water in a pug-mill before use.

Bricks were originally moulded as for adobe, but in the late 12th century two other methods—pallet-moulding and slop-moulding—both done on a bench, were introduced, using sand and water respectively to release the brick from the mould; both methods continue to be used worldwide in non-mechanized brickyards. In the former process the mould, dusted with sand, fits over a stock board, shaped to form the 'frog' (indent) in the brick and nailed to the bench. More sand is sprinkled on the bench, and sufficient clay is rolled in it to form a rectangular clot, which is thrown hard into the mould, filling every corner. The excess is cut away with a wire and the top smoothed with a stick dipped in water. The full mould is lifted off the stock, and the wet brick is turned out on to a pallet board to be removed for drying on a special flat-topped barrow. In slop-moulding the mould is dipped in water and placed directly on the bench. The clot is rolled in sand. The moulded brick, being softer, is laid on a 'flat' (carefully levelled and sanded surface) to stiffen for at least a day before being set on the drying hack. The soft-mud process is a mechanized form of pallet-moulding, in which a pug-mill forces clay of hand-moulding consistency into sanded multiple moulds, and the bricks are turned out on to boards for drying.

In the early 19th century large quantities of cheaply produced bricks, formed by extrusion (wirecut) or pressing, were needed to meet the demand from engineering work and the growing cities. In the wirecut process a column of pugged clay, the length and width of a brick in section, is extruded and pushed sideways against wires, which slice it into bricks. Early wirecut bricks were pressed to give squarer edges for facing work. Around 1900 de-airing was introduced for a denser, more plastic clay. Wirecut bricks are frequently perforated to reduce weight and for easier drying and firing.

The stiff-plastic process suits harder clays, which are ground, screened, dampened and pugged. An initial pressing forms a rough clot, which a second pressing forms into a smooth-faced brick with a 'frog' top and bottom. This process has been replaced in the late 20th century by stiff-extrusion, forming wirecut bricks using a stiff-plastic clay. Semi-dry pressed bricks are made of hard shale ground to a coarse powder and screened. No water is added. The powder is passed through hoppers and powerfully pressed two to four times. Trapped air is released after the first pressing, and further pressings consolidate the bricks. This method is used to produce the Fletton bricks of Peterborough and Bedford in

England from Lower Oxford Shale. In all these processes moulds are sized to allow for shrinkage in drying and firing. Textured facing bricks are made by sandblasting or scraping the surfaces of machine-made bricks.

Bricks should be thoroughly dried before firing. In pallet-moulding the bricks are lifted off the barrow between two pallet boards and set on the hack on edge, one course at a time. When stiffened they are 'skintled', set diagonally and further apart to speed up drying, which takes three to six weeks. From the early 19th century hot-floor dryers, heated by a furnace or by steam, allowed year-round brickmaking. The tunnel dryers and corridor dryers used in modern works are groups of long chambers heated by steam pipes, air-heaters or waste heat from the kilns. In corridor dryers the bricks dry on boards resting on ledges on the walls, while in tunnel dryers they are stacked on slow-moving trucks. Drying begins with cool humid air to avoid cracking the bricks and ends with hot dry air.

To produce a solid building material bricks must be fired at a bright red heat (950–1150°C). From the earliest times clamps with channels in the base, in which the fuel was burnt, or updraught kilns, similar to contemporary pottery kilns, were used. Horizontal-draught and downdraught kilns have been used in the Western world from the early 19th century but for much longer in East Asia. Continuous kilns, of which the Hoffmann kiln is the best known of the many variations on that principle, were introduced from the 1860s. Tunnel kilns rapidly became more numerous in brickworks from the mid-20th century, as technical difficulties that had previously outweighed their advantages of fuel economy and better working conditions were overcome. In the firing process the bricks are stacked on edge, slightly apart to allow even heating from the fuel (wood, coal, oil or gas) burnt among and around them. For 'close-clamping', as practised in south-east England, 'town ash' from old refuse heaps or coke and anthracite dust is mixed with the clay, and the bricks themselves burn, packed tightly together and ignited by coke breeze or gas jets at the base of the clamp.

E. Dobson: *A Rudimentary Treatise on the Manufacture of Bricks and Tiles*, 2 Vols (London, 1850/*R* ed. F. Celoria, Stoke-on-Trent, 1971; rev. London, 14/1936)

H. Ward: 'Brickmaking', *Proceedings of the Institute of Civil Engineers*, lxxxvi/4 (1886), pp. 1–38, pls 7–8

C. E. Bourry: *Traité des industries céramiques* (Paris, 1897; Eng. trans., London, 1901, rev. 4/1926)

A. B. Searle: *Modern Brickmaking* (London, 1911, rev. 4/1956)

N. Lloyd: *A History of English Brickwork* (London, 1925/*R* Woodbridge, 2003)

F. H. Clews: *Heavy Clay Technology* (Stoke-on-Trent, 1955)

N. Davey: *A History of Building Materials* (London, 1961)

A. Clifton-Taylor: *The Pattern of English Building* (London, 1962)

F. J. Goodson: *Clay Preparation and Shaping* (London, 1962)

E. Rowden: *The Firing of Bricks* (London, 1964)

C. R. Atkinson: *Clay Winning and Haulage* (London, 1967)

K. C. Leslie: 'The Ashburnham Estate Brickworks, 1840–1968', *Sussex Industrial History*, i (1971), pp. 2–22

K. Hudson: *Building Materials* (London, 1972)

J. Wight: *Brick Building in England from the Middle Ages to 1550* (London, 1972)

L. S. Harley: 'A Typology of Brick', *Journal of the British Archaeological Association*, 3rd ser., xxxvii (1974), pp. 63–87

J. Woodforde: *Bricks to Build a House* (London, 1976)

R. Brunskill and A. Clifton-Taylor: *English Brickwork* (London, 1977)

M. D. P. Hammond: 'Brick Kilns: An Illustrated Survey', *Industrial Archaeology Revue*, i (1977), pp. 171–92

P. J. B. L. Penfold: *Modern Brickmaking* (Ripley, Derbys, 1978)

J. P. M. Parry: *Brickmaking in Developing Countries* (Watford, 1979)

M. Hammond: *Bricks and Brickmaking* (Princes Risborough, 1981, rev. 1990)

R. Hillier: *Clay that Burns* (London, 1981)

R. W. Brunskill: *Brick Building in Britain* (London, 1990/R 1997)

W. Facey: *Back to Earth: Adobe Building in Saudi Arabia* (Riyadh, 1997)

J. W. F. Campbell and A. Saint: 'The Manufacture and Dating of English Brickwork, 1600–1720', *Archaeological Journal*, clix (2002), pp. 17093

J. W. P. Campbell and W. Price: *Brick: A World History* (London, 2003)

S. Mutal: 'Adobe Architecture: Past and Present', *World Heritage Review*, xxxi (June 2003), pp. 3–21

(iii) Terracotta. The manufacture of structural terracotta (*see* TERRACOTTA, §I and CERAMICS, §I) involves a critical process of mixing clay, drying and firing. Clays selected for purity, heavy silicate content and good colour are fired at a high temperature to produce a fine-grained body resembling stoneware. The chemical recipes for terracotta and its 18th-century derivatives, Lithadipra and Coade stone, were guarded secrets, but common additives included feldspar, ground glass, sand, china stone and ground-up old ware (grog) to control shrinkage. Terracotta can be hand-sculpted, moulded, cast or extruded and requires a rigorous, labour-intensive production process that is often dependent on timing and the placement of each piece in the kiln. Specifications for three-dimensional blocks, including the choice of webbing for a metal anchoring system in each hollow block, are produced by the architect and redrawn by the manufacturer at a scale of 13:12 to allow for shrinkage during firing. The precise specifications are then reproduced by modellers, since cutting or altering the blocks breaks the surface glaze, allowing water to penetrate the masonry.

Encaustic tiles are the most complex form of terracotta. Medieval examples have raised ridges to separate the areas for the secondary clay colours, which were added before firing. The process was lost in western Europe after the 16th century. A dust-pressed encaustic tile that combined different colours of clay in powder form under pressure before firing was developed by Prosser, Blashfield and Minton in the early 1840s and soon became the standard manufacturing method.

2. FINISHING. Bricks produced from moulds of different shapes are used where large numbers of similar, non-standard forms are required to reproduce architectural details normally executed in stone. Segmental and circular bricks were used in ancient Rome for columns and elsewhere in the Roman Empire. Tracery and mouldings in brick occur in medieval buildings, and in the 16th century great skill was shown in the manufacture of bricks for ornamental chimney-shafts using collapsible moulds, for example at Hampton Court Palace, London (*c.* 1520). Large Staffordshire blue coping bricks were made in the 19th century for railway engineering work. From about 1850 a wide range of shaped bricks evolved in Britain; ranges in other countries are less extensive.

Bricks were also carved for decorative features or to produce different shapes. They were cut with a chisel and finished by rubbing with an abrasive stone. Simple carving was done from the Middle Ages by chamfering the corners off standard bricks to form 'squints' for turning 45° angles or 'cants' as part of a moulding. By the 17th and 18th centuries this technique had evolved into rubbed and gauged

1. Baked brick with colour-glazed relief decoration, showing striding lion, h. 972 mm, from Babylon, reign of Nebuchadnezzar II (*reg* 604–562 BC) (New York, Metropolitan Museum of Art, Fletcher Fund, 1931 (31.13.2)); image © The Metropolitan Museum of Art

work for arches, niches and pilasters set into and contrasting in colour with the main brickwork face. 'Rubber' bricks of a sandy clay, carefully prepared to exclude stones and burnt to an even colour throughout, were made oversize for cutting, rubbing and carving to the precise shape required and laid in lime putty with thin joints.

Glazed bricks are known from the 12th century BC in the Ancient Near East, where they were produced by methods similar to those of pottery and glass (see colour pl. II, fig. 1). Lead- or soda-based glazes were applied to individual bricks, forming pictorial and geometrical bas-relief panels (see fig. 1). Blues and yellows predominated. The Ishtar Gate (reconstructed in Berlin, Pergamonmuseum) at Babylon, built for Nebuchadnezzar II (reg 604–562 BC), was executed in this technique. Modern glazed bricks are made from fireclays and dipped in ceramic glazes before firing. Brown, salt-glazed bricks are produced by vapourized salt thrown in the kilns at the height of firing. Wood firing at a high temperature also forms a glaze on the exposed surface of the bricks, usually the end, header, face. These 'flared headers', varying in colour from light grey to almost black, were used in England in the diaper patterns of Tudor brickwork (see §3(iii) below).

Such effects are imitated in polychrome brickwork. Clays may be blended and stained to produce a wide range of colours; in the 19th century improved transport allowed bricks different in colour from locally made examples to be imported. Staffordshire blue bricks were used with red and white bricks and yellow 'London Stocks'. A notable exponent of this style, which has lately been revived, was William Butterfield (1814–1900), for example at Keble College (1867–83), Oxford (see also POLYCHROMY, §1). Brickwork may be painted to protect poor-quality bricks from weathering or to improve the colour of facing brickwork. Limewash, sometimes tinted, is traditional but has been replaced by special masonry paints. A red ochre wash was sometimes applied to brickwork that was too pale or uneven in colour.

For bibliography see §1(ii) above.

3. BRICKLAYING.

(i) Bonds. Bonding is the arrangement of bricks in a wall. Bricks are normally laid on their widest surface but may also be laid on edge (Rat-trap bond; see fig. 2g) or, for decorative use, on end (tack bond). The long face of the brick is known as a stretcher, the short end a header. Different bonds show in the face of a wall as different patterns of headers and stretchers. The bonding of all except the earliest walls falls into three main classes. In English-type bonds each course comprises either headers or stretchers: in English bond itself (2a) single courses of headers and stretchers alternate, while in English garden-wall bond (2b; known as Colonial bond in Australia) single courses of headers are separated by three, five or seven courses of stretchers. Flemish-type bonds have headers and stretchers in every course: in Flemish bond itself (2c) single headers and stretchers alternate, but in Sussex bond (2d) there are three stretchers to each header and in Monk bond (2e) two. The third category, hybrid bonds, has courses of Flemish, Monk or Sussex bond separated by varying numbers of stretcher courses. These are named Flemish stretcher (2f), Monk stretcher and Sussex stretcher bonds respectively. In addition, walls of pure header or pure stretcher bond are also found. In Britain the use of these bonds has varied in different periods and in different areas. Modern cavity walls are normally laid in stretcher bond, but by the use of half-bricks the appearance of any of the traditional bonds can be imitated.

R. Brunskill and A. Clifton-Taylor: English Brickwork (London, 1977)

A. D. Brian: 'The Distribution of Brick Bonds in England up to 1800', Vernacular Architure, xi (1980), pp. 3–11

G. C. J. Lynch: Brickwork: History, Technology and Practice, 2 vols. (London, 1994)

R. S. Burn: Masonry, Bricklaying and Plastering (Shaftesbury, 2001)

S. Thurley: Hampton Court: A Social and Architectural History (New Haven and London, 2003)

(ii) Nogging. The 'brickefillyng' of timber-framing was practised by the mid-15th century, for example at Ewelme Almshouses (founded 1437) and Stonor Park, both Oxon, and Hertford Castle gate-house (1462–5). The panels form simple patterns with bricks laid diagonally, horizontally and in a herringbone fashion. Standard bricks were normally used,

2. Types of brick bond: (a) English bond; (b) English garden-wall bond; (c) Flemish bond; (d) Sussex bond; (e) Monk bond; (f) Flemish stretcher bond; (g) Rat-trap bond

and 15th-century framing commonly had hollowed sides to key the mortar. This decorative style continued into the 17th century, becoming simpler and widespread across central and southern England. In York, however, special bricks only *c.* 40 mm thick were laid on edge, in plain panels. Plain brick-nogged framing continued in use for vernacular architecture in the 18th century, and original wattle and daub was often replaced by brick nogging in the 18th and 19th centuries.

An Inventory of Historical Monuments in the City of York, Royal Commission on the Ancient and Historical Monuments and Constructions of England, iii (London, 1972)

J. McCann: 'Brick Nogging in the Fifteenth and Sixteenth Centuries, with Examples Drawn Mainly from Essex', *Transactions of the Ancient Monuments Society*, xxxi (1987), pp. 106–33

(iii) Diapering. The patterning of red brickwork with different coloured bricks, generally dark or glazed, is known as diapering. Although employed in Byzantine architecture, it was most popular in England in the early 15th century. Eton College (1440s), Bucks, introduced several influential, highly developed patterns, including tall crosses on stepped bases and abstract designs that are linked with examples in the Low Countries and Belgium. The most inventive period was in the 1470s and 1480s, for example at Buckden Palace, Cambs, Bishop Waynflete's Tower (*c.* 1475–80; rest. *c.* 1733) at Esher Place, Surrey, and Kirby Muxloe Castle (1480), Leics, which included heraldic and other pictorial designs. The imaginative phase continued until the 1520s, for example in the gate-houses at Hadleigh Deanery (begun 1497), Suffolk, and Layer Marney Hall (*c.* 1520), Essex, but diapering later declined into predominantly trellis patterns on East Anglian buildings and was used less after 1600.

N. Lloyd: *A History of English Brickwork* (London, 1925/*R* Woodbridge, 2003)

N. J. Moore: 'Brick', *English Medieval Industries*, ed. J. Blair and N. Ramsay (London, 1991)

G. C. J. Lynch: *Brickwork: History, Technology and Practice*, 2 vols. (London, 1994)

II. Conservation. From Roman times brick has been considered more resistant than marble, but nonetheless it is susceptible to deterioration. This can be caused by several factors and diverse mechanisms, resulting in different decay patterns. The main causes of deterioration are salt crystallization and frost; such other factors as air pollution and biological action play a lesser role.

The presence of soluble salts, either in the brick or mortar or in the foundations on which the bricks are laid, in an environment with alternating wet and dry cycles can cause rapid deterioration in a very short time. The deterioration is caused by the pressure exerted by the crystallizing salts as the water that carried them into the porous body evaporates. The damage produced will be proportional to the amount of salt that crystallizes and the number of wetting and drying cycles to which the masonry is exposed (see both Lewin and Pühringer). This deterioration is compounded if, during fluctuations of temperature and relative humidity, the crystallizing salts form hydrates. Transitions between the two forms can then take place, and the secondary crystallization process can be far more destructive than the simple crystallization of a non-hydrate-forming salt. When several salts are present, a distribution pattern can be observed in the masonry: the most soluble salts will tend to migrate up the wall, while the less soluble ones will crystallize closer to the ground. The relative porosity of brick and mortar will determine which material will deteriorate first, since crystallization will take place preferentially in the more porous.

The deterioration produced by frost cannot be totally attributed to the volume increase that water undergoes when freezing. Several arguments have been put forward to explain the development of pressures large enough to disrupt the matrix of the brick mechanically: the main ones attribute these pressures to ice crystal growth (a process similar to salt crystallization) or to liquid water trapped between a frozen core and an advancing freezing front (see Binda, Baronio and Charola; also Nägele). The susceptibility of brick to frost damage will depend upon its porosity and pore-size distribution. The extent of the deterioration will depend on the degree of water saturation, the number of freeze–thaw cycles, the length of the freezing period and the rate at which the temperature changes take place.

The deterioration caused by air pollution alone is negligible, but because it can produce soluble salts upon reaction with lime mortar, it can eventually cause damage to the masonry (see Binda and Baronio). Biological action cannot be considered a major agent of deterioration, except when plants grow in a masonry structure and destroy it mechanically.

As the deterioration of brick is caused either directly or indirectly by the action of water, the main conservation concern is that of keeping the masonry dry. The source of water infiltration has to be identified and stopped before any protective measures can be applied successfully to the masonry. The best protection is provided by hydrophobization agents, the most successful being those based on alkyl alkoxy silanes, siloxanes or silicone resins (see Charola and Lazzarini). Attempts at pre-treating bricks with these agents before they are used in masonry have not been successful. The conservation of brick cannot be undertaken independently of the masonry of which it forms part. When bricks are replaced or an old masonry structure is repointed, care must be taken that the porosity of the new materials matches that of the old. As with new masonry, the correct setting of the bricks in the mortar is important to ensure an effective bond between the two materials. This will diminish water penetration, thus increasing the durability of the masonry.

T. C. Powers: 'Basic Considerations Pertaining to Freezing–Thawing Tests', *American Society for Testing and Materials Proceedings*, lv (1955), pp. 1132–55

D. H. Everett: 'The Thermodynamics of Frost Damage to Porous Solids', *Transactions of the Faraday Society*, lvii/9 (1961), pp. 1541–51

J. Iñiguez Herrero: *Alteración de calizas y areniscas como materiales de construcción* (Madrid, 1961)

J. Iñiguez Herrero: *Altération des calcaires et des grès utilisés dans la construction* (Paris, 1967)

G. G. Litvan: 'Freeze–thaw Durability of Porous Building Materials', *Durability of Building Materials and Components*, American Society for Testing and Materials: Special Technical Publication, 691 (Philadelphia, 1980), pp. 455–63

G. Torraca: *Porous Building Materials* (Rome, 1981)

A. Arnold: 'Rising Damp and Saline Minerals', *Proceedings of the IVth International Congress on the Deterioration and Preservation of Stone Objects: Louisville, KY, 1982*, pp. 11–28

S. Z. Lewin: 'The Mechanism of Masonry Decay through Crystallization', *Conservation of Historic Stone Buildings and Monuments* (Washington, DC, 1982), pp. 120–44

J. Pühringer: *Salt Disintegration: Salt Migration and Degradation by Salt—A Hypothesis*, Swedish Council for Building Research; Document D15:1983 (Stockholm, 1983)

H. Weber: *Mauerfeuchtigkeit* (Sindelfingen, 1984)

L. Binda and G. Baronio: 'Alteration of the Mechanical Properties of Masonry Prisms due to Aging', *Proceedings of the 7th International Brick Masonry Conference: Melbourne, 1985*, pp. 605–16

L. Binda, G. Baronio and A. E. Charola: 'Deterioration of Porous Materials due to Salt Crystallization under Different Thermohygrometric Conditions. I. Brick', *Proceedings of the Vth International Congress on Deterioration and Conservation of Stone: Lausanne, 1985*, pp. 279–88

C. T. Grimm: 'Durability of Brick Masonry: A Review of the Literature', *Masonry: Research, Application, and Problems*, American Society for Testing and Materials: Special Technical Publication, 871 (Philadelphia, 1985), pp. 202–34

E. Nägele: 'Hydrophobierung von Baustoffen: Theorie und Praxis', *Bautensschutz + Bausanierung*, viii/4 (1985), pp. 163–72

A. E. Charola and L. Lazzarini: 'Deterioration of Brick Masonry due to Acid Rain', *Materials Degradation caused by Acid Rain* (Washington, DC, 1986), pp. 250–58

J. Warren: *Conservation of Brick* (Oxford and Boston, 1999)

J. Ashurst and N. Ashurst: *Brick, Terracotta and Earth*, (1988) ii of *Practical Building Conservation* (New York, 1988)

J. Warren: *Conservation of Brick* (Oxford and Boston, 1999)

Bronze. Alloy of copper and tin. In the West bronze was largely superseded by Brass, the alloy of copper and zinc, by the 5th century AD; many brass artworks, however, are commonly described as 'bronze'. In early times most languages had just one term for copper and copper alloys, thus for example the Chinese had the word *tang*, the Tibetans *li*, the Greeks *khalkos* and the Romans *aes*. (For copper–zinc alloys produced by cementation (*see* Brass, §II) the Greeks had the term *oreikhalkos* and the Romans the related term *aurichalcum*, but these were not often used in general literature.) The equivalent Anglo-Saxon general term was 'brass', and up to the 17th century this simply meant copper or one of its alloys. Various terms for copper–zinc alloys, such as *latten* and *maslin*,

were in use in the late medieval and early post-medieval periods (see Blair and Blair, pp. 81–106). At about this time the term *bronzo* came into use in Italy, specifically for the copper alloys used in the ancient world. In particular, it was applied to the corroded, copper-base metals of the antiquities that were being dug up in Italy. These had an attractive patina, which was held to be due to some lost alloy. Much of this Classical metalwork was of copper alloyed with tin, whereas in Renaissance Italy copper alloyed with zinc was prevalent. Thus, the quite accidental association of bronze with patinated metal and of brass with a bright, clean finish was established.

By the time the word 'bronze' entered the English language, sometime in the late 17th century or the early 18th, it was associated with decorative or art metalwork, especially ancient metalwork and thus, by implication, with copper–tin alloys, while the term 'brass' continued to be used for everyday metalwork, which tended to be of copper and zinc. However, as late as the mid-18th century Samuel Johnson still regarded the two words as synonymous when he compiled his *Dictionary*. Only in the 19th century did engineers and metallurgists (and the *Oxford English Dictionary*) specify that bronze was an alloy of copper and tin, and brass an alloy of copper and zinc.

Popular usage, however, continued to apply the terms quite loosely. 'Bronze' still tends to be the slightly more prestigious word, used for copper-based metals that are obviously old, patinated or decorative; whereas 'brass' tends to be used for bright, shiny, utilitarian, obviously new items, regardless of composition. In truth, without analysis it is impossible to tell which has been used, so there is perhaps a strong case for retaining the more general usage of the term 'bronze'.

This article discusses the early history of copper alloys and bronze in the West, and its development elsewhere. *See also* Copper, §2(ii), for the use of bronze in architecture.

C. Blair and L. Blair: 'Copper Alloys', *English Medieval Industries*, ed. J. Blair and N. Ramsay (London, 1991), pp. 81–106

I. Blanchard: *Mining, Metallurgy, and Minting in the Middle Ages*, 3 vols (Stuttgart, 2001–2005)

F. Zagari: *Il metallo nel Medioevo: Tecniche, strutture, manufatti* (Rome, 2005)

I. Properties. The colour of bronze depends on the tin content. It ranges from an attractive golden shade with *c.* 5% tin, to a steely grey when the tin exceeds 20%. The metal is easy to cast but suffers from problems of segregation and sweating (*see* Metal, §III). The hardness of the alloy increases with the tin content. With up to *c.* 10% tin the metal may be safely cold-worked, with periodic annealing, hence the popularity of this alloy range for hammered bronzes in antiquity. As the tin content increases, so the danger of cracking increases, and with more than 15% tin it is not possible to carry out cold work. When the tin content exceeds 20%

the metal becomes extremely brittle. However, bronzes containing 20–25% tin may be satisfactorily hot-worked (*see* §II below).

R. Chadwick: 'The Effect of Composition and Constitution on the Working and on Some Physical Properties of Tin Bronzes', *Journal of the Institute of Metals*, lxiv (1939), pp. 331–47

D. Hanson and W. T. Pell-Walpole: *Chill Cast Bronzes* (London, 1951)

A. R. Bailey: *A Textbook of Metallurgy* (London, 1964)

D. A. Scott: *Copper and Bronze in Art: Corrosion, Colorants, Conservation* (Los Angeles, 2002)

P. Craddock and J. Lang, eds: *Mining and Metal Production through the Ages* (London, 2003)

II. Technical history.

1. Early history. 2. The Classical world. 3. China and South-east Asia. 4. Indian subcontinent. 5. West Africa. 6. Special bronzes.

1. EARLY HISTORY. Copper and lead had been used on a limited scale from the inception of the Neolithic period in the 8th millennium BC. However, for almost the first half of this immensely long era, metal was insignificant both economically and artistically, limited to what has been called 'trinket technology' (Moorey, 1988). It was not until the later 4th millennium BC that metal tools, weapons and ceremonial items rapidly became common throughout the eastern Mediterranean and the Middle East. An important reason for this may well have been the introduction of alloying.

Copper, which is rather viscous when molten, is quite difficult to cast satisfactorily, and it is rather soft, making it unlikely to retain an edge (*see* COPPER, §1), but these properties can be improved by the addition of arsenic. Smelting of copper ores rich in arsenic may have resulted in a natural alloy, and certainly from the end of the 4th millennium BC arsenical copper became quite common. The attractive silvery colour of the arsenical copper may also have been desirable.

Although arsenical copper was eventually supplanted by tin bronze, it is by no means certain that it pre-dates bronze: the use of both metals seems to have begun in the later 4th millennium BC. Around 3000 BC copper–lead alloys were briefly in vogue for castings, and it is likely that it was the adoption of the concept of alloying, rather than any one alloy, that caused the rapid expansion of metal usage. Tin bronze held obvious advantages over arsenical copper, which was made from smelting arsenic-rich copper ores or by adding arsenic minerals to molten copper. Since it was impossible to prepare metallic arsenic, and because of the great volatility of arsenic in the molten copper, it was difficult to effect any sort of quality control. These problems were further compounded by the great variation in the properties of the alloy over a small composition range. Finally, there was the toxicity of the arsenic fumes. By contrast, metallic tin was easy to smelt from its ores, and precise alloys could be easily formed by mixing weighed quantities of the two metals.

Why then was arsenical copper more prevalent until at least the 2nd millennium BC? The answer is simple: copper ores are frequently associated with arsenic minerals but rarely with tin, and exploitable tin deposits are quite rare. There are no significant sources within the Mediterranean region or the Middle East; the nearest are in south-west Britain, Central Europe, east Asia, South-east Asia and Nigeria, all far too distant to have played any part in the inception of Middle Eastern bronze metallurgy. Indeed, the vexed question of the source of the tin in the earliest Middle Eastern bronzes was only resolved in the 1980s with the discovery of tin deposits in Afghanistan and, even more important, the discovery of a tin mine at Kestel in central Turkey, dating from the 3rd millennium BC. By the mid-3rd millennium BC tin bronze was becoming quite common from the Aegean and the Troad through to Mesopotamia, notably at Ur and Iran. The tin must have come from such sources as Kestel, within the region where metallurgy was already practised.

By the end of the 3rd millennium BC metallurgy had developed through much of Europe and also in China and South-east Asia, and therefore the major tin fields were potentially available. In these areas, tin bronze rapidly became prevalent: in Britain, for example, after a very brief 'copper age', bronze became almost universal from *c.* 2000 BC (see fig. 1). By contrast, in the Mediterranean region and the Middle East, which lacked major indigenous tin sources, the change from arsenical copper to tin bronze was much more gradual, extending through the 2nd millennium BC.

Occasionally the availability of the two distinct metals, silvery arsenical copper and golden bronze, was used to create polychromy. The superb lions from the temple at Tell al-Ubaid (mid-3rd millennium BC; London, British Museum) have heads wrought from arsenical copper and bodies of bronze hammered over bitumen cores. Unfortunately, the metal is totally corroded, but the original polychromy, together with the eyes inlaid with stone, must have been striking.

By the mid-2nd millennium BC, bronze metallurgy was well developed in southern China and South-east Asia (*see* §3 below). Excavations carried out at Ban Chiang and other sites in north-east Thailand in the 1960s and 1970s revealed bronze artefacts in association with highly sophisticated ceramics, including spear points, socketed tools, bracelets, pins and other ornaments.

At this time, in both Mycenaean Greece and China, lead began to be added to bronze casting alloys. The lead lowered the melting point of the alloy and made the molten metal more fluid. This was a great advantage in casting, as the metal flowed more easily through the mould, filling all the details and enabling quite intricate patterning—for example that worked on the moulds of the early Chinese bronzes—to be picked up accurately. Through the

1. Bronze necklace (torc), Celtic, 3rd century BC (Copenhagen, Nationalmuseum) photo credit: Erich Lessing/Art Resource, NY

1st millennium BC leaded bronze became quite prevalent for cast-bronze work, especially when large supplies of cheap lead became available in Greece and the Middle East as a by-product of smelting silver for coinage.

Together with the developments in alloying, rapid improvements in casting, joining and metalworking techniques took place from about the 4th millennium BC. Thus, the sophisticated technique of lost-wax casting seems to have originated at that time, as demonstrated by an unused clay mould for making a lost-wax casting of an axehead from Poliochni, on the Aegean island of Lemnos. Of similar date is the extraordinary hoard of metalwork found at Nahal Mishmar in the hills above the Dead Sea. It contained several hundred maceheads, sceptres and crowns (Jerusalem, Israel Museum), which were mainly lost-wax castings of a complex copper–antimony–arsenic alloy. Even more extraordinary than the number of objects and the weight of metal is the advanced nature of the technique: many of the sceptre shafts were hollow castings, and the maceheads were cast around clay cores. Clearly, the technique of hollow casting around a core supported from the walls of the outer mould by chaplets (see METAL, §III) was fully understood by this date. The quantity of cast decorative and ritual metalwork in the Nahal Mishmar hoard is exceptional, but it is clear from other finds that arsenical copper and bronze had always been cast for decorative fittings, ritual items, jewellery and small sculpture, as well as for tools and weapons. In addition, there is evidence of major work in sheet-metal hammered over wooden or bitumen formers. The spectacular finds from the Royal Graves at Alaca

Höyük in central Anatolia, dating from the mid-3rd millennium BC, include complex bronze standards and finely modelled figures of deer, inlaid with precious metals, which are accomplished works by any standard.

This was the period of the rise of the great civilizations in Mesopotamia. The grave goods from the Royal Cemetery at Ur contain a comprehensive range of bronze and copper tools, weapons, vessels and ornaments, and contemporary Early Dynastic copper figurines made by the lost-wax technique are known from elsewhere in Mesopotamia. Towards the end of the 3rd millennium BC the Akkadians produced some excellent hollow lost-wax castings, including the material from Diyala region and the male head from Nineveh known as the 'Head of Sargon' (Baghdad, Iraq Museum). The detail on this head is very fine: there is evidence of tool marks left by finishing work after casting, but most of the detail was crisply reproduced from the mould.

Other techniques of working bronze were also developed in this period. Quite proficient bronze vessels were raised by hammering, and some even had handles or lugs attached by tin solder. Thus, by the end of the 3rd millennium BC, bronze was firmly established throughout the Middle East, the eastern Mediterranean and beyond, utilizing such sophisticated processes as lost-wax and hollow casting, polychromy, raising and soldering to produce artefacts that rival those of later civilizations.

Ornaments and tools of copper, bronze and other alloys also formed a significant part of New World technology in the high civilizations of the Andean areas from the 1st millennium BC (although

goldworking dates from the 2nd millennium BC) and of Mesoamerica from the 9th century AD.

F. Heger: *Alte Metalltrommeln aus Südostasien* (Leipzig, 1902)

S. Lloyd: *Early Highland Peoples of Anatolia* (London, 1967)

K. Branigan: *Aegean Metalwork of the Early and Middle Bronze Age* (Oxford, 1974)

P. T. Craddock: 'Deliberate Alloying in the Atlantic Bronze Age', *The Origins of Metallurgy in Atlantic Europe*, ed. M. Ryan (Dublin, 1978), pp. 369–85

H. McKerrell: 'Non-Dispersive XRF Applied to Ancient Metalworking in Copper and Tin Bronze', *PACT*, i (1978), pp. 138–73

P. Bar-Adon: *The Cave of the Treasure* (Jerusalem, 1980)

E. A. Braun-Holzinger: 'Figürliche Bronzen aus Mesopotamien', *Prähistorische Bronzefunde*, IV/i (Munich, 1984)

P. R. S. Moorey: *Materials and Manufacture in Ancient Mesopotamia*, British Archaeological Reports, International Series, no. 237 (Oxford, 1985)

P. R. S. Moorey: 'Early Metallurgy in Mesopotamia', *The Beginning of the Use of Metals and Alloys*, ed. R. Maddin (Cambridge, MA, 1988), pp. 28–33

J. D. Muhly: 'The Beginnings of Metallurgy in the Old World', *The Beginning of the Use of Metals and Alloys*, ed. R. Maddin (Cambridge, MA, 1988), pp. 2–20

K. A. Yenner and others: 'Kestel: An Early Bronze Age Source of Tin Ore in the Taurus Mountains, Turkey', *Science*, ccxliv (1989), pp. 200–03

P. T. Craddock: 'Recent Progress in the Study of Early Mining and Metallurgy in the British Isles', *Historical Metallurgy*, xxviii/2 (1994), pp. 69–83

'Bronze', *Lexikon des künstlerischen materials: Werkstoffe der modernen Kunst von Abfall bis Zinn* (Munich, 2002), pp. 49–56

M. Bartelheim, E. Pernicka and R. Krause, eds: *Die Anfänge der Metallurgie in der alten Welt/The Beginnings of Metallurgy in the Old World* (Rahden, 2002)

L. R. Weeks: *Early Metallurgy of the Persian Gulf: Technology, Trade, and the Bronze Age World* (Boston, 2003)

R. Krause: *Studien zur kupfer- und frühbronzezeitlichen Metallurgie zwischen Karpatenbecken und Ostsee* (Rahden, 2003)

'Antike Bronzekunst', *Antike Welt*, xxxvii/2 (2006), pp. 8–30

2. THE CLASSICAL WORLD. The Minoans and Mycenaeans produced a wide range of bronzework on a considerable scale, as attested by the discovery of shipwrecks, for example those off southern Turkey at Cape Gelidonya and at Kaş, with cargoes that included several tonnes of copper and tin ingots. The range of Minoan bronzework included beaten bronze vessels and small statuettes for votive and probably purely ornamental use. The latter were usually solid cast by the lost-wax process and are rarely more than about 100 mm in their maximum dimension. These small figures, typically depicting bulls or humans, seem to have been especially common in the Late Minoan period, but, following the collapse of the Minoan civilization, their production ceased in the Aegean world for several centuries, in common with that of other luxury items.

With the return of stability and prosperity in the 1st millennium BC the production of bronze decorative items was resumed, notably the elaborate bronze brooches and figurines of the Geometric period.

These were also solid lost-wax castings. The small quadrupeds often have their bodies hollowed out and open on the underside. It seems the craftsman modelled the wax around a wedge of clay, which remained exposed beneath. The wax and clay would then be invested with more clay, and the usual procedure of lost-wax casting followed. After the casting had cooled, the mould was broken away, and the clay wedge dug out. In the succeeding Archaic period of the 6th and 7th centuries BC, true hollow castings were made in which the clay core was totally encased inside the modelled wax and supported by chaplets.

From the Minoan period the Greeks had been skilled in hammered metalwork for vessels or even armour, as the extraordinary example from Dendra testifies (late 2nd millennium BC; see fig. 2). In the Geometric period large statuettes were made from sheet bronze riveted together on a wooden support. This technique was known by the Greeks as *sphyrelaton*, meaning 'wrought by hammering'. The first person to make major statues of bronze was said to be Daidalos of Crete. He may well be a mythical figure, but several large works dating from the 8th century BC have been found, for example at the Cretan shrine of Dreros (Herakleion, Archaeological Museum).

2. Hammered sheet-bronze suit of armour, Mycenaean, from Dendra, Greece, late 2nd millennium BC (Navplion, Archaeological Museum); reconstruction drawing

The body of the Dreros statue is very simplified, which possibly suggests the work of an armourer.

By the 7th century BC the technique of true hollow casting had been developed by the Greeks for life-size statues of both humans and animals. It is true that life-size statues had been made before, but not on a regular basis: such early examples as the statue of Pepy I of Egypt (*reg c.* 2289–*c.* 2256 BC; Cairo, Egyptian Museum) are more famous for their early date and rarity than for any technical or artistic accomplishment. The popularity of bronze statuary among the Greeks gave rise to a level of technical excellence that has rarely been matched since, the greater naturalism and detail of depiction calling for extreme skill in both casting and finishing. Detailed studies of such masterpieces as the two 5th-century BC life-size warriors (Reggio Calabria, Museo Nazionale; see fig. 3) found in the sea off Riace, Calabria, and the excavation of workshops with casting pits in the Athenian Agora and at Olympia have shown in considerable detail exactly how the Greeks set about the casting of a large statue.

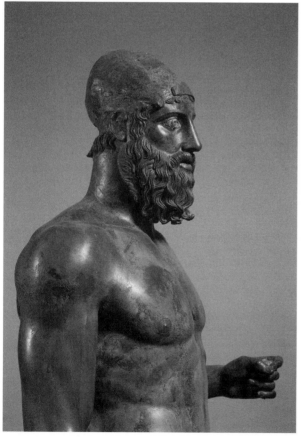

3. Bronze bust of *Warrior* (Statue B; detail), h. 1.97 m, from Riace, *c.* 450 BC (Reggio Calabria, Museo Nazionale); photo credit: Scala/Art Resource, NY

The technique of indirect lost-wax casting (*see* METAL, §III) was perfected by the Greeks and later adopted by the Romans; it changed very little until the late 20th century. A plaster cast was taken from the clay or wax original, and the plaster cut into sizes convenient for the production of moulds for casting by the lost-wax process. Such details and extremities as hands, long curls and even toes were often cast separately: a life-size statue could easily be made up of 30 or more components, but so carefully joined and finished afterwards that they appear as one casting. The sections seem to have been joined by pouring on bronze of a similar composition to the statue itself, so fusing the components together. The join would then have been carefully scraped, filed and polished on the outside, but the pours of metal remain visible on the inside. Casting faults in the main castings, for example where the metal failed to flow or where the mould was damaged, were cut out, and a rectangular patch inserted. Careful examination of Classical statuary can sometimes reveal dozens of these minor repairs, but they are so well worked and finished as to be almost invisible.

Classical bronzes are now usually covered by a uniform brown or green PATINA, but originally the bronze would have had more polychromy. The bronze itself would have been kept polished, and perhaps oiled to give it a lustrous hue, but such details as the lips and nipples were usually of red copper, and the teeth might be of silver, as on the Riace bronzes. The eyes would have been made up of shell or stone, as for example on the life-size head of Augustus (late 1st century BC; London, British Museum) from Meroë in the Sudan, where even the inner corners of the eye are depicted with inlays of tiny fragments of red garnet.

Greek statues were, in general, never gilt, though a few were covered with gold foil, as evidenced by the grooves in the bronze into which the edges of the foils were hammered (e.g. the small head of Nike; late 5th century BC; Athens, Agora Museum). According to Pliny the elder (AD 23/4–79) (*Natural History* XXXIV. lxiii), even as late as the time of Nero (54–68 AD) gilded statues were not popular. However, in the later Roman Empire the taste for gilding grew, and statues were regularly gilt; the superb late Roman life-size statues of the four horses of S Marco, Venice, for example, were cast from almost pure copper to aid the process of mercury gilding (*see* GILDING, §I, 3). The practice of adding lead to the bronze alloy became steadily more prevalent through the 1st millennium BC. The early Greek statues had been of unleaded bronze, but during the Hellenistic period lead began to be included, and the Romans almost universally added considerable quantities, typically 10–30%. This made the molten metal more fluid, enabling it to flow through narrow spaces, and the bronze in some Roman statues is as little as 20 mm thick. Although brass became steadily more common through the Roman period, largely superseding bronze by

the 5th century, it was never used for statuary, an interesting example of artistic conservatism.

H. Maryon: 'Fine Metalwork', *A History of Technology*, ed. C. S. Singer and H. J. Plenderleits, i (Oxford, 1954, rev. 3/1957), pp. 623–62

J. Boardman: *The Cretan Collection in Oxford* (Oxford, 1961)

A. M. Snodgrass: *Greek Arms and Armour* (Edinburgh, 1964)

G. F. Bass: 'Cape Gelidonya: A Bronze Age Shipwreck', *Transactions of the American Philosophical Society*, vii (1967) [whole issue]

P. T. Craddock: 'The Composition of Copper Alloys Used by the Greek, Etruscan and Roman Civilisations, I', *Journal of Archaeological Science*, iii (1976), pp. 93–113

W. A. Oddy, L. Borrelli Vlad and N. D. Meeks: 'The Gilding of Bronze Statues in the Greek and Roman World', *The Horses of San Marco*, ed. G. Perocco (London, 1979), pp. 182–6

C. C. Mattusch: *Bronzeworkers in the Athenian Agora* (Princeton, 1982)

E. Formigli: 'Due bronzi da Riace', *Bollettino d'arte*, special ser., iii/1 (1984), pp. 107–42

G. F. Bass: 'Oldest Known Shipwreck Reveals Bronze Age Splendors', *National Geographic*, clxxii (1987), pp. 693–734

W.-D. Heilmeyer and G. Zimmer: 'Die Bronzegiesserei unter der Werkstatt des Phidias in Olympia', *Olympiabericht*, ii (in preparation)

D. Haynes: *The Technique of Greek Bronze Statuary* (Mainz am Rhein, 1992) *I Bronzi di Riace: Restauro come conoscenza*, 2 vols (Rome, 2003)

L. Hakulin: Bronzeworking on Late Minoan Crete: A Diachronic Study (Oxford, 2004)

P. P. Betancourt: *The Chrysokamino Metallurgy Workshop and its Territory* (Princeton, c. 2006)

3. CHINA AND SOUTH-EAST ASIA. Research in northern China since the mid-1970s has revealed the slow development of metallurgy from the 4th millennium BC. Shortly after 2000 BC there arose in that region the remarkable Shang bronze-founding tradition, which was to shape the course of Chinese bronzeworking for millennia to come. The typical products of this industry were ornate and highly decorated ritual vessels cast in piece moulds. The bronzes themselves have been extensively studied to discover how they were made, and from the 1930s bronze foundries were excavated at such ancient Shang-period settlements as Erlitou, Zhengzhou, Panlongcheng (Hubei Province) and, in particular, Anyang in northern China. The bronze alloy frequently contained considerable quantities of lead, which would have enabled the molten bronze to pick up the intricate detail on the moulds. The moulds were of fine loessic clay, which occurs all over northern China and may be said to be partially responsible for the development of the piece moulding industry. This clay has the invaluable property that it does not distort or shrink on firing, which is essential if the assembled components of the piece-mould are to remain in accurate location after firing.

The basic form of the vessel was first made in wood or clay. Prepared clay was pressed against this to make a mould and then cut up and pulled away in sections. The intricate designs would be incised into the mould surface before the pieces were reassembled, fitting tightly together to form the moulds for the inside and outside of the vessel. The inner and outer moulds were separated by bronze or clay pegs. Pouring channels, risers and sprues were added, and the completed mould fired. Then, while the mould was still hot, the bronze was poured in. The resulting casting came from the mould virtually finished, complete with handles and all the decoration, requiring only a little cleaning up and polishing. Where the mould sections met there are sometimes seams into which the molten metal ran, and there is sometimes evidence of slight misalignment of two mould pieces on running or repeating patterns. The high tin and lead content of the bronze rendered it too brittle for extensive chiselling, and if the bronzes receive a sharp blow they tend to break rather than bend.

Lost-wax casting was introduced only during the 6th century BC. At first the technique appears to have been used in combination with the piece-mould method; sometimes precast appendages (e.g. handles) were produced by the lost-wax method and then soldered on to the main body. Large, flamboyant, openwork pieces were produced in the state of Chu, south China, by this means. Later, during the 2nd century BC, complex three-dimensional scenes of figures, animals and architecture were similarly cast on the lids of large, drum-shaped containers in the kingdom of Dian in south-west China.

About 500 BC the bronze- and iron-using Dong Son culture developed in Yunnan and the Red River Valley area of northern Vietnam, which was then subject to the Chinese Han dynasty. The most characteristic products of this culture are single-ended, waisted drums in a bronze alloy containing a high proportion of lead and generally also a small quantity of iron, which are claimed to have been cast either in a stone mould or by the lost-wax method. Most of them have elaborate incised decoration. Dong Son drums and other bronze artefacts have been found throughout South-east Asia and were traded as far as New Guinea.

In China bronze ritual vessels had lost their function as symbols of political authority by the Han period (206 BC–AD 220), and thereafter much of the production relied on the shapes and styles of earlier ages. However, production continued on a considerable scale, and with their superb furnace and mould technology the Chinese were able to produce bronze castings of a size and complexity that were not attained in Europe until the 18th and 19th centuries.

The early bronzes had relied extensively on cast detail for their decoration, but from the 6th century BC vessels were frequently inlaid with silver foil, or gilded and silvered to create polychrome work. During the Song (AD 960–1279) and Ming (1368–1644) periods archaistic bronzes were made with superb, chemically induced patinas, in imitation of those on the ancient bronzes recovered from subterranean tombs. Inlays of malachite and jade were also frequently added.

The alloys continued to be of leaded bronze apparently through to the end of the Ming period. They were then rapidly supplanted by brass, following the introduction of zinc smelting in China at the end of the 15th century (*see* BRASS, §II).

O. R. T. Janse: *The Ancient Dwelling Site of Dong-so'n (Thanh Hoa-Annam)*, iii of *Archaeological Research in Indo-China* (Bruges, 1958)

A. J. Bernet Kempers: *The Kettledrums of Southeast Asia: A Bronze Age World and its Aftermath* (Rotterdam, 1988)

I. Blanchard: *Asiatic Supremacy, 425–1125* (2001) i of *Mining, Metallurgy, and Minting in the Middle Ages*, 3 vols (Stuttgart, 2001–2005)

P. T. Craddock and others: 'Chinese Cast Iron through Twenty-five Hundred Years', *Scientific Research in the Field of Asian Art: Proceedings of the First Forbes Symposium at the Freer Gallery of Art, Washington, DC, 2001*, pp. 36–46

K. M. Linduff, ed.: *Metallurgy in Ancient Eastern Eurasia from the Urals to the Yellow River* (Lewiston, NY, 2004)

4. INDIAN SUBCONTINENT. The use of copper can be traced back to the pre-Harappan settlements in Pakistan dating to the 4th–3rd millennia BC. Small but well-observed naturalistic statuettes in bronze (e.g. *Dancing Girl*; New Delhi, National Museum) made by the lost-wax method have been found at Mohenjo-daro and other sites of the Harappan civilization of 2500–1700 BC. Copper weapons dating from *c.* 1000 BC (e.g. New Delhi, National Museum) have been recovered from various sites in north India, but bronze sculptures are rare for a period of some 1000 years following the collapse of the Harappan civilization. Isolated finds include the cast figurines of an elephant, a rhinoceros, a buffalo and a chariot, all mounted on wheels, from Daimabad (Archaeological Survey of India, on loan to Bombay, Prince of Wales Museum of Western India). Together they weigh about 60 kg, and they are apparently prehistoric. Bronze statuettes seem to have become common again only in the early 1st millennium AD. They were produced in the north-west region of Gandhara, where a Hellenizing influence can be seen in the style, and in other parts of India, where the style is purely Indian. By the Gupta period (4th–6th century AD) brass was already becoming the dominant alloy. The surviving pieces are mainly small, but examples such as the life-size statue of the Buddha (*c.* 7th century AD; Birmingham, City of Birmingham Museum and Art Gallery) found in the ruins of a monastery at Sultanganj in Bihar show that major castings could be performed. It is a lost-wax hollow casting of impure copper that was apparently cast in one piece and mercury gilded. The Chinese Buddhist monk Xuan Zang in his travels through north India in the 7th century AD recorded other monumental castings, including a statue of Buddha 31.5 m high at the monastery of Nalanda in Bihar.

The origins of bronzeworking in south India are not known, but by the mid-1st millennium BC quite sophisticated small decorative bronzes were being produced, as attested by the finds from Nagpur-culture burials at Adichanallur in the Tirunelveli District of Tamil Nadu. By the 1st millennium AD

major castings existed of the full pantheon of Hindu deities. Many of these statues are of copper, which, as noted above, is rather viscous when molten, and perhaps for this reason the pieces were often solid cast and thus of enormous weight. The art of fine bronze-casting developed during the Chola period (9th–13th centuries), and from the 10th century many great masterpieces of near life-size figures were produced for Hindu temples.

The Chola bronzes were usually of leaded tin bronze, and the major figures were hollow castings. Although the aesthetic quality of the bronzes may have declined since the Chola period, the production of major pieces has continued apparently without interruption to the present day at such centres as Swamimalai in Tamil Nadu, and government-sponsored schools of traditional image casting have been established at Mahabalaipuram, near Madras. The image is sculpted from a mixture of wax and a natural resin, *kunguliyam*. This has similar properties to wax alone, but is rather harder and stronger. The model is covered with a fine clay slip, and around that a stronger layer of clay, heavily tempered with rice husks, is built up. Even quite major figures are usually cast in one piece in a casting pit, with the metal poured from a series of crucibles in a carefully orchestrated sequence. After casting, the surface of the bronze is extensively worked with scraper and chisel, a process that sometimes lasts over a period of weeks, before the final polish is applied. The methods used at Swamimalai are close to those of the Chola period, though a little zinc is added to the bronze to help deoxidize the metal.

By contrast, the tradition in north India, Nepal and Tibet has always favoured brass. This difference is due to the proximity of the zinc sources in north India and the strong contacts between south India and the tin-producing lands in South-east Asia.

P. Ray: *History of Chemistry in Ancient and Medieval India* (Calcutta, 1956)

C. Sivaramamurti: *South Indian Bronzes* (New Delhi, 1963)

M. V. Krishnan: *Cire Perdu Casting in India* (New Delhi, 1976)

P. T. Craddock: 'The Copper Alloys of Tibet and Their Background', *Aspects of Tibetan Metallurgy*, ed. W. A. Oddy and W. Zwalf (London, 1981), pp. 1–36

D. P. Agrawal: *The Archaeology of India* (London, 1982)

B. Allchin and R. Allchin: *The Rise of Civilisation in India and Pakistan* (Cambridge, 1982)

B. A. Rathnasabapathy: *The Divine Bronzes* (Thanjavur, 1982)

A. K. Biswas: *Minerals and Metals in Ancient India* (New Delhi, 1996)

D. P. Agrawal: *Ancient Metal Technology and Archaeology of South Asia: A Pan-Asian Perspective* (New Delhi, 2000)

J. Van Alphen: *Cast for Eternity: Bronze Masterworks from India and the Himalayas in Belgian and Dutch Collections* (Antwerp, *c.* 2005)

Chola: Sacred Bronzes of Southern India (exh. cat. by V. Dehejia and others; London, Royal Academy of Arts, 2006)

5. WEST AFRICA. Relatively little is known of the origins and cultural affiliations of the various bronze- and brass-casting traditions of West Africa. There

was a proficient ironworking industry there from the late 1st millennium BC, but little evidence exists for copper- or bronzeworking, much less for a tradition of casting tools and weapons out of which a major art medium could grow. Yet the earliest dated pieces of art bronzework are among the most accomplished. These are the hundreds of ritual vessels and regalia found with a burial at Igbo-Ukwu in southeast Nigeria, dated by radiocarbon analysis to the 10th century AD. The vast majority are lost-wax (or, more probably, lost-latex) castings of bronze or leaded bronze. They are among the most inventive and technically accomplished bronzes ever made. Great vessels of 250–400 mm in diameter were cast in one, with walls never more than 1 or 2 mm thick, complete with handles and with each detail of the complex decorative scheme on the mould perfectly picked up by the metal (e.g. bronze bowl; Lagos, National Museum). The apparent absence of a bronzeworking tradition leading up to this level of achievement, coupled with the mistaken belief that copper was not available in Nigeria, led many to believe that the metalworking skills, if not the metal itself, must have come from across the Sahara. Recent careful study of the Igbo bronzes has shown that the range of metalworking skills was actually very limited, and that the usual metalworking techniques of raising, soldering, riveting and wire-making were unknown to the Igbo smiths. Also, at the period when the Igbo bronzes were made, all the civilizations to the north of the Sahara were using brass. However, in the 1980s copper and lead sources with signs of early exploitation were identified in southeast Nigeria, and of course Nigeria is one of the world's major sources of tin. Thus the craft of bronze-casting is likely to be an indigenous development within West Africa.

The Igbo bronzes remain an isolated phenomenon at present, but several centuries later other major bronze-casting traditions were developing elsewhere in Nigeria, as exemplified by the hollow-cast, half life-size figure of a man (of unknown date; Lagos, National Museum) from Tada in central Nigeria made of impure copper. Although part of an isolated find, this too must stand at the head of a long tradition of casting technology. From Benin City in the Kingdom of Benin, west of the Niger River, a whole series of life-size, naturalistic bronze heads are known (also referred to as brass). The majority of the pieces are likely to predate 1600. These are lost-wax hollow castings with uniform thin walls, the clay cores held in place by iron chaplets, evidencing great technical skill.

These bronzes may well have been made from local metal (although not from the same source as the Igbo bronzes as the trace-element composition is different), but from the 12th century Arab caravans began to cross the Sahara bringing brass, which was certainly in use by the 15th century at Ife in southern Nigeria to cast the famous life-size heads found there. At the end of the 15th century the first European vessels reached the West African coast,

and within a short time enormous quantities of copper and brass were being imported into the hinterland of West Africa. This new supply of metal triggered a huge increase in the production of copper-alloy art metalwork all over West Africa, especially at Benin, but at the expense of the local copper and lead industry, which seems to have died out completely, though tin production continued.

T. Shaw: *Igbo-Ukwu* (London, 1970)

P. T. Craddock and J. Picton: 'Medieval Copper Alloy Production and West African Bronze Analyses, II', *Archaeometry*, xxviii (1986), pp. 3–32

V. E. Chikwendu and others: 'Nigerian Sources of Copper, Lead and Tin for the Igbo Ukwu Bronzes', *Archaeometry*, xxxi (1989), pp. 27–36

I. Blanchard: *Afro-European Supremacy, 1125–1225* (2001), ii of *Mining, Metallurgy, and Minting in the Middle Ages*, 3 vols (Stuttgart, 2001–2005)

I. Blanchard: *Continuing Afro-European Supremacy, 1250–1450* (2005), iii of *Mining, Metallurgy, and Minting in the Middle Ages*, 3 vols (Stuttgart, 2001–2005)

6. SPECIAL BRONZES. In addition to what may be termed the 'usual' bronzes discussed above, made either by cold hammering or casting, there were a number of uses for which special fabrication methods and specific alloys, usually containing much more tin, were employed. These special bronzes often continued in use long after ordinary bronze had been supplanted by brass.

Early mirrors in the West tended to be made of bronze with $c.$ 10% tin, which gave a rather golden reflection. In China, however, from the Shang period in the 2nd millennium BC, mirrors were always made of a bronze alloy with $c.$ 20–25% tin and a little lead. This was a silvery and extremely hard alloy that was capable of taking a high polish as well as being resistant to scratches and deformation. A similar alloy began to be used for mirrors in the Hellenistic world at the end of the 1st millennium BC; it was also the usual composition for Roman mirrors. Although silvered glass became increasingly popular, bronze continued to be used for Byzantine mirrors and for those in the Islamic and medieval periods long after brass had replaced bronze for most other uses.

The resonant properties of high-tin bronze made it especially suitable for bells. Large bells seem always to have been made of an alloy containing $c.$ 20% tin. They seem to have originated in late antiquity and to have first been cast by the smiths who made large statues. The earliest specific mention of a campanile to hold large church bells would seem to be in Italy in the 8th century AD. An excellent account of medieval bell casting is given by Theophilus. Because the bells were so large they were often cast on site, and casting pits containing the fragments of the crucibles and moulds are frequently encountered during the excavation of medieval churches.

Bronze containing $c.$ 20% tin is extremely brittle when cold but can be beaten out quite readily at red heat. High-tin bronze vessels were hammered out and then quenched from red heat in Thailand in the

late 1st millennium BC. The resulting metal is very attractive, with a bright silver or golden surface; it was also used for vessels in the Nilgiri Hills of south India. The same metal was used by the Sasanians and, later, in the Islamic world. Metalworkers in Kirman refer to it as *haftjūsh* (meaning 'boiled or heated seven times') and claim that it contains copper, silver, tin, antimony, lead, gold and iron, though analysis shows it to be copper with *c.* 20% tin. The special quality of vessels made from it lies in the alloy and the hot working they receive.

This same alloy, made resonant and strong by hammering and quenching, is the traditional material for cymbals and gongs. The traditional gongs of South-east Asia have been hammered out of high-tin bronze at high temperature for centuries, and it is tempting to link that technology with the similar process used to make the bronze bowls in Thailand.

Apart from these specialized uses outlined above, simple bronzes are now very rarely used: brass is both cheaper and easier to work. Even statuary bronze usually contains *c.* 5% each of tin, lead and zinc with the copper.

Theophilus [Rugerus]: *De diversis artibus* (?1110–40); Eng. trans. by J. G. Hawthorne and C. S. Smith as *On Divers Arts* (Chicago and London, 1963), pp. 167–76

A. S. Melikian-Chirvani: 'The White Bronzes of Early Islamic Iran', *Metropolitan Museum Journal*, ix (1974), pp. 123–51

P. T. Craddock: 'The Copper Alloys of the Medieval Islamic World', *World Archaeology*, xi (1979), pp. 68–79

W. Rajpitak and N. J. Seeley: 'The Bronze Bowls from Ban Don Ta Phet, Thailand', *World Archaeology*, xi (1979), pp. 26–31

M. Goodway and H. C. Conklin: 'Quenched High-tin Bronzes from the Philippines', *Archaeomaterials*, ii (1987), pp. 1–27

W. Rodwell: *Church Archaeology* (London, 1989)

P. T. Craddock and A. Giumlia-Mair: 'Beauty Is Skin Deep: Evidence for the Original Appearance of Classical Statuary', *Metal Plating and Patination*, eds S. La Niece and P. T. Craddock (London, 1993), pp. 30–38

P. T. Craddock and A. Giumlia-Mair '*Hśmn-km*, Corinthian Bronze, *shakudo*: Black Patinated Bronze in the Ancient World', *Metal Plating and Patination*, eds S. La Niece and P. T. Craddock (London, 1993), pp. 101–27

Jun Change Yang: 'Scientific Research and Conservation Treatment on the Yang Sui Excavated from Zhou Yuan Ruins', *Studies in Conservation*, xliv/1 (1999), pp. 63–6

Brush. A painting tool made up of a group of fibres bound and inserted into a handle. A brush should hold a quantity of paint and release it gradually as it is applied by the artist to make a consistent mark. The type of fibre, its length and the shape of the brush all affect the type of mark made.

1. Materials and manufacture. 2. History. 3. Uses and care.

1. MATERIALS AND MANUFACTURE. Various brush-making materials have been used over the centuries. In ancient Egypt macerated reed fibres were employed. Feathers and human hair have been used in East Asia, as have goat, deer, fox and wolf hair (although Sickman suggested that so-called wolf hair might in fact be that of weasel). The tail fur of the polecat, ermine, mink and sable (all varieties of *Mustela*) are mentioned in many sources as the best material for watercolour brushes. Miniver, a term used in England up to the 17th century, probably indicated ermine, the winter fur of the stoat. In the West other hair that has been used includes squirrel (tail), ox (ear), badger (back) and bear; the so-called camel hair mentioned in this context is an English misnomer for squirrel. Hair for brushes should be straight, resilient and finely tapered. Kolinsky sable (*Mustela sibirica*) has these characteristics plus good length and a faceted shape that allows hairs to hold together well for an easily controlled brush; squirrel is softer, less resilient and has a shape that offers less control; ox-ear hair is coarser and used largely for flat brushes, while badger (now obsolete) was more bristly.

Hog bristle is another natural material that has been used for centuries in both East and West for brushes that need to withstand hard wear. It has a slight natural curve, which is incorporated into the 'turn-in' of a well-shaped bristle brush, and a 'flag' or divided end at the tip, which holds paint well; as long as the bristle is not cut or damaged, this unwinds so that the flag remains as the bristle wears down with use.

Synthetic fibres were introduced to brushmaking in the late 1960s. Initially, inexpensive brushes were made of nylon, but these were unsuitable for high quality painting as they were slippery, did not hold colour well and were poorly tapered. Later, polyester fibre with individually shaped filaments offered an improvement, and for flat brushes the fibre could also be given a splayed tip that facilitated colour holding. By 1980 tapered polyester and sable mixture brushes with good 'point' were produced, combining the toughness of polyester with the resilience and colour-holding properties of sable.

Brush manufacture is a skilled traditional craft. Hair must be sterilized and then 'dressed': taking sable as an example, the end of the tail is broken off and discarded, the hair is cut from the tailbone with scissors, the short, soft hair is combed out from the guard hairs and discarded and the guard hairs are 'dragged' so that the hair is grouped according to length. Blunt or reversed hairs are then removed as the hair in any group must remain with root at one end and tip the other; any mixed group is sorted by means of a 'turning stick', a skilful operation that is dependent on the taper of the hair. Small or medium size brushes incorporate a single, uniform length of hair, whereas large sables have several lengths blended together. A quantity of hair is selected, tried for size through the appropriate ferrule, withdrawn, knocked down in a small metal cylinder called a 'cannon' so that the ends are level and then tied and knotted loosely with thread. The hair is then 'domed' for a pointed brush by rotating and shaping it with the fingers, the knot is tightened, the thread cut, and the hair is placed in the ferrule, drawn through and measured for length. The knot and back of the brush are

glued into the ferrule, which is then fitted and crimped on to a wooden handle so that it is secure and water is excluded.

Manufacture of hog tools varies a little in that the bristle is obtained in bundles of uniform length and treated so that groups of bristle have a uniform curve. This curve must be incorporated into the 'turn-in' of the brush whether it is to be round or flat; this may be done by manipulation or, for some types of flat brush, by tying two groups together, each of which curves inwards. A round brush has some of the bristle pushed up in the centre to give a rounded shape before being tied and placed in the ferrule. Filbert brushes (a flat brush with a domed shape) are also shaped by manipulation at this stage. Filberts and flat brushes are placed in round ferrules, which are then carefully flattened with pliers, while fan brushes and larger varnish brushes have specially shaped ferrules. The older quill mounts, of duck, goose and swan, were boiled to make them pliable while constructing the brush. On drying they contracted to hold the hair tightly and were tied with silk threads, the colours of which denoted different brush sizes. Seamless metal ferrules of nickel-plated brass or cupro-nickel are now very largely used. Brush handles must be smooth and well balanced; Western examples are usually made of hardwood and varnished or enamelled while in East Asia brushes are commonly mounted in bamboo and so no ferrule or handle is needed.

2. History. Since brushmaking is so specialized a craft, it is probable that artists made use of specialist brushmakers from very early on. Although Cennino Cennini (c. 1370–c. 1440), writing in the 1390s in Il libro dell'arte, mentions both miniver and bristle brushes, his description of how to make them is perfunctory and hard to follow and does not appear to reflect any first-hand knowledge of the technique. Certainly by the 17th century artists spoke of choosing rather than making brushes for themselves. These would generally have been mounted in quills, with a wooden or bone handle. Bristle brushes could be bound with cord on to a wooden handle or placed in tin holders (Excellency of Pen and Pencil, London, 1655, p. 95). Metal ferrules of silver or tin were introduced in the 19th century and encouraged a much greater variety of brush shapes, including the fan shape in sable or bristle.

Historically, any artist's brush, whether of hair or bristle, pointed or 'fitched' (flat, square-ended brushes, known in the USA as 'brights'), was called a 'pencil'. Different shapes and sizes were available for a variety of purposes. Early artists painting in egg tempera would have used a soft hair brush with a fine point to work with fine hatching strokes in this quick-drying medium. Many of the first artists to use oil paint would have employed similar brushes in order to achieve a smooth paint finish and fine details without evidence of brushstrokes. Again, a brush with a short length of hair for controlled detail would have been used for miniature painting, while both pointed and fitched pencils were recommended

for portrait painting in oil. In the 18th and 19th centuries large brushes made of stiffish badger hair were sold to be used dry for blending oil colours on the canvas. Known as 'sweeteners' or 'softeners', they were particularly useful in achieving sfumato effects and may have been in use earlier than this. Other specialized brushes in sable were known as 'riggers' and had very long hair to paint long, unbroken lines, as, for example, in ships' rigging (Artist's Repository and Drawing Magazine, London, 1784–6, p. 63). In the 20th century flat lettering or one-stroke brushes and pointed sables with an extra length of hair became available to commercial artists: the former for flat washes in gouache and the latter allowing long, unbroken application in watercolour.

From the 17th century artists in oil colours could also have made use of brush-washers, to avoid having to clean their brushes completely between use on consecutive days. These ranged from simple slanted metal containers, in which brushes might be laid so that the bristles but not the handles were immersed in oil, to a more sophisticated container that held the brushes between wires so that the bristles were suspended in oil (London, British Library, Harley MS. 6376, pp. 88–9). This ensured that any residual paint would not harden; however, the brushes had to be prevented from slipping down and bending the bristles. The same containers could also have been used with turpentine. In the 19th century some brush-washers illustrated in colourmen's catalogues were even more elaborate and had a compartment for washing the brushes, with solvent, metal clips for suspending them while drying and a drip tray.

3. Uses and care. The recommended purposes of individual types of brushes are usually explained in colourmen's catalogues. The highest quality sable is reserved for pointed watercolour brushes, made in sizes 000 to 14. These are costly, but, if well cared for and used with traditional watercolour on paper, they will last a long time. A large brush of this kind is versatile in that, being composed of several lengths of hair, it goes from a fat belly to a long, fine point. It is therefore capable of holding a large quantity of colour so that a broad, sweeping wash can be applied, while, if the tip only is used, fine lines are possible. Sable brushes with short hair for absolute control are made for photographic spotting. Flat, soft hair brushes are made up to 25 mm wide for application of broad washes of watercolour; the full width can be used, or a line may be painted with the edge of the brush. Squirrel-hair brushes can be used for broad watercolour washes (some are made in a large mop shape for the purpose) and for watercolour work in which precise detail is not required. Sable brushes that are used with oil or synthetic resin media on canvas or board in order to achieve a smooth finish will wear out rapidly. It is best to use for this purpose sable brushes specifically intended for oil painting, which are made from second-quality sable in round, flat and filbert shapes. Polyester/sable mixture brushes in the same shapes will give even longer wear.

Ox-hair or bristle brushes can be used with aqueous colours when a bold effect with obvious brushstrokes is wanted, but, because of their hard-wearing and good paint-holding properties, bristle brushes are used mainly for painting in oil or alkyd colours. Additionally, the bristles add a varied texture to impastoed paint. A brush with long bristles can produce sweeping strokes of some length, while short, square bristle brushes produce well defined, stubby strokes that are likely to be obvious when looking at the painting. For less definite feathery touches and for blending colours on the painting, a fan brush of sable or bristle can be used.

An artist can achieve certain effects through appropriate choice of brush, but the way the brush is held and moved is another factor, allowing a variety of brushstrokes through variations of technique. Stout (1941) pointed out that representations of early European artists show them with the brush at right-angles to the fingers, a grip that makes full use of elbow and shoulder muscles. The usual modern grip is with the brush parallel to the fingers, as with a writing instrument. This encourages movement with the fingers and wrist. An alternative grip with long-handled bristle brushes is to place the hand further along the handle, holding it as if it were a knife, again giving scope for arm movement.

The care of brushes is applicable to all types. They should be cleaned immediately after use; if paint is allowed to clog the ferrule the brush shape will be spoiled. Brushes for watercolours and acrylics should be washed in cool water. Bristle brushes should be cleaned with white spirit and afterwards washed in soap and water. A soft hair brush should never be allowed to rest on the tip nor be left in water; in the first case the hairs will be permanently deformed and in the second the wooden handle will swell and cause the coating to flake off. Soft hair or bristle brushes should never be trimmed with scissors, but a single stray hair may be broken off with a knife close to the ferrule. Soft hair brushes are subject to moth damage, and any brushes used infrequently should be stored dry, preferably in a metal case, with moth deterrent.

See also AIRBRUSH.

C. Cennini: *Il libro dell'arte*, MS. trans. by D. V. Thompson as *The Craftsman's Handbook* (New Haven, 1933, rev. New York, 2/1960)

L. Sickman: 'Some Chinese Brushes', *Technical Studies in the Field of Fine Arts*, viii (1939), pp. 61–4

G. L. Stout: 'The Grip of the Artist's Brush', *Technical Studies in the Field of Fines Arts*, x (1941), pp. 3–17

R. J. Gettens and G. L. Stout: *Painting Materials: A Short Encyclopaedia* (New York, 1942, rev. 1966), pp. 279–81

P. J. Garrard: 'The Making of a Brush', *The Artist*, xci/7 (July 1976), pp. 29–31

P. J. Garrard: 'The Making of a Brush (II)', *The Artist*, xci/8 (Aug 1976), pp. 26–8

R. D. Harley: 'Artists' Brushes—Historical Evidence from the Sixteenth to the Nineteenth Century', *Conservation and Restoration of Pictorial Art*, ed. N. Brommelle and P. Smith (London, 1976), pp. 123–9

Y. Nishio: 'Introduction to Japanese Painting', *Preprints of the American Institute for Conservation of Historic and Artistic Works: 9th Annual Meeting*, Philadelphia, 1981, pp. 137–45

P. Wills, A. Thompson and N. Pickwoad, eds: 'Japanese Brushes for Conservation', *Paper Conservator*, ix (1985), pp 137–45

J. Turner: Brushes: *A Handbook for Artists and Artisans* (New York, 1992)

Burin [graver]. Tool for incising lines into a metal plate to create an engraving. It consists of a sharpened steel point with a diamond-shaped cross section, mounted in a wooden handle. A burin gouges out a thin section of metal, leaving an incised groove with a shape depending on the size and width of the point and the force of application.

Burnisher. Tool with a hard, smooth, tip, mounted in a wooden handle, used for smoothing or polishing. In water gilding, a burnisher of polished agate is used to smooth the underlying gesso and bole after the gold is applied, giving a highly reflective surface. Burnishers used to burnish ancient pots are depicted in Egyptian wall paintings from the 14th century BC. In 13th-century Italy, burnishers of haematite or dog's tooth were recommended. A steel-bladed burnisher is used in intaglio printing for the correction of errors or scratches on the metal plate or for the reduction of dark areas (*see also* PRINTS, §III, 2).

Burr. Term applied in printmaking to the sharp ridge of metal raised especially by a drypoint needle as it scratches the plate; it can also be produced by the action of a burin in engraving but is usually removed. Burr prints as a rich, slightly smudged line or area, as the curled metal holds a quantity of ink; eventually the metal fragments flake off in printing, so the effect, which was exploited by artists such as Rembrandt van Rijn (1606–69), is limited to a small number of early impressions. The effect can be easily detected with a magnifying glass and contrasts with sharp and precise engraved lines.

C

Callipers. Pair of hinged jaws, of wood or metal, used to take measurements from a figure, model or drawing. Proportional callipers, which possess a movable pivot with jaws at both ends, can be employed to reduce or increase measurements when making a copy from an original.

Camaieu [Fr. *en camaïeu*: 'like a cameo']. Painting with a single colour (monochrome) in two or three tones only; the technique is often employed to give the spectator the illusion that the image is carved (*see also* GRISAILLE).

Cameo. Design engraved, carved or moulded in relief on gemstones, glass, ceramics etc; it uses layers of different colours, which can be transparent or opaque, so that the background and raised ground contrast. There are often just two colours: one dark colour, the other lighter, often white (see fig.). The most common form is a medallion with a profile portrait. The cameo technique is the opposite of intaglio (see GEM-ENGRAVING). Cameos were made in Classical Greece and Rome and were revived during the Renaissance.

Camera lucida [Lat.: 'light chamber']. Optical device used as an aid for drawing or copying. Its somewhat misleading name is derived from the fact that it performs the same function as the CAMERA OBSCURA but in full daylight. Far more easily portable than a camera obscura, a camera lucida basically consists of a prism mounted on an adjustable stand and a drawing-board. The prism has to have one right angle, two of 67.5° and one of 135°. When the stand is adjusted so that the prism half covers the pupil of the eye, the draughtsman using it has the illusion of seeing both the object he wishes to draw, which is reflected through the prism by rays of light, and its outlines on the drawing-board. If paper is placed on the drawing-board the outlines can easily be traced off.

A much more sophisticated apparatus than the camera obscura, the camera lucida was perhaps invented, and certainly given its final form, by Dr William Hyde Wollaston (1766–1828), who patented it in 1807. Examples have been found as parts of portable drawing outfits used by amateur sketchers as well as by professional draughtsmen and artists. The apparatus has also been adapted for use with a microscope.

Various examples of sketches made with a camera lucida are known, such as the *Temple of Juno at Grigenti, Sicily* (pencil, 110×160 mm; London, Science Museum) and *Bonneville near Geneva on the Road to Chamonix* (pencil, 194×290 mm; Los Angeles, J. Paul Getty Museum; see fig.) both by Sir John Herschel (1792–1871). While unmistakably mechanical in appearance, this illustrates the kind of virtuoso effects that could be achieved and is free of the sort of distortion at the edges of the image that could result from the use of a camera obscura with its much more primitive lens.

The camera lucida could also be used to make enlargements or reductions from an original, depending on how the user altered the distances between the copy being made, the prism and the object being copied. It did have its disadvantages, however: the draughtsman had to be able to manoeuvre himself, or move the image on the board, so that it was possible to see both it and the pencil-point; any movement of the head made accuracy difficult; and in bright sunlight prolonged use of the camera lucida must have been very tiring.

D. Brewster: *A Treatise on Optics* (London, 1831), p. 195

H. Hutter: *Die Handzeichnung* (Vienna, 1966); Eng. trans. as *Drawing, History and Technique* (London, 1968), pp. 145–6

H. Osborne, ed.: *The Oxford Companion to Art* (Oxford, 1970)

C. Ashwin: *Encyclopedia of Drawing* (London, 1982)

J. H. Hammond and J. Austin: *The Camera Lucida in Art and Science* (Bristol, 1987)

M. M. Hambourg: 'Cabinet of Wonders: William Talbot's Early Use of Photographic Paper', *On Paper*, ii (Sept–Oct 1997), pp. 2–3

D. Hockney: *Secret Knowledge: Rediscovering the Lost Techniques of the Old Masters* (London, 2006)

C. Berwick and K. Rosenberg: 'Optical Illusions', *ARTnews*, ci/2 (Feb 2002), p. 38

Camera obscura [Lat.: 'dark chamber']. Light-tight box with a small hole in one side, sometimes fitted with a lens, through which light from a well-lit scene or object enters to form an inverted image on a screen placed opposite the hole (see fig.). A mirror then reflects the image, right way up, on to a drawing surface where its outlines can be traced. The camera obscura was the direct precursor of the modern camera, and its use by earlier artists can be compared to that made of the camera by artists of the 19th and

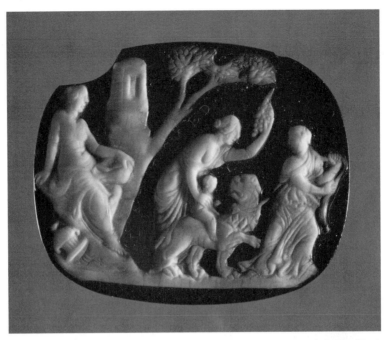

Cameo depicting the *Infancy of Dionysos,* 40×32 mm, Greek, Hellenistic period (323–27 BC) (Naples, Museo Archeologico Nazionale); photo credit: Erich Lessing/Art Resource, NY

Bonneville near Geneva on the Road to Chamonix, graphite drawing made by John Herschel with the use of a camera lucida, 194×290 mm, 1821 (Los Angeles, CA, J. Paul Getty Museum, Gift of the Graham and Susan Nash Collection); photo credit: The J. Paul Getty Museum

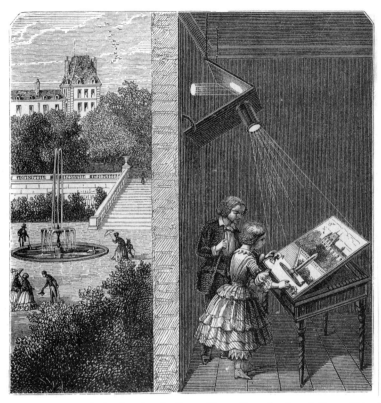

Children Watching an Outdoor Scene through a Camera Obscura, illustration from A. Ganot: *Natural Philosophy* (London, 1887) (Oxford, Oxford Science Archive); photo credit: HIP/Art Resource, NY

20th centuries. Moreover, a camera obscura was the device used by Thomas Wedgwood (1771–1801) and Humphry Davy (1778–1829) in the late 18th century in their attempts to project an image on to paper and leather coated with a silver nitrate solution; the image was finally fixed by Nicéphore Niépce (1765–1833) in 1826–7.

The origins of the camera obscura go back at least to Aristotle, who noted the principle on which it works in his *Problems*. This was also noted by the Arabian philosopher Ibn al-Haytham (Alhazen; *c.* 965–1039) who recommended it to astronomers as a means of observing eclipses safely; it was frequently used for this purpose, often in conjunction with an astronomer's reticle. This appears to have been its main use at least until the 16th century, though the English scholar Roger Bacon (1214–94) appears to have known of the mirror device by which the camera obscura was of interest and value to artists. Giorgio Vasari (1511–74) mentions an invention of Leon Battista Alberti (1404–72) that sounds as if it may have been a camera obscura, but it was not until the publication of the *Magia Naturalis* (Naples, 1558) by the Neapolitan physician Giovan Battista della Porta (*c.* 1535–1615) that the camera obscura became popularized as a mechanical aid to drawing, and not until the early 1600s that Johannes

Kepler (1571–1630) gave it the name by which it is now known.

Following this the camera obscura became increasingly popular and important. Both Johannes Torrentius (1589–1644) and Johannes Vermeer (1632–75) are known to have used it (the former thus laying himself open to a charge of witchcraft); so, notably, did Canaletto (1697–1768), who had a camera obscura made by the Venetian optical-instrument maker Domenico Selva (*d* 1758). Among other painters who enthusiastically adopted it were Francesco Guardi (1712–93), Michele Giovanni Marieschi (1710–43), Luca Carlevaris (1663–1730) and Sir Joshua Reynolds (1723–92). John Harris (?1667–1719) mentions the camera obscura in his *Lexicon Technicum* (London, 1704) as being on sale in London; indeed, throughout the 18th century their use became a craze. They were enjoyed equally for the views they made possible, particularly the chiaroscuro effects produced by looking from or through a darkened area at a well-lit subject (perhaps similar to those created by the Claude glass and satisfying a similar 18th-century taste). Horace Walpole (1717–97) and Johann Wolfgang von Goethe (1749–1832) are among those known to have owned and used a camera obscura, presumably for this reason. In 1747 the London instrument maker John Cuff (1708–92)

published an anonymous contemporary poem praising the camera obscura, which gives some indication of the healthy market there was for these instruments. It contains much fulsome praise:

Say, rare Machine, who taught thee to design?
And mimick Nature with such Skill divine …
Exterior objects painting on the scroll
True as the Eye presents 'em to the Soul….

The camera obscura came in many sizes, some large enough, though portable, to warrant being covered with a tent; these could easily accommodate a man standing (and drawing) inside. Others, like sedan-chairs, were fitted with bellows, which the artist or viewer worked with his feet to improve ventilation. Sir Joshua Reynolds owned one (London, Science Museum) that, with great ingenuity, collapsed down to the size and appearance of a book and could be stored as such.

G. Vasari: *Vite*, ii (1550, rev. 2/1568); ed. G. Milanesi (1878–85), pp. 535–48

H. Hutter: *Die Handzeichnung* (Vienna, 1966); Eng. trans. as *Drawing, History and Technique* (London, 1968), p. 145

H. Osborne, ed.: *The Oxford Companion to Art* (Oxford, 1970)

H. Schwarz: 'An Eighteenth Century English Poem on the *camera obscura*', *Festschrift für Beaumont Newall* (Albuquerque, 1975), pp. 127–38

Thomas Gainsborough's Exhibition Box and Transparencies (exh. cat., Gainsborough's House, Sudbury, Suffolk, 1979)

J. H. Hammond: *The Camera Obscura: A Chronicle* (Bristol, 1981) [with bibliog.]

C. Ashwin: *Encyclopedia of Drawing* (London, 1982), pp. 16–20

J. H. Hammond and J. Austin: *The Camera Lucida in Art and Science* (Bristol, 1987)

M. M. Hambourg: 'Cabinet of Wonders: William Talbot's Early Use of Photographic Paper', *On Paper,* ii (Sept–Oct 1997), pp. 2–3

D. Hockney: *Secret Knowledge: Rediscovering the Lost Techniques of the Old Masters* (London, 2006)

C. Berwick and K. Rosenberg: 'Optical Illusions', *ARTnews*, ci/2 (Feb 2002), p. 38

Cane. The stem of the rattan palm. The technique of interweaving split cane to form an open mesh originated in East Asia; it was first used in England during the Restoration period in the second half of the 17th century for the bottoms and backs of seat furniture, supplies of the palm being shipped to Europe from the Malay Peninsula by the East India Co. Caning was also widely used by Dutch Colonial furniture-makers. After declining in favour, caning again became popular in the late 18th century for chairs, cradles, bedheads and, as Thomas Sheraton (*d* 1806) observed, 'anything where lightness, elasticity, cleanness, and durability, ought to be combined'. In the late 19th century and the early 20th there was a worldwide demand for furniture constructed entirely of the tough, fibrous core of the rattan palm; a wide range of articles, often described as 'art cane furniture', was available for gardens, conservatories, steamers, cafés, drawing-rooms and hotels. The cane is sometimes combined with fixed upholstery, and

some makers used brightly coloured stains. A large collection of Edwardian trade catalogues issued by leading cane manufacturers, including W. T. Ellmore & Son (Leicester), E. A. Day and Morris Wilkinson & Co. (both Nottingham), is owned by the City Art Gallery, Leeds.

See also Bamboo, Basketwork and Wicker.

P. Macquoid and R. Edwards: *The Dictionary of English Furniture*, 3 vols (London, 1924–7, rev. 1954/*R* 1983)

P. Kirkham: 'Willow and Cane Furniture in Austria, Germany and England *c*. 1900 14', *Furniture History*, xxi (1985), pp. 128–33

M. Campbell: 'From Cure Chair to *chaise longue*: Medical Treatment and the Form of the Modern Recliner', *Journal of Design History*, xii/4 (1999), pp. 327–44

Cangianti [It.: 'colour changes', from present participle of *cangiare*: to change; Fr. *changeant;* Eng. changeables]. The practice of using two or more hues of different lightness to imitate the effects of light and shadow on a surface. Cangianti often imitate the appearance of shot silk where the woof and the warp are two different colours, a weaving practice that causes the fabric to appear to change in colour with its orientation to the light. Cangianti modelling emerged in 14th-century Italian painting as an alternative to Chiaroscuro modelling. Its greatest exponents in later centuries were Michelangelo (1475–1564) and Federico Barocci (c. 1535–1612).

Canvas. Type of strong, substantial cloth originally made of hemp (*Cannabis sativa*, from which it takes its name) but more likely to be of a coarse flax or tightly woven linen; similar textiles of cotton or jute are also called canvas. A cloth type rather than a specific cloth, with varied practical applications, canvas is important as a material used for making painting supports. 'Canvas' has therefore come to mean not only the raw cloth but also a piece of fabric mounted on a stretching frame and prepared for use in painting or a finished painting, usually in oils, painted on a textile support.

1. Properties and types. 2. History and use. 3. Conservation.

1. Properties and types.

(i) Properties. Canvas is most often a plainly woven cloth with a weft that passes alternately under and over each warp thread. The warp and weft are usually of equal strength, but the tightness of the weave may vary: substantial canvases might have coarse, robust threads, loosely woven, or fine ones tightly packed together. The weave affects the stability of the cloth, the ease with which it can be prepared for painting and the texture (tooth) that the prepared surface presents. The choice of canvas, although often based on practicalities, therefore has an influence on the final appearance of the painting. The more complex twill weaves sometimes used for canvas produce a pronounced surface pattern either of parallel diagonal lines or of a herringbone design. Such cloth is a particular feature of the work of Paolo Veronese

(1528–88). Sir Joshua Reynolds (1723–92) used it in imitation of Veronese, and in some works by Camille Pissarro (1830–1903) and Paul Gauguin (1848–1903) its employment also seems intentional. However, its early use by Andrea Mantegna (1430/31–1506) and the unusual occurrence of an even more complex damask cloth beneath *Erminia and the Shepherds* (*c.* 1623–5; Paris, Musée du Louvre) by Domenichino (1581–1641) rather suggest the ad hoc use of any suitable fabric. The development of Craquelure, accretions of dirt and varnish and certain types of paint loss are subsequently attributable to the type of canvas weave.

The transition from hand weaving to machine weaving effected a slight change in the character and behaviour of canvas cloths. Later machine-woven canvases tend to be smoother and more tightly woven. Wider cloth can be made by machine, but since canvas can always be joined easily to make larger pieces this has not affected its use.

Being a loose and flexible material, canvas is not fit to be painted on in its natural state. It must first be stretched taut across a frame to create a flat and relatively firm surface. Canvases are generally prepared from unfinished cloth, the deep, variable colour and fibrous nature of which are also unhelpful to the artist, so it is usual to prepare the cloth before painting on it. A coating of Size stabilizes the stretched canvas and prevents the paint from soaking into it, a potentially destructive occurrence in the case of oil paint; for most purposes a Ground preparation is applied on top of that. Nevertheless, the inherent properties of the raw cloth are not entirely suppressed. A stretched and prepared canvas remains semi-flexible and will continue to respond to temperature and humidity changes, mostly at its unprimed reverse side. This causes continual movement due to the fluctuating tension in the threads and renders the support technically unstable, though within certain tolerable limitations.

Although the life-expectancy of a painting on canvas is often less than the supposed durability of the fabric employed would suggest (*see* §3 below), the conveniences of canvas outweigh its disadvantages. Its low cost and light weight are in its favour, while its tooth and the slight give of its surface when painted on are felt by many artists to add to the pleasures of painting.

(ii) Types. True hemp comes from the Indian plant *Cannabis sativa*, but the name is loosely applied to other vegetable fibres used for similar purposes. Hemp was originally used for ropemaking and for coarse cloth for sails. Jacopo Tintoretto (1519–94) and Nicolas Poussin (1594–1665) are known to have used cloth of hemp, and its employment probably continued into the 19th century. It is easily confused with flax, the plant *Linum usitatissimum*, from which linen is made (and which also yields linseed oil). The names flax and linen both apply to this cloth and may be used indiscriminately, though flax usually refers to

a heavy, coarse version of the cloth with robust threads, and linen to the finer-quality fabrics made from the same fibre. The raw cloth is grey-brown, sometimes with specks of woody matter enmeshed in the weave. Flax has a rougher, more fibrous surface than linen. Linen and flax are strong, hard-wearing fabrics, with a theoretical life-expectancy of up to 1000 years, and their use has largely dominated painting on canvas. Handmade linen canvas continued to be used into the 19th century. Probably since the 19th century specific qualities of 'artists' linen' have been manufactured in Belgium and Ireland. Different weave qualities and weights may be used selectively for different styles or subject-matter. The most finely woven ones are sometimes referred to as 'portrait linen'. Ticking, onion bag, holland and cambric are some of the now defunct or little-used terms for canvas varieties.

Cotton is softer and less durable than linen. It is produced in a great variety of weights and weave qualities; the heavier qualities of cotton 'duck' are sometimes described as canvas, and it is usually these that are employed in painting. Cotton is naturally a creamy off-white in colour and has a smoother surface than linen. Although the cotton industry was mechanized before the linen industry, it was only in the 20th century that cotton canvas supplanted linen, largely because cotton was more economical to use. Cotton canvases are widely used by amateur painters and students but since the 1960s have enjoyed a popularity at all levels of activity. *A Bigger Splash* (1967; London, Tate) by David Hockney (*b* 1937), for example, is on a cotton duck.

Hessian is a coarse cloth made from jute, the fibre from the inner bark of *Corchorus capsularis* and *Corchorus olitorius*. It has large fibrous threads and presents a rough, hairy surface, giving a canvas with a bold and pronounced tooth when prepared. It is a slightly orange yellow-brown in colour. Hessian has a short life-expectancy and becomes brittle and friable after 50–100 years. It is nevertheless occasionally used by painters, especially where a rugged surface texture is desired. Gauguin's *Te rerioa* (1897; London, University of London, Courtauld Institute Galleries) is on a hessian canvas, perhaps improvised from discarded sacking or a bale covering.

Synthetic fibres have as yet found little use in artists' canvases, as their preparation presents difficulties and most painters have a conservative attitude towards them. They are now being employed, though not very extensively. Synthetic fibres would potentially make durable and stable canvases, but they are not sympathetic towards some of the established practices of painting and at present are of greater interest to conservators.

M. Doerner: *Malmaterial und seine Verwendung im Bilde* (Munich, 1921, rev. 4/1933); Eng. trans. as *The Materials of the Artist* (London, 1935/*R* 1979)

R. Mayer: *Dictionary of Art Terms and Techniques* (London, 1969/*R* New York, 1981)

J. Stephenson: *The Materials and Techniques of Painting* (London, 1989)

E. Hermens, ed.: *Looking through Paintings: The Study of Painting Techniques and Materials in Support of Art Historical Research* (Baarn and London, 1998)

2. HISTORY AND USE. Canvas was originally used for ships' sails, tents, sacking and similar practical applications. Its adoption for painting has been conditioned by local availability, fashion, cost and, perhaps, personal preference. The early evidence of painting on cloth is circumstantial or consists of isolated examples. As the materials involved are perishable, the incidence of their use and the relative importance of such works cannot be established. Painted linen has been found in an Egyptian tomb of Gebelein dating from *c.* 3500 BC (Turin, Museo Egizio), the painted decoration of textiles features in Pre-Columbian South American art, and paintings on silk were an established art form of the Chinese Han dynasty (206 BC–AD 220). Pliny the elder (AD 23/4–79) mentioned the use of canvas for a portrait, 36 m high, of the Roman emperor Nero (*reg* AD 54–68). It is generally accepted that in Western art the transition from using panels to using canvases for important paintings began during the 15th century, but there is documentary evidence from the 14th century that painting on cloth was then already widely practised. At least one of the methods in use was German or English in origin, while another was probably Flemish. An Italian public record dated 1335 refers to 'pictures on cloth in the German method' (Eastlake, i, pp. 90–91) by a Maestro Marco and his brother Paolo, living in Venice, who had either learnt or copied the method from a German friar who had painted similar works on cloth. The early date is significant, but so too is the location: Venetian artists developed an enthusiasm for canvas before the rest of Italy, and its exploitation there during the Renaissance more than 100 years later represents a turning-point in art history.

A manuscript (Paris, Bibliothèque Nationale, MS. 6741) of 1410 confirms that the English painted on cloth at about this time and describes a method of painting on cloth using transparent watercolours. Finely woven linen was soaked in gum solution and, when dry, stretched out and laid flat on an absorbent layer of coarse woollen cloth. The artists walked over it with clean feet and painted as they went with colours that might well have been organic dyes rather than pigmented paints. The woollen cloth covering the floor absorbed the excess moisture, while the gum prevented the colours from running. (This unusual method of working on cloth probably accounts for the confused distinction between 'painters' and 'stainers' that surfaced later in the English guild system: 'painters' worked on panels, 'stainers' on cloth.) Whether the English and German methods were the same is not known, but evidently a similar technique was known in Germany as, according to Giorgio Vasari (1511–74), Albrecht Dürer (1471–1528) sent Raphael (1483–1520) a painting in transparent watercolours on fine linen that could be viewed from both sides, the highlights being derived

from the cloth without the use of white. Leonardo da Vinci (1452–1519) may also have known this method of painting.

Other methods of working on cloth were given by Cennino Cennini (*c.* 1370–*c.* 1440) in *Il libro dell'arte* (*c.* 1390): linen or silk was used to make religious processional banners; black or blue cloths were used for painted decorative hangings, probably in imitation of tapestries; silk painted on both sides is mentioned for palls, ensigns and again banners; and the painting and gilding of velvet to make sumptuous, exotic cloths and of woollen cloth for heraldic devices on noblemen's apparel are discussed. In the case of religious banners, the preparation for painting involved stretching the cloth on a frame, although Cennini referred to its being rolled or folded, implying that it was later removed. His suggestions that a size solution weaker than usual might be used and that starch or sugar should be added (to act as a plasticizer) and his concern for the thinness of the gesso ground all indicate the need for maximum flexibility and tend to confirm that the finished paintings hung loosely. The *Virgin of Humility* (late 14th century; London, National Gallery) by Lippo di Dalmasio (*d c.* 1410), contemporary with Cennini's account, is probably the remnant of a processional banner such as he described. Canvas was also used for other short-lived decorations at festivals and, as today, for theatrical scenery.

In this early period a connection existed between painters, embroiderers and tapestry-makers. The English method of painting detailed above was actually related by an embroiderer, and Cennini wrote of painting on to cloth to provide designs for embroiderers to work over. Other instances of cooperation between these activities are also indicated. Tapestry cartoons were provided by painters, as the later examples (London, Victoria and Albert Museum) by Raphael confirm. It is quite likely that some of these were executed on to cloth as a convenient way of achieving the large scale needed. Painted imitations of tapestries were also produced as a less costly alternative to them. Large painted hangings were a particular product of the Netherlands in the early 15th century. Karel van Mander I (1548–1606) commented on their frequent use as room decorations there and expressed the opinion that some that he had seen were by Roger of Bruge (?Rogier van der Weyden (*c.* 1399–1464)). These 'Flemish cloths' reached Italy in quantity, and it is generally supposed that they provided the inspiration for the north Italian artists who then began painting on canvas supports, though, as discussed above, painting on cloth had been introduced to Venice much earlier.

Canvas was also applied to the wooden panels employed for tempera painting, as a cover either for the joints where stress might occur or for the whole of the surface to be worked on. Its use in this context was mentioned by Theophilus in *De diversis artibus* (1110–40) and afterwards by Cennini and others. Painting directly on to canvas need not have involved a radical change in concept. The earliest works on

canvas were probably painted that way for ease of transportation and were then installed *in situ* on top of a panel. Andrea Mantegna's *Virgin and Child with St Mary Magdalene and St John the Baptist* (*c.* 1495; London, National Gallery) was formerly mounted in that fashion, and his *Presentation in the Temple* (*c.* 1454–5; Berlin, Gemäldegalerie) still is. Other canvases of this period show signs of having originally been fixed over panels.

Cennini's method of preparing canvas for banners was sensitive to the shortcomings of textile supports generally, and the progression from there to the fixed canvas supports of the 15th and 16th centuries involved little more than leaving the canvas on its stretcher and painting on only one side of it. Apparently the typical practice was to prepare and paint the canvas on a temporary stretcher and to transfer it to another one, probably of lighter construction, or to a panel for display. This could permit an adjustment to the pictorial space if necessary and certainly favours easy transportation. Mantegna noted that canvas could be 'wrapped around a rod when being moved', showing his awareness of its portable nature. Until the 17th century depictions of artists at work often showed canvases lashed to temporary frames while being painted on, as for example in the *Artist as Zeuxis Painting an Ugly Old Woman* (?*c.* 1670–80; Frankfurt am Main, Städelsches Kunstinstitut und Städtische Galerie) by Arent de Gelder (1645–1727). Thomas Gainsborough (1727–88) was still doing this in the 18th century, but by then it would have been unusual.

Netherlandish and northern Italian painters started to use canvas for quality work in the 15th century. Some early examples are in size colour, suggesting a possible link with the English and German methods noted, but it was the combination of oil paint with canvas that ensured its future success. The focal point of this development was Venice. Although Mantegna was not a Venetian painter, his father-in-law, Jacopo Bellini (*c.* 1400–70/71), was, and these two artists represent the obvious beginnings of painting on canvas in Italy. Bellini's sons Gentile (?1429–1507) and Giovanni (?1431/6–1516) also favoured canvas, and together they dominated Venetian painting for the rest of the century. Giorgione (?1477/8–1510), Titian (*c.* ?1485/90–1576) and Sebastiano del Piombo (?1485/6–1547) trained in Giovanni Bellini's studio, and in the hands of Titian in particular the dominance of canvas was finally confirmed. Tintoretto and Veronese took still more advantage of the potential scale on which canvas could be used. The inability of frescoes and tempera paintings on wooden panels to survive in Venice's humid, salty atmosphere explains the Venetian willingness to adopt both oil paint and canvas, but the suitability of that combination was probably known already. Canvas was cheap, lightweight and readily available, especially in a maritime nation such as Venice, and pieces could be sewn together to make supports of any size. These factors were enough to guarantee its popularity from the late

Renaissance onwards, since when its essential use has not changed. In the 17th century a full-length portrait painted on canvas commonly corresponded in width to the typical width of handmade cloth, a factor determined by how far the shuttle could be thrown. In the sale of the studio contents of Peter Lely (1618–80) in 1682, some items were described as canvas, others as sacking, some indeterminately as 'cloth'. Canvas sizes relating to portraiture were quoted as whole length and half length, but it cannot be supposed that these were an exact specification. In the 18th century, when the commercial production of artists' canvases replaced their preparation within the studio, there was increasing standardization of canvas sizes and the frames that went with them, and by the 19th century a full range of sizes for landscape and portraiture had been developed. Commercial production favoured the preparation of large pieces that were then cut down to make smaller sizes. This eventually led to the introduction of the now-familiar wedged stretcher that permits an already primed canvas to be tightened by a slight expansion of its carrying frame.

C. Cennini: *Il libro dell'arte* (*c.* 1390); Eng. trans. and notes by D. V. Thompson jr (1933)

G. Vasari: *Vite* (1550; rev. 2/1568); ed. G. Milanesi (1878–85)

C. Eastlake: *Materials for a History of Oil Painting* (London, 1847); repr. as *Methods and Materials of Painting of the Great Schools and Masters*, 2 vols (New York, 1960) [esp. vol. i]

M. K. Talley: *Portrait Painting in England* (diss., University of London, 1978; privately pubd, London, 1981)

Paint and Painting (exh. cat., London, Tate, 1982)

J. Ayres: *The Artist's Craft* (London, 1985)

A. Callen, ed.: *Techniques of the Great Masters of Art* (London, 1985)

E. Van De Wetering: 'The Canvas Support', *A Corpus of Rembrandt Paintings, 1631–1634*, eds J. Bruyn and others (Dordrecht, 1986), ii of iii (1982–90), pp. 15–43

Z. Veliz: *Artists' Techniques in Golden Age Spain* (Cambridge, 1986)

R. D. Harley: 'Artists' Prepared Canvases from Winsor & Newton, 1928–1951', *Studies in Conservation*, xxxii/2 (May 1987), pp. 77–85

D. Wolfthal: *The Beginnings of Netherlandish Canvas Painting, 1400–1530* (Cambridge, 1989)

J. Dunkerton and others: *Giotto to Dürer: Early Renaissance Painting in the National Gallery* (London, 1991)

S. M. Warner and N. B. Thompson: 'Sailing to New Worlds: A History of Canvas Products in America', *Industrial Fabric Products Review*, lxxii/5 (1995), pp. 45 and following; lxxii/12 (April 1996), pp. 46–8

L. Campbell and S. Foister: 'The Methods and Materials of Northern European Painting 1400–1550', *National Gallery Technical Bulletin*, xviii (1997), pp. 6–55

C. Mancusi-Ungaro: 'The Paintings of Barnett Newman: "Involved Intuition at the Highest Level"', *Barnett Newman: A Catalogue Raisonné*, ed. E. C. Allison (New Haven and London, 2004), pp. 117–41

Grossgemälde auf textilen Bildträgen [monographic issue of *Restauratorenblätter*, xxiv–xxv] (Klosterneuberg, 2005)

S. Cove: 'The Painting Techniques of Constable's "Six-footers"', *Constable: The Great Landscapes* (exh. cat., ed. A. Lyles; London, Tate and Washington, DC, National Gallery of Art, 2006), pp. 50–69

3. CONSERVATION. Canvas is susceptible to rot, pest attack, accidental damage and the general degradations of time. It is, in fact, quite fragile when stretched and is easily cut or punctured. The conservation of canvas is often a matter of restoration and repair (see CONSERVATION AND RESTORATION, §II, 1 and 2(i)). The primary object is to preserve and conserve the painting on the canvas, and to achieve that end the integrity of the cloth support is often compromised. In extreme circumstances the canvas has been removed entirely and the paint layers and ground transferred to another support. Only in comparatively recent times has attention been given to the notion of keeping a work of art intact by slowing down, arresting or reversing the degradation of its fabric support with the minimum of alteration to that support. In less than ideal conditions canvases do not age well, so the vast majority of works on canvas have already been committed to the traditional processes of restoration that are mostly variants of lining or relining the canvas. Once (re)lining has been decided on, the process must be repeated at periodic intervals, as, although relining is in some degree reversible, it is not possible to go back to an even earlier stage in the canvas's history and choose an alternative form of conservation action.

Where a canvas has not been relined, it may be possible to consider other methods of conservation, although much depends on the condition of the canvas. A gentle reintroduction of moisture can partially rejuvenate a canvas, by regenerating the layer of size and relaxing the threads of the canvas, allowing the distortion in the paint layers to be corrected. This reintroduction of moisture takes place during the old-fashioned glue relining process. Vapour treatment on a vacuum hot-table or a low-pressure table is a modern, controlled method of achieving the same result. Vapour treatment was used successfully to conserve *Mr and Mrs Coltman* by Joseph Wright of Derby (1734–97; London, National Gallery), a painting dated to *c.* 1771 that had never been lined. Remounting the treated canvas on a blind stretcher, with solid panels fitted between the members of the frame, was then sufficient to conserve the canvas in its existing condition.

Control of temperature and humidity is of major importance in the conservation of canvas, as changes in these cause movement in the canvas, subject it to stress and promote differential behaviour between the canvas, paint and ground layers. Unfavourable conditions also promote biological attack. A constant temperature of 18°C and a relative humidity of between 50% and 55% is considered the most suitable environment for canvas. Such conditions, of course, are only likely to exist in galleries or museums. In less favourable circumstances, some means of preventing the surrounding atmosphere from gaining access to the back of the canvas, where it is most vulnerable, is usually beneficial. Mounting canvas on panel, not permanently as in the 'marouflage' technique where it is glued down,

but with the panel acting merely as a stretcher, or alternatively using a blind stretcher greatly reduces the effects of temperature and humidity changes on the canvas. It will also protect against accidental damage to the canvas from the rear. Thin sheets of metal and plastic have been used to back canvases successfully in a similar manner, but in using these materials there is a potential danger from condensation or trapped moisture. Generally, anything that encloses the back of the canvas and creates a more stable micro-climate is advantageous. Even a piece of lightweight card or strong paper used to enclose the back of the stretching frame will be beneficial. The use of a double canvas will also protect the canvas from changes in temperature and humidity: a second canvas stretched on the same frame can act to reinforce the one that is painted, also creating a barrier or buffer between the painted canvas and the atmosphere. In the 19th century a number of artists' colourmen used this method. Many of the later paintings by J. M. W. Turner (1775–1851) are or were originally 'loose lined' in this way. *Our English Coasts* (1852; London, Tate) by William Holman Hunt (1827–1910) is an example of a painting backed by a second, primed canvas, a more effective protection than the unprimed backing cloths that were sometimes used.

Even when a canvas is carefully prepared and well looked after, it is still inclined to wear at the edges where it is in contact with the stretcher. Stretchers with rounded edges are much less damaging than ones with angled edges. Strip-lining an affected canvas to repair damage at the edges involves minimal interference with the canvas. Unless the stretcher is original to the painting and therefore part of its history, it may be preferable to replace the stretcher with a better one. Rough handling is bad for canvases and shock or vibration should be guarded against during transportation. Other risks to canvases include oxidation of the canvas caused by air pollution and the detrimental effects of ultraviolet light. A controlled environment is again the solution to these problems.

If the canvas is penetrated by oil, it will become brittle and decay. Proper preparation of the canvas and the employment of sensible techniques by the painter should substantially prevent this. However, even with the greatest of preparatory care, canvas inevitably becomes acidic and brittle with age. Treatments of oil to the back of canvases as a protection against damp must be avoided. The preservation of present and future works would be greatly enhanced if painters and the art materials trade took greater notice of some of these conservation factors. Poor preparation and the unsuitability of the materials and techniques used are likely to pose major threats to the life-expectancy of some modern works, which may require serious intervention rather than minor conservation procedures to preserve them.

C. Wolters and others: 'The Care of Paintings & Fabric Paint Supports', *Museum: Revue trimestrielle publiée par l'UNESCO,* xiii (1960), pp. 134–71

J. Lodewijks: 'The Latest Developments in the Conservation of Old Textiles by Means of Heat Sealing', *ICOM, Mixed Conference: Laboratories and Treatment of Paintings: Brussels, 1967*

W. P. Prescott: 'The Lining Cycle', *Conference on Comparative Lining Techniques: London, 1974*

G. Berger: 'Unconventional Treatments for Unconventional Paintings', *Studies in Conservation*, xxi/3 (1976), pp. 115–28

G. Emile-Mâle: *The Restorer's Handbook of Easel Painting* (New York, 1976)

M. Watherston: 'Treatment of Cupped and Cracked Paint Films Using Organic Solvents and Water', *Conservation and Restoration of Pictorial Art*, ed. N. Bromelle and P. Smith (London, 1976), pp. 110–25

D. Bomford: 'Moroni's *Canon Lodovico di Terzi*: An Unlined Sixteenth Century Painting', *National Gallery Technical Bulletin*, iii (1979), pp. 34–42

A. Reeve: 'A New Multi-purpose Low-pressure Conservation Table for the Treatment of Paintings', *Studies in Conservation*, xxix/3 (1984), pp. 124–8

M. Wyld and D. Thomas: 'Wright of Derby's *Mr and Mrs Coltman*: An Unlined English Painting', *National Gallery Technical Bulletin*, x (1987), pp. 28–32

P. Ackroyd, A. Phenix, and C. Villers: 'Not Lining in the Twenty-first Century: Attitudes to the Structural Conservation of Canvas Paintings', *The Conservator*, xxvi (2002), pp. 14–23

Carborundum print [Fr. *Gravure au carborundum*]. Print made by combining carborundum—a carbon and silicon compound customarily used for polishing by abrasion—with synthetic resin or varnish (*see also* PRINTS, §III, 5). The mixture is then hardened on a plastic or metal support. The process was invented during the 1960s by the French artist Henri Goetz (1909–89), who realized that the carborundum provided an ink-holding 'tooth'. The technique can be combined with intaglio processes or used as an alternative to them.

Goetz approximated conventional intaglio effects either by using heated tools to cut into a coating of varnish hardened on its support, or by suspending grains of carborundum in liquid varnish before it dried. The materials specified in his 1968 treatise included carborundum in eight gradations from 80–1200, synthetic varnishes and resins in crystal and liquid form, appropriate solvents, pyrogravure tools, emery and glass papers, and intaglio printing equipment, including a hot-plate. The technique's outstanding advantage, in addition to its speed, is that corrections can be made by dissolving the varnish with trichlorethylene, which also allows economic recycling of the support. The quality of line is determined by the thickness of the varnish and the temperature and nature of the point. Pastel or lithographic crayon marks, or textural impressions executed on the varnish in thinned typographic ink, can be sprinkled with carborundum dust, which is fixed to the varnish by passing a flame over it. The carborundum's fineness or coarseness determines the character of the mark. Effects similar to aquatint can be created by mixing ground resin crystals with colorant, solvents and various grades of carborundum. Such mixtures can be brushed on to the support or applied thickly by palette knife. For finer applications Goetz suspended carborundum in ether and devised a pseudo-mezzotint by spreading salt on a thick layer of varnish, heating it, then, after cooling, washing the salt away to leave ink-retaining indentations. Although much work with carborundum resembles intaglio printing, pyrogravure in thick varnish produces an idiosyncratic weal in the printed sheet, while built-up textures, requiring simultaneous printing from the relief and the intaglio, palpably emboss and/or deboss the paper.

Goetz made many abstract prints employing his discoveries, as did another French artist, Max Papart (1911–94). The Spaniards Antoni Clavé (1913–2005) and Antoni Tapiés (*b* 1923) also employed carborundum, but its most celebrated exponent was their countryman, Joan Miró (1893–1983), who, in experiments from 1967, often built out a thickened paste well above the support, to suggest impasto strokes and textures in the print. Working with Dutrou, Morsang or Arte Adrien for Maeght Editeur, Miró enjoyed the grand scale and liberation the process afforded and wrote to Goetz enthusing about the freshness and spontaneity of the technique compared to conventional processes. Kelpra Studio, London, introduced the technique to Britain in the early 1980s and worked with John Piper (1903–92) and Jim Dine (*b* 1935). Joe Tilson (*b* 1928) has also used carborundum to brilliant large-scale effect.

H. Goetz: *Gravure au carborundum: Nouvelle technique de l'estampe en taille# douce* (Paris, 1968, rev. 2/1974)

G. Bergström: *L'Oeuvre gravé de Henri Goetz, 1940–72* (Stockholm, 1973) *Miró: L'Oeuvre graphique* (exh. cat., Paris, Musée d'Art Moderne de la Ville de Paris, 1974)

K. Masrour, ed.: *L'Oeuvre gravé de Goetz* (Paris, 1977)

R. Passeron: *Antoni Clavé: Graphic Work, 1939–1976* (Fribourg, 1977)

S. Lohensson, M. Bohbot and M. Papart: *Catalogue de l'oeuvre gravé de Max Papart* (Stockholm, 1979)

C. Medley-Bruckner: 'Carborundum Mezzotint and Carborundum Etching', *Print Quarterly*, xvi/1 (March 1999), pp. 34–49

Carpet. Originally a thick cover for a bed, table etc. From the 16th century the term included knotted carpets from the Middle East; it gradually became exclusively associated with knotted carpets placed on the floor. By the early 18th century other forms of fabric floor covering had assumed the same name. (*See also* RUG.)

1. Types and techniques. 2. History.

1. TYPES AND TECHNIQUES.

(i) Hand-knotted. This is considered the quintessential carpet. Woven originally in Asia, such carpets were highly prized and later copied in many parts of Europe. The knots, tied in cut lengths of yarn, the ends of which formed the pile, were inserted during the process of construction, or weaving; they were tied in rows across the warps, each row of knots being separated by one, two or three picks of weft,

laid in as alternate rows of plain weave (see TEXTILE, §II, 1). Hand-knotted carpets can be divided into several categories, according to the knot used; this is, consequently, a means of establishing a carpet's provenance. There are four types of knot, each type known by several names. The first is the Turkish, Ghiordes or symmetrical knot (see fig. 1a) and the second the Persian, Senna or asymmetrical knot (1b). A third type, based on the first two but worked over four warps instead of two, is known as the jufti knot; depending on the style, this may be the Turkish jufti or the Persian jufti (1c). The fourth type of knot is the Spanish or single-warp symmetrical knot (1d).

The warp of Middle Eastern carpets was almost exclusively tightly spun wool, often a dark natural colour; in some very fine Persian carpets, tightly spun silk was used for the warps, as it was stronger and less bulky than wool, and a loosely spun silk for the wefts. In Persian and Indian carpets the silk warps were later replaced by factory-spun cotton. In Turkish carpets wefts were usually of a softer wool, often dyed red; cotton was sometimes used, especially in Caucasian rugs. In 19th- and 20th-century rugs a combination of materials has sometimes been used for the weft, and some late Indian carpets have employed jute. The knots of Middle Eastern carpets were almost invariably of wool, although of widely differing qualities. Silk was used in particularly rich carpets, and occasionally small amounts of cotton were used. The density of the knots varied enormously according to the quality of the carpet, and could range from 5 knots to 2000 knots per 25 sq. mm, a broad average lying between 10 and 40 knots per 25 sq. mm.

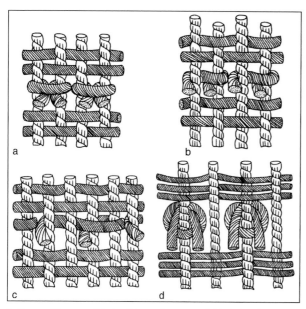

1. Types of knot used in hand-knotted carpets: (a) Turkish, Ghiordes or symmetrical knot; (b) Persian, Senna or asymmetrical knot; (c) jufti knot; (d) Spanish knot

A different form of hand-knotted carpet are the *ryijy* and *ryer* rugs woven in Finland and Norway. They were made entirely of wool, the knots being worked in rows between larger areas of plain weave. A group of yarns, sometimes of contrasting colours, was used for each knot, which was worked in the Turkish or symmetrical fashion across the warps. The weaving was much coarser than that of the classic Eastern carpets; in each pick there might be only three knots per 25 mm, and the rows of knots were spaced on average about 25 mm apart, giving only three knots per 25 sq. mm. The pile was generally much longer than that of Eastern carpets, up to 25 mm long. Early *ryijy* and *ryer* are found with pile on both front and reverse, but fewer knots were worked on the reverse, and the pile was left longer. The front and reverse knots were usually worked at the same time along the same row or pick.

(ii) Tapestry-woven. Such carpets and rugs, which have been woven in many parts of the world, have a plain woven weft-faced structure in which the weft is beaten down very hard to cover the warp entirely (see TAPESTRY §1). Their distinctive feature is the use of discontinuous coloured weft threads, which travel only a short distance along the pick in creating the pattern. Differently coloured areas of the pattern are not necessarily joined in the weaving process, and slits running in the direction of the warps may form between two colours. In the type produced in West Asia, known as kelims, kilims, khelims or ghilleems, such slits are common, but they are not invariable, and various joining methods are employed. Interlocking techniques are found in early Peruvian tapestry, in Navajo rugs and blankets and in Swedish and Norwegian *rølakan* rugs.

With single interlocked joins, like those found in Norwegian *rølakan*s and in some kilims from central to south-west Persia, the finish is the same on both sides of the weaving. With double interlock joins, as used on Swedish *rølakan*s and some Persian kilims, particularly those woven by the Baktari tribes, although the front looks the same as single interlock, on the back the join is more obvious, and a ridge is visible (see fig. 2a). Another method of making vertical joins is dovetailing, which gives a jagged saw-tooth line (2b); it is used in kilims from Thrace and north-west Persia. Hatching is a steep zigzag joining technique that gives a softer edge (2c). In intricate or curved areas of the design, wefts sometimes travel around a contrasting pattern area, instead of remaining strictly perpendicular to the warp; known as eccentric or curved-weft tapestry, this is also found mainly in Thracian kilims. In large areas of a single colour, 'lazy lines' can sometimes be seen; these were created when the weaver, having taken the weft over a limited number of warps, moved it along to work on the next area, forming a diagonal line in the weave. Such lines have sometimes been used as a pattern feature, progressing across one or two warps at a time to produce a smooth line, while a stepped diagonal line was a distinctive feature of patterns in kilims (2d). Soumak and small areas of brocading (see §(iii) below) were occasionally used in kilims.

(iii) Flat-woven. Rugs and carpets woven without a pile or raised surface texture have been made in all parts of the world and vary from the highly prized and richly adorned to the simplest and most basic of matting. Carpets can be woven using basic plain weave, with simple or complex patterns ranging from warp- or weft-faced stripes to intricate designs. Looms with three, four, six and eight shafts give vast scope for pattern and surface texture on the warp or weft face; these range from simple twills, with all their variations of diaper and broken twills, to shadow weave, spot weave, honeycomb, block patterns and brocades.

Warp-faced carpets and rugs, in which only the warp yarns are visible, are considered to be more hard-wearing, because warp yarns have generally tended to be stronger and more tightly spun. Examples include Bedouin saha or tent curtains made of goat hair, and Venetian carpets, first recorded in 1803, which had a striped worsted warp and a wool weft (by the end of the 19th century this was often replaced by jute). References to Venetian carpeting show that it was used for halls and stairs; it is known to have been made in Kidderminster, Yorkshire and Scotland and had no known connection with Venice. List carpets, first recorded in 1747 and noted to be like an inferior version of the Venetian, were wiry, plain-weave coarse carpets in which the weft was made of selvages, then called lists, cut from other fabrics. Such carpets were made of cotton, with narrow, coloured stripes; seldom found in Britain, they were quite popular in America.

Soumak is a weft-faced technique, used in Caucasian rug-making, that involved repeatedly wrapping the weft yarn around the warps to create a distinctive surface texture (see fig. 3). The yarn may travel from selvage to selvage, using a continuous weft, but its path is not direct; it can be wrapped around each individual warp or around two or more, while the progress of the weft moves one warp along with each wrap (rather like backstitch in needlework), giving a diagonal appearance to the surface. This diagonal can be alternated with the ground weave, in which case it is called soumak brocading, or it can be worked without any ground weaving in between, called soumak wrapping. The diagonal can also be reversed, giving a zigzag effect. There are many different variations: the soumak wefts are sometimes used for patterning across part of the warp, employing discontinuous wefts, to produce blocks of different colours or textures.

Hard-wearing double and triple cloths used as floor coverings are known as Kidderminster, Scotch, Ingrain, Union or two- or three-ply carpets. A double cloth has two independent sets of warps and wefts of plain weave, one on top of the other. They can be crossed, so that the top set intersects the lower one and changes places with it. If different colours are used for each set of warps and wefts, a pattern can be formed by moving the sets back and forth at chosen intervals. This method gives a reversible product with a choice of two sets of colours. Triple cloth works in a similar fashion, but

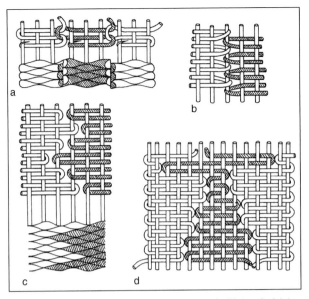

2. Joining techniques in tapestry-woven carpets: (a) double interlock joins; (b) dovetailing; (c) hatching; (d) stepped joins

with three sets of warps and wefts, giving a choice of three sets of colours. The first mention of carpets of Kidderminster cloth is found in 1634 in an inventory of the Countess of Leicester, but it is not known whether that cloth corresponded to Kidderminster double cloth, first made there in 1735. Double-cloth carpets were introduced in 1778 to Kilmarnock, Scotland, where in 1824 the triple-cloth technique was perfected. These types of carpet were mainly all-wool products and tended to have worsted yarn in the warp and wool in the weft. Early carpets using double and triple cloths were made by sewing together strips 910 mm wide, with approximately 15 ends and picks per 25 mm. By the early 20th century improved technology had made possible the weaving of wide seamless carpets (*see also* §(vi) below).

(iv) Embroidered and needle-worked. Embroidered carpets could be worked in a variety of stitches on a canvas ground. Early embroidered carpets, dating from the 16th century, were on single-thread canvas; those of the 19th century and after seem to have favoured double-thread canvas. As early as the 17th century patterns already drawn on the canvas were sold with a set of wools or silks, ready to be executed. The stitches, although sometimes coarser, were the same as those used for other canvaswork, using primarily wool and occasionally small amounts of silk. The most common stitches found in early examples are tent stitch and cross stitch; from the 19th century embroiderers made use of variations of cross stitch, half-cross stitch and herringbone stitch, as well as knotted stitch, chain stitch and rice stitch.

Two types of hand-knotted pile rug that were popular in the late 19th century and the 20th were the long-pile rug and the short-pile rug. Both used a

canvas ground and almost exclusively used wool for the pile. The long-pile method used pre-cut lengths of wool (an instrument known as a 'turkey gauge' was sometimes used to ensure evenness of length) that were drawn through the canvas and knotted one at a time using a latched hook. In the short-pile method, a needle threaded with a long piece of yarn was used to make a knot or double stitch on the canvas; the thread was taken around a gauge, and a second knot or double stitch was made one space further along. Repeating this process created a row of the pattern; the loops were cut before the gauge was moved on to a new area.

(v) Pile-woven. The techniques employed for these carpets contributed towards the eventual mass production of carpets; the looms used to produce them were subsequently fitted with jacquard montures (a mechanism for controlling the selection of heddles to be lifted in weaving) and were later adapted to become power looms (*see* §(vi) below).

In Chenille carpets, originally called Patent Axminsters, the pile was created by means of a specially prepared form of chenille yarn, made by weaving a flat cloth with a wool weft, and a warp, usually of linen, arranged in groups with spaces between. The cloth was then cut along the length of the warp between the groups. The resulting long strips were used as pile warps in the carpets; the cut wool wefts formed the tufts. In the weaving of the chenille cloth, the colour of the weft could be changed, so that the cut strips used as pile warps formed the pattern. Colour changes along the strip could range from 12 to 20 per 25 mm. The density of chenille in construction is 3.5–5 per 25 mm, corresponding roughly to 42–100 knots per 25 sq. mm. In weaving chenille carpets, it was difficult to maintain accurate registering of the pattern; also, the chenille was apt to break away from the surface of the carpet, as it did not have a very strong anchor, while a binding warp that was too strong sometimes crushed the pile.

The looped-pile or Brussels carpet was first patented in England at Wilton in 1741 and the first loom for weaving it was built at Kidderminster in 1749. The construction was like that of terry-towelling but woven with multi-coloured supplementary warps, from which groups of threads were looped proud of the ground warp when required to form the pattern (see fig. 4a). Up to six colours could be used, but often only two were required, and self-coloured Brussels carpets were also made. Brussels carpet was considered durable and clean and could render a wide variety of patterns, although the complicated shedding motion made it unsuitable for long pattern repeats. It was uneconomic in patterning, as much expensive worsted yarn lay below the surface. The weaving of wide carpets was impractical, and even with a jacquard monture, the heavy machinery could not be worked at great speed. The carpets were usually 700 mm wide and up to 46 m long; several widths could be joined, the borders being woven separately. There were 40 to 100 loops per 25 sq. mm. The surface quality was considered to be lacking in richness, and on poorer versions the foundation weave showed through.

Wilton carpets were originally made around Wilton, near Salisbury, in large quantities. The technique was almost the same as that of Brussels, but the pile was cut (see fig. 4b). The number of colours, or pattern warps, varied from two to six, although again, self-coloured carpets of this type were also made. The carpets were woven in widths ranging from 690 mm to 910 mm, with 50–150 loops per 25 mm. Carpets up to 2.7 m wide were known, but they were rare, being technically difficult and therefore expensive. Wilton had the same disadvantages as Brussels, but the cut pile gave it a richer surface texture and more covering power. It was considered the best kind of machine-made carpet; the close-piled quality was sometimes called velvet carpeting.

(vi) Power-loom woven. Up to the 1830s and 1840s the looms used in factories to produce Kidderminster, Ingrain, Brussels and Wilton carpets did not differ

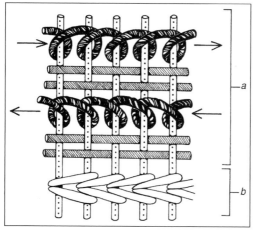

3. Soumak technique of rug-making

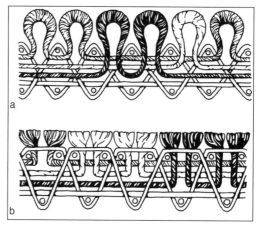

4. Looped-pile carpet: (a) Brussels carpet; (b) Wilton carpet

greatly from those used domestically. In 1825 a jacquard monture was first used in Kidderminster for Ingrain carpets and soon after for Brussels and Wilton. This simplified the weaving process and made possible looms operated by only one person. In 1842 Wood of Pontefract patented the first steam loom to be used for Brussels carpets. In 1847 John Crossley of Halifax purchased Wood's patent and tried it for tapestry, or warp-tinted carpets (see §(vii) below). In 1839 Erastus Brigham Bigelow (1814–79), an American engineer, had begun to work on perfecting a power loom for Ingrain carpets (see §3(iii) above). The early results were technically excellent, producing a superior article, but the loom did not at first increase speed or productivity. In 1846, when his Ingrain loom was being launched, Bigelow took out a British patent for a new power loom for Brussels carpet (see §(viii) below). The final version was said to combine the driving motions of Bigelow's Ingrain loom, the power of the Jacquard loom and, for the pile, a terry wire mechanism that Bigelow had previously devised for a coach-lace loom. It was only after he had displayed his looms in London at the Great Exhibition of 1851 that carpet manufacturers began to show enthusiasm for power-loom weaving. Crossleys of Halifax bought Bigelow's patent for £10,000 and proceeded to sell licences to build the looms to various British manufacturers.

(vii) *Warp-printed*. These are sometimes misleadingly known as tapestry carpets, although they are not tapestry-woven but have a ground warp and a pattern warp and are woven in a similar way to velvet (see TEXTILE, §III, 1(i)). The pattern warp is six times longer than the ground warp and is woven in over rods to create a looped pile, which can, as in velvet, be cut or can be left in loops. Before weaving, the pattern warp is dyed or printed in different colours so as to form a pattern in weaving. Because the quality of dyefastness is poorer in partially dyed or printed textiles, these carpets were not considered to have the durability of other carpets, where the whole yarn was immersed in the dye vats. Another disadvantage was that the pattern did not always register perfectly in the weaving. This kind of carpet could be woven up to 2.7 m or 3.65 m wide, with 7–9 tufts per 25 mm, 64 per 25 sq. mm.

(viii) *Machine-tufted*. Although Axminster was known as a weaving centre for carpets, the carpet known as machine-tufted, and also as Axminster, has apparently no connection with the town. It was Tomkinson & Adam who introduced machine-tufted carpets, which were woven on a loom developed from a patent bought from Halcyon Skinner, an American. They were known as Royal Axminster carpets and were closer in general appearance to hand-knotted carpets than anything so far achieved. Unlike Brussels and Wilton carpets, they entailed no waste of valuable worsted. A separate row of warp rollers, sometimes known as spools, was made up for each line or pick of pattern in the carpet; these rotated in

sequence above the loom, and at the appropriate time the correct roller was presented to the loom. The necessary amount of yarn was then taken for each tuft and cut. The row of rollers then moved on, and the next one in the sequence was presented. The texture was not very fine; the first Royal Axminsters had about 30 tufts per 25 sq. mm, and the Imperial Axminsters marketed by Tomkinson & Adam in 1893 had 48 tufts per 25 sq. mm. By the 1930s this had improved to 63 tufts per 25 sq. mm. The number of colours that could be used was virtually unlimited, and carpets up to 2.7 m wide could be woven. In 1910 Tomkinson & Adam acquired machines from the French company of Renard, which made knotted carpets resembling hand-made ones. In 1927 Jacquard or Gripper Axminsters were introduced, dispensing with the need to pre-arrange colours on a series of rollers or spools. The colours required for the whole pattern were set up; the jacquard device selected those that were needed for each row and, by means of a gripper, pulled off the required lengths of yarn, cut them and took them to the correct place on the loom. Up to 16 colours were practicable, which was ample for most designs. These carpets wasted less wool than Imperial Axminsters, and the method could be used for making both small and large quantities. The spool and gripper methods were later combined in the Spool Gripper Axminster to maximize the advantages of both types.

Since World War II many changes in carpet-making have taken place. In the 1950s looms that weave face-to-face carpets were introduced. Two separate backings were woven, with a single set of loops between them, which, when cut, produced two identical carpets. New synthetic fibres, such as nylon, acrylic, rayon, polyester and polypropylene, were introduced. Perhaps the most radical change was mechanical tufting, introduced by an American carpet manufacturer. Instead of weaving the pile in, cut tufts were attached to a ready-made backing; this was at first a woven backing and later a sheet backing. This method was found to be 10 to 20 times faster than any other method of carpet weaving. In the 1960s and 1970s methods of introducing patterns to tufted carpets were explored. First, the tufts could be made high or low, giving a self-coloured, raised pattern. Then printing of colours on to an uncoloured tufted base was developed, using machinery that resembled sets of hypodermic needles. A third way was to move the backing back and forth during tufting to produce simple geometric patterns. Since the 1970s hand-held tufting guns have been used by designer-craftsmen to make one-off gallery pieces or individual commissions.

C. E. C. Tattersall: *Notes on Carpet Knotting and Weaving* (London, 1920/R 1927)

A. B. Roth: 'A Brief Survey of Carpet Manufacture', *Journal of the Textile Institute*, xxv (1934), pp. 134–43

C. E. C. Tattersall: *A History of British Carpets* (London, 1934)

A. H. Cole and H. F. Williamson: *The American Carpet Manufacture* (Cambridge, MA, 1941)

J. S. Ewing and N. P. Norton: *Broadlooms and Businessmen: A History of the Bigelow Sanford Company* (Cambridge, MA, 1955)

A. Crossland: *A Modern Carpet Manufacture* (Manchester and London, 1958)

A. F. Stoddard: *The Carpet Makers* (Elderslie, 1962)

G. Robinson: *Pitmans Common Commodities and Industries: Carpets* (London, 1966)

P. Collingwood: *The Techniques of Rug Weaving* (London, 1968/R 6/1979; rev. 1993)

A. F. Stoddard: 'The Story of British Carpets', *Carpet Review* (1972)

I. Bennett, ed.: *The 'Country Life' Book of Rugs and Carpets of the World* (London, 1978)

J. N. Bartlett: *Carpeting the Millions* (Edinburgh, 1978)

Y. Petsopoulis: *Kilims: The Art of Tapestry Weaving in Anatolia, the Caucasus and Persia* (London, 1979/R 1982)

The Eastern Carpet in the Western World (exh. cat., ed. D. Sylvester and D. King; London, Hayward Gallery, 1983)

W. Shea: *Carpet Making in Durham City* (Durham, 1984)

P. Collingwood: *Rug Weaving Techniques: Beyond the Basics* (London, 1990)

J. Wearden: *Oriental Carpets and their Structure: Highlights from the V&A Collection* (London, 2003)

For further bibliography *see* §2 below.

2. HISTORY. It is not possible to establish when and where carpets were first produced, but the survival of the Pazyryk Carpet in a burial mound in the Gorno-Altay Mountains, on the border between Russia, Kazakhstan and Mongolia, shows that the knotted-pile technique (*see* §1(i) above) was well understood by the 4th century BC. Excavated fragments from various sites, including Turfan and Loulan (both Xinjiang Uygur Autonomous Region, China), the At-Tar Caves in Iraq and al-Fustat, Old Cairo, show that the use of the technique was widespread from the 3rd century BC to the 6th century AD, but it is not known if it spread from one centre or developed independently in several places. It seems probable that the technique was introduced into much of Europe from the Islamic world, but independent discovery remains a possibility.

Documents show that fine carpets were being woven in Spain in the 12th century; surviving fragments (Quedlinburg, St Servatius) from a convent in Quedlinburg, Germany, show that the technique was being practised in central Europe at the end of the 12th century. Documents and, more importantly, paintings in the 14th and 15th centuries attest to the spread of Turkish carpets along trade routes in Europe. What are considered to be the finest and the most important carpets were woven in Persia in the 16th century and in Mughal India in the 17th. By then the number of Persian carpets being traded in Europe had increased considerably; documents and surviving pieces show that European merchants were commissioning carpets from the Middle East. They continued to take an interest even when production in the weaving centres of Turkey and Persia declined in the 18th century as a result of economic and political turmoil. The continuing demand for

imported carpets prompted the establishment of carpet-weaving workshops in several European centres, leading eventually to the mechanization of the industry in the 19th century.

By the middle of the 19th century the carpet industry in the Middle East had revived, but it came under direct European influence; traditional designs and palettes were adapted to suit European and American tastes, and new designs were introduced for the Western market. At the same time, private and public collections of antique carpets were formed, and exhibitions and publications were used to introduce oriental carpets to a wider audience. Because few antique carpets were available in the 20th century, interest was focused on tribal pieces: domestically woven carpets and storage bags made and used by nomadic tribes in the Middle East. Because of their functional nature, no examples have survived from before the middle of the 19th century, but the variety of techniques used and the exuberance of the designs have proved just as challenging as the classic carpets of four centuries before.

A. F. Kendrick and C. E. C. Tattersall: *Handwoven Carpets, Oriental and European* (London, 1926)

U. T. Sirelius: *The Ryijy Rugs of Finland* (London, 1926)

V. Sylwan: *Svenska ryor* [Swedish long-pile carpets] (Stockholm, 1934)

C. E. C. Tattersall: *A History of British Carpets* (Benfleet, 1934)

F. L. May: 'Hispano-Moresque Rugs', *Notes hispaniques*, iv–v (1944–5), pp. 31– 69

H. Engelstad: *Norske ryer* [Norwegian shag rugs] (Oslo [1946])

E. Kühnel and L. Bellinger: *Spanish Rugs, 12th Century to 19th Century*, ii of *The Textile Museum Catalogue* (Washington, DC, 1953)

M. Jarry: *The Carpets of the Manufacture de la Savonnerie* (Leigh-on-Sea, 1966)

C. E. C. Tattersall and S. Reed: *British Carpets* (London, 1966)

M. Jarry: 'Designs and Models for Savonnerie Carpets in the 18th Century', *Burlington Magazine*, cx (1968), pp. 258–62

B. Jacobs: *Axminster Carpets* (Leigh-on-Sea, 1969)

M. Jarry: *Carpets of Aubusson* (Leigh-on-Sea, 1969)

M. Jarry: 'Design in Aubusson Carpets', *Antiques*, xcv (1969), pp. 702–7

M. Jarry: 'Savonnerie Panels and Furnishing Materials of the 17th and 18th Centuries', *Connoisseur*, clxx (1969), pp. 211–19

S. B. Sherrill: 'The Islamic Tradition in Spanish Rug Weaving', *Antiques*, c (1974), pp. 532–49

C. Gilbert, J. Lomax and A. Wells-Cole: *Country House Floors*, Temple Newsam Country House Studies, no. 3 (Leeds, 1987)

P. Wardle: 'Salvation and Virtue: An Embroidered Table Carpet of the Late Renaissance', *Museum Studies*, xvi/2 (1990), pp. 120–31

C. Alexander: *A Foreshadowing of 21st Century Art: The Color and Geometry of Very Early Turkish Carpets* (New York, 1993)

D. E. Kraak: 'Ingrain Carpets', *The Magazine Antiques*, cxlix (Jan 1996), pp. 182–91

C. Boydell: *The Architecture of Floors* (London, 1996)

D. Walker: *Flowers Underfoot: Indian Carpets of the Mughal Era* (New York, 1997)

I. Bennett, ed.: *Rugs & Carpets of the World* (London, 1997)

V. Bower and others: *Far Eastern Ceramics and Paintings, Persian and Indian Rugs and Carpets*, ii of *Decorative Arts*, Washington,

DC, National Gallery of Art cat. (Washington, DC, 1998)

M. L. Eiland and M. Eiland: *Oriental Carpets: A Complete Guide* (Boston, 4/1998)

C. Overby: 'Stitching across Centuries: The Carpets of Arraiolos, Portugal', *Piecework*, vii/5 (Sept–Oct 1999), pp. 38–41

S. M. Levey: 'Bess of Hardwick Hall and her Household Stuffe', *Piecework*, viii/1 (Jan–Feb 2000), pp. 22–7

A. Volker: *Die orientalischen Knüpfteppiche im MAK, Österreichisches Museum für Gewandte Kunst, Wien* (Vienna, 2001)

N. Chaldecott: *Dhurries: History, Pattern, Technique, Identification* (New York, 2003)

J. Thompson and S. R. Canby: *Hunt for Paradise: Court Arts of Safavid Iran, 1501–1576* (Milan and London, 2003)

R. Pinner: 'The Turkmen Ensi in Literature and in Life', *Hali*, cxxxii (Jan–Feb 2004), pp. 96–107

Cartoon. Drawing, sometimes coloured, made specifically as a pattern for a painting, textile or stained-glass panel. It is produced on the same scale as the final work and is usually fairly detailed. The transfer of the image works best if the drawing in the cartoon is of a linear nature and if the composition has crisp, clear outlines.

1. TECHNIQUE. In painting there are two methods of transferring a cartoon to the support, which may be a canvas, panel or wall. The first is similar to TRACING. The back of the cartoon is rubbed over with chalk; the paper is attached to the support; and the main lines are drawn over with a stylus, thus transferring the chalk from the back of the cartoon to the new support. In the second method, which is called POUNCING, the main lines of the cartoon are pricked through with a needle or stylus, the size and closeness of the holes varying according to the detail in the drawing. Sometimes in order to preserve the drawn cartoon, a supplementary cartoon or *spolvero* is made by pricking through the original cartoon and a blank sheet of paper at the same time. The cartoon or supplementary cartoon is then laid flat against the support, and the pricked lines firmly dabbed with a muslin bag containing powdered charcoal. The charcoal dust penetrates the pounce bag and is forced through the holes in the cartoon on to the support beneath. Another method of transfer is to rub over the holes with a large stick of soft charcoal or red chalk and then to smear the medium through the holes and on to the support by using a finger.

When the cartoon is removed from the support, the original drawing is duplicated in a series of dots, which can be joined up to make a complete drawing using whatever instrument or medium the artist prefers. The original can be referred to if necessary to supply any details missing from the transfer. If a reversed image is required the *spolvero* is turned over before it is used. In surviving cartoons it is possible to tell which method was used for transfer from the prick marks or from the indentation of the lines.

2. HISTORY. Cartoons were used by illuminators, textile workers and stained-glass artists from the early medieval period, but their first appearance in painting occurs only in the second half of the 14th century. Cennino Cennini (*c.* 1370–*c.* 1400), writing *c.* 1390, gave detailed instructions for the execution of textile patterns using a parchment cartoon, a procedure that has been verified in Tuscan panel paintings of the period. In the following century such artists as Piero della Francesca (*c.* 1415–92) began to use cartoons for figure compositions, whereas previously they had been employed only for the repetition of decorative motifs.

From the late 15th century cartoons became an essential part of studio practise, particularly with the systematic working methods of such artists as Raphael (1483–1520). For important areas of a painting, faces for example, auxiliary cartoons were made: outlines were pounced from the main cartoon on to a further sheet of paper, which was worked up in greater detail before transfer. Since cartoons were used again and again, for copying whole compositions or for reproducing individual figures, they were considered valuable studio property. Cartoons by the greater artists were especially prized: those, for example, by Leonardo da Vinci (1452–1519) and Michelangelo (1475–1564) for the Sala della Signoria in the Palazzo Vecchio, Florence (1504–5), were copied until they disintegrated. However, one cartoon by Leonardo does survive, the *Virgin and Child with SS John the Baptist and Anne* (black and white chalk on tinted paper, *c.* 1507–8; London, National Gallery); although it seems to have been intended for a painting, it has not been pricked or incised.

In fresco painting cartoons were rarely used alone. Until the 16th century they were combined, to a greater or lesser extent, with *sinopia* underdrawing, and later they were employed in conjunction with freehand drawing, squaring up and other quick methods of transfer. They were much used by Annibale Carracci (1560–1609) in the 17th century, with his deliberate emulation of Raphael's technique, and again by the Nazarenes in the 19th century for the same reason, but in the 20th century they were finally superseded by photoprojection.

In textile design cartoons have always been necessary. Silk-weavers used to work from full-colour cartoons that reproduced one section of the repeat, and embroiderers still pounce designs through to the ground fabric. In tapestry-weaving the cartoons were coloured (e.g. the series by Raphael depicting the *Missions of SS Peter and Paul, c.* 1514–17; British Royal Collection, on loan to London, Victoria and Albert Museum) until the 20th century, when outline drawings became more usual (*see* TAPESTRY, §1).

See also FRESCO, §1(2) and STAINED GLASS, §1, ii.

C. Cennini: *Il libro dell'arte* (*c.* 1390); Eng. trans. and notes by D. V. Thompson jr as *The Craftsman's Handbook: 'Il libro dell'arte'* (New Haven, 1933/R New York, 1954), pp. 87, 111

G. Vasari: *Vite* (1550, rev. 2/1568); Eng. trans. by L. S. Maclehose, ed. G. B. Brown, as *Vasari on Technique* [intro. prefixed to the *Vite*] (London, 1907/R New York, 1960), pp. 213–15

J. Watrous: *The Craft of Old-Master Drawings* (Madison, 1957)

P. Goldman: *Looking at Drawings: A Guide to Technical Terms* (London, 1979)

P. Joannides: *The Drawings of Raphael, with a Complete Catalogue* (Oxford, 1983)

P. Mora, L. Mora and P. Philippot: *Conservation of Wall Paintings* (London, 1984)

Art in the Making: Italian Painting before 1400 (exh. cat. by D. Bomford and others, London, National Gallery, 1989–90), pp. 130–35

J. Foucart: *Ingres: Les cartons de vitraux des collections du Louvre* (Paris, 2002)

Z. van Ruyven-Zeman, X. Van Eck and H. Van Dolder-De Wit: *Het geheim van Gouda: De cartons van de Goudse glazen* (Zutphen, 2002)

D. E. Schoenherr: 'The "Cartoon Book" and Morris & Company's Sale of Burne-Jones's Cartoons in 1901–1904', *Journal of Stained Glass*, xxix (2005), pp. 82–134

Casein. Complex protein found in milk that may be used as a glue (*see* ADHESIVES, §§1(i) and 2) or as a binding medium for paint (*see* PAINT, §1). It exists in different forms, isolated from the milk and activated for use by various methods. There are significant differences in the properties of the casein obtained by each method of preparation. Casein was originally produced by reacting curd or skim milk directly with an alkali, originally lime and later ammonia. Monoamvonium caseinate is easier to employ and is generally of good quality, but a purer type of casein in powder form is now more widely used, and the convenient tube colours are most generally employed.

Lime casein, being practically insoluble in water and possessing great adhesive strength, has been important as a glue. Casein is likely to have been employed for bonding wood in ancient Egypt, Greece and Rome and perhaps also on the Indian subcontinent and in China. Firm evidence of its use in Europe is found from the Middle Ages; descriptions of its preparation from cheese, probably a reference to some form of purified curd, appear in several manuscripts, including Theophilus's *De diversis artibus* (12th century). Cennino Cennini (*c.* 1370–*c.* 1440) described casein in *Il libro dell'arte* (*c.* 1390) specifically as a woodworker's glue and mentioned its use for joining pieces of wood to make up large panels for painting (*see* PANEL PAINTING, §2).

Although the use of casein in fine art painting has been limited, it may have been quite extensively employed for durable decorative coatings. References to the use of curd in decorative painting appear in ancient Hebrew texts. Casein has been identified in 18th-century vernacular ceiling paintings in Bavaria and the Tyrol and is sometimes associated with wall painting (*see* WALL PAINTING, §I and CONSOLIDANT). Its application as a medium for fine art painting from at least the 19th century stems from its industrial and commercial use at that time. The confused rediscovery of materials for tempera painting during the 19th century also enhanced its status as a painting medium. In North America the availability of a commercially manufactured brand of casein colour in tubes has ensured its use for painting during the 20th century. Despite its unique matt or semi-matt appearance, no specific style or method of painting has been associated with the medium, and it tends to be employed as an alternative form of tempera; it has also been used in mixed-media work.

When applied as a paint, casein presents difficulties: its adhesive strength and brittleness may provoke defects, and the paint film is susceptible to mould (*see* PLASTIC, §3). Tube casein must be well thinned with water, and brushes must be wetted before being placed in the paint. Although not an emulsion, casein may be emulsified with oil, but the resulting medium yellows badly.

Theophilus: *De diversis artibus* (?1110–40); Eng. trans. by J. G. Hawthorne and C. S. Smith as *On Divers Arts* (Chicago and London, 1963)

C. Cennini: *Il libro dell'arte* (MS.; *c.* 1390); trans. and notes by D. V. Thompson jr (1933)

C. Eastlake: *Methods and Materials of Painting of the Great Schools and Masters*, 2 vols (London, 1847/*R* New York, 1960)

R. J. Gettens and G. L. Stout: *Painting Materials: A Short Encyclopaedia* (New York, 1942, rev. 1966)

A. Dehn: *Watercolour, Gouache and Casein Painting* (New York, 1955)

S. Quiller and B. Whipple: *Water Media: Processes and Possibilities* (New York, 1986)

N. Olonetzky: 'Balthus' Painting Technique', *Du*, ix (Sept 1992), pp. 53–68

C. Willard: 'Rediscovering the Oldest Medium: Casein', *American Artist*, lxvi (Sept 2002), pp. 12–15

Cast. Reproduction of a three-dimensional object produced by means of a mould.

1. MATERIALS AND TECHNIQUES. While moulds can be fashioned directly, for example by carving wood or stone, both mould and cast are usually made in a pliable or amorphous material, such as plaster of Paris, wax or clay. The model is encased in the chosen material, so as to hold an impression of its shape and surface in negative: the mould is then carefully removed and the hollow interior filled to make the positive cast. A piece-mould, a mould constructed in numerous sections, is used to facilitate removal, the small sections sometimes held in place by an outer 'case' mould. The modern process of casting has been simplified by the use of synthetic rubbers that can be peeled away from undercut forms and reused. Other, less versatile, flexible materials for moulds include wax, gelatin and latex rubber (*see* PLASTIC, §1). Alternatively, a one-off cast can be made with a waste-mould. If the original form is modelled in soft clay, a plaster mould of few sections is easily removed, but if there are undercut forms the mould is 'wasted' or chipped away from the cast. Plaster, concrete and glass-fibre reinforced polyester resin (GRP or fibreglass) are frequently cast in waste moulds. In the lost-wax method of casting metal, a wax positive can be modelled direct (direct lost-wax method) or, as is now more common, cast hollow from a piece-mould taken from the model or master (indirect lost-wax

method; for a full description of both techniques *see* METAL, §III, 1(iv) and (v).

Casts are generally stronger, as well as lighter and cheaper, if hollow. This is true not only of casts in bronze and other metals but also of those in terracotta, plaster, concrete and GRP. Unless small in size, solid forms are liable to crack or distort owing to the uneven contraction when the cast material cures, cools or is fired. With cold-cast materials, some moulds are filled with a single form, while others are filled in sections, which are then assembled or 'squeezed' together with a joint of fresh material. Clay can be press-moulded or poured as liquid 'slip' (*see* CERAMICS, §I, 3); larger figures may be first cast in pieces and then joined before firing. Most cast objects need to have their seams and surfaces made good after being removed from a mould.

See also METAL, §III, 1.

J. C. Rich: *The Materials and Methods of Sculpture* (New York, 1947)

J. W. Mills: *The Technique of Casting for Sculpture* (London, 1990)

2. HISTORY AND USES. The process of casting enables the sculptor to create works initially in a malleable substance, for example clay or wax, to produce a preliminary model (*see* MODELLO, §2), without concern for its impermanence, as the final cast can be made of a material of greater hardness, durability and value. Due to its tensile strength, bronze can be cast in complex, sculptural forms that would be weak or precarious in stone or terracotta. The cast may have distinctive surface qualities, showing evidence of modelling techniques such as fingermarks, or qualities intrinsic to the cast material, for example the patination of bronze. The option of duplication or limited editions can have obvious labour-saving and commercial advantages, as well as providing replicas for study or restoration purposes.

Bronze-casting has been used in many cultures and ancient civilizations, most notably in China from the mid-2nd millennium BC. The Sumerians were casting metal figurines by the lost-wax method as early as the 3rd millennium BC and making simple figural reliefs with terracotta press-moulds. Terracotta piece-moulds were used in China at least as early as the 5th–3rd century BC, although most terracotta sculpture from this date appears to be directly modelled. While the Romans used cast concrete in architecture, its use in cast sculpture has been far less significant. In the 5th century BC the Greeks cast life-size bronze statues from wooden figures, for example the Delphi *Charioteer* (*c.* 470 BC; Delphi, Archaeological Museum). Most of the sophisticated Greek bronzes cast by the lost-wax process (*see* METAL, §III, 1(iv) and (v)) are known only through Roman copies in marble. The marble *Diskobolos* (Rome, Museo Nazionale Romano), a copy of a 5th-century BC bronze by Myron of Eleutherai, illustrates, by its additional bracing and mock tree, the structural disadvantages of carved marble compared to cast bronze. Brass and bronze casts of celebrated quality were made from the 14th century to the mid-16th

by the Benin people of Nigeria, for example the *Queen Mother Head* (brass, mid-16th century; London, British Museum). Cast metal sculpture of pure copper, iron, lead, silver or gold is less common than that of bronze or brass, which is hard and durable and melts at a lower temperature than pure copper; the gold salt-cellar of Francis I (1540–43; Vienna, Kunsthistorisches Museum) by Benvenuto Cellini (1500–71) is a rare example of a high-quality sculpture cast in precious metal. *Eros* (London, Piccadilly Circus) by Alfred Gilbert (1854–1934), unveiled in 1899, was the first major public sculpture in Britain to be cast in aluminium. Technical difficulties and expense have, however, always been important factors in the casting of large-scale works in metal.

Although well suited to mouldmaking, the impermanence of plaster has restricted its use for sculpture. There are, however, plaster (gypsum) death-masks from Egypt dating from 2400 BC. Cast plaster models have also been used by sculptors in the technique of 'indirect' stone carving, by which measurements are transferred, usually with a pointing machine, from the model to the block of stone. With the establishment of art academies in Europe in the 17th and 18th centuries students could copy plaster casts of antique sculptures before drawing from life, to gain an understanding of classical proportions and style. Between 1769 and 1820 cast artificial stone statuary and ornament was made by Eleanor Coade (1733–1821) in London and widely distributed.

Before the late 19th century most cast sculpture was intended to have a highly finished and seamless surface, but the bronze casts of Auguste Rodin (1840–1917) drew attention to the plasticity and texture of the original clay model. Rodin allowed the moulding lines to enrich the surface of the finished bronze, for example in the *Large Head of Iris* (1890–91; London, Victoria and Albert Museum). While traditional casting methods continue to be used, often with modern modifications, cast sculpture also reflects the diversity and innovations of 20th-century art. Collage models, including *objets trouvés*, were cast into bronze by Pablo Picasso (1881–1973) and Joan Miró (1893–1983). A method of investing and burning out organic forms before casting directly in bronze, then welding and enamelling, was employed by Nancy Graves (1939–95). Duane Hanson (1925–96) produced life-cast figures in synthetic vinyl, and Bruce Nauman (*b* 1941) cast wax heads within installations of electronic media.

A late 20th-century development was the use of cast replicas to replace sculptures vulnerable in their outdoor locations, the originals being transferred to museums, for example the bronze horses (now in Venice, Museo di S Marco) of S Marco, Venice.

Pliny the elder: *Natural History: A Selection* (MS. *c.* 77); ed. J. F. Healy (London, 1991)

B. Cellini: *Vita* (MS. *c.* 1558–67); Eng. trans. by G. Bull (London, 1956)

G. Vasari: *Vasari on Technique*; Eng. trans. by L. Maclehose, ed. G. B. Brown (London, 1907/*R* New York, 1960)

W. Watson: *Ancient Chinese Bronzes* (London, 1962)

M. Sullivan: *The Arts of China* (Berkeley, CA, 1967)

E. G. Robertson and J. Robertson: *Cast Iron Decoration: A World Survey* (New York, 1977, rev. 2007)

R. Wittkower: *Sculpture* (London, 1977)

P. Ben-Amos: *The Art of Benin* (London, 1980)

C. Rolley: *Greek Bronzes* (London, 1986)

D. L. Schodek: *Structure in Sculpture* (Cambridge, MA, and London, 1993)

L. D. Glinsman: 'Renaissance Portrait Medals by Matteo de' Pasti: A Study of their Casting Materials', *Studies in the History of Art*, lvii (1996–7), pp. 92–107

C. Gore: 'Casting Identities in Contemporary Benin City', *African Arts*, xxx (Summer 1997), pp. 54–61

J. Taylor, P. Craddock and F. Shearman: 'Egyptian Hollow-cast Bronze Statues of the Early First Millennium BC: The Development of a New Technology', *Apollo*, cxlviii/437 (July 1998), pp. 9–14

M. Meurs: 'De gipscollectie van het Rijksmuseum', *Bulletin van het Rijksmuseum*, xlviii.3 (2000), pp. 200–37; 1/2 (2002), pp. 254–93

J. Fearn: *Cast Iron* (Princes Risborough, 2/2001)

R. E. Stone: 'A New Interpretation of the Casting of Donatello's *Judith and Holofernes*', *Studies in the History of Art*, lxxii (2001), pp. 54–69

C. C. Hemingway: 'On the Sculptural Technique of Antonio Canova and his Plaster Casts', *Sculpture Review*, li/4 (Winter 2002), pp. 18–23

P. Tuchman: 'George Segal', *Sculpture Review*, li/4 (Winter 2002), pp. 8–13

G. Bresc-Bautier: 'Parisian Casters in the Sixteenth Century', *Studies in the History of Art*, lxiv (2003), pp. 94–113

J. Nevadomsky: 'Casting in Contemporary Benin Art', *African Arts*, xxxviii/2 (Summer 2005), pp. 66–77, 95–6

J. Van Alphen: *Cast for Eternity: Bronze Masterworks from India and the Himalayas in Belgian and Dutch Collections* (Antwerp, 2005)

'Antike Bronzekunst' *Antike Welt*, xxxvii/2 (2006), pp. 8–30 [special section]

R. E. Stone: 'Severo Calzetta da Ravenna and the Indirectly Cast Bronze', *Burlington Magazine*, cxlviii (Dec 2006), pp. 810–19

Ceramics. Items of clay fashioned using a variety of techniques and hardened by heat. The ingenuity of the potter and the types of materials and processes used have varied enormously over time and geographical location. This survey describes the basic principles involved in ceramic production and discusses conservation.

I. Materials and techniques. II. Conservation.

I. Materials and techniques.

1. Clay. 2. Ceramic bodies. 3. Forming techniques. 4. Decoration. 5. Glazes. 6. Kilns and firing.

1. CLAY.

(i) Constituents. The basic material required for the production of all types of ceramics is clay, which reflects the general composition of the earth's crust. The quantity of flint (a source of silica) is just below

60%, alumina *c.* 15–20% and iron oxide *c.* 7%. The remainder of the earth's crust and most common clays contain water and small amounts of such other oxides as magnesium, calcium, sodium and potassium. Clay deposits develop as the result of the disintegration of granite and igneous rock. Clays that are suitable for the production of ceramics are typically divided into two categories, primary and secondary clays (*see* §§(ii) and (iii) below). They must be plastic but also rigid enough to retain their form when shaped. Before firing, clays must be able to be reduced to liquid (slip) by the addition of water, while after firing they become hard, insoluble and sometimes vitrified.

Silica (silicon dioxide) is a primary constituent of ceramic clays and is usually derived from flint or sand; the former is more desirable as it is comparatively free from impurities. Silica reduces plasticity and the tendency towards clay shrinkage, while increasing the ease of vitrification. The quantity of silica varies and depends on the purity of the clay. Feldspar (feldspathic rock) is found in abundance in the earth's crust and is a rich source of silica, alumina and various oxides of an alkaline nature. It is a form of natural frit or 'glass' made of a melt of ceramic materials, some of which are more difficult to work with in isolation. Feldspar, ground fine and added to clay or glaze mixtures, acts as a flux, facilitating the fusion point. It forms the principal component of high-firing glazes and melts to glass at *c.* 1250–1450°C. Alumina is refractory and melts at *c.* 2040°C. It makes a glaze more viscous, thus preventing it slipping off the ware during firing. It also prevents devitrification and crystallization during the cooling of the body and glaze, as well as adding hardness, durability and tensile strength. The degree of iron oxide content, which can cause discoloration, determines the colour of the clay when fired.

(ii) Primary clays. These clays, also called residual, are formed from disintegrated feldspathic rock and rest at the site of their origin. As they are unmoved, they tend to be mostly free of such impurities as iron oxide and organic materials, which can cause firing problems. The particles tend to be fairly rough and large-grained. Such clays are thus relatively non-plastic and have a comparatively low shrinkage rate. Characteristically light-coloured when fired, primary clays are refractory, requiring high temperatures to melt; other ingredients must therefore be added to reduce firing temperatures and increase plasticity.

The most nearly pure primary clay is kaolin (china clay), a key component of hard-paste porcelain and some other ceramic bodies. It is feldspathic and is predominantly composed of silica, alumina and water. The term 'kaolin' is derived from the Chinese Gaoling (Kao-ling) shan, a hill from which the clay was extracted for use at the nearby kilns of Jingdezhen in Jiangxi Province. The material was first used by the Chinese to produce 'true' porcelains. Kaolin deposits are less common than secondary clay deposits. Kaolin's high melting point, expense and need for

additives to increase plasticity and lower firing temperatures have rendered it technically unsuitable for unsophisticated earthenwares and stonewares, even where it was available locally.

(iii) Secondary clays. These clays, also called sedimentary, have been moved by wind or water from the parent rock. This motion grinds the coarse particles of clay, giving them a smoother profile, and with natural levigation increases plasticity and reduces particle size. During the movement of the alluvium, the clay particles acquire organic and inorganic impurities, which must be removed to a degree dependent on the desired fineness of the final ware. This type of clay usually fires to shades of red or brown, primarily because of its iron-oxide content.

High-quality sedimentary clays—so-called ball clays—burn to a light grey or buff because of their reduced iron-oxide content. The name is derived from the English practice of rolling the clay into balls after mining. English ball clay is of quite a high quality and is a desirable additive to earthenware bodies requiring greater plasticity, such as those with a high kaolin content. Used extensively in whitewares, ball clays do have traces of iron oxide and because of the discoloration this can cause are added to the mixture in limited quantities. They are not used alone because of their great shrinkage rate (up to 20%); grog (ground, fired clay), which has completely shrunk, is sometimes added to lessen reduction during drying and firing. Other secondary clays are stoneware clays, red clays, pipe clays, marls and loams. With the exception of the first, which can produce high-quality wares, the others are used for primitive wares.

(iv) Preparation. The following processes are described in terms of traditional methods. Electricity and highly technical equipment, in addition to the availability of ready-made materials, have enabled many potters to leave out some of these preparatory steps.

Many clays can be acquired by digging from local pits, and if comparatively easy transportation is available, clays and their additives can be imported from different regions, making the production of more sophisticated wares possible. After the clay is dug it is sometimes left to 'winter' or 'weather' in outdoor storage bins. The freezing and thawing of the clay breaks it down so that it becomes more malleable. The clay is then pulverized in one of several types of mills. It is mixed with water, which lends it plasticity during shaping and aids purification and grinding during the preparatory stages. Slip-casting clays (*see* §3 below) require a great deal of water to keep their particles in suspension. A reduction in water content resulted from the 18th-century discovery of the effect of deflocculants (electrolytes), which cause the clay particles to disperse evenly throughout the slip; this made slip-casting easier to execute and reduced shrinkage, warping and drying times.

The mixture is then ground further to increase its fineness and is sieved to remove large-grained particles and impurities. In some cases the liquid slip was boiled to remove the water, although in England the slip was poured in shallow pits called 'sun kilns' and left to dry. In the early 18th century this method was hastened by the use of indoor, coal-burning drying vats. At this point more water can be added to the mixture according to the state of liquidity required. A machine called a blunger can be employed; this mixes water with the clay through the use of rotating paddles that break up the pieces of clay into a smooth, fine-grained slip. This evenly liquefied clay can then be dried to a workable state through the use of a filter press fitted with canvas bags, which are filled with slip and squeezed to remove excess water.

The rather fine-grained clay is now subjected to the de-airing process, which can be achieved by slapping down, beating and kneading balls of clay. This process ('wedging') works the clay into an even consistency, leaving it in 'balls' ready for working. In the 19th century the pug-mill was developed: the malleable clay is shredded in one section of the machine and then proceeds through a vacuum chamber to remove any air pockets. The de-aired clay is compressed and extruded as a dense, tubular roll. It can then be stored or 'aged', during which time bacteria develop, creating a gel-like substance that increases plasticity.

2. CERAMIC BODIES.

(i) Earthenware. Most earthenwares have traditionally been made of secondary clays, receiving relatively little purification after being mined. Common clays tend to contain iron oxide and other impurities, which reduce firing temperatures to between 800–1100°C. Iron, a natural flux, facilitates the melting together of the other ingredients. Earthenware clay can be highly plastic or less plastic because of sand or other rocky fragments. After firing the clay remains unfused and is therefore porous, opaque and less sturdy than higher-fired wares. Earthenware clays rich in iron oxide fire from buff to tan, red, brown or black, depending on the clay and firing conditions. They take low-temperature glazes, such as certain alkaline and lead-oxide types, to render them non-porous. In the simplest method the body and glaze are hardened during a single firing. Finer, more pure earthenware bodies, some with higher firing temperatures, require an initial (biscuit) firing to harden the unglazed body. A lower temperature glaze or 'glost' firing leaves the wares impervious to liquid. This two-firing system facilitates the execution of crisp underglaze decoration, which is fixed in the body-firing and is thus less likely to run when the glaze is fired. Such overglaze decoration as enamelling or gilding is hardened in subsequent lower temperature firings.

(ii) Stoneware. There are secondary clays needing a higher firing temperature (1200–1300°C) than earthenware. These temperatures facilitate vitrification, while requiring less flux than earthenware clays. Fired stoneware typically ranges from grey to buff to brown, although

some paler versions have also been produced. Depending on the purity and make-up of the body, stoneware can be opaque or slightly translucent, ranging in texture from fine-grained to rough. Its firing temperature brings it above the usable range of lead glaze, so that salt, slip and some alkaline, feldspathic and other high-firing glazes are used. In some cases fine, non-porous stoneware bodies are left unglazed, exposing a satiny surface that can be lapidary polished.

(iii) Hard-paste porcelains. Porcelain clays vary widely in composition. Hard-paste ('true') porcelains began to be developed by the Chinese in the 5th century AD and fire to a highly vitrified, white body. In addition to flint they contain a high percentage of kaolin and china stone called petuntse (from the Chinese *baidunzi* (pai-tu-nai), meaning 'little white bricks'). The flint helps to reduce clay shrinkage in porcelain and to give strength to the body, as well as helping the glaze 'fit'. Ball clays can also be added to increase plasticity, although in China they are sometimes omitted, as the local kaolin is unusually plastic. Like stoneware, hard-paste porcelains are fired to a temperature too high for lead-oxide glazes. The unglazed bodies are hardened, or biscuit-fired, at over 1300°C, then dipped in glazes fluxed with feldspar or lime before being fired to up to *c.* 1250°C.

The glaze is made from a composition fairly similar to that of the body, increasing the fit of the hard, glassy coating. Underglaze coloured oxide decoration on these wares is limited in palette by the high firing temperatures. Brilliant enamels and gilding, however, can be applied after the glost firing and then fixed at lower temperatures (see colour pl. III, fig. 1). The result is a fine-grained whiteware that is usually, but not necessarily, translucent. Although normally glazed, hard-paste porcelain, like stoneware, is sometimes left unglazed to expose a fine, satiny surface.

(iv) Soft-paste porcelains and bone-china. Among the most well-known attempts to imitate hard-paste porcelains are soft-paste porcelains, produced in Europe from a wide range of formulae. Soft-paste porcelain contains pale clays and a glassy frit with little or no kaolin. It is characteristically opaque, with a soft, sometimes milky appearance. This porcelain fires at a lower temperature than hard paste, usually below 1300°C. Like hard-paste wares, they are biscuit-fired before the application of a glaze.

Bone-china, which was invented in England during the 1740s at the Bow Porcelain Factory and which was improved throughout the 19th century, is similar in composition to soft-paste porcelain. Refinement of the paste increased its translucency and visual similarity to hard-paste porcelain. The composition includes kaolin, china stone and bone ash (calcium phosphate) and is biscuit-fired at *c.* 1250–1300°C. The glost firing fixes a lead or borax glaze at 900–1000°C.

3. FORMING TECHNIQUES. The simplest methods of shaping ceramic wares are performed by hand. Among the earliest used were coiling and pinching: the former produces hollowwares with walls built of clay ropes formed by rolling the plastic clay between the palms or on a flat, dampened surface and then layering and joining them together. The joints are then smoothed to prevent cracking during firing. Pinching involves shaping a piece by working from a ball of clay held in the hand. A depression is made in the centre, and the sides are manipulated to form rough walls. The shape is refined by rotating the piece and smoothing the profile. Slab-construction involves the joining together of flat clay slabs. Hollow-building is a term sometimes used interchangeably with slab-construction; it can include the use of clay tubes and rolls, as well as slabs, as part of the composition. In such shaping methods, slip acts as the adhesive for joining or 'luting' the parts of the leather-hard clay bodies. The surfaces to be joined are scored for extra 'bite' before being stuck together.

Throwing on a wheel appears to have developed from simple, hand-spun turntables, on which round, coiled or pinched vessels could be centred for trimming or applying decoration. Gradually, heavy weighted wheels were adopted, which spun longer because of increased momentum. Hand-spun wheels gave way to kick-wheels and treadles, leaving the potter's hands free to work the clay. Water, steam and electrical power later provided constant and infinitely adjustable speeds of rotation. The process of throwing involves centering the clay by sharply throwing it down on to the middle of the wheel. The clay, firmly grasped and guided as the wheel spins, is adjusted so that the mass is centred over the shaft of the wheel. As the wheel turns, the potter hollows out the mound of clay, raising and shaping the walls by applying an even and controlled upward pressure with both hands. Various tools can be used to refine the shape, a process known as turning, or to produce decorative effects while the clay is still on the wheel. Handles, spouts and relief decoration are applied with slip when the body is leather hard.

Moulding facilitates the creation of irregular shapes not easily formed on the wheel. Press-moulding involves the application of clay by pressure to shaped single or multipartite moulds. It has been most widely used for forming such flatware as dishes and plates. Domed moulds, negatives of the interior of a dish, have traditionally been made of alabaster, plaster or fired clay. Slabs of evenly rolled clay are pressed into the mould, with the reverse of the dish sometimes being refined on a wheel through the use of a profile or by pressing a second mould on to the back of the piece, a process known as 'jiggering'. The edges are trimmed, and the dish is removed from the mould.

Slip-casting consists of pouring slip into a multipartite plaster of Paris or other absorbent mould, commonly the negative of a master-block mould. Some of the excess water is absorbed by the mould, leaving a sort of clay skin on the inside. When an appropriate thickness of clay has been formed, the excess slip is poured off and the clay is left to dry and shrink away from the mould. The clay body is then removed from the mould, and the seam marks are cleaned away, a process known as 'fettling'.

4. Decoration.

(i) Texture. A natural adornment to simple wares is the introduction of consciously ornamental textures. Finger pressure can be used for simple, impressed designs, and pointed tools with single or multiple tips create incised linear and other carved or combed patterns. Impressed designs were originally made with stiff reeds, whittled ends of sticks, shells, fabrics and other available materials.

Gradually the sophistication of these stamps or dies increased, and they were replaced by carved stone, fired clay, plaster or metal implements. Rouletting wheels with carved cylindrical dies were mounted on sticks and created bands of repeated relief ornament. In the 18th century engine-turning was introduced: the ware, in a leather-hard state, was turned on a lathe with an eccentric motion to produce fluted, geometric and diced patterns.

Mould-applied and sprigged decoration requires the use of small, intaglio plaster-of-Paris moulds, into which soft clay is pressed. Mould-applying requires the clay-filled mould to be pressed on to a leather-hard clay body, leaving the motif in relief on the ware with slip. Sprigged decoration involves the clay being removed from the mould before being adhered with slip to the body and is more sturdy than mould-applied decoration.

Press-moulding or slip-casting bodies facilitates the employment of relief decoration. Elaborately patterned moulds created by highly skilled craftsmen were used as prototypes for working moulds, which could be used to create large numbers of identically ornamented wares.

Alterations in glazes, body clays and kiln atmospheres can create interesting textures, ranging from smooth, clear, highly refined porcelain glazes to the mottled coatings found on some folk earthenwares and stonewares. Fire-clay, sand and other materials can give a rougher, more earthy quality to clay bodies. Additives and adjustments of the firing atmosphere can create such decorative effects as the crazing or crystallization of glazes.

(ii) Colour. This form of decoration depends primarily on the clay, glaze (*see* §5 below) and firing conditions, as well as being effected by the types of colouring metallic oxides used. Iron oxide illustrates the impact of all such factors. Fired in an oxidizing atmosphere in a lead glaze, it burns to shades of red or brown. Traces of iron oxide in alkaline glazes burnt in reduction kilns produce the delicate blue-greys or green-greys with titanium oxide additions of Chinese celadon wares.

Other widely used colouring oxides include copper oxide, which in an alkaline glaze high in sodium or potassium can burn to a brilliant turquoise called 'Egyptian blue'. In a lead glaze under oxidation, copper fires to green, while in other glazes under reduction, it can burn to brilliant shades of red. Cobalt oxide is one of the most widely used colorants and, with a few unusual exceptions, burns consistently to an intense blue. These and other oxides are used singly or in combination to form a wide colour palette, somewhat dependent on firing temperatures, but they can be applied under the glaze to the biscuit body as they are able to withstand the heat of the glost kiln.

Naturally occurring or added oxides can be combined with the body clay mixture, and even, rich and sometimes transparent layers of colour can be the result of suspending the oxides in glazes. Colouring oxides can also be applied to the clay body in slip. 'Slipware' typically refers to wares decorated with one or more clay slips, of greater or lesser iron content than the body clay. The clays fire to a contrasting colour or shade with the body. Slipwares are decorated by pouring, dipping, painting, daubing or trailing slips on to the unfired—or sometimes once-fired—body. After application the slip can be manipulated by twisting the piece, which causes the colours to run across the surface in irregular marbled patterns. Alternatively, it can be combed into more regular designs or, after drying to a tacky consistency, can be carved to expose contrasting ground slips and body colours in a method called Sgraffito. The application of slip virtually always precedes glazing.

Over-glaze decoration, using pigments that will not withstand the heat of a glost firing, are applied on to fired glazes and include enamelling and gilding. Enamel, an opaque or transparent vitreous pigment containing silica, oxides and other ingredients, is most often applied by painting. Usually smooth and transparent, some enamels can stand in relief and indicate textures. Enamelled and underglaze colour decoration can also be printed with patterns taken from engraved metal plates. These transfers were executed through the use of inked tissue-paper or with gelatin bats carrying the decorative pattern in a sticky medium, which after application is dusted with powdered colouring oxides. Transfer-printing was later superseded by lithographic decoration.

Wares can be gilded by various methods: an adhesive pattern can be affixed to the fired glaze, which is then applied with gold leaf and burnished or dusted with powdered gold. Pulverized gold can be applied with a brush in a mercury amalgam or in such gummy media as honey or size. Honey-gilding and mercuric gilding are fixed in a low-firing muffle kiln. Gilding that has been secured by oil or size and is unfired ('cold-gilt') is not very durable. Other metallic surface finishes, called lustres, are achieved by coating the ware with an oily medium in which metallic oxides are suspended; the wares are then fired in a reduction kiln, and a very thin film of free metal is deposited on the surface. Gold produces a ruby-red flashing, silver a straw-yellow colour and platinum a silver colour.

5. Glazes. A glaze is a glassy coating applied to clay bodies to make them impervious to liquids or more visually pleasing. The high silica content of most glazes provides the 'glass', while small amounts of alumina control the fluidity of the glaze. These materials can be present either in the glaze mixture or available in the body clay. The common names for

glazes are usually in reference to the flux being used. Lead glazes, for example, are fluxed with lead oxides; they are reliable, easy to control, smooth, glossy, nearly colourless and transparent, although they can be opacified by the addition of tin oxide to produce a tin glaze. Lead glazes must be fired at a low temperature, in an oxidizing atmosphere, as reduction reduces it to its blackened metallic state. Disadvantages include solubility in mild acids, problems with 'fitting' the glaze to the body and its poisonous nature (a danger reduced by fritting the oxide). Bristol glaze, developed in England in the 19th century, contains a high zinc oxide content and is a safe alternative to lead. Although popular, it did not have the clarity and range of lead-fluxed glazes.

Iron oxide, an effective flux, is found in high percentages in slip glazes. Fired in oxidation, the glaze burns to a rich, dense, opaque brown, sometimes with controlled decorative crystalline textures. Because of the large clay content in slip glazes, relatively high temperatures are required to fuse the glaze, thus restricting its use to high-firing stoneware and porcelain.

Alkaline glazes are typically fluxed with such alkalines as lime, soda or potash; they are glassy and soft with a tendency to craze. They are often used on low-firing wares, although for higher-burning ceramics the temperature can be raised with an addition of feldspar. Alkaline glazes can create brilliant but different coloured oxide effects than lead glaze. Mottled ash glazes are dependent on the type of ash used for their colour and textural effects.

Salt glazing takes place during a single firing, which hardens and glazes stoneware. As the clay reaches its 'maturing' temperature (1200–1300°C) salt is introduced into the kiln through special holes. As the salt vaporizes and splits into its component elements, the sodium combines with the silica in the body to form a thin, glossy, orange-peel textured glaze; the chlorine escapes out of the kiln chimney as hydrochloric gas.

Feldspathic glazes include those used on high-fired wares. Formed in part of kaolin and petuntse, they require high temperatures to fuse them to the clay body. The glaze is fired at the same time as the body and forms a clear, very hard and durable glossy finish. Feldspar is also an ingredient in some lower-fired glazes and clay bodies.

To prepare the glaze, the raw materials are purified and pulverized into a uniform fine-textured mixture; some ingredients can be fritted (melted and ground) first. The glaze is applied to the clay body as a powder or as a suspension in water. After drying, the body and glaze can be hardened in a single firing, or a 'glost' firing fuses the glaze if the clay has already been biscuit-fired. Firing fuses the glaze materials, as well as adhering them to the body surface. Such higher-fired wares as hard-paste porcelains with nearly similar glaze and body recipes acquire the best-fitting glazes. Lower-fired earthenwares can show a different shrinkage rate between the body and glaze, resulting in crazing or flaking.

6. KILNS AND FIRING. One of the earliest methods of hardening clay bodies was simply to dry them in the sun. Later wares were burnt near fires, and gradually primitive kilns appeared. Kilns can be divided into three basic categories, the up-draft, cross-draft and down-draft kiln, depending on the direction of hot-air flow. All have certain essential components: an area in which fuel is burnt and heat generated; a chamber in which the wares are placed and which will retain heat; and an exit that creates a draught for the escape of hot gases. The placement of the wares stacked in the kiln depends on the shapes and materials to be fired. Pieces with glazes dependent on draft-carried ash from burning wood might be positioned so as to increase the decorative effects. Larger, less valuable pieces might be placed closer to the fire, providing a 'muffle' to protect more delicate items from direct contact with the flames. Muffles can also be created by walls built into the kiln.

Saggars, similar in use to muffles, are containers into which items can be placed as protection from direct contact with the flames while allowing the hot air to circulate. Saggars are usually made of a highly refractive stoneware clay, called fire-clay, which can withstand repeated firing at high temperatures without sustaining damage. Fire-clay is sometimes used as a component of the kiln and also for such kiln furniture as shelves, stilts, trivets (used to support flatware during firing), girders (used as a prop for tiles) and cones (supports). Fire-clay and such other refractive materials as flint and sand can be sprinkled on the horizontal surfaces of the kiln to prevent glazed wares from sticking during firing.

Drying is of primary importance when preparing to fire ceramic bodies. After shaping, the pieces are usually left to air-dry on plaster of Paris or wooden shelves called bats. In some cases they are placed in a low-firing drying kiln. Care must be taken in the transition from the comparatively damp, raw or green state through the stiffer leather-hard state to the point when the clay body is completely air-dried, which results in a shrinkage rate of 5–8%. To avoid cracking and buckling, the body must dry evenly. Fire-clay or grog is sometimes added to clay; this reduces shrinkage while aiding the drying process by opening the pores to the surface. Further drying occurs during firing, so the temperature in the kiln must be raised very gradually to avoid bursting the clay surface as gaseous water escapes. Free water in the clay is removed at c. 100°C, and chemically-bound water is completely burnt off at c. 500°C. The ceramic is then dehydrated and can no longer be returned to slip or made soluble by the addition of water. In an oxidizing atmosphere all the materials in the clay are reduced to an oxide by c. 900°C. The correct placing of the pieces in the kiln ensures good air circulation during this process.

Vitrification, or the fusing of materials in the clay, takes place at red heat, a temperature dependent on the composition of the clay. Earthenwares

remain porous after firing and are less highly vitrified than higher-firing stonewares and porcelains. If the firing temperature is too hot, clays can melt or collapse, while too low a firing will not harden the body. Temperatures can also affect glazes: for example, if too low, the glaze may not fully vitrify, and the result is a soft, matt surface. If fired too high, the glazes can crack, blister or discolour. Aids to controlling temperatures include testing 'by eye' as well as using pyrometric cones, pyrometers and a thermocouple. Pyrometric cones are used to indicate the temperature inside the kiln and sag at a predetermined level. The thermocouple gauges the temperature, which is indicated on the outside of the kiln by the pyrometer.

Two types of firing atmospheres can be used individually or in combination: oxidation requires a large amount of free oxygen during firing and is the only atmosphere that can be used with lead glazes; reduction requires an oxygen-starved kiln during firing. This is usually achieved by allowing smoke into the kiln or closing off air-vents. Among the most interesting effects of these atmospheric changes are colour alterations; firing in oxygen oxidizes metallic oxides, which create rusty shades from iron, while reduction converts oxides to their original metal, producing reds from copper.

D. Rhodes: *Clay and Glazes for the Potter* (New York, 1957, rev. 2/1958)

F. Hamer and J. Hamer: *The Potter's Dictionary of Materials and Techniques* (London, 1975, rev. 1986)

M. Medley: *The Chinese Potter* (Oxford, 1976)

W. D. Kingery and P. B. Vandiver: *Ceramic Masterpieces: Art, Structure and Technology* (London, 1986)

P. M. Rice: *Pottery Analysis: A Source Book* (Chicago, 1987)

B. V. Harrisson: *Later Ceramics in South-East Asia, Sixteenth to Twentieth Centuries* (Kuala Lumpur, New York and Oxford, 1995)

R. Scott and J. Guy: *South East Asia & China: Art, Interaction & Commerce* (London, 1995)

R. L. Wilson: *Inside Japanese Ceramics: A Primer of Materials, Techniques and Traditions* (New York/Tokyo, 1995)

S. Pierson: *Earth, Fire and Water: Chinese Ceramic Technology: Handbook for Non-specialists* (London, 1996)

C. J. A. Jörg: *Chinese Ceramics in the Collection of the Rijksmuseum, Amsterdam: The Ming and Qing Dynasties* (London, 1997)

R. Singer and H. Goodall: *Hirado Porcelain of Japan* (Los Angeles, 1997)

J. Stevenson and J. Guy: *Vietnamese Ceramics: A Separate Tradition* (Chicago, 1997)

J. Carswell: *Iznik Pottery* (London, 1998)

T. Schreiber: *Athenian Vase Construction: A Potter's Analysis* (Malibu, CA, 1999)

N. Wood: *Chinese Glazes: Their Origins, Chemistry and Recreation* (London and Philadelphia, 1999)

P. Scott: *Painted Clay: Graphic Arts and the Ceramic Surface* (New York, 2000)

K. Barclay: *Scientific Analysis of Archaeological Ceramics* (Oxford, 2001)

M. Burleson: *The Ceramic Glaze Handbook* (New York, 2001)

J. Harrison-Hall: *Catalogue of Late Yuan and Ming Ceramics in the British Museum* (London, 2001)

E. Stober: *'La maladie de la porcelaine': East Asian Porcelain in the Collection of Augustus the Strong* (Leipzig, 2001)

L. Chabanne and C. Shimizu: *L'Odyssée de la porcelaine chinoise: Collections du Musée national de la céramique, Sèvres, et du Musée national Adrien Dubouché, Limoges* (Paris, 2003)

A.-M. Keblow: *Early Islamic Pottery: Materials and Techniques* (London, 2003)

A. Turner: *Glazes: Materials, Recipes and Techniques: A Collection of Articles from Ceramics Monthly* (Westerville, OH, 2004)

A. Caubet and G. Pierrat-Bonnefois: *Faïences De l'Antiquité: De l'Égypte à L'Iran* (Paris, 2005)

II. Conservation.

1. Deterioration and prevention of damage. 2. Examination. 3. Cleaning and removal of old restorations. 4. Consolidation and bonding. 5. Replacing missing material. 6. Retouching and surface finishing.

1. DETERIORATION AND PREVENTION OF DAMAGE. The nature of the deterioration and damage to which ceramics are subject varies with the physical and chemical properties of the different types of ware. Although ceramics are among the most stable materials used in art objects, they are very susceptible to mechanical shock, and this is the most common cause of damage. Lower-fired wares are porous to liquids, which may cause staining and contamination of the body. If these wares are soaked in water for extended periods, for example during burial, soluble fractions of the original composition can leach out. Higher-fired wares become partially vitrified during firing, so their porosity is low, and they are not susceptible to damage in this manner.

Unlike hard-paste porcelain and stonewares, where the glaze and body fuse together during firing, the attachment of the glaze to low-fired wares may be weak, and the glaze may be easily scratched or chipped off. Minor damage of this type may be accepted as natural wear and tear, characteristic of the ceramic type. Decoration that is applied over a high-fired glaze, such as overglaze enamel or gilding, is also fired at lower temperatures, making its attachment to the glaze weak and liable to flake off. Gilding is easily scratched and may be damaged by adhesive tapes or labels. Damage or disfigurement can also be caused by the use of unsuitable conservation materials and techniques. Damage caused by mechanical shock can be avoided by careful handling and storage. In addition, display conditions should be dry and dust-free, and lighting that has a strong heating effect should not be used. Plate-hangers should be avoided and stands used with care.

2. EXAMINATION. Before any treatment is carried out the ceramic is examined to establish the type of ware and the nature of any decoration, as this will affect the choice of treatment; for a detailed examination a microscope is necessary. Contamination or damage is noted, as is evidence of any previous treatment. These may not be immediately evident: stains and breaks may be disguised by paint, and bonds may

be reinforced with hidden dowels. Former restorations can sometimes be located by discoloration, by the presence of misting at the edges of sprayed retouches and by the lack of gloss or of glaze characteristics such as crazing or bubbling. They may be revealed by the use of a raking light. Touch can also give clues: a needle or scalpel tip pressed gently against the surface will mark a retouched area. Ultraviolet lamps can show up fillings or areas of retouching, and X-radiography can reveal internal supports or dowels. Small hand-held metal detectors are used to detect dowels and armatures. The best time to examine the composition and method of manufacture is while the object is in pieces (if it has been previously broken). Thin sections can be prepared to examine the structure in detail, and various scientific techniques are used to analyse the composition of body, glaze and decoration.

3. CLEANING AND REMOVAL OF OLD RESTORATIONS. Cleaning is carried out to remove surface deposits or deep staining. Surface deposits may hold important information about the history of the object, in which case they should not be removed unless they are a potential source of damage, and if they are, a sample should be kept. Deposits may be removed mechanically, using a soft brush, a needle or a scalpel; the advantage of a mechanical method is that there is no risk of dirt being drawn into the body of the object. If the surface of the object is unsound, a binocular microscope is used to ensure that no damage is done. Powdered rubber can be used for dry-cleaning unglazed earthenwares. Mild abrasive pastes containing solvents can be used for cleaning glaze surfaces, especially where dirt has become ingrained in scratches in the glaze.

Solvents, usually water, are often used for cleaning. A spot test is made first to check that the object will not be damaged by the solvent. If they are sound, high-fired wares can be submerged in warm water and washed with a soft brush or cotton-wool swabs. Non-ionic detergent may be added to the water as a degreasant. Soaps and household detergents are not used, as they may contain substances that would contaminate the object or damage the decoration. After rinsing, the object is blotted and left in freely circulating air to dry completely. Many glazed earthenwares can also be washed in this way, but prolonged soaking should be avoided. As they are porous they take longer to dry.

In certain circumstances immersion is undesirable, for example when old restorations are present or when there is a danger of pushing the dirt from the surface deeper into the body. Instead, water is applied on cotton-wool swab sticks. The swab is rolled, rather than wiped, over the object so the dirt is lifted off the surface and not pushed into it. In cases where the decoration is unstable to water or where water is ineffective, other solvents may be used, usually applied on cotton-wool swabs. If the staining is beneath the surface the solvent can be applied in a poultice or pack made of blotting-paper or hydrated magnesium tri–silicate.

Calcium deposits, such as those formed during burial, can be removed with dilute acid. Dilute hydrochloric, nitric, oxalic, citric and acetic acids may be used as appropriate, but care is taken to check that the object itself is not attacted by acid. Sequestering or chelating agents have been used to remove calcium salts. There is evidence, however, that powerful sequestering agents can attack metal ions in the body or overglaze decoration and even penetrate glazes, removing the metals from underglaze lustre decoration. The method is therefore used with caution.

If a stain cannot be removed it may instead be rendered colourless by bleaching. Household bleaches are never used, as they contain chloride ions, which are released in the bleaching process and can remain in the body even after repeated rinsing. These can cause damage later by crystalizing at the surface of the object or under the glaze. Hydrogen peroxide, applied on cotton-wool swabs, can be safely used on porcelain; on earthenware it should be used with caution. If a ceramic object is contaminated with chemical salts—usually the result of burial or injudiciously applied conservation treatments—the salts are removed by soaking in de-ionized water. If the body or glaze is damaged it may be necessary to consolidate it first.

Old restorations, like dirt, can be of intrinsic interest and are therefore not automatically removed, unless they are unsafe, unsightly or misleading. Samples of the restoration materials should be kept for record purposes. Usually the first material to be removed is overpaint. If the old paint is dried and flaking it can be easily removed with a sharp scalpel. Modern surface coatings tend to be more durable and may require the use of a solvent. Earthenwares may be pre-soaked in water to reduce their porosity before other solvents are used. Underneath the paint there may be fillings, usually made in the past of plaster or plaster-based compounds. If the restoration is more recent, epoxy resin and polyester compositions may have been used. Plaster fillings that have been subjected to damp may produce growths of salt crystals on the surface of the filling or in the surrounding ceramic. Fillings may be removed with a scalpel, file, hack-saw or drill or by softening with solvents. The use of mechanical methods alone reduces the risk of dispersing the material into the body, but care must be taken to avoid damaging the break edges.

Although some adhesives are thermoplastic and can be softened in warm water, old bonds are usually broken down with appropriate solvents. The object may need some support during this process to prevent any damage occurring when the bonds give way. Rivets are sawn in half before being removed. This is because they are set into holes drilled at an angle towards the break, and the rivets are stretched into place with pliers. If they are pulled straight out there is a risk of damaging the edges of the holes. Iron rivets may leave rust stains. These can be removed with acid, but care must be taken with its use on earthenwares. When the pieces have been parted, all

traces of adhesive, filler and paint must be removed from the break edges; residues may interfere with the new repair and make it more obvious. A microscope may be used to ensure that no damage is done to the ceramic and that all traces are removed.

4. CONSOLIDATION AND BONDING. Consolidation is necessary if the body of a ceramic object is crumbling or if a glaze or enamel decoration is flaking. It is done by introducing a consolidant locally or by soaking the whole object in the consolidant. The consolidant should not alter the reflectance, colour or tonal quality of the object and should remain reversible without damage to the object. Vinyl and acrylic resins are the materials most commonly used.

Adhesives should have curing times that allow for assembly of the joints; they must be strong and durable, but reversible to allow future dismantling of the object without damage. The choice of adhesive depends on the ceramic. With porous wares an adhesive of too low a viscosity will become absorbed into the break edges, and the bond will not form properly. Also, a 'shadow' will be caused by the adhesive on either side of the break, and this will become even more unsightly if the adhesive discolours. For non-porous wares, however, low-viscosity adhesives are preferred, as very tight joints can be achieved. For pale-coloured or translucent wares adhesives should be clear and colourless and remain so for as long as possible. High-fired wares usually require epoxy-resin adhesives; these fulfil most of the desired criteria, but they do discolour to varying degrees. The lower-viscosity grades, however, form tight joints, so the discoloration is less significant. For low-fired wares adhesives based on polyester, acrylic and vinyl resins and cellulose nitrate are used.

The efficiency of any adhesive is affected by the care taken in its use. For two-part adhesives the quantities are very carefully measured out and mixed. The edges to be joined are kept scrupulously clean, as are tools and hands. Unnecessarily heavy use of adhesive is avoided, as it prevents a close joint, and if a series of breaks is bonded distortion will result. Also, thick layers of discoloured adhesive are unsightly and distracting.

Objects with multiple breaks are bonded together in one operation: any slight error in positioning one piece will become obvious as further pieces are added; adjustments can be made before the adhesive cures (see fig.). The pieces must be bonded in an order that will not cause any of them to be 'locked out'. A dry run, in which the pieces are assembled with adhesive tape, is often carried out to establish the best order. At all stages care is taken not to grate the break edges together so as to damage them and cause small fragments to become trapped in the joints.

The adhesives used in bonding multiple breaks should be slow-acting, and the joints must be held precisely in place for the curing time. With some polyester adhesives this may be as little as ten minutes; if these are used, simple joints can be hand-held while curing. Other adhesives have curing times of anything up to several days, so the joints must be propped in place or held together with some form of strapping. This usually involves stretching short lengths of adhesive tape at right angles across the joint; equal force is applied to the back and front of the joint to prevent distortion. The alignment of the pieces is checked with the tip of a fingernail and by using such clues as lines in the pattern or scratches on the surface of the object. In cases where the pieces cannot be strapped or propped satisfactorily, it is sometimes possible to

Reassembly of a Greek kylix vase (Los Angeles, CA, J. Paul Getty Museum); photo courtesy of the Antiquities Conservation Department of the J. Paul Getty Museum

use a fast-setting cyanoacrylate adhesive to tack them together. The joints are then consolidated by running in a low-viscosity epoxy resin. This technique can be used only on non-porous wares. Occasionally breaks will have 'sprung', a deformation caused by the release of inbuilt tensions in the object. When such breaks are bonded force has to be applied to align the joints properly. It is sometimes necessary to accept a step in the joint rather than risk using too much force and damaging the object further.

5. REPLACING MISSING MATERIAL. Missing material may range from small chips to whole parts of an object, such as a limb of a figurine or the handle of a vase. It may be replaced with a suitable filler, tinted or painted to match the original. The properties required of a filler are good adhesion to the ceramic, dimensional stability, durability and reversibility. Again, the material used will vary according to the ceramic. Harder, denser materials are used for high-fired wares, and for finely potted porcelains a certain amount of translucency is required. If the filling is going to be tinted and not painted, good colour stability is also necessary.

For high-fired wares epoxy or polyester resins are commonly used. Inert materials such as fumed colloidal silica, barium sulphate or talc may be added to give the desired consistency and texture, and pigments or dyes are added to give the required tint. For earthenware other plaster- or calcium-based materials, tinted as necessary, are mainly used. For simple fillings the material is applied with a spatula and modelled into shape. Shaping can be carried out before the filling has cured using modelling tools and solvents, or after it has set using scalpels, files, abrasive papers and even small dental drills. For larger and more intricate fillings some support may be needed to hold the filler in shape while it cures. Supports range from simple props such as Plasticine or adhesive tape to full-scale moulds into which the filling is cast. Moulds may be made with wax, rubber latex or silicone rubber and may be of one or several pieces. Internal supports of wire or metal dowelling are sometimes used.

6. RETOUCHING AND SURFACE FINISHING. A surface coating may be applied to disguise fillings. The medium used must coat the filling material satisfactorily; it must be compatible with pigments or dyes, and it must set to a hard finish that can be smoothed down and polished with fine abrasives. As with all other conservation materials, it must be reversible without causing damage to the object. The choice of material is perhaps the most unsatisfactory area of ceramics restoration. Surface coatings based on ureaformaldehydes, acrylics, alkyds, epoxy resins and polyurethanes are in use, but all have drawbacks. For the safety of the object a cold-curing medium is preferable, but media that cure by solvent loss are often unsuitable, as the initial coats can be disturbed by subsequent applications. Media that cure by the addition of a hardener are commonly used, but they

tend to have poor colour stability. However, they are generally more satisfactory in other respects.

Pigments or dyes are mixed with the medium to give the required colour, and matting agents or reflective pigments can be added to alter the reflective qualities. The medium is applied to the ceramic with a hand-held paint brush or an airbrush. The former method allows the paint to be limited to precise areas. The benefit of an airbrush is that the retouching can be faded off at the edges, but there is also a danger of covering an unnecessarily large area of undamaged surface.

The colour is usually built up in several layers, with any brushstrokes or unevenness in-between being smoothed out with abrasive papers. If the ceramic has a glassy finish clear layers of the medium are applied on top of the colour; when cured they may be polished with fine abrasive papers or burnishing creams. The effect of overglaze enamels can be achieved by painting over these layers. Gilding is reproduced using gold leaf or metal powders. It is not usually possible to match satisfactorily the deep colour and brilliance of fired gilding. Lustres are also difficult to match, but good effects can be achieved with bronze powders and special reflective pigments.

W. M. Parsons and F.H. Curl: *China Mending and Restoration* (London, 1963)

E. West Fitzhugh and J. Gettens: 'Calcite and Other Efflorescent Salt on Objects Stored in Wooden Museum Cases', *Science and Archaeology*, ed. R. Brill (Cambridge, MA, 1971), pp. 91–101

J. Larney: *Restoring Ceramics* (London, 1975)

Proceedings of I.I.C. Congress. Conservation in Archaeology and the Applied Arts: Stockholm, 1975 [contains four articles on ceramics conservation]

A. O. Shepard: *Ceramics for the Archaeologist* (Washington, DC, 1980)

M. White: *Restoring Fine China* (London, 1981)

N. Tennent: 'The Selection of Suitable Ceramic Retouching Media', *Proceedings of SSCR Conference. Resins in Conservation: Edinburgh, 1982*, pp. 9.1–9.10

E. Evetts: *China Mending: A Guide to Repairing and Restoration* (London, 1983)

N. Williams: *Porcelain Repair and Restoration* (London, 1983)

H. Hodges: 'The Conservation Treatment of Ceramics in the Field', *Proceedings of the International Institute for Conservation Congress. In Situ Archaeological Conservation: Mexico, 1986*

S. Koob: 'The Use of Paraloid B-72 as an Adhesive: Its Application for Archaeological Ceramics and Other Materials', *Studies in Conservation*, xxxi (1986), pp. 7–14

A. Paterakis: 'Deterioration of Ceramics by Soluble Salts and Methods for Monitoring their Removal', *Institute of Archaeology Jubilee Conservation Conference: London, 1987*, pp. 67–72

S. Taylor: 'Consolidation of Earthenware', *Conservation News*, xxxiii (1987), pp. 24–5

Preprints of ICOM Committee for Conservation, 8th Triennial Meeting: Sydney, 1987 [contains two articles on ceramics conserv.]

N. Lacoudre and M. Dubus: 'Nettoyage et dégagement des agrafes au Musée National de Céramique à Sèvres', *Studies in Conservation*, xxxiii (1988), pp. 23–8

N. Williams: 'Ancient Methods of Repairing Pottery and Porcelain', *Early Advances in Conservation* (London, 1988)

M. Elston: 'Technical and Aesthetic Considerations in the Conservation of Ancient Ceramics and Terracotta Objects in the J. Paul Getty Museum: Five Case Studies', *Studies in Conservation*, xxxv (1990), pp. 69–80

S. Buys and V. Oakley: *The Conservation and Restoration of Ceramics* (London, 1994)

N. H. Tennent: *The Conservation of Glass and Ceramics* (London, 1999)

V. Oakley: *Essentials in the Care and Conservation of Historic Ceramic Objects* (London, 2002)

N. Williams: *Porcelain Repair and Restoration* (Philadelphia, 2002)

Cerography. Painting method in which wax is used as the binding medium (*see* ENCAUSTIC PAINTING). Wax engraving, also known as cerography, was a printing process used to make thousands of maps, technical drawings, business forms, and some works of art from the mid-19th century to the mid-20th century.

N. Purinton: 'A Historical Map-printing Technique: Wax Engraving', *Journal of the American Institute for Conservation*, xlii/3 (2003 Fall–Winter), pp. 419–24, 443–5 [French, Spanish and Portuguese summaries]

Certosina. Term for a type of intarsia MARQUETRY that was especially popular in Lombardy, Venice and the Veneto in the 15th century. It was made with polygonal tesserae of wood, bone, metal and mother-of-pearl arranged in geometrical patterns (*see* MARQUETRY, §1).

Chalk. Drawing medium of natural, coloured earth or its synthetic or fabricated equivalent.

1. TYPES AND HISTORY. Natural chalks, available until the late 18th century and early 19th, were made from a relatively few types of coloured earth. The restricted number of suitable sources reflects the fact that to be a good drawing material, the chalk had to be dense and consistent in colour and value. Moreover, as Giorgio Vasari (1511–74) wrote in 1550, it must be 'soft enough to be easily sawn and reduced to a fine point suitable for marking on leaves of paper'. Until the introduction of manufactured chalks in the late 18th century, the colours of chalk were restricted to black, red and white.

Natural black chalk, a soft carbonaceous schist, has carbon and clay as its principal ingredients. Cennino Cennini (*c.* 1370–*c.* 1440) described it thus in his technical manual of *c.* 1390:

> Also for drawing, I have come across a certain black stone, which comes from Piedmont; this is a soft stone and it can be sharpened with a penknife, for it is soft. It is very black. And you can bring it to the same perfection as charcoal. And you can draw as you want to!

Although known to Cennini, black chalk was apparently little used for drawing until the end of the 15th century, becoming popular in the 16th century, when, according to Vasari, it was found in the hills of France. Black chalk strokes tend to be linear because of the compressed and cohesive structure of the granular material, though softer effects can be achieved, especially by smudging the lines with a stump or finger. Black chalk allows greater contrast than red chalk and is therefore best suited for the preparation of scenes of dramatic contrast, when the suggestion of broad areas of light and shade is more important than precise detail. Black chalk was originally available throughout Europe, but as stocks ran out, it was replaced by graphite and by fabricated chalks, which are more friable than the natural variety.

Natural red chalk, also called *sanguine*, is a dry earth pigment, a red ochre variety of haematite that has been known for thousands of years. It was used by the ancient Egyptians and ancient Romans for wall painting. As a drawing medium, it did not become as popular as black chalk until the 16th century. Leonardo da Vinci (1452–1519), at the end of the 15th century, was the first major artist to use it, and his example was quickly followed. It became popular on its own and in combination with other media, particularly black chalk. It was found in a number of European locations (e.g. the mountains of Germany in Vasari's day), the colour ranging from warm blood-red to a darker cooler red depending on the mineral's origins. Being usually harder than black chalk, it was suitable for small, tight drawings. It could also, however, be smudged for broad, soft effects, wetted to make a dark solid line or ground up and diluted with water for use as wash. Because it is inherently lighter in tone, it allowed greater subtlety in the gradations, and, given its closeness to flesh tones, it was the perfect medium for figure and head studies.

There were two types of natural white chalk: calcite or calcium carbonate, a soft and fairly brilliant white, and soapstone or steatite, a slightly harder and bluish-white. The softness of the natural white chalks permitted them to be sawn and shaped into fine drawing sticks especially suitable for highlights and modelling. Antoine Watteau (1684–1721) was a master at handling all three natural chalks, as can be seen in his *Four Studies of a Young Woman's Head* (London, British Museum), which is in black, white and two shades of red chalk, a technique that has been called *aux quatre crayons*. This is a variation on the term *aux trois crayons*—commonly used to describe the combination of red, black and white.

Fabricated black chalks, made from carbon and a binder, were available as early as the 17th century, but it is difficult to distinguish them from natural varieties. During the late 18th century and the early 19th the popularity of natural chalks rapidly declined due to the deterioration of the quality of the sticks. (The increased production of excellent graphite pencils also contributed to their loss of favour.) This gradually led to the development, in the late 18th century, of manufactured chalk crayons. These are made from coloured pastes prepared by mixing dry pigments with water-soluble binding media, such as glue, milk, beer and gum arabic. This mixture was then rolled or pressed into sticks and dried. Unlike natural chalks, a wide range of colours, tints and

hardnesses can be produced with manufactured chalks, the softest of which is known as PASTEL.

For sticks made with oily, fatty or waxy binding media *see* CRAYON; *see also* DRAWING, §III; UNDERDRAWING; CARTOON, §1; and POUNCING.

2. CONSERVATION. Chalk and pastel drawings pose particular conservation problems beause the surface is friable and may be quite loose. Great care must be taken not to touch the surface, since this might lift off the chalk or smudge it, resulting in the loss of some detail. The drawings should generally be kept flat and face up, but never piled up on top of each other unless protected by mounts. A deep window mount or mat is usually advised to protect the fragile front surface, while a back board supports and preserves the back. Framing the work provides further protection, though there are risks of fading if it is hung in an area exposed to bright light (*see* PAPER, §VI). Glass rather than Perspex should be used for pastels, since the static created by the latter can sometimes loosen and attract the particles of the drawing. A double-sided chalk drawing should be firmly held in a deep double window-mount, so that neither surface can brush against any other surface. Front and back boards can be attached to the mount to forestall the further danger of the sheet being pierced. Mounted but unframed chalk drawings should be stored horizontally in a solander box made of conservation-grade materials. The materials of the mount itself should be acid-free, the board ideally 100% cotton rag. Adhesives and tapes used in the construction of the mounts and frames must also be acid-free and reversible.

C. Cennini: *Il libro dell'arte* (MS., *c.* 1390); Eng. trans. and notes by D. V. Thompson jr as *The Craftsman's Handbook: 'Il libro dell'arte'* (New Haven, 1933/*R* New York, 1954)

G. Vasari: *Vite* (1550, rev. 2/1568); Eng. trans. by L. S. Maclehose, ed. G. B. Brown, as *Vasari on Technique* [the intro. prefixed to the *Vite*] (London, 1907/*R* New York, 1960)

A. P. Laurie: *The Painter's Methods and Materials* (Philadelphia, 1926/*R* New York, 1967)

J. Watrous: *The Gift of Old-Master Drawings* (Madison, 1957)

C. James and others: *Manuale per la conservazione e il restauro di disegni e stampe antichi* (Florence, 1991)

T. Burns: 'Distinguishing between Chalk and Pastel in Early Drawings', *The Broad Spectrum: Studies in the Materials, Techniques and Conservation of Color on Paper*, eds H. K. Stratis and B. Salvesen (London, 2002), pp. 12–16

M. Wagner, D. Rübel and S. Hackenschmidt: *Lexikon des künstlerischen Materials: Werkstoffe der modernen Kunst von Abfall bis Zinn* (Munich, 2002)

Charcoal. Black pigment. It is a solid residue containing impure carbon produced by slowly heating animal and vegetable substances, such as wood, bone and nutshells, at high temperatures under reducing conditions to remove the volatile constituents.

Charcoal was probably discovered as a by-product of wood fires. Since prehistoric times it has been used and intentionally produced as a superior and very efficient fuel. Traces of charcoal have been found in the blackened hearths of caves occupied in Palaeolithic times. It was undoubtedly used for drawing on cave walls because of its convenience. Technical analysis has confirmed the presence of vegetable and wood charcoals in prehistoric cave paintings from, for example, Altamira and Niaux, along with other black pigments such as calcined bones and manganese oxide. Charcoal was probably used for drawing in Classical times; it is mentioned by Pliny the elder (AD 23/4–79) and has been found at Pompeii. Charcoal from grape twigs was one of the two standard medieval blacks. Vine-charcoal black (*nigrum optimum*, 'best of blacks') was used in sticks for drawing and ground to powder for painting.

Charcoal for drawing was probably made by artists themselves (*see* DRAWING, §II), who would have learnt the technique from professional charcoal burners. Cennino Cennini (*c.* 1370–*c.* 1440), in his *Libro dell'arte* of *c.* 1390, was the first to describe its production. Descriptions of the process were subsequently given by Filippo Baldinucci (1625–97), Giovanni Battista Volpato (1633–1706) and in the Mt Athos Painters' Guide used by later Byzantine painters. Even-textured woods, such as willow, lime, beech and maple, straight and free from knots, produce the best charcoal; the denser the original material, the richer the black. Vines, twigs or thin wood slips are bundled, sealed in airtight containers and heated under the subsiding embers of a fire. The exclusion of air during heating produces charred wood rather than ashes. Gradual cooling completes the process. The slower and more prolonged the heating, the softer the product; if the process is too sudden, the charcoal is brittle and fragments. If the charcoal is not thoroughly reduced, the colour can be brownish and the consistency unpleasant. Charcoal has been prepared in this way up to the 21st century. In commercial production huge kilns have replaced Cennini's casserole, and the heat is precisely controlled so that exact degrees of hardness or softness are obtained.

Artists' charcoal retains, in part, the fine structure of the wood from which it derives. Viewed microscopically, it appears as small, opaque, elongated particles. The individual particles are virtually weightless; they tend to splinter from the stick and to be deposited unevenly on the support, in the case of paper sinking into depressions in the matted surface rather than adhering to the raised fibres. The result is an open, irregular line with limited covering power and a less intense colour than is obtained from other friable blacks such as chalk (*see* CHALK, §1) or conté crayon (*see* CRAYON).

In the 19th century various types and proprietary brands of charcoal were developed: R.M.G. charcoal crayon, Rouget's and Venetian charcoal and compressed charcoal sticks. Charcoal also appeared in new formats: fine, powdered charcoal in tins and pencils of charcoal compressed into very thin sticks and sheathed in wood. Charcoal thus became available in a range of tones, from the most intense blacks through shades of grey, and in every quality from coarse to fine and from soft to hard.

The first tools used by artists to manipulate charcoal were very simple: a feather or pellets of soft bread to brush or lift the weightless particles from the support. Erasers were used from the late 18th century. Initially these were hard and abrasive, and *dolage* (scrapings of soft leather) was preferred. Later, methods of plasticizing crude rubber and introducing various grades of abrasives gave erasers a range of properties. Knives and metal scrapers have long been used for scratching out highlights. Edges of shapes could be softened and tones smoothed by artists rubbing the charcoal into the paper with their fingers. But by the 18th century, stumps for blending were made from soft leather, paper or felt tightly rolled into small tapered sticks.

Fixatives (*see* FIXATIVE) were first used in the late 15th century, when drawings were immersed in gum baths or the support was prepared with gum and the drawing steamed. Oiled charcoal, made by soaking the stick in linseed oil so its line would be indelible, has been documented since the 16th century. Used only rarely (e.g. by Nicolaes Berchem (1620–83)), this technique preserves charcoal without fixative. It is characterized by rich saturated blacks, but excess oil can leach from the charcoal and cause a brownish halo along the lines and on the support *verso*. The technique was mentioned by both Volpato and Samuel van Hoogstraten (1627–78), but it was little known before Meder's researches. In the 19th century resin and alcohol fixatives applied by brush or atomizer and proprietary brands with secret ingredients were introduced.

Works in charcoal rarely survived before the development of fixatives in the late 15th century. As a result, the evidence for the nature and extent of charcoal usage is distorted. By the 16th century stylistic changes, the larger scale of drawings and the greater availability of paper led to an increased use of charcoal. Drawings by Titian (*c.* ?1485/90–1576) and Jacopo Tintoretto (1519–94) and cartoons by Raphael (1483–1520), Guido Reni (1575–1642) and others seem not to have been executed in charcoal, as traditionally stated; however, charcoal has been identified as the medium in head studies by Bernardino Luini (*c.* 1480/85–1532) and Hans Burgkmair the elder (1473–1531).

Because of its lightness and lack of binder, charcoal erases and smudges easily. This means, however, that artists can improvise freely and alter their drawings as they work. Once established, the design can be redrawn in a more permanent medium and the charcoal brushed away. The use of charcoal has traditionally been associated with underdrawings and preparatory studies, especially of heads (*see* CARTOON, POUNCING and UNDERDRAWING), with bold, rapid handling and a large scale; but these characteristics in a drawing do not guarantee its presence. In the 15th and 16th centuries, chalk, not charcoal, predominated. Charcoal was also used in preparatory work for mural painting: Cennini recommended that the design be sketched in charcoal on the *intonaco* before being finalized with the SINOPIA. The traditional preparatory uses of charcoal persisted into the 19th century.

From the 1830s the use of charcoal for drawing increased rapidly, particularly for academic studies from the nude, landscape drawings and evocative compositions. Much art of the period was dominated by the broader tonal and colouristic vision of Romanticism. This contributed to the new importance of charcoal, although black chalk, conté, graphite and other materials also flourished as tonal media. By the mid-19th century charcoal had become an important independent medium and was discussed in manuals by Maxime Lalanne (1827–86), Auguste Allongé (1833–98) and Karl Robert [Georges Meusnier] (*d* 1848). The designation *dessin au fusain* appeared for the first time in the official catalogue of the Salon du Louvre, Paris, in 1848; charcoal was used to achieve a wide range of effects in finished exhibition drawings of genre and landscape subjects. Meanwhile, other artists, such as Edgar Degas (1834–1917) and John Singer Sargent (1856–1925), continued to use it in the traditional manner for underdrawing and preparatory sketches. In the 20th century charcoal was used for preparatory drawing by such artists as Fernand Léger (1881–1955) and Umberto Boccioni (1882–1916); others, for example Ernst Barlach (1870–1938), Ernst Ludwig Kirchner (1880–1938) and Käthe Kollwitz (1867–1945), used it as an independent medium.

C. Cennini: *Il libro dell'arte* (*c.* 1390); Eng. trans. and notes by D. V. Thompson jr as *The Craftsman's Handbook: 'Il libro dell'arte'* (New Haven, 1933/*R* New York, 1954)

J. Meder: *Die Handzeichnung* (Vienna, 1919); Eng. trans. by W. Ames as *The Mastery of Drawing* (New York, 1978)

J. Watrous: *The Craft of Old Master Drawings* (Madison, 1957/*R* 1975)

T. Jirat-Wasiutynski [T. Burns] and V. Jirat-Wasiutynski: 'Uses of Charcoal in Drawings', *Arts Magazine*, lv/2 (1980), pp. 128–35

V. Jirat-Wasiutynski: 'Tonal Drawing and the Use of Charcoal in Nineteenth-century France', *Drawing*, xi (1990), pp. 121–4

V. Jirat-Wasiutynski: 'The Charcoal Drawings of Odilon Redon', *Drawings: Masters and Methods, Raphael to Redon*, ed. D. Dethloff (London, 1992), pp. 145–58

T. Burns: 'Nineteenth-century Charcoal Drawing: The Evidence of the Technical Literature and the Works of Art', *Conservation of Historic and Artistic Works on Paper: Postprints of Symposium 88*, ed. H. D. Burgess (Ottawa, 1994), pp. 119–25

H. Stratis: 'Beneath the Surface: Redon's Methods and Materials', *Odilon Redon: Prince of Dreams, 1840–1916* (exh. cat. by D. W. Druick and others; Chicago, IL, Art Institute of Chicago; Amsterdam, Rijksmuseum Vincent van Gogh; London, Royal Academy of Arts; 1994), pp. 353–77, 427–31

C. Weingrod: 'The Essence of Charcoal', *American Artist*, lvii (Nov 1993), p. 10 and following

D. Cameron and C. Christov-Bakargiev: *William Kentridge* (London, 1999)

Chasing. *See under* TOOLING and METAL, §IV.

Chemitype. Method used in the 19th century to transform an intaglio plate into a relief block for the

convenience of printing illustrations simultaneously with type. It was invented in Denmark in 1846 by C. Piil. In the chemitype process a zinc plate was etched in the usual way, then fusible metal filings were melted on the plate, so as to run into the incisions. When cool, this metal coating was planed down to reveal the zinc, which was then etched away with hydrochloric acid, leaving the fusible metal as a relief cast of the intaglio design. Chemitypes were exhibited by the Imperial Printing Office of Vienna at the 1851 Great Exhibition in London, but, according to Wakeman, all English books illustrated by chemitype were produced in Denmark. They include several volumes about runic monuments by Professor George Stephens of Copenhagen University, spanning the years 1866–84.

G. Wakeman: *Victorian Book Illustration: The Technical Revolution* (Newton Abbott, 1973), pp. 59–60

I. Haugsted: 'Kobberstiksamlingens første fotograf: Opfinderen og guldsmeden Christian Piil', *Kunstmuseets årsskrift*, lxviii (1990), pp. 24–39

Chiaroscuro [Fr. *clair obscur*]. Term from the Italian compound of *chiaro* ('light', 'clear') and *scuro* ('dark') used to refer to the distribution of light and dark tones with which the painter, engraver or draughtsman imitates light and shadow; by extension it refers to the variations in light and shade on sculpture and architecture resulting from illumination. Chiaroscuro has four accepted current usages: (1) the gradations in light and dark values of a colour on a figure or object, which produce the illusion of volume and relief as well as the illusion of light and shadow; (2) the distribution of light and dark over the surface of the whole picture, which serves to unify the composition and creates an expressive quality; (3) monochrome pictures, including GRISAILLE paintings (in grey, black and white, usually in imitation of sculpture), painting en camaieu (painting in a single colour in imitation of cameos on pottery, porcelain and enamels (see CERAMICS, §I, 3) and graphics in a uniform colour with light and shadow indicated by hatching and stippling; (4) woodcuts in three or more tones made from successive blocks, a technique popularized in the 16th century by Lucas Cranach the elder (1472–1553), Ugo da Carpi (fl c. 1502–32), Hendrick Goltzius (1558–1617), Hans Burgkmair the elder (1473–1531) and others (see WOODCUT, CHIAROSCURO). The first two usages, the most frequent, are considered below.

The concept of chiaroscuro originated in Italian art theory in the 15th century. Cennino Cennini (*c.* 1370–*c.* 1440) described the way that painters use gradations of light and dark tones to create the illusion of relief. In practice, these gradations of light and dark emerged in the 13th century as a means of modelling form, supplanting the medieval techniques (called *incidendo* and *matizando*) of laying white and brown or black in linear patterns over a uniformly coloured surface to mark the protrusions and recessions of a relief. Late Gothic panel painters, such as Cimabue (*fl* 1272; *d* before 1302) and Giotto

(1267/75–1337), achieved gradations of light and dark tones of colour by mixing successively greater amounts of white with pigment to create four to six gradations of a given colour; these would then be applied using the lighter tones to indicate projections and the darker tones to indicate receding parts of figures; edges were blended or overlapped to create gentle transitions from one tone to another. In fresco and manuscript illuminations (as in works by Giotto, Master Honoré (*fl c.* 1288–1300) and Pietro Cavallini (*c.* 1240–after *c.* 1330), a technique of modelling from underneath was frequently employed; in this an underpainting of a dark colour would indicate the shadows, leaving the white of the page or wall to indicate the lights; when semi-transparent layers of coloured pigments were then superimposed, the chiaroscuro underpainting would affect the luminance of the final picture.

The technique of modelling from underneath became widespread in oil painting, particularly in the works of Leonardo da Vinci (1452–1519), who used much black and grey in his underpaintings. The prominence of Leonardo's example has led to the distinction between 'modelling in chiaroscuro', referring to the use of black in the shadows, and 'modelling in colour', referring to systems that use darker hues of colour to indicate shadow, as in CANGIANTI modelling.

The use of chiaroscuro as a means to create volume and relief remained characteristic of Western painting until the late 19th century, but the concept of chiaroscuro became broader. In the Italian Renaissance, it began to signify the imitation of light and shadow in the setting of the picture—not just the luminance gradations of modelling. Leon Battista Alberti (1404–72) identified the reception of light as the third part of painting, advocating that the painter should use white to represent light and black to represent shadow. Leonardo frequently equated *chiaro* and *scuro* with light and shadow in his notebooks: 'il chiaro e lo scuro, cioè il lume et le ombre'. It was in this sense that the words first appeared in print in *Il libro del cortegiano* (1528) by Baldassare Castiglione (1478–1529), in which he wrote that the painter imitates light and shadow with light and dark: 'col chiaro, & scuro'. A few passages by Leonardo also indicate a new way of thinking about chiaroscuro as a single entity rather than as a dichotomy: 'the *chiaro scuro* of the shadows' and 'the *chiaro scuro* of a tree'.

In the later 16th century, chiaroscuro also came to refer to works in monochrome and to prints in three colours. Giorgio Vasari (1511–74) used it to describe the black-and-white mosaics at Siena Cathedral by Domenico Beccafumi (1484–1551), grisaille paintings in imitation of relief sculpture, the woodcuts of Ugo da Carpi and the shaded drawings of Raphael (1483–1520).

In the 17th century, the concept of chiaroscuro expanded to include the organization and distribution of light and dark areas in the overall composition. Charles-Alphonse Du Fresnoy (1611–68) recommended that the painter achieve unity by creating one principal area of light and one principal mass of

shadow, with all other lights and shadows subordinate to them in size and intensity. In advocating the massing of light and shadow as the principal precept of chiaroscuro, Roger de Piles (1635–1709) frequently invoked a metaphor attributed to Titian (c. ?1485/90–1576), in which a painting was likened to a bunch of grapes: while each individual grape has its own particular light and shadow, all the grapes taken together present a general mass of light sustained by a broad mass of shadow; similarly, the figures and objects in a painting should be clustered into areas of illumination, full shadow and partial shadow, instead of treating the chiaroscuro of each independently. De Piles also extended the concept of chiaroscuro to include the arrangement of light and dark colours, whether or not they represented light and shadow.

This view dominated art criticism from the 18th to 19th centuries, with one significant change. In the late 18th century, Denis Diderot (1713–84) distinguished chiaroscuro from the representation of light and shadow: chiaroscuro was said to be based on the imagination of the painter, while light and shadow depended on scientific principles. This paved the way for a greater appreciation of the expressive potential of chiaroscuro in writings by Thomas Couture (1815–79), Charles Blanc (1813–82), John Ruskin (1819–1900) and others, where the selection of lighting conditions as well as the exaggeration of natural effects were understood as artifices to heighten sentiment. However, during the 17th and 18th centuries, the scientific theory of light and shadow continued to develop within the tradition of perspective treatises and artists' manuals in the writings of Matteo Zaccolini (1618–22), Pietro Accolti (1625), Pietro Testa (MS.; c. 1630–50), Jean Dubreuil (1642–8), Abraham Bosse (1648), André Félibien (1666–88), Henri Testelin (1696), Edme Sebastien Jeaurat (1750), Max Dupain (1786), Pierre-Henri Valenciennes (1799–1800), Etienne-Jean Delécluze (1828) and S. E. Warren (1867). A most original approach was taken by the physicist Johann Lambert (1760 and 1768), who, inspired by his collegue at the Berlin academy, the art theorist J. G. Sulzer (1720–79), quantified the sensible effects of brightness and devised an accurate colour-value scale to guide the painter in coordinating colour with chiaroscuro.

Most painters renowned for their use of chiaroscuro have made use of strong contrasts and large areas of shadow. Among them are Leonardo, Titian, Jacopo Tintoretto (1519–94), Michelangleo Merisi da Caravaggio (1571–1610) and most of the tenebrists, Rembrandt van Rijn (1606–69), Jacques-Louis David (1748–1825), Théodore Gericault (1791–1824) and Eugène Delacroix (1798–1863). At other times in history, however, critics have praised the lighter, natural chiaroscuro of Correggio (?1489–1534), Paolo Veronese (1528–88), Nicolas Poussin (1594–1664) and Domenichino (1581–1641). Polidoro da Caravaggio (c. 1499–c. 1543) is especially known for his chiaroscuros imitating ancient bas-reliefs. Many

modern artists, starting with the Impressionists and the Symbolists, have rejected chiaroscuro in order to preserve the beauty of unmixed colour and capture the brilliance of sunlight. The Cubists used random chiaroscuro, dissociating it from line and form; in their paintings, it ceases to function as an illusionistic device but rather creates a decorative pattern of light and dark over the picture surface.

A number of critical concepts have been associated with chiaroscuro. *Sfumato* (It.) is the rendition of blurred, transparent shadows along the contours and edges of interior details, which give the appearance of a veil of smoke. *Unione* (It.) refers to the gradual, imperceptible transition at the point where light and shadow come together. Sweetness (It. *dolcezza*), softness (It. *morbidezza*) and tenderness (It. *tenerezza*) have been regarded as ideal qualities in the practice of chiaroscuro and refer in various contexts to the transparency of shadows, gradual or soft transitions from light to shadow, blurred edges of shadow and the absence of strong contrasts of light and dark. *Passage* (Fr.) describes the placement of a light shadow or half-tone between masses of light, which, instead of separating them, unites them by serving as a smooth passage for the eye.

Early sources

C. Cennini: *Il libro dell'arte* (c. 1400); ed. D. Thompson (New Haven, 1932); Eng. trans. by D. Thompson as *The Craftsman's Handbook* (New Haven, 1933/R 1954)

L. B. Alberti: *On Painting and On Sculpture: The Latin Texts of De Pictura and De Statua* (1434); ed. C. Grayson (London and New York, 1972)

L. B. Alberti: *Della pittura* (1436); ed. C. Grayson (Bari, 1975)

Leonardo da Vinci: *Trattato della pittura*; ed. P. McMahon, 2 vols (Princeton, 1956) [facs. and trans.]

B. Castiglione: *Il libro del cortegiano* (Venice, 1528); Eng. trans. by G. Bull (Harmondsworth, 1967, rev. 1976)

G. Vasari: *Vite* (1550, rev. 2/1568); ed. G. Milanesi (1878–85)

M. Zaccolini: *Prospettiva del colore* (1618–22); in J. Bell: *Color and Theory in Seicento Art: Zaccolini's Prospettiva del Colore and the Heritage of Leonardo* (diss., Providence, RI, Brown University, 1983)

P. Accolti: *Lo inganno degli occhi* (Florence, 1625)

J. Dubreuil: *La Perspective pratique nécessaire à tous peintres, graveurs, sculpteurs, architectes, orfèvres, brodeurs, tapissiers, et autres qui se me ent de desseigner par un Parisien religieux de la Compagnie de Jésus*, 3 vols (Paris, 1642–8)

A. Bosse: *Manière universelle de M. Desarques pour pratiquer la perspective par petite-pied, comme le Géométral: Ensemble les places et proportions des fortes et foibles touches, teintes et couleurs* (Paris, 1648)

A. Félibien: *Entretiens sur les vies et les ouvrages des plus excellens peintres, anciens et modernes*, 5 vols (Paris, 1666–1688, 2/1725, R 1967); i and ii, ed. R. Démoris (Paris, 1987)

C.-A. Du Fresnoy: *De arte graphica* (Paris, 1668); Fr. trans. by R. de Piles as *L'Art de peinture de Charles-Alphonse Du Fresnoy, traduit en français, avec des remarques nécessaires et très amples* (Paris, 1668, 2/1673/R 1973); Eng. trans. by J. Dryden as *The Art of Painting…with Remarks* (London, 1695, 2/1716, 3/1750, rev. 1769)

H. Testelin: *Sentiments des plus habiles peintres sur la pratique de la peinture et sculpture, mis en tables de préceptes avec plusieurs discours académiques temps* (Paris, 1696/*R* 1972)

R. de Piles: *Cours de peinture par principes* (Paris, 1708); Eng. trans. as *The Principles of Painting* (London, 1743/*R* 1969)

E. S. Jeaurat: *Traité de perspective à l'usage des artistes* (Paris, 1750)

J. H. Lambert: *Photometria sive de mensure et gradibus luminis, colorum et umbrae* [Scale to measure the value and degrees of light, colours and shadows] (Augsburg, 1760)

J. H. Lambert: 'Mémoire sur la partie photométrique de l'art du peintre', *Mémoires de l'Académie de Berlin*, xxiv (1768), pp. 80–108

M. Dupain: *La Science des ombres par rapport au dessin* (Paris, 1786)

P.-H. Valenciennes: *Elémens de perspective pratique à l'usage des artistes* (Paris, 1799–1800/*R* 1973)

E. J. Delécluze: *Précis d'un traité de peinture, contenant les principes du dessin, du modelé, et du coloris, et leur application à l'imitation des objets et à la composition* (Paris, 1828)

J. Ruskin: *Modern Painters*, 4 vols (London, 1843–60)

J. Ruskin: *Stones of Venice*, 3 vols (London, 1851–3)

T. Couture: *Méthode et entretiens d'atelier* (Paris, 1866, rev. 2/1868); Eng. trans. by S. E. Stewart as *Conversations on Art Methods* (New York, 1879, 2/1881)

C. Blanc: *Grammaire des arts du dessin, architecture, sculpture, peinture* (Paris, 1867, 2/1870, 3/1876); Eng. trans. by K. Doggett as *The Grammar of Painting and Engraving* (New York, 1874) [3rd book]

S. E. Warren: *General Problems of Shades and Shadows* (New York, 1867)

C. Ravaisson-Mollien, ed.: *Les Manuscrits de Léonard de Vinci de la bibliothèque de l'Institut* (Paris, 1881–91)

Secondary literature

F. Severi: 'La luce e l'ombra nella pittura di Leonardo', *Il Vasari*, n. s., xvii (1959), pp. 123–8

H. Ruhemann: 'Leonardo's Use of Sfumato', *British Journal of Aesthetics*, i (1960–61), pp. 231–6

M. Rzepinska: 'Light and Shadow in the Late Writings of Leonardo da Vinci', *Raccolta vinciana*, xix (1962), pp. 259–66

J. Shearman: 'Leonardo's Color and Chiaroscuro', *Zeitschrift für Kunst*, xxv (1962), pp. 13–47

W. Strauss: *Chiaroscuro: The Clair-obscur Woodcuts by the German and Netherlandish Masters of the XVIth and XVIIth Centuries* (Greenwich and London, 1973)

J. M. Parramon: *Light and Shade for the Artist* (Kings Langley, 1975)

J. L. Whiteley: 'Light and Shade in French Neo-classicism', *Burlington Magazine*, cxvii (1975), pp. 768–73

J. Bury: 'The Use of Candlelight for Portrait Painting in Sixteenth-century Italy', *Burlington Magazine*, cxix (1977), pp. 434–6

J. Ackerman: 'Alberti's Light', *Studies in Late Medieval and Renaissance Painting in Honor of Millard Meiss*, ed. I. Lavin and J. Plummer (New York, 1978), pp. 1–28

C. Brandi: 'L'ombra in Giorgione', *Arte veneta*, xxxii (1978), pp. 85–7

R. Verbraeken: *Clair-obscur, histoire d'un mot* (Nogent-le-Roi, 1979) [philological study with extensive bibliog.]

E. Cropper: 'Poussin and Leonardo: The Evidence of the Zaccolini Manuscripts', *Art Bulletin*, lxii (1980), pp. 570–83

P. Marshall: 'Two Hitherto Unpublished Scholastic Discussions of the Perception of Depth by Shading', *Journal of the Warburg and Courtauld Institutes*, xliv (1981), pp. 170–75

J. Johnson: 'Ugo da Corpi's Chiaroscuro Woodcuts/I chiaroscuro di Ugo da Carpi', *Print Collector/Il conoscitore di stampe*, lvii–lviii (1982), pp. 2–87 [bilingual text]

C. Maltese: 'Gli studi di Leonardo sulle ombre tra la pittura e la scienza', *Arte lombarda*, lxvii (1983), pp. 95–101

P. Hills: *The Light of Early Italian Painting* (New Haven, 1986)

N. A. Bialler: *Chiaroscuro Wood-cuts: Hendrick Goltzius and his Time* (Amsterdam, [1992])

P. Taylor: 'The Concept of "houding" in Dutch Art Theory', *Journal of the Warburg and Courtauld Institutes*, lv (1992), pp. 210–32

V. I. Stoichita: *A Short History of the Shadow* (London, 1997)

E. Valdivieso: 'Zurbarán: Problèmes de chronologie et de style', *Gazette des beaux arts*, ser. 6, cxxxii (Oct 1998), pp. 185–92

P. Carofano: *Luce e ombra: Caravaggismo e naturalismo nella pittura toscana del Seicento* (Pisa, 2005)

M. van Berge-Gerbaud: *Chiaroscuro: Chiaroscuro Wood-cuts from the Frits Lugt Collection in Paris* (Tokyo, 2005)

J. van Gastel: 'Hoc opus exculpsit io. Bologna. Andreas Andreanus Incisit: Andrea Andreani's chiaroscuro houtsneden naar Giambologna', *Bulletin van het Rijksmuseum*, lv/1 (2007), pp. 14–39, 99–102

Chromium. Lustrous silvery metal obtained from lead chromates by smelting or aquaceous electrolysis. It was first produced *c.* 1797 in France and was named chrome (Gr.: 'colour') due to the pigments observed in its compounds. It is widely dispersed in natural deposits as dark brown to jet black chromite, the largest producer being Albania. Rarely used in its pure form, it is usually plated on to base metal above a coat of nickel, by a process that was first mentioned in 1854. As chromium is resistant to corrosion, it was used in World War I for projectile covers, although it was not until 1924 that it was commercially produced in the USA and Germany and later in Britain.

The decorative potential of its colour and brilliance was quickly and enthusiastically recognized by the innovative designers of the 1920s and 1930s, for example Le Corbusier (1887–1965), Eileen Gray (1879–1976) and Marcel Breuer (1902–81), who employed chromium-plated tubular steel in furniture (e.g. B32 side chair, 1928; New York, Museum of Modern Art). Lighting fixtures, clocks and such decorative articles as figurines and car mascots were also chromium-plated. Chromium was utilized with superb effect in jewellery, both by French avant-garde designers and in cheaper mass-produced work where it was often combined with plastics. It continued to be used after World War II but has gradually declined in competition with stainless steel.

A. H. Sully and E. A. Brandes: *Chromium* (London, 1967)

J. K. Dennis and T. E. Such: *Nickel and Chromium Plating* (London, 1972)

R.A. Rigney: 'A Mies Masterpiece', *ARTnews*, xcviii/9 (Oct 1999), pp. 118 and following

W. Tegethoff: 'La storia di un "trono": L'Archeologia della poltrona Barcellona', *Casabella*, Lxiv/684–5 (Dec 2000–Jan 2001), pp. 44–9

P. Harris and D. Lyon: 'This Not-so-old House', *Modernism Magazine*, iv/4 (Winter 2001–2002), pp. 50–56

I. C. Freestone and others: 'The Possible Early Use of Chromium as a Glass Colorant', *Journal of Glass Studies*, xlv (2003), pp. 183–5

Chromolithography. See under LITHOGRAPHY and PRINTS, §III, 6(ii)(b).

Chrysography. Term applied to gold writing in manuscripts. Two techniques have been used for writing in gold. In the older, chrysography with gold ink, powdered gold is mixed with glair or gum and used as ink, then burnished when dry. This is the method described by Theophilus, who stated that silver could also be used, or gold imitated with ground tin, dyed with saffron after burnishing. The second technique, mordant gilding, was developed in the 12th century. This involves writing in gum or glair and sticking gold leaf on to the letters before the mordant is dry. This was a much cheaper process since only a fraction of the amount of gold was used, but it is technically much more difficult. The mordant dries quickly, especially at the edges of the stroke, and when it is dry the gold will not stick. Usually red or yellow pigment was mixed with the mordant, which both camouflaged any bare patches and made the stroke easier to see when gilding. Other additions to the mordant were chalk, to give bulk and raise the letters, and sugar or honey, which slowed the drying process by making the mordant hygroscopic.

Suetonius: *The Twelve Caesars*, VI.x; Eng. trans. by R. Graves (Harmondsworth, 1957/*R* 1978), p. 214

D. V. Thompson: *The Materials and Techniques of Medieval Painting* (New York, 1956)

P. Metz: *The Golden Gospels of Echternach* (London, 1957)

J. G. Hawthorne and C. S. Smith, eds: *Theophilus On Divers Arts* (Chicago, 1963, rev. New York, 2/1979)

C. Nordenfalk: *Celtic and Anglo-Saxon Painting: Book Illumination in the British Isles 600–800* (London, 1977)

R. Kashnita, U. Mende and E. Rücker: *Das Goldene Evangelienbuch von Echternach* (Frankfurt am Main, 1982)

D. Bommarito: 'Il ms. 25 della newberry Library: La tradizione dei ricettari e trattati sui colori nel Medioevo e Rinascimento Veneto e toscano', *Bibliofilia*, lxxxvii/2 (1985), pp. 1–38

C. De Hamel: *A History of Illuminated Manuscripts* (Oxford, 1986, rev. 2/1994)

H. Mayr-Harting: *Ottonian Book Illumination*, 2 vols (London, 1991, rev. 2/1999)

K. P. Whitley: *The Gilded Page: The History and Technique of Manuscript Gilding* (London, 2000)

Cire perdue [Fr.: 'lost wax']. Method of hollow casting with wax (*see* METAL, §III, 1(iv)).

Claude glass [Claude Lorrain glass]. A small mirror, slightly convex in shape, with its surface tinted a dark colour. Carried in the hand, it was used by artists, travellers and connoisseurs of landscape and landscape painting. It has the effect of abstracting the subject reflected in it from its surroundings, reducing and simplifying the colour and tonal range of scenes and scenery to give them a painterly quality, similar in appearance to the work of Claude Lorrain (?1604/5–82), hence its name. A larger variant, which could be fixed to the side of a carriage window to reflect the passing scenery, also appears to have existed.

The Claude glass could be used either as an aid for painting, enabling the artist to assess the relative tonality of a particular scene, or simply in order to appreciate the scenes reflected in it. It is an interesting example of Art subduing Nature to its own purposes, especially as the viewer had to turn his back—both physically and metaphorically—on the 'real' landscape he wished to view. Not surprisingly, the greatest vogue for its use occurred during the days of European travel and the Grand Tour in the Romantic period at the end of the 18th century. In his biography of Thomas Gray (1882) Sir Edmund Gosse recorded that the poet 'walked about everywhere with that pretty toy, the Claude Lorrain glass, in his hand, making the forms of the landscape compose in its lustrous Chiaroscuro' as they would presumably have otherwise failed to do. William Gilpin (1724–1804) is still more explicit in his enthusiasm and preference for the scenes thus reflected over those in existence: 'The only picturesque glasses are those which the artists call Claud Loraine glasses… they give the objects of nature a soft, mellow tinge like the colouring of that master.' In the 19th century Camille Corot (1796–1875) was a late user of the Claude glass precisely because it imparted this tonal unity.

W. Gilpin: *Three Essays: On Picturesque Beauty, on Picturesque Travel, and on Sketching Landscape* (London, 1792; rev. 1808)

C. Ashwin: *Encyclopedia of Drawing* (London, 1982), pp. 16–20

A. Maillet: *Le mirror de Claud* (Marcellaz-Albanais, 1999); Eng. trans. as *The Claude Glass: Use and Meaning of the Black Mirror in Western Art* (New York, 2004)

Cliché-verre [Fr.: 'glass negative']. Name most widely used for the process that uses light to print or to transfer on to photo-sensitized paper a drawing rendered on a glass plate or other transparent or translucent surface (e.g. thin paper, plastic sheets or film). The resulting cliché-verre print has the characteristics of both printmaking and photography. Other names include *cliché-glace, dessin héliographique, dessin sur verre bichromaté, cliché photographique sur verre, autographie photographique, procédé sur verre*, photogenic etching, etching on glass, autograph etching and glass print.

1. MATERIALS AND TECHNIQUES. The cliché-verre process involves two basic steps. The artist first makes an image on a matrix (as in printmaking) that is transparent or partially transparent. Then the hand-drawn matrix is used in the manner of a photographic negative when it is superimposed on light-sensitive paper and exposed to light. The light acts as the printing agent, replicating the image on to the sheet below as a positive print, as in photography. Unlike other printmaking or photographic techniques, however, neither ink nor camera apparatus is used to

create a cliché-verre. While these basic steps do not change, materials, modes of drawing on the transparent or translucent plate and methods of printing photographically may vary.

The original method of producing a cliché-verre involves coating a transparent glass plate with an opaque pale-coloured ground (initially of collodion, later replaced by printer's ink dusted with powdered white lead). The artist then draws through the ground with an etching needle or other sharp instrument to reveal the glass plate surface. Although the resulting image is primarily a linear one, more tone can be created by varying the thickness of the lines, by hatching and crosshatching or by tapping the coated plate with the stiff bristles of a brush to obtain a dotted tonal area. The hand-drawn glass plate is then placed on light-sensitive paper and exposed to light, which passes through the drawn areas of the glass plate to darken the corresponding portions on the photographic paper below; wherever the opaque ground prevents the passage of light, the corresponding areas of the positive print remain in paler tones. During exposure, light strikes evenly through the scratched lines on the drawn plate, thereby transferring each line to the photo-sensitive paper with equal intensity. After exposure, depending on the type of photo-sensitive paper used, the cliché-verre print is usually developed or washed in the same way as is a photographic print.

Another method of making the cliché-verre 'negative' is more painterly. Opaque oil paint is brushed, finger-painted or blotted on the glass plate to make an image with modulated areas of opacity (or density). Details or outlines can be delineated through the paint with a pointed tool. This method results in a range of tonal effects in the final print: the thicker the opaque paint on the plate, the lighter the area in the print.

In the usual method of exposure, the drawn (or painted) side of the glass plate is in close contact with the photo-sensitive paper, resulting in a sharp and distinct printed image, albeit in reverse from the image drawn on the plate. To create a softer image, the plate can be placed with the clear surface of the glass against the paper (i.e. the drawn side face up). During exposure, the light bends and refracts as it passes through the thickness of the glass beneath the drawing, giving the lines and tones a diffused halo effect. This effect can be heightened by interposing a second piece of clear glass between the drawn plate and the paper; in such cases the drawing prints in the same direction as that in which it was drawn.

Artists in the 19th century made clichés-verre by either of these methods, printing on either salted or albumenized photographic paper, although occasionally the cyanotype or blueprint printing process was used. Since then the technique has become more elaborate, with a wider choice of transparent materials, image size and photo-sensitive surfaces (e.g. gelatin-silver print or other commercially prepared printing papers) and improved colour printing techniques (e.g. dye transfer, gum bichromate etc). Variations in

making a matrix image include drawing on plastic sheets (cellophane, acetate, Mylar), film or translucent paper; painting or manipulating viscous substances on plastic sheets; scoring or scratching exposed film; making a collage with translucent materials; manipulating film emulsion; and creating tonal effects with smoke or shadows on glass, plastic or film. Most hand-drawn negatives are contact-printed, although for larger prints the cliché-verre matrix may be placed in an enlarger. Depending on the printing process, the image may be printed in black and white, in monochrome or in colour; the print can also be enhanced with hand colouring.

The cliché-verre process has advantages as well as some drawbacks. While the technique of drawing on a transparent plate is easy to master, some photographic printing processes are complicated. Many materials are freely available, inexpensive and portable (compared with other printmaking processes), but some, such as glass or certain photo-chemicals, require careful handling. Light provides the means for identical printing of large editions of clichés-verre, but flat, undifferentiated tones are inherent in a light-printed medium. There are also conservation considerations. As might be expected in a print made with light-sensitive substances, prolonged exposure to light may cause the image to fade or discolour, despite careful processing; and if cliché-verre prints are improperly fixed, residual chemicals may cause the image to yellow or discolour. Although such unpredictable light effects are discouraging, many artists have been inspired to experiment and explore the printing possibilities and aesthetic merits of cliché-verre.

2. HISTORY. Cliché-verre evolved from experiments that triggered the invention of photography. Partly inspired by William Henry Fox Talbot's description (January 1839) of his 'photogenic drawings', which were contact-printed 'natural and artistic' objects on sensitized paper to achieve negative and positive, three English engravers—James Tibbitts Willmore (1800–63), William Havell (1782–1857) and his younger brother Frederick James Havell (1801–40)—announced their version of the process in March 1839. Their photographic process precisely replicated the work of an artist's pencil: 'Mr. J. F. [sic] Havell and Mr. Willmore have, by covering glass with etching ground and smoke, sketched designs upon it. Through the glass thus exposed by the scratches, the photogenic paper receives the light, and the design, which the sun may be said to print, may be multiplied with perfect identity forever!' (Literary Gazette, London, 23 March 1839, p. 187). Unfortunately, few early English examples exist, since despite the initial excitement over the discovery, the process was regarded as more of a curiosity than a viable artistic medium. The earliest extant 'etching on glass' is the portrait of Peter Wickens Fry by George Cruikshank (1792–1878) (1851; Austin, TX, University of Texas, Harry Hunt Ransom Humanities Research Center). In 1864 the London

publisher Joseph Cundall (1818–95) issued the illustrated pamphlet *Electrophotography or Etching on Glass*. The American painter and illustrator John W. Ehninger (1827–89) brought cliché-verre to the American public with his 1859 album *Autograph Etchings by American Artists*, which included 12 illustrations. There were other minor cliché-verre inventors, but the artistic importance of the medium relies on the prints made from 1853 to 1874 by the French artists Camille Corot (1796–1875), Charles-François Daubigny (1817–78), Eugène Delacroix (1798–1863), Paul Huet (1803–69), Jean-François Millet (1814–75) and Théodore Rousseau (1812–67).

In 1921 the Parisian art dealer and publisher Maurice LeGarrec issued *Quarante clichés-glace*, a portfolio of reprints of 19th-century cliché-verre plates by Corot, Daubigny, Delacroix, Millet and Rousseau in an edition of 150. Although these modern impressions were black-toned, unlike the characteristic brown tones of 19th-century impressions, the portfolio increased public awareness of the process.

In the 20th century the medium interested painters, printmakers and photographers sporadically. The best-known artists to have dabbled experimentally in cliché-verre are Paul Klee (1879–1940), Man Ray (1890–1976), Max Ernst (1891–1976), Brassaï (1899–1984) and Pablo Picasso (1881–1973). Between the 1930s and the 1980s several American photographers, although unaware of their predecessors in the medium, made camera-less, abstract photographs that were essentially clichés-verre: Francis Bruguière (1880–1945), György Kepes (1906–2001), Henry Holmes Smith (1909–86) and Frederick Sommer (1905–99). Most of these clichés-verre were printed on black-and-white, or gelatin-silver, photographic paper. From 1957 and throughout the 1960s Caroline Durieux (1896–1989), an American printmaker in Baton Rouge, LA, adapted the colour dye-transfer photographic technique to make clichés-verre in colour. Since 1968, and particularly during the 1970s, printmakers and photographers in several American university art departments, most notably in Detroit, MI, have enthusiastically sustained Durieux's innovative technique, along with traditional and experimental cliché-verre methods. Nevertheless, no major 20th-century artist of equal stature to Corot has created a substantial body of work in the cliché-verre medium.

G. Hédiard: 'Les Procédés sur verre', *Gazette des beaux-arts*, n. s. 3, xxx (1903), pp. 408–26

L. Delteil: *Le Peintre-graveur illustré*, 31 vols (Paris, 1906–30/*R* New York, 1969) [D]

O. H. Barnard: 'The "Clichés-verre" of the Barbizon School', *Print Collector's Quarterly*, ix/2 (1922), pp. 149–72

M. Melot: *L'Oeuvre gravé de Boudin, Corot, Daubigny, Dupré, Jongkind, Millet, Théodore Rousseau* (Paris, 1978), pp. 21–4, 262–7, 282, 283, 290, 292

E. Glassman and M. F. Symmes: *Clichés-verre: Hand-drawn, Light-printed, a Survey of the Medium from 1839 to the Present* (Detroit, 1980)

W. Halstenberg: *Cliché-verre: Zur historischen Funktion eines Mediums* (Munich, 1985)

A. Paviot: *Le cliché-verre: Corot, Delacroix, Millet, Rousseau, Daubigny* (Paris, 1994)

M. R. Mason: 'Les clichés-verre de Corot: Objets de la modernité', *Corot, un artiste et son temps: Actes du colloques, Paris, 1–2 mars 1996*, pp. 43–58

A. Baldessari: 'Picasso, l'expérience des clichés-verre: Un collaboration avec Dora Maar;, *Revue du Louvre et des musées de France*, Xlix/4 (Oct 1999), pp. 72–80

Coated fabric. See LEATHER, IMITATION.

Codicology. Term used to describe the study of physical aspects of the medieval handwritten book or manuscript. Codicological studies are also described, or referred to, as the archaeology of the book. As a discipline or science the fundamental philosophical and methodological principles of codicology are still being debated. For some, codicology is an area of study more or less complete in itself: the examination of materials, tools and techniques. For others, codicology only supports the older disciplines of textual analysis, criticism and transmission, the study of scribes and scripts, the history of illumination and decoration and the history of book collections and libraries.

L. E. Boyle: *Medieval Latin Palaeography: A Bibliographical Introduction* (Toronto, 1984)

D. Muzerelle: *Vocabulaire codicologique* (Paris, 1985)

Introduction à la codicologie (Louvain-la-Neuve, 1989)

M. Beit-Arié: *The Makings of the Medieval Hebrew Book: Studies in Palaeography and Codicology* (Jerusalem, 1993)

R. Gameson, ed.: *The Early Medieval Bible: Its Production, Decoration, and Use* (Cambridge, 1994)

Coffering. Type of panelling on a ceiling, in which beams are interspersed with crossbeams; the spaces created between them are called the coffers.

1. Western. 2. Islamic

1. WESTERN.

(i) Greek and Roman. In ancient Greek architecture flat ceilings were usually made with long beams of stone or wood interspersed with short crossbeams; the coffers between carried elaborate decorations, such as the rosettes found in the east cella of the Erechtheion at Athens (421–405 BC) and the lotus flowers of the peristyle of the Thymele at Epidauros (4th century BC). Greek coffers were often surrounded by an astragal, as at the Erechtheion. Sometimes coffers were decorated with paint, as in the Propylaia on the Acropolis at Athens (437–432 BC).

The coffers of the ceilings of ancient buildings do not often survive, since the roofs themselves do not survive. There are, however, remains of the sunken coffers in the dome of the Pantheon in Rome (*c.* AD 118–*c.* 125; see fig.). They were designed to exaggerate the perspective of the dome: the series gradually gets smaller towards the top and the individual coffers have sloping sides, being wider at the bottom than the top. Their decoration is lost. There are also

Coffered ceiling of the interior of the Pantheon, Rome, *c.* AD 118–27; photo credit: Vanni/Art Resource, NY

remains of the sunken hexagonal coffers in the vault of the basilica of Maxentius in Rome (*c.* AD 306–*c.* 325). Coffers such as these of the Roman period were usually sunk in the concrete forming the vault or dome of the building, whereas the Greek ones were made of stucco overlying the rafters. The coffers sunk in the vault of the arches of triumphal arches such as those of Titus (AD 81) or Septimius Severus (AD 203) in Rome or the arch at Arausio (now Orange; after AD 21) merely add to the decorative value of these monuments; unlike Greek coffers, they are not structurally necessary. Finally, the coffering in the peristyle of the 'Temple of Bacchus' at Baalbek is partially extant, decorated with busts of neighbouring cities (2nd century AD).

D. S. Robertson: *A Handbook of Greek and Roman Architecture* (Cambridge, 1929, rev. 2/1943); repr. as *Greek and Roman Architecture* (London, 1969)

A. W. Lawrence: *Greek Architecture*, Pelican History of Art (Harmondsworth, 1962, rev. 4/1983)

H. Saalman: 'The Pantheon Coffers: Pattern and Number', Architectura, xviii/2 (1988), pp. 121–2

K. Tancke: 'Deckenkassetten in der griechischen Baukunst', *Antike Welt*, xx/4 (1989), pp. 24–35

W. Hoeopfner: 'Bauliche Details am Pergamonaltar', *Archäologischer Anzeiger*, ii (1991), pp. 189–202

(ii) Renaissance and after. During the Renaissance, coffering, or the insertion of an infill panel between the beams of a flat ceiling as a means of articulating the curved inner surfaces of a vault or dome, regained its Classical importance as a decorative feature. Acting as a light mesh between a web of beams, coffering often retained its structural validity as its surface was stepped down in cantilevered slabs to reduce the size of the final panel, and even this stepping device was used to evolve decorative patterns. Thus the flat, recessed surface of the panel was separated from the structural beams by rolled mouldings in cyma recta, ovolo or egg-and-dart, and the central panel became a field for the carving or painting of circular patterns, often in the form of rosettes or other natural foliage. Coffering was a favourite device for painters to emphasize perspective recession and concentrate attention on a central feature in a painting as, for example, in the *Trinity* (*c.* 1427) by Masaccio (1401–28) in S Maria Novella at Florence and in the Montefeltro Altarpiece (Milan, Pinacoteca di Brera) of the mid-1470s by Piero della Francesca (*c.* 1415–92).

Inspired by such Roman examples as the Pantheon, Leon Battista Alberti (1404–72) wrote that 'the ornaments of vaulted roofs, which consist in the forms of their panels or excavations, are in many places exceedingly handsome, and particularly in the Rotonda at Rome' (*De re aedificatoria* VII.xi). But, he complained, 'we have nowhere any instruction left us in writing how to make them'. This did not prevent him from using deep coffering in the vaulting of S Andrea (begun 1472) at Mantua, or many other

Renaissance architects from following his example, as can be seen in the Pazzi Chapel (1442–*c.* 1465) and in the dome by Michelangelo (1475–1564) of his New Sacristy (begun 1579) at S Lorenzo, both in Florence.

Sebastiano Serlio (1475–?1553/5) (*De architettura III*; 1540) illustrated the coffering in the vault of the Pantheon together with drawings showing the potential for intricate patterns which could be created to form coffering. Panels, though usually square, could be rectangular, octagonal or formed in a variety of shapes. In subsequent developments, mouldings were adjusted in profile to allow for foreshortening when seen from below. By the beginning of the 16th century elaborate decoration gave way to the use of a play of line on flat surfaces as, for example, on the vault of the choir (completed 1509) by Donato Bramante (?1443/4–1514) in S Maria del Popolo in Rome, where the architect created a coffered vault with a succession of plain, flat surfaces to delineate his fascination with proportional relationships. Thus it can be seen that, from the time of the Renaissance, coffering became an important device in both the decorative and the proportional exploitation of architectural and artistic surfaces. It has continued to be used in historicist revivals down to the 20th century, as in the central hall of the eclectic extensions (1906–9) by German Bestelmeyer (1874–1942) to Munich University.

J. Q. Hughes and N. Lynton: *Renaissance Architecture* (London, 1962), p. 72

P. J. Jacks: 'Alexander VI's ceiling for S Maria Maggiore in Rome', *Römisches Jahrbuch für Kunstgeschichte,* xxii (1985), pp. 63–82

2. ISLAMIC. Wooden coffering was used in the Islamic architecture of the Mediterranean lands and the Yemen, but not in the eastern Islamic world, where wood was scarce and vaulted brick ceilings prevailed. The technique of creating a ceiling with long wooden beams carrying short crossbeams to support the planks of the ceiling itself had long been known in the Mediterranean lands. The earliest preserved example in Islamic architecture is found in the ceiling of the ambulatory of the Dome of the Rock in Jerusalem (AD 691–2). Fragments of coffered ceilings are found at the Great Mosque at Kairouan (Tunisia), where painted beams of the 9th century and coffered and painted ceilings of the 11th have been preserved. Coffered ceilings were also used in Spain, for the Umayyad caliph al-Hakam II (*reg* 961–76) ordered a lavishly carved and painted coffered wooden ceiling for the Great Mosque of Córdoba. The halls of Madinat al-Zahra', the palace-city founded outside Córdoba in the 10th century by the Umayyads, were also covered with coffered wooden ceilings, the beams of which were supported by carved wooden consoles. This type of ceiling was used in Mudéjar buildings of the 12th and 13th centuries, for example at the Romanesque church of S Millan in Segovia and the chapter house of the monastery of Sigena (Huesca; destr. 1936), and

continued in Spain until the late 17th century. Several examples of coffered ceilings are preserved in the Islamic architecture of Cairo. The tomb of Imam al-Shafi'i (1211) has a wooden ceiling with 20 octagonal coffers, a type that remained popular for centuries. The most splendid examples are found in the complex of Qala'un (1284–5), where several types of elaborately gilded and decorated coffers are combined. Coffered ceilings were also used in secular architecture (e.g. the mid-14th-century palaces of Beshtak and Amir Taz). Coffering was also used in the Yemen. The east hall of the Great Mosque of San'a, for example, preserves a beautifully carved and painted ceiling ascribed to the late 9th century, and many later examples have survived.

K. A. C. Creswell: *A Short Account of Early Muslim Architecture* (Harmondsworth, 1958); rev. 2, ed. James W. Allan (Aldershot, 1989)

K. A. C. Creswell: *The Muslim Architecture of Egypt,* ii (Oxford, 1959), pp. 68, 193

M. Salcedo Hierro: *La Mezquita, catedral de Córdoba* (Córdoba, 2000)

Collage [Fr. *coller*: 'to stick, glue']. Art form and technique, incorporating the use of pre-existing materials or objects attached as part of a two-dimensional surface. Despite occasional usage by earlier artists and wide informal use in popular art, collage is closely associated with 20th-century art, in which it has often served as a correlation with the pace and discontinuity of the modern world. In particular it often made use of the *objet trouvé*, while the principle of collage was extended into sculpture in the form of the assemblage. The first deliberate and innovative use of collage in fine art came in two works by Pablo Picasso (1881–1973) in the spring of 1912. In *The Letter* (untraced, see Daix and Rosselet, cat. no. 275) he pasted a real Italian postage stamp on to a depicted letter, while *Still-life with Chair-caning* (Paris, Musée Picasso) included printed oil-cloth simulating a chair-caning pattern, the oval canvas surrounded by a 'frame' made of a continuous loop of rope. Picasso followed this by affixing a piece of gingerbread (untraced) to the lower part of *Guitare: 'J'aime Eva'* (artist's estate, see Daix and Rosselet, cat. no. 282) from the summer of 1912. His Cubist colleagues were meanwhile experimenting with adapting the technique for their own purposes. Juan Gris (1887–1927) added fragments of a mirror, for example, to the *Hand Basin* (private collection, see Cooper, p. 47), which he sent to the *Salon de la Section d'Or* in October 1912, where the first Cubist collages were publicly exhibited. At about the same time Georges Braque (1882–1963) purchased imitation wood-grain paper, generally used for interior decoration, at a shop in Avignon. By combining this *faux bois* paper, affixed to a white sheet, with drawing, Braque created the papier collé ('pasted paper'), a specific form of collage, closer to traditional drawing than to painting, consisting essentially of a collage of paper elements with a paper support (e.g. *Glass and Playing Cards*, 1912; Los Angeles, CA, County

Museum of Art). Braque and then Picasso made many papiers collés in the last three months of 1912 and in early 1913, with Picasso often using cuttings from the newspaper *Le Journal* to introduce the possibility of allusion to everyday events in the very fabric of the work, whereas Braque tended to restrict himself to the more abstract wood-grain papers, carefully arranged for formal effect. Picasso also developed the idea of collage into three-dimensional work with the first assemblages, such as the cardboard *Guitar* (1912; New York, Museum of Modern Art).

In 1914 collages were produced with more complex materials by Picasso, Braque and especially Gris, who imitated the effects of painting in dense networks of dozens of cut and pasted papers (see colour pl. X, fig. 2). The technique was also adopted by such Italian artists as Umberto Boccioni (1882–1916), Carlo Carrà (1881–1966), Gino Severini (1883–1966) and Ardengo Soffici (1879–1964), and by Kazimir Malevich (1878–1935), who affixed new materials such as a thermometer, for example, in *Soldier of the First Division* (1914; New York, Museum of Modern Art). Carrà, working with the Futurist poet Filippo Tommaso Marinetti (1876–1944), developed the hybrid *dipinto parolibero* ('free-word painting') to describe their word-poems in collage. Much of this spirit of experimentation did not, however, survive the first year of World War I, and subsequently these artists rarely, if ever, used collage. The Dadaists, however, adapted it to their own ends. Hans Arp (1886–1966) produced abstract collages such as *Untitled* (1915; Berne, Kunstmuseum), and Kurt Schwitters (1887–1948) used the form extensively, notably in his series of *Merzpictures* (*Merzbilder*), made from discarded materials found in the streets of Hannover. Other artists associated with the Berlin Dada group used photographs and newspaper cuttings in a political, satirical and socially critical fashion (*see also* PHOTOMONTAGE). Max Ernst (1891–1976) also began experimenting with collage and developed the 'collage–novel', pasting paper on old engravings of narrative scenes to create the visual, dream-like 'text' of *La Femme 100 Têtes* (1929), for example. Another important Surrealist collagist, especially in the late 1920s and 1930s, was Joan Miró (1893–1983) (e.g. *Painting–Collage*, 1934; Philadelphia, PA, Museum of Art), while at the same time abstract collage was further developed by El Lissitzky (1890–1941) and other Constructivists. More recently the possibilities of fantasy and disjunction on one hand (in the work of Joseph Cornell (1903–72), for example) and a recurrent interest in material texture and shape on the other (in the work of Ann Ryan (1899–1954) and Jean Dubuffet (1901–85)) continued to attract the attention of 20th-century artists. In the USA Robert Motherwell (1915–91) used collage extensively in the 1940s and 1950s, while Lee Krasner (1908–84) produced important collages by cutting up and reusing her paintings and drawings. In Europe in the 1950s Raymond Hains (1926–2005) and other artists associated with Nouveau Réalisme, such as François Dufrêne (1930–82) and Mimmo Rotella (1918–2006),

experimented with *décollage*, a process of stripping away layers of glued paper. In the 1960s Robert Rauschenberg (*b* 1925) and many artists associated with Pop art also used collage extensively to reflect the omnipresence of the printed word and image in modern society, as well as Richard Hamilton (*b* 1922), who continued to apply paper and *objets trouvés* in his works. In the decorative arts the influence of collage was reflected in embroidery. Although pure sticking techniques only replaced stitching briefly during the 1960s, embroiderers continued to produce combinations of fabric, paper and other materials.

H. Wescher: *Collage* (New York, 1968)

D. Cooper: *Juan Gris* (Paris, 1977)

P. Daix and J. Rosselet: *Le Cubisme de Picasso: Catalogue raisonné de l'oeuvre, 1907–1916* (Paris, 1979)

Georges Braque: Les Papiers collés (exh. cat. by E. A. Carmean jr and I. Monod Fontaine, Washington, DC, National Gallery of Art; Paris, Centre Georges Pompidou; 1982)

L. Kachur: 'Gris, cubismo y collage', *Juan Gris, 1887–1927* (exh. cat., ed. G. Tinterow; Madrid, Salas Picasso, 1985), pp. 33–44

E. F. Fry: 'Picasso, Cubism, and Reflexivity', *Art Journal* [New York], xlvii (1988), pp. 296–310

K. Varnedoe and A. Gopnik, eds: *High & Low: Modern Art and Popular Culture* (New York, 1990)

C. Poggi: *In Defiance of Painting: Cubism, Futurism and the Invention of Collage* (New Haven and London, 1993)

E. Adamowicz: *Surrealist Collage in Text and Image: Dissecting the Exquisite Corpse* (Cambridge, 1998)

B. Taylor: Collage: *The Making of Modern Art* (London, 2004)

Mestres del collage: De Picasso a Rauschenberg (exh. cat. by D. Walkman, D. B. Kuspit and C. Ratcliff; Barcelona, Fundació Joan Miró, 2005)

Collagraph [collage intaglio; collagraphy]. Printmaking technique in which the plate is constructed of adhered elements. A collagraph plate can be inked in both relief and intaglio, and an embossed impression can be obtained by printing the plate dry without inking it. It can be combined with other techniques, for example by incorporating etched or photo-etched plates on to the collagraph plate. The origins of the technique probably lie in the one-off collages of artists such as Paul Klee (1879–1940), Pablo Picasso (1881–1973) and Kurt Schwitters (1887–1948). Its earliest developed use as a collage technique applied to printmaking is by Rolf Nesch (1893–1975), who referred to his prints as metalcuts. In 1932 Nesch started to solder pieces of metal to his plates, drill the plates and sew elements together with metal wire. Early, American examples of adherents applied to plates are the prints of Boris Margo (1902–95), who used celluloid dissolved in acetone to build up areas on a celluloid plate. He then embedded textures and materials into the plate and scratched it to achieve further texture (e.g. *Night of the Atom*, cellocut, 1946). Other materials used in collagraph prints include cardboard, paper, cloth and chipboard. The invention of water-based acrylic adhesives in the mid-1950s opened up new possibilities for quickly and permanently fixing materials to the matrix. Other

artists to use the collagraph technique include Anne Ryan (1889–1954), Edward Stasack (*b* 1929), James [Jim] Louis Steg (1922–2001), Dean Meeker (1920–2002) and Clare Romano (*b* 1922).

M. A. Wenniger: *Collagraph Printmaking* (London, 1975)

C. Romano and J. Ross: *The Complete Collagraph: The Art and Technique of Printmaking from Collage Plates* (London, 1980)

Books by John Ross, Books by Clare Romano, 2 vols (exh. cat. by J. Brodsky; Piscataway, NJ, Rutgers University Libraries, 2000)

Collotype [Fr. *phototypie*; Ger. *Lichtdruck*]. First viable commercial printing process capable of translating the continuous tones of photography into the permanency of printer's ink. Patented in 1855 by the Frenchman Alphonse Louis Poitevin (?1819–82), the technique involved printing from a surface of photosensitized gelatin, hence its English name (from Gr. *kolla*: 'glue'). During the 19th century collotype was called by a bewildering variety of names: some, such as 'Photopane', 'Hoeschotype' and 'Autotype Mechanical Process', deriving from the names of individuals or companies who adopted it and others, such as 'photogelatine process', referring to its technical features. 'Ink photos', made by transferring to lithographic stone an image developed as a coarse collotype grain on gelatin, were used in the 1880s before relief half-tones were possible.

1. MATERIALS AND TECHNIQUES. Modern collotypes are made by pouring a solution of gelatin and potassium bichromate over a sheet of plate-glass. When dry, the plate is placed in contact with a continuous tone negative and exposed to light. Where the light shines through the negative and strikes the sensitized gelatin, the coating hardens in such a way that it later rejects moisture but accepts printing ink. Where the sensitized gelatin is completely or partially protected from light by the blacks and greys in the negative, it will reject or selectively accept printing ink in proportion to its exposure. Gelatin crazes as it dries, forming a reticulation of surface cracks that provide a natural, rather than a mechanical, half-tone. This feature identifies collotype, which, under magnification, displays a characteristic random ink pattern like fine crinkling.

The subtlety of collotype for reproducing drawings, watercolours and prints has never been surpassed. However, registration proved fickle in humid conditions, and the process has now been largely superseded by screenless photolithography.

2. HISTORY. Poitevin, collaborating with the Paris lithographer Rose-Joseph Lemercier (1807–87), first used his sensitized coating on lithographic stones. Adhesion proved problematic, however, as it did for C. M. Tessié du Motay (1819–80) and Charles-Raphael Maréchal who in the mid-1860s substituted copper for their 'phototypes'—a name first given to an experiment of 1860 by F. Joubert. It was Josef Albert (1825–86) of Munich who introduced plate-glass and a double layer of emulsion to improve adhesion, hardening the underside by exposure through the

back of the plate; he exhibited his 'Albertotypes' at the third Deutsche Photographische Ausstellung in Hamburg in 1868. In November 1869 Albert received the first American patent for the process; it was used under the name of Artotype for the remainder of the century. In Prague Jakob Husnik (1839–1916) had arrived at a viable method simultaneously. Albert bought him out to remove competition, using the first powered collotype presses in 1873, which allowed editions of a few thousand. He introduced three-colour collotype a year later.

Max Gemoser reverted successfully to the use of stone in Munich in 1868, coining the name 'Lichtdruck', the most common term for the process in Germany. In England the process was patented in October 1869 by a subsidiary of the Autotype Company and used extensively for book illustration. In December 1869, Ernest Edwards (1837–1903) patented a version called 'Heliotype'. Edwards toughened the gelatin with alum, removed the film from the glass, adhered it to pewter and then printed simultaneously with two inks—a stiff one for the deepest shadows and a thinner one for lighter tones. Edwards moved to the USA in 1872. In the 1880s he was associated with the New York Photogravure Company which produced the 781 plates for *Animal Locomotion* (1887; see fig.) by Eadweard Muybridge, one of the most complex undertakings in the history of collotype.

Collotype was at its peak from 1870 to 1890 and was used, according to Wakeman, for some 4–5% of quality book production. Colour collotype, first used in England in August 1891, was used in France for 32 prints by artists in the 24 portfolios of *L'Estampe moderne* (1897–9). It was taken up by the Medici Society early in the 20th century for the reproduction of Old Master drawings, a tradition maintained by the Trianon Press, which used it to reproduce all the books of William Blake (1757–1827). Collotype has also been used for limited edition reproductions, such as the frottages of Max Ernst (1891–1976) for *L'Histoire naturelle* (Jeanne Bucher, 1926) and those after watercolours by William Russell Flint (1880–1969), and in the 1970s after paintings by Norman Rockwell (1894–1978) and Andrew Wyeth (*b* 1917). It has also been used for original prints by a few artists. In 1949 Henry Moore (1898–1986) experimented for Ganymed with an adaptation of the process, which he called collograph; the colour prints he produced, such as *Woman Holding Cat* (1949), were the sum of several hand-drawn monochrome separations made on transparent film for transfer to collotype plate. Another English artist, Richard Hamilton (*b* 1922), made more than 20 collotypes in the 1970s and 1980s, working closely with the technicians at Schreiber, first using the process in combination with screenprinting in *A Portrait of the Artist by Francis Bacon* (1970–71; see Hamilton, no. 76).

By the 1990s collotype had all but died out commercially, although in March 1994 Karl Nolle founded Lichtdruck Werkstatt in Dresden, a 'living museum' where exquisite collotypes are printed from stone up to 1.18×0.84 m in size. The last British company, Cotswold

Collotype by Eadweard Muybridge: *Woman Ricocheting on One Foot*, 263×295 mm, printed in *Animal Locomotion, c.* 1887; (Washington, DC, Smithsonian American Art Museum); photo credit: Smithsonian American Art Museum, Washington, DC/Art Resource, NY

Collotype, collaborated in the 1970s with the Royal Photographic Society, producing reproductions of historical photographs. Dates of other celebrated collotype companies are as follows: Meriden Gravure, 1888–1967; Black Box Collotype, Chicago, 1948–mid-1980s; Triton, 1949–86; Trianon, Paris, late 1940s–1980; Ganymed, England, 1949–63. The pre-eminent Viennese firm Max Jaffé (1875–early 1990s) was renowned for its superb fine art reproductions. Its American subsidiary, the Arthur Jaffé Heliochrome Company, closed in the 1980s, but Thomas Reardon bought 6000 of Jaffé's plate glass negatives and re-established it as a private press in Dalton, MA. Collotype also survives at Kent Kirby's Light-print Press in Riverdale, MI, begun in 1975. Through his efforts several American universities teach the process.

F. Joubert: 'The Phototype Printing Process', *Journal of the Photographic Society*, vi (1860), p. 287 [recent research suggests Joubert's image was really a carbon print]

E. Edwards: 'On Heliotypy as a Means of Reproducing Works of Art', *Photographic News*, xiv (1870), pp. 538–9, 559–60

E. Edwards: 'Improvements in Photo-collographic Printing', *Photographic News*, xv (1871), pp. 566–7

E. Edwards: *The Heliotype Process* (London, 1874)

J. Schnauss: *Collotype and Photolithography Practically Elaborated*, trans. by E. C. Middleton (London, 1889, 2/1895)

W. T. Wilkinson: *Collotype* (London, 1895)

A. Albert: *Lichtdruck* (Halle, 1898)

A. Albert: *Die verschiedenen Methoden des Lichtdruckes* (Vienna, 1900)

A. W. Fithian: *Practical Collotype* (London, 1901)

J. M. Eder: *Geschichte der Photographie* (Vienna, 1905, rev. Halle, 4/1932; Eng. trans., New York, 1945/R 1978), pp. 554, 563, 617–21, 646–7, 653–4

R. M. Burch: *Colour Printing and Colour Printers* (London, 1910/R New York, 1980)

T. A. Wilson: *The Practice of Collotype* (Boston, 1935)

H. Gernsheim and A. Gernsheim: *The History of Photography, 1685–1914: From the Camera Obscura to the Beginning of the Modern Era* (New York, 1969), pp. 545–7

G. Cramer, A. Grant and D. Mitchinson: *Henry Moore: Catalogue of Graphic Works* (Geneva, 1973)

G. Wakeman: *Victorian Book Design: The Technical Revolution* (Newton Abbott, 1973), pp. 111–18

Henry Moore: Graphics in the Making (exh. cat. by P. Gilmour, London, Tate, 1975), pp. 13–14, 32–3

W. Crawford: *The Keepers of Light* (New York, 1979)

S. Chayt and M. Chayt: *Collotype: Being a History, Practicum, Bibliography* (Winter Haven, 1983)

R. Hamilton: *Richard Hamilton Prints, 1939–83: A Complete Catalogue of Graphic Works* (Stuttgart, 1984)

K. Rush: 'Collotype Printing from Film Matrices', *Tamarind Papers*, x (1987), pp. 79–84

Imperishable Beauty: Pictures Printed in Collotype (exh. cat. by H. E. Wright; Washington, DC, National Museum of American History, 1988)

K. B. Kirby: *Studio Collotype: Continuous Tone Printing for the Artist, Printmaker and Photographer* (Dalton, MA, 1988)

R. Hamilton: 'Endangered Species', *Tamarind Papers*, xiii (1990), pp. 34, 94

L. Nadeau: *Encyclopedia of Printing, Photographic, and Photomechanical Processes*, 2 vols. (Fredrickton, 1989–1990)

Computer art. Term formerly used to describe any work of art in which a computer was used to make either the work itself or the decisions that determined its form. Computers became so widely used, however, that in the late 20th century the term was applied mainly to work that emphasized the computer's role. It can cover artworks that use computers or other digital technology not only for their creation but for their display or distribution. It can also include interactive works, installation art and art created for the internet.

1. HISTORY. Such calculating tools as the abacus have existed for millennia, and artists have frequently invented mathematical systems to help them to make pictures. The golden section and the formulae of Leon Battista Alberti (1404–72) for rendering perspective were devices that aspired to fuse realism with idealism in art, while Leonardo da Vinci (1452–1519) devoted much time to applying mathematical principles to image-making. After centuries of speculations by writers, and following experiments in the 19th century, computers began their exponential development in the aftermath of World War II, when new weapon-guidance systems were adapted for peaceful applications, and the term 'cybernetics' was given currency by Norbert Wiener (1894–1964). After the war, 'mainframe' computers, which first used vacuum tubes and later transistors and silicon chips, became widespread in their application. Their prohibitive size and cost, however, restricted their use to government agencies, major corporations, universities and other large institutions. It was at these institutions that early attempts at using computers to create simple geometric visual images were carried out. Artists began to exploit computers' ability to execute mathematical formulations or 'algorithms' from 1950, when Ben F. Laposky (*b* 1930) used an analogue computer to generate electronic images on an oscilloscope. Once it was possible to link computers to printers, programmers often made 'doodles' between their official tasks. From the early 1960s artists began to take this activity more seriously and quickly discovered that many formal decisions could be left to the computer, with results that were particularly valued for their unpredictability.

The first exhibition of computer art as such appears to have been an exhibition called The World of Computer Graphics held at the Howard Wise Gallery, New York in 1965. Throughout the 1960s and 1970s, as computer graphics programmes were developed for industrial and broadcast-television uses, increasing numbers of artists began to take advantage of these technologies. From the mid-1970s the painter Harold Cohen (*b* 1928) developed a sophisticated programme, AARON, which generated drawings that the artist then completed as coloured paintings. Although the computer became capable of that task as well, Cohen continued to hand-colour computer-generated images (e.g. *Socrates' Garden*, 1984; Pittsburgh, PA, Buhl Science Center).

Until *c.* 1980 graphic output was relatively slow: the artist entered instructions, and a line plotter would eventually register the computer's calculations as a visual depiction of mathematical formulae. Alternatively, drawings, photographs or video pictures could be 'digitized': tones broken down into patterns of individual units or 'pixels', and lines rendered as sine-curves. These elements could then be manipulated by the computer as sets of digits. Using complex algorithms known as 'fractals', artist–programmers have since evolved spectacular depictions of realistic and fantastic objects and scenes. It eventually became possible for artists to work interactively in real time with a display screen, using a 'light pen' or stylus. In the USA in the mid-1970s David Em (*b* 1952) made contact with computer programmers developing this technology. He developed both geometric patterns and illusionistic images. In Europe related developments included the patterns of forms and colours produced by such artists as the German Jürgen Lit Fischer (*b* 1940). The Quantel Paintbox was an early example of a sophisticated interactive graphic computer, designed to generate captions for television, as video images or as colour prints. Such artists as Richard Hamilton (*b* 1922) and David Hockney (*b* 1937), both keenly interested in technical innovations, worked with it, and the painter Howard Hodgkin (*b* 1932) used it to produce stage designs.

Computers also became part of works created for other media. Some artists used computers to create film animation (e.g. *Poem Fields* by Stan Vanderbeek (1927–84), 1964); others used computers to control video displays in interactive works (e.g. *The Erl King* by Grahame Weinbren (*b* 1947) and Roberta Friedman, 1982–5) and non-interactive installations. (e.g. *Video Flag* by Nam June Paik (1932–2006), 1985–96). Artists also used computer programmes to control complex movements in kinetic sculpture, to compose and perform music and to choreograph dance works. For makers of film and video (see EXPERIMENTAL FILM and VIDEO ART), the computer offers unlimited possibilities in generating and transforming images and movement. From 1986 the artist Tom Phillips (*b* 1937) and the film director Peter Greenaway (*b* 1942) collaborated on a television version of Dante's *Inferno* in which the elaborate visual effects were achieved using a computer. By the 1990s personal computers could perform tasks that once required large, expensive items of hardware, while computer skills became a standard element in art and design education. The personal computer (PC) revolution of the 1980s, which brought computers within financial reach of many individuals, also revolutionized the world of computer art. From that point forward, the field of computer-based art became overwhelmingly diverse. The growth of the internet in the late 1990s added another component to the field—the ability to deliver works remotely to audiences around the world. As the capacity of computers increases continuously, it would be unwise to predict the kinds of computer art that may evolve.

However, it is clear that in the culture that computers help to create, many things will become commonplace that were previously assumed to be impossible.

J. Reichardt, ed.: *Cybernetics, Art and Ideas* (London, 1971)

M. L. Prueitt: Art and the Computer (1984)

Digital Visions: Computers and Art (exh. cat. by C. Goodman; Syracuse, NY, Everson Museum of Art, 1987)

Art and Computers: A National Exhibition (exh. cat., intro. J. Lansdown; Middlesbrough, Cleveland Gallery, 1988)

The Second Emerging Expression Biennial: The Artist and the Computer (exh. cat., intro. L. R. Cancel; New York, Bronx Museum of the Arts, 1988)

C. Giloth and L. Pocock-Williams: 'A Selected Chronology of Computer Art Exhibitions, Publications, and Technology', *Art Journal*, xlix/3 [Computers and Art: Issues of Content] (Autumn 1990), pp. 283–97

P. Hayward, ed.: *Culture, Technology & Creativity in the Late Twentieth Century* (London, 1990)

F. Popper: *Art of the Electronic Age* (London, 1993)

L. Manovich: *The Language of New Media* (Cambridge, MA, 2001)

R. Greene: *Internet Art* (London and New York, 2004)

M. Rush: *New Media in Art* (London, 2/2005)

T. Corby, ed.: *Network Art: Practices and Positions* (New York, 2006)

J. Raimes: *The Digital Canvas: Discovering the Art Studio in Your Computer* (New York, 2006)

F. Popper: *From Technological to Virtual Art* (Cambridge, MA, 2007)

2. CONSERVATION. The conservation of computer-based art is extremely challenging; the playing field is changing rapidly and constantly. Some basic principles, however, can guide the conservator toward assuring the longevity of these works.

One point is critical to remember: when dealing with digital art, the conservator is dealing with the maintenance of digital data. Though the ethics of conservation still apply, maintaining the viability of digital data is much the same whether one is preserving a work of art or a conventional database. Thus much of the work of conserving digital art moves from the specialized realm of art conservation and into the much larger worlds of information technology (IT) and digital asset management. Consequently, conservators may find it valuable to form alliances with other departments, such as the IT department, in their institutions.

All computer-based works require a storage medium of some kind. The two most common categories of storage media are magnetic (e.g. floppy discs or hard drives) and optical (e.g. CD-ROMs and DVDs). Magnetic media, which consists of a layer of metal oxides that are read by a magnetic head (see MAGNETIC TAPE), can be damaged—and rendered unusable—by exposure to dust, dirt, temperature extremes, or magnetic fields. Optical media, which consists of discs containing digital data that is read by a laser, can be damaged by scratching or careless handling. Moreover, CD-ROMs and DVDs, which are made of a 'sandwich' of laminated plastics, have been seen in the short term to be extremely unstable.

Consequently, a preferred method of long-term storage of digital artworks is to use a system that involves automatic redundancy and backup of data, such as a server or RAID array.

All computer storage media, whether magnetic or optical, and all computer-based works in general, face serious problems of obsolescence. Technological changes in the computer realm are driven by market forces and a desire on the part of users for faster performance and lower prices, among other factors. The rapid changes in technology that result are antithetical to the idea of long-term conservation. Obsolescence can come quickly to any and all aspects of the technology needed to display an artwork. Hardware, including the drives needed to play back computer discs, can go out of production and very rapidly become difficult to find. The once-prevalent 5¼ inch 'floppy' discs are a prime example. Software programmes—including the system software (e.g. Mac OSX or Windows) that control the range of tasks a computer carries out, as well as the application software (e.g. QuickTime or Macromedia Director) that carries out a specific task—are also constantly being changed and updated. Works that are only a few years old may have been created by software that is several versions out of date, and that may not be forward-compatible—in other words, may not be playable on newer versions of the software. Computer-based art therefore requires a regular process of what is known as migration, the copying of older works forward to new software and hardware to make sure that they remain viable. (Retention and careful storage of original computer hardware can also be a critical tool in keeping a computer-based work alive.)

Unfortunately, the migration process can cause changes in a work if it not carried out properly. Image files may display colour shifts, for example, or video files may play back at a different speed. For this reason, it is critical that a computer work be very carefully documented as early in its life as possible—ideally, at the time of a work's accession. The documentation process can involve careful observation and notation of the work's behaviour, as well as of the hardware, software, file formats and storage devices in use. Another vital source of information about the work is the artist's interview. Wherever possible, conservators should make the artist a component of the conservation process, using the interview to understand as clearly as possible how the work should behave, what components are inherently part of the work and what components could be replaced, and what restrictions the artist may place on the future migration of his or her work.

Another strategy employed in the conservation of computer art is emulation—the creation of an entirely new software programme or other application that precisely re-creates—or emulates—the behavior of the original work, or an obsolete piece of software used to operate the work. The emulated work then serves as a replacement for the original. This idea, though seemingly antithetical to many basic principles

of art conservation, is proving to be extremely valuable to the conservation of digital and computer-based art.

H. Besser: 'Digital Longevity', in *Handbook for Digital Projects: A Management Tool for Preservation and Access* (Andover, 2000), pp. 155–66

P. Laurenson: 'Developing Strategies for the Conservation of Installations Incorporating Time-based Media: Gary Hill's Between Cinema and a Hard Place', *Journal of the American Institute of Conservation*, xl/3 (2001), pp. 259–66

A. Depocas, J. Ippolito and C. Jones, eds: *Permanence Through Change: The Variable Media Approach* (New York, 2003)

F. R. Beyers: *Care and Handling of CDs and DVDs: A Guide for Librarians and Archivists*, Council on Library and Information Services and National Institute of Standards and Technology (Washington, DC, 2003)

L. Duranti: 'Preserving Authentic Electronic Art Over The Long-Term: The InterPARES 2 Project', *Electronic Media Group Annual Meeting of the American Institute for Conservation of Historic and Artistic Works, Portland, Oregon June 14, 2004*

Concrete. Synthetic material comprising an aggregate (small pieces of stone or other hard materials, such as broken brick or clinker, usually graded with sand) and a binding agent (usually a mortar made of cement and/or lime), mixed with water. This gives a semi-fluid workable mass that sets to form a material as hard as brick or stone and of great compressive strength, although weak in tension. Its ultimate appearance is determined by the detailed design of the SHUTTERING or formwork in which it is cast, and by the use after the removal of the shuttering of such surface treatments as bush-hammering, spraying and rendering; alternatively, it can be left in its raw state, showing the marks of the shuttering, as in board-marked concrete (*béton brut*). Chemical set-retardants can also be used to leave decorative aggregates exposed.

Concrete was first used as a building material in Classical times, when its plastic properties stimulated remarkable architectural developments in ancient Rome. It did not regain an equivalent importance until the 19th and 20th centuries, when new techniques to produce hydraulic cement (which sets even under water) and to improve its performance under tension were introduced. These made it particularly suitable for such engineering projects as the construction of docks, harbours and bridges, while the relatively low production costs and ease of use also made concrete suitable for large-scale architectural developments, such as low-cost housing and specialized industrial buildings. The possibilities for social construction that were presented by the ready availability of concrete were welcomed particularly by the architects of the Modern Movement, who also explored the dramatic aesthetic implications of the modern material. These were also recognized by some artists in other fields, who from about the mid-20th century began to experiment with concrete as a sculptural material. The susceptibility of concrete to deterioration under certain environmental conditions, however, raises particular problems of conservation.

I. Types and properties. II. History and uses. III. Conservation.

I. Types and properties. The simplest type of concrete is mass concrete, which contains no reinforcing agents and is used in bulk for building elements normally supported directly on the ground, such as ground-floors, load-bearing walls, docks and fortifications. Like masonry, mass concrete is strong in compression and when fully set will efficiently transmit direct structural loads to the ground. Also like masonry, it is weak in tension, and if subjected to bending stresses in trabeated structures, such as floor slabs and beams, it tends to structural failure under deflection. It can be reinforced, however, by the addition (while the concrete is still in a fluid state) of filaments or grids of high tensile strength placed so as to counteract the tendency to crack under tension. This reinforced concrete (or ferro-concrete) commonly contains mild steel rods or welded mesh grids held in place within the formwork by stiff wire 'stirrups' while fluid concrete is compacted around them. The concrete adheres to the reinforcement on setting and prevents differential movement between the constituents. In modern proprietary systems, non-metallic materials such as fibreglass are also used as reinforcement. In prestressed concrete, tensile stresses are counteracted by permanently imparted compressive stress. Prestressed concrete can be either pre-tensioned or post-tensioned, using high tensile steel rods or wires. In the former (usually associated with precast units) the reinforcement is stretched and fastened to the formwork before the concrete is placed and released after the concrete sets; in the latter (associated with larger-scale *in situ* construction, i.e. poured on site), the reinforcement is passed through tubes cast into the concrete and stretched when set, against anchor blocks. In both cases, on release the tensioned reinforcement tends to contract against the friction of the set matrix to hold the member in permanent compression.

Both mass concrete and reinforced concrete can be supplied in their fluid state or mixed on the building site and immediately placed in prepared formwork in its permanent position. The formwork can be made of sawn timber, plywood and other boards or metal, and it can be purpose-made for single applications or produced in demountable form for reuse on repetitive elements of the building. Precast concrete, usually mixed and moulded under controlled conditions away from the building site, is made in a wide variety of forms and may be reinforced or pre-stressed. Products range from the smallest dense concrete floor and roof tiles, through bricks and blocks, solid or hollow, dense or lightweight, to suspended floor systems, lintels, stair treads, paving slabs and cladding panels. Precast concrete can also include large-unit construction systems, in which elements weighing many tons are precast and cured on the building site and lifted into place by crane or jack.

S. B. Hamilton: 'Building and Civil Engineering Construction', *A History of Technology*, ed. C. Singer and others, 7 vols (Oxford, 1958), iv, pp. 442–88

N. Davey: *A History of Building Materials* (London, 1961)

R. Mainstone: *Developments in Structural Form* (London, 1975)

B. S. Benjamin: *Structural Evolution* (Lawrence, KS, 1990)

P. Klieger and J. F. Lamond, eds: *Significance of Tests and Properties of Concrete and Concrete-making Materials* (Philadelphia, 4/1994)

P. C. Hewlett, ed.: *Lea's Chemistry of Cement and Concrete* (London and New York, 4/1998)

C. Croft: *Concrete Architecture* (London, 2004)

II. History and uses.

1. Architecture. 2. Sculpture.

1. ARCHITECTURE.

(i) Ancient. Lime obtained by burning calcareous rocks and slaked with water was known to the Phoenicians, the Egyptians, the Etruscans and the Greeks, from whose southern Italian colonies it was probably introduced to the Romans in the 3rd century BC. Lime mortars, however, harden only on the surface by carbonation in contact with the air, and they were therefore principally used as plasters or stuccos until the Romans discovered that by making a lime mortar from what they took to be sand, but was actually pozzolana (siliceous volcanic ash from around Pozzuoli, near Naples), they could produce a material that set throughout its depth and hardened even under water. These properties were recognized by Vitruvius (II.vi.2), although their precise chemical action was not fully understood. Roman concrete (*opus caementicium*) consisted of pozzolanic mortar mixed on-site with an aggregate (*caementa*) of broken stone, brick and tiles and laid out in horizontal courses that were continuous across the building, comprising such elements as walls, piers, arches and vaults. At first, timber shuttering (formwork) and centering were used to shape the concrete mass and to support it until it set, and stone—either in an irregular stone patchwork (*opus incertum*) or in a neat chequerboard (*opus reticulatum*)—or brick facing (*opus testaceum*) was used as permanent shuttering. Concrete buildings were usually stuccoed inside and outside.

In the 2nd and 1st centuries BC, use of the new material was still restricted to purely utilitarian buildings, such as aqueducts and bridges. In the 1st century AD, however, as the technique was refined and the plastic nature of the material was more fully appreciated, a new architecture began to emerge, introducing new concepts of curvilinear space enclosure. The first building to embody this approach was Emperor Nero's Domus Aurea, in which a central octagonal space was domed with concrete; this building, constructed after the devastating fire in Rome in AD 64, also reflected an appreciation of the fireproof qualities of concrete. The erection of many large buildings in Imperial Rome provided further opportunities for experimentation with concrete vaults and domes;

examples include bath buildings, for which concrete vaults were ideally suited (e.g. Baths of Caracalla, early 3rd century AD), and, most famously, the Pantheon (*c.* AD 118–25) its thick walls surmounted by a massive concrete dome. The weight of the dome was lightened by careful grading of the aggregate, with very light material (pumice) at the top. No buttressing was required, as the concrete, once set, formed a monolithic shell that exerted no lateral thrust. No concrete structures of a comparable sophistication were erected until the 20th century.

In the early 4th century AD the Lateran Basilica used concrete on the tops of the walls, faced with alternating courses of brick and stone (*opus listatum*), and concrete was also used at Old St Peter's. Outside Rome, the land walls of Constantinople (AD 412) were in concrete, faced with small limestone blocks and reinforced by brick bands at varying intervals. Early uses of concrete were not confined to Europe, however. A form of the material was also known in Pre-Columbian America and was used, for example, at Tajin Chico in the Gulf Coast region, where the 7th-century structure known as Platform A had massive slabs of lime and pumice-stone, poured on to temporary centering.

G. Giovannoni: *La tecnica della costruzione presso i romani* (Rome, 1925)

G. Lugli: *La tecnica edilizia romana con particolare riguardo a Roma e Lazio*, 2 vols (Rome, 1957)

N. Davey: *A History of Building Materials* (London, 1961)

J. B. Ward-Perkins: *Roman Imperial Architecture*, Pelican History of Art (Harmondsworth, 2/1981), pp. 97–120

B. Fletcher: *A History of Architecture* (London, 19/1987), pp. 180–86

L. C. Lancaster: *Concrete Vaulted Construction in Imperial Rome* (Cambridge, 2005)

(ii) Renaissance. Concrete continued to be used during the medieval period but generally served only as a foundation material or as filling in the cores of massive piers. Renaissance builders revived ancient Roman architectural forms and showed great interest in Roman construction methods, but they did not revive the use of concrete as a common building material. This was perhaps partly due to a shortage of timber for formwork: many forests had been cleared during the Middle Ages to extend farming land, and timber was more highly valued for shipbuilding, domestic construction and the development of such industries as the production of iron, copper, glass and gunpowder. In addition, the properties of Roman concrete were not clearly understood in the Renaissance period, partly because of obscurities in Vitruvius' treatise.

There was, nevertheless, an interest in concrete during the Renaissance. Roman construction may have been studied by Filippo Brunelleschi (1377–1446), whose understanding of sophisticated structural design, including the use of tension reinforcement in masonry, is revealed in his revolutionary double-shell dome for Florence Cathedral. Donato Bramante (?1443/4–1514) also experimented with Roman

methods of concreting and stated that he used concrete in the ancient manner for the cores of his piers at St Peter's, Rome. These formed part of his design (1506; unexecuted) for the dome of St Peter's, a solid, hemispherical structure clearly inspired by the ancient Roman Pantheon and with its drum supported on four semicircular arches resting on four massive piers. Although the design of the drum and dome was subsequently altered and a brick, double-shell structure with tension reinforcement was built (1585–90) by Giacomo della Porta (1532–1602), the great arches and concrete-core piers were constructed by Bramante. They were later enclosed by Antonio da Sangallo II (1484–1546) and Michelangelo (1475–1564), who successively strengthened them.

G. Haegermann, G. Huberti and H. Moll: *Vom Caementum zum Spannbeton*, 2 vols (Wiesbaden, 1964)

W. B. Parsons: *Engineers and Engineering in the Renaissance* (Cambridge, MA, 1967)

H. J. Cowan: *The Master Builders: A History of Structural and Environmental Design from Ancient Egypt to the Nineteenth Century* (New York and London, 1977)

(iii) Modern. From the middle of the 18th century there was renewed interest in the use of mechanically strong cementitious materials. At first this was largely confined to the development in Europe and the USA of natural and artificial mortars that did not require the presence of air for setting and performed well under wet conditions, the same concerns that had stimulated developments two thousand years earlier in Italy. The introduction around the middle of the 19th century of reinforced concrete, however, encouraged engineering applications that began to indicate the hitherto unrecognized architectonic potentialities inherent in the material. It was only after World War I, though, that these were fully realized, leading to a global revolution in architectural aesthetics.

(a) c. 1750–c. 1850: Hydraulic cements and mass concrete. The first significant experiments were undertaken by the British engineer John Smeaton (1724–92), who was commissioned to build the fourth Eddystone Lighthouse (1756–9; destr. 1882) in the English Channel. Seeking to avoid the destructive effect of wave action on traditional lime mortar, he discovered that roasting limestone with a small clay content gave a lime that hardened under water. He did not publish his results, however, until 1791. This stimulated research in Britain, and in 1796 James Parker fired septaria taken from London clay along the Thames estuary and patented it as 'Roman cement'. Its first significant use was in the construction of the East India Dock (1800), London, by William Jessop (1745–1815), and after 1800 it was used in foundations by a number of architects, including Sir John Soane (1753–1837) and Sir Robert Smirke (1780–1867). Pozzolanic deposits were also discovered elsewhere, for example by the American engineer Canvass White (1790–1834) in 1818. He called it 'water lime' and used it in engineering work

associated with the Erie Canal. Artificial cements with similar properties began to be made around the same time by grinding together limestone and clay and then firing the mixture. A French engineer, Louis-Joseph Vicat (1786–1861), produced various grades of cement that set under water, named them 'hydraulic' and classified them according to degrees of hydraulicity: his results (pubd 1818) formed the basis of quality control in the manufacture of cements. In 1824 the British builder Joseph Aspdin (1779–1855) patented a cement made by firing a mixture to higher temperatures, at which it vitrified or sintered; he called the resulting product Portland cement because its appearance was reminiscent of Portland stone. A similar product was made in New York in 1830 by Obadiah Parker, who used it to build a number of houses with concrete walls.

In France the first person to use mass concrete for the construction of buildings was François-Martin Lebrun (*d* 1849), who used it in the manner of pisé or rammed-earth—common in south-west France, where the availability of stone is limited—for the foundations of a building at Gaillac and for the Protestant church at Corbarieu (1837) and a bridge at Grisolles (1840), both near Montauban (Midi-Pyrénées). The industrialist François Coignet (1814–88) was probably unaware of Lebrun's work but effectively took up the thread, building a factory (1851) at Saint-Denis, Paris, using precast clinker blocks. As though to demonstrate the versatility of the material, Coignet used precast artificial stone in 1853 in a house in Paris designed by Théodore Lachez. The process was still not perfected, though, and a decade later Louis-Charles Boileau (1837–1914) complained of poor adhesion and moisture penetration in the vaults of his church of Ste Marguerite (1862–5), Le Vésinet (Seine-et-Oise), designed in collaboration with Coignet.

(b) After c. 1850: Reinforced concrete. In Britain Thomas Telford (1757–1834) had used wrought-iron bars in concrete to strengthen the abutments of his bridge (1818–26) over the Menai Straits in Wales, but the earliest direct application of reinforced concrete to buildings was that of a builder from Newcastle upon Tyne, W. B. Wilkinson (1819–1902), who in 1854 patented an on-site reinforced-concrete flooring system using precast gypsum-plaster ceiling coffers as permanent shuttering for a concrete floor slab: the beams and sub-beams between the shuttering were reinforced with wire rope and iron rods respectively. From 1845 Joseph-Louis Lambot (1814–87), a French farmer, used iron mesh coated with concrete to manufacture small objects such as water tanks and even a rowing boat, which he exhibited in 1855 at the Exposition Universelle, Paris. Then in 1861 Joseph Monier (1823–1906), a Paris market gardener, patented tubs for orange trees that were made in a similar way. In 1885 he licensed his patents in Germany through a Frankfurt engineer, G. A. Wayss (1851–1917), whose firm commissioned Matthias Koenen (1849–1924) to investigate the theoretical basis of reinforced concrete. In the USA

there were parallel activities associated with two British expatriates. Thaddeus Hyatt (1816–1901), a British lawyer who had settled in New York in the 1850s, commissioned experimental work in England and published the results in 1877. He took out an American patent in 1878 but seems to have had little commercial success. Ernest L. Ransome (1852–1917), who went to San Francisco in 1869, joined the Pacific Stone Company, one of many set up in the USA around this time to make artificial stone. The material performed well in the Chicago fire of 1871 and was soon in general use for fireproof casing of the new iron- and steel-framed buildings (*see also* IRON AND STEEL, §II, 1). He formed the Ransome Engineering Company, which built many buildings across the country and became one of the most important pioneers of reinforced concrete in the USA. Many French patents were taken out in the last 15 years or so of the 19th century, including a system designed by Edmond Coignet (1856–1915) and another for the stirrup girders (1892 and 1894) designed by François Hennebique (1842–1921), which formed the basis of the latter's highly successful reinforced-concrete construction system. This enabled Hennebique, through dozens of agencies across the world, to construct nearly 3000 buildings by 1900: the Weaver Flour Mill (1895–7), Swansea, Wales, is a well-known early example that rises to seven storeys. The new material continued nevertheless to be regarded with suspicion. A course in reinforced-concrete construction was introduced in the Ecole des Ponts et Chaussées, Paris, in 1897 by Charles Rabut (1852–1925), but after the collapse of a gangway at the Exposition Universelle in Paris in 1900, an earlier abortive government commission was reconvened to make recommendations (pubd Oct 1906) on calculation techniques.

The first French architect to explore the potential of reinforced concrete in terms other than as a substitute for timber or metal was Anatole de Baudot (1834–1915), who had worked on the restoration of Gothic buildings. His church of St Jean in Montmartre (1897–1904; with Paul Cottancin (1865–1928)) was the first religious building in reinforced concrete: the thin (70 mm) infill panels and the flat decoration applied to the concrete surfaces emphasize the characteristic paper-thin appearance of the nave arches and the pierced balcony rails. Hennebique's first block of flats in reinforced concrete at 1 Rue Danton, Paris (a site so narrow that no other material could plausibly have been used), was begun in 1898: the façade was designed to imitate façades in stone. Most architects in the early decades of the century hid their reinforced-concrete structures under a ceramic or other skin, uncertain of its impermeability. The concrete frame of the flats at 25-bis Rue Franklin, Paris (1903), by Auguste (1874–1954) and Gustave (1876–1952) Perret (with Hennebique), boasted ceramic panels by Alexandre Bigot (1862–1927); infill panels in concrete flats of the same date by Henri Sauvage (1873–1932) at 7 Rue Trétaigne, Paris, were built in brickwork. A contemporary urban

building in Britain, the eight-storey Lion Chambers (1905–6), Hope Street, Glasgow, by the partnership of Salmon & Gillespie, also has a Hennebique frame, although its elevations give no hint of the structure.

Other architects to experiment with reinforced-concrete construction in the early years of the 20th century included Karl Hocheder (1854–1917) (e.g. Bavarian Ministry of Transport building in Munich, 1905–13) and Gabriel von Seidl (1848–1913; e.g. Deutsches Museum, Munich, 1906–13). By 1908 second-generation concrete designers such as Robert Maillart (1872–1940) in Europe and C. A. P. Turner (1869–1955) in the USA were introducing refinements to eliminate downstand beams in simple building structures through the use of mushroom columns with slabs, an integration of support and loading surface that also informed Maillart's elegant bridge designs (e.g. Schwandbach Bridge, 1933). The slenderness achievable in reinforced-concrete structures, clearly apparent in Maillart's bridges, was also seen in work by the Perret brothers. Growing confidence in reinforced concrete as a principal medium of Modernism was indicated by two other buildings of widely differing intent: the Jahrhunderthalle (1913), Breslau (now Wrocław, Poland) by Max Berg (1870–1947), and the Fiat Factory (1916–25), Lingotto, Italy by Giacomo Matte' Trucco (1869–1934). The 65-m diameter dome of the former, spanned by radiating reinforced-concrete ribs, was the world's largest enclosure of its day, while the latter is the ultimate trabeated reinforced-concrete industrial building, its paraboloid, banked roof-level testing track reflecting the dynamism of Italian Futurism. Almost precisely contemporary with it were the dirigible hangars built by Eugène Freyssinet (1879–1962), a pupil of Rabut, at Orly, near Paris (1921; destr. 1944: the parabolic arches, only 90 mm thick, were linked together in corrugated form to impart lateral strength and were among the earliest prototypes of shell construction. Work on a bridge (1910; destr. 1940) over the River Allier at Le Veudre, near Nevers, however, led Freyssinet to the discovery and development of pre-stressed concrete, and from the mid-1930s he used it in many engineering works, especially bridges, including five over the River Marne between 1947 and 1951. The best-known of Freyssinet's few applications of pre-stressed concrete to architecture was the underground basilica of St Pius X at Lourdes (1956–8; with Pierre Vago (1910–2002)).

Concrete also came to be associated with some of the most important and diverse projects of the early Modern Movement, from the rectilinear *Cité industrielle* (1901–4) of Tony Garnier (1869–1948) to the plastic building forms of Erich Mendelsohn (1887–1953). The flat roofs, unimpeded floor slabs, cantilevers and continuous window openings, the 'white' concrete image—if not the reality—of the Weissenhofsiedlung in Stuttgart (completed 1927), were propagated in buildings as dissimilar as the experiments in reinforced-concrete housing (1925–8) at Pessac, near Bordeaux by Le Corbusier (1887–1965),

the Van Nelle Factory (1925–31) in Rotterdam, where Turner's mushroom slab system was used, and the great cantilevered decks of Fallingwater (1935–9), Bear Run, PA, by Frank Lloyd Wright (1867–1959). Its use also characterized the developing Italian Rationalist movement—for example in the Casa del Popolo (1932–6), Como, by Giuseppe Terragni (1904–43)—and the burgeoning school of modern architecture in Latin America, most notably at the Ministry of Education and Health in Rio de Janeiro (now the Palácio da Cultura, 1937–43) by Lúcio Costa (1902–98) and others, with Le Corbusier as their consultant. The integral role of concrete in Modernist design was continued in the *béton brut* of Le Corbusier's Unité d'Habitation in Marseille (1945–52). This spread internationally, from Le Corbusier's buildings for Ahmadabad and Chandigarh (1947–64) to the multi-level Temple Street Car Park (1959) at New Haven, CT, by Paul Rudolph (1918–97), the Cultural Centre (1961–3) at Nichinan, Japan, by Kenzō Tange (1913–2005), and the United Nations buildings (1966) in Santiago, Chile, by Emilio Duhart (1917–2006). In other structures of this period, a rough finish was achieved by casting vertical ribs in the concrete, then hammering them to expose the aggregate (e.g. the Elephant House, London Zoo, 1962–5).

Although Mendelsohn's concrete-inspired Einstein Tower (1920–24), Potsdam, Germany, was in fact realized partly in other materials, the plasticity of concrete has continued to be associated with curvilinear buildings, including such well-known examples as the Penguin Pool (1934) at London Zoo by Tecton and Le Corbusier's pilgrimage chapel of Notre-Dame-du-Haut (1950–55) at Ronchamp in the Vosges. The fullest development of curvilinear geometry, however, has been the work of the great architectural engineers: Freyssinet in France, Pier Luigi Nervi (1891–1979) and Riccardo Morandi (1902–89) in Italy, Eduardo Torroja (1899–1961) in Spain and Félix Candela (1910–97) in Mexico. Following Freyssinet's hangars at Orly there were numerous experiments with concrete shells: notable examples include Torroja's flying fluted grandstand roofs (1935) at the Zarzuela racecourse, Madrid, the great open parabolic vault of Maillart's Zementhalle at the Swiss Provinces Exhibition of 1939 in Zurich, and Candela's cosmic ray laboratory (1951, with Jorge González Reyna) for the Ciudad Universitaria, Mexico City, with its fluted paraboloid vaults, 15 mm thick at the crown. This was followed by numerous complex shell and umbrella vaults, sinoidal and folded slabs and hypars (hyperbolic paraboloids), including the Centre National des Industries et Technologies (CNIT; 1953–8), Paris, by Bernard Zehrfuss (1911–96) and others, and Candela's groin-vaulted restaurant at Xochimilco, Mexico City (1957–8; with Joaquín and Fernando Alvárez Ordóñez). Nervi, who believed that concrete design could lead to a new architectural aesthetic, developed finer concrete mixes and reinforcement meshes (*ferro-cimento*) to produce smaller and more accurately made

precast elements, which he elevated into vast space enclosures by grouting on site, often in combination with rhythmic directional elements and shells: his two exhibition halls (1947–50) in Valentino Park, Turin, are among the most daring examples. Hydraulically pre-stressed members were used later in such major buildings as the sports halls (Palazzetto dello Sport) for the Olympic Games in Rome in 1960.

Nervi was also involved in the design of some of the most notable reinforced-concrete skyscrapers, including the Pirelli Building (1956–8), Milan by Gio Ponti (1891–1979), for which Nervi designed a minimalist tree-like structure, and the MLC Centre (1972–5), Sydney by Harry Seidler (1923–2006), in which the pre-stressed façade beams are sculpted to the lines of stress. The aesthetic potential of concrete has also been realized by many other architects. Its lyrical possibilities are expressed in the undulating shells and *azulejo*-clad spandrels of S Francisco (1943), Pampulha, Belo Horizonte by Oscar Niemeyer (*b* 1907), and the reversed domes of his Palácio do Congresso Nacional (1958–60), Brasília, while a new form of Expressionism is demonstrated in the TWA Terminal (1956–62) at Kennedy International Airport, New York by Eero Saarinen (1910–61), and in the Sydney Opera House (1957–73; Jørn Utzon (*b* 1918) with Ove Arup (1895–1988)), its sail-like shells clad in white ceramic tiles.

J. Smeaton: *A Narrative of the Building and Description of the Construction of the Edystone Lighthouse* (London, 1791, rev. 3/1813)

L.-J. Vicat: *Recherches expérimentales sur les chaux de construction* (Paris, 1818)

T. Hyatt: *Experiments with Portland Cement Concrete* (New York, 1877)

M. Koenen: *Das System Monier* (Frankfurt am Main, 1887)

S. Giedion: *Bauen in Frankreich, Eisen, Eisenbeton* (Leipzig, 1928) Eng. trans. *Building in France, Building in Iron, Building in Fer-roconcrete* (Santa Monica, 1995)

F. K. Onderdonck: *The Ferro-concrete Style: Reinforced Concrete in Modern Architecture* (New York, 1928/R Santa Monica, 1998)

S. Giedion: *Space, Time and Architecture* (Cambridge, MA, 1941, rev. 3/1967)

H. Straub: *Die Geschichte der Bauingenieurkunst* (Basle, 1949; Eng. trans., London, 1952)

C. C. Handyside: *Building Materials: Science and Practice* (London, 1950)

S. B. Hamilton: *A Note on the History of Reinforced Concrete in Buildings*, National Buildings Studies Special Report (London, 1956)

S. B. Hamilton: 'Building Materials and Techniques', *A History of Technology*, ed. C. Singer and others, 7 vols (Oxford, 1958), v, pp. 466–98

A. A. Raafat: *Reinforced Concrete in Architecture* (New York, 1958)

P. Collins: *Concrete: The Vision of a New Architecture* (London, 1959)

A. W. Skempton: 'Portland Cements, 1843–87', *Transactions of the Newcomen Society*, xxxv (1962–3), pp. 117–52

J. Joedicke: *Shell Architecture* (New York, 1963)

J. M. Brown: 'W. B. Wilkinson, 1819–1902', *Transactions of the Newcomen Society*, xxxix (1966–7), pp. 129–42

C. W. Condit: *American Building* (Chicago, 1968, rev. 1982)

R. Gargiani: *Auguste Perret, 1874–1954: Teoria e opere* (Milan, 1993)

P. Oldham: *Pill Boxes on the Western Front: A Guide to the Design, Construction and Use of Concrete Pill Boxes, 1914–1918* (London, 1995)

D. P. Billington: *Robert Maillart: Builder, Designer, and Artist* (Cambridge, 1997)

M. Culot, D. Peyceré and G. Ragot: *Les frères Perret: L'Oeuvre complete* (Paris, 2000)

J.-L. Cohen, J. Abram and G. Lambert: *Encyclopédie Perret* (Paris, 2002)

2. Sculpture. The use of concrete in sculpture began in the 1920s, when it was characterized as an exciting new material with the strength, hardness and potential of carved stone. Sculptors discovered that fine aggregates were eminently suitable for casting work in the semi-figurative, Cubist-inspired styles then current. Pieces were generally reinforced with mild-steel mesh and rendered hollow, which proved more durable than solid shapes. Henry Moore (1898–1986) was among the first to take advantage of the low cost and malleability of concrete, which he cast by traditional methods in plaster moulds and then shaped and carved before it hardened; between *c*. 1925 and 1933 he produced a number of figures in cast and reinforced concrete (e.g. *Half-figure No. 2*, concrete, h. 394 mm, 1929; Norwich, University of East Anglia, Sainsbury Centre for Visual Arts). Despite Moore's contribution, however, the use of concrete for sculpture remained rare until after World War II.

In the 1950s, when new suburbs, towns, airports and industrial complexes were being built across western Europe, the USA and Latin America, there was a general movement to interrelate sculpture with modern architecture. In his Unité d'Habitation apartment building for Marseille (1945–52), Le Corbusier (1887–1965) animated the blank concrete wall of an elevator shaft with a shallow, impressed design of abbreviated human figures, which integrated with the concrete skin of the building in an original way. Works such as these were the genesis of an urban sculpture, for which concrete as an outdoor material was ideal. Public sculpture gave a younger generation of sculptors who were conditioned to abstract form the opportunity to work on large-scale pieces. With the technology to hand, forms were often cast on-site by the contractor to the sculptor's design, using wood, plastic or steel moulds. Surfaces were either left untreated or honed until satiny smooth; rarely were works of this period painted. Whether in the form of architectonic reliefs or as free-standing pieces, concrete sculpture in the 1950s ranged from hermetic, independent works to sculpture freely evocative of the site, as in *Arrow by Henri-Georges Adam (1904–67)*, which was executed for the port of Le Havre as an expression of the spirit of travel. Another associative work was the

striking *Towers of Satélite* (painted concrete pylons, h. 36.9 m, 1957) by the German–Mexican sculptor Mathias Goeritz (1915–90), installed in the manner of obelisks near one of the approaches to Mexico City.

Such romantic attitudes were eschewed by sculptors of the following generation, who sought formal solutions in line with the Constructivist–Minimalist ideas prevalent during the 1960s. Concrete was used in prefabricated slabs, often in combination with wood or steel, as new spatial concepts were explored; *Declaration* (concrete and marble chippings, l. 2.08 m, 1961; artist's collection, see 1981–2 exh. cat., p. 174) by Phillip King (*b* 1934) is a good example. As the 1960s progressed, however, the use of concrete waned as sculptors turned increasingly to steel and plastics. The emergence of environmental and Land art in the 1970s helped to reintroduce concrete, sometimes functioning as mortar to secure potentially shifting elements. A good example is *City-Complex One* (earth mound with concrete frame, h. 7.16 m, l. 4.27 m, 1972–6; see Hammacher, p. 425) by Michael Heizer (*b* 1944) in south central Nevada; this is a serene, geometric work of which concrete is an essential component.

During the 1980s concrete was used for such monolithic outdoor pieces as *The Promise* by William Tucker (*b* 1935), a linear work extending 9.45 m (concrete, stucco and steel, 1982; Coconut Grove, FL, Martin Z. Margulies private collection, see Hammacher, pp. 426–7). However, it also began to be employed in subtler, more nuanced ways. Appreciated as stronger and more predictable than cast polyester resins and less subject than moulded fibreglass to scratches and damage, concrete was again worked by the sculptor and frequently finished with paint or mixed directly with other media. In several sculptures produced in the early 1980s, for example *White Sand, Red Millet, Many Flowers* (wood, cement and pigment, 1.0×2.40×2.17 m, 1982; Arts Council England Collection), Anish Kapoor (*b* 1954) used wood and cement to build his oddly shaped, metaphysical works, smothered in raw coloured pigment.

U. Boeck: *Sculpture on Buildings* (London, 1961)

J. W. Mills: *Sculpture in Concrete* (London, 1968)

D. Kowal and D. Z. Meilach: *Sculpture Casting: Mould Techniques and Materials, Metals, Plastics, Concrete* (London, 1972)

British Sculpture in the Twentieth Century (exh. cat., eds S. Nairne and N. Serota; London, Whitechapel Art Gallery, 1981–2)

S. H. Fairweather: *Picasso's Concrete Sculptures* (New York, 1982)

A. M. Hammacher: *Modern Sculpture: Tradition and Innovation* (New York, 1988)

R. M. Bradfield: *The Daglingworth Sculptured Panels Reconsidered* (Cirencester, 1997)

III. Conservation. The conservation and restoration of concrete are usually necessitated by its deterioration through erosion or spalling (splintering or chipping). Erosion is mostly caused by a fault in the composition of the concrete itself, the result, for example, of poor mixing. Spalling can occur for a number of reasons. If the surface is coated, any moisture that collects between the concrete surface

and the coating will expand if it freezes, causing spalling and delamination. Exposure to atmospheric pollution and/or soil moisture can lead to the concrete being attacked by sulphate. This reacts with the cement to form calcium sulpho-aluminate, which expands up to 10% within the concrete. Eventually this can lead to a complete loss of cohesive strength, especially in small-sectioned components. The most common and most dramatic spalling is due to the corrosion of steel reinforcement within the concrete. This can occur when the concrete undergoes a natural and inevitable process known as carbonation, in which the alkalinity of fresh concrete (which originally protects the steel reinforcements) is neutralized by exposure to atmospheric carbon dioxide. The immediate environment of the reinforcement slowly turns from alkaline to acidic. If moisture is present, the reinforcement will corrode and expand. Pressure from this expansion will then cause spalling of the surrounding concrete. The carbonation process cannot be prevented, and carbonated concrete in itself does not pose any problems or lose any of its strength. Only the addition of moisture, for example through cracks, will cause the problematic corrosion of the reinforcement rods.

The prime objective of preventive conservation is therefore the exclusion of moisture. Depending on the specific situation, this can be achieved in a variety of ways, for example by ensuring adequate drainage of flat roofs and adequate ventilation or by the use of protective coatings that keep the concrete dry yet allow it to breathe. If corrosion has already occurred, major interventionist repairs are necessary. The affected concrete has to be removed, the reinforcement rods cleaned or replaced and then the concrete itself replaced. It is usually not possible to save much of the original fabric. Many buildings of the Modern Movement, technically innovative structures in their day, have in recent years been repaired and restored, including the Weissenhofsiedlung in Stuttgart (restored 1981–6 by the city's architectural department) and Tecton's Penguin Pool at London Zoo (rest. 1987 by Avanti Architects).

R. T. L. Allen and S. C. Edwards, eds: *The Repair of Concrete Structures* (London, 1987)

C. L. Searls and S. E. Thomasen: 'Deterioration and Restoration of Historic Concrete Structures', *Structural Repair and Maintenance of Historical Buildings*, ed. C. A. Brebbio (Basle, 1989)

J. Allan: 'Renovation: An Account of Technical Issues Involved in the Restoration of Tecton's Concrete at Dudley Zoo', *Architectecture Today* (13 Nov 1990), p. 91

D. Campbell-Allen and H. Roper: *Concrete Structures: Materials, Maintenance, and Repair* (Harlow and New York, 1991)

B. Bauchet and H. Rio: 'La Maison du Brésil, Cité universitaire, Paris', *Monumental: Revue scientifique et technique des monuments historiques* (2001), pp. 184–91

C. Calderini: 'Cultura e tecnica del cemento armato nel restauro dei monumenti in Italia (1900–1945)', *Palladio*, xvi/32 (2003), pp. 93–102

Conservation and restoration. Terms for the preservation of the manmade material remains of the past. Conservation is an all-embracing term that includes the processes of cleaning, stabilization, repair and restoration. To many people, the words 'conservation' and 'restoration' are interchangeable, and this confusion is exacerbated by the fact that in French a *conservateur* is the equivalent of an English curator, and a *restaurateur* is most usually rendered in English by the title conservator. The English title of restorer is now little used within the museum profession but is widely employed in the antiques and antiquities trade to mean someone who 'restores' a painting or an object to make it more functional and/or saleable. Restoration is also in general use as a term to describe the repair and renovation of ancient buildings and historic monuments, but its meaning is not really so far removed from the limited use in the museum to mean a part of the whole process of conservation.

The four processes of conservation are relevant to objects as diverse as a medieval building and an Iron Age sword. But there is one fundamental difference between a medieval building and an Iron Age sword: the first is a 'living' object still (sometimes) performing its original function, while the second has no further purpose other than as an object for display and study. One other process is often included under conservation in the museum meaning of the word, and that is the technical examination of the 'artefact'. The conservation of neither the Iron Age sword nor the medieval building can proceed to completion until the original object is fully understood and all changes wrought either by time (in the case of the sword) or by time and man (in the case of the building) have been fully elucidated.

The following survey discusses the general principles and techniques of conservation and the training and institutes of conservators. Information on the conservation of specific media and art forms can be found in the relevant articles.

See also ARCHITECTURAL CONSERVATION AND RESTORATION and TECHNICAL EXAMINATION.

I. Processes and ethical considerations. II. Techniques. III. Training. IV. Institutes.

I. Processes and ethical considerations.

1. Cleaning. 2. Stabilization. 3. Repair. 4. Restoration. 5. Technical examination. 6. Research. 7. Practice.

1. CLEANING. At its simplest, cleaning means the removal of dirt that is present either as soil residues resulting from burial or as airborne grime, which is partly natural and partly manmade (arising from industrialized energy production and manufacturing processes; see fig. 1). However, 'cleaning' also raises ethical considerations. Should the blood stain be removed from the shirt that President Lincoln was wearing when he was assassinated? Should food residues be removed from kitchen vessels and tableware? Should remains of libations be removed from

1. Detail of relief, marble, c. 1630, Salzburg Cathedral; shown (left) before cleaning and (right) after cleaning; photo credit: Manfred Koller

objects of religious use? Questions such as these are endless, but the answer to them all is almost invariably in the negative. However, the concept of 'ethnographic dirt', as such deposits are now known, was developed in Western Europe and North America and is far from being universally accepted. In countries where traditional cultures survive, there is still a tendency to present artefacts in as pristine a condition as possible. Nevertheless, in these societies the recording of the use of the objects in the field by ethnologists does, to some extent, obviate the need to retain traces of extraneous materials on the surface, although a trained conservator will always argue for the retention of any evidence of original use.

Difficulties arise, however, when the ethnographic dirt is contributing to the deterioration of the object, and this may be the case with organic residues where the process of natural biodeterioration may lead to staining of the support. One solution to the problem is storage of the object in an environment in which the biodeterioration cannot take place, and another is to analyse the deposit and take archive samples before cleaning it away. Removal should be a last resort, although in the past this was normal procedure.

Cleaning becomes even more problematical when it is a part of the original object that is obscuring its aesthetic or scientific appreciation. For instance, should discoloured original varnish be removed from easel paintings, and should corrosion products be removed from metal objects? In both cases the integrity of the original object as it was produced by the artist or craftsman is compromised by removal. But the original conception of the artist or craftsman is also compromised by the presence of discoloured varnish and thick layers of corrosion products. Most conservators would argue for the skilled removal of such deposits so that the original intention of the artist or craftsman is elucidated, but not all art historians and art critics would agree, hence the fierce debate about the cleaning of paintings in the National Gallery in London, which has rumbled on since the 1840s, and the more recent debate about the

cleaning of the Sistine Chapel ceiling in the Vatican, Rome, in the 1980s.

The philosophy of cleaning also has a geographical divide, and what is considered normal in one part of the world may be seen as abnormal in another. To return to the question of corroded metals, silver will slowly tarnish in the atmosphere and turn black. This process is inevitable, as the atmosphere contains traces of hydrogen sulphide, which react with the silver. In Western Europe silver plate in museums is invariably kept free from black tarnish by lacquering the silver or by regular cleaning. In Eastern Europe silver displays are often deliberately left tarnished. The cleaning of three-dimensional objects is, however, not usually controversial; few would argue, for example, with the removal of corrosion products and soil from the surface of a Roman dagger scabbard when a pattern of inlaid silver is thus revealed.

2. STABILIZATION. Stabilization means identifying the causes of continuing deterioration and taking action to eliminate or minimize them. Examples would be the insertion of a damp course in a historic building, the treatment of furniture to kill woodworm, the relining of an easel painting or the removal of soluble salts from excavated ceramics. These examples are all of interventive treatments, but non-interventive treatments are possible in some cases. For instance, the damage caused by soluble salts in porous ceramics can be eliminated either by removal of the salts by soaking in distilled water (interventive) or by storage of the pottery in a room or display case where the relative humidity of the air is controlled (non-interventive). Similarly, woodworm can be killed either by injecting an appropriate insecticide into the flight holes (interventive) or by fumigation of the whole object with an inert gas (non-interventive). The latter course of action is much to be preferred in the case of woodworm, although fumigation does not confer any protection against future attack. In the case of the pottery, however, it is the interventive action that is generally preferred, as the cost of salt removal by washing is generally less than

the ongoing cost of providing a controlled atmosphere. There is also a difference from the ethical point of view. The removal of salts does not compromise the integrity of the object; in fact, it restores the object to a condition nearer to that in which it was originally created. However, the killing of woodworm with an insecticide does compromise the integrity of the object by permanently adding a foreign substance to the wood, while fumigation (normally) leaves no traces of having been carried out, apart from the corpses of the insects.

3. REPAIR. Repair involves sticking all the original parts of the object together again (for illustration see CERAMICS). This may be preceded by a dismantling operation, particularly if a previous conservation was less than successful. This is often the case with ceramics, where unacceptable adhesives were used in the past or where the adhesives have discoloured, or simply where too much adhesive has been used so that the sherds do not fit together exactly. In many cases, dismantling will actually precede cleaning, as, to take the case of ceramics again, it is not only the faces of the sherds that need cleaning but also their edges if reconservation is to be carried out successfully. Dismantling does not apply only to objects that have been stuck together in the past but sometimes also to composite objects made of several components. By taking them apart all the components can be thoroughly cleaned and then all traces of the cleaning agents removed, without the danger of cleaning agents getting trapped in crevices, where they might be the cause of continuing decay in the future. The dismantling of a 14th-century chalice known as the King John Cup allowed not only thorough cleaning but also an examination of the object to look for maker's marks on the hidden surfaces.

The re-treatment of a previously conserved object must be approached with caution. The previous restoration may be of historic importance and worthy of recording at the very least, if not of actual preservation. This arises from the fact that the keeping of conservation records is a relatively modern activity, which is still far from universally normal. Many of the 'conservators' of former years were very secretive about their materials and methods and never committed anything to paper: the only record is often the objects themselves. Thus it is important to analyse adhesives, consolidants and fillers and to add this information to the modern conservation record. There has recently been an upsurge of interest in old methods of conservation, and there have been at least two conferences (1988, 1989) devoted to the subject.

4. RESTORATION. Restoration usually means filling in missing areas; it can also mean the 'painting' or 'retouching' of the filled areas or of those parts of the surface of the object where the original decoration or painted layer has been lost (for the techniques used in restoration see §II, 2 below). It is this aspect of restoration that leads to most controversy, and there is no universal agreement on the ethics of the process between conservators of different types of artefact or between museums and the private sector.

The process of infilling is also controversial in some cases. The museum conservator sees his role as being first to preserve every vestige of the original object but then to re-create the original shape (and perhaps the original appearance) by judicious infilling, if this course of action is thought desirable by both the curator and the conservator. This can only be carried out where the original shape is known, either because records exist or because the object was or is symmetrical. Thus, in a museum, the restoration of ceramic vessels is common, but the restoration of ancient sculpture is not. In the antiques/antiquities trade it is more usual to carry out invisible repairs and to disguise the fact that an object has been conserved. (Whether the object is then sold as undamaged or not is another matter.) The fact that objects are still often required to be functional also dictates the lengths to which a conservator will go. If the leg of a chair has broken because it is riddled with woodworm, the private owner may want the leg replaced with an exact replica so that the chair can continue in use. In a museum, the chair would not be used, and this 'treatment' is not acceptable. The conservator must first kill the insects and then consider whether the original leg needs strengthening by consolidation. It would never be discarded in favour of a replica.

Even museums sometimes have to break this 'rule' when conserving objects that are continuing in use, the most obvious examples being clocks and watches. If kept running they will wear out, but if they are not working they are generally regarded as unsatisfactory exhibits. One solution is to archive the worn-out parts when they are replaced and to mark the replaced parts so that they can never be mistaken for original components. Marking can be carried out by engraving, but a more subtle approach is to use a different material (such as another metal or an unusual alloy) for the replacement component, analogous to the use of plaster of Paris for infilling pottery. The use of the same material as the original for restoration is usually avoided on three-dimensional inorganic objects; plaster of Paris or various different synthetic resins (with or without appropriate fillers) are commonly used on stone, ceramic, glass and metal objects. Organic artefacts, such as furniture, textiles and ethnographia, present aesthetic problems when conserved with different materials, and these are often only overcome by using the same materials and carefully documenting the restoration. Easel paintings, watercolours, drawings and prints also set aesthetical problems, which merge into the ethical question of whether the restoration should be visible on close inspection.

This difference between the perception of fine and applied art and between organic and inorganic artefacts is partly a matter of taste but also partly a matter of training and outlook in the eye of the beholder. Most people are no longer surprised to see ancient sculpture with parts missing on display in a museum,

but almost nobody wants to look at an easel painting with a hole in the canvas. This is, however, a recent change in outlook; in the 1960s missing parts of Egyptian sculpture in the British Museum, London, were still being restored, while 19th-century restorations to Greek and Roman sculptures were being removed. In many museums containing antiquities and applied art, restoration is governed by the 'six inch, six foot' rule. What is desired is a restoration that makes the object appear undamaged to the casual observer (from a distance of six feet) but that allows a close inspection (from six inches) to detect what is old and what is new. This philosophy is not universal, and many 'art' museums prefer essentially invisible restoration for sculpture, as well as for painting.

The discussion so far applies to Western Europe and North America, but in Eastern Europe, East Asia and Africa other philosophies apply. Sometimes these are dictated by long tradition and sometimes by practical considerations. In museums in developing countries traditional objects are often 'conserved' by employing traditional craftsmen to 'repair' them. One example of this is the repair of beadwork in southern Africa by employing those women still engaged in making similar objects to repair the museum specimens. This is, of course, ethically dubious. In most cases it will be impossible to distinguish between the old and the new, and the keeping of detailed photographic records is only a partial solution. But how important is it to make this distinction if the original tradition is still very much alive and the repairs are made skilfully? In fact, it does matter, especially if the collections are ever to be an academic resource. Even if the practical techniques of the modern craftsmen are indistinguishable from those of their ancestors, it is unlikely that the materials they use will be entirely traditional. To return to the beads, they may be identical in size, and the glass may be similar in composition, but will the colouring agents in the glass be the same, and will the thread used to sew the beads be made from the traditional fibre? If the materials are not correct, then the fact that the object has been restored will be obvious, although it may require technical examination to identify the repairs. But if the date of the repairs was not recorded, it may appear that the repairs were carried out before the object was collected, and this will mislead those who use the collection for study.

In some countries it is common to restore ceramics by making the replacement parts in clay and then firing and, if necessary, glazing them. These 'sherds' are then stuck in position. If the correct clay has been used and then fired under similar conditions to those of the original vessel, the colour and fabric of the replacement sherds may be almost indistinguishable from those of the original vessel. In this case, only dismantling of the pot and close examination of the breaks will reveal what is old and what is new. A similar approach can be seen in the restoration of historic buildings in Japan. These were made largely of wood, and as this decayed through the centuries pieces were removed and replaced with matching modern timbers. This process of restoration continues, with no apparent worry that over the course of a millennium much of the fabric of a building will have been replaced, perhaps several times. Interestingly, the buildings are commonly ascribed to their original period. The concept of complete restoration of historic buildings following disasters (e.g. fire) is being contemplated, and even carried out, in Western Europe, for example in England at Hampton Court Palace, at Windsor Castle, Berks, and at Uppark, W. Sussex.

Traditional craftsmanship dictating restoration policy is also seen in the Asian approach to the conservation of hanging scrolls and folding screens. In Japan and China the profession of the mounter can be traced back for more than 1000 years. Hanging scrolls are subject to considerable wear in the course of their normal use in temples and in the home. As a result, they have frequently been remounted, and this often included discarding the original patterned silks that surrounded the actual painting and replacing them with new ones. In some studios this practice continues, although the new silks are likely to have been selected to replicate the type of pattern used originally. In museums, however, the retention of the old mounting silks is beginning to be more usual, so that it is only the layers of the paper support that are replaced.

5. TECHNICAL EXAMINATION. This is carried out to elucidate the causes of deterioration of a monument or artefact and/or to learn about the materials and techniques used in its production. The examination starts with a thorough visual inspection, aided by hand-held magnifiers and then microscopes. The visual inspection may be extended by the use of instruments or techniques that can see below the surface: radiography in all its variations, ultraviolet (UV) fluorescence and infra-red (IR) photography. The development of IR image converters and 'real time' radiography means that it is no longer necessary to wait until a film has been developed before being able to see the results. (For descriptions of these and other techniques in greater detail see TECHNICAL EXAMINATION.)

The aim of this examination from a conservation point of view is a complete understanding of the condition of the object with the provision of answers to questions such as: has it been 'conserved' previously? are the components all contemporary, or is there evidence of earlier repairs? is the object subject to ongoing deterioration? if so, why? and what is the recommended conservation treatment? Such a close inspection will also, almost inevitably, disclose information about the materials and techniques used in the manufacture of the object, and these will need to be recorded for cataloguing purposes.

These techniques are completely non-destructive, but they may be complemented by analytical techniques, which usually involve the taking of a sample, however small. In the furtherance of conservation, it may be necessary to analyse alteration products on many materials, but particularly metals, glass and stone, in

order to devise a treatment for arresting the decay. For example, museums in the late 20th century are plagued by the growth of white, needle-like crystals on some metals. Analysis has shown these to be formates and acetates formed as a result of changing patterns of air pollution, resulting from the widespread use of synthetic resins in the manufacture of household fittings and furniture. In some cases the decay will only be fully explained by analysing the material of which the object was originally made: pure lead, for example, is more susceptible to this type of corrosion than lead containing a small percentage of tin.

6. RESEARCH. Conservation work needs to be backed up by research into mechanisms of deterioration, materials for conservation and methods of conservation. Mechanisms of deterioration include the yellowing of varnish on easel paintings, the fading of pigments and dyes on paintings, graphic art and textiles, the growth of corrosion products on metals, the alteration of glass and stone, the disintegration of organic materials and the growth of efflorescences on a range of porous objects. All need to be investigated to understand why and how they are taking place.

The investigation of materials to be used for conservation is important to ensure that the materials themselves will not adversely affect the objects. Many modern adhesives, paints and even some species of wood slowly give off vapours that corrode some metals, and these reactions may accelerate in the confined space of a well-sealed display case. Some modern adhesives and consolidents slowly become insoluble on ageing and should not be used on antiquities unless there is no alternative treatment and until the consequences of insolubility have been evaluated. Measuring the strength of adhesive bonds is important, as it is a general rule that the strength of the adhesive should match that of the material it will be used to repair. Thus, epoxy resins would not (normally) be used on earthenware pottery, but soldering may (sometimes) be used on metals.

The development of new techniques for conservation may involve sophisticated instrumentation, such as the use of lasers for cleaning stone, hydrogen plasma for cleaning metals and freeze-drying for removing water from waterlogged wood. Lasers and plasma are still experimental and are not yet widely used. As a technique, freeze-drying is not new, but it is still far from universally successful, and conservators continue to research the best material(s) for impregnating the wood before it is freeze-dried. Other new techniques are delightfully simple, such as the use of a Japanese paper join for inlaying works of art on paper, which has greatly simplified the actual inlaying process and almost eliminated the cockling that sometimes occurs later. Another simple technique is the use of a thixotropic chemical to hold a solvent in position on a restricted area of a surface.

7. PRACTICE. Conservation is essentially a one-to-one relationship between an object and the conservator, and very little conservation on individual objects is carried out by teams. The exceptions are usually when large objects are concerned, such as tapestries, wall paintings and buildings. Several people may be involved throughout the different stages of the conservation process, particularly where a variety of specialisms or very basic work are concerned. Thus the desalination of archaeological pottery may be done by an assistant before the conservator assembles and restores it, and the mounting of graphic art may be performed by technicians after the conservation of the item in question has been completed.

One of the problems of this traditional approach is the processing of large quantities of material, such as books made from modern unstable paper or sacks of pottery from excavations. A special problem in this category is the conservation of treasure trove, which may contain tens of thousands of individual coins. Individual treatments are not possible, and the mass deacidification of books and the cleaning of ceramic sherds and coins in batches has to be acceptable. Nonetheless, in the end each book and coin will need individual inspection, however cursory, before it is returned to the curator; and the assembly of the pottery fragments into vessels can never be anything other than a one-to-one task.

Because of the impossibility of treating everything to the highest standards, 'selection' has become an integral part of the museum vocabulary, from deciding what to keep from an excavation to deciding what to conserve for exhibition. The danger is that the selection will be made on the wrong grounds, that is on the basis of market value rather than historical importance. Thus an indifferent amateur 19th-century watercolour of a village street may be the only evidence for that village street as it once was, but the watercolour will be 'worth' only a fraction of what a Rembrandt etching would realize, even though there will be other copies of the same etching in other museums.

Conservation is labour-intensive and therefore expensive, and museums and other owners are turning more and more to preventive conservation (see §II, 1 below) by improving the environmental conditions in storage and display areas to eliminate (or minimize) deterioration. If decay can be eliminated, then interventive conservation can be restricted to those objects needed for study and display. Even then, resources can be maximized by not conserving all objects to display standard. To return to the stages of the conservation process outlined above, it is only essential, in many cases, to carry out cleaning and stabilization; the repair, restoration and scientific examination can wait until an object is to be studied, published or exhibited.

G. B. Cavalcaselle: *Sulla conservazione dei monumenti ed oggetti di belle arti* (Turin, 1863)

H. Ruhemann: *The Cleaning of Paintings: Problems and Potentialities* (London, 1968)

M. S. Tite: *Methods of Physical Examination in Archaeology* (London, 1972)

Carta del restauro 1972, Rome, Ministry of Education circular, cxvii (Rome, 6 April 1972)

Science for Conservators, 3 vols (London, 1982–1983/*R* 1992; 2003)

V. Daniels, ed.: *Early Advances in Conservation*, British Museum, Occasional Papers, lxv (London, 1988)

Histoire de la restauration en Europe: Interlaken, 1989

S. Bowman, ed.: *Science and the Past* (London, 1991)

A. Oddy, ed.: *The Art of the Conservator* (London, 1992)

A. Oddy, ed.: *Restoration: Is it Acceptable?*, British Museum, Occasional Papers, xcix (London, 1994)

UKIC (United Kingdom Institute of Conservation) Code of Ethics and Rules of Practice (London, 1996)

E. Hermans, ed.: *Looking through Paintings: The Study of Painting Techniques and Materials in Support of Art Historical Research*, Leids kunsthistorisch jaarboek, xi (Baarn, 1998)

H. J. Plenderleith: 'A History of Conservation', *Studies in Conservation*, xliii/3 (1998), pp. 129–43

K. Nicolaus: *Handbuch der Restaurierung* (Cologne, [1998]); Eng. Trans. as *The Restoration of Paintings* (Cologne, 1999)

A. Oddy and S. Carroll, eds: *Reversibility: Does it Exist?*, British Museum, Occasional Papers, cxxxv (London, 1999)

R. A. Rushfield and M.W. Ballard, eds: *The Materials, Technology, and Art of Conservation* (New York, 1999)

Code of Ethics and Guidance for Practice of the Canadian Association for Conservation of Cultural Property and of the Canadian Association of Professional Conservators (Ottawa, 3/2000)

A. Kirsh and R. S. Levenson: *Seeing through Paintings: Physical Examination in Art Historical* (New Haven, *c.* 2000)

I. Jenkins: *Cleaning and Controversy: The Parthenon Sculptures* (London, 2001)

R. van Schoute and H. Verougstraete, eds: *La peinture et le laboratoire: Procédes, méthodologie, applications* (Sterling, VA, 2001)

M. Andaloro, ed.: *La teoria del restauro nel Novecento da Riegl a Brandi* (Florence, 2003)

M. Faries and R. Spronk, eds: *Recent Developments in the Technical Examination of Early Netherlandish Painting* (Cambridge, MA, 2003)

J. H. Townsend, K. Eremin and A. Adriaens, eds: *Conservation Science 2002* (London, 2003)

L. Vlad Borrelli: *Restauro archeologico: Storia e materiali* (Rome, 2003)

A. B. Rogers: *The Archaeologist's Manual for Conservation: A Guide to Non-Toxic, Minimal Intervention Artifact Stabilization* (New York, 2004)

D. Stulick and others: *Solvent Gels for the Cleaning of Works of Art: The Residue Question* (Los Angeles, 2004)

T. Joffroy, ed.: *Traditional Conservation Practices in Africa* (Rome, 2005)

J. H. Stoner and J. Hill: 'Changing Approaches in Art Conservation: 1925 to the Present', *Scientific Examination of Art: Modern Techniques in Conservation and Analysis* (Washington, DC, 2005), pp. 40–57

S. Garnero: *Conservazione e restauro in Francia, 1919–1939: I lavori della Commission des monuments historiques* (Florence, 2006)

M. Jones, ed.: *Conservation Science: Heritage Materials* (Portsmouth, 2006)

II. Techniques.

1. Preventive. 2. Restoration.

1. PREVENTIVE. The conservation of artefacts has traditionally been understood to mean their restoration, but in the second half of the 20th century the term came to include the protection of objects from damage and deterioration. The materials from which artefacts have been constructed, and the techniques that have been used to assemble them, are invariably impermanent. The timescale of their 'lives' varies from a few years (in the case of collections that are appropriately called 'ephemera') to millennia. The objects that have survived from the distant past give clues to the permanence of different materials—textiles are rarely found in archaeological excavations, but stone and ceramic objects are often recovered.

Deterioration can be brought about by physical, chemical and biological changes, and an understanding of these processes is the key to their prevention. Some events can be dramatic, for example the breaking of a piece of ceramic; others are more insidious. Chemical ageing processes often occur slowly. Their effects may not be noticed unless a comparison can be made with how an object looked in the previous century. Unfortunately this deterioration is irreversible, and there is nothing in the art or craft of the conservator that can turn back the clock. The prevention, or at least the slowing down, of the ageing process is essential. In order to control the environment in which objects are kept, it is important to understand what conditions will cause the slowest rate of deterioration, and it is important to know what the enemies are: they include fire, theft, breakage, handling, shock, vibration, light, water, damp, dryness, air pollution, insects and mould. Security and fire prevention are the most important considerations in the care of any collection, but they are specialist subjects for which the conservator is not responsible. The conservator advises on the way in which an object is exhibited, stored or transported. This includes lighting, heating, relative humidity control, mounting methods, storage materials and air pollution. Having specified the optimum conditions, measurements must be made to decide if methods of control need to be introduced. Attempts to improve the environment should be monitored to check that they are effective.

This section outlines those aspects of the environment that can be harmful to artefacts at inappropriate levels. They have been considered in a general sense, and an attempt has been made to recommend levels that will be suitable for mixed collections of artefacts. There can be no doubt that these measures to improve the environment in which artefacts are kept, although they may involve short-term expenditure, will reap enormous benefits in the long term by reducing the need for costly restoration or, at least, by increasing the length of time between treatments. No attempt has been made here to recommend methods of handling or mounting objects, because this is so dependent on the material involved. Nevertheless, this is an extremely important subject to consider in preventing damage, and it is discussed in some detail, along with other specific requirements, in other articles on art forms and materials.

(i) Light. (ii) Temperature. (iii) Relative humidity. (iv) Air pollution. (v) Air-conditioning. (vi) Display cases.

(i) Light. Light is a type of electromagnetic radiation. It is a source of energy that is capable of causing photochemical changes in materials that absorb it. The human eye is sensitive to radiation with wavelengths between 400 and 700 nm (1 nm = 1 nanometre = 10^{-9}). This part of the electromagnetic spectrum is perceived as violet at the short wavelength end, passing through the rainbow colours, blue, green, yellow, orange to red, at the long wavelength end. Beyond the violet end of the spectrum lies the ultraviolet (UV) region. The energy is greatest at short wavelengths, and UV is a particularly potent cause of photochemical damage. This potency decreases through the visible part of the spectrum. Blue and green light cause some damage, but yellow, orange and red wavelengths cause little or no damage. Beyond the red end of the spectrum is the infra-red (IR) region, which heats objects and, by raising temperature, can cause damage by drying (*see* §(ii) below).

Organic materials, that is those of animal or vegetable origin, are likely to be affected by photochemical change. This may become apparent when a colour change is seen: a textile dye might fade, or a green copper resinate pigment might turn brown. Photochemical reactions also weaken materials; textile fibres break, and, of these, silk is the most sensitive. The long horizontal tears sometimes seen in tapestries are where the silk weft threads have broken, leaving the wool warp threads intact. Eventually the wool threads will also break. Unfortunately, many artefacts are made wholly or partially from organic materials, and only the inorganic materials—glass, ceramic, stone and metal—are not affected by this photochemical deterioration.

(a) Elimination of ultraviolet radiation. As the eye is not sensitive to UV wavelengths, there is no visual penalty in removing it from light sources. Daylight contains the highest proportion of UV, but there are also significant amounts in most fluorescent lamps, tungsten halogen lamps and metal halide lamps. It can be eliminated by using a filter that absorbs the short wavelength radiation up to 400 nm but allows the visible wavelengths to pass through. UV is measured in units of microwatts per lumen, and the proportion emitted by tungsten incandescent bulbs (as in domestic lighting) has been considered the maximum level acceptable for illumination in museums. This level is 75 microwatts per lumen. It can be measured directly using an ultraviolet monitor.

Glass absorbs wavelengths only up to 320 nm, and therefore it is not an adequate filter for daylight. Unfortunately, it is not possible to prepare glass with a UV filter, as the temperature at which the sheets of glass are manufactured breaks down the chemicals used. Laminated glasses, which consist of two sheets of glass sandwiched together with a plastic containing a UV filter, are available. They have the advantage of giving additional security as they are extremely difficult to break. Plastic acrylic and polycarbonate sheets are also manufactured as UV absorbers, but they tend to scratch and are therefore not suitable as window glazing materials. However, they are extremely useful for picture glazing and display cases. The most economical and effective way of treating windows is to apply UV-absorbing varnishes or polyester films. These are transparent and colourless and are usually guaranteed for five years. The polyester films are available as sleeves that can be slipped over fluorescent lamp tubes. They usually last for two or three changes of tube. Tungsten halogen lamps emit a small proportion of highly energetic, very short wavelength UV radiation, which can be filtered using a plain glass filter (plastic filters cannot be used with these lamps as they operate at a high temperature). Alternatively, heat-resistant dichroic filters can be used to filter all of the UV content of tungsten halogen lamps.

UV filtering should be checked with the UV monitor every six months and renewed if necessary. It is not usually a reduction in the UV absorbing properties that makes replacement necessary; more often it is occasioned by a problem with the appearance of the filter material, for example the acrylic sheets being scratched or the polyester film lifting off a window that suffers from condensation.

(b) Reduction of exposure time. The damage caused by photochemical change is cumulative, and the rate of deterioration is proportional to the light level and the time of exposure. Objects should be exposed to light for as little time as possible. Storage areas should always be dark unless a person is working there; exhibition areas should be blacked out whenever the museum is closed; opening hours should be kept as short as possible (the opening of a historic house for seven days a week rather than five will increase the deterioration of the contents by 40%).

Blackout can be achieved by various means. The most sophisticated method might involve motorized blinds that are programmed to close when the museum closes. Manually controlled louvred blinds or dark roller blinds achieve the same effect at less expense. Many old houses have wooden shutters, which eliminate daylight very effectively when they are closed. During opening hours, exposure of particularly sensitive artefacts can be reduced by using artificial lighting that is switched on by the visitor for a few moments only or by protecting exhibition cases with curtains that are drawn back by the viewer. Exhibition of these objects can be alternated with periods of storage in the dark.

(c) Reduction of light levels. There is no threshold below which photochemical damage will not occur. Even the lowest light levels will cause damage if objects are exposed to them for a long time. A compromise has to be made between the need for the viewer to be able to see and the requirement for most artefacts to be exposed to as low a light level as possible. The recommended levels of illumination are 200 lux for oil and tempera paintings and 50 lux for

more sensitive items: textiles; prints, drawings and other works of art on paper; miniatures, wallpapers and dyed leather; and most natural history exhibits, including botanical specimens, fur and feathers. The 50 lux level is the minimum that will give satisfactory visual acuity for the viewer. A light meter should be used to measure light levels, as the eye is a bad judge because of its ability to adapt to changes in intensity.

When reduced light levels are used there are a number of precautions that must be taken to make the most of the available light. It is very important that the eye does not lose its adaptation to the low light levels. Even in areas where there are no light-sensitive materials, light levels should not be allowed to rise above 300 lux. Glare from artificial lighting should be avoided; spotlights should not shine into viewers' eyes, nor should their reflections be visible in the glazing of paintings or of display cases. It has been found that the best viewing conditions are when objects are lit at levels between two and three times as bright as their surroundings. It is a fallacy to think that an illuminated object in dark surroundings will be more visible.

Daylight is much more difficult to control than artificial lighting. It changes all the time, and the levels vary from dark to more than 50,000 lux. The highest light levels come from sunlight: this causes a high rate of photochemical damage and also heats any surface on which it shines, because of the high levels of infra-red radiation it contains. The method of reducing daylight to the recommended level must be very flexible. The only satisfactory way of limiting to within a reasonable range of 200 lux is by using motorized blinds controlled by photocells. The photocells measure the light level and then open or close the blinds as required. However, this involves the installation of complicated and expensive machinery, which may be unsuitable for many collections. Manually controlled blinds may be an adequate solution. It is essential that sunlight is eliminated by the rigorous use of blinds, and even if no more is done than closing the blinds when the sun shines into a room, this at least will prevent excessive photochemical damage. If staff are available, the blinds should be adjusted, using a light meter, as the light changes during the day. Another possibility is to apply solar-control films to windows. These are usually metallized polyester films, and they are available with added UV filters, which give them a double use. They will always reduce the daylight by the same amount, so if the density is selected to give acceptable levels on a bright day, then artificial lighting will be needed to supplement the lighting on duller days.

50 lux of daylight appears gloomy, so artificial lighting is preferable at this level. A light meter should be used when the lights are first installed to ensure that no artefact is over-illuminated. For 50 lux illumination a warm or reddish coloured lamp is better than a cool or bluish coloured one. (The 'warmth' or 'coolness' of a lamp is quantified by its colour temperature, which is a measure of the appearance of the lamp.) The other important consideration when selecting a lamp is its colour rendering index. This is a measure of the distortion of the appearance of objects in that light. A lamp with good colour rendering will cause no distortion. Tungsten and tungsten-halogen incandescent lamps have excellent colour rendering properties and a low colour temperature, so they are particularly suitable for lighting at 50 lux. There is a huge range of fluorescent, triphosphor and polyphosphor lamps, some of which have good colour rendering properties; the low colour temperature ones are also suitable for lighting at 50 lux. Metal halide lamps tend to have poor colour rendering properties, but they are improving and may be useful because of their very high efficacy (producing high light levels with low energy consumption).

Another approach for the control of lighting is to set an exposure value for the year. For a museum that is open from 10 a.m. to 6 p.m. throughout the year, 200 lux is equivalent to 666,000 lux hours of exposure. Light levels could be allowed to rise above 200 lux, provided they are compensated for with periods of lower illumination or darkness.

(ii) Temperature. People are very conscious of temperature, and many assume that it is the most important environmental condition to control. In a domestic situation this is certainly the case, since the comfort of people is the prime consideration, but in the conservation of artefacts temperature is the factor to which they are least sensitive. The rate of all chemical and biological changes increases as the temperature rises, and therefore lower temperatures will slow down all rates of deterioration. Also, materials expand and contract as temperature increases and decreases. If these changes are dramatic, metal objects, which have high-temperature coefficients of expansion, may be damaged, particularly if they are made from more than one metal. Temperature is closely related to relative humidity (*see* §(iii) below). As it is extremely important to keep the relative humidity under control, temperatures must be selected to give the correct levels.

The levels of temperature recommended in museums (18–25°C) are governed by the comfort of visitors. When people do not have to be considered, as, for example, in historic houses that close during the winter, the temperature can be controlled to give the required relative humidity. Direct heating should be avoided since it can cause local drying. Chimney-breasts and the areas above radiators can be dangerous. Sunlight, powerful spotlights and lights in confined spaces will cause heating. Condensation should be avoided by not allowing any object to fall in temperature below the dew point of the air surrounding it. If storage areas are kept at lower temperatures than exhibition areas, then care should be taken not to allow warm, damp air to leak in. Care should also be taken to avoid condensation forming on cold objects brought into the warm. This can be a particular risk when objects have been transported during the winter or in cold aircraft holds.

(iii) Relative humidity. Relative humidity (RH) is a measure of the amount of water that the air holds (absolute humidity) compared with the maximum that it can hold at that temperature. The higher the temperature, the more water air can hold. All materials that contain water react to the amount of water in the air surrounding them. In dry air, with a low RH, they lose water, and in damp air, with a high RH, they gain water. The moisture content of an object is in a dynamic equilibrium with the relative humidity of the air surrounding it. As the RH of the air changes, the moisture content of objects changes. Such changes are undesirable because of their effect on physical dimensions.

High relative humidity encourages biological activity, causes changes in physical dimensions and accelerates some chemical reactions. Mould growth will occur on most organic materials when the RH is higher than 65%. It is encouraged by still air and warm temperatures. Insect attack also occurs more readily at high RH. Some insects, such as the death-watch beetle, will only attack wood that has already been rotted by moulds and fungi. Silver-fish and booklice live on the moulds that thrive on books kept in damp conditions.

Many organic materials contain water, and they swell when high relative humidity causes them to absorb water from the atmosphere. Anisotropic materials, such as wood, swell more across the grain than along it. This can set up severe tensions in furniture, when the wood is restrained by the construction of the piece. An apparent contradiction of this is canvas and other woven fabrics, which shrink in high RH. This contraction is caused by the fibres swelling across their width, which tightens the weave. The canvases of some paintings shrink dramatically in damp conditions, and since the ground and paint layers cannot shrink by the same amount, cleavage occurs between the canvas and the ground. The corrosion of metals increases in high RH, particularly if the air is acidic. Photochemical damage to textiles and dyes is also accelerated. Some glass is moisture-sensitive and becomes opaque and brittle if exposed to high RH.

If the RH is low, water-containing materials shrink. Wooden objects are particularly affected and may crack and distort. Leather shrinks, textile fibres break, and adhesives fail. Veneers may lift during periods of low humidity, partly because of adhesive failure and partly because of dimensional changes in the thin slivers of wood.

Fluctuating RH is particularly damaging for objects made from a number of different materials that are affected by water by varying amounts. As the RH rises and falls, each material swells and contracts at a different rate. Repeated cycles (such as may occur during the winter in rooms that are centrally heated during the day but not during the night, resulting in dry air during the day alternating with damper air at night) will cause panel paintings to warp and the paint to cleave. The speed with which objects react to changes depends on the material. Paper and textiles react in minutes, large pieces of wood in hours. Fluctuating RH can cause the growth of soluble salts on the surface of porous materials; a head of *Amenophis III*, for example, was relatively intact when first photographed in 1896, but its condition has since deteriorated because of the effect of soluble salts.

(a) Recommended levels. In conservation literature there is a bewildering variety of specifications for the 'ideal' relative humidity for particular types of objects. It is clear, however, that one of the most important considerations is the environment to which an object has become acclimatized. A museum in the humid tropics will probably select an RH in the region of 65%, because the cost of running an air-conditioning plant (*see* §(v) below) to further reduce the RH would be prohibitive. A museum in Canada or northern Europe might select an RH in the region of 45–50%. If the RH in the building is higher than this during the winter, water diffusing through the walls of the building can freeze, and repeated cycles of freezing and thawing within the walls can weaken the structure of the building to the point of failure.

Although it is misleading to speak of the 'ideal' RH for particular objects, there are certainly ranges of relative humidity within which artefacts will deteriorate at a lower rate. RH levels above 65% and below 45% should be avoided, except for metal-only collections, which should be kept at as low a level as possible. Within this range, levels should be maintained within a 10% band and should be as constant as possible. In practice, it is very difficult to keep the RH this constant, except within exhibition cases, unless an effective air-conditioning plant has been installed. If free-standing RH control units are used, then it is at least possible to avoid the damaging extremes.

(b) Measurement. Relative humidity is measured with hygrometers. Wet-and-dry bulb hygrometers (psychrometers), when used correctly, give accurate results against which all other hygrometers can be calibrated. The whirling hygrometer is the simplest and least expensive of these instruments. It consists of two thermometers, one of which has a fabric sleeve around its bulb. The sleeve is moistened with distilled water, and air is moved past the wet-bulb thermometer by whirling the hygrometer like a football rattle. Water will then evaporate from the fabric sleeve and cool the thermometer bulb. The amount of cooling depends on the amount of water that evaporates, which in turn depends on the relative humidity of the air. The lower the RH the greater the depression of the wet-bulb thermometer will be with respect to the dry bulb. A scale is provided that shows the RH for various wet- and-dry bulb temperatures. In some wet-and-dry bulb hygrometers the air is drawn past the thermometer bulbs by an electric fan; a micro-processor to calculate the RH automatically may also be incorporated. These models are easier to use but more expensive than whirling hygrometers.

Dial hygrometers and the recording thermohygrograph rely on the expansion and contraction that changes in RH cause in moisture-sensitive elements. Hair and paper react quickly and with a large enough change in dimension to be used for this purpose. In a paper hygrometer, two strips of paper that respond differently to changes in RH are glued together and coiled, so when the RH changes the coil twists and moves the pointer to which it is attached. In the recording thermohygrograph hair elements are used. A bundle of hairs is attached by a series of levers to a pen, while the temperature is recorded by another pen that is moved by the twisting of a coiled bimetallic strip. These are not accurate instruments, and they require frequent calibration. Electronic instruments depend on moisture-sensitive elements that undergo a change in electrical property as the RH varies. These are available as meters or as dataloggers, for recording readings. They are very versatile, and if the calibration caps with which they are supplied are used, they are as accurate as the wet-and-dry bulb instruments.

In automatic RH control humidistats are essential. The most common types have bundles of hair as the moisture-sensitive elements, but electronic versions are also available. Frequent calibration is still required.

(c) Control. The control of relative humidity can be achieved by air-conditioning (*see* §(v) below), but other methods are more suitable for collections that do not have the resources or space to install air-conditioning or for buildings in which a plant would be intrusive. In areas where it is not needed for the comfort of people heating can be used to control the relative humidity at the desired level. In Britain, where the outside monthly average RH is between 75–85%, the inside RH can be reduced to below the mould damage threshold of 65% by raising the temperature by only 5°C. In most summers solar gain raises temperatures by this amount, but in winter heating can be used. If the heating system is controlled by a humidistat, then the RH control can be quite accurate. The system tends to work particularly well in rooms that are individually heated, for example with electric heaters. Central-heating systems take longer to react to changing environmental conditions. In addition to benefiting artefacts, these lower winter temperatures allow great savings in energy costs. A minimum inside temperature of 5°C should be set to avoid frozen pipes and the danger of subsequent flooding.

The use of temperature to control RH is only possible in storage areas and in collections that are not open during the winter. The main problem with museums that are open during the winter is the dryness caused by the heating needed for the comfort of people. To combat this, humidifiers must be used to add enough water to the air in a controlled manner. There are four types of humidifier available: evaporative, steam, ultrasonic and atomizing. The most suitable for museum use is the unheated evaporative humidifier. A hollow rotating drum carrying a sponge belt picks up water from a reservoir, and a fan in the centre of the drum blows water off the sponge into the air. This type can be used with tap water, as any hard-water salts remain behind on the sponge. It is important to keep these machines clean, by using a fungicide in the reservoir and by removing the hard-water salts periodically. Steam humidifiers work on the electric-kettle principle and consume large amounts of energy. Ultrasonic humidifiers contain a plate that vibrates rapidly, forcing water droplets into the air. Atomizing humidifiers contain rapidly rotating blades that disperse water into the air. Both ultrasonic and atomizing humidifiers will add any hard-water salts to the air and must therefore be used with distilled water to prevent a thin film of salts from being deposited around the room.

There are two types of room dehumidifiers: dessicant and refrigerative. The dessicant type contains a salt that absorbs water from the air. The water is removed from the salt by heating and is then exhausted from the machine, either as warm, moist air vented to the outside through a tube, or by being condensed and drained by a hose. It is efficient at all temperatures and therefore more suitable for areas where there is no heating in winter. The refrigerant dehumidifier works on the same principle as the domestic refrigerator. Water from the air condenses on the cold expansion coils, and the air is then reheated by passing over the warm condensing coils. Every 20 minutes or so, the machine enters a defrost cycle for a couple of minutes: the water melts off the cold coils and is drained from the machine by a hose. This type is cheaper to buy, but its efficiency drops off dramatically as the temperature falls, until at temperatures near freezing it is incapable of removing any water from the air.

It is important to ensure that air circulates around a room. A hygrometer should be used to check that there are no pockets of stagnant air in the corners or behind furniture. If the RH is high in these areas, then mould may grow. Fans can be used to improve air circulation. The capacity of the humidity controllers and the number of units required depends on the size of the room, the effectiveness of draught exclusion and the difference between internal and external conditions. In practice, it has been found that dehumidifiers work best in areas that are well sealed. In storage areas, an effective sealed area can be made cheaply by constructing a polythene tent over a wooden batten frame.

It is possible to control the relative humidity of small volumes of air using buffering materials that are preconditioned to the required level. Any moisture-containing material (e.g. wood, paper or cellulosic textile fibre) can be used, but the amount of water it can hold and the speed with which it reacts will often not be adequate for conditioning purposes. Silica gel is a suitable buffering material because it holds sufficient water, responds rapidly to changes in RH and is chemically inert. Its use in display cases is considered in §(vi) below.

(iv) Air pollution. Air pollution levels are highest in urban and industrial areas, since it is a product of the

burning of fossil fuels and the exhaust from motor cars. Unfortunately, few areas in the world are free of air pollution, so it must be considered a problem for all collections of artefacts. There are two types of air pollutant, particulate or gaseous. Particulate matter has many sources. Some is produced by mechanical action, some, for example pollen, occurs naturally, and others are formed by chemical processes in the air. There are two main types of gaseous pollutant, acidic and oxidant. Acidic sulphur dioxide results from the burning of fossil fuels, all of which contain sulphur. Sulphur dioxide reacts with oxygen and water in the atmosphere to form sulphuric acid, which is extremely damaging to any surface on which it is deposited. Ozone is produced naturally in the upper atmosphere and forms a layer that protects the planet from damaging short-wavelength ultraviolet radiation. However, at ground level, where it is generated in certain types of electrical equipment, such as photocopying machines, and by the action of sunlight on car exhaust fumes, it is an oxidizing pollutant gas. Nitric oxide and nitrogen dioxide are both produced in car exhaust fumes. Water converts nitrogen dioxide to nitric acid, which is an oxidizing agent as well as an acid.

Particulates attach themselves to surfaces, where they will eventually form an unsightly layer, particularly if they contain a high proportion of sooty material from the incomplete burning of fossil fuels. This surface dirt will need to be removed periodically, and the cleaning operation can be dangerous for objects. The particles are often acidic from adsorbed sulphur dioxide.

Acids attack calcium carbonate. Sulphuric acid will convert insoluble calcium carbonate to calcium sulphate, which is slightly soluble. Both marble and limestone are forms of calcium carbonate, and buildings or statues made of these materials are damaged by the acidic rain that results from industrial air pollution. The calcium sulphate that is formed is washed away by the rain, thereby exposing a fresh surface of calcium carbonate to be attacked. Frescoes, in which the pigment particles are embedded in a matrix of calcium carbonate crystals, are also vulnerable to sulphuric acid attack. Cellulosic materials (paper, cotton) and proteinaceous materials (wool, silk, leather) are embrittled and discoloured by sulphur dioxide. The rusting of iron is accelerated by the presence of sulphur dioxide. Nitric acid has a similar damaging effect to sulphuric acid. Ozone is an extremely powerful oxidizing agent and will react with most organic materials. It weakens cellulosic materials, discolours dyes and damages varnish and oil paint films.

There is no acceptable minimum level of pollution. The solution lies in the removal of air pollution by air-conditioning with a filtration system. It is impractical to try to eliminate all particulate matter using filters, since high pressure is needed to pass air through 'absolute' filters, and particulates are also introduced into collections by visitors. Viscous filters, which use such a liquid as oil to trap coarse particulates, are suitable for rough filters when the air first enters a building. Fabric filters, which are bags made of layers of fibres, are used for more efficient particle filtering.

The filters must be changed periodically. As they remove particles they become more resistant to the passage of air through them. This results in a pressure difference across the filter, and when this reaches a level specified by the manufacturers the filters should be changed. It is possible to remove particulates using electrostatic precipitators. The air passes positively charged wires, from which the particulates gain a positive charge. The particulates are then collected on negatively charged collector plates downstream. As these precipitators produce small quantities of ozone they should not be used in museums.

Sulphur dioxide and nitrogen dioxide, which are soluble in water, can be removed by water sprays. However, these are not effective against ozone. Activated carbon filters adsorb all pollutant gases; like particle filters, they need periodic replacement. The only alternative to air-conditioning for the removal of air pollution is the use of display cases (*see* §(vi) below).

(*v*) *Air-conditioning*. An air-conditioning plant removes particulates and pollutant gases from the air and then distributes it at a required temperature and RH to all parts of the building through a system of ducts. The installation must be designed and supervised by specialist engineers, and its successful operation relies on a competent maintenance team. It is vital that the temperature and humidity sensors located in the ducting and near the outlets to the rooms are correctly calibrated and maintained, since these control the system. As with fire and security, air-conditioning is too specialized a subject to fall within the responsibility of the conservator. However, it is important for conservators to monitor environmental conditions in air-conditioned rooms and check that the system is working to specification.

(*vi*) *Display cases*. These can provide a microclimate within a room that would otherwise expose objects to an unsuitable environment. Since the aim is to isolate the objects from external conditions the case should be sealed as efficiently as possible. If the RH outside the case changes, the RH within the case will also change, but at a slower rate and to a lesser extent because of the buffering effect of moisture-containing materials within the case. A case made of wood and lined with fabric will provide a considerable volume of buffer. Within a well-sealed case it is possible to maintain a higher or lower average RH than that of the room. This can be achieved with the use of a conditioning material such as silica gel. Conditions within the case should be monitored with a hygrometer.

Light sources should be outside the case, in a top or side panel. This overcomes the problem of heat build-up and enables bulbs to be replaced without disturbing the display. If the lamps can be positioned only within the case, less heat will be generated by fluorescent than incandescent lamps, provided the fluorescent lamp ballast is outside the case. Fibre

optic light systems allow light from a projector to be transmitted along a glass fibre light guide. They are useful for lighting display cases because they are so unobtrusive. The glass fibre absorbs ultraviolet and infra-red radiation, and this reduces the risk of damage to artefacts.

In a sealed case, it is important that no materials are used in the construction that give off air pollutants. Glass and metal are safe, but wood can produce formic and acetic acids, which attack metal and organic materials. Undyed cotton and linen are harmless, but fabrics made of silk and wool, or those dyed with certain dyes, can produce dangerous levels of sulphides, which tarnish silver and corrode some metals.

General

Contributions to the IIC Conference. Museum Climatology: London, 1967 [various articles]

G. Thomson: *The Museum Environment* (London, 1978, 2/1986)

H. Sandwith and S. Stainton: *The National Trust Manual of Housekeeping* (London, 1984, rev. 2/1990)

J. M. A. Thompson, ed.: *Manual of Curatorship: A Guide of Museum Practice* (London, 1984)

S. Keene: Managing Conservation in Museums (Boston, 1995; rev. Oxford, 2/2002)

E. Pye: *Caring for the Past: Issues in Conservation for Archaeology and Museums* (London, *c.* 2001)

K. L. Lithgow and others, eds: *The National Trust Manual of Housekeeping: The Care of Collections in Historic Houses Open to the Public* (Oxford, 2006)

Specialist studies

Lighting

N. S. Brommelle and J. B. Harris: 'Museum Lighting', *Museum Journal: The Organ of the Museums Association*, lxi (1961), pp. 169–76, 259–67; lxii (1962), pp. 337–46, 178–86

G. Thomson: 'A New Look at Colour Rendering, Level of Illumination, and Protection from Ultraviolet Radiation in Museum Lighting', *Studies in Conservation*, vi (1961), pp. 49–70

R. L. Feller: 'Control of the Deteriorating Effects of Light on Museum Objects', *Museum* [Paris], xvii (1964), pp. 57–98

R. L. Feller: 'The Deteriorating Effect of Light on Museum Objects', *Museum News Technical Supplement*, iii (1964), pp. i–viii

G. Thomson: 'Annual Exposure to Light within Museums', *Studies in Conservation*, xii (1967), pp. 26–36

CIBS Lighting Guide: Museums and Art Galleries, Chartered Institution of Building Services (London, 1980)

D. L. Loe, E. Rowlands and N. F. Watson: 'Preferred Lighting Conditions for the Display of Oil and Watercolour Paintings', *Lighting Research and Technology*, xiv (1982), pp. 173–92

J. Turner, ed.: *Light in Museums and Galleries* (London, 1984)

G. Thomson and S. Staniforth: *Conservation and Museum Lighting*, Museums Information Sheet, no. 6 (London, rev. 4/1985)

Preprints of the Two Day Museums Association, UKIC and Group of Designers and Interpreters in Museums Conference. Lighting in Museums, Galleries and Historic Houses: Bristol, 1987 [various articles]

M. Belcher: 'The Use of Daylight as the Main Source of Lighting Exhibitions', *Where to Start, Where to stop?: Papers from the British Museum/MEG, Ethnographic Conservation Colloquium, London, 1989*, pp. 63–8

B. L. Ford: 'Monitoring Colour Change in Textiles on Display', *Studies in Conservation*, xxxvii/1 (Feb 1992), pp. 1–11

P. Wilson: *Colour Changes in Works of Art on Paper During Exhibition* (Kingston, Ont., 1998)

T. T. Schaeffer and T. Terry: *Effect of Light on Materials in Collections in Hot and Humid Climates: A Report Prepared for the Collections in Hot and Humid Environments Project of the Getty Conservation Institute* (1999)

C. L. Craft and M. N. Miller: 'Controlling Daylight in Historic Structures: A Focus on Interior Methods', *APT Bulletin*, xxxi/1 (2000), pp 53–9

C. Cuttle: 'A Proposal to Reduce the Exposure to Light of Museum Objects without Reducing Illuminance or the Leval of Visual Satisfaction', *Journal of the American Institute for Conservation*, xxxix (Summer 2000), pp. 229–44

L. Eaton: 'Let There be Light: Winterthur's Lighting Project', *Textiles Revealed: Object Lessons in Historic Textile and Costume Research*, ed. M. M. Brooks (London, 2000), pp. 93–7

T. T. Schaeffer: *Effects of Light on Materials in Collections: Data on Photoflash and Related Sources* (Los Angeles, 2001)

J. Ashley-Smith, A. Derbyshire and B. Pretzel: 'The Continuing Development of a Practical Lighting Policy for Works of Art on Paper and Other Object Types at the Victoria and Albert Museum', *Preprints of the ICOM Committee for Conservation, ICOM-CC: 13th Triennial Meeting, Rio de Janeiro, 22–27 September 2002*, i, pp. 3–8

Relative humidity

K. J. MacLeod: 'Relative Humidity: Its Importance, Measurement and Control in Museums', *Canadian Conservation Institute Technical Bulletin*, i (1975)

Preprints of the IIC Congress. Conservation within Historic Buildings: Vienna, 1980 [articles by W. Beck and M.Koller, and J. R. Briggs]

G. Thomson: 'Control of the Environment for Good or Ill? Monitoring', *National Gallery Technical Bulletin*, v (1981), pp. 3–13

R. H. Lafontaine and S. Michalski: 'The Control of Relative Humidity: Recent Developments', *Preprints of the ICOM Committee for Conservation, 7th Triennial Meeting: Copenhagen, 1984*, pp. 84/17/33–7

N. Stolow: *Conservation and Exhibitions: Packaging, Transport and Storage Considerations* (London, 1985)

G. Thomson and S. Staniforth: *Simple Control and Measurement of Relative Humidity in Museums*, Museums Information Sheet, no. 24 (London, rev. 2/1985)

S. Staniforth and B. Hayes: 'Temperature and Relative Humidity Measurement and Control in National Trust Houses', *Preprints of the ICOM Committee for Conservation, 8th Triennial Meeting: Sydney, 1987*, pp. 915–26

Preprints of a Two Day Meeting of the SSCR and the Museums Association. Environmental Monitoring and Control: Dundee, 1989 [various articles]

M. Cassar and J. Hutchins: *Relative Humidity and Temperature Pattern Book: A Guide to Understanding and Using Data on the Museum Environment* (London, 2000)

S. Staniforth and K. Lithgow: 'When Conservator Meets Architect and Engineer', *Conservation of Historic Buildings and their Contents: Addressing the Conflicts,* eds D. Watt and B. Colston (London, 2003), pp. 66–79

D. Saunders and J. Kirby: 'The Effect of Relative Humidity on Artists' Pigments', *National Gallery Technical Bulletin*, xxv, (2004), pp. 62–72

Air pollution

G. Thomson: 'Air Pollution: A Review for Conservation Chemists', *Studies in Conservation*, x (1965), pp. 147–67

S. M. Blackshaw and V. D. Daniels: 'The Testing of Materials for Use in Storage and Display in Museums', *The Conservator*, iii (1979), pp. 16–19

T. Padfield, D. Erhardt and W. Hopwood: 'Trouble in Store', *Preprints of the IIC Washington Congress: 1982*, pp. 24–7

S. Hackney: 'The Distribution of Gaseous Air Pollutants within Museums', *Studies in Conservation*, xxix (1984), pp. 105–16

P. Brimblecombe: 'The Chemistry of Museum Air', *Preprints of a Two Day Meeting of the SSCR and the Museums Association. Environmental Monitoring and Control: Dundee, 1989*, pp. 56–64

W. Nazaroff and others: *Protection of Works of Art from Soiling Due to Airborne Particulates*, GCI Scientific Program Report (Marina del Rey, 1992)

P. B. Hatchfield: *Pollutants in the Museum Environment: Practical Strategies for Problem Solving in Design, Exhibition, Storage* (London, 2002)

Air-conditioning

R. D. Buck: 'Specifications for Museum Air Conditioning', *Museum News Technical Supplement* [Washington], vi (1964), pp. 53–7

W. P. Jones: *Air Conditioning Engineering* (London, rev. 2/1973)

J. R. Briggs and P. Smith: 'Engineering Systems for Galleries', *Studio International* (May–June 1975), pp. 220–22

A. Reading: 'A Control Philosophy for the Economical Air Conditioning of Museums and Galleries', *Building Services Engineering Research and Technology*, iv (1983), pp. 97–105

D.V. Chadderton: Air Conditioning: A Practical Introduction (London and New York, 1993; rev. 2/1997)

American Society of Heating, Refrigerating and Air-Conditioning Engineers: ASHRAE handbook: heating, ventilating, and air-conditioning applications (Atlanta, 2003)

Display cases

K. Toishi: 'Humidity Control in a Closed Package', *Studies in Conservation*, iv (1959), pp. 81–7

G. Thomson: 'Relative Humidity: Variations with Temperature in a Case Containing Wood', *Studies in Conservation*, ix (1964), pp. 153–69

T. Padfield: 'Control of Relative Humidity and Air Pollution in Showcases and Picture Frames', *Studies in Conservation*, xi (1966), pp. 8–30

G. Thomson: 'RH Stabilisation in Exhibition Cases: Hygrometric Half-time', *Studies in Conservation*, xxii (1977), pp. 85–102

P. Brimblecombe and B. Ramer: 'Museum Display Cases and the Exchange of Water Vapour', *Studies in Conservation*, xxviii (1983), pp. 179–88

M. Cassar: 'Choosing and Using Silica Gel for Localised Protection in Museums', *Preprints of a Two Day Meeting of the SSCR and the Museums Association. Environmental Monitoring and Control: Dundee, 1989*, pp. 30–46

D. Grosjean and S.S. Parmar: 'Removal of Air Pollutant Mixtures from Museum Display Cases', *Studies in Conservation*, xxxvi/3 (Aug 1991), pp. 129–41

M. K. Rust and J. M. Kennedy: *The Feasibility of Using Modified Atmospheres to Control Insect Pests in Museums*, GCI Scientific Program Reports (Marina del Rey, 1993)

S. Maekawa, ed.: *Oxygen-free Museum Cases* (Marina del Rey, 1998)

J. A. Bamberger, E. G. Howe and G. Wheeler: 'A Variant Oddy Test Procedure for Evaluating materials Used in Storage and Display Cases', *Studies in Conservation*, xliv/2 (1999), pp. 86–90

P. Camera, L. Di Mucci and F. Sciurpi: *La vetrina per il museo: Caratteristiche e requisiti di funzione* (Florence, 2004)

D. D. Thickett: *Selection of Materials for the Storage or Display of Museum Objects* (London, 1996, rev. 2004)

2. Restoration.

(i) Painting. (ii) Sculpture.

(i) Painting. While much restoration of easel paintings in the past was excessive, few paintings of any age survive completely undamaged. The damage may vary greatly in extent and type. The losses may be relatively small, such as those from minor flaking, scratches and woodworm exit holes through the painted surface of panels; or the damage may be principally to the upper paint layers, as in abrasion from past cleanings and the use of over-hot irons in the relining of canvases (*see* Canvas, §3). Panels may have split or the joins opened up (*see* Panel painting, §3), and canvases are vulnerable to tears and punctures. In extreme cases faulty technique, neglect or accidents may lead to a large part of the picture surface being lost. Modern approaches to restoration vary equally widely. Decisions as to how to restore a painting are generally made by considering such factors as the type and extent of the damage, the style and likely intentions of the painter, the past and present function of the work and the traditions and philosophies of the institutions, whether museums, collectors or the art trade, for which the work is being restored.

Whatever the approach chosen, certain basic ethical principles should be followed. The first of these is the reversibility of the restoration. It should be readily removable by any restorer of the future without any risk to the original paint. For this, the medium of the paint used in the restoration needs to be stable. It should not undergo changes in its chemical structure that make it less soluble with age, and ideally it should not darken or change in appearance. Oil paint, for example, is disqualified on both these grounds (*see* Oil painting). Egg Tempera, although theoretically likely to become insoluble, can be used in such a way that it remains removable. Its advantage is that it does not darken with age. Watercolours are also sometimes used, especially for thin glazes. However, probably the most commonly used retouching media are those based on various types of natural and synthetic Resin, often the same resins used in the varnishing of paintings. Commercially manufactured paints for restoration are available, or, alternatively, restorers can combine dry pigments with the resins in solution. Polyvinyl acetate (PVA) and the most stable acrylic resins, such as Paraloid B-72, are often used. Appropriate modern pigments can be substituted for those traditional pigments that may be difficult to obtain or that are toxic or unstable.

The second basic principle is that restoration should be confined to areas of damage only. The term 'inpainting' used by American conservators is often appropriate, in that it suggests clearly the filling-in of missing areas. However, the more old-fashioned term 'retouching' perhaps better describes restoration to abraded upper layers of paint and, in those instances where a partial or selective cleaning has been carried out, to the old varnish coatings (see fig. 2). Unlike the painter–restorers of the past, restorers are no longer expected to alter and correct areas of a painting to make it conform to contemporary taste. Any restoration should be on the basis of internal evidence from the painting itself or, in more exceptional circumstances, from reproductions of the work, for example painted copies, prints, drawings and photographs. In addition, previously executed retouchings can be discovered through technical examination; they will generally absorb untraviolet and appear dark when the painting is viewed by ultra-violet light, although this effect is eventually lost once the varnish layers applied over them have aged sufficiently to fluoresce more strongly. Retouchings also tend to show in infra-red photographs and reflectograms. Detailed photographic documentation of the painting made after cleaning and before restoration provides a control over the extent of restoration.

Photographic documentation is particularly important when so-called 'imitative', 'illusionistic' or 'integrated' retouching methods are employed. Here the restorations are made more or less to match in colour and condition the original parts of the painting. They can be made to match the original paint in texture as well by carving and texturing the fillings. Losses, especially those from flaking, canvas tears and splits in panels, usually need to be filled to bring the surface level with that of the original paint film. The putty or filling material is generally either a combination of an adhesive (see ADHESIVES) and a white inert, for example chalk or gypsum or increasingly a commercially manufactured product, often bound with synthetic resin emulsions. Pigment can be added to colour the filling if the painting to be restored has a coloured ground. The main argument presented in support of imitative restoration is that it restores to the fullest extent the legibility of the image, allowing the viewer to look at the work without being disturbed by damage or distracted by one of the more visible methods of restoration (as described below). The disadvantages are that a misleading impression of the condition of the painting may be given, especially to the non-expert, while the expert who needs to know its true condition will have to obtain access to the photographic documentation. Furthermore, if the losses are very large and there is no evidence on which to base a reconstruction, then the restoration could become as inventive and misleading as some of the extensive repaintings of works carried out in earlier centuries.

Those who favour more visible methods of restoration argue that any damage suffered by a painting is a part of its history that should not be hidden. At its most extreme this approach leads to a complete absence of restoration, with large losses in a panel painting, for example, not even filled so that the bare wood of the panel is left exposed where the paint and ground have flaked away. Alternatively, the losses are filled and then toned down to some extent with an application of an unmodulated and supposedly neutral colour. Unfortunately no single colour can be neutral to all the hues and tones in a painting. 'Neutral' restoration inevitably compromises the legibility and balance of the work; some reduction of the visual disturbance caused by damage is therefore usually considered necessary, but the technique used for this retouching should make clear the distinction between the restoration and the original paint.

In different centres in Italy, where visible methods of restoration are perhaps most widely applied, several techniques have been developed and their methods and philosophies codified. In the simplest of these, the restoration can be recognized by the use of

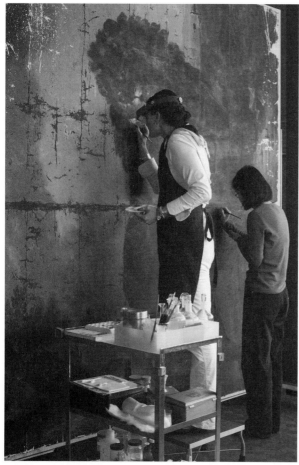

2. Conservators of the Getty Museum's Paintings Conservation Department retouching Jean-Baptiste Oudry's *Lion* from the Staatliches Museum Schwerin, Germany (Los Angeles, CA, J. Paul Getty Museum); photo credit: The J. Paul Getty Museum, Los Angeles

regular and equal sized vertical brushstrokes, called in Italian *tratteggio* or *rigatini*. Areas of damage may be reconstructed and the colours of the original matched, but the brushstrokes always remain consistent in their direction. In a variant of the technique developed in Florence and called 'chromatic selection' (*selezione cromatica*), the brushstrokes are allowed to follow the direction of the form of the area being restored, for instance the sweep of a drapery fold, or can be applied vertically and diagonally to form an interlaced mesh of brushstrokes. The colours for the restoration are chosen from the three primary and three secondary colours and mixed optically by the juxtaposition and interlacing of stippled dots of colour, as in the Pointillist colour theories employed by, for example, Georges Seurat (1859–91). It is argued that, while remaining readily detectable, the technique produces a vibrant effect suited to the intense palette of medieval and Italian Renaissance paintings.

Similar optical principles apply to the technique of 'chromatic abstraction' (*astrazione cromatica*), also of Florentine origin. This method is employed when the losses are too large to suggest the forms and colours that may have been present and is intended to supply a more satisfactory solution than the so-called 'neutral' restorations. The strokes, which are not directional, are painted with the three primary colours and black, the proportions of the colours determined by (or 'abstracted' from) the colours of the areas surrounding the loss. If, for example, the loss is principally in an area of blue drapery but also extends into areas of red and green, a preponderance of blue strokes may be applied, but the presence of some red and yellow (suggesting green) strokes will in theory make the restoration visually compatible with the red and green areas as well. Perhaps the main argument against these techniques is that, while the reasoning behind them may be clear to the restorers and art historians responsible for the restorations, they are not always apparent to those looking at the paintings. In addition, they have their own fascination, which may end up drawing too much attention to the restoration, thereby competing with the surviving parts of the original painting.

U. Forni: Il manuale del pittore restauratore (Florence, 1866/*R* 2004)

G. Secco Suardo: *Manuale ragionato per la parte meccanica dell'arte del ristauratore dei dipinti* (Milan, 1866)

Manuel de la conservation et restauration des tableaux (Paris, 1939); Eng. trans. as *Manual on the Conservation of Paintings* (London, 1997)

G. L. Stout. *The Care of Pictures* (New York, 1948/*R* 1975)

H. Ruhemann: *The Cleaning of Paintings* (London, 1968/*R* New York, 1982), pp. 240–68

A. Conti: *Storia del restauro e della conservazione delle opere d'arte* (Milan, 1973, rev. 2/1998)

C. Brandi: *Teoria del restauro* (Turin, 1977; Eng. trans. Rome, 2005)

U. Baldini: *Teoria del restauro e unità di metodologia* (Florence, 1978)

O. Casazza: *Il restauro pittorico nell'unità di metodologia* (Florence, 1981)

S. Walden: *The Ravished Image: An Introduction to the Art of Picture Restoration and its Risks* (London, 1984, rev. 2004)

S. Bergeon: *'Science et patience' ou la restauration des peintures* (Paris, 1990), pp. 188–257

Preprints of the Contributions to the Congress of the International Institute for Conservation: Cleaning, Retouching and Coatings: Brussels, 1990 [articles by G. A. Berger, pp. 150–55, and H. Lank, pp. 156–7]

C. Rossi Scarzanella and T. Cianfanelli: 'La percezione visiva dei dipinti e il restauro pittorico', *Problemi di restauro: Riflessioni e ricerche*, ed. M. Ciatti (Florence, 1992), pp. 185–211

K. Dardes and A. Rothe, eds: *The Structural Conservation of Panel Paintings* (Los Angeles, 1998)

K. Nicolaus: *Handbuch der Gemälderestaurierung* (Cologne, 1998); Eng. trans. as *The Restoration of Paintings* (Cologne, 1999)

A. P. Torresi: *Dizionario biografico di pittori restauratori italiani dal 1750 al 1950* (Ferrara, 1999–2003)

G. A. Berger: *Conservation of Paintings: Research and Innovation* (London, 2000)

N. J. Koch: *Techne und Erfindung in der klassischen Malerei: Eine terminologische Untersuchung* (Munich, 2000)

G. Perusini: Il restauro dei dipinti nel secondo Ottocento: Giuseppe Uberto *Valentinis e il metodo Pettenkofer* (Udine, 2002)

P. Garland, ed.: *Early Italian Painting: Approaches to Conservation* (New Haven, 2003)

M. Leonard, ed.: *Personal Viewpoints: Thoughts about Painting Conservation* (Los Angeles, 2003)

D. Bomford and M. Leonard, eds: *Issues in the Conservation of Paintings* (Los Angeles, 2004)

Y. Nishio: 'History of Japanese Painting Conservation in the United States', *Book and Paper Group Annual*, xxii (2004)

P. Jett, J. Winter and B. McCarthy, eds: *Scientific Research on the Pictorial Arts of Asia* (London, 2005)

Studying and Conserving Paintings: Occasional Papers on the Samuel H. Kress Collection (London, 2006)

(ii) Sculpture. In earlier times creative sculptors were also occasionally restorers; in the early 21st century sculpture restoration is a separate profession in its own right. The history of sculpture restoration provides numerous examples of formal reconstitutions in which errors of stylistic interpretation have been recognized. A notable example of this is the famous *Laokoon* (Rome, Vatican, Museo Pio-Clementino), which was given a new arm, the gesture and position of which constituted a Baroque explosion rather than dramatic Hellenistic intensity; the rediscovery of the authentic arm was a lesson in humility for the restorers. The restoration of nearly a third of the ancient Greek pediments (Munich, Glyptothek) from the Temple of Aphaia in Aigina carried out by Bertel Thorvaldsen (1770–1844) in 1816 consisted of new elements, and in about 1970 provoked a 'derestoration' that was in every regard as radical as the first intervention. The recent history of art restoration has laid down stricter regulations. The trend should be towards preventive conservation (*see* §1 above and the conservation sections of the articles on metal, stone, wood etc); formal restitutions should be kept to an absolute minimum, especially in the case of the art of antiquity and the Middle Ages, with a little less rigidity in the case of more recent architectural sculpture or of Baroque or modern ensembles. The restorer must consider faulty restorations made previously that may have altered the form through excisions or additions.

There has also been a development in the surface treatment of works of sculpture. It is now recognized that partial or total polychromy was the final expressive touch of most sculpture since antiquity, with only very brief periods when monochrome was the rule; but few works of sculpture have survived in their historical integrity. Original polychromy may have deteriorated through time and bad weather or may have been scoured away intentionally to suit a change in taste; or the work may have been overpainted to adapt its iconography. Thus a 12th-century sculpture of a glorious Christ wearing a royal crown was often transformed in the 16th century into a Christ groaning under a crown of thorns. Removals or modifications of polychromy or their overpaintings are an important factor for the restorer, since they alter the distribution and import of the colours and may thicken the forms to the point of disturbing their legibility.

Before restoration, the work must be thoroughly examined. Documentation is based on the study of old photographs, archives and publications to try to establish the original appearance. Technical examination makes it possible to determine how many times the work has been repainted and what materials, techniques and styles were used.

The removal of overpainting is an operation in regard to which a decision can be taken only if there is enough original polychromy or other historic polychromy of quality under the whitewash, colourwash or overpainting, which can severely alter the interpretation of the work. The actual execution must be as perfect as possible, while leaving some evidence of the different historical layers. Work discipline is essential, and the stages of the restoration should be documented by photographs. The start is always made dry, with a scalpel under a binocular microscope, followed by the use of solvents and scourers. The time it takes to remove polychromy is always considerable and the cost extremely high, but the result is often spectacular.

Formal reconstitutions are kept strictly to the absolute minimum necessary: they should be made only if the formal integrity of a work is excessively disturbed or if the damage presents a risk for conservation (lack of stability, e.g. in the base or at the joints of the various fragments). The materials selected for consolidation or restitutions should be reversible without causing damage to the original. Sometimes the fragment of an arm or hand has to be completely restored, in which case the work is done by modelling the deficiency, then making a mould. The piece is cast in a material suitable to the original and is inserted in the work with the minimum of effect on the substance. The gudgeoning used to attach the new addition must be easily reopenable, the gudgeons sliding in inoxidizable sheaths.

Retouching on monochrome or polychrome sculptures is designed to restore the optical continuity of the surface so that the normal play of light and shade takes place in a natural way on the volumes. Retouching must be honest, that is to say, whether it be visible or not, it must not overflow on to the original material, it must be reversible without difficulty and it must be documented. It is often sufficient for retouching to be limited to actual wear, to the edges of gaps and the harmonization of the tonality of the medium visible in the gaps. To this minimum might, however, be added the practice of 're-adorning', a somewhat more ambitious retouching with total or local levelling up of gaps, using a selected preparation (calcium carbonate, calcium sulphate, kaolin), followed by the actual retouching. Retouching of gilt work is particularly delicate, and, out of respect for the original material, regilding is carried out less and less. Each case requires careful thought, choice of materials and method (watercolour, dry and light pigments, Pointillism, *tratteggio*, illusionism; *see* §(i) above). Light and minimal retouching, bringing out the original material, is to be preferred. Excessive intervention in fact becomes a hazardous affair and should properly be called repainting. It often destroys the original expression of the work.

Sometimes a finishing or protective layer has to be applied locally. Unlike painting, it is very rare that polychrome sculptures were originally glazed completely: polished golds may have been 'dulled' with a light pasting; leaves of silver or metal alloys are protected by glazes or coloured varnishes; dull colours are left without any special finishing; 'naked' woods are waxed, stained or varnished; terracotta and bronzes often receive a 'patina'. Finishing must therefore scrupulously respect the original appearance and be carried out with the aid of reversible protective products.

C. Brandi: *Teoria del restauro* (Rome, 1963; Eng. trans. London, 2005)

P. Philippot: 'La Restauration des sculptures polychromes', *Studies in Conservation*, xv (1970), pp. 248–52

M. Serck-Dewaide: 'Les *Sedes sapientiae* romanes de Bertem et de Hermalle-sous Huy', *Bulletin de l'Institut royal du patrimoine artistique*, xvi (1976–7), pp. 56–76

J. Taubert: *Farbige Skulpturen: Bedeutung, Fassung, Restaurierung* (Munich, 1978)

M. Koller: 'Problemen und Methoden der Retusche polychromer Skulptur', *Maltechnik, Restauro*, i (1979), pp. 14–39

L. Lazzarini and M. L. Tabasso: *Il restauro della pietra* (Padua, 1986)

M. Serck-Dewaide: 'The History and Conservation of the Surface Coating on European Gilded Wood Objects', *Gilded Wood, Conservation and History* (Madison, CT, 1991), pp. 65–78

J. Heuman, ed.: *From Marble to Chocolate: The Conservation of Modern Sculpture* (London, 1995)

M. G. Vaccari: *La scultura in terracotta: Tecniche e conservazione* ([Florence, 1996])

P. Lindley, ed.: *Sculpture Conservation: Preservation or Interference?* (Brookfield, VT, [1997])

J. Heuman, ed.: *Material Matters: The Conservation of Modern Sculpture* (London, 1999)

W. Yonqi and others: *The Polychromy of Antique Sculptures and the Terracotta Army of the First Chinese Emperor: Studies on Materials, Painting Techniques and Conservation* (Munich, 2001)

I bronzi di Riace: Restauro come conoscenza (Rome, 2003)

J. B. Grossman, J. Podany and M. True, eds: *History of Restoration of Ancient Stone Sculptures* (Los Angeles, 2003)

V. Brinkmann and R. Wünsch, eds: *Bunte Götter: Zur Farbigkeit antiker Skulptur* (Munich, 2004)

M. Kühlenthal and M. Sadatoshi, eds: *Historische Polychromie: Skulpturenfassung in Deutschland und Japan/Historical Polychromy: Polychrome Sculpture in Germany and Japan* (Munich, 2004)

III. Training. Conservation is not only a relatively new discipline, but it is developing at an amazing rate, and training for conservation is having to adapt rapidly. Change is being fuelled by a burgeoning consciousness of national and international heritage, resulting in new values being placed on objects that are part of that heritage; the quality of training is seen as fundamental to its long-term survival. Change is also being fuelled by the even more explosive growth in the science and technology available to conservators. The nature of vocational training in general has undergone profound changes in the course of the 20th century. The virtual disappearance of the apprenticeship system of 'on the job' training has been part of a worldwide trend towards the formalization of training in institutions rather than in the workplace.

This shift towards a formal framework has in part been justified by a change in the nature of conservation itself. An untempered apprenticeship system, while it provides for the handing down of skills, is less effective at analysing causes and effects that require a more experimental approach and at handing down knowledge that is too complex to be conveyed at the bench or the easel. The achievements of earlier restorers, to many of whom enormous respect is owed, may justifiably be noted, but there are constant reminders of their well-intentioned mistakes. Only by a deeper understanding of materials, how they deteriorate and the effects of applying new materials and processes, can those early efforts be improved on. The recent tendency to see conservation less as a craft and more as an applied science or a profession has also had profound implications for the way in which it is taught. The pattern worldwide is by no means uniform and varies not only from country to country but from one discipline to another. Many of the skills associated with buildings are still classified as crafts or trades, while the care of oil paintings is increasingly seen as a specialized profession. The fact that the underlying nature of the problems and their solutions are remarkably similar—based essentially on an understanding of materials—seems to have made little impact. The complex causes for this inertia, derived in part from tradition and social conditioning, would repay further study.

Art and Archaeology Technical Abstracts (London, 1955–) [extensive bibliography; can be accessed through the Conservation Information Network]

N. S. Baer, ed.: *Training in Conservation: A Symposium on the Occasion of the Dedication of the Stephen Chan House, Institute of Fine Arts, New York University: New York, 1983*

C. Pearson and P. Winsor, eds: *The Role of Science in Conservation Training: Proceedings of the Interim Meeting of the ICOM Committee for Conservation Working Group on Training in Conservation and Restoration: London, 1986*

J. Hale: *Museum Professional Training and Career Structure*, Museums & Galleries Commission (London, 1987)

International Index on Training in Conservation of Cultural Property, IC-CROM and the Getty Conservation Institute (Rome, 1987)

J. M. Cronyn and E. Pye: 'The Training of Conservators: Unity in Diversity', *Conservation Today: Papers Presented at the UKIC 30th Anniversary Conference: London, 1988*, pp. 21–3

Training in Conservation: A Guide to Full-time Courses in the United Kingdom, The Conservation Unit and the UK Institute for Conservation (London, 1988, rev. 1990)

The Graduate Conservator in Employment: Expectations and Realities. Proceedings of the 1989 Interim Meeting of the Working Group on Training in Conservation and Restoration of the ICOM Committee for Conservation: The Hague, 1989

G. Edson: *International Directory of Museum Training* (London and New York, 1995)

S. Bergeon, G. Brunel and E. Mognetti, eds: *La conservation restauration in France/Conservation Restoration in France* (1999)

Defining and Measuring Effectiveness in Education and Training: Proceedings of the Interim Meeting of the ICOM-CC Working Group on Training in Conservation and Restoration, Vantaa, 1999

IV. Institutes. There are a large number of institutes throughout the world concerned with training in conservation (*see* §III above), research and the coordination and dissemination of information. The first of the major international organizations to be founded, in 1950, was the International Institute for Conservation of Museum Objects (now the International Institute for Conservation of Historic and Artistic Works or IIC). It originated in the international cooperation for the repatriation of art treasures after World War II, and its founders, experts from Britain, Europe and the USA, had two main aims: to raise the status of conservators by forming a professional, self-electing body; and to end the concept of restoration, based on the 'secrets of the old masters', by the publication of abstracts of technical literature and original work with a scientific bias. Based in London, IIC has over 3500 members in 65 countries, drawn both from museum personnel and from independent professional conservators. Members are able to keep abreast of technical advances and in contact with their colleagues worldwide through IIC's publications, conferences and groups. The IIC publishes two principal journals, *Studies in Conservation* (1952–) and *Art and Archaeology Technical Abstracts* (1955–), the latter published with the support of the Getty Conservation Institute (see below). International conferences are held every two years, and the published papers form an important addition to conservation literature. Regional groups operate autonomously in a number of countries, representing the particular interests of their members and in many cases publishing their own journals, for example the *Journal of the IIC Canadian Group* and the *Restauratorenblätter* of the Österreichische Sektion des IIC.

The International Centre for the Study of the Preservation and the Restoration of Cultural Property, now known as ICCROM, was founded in Rome by UNESCO in 1959 as an autonomous intergovernmental scientific organization. It has more than 70 member states and some 62 associate

members—public and private non-profit cultural institutions—throughout the world, which together provide its budget through regular contributions. Apart from training, ICCROM's aims are to coordinate, stimulate and initiate research; to advise and make recommendations by means of missions, meetings and publications; and to collect, study and circulate information on the conservation of cultural property. The ICCROM library is the largest in the world devoted to conservation of cultural property, and since 1977 all accessions have been indexed, abstracted and made available on-line. ICCROM's publication programme includes basic texts on conservation, symposia proceedings and international indexes on training opportunities and on research in progress. ICCROM operates a Technical Assistance Programme of particular value to developing countries in terms of training, provision of publications and technical support.

The International Council of Museums (ICOM), associated with UNESCO, has a Committee for Conservation, created in 1967 and based in Paris. The aims of the Committee are: to achieve and maintain the highest standards of conservation and examination of historic and artistic works by bringing together from all countries those responsible for cultural property (administrators, curators, art historians, archaeologists, architects, scientists and conservators/restorers); to promote relevant scientific or technological research; to collect information about materials and workshop methods; and to make this information available, by publication or otherwise. The Committee has over 700 members, who are organized into 26 working groups conducting research in specific areas relevant to the conservation of cultural property. It meets every three years to review the state of research in the areas covered by the working groups and to establish a programme of activities for the following three years.

The Getty Conservation Institute (GCI) was established in 1982 in Los Angeles, CA. It is committed to documentation, scientific research and training, as well as to field conservation projects and multidisciplinary activities jointly organized with other professional organizations, including those mentioned above. The documentation programme facilitates the collection and dissemination of technical information in the conservation field: its activities include *Art and Archaeology Technical Abstracts* (see above) and the GCI library. There is also an extensive publication programme. The scientific research programme conducts studies in support of conservation practice for movable and immovable cultural property. Research is carried out in laboratories in Marina del Rey, at the J. Paul Getty Museum in Malibu, CA, and in collaboration with research institutions and individuals worldwide. The GCI was closely involved in the development of the Conservation Information Network, which is now operated by the Canadian Heritage Conservation Network. The Conservation Information Network has made available three on-line databases: a conservation bibliography database, a conservation materials database and a product and supplier database.

Other organizations operate on an international basis in specific areas of conservation. For example, ICOMOS, the International Council on Monuments and Sites, founded in 1965, is an international, non-governmental organization intended to promote the theory, methodology and technology applied to the conservation, protection and enhancement of monuments, historic areas and sites. The Institute of Paper Conservation, based in the United Kingdom, is a specialist organization concerned with the conservation of paper and related materials; its aim is to increase professional awareness by coordinating the exchange of information and facilitating contacts between its members, both nationally and internationally. The Association for Preservation Technology International (APT) in North America is an association of preservationists, restoration architects, furnishings consultants, museum curators, architectural educators, archaeologists, craftspeople, and others directly or indirectly involved in preservation activities.

National institutes in a number of countries have gained international reputations through their activities, particularly research and publications. Notable among governmental bodies are the Canadian Conservation Institute, based in Ottawa, and the Tokyo National Research Institute of Cultural Properties. Non-governmental national organizations include the United Kingdom Institute for Conservation (UKIC) and the American Institute for Conservation (AIC), both of which had their origins in IIC regional groups. Other high-profile groups are the Australian Institute for Conservation of Cultural Material (AICCM) and the Nordisk Konservatorforbund in Scandinavia. There are many other governmental and non-governmental agencies operating on a national or local level that fulfil a variety of purposes. These may be active centres of practical restoration and research (VNIIR, Moscow), centres for the coordination and dissemination of information (the Conservation Unit of the Museums & Galleries Commission, London) or bodies investigating and reporting on the needs of conservation and conservators (the National Institute for the Conservation of Cultural Property, Washington, DC). Other organizations represent the professional interests of conservators, for example ECCO (European Confederation of Conservator–Restorer's Organizations) in Europe, and APOYO (Association for the Conservation of Cultural Patrimony of the Americas) in Latin America.

Art and Archaeology Technical Abstracts [formerly *IIC Abstracts*], Getty Conservation Institute in association with IIC (Marina del Rey, 1955–)

Conservation in Museums and Galleries: A Survey of Facilities in the United Kingdom, IIC (London, 1974)

E. Batchelor, K. Mulvaney-Buente and G. T. Nightwine: *Art Conservation: The Race against Destruction* (Cincinnati, 1978)

P. Ward: *The Nature of Conservation: A Race against Time* (Marina del Rey, 1986)

International Index of Conservation Research, ICCROM (Rome, 1988)

G. Edson: *International Directory of Museum Training* (London and New York, 1995)

Conservatori-restauratori di beni culturali in Europa: centri di istituto di formazione/Conservator-restorers of Cultural Heritage in Europe: Education Centers and Institutes/Conservateurs-restaurateurs de biens culturels en Europe: Centres et instituts de formation, Associazione Giovanni Secco Suardo (Lurano, 2000)

Consolidant. Fluid that is impregnated into an object and then sets to a solid, so binding separate parts into a whole. The process of consolidation aims to strengthen a fragile, porous object. Few new artefacts are made of friable materials, but consolidation is occasionally used as part of the original design, for instance when a shape is created in an easily moulded material and then strengthened by consolidation for further use. During conservation treatments, however, consolidants are regularly added to degraded objects to enable their continued use or survival. Applications range from preventing the powdering away of feathers by impregnating with polymer solutions to incorporating reinforced concrete in collapsing masonry. The type of consolidant used depends on the structure and components of the object.

A consolidant can act in two ways, usually concurrently, on friable material. It may create an adhesive join between adjacent particles. In this case, the strength and other properties of the final object have contributions from both the particles and the consolidant. Alternatively, the consolidant may encapsulate the particles, so making the final properties of the object close to those of the consolidant. In the late 20th century there has been a tendency to choose consolidants that closely match the original object physically and chemically. Because the consolidant is then so thoroughly integrated with the original, it is possible to remove no more than a small part of it, and often none at all. Consolidation is therefore an irreversible treatment that must be carefully considered before use.

On painted surfaces traditional consolidants, commonly called fixatives, have long been used. A polysaccharide extract from seaweed (*funori*) is used to refix pigments in Japan. Parchment size and similar animal glues are used for consolidating oil paint films. In the past they were also used on frescoes, and they were one cause of the deterioration of the ceiling of the Sistine Chapel (Rome, Vatican). Wall paintings have been fixed with many other materials, including beeswax, paraffin wax, CASEIN, shellac, DRYING OILS, solutions of calcium hydroxide (limewater) or barium hydroxide, and a range of modern synthetic resins. Most of these cause considerable changes to the optical properties of the paint, in some cases disfiguring the image. The fixing of ethnographical painted surfaces provides an extreme demonstration of this difficulty because little or no medium was used initially in the paint. When a binding medium is applied the coating may disappear. Various media have been suggested, such as cellulose ethers and acrylic resins, but no widely acceptable materials have been found.

In many painted objects the substrate is as fragile as the painted surface. Canvas has traditionally been consolidated with wax and wax–resin mixtures as part of the relining process. This technique was adapted to the strengthening of wood panels. Dry wood has been consolidated with a wide range of resins; pine resin, wax and glue being used from the 12th century. Polymers applied in solvents (e.g. polyvinyl butyral and acrylic polymers), as well as such cross-linking resins as epoxy, polyester and polyurethanes, have been widely used since the 1930s. All of these penetrate with difficulty into the pores of the wood, so resulting in uneven consolidation and physical properties. Low molecular weight monomers, particularly acrylates, have been polymerized *in situ* using radiation or elevated temperatures to initiate the polymerization reaction. These cross-linking and polymerization methods have been used extensively on both wood and stone movable statuary, but some difficulties have been experienced with cracking and spalling caused by the changes of volume and the heat produced during polymerization.

On stone, alternative materials that more closely match the original chemical constituents are increasing in popularity. These include silane monomers that polymerize to a structure similar to silica. They were developed for sandstone and have been applied widely to other materials, even to leather. Another consolidant for stone is limewater, which dries and reacts with atmospheric carbon dioxide to form calcium carbonates; it has many proponents for the consolidation of limestone.

Vast quantities of rapidly degrading paper in libraries and archives have prompted an urgent search for more efficient methods of consolidation than the soaking of individual sheets in water baths of cellulose fibre, polyvinyl alcohol or acrylic polymer dispersions. Mass treatments involve gaseous impregnation with either acrylic or xylylene monomers, which are then polymerized *in situ*. Theoretically, large numbers of books can be treated at once.

The preservation of waterlogged wood proved difficult for many years. The water has to be removed without causing shrinkage and distortion of the wood structure during drying. Highly degraded and fragile wood has to be strengthened to prevent both surface marring and gross breakage. A late 19th-century treatment, involving the impregnation and deposition of alum within the wood, achieved a success that has not proved repeatable. During the 20th century various materials, including dammar resin and rosin, melamine-formaldehyde resin, sugar and polyethylene glycol (PEG), were introduced. PEG, with refinements in material and techniques, has proved successful in many instances, especially when dealing with large structures, for example the boats *Wasa* (Stockholm, Wasavarvet) and *Mary Rose* (Portsmouth, Mary Rose Museum)

Archaeological objects are frequently degraded and so require consolidation. Although wax was used until the 1930s, augmented after 1900 by cellulose nitrate, a wide range of modern polymers has been

used, frequently polyvinyl acetate and acrylic resins applied either in solution or as dispersions in water. The conservation of iron provides an example of the misuse of a consolidant. For decades it was standard practice to impregnate rusted iron with wax in order to strengthen the rust and prevent corrosion. Unfortunately the wax merely delayed and disguised the corrosion process that continued to destroy the objects. The wax also obstructed the further stabilization of the iron. Consolidation has frequently been carried out unnecessarily, or too enthusiastically. One of the more difficult tasks of conservators is to remove excess consolidant prior to re-treatment.

See also ADHESIVES and RESIN.

Manual on the Conservation of Paintings, International Museums Office (Paris, 1940)

B. M. Feilden: *Conservation of Historic Buildings* (London, 1982, rev. Amsterdam, 3/2003)

D. W. Grattan: 'A Practical Comparative Study of Several Treatments for Waterlogged Wood', *Studies in Conservation*, xxvii (1982), pp. 124–36

G. G. Amoroso and V. Fassina: *Stone Decay and Conservation* (Amsterdam, 1983)

N. S. Brommelle and others, eds: *Adhesives and Consolidants* (London, 1984)

P. Mora, L. Mora and P. Philippot: *Conservation of Wall Paintings* (London, 1984)

J. M. Cronyn and C. V. Horie: *St Cuthbert's Coffin* (Durham, 1985)

C. V. Horie: *Materials for Conservation: Organic Consolidants, Adhesives and Coatings* (London, 1987, rev. 1990)

E. F. Hansen, E. T. Sdoff and R. Lowinger: 'A Review of Problems Encountered in the Consolidation of Paint on Ethnographic Wood Objects and Potential Remedies', *Preprints of the Triennial Meeting of the International Council of Museums Committee for Conservation: Dresden, 1990*, pp. 163–8

M. W. Phillips: 'Aqueous Acrylic/Epoxy Consolidants', *APT Bulletin*, xxvi/2–3 (1995), pp. 68–75

B. Prueher: 'Consolidants, Coatings, and Water-Repellent Treatments for Historic Masonry: A Selected, Annotated Bibliography', *APT Bulletin*, xxviii/4 (1995), pp. 58–64

Konserveringsmidler & Konserveringsmetoder/Consolidants and Conservation Methods: Nordisk Konservatorforbund XIV: Kongress Preprints, Oslo, 1997

W. S. Ginell and R. Coffman: 'Epoxy Resin-Consolidated Stone: Appearance Change on Aging', *Studies in Conservation*, xliii/4 (1998), pp. 242–8

M. Young, P. Cordiner and M. Murray: *Chemical Consolidants and Water Repellents for Sandstones in Scotland* (Edinburgh, 2003)

Contrapposto. Term used in modern writing about art for the posture of a sculpted figure standing at rest with weight shifted on to one leg. Polykleitos' Doryphoros (c. 440 BC; copy, Minneapolis, MN, Minneapolis Institute of Arts) is an early example of this posture, which displays the human body as a self-contained static system, in balance in the pose itself but visibly arrested and therefore implying past and future movement. Contrapposto, like acanthus ornament and wet drapery, became a signature of the Greek Classical style and its influence. The formula appears in innumerable Greek and Roman figures as well as in Far Eastern art and in medieval

'renascences', finally to be revived and developed as part of the Neo-classicism of the Italian Renaissance.

The modern term retains only a fraction of its earlier meanings. The word 'contrapposto' is not simply the past participle of the Italian word meaning 'to counterpose'; it is more properly a translation of the Latin *contrapositum*, in turn a translation of the Greek *antithesis*, a figure as fundamental to Classical rhetoric as the pose under discussion is to Classical art. It was argued from Aristotle's *Rhetoric* (1409b–1410a) until modern times that matters are most pleasing and convincing when words are presented in direct opposition to one another. A line from Petrarch's *Canzoniere ccxv* provides one of innumerable examples in this long tradition: '*E non so che nelli occhi… Po chiara la notte, oscuro il giorno*' ('And I know not what in [her] eyes can brighten night, darken the day'). Such antithesis always implied embellished diction, and when in 1435 Leon Battista Alberti (1404–72) used the model of Classical rhetorical composition to define pictorial composition, antithesis became a fundamental part. (It is not known if there were corresponding theories of pictorial composition in antiquity, although figural composition in Classical painting and sculpture often underwent an elaboration comparable to that to be seen in the Renaissance.) For the sake of the *varietas* of the composition, Alberti recommended that the limbs of individual figures should be contrasted (high and low, advancing and receding) and that the painting as a whole should contain many oppositions (such as nude to clothed, young to old, female to male). For him, contrapposto achieved both aesthetic and descriptive ends, providing a formula for the pleasing artificial construction of human movement and a schema for its observation. It was explored in both ways by Leonardo da Vinci (1452–1519), and the *figura serpentinata* (as it was later called by Giovanni Paolo Lomazzo (1538–1600), who attributed the idea to Michelangelo (1475–1564)), a three-dimensional contrapposto, became an element of the embellished High Renaissance style, a basic theme of the art of Michelangelo and a theme for the elaborations and variations of such artists as Giambologna (1529–1608).

CHIAROSCURO is also an important contrapposto in the original sense, and pictorial composition based on this principle (again conspicuous in the work of Leonardo da Vinci) carried the quest for rhetorical vividness in painting to a high pitch, sustained perhaps most vividly in the work of Michelangelo Merisi da Caravaggio (1571–1610) and his followers. The Renaissance notion of contrapposto developed in academic practice and criticism into the staple idea of 'contrast'. Contrasts in compositions could be praised as serving to 'persuade through delight' if used judiciously or censured if used so as to be evident in themselves as displays of virtuosity, at the expense of subject-matter and decorum. Joshua Reynolds (1723–92), for example, condemned the Venetians for their 'violent and affected contrasts, whether of figures or of light and shadow'. The general notion of composition as based on contrasts may persist in the

conviction of Clement Greenberg (1909–94) that formal opposition was the last and deepest convention of easel painting or in the contention of Ernst Gombrich (1909–2001) that oppositions of value are fundamental to the structure of all illusion.

J. Reynolds: *Discourses on Painting and the Fine Arts* (London, 1778)

E. Gombrich: *Art and Illusion* (New York, 1960)

J. Shearman: *Mannerism* (Baltimore, 1967)

M. Baxandall: *Giotto and the Orators: Humanist Observers of Painting in Italy and the Discovery of Pictorial Composition* (Oxford, 1971)

D. Summers: 'Maniera and Movement: The Figura Serpentinata', *Art Quarterly* [Detroit], xxxv (1972), pp. 269–301

D. Summers: 'Contrapposto: Style and Meaning in Renaissance Art', *Art Bulletin*, lix (1977), pp. 336–61

M. Cole: 'The Figura Sforzata: Modeling, Power and the Mannerist Body', *Art History*, xxiv/4 (Sept 2001), pp. 520–51

Contre-jour [Fr.: 'against day']. In painting, a *contre-jour* form is one that is back lit and so almost silhouetted.

Copper. Type of metal.

1. Properties. 2. Uses.

1. PROPERTIES. Copper is a dense, rather soft, reddish-coloured metal, with a specific gravity of 8.95 and melting at 1083°C. It is an excellent conductor of both heat and electricity (see Copper Development Assoc iation publications for more specific technical data). It is ductile and thus can be easily worked to shape by any of the standard methods described in METAL, §III, although it is difficult to cast satisfactorily. It can take and retain a good polish. Apart from gold, it is the only metal that is not white and thus from early times has featured in polychrome decorative schemes with other metals (*see* METAL, §V). Its resistance to corrosion and weathering has led to its widespread use for vessels, as well as for protecting buildings from the elements.

Copper ores are widely distributed over the earth's surface, although copper is sometimes found as a native metal in the upper, oxidized levels of deposits and thus was the first metal to be utilized by man. It continues to find wide application both by itself and as the basis of a wide range of alloys (*see* BRONZE and BRASS). The metal is commonly available as tough pitch copper, which has a small amount of oxygen that increases strength, although at the expense of ductility; deoxidized copper, which is mainly used where high-temperature work, such as welding, is envisaged; or oxygen-free copper, which is also employed for high-temperature work or very heavy extrusion or spinning work. Arsenical copper, containing about 0.3% arsenic, was formerly used extensively in boiler pipework for steam locomotives etc, but this has now declined (see Copper Development Association Publication 43 for more extensive notes on the commercially available grades of copper and their properties).

Copper Data, Copper Development Association Publication 12 (London, 1935, rev. 13/1953)

Copper and its Alloys, Copper Development Association Publication 43 (London, 1948)

W. G. Davenport and others: Extractive Metallurgy of Copper (Oxford, 4/2002)

2. USES. Most of the early history of the use of copper is discussed in BRONZE, §II, partly because in very ancient times the words for copper and bronze were used somewhat indiscriminately, with one term sometimes being applied to both metals, and also because so few of the extant pieces have been analysed, making it difficult to know whether they are composed of copper or one of its alloys.

(i) Specific uses of copper for artefacts. Small amounts of naturally occurring native copper were used from about the 8th millennium BC; the smelting of copper from its ores began about the 6th millennium BC, and the alloying of copper with other metals, notably tin to make bronze, was introduced in the 4th millennium BC. In North America there are vast deposits of native copper, particularly in the region around Lake Superior, and a very competent metalworking tradition developed from *c.* 3000 BC using this resource to make an extensive range of ornaments, tools and weapons. As the native metal in this region was so freely available, smelting was never developed there. There is also no evidence that the metal was ever melted to be cast; it is probable that it was shaped by hammering, forging and annealing.

As copper can be difficult to cast but is easy to shape by hammering, it has been used since very early times to make items of beaten sheet metal. Copper vessels have always been popular, although, as the unalloyed metal is rather soft, they are easily damaged and thus tend to form the more humble cooking utensils, with the golden-coloured bronze and brass used for more prestigious purposes. At the end of the 19th century beaten copper was favoured by the craftsmen of the Arts and Crafts Movement in Europe and North America. Together with wrought iron and pewter it was deemed a simpler and purer material than brass and the precious metals. As copper was cheap but very easily worked, it was also eminently suited to the many amateur craftsmen that the various local guilds attracted.

Copper has been widely used in conjunction with a number of other materials. As it takes enamel very well, it has always been the favoured metal for this medium. Medieval Mosan and Limoges enamels, for example, are set in copper; where enamelwork was used on brasses in the medieval period, the actual enamelwork was often done on thin copper trays that were then let into the brass. The combination of enamelwork and copper was also popular among designers and craftsmen of the Arts and Crafts Movement. (For the use of copper as a support for enamel painting *see* §(iv) below.) Copper also takes fire gilding (*see* GILDING, §I, 3) better than its alloys,

and many examples of the deliberate use of copper, rather than the more usual bronze or brass, for objects to be fire gilded are known. Copper has a pleasing and distinctive colour and has always been widely used for inlays into other metals, notably silver or the more golden bronze or brass. The black-patinated *shakudō* copper alloys (*see* METAL, §V) inlaid with silver, gold and brass have been used extensively by the Japanese, particularly for sword guards and other sword fittings.

G. A. West: *Copper: Its Mining and Use by the Aborigines of the Lake Superior Region* (Milwaukee, 1929/*R* Greenwood, 1970)

U. M. Franklin and others: *An Examination of Prehistoric Copper Technology and Copper Sources in Western Arctic and Subarctic North America*, National Museum of Man, Mercury series (Ottawa, 1981)

M. Wayman, J. King and P. T. Craddock: *Aspects of Early North American Metallurgy*, British Museum, Occasional Papers, lxxix (London, 1992)

G. Egan: 'Some Archaeological Evidence for Metalworking in London *c.* 1050 AD–*c.* 1700 AD', *Historical Metallurgy*, xxx/2 (1996), pp. 83–94

A. Giumlia-Mair and S. Quirke: 'Black Copper in Bronze Age Egypt', *Revue d'egyptologie*, xlviii (1997), pp. 95–108

J. Riederer: 'The Use of Standardized Copper Alloys in Roman Metal Technology', *I bronzi antichi: Produzione e tecnologia* (Montagnac, 2002), pp. 284–91

D. Scott: *Copper and Bronze in Art: Corrosion, Colorants, Conservation* (Los Angeles, 2002)

R. Brownsword: 'Medieval Metalwork: An Analytical Study of Copper-alloy Objects', *Historical Metallurgy*, xxxviii/2 (2004), pp. 84–105

L. Klassen: *Jade und Kupfer: Untersuchungen zum Neolithisierungsprozess im westlichen Ostseeraum unter besonderer Berücksichtigung der Kulturentwicklung Europas 5500–3500 BC* (Århus, 2004)

(ii) Copper and its alloys in architecture. Copper and its alloys have found widespread application as building materials, both for the embellishment of roofs, cladding, window-frames and entrances, and for such protective uses as roofing, guttering, damp courses and, not least, lightning conductors. The use of copper and bronze in the architecture of public and prestige buildings has a long history. Doors and even whole buildings were sometimes clad in beaten copper or bronze. The set of massive copper bands on the gates of the Assyrian city of Balawat (8th century BC; London, British Museum; Baghdad, Iraq Museum) is the only surviving example of what was then quite a standard form of embellishment and visible display of wealth and power (Curtis, 1988). Early references to gates and other architectural fittings show clearly that they were kept bright and shiny in contrast to the green or brown patination of modern copper or copper alloy fittings. Thus in ancient Egypt the copper or bronze caps on the obelisks were said to 'reflect rays like the solar disc'. Although classical buildings are generally considered to have been constructed exclusively in stone and wood, metal, and probably copper alloys in particular, could often be an important feature, especially in the

most prestigious. Little has survived, however, and information can be obtained only from contemporary descriptions and from poetic invention, such as the description given in the *Odyssey* of the palace of Alcinous, which had 'brazen' wall-surrounding pilasters of silver and walls of gold. Similarly, in the *Critias*, Plato described the capital of Atlantis as having the wall around the acropolis plated with *oreichalkos* (a copper–zinc alloy), 'which had a fiery resplendence' (Caley, 1964, p. 20).

Copper makes a good roofing material, being durable, weatherproof and relatively light. It can be used in the form of tiles, such as originally covered the Pantheon (*c.* AD 118–25), Rome, and can be seen on such modern buildings as the West Pumping Station (1875) on the Chelsea Embankment, London, or more usually in the form of sheet, particularly for domes. The copper or bronze tiles from the Pantheon were removed in the 7th century AD, but the copper sheeting beneath was removed over a thousand years later by Pope Urban VIII (*reg* 1623–44), yielding over 200 tonnes of copper sheet and four tonnes of copper nails. By contrast the roof on the Anglican Cathedral (1909–10) in Liverpool, England, contains only 40 tonnes. There was a vogue for highly ornate gilded copper domes and portals in late 19th-century Russia.

Copper in Architecture, Copper and Brass Extended Uses Council (Birmingham, 1927)

G. W. P.: *Copper through the Ages*, Copper Development Association (London, 1934, rev. Radlett, Herts, 1955) [esp. chap. VI]

E. A. Caley: *Orichalcum and Related Ancient Alloys*, American Numismatic Society Monographs, 151 (New York, 1964)

J. Curtis: 'Assyria as a Bronzeworking Centre in the Late Assyrian Period', *Bronzeworking Centres of West Asia*, ed. J. Curtis (London, 1988), pp. 83–96

(iii) Prints. The production of prints from engravings and etchings on metal plates began in the first half of the 15th century in southern Germany, some time after printing from woodcuts had become established. Copper became the standard material for plates in intaglio methods of printing (*see* PRINTS, §III, 2): being a relatively soft metal, it is quite easy to engrave, resulting in greater clarity and finer detail, but it has sufficient strength for many hundreds of prints to be taken before the image is totally worn down. Designs on copper plates can also be altered by 'knocking out' the back of the plate with a small hammer to remove unwanted lines or areas and by grinding and repolishing. Although steel facing of copper plates was introduced *c.* 1840, this was mainly used for commercial work where very large numbers of prints were required, and copper has remained the favoured medium for line engraving among artists.

(iv) Painting support. Copper sheet may be used as a support for paintings in oil or enamel, mostly for small paintings and miniatures, as size is limited by such practicalities as weight. The first mention of painting in enamel on copper was made by Leonardo

da Vinci (1452–1519); it has been suggested that oil painting on copper was inspired by this, although the two techniques probably developed separately.

The technique of oil painting on copper dates from the 16th century and flourished during the early 17th. The practice can be linked to the use of copper plate for intaglio printmaking (*see* §(iii) above) through the artists involved and examples that were also engraved. The *Tower of Babel* (*c.* 1595; London, Museum of London) by Marten van Valckenborch (1535–1612) is on a copper plate originally used to print a map.

Roger de Piles (1635–1709) recommended preparing copper for oil painting by rubbing it with garlic juice. Similar instructions are given in other accounts, but later authorities considered that a ground is necessary. Rich glowing colours, a smooth finish and minute detail are characteristics of works in oil on copper (e.g. *Tobias and the Angel Raphael* by Adam Elsheimer (1578–1610), London, National Gallery). Dutch artists, in particular Elsheimer and Paul Bril (*c.* 1554–1626), are noted for their small works on copper. There are also fine examples by Jan Breughel I (1568–1625), Karel van Mander I (1548–1606) and Domenichino (1581–1641). The only definite attributions to the elusive English painter William Larkin (*c.* 1585–1619) are life-sized, head-and-shoulder portraits in oil on copper of *Lord Herbert of Cherbury* and *Sir Thomas Lucy* (both *c.* 1609–10; Charlecote Park, Warwicks, NT). In a development of miniature painting, oil on copper was also used for small copies of full-sized paintings.

The ability of copper to withstand heat, its good conductivity and comparative stability also make it suitable for paintings in enamel; the fact that enamel will fuse to it is also significant. The attractions of the medium are its absolute permanence and superb colour quality. The technique is difficult to master, however, and has never been widely practised. It has been applied principally to portrait miniatures; for example, *William III* (1690–99) by Charles Boit (1662–1727), *William Augustus, Duke of Cumberland* (1740–50), attributed to Christian Friedrich Zincke (1683/5–1767), and *Queen Charlotte* (1801; all London, National Portrait Gallery) by Henry Bone (1755–1834). During the 18th century George Stubbs (1724–1806) experimented successfully with enamel on copper on a larger but still modest scale. He produced such small paintings of animals as *Horse Attacked by a Lion* (1769) and *Lion and Lioness* (1770; both London, Tate). Stubbs's experiments were made in collaboration with Josiah Wedgwood (1730–95) and evolved to employ an earthenware support in place of copper.

For the use of copper compounds in pigments *see* PIGMENT, §§III and V.

J. A. van de Graaf: 'Development of Oil Paint and the Use of Metal Plates as a Support', *Conservation and Preservation of Pictorial Art*, ed. N. S. Brommelle and P. Smith (London, 1976), pp. 43–53

S. Hackney, ed.: *Completing the Picture: Materials and Techniques of 26 Paintings in the Tate Gallery* (London, 1982), pp. 26–9

E. K. J. Reznicek: 'Hendrick Goltzius 1961–1991: Een overzicht van dertig jaar onderzoek', *Goltzius-studies: Hendrick Goltzius, 1558–1617*, ed. R. Falkenburg and others (Zwolle, 1993), pp. 121–44

Copper as Canvas: Two Centuries of Masterpiece Paintings on Copper, 1575–1775 (exh. cat., Phoenix, AZ, Art Museum, 1999)

S. Vassallo: 'Dipinti su lastra di rame: I materiali e le tecniche', *Kermes*, Xiii/39 (July–Sept 2000), pp. 63–70

Coral. A secretion of the coral polyp, largely consisting of calcium carbonate.

1. MATERIAL, SOURCES AND TECHNIQUES. Red or precious coral (*Corallium rubrum*) is the species most used by craftsmen and is most widely distributed in the Mediterranean. It can be found in the shallower coastal waters of North Africa around Tunisia, Algeria and Morocco, around the islands of Sicily, Corsica and Sardinia, around Naples and the Ligurian coast and around Barcelona and Marseille; it is also found in the Fiji Islands. Since the end of the 19th century deposits in the Pacific, principally the Japanese archipelago, have become increasingly important, especially for coral sculpture. Pacific coral may be distinguished from Mediterranean by its greater hardness, weight and size and by the diversity of its colour. Coral is fished, either by divers or from boats that drag wooden or iron crosses across the sea bed with ropes; at each extremity of the cross is a net bag that collects the uprooted coral bushes. Coral is a relatively soft material. To work it, individual branches are removed from the main stem with a pair of heavy pliers. The outer covering of the branch, known as *sacosoma*, is ground away, then the branch is polished on a grindstone with the aid of fine sand. The coral is then cleaned and polished under running water on the grindstone and, if necessary, filed again. Sculptural pieces are worked with a gouge. Coral can also be left in its natural branch form (see colour pl. III, fig. 2).

2. HISTORY AND USES. Throughout history magical or medicinal properties have been attributed to coral. Ovid (*Metamorphoses*, IV.741–51) described its origin as the blood that flowed from Medusa's head after it had been cut off by Perseus, the blood turning to stone. As a result, coral was ground and used as a treatment for bleeding. The exact composition of coral, however, remained unknown, and it retained an ambivalent status between plant and stone until Pliny the elder (AD 23/4–79) made the first attempt at a scientific analysis (*Natural History* XXXII.xi.464; XXXVII.lix.665) and described its occurrence and use. Documentary sources reveal the use of coral in amulets and as a fertility symbol in ancient Rome. Examples of the latter, mainly from Pompeii, have survived (Naples, Museo Archeologico Nazionale; Hannover, Kestner-Museum), in addition to various depictions of the use of coral (e.g. a mosaic seascape, Piazza Armerina, Villa Casale). Coral was also worn as a talisman around the neck, particularly by children.

The Romans created figural works from coral, the most significant being the *Medusa* cameo (1st–2nd century AD; Cologne, Wallraf-Richartz-Museum) and the bust of *Jupiter Serapis* (?1st century AD; London, British Museum).

Coral was commonly used from the 5th to the 3rd centuries BC in Celtic Europe to decorate bronze weapons and for jewellery. A 4th-century BC French flagon shows unprecedented use of coral and enamel inlays. Throughout the Middle Ages coral continued to be used for amulets and as a medical remedy, as well as for decorative beadwork in textiles. A large number of 14th- and 15th-century Italian paintings depict the Infant Christ with a branch of coral worn around his neck as an amulet (e.g. Senigallia *Madonna*, 1474–8; Urbino, Palazzo Ducale by Piero della Francesca (*c.* 1415–1492)). The earliest surviving works using coral carved into simple geometric forms are paternosters. Workshops in Genoa, Trapani, Paris, Lyon and Barcelona producing large numbers of these items were recorded in the 12th century.

During the Middle Ages it was also believed that coral had the power to detect poison in food, and thus it was used in cutlery. In the 13th century silver-gilt spoons, forks and knives with coral handles were frequently recorded: some cutlery sets have survived that may be from 16th-century Genoa (examples in Dresden, Grünes Gewölbe; London, Victoria and Albert Museum). This magical property attributed to coral is highlighted in the case of credenzas, in which a coral branch, usually mounted in precious metal, is further set with fossilized sharks' teeth, also known for their power to detect poison (e.g. in Vienna, Schatzkammer des Deutschen Ordens). Coral is also recorded in connection with salts: the inventory (1401–16) of Jean, Duc de Berry, mentions a *saliera* of gold with a coral base.

Coral attained even greater significance in the Renaissance, due to the discovery of new deposits in the Mediterranean, especially near Corsica and Sardinia; the successful, if temporary, defeat of piracy by Emperor Charles V (*reg* 1519–58); and the growth of princely art collections, in which coral was categorized as 'naturalia'. Analysis of coral by Pliny the elder (AD 23/4–79) was used to equate the material with the element of water in the natural order. As a naturally occurring rare material that is soft enough to be worked by skilled carvers, it became one of the most sought-after items for collectors. At the same time, however, its traditional role as an amulet with apotropaic powers was not forgotten.

Despite the prevalence of coral objects in many European collections from *c.* 1570, it has not yet been possible to confirm that surviving examples from the 16th century were manufactured in Trapani or Genoa, which documentary sources reveal were the major centres of production; this is partly due to the fact that the raw material was often not carved until it reached the court artists north of the Alps. William V, Duke of Bavaria (*reg* 1579–98), is said to have supported a coral-carving workshop in Landshut. The most important collections of 16th-century coral objects are in Schloss Ambras, Innsbruck, and the Galleria Doria-Pamphili, Rome.

Goldsmiths' work was often decorated with coral during this period. The continued association of coral with blood, as well as its relative softness, made it the most suitable material for teething toys and rattles set in goldsmiths' work, which were popular from the late 16th century to the 19th.

A characteristic of coral work in the 17th century was the development of inlay: small pieces of coral were inset into gilded copper, bronze or silver. In addition to jewellery, textiles and figural statuary, there was at this time an increased use of coral for ecclesiastical objects, as well as secular household items. In the 17th century the most significant centre for coral work in Europe continued to be Trapani. The importance of Genoa, however, declined, partly because France held the monopoly on coral fishing off the North African coast until the French Revolution.

In the 18th century the art of coral-carving was revived in Naples, Livorno and Genoa, and work from these centres and Trapani was exported throughout Europe, as well as to India and China. The style of coral objects of this period reflected fashionable Baroque forms, with curving plant decoration as well as figurative ecclesiastical or secular subjects. Contemporary coral decoration was attached with pins rather than inlaid. It is often combined with such other colourful materials as enamel, amber or tortoiseshell, for example in caskets (e.g. Pommersfelden, Schloss Weissenstein) and frames (e.g. Naples, Museo Nazionale della Ceramica). Northern artists, such as Peter Boy (1648–1727), continued to work in coral (e.g. a vessel, 1700; Pommersfelden, Schloss Weissenstein), although their style was quite different from that of the Italian workshops.

Coral was widely used for jewellery during the 19th century, a pale pink colour being particularly suitable for cameos (e.g. a pendant and pair of brooches carved with cameo portraits of *Bacchus*, *Apollo* and *Venus*, *c.* 1854; London, Victoria and Albert Museum). In the Art Deco period, coral continued to be used to introduce colour into jewellery and was often carved into abstract geometric shapes and contrasted with transparent gemstones, precious metals or lacquer.

Silver boxes decorated with coral beads have been found in Chinese tombs of the Han period (206 BC– AD 220), and coral was frequently used in hair ornaments and jewellery during the Ming period (1368–1644). The use of coral in Tibet, where it is traditionally considered a symbol of longevity, was noted by Marco Polo (1254–1324), and coral jewellery continues to be produced there and in Mongolia, often set in thick silver mounts in conjunction with turquoise and hardstones. It is also used to decorate women's headdresses and such metal artefacts as amulet boxes, teabowls and ritual vessels. Black coral has been employed for *netsuke* in Japan. It was not customarily incorporated into ornament in Pre-Columbian America but may have been used as an abrasive for stonework and carving, although the evidence is unclear.

A. Daneu: *L'arte trapanese del corallo* (Naples, 1964)

G. Tescione: *Il corallo nella storia e nell'arte* (Naples, 1965)

E. von Philippovich: *Kuriositäten/Antiquitäten*, Bibliothek für Kunst- und Antiquitätenfreunde, xlvi (Brunswick, 1966), pp. 121–38

P. Junquera: *Belenes Monasticos del Patrimonio Nacional: Reales Sitios*, v/3 (Madrid, 1968), pp. 24–35

E. Scheicher: 'Korallen in fürstlichen Kunstkammer des 16. Jh.', *Weltkunst*, lii/23 (1982), pp. 3447–50

B. Liverino: *Il corallo: Esperienze e ricordi di un corallaro* (Bologna, 1983)

L'arte del corallo in Sicilia (exh. cat., Trapani, Museo Regionale Pepoli, 1986)

Coralli, talismani e profani (exh. cat., ed. C. Maltese; Trapani, Museo Regionale Pepoli, 1986)

J.-P. Morel, C. Rondi-Costanzo and D. Ugolini: *Corallo di ieri, corallo di oggi* (Bari, 2001)

B. Jordan: 'Lamu: Coral Garden of the Swahili', *World Heritage Review*, xxix (Feb 2003), pp. 54–63

S. P. Singh and A. Srivastava: 'Some Scientific Aspects about the Use of Coral as Decorative Art', *Studies in Art and Archaeological Conservation: Dr. B.B. Lal Commemoration Volume*, eds A. S. Bisht and S. P. Singh (Delhi, 2004), pp. 169–84

Cotton. Fibre made from the long, soft hairs (lint) surrounding the seeds of the cotton plant (*Gossypium*). In the right climate (temperate to hot), cotton is easy to grow; it is also cheap to harvest and easily packed into compact bales for transport and export. Indigenous to India, the Sudan and Ethiopia, it was later grown in Egypt, China, western Central Asia, North America and elsewhere. Cotton is a very versatile fibre: used alone it can produce very fine, light and quite strong textiles (lawn and muslin), and used alone or in combination with other fibres it can make extremely durable and heavy fabrics (e.g. for use in bedspreads, rugs and carpets). It takes dye-stuffs very well and can be painted or printed with designs. The first mention of cotton is in the *Annals of Sennacherib of Assyria* (reg 705–681 BC), although it became important there only after the introduction of Islam in the mid-7th century AD. It was imported into the Middle East and North Africa in the 1st century AD and from there was traded throughout Spain and gradually through the rest of Europe. This article provides an overview of the production and use of cotton in the Western world. (For a discussion of the properties, manufacture and conservation of cotton *see* TEXTILE.)

1. IMPORTS AND EUROPEAN MANUFACTURE. In England in the 16th century the term 'cotton' appears to have been applied to cheap, thick woollens, but almost simultaneously real cotton was also being made. Through the establishment of the East India companies in the Netherlands (1597), England (1600) and France (1664), raw cotton and painted cottons were imported into Europe from India. They were known first as calicos, as they were imported from the port of Calicut in south-west India. Despite the distances involved in importing cotton, by the end of the 17th century it was displacing the cheaper types of linen. The popularity of cheap, lightweight Indian fabrics and especially of the painted cottons alarmed manufacturers in Europe. Textiles from the 'Indies' were accordingly prohibited for sale in England in 1699 and in France in 1717. They could, however, be re-exported both to other countries in Europe that did not have indigenous industries and to the American colonies. Lightweight, mixed fabrics of silk and cotton or pure cotton were very suitable for the American summer climate. Imported Indian textiles—including those for which the patterns were sent from Europe to be made in India—were, with such other 'luxury' items as porcelain and silk, hugely influential on the decorative arts in Europe and contributed to the rise of chinoiserie.

The huge popularity of the imported cotton led to imitation, and the ease with which cotton could be grown in a suitable climate inspired English colonists to set up plantations in the southern American colonies. A rearguard action was fought in England against the production of such cottons, and an act of 1736 allowed that it was legal in England to produce 'fustian', a fabric with a linen warp and a cotton weft; this was to prove very important to textile printing in the United Kingdom (*see* §2 below).

From its introduction into Europe, cotton was woven into cheap materials for underwear and stockings, and by the mid-18th century it was used for cotton velveteen and corduroy; an English corduroy waistcoat (London, Victoria and Albert Museum) is so decorative that it is comparable with contemporary silks. Also in the 18th century there was a steadily growing quilt-making industry in Bolton, Lancs: production was based on two types, one with a looped pile (caddy), and the other flat-woven in double cloth, imitating hand-quilted covers made in Marseille and hence called 'Marseille' or 'Marcella' quilts (*see* QUILTING). The second technique was also used for men's summer waistcoats and for ladies' pockets, of which there are a few examples from the 18th century and many from the 19th, woven on power looms with jacquard control (*see* TEXTILE, §II, 1(ii)).

Although the finest Indian painted cottons continued to be imported throughout the 18th century into Europe despite the restrictions, there was an increasing emphasis on the import of the raw fibre. Large factories were established in Lancashire for the production of cotton fabrics. Robert Peel, grandfather of the 19th-century prime minister, was a Lancashire cotton manufacturer who controlled spinning mills, weaving and cotton-printing factories. Lancashire cottons of all kinds dominated the European market for most of the 19th century. Cotton was also combined with worsted wool to make furnishings and men's waistcoats, thus meeting a new demand in the 19th century from a burgeoning middle class. Most of these fabrics were made on the borders of Lancashire and Yorkshire, and some made in Halifax were exhibited at the Great Exhibition of 1851 in London. Cotton was also used to make enormous shawls in the 1850s and 1860s.

The designs originated in the *shāls* woven from delicate goat's wool in Kashmir in the late 18th century. By the late 19th century jacquard-woven cottons manufactured on power looms were also creating serious competition for the Irish table-linen industry. The growth of the Lancashire cotton industry was reflected in a decline in the Indian cotton industry. The export of American cotton to newly established cotton industries in other parts of Europe hastened this decline still further. The collapse, however, of virtually all the European cotton industries in the second half of the 20th century led to a revival in India of both hand- and machine-woven fabrics. Good cotton and the use of traditional patterns and cheaper modern dyestuffs are favourable to the Indian manufacturer.

2. PRINTED COTTONS. Not until the import of painted cottons from India in the 17th century was there any real attempt in Europe to create a pattern by printing instead of by weaving. There had been some linens printed in the 15th and 16th centuries with printer's ink, but the colours were not fast. The impact of Indian painted cottons was huge: the fabric itself seemed impossibly fine to the European customer, and the use of vibrant colours encouraged competition (*see* TEXTILE, §III, 1(ii)(f)). By the late 17th century both the Dutch and the English were printing rather hesitantly in madder colours. The cottons produced have a naive charm but do not compare in quality with the cottons from India. By using different mordants, however, colours ranging from nearly black to pale pink could be achieved; it took another half century to achieve indigo printing. Despite the difficulties of using it, indigo yielded a crisp, fast blue that was particularly good for the large-scale, monochrome, copperplate-printed textiles made from the 1750s. English printers led Europe in these developments, and some of the finest furnishing copperplate textiles printed by Robert Jones at Old Ford or the Bromley Hall factory have never been equalled and were even imitated later by French factories. From the late 17th century a large number of snuff handkerchiefs were produced in Europe, the majority of which were copperplate-printed. Some printers concentrated specifically on the production of handkerchiefs, while others produced them as part of their range. Although many 18th-century handkerchiefs depicted such topical or political subjects as the *Trial of Dr Sacheverell* or the *Brentford By-election*, by the 19th century they were being produced for a much wider market. By the mid-18th century English block-printed textiles were printed in a full range of colours, which could copy both the patterns and the colouring of contemporary dress silks. Block-printing of cotton was used to great effect by William Morris (1834–96) in the 19th century.

By the 1730s English printed fustians were being exported to the American colonies and, from the 1770s, pure cottons. A parliamentary act of 1774 permitted the use of British all-cotton cloths for printing, provided that they had three blue threads woven into their selvages to distinguish them from French and Indian cottons. This act was not repealed until 1812. The raw cotton, however, might have originally come from the southern American colonies. Even after American Independence (1776), English traders continued to export their cottons, thus discouraging the Americans from setting up their own cotton-printing industries. Only in the later 19th century were American cotton printers sufficiently skilled to compete with the English.

In France it became legal to print cottons in 1759. Factories were set up in various regions, notably in Rouen, Nantes and Jouy-en-Josas. Significantly, there is evidence that Christophe-Philippe Oberkampf (1738–1815), founder of the Jouy factory, bought his cottons for printing from the East India Company sales in London because French cottons were not fine enough. It is not always easy to identify a cotton printed in Mulhouse in France in the late 18th century from one printed in Lancashire, especially if it has a dark ground (very fashionable at the time), which would make it impossible to see the obligatory three blue threads of an English cotton dating from between 1774 and 1812.

Factories for printing cottons were also set up in other parts of Europe, especially in Germany, Switzerland and Bohemia. Most of their products were made to be sold locally or in nearby states. In Italy the factories produced printed cottons for local use, and the *mezzara* of Genoa, large shawls with patterns inspired by those of contemporary imported Indian painted bedspreads, became particularly well known throughout Europe. Another development, of the mid- and late 19th century, was the production of cottons printed for overseas markets. Turkey red printed cottons were produced in Scotland for the African market and in Moscow for the Central Asian and Swiss markets. Printed cottons were traded in both Europe and America through the use of pattern cards, which were sent by an agent to his counterpart abroad; the recipient then ordered the required fabric by number. Nathan Meyer Rothschild (1777–1836) from Frankfurt am Main was a particularly successful cotton printer: he traded Lancashire printed cottons all over Europe and established his family's fortune in Britain.

J. Taylor: *A Descriptive and Historical Account of the Cotton Manufacture of Dacca, in Bengal* (London, 1851)

D. King: 'Textiles and the Origins of Printing in Europe', *Pantheon*, xx (1962), pp. 23–30

M. Edwards: *The Growth of the British Cotton Trade, 1780–1815* (Manchester, 1969)

J. Irwin and K. B. Brett: *Origins of Chintz* (London, 1970)

F. Montgomery: *Printed Textiles: English and American Cottons and Linens, 1700–1850* (London, 1970)

A. L. Eno, ed.: *Cotton Was King: A History of Lowell, Massachusetts* (Lowell, 1976)

S. D. Chapman and S. Chassagne: *European Textile Printers of the Eighteenth Century* (London, 1981)

Colour and the Calico Printer (exh. cat., Farnham, West Surrey College of Art and Design, 1982)

J. Brédif: *Toiles de Jouy: Classic Printed Textiles from France, 1760–1843* (London, 1989)

V. Gervers: 'Cotton and Cotton Weaving in Meroitic Nubia and Medieval Ethiopia', *Textile History*, xxi/1 (Spring 1990), pp. 13–30

B. Lemire: *Fashion's Favourite: The Cotton Trade and the Consumer in Britain, 1660–1800* (Oxford, 1991)

W. Hefford: *The Victoria and Albert Museum's Textile Collection: Design for Printed Textiles in England, 1750–1850* (London, 1992)

R. Barnes: *Indian Block-printed Textiles in Egypt: The Newberry Collection in the Ashmolean Museum, Oxford*, 2 vols (Oxford, 1997)

D. Swallow: 'The India Museum and the British-Indian Textile Trade in the Late 19th Century', *Textile History*, xxx/1 (Spring 1999), pp. 29–45

Counterproof [Fr. *contre preuve*; offset]. Reversed image of a print or drawing. It is made by pressing a blank sheet of paper against the original, both being dampened slightly and then run through a rolling press together. The counterproof image, usually fainter than the original, is transferred on to the second sheet in reverse. A counterproof is often made as part of the working process: after gauging the effects of the reversal, the printmaker or draughtsman is able to revise, correct or introduce new elements to the original as seems appropriate.

The process of pulling a counterproof is especially useful in between states of a print, since the counterproof is in the same direction as the printing-plate on which the artist is working. Such a counterproof can only be made from a newly printed proof that still has wet ink. The proof itself is damaged by the process: the intense pressure used to transfer the image removes ink from the original print and smooths out the impression marks.

For draughtsmen, pulling a counterproof is a simple method of reversing a design, for example for an engraving, book illustration or tapestry. It also enables a designer to reproduce a motif or series of motifs around two or four axes without further effort, as in the design for a damask napkin.

Some artists, including Thomas Rowlandson (1757–1827), have used counterproofing as a measure of reproducing their own work for sale; counterproofs of Old Master drawings have also been produced by forgers, especially in the 18th century. In both cases, the counterproof drawing is often gone over by hand to increase its veracity. Unless retouched, a counterproof drawing has a pale, rather monotonous and flat appearance. It is also sometimes recognizable from the shading, which appears left-handed, and from any inscription, heraldic motif or collector's mark, which is similarly reversed. As with prints, the process is harmful to the original drawing, because it lifts and thins the original medium, causing the surface to become flatter in texture and fainter in hue. The actual colour of the original may also change as a result of being moistened; red chalk, for instance, assumes an orange-red cast.

J. Hankwitz: *An Essay on Engraving and Copper-plate Printing* (London, 1732)

C. Klackner: *Proofs and Prints, Engravings and Etchings* (New York, 1884)

J. Watrous: *The Craft of Old Master Drawings* (Madison, WI, 1957)

D. Brown and D. Landau: 'A Counterproof Reworked by Perino del Vaga, and Other Derivations from a Parmigianino *Holy Family*', *Master Drawings*, xix/1 (Spring 1981), pp. 18–22

Cradle. Additional support applied to the back of a wooden panel painting to prevent or correct warping or splitting. It consists of a latticework of wooden batons, which are designed to allow some movement perpendicular to the grain of the panel in response to changes in humidity. Cradling has been used extensively since the 18th century or earlier, and many panel paintings have been thinned to accept a cradle, often with damaging long-term results. Because of the inevitable constraints on the expansion and contraction of the painting, cradling may cause more damage than it prevents and is thus no longer considered an acceptable method of reinforcement or repair (for further discussion *see* PANEL PAINTING, §3).

Craquelure [Fr.: 'cracking']. Pattern or network of small cracks on a painting. This may be due entirely to ageing of the structure of the painting, or it may have been provoked by defective or unsuitable materials, poor storage, technical error or the painter's incompetence. As a consequence of ageing alone, craquelure is seldom disfiguring and is simply regarded as a characteristic feature of older paintings (for which reason it has been faked). Movement of the support and shrinkage or embrittlement of the ground, paint and varnish are the main causes. The cracks occur in distinctive formations related to the type of support or to weaknesses and irregularities that act as focal points for stress. A circular pattern of cracks, known as 'rivelling', occurs on the *Guitar Player* (*c.* 1672–5; London, Kenwood House) by Johannes Vermeer (1632–75) and *Mrs Siddons as the Tragic Muse* (1784; San Marino, CA, Huntington Library and Art Gallery) by Joshua Reynolds (1723–92). Cracks that originate within the paint layer, often due to poor technique, are more likely to detract from the painting's appearance. Reynolds's use of bituminous pigments provides many examples of *'craquelure anglaise'*. Premature overpainting, especially of thick layers of oil paint, and not painting 'fat over lean' are other common causes. Sometimes another colour is revealed through the cracks, for example in the *Bellelli Family* (1858–67; Paris, Musée d'Orsay) by Edgar Degas (1834–1917), in which an underlayer of red is visible through a fractured layer of black. Acrylic paints are affected by low temperatures and can evolve a form of craquelure despite their elasticity.

Craquelure is often produced intentionally as a decorative effect in glazes, particulary on ceramics (*see* GLAZE).

E. M. Gilberte: *The Restorer's Handbook of Easel Painting* (London, 1976)

H. W. M. Hodges: 'The Formation of Crazing in Some Early Chinese Glazed Wares', *The Conservation of Far Eastern Art*, eds J. S. Mills, P. Smith and K. Yamasaki (London, 1988), pp. 155–7

S. Bucklow: 'The Description of Craquelure Patterns', *Studies in Conservation*, xlii/3 (1997), pp. 129–40

S. Bucklow: 'Consensus in the Classification of Craquelure', *Hamilton Kerr Institute Bulletin*, iii (2000), pp. 61–73

C. Arcolao: 'La "crequelure" o 'cavillatura' superficiale: Un'alterazione caratteristica delle superfici dipinte: Cause, effetti, evoluzione tra storia e sperimentazione', *Sulle pitture murali: Riflessioni, conoscenze, interventi*, eds G. Biscontin and G. Driussi (Marghera-Venezia, 2005), pp. 549–56

Crayon. Except for consistent reference to a stick of dry colour, the term 'crayon' is ambiguous. Historically it has denoted various fabricated, direct-line drawing instruments, made of ground pigment and binder, that are cut or moulded into cylindrical rods or straight-sided sticks about 60–70 mm in length and 10 mm in thickness. Included in this definition are PASTEL, red and black CHALK and *crayons de couleur* (wood-encased crayons), also oil, CHARCOAL, conté, lithograph and wax crayons. 'Crayon' has become a generic term for colour sticks made with oily, fatty or waxy binding media, such as lithograph, conté or children's wax crayons.

1. TYPES AND PROPERTIES. The type and percentage of the binder in a crayon determines and modifies its physical and optical properties, such as texture, tenacity, light reflection and colour saturation (see fig.). A high percentage of an oleo-resinous medium, such as wax, oil, fat or soap, will produce a greasy or dense stroke, whereas a small amount of a gum or clay binder produces dry, friable crayons, such as pastel, fabricated chalk and charcoal, because the particles lack adhesion.

Coloured oleo-resinous crayons were never in widespread use and are rarely mentioned in treatises on artists' materials. The earliest reference to wax crayon is in Leonardo da Vinci's notebooks (*c.* 1492–1515): 'To make points for colouring dry. Temper with a little wax and it will not come off...; you will thus make good crayons...' (J. P. Richter, ed.: *The Literary Works of Leonardo da Vinci*, i (London, 1888, rev. 1970), pp. 301, 359). In the 16th and 17th centuries references exist only to modifying pastel to increase its hardness and tenacity by varying the binder (Petrus Gregorius recommends fish glue, fig juice and gum arabic, and Edward Norgate refers to milk, beer, wort and gum). Hard pastel was soaked in olive or linseed oil to improve its working and visual properties. Alexander Browne described this process in 1675 in *Ars pictoria*: '[When dry] take a feather and some sallet Oyl and oyl them lightly over, let dry till the oyl be soaked well into them which will make them work free and easie'. William Salmon in 1685 claimed that this 'will not rub off, nor any part of it stir. [These crayons] are extremely neat, brisk, lively and (like Oyl-painting) very strong'. He also described an early method for producing fatty crayons by preparing a paste of finely ground chalk or pigment tempered with oil. A more typical process was to soak charcoal in a fatty binder (Giovanni Battista Volpato specified common oil) to increase its smudge resistance, enhance its tone and yield broader, softer lines; Guercino (1591–1666), Jacopo Tintoretto (1519–94), Peter Paul Rubens (1577–1640) and Hendrick Goltzius (1558–1617) used such a crayon. Samuel van Hoogstraten and Willem Goree noted that coal soaked in linseed oil is suitable for life-size nudes: this medium was used by Nicolaes Berchem (1620–83) and Herman Saftleven II (1609–85).

In 1764 Robert Dossie, in *The Handmaid to the Arts*, referred disparagingly to pastel with a beeswax binder: '[It will] render the cartoon secure from flaking off and [will] bear rubbing with a brush—but such crayons cannot make delicate touches and thus can be employed only for coarse purposes'. In the late 18th century other tenacious crayons were produced. In 1797 C. F. A. Hochheimer gave recipes for crayons made with wax, tallow and spermaceti. At the same time (1796–1800), J. N. F. Alois Senefelder (1771–1834) was experimenting with lampblack, tallow, soap and various waxes cast into hard, or soft and greasy sticks. Intended for lithographic stone, their rich colour and lustrous texture encouraged such artists as George

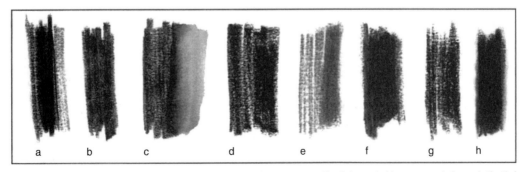

Crayon types: (a) conté crayon; (b) wax crayon; (c) water-soluble wax crayon; (d) oiled pastel; (e) compressed charcoal; (f) oiled compressed charcoal; (g) lithographic crayon; (h) pastel

Bellows (1882–1925) and Käthe Kollwitz (1867–1945) to use them for drawing on paper.

The early wood-encased conté, patented by the French engineer Nicolas-Jacques Conté (1755–1805) in 1795 as a substitute for embargoed Burrowdale GRAPHITE, was made from compressed and fired graphite and clay. In 1840 the fluidity of its stroke was enhanced by impregnation with spermaceti. Fatty oils are now also used for this purpose. Conté crayons, widely employed in the 19th century, most notably by Georges Seurat (1859–91), while not powdery like natural chalk blend readily to produce delicate tonal gradations.

The scarcity of graphite and the popularity of conté stimulated further invention. In 1818 a method was published in *Annales de chimie et physique* for controlling hardness by immersing charcoal in mixtures of wax and resins, tallow or butter. In the 1840s the first compressed charcoal, available as a greasy (*trempé*) or dry stick, was marketed, and it was used extensively by academicians. In 1835 J. S. Staedtler developed a wood-encased coloured crayon, now called PENCIL, with a wax-impregnated 'lead'. The hardness of these crayons causes them to have a limited value range because the pigments are tightly bound with wax and other additives. This compresses the pigments, optically reducing the amount of light the colours reflect, and limiting the amount of powder obtained from the stick as it is drawn across a drawing surface. These crayons were used by late 19th-century artists, including Henri de Toulouse-Lautrec (1864–1901) and Jacques Villon (1875–1963). Modern coloured pencils are mixtures of waxes, kaolin and other clays, to which dyes or pigments have been added. In the late 19th century the Realist painter Jean-François Raffaëlli (1850–1924) developed a modified pastel: a soft crayon containing cocoa butter, tallow, Japan wax and non-drying oils. They have been referred to as Raffaëlli colours, oil pastels and oil crayons. They were claimed to have the durability and lustre of oil painting, but no work in this medium is extant, presumably because the colours darkened. Oil crayons became popular from the 1940s despite the tendency of the binders to seep into the paper.

In 1903 extruded, paper-wrapped wax crayons were developed, composed of high percentages of paraffin and stearic acid and low percentages of pigment and synthetic lakes. They require bearing down to produce strong colour, the palette is limited and mixing restricted, hence they are more frequently associated with the work of children than of professional artists, though they were used by Henry Moore (1898–1986), Pablo Picasso (1881–1973), Roberto Matta (1911–2002) and Arshile Gorky (1904–48). Some wax, wood-encased crayons are water-soluble and thus may be used dry or in washes, as in the work of Jackson Pollock (1912–56) and Frank Lloyd Wright (1867–1959).

2. CONSERVATION. There is no standard technique for cleaning crayon drawings. The type of crayon must be tested to determine the solubility and friability of the medium and pigment, and the condition of the support must also be examined. Even familiar materials must be tested, since drawings executed in the same type of crayon will age at different rates depending on environmental factors, such as light and humidity, and on the components of the support and mount. Surface cleaning is usually inadvisable because of the tendency of these media to smudge. As with any work on paper, the feasibility of either local or general cleaning will depend on finding a suitable method and the correct aqueous solution or organic solvent for the type of discoloration. (*See also* PAPER, §VI.)

The preservation of crayon drawings rests equally on safeguarding the support and the medium. Many wax crayons and coloured pencils are made with dyes and pigments of questionable lightfastness, hence limited exhibition time (two to three months) and light intensity (50 lux maximum) is necessary. Framing should be under ultraviolet-filtering acrylic sheeting separated from the surface of the art work by at least 3.18 mm. Conté crayons and oiled charcoal are light stable, but their slightly powdery nature requires framing with glass. Acid-free mounting materials are essential for storage and framing.

P. Gregorius: *Syntaxeon artis mirabilis* (Lyon, 1574) [see J. Meder: *Die Handzeichnung* (Vienna, 1919); Eng. trans. as *The Mastery of Drawing*, abridged, by W. Ames (New York, 1978), p. 100]

E. Norgate: *Miniatura, or the Art of Limning* (London, 1648–50), p. 75

A. Browne: *Ars pictoria* (London, 1675), p. 30

S. van Hoogstraten: *Inleyding tot de hooge schoole der schilderkonst, anders de zichtbaere werelt* [Introduction to the academy of painting, or the visible world] (Rotterdam, 1678/R Soest, 1969); Ger. trans. by E. von Gosen in *Einführung in die hohe Schule der Malerei* (Ann Arbor, 1980), p. 32

W. Salmon: *Polygraphice* (London, 1685), p. 6

W. Goree: *Inleyding tot de al-ghemeene teyckenkonst* [Introduction to the general art of drawing] (Middelburg, 1697), p. 94

G. B. Volpato: *Modo da tener nel dipinger* (Bassano, c. 1700); Eng. trans. by Mrs Merrifield as *Original Treatises on the Arts of Painting*, ii (London, 1849), p. 752

R. Dossie: *The Handmaid to the Arts* (London, 1758, 2/1764), p. 205

C. F. A. Hochheimer: *Chemische Farben-lehre* (Leipzig, 1797), p. 234

Annales de chimie et de physique, 2nd ser., ix (1818), pp. 334–5

K. Robert: *Charcoal Drawing* (Cincinnati, 1880)

M. Doerner: *Materials of the Artist* (New York, 1934)

E. Voice: 'The History of the Manufacture of Pencils', *Transactions of the Newcomen Society*, xxvii (1949–51), pp. 131–41

J. Watrous: *The Craft of Old Master Drawings* (Madison, 1957)

C. Hayes: *The Complete Guide to Painting and Drawing Techniques and Materials* (New York, 1976)

P. Schatborn: *Dutch Figure Drawings from the 17th Century* (The Hague, 1981)

R. Mayer: *The Artist's Handbook of Materials and Techniques* (New York, 5/1991)

M. Wagner, D. Rübel and S. Hackenschmidt: *Lexikon des künstlerischen Materials: Werkstoffe der modernen Kunst von Abfall bis Zinn* (Munich, 2002)

A. Zvereva: *Les Clouet de Catherine de Médicis: Chef-d'oeuvre graphiques du Musée Condé* (Paris, 2002)

Crayon manner. Type of copperplate-engraving process that reproduces a drawing in chalk or pencil in facsimile. It was invented in the 18th century, but it was superseded by the stipple technique (*see* STIPPLE, §1).

1. Materials and techniques. 2. History.

1. MATERIALS AND TECHNIQUES. The crayon manner aims to imitate drawing as the collection of a multitude of dots corresponding to marks left by a pencil on the grain of paper rather than as an assemblage of lines. It can be executed directly on to the bare copper but is more often prepared by etching. The engraver counterproofs the drawing that he is using as a model (or a copy if he has made one) on to the ground; he then follows the marks of the main contour lines using single or multiple-point punches, or an instrument made of various sized needles fastened together. Rather than tracing a line, dots are hammered out close together right along the line, which gives the contours the grainy appearance of a drawing. The dark masses of shadow and the half-tones are then distributed by using mattoirs; the large number of points of various sizes irregularly distributed on the end of the mattoir makes it possible to engrave dots that are irregular in shape and depth. The work can be speeded up by using roulettes, mattoirs with wheels embellished with the same type of points as the mattoir. The engraver uses these tools to follow all the pencil lines that make up the drawing. Once the plate has been bitten by the acid, work on the bare copper is completed with the help of these same instruments. A hammer may also be used to knock the needles and punches into the plate. Some engravers execute the whole engraving in this way.

Whatever the method, the engraver keeps to the same basic rules: first he must lay down the main lines and hatching of the drawing that serves as the model and then distribute dots across the rest of the engraving as irregularly as possible. In the dark parts the different dots may tumble over each other; in the half-tones they are not so deep, and the untouched areas that are not engraved are usually limited. The engraved plate is then printed by a copperplate press. Use of a dark grey ink makes it possible to imitate a black pencil drawing, while ochre or red give the appearance of a sanguine drawing. The presence of numerous shallow dots makes the plate relatively fragile, and the number of prints pulled has to be limited. In the late 20th century one might pull 50 proofs, but 18th-century engravers seem to have continued using their plates after pulling 200 prints.

Crayon manner was also used for multiple-plate printing. Its most immediate application was the reproduction of drawings in several colours (sanguine, black, and white highlights). Using the techniques described above, the line of each colour was engraved on each plate; having been coated with an ink corresponding to the desired colour, each plate was then pulled in succession. Like mezzotint or aquatint, crayon manner makes colour printing possible with the use of several juxtaposed plates; this is referred to as pastel manner. Printing is done by following guiding marks. The number of plates can vary from three to eight, according to the subject engraved and the quality of gradation desired by the artist. Using principles of prismatic analysis of primary colours based on the theories of Sir Isaac Newton, the engraver invariably uses four plates, successively coated in black, yellow, blue and red ink. However, a more delicate approach allows the engraver to juxtapose rather than blend colours, in the manner of a pastellist; the number of plates is then greater, and, by inking with a dauber, each one can contain several colours. Although using the same mattoirs and roulettes as for the crayon manner, the results are different, especially on the first plates to be printed, being engraved in a looser manner. The sheet has to be passed under the press several times, and the dots appear smudged, which gives the hatchings the blurred effect of pastel drawings. Pastel-manner engraving allows for only a small number of good proofs: as soon as the least deeply engraved plate is worn, the colour of the prints is set at variance.

The crayon-manner technique is clearly faster than traditional copperplate engraving, the roulettes and mattoirs allowing for swifter work. The same effects can, however, be produced more quickly by soft-ground etching and by lithography; the latter has made crayon manner virtually disappear. The investigations it prompted originated an increasing use of stipple engraving and other methods of engraving with tools (e.g. GOUACHE MANNER).

2. HISTORY. Although the technical invention of crayon manner dates from the 18th century, as early as the 16th century certain engravers, in particular Domenico Campagnola (1500–64) and Giulio Campagnola (*c.* 1482–after 1515), favoured the use of dots, as opposed to strokes, and their work resembles crayon-manner engraving. In the 17th century some engravers, including Johannes Lutma II (1624–89), used several goldsmiths' tools, such as punches and mattoirs with wheels, in their work, but it is hard to speak of their engravings as facsimiles of pencil drawings, if only because of the excessive regularity of the dots. In the 18th century the interest shown in drawings as works of art worth collecting led certain engravers to seek means of reproducing them with the greatest possible fidelity. Drawings by Antoine Watteau (1684–1721) were the object of the first attempts. Around 1727 Benoît Audran II (1698–1772) engraved a woman sitting on the ground (*Figures de différents caractères*, ii, no. 154) by working in very fine parallel strokes, completed with short crosshatchings. This mixture of strokes made it possible to imitate a pencil stroke broken down into a multitude of lines rather than dots. In London, Arthur Pond (1701–58) made similar attempts

between 1736 and 1742, notably in engraving *Dr Misabin* (1739; Dacier and Vuaflait, i, fig. 81) after Antoine Watteau (1684–1721). He perfected Audran's system by using irregularly shaped strokes completed with dots and therefore better suited to imitating pencil strokes.

The invention of this new manner of engraving must, however, be ascribed to Jean-Charles François (1717–69). His first efforts resulted in his book *Principes de dessein faciles et dans le goût du crayon* (Lyon, 1748). At this time his technique was rudimentary, with his models engraved in fine parallel strokes by a burin; the print was then counterproofed, so that the strokes that merged into each other gave the impression of a relatively thick and fluid line. Despite the various improvements that François made to this technique until the 1750s, it was insufficient. He owed to Gilles Demarteau (1722–76) the idea of using goldsmiths' chasing-tools and marking-wheels. Demarteau, a former goldsmith's apprentice, had used them in 1736 to shade the lines in a series of *Trophies* (e.g. Hérold, no. 12). François, by then a partner of Demarteau, conceived of using such tools to engrave the entire plate. He had the mechanic Alexis Magny (1711–95) make him tools that were better adapted to his needs and that allowed him to engrave in irregular dots; in 1757 he engraved his first three plates in crayon manner, directly on to the copper. To accelerate the work, he etched three other plates using different-size needles bound together. These six plates, published in the book *L'Amour du dessein ou cours du dessein dans le goût du crayon* (Paris, 1757), were submitted to Abel-François Poisson de Vandières, Marquis de Marigny (1727–81), and to the Académie Royale de Peinture et de Sculpture.

François's invention was swiftly contested. Magny, who had made François's instruments, perfected and then exploited them. He made an articulated machine, in which pressure on the mattoir was obtained with a lever worked by a foot pedal. The engraver had only to move his tools with his hand, but the cutting itself required no effort. Magny became a partner of Jean-Baptiste Delafosse (1721–1806) in order to exploit his machine, and his first engraving, a *Head of an Old Man* after François Boucher (1703–70; Hérold, no. 19), appeared in November 1757. Magny and Delafosse separated after their second engraving had appeared, and it was not until after legal proceedings lasting until 1761 that Magny, by then in partnership with another engraver, Pierre Gonord, began once more to publish engravings in the crayon manner. He then tried unsuccessfully to challenge the anteriority of François's invention. By refining his tools, Magny published the first imitation of stump drawing: a *Women's Academy* (1762) after Charles-Nicolas Cochin II (1715–90).

François was also rivalled by Demarteau. The two engravers separated in 1757, and in 1759 Demarteau brought to his studio Louis-Marin Bonnet (1736–93), who had been a student of François and was acquainted with his processes. In 1759 Bonnet engraved his first plate for Demarteau, and the latter executed the first of *c.* 300 plates after Boucher, which would constitute the major part of his work. Despite not inventing the crayon manner, Demarteau was its main exponent in France. A better draughtsman and engraver than François, he was also capable of recognizing public taste.

The success of crayon-manner engraving soon led to attempts to improve it. In 1760 François wanted to execute engravings with two pencils, black and white, on coloured paper, but neither he nor Joseph Varin (1740–1800), who published this type of engraving in 1761, succeeded in finding a white ink that did not turn yellow. Bonnet did succeed and in 1764 published a two-colour engraving. He was, moreover, the first to make a multiple-plate print, pinning the plates in place rather than fitting the second into the plate mark made on the paper by the first plate. In April 1767 Demarteau submitted his first two-colour plates (sanguine and black) to the Académie and received its approval, which encouraged Bonnet to publish a three-colour head the same year. After several attempts at five-plate engravings (black, blue, red, yellow and white), in July 1769 Bonnet published a pastel-manner engraving using eight plates, a *Head of a Woman* after Boucher. In the 1770s his investigations led him to the GOUACHE MANNER. François also continued to search for new techniques. A mediocre engraver, he perfected a method using no metal tools, which he kept secret; it was probably soft-varnish engraving. He failed in his attempts to interest the Académie and the Marquis de Marigny in this invention, but his secret was discovered in the Netherlands by Cornelis Ploos van Amstel (1726–95) and in England by Benjamin Green (*c.* 1736–1800).

Crayon-manner engraving and its various offshoots were successful mainly in France. It was above all adapted to drawings in wax crayon (sanguine and stone black) used by 18th-century French artists whose work was in great demand. From 1757 the engraver Charles-Nicolas Cochin II had noted in relation to a request from François that most of the early drawings in the Cabinet du Roi could not be used as models. The field for this type of engraving was therefore limited outside France and countries where 18th-century French drawing was appreciated. Moreover, crayon-manner engraving was a fairly quick process: Demarteau engraved nearly 600 plates in less than 20 years, and the work published by Bonnet is more or less comparable. There were therefore enough Parisian artists to satisfy demand in France and Europe, and the development of engraving in the crayon manner in the provinces and overseas remained limited. In England, however, the new technique had important consequences. It was introduced by William Wynne Ryland (1732–83), who had spent time in Paris in the studio of Jacques-Philippe Lebas (1707–83), where he stayed until 1765, learning the new techniques and engraving several plates. On his return to London he introduced crayon-manner engraving, also practised by Francesco Bartolozzi (1727–1815). However, their association

with Angelica Kauffman (1741–1807) led to a transformation of the technique into stipple. Although the crayon manner's success was limited to the period between 1757 and the French Revolution (1789–95), it paved the way for most of the technical investigations at the end of the 18th century.

A. Bosse: *De la manière de graver à l'eau-forte et au burin*, ed. C. N. Cochin (Paris, 1645, 2/1758 [1769])

F. Courboin: *L'Estampe française: Graveurs et marchands* (Brussels and Paris, 1914)

E. Dacier and A. Vuaflait: *Jean de Jullienne et les graveurs de Watteau au XVIIIe siècle*, 4 vols (Paris, 1921–9)

J. Hérold: *Gravure en manière de crayon: Jean-Charles François, catalogue de l'oeuvre gravé* (Paris, 1931)

J. Hérold: *Louis-Marin Bonnet (1756–1793): Catalogue de l'oeuvre gravé* (Paris, 1935)

R. T. Godfrey: *Printmaking in Britain* (Oxford, 1978)

V. Carlson and others: *Regency to Empire: French Printmaking, 1715–1814* (Baltimore, 1984)

B. Gascoigne: *How to Identify Prints* (London, 1986/R 1995)

A. Griffiths: *Prints and Printmaking: An Introduction to the History and Techniques* (London, 1996)

Cyanotype. *See under* PHOTOGRAPHY, §I, 2.

D

Dabber. Pad made of cotton, silk or leather used to apply ink or paint.

Damascene. Technique of decorating metalwork with an inlay of precious metal (*see* METAL, §V).

Damask. See LINEN DIAPER AND DAMASK.

Dammar. Natural resin widely used as a picture varnish and as an additive to oil paint (*see* RESIN, §1). It is obtained from several species of tree growing in South-east Asia. Dammar becomes yellow with age but is less prone to surface disfigurement than mastic, which it gradually superseded during the 19th century.

Dead colouring [laying in]. Term used in oil painting to describe the first application of paint or underpainting in monochrome or reduced colour on top of the ground and underdrawing. This fixes the tonal relationships and composition, before further layers of paint are applied to give colour and details of texture. This traditional painting method, which developed from egg tempera painting practice, is in direct contrast with *alla prima* methods of painting, in which a single application of paint creates the effect.

Die (i). Intaglio stamp used for impressing a design when striking coins or embossing paper.

Die (ii). Hollow mould in metal-casting.

Diluent. SOLVENT used to dilute or thin a solution such as turpentine for oil paint.

Distemper [Fr. *peinture à la colle*]. Aqueous paint composed of pigments held together by animal glue or casein. It has been used since ancient Egyptian times for wall painting, house decoration and the painting of theatrical scenery. It has been employed only occasionally for easel painting.

Dotted print [Fr. *criblé*; Ger. *Schrotblatt*]. Type of print made by a process of relief-engraving on metal, used by goldsmiths in the second half of the 15th century. The plates were usually made for printing on paper but sometimes for decoration. The metal used was a malleable one, such as copper, tin, brass

or lead. It was cut using a hammer to hit punches of different thicknesses; on one end of the steel stem of each punch was a motif in relief that, when punched into the metal plate, created an indented cavity. These motifs included dots, crosses, fleurons, lozenges, stars and circles. The background, which constitutes the part in relief, carries the ink and appears black when printed; the hollows of the punch marks, of varying size and proximity to each other, produce the whites that make up the subject and suggest the modelling and half-tones. The white, positive part of the image is rarely composed solely of white dots, although they predominate; white strokes and hatch marks are also used. The process of the dotted manner is similar to goldsmith's work and to the way plates are worked for tooling leather, for instance in bookbinding. Dotted prints intended to be printed on paper bear traces of the nails that pinned them down, which suggests that the plate was fixed to wood and then put through a press. Such impressions bear inscriptions that appear the right way round, while proofs with inscriptions in reverse come from plates that were probably made for goldsmith's work (enamel) or for decorating an object. In several cases plates appear to have been reused for PASTEPRINTS.

The dotted manner was restricted to regions of the Rhine, and to the Netherlands, Cologne, Basle and Lake Constance. The earliest-known dotted print with a date is of *St Bernardino of Siena* (Paris, Bibliothèque Nationale). At the foot of the plate, a five-line text is engraved, with the date 1454. The plate is highly developed technically and can perhaps be linked to a group of images in the same style, with the subject in relief, against a white background, and with borders of ribbons festooned to look like clouds in a black sky scattered with stars; the corners are occupied by medallions bearing the symbols of the Evangelists. The *St Bernardino* is coloured in several arcs with yellow-green, brownish red and bright red. The most spectacular dotted prints are those for which the engraver used virtually nothing but a punch; these are vigorously modelled, with a decorative quality far removed from ordinary prints. Dotted prints were succeeded by metalcuts, which made possible a greater variety of effects and which mixed black- and white-line engraving, relief and dotted manner printing. It is practically impossible to isolate

the different techniques of relief-engraving on metal and to describe their history separately, since they were rarely used in isolation but were mixed on the same plate.

W. L. Schreiber: *Manuel de la gravure sur bois et sur métal au XVe siècle*, 5 vols (Berlin and Leipzig, 1891–1910; 10 vols, Stuttgart, 3/1969)

H. Bouchot: *Les Deux Cents Incunables xylographiques du Département des Estampes* (Paris, 1903)

P. Gusman: *La Gravure sur bois et d'épargne sur métal du XIVe au XXe siècle* (Paris, 1916)

P. Gusman: 'La Gravure en taille d'épargne sur métal', *Byblis*, iii (1922), pp. 118– 24

A. Blum: 'Les Débuts de la gravure sur métal', *Gazette des beaux-arts*, vi (1931), pp. 65–77

A. M. Hind: *An Introduction to a History of Woodcut with a Detailed Survey of Work Done in the Fifteenth Century*, 2 vols (London, 1935; R London and New York, 1963)

Fifteenth-century Woodcuts and Metalcuts from the National Gallery of Art (exh. cat. by R. S. Field; Washington, DC, National Gallery of Art, 1966)

G. Petardi: *Printmaking: Methods Old and New* (New York, 1980)

Doublure. Ornamental lining, often of leather or parchment, on the inside face of a book cover (*see* BOOKBINDING, §I).

Drawing. Term that refers both to the act of marking lines on a surface and to the product of such manual work. Whether it is summary or complete, a drawing is defined less by its degree of finish or support than by its media and formal vocabulary. Manipulating line, form, value and texture, with an emphasis on line and value rather than colour, drawing has been employed since ancient times for both aesthetic and practical purposes. The language of drawing has been used to record, outline and document images that the draughtsman has observed, imagined, recalled from memory or copied.

I. Introduction. II. Function and purpose. III. Materials and techniques. IV. History. V. Conservation.

I. Introduction. There are several qualities unique to drawing that distinguish it from other art forms. It has always been considered among the most intimate and personal of all the arts. Since the early Renaissance, a drawn sketch was central to the process of artistic creation as thoughts and images were first rendered into graphic form. Although 'first idea' sketches represent only one aspect of the creative process (*see* §II, 1 below), idea-generating sketches possess the aura of fiery inspiration. That spirit of invention and originality has lent allure and renown to the drawings of great masters, such as Leonardo da Vinci (1452–1519), Rembrandt van Rijn (1606–69), Edgar Degas (1834–1917) and Pablo Picasso (1881–1973).

Drawing has traditionally served as the foundation for all the arts. To attain sovereignty in painting, sculpture or architecture, first it was necessary to master the fundamentals of drawing, for as the great 19th-century French painter Jean-Auguste-Dominique Ingres (1780–1867) declared, 'drawing is the probity of art'. Training consisted of copying the master's own designs and drawings before progressing to the stage of drawing from the nude (the preferred method of studying the figure in art academies). Anatomy and perspective were also subjects learnt through drawing. As an exercise, drawing trained the eye and the hand, conferring judgement and teaching discipline. In the workshop, academy or drawing-room, the practice of drawing has sustained professional art education and served as the ideal pastime of the cultivated amateur and dilettante. Moreover, the infinite variety that can be achieved with the sparest of means makes drawing an ever-challenging artistic activity. Drawings can be appreciated as works of art in their own right, independent of any auxiliary function they may serve in relation to the design and execution of a project. A copy or a reworked drawing, when the corrections are executed by great masters such as Peter Paul Rubens (1577–1640) or Rembrandt, disclose fresh insights about the nature of an original and the creative process itself.

Since drawings first served as adjuncts to the working process, they were generally unsigned. Yet even though they are usually less ambitious or finished compared to works in other media, they often reveal the genius and style of their creators in a clear and characteristic way. The traditional approach to the study of drawings, particularly Old Master drawings, has consequently been to investigate problems of attribution and style. The connoisseur's primary mission has been to define an authoritative corpus of drawings for individual masters and their followers, for localized workshops or regional schools.

Since the 1960s, however, new approaches to the study of drawings have been advanced, which focus, for instance, on the role of drawings and their function within the creative process. Furthermore, as a result of developments in scientific examination and the restoration of paintings and frescoes, an entirely new category of drawings, UNDERDRAWING, has emerged. The study of underdrawings—defined as any drawing forming the starting-point in the execution of a work of art that is completely covered during the working process—has resulted in an exciting new field of scholarship, modifying previous assumptions about the definition of the medium.

Throughout the 20th century creative drawing has served to stimulate an original approach to form. From Fauve watercolours to Cubist collages or Surrealist 'automatic drawings', the role of drawing has been continually redefined and expanded. For such artists as Picasso, Henri Matisse (1869–1954), Joan Miró (1893–1983), Stuart Davis (1892–1964) and Jackson Pollock (1912–56), as well as Cy Twombly (*b* 1928), Joseph Beuys (1921–86) and Keith Haring (1958–90), drawing has been not only a source of artistic inspiration but also a means of expression. The trend towards abstraction and non-representational art, combined with the influence of

Sigmund Freud's theories of the subconscious, demanded a new approach to the creative process and new attitudes about its product. In addition, the tendency of 20th-century artists to use popular culture as a source has spurred interest in a variety of non-traditional artistic media. In the same period the artistic use of mixed media has served to sever the boundaries between the traditional media. Practitioners have continually adapted and redefined the nature of the format and the support as their artistic goals have changed, thus constantly renewing and expanding the expressive potential of one of the oldest art forms.

II. Function and purpose.

1. CREATIVE DRAWINGS. The process of formulating a design is often initiated by the *première pensée*, a quick thumb-nail sketch or even a doodle. Such form-searching sketches serve to explore a range of alternatives, with many ideas sometimes jotted down on a single page. The key purpose is to generate creative energy and record the process of brainstorming on paper. Another form of creative drawing, executed either as a finished work or without explicit purpose, is the independent drawing, such as a portrait, botanical illustration or caricature, in which the creative impulse is not only materialized but also completely articulated. Since creative drawings may appear as finished, as detailed or as free as the artist or designer wishes, they include drawings at opposite ends of the creative spectrum: both the inchoate or experimental stage of idea generation and the final or definitive statement realized within a graphic medium.

2. STUDY DRAWINGS. These are subsidiary drawings—preparatory drawings, detail drawings and process drawings—produced in relation to the execution of another work of art or design, which is usually in a different medium. Preparatory and detail drawings help an artist to work out the final form of a composition. Process drawings, on the other hand, assist in the transfer of an image to a different scale or format; they have a mechanical function and contribute to the routine replication of both unique and popular images.

Before the 15th century it was customary for artists' workshops, when commissioned to produce a new work, to reuse a rather restricted set of compositional designs, elaborating and adapting previous work as circumstances required. These exempla, mounted and bound together in a model or pattern book, were a valuable workshop resource: serving as storehouses of available models, they helped to streamline workshop production. For artist and patron alike, tradition and custom governed decision-making rather than originality and invention. However, as a consequence of the 15th-century revival of humanism, with a renewed interest in the written and material heritage of the ancient world and a growing awareness of the natural world, both artist and patron placed a new premium on originality.

To devise and fabricate customized designs, it was necessary to spend more time and effort in compositional planning and analysis. Renewed interest in anatomy, linear perspective and the representation of the illusion of the human figure moving through space inspired artists to study drapery and the human figure, in the nude and costumed, in greater detail than ever before. Artists copied fragments of antique statuary, dissected corpses and posed living models to perfect their understanding of the human form. The drapery study evolved to aid the artist in his examination of the structure of the body and the covering garment as well as the play of light and shadow on solids and voids. The representation of gesture and the illusion of movement were enhanced by an understanding of how drapery moved, both revealing and concealing the human form, while artists also paid attention to the contribution of the ornamental pattern of drapery to the overall surface design and to the expression of human feelings. In costume studies, unlike drapery studies (which may be regarded as fabric still-lifes), drapery and the human figure were integrated in order to record the harmony between movement and expression, in which the drapery defined the body's structure, accentuated motion or underscored the spiritual content of the picture. Based on prototypes inspired by Classical sculpture, studies of draped figures were a form of routine drawing exercise, independent of a specific project, although the large number of surviving examples also reflects their use as direct preparatory studies.

Drapery and costume studies were usually executed at a relatively advanced stage in the development of a design, immediately before the final preparatory compositional drawing or modello (see MODELLO, §1), or before beginning work on the intended support. The custom was to work out a composition in stages, beginning with a rapid notational sketch of various ideas, followed by a more definitive drawing fixing the outlines of the composition and detail studies from posed models to clarify the individual figures. The posed models were often sketched first as nudes and only at a later stage as clothed figures, with the drapery or garment delineated over the anatomical sketch. Costume studies of draped figures served a similar role to that of other detail studies drawn from the posed model, particularly *garzone* drawings, so called after the Italian word for studio assistant. Dressed in everyday clothes, the *garzone* assumed the poses of both male and female figures. In some instances, notably in the work of Raphael (1483–1520), successive stages of compositional development were combined on a single sheet.

Before the 15th century all stages of work, including both design and execution, were customarily executed on the support itself (e.g. wall or panel) and not as an adjunct drawn on an independent surface. Such underdrawings, including the *sinopia* design for a fresco, were usually concealed under the subsequent layers of paint. Although not intended to be seen by the viewer, some detailed compositions are

thought to have been prepared for the approval of the patron. Knowledge of this aspect of drawing practice, previously documented only in damaged or incomplete works as well as in examples partially visible to the naked eye, has been expanded by the discovery of new procedures to detach frescoes from the wall and separate layers of paint and plaster, as well as advances in scientific methods of technical examination of Netherlandish panel painting of the 15th and 16th centuries, particularly infra-red photography and reflectography (*see also* TECHNICAL EXAMINATION, §II). The discovery of *sinopie* on walls and underdrawings on panels has dramatically expanded the corpus of graphic material from a period from which relatively little independent work on paper survives. Research has yielded new information about a range of art-historical problems, including issues of attribution, chronology, studio practice and personal style, as well as drawing function, for example, the relationship between underdrawings and preliminary drawings on paper and printed graphics.

Process drawings, utilized as tools to assist in basic workshop production, were seldom thought to possess any intrinsic artistic value, and such sheets were customarily disregarded after use. The process of transferring, reducing or enlarging the approved preliminary design to the final support often distorted the image. It was an exacting job and was usually delegated to trained assistants. Even when a composition is worked up on the support itself rather than independently on paper, process drawings retain a central role in the operations of successful workshops. Commercial production of reproductive engravings and book illustrations requires that images be transferred from one medium and format to another. Designs for tapestries, stained glass, costumes, stage designs, ornaments and decorative and religious objects are conceived with their translation into different media in mind.

3. PRESENTATION AND CONTRACT DRAWINGS. A presentation drawing is a type of detailed compositional drawing prepared for the patron's approval, which explicitly outlines the agreed composition. Such designs are often coloured so that the patron can both evaluate the colour scheme and more easily envisage the final outcome. A contract drawing is a specific type of formal presentation drawing in which the artist and patron sign the agreed design, giving the drawing the force of a legal contract. For durability and because long-term projects, particularly architectural and decorative schemes, required years to complete, presentation and contract drawings were often executed on parchment. The contract drawing was required to serve as a reference for the numerous parties involved in a project.

III. Materials and techniques.

1. Supports. 2. Media and tools. 3. Techniques and processes.

1. SUPPORTS. Almost any plane surface may serve as a SUPPORT for a drawing. Stationary or fixed supports range from the walls of prehistoric caves to the tombs of ancient Egypt and Etruria. From the temples of Classical Greece and the villas of ancient Rome to the Renaissance and Baroque buildings of Italy, walls, ceilings and even floors have served as supports for drawings. The most popular portable supports for writing—papyrus, parchment, cloth and paper—have also been the most favoured for drawing. Even in prehistoric and ancient times and in the many centuries before the availability of paper, artists sketched designs and drafted plans with a stylus, brush, charcoal or pen and ink on such reusable or disposable supports as chiselled stones, painted terracotta and limestone shards (ostraca), palimpsests and prepared tablets made of clay, wax or boxwood.

PAPYRUS, grown in the Nile Delta and used by the ancient Egyptians as a writing and drawing surface, is a thick, fibrous water-plant, strips of which were beaten with a mallet until they were cemented together by the natural sap. The sap also acted as size to reduce absorbency and prevent ink from 'bleeding'. Papyrus was an ideal support for writing and drawing on scrolls because of the ease with which it could be extended by the addition of new strips. Its successor from the 5th century AD was PARCHMENT, a protein substance derived from treated animal skins, usually sheep, goat or calf. Vellum is a superior grade of parchment made from unblemished calf skins. For centuries prepared skins served as a support for writing, manuscript illumination and drawing because of their translucent ivory colour, large format, even finish, double-sided surfaces, flexibility, durability and strength. Bleached and degreased parchment formed a flawless white writing surface; rubbed with powdered pumice, chalk and resin, then burnished, it formed a smooth, opaque ground for illumination. Adding pigment produced a coloured or toned ground. Although by the mid-15th century paper was less costly and easier to prepare than parchment, which it superseded as the writing and drawing support most commonly used, parchment continued to be preferred for works intended for frequent use and multiple users, including architectural plans, pattern books and designs. Moreover, the durability of parchment made it a favoured support, especially in northern Europe, for highly finished independent drawings such as portraits, miniatures, botanical illustrations and official documents.

PAPER is a substance made in the form of thin sheets or leaves from rags, straw, hemp, wood, bamboo, mulberry bark or other vegetable fibres. According to tradition, it was invented in China in AD 105. East Asian or 'Oriental' papers may be distinguished from Western examples by their smooth but porous surface texture as well as their translucency and sheen. Through commerce and conquest, paper and papermaking gradually moved westward from Asia through the Islamic world; by the 12th and 13th centuries paper was being manufactured in Spain and Italy. Papermaking in Europe from 1300 to 1800 was

a highly skilled and regulated craft, producing a pure, permanent and durable surface, which was resistant to internal deterioration. At the beginning of the 19th century the discovery that wood products could be used for making paper and that paper itself could be formed in continuous lengths changed papermaking from a skilled handicraft into a modern industry. From the end of the 20th century the computer monitor began to replace paper as the most common support for drawing.

2. MEDIA AND TOOLS. The interplay between supports and media presents the artist with an almost infinite variety of creative possibilities. Identifying media and interpreting their sequence of application is not an exact science, but cataloguers of drawings generally list media and techniques according to their order of application, from the initial line or stroke to the finishing touches or highlights and heightening accents. The subject is generally divided into two categories: either by fine or broad strokes or by dry or wet application. Fine strokes characterize metalpoint and pen and ink, while broad strokes are typical of chalk, pastel, crayon (conté, greasy or coloured), charcoal and graphite; dry media include chalks, pastels, charcoal, crayon and graphite, while wet media include inks, washes, watercolour, gouache and tempera. Almost all the basic drawing media and tools were in use by the first half of the 16th century, their application having been thoroughly investigated by many 15th-century artists, including Hieronymus Bosch (c. 1450–1516), Martin Schongauer (c. 1435/50–91), the Housebook Master ($fl c$. 1470–1500), Jean Fouquet (c. 1425–c. 1478), Pisanello (c. 1395–c. 1455), Domenico Ghirlandaio (1448/9–94) and Leonardo da Vinci. Later, technical innovation was related to the realization of new expressive effects by combining media, highly personal experimentation (evident, for example, in the work of Giovanni Benedetto Castiglione (1609–64)) or finding new applications of seemingly outmoded techniques (e.g. the 19th-century revival of metalpoint, watercolour and pastel). In the 20th century traditional definitions of drawing have been challenged as much by the choice of ephemeral materials (e.g. the use of river mud by Richard Long (b 1945)) as by the techniques with which they are applied.

(i) Ink and wash. The most common colouring agent is INK, which is available in a wide range of colours and can be applied with either a pen or brush. India or Chinese ink is produced from lampblack, an oily carbon substance, mixed with gum arabic hardened by baking. Its deep black colour resists fading but reacts to moisture; diluted with water, it becomes grey WASH. 'Iron-gall' ink, which was cheap and easy to produce, was traditionally the principal writing and drawing medium. Made from gall-nuts and iron rust, filings or salts mixed with gum arabic, it initially flows violet–black in colour but fades with age to tones of brown and yellow. Sometimes mixed with vitriol, iron-gall ink is highly acidic; it corrodes and eats

holes through paper fibres (*see* INK). Bistre is a light, transparent brown pigment extracted from wood soot, preferably beechwood; sepia is a deep brown ink obtained from the secretions of the cuttlefish.

The PEN, commonly used since antiquity for writing, has also been the most important and popular instrument for drawing. Quill pens, cut from the flesh end of the wing feathers of birds or fowl, pared and slit to a blunt, medium or fine point, were a versatile instrument yielding effortlessly to the personal pressure, touch and calligraphic style of draughtsmen. More fragile and less flexible than the quill, the reed pen is cut from the stems of bamboo-like grasses and is used for short strokes, producing broad, uniform, angular effects. When employed by such masters as Rembrandt and Vincent van Gogh (1853–90), the superiority of the reed pen for hatching and emphatic, expressive linework is self-evident. Metal pens, which were first produced in the 19th century, are mass-produced in many shapes and sizes; the hard, crisp, regular strokes of their steel points may be seen in the pen drawings of such artists as Picasso and Henry Moore (1898–1986). The BRUSH, although generally used for the broad application of wash or watercolour, is also used to render fine, supple lines, evident, for example, in the many studies (Berlin, Kupferstichkabinett; Vienna, Graphische Sammlung Albertina) by Albrecht Dürer (1471–1528) for the Heller Altarpiece (1508; ex-Residenz Munich, destr. 1729). Made from animal hairs or bristles, the most sought-after brushes were composed of badger, squirrel or sable hair.

(ii) Friable sticks. Of the dry media, CHARCOAL, a carbon residue obtained by charring sticks of wood, preferably willow, in a fire, is probably the oldest drawing medium. Friable, easily rubbed and of moderate intensity, once applied it must be sprayed with a FIXATIVE. Because it is easily erased, charcoal was recommended for preliminary sketches such as underdrawings and cartoons for frescoes. The Venetians, notably Jacopo Tintoretto (1519–94) and Jacopo Bassano (c. 1510–92), produced velvety effects with charcoal by dipping the sticks in linseed oil, which also served as a permanent fixative. This technique was later adopted by other artists, such as the 17th-century Dutch Italianate Nicolaes Berchem (1620–83).

CHALK is available in both natural and synthetic form. In its natural state it is simply one of several minerals cut into sticks: calcite or calcium carbonate (white), carbon (black) or haematite (red). Black or 'Italian' chalk is a compact, clayey schist traditionally from Piedmont; it varies in tone from black to grey, Red chalk, sometimes called *sanguine* (from Lat. *sanguis, sanguinis*: 'blood'), is iron oxide mixed with clay. It displays great warmth and chromatic strength but has a limited value range: it varies widely from an orange–red and brown–red to a deep purplish–red colour. Although indelible, it responds to rubbing with the finger or a stump (a coil of leather or paper ending in a point, used for blending chalk lines into

an area of tone; *see* STUMPING). In the form of calcite or steatite (tailor's chalk), natural white chalks have been used for heightening and highlights. For evoking the natural range of flesh tints the combination of red, black and white chalk, a three-colour technique known as *aux trois crayons*, was greatly favoured by Rubens, Antoine Watteau (1684–1721) and Paul-César Helleu (1859–1927).

PASTEL is a coloured chalk fabricated from powdered, dry, natural pigments mixed with chalk and a binder, such as gum tragacanth, and pressed into a stick. Mixing powdered pigments together extends the range of available hues and tones. With each stroke, friction causes the pigment to powder and rub off as the rough texture of the paper holds the colour. Rosalba Carriera (1675–1757), Maurice-Quentin de La Tour (1704–88) and Jean-Etienne Liotard (1702–89) made pastel portraits highly fashionable in the 18th century, but Edgar Degas (1834–1917; see PASTEL, colour pl. IX, fig. 2) and the Impressionists extended the expressive range of the medium to include all the genres traditionally associated with painting.

(iii) Metalpoint. A STYLUS with a point of metal (gold, silver, lead or copper) used in combination with a toned or coloured ground is one of the oldest recorded techniques; it was used by the Romans on writing tablets and by medieval scribes to lay in their lines. An inelastic medium, METALPOINT produces a delicate, even, permanent stroke, which is nevertheless responsive to disciplined individual handling. Only leadpoint (graphite) yields a visible mark on unprepared paper; metalpoint strokes oxidize to a grey–brown colour. The necessary surface preparation, applied with a brush in layers and then burnished after drying, consists of whiting or gypsum, powdered bone, pigment and size. Coloured grounds in shades of pink, mauve, ochre, green and blue were popular in Italy; the tonal range of metalpoint was further expanded by the addition of white heightening with a brush, as in the cursive silverpoint sketches of Filippino Lippi (*c.* 1457–1504) and Raphael (1483–1520). Recommended by Leonardo for open-air sketching in pocketbooks, metalpoint was the first easily portable medium and the predecessor of the pencil. It flourished in Italy, Germany and the Netherlands in the 15th century for figure, portrait and animal studies but fell into disuse after *c.* 1525, when broader and more forceful effects were sought. By the 17th century metalpoint was, with few exceptions, used only for small-scale portrait drawings, of which one of the most touching is Rembrandt's inscribed portrait of his young wife, *Saskia van Uylenburgh* (1633; Berlin, Kupferstichkabinett).

(iv) Graphite and pencil. GRAPHITE, which was first quarried in Cumberland, England, in 1560, is a crystalline form of carbon that produces a hard, thin and supple grey line. From its metallic lustre and colour, it can be distinguished from the darker, duller finish of black chalk. It was popular in the 17th and 18th

centuries for small-scale portrait drawings on parchment. Watteau used it in combination with red chalk for softer, more tonal effects. When the Napoleonic Wars led to a restricted supply of English graphite in France during the 1790s, a French chemist, Nicolas-Jacques Conté (1755–1805), formulated a mixture of refined graphite and clay to serve as a substitute (*see* CRAYON); from this developed the modern wood-encased 'lead' PENCIL. The pencil drawings of Jean-Auguste-Dominique Ingres (1780–1867) suggest the purity of line that made pencil the favourite instrument of such draughtsmen as Edward Burne-Jones (1833–98), Degas, Adolph Menzel (1815–1905), Gustav Klimt (1862–1918) and Picasso.

(v) Pigments. WATERCOLOUR, a mixture of coloured pigments and a clear binder (gum arabic) soluble in water, produces a transparent colour layer that becomes completely integrated with the paper support (or the parchment support in the cases of botanical and scientific illuminations). GOUACHE, or bodycolour, is an opaque pigment produced by the addition of white lead and size to watercolour; when it fully coats the surface it resembles painting. Often these media were applied together: Dürer's series of panoramic alpine landscapes (1494–5; e.g. Berlin, Kupferstichkabinett; Bremen, Kunsthalle; Oxford, Ashmolean Museum; Paris, Musée du Louvre) displays the luminous qualities of watercolour alternating with the depth of colour and solidity of gouache, an effect that may also be seen in a more intimate vein in the elegant compositions depicting French gardens by Louis-Gabriel Moreau (1740–1805). The 18th-century revival of watercolour in England, evoking the sketches of the English countryside by Anthony van Dyck (1599–1641), was again inspired by the desire to record landscape observed directly from nature, culminating in the work of John Constable (1776–1837), Richard Parkes Bonington (1802–28) and J. M. W. Turner (1775–1851), who influenced the French Romantics, such as Eugène Delacroix (1798–1863), the Impressionists and Paul Cézanne (1839–1906).

3. TECHNIQUES AND PROCESSES. The draughtsman may employ any one or a combination of four categories of techniques, usually in the following order: preparatory, creative, corrective and transfer to another support.

(i) Preparatory. The preliminary steps of readying media and preparing the support to receive its application by the master were usually undertaken by workshop assistants as part of their training. Numerous manuals relate how to grind or select colours, make charcoal, choose inks, cut quills and buy paper. Such treatises outline how to apply, colour and burnish a ground and how to give a paper a 'tooth' to accept pastel. The durability and lasting beauty of a drawing depend on the purity of materials and the practitioner's understanding of the rules of the craft.

(ii) Creative. The creative stage of drawing refers to its execution. A mark or line used to convey an artistic effect on a blank surface constitutes the basic element of drawing, but form may also be conceptualized in relation to light and shade as well as lines and planes. While a pen drawing by Henri Matisse (1869–1954) or Paul Klee (1879–1940) exemplifies the purely linear approach, a conté crayon study on textured paper by Georges Seurat (1859–91) illustrates the search for pure tone. Through inflected lines or contours, the draughtsman suggests and circumscribes form. To model forms and evoke a sense of space or atmosphere, the artist employs additional techniques. 'Hatching' refers to shading by setting down parallel straight or curved lines at various intervals; 'crosshatching' refers to shading with sets of lines in two or more directions. 'Graining' describes the process of turning from the point to the side of the stick of chalk, crayon, pastel or pencil to create a series of broad, parallel strokes. Gradations of tone achieved by rubbing chalk, charcoal or pastel with the finger, brush or stump is called 'stumping'. To emphasize the play of light, the artist applies accents or highlights, often referred to as 'white heightening'. In chiaroscuro drawings a toned or coloured surface preparation serves as the 'middleground' for the application of highlights and shading.

(iii) Corrective. In terms of the corrective process, on working drawings intended to be seen only by other members of the workshop scant effort was wasted on masking changes, making it relatively easy to identify pentiments (*see* PENTIMENT). Breadcrumbs or feathers were traditionally employed to rub out errors in broad media; for fine media a coat of opaque pigment was used for covering the rejected passage before redrawing the motif. Sometimes a 'silhouette' or redrawn paper patch was used, trimmed to cover exactly the area to be corrected. Sometimes a work was retouched, involving the superimposition of the work of one master on top of another. A discrepancy in technique and style between the original design and the graphic additions is often an indication of retouching, as in Rembrandt's corrections over the compositional exercises of his pupils or in Rubens's enthusiastic revisions with the brush on drawings in his collection.

(iv) Transfer. The transfer, reduction or enlargement of the approved preliminary design to the designated surface for the finished work was a central element of workshop routine. Traditional techniques included placing the drawing over a blank surface or sheet of paper, rubbing the *verso* with chalk and incising the contours with a stylus, but it could also be done 'blind'; applying a sheet of tracing paper and copying the outlines by tracing; and pricking the contours of the design, especially a full-sized CARTOON, with a needle and pouncing coloured dust or charcoal through the holes on to a new support. Changing the scale of an image without changing the proportions could be achieved using grid lines, usually at right angles, ruled on to a drawing, a process known as squaring. An exact but reversed duplicate of an original drawing, called a counterproof, offset or squeeze, is made by placing a thin sheet of moistened paper on top of a drawing and running both sheets through a press. For procedures involving image reversal, such as printmaking or tapestry-weaving, counterproofs allow the designer to see the composition in the same direction as the craftsman assigned to reproduce it.

J. Meder: *Die Handzeichnung* (Vienna, 1919); Eng. trans. by W. Ames and rev. as *The Mastery of Drawing*, 2 vols (New York, 1978)

C. A. Mitchell: *Inks: Their Composition and Manufacture* (London, 1937)

C. de Tolnay: *History and Technique of Old Master Drawings: A Handbook* (1943)

J. Watrous: *The Craft of Old-Master Drawing* (Madison, 1957/R 1975)

R. W. Scheller: *A Survey of Medieval Modelbooks* (Haarlem, 1963)

D. M. Mendelowitz: *Drawing* (New York, 1967)

R. R. Johnson: *The Role of Parchment in Graeco-Roman Antiquity* (diss., microfilm, Ann Arbor, 1968)

R. D. Harley: *Artists' Pigments, 1600–1835* (London, 1970)

R. Reed: *Ancient Skins, Parchments and Leathers* (London and New York, 1972)

D. E. Greene: *Pastel* (New York and London, 1974)

N. Lewis: *Papyrus in Classical Antiquity* (Oxford, 1974)

P. Marzio: *The Art Crusade: An Analysis of American Drawing Manuals, 1820–1860*, Smithsonian Studies in History and Technology, xxxiv (Washington, DC, 1976)

Wash and Gouache: A Study of the Development of the Materials of Watercolors (exh. cat. by M. Cohn; Cambridge, MA, Fogg Art Museum, 1977)

E. Andrews: *A Manual for Drawing and Painting* (London, 1978)

B. Chaet: *An Artist's Notebook: Techniques and Materials* (New York, 1979)

P. Goldman: *Looking at Drawings: A Guide to Technical Terms* (London, 1979)

T. Jirat-Wasiutynski and V. Jirat-Wasiutynski: 'Uses of Charcoal in Drawings', *Arts Magazine*, lv/2 (1980), pp. 128–35

C. Ashwin: *Encyclopaedia of Drawing* (London, 1982)

M. Hambly: *Drawing Instruments: Their History, Purpose and Use for Architectural Drawings* (Cambridge, MA, 1982)

J. Bolton: *Method and Practice: Dutch and Flemish Drawing Books, 1600–1750* (Landau, 1985)

P. Bicknell: *Gilpin to Ruskin: Drawing Masters and their Manuals, 1800–1860* (London, 1987)

J. Krill: *English Artists' Paper: Renaissance to Regency* (London, 1987)

I. Simpson: *The Encyclopaedia of Drawing Techniques* (London, 1987)

J. Stephenson: *Graphic Design Materials and Equipment* (London, 1987)

M. Hambly: *Drawing Instruments, 1580–1980* (London, 1988)

Art and Computers: A National Exhibition (exh. cat., intro J. Lansdown; Middlesbrough, Cleveland Gallery, 1988)

Creative Copies: Interpretive Drawings from Michelangelo to Picasso (exh. cat. by E. Haverkamp-Begemann; New York, Drawing Center, 1988)

J. Martin: *The Encyclopedia of Coloured Pencil Techniques: A Unique A–Z Directory of Coloured Pencil Drawing Techniques with a Step-by-step Guide to their Use* (London, 1992)

K. A. Foster, ed.: *A Drawing Manual by Thomas Eakins* (Philadelphia, and New Haven, 2005)

IV. History.

1. Ancient. 2. Medieval. 3. Renaissance. 4. 17th century. 5. 18th century. 6. 19th century. 7. 20th century.

1. ANCIENT. From the animal imagery preserved on the walls of the prehistoric caves of Lascaux, France, and Altamira, Spain, to the linear geometric designs decorating archaic Greek vases and the etched figures ornamenting Etruscan bronze mirrors, drawing is one of the oldest surviving examples of material and artistic culture. From the earliest recorded history art was placed in the service of religion and ceremony. Even after nomadic life gave way to a settled and organized social existence, surviving artefacts demonstrate that beliefs about gods and the heavens, the natural world and the afterlife were most powerfully conveyed through drawn representations, for example in such ancient Egyptian papyri as the Books of the Dead, the surface decoration of ancient Greek vases (and ancient Roman pinakes—small pictures drawn or painted on marble, which were framed and hung on the wall—of which fine examples have been excavated from the ruins of villas at Herculaneum and Pompeii).

2. MEDIEVAL. Evidence of medieval drawing practices derives principally from manuscripts, particularly illuminated manuscripts (see MANUSCRIPT, §2), which were produced first in the scriptoria of major monastic centres, for example Reims, St Gall, Winchester, Canterbury and Regensburg, and later in workshops in the major urban centres, such as Paris and Bruges. The most lavishly illuminated religious and literary manuscripts were commissioned for the clergy, aristocracy or monarchy, but many practical or didactic treatises were also produced. These included diagrams, maps, architectural plans and scientific illustrations. In addition, studies of figures, motifs and narrative scenes were carefully copied into model books to be used by artists in new commissions.

With the early medieval change in text format from the continuous SCROLL to the paginated codex, or book, the scribe and illuminator were faced with new formal problems for the pictorial representation of text and image. In the codex marginal sketches occasionally enlivened the borders of single pages as comic or grotesque figurative imagery spilt beyond designated text columns and provided a genial commentary on the limits imposed by the codex format. The newly Christianized regions of northern Europe possessed indigenous artistic styles, for example the 'carpet' and animal interlace, the abstract motifs of which provided new sources of visual inspiration when combined with Christian or other texts. Among the most magnificent examples are the Lindisfarne Gospels (c. AD 698; London, British Library) and the Book of Kells (late 8th century; Dublin, University of Dublin, Trinity College). The celebrated Utrecht Psalter (9th century; Utrecht, Bibliotheek der Rijksuniversiteit) emulates the page layout and script of Late Antique codices. Echoing the illusionistic pictorial style derived from such 5th-century manuscripts as the Vatican Virgil (Rome, Vatican, Biblioteca Apostolica, MS. Lat. 3225), the sketchy, graphic outline idiom, with its insistent linear rhythms, is a touchstone of medieval religious fervour as well as draughtsmanship.

The notebooks of the 13th-century French architect Villard de Honnecourt (fl c. 1220–40) occupy a unique position within the medieval graphic tradition, combining an instructional manual with theoretical precepts. His schematic and uninflected method of constructing figures, animals and structures in outline from geometric shapes documents the medieval artist's functional but purely conceptual and unnaturalistic approach to drawing form. Executed in pen and ink over leadpoint or stylus, the collection of 33 parchment leaves (c. 1230–40; Paris, Bibliothèque Nationale, MS. Fr. 19093) is noteworthy for its wide-ranging categories of subject-matter and commentary. Some have dismissed Villard's collection of drawings as too discursive and fragmentary to have served as a practical pattern book for working craftsmen, but it remains the most explicit surviving document to detail the working procedures of the Gothic artist.

During the later Middle Ages pattern books were routinely employed by artists or craftsmen as practical aids to streamline workshop production and to transmit standardized formal and iconographic elements. Such compendia of miscellaneous drawings were composed of copies after other works of art, not studies from nature; the finest surviving example of the naturalistic type is that associated with the workshop of the Lombard illuminator Giovannino de Grassi (fl 1380s), whose designs consist not only of animals and birds (e.g. Bergamo, Biblioteca Civica A. Mai, MS. vii. 14, fol. 4v) but also a decorative 'human alphabet', executed in pen and ink, heightened with wash and watercolour. Cennino Cennini (c. 1370–c. 1440) recognized the central role drawing held in the training of the apprentice, whose artistic formation evolved from copying the master's own drawings and other models before progressing to working from nature or casts.

3. RENAISSANCE. In terms of drawing practice, one of the key signals of the transition from the height of the international phase of the Late Gothic period during the 14th century to the Early Renaissance was the transformation of the medieval model book or pattern book tradition into that of the modern sketchbook. The increase in the availability and reduction in cost of paper during the 15th century encouraged the trend towards active and incidental drawing. Painters were attracted by its ease of use, informality and the freedom to experiment that it allowed. Within 50 years the fixed imagery of the pattern book was replaced by instantaneous responses to natural phenomena, contemporary events or imaginary conceits captured on paper.

Breaking with the static formulae of the pattern book while retaining its format, the two celebrated bound albums of drawings by the Venetian artist Jacopo Bellini (c. 1400–71; Paris, Musée du Louvre; London, British Museum) are unique in the 15th century in size, shape and content. Handsome, oversize and intentionally sumptuous, the albums are characterized by an elegance of material (leadpoint on paper for the London volume, silverpoint or pen and ink on parchment for the Paris volume), handling and concept, prompting scholars to conclude that they must have been intentionally designed as precious and independent works of art, to be admired and treasured as symbols of the artist's originality and genius. They also illustrate several major artistic trends that developed during the early Renaissance, although in general the most lasting changes in drawing practices took place in Tuscany rather than in the Veneto. At this time drawing gained a new importance as the foundation for artistic theory, training and practice. The concept of an artist possessing a recognizable drawing style was in the process of emerging as a fundamental artistic issue. In addition, drawing became the means by which a new kind of pictorial realism could be achieved. Artists were able to plan and organize multifigure narrative compositions of unprecedented complexity on paper, which was portable, yet permanent, rather than on the wall or canvas.

Sketching and sketchbooks were expressive of the Renaissance outlook, being an individual rather than a shared or communal mode of graphic expression. The transition from pattern book to a modern sheet of studies is exemplified in the pen-and-ink *Studies of Hanging Corpses* (c. 1430s; London, British Museum) by Pisanello (c. 1395–c. 1455), obviously meticulously observed from a gallows and drawn on the same sheet as a bust of a boy and a woman in profile.

Drawings were instrumental in the effort to create new and original artistic forms within the context of the revival of theories and models based on Classical antiquity. Documenting and copying ancient architectural prototypes as in the Codex Escurialensis (compiled c. 1500 in the Ghirlandaio workshop; Madrid, El Escorial, Biblioteca del Monasterio de S Lorenzo, MS. Vit. 17), was one method of study, as was the drawing of human anatomy through dissection of cadavers and study of ancient statuary. The most famous 15th-century anatomical studies were those of Leonardo da Vinci (1452–1519; Windsor Castle, Berks, Royal Library), but the heroic nudes of Andrea Mantegna (1430/31–1506), Antonio Pollaiuolo (c. 1432–98) and Luca Signorelli (c. 1450–1523) were significant sources of influence for the depiction of the human figure in full motion and the display of physical exertion. Scientific research also culminated in the rediscovery of the principles of linear and aerial perspective, which enabled artists to render not only the play of light and shade on solid forms in space but also the optical effects of spatial recession within an ambient light and atmosphere.

By 1500 the type of personal, casual and exploratory drawing pioneered by Leonardo had been accepted as the first step in solving problems of artistic design: whether carried out in the exacting medium of silverpoint or the more fluid medium of pen and ink, or even chalk, ideal for those mysterious effects of shading and *sfumato* for which he remains so famous, Leonardo's drawings united conceptual power and often violent themes with unsurpassed delicacy of touch and precision of handling. Sometimes executed in small, prepared-paper pocketbooks (*taccuino de viaggi*), his anatomical, drapery and nature studies, as well as his 'brainstorming' figure studies depicting rapidly jotted alternative renderings of a single motif on one sheet, laid the groundwork for the development of a new creative procedure based on a system of drawing.

Virtually all the great painters of the Renaissance in Italy were also great draughtsmen. As the 16th century progressed, drawing was acknowledged in both theory and practice as the foundation of all the arts of design. Frequently, it is the apparently ephemeral drawings and the various preliminary studies for major commissions that have survived to document decayed or otherwise destroyed work in more monumental formats.

It was in the workshops of Raphael (1483–1520) and Michelangelo (1475–1564; see colour pl. III, fig. 3) in Rome during the second decade of the 16th century that the formal and technical experiments of the painters of the previous century came together to produce a rationalized procedure based on drawing, which encompassed the essential preparatory stages in the development and execution of monumental compositions, including frescoes, tapestries and paintings on canvas. Under Raphael's leadership and in his workshop these practices flourished. It was there, also, that the leading painters of the first generation of Mannerism, such as Giulio Romano (?1499–1546) and Perino del Vaga (1501–47), were trained, emerging to spread not only their elegant and expressive new style across Europe but also the distinctive, systematic approach to developing a composition by means of a progressive sequence of drawings (exploratory first-idea sketch; schematic composition drawing; study sheets of particular motifs, detail studies of single figures, drapery, heads and other individual compositional elements; finished composition drawing squared for transfer; cartoons; auxiliary cartoons for details; record drawing to be retained by the workshop). This procedure, which evolved gradually over several generations, enabled the master of such a large assemblage of talents to streamline the labour of completing numerous commissions on a scale scarcely undertaken before.

This example soon influenced artists in northern Europe, who returned home after visiting Italy imbued with a style and technique based on modern artistic ideals, including the cultural heritage of the Antique—the heroic and beautiful depiction of the human figure in motion and at rest and curiosity about the natural world. Albrecht Dürer (1471–1528)

was one of the first such artists to travel to Italy. His two visits to Venice, in 1494–5 and 1505–6, had a decisive impact on his style and technique as a draughtsman. His published treatises on perspective and human proportion and his adaptation of prepared blue-ground drawing supports, based on Venetian dyed blue paper, suggest the strong and lasting influence of his encounters.

Northern artists working in native styles also made major contributions to the development of drawing in the 15th and 16th centuries. An original and expressive approach to the depiction of landscape and portraiture, derived from the traditions of manuscript illumination, is exemplified by such masterpieces as the Limbourg brothers' Très Riches Heures (Chantilly, Musée Condé, MS. 65), with its detailed and descriptive sense of local colour in the representation of the activities associated with the months of the year, and the Turin–Milan Hours (c. 1416; Paris, Bibliothèque Nationale, MS. nouv. acq. lat. 3093; Paris, Musée du Louvre, R.F. 2022–5; Turin, Museo Civico d'Arte Antica, MS. 47; section in Turin, Biblioteca Nazionale Universitaria, MS. K. IV.29, destr. 1904), formerly attributed to Jan van Eyck (c. 1395–1441), in which a unified depiction of the land and light endows the images with unprecedented naturalism. A more romantic attitude towards nature is evident in the landscapes of Wolfgang Huber (c. 1485–1553) and Albrecht Altdorfer (c. 1480–1538). Incisive character studies were produced by Jean Fouquet (c. 1425–c. 1478), Dürer, Lucas van Leyden (c. 1494–1533), Gerard David (c. 1460–1523) and especially Hans Holbein the younger (1497/8–1543). The attention and care lavished on the particularities of human appearance and costume reveal the intensity of the artist's desire to capture and record the unique features of each sitter. Generally bust-length and in full or three-quarter face, portraits were often heightened with coloured chalks to give a more naturalistic range of flesh tints.

In the second half of the 16th century there were few formal or technical breakthroughs in drawing, with the exception of the graphic work of the Umbrian painter Federico Barocci (c. 1535–1612), who succeeded in uniting colorito and disegno. Using pastel and oil paint to heighten the naturalism of his head and figure studies, his sketches turned away from the complexity and stylish artifice of Mannerism and pointed instead to the formal innovations that defined the Baroque.

4. 17TH CENTURY. The triumphant spirit of the Counter-Reformation contributed to the sense of energy, power and emotion so characteristic of the Baroque, the dominant style of the 17th century, at least in southern Europe. It would be difficult to pinpoint external religious and political events that served to modify drawing styles and practices during this period, in contrast with painting, sculpture and architecture, for which the patronage, iconography and decoration were strongly influenced by religious edicts and dynastic changes. Nevertheless, social and economic developments did contribute to trends in drawing, especially after the mid-century, when artists began to gain artistic independence, new social stature and privileges once they became associated with new, royally chartered academies.

For the first time genre and landscape gained prominence as legitimate independent artistic subjects: domestic scenes, industry, trades, commerce and pastimes were regularly depicted, as were landscapes, whether idealized and classicizing or topographically accurate. In addition, artists were inspired to treat the transient phenomena of the natural world as their subject, even if the work were still couched in allegorical terms: the times of day, the seasons and the elements. In drawings, this feeling for nature was rendered in sketches sur le motif; these studies were later worked up into compositions in the studio. Rather than serving as subsidiary or preparatory studies, genre and landscape drawings were often conceived and executed—particularly in the northern Netherlands—as independent works of art that could be sold. Typical of this sort of decoration were the watercolours by Hendrick Avercamp (1585–1634) depicting skaters enjoying the ice on frozen rivers, scenes of tavern life by Adriaen van Ostade (1610–85) and Cornelis Dusart (1660–1704) or chalk drawings of the Dutch countryside by Pieter Molyn (1595–1661). Other lasting contributions to drawing practices were also made in the northern Netherlands, such as 'naer het leven' (Dut.: 'from life') figure studies and especially scientific illustration.

The greatest contributions to the graphic arts in the northern Netherlands in the 17th century, however, were made by a single artist: Rembrandt van Rijn (1606–69). He not only recognized the unexplored possibilities within familiar techniques and media, but he also left an enormous drawn oeuvre—a poignant, sometimes humorous, yet unsparing personal artistic diary carried out with an often stunning economy of means. His most original contribution to the functional history of drawings derived from the routine production of practice drawings by his workshop. Rembrandt would assign a subject, usually a life study or a biblical scene, which both he and his pupils would depict, not as the basis for a painted composition or a print, nor as a work to be sold, but as an exercise in composition, interpretation and technique. Vast numbers of Rembrandt school drawings of this type survive; they continue to vex connoisseurs and defy consensus with respect to their attribution.

Robust, economical and direct are terms that apply not only to Rembrandt's draughtsmanship but also to the approach to drawing practised by Ludovico (1555–1619), Agostino (1557–1602) and Annibale (1560–1609) Carracci, founders of a teaching academy in Bologna. In Italy the return to study from life, to a realistic attitude to the figure coupled with a renewed appreciation of the classical values of the High Renaissance, pointed the way towards stylistic renewal. Annibale's decorations of the Gallery of the Palazzo Farnese in Rome (completed in 1599) gave

monumental form to the subsequent Baroque heroic figural ideal. Many figure studies attest to the careful preparation these frescoes entailed, but, as a draughtsman, his most lasting influence stems from his treatment of landscape, genre and caricature. His linear pen-and-ink landscape drawings, which combined 16th-century Venetian conventions and classicizing motifs, served as a point of reference for refinements engineered by his pupil Domenichino (1581–1641) and, later, by Guercino (1591–1666; see fig.) and, more conventionally, Giovanni Francesco Grimaldi (1606–80). Nicolas Poussin (1594–1665) and Claude Lorrain (?1604/5–82) were imbued with the same spiritual allegiance to the Antique, but in their drawings it was expressed more pictorially with a richer technique in which the penwork was either mixed with additional media or even replaced by wash.

The simplicity of their pure wash landscapes depicting the Roman campagna display an almost oriental sensibility.

Venetian-inspired pastoral landscapes with travellers, shepherds and flocks of animals displayed a Romantic attitude (which was to find great resonance in the 18th century). In the work of the technically innovative Giovanni Benedetto Castiglione (1609–64; the inventor of the monotype), dilute colour pigments were bound in oil to resemble coloured washes. His drawings occupied a place at the intersection of the arts of painting, drawing and printmaking.

Caricature drawings, which first appeared in Italy in the 17th century in the studio of the Carracci, had two sources of inspiration: Leonardo, who was the first in Italy to experiment with the manipulation of physical deformity and distortion for artistic

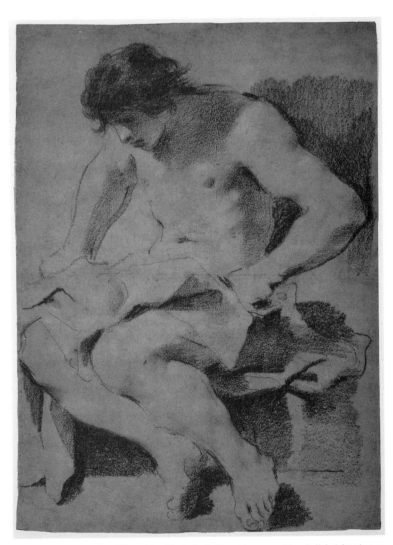

Guercino: *Study of a Seated Young Man,* black chalk dipped in gum, white chalk heightening on grey-brown paper, 522×427 mm, *c.* 1619 (Los Angeles, CA, J. Paul Getty Museum); photo credit: The J. Paul Getty Museum

effect, and the fantastic creatures devised by Hieronymus Bosch (c. 1450–1516), Pieter Bruegel the elder (c. 1525/30–69), and Jacques de Gheyn II (1565–1629), which reflected an enduring north European tradition of symbolic associations within a social and narrative context. As an art form, caricature found its most persuasive artistic expression in drawings and prints as a blend of genre, portraits and allegory. Combining humour and distortion, it began as an extension of the realistic portrayals of anonymous types drawn from common life combined with the comic, recognizable but unofficial pen portraits of specific and often celebrated individuals. The existence of many of these fluent, witty pen sketches by Gianlorenzo Bernini (1598–1680), Guercino, Pier Francesco Mola (1612–66) and Pietro Testa (1612–50) affirm the popularity of caricature in 17th-century Rome.

The establishment of the Académie Royale de Peinture et de Sculpture in Paris in 1648 must be regarded as the most significant French contribution to the development of drawings in the 17th century, because of its effect on codifying drawing categories and artistic procedures. The Académie's central influence in terms of the history of drawings derived from its teaching programme based around the life-drawing class. (From this institution and from its product, drawings of male nudes studied from life, the term 'academy' came to refer to all drawings of nudes.) Among the greatest French draughtsmen were Poussin and Claude, although they spent almost their entire careers in Italy. Poussin's intellectual rigour and allegiance to the Antique was countered by Claude's more romantic and pictorial sensibility. Claude placed an unprecedented value on his drawings, especially as a documentary record to authenticate his paintings. His *Liber veritatis* (London, British Museum) is a lifelong record not only of his major compositions but also of his own graphic development.

5. 18TH CENTURY. By 1700 the locus of artistic, technical and thematic innovation in the graphic arts had shifted away from Rome, Antwerp and Amsterdam to Venice, Paris and London. Political developments in France and England as well as social and economic trends helped to shape the culture of the Enlightenment, a period in which the intellectual and philosophical foundations of the modern age were largely established. During this period, generations of English gentlemen travelled to the Continent on the Grand Tour to find inspiration for the design of their country seats, to collect antiquities and to commission decorations for their estates. They also demonstrated their cultivation by forming collections of drawings. In France, patronage shifted from the Crown and court at Versailles to wealthy financiers in Paris, which became the new artistic capital of Europe. The refinement of this worldly lifestyle was chronicled in drawings, which were often arranged as part of the décor of small rooms or *cabinets*. In addition, contemporary drawings, especially designs for book illustrations, vignettes and frontispieces, popularized Parisian life and manners throughout Europe.

Among the most significant developments during the 18th century was the appreciation of drawings as an independent form of artistic expression, regardless of their original purpose. As a consequence of an increase in their popularity and value as collectibles, and the growth of public art exhibitions and auctions, drawings began to be executed as autonomous works and transformed into objects to be framed and displayed rather than to be stored and consulted on an occasional basis. As the price of original drawings increased, so did the need to supply inexpensive yet high quality substitutes: inventions in reproductive printmaking made it possible to imitate all kinds of drawing media, including pastel, chalk, wash and watercolour.

Eclipsed by Rome since the end of the 16th century, Venetian artists once again came to the forefront in the 18th century: from Giovanni Antonio Pellegrini (1675–1741), Sebastiano (1659–1734) and Marco Ricci (1676–1730), Giovanni Battista Piazzetta (1682–1754) and Canaletto (1697–1768) to Giambattista (1696–1770) and Giandomenico (1727–1804) Tiepolo, Giovanni Antonio (1699–1760) and Francesco (1712–93) Guardi to the architect and graphic artist, Giovanni Battista Piranesi (1720–78), an optical and atmospheric approach to form conveyed through pen and vaporous wash on brilliant white paper served as the dominant Venetian stylistic mode throughout much of the century. The Venetians also developed new types of drawings, such as the capriccio, a type of landscape in which identifiable monuments and sites have been imaginatively rearranged according to the artist's fancy. In the hands of such view painters as Giovanni Paolo Panini (1691–1765) or, later, Hubert Robert (1733–1808), the poetic and atmospheric qualities so evident in the capriccios of the Venetians were replaced by a more anecdotal approach, blending architectural precision with human activities. Another drawing type to flourish in Venice in the 18th century was the *scherzi di fantasia*, inventive compositions in which the artist explored the sources of his own private dreams and demons in mysterious, personal fantasies. Also utilized as pretexts for invention and composition were traditional themes, for example the life and death of Punchinello, the Everyman drawn from the improvisational theatrical tradition of the *commedia dell'arte*, which was chronicled in Giandomenico Tiepolo's celebrated cycle of over a hundred drawings, ironically entitled *Divertimento per li regazzi*. The Tiepolos' imagery did indeed border occasionally on the macabre. In fact, an undercurrent of disquiet flowed throughout the century and gained strength, with a sense of the bizarre in works by Henry Fuseli (1741–1825) and the menacing visions of Francisco de Goya (1746–1828), which sought to define the fearful realm beyond reason. Goya's nightmarish wash drawings illustrate a world in which witchcraft flourished and where the forces of darkness have overtaken the spirit and have extinguished the light of reason.

At the other end of the spectrum is the pastel portrait, which although usually associated with 18th-century France (*see* PASTEL, §2), was actually introduced there by the Venetian artist Rosalba Carriera (1676–1757), who visited Paris in 1718. Her light palette and impressionistic touch were highly regarded and inspired French artists to emulate her technique and French patrons to appreciate the freshness and delicacy of this new art form. The pastels of Maurice-Quentin de La Tour (1704–88) and Jean-Baptiste Perronneau (1715–83) are haunting reminders of an age that wished to be remembered as carefree; in fact, pastel portraiture has become synonymous with the 18th century.

As practised during the 17th century, caricature was based on the humorous depiction of individual likeness, but it developed in the 18th century from the description of likeness to that of manners and situation. Moreover, it was carried out not as a pastime but as a professional activity. As society itself became increasingly complex and fluid, social commentary and political satire in the graphic arts developed as one aspect of the Enlightenment attitude. The questioning of values and standards, so central to the enterprise of the Enlightenment, assumed visual form through drawings and prints intended to be interpreted as social commentary and political satire. The humorous renditions of local dignitaries and the touring English *milordi by* Pier Leone Ghezzi (1674–1755), as well as the work of William Hogarth (1697–1764) and Thomas Rowlandson (1756/7–1827), suggest that the English, as subjects and authors, possessed a special genius for this form of social critique. At the end of the century, it gained a political dimension after the outbreak of the French Revolution and the Napoleonic Wars with the invention of modern political propaganda and cartoons directed towards a mass audience.

The impulse to record motifs and compositions for future reference, in the style of model book pages, is seen at its most eloquent in the 18th century in the works and working method of Antoine Watteau (1684–1721). Abandoning academic practices, which required the working-out of each new composition through a series of sketches and studies of individual figures, he instead favoured the earlier pattern book tradition, whereby he composed new paintings by consulting his sketchbooks for appropriate figures, a practice that attracted criticism from his biographers. Nevertheless, in Watteau's drawings many diverse stylistic and technical traditions were exquisitely united, from the legacy of Venetian 16th-century landscape to the use of *trois crayons* to give warmth to flesh tones. His *mise-en-page*, with clusters of figures and heads viewed from different angles depicted on the same sheet of studies, exerted lasting influence throughout the 18th century and into the 19th.

6. 19TH CENTURY. Late 18th-century and early 19th-century drawing is characterized by a renewed emphasis on line, from the pure outline drawings of the Neo-classical artist John Flaxman (1755–1826) to those of the Art Nouveau illustrator Aubrey Beardsley (1872–98), a reductive linear style that extended beyond England as a result of commercial printmaking and illustration. The uninflected contours and economical graphic language of Neo-classical drawing represented a belief in the perfectibility of form through adherence to both academic and antique precepts. In Beardsley's case, the serpentine line conveys a *fin-de-siècle* unease, even menace, and serves as a carrier of emotion and symbolism.

Technological advances had a significant impact on the graphic arts: for example, the invention of synthetic graphite (first produced in France during the Napoleonic Wars), combined with the industrial production of machine-woven paper (later manufactured from wood pulp instead of rags), made it possible for such artists as Jean-Auguste-Dominique Ingres (1780–1867) to achieve the nuanced effects created by a fine, hard pencil line on a polished, smooth drawing surface. Printing processes, such as lithography and industrial wood-engraving, stimulated the growth of popular illustration. Most significantly, however, the invention of photography irrevocably severed the direct and heretofore necessary association between drawing and representation. Photography forced artists to search for new reasons to draw, new artistic graphic forms and new expressive meanings.

In the early 19th century artists from the German-speaking lands attained prominence as graphic innovators for the first time since the early Renaissance. Evoking a style and technique reminiscent of Italian quattrocento drawings, the Nazarenes, a group of artists banded together in a form of monastic brotherhood centred in Rome, strove for a simplicity in art and human values, which they believed was missing from contemporary life. North of the Alps, landscape, evocative of the awesome drama and power of nature, was a favourite theme of the German Romantics, such as Caspar David Friedrich (1774–1840). Among the leading 19th-century German draughtsmen was Adolph Menzel (1815–1905), whose corpus of drawings, in size and quality, is on a par with that of Edgar Degas, although his range was more restricted.

The English school also attained unprecedented prominence in the graphic arts during the 19th century. During the first half of the century English artists turned both to landscape and watercolour with a degree of originality and application that set an example for artists in the rest of Europe as well as in the USA, which was beginning to develop its own artistic vision and traditions. Although American artists, beginning with John Singleton Copley (1738–1815) and Benjamin West (1738–1820), continued to travel to Europe to perfect their training, a native idiom, best expressed in the work of Winslow Homer (1836–1910), was also born. Other American artists, including John Singer Sargent (1856–1925) and James McNeill Whistler (1834–1903), resided and worked abroad, although they are also representative

of 19th-century American art, in particular the desire to measure up to European artistic standards in form and technique.

For their attempt to observe, study and record ephemeral atmospheric effects, both Constable and Turner represent a point of intersection between science and art that is reminiscent of the drawings not only of Leonardo but also of Claude, whose work was a great source of inspiration to the English school. The drawings of J. M. W. Turner (1775–1851), John Ruskin (1819–1900) and John Constable (1776–1837), among others, especially the watercolours, express a pictorial vision in which atmosphere is bathed in tone and colour. The Pre-Raphaelites, in contrast, retreated from the actuality of both the natural and manmade world and espoused idealized beliefs about the artistic and social values of the early Renaissance, which they conveyed through a delicacy of line and a poetic dreaminess of interpretation.

During the first half of the 19th century French art was again divided by the perennial argument about colour versus line, the latter exemplified by the drawings of Ingres and Eugène Delacroix (1798–1863). Ingres's pencil united the sensuous rhythm and feeling of a poet united with the precision and detachment of a scientist of human nature. Delacroix's watercolours of tiger hunts, *odalisques* and Arab horsemen ushered in a new chapter in Europe's romance with exoticism and the Orient. The *odalisques* and female nudes by Ingres attain a degree of formal artifice and stylized elegance unmatched since the appearance of the court style of the school of Fontainebleau. In his portrait drawings an era and a way of life are reflected: sitters are silhouetted against a pure white background, thus heightening the graphic abstraction. Indeed, exploiting the *mise en page* as an element of formal harmony was another feature of Ingres's artistry.

Later in the 19th century, also in France, Edgar Degas (1834–1917), along with Paul Cézanne (1839–1906), might almost be said to have invented the modern drawing. In his scenes from contemporary life, especially the ballet, the theatre and the racetrack, Degas's restless curiosity was expressed through continuous experimentation, as in his work in monotype, pastel and mixed media. A classicist by temperament and training, he rejected academic formulae or definitions of beauty and absorbed new influences, such as Japanese prints and the invention of photography. Impressionist drawings broke with previous traditions partly in their reduced emphasis on line in favour of a more pictorial, tonal and atmospheric approach to drawing. Focused on finding new ways to represent the effects of light, the Impressionists' efforts reflected scientific experiments in optics and new developments in colour theory, as well as the influence of photography, with its dissolved outlines. Pastel and watercolour were their favoured media, exemplified above all by the work of Auguste Renoir (1841–1919). Cézanne, whose pioneering work influenced the Cubist and Fauve experiments during the first decade of the

20th century, discovered that light could be employed to create space and volume as well as atmosphere. Judiciously placed strokes of chalk and touches of watercolour were intended to be constructive as the artist evoked the illusion of solid form with the sparest of means.

7. 20TH CENTURY. The protagonists in the history of drawing in the 20th century are Pablo Picasso (1881–1973) and Henri Matisse (1869–1954), whose creativity had a major influence on artistic life throughout the century. Their rejection of the status quo and continual redefinition of the terms of artistic engagement remain their most lasting legacy; each worked to find artistic renewal and entirely new forms of expression based on graphic means.

The invention of COLLAGE during the first decade of the century was the single most original feature associated with 20th-century drawing. With collage, followed by the application and redefinition of found objects, a process was initiated in which the boundaries between drawing and other art forms became increasingly blurred. Moreover, during the 20th century the broad and fine media by which drawings had traditionally been created, such as chalk, pen and wash, were supplemented or even replaced with new media (e.g. felt-tipped pens and wax crayons), new techniques and alternative supports.

In addition to changes in the craft of drawing, the function of drawing also underwent a transformation. While Cubist precepts continued to posit the value of representation and links with the observed world, other artistic trends favoured abstraction, non-representational imagery and, in the case of the Surrealists, automatic writing. During the post-war period this trend intensified, although with Abstract Expressionism and even Pop art some artists reverted to a more traditional view, in which drawings often served as preparatory studies and explorations of pictorial ideas on a reduced scale. It should also be noted, however, that as drawings became increasingly complex in their technique and larger in scale, the sense that they were entirely autonomous forms of artistic expression was enhanced. Also indicative of the lack of clarity differentiating art forms, drawing and writing became increasingly indistinguishable as forms of artistic expression, such as in the work of the conceptual artists Joseph Beuys (1921–86), Joseph Kosuth (*b* 1945) and Jenny Holzer (*b* 1950). This convergence is most compellingly demonstrated in the work of graffiti artists, such as Keith Haring (1958–90).

General

L. Fagan: *Handbook to the Department of Prints and Drawings in the British Museum, with Introduction and Notices of Various Schools: Italian, German, Dutch and Flemish, Spanish, French and English* (London, 1876)

Old Master Drawings (1926–40)

H. Leporini: *Die Künstlerzeichnung: Ein Handbuch für Liebhaber und Sammler* (Berlin, 1928)

A. E. Popham: *A Handbook to the Drawings and Water-colours in*

the Department of Prints and Drawings, British Museum (London, 1939)

H. Tietze: *European Master Drawings in the United States* (New York, 1947/R 1973)

Drawings by Old Masters (exh. cat., London, Royal Academy of Arts, 1953)

P. J. Sachs: *Modern Prints and Drawings: A Guide to a Better Understanding of Modern Draughtsmanship* (New York, 1954)

L. Grassi: *Storia del disegno: Svolgimento del pensiero critico e un catalogo* (Rome, 1957)

J. Rosenberg: *Great Draughtsmen from Pisanello to Picasso* (Cambridge, MA, 1959)

I. Moskowitz, ed.: *Great Drawings of All Time*, 4 vols (New York, 1962)

Master Drawings (1963–)

H. Hutter: *Drawing: History and Technique* (London, 1966)

M. Evans: *Medieval Drawings* (London, 1969)

P. Rawson: *Drawing* (London, 1969)

W. Vitzthum, ed.: *Disegni dei maestri*, 16 vols (Milan, 1970–71)

C. O. Baer: *Landscape Drawings* (New York, 1973)

Old Master Drawings from American Collections (exh. cat. by E. Feinblatt; Los Angeles, CA, County Museum of Art, 1976)

G. Monnier and B. Rose: *Drawing* (New York and Geneva, 1979)

Drawing (1979–)

W. Strauss and T. Felker, eds: *Drawings Defined* (London, 1987) [paper presented to the Ian Woodner Master Drawings Symposium at Cambridge, MA, Fogg]

Le Paysage en Europe du XVIe au XVIIIe siècle (exh. cat., Paris, Musée du Louvre, 1990)

G. C. Sciolla, ed.: *Drawing*, 3 vols (Milan, 1991–3)

D. Dethloff, ed.: *Drawing: Masters and Methods, Raphael to Redon* (London, 1992) [pap. presented to the Ian Woodner Master Drawings Symposium at London, Royal Academy of Arts]

R. W. Scheller: Exemplum: *Model-book Drawings and the Practice of Artistic Transmission in the Middle Ages (ca. 900–ca. 1470)* (Amsterdam, 1995)

M. Vasselin: *Vivre des arts du dessin: France, XVIe–XVIIIe siècle* (Aix-en Provence, 2007)

V. Conservation. The purpose of drawings conservation is both to preserve and restore chemical, physical and visual integrity by removing or correcting those conditions that have contributed to the deterioration or disfigurement of the object. Deterioration of drawings may be attributed to the inherent components of the paper (e.g. high lignin content in wood-pulp paper); residues from the manufacturing process (e.g. iron or chlorine); contact with acidic materials as a result of framing or storage; incompatible materials used by the artist or in subsequent restoration (e.g. iron-gall ink); or over-exposure to light, air pollution, extremes or fluctuations in temperature and humidity, biodeterioration or rodent activity, and mishandling. Treatment of the resulting damage depends not only on the type and condition of the paper and medium but also on the subtle aesthetic relationship of the two, and an understanding of the artist's intentions, the original appearance of the piece and its history. In the past, many empirical methods were used solely to improve a drawing's appearance, but since the mid-20th century drawings conservation has sought to preserve the work by arresting deterioration and stabilizing its condition, ideally using a process that is reversible. Preservation entails controlling the environment and the housing of an object: mounting, storage, framing and atmospheric conditions, including light, air quality, temperature and relative humidity. Conservation entails the application of intervention techniques that will effect a change in the physical condition and/or appearance of the drawing, using chemical and mechanical procedures.

1. Preservation. Because of the vulnerability of pigments, inks and paper, and the susceptibility of their organic constituents to change under adverse climatic conditions, the temperature, humidity and lighting levels of the immediate environment must be thoroughly monitored. The recommended level of illumination for drawings in the museum environment is 50 lux (5 footcandles) for a maximum continuous period of three months; in all circumstances direct illumination from windows and exposure to ultraviolet radiation should be avoided. With the exception of pastels, charcoals and gouaches with a tendency to flake, most drawings should be framed with ultraviolet-filtering acrylic plastic or laminated glass with an ultraviolet filter, which, as with glass, should be separated from the art work by a mount or spacers. To guard against buckling, staining from condensation, mould growth, insect activity and desiccation of paper and binding media, drawings must be displayed and stored in a stable, air-conditioned environment of c. 20–22°C and 50% relative humidity. All storage and mounting material in contact with a drawing should be 100% acid free. The extra depth provided by a ragboard window mount will also protect the surface of a drawing from abrasion and its edges from damage, and, being non-acidic and hygroscopic, will help to equilibrate slight variations in humidity. Older mounts are often historically relevant to their drawings or were designed by the artist and should not therefore be removed, despite their acidity; in such instances, it is particularly important that all other environmental and presentation recommendations are followed in order to minimize such adverse reactions as acid migration.

2. Conservation. Because of the diversity of media and paper and their respective components, and the differences in condition that result from ageing, aesthetic and material benefits of any conservation procedure must be assessed for each object before embarking on any treatment. The artist's handling, pigments, the tone and texture of the sheet, and the changes that have occurred must be understood. If chemical treatment is to be pursued each component of the composition must be tested for stability. Among the most common procedures for the conservation of drawings where appropriate is washing, with or without alkalinization, ranging from

immersion to humidification, and aimed at reducing discolouration, embrittlement and the acidity in paper. The mechanical strength of the support, its chemical nature and physical properties, and the solubility and textural qualities of the medium must be evaluated to determine their reaction to contact with moisture. In many instances, a severely discoloured and stained graphite drawing, for example, which is generally stable in water, may be washed by immersion, and the sheet flattened; in other cases, however, moisture cannot be used in treating a graphite composition because the extreme embrittlement of the paper cannot withstand expansion and contraction, or the work includes a mount of historical significance, or the heavy application of the medium is readily disrupted, or simply because the sheet bears a collector's stamp that is water-soluble. Acqueous and non-acqueous deacidification, although suitable for archival material or books that will be handled, can cause subtle colour changes to paper, inks or pigments due to the chemicals and moisture used in the process. Ragboard, housing and providing a stable climate and minimal lighting will also help to slow down acid reactions. Discolouration, staining or foxing can also be reduced by bleaching, a process that utilizes a variety of reagents, applied using a range of techniques, depending on the constituents of the paper and media and the overall condition of the object. Bleaching can be detrimental and using alternative treatments, such as alkaline water or enzymes, may have to be considered.

There is rarely any question as to the desirability of repairing tears, as left unmended they are likely to enlarge when the drawing is handled, and the exposed fibres will collect dust and dirt from the air. The extent to which a loss in a drawing support should be obscured or revealed will depend on historic and aesthetic considerations. All materials used for repairing tears or losses should be compatible with the original support and the process reversible. There are no pressure-sensitive tapes that fulfil these requirements. Moreover, the repair work should be visible from the *verso* of the sheet or in transmitted light.

Whereas in the past many drawings were laid down on to a semi-rigid mount composed of several layers of paper, or on to wood-pulp board, today these backings are usually removed. Aesthetically, the slight undulations in a sheet of paper, and the textural qualities of the primary support, can be fully appreciated only if the sheet is unrestricted in its movement, while the adhesives used to bond drawings to mounts, and the acidic components of most cardboards, provoke staining, discolouration and embrittlement. In removing a backing it is necessary to consider the sensitivity of the paper and media to moisture, pressure or solvents, the benefits of removal and the historical significance of the mount: backing removal may not always be the preferred treatment when a drawing is on an extremely thin sheet or is rendered in pastel, which would easily rub, or is in such an acidic medium as iron-gall ink, which would fracture in this process.

A drawing is generally lined to strengthen the support, consolidate a severely torn sheet, remove creases or planar distortions, or stabilize the paint layer. Because it exerts tension on the primary support, light-weight, high-quality Japanese tissue applied with starch paste or methyl cellulose is customarily used. Lining a drawing may result in changes to the textural properties of the sheet and should therefore be done only when essential for the preservation of the art work. Dry-mount tissues are not desirable for lining because the heat and pressure required for their application can flatten the paint layer and paper; some also tend to yellow on ageing, and reversing the process may require toxic and damaging solvents.

Works on paper may require flattening (using moisture, pressure or tension) if, for example, they have been rolled, are creased or have become distorted from changes in humidity. Not only must the sensitivity of the design layer be considered but also the delicate balance between maintaining the textural properties of the art work and eliminating the distraction of ripples and shadows. Except for drawings in media that tend to flake, a slight amount of undulation of the support in response to fluctuations in relative humidity will generally not provoke damage.

See also CONSERVATION AND RESTORATION, §II; CHALK, §2; INK, §III; and PAPER, §VI.

Art and Archaeology Technical Abstracts (1966–)

A. Clapp: *Curatorial Care of Works of Art on Paper* (New York, 1972, rev. New York, 3/1987)

Bulletin of the American Institute for Conservation of Historic and Artistic Works (1973–91)

Paper Conservator (1976–90)

G. Thompson: *The Museum Environment* (London, 1978)

Book and Paper Group Annual (1982–91)

Paper Conservation Catalogue (1984–)

M. H. Ellis: *The Care of Prints and Drawings* (Nashville, TN, 1987/R Walnut Creek, CA, 1995)

M. Shelley: *The Care and Handling of Art Objects* (New York, 1987, rev. 2/1992)

C. James and others: *Manuale per la conservazione e il restauro di disegni e stampe antichi* (Florence, 1991); Eng. trans. as *Old Master Prints and Drawings: A Guide to Preservation and Conservation* ([Amsterdam, 1997])

D. Bomford and others, eds: *Underdrawings in Renaissance Paintings* (London, 2002)

J. M. Kosek: *Conservation Mounting of Prints and Drawings: A Manual Based on Current Practice at the British Museum* (London, 2004)

M. Schweidler: *The Restoration of Engravings, Drawings, Books, and Other Works on Paper* (Los Angeles, 2006)

Drypoint [Fr. *pointe sèche*; Ger. *Kaltnadel*; It. *punta secca*; Dut. *droognaald*; Sp. *punta seca*]. Type of intaglio print. The process involves scratching lines or tones into the surface of a bare metal plate with a sharp point or other abrasive tool. The term may also refer to the process or to the tool used. It differs from etching in that acid is not used to bite the design into the plate (hence no protective ground is necessary) and from engraving in that the incising point is not pushed

through the surface but rather used as a drawing tool. Drypoint may be used alone or in combination with other intaglio techniques. It may also be employed to retouch or reinforce designs on etching plates that have been worn out or blurred by use. Its earliest use dates to the 15th century.

1. Materials and techniques. 2. History.

1. MATERIALS AND TECHNIQUES. The most basic drypoint technique involves using a sharp metal point, held in the hand like a pen or pencil, to scratch lines in the surface of a metal printing plate. The traditional drypoint tool is a round steel needle sharpened to a point, although diamond or ruby points are often used. Artists have also used such unconventional tools as steel brushes, emery pencils or carbon rods to scratch marks of varying tonal and linear qualities into the plate. The action of drawing the tool through the plate pushes a ridge of metal called a burr on one or both sides of the furrow. The configuration and height of the burr depend on both the angle at which the tool is held and the force employed. In addition to the line itself, this upturned burr will also retain ink, and the resulting impression will reveal a soft, broad area of ink in certain areas on the print (also called burr), giving drypoint its unique character. It can also be used for thin, delicate accent lines without printed burr, in which case the metal burr is removed with a scraper.

Copper is the material most often used for the printing surface, although pewter, aluminium, zinc, steel, iron and even gelatin have been employed. The raised burr of the printing surface is quite fragile and is quickly worn down by the pressure employed in printing intaglio plates. Very few impressions are therefore able to retain the characteristic printed burr of drypoint, unless the plate is electrolytically steel-faced for reinforcement. Usually only 20 or 30 fine impressions are possible on an unfaced plate, but 100 or more can be achieved from a reinforced surface.

The most characteristic appearance of drypoint in a print is the soft texture of a printed line that has been created by a drypoint burr. Another feature (most readily seen under magnification) is the visibly sharp impression made in the paper by the metallic burr itself; this is sometimes seen as a single white line (where the ridge of burr has been wiped clean) amid a thicker black line and sometimes as a double white line if there is burr on both sides of the scratched line. In addition, because of the force and degree of control necessary to wield the point itself, a drypoint line will have a taut, almost excited quality, which is not as fluid as an etched line nor as smoothly controlled as an engraved line. Drypoint created by broad tools, such as metal brushes or emery pencils, appears as a tonal area that under magnification reveals many fine, hairlike scratches. However, drypoint can be very difficult to recognize, especially when used in combination with other intaglio techniques. In many cases where the burr has been removed from an area of lighter drypoint detail, it can be virtually impossible to distinguish.

Drypoint has never been a major primary intaglio technique, partially because of the small number of good impressions possible and also as a result of its deceptive simplicity. Artists' manuals stress the freedom inherent in the ability to sketch directly on the plate but warn of the skill needed to control the point as it is guided through the resistant metal.

2. HISTORY. The first artist to work entirely with drypoint was the Housebook Master (also known as the Master of the Amsterdam Cabinet), active from c. 1470 to 1500. The Master executed at least 89 plates, entirely in a lively, sketchy drypoint technique, worked in a soft metal such as pewter. Albrecht Dürer (1471–1528) executed three drypoints in 1512; St Jerome by the Pollard Willow (Boston, MA, Museum of Fine Arts; B. 59) shows the technique's potential for suggesting atmospheric effects.

Several northern Italian printmakers experimented during the early 16th century with techniques resembling drypoint. These included Andrea Mantegna (1430/31–1506), Giovanni Antonio da Brescia (c. 1460–c. 1520), the Master of 1515, Jacopo de' Barbari (c. 1460/70–1516), Domenico Campagnola (1500–64), Pellegrino da San Daniele (1467–1547) and Marcello Fogolino (1483/8–after 1548). In addition the Venetian painter and printmaker Andrea Schiavone (c. 1510–63) used drypoint during the 1540s and 1550s quite extensively to supplement etched lines in a tonal fashion.

During the 17th century drypoint used alone remained rare, although landscape and genre etchers, especially in the Netherlands and Italy, frequently used it without burr to add fine accents to their prints. A unique experiment was the use of closely worked, tonal patches of parallel drypoint lines with burr by Hercules Segers (1589/90–1633/8). The Dutch printmaker Pieter de Grebber (c. 1600–52/4) executed pure drypoints. In the Netherlands it was Rembrandt van Rijn (1606–69) who made the most extensive use, until that time, of drypoint. He began adding it to his etchings in the early 1640s. He exploited drypoint burr to produce a soft yet strong effect of depth, often combining etching, engraving and drypoint to achieve a rich tonality of shadows. In more lightly worked etchings he added drypoint accents to establish depth and volume. Rembrandt's only pure drypoints were Landscape with a Road beside a Canal (c. 1652; B. 221) and Clump of Trees (1652; B. 222), the portrait of Thomas Haaringh (1655; B. 274) and his two large masterpieces, Ecce homo (or Christ Presented to the People, 1655; B. 76) and the Three Crosses (1653; B. 78). He often experimented with unusual printing papers to bring out the softness of the drypoint burr, including warm-toned Japanese papers and vellum.

Rembrandt's influence was paramount in the diffusion and development of the original drypoint style. Indeed, the next significant group of drypoint artists were 18th-century British enthusiasts for his

prints, often amateurs, who even copied Rembrandt's drypoints in the same medium. These included Arthur Pond (1701–58), Benjamin Wilson (1721–88), Thomas Worlidge (1700–66; known as the 'English Rembrandt'), James Bretherton (*fl* 1770–90) and the Rev. Richard Byron (1724–1811). Outside Great Britain, drypoint appeared occasionally in the work of more isolated European printmakers such as Jean-Jacques de Boissieu (1736–1810), Jan Piotr Norblin de la Gourdaine (1745–1830; also influenced by Rembrandt), Daniel Nikolaus Chodowiecki (1726–1801) and Jean Baptiste Bernard Coclers (1741–1817). However, in an age dominated by the reproductive engraving, drypoint was used primarily only in the finest details in combination with other intaglio techniques, as specified by contemporary manuals and encyclopedias.

During the early decades of the 19th century another group of English and Scottish artists employed drypoint, including David Wilkie (1785–1841), Andrew Geddes (1783–1844), the Rev. Edward Thomas Daniell (1804–42) and David Charles Read (1790–1851). From mid-century, however, two developments assured a broad resurgence of interest in drypoint as an independent medium. These were the Etching Revival in France and the steel-facing of printing plates, the latter assuring larger editions than was previously possible. In both England and France the increased emphasis on free draughtsmanship in printmaking also fostered many drypoint efforts, as did the advantage of sketching directly on the plate outside the confines of the studio.

In England the drypoint renaissance was spurred in the late 1850s by Seymour Haden (1818–1910) and James McNeill Whistler (1834–1903). Influenced by his personal print collection (which included works by Rembrandt) and the French Etching Revival, Haden used drypoint accents more and more strongly in his landscape etchings. Whistler executed several bold drypoint portraits in 1859–60 and continued to exploit the technique in both landscape and portraiture into the early 1870s.

Whistler's subsequent influence was very strong in Europe and the USA, especially on the drypoints of such later British printmakers as Mortimer Menpes (1855–1938), Elizabeth Stanhope Forbes (née Armstrong; 1859–1912), Muirhead Bone (1876–1953), David Young Cameron (1865–1945), Frank Short (1857–1945) and Walter Sickert (1860–1942). American followers included Joseph Pennell (1857–1926), John H. Twachtman (1853–1902) and Julian Alden Weir (1852–1919). The American Etching Revival of the 1880s included such artists as Thomas Moran (1837–1926) and Mary Nimmo Moran (1842–99) and James Smillie (1833–1909) experimenting with drypoint technique.

In France drypoint was used extensively after mid-century by many, varied artists. Edgar Degas (1834–1917) and the expatriate American Mary Cassatt (1844–1926) experimented freely with such non-conventional tools as steel brushes and carbon rods to create tonal drypoint areas (see fig.). Félix Buhot (1847–98) and Rodolphe Bresdin (1822–85)

experimented with using gelatin plates, and at this time unique works were created by scratching lines in thin gelatin sheets, inking them and framing them against a light-coloured background. In the 20th century in France, the earliest *Saltimbanque* prints (1905–6) by Pablo Picasso (1881–1973) included several drypoints, and he experimented with the technique until the end of his career. Important Cubist prints of 1911 by Picasso and Georges Braque (1882–1963) were wholly or largely made in drypoint. Other French artists who used drypoint extensively were Jacques Villon (1875–1963), Edouard Vuillard (1868–1940) and André Dunoyer de Segonzac (1884–1974). The Surrealist André Masson (1896–1987) worked in drypoint, as did the later abstractionist Wols (1913–51).

In Germany such Expressionists as Erich Heckel (1883–1970), Ernst Ludwig Kirchner (1880–1938), Karl Schmidt-Rottluff (1884–1976), Max Pechstein (1881–1955), Emil Nolde (1867–1956), Max Beckmann (1884–1950), Wilhelm Lehmbruck (1881–1919) and, later, Rolf Nesch (1893–1975) began to exploit drypoint's directness of approach as early as 1907, finding the tension of its lines well suited to their aesthetic. Vasily Kandinsky (1866–1944) and Marc Chagall (1887–1985) also executed innovative drypoints in Germany during the 1910s and 1920s.

In the USA there was an active period of printmaking between the World Wars when drypoint was used by such artists as Elie Nadelman (1882–1946), Peggy Bacon (1895–1987), George 'Pop' Hart (1868–1933), Armin Landeck (1905–84) and Milton Avery (1893–1965). After 1945 innovations were originally stimulated by the work of S. W. Hayter (1901–88) at Atelier 17, with Jackson Pollock (1912–56) and Mauricio Lasansky (*b* 1914) using the freedom of drypoint.

In the late 20th century, innovations in drypoint have included the use of 'accidental' drypoint texture, found, for example, on plates by Jim Dine (*b* 1935) and Michael Heizer (*b* 1944), and the use of plastic printing plates by Richard Artschwager (*b* 1924). Dine also pioneered the use of abrasive electric tools to achieve tone and burr in his drypoints. Other artists working with drypoint in the late 20th century have included the German Georg Baselitz (*b* 1938) and Austrian Arnulf Rainer (*b* 1929). Perhaps the largest drypoints ever executed were the 1.82 m high abstract works by Rolf Iseli (*b* 1934). The Italian Mimmo Paladino (*b* 1948) adapted drypoint to his expressive draughtsmanship.

E. Chambers: 'Engraving', *Cyclopaedia*, 5 vols (London, 1779–86), ii, no. 114 [ff 4E2*v*–4F*v*: the folios are not paginated]

E. Chambers: 'Engraving', *Encyclopaedia Britannica*, 18 vols (Edinburgh, 3 /1797), iv, pp. 667–72

A. von Bartsch: *Le Peintre-graveur* (1803–21) [B.]

M. Lalanne: *Traité de la gravure à l'eau forte* (Paris, 1866, 2/1878; Eng. trans., London, 1880, 2/1926/*R* 1981), pp. 48–50, 79–80

P. G. Hamerton: *Etching and Etchers* (London, 1876), pp. 140–41

Drypoint by Mary Cassatt: *The Bath, c.* 1891; photo credit: Art Resource, NY

S. R. Koehler: *Etching: An Outline of its Technical Processes and its History, with Some Remarks on Collections and Collecting* (New York, 1885)

A. Delâtre: *Eau-forte, pointe sèche et vernis mou* (Paris, 1887)

A. M. Hind: *A History of Engraving and Etching from the 15th Century to the Year 1914* (London, 1908, rev. 1923/R New York, 1963)

P. Smith: 'Some Notes on Drypoint', *On Making and Collecting Etchings*, ed. E. H. Hubbard (London, 1920), pp. 57–64

E. S. Lumsden: *The Art of Etching* (London, 1925), pp. 45–7, 127–34

S. W. Hayter: *New Ways of Gravure* (London and New York, 1949, 2/1966, rev. New York, 1981), pp. 16–24

A. H. Mayor: *Prints and People* (New York, 1971) [esp. pls 124–9]

A. Griffiths: *Prints and Printmaking* (London, 1980), pp. 74–8

B. Gascoigne: *How to Identify Prints* (New York, 1986), see II

K. Brown: *Ink, Paper, Metal, Wood—How to Recognize Contemporary Artists' Prints* (San Francisco, 1992), pp. 18–19

A. Griffiths: *Prints and Printmaking: An Introduction to the History and Techniques* (London, 1996)

A. Phillips: 'Drypoint', *Drawing*, iii/8 (Winter 2006), pp. 6–21

Dye. Compound that can be applied to textiles (or to such other materials as leather or the gelatin in a photographic emulsion) with the effect of changing their colour more or less permanently. Not every strongly coloured compound will behave as a dye: the term is used of a substance that can be dissolved and will then migrate from its solution to a fibre, remaining there when the fibre is rinsed free from excess dye. Ideally, it should survive subsequent washing, exposure to light and rubbing without change in colour. If, in addition, it resists the effects of moderately acidic and alkaline liquids, which are common hazards in normal life, it is a good, fast dye. Unfortunately, the dyes used in the past, and most that are used in the late 20th century, are less resistant than the textiles to which they are applied, so care is needed to avoid damaging them.

Dyes have nothing in common with the substances used to impart colours to glass or to the glazes used on the surface of ceramics. The pigments that constitute paints when suspended in a medium, usually oil or water, may relate to dyes (*see* LAKE), may

be effectively powdered glass or may be minerals unrelated to either type of colouring matter.

1. Introduction. 2. Natural. 3. Synthetic.

1. INTRODUCTION. Dyes can be divided according to the methods used to fix them to textiles. The simplest to use are the 'direct' dyes, which are absorbed from an aqueous solution, often made weakly acidic or alkaline. They then form saltlike linkages—involving attraction between positive and negative charges—to the basic or acidic groups present in the fibre. This is usually a protein fibre, that is wool or silk. A few direct dyes do exist for the cellulose fibres cotton and linen, but they rely on adsorption forces only for their adhesion to the fibre. Leather and other types of animal skin, horn or feathers may also be coloured by direct dyes. 'Reactive' dyes behave similarly, but they form covalent chemical bonds to the fibre molecules. Whereas direct dyes are sometimes unstable to washing (they may run and migrate to adjacent areas) because the links between the dye molecules and the fibre are not always sufficiently strong, reactive dyes are completely fast to washing. These two types of dye are rare, and neither has played a large part in the history of dyeing.

More important are the 'mordant' and 'vat' dyes, which have probably been known since remote antiquity: what look like representations of dyed kilim wall-hangings have been found on mud-brick walls excavated in Çatal Hüyük, Anatolia, and dated to the pre-ceramic Neolithic, around the 8th millennium BC. Mordant dyes are divided into acid dyes and basic dyes. Acid mordant dyes are applied by first soaking the fibre in the salt of a metal, usually aluminium, iron, chromium or tin. The fibres are dried, then transferred to an acidic dye-bath. The dye combines with the metallic salt, the mordant, to form a lake. (The lakes can be suspended in suitable media and used as paints.) Acid mordant dyes are usually stable to rubbing and washing, but strong acids will break the bond to the mordant. Basic dyes can similarly be fixed with tannins, which again form a chemical bridge from the dye to the fibre.

Vat dyes are converted by means of reduction to a leuco-compound that is soluble in water and usually less coloured. The fibre is soaked in the solution, removed and allowed to come into contact with air, whereupon the leuco-compound oxidizes back to the original dyestuff. The dye is now very intimately associated with the fibre, and the process can be repeated until the desired colour has been built up. Vat dyes are stable to washing and to any acids or bases that the fibre itself will resist, but they can be lost by mechanical creasing or rubbing. They are usually fast to light.

Dyes are coloured because they absorb light of a particular range of wavelengths roughly complementary to their perceived colour. When this happens, the dye molecule acquires a considerable amount of energy. In favourable circumstances the dye can lose this energy by conversion to heat, but in practice it frequently undergoes a chemical reaction that makes

it lose its colour. Different types of dye undergo this photochemical bleaching to varying degrees, but the problem is generally most serious for yellow dyes, which absorb in the high-energy, short-wavelength region, and least serious for such blue dyes as indigo. One type of dye, a gallotannin (often derived from oak galls) on an iron mordant, is used for black. On excitation it reacts with the fibre molecule, rendering the fibre mechanically weak, hence the black wool in a tapestry or carpet may have been replaced several times. Other iron-mordanted dyes can show the same effect to some degree.

2. NATURAL. Until 1740 all dyes had an animal or vegetable origin. These early dyes can be investigated in two ways: by finding and examining dyes, dyed materials and dye by-products or by reading contemporary accounts of the dyeing methods used. The first method suffers from a shortage of examples. Sometimes the actual dyestuff, for example plant material identifiable as madder or weld, has been excavated. Surviving textiles fall into two very different groups: the carefully treasured articles, more or less complete specimens that have always been kept dry and dark, and archaeological fragments from midden heaps, burials and other sources. Undoubtedly more will be learnt as more museum specimens are tested and more excavated scraps recovered, particularly from waterlogged sites. The second method, reading contemporary accounts, suffers more than is sometimes realized from problems of language. Even when the language is as well known as English or Latin, technical terms like 'grain' or *fucus* may be ambiguous, and the problem is of course greater with more obscure languages, those of Mycenaean Greece or ancient Egypt, for example.

(i) Indigo. Chemically, this is a mixture of indigotin (blue) and a little indirubin (pink). It is obtainable from many plants, of which woad (*Isatis tinctoria*) and indigo (*Indigofera tinctorum*) are the most familiar. It is by far the most important vat dye and has probably been used in every culture; it continues to defy predictions that it will give way to modern improvements (the indigo used for colouring denim jeans, however, is synthetic). On textiles indigo is extremely fast to light, and after some loosely fixed dye has been removed by washing, the remainder resists removal well. Mechanical rubbing and creasing, however, give irregular colour effects. Being a highly purified compound, of high value for its weight, indigo has always been traded over long distances.

(ii) Madder. A number of plants of the Rubiacae family contain alizarin (1,2–dihydroxyanthraquinone), purpurin (1,2,4–trihydroxyanthraquinone) and similar compounds, which make excellent mordant dyes. Madder (*Rubia tinctorum*) is the best of these. It has been grown for so long and so widely that it no longer occurs in a clearly wild state. These dyes give a range of colours from red, when the mordant is pure aluminium, to violet when it is pure iron. The colour

varies with the variety, age and technique of dyeing, and it was controlled with great skill by both home and professional dyers. Turkey red, a bright, fast red associated with cotton, was obtained by impregnating the fibre with oil, then treating it with dung and gall-nuts before the mordanting and dyeing processes. The technique was developed in the Middle East, and it was only in the mid-18th century that Europeans succeeded in emulating it. The attraction of Turkey red lay in the fact that the insect dyes (*see* §(vi) below) that gave bright reds on the protein fibres (i.e. wool and silk) were not suitable for cellulose fibres.

Madder is reasonably fast to light but dulled by prolonged exposure. Like other acid mordant dyes, it is easily stripped by strong acids, which break the bond to the mordant; if the acid is neutralized with a mild alkali before the mordant is washed out, the dye is refixed, and the yellow area returns to its former shade. Madder has also been traded internationally, but it is much less concentrated than indigo, and the incentive to grow it near a point of use was greater.

(iii) Yellow, black and brown dyes. Yellow dyes are readily available because the majority of plants contain compounds of the flavone and flavonol groups, which are adequate mordant dyes, giving yellow with aluminium. In traditional practice, residues from food crops (vine leaves, onion skins and millet husks) were often used, or common wild plants were gathered. For best results, however, a good source of a flavone such as weld (*Reseda luteola*) was grown. Dyes containing flavones (e.g. luteolin, found in weld) are more stable to light than those with flavonols (e.g. quercetin, which is very widely distributed in the plant kingdom), but all these natural yellows are much more easily bleached than madder or indigo. Indeed, it is common to find pale cream areas that are practically devoid of dyestuff but were probably once bright yellow. Weld was traded, but locally produced dyes are the rule for yellows.

A black colour can be obtained from any of a large range of gallotannins applied to an iron mordant, but because of the tendency of iron-black to damage the fibre, its use has often been avoided or proscribed. For wool, the natural brown or black fleece of many sheep could be used, though natural black wool (pigmented with the polymeric compound melanin) is not particularly fast to light and turns a golden brown.

(iv) Mixtures and overdyeing of indigo, madder and yellow, black and brown dyes. Many textiles were made with black and white wool, the latter dyed only with madder or an equivalent, indigo and one of the flavonoid yellows. Mixtures of mordant dyes, such as madder and a yellow to give orange, or madder and a gallotannin with an iron mordant to give brown, are common. It is likely that minor additions were frequently made to a dye-bath to vary the exact shade. Natural dark wool may be dyed with iron-black or with madder. On white wool, double dyeing with

indigo, and in a separate process with a yellow to give green, was also common. Since the yellow tends to be fugitive, these once bright greens often fade to blue. Although one might expect indigo and madder to be used similarly to give purple shades, in practice this is rare: the soft purples from iron mordants and madder alone are more often found. Black can be obtained by mixing madder and a yellow, then over-dyeing with indigo, but this also was a rare technique. The range of colours available from so simple a palette is remarkable, and in the West it is likely that, until the advent of synthetic dyes, the majority of textiles were dyed with these alone. There are, however, many other natural dyes.

(v) Dyewoods. Brazil-wood, logwood, camwood and others appear frequently in documents and must have been in common use. They do not survive well in archaeological textiles but are found in fabrics that have been cared for all their lives. They are acid mordant dyes, logwood in particular giving a good black with an iron mordant. Brazil-wood from trees of the *Caesalpinia* spp., native to Asia and the Americas, gave various shades of red. It was widely used in Europe but may have become less competitive when cochineal, a faster dye, became available.

(vi) Insect dyes. While the clear reds obtained from madder were most common, the rich wine-red (crimson) colour from the kermes insect (*Kermes vermilio*), a parasite found on the kermes oak, was always more valued, and it appears often on the fine cloth of medieval state robes and church vestments. These garments have often survived when those of most of the population have been lost. In eastern Europe its place was taken by an equivalent insect dye, 'Polish cochineal' (*Porphyrophorba polonica*), found on a grass; in the Near East another equivalent dye, lac (*Kerria lacca*), was found as an exudate containing a natural plastic, shellac, from which it was separated. Other similar insects were used in different areas; the entomology is far from simple. All these dyes gave way when the New World insect dye, cochineal, became available after the conquest of Mexico in the early 16th century. Found on the nopal cactus, an arborescent prickly pear, the cochineal insect (*Dactylopius coccus*) had been used for centuries in Mexico and was farmed by the Aztecs. Its advantage was economic, since the insect contains far more colouring matter than, for example, kermes. It steadily replaced kermes and Polish cochineal in Europe during the 16th century. With greater difficulty it replaced lac in Turkey and finally in Iran, but in India it appears that lac held out until synthetic dyes arrived in the 20th century.

Kermes contains kermesic acid, cochineal has carminic acid, Polish cochineal carries a mixture of these two compounds, and lac contains a complex mixture of the laccaic acids. As there are chemical differences (though little or no visible distinctions) between these compounds, it is possible to use analysis (*see* TECHNICAL EXAMINATION, §VIII, 9) to date textiles containing these dyes, with suitable caution:

in Iranian carpets, lac suggests a pre–1800 or at least 1850 date, cochineal being used later, but in Britain, cochineal was used in tartans in the 18th century, whereas in the early 19th century a wish to encourage Indian exports led to lac being substituted. Particular care is needed in using written sources dealing with these dyes. The word 'kermes' seems to have been first applied to a little-known Armenian dye (*Porphyrophora hameli*) from Mt Ararat, which is chemically similar to cochineal but contains much less dye. Its normal meaning is the dye of the kermes insect. The word is derived from the same root as 'crimson', and in many languages (e.g. Farsi) it seems to be general for these crimson dyestuffs and applicable to cochineal itself. 'Grain', describing the appearance of the dyestuff, is similarly used in a general sense in English. All these insect dyes have always been valuable and were traded over long distances.

(vii) Lichens and other dyes. A group of dyes less easy to discuss than those listed above derives from lichens. These dyes fall into two classes: one consists of hydroxyaldehydes, which on heating, usually by boiling, with a protein fibre act as reactive dyestuffs and colour the fibre a golden-brown shade, completely unremovable and therefore difficult to study. It may well be that these dyes are also hard to use with precise control and were therefore more important to folk-craft than to any sort of industrial use. The other group of dyes from lichens involves treatment with ammonia, urine being the main traditional source. These are direct dyes. Much the best known is the violet dye orchil, *Roccella tinctoria*, which gave its name to a prominent Florentine family, the Rucellai. They may be either basic or acidic; they are formed as complex mixtures that can be varied by the choice of species used and by controlling the conditions of the reaction between the lichen constituents. The colours are often very brilliant, but they have two general disadvantages: they are seldom fast to light, and they frequently change colour to a noticeable extent on treatment with mild acids, fruit juice for example, or alkalis. (Litmus, a widely used indicator of acidity, is one of these dyes.) Despite these drawbacks, their use has a long history that may well go back to Classical times: a dye called *fucus* is discussed by Pliny the elder (AD 23/4–79). He associated it with the seashore, and although Fucus is a genus of seaweed, few seaweeds give acceptable dyes, and a lichen may well have been meant. A dye corresponding to Pliny's description (blue–red colour) has been found in 10th-century silks believed to be of Byzantine or Islamic origin and in fragments of excavated wool of late Classical date; this could well be a lichen dye.

Safflower is a sharp pink dye obtained from the flowers of a thistle, *Carthamus tinctorius*, native to India and the Middle East. It is mainly used on silk and is not at all fast to light, fading to a characteristic peach–yellow shade. It is not known how commonly it was used, but it was probably restricted to those textiles that were only seen by candlelight.

A dye much discussed but hardly ever found in surviving textiles is shellfish purple, derived from *Murex* and other genera. Chemically this is a close relative of indigo and shares its advantages, but it was very expensive and often reserved for élite persons. Late antique Coptic textiles have been found dyed with true purple, but more frequently they contain madder–indigo combinations, rare in most traditions and therefore probably an imitation of Tyrian purple. The commercial production of purple seems to have ceased in Byzantine times. Another rare but much discussed dye is saffron, a yellow of poor light-fastness that must have been expensive as a dye and was mainly used as a food colour. These dyes, and kermes, should never be assumed to be present without chemical analysis, nor should written descriptions be accepted without caution.

This account has focused on the dyes of Europe and the Near East, which progressively converged into a single tradition. In East Asia other dyes have been used; in Japan, for example, *Rubia akane* (which contains purpurin but no alizarin) roughly takes the place of madder; indeed, madder is known by a name equivalent to 'western *akane*'. India is an intermediate case, with some local dyes and some known also in the West. Pre-Columbian America is a distinct dye province, with one or more sources of indigotin, cochineal available from an early date and various little-known dyes, for example *Relbunium hypocarpium*, a madder equivalent. Here, too, traditions have merged, this process having been cut short by the arrival of synthetic dyes.

3. SYNTHETIC. In 1740 the first reference occurs, in French, to what became known as 'essence of indigo', indigodisulphonic acid, which is obtained by treating indigo with concentrated sulphuric acid. It is a blue acid direct dye. It can be found in, for example, English samplers, sometimes with late 18th-century dates, and it easily runs on washing. It reached Turkey *c.* 1850. The first two fully synthetic dyes came on the market in 1856: picric acid in France (a direct acid yellow) and mauvine (a direct basic mauve) in England. Far more important than either was fuchsine, discovered in 1858, a bright magenta and again a direct basic dye. It was much cheaper than mauvine but less fast to light and mild alkalis. A number of relatives of fuchsine were discovered between 1860 and 1870, extending the colour range into blue and green shades, but these very brilliant 'early anilines' (so-called because oxidation of aniline derivatives was the method of preparation) are all fragile; most faded rapidly, giving synthetic dyes a poor reputation. A second important group of dyes, the direct acid azo-dyes, were introduced from 1875 and provided shades of yellow, orange and red. They did not fade, but many ran easily. Other major and minor groups of synthetic dyes followed, and before long the whole spectrum was covered. The new dyes, essentially pure chemical compounds, were more consistent and often more brilliant and cheaper than the natural dyes previously used. However, the many

other qualities needed by the user were not always available, and the synthesis of improved dyes continued to be a main preoccupation of organic chemists. One obvious way of obtaining the advantages of the natural dyestuffs was to synthesize the compounds they contain. Thus alizarin, the main colouring matter of madder, was prepared artificially in 1880, giving dyers in Europe all the advantages of that excellent and versatile dye. Similarly, indigo was made commercially in 1897; the synthetic version is exactly equivalent to and indistinguishable from the natural dyestuff. These achievements dealt a blow to the regions that had grown these once lucrative crops, but they improved both the economics and the technique of dyeing.

By the end of the 19th century thousands of synthetic dyes were available, covering every possible shade, and many (e.g. the chrome dyes, a set of azo-dyes mordanted with chromium salts) had excellent fastness. Around 1920 the last important niche, a green dye of good stability for natural fibres, was filled by Caledon Jade Green, a vat dye. The arrival of synthetic fibres presented new problems, as they proved difficult to dye. New types of dye were produced, the technology becoming progressively more specialized. For example, the advent of photography led to the use of the extremely labile cyanine dyes for the sensitization of silver bromide emulsions to yellow and red light, giving the panchromatic plates and films introduced in the 1920–40 period. Colour photography led to other demands for relatively stable dyes. If the dyes used in the late 20th century have faults, it is usually because low cost has been preferred to high quality; neither impermanence nor unsubtle shades are inevitable. By skilful use of the immense range of modern synthetic dyes, high-value textiles can be produced in any shade imaginable (including the most subtle), with all the desired fastness to washing and good resistance to light.

The use of natural dyes, however, has not entirely disappeared. Since the 1960s craftsmen have been interested in those dyes that can be grown and used in a domestic environment; and in the 1980s natural dyes were seen as an ideal alternative to the cheap synthetic ones that had damaged the reputation of traditional weaving.

See also TEXTILE, §III, 1(ii)(a) and WOOD, §III, 5.

S. Muspratt: *Chemistry: Theoretical, Practical and Analytical* (London, Glasgow and Edinburgh [1860])

A. G. Perkin and A. F. Everest: *The Nature of Organic Colouring Matters* (London, 1918)

The Colour Index, Society of Dyeists and Colourists, 2 vols (Bradford, 1924), rev. in 5 vols (Bradford, 3/1971)

Ciba Zeitschrift (1937–70) and *Ciba-Geigy Quarterly* (1971–5) [articles on various topics relating to dyes]

H. A. Lubs, ed.: *The Chemistry of Synthetic Dyes and Pigments* (New York, 1955)

E. N. Abrahart: *Dyes and their Intermediates* (Oxford, 1968)

F. Brunello: *L'arte della tintura nella storia dell'umanità* (Vicenza, 1968; Eng. trans., Cleveland, 1973)

S. Robinson: *A History of Dyed Textiles* (London, 1969)

R. L. M. Allen: *Colour Chemistry* (London, 1971)

J. H. Hofenk de Graaff and W. G. T. Roelofs: 'On the Occurrence of Red Dyestuffs in Textile Materials from the Period 1450–1600', *ICOM Committee for Conservation: Madrid, 1972*

P. Rys and H. Zollinger: *Fundamentals of the Chemistry and Application of Dyes* (New York, 1972)

J. B. Harbourne, T. J. Mabry and K. Mabry: *The Flavonoids* (London, 1975)

T. W. Goodwin, ed.: *The Chemistry and Biochemistry of Plant Pigments*, ii (London, 1976)

J. Griffiths: *Colour and Constitution of Dyes and Pigments* (London, 1976)

Hali (1977–) [occasional articles on dyes]

K. Venkataraman, ed.: *The Analytical Chemistry of Synthetic Dyes* (New York, 1977)

J. H. Hofenk de Graaff and W. G. T. Roelofs: 'The Analysis of Flavonoids in…Textiles', 'Natural Yellow Dyestuffs Occurring in Ancient Textiles', *ICOM Committee for Conservation, 5th Triennial Meeting: Zagreb, 1978*

L. Masschelein-Kleiner and L. Maes: *Ancient Dyeing Techniques in Eastern Mediterranean Regions* (Zagreb, 1978)

M. C. Whiting: 'The Identification of Dyes in Old Oriental Textiles', *ICOM Committee for Conservation, 5th Triennial Meeting: Zagreb, 1978*

M. Grayson, ed.: *Kirk-Othmer Encyclopedia of Chemical Technology*, viii (New York, 1979)

K. Ponting: *A Dictionary of Dyes and Dyeing* (London, 1980)

M. Gittinger: *Master Dyers to the World* (Washington, DC, 1982)

J. B. Harbourne and T. J. Mabry: *The Flavonoids: Advances and Research* (London, 1982)

Dyes on Historical and Archaeological Textiles (1982–)

K. McLaren: *The Colour Science of Dyes and Pigments* (Bristol, 1986)

R. H. Thompson: *Naturally Occurring Quinones: Recent Advances* (London, 1987)

H. Zollinger: *Colour Chemistry* (New York, 1987)

F. Delamare and B. Guineau: *Colours: The Story of Dyes and Pigments* (New York, 1990)

Pigments et colorants de l'Antiquité et du Moyen Age: Teinture, peinture, enluminure: Etudes historiques et physico-chimiques (Paris, 1990)

J. Storey: *The Thames and Hudson Manual of Dyes and Fabrics* (London, 1992)

J. E. Gaunt: 'History of Yarn Dyeing Machinery, pt 2', *Journal of the Society of Dyers and Colourists*, cix/7–8 (1993), pp. 233–7

H. Schweppe: *Handbuch der Naturfarbstoffe: Vorkommen, Verwendung, Nachweis* (Hamburg, 1993)

R. Paul, M. Jayesch and S. R. Naik: '"Natural Dyes: Classification, Extraction and Fastness Properties', *Textile Dyer and Printer*, xxix/22 (1996), pp. 16–24

J. Balfour-Paul: *Indigo in the Arab World* (Richmond, 1997)

G. Sandberg: *The Red Dyes: Cochineal, Madder, and Murex Purple: A World Tour of Textile Techniques* (Asheville, NC, c. 1997)

J. Balfour-Paul: *Indigo* (London, 1998/R 2006)

S. Garfield: *Mauve: How One Man Invented a Colour that Changed the World* (London, 2000)

F. Pritchard: 'Mariano Fortuny (1871–1949): His Use of Natural Dyes', *Dyes in History and Archaeology*, xvi–xvii (2001), pp. 39–42

D. Cardon: *Le monde des teintures naturelles* (Paris, 2003)

C. Cooksey and A. Dronsfield: 'Pre-Perkin Synthetic Routes to Purple', *Dyes in History and Archaeology*, xix (2003), pp. 118–25

J. H. Hofenk de Graaff: *The Colourful Past: Origins, Chemistry and Identification of Natural Dyestuffs* (London, 2004)

R. Laursen: 'On the Trail of Ancient Dyes in Central Asia', *Oxford Asian Textile Group Newsletter*, xxxv (Oct 2006), pp. 4–8

Dye transfer. Method of producing archival quality, colour photographic prints subject to aesthetic control at every stage. The technique, introduced by Eastman Kodak in the mid-1930s and improved in 1946, can be used for reflection images on paper as well as for transparent ones on a film base; it derives, ultimately, from the 'subtractive' technique of colour photography (*see* PHOTOGRAPHY, §I, 2).

Colour information can be taken from various types of originals: in-camera separation negatives, colour negatives or positive colour transparencies. A colour transparency is translated by means of red, green and blue filters into continuous-tone separation negatives on panchromatic sheet film. Each separation is exposed on to a special paper through an enlarger and then developed, fixed and washed in hot water to remove unexposed gelatin. This results in a relief matrix of gelatin selectively hardened according to the amount of light reaching it. Each matrix—a red-, green- or blue-record separation positive—is soaked in the appropriate bath of powerful cyan, magenta or yellow dye, which charges the printing surface with colour in proportion to the thickness and receptivity of the gelatin. A good quality 'receiver paper' is soaked in distilled water and placed, gelatin emulsion side up, on a sheet of glass. After being rinsed to remove surplus dye, the first matrix is rolled or squeegeed, emulsion side down, on to the printing paper, where it is left long enough for dye to transfer; the other matrices, registered by locating pins, follow. The length of contact and colour sequence provide some of the creative variables, while colour balance and density can be adjusted by adding chemicals to rinse baths. Matrices can also be painted with specially mixed colours. Although the method is not suited to mass production, as many as 800 prints can be made from a set of matrices. The maximum size of regularly produced prints is 1.01 × 1.57 m, and each print takes at least

20 minutes to make. Under magnification, the colour has the soft, slightly unfocused appearance characteristic of photographic enlargements.

Although exquisite monochrome prints can be made, the control possible in dye transfer has proved of particular interest in advertising and illustration and to such creative colour photographers as Eliot Porter (1901–90) and William Eggleston (*b* 1939). Richard Hamilton (*b* 1922), several of whose works have explored focus and its relationship to photographic 'truth', is the best-known painter to have adopted the process, working in 1969 at Creative Colour in Hamburg. In such works as *Bathers (b)* (see Hamilton, no. 72), *Vignette* (see Hamilton, no. 73) and '*I'm Dreaming of a White Christmas*' (1969, see Hamilton, no. 71), Hamilton's approach ranged from the straightforwardly commercial to the extensively interventionist. In 1985 he took up the method again for *The Citizen*, producing a seamless collage from fragments of 16 mm film by laser. In the late 1980s he continued to experiment with dye transfer to record images made with the Quantel computer paint-box.

D. B. P. Hanworth: *Amateur Dye Transfer Colour Prints* (London, 1955)

William Eggleston's Guide (exh. cat., intro. J. Szarkowski; New York, Museum of Modern Art, 1976)

The Dye Transfer Process, Eastman Kodak Company, Pamphlet E.80 (Rochester, NY, 1978, rev. 1980)

M. Beede: *Dye Transfer Made Easy* (New York, 1981)

A. Gassan: *The Color Print Book*, Extended Photo Media Series, iii (Rochester, NY, 1981), pp. 42–8

D. Doubley: *The Dye Transfer Process* (Detroit, 8/*c*. 1984)

R. Hamilton: *Richard Hamilton Prints, 1939–83: A Complete Catalogue of Graphic Works* (Stuttgart, 1984)

R. W. Haines: *Technicolor Movies: The History of Dye Transfer* (Jefferson, NC, 1993)

D. E. Williams: '"When Worlds Collide', *American Cinematographer*, lxxix/7 (July 1998), pp. 40–50

N. Kernan: 'William Eggleston's Democratic Photography: The Los Alamos Project', *Art on Paper*, vi/2 (Nov–Dec 2001), pp. 64–9

H. Chandès: *William Eggleston* (London, 2002)

E

Earthenware. See CERAMICS, §I, 2(i).

Easel. Stand or rest for a painting during its execution. Some such device is a practical necessity whenever a portable or self-supporting painting is made, hence the term EASEL PAINTING. The most widely used form of easel consists of a rigid frame, made from two front legs, slightly splayed and joined by one or more crossbars; a third hind leg hinges backwards, and the whole forms a stable tripod structure. The front legs are fitted with pegs on which rests the bottom of the painting or a narrow shelf that holds the painting. A series of evenly spaced holes in both front legs allows the pegs to be moved, enabling the easel to accommodate paintings of different sizes.

An object depicted in an ancient Egyptian relief in the tomb of the vizier Mereruka at Saqqara, dating from the Old Kingdom (*c.* 2575–*c.* 2150 BC) has been interpreted as the earliest form of easel. The *machina* referred to by Pliny the elder (AD 23/4–79) in connection with Apelles is also assumed to have been an easel. In the Middle Ages a desk or lectern may have been used to support a painting, but, with the growth of painting on panels and canvases, the easel assumed greater importance from the Renaissance. It was generally a variation on the simple three-legged trestle, as depicted in the late 15th-century illumination *Zeuxis Painting Girls in his Studio* (Ghent, Bibliotheek van de Rijksuniversiteit) and in *St Luke Painting the Virgin and Child* (*c.* 1513; London, National Gallery) by the school of Quinten Metsys (1466–1530). It was also illustrated by Rembrandt van Rijn (1606–69) in the *Painter in his Studio* (*c.* 1629; Boston, MA, Museum of Fine Arts), and 18th-century examples appear in the self-portrait by William Hogarth (1697–1764), *Hogarth Painting the Comic Muse* (*c.* 1757; London, National Portrait Gallery) and *Alexander the Great and Campaspe in the Studio of Apelles* (*c.* 1740; Los Angeles, CA, J. Paul Getty Museum; see fig.) by Giambattista Tiepolo (1696–1770). An ornate American easel of this type (*c.* 1805–15; Boston, MA, Museum of Fine Arts) was possibly intended for the display of finished work. Later examples are shown in the *Studio in the Batignolles Quarter* (1870; Paris, Louvre) by Henri Fantin-Latour (1836–1904) and in the background of a photograph of *Renoir at Work* (1914; Rewald, p. 584).

During the 18th century portable and collapsible easels, as shown in the aquatint *Artist Travelling in*

Wales (1799; London, British Museum) by Thomas Rowlandson (1756/7–1827), were developed; these were favoured by itinerant painters and by the increasing number of landscape and amateur painters who worked out of doors. Henry Raeburn (1756–1823) also owned an easel of this type (Edinburgh, Royal Scottish Academy). Studio easels, however, became more complicated and imposing and were intended to impress as well as perform; the oblong framed mahogany easel (London, Royal Academy of Arts) belonging to Joshua Reynolds (1723–92) illustrates this tendency.

By the 19th century the studio easel had evolved a definite form—upright on two legs, rising from heavy feet or a base, often on casters, with the painting resting on a grooved ledge that could be raised or lowered mechanically. Large canvases could be accommodated, even displayed, on such easels, the weighty presence of which, especially within the increasingly formal, spacious and imposing artists' studios, implied professionalism. A moderately sized example belonging to Eugène Delacroix (1798–1863; Paris, Musée Delacroix) survives, although a more robust example is depicted in the *Self-portrait* (1867; Bodelwyddan Castle) by William Powell Frith (1819–1909). A photograph (Paris, Collection H. Roger-Viollet) of the studio of Claude Monet (1840–1926) in 1920 shows a towering example, and, in comparison, the heavy wheeled easels or cradles carrying his huge paintings of *Waterlilies* shown in photographs *c.* 1924–5 (Paris, Collection Durand-Ruel) look merely workmanlike, though they must surely be the greatest manifestation of the studio easel.

The Impressionists' passion for *plein-air* painting led them to favour lightweight sketching easels. These are illustrated in *Monet Working in his Garden at Argenteuil* (1873; Hartford, CT, Wadsworth Atheneum) by Auguste Renoir (1841–1919) and in *Camille Pissarro at Work* (*c.* 1870; private collection; see *Pissarro*, exh. cat., Arts Council of Great Britain, 1980, no. 322) by Ludovic Piette (1826–78). Their versatility is clearly demonstrated by *Monet Working on his Boat in Argenteuil* (1874; Munich, Neue Pinakothek) by Edouard Manet (1832–83).

In the 19th century various combinations of easels with stools or paintboxes (*see* PAINTBOX) were also developed, mostly for the convenience of amateur painters, though the easel-topped workbox used by

Easel depicted in *Alexander the Great and Campaspe in the Studio of Apelles* by Giambattista Tiepolo, oil on canvas, 421×540 mm, *c.* 1740 (Los Angeles, CA, J. Paul Getty Museum) photo credit: Erich Lessing/Art Resource, NY

miniature painters was already an established form. The most practical of these, the paintbox easel with a tray of materials at waist height and a canvas carrier above, possibly features as a backpack carried by Paul Cézanne (1839–1906) in a photograph (*c.* 1874; see Rewald, p. 296) of him on his way to work near Pontoise and even earlier in *The Meeting or Bonjour Monsieur Courbet* (1854; Montpellier, Musée Fabre) by Gustave Courbet (1819–77).

While the traditional form of easel continues to be used, new styles, such as the narrow upright radial easel, are also widely employed; steel and aluminium, as well as wood, are used for the manufacture of easels and drawing boards. The lightweight sketching easel developed to accommodate the watercolourist often tilts from the centre to hold a drawing board horizontally. (Oil paintings are usually held vertically or near vertically during work.) The artist's donkey, a long, narrow stool with a small easel at one end, which has also proved an enduring design, may have originated in the early academies.

J. Rewald: *History of Impressionism* (New York, 1966, rev. 4/1973/*R* 1980)

J. Ayres: *The Artist's Craft* (Oxford, 1985)

J. Stephenson: *The Materials and Techniques of Painting* (London, 1989)

J. Stephenson: *Paint with the Impressionists* (London, 1995)

Easel painting. Painting executed on an EASEL or other portable support, i.e. the majority of paintings on canvas and panel. Easel painting became pre-eminent in the 16th century and has remained so. The term implies not only physical aspects but also inherent concepts that are very different from those associated with wall paintings or those intended for a fixed position or an architectural scheme. Easel painting is therefore associated with the increased secular use of art from the 16th century and with the identification of paintings as objects of worth in their own right. The rise of easel painting involved a subtle assertion of the independence of the art of painting and the profession of painter. The status afforded to painting in the writings of, for example, Leonardo da Vinci (1452–1519) and Giorgio Vasari (1511–74) reflects these developments and anticipates the increased social and intellectual status of the individual artist.

Ebauche [Fr.: 'sketch']. Term applied to the first stage of blocking-in the underpainting in an oil painting.

Echoppe. Type of etching needle with a sharp, but rounded end. It was developed by Jacques Callot (1592–1635) to make etchings look like engravings, since the line produced can imitate the swelling lines of a burin. It was also extensively used by Abraham Bosse (1602–76).

Electrography [electrophotography; xerography]. Term for processes involving the interaction of light and electricity to produce images and for the production of original works of art by these processes. Since these processes are used by nearly all photocopiers, the production of such works has also been referred to as 'copy art', although this is misleading, since it suggests the mere replication of already existing works. Artistic photocopies were made in California

in the late 1950s, but electrography proper as an international art form dates from the early 1960s, when electrographers developed its basic techniques. The pioneering works, workshops and publications by Bruno Munari (1907–98), starting in 1963, foreshadowed the preponderant role played by Europe in the history of electrography, to which important exhibitions at the Musée National d'Art Moderne in Paris (1980) and in Valencia (1988) later testified. Electrographs vary widely in size and can be over 1 km in length; materials used include not only paper but also canvas and leather. In the mid-1970s xeroradiography (a xerographic process in which an X-ray gun is used to obtain X-ray pictures) and telecopy respectively gave rise to electroradiographic art and fax art. The advent in the 1980s of the digital copier, with its creative programmes, also created new possibilities, and from 1989 the colour laser copier could be connected to a computer or a video camera, thereby increasing the creative potential of electrography. At the end of the 20th century it was one of the most practised technological art forms, with Pol Bury (1922–2005) and David Hockney (*b* 1937) among its prominent exponents. The Museo Internacional de Electrografía in Cuenca, Spain, is the leading institution devoted to the subject.

2 *Bienal internacional electrografía*, 3 vols (exh. cat. by C. Rigal and others, Valencia, Ayuntamiento, 1988–91) [texts in Eng. and Sp.; the third vol. is a video cassette]

C. Rigal and others: *Electrografías: La colección Museo Internacional de Electrografía* (Cuenca, 1991) [texts in Eng. and Sp.]

P. E. Zamorano Pérez: *Trans-art: Arte y electrografía: Muestra internacional* (Santiago, 2005)

Electroplating. Deposition by electrolysis of a layer of metal, often gold, silver or chromium, on to a metal. Experiments into the electrodeposition of metals were carried out from the 18th century, and very soon the commercial potential of this method of gilding or silvering was recognized. However, the electrolytic solutions then available gave disappointing results, since the plated layers were loose and unsightly. By the end of the 1830s a great deal of research had been carried out, notably in Britain, France, Germany and Russia, but without any commercial success. At this point, George Richards Elkington (1801–65) and his cousin, Henry Elkington (*c.* 1810–52), who ran a large firm making silverwares in Birmingham, decided to advance gold and silver cyanide solutions as electrolytes. This led, in the 1840s, to the successful electroplating of copper and other base metals with continuous, durable and shiny layers of precious metal.

In outline, the processes for both gold and silver plating are broadly similar and have not changed appreciably over the years. The favoured base metal, which acted as a cathode, was copper or nickel-silver (a copper-zinc-nickel alloy), hence the familiar EPNS mark. This was carefully cleaned and polished, then either acid-treated or lightly scratch-brushed to create a suitable surface to which the plating would adhere. Items to be silver-plated were treated with

mercury salts to prevent ordinary electrochemical deposition, before being placed in vats filled with the appropriate cyanide-solution electrolyte with anodes of gold or silver to replenish the solution. After careful washing, the plated items were polished or brushed to produce the required finish.

The conditions could be manipulated to give a variety of colours and textures to the plated layer. Sometimes this was done at the plating stage by, for example, varying the composition of the electrolyte to give red, rose or even greenish tinged gilding. A special effect was produced by plating out lead oxides on to steel plates to give beautiful prismatic colorations. These metallo-chromes, as they were called, were quite widely used in the latter part of the 19th century (before the days of stringent health requirements) for colouring the hands and dials of Swiss clocks, and the small ornamental toys made at Nuremberg.

Within a few years electroplating had largely replaced all other plating methods and formed a very substantial industry. Such firms as Elkington, Mason & Co. in Britain, Christofle in France and the Gorham Manufacturing Co. in the USA produced an enormous range of plated goods, which exceeded both in quantity and elaboration those covered by other, earlier forms of plating. This was largely because the traditional form of silver plate, known as SHEFFIELD PLATE or fused plate, had a number of commercial as well as practical disadvantages. It was wasteful of materials and required a great deal of highly skilled, and thus expensive, labour. Edges naturally come in for heavy wear, but unfortunately the Sheffield plating process left the edges relatively poorly protected, whereas electroplating automatically deposits more metal at extremities. An even more serious drawback was that Sheffield plating could not be applied to castings. This was partially overcome by die-pressing complex components separately and even making electrotypes, but as prevailing taste favoured ever more ornate designs so casting the whole item and then electroplating it became the only commercially viable method of production. The clean, simple, classical designs of the late 18th century were ideally suited to Sheffield plate, but the increasing complexity of late Regency silverware in the following century may well have encouraged the search for a technique better suited to its production. The advent of electroplating certainly encouraged the development of the ornate Victorian style, not least by bringing down the price and encouraging the dissemination of plated wares to a wider sector of the population.

Electroplating also transformed gilding technology, replacing fire-gilding and to a lesser extent leaf-gilding (*see* GILDING, §I, 1 and 3). One especially interesting application was the electrogilding of such large items as statues or even whole roofs. This was developed to a high degree in 19th-century Russia, especially by the St Petersburg Electroforming, Casting and Mechanical Plant set up by Moritz Hermann von Jacobi (1801–74), which gilded the domes on such buildings as St Isaac's Cathedral,

St Petersburg, and the Bol'shoy Theatre, Moscow. The gilded layers were much thinner than could have been achieved by any other method, but even so hundreds of kilograms of gold were used on each roof.

Developments in electroplating continued, especially in new alloys that would be cheaper and more resistant to corrosion. There was considerable research into developing a plate that would protect silver jewellery mounts from tarnish. Platinum and palladium platings were used in the 19th century, but they were expensive and looked different from silver. In the 1930s rhodium plating was introduced for diamond settings. It rapidly spread to a wide range of silver and even silver-plated goods, because although rhodium was very expensive, only an extremely thin layer was needed to give full protection, and the colour and finish were held to be indistinguishable from silver itself.

The search for plating metals that would give a cheap, weather-resistant but attractive finish was pursued with vigour. Thus, at the end of the 19th century such plating alloys as Arcas, three-quarters silver and a quarter cadmium, were developed. These resembled silver but were significantly cheaper and had superior resistance to tarnish—so much so that similar alloys were used to plate cycle handlebars. Nickel plating was also widely used to give protection to exposed copper and brass fittings. However, the major advance was made only in the 20th century with the introduction of chromium plating. This made it possible to give metals, including iron and steel, a durable, silvery finish that was both weather-resistant and attractive.

Chromium had been isolated as a metal in 1795, and by the mid-19th century scientists were performing electroplating experiments with it, but without great success. They realized the potential of a shiny plated layer, which was extremely resistant to weathering, but it proved difficult to make the chromium adhere satisfactorily. The problems were not fully overcome until the 1920s, and chromium plating was then rapidly taken up in Europe and the USA, especially by the motor industry.

The iron or steel is first plated with nickel, then cleaned, polished and electroplated from an electrolyte of chromic acid, catalyzed by sulphate and silicofluoride ions, in a steel bath lined with lead and with lead or lead-alloy anodes. The plated items emerge from the bath in a bright condition and require little or no further polishing. Plating of plastics began in the 1960s, and many minor items, for example buttons, that were traditionally of metal are very often of chromium-plated plastic.

The advent of chromium plating had a profound effect on the appearance of a wide range of iron and steel consumer goods and even buildings. This was especially true of the motor-car. Prior to this, bright finishes had had little place in automobile design—the few areas that were not painted were of brass, possibly nickel-plated, and would tarnish rapidly unless polished. Shortly after the introduction of chromium plating, considerable areas of bright, shiny

plating were being emphasized—Oldsmobile radiator shells, for example, were chromium plated by 1926—and the whole of vehicle design underwent a rapid change in response to the new material. Similarly, the brass handles and fittings of many kitchen and bathroom goods were plated, as was the tubular steel used in Modernist furniture. The same was true of buildings, where previously shiny metal had been strictly limited to brass door furniture, and other exposed structural metalwork had been galvanized and painted. With chromium plating, structural steelwork could be emphasized and purely decorative items added. Indeed, chromium plating became an essential element of modern design.

G. Langbein and W. T. Brannt: *A Complete Treatise on the Electro-deposition of Metals* (Philadelphia, 1891)

A. Watt and A. Philip: *The Electro-plating and Electro-refining of Metals* (London, 1911)

Handbook on Electroplating, Polishing, Lacquering, Burnishing, Enamelling (Birmingham, 1922)

Electro-plating (Birmingham, [1930s])

E. H. Laister and R. R. Benham: *Rhodium Plating* (London, 1954)

W. G. L. Miller: 'Acceptance Requirements for Nickel–chromium Plating', *Nickel–chromium Plating, London, 1960*, pp. 77–98

O. I. Pavlova: *Electrodeposition of Metals: An Historical Survey* (Moscow, 1963; Eng. trans., Jerusalem, 1968)

S. Bury: *Victorian Electroplate* (London, 1971)

G. Dubpernell: *Electrodeposition of Chromium* (New York, 1977)

J. K. Dennis and T. E. Such: *Nickel and Chromium Plating* (London, 1986)

C. Raub: 'The History of Electroplating', *Metal Plating and Patination*, ed. S. La Niece and P. T. Craddock (Oxford, 1993)

S. La Niece and P. Craddock, eds: *Metal Plating and Patination: Cultural, Technical and Historical Developments* (Oxford, 1993)

Electrostatic printing. See under PHOTOGRAPHY, §I.

Embossing [Fr. *papier gaufré*; Ger. *Blinddruck, Blindpressung*]. Term used in printmaking and the decorative arts to describe an intentional relief produced by stamping or moulding. It is derived from 'boss' (Mid. Eng. boce, bose), meaning a convex protuberance. The following article discusses the process in the context of printmaking; for embossing in metalwork *see* METAL, §IV; GOLD, §2; and SILVER, §3.

The process is usually carried out on dampened paper, but materials such as lead or leather can also be embossed (*see* LEATHER, §2(ii)), and the vacuum-forming of sheet plastic gives comparable effects. Although colour can be used, embossed prints are often made without ink, a method known as blind embossing, which has affinities with Braille. Paper can be embossed by causing it, when damp and under pressure, to expand into incisions or broader areas cut out of plates of metal or blocks of wood, or it can be debossed by pressing it from above with a stamping device. The technique is still popular for wallpaper, and during the 19th century it was used in 'oleographs' (reproductions of paintings stamped with a texture to

imitate canvas). Die stamping, used for high-quality visiting cards or letterheads, involves compression between 'male' and 'female' plates, one plate being incised with the image in intaglio, the other bearing its counterpart in relief. Lever-operated, desktop machines that blind stamp notepaper with an address are based on this principle. Similar devices, known as chops, are used to emboss symbols indicating artists, printers or publishers on 20th-century prints.

The earliest inkless prints to survive in the West are the rare 15th-century 'seal prints', imitating bone or ivory reliefs. Embossing was first systematically used in the mid-18th century by Arthur Pond (1701–58) and Elisha Kirkall (c. 1682–1742). Working in Venice in the 1740s, the English artist John Baptist Jackson (c. 1701–c. 1780) made several unusual reproductive mural prints combining colour woodcut with passages of uninked embossing. These prints preceded by almost 20 years the full-colour Japanese *ukiyoe* woodcuts, often refined by blind embossing called 'gaufrage' (Fr. *gaufrer*: 'to goffer or emboss'), a technique that had been used on monochrome Japanese prints from c. 1730. Examples of these Japanese prints, imported into Europe from the mid-19th century, inspired French Art Nouveau artists, among them Alexandre Charpentier (1856–1909), Maurice Dumont (1870–1899) and Pierre Roche (1855–1922). To illustrate *La Loïe Fuller* (Evreux, 1904), Roche employed gypsography, a Victorian technique of 1837 based on the use of incised plaster as a mould for stereotyping.

Intaglio experimentation between World War I and World War II resulted in greater awareness of paper's sculptural potential. In 1925 Rolf Nesch (1893–1975) accidentally bit a hole in an etching plate and exploited it pictorially after realizing it would create a bubble in the paper. S. W. Hayter (1901–88), at his Parisian workshop, Atelier 17, also capitalized on the ability to model paper three-dimensionally by the use of deep-etched plates. Etienne Hajdu (1907–96), who worked with Hayter in the late 1950s, found a graphic equivalent for his polished marble sculptures by smoothing the rugosity of a heavy paper with loose zinc shapes placed on the bed of the press. Hajdu's 'estampilles' marked a revival of white-on-white and were used, for example, to adorn a book of Pierre Lecuire's poetry, *Règnes* (Paris, 1961). The Colombian Omar Rayo (b 1928), the Yugoslav Marjan Pogačnik (1920–2005), the German Günther Uecker (b 1930), the Japanese Kazumasa Nagai (b 1929) and the Americans Boris Margo (1902–95) and Romas Viesulas (1918–86) are among innumerable artists who exploited inkless embossing around the same time. The Swedish artist Birgit Skiöld (1923–82) won the *Aigle d'or* at the 1970 Festival Internationale du Livre in Nice with an interpretation of *Chimes* (Guildford, 1969) by Dante Gabriel Rossetti (1828–82). Both *Chimes* and her *Zen Gardens* (Guildford, 1973) utilized blind printing from cut lino, the latter framing photo-etchings within wide embossed borders suggesting raked Japanese gardens. In 1969, Josef Albers (1888–1976) and Jasper Johns (b 1930)

exploited embossing at Gemini GEL Workshop in Los Angeles; Johns tried it on paper and lead, while Albers, the former Bauhaus master, had precision drawings for his *Embossed Linear Constructions* translated into digital tape to direct an automatic engraving mill to cut the plates, making images not imposed on the surface of the sheet, but 'drawn out of its very substance'.

T. P. Herrick, ed.: *Embossing, Blocking and Die Stamping: A Practical Guide to these Processes* (London, n.d., rev. 2/c. 1908)

A Practical Guide to Embossing and Die Stamping, Maclean-Hunter Publishing Corp. (Chicago, 1908)

S. W. Hayter: *About Prints* (London, 1962)

T. R. Newman: *Innovative Printmaking: The Making of Two and Three-dimensional Prints and Multiples* (New York, 1977)

Paperwork (exh. cat. by P. Gilmour and A. Willsford; Canberra, National Gallery of Australia, 1982)

A. Stohlman: *The Art of Embossing Leather* (Fort Worth, n.d. [c. 1986])

E. Wolf: *From Gothic Windows to Peacocks: American Embossed Leather Bindings, 1825–1855* (Philadelphia, 1990)

G. Armgart: *Treibverzierte Bronzerundschilde der italischen Eisenzeit aus Italien und Griechenland* (Stuttgart, 1994)

J. Hall: *Embossed Images on Paper: A Display: The Victoria and Albert Museum*, 2 vols ([Kingston, Surrey], 1996)

M. Y. Treister: *Hammering Techniques in Greek and Roman Jewellery and Toreutics* (Leiden, 2001)

Embroidery. Method of decorating a ground material by stitching, cutting or withdrawing threads or by applying beads, pieces of fabric etc. Embroidery has been used throughout the world from the earliest times. From the beginning its form varied according to climatic and social conditions and the local availability of materials. These long-established differences persisted, though archaeological evidence shows that embroidered goods and the materials were widely traded as early as the 5th century BC. Techniques and styles were also spread by migration and conquest, though they were often modified by local practice, as in the two-way exchange between England and India in the late 17th century and early 18th.

The importance of embroidery has fluctuated with the availability of other decorated textiles, such as patterned silks, and with changing fashions in dress and furnishings. Embroidery has been used to decorate churches, temples, palaces and the robes of princes of church and state, yet it has also existed within poor and isolated communities. It has been made by both skilled professionals and amateurs and has always been done by men as well as women. When worked for the leaders of society and the international market, embroidery has reflected stylistic developments as accurately as other luxury goods. It has been a major means of expression for styles as varied as those of the Early Horizon in the Central Andes (c. 900 BC–c. 200 BC), Gothic Europe (c. 1000–1450) and the Mughal empire (c. 1550–1700). It is also a medium in which styles and techniques have been preserved over long periods, as on the dress and household furnishings that distinguish peasant

communities, tribal groups and minority populations in many parts of the world.

1. BEFORE 1850. The earliest surviving embroideries show an outstanding mastery of technique; the saddle-cloth and hanging discovered at Pazyryk (4th century BC; St Petersburg, Hermitage), for example, are decorated in brightly coloured felt appliqué with kings, horsemen, fighting animals and mythical beasts. A Chinese silk cloth embroidered with birds and foliage in chain stitch was found with them, and the existence of an established trade in embroidery is confirmed by a similar find of woollen embroidery decorated in couched work with a cavalcade of horsemen between borders of fighting griffins and dragons, probably from Bactria or southern Russia, together with Chinese chain stitch embroideries, in the tombs of Noin Ula in northern Mongolia, which date from the 1st century BC to the 1st century AD.

The oldest European embroideries include two from France: a gold-embroidered border of c. AD 590–600 from a tomb formerly believed to be that of Queen Arnegunde at Saint-Denis and a silk robe of c. 660–64, associated with Queen Bathilde, embroidered with motifs imitating jewellery, from the treasury at Chelles (Chelles, Musée Alfred-Bonno). From England there survive the chasuble of SS Harlindis and Relindis (c. 800; Maaseik, St Katharinakerk), worked with silk and gold and silver thread, and the stole and maniple of St Cuthbert (909–16; Durham Cathedral), which are densely embroidered with couched gold thread and coloured silks. Three mantles associated with the Holy Roman Emperor Henry II and his wife, Kunigunde (Bamberg, Domschatzkammer), of silk embroidered with gold thread and coloured silks, were worked in southern Germany, perhaps in Regensburg, as was possibly the chasuble that was

later converted into the coronation mantle of the Hungarian kings (1031; Budapest, Hungarian National Museum). The 12th-century coronation mantle of the Holy Roman emperors (Vienna, Schatzkammer; see colour pl. IV, fig. 1) is spectacularly decorated with two enormous lions attacking camels, worked in couched gold, enamels, beads and jewels on a red silk ground. The kufic inscription embroidered on it states that it was made in the royal workshops in Sicily in 1133–4. The chasuble formerly associated with Thomas Becket (Fermo Cathedral), which was embroidered in Almería in Islamic Spain in 1116, is also dated by its kufic inscription. In contrast to these rich embroideries are those made of wool and linen, notably the Bayeux Tapestry (Bayeux, Musée de la Tapisserie de la Reine Mathilde; see fig.), which was worked in England, possibly at Canterbury c. 1080, with brightly coloured wools on linen. The large hanging in Girona Cathedral, which shows *Christ* surrounded by scenes of the *Creation*, was produced at about the same time but in a very different style; the whole surface is covered with laid and couched coloured wools.

Fine linen entirely covered with underside-couched gold thread and silk embroidery in split stitch is a feature of Italian, French and English ecclesiastical embroidery from the late 12th century to the 14th. *Opus anglicanum* was greatly prized for the quality of its work and the delicacy of its coloured figurative subjects set against gold-embroidered silk or velvet grounds. Metal thread embroidery in a different style was made in Germany, for example the antependium of c. 1230 from Rupertsberg, which is decorated with majestic figures in silver and gold on a ruby-red silk ground. *Opus teutonicum* was made in German-speaking areas, notably Switzerland, Hessen, Lower Saxony and Lübeck: this was white linen embroidered with white linen thread and sometimes

Embroidered Bayeux Tapestry, detail of section depicting the *Battle of Hastings*, linen with wool, h. c. 500 mm, probably before 1082 (Bayeux, Musée de la Tapisserie de la Reine Mathilde); photo credit: Scala/Art Resource, NY

a little coloured silk or wool in a variety of stitches, including drawn-thread work. Early examples of whitework survive in many European countries.

During the 14th century plain velvet began to be used as a ground. At first the embroidery was worked through fine silk or linen laid on the surface of the velvet, but later, in a quicker but coarser technique, it was worked separately and applied. At the same time fine silk embroideries, skilfully shaded in the needle-painting technique, were made in the Italian city states, notably Florence and Venice, and also in central Europe. Produced initially in Bohemia but influencing a wide surrounding area, this embroidery had a distinctive style marked by the emotional power of its figurative subjects.

In the south Netherlands the needle-painting technique was combined, in the early 15th century, with a new way of shading laid gold threads with coloured silks to achieve a metallic, shot-silk effect known as *or nué*. The most famous example is probably the large mass set (*c.* 1425–75; Vienna, Schatzkammer), almost certainly worked in Brussels, which was commissioned by Philip the Good of Burgundy (*reg* 1419–67) and given by him to the Order of the Golden Fleece. The designs were based on the work of contemporary artists, as was also the practice in Italy, where the *or nué* technique was employed to work pictorial pieces in sharp perspective, as for example the scenes from the *Life of St John the Baptist* designed by Antonio Pollaiuolo (*c.* 1432–98) for a set of vestments (1466–79) for Florence Cathedral (Florence, Museo dell'Opera del Duomo). The use of raised or padded embroidery also developed at this date. It was sometimes confined to the moulded borders of pictorial pieces, as in many Spanish embroideries, but it was also used in three-dimensional figurative work, particularly in Bohemia and Austria.

The number of surviving secular embroideries increases from the mid-16th century. Many were made domestically or within insular communities, where they later formed the basis of peasant traditions, but the majority come from professional workshops established in the major centres to serve a discerning clientele. During the 16th, 17th and 18th centuries embroiderers provided vestments and items of secular dress, wall coverings for whole rooms, pictorial hangings, canopies, valances and bed curtains, a variety of covers, cushions, carpets and, by the late 17th century, upholstery, as well as a host of smaller items, in a wide variety of techniques. Thus, during the 16th century and early 17th, Renaissance ornament designs were embroidered in outline stitches on linen covers and items of dress; furnishings of silk and velvet were decorated in appliqué with Renaissance strapwork or swirling Baroque foliage; needle-painting techniques were used on large woollen hangings and on more delicate silk pieces; and canvas-based seat furniture and wall and screen panels were worked in cross and tent stitches. By the mid-18th century the old technique of inlaid appliqué had begun to change its form, and by the end of the century European printed cottons were widely used in a combination of appliqué and patchwork techniques.

Despite time-lags and regional variations, professional workshops followed the general stylistic progression from Renaissance to Baroque, from Rococo to Neo-classicism, and embroidery shared common design sources with woven silks, printed cottons, ceramics and other decorative arts. The controlled use of decoration in the Neo-classical period sharply reduced the amount of embroidery applied to furnishings and dress and also led to a simplification of techniques and patterns. Some elaborate room settings in the Etruscan and Egyptian styles (e.g. Lyon, Musée Historique des Tissus and Paris, Mobilier National) were produced in France in the early 19th century, worked largely in appliqué and chain stitch, but they were not typical of embroidery as a whole.

Professional workshops were mainly engaged in working vestments for the Catholic Church, ceremonial and military furnishings and dress (often almost entirely in metal threads) and, in contrast, exceptionally fine whitework. In the first half of the 19th century there was a steady decline in standards of design in a coarsening of techniques. Thus delicate whitework gave way to broderie anglaise, and needle-painting with silk threads gave way to canvaswork.

2. 1850 AND AFTER. In the mid-19th century avant-garde church architects in England, notably A. W. N. Pugin (1812–52) and G. E. Street (1824–81), strove to improve standards of embroidery. Many later architects were to follow their lead in seeing textile furnishings as an essential feature of secular and ecclesiastic interiors. Embroidery was the first textile craft with which William Morris (1834–96) became involved: during the late 1850s and the 1860s he experimented with woollen threads on wool and linen grounds to make hangings decorated with floral and pictorial subjects. Morris drew his inspiration from historical embroideries, but his designs were never simply derivative. This is also true of the followers of the Arts and Crafts Movement throughout Europe and the USA in the latter part of the century. Most were influenced by the simpler embroideries of the past; linen and wool were favoured over silk, though plain silk was used to considerable effect in some of the bold appliqué pieces by such designers as M. H. Baillie Scott (1865–1945). At the end of the century embroidery was used by several designers working in the Art Nouveau style, for which the fluidity of the technique was particularly suited. Progressive colleges of art and design throughout Europe emphasized the importance of design, while techniques, though worked to a high standard, were usually relatively simple. By contrast, the professional workshops were again using a full range of rich materials and techniques for both secular and ecclesiastical furnishings and dress. Elaborate effects were also created by embroidery machines, which had been used for the commercial production of white cotton and coloured silk embroidery from the mid-19th century.

The developments of the late 19th century continued into the 20th with an increasingly marked separation, in design and technique, between commercial work (both hand and machine) and that of artist-craftsmen and amateurs. Although within the schools, colleges and artistic communities there was an emphasis on the craft aspect of the technique, there was also an increasing tendency to follow the stylistic developments in fine and graphic art. From the late 1950s there was a resurgence of interest in embroidery, and although initially based on ecclesiastical work this spread to all branches of the craft. In the late 20th century methods had become increasingly experimental: hand- and machine-embroidery were frequently combined; photographic, paint and dye techniques are incorporated; and a variety of materials was used, from traditional textiles to wood and plastic. Embroidery has become a recognized form of gallery art.

L. de Farcy: *La Broderie du XIe siècle jusqu'à nos jours*, 4 vols (Paris, 1890–1919)

E. Chartraire: *Inventaire du trésor de l'église principale métropolitaine de Sens* (Paris, 1897)

H. B. Southwell: *A Descriptive Account of Some Fragments of Medieval Embroidery Found in Worcester Cathedral* (n.p., 1914)

M. Symonds and L. Preece: *Needlework through the Ages* (London, 1928)

A. Branting and A. Lindblom: *Medeltida vävnade oche broderier i Sverige*, 2 vols (Uppsala, 1928–9); Eng. trans. as *Medieval Textiles in Sweden* (Uppsala, 1932)

E. Iklé: *La Broderie mécanique, 1828–1930* (Paris, 1931)

Mrs A. H. Christie: *English Medieval Embroidery* (Oxford, 1938)

G. M. Crowfoot: 'The Tablet-woven Braids from the Vestments of St Cuthbert at Durham Cathedral', *Antiquaries Journal*, xix (1939), pp. 57–122

V. Trudel: *Schweizerische Leinenstickereien des Mittelalters und der Renaissance* (Berne, 1954)

A. Geijer: 'Engelske broderier av romansk typ', *Nordenfieldske kunstindustrimuseum Årbok* (1956), pp. 43–69

Y. Hackenbrock: *English and Other Needlework, Tapestries and Textiles in the Irwin Untermeyer Collection* (New York and London, 1960)

A. Nahlik: *Tkaniny welniane importowane i meijscowe Nowogrodu Wielkiego X–XV wieku* [Woollen fabrics, 10th–15th centuries: imported and local products found in Old Novgorod] (Warsaw, 1964)

M. Schuette and S. Müller-Christensen: *The Art of Embroidery* (London, 1964)

A. Nahlik: *Tkaniny wsi wschodnioeuropejskiej, X–XIII w* [Eastern European textiles, 10th–13th centuries] (Łódź, 1965)

R. Kroos: *Niedersächsische Bildstickereien des Mittelalters* (Berlin, 1970)

H. Bridgeman and E. Drury, eds: *Needlework: An Illustrated History* (New York and London, 1978)

J.-P. Laporte: *Le Trésor des saints de Chelles* (Chelles, 1988)

K. S. Robinson: 'The Textiles from Pazyryk: A Study in the Transfer and Transformation of Artistic Motifs', *Expedition*, xxxii (1990), pp. 49–61

P. Périn: 'Pour une révision de la datation de la tombe d'Arégonde, épouse de Clotaire Ier, découverte en 1959 dans la basilique de St-Denis', *Archéologie médiévale*, xxi (1991), pp. 21–50

K. Staniland: *Embroiderers*, Medieval Craftsmen (London, 1991)

S. M. Levey: *The Embroideries at Hardwick Hall: A Catalogue*, National Trust (London, 2007)

Embu. Effect of paint colours sinking into the canvas, which results in the image appearing dull.

Emulsion. Apparently homogeneous mixture made up of two distinct liquid substances that would not normally mix, one existing in the form of finely divided particles, suspended in and surrounded by a continuous phase of the other. Naturally occurring emulsions include egg and milk, both of which are composed of fats and water. Invariably, an emulsifying agent is also present, either occurring naturally or specifically introduced. This acts on the interface between the two substances, allowing them to co-exist without repelling each other. The small size of the dispersed particles and the characteristics of the film formed around their surfaces prevent their coming together when a stable emulsion is formed. In egg, for example, lecithin, present mostly in the yolk, acts as an emulsifying agent for the oils, fats and water that the yolk contains. The gelatinous colloids present in solutions of various natural gums and glues with water are also effective emulsifying agents, and any of these substances will emulsify drying oils into mixtures that can be thinned with water. Alkalis and compounds derived from them also act as emulsifying agents, soap being a simple example.

Emulsions do not form spontaneously: the ingredients must be stirred or shaken vigorously to break down the particle size and achieve an even distribution of one liquid throughout the other. The surrounding liquid (the external phase) will determine how the emulsion behaves. The practical value of an emulsion usually lies in its combination of the properties of each parent liquid in a single medium. In an emulsion of glue size and oil, for example, the size contributes fast drying and ease of use, with water used as thinner, while the oil imparts a degree of water-resistance and flexibility to the film formed as the emulsion dries out. The term 'emulsion' may also be used to describe the dried film, and the term 'emulsifying agent' is sometimes loosely applied to any substance performing a stabilizing function.

Egg tempera painting employs a natural emulsion (*see* TEMPERA) and may be distinguished from other emulsions manufactured specifically for painting. Evidence of the use of these before the 19th century is scarce. Modern scientific analysis of paint media, however, has supported the traditionally held view that tempera and oil paint were sometimes used together in the same work, particularly during a transitional period in the 15th century but quite possibly extending from before that date until perhaps as late as the mid-17th century. Egg and oil are occasionally detected in the same sample dating from this time, but more often they are found separately, and at best it can be tentatively supposed that slight modifications of egg tempera with oil were not unusual.

Whether this was an established practice or merely an experimental response to the increasing dominance of oil painting is difficult to determine. In the 19th century Charles Lock Eastlake (1793–1865) also quoted two recipes for the preparation of wax and size emulsions involving the use of alkali; he suggested that these recipes were invented in the Middle Ages, though the documents in which they originally appear are not that old. In any event, they illustrate the use of relatively sophisticated emulsions at an early date, and it seems almost inconceivable that the painters of the time should not also have been acquainted with the possibilities of other, more easily formed emulsions involving drying oil and the tempera media of egg, glue and gum.

Despite evidence of their use in the late medieval period, subsequent records of emulsions in painting did not occur until the mid-16th century, when Giorgio Vasari (1511–74) referred to a canvas priming made of flour paste, oil and white lead. Similar recipes were given in the 17th century by Francisco Pacheco (1564–1644) and at the beginning of the 18th century by Antonio Palomino (1655–1726). A starch paste is convenient for filling the pores of a loosely woven canvas, but it is evident from Vasari's descriptions that the flexibility introduced by the addition of oil was also important. The use of emulsion grounds (see GROUND) was not confined to Italy and Spain: they occur also beneath paintings by Rembrandt van Rijn (1606–69) and Johannes Vermeer (1632–75), though the composition varies. An animal glue and resin binder was used in the ground of Rembrandt's *Feast of Belshazzar* (c. 1635; London, National Gallery); that of Vermeer's *Guitar Player* (c. 1672; London, Kenwood House) is bound with a glue size and oil emulsion.

In the 19th century the rediscovery of tempera painting led to many fanciful experiments with emulsion paints (see PAINT, §I) by such artists as Arnold Böcklin (1827–1901); this trend, also promoted through the technical writings of Max Doerner (1870–1939), influenced artists well into the 20th century. Emulsion paints were also employed as household and industrial paints, and the technology of their commercial manufacture may well have influenced the artists' colour trade of the time. Egg and oil emulsion tempera paints were probably available in tubes from the late 19th century.

In the late 20th century emulsions were represented by acrylic paints (see ACRYLIC PAINTING, §1) and the acrylic and PVA media that are used as glues in various arts and crafts. Aqueous emulsion acrylics were first introduced in the 1950s and became available as artists' materials soon afterwards. The Pop artists of the early 1960s, including David Hockney (*b* 1937) and Andy Warhol (1928–87), were among the first to adopt them. Although technically emulsions, acrylic paints are unrelated to the other types of emulsions discussed and represent more advanced technology. The light-sensitive coatings used in photography are also known as emulsions and are based on particles of silver bromide

or other photosensitive chemicals dispersed within a matrix of pure gelatin. The 'compo' used in decorative arts from the 18th century can also be identified as an emulsion. The usual formula combined animal glue, boiled oil and resin, which was then packed with powdered chalk to make a dough-like substance that could be pressed into moulds.

G. Vasari: *Vite* (1550, rev. 2/1568); ed. G. Milanesi (1878–85), intro. trans. by L. S. Maclehose as *Vasari on Technique* (London, 1907, rev. New York, 1960)

C. L. Eastlake: *Methods and Materials of the Great Schools and Masters*, 2 vols (London, 1847/R New York, 1960)

M. Doerner: *Malmaterial und seine Verwendung im Bilde* (Stuttgart, 1933); Eng. trans. by E. Neuhaus as *The Materials of the Artist* (London, 1934/R 1979)

R. J. Gettens and G. L. Stout: *Painting Materials: A Short Encyclopaedia* (New York, 1965)

National Gallery Technical Bulletin (1977–)

Z. Veliz, ed. and trans.: *Artists' Techniques in Golden Age Spain* (Cambridge, 1986)

J. Stephenson: *The Materials and Techniques of Painting* (London, 1989)

R. Mayer: *The Artist's Handbook of Materials and Techniques* (New York, 5/1991)

Enamel. Vitreous or glass paste used in a variety of ways to decorate a metal or, more rarely, ceramic surface. The word 'enamel' is of obscure origin. It probably derives from *smelzan* (Old High Ger.: 'to smelt') and *esmail* (Old Fr.). The Greek philosopher Philostratos Lemnios wrote that 'barbarians…pour these colours into bronze moulds, so that the colours become hard as stone' (*Imagines* I. xxviii); the 'colour' probably refers to molten glass. This may have been a description of a process which was not enamelling but its precursor. The art of enamelling was a logical progression in the artistic alliance between the goldsmith and the glassworker. During the 15th century BC in Egypt coloured, cut-glass pieces were decoratively embedded into gold *cloisons* (cells); the inclusion of molten glass may have been a later refinement of the Greeks and the Celts.

1. Materials. 2. Techniques. 3. Conservation.

1. MATERIALS. The enamelling process is the fusing of a vitreous substance on to a prepared metal surface, either in a kiln (furnace) or with the application of intense local heat (e.g. with a blowtorch), at temperatures ranging from 300°C for the softest (opaque) enamels to 850°C for the hardest (transparent) enamels. The vitreous compound is itself called enamel, but it is the bipartite, heat-bonded combination of often noble metal with it that is referred to as enamel.

The vitreous substance is composed of sand or flint, soda or potash and sometimes red lead. These ingredients are heated together (fritted) for 15 hours to form an almost colourless transparent flux. Metallic oxides are added to the mixture to produce the colours. The first known true enamel, found in small quantities

on Greek gold jewellery (4th century BC), was blue, made by the addition of cobalt oxide. Copper oxide gives turquoise and some greens; gold oxide gives red and oxides of antimony or uranium give yellow. Different quantities of ingredients produce enamels that are 'soft' or 'hard': soft enamel, containing a higher proportion of red lead, fuses at a lower temperature but can be scratched easily. Transparent and translucent enamels fuse at the highest temperature and are the most durable; all enamels, however, are damaged by shock, scratching and flexing. Variations in the combination of ingredients or of additives result in the four accepted categories of enamel: opaque, opalescent, translucent and painted transparent, terms that indicate their fired visual and physical state.

The metal base to which enamel is fused was historically noble (i.e. gold or silver). Platinum is rarely used, except in a 5% alloy in platinum-silver. In its pure state, even keyed, platinum shows poor adherence to enamel. This is due to its extremely high melting point (1630°C) and rapid rates of expansion and contraction. Copper was increasingly used as a base from the 1740s. It became particularly fashionable in England at the Battersea Enamel Factory, London (est. 1753), which produced wares including enamelled snuffboxes and wine-labels. Such alloys as bronze have also been extensively used.

Before the addition of enamel, the metal surface is prepared to remove oxides or grease: it is annealed (heated to red hot) and then immersed in an acid bath (pickled). The acid, which is usually diluted, may be nitric (undiluted), for copper, or sulphuric, for gold or silver. The metal is then alkalized and the powdered enamel applied as soon as possible to arrest renewed oxidation. Pure gold does not oxidize, hence its popularity as a metal base. As some colours react chemically with certain metals during firing, the metal is often first coated with a flux.

The enamel is ground to a fine powder from the frit by pulverization, washed under water and then dried. It is then mixed to a paste with water or, for painted enamel, a volatile oil such as spike (lavender oil) and applied to the prepared metal surface, which may also have been worked (etched, engraved, modelled, formed and soldered) and finally fired. Enamel fuses at a lower temperature than the metals to which it is applied, although *grand feu* colours (those that have a melting point of *c.* 850°C) approach the melting point of silver. Due to the different expansion co-efficients of glass and metal (metal contracts at a faster rate than the enamel), fired objects are subject to enormous stresses on cooling. To counteract the buckling and cracking, the metal 'back' is counter-enamelled with a layer of flux of equal thickness to the surface enamel, which minimizes the problem.

2. TECHNIQUES.

(i) Cloisonné [Fr.: 'cell-work']. A metal surface, usually of finely beaten gold, is decorated by soldering, edge-on, metal fillets of flattened wire. These delicate cells (*cloisons*) are filled with coloured and powdered enamel, fired and then ground flat with carborundum,

exposing the gold pattern beneath. *Cloisons* mimic jewels, create rigidity and also break the surface of the item; it is very difficult to enamel a large surface (*en plein*) evenly. Byzantine enamels, developed from Greek antecedents, were generally cloisonné. From the 9th to the 12th century AD precious cloisonné enamelling, as seen in the Pala d'Oro (AD 976; present setting 1342–5; Venice, S Marco), was extensively used. In the later Middle Ages, the technique was also referred to as *émail de plique*. Historically, both opaque and translucent enamels have been used for cloisonné. In China the technique was introduced during the Yuan period (1279–1368) by Islamic artisans; in India the technique was well established by the 16th century, although no extant objects predate *c.* 1600; early Islamic cloisonné enamelling was possibly inspired by Byzantine enamelling and was used from the 10th to the 15th century and again in the 18th and 19th centuries. In Russia the earliest enamels date from the 11th to the 12th century and were influenced by Byzantine enamels. From the 16th century fine, twisted gold or silver wire filigree *cloisons* were used to produce an effect resembling complex indigenous embroidery.

(ii) Champlevé [Fr.: 'raised field']. This is a potentially economical alternative to cloisonné enamelling and is therefore often used on larger objects. Into a thicker metal base—which can be gold but is more often bronze—troughs are gouged, or in modern champlevé, of which Surrey enamel (*see* §(viii) below) is a precursor, cast. The depressions are then filled with powdered enamel, which is fired, and the surface ground flat. In champlevé the metal areas are left plain, engraved, gilded or decorated in other ways, including cloisonné enamel. In Gothic and Chinese champlevé enamelling, the surface metal is generally mercury or fire gilded. Romano-Celtic artists also filled some cells with designs of tiny patterns known as *millefiori* (It.: 'thousand flowers'). The Alfred Jewel (9th century; Oxford, Ashmolean Museum), aesthetically in the 'Celtic' style associated with champlevé, is actually cloisonné. Spectacular Romanesque champlevé, enamelling from Limoges (see colour pl. XIII, fig. 1), southern France, Christian Spain and the Meuse and Rhine valleys, often using gilded copper or bronze, survives from the 12th and 13th centuries. During the Middle Ages large chasses (chests) and reliquaries made in the Limousin were in demand throughout Europe.

(iii) Basse taille [Fr.: 'shallow cut'; It. *lavoro di basso rilievo*]. Chased or engraved metal (often silver or silver gilt) with bas-relief compositions or patterns is entirely covered with translucent enamel. A rich tonal quality is created by the varying degrees of engraving and depth of enamel. Chasing the object also provides key (grip) for the enamel and facilitates application to larger areas. The earliest surviving example of *basse taille* is the chalice of Pope Nicholas IV (1288–92; Assisi, Tesoro del Museo della Basilica di S Francesco) made by the Italian goldsmith Guccio di Mannaia (*fl* 1288–1318). One of the most spectacular examples

is the Royal Gold Cup of the Kings of France and England (*c.* 1380–90; London, British Museum). The Russian goldsmith Carl Fabergé (1846–20) developed a method of 'water-marking' precious metals by engraving them with repetitive wavelike patterns, known as guilloche, on a rose-engine lathe. Translucent enamels were then applied over the decorated surface.

(iv) En ronde bosse [Fr.: 'in rounded relief'; encrusted enamel]. In France at the end of the 14th century it became possible to decorate three-dimensional objects or very high-relief surfaces with an enamel covering. The objects were often small but precious, as in such Gothic emblems as the Dunstable Swan Jewel (*c.* 1400; London, British Museum), or the exquisite Goldenes Rössel (1403–4; Altötting, SS Philipp und Jacob, Schatzkammer), the most lavish of all *en ronde bosse* enamels. Technical difficulties necessitated keying (roughing) the metal in order to support the enamel covering. There were also problems achieving naturalistic flesh tones, as seen in the figure of the *Virgin* in the house-altar of Albert V, Duke of Bavaria (1573–4; Munich, Residenz), in which the gold and polychrome work contrasts with the glaring, milky-pink skin tones.

(v) Plique à jour [Fr.: 'against the light']. In the late 14th century, under the patronage of the courts of France and Burgundy, this technique developed to fully display the 'stained glass' potential of translucent enamel. In a technique related to cloisonné, a network of metal wires or strips is created and set against a metal backing. These cloisons are then filled with translucent enamel and fired; when the backing melts, the enamel is left suspended in the *cloisons*. The Mérode Cup (*c.* 1430; London, Victoria and Albert Museum), made in Burgundy or France, incorporates a band imitating stained-glass windows and is the only extant medieval example of this technique. The Chinese made exceptional *plique à jour* vases. René Lalique (1860–1945) incorporated the technique in his jewellery, and at the end of the 19th century the firm of J. Tostrup in Oslo also created magnificent *plique à jour* tableware. In the case of small *cloisons*, surface tension holds the enamel in place as it is fired, so backing is not required.

(vi) En résille sur verre [Fr.: 'in grooves on glass']. This is a rare form of enamelling that is closely related to the cloisonné technique. A design is cut into a glass ground which is coloured blue or green; the grooves are then lined with gold foil and filled with powdered enamel of extremely low fusibility. The process was introduced by French goldsmiths in the late 16th century and early 17th, on such highly ornamental, valuable objects as pendants and mirror backs. The German engraver Valentin Sezenius is also attributed with works in this technique dating from 1619 to 1625. Roman glassworkers of the 1st century AD may have attempted a similar technique, possibly by pressing molten glass into the *cloisons*.

(vii) Painted. The object, usually made of copper, is covered in a layer of white, opaque enamel and then fired; it is then gradually decorated with coloured enamels, which require different firings. The earliest surviving examples are Netherlandish (*c.* 1425). By the early 16th century Limoges had become the centre for painted enamels on copper, and the Pénicaud family from this town are particularly associated with its development. Nardon (Léonard) Pénicaud (1470–1542/3) used polychrome enamels on a clear, fluxed ground, outlined with dark enamels. The wet enamel is also often scratched with a needle to create delineation or uses *paillons* (small pieces of gold foil) for details. Limoges enamels from *c.* 1535 to *c.* 1575 were principally decorated with grisaille (grey-toned) enamels, which gave a relief effect created by repeated firings of white, translucent enamels over a dark ground (see colour pl. IV, fig. 2). Coloured enamels were found to be suitable for painting small portraits, jewelled boxes and plaques, and their popularity spread throughout Europe; the Swiss miniature painter Jean Petitot (1607–91), for example, introduced the technique into England. Painted enamels were introduced into China at the court of the Kangxi emperor (*reg* 1662–1722) by Jesuits. Enamel painting eventually led to transfer-printed enamelling in England, first at the York House in Battersea (1753–6) and then at Bilston, in Wednesbury and in Birmingham in the late 18th century.

(viii) Surrey [Stuart]. A short-lived, rarely described class of enamelling using cast-brass objects of sometimes substantial size as ground for the enamel. The surfaces of the objects were cast in low-relief and generally filled with a bichrome palette of enamel, especially black-and-white or blue-and-white (e.g. Warwick Candle, 1650–60; London, British Museum). Surrey enamels were made in England in the second half of the 17th century, probably near the brass mill (est. 1649) at Esher, Surrey. Two Germans, Daniel Diametrius and his partner Joseph Momma, may have influenced the production of such items as firedogs and candlesticks.

L. F. Day: *Enamelling* (London, 1907)

L. E. Millenet: *Enamelling on Metal* (Kingston Hill, 1927/*R* 1951)

K. F. Bates: *Enameling: Principles and Practice* (New York, 1951)

P. Michaels: 'Technical Observations on Early Painted Enamels of Limoges: Their Materials, Structure, Technique and Deterioration', *Journal of the Walters Art Gallery*, xxvii–xxviii (1964–5), pp. 21–43

B. Newble: *Practical Enameling and Jewelry Work* (London, 1967)

J. Cherry: 'The Dunstable Swan Jewel', *Journal of the British Archaeological Association*, xxxii (1969), pp. 38–53

A Thousand Years of Enamel (exh. cat. by K. Snowman; London, Wartski, 1971)

S. Benjamin: *Enamels* (New York, 1983)

M. Campbell: *An Introduction to Medieval Enamels* (London, 1983)

H. Tait, ed.: *The Art of the Jeweller* (London, 1984)

Contemporary British Enamels (exh. cat., Gateshead, Shipley Art Gallery, 1985)

S. Gaynor: 'French Enameled Glass of the Renaissance', *Journal of Glass Studies*, xxxiii (1991), pp. 42–81

J. Zapata: 'American Plique-à-jour Enameling', *The Magazine Antiques*, cl (Dec 1996), pp. 812–21

E. Speel: *Dictionary of Enamelling* (Aldershot, 1998)

E. Taburet-Delahaye, ed.: *Paris 1400: Les arts sous Charles VI* (Paris, 2004)

L. Bachrach: *Contemporary Enameling: Art and Techniques* (Atglen, 2/2006)

M. Beyssi-Cassan: *Le métier d'émailleur à Limoges, XVIe–XVIIe siècle* (Limoges, 2006)

3. CONSERVATION. The conservation of enamel requires caution, as both the vitreous material and the metal support must be taken into account when carrying out a treatment. In some cases, the object can be cleaned simply by dusting with a soft brush. If this is not adequate, and the enamel is in very good condition, it can be cleaned with a mild, aqueous detergent in de-ionized water, but metal areas should be avoided, and the object should be allowed to air dry immediately after cleaning to avoid corrosion to the underlying metal. Enamels may also be cleaned with a 50:50 mixture of ethanol and acetone, applied with a swab or soft brush. Dirt and grime in cloisonné enamel can be mechanically removed using a soft, pointed wooden stick, followed by the ethanol and acetone mixture, which will also serve to degrease the metal.

If the enamel has deteriorated, due to burial conditions or inherent chemical instability, it can be consolidated with synthetic resins, for example the acrylic resin Paraloid or Acryloid B-72 (manufactured by Rohm and Haas). However, when the deterioration is due to chemical instability, consolidation may provide initial visual improvement, but the deterioration will probably continue. If possible, the cause of the deterioration should be determined, and the object stored in a stable environment.

In contrast to the repair of glass, the adhesives used for enamels do not usually require great structural strength, nor is the refractive index of as much importance. As the repair usually includes returning the enamel to place on a metal substrate, acrylic resin adhesive is used in preference to epoxies, which are corrosive to metal and should be avoided unless structural strength is required. If epoxies are used, an isolating layer of an acrylic resin over the metal will prevent corrosion. The repair of metal parts may consist of straightening cloisonné bands or adhering metal pieces, again using an acrylic resin adhesive. Heat or soldering is not used, as the application of heat can cause further damage to the enamel.

For opaque enamels, restoration of missing parts may be carried out using one of the commercially available vinyl-based fill materials, after first applying an isolating layer of acrylic resin over the metal substrate. The fill can then be inpainted with acrylic or natural resin colours. For translucent enamels, acrylic resins toned with dry pigment may be used, but if the missing area has greater depth, a toned epoxy or polyester is more suitable, once the metal has been isolated with an acrylic resin. Epoxies and polyester resins can be toned with dyes, but these tend to alter in colour over time. Hard waxes have also been used for enamel fills: a hard synthetic wax should be used instead of a natural wax, which may have organic acids that cause corrosion to metal.

L. Bacon and B. Knight, eds: *From Pinheads to Hanging Bowls: The Identification, Deterioration and Conservation of Applied Enamel and Glass Decoration on Archaeological Artifacts* (London, 1987)

R. Newton and S. Davison: *Conservation of Glass* (London, 1989)

T. Drayman-Weisser: 'The Early Painted Enamels of Limoges in the Walters Art Museum: Historical Context and Observations on Past Treatments', *Journal of the American Institute for Conservation*, xlii/2 (Summer 2003), pp. 279–312

Encaustic painting. Method of painting with molten wax first used by ancient Greek and Roman artists. The word derives from the Greek *enkaustikos*, 'to burn in'. The term encaustic is also used occasionally to designate certain types of ceramics, but these are unrelated to encaustic painting.

1. Materials and techniques. 2. History. 3. Conservation.

1. MATERIALS AND TECHNIQUES. The basic method calls for dry pigments to be mixed with molten wax on a warm palette and then applied to any ground or surface, including wood, plaster or canvas. It is traditional to pass a heat source close to the surface of a finished painting to 'burn in' the colours by fusing and bonding them to the support. Once hardened, encaustic paint is as durable as any other paint surface. No additional varnish is necessary, but the surface can be polished to a dull sheen with a soft cloth.

Wax is resistant to moisture and does not yellow, properties that make it an ideal medium for painting. It has a pleasing translucency and a matt finish favoured by some artists, and it is both economical and clean. White, refined beeswax is the type most commonly employed in encaustic painting, and this can be supplemented with small portions of carnauba wax, which acts as a hardener, or microcrystalline wax, a plasticiser. A small amount of damar resin may also be added to the beeswax to improve its consistency and hardness. All pigments suitable for oil painting can be used successfully with wax. The proportion of pigment to wax varies, but in general less is needed to colour a wax than an oil medium. Batches of coloured wax may be mixed in advance and kept in small containers, which can easily be reheated on the warm palette. Molten colours are applied either with brushes or with palette knives.

Modern encaustic painting has been greatly facilitated by electrically heated equipment. Although wax has a fairly low melting-point (beeswax melts at approximately 60–65°C while carnauba wax requires a higher temperature of 83–86°C), the ideal temperature for keeping wax colours fluid is around 200°C.

For this purpose electrically heated aluminium palettes are available commercially. These are generally quite small and ill-suited to making large batches of colour for sizeable paintings. Larger palettes can be improvised by placing sheets of iron or stainless steel over an electric stove or hot plate. The final burning-in is the most challenging part of the encaustic painting process. It can be accomplished by laying the painting flat on a table and passing a reflector light bulb or an infra-red heat bulb above it slowly and evenly, which is very time-consuming, by using an ordinary clothes iron or by adapting a hot plate or other heating element. Most artists use an electrically powered heat gun. Whatever is chosen, it is important to guard against bringing the heating element too close to the finished surface.

This is the classic method of encaustic painting as it uses melted wax colours and heat in the final burning-in process, but the wax can also be dissolved, saponified or emulsified and then used in combination with oil, casein or tempera paints. It is soluble in turpentine, mineral spirits or carbon tetrachloride and can be saponified and made water-soluble through the addition of alkali. One recipe for a wax–oil emulsion recommends melting equal parts of white beeswax in castor oil and thinning the resulting mixture with five parts of turpentine. A cold wax medium (Dorland's Wax Medium) made of waxes, resins and oils, which has the consistency of lard, is available commercially in the USA. This may be mixed directly with tube oil paints or with dry pigments, then fused with a final application of heat in imitation of classic encaustic, though heat is not essential. There is much disagreement as to whether other painting methods involving wax can properly be classified as encaustic (see WAX, §II, 2).

2. HISTORY.

(i) Pre-Renaisssance. The earliest references to encaustic painting are found in the works of Roman authors, including Pliny the elder (AD 23/4–79), Vitruvius (1st century BC) and Plutarch (c. AD 50–after 120). The most extensive references are in book XXV of Pliny's Natural History. Pliny states that 'We do not know who first invented the art of painting with wax colours and burning in the painting'. He mentions several Greek artists active in the 4th century BC—including Aristeides, Praxiteles and Polygnotos—who can be credited with the earliest use of the medium and says that Pausias was the first well-known master in this style, having learnt the process from Pamphilos, the master of Apelles. Pausias painted small pictures on wood, which he was able to execute very rapidly, probably owing to the speed with which the wax hardened as it cooled. In another section of book XXV, Pliny indicated that there were three different methods of encaustic painting: 'one with wax, the other further on ivory—by means of a cestrum or a sharp point', and the third, introduced when it became fashionable to paint ships of war, 'of

melting the wax by fire and using a brush'. This third method attests to the medium's impermeability and permanence.

Vitruvius offered another variation on the encaustic methods described by Pliny, in his description of a process for protecting paintings on plaster with a coat of wax varnish. He recommended the application with a strong brush of 'Punic wax melted in the fire and mixed with a little oil. Then putting charcoal in an iron vessel, and heating the wall with it, let the wax first be brought to melt, and let it be smoothed over with waxed cord and clean linen cloths, the same way as naked marble statues.' The actual composition of Punic wax has given scholars much cause for debate. Pliny described its preparation as follows: yellow beeswax was exposed to the air for some time, then cooked with repeated boilings and additions of sea water and potassium carbonate. The foamy mass was then poured into cold water and afterwards exposed in a basket to the bleaching action of sunlight. However, the actual proportions are not indicated, and it is unclear from this reference whether Punic wax was merely a form of purified beeswax or whether the addition of potassium carbonate actually caused it to become saponified.

The tools of the encaustic painter included the stylus or cestrum (a long-handled instrument with a spoon-like end), the cauterium (a pan of coals used for the final burning-in process), a spatula and cakes or tablets of coloured waxes. The tomb of a 3rd-century AD woman painter excavated at Saint Médard-des-Prés, France, contained materials for encaustic painting, of which two bronze cestri were of special interest. Another, slightly later, tomb, excavated at Herne-Saint-Hubert, Belgium, contained coloured waxes in which oil had also been used as a binder.

The earliest surviving examples of encaustic painting are portraits from the 2nd century AD on small wooden panels that were attached to mummy cases or the wrappings of the deceased (see WAX, colour pl. XVI, fig. 2). They are believed to have been executed by Greek artists residing in Egypt. From the beginning of the 19th century over 600 have been excavated in the Faiyum district. Most are painted directly on ungessoed wooden panels, and the well-preserved paint surfaces exhibit a remarkable degree of naturalistic detail. Greek artists in North Africa continued to practise encaustic painting during Late Antiquity, receiving patronage from the Christian court at Constantinople in particular. In the Byzantine Empire encaustic was used for icons in the 6th and 7th centuries, after which it was largely replaced by egg tempera. Wax was also used throughout the early Middle Ages as a wall varnish in fresco painting and to treat marble sculpture;

For the most part, however, the practice of encaustic painting was superseded in the West by the use of tempera, fresco and ultimately oil painting. Encaustic may have enjoyed a minor revival during the Renaissance period, when Lucas Cranach I (1472–1553) and Andrea Mantegna (1430/31–1506) reputedly experimented with the medium. Scholars

have speculated that the *Battle of Anghiari* by Leonardo da Vinci (1452–1519) may also have been a failed experiment with encaustic, ruined in the final burning-in process.

(ii) Post-Renaissance revival. Encaustic painting did not enjoy its first full-scale revival until the mid-18th century, when the French antiquarian the Comte de Caylus (1692–1765) took issue with earlier translators of Pliny and set out to demonstrate the art of encaustic painting. Encouraged by the discoveries made at Herculaneum in 1738 and Pompeii in 1748 of beautifully preserved fragments of wall paintings, Caylus hired a chemist named Majault and engaged the artist Joseph-Marie Vien (1716–1809) to experiment with the wax medium. Vien successfully painted a small *Head of Minerva* (St Petersburg, Hermitage Museum) on panel in the encaustic medium, which Caylus proudly exhibited at the Académie Royale des Inscriptions in 1754. However, since he did not immediately reveal the details of his encaustic process, a number of experiments were made by other enthusiasts. One of these, in an anonymous treatise entitled *L'Histoire et le secret de la peinture en cire*, challenged Caylus's claim to have rediscovered the encaustic process. The author of this treatise (recognized by his contemporaries as none other than Denis Diderot (1713–84)) condemned Caylus for his secrecy and championed instead the experiments of the artist Jean-Jacques Bachelier (1724–1806). The ensuing controversy between supporters of Caylus and of Diderot is demonstrated by the large number of articles, letters and pamphlets published on this matter between 1755 and 1757.

Vien exhibited six paintings in encaustic at the Salon of 1755. Other artists also showed wax paintings, including Alexander Roslin (1718–93), who exhibited a self-portrait in Caylus's process, and another of Caylus's protégés, Louis-Joseph Le Lorrain (1715–59), who exhibited two encaustics. Jean-Jacques Bachelier exhibited four paintings using his own, rival method of painting with wax. The revival of encaustic painting in France was connected with the new interest throughout Europe in the art of antiquity. In Sweden Carl Gustaf Pilo (1711–93) tried Bachelier's technique, and in England the process was communicated to the Royal Society and employed by the illustrator and naturalist George Edwards (1694–1773), and by Johann Heinrich Müntz (1727–98), who conducted his experiments with wax under the supervision of Horace Walpole (1717–97) at Strawberry Hill. Müntz later published an English translation and interpretation of Caylus's treatise. Inspired by the general interest in encaustic painting, George Stubbs (1724–1806) and Joshua Reynolds (1723–92) both experimented with wax media; and Stubbs also worked with Josiah Wedgwood (1730–95) to develop a technique for painting with matt enamel on flat ceramic plaques. Wedgwood, who took out a patent in 1769 for 'encaustic' vase painting (a process used to imitate Greek red-figure vases), was well aware of the French experiments

and eager to rival them. Vincenzo Valdré (1742–1814) and John Francis Rigaud (1742–1810) used encaustic for large, classicizing mural decorations at Stowe, Bucks, and Packington Hall, Warwicks, respectively.

In Germany, Benjamin Calau (1724–85) and Joseph Fratrel (1730–83) introduced wax painting to other German artists, including Christian Bernhard Rode (*d* 1755) and Johann Christoph Frisch (1738–1815). Their technique called for a pre-emulsified liquid wax substance and did not require a final burning-in. Jacob Wilhelm Christian Roux (1775–1831) and Franz Xavier Fernbach (1793–1851) also experimented with encaustic painting. In Munich, it attracted the attention of Ludwig I, King of Bavaria (*reg* 1825–48), who commissioned Julius Schnorr von Carolsfeld (1794–1872) to paint several scenes in encaustic in the Residenz in 1831. Other Munich artists also employed the encaustic media described by Fernbach in his manual *Die enkaustische Malerei* of 1845.

In Italy, in 1784, Vincenzo Requeno (1743–1811) published a treatise on encaustic painting that attracted a flurry of controversy not unlike that which had greeted Caylus's work in France three decades earlier. Requeno later expanded his work into two volumes, published in 1787. Italian artists also experimented with wax media, including Vincenzo Martinelli (1737–1807), Giovanni David (1743–90) and Andrea Appiani (1754–1817). In Rome, Christoph Unterberger (1732–98) supervised the production of a small cabinet painted in encaustic with designs borrowed from Raphael and supplemented with antique motifs, for Catherine the Great (*reg* 1762–96). The Italian artists Giuseppe Cades (1750–99), Felice Giani (1758–1823), Luigi Campovecchio (1754–1804) and Giovanni Battista dell'Era (1765–98) assisted him. Destined for Catherine's summer palace Tsarskoye Selo in St Petersburg, the cabinet was destroyed during World War II.

The Italian experiments with encaustic attracted considerable notice. Jacques Nicolas Paillot de Montabert (1771–1849) travelled to Italy, met Campovecchio and dell'Era and compiled an eight-volume treatise on painting techniques published in 1829, one volume of which was dedicated to encaustic. Paillot de Montabert was closely affiliated with a group of Jacques-Louis David's students known as Les Primitifs for their radical interest in primitive painting styles, to which the encaustic medium was well suited.

By the mid-19th century encaustic techniques derived from Paillot de Montabert's formulae were in common use, especially for mural decorations. In France, such artists as Pierre Puvis de Chavannes (1824–98), Eugène Delacroix (1798–1863) and Hippolyte Flandrin (1809–64) experimented with wax medium techniques. The Swiss artist Arnold Böcklin (1827–1901) also worked with wax. The inclusion of a chapter on encaustic in Charles Blanc's popular *Grammaire des arts du dessin* and the publication in 1884 of César-Isidore-Henri Cros and Charles

Henry's *L'Encaustique et les autres procédés de peinture chez les Anciens* demonstrate the wide acceptance that the medium enjoyed. In England, W. B. Sarsfield Taylor documented the process in *A Manual of Fresco and Encaustic Painting*, and Charles Eastlake included a chapter on encaustic and fresco in his influential history of oil painting.

Several 20th-century painters have used encaustic painting, including Georges Rouault (1871–1958) and Diego Rivera (1886–1957). It enjoyed a modest popularity in the 1940s in the USA, largely due to the efforts of Karl Zerbe (1903–72), the head of the Painting Department at the Boston Museum School, but this cannot compare with the prominence encaustic received through the work of Jasper Johns (*b* 1930). Johns is one of the most devoted practitioners in this medium, and his bold use of the technique, recorded in the film *Painters Painting* (1972), has been a source of inspiration to younger artists. Wax and encaustic media are found in the work of contemporary artists as diverse as Julian Schnabel (*b* 1951) and Mimmo Paladino (*b* 1948).

3. CONSERVATION. Judging by the state of preservation of many of the Faiyum mummy portraits, classic encaustic paintings are extremely durable. Surface cleaning with swabs moistened in distilled water is generally sufficient, but for more tenacious dirt, a solution of beeswax and carbon tetrachloride is recommended. One of the challenges in the proper identification and treatment of wax or encaustic paintings is the large number of different waxes used and the many materials they can be mixed with, such as resins and oils. Wax may be identified by its physical properties (i.e. its melting point, specific gravity and refractive index), but there is often not enough wax in the medium to allow for ready identification through physical examination alone. Infra-red photography and gas chromatography have been used successfully to identify wax media. A knowledge of the history of the medium and of the variety of different recipes for encaustic painting is also of assistance in proper identification.

A.-C.-P., Comte de Caylus: *Mémoire sur la peinture à l'encaustique et sur la peinture à la cire* (Geneva, 1755)

[D. Diderot]: *L'Histoire et le secret de la peinture en cire contre le sentiment du Comte de Caylus* (n.p., [1755])

J. Müntz: *Encaustic or Count Caylus's Method of Painting in the Manner of the Ancients* (London, 1760)

V. Requeno: *Saggi sul ristabilimento dell'antica arte de' greci e romani pittori*, 2 vols (Parma, 1784; rev. 1787)

J.-N. Paillot de Montabert: *Encaustique* (Paris, 1829), viii of *Traité complet de la peinture*

W. B. Sarsfield Taylor: *A Manual of Fresco and Encaustic Painting* (London, 1843)

C. L. Eastlake: *Materials for a History of Oil Painting*, 2 vols (London, 1847–69); rev. as *Methods and Materials of Painting of the Great Schools and Masters*, 2 vols (New York, 1960)

C. Blanc: *Grammaire des arts du dessin* (Paris, 1870)

H. Cros and C. Henry: *L'Encaustique et les autres procédés chez les anciens, histoire et technique* (Paris, 1884)

A. P. Laurie: *Greek and Roman Methods of Painting* (Cambridge, 1910)

H. Schmid: *Encaustik und Fresko auf antiker Grundlage* (Munich, 1917)

H. Schmid: *Neuzeitliche Enkaustik* (Munich, 1932)

R. Mayer: *The Artist's Handbook of Materials and Techniques* (New York, 1940, rev. London, 4/1987)

F. Pratt and B. Fizec: *Encaustic Materials and Methods* (New York, 1949)

M. Borda: *La pittura romana* (Milan, 1958)

P. R. Büll: *Wachsmalerei: Enkaustik und Temperatechnik unter besonderer Berücksichtigung antiker Wachsmalverfahren* (Frankfurt, 1963), i of *Vom Wachs*

R. Beyer: *Enkaustik* (Stuttgart, 1967), v of *Reallexikon des deutsches Kunstgeschichte*

D. Rice: *The Fire of the Ancients: the Encaustic Painting Revival, 1755 to 1812* (diss., New Haven, CT, Yale University, 1979)

A. Massing: 'From Books of Secrets to Encyclopedias: Painting Techniques in France between 1600 and 1800', *Historical Painting Techniques, Materials, and Studio Practice: Preprints of a Symposium, University of Leiden, 26–29 June 1995*, pp. 20–29

H. Dubois: '"Use a Little Wax with Your Colours, but Don't Tell Anybody": Joshua Reynolds's Painting Experiments with Wax and his Sources', *Hamilton Kerr Institute Bulletin*, iii (2000), pp. 97–106

J. Mattera: *The Art of Encaustic Painting: Contemporary Expression in the Ancient Medium of Pigmented Wax* (New York, 2001)

A. Freccero: *Encausto and Ganosis: Beeswax as Paint and Cating During the Roman Era and its Applicability in Modern Art, Craft and Conservation*, Acta Universitatis Gothoburgensis (Göteborg, 2002)

M. Duffy: 'Contemporary Encaustic Techniques—Johns, Marden, Thek', *Postprints: American Institute for Conservation of Historic and Artistic Works. Paintings Specialty Group*, 18 (2006), pp. 84–93

L. Mayer, Lance and G. Myers: 'Painting with Wax in Britain and America During the 18th and Early 19th Centuries', *Postprints: American Institute for Conservation of Historic and Artistic Works. Paintings Specialty Group*, 18 (2006), pp. 53–66

M. D. Gottsegen: *The Painter's Handbook* (New York, 2006)

Engraving. Technique of intaglio printmaking in which an image is cut with tools into a plate from which multiple impressions may be made; the term is also applied to the resulting print, which has characteristic lines created by the tools and techniques of cutting. The incised image, which lies below the plate's surface, is filled with ink, and then pressure is used to force the paper into the inked lines, creating a slightly raised three-dimensional line and an embossed platemark.

The printing of images from engraved metal plates began in the 15th century and spread to Asia from the 16th. Woodblock engraving had been used in Japan from the 8th century to make prints of religious texts under the auspices of Buddhist temples and the aristocracy, but the earliest copperplate engravings in Japan date to the 16th century. In China the influence of European graphic art spread as early as the Ming period (1368–1644), continuing in the Qing (1644–1911). Western engravings were the model for the *Chengshi moyuan* given to Cheng Dayue

by Matteo Ricci (1552–1610), and the Jesuits were involved in printmaking activities in China in the 17th and 18th centuries. The technique of copperplate-engraving was introduced into South-east Asia in the 16th century by Portuguese, Spanish and Dutch colonizers.

I. Materials and techniques. II. History.

I. Materials and techniques. The preferred metal for engraving plates is copper, which is easily incised, yet strong enough to withstand repeated passes through a press under pressure. Silver, zinc, steel and plastic plates are also used. Metal plates can also be steel- or chrome-faced by electrolysis. This protective layer, consisting of a microscopically thin coating of a stronger metal, is useful in large editions, in which the line quality gradually deteriorates. Since the 1950s some artists have engraved on transparent plastics, with the advantage that a drawing placed underneath can be seen.

Specialized engraving tools are used, and each has a characteristic cut that produces a distinctive printed line. The graver or burin is a steel shaft, square or lozenge in section, mounted in a rounded wooden handle. Burins come in a variety of sizes. The end of the shaft, which can be straight or bent, is sliced off at a 35–45° angle. The resultant line has an innate formality resulting from the method of cutting. The engraver holds the tool with the palm of the hand, low to the plate, and cuts straight ahead, turning the plate against the tool as the line curves. The burin is capable of a range of strokes, from the most delicate to rather wide, depending on the pressure exerted. As the tool moves in a V-shaped cut, it produces a curl of metal ahead of the engraver; the line swells and tapers according to the depth of the cut and whether the graver is held straight or is rotated to the side. The end of a line appears to come to a point. If the cut is not absolutely clean, a sharp burr remains, which is generally scraped away. Burr left along the line will hold ink and adds richness to the print. This richness is characteristic of the earliest impressions from a plate, for burr will soon be flattened by repeated printings.

Other tools used for engraving include drypoint needles or scribers for lightly scratching the design on the plate; and compasses and dividers for measuring and scribing. Tools for producing tones and textures include stipple gravers, burin-like tools with curved shafts; multiple lining tools; roulettes, tools with small wheels that perforate; mattoirs (or mace heads), whose end has irregular points, and mezzotint rockers, which have curved blades with serrated edges. Machine oil and good whetstones are necessary to maintain the sharpness of engraving tools. The engraver also uses files for bevelling the edges of the plate, scrapers and burnishers, callipers, hammers and pumices and fine grits for correcting errors. Many engravers rest their plates on a leather cushion or ball to assist in turning the plate. Some engravers use magnifying lenses or eyepieces, worn on a headband or supported by a stand.

The design for an engraving can be transferred from paper to a plate in a variety of ways. One method is to rub the *verso* of a drawing on paper with chalk. The plate is then coated with wax or asphaltum, or carbon paper can be placed between a drawing and the coated plate. A scriber is used to retrace the outlines of the drawing, imprinting a transferred line on to the plate in the same direction as the original drawing. The resulting print will be a mirror image of the original drawing. A second method enables the engraver to produce a print in the same direction as the original drawing. The plate is coated with wax or asphaltum, and a soft graphite drawing or ungummed ink on a smooth surface such as tracing paper is placed face down on the plate. The drawing is either rubbed or run through the press, and the transferred drawing prints in reverse on to the plate. After engraving, when the plate is printed, the impression is in the same direction as the original drawing. Ungummed-ink transfers to engraving plates were used as early as 1605.

During the course of the engraving process, engravers often print trial prints or 'proofs' to show the progress of the work, and these can be drawn on to explore alternatives for further engraving. A counterproof (a print made from a freshly printed proof) is sometimes made to reverse the reversal of the original design.

Papers for printing engravings must be able to be soaked or dampened to remove the sizing and relax the fibres, and be strong enough to withstand the reshaping of the sheet under pressure without tearing. Lightweight, translucent, laid and heavier opaque mould-made papers are suitable. Evenness of pulp is desirable, and coloured papers have often been used. Paper is an important factor in the appearance of an impression. Alternatives to paper, used especially in the 19th century, include satin, which is extremely receptive to the printed image, and silk. Decals printed with ceramic inks from engraved plates have been transferred to porcelain and fired, fusing the ink into the glaze. In the 20th century S. W. Hayter (1901–88) introduced the process of printing engraved plates by casting them in plaster.

Printing inks are prepared from well-ground pigments that are worked into reduced linseed oil (burnt-plate oil) until the mixture is very stiff and well saturated with pigment. Both black and coloured inks are used. It can take a week or more for oil-based inks to dry. Additives used in modern commercial inks include driers, varnishes and fillers. Solvents for cleaning include paint-thinner and turpentine; some formerly used, such as benzine, are now banned as health hazards.

The plate is inked with one of a number of devices for spreading it across the surface and forcing it down into the lines. An inking ball of leather or a *poupée* (a cylinder of tightly wound felt) are traditional, and brayers and squeegees are often used today. Fabrics, such as stiffly starched mesh, called 'tarlatan' cloth, and newspaper are used to wipe the surface. The printer can wipe the plate's surface perfectly clean or

leave a film of plate tone either all over or in selected areas. Wiping is finished using the heel of the hand with whiting (calcium carbonate). Multiple colour prints are made using separate plates for each colour and printed wet on wet (to avoid registration problems arising from paper shrinkage) or *à la poupée*, that is all the colours carefully applied and blended on a single plate.

The press used for printing engravings consists of a structure that supports two heavy cylinders arranged horizontally, one above the other, separated by a flat pressbed that moves horizontally between them. In modern presses the cylinders are attached to powerful springs that are tightened by pressure screws. A flywheel drives the cylinders either directly or by means of gears. Formerly presses were built of wood, but since the 19th century they are of cast-iron or steel; since the late 20th century plastic laminates have also been used.

The wiped plate is placed face up on the press bed, and dampened, blotted paper laid on top of the plate. Felts (blankets) are placed on top of the paper, and then the bed passes between the rollers, forcing the paper into the inked lines. For each impression made, the plate must be re-inked and wiped.

Engraving can combine in the same plate with any other of the intaglio methods such as drypoint, etching, mezzotint and aquatint. Since engraved plates are printed by intaglio, they cannot be printed simultaneously with cast type in the same printing run. Early illustrated books were illustrated by relief-printed blocks and metal plates, but in the 16th century engraved metal plates were recognized as having greater endurance, finer detail and greater ability to show certain pictorial effects of atmosphere. By the second quarter of the century engraving and typography were routinely combined in books and single sheets printed by means of two different presses. In the 20th century experimental printmakers began combining engraving with woodcut, lithography, serigraphy and monotype printed on the same sheet.

A tradition of signing and inscribing titles and publishing information has grown up with engraving. Early engravers used a hallmark or monogram and later personal names, sometimes inscribed in a plaque or tablet within the image. The work of producing an engraving was divided among specialists, and the artist, engraver, printer and publisher were frequently different individuals. By the 16th century an inscriptional space was frequently left on the lower edge of a plate, where a variety of customary Latin words and phrases were used to identify the work and claim rights of publication: the artist *invenit* (invented), *delineavit* (drew) or *pinxit* (painted) the image; the engraver *sculpsit* (engraved) or *fecit* (made) the plate; the publisher *excudit* or *divulgavit* (published) the print, often *cum privilegio* (with the permission and copyright protection) of a governmental authority for a certain period of time. Works were also frequently *D.D.* (dedicated) to some valued patron. The engraving of lettering was a speciality and was often done by someone other than the pictorial engraver.

The idea of limiting the size of editions arose in the 18th century, and the custom of autographing original prints in the lower margin outside the platemark began in the 19th century, as did the concept of artist's proofs. The practice of fractional numbering of the impressions in an edition (for example, '3/50', i.e. third impression of an edition of 50) began *c.* 1900.

A. Bosse: *Traicté des manières de graver en taille douce sur l'airin par le moyen des eaux fortes* (Paris, 1645/*R* Bologna, 1937)

J. Evelyn: *Sculptura* (1662); ed. C. F. Bell (Oxford, 1906) [with previously unpubd second part]

W. Faithorne: *The Art of Graveing and Etching* (London, 1662 and 1702/both *R* New York, 1970; ed. J. Kainen)

S. W. Hayter: *New Ways of Gravure* (New York, 1949, rev. 1966)

A. Floçon: *Traité du burin* (Paris, 1952, rev.1981)

A. Brittain and P. Morton: *Engraving on Precious Metals* (London, 1958/*R* 1980) [traditional craft techniques for goldsmiths]

G. Peterdi: *Printmaking: Methods Old and New* (New York, 1959)

J. Ross and C. Romano: *The Complete Printmaker* (New York, 1972, rev. 2/1990)

W. Chamberlain: *The Thames and Hudson Manual of Etching and Engraving* (London, 1972; rev. 2/1992)

J. B. Meek: *The Art of Engraving: A Book of Instruction* (Montezuma, IA, 1973)

F. Eichenberg: *The Art of the Print: Masterpieces, History, Techniques* (New York, 1976)

R. Leaf: *Etching, Engraving and other Intaglio Printmaking Techniques* (New York, 1984)

A. Lyles and D. Perkins: *Colour into Line: Turner and the Art of Engraving* (London, 1989)

L. Lo Monaco: *La gravure en taille-douce: Art, histoire et technique* (Paris, 1992)

F. De Denaro: *Domenico Tempesti e 'I discorsi sopra l'intaglio ed ogni sorte d'intagliare in rame da lui provate e osservate dai più grandi huomini di tale professione'* (Florence, 1994)

B. Hunnisett: *Engraved on Steel: The History of Picture Production Using Steel Plates* (Brookfield, VT, 1998)

S. Bann: 'Photography by Other Means? The Engravings of Ferdinand Gaillard', *Art Bulletin*, lxxxviii/1 (March 2006), pp. 119–38

II. History. The incising of images into metal and other hard materials was practised long before engraved surfaces were used as printing matrices (*see* METAL, §V; *see also* GOLD, §2, and SILVER, §3). Engraved stone, bone, ivory and shell objects from Palaeolithic sites are evidence that incising an image is old and widespread. Mesopotamian engraving, for example, was highly developed in technique, style and subject-matter, and cylinder seals impressed into clay of *c.* 3300 BC are perhaps the earliest examples of printed, engraved images. The art of niello, in which a powder of sulphur, mineral oxides and borax was rubbed into the lines of an engraved design and then heated to form a shiny black deposit, was a precursor of printed engravings. It was practised by the ancient Egyptians and was popular among the Greeks, Romans, Byzantines and Anglo-Saxons and throughout the Renaissance. The Florentine niellist and draughtsman Maso Finiguerra (1426–64) is credited by Giorgio Vasari (1511–74) with inventing the idea of printing engravings on paper from niello

plates, but scholars question whether he was actually printing on paper from the casts (*see* NIELLO PRINT, §2).

1. BEFORE *c.* 1430. The invention of printing engravings on paper was connected to three factors: the idea of using an engraved plate as a means of reproducing an image, the availability of paper and the means of applying pressure. The precise location at which these came together has been the subject of debate, with both Germany and Italy having its proponents. Most scholars believe that the practice of impressing paper on engraved plates originated in the workshops of south German goldsmiths in the Rhine Valley in the second quarter of the 15th century. Goldsmiths would make a record of designs incised in metal by filling the lines with ink and impressing paper against it. These printed designs could be used to help in the transfer of symmetrical and repeated elements and for training and record-keeping.

The first important centre of paper manufacture in Italy was set up at Fabriano *c.* 1276. Other mills were established in northern Italy during the 14th century, supplying not only Italian but also south German demand. Paper mills were first established in Germany *c.* 1320 near Cologne and Mainz, and in the Netherlands by the beginning of the 15th century. The use of paper for writing became common throughout Europe by the second half of the 14th century, essentially replacing vellum in the 15th. This new availability of paper was the key to the 'invention' of printing in Europe and first appeared in connection with relief printed blocks. Vertical pressure presses (wine presses) existed in the Rhineland and had already been adapted for printing woodcuts *c.* 1400. The dual cylinder or 'etching' press seems to have come into use by 1500. Oil-extended solid inks were also a German invention.

2. *c.* 1430–*c.* 1500. Because engraving was not so much invented as joined to the new technology of printing, one cannot speak of a 'primitive' phase; goldsmith-engravers continued to use techniques developed previously. Fifteenth-century northern European engraving is firmly rooted in the Gothic style. The earliest engravings are not purely linear but incorporate texture, shadow, modelling and pattern, which is unsurprising, since goldsmiths had been dealing with such pictorial problems for centuries. While many early engravers were trained as goldsmiths, others, however, seem to have been trained as painters, judging from their broader handling of form and detail. In the work of such an engraver-painter as the Master of the Playing Cards (*fl c.* 1425–50), contours were firmly engraved with a descriptive and restless line, and internal forms, such as facial features, were cut with delicacy. Certain mannerisms taken from drawing and also seen in early woodcuts, such as the 'fish-hook' end to a line in drapery, were used by this master and his contemporaries. Early engravers

used a variety of cuts to create tonality and modelling. These include laying down hundreds of tiny straight strokes, with no particular reference to the direction of a plane, long hatchmarks and random crosshatching, with or without stippling.

The Master E.S. (*fl c.* 1450–67), believed to have been a goldsmith, was active near Lake Constance and produced over 200 prints. He seems to have been the first to turn his plate against the burin as he cut modelling lines, resulting in a more logical system that followed and expressed form sculpturally. He also developed a systematic method of crosshatching that responds to form and produces a greatly enriched range of darks. Developments in northern European engraving after 1450 included increased interest in light, shade and environment, construction of pictorial space and use of the expanded narrative series as a focus for human drama.

By the last quarter of the 15th century northern European engraving was capable of a greatly expanded range of pictorial effects. It evolved from a predominantly linear mode, which described static form in an uncolouristic way, to the expression of a rich range of contrasts, as well as textures, by means of linear systems, of which contour was only one element.

Italian engraving was also rooted in and influenced stylistically by goldsmithing and niello. Florence was the first major centre, with Ferrara, Bologna, Mantua, Milan and Venice having significant activity later in the 15th century. All the major early Florentine engravers had a background in goldsmithing and were in contact with the niellist Finiguerra. Most, however, did not merely reproduce the niello manner of engraving light against dark but worked in a more open style, emphasizing outline and form against a light ground. Many 15th-century engravings are printed in a pale grey ink, in contrast to the more densely pigmented German inks, so the overall print has less contrast between the line and the paper.

From the outset, Italian engraving was closely connected with drawing in pen and wash. Early Italian engraving shares with contemporary drawing clarity of design, monumentality of form, firmness of outline and rational space. Early Italian engraving prints are traditionally grouped in two categories: 'fine manner' and 'broad manner'. In fine-manner prints contour lines define forms, and fine, delicate hatching and crosshatching strokes express modelling, imitating the effect of pen and wash, as in the work of Baccio Baldini (?1436–87). Broad-manner engraving reflects vigorous pen drawing, with the back-and-forth hatching reproduced by the burin; Francesco Rosselli (1448–1513) was one of the most important practitioners of this style. Antonio Pollaiuolo (*c.* 1432–98), painter, sculptor and goldsmith, designed and engraved only one surviving print, the *Battle of the Ten Nudes* (*c.* 1470–75). It is one of the most important 15th-century engravings and was the largest, most complex plate and also the earliest to be fully signed.

3. *c.* 1500–*c.* 1600. The 16th century was dominated by Albrecht Dürer (1471–1528), Marcantonio Raimondi (*c.* 1470/82–1527/34), Lucas van Leyden (*c.* 1494–1533) and Hendrick Goltzius (1558–1617) and their differing conceptions of engraving. The print's function as an original work of art was firmly established, notably by Dürer. Two major approaches to engraving technique evolved: one stressed contour, texture and light by a complex but often unsystematized linear vocabulary; the other stressed the rendering of solid form rather than surface and light, depending on geometric, abstract line systems. This second approach dominated 16th-century reproductive engraving, and its graphic language of evenly spaced, unmodulated lines and dots influenced the way in which styles, paintings and sculptures were known and understood. The beginnings of etching *c.* 1510 were also crucial for important interrelationships; printmakers often worked in both media, even in the same plate. At first most artists saw etching primarily as a fast way to make engravings and drew on plates in ways that imitate engraving. Etching gradually achieved independence and developed its own language (*see* ETCHING, §II).

During the 16th century engraving became an important international cultural and commercial activity (*see* PRINTS, §IV, 2). As engravings and engravers began to circulate, prints became the primary agent of the transmission and interchange of image, style and graphic technique Engravings began to be used for book illustrations, with the engraved title-pages first appearing in Venice *c.* 1518 and every year from 1548. Despite the need for passing a sheet through two different presses, one for the text in relief and the other for the intaglio image, engraving gradually replaced the woodcut for book illustration. Engraving was capable of producing more impressions and was favoured for its greater ability to represent three-dimensional form, details and tone. The development of engraving technique was greatly affected by the expansion of the commerce in prints. Publishers needed plates that could withstand large print runs or could be easily reworked. This favoured the use of Raimondi's regularly spaced line systems and impersonal styles.

4. *c.* 1600–*c.* 1750. Although a small group of engravers worked in a richly tonal and descriptive style, engravers throughout Europe favoured parallel-line or lozenge-hatched line systems. Fewer artists executed original engravings, preferring the freedom of etching for their printmaking. Engraving became largely concerned with reproduction, portraiture, book illustration, maps and music. After *c.* 1620 printmakers trying to create a graphic equivalent for dark tone turned to mixed techniques such as etching in combination with drypoint and engraving, monotype and tonal wiping and finally to mezzotint.

5. *c.* 1750–*c.* 1900. By the mid-18th century pure engraving had largely been replaced by mixed etching–engraving techniques, the tonal engraving processes of mezzotint, roulette and stipple and the tonal etching processes of soft ground and aquatint. The word 'engraving' had come to mean any intaglio process, as opposed to 'line-engraving', which referred to burin-engraving. Paris remained the most important centre for line engraving, while London became important for mezzotint, stipple engraving and mixed intaglio prints.

6. *c.* 1900 AND AFTER. Freed from its reproductive role, burin-engraving regained vitality in the early 20th century and developed in two radically different ways. One direction was associated with the avant-garde and formalism, which emphasized pure line as an element of interest in itself. Such printmakers were involved with abstraction, technical experimentation and colour printing and often used engraving in combination with other techniques. The second direction, centred in Britain and figurative in content, looked back to engraving's early history for inspiration. The artists of such prints often specialized in engraving and did not mix techniques. Less formalist in their approach, they tried to recapture the line quality of 15th-century engraving, and for these engravers line did not exist independent of image.

(i) Modernism and Cubism. The idea that an engraving could be an original print returned under the auspices of Cubism, with its geometric rather than organic line quality. The early prints of Pablo Picasso (1881–1973) were etchings and drypoints, but in such later Cubist prints as *Man with Guitar* (1915) he used the burin to rework an etched image in a completely novel way; he exploited the rich blackness of the engraved line, showing its crisp directionality, graceful arcs, sharpness and burr. To this he added heavy plate tone and spot wiping to achieve a new context for the engraved line. Throughout his career Picasso enjoyed and used aspects of engraving that had never been admitted before, such as the resistance of the metal. He often worked with an unsharpened tool, which stuttered its way through the copper, kicking up sharp burr. He also deliberately signed and dated his plates, so that his script prints in reverse.

The Cubist Emile Laboureur (1877–1943) experimented with a variety of etching techniques before taking up the portable technique of engraving during his war service (1914–16). He engraved his distinctive stylized images using crisp lines and arcs against white paper, which were interspersed with hatching that flattens and patterns rather than modelling form. Paul Dubreuil also worked in a manner reminiscent of Laboureur's style. John Marin (1870–1953), one of the few American artists influenced by Cubism who engraved, made six prints using the burin in the 1920s. The Polish artist Joseph Hecht (1891–1952) studied in Kraków and in Norway before moving to Paris in 1921. Along with other Polish engravers, he incorporated elements of folk art and decorative patterning in his manner of drawing animals and landscapes with the burin. Despite his traditional craft training as a professional engraver, he came to see the

engraved line as interesting in itself apart from what it described and was interested in how it functioned with white paper. His approach to engraving was profoundly to influence printmaking.

(ii) Historical revival. In Britain engravers approached engraving in a very different manner from the modernists, sustaining a connection with the past through a high level of craftsmanship, a sense of historicism and preservation of the print's intimate scale. Robert Sargent Austin (1895–1973), the leading British engraver in the 1920s, emulated Dürer's early style with great delicacy and rigorous drawing. Many of the British engravers active in the 1920s and 1930s were associated with the Royal Society of Painter–Etchers and Engravers (which admitted engravers only in 1926) and with the Bank of England. During the 1930s, while many American artists were making lithographs, the American scene-painter and etcher Reginald Marsh (1898–1954) learnt to engrave in a formal style by taking private lessons from a retired banknote engraver. By 1939 he was making pure engravings that startlingly combined his Realist drawing style with the lozenge crosshatching of banknote engraving. Armin Landeck (1905–84) was another printmaker who found engraving well suited to his expressive architectural imagery, drawn with closely massed parallels and spider-web line networks.

(iii) S. W. Hayter, abstraction and experimentation. Under the influence of Surrealism and Automatism, S. W. Hayter (1901–88), who had studied engraving with Joseph Hecht (1891–1951) in Paris (1926), liberated line from literal pictorial description. He created abstract, non-objective images through the constant turning of the plate as the burin passed through the copper. He engraved over passages of textured soft ground, combined engraving with lift-ground etching and gouged out areas (*gaufrage*) that print as uninked three-dimensional relief. He introduced the idea of surface and intaglio printing from the same plate, perfected colour viscosity printing and took casts of engravings in plaster.

In 1927 Hayter founded Atelier 17 (Paris, 1927–40; New York, 1945–50; Paris, 1950–) as a workshop for experimental intaglio printmaking. Hundreds of artists who worked at Atelier 17 tried engraving but most found the medium too disciplined and indirect. Hayter's personal engraving style, based on improvisation and chance, influenced Jackson Pollock (1912–56), who made seven engravings with Hayter in 1944–5. Hayter's experimental approach and his bringing together intaglio printmaking and abstraction were major influences on European and American printmaking in the 1940s and 1950s.

Affected by the large scale of Abstract Expressionist paintings, printmakers expanded the scale of their works. This encouraged changes in burin technique, such as the use of powerful, deeply cut, expressive, long, sweeping strokes and violent jabs. The virtuosity, control and strength required to cut such lines is, in some ways, reminiscent of Mannerist engraving.

The practice of engraving in the USA after World War II was due largely to Hayter. Many of the artists who worked with him set up their own printmaking workshops in art schools and universities, such as Gabor Peterdi (1915–2001) at Yale University, New Haven, CT. Mauricio Lasansky (*b* 1914) made large, mixed intaglio colour prints containing powerful passages of engraving, and his grotesque, mythic, apocalyptic and political images were drawn with impassioned intensity. He established an important centre of experimental intaglio printmaking at the University of Iowa, Iowa City. He saw engraving as a central skill and insisted that his students master it. Although most of Lasansky's students did not continue to use engraving, by the late 20th century the majority of American artists working with the burin were Iowa-trained. Some printmakers combined electric engraving tools, dental tools and multiple-line gravers with the traditional burin, for example Virginia Myers (*b* 1927), who also used engraving with a metallic-foil stamping process in her gesturally drawn figure and landscape prints.

(iv) Late 20th-century engraving. Intaglio printmaking branched in two distinct directions *c.* 1970: artists who made their own prints, and those who worked collaboratively. Printmakers who made their own prints became associated with 'academic' printmaking. Most contemporary engraving falls in this category. Publisher-financed collaborative printmaking, involving well-known painters working with master printers, favoured complicated, innovative and expensive processes but produced little in the way of engraving. Since engraving is image-oriented rather than process-oriented, solitary, technically demanding and time-consuming it has no need of a collaborative situation. One artist who worked collaboratively, Frank Stella (*b* 1936), updated Hayter's approach by combining engraving with computer-generated imagery, relief, aquatint and etching in enormous, multiplate prints produced at Tyler Graphics in the 1980s.

In the late 20th century many American printmakers were using engraving in combination with other intaglio techniques, including Peter Milton (*b* 1930), who combined elegant burin work with photosensitive ground, aquatint and lift-ground etching in his black-and-white prints. Pure engraving at the end of the 20th century had moved beyond the earlier formalist focus on line *per se* to focus on figurative imagery with a renewed interest in rich tone. The few artists working as engravers selected the burin for its unique ability to produce its characteristic lines and tones and for its simplicity of means. In the USA they included Beth van Hoesen (*b* 1926), Evan Lindquist (*b* 1936), Brian Paulsen (*b* 1941) and Amy Worthen (*b* 1946). The situation in Britain was more diverse. Such Hayter-trained engravers as American-born Jean Lodge (*b* 1941) flourished, while traditional engravers in the Royal Society of Painter–Etchers and Engravers continued to dominate the British conception of the

medium. Henry Wilkinson (*b* 1921), David Wickes, Ann Le Bas (*b* 1930) and Lawrence Josset (1910–95) made delicate engravings executed with the highest craftsmanship. Britain remained the one place where traditional engraving techniques for silversmiths, gunmakers and banknote engravers as well as artists continued to be taught. Students from Britain and other countries came to study engraving in the three-year silversmiths' course at the City of London Polytechnic (now London Guildhall University), Sir John Cass College of Art, intended primarily for students planning to qualify by examination for the guilds.

Burin-engraving flourished perhaps most conspicuously in France, where the country's rich and varied tradition of engraving was reflected in the strength and variety of its engravers, including Albert Flocon (1909–94), a major practitioner and theorist of modernist burin engraving and its relationship to geometry and curvilinear perspective. Both experimental and traditional engraving techniques were taught to printmakers trained in the fine arts academy system. At the Ecole Nationale des Beaux-Arts burin engraving became a required part of the training of printmakers. To qualify for the Prix de Rome, students were required to execute a plate engraved with a burin. In central France, at the Ecole Régionale des Beaux-Arts in Saint-Etienne, the traditional craft of gun engraving, long associated with that city, continued to be taught side by side with engraving for printmakers.

Surrealism continued to inspire some of the most interesting European engraving, including the work of a number of French artists outside the Hayter circle. Marc d'Autry engraved grotesque and mythological creatures with a technique inspired by Dürer. Philippe Mohlitz (*b* 1941) of Bordeaux, a spiritual successor to Jean Duvet (*c*. 1485–after 1561) and Rodolphe Bresdin (1822–85), made obsessive Surrealist fantasies designed with grim humour. His lines are delicately engraved but densely packed, creating rich, velvet blacks. Surrealism also influenced the Italian engraver Carla Horat (*b* 1938). The Italian artist Luce Delhore (*b* 1952), born in Belgium, is an exception to the generally figurative style of contemporary engraving: he combined burin, drypoint and roulette in rich, luminous abstractions. Engraving and mezzotint became popular in Japan, with an emphasis on contemporary design and craftsmanship. Mitsuru Ishibashi (*b* 1951) engraved mechanical and graphlike abstractions, using straight, rich burin lines with impressive effect.

A. P. F. Robert-Dumesnil: *Le Peintre-graveur français* (1835–71)

R. Portalis and H. Béraldi: *Les graveurs du dix-huitième siècle* (Paris, 1880–1882/*R* 2001)

A. von Bartsch: *Le Peintre-graveur* (1803–21) [B.]

A. M. Hind: *A History of Engraving and Etching from the 15th Century to the Year 1914* (London, 1923, rev. New York, 3/1963)

F. W. H. Hollstein: *Dutch and Flemish Etchings, Engravings and Woodcuts, c. 1450–1700* (Amsterdam, 1949–)

F. W. H. Hollstein: *German Engravings, Etchings and Woodcuts, c. 1400–1700* (Amsterdam, 1954–)

A. H. Mayor: *Prints and People: A Social History of Printed Pictures* (New York, 1971)

L. Mason and J. Ludman: *Print Reference Sources* (New York, 1975, rev. 2/1979)

R. Godfrey: *Printmaking in Britain: A General History from its Beginnings to the Present Day* (New York, 1978)

M. Melot and others: *Prints: History of an Art* (Geneva, 1981)

T. Riggs: *The Print Council Index to Oeuvre-catalogues of Prints by European and American Artists* (New York, 1983)

A. Griffiths and R. Williams: *The Department of Prints and Drawings in the British Museum: User's Guide* (London, 1987)

Engravings-USA (exh. cat., St Joseph, MO, Albrecht Art Museum, 1974)

S. W. Hayter and Atelier 17 (exh. cat. by J. Moser; Madison, WI, University of Wisconsin, Elvehjem Art Center, 1977)

The Cubist Print (exh. cat. by B. Wallen and D. Stein; Santa Barbara, CA, University of California, University Art Museum, 1981)

J. Watrous: *A Century of American Printmaking, 1880–1980* (Madison, 1984)

J. Clark: *Japanese Nineteenth-century Copperplate Prints* (London, 1994)

G. Lambert, ed.: *Les premières gravures italiennes: Quattrocento—début du cinquecento: Inventaire de la collection du département des estampes et de la photographie* (Paris, 1999)

S. Martin-de Vesvrotte: *Dictionnaire des graveurs-éditeurs et marchands d'estampes à Lyon aux XVIIe et XVIIIe siècles et catalogue des pièces éditées* (Lyon, 2002)

A. Griffiths: *Prints for Books: Book Illustration in France, 1760–1800* (London, 2004)

N. van Hout, ed.: *Rubens et l'art de la gravure* (Ghent, 2004)

U. Weekes: *Early Engravers and their Public: The Master of the Berlin Passion and Manuscripts from Convents in the Rhine-Maas Region* (London, 2004)

B. Wilson: *The World in Venice: Print, the City, and Early Modern Identity* (Toronto, 2005)

Enlarging. *See under* PHOTOGRAPHY, §I.

Etching [Fr. *eau-forte*; It. *acquaforte*; Ger. *Ätzung*; Sp. *aguafuerte*]. Type of intaglio print, the design of which is printed from grooves corroded into a plate by acid; the term is applied also to the process by which the composition is bitten into the printing plate.

I. Materials and techniques. II. Historical survey.

I. Materials and techniques. The usual material for the etching plate is copper, although the earliest German etchings, at the beginning of the 16th century, were made on iron plates. Since the third quarter of the 19th century zinc has often been used, being cheaper and more sympathetic to coarser effects. Brass, aluminium and even composite metals, such as tinned or chromed steel, have also been employed. To prepare the plate, it is highly polished, then coated with an acid-resistant ground, dry to the touch but soft and flexible enough to be drawn through with a metal point without flaking.

The usual ground is formed from wax, asphalt and a resin such as mastic. A harder ground in which a drying oil is substituted for wax was developed in the

second quarter of the 17th century for etchings produced in imitation of engraving. In the 18th century a softer, sticky ground was invented, which included tallow or, more recently, petroleum jelly. This so-called 'soft ground' is used under a membrane such as thin paper on which the drawing is executed with a pencil or stylus (see ETCHING, SOFT-GROUND). Thus instead of being scraped from the metal plate by the point itself, the ground is lifted from the plate where the pressure of the point has adhered the ground to the reverse of the paper; the resulting line reproduces the texture of the overlaying paper. In the 20th century other substances, such as fabric, string, etc., have been used to pick up the ground, imprinting their individual silhouettes and textures.

The conventional wax-based ground is traditionally formed into a small ball wrapped in lint-free silk or other cloth and applied by rubbing the ball over the surface of the metal plate, which has been warmed. The melted ground is smoothed and thinned with a dabber, a pad for dabbing ink on plates or blocks, which is also wrapped in lint-free cloth or leather. Melted etching ground may also be spread with a roller made of hard rubber, linoleum or leather, or dissolved in a rapidly drying solvent and brushed or poured over the tilted plate.

After the ground is laid, it is usually coated with soot from a smoking flame to increase the contrast between the uncoated ground, which is luminous brown, and the metal exposed by drawing. It is thought by some that the smoking action enables the ground to resist the action of acid better. Alternatively, a white pigment may be incorporated into the ground, to simulate on copper the effect of a line drawn in red on white paper.

Preliminary drawings may be transferred to the grounded plate by means of carbon paper (or some comparable intermediary pigment layer), or a drawing in loose pigment (such as graphite or chalk) may be laid face down on the grounded plate and run through the roller press. This latter process obviates the need for the composition to be designed in reverse. The artist draws on the grounded plate with an etching needle or metal point sharp enough to penetrate the ground but polished so that it does not catch on the plate. Points may be of various thickness, but the width of the etched line is usually determined by the process of biting rather than drawing.

Alternatively, in a process possibly invented by the 17th-century Dutch etcher Hercules Segers (1589/90–1633/8) and greatly developed in the 19th century, the artist may execute his drawing on the ungrounded plate in water-soluble ink, usually containing a high proportion of sugar syrup, then covering it with a water-permeable ground. The plate is then immersed in water so that the areas of ground above the ink lift away as the ink dissolves. If the drawn lines are of substantial width, they may be covered with an AQUATINT ground, which ensures better retention of printing ink. Once the design has been executed on the grounded plate, the plate is exposed to the action of acid, so that all areas of bare

metal are corroded. This acid, known as the mordant, may be nitric acid, usually diluted to half strength or less, or a combination of chemicals, such as hydrochloric acid and potassium chlorate (so-called Dutch mordant), ferric chloride, potassium dichlorate, dilute sulphuric acid, hydrochloric acid (for aluminium) etc. It is the action of the mordant that gives printed etched lines their characteristic coarseness compared to engraved lines of equal strength; bitten grooves always retain a degree of roughness compared to the sharp incisions made by a burin or engraving tool, and this characteristic is transmitted to the ink lines formed in the grooves.

The various mordants each have restrictions as well as advantages; the by-products of such chemicals include the release of gas. Nitric acid, depending on its concentration, can bite very rapidly, forming gas bubbles along the lines. These must be continually brushed away for the bite to continue evenly, although their presence is a useful guide to where and how rapidly biting is progressing, so that foul biting or lack of reaction may be detected early on. In the case of ferric chloride, a gentle and predictable mordant, the action of biting forms sediment in the grooves, impeding its continuation. To forestall this, the plate is usually bitten while suspended upside down in the acid bath, so that the sediment falls away from the grooves. Thus the benefit of a dependable mordant is somewhat offset by the inability to monitor its action. Dutch mordant, another easily controlled agent, tends to bite more directly downward rather than also eating away at the sides (a characteristic of nitric acid). It is therefore preferred especially in areas of close hatching where individual lines are at risk of merging into a broader pit. However, as Dutch mordant does not release gas as it bites, its action cannot so easily be followed except by periodic probing of the lines to determine their depth. In sum, mordants are selected depending upon the type of metal plates, the sequence of intended biting procedures and the ultimate technical and visual effect desired.

Acid may be applied in various ways. Traditionally, a grounded plate was edged with a wax lip forming a shallow pan into which the acid was poured. Another method was to lay the plate, its edges and underside coated with an acid-resistant varnish, into a wooden or earthenware tray set at an angle over a receptacle: acid was repeatedly poured over the plate, which was rotated so that the acid affected all lines equally.

From the 19th century it became more common for the plate, its edges and back protected, to be immersed in an acid bath. Acid may also be applied directly to local areas of the plate with a brush or feather, the plate ungrounded in the *lavis* process (in which the plate is worked to create tonal areas imitative of ink and wash drawing): or it may be mixed into a paste which is spread on to the plate. These techniques permit local areas to be bitten with varying degrees of strength. Using acid in tandem with a viscous liquid (such as saliva), the action of the acid and the area affected may also be modified.

After the lines have been bitten to the desired width and depth (determined by probing the grooves with a needle as they form or by timing the bath in a mordant of known strength), the plate is rinsed to halt the action of the acid and the ground removed, traditionally by polishing with charcoal or by the use of a suitable solvent.

Plates are commonly executed in a sequence of bitings in order to obtain tonal gradation through variation of line width. After the first biting, those lines that have been shallowly bitten and that are to remain the lightest in the final composition are covered with an acid-resistant substance, such as grease, fluid ground or varnish, in a procedure called stopping-out, so that those lines which are to appear darker are further exposed to acid. Alternatively, additional lines are drawn on the grounded plate, so that lines already bitten will bite more deeply in a second bath compared to the new lines, whose exposure to the mordant action is shorter; or the plate may be re-covered completely with a transparent ground on which new lines are drawn to be bitten in a completely separate operation. A combination of these sequences of biting, stopping-out, redrawing and regrounding may also be undertaken. Each acid bath exposes the plate to additional risk of foul biting, and the more complex the process the greater the chance of technical miscalculation.

Once the plate is bitten and the ground removed, it is printed in the usual manner of all intaglio plates, by wiping ink into the lines, wiping clean the surface of the plate and passing the inked plate together with dampened paper through a roller press under concentrated pressure. Similarly, corrections to the plate are prepared in the same manner as in other intaglio processes: the faulty area is burnished or scraped down, the plate being pounded level from behind if a substantial amount of metal has been removed; its surface is polished before regrounding and re-etching. There is no technical obstacle to combining etching with other intaglio processes on the same plate. The final printed image may therefore contain etching, engraving, drypoint, aquatint and mezzotint in any combination, although different artists and schools of printmaking have held vastly differing ideas about the value of purity of technique.

II. Historical survey.

1. Origins. 2. 17th century. 3. 18th century. 4. The 19th-century Etching Revival. 5. 20th century.

1. ORIGINS. Etching as a printed art form is believed to have been derived from the use of etching to decorate iron (steel) armour in northern Europe in the 15th century, or earlier. Technical instructions appear in early 15th-century manuscripts (London, British Library, MS. Sloane 962; Oxford, Bodleian Library, MS. Ashmole 1397), and surviving specimens date from the last decades of the century.

(i) Germany and the Netherlands. The earliest printed etchings are believed to have been made by Daniel Hopfer (c. 1470–1536), Hieronymus Hopfer (fl 1520) and Lambert Hopfer (fl 1520–30) of Augsburg at the beginning of the 16th century. The earliest dated etching that survives, a Girl Washing her Feet (1513; Hollstein, no. 9), is by the Swiss Urs Graf (c. 1485–1527/9). Another early, though undated, example, Venus and Mercury (Hollstein, no. 834), by Hans Burgkmair I (1473–1531), is of special interest due to its origin in Augsburg, the centre of the German armourers' industry. Contemporary impressions from these plates are extremely rare.

The first notable artist to use the process for original compositions, and whose etchings survive in contemporary impressions in significant numbers, was Albrecht Dürer (1471–1528). He executed six etchings; the Man of Sorrows (Hollstein, no. 22), which by its technical simplicity is probably the earliest, is dated 1515, and the latest, The Cannon (Hollstein, no. 96), is dated 1518. These experiments with a new printmaking technique were virtually simultaneous with Dürer's even fewer ventures into drypoint; they came immediately after his extended concentration on the publication of his four great woodcut series and his production of three iconographically elaborate, technically virtuosic engravings. Like his few predecessors in etching, Dürer used only a single bite.

Most of Dürer's etched plates are notable for an unprecedented vigour of line, which is dramatically more bold in his Abduction of Proserpine (Hollstein, no. 67; see figs 1 and 2), for instance, than that of Hieronymus Hopfer in his etched copy, also on iron, of Dürer's plate (Hollstein, no. 47). Thus the effect from a clean-wiped impression of a Dürer etching would be exceptionally stark in the contrasts of line with blank paper. However, many impressions of his etchings (produced by the artist himself) that show no signs of having been printed from a rusted plate and are presumably early were printed with significant amounts of plate tone (that is, with a film of ink left on the surface of the plate to darken areas of the print). Perhaps regretting the absence in these single-bite etchings of the subtle transitions possible in engraving, Dürer exploited the emotive device in the intaglio printer's repertory that would become the hallmark of several master etchers of later centuries.

At virtually the same time as Dürer abandoned etching, other northern European printmakers brought technical innovations to the process and applied it to subjects in ways that likewise would have consequences to this day. Lucas van Leyden (c. 1494–1533) and Albrecht Altdorfer (c. 1480–1538) were among the first to adopt for etching the copper plates traditional for engraving and to combine the two intaglio techniques: Lucas van Leyden's portrait of the Emperor Maximilian I (1520; B. 172) is considered the earliest dated example of etching on copper. In this plate the general composition is laid in with etching, with engraving reserved for areas of subtle tonal transitions such as the flesh, establishing a systematic division of the two processes that would be developed and exploited to its ultimate refinement in

reproductive 'engravings' in 18th-century Britain, which were in fact based entirely upon etching.

Only a decade later the Italian artist Parmigianino (1503–40), working in combination with a cutter of chiaroscuro blocks, combined etching for line and woodcut for tone in a reproduction of the tapestry design *Peter and John Healing the Lame Man* (*c.* 1523–7; b. 7) by Raphael (1483–1520). This combination of etching with a relief process, more complex in its production requirements, was far more rare over succeeding centuries than the combination of etching and engraving, or other intaglio techniques, in a single plate.

The early application of etching by the Germans Albrecht Altdorfer, Hanns Lautensack (*c.* 1520–1564/6) and Augustin Hirschvogel (1503–53) to landscape subjects prefigured the development of the technique as a special province of landscape artists. Furthermore, the use of multiple biting was first clearly exploited in landscape etchings by Hirschvogel, in the strengthening of foreground details to enhance the illusion of recession into space. An additional technical advantage of etching, which was realized early by German etchers, was its speed of execution, so that it was employed to record topical events.

(ii) Italy. Although Marcantonio Raimondi (*c.* 1470/82–1527/34) and other far less consequential early 16th-century printmakers were acquainted with etching as a preliminary to engraving, the first independent and significant etched plates were executed by Parmigianino, a pre-eminent painter and not a professional engraver. Some time after 1527, when Parmigianino fled Rome for Bologna, he executed *c.* 16 plates on copper in a single-bite technique, which were often finished by burin touches. They are notable for the openness of their graphic structure, and, far more even than the deftly linear landscapes of Hanns Lautensack, they imitate the rapid line possible in pen sketching. The informality and breadth of handling of Parmigianino's etchings, combined with a compositional exploitation of broad areas of white paper untouched by printed lines, set the style for much of Italian etching for the next 200 years.

A chain of influence from Parmigianino through the Venetian painters Andrea Schiavone (*c.* 1510–63), who copied Parmigianino's etchings, and Battista Franco (?1510–61) leads to the other great innovator among 16th-century Italian etchers, Federico Barocci (*c.* 1535–1612) of Urbino, a pupil of Franco. He executed only four prints, all in the 1580s, which demonstrate a systematic use of rebiting far more ambitious than anything previously attempted. Even repeated biting did not, however, forestall additional work with the burin to blend the linear networks and enrich the tonal complexity of his plates further, which in a work such as the very large *St Francis in the Chapel* (1581; b. 4) approaches that of painting. As a painter and not a professional engraver, Barocci, like Parmigianino before him and many other etchers to follow, seems to have preferred etching as the fundamental printmaking process because of the direct

relation of the use of the needle to that of draughtsman's and painter's tools. Indeed, bundles of close hatching in Barocci's prints approximate brushed passages. His use of the burin remained a subtle adjunct to the basic etched work and was never systematized for specific kinds of depicted surfaces or effects in the manner of professional printmakers.

(iii) France. Etching was probably imported into France by a Bolognese pupil of Parmigianino, Antonio Fantuzzi (*fl* 1537–50), who emigrated to Fontainebleau with other Italian and also Flemish painters to join with native artists in establishing a new style in the decoration of the royal country residence. Many of their etchings, all created between 1542 and 1548, reproduce compositions by the Italian painters Rosso Fiorentino (1494–1540), Francesco Primaticcio (1504/5–70) and Luca Penni (1500/04–57) for this project. The most important etchers were Fantuzzi, Léon Davent (*fl* 1540–56), trained as an engraver, Jean Mignon (*fl* 1535–55) and Domenico del Barbiere (*c.* 1506–65). Their works are characterized by a rough, open, single-bite technique applied on to imperfectly polished plates on which highlight areas are sometimes burnished. In early impressions the result is a tonal effect of coarse black lines on a grey background, accented occasionally with paler modelling. Ornamental effect is emphasized, as in the case of Fantuzzi's landscape views, in which decorative borders dominate naturalistic central motifs. In the case of figural etchings by Justin de Juste (*fl c.* 1537; *d c.* 1559), the antics of acrobats and contortionists are assembled on the printed page as entirely fantastic tableaux coalesced into a single ornament.

2. 17th century.

(i) France and Italy. The divergent paths of 17th-century etchers who continued the technical development of the medium are epitomized by the two leading French practitioners: Jacques Callot (1592–1635) and Claude Lorrain (?1604/5–82). Significantly both artists, natives of Lorraine, learnt to etch in Rome, where at the end of the 16th century and beginning of the 17th there was a large and varied international colony of painters, printmakers and publishers. The most prominent among the painters who etched were the Italians Pietro Testa (1612–50) and Giovanni Benedetto Castiglione (1609–64), the Fleming Paul Bril (*c.* 1554–1626) and the Dutchman Bartholomeus Breenbergh (1598–1657). Callot, in Italy from *c.* 1608 to 1621, was presumably introduced by the Florentine painter and prolific etcher Antonio Tempesta (1555–1630) into Medici circles, where he obtained the patronage that set the style for his witty, exact and mannered art. In one procedural development Callot substituted a hard ground made from oil and mastic (lutemaker's varnish) for the by-then traditional, softer, wax ground. In another he bevelled the tip of the etcher's round steel needle to form the oval-faceted

échoppe, which could be rotated between the fingers to cut a smoothly tapered line in the new hard ground in easy emulation of engraving but which retained the greater flexibility of etching. Yet another potential inherent in etching was perhaps even more important to Callot, a professional, production-orientated print designer whose court and clerical patronage in Florence and, after 1621, in Nancy and Paris demanded the intricate, systematic rendering of elaborate iconographies. He exploited multiple biting to an innovative degree of technical complexity, again to the end of gaining speedily for his plates the rich colouration of traditional, tediously elaborated, prestigious engraving. While his larger compositions, such as the two versions of the *Fair at Impruneta* (1620, *c.* 1622; Lieure, nos 361, 478) and the *Temptation of St Antony* (1611, *c.* 1635; Lieure, nos 188, 1416) and the six-plate *Siege of Breda* (1628; Lieure, no. 593), are more obvious *tours-de-force*, miniature images such as those of the *Balli di Sfessania* (*c.* 1621–2; Lieure, nos 379–402) and the *Large Miseries of War* (1633; Lieure, nos 1339–56) offer equally virtuosic demonstrations of a fully realized etched style dependent upon absolute mastery over its materials.

All these technical developments were widely disseminated by their description by Abraham Bosse (1602–76) in *De la manière de graver à l'eau forte et au burin* (1645), which became the manual for generations of etchers. His book has given Callot a false position as the inventor of tools and techniques that he only standardized and popularized. Even more of a barrier to a correct understanding of technical developments in etching in the 17th century is Bosse's dearth of praise for painterly expedients, which in fact were the primary innovative focus of 17th-century etching. Two painters (and, significantly, not professional printmakers), Claude and Jacques Bellange (*c.* 1575–1616), another native of Lorraine but of an earlier generation, played important roles in these developments. They followed the lead of Barocci towards greater tonal complexity achieved not through systematic rebitings but through complex interweavings of bitings, burnishing and additions of tone and line by other intaglio means than conventional etching.

Bellange was painter to the court of the duchy of Lorraine at Nancy by 1602; thus his prominence as a leading creative artist antedated by a decade the introduction of intaglio printing to the court in 1610. Before his death, however, he produced at least four dozen plates in less than ten years. His characteristic images are distinguished by extensive reworkings with needle and burin and by burnishing. This burnishing, together with an almost compulsive use of stippling derived from Barocci and the innovative willingness to let the contour of brushstrokes of stop-out varnish stand as positive passages of light, resulted in surfaces of a peculiarly lunar luminosity, especially in early impressions, in which highlights shine against a grey tone surviving from residual plate-polishing scratches. All these characteristics are seen in *St James* (Robert-Dumesnil, no. 24) and *St John*

(Robert-Dumesnil, no. 29). Far more elaborate compositions, such as *Christ Carrying the Cross* (*c.* 1616; Robert-Dumesnil, no. 7) and the *Adoration of the Magi* (*c.* 1610–16; Robert-Dumesnil, no. 2), demonstrate Bellange's technical mastery of etching, which hitherto had never been used reliably for such complex conceptions.

Claude, like Barocci before him, seems to have turned to etching early in his artistic career when he was without important commissions. After producing *c.* 40 plates up to *c.* 1640, when demand for his paintings was strong, he abandoned printmaking for at least a decade, resuming with five plates over the next 13 years, which are among the most fully realized compositions of his printed works. His etched output is distinctive for its survival in many states. Although the trivial addition or correction of numbering and the nature of the paper in later states often point to posthumous reworking and reprinting, study of earlier-state sequences makes clear his interest in developing the effect of the plate even after the composition was fully established (usually in the first state) through rebiting, redrawing, burnishing and even, in the case of the *Shepherd with Goats* (*c.* 1634; Robert-Dumesnil, nos 26–7), cutting a completed image into halves. His etched work, especially his rework, is the antithesis of the clear and concise graphic idiom perfected by Callot. In Claude's work individual lines are suppressed into tone, whether in the mossy shadows of a copse or the sheen of a becalmed harbour. To achieve his rugose woodland textures, he often used a blotched or pitted line; in order to represent sun-struck clouds without lines, he even resorted in the large *Landscape with Country Dance* (1639; Robert-Dumesnil, no. 24; see fig. 3) to brushing acid directly on to the plate. These technical expedients, equivalent to the exquisite adjustment of glazes in his painted landscapes, did not bite deeply into the copper plate, and their intention and effectiveness can be gauged only in early impressions. When he combined his etching methods with individualistic plate wiping, the effect in a few impressions is comparable to his drawings executed in blended brown and black inks and washes and crumbled black chalk. His etchings demonstrate the affinity with drawing that the medium seemed uniquely to hold for painters; that is, the effect of his plates seen in their best impressions is to his chalk and wash drawings as, for example, the open etched style of Parmigianino is to his quill-pen drawings. The two painters' etching techniques, diametrically opposite from each other, are equally distant from the commercially more viable idiom of deeply bitten, clearly structured linear systems of the professional etcher Callot.

The subordination of the etched line into idiosyncratically blended touches, the development of actual etched tones and the exploitation of white line and tone masses, all non-commercial techniques in that they could produce only a few fully realized impressions per plate, were characteristic of many 17th-century artists. The Italians Giovanni Benedetto

Castiglione and Stefano della Bella (1610–64), who worked in Paris, and the Czech Wenceslaus Hollar (1607–77), who worked in Strasbourg, Cologne, London and Antwerp and travelled elsewhere, are notable for their success in conveying the flickering shadows of wooded glades and torch-lit ruins, and the soft textures of fur, hair and delicate textiles.

(ii) *The Netherlands*. In the work of two Dutch etchers of the 17th century, Hercules Segers (1589/90–1633/8) and Rembrandt van Rijn (1606–69), technical expedients adopted and, indeed, invented to enhance the tonal potential of etching brought this intaglio print form into command of its full resources. These two pre-eminent etchers were preceded and joined in the Netherlands by others of great technical capacity, notably Esaias van de Velde (1587–1630), his cousin Jan van der Velde II (*c*. 1593–1641), Willem Buytewech (1591/2–1624), Jan Lievens (1607–74), Jan Both (*c*. 1618–52), Jacob van Ruisdael (1628/9–82) and Simon de Vlieger (*c*. 1600/01–53). All these, and most of the other etchers in the Netherlands, were also painters. Their common preoccupation with tone, often achieved at the expense of orderly linear structure or at least through the means of stippling and other alinear graphic systems, conveys their attentiveness to effects of light, reflection and atmosphere developed by the 17th-century Dutch schools of landscape, interior and still-life painting. In such an etching as *Cottage and Clump of Trees near a Small Stream* (1646; Hollstein, no. 7) by van Ruisdael, line can fairly be said not to exist. This is not, however, to overlook the vigour of Dutch painter–etchers' line, liberated from the conventions of the reproductive printmaker. While *Bathsheba Reading David's Letter* (*c*. 1615; Hollstein, no. 4) by Buytewech is modulated by stippling, the contour and hatching lines dramatically force the figure to the very edges of the plate. The sketched peasants by Cornelis Bega (1631/2–64) are so boldly needled into the ground, in their lumpy clothes and hunched forms, that they become granitic.

In the rare works by Hercules Segers, etching is brought through several technical innovations into an actual approximation of painting. First he often printed his etchings on cloth, adopting the physical support of painting; and he frequently toned his support, whether cloth or paper, often with several hues, to provide a coloured ground for the printing ink, which frequently in his works is itself not the conventional black but blue, green, burnt orange or even yellowish white. The colouring of his etchings is supported by a tonal complexity generated by his innovative use both of stop-out varnish to provide detailed highlights to entire compositions, as in the *Large Tree* (Haverkamp-Begemann, no. 34), and of LIFT-GROUND ETCHING, apparently his own invention, as seen in the *Large Tree* and a *Road Bordered by Trees* (Haverkamp-Begemann, no. 26), to produce a full range of painterly values.

This obsessive interest in variation of impression, which ran counter to the contemporary commercial development in Flanders of etching as a formulaic basis for finished engravings after painting, was brought to its highest pitch by Rembrandt. He converted etching from a linear medium to a tonal one, particularly in his experimentation with wiping a film of ink overall or in strategically blended locales to focus on a character or an action or to modulate the mood or atmosphere of a scene. Such effects of wiping are, however, potential in the printing of any intaglio plate; and, indeed, in his later years Rembrandt's 'etchings' were in fact amalgams of engraving and drypoint (usually) superimposed on an etched basis, which might well be almost obliterated in the process (see fig.). Thus it may fairly be said that the usual estimate of Rembrandt as the consummate creative etcher should be revised to rate him as the consummate creative intaglio printmaker; his accomplishment thus falls outside the scope of this article.

Three aspects of Rembrandt's achievement nevertheless derive purely from the etched process. First, throughout his career, from the tangled netting of such early prints as the *Great Jewish Bride* (1635; B. 340) through the unelaborated scrawl of such sketches as *Six's Bridge* (1645; B. 208) to the hatched screens of such late prints as the transcendant *Christ Appearing to the Apostles* (1656; B. 89), his etched lines exploit as do no other artist's the technique's potential for conveying the idiosyncratic touch of the draughtsman at a particular instant with a specific intention. Secondly, Rembrandt used the process of biting to exquisite variety of effect. From the tender portrait of *Saskia* (1641–2; B. 359), in which his dying wife is portrayed with the delicacy of silverpoint, to the brusque large *Christ at Emmaus* (1654; B. 87), he adjusted the action of his acid as carefully as he did his etching needle, wiping rag, paper and press. Thirdly, the building of black through repeated overlays of cross-hatching (achieved, presumably, through repeated groundings and bitings, although successive states do not usually survive) marks a new extension of the tonal resources of etching. The prints in which he used only etching for this effect, with no added drypoint, such as the *Annunciation to the Shepherds* (1634; B. 44) and *Joseph and Potiphar's Wife* (1634; B. 39), date from the earlier years of his career. His willing recourse later to drypoint to establish a full tonal range, rather than for accents or correction, operated in tandem with his ever-deepening commitment to exploration of the potential of the individual impression at the expense of the durability or reproductiveness of the image, which etching would have been more suited to preserve.

Over the next 200 years Rembrandt's demonstration of the aesthetic and spiritual power of black would be appropriated by the masters of other, new intaglio processes, notably the mezzotint artists Valentine Green (1739–1813), Richard Earlom (1743–1822) and David Lucas (1802–81) and the aquatint artist Francisco de Goya (1746–1828). Rembrandt's exploitation of the capacity of the etched line faithfully to mirror the draughtsman's

Rembrandt van Rijn: *Three Trees*, etching with drypoint and engraving, 213×283 mm, *c.* 1643 (Chantilly, Musée Condé, Château de Chantilly); photo credit: Giraudon/Art Resource, NY

touch, however, an emphasis shared by his painter-etcher contemporaries of every nationality, was maintained by artists through the 18th century.

3. 18TH CENTURY. By this time etching had become the indispensible basis to reproductive engraving. Practically every commercial plate, invariably known as an engraving, a technical term by then synonymous with the concept of the reproduction of a painted composition, was in fact largely an etching. Although the burin was conventionally employed to complete and enrich the preliminary etched design, the visual effects of the etched line (its irregular outline, variously rugged or tremulous, and its potential for opaque and crusty blacks) were exploited in the finished impression as counterpoint to the metallic or velvety sheen of engraved passages.

Should he seek to make an original print, the 18th-century artist who employed pure etching, such as the Italians Giambattista Tiepolo (1696–1770), Giandomenico Tiepolo (1727–1804), Canaletto (1697–1768) and Giovanni Battista Piranesi (1720–78), and the Frenchman Jean-Honoré Fragonard (1732–1806), would rarely fully escape the linear conventions of contemporary reproductive engraving. Only occasionally, as in Fragonard's *Small Park* (1763; Wildenstein, no. 2), was the touch free from formulized stippling and hatching. These artists could

and did, however, transform the linear conventions derived from reproductive engraving into idiosyncratic representational schemes for foliage, masonry and cloth and, more distinctively, water, cloud and light. Such etchings as Canaletto's *A la Porte del Dolo* (*c.* 1735–after 1744; de Vesme, no. 5), Giandomenico Tiepolo's series of the *Flight into Egypt* (1753; de Vesme, nos 1–27) and, in an extreme manifestation of pure graphicness, Piranesi's view of the foundation blocks of the column of Antoninus Pius (Focillon, no. 581) are dominated by the effects special to etching: the uniform weight of clusters of lines all bitten at a single pass; the easy replication of a cultivated tremor of stroke, the subliminal roughness of both the edge and the surface of the inked line. At its best, 18th-century original etching participates in the contemporary blond, colouristic aesthetic with an added potential for lively surface and sonorous blacks, a combination as unattainable in the mezzotints and engravings as it was unanticipated in the painted confections of the period.

Etching, with its capacity for rapidly executed clear line, its relative ease of technical mastery and its durability compared to mezzotint and engraving, was the medium chosen for the new idiom of the caricature, which developed first in mid-18th-century Britain and then spread rapidly to Europe and even the New World by the end of the century. Social, commercial

and political revolutions drove and depended upon this visual arm of the popular press, and William Hogarth (1697–1764), Thomas Rowlandson (1756/7–1827), James Gillray (1756–1815) and countless lesser-known and anonymous followers produced a new style of etching, stripped of ornament and modulation, suited for cheap production and gaudy hand-colouring.

SOFT-GROUND ETCHING, a mid-18th-century technical innovation comparable in its easy replication of the draughtsman's touch to the graphic quality of caricature but thoroughly aesthetic in its application, was also a predominantly British phenomenon. It appealed primarily to draughtsmen, such as Thomas Gainsborough (1727–88), Thomas Girtin (1775–1802) and John Crome (1768–1821), who sought in a reproductive medium the picturesque sensibility of their chalk or graphite landscape renderings. The technique barely became known, however, before it was rapidly displaced by LITHOGRAPHY, which was even more suited to the purposes of the draughtsman who wanted to reproduce his designs without technical re-education and who relished the suggestive tonality of crayon over the strict linearism of pen.

Another English artist, William Blake (1757–1827), nevertheless perfected RELIEF ETCHING at the end of the 18th century, a technical advance tailored to his need as an impoverished poet to publish verse united with illustration and ornamentation. Although his exact materials and method remain unclear, it is possible that he devised a means to transfer text and decoration applied in an acid-resisting fluid to copper plates; the image being reversed by the transfer process, it would print in the correct orientation. The grounded plates were bitten to reduce the level of areas that were to remain uninked, and to print, the highest surface of the plate (that is, the unetched areas) would be inked, often in Blake's prints with a coloured ink. The resultant monochromatic page would be further enriched with watercolour applied by hand. In his most elaborate productions, such as copies of *The First Book of Urizen* (London, 1794–6), Blake experimented with multicoloured printing, applying inks of varying viscosities to all levels of the plate; the impression was then pulled with sufficient pressure to draw ink from the etched grooves and pits as well as from raised surfaces, creating multicoloured, dappled effects marked by reticulations of pulled points of stiffened pigment.

4. THE 19TH-CENTURY ETCHING REVIVAL. Such idiosyncratic and fragile processes as William Blake's version of relief etching and also the more widely practised soft-ground etching, all tending towards tone and colour and none suited to long press runs and commercialization, anticipated in artistic intention, if not technique and effect, a dramatic revitalization of etching as a popular creative process. After tentative beginnings by Adolph Menzel (1815–1905) in Germany and Rodolphe Bresdin (1822–85), Charles Jacque (1813–94) and Charles Meryon (1821–68) in France, an etching revival gathered

momentum in the third quarter of the 19th century; pure etching overwhelmed lithography as the print medium favoured by creative artists throughout Europe and North America for original expression. The Etching Revival movement was promoted as much by critics, printers and publishers as by the artists themselves, an alliance that was doubtless modelled on its major commercial competitor, the reproductive print unions (*lotteries*), which were promoted by painters and their critical supporters and publishers. The expressive potential of the pure etched line, in its reflection of the artist's idiosyncratic touch, and also tonal wiping, in its enhancement of each impression as a unique art object, were assets for advocates of the original print in their aesthetic and economic battle against reproductive prints.

The Etching Revival can also be seen as a complement to the renewed favour found by Rembrandt among painters and collectors of the Romantic and Realist generations and as a reaction against both the cold perfection of earlier Neo-classical engraving and the invention of photography. Indeed, in his preface to the first portfolio (1863) of the French Société des Aqua-fortistes, the critic Théophile Gautier (1811–72) raised etching to the status of moral imperative: 'The necessity of reacting against the positivism of the mirror-like apparatus has made many a painter take up the etcher's needle.'

While adherents of the Etching Revival movement were united against the reproductive print industry, they soon fell into dissension among themselves. The pre-eminent artistic talent among them, James McNeill Whistler (1834–1903), practised a style of interpretive printing of the plates of his mature years, such as those of his *Venice* sets (1880, 1883) and the *Amsterdam* series of the late 1880s, in which the etched lines are often only scantlings for the pictorial structure's cladding of ink tone. This metaphor takes literal form in his *Savoy Scaffolding* (*c.* 1886; Kennedy, no. 267), a bare sketch of builders' staging printed with gradated tone to establish the height and distance of the viewer from the scene and also to enhance the dematerialization of form already implied by the absence of any suggestion of the structure against which the scaffolding rests.

The surgeon Seymour Haden (1818–1910), Whistler's relative by marriage and eventual personal and professional antagonist, took the opposite stance. Like Meryon before him, he came to abjure plate tone and other artefacts of printing. Primarily an etcher of landscape, he developed his representations of scenic detail and atmosphere through expressive line, which in his plates moves quickly from dense hatching to summary sketching after the manner of Rembrandt, his graphic *atavus*.

Both Whistler and Haden, leaders of the British Etching Revival, made innovations in the techniques of biting in order further to refine the capacity of line to respond as sensitively as a pen to the draughtsman's touch. Whistler preferred to bite his plates by dabbing acid on them, so that instead of all his

needled lines being exposed to acid for the same duration, each could be individually bitten, the depth varying from line to line and even along the extent of a single line. Haden and Maxime Lalanne (1827–86), the French author of a highly influential treatise on etching, developed a method of needling the plate while it was immersed in the acid bath, calculating which lines ultimately were to print darkest so drawing them first and which were to print lightest so drawing them last, with a continuous range of intermediate intensity being drawn in the interval. Such a plate as Haden's *Dundrum River* (1863; Salaman, no. 49) was simultaneously drawn and bitten before the scene, thus assimilating the gradation of light and shade that the artist observed in the river prospect.

Whistler was a painter and a master etcher; Haden was, however, purely a printmaker. Comparable diversity was found among the French etchers, where 'peintres–graveurs' (artists who etched their own designs) such as Meryon, Bresdin and (the supreme technician) Félix Bracquemond (1833–1914) were printmakers, while Jacque, Camille Corot (1796–1875), Edgar Degas (1834–1917) and Camille Pissarro (1830–1903) were primarily painters. Within the work of the last two the most significant technical advances were made, although, as both Degas and Pissarro consistently employed a mixture of intaglio techniques on their plates, they cannot be considered pure etchers. The usage of the period nevertheless stipulated that the more original the print, both in the sense of the design being the etcher's own and in the sense of the impression being individualized through printing technique, the more it merited the designation 'etching'. Degas and Pissarro were therefore among the most important etchers of the period.

Degas was introduced to the monotype by the minor etcher Ludovic Lepic (1839–89), who, carrying the potential of creative printing to its extreme, used bitten lines simply as suggestive guides for compositional variations executed entirely by plate wiping. The subsequent progress of Degas in monotype is but one aspect of the greater artist's preoccupation with the evolution of his image on the plate, which in his etchings often resulted in multiple states, up to a dozen or more in some cases, of which only one or two impressions might be pulled. In a print such as *Leaving the Bath* (c. 1880; Reed and Schapiro, no. 42), for which 22 states have been identified and 33 impressions are known, it seems by the end of the life of the plate that Degas had exhausted rather than realized the potential of his etched expression. Camille Pissarro was equally devoted to developing his images through multiple states and unconventional manipulations of intaglio processes. His most innovative achievement as an etcher was the adaptation of four-colour printing applying the three primary hues and black to the Impressionist aesthetic.

Almost as quickly as etching asserted the value of printmaking as an original art form, it was displaced by other techniques. The broader effects of colour lithography and woodcut seemed more appropriate in the European responses to Japanese aesthetics and to the sculpture crafts and painted imagery of cultures that had not arisen in urbanized European or Asian contexts and that were newly appreciated by scholars and aesthetes from the colonial powers. Together with drypoint, colour lithography and woodcut seemed to allow even greater scope for individualistic expression. Partly because of its gross over-commercialization, etching, as caricatured by second-generation etching-revival advocates' emphasis on wiping, preciosity of line and paper choice, was viewed as effete and corrupt by most truly creative printmakers at the beginning of the 20th century.

5. 20TH CENTURY. In the 20th century a number of technical advances were made in etching, which derived both from modern materials and from a modern enthusiasm for disrupting conventions of technical usage. From the 1920s, for instance, the German Rolf Nesch (1893–1975) capitalized on the accidental overbiting of a plate in which a hole was eaten through the copper; he developed designs that depend upon the contrast of bulging white, uninked positive forms, haloed by ink caught in their corroded edges, with conventional black etched lines. The idea of voids led Nesch and other etchers logically to the build-up of forms on printing plates, so that ultimately a three-dimensional surface was wiped, with ink held both by lines below the surface and by the contours of superimposed forms, with the final impression produced as much by the low relief pressed into the paper as by the ink deposited within and across its topography. When complex relief/intaglio plates were inked in several coloured inks of differing viscosity with rollers of varying elasticity, in a systematic development in the 1950s by S. W. Hayter (1901–88) of Blake's innovations, images of tremendous colouristic and textural density could be produced.

A technical enlargement of the potential of softground etching dependent upon modern materials was the idea of automatically establishing registration for colour printing by drawing in successive colours on a sheet of transparent plastic film laid over each of the grounded plates in turn; it was first proposed to Pablo Picasso (1881–1973) by his printers, the brothers Albert-Jean Crommelynck and Robert-Hubert Crommelynck. The concept was ultimately realized in the 1970s by David Hockney (b 1937). Soft-ground etching and many other tonal bitten techniques (expanding on traditional and sugarlift aquatint into *lavis* and spitbite) became an accepted part of the conventional etched repertory. Many artists collaborated with master printers, such as the Crommelyncks in Paris and Kathan Brown in San Francisco, who provided versatile technical resources, not only to printmakers who were familiar with traditional etching practices but also to painters and others who wanted to incorporate into prints effects that initially they could visualize only in terms of work in other media. The most significant and

productive advance in modern etching was probably, however, the assimilation into the artist's technical and creative repertory of that process against which 19th-century printmakers had revolted, that (to quote a 19th-century reproductive engraver) 'foe-to-graphic' art, the photograph. Indeed, the first fixed image created by the exposure to light of photosensitive material through an image that was opaque in areas that read as dark and translucent in areas that read as light was for the purpose of producing an etching plate. In 1827 the Frenchman Nicéphore Niépce (1765–1833) applied bitumen, which hardened when exposed to light, as a ground to a pewter plate and laid over it a 17th-century engraving on paper, which in this application acted as a photographic negative. After light had selectively hardened the 'white' areas of the image transmitted on to the bitumen, the still-soluble 'black' areas were washed away and the plate was bitten in acid to create a functional printing plate, which reproduced the engraving.

The technology of photoreproduction developed rapidly, so that within half a century reproductive engravers on wood and copper were virtually displaced. Photogravure, an etching process, was perfected for luxury productions (see PHOTOGRAPHY, §I, 2; see also PRINTS, §III, 4), and in popular illustration the ubiquitous wood-engraving was replaced by 'linecuts', black-and-white drawings photographically reproduced as relief etchings. In another aspect of the photographic revolution, artists, including etchers, quickly adopted the photographic imagery as models. A 19th-century example that transcends the etching revival's valorization of successive states is a Self-portrait (1889; Delteil, no. 67) by the Belgian James Ensor (1860–1949), closely drawn in its first state after a conventional portrait photograph. In a profound penetration of the appearance of reality provided by the photograph, the print in its third state became My Portrait Skeletonized.

Although photogravure portraits were occasionally surrounded by hand-drawn and etched framing motifs in the 19th century, only in the 20th century did artists fully integrate photographically produced etchings within their plates. In his series Miserere et guerre (1927), Georges Rouault (1871–1958) reworked photogravures of his own drawings with etching, roulette and aquatint to produce prints in which the heavy blend of optical and tactile textural effects contribute substantially to the hallucinatory power of his morbid imagery.

The direct transfer of 'real-world' photographic imagery on to an intaglio printing plate as an element in a composition may have begun in 1948 with an isolated example, Attack on Marshall Gilbert, by Kenneth Kilstrom (1922–95), working in Hayter's New York Atelier 17. Lithography and silkscreen artists of the 1960s incorporated photographic images into their prints far more avidly than those working in etching, and it was not until the 1980s that it became common in the intaglio medium. By this time, however, some artists had forgone hand-drawn

revisions of the photographic image. In the Razorback series (1981) by Robert Rauschenberg (1925–2008), each print comprises several photo-etched plates of photographic images, which are printed in different-coloured inks on variously coloured layers of chine appliqué, leaving the white margins of the backing sheet to frame the silhouette of joined oblongs that the combined images present. The artist's creation lies in the choices he has made and in their realization by his printer. In a completely different creative procedure, yet one equally dependent upon photo-etching processes, Peter Milton (b 1930) drew in opaque ink on transparent films and photo-etched his designs, often composites of individual pictorial elements that could also incorporate photographic imagery, on to lift ground. Through reuse of the films, fragments of one print could reappear in another, even in reverse, as in the bust of the writer Henry James, derived from a photograph, which appears facing right in the Jolly Corner III:3 and left in the Jolly Corner III:5 (1971; McNulty, nos 78, 80).

Thus, while it cannot be said that etching dominated creative printmaking of the late 20th century in the sense that it did the late 19th century, certainly its adaptibility to technical innovation has encouraged its use to express the modernist disruption of traditional forms. Likewise, in such prints as the linear grids of calculated density by Sol LeWitt (b 1928), etching in its simplest, most conventional conjunction of the artist's touch and the uniform bite continued into the late 20th century to serve as a vehicle for new visual concepts.

A. Bosse: Traicté des manières de graver en taille douce sur l'airin, par le moyen des eaux fortes… (Paris, 1645)

A. von Bartsch: Le Peintre-graveur (1803–21) [B.]

A. P. F. Robert-Dumesnil: Le Peintre-graveur français (1835–71)

M. Lalanne: Traité de la gravure à l'eau-forte (Paris, 1866, 2/1878; rev. and Eng. trans. as A Treatise on Etching, Boston, 1880)

A. de Vesme: Le Peintre-graveur italien (Milan, 1906/R London, 1979)

L. Delteil: Le Peintre-graveur illustré (Paris, 1906–30)

A. M. Hind: A Short History of Engraving and Etching: From the 15th Century to the Year 1914 (London, 1908, rev. 3/1923)

H. Focillon: Giovanni-Battista Piranesi: Essai de catalogue raisonné de son oeuvre (Paris, 1918)

M. C. Salaman: The Etchings of Sir Francis Seymour Haden PRE (London, 1923)

J. Lieure: Jacques Callot, 6 vols (Paris, 1924–7)

R. S. Lumsden: The Art of Etching (Philadelphia, 1925)

O. Schmitt and others, eds: Reallexikon zur deutschen Kunstgeschichte (Stuttgart, Metzler and Mainz, 1937–)

F. W. H. Hollstein: Dutch and Flemish Etchings, Engravings and Woodcuts, c. 1450–1700 (Amsterdam, 1949–)

F. W. H. Hollstein: German Engravings, Etchings and Woodcuts, c. 1400–1700 (Amsterdam, 1954–)

G. Wildenstein: Fragonard aquafortiste (Paris, 1956)

C. White: Rembrandt as an Etcher (London, 1969)

H. Zerner: The School of Fontainebleau: Etchings and Engravings (New York, 1969)

J. Bailly-Herzberg: L'Eau-forte de peintre au dix-neuvième siècle: La Société des Aquafortistes, 1862–1867 (Paris, 1972)

W. Chamberlain: *The Thames and Hudson Manual of Etching and Engraving* (London, 1972; rev. 2/1992)

H. D. Russell: *Rare Etchings by G. B. and G. D. Tiepolo* (Washington, DC, 1972)

E. Haverkamp-Begemann: *Hercules Seghers: The Complete Etchings*, 2 vols (Amsterdam, 1973)

E. G. Kennedy: *The Etched Work of Whistler* (New York, 1974)

H. D. Russell, J. Blanchard and J. Krill: *Jacques Callot: Prints and Drawings* (Washington, DC, 1975)

The Etchings of Jacques Bellange (exh. cat. by W. R. Reed and A. N. Worthen; Des Moines, IA, Art Center; Boston, MA, Museum of Fine Arts; New York, Metropolian Museum of Art; 1975)

K. M. Guichard: *British Etchers, 1850–1940* (London, 1977)

K. McNulty: *Peter Milton: Complete Etchings, 1960–1976* (Boston, 1977)

D. Bindman: *The Complete Graphic Works of William Blake* (New York, 1978)

P. Gilmour: *The Mechanised Image: An Historical Perspective on 20th-century Prints* (Twickenham, 1978)

I. de Groot: *Landscape Etchings by the Dutch Masters of the Seventeenth Century* (Amsterdam, 1979)

C. S. Ackley: *Printmaking in the Age of Rembrandt* (exh. cat., Boston, MA, Museum of Fine Arts, 1981)

H. D. Russell: *Claude Lorrain, 1600–1682* (exh. cat., Washington, DC, National Gallery of Art, 1982)

V. Carlson and others: *Regency to Empire: French Printmaking, 1715–1814* (Minneapolis, 1984)

K. J. Lochman: *The Etchings of James McNeill Whistler* (New Haven, 1984)

S. W. Reed and B. S. Shapiro: *Edgar Degas: The Painter as Printmaker* (Boston, 1984)

R. Hauff and others: *Radierungen im 20. Jahrhundert* (Stuttgart, 1987)

S. W. Reed and R. Wallace: *Italian Etchings of the Renaissance and Baroque* (exh. cat., Boston, MA, Museum of Fine Arts, 1989)

F. De Denaro: *Domenico Tempesti e 'I discorsi sopra l'intaglio ed ogni sorte d'intagliare in rame da lui provate e osservate dai più grandi huomini di tale professione'* (Florence, 1994)

D. Landau and P. Parshall: *The Renaissance Print* (New Haven and London, 1994)

R. Michler and L. W. Löpsinger, eds: *Salvador Dalí: Catalogue Raisonné of Etchings and Mixed-media Prints, 1924–1980* (Munich, 1994)

A. E. Pérez Sánchez and J. Gállego: *Goya: The Complete Etchings and Lithographs* (Munich, 1995)

M. Gilles, A. B. Kowalczyk and J. Rodgers: *Rembrandt et les peintres-graveurs italiens, de Castiglione a Tiepolo* (Ghent, 2003)

E. Ornstein-Van Slooten and M. Holtrop: *The Rembrandt House: A Catalogue of Etchings* (Zwolle, 2006)

M. Cole, ed.: *The Early Modern Painter-etcher* (University Park, PA, 2006)

E. Hinterding: *Rembrandt as an Etcher* (Rotterdam, 2006)

C. Gale: *Etching and Photopolymer Intaglio Techniques* (London, 2006)

Etching, lift-ground [sugarbite or sugar-lift aquatint]. Intaglio printmaking technique and type of print made by such a process. The design is drawn on to an intaglio plate with a pen or brush and water-soluble ink mixture, of which ordinary sugar is usually the main component, although many recipes exist. (Other ingredients can be soap, gum arabic or honey.) The whole plate is then covered with fluid, acid-resistant etching ground. When soaked in water, the special ink mixture dissolves and lifts the ground from the plate, thus exposing the metal of the plate where the image has been drawn. Before or after this step the bare plate may be covered with a substance such as aquatint. As well as the basic technique, a number of variations exist. The whole plate may be covered with the special ink and left to dry. A design is then scraped into this with an etching needle, the plate grounded and then lifted. The ground is left where the design is scraped away. The resulting etching reveals white lines on a dark background. In another method the bare metal is greased, so that when the drawing is made the ink contracts, giving structured lines.

Between 1620 and 1640 the Dutch artist Hercules Segers (1589/90–1633/8) experimented with processes similar to the 'pen method', first described by Maxime Lalanne (1827–86) in 1866. In this method the design is made with plain India ink and pen and the metal bitten only once. The resulting etching resembles a pen-and-ink drawing. Although the Frenchman Jean-Baptiste Le Prince (1734–81) applied a sugar solution to make powdered resin stick to the plate for his aquatints, this was not a lift ground proper (*see* AQUATINT, §2(ii)). It was the Englishman Paul Sandby (1731–1809) who invented the sugar-lift process. Having etched the outlines of his drawing in the ordinary way, he then cleaned the plate and applied a liquid aquatint ground. He drew all the shadows with the special sugar solution, grounded, lifted and etched the plate like an aquatint. Thomas Gainsborough (1727–88) learnt the technique from Sandby and went one step further: he first painted all the outlines with special ink, lifted and etched them; he then proceeded as Sandby. Other British artists followed, and Theodore Henry Adolphus Fielding (1781–1851) published a description in 1841. Evidence of the use of lift ground in the 18th and early 19th centuries has been found in areas of Europe where aquatint has been known. About 1890 the Belgian Armand Rassenfosse (1862–1934) developed a refined recipe for a special ink. Around 1923 he also developed a technique whereby the problem of printing a mirror image was avoided, by drawing on smooth paper with the special ink and then immediately laying this on the plate and running it through the press. After offsetting the drawing he powdered the plate with whiting or zinc oxide. The excess powder would then be removed and the plate covered with a very thin layer of varnish. The acid would attack the particles that stuck through the varnish and then the metal underneath each particle. In this way he obtained crayon-like lines.

After the French printmaker Roger Lacourière (1892–1966) taught Pablo Picasso (1881–1973) and S. W. Hayter (1901–88) the process, it became a popular intaglio technique. Hayter created his own version of the technique at Atelier 17, probably before 1980,

in which a paste of whiting and alcohol is used to make the design. Once the alcohol has evaporated the whiting is sprayed with fixative or diluted varnish. When dry the plate is laid in vinegar or acetic acid, which dissolves the whiting to reveal the metal.

Detecting the use of lift ground in reproductive prints is difficult, since it is almost always mixed with other techniques.

Unpublished sources
Amsterdam, Rijksmus. [*Manier om op de Engelsche wijze in het koper te graveeren door hun genoemd Aqua Tinta* (Manner to engrave into the copper in the English way by them called Aqua Tinta), 1810]

Bibliography
A. M. Perrot: *Manuel du graveur* (Paris, 1830, rev. 3/1865/*R* 1988)
T. H. A. Fielding: *The Art of Engraving, with the Various Modes of Operation* (London, 1841, 2/1844)
C. Jaque: 'Gravure et imprimerie en taille-douce', *Magazine pittoresque*, xx (1852), p. 333
J. M. H. Hammann: *Des arts graphiques* (Geneva, 1857)
F. A. M. Lalanne: *Traité de la gravure à l'eau forte* (Paris, 1866, 6/1897; Eng. trans. 1880/*R* 1981)
J. Hedon: *Jean Le Prince et son oeuvre* (Paris, 1879)
W. Ziegler: *Die Techniken des Tiefdrucks* (Halle an der Saale, 1901, rev. 4/1923)
E. S. Lumsden: *The Art of Etching* (London, 1925/*R* 1961)
S. W. Hayter: *New Ways of Gravure* (London, 1949, 3/1981)
W. van Leusden: *The Etchings of Hercules Seghers and the Problem of his Graphic Technique* (Utrecht, 1961)
E. Rouir: *Armand Rassenfosse: Catalogue raisonné de l'œuvre gravé* (Brussels, 1984)
A. Griffiths: 'Notes on Early Aquatint in England and France', *Print. Quarterly*, iv (1987), p. 269

Etching, relief. Relief printmaking process in which a metal block is prepared by etching and the design is left in relief. It was first used by Leonardo da Vinci (1452–1519) and then most notably by William Blake (1757–1827). Interested in all aspects of printmaking, Leonardo was aware of the lack of a method of making blocks that would give impressions nearer to original drawings than the somewhat crude woodblocks then available. Intaglio engravings could give a close approximation but presented many difficulties, such as the necessity either of putting the leaves through two presses—one for the relief type, another for the intaglios, which required greater pressure—or printing type and illustrations on separate leaves. Relief etching would make it possible to print everything simultaneously and provide lines sufficiently sharp to reproduce a drawing with considerable accuracy.

Leonardo's method involved coating an iron or copper plate with a water-soluble mixture of albumen and white lead. The design was scratched through this in reverse, following which the whole surface was coated with a brittle, acid-resisting varnish containing minium (red lead) or *giallorino*, an opaque lead approximating to Naples yellow (lead antimoniate). Once dry, it was soaked, allowing the varnish to break away from the clear areas. The plate was then bitten with nitric acid, leaving the design in relief. Alternatively, the varnish consisted of minium and hard resin applied warm; being more brittle, this broke away more easily. Although Leonardo's relief etching did not progress beyond experiments, it was shown to be a feasible technique by the Italian artist Attilio Rossi (1909–94); using Leonardo's receipt, he reproduced a Leonardo drawing of the bones of the human hand and of part of the forearm (Windsor Castle, Berks, Royal Collection, 19009*v*).

Little, if any, relief etching was done after Leonardo until it was used by William Blake, mainly for the production of his illuminated books between 1788 and 1822. Blake's technique has not been finally ascertained, but there are two main hypotheses. In 1947 S. W. Hayter (1901–88) experimented with a technique he considered identical to Blake's. Lettering and design were applied in a solution of asphaltum and resin in benzine on paper coated with a mixture of soap and gum arabic. This was transferred in a press to a heated clean copperplate. The paper was dampened and removed, the lettering and design remaining on the plate, which was then bitten for about nine hours in a mordant of one part nitric acid to two parts water; this left the lettering and design in relief. Alternatively the design (but not the lettering) might be painted directly on to the plate. Hayter concluded that Blake used some such transfer method, since his lettering is not always correctly aligned on the plate. However, the art historian Robert N. Essick asserted that Blake's method was closer to Leonardo's, both design and lettering being painted directly on to the plate in reverse with a fine brush, in a resist of asphaltum and linseed oil, or of olive oil boiled with purified suet. This is now the more generally accepted hypothesis.

The problem of ascertaining Blake's method is exacerbated by the fact that only one remnant of his original plates has survived: a corner of a rejected plate for *America: A Prophecy* (1793). This shows that the biting left an average depth of 0.12 mm on a plate 1.41 mm thick. Blake probably inked his plates with an inking ball, using home-made inks of various colours (their composition is unknown), and probably pulled impressions on dry paper.

According to John Thomas Smith, in *Nollekens and his Times* (London, 1829), Blake characteristically claimed that the process was revealed to him by his dead brother, Robert, in a vision. Blake probably partly derived the idea from experiments by his friend the dilettante George Cumberland (1754–1848), who engraved texts on copperplates and took counterproofs from them. From this to a reversal of the standard etching process was but a step. To Blake, relief etching assumed a spiritual dimension; in his book *The Marriage of Heaven and Hell* (c. 1790–93) he said he would print 'in the infernal method, by corrosives, which in Hell are salutary and medicinal, melting apparent surfaces away, and displaying the infinite which was hid'. Blake made 12 books in relief

etching in addition to several single prints. No other artist made such wide, varying and convincing use of the technique.

During the 19th century, many chemical, mechanical and photographic relief techniques were invented and widely used. Typical was the French method, *aciérage* or *en épargne*, in which a master die is engraved in intaglio, from which a mould is made in papier mâché or plaster; in this, relief blocks are made by casting or by electrolytic deposit. *Aciérage* was useful if it was necessary to have a number of identical impressions at one printing, as in postage-stamp production. The highly successful Comte process relied on more traditional methods: a zinc plate was spread with a ground of zinc white and Dutch pink (a yellow lake). The design was scratched through this, the plate coated with acid-resisting ink and placed in water, in which the ground floats off from the clear areas. It could then be bitten. The Comte method was used notably by Karl Bodmer (1809–93) for illustrations in quality magazines, such as the *Monde illustré* and the *Magasin pittoresque*. Among engravers who successfully used photo-mechanically produced etchings were Firmin Gillot of Paris (1820–72), who patented his process, and his son Charles Gillot (1853–1903).

Relief etching has taken its place among modern printmaking techniques and was used with conspicuous success in combination with intaglio by Picasso's master printer, Roger Lacourière (1892–1966), and John Buckland-Wright (1897–1954); S. W. Hayter also used it in conjunction with other techniques achieved by pressing different materials into the ground before etching it. Nylon, cotton, silk, leaves, string, crumpled paper, even wood-shavings have been used thus. J. G. Lubbock (*b* 1915) used relief etching integrated with intaglio etching, engraving, aquatint, grinding and drilling for illustrations to his own books, including *Aspects of Art and Science* (Leicester, 1969) and *From the Snows to the Seas* (London, 1986).

S. W. Hayter: *New Ways of Gravure* (London, 1966)

L. Reti: 'Leonardo da Vinci and the Graphic Arts: The Early Invention of Relief-etching', *Burlington Magazine*, cxiii (1971), pp. 188–95

J. Wright: 'Towards Recovering Blake's Relief-etching Process', *Blake Newsletter*, vii (1974), pp. 32–9

R. Lister: *Infernal Methods: A Study of William Blake's Art Techniques* (London, 1975)

R. N. Essick: *William Blake: Printmaker* (Princeton, 1980)

R. Lister: *Prints and Printmaking: A Dictionary and Handbook of the Art in Nineteenth-century Britain* (London, 1984)

J. Viscomi: *Blake and the Idea of the Book* (Princeton, 1993)

Etching, soft-ground. Intaglio printmaking technique in which a particularly soft ground is used; the term is also applied to the type of print made by such a process.

Soft ground is a mixture, usually in equal parts, of ordinary etching ground and a greasy substance, such as tallow or petroleum jelly, although many recipes exist. The etching ground is carefully melted and the greasy component stirred in. The mixture may be poured into pots while still warm, or, once cool, may be formed into balls, which are then wrapped in fine cloth. The soft ground is made fluid by dissolving in turpentine or petrol. It is rolled or brushed on to the plate as ordinary etching ground, but no degreasing is necessary, since it is greasy in itself. Nor is smoking of this ground necessary because of the techniques used. Soft ground is also sold ready-made.

There are many techniques that may be used with soft ground. In one the soft ground is covered with paper, on which a drawing is then made or traced. Since the paper adheres to the ground, when removed, it takes the soft ground with it, laying bare the metal and the impression of the drawing. The etching made from this has the appearance of a crayon drawing. In another method the plate is placed on the bed of a roller press and the soft ground covered with some kind of texture. Waxed paper is then laid over it, the pressure reduced and the plate run through the press; the plate is to be etched like an aquatint. Alternatively, the plate is placed on the bed of a roller press and a flat object or material (e.g. leafs, rope or wrinkled paper) laid on the soft ground and waxed paper laid on top. The pressure is reduced and the plate is run through the press; once etched, the image gives the effect of nature printing. Drawing may also be made in the soft ground by such means as match, thumbprint or comb, and soft ground may also be applied to a fabric, which is then laid on a clean plate, or covered with waxed paper and run through the press.

A craquelure effect may be achieved by covering the soft ground with a quick-drying varnish, which, when dry, starts to crack, taking the ground underneath with it. A marbled or 'bubbled' appearance is obtained by covering the soft ground with varnish and heating the plate until ground and varnish begin to move and contract.

Multiple-plate colour prints are produced using two or more plates of equal size. A drawing is made on a piece of paper. After each colour is drawn, the paper is changed to another plate. Drawing with coloured crayon makes the intended result visible. For perfect register, a rectangular or L-shaped frame, with the paper stretched over it, is used. The plates fit within the rectangle or in the corner of the L. Zinc may be etched with a weak nitric acid, copper with 'Dutch mordant' or a ferro-chloride solution. Printing is executed like an aquatint.

As early as the 16th century line engravings and line etchings were printed in red or brown, possibly to give them the appearance of drawings. This also strengthened their reproductive qualities. From the 16th to the 18th century several attempts were made to imitate a crayon line by means of dotting or scribbling with a burin, etching needle, or roulette. Successful experiments were executed by Marcello Fagolino (*fl* 1519–48), who used some kind of transfer etching technique. Around 1760 Jean-Etienne Liotard (1702–89) used a technique in which he pressed a fabric into ordinary etching ground while this ground was still warm. He then etched it like an aquatint.

Jean-Charles François (1717–69) invented the crayon manner, using roulettes and other instruments to reproduce high-dotted, crayon-like lines. He published his first print in this technique in 1757. Besides other inventions he developed a 'secret' etching process in 1757. It was probably similar to that used by Cornelis Ploos van Amstel (1726–98) and others, who tried to reproduce crayon drawings. It has since become known as 'sand-grain'. In 1756 Ploos van Amstel started experimenting successfully with this technique, employing assistants from 1765. For the sand-grain method a normal grounded plate is covered with a piece of paper, to the back of which is glued a hard, powdered material (e.g. sand or copper filings). The drawing is made in the normal way, the hard particles are pressed through the ground, the plate is etched and the print shows finely dotted lines. (In the 20th century ordinary sandpaper is used, giving the same results.) Johann Heinrich Tischbein II (1742–1808) used sand and pulverized tartaric acid, which he melted on top of an ordinary etching ground. Paper was laid on this ground. When drawing, the hard particles were pressed through, the plate was etched and the print showed finely dotted lines. The Dutch chemical engineer Marius Holleman (1878–1926) perfected Tischbein's form of sand-grain technique.

Credit for the invention of soft-ground etching should go to Benjamin Green (c. 1736–1800), who showed his first results in 1771. He was followed by Thomas Gainsborough (1727–88) and Paul Sandby (1731–1809) c. 1775. Sandby gave the first description of this technique. Soft ground became popular in Britain, where it was used mainly for drawing-books, the technique being excellently suited to reproducing drawing techniques. It was applied by such artists as Thomas Rowlandson (1756/7–1827), Thomas Girtin (1775–1802) and Richard Parkes Bonington (1802–28) after 1800. Scottish-born William Charles went from London to Philadelphia, where he made some soft-ground etchings before his death in 1820, the first of this kind on the American continent.

By the end of the 18th century the process became known to non-English artists. In 1792 the Dutch painter Hendrik Meyer (1737–93) had published a set of 12 landscapes in soft ground while working in London. Around 1800, soft ground became known in France when Michel Vauthier (fl c. 1800) and Jacques Couché (1750/59–? after 1820) published a *Collection de gravures dans la manière du crayon* in this technique. A second enlarged edition was published in 1802 as *Recueil de paysages enrichis de figures et animaux.*

The use of soft ground as a reproductive medium diminished, however, after 1825 when it was replaced by lithography. In 1817 Ernst Willem Jan Bagelaar (1775–1837) published a small treatise in which he described the soft-ground process, among others. From 1840 the technique is usually mentioned in books and articles about etching and engraving, and from that period French artists used soft ground regularly, first in reproductive prints, often combining it with aquatint, line etching and roulette, and shortly afterwards as a medium for originals.

In 1862 the Société des Aquafortistes was founded in France. Several of its members applied soft ground in their etchings, including Maxime Lalanne (1827–86), whose influential manual on etching contains a paragraph on soft ground. The Impressionists Camille Pissarro (1830–1903) and Edgar Degas (1834–1917), guided by Félix Bracquemond (1833–1914), taught themselves etching, and by 1879 they were familiar with soft ground. They were soon followed by other Impressionists. From c. 1890 onwards soft-ground etching was fairly popular among French printmakers, and some even used it in multiple-plate colour prints. The Belgian Félicien Rops (1833–98) started using soft ground in the 1870s, developing a method in which he used several kinds of paper for one plate. He also had his crayon drawings photomechanically transferred to intaglio plates. The ordinary soft ground mixture did not suit him well for reworking such plates, and so he developed a special soft ground in cooperation with Armand Rassenfosse (1862–1934). By 1892 they worked out the final recipe, which they called 'Ropsenfosse'. Rassenfosse mixed many different soft-ground recipes and was probably the first to make colour prints with soft ground, using two or more plates, from 1900. In 1885 the Nederlandsche Etsclub was founded. Some of its leading members taught themselves etching, using Lalanne's manual. In the next few decades the technique spread to German, Austria, Poland, Sweden, and Russia.

In the 1920s the use of soft ground spread further, being used by the American Arthur Davies (1862–1928), the Czech Frantiek Kobliha (1877–1962) and (probably) the Japanese artist K. Takekoshi. S. W. Hayter(1901–88) and his students from Atelier 17 (in Paris from 1927, in New York during World War II) made the use of this technique truly international. By the late 20th century soft ground was an intaglio technique much in use by prominent artists including David Hockney (b 1937), Jasper Johns (b 1930) and Jim Dine (b 1935).

J. H. Tischbein II: *Kurzgefaszte Abhandlung über die Aetzkunst* (Kassel, 1790)

A. Fokke Simonsz.: *De graveur* (Dordrecht, 1796)

E. W. J. Bagelaar: *Verhandeling over een nieuwe manier om prenttekeningen te vervaardigen* [Treatise about a new way of making print drawings] (Haarlem, 1817)

F. A. M. Lalanne: *Traité de la gravure à l'eau forte* (Paris, 1866, 6/1897; Eng. trans., 1880/R 1981)

A. Delâtre: *Eau forte, pointe sèche et vernis mou* (Paris, 1887)

A. M. Hind: 'Notes on the History of Soft-ground Etching and Aquatint', *Print Collector's Quarterly*, viii (1921), pp. 377–405

M. Holleman: *Nieuwe etstechnieken* [New etching techniques] (Utrecht, 1927)

M. Hardie: 'Letters from Paul Sandby to John Clerk of Eldin', *Print Collector's Quarterly*, xx (1933), pp. 362–4

M. Guérin, ed.: *Lettres de Degas* (Paris, 1945), p. 53

A. J. M. van Moorsel: 'Een vergeten Toorop' [A forgotten Toorop], *Oud-Holland*, xc (1976), pp. 275–6

E. Rouir: *Armand Rassenfosse: Catalogue raisonné de l'œuvre gravé* (Brussels, 1984)

S. Lambert: *The Image Multiplied* (London, 1987)

P. D. Cate and M. Grivel: *From Pissaro to Picasso: Color Etching in France* (Paris, 1992)

Experimental film [avant-garde; fine art film]. Term referring to MOTION PICTURE FILMS that are distinguished by their concern to analyse and extend the medium, not only by means of new technology or subject-matter but also in terms of new formal or aesthetic ideas. Work of this kind is generally produced on a small budget and is screened in galleries and specialized venues; it maintains close links with avant-garde literature and art. The first decade of film making (after 1895) necessarily involved a great deal of experiment, although most participants saw film as a medium for entertainment rather than art. The work of two early French directors, Georges Méliès (1861–1938) and Emile Cohl (1857–1963), was later singled out by film makers. Méliès, a professional magician, showed the power of the film medium to transform time and space in *An Up-to-date Conjuror* (1899) and *Voyage to the Moon* (1902). In *The Joyous Microbes* (1909) Cohl demonstrated the linear freedom possible in film animation. In the 1910s and 1920s many artists associated with Modernism were drawn to film as a product of new technology and a medium unencumbered by tradition. It also offered artists the opportunity to animate their images. The Italian Futurists issued a manifesto about the possibilities of 'Futurist cinema' in 1916. The major Futurist films appear to have been lost, although an essay of 1912 by Bruno Corra (1892–1976) provided a detailed description of animation work. He and Arnaldo Ginna (1890–1982) bypassed the camera by painting directly on celluloid. Their work attracted so little attention that this method of direct film making was reinvented two decades later.

In the early 1920s artists in Germany developed the 'absolute' or 'non-objective' film. Their animated films featured geometrical forms that moved and changed rhythmically, and their titles implied a parallel between abstract art and music. Between 1921 and 1925 Walther Ruttmann (1887–1941) made *Opus One* to *Opus Four*; Viking Eggeling (1880–1925) made *Diagonal Symphony*; and Hans Richter (1888–1976) made *Rhythmus 21* and *Rhythmus 23*. Richter and Oskar W. Fischinger (1900–67) were the first to build up long careers as experimental film makers. Fischinger continued to develop new methods of animation, from his abstract studies of the 1920s to his film *Motion Painting No. 1* (1947), which followed the development of an oil painting through thousands of images. Other films of the 1920s demonstrated the variety of ways in which live action could be transformed by an artist's framing, editing and processing. In *Ballet mécanique* (1924) Fernand Léger (1881–1955) created an abstract vision of everyday objects. His collaborators were the American cameraman Dudley Murphy (1897–1968) and the American composer Georges Antheil (1900–59). *Anemic Cinema* (1925) by Marcel Duchamp (1887–1968) was an important forerunner of structural or conceptual film making. Duchamp based the film on his experiments with 3-D and kinetic sculpture. Many artists' films have similarly grown out of installations or kinetic sculpture, for example *Light-play: Black and White and Grey* (c. 1930) by László Moholy-Nagy (1895–1946). Man Ray (1890–1976) created *Return to Reason* for a Dada event in 1923. The film was a vivid demonstration that the 'rayograph' method of making exposures directly on photographic paper without a camera could be applied to cinematography. Another notable Dada film was *Entr'acte* (1924) by Francis Picabia (1879–1953) and the French film maker René Clair (1898–1981) with the involvement of Ray, Duchamp and the composer Erik Satie (1866–1925). The Surrealists also took an intense interest in films, which they saw as closely related to dreams. The best-known Surrealist films included two made in 1928: *The Seashell and the Clergyman*, based by the French film maker Germaine Dulac (1882–1942) on a script by Antonin Artaud, and *Un Chien andalou* by the Spanish film maker Luis Buñuel (1900–82) and Salvador Dalí (1904–89), which began with the slicing of a person's eye, one of the best-known of all film images. Buñuel and Dali's other film, *L'Age d'or* (1930), was confiscated by the police.

By the late 1920s there were enough 'cine poems' or examples of 'pure cinema' to justify the claim that film had become a fully independent art. In Europe the audience was expanded by cine clubs, film societies and art cinemas. In the 1930s, however, experimental film making declined as Fascist governments suppressed modernism. Also, the introduction of sound had considerably increased the cost of film making. Some artists were able to fund abstract films set to music by including a sponsor's message. Such 'prestige commercials' were greeted by cinema audiences with a mixture of delight and bewilderment. Both Fischinger and Len Lye (1901–80) used this genre to experiment with the artistic possibilities of colour. Lye created new styles of direct or cameraless animation as he painted and stencilled such films as *Colour Box* (1935) and *Swinging the Lambeth Walk* (1939). The fluid nature of animation lent itself particularly well to experiment, shown also by the work of the German Lotte Reiniger (1899–1981), the American Mary Ellen Bute (1906–83) and the Scot Norman McLaren (1914–87).

After World War II the USA became an important centre of experimental film making. One of the catalysts was the presence of Fischinger, Lye, Richter and other European artists. The Russian film maker Maya Deren (1917–61) and the Czech film maker Alexander Hammid (1907–2004) created the poetic *Meshes of the Afternoon* in California in 1943. Deren applied her interest in modern dance and magic to five other dream-like films. Her genre of 'psychodrama' or 'personal film' was central to this first phase of the

New American Cinema. Another powerful example was *Fireworks*, made in 1947 by Kenneth Anger (*b* 1930). Stan Brakhage (1933–2003) made psychodramas in the 1950s but then concentrated on exploring new forms of perception 'unruled by man-made laws of perspective', as demonstrated by *The Art of Vision* (1961–5). This approach has been described as 'lyrical' or 'visionary', although it is difficult to categorize a body of work that includes more than 200 films. Brakhage experimented with material aspects of the medium (*Mothlight*, 1963) as well as new ways of seeing (*Text of Light*, 1974). In the late 1950s and early 1960s a strong 'underground film' movement developed in the USA, combining artistic experiment with cultural and political radicalism. Its connections with the Beat movement in literature were represented in *Pull my Daisy* (1959) by Robert Frank (*b* 1924) and Alfred Leslie (*b* 1927). *Flaming Creatures* (1962) by Jack Smith (1932–89) was one of many films that challenged sexual taboos. The underground had learnt a great deal from Dada and Surrealist films and from a few American precedents such as *Rose Hobart*, which Joseph Cornell (1903–72) started to work on in 1936, reducing a Hollywood feature film to a bizarre 13-minute short.

France had its own underground movement during the 1950s. *Un Chant d'amour*, made in 1950 by Jean Genet (1910–86), was an experiment in the representation of homosexuality as startling as Anger's *Fireworks*. The Lettrist movement challenged all aspects of established culture, provoking audiences with *The Film Has Already Started?* (1951), by Maurice Lemaître (*b* 1926) and *Howls in Favour of Sade* (1952) by Guy-Ernest Debord (1931–94). Lettrist work was introduced to the USA in 1962 by the Fluxus movement, which created its own 'anti-films' such as the imageless *Zen for Film* by Nam June Paik (1932–2006). In the 1960s Pop art and conceptual art formed close links with experimental film making. Andy Warhol (1928–87) created films of 'real time', in which a static camera was trained on a person (*Sleep*, 1963) or object (*Empire*, 1964). His production-line approach ignored the assumption that experimental films were personal in style and emotion. Emphasis shifted to the concept of the film and the activity of the viewer. Warhol was an important influence on the development of 'structural film', which became the leading tendency of the 1970s (see below). Other predecessors included two Austrians: Peter Kubelka (*b* 1934), who made films such as *Schwechater* (1958), in which a few images were put through complex variations; and Kurt Kren (1929–98), who shared Kubelka's interest in mathematical styles of editing, as in *Trees in Autumn* (1960).

Structural film, also known as 'formal' or 'materialist' film, was a broad range of work that questioned the physical nature of the medium and the arbitrariness of its codes of representation. American examples included *Film in which There Appear Edge Lettering, Dirt Particles, Sprocket Holes, etc.* (1965) by George Landow (*b* 1944) and *Tom, Tom, the Piper's Son* (1969) by Ken Jacobs (*b* 1933). Jacobs began with a ten-minute film

from 1905, which he then fragmented and reworked for 90 minutes, revealing an astonishing wealth of detail before once again screening the original. Other American structural film makers included Ernie Gehr (*b* 1943), Hollis Frampton (1936–84) and Paul Sharits (1943–93). In Canada Joyce Wieland (1931–98) made *Sailboat* (1967), exploring subtle variations in the movement of boats across the screen. In the same year her husband Michael Snow (*b* 1929) completed *Wavelength*, a 45-minute camera zoom towards the far wall of a loft. This has remained the best known of all structural films, although Snow went on to such other extraordinary projects as *The Central Region* (1971), in which he programmed a camera to explore a landscape in ways that challenged normal perception. The structural-materialist film was developed in England by Malcolm Le Grice (*b* 1940) in films such as *Yes No Maybe Maybe Not* (1967) and *Little Dog for Roger* (1967–8), and by Peter Gidal (*b* 1946) in *Hall* (1968) and *Condition of Illusion* (1975). Other film makers included Annabel Nicholson (*b* 1946), who experimented with film loops and elements of live performance (e.g. *Precarious Vision*, 1973). Important work was also done in other countries, as illustrated by the multi-screen films (1971–3) and *Three Colour Separation Studies* (1976) by the Australian film makers Arthur Cantrill (*b* 1938) and Corinne Cantrill (*b* 1928).

Animation continued to be a strong area of experiment, with the American Robert Breer (*b* 1926) emerging as a major figure. His rapid juxtaposition of images and styles in *Recreation* (1956) and *Fist Fight* (1964) anticipated some of the concerns of structural films. In 1958 Len Lye summed up a lifetime of experiment in direct animation when he scratched the black-and-white patterns of *Free Radicals*, reducing the medium to its most basic and powerful elements. In the 1960s computers became an important area of research for animators such as the American brothers John Whitney (1917–95) and James Whitney (1921–82), who had been making abstract films since 1940. Their most important computer work included *Lapis* (1966) by James Whitney and *Permutations* (1967) by John Whitney.

Experimental film making has often been energized by political ideas. In the 1970s, for example, there was a strong development of feminist film theory that encouraged a radical approach to the language of film. A variety of new forms emerged, as shown by British work such as *Riddles of the Sphinx* (1976) by Laura Mulvey (*b* 1941) and Peter Wollen (*b* 1938), *Light Reading* (1978) by Lis Rhodes (*b* 1942), *Thriller* (1979) by Sally Potter (*b* 1949), and *I Dish* (1982) by Jayne Parker (*b* 1957); or American work such as *Film about a Woman who ...* (1974) by Yvonne Rainer (*b* 1934) and *Double Strength* (1978) by Barbara Hammer (*b* 1939). In general the 1980s was a more eclectic period than the 1970s, with film makers freely combining lyricism with structural concerns. Influential examples include the films of the Peruvian film maker Rose Lowder (*b* 1941), such as *Sunflowers* (1982) and *Impromptu* (1989), or those of the French

film maker Yann Beauvais (*b* 1953), who explored visual deconstruction in *Untitled* (1984), verbal politics in *VO/ID* (1985) and complex diary form in *Divers épars* (1987). One tendency that continued to grow in strength was the interest in semiotics, shifting attention from material aspects of the medium to its use of signs. Many film makers returned to traditional genres and mainstream imagery to play subversively with them, in such films as *Mayhem* (1987) by the American film maker Abigail Child (*b* 1948) and *Cruises* (1989) by the French film maker Cécile Fontaine (*b* 1957).

B. Corra: 'Musica cromatica', *Il pastore, il gregge e la zampogna*, i (1912)

P. Adams Sitney, ed.: *Film Culture Reader* (New York, 1970)

U. Apollonio, ed.: *Futurismo* (Milan, 1970); Eng. trans. as *Futurist Manifestos* (New York, 1973)

D. Curtis: *Experimental Cinema* (London, 1971)

P. Adams Sitney: *Visionary Film* (New York, 1974)

P. Adams Sitney: *The Essential Cinema* (New York, 1975)

S. Dwoskin: *Film Is: The International Free Cinema* (Woodstock, 1975)

S. D. Lawder: *The Cubist Cinema* (New York, 1975)

P. Gidal, ed.: *Structural Film Anthology* (London, 1976)

R. Russett and C. Starr: *Experimental Animation* (New York, 1976, rev. 1988)

M. Le Grice: *Abstract Film and Beyond* (London, 1977)

Film as Film: Formal Experiment in Film, 1910–75 (exh. cat., ed. D. Curtis and R. Francis; London, Hayward Gallery, 1979)

Trente ans de cinéma expérimental en France (1950–1980) (exh. cat., ed. D. Noguez; Paris, A.R.C.E.F., 1982)

The Elusive Sign: British Avant-garde Film and Video, 1977–1987 (exh. cat., ed. D. Curtis; Arts Council Great Britain, 1987)

R. E. Kuenzli: *Dada and Surrealist Film* (New York, 1987)

P. Gidal: *Materialist Film* (London, 1989)

P. Mellencamp: *Indiscretions: Avant-garde Film, Video & Feminism* (Bloomington, 1990)

S. MacDonald: *Avant-garde Film: Motion Studies* (Cambridge, 1993)

J.-C. Horak: *Lovers of Cinema: The First American Film Avant-garde, 1919–1945* (Madison, 1995)

M. Le Grice: *Experimental Cinema in the Digital Age* (London, 2001)

P. A. Sitney: *Visionary Film: The American Avant-garde, 1943–2000* (Oxford and New York, 2002)

W. Winston-Dixon and G. A. Foster: *Experimental Cinema: The Film Reader* (London, 2002)

S. Basilico: *Cut: Film as Found Object in Contemporary Video* (Milwaukee, 2004)

P. Arthur: *A Line of Sight: American Avant-garde Film since 1965* (Minneapolis, 2005)

J. Skoller: *Shadows, Specters, Shards: Making History in Avant-garde Film* (Minneapolis, 2005)

C. Grenier, ed.: *Los Angeles, 1955–1985: Birth of An Art Capital* (Paris, 2006)

J. Hatfield, ed.: *Experimental Film and Video: An Anthology* (Eastleigh, 2006)

P. G. Pickowicz and Y. Zhang: *From Underground to Independent: Alternative Film Culture in Contemporary China* (Lanham, 2006)

F

Faience (i). Term used to describe a material widely employed in antiquity consisting of a sintered-quartz body covered with an alkaline glaze (see BEADWORK, colour pl. II, fig. 3). This material is sometimes also referred to as 'composition' or, if unglazed, as FRIT.

Faience (ii). Term probably derived from the Italian town of Faenza, famous for its popular maiolica. It is often used to describe French, German and Scandinavian tin-glazed earthenware but is also interchangeable with the terms maiolica and Delftware.

Featherwork. Collective term for artefacts made of or decorated with feathers.

1. MATERIALS AND TECHNIQUES. Feathers are composed of the protein keratin and form the protective covering of birds; they make flight possible (in most species), provide protection from wetting, regulate body temperature and provide insulation. They grow in follicles, arranged in tracts over a bird's body. When fully grown, feathers, like hair, have no connections to the blood supply or nervous system and are dead material. Most bird species moult and regrow their feathers at least once a year.

There are three main types: contour feathers, semiplumes and down. Contour feathers form the visible outer covering of most birds (see fig.). They have a well-developed hollow quill (a) and a shaft (b) with a vane (c) on either side. The vane consists of barbs, which are subdivided into interlocking barbules. It is the fine structure of hooks and hollows on the barbules that holds the vane together (d). Semiplumes have a less cohesive vane: the hooks and hollows are poorly developed, so the barbs remain largely unconnected (e), as in ostrich feathers. Down feathers lack any shaft, the barbs spring directly from the short quill and have no significant barbules (f).

Feathers exhibit an extremely wide range of colours, from blacks and browns to vivid reds and metallic blues and greens. The principal pigments are melanin, which is synthesized within the bird's body, and carotenoids, which are absorbed from food. Melanin is responsible for shades from black to pale yellow, and carotenoids for some of the brightest reds and yellows. Other colours are the result of optical effects caused by the reflection or refraction of light on the outer layers of the feather keratin, modified by the presence of pigments in the underlying layers.

Birds maintain their feathers, mainly through preening: they rearrange the feathers and apply preen oil, a greasy substance largely composed of monester waxes that lubricates the feather keratin to retain suppleness and repel water. Feathers are generally strong and resilient, but they may be damaged on the bird through dietary deficiencies, wear and tear or parasite attack. Once incorporated into an object, feathers should be protected from such insects as clothes-moths and carpet beetles and from strong light, which may cause colours to fade and fibres to become embrittled.

Flight contour feathers appear most frequently on featherwork artefacts, but body contour feathers, semiplumes and down have also been used. They are rarely used to form objects on their own and are commonly found in combination with such materials as textiles, fibre netting, basketwork, skins and wood. Individual feathers or bunches of feathers are attached to each other and to a foundation in a variety of ways, including tying, binding, sewing, weaving and sticking. Techniques of attachment may be very simple, pushing the quills through basketwork for example, or they may be complex systems of bending and tying. Rows of feathers are often laced together through their shafts to create semi-rigid structures, as seen in many Native American war bonnets. Animal and fish glues and natural resins have also been used to stick feathers to paper, wood and textiles; much Amazonian featherwork, for example, utilizes resin-impregnated thread to bind feathers to decorative objects.

The visual qualities of feathers may be enhanced by such techniques as splitting the shaft to give a softer effect, stripping off part of the vane or cutting it into decorative shapes. The careful arrangement of natural and artificial shapes and colours to create patterns and collage is widespread. Feathers can be dyed easily and curled with the use of heat or steam. In some cultural groups bird quills have been used in place of porcupine quills to produce a form of decorative quillwork. Bird skins with the feathers still attached have been used, for example in Hawaii and South America. This technique is most often found where the feathers are very small or where the

Contour feather: (a) quill; (b) shaft; (c) vane; (d) strong barbs and barbules; (e) poorly developed hooks; (f) no true barbules

dramatic effect of the natural feather arrangement was valued. Bird parts, for instance wings, heads and plume sprays, and even whole birds, are frequently incorporated into artefacts.

2. USES. Feathers have been used to decorate the human body in a wide variety of ways. In one of its simplest forms, down feathers were stuck directly to the skin, but such objects as necklaces, bracelets, ear and nose decorations and head ornaments are more widespread. Fine examples can be seen from Hawaii, Papua New Guinea and the Amazonian tribes of South America. Elaborate forms of featherwork headdress are found among the Maasai in Kenya, and the Mende of Sierra Leone use feathers in some of their masks. In Hawaii helmets and headdresses were produced incorporating millions of feathers that completely covered complex cane foundations. Costumes and headwear incorporating feathers were often designed to display the wearer's status, as in the outstanding feathered cloaks and gorgets created in Polynesia and by the Incas and Aztecs in Mesoamerica (see colour pl. V, fig. 1). In Maori cloaks the feathers were usually incorporated in the weaving rather than being tied on afterwards, as was the practice elsewhere in Polynesia. In Japan feathers were also used to decorate the garments of high-ranking individuals, although few examples survive. In China blue kingfisher feathers were used with hardstones, gems, gold and silver in the ceremonial headdresses or crowns of emperors, empresses and courtiers and Chinese immigrants in South Africa have produced capes with feather patterns and swans' down linings. In Europe, particularly in the 18th and 19th centuries,

the decorative value of feathers in self-adornment was exploited for the trims of gowns and for elaborate millinery, often including whole birds.

In many cultures feathered objects embody a ritual or sacred element. This is true of many Native North American examples where eagle feathers or skins are incorporated in sacred headdresses, medicine pipes and charms. Dance masks and costumes frequently include featherwork for ritual and decorative value, for example in West Africa. The trophy heads of the Jívaro and Mundurucú in South America were often embellished with feathers. In the Hawaiian Islands feathers formed an integral part of god images, sacred bundles and temples. Some bird species, such as the quetzal in Mesoamerica, had an extremely powerful ritual value, and the use of its feathers was fiercely controlled.

Feathers have been used to decorate everyday objects from the earliest times. The use of feathers to fletch arrows and to decorate spear shafts and shields is widespread (Europe, South America, New Guinea). Utilitarian clothing has sometimes been made from feathers, although it is generally too delicate for everyday use. Some Inuit groups have made parkas using eider-duck skins stitched together with the feathers on the inside for warmth; more commonly, utilitarian garments are decorated with feather trimmings. Feathers have been used to decorate hammocks (Amazonia), baskets (Pomo Indians, North America), ceramic vessels (New Guinea) and canoes (Maori, New Zealand); in Europe they have been used for such diverse purposes as writing quills (*see* PEN, §2), fans, stuffing for mattresses, bedcovers and pillows and as decorative plumes for military headgear, four-poster beds and hearses. The use of feathers to create decorative features in interiors is infrequent, but impressive where it survives: largely as a women's pastime of the 18th and 19th centuries (particularly in Britain), feathers were stuck on to card to make panels and friezes (e.g. *c.* 1795; drawing-room and gallery, A la Ronde, Devon, NT). The gilt-leather wall coverings found in some German castles of the same period occasionally incorporate featherwork.

R. W. Doughty: *Feather Fashions and Bird Preservation* (London, 1975)

H. Cobbe, ed.: *Cook's Voyages and Peoples of the Pacific* (London, 1979)

V. Elbin: *The Body Decorated* (London, 1979)

D. S. Farner and J. R. King, eds: *Avian Biology* (London, 1982)

J. C. Welty: *The Life of Birds* (London, 1982)

A. P. Rowe: *Costumes and Featherwork of the Lords of Chimor* (Washington, DC, 1984)

E. Carmichael and S. Hugh-Jones: *The Hidden People of the Amazon* (London, 1985)

The Spirit Sings: Artistic Traditions of Canada's First Peoples (exh. cat. by J. D. Harrison and others; Calgary, Glenbow–Alta Institute, 1987)

Feather Masterpieces of the Ancient Andean World (exh. cat., ed. T. Gibson; London, Gibson Fine Art, 1990)

T. Castello Yturbide: *The Art of Featherwork in Mexico* (Mexico City, 1993)

C. F. Taylor: *Wapaha: The Plains Feathered Head-dress/Die Plains-Federhaube* (Wyk auf Foehr, 1994, rev. 3/1998)

S. Ferraro Dorta and M. X. Cury: *A plumária indígena brasileira: No Museu de Arqueologia e Etnologia da USP* (São Paulo, 2000)

B. Jackson: *Kingfisher Blue: Treasures of an Ancient Chinese Art* (Berkeley, 2001)

S. McLendon: 'California Feather Blankets', *Studies in American Indian Art: A Memorial Tribute to Norman Feder*, ed. C. F. Feest (Altenstadt, 2001)

'Federn', *Lexikon des künstlerischen Materials: Werkstoffe der modernen Kunst von Abfall bis Zinn* (Munich, 2002), pp. 85–9

Feather Creations: Materials, Production and Circulation: Anthology of Abstracts and Readings ([New York, 2004])

Felt. Non-woven textile usually made from sheep's wool and from goat or camel hair, but the hair or wool from many other animals can be used, even that of humans. It is also possible to incorporate such vegetable fibres as jute. The wool is used in its natural colours—ivory, light brown and dark brown—or it is dyed. Traditionally, the dyes were such locally obtainable plants as madder and pomegranate, but widely traded dyes, indigo and cochineal for example, were introduced in many areas; all have now been replaced by synthetic dyes.

The methods by which felt is made vary in different countries. On the Asian steppe felt is usually, but not exclusively, made by women. A reed mat is placed on the ground, and the shorn wool is beaten or teased by a felting bow made of a length of gut attached to an L-shaped piece of wood. The worker holds the bow firmly over the wool with one hand and with the other hand strikes the tautened gut with a mallet. The vibration causes the wool fibres to loosen and disentangle. The Turkoman tribes card the fibres through a large comb standing on the ground, its metal teeth pointing upwards. The wool is then laid in clumps on the mat and spread evenly, without gaps, to the required depth. The thickness required of the final product dictates the amount of wool put down on the mat; it may be as much as 400 mm deep. The wool is sprinkled with warm water and an alkaline solution (e.g. urine or soap powder), then rolled tightly in a bundle and tied. Depending on the width of the piece being made, up to ten women, elbow to elbow, roll it for several hours. The larger and thicker the material required, the more pressure, workers and time are needed. In Turkey men make the felt. Having tied up the bundle, they roll it with their feet, standing in a row, their hands pressing on one knee to give the greatest weight. They work to music, singing in rhythm. In Afghanistan both sexes make felt: normally, the women lay out the pattern, and the men do the heavy work.

In finer pieces, the work is sometimes unrolled for inspection and adjustment before completion; the edges are tidied, and then it is rolled again. When dried, the surfaces are smoothed by a burnishing stone or roller. Rougher rugs are not inspected, just unfolded and put out to dry. The finished felt varies in thickness from 15 mm, when used for tents, to 2 mm for fine appliqué.

In hat-making, the felt is prepared in a shallow dish, kneaded until soft and pliable, then moulded around a block to form the required shape. It is then pressed until ready. A hatter in Iran can make up to 30 hats a day, before putting them outside to dry and finally polishing them.

There are a number of ways of patterning and decorating felt. Two or more colours can be felted together at random. Alternatively, predyed clumps of fibre, arranged in a pattern, are placed on the mat, and the rest of the wool laid on top of them; the wool will felt together in one piece. If a pattern is to appear on the back of the finished felt, more coloured wool is placed on the top of the mass. If layers of different coloured felt are superimposed, contrasts of shape may be achieved with, for example, incisions and saw-tooth edges. Plain felts can be decorated by painting, stencilling or block-printing.

Sewing techniques are also used to decorate felt. In Afghanistan it is common to find appliquéd motifs of felt, silk, cotton, feathers, bark or leather. A mosaic effect can be achieved by sewing small pieces of felt together, with the stitches hidden in the seams. This technique is often found in Afghanistan and the Commonwealth of Independent States. Edges can be applied as decoration and to strengthen the article. These may be of cord, silk or leather and surround either the complete article or individual design motifs. Further protection is afforded by decorative quilting stitches, often zigzags or spirals: these are used on such items as camel, horse and donkey trappings, which come under great strain. Sometimes felts are richly embroidered, which reinforces the fabric as well as enhancing its appearance.

J. Smith: *True Travels, Adventures and Observations in Europe, Asia and America from 1593 to 1629* (London, 1630)

J. Chardin: *Voyages du chevalier Chardin, en Perse, et autres lieux de l'orient*, ed. Langlès, iv (Paris, 1811), pp. 18–19

C. Tomlinson, ed.: *Tomlinson's Cyclopedia of Useful Arts and Chemical Manufactures, Mining and Engineering* (London and New York, 1854)

W. W. Rockhill, ed.: *The Journey of William of Rubruck to the Eastern Parts of the World* (London, 1900)

J. H. Hawkins: *History of the Worshipful Company … of Feltmakers of London* (London, 1917)

A. Stein: *Serindia*, v (Oxford, 1921), pp. 246–50

B. Laufer: 'The Early History of Felt', *American Anthropologist*, xxxii (1930), pp. 1–18

J. Harada: *English Catalogue of Treasures in the Imperial Repository, Shōsōin* (Tokyo, 1932)

W. Meister: 'Zur Geschichte de Filzteppichs im I. Jahrtausend n. Chr.', *Ostasiatische Zeitschrift*, n. s., xii (1936), pp. 47–61

L. Olschki: *The Myth of Felt* (Berkeley and Los Angeles, 1949)

S. I. Rudenko: *Kultura naseleniya gornogo Altaya v. skifskoe vremya* (Moscow and Leningrad, 1953); Eng. trans. as *Frozen Tombs of Siberia: The Pazyryk Burials of Iron Age Horsemen* (London, 1970)

'Felt', *Ciba Zeitschrift* (1958), no. 129 [Gesellschaft für chemische Industrie]

J. F. Haskins: 'The Pazyryk Felt Screen and the Barbarian Captivity of Tasi Wei Chei', *Bulletin of the Museum of Far Eastern Antiquities*, xxxv (1963), pp. 141–60

H. Bidder: *Teppiche aus Ost-Turkestan, bekannt, als Khotan-, Samarkand- und Kansu-Teppiche* (Tübingen, 1964; Eng. trans., London, n.d.)

K. Jettmar: *Kunst der Welt: Die frühen Steppenvölken* (Baden-Baden, 1964); Eng. trans. as *Art of the Steppes: The Eurasian Animal Style* (London, 1967)

J. P. Wild: *Textile Manufacture in the Northern Roman Province* (Cambridge, 1970), p. 171

V. Gervers-Molnar: *The Hungarian Szur: An Archaic Mantle of Eurasian Origin*, Toronto, Royal Ontario Museum (Toronto, 1973)

V. Gervers and M. Gervers: 'Felt-making Craftsmen of the Anatolian and Iranian Plateau', *Textile Museum Journal* (1974), iv, pp. 14–29

R. Michaud and S. Michaud: *Caravanes de Tartarie* (Chêne, 1977; Eng. trans., London, 1985)

The Art of the Felt Maker (exh. cat. by M. E. Burkett; Kendal, Abbot Hall Art Gallery, 1979) [extensive bibliog.]

H. Bidder and I. Bidder: *Filtzeteppiche: Ihre Geschichte und Eigenart* (Brunswick, 1980)

B. Gordon: *Feltmaking* (New York, 1980)

Felting, American Craft Museum (New York, 1980)

M. L. Nabholz-Kartaschoff and P. Bucherer-Dietschi, eds: *Textilhandwerk in Afghanistan: Filz, Gewebe, Kleidung, Stickerei* (Liestal, 1983)

M. E. Burkett: 'A Knotted Rug with a Felt Motif', *Feltmaker's Association Journal.* (Jan 1986), p. 5

Internationalt Filtsymposium (exh. cat., Århus, Studenternes Hus, 1990)

E. J. W. Barber: *Prehistoric Textiles: The Development of Cloth in the Neolithic and Bronze Ages, with Special Reference to the Aegean* (Princeton, 1991)

D. Corner: 'The Tyranny of Fashion: The Case of the Felt-hatting Trade in the Late Seventeenth and Eighteenth Centuries', *Textile History*, xxii (Aug 1991), pp. 153–78

J. Harris: 'Felt and Bark Cloth', *Textiles: 5,000 Years* (New York, 1993), pp. 50–53

L. Batchuluun: *Felt Art of the Mongols* (Ulaanbaatar, 2003)

Fibre art. Collective term, coined in the 1970s, for creative, experimental fibre objects. A wide range of techniques is used, often in combinations that encompass both traditional (e.g. felting, knotting) and modern (e.g. photographic transfer) practices. The eclectic range of materials includes many not previously associated with textiles, such as paper, wood, iridescent film, nylon mesh and wire.

The first experimental work was done during the 1920s and 1930s by such artists as Anni Albers (1899–1994) in Germany. Equally innovative work was produced in the 1940s and 1950s by Trude Guermonprez (*d* 1975), Luba Kreje (*b* 1925), Lenore Tawney (*b* 1925), Loja Saarinen (1879–1968), Dorothy Liebes (1897–1972), Marianne Strengell (1909–98) and others. These artists were concerned with natural and manmade materials, vibrant colours, formal pattern-making and texture derived from construction. By the 1960s a new direction in tapestry was replacing the tradition of the painter's cartoon woven by artisans, although that was still practised. Inspired by the decade's concern for freedom, revolution and primitive vigour, a second generation of fibre artists began to define and expand their ideas. Loom-woven hangings gave way to variously constructed pieces for display on the floor, on pedestals or hung from the ceiling. These included shaped, woven sisal work with an emphasis on form (e.g. by Magdalena Abakanowicz (*b* 1930) in Poland; floor pieces made of wrapped and stitched modular units (e.g. by Sheila Hicks (*b* 1934) of the USA); cascading wrapped and knitted components (Claire Zeisler (1903–91), USA); large objects of such unusual fibres as rope (Françoise Grossen (*b* 1943), Switzerland); shaped tapestry weave (Herman Scholten (*b* 1932), Netherlands); synthetic materials, newsprint and raffia in basketry (Ed Rossbach (1914–2002), USA; see colour pl. IV, fig. 3); and ceiling-hung concentric layers of slit tapestry (Jagoda Buic (*b* 1930), Croatia).

In the 1970s and early 1980s there was intense activity by a third generation of artists. Continuing experimentation, together with a general maturation of style, resulted in huge, dynamic works. At the same time there was renewed interest in loom-woven and loom-controlled work and contemporary application of traditional techniques. There was a continued exploration of materials and techniques and a flowering of three-dimensional form. Fibre art was designed for use in architectural spaces (e.g. public buildings) and also in landscapes, and fibrous materials were used to create sculpture and painting. Examples from this period include outdoor work in twisted paper in large plaited forms (Neda Alhilali (*b* 1938), USA); ritualistic objects made of twisted paper tapes (Dominic DiMare (*b* 1932), USA); needle techniques on cloth (Emilia Bohdziewicz (1941–94), Poland); combinations of knitting and plaiting (Ann Sutton (*b* 1935), England); basketry work of morning glory vines, leaves and milkweed manipulated in tapestry weave (John McQueen (*b* 1943), USA); mended sheet and shirt environments (Sheila Hicks); plaited horsehair and gesso panels (Olga de Amaral (*b* 1932), Colombia); free spatial forms on textile reliefs (Peter Jacobi (*b* 1935) and Ritzi Jacobi (*b* 1941), Germany); a mural of warp-face repp, space-dyed warp with shaped polyurethane weft, mixing wool, jute and cotton (Lia Cook (*b* 1942), USA); a double plain-weave that becomes a three-dimensional construction (Warren Seelig (*b* 1946), USA); and interwoven cotton strands (Masakazu Kobayashi (*b* 1944), Japan).

During the 1980s a fourth generation of artists widened their approach even further. Some traditional methods were revived and used in combination with new technology. There was an incredible expansion of form, driven by the insistence on art as a vehicle for ideas. The wide range of techniques is reflected in such diverse works as the loom-woven hangings of Sheila Hicks; the *shibori* indigo dyeing of Shihoko Fukomoto (*b* 1945, Japan); the story-telling quilts in painted and pieced fabric of Faith Ringgold Inese Malitis (*b* 1959) and Ivars Malitis (*b* 1956, Latvia); the non-functional baskets of Ed Rossbach (1914–2002); the pressed, hammered, dyed and painted rayon of Lia Cook; the computerized weaving

of abstract imagery of Cynthia Schira (b 1934, USA); the fibre optic weaving of Peggy Osterkamp (b 1940, USA); and by Hideho Tanaka (b 1942, Japan), sisal and stainless steel elements that absorb, reflect and transmit light.

See also BASKETWORK.

A. Albers: *On Weaving* (Middletown, CT, 1965)

I. Emery: *The Primary Structures of Fabrics* (Washington, DC, 1966)

M. Constantine and J. L. Larsen: *Beyond Craft: The Art Fabric* (New York, 1973, rev. Tokyo, 2/1986)

M. Constantine and J. L. Larsen: *The Art Fabric: Mainstream* (New York, 1973, rev. Tokyo, 2/1986)

A. Kuenzi: *La Nouvelle Tapisserie* (Geneva, 1973)

E. Rossbach: *Baskets as Textile Art* (New York, 1973)

J. L. Larsen, A. Bühler, B. Solyom, G. Solyom: *The Dyer's Art: Ikat, Batik, Plangi* (New York, 1976)

J. L. Larsen and B. Freudenheim: *Interlacing: The Elemental Fabric* (Tokyo and New York, 1986)

Frontiers in Fiber: The Americans (exh. cat. by M. Constantine and L. Reuter; Grand Forks, ND, North Dakota Museum of Art, 1988)

Restless Shadows: Japanese Fibreworks (exh. cat., London, Goldsmiths' Gallery, 1991)

K. Tsuji, ed.: *Faiba ato Japan / Fiber art Japan* (Tokyo, 1994)

P. Ulrich: *Material Difference: Soft Sculpture and Wall Works* (Western Springs, IL, 2006)

G. Adamson: 'The Fiber Game', *Textile*, v/2 (Summer 2007), pp. 154–77

Fibreglass. Term commonly used to describe glassfibre reinforced plastic, also known as glassfibre reinforced polyester or GRP. It is a light but strong and durable material, and, unlike most plastics (*see also* PLASTIC, §1), its use involves low-level technology, making it accessible as an artist's material, although its major uses are commercial and industrial.

The first stage in the manufacture of fibreglass involves the addition of a catalyst to crystic polyester resins, unsaturated, liquid forms of polyester (*see* RESIN, §2). The resulting solid plastic is, however, fairly brittle and thus is reinforced by glassfibre to give a composite material of greatly increased strength. Glassfibre consists of thinly drawn out molten glass, cooled rapidly to produce a continuous filament of exceptional tensile strength. It is made into rovings, a loosely spun thread and tape, as well as into woven tissue, chopped strand mat and woven rovings, all in thin, flexible sheets. These are embedded in the resin while it is liquid and become saturated and surrounded by it. Carbon fibre and 'Kevlar', a brand of para-aramid fibre, are also used to reinforce the resin and may be used in combination with glassfibre where even greater strength and impact resistance is required.

There are two basic methods of employing fibreglass, from which its artistic use has generally been adapted. The first is casting: after being activated by its catalyst, the syrupy liquid resin is painted or poured into a mould. The inclusion of glassfibre in the resin allows the production of large, but lightweight castings by using only a thin coating of the mould. When set, the casting retains the form and texture of the mould; a very smooth finish can be produced by this method. Casting is particularly suitable for figurative sculpture or at least works with a detailed form. Complex sculptures are cast in pieces and are then assembled with epoxy resin adhesive or additional applications of GRP materials. GRP is also a useful material for the production of moulds; because of its strength, slight flexibility and capacity to reproduce detailed features it is particularly suited to large moulds, where ease of handling is an important consideration and the production of clean castings presents difficulties. Concrete and artificial stone can be cast in fibreglass moulds, as well as the material itself. The alternative method is to build up layers of resin-impregnated glassfibre cloth on to an armature or framework. This method has various commercial and industrial uses but is limited as a sculptural technique to abstract compositions.

Experimentation with fibreglass as a sculptural medium occurred soon after it was first introduced (*see* PLASTIC, §2 (iii)). It was used, for example, by Mark Boyle (1934–2005) in his sculptures of urban terrain (e.g. *Holland Park Avenue Study*, 1967; London, Tate). The theme of life-size polychrome figures, sometimes shocking or humorous, has frequently been used as a subject, and it was employed by such Pop artists as Allen Jones (b 1937; e.g. *Hatstand, Table, Chair*, 1969; Aachen, Neue Galerie). The initial enthusiasm for fibreglass as an artist's medium has not, however, been maintained, and its main use remains commercial and industrial, for example boat building and the manufacture of racing car bodies.

Polyester resins can also be cast or modelled without glassfibre additions, usually for smaller objects. Known as cold cast resin metals, they can be filled with inert materials, pigments or powdered metals to give finely detailed castings that closely resemble other materials, particularly metals. They are used for mass-produced decorative sculptures and for such items as reproduction armour for theatrical costumes. They are also increasingly employed by sculptors for the production of limited editions, as the use of cold cast resins is less expensive than that of other materials, such as plaster, employed in traditional methods of reproducing sculpture. 'Clear embedding' resin, a type of polyester that cannot be used for glassfibre laminations, has also been employed by sculptors, notably by Fernandez Arman (1928–2005): *Torse aux gants* (1967; Cologne, Wallraf-Richartz-Museum) is his best-known work in this medium. Although easy to employ, GRP and related cold cast polyester resins involve materials that can be unpleasant to use and that give rise to some health and safety considerations (*see* PLASTIC, §3). These are sufficient reasons to deter some artists from using them.

J. W. Mills: *The Techniques of Casting for Sculpture* (London, 1967, 2/1990)

E. Lucie-Smith: *Arte oggi: dall'espressionismo astratto all' iperrealismo* (Milan, 1976); Eng. trans. as *Art Today* (Oxford, 1977, 2/1983)

Polyester Resin, Glassfibre, Cold Cast Resin Metals, Clear Embedding Resins (Reading and London, 1989)

Crystic Polyester Handbook (Wollaston, 1990)
The Strand Guide to Glassfibre (Wollaston, [1990]) [booklet]

Filigree [Fr. *filigrane*; It. and Sp. *filigrana*; Ger. *Drahtegeflecht*]. Metalwork decoration in which fine precious metal wires, usually gold or silver, are delicately soldered in an openwork pattern. It is used especially in jewellery and the ornamentation of other small objects (*see* METAL, §V, 3).

Film. *See* EXPERIMENTAL FILM; MOTION PICTURE FILM.

Fixative. Adhesive or consolidant applied to a friable pigment coating in order to fix it to the substrate or prevent crumbling. The aim of using a fixative is to provide increased strength with minimal change in appearance. Most adhesives that can be applied in low viscosity have been used. Solvent-applied resins, such as dammar, mastic and shellac, were commonly employed by artists. Polysaccharides, gum arabic and *funori* (a seaweed extract) have been used in water solutions. Polysaccharides will cross-link and become insoluble by reaction with many pigments used. It is unlikely that appreciable amounts of fixative can be removed from a treated surface without harming the pigment layer.

The problems of stabilizing pigment surfaces have not been solved. Early attempts on wall paintings using wax and casein caused severe changes in colour and are almost impossible to remove. Wax causes dirt accumulation and further disfigurement of the image, while calcium caseinate shrinks, removing the surface layer. Agar-agar applied in solution (with polyvinyl alcohol) gels then shrinks while drying, causing damage to the surface. Fixatives are increasingly being chosen to provide only the minimum reinforcement necessary to hold the particles of pigment in place. Polymers, such as the cellulose derivatives carboxymethyl cellulose and methyl cellulose, tend to be poor formers of film and therefore create poor optical contact between particles and support. This retains the matt appearance of the surface and avoids the saturation of the colours. Alternatively, the adhesive, for example Parylene, can be applied as a vapour that condenses to form a polymer film without disturbing the surface.

See also CONSOLIDANT.

R. J. Gettens and G. L. Stout: *Painting Materials* (New York, 1966)

E. F. Hansen, E. T. Sdaoff and R. Lowinger: *A Review of Problems Encountered in the Consolidation of Paint on Ethnographic Wood Objects and Potential Remedies*, Preprints of the Triennial Meeting of the International Council of Museums Conservation Committee (Dresden, 1990), pp. 163–8

C. V. Horie: *Materials for Conservation: Organic Consolidants, Adhesives and Coatings* (London, 1990)

M. H. Ellis: 'The Shifting Function of Artists' Fixatives', *Journal of the American Institute for Conservation*, xxxv/3 (1996), pp. 239–54

H. Wallner-Holle and O. Wächter: 'Festigen und fixieren: Das Dauerpostulat an den Konservierenden', *Papier, Pergament, Grafik, Foto*, Restauratorenblätter, xxii–xxiii (2001–2002), p. 11

Flock and tinsel prints. Collective term for a type of woodcut to which powdered wool (flock) or tinsel (small fragments of metal) was applied. Such prints are rare. The technique was developed to imitate patterned velvet in texture and appearance, its French and German names reflecting its appearance: *empreinte veloutée*, *Samt-Teigdrucke*. Of the seven examples of flock prints (including one duplicate) recorded by Hind, at least five were printed in red. It is not certain how flock prints were produced, but the process was probably as follows. The surface of the paper was first prepared to look like a textile web by the impression of an actual textile on the paper. The paper was then varnished or, alternatively, the textile was coated with varnish before its application to the paper. A woodblock carrying the image cut in relief was coated with a paste or glue and impressed on to the prepared paper. Flock was sprinkled, probably through a sieve, over the impression while the paste was still wet. The sheet was shaken to remove the flock from the unpasted areas. All the impressions known to Hind are south German and date to *c.* 1450–75: *St George* (Nuremberg, Germanisches Nationalmuseum), *St Barbara* (Würzburg, Universitätsbibliothek), the *Christ Child with Angels and Signs of the Passion* (Würzburg, Universitätsbibliothek), *St Catherine* (Munich, Staatliche Graphische Sammlung), *Christ on the Cross between the Virgin and St John* (Oxford, Ashmolean Museum) and an *Allegorical Device, with Castle, Hind and Panther* (Munich, Staatliche Graphische Sammlung).

Surviving examples of tinsel prints date from *c.* 1430–60. Small fragments of thin and sparkling metal and/or small quartz crystals were applied by paste or gum in addition to colour to embellish woodcuts. In the *Christ Child* (Munich, Staatliche Graphische Sammlung; Schreiber, no. 810) and the *Man of Sorrows* (Hannover, Universität Hannover, Sammlung Haupt; s 868) gold tinsel is used to enhance a black background. A further category of print, which employed tin foil to elaborate decorative effect, is the theatrical tinsel print, a genre that flourished in Britain between *c.* 1814 and 1830. These engravings of contemporary actors and other popular figures could be purchased uncoloured ('plain') for a penny or coloured for two pennies. Male actors were particularly popular, often represented in a dramatic pose and wearing full or partial armour, allowing for a generous surface area of tinsel. The bright, primary colours and elaborate tinsel stencils were offset against a simple watercolour background, with the actor and publisher's name printed at the lower edge, and frequently mounted in a maplewood frame. The standard sheet size was 8×10 inches (200×250 mm). These were essentially popular prints and therefore anonymous, but the involvement of George Cruikshank (1792–1878) has been suggested.

W. L. Schreiber: *Manuel de la gravure sur bois et sur métal au XVe siècle*, 5 vols (Berlin, 1891–1910) [s]

W. L. Schreiber: *Die Meister der Metallschneidekunst nebst einem nach Schulen geordneten Katalog ihrer Arbeiten* (Strasbourg, 1926)

C. Dodgson: *Woodcuts of the XV Century in the Ashmolean Museum* (Oxford, 1929)

A. M. Hind: *An Introduction to a History of Woodcut*, 2 vols (London, 1935, 2/1963)

A. Griffiths: *Prints and Printmaking* (London, 1980)

J. Hermans and P. Mahoney-Phillips: 'Paper, Textiles and Tinsel Prints', *Paper and Textiles: The Common Ground: Preprints of the Conference Held at the Burrell Collection, Glasgow, 19–20 Sept 1991*, pp. 125–32

Foil. Thin leaf or sheet of gold, silver or other metal used to decorate works of art (*see* GILDING, §I, 1).

Foul-biting. Term used in etching when the ground collapses, allowing the acid to attack the plate underneath indiscriminately and uncontrollably so that when printed, there are dots or irregular areas. Foul-biting occurs when the ground is imperfect, the plate is left in the acid-bath too long or when the etched lines are drawn too close together.

Foxing. Term for brown or yellow stains that appear on old paper in a scattered pattern of spots and blotches. It is caused by a type of mould and can be distinguished from iron or other brown stains by its continuous development in suitable conditions (*see* PAPER, §VI, 1). Foxing can be removed by using dilute bleach solutions.

Fresco. Wall painting technique in which pigments are dissolved in water only and then applied to fresh, wet lime plaster (the *intonaco*). As the wall dries, the calcium hydroxide of the plaster combines with carbon dioxide in the atmosphere to form calcium carbonate. During this process the pigments become an integral part of the wall, forming a fine, transparent, vitreous layer on its surface. Fresco is particularly vulnerable to damp and for this reason is suitable only for dry climates. This article discusses the technique as systematized in Italy from the 14th century; for additional information, as well as the conservation of fresco, *see* WALL PAINTING, §§I and II.

Fresco painting was technically demanding and was usually carried out on a large scale (see colour pl. V, fig. 3), so the painter had to be accurate in drawing up his composition and capable of organizing a team of skilled hands, from the masons to the assistant painters who were assigned the less important parts of the work.

1. PREPARATION OF THE WALL. The wall was first carefully brushed and dampened. A layer of coarse plaster with a rough finish (the *arriccio*) was then applied. This could be done several years before the *intonaco*, though if the *arriccio* was old it had to be well brushed and wetted before the *intonaco* was applied. Usually the painting was carried out on the *intonaco* (*see* §4 below), but occasionally a further layer, an *intonachino*, was applied as a base for the paint. This

can be found in Roman frescoes but rarely in Renaissance ones.

The plaster of the various layers was composed of slaked lime and an inert filler, such as sand, ground marble or pozzolana (a baked clay of volcanic origin). The proportions were the same for the *arriccio* and the *intonaco*, although for the *arriccio* the aggregate, or filler, was coarse grained, while for the *intonaco* it was fine grained. There were two standard mixes: strong or fat mortar, which was composed of one part lime to two parts filler and tended to crack as it dried, and lean mortar, which had one part lime to three of filler. If a lean mortar contained pozzolana, the proportion could be one part lime to 1.75–2 parts pozzolana. The lime is obtained by firing calcareous rocks, composed largely of calcium carbonate ($CaCo_3$), at a temperature of 850–900°C. By adding water to the resulting quicklime (CaO), slaked lime (calcium hydroxide, $Ca(OH)_2$) was obtained.

Good slaked lime underwent a long maturing process in vats or pits covered with water—the Romans allowed their lime to mature for at least three years. Microcrystalline limestones produced lean lime, which required less water in its manufacture, while cryptocrystalline or compact limestones produced fat lime, which required more water. The sand (silicon dioxide) had to be sharp sand obtained from a quarry or river, not from the seashore, where it contains salt; the individual grains had to be angular, not rounded, to encourage bonding with the lime. Pozzolana is found as a natural rock in the regions surrounding Rome and Naples. Violet or black in colour, it produced a compact plaster superior to that obtained from sand or ground marble.

The appearance of the finished fresco depended on the way in which the *intonaco* was applied. Until the 15th century it was worked with a trowel to obtain an almost smooth surface, while from the 16th century, in an attempt to emulate painting on canvas, a rougher texture was created by working up the surface with short strokes of a brush.

2. LAYING OUT AND TRANSFERRING THE COMPOSITION. The vertical, horizontal and diagonal lines of the composition were laid out on the *arriccio* with cords pulled tight and pressed hard against the plaster. The rest of the composition was sketched out in charcoal, which enabled the artist to make corrections as necessary. The definitive design, the SINOPIA, was brushed in and served as a guide for the final execution of the painting. The whole composition was drawn full scale on a CARTOON, which was cut up into sections of varying sizes so the painting could be done piecemeal (*see* §4 below). As each section of the *intonaco* was applied, the design was transferred from the cartoon by POUNCING or by running a stylus over the outlines. (In the 14th century the design was transferred by pouncing and then painted in yellow ochre, so the artist could make any necessary adjustments before proceeding.) The lines of painted frames and architectural forms were often incised directly on to the plaster without a cartoon,

with the aid of compasses, rulers, set squares and cords pulled taut.

Another method of transfer, used especially in the 17th century for vast ceiling frescoes, was squaring, which replaced the time-consuming and costly cartoon technique. The small-scale compositional drawing was squared, as was the surface to be painted, sometimes with the aid of cords or shadows projected from a light source covered by a wire mesh. In each new square the painter copied the lines contained in the corresponding smaller square in the drawing.

3. PIGMENTS. The range of colours for fresco was restricted to those that could withstand the alkaline action of the lime. Other colours could be used *a secco*, but a good fresco painter used secco colours as little as possible, since they were less durable. Fresco colours included vine black, black earth, ivory black; red ochres (particularly those rich in haematite), cinnabar (which is mixed with white to give a pink flesh colour); yellow ochre, yellow earth, Naples yellow, green earth, umber, raw and burnt sienna; *bianco sangiovanni*; and finally, smalt (see colour pl. V, fig. 2). All the other traditional colours, including ultramarine, azurite, malachite and erinite, were not suitable for fresco and were therefore applied *a secco*.

The pigments had to be finely ground in water. They could not be mixed on the palette because in drying they altered in tone and intensity and so could not be easily repeated. Instead, the whole range of colours in their various tonal gradations was prepared in advance in sufficient quantities to complete the composition. The colours were then kept in jars of water called *mestiche*. While the work was in progress the colours for each *giornata* (*see* §4 below) were taken from the jars as necessary.

4. APPLICATION OF THE PIGMENTS. The composition was divided into sections that could be worked in one day, called *pontate* or *giornate*. *Pontate* were used in Roman, Byzantine and 13th-century frescoes; they followed the arrangement of the scaffolding (It.: *ponteggio*), so were rectangular in shape and usually fairly large. *Giornate* were occasionally used in Roman murals but only became widespread from the 13th century. They followed outlines in the composition and so were irregular in shape; they were usually applied from top to bottom and from left to right.

Once the design or guidelines of a *giornata* had been traced, work could begin on the painting and could continue for several hours, depending on the climate and the season. The best time to begin painting was two or three hours after the laying down of the *intonaco*; conditions for work were optimum for at least two hours, after which the plaster began to form its crust of calcium carbonate. Work then became increasingly difficult, and the results correspondingly disappointing as the pigment was no longer absorbed. If the plaster was sprayed with water, work could continue for another hour, but during this stage only liquid colours could be used.

Finally, when those colours that are mixed with the white pigment *bianco sangiovanni* began to dry and turn whitish in an irregular fashion, work had to cease, and the unpainted plaster was removed with an oblique cut. This was the moment when highlights were applied, an operation that required experience and dexterity because colours with a green or black base became lighter as they dried, while those containing iron oxides became darker.

Any areas that could not be painted in fresco were done later, when the composition was completely finished and the plaster thoroughly dry. These included colours incompatible with fresco and figurative motifs that overlapped several *giornate* (lances, festoons, ribbons etc). This operation was carried out *a secco* with pigments bound in adhesive. For each colour, a complementary undercoat was prepared *a fresco*: white for the blues, with shadows in yellow ochre for drapery, and black, red ochre or grey–blue for monochrome backgrounds. Metal leaf enamel—either gold or tin glazed with yellow to imitate gold—was also applied *a secco*, most frequently for armour and decorative motifs. Some gold areas, such as haloes or crowns, may have been raised in relief with a doughy mortar (not too moist) worked with a spatula, a mixture of flour and varnish worked with the tip of a paint brush or a mixture of warm beeswax and resin.

Fresco required no protective or enhancing finish like the varnish that was applied to canvas or panel paintings. Indeed, this would have prevented the formation of the transparent, glassy layer of calcium carbonate that gives fresco painting its characteristic force and beauty, as well as its resilience. Easily subject to decay or change, the organic substances in any such varnish would have compromised both the appearance and the preservation of the painting.

See also LIME SECCO, SECCO, SGRAFFITO and WALL PAINTING.

Early sources
C. Cennini: *Il libro dell'arte* (*c.* 1390); Eng. trans. and notes by D. V. Thompson jr as *The Craftsman's Handbook: 'Il libro dell'arte'* (New Haven, 1933/R New York, 1954)
G. Vasari: *Vite* (1550, rev. 2/1568); ed. G. Milanesi (1878–85)
G. B. Armenini: *De' veri precetti della pittura* (Ravenna, 1587)
A. Pozzo: 'Breve istruttione per dipingere a fresco', *Prospettiva de' pittori ed architetti* (Rome, 1692)

Specialist studies
R. La Montagne St Hubert: *The Art of Fresco Painting* (Paris, 1923)
R. Mayer: *The Artist's Handbook* (New York, 1940, rev. 5/1991)
Frescoes from Florence (exh. cat. by V. Procacci and others; London, Hayward Gallery, 1969)
U. Procacci and L. Guarnieri: *Come nasce un affresco* (Florence, 1975)
G. Botticelli: *Tecnica e restauro delle pitture murali* (Florence, 1980)
G. Ronchetti: *Pittura murale* (Milan, 1983)
E. Borsook and F. Superbi Gioffredi, eds: *Tecnica e stile*, 2 vols (Milan, 1986)
G. Colalucci: 'The Frescoes of Michelangelo on the Vault of the Sistine Chapel: Original Technique and Conservation',

The Conservation of Wall Paintings: Proceedings of a Symposium Organized by the Courtauld Institute of Art and the Getty Conservation Institute, London, 13–16 July 1987, pp. 67–76

K. Weitzmann and H. L. Kessler: *The Frescoes of the Dura Synagogue and Christian Art* (Washington, DC, 1990)

U. Baldini and O. Casazza: *The Brancacci Chapel Frescoes* (London, 1992)

M. Hall: *Colour and Meaning: Practice and Theory in Renaissance Painting* (Cambridge, 1992)

G. Basile: *Giotto, the Arena Chapel Frescoes* (London, 1993)

S. Roettgen: *Italian Frescoes* (New York, 1994)

M. R. Katz: 'William Holman Hunt and the "Pre-Raphaelite Technique"', Historical Painting Techniques, Materials, and Studio Practice: Preprints of a Symposium, University of Leiden, 26–29 June, 1995, pp. 158–65

R. Bugini and L. Folli: 'Materials and Making Techniques of Roman Republican Wall Paintings', *Roman Wall Painting: Materials, Techniques, Analysis and Conservation: Proceedings of the International Workshop, Fribourg, 1996*, pp. 121–30

J. T. Wollesen: *Pictures and Reality: Monumental Frescoes and Mosaics in Rome around 1300* (New York, 1998)

G. Basile, ed.: *Giotto: The Frescoes of the Scrovegni Chapel in Padua* (Milan and London, 2002)

P. Lindley: *Making Medieval Art* (Donington, 2003)

J. Kliemann and M. Rohlmann: *Italian Frescoes, High Renaissance and Mannerism, 1510–1600* (New York, 2004)

M. Marabelli and others: 'La tecnica pittorica di Giotto nella Cappella degli Scrovegni/Giotto's Painting Techniques in the Scrovegni Chapel' [special issue of *Bollettino d'arte*] (2005) pp. 17–46

J. Poeschke: Italian *Frescoes: The Age of Giotto, 1280–1400* (New York, 2005)

Frit. Term used in glass technology to describe a mixture of sand and fluxes heated together to form a semi-vitrified mass as a first stage in the production of glass. This material is then pulverized and may be used in the manufacture of glass or ceramic glazes. The term is also applied to moulded, unglazed, sintered-quartz bodies. At the site of el-Amarna in Egypt cakes of differently coloured frits were found in a workshop of the 14th century BC. Particularly fine frit beads, objects and vessels were produced in ancient Egypt (e.g. London, British Museum). In a coloured frit the colour runs throughout, whereas in faience (a glazed sintered-quartz body often wrongly described as a frit) only the glaze may be coloured. The terms 'glass paste' or *'pâte de verre'* are sometimes used to denote frit and opaque glass. In ceramics, the term 'frit' is also used to denote the vitreous composition from which soft porcelain is made. Fritware is a sintered-quartz faience with a coloured glaze, first introduced by Islamic potters in the 12th century.

P. R. S. Moorey: *Materials and Manufacture in Ancient Mesopotamia: The Evidence of Archaeology and Art—Metals and Metalwork, Glazed Materials and Glass*, British Archaeological Reports, International Series, ccxxxvii (Oxford, 1985)

D. Ullrich: 'Egyptian Blue and Green Frit: Characterization, History and Occurrence, Synthesis', *PACT*, xvii, (1987), pp. 323–32

R. Barden: 'The Analysis and Reconstruction of Islamic Glass-frit Ceramics and Comparative Methods of Desalination', *Objects Specialty Group PostprintsSt Paul, MN, 1995*, iii, pp. 64–9

P. S. Griffin: 'Reconstructing the Materials and Technology of Egyptian Faience and Frit', *Materials Issues in Art and Archaeology VI: Proceedings of the Materials Research Society Symposium, Boston, 2001*, dccxii, pp. 323–55

Frottis. Thin transparent or semi-transparent layer of pigment lightly rubbed into the ground during the early stages of a painting.

Fugitive. Term used to describe pigments or dyes that fade or change colour due to the action of light. (It does not refer to colour changes caused by chemical reactions with the atmosphere or surrounding materials.)

G

Gem-engraving. Engraved gems are gemstones, whether quartzes or the harder, more precious stones, either engraved in intaglio, as for seals, or cut in cameo to give a raised relief image. In a wider sense gem-engraving encompasses shell cameos and moulded, glass-paste imitations of engraved gems. Gem-engraving in various manners has been practised widely throughout the world since the Predynastic period (*c.* 6000–*c.* 2925 BC) in ancient Egypt.

See also GEMS and HARDSTONES.

Gems. Minerals, usually of crystallized matter, used for personal adornment (e.g. jewellery; see colour pl. XIII, fig. 2) or for decorating such items as textiles and liturgical objects. Rubies, sapphires, diamonds and emeralds are regarded by the layman as the high monetary value gems, while such stones as opals, topazes, tourmalines and garnets, and the organic gems IVORY, AMBER, JET and CORAL are considered to be of lesser value. The value of any gem is dependent upon its beauty, rarity, quality and size: a diamond, for example, may be of lesser value than an emerald of a similar size, and a mediocre to poor-quality ruby may be of a lower value than an example of demantoid, the rare green variety of garnet. Such rare and lesser-known gems as alexandrite and chrysoberyl cat's-eye, two of the members of the chrysoberyl family, can also command very high prices depending not only upon rarity, quality and size but also upon the market in which they are sold: a chrysoberyl cat's-eye sold in England may have a lower market value than if it were sold in Japan.

Gems are tested by gemologists for authenticity in a variety of ways: the refractive index is tested with a gem refractor; the hardness by scratching the surface and measuring the result against the Mohs scale—talc (1) being the softest and diamond (10) being the hardest. If these methods do not suffice, then the gem can be tested using X-ray diffraction or chemical analysis. In the case of diamond, unlike any other gem, there are internationally recognized quality-grading standards and a clear pricing structure according to the clarity, colour, cut and weight. The most widely accepted system for grading diamonds is that of the Gemological Institute of America (GIA). The top GIA clarity grade is 'Flawless' and the lower grades run down through VVS, VS, SI and L. The top

colour grade is denoted by the letter 'D', and with increasing yellowness they run through to 'Z'.

1. SOURCES AND MINING. Such gems as ruby, sapphire, diamond, emerald, topaz and tourmaline are found in the form of crystals, or as water-worn pebbles in sands and gravels. It is as rounded, worn pebbles that such gems as blue, yellow and pink sapphire are found in the alluvial deposits in Sri Lanka, sometimes known as the 'Gem Island'. One of the earliest records of Sri Lanka as a source of gems was in 334 BC, and probably hundreds of thousands of carats of gem-quality sapphire, chrysoberyl, spinel and other gems have been mined there over the centuries. The local miners search the surface of likely mining areas looking for rounded pebbles, often located in rice fields. The miners sink their pits as deep as 15 m in search of the gem-bearing gravel known as illam. The gravel is brought to the surface, washed in baskets, and the gem-bearing material is sorted from the waste.

The mining operations in Sri Lanka are simple, and each pit is operated by comparatively few people. Similar operations take place in Burma, Thailand and Brazil. When local conditions and economics permit, much larger and more mechanized operations take place. An example of this is the huge sapphire mining operation in the state of New South Wales, Australia, where farmland may be removed to a depth of 15 m to the gem gravels. The gravel is then sorted, and the top soil replaced so that farming can recommence. In the Lightning Ridge opal fields, also in New South Wales, the mining is initially simple: shafts are sunk until an opal seam is discovered and followed. The entire area of Lightning Ridge thus becomes a warren of tunnels. When such tunnel-type mining becomes uneconomic, a larger company will often buy up the claims and resort to an open-cast type of mining to claim the remainder of the opal. In Colombia, large numbers of people are employed to pick through the soft rocks containing veins of emerald bulldozed from the sides of mountains.

Diamond mining can be quite a simple operation using a small dredger to expose the gravels from, for example, the smaller rivers in Brazil, or more complex using huge dredgers containing full recovery plants, bringing up the gravels of the larger rivers. This type of diamond mining of alluvial or placer

deposits is known as secondary deposit mining. Primary deposit mining in Australia, South Africa and Russia is a much bigger operation, drilling through the earth to kimberlite. When diamond-bearing kimberlite pipes were first discovered in South Africa, the ground at the surface (yellow ground) was quite easily mined with a pick and shovel. As the depth of the mine increased the yellow ground gave way to a very hard material known as blue ground, which was thought to be barren. It was later discovered that the blue ground was the unweathered form of the yellow ground and still contained diamond. These pipes are mined in a highly mechanized manner: when a pipe is discovered, huge diggers move in to carry out open-cast mining. When this form of mining becomes uneconomic, shafts are sunk in the country rock around the pipe, and tunnels are then driven into the pipe; the remainder of the mining takes place underground. This can involve miners working at considerable depths: the mines in the Kimberly area of South Africa reach a depth of c. 915 m.

On 26 January 1905 the largest rough diamond ever discovered, weighing 3106 carats and known as the Cullinan Diamond, was found in the Premier Mine near Pretoria, South Africa. The largest two stones cut from it are the Star of Africa (the largest faceted diamond in the world), which is set in the head of the Royal Sceptre, and the Second Star of Africa, which is set in the Imperial State Crown, both of which are from the British Crown Jewels, held in the Tower of London.

2. CUTTING. The cutting of diamond requires a knowledge of its hardness and cleavage properties (which are regarded as perfect), and the skill to produce the correct angle between the various portions of the finished stone, and correctly proportioned facets. Various organizations differ about what the ideal measurements for the round brilliant cut should be: one proposal suggests 57.5% for the table facet proportion (100% being the diameter of the stone) and 34.5° for the 'crown angle', which is the angle made between the crown (upper) facets and the line of the girdle.

As diamond is optically isotropic, for the most part it does not have any directional properties in terms of colour (while diamond is mostly regarded as a 'colourless' stone it is also found in numerous colours, e.g. blue, green, yellow, orange, brown and pink), and therefore the colour factor is not, usually, taken into account during the cutting process. This is different from a great many other coloured stones. Both ruby and sapphire, which are members of the corundum family, are dichroic, and, depending upon the angle of view, a different colour or shade of colour will be seen. Colour and clarity are the most important factors in assessing a faceted ruby or sapphire, but during the cutting process the lapidary's main objectives are to produce the best 'face up' colour from the rough material being worked, while at the same time preserving the maximum weight.

The art of polishing diamonds began in the early 14th century when it was used on stones from India. At that time small facets were polished on crystals using a leather lap. Such a technique inevitably could not achieve the perfectly flat surfaces produced by the modern cutting methods (see fig.) which involve cleaving (dividing) or sawing a rough diamond (a), cutting the stone into the approximate shape desired (b and c), bruting (grinding or shaping) the top into a circular shape (d) and grinding and polishing on a rotating wheel (e), which yields a finished, multi-faceted gem (f)–(j). A notable example of a diamond with easily observable undulating facet surfaces is the slightly pink 56.71 carat Shah Jahan Diamond.

The modern 58-facet, brilliant cut (j) evolved from the point cut employed during the Middle Ages. This cut is little more than a slight alteration to the angles of the octahedral crystal habit in which diamond is normally found. The first 'true cut' for diamond was the table cut, and it was this cut that dominated throughout the 16th century. The table cut is an octahedral crystal on which one point is flattened to a square table with the opposite point also sometimes flattened to a lesser extent. The rose cut, in which

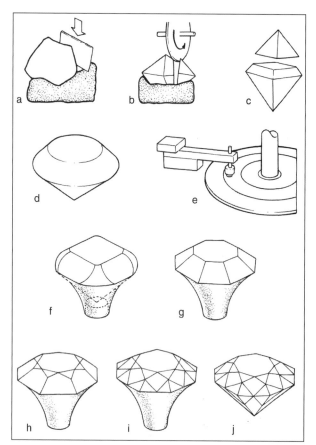

Gem-cutting processes: a. cleaving, b. cutting, c. cut shape, d. bruted stone, e. rotating wheel for grinding and polishing, f-j. faceted and polished brilliant-cut stone

the base is flat and the upper portion multi-faceted sometimes rising to a point, may be as old as the table cut. As more facets were added to the table-cut diamond it passed from the English square cut, to the single cut, the old mine cut, the European round brilliant cut and finally to the modern brilliant cut.

The enhancing of other coloured stones by altering their appearance, as with diamond, started merely by polishing the surface of the stone while keeping the basic crystal shape. An excellent example of this is the Black Prince's Ruby set in the British Imperial State Crown (London, Tower). This is a large polished red spinel, which retains its octahedral crystal shape. Probably originally intended as a turban ornament, the Black Prince's Ruby was drilled several times, once through the entire length of the stone to accommodate the necessary pins and perhaps to thread on to a necklace.

3. OTHER TREATMENTS. The enhancement of gems very often goes beyond the faceting of the crystals. The disguising of flaws and the alteration of colour are two common practices. The flaws in emeralds have been artificially filled with an oil (colourless or dyed green) of a similar refractive index for many years. More recently these flaws have been hidden with the aid of resin. A similar problem with the visibility of flaws in diamond has been solved by two different methods: when there is a black inclusion in the stone, which does not reach the surface, a narrow tunnel is 'drilled' or burnt by a laser into the object; the inclusion is then treated with acid down the laser hole, bleaching it from black to a less visible white. Some fractures in diamonds reach the surface and with the aid of a vacuum process, glass can be made to fill the fracture and make it less visible.

The colour of a gem can be changed or enhanced through staining, heat treatment or irradiation. Many types of chalcedony are stained either to imitate more expensive gems or to produce unnatural colours. Ruby, sapphire, zircon, aquamarine and citrine are examples of stones that may have their colour improved by heat treatment. Diamond, topaz and tourmaline are examples of stones that may have their colour changed by irradiation. In ancient times the drilling of high-value gems was common practice, but in the late 20th century it was considered wasteful and uneconomic.

See also HARDSTONES.

G. F. Herbert Smith: *Gemstones* (London, 1912, London, rev. 14/1972)

E. H. Kraus and C. B. Slawson: *Gems and Gem Materials* (New York, 1925, New York and London, rev. 5/1947)

R. Webster: *Gems, their Sources, Descriptions and Identification* (London, 1962, rev. by P. G. Read, Oxford, 5/1994)

P. E. Desautels: *The Gem Kingdom* (New York, 1971)

P. G. Read: *Gemmology* (Oxford, 1991, rev. Amsterdam and London, 3/2005)

C. Oldershaw, C. Woodward and R. Harding: *Gemstones* (London, 2/2001)

W. Schumann: *Gemstones of the World* (London, 1997)

A. M. Giusti: *Pietre Dure: The Art of Semiprecious Stonework* (Los Angeles, 2006)

M. O'Donaghue, ed.: *Gems: Their Sources, Descriptions and Identification* (Oxford, 6/2006)

Beyond Belief (exh.cat. by D. Hirst; London, White Cube, 2007)

Gesso. White coating used as a ground for painting (*see* GROUND) and in the preparation of wood for gilding. It comprises glue-size (*see* SIZE), mixed with either calcium sulphate (a form of gypsum), which produces the soft gesso that was used in Italy in the Renaissance, or calcium carbonate (chalk), which produces a hard gesso that was used in northern Europe. It is inflexible and absorbent and, once dry, may be worked to produce a smooth surface. Variations on the basic recipe occur, notably the inclusion of white pigment to increase its brilliance. *Gesso grosso* is a traditional form made from burnt gypsum and hide glue. The glue slows down the setting action of the plaster and makes it considerably harder when dry. Similar compositions are used in decorative plasterwork. *Gesso grosso* is comparatively coarse and was used as a base coat on wooden panels being prepared for tempera painting (*see* TEMPERA, §1). It would be covered with several coats of *gesso sottile*, another traditional form made by steeping burnt gypsum in an excess of water and stirring it to prevent setting. *Gesso sottile* is fine, soft and smooth; it was originally bound with parchment glue for use. Cennino Cennini (*c.* 1370–*c.* 1440), describes the use of these materials, as does Francisco Pacheco (1564–1644), who refers to them as *yeso grueso* and *yeso mate*.

In ancient Egypt, small gesso-coated panels were employed for writing and painting, and also for late Egyptian mummy portraits in encaustic (examples in London, British Museum). Little gessoed panels are described as reusable drawing surfaces, and gessoed card may occasionally have been used as a support for miniature painting. Such materials were used for temporary record keeping throughout the Middle Ages and Renaissance. A prepared surface of hard gesso was also used in conjunction with metalpoint. From the Byzantine era until the late Renaissance gesso was applied in layers to wooden panels to produce a thick, luminous ground. Its smooth finish suited the detailed style, small brushstrokes and translucent paint of the tempera technique. Its use as a base (under bole) for water gilding was exploited to the full on icons and altarpieces (*see* GILDING, §II, 1) by such Sienese artists as Simone Martini (*c.* 1284–1344), who also used carved and punched gilded gesso to add surface detail to haloes and decorative textiles (*see* PUNCH). Gesso, often in the form of a chalk ground suitably modified to reduce its absorbency, was also employed in oil painting on panel, where its smooth surface and strangely reflective quality was exploited by such artists as Robert Campin (*c.* 1375/9–1444), Jan van Eyck (*c.* 1395–1441; e.g. the *Arnolfini Marriage, c.* 1434; London, National Gallery), Rogier van der Weyden (*c.* 1399–1464) and Antonello da Messina (*c.* 1430–79). The stability of gesso on wood may have helped preserve such works. Gesso applied to canvas must be kept thin and should be used only to fill the pores of the cloth; Cennini describes such preparation for painted banners. Many paintings by Titian (*c.* ?1485/90–1576)

in oil are on a gesso ground, probably coated with glue. However, the comparative instability of canvas and the comparative inflexibility of gesso make them incompatible, particularly on a large scale, and it was the widespread adoption of canvas and oil paint that led to a decline in the use of gesso. Since the 19th century, however, there has been a steady revival of interest in its use not only in painting but also in the decorative arts. From the early 1940s the American painter Andrew Wyeth (b 1917) started to use egg tempera on gesso board in such paintings as *Christina's World* (1948; New York, Museum of Modern Art); David Tindle (b 1932) also used the traditional tempera on panel technique. Conservation research has highlighted the potential superiority of the traditional gesso ground on panel. Gesso is also used as a filler and surface coating for wooden sculpture, furniture and picture frames, where it not only serves as a ground for a painted finish or gilding (*see* GILDING, §§I, 1(i) and II, 2 and 3) or carving but also suppresses the wood grain and any roughness of finish. It may be worked as low relief carving or cast as small motifs for decorated panels (*see* PASTIGLIA) or sculpture. In sculpture, the term gesso may be a direct reference to plaster. It is also applied to a modern acrylic primer known as 'acrylic gesso'.

C. Cennini: *Il libro dell'arte* (MS.; c. 1390); trans. and notes by D. V. Thompson jr (1933)

R. J. Gettens and M. E. Morse: 'Calcium Sulphate Minerals in the Grounds of Italian Paintings', *Studies in Conservation*, i (1954), pp. 174–89

J. Ayres: *The Artist's Craft: A History of Tools, Techniques and Materials* (London, 1985)

J. Stephenson: *The Materials and Techniques of Painting* (London, 1989)

Art in the Making: Italian Painting Before 1400 (exh. cat. by D. Bomford and others; London, National Gallery, 1989)

J. Dunkerton and others: *Giotto to Dürer: Early Renaissance Painting in the National Gallery* (London, 1991)

Z. Véliz: 'Wooden Panels and their Preparation for Painting from the Middle Ages to the Seventeenth Century in Spain', *The Structural Conservation of Panel Paintings*, eds K. Dardes and A. Rothe (Los Angeles, 1998), pp. 136–48,

P. Lindley: *Making Medieval Art* (Donington, 2003)

Gilding. The decoration of works of art and architecture with gold or silver or other metals. Traditionally the term describes the application of thin sheets of metal to a surface by means of an adhesive; it is also possible to use the metal in powdered form.

See also GOLD.

I. Materials and techniques. II. Uses. III. Conservation.

I. Materials and techniques.

1. Leaf. 2. Powder. 3. Fire gilding.

1. LEAF.

(i) *Types and application.* The earliest application of gold as decoration was in Mesopotamia and in Predynastic Egypt. In gilded figures from Ur (dating from before 2500 BC) and from Egypt (c. 2400 BC), sheet gold was nailed to a wooden core, but by 1500 BC leaf gold was being applied to a variety of materials, notably ivory (known as chryselephantine work). Silver leaf has been extensively used, both on its own and, covered with a golden yellow transparent coating, as a substitute for gold, despite the fact that it tarnishes. Written sources from as early as the late 3rd century AD describe the tinting of metals in imitation of gold, as well as the alloying of gold and silver with base metals. Gold may be naturally or deliberately coloured by the presence of traces of metals such as copper, iron or silver. These also alter its hardness. Gold leaf is obtained today in various shades and degrees of hardness, pure 24 carat gold being the softest. Tinted silver was widely used on polychrome sculpture, in interior decoration and on furniture, notably in 17th- and 18th-century Europe (*see* §II, 3 below). Tin leaf, which does not tarnish, was coloured to imitate gold in addition to being used alone. Leaf is also now produced from white gold, palladium and platinum; aluminium may be used as a cheap alternative.

A laminated leaf, resembling gold leaf, was made by placing a thin sheet of gold over a similar sheet of silver (or tin) and hammering the two together. The gold–silver laminate is known as *Zwischgold* (Ger.), *partijtgoud* (Dut.) or *or parti* (Fr.); according to Skaug (1993), the Italian *oro di metà* refers to the same material. Unlike pure gold leaf, however, it tarnishes, as the thin gold cannot protect the silver below. The gold–tin leaf was rather more robust than gold leaf and has been identified in 14th- and 15th-century Italian mural paintings (*see* §II, 1 below). Gold-coloured alloys used for leaf include the copper–zinc *Schlagmetall* ('beaten metal') or 'Dutch metal', used from the 19th century. The use of copper–tin alloy leaf (now blackened) has been reported in the frescoes (c. 1305) attributed to Giotto (1267/75–1337) and his school in the Arena Chapel, Padua; this may correspond to the little-known *orpello* ('tinsel'), occasionally referred to in 14th- and 15th-century Italian documents.

The manual method of hammering gold into leaf is known as goldbeating, and medieval European guild statutes indicate that it was a separate, although related, trade to that of goldsmiths and other workers in precious metals. Although the process was successfully automated in the 1920s, the basic procedure has remained essentially unchanged over the centuries. A small gold ingot is pressed between steel rollers to give a continuous ribbon 25μm thick and about 50 mm wide; 200 squares (50 × 50 mm) cut from it are interleaved with sheets of parchment 100 mm square; this pack or 'cutch', bound in parchment, is beaten until the gold extends to the edges of the parchment. The pieces are quartered and the process repeated. The gold is quartered again; 800 pieces are placed in a 'shoder' of goldbeater's skins (prepared from ox gut) and beaten, this procedure being carried out twice. Lastly, the leaf is beaten in a 'mould' of very thin skins, cleaned with calcined gypsum powder. It is cut, on a leather cushion, into pieces 80 mm square and inserted loose between sheets of rouged tissue into a book containing 25 leaves. According to

Cennino Cennini, late 14th-century Italian gold-beaters could obtain 145 leaves, similar in size to modern leaf, from a Venetian ducat, which, at that time, weighed about 3.5 g. The thickness of such leaf can be estimated to have been about 0.2µm (0.0002 mm). Modern leaf can be even thinner—*c.* 0.1µm if machine made, *c.* 0.05µm if hand beaten. At this thickness it is translucent, transmitting greenish light. Transfer gold leaf (patent gold) is loosely attached to sheets of tissue by pressing and can be used only for oil gilding. It was first made in strip venient format for gilding vehicles; i form in the early 20th century, providing a more con n the 1930s a method of sputtering gold on to the waxed paper carrier was devised. Modern foil is manufactured by vaporizing the gold; the carrier film is polyester. It can be obtained with a brilliant metallic finish and is used extensively in manufacturing industries for gold decoration.

An artefact can be gilded using simple, unpigmented adhesives; the choice depends partly on the effect desired and the nature of the substrate. Resin-like substances and oil/resin varnish mixtures have been used for gilding textiles. In Japan, for example, gold or silver leaf was applied to cloth during the Momoyama period (1568–1600) using a technique copied from imported Chinese textiles. Such plant gums as gum arabic have been widely employed for gilding materials as diverse as ivory, wood, parchment and paper (*see* PAPER, DECORATIVE). Other simple adhesives have included beaten egg white (glair), used in manuscript illumination and for gilding leather (*see* §II, 5 below), and shellac, also used for the latter. The use of such other substances as garlic juice is recorded in historical sources.

Water gilding and oil or mordant gilding are the two main methods of applying gold leaf used, notably on easel and wall paintings, furniture and sculpture, since medieval times. Water gilding was certainly known in Europe by the early 12th century. This method is used where a shining burnished finish, imitating solid metal, is desired, for example in the gold backgrounds of icons and medieval altarpieces (*see* §II, 1 below) and in manuscript illumination. Gold applied using an oil mordant cannot be burnished, as the adhesive holds the gold too firmly; it therefore appears yellower and has a diffusely reflecting surface. This difference in appearance may be exploited by using both types of gilding in the same piece of work.

In water gilding the object is usually coated with several layers of gesso or chalk mixed with parchment size. When this is hard, it is scraped and polished to a perfectly smooth finish. A soft, slightly greasy, reddish-coloured clay, known as bole, mixed with dilute size, is then applied and, when dry, burnished or polished (see fig.). A sheet of leaf is

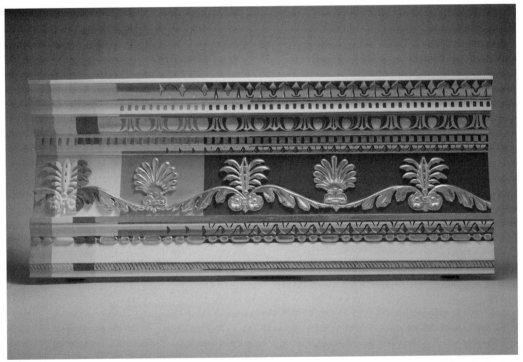

Reconstruction of cornice section in which the working methods of 15th-century artisans have been re-created, from the Studiolo of Federigo II da Montefeltro, by Giuliano da Maiano and designed by Francesco di Giorgio Martini, of walnut, beech, rosewood, oak and fruitwoods, from left to right: poplar base, gesso layers, bole and gilding, underpaint, and, from middle to right edge, as completed, Palazzo Ducale, Gubbio, completed *c.* 1478–82 (New York, Metropolitan Museum of Art, Rogers Fund, 1939 (39.153)); image © The Metropolitan Museum of Art

placed on a padded leather gilder's cushion, cut to size if necessary and picked up using a gilder's tip—a thin, flat, hair brush (in medieval times, tweezers and card would have been used). The bole is moistened with water to which a little size may be added. The leaf is held above it, just touching the surface, and is sucked on to the bole by capillary action. It may be patted down afterwards if necessary. When the work is dry, the gold is burnished; modern burnishing tools are usually made of agate, but in earlier times haematite and even dogs' teeth were used.

For oil gilding a mordant, consisting principally of linseed oil heated with a lead drier, is used; frequently a natural resin varnish is also incorporated. The mordant may be pigmented (e.g. with yellow ochre), which not only enables the design seen on the surface to be decorated but may also help to disguise small flaws in the gilding. The mordant is painted on and left until tacky, when the gold is applied; this technique is used for delicate linear designs or lettering (see CHRYSOGRAPHY).

Gold and silver leaf were applied to, or encased in, glass to produce the gold and silver tesserae that profoundly influenced the character of post-Antique and medieval mosaics (see MOSAIC, §I, 2). According to medieval sources, such as the *Compositiones variae* (Lucca, Biblioteca Capitolare, MS. 490), the leaf was placed on a small thick sheet of glass, and covered with a very thin glass sheet and heated in a furnace until the glass began to melt; later sources suggest the use of powdered glass, giving a very thin surface layer. After cooling, the surface of the thinner glass was polished with emery powder or a similar abrasive. The slab was then broken into square tesserae. Variations in the appearance of the gold could be obtained by the deliberate use of brownish or greenish glass, rather than colourless, and by applying the tesserae upside down, with the thicker glass at the top.

See also GOLD, §2(iv).

C. Cennini: *Il libro dell'arte* (MS.; *c.* 1390); ed. F. Brunello (Vicenza, 1971); Eng. trans. and ed. by D. V. Thompson, as *The Craftsman's Handbook: The Italian 'Il libro dell'arte'* (New Haven, 1933, R/New York, 1960), pp. 60–63, 79–89, 96–8, 100–04, 106–8, 112–13, 118–19

W. Lewis: *Commercium philosophico-technicum*, 2 vols (London, 1763–5), i, pp. 38–229

C. Singer, ed.: *A History of Technology*, 7 vols (Oxford, 1954–78), i, pp. 581–2, 623–62, 677; ii, pp. 174, 342–3

S. M. Alexander: 'Medieval Recipes Describing the Use of Metals in Manuscripts', *Marsyas*, xii (1964–5), pp. 34–51

C. S. Smith and J. G. Hawthorne: 'Mappae Clavicula: A Little Key to the World of Medieval Techniques', *Transactions of the American Philosophical Society*, n.s., lxiv (1974), pp. 3–122 [especially p. 48]

B. J. Sitch: 'Transferable Gold Coatings: Historical and Technical Aspects of their Development', *Gold Bulletin*, xi (1978), pp. 110–15

E. D. Nicholson: 'The Ancient Craft of Gold Beating', *Gold Bulletin*, xii (1979), pp. 161–6

P. MacTaggart and A. MacTaggart: *Practical Gilding* (Welwyn, 1984) Repr. (London, 2002)

M. Matteini and A. Moles: 'Le tecniche di doratura nella pittura murale', *Le pitture murali: Tecniche, problemi, conservazione*, eds C. Danti, M. Matteini and A. Moles (Florence, 1990), pp. 121–6, 148–9

A. Meyer: 'Mosaik', *Reclams Handbuch der künstlerischen Techniken*, ii (Stuttgart, 1990), pp. 399–498 [especially pp. 427–9]

D. Bigelow, E. Cornu, G. J. Landrey and C. van Horne, eds: *Gilded Wood: Conservation and History* (Madison, 1991)

Gilding and Surface Decoration: Preprints of the UKIC Conference Restoration '91: London, 1991

E. Skaug: 'Cenniniana: Notes on Cennino Cennini and his Treatise', *Arte cristiana*, lxxxi/754 (1993), pp. 15–22

L. L. Brownrigg, ed.: *Making the Medieval Book: Techniques of Production* (Los Altos Hills, CA, 1995)

A. Bartl and M. Lautenschlager: 'Wie man sol machen ein güte goltz grunndt: Anweisungen zur Blanzvergoldung in der Buchmalerei', *Restauro*, cvi/3 (2000), pp. 180–87

K. P. Whitley: *The Gilded Page: The History and Technique of Manuscript Gilding* (New Castle, DE, 2000)

T. Drayman-Weisser: *Gilded Metals: History, Technology and Conservation* (London, 2000)

(ii) Decoration. A burnished water gilded surface may be decorated by the use of ornamental punches and incised lines while the gesso is fresh enough to be sufficiently flexible. The punch is held at right angles to the gilded surface and tapped lightly with a hammer, thus indenting the gesso ground without breaking the surface. Combinations of punches, the designs of which may range from simple circles or rings to complex rosettes and leaf shapes, are used to create patterns (see also PUNCH). A stylus may also be used to indent lines, often combined with patterns produced by a punch. Rich and complex textural effects may thus be achieved. This technique probably evolved from the use of iron punches and gravers to produce raised decoration in sheet metal and from blind tooling (decorative punching without the use of gold), which developed in Europe for the decoration of leather, particularly for book bindings, certainly by the 11th century AD (see BOOKBINDING, §II). Gold-tooling of leather, although a very old technique in the Middle East, reached Europe only in the 15th century; 'gilt' leather, however, had been produced in the late 14th century (see LEATHER, §2(ii)). In China, metal leaf was used in conjunction with the lacquer to decorate Tang mirrors in such Southern Song (1127–1297) techniques as *qiangjin*, in which gold leaf was tooled into depressions incised into the surface of the lacquer.

Metal leaf can also be painted, either with opaque paint or with translucent glazes; opaque and transparent paints can also be used together. Opaque paint may be used to paint a design over gold, but its most effective use is in the *sgraffito* technique: areas of colour are painted over the gold and then scraped off when the paint is partly dry, revealing the gold beneath in the desired pattern. Richly detailed effects may be obtained, particularly in the representation of brocades and other textiles, for example in 14th- and 15th-century European altarpieces where egg tempera paint has been applied to burnished gold (see §II, 1 below. Transparent glazes are applied thinly, in an oil-based

medium, to reduce the brilliance of the metal as little as possible. They were widely used on painted altarpieces and in 17th- and 18th-century Europe on polychrome sculpture, leather items and other decorative objects. Gamboge, saffron and the evaporated juice from certain species of aloe were among the yellow colorants; red colorants included lac dye and dragon's-blood. Annatto gave an orange, and green could be obtained using verdigris. A number of synthetic organic dyestuffs are available; certain pigments, such as alizarin crimson or Prussian blue, are also suitable.

E. Skaug: 'Punch Marks—What Are they Worth? Problems of Tuscan Workshop Interrelationships in the Mid-fourteenth Century: The Ovile Master and Giovanni da Milano', *La pittura nel XIV e XV secolo: Il contributo dell'analisi tecnica alla storia dell'arte: Atti del XXIV congresso internazionale di storia dell'arte: Bologna, 1979* (Bologna, 1983), pp. 253–82

R. E. Straub: 'Tafel- und Tüchleinmalerei des Mittelalters', *Reclams Handbuch der künstlerischen Techniken*, i (Stuttgart, 1984), pp. 189–98, 229–36

Art in the Making: Italian Painting before 1400 (exh. cat. by D. Bomford and others; London, National Gallery, 1989–90), pp. 24–6, 130–35

C. Cession: 'The Surface Layers of Baroque Gildings: Examination, Conservation, Restoration', *Cleaning, Retouching and Coatings: Preprints of the Contributions to the IIC Brussels Congress, 1990*, pp. 33–5

E. S. Skaug: *Punch Marks from Giotto to Fra Angelico: Attrubution, Chronology, and Workshop Relationships in Tuscan Panel Painting: With Particular Consideration to Florence, c. 1330–1430* (Oslo, 1994)

M. S. Frinta: *Punched Decoration on Late Medieval Panel and Miniature Painting* (Prague, 1998)

A.-M. Hacke, C.M. Carr and A. Brown: 'Characterisation of Metal Threads in Renaissance Tapestries', *Scientific Analysis of Ancient and Historic Textiles*, ed. P. Wyeth (London, 2005), pp. 71–9

M. Járó: 'The Gold Threads in the Hungarian Coronation Mantle', *The Coronation Mantle of the Hungarian Kings*, ed. I. Bardoly (Budapest, 2005)

2. POWDER. Recipes for powdering gold (and other metals) appear as early as the 3rd century AD and include amalgamation of gold leaf with mercury and grinding leaf with salt. Shell gold (so called because of the traditional method of storing it in mussel shells) was made by grinding leaf gold with honey (a method known since at least the 14th century) and mixing it with a gum or other appropriate medium so that it could be used as a paint (*see* §II, 1 below). Powdered gold was used in such Chinese techniques as *maiojin* ('painting in gold') and *tianqi* ('filled-in lacquer') to decorate lacquer in the Song period (AD 960–1279); it may also be strewn or dusted lightly over an adhesive to give a glittering appearance, a technique much used on East Asian lacquerware (for further discussion *see* LACQUER, §I, 1(ii)(h)). Powdered gold suspended in varnish was also used in early bookbinding decoration (*see* §II, 5 below). Mosaic gold—*aurum musicum* or *purporino* (It.)—is a

gold-coloured tin sulphide prepared by prolonged heating of tin–mercury amalgam, sulphur and sal ammoniac. By the 14th century recipes for the material abounded, although its use has seldom been confirmed in practice. One rare example is the metal rail in the painting of *St Vincent Ferrer* (*c.* 1473; London, National Gallery) by Francesco del Cossa (*c.* 1435–76/7). It is thought to have been used as a substitute for real powdered gold, mainly in the illumination of manuscripts and in miniature paintings. The now widely used bronze powders were developed in the 19th century and are used predominantly in the decorative arts, in particular on furniture, picture frames and mirrors (*see* §II, 3 below). These powders are generally copper–zinc alloys, their colour depending on the relative proportions of the two metals present. Aluminium flake powders may be used instead of silver.

C. Cennini: *Il libro dellarte* (MS.; *c.* 1390); ed. F. Brunello (Vicenza, 1971); Eng. trans. and ed. by D. V. Thompson, as *The Craftsman's Handbook: The Italian 'Il libro dellarte'* (New Haven, 1933, R/New York, 1960), pp. 101–2

S. M. Alexander: 'Medieval Recipes Describing the Use of Metals in Manuscripts', *Marsyas*, xii (1964–5), pp. 37-43

P. E. Rogers, F. S. Greenawald and W. L. Butters: 'Copper and Copper Alloy Flake Powders', *Pigment Handbook*, ed. T. C. Patton, 3 vols (New York, 1973), i, pp. 807–17

R. Rolles: 'Aluminium Flake Pigment', *Pigment Handbook*, ed. T. C. Patton, 3 vols (New York, 1973), i, pp. 785–806

A. Smith, A. Reeve and A. Roy: 'Francesco del Cossa's *St Vincent Ferrer*', *National Gallery Technical Bulletin*, v (1981), pp. 44–57

F. Ames-Lewis: 'Matteo de' Pasti and the Use of Powdered Gold', *Mitteilungen des Kunsthistorischen Instituts in Florenz*, xxviii (1984), pp. 351-62

L. L. Brownrigg, ed.: *Making the Medieval Book: Techniques of Production* (Los Altos Hills, CA, 1995)

R. K. Dube: 'An Analysis of Ants' Gold in Ancient India', *Kinzoku Hakubutsukan kiyō*, xxv (1995), pp. 1–13

K. P. Whitley: *The Gilded Page: The History and Technique of Manuscript Gilding* (New Castle, DE, 2000)

3. FIRE GILDING [Mercury, amalgam or parcel gilding]

(i) *Technique*. This method of gilding made use of the property of mercury readily to form an amalgam with gold and was usually applied to copper or silver. The technique as practised in the medieval period was described in detail by Theophilus (*fl* first half of the 12th century) in *De diversis artibus*, and many 19th-century workshop manuals (e.g. those by Spon and Thorpe) contain detailed accounts of this process. There were two basic methods: applying either gold leaf or a gold–mercury amalgam to a surface that had already been treated with mercury.

In both methods the metal had to be carefully cleaned free of all grease and scratch-brushed to key the surface; then mercury was applied. In the more remote past metallic mercury was vigorously worked into the surface with a short, stiff brush until the surface was uniformly covered. From the 18th century the usual practice was to dip the cleaned

metal into a solution of mercuric nitrate, which precipitated mercury on to the surface in a thin, continuous layer. This process was known as quicking.

In the first method of fire gilding thin sheets of gold were laid on to the prepared surface, vigorously burnished and then heated to drive off the mercury. This seems to be the process described by Pliny the elder (AD 23/4–79) in his *Natural History* (xxxiii.32; Rackham, 1968, p. 77). In the second process an amalgam of mercury and gold was first prepared by heating mercury to about the temperature of boiling water and then adding about half the weight of pure gold filings, stirring with an iron rod until the amalgam had the consistency of butter (hence the term 'butter of gold'). The health hazards of handling mercury were recognized even in medieval times, and the prepared amalgam was stored under water. The amalgam was then applied to the freshly quicked surface by brushing. When the piece was covered it was gently warmed to evaporate the mercury, while the gilding continued to be worked with a stiff brush to ensure even coverage. Alternatively the amalgam could be carefully applied and brushed in with a wire brush that had itself been quicked to promote even coverage, then heated in a closed furnace. In the latter process, however, the piece had to be kept under constant observation, periodically moved and the amalgam layer worked if necessary to keep the gilding even as it formed. The freshly gilded surface had a rather matt, granular appearance, which could then be further treated by scratch brushing, burnishing or by the use of chemicals to produce the desired colour and texture.

(ii) History. The technique of fire gilding has been identified on metalwork from China in Han burials of the 3rd century AD (Lins and Oddy, 1975), and on some Hellenistic metalwork (Craddock, 1977), including items (Thessaloniki, Archaeological Museum) from the tomb of Philip II, King of Macedonia (*reg* 359–336 BC), at Vergina (Assimenos, 1983). The use of mercury gilding at an early date in China is to be expected, given the importance attached to mercury and mercury-based gold elixirs (potable gold) by the Daoist philosophers and alchemists (Needham, 1980). Oddy (1982) has doubted the existence of mercury gilding in the West before the Romans, and certainly leaf gilding was prevalent until well into the Imperial period, when gold plating of bronze statuary and of architectural fittings became extremely popular. Fire gilding provided a much more durable bond than could be achieved with leaf gilding, and, although it could not be used on ordinary bronze, the greater resistance to corrosion and reduced maintenance costs on exterior metalwork in particular made fire gilding prevalent, although it never completely superseded the other methods.

Even in the early medieval period, when supplies of mercury must often have been difficult to obtain in Europe, fire gilding was the favoured method for gilding metalwork and remained so until the mid-19th century, when, in common with most other traditional plating techniques, it was challenged and rapidly replaced by electrogilding. Although it continued for some time to be favoured for applications where either its durability or the special surface effects were required on work of the highest quality, the process has become virtually extinct in Europe and North America because of the extra cost and stringent health regulations. Fire gilding is still used in Tibet, however, although in other countries where traditional metalworking methods still thrive, for example Nepal, and where amalgam gilding was practised until the late 20th century (Oddy, 1981), it has now been replaced by electrogilding (*see* ELECTROPLATING).

See also GOLD, §2(iv).

Theophilus: *De diversis artibus* (MS.; 12th century); ed. and trans. J. G. Hawthorne and C. S. Smith (Chicago, 1963/*R* 1979)

E. Spon: *Workshop Receipts* (London, 1882/*R* 1932)

E. Thorpe: *Dictionary of Applied Chemistry* (London, 1890–93)

H. Rackham: *Pliny: The Natural History* (London, 1968)

P. Lins and W. A. Oddy: 'The Origins of Mercury Gilding', *Journal of Archaeological Science*, ii (1975), pp. 365–73

P. T. Craddock: 'Copper Alloys Used by the Greeks II', *Journal of Archaeological Science*, iv (1977), pp. 103–23

J. Needham: *Science and Civilization in China*, v/4 (Cambridge, 1980)

W. A. Oddy, M. Bimson and S. La Niece: 'Gilding Himalayan Images', *Aspects of Tibetan Metallurgy*, ed. W. A. Oddy and W. Zwalf, British Museum Occasional Papers, xv (London, 1981), pp. 87–103

W. A. Oddy: 'Gold in Antiquity', *Journal of the Royal Society of the Arts*, cxxx (1982), pp. 1–14

K. Assimenos: 'Technological and Analytical Research on Precious Metals from the Chamber Tomb of Phillip II', *Preprints of the Second International Symposium: Historische Technologie der Edelmetalle: Meersburg, 1983*

K. Anheuser: 'The Practice and Characterization of Historic Fire Gilding Techniques', JOM, xlix/11 (1997), pp. 58–62

K. Anheuser: *Im Feuer vergoldet: Geschichte und Technik der Feuervergoldung und der Amalgamversilberung* (Stuttgart, 1999)

II. Uses.

1. Painting. 2. Sculpture. 3. Furniture and woodwork. 4. Metalwork. 5. Bookbinding.

1. PAINTING. Gilding in painting is particularly associated with the embellishment of such religious works as the icon and the altarpiece, where it serves to glorify the subject-matter and, because of the cost and effort involved, symbolizes an act of devotion on the part of the patron or artist. It serves a similar function in the illumination of religious manuscripts. The secular applications include the illumination of early books (for a description of the technique *see* MANUSCRIPT, §2(iii)), gold writing (*see* CHRYSOGRAPHY), miniature paintings, heraldic devices, dynastic portraiture and allegorical and mythological paintings, where gilding ranges from mere decoration to an ostentatious display of wealth.

In icon painting gold leaf was applied to a wooden surface using the water gilding technique (*see* §I, 1(i) above) on a layer of red bole that helped to bind it

to the wooden surface. The small overlapping pieces of leaf could then be burnished to provide a shining gold ground (e.g. icon of the *Annunciation*, late 12th century; Mt Sinai, Monastery of St Catherine). In the 14th century the example of the Byzantine icon was developed in Italy where the altar became the primary setting for panel painting. Such altarpieces made extensive use of gold and silver leaf throughout the 14th century and into the 15th, when these materials were used in Northern Europe as well as Italy (e.g. *Virgin and Child Enthroned, with Four Angels* by Quinten Metsys (1466–1530), *c.* 1490–95; London, National Gallery). A variety of techniques was used to provide surface decoration on gilding. Gilded haloes were often tooled with patterned and incised punches (*see* PUNCH) or with freehand incised lines. Prior to gilding, raised patterned surfaces were built up of pastiglia or gesso to provide such detail as patterns on haloes or embroidery on garments. In the workshop of Simone Martini (*c.* 1284–1344), for example, this technique was used to imitate such metallic dress accessories as buckles and belts. In oil gilding, mordants of varying thicknesses and made of a variety of materials (*see* §I, 1(i) above) could be painted on and, while still tacky, were coated with gold leaf to provide details that stood proud of the surface, in particular highlights and decoration on textiles. These oil-gilded details could not be burnished and therefore remained matt, and the contrast between burnished water gilding and matt oil gilding in proximity provided another decorative device. For example, in the Rucellai *Madonna* (begun 1285; Florence, Galleria degli Uffizi), Duccio (*d* before 1319) uses mordant gilding on the throne and the child's robe against a water-gilded ground, a further decorative device being the haloes patterned with a burin or composite rosette punches. In the technique known as imitation relief brocade, tin foil, which had been pressed into a mould of a brocade pattern, was subsequently tinted, painted and then applied to the surface of a painting with an adhesive to imitate costly garments. The *sgraffito* technique, in which paint was applied over gold leaf and, when dry, scraped away to expose the gold beneath (*see* TEMPERA, §1(i)), was also used to create details on textiles.

The decorative relief technique was also used in conjunction with gilding in wall painting. An early example is gilded stucco in the Aula of Isis (*c.* 20 BC), Rome, and was used in medieval wall paintings. Notable examples are Simone Martini's *Maestà* (1315–16; Siena, Palazzo Pubblico), painted in a decorative secco method (*see* WALL PAINTING, §I) and the wall paintings in Sainte-Chapelle, Paris, which also incorporated glazed metal leaf. Gilding was also used in other wall-painting traditions, for example Islamic wall paintings of the Safavid period (1501–1732) and 18th- and 19th-century Thai wall paintings.

For finer, more delicate highlights and detail, shell gold or silver—the metal ground to a powder with egg white or a solution of gum (*see* §I, 2 above)—was applied with a brush, a technique also used in manuscript illumination and miniature painting. Shell gold was used in this way by Sandro Botticelli

(1444/5–1510), whose illusionistic use of gold also included the *sgraffito* technique described above.

By the 16th century altarpieces had less gilding, and Botticelli was one of the last Italian artists to make extensive use of gold in painting. In Britain, however, gold continued to be used in painting in the enclosed environment of the Tudor court, and gilding played an important part in Spanish and German painting until well into the 16th century.

C. Cennini: *Il libro dell'arte* (MS; *c.* 1390); ed. F. Brunelli (Vicenza, 1971); Eng. trans., ed. D. V. Thompson, as *The Craftsman's Handbook: The Italian 'Il libro dell'arte'* (New Haven, 1933, *R* New York, 1960), pp. 60–63, 79–89, 96–8, 100–04, 106–8, 112–13, 118–19

D. V. Thompson: *The Materials and Techniques of Medieval Painting* (New Haven, 1936/*R* New York and London, 1956)

Z. Veliz: *Artists' Techniques in Golden Age Spain* (Cambridge, 1968)

Art in the Making: Italian Painting before 1400 (exh. cat. by D. Bomford and others; London, National Gallery, 1989–90)

J. Dunkerton and others: *Giotto to Dürer: Early Renaissance Painting in the National Gallery* (London, 1991)

H. F. von Sonnenberg: 'Zur Technique der Goldgrundtafeln', *Frühe italienische Gemälde aus dem Bestand der Alten Pinakothek* (Munich, 1990), pp. 28–32

E. S. Skaug: *Punch Marks from Giotto to Fra Angelico: Attribution, Chronology, and Workshop Relationships in Tuscan Panel Painting: With Particular Consideration to Florence, c. 1330–1430* (Oslo, 1994)

M. S. Frinta: *Punched Decoration on Late Medieval Panel and Miniature Painting* (Prague, 1998)

2. SCULPTURE. Gold has been applied to sculpture as protection against corrosion (*see* §4 below), for embellishment and as a mark of religious devotion; gilding was also applied to some 19th-century non-metal sculptures to imitate the highlights on bronze sculptures (e.g. model for the tomb of the Duke of Clarence and Avondale KG, polychrome plaster on a marble base, 1592–4; Windsor, memorial chapel). It may cover the sculpture completely (e.g. gilt-bronze effigy of *Richard Beauchamp, Earl of Warwick*, *d* 1439; Warwick, St Mary) or cover only parts of it (e.g. gilded mantle on the *Annunciation* and *Passion*, polychromed limestone altarpiece, 1525; London, Victoria and Albert Museum). It may be used to highlight a feature (e.g. *dhoti* of the wooden sculpture of the *Bodhisattva Guanyin*, China, Jin period, 1115–1234; London, Victoria and Albert Museum) or to provide decorative pattern (e.g. robe of a tomb guardian figure, earthenware, China, Tang period, 618–907; London, Victoria and Albert Museum).

Sheet gold decorations were applied to figures in Predynastic Egypt before 2500 BC (*see* §I, 1(i) above), in China in the 7th and 6th centuries BC, and similar techniques were used in chryselephantine work in Ancient Greece and in Ancient Rome. Water gilding (*see* §I, 1(i) above) was used in the Archaic period in Ancient Greece to apply gold leaf as detail on bronze sculptures and sometimes to cover the whole statue; in Japan it was used to apply gold leaf to lacquer (*shippaku*). Water gilding was also used for the great

Gothic lime-wood altarpieces (e.g. the Herlin altarpiece, 1466). In Ancient Rome small gilded cult images were produced in terracotta and plaster, and leaf was used to highlight such details as eyes on bronze statues, and hair and eyes on marble statues. In Japan gilding was applied to statues of clay, wood and lacquer; it was also used extensively in the Burmese wood-carving tradition. Leaf applied by the oil gilding technique (see §I, 1(i) above) cannot be burnished and may be used to provide decorative patterns (e.g. robes on figures, 1216–20; South Portal, Lausanne Cathedral). Gold–silver laminate leaf (see §I, 1(i) above) was used as a cheaper form of gilding (e.g. reredos of the high altar, 1508; Schwabach, SS Johann und Martin) even though it tarnished. Powdered gold can be painted on sculpture in the form of shell gold (see §I, 2 above); or, in the Japanese *kindei nuri* technique, strewn over animal adhesive, or in *fundami nuri*, sprinkled over the surface of a sculpture dampened with lacquer. Fire gilding (see §I, 3 above) was used for ceramic sculptures. In China there are dated gilt-bronze Buddha images from as early as AD 38, and in Korea small gilt-bronze Buddha images were produced from the 4th century AD; in Japan, too, fire gilding was used for bronze Buddhist sculptures. Fire gilding was also used to produce the four life-size gilt-bronze statues of horses in S Marco, Venice (Venice, Museo di S Marco), looted from Constantinople in 1204.

Gilding on sculpture can be modified in colour and texture. The colour of the foundation clays or boles to which the gold leaf is applied will affect the colour of the gilding, and gilded metal may be modified in colour by the application of transparent or translucent coloured glazes (e.g. *Allegory of Fame* by Louis-Ernest Barrias (1841–1905, artist's collection; see also GLAZE). Opaque pigment may be applied over gold to create a pattern or be scratched away to reveal the gold beneath using the *sgraffito* technique. Gold can be applied to textured surfaces, complex patterned areas of carving (including carved gesso), or applied to modelled relief work in gesso (e.g. crucifix at Gotland, Hemse church, 1170–90) or clay. Water-gilded gesso can be stamped or punched with a design (see §I, 1(i) above), and gilded bronze sculpture has also been decorated with a punched pattern (e.g. tomb effigy of *Richard II*, completed *c.* 1396; London, Westminster Abbey).

Gilded decorations in various materials have been stuck on to sculpture: they include gilded paper spots, as on the mantle of the Virgin on the Boppard Altarpiece (first quarter 16th century; London, Victoria and Albert Museum); embossed paper; gesso and composition materials; lead (e.g. gilded reliefs on the robe of St Margaret, altarpiece, North German, early 16th century; London, Victoria and Albert Museum), gilded lead–tin alloys and inset glass with coloured and gilded backgrounds. Among the most opulent gilded decorations applied to sculpture are the imitation relief brocades (see §1 above) that simulate sumptuous fabrics as used, for example, on the 15th-century limestone tomb effigies of *William, 9th Earl of Arundel and his Wife Joan Nevill* (Arundel, Fitzalan Chapel).

C. R. Ashbee, trans.: *The Treatises of Benvenuto Cellini on Goldsmithing and Sculpture* (New York, 1967), pp. 96–7

G. Savage: *Porcelain through the Ages* (London, 1969)

M. Broekman-Bokstijn and others: 'The Scientific Examination of the Polychromed Sculpture of the Herlin Altarpiece', *Studies in Conservation*, xv (1970), pp. 388–90

K. Kamasaki and K. Nishikawa: 'Polychromed Sculptures in Japan', *Studies in Conservation*, xv (1970), pp. 280, 282

P. Tångeberg: 'The Crucifix from Hemse', *Maltechnik, Restauro*, xc (1 Jan, 1984), p. 28

A. Broderick and J. Darrah: 'The Fifteenth-century Polychromed Limestone Effigies of William Fitzalan, 9th Earl of Arundel, and his Wife Joan Nevill, in the Fitzalan Chapel, Arundel', *Journal of the Church Monuments Society*, i/2 (1986), p. 71, pl. 4

T. Drayman-Weisser: *Gilded Metals: History, Technology and Conservation* (London, 2000)

3. FURNITURE AND WOODWORK. The use of gold leaf as a surface decoration for furniture and woodwork not only gave a rich lustre unrivalled by any other material but also had the practical side-effect of reflecting light. When gilt furniture and *boiseries* (e.g. Music Room from Norfolk House, completed 1756; London, Victoria and Albert Museum) were at the height of fashion, houses were illuminated by candles, and gilded surfaces, often burnished, reflected the light and increased the candlepower. With the introduction of electricity, the use of gold decoration diminished and, in the late 20th century, virtually disappeared.

The high cost of gold encouraged gilders to seek cheaper substitutes and many 17th-century pieces were silvered and then lacquered with a yellow varnish to simulate gold. The Victorians introduced an alloy of copper and zinc (*Schlagmetall*) or copper and tin, which closely resembled gold leaf in colour and reflective powers but could only be applied with quick drying oil and had to be lacquered to prevent tarnishing. This metal leaf was largely used for decorating high ceilings, but was occasionally used to decorate picture frames. Gold-coloured bronze powders have also been used on furniture and picture frames as a substitute for gold leaf. With the advent of colour printing on paper, these powders became so fine that, when skilfully applied, it was difficult to distinguish them from gold leaf.

Oil gilding (see §I, 1(i) above) was generally used on surfaces that were exposed to the elements, for example wrought ironwork, stone and sometimes wood. It may also be used for the decoration of furniture in contrast to water gilding, or to obtain a particular effect; for example oil gilding an oak surface without the usual gesso foundation accentuates the flecks and rays in the grain, a technique often employed by the Victorians. Fire gilding (see §I, 3 above) was used to produce ORMOLU, gilt bronze decorative objects such as furniture mounts, some of the finest of which were used on 18th-century French furniture.

Textured surfaces, ranging from silversand to rice and sago, were used with gilding to obtain differing

light reflection. Stippled, cross-hatched or stamped gesso was used to obtain this effect (e.g. medallion with 'grain d'orge' on a French *boiserie*, carved and gilded oak, *c.* 1703–7; Malibu, CA, J. Paul Getty Museum). Although there are some examples of oil-gilded chairs, furniture was generally water gilded and burnished (*see* §I, 1(i) above). By the late 17th century furniture of carved wood was gilded using gesso ground, which suited the low relief ornament fashionable in the early 18th century. Flat water gilding was sometimes coated with ormolu size, often coloured to give a particular hue, for protection. Burnished gold leaf was generally left unprotected in order to retain the maximum lustre on the highlights.

P. Verlet: *Les Bronzes dorés français du XVIIIe siècle* (Paris, 1987)

D. Bigelow, ed.: *Gilded Wood: Conservation and History* (Madison, CT, 1991)

D. Fennimore: 'Gilding Practices and Processes in Nineteenth-century American Furniture', *Gilded Wood: Conservation and History*, eds D. Bigelow and others (Madison, CT, 1991), pp. 139–51

T. Drayman-Weisser: *Gilded Metals: History, Technology and Conservation* (London, 2000)

H. Baja: 'Original Gilding on Auricular Frames: Unusual Gilding Techniques Practiced in Holland, 1640s–1670s', *ArtMatters: Netherlands Technical Studies in Art*, iii (2005), pp. 9–19

4. METALWORK. Metals have been plated with gold for three reasons: embellishment, protection and deception. The earliest surviving example of gilding on metal occurs on the heads of some silver nails (*c.* 3000 BC; London, British Museum) from Tell Brak, on which the gold foil covering the heads grips the silver with the edge. Many different methods of attaching gold foil were evolved using adhesives or pressing the edges into specially prepared grooves, sometimes even filling the groove with lead into which pins could be driven to hold the foils. The techniques of true leaf gilding, introduced in the late 2nd millennium BC, and mercury gilding, introduced about a thousand years later, resulted in a much more continuous gilding but at the same time used far less gold than foil gilding, and so gilding on metalwork became much more prevalent.

A leaf- or mercury-gilded surface gives considerable protection against corrosion, an important consideration for metal sculptures or metal architectural features that were exposed to weathering. Thus Hill (1969) suggested that Roman statuary bronze was gilded in order to preserve the shining appearance of polished metallic surfaces with a minimum of maintenance. This advantageous aspect of gold plating is still exploited, as electrical contacts are often gold plated in order to keep them free from tarnish and thus conducting.

Surface platings by their very nature conceal the metal beneath, and thus soldered joins and other repairs can be hidden by gilding. Base metal can be given the appearance of solid gold by a good continuous plating, or an alloy with only a little gold can be made to appear much richer by surface treatment. How much this was done in the past with the specific intent to deceive, rather than just to embellish, is difficult to assess, except in the case of coinage, where there have been plated forgeries that quite clearly were intended to deceive (Craddock, 1990). For example, among the well-known hoard of 15th-century gold nobles and jewellery found at Fishpool, Notts, were several forgeries (London, British Museum) made by wrapping a gold foil around a silver blank and striking this in a coin die. In general, however, there were great problems in creating convincing forgeries of gold coins, not least because of the great density of gold. In the past platinum was quite inexpensive, and as it has a similar density to gold it was an ideal substrate for plated false coins; many of this type were made in the 19th century in Spain and Russia.

D. K. Hill: 'Bronze Working', *The Muses at Work*, ed. C. Roebuck (Cambridge, MA, 1969)

N. von Merhart: *DuMont's Handbuch Vergolden und Fassen* (Cologne, 1987)

P. T. Craddock: 'The Art and Craft of Faking', *Fake?* (exh. cat., ed. M. Jones; London, British Museum, 1990), pp. 247–90

R. Hughes: *The Colouring, Bronzing and Patination of Metals: A Manual for the Fine Metalworker and Sculptor* (New York, 1991)

T. Dell: *Furniture and Gilt Bronzes*, vi of *The Frick Collection: An Illustrated Catalogue*, ed. J. Focarino (New York, 1992–2003)

S. La Niece and P. T. Craddock, eds: *Metal Plating and Patination* (London, 1993)

K. Anheuser: 'Antike und neue Techniken zur Vergoldung von Metallen und Nichtmetallen', *Berliner Beiträge zur Archäometrie*, xiii (1995), pp. 87–97

T. Drayman-Weisser: *Gilded Metals: History, Technology and Conservation* (London, 2000)

M. Becker and others: 'Reine Diffusionsbindung: Rekonstruktion einer antike Vergoldungstechnik und ihrer Anwendungsbereiche im damaligen Metallhandwerk', *Jahresschrift für mitteldeutsche Vorgeschichte*, lxxxvi (2003), pp. 167–90

D. Alcouffe: *Gilt Bronzes in the Louvre* (Dijon, 2004)

5. BOOKBINDING. Both the covers and the edges of the leaves of books can be decorated with gold. Gilded decoration is found primarily on covers made of leather, but also on those of parchment, paper and cloth. In early examples the gold, in the form of powder suspended in varnish, was applied to the covers with a brush; there are examples extant from the Middle East (6th or 7th century AD), and an apparently unique European example from northern France (late 12th century; both New York, Pierpont Morgan Library), though this technique was not widely used in Europe. Islamic binders also set gilded, punched dots into the leather covering, a technique found in 15th-century Spanish and Italian work as a direct result of Islamic influence. The technique known as gold tooling, which involves pressing heated engraved tools through gold leaf on to glair painted on to the surface, is also of Islamic origin. The earliest known example is on a Koran (Marrakesh,

Bibliothèque Ben Youssef) written in Morocco in 1256; the technique is first found in Europe in the second half of the 15th century, both in Spain and Italy (arriving through both Naples and Venice). The earliest designs in both countries also derive from Islamic work, especially the use of intricate interlace patterns and arabesques. From Italy, the technique spread northwards, reaching France by 1507, the date of a gold-tooled binding on a manuscript (Paris, Bibliothèque Nationale) dedicated to Louis XII (reg 1498–1515), and England some 20 years later. Parisian binders in the 1530s quickly established a pre-eminence in Europe in both design and technique that continued into the 20th century.

Books decorated elaborately by hand-tooling were largely the preserve of the wealthy and form a tiny proportion of the total output of bindings. At different times various European countries, other than France, produced work of particularly high quality, for example English bindings of the second half of the 17th century, often using East Asian textile designs with applied pigments and onlays of coloured leathers. Some bindings made in Dublin in the mid-18th century have a splendour and inventiveness not equalled elsewhere, and a notable group of immigrant German binders working to Neo-classical designs in London at the end of the 18th century and beginning of the 19th produced work of great elegance and the highest quality (see BOOKBINDING, §II).

As the production of books increased from the 17th century, less elaborate forms of gold tooling became commonplace. From the same period more libraries adopted the method of shelving books vertically with their spines outwards, and this in turn led to a concentration of gold tooling on the spine, with tooling on the boards found only on their edges and/or a narrow border, if at all. In 1832 a successful machine for blocking designs in gold on bookcloth was developed, and elaborate gilt designs became available for the mass market for the first time, although large numbers of hand-tooled leather-bound books continued to be produced to very conventional designs by the large commercial binderies.

In the 19th century there was, in common with other decorative arts, both renewed interest in earlier designs and remarkable technical skill in fine binding, resulting in books that are technically perfect but often somewhat sterile in design and character. Both the Arts and Crafts Movement and Art Nouveau had a fundamental influence on design and on the elevation of binding design as an art form.

The application of gold to the edges of the leaves of a book is known as edge-gilding, but its early history is obscure, as few examples survive intact. Some paintings, for example the Lamb of God (Ghent, St Bavo) by Hubert van Eyck (c. 1385/90–1426) and Jan van Eyck (c. 1395–1441), show that gilt and gauffered edges were executed in the early 15th century. Edge-gilding became usual for fine and presentation bindings thereafter, sometimes combined with

other decorative techniques. In England the earliest example of the practice of gilding only the top edge of leaves dates from 1851, and this technique did not become common until the end of the 19th century. Gold and silver gilt clasps and bosses, in use from at least the early Middle Ages, would not normally be made by binders but by specialist craftsmen.

E. P. Goldschmidt: Gothic and Renaissance Bookbindings, 2 vols (London, 1928, 2/Amsterdam, 1967)

G. D. Hobson: Bindings in Cambridge Libraries (Cambridge, 1929)

H. Thomas: Early Spanish Bookbindings (London, 1939)

G. D. Hobson: English Bindings in the Library of J. R. Abbey (London, 1940)

L.-M. Michon: La Reliure française (Paris, 1951)

M. Craig: Irish Bookbindings, 1600–1800 (London, 1954)

D. Miners: The History of Bookbinding, 525–1950 AD (Baltimore, 1957)

B. Middleton: A History of English Craft Binding Technique (London, 1963/R 1978)

H. M. Nixon: Bookbindings from the Library of Jean Grolier (London, 1965)

H. M. Nixon: Sixteenth-century Gold-tooled Bookbindings in the Pierpont Morgan Library (New York, 1971)

H. M. Nixon: English Restoration Bookbindings (London, 1974)

H. M. Nixon: Five Centuries of English Bookbinding (London, 1978)

M. M. Foot: A Catalogue of North-European Bindings (1979), ii of The Henry Davis Gift (London, 1979–83)

P. Needham: Twelve Centuries of Bookbindings, 400–1600 (New York, 1979)

G. Bosch, J. Carswell and G. Petherbridge: Islamic Bookbindings and Bookmaking (Chicago, 1981)

A. R. A. Hobson: Humanists and Bookbinders (Cambridge, 1989)

III. Conservation. The conservation of an object with surface decoration of gold leaf, as distinct from its restoration, requires considerable skill and familiarity with the practical techniques involved. Where necessary, any damage or deterioration that was caused by earlier treatments should be repaired using original techniques and materials, but fair wear and tear resulting from the ageing of the object should not be disturbed.

All water- and oil-gilded surfaces, with the possible exception of burnished gold, will have been protected with a coat of parchment size or weak rabbit skin size when the object was originally gilded. In order to clean the gilding of surface dirt, it is possible to use a solution made from Quillaia bark (Panama wood). The crushed bark is left for 24 hours in water and then strained ready for use. It is used cold with a soft brush and soft, natural sponge. This solution will not work on all objects; some gilded surfaces will require a solution of weak ammonia in lukewarm water on a cotton-wool swab, which may need an added liquid detergent before it is effective. It is advisable to test each solution on a remote corner of each separate object. Water-gilded surfaces may require a different solution from oil gilding on the same object. Most cleaning will remove the coat of

protective size, which must be replaced. Should the object have been previously restored, there may be areas of new gold that have been colour toned to blend with the original. This colour toning could be removed in error during a cleaning process, and even the professional conservator must be very wary.

Conservation of gilding often requires the removal of several later layers of gilding to reveal the original. Before this kind of work is undertaken, the object should be examined to reveal the original methods of application. If the original layer is water gilding and the subsequent layers are oil paint or oil gilding, the later layers may be removed using a non-caustic, spirit-soluble solvent stripper that contains methylene chloride for quick evaporation. If the original is covered by later layers of water gilding with gesso foundation, however, they must be removed by careful scraping or chipping. The leather worker's bent awl is a very useful tool for this purpose: the spring steel of the awl enables the conservator to flick off the later layers, using very little finger pressure and without damage to the original, but the skill required takes many hours of practice. After stripping, the original gilding may need some restoration, and, where this is necessary, it should blend in, remaining faithful to the original methods and colours.

Many gilded objects have sculptural or relief ornamentation that is made from 'gilder's compo': a composition of glue, resin, whiting and linseed oil. This is usually applied after the surface has been prepared with gesso and is attached with an adhesive. The compo will shrink with age, producing cracks in the ornamentation that will allow moisture from the cleaning process to attack the gesso foundation. Extra care must be exercised when cleaning this type of surface. Gilded surfaces are extremely susceptible to moisture, and therefore humidity controlled storage is beneficial. Storage in a damp atmosphere will break down the stable structure of the gesso, causing disintegration. Consolidation of perished gesso has been been successfully attained using Paraloid B-72, a co-polymer of methyl acrylate and ethyl methacrylate, in toluene. This mixture has now largely replaced parchment size for this purpose.

It is essential to match the various colours of foundation clays and boles so that when the gold is 'distressed' the wear and tear of the object may be simulated. Where burnished gold is involved, the act of rubbing with the agate stone will darken the bole colour, which will eventually show after distressing. Colour toning, after gilding, to simulate age, must be carried out with a translucent wash, thus retaining the lustre of the leaf. To ensure reversibility, oil gilding should be toned with parchment size as the mordant, while water gilding may be toned with oil colour or wax as the mordant. The surface craquelure of antique water-gilded gesso can be simulated by cutting the gesso with a sharp tool to create the necessary pattern, but it is possible to create the craquelure by applying gesso to a strip of cloth which, when dry, may be cracked by bending round a right angle, and then attached to the surface of the object. Subsequent layers of clay and bole will not cover these applied cracks, and a fair simulation is created. Pipe clay, a by-product from coal mining, mixed with earth colours and parchment size, will enable the conservator to manufacture any bole colour to match and blend with the original burnishable bole. Matt gold size is manufactured from the same materials but a little glycerin is added to prohibit the burnish.

Powdered gold in solution with gum arabic is another material useful for simulating a particular effect brought on by wear and tear of age. It is an expensive material, but the use of cheaper bronze powders as a substitute should be avoided because of their tendency to oxidize. Generally, bronze powder merely delays proper conservation and will add to the eventual costs when it has to be removed at a later date. Most leaf is manufactured to $c.$ 84 mm square to allow a 76 mm surface when laying. After distressing, the size of the leaf will be revealed on burnished gold because of the overlaps, and it is therefore important to match the size of the gold leaf when blending restoration to the original.

See also CONSERVATION AND RESTORATION.

C. Cession: 'The Surface Layers of Baroque Gildings: Examination, Conservation, Restoration', *Cleaning, Retouching and Coatings: Preprints of the Contributions to the IIC Brussels Congress, 1990*, pp. 33–5

D. Bigelow, ed.: *Gilded Wood: Conservation and History* (Maddison, CT, 1991)

Giornata [It.: 'day's work']. Term used in true fresco painting for the area of wet plaster that could be painted in a single day's work. The extent of each *giornata* is often obvious from the seams in the surface of the fresco.
See also PONTATA.

Glair. Term for egg white, a colloidal solution of albumen, used as an adhesive for gilding or as a painting medium in manuscript illumination from at least the 17th century. Until the 19th century it was employed occasionally as a varnish for egg tempera and oil painting.

Glass. In layman's terms, glass is understood to refer to the manmade silica-based material used to make such items as window panes, bottles and drinking vessels. To the materials scientist, however, the term glass refers to a specific state of matter, often called the 'glassy' state; its defining property is that, regardless of its chemical composition, the material has solidified from the liquid state without forming any crystals, and thus at the atomic level lacks the regular ordered structure of normal crystalline solid materials. The 'glassy' state of matter is therefore the random, three-dimensional network of atomic bonds in the liquid state, which is preserved in the solid state; glass is therefore sometimes described as a 'super-cooled' liquid. It is a truism of science therefore that almost anything can be made into a glass if it is cooled down fast enough from the liquid state to prevent the

formation of crystals as the material solidifies; the required rate may very well be measured in millions of degrees per second.

Occasionally, and under fairly dramatic circumstances, glass is formed in nature. Some volcanoes produce the mineral obsidian, a natural form of black glass, which when viewed in very thin section can be seen to be a translucent grey. It has been used by Native Americans to make carvings and tools, as large quantities were formed by the vast volcanoes that made up the Jemez Mountains of northern New Mexico. Natural glass is also formed when lightning strikes a sandy desert during a violent electrical storm. The immense energy discharged at the point of contact causes the sand to vaporize down the electrical path the lightning takes, leaving a fulgurik, a tube of melted sand, which solidifies without crystallizing to form an almost pure silica glass.

F. Nenburg: *Ancient Glass* (London, 1962)

R. Hurst Vose: *Glass* (London, 1975)

G. Beard: *International Modern Glass* (London, 1976)

H. Newman: *An Illustrated Dictionary of Glass* (London, 1977)

R. J. Charleston: *Masterpieces of Glass, a World History, from the Corning Museum of Glass* (New York, 1980)

F. Mehlman: *Phaidon Guide to Glass* (Oxford, 1982)

R. J. Charleston: *English Glass, the Glass Used in England, c. 1400–1940* (London, 1984)

D. Klein and W. Lloyd: *The History of Glass* (London, 1984)

D. Barag: *Catalogue of Western Asiatic Glass in the British Museum* (London, 1985)

B. Klesse and H. Mayr: *European Glass from 1500–1800* (Vienna, 1987)

D. Klein: *Glass, a Contemporary Art* (London, 1989)

H. Tait, ed.: *5000 Years of Glass* (London, 1991)

'Glas', *Lexikon des künstlerischen Materials: Werkstoffe der modernen Kunst von Abfall bis Zinn* (Munich, 2002), pp. 113–20

J. H. Opie: *Contemporary International Glass: 60 Artists in the V&A* (London, 2004)

I. Materials. II. Processes. III. Decorative techniques. IV. Uses. V. Conservation.

I. Materials.

1. BATCH. Sand, the main constituent of manmade glass, is silicon dioxide, often referred to as silica, which has a melting-point of *c.* 1720°C. The melting-point (fusion point) of pure silica can be significantly lowered by over 1000°C by adding alkalis that serve as fluxes, notably the carbonates of sodium and potassium. A simple binary composition of silica and sodium carbonate (soda) will produce a non-durable glass, which will react easily with water. Some silica and potassium carbonate glass rapidly and completely dissolves in water. These binary compositions can be made durable by the simple and relatively low concentration of calcium carbonate (lime). Simple glass of the soda–lime–silica type is by far the most common type manufactured; the composition generally approximates to 75% silica, 15% soda and 10% lime. Glass of this type is suitable for windows and such industrially made wares as bottles; it is not, however, very suitable for handworking as it hardens very quickly on cooling (short working-range) owing to its relatively high lime content.

For handworking, glassmakers require a glass with an extended working-range, which allows sufficient time for the various forming processes to be completed without the need for constant reheating (annealing). This has been achieved in different ways depending on the materials available. Glassmakers based around the Mediterranean seaboard during the Roman period worked glass with a soda content frequently over 20% and lime significantly less than 10%. Soda was easily available either being imported directly from Egypt or prepared by burning certain types of littoral plants.

Early northern European glassmakers burnt beechwood or oak in pits and used the potassium-rich ash (potash) as the flux (see fig.). Characteristically potassium imparts a longer working-range to glass than sodium. Throughout England, samples from furnace sites as wide apart as Surrey and Yorkshire indicate that medieval glassmakers mainly used a flux with a very high concentration of lime, sometimes as high as 22%. The glass produced had to be worked while extremely hot as it tended to crystallize if left for any significant period below 1290°C.

For several centuries glassmakers made use of lead in glass in a wide range of concentrations to achieve glass that was highly suitable for handworking. During the 1990s the use of such toxic, heavy metals in glass as lead and barium became a controversial issue because of environmental considerations, and the possibility of lead leaching out of the glass container into its contents. The benefits derived from the use of lead are that it imparts a very long working-range to the glass, especially when it completely replaces lime, and that lead, being a heavy metal, increases the density of the glass, which in turn raises the refractive index of the glass, thereby making the glass far more brilliant.

It was the introduction of lead into the manufacture of English glass by George Ravenscroft (1633–83) in 1676 that eventually gave rise to the cut-glass industry in England. Full lead-crystal contains a minimum of 30% lead and is fluxed with potassium; when cut and polished it is sparkling and brilliant. Lead is also used, albeit in much lower concentrations, by glass artists, simply as a means of achieving highly workable glass: for example many glass compositions contain concentrations of lead in the range of 4%–10%.

2. COLOUR. Hot liquid glass is a universal solvent for oxides of every element. A group of elements known as transition metals share the characteristic of having incomplete inner electron shells. Metal-oxides from this group frequently have a colouring effect when dissolved in glass. Usually it becomes more difficult to achieve certain colours proceeding from blue in the spectrum. Not all colours, however, are produced by oxides of transition metals: particularly at the red end of the spectrum no transition-metal

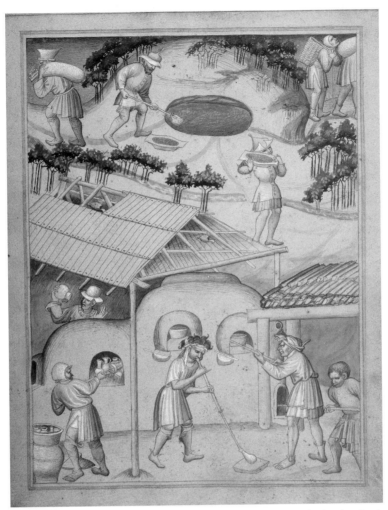

Manufacture of glass showing journeymen collecting sand and beech logs for charring; the pit for mixing sand, potash and lime; and glassblowers gathering, blowing and marvering glass; *The Foss of Memnon,* miniature, from the *Travels of Sir John Mandeville,* Bohemian copy, *c.* 1410 (London, British Library, MS. Add. 24189); photo credit: HIP/Art Resource, NY)

oxide dissolved in glass will create a red colour. Other colouratic techniques involve the precipitation of a metal in the glass as a mass of colloidal particles each containing between 50 and 200 atoms, another involves the formation of sulphides or sulpho-selenides of particular metals.

Glass can be made opaque white by the deliberate growing of a large mass of crystals within the glass, and throughout the history of glassmaking many different chemical means of achieving this have been used. The most important technique in use at the end of the 20th century is the inclusion of a considerable quantity of fluorine into the batch, which on cooling forms a mass of crystals that are fluorides of every element in the glass.

Blues are very easily achieved: cobalt oxide is the basis of a strong, rich blue. Copper oxide dissolved in glass produces a huge variety of colours depending on the concentration and the level of oxygen allowed to remain in combination with the copper. Fully oxidized copper oxide (cupric oxide) in a pure soda–lime glass gives a pure, sky blue, which becomes increasingly turquoise if the glass contains either lead, boron or titanium. At concentrations of *c.* 0.2%, and if carefully stripped of its oxygen using a small quantity of tin as a reducing agent, colloidal particles of metallic copper will precipitate to produce a very rich, translucent red. The ancient Egyptians' only method of producing an opaque, blood-red glass was by the precipitation of crystals of the intermediate cuprous oxide. The Venetians discovered that it was possible to precipitate crystals of pure metallic copper in glass, which grew as optically perfect, small flat 'mirrors', dispersed randomly throughout the glass, imparting a sparkling effect. This became known as 'aventurine' from the Italian *per avventura* (by accident), and it continues to be one of the most difficult types of glass to manufacture.

Green glass can be made by the addition of iron, and in very high concentrations is the means by which the dark-green, protective glass used by welders is produced. Chromium (a metallic agent) also produces green glass, which varies from a yellowish-green, if the glass is fully oxidized, to an emerald-green if the oxygen level is reduced. Most commercial green bottles are produced by a mixture of iron and chromium.

Yellow glass can be made in a variety of ways. A greenish-yellow can be made by the addition of a small amount of uranium oxide, which makes Vaseline glass. If a low concentration of silver is dissolved in glass, a clear, golden yellow is produced. The colour is created by the precipitation of colloidal particles of silver in the glass, which occur when the glass is cooled. Straw-yellow is produced using the iron/manganese system employed by the north-European medieval glassmakers; it is, however, difficult to achieve and is not now used commercially. Lime-yellow glass is produced by forming cadmium sulphide in the glass, which in high concentrations creates an opaque, lemon-yellow.

Orange glass is extremely difficult to produce reliably. It is a modification of cadmium sulphide, achieved by the addition of selenium and can be made either transparent or opaque depending on the concentration. This technology was introduced at the end of the 19th century and is notoriously unpredictable.

Red glass is very difficult to produce (see colour pl. VI, fig. 3); apart from the use of copper, there are three methods of making red glass: first is by a further addition of selenium to cadmium sulphide glass, which produces either a translucent or opaque glass; this method is the only known way of making bright red, opaque glass. Gold dissolved in glass in very low concentrations of $c.$ 0.02% imparts a transparent, pinkish red; the higher the lead content, the redder the glass. The colour is produced by a colloidal dispersion of the metal in the glass. A very intense, transparent red can be made by forming antimony sulphide in a batch; this method, however, is extremely difficult, and creates such an intense colour that it is of technical interest only.

W. A. Weyl: *Coloured Glasses* (Sheffield, 1951)

G. O. Jones: *Glass* (London, 1956)

H. Rawson: *Inorganic Glassforming Systems* (London, 1967)

C. R. Bamford: *Colour Generation and Control in Glass* (Amsterdam, 1977)

P. Dreiser and J. Matcham: *Techniques of Glass Engraving* (London, 1982, rev. 2/2006)

International Commission on Glass: Dictionary of Glass-making/ Dictionnaire de verrerie/Glas-Fachwörterbuch (Amsterdam and New York, 1983)

M. B. Wolf: *Chemical Approach to Glass* (Amsterdam, 1984)

R. G. Newton: 'Eighth W. E. S. Turner Memorial Lecture', *Glass Technology*, xxvi (1985), pp. 93–103

P. T. Nicholson: *Egyptian Faience and Glass* (Princes Risborough, 1993)

C. Bray: *Dictionary of Glass: Materials and Techniques* (London and Philadelphia, 1995)

Ward, R., ed.: *Gilded and Enamelled Glass from the Middle East* (London, c. 1998)

P. Hills: *Venetian Colour: Marble, Mosaic, Painting and Glass, 1250–1550* (New Haven and London, 1999)

P. McCray: *Glassmaking in Renaissance Venice: The Fragile Craft* (Aldershot, 1999)

E. M. Stern: *Roman, Byzantine, and Early Medieval Glass, 10 BCE–700 CE: Ernesto Wolf Collection* (New York, c. 2000)

S. Carboni: *Glass from Islamic Lands* (New York, 2001)

S. Carboni and others: *Glass of the Sultans* (New Haven, 2001)

S. Carboni: *Mamluk Enamelled and Gilded Glass in the Museum of Islamic Art, Qatar* (London, 2003)

M. Eidelberg and others: *The Lamps of Louis Comfort Tiffany* (London, 2005)

C. Hess and K. Wright: *Looking at Glass: A Guide to Terms, Styles, and Techniques* (Los Angeles, 2005)

S. M. Goldstein: *Glass: From Sassanian Antecedents to European Imitations*, The Nour Foundation (London, c. 2005)

Czech Glass, 1945–1980: Design in an Age of Adversity (exh. cat., ed. H. Ricke; New York, Corning Museum of Glass, 2005)

C. Schack von Wittenau: *Neues Glas und Studioglas: Ausgewählte Objekte aus dem Museum für Modernes Glas/New Glass and Studio Glass: Selected Works from the Museum of Modern Glass* (Regensburg, c. 2005)

D. Whitehouse: *Sasanian and Post-Sasanian Glass in the Corning Museum of Glass* (Corning, NY, 2005)

H. Elkadi: *Cultures of Glass Architecture* (Burlington, VT, 2006)

J.-A. Page: *The Art of Glass* (Toledo, OH, and London, 2006)

J. S. Spillman: *European Glass Furnishings for Eastern Palaces* (Corning, NY, c. 2006)

II. Processes.

1. Glassmaking. 2. Furnaces.

1. Glassmaking.

(i) Casting. The purpose of casting is to fill the void of a mould of the desired shape with molten glass, using heat to fuse it. This process usually takes place inside a kiln. The processes are slow and labour intensive and normally used to create 'one-off' or expensive, limited-edition items. Casting was first developed in Mesopotamia $c.$ 700 BC and inspired by the process of casting used to make gold and silver objects. The early vessels are almost exact replicas of the metal originals. Casting continued to be used until Roman times but was eventually replaced by blowing (*see* §(iii) below). The main problem with casting is that the nature of glass is, even at its most liquid, 100 times more viscous than water and therefore resistant to flowing into a mould. How the glass is introduced into the mould and in what form are of basic importance, and it is generally variations of these that give the cast objects their particular qualities. The three main requirements for casting an object are a mould, glass and heat.

The complexity of a cast form and the necessary levels of heat usually mean that the moulds are destroyed every time a cast is made. They are often refractory based, being amalgams of castable materials, which can include plaster, crystobolite and clay. Moulds are produced by pouring a castable mixture around an image (often wax) and leaving a hole in the base. When the castable mix is solid the wax can

be steamed out; this technique is known as the lost-wax (*cire perdue*) process. The void is then filled with glass. This can be introduced in a variety of forms: hot liquid, small marbles, sintered fragments or fine powder depending on the shape to be filled, internal colour effects or required surface qualities. After the glass has cooled, the mould can be broken away. This technique was used to make small glass sculptures in ancient Egypt.

The mould is usually placed in a kiln and filled with glass prior to heating. The kiln is heated until the glass becomes sufficiently molten to fill the details in the mould. At a high temperature—usually *c.* 1000°C—the glass can be topped up with more glass as the mould is filled. Alternatively liquid glass can be poured into an empty mould from a previously heated crucible. After filling, the mould is slowly brought down to room temperature (annealing) to release the strain in the glass. The thicker the cast, the longer and more carefully this must be done. On cooling the mould is broken away to reveal the glass cast. Casts are invariably finished by grinding, polishing, engraving or acid working to remove minor imperfections and to improve and vary the surface quality (*see* §III below).

Although the process of making glass known as *pâte de verre* had been known in ancient Egypt during the 18th Dynasty (*c.* 1540–*c.* 1292 BC), the term was only coined in the late 19th century to describe a range of variations of casting used by individual artist–craftsmen, especially in France. The objects made often resembled gems or hardstones. Glass powder, coloured with metal oxides, was carefully packed into a mould to ensure an accurate dispersal of colour into the fine details. The precise technique varied, but consisted of personal methods of filling moulds, types and form of glass used and subtleties of firing. Important exponents included Gabriel Argy-Rousseau (1885–1953), Albert-Louis Dammouse (1848–1926) and François Emile Décorchement (1880–1971). *Pâte de verre* casting was largely discontinued during the 1920s, but was revived in the late 20th century.

(ii) Moulding. At its most simple, this method involves a negative mould (usually metal) with an opening into which molten glass is introduced; the exposed area of the glass is pressed with a plunger to force the molten liquid into the form and detail of the mould. Originally developed by the Romans, press-moulding was used to make low-relief plaques for architectural use as this basic method did not allow for undercuts or for the manufacture of hollow objects. This method remained unchanged—except for the occasional substitution of metal for clay moulds—until the 19th century when the first simple pressing machine was developed. The market, however, needed cheap, easy to produce, decorative containerware and the process had to become more complex in order to produce three-dimensional forms. The press consisted of a base plate and plunger, which were brought to bear on each other by the use of a hand-operated side lever. The moulds, invariably metal, consisted of three main parts: the base mould, fitted to the base plate of the press, provided the exterior shape of the object; the plunger, fitted to the plunger arm, formed the interior of the object; and the cap ring, a plate fitted in between the two, which helped to form the rim and allow for small variations in the amount of hot glass fed into the mould. The hot glass was placed in the base mould, the cap ring placed on top and the plunger brought down by the lever, through the cap ring to squeeze the glass against top and bottom moulds. The lever press was capable of quickly producing vast numbers of identical pieces with the minimum of skill. The first patented press was in operation in the USA in 1829. There were, however, limitations: pressed glass suffers from an irregular surface caused by chilling. Designers countered this with such strategies as covering the entire surface with delicate, decorative detail as in American 'Lacy' glass or acid etching to create a frosted effect.

As demand grew the simple side-lever press developed into a more complex version in order to facilitate greater speed and the production of more sophisticated and varied objects. The press became automated and was run by compressed air; moulds became multi-partite allowing for the production of heavily undercut and complex shapes. The high cost of the metal moulds gradually became prohibitive and after 1945 pressing was less adventurous.

Flat-glass production developed from crudely hand-pressed and polished sheets in the 17th century to continuous pressing in the 19th and 20th centuries, achieved by forcing hot glass through pre-set metal rollers. This allowed for the development of patterned glass by the use of indented rollers. The centrifuge process is a 20th-century development, where the mould, after being filled with hot glass, is rotated at speed. The centrifugal force pushes the glass into the required shape without the use of a plunger. In slumping pre-cut sheet glass is placed on a mould and heated until it softens and deforms under its own weight into the desired shape. This method is used to make architectural feature windows and simple repetitive decorative items, which are often enamelled at the same time as the glass is deformed. The press-and-blow technique is a combination mass production machine technique, where form and texture can be pressed into the glass prior to its final inflation in a mould.

(iii) Blowing. This technique was developed around the Syro-Palestinian region during the 1st century BC, possibly in response to the growing need for containers for use in trade throughout the Mediterranean. It rapidly became the dominant method of forming glass and especially of making vessels until the 19th century, when many of the basic processes were supplanted by automation, during the Industrial Revolution.

The usual means of blowing hot glass is through a hollow, metal tube (blowing-iron) *c.* 135 mm long and

17 mm in diameter. This is dipped into a crucible containing molten glass, through an opening in the furnace; by rotating the iron a mass or 'gather' of viscous glass is accumulated at one end blocking the hole. This mass can be inflated by blowing, and hot glass can be added to it in a variety of ways. The conversion of this glass bubble (parison) into the desired form requires great skill and often the combined efforts of a team. The master craftsman (gaffer), as head of the workshop, gradually forms the object on the blowing iron and is supported by a range of assistants (servitors) who provide him with constant backup and materials.

There are many ways in which the basic parison can be given useful form. The most simple is mould-blowing when it is introduced into a mould made from clay, wood or metal depending on the numbers required and inflated. This causes the glass to harden by cooling rapidly as it touches the mould and assumes the shape of the mould. Mould-blowing is an excellent method for manufacturing repetitions of the same form with the minimum of skill and time. It is also possible to create forms that are impossible by ordinary hand manipulation. It was first introduced by Roman glassmakers *c.* AD 25 and the most popular items were flasks in the shape of a head or a bunch of grapes. Further gathers of hot glass can be added, initially as blobs, from which the gaffer can form such details as handles or rims using a variety of such simple tools and devices as pucellas (used to form the diameter of the object) and pincers. Objects made without moulds are known as 'free' blown or 'off-hand' blown and require a more complex set of procedures and greater levels of skill.

Any container that has been made from a single parison has to be removed (cracked off) from the blowing iron at the point of inflation. Once cooled this roughened area is smoothed and polished to provide the vessel opening. This method, however, has formal limitations, and to convert a bubble into such an open shape as a dish or plate requires the transfer of the still hot parison on to a solid iron (pontil iron) at a point directly opposite its connection to the blowing iron with a spot of hot, sticky glass. When adhered to the pontil the parison is broken from its original iron and is therefore attached only to the pontil; the open end can then be flared out. These procedures are very time-consuming, and once glass is gathered from the furnace it immediately cools and solidifies. To carry out more than simple mould-blowing the object being worked must be periodically reheated to restore malleability to the glass. A special furnace (glory hole) is used for this reheating. This process of shaping must be accompanied by the constant, skilled movement of the glass on the iron to keep it central, while forming and decorating the glass with various tools. The process can be extended by further additions of hot glass. These may include other parisons to create complex amalgams to form rims, feet, stems and handles, all of them created from hot, liquid glass using skill, simple tools and the constant centrifugal movement of the blowing iron.

Much of the forming is carried out while the gaffer sits in a special chair (bench) to which are attached two horizontal rails; along these the blowing iron is rolled back and forth with one hand, to keep the mass central, while the other hand is used to tool the glass.

After forming, the cooled object is rigid but full of stress and therefore has to be gradually brought from *c.* 550°C to room temperature (annealing) in a lehr. The exact timing depends on the thickness of the glass, but is usually a minimum of 12 hours. When cold the glass is ready for decorating (*see* §III below).

H. McKearin and G. S. McKearin: *Two Hundred Years of American Blown Glass* (New York, 1948)

H. Anderson: *Kiln-fired Glass* (London, 1971)

H. Littleton: *Glass Blowing: A Search for Form* (New York, 1971)

A. Pepper: *The Glass Gaffers of New Jersey* (New York, 1971)

A. Polak: *Glass: Its Makers and Public* (London, 1973)

R. Flavell and C. Smale: *Studio Glass Making* (New York, 1974)

F. Kulasiewicz: *Glass Blowing: The Technique of Free-blown Glass* (New York, 1974)

P. Rothenberg: *The Complete Book of Creative Glass Art* (New York, 1974)

C. Lattimore: *English 19th Century Press Moulded Glass* (London, 1979)

J. S. Spillman: *American and European Pressed Glass in the Corning Museum of Glass* (New York, 1981)

K. Cummings: *The Technique of Glass Forming* (London, 1986)

R. Slack: *English Pressed Glass, 1830–1900* (London, 1987)

J. Thompson: *The Identification of English Pressed Glass, 1842–1908* (n.p., 1989/*R* 2000)

P. Hills: *Venetian Colour: Marble, Mosaic, Painting and Glass, 12501550* (New Haven and London, 1999)

P. McCray: *Glassmaking in Renaissance Venice: The Fragile Craft* (Aldershot, 1999)

2. FURNACES. The main requirements of a glass-melting furnace are first that it should be constructed from materials able to withstand both the heat and the corrosive attack of the glass. This has generally been met either by using alumina-rich clays (fire-clay) or stone with a high silica content (e.g. sandstone). Secondly, the furnace should be capable of reaching and maintaining the temperatures required for the conversion of the fluxed sand to a homogenized liquid. The most commonly used fuel for the furnace has been wood, but coal-fired furnaces pioneered in England at the beginning of the 17th century were used for a while until they were replaced by gas-fired furnaces; there are a few instances of those using electricity; wood and diesel oil are used only in exceptional cases.

Glass-melting furnaces for craftsmen fall into two types: the tank and the pot furnace. The tank furnace is more simple to construct, but is less efficient to run. The walls of the tank act as the container for the glass, and the heat is transferred into the glass through the top surface; the five remaining glass surfaces shed heat into the tank. The pot furnace contains a crucible made from alumina-rich, clay-based materials, which is placed in the combustion chamber, preferably with a gap between

the base of the pot and the furnace floor; heat is then transferred into the glass from all directions. This has been the most common type of glass furnace used throughout history.

Wood-fired furnaces can reach quite high temperatures; the fuel is introduced in the form of long, thin sections with the greatest possible surface area. This time-consuming process causes the fastest possible rate of combustion. The development of coal-fired furnaces involved the use of fire grates, which could be loaded with enough fuel to burn for 10 to 15 minutes and the air was drawn through from underneath the grate.

Gas is the easiest fuel to use and has led to dramatic improvements in thermal efficiency in glassmakers' furnaces. Combustion uses oxygen from the air, but 80% of air is nitrogen, which plays no part in the process, merely absorbing nearly three-quarters of the heat produced and then being exhausted as very hot waste gas. The improvements in glass craftsmen's furnaces were due to the recovery of the heat in the waste gases, and returning it to the furnace by preheating the air supply. When done well this reduces the fuel used by more than 50%, and makes a very substantial contribution to ensuring the economic viability of operating craft-based art-orientated workshops. This technique is called recuperation.

The handworking of glass can be a lengthy process and the glass often requires reheating, to return it to a workable state. The special furnace used by glassmakers is called a glory hole. This horizontal cylindrical furnace is generally run at c. 100°C higher than the glass furnace during glassworking. The skill of a glassmaker largely depends on the successful use of a glory hole to reheat parts of the semi-formed article.

A peculiarity of glass is that it does not have a fixed melting-point; it changes slowly between the liquid and solid states between 450°C and 370°C. If glass is cooled too quickly the outer parts of the glass set solid, while the inner parts are still liquid; the different rates of contraction can cause enormous permanent stresses in the article, sufficient to cause it to fracture. To avoid this, glassmakers slowly cool the finished glass articles in additional chambers called annealing furnaces.

R. J. Charleston: 'Glass Furnaces through the Ages', *Journal of Glass Studies*, xx (1978), pp. 9–34

K. Cummings: *The Technique of Glass Forming* (London, 1980)

D. R. Uhlmann and N. J. Kreidl: *Glass-forming Systems*, i of *Glass: Science and Technology* (New York and London, 1983)

W. Trier: *Glass Furnaces: Design, Construction and Operation* (Sheffield, 1987)

K. Cummings: *Techniques of Kiln-formed Glass* (London, 1997. R 2001)

III. Decorative techniques. The ways to decorate glass are many and varied. Some techniques may be used only on specific metals depending on how hard, malleable or plastic the glass is and what pressure it can withstand. This article deals with the methods by category. Such potentially decorative techniques as moulding and colouring are discussed in greater detail in §§I and II above.

1. Hot-working. 2. Cold-working. 3. Coloured glass. 4. Painting. 5. Other.

1. HOT-WORKING. This section deals specifically with decoration created while the glass is in a plastic, malleable state.

(i) Moulded and pressed. Some of the simplest and most effective ways of decorating glass may be carried out during these forming processes. The molten metal is forced into the receptacle of the desired shape either by blowing, casting or pressing. These techniques are discussed in full in §II above.

(ii) Combing and trailing. Molten glass is gathered on to a metal or wooden rod covered with a hard core of clay, sand and animal dung (core-forming). Soft glass of a different colour is then trailed on to the vessel and wound around from top to bottom. After reheating the trailed thread is tooled and combed with a pointed instrument into festoons and then marvered (rolled) on a flat surface to even out the wall thickness (see colour pl. VI, fig. 2). Combed decoration was one of the earliest forms of decoration used on glass and was first used in Mesopotamia and extensively employed by the Egyptians. The same basic technique was also employed to create designs that were not marvered into the body; items with this type of decoration date from the late 1st century AD in the Ancient Near East. Trailing was used to great effect on Roman glass, particularly with 'snake-thread' trails. In the Merovingian and Carolingian periods long, vertical and spiral trails, nipped together to form a lattice pattern, were extensively used.

(iii) Prunts. To create this type of decoration blobs of molten glass are dropped on to the surface of the glass randomly or in a pattern. They were made in a variety of forms and sizes and left either plain or sometimes impressed with a stamp to create such forms as 'raspberries', which are often a feature on the roemer. The 'claw beaker' or *Rüsselbecher* was formed by drawing out the applied blob of glass into a hollow proboscis, pulling it out and fusing it to another part of the object; these vessels were made extensively in northern Europe during the Frankish period (5th–8th century AD). The claws were sometimes further decorated with trails (e.g. beaker, 6th century; London, British Museum). From the medieval period the Rhenish glassmakers decorated beakers with rows of prunts (e.g. *Stangenglas*, early 16th century, London, British Museum). Finger cups (*Daumenglas*) were formed using the same basic principle but the applied blobs were flattened and then drawn inwards when the glassblower inhaled through the blow-pipe so that the blobs intruded creating convenient indentations for the fingers.

(iv) Air bubbles and twists. Accidental or deliberate inclusions of air in the glass have been used to decorative effect since glassmaking began. Trapped single or multiple air bubbles, for example, are one of the simplest methods of decorating a stem. A 'teardrop' stem is formed by indenting (pegging) a small depression in the still plastic rod of glass, which is then engulfed with a gob of molten glass to trap the air; the ductile rod is then drawn out so that the air forms the shape of a teardrop. To create a single air-twist stem the same principle is used and the rod twisted so that the air bubble becomes a helix. To produce a multiple air-twist stem the top of the malleable glass rod is tweaked with tools to create furrows; the shape is then immersed in molten glass, which seals in the pockets of air; the pontil is then securely held while the other end is rotated to create shafts of twisted air throughout the stem; the process can be repeated many times to produce more twists. Opaque-white or coloured strands of glass can be imbedded in transparent glass by rolling a gather of glass over canes set at regular intervals, marvering and blowing the gather into the desired form. Stems of this type of decoration were known as cotton-twist stems. The generic term for decoration using imbedded tapers of opaque-white or coloured glass is *filigrana* (filigree) and although first used in Murano during the early 16th century, it was probably inspired by the rolled edges used to decorate mosaic glass made during the Hellenic period in Europe.

2. COLD-WORKING. Once the object has been formed and allowed to cool and harden, it can be decorated by incising, the techniques for which are discussed below, or painting (*see* §4(i) below).

(i) Incising.

(a) Engraving. This technique involves cutting a design on to a glass surface, using such sharp implements as flints, diamond needles or wheels; the process is similar to gem-engraving. The method of wheel-engraving was first used to decorate Roman glass from the third quarter of the 1st century AD; the process involves cutting patterns on the surface of the glass using discs of hard materials (e.g. copper) and an abrasive (e.g. emery). Suitable metals for wheel-engraving are potash lime glass and lead glass invented by the English glassmaker George Ravenscroft (1633–83) in 1676. Caspar Lehmann (*c.* 1563/5–1623), a gem-engraver working in Prague at the court of Rudolf II, is credited as being the first glass-engraver in modern times to have used wheel-engraving. The two types of wheel-engraving are high-relief engraving (*hochschnitt*), where the ground is cut back leaving the design in relief, and intaglio (*tiefschnitt*), where the design is formed by incisions into the surface. Diamond-point engraving involves creating a design by lightly scratching on to the surface of the glass with a diamond point. The technique was possibly first used in ancient Rome and in Venice

in the 16th century and by glassmakers imitating the Venetian style. Another form of diamond-point engraving, known as stipple-engraving, was introduced *c.* 1621 by Anna Roemer Visscher (1583–1651) in Holland and was developed during the 17th century. A diamond point is set into a hammer and very gently tapped on to the surface of the object creating a series of dots; highlighted areas contain a high concentration of dots, while dark areas have few or no dots.

(b) Cutting. This process involves faceting or cutting furrows in a variety of decorative designs by subjecting the glass to a rotating iron or stone disc and abrasives. The technique was used in Mesopotamia during the 5th and 6th centuries and was very common in Roman times. It reached its apogee in England and Ireland during the late 18th and 19th centuries when lead glass—the most suitable metal for deep cutting—was available.

(c) Cameo and cased glass. The creation of this type of glass decoration was first introduced around the beginning of the 1st century AD after the invention of glass blowing. There are two basic ways to achieve cameo glass: the first is by the dip-overlay method in which a gather of glass of one colour is partially dipped into molten glass of another colour, so that it is covered in a thin layer of glass (flashing); the two are fused together during annealing and when cold the outer casing of glass is cut back to reveal the layer beneath. The Romans perfected this technique between the 1st century BC and the 1st century AD; the most famous example of this method is the Portland Vase (London, British Museum). The second method, called 'casing', involves glass of one colour being fused to the inside surface of another, differently coloured glass. This method can be repeated many times to produce multiple layers of glass. The outer casing is made first by blowing a gather and opening it up at one end and placing it in a mould. A second gather is then blown into it and the layers fuse together. The outer layer is thicker than that used for flashed glass and is known as overlay. Cameo decoration was extensively employed on Chinese snuff bottles during the 18th century. During the 19th century the term 'plating' was used in the USA to describe casing. Cameo glass was popular in the Art Nouveau period when the leading exponent was Emile Gallé (1846–1904).

(d) Etching. This technique was first introduced in Europe during the 17th century and was extensively used in the 19th century using hydrofluoric acid. The glass is first covered with an acid resist (usually wax) and a design is cut through. The item is then immersed in an acid bath and the exposed design is corroded. The finish is either satin or very matt depending on the length of immersion. For an overall, matt surface the whole item can be immersed, unprotected, into the acid. This technique has been largely superseded by sand blasting.

(e) *Sand blasting*. This technique involves subjecting the surface of the glass, which was partly covered by a steel template, to a jet of air containing sand, crushed flint or powdered iron. It was invented in 1870 by Benjamin Tilghman (1821–1903) in Philadelphia and proved to be a highly effective method of decorating. It has largely replaced acid etching as it is both safer and cheaper.

3. COLOURED GLASS. This is achieved either by accidental discolouration owing to impurities in the batch or through the deliberate addition of metal oxides. (For a full discussion of the oxides required to achieve coloured glass *see* §I, 2 above.) Early glass was often coloured in order to imitate such hardstones as agate, lapis lazuli, jasper, turquoise, chalcedony or porphyry. In order to create the opaque, marbled effect of some of these stones, differently coloured opaque glass is briefly mingled in a melting pot before being gathered and shaped. The process was first used in the eastern Mediterranean from the 2nd century BC. The process was revived in Venice during the early 15th century, when chalcedony glass was produced. During the 19th century variegated, polychrome glass was very popular throughout Europe; the most notable exponent of this technique was the Bohemian glassmaker Friedrich Egermann (1777–1864) who in 1828 created 'Lithyalin' glass, which imitated the appearance of hardstones through the combination of both opaque and translucent glass; the surface of the finished items very often has the appearance of wood grain.

Mosaic glass refers to glass objects rather than the panels made from tiny tesserae embedded in floors, walls and ceilings (*see* MOSAIC). This process involves fusing together varicoloured blobs of glass and drawing them out into thin canes. Once cooled the canes are sliced horizontally. The slices are then applied to a mould of the desired shape and then another mould is fitted over in order to keep the slices in position while in the furnace. The surface of the cooled object is ground smooth.

Another method for making such objects as mosaic, hemispherical bowls is by arranging the slices of cane on a flat fireproof clay surface and firing them in the furnace until fused. The disc of glass is then surrounded by a twisted cane of glass and reheated; while still soft it is placed over a clay form and reintroduced into the furnace where it slides down around the mould. Once cooled the object can be ground smooth and polished. This process is known as slumping.

Mosaic beads are made by rolling small blobs of glass over a flat surface covered with tiny slices of the cane. The sections are caught up and marvered into the parent glass and once cooled the beads can be smoothed and polished. *Millefiori* (It.: 'thousand flowers') glass is made using the same basic techniques as those for making mosaic glass. The gathers to make the canes are arranged so as to resemble flowers and when sliced are embedded in a matrix of molten, coloured or colourless glass. The basic technique was probably first introduced in northern Mesopotamia during the 15th century BC (e.g. fragment of a beaker from Tell el-Rimah, mid-15th century BC; London, British Museum). It was also used with a degree of sophistication by the Hellenistic glassmakers during the second half of the 3rd century BC. The technique reached its apogee in Venice where it was reintroduced and reinvented at the end of the 15th century.

4. PAINTING.

(i) *Cold painting*. Lacquer colours or oil paints can be applied to glass but are not fired. They are sometimes applied to the back of the object in order that the decoration be protected, otherwise it is liable to rub off. The colours are usually applied to objects too large to fit into the muffle kiln or to those that cannot withstand a second firing to fix the colours.

(ii) *Enamelling*. Enamel colours are metallic oxides mixed with finely ground glass suspended in an oily medium. While the item is fired at a low temperature (700–900°C) in a muffle kiln, the medium is fired away and the colours are fused as a film on the surface of the object. Enamelling was used on both Roman and Byzantine glass and was combined with extensive gilding on Islamic glass. The *Hausmaler* refined the Dutch method of decorating with transparent, black enamel (*schwarzlot*) during the 17th century. After *c.* 1810, thick opaque enamels were largely superseded by transparent, polychrome enamels developed in Bohemia.

(iii) *Lustering*. In order to achieve an overall lustrous effect the surface of the glass is painted with an oily medium in which metallic oxides of gold, silver, copper or platinum dissolved in acid are suspended. The glass is then fired in a reducing atmosphere and a thin film of metal is fused to the surface. This technique was first used in Egypt from the 9th century AD. Lustre-painted glass is also known as iridescent glass and was used to great effect during the Art Nouveau period in Europe and the USA by such artists as Louis Comfort Tiffany (1848–1933), and at such factories as Lötz Witwe in Bohemia.

(iv) *Staining*. Pigments of various colours can be brushed on to the surface of the glass in order to give the impression of stained glass. In the late 13th century silver chloride was brushed on to small panes of glass and fired for use in stained-glass windows (*see* STAINED GLASS). The technique was used on early Islamic glass, and during the 9th century silver chloride was used to produce a yellow stain on Bohemian glass. Glass with staining can be cut through in order to reveal the colourless, transparent glass beneath.

(v) *Gilding*. This process involves applying gold in the form of leaf, paint or powder to the surface of glass.

Gilding can be used alone, with enamelling or with engraving. Gold can be used to decorate the edges of objects or more extensively to create a series of intricate motifs or scenes. It can be applied to the surface of the object in a number of ways using a suspension of honey or mercury or a fixative. With honey gilding the gold leaf is mashed up with the sticky substance, painted on to the object and fired at a low temperature; the deposit is a very soft lustrous gold. The process of mercury gilding involves applying an amalgam of gold and mercury on the surface of the glass; when the mercury burns away, the gold is deposited on the surface. Gold applied in both of these ways can be burnished. Cold gilding or oil gilding involves applying gold leaf to a surface already brushed with linseed oil. This form of decoration is not very permanent and easily rubs off.

(vi) Gold engraving. This form of decoration involves engraving gold leaf with a fine needle and applying it to the outer surface of the glass. Unless it is somehow protected, however, the gold will rub off. One of the ways to ensure the longevity of the gold leaf is by sealing it between two layers of glass. The process involves applying gold leaf to the surface of a usually clear, colourless object, covering it entirely with another sheet of glass and fusing the two layers together. The earliest known examples of this type of decoration are Hellenistic (e.g. Canosa bowls *c.* 200 BC; London, British Museum). During the first half of the 18th century, the technique became particularly popular in Germany and is known as *Zwischengoldglas.* In France the technique is known as *verre églomisé.* Gold leaf can also be protected by a layer of varnish or metal foil.

5. OTHER.

(i) Ice glass. This decorative glass, the surface of which appears frosted or cracked, is achieved by one of two methods: the first involves plunging a blown gather of glass in a tub of water and then quickly reheating it; the second method involves rolling the gather of glass on a clay or metal surface on which randomly placed fragments of glass have been positioned so as to adhere to the gather. The technique was first introduced in Venice during the 16th century.

(ii) Sulphides. During the 19th century, cut glass was sometimes further decorated with small cameo-like encrustations known as sulphides. These opaque-white ceramic medallions usually depicting busts or figures were embedded on the sides or bottoms of clear, often colourless, glass objects. The technique was invented by Barthélemy Desprez (*fl* 1773–1819) in France. The technique was also extensively used to decorate paperweights.

R. J. Charleston: 'Dutch Decoration of English Glass', *Transactions of the Society of Glass Technology*, xli (1957), pp. 229–43

R. J. Charleston: 'Wheel Engraving and Cutting: Some Early Equipment', *Journal of Glass Studies*, vi (1964), pp. 83–100; vii (1965), pp. 41–54

D. C. Davis and K. Middlemas: *Coloured Glass* (London, 1968)

P. Jokelson: *Sulphides: The Art of Cameo Incrustation* (New York, 1968)

R. J. Charleston: 'Enamelling and Gilding on Glass', *Glass Circle*, i (1972), pp. 18–32

T. H. Clarke: 'Lattimo: A Group of Venetian Glass Enamelled on an Opaque White Ground', *Journal of Glass Studies*, xvi (1974), pp. 22–56

J. Spillman and E. S. Farrar: *The Cut and Engraved Glass of Corning, 1868–1940* (Corning, NY, 1977)

V. I. Evison: 'Anglo-Saxon Glass Claw Beakers', *Archaeologia* [Society of Antiquaries of London], cvii (1982), pp. 43–76

S. M. Goldstein, S. Rackow and J. K. Rackow: *Cameo Glass Masterpieces from 2000 Years of Glassmaking* (Corning, NY, 1982)

J. S. Spillman: *Pressed Glass, 1825–1925* (Corning, NY, 1983)

D. R. Uhlmann and N. J. Kreidl: *Glass-forming Systems*, i of *Glass: Science and Technology* (New York and London, 1983)

W. Trier: *Glass Furnaces: Design, Construction and Operation* (Sheffield, 1987)

K. Cummings: *Techniques of Kiln-formed Glass* (London, 1997/R 2001)

IV. Uses.

1. Decorative arts. 2. Architecture. 3. Sculpture.

1. DECORATIVE ARTS. Glass has been manufactured throughout history for the production of decorative arts by many different cultures and civilizations. The ability of glass to be shaped into an endless variety of forms, cut and coloured has ensured its popularity.

Glass has often been regarded as a luxury commodity and the earliest use of glass reflects this attitude. Such items as amphoriskoi and alabastra were made from glass as containers for expensive oils, perfumes and unguents. Beads, at first made in blue and black glass and later in a variety of colours and decorated with stripes and spots and later zigzags and chevrons, were first made in Egypt during the 5th Dynasty (*c.* 2465–*c.* 2325 BC); they were threaded into necklaces and bracelets (*see* BEADWORK). Other early uses of glass included gaming-pieces, amulets, pendants and such small sculptures as sacred bulls and rams and shabtis. During the New Kingdom (*c.* 1540–*c.* 1075 BC) glass inlays were made for jewellery and furniture and for setting in gold or other precious metals. In China, glass was first used in the Western Zhou period (*c.* 1050–771 BC), to make mosaic beads, eyebeads (*bi*) and decorative hairpins. Glass beads were also made during the Iron Age in Europe, as were gaming-pieces, bracelets and inlays for jewellery. The Romans used glass for a variety of purposes and many examples are extant. Glass was used extensively to make tesserae for mosaics (*see* MOSAIC). Glass was also the principal source for the tesserae needed for mosaics and *opus sectile* panels used in Early Christian and Byzantine art to decorate walls and ceilings.

Because of the refractive nature of glass, it is supremely suitable for lighting fixtures; glass examples are known from the Roman period (e.g. lamp, 2nd century AD; London, British Museum).

Particularly fine Islamic mosque lamps, many of which have survived, were made towards the end of the 13th century. These three-sectioned lamps (spread base, bulbous body and flared neck) were fitted with rings so that they could be suspended from the ceiling. As the skill of the glassmaker developed, lighting fixtures became increasingly sophisticated and intricate. The chandelier took numerous forms: simply decorated upward branches soon gave way to such intricately decorated chandeliers known as *ciocche* made by the Venetian glassmaker Giuseppe Lorenzo Briati (1686–1772). During the late 18th century and early 19th, the basic form was suspended with numerous pendants and cascades of cut and multi-faceted drops, which sparkled brightly and created a magnificent display when the candles were lit.

Glass has been used to make mirrors since at least the 1st century BC, when mirrors were made of silvered glass in Egypt. Roman glassmakers backed their mirrors with a metallic substance or a dark resin to create a reflective surface. By the 16th century the Venetians had produced a superior mirror backed with an amalgam of tin and mercury; the process was known as silvering. Mirrors were in great demand from the 17th century and were framed with lavish surrounds of wood decorated with paint, lacquer, gilding, ivory or precious metals. Such was the expense of glass in the 17th and 18th centuries that rulers, eager to show off their wealth, would sometimes decorate whole rooms with panels of glass; the most famous example is the Galerie des Glaces at Versailles. Coloured glass inlays have been used to decorate furniture since they were first employed in this capacity in ancient Egypt and were used to decorate drawer fronts on some bureaux in Venice during the 18th century. During the 19th century press-moulded drawer handles were widely produced in both Europe and the USA and even entire pieces of furniture were made of glass. During the 19th century, many unlikely items were made entirely of glass (e.g. birdcages and clock-cases), some specifically for the international exhibitions in order to demonstrate the virtuosity of the maker; one of the most outstanding examples was the glass fountain (destr. 1936), made by F. & C. Osler of Birmingham, that formed the centrepiece of the Crystal Palace in London where the Great Exhibition of 1851 was held. The popular paperweight, another 19th-century invention, was made in a variety of forms and decorated using a wide range of techniques from cutting to decorative inclusions.

A. Pellatt: *Curiosities of Glassmaking* (London, 1849)

F. Buckley: 'Old Glass Lamps and Candlesticks', *Country Life* (April 1929), pp. 492–4; (May 1929), pp. 710–12

G. M. Crowfoot and D. B. Harden: 'Early Byzantine and Later Glass Lamps', *Journal of Egyptian Archaeology*, xvii (1931), pp. 196–208

P. Hollister: *The Encyclopedia of Glass Paperweights* (New York, 1969)

B. Morris: *Victorian Table Glass and Ornaments* (London, 1978)

R. Grover and L. Grover: *Art Glass Nouveau* (Tuttle, Rutland VT, 1979)

V. Arwas: *Glass, Art Nouveau to Art Deco* (London, 1980)

R. von Strasser and W. Spiegel: *Dekoriertes Glas: Renaissance bis Biedermeier: Katalog Raisonné der Sammlung Rudolph von Strasser* (Munich, 1989)

P. T. Nicholson: *Egyptian Faience and Glass* (Princes Risborough, 1993)

R. Ward, ed.: *Gilded and Enamelled Glass from the Middle East* (London, 1998)

E. M. Stern: *Roman, Byzantine, and Early Medieval Glass, 10 BCE–700 CE: Ernesto Wolf Collection* (Ostfildern, c. 2001)

S. Carboni: *Glass from Islamic Lands* (New York, 2001)

S. Carboni, Stefano and D. Whitehouse: *Glass of the Sultans* (New Haven, 2001)

S. M. Goldstein: *Glass from Sassanian Antededents to European Imitations* (London, 2005)

D. Whitehouse: *Sasanian and Post-Sasanian Glass in the Corning Museum of Glass* (Corning, NY, 2005)

J.-A. Page: *The Art of Glass* (Toledo, OH, and London, 2006)

J. S. Spillman: *European Glass Furnishings for Eastern Palaces* (Corning, NY, 2006)

M. Eidelberg and others: *The Lamps of Louis Comfort Tiffany* (London, 2005)

C. Schack von Wittenau: *Neues Glas und Studioglas: Ausgewählte Objekte aus dem Museum für Modernes Glas/New Glass and Studio Glass: Selected Works from the Museum of Modern Glass* (Regensburg, c. 2005)

Czech Glass, 1945–1980: Design in an Age of Adversity (exh. cat., ed. H. Ricke; Corning, NY, Museum of Glass, 2005)

2. ARCHITECTURE. Glass has long played a central role in architecture, particularly in the West, where it has been highly valued for both its functional and aesthetic attributes. Its ability to provide transparent weatherproofing has made it an indispensable component in buildings, from its use in windows to the development of iron-and-glass skeletal structures in the 19th century and glass curtain walls in the 20th. At the same time, its transparency, reflective properties and the brilliant effects of coloured glass were fundamental to the creation of some of the most celebrated buildings in the western world. Flat glass for windows was traditionally made by the cylinder and the crown processes. In the former, glass was blown and swung into a cylindrical form; the ends were pierced and opened, the cylinder split longitudinally, flattened by reheating and then polished. Crown glass was made by blowing glass into a globe and then spinning it into a flat, circular shape, the maximum thickness being at the centre where a distinctive 'bull's eye' was left by the pontil iron; only small panes could be cut from the circle, but the glass was brilliant and clear, needing no further polishing. These methods were not significantly improved until the 17th century (when plate glass was introduced), with further developments in the 19th and 20th centuries (when drawn sheet and float glass were introduced). In the 15th century only the wealthy could afford glass in architecture. By the end of the 20th century it had become one of the cheapest building

materials available and, in response to the pressures of developing technology and commercial and functional requirements, it was increasingly related to the development of architectural form itself.

P. Scheerbart: *Glasarchitektur* (Berlin, 1914/*R* Munich, 1971); Eng. trans., ed. D. Sharp (London, 1972)

R. McGrath and others: *Glass in Architecture and Decoration* (London, 1937, rev. 1961)

N. Davey: *A History of Building Materials* (London, 1961)

D. B. Harden: *Domestic Window Glass: Roman, Saxon, Medieval*, Studies in Building History, ed. E. M. Jope (London, 1961)

E. Schild: *Zwischen Glaspalast und Palais des Illusions* (Berlin, 1967)

P. R. Banham: *The Architecture of the Well-tempered Environment* (London and Chicago, 1969)

M. Hennig-Schefold: *Transparenz und Masse* (Cologne, 1972)

J. Hix: *The Glass House* (London, 1974)

H. J. Cowan: *The Master Builders: A History of Structural and Environmental Design from Ancient Egypt to the Nineteenth Century* (New York, 1977)

R. H. Bletter: 'Interpretations of the Glass Dream: Expressionist Architecture and the History of the Crystal Metaphor', *Journal of the Society of Architectural Historians*, xl (1981), pp. 20–43

M. Foster, ed.: *Architecture: Style, Structure and Design* (New York, 1982), pp. 146–65

S. Koppelkamm: *Glasshouses and Wintergardens of the 19th Century* (London, 1982)

M. Wigginton: *Glass in Architecture* (London, 1990/*R* 2002)

S. Behling, S. Behling and J. Achenbach: *Glas: Konstruktion und Technologie in der Architektur* (Munich and London, 1999)

H. Elkadi: *Cultures of Glass Architecture* (Burlington, VT, 2006)

3. SCULPTURE. The contemporary metamorphosis of glass as a medium for making sculpture began in the 1950s as part of a general movement to explore its possibilities for artistic expression. Generally 20th-century art works in glass revealed the influences of the various modern movements in painting and sculpture, ranging from Cubism to Pop art. The main tendency among sculptors, painters and craftsmen, however, was to exploit the malleability and unique properties of glass: its hardness, brilliance, transparency and unlimited colour range. Glassmakers of the 1950s and 1960s were fascinated by the decorative glassware from the Art Nouveau and Art Deco periods, with its rich infusions of abstract colour effects, which they saw as relevant to Abstract Expressionist painting. Small, highly original decorative glass sculptures and figures produced from *c.* 1900 to the 1930s were also influential. The thick-walled, sculptural vases and bowls created in heavy blown glass by Maurice Marinot (1882–1960) between 1920 and 1937 were an uncompromising example of artistic independence and a pointer to future possibilities. Such enhancing 'accidents' as bubbles, impurities in the batch and embedded skeins of colour, as well as such surface abrasion techniques as acid-etching and deep wheel-cutting derived from well-established practices, were owed to the research and experimentation of Marinot and others between the two world wars.

The studio glass movement first took root in Europe among painters, sculptors and glass designers who worked independently, away from the factory environment or in workshops attached to factories. At such large glassmaking factories as those of the Daum brothers in Nancy, the Royal Leerdam Glassworks near Utrecht in the Netherlands and the Barberini and Fratelli Toso families in Murano, Venice, professional craftsmen produced glass sculpture from designs by well-known artists. Some painters and sculptors also created independent pieces under factory conditions, among them Paul Jenkins (*b* 1923), who in the 1960s worked in Italy with the Fucina degli Angeli factory. By the early 1960s the movement had spread to the USA, led by Harvey K. Littleton (*b* 1922), who established two glass workshops at the Toledo Museum of Art, OH. Littleton employed a range of techniques from blown glass to assemblages of cut, softened (slumped) glass sheets and rods. Much modern glass sculpture in the USA was the product of individual workshops using small furnaces and developing new formulae for creating glass that could be melted at lower temperatures. During the 1970s methods were greatly refined. Pieces were free- or mould-blown and surfaces were smoked, sandblasted or electroplated. Styles were frequently playful, replete with allusions to nature or the human figure. Abstract forms, however, predominated and sculptors took full advantage of the medium's fluid, expressionistic qualities as well as its clarity. Abstract work was vital to modern glass sculpture produced in Europe and Scandinavia and exhibited throughout the world. This modern glass sculpture brought new direction to a material once dominated by utilitarian traditions.

J. E. Hammesfahr and C. L. Strong: *Creative Glass Blowing* (San Francisco, 1968)

American Glass Now (exh. cat. by O. Wittmann; Toledo, OH, Museum of Art and elsewhere, 1972–4)

International Glass Sculpture (exh. cat. by K. M. Wilson, A. Gasparetto and R. M. Willson; Coral Gables, FL, University of Miami, Lowe Art Museum, 1973)

New Glass: A Worldwide Survey (exh. cat. by R. Lynes and others; Corning, NY, Museum of Glass and elsewhere, 1979–81)

Czechoslovakian Glass, 1380–1980 (exh. cat. by D. Hejdová and others; Corning, NY, Museum of Glass; Prague, Museum of Decorative Arts; 1981)

D. Klein and W. Lloyd, eds: *The History of Glass* (London, 1984)

J. H. Opie: *Chihuly at the V&A* (London, 2001)

C. Schack von Wittenau: *Neues Glas und Studioglas: Ausgewählte Objekte aus dem Museum für Modernes Glas/New Glass and Studio Glass: Selected Works from the Museum of Modern Glass* (Regensburg, *c.* 2005)

V. Conservation.

1. DETERIORATION AND PREVENTION OF DAMAGE. Although glass can be formulated and toughened in such a way that it can withstand high temperatures, the glass used for creating objects of art

tends to be brittle and susceptible to thermal shock. Its hardness, and thus the ease with which it becomes scratched or worn, varies and decorative applications of enamel, paint or gilding may be subject to flaking or wear. Some of the recipes used through the history of glassmaking have produced glass that is chemically unstable. The glass may suffer from diminished transparency owing to fine surface crizzling, and small pieces of glass may spall off the surface. In certain conditions the surface becomes sticky, or beads of moisture appear. This type of deterioration is referred to as glass 'disease' or glass 'sickness'. In some cases where manganese has been used as a decolourant in the glass batch the glass may take on a pinkish hue because of oxidation of the manganese. It is thought that the composition of 'sick' glass is unstable owing to an inadequate level of lime and too much alkali, which causes the glass to be susceptible to hydrolytic attack. Alkalis leach out on to the surface where they form hydroscopic salts. In conditions of high humidity this produces a weeping effect. If the glass is subjected to low relative humidities these salts crystallize and water, which has replaced the alkalis in the glass network, will dry out, causing the glass to crizzle.

Water may corrode glass vessels that have contained liquids for an extended period and a milky or iridescent surface is deposited on the inside. Deterioration may also occur when glass has been buried, which results in surface pitting or the formation of weathering crusts. Weathering crusts are usually opaque and may be iridescent, and have a tendency to flake off.

Damage is preventable through careful handling and controlled storage conditions. Fingerprints may attract dirt and moisture, and the acid from skin can cause corrosion. Glass should be stored in dust-free display cases, and controlled conditions of relative humidity (42–45%) are recommended for glass that shows signs of glass disease. This is important as at the present time there are no other methods of preventing deterioration of 'sick' glass. The temperature should be kept reasonably stable and bright lights that heat up the case should be avoided. Stacking of glass objects should also be avoided, and there should be sufficient space between objects to allow safe handling.

2. EXAMINATION. Glass objects are examined in order to define the nature of any damage or deterioration, and to establish the composition and methods of manufacture. Most damage and old restorations are clearly visible to the naked eye. Microscopes are useful for examining the surface in detail and for examining inclusions in the glass. Air bubbles, which are usually elliptical, will indicate which way the metal was stretched during forming. X-radiography may be used for examining the structure of opaque glass, and ultraviolet light will sometimes provide information as to the composition of the glass. Various analytical techniques can be used to provide detailed information about the composition of glass.

3. CLEANING. Sound glass may be washed in warm water with the addition of non-ionic detergent. (Detergents that have a high phosphate content, such as those used in dish-washers, can cause clouding of lead glass, and spots or rings on high-alkaline soda glass when used in hot water.) This is followed by careful rinsing and drying. If vulnerable decoration is present or if there are any old restorations, the object is cleaned using cotton-wool swabs dipped in water. Drying may be aided by swabbing with industrial methylated spirit. If the surface is friable a brush may be used instead of cotton-wool swabs to avoid snagging any flakes.

'Sick' glass with sticky or weeping surfaces may be rinsed in de-ionized water to remove surface dirt and salts but must be dried thoroughly using industrial methylated spirit. Weathered layers from archaeological glass are not usually removed as this alters the dimensions of the object and removes any surface decoration. Excess dirt is removed with a dry brush. Ultrasonic cleaning tanks can be safely used to remove dirt from inaccessible places provided the glass is undecorated and sound.

4. BONDING. The smooth edges of glass make bonding difficult and the transparency makes total concealment impossible. Greatest success is achieved when an adhesive that has a refractive index as close as possible to that of the glass is used. The adhesive should also be water white, durable and reversible without damage to the object. A range of epoxy resins, acrylic and vinyl polymers and cellulose nitrate adhesives are used.

The edges of the glass are degreased with solvent before applying the adhesive, which must be spread evenly over the glass to avoid air bubbles in the joint. Depending on the adhesive used, the joints are then held in place with adhesive tape, hand-held or propped in position while the adhesive cures. Alternatively, when there are multiple breaks, the object can be assembled 'dry' with tape and afterwards a low viscosity adhesive fed in along the joints. Care is taken to avoid applied surface decoration if tape is used.

Occasionally such breaks as those in the stems of glasses or vases may need the added strength of a dowel. This is usually made of glass or Perspex and is inserted with adhesive in holes made with a drill and diamond burr.

5. RESTORATIONS. When material is missing from a glass object, it may be reassembled on a glass or Perspex support. Alternatively small chips or larger missing areas may be filled: an ideal filling material for glass should be transparent and colourless. It should adhere well to the glass, should not shrink and should be capable of being polished to a high shine. It should also be durable and reversible without

damage to the object. Those most commonly used are acrylic, polyester and epoxy resins.

Preformed polymethacrylates are cut out, heated and bent to the required shape. They are then secured in position with adhesive. Other materials used are liquid until cured and are usually used in conjunction with a mould made from dental wax, clay or silicone rubber. If the object is coloured, dyes or pigments are mixed into the casting material and if the glass is opaque, such fillers as fumed colloidal silica are added to give the desired effect. After it has cured, the filling may be polished using abrasive pastes or a polishing burr on a small dental drill. Any surface decoration is painted on to the surface of the cured resin with dyes or pigments mixed into acrylic or epoxy resins, or one of the lacquers commonly used for retouching ceramics. Gilding is replicated using gold leaf, gold or bronze powders.

M. Bimson and A. E. Werner: 'The Danger of Heating Glass Objects', *Journal of Glass Studies*, vi (1964), pp. 148–50

R. M. Organ: 'The Safe Storage of Unstable Glass', *Museum Journal*, lvi (1965)

R. Errett: 'The Repair and Restoration of Glass Objects', *Bulletin of the American Group IIC*, xii (1972), pp. 48–9

R. Newton: *The Deterioration and Conservation of Painted Glass*, Corpus vitrearum medii Aevi (Oxford, 1974)

R. H. Brill: 'Crizzling: A Problem in Glass Conservation', *IIC Conference: Conservation in Archaeology and the Applied Arts: Stockholm, 1975*

J. C. Ferrazzini: 'Reaction Mechanisms of Corrosion of Medieval Glass', *IIC Conference: Conservation in Archaeology and the Applied Arts: Stockholm, 1975*

S. Davison: 'The Problems of Restoring Glass Vessels', *The Conservator*, ii (1978)

N. Tennent: 'Clear and Pigmented Epoxy Resins for Stained Glass Conservation', *Studies in Conservation*, xxiv (1979)

S. M. Bradley and S. E. Wilthem: 'The Evaluation of Some Polyester and Epoxy Resins Used in the Conservation of Glass', *Preprints of ICOM Committee for Conservation, 7th Triennial Meeting: Copenhagen, 1984*

S. Davison: 'A Review of Adhesives and Consolidants Used on Glass Antiquities', *IIC Conference: Adhesives and Consolidants: Paris, 1984*

R. Errett, M. Lynn and R. Brill: 'The Use of Silanes in Glass Conservation', *IIC Conference: Adhesives and Consolidants: Paris, 1984*

P. Jackson: 'Restoration of Glass Antiquities', *Preprints of ICOM Committee for Conservation, 7th Triennial Meeting: Copenhagen, 1984*

N. Tennent and J. Townsend: 'Factors Affecting the Refraction Index of Epoxy Resins', *Preprints of ICOM Committee for Conservation, 7th Triennial Meeting: Copenhagen, 1984*

N. Tennent and J. Townsend: 'The Significance of the Refractive Index of Adhesives for Glass Repair', *IIC Conference: Adhesives and Consolidants: Paris, 1984*

S. Davison and P. Jackson: 'The Restoration of Decorative Flat Glass: Four Case Studies', *The Conservator*, ix (1985)

R. Newton and S. Davison: Conservation of Glass (London, 1989, rev. 2/1996)

N. Williams: *The Breaking and Remaking of the Portland Vase* (London, 1989)

N. H. Tennent: *The Conservation of Glass and Ceramics* (London, 1999)

S. Davidson: *Conservation and Restoration of Glass* (Oxford, 2003)

M. Jones, ed.: *Conservation Science: Heritage Materials* (Portsmouth, 2006) [chap. on glass and ceramics]

Glass painting. Method of producing pictures and ornamental designs on the back of a clear glass panel to be viewed from the opposite side in reflected light. Unlike translucent stained glass, the reverse painted decoration is not fused to the support by firing. The powdered colours are mixed with a binding substance and applied directly to the glass, which becomes an integral part of the picture by providing both the base and the transparent cover for the artwork when the panel is turned. The layer of pigment adheres firmly to the smooth surface, and the colour retains the freshness reminiscent of enamels.

The process begins with a drawing of the subject, positioned under a suitable glass surface. The outline of the pattern is traced and filled in with a blend of colours to fit the design. Working with opaque pigments, the artist has to reverse the standard procedure and begin the painting by exactly placing the highlights and fine details that would normally be put down last. The image must be developed around these fixed points, and corrections by covering the error with additional pigment cannot be made. The laborious method of painting backward is not employed when thin layers of translucent colours are superimposed following a standard production sequence.

Cold painting on glass was known in the Roman world: numerous fragments of polychrome images have survived, but complete objects are rare. An important example of the latter is a circular plate of colourless glass (diam. 210 mm, c. 3rd century AD; Corning, NY, Museum of Glass) reputedly found in southern Syria. The shallow dish of the plate is reverse-painted on the exterior with the *Judgement of Paris* in black, white, shades of grey, yellow, brown and violet on a red background. This technique seems to have been forgotten until the Renaissance, and the sudden flowering of reverse-painted flat glass in northern Italy at this time was without apparent precedent.

In the 14th century unfired pigment was used on the reverse of small glass panels in reliquaries and house altars. Through the following centuries glass painting, in combination with gold-leaf engraving, was found on a vast assortment of devotional objects and ornaments (extensive holdings in Turin, Museo Civica d'Arte Antica). Luxury goods from Lombardy reached the Low Countries and the Rhineland, but a variety of painted glass objects was eventually produced in the area, including the major manufacturing centres at Nuremberg and Augsburg. The secular use of glass painting evolved during the 17th century, with elaborate mirrors, wall pictures and panelled cabinets featuring in patrician houses and princely collections. Glass painting became a recognized European art form. In Switzerland, for example, Carl Ludwig Thuot (c. 1677–88) executed a

notable *Adam and Eve* (1686; Zurich, Schweizerisches Landesmuseum).

Towards the end of the 18th century a cottage industry was established in the German and Austrian countryside to meet the demand for inexpensive religious pictures sold at markets and church festivals. For most of the 19th century small village workshops produced extraordinary numbers of reverse paintings on glass (examples in Munich, Bayerisches Nationalmuseum; Vienna, Museum für Völkerkunde) using popular prints as patterns, and the wholesale distribution of these works reached far beyond regional boundaries. Between 1852 and 1864 a single family workshop in Sandl, Austria, produced 386,000 pictures. By 1900 chromolithography had replaced the painting tradition, but the colourful pictures are collected and valued as folk art.

H. W. Keiser: *Die deutsche Hinterglasmalerei* (Munich, 1937)

G. M. Ritz: *Hinterglasmalerei* (Munich, 1972)

L. Schmidt: *Hinterglas* (Salzburg, 1972)

W. Brückner: *Hinterglasmalerei* (Munich, 1976)

S. Pettenati: *I vetri dorati graffiti e i vetri dipinti* (Turin, 1978)

Glaze. A transparent or semi-transparent paint layer, applied either directly over the ground or over an underpaint to modify the colour of the ground or underpaint. With the use of appropriate glazes the tonal range of a colour can be extended to give a greater contrast between highlights and shadows. Since the glaze is transparent, the colour of the underpaint or ground, which is generally lighter, plays a part in the final optical effect.

The term 'glaze' is often used imprecisely to mean any thinly applied paint layer, particularly the final finishing touches to a painting. However, these can include combinations of pigments and media that are normally opaque or semi-opaque: it is simply the thinness of application that allows the underlying layers to contribute to the optical effect. Properly, thin layers of opaque colour applied to modify the underlying colours should be called 'scumbles'.

Glazes are usually made by combining pigments and paint media that have similar or identical refractive indices (*see* PIGMENT, §I): that is, they transmit light to a similar or equal degree so the light is not bent or refracted at the interface between the medium and the pigment particle. Media such as egg tempera, glue distemper, casein, gouache and some paints based on synthetic resins have refractive indices that are lower than those of any artists' pigments: therefore they cannot be used to make truly transparent glazes. At best, the paint layers can only be translucent. Drying oils, however, have higher refractive indices, approaching those of certain pigments. Their refractive indices can be raised further by the addition of natural resins, usually those used in varnish making, for example copal, sandarac, pine resins, mastic and dammar.

Pigments that form transparent or semi-transparent glazes when combined with drying oils fall into three groups. The first contains pigments with refractive indices close to those of drying oils. They include several blue pigments (e.g. natural and artificial ultramarine, smalt and Prussian blue), but they are not completely transparent because their refractive indices are still slightly higher than those of the oil-based media. The second, and perhaps most important, group comprises the red and yellow LAKE pigments. The red and yellow dyestuffs from which they are made do not themselves have low refractive indices, but when they are to be used as transparent lakes they are precipitated on to colourless substrates of low refractive index, traditionally alum (hydrated alumina) or chalk (calcium carbonate). The third group consists of pigments that are wholly or partially soluble in the paint medium. Since there is no longer any interface between pigment and medium to refract and scatter the light, the refractive index of the pigment is irrelevant. This group includes copper resinate (verdigris dissolved in an oil-resin medium), such coloured resins as gamboge and dragon's-blood, and the various bituminous brown pigments.

1. HISTORY. In medieval painting glazes composed of pigments in oil-based media seem to have been used principally in conjunction with gilding (*see* GILDING, §I, 1), both on panel paintings and on polychrome sculpture. Recipes for the glazing of tin leaf with yellow pigmented oil varnishes to imitate gold leaf can be traced back to at least the 8th century AD, and descriptions of painting with coloured oil glazes over metal leaf are given by Theophilus in the 12th century and by Cennino Cennini (*c.* 1370–*c.* 1440) at the end of the 14th century. Similar techniques were also used in the painting of glass. Oil-based glazes have been identified on 13th- and 14th-century paintings from northern Europe, in particular England (e.g. the Westminster Retable, London, Westminster Abbey) and Norway (especially altar frontals; see Dunkerton), and from Italy. In the Italian examples egg tempera remains the principal paint medium: the oil glazes are associated with the decoration of gilding or with the use of copper resinate (*see* PIGMENT, §V, 2).

In the early 15th century northern European artists, particularly such Netherlandish painters as Jan van Eyck (*c.* 1395–1441), Robert Campin (*c.* 1375/9–1444) and Rogier van der Weyden (*c.* 1399–1464), began to use transparent oil glazes over lighter opaque underpaints to obtain rich saturated colours but also, by varying the thickness of the glazes, to achieve relief and greater tonal variation in the modelling of forms. Modelling by means of glazes is one of the main features of early Netherlandish oil painting. These glazing techniques were transmitted to southern Europe. They first appeared in Italy in the mid-15th century and were soon widely adopted, above all in Venice, where Antonello da Messina (*c.* 1430–79) pioneered their use, and after him Giovanni Bellini (?1431/6–1516) applied them to great effect. In the 16th century, as the handling of oil paint became freer, so the use of glazes became less ordered and systematic. In the late 16th century and the 17th, when coloured grounds were frequently

employed, the opaque underpaint was sometimes omitted, the transparent shadows being applied directly over the ground. By adding other pigments to act as driers, it was also possible to apply glazes with some bulk and impasto (as opposed to the repeated thin applications of Netherlandish painting).

Changes in art education in the 18th and 19th centuries led to the breakdown of the master–apprentice craft tradition. As a result, to imitate the depth and saturation of earlier works, particularly the greatly admired Venetian paintings of the 16th century, painters increasingly experimented with unsuitable and often impermanent materials in their glazes. These included bituminous brown pigments, which may never dry, and media containing wax or soft resins more often used for varnish making. Later, 19th- and 20th-century attitudes to the optical and physical properties of oil paint meant that few painters have consciously or deliberately employed oil-glazing techniques. Some colour-field painting involves the superimposition of thin layers of colour, but these occur more as dilute washes and stains than as medium-rich and transparent glazes.

The glazes on many paintings have changed with time: the red and yellow lake pigments are prone to fade, particularly where thinly applied; blue and brown glazes can darken and become more opaque than intended; and copper resinate can discolour from its original bright green to a warm reddish brown. Glazes can also be damaged by conservation treatments, especially by cleaning and by the sometimes over-hot irons used in the past for flattening blistered paint and relining canvases. A glaze on a 19th-century painting that contains wax or a soft resin may be soluble in the solvents that are used to dissolve the discoloured varnish. Glaze layers on earlier paintings, which consist principally of oil, may be no more soluble than other areas of paint, but they are vulnerable to damage because they are often very thin. Thickly applied glazes, on the other hand, may have dried poorly, developing a wrinkled surface and wide drying cracks, or they may have become brittle and consequently tend to flake.

See also CERAMICS, §I, 5.

Theophilus [Rugerus]: *De diversis artibus* (?1110–40); Eng. trans. by J. G. Hawthorne and C. S. Smith as *On Divers Arts* (Chicago and London, 1963)

C. Cennini: *Il libro dell'arte* (c. 1390); Eng. trans. and notes by D. V. Thompson jr as *The Craftsman's Handbook: 'Il libro dell'arte'* (New Haven, 1933/R New York, 1954)

C. L. Eastlake: *Materials for a History of Oil Painting* (London, 1847); R as *Methods and Materials of the Great Schools and Masters* (New York, 1960)

R. Mayer: *The Artist's Handbook of Materials and Techniques* (New York, 1940, rev. London, 5/1991)

R. J. Gettens and G. L. Stout: *Painting Materials: A Short Encyclopaedia* (New York, 1942, rev. 1966)

D. Bomford, C. Brown and A. Roy: *Art in the Making: Rembrandt* (London, 1988)

J. Dunkerton and others: *Giotto to Dürer* (London, 1991)

E. van de Wetering: *Rembrandt: The Painter at Work* (Amsterdam, 1997)

R. Woudhuysen-Keller and P. Woudhuysen: 'Thoughts on the Use of the Green Glaze called "copper" resinate and its colour changes', *Looking through Paintings: The Study of Painting Techniques and Materials in Support of Art Historical Research*, eds E. Hermens, A. Ouwerkerk and N. Costaras (London, 1998), pp. 133–46

N. Wood: *Chinese Glazes: Their Origins, Chemistry and Recreation* (Philadelphia, 1999)

A. Turner: Glazes: *Materials, Recipes and Techniques: A Collection of Articles from Ceramics Monthly* (Westerville, OH, 2004)

D. Creber: *Crystalline Glazes* (London, 2/2005)

Gold. Yellow metallic element, with an atomic weight of 197.2 and a specific gravity of 19.32. It is one of the so-called 'noble' metal group, which also includes silver and platinum. Gold has always been highly valued for its intrinsic beauty, its working properties and its rarity—until recent times it was used to underpin the currencies of the major trading nations, and it is still a traditional refuge in times of financial instability. It is first known to have been worked in Mesopotamia in the 6th millennium BC. Since then it has been prized as a material to fashion or to decorate a wide variety of objects, including jewellery, coins, ritual items, tableware and furniture.

A scarce element, representing between 1 and 9 mg per tonne in the composition of the earth, gold is found mainly in the native state, in contrast with most other metals, which are found as ores. Deposits of gold occur either in the original formations (e.g. as veins in quartz) or as 'placer' in alluvial deposits. Traditionally, the gold was extracted by crushing the ores and then washing them over sloping troughs with lateral ribs. Because of its density, the gold was deposited against the ribs towards the top of the trough. As a final stage, the slurries were sometimes washed over sheepskins, a practice that may have given rise to the legend of the Golden Fleece. Although small amounts of gold are found in most parts of the world, the main commercial deposits are in Witwatersrand and the Orange Free State in South Africa. Famous gold-rushes occurred in the 19th century in California, Australia and the Yukon in Canada.

See also GILDING, §§I and II

1. Properties. 2. Techniques.

1. PROPERTIES. Gold is one of the densest of metals, being approximately twice the density of silver and over seven times that of aluminium. The rich yellow of the pure metal is unmatched by other materials. This is enhanced by the ability of gold to take a high polish and keep its lustre almost indefinitely, owing to its extreme resistance to corrosion. Gold can normally only be chemically attacked by aqua-regia, a mixture of hydrochloric and nitric acids. These properties led to the use of gold as a protective coating for other less durable materials, from medieval reliquaries to modern aerospace components. Gold melts at 1063°C and will then flow freely, making it an ideal casting metal. In its pure state, it is one

of the most easily worked of all metals because of its molecular structure, which is in the form of a lattice made up of cells of the face-centred cube type. This, combined with the type of atomic bonding that distinguishes metals from other elements (*see* METAL, §I), means that gold can be worked heavily and continuously without any appreciable hardening or stiffening. It is highly malleable and can be severely deformed by hammering or rolling into very thin sections, the most extreme example being gold leaf. The ductility of gold is also exceptional, enabling the production of very thin wires, slender enough to use in embroidery (*see* TEXTILE, §I, 2).

Because of its softness, pure gold is impractical for many purposes. It is, in fact, rarely used in its pure form and from the earliest times has been mixed with other metals, particularly silver. It is not clear at what date goldsmiths began deliberately to mix their metals, but an alloy composed of approximately 80% gold and 20% silver was given the name *elektron* by the Greeks. The Snettisham Torc (1st century BC; London, British Museum), made in Britain during the late Iron Age, is a good example of an electrum-type alloy, being composed of approximately 60% gold and 40% silver.

Gold alloys are usually referred to in terms of carats. This represents the proportion of gold in the alloy, a carat (ct) being a 24th part. Thus 18-carat gold contains 18 parts gold and 6 parts other metals. Current practice in the developed world has led to some standardization of gold alloys, and four are now almost universally accepted—9, 14, 18 and 22 carat. These are also referred to by the decimal equivalents (parts per thousand), respectively 375, 585, 750 and 916. The majority of gold artefacts made in the West are of 14ct or 18ct, although 9ct is used extensively in Britain. Other alloys are used in various parts of the world, largely in accordance with the prevalent system of quality marking: alloys purer than 18ct are much favoured in the Middle East and the Indian subcontinent. Systems of quality control, usually known as hallmarking, have been in existence in Europe since the 13th century. Systems vary, but usually the completed articles are tested or assayed to assess the gold content and then struck with punches to denote the metal quality, place of testing, date and the maker's name.

The particular metal or metals added to the gold will affect both the working qualities and the colour of the alloy. The larger the amount of additions, the more controllable the alloy. All 9ct gold alloys can be adapted to the widest range of uses, including such items as pins and springs where hardnesses are required that could never be attained by the purer alloys. In gold alloys, the other metals will tend to make the metal stiffen and eventually fracture when it is worked. By heating the metal to between 550°C and 700°C, the original characteristics can usually be restored, and work can continue. Colour can be affected by the choice of additional metals: copper will redden a gold alloy; silver will tend to give a colder, greener colour; silver, zinc and palladium in various combinations will give a white alloy. Such coloured alloys are mostly found from the late 19th century, in the work of Carl Fabergé (1846–1920), for example, and in work by such contemporary German artists as Gerd Rothman (*b* 1941) and Claus Bury (*b* 1946).

2. TECHNIQUES. The long history of goldworking has led to the evolution of a large range of manipulative techniques. These can be classified under three main headings: forming, cutting and joining, and decorating. Gold can also be used to enhance the surface of other objects by the process of gilding. (Many of the processes are described in greater detail in METAL, §§IV and V.)

(i) Forming. (ii) Cutting and joining. (iii) Decorating. (iv) Gilding.

(i) *Forming*. The most basic method of forming metal is casting. Essentially the pouring of molten metal into a shaped mould, it is used at its simplest merely as a preliminary stage in the manufacture of an artefact, to produce an ingot that can then be further worked by hammering into sheet or wire form. There are limits to what can be done by this simple method: where gravity feeds the molten gold into the mould, the surface tension of the liquid metal is sufficiently strong to prevent the reproduction of fine detail and narrow sections, so from very early times centrifugal force has been used to drive the metal into such forms. To do this, the metal is melted on top of the mould, which is then placed in a cradle held with chains and swung vigorously by the goldsmith. It is probable that this technique was used by the Etruscans and the Hellenistic Greeks to produce some of their extremely finely detailed jewellery. A technique closely associated with centrifugal casting is that of lost-wax casting. Here, a wax model is made of the item to be cast. This is then covered in a ceramic material and fired in a kiln, which both vitrifies the mould and melts out the wax. The resulting mould is filled with molten metal. Almost all centrifugal castings are done in this way. A highly versatile process, the lost-wax method is still in extensive use, in association with either centrifugal casting or vacuum casting, where atmospheric pressure is used to force the metal into the mould. A large proportion of modern production in gold jewellery is made by this means.

Gold can be easily beaten into rod or wire, which can then be further hammered to control the form and line. Alternatively, a rod can be drawn through metal plates to produce wires of any thickness or section. Gold can also be hammered out into sheet on a flat surface. This is quite feasible even with wooden tools, but stone tools are far more effective and were used with much skill before the advent of bronze or iron ones.

There are three main techniques for producing hollow vessels from a flat sheet: blocking, raising and spinning. In blocking, the metal is hammered into a hollowed piece of wood or on to a sand-filled leather

bag, thereby stretching it to produce simple forms. Another version is sinking, which involves the use of a round-faced hammer and a flat 'stake'. This again is a stretching process, which was mainly used to make vessels with thick rims by starting with a thick piece of metal and stretching the centre downwards. Blocking is most often used as a first step in the formation of a vessel, prior to raising; in this process the metal is compressed into shape by being hammered down on to stakes (shaped pieces of hard wood, bronze, iron or steel) of the appropriate form. The vast majority of hollow-ware produced before the Industrial Revolution was made using this method. It is, in skilled hands, a highly versatile technique, which can be done surprisingly rapidly. Nearly all medieval gold vessels were made this way, although the evidence is often obscured by subsequent work and decoration.

While mainly a decorative technique, repoussé was sometimes used as a forming method. Benvenuto Cellini (1500–71), in his treatises on goldsmithing and sculpture and in his autobiography, described the making of a gold figural salt for Francis I of France (c. 1540–43; Vienna, Kunsthistorisches Museum) by this method. The metal is initially supported on a bed of pitch, which provides a base that is both adhesive and resilient. It is then worked with hammers and punches to push it down into the pitch, so taking up the desired form. The work continues from behind until the edges begin to meet at the back, at which point it is itself filled with pitch and worked from the outside. Although this is time-consuming and requires great skill, it allows the production of very complicated hollow forms. This technique has been in use for at least 3500 years, the funeral mask of Tutanhkamun (c. 1361–1352 BC; Cairo, Egyptian Museum; see colour pl. VI, fig. 1) being an early and outstanding example.

During the early 19th century spinning was introduced. There is some evidence for a form of the process existing as early as Roman times, but the exact nature of its use is controversial. Spinning involves the use of a fairly powerful lathe. A turned shape, in the form of the inside of the vessel, is fixed to the powered end of the lathe. A disc of gold is clamped against this, and the whole assembly set spinning. A steel tool is then worked against the rotating disc, forcing it down on to the turned shape, or chuck. This technique is most appropriate for batch and mass production and is only rarely used for gold.

Another relatively modern technique is electroforming, which was first demonstrated in 1837. Here, gold is grown on to a preformed matrix or model by means of electrolysis. The matrix need not necessarily be of metal; it is often of wax, although it is normally coated with copper before the gold deposition begins. The process has been used extensively in the production of copies of such antique metal items as coins, when it is known as electrotyping. It is less widely seen in the production of works of art, but the American jeweller Stanley Lechtzin (b 1936) used it extensively, and the crown designed and finished by Louis Osman (1914–96) for the investiture of Prince

Charles as Prince of Wales (1969; London, Tower of London) was produced by this technique.

(ii) Cutting and joining. These techniques are used in goldsmithing for both practical and decorative reasons. One of the most primitive methods was to cut thin sheet metal with stone knives. A later extension of this was cold-chiselling, where sharp stone or metal tools are driven through the metal by hammering. Blacksmiths continue to use this technique on iron, but it has to be red-hot, whereas gold can be cut perfectly well when cold. The Pre-Columbian cultures of Mesoamerica and South America achieved highly sophisticated decorative effects by this means, using stone and metal tools. There are examples surviving of quite fine-scale piercing on relatively thick metal. When iron tools became practicable, shears or snips began to be used for cutting sheet metal. Working on the same principle as scissors, these cut through the metal in a relatively crude way, leaving a sharp edge that needs to be rounded off. The advantage to the goldsmith is in speed of use. Piercing, where sheet metal is cut by a fine saw similar to a woodworker's fretsaw, has been in use for decorative purposes since the mid-18th century, when thin and reliable blades became available (there are earlier examples that are almost certainly saw-pierced, but these are rare). The usual technique was to engrave the design and then cut down the engraved lines with the saw. Fine lace-like patterns were produced in hollow-ware by this means. Gold tableware is uncommon, but the technique was used for wine-coasters, fruit-baskets and the like. There was some interest in the technique in Germany and Scandinavia from the 1970s, mainly for its decorative and graphic potential. In much of this work, the saw is used simply to cut lines rather than to remove areas of metal. Sometimes the metal between the lines is slightly bent to give extra form to the piece.

There are several ways of joining gold components, perhaps the oldest of which is riveting. Here, the two pieces are drilled to take a wire or rod, which is passed through the holes, trimmed to length and then spread out at the ends by hammering. This traps the two pieces and pulls them tightly together as the ends of the rivet are spread. The rivet ends may be decorative in themselves or can be hidden. Extensive use was made of rivets in prehistoric gold work, probably due to ignorance of, or difficulties in, soldering. The handle of the Rillaton Gold Cup (1400–1000 BC; London, British Museum) is riveted on, and such items as the Broighter Collar (Dublin, National Museum of Ireland) make use of rivets as an essential means of construction. At later dates riveting was used because of the fact that no heat is required to make the joint. This is advantageous in such applications as enamelling, where heat would damage the decorated parts. There are numerous examples of enamelled pieces being riveted together, an interesting piece being the Royal Gold Cup of the kings of France and England (c. 1380; London, British Museum). This had an additional part let into

the stem in the 16th century, but because the original cup was extensively enamelled, as was the additional part, the join was made with rivets to avoid damage.

The most common method of joining gold is soldering. This is the term used by goldsmiths, although strictly speaking it is high-temperature brazing, since it is mainly carried out at temperatures in excess of 750°C. The pieces to be joined are made to fit together perfectly, then coated with a flux. The traditional flux, which is still used widely, is borax (sodium tetraborate). Its function is to exclude atmospheric oxygen from the joint as it heats, preventing oxidization and thus allowing the solder to flow freely. The use of flux is not necessary when gold of high purity is used, since it does not oxidize. The solder itself is a gold alloy, designed to melt at a lower temperature than that of the metal from which the piece is made. The parts are placed together on the hearth and heated until the required temperature is reached. At this point the solder is applied, and two things happen: the solder melts and runs into the joint by virtue of capillary attraction, and, once there, it soaks into the two parts being joined. This gives an extremely strong joint, which is, in effect, one continuous piece of metal. It has been widely used since medieval times and continues to be the normal method.

Until at least the early medieval period, another method of soldering was used for gold. This is known as granulation or eutectic soldering, and it was described in the 12th century by Theophilus in his treatise *De diversis artibus*. The essential difference between this and the modern method is that the former does not require the use of separate pieces of solder; the solder is manufactured on the spot. A copper salt is mixed with an organic binder such as flour paste, and with this mixture small parts are stuck to the work, which is then heated on a hearth. The organic binder first dries, then carbonizes. This in turn reduces the copper salt to metallic copper, which with the gold forms an alloy with a lower melting-point than the parts being joined, thus creating what is effectively a solder. Because of the capillary attraction that occurs when the paste is applied, the bonding only takes place at the points of contact between the parts. It is thus a crisp and elegant way of joining gold components. The only drawback is that the temperature at which the solder is created (the eutectic) is rather close to the melting-point of the gold. It is, however, a technique that works better with gold than with any other metal, and it was used extensively in the ancient world.

(iii) Decorating. A wide range of decorative techniques is available to the goldsmith, the majority of them adaptations of constructional techniques. A good example of this is granulation, which exploits the special qualities of eutectic soldering. The most typical form of granulation is where tiny spheres of gold, often only a fraction of a millimetre in diameter, are arranged in patterns on the surface of an object and soldered in position by the method described above. In the best examples, there is no sign of a join; the granules appear simply to sit on the surface of the piece. This kind of work is most closely associated with the Egyptians, the Hellenistic Greeks and in particular the Etruscans, although many cultures throughout the world have used it. Some continue to use it, as, for example, the Nepalese, while the American jeweller John Paul Miller (*b* 1918) is an outstanding exponent of the technique. During the 19th-century vogue for archaeological jewellery, several workshops specialized in granulation, the Castellani family especially achieving technically brilliant results.

Filigree work is related to granulation, especially in that of the early periods. The term refers to fine wirework, either open or backed, and the technique has a wide geographical and historical distribution. It was used in Mesopotamia, Egypt and Ancient Greece, and by the Etruscans, and in the late 20th century it was still employed. The wires can be of plain rectangular section, twisted or beaded, but they are always flattened laterally. This not only increases the apparent delicacy of the piece but also aids construction. The normal method is to build up the design from a series of units, often repeated ones. Frames of slightly thicker wire are made to these shapes, which are then filled with units of smaller wires, tightly packed in place, with the work resting on a flat background such as a steel plate. The points of contact between the wires are painted with a paste made from finely divided solder and borax. The piece is then transferred to the hearth, and, when heated sufficiently, the solder melts and joins all the parts in one operation. Where the filigree is attached to a backing plate, the process is slightly easier, since the whole assembly can be handled safely. Ancient filigree is mainly of this type, and the parts are almost certain to have been joined by eutectic soldering. Most late 20th-century production in filigree is of the openwork type. While this is mainly of silver and Italian in origin, gold filigree is also practised, especially in the Islamic world, with much work being done by traditional methods in India and the Middle East.

Repoussé and chasing are two closely related techniques; indeed, they are really the same technique carried out from opposite sides of the metal. They are used to enrich the surface of a form with low- or high-relief designs, either raised up from the surface (repoussé) or pushed down into it (chasing). The normal method is to draw out the design on the surface of the metal and then set the piece into a pitch bowl. This is a heavy, hemispherical, cast-iron bowl filled with pitch. The pitch is mainly bitumen, combined with an organic resin known as Swedish pitch, linseed oil, tallow and brick dust or plaster of Paris. The proportions of the constituents depend on the working qualities needed. The surface of the pitch is heated until it begins to melt, at which point the metal is set into it. Using a hammer and punches, the metal is beaten down into the pitch, which both adheres to it and supports it, while allowing the metal to move and take up its new form. The piece can be

removed from the pitch and worked on from the other side, after having been annealed. Hollow vessels are often filled with pitch and worked from the outside. If they are sufficiently large, it is possible to work from the inside also, but in cases where this is not practicable a technique known as snarling is used. A snarling iron is a long slender stake, with its ends bent at right angles in opposite directions. One end is fixed in a vice, while the other, which is shaped like a small rounded hammer head, is placed inside the vessel, which is pressed down on it. The snarling iron is then struck with a hammer at a point near the vice, and the rebound pushes up an area of metal on the surface of the vessel. Although this is a rather crude process, in skilled hands it is quick and effective. The vessel can then be filled with pitch, and the design refined from the outside. This technique is widely used in the decoration of hollowware in both gold and silver.

Earlier work was done without the aid of metal tools, and possibly without pitch, but even without these, the properties of gold facilitate this method of decorating. Many ancient pieces seem to have been worked by pushing or rubbing them with wooden or bone tools into carved pieces of the same materials. A fine example, almost certainly produced by this method, is the pectoral ornament from Camirus, Rhodes (7th century BC; London, British Museum), which includes five almost identical plaques showing the goddess Artemis. There are individual differences between the plaques, but these are not inconsistent with such a method of production. The Greeks and Etruscans refined the technique further, probably making shaped bronze punches with which they hammered small, thin pieces of gold into some soft material, for example pitch or lead. This produced repeated units, which were then assembled to create a very rich appearance. An advantage of the process is that it strengthens the metal on the same principle by which corrugated iron gains its rigidity; thus, thin sections can be used with a reduced risk of damage.

Repoussé and chasing have been used wherever gold has been worked, and fine examples come from the very earliest cultures (e.g. the 'diadem' found by Heinrich Schliemann (1822–90) at Mycenae; 16th century BC; Athens, National Archaeological Museum). There was a great vogue for this type of decoration during the later Middle Ages in northern Europe, especially in Germany, where goldsmiths produced some particularly exaggerated examples. Gold pieces in England in the early 18th century were often richly decorated by this method, and many of the Art Nouveau and Arts and Crafts jewellers, for example René Lalique (1860–1945), Georges Fouquet (1862–1957) and Henry Wilson (1864–1934), used chasing and repoussé extensively in their designs. Late 20th-century jewellers and goldsmiths continued to employ the techniques, but the intensive labour involved has reduced their use.

An extension of the chasing technique, which was used particularly during the 18th century, is flat chasing. The metal is fixed to a solid, flat surface, a piece of steel for example, and worked on with very fine punches. By this means it is possible to create an effect almost indistinguishable from engraving. It is only really suitable for flat surfaces and therefore was mainly used for coats of arms on trays and salvers. Another related technique, somewhat cruder and of earlier origin, is punch-work, in which shaped punches are used repeatedly over the surface of a piece of gold to produce what can be a very rich pattern. The gold is supported on either a solid backing or a resilient one. Good examples of its use are the Mold Cape from Gwynedd (c. 1400 BC; London, British Museum) and the Gleninsheen Gorget (c. 700 BC; Dublin, National Museum of Ireland).

Engraving involves the use of small chisels to remove metal, the technique probably deriving from the designs scratched with sharp stones on to the surface of the earliest pieces of goldwork. A good example of this, and one of the earliest, is the lunula from Ross, Co. Westmeath (1800 BC; Dublin, National Museum of Ireland). With the advent of iron and steel tools, it became a widely used decorative technique, mainly for the enhancement of plain areas of metal. From the Middle Ages it was frequently used for the depiction of armorial bearings. A later development of engraving is engine-turning or guilloche work. Practised since the 16th century on such organic materials as wood and ivory, it was used on the precious metals from the mid-18th century. The cutting tool is connected to a geared holder on a complex lathe, which enables both the work piece and the tool to move in predetermined ways. Highly controlled designs, composed of identical but staggered lines, or of gradually changing lines or shapes, can be built up using these lathes. A very specialized technique, it can be employed on both flat and curved surfaces. It was very popular with goldsmiths from the late 19th century until World War II for such items as powder compacts and cigarette cases. Fabergé used guilloche work behind transparent enamels to achieve iridescent and silk-like effects.

Carving is related to engraving, but larger amounts of metal are removed. Some early methods probably evolved in parallel with those for carving organic materials, as well as for stone. One such is chip-carving, where a small chisel is hammered towards a central point from three or four directions, thereby removing a chip of metal. This leaves a deep triangular or rectangular recess made up of flat facets. Sometimes carving is used to create recesses that are to be filled with such other materials as enamel or niello. The latter is a black or dark silvery-grey material used as an inlay to contrast with gold. It is usually a mixture of silver, lead and sulphur, the exact proportions of which vary. The resulting compound is applied to the hot metal in granular form and worked down into the recesses with a spatula. Once cool, the surface is smoothed out and polished to give a crisp contrast between the gold and the niello. The technique has been used extensively throughout Europe and Asia and continues to be used in such places as Morocco, Thailand and Russia.

(iv) Gilding. Gold is frequently used to decorate works made of other metals, and this is known as GILDING. Various methods have been used in the past, the commonest being mercury amalgam or fire-gilding (see GILDING, §I, 3). With this technique, it is possible to leave areas of the object ungilded, a practice that is known by the medieval term 'parcel gilding'. Since the late 19th century ELECTROPLATING has been the main gilding process. When gold is applied to non-metallic materials, it is also called gilding, but this is done using gold leaf: extremely thin gold sheets hammered out to thicknesses of 0.0001 mm or less (see GILDING, §I, 1). Panel paintings and many interior artefacts such as furniture, frames, plasterwork and decorative carvings have been enhanced by gilding with gold leaf, as have such external features as wrought-iron gates, copper roofs and the inscriptions on monuments.

Theophilus: *De diversis artibus* (MS.; *c.* 1123); ed. and trans. by J. G. Hawthorne and C. S. Smith (Chicago and London, 1963, 1979)

B. Cellini: *I trattati dell'oreficeria e della scultura di Benvenuto Cellini* (1568); Eng. trans. by C. R. Ashbee as *The Treatises of Benvenuto Cellini on Goldsmithing and Sculpture* (London, 1888/*R* New York, 1967)

R. Turner: *Contemporary Jewelry* (London, 1975)

A. K. Snowman: *Fabergé, 1846–1920* (London, 1977)

W. Bray: *The Gold of El Dorado* (London, 1978)

O. Untracht: *Jewelry Concepts and Technology* (New York, 1982)

G. C. Munn: *Castellani and Giuliano* (London, 1984)

M. Grimwade: *Introduction to Precious Metals* (London, 1985)

R. F. Tylecote: *The Pre-History of Metallurgy* (London, 1985)

Wenzel Jamnitzer und die Nürnberger Goldschmiedekunst 1500–1700 (exh. cat., Nuremberg, Germanisches Nationalmuseum, 1985)

V. Becker: *The Jewellery of René Lalique* (London, 1987)

T. Osterwold, ed.: *Das goldene Zeitalter: die Geschichte des Goldes vom Mittelalter zur Gegenwart* ([Stuttgart], 1991)

T. B. Schroder: *The Gilbert Collection of Gold and Silver* (Los Angeles, 1988)

J. P. Fallon: *Marks of London Goldsmiths and Silversmiths, 1837–1914* (London, 1992)

P. G. Guzzo: *Oreficerie dalla Magna Grecia: Ornamenti in oro e argento dall'Italia meridionale tra l'VIII ed il I secolo* (Taranto, 1993)

K. A. Citroen: *Dutch Goldsmiths' and Silversmiths' Marks and Names Prior to 1812* (Leiden, 1993)

L. H. White: *The History of Gold and Silver*, 3 vols (London, 2000)

S. W. Soros and S. Walker, eds: *Castellani and Italian Archaeological Jewelry* (New Haven and London, *c.* 2004)

Y. Egami: 'Materials for "Gold" and "Silver" Tints in Pictorial Ornamentation of Twelfth-century Japanese Manuscripts', *Scientific Research on the Pictorial Arts of Asia*, eds P. Jett, J. Winter and B. McCarthy (London, 2005)

Gouache [bodycolour]. Commercially manufactured opaque watercolour paint popular with designers, illustrators and airbrush artists. The term also, and more correctly, refers to the use of opaque watercolours in a loosely defined area of technique and the materials and effects associated with such painting. Gouache, also called bodycolour,

is simply water-based paint rendered opaque by the addition of white paint or pigment (e.g. Chinese white) or a white substance, such as chalk or even marble dust. It is an evolved form of TEMPERA paint, descended from distemper. The application of the term gouache is often imprecise, but it is most often associated with colours bound in glue-size or gum. The commercial product varies considerably. It is usually bound with gum arabic or dextrin. An inferior version is known as poster colour or poster paint. Gouache produces flat, matt, even colour, and, being thinned with water for use, it is a convenient and quick medium to employ, hence its continuing popularity with designers and illustrators.

The history and evolution of gouache are vague, as its characteristics are common to several types and traditions of painting. Ancient Egyptian wall paintings and Indian miniatures, for example, answer to its general description. Although in Western art it is associated at first with tempera painting and manuscript illumination, it is reasonable to assume a wider use, perhaps of considerable antiquity. The tapestry cartoons of the *Lives of SS Peter and Paul* (1515–16; British Royal Collection, on loan to the Victoria and Albert Museum, London) by Raphael (1483–1520), can quite reasonably be described as gouache paintings, as can the watercolour studies of the *Young Hare* (1502) and *Large Piece of Turf* (1503; both Vienna, Graphische Sammlung Albertina) by Albrecht Dürer (1471–1528). From the 16th to the 18th century gouache is represented by the bodycolour of the limner or miniature painter and by the decorative use of distemper. It then emerged as a rediscovered medium, perhaps associated in some way with the development of pastels and transparent watercolours during the 18th century. It was certainly combined with these materials from that point onwards. In the 20th century it was used by Henri Matisse (1869–1954) (e.g. *The Snail*, 1953; London, Tate).

See also WATERCOLOUR.

R. Mayer: *The Artist's Handbook of Materials and Techniques* (London, 1951, rev. 5/1991)

M. B. Cohn: '*Wash + Gouache': A Study of the Development of Materials of Watercolour* (1939/*R* Cambridge, MA, 1977)

J. Stephenson: *The Materials and Techniques of Painting* (London, 1989)

Gouache manner [Fr. *gravure en teinte aux outils*]. Type of copperplate-engraving process that attempts to imitate a gouache or watercolour drawing. It unites detailed tool work on the copper (creating a very tight network of dots and short strokes) with colour printing using four or more plates. The tints of the original drawing are reproduced by printing primary colours in superimposed layers, and shading is created by having a background delicately worked with a battery of tools. The technique was allegedly begun by Jean-François Janinet (1752–1814) in 1771, but in fact he merely synthesized the inventions of others (*see* §2 below).

1. MATERIALS AND TECHNIQUES. The main contours of the subject to be reproduced are etched on an initial plate. From this first plate proofs are pulled that will be used as counterproofs on the other plates to ensure exact superimposition. Three other plates similarly prepared are then engraved or, less often, etched according to the colour they will carry. The copper is left intact in the parts in which colour is not to appear and hollowed out to a greater or lesser depth according to the desired shade. When a pure colour is to appear in the final print, the copper is worked more.

The tools used are those employed for the CRAYON MANNER: chasing tools; mattoirs with points that are generally sharper than those used in crayon manner, and called mushrooms; mattoirs with roller wheels; and also more traditional instruments (burins, engraving needles, scrapers, burrcutters, burnishers). (The engraver Laurent Guyot's inventory after his death in 1808 included 157 mushrooms and 23 roulettes of various sizes.) The aim is to create a network of dots and shading traditionally obtained by mezzotint, and from the 1760s by aquatint, with very dense work executed directly on to the copper. Although a longer process, it has the advantage of responding more precisely to the needs of the engraver, who can, in reworking the copper, blend tones, join them together, take up preliminary sketches, increase their liveliness by further hollowing out the dots or decrease it by using a burnisher.

The plates worked in this way are coated with coloured inks and then pulled, one after the other, fixed in place by a pin in the traditional order: yellow, red and blue; a supplementary plate for carmine or white highlights can also be used. The inks must be relatively transparent in order to blend when superimposed. However, all the gradations of tone, the shadows and highlights, are given by the fourth plate pulled in black ink. Usually it is the first plate on which the contours have been engraved that is reworked using the same tools. The plate pulled in black is the basis of the engraving; in the rare places in which the colour has to remain pure, it is left intact, the half-tones marked by less deeply cut and finer dots, the darker tones by more concentrated work applied to the shadows on the brown made up of the three superimposed primary colours.

In relation to other techniques of multiple-plate engraving, mezzotint or aquatint, the use of tools for gouache-manner engravings allows the engraver to master his gradations of tone better and above all to take advantage of good proofs, since copper worked in this way wears out less quickly. Long and meticulous work is, however, needed, which some methods can accelerate. Numerous engravers use resin aquatint, at least to prepare their plates before finishing the work with their tools. It is not always easy in the final proof to distinguish the respective parts played by chemical and mechanical processes, and as intermediate stages have not been preserved, specialists freely debate the technique used. Likewise, to reduce the number of plates to be engraved, some artists use the ink-and-dauber method (also known as à la poupée). This consists of arranging the colours on a single plate with a small rag, called 'doll' (or dauber) by French publishers. The print is then printed in a single pull. The difficulties posed by superimposing primary colours, arranged on several plates, each engraved in relation to the others, are therefore eliminated, but the quality of the print henceforth depends on the printer and not on the engraver. Inking with a dauber is often linked to a more simple use of engraving with tools: stipple (see STIPPLE, §1). To gain time, some engravers use multiple-plate printing in conjunction with the dauber.

2. HISTORY. Colour printing with three or four plates had been discovered at the beginning of the 18th century by Jacob Christoph Le Blon (1667–1741) who had sought to apply the colour theory of Isaac Newton (1642–1727) to the field of engraving. After commercial failure in Britain, he travelled to France in 1734 and on 12 November 1737 obtained an exclusive privilege from Louis XV, King of France (reg 1715–74), lasting 20 years, to publish colour prints. He used four plates (although he only admitted to using three) engraved in mezzotint and aspired to imitate oil painting. After his death, his privilege passed to Jacques-Fabien Gautier-Dagoty (1716–85), who used it only to engrave a few anatomical plates. The process had only limited success, aroused more by curiosity than by admiration. The exclusive privilege of Le Blon, and then of Gautier-Dagoty, theoretically forbade any other engraver to publish his prints using their method until 1757; furthermore, its basis was mezzotint, generally scorned in France for its lack of vitality and for the small number of proofs that could be pulled. Few engravers were therefore in a position to use it, owing to lack of experience.

Interest in work with tools on copper, designed to create a dense network of irregular dots, had been aroused through the discovery in 1757 of crayon-manner engraving. Jean-Charles François (1717–69), the inventor of this technique, tried as early as 1758 to reproduce the effect of wash with aquatint, to which he added finishing touches with the tools used for crayon manner: roulettes and mattoirs. These investigations had been taken up by Louis-Marin Bonnet (1736–93), who had added to working on copper with tools the use of multiple-plate printing, notably in his pastel-manner engravings. However, he sought more to juxtapose than superimpose his colours and coated some of his plates with different-coloured inks manually, with a dauber. Jean-François Janinet worked in Bonnet's studio in 1771, the date at which the latter brought out two small unsigned colour prints imitating watercolour after Clément-Pierre Marillier (1740–1808), The Procurator and The Tailor (Hérold, nos 35.2, 35.3), printed with four plates. Janinet was probably the author, and in 1772 under his own name he brought out two prints,

The Operator and *The Meeting* (*Inventaire du fonds français*, nos 1, 2), after Peter-Paul Benazech (*c.* 1730–after 1783), in the margin of which he declared himself the inventor of engraving 'imitating coloured wash'. Relegating his roulettes to second place, he had made some finer-grained mattoirs, also known as mushrooms, but he virtually never used chemical aquatint. Like Bonnet, and in contrast to Gautier-Dagoty and Le Blon, he would leave the plate inked in black to be pulled last. He was also astute enough to demand of multiple-plate engraving that it should try to render the effect not of paintings but of gouache drawings or, with a finer web and more transparent inks, watercolours. He specialized in the 'gallant' subjects that Pierre-Antoine Baudouin (1723–69) had made fashionable and that Niclas Lafrensen (1737–1807) gave him, and the landscapes drawn by Pierre Antoine de Machy (1723–1807) and Hubert Robert (1733–1808). The general vogue for this type of engraving encouraged many artists. In Paris the most famous were Charles-Melchior Descourtis (1753–1820), a pupil of Janinet, Laurent Guyot (*c.* 1575–after 1644) and above all Philibert-Louis Debucourt (1755–1832).

In Britain coloured stipple engravings were occasionally produced with several plates, more often inked with a dauber. The fame of such artists as William Wynne Ryland (1732–83) and Francesco Bartolozzi (1727–1815) quickly spread to France, where their prints after Angelica Kauffman (1741–1807) were immediately snatched up. Louis Marin Bonnet attempted to exploit their popularity; from 1777 he published 'English prints' in colour, stipple engraved, with titles and inscriptions in English (and sometimes false signatures of these masters), but printed with several plates and not with a dauber. From 1778, while continuing his imitations, he also published several gouache-manner prints. In 1775–85, in a desire to take advantage of the vogue for colour prints, Jacques-Fabien Gautier-Dagoty and his sons also published several reproductions of paintings engraved in mezzotint and printed in four colours, according to Le Blon's method; they had little success, however, for the public was used to seeing gouaches rather than oil paintings reproduced in colour.

It was not until Philibert-Louis Debucourt that the number of engraving techniques successfully increased. He had no doubt learnt from Laurent Guyot, between 1782 and 1785, the technique of engraving with tools. As a painter and draughtsman he engraved mainly from his own compositions and felt the need to vary his technique in order to reach a more exact equivalence between his originals and his prints. Through using more delicate instruments, he developed engraving in the wash manner, but above all he did not hesitate to take up mezzotint (e.g. *Broken Jug*, 1787; *Inventaire du fonds français*, no. 8), aquatint engraving with resin (e.g. *Crossing*, 1792; *Inventaire du fonds français*, no. 23), swiftly completed by working with tools (e.g. *Public Promenade*, 1792; *Inventaire du fonds français*, no. 26). In this last type of engraving, aquatint allowed him to lay in the main areas of the composition, and tools then served to soften, accentuate or vary the tones.

With the French Revolution (1789–95), scenes of gallantry, the topic most often reproduced in engravings, passed out of fashion; moreover, the market diminished for lack of custom, and finally the predominance of drawing over work in colour was once more reaffirmed. Engravers therefore sought to simplify their work, and more of them adopted inking with daubers, which required only one engraved plate. The British techniques did, however, develop, better adapted to this type of inking: mezzotint and stipple engraving. Sometimes there was even a reversion to the traditional use of manuscript illumination of a simple etched line. Engravers still faithful to multiple plates tended, following Debucourt, to prepare their plate with chemical aquatint. Genre scenes and even portraits continued to be engraved, but increasingly colour printing was reserved for illustrating scientific works, such as the flower books by Pierre-Joseph Redouté (1759–1840), *Liliaceae* (Paris, 1802–16) and *Roses* (Paris, 1817–24). Gouache-manner engraving survived during the first third of the 19th century without recovering the status it had enjoyed at the end of the Ancien Régime. It disappeared only after the invention of colour lithography by Godefroy Engelmann (1788–1839) in 1837.

J. Frankau: *Eighteenth-century Colour Prints* (London, 1900)

Les Procédés de gravure: Exposition Debucourt (exh. cat. by A. Vuaflard and J. Hérold; Paris, Musée des Arts Décoratifs, 1920), pp. 65–124

J. Hérold: *Louis Marin Bonnet (1756–1793): Catalogue de l'oeuvre gravé* (Paris, 1935)

Inventaire du fonds français: Graveurs du dix-huitième siècle, vi (Paris, 1949), xii (Paris, 1973)

V. Carlson, J. W. Ittman and others: *Regency to Empire, French Printmaking, 1715–1814* (Baltimore, 1984)

O. M. Lilien: *Jacob Christoph Le Blon, 1667–1741: Inventor of Three- and Four-colour Printing* (Stuttgart, 1985)

A. Griffiths: 'Notes on Early Aquatint in England and France', *Print Quarterly*, iv (1987), pp. 255–70

J. C. Walsh: 'Ink and Inspiration: The Craft of Color Printing', *Colorful Impressions: The Printmaking Revolution in Eighteenth-century France* (exh. cat. by I. E. Phillips and others; Washington, DC, National Gallery of Art, 2003–4), pp. 23–33.

Grangerize. Term applied in its strictest sense to the practice that became fashionable in England towards the end of the 18th century of collecting portrait prints and adding them as extra illustrations to a text. It began after the Rev. James Granger published the *Biographical History of England from Egbert the Great to the Revolution … Adapted to a Methodical Catalogue of Engraved British Heads* (1769; suppl. 1774). The term is also sometimes associated with any album (no matter what subject) that has been extra-illustrated.

T. Parkin: *On the Grangerizing and Bowdlerizing of Books* (n.p., [1923?])

M. Pointon: *Hanging the Head: Portraiture and Social Formation in Eighteenth-century England* (New Haven and London, 1993), pp. 53–78

Graphite [black lead; plumbago]. Crystalline allotropic form of carbon, used primarily as a drawing material, in the form of a PENCIL. It is a friable substance, composed of flat, flaky grains, which are transferred to the surface of the support (usually paper) as the artist draws and impart a delicate sheen to the strokes. Synthetic graphite, which has been produced commercially since 1897, is obtained from carborundum.

Graphite was first excavated in Bavaria in the early 13th century, but its potential as an artists' medium remained unexploited until the discovery in the mid-16th century of pure graphite at Borrowdale in Cumbria, England. The Borrowdale mine was in full operation by the 1580s, when native graphite was taken from the mine, sawn into sheets and then into slender square rods forming the 'lead' and then encased in wood to form the pencil. Graphite seems to have been used first for underdrawing in the 16th century, supplanting the leadpoint stylus from which the term 'lead' pencil probably derived. Graphite does not seem to have been commonly used for drawing until well into the 17th century, and even though it was gaining popularity, black chalk and charcoal were still favoured for either preliminary sketches or finished drawings up to the 18th century. Graphite became widespread only in the 18th century, with the increasing difficulty of obtaining good-quality natural chalks and the simultaneous production of a fine range of graphite pencils. The medium still remains very popular today.

A. P. Laurie: *The Painter's Methods and Materials* (Philadelphia, 1926/*R* New York, 1967)

R. J. Gettens and G. L. Stout: *Painting Materials: A Short Encyclopaedia* (New York, 1942, rev. 1966)

J. Watrous: *The Craft of Old-Master Drawings* (Madison, 1957)

M. Lefebure: *Cumberland Heritage* (London, 1970)

H. Petroski: *The Pencil: A History* (London, 1990)

M. Finlay: *Western Writing Implements in the Age of the Quill Pen* (Wetheral, 1990)

K. Nichols: 'Turner's Use of Graphite Underdrawing in his Watercolor Cassiobury Park, Hertfordshire', *Master Drawings*, xl/4 (Winter 2002) pp. 299–304

M. Wagner, D. Rübel and S. Hackenschmidt: *Lexikon des künstlerischen Materials: Werkstoffe der modernen Kunst von Abfall bis Zinn* (Munich, 2002)

Graver. *See* BURIN.

Grisaille [Fr.: 'grey in grey painting']. Term applied to monochrome painting carried out mostly in shades of grey. The use of the French word can be traced only to 1625, since although grisaille painting was done in preceding centuries, it was not referred to as such. The alternative expression *peinture en camaïeu (gris)* is also documented only more recently. In the 16th century there are occasional references to 'dead colour', but this term is no longer used. At the time of its origin, in the medieval period, grisaille painting was simply called 'painting in black and white', as is clear, for example, from an entry in the inventories of Jean de France, Duc de Berry, of 1401, 1413 and 1416: 'Item, unes petites heures de Nostre Dame … enluminées de blanc et de noir'. However, this description is not very precise, as grisaille painting was never merely black and white but was always combined with (more or less sparingly used) colours. The term 'grisaille', as commonly used today, itself only inadequately describes the various modes it subsumes. Their only common feature is the more or less exclusive use of non-coloured pigments, while they diverge technically and aesthetically to an often astonishing extent.

1. Before *c.* 1400. 2. From *c.* 1400.

1. BEFORE C. 1400.

(i) Stained glass. (ii) Wall painting. (iii) Manuscript illumination. (iv) Other portable paintings.

(i) Stained glass. Probably the oldest form of grisaille in Western art appeared in stained-glass painting in the 12th century. Following the prohibition on colour issued by the Cistercian Order in 1134, artists in Cistercian monasteries were restricted exclusively to interlaced windows in clear glass with (black) lead stripes and black enamel drawing. Despite all the prohibitions, however, small amounts of coloured glass were soon introduced (e.g. in a window of *c.* 1210 in La Bénisson-Dieu, Loire). Perhaps as a result of this shift from rigorous severity to aesthetic charm, grisaille glass painting enriched with some colour also gained importance outside the Order in the course of the 13th century. In the third quarter of the century, grisaille windows were standard fittings in French churches, where they often alternated with polychrome figural panes. Occasionally the whole glazing of a church was done with grisaille windows, or they were given at least a prominent place in combination with figural depictions, as a contrasting frame. Among the earliest examples of this use of grisaille are the windows (*c.* 1270) of the church of St Urbain, Troyes. Hand in hand with the dominance of grisaille glass with coloured inserts went a change in the use of colour in figural glass painting. The strong reds and blues of the early 13th century were replaced by more delicate and transparent tones, but there were still no figural windows that even approached a monochrome treatment.

The preconditions for monochrome figural glass painting were created around 1300, with the development of the technique of silver stain painting (*see* STAINED GLASS, §1, iv), which made it possible to stain a pane in any colour, usually transparent and with a yellow tone. In this way a glass surface could be painted in two colours without the need for lead strips (to hold the different-coloured pieces together). This meant an enormous increase in the artistic qualities of a painted window, which also profited from new, more subtle black enamel techniques. This advance, however, was not adequately exploited either in France or in the neighbouring countries during the whole of the 14th century. While the white and

silver-stained parts took an important place within figure depictions from the second quarter of the century, they seldom made up the whole painting. One of the few surviving exceptions is a strip in the lower part of an older window in Chartres Cathedral, donated by a Canon Thierry in 1327. The figures (the Virgin with saints and the donor), exclusively in white, grey and silvery yellow, are seen against an ornamental grisaille background, which (like all patterned grisaille windows painted with a silver-stain) no longer has an interlace pattern but one of irregularly strewn flowers and leaves. Because of their rarity, figural grisaille windows such as this one should be seen as reflecting developments in other genres. Not until the 15th and 16th centuries did they become established as the dominant element within their own medium, often in conjunction with a Renaissance treatment of figures and landscape, which thus shows them to be innovations drawn from other branches of art.

(ii) *Wall painting*. The origin of monochrome figure painting is to be found in Italian wall painting. Between 1303 and 1306 Giotto (1267/75–1337) painted the stone-coloured allegories of the *Virtues* and *Vices*, conceived as statues facing each other in fictive niches on the walls of the nave, in the dado area of his fresco cycle in the Arena Chapel in Padua. Their monochrome, which can be referred to only in part as grey (apart from lime white and vegetable black, earth pigments such as terra verde and ochre were used), is the colour of the material of which they appear to consist. Though opinions differ slightly on this point, it seems most likely that neither a systematic abstraction of form from colour, nor an autonomous artistic method was intended, but that monochrome painting here is used just as a means of reproducing stone. The allegories, subordinated by their stone quality to the coloured (and therefore more lifelike) figures in the scenes from the *History of Salvation*, have nonetheless the highest degree of reality within the picture programme because of their illusionistic presentation.

Simultaneously with Giotto's illusionistic sculptures, painted statuettes appeared in the internal context of pictures, as in the images of the cycle of the *Legend of St Francis* (Assisi, Upper Church of S Francesco) and in the scenes from the *History of Salvation* in the Arena Chapel; precedents of these internal grisailles can be found in Byzantine painting. They too are painted entirely in monochrome and thus, like the allegories, do not follow the usual polychrome appearance of contemporary sculpture. The stone colour clearly served to distinguish them from the painted living persons and to define them as of the same material as the painted architecture.

Surprisingly, few works produced in the following years of the 14th century have this sculptural character. The grisaille painted statues of prophets (?*c.* 1340) in the refectory of the abbey of Pomposa, near Ferrara, are an exception. Giotto's innovations were modified in two ways: either figures presented in a sculptural manner were painted in colour, which made it unclear whether they were intended as painted statues or living beings, or the stone character of monochrome figures was relativized by showing them in non-sculptural and sometimes quite incongruous settings. Examples of the latter are the vault paintings (*c.* 1328) in the Baroncelli Chapel in Santa Croce, Florence by Taddeo Gaddi (*d* 1366), in which monochrome figures (also allegorical) float in fictitious openings in the ceiling in a quite unsculptural manner. Moreover, grisaille painting increasingly appeared only in thematically or formally subordinate areas and would thus have been considered inferior to polychrome painting, which was not true to the same extent of Giotto's relatively large allegories painted as a *trompe loeil*.

(iii) *Manuscript illumination*. French manuscript illumination established itself as another field for grisaille in the first half of the 14th century. The first surviving manuscript illuminated entirely in this technique is the Hours of Jeanne dEvreux (New York, The Cloisters, MS. 54.1.2), attributed to the Paris illuminator Jean Pucelle (*fl c.* 1319–34). The miniatures already show the distribution of colours that was to be adhered to in *camaïeu* painting throughout the 14th century: only the garments of the figures are monochrome grey, while the background and the (still relatively few) architectural and other backdrops have undergone varying degrees of colour treatment. Although the drawn architectural frames and the enamel-like backgrounds recall other genres (such as goldsmiths' work), suggesting a kind of media-specific context, the grisaille figures, unlike Italian monochrome paintings, were clearly intended from the outset not to seem made from a particular material such as marble or ivory. Rather, the many allusions to other, highly prized art forms lend the miniatures of this manuscript—and thus the technique of grisaille—an aura of extreme value and refinement. That grisaille retained this aura, so that the *camaïeu* technique became synonymous with something rare and precious, is shown by its further application in French manuscript painting: it was generally used only in first-class manuscripts often intended for the highest stratum of patrons, without any allusion to other media. The quality of its surface did not allow associations with particular materials. The modelling was produced solely by applying a more or less thinned black pigment with sparing white heightening.

Grisaille painting should not be confused with drawing: whereas drawings in the 14th century were either given a coloured wash or hatched, *camaïeu* modelling was applied with a fairly dry brush and rather dense pigment. Unlike drawing, which reproduces without colour a depiction that is in principle thought of as coloured as a kind of abbreviation or which unmistakably indicates the polychromy of the protagonists by delicate tinting, in the *camaïeu* image it is the figures that are in grisaille and are unavoidably seen in monochrome in contrast to their polychrome surroundings.

(iv) Other portable paintings. Grisaille was also used for 14th-century panel paintings, though far less frequently and only in special cases, as in two paintings with scenes from the *Apocalypse* produced in Naples (both *c.* 1340; Stuttgart, Staatsgalerie). Although these works were not painted with grey, but rather with brownish pigments on white chalk priming, the manner of application and the effect are essentially the same as the techniques used for grisaille manuscript illumination. Grisaille was given a somewhat different interpretation in works on cloth. Thus the *Parement de Narbonne* (*c.* 1375–80; Paris, Musée du Louvre), painted on silk exclusively in modulations of black, may have been a Lenten veil, so that its lack of colour is explained by its function. Here French *camaïeu* painting, usually regarded as having a positive value in itself, is reinterpreted as a deliberate renunciation of colour. However, merely the exquisite execution of such works suggests that grisaille was also chosen for aesthetic reasons and not only for ascetic ones.

2. FROM *c.* 1400. The 15th century, with its stylistic innovations, brought changed conditions for grisaille painting. This applies primarily to panel painting. In manuscript painting, despite the stylistic advances, the basic concept and meaning of grisaille were unchanged, though its status declined.

(i) Imitating stone and other materials. (ii) Other artistic aims.

(i) Imitating stone and other materials. In the Netherlands, in particular, the relatively new field of the winged altarpiece brought with it a reappraisal of monochrome in terms of form and content and an apparent return to Giotto's concept of 'stone painting'. Like the latter, Netherlandish grisaille appeared in two variants: as an autonomous sculptural image presented illusionistically on the outer faces of winged altars (i.e. in a similarly 'marginal' zone to the stone paintings of Italy) and as sculpture inserted into polychrome scenes. The so-called 'arch motif' has a special place: it is a painted architectural frame filled with statues, as in the altar of *St John* (after 1450; Berlin, Gemäldegalerie) by Rogier van der Weyden (*c.* 1399–1464), which was intended as an internal part of the picture but also had a mediating role with the beholder's reality and was thus brought closer to the autonomous sculptural image. The somewhat more illogical use of painted stone images on the outer sides of wooden altarpieces, as compared to their role in Giotto's frescoes, was counterbalanced by the perfect illusionistic rendering of their surface and their convincing presentation on socles and in niches. The earliest surviving examples are deliberately presented as statue images, as on the lower outer wings of the Ghent Altarpiece (*c.* 1423–32; Ghent, St Bavo) by Hubert van Eyck (*c.* 1385/90–1426) and Jan van Eyck (*c.* 1395–1441); on the outer panel of the *Marriage of the Virgin* (*c.* 1425; Madrid, Museo del Prado) by the Master of Flémalle (*fl c.* 1420–*c.* 1440); on the outer wing of Jan van Eyck's triptych with the

Virgin and Child (1437; Dresden, Gemäldegalerie Alte Meister); and in his diptych with the *Annunciation* (*c.* 1435–40; Madrid, Museo Thyssen-Bornemisza). Yet even in these cases—not unlike the situation in Italian monochrome painting—a disconcertingly living quality cannot be denied and has even given rise in the literature to the term 'living stones'; in extreme cases, this could entirely nullify the sculptural character of the grisaille figure.

As in the 14th century, two directions in the transformation of stone painting can be discerned: either the monochrome figures show a more or less unstatuesque agility in a context that is not expressly made for pieces of sculpture and may even be coloured; or (partly) coloured figures appear in monochrome surroundings or are presented in a deliberately sculptural way. One of the few examples of the last variant is the depiction of the prophet *Jeremiah* by the Master of the Aix Annunciation (1443–5; Brussels, Musée dArt Ancien), in which the fully coloured figure stands in a statuesque pose on a fictive stone plinth in a fictive stone niche (enriched with coloured objects), so that its sculptural quality is not quite lost despite its polychromy. Much more frequent, however, is the first variant; nearly monochrome figures were given a degree of life that blurred their character as creatures of stone. For example, in the *Annunciation* on the outer sides of the wings of the Bladelin Altarpiece (*c.* 1450; Berlin, Gemäldegalerie) by Rogier van der Weyden, the frames have lost their character as niches and the figures their socles, so that there is no compelling association with sculpture, despite the stone-colour.

Between these two extremes there are various intermediate stages; monochrome figures presented in a sculptural context with only a hint of life are the most frequent. In addition, grisaille images with little resemblance to the appearance of stone and even somewhat reminiscent of the *peinture en camaïeu* of manuscript illumination were produced at a relatively early stage. Among the comparatively few examples of this variety are Rogier van der Weyden's *Crucifixion* diptych (*c.* 1450; Philadelphia, PA, Museum of Art) and the slightly later *Crucifixion* panel (*c.* 1455–6; Madrid, El Escorial). That it was themes of this kind that were painted *en camaïeu* appears to confirm the idea that the striking success achieved by grisaille in Netherlandish panel painting is to be explained at least in part by an almost liturgical use of 'ash colour', a use ultimately reserved for Lent. However, neither Italian stone painting nor French *camaïeu* painting admits such a negative interpretation, a fact that should be borne in mind in assessing Netherlandish statue images, and indeed recent scholarship has begun to distance itself from this somewhat one-sided view.

The Netherlandish variant of grisaille painting established itself in neighbouring France and Germany. French works tended towards a sculptural approach, as in the outer side of the *St Bertin* altarpiece (*c.* 1454–9; Berlin, Gemäldegalerie) by Simon Marmion (*c.* 1425–89) or the outer sides of the wings of the triptych of

Moses (1476; Aix-en-Provence Cathedral) by Nicolas Froment (*fl c.* 1460–*d* before 1484). In Germany examples of a fairly independent use of the technique appeared at an early stage, perhaps due to the hierarchy of genres prevalent there (real sculptures inside reliquaries, paintings on their outsides). The retable (*c.* 1450; Munich, Alte Pinakothek) by the Master of the Tegernsee Altar (*fl c.* 1440–60) shows grisaille figures at the centre of the panel, flanked by monochrome saints presented in a sculptural manner and small grisaille-coloured statuettes in frames, the degree of life in the figures rising in inverse proportion to the use of colour. There were also in Germany, until well into the 16th century, depictions of statues on the outer sides of altarpiece wings. However, some of them are treated in an extremely painterly and living manner, such as the saints in the Heller Altarpiece (*c.* 1509; Frankfurt am Main, Städelsches Kunstinstut und Städtische Galerie) by Matthias Grünewald (*c.* 1475/80–1528), which are directly based on the Netherlandish tradition.

In Italy, too, the most diverse variants of monochrome painting can be traced in the 15th century. The primary opportunity for grisaille remained monumental wall painting. Grisaille is found in this medium and—though fairly infrequently—in paintings on panel and canvas. Examples of the use of grisaille to imitate sculpture are the painted monuments in Florence Cathedral showing *Sir John Hawkwood* and *Niccolò da Tolentino on Horseback*, executed by Paolo Uccello (*c.* 1397–1475) in 1436 and Andrea del Castagno (1419–57) in 1456 respectively or the fictive reliefs painted on small-format canvases by Andrea Mantegna (1430/31–1506), for example the *Sacrifice of Abraham* (*c.* 1490; Vienna, Kunsthistorisches Museum) or *Samson and Delilah* (late 1490s; London, National Gallery). In contrast, the *Crucifixion* fresco (1445) in the Palazzo Comunale at Arezzo by Parri Spinelli (1387–1453) or the frescoes (*c.* 1523) in the Chiostro dello Scalzo in Florence by Andrea del Sarto (1486–1530) show a purely painterly use of monochrome painting, as became more usual in the north, too, after 1500. Many of these works can no longer be read as depictions of statues, not only because the sculptural context, such as a niche, is lacking but because of the extreme spatial depth of their conception. In them, grisaille appears as a pure abstraction of form from colour, an autonomous artistic method without significance for the interpretation of the subject-matter.

Nevertheless, the explicit imitation of stone continued to play an important role, though one that was increasingly subordinate to polychrome painting. In the large fresco programmes of the 16th, 17th and 18th centuries it helped to spread illusionism to painting in colour; until that time it had essentially been confined to grisaille. The polychrome prophets and sibyls (1508–12) by Michelangelo (1475–1564) on the ceiling of the Sistine Chapel in Rome are placed between grisaille figures appearing like reliefs or caryatids on pilasters and are thrust by them into the beholder's space. The case is similar with the frescoes (1597–1600) of the Galleria of the Palazzo Farnese in Rome by Annibale Carracci (1560–1609) or the wall paintings (1561–2) in the Villa Barbaro in Maser by Paolo Veronese (1528–88).

Even in easel paintings the imitation of sculpture enjoyed increasing popularity in the following centuries. It developed into a bravura piece with which artists achieved astonishing *trompe loeil* effects, as did Jacob de Wit (1695–1754) in his oil painting of *Vertumnus and Pomona* (1752; Paris, Musée des Arts Décoratifs) or Jean-Josèphe Delvigne (*fl c.* 1770) in his picture *The Bronze Serpent* (Paris, private collection). Grisaille was used not only to render stone illusionistically, it could even imitate other media such as prints, as in the *Wandering Musicians* (*c.* 1760–70; Dijon, Musée des Beaux-Arts) by François-Xavier Vispré (*c.* 1730–89), which depicts a torn reproductive engraving under broken glass after a painting by Adriaen van Ostade (1610–85). Despite their technical perfection, such works were mainly curiosities that could no longer match the astonishing prestige attained by grisaille painting in the 14th and 15th centuries.

(ii) Other artistic aims. Grisaille painting was also used for purposes other than imitating stone and other materials, though increasingly these were of a practical nature. For example, it was adopted for preparatory oil sketches that preceded finished (coloured) paintings by the same artist in order to clarify the distribution of light and shade, as in the oil sketch (*c.* 1590; Oxford, Ashmolean Museum) by Federico Barocci (*c.* 1535–1612) for the altarpiece of the *Virgin and Child with St Dominic* (the 'Madonna del Rosario', finished *c.* 1593; Senigallia, Palazzo Vescovile); it could also be used for the modello for a reproductive print to be executed by someone other than the author of the sketch: Peter Paul Rubens (1577–1640) provided numerous such grisaille modelli, for instance the *Christ Carrying the Cross* (*c.* 1623; Berkeley, CA, University of California, University Art Museum). Acting as links between polychrome paintings and engravings, such monochrome oil sketches helped the engraver to translate the different colours into tonal values, as in the oil sketch of *Carlo and Ubaldo See Rinaldo Conquered by Love for Armida* (*c.* 1634–5; London, National Gallery) by Anthony van Dyck (1599–1641), with its squared grid for transfer clearly visible.

In the 19th century grisaille paintings were also used as preliminary studies for various book illustration techniques, such as photogravure and even photography, since it was recognized that coloured models did not produce the modulations of grey needed for black-and-white photography. An example is the oil painting of the *Fairman Roger's Four-in-Hand* (1899; St Louis, MO, Art Museum) by Thomas Eakins (1844–1916), which was intended to be photographed for a publication on carriage-driving. A similarly close connection with black-and-white photography, though of a quite different kind, is found in monochrome photorealistic paintings such as the monumental portrait of *Phil* (1969; New York,

Whitney Museum of American Art) by Chuck Close (*b* 1940), which uses, and estranges, grisaille in an entirely new way as a media-orientated *trompe loeil*. Admittedly, such examples do not exhaust the important role played by monochrome painting in the 20th century. It is found in a key work by Pablo Picasso (1881–1973), *Guernica* (1937; Madrid, Centro de Arte Reina Sofía), and in the works of the American post-war generation (e.g. Jasper Johns (*b* 1930), Robert Rauschenberg (1925–2008) and Frank Stella (*b* 1936)).

Used more than ever as an autonomous artistic method without any practical function, the technique of grisaille can throw light on the mental and spiritual state of the artist (not necessarily in a negative way) rather than on the qualities of the object depicted. It can no longer be described as the abstraction of form from colour, for often enough monochrome is at the same time abstract painting. It is thus a paradox: the abstraction of colour from colour and therefore the purest form of grisaille ever produced in Western art.

L. de Laborde: *Glossaire français du moyen âge* (Paris, 1872), p. 191

N.-C. de Fabri de Peiresc: *Lettres à sa famille et principalement à son frère, 1602–1637*, vi (Paris, 1896), p. 173 [first known use of the term]

M. Teasdale Smith: 'The Use of Grisaille as Lenten Observance', *Marsyas*, viii (1959), pp. 43–54

S. Sulzberger: 'Notes sur la grisaille', *Gazette des beaux-arts*, n. s. 5, lix (1962), pp. 119–20

K. Kraft: *Zum Problem der Grisaille-Malerei im italienischen trecento* (diss., Munich, Ludwig-Maximilians-Universität, 1963)

M. Kozloff: 'The Many Colorations of Black and White', *Artforum*, xi (1964), pp. 22–5

P. Philippot: 'Les Grisailles et les "degrés de la réalité" de l'image dans la peinture flamande des 15e et 16e siècles', *Musées royaux des beaux-arts de Belgique: Bulletin*, xv (1966), pp. 225–42

D. Coekelberghs: 'Les Grisailles de van Eyck', *Gazette des beaux-arts*, n. s. 5, lxxi (1968), pp. 79–92

D. Coekelberghs: 'Les Grisailles et le *trompe l'œil* dans l'œuvre de van Eyck et de van der Weyden', *Mélanges d'archéologie et d'histoire de l'art offert au professeur Jacques Lavalleye* (Leuven, 1970), pp. 21–34

A. Legner: *Polychrome und monochrome Skulptur in der Realität und im Abbild vor Stefan Lochner: Die Kölner Maler von 1300–1430. Ergebnisse des Kolloquiums und der Ausstellung* (Cologne, 1974), pp. 140–63

Gray is the Color: An Exhibition of Grisaille Painting, XIIIth–XXth Centuries (exh. cat., Houston, TX, Rice University Institute for the Arts, Rice Museum, 1974)

H. Jackson Zakin: *French Cistercian Grisaille Glass* (diss., New York, Syracuse University, 1977)

La Grisaille (exh. cat., Paris, Musée d'Art et d'Essai, 1980)

M. Osterstrom Renger: 'The Netherlandish Grisaille Miniatures: Some Unexplored Aspects', *Wallraf-Richartz-Jahrbuch*, xliv (1983), pp. 145–73

E. Ostländer: *Gemalte Plastik: Studien zur Rolle und Funktion der Skulptur in der französischen Malerei des 18. Jahrhunderts* (diss., Universität zu Köln, 1983)

M. Krieger: *Die Grisaillemalerei im Stundenbuch der Jeanne d'Evreux und ihre Bedeutung für das Entstehen der neuzeitlichen Kunstauffassung* (diss., Universität Wien, 1984)

M. Grams-Thieme: *Lebendige Steine: Studien zur niederländischen Grisaillemalerie des 15. und frühen 16. Jahrhunderts* (diss., Universität zu Köln, 1988)

R. Preimesberger: 'Zu Jan van Eycks Diptychon der Sammlung Thyssen-Bornemisza', *Zeitschrift für Kunstgeschichte*, liv (1991), pp. 459–489

D. Täube: *Monochrom gemalte Plastik: Entwicklung, Verbreitung und Bedeutung eines Phänomens niederländischer Malerei der Gotik* (diss., Bonn, Rheinische Friedrich-Wilhelms-Universität, 1991)

T. Dittelbach: *Das monochrome Wandgemälde: Untersuchungen zum Kolorit des frühen 15. Jahrhunderts in Italien* (Hildesheim, Zürich and New York, 1993)

M. Krieger: *Grisaille als Metapher: Zum Entstehen der peinture en camaieu im frühen 14. Jahrhundert* (Vienna, 1995)

M. Krieger: 'Die niederländische Grisaillemalerei des 15. Jahrhunderts: Bemerkungen zu neuerer Literatur', *Kunstchronik*, xlix/12 (Dec 1996), pp. 575–88

D. Royce-Roll: 'Twelfth-century Stained Glass Technology According to Theophilus and Eraclius', *AVISTA Forum*, x/–xi/1–2 (Fall 1997–Spring 1998), pp. 13–23

K. Plonka-Balus: 'Grisailles in the Illuminated Manuscripts in the Time of Dirk Bouts: Technique, Function and Meaning', *Bouts Studies* (Leuven 2001), pp. 151–9

S. Blumenroder: 'Andrea Mantegna's Grisaille Paintings: Colour Metamorphosis as a Metaphor for History', *Symbols of Time in History of Art* (Turnhout, 2002), pp. 41–55

K. Boulanger: 'De la couleur ou pas: Le vitrail médiéval entre narration et simple décor', *Le symbolisme de la lumière au Moyen Age* (Chartres, 2004), pp. 47–56

Ground. Preparatory coating or foundation layer on a Support that renders it more suitable for the application of paint or other artists' media. The term is also used in a more general sense to refer to the background of a painting or drawing. Where no special preparation is required, the surface of the support may itself be regarded as the ground. In the term's historical usage the notion of the ground as a background or foundation is sometimes extended to incorporate underpainting and dead-colouring within its meaning; the term then refers to isolated areas of preparatory colouring, instead of the preliminary overall covering normally implied.

The term 'priming' is often interchanged with the term 'ground', though technically it is possible to differentiate between them. A priming is the material applied to create a ground and may also be a further preparatory layer on top of a ground, sometimes referred to as 'imprimatura'. Each of these terms can be applied with varying degrees of general or specific meaning, depending on whether they are used technically or as loose descriptions. In printmaking, the ground refers to the dark protective acid-resistant coating, which usually consists of wax, asphalt and resin, applied to the metal plate in the process of etching (*see* Etching, §I). A softer ground, including tallow, was also developed in the 18th century (*see* Etching, soft-ground) and was widely used for the reproduction of drawings. The aquatint (*see* Aquatint, §1) and mezzotint (*see* Mezzotint) methods of intaglio printmaking also involve the use of stages described as grounds that

produce overall areas of tone. The following sections primarily describe the use of grounds in Western easel painting. For information on the use of grounds in wall painting *see* WALL PAINTING, §I.

1. Function. 2. Types. 3. History and use.

1. FUNCTION. In painting the application of a ground performs several functions. Firstly, it stabilizes the support, by restricting its ability to move and/or by reducing the effect of environmental factors, chiefly changes in temperature and relative humidity, by acting as a sealant. Canvas (*see* CANVAS, §1), for example, is stretched across a frame and then fixed by a coating of SIZE, usually with further ground layers on top. The size layer may be regarded as a component part of the ground. The result is a semi-rigid surface in which individual threads in the canvas are no longer free to move separately. The inherent instability of the support material is thus much reduced. With canvas, the combination of a ground with a loose lining of cloth, especially if that is also prepared with a ground, reduces movement to a minimum. A secondary form of stabilization occurs coincidentally as a result of the sealant action of the ground; deterioration by the effect of environmental factors such as temperature changes can be reduced by an equivalent treatment of the rear of a support. With panels, for example, a coating applied to the back that balances the ground and paint layers on the front prevents warping. The double portrait of *Giovanni Arnolfini and Giovanna Cenami* by Jan van Eyck (*c.* 1395–1441), commonly known as the *Arnolfini Marriage* (1434; London, National Gallery), has been treated in this way.

Secondly, the ground protects both the support and the superimposed painting by separating them from each other: a ground can act as a buffer between incompatible chemistries and may thus preserve a painting that might otherwise decay. For example, without a ground, oil would penetrate canvas or paper, and the acidity of the oil would accelerate the decay of the support. The third and, from the artist's standpoint, most important function of a ground is its modification of the support for its intended purpose: depending on the type of fibre and nature of weave, cloth may present a surface that is hostile to paint on; a ground, however, fills the pores of the cloth, flattening any surface roughness and smoothing out irregularities; it can also alter the colour. Although a tooth or surface texture conditioned by the weave is generally retained on canvas, the ground presents a smoother surface than would otherwise have been present.

Since the physical properties of the ground may be varied in order to make the support more receptive to a certain paint type or technique, the choice of ground may affect the evolution of the painting and the longevity of the completed work. Deliberate tailoring of the ground and the marrying of support, ground and manner of painting have been recurrent themes throughout the history of grounds and their use.

2. TYPES. There are at least two ways to categorize the different kinds of ground used in painting: the first is by reference to their composition and, in particular, to the binding medium employed. For example, 'oil ground' describes the general type of ground that contains a drying oil as a major ingredient. The second is by reference to the specific physical properties: a ground may be described as 'elastic and non-absorbent'. There is, however, often a close relationship between certain ground compositions and certain sets of characteristic properties: an oil ground is in fact usually non-absorbent and elastic. A full technical description of a given ground may often be complex, for example a smooth, white gesso ground, rendered non-absorbent by an oil priming applied as a honey-coloured glaze. The following categories of ground are not intended to be exhaustive, though they probably cover most commonly used types.

(i) Gesso or chalk. This type of ground consists of powdered gypsum or chalk, bound with animal glue size, likely to be hide glue, gelatin or a historical equivalent (*see also* GESSO). These ingredients produce a white ground that is inflexible and consequently best suited to panels; it is easily built into a thick application and readily worked to a smooth finish. Such grounds are also absorbent, making them suitable for water-based paints, e.g. tempera, but ideally need to be sealed or primed if they are to be worked on with oil colour. They are, however, compatible with all types of paint and, though susceptible to impact and stress, are the most stable and durable types of ground.

(ii) Emulsion or half-chalk. This type of ground is a modification of the basic gesso or chalk ground by the addition of an emulsified binding medium (*see* EMULSION), which also results in differing properties to those of a gesso ground. Emulsion grounds typically contain a small amount of oil, as well as animal glue size, but often also egg and resin. The oil gives the ground some elasticity and reduces its absorbency, though some drawing in of the paint medium remains a feature. Unless deliberately coloured, the colour of this type of ground is usually an off-white tending towards yellow. Emulsions of flour, starch and oil or of resin mixed with animal glue also occur in grounds of this type. They are better suited to use on canvas and to the use of oil paint than gesso or chalk grounds.

(iii) Oil. Oil grounds are bound either entirely or predominantly by a drying oil. Emulsion grounds with a very high oil content properly belong in this category, but a paint-like preparation of pigment and oil would be the more usual interpretation of this term, with solvents and resins and different types of oil preparation being incorporated into variant recipes. Oil grounds are comparatively flexible until they begin to age and are therefore well suited to canvas supports, even allowing them to be rolled while removed from their stretchers. Oil

grounds are also less susceptible to temperature and humidity changes and to microbiological attack than other traditional types of ground and are therefore, in theory, more durable; in practice this is not always the case.

Oil grounds are compatible only with oil paint, because they are usually non-absorbent and may present a slick surface with which it is difficult to form a permanent bond. Even oil paint might not always adhere well, were it not for the aid of the tooth derived from the canvas grain. In the long term, various complications can arise. The basically unsympathetic nature of an oil ground can create problems within the superimposed paint layers, as can latent faults in the ground itself. For example, oil grounds may take a long time to dry thoroughly and can develop faults as a result of being painted on too quickly. Paint can also crack or even flake off because it does not have a firm hold on the ground (see CRAQUELURE), and colours can be spoilt by an excessive use of oil encouraged, or at least aggravated, by the non-absorbent oil ground. The obvious advantages of oil grounds are thus accompanied by inherent risks, and many paintings on them are not preserved well.

(iv) Acrylic. This type of ground, sometimes known as acrylic gesso, together with the related 'universal primings' were introduced in the late 20th century (*see also* ACRYLIC PAINTING, §1). They use synthetic resins as binding media, with the apparent advantages of permanent elasticity, as well as a degree of stability that prevents deterioration. Although to date they have proved compatible with both acrylic and oil paint, it is argued that they are less suitable for oil colour in the long term, because of differentials in the way they age. Acrylic grounds are usually brilliant white. They can be quite absorbent but more often present a rather plastic surface. They are susceptible to extreme cold, and the wisdom of applying them directly on to cloth without preliminary sizing is disputed. However, it is not yet possible to assess in detail the advantages and disadvantages of acrylic grounds and universal primings.

(v) Bole and coloured. These terms refer to coloured grounds of any composition, but the techniques applied on them are different from those used on white or near white grounds and may relate closely to the colour. The term 'bole' originally referred only to Armenian bole, a natural red-brown clay used, usually on top of gesso, specifically as a ground for water gilding (*see* GILDING, §I, 1(i)). The hydroscopic nature of the clay assists the laying of the gold leaf, while its colour makes the translucent leaf appear redder and warmer in hue. If a cooler look is required, a green foundation layer, traditionally containing terra verde, is applied instead. In both cases, the effect of the underlying colour becomes even more apparent when the gold is distressed.

Coloured grounds can influence paint in the same way, though there are other potential advantages and methods of using them. The term 'bole ground' has come to mean any relatively dark, solidly coloured ground or priming, including various shades of red, brown and grey. Much more luminous coloured grounds that behave rather differently are achieved by laying a thin, coloured priming, sometimes a tinted transparent glaze, over a lower white ground layer. For a double ground, a priming of one colour is laid in a half-covering fashion over a lower ground of another colour; double grounds usually present a colour value or optical quality that would be difficult to achieve by more direct means.

Coloured grounds are employed by painters to abbreviate their painting method, to establish a sense of atmosphere or to exert an overall influence on the colouring. Their use is chiefly associated with oil painting, though coloured paper beneath gouache or pastel can also be classified as a coloured ground. Colour-tinted grounds are also a feature of drawings in chalk, charcoal or crayon and in metalpoint.

(vi) Composite. In practice, many grounds are composite, i.e. multi-layer preparations that combine the properties of several different basic ground types, often in order to suit the materials being used. For example, a gesso ground is best suited to a panel and can present a superbly smooth surface ideal for fine detail, but its capacity to absorb medium restricts the artist's ability to manipulate oil paint; this can be corrected by coating it with a layer of oil ground, a process sometimes referred to as 'isolating' the gesso. An emulsion ground might be used to fill the pores of a loosely woven cloth, with an oil ground placed on top to coat the consolidated surface, covered perhaps with a layer of priming to modify the colour. Many coloured grounds can also be described as composite grounds.

3. HISTORY AND USE. Painting grounds have evolved through adaptation to suit changes in painting materials, the most significant being the introduction of oil paint and canvas, and the development of different techniques. The evolution of the manufacture and use of grounds may have been influenced by the availability of certain constituent materials and by locally established technical practices. There is evidence of alternative but essentially similar solutions to the same problems being found by different artistic communities, of the dissemination of different types of ground through trade, of certain grounds being associated with the work of particular painters and, in the 19th and 20th centuries, of the circumstantial influence of commercial availability.

With regard to technique, it is difficult to distinguish whether grounds have influenced painting methods or vice versa, but there has obviously been a close relationship between them. Colour and tone may oblige a painter to work away from shadow if the ground is dark or towards it if it is light and thus may affect the thickness or thinness with which the paint is applied. The colour of the ground may likewise affect the painter's palette, and its surface finish or degree of absorbency can also materially affect the

methods used. The extent to which grounds may help or hinder attempts to paint in a certain manner is not instantly apparent to the observer of a finished work, but it can safely be assumed that, at least prior to the 19th century, most painters were aware of it; it might even be argued that ignorance of how best to employ grounds has since contributed to the development of different painting techniques, as less technically informed artists have sought refuge in simple and direct methods. The changing use of grounds is therefore an element of considerable importance in the development of painting.

Gesso, the oldest and most simple ground used in Western painting, probably has origins in antiquity and is paralleled by similar materials in the art of other cultures, for example the white foundation, known as *khadi*, of Indian miniature painting. From the full account given by Cennino Cennini in *Il libro dellarte* (*c.* 1390) of the use of gesso in Italy at the beginning of the Renaissance it is evident that gesso was applied to both panels and cloth, though its shortcomings on the latter were known. A thick, multi-layered coating was applied to panels, but on cloth a variant recipe with starch or sugar added as a plasticizer was firmly pressed into the fabric, with the object of producing as thin a ground as possible.

As oil painting evolved in the medieval period, painters in northern Europe prepared panels as for tempera painting but with an additional priming. The unfinished *St Barbara* (1437; Antwerp, Koninklijk Museum voor Schone Kunst) by Jan van Eyck appears to be on gesso coated with a yellowish glaze, quite possibly a prepared oil or oil-and-resin varnish rubbed thinly over the ground, in a similar manner to the established practice of varnishing tempera paintings. The Florentine Filarete (*c.* 1400–*c.* 1469), referring in his *Trattato di architettura* (1461–4; see Eastlake) to oil painting as practised by Jan van Eyck and Rogier van der Weyden (*c.* 1399–1464), specifically described an oil priming on top of gesso on panel. He recommended white but clearly acknowledged the use of tinted or coloured grounds. He also described the process of highlighting with white in the underpainting, a process greatly facilitated by the use of a coloured or toned ground. Coloured, tinted and glazed grounds may therefore have evolved from the introduction of colour to the primings applied to gesso in order to render them fit for painting on in oil.

Italian restorers at the beginning of the 19th century believed that Titian (*c.* ?1485/90–1576) had painted on a gesso ground coated with glue size (Merryfield); modern scientific study tends to confirm this. The generation of painters that followed Titian, however, began to use grounds of oil paint applied on top of the thin filler coat of gesso. These were coloured imprimatura or *mestica* of a substantial thickness, compared with the transparent or translucent coatings of the Flemish tradition, described as '*primuersel*' by Karel van Mander I (1548–1606). Painters often favoured certain colours, for example

a grey-green in the case of Paolo Veronese (1528–88) and much darker hues, sometimes in fact black, in that of Jacopo Tintoretto (1519–94). The influence of these primings and grounds is apparent in the colouring and tonal values of their respective works, but artistic preference was not the only important factor: Giorgio Vasari (1511–74) described such primings as being made with siccative pigments that promoted a rapid and thorough drying of the oil; these included white lead and the earth colours, which either individually or in combination could explain many of the colours of grounds. There is some evidence of palette scrapings being added to such grounds or of their being boiled with oil to extract their siccative qualities. In the early 17th century Richard Symonds (1617–60) referred to *ogliaccio* ('dirty oil') being used as a priming, which could have been of this type and which may have influenced the often dull and indeterminate colouring of the grounds used at that time.

Vasari also described the use of a flour paste emulsified with oil and mixed with white lead, in place of the initial coating of gesso. This would have been more flexible and therefore better suited to canvas. According to Vasari, the coloured oil priming was beaten on with the palm of the hand, suggesting that it was a thick and sticky paste. Similar accounts of canvas preparation were given in 17th-century Spanish sources, though Francisco Pacheco (1564–1644) recommended the use of clay mixed with oil, applied on to a canvas sized with weak glue. Pacheco also described the use of ashes in place of gesso and primings of red earth or of a mixture of white lead, red lead and charcoal black that must have produced a brown or dirty pink ground. El Greco (*c.* 1541–1614), for example, used a dark red-brown 'bole' ground. Diego Velázquez (1599–1660) also seems to have employed darkish brown, grey and red-brown grounds.

Although by the late 16th century and early 17th the use of panels was in decline in northern Europe, Henry Peacham (1578–?1644), in *The Compleat Gentleman* (London, 1622), gave a method for preparing a ground for oil painting on panel that, for all practical purposes, is the same as Filarete's. He did however recommend a priming of red lead or another colour.

In the 17th century the use of solid, dull-coloured grounds influenced technique and encouraged the use of paint in variable thicknesses, with dense, opaque paint being massed in the highlights. The paintings of Rembrandt van Rijn (1606–69) are an extreme example of this, though in addition to dark grounds he favoured double grounds, consisting of a coloured ground over which a priming of another colour is applied. The dark, vaporous voids in Rembrandt's paintings would have been easier to achieve on grounds of this type. Evidence of a selective use of grounds by Velázquez in his *Rokeby Venus* (*c.* 1648–9; London, National Gallery) suggests that the potential of coloured grounds was being explored to its limits during the 17th century.

The use of coloured grounds over a primary layer of white, providing luminosity, is often evident in the work of Peter Paul Rubens (1577–1640), where it tends to be of a distinctive form, consisting of a streaky or scrubbed-on colour through which a white base is visible. In his *Samson and Delilah* (*c.* 1609–10; London, National Gallery), for example, a warm, honey-coloured priming is evident in many places and indeed is used quite deliberately to trick the viewer into perceiving areas of minimal painting as being complete. A similar streaky ground is visible in his portrait of *Susanna Fourment* (*c.* 1622–5; London, National Gallery), and his use of coloured grounds is further and emphatically illustrated by his series of modelli (1636–7; London, National Gallery) in which the grounds form the greater part of the work.

Prepared supports were already available in the 17th century, but in the 18th century there was increasing standardization and a progressive separation of the artist's craft and the colourman's trade. Eventually a simple preparation of white lead in oil became the typical commercially produced ground, probably representing the lowest common denominator of customers' requirements. J. M. W. Turner (1775–1851), who as a watercolourist was familiar with the use of a white ground (consisting of gouache), may have been the first major European painter to adopt this plain white ground for oil paintings. As with earlier painters, his choice of ground can be related to his methods, as can that of John Constable (1776–1837), who continued to use coloured grounds, favouring red-browns and a warm pink, probably made to order, which features his *Chain Pier, Brighton* (1827; London, Tate). Attempts to rediscover traditional painting practices during the 19th century did lead to some experimentation with differing ground types, a fascinating example being furnished by the portrait of *Carlo Pellegrini* (*c.* 1864; Bodelwyddan Castle) by Henry Thompson (1820–1904).

As the 19th century progressed, the continued simplification of painting methods, exemplified by the direct application of opaque paint by the Impressionists and their followers, made the colour of the ground increasingly irrelevant, and the skilful exploitation of coloured grounds was no longer prevalent. Relatively light grounds in pale grey, cream and buff feature in the work of Claude Monet (1840–1926), Auguste Renoir (1841–1919) and Vincent van Gogh (1853–90), but the significance of their delicate colours is often marginal because of the heavy and unvarying method of applying paint and the concentration of all aspects of colour, design and form within the paint layer. Possibly nothing more than experimentation with various commercially available grounds is evident in these works. From the practical point of view, pale grounds are less challenging than starkly white ones and make the careful covering of every bit of support less necessary. This explains the common practice among painters of toning down white grounds with a wash of colour prior to painting.

In the 20th century white grounds continued to dominate, but preparations of white lead in oil were superseded during the last quarter of the century with alkyd primers, often containing titanium white. Even in that form, however, oil primers are no longer as important as commercially made acrylic primings, although a few technically minded painters have also continued to employ traditional materials, such as gesso, and various forms of coloured ground.

C. Cennini: *Il libro dell'arte* (*c.* 1390); Eng. trans. and notes by D. V. Thompson jr (1933)

G. Vasari: *Vite* (1550, rev. 2/1568); ed. G. Milanesi (1878–85); intro. trans. by L. S. Maclehose as *Vasari on Technique* (London, 1907; rev. New York, 1960)

T. Bardwell: *The Practice of Painting and Perspective Made Easy* (London, 1756)

C. L. Eastlake: *Methods and Materials of the Great Schools and Masters*, 2 vols (London, 1847/*R* New York, 1960)

M. P. Merryfield: *Original Treatises Dating from the XIIth to XVIIIth Centuries on the Arts of Painting*, 2 vols (London, 1849)

R. J. Gettens and M. E. Morse: 'Calcium Sulphate Minerals in the Grounds of Italian Paintings', *Studies in Conservation*, i (1954), pp. 174–89

P. Hendy, A. Lucas and J. Plesters: 'The Ground in Pictures', *Museum: Revue trimestrielle publiée par l'UNESCO*, lxxxiv (1968), pp. 245–76

G. Emile-Mâle: *The Restorers' Handbook of Easel Painting* (New York, 1976)

National Gallery Technical Bulletin (1977–)

M. K. Talley: *Portrait Painting in England: Studies in the Technical Literature before 1700* (London, 1981)

Z. Veliz, ed. and trans.: *Artists' Techniques in Golden Age Spain* (Cambridge, 1987)

Art in the Making: Rembrandt (exh. cat. by D. Bomford, C. Brown and A. Roy; London, National Gallery, 1988)

J. Stephenson: *The Materials and Techniques of Painting* (London, 1989)

Art in the Making: Italian Painting before 1400 (exh. cat. by D. Bomford and others; London, National Gallery, 1989)

D. Bomford and others: *Art in the Making: Impressionism* (London, 1990)

J. Dunkerton and others: *Giotto to Dürer: Early Renaissance Painting in the National Gallery* (London, 1991)

E. Hendriks and others: 'The Painting Technique of Four Paintings by Hendrick Goltzius and the Introduction of Coloured Ground', *Nederlands kunsthistorisch jaarboek*, xlii–xliii (1991–1992), pp. 481–9

Garrido, María Carmen. *Velázquez: Técnica y evolución.* (Madrid, 1992)

J. H. Townsend: 'The Materials and Technique of J. M. W. Turner: Primings and Supports', *Studies in Conservation*, xxxix (Aug 1994), pp. 145–53

J. Stephenson: *Paint with the Impressionists* (London, 1995)

N. van Hout: 'Meaning and Development of the Ground Layer in Seventeenth-century Painting', *Looking through Paintings: The Study of Painting Techniques and Materials in Support of Art Historical Research*, eds E. Hermens, A. Ouwerkerk and N. Costaras (London, 1998), pp. 199–225

K. M. Groen: 'Earth Matters: The Origin of the Material Used for the Preparation of the *Night Watch* and Many Other Canvases in Rembrandt's Workshop after 1640', *ArtMatters: Netherlands Technical Studies in Art*, iii (2005), pp. 138–54

A. Raft: 'Quellenschriften des 17. und 18. Jahrhunderts zur mehrfarbigen Grundierung', *Grossgemälde auf textilen Bildträgern: Restauratorenblätter*, xxiv–xxv, eds M. Koller and U. Knall (Klosterneuberg, 2005), pp. 65–75

S. Cove: 'The Painting Techniques of Constable's "Six-footers"', *Constable: The Great Landscapes* (exh. cat., ed. A. Lyles; London, Tate, and Washington, DC, National Gallery of Art, 2006), pp. 50–69

Gum. Water-soluble or water-dispersible carbohydrate of vegetable origin. (For proteinaceous animal glues *see* ADHESIVES, §1(i).) Gums have been the principal binding medium for watercolour paints as used for watercolours, miniatures and, to some extent, manuscript illumination. They have also found uses as adhesives.

Gums are polysaccharides, that is to say polymers formed by the linking together of monosaccharides—the sugars—through glycoside linkages. Sugar molecules have many free hydroxyl groups on them, and many of these are still free in the polysaccharides: it is this that gives them their water solubility. The particular components present in individual gums and their proportions have in many cases been identified, though the order in which the various sugars and uronic acids (sugar derivatives containing carboxylic acid groups) are linked together is not known exactly.

The most important gum is gum arabic or gum acacia, a product of the tree *Acacia senegal* and other species. Its main source has always been the Sudan and neighbouring parts of Africa, and it was therefore well known to the ancient Egyptians, though speculation that it formed the medium of Egyptian painting has never been confirmed experimentally. It is still collected in large amounts as it is important in the food industry. Compounded principally of arabinose, galactose and a lesser amount of rhamnose together with galacturonic acid, it is in consequence acidic and actually exists as a salt with calcium, magnesium and potassium cations. Solutions of gum arabic become less viscous with heating due to breakdown of the polymer chains, but it is not known how stable the dried material may be. When it is used as the medium for watercolours, it is usual to add sugar, honey or glycerol to improve its mixing qualities with water and the flexibility of the medium when dry.

Gum tragacanth, another widely used gum, is obtained from *Astragalus* species (Leguminosae family). It is more troublesome to collect than gum arabic and consequently more expensive. As it is of higher molecular weight than gum arabic, it produces more viscous solutions (or rather dispersions, since it is not wholly water-soluble), but it shares the same uses.

Cherry gum, as well as gums from related *Prunus* species such as plum, peach and almond, has found some use in painting practice. Cherry gum is mentioned in manuscript treatises such as that of Theophilus. It has also been detected by analysis in Central Asian wall paintings. Other gums of some economic importance, which may also have been used in artistic practice, are locust gum (from the carob or locust tree, *Ceratonia siliqua*), tamarind seed mucilage (*Tamarindus indica*), guar gum (*Cyanaposis tetragonolobus*) and ghatti gum (*Anogeissus latifolia*). In Japan a mucilage obtained from seaweed is sometimes employed, the main source being the marine alga *Gloiopeltis furcata*. It is used in *kirikane*, a cut gold- or silver-leaf decorative technique.

F. N. Howes: *Vegetable Gums and Resins* (Waltham, MA, 1949)

F. Smith and R. Montgomery: *Chemistry of Plant Gums and Mucilages* (New York, 1959)

J. W. Twilley: 'The Analysis of Gums in their Artistic Applications: An Interim Report', *Archaeological Chemistry III*, ccv (1984), pp. 357–94

J. S. Mills and R. White: *The Organic Chemistry of Museum Objects* (London, 1987)

M. Ash and I. Ash: *Resins* (London, 1990)

J. H. Townsend and R. Hamlyn, eds: *William Blake: The Painter at Work.* (London, 2003)

H

Hardstones. Mineral substances mostly non-transparent, compact, differently coloured and capable of being highly polished. Since prehistoric times they have been prized and have had a vast, uninterrupted popularity in the artistic culture of the West. Many factors have contributed to the popularity of these beautiful materials, which has endured through the history of art. First are the fascinating physical characteristics of these smooth, gleaming stones, the fabulous range and variety of colour of which are unrivalled in nature. Another reason for the great value of polished hardstones is that they are also less vulnerable to deterioration than many other materials. Patrons and collectors have been especially attracted to works of durable beauty, in which the intrinsic nature and rarity of the stones are enhanced by their sophisticated artistic treatment. Artists, in turn, have been inspired to experiment and perfect the difficult technique required to impose their inventive ideas on these resistant materials. The art of hardstone cutting and engraving had its greatest flowering in societies of extraordinary refinement and cultural development, such as the Greek and Roman civilizations and that of the Renaissance.

Some peripheral factors have also contributed to the high status of these minerals, especially the widespread belief in the magical qualities of stones, which dates from very ancient times and even survived in the late 20th century. There is a vast literature on this subject, written from the Classical age to the Renaissance. An important Renaissance example is the *Trattato delle pietre* (Florence, 1597) by Agostino del Riccio, composed in the climate of alchemical and naturalistic studies favoured by the court of Francesco I de' Medici (*reg* 1574–87). This treatise gives a careful definition of the different varieties of stone, as well as an account of their amazing magic virtues. These beliefs declined from the 17th century, with the increasingly naturalistic and scientific approach to minerals. At the same time, however, there was an increased interest in studying and using these fascinating natural materials, which was reflected in the field of art.

See also GEM-ENGRAVING, GEMS, JADE, JET, MOSAIC, PIGMENT, ROCK CRYSTAL.

1. Types. 2. Cutting and carving techniques. 3. History and uses.

1. TYPES. In Antiquity minerals were divided into three categories: very hard, hard and soft. The first group included those that cannot be scratched with a steel point (diamond, corundum, topaz, quartz etc), and the softest included talc, gypsum and graphite, which can be easily scratched. In 1812 the Austrian mineralogist Friedrich Mohs (1773–1839) proposed a scale of hardness, although its gradations are approximate, as they are based on the ability of one mineral to scratch another of similar or lower degree. The Mohs scale has ten degrees of hardness, each corresponding to a common mineral that can be found in nature in its pure state, and thus serves as a useful standard for comparison. The ten degrees are: 1. talc; 2. gypsum; 3. calcite; 4. fluorite; 5. apatite; 6. orthoclase; 7. quartz; 8. topaz; 9. corundum; 10. diamond. True hardstones are those in the 6th and 7th degrees on the Mohs scale, but in an artistic context a broader definition of hardstones can be used.

(i) True hardstones. The stones used most widely for cameos, intaglios and *commesso di pietre dure* (Florentine mosaic) can properly be called hard according to the Mohs scale, as they belong to the large group of quartzes. These include rock crystal, amethyst, chalcedony, agate, jasper and petrified wood. These minerals are based on silicon; they are subdivided into numerous varieties the nomenclature of which varies according to their colour or place of origin.

ROCK CRYSTAL (hyalite quartz) has been valued and worked since ancient times because of its glassy appearance and rainbow reflections, which produce a special effect when the stone is engraved. The largest deposits are in the Alps, despite extensive exploitation.

The fibrous variety of quartz known as chalcedony includes a wide range of stones, among which certain types are more widely used and valued for carving. The types that are light and generally uniform in colour are called 'common' chalcedony; these were used, for example, by the Grand Ducal Workshops in Florence for flesh tones in polychrome pietre dure sculpture. One of the best-known and most valued types is cornelian, a translucent stone that varies in colour from bright red to light yellow; it was widely used by the Romans, who obtained it in the Near East and India. Another type of chalcedony especially famous

and valued in Antiquity is bloodstone, which is dark green with small blood-red flecks or veins. It comes mainly from India and was often used for goblets and vases in Roman times and in the Renaissance. Agates, known by different names according to the type of colouring and markings, are the semi-transparent or translucent varieties of chalcedony, of various colours, with a structure of parallel or concentric striations. Agate sardonyx, from India, Asia Minor and China, is a translucent type with zones of black or brown sard (a type of chalcedony). Onyx-chalcedony, with black zones alternating with bluish-grey or white ones, was often used for cameo work, using the light strata for the figure. Vast deposits of German agate, with regular zones of various colours, were widely exploited in the Middle Ages. In Renaissance Italy, Sienese agate was frequently used; this type has parallel striations in various shades from ochre to brown. Jaspers are similar to chalcedonies in hardness and composition but unlike the latter are completely opaque, although when polished they shine brightly. Blood jasper, with its vivid red colour, was known in Egypt from the most ancient times and was later quarried in the Alps, Germany and Sicily. Flowered jasper includes veins or flecks of semi-transparent agate and is prized for its variety of colours and alternating effects of opacity and transparency. Bohemian jasper, in delicate pastel tones enlivened by spots and speckles, was the material most favoured by the workshop established in 1588 in Prague by Ottavio Miseroni (1567–1624) on the invitation of Emperor Rudolf II (reg 1572–1607).

A geological curiosity much appreciated by artists is petrified wood (hardness 6.5–7). This is derived from tree trunks hardened by a process in which the organic matter is completely replaced by dissolved minerals that then crystallize. The structure of petrified wood is often so well preserved that the particular species of tree from which it came can be identified. It was obtained from the petrified forests of Germany and France and was used in European workshops mainly between the 16th and 19th centuries for mosaics and wall surfaces.

(ii) Other stones. In an artistic context the term 'hardstone' extends to include some stones that are below the 6th degree on the Mohs scale. Lapis lazuli (hardness 4–5 degrees) has a distinctive intense ultramarine blue colour, with minute pyrite crystals, sometimes gold in colour, creating a beautiful golden shimmer. Some less pure varieties have white or grey spots owing to the presence of limestone. These have less commercial value but were widely and very successfully used by Florentine mosaicists, especially in the early 17th century, for example in the rendering of the sky with clouds or seascapes flecked with foam. During the Renaissance the type with the most intense and uniform colour came from the Badakhshan district in Afghanistan to the east of Iran. More mottled varieties were discovered in France, and at the end of the 18th century the

discovery of vast, high-quality deposits in Siberia made Russia the main European centre for export.

Another stone widely used for decorative work is malachite (hardness 3.5–4 degrees), with its characteristic striations varying from brilliant green to dark black-green, arising from its chemical composition of copper carbonate. It was used in Ancient Greece and Rome and was popular again in the late 18th century and early 19th, when large deposits were found in the central Urals.

L. Dolce: *Trattato delle gemme che produce la natura* (Venice, 1617)

F. Corsi: *Delle pietre dure antiche* (Rome, 1845)

M. Weinstein: *Precious and Semi-precious Stones* (London, 1944)

S. Cavenago-Biagnami Moneta: *Gemmologia* (Milan, 1965)

H. J. Schubnel: *Pietre preziose, gemme e pietre dure* (Novara, 1967)

A. Pampaloni Martelli: 'Le raccolte lapidee dell'Opificio delle Pietre Dure', *Splendori di pietre dure: L'arte di corte nella Firenze dei Granduchi* (exh. cat., ed. A. M. Giusti; Florence, Palazzo Pitti, 1988–9), pp. 260–75

2. CUTTING AND CARVING TECHNIQUES. There are basically two techniques for working hardstones, depending on whether they are being fashioned into two- or three-dimensional objects. In both cases the resistance of the stones makes it necessary to use such abrasives as siliceous sands, metal powders or diamond chips, together with metal instruments for cutting or incising the surface.

Two-dimensional works in hardstone include a wide range of types, from simple geometrical slabs used for floors, wall cladding, table-tops etc to the complex ornamental or figurative images of the *commesso di pietre dure* (Florentine mosaic). The working of plain slabs involves two basic processes: cutting the block of stone, using metal saws lubricated with a dampened abrasive, and polishing the surface by repeated applications of an abrasive rubbed with lead blocks. A far more complex technique is required for the execution of *commesso di pietre dure*. A sketch, usually in watercolour or oil, is made and then traced in pen or pencil. On this 'cartoon' the different sections of the mosaic are laid out. Each of the sections is created using slices (small flat plates a few millimetres thick) cut from the block of hardstone, from which the artist chooses the appropriate colours for the desired effect. A paper pattern with the required outline is glued to each slice, which is then fixed in a vice and cut to shape using a saw made of a chestnut bow and a soft steel wire, with emery as an abrasive. The craftsman works the saw with one hand in regular movements, and in the other he holds a spatula with which he continually deposits the wet abrasive on the wire to provide the cutting action. Once the stone sections are cut the edges are filed smooth so that the single pieces can be set together. To produce an inlay the sections are inserted in spaces carved (again with the abrasive wire) in the background stone, which remains in view. In the most traditional type of *commesso di pietre dure*, however, the entire composition is formed by fitting together the different stone sections; these are mounted on a support usually

made of slate, which remains invisible. In both cases, the sections are bonded to the base and to each other with a glue made of hot beeswax and rosin or colophony. The final phase is the polishing and buffing of the surface by repeated rubbing with abrasive powders applied with lead blocks or cloth-covered pads to produce a mirror-like smoothness.

'Glyptics', the art of carving hardstones either by incising or in relief, is a term that is applied mainly to the production of cameos, gems, vases and small sculptures. To carve a hardstone vase, especially popular in the 16th and 17th centuries, large metal discs were fixed to a *castelletto* (vertical stand); their rotation with the abrasives (metal powders or diamond or ruby dust mixed to a paste with wax or petroleum jelly) modelled the forms of the vases. Any engraved sections were executed with finer-pointed instruments. Mosaic sculpture in the round or in high relief was practised almost exclusively in the Grand Ducal workshop in Florence and in Prague. This was built up of pieces of hardstone worked individually with the *castelletto*, using the same method as for engraving cameos. The hardstone is placed in the *castelletto*, which holds a transverse shaft into which the craftsman fixes the various drill points to suit the different requirements. The drill points are made to rotate by pulleys linked to a wheel that is turned by an assistant or worked by a pedal. The hardstones are then fixed together with small, invisible pins and glued.

Unpublished sources
Florence, Biblioteca Nazionale Centrale, MS. Misc. Palagi 478 [G. A. Torricelli: Trattato delle gioe e pietre dure e tenere, che s'adoperano nella Real Galleria e nella Cappella di San Lorenzo]

Bibliography
P. J. Mariette: *Traité des pierres gravées* (Paris, 1750)
A. P. Giulianelli: *Memorie degli intagliatori moderni in pietre dure, cammei e gioie* (Livorno, 1753)
K. T. Hecker: *Traité de la méthode antique de graver en pierres fines comparée à la méthode moderne* (London, 1754)
E. Kris: *Meister und Meisterwerke der Steinschneidekunst in der italienischen Renaissance*, 2 vols (Vienna, 1929)
H. C. Dake: *The Art of Gem Cutting* (Portland, 1957)
F. Rossi: 'Le pietre dure, come si lavoravano, come si lavorano', *Scritti di storia dell'arte in onore di Ugo Procacci*, ii (Florence, 1977), pp. 637–51
V. Donati and R. Casadio: *Bronzi e pietre dure nelle incisioni di Valerio Balli vicentino* (Ferrara, [2004])
A. Giusti: *Pietre dure: The Art of Semiprecious* Stonework (Los Angeles, 2006)
Beyond Belief (exh. cat. by D. Hirst; London, White Cube, 2007)

3. HISTORY AND USES. There are many different types of artistic treatment of hardstones, but these reflect a certain continuity of tradition from ancient to modern times. Through all the changes in iconographies and styles, hardstones have always been carved in the form of cameos, gems, vases and small sculptures. In goldsmith's work they have been used in complex decorative schemes; they have also been used in monumental furnishings, mosaic floors and walls, such architectural structures as tabernacles, altars etc and such furniture as tables, cabinets, jewellery cases, clocks, reliquaries etc (see colour pl. VII, fig. 1). In architectural work and furniture hardstones are often used in geometric, decorative or figurative mosaic compositions that exploit the natural colouring of the stones.

While widely used in goldsmith's work in the 20th century, hardstones have suffered a decline in other applications. This is due to changed economic and social conditions, which no longer favour such an élitist and sumptuous art form, and also to the development of industry and a consequent decline in manual skills.

A. B. De Boodt: *Gemmarum et lapidum historia* (Hanau, 1609)
P. Mariette: *Traité des pierres gravées*, 2 vols (Paris, 1750)
A. P. Giulianelli: *Memorie degli intagliatori moderni in pietre dure, cammei e gioie dal secolo XV fino al secolo XVII* (Livorno, 1753)
A. F. Gori: *Historia gliptographica* (Florence, 1767)
E. Kris: *Meister und Meisterwerke der Steinschneidekunst in der italianischen Renaissance*, 2 vols (Vienna, 1929)
H. Wentzel: 'Mittelalterliche Gemmen in den Sammlungen Italiens', *Mitteilungen des Kunsthistorischen Instituts in Florenz*, vii/3–4 (1956), pp. 239–78
H. Michel: *Cristal de roche et cristalliers* (Brussels, 1960)
M. L. Vollenweider: *Die Steinschneidekunst und ihre Künstler in spätrepublikanischer und augustinischer Zeit* (Baden Baden, 1966)
J. Boardman: *Greek Gems and Finger Rings, Early Bronze Age to Late Classical* (London, 1970)
Il tesoro di Lorenzo il Magnifico (exh. cat., Florence, 1972)
R. Diestelberger: 'Die Sarachi-Werkstatt und Annibale Fontana', *Jahrbuch der kunsthistorischen Sammlungen in Wien*, lxxi (1975), pp. 95–164
A. M. Giusti, P. Mazzoni and A. Pampaloni Martelli: *Il Museo dell'Opificio delle Pietre Dure a Firenze* (Milan, 1978)
E. Koch: *Shah Jahan and Orpheus: The Pietre Dure Decoration and the Programme of the Throne in the Hall of Public Audiences of the Red Fort of Delhi* (Graz, 1988)
Prag um 1600: Kunst und Kultur am Hofe Kaiser Rudolfs II (exh. cat., Essen, Villa Hügel; Vienna, Kunsthistorisches Museum; 1988)
Splendori di pietre dure: L'arte di corte nella Firenze dei Granduchi (exh. cat., ed. A. M. Giusti; Florence, Palazzo Pitti, 1988–9)
A. M. Giusti: *Hardstone in Furniture and Decoration* (London, 1992)
A. González-Palacios: *Pittura per l'eternita: Le collezioni reali spagnole di mosaici e pietre dure* (Milan, 2003)
A. M. Giusti: *L'Arte delle pietre dure: Da Firenze all'Europa* (Florence, 2005; Eng. trans., Los Angeles, 2006)

Hatching. Method of suggesting relief by shading in closely set parallel lines. It is used in linear styles of drawing, engraving and etching, and sometimes in painting. In egg tempera, the paint was sometimes applied in hatched single strokes so that it did not blend with the layer below. Crosshatching consists of two layers of parallel lines, crossing at an angle.

Heightening. Term for the addition of white or a pale tone on top of a darker tone or background colour to complete the depiction of form in a painting or drawing. During the Renaissance an application of lead white in an aqueous medium was used, for instance, to heighten drawings in metalpoint on tinted paper; this lead white often oxidizes, negating the original function of the heightening, but the process is reversible through conservation.

Hologram. Image with the illusion of three-dimensionality, recorded on light-sensitive plates, paper or film. It is made by using a laser beam of high-intensity coherent monochromatic light. The original holographic process was discovered in the late 1940s by the British scientist Dennis Gabor (1900–77), who gave it its name; deriving from the Greek words *holos* ('whole, entire') and *gramma* ('picture'). The medium was developed only after the invention of the laser in 1960. After that, many scientists joined in perfecting variations of the process, which captured and stored all visible detail in a subject. By moving in front of a holographic plate, the viewer has the sensation of looking over and around holographed foreground objects.

Although holographic techniques differ in detail, the basic principle is to split the laser beam so that one part reflects light waves over the surfaces of the subject and from there towards a very fine-grain photosensitive surface. The second part of the reference beam comes unimpeded towards the photo-plate, where the interference pattern, made when the object waves interact with the light waves of the reference beam, is recorded. Early holograms were viewed by projecting a duplicate of the recording laser beam through the plate to reconstruct the original three-dimensional light image of the subject.

A holographic subject must remain absolutely still for all details to be accurately recorded. Many initial efforts by artists and scientists were straight holographic records of three-dimensional objects, seen floating eerily and inaccessibly within their monochromatic red, blue or green worlds. The colour was determined by the kind of laser used. Early plates were small, and an 8×10–inch plate was considered large. From a distance one saw the space visible through the frame of the holographic plate; closer, one could look obliquely behind the frame to see things hidden in the distant view. Light waves were reflected from the full-scale object, so larger subjects had to be placed some distance behind the holographic plate to 'fit' easily within the frame.

The most satisfying early holographic subjects were still-life arrangements of small-scale objects, such as the toy train (1964; see Heckman, p. 14) in a famous hologram by scientists Juris Upatnieks (*b* 1936) and Emmett Leith (1927–2005). Developments in holography enabled portraits to be made with a pulsed laser, which froze living subjects in short bursts of light, in the same way that a strobe light captures motion. It also became possible to use larger holographic plates, to make images to be seen in incandescent light or sunlight, to produce holographic films, to design abstract works with pure colours of the spectrum or to adopt new hybrid media that combined holography with video and computer graphics.

Researchers developed new techniques to make the medium more flexible: images can be made to float in front of or behind the plate; circular holograms can provide full 360° recordings, which have been combined with image-packing techniques to create three-dimensional colour holographic films. Mass-production techniques have introduced holograms into commercial art in the form of magazine covers, credit-card logos and advertisements.

Artists were attracted to holography from the outset. Holographic pioneers, like many early photographers, had to be technicians as well as artists. Because the equipment was expensive and access was limited, practitioners such as Harriet Casdin-Silver (*b* 1925) often formed partnerships with engineers. By 1970 well-known artists such as Bruce Nauman (*b* 1941) and Salvador Dalí (1904–89) had experimented with the medium (e.g. Dalí's *Sardana*, see Dorra, p. 27), and holograms had been shown in New York galleries including Knoedler's and Leo Castelli. Difficulties with display and storage dampened some of the enthusiasm for collecting holograms. Although there was a decline in technical development during the 1970s, a band of dedicated holographic artists, scientists and teachers persevered.

Holography gained stature as an art medium as artists explored the expressive qualities unique to the process. Holographers such as Doug Tyler (*b* 1949) in the USA and Margaret Benyon (*b* 1940) in Britain used double exposure and collage to create impossibly co-existing multiple realities. Benyon's *Tigirl* (1985; see 1985 exh. cat., no. 2), for example, superimposes a print of a tiger with a holographic self-portrait made using a pulsed laser, interweaving two contradictory representations of spaces. Other possibilities were suggested by holographic sculpture. Doris Vila's *15 to Blue Island* (1987; Eau Claire, WI, University of Wisconsin, School of Nursing) depicts an environment filled with wondrous rainbow colours, radiating from diffraction-grating holograms, activated by the shifting ambient light of the site.

Holography has also been used in museums. In Italy, for example, holographic techniques used in industry to test for metal stress were adapted for use in the conservation of 15th-century sculpture by Lorenzo Ghiberti (1378–1455). In the former USSR multiple holograms of works of art allowed rare or delicate objects to be shared by many museum collections. The use of holograms of works of art

for special exhibitions, rather than the loan of originals, is an important development. With the establishment of holography as a medium, museums, including the Victoria and Albert Museum, London, began to acquire individual works, and many colleges, universities and art schools launched courses in holographic art. Combined with video, cinema and computer graphics, it is a potentially powerful art tool. From 1976 the Museum of Holography, New York, published the journal *Holosphere*, and in Britain from 1985 the Holographic Group of the Royal Photographic Society published the journal *Real Image*.

W. E. Kock: *Lasers and Holography: An Introduction to Coherent Optics* (New York, 1968/R 1981)

E. N. Leith: 'White-light Holograms', *Scientific American*, ccxxxv/4 (1976), pp. 80–95

Light Fantastic (exh. cat. by J. Wolff, N. Phillips and A. Furst; London, Royal Academy of Arts, 1977)

M. Benyon: *Understanding Holography* (New York, 1978)

Phases: A Twelve-year Retrospective of the Work of Margaret Benyon (exh. cat. by R. Jackson, J. Phipps and D. Brooks; New York, Museum of Holography, 1980)

T. H. Jeong: 'Holography', *International Exhibition of Holography* (exh. cat., Lake Forest, IL, Lake Forest College, 1982)

Harriet Casdin-Silver in Collaboration with Dov Eylath: Thresholds (exh. cat., New York, Museum of Holography, 1983)

Holography Redefined (exh. cat. by D. Kirkpatrick, M. Merryman-Means, R.-P. Barilloux, A. Farkis and others; New York, Museum of Holography, 1983)

Holography Works: Application of Holography in Industry and Commerce (exh. cat. by R. Jackson, H. J. Caulfield and R.-P. Barilloux; New York, Museum of Holography, 1983)

B. Dorra: 'Holografie: Ein neues kunsthistorisches Medium?', *Das Kunstwerk*, xxviii/8 (Feb 1984), pp. 5–27

J. E. Kaspar and S. A. Feller: *The Hologram Book* (Englewood Cliffs, 1985) [tech.]

1985: The Second International Exhibition of Holography (exh. cat., Lake Forest, IL, Lake Forest College, 1985)

P. Heckman: *The Magic of Holography* (New York, 1986) [tech. and hist.]

D. Kirkpatrick: 'Recent Art, Science and Technological Interactions in Chicago', *Making Waves: An Interactive Art/Science Exhibit* (exh. cat., Evanston, 1986), pp. 8–24

Light Dreams: The Art and Technology of Holography (exh. cat. by D. Tyler; Kalamazoo, MI, Kalamazoo Institute of Arts, 1987)

F. Popper: *Art of the Electronic Age* (London, 1993)

L. Tarlow: 'Harriet Casdin-Silver, a Pioneer in Holography' [interview], *Art New England*, xv (Feb–March 1994), pp. 18–20

G. Dyens and others: 'New Media Dictionary—Part IV: Holography', *Leonardo*, xxxiv/4 (2001), pp. 370–80

S. F. Johnston: *Holographic Visions: A History of New Science* (Oxford, 2006)

Horn and antler. Horn is the permanent keratinous sheath surrounding the bony outgrowth (*os cornu*) on the skulls of animals such as cattle, goats, antelope and sheep; it is a modified form of skin tissue, and so distinct from the bony and deciduous antlers or 'horns' of certain species of deer. In the past most kinds of horn have been used, including, in China, rhinoceros horn, but modern application is confined to horn from European and African cattle and sheep and particularly from domestic buffalo and goats.

Once removed from its bony core, horn is more or less hollow, with only the tip being solid. The proportion of solid tip to hollow body varies from species to species or, in the case of domestic animals, with breed, as do colour and shape. The material is supremely utilitarian, being light and strong but quite easily worked with simple tools. It can be sawn, filed, drilled, carved and turned on a lathe. Pieces can be fixed together by jointing, gluing, screwing or nailing. Horn is thermoplastic and can be softened by boiling or steaming to produce flat sheets or simple shapes using dies and moulds, which can then have designs stamped or pressed on to them.

A typical kit of horners' tools contains saws for cutting the horn to size and shape and a selection of files, rasps and floats for surface preparation, shaping and finishing. Steel scrapers are used for fine finishing, gravers of various kinds for engraved decoration, chisels, gouges and knives for carved work and drills for making fixing holes or for pierced work, which can then be completed using a piercing or fretsaw. Larger equipment includes boilers or steamers for softening the horn and presses for flattening sheets or making cups, beakers or boxes and for ornamental die pressing. A lathe, together with a variety of profiled cutters and scrapers, is used for turned work.

Horn can be used virtually unmodified to produce drinking, powder and sounding horns (trumpets). The hollow portion can be cut transversely to produce beakers, cups and circular boxes; or sliced longitudinally, flattened, split and then further moulded to make knife scales, book covers, lantern (lanthorn) plates and shoe horns; or cut and filed into combs and brush backs. The solid tip can be cut transversely to make buttons, toggles and bottle or jar stoppers. It can be used in its natural state for cutlery handles or turned to make small cylindrical objects of various types. These products can then be further ornamented by carving, engraving, hot pressing, turning and polishing. Some of the finest examples of horn-carvings are found in Japanese *netsuke*.

Antler has a similarly long history of use, ranging from its use as a material for prehistoric tools and carvings (see fig.), through to its use in creating chandeliers and furniture in the modern period. Antlers were used in medieval Europe to make the circular Gothic chandeliers known as Kronleuchters. They were also used for the display of trophies; early displays always used real stag skulls and antlers, but from the 17th century carved wooden imitations were sometimes used. In 19th-century Germany, antlers were used to make furniture. The first company to do so commercially was that of Josef

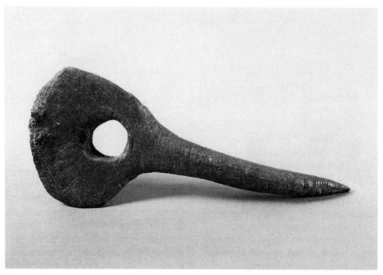

Stag's antler sceptre with carved geometric patterns, prehistoric (Genoa, Museo Archeologico di Pegli); photo credit: Scala/Art Resource, NY

Ulrich Danhauser (1780–1829). In the mid-19th century, the most important manufacturer was H. F. C. Rampendahl of Hamburg, who made chairs (e.g. antler horn chair with velvet cover, *c.* 1840; London, Victoria and Albert Museum), sofas and tables from antler. Other manufacturers included R. Friedrich Böhler (Frankfurt), Kraftverkehr (Bitterfeld) and C. W. Fleischmann (Nuremberg).

A. MacGregor: *Bone, Antler, Ivory and Horn* (Beckenham, 1941)

P. Hardwick: *Discovering Horn* (London, 1981)

J. Blair, ed.: *English Medieval Industries: Craftsmen, Techniques, Products* (London, 1991/*R* 2001)

L. P. Smith: 'Horn and Plastics: The Natural Connection', *Plastiquarian*, xii (1993), pp. 4–5

R. Beilly: 'Horn and Antler Furniture', *Interior Design*, lxv (Sept 1994), p. 114

I

Image d'Epinal. Cheap woodcut print, coloured by hand or stencil. Such prints were made in a number of French provincial towns and take their name from the major 19th-century centre of production, where prints are still made. The family dynasties of publishers who made and marketed them are part of the long tradition of French *imagerie populaire*. The 19th-century prints from Epinal treat secular as well as religious subjects; the latter predominated in the 18th century. Secular subjects were produced in large numbers during the French Revolution, by publishers such as Jean-Baptiste Letourmy (in Orleans) and André Basset (in the Rue St Jacques, Paris). Napoleonic themes and portraits became increasingly important particularly during the Second Empire (1852–70). At this time an imagery specifically designed for children emerged, and the Pellerin family built their business in Epinal into an international success.

P. L. Duchartre and R. Saulnier: *L'Imagerie parisienne: L'Imagerie de la rue Saint Jacques* (Paris, 1944)

J. Mistler: *Epinal et l'Imagerie Populaire* (Paris, 1961)

J. Adhémar: *L'Imagerie Populaire française* (Paris and Milan, 1968)

French Popular Imagery: Five Centuries of Prints (exh. cat., London, Hayward Gallery, 1974)

M. Shapiro: 'Courbet and Popular Imagery: An Essay on Realism and Naïveté', *Modern Art* (1979)

F. Demange, ed.: *Images de la Révolution: L'Imagerie Populaire orléanaise à l'époque révolutionnaire* (Paris, 1989)

N. Garnier: *L'Imagerie Populaire française. Gravures en taille-douce et en taille d'épargne* (1990), i of Réunion des musée nationaux (Paris, 1990–)

Imitation leather. See LEATHER, IMITATION.

Impasto. Term for paint that is thickly applied to a canvas or panel so that it stands in relief and retains the marks of the brush or palette knife. Early panel paintings show little impasto, but with the adoption of oil painting on canvas, painters such as Titian and Rembrandt explored the possibilities of the technique. Impressionist works may be heavily impasted in many areas.

Imprimatura. Thin transparent coloured paint layer applied over the ground and underdrawing to tone down the brilliant white layer below and to provide a preliminary colour on which to work. Imprimatura may also be loosely applied to any coloured ground layer.

Ink. Imprecise term applied to a number of more or less fluid materials that are used for either writing or printing the written word or have evolved for a variety of illustrative and artistic purposes. Most inks for the written and printed word have always been black, or nearly so, but coloured inks also evolved for some writing, for embellishment and for pictorial work.

See also PIGMENT, especially §§II and IV.

I. Types and properties. II. Uses. III. Conservation.

I. Types and properties. A primary distinction can be made between inks used for writing and drawing and those used for printing. The former are usually water-based and are sometimes barely distinguishable from watercolour paints, especially in the case of coloured inks. Printing inks may be water-, oil- or solvent-based. Ink for writing and drawing must flow freely from the pen or brush and must be of adequate tinting strength. These properties can be provided by black pigments held in suspension or by solutions that are or become black, but in each case only a few preparations have been found adequate, at least before modern times. Carbon, in various forms, has provided the usual black pigment. Historically, however, the most important aqueous solutions used as inks have been those of metal tannates, which evolved into iron-gall (iron gallotannate or gall-nut) ink. Ink is also judged by its stability, either in the sense of its adhesion to the support or the permanence of its colour over time.

1. Writing and drawing. 2. Printing.

1. WRITING AND DRAWING.

(i) Asia. (ii) Middle East and the Western world.

(i) Asia.

(a) Black. Chinese ink (Chin. *mo*; Jap. *sumi*; Kor. *mŏk*) is not the earliest carbon-based ink, but it became the most highly perfected, and its development is well documented. Essentially, it is an intimate mixture of soot or lampblack with animal glue (other constituents have been added, but they are more

variable). Such a mixture, differing only in details from later recipes, was described in the *Qimin yaoshu* ('The essential ways for living of the common people'), an agricultural encyclopedia of the 6th century AD by Jia Sixie. Some historical accounts refer to the earlier use of lacquer for writing and also to a material called 'stone ink' (Chin. *shimo*), but their existence or importance remains uncertain. In any event, extant inscriptions on wood, bamboo and silk, as well as wall paintings from the Han period (221 BC–AD 220), suggest the use of a fluid black ink, which was applied with a brush and did not differ in its general properties from later versions.

The earliest recorded type of carbon is pinesoot black, which was made with considerable care from pine-wood soot. Various accounts describe and illustrate structures designed to burn the wood in a restricted air supply, then to cause the soot so formed to drift through a series of chambers or down an extended tunnel-like arrangement. This process eliminated impurities such as fly ash and tarry materials, leaving the very fine carbon particles produced by a sooting flame. The soot that drifted the furthest was considered to be of the best quality, while soot that drifted shorter distances through the structure was deemed of progressively lower quality. The use of lampblack, made by burning oil at a wick, began from about the Song period (960–1279). Typically, a simple lamp made from a bowl of oil with a wick at the edge had an inverted funnel or heavy saucer propped over the flame to catch the lampblack. Vegetable oils, such as tung, rapeseed, hemp or sesame oil, were used, as were other fuels: for instance, spoiled lacquer is supposed to have afforded a good product, and later accounts suggest that pigs' fat and petroleum products were also effective. In modern inkmaking practice, commercially produced carbon blacks are often preferred.

For the best ink, much care was also taken over the selection of the second main constituent, the animal glue. When the protein collagen (the main constituent of animal connective tissue such as skin and tendon) is heated in water, the protein chains are disarranged and dispersed to give a solution that gels on cooling and acts as an effective adhesive and sizing agent (*see* ADHESIVES, §1(i)). The skins of bovine animals were apparently the main raw material, but in China, specifically, fish skins and other fish products may have featured, besides less common materials such as horn and antler. Up to 1100 other additives are known (Franke). Some are vegetable extracts, such as that of the bark of the tree *Fraxinus pubinervus*, which may have helped disperse the carbon. Others are natural dyes, which may have modified or 'toned' the colour. Perfumes such as camphor or musk recur and may have helped retard or disguise the effects of bacterial decomposition. Such secondary constituents were usually added when the carbon was mixed with an aqueous solution of the animal glue. All accounts stress that the mixing process is important and must be performed thoroughly and at length to obtain a good product. The pasty mixture, about the

consistency of potters' clay, was repeatedly steamed, sprinkled, pounded and rolled. Carbon itself is a hydrophobic (water-repellent) substance, and the thoroughness of the compounding with glue is clearly one of the secrets of modifying it so that it disperses readily in water to form a stable suspension.

Portions of the carbon and glue paste were moulded under pressure into sticks or cakes, usually in wooden moulds carved with characters or designs that were impressed on the surface of the sticks. The inksticks were then dried carefully and slowly to avoid the ever-present danger of cracking. They were also commonly painted or gilded, resulting in decorative pieces that have often been collected for their own sake. Many connoisseurs claim that inksticks improve with ageing, and that lighter sticks are better than denser ones. A purple glint off a fractured surface has also been considered by some to indicate the best-quality ink.

The same process of making ink spread to Korea and Japan at an early date: it was introduced into Japan in the 7th century AD, according to the *Nihon shoki* ('Chronicle of Japan'; completed AD 720), and it was certainly known in Korea before then. The Koreans apparently had available both a very suitable pine-wood for the soot and a high-quality animal glue for the binding medium, which resulted in a particularly fine version of ink. In the 20th century Chinese ink in stick form was made in Japan, Korea and Taiwan, as well as on the Chinese mainland.

Being based on carbon as the pigment, Chinese ink has always been free of fading or similar chemical changes. Mechanical stability, or resistance to flaking and powdering, is related both to the adhesive strength of the binder and to the degree of penetration of the ink into the support. The second factor is helped by the widespread use in East Asia of silk or paper supports that, except when heavily sized, are more or less readily penetrated by ink. In addition, selection of a finely divided carbon and high-quality glue, combined with great thoroughness in the blending, gives an ink that disperses very finely to afford the best attainable penetration and adhesion. When viewed through an electron microscope, ink that has penetrated the support well is seen as small carbon particles spread over the surface in a matted layer or small groups.

The black inks that gradually came into use in India were based on carbon in the form of lampblack and of charcoal from various plant materials, but they otherwise owe little to Chinese inksticks. One type of ink for writing on birch bark was made by boiling charred almond shells with cows' urine, but, more usually, plant gums such as acacia gum were the dispersal and binding medium. Carbohydrate-based, these are more readily soluble and have less adhesive strength than the animal glues of East Asia. Inks seem usually to have been made in liquid form, and writing was with pens (made, for example, from reeds) rather than with the brush. Inks from other areas of Asia show affinities either with those from China, those from India, or both.

(b) Coloured. Coloured inks in East, South and Central Asia are essentially the same as watercolour paints, being a dispersion of finely divided pigment in a solution of the same binders as noted above. Gold and silver inks have often been used for religious writings and are most often found in areas and periods where religions, especially Buddhism, have been strongly established. Gold is chemically stable and also adheres to most supports well, but silver tarnishes readily and has often turned black. It survives best where it is well protected, such as in handscrolls that have been infrequently unrolled. In addition, silver often causes brown discolorations on paper supports. In South-east Asia, white and yellow inks have frequently been used to write on black paper. There have been differing claims for the pigments used. Red inks have long been used in many parts of Asia, the most common pigment being vermilion (red mercuric sulphide). When they are employed for writing, the same water-based media are employed as for black ink, and in East Asia red and other pigments have sometimes been made up into stick form.

A different red ink in East Asia is that used for impressing seals on paintings, documents etc. Chinese seals were usually impressed into clay until silk and paper came into widespread use for writing, when vermilion seal ink was introduced. The earliest version was probably dispersed in water, and some accounts indicate that honey was used as the dispersing medium and binder. The use of oil-based ink later became dominant, especially after the development of the seal pad in the 12th century. A punk of dried moxa leaves (*Artemisia moxa*) was mixed with oil and vermilion to give a pasty mass that served to ink the seal after the fashion of a modern inkpad. Castor, rapeseed and some other oils have been used, but in modern times linseed oil is favoured because of its better drying properties.

(ii) Middle East and the Western world.

(a) Black and brown. The history of the development of black writing ink in the world of Islam and Judaism parallels that of western Europe. In both cases, carbon-based inks came first. They later coexisted for some time with metal tannate preparations, which eventually largely displaced them for ordinary writing, although not entirely for artistic purposes. The earliest known type of ink is the carbon-based ink of ancient Egypt, a type that continued to be used in the Mediterranean area throughout Classical times. The Romans made soot by burning resin in special furnaces, as well as using charcoal, yeast black (made by roasting wine sediment) and probably lampblack and ivory black (carbonized ivory or, more usually, bone). Plant gums were probably the dispersing and binding medium for most of these early inks. The mixture was dried to give cakes that were either mulled with water or wetted before a pen was rubbed on the surface. Preparations such as these are readily water-soluble and are known to have been easily erasable with water. This property was due in part to the impenetrable nature of the papyrus or parchment used as supports. The ink remained largely on the surface and rather weakly attached to it, unlike the Chinese ink used in East Asia (*see* §(i) above).

In the Middle East, inks based on carbons mixed with plant gums also form the earliest known types, which date, at least in the Jewish case, to biblical times. Acacia and tragacanth gums have been cited as media and lampblack from olive oil or soot from burning resin, pine-wood or other fuels as the pigments. These preparations clearly had the same erasable property.

The introduction of metal tannates as inks did not happen quickly or simply. Tannins are a group of vegetable products that occur widely. Many (though not all) of them form a deep blue-black colour with iron in the ferric (trivalent) state; the colour forms after oxidation by atmospheric oxygen of the soluble product with ferrous (divalent iron) sulphate solution. Eventually, extracts of gall-nuts or oak-apples (an abnormal growth found on certain trees and a rich source of suitable tannins) mixed with a solution of an iron salt came to be used for the writing ink known as iron-gall ink. Such mixtures may be connected to the use of metal salts as mordants for vegetable dyes, some of which are based on tannins. However, the earliest recipes involving these materials usually include them in mixtures with a carbon-based preparation and often seem to specify salts of metals other than iron—for example alum or copper sulphate (blue vitriol). In this period of experimentation, the objective may have been to improve the notoriously poor adhesion of a carbon and gum ink to the underlying surface. Mixtures of metal salts and tannins produce small amounts of acid, depending on the exact materials and proportions, and this, by corroding or biting into the support surface, may have been found to make the writing more permanent.

From the 9th century, authors in the Islamic world knew and distinguished between carbon-based and metal tannate inks, even though many recipes were mixtures. A wide variety of recipes has been preserved, perhaps because inks were made up by scribes themselves rather than by specialists as in China. Authors such as the Zirid prince al-Mu'izz ibn Badis (*reg* 1016–62) describe inks in both solid and liquid form and of various qualities, as well as the *liq*, an ink-soaked felt or wool pad for use with the pen. A generally similar evolution took place in Europe, where the practice of using metal tannates may have been introduced from the Arabs. *De diversis artibus* by Theophilus (12th century) describes an iron tannate preparation; before that time all recipes were carbon-based. From the 13th century, iron-gall inks were described and in common use, and by the 16th century the texts are all based essentially on the same model: an extract of galls with gum arabic and vitriol (though it is still not always clear whether copper sulphate or ferrous sulphate was intended). In due course ferrous sulphate and gall extracts, with

the recommended addition of gum arabic or other materials, formed the standard basis for writing inks.

Because a solution of ferrous sulphate with tannin is only slightly coloured and may take several days to develop its typical blue-black colour, ink manufacturers since about the 18th century have added a provisional colour such as indigo (later synthetic dyes) to make the writing easily visible at once. Before this was done, it was usual to oxidize the ink deliberately to give enough ferric tannate complex to make the ink usable. This complex is, however, insoluble, forming in effect a dispersed pigment, and the function of the gum present in virtually all recipes was probably to stabilize this dispersion and attach it to the support. It thus had the same drawback as a carbon pigment, even though the soluble ferrous tannate could penetrate the support slightly before being oxidized and thus become more firmly attached to it. Indeed, it seems to have been recognized that an ink that was quite pale at the writing stage would ultimately prove the most stable.

Iron tannates, blue-black to fully black after the initial oxidation, fade somewhat in time to a brown or greyish-brown colour (the exact shade may depend on impurities). They tend therefore to be more mechanically stable but less lightfast than carbon-based inks. Moreover, it has long been known that they can sometimes chemically attack and destroy supports, some preparations being quite markedly acid (see §III below).

Other important black or brown inks are sepia and bistre. Bistre is more of a watercolour paint than an ink and is made from wood soot, often using beech-wood. The soot, collected from close to the fire, contains much tarry material as well as carbon particles. The coarser material is removed by extracting with water, decanting and allowing the solution to evaporate. The colour varies from yellowish-brown to dark brown, depending on the wood and the exact method of preparation. Although bistre contains carbon, it is not lightfast, since the tarry materials fade with exposure, usually making the overall colour cooler and paler. The first known literary mention of bistre was by Jehan Le Begue in 1431.

True sepia is made from the dried ink sacs of various cephalopods, the best known being the Mediterranean cuttlefish (Sepia officinalis). It was described by Roman authors, but it is not clear how far it may have been used as an ink at that time. It was introduced by Professor Jacob C. Seydelmann in Dresden sometime after 1778 and appears to have displaced bistre and carbon-based inks for wash drawings. Sepia is prepared by pulverizing the dried ink sacs, then dissolving the pigment in alkali, filtering, reprecipitating with acid, washing and drying. The product consists chiefly of the nitrogenous compound melanin and is not lightfast. Many modern products marketed as 'sepia' are, in fact, watercolour paints based on earth pigments.

Carbon-based ink in the form of Chinese ink-sticks was imported into Europe, possibly as early as the 16th century. Frequently referred to as 'Indian' or 'India' ink, it began to be mentioned in art manuals in the 17th century. These Chinese carbon-based inks were soon imitated, for example in the Netherlands, and the term 'Indian' ink began to be used also for the European product. This process resulted in an improvement in the technical standard of the ink: it has become the draughtsman's ink of more recent times and is also used by artists requiring a heavy, dense black.

(b) Coloured. A red ink, based on red iron oxide, was used in ancient Egypt for the rubrication of headings, notes etc. The Arabs used a wider variety of coloured inks for rubrics, capitals and various embellishments, using either pen or brush. According to al-Mu'izz ibn Badis, red, yellow and green were the most important colours, though others were also used. Vermilion and red lead were used as red pigments, orpiment for yellow and verdigris for green; the media were the same plant gums as before. Yellow inks may sometimes have been intended to mimic gold, though gold inks, as well as those of silver, tin and even copper, were also employed.

Colours were used to illuminate and embellish European manuscripts, but these are essentially paints. From the 19th century, a variety of synthetic colouring materials began to be used for Western inks to give reds, violets or other colours, though these were usually light-fugitive. Better-quality synthetic dyes developed in the later 20th century have led to the production of felt-tipped or fibre-tipped pens in a wide variety of colours, including black.

2. PRINTING.

(i) Asia. Printing with ink, usually on to paper, began in East Asia, probably in China. The black ink used was the same mixture of lampblack or soot with glue as used for writing and painting, though the quality of the materials may not have been as high as that used for the finest calligraphy. This water-based ink worked well on the carved woodblocks with which the majority of East Asian printing was done. Metal type was also introduced, especially in Korea, where it is known to have been in use by 1234: this implies the use of an oil-based printing ink (water-based inks do not spread properly on metal surfaces), but little seems to be known of its composition. The concurrent use of oil-based vermilion seal inks suggests that such a preparation would have been technically feasible.

Colour-printing from woodblocks was also practised in East Asia. The earliest known example is a Diamond Sutra printed in 1341 in red and black by the Zifu Temple in modern Hebei province. Polychrome book printing was under way in China at the beginning of the 17th century, a notable example being the prints in the Treatise on Calligraphy and Painting of the Ten Bamboo Studio, produced between 1619 and 1633. The best-known East Asian colour prints are those of the Japanese ukiyoe school centred on Edo (now Tokyo). Printing in two colours (in addition to black) began there around 1742, that in multiple colours in the mid-1760s. Colour printing (like any other printing) requires finely divided colorants

of high tinting strength, which has precluded the use of some of the pigments used for painting. Many of the traditional print colours have been organic dyestuffs. In Japan they have included *beni* (safflower pink from *Carthamus tinctorius*), *ukon* (turmeric yellow from *Curcuma longa*), *ai* (indigo from *Polygonum tinctorium*), *aigami* (dayflower blue from *Commelina communis*), *suō* (sappan-wood red from *Caesalpinia sappan*), *kihada* (yellow from *Phellodendron amurense*), *enji* (red from various scaled insects, including cochineal) and various others. Common inorganic pigments have been red lead (orange), iron oxides (reds and browns) and, from about the beginning of the 19th century, Prussian blue. However, less is known about the sources and history of colorants in *ukiyoe* and other East Asian prints than is the case with painting materials.

(ii) Western world. Inks are used for all four basic types of printing: relief, intaglio, planographic and porous printing. Although relief prints, such as woodcuts and wood-engravings, can be printed with a water-based ink, nearly all printing processes in Europe and the West required the development of oil-based inks. Aqueous vehicles will not spread uniformly and reliably on the metal surfaces of types and plates, and the process of movable type printing attributed to Johann Gutenberg *c.* 1450 depended on, among other things, the development of a suitable ink. The ink used in Gutenberg's productions is considered to be of very high quality, being densely black and free of an oily halo formation around the letters. Inks for typographic and other relief-printing generally used a lampblack as the pigment, often made by burning resins and pitches. For the best product, the black first obtained from the burning was reheated at a high temperature in a closed vessel in order to rid the pigment of incompletely carbonized materials. It was then washed and ground to a fine powder, removing gritty impurities. Other fuels used to make lampblack were animal fats and, later, coal tar; these blacks have been superseded by industrial carbon blacks, first manufactured in 1872 from natural gas. The addition of blue pigments, such as indigo or, later, Prussian blue, has sometimes been described as a way of giving a blacker appearance to the ink in typographic and line printing. Inks for certain printing methods, such as intaglio work, have often used other carbons, such as yeast black, vine black (carbonized vine twigs) or ivory black.

The vehicle used is oleo-resinous. A variety of resins have been tried at times, including mastic, dammar and Copaiba balsam. Other additives include varieties of soap, which help the ink 'lift' from the printing surface on to the paper. The major component, however, is the oil, the usual types being linseed and walnut oil. To give the oil satisfactory drying properties, it had to be 'boiled' or heated in a large vessel to a high temperature. The boiling process was both unpleasant, since acrid fumes were produced, and dangerous, since the oil could easily froth over and ignite; indeed, recipes often required it to be deliberately ignited or 'burnt'. Boiling the oil was

nevertheless important for making good ink. In many cases it was done with the addition of siccatives such as litharge (lead monoxide), and a recurring theme is the insertion into the hot oil of breadcrusts and sometimes onions. These may have absorbed and helped remove mucilagenous impurities. Until the second half of the 19th century, many printers made their own ink, often moving temporarily to an open place to boil the oil. Modern methods are based on the use of super-heated steam. Inks for intaglio and planographic printing are similar in principle to those for relief printing, but with some adjustment of the detailed properties.

Printing ink is a thick, pasty material. Its physical behaviour during printing is expressed by the empirical concepts of 'length' and 'tack'. A 'long' ink is stretchy and elastic when pulled out; a 'short' one is rather buttery. 'Tack' indicates the tendency to stick to a surface on contact. Both properties must be optimized for best results. Intaglio inks, for example, are quite 'short' to avoid the ink being pulled from the incisions when the plate is wiped of surplus ink. In fine art printing, the artist usually adjusts his own ink in the light of the properties of the plate and the effect for which he is striving.

Two distinct materials have been referred to as lithographic inks: that used by the artist to draw his design on the stone (usually a crayon but sometimes a liquid, and almost always black) and that used to print from the stone. They are, however, of rather similar composition, both being oleo-resinous with a high proportion of oil. Lithographic printing inks are formulated to 'take' readily on the oleophilic areas of the stone or plate and to be repelled by the wetted areas without having any tendency to emulsify with water. They need a high enough 'tack' to keep printing consistently through a run and are usually rather slow drying. Many coloured pigments, if of fairly high tinting strength and sufficiently finely ground, work well in lithographic printing.

'Porous printing' embraces stencil and silkscreen methods, for which water-based, oil-based and solvent-based inks have all been used. Screenprinting is based on pushing an ink across the screen, which has non-printing areas blocked out. The ink type chosen may depend on the blocking out method, and it is formulated 'short' so as not to drag on the squeegee and to release cleanly from the screen after the printing pass.

II. Uses. The basic uses of ink are for writing and printing. However, the materials and their uses have both undergone an evolution as artists began employing inks for artistic purposes. Those purposes have themselves evolved, resulting in the blurring of the distinction between ink and paint. This evolution is more marked in the Western world than in Asia, where black ink has changed little. In the West, writing is normally done with the PEN, which distinguishes it from painting; but as fine writing began to demand embellishment and associated pictorial work evolved, artists who began with pen and ink

soon found the need for effects produced with the Brush. Thus drawing evolved towards watercolour painting, and the distinction between the two sometimes tends to be arbitrary. Inks for Western printing have changed less as basic types, though printing methods have also evolved, and modern methods such as screenprinting do not distinguish sharply between ink and paint. Such developments have resulted in considerable artistic diversity, as well as imprecise terminology.

1. East Asia.

(i) Painting and calligraphy. Both these art forms have a long history in China. They use the same instrument— the brush—and, to a large extent, the same black ink. Ink and brush together offer great flexibility and precision and in China have served as a constant means of expression for writing, drawing and painting, while in the West several tools and materials have been produced to meet the same ends. Although Chinese ink is arguably the most important single material in both painting and calligraphy, its use cannot be divorced from the characteristics of either the brush or the support (see also Paper and Silk).

Good-quality Chinese ink results from grinding the inkstick with water on the inkstone to yield a dense black, free-flowing and stable dispersion. It is usual to grind at least as much ink as will be needed for the proposed work, as the necessity to regrind may result in differences of ink density. The dispersion may be diluted, either in the well of the inkstone or after pouring off the ink into a separate dish. Calligraphy is usually done with a fairly dense ink, though the brush may be charged fully to allow a 'wet' ink effect, or only partially to produce a 'dry' effect. A wide variety of types and styles of ink painting has been produced in East Asia. In the highly conservative tradition of Buddhist temple paintings, ink is used to form outlines that are filled in with colour. However, it is with paintings in ink only, or with slight additions of colour, that the full versatility of the material is revealed. Such painting is often held to be essentially linear in concept. Many types of ink lines and dots have been distinguished and named, and their uses in building up different painting features have been discussed in Chinese manuals, as in the Jiezi yuan huazhuan ('Mustard seed garden manual'), compiled by Wang Gai (1679–1701).

(ii) Printing. Traditional East Asian printing in black uses the same conventional Chinese ink as for calligraphy and painting, though not necessarily of the same quality. The usual printing elements were wooden blocks carved in relief with the characters or design to be printed. The relief surface had the liquid ink applied with a brush and the piece of paper laid on it and burnished down firmly using either a brush or a burnisher. The earliest surviving examples of woodblock-printing appear to be Buddhist images or charms dating to the latter part of the 6th century AD.

The earliest known example of the printed word is a Buddhist text fragment that was enclosed in AD 751 in a stone stupa in the temple of Pulguk, in Kyŏngju, Korea.

Woodblock colour-printing uses a separate block for each colour, with black most often serving for the outline. In the traditional ukiyoe technique, a dispersion of the colorant in animal glue is placed on the block along with a little starch paste, and the two are mixed and spread over the printing surface with a soft brush. Shading effects are achieved either by wiping away part of the ink or by a preliminary graded damping of certain areas to decrease the amount of ink taken over those areas. Other printing methods have been incorporated. Gold can be applied by first printing a wet adhesive mixture, then sprinkling and brushing out gold powder over it. Mica could be applied in the same way, but a better method was to brush in the mica and glue mixture through a stencil.

2. Western world.

(i) Writing and drawing. Writing in the West usually involves ink applied with a pen rather than a brush. During the Middle Ages, up to about the 15th century, script was an important art form. Illumination and embellishment of both religious and secular manuscripts were either executed with the same pen-and-ink system as used for the script or by the addition of colours and gilding. From the early Renaissance period, however, Drawing became independent of textual illustration and evolved into an art form in its own right. Drawing, as opposed to script or calligraphy, thus became dominant in terms of the artistic use of ink, the emphasis on script diminishing in any case after the introduction of typographical printing in the 15th century. Iron-gall ink, already established as the standard writing material, was naturally used for drawings, for which bistre and true sepia were also eventually available. These inks are all intermiscible and were almost certainly sometimes used as mixtures. Depending on the tool chosen, the same ink, in various dilutions, produced different effects. Pen and ink produces an incisive line, eliminating all but linear essentials and retains this character even when it is used to describe shading and texture. The brush-and-ink system is more flexible, allowing expressive variations, and is, of course, necessary for applying washes.

(ii) Printing. The Woodcut, the main relief process, can use either water- or oil-based inks. Those that predate the development of typographic Printing in the mid-15th century may well have used a water-based carbon ink. Line-blocks, incorporated into text as illustrations, were inked at the same time as the text. The later development of half-tone blocks for printing continuous tones is almost entirely commercial in nature but in any event uses a similar ink, usually with a rather softer body.

Many ways of making intaglio plates have been devised, the most direct being Engraving, which

dates back to at least 1446, and ETCHING, from the early 16th century. The earliest engravings may well have been printed with a water-based carbon ink. However, intaglio printing was developed at roughly the same time as text printing from movable type and soon began using a similar oil-based ink. After an engraved or etched plate is inked, the surplus ink is wiped from the relief surface. To be successful, this requires an ink that is 'short', heavily pigmented and unlikely to streak during the wiping. A very fine pigment such as lampblack tends not to meet the last criterion. Earth pigments, such as umber, may be added to give a warmer tone. The properties and versatility of carbon pigments have made it easy to formulate black inks for a variety of intaglio applications, leading to a concentration on monochrome black. However, colours can perfectly well be printed, and in more recent times several methods of printing different colours from the same plate have been used. These have included the application of inks that do not mix readily to different areas of the same plate, which can then be printed in one pull through the press. A suitable ink will also enable an intaglio plate to be printed from the relief areas, so that the same plate can fill empty space with a desired colour.

In LITHOGRAPHY an image is created on a suitable surface (originally, and for the fine arts often still, a slab of limestone) using water-repellent crayons and inks, treating the surface to make the non-image parts receptive to water, damping and then inking the surface so that the oil-based ink 'takes' only on those parts where the image was drawn and is repelled from the water-receptive parts.

The stencil method uses almost any kind of 'ink' (see STENCILLING), while various kinds can be employed for SCREENPRINTING, providing they are compatible with the blocking-out method used on the silkscreen. A common blocking-out method is based on the use of a water-soluble glue, applied to the screen after the design has been drawn in a waxy resist. Water-soluble inks are incompatible with this technique as they would damage or dissolve the glue block. Oil paints or solvent-based poster paints have often been favoured as the inks. Solvent-based types have the advantage of being fairly quick-drying, so that successive colours can be printed without undue delay.

III. Conservation. For the conservator the problems posed by inks include lack of adhesion between ink and support; attack of the support material by the ink; changes in colour; and biological attack. Cleaning or repair procedures have to take account of the properties of any ink present.

Lack of adhesion leads to flaking or powdering of the ink and can be a problem with some carbon-based types. Much depends on the quality of the binder and the extent to which the carbon has penetrated the support. East Asian paintings on heavily sized paper may have the ink lying entirely on the surface, when it sometimes tends to flake off.

Treatments are based on reattachment and consolidation with various natural and synthetic adhesives. Some scroll paintings and calligraphy, especially from China, show 'smearing' of the ink as a result of over-vigorous cleaning or demounting operations in the past.

Iron-gall inks, being more or less acidic, are liable to attack paper supports, which are particularly vulnerable to acids. (Proteins such as vellum survive such conditions much better.) The amount of acid in ink varies according to the materials and method of preparation, and some papers have enough alkaline reserve to neutralize the acid present. Many drawings and passages of writing in iron-gall ink thus survive quite well, but some undergo serious attack. White pigments used for highlighting, which are usually carbonates such as lead white, can also be destroyed by the underlying ink. Treatment usually calls for repair of the support and perhaps inpainting of losses. A number of deacidification procedures are available, but their feasibility depends on the individual case and is a matter for the experienced conservator.

Changes in colour, such as fading, affect iron-gall ink, bistre, true sepia and many coloured inks. It should be remembered that bistre and sepia have been imitated by other pigments, generally earth colours, that are much more lightfast. Many Old Master drawings in ink have faded and no longer show the same colours as when they were produced. Such changes are irreversible and largely a function of light exposure, which should be limited for both drawings and prints. Faded writing in iron-gall ink can be chemically intensified; these methods, however, also change the ink's colour, making their use unacceptable for works of art. Some coloured inks fade quite badly, among the most sensitive being those in Japanese pre-Modern prints. Apart from inpainting faded areas, no longer considered an ethical conservation practice, there is no cure for these changes, only prevention.

Microbiological attack is not usually a serious problem but may occasionally happen. Such attack is inhibited by iron gallotannates. It is preventable by the avoidance of high atmospheric humidities, or by the use of fungistats such as thymol; it is treated by sterilizing the affected areas and removing any existing mould growth.

See also DRAWING, and PRINTS.

E. S. Lumsden: *The Art of Etching* (London, 1925/R New York, 1962), pp. 85–98

B. March: *Some Technical Terms of Chinese Painting* (Baltimore, 1935)

C. A. Mitchell: *Inks: Their Composition and Manufacture* (London, 1937)

H. J. Plenderleith: *The Conservation of Prints, Drawings and Manuscripts* (London, 1937)

Mai-mai Sze, ed.: *The Mustard Seed Garden Manual of Painting: 'Chieh tzŭ yüan hua chuan', 1679–1701* (New York, 1956, rev. 1963)

J. Watrous: *The Craft of Old-master Drawings* (Madison, WI, 1957)

F. van Briessen: *The Way of the Brush* (Rutland, VT, 1962)

H. Franke: 'Kulturgeschichtliches über die chinesische Tusche', *Abhandlungen der philologisch–historischen Klasse der Bayerischen Akademie der Wissenschaft*, n. s., liv (1962) [whole issue]

M. Levey: 'Mediaeval Arabic Bookmaking and its Relation to Early Chemistry and Pharmacology', *Transactions of the American Philosophical Society*, n. s., lii/4 (1962), pp. 1–79 [commentary on and trans. of early 11th-century text by Ibn Badis]

M. Levey: 'Some Black Inks in Early Medieval Jewish Literature', *Chymia*, ix (1964), pp. 27–31

C. H. Bloy: *A History of Printing Ink, Balls and Rollers, 1440–1850* (London, 1967)

D. M. Mendelowitz: *Drawing* (New York, 1967)

F. Eichenberg: *The Art of the Print: Masterpieces, History, Techniques* (New York, 1976)

Pochoir: Flowering of the Hand-color Process in Prints and Illustrated Books (exh. cat., Santa Barbara, CA. University of California, University Art Museum, 1977)

M. Zerdoun Bat-Yehouda: *Les Encres noires au moyen âge (jusqu'à 1600)* (Paris, 1983)

R. L. Feller, M. Curran and C. W. Baillie: 'Identification of Traditional Organic Colorants Employed in Prints and Determination of their Rates of Fading', *Japanese Woodblock Prints: A Catalogue of the Mary A. Ainsworth Collection* (exh. cat., Oberlin, OH, Oberlin College, Allen Memorial Art Museum, 1984), pp. 253–66

T. H. Tsien and J. Needham: *Chemistry and Chemical Technology, Pt 1: Paper and Printing* (1985), v of *Science and Civilisation in China* (Cambridge, 1954–)

R. van Gulik and N. E. Kersten-Pampiglione: 'A Closer Look at Iron Gall Ink Burn', *Restaurator*, xv (1994), pp. 173–87

M. Kao: 'The Paintings of Zhang Daqian (Chang Dai-Chien): Unity of Tradition and Modernity', *Arts of Asia*, xxiv (May–June 1994), pp. 58–67

M. Pai: ['Three Contemporary Chinese Ink Painters'], *Oriental Art* (Spring 1994), pp. 72–4

F. van Briessen: *The Way of the Brush: Painting Techniques of China and Japan* (Boston, 1998)

B. Rhodes: *Before Photocopying: The Art and History of Mechanical Copying, 1780–1938* (New Castle, DE, 1999)

P. Shaw: 'Phytochromography—Screen Printing with Plants: Research into Alternative Ink Technology', *Leonardo*, xxxii/1 (1999), pp. 33–9

A. Caffaro: *Scrivere in oro: Ricettari medievali d'arte e artigianato, secoli IX–XI: Codici di Lucca e Ivrea* (Naples, 2003)

J. C. Walsh: *Ink and Inspiration: The Craft of Color Printing* (Washington, DC, 2003)

B. Thompson: *Printing Materials: Science and Technology* (Leatherhead, 2/2004)

Inpainting. Term used in the conservation of paintings or objects for the toning or imitative matching of an area of paint loss, without obscuring any original paint.

Intaglio. Process in which the design is hollowed out, the opposite of relief. The term is applied to gemstones (*see* Gem-engraving) and to a class of printmaking techniques, most notably Engraving and Etching (*see* Prints, §III, 2).

E. C. DeRose: *Jasper Johns: From Plate to Print* (New Haven, 2006)

Intarsia [tarsia]. Decorative wood technique in which the design or pattern is made by assembling small, shaped pieces of veneer. The term, which derives from 15th-century Italy, is commonly used on the Continent to describe both marquetry, in which the entire surface is veneered (*see* Marquetry, §1), and inlay, in which the pattern pieces are laid into a solid ground.

Intonaco. Term used in the true fresco technique for the final, smooth coat of plaster to which the pigments are applied, while the plaster is still wet (*see* Fresco, §1).

Iron and steel. Metals closely related in nature, use and history, steel being a purified form of iron. Iron is the fourth most abundant element and the second most common metal (after aluminium) in the earth's crust, of which it comprises about 5%. Both iron and steel are notable for their strength, although pure iron is soft and silvery white in colour. It is seldom found in its pure state, however, and it exists most commonly as iron oxide combined with numerous other minerals in iron ore, while meteoric iron contains about 10% of nickel. Iron is extracted from ore by a process of smelting, during which the iron generally absorbs carbon as well as retaining some impurities. Steel is a form of iron with its impurities reduced to a minimum and its carbon content carefully controlled. The earliest examples of meteoric iron fashioned into decorative objects date from the 4th millennium BC, and man-made iron was produced *c.* 2800 BC (*see* §II, 3 below), but the modern tradition of ironworking can be traced back to techniques mastered *c.* 1500 BC by the Hittites in Anatolia. From there these spread eastwards to China and west to Europe, allowing iron to replace bronze as the metal most commonly used for tools and especially arms and armour throughout Europe and Asia and heralding the gradual supersession of the Bronze Age by the Iron Age: the English name 'iron' may derive from the Celtic *isarno*, which in turn is probably related to the Latin word for bronze, *aes*. Steel was also known in antiquity, and the two metals remained important materials in the decorative arts traditions of most European and Asian countries. Iron also came to be used in Byzantine, Gothic and Islamic architecture, particularly for highly decorative elements, including grilles, railings and door hinges. From the mid-18th century, however, when techniques for its mass production were developed, iron took on a new importance, playing a vital role in the Industrial Revolution through its suitability for use in transport and engineering, including the construction of railways and bridges. In the 19th century wrought and cast iron began to be used for structural members, but in the late 19th century advances in steel technology led to the establishment of that material as the primary structural building material, often used to reinforce concrete (*see* Concrete, §II, 1(iii)) and often used in alloys with other metals. It also came to be commonly used for the mass production of

countless everyday and household items, including cars, furniture and domestic implements. Wrought iron in particular, however, continued, with steel, to be an important material not only in the applied arts but also in sculpture.

I. Types and properties. II. History and uses.

I. Types and properties. The types and properties of iron and steel relate to the techniques used for their production. The technique of extracting iron from ore by smelting was, until the medieval period, carried out in a hole in the ground, in a stone shaft or (later) in a cupola-shaped shaft made of fired clay. Charcoal and iron ore were heated together and then cooled to form a lump known as a 'bloom', mixed with impurities that could be removed by hand-hammering. The resulting wrought iron was light grey in appearance, with a woody grain. This could be shaped quite freely, hammered (i.e. forged), cut, twisted, stretched, cut and pierced, made malleable by annealing (a process of heating and then slowly cooling the iron). In Europe and the Middle East all iron was produced as wrought iron until the Middle Ages and was available only in fairly small quantities.

Cast iron is produced by melting iron ore in a high-temperature furnace, where it generally absorbs some of the carbon from the fuel used to heat the furnace. The liquid metal is then drawn off and channelled either into finished moulds or into intermediary blocks ('pigs'), which can later be remelted and cast into finished objects. A wide variety of often very intricate forms is therefore possible. Considerable numbers of cast-iron tools and moulds have been excavated from what appears to have been a large foundry in China, dating from the 3rd century BC. The production of cast iron in Europe, however, dates only from the medieval period and the introduction of such technological developments as the Catalan hearth, an early form of blast furnace that used bellows to heat the charcoal-fuelled furnace to unprecedented temperatures. A shortage of wood and hence charcoal in the 17th century prompted the search for an alternative fuel. Around 1710, at Coalbrookdale, Salop, Abraham Darby II (1711–63) successfully developed coke, a by-product of coal, which could both achieve the required temperatures to liquefy the iron and support larger quantities of ore in the furnace, and this enabled the massive expansion of the cast-iron industries in the 18th and 19th centuries to take place.

In addition to the elemental iron, the chemical components of the common commercial grades of cast iron include carbon (varying from 1.7% to 4%); phosphorus, silicon and sulphur (regarded as impurities and totalling something between 1.1% and 4.2%); and manganese (0.5% to 1%). Cast iron has a high compressive strength, commonly 42,000 kilonewtons, but a relatively low tensile strength, ranging from 13,000 to 18,000 kN. The metal is thus hard but somewhat brittle, making it suitable for structural members in compression (i.e. columns)

but unsuitable for those subject to bending and hence tension (i.e. beams); it is also abrasion-resistant and comparatively resistant to corrosion. Modern industrial wrought iron is produced by refining cast iron through reheating it in a furnace in the presence of iron oxide to reduce the amount of carbon. This produces a slag that is then mixed with the iron to produce a workable metal. The iron is not heated to fusion but to a plastic state in which it is rolled or worked to the ultimate form. Wrought iron is hence low in carbon, of which it seldom contains more than 0.02%, and is relatively free also of the usual impurities, which seldom exceed 1.2%. Slag (chiefly iron silicate) runs to 2.5% and is an important factor in giving the worked metal its fibrous structure. Wrought iron has a high tensile strength in the direction of the fibres, ranging from 34,000 to 42,000 kN. This property led to its use in the 19th century for such structural members as beams and girders.

Steel, combining the strength of wrought iron with the malleability of cast, was also produced in antiquity, when it was discovered that cakes of iron partially carburized in charcoal fires produced a material of great hardness and flexibility that could be forged by continued hammering and reheating into swords and other sharp-edged implements. In India and Sri Lanka, a type of crucible steel (*wootz*) was developed, and crucible steel was later produced in Europe. Both methods required great skill, however, and produced only small quantities of steel. Steelmaking therefore remained a specialized and therefore somewhat restricted craft until the late 1850s, when a process for its mass production was introduced by Henry Bessemer (1813–98). This involved forcing air through a bath of molten pig iron, thus bringing oxygen into contact with the iron and reducing its carbon content to the required level. The Bessemer converter also allowed the addition of other elements to improve the qualities of the steel to be strictly controlled, and it facilitated the production of steel for construction and other industrial purposes. Subsequent variations on the Bessemer process were developed in the 1860s (Siemens-Martin or open-hearth method, which allows the use of a large proportion of scrap) and in the 1950s (basic oxygen process, which greatly reduces the time taken in the process). Steel has all the physical properties of cast and wrought iron and only one comparative defect: its vulnerability, except in some special alloys, to oxidation, resulting in the formation of greenish-black ferrous (Iron II) oxide, reddish-brown ferric (Iron III) oxide (rust) or iron ferrous-ferric oxide, containing both Iron II and Iron III. Most steel used for structural and commercial purposes is plain-carbon steel (i.e. it contains no alloys), and any exposed surfaces therefore require frequent painting; galvanized steel, with a protective zinc coating, is commonly used for roof sheeting. The chemical components of plain-carbon steel indicate its relative purity: the essential element, carbon, comprises no more than 0.22% of the total, while the

impurities are held to a total of less than 0.3%. In elasticity, stiffness, ductility and malleability, steel is far superior to wrought or cast iron; its tensile strength ranges from 34,000 to 46,000 kN, and its compressive strength matches the 42,000 kN of cast iron. By the end of the 20th century, the majority of iron produced was used as a raw material for the production of steel.

A wide range of alloy steels has been developed to meet the special requirements of hardness, machinability, extreme conditions of stress, and abrasion-, heat- and corrosion-resistance demanded in the modern construction industry and for the manufacture of engines, aircraft and machinery. The two kinds of alloy most commonly used for building purposes are stainless steel and self-weathering steel. The former, which may contain up to 19% chromium (in addition to nickel, manganese and molybdenum), is almost entirely corrosion-resistant and has a tensile strength of up to 77,000 kN. It is primarily used for decorative elements and for the external cladding of buildings or for the external covering of spandrels and columns; its high cost prevents its use for structural members, to which it is otherwise ideally suited. Self-weathering steel (usually identified under manufacturers' trade names, e.g. Cor-Ten steel) does not resist oxidation but renders the oxide that forms on it into a self-renewing protective coating. The alloying elements are generally chromium, copper, manganese and nickel, used in roughly equal proportions. It is the only metal commonly used in building construction to have a distinctive aesthetic quality, because of its dark reddish-brown colour and its soft external texture. Again, because of its high cost it is seldom used for structural purposes and is mainly employed to cover the fire-resistant cladding on structural elements in multi-storey buildings.

Methods of shaping steel include the continuous casting of bars and rods, and the processing of industrial products in a variety of rolling mills; among these are hot-strip and cold-strip mills for sheet steel, and mills for plates, rails, pipes, rods and wire, bars and various structural steel sections. Details of other methods for the shaping and joining of iron and steel (e.g. forging, casting, riveting and welding), as well as decorative techniques (e.g. blueing, carving, damascening and embossing), which are not peculiar to iron and steel, are discussed under METAL, §§III, IV and V.

See also CHROMIUM and ELECTROPLATING.

C. Hornbostel: *Materials for Architecture* (New York, 1961)

W. H. Cubberly: *Metals Handbook*, i (Metals Park, OH, rev. 10/1990, ed. by J. R. David)

V. F. Buchwald: *Iron and Steel in Ancient Times* (Copenhagen, 2005)

II. History and uses.

1. Architecture. 2. Sculpture. 3. Applied arts.

1. ARCHITECTURE. From earliest archaeological times until late in the 18th century timber and masonry, in one form or another, dominated almost

all building construction. In just over two centuries since, the methods of supporting all but the simplest buildings have been revolutionized, first by the introduction of cast iron, then industrialized wrought iron and finally steel. The heyday of structural cast iron lasted from *c.* 1790 to the mid-1840s, when wrought iron began to take over, remaining the supreme structural material until in turn it gave way to steel in the last quarter of the 19th century. Cast iron continued to be used quite frequently for columns (always in compression) or for lowly stressed brackets until *c.* 1900. Today scarcely any truly structural cast iron is used, and no wrought iron is made. Steel is wholly dominant. There are, however, some signs of a limited revival of cast iron, particularly in the new ductile form available since the 1940s. Because of their distinct properties (*see* §I above) and periods of supremacy, it is convenient to consider the achievements with these three ferrous materials during three separate but overlapping ages.

(i) c. 1750–c. 1850. It was not until the mid-18th century, after the introduction of coke for smelting, that cast iron became cheap and plentiful enough and of sufficiently high quality to allow it to play a significant role in architecture—an example of new material being introduced either for its greater economy or to solve specific problems. Fire was one such recurring problem, and it was almost certainly the reason for one very early application of cast iron, in the columns supporting the vast cooker hood and chimney (1752) at Alcobaça Abbey in Portugal. In Britain, cast iron was used in churches from the 1770s, partly for the cheap reproduction of Gothic ornament but also for structural columns, as well as in the construction of a number of bridges. The first of these was an arched bridge (1777–9) over the River Severn, designed by Thomas Farnolls Pritchard (1723–77) and built by Abraham Darby III (1750–91) at Coalbrookdale, where a 30-m span of cast iron replaced the traditional stone arch. In Russia, architectural cast iron was used extensively throughout the 18th century, but it is unclear to what extent it was also used to support floors and roofs. Cast iron was a rarity in 18th-century France, but some highly innovative wrought-iron floors and roofs were built, such as the roof at the Théâtre du Palais Royal (1786–90) in Paris by Victor Louis (1731–1800), which spanned 21 m.

It was in the multi-storey textile mills of Britain in the 1790s that cast iron was first shown to have an important future in buildings, the disastrous fire at Albion Mill, Blackfriars, London, in 1791 being perhaps the biggest incentive for change. Charles Bage (1752–1822) and William Strutt (1756–1830) were the most important pioneers, developing incombustible interiors with cast-iron columns and brick jack arches spanning between the beams (e.g. Bage's Benyon Marshall & Bage Flax Mill, Shrewsbury, Salop, 1796–7, and Strutt's North Mill, Belper, Derbys, 1803). The earliest interiors had floor spans of only *c.* 2.5–3 m in each direction, as had been the

case with timber interiors. Later this iron mill construction spread to warehouses with a gradual opening of spans.

Cast-iron beams were also important in public buildings and large houses, where there was a growing desire for long-span floors that did not sag or bounce. Timber had generally proved inadequate, and between c. 1800 and the 1840s there was an increasing interest in cast-iron floor beams, some with floor spans of 12 m or more. At first these castings were used as simple substitutes for the main timbers in essentially timber flooring, but later, brick jack arches—as in the mills of c. 1810—or stone slabs were combined with long-span cast-iron beams to give rigidity, sound insulation and fire protection. This development reached its climax in the Palace of Westminster (1837–67), London, by Charles Barry (1795–1860) with A. W. N. Pugin (1812–52), in which the iron roof-plates are the only visible parts of the iron structure. Little is known about the engineers responsible for fixing the shape and size of the beams used by Barry and other architects of this period. Thomas Tredgold's *Practical Essay on the Strength of Cast Iron* (1822) was undoubtedly influential but was dangerously in error in some respects. In most cases it is probable that the widely used test loading of beams provided the main safeguard against misconceptions and poor workmanship.

In the first half of the 19th century cast iron was applied to a wide variety of other uses besides mills and long-span floors, sometimes on its own for complete structures, as for example Hungerford Market (1836) and J. B. Bunning's highly decorated Coal Exchange (1847–9), London, and often in combination with timber, as in the New Tobacco Dock (1811–14; destr.), London, or with wrought iron as in the 1837 roof of Euston Station, London. After c. 1840 the scale of iron construction and the proportion of wrought iron in composite structures increased substantially. The Palm House at Kew Gardens (1845–8; rest. 1984–91), by Richard Turner (c. 1798–1881) and Decimus Burton (1800–81), was a marked advance on earlier glasshouses and arguably incorporated the world's first rolled I sections. Wrought-iron roofs of increasing spans on cast-iron columns proliferated in the naval dockyards and railway stations, culminating in the roof (1849) designed by Richard Turner for Lime Street Station, Liverpool, which spanned 47 m.

Outside of Britain cast iron was used more sporadically. Around 1850 American buildings were still largely of timber, while the 'cast-iron age' largely bypassed France, where the wrought-iron techniques of the pre-Revolutionary period lingered, although in the 1830s and 1840s these were applied in combination with cast-iron technology. Nevertheless, some notable iron structures in France date from this period, such as the replacement roof (1837–9) by Théophile Mignon for Chartres Cathedral; the iron dome constructed over the Halle au Blé (1813; rebuilt 1889 as the Bourse de Commerce), Paris, by François-Joseph Bélanger (1744–1818) and Jacques-Ignace

Hittorff (1792–1867); the earliest railway stations; and the Bibliothèque Sainte-Geneviève (1843–51), Paris, in which Henri Labrouste (1801–75) achieved a new, monumental expression for an iron structure in an important public building. It also seems certain that the rolled wrought-iron I-beam was first established commercially in France, by Ferdinand Zorés in 1848. In Russia there was a considerable amount of iron construction in the first half of the 19th century, for example at the Alexandrinsky (now Pushkin) Theatre (1828–33; by Karl Rossi (1775–1849) and Matthew Clark) and in the cast-iron dome (1837–41; by August Ricard de Montferrand (1786–1858)) of St Isaac's Cathedral, both in St Petersburg. A form of riveted plate girder was devised in 1838 for the repair of the Winter Palace after the fire of 1837, ten years before the independent development of riveted wrought-iron beams in Britain.

(ii) c. 1850–c. 1880. By the middle of the 19th century, partly as a result of the gradual collapse of five storeys of Radcliffe's Mill in Oldham, Lancs, in 1844 and the failure of the Dee Bridge in Scotland in 1847, cast iron was losing much of its reputation for reliability, especially when used for beams. In this context, its place was largely taken by riveted wrought iron, as a result of a brilliant programme of research and testing carried out in 1845–8 by Eaton Hodgkinson (1789–1861) for the Britannia Bridge, Anglesey, designed by Robert Stephenson (1803–59) and Francis Thompson (*fl* 1839–50), and patented flooring systems were freely available for public and commercial buildings. In the decades that followed, a mastery of the theoretical structural issues combined with a burgeoning iron industry, not only in Britain but also on the Continent, to enable some of the most spectacular iron-and-glass structures with long-span roofs to be built. Among the best known and most significant was the Crystal Palace, built by Joseph Paxton (1803–65) for the Great Exhibition in London in 1851; it had an exhibition space of 98,000 sq. m and was prefabricated away from the site, being erected in only six months. It was followed by several notable works in London, including Paddington Station (1852) by Isambard Kingdom Brunel (1806–59) and Matthew Digby Wyatt (1820–77), and the 73 m wrought-iron arches of St Pancras Station (1866–8); the ribbed cast-iron dome of the British Library Reading Room (1854–7) by Sydney Smirke (1798–1877); and the wrought-iron trussed dome of the Royal Albert Hall (1867–71; by Francis Fowke (1823–65) and Henry Young Darracott Scott (1822–83)). These were matched in France by Les Halles (1854–68), Paris, by Victor Baltard (1805–74), which became a prototype for market halls elsewhere in Europe; and in Italy by the Galleria Vittorio Emanuele II, Milan (1861–77), the culmination of iron-and-glass design for shopping arcades. Most of these buildings, however, had traditional masonry façades: the notable exceptions were the Crystal Palace and Les Halles.

In the USA, too, the superior strength of iron as a primary building material was recognized, for example

in the cast-iron dome of the Capitol (1855–63) in Washington, DC, by Thomas Ustick Walter (1804–87) and Montgomery Meigs (1816–92), and in the wrought-iron structural support of such early skyscrapers as the Cooper Union Building in New York in 1859 by Frederick A. Peterson. Decorated cast-iron façades also continued to be used, their structural and decorative possibilities exemplified in the cast-iron and glass commercial buildings in the SoHo district of New York. In 1850 James Bogardus (1800–74) patented a prefabricated 'fireproof' iron building, an important forerunner of modern building technology. In his Laing Stores (1848–9), New York, he translated the traditional post-and-lintel system from granite to iron. Cast-iron columns had the effect of providing larger display areas, and the façades were viewed as contemporary, inexpensive and long-lasting. Several companies, such as the Architectural Iron Works founded by Daniel D. Badger (1806–84) in New York, took advantage of the new market, creating detailing and ornamentation. Many companies used iron construction from the 1860s to the 1880s (when new fire regulations prohibited the exposure of unprotected iron frames), and the use of prefabrication spread throughout the USA and into Europe, with prefabricated components (e.g. railings) and whole buildings being exported to other continents, such as Africa and Australia.

Iron continued to be popular for ornamental work elsewhere: the Oriel Chambers office building (1864), Liverpool, by Peter Ellis (1804–84) employed iron panels hung between stone piers to create a delicate effect, and cast iron was used for the many new balustrades and railings built in such cities as Paris and New Orleans: the cast-iron fence (1855) of the Cornstalk Hotel, New Orleans, with its ears of corn on their stalks, is a distinctive example. Gates, fences, window lintels, grilles, lighting fixtures and decorative elements from rosettes to graceful openwork are examples of the proliferation of ironwork in the 19th century. Decoratively stamped pressed sheet iron was also used for ceilings. In contrast to some buildings that adopted a simple approach to the design of structural ironwork, ornamental structures reached their peak with such buildings as the University Museum (1855–61), Oxford, by Deane & Woodward, which has a delicate Gothic Revival iron structure supporting a glass roof; the reading room at the Bibliothèque Nationale (1860–67), Paris, by Henri Labrouste, with multiple domes supported on ornamental iron arches; the department store Au Bon Marché (1867–76), Paris, by Louis-Auguste Boileau (1812–96) and others, with its huge, ornamented stairwells; and the Menier Chocolate Factory (1871) at Noisiel-sur-Marne, by Jules Saulnier (d 1900), in which an ornamental effect was achieved with diagonal iron bracing expressed on the exterior of a patterned masonry infill wall. This building was favourably mentioned by Eugène-Emmanuel Viollet-le-Duc (1814–79), who promoted the use of iron as a rational structural technique and produced some extraordinary proposals.

(iii) After c. 1880. Although wrought iron had a greater tensile strength than cast iron, it was much more expensive. A cheaper solution to the deficiencies of cast iron was provided in 1856, when Henry Bessemer (1813–98) invented an industrial process for steel production (*see* §I above). Some remarkable iron structures continued to be built, such as the Eiffel Tower in Paris (1887–9), but by the 1870s and 1880s steel had become the primary structural material, with rolled steel joists being produced in Britain by the mid-1880s. In the USA similar systems of production were developed, and such companies as Carnegie Phipps & Co., who were producing rolled steel beams by 1885, set the stage for that country to become the chief steel-producing nation. Steel soon became the most popular building material in the railway industry as well as in bridges: the Eads Bridge (1867–74; by James Buchanan Eads (1820–87)) across the Mississippi River at St Louis, MO, for example, used steel trusses; the Brooklyn Bridge (1869–83) employed steel cable that had been spun, an idea developed by its builder John Augustus Roebling (1806–69); and the Firth of Forth Bridge (begun by 1883; by Benjamin Baker (1840–1907) and John Fowler (1817–98)), near Edinburgh, proved that steel was the ideal material for long spans (here 520 m). Steel was not only used to build ever taller buildings but also to achieve greater spans. By 1889 the 73 m arches at St Pancras Station had been surpassed by the 115 m span of the Galerie des Machines, Paris, while in the late 20th century, roofs of much larger spans became quite common: the Louisiana Superdome, New Orleans, for example, built in 1975, is 207 m in diameter, more than $3\frac{1}{2}$ times the span of the Royal Albert Hall.

Most importantly, the mass production of steel, together with such technological developments as the introduction of the passenger lift, gave birth to the fully framed tall building, which enabled unprecedented building heights to be achieved. The change from internal metal framing with masonry external walls to full skeletal framing was a gradual process, with most of the advances made in the USA. The first virtually fully framed tall building was the 11-storey Home Insurance Building in Chicago (1883–5; destr. 1931), by William Le Baron Jenney (1832–1907). This used a framework of load-bearing steel and iron that allowed the building to have lighter masonry walls and larger windows, thereby creating more rentable space. Other architects of the Chicago school turned the city's Loop district into a commercial zone of bold steel-framed structures, with masonry walls becoming mere curtains connected to a steel skeleton frame by spandrels. Some of the skyscrapers using steel-frame technology were built in New York in a variety of architectural styles, from the Gothicized Woolworth Building (1910–13) to the classicized Flat Iron Building (1902) by Daniel H. Burnham (1846–1912). The Ritz Hotel (1904–5; by Mewès & Davis), London, is usually considered to be the first building in the UK with a full metallic frame. In fact the Boat Store (1858–60; by Godfrey Greene) at Sheerness, Kent, has a better claim to this title, but

the design of the Ritz clearly owes more to developments in the USA. Elsewhere in Europe, the use of steel provided early demonstrations of the modernist belief that function and structure should be the only expressive media; such buildings include the Beursgebouw (1896–1903), Amsterdam, by H. P. Berlage (1856–1934); the beautiful Art Nouveau structures by Victor Horta (1861–1947) in Brussels, including the Maison Tassel (1892–3); and the AEG Turbinenfabrik (1909), Moabit, Berlin, by Peter Behrens (1868–1940).

From the 1850s iron had been used to reinforce concrete (see CONCRETE, §II, 1(iii)), and in the 1870s and 1880s steel reinforcement was rapidly developed, its inherent resistance to fire being an important consideration. Ernest L. Ransome (1852–1917) developed a reinforced concrete frame similar to the steel frames being used in Chicago and elsewhere. In Europe, the Perret brothers, Auguste (1874–1954) and Gustave (1876–1952), became known for their innovative use of visible reinforced concrete frames (e.g. 25-bis Rue Franklin, 1903; with François Hennebique (1842–1921)). From the 1940s glass curtain wall and steel buildings became common among architects associated with the International style, many of whom were influenced by the work of Ludwig Mies van der Rohe (1886–1969); his buildings, for example for the Illinois Institute of Technology, Chicago (e.g. Crown Hall, 1950–56; have elegantly detailed, exposed steel columns and steel girders, from which the roof hangs. This form of steel architecture, which allows for uninterrupted interior spaces, harks back to earlier Chicago models of steel-frame construction. In the 1950s and 1960s reinforced concrete was particularly popular for many buildings, although steel began to be used prominently in tensile architecture and associated buildings, such as the National Gymnasia (1964), Tokyo. Towards the end of the 20th century there was a strong revival of structural steel, encouraged by the pursuit of 'fast-track' construction and the maintenance requirements of reinforced concrete. This trend was marked by the use of steel space-frames, and a shift towards High Tech styling, seen in the Centre Georges Pompidou (1971–7; by Renzo Piano (b 1937) and Richard Rogers (b 1933)); the Lloyds Building (1979–87), London; the Hongkong & Shanghai Bank (1985), Hong Kong; and the Renault Distribution Centre (1984), Swindon, Wilts, a cable-stayed structure, also by Norman Foster (b 1935).

Steel has also been used in combination with other materials. Stainless steel, or chromium nickel steel, although very expensive (for which reason it is not usually found as the structural element in large-scale projects), is relatively economical when the cost of maintenance is taken into consideration, making it suitable for decorative purposes. The best example of its decorative use is the Chrysler Building, New York (1928–1930), by William Van Alen (1888–1954), which has cast stainless steel radiator-cap gargoyles, beautifully fabricated basket-weave entrance portal decorations and lift doors in steel inlaid with wood. With the rise of Art Deco and the taste for streamlining, steel became important as a decorative element: stainless steel doors, lamps and lettering were common in the 1920s and 1930s, as were stainless steel American diners in the 1940s. These usually included coloured enamelled steel panels juxtaposed with stainless steel on the exteriors and stainless steel equipment on the interiors. Steel is also sometimes combined with a small percentage of copper, which creates a patina that resists corrosion. This self-weathering 'Cor-Ten' steel became popular with some sculptors (see §2 below) but was used only occasionally by architects (e.g. Bush Lane House, Cannon Street, London, 1970–76; by Ove Arup (1895–1988)); in this building, as in the Centre Pompidou, the externally expressed steel frame was filled with water for fire protection.

T. Tredgold: *A Practical Essay on the Strength of Cast Iron* (London, 1822)

C. L. G. Eck: *Traité de l'application du fer de la fonte et de la tôle* (Paris, 1841)

J. P. Rondelet: *Traité théorétique et pratique de l'art de bâtir* (Paris, 1847–8)

W. Birkmire: *Architectural Iron and Steel, and its Application in the Construction of Buildings* (London, 1891, rev. 1976)

T. C. Bannister: 'The First Iron-framed Buildings', *Architectural Review* [London], cvii (1950), pp. 231–46

S. P. Timoshenko: *History of the Strength of Materials* (New York, 1953)

H. R. Johnson and A. W. Skempton: 'William Strutt's Cotton Mills', *Transactions of the Newcomen Society*, xxx (1955–7), pp. 179–205

H. R. Schubert: *History of the British Iron and Steel Industry, from 450 BC to AD 1775* (London, 1957)

R. Maguire and P. Mathews: 'The Iron Bridge at Coalbrookdale', *Architectural Association Journal*, lxxiv (1958), pp. 30–45

A. W. Skempton and H. R. Johnson: 'The Boat Store, Sheerness (1958–60) and its Place in Structural History', *Transactions of the Newcomen Society*, xxxii (1959–60)

S. Giedion: *Space, Time and Architecture* (Cambridge, MA, 1962)

A. W. Skempton and H. R. Johnson: 'The First Iron Frames', *Architectural Review* [London], cxiv (1962), pp. 175–86

P. Temin: *Iron and Steel in Nineteenth Century America: An Economic Inquiry* (Cambridge, MA, 1964)

C. W. Condit: *American Building* (Chicago, 1968)

F. Hart, W. Henn and H. Sontag: *Multi-storey Buildings in Steel* (New York, 1978)

Metals in America's Historic Buildings, US Department of the Interior (Washington, DC, 1980)

J. G. James: 'The Application of Iron to Bridges and Other Structures in Russia to about 1850', *Transactions of the Newcomen Society*, liv (1983)

F. H. Steiner: *French Iron Architecture* (Ann Arbor, 1984)

R. J. M. Sutherland: 'The Birth of Stress: A Historical Review', *75th Anniversary International Conference of the Institution of Structural Engineers: London, 1984*

S. Kostoff: *A History of Architecture: Settings and Rituals* (New York, 1985)

P. G. Kreitler: *Flatiron: A Photographic History of the World's First Steel Frame Skyscraper, 1901–1989* (Washington, DC, 1990)

N. Cossons and B. S. Trinder: *The Iron Bridge: Symbol of the Industrial Revolution* (Chichester, 2/2002)

J.-F. Belhoste: 'Du fer à l'acier: Paris, capitale de la construction métallique au XIXe siècle', *Monumental* (2003), pp. 206–15

P. Trebilcock and R. M. Lawson: *Architectural Design in Steel* (London, 2004)

2. SCULPTURE. Steel was first used by artists shortly before World War I, and several factors soon contributed to its popularity as a material for sculpture. Its extensive use in industry attracted those artists who were seeking forms appropriate to the machine age; it also provided an inexhaustible supply of cheap metal in the form of prefabricated parts, offcuts and scrap. Until the 1930s the metal used in sculpture was usually referred to as iron, although much of it must have been steel, which is more difficult to forge than wrought iron but stronger and more readily available. The malleability and ductility of steel, which enable it to be welded, forged, rolled and extruded, made it possible for artists to express openly the construction of the work and their involvement in it: direct-steel sculpture is assembled with no intervening stage, unlike cast metalwork. Conversely, other artists, especially those associated with Minimalism, deliberately distanced themselves from this manipulation of the material and had their designs fabricated in anonymous industrial conditions. Steel is available in different forms and finishes (*see* §I above), and corroded, chromed, stainless and perforated varieties are among those that have been used by artists; it may also be lacquered or painted.

The impetus for the use of iron and steel for sculpture can be traced to masks made by Pablo Gargallo (1881–1934) as early as 1907. Mask-making is usually associated with the decorative arts, and Gargallo's work, in wrought iron and copper, stemmed from the Catalan crafts tradition. When Pablo Picasso (1881–1973) saw the masks, he was inspired to create the first steel sculpture, *Guitar* (1912; New York, Museum of Modern Art), which is made of flat sheets of steel cut with tin snips. The primary significance of this work, however, was as a sculptural response to Cubist painting, and the importance of the material lay in its flatness rather than its inherent qualities as steel. Picasso also initiated the art form known as assemblage, which later became important to steel sculpture. His first such work, *Glass of Absinthe* (1914; New York, Museum of Modern Art), a cast bronze incorporating a real spoon, created a precedent for the use of objects with their original identity intact. Welding proved an appropriate method for joining together existing forms rather than creating them anew, and as the process is usually carried out in iron or steel, artists encouraged the further use of these materials in sculpture. Gargallo meanwhile perfected his characteristic style working in iron on such sculptures as *Harlequin with Flute* (1931) and *Antinoüs* (1932).

A consistent use of steel as a sculptural material can be traced to developments in the late 1920s. Artists associated with Constructivism, such as Antoine Pevsner (1886–1962) and Naum Gabo (1890–1977), began to use steel in their work, liking its strength and rigidity as well as its associations with engineering. From 1928 to 1931 Picasso made a series of sculptures in collaboration with Julio González (1876–1942) in the latter's workshop, using iron wire and flattened metal already available there; González taught Picasso to weld. He himself used cut and wrought sheet iron in masks and planar heads inspired by Cubism and by

African art (e.g. *Head of Pilar in the Sun*, h. 180 mm; Paris, Centre Georges Pompidou). The open-form constructions that Picasso created introduced a radically new approach to space. He continued with heads and figures composed of found-iron pieces, including kitchen utensils, garden tools and scraps of machinery (e.g. *Head of a Woman*, painted iron, h. 1 m; Paris, Musée Picasso). The use of a three-dimensional structure to enclose and delineate volume became a constant theme in later steel sculpture. Picasso's liberating influence redirected González's own work: from dabbling in various media, he concentrated on direct, welded iron assemblages and works rooted in Constructivism and drawn from a surreal fantasy of imagined forms.

Also in the late 1920s the American Alexander Calder (1898–1976) began to use steel wire for abstract constructions, and in the early 1930s he made his first mobiles of wire and sheet metal, which he exploited for its elegance and relative lightness; these were followed by vast metal-plate sculptures that he called stabiles, which proved particularly influential on other artists in the 1960s. Another prominent sculptor associated with the use of welded steel was the American David Smith (1906–65), who became aware of González's work and of his collaborations with Picasso through articles in *Cahiers d'art* published in 1929 and 1935. Smith prized steel for its particular qualities rather than just for its convenience, using prefabricated parts and discarded objects but treating their surfaces in an expressive and individualistic manner by burnishing, polishing and grinding them, as in his *Tanktotem* series of the 1950s, which incorporated industrial. These and subsequent works, notably the *Voltri* and *Cubi* series of the 1960s, confirmed the validity of steel as a material for sculpture. Such works influenced younger sculptors, such as the English artist Anthony Caro (*b* 1924), who from the early 1960s used steel offcuts and prefabricated parts, often painted in bright colours, as the basis for his elaboration of form. Prominent among other artists in Britain alone who began in the 1960s to produce abstract sculpture in steel (including stainless, painted and corroded steel) were Phillip King (*b* 1934), Tim Scott (*b* 1937), William Tucker (*b* 1935) and William Turnbull (*b* 1922).

González continued to use iron. The Danish sculptor Robert Jacobsen (1912–93), arriving in Paris in 1947, chose scrap iron as his medium, cutting and welding the metal in cold state. His early pieces were whimsical anthropomorphs, largely derived from González's example (e.g. *Passenger*, 1955; Copenhagen, Statens Museum for Kunst). González's linear style was also influential on Eduardo Chillida (1924–2002), who moved towards a muscular, abstract language of his own. In collaboration with the local blacksmiths of his native Basque region, he welded fat iron bars and tubes into twisted, interlocking or gestural forms, free from superfluous detail (e.g. *Dream Anvil XX*, h. *c*. 1.48 m, 1962; Basle, Kunstmuseum).

In the period after World War II the recycling of discarded objects into art through welding was

integral to the work of sculptors associated with junk art, such as Richard Stankiewicz (1922–83), who made elegant constructions out of scrap and industrial parts, and John Chamberlain (*b* 1927) and César (1921–98), who used crushed cars as their raw material. Kinetic artists also used steel: Jean Tinguely (1925–91), for example, in assemblages made from motors and found parts; Julio Le Parc (*b* 1928) in objects using lateral sources of white light against polished metal surfaces; and George Rickey (1907–2002) in delicately balancing constructions. Minimalist sculptors such as Sol LeWitt (*b* 1928), Tony Smith (1912–80) and Donald Judd (1928–94) exploited the impersonal machined quality of steel, especially in industrially fabricated units, which were ideally suited to an expression of serial repetition. Whether taken in the form of industrial refuse or in specially produced sheets, steel continued to prove a popular material for sculptors, particularly for those involved with assemblage and other varieties of constructed or welded sculpture.

H. Read: *A Concise History of Modern Sculpture* (London and New York, 1964)

American Sculpture of the Sixties (exh. cat., ed. M. Tuchman; Los Angeles, CA, County Museum of Art, 1967)

J. Burnham: *Beyond Modern Sculpture: The Effects of Science and Technology on the Sculpture of This Century* (New York and London, 1968)

H. H. Arnason: *History of Modern Art: Painting, Sculpture, Architecture* (New York and London, 1969; rev. 3/1986)

The Alistair McAlpine Gift (exh. cat., essays by A. Seymour, R. Morphet and M. Compton; London, Tate, 1971) [British sculptors of the 1960s]

R.W. Krauss: *Terminal Iron Works: The Sculpture of David Smith* (Cambridge, MA, 1971)

W. Tucker: *The Language of Sculpture* (London, 1974)

R. Krauss: *Passages in Modern Sculpture* (London, 1977)

T. Faulkner: *Direct Metal Sculpture* (London, 1978)

E. Lucie-Smith: *Sculpture since 1945* (London, 1987)

David Smith: A Centennial (exh. cat. by C. Gimenez; New York, Solomon R. Guggenheim Museum and London, Tate, 2006)

Richard Serra Sculpture: Forty Years (exh. cat. by K. McShine and others; New York, Museum of Modern Art, 2007)

3. APPLIED ARTS. The uses of iron and steel in the applied arts reflect the strength that is the metals' most notable characteristic. Essentially, two traditions have evolved, one relating to the art of working iron and the other to the use of the more malleable but stronger steel; cast iron has a much less extensive history in the applied arts.

(i) Iron. Beads fashioned from meteoric iron and dating from *c.* 3500 BC have been found at Jirzah in Egypt, but the first man-made iron was probably not produced until *c.* 2800 BC, the date ascribed to fragments of a wrought-iron dagger found at Tell-al-Azmar in Mesopotamia. In northern China wrought-iron artefacts dating from at least the 8th century BC have been found. These may have been brought from the West, but iron artefacts have also been found that were produced within China and dating from the early 5th century BC. Iron (and steel) implements dating from the early historic period (3rd century BC–4th century AD) have also been found in Sri Lanka, where high-quality iron was later produced using monsoon winds to generate high temperatures in furnaces. Superior weapons-grade iron, and iron arms and armour, were exported from Sri Lanka from the 7th–8th centuries AD, especially to the Islamic world. Some of the most spectacular iron artefacts from the early Iron Age in Europe include iron swords found at Hallstatt, Austria, and in Germany. Other early examples of wrought ironwork in the West include a Celtic firedog, dating from the 1st century AD (Cardiff, National Museum of Wales). Originally one of a pair, its side terminates in a ram's head finial. The treasure from the Sutton Hoo Ship Burial (7th century AD; London, British Museum) includes an iron cauldron chain consisting of interlocking loops, some shaped as stylized rams' horns.

The early uses of iron were chiefly functional, for example for military equipment. From the medieval period, however, it came to be used more decoratively in the production of such items as wrought-iron gates and grilles, often being worked, for example, into patterns resembling those used in Gothic tracery. Notable examples are found in the screens (*rejas*) made for Spanish cathedrals and in grilles for windows. Its suitability for such purposes ensured that its use in this context continued for many centuries. In the Baroque period, for example, Jean Tijou (*fl* 1689–1712), who transformed wrought ironwork in England, executed between 1689 and 1699 the wrought-iron gates and screen to the Fountain Garden (now the Privy Garden) at Hampton Court Palace; Jean Lamour (1698–1771) designed the wrought-iron grilles (*c.* 1755) at Place Stanislas, Nancy; and Henrik Fazola (*c.* 1730–79) produced the intricate Rococo wrought-iron gates (1758–61) at County Hall, Eger. During the 19th century wrought iron was frequently used in a similar manner by the artists of the Gothic Revival, while cast-iron techniques were used to produce the miles of decorative railings that characterized the streets of London.

Other items maintained the association with security: iron was frequently used decoratively, for example, in the cladding of doors and in the manufacture of locks, hinges and clasps on wooden chests and caskets. Locksmithing required extraordinary feats of patience and precision in cold-cutting and carving the metal, as well as considerable sophistication in devising elaborate systems of lock construction. The art reached its apogee in France, Switzerland and Germany during the 16th century. French locksmiths executed fine door furniture for the châteaux of Fontainebleau and Anet, for example, and a number of highly elaborate keys survive, including the 'Strozzi key' (London, Victoria and Albert Museum), reputedly made to admit Diane de Poitiers, the mistress of the French king Henry II (*reg* 1547–59), to the latter's private apartments. Probably dating in fact from the early 17th century, the key closely resembles

a design in a locksmithing treatise, *La Fidelle Ouverture de l'art du serrurier*, published by Mathurin Jousse (1607–before 1692) in Paris in 1627. Its bow (the loop forming the handle) consists of two grotesque figures back-to-back, a design typical of the period.

In some cases, chests and strong boxes were not only decorated with but also fashioned from iron. Outstanding examples include the 'Armada chest', made in Nuremberg in the 17th century. A form of early safe, this is made of painted wrought iron, with an engraved steel lock plate that occupies the whole of the underside of the lid. Such chests generally have eight and sometimes as many as twelve bolts, which catch the inturned edges of the sides. Erroneously called 'Armada chests' in the 19th century, most examples were made in southern Germany, and especially in Nuremberg, between the end of the 16th century and the last quarter of the 18th. From there they were exported throughout Europe. Similar late-16th-century chests include Bodley's chest (Oxford, Bodleian Library) and the University chest (Cambridge, Cambridge University, Old Schools). Another notable late-16th-century German item is the remarkable chiselled iron throne once owned by the Holy Roman emperor Rudolf II (*reg* 1572–1607) (Longford Castle, Wilts). Signed and dated 1574, it was made by Thomas Rucker of Augsburg (*c.* 1532–1606), astonishingly apparently as a speculative venture. It was acquired by the City of Augsburg, who presented it to the Emperor. The iconography of its immensely elaborate decoration is thought to represent the history of the Roman Empire from the departure of Aeneas from Troy to the time of Rudolf II.

At a humbler level, cast iron was used extensively from the 15th century for a wide variety of domestic utensils and—because of its resistance to heat—firebacks and stoves. It was also popular from the early 19th century for furniture and occasionally jewellery. During the 18th and 19th centuries, the more progressive manufacturers adopted adventurous design policies, working with a number of leading artists, architects and designers. These included the Carron Ironworks, near Falkirk, Scotland, who commissioned Robert Adam (1728–92) to design a number of elegant fire surrounds, stoves and grates. In preparation for the Great Exhibition of 1851, the Sheffield ironfounders Henry Hoole & Co. commissioned the British sculptor Alfred Stevens (1817–75) to design a series of firegrates, while the Coalbrookdale Company at Ironbridge, Salop, invited Christopher Dresser (1834–1904) to design hall and garden furniture for them in the 1870s. Charles Rennie Mackintosh (1868–1928) also worked with iron on a domestic scale, for example the fireplace (1904; London, Victoria and Albert Museum) from the Willow Tea-room, Glasgow.

In France and the USA in the 1920s leading exponents of ironwork included Edgar Brandt (1880–1960) in Paris and Samuel Yellin (1885–1940) in Philadelphia. Brandt's elegant stylization epitomized the stylishness of Art Deco, for example in his treatment of firescreen designs, while Yellin drew on his mastery of wrought iron to work in a more eclectic manner, building up an immensely successful practice that at its height employed 300 smiths. Later in the 20th century there was a considerable international revival of interest in ironwork, stimulated by the high quality of work produced in Germany by a number of leading smiths, including Fritz Kuhn (1910–67). Other outstanding modern exponents include the Italian sculptor Antonio Benetton (1910–96) and the American Albert Paley (*b* 1944).

L. N. Cottingham: *The Smith and Founder's Director* (London, 2/1824)

H. Havard: *Les Arts de l'ameublement: La Serrurerie* (Paris, 1892)

J. Starkie Gardner: *English Ironwork of the 17th and 18th Centuries* (London, 1911)

L. A. Shuffrey: *The English Fireplace and its Accessories* (London, 1912)

C. J. ffoulkes: *Decorative Ironwork from the 11th to the 18th Century* (London, 1913)

Old English Pattern Books of the Metal Trades (London, 1913)

O. Hoever: *An Encyclopedia of Ironwork* (London, 1927); repr. as *A Handbook of Wrought Iron* (London, 1962)

J. Seymour Lindsay: *Iron and Brass Implements of the English House* (London, 1927/R 1964)

J. Starkie Gardner: *Ironwork: From the Earliest Times to the End of the Medieval Period* (London, 1927/R 1978)

M. Ayrton and A. Silcock: *Wrought Iron and its Decorative Uses* (London, 1929)

Wrought Ironwork (London, 1953; rev. 9, Salisbury, 1989)

R. Lister: *Decorative Wrought Ironwork in Great Britain* (London, 1957/R Newton Abbot, 1970)

R. Lister: *Decorative Cast Ironwork in Great Britain* (London, 1960)

J. Needham: *Crafts and Craftsmen in China and the West* (Cambridge, 1970), chap. 8

J. F. Hayward: 'Thomas Rucker's Iron Chair', *Waffen- und Kostümkunde*, ii (1976), pp. 85–98

J. Andrews: *Edge of the Anvil* (Emmaus, PA, 1977)

E. J. Robertson and J. Robertson: *Cast Iron Decoration: A World Survey* (London, 1977)

J. F. Hayward: 'A Chair from the Kunstkammer of the Emperor Rudolf II', *Burlington Magazine*, cxxii (1980), pp. 428–32

Towards a New Iron Age: The Art of the Blacksmith Today (exh. cat., ed. M. Campbell; London, Victoria and Albert Museum, 1982)

M. Campbell: *An Introduction to Ironwork* (London, 1985)

J. Fearn: *Cast Iron* (Princes Risborough, 1990, rev. 2/2001)

M. Campbell: *Decorative Ironwork* (London, 1997)

J. Geddes: *Medieval Decorative Ironwork in England* (London, 1999)

(ii) *Steel.* While steel implements dating from the 3rd century BC to the 4th century AD have been found in Sri Lanka, the earliest uses of steel in the West probably date from *c.* AD 100, when swords made from twisted steel and iron rods began to be made (*see* METAL, §V); known as pattern-welded steel, this technique continued in use for many centuries, some examples revealing a distinctive woven effect (e.g. Viking sword blade, *c.* AD 800; Copenhagen, Nationalmuseum). Perhaps a more significant tradition, however, relates to the use, first developed in India, of watered steel (*wootz*), a high-furnaced metal

with a surface finish resembling watered silk. This was used for centuries in South and East Asia to make weapons, small boxes, clasps and other articles (e.g. Sword of Aurangzeb, watered steel and gold, Mughal, late 17th century; London, Victoria and Albert Museum). It was the favoured steel for damascene work, a process traditionally associated with swords and daggers made in India and the Islamic world.

The quality of steel was improved by technical processes introduced in the late 14th century and again from the 16th, when steel was most important for use in armour (e.g. steel gorget, chased with figures in relief, France, c. 1610; London, Victoria and Albert Museum and engraved breastplate, Italy; Graz, Landeszeughaus; see fig. 1); armour incorporating steel scales knitted to leather was also produced. Indian watered steel was highly prized in Europe for more delicate work, but all attempts to reproduce it failed, apart from a crucible steel approximating its properties developed by the Englishman Benjamin Huntsman (fl 1742–81). Steelworking remained an art form until the large-scale production of steel for machinery and the construction industries in the 19th century. In areas renowned for metalwork, steel objects, including keys, locks and scissors, were decorated with etched designs and polished, or worked by jewellers and goldsmiths with inlays of gold, silver, copper or bronze (e.g. rapier hilt, blued steel encrusted with gold, France, c. 1730; London, Victoria and Albert Museum). Beautiful examples of this type of work were also produced for mirrors, for example in Islamic art.

In Britain the area of Woodstock, Oxon, was a centre for cut and polished steel objects, and riveted, facet-cut steel nail heads were first used there in the late 17th century to decorate such items as steel boxes, buckles and military medals. Cut-steel jewellery, faceted to resemble the sparkle of diamonds (see fig. 2), was introduced by the British around the mid-18th century and later made in France and elsewhere. Birmingham, notably the factory of Matthew Boulton (1728–1809), was famous for light steel toys and, from the late 18th century, also produced quantities of cut-steel jewellery. French designs included steel *pampilles*, or cascades of tiny steel drops. The town of Sheffield meanwhile became a leading centre for the production of steel cutlery, the major manufacturers including Joseph Rogers & Sons and Thomas Wilkinson & Sons. In Russia the armourers of Tula, near Moscow, were celebrated during the 18th century and early 19th for their luxurious steel furniture and for such objects as chandeliers, candlesticks, sconces, perfume burners, writing sets, toilet boxes, vases and caskets. Following the European styles of the time, they produced hugely expensive pieces, lavishly decorated with gold, silver (often niello) or gilt-bronze and rose-cut steel facets, sometimes incorporated with the royal cipher or heraldic arms. Cut-steel cross-legged folding chairs and armchairs were popular with the nobility in the 1740s and 1750s, invariably finished with gold, silver or brass detail.

From 1870 such other materials as chromium and nickel were added to molten carbon steel to produce high-alloy or crucible steels used in the manufacture of cutlery, medical instruments and cutting tools. The principles of a streamlined modernist aesthetic sparked a revival in the decorative uses of steel from

1. Steel breastplate (detail), engraved, from a half armour, Italian (Graz, Landeszeughaus); photo credit: Erich Lessing/Art Resource, NY

2. Steel beads, photomacrograph showing cut steel beads (Boston, Museum of Fine Arts); photo credit: Keith Lawrence, Museum of Fine Arts, Boston

the 1920s to the 1950s. The first tubular steel cantilevered chair was conceived by Mart Stam in the 1920s and refined by such artists as Ludwig Mies van der Rohe (1886–1969) (e.g. *MR* side chair, chrome-plated steel, wood and cane, 1928; New York, Museum of Modern Art), Marcel Breuer (1902–81) and other artists associated with the Bauhaus. Hailing it as a new material, designers discovered a variety of ways to employ chromium-plated or satin-polished steel, from bar-stools, lamps (e.g. table lamp, chromium-plated and enamelled steel and brass, USA, *c.* 1935; New York, The Brooklyn Museum), cocktail shakers and clocks to the trim on automobiles. Stainless steel proved of enduring value for such household items as kitchen sinks.

For information on the use of steel in engraving *see* Engraving, §I.

J. Evans: 'Cut-steel Jewellery', *Connoisseur*, xlix (1917), pp. 33–6

L. Aitchison: *A History of Metals* (London, 1960)

H. Hodges: *Artifacts: An Introduction to Early Materials and Technology* (London, 1964)

A. Clifford: *Cut-steel and Berlin Iron Jewellery* (Bath, 1971)

M. D. Malchenko: *Art Objects in Steel by Tula Craftsmen* (Leningrad, 1974)

B. Campbell-Cole and T. Benton: *Tubular Steel Furniture* (London, 1979)

K. C. Barraclough: *Steelmaking, 1850–1900* (London, 1990)

G. Young: 'Cut Steel and the Influence of Matthew Boulton', *Antique Collecting*, xxviii/9 (Mar 1994), pp. 31–5

B. Grotkamp-Schepers, ed.: *Cut Steel: Ein Jahrhundert Schmuck und Accessoires aus Stahlbrillanten, 1774–1870* (Hanau, 1997)

C. Benton: 'From Tubular Steel to Bamboo: Charlotte Perriand, the Migrating "Chaise-longue" and Japan', *Journal of Design History*, xi/1 (1998), pp. 31–58

Ivory. Material, technically known as dentine, from which the teeth of elephants and other mammals are mainly composed. It is similar in appearance to Bone and is chemically indistinguishable from it. When freshly cut it is creamy white in colour and displays a variety of grain patterns in transverse or longitudinal section depending on the type of animal from which it was derived.

1. Types. 2. Techniques. 3. History and uses. 4. Conservation.

1. Types. True ivory comes from the incisor teeth, or tusks, found in the upper jaw of the African and Asiatic elephant. Those of the African are normally larger and of better quality than the Asian; they average 23 kg in weight and measure up to 2 m in length and 0.18 m in diameter. Tusks weighing 70 kg, measuring 3 m in length, were not uncommon in the past: the largest known pair is reputed to have weighed 208 kg and measured 8 m in length. The tusks are conically hollow for about one third of their length from the proximal end. A distinguishing feature of elephant ivory is the appearance on the end grain or transverse section of the lines of Owen and the lines of Retzius, which give an engine-turned effect.

Mammoth ivory is virtually indistinguishable from elephant once worked, but it tends to age to a distinctly yellowish-cream colour and to have a more opaque surface finish. Considerable finds have been made on the Siberian tundra, and large quantities have been exported to Europe and East Asia. Mammoth ivory has sometimes been mineralized and stained during burial by mineral deposits. The Alaskan deposits produce a form known as

odontolite, which can be a bright turquoise blue, but the more common, Siberian ivory is a mottled nutty brown.

Hippopotamus ivory is derived from six teeth set in the animal's lower jaw. Four are comparatively small and of limited utility, providing solid material no more than 100 mm long and 40 mm in diameter. The canines can reach a considerable size, but they are sharply curved and covered with a hard enamel layer that is difficult to remove even with modern techniques. The ivory is harder and whiter than elephant. It will take a higher polish and does not tend to yellow with age. The objects made from it are comparatively small and may reflect the triangular section of the unworked tooth.

Walrus ivory, also known as morse ivory, is derived from the highly modified canines carried by the male animal. They have an average length of 600 mm but a diameter of only 60 mm, although much larger examples have been reported. The tusks are hollow for 60–70% of their length and possess a thick core of highly crystalline secondary dentine, which can form up to 75% of their volume. Artefacts manufactured from walrus ivory are readily identified by their generally small cross-section and by the presence of secondary dentine.

Pig or boar's tusk ivory is derived from the modified canines of the wild pig (*Sus scrofa*). The tusks are very heavily curved, sometimes forming complete circles up to 100 mm in diameter, but they rarely exceed 20 mm in thickness. A tough enamel layer covers all but the extreme tip of the tusk. Objects manufactured from boar's tusk will always be of small diameter and usually triangular in section. The ivory is very dense, so no grain is visible even under moderate magnification.

Whales provide two further sources of ivory. The Arctic whale or narwhal has a highly modified left canine, which forms one spiral, conical tusk up to 2.5 m long. The right canine is similar in form, but only *c.* 30 mm long and both tusks are hollow for most of their length. The sperm-whale carries approximately 45 teeth in its lower jaw, each up to 200 mm long and 80 mm in diameter. About 50% of the tooth is hollow, but the tips provide much useful material. (*See also* SCRIMSHAW.)

In addition to bone, there are a number of substitutes for ivory. The helmeted hornbill has a large excrescence on top of its beak, known as the casque, which is composed of a material as dense as elephant ivory. It is rarely more than 60 mm long, 40 mm high and 20 mm wide, and it ranges in colour from a deep creamy white to pale orange. Vegetable ivory is actually the kernel of the nut of certain species of palm tree, principally *Phytelephas macrocarpa*. It is smooth and white when fresh but darker when dry. Synthetic ivory was first produced in 1865 by John Hyatt of New York. His composition was based on highly flammable nitrocellulose mixed with ivory-coloured pigments. Similar substances were manufactured under the trade names of Cellonite, Pyralin and Xylonite. In the 1920s and 1930s Ivorine and Ivorite were manufactured:

these were essentially similar to the earlier products, but contained a plasticizer that made them less brittle and more versatile. Celluloid was particularly successful at imitating ivory grain. Since the 1960s epoxy and polyester resins have been used to make reasonable facsimiles of ivory. (*See also* PLASTIC, §1.)

For the identification of ivory *see* TECHNICAL EXAMINATION, §VIII, 8.

2. TECHNIQUES. Ivory can be sawn, drilled, filed and worked with scrapers. It can be fixed with and made into screws, and glued to itself or to other supports, for example wood. It is a very dense material and therefore capable of accepting both fine carved or engraved detail and a high degree of surface finish. It has reasonable bending properties and can be worked down to a very thin cross-section without breaking. Thin sections can be permanently curved by steam heating.

Much ivory carving is done in the round and conforms to the general shape and dimensions of the tusk or portion of tusk from which it has been carved. The most obvious examples of this type of carving are oliphants or horns and the Chinese figurines representing the Eight Immortals of Daoism, which are heavily carved but still follow the shape of the tusk, even to the extent of incorporating its curvature into the design. The proximal end of the tusk, which is hollow and generally circular in section, is used in the manufacture of bangles, armlets and circular boxes. This obviates the need to create a hollow section.

The techniques employed by the modern carver (excluding the use of power tools) are largely the same as those used in antiquity since the development of metal tools. Coping and fret saws are relatively recent additions to the carver's kit, but the other tools, for example saws, chisels, gouges, gravers, files, drills and abrasives, differ from those of the ancient Egyptians only in the material of manufacture and the number of types available. For carvings in which the shape or size departs from that of the tusk, the ivory is first prepared by sawing out a block or slab that will accommodate the required design. Preliminary shaping is achieved by sawing away any large unwanted areas. Detailed shaping follows, using chisels, gouges, knives and files. The chisels and gouges are rarely, if ever, struck with a mallet or hammer: hand pressure is used instead to produce a paring cut. Deep undercuts, as found in drapery, are produced by drilling and carving. Pierced work is produced by drilling a small through hole to allow access for the blade of a frame saw, a coping saw for coarse work or a piercing saw for fine work. Shallow patterning and precise detail is worked with simple points or engraver's tools, known as burins and gravers.

Turned work is produced on machines as simple as the bow lathe or as sophisticated as the ornamental turning lathe. The hand tools employed in turning can be the same as those used by the wood turner, especially when working between centres on spindle work. However, the density of ivory lends it to the use of the scraper. Seven main patterns are used,

the straight, the round, the half round, the point, the bead and the left and right side. In addition, a wide range of special-profile scrapers is used to produce fixed patterns. In face-plate turning only the scrapers are used, as in ornamental work.

Veneers and inlay pieces are usually made by sawing the tusk longitudinally, but transverse sections of elephant ivory have been used to display the engine-turned effect seen on the end grain. Machine-made rotary-cut veneers have been made since the mid-19th century.

Ivory can be bleached and polished to enhance its natural translucency, or gilded, painted and stained with oils and dyes. Many ivories have lost their original polychromy, so their present appearance may be misleading.

3. HISTORY AND USES. Throughout history ivory has been used in many different cultures for a wide range of religious, secular and utilitarian objects, for jewellery, for inlay and marquetry, and even, when burnt, as a pigment (see PIGMENT, §II). Its popularity has been due to its attractive colour, its smooth, translucent appearance and the ease with which it can be carved and coloured. Also, for many cultures the exotic origin of ivory has made it a prestigious material with symbolic and magical associations. For art historians ivory is of special interest because it has been widely traded, it cannot be melted down and it survives when many other materials disintegrate. It is therefore an important indicator of stylistic evolution.

The earliest known ivories date from the Upper Palaeolithic era, when decorated jewellery and stylized representations of human and animal figures were made in mammoth ivory by people of the Gravetian culture (22,000–18,000 BC) living between south-west France and Siberia. Later, in the Ancient Near East, ivory was a valuable trade commodity, its status so great that it was frequently included in tribute and royal gifts. It was used for both practical and luxury goods, some of the earliest examples being found in Egypt, where cosmetic items, jewellery and game-pieces were produced from Neolithic times to the end of the Dynastic period (c. 4500–30 BC). Ivory objects from the tomb of Tutankhamun (reg c. 1332–c. 1323 BC) indicate that almost every ivory-working technique was then known and used. As in other Near Eastern cultures, the material was gilded and coloured, carved in relief or in the round, or applied to furniture and boxes in the form of veneer or inlay. Further to the east, ivory was used by the Indus civilization (c. 2550–2000 BC): pieces found at Harappa include fragments of inlay and such utilitarian items as combs.

Over the centuries ivory naturally became most widely used in the regions in which it was readily available, notably the Indian subcontinent, Africa and the Arctic regions of north-west America and Siberia. Although ivory was less widespread in Europe, its use was significant in the expression of certain artistic styles, especially during the Early Christian and Byzantine era and in the Middle Ages.

(i) Ancient and Classical. In the 1st and 2nd millennium BC the distribution of ivory products throughout the Near East and Mediterranean area was largely due to the Phoenicians. The trade declined in the 8th century BC, but by then ivory had become established in neighbouring cultures for use in furniture and a variety of small objects, including toilette articles, seals and game-pieces. In ancient Greece enormous chryselephantine statues were made in the 5th century, in which ivory, representing flesh, and gold foil were applied to a wooden base; none survives.

In the Italian peninsula ivory was used by the Etruscans, but the craft declined in the 3rd century. It was revived by the Romans in the 2nd century when the Carthaginian wars brought them into contact with the Hellenistic cultures of southern Italy and Sicily. Cheap imports from East Africa enabled the Romans to use ivory lavishly, even on buildings. It was still widely used for both secular and religious objects in the Early Christian era (see fig. 1), but by the Byzantine period it was largely reserved for sacred images and liturgical objects. Many of these continued the formats originally used by the Romans: the consular diptych (a hinged pair of oblong panels inscribed with the image and name of a consul, as well as the offices he held), for example, was adapted for book covers and a variety of devotional objects, while the pyx, a small round box readily made from a hollow tusk, was used for the sacramental bread.

(ii) Medieval. In northern Europe there was a native tradition based on marine ivory, but Byzantine ivories, acquired as gifts, booty or trade items, were highly prized, and from the 9th century a great revival of ivory-carving took place in which the Byzantine products were copied and even reused (see BOOKBINDING). Ivory was reintroduced to southern Europe by the Muslims in the 10th century. They produced very fine work in the royal workshops in Spain and later were probably responsible for many of the ivories produced in Italy and Sicily in the 11th, 12th and 13th centuries. By the Romanesque period schools of ivory-carving had become established in Germany, Italy, England, Spain and France.

Ivory-carving in Europe peaked in the 13th and 14th centuries, when elephant ivory was widely available for use in a great range of liturgical and secular objects: tabernacles, reliquaries, statuettes, diptychs, triptychs, caskets and altarpieces; combs (see fig. 2), lanterns, writing-tablets, knife-handles, buttons, belts and mirror-cases. The craft, which was now based in urban workshops rather than monasteries, became highly organized, and the products, in particular the Virgin and Child statuettes made in Paris in the 13th century, are among the most innovative and expressive art forms of the period.

(iii) 1600 and after. The craft declined during the Renaissance but flourished again in the 17th century and the early 18th, when supplies were plentiful, and ivory was used to advantage in new sculptural

1. Ivory throne of Maximian (detail), showing *Miracle of the Loaves and Fishes*, wood core, h. 1.19 m, mid-6th century AD (Ravenna, Museo Arcivescovile); photo credit: Erich Lessing/Art Resource, NY

and decorative forms. In Germany and the Low Countries it was popular for low-relief plaques, small, virtuoso figure groups and illusionistic compositions in which it was combined with wood and precious metals. It was also increasingly used for such costly decorative and utilitarian objects as cutlery handles, tankards, table salts, powder flasks, perfume-bottle holders and fans. Ivory turning with a lathe became a favourite aristocratic hobby. On a more practical level, ivory was found to be ideal for anatomical models, scientific instruments, portrait medals and as a support for miniatures.

Later, specialized machines were developed that further reduced the price and increased the variety of ivory objects. Apart from the ornamental turning lathe, which underwent continual development, notable innovations include H. Pape's veneer-cutting machine of 1826, Benjamin Steadman and Fenner Bush's rotary veneer cutter of the 1840s and machines for duplicating and reproducing carvings

built by James Watt (1736–1819) in 1800 and by Benjamin Cheverton (1794–1876) and John Hawkins in 1828. By the end of the 19th century ivory was used decoratively in jewellery and furniture inlay, as well as for a multitude of utilitarian and craft purposes, from shirt buttons to model ships. In the 20th century it was soon superseded by synthetic ivory, although true ivory was highly popular in the Art Deco period and has occasionally been used by sculptors. From the 1950s the availability of the material was severely curtailed by attempts to protect the African elephant. One of the few remaining legitimate sources is the deposits of mammoth tusk in Siberia, which is still used by the Yakut people to carve chess sets, decorated boxes and figurines for the export and tourist market.

4. CONSERVATION. Ivory is a mixture of organic and inorganic material, the former being ossein, the latter hydroxyapatite, which is calcium phosphate in

2. Ivory comb showing scenes from *Susanna and the Elders*, carved on both sides, probably French, Gothic period (Florence, Museo Nazionale del Bargello); photo credit: Alinari/Art Resource, NY

association with carbonate and fluoride. It is hygroscopic and anisotropic, so prone to splitting and warping on exposure to moisture and/or heat. The ossein is decomposed by hydrolysis on prolonged exposure to water, and the hydroxypatite is readily attacked by acids.

Ivory derived from an archaeological context is always degraded to some extent, which makes it porous, chalky and brittle. In this condition it is particularly prone to impact damage and delamination and will often require consolidation. Ivory excavated from a wet context requires very careful drying. Incorrect or badly controlled drying can result in warping and partial delamination or even the complete disintegration of the object. In this condition an ivory is very fragile, and the slightest pressure can cause cross-grain breaks. Material recovered from salty contexts will contain absorbed soluble salts, which have a tendency to crystallize out in the inter-lamellar spaces. This can cause serious delamination, or even the total loss of the outer surface of an ivory. The condition can be remedied by carefully controlled and timed washing in distilled water, followed by dehydration with organic solvents.

Degraded ivory can be cleaned with a non-ionic detergent in distilled water, provided that the exposure

to water is kept to a minimum. Concretions on the surface of an object can often be removed by careful picking with a needle, or, where they are particularly firmly fixed, by treatment with dilute acids. Undegraded ivory can warp and split with the grain if exposed to adverse environments; objects or parts of objects that have been worked to a thin section are especially prone to this form of damage. If the ivory is both degraded and warped, it is not usually possible to correct the warping, but splits can often be closed by exposing the object to relative humidities in excess of 60%. If the humidity is then very gradually reduced to ambient, the cracks tend to stay closed. A common form of damage is cross-grain breakage caused by impact. These breaks are usually clean and present a good surface area, so they are easily repaired with a spirit-soluble adhesive. Difficulties arise if the break occurs across a small section or at a steep angle; it may then be necessary to reinforce the break area by dowelling or splinting. Where this is impractical, the only recourse is to stronger adhesives, usually the epoxy resins. Cyanoacrylates should never be used.

Ivory objects should be stored and displayed out of direct sunlight and away from sources of heat. The relative humidity of the display or storage area

should be maintained at 50–55%, at 19°C. Where this is not possible, a stable environment that is neither too moist nor too dry is desirable.

R. Owen: *Odontography: Or a Treatise on the Comparative Anatomy of Teeth* (London, 1840)

T. K. Penniman: *Pictures of Ivory and Other Animal Teeth, Bone, and Antler*, Occasional Papers on Technology, v (Oxford, 1952)

H. Hodges: *Artifacts* (London, 1964)

C. I. A. Ritchie: *Ivory Carving* (London, 1969)

N. S. Baer and L. J. Majewski: 'Ivory and Related Materials', *Art and Archaeologu Technical Abstracts*, viii/2 (1970), pp. 229–72

R. Silverberg: *Mammoths, Mastodons and Man* (London, 1970)

H. J. Plenderleith and A. E. A. Werner: *The Conservation of Antiquities and Works of Art* (Oxford, 1971)

V. Arwas: *Art Deco Sculpture: Chryselephantine Statuettes of the Twenties* (New York, 1975)

H. Osborne, ed.: *The Oxford Companion to the Decorative Arts* (Oxford, 1975)

Tardy [H. Lengellé]: *Les Ivoires: Evolution décorative du 1er siècle à nos jours*, 2 vols (Paris, 1977)

D. Gaborit-Chopin: *Ivoires du moyen âge* (Fribourg, 1978)

R. D. Barnett: *Ancient Ivories of the Middle East and Adjacent Areas*, Quedem, xiv (Jerusalem, 1982)

B. Burack: *Ivory and its Uses* (Rutland, VT, 1984)

A. Cutler: *The Craft of Ivory: Sources, Techniques and Uses in the Mediterranean World*, AD *200–1400* (Washington, DC, 1985)

A. MacGregor: *Bone, Antler, Ivory and Horn: The Technology of Skeletal Materials Since the Roman Period* (Beckenham, 1985)

[M. Vickers and others]: *Ivory: A History and Collector's Guide* (London, 1987)

O. Krzyszkowska: 'Ivory and Related Materials', *Bulletin of the Institute of Classical Studies of the University of London, Supplementary Papers*, lix (1990)

F. Minney: 'The Conservation and Reconstruction of a Late Bronze Age Ivory Inlaid Box from Palestine', *The Conservator*, xv (1991), pp. 3–7

A. Caubet and F. Poplin: 'Les Objets de matière dure animale: Etude du matériau', *Ras Shamra-Ougarit*, cxi, pp. 273–306

D. H. Ross: *Elephant: The Animal and its Ivory in African Culture* (Los Angeles, 1992)

J. L Fitton, ed.: *Ivory in Greece and the Eastern Mediterranean from the Bronze Age to the Hellenistic Period* (London, 1992)

J. P. Barbier, ed.: *Art of Côte d'Ivoire: From the Collections of the Barbier-Müller Museum*, 2 vols. (Geneva, 1993)

Elephant: The Animal and its Ivory in African Art (exh. cat., ed. D. H. Ross; Los Angeles, CA, University of California, Fowler Museum of Cultural History; New York, Metropolitan Museum of Art; 1993–4)

M. Gibson: *The Liverpool Ivories* (London, 1994)

S. Fraser-Lu: *Burmese Crafts: Past and Present* (Kuala Lumpur and New York, 1994)

P. Barnet, ed.: *Images in Ivory: Precious Objects of the Gothic Age* (Detroit, 1997)

A. Cutler: *Late Antique and Byzantine Ivory Carving* (Aldershot, 1998)

Meisterwerke aus Elfenbein der Staatlichen Museen zu Berlin (Berlin, 1999)

K. D. S. Lapatin: *Chryselephantine Ivories: Statuary in the Ancient Mediterranean World* (Oxford, 2001)

V. Glenn: *Romanesque & Gothic Decorative Metalwork and Ivory Carvings in the Museum of Scotland* (Edinburgh, 2003)

A. StClair: *Carving as Craft: Palatine East and the Greco-Roman Bone and Ivory Carving Tradition* (Baltimore, 2003)

M. McArthur: *The Arts of Asia: Materials, Techniques, Styles* (London, 2005)

J

Jade. Descriptive term rather than the name of a specific material that in the West refers to two silicate minerals, nephrite and jadeite, which are notable for their hardness, toughness and attractive appearance when worked into a variety of objects (see fig.). Green is the colour usually associated with jade but many other colours are known. The Chinese term *yu* refers not only to jade but also to softer stones such as serpentine, steatite, pyrophyllite, muscovite, olivine and sillimanite; all these minerals have been identified among early Chinese 'jades'. Other minerals exist that resemble jade to a certain degree such as idocrase, grossular, amazonite and chrysoprase. Also, nephrite and jadeite are not simple minerals: other minerals are often included within their structure.

1. Types and properties. 2. Techniques. 3. History, sources and uses.

1. TYPES AND PROPERTIES. Nephrite is a calcium magnesium silicate from the amphibole group of minerals. It is a compact variety of the mineral series tremolite–actinolite in which the fibrous hair-like crystals are tightly felted and matted together; this dense structure accounts for its extreme toughness and hardness. Nephrite has a hardness of 6.5 on the Mohs hardness scale. (The scale ranges from 1 to 10, diamond at 10 being the hardest.) The specific gravity of nephrite is 2.90–3.09, so it is three times denser than water. Its mean refractive index is 1.62. Polished nephrite has an oily or waxy lustre. The colour of nephrite ranges widely from white, yellow and various shades of green, to brown, grey and black. The Chinese called white or pale-coloured nephrite 'mutton fat jade' (*yang zhi yu*). The nephrite of ancient Chinese jades (*c.* 7000–256 BC) is often variegated rather than being one colour throughout. The green of nephrite can be due to traces of iron, but white jade sometimes has a high iron content. The green colour can also be attributed to chromium and nickel, and a red–brown colour can be due to the presence of titanium.

Jadeite is a sodium aluminium silicate mineral from the pyroxene group. It is rarer than nephrite. The individual blocklike crystals of jadeite are interlocked in a complex way to give a granular appearance which is especially noticeable at broken edges. The crystals are not fibrous and matted as in nephrite, and therefore jadeite is less tough. It is somewhat harder than nephrite, being 7 on the Mohs scale, and also denser, with a specific gravity of 3.30–3.36. Its mean refractive index is 1.66. Polished jadeite has a vitreous appearance. The typical colour of jadeite is a bright emerald green, but it can also be black, white, red, pink, orange, purple or blue. The emerald green colour in Burmese jade is thought to be due to chromium, and chromium has been identified in green Mesoamerican jades. Central American jadeite generally has less variety in colour than the Burmese material, ranging from shades of green, including one that is almost blue, to grey and white. Diopside–jadeite, in various shades of green, and albitic jadeite, which is white or pale grey mottled with green, are two varieties found exclusively in Central America. Chloromelanite is a dark green to black variety of jadeite found in Mesoamerica and New Guinea and, in the forms of tools, in European Neolithic sites. Ureyite, a deep green sodium chromium silicate analogous to jadeite, is found in Burma, and in Mexico and South Africa with jadeite.

Chinese nephrite tomb jade, dating from the Neolithic period through the Zhou period (from *c.* 6500 BC to *c.* 1100–256 BC), has sometimes undergone alteration during burial; it is known as 'calcified' or 'calcined' jade or described as having 'jade patina'. The light-coloured, sometimes patchy, altered areas retain the shape or design of the original except when decomposition has progressed so far as to cause loss of the surface. The alteration is evidently caused by exposure to ammoniacal conditions during burial, probably due to the decomposition of bodies in the tombs. These altered areas are still nephrite but are softer than normal jade.

In another type of alteration the nephrite develops a curious opaque, chalky, ivory-like appearance. This is called 'chicken-bone white' (*ji gu bai*) jade by the Chinese and is also sometimes termed 'burnt' jade. Nephrite assumes this appearance when heated to 1025°C, whereupon it alters to diopside, a different calcium magnesium silicate. Areas with this appearance on Chinese nephrite jades have been identified as diopside and some late Neolithic Chinese nephrite jades are known to have been deliberately exposed to fire. Jadeite when heated behaves differently: it turns glassy and small pieces may even melt out of shape.

Jade pendant, with confronting dragons and taotie mask, 154×155 mm, Qing period (Paris, Musée Guimet); photo credit: Thierry Ollivier/Réunion des Musées Nationaux/Art Resource, NY

Various tests can be used to identify jade. Determination of hardness can suggest that the mineral is jadeite or nephrite and not some softer mineral, but it will not differentiate between the two jades. Neither mineral can be scratched by a metal tool such as a penknife, though misleading results may arise from testing soft areas of surface alteration. Also, there are minerals that are as hard as jade and might be mistaken for it: bowenite, for example, a pale green variety of serpentine, has a hardness of 6 and looks very much like jade. Determination of specific gravity or refractive index may indicate if the mineral is jadeite or nephrite, or neither, but it will not provide certain identification.

X-ray powder diffraction is the most definitive identification method and requires only a tiny sample the size of a few grains of salt scraped from the object. Identification of the unknown sample depends on the fact that every crystalline material gives a reproducible and individual pattern, recorded either as lines on photographic film or as peaks in a graph. This method can differentiate nephrite from jadeite and both varieties of jade from other minerals.

2. TECHNIQUES. The hardness of jade has always presented a challenge to those who mine and work it. Quarrying of nephrite jade from the mines in Sino-Central Asia was described as early as 1133 in a Chinese lapidarium, *Yun lin shi pu*, by Du Wan. Fires were built next to the jade to heat it and water was then thrown against the rock face, causing it to crack because of the rapid temperature change. Wooden wedges were used to drive the pieces apart. This treatment damaged the material, so the best jade came from pebbles and boulders found in streams. The brown rind often found on these boulders is sometimes incorporated into the design of carved jades. In Burma jadeite was mined by methods similar to those used in Sino-Central Asia, using heat and wedges to extract the extensive occurrences from mines dug into the hillsides; also, boulders and loose blocks of jade were found in the river valleys.

The breaking and chipping techniques used to carve other stones are not effective on jade because of its toughness. Even though Chinese jades are often described as carved, the working of jade from ancient times to the present day has always been achieved by abrasion with a harder material. In early times without metal tools this was a slow and laborious process, and even with modern abrasives jade cannot be worked rapidly. The first abrasive used in China, and probably the only one available for several millennia, was quartz, a commonly occurring mineral with a hardness of 7, harder than jade. Early artisans could have used quartz sand, crushed sandstone or crushed loess, the main constituent of which is fine quartz particles. Crushed almandine garnets (hardness 7.5), the "red sand" of Chinese jade workers in the 1930s, were probably used beginning in the Song period. A new abrasive that appeared in the 12th century may have been emery, a naturally occurring black mineral mixture containing corundum (hardness 9), the "black sand" of the 1930s workers.

The abrasive is applied with various tools. At an early date only bamboo or bone drills were used. The earliest reference to rotary cutting and grinding tools was made *c.* 1500 by a Chinese author, in *Taicang zhou zhi* (Topography of Taicang), in Jiangsu Province,

but there is some evidence of the use of rotary tools on earlier objects, a significant development in the technique of jadeworking. Metal tools, probably first copper and then iron, were another significant advance, introduced in the late Zhou period (c. 1050–256 BC). The use of rotary tools was probably essential for the working of hollow jade vessels. An early reference to 'toad fat' used for working jade probably referred to a grease containing abrasive material. Jade-bead workers in Idzumo province, Japan, still use oil with the abrasive, but Chinese workers suspend the abrasive in water. Jadeworking methods in the 20th century give some clues as to earlier procedures, the chief difference being that harder abrasives such as carborundum, a synthetic product (hardness 9.5), and diamond (hardness 10) are now available. It has been suggested that diamond abrasive, the hardest material, was available to the early Chinese, but no definite evidence for this exists.

Since jade was so expensive and difficult to work, the pieces were often created with a minimum of change to the contours of the stone and any discarded pieces were reused. Forms were designed to coincide with the natural colour variations in the mineral.

The jadeworking techniques of the Maori were described by Captain James Cook (1728–79), the discoverer of New Zealand, in 1769. Their methods had probably been unchanged for centuries. They had no metal and made use of slate, flint and laminae of sandstone for abrading and cutting. Holes were made with rotary drills of wood, bamboo or hollow bone, used with wet sand. (In North America, in the Fraser River area of British Columbia, workers used thin flat slabs of sandstone as saws.)

Information on jadeworking techniques in Mesoamerica comes from a text (1558–9) by the Spanish missionary Bernardino de Sahagún, describing the art of the lapidary as practised by the Aztecs at the time of the Spanish Conquest in the 16th century. These techniques must have been derived from, and been essentially the same as, those used in earlier indigenous cultures. The material was shaped and rubbed down with some hard stone and then ground and polished, using wood or bamboo with suitable abrasives, probably garnet, pyrite, haematite and quartz, which are as hard as jade or even slightly harder. Evidence of working techniques can also be inferred from the objects themselves. Objects from Guatemala show evidence of pecking, grinding, rasping, sawing, drilling, reaming, polishing, incising, graving and string sawing. Sawing may have been done with copper tools, otherwise with hard wood or bamboo, used with abrasives. Drilling may have been done with jade-tipped rods; cylindrical, pointed jade objects that may be drill points have been found. Crushed jade was also used as an abrasive.

3. HISTORY, SOURCES AND USES. The names of the jade minerals have a complex history. No reference to jade occurs in Western mineralogical or pharmacological literature before the discovery of the Americas in the 16th century. When Marco Polo (1254–1324) described jadeworking in Sino-Central Asia in the late 13th century, he described the stone there as jasper and chalcedony. The Spaniards found a green stone, called *chalchihuitl* by the Aztecs, being used for decorative carving by the natives of Mesoamerica. They attributed curative properties, especially for the kidneys, to this stone and hence named it *piedra de ijada* ('stone of the loins'). From the French *pierre l'ejade* came *le jade*, and thus 'jade'. When carved stone objects from East Asia began to reach Europe in the mid-17th century, the name 'jade' was transferred to them, though by that time Mesoamerican jade was rare and nearly forgotten. 'Nephrite' as a mineral name first appeared at the end of the 18th century; it derived from the Latin *lapis nephriticus*, another version of the Spanish name. Finally, in 1863 the French mineralogist Alexis Damour established the existence of two distinct jade minerals of different chemical composition, the one from Sino-Central Asia for which he retained the name 'nephrite', and the one from Central America and Burma for which he coined the name 'jadeite'. The Chinese use the word *yu* to describe any stone used for carving, not just nephrite and jadeite. The name *feicui*, the Chinese word for kingfisher, originally applied to a fine green nephrite from Sino-Central Asia; it was revived in the 19th century to apply to emerald green Burmese jadeite.

(i) Asia. (ii) The Pacific. (iii) The Americas. (iv) Europe and Africa.

(i) Asia. Although China has been a jade-carving centre from at least the 7th millennium BC to the present, no sources of jade are known in China proper. From early times until the 19th century the only source of nephrite for the Chinese was Sino-Central Asia, now the Chinese province of Xinjiang. Jade is found there near Yarkand and Kashgar and in river valleys of the western Kunlun mountain range that divides Tibet from the Taklamakan Desert. North of Khotan, an oasis on a loop of the ancient silk route across Central Asia, two of these rivers come together, the Karakash (the Turkic *kara kaş* means black jade) and the Yurungkash (*ür ñ kaş* means white jade). The jade trade in Khotan was witnessed by Marco Polo in 1272, and mention is made of jade mines in those valleys by a Manchu writer, Qishiyi, in *Xiyou wenjian lu* ('Observations from the "Western Regions"', 1777). In the early 1870s European travellers described seeing pale green jade in veins over 3 m thick in the workings there. Nephrite was also known in the Mansi area north of the east Tian shan range.

From the late 14th century to the late 15th the jade-producing areas of Sino-Central Asia were controlled by the Timurids. They established a two-way trading relationship with the Ming dynasty emperors in China, and the earliest extant Islamic jades are attributed to them. Their descendants, the Mughals, introduced jadeworking to India in the 16th century, and at the end of the century the Mughal emperor Akbar (*reg* 1556–1605) gave a certain trader the rights

to prospect the banks of the rivers near Kashgar. Sino-Central Asia continued to be the source worked by the Mughals. The Ottoman Turks, too, used jade, producing lavishly decorated nephrite objects from the 16th century, and their source must also have been Sino-Central Asia.

The only other known source of nephrite in continental Asia is central Siberia in the area of Lake Baikal. Nephrite was also found along the Onot River south of Irkutsk. Siberian jade is green with minute flecks of black chromite scattered through it: the Chinese call it 'spinach' jade (*bocai yu*). It was used in prehistoric times in this area for axes, ornaments and trade pieces and appears to have been exported to China in the Neolithic period, though written evidence of this trade exists only from the 19th century. In the 19th century jade was used by Russian jewellers and lapidaries. Carl Fabergé (1846–1920) used Siberian jade for the bases of his decorated eggs and for the leaves of artificial flowers. The Russians also used the material for monumental purposes; the sarcophagus of Alexander III (*reg* 1881–94) was made of Siberian nephrite.

The finest jadeite in the world comes from northern Burma, near the villages of Tawmaw and Hpakan, in the Kachin Mountains near Mogaung, and in the valley of the Uru River. Burma became an important source of jade for the Chinese and spectacular objects were produced. The Chinese sometimes refer to Burmese jade as Yunnan jade because it entered China through Yunnan Province, just north of the jade-producing area of Burma.

In addition to the nephrite of Sino-Central Asia and Siberia and the jadeite of Burma, confirmed jade mineral deposits in continental Asia include nephrite in Korea and jadeite in the polar Ural Mountains of Russia and in the east Sayan Mountains of Siberia. Jadeite occurs in several locations in Japan, but only the jadeite found in the Niigata Prefecture in central Japan seems to have been exploited as a raw material. Jadeite *magatama*, comma-shaped beads, have been found in large numbers in grave sites in Japan (2nd–3rd century AD) and Korea (4th–6th century AD). Since 1961 nephrite has been mined on the island of Taiwan, but this source was not exploited in earlier times.

(ii) The Pacific. There are several occurrences of jade in the South Pacific area, and jade tools have been widely reported throughout Oceania. Nephrite, most commonly dark or grass green, occurs in New Zealand where it is called greenstone; it was used by the Maoris, who probably arrived in New Zealand in the mid–14th century, for tools, weapons and ornaments. Nephrite is found in New South Wales, Australia and, in small quantities, in New Caledonia. Jadeite is known in the Celebes and in New Guinea, where unworked loose nephrite and nephrite celts as well as chloromelanite have also been found.

(iii) The Americas. Radiocarbon dating has shown that jadeite was worked by the indigenous races of Central America and Mexico as early as 1500 BC: the Olmecs,

the Maya and, finally, the Aztecs used it for ornaments, amulets and badges of rank (see colour pl. VII, fig. 2). The first carved jades were brought to Europe by Spanish navigators, but jadeworking in Mesoamerica ceased soon after the Spanish Conquest. The source of the jadeite used in Mesoamerican jades was uncertain until the finding of jadeite in Guatemala in 1952, followed by subsequent finds of jadeite throughout the area.

In South America nephrite is known at a single locality at Babytinga, Bahia, Brazil, and nephrite celts are known among the aborigines of the Amazon River basin. Jade artefacts, not definitely identified, are reported from Peru, Colombia and Chile.

In North America, jade was worked by the Inuit of Alaska, where enormous nephrite deposits are found along the Kobuk River in the area of Jade Mountain. In British Columbia large deposits are located along the Fraser River, where artefacts worked by the Native Americans dating to 1500 BC have been found. Nephrite and jadeite occur in the western United States, but no artefacts have been reported. The nephrite of Wyoming, first discovered in 1936, is the best North American material and compares well with nephrite from Sino-Central Asia and Siberia. Both minerals occur in California and a few isolated deposits have been reported elsewhere. In the late 19th century Chinese gold-miners and railroad workers exported tonnes of nephrite to China from California and British Columbia. Some Chinese carved jades of the period may have been made from this material.

(iv) Europe and Africa. In Europe jade was used by Neolithic lake dwellers for axes and celts of nephrite, jadeite and chloromelanite. Nephrite was first located in Europe in 1885, near Jordansmuhl in Silesia, Poland. Until then, it was thought that the material for European Neolithic jades was imported from Asia. Both minerals are now known to occur in Poland, Italy, Germany and Switzerland, and prehistoric jade ceremonial weapons have been found in Spain, Portugal, Germany and Great Britain.

In Africa a single nephrite deposit is known in Zimbabwe and nephrite is also reported in Egypt in the Eastern Desert; the use of nephrite and jadeite for artefacts in Ancient Egypt is unconfirmed.

B. de Sahagún: *Historia general de las cosas de Nueva España* (1558–9; trans. A. Anderson and C. Dibble, Santa Fe, NM, 1955)

W. F. Foshag: 'Mineralogical Studies on Guatemalan Jade', *Smithsonian Institute Miscellaneous Collection*, cxxxv/5 (1957) [monograph]

J. Needham: *Mathematics and the Science of the Heavens and the Earth* (Cambridge, 1959), iii of *Science and Civilization in China*, Section 25: Mineralogy; pp. 663–9: Jade and Abrasives

E. H. West: 'Jade: Its Character and Occurrence', *Expedition*, v/2 (1963), pp. 3–11

W. A. Deer, R. A. Howie and J. Zussman: *An Introduction to the Rock-forming Minerals* (London, 1966)

S. H. Hansford: *Chinese Carved Jades* (London, 1968)

A. M. Gaines and J. L. Handy: 'Mineralogical Alteration of Chinese Tomb Jades', *Nature*, ccliii (1975), pp. 433–4

A. R. Woolley: 'Jade Axes and Other Artefacts', *The Petrology of Archaeological Artefacts*, ed. D. R. C. Kempe and A. P. Harvey (Oxford, 1983), pp. 256–76

Xia Nai: *Jade and Silk of Han China*, trans. & ed. Chu-tsing Li (Kansas City, MO, 1983)

R. L. Bishop, E. V. Sayre and L. Van Zelst: 'Characterization of Mesoamerican Jade', *Application of Science in Examination of Works of Art* (Boston, 1985), pp. 151–6

Jeffrey Yu-teh Kao: *The Archaeology of Ancient Chinese Jades: A Case Study from the Late Shang Period Site of Yinxu* (diss., Cambridge, MA, Harvard University; microfilm, Ann Arbor, 1985)

P. E. Desautels: *The Jade Kingdom* (New York, 1986)

T. W. Lentz and G. D. Lowry: *Timur and the Princely Vision: Persian Art and Culture in the Fifteenth Century* (Washington, DC, 1989)

Wen Guang and Jing Zhichun: 'Chinese Neolithic Jade: A Preliminary Geoarchaeological Study', *Geoarchaeology*, vii/3 (1992), pp. 251–75

A. Forsyth and B. McElney: *Jades from China: The Museum of East Asian Art* (Bath, 1994)

R. M. Barnhart and others: *The Jade Studio: Masterpieces of Ming and Qing Painting and Calligraphy from the Wong Nan-p'ing* (New Haven, 1994)

J. Rawson: *Chinese Jade: From the Neolithic to the Qing* (London, 1995/R 2002)

R. Scott, ed.: *Chinese Jades* (London, 1997)

L. Klassen: *Jade und Kupfer: Untersuchungen zum Neolithisierungsprozess im westlichen Ostseeraum unter besonderer Berücksichtigung der Kulturentwicklung Europas 5500–3500 BC* (Århus, 2004)

M. Wilson: *Chinese Jades* (London, 2004)

Japanning. See under LACQUER, §I, 3.

Jet. Form of lignite, black and consisting largely of carbon. It is driftwood from pines related to the Araucaria genus (monkey-puzzle tree) that has been subjected to chemical action in stagnant water and then to great pressure in the ocean floor. It is found in the bituminous shales of the Upper Lias, which was laid down about 170 million years ago, and occurs in the form of horizontal wedge-shaped strata up to 400 mm wide, 150 mm long and 100 mm deep. Sometimes it is washed up on beaches as pebbles. The best jet is found in England, at Whitby (N. Yorks), and the only other major deposits are in northern Spain in the Asturias. Lesser deposits have been found in France, Germany, the Czech Republic, Slovakia, Italy, Portugal, Canada and the USA.

1. Properties and techniques. 2. History and uses.

1. PROPERTIES AND TECHNIQUES. Jet is compact, smooth, light, warm to the touch and fairly hard. It is frangible and breaks with a conchoidal fracture; sometimes the annual growth rings of the original tree can be seen. It burns with a greenish flame, shrinking back on itself and giving off a great deal of smoke with a bituminous and sometimes fetid smell. If rubbed or warmed, good-quality jet becomes magnetized.

Jet is divided into two grades. The hard variety is found in the lower bed of the Upper Lias and has a hardness of 3 on the Mohs scale. Soft jet is found in the upper bed and has a hardness of 2; it is brittle and flakes easily, so it cannot be engraved or worked in any detail. The best jet is found in a compact block without veins or impurities, which enables it to be cut in any direction, but often the material has inclusions of quartz, lias or alum where the driftwood was cracked, and these affect the way the pieces are worked. Jet is also judged by the size of the pieces, which usually ranges from 30 mm to 150 mm. The figure of St James in the Instituto de Valencia de Don Juan, Madrid (Osma, no. 13), which is 320 mm high, is exceptionally large.

Jet is easily worked with lathes, grindstones, drills, saws, files, knives and engraving tools, but since it breaks easily it is very difficult to carve detailed figures and openwork. When rubbed with a fine abrasive, such as emery-powder, rottenstone or jeweller's rouge, it develops a brilliant reflective polish, which does not lessen with time. In prehistoric times it was polished with scrapings of jet mixed with oil and applied with a piece of sheepskin.

Lignite, Kimmeridge coal, shale and cannel coal have been erroneously called jet. Imitations of jet include black glass (also known as Paris jet), Vauxhall glass, dyed chalcedony, black tourmaline, obsidian, melanite, ebonite and vulcanite. True jet can be identified by the smell it gives off when touched with a heated needle.

2. HISTORY AND USES. Jet was known in antiquity and was described by various Classical writers, including Pliny the elder (AD 23/4–79) (*Natural History* X. xxxvi.34, 141), who called it *lapis gagates* (from Gages, a town and river in Lycia, Asia Minor, where the substance was then obtained). He and, earlier, Aristotle noted its efficacy for soothsayers and listed its medicinal properties, including the relief of toothache. Indeed, throughout history talismanic and mystical properties have been attributed to jet on account of its deep black colour, brilliancy and relative scarcity. The 11th-century lapidarium of Marbodus, drawing extensively from the 3rd-century author Solinus, claims that it cures dropsy, fixes loose teeth, relieves afflictions of the womb, reveals epilepsy, lures the viper and chases away the powers of hell, confounds spells, eases the pain of childbirth and tests virginity.

In particular jet was considered to be an effective prophylactic against the evil eye. The effect of this dread force was supposed to 'divide the heart', but jet, by drawing the evil into itself and shattering it, protected the wearer. Belief in the evil eye was deeply rooted among Muslims, and mothers hung hands made of jet around their children's necks; Spanish children wore similar amulets, and in north-west England jet crosses were hung in houses against the evil eye up to the early 20th century. From the medieval period, particularly in Spain, an accumulation of Christian beliefs was added to this pagan tradition.

(i) Spain. Jet hand amulets have been found in a 3rd-century BC Carthaginian necropolis in Ibiza and in later Roman and Muslim sites on the mainland, but it was only in the 13th century that a significant jet

industry developed in Spain. The centre of the industry was undoubtedly Santiago de Compostela. This city, which housed the shrine of St James the Greater, became one of the most important pilgrimage centres in Europe from the 11th century, and the jet industry was inextricably connected with the cult. Initially jet was used by members of the shellmakers guild, but in 1443 the jetworkers formed a guild of their own, the Cofradía de Azabacheros, and drew up regulations to safeguard the industry and its workers. The trade reached its peak in the mid-16th century. It then became dispersed around Compostela and in the Asturias, notably at Villaviciosa, and although it continued to flourish throughout the 18th century the quality of the workmanship declined.

The vast majority of the jet items produced in Compostela were pilgrim badges and religious mementos. Since jet was expensive, these carvings were available only to the wealthy, who wore them for the return journey and then hung them in their houses or private chapels.

One of the principal subjects was St James, who was depicted either alone or accompanied by one or two kneeling pilgrims. Several other saints were carved in jet. St Sebastian, who from the early 16th century was the patron of the jetworkers guild, was a frequent subject, as were the apostles Andrew and Bartholomew and the Franciscan saints Francis, Clare and Anthony of Padua.

The Virgin and Child were often depicted, the finest example being that in the Capilla del Condestable in Burgos Cathedral. The Virgin's robe is of highly polished jet, her throne and crown are of gold decorated with pearls and precious stones, and her face, as well as the body of the Christ Child, is of ivory (see Gaborit-Chopin, fig. 11). This remarkable piece may have been carved by a French artist and probably dates from c. 1400; a similar Virgin and Child is described in the inventory of 1467 of the collection of Jean II, Duc de Berry. Another popular subject was the Pietà (in an inventory of 1551 of the jetworker Gómez Cotón, 50 such pieces are mentioned), but during the Counter-Reformation the Virgin was more often identified with the Immaculate Conception. There are also depictions of Christ, either bound to the pillar or on the cross flanked by the Virgin and St John.

Another aspect of jet work that brought fame to the guild was the making of liturgical objects, especially the processional crosses used for funeral occasions from the 14th century. One was listed in the inventory of 1504 of Ferdinand II, King of Aragon and Sicily and Isabella, Queen of Castile and León. In the 15th and 16th centuries the pax was sometimes made in jet. This was a small tablet kissed before the communion, first by the priest and then by the other clergy and the congregation. The Pietà and the Crucifixion were often represented on the pax; in one example dating from the second half of the 16th century (Madrid, Instituto de Valencia de Don Juan, see Osma, no. 4) the Crucifixion scene was probably derived from a 15th-century Flemish Book of Hours.

The scallop shell was an important pilgrim emblem, and the jetworkers eventually took over the shell trade. The shell appears on its own, or as an attribute of St James, or as a support for other figures. Rosaries, too, were often made in jet: in the Instituto de Valencia de Don Juan there is a fine example with large and small beads, the large ones decorated in relief with the Calvary scene, apostles and saints and the small ones carved with scallop shells (see Osma, no. 33); the pendant depicts Christ on the Cross and, on the reverse, St James.

Sometimes the rosary pendant took the form of a hand amulet—one of the many instances in which this pre-Christian talisman was combined with a Christian symbol. Hand amulets remained popular in Spain for centuries, despite occasional disapproval from the Christian authorities; they were worn by all social classes from royal infantes downwards (e.g. *Prince Felipe Próspero* (c. 1659–60) by Diego Velázquez (1599–1660); Vienna, Kunsthistorisches Museum), and even the Christ Child is sometimes depicted with one around his neck. The earlier, Muslim amulets took the form of an open hand, known in Europe as the 'hand of Fatima', but in the 16th century the 'fig' or *higa* gesture largely replaced the open hand. In this, the hand is clenched, and the thumb is seen protruding between the index and third fingers in the traditional Latin gesture of contempt. From the 16th century to the 18th a variety of composite images was produced in which the hand carried an additional image, such as a human-faced crescent, a heart or a cherub. The wrist was often carved in an open, skeletal form, or included a further image, of open hands, a pair of eyes, a saint or a Christian scene. The use of the *higa* continued up to the early 20th century in the regions of Asturias and León and still survives, though largely for decorative rather than protective purposes.

Jet was used also for secular objects. Two magnificent mid-16th-century openwork caskets surmounted by lions and decorated with gilding can be seen in the Instituto de Valencia de Don Juan (see Osma, nos 23 and 24): these pieces were often made by apprentices in order to gain their mastership. Jet was used for seals, perfume bottles and jewellery, including rings and pendants associated with mourning. In peasant necklaces dating from the 17th century to the 19th, jet was sometimes alternated with coral and other materials.

(ii) England and Scotland. As in Spain, the magical powers of jet and the limited size of the pieces made it suitable for use in jewellery as well as amulets from early times. It was used widely in Britain from the Neolithic period, and rings, beads, necklaces, toggles, pendants and charms have been found in Bronze Age burials in Scotland and north-east England. Since these finds are far from Whitby, the only source, it appears that jet was used for barter or trade. The Melfort necklace, for example (London, British Museum, see Tait, p. 41), was found in Argyll, Scotland, and dates from c. 1800–1500 BC; it is formed

of triangular and rectangular plaques, decorated in pointillé designs and connected by rows of beads.

The Romans traded jet throughout Britain and as far afield as the Rhineland, Germany. Although much of the raw material was probably obtained from pebbles, it is likely that the Romans also mined it, since some of the objects were fairly large. Although much of the jet-manufacturing debris was from York, there is evidence that it was worked at other sites in North Yorkshire, especially Malton and Goldsborough. The industry seems to have been fully productive from the end of the 2nd century AD to the 4th. The most typical products are such personal ornaments as hairpins, bracelets, finger-rings and beads. Less commonly found items include relief-carved betrothal medallions, knife-handles, spindle-whorls and distaffs; a flat plaque (York, Yorkshire Museum), probably intended for insertion in a box or piece of furniture, features a dancing figure tentatively identified as a satyr.

In the medieval period jet was used for secular objects, such as gaming pieces, and for religious items (e.g. the jet crook of the last quarter of the 12th century in Chichester Cathedral; 1984 exh. cat., no. 272). But it was not until the early 19th century that jet was extensively mined and a large-scale industry developed in Whitby. This expansion was initiated by the introduction soon after 1800 of the treadle-wheel lathe by a retired naval officer, Captain Tremlett. Two entrepreneurs, Robert Jefferson and John Carter, were encouraged to establish a business, and by the 1850s the trade was fully established. It exhibited successfully at the Great Exhibition of 1851, London, and in 1856 was producing exports to Europe and America worth £20,000; at its peak, 1870–72, 1400 workmen were employed.

Much of the success of the Whitby jet industry was due to the Victorian obsession with mourning, particularly after the deaths of Arthur Wellesley, 1st Duke of Wellington, in 1852 and Prince Albert, prince-consort of England, in 1861. Queen Victoria (reg 1837–1901) introduced the wearing of jet in court circles, and among the Whitby suppliers was Thomas Andrews of New Quay, Jet-ornament Maker to Her Majesty. Mourning jewellery included bracelets, necklaces, pendants, lockets, earrings and brooches, but other items were also made, such as cardcases, seals and paper-knives. When mourning ceased to be fashionable the industry declined with it. Also, excessive competition had given rise to poor standards of workmanship and the use of soft, inferior jet that gave products a bad reputation. Finally, in the 1880s cheaper substitutes were introduced and the boom was over; by 1884 there were less than 300 jet workers, and by the 1930s the industry was virtually extinct.

P. Hill: *Whitby Jet* (n.p., n.d.)

J. A. Bower: 'Whitby Jet', *Journal of the Society of Arts*, xxii (1873), pp. 86–7

W. L. Hildburgh: 'Further Notes on Spanish Amulets', *Folk-Lore*, I/xxiv (March 1913), pp. 63–74

W. L. Hildburgh: 'Notes on Spanish Amulets', *Folk-Lore*, II/xxv (June 1914), pp. 206–12

G. de Osma y Scull: *Catálogo de azabaches compostelanos, precedido de apuntes sobre los amuletos contra el aojo, las imágenes del apóstol y la Cofradía de los Azabacheros de Santiago* (Madrid, 1916)

B. I. Gilman: *Hispanic Notes and Monographs: Catalogue of Sculpture (Sixteenth to Eighteenth Centuries) in the Collection of the Hispanic Society of America* (New York, 1930)

Hispanic Notes and Monographs: Jet in the Collection of the Hispanic Society of America (New York, 1930)

H. P. Kendall: *The Story of Whitby Jet: Its Workers from Earliest Times* (Whitby, 1936)

W. Hagen: 'Kaiserzeitliche Gagatarbeiten aus dem rheinischen Germanien', *Bonner Jahrbücher des Rheinischen Landesmuseums in Bonn und des Vereins von Altertumsfreunden im Rheinlande*, cxlii (1937), pp. 77–144

W. L. Hildburgh: 'Images of the Human Hand as Amulets in Spain', *Journal of the Warburg and Courtauld Institutes*, xviii (1955), pp. 67–89

A. Webster: 'Amber, Jet and Ivory', *Gemmologist*, xxvii/27 (1958), pp. 65–72

Eburacum: Roman York (1962), i of *An Inventory of the Historical Monuments in the City of York*, Royal Commission on the Ancient and Historical Monuments and Constructions of England (London, 1962)

B. I. Gilman: 'The Use of Jet in Spain', *Homenaje al Prof. Rodríguez-Moñino* (Madrid, 1966)

B. I. Gilman: 'A Token of Pilgrimage', *Arts in Virginia*, x (1969), pp. 24–31

C. I. A. Ritchie: *Carving Shells and Cameos, and Other Marine Products: Tortoiseshell, Coral, Amber, Jet* (London, 1970)

A. J. Lawson: 'Shale and Jet Objects from Silchester', *Archaeologia* [Society of Antiquaries of London], cv (1976), pp. 241–75

D. Gaborit-Chopin: *Ivoires du moyen âge* (Fribourg, 1978)

H. Muller: *Jet Jewellery and Ornaments* (Princes Risborough, 1980)

J. Musty: 'Jet or Shale?', *Current Archaeology*, vii (1981), p. 277

L. Allason-Jones and R. Miket: *The Catalogue of Small Finds from South Shields Roman Fort* (Newcastle upon Tyne, 1984)

English Romanesque Art, 1066–1200 (exh. cat., ed. G. Zarnecki and others; London, Hayward Gallery, 1984)

V. Monte-Carreño: *El azabache en Asturias* (Principado de Asturias, 1984)

A. Franco Mata: 'Azabaches del M.A.N.', *Boletín del Museo arqueológico nacional de Madrid*, iv (1986), pp. 131–67

H. Tait, ed.: *Seven Thousand Years of Jewellery* (London, 1986)

A. Franco Mata: 'El azabache en España', *Compostellanum*, xxxiv (1989), pp. 311–36

A. Franco Mata: 'Valores artísticos y simbólicos del azabache en España y Nuevo Mundo', *Compostellanum*, xlvi (1991), pp. 467–531

M. McMillan: *Whitby Jet through the Years* (Whitby, 1992)

G. Kornbluth: *Engraved Gems of the Carolingian Empire* (University Park, PA, 1995)

L. Allason-Jones: *Roman Jet in the Yorkshire Museum* (York, 1996)

M. Trusted: *Spanish Sculpture: Catalogue of the Post-medieval Spanish Sculpture in Wood, Terracotta, Alabaster, Marble, Stone, Lead and Jet in the Victoria and Albert Museum* (London, 1996)

K

Knitting. Technique for producing fabric that consists solely of parallel courses of yarn, with each course looped into the bights of the courses above and below, the loops being either closed (crossed) or open (*see* TEXTILE, §II, 2(i)). Knitting (more correctly, weft knitting) is thus distinguished from other single-element fabrics, such as crochet, where loops are meshed laterally as well as vertically; and from netting, which is meshed by knots, requiring the end of the yarn to be drawn through the loops.

The earliest method of knitting was nalbinding, which used short lengths of yarn and a single eyed needle to produce a fabric of closed loops. Silk braids made by this method, using complex stitch structures unknown in southern Europe, were applied decoratively to clothing in China as early as the 3rd century BC (see Rutt, 1991). Fragments of knitted fabrics from Dura Europos, Syria (New Haven, CT, Yale University Art Gallery.), date from the 3rd century AD, and sandal-socks from Roman Upper Egypt (Leicester, Jewry Wall Museum; London, Victoria and Albert Museum; Paris, Musée du Louvre; Toronto, Royal Ontario Museum) from the 5th–6th century AD. These examples were made by nalbinding, which was also used in Pre-Columbian Peru to make cotton or wool cords for decorating the edges of garments. It is not clear how true open-loop knitting developed, nor whether this was first done with hooked rods, plain rods or peg-frames. In the late 20th century hooked rods are found in Portugal, Greece, Turkey and Central America. Peg-frames, used in Germany in the 16th century, are still to be found in Mexico and are used as toys in western Europe, although their history has not been studied. Since the 16th century plain rods, known as needles, pins or wires, have been the usual knitting tools in western and northern Europe. Most were made of steel, although bone, wood, ivory and other materials have been used since the 18th century.

Examples of knitting from medieval times with multicoloured patterns survive in Spain (e.g. cushions, 13th century; Burgos, Real Monasterio de las Huelgas, Museo de Telas y Preseas), Switzerland (e.g. relic purses, 14th century; Chur Cathedral, Treasury; Sion Cathedral, Treasury) and France (e.g. relic purse, ?13th century; Sens Cathedral, Treasury). The Spanish cushions are *Mudéjar* work, but no relationship is discernible to Egyptian multicolour fragments of similar

or slightly earlier date, and the Egyptian work uses stitch structures similar to those of the Chinese braids mentioned above. Some 14th-century Italian paintings, and one by Master Bertram of Minden (Hamburg, Kunsthalle), depict the Virgin Mary knitting in the round with several needles and with several colours. There are episcopal gloves in coloured knitting of the same period (examples in Toulouse, St Sernin; Prague, St Vitus; London, Victoria and Albert Museum and Museum of London; Oxford, New College). Silk, probably from Italy, and wool were both used.

Caps, knitted in wool and felted and teased into a nap, may have been produced in the 14th century and were the principal products of professional guilds in Spain, France, England and Germany in the late 15th century and the 16th. Hosiery was knitted in the same regions from shortly before 1500 but probably not as early as caps. Stockings remained the principal knitted product until the end of the 18th century. The Channel Islands and Shetland exported much hand-knitted hosiery from 1600 to 1800, and England was also a major exporter of knitted stockings until about 1780. Although stockingers' guilds continued to exist after 1550, stocking-knitting quickly became a cottage industry, a move encouraged by the development of steel wire-drawing, which made knitting needles cheaper. About 1589 William Lee, a freeholder from Nottinghamshire, devised the first knitting machine using a bank of hooked needles. For reasons that are far from clear, his machine was not accepted in England, and he took it to Rouen c. 1610, whence it spread to the rest of Europe and back to England. Machine knitting made slow progress at first and was for long restricted almost entirely to the production of hosiery.

Knitted body-garments (examples in Dresden, Historisches Museum; London, Victoria and Albert Museum and Museum of London; Norwich, Strangers Hall Museum), usually undergarments, had been made by hand at least since 1550. During the 17th century jackets were knitted with silk and metal yarns in imitation of damask and coloured brocade (e.g. London, Victoria and Albert Museum). The craft had reached Scandinavia and Iceland by the 16th century, but many extant specimens are difficult to date and attribute to a region. There is no record of knitting in Russia before the 1630s. In Alsace and Silesia between 1600 and

1780 magnificent multicoloured carpets (table covers and wall hangings) were worked in wool, apparently on peg-frames. Cotton began to be widely used for knitted hosiery, quilts, petticoat skirts and baby-clothes in the latter part of the 18th century. Beads were introduced into knitting by 1800, especially for purses. The diffusion of merino sheep throughout Europe during the 18th century led to widespread production of soft wools that could be dyed in many colours, especially in Germany during the post-Napoleonic years. During the 19th century knitting began to be used in the creation of bijouterie (small boxes, purses and toys) by ladies of leisure. Shetland produced extremely fine, woollen knitted lace from 1840, while at about the same time the Azores became a centre for very fine lace (e.g. New York, Hispanic Society of America) of *pita* thread, made of fibre from the agave plant. There was a revival of fine cotton knitted lace in Germany and Austria in the 1920s and 1930s.

Fishermen's jumpers became popular throughout north-western Europe during the 19th century. The names 'jersey' and 'guernsey' were old words for knitted fabric, dating from the great 16th–17th-century output of stockings from the Channel Islands. A combination of fishermen's jerseys and the decorative fabrics of central European knitters was the basis for the traditional Aran jumper of western Ireland in the 20th century, and Scandinavia and Shetland also developed local traditions of coloured jumpers in the 19th and 20th centuries respectively, with the appearance in the 1920s of the Fair Isle (or Shetland) jumper with coloured patterns in horizontal bands. The sleeveless pullover followed about 1930.

Machine knitting of body garments had begun in the 19th century and was further stimulated by improvements to the flat knitting machine by the American Isaac N. Lamb in 1866. Increased interest in outdoor sports, especially golf, tennis and swimming, drew attention to the value of knitted fabric for leisure wear, and such items as the cardigan were widely accepted by World War I. Thereafter, knitwear found its way into fashion. In the 1960s the track-suit and cat-suit, invariably machine-knitted, were extremely popular. Since World War II such man-made fibres as acrylic, polyamide and elastane have vied with wool, silk and cotton as knitting materials. Domestic knitting machines, available since the 1880s, have increased rapidly in popularity since 1970, while at the same time industrial knitting has made enormous technological advances. In the West the low cost of machine knitwear has almost put an end to domestic knitting, which is now practised mainly for pleasure or to create high fashion. Further developments in the design of fabric structure can be expected from machine knitting, which has long gone beyond the definition of weft knitting, branching out into warp knitting to produce structures with some similarity to crochet, and hybrid knitweave structures. Since 1960 hand knitters have been experimenting with knitting as a sculptural technique, producing works of art both representational and abstract (*see* FIBRE ART).

A distinct tradition of hand knitting, different in technique and design from western European knitting and distinguished by a frequent use of closed-loop structure, exists in the Islamic world, extending from Serbia to Kansu, from Algeria to Kashmir. Nalbinding is still used in West Africa to make ceremonial costumes of bast fibres. In the Roraima Mountains on the Venezuela–Guyana border several tribes make narrow knitted bands in vegetable fibres, using either a set of skewers, or a peg-frame with no baseboard, or hooked wooden needles.

The single-element structure of knitting imposes strict limitations on its artistic potential. Knitters have traditionally drawn their motifs from such other crafts as weaving, embroidery, patchwork, carpets and needle-lace. Knitted fabric has a natural elasticity that no other textile could match before the invention of elastomeric fibres c. 1960. This elasticity has made possible the development of body-contour fashion, beginning with 16th-century hosiery and culminating in modern aquadynamic swimwear. At the same time it elicits a topological interest that has led to the combination of the knitting technique with metals and resins for the production of specialized elements in engineering technology.

F. A. Wells: *The British Hosiery and Knitwear Industry* (London, 1935)

H. Diettrich and K. Hahnel: *Atlas für Gewirke und Gestricke* (Leipzig, 1959)

J. A. Smirfitt: *An Introduction to Weft Knitting* (Watford, 1975)

I. Turnau: *Historia dziewiarstwa europejskiego do początku XIX wieku* [History of European Knitting to the Beginning of the 19th century] (Warsaw, 1979)

D. Spencer: *Knitting Technology* (Oxford, 1983)

M. W. Phillips: *Creative Knitting* (St Paul, MN, 1986)

R. Rutt: *A History of Hand Knitting* (London, 1987)

C. Le Count: *Andean Folk Knitting: Traditions and Techniques from Peru and Bolivia* (St Paul, MN, 1990)

R. Rutt: 'Knitted Fabrics from China, 3rd Century BC', *Journal of the Textile Institute*, lxxxii/3 (1991), pp. 411–13

D. L. Wykes: 'Origins and Development of the Leicestershire Hosiery Trade', *Textile History*, xxiii/1 (Spring 1992), pp. 23–54

J. Harris: 'Knitting', *5000 Years of Textiles: An International History and Illustrated Survey*, ed. J. Harris (New York, 1993), pp. 46–8

L. G. Fryer: *'Knitting by the Fireside and on the Hillside': A History of the Shetland Hand Knitting Industry, c. 1600–1950* (Lerwick, 1995)

C. M. Belfanti: 'Fashion and Innovation: The Origins of the Italian Hosiery Industry in the Sixteenth and Seventeenth Centuries', *Textile History*, xxvii/2 (1996), pp. 132ff

R. M. Candee: 'British Framework Knitters in New England: Technology Transfer and Machine Knitting in America, 1820–1900', *Textile History*, xxxi/1 (May 2000), pp. 27–53

S. A. Mason: *The History of the Worshipful Company of Framework Knitters: The Art and Mystery of Framework Knitting in England and Wales* (Oadby, Leicester, 2000)

L

Lace. Decorative textile produced by manipulating threads independently of any woven textile ground (see fig. 1). It is usually made of linen, silk, cotton or metal thread, but other materials, including wool, parchment and beads, have also been used.

1. Techniques. 2. History and uses.

1. TECHNIQUES. One early form of lace, which overlaps with embroidery to some extent, is lacis (darned netting). The patterns are worked with a needle in darning and filling stitches on a knotted net. A variant of lacis, called *burato*, is worked in silk on an open woven gauze. Another early relative of lace is macramé, which probably developed from the knotting of loose warp threads as a finish for woven linen towels or covers. Otherwise lace techniques fall into two distinct types, which both have machine imitations.

(i) Needle lace. This developed out of drawn-thread work and cutwork on linen. The *medas*, or *sol*, lace peculiar to Spain and Spanish America, with its characteristic radial circles, is a refined form of drawn-thread work. It gave rise to the similarly patterned Tenerife needle lace.

Needle lace is worked with a needle and thread on threads laid down over a pattern drawn on parchment (see fig. 2). Basically only one stitch is used, buttonhole stitch. Sometimes this is a knotted buttonhole stitch as in Italian *puncetti*, English hollie point and the *bibila* lace of the Eastern Mediterranean, but usually it is a simple looped stitch, worked in close rows to form the solid parts of the pattern, or loosely to form a mesh. Sometimes bobbin-made or woven tape is used for the main part of the design. Numerous fancy fillings can be worked with buttonhole stitch, and methods of introducing three-dimensional relief include working over a padding of threads (e.g. Venetian *gros point*), working raised outlines over horsehair (e.g. Alençon) or adding extra, partly detached, petals to flowers (e.g. Brussels *point de gaze*). The ground is composed of bars (*brides*), with or without tiny decorative projections called *picots*, as in 17th-century Venetian needle lace and *point de France*; or of a mesh, as in the square mesh with twisted sides of Alençon, the buttonhole-stitched hexagonal mesh of Argentan or the delicate looped mesh of *point de gaze*.

(ii) Bobbin (or pillow) lace. This probably developed out of the plaiting and braiding of cords, braids and openwork insertions. The threads, wound on bobbins, are plaited, twisted or woven together around pins inserted in a pricked parchment pattern attached to a pillow. Various lace 'stitches' are used for the motifs. Whole stitch creates a dense clothwork or *toilé*, comparable to a tabby-woven textile, half stitch gives a more open, net-like effect, and fancy fillings introduce variety and texture. The ground can consist of *brides*, which join the motifs in either a haphazard way or a structured mesh-like formation, or it may be a more delicate mesh.

There are two main types of bobbin lace: straight (continuous) laces and part (non-continuous) laces. Straight laces are worked in one piece, pattern and ground together. Classic examples are Valenciennes, with solid motifs and a strong diamond mesh closely plaited on all sides; Binche, in which the motifs tend to merge into the cobwebby snowflake or *point de neige* ground; Mechlin (Mechelen) or Malines, with motifs outlined by a thicker thread (*cordonnet*) and a hexagonal mesh with two plaited sides; and Lille, with motifs outlined by a *cordonnet* and a simple twisted hexagonal mesh. Other simple grounds used in straight laces are *point de Paris* and *torchon*. In part laces, the motifs are made separately and the ground worked round them afterwards. Classic examples of part laces are 17th-century Milanese and Flemish laces, with grounds made up of *brides*, and Brussels bobbin lace, which has raised edges to some of the motifs and a hexagonal mesh with two plaited sides. Separate motifs can also be applied to a ground of hand- or machine-made net, a form of lace known as application lace.

Laces of mixed technique range from heavy tape laces with needle-made fillings and bars to bobbin laces with needle-made insertions (e.g. Duchesse), or needle-made motifs with a Brussels bobbin-made ground (e.g. *vrai drochel*).

(iii) Machine lace. The first imitation laces were based on the machine-made nets that began to be produced in England in the 1770s on adapted versions of the stocking frame. Many of the early nets had looped stitches, which tended to run, but the bobbin-net machine, patented by John Heathcoat (1793–1861) in 1808, produced a perfect imitation of the simple twist net of Lille lace. All the machine-made nets

1. Lacemaking (and buttonmaking left); from D. Diderot: *Encyclopédie, ou Dictionnaire raisonné des sciences, des arts et des métiers* (Paris, 1751–65); photo © Visual Arts Library (London)/Alamy

were decorated with tamboured (chain stitch) or needle-run patterns; these are known as Limerick lace or *point de Lierre*. Later the nets were used as a basis for applied motifs in lace or muslin (Carrickmacross work).

Patterned laces imitating bobbin laces began to be produced in the 1840s on the pusher, warp, Leavers and curtain-net machines, developments from the bobbin-net machine. Machine laces generally lack the clear 'woven' structure of bobbin lace; Leavers lace, for example, has a characteristic ridged appearance, and the *cordonnets* around the motifs have cut

ends, unlike those in bobbin lace. Most bobbin laces were being successfully imitated by machine by the third quarter of the 19th century.

In the 1880s imitation needle lace began to be produced in Saxony and Switzerland on embroidery machines. These were initially used to make imitation tamboured and needle-run net, the latter with a typically muddled appearance. The invention of chemical lace followed shortly afterwards. Patterns were embroidered in cotton on a silk ground that was then burnt away by chlorine or caustic soda. The excellent imitations of Venetian needle lace produced by this

2. Making lace by hand; from Edmond Tapissier: *The Lacemaker*, oil on canvas, 900 × 1100 mm, 1889 (Nemours, Château Musée); © 2007 Artists Rights Society (ARS), New York/ADAGP, Paris, photo credit: Réunion des Musées Nationaux/Art Resource, NY

method are easily recognized by the absence of buttonhole stitches. A final development was the Barmen machine, patented in France in 1894. This produced narrow edgings and insertions virtually indistinguishable from handmade *torchon* lace.

2. HISTORY AND USES. Lace exists in many forms, from extremely refined to quite crude. It has been made by peasant communities as much as by sophisticated urban lacemakers, and it spread from Europe to many other parts of the world, partly because it has from the beginning been seen as a means of helping the poor to help themselves. As a high-fashion textile, lace has undergone many economic vicissitudes, but it has always been recognized for its supreme artistry.

(i) 1500–1629. (ii) 1630–1699. (iii) 1700–1799. (iv) 1800–1899. (v) 1900 and after.

(i) 1500–1629. Its history begins in the 16th century, when the development of lace as a costly trimming for furnishing textiles and articles of dress reflected

the growing prosperity of the period. About 1500 men's shirts and women's smocks were already being trimmed with simple decorative edgings at the neck and wrists. At first these were embroidered in coloured silk thread, but gradually white linen thread began to predominate. The designs became more open with the use of drawn threads, until they culminated in the fine, geometrical cutwork or *reticella* that was the leading fashion lace from about 1560 to 1620. Standing collars, cuffs and handkerchiefs of fine linen were edged with cutwork, or composed entirely of *reticella* edged with *punto in aria* (points of needle lace). Needle laces were also used for cloths and covers, as was lacis, which had developed concurrently to the stage where it could be used on a grand scale (e.g. for bed-hangings).

The making of needle lace and lacis was a favourite pastime of noble ladies at this period, in keeping with the rise of domestic embroidery during the Renaissance. This was partially inspired by the classical pattern of domestic virtue: Joannes Stradanus (1523–1605) showed Cornelia, mother

of the Gracchi, making either *reticella* or lacis in one of his engravings. Pattern books for lacis and needle lace published from the 1580s by Federigo de Vinciolo (active late 16th century), Cesare Vecellio (1521–1601), Isabetta Catanea Parasole (active 1597–1616) and others were often dedicated to a royal or noble patron.

At this period Flanders and Italy were the leading centres for the production of needle lace. Flemish lace was already distinguished by the extreme fineness of the thread, while in Italy flowing patterns of flowers, leaves, birds and even human figures soon replaced geometrical ones.

Bobbin lace, as a development of passementerie, came into its own when trimmings of coloured silk and metal thread, often with spangles, seed pearls and little beads, became fashionable around the middle of the 16th century. These were laid down on silks and velvets, or used as an edging. Vast sums were expended on gold lace in particular. Bobbin lace was also made in linen thread, and by 1600 it was being used to edge cutwork as an alternative to *punto in aria*. At first bobbin lace imitated the geometrical designs of cutwork, but by the 1620s both bobbin and needle lace had developed more fluent patterns with flowers. These can be seen at their most sumptuous in the pattern books of Bartolomeo Danieli, published in Siena and Bologna between 1630 and 1643.

(ii) 1630–1699. The supple, scalloped bobbin laces made in Flanders perfectly complemented the new fashion for falling collars edged with lace, which began in France and spread throughout Europe from the mid-1620s. The deep scallops of the 1630s, made by the part-lace technique, gradually diminished in size, while the patterns became denser and lost much of their definition. By the middle of the century the laces were straight-edged and closely patterned with flowers, often symmetrically arranged on coiling stems. Later the designs began to open up again, and the beginnings of a mesh appeared between the flowers.

Venetian needle lace followed this development, but from *c.* 1660 it resumed the lead over bobbin lace with sumptuous Baroque designs in heavy lace of a sculptural quality. The needle-lace technique lent itself to the splitting up of designs and the distribution of motifs among specialist workers, so that large pieces could be produced for such divergent uses as antependiums, borders and cuffs for albs, domestic covers, aprons and deep flounces for dresses, as well as collars and narrower trimmings. In the last three decades of the 17th century Venetian needle lace was pre-eminent, and it was the conspicuous consumption of it in France that led to the establishment there of an official needle lace industry. In addition to the heavy, raised *gros point de Venise*, there was also a flatter variety, and Venetian lace was much imitated in tape lace. The Baroque designs were also copied in the bobbin lace made in Milan, and in the similar Flemish bobbin lace, both of which had developed mesh grounds before the end of the century. Baroque laces were also made in thick silk or metal thread, or in strips of parchment wrapped in silk. This kind of lace continued into the 18th century as a trimming for furnishings, costume, christening cloths etc.

In the last quarter of the 17th century lighter kinds of lace developed. Venetian needle lace now often showed more open scrollwork, with much smaller flowers and leaves and an abundant use of frothy *picots*. French needle lace (*point de France*) became even more refined under the influence of the designer Jean Berain I (1640–1711), and this delicate lace, with its scrolls, chinoiserie figures, trophies, birds etc, gradually superseded Venetian lace.

(iii) 1700–1799. At the beginning of the 18th century a change in fashion away from lace in favour of lighter accessories in muslin caused a slump in the lace industry. This spelt the end of Venetian needle lace as a fashion lace, though it was still in demand for furnishings and ecclesiastical use. When a revival began in the second decade of the century, Flanders again took the lead, with laces of a muslin-like fineness. These were at first closely patterned with large flowers and leaves, vases, cornucopias, scrolls and cartouches, like the woven silks of the day. The mesh ground was reduced to a minimum, but there was a proliferation of fancy fillings. It was now that the distinct types of bobbin lace appeared: Binche, Valenciennes, Mechlin and Brussels, which went by the names of the towns where they were perhaps originally, but certainly not exclusively, made. Brussels also produced a fine, flat needle lace with similar dense designs and laces in which the bobbin and needle techniques were combined. In France *point de France* followed the new fashion, and two more distinct types of needle lace emerged, Alençon and Argentan. All these laces were seen in their finest forms in sets of neck ruffles and sleeve flounces, cap crowns, borders and lappets, which were extremely expensive and often *tours de force* of textile art. Cravats, aprons and even whole dresses were made of lace, and toilet tables were bedecked with frothy flounces. Lace also continued to be much used in the Roman Catholic Church.

In the early 1730s, again following changes in patterned silks, the designs became more open, with smaller sprigs of flowers or other motifs, sometimes of a chinoiserie character, set against a mesh ground in patterned cartouches. By the middle of the century borders and lappets were patterned with wavy trails or ribbons and small flower sprigs. From the 1780s the ground began to predominate, with only a border of small motifs and tiny flowers or sprigs arranged in staggered rows above it. *Blonde* (silk bobbin lace) became fashionable after the middle of the century, as did Lille and *point de Paris*. In the portrait of *Mme de Pompadour* (1756; Munich, Alte Pinakothek) by François Boucher (1703–70) the skirt is trimmed with ruched borders of *blonde* lace mixed with artificial flowers, while the sleeve ruffles are of French needle lace.

In the last decades of the 18th century Neo-classical fashions, with their emphasis on muslin and gauze, led to a crisis in the lace industry, which was compounded by the French Revolution and Napoleonic Wars. Only *blonde* was able to maintain its position to some extent. Moreover, machine-made nets of various kinds were being produced in England by the 1770s, and the most successful, point net, was being made in enormous quantities by the end of the century. In France Napoleon's attempts to revive the lace industry seem to have benefited the lacemakers of the Austrian Netherlands more than those at home. The finest laces of the First Empire include sets of bed-hangings and coverlets of bobbin and needle-made net with applied figures and classical motifs (examples New York, Metropolitan Museum of Art; Brussels, Musées Royaux d'Art et d'Histoire).

(iv) 1800–1899. Net grounds continued to dominate lace of all types in the first decades of the 19th century, and embroidered machine-made nets were equally popular. Narrow borders were used to trim dresses, and there was a vogue for airy lace scarves and bonnet veils. From the mid-1820s *blonde* increased in popularity again, and there was a return to more boldly patterned lace in the form of flounces and wide collars edged with large, curving flower sprigs. Whole dresses were made of *blonde* or embroidered net.

In the 1840s the handmade lace industry began to revive. Brussels bobbin lace, most of it by then made of cotton, soon became the principal fashion lace again, and there were revivals of Mechlin and Valenciennes, the latter with a new and much lighter diamond mesh ground. Belgian and French needle laces returned to favour, and Chantilly, a new type of black silk bobbin lace, first became extremely successful. Patterned machine laces also began to be made. At first these stimulated the handmade lace industry rather than posing a threat, and the early machine laces were of the high quality still needed to compete with the handmade product. The designs of the 1840s generally comprise rather amorphous assemblages of flowers and foliate scrolls in a weak echo of the Rococo style.

During the Second Empire lace was immensely popular. Designs became very confident, with much use of patterned strapwork and naturalistically drawn flowers in swags and large bouquets. These designs were inspired by mid-18th-century lace but were unmistakably 19th-century in spirit. The eclecticism of the age also led to a fashion for antique lace and the beginning of reproduction lace. One important technical innovation of the period was the adoption of machine net as a ground for Brussels bobbin and needle-made motifs: another was the use of the part-lace technique for Valenciennes. These devices allowed much larger pieces to be made with relative ease, as did the practice of making Chantilly lace in narrow strips, which were joined together by an invisible stitch. Large Chantilly shawls were an essential fashion accessory,

as were bertha collars and sets of flounces of varying depths for crinolines.

France and Belgium led the way in these developments, and in Belgium two new laces, *point de gaze* and Duchesse, were introduced. In England there was a revival of Honiton and East Midlands lace, and in Ireland the flourishing needle-run net industry of Limerick was followed by a similar enterprise in Carrickmacross, using muslin motifs applied to net or joined by bars, and by a new needle-lace industry at Youghal. Crochet and tatting, two more imitation laces, also appeared at this time. Lace of all types, both handmade and machine, was shown at the Great Exhibition (1851) and subsequent International Exhibitions (1855 onwards).

After the fall of the Second Empire the fashion changed to severe, tailored styles with little scope for lace. The narrow borders and handkerchiefs of this period had much more restrained patterns, but when a revival began again in the mid-1880s heavier and more showy laces were much in demand, notably Venetian lace. Quantities of antique lace were remodelled at this period, work that underpinned the revival of the lace industry in Venice and assisted the survival of that at Honiton. There was also a revival of peasant lace, especially Slav lace, for fashion use.

(v) 1900 and after. Around the turn of the century there was a final resurgence of lace, marked by an extraordinary contrast between ethereally fine *point de gaze* or Chantilly in wild flamelike patterns of Rococo inspiration, and extremely coarse tape lace with rudimentary needle-made fillings and bars, which was used with abandon for whole dresses and jackets. Machine lace was gaining ground ever more rapidly. It was more economic than handmade lace for borders and smaller items, and it could also be made in dress lengths. Even before World War I broke out a decline had set in, and that conflict effectively put an end to the hand lace industry in its traditional form.

One of the ways of combating the competition from machine lace was to emphasize good modern design. Needle lace of high technical quality and superb naturalistic Art Nouveau designs was made in Vienna; it created a sensation at the 1900 Exposition Universelle in Paris. This lead was followed sporadically elsewhere, notably in Germany, and in Belgium the involvement of artists in lace design during World War I actually led to a minor revival of the industry. The Vienna initiative was continued after the War by the Wiener Werkstätte, which produced bobbin lace and needle-run net in modern designs. Modern laces, mostly for home decoration (e.g. small table mats and runners), were also made intermittently in Belgium and in centres of the revived lace industry in Italy, for example Cantu. However, it was not until after World War II that lace finally became an art form in its own right. Monumental three-dimensional works as well as flat decorative panels were produced in Czechoslovakia and Germany, and later in Belgium and North America. Throughout the 20th century

there was also a steady increase in amateur lacemaking, which resulted in a genuine revival of the craft after World War II.

Mrs B. Pallister: *A History of Lace* (London, 1865, rev. 1902)

W. Felkin: *A History of the Machine-wrought Hosiery and Lace Manufacturers* (n. p., 1867/*R* Newton Abbot, 1967)

S. F. A. Caulfeild and B. C. Saward: *The Dictionary of Needlework* (London, 1882/*R* New York, 1972)

H. Hénon: *L'Industrie de tulle et dentelles méchaniques dans le Pas-de-Calais, 1815–1900* (Paris, 1900)

M. Jourdain: *Old Lace* (London, 1908)

E. Iklé: *La Broderie méchanique, 1828–1930* (Paris, 1931)

A. Lotz: *Bibliographie der Modelbücher* (Leipzig, 1933)

L. Paulis: *Pour connaître la dentelle* (Antwerp, 1947)

M. Schuette: *Alte Spitzen* (Brunswick, 1963)

P. Wardle: *Victorian Lace* (London, 1968/*R* Carlton, 1982)

K. Kliot and J. Kliot: *Bobbin Lace: A New Look at a Traditional Textile Art* (New York, 1973)

E. E. Pfannschmidt: *Twentieth-century Lace* (New York, 1975)

B. M. Cook and G. Stott: *The Book of Bobbin Lace Stitches* (London, 1980)

P. Earnshaw: *The Identification of Lace* (Princes Risborough, 1980)

M. Risselin-Steenebrugen: *Trois Siècles de dentelles* (Brussels, 1980)

P. Earnshaw: *A Dictionary of Lace* (Princes Risborough, 1984, rev. 2/1988/*R* Mineola, 1999)

F. Schoher: *Enzyklopädie der Spitzentechniken* (Leipzig, 1980)

M. Coppens: 'La Stylistique dentellière à l'époque Art Nouveau: Son évolution jusqu'à la première guerre mondiale', *Revue des archéologues et historiens d'art de Louvain*, xv (1982), pp. 218–49

S. M. Levey: *Lace: A History* (Leeds, 1983)

Lace in Fashion: Fashion in Lace, 1815–1914 (exh. cat. by P. Wardle and M. de Jong; Utrecht, Centraal Museum, 1985)

P. Earnshaw: *Lace Machines and Machine Laces* (London, 1986, rev. Guildford, 1994–5, 2 vols)

H. J. Yallop: *The History of the Honiton Lace Industry* (Exeter, 1992)

E. Spee: *International Lace* (Ghent, 1994)

A. Kraatz: *Calais: Musée de la dentelle et de la mode: Dentelles à la main* (Paris, 1996)

P. Palmer: *Tatting* (Princes Risborough, 1996)

M. Bruggeman: *L'Europe de la dentelle: Un aperçu historique depuis les origines de la dentelle jusqu'à l'entre-deux-guerres* (Bruges, 1997)

J. L. Gwynne: *The Illustrated Dictionary of Lace* (London, 1997)

L. de Chaves: *Greek Lace in the Victoria & Albert* (Athens, 1999)

P. Wardle: *75 x Lace* (Zwolle, Waanders and Amsterdam, 2000)

T. Schoenholzer Nichols, ed.: *Musei civici di Modena la collezione Gandini: Merletti, ricami e galloni dal XV al XIX secolo* (Modena, 2002)

C. W. Browne: *Lace from the Victoria and Albert Museum* (New York, 2004)

Lacquer. Liquid coating substance that dries to a hard finish. In most lacquers RESIN is dissolved in a volatile SOLVENT or a drying oil and hardens by evaporation. *Urushi* lacquer, however, hardens by oxidative polymerization when thin coatings are exposed to high humidities at moderate temperatures. There is also no general agreement concerning the differences

between a lacquer and a VARNISH, particularly in modern production. Some lacquers, when sold as artists' materials, are often called 'varnishes' or 'spirit varnishes' (*see also* §I, 4 below).

Urushi, which is sometimes called 'true' lacquer, is the Japanese name for the resinous sap of *Rhus vernicifera*, but in the late 20th century it became the accepted term for the saps of other species possessed of similar properties. This was done to differentiate *urushi* lacquers and lacquerwares from those made from other plant resins and gums or from such insect-derived resins as shellac. The various European imitations of Asian lacquer, for example *vernis Martin*, are all best described as 'japanning'. *Urushi* is used in East and South-east Asia, and shellac in the Indian subcontinent, the Middle East and the Near East. European lacquerware employs a variety of substances and techniques but only very rarely *urushi*.

J. Bourne and others: *Lacquer: An International History and Collector's Guide* (Marlborough, 1984)

I. Types and techniques. II. History. III. Conservation.

I. Types and techniques.

1. Urushi. 2. Insect. 3. Imitation. 4. Industrial.

1. URUSHI. In Japan and China *urushi* is derived from *Rhus vernicifera*. A related species, *Rhus succedanea*, which also grows in south China and parts of Southeast Asia, is the principal source of *urushi* in the Ryūkyū Islands. In South-east Asia the main sources are *Melanorrhoea laccifera* and *Melanorrhoea usitata*.

Urushi differs from other varnishes and paint media in that it sets much harder and is resistant to abrasion, all common solvents and even high concentrations of acid. These properties have led to its use as a decorative and protective coating on a wide range of artistic and utilitarian objects (see fig.), as well as on architectural structures. It can be successfully applied to a variety of substrates, including wood, metal, basketry, leather and textiles, and can be built up into layers of sufficient thickness for carving. With such additives as wood ash or vegetable matter, an *urushi* paste can be made from which it is possible to cast small objects or small parts of larger pieces.

Natural gums and resins usually require relatively dry and warm conditions in which to set, but *urushi* is unique in requiring very humid conditions. Another peculiarity of *urushi* is that thick films will dry faster than thin films exposed to the same humidity. The reasons for this are complex but may be summarized as being due to the oxidative polymerization of uroshiol (laccol in *Rhus succedanea*, thitsiol in *Melanorrhoea usitata* and moreacol in *Melanorrhoea laccifera*) by the enzyme laccase in the presence of water. The relationship between the water content and the availability of oxygen governs the drying characteristics of *urushi* films. Water is present in both the film and the atmosphere, while oxygen is derived from the air. If the atmospheric water content (relative humidity or RH) is low, the films lose water rapidly. In these conditions the inherent water content of a thick film is

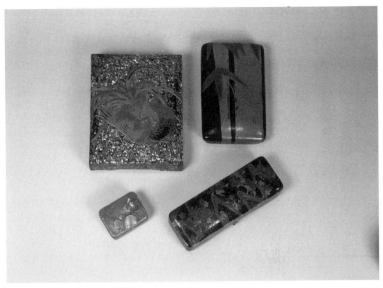

Urushi lacquer (anticlockwise), writing cases, *kobako* (small box) and a message box by Ogata Kōrin (attrib.) and Kajikawa, Edo period, 17th–18th centuries (Paris, Galerie Janette Ostier); photo credit: Giraudon/Art Resource, NY

soon reduced, and therefore the film absorbs oxygen more slowly and requires a long drying time. At a higher RH the water evaporates more slowly, so sufficient oxygen can be absorbed to harden the film fairly rapidly at the surface, but because the water content of the hardened film remains high, the film may be opaque and unevenly set. With thin films, the rate of water diffusion within the lacquer can be disregarded, and the hardening is dependent only on the atmospheric water content. However, if the RH is too high, the film dries so rapidly that some water is left in the film, and it becomes opaque. Therefore, if *urushi* films are to harden in a reasonable time and maintain their clarity and colour, they must be applied very thinly and be exposed to carefully controlled humidities of *c.* 65–80% RH. A further factor is the water content of the substrate. If this is high (*c.* 12%), clear films will not be obtained even at a low RH. If the water content is low (*c.* 8%) and hardening time is disregarded, hard, clear films are obtainable at a low RH.

The *urushi* craftsmen had a saying: 'The longer the drying time, the greater the adhesion', by which they meant the durability. This requirement led to the development of a variety of techniques to control the humidity. In Japan and parts of China and Korea a slatted wooden 'stove' was constructed. In other areas, including throughout South-east Asia, underground chambers were specially made for this purpose.

(i) Extraction, refining and colouring. The resin is extracted by a tapping process similar to that used for rubber. The procedures outlined below are those of the Japanese *urushikaki* (*urushi* processor); they differ in detail from country to country, but the principles remain the same. The trees may be tapped once they are about ten years old, and collection begins during the flowering period. A broad, V-shaped strip of bark *c.* 3 or 4 mm wide (the precise shape may vary according to local custom) is removed to allow the sap to ooze into a container that is fixed to the tree for the duration of the collection period. About six successive incisions are made over a period of four or five weeks, the sap from the first collections being known as *hatsu urushi*, that from the second as *sakari urushi* and that from the third and final ones as *ura urushi*. The accumulated sap, which ranges in colour from milky white to greyish, is stored in wooden buckets in a cool, dark place. A sheet of *shibugami* paper is floated on the surface to regulate the contact with the air and to collect the foam that is produced by the sap as it matures. The foam is removed daily, which aids the process of maturation by periodically exposing the sap to the atmosphere. When mature, the sap forms distinct layers within the container, pale and virtually transparent at the top with a brown sedimentary layer at the bottom. It is then further refined by gentle heating and stirring in the presence of air. Numerous other processes are carried out to produce various grades of *urushi*. Such oils as tung and perilla may be added as extenders or to achieve a particular effect. Solvents, including turpentine and ligroin, may be used to increase the working time, and camphor may be added to adjust the brushability. A lower-quality *urushi*, known as *seshime*, is produced by boiling twigs and tree branches. It is used in pastes and foundation layers.

Coloured *urushi* is made by the addition of finely ground pigments, but until the 19th century the palette was limited by the fact that *urushi* reacts with the majority of pigments and turns black or grey. Before

c. 1840 the main pigments used in *urushi* ware were cinnabar for red, orpiment for yellow and lampblack or iron salts for black (although the *Melanorrhoea* resin, *thit-si*, used in Burma, dries to a natural deep black). In China and Japan azurite was occasionally used for blue and indigo for a darker blue. A mixture of indigo and orpiment or gamboge was used to make green. In South-east Asia indigo was the only source of blue, but it was rarely used as such and was usually mixed with orpiment to provide a green. A red or reddish yellow was sometimes prepared from an extract of safflower and a brownish red from red ochre. Brown is made by mixing a lower proportion of cinnabar with the *urushi*, although with *Rhus* a deep, lustrous brown can be produced simply by using multiple layers of lacquer. Any other colours found on *urushi* wares produced before the early 17th century were applied in an oil or glue size medium, but in the late Edo period the Japanese broadened the palette by developing several new colours or shades, including a good white, which was made by mixing the finest transparent *urushi* with ground shells or lead white.

(ii) Techniques. A wide variety of techniques and materials are utilized in the manufacture of *urushi* ware, but since the majority differ only in final finish, they are usually treated in eight major groups: carved, incised, inlaid, sprinkled, painted, dry, moulded and gilt. Two or more techniques may be used on the same object, for example shell inlay may be combined with carved *urushi* or hardstone and bone with painted or gilt *urushi*.

All of these techniques, with the exception of dry *urushi*, are mostly carried out on wooden substrates. However, metal can be decorated with painted, carved or inlaid *urushi*, leather with painted and overlaid *urushi* and basketry with painted, overlaid or moulded *urushi*. Porcelain is usually painted, but examples of incised ware are known.

The durability and finish of *urushi* ware is dependent on the quality and preparation of the substrate, and it is this more than any other factor that determines the quality of the finished product. Even in the lesser products the construction will be executed with great care, although the quality of the materials may vary. It is in the selection of materials and the intermediate preparatory processes that the greatest variations in quality occur, with various stages being omitted or shortened.

To produce the finest wares fifty to sixty stages of coating and polishing may be required, with a drying period of one to five days between each one. The technique described below is an abbreviated form of that used by Japanese for tea boxes and other high-quality products, but variations of this technique are used for high-quality wares throughout Japan, China and parts of South-east Asia. First the wooden substrate is carefully prepared from good quality, well-seasoned wood. Then a layer of raw *urushi* (*ki-urushi*) is applied, followed by a layer of *urushi*-soaked textile (usually hemp in Japan and silk or hemp in China).

The next layer is a paste, known as *kokuso* in Japan, *htei-thayo* in parts of South-east Asia and *nizu* in China, made from *urushi* mixed with a filler. In China the filler may be wood ash, pig's blood or finely divided riverine clays. In Japan special baked and ground earths, ground ceramic and shell are used, while in South-east Asia wood ash, baked teak sawdust, rice husks and cow-dung are utilized. When this layer has cured and been smoothed, two or three coats of clear *urushi* are applied, followed by the decorative layers.

(a) Carved. (b) Incised. (c) Inlaid. (d) Sprinkled. (e) Painted. (f) Dry. (g) Moulded. (h) Gilt.

(a) Carved. This technique is primarily the speciality of China and the Ryūkyū Islands, but it has been practised in Japan. Traditionally the substrate was wood, but metal has also been used, especially for bowls, and it has become the standard substrate for modern work. In the finest carved ware the substrate is prepared by the method described above, and high-quality *urushi* mixed with pigment is gradually built up to the thickness required for carving. Two or three hundred layers are needed, each requiring about five days to harden, so simply preparing the object for carving can take up to five years.

The pigment is usually red, but black, bichrome and trichrome wares are also made. These are prepared in the same way as red *urushi* with the different colours laid in the reverse order to that which appears in the finished article. For example, in a polychrome piece with yellow flowers on green foliage against a black ground, the prepared substrate is coated with black, then green, then yellow. The floral details are cut into the plain yellow surface and the surplus yellow carved away to expose the green layer. Foliar motifs are then carved into the green layer and the surplus removed to reveal the black ground, into which background details are carved if required. The Chinese have only two terms to describe carved *urushi*: *diaoqi*, for carved *urushi* in general, and *dihong*, for red ware. The Japanese, with their propensity for naming the minutiae of craft techniques, have 24, among which are *tsuishitsu* for red and *tsuike* for red on yellow with one black line in the red. *Kinshi* has a yellow ground covered by ten alternating layers of red and yellow, finishing at red.

Guri ware. The carved lacquer known in Japan as *guri* ware and in China associated with *tixi* lacquer is a type of marbled *urushi* (*see* §(b) below). It is made by laying up alternating layers in various colours, usually red and black but often red, black and yellow with the occasional addition of green. The prepared surface is then polished and carved with a series of motifs, characteristically cloud scrolls (known as *guri* in Japan) in U- or V-shaped grooves to reveal the laminated structure.

Imitation carved urushi. An imitation carved *urushi*, known in China as *duihong*, was made by modelling a putty-like material similar to the *urushi* pastes used

for foundation layers on other wares; a variation known as *zhaohong* was made using modelled and carved plaster. When dry, these were painted with one or two coats of red or black *urushi*, and the best of them bear a close resemblance to true carved wares. Another Chinese technique, called *duicai*, employs a paste made by blending *urushi* with tung oil, powdered ashes and pigments. This is piped on to a prepared surface on which the design has been drawn. Once set, the design may be highlighted by overpainting with other colours. In the Ryūkyū Islands raised designs are produced using an appliqué technique known as *tsui kin*. The object is coated with a layer of paste made by blending *urushi*, pig's blood and filler powder. Coloured pastes are rolled out into thin, flat sheets from which the design elements are cut, and these are fixed on to the object using a mixture of animal glue and *urushi*.

Kamakurabori. In Japan a technique known as *kamakurabori* was developed in the 13th century. Initially it was seen as a more easily produced substitute for carved red ware, but later it was recognized as a craft in its own right. A carefully prepared wooden substrate is carved all over, usually with floral and geometric motifs, and a coat of clear *urushi* is applied to consolidate the wood fibres. This is followed by several coloured coats, generally red. The red is often applied over a black base coat and then polished away in places to expose the black (similar to *negoro-nuri*, *see* §(e) below). An all-black version is also made, and various inlay techniques are sometimes used as ornament.

(b) Incised. This is a general term used to describe several related techniques that are based on the engraving or incision of a design into a prepared *urushi* surface.

Marbled urushi. Known in Japan as *tsugarunuri*, this is sometimes also described by the Chinese term *xipi* (a term that is not fully acceptable but was used in the past). A ground colour, usually black or brown, is built up to a thickness suitable for shallow carving. It is then rubbed down, polished flat and engraved with the part of the chosen design that is to be shown in the first contrasting colour. The engraving is then filled with repeated coats of coloured *urushi*, until it is level with the original surface, when it is again polished flat. Remaining parts of the design, in various colours, are treated similarly in sequence until the desired effect is achieved. The motifs normally employed are formalized cloud patterns and scrolls.

Gilt-engraved urushi. In China this is called *qiangjin* (*qiangyin* when silver is used) and in Japan *chinkinbori*. The chosen design is lightly engraved or scratched into a finished surface and inpainted with yellow *urushi*. Metal powder is then sprinkled on before the *urushi* dries, or gold powder in a clear *urushi* medium is painted directly into the engraving. It has been suggested that in *chinkinbori* the engraving is inpainted

with *seshime*, then leaf gilded, and that the leaf breaks up when it is pressed into intimate contact with the *urushi* size and has therefore been mistaken for gold powder.

'Filled-in' urushi. One of the most decorative of the true *urushi* techniques, this is known in China as *tianqi* (*diaotian*) and in Japan as *zonseinuri* (an imprecise term that can be applied to all forms of inlaid *urushi*). It is also still practised in South-east Asia, including Burma, where it is called *yùn*. 'Filled-in' *urushi* exhibits a wider range of colours or shades on one object than that produced by any other method. Red and yellow are used alone or in combination to provide a variety of oranges, and black, blue and green are also used. The finished design is outlined and accentuated with incised gold. The technique is similar to *qiangjin*, from which it was derived. Part of the design is lightly engraved or carved into a prepared surface and inpainted with coloured *urushi* until the incised area is completely filled. The surface is polished flat, and those parts of the design that are to be filled with the next colour are prepared. The process is repeated until the design is completed in as many colours as are required. The completed design is then outlined with an engraved line filled with gold *urushi* as in *qiangjin*. In South-east Asia coloured *urushi* is not used for the inpainting. Instead the engraved design is filled in with a pigment paste, which is fixed with resin after each stage. Also, the gold outline is usually omitted.

Hari-bori. This is a Japanese mixed technique in which the design is produced by sprinkling a pigment or metal powder on to a wet ground. The details are then delineated by cutting or scraping through the pigmented layer before the *urushi* has fully hardened.

(c) Inlaid. A variety of materials, including mother-of-pearl, glass, ivory, bone, stone and various metals, are used as inlay in *urushi* ware. The majority of inlay techniques are executed using the wet method outlined below for mother-of-pearl, but a true dry inlay technique known as *xiangjian* or *baibaojian* was used in China. This involved carving the outline of the inlay into a finished surface, then fixing the inlay element into the space with *urushi* paste. In a Korean variation known as *ya yu* the inlays are pressed into a partially dried *urushi* paste in which they are held once the paste is fully dry. A Japanese technique, in which inlays of fired and glazed ceramic, pewter and carved ivory or bone are used together, is known as *haritsuzaiku*. The distinguishing feature of *urushi* ware made by this group of techniques is that the inlays are significantly proud of the surface, whereas in those produced by the wet methods they are level with or only slightly higher than the surface.

Mother-of-pearl inlay (*see* MOTHER-OF-PEARL, colour pl. IX, fig. 1), in which the wet method is used, is known in China as *luodian* or *bingtuo* (for the finer variety), in Japan as *raden* or *aogai* and in Korea as

najŏn chi'ilgi. Originating in China, the technique was refined and developed by the Koreans and became their main type of decorated *urushi*. The usual substrate of shell inlay is wood, but metals and ceramics have also been used. Several different types of shell are employed, one of the finest being the *haliotis* or 'sea ear', known in Japan as *awabi*. Extremely thin sheets of the highly iridescent blue-green shell are cut to produce mosaic pictures, in which the colouring of the shell simulates shading effects.

The wooden substrate of the required item is carefully prepared from selected, thoroughly seasoned wood. The finished object is brought to a smooth finish using steel scrapers and various abrasives, then sealed with one or two coats of *urushi*. The subsequent procedures fall into two categories. In the first (used for the best quality wares) a layer of hemp cloth impregnated with *urushi* is applied. This is followed by a coat of *urushi* paste. After drying and smoothing, a consolidating coat of *urushi* is applied and the design laid out using the shaped pieces of shell fixed in place with a mixture of starch paste and glue (*urushi* adhesive is not used because it darkens as it cures and would discolour the inlay). Once the adhesive has set, the inlays are defined with added engraved detail. Successive coats of *urushi* are then applied until the spaces between the design elements are filled, and the shell is covered. The final process is a graduated polishing, which continues until the shell inlay is exposed, leaving deposits of *urushi* in the previously engraved details. In the second technique, employed for lower quality wares, the textile layer is often omitted, and the shell mosaic is infilled with a paste then finished with one or two coats of *urushi*.

Other Japanese inlay techniques using various materials include *rakuyaki*, in which pieces of glazed and fired pottery are used; *okibrame* (*pingtuo* in China), in which small geometric shapes cut from gold or silver foil are used to decorate red or black coated surfaces; and *shuronke-togidashi*, in which short palm fibres are laid on a wet black surface and then overpainted until the surface is flat. The surface is then polished away to reveal the fibres embedded in the *urushi*. Eggshell inlay, known as *keiran-nuri* or *tamagoji*, is also a Japanese technique. Eggshells are pressed into a wet paste made from *seshime*, rice paste and flour. Once dry, the surface is overpainted with *sabi*, a mixture of *seshime* and a filler powder, until the shell is completely covered. A further period of drying is followed by polishing to re-expose the shell, then two or three coats of transparent *urushi* are applied and polished flat.

Glass-inlaid *urushi* is a speciality of parts of Southeast Asia, especially Thailand and Burma, the Burmese name being *hman-zi shwei-chá*. Small pieces (commonly discs) of coloured glass, often backed with gold or silver leaf, are fixed to the object using *urushi*. When fixed, the pieces may be framed with ornamental mouldings made from a paste known as *thayò* (*see* §§(f) and (g) below). This technique is often used on religious or ceremonial wares.

(d) Sprinkled. Sprinkled *urushi* is a Japanese technique with numerous variations, some of which are also practised in China. Designs are formed by sprinkling powder pigments and gold and silver filings of various sizes, shapes and colours on to a wet *urushi* surface. By varying the composition of the gold alloys a range of colours can be produced. Other effects are achieved by varying the shape of the dust grains or the density of the sprinkling. Some of the different techniques are listed below; they are often used in combination.

Makie. By this technique pictures are built up using various sizes, shapes and colours of gold powder with the occasional addition of silver and other pigments. The first part of the design is sprinkled on to a wet ground using the selected grade of powder or powders. In a landscape this would be the background, the development of which is called *maki-bokashi*. When dry, one or more coats of transparent *urushi* are applied, and the surface is polished. Another coat of *urushi* is applied, and the next part of the design is sprinkled on, then painted over and polished. The process is repeated until the design is complete. The final application of gold may be left unpainted or it may be coated and polished. The polishing process cuts through some of the powder grains, leaving bright spots of polished metal. The final result is a surface decoration of great clarity and almost tangible depth.

Fundame. In this technique a gold or silver ground is used as a base for other techniques. Fine gold or silver powder is densely sprinkled on to a wet ground. Once dry, the metal layer is burnished to a dull, flat finish resembling leaf.

Hiramakie. This is flat or low-raised *makie*. The design is painted on to a prepared and polished ground using a mixture of red ochre and raw urushi (*e-urushi*) and sprinkled with the finest metal powders. When dry the design elements are overpainted with several layers of *urushi* diluted with camphor.

Monsha-nuri. In this technique a design is painted on to a polished black ground with *seshime*, then sprinkled with very finely ground pine charcoal. Once the sprinkled layer has dried, a coating of *rōiro urushi* (a highly prized black *urushi*) is painted over the entire surface. When this layer has dried, it is carefully polished away to leave a matt black design against a polished black ground. A variation, known as *kuromakie*, produces a bright black pattern in *rōiro urushi* against a dull or matt ground.

Nashiji. A gold *urushi* technique with numerous variations. Powders of differing particle sizes in pure gold, pure silver and various gold and silver alloys are flattened by rolling on a polished iron plate. Designs are formed by sprinkling the powders on to a wet black ground. When dry, a coating of *nashiji urushi*, made by mixing *ki urushi* with gamboge or the sap of

Gardenia florida, is applied until the powder particles are completely covered. This process imparts a warm reddish yellow tone that becomes paler and more brilliant with age. A low-quality variety (*shari-nashiji*) uses tin or bronze powders. This becomes dull and brownish with age.

Togidashi. A variety of *makie* in which all of the sprinkling is done with gold powders on one layer of *urushi* (usually black). This is over-lacquered with the same colour until the sprinkling is completely covered. When dry the overpainting is polished away until the design reappears as a completely flat layer embedded in the remains of the overpaint.

Takamakie. This is a form of raised *makie*. The design is relief modelled in either a charcoal *urushi* paste or in *sabi*. A coat of *urushi* is applied and polished when dry. The design elements are coated with clear *urushi* and sprinkled with the desired colours.

(e) Painted. All *urushi* ware is in a sense painted, but the techniques listed below are those in which the decoration or finish is applied with a brush with little or no further embellishment. The use of *urushi*-bound pigments to produce paintings on paper (known in China as *huaqi/huachi* and in Japan as *urushie*) was not successful until the 1870s, when the painter and *shitsu-gaki* Shibata Zeshin (1807–91) developed specialized blends and techniques to produce his accomplished and highly praised works. Few later artists have mastered the skills necessary to emulate his success.

In Burma a wide range of *urushi*-painted containers is made for everyday use. Wood is sometimes used as a substrate, but the best quality wares are made from bamboo (*Cephalostachyum pergacile* or *Dendrocalamus strictus*). Dried bamboo is cut into long, thin strips, their thickness varied to suit the weight and flexibility of the item to be produced. They are then coiled or woven into the desired shape. A particularly fine ware is produced using very thin bamboo stakes and horsehair weavers. Once the construction of the object is finished, the surface is sealed with a mixture of fine ground clay, ash and *thit-sì*. This is smoothed and polished using pumice stone on a simple bow-lathe. A smoother paste, *htaung-tha-yò*, made from sifted teak sawdust ash, *thit-sì* and occasionally rice paste, or an even finer paste (*htei-tha-yò*), made from the sifted ashes of cow-dung, paddy husk or bone mixed with *thit-sì*, is then applied. Once this is hard and smooth, successive coats of *thit-sì* are applied and smoothed until the desired finish is achieved. Various abrasives are used in the smoothing and polishing processes, including ground fossil wood, teak charcoal, paddy husks and the dried leaves of the *dahat* tree (*Textona hamiltonia*). These wares are left black or are coloured with one or two coats of a red paint known as *hin-thabada*, ground cinnabar mixed with *thit-sì* and a little tung oil. In the late 20th century, brown became a popular colour. It is produced by mixing a lower proportion of *hin-thabada*

with the *thit-sì*. Occasionally the wares are painted green using a mixture of indigo and orpiment in *thit-sì* or, in modern times, commercial oil-based paints.

Wet inlay. This is a Chinese technique that has been associated and even confused with *tianqi* (*see* §(b) above). It is, however, a true painting technique that exhibits a similar colour range. An *urushi* surface is prepared and polished and a coloured coat, usually red or black, applied. While this is still thoroughly wet, the design is painted on. The colours sink into the wet ground and preserve a somewhat fluid aspect, in contrast to the sharp, clearly delineated appearance of *tianqi*.

Jogahana-nuri. This is a Japanese technique that developed in the village of Jogahana in the province of Etchu. An *urushi* ground is prepared and polished, then decorated with pigments bound in oil or a mixture of oil and *urushi*. This technique is probably synonymous with *mitsudaso*, which is the Japanese name for the Chinese method known as *mituoseng*, which is itself derived from the Iranian *murdasang*. *Jogahana-nuri* may differ from *murdasang* in that litharge is added to the pigment as a siccative or drying agent before the oil or oil–*urushi* medium is added. The litharge probably facilitates the application of thicker decorative layers. The use of oil as a medium allows the use of colours, especially white, that cannot be used in the true *urushi* technique.

Johoji-nuri. This is a Japanese technique in which shiny, rather 'rustic', wares are painted with yellow and green designs on a red ground with applied metal foils. It is used on the products of the temple Jōhōji in the Mutsu (Iwate) Prefecture.

Kingindeigawa. In this technique finely ground gold or silver powders are mixed with *urushi* and applied with a brush in the manner of true painting, as opposed to a *makie* technique. It is known in China as *miaojin*.

Sai-kai. In this technique a finished *urushi* ground is decorated with pigments carried in a glue medium over which an oil glaze is applied, giving a superficial resemblance to *mitsudaso*.

Tanida-makie. This is not a *makie* but a true *urushi* technique practised on a red ground. It was supposedly developed by Tanida Chubei, an *urushibe* active in Edo (now Tokyo) *c.* 1751–71, who painted in the style of Ogata Kōrin (1658–1716). The details of the technique are unknown.

Negoro-nuri. For this Japanese technique a fine black *urushi* ground is painted with two or three coats of red; these are polished so that the black undercoat is revealed in a way that simulates wear.

Hibi-nuri. For this Japanese technique a craquelure effect is produced by coating the final layer of *urushi* with egg white before it has dried.

(f) Dry. This technique is known in China, where it was first developed, as *tuodai*, in Japan as *kanshitsu* or *kyocho* and in Burma, where it was produced into the early 20th century, as *man-pnaya*. It has been used to produce bowls and boxes, but its best-known use is in the manufacture of Buddhist statuary. In the Burmese technique a clay model is constructed over a wooden or bamboo framework. This is covered with a layer or two of cloth that has been soaked in *thit-sì*. When dry and hard, the textile shell is cut open and the core removed. The hollow shell is fixed back together with another layer of textile and then coated with successive layers of *thit-sì* paste (*thayò*), each of which is modelled and smoothed to follow the contours of the original core, until the required thickness has been achieved. The thickness increases more or less in proportion to the size of the figure and can exceed 15 mm in over life-size examples. Fine details are worked in before the last paste layer is fully hardened. A smooth finish is produced using graded abrasives. Cast *thayò* ornaments (*see* §(g) below), sometimes combined with glass inlay, are fixed with a *thit-sì* adhesive and painted over with a consolidating coat of pure *thit-sì* (in Burma this is a natural black). Gold leaf may be applied before this layer is dry, or a red coat may be applied and gilded. The technique used in Japan and China differs from the Burmese in that the bulk of the construction is done in layers of *urushi*-soaked cloth, and only a relatively thin layer of *kokuso* is added to fill the textile pores and model fine detail.

It has been suggested that some Chinese wares were made in moulds, and certainly many of the boxes and bowls must have had some form of a support until the object was self-supporting. Statuary would have to have been piece-moulded, but no empirical evidence for this has been discovered, although some of the larger Burmese statues do show signs of several pieces having been joined together in a way that is unlikely to be the result of separating the cloth shell from a clay core.

(g) Moulded. A paste suitable for moulding or casting can be made by mixing a high proportion of wood ash and other fillers in an *urushi* binder. The techniques necessary for the production of moulded *urushi* were known in China in the 2nd century BC and probably earlier, but, because of the relative coarseness of the material and the difficulty of producing fine detail with a high degree of precision and finish, production seems to have been limited to small mouldings applied to larger objects. Some modern Burmese craftsmen also use such a paste (*thayò*) to cast small ornaments in soapstone moulds for application to larger lacquered objects.

See also IMITATION CARVED URUSHI in §(a) above.

(h) Gilt. The finest gilt ware is probably that of South-east Asia. Craftsmen in Japan and China made extensive use of gold in *urushi* decoration, but it was generally applied in the form of powder or foil, not as leaf. Gold leaf was usually used as a simple, unrelieved layer applied to large areas of an object, for example the inside of bowls or cups or the robes of sculpted figures.

In South-east Asia a technique of pictorial gilding (Burm.: *shwei-zawa*; Thai: *lai rod nam*) has been developed to a high degree. It is usually executed on a black ground, but red is sometimes used. The substrate is normally constructed of fine split bamboo or a combination of bamboo and wood. It is worked up to a fine finish using graded layers of *thayò*. Several coats of selected *urushi* are then applied, and the surface is brought to a smooth, matt finish by polishing with rice-husk ash and water, followed by burnishing with stone burnishers of increasing fineness. A somewhat thick-bodied black or occasionally red coat is then applied, which serves as a gold size. Once sufficiently dried, the design is painted on using a mixture of orpiment, water and gum arabic with the occasional addition of gamboge, which acts as a resist to the gilding. The design may be painted in positive or negative depending on the desired effect. Gold leaf (*shwei-bya*) is laid over the entire surface, adhering to the unpainted, not fully dry areas of the *urushi* ground. Once the *urushi* is dry, the object is washed with water, which removes the water-based painting but leaves the gold leaf adhering to the *urushi* surface.

A decorative gilt lacquer technique, known by the Japanese term *kinrande*, was developed in China for use on ceramics and later adapted by the Japanese as an *urushi* technique. A polished black ground is painted with a design in red, which is gilded before it is completely dry. When this *urushi* underpainting is dry, the excess gold leaf is removed with water, and the gilt design is enhanced by cutting through the gilding to expose the underpainting.

2. INSECT. Various species of insect in different parts of the world produce resinous substances, usually as secretions that are deposited on their food plants, often encasing the insect. In South and Central America the deposits left by the *Coccus nige* are scraped off and crudely refined by boiling. The resulting black, waxy, resinous material is used to decorate gourds and ceramic pots: brisk rubbing produces heat by friction, which causes the material to melt and adhere to the substrate.

However, the principal material used in insect lacquer is lac, also known as shellac. This is derived from a deep brownish-red secretion produced as a protective coating in India, Thailand and parts of Burma by the larvae of certain species of insect, the most important being *Coccus lacca*. Originally the resin was obtained as a by-product of the process used to extract the bright red dye known by the same name, 'lac' (from which the English term LAKE is derived). Today, however, the dye is a by-product of shellac production. Lac has been used for many centuries as a decorative material, either in alcoholic solution as a VARNISH and medium for pigments, or in a solid form that is melted on to the object being decorated. The combined properties of low melting-point,

thermoplasticity, ease of solubility in alcohol, general stability in a range of environmental conditions and its ability to act as an electrical insulator also led to the use of shellac throughout the 19th century and early 20th in a number of industrial processes.

(i) Cultivation and processing. The insect *Kerria lacca* parasitizes various species of trees and bushes, especially *Butea monosperma*, *Zisyphus jujuba*, *Schleichera oleosa* and a number of acacias. Lac produced on *Schleichera oleosa* (*Kusum*) is generally held to be the best. In northern India the insects swarm twice a year, in July and December. At this time the small (*c.* 0.5 mm) crimson larvae emerge and immediately search for a suitable feeding place on a young branch or twig. They fix themselves in place (the females permanently and the males until maturity), lying so closely together that the resinous secretions of the individual insects form a continuous coating under which the larvae develop and metamorphose. After mating, the feeding rate of the females increases, as does the rate of resin secretion.

Most lac production is still carried out by peasant farmers, who grow a few trees on the margins of their fields. A certain degree of cultivation is required to ensure continuity of production, but this is limited to pruning to stimulate fresh, soft growth on which the larvae can feed. In India the harvest may occur at any time, but it is usually confined to a summer crop (known as *baisakhi*), which is collected from June to July, and a winter crop (*katki*), in October to November. After the collection the encrusted twigs are cut to a convenient length and air-dried. They may then be refined locally or sold on for large-scale factory processing.

The basic refining techniques are similar. In the local process the first stage is the separation of the crude lac from the twigs. This may be done by scraping with a knife, hand-beating with mallets or with a simple rolling-mill. The products of this process are a granular lac (known as 'seed lac'), resin dust and the scraped twigs, which are used as fuel in the later stages of the refining process. The seed lac is washed by agitation in water to remove the red dye. Most washed seed lac is exported and further refined by its consumers, but until the mid-20th century it was usually refined locally, and a proportion is still traditionally prepared for domestic use. Good quality, locally refined lac is generally regarded as superior to the factory product. This is probably due to the lower temperatures used in local refining.

For the refining process the seed lac is packed into a coarse calico bag about 50 mm in diameter and 7.5 m long. This is passed back and forth before an open fire, and, as the lac melts, the bag is twisted, causing the lac to ooze out on to metal or ceramic plates. The molten lac is worked up with iron spatulas to prevent separation of the wax components, then rapidly spread over metal cylinders or glazed ceramic pots filled with hot water. When the resultant sheet has cooled sufficiently, it is removed and flattened. When completely cool, it is broken into flakes in which form it is sold as shellac.

The shellac may be used at this stage, or it may be melted and filtered a second or third time to improve the purity. A type of lac known as button lac, which is produced by allowing the filtrant lac to drip on to a cold surface and set, may be made from the first filtration but is commonly made from the purer second. A distinctly red, somewhat lower grade, known as garnet, is made from unwashed seed lac and is used in low-quality work or as the foundation layer for better grades. It can be processed as shellac or button lac but is often made in lump form. The residue that is left in the bags following the extraction of the pure lac contains 50–60% residual lac and is a marketable product known as *kiri*. The lac is extracted with solvents and used in minor local crafts. Differing qualities of seed lac may be blended prior to filling the bags, and colophony may be added to improve the flow of the melted lac and/or to reduce the melting point; lacquers made from this mixture have a brighter finish but can be brittle and inclined to flaking, unless the amount of colophony is carefully controlled.

(ii) Techniques. In contrast to *urushi*, insect lacquer can only be applied as a coating. A variety of substrates is used, including wood, paper, papier mâché, leather, ceramic and metal. The two main types are melted or turned lacquer and painted lacquer; both are produced in the Indian subcontinent, Sri Lanka and the Maldive Islands and the latter also in the Islamic world.

(a) Melted. In the case of metal or ceramic flatware the lacquer can simply be melted in place, but it is more common to apply the lacquer by friction against a turned object. The objects are produced on a lathe from a variety of woods, the most usual being poplar but the best tamarisk. After turning, they are smoothed, if necessary, with sandpaper and decorated using sticks (*batti*) of moulded shellac to which pigments have been added. The *batti* are made by melting seed lac on an iron plate and mixing it to an even consistency with finely ground mineral pigments (carbon black, vermilion, orpiment yellow and indigo or orpiment green). They are then modelled to a convenient shape and left to cool and set. When the *batti* is pressed firmly against the revolving object, the friction causes the shellac to melt and adhere to the object. The *batti* is moved smoothly backwards and forwards until a reasonably even coating is produced. The shellac will still be somewhat uneven and streaky, so it is levelled with the sharpened edge of a slip of stiff bamboo or the end of a dry palm-leaf spathe, applied to the revolving object under moderate and then light pressure. The final finish is achieved by polishing the revolving object with abrasive leaves of coarse muslin lubricated with ground-nut oil. Additional layers of different colours are applied, if required, after the initial smoothing with the bamboo.

The objects may be further ornamented by a technique known as *nakshi* cutting through the lac layers to reveal the underlying colour or the wood. Lines

and bars of different colours are produced on the lathe, while naturalistic or geometric designs are done by hand with small chisels. Mottled or marbled effects are produced by holding a lac-stick of harder than usual composition rather loosely against the spinning object, so that the colour adheres in isolated patches. This is repeated with other colours until the object is thoroughly covered with lac, at which point it is finished as above.

(b) Painted. In this technique the lacquer is simply applied as a varnish over watercolour or oil painted decoration. In the Indian subcontinent the most usual substrate is papier mâché, followed by wood. The papier mâché, after normal preparation, is coated with a paste of plaster and glue and smoothed with a polished stone. A sheet of paper is then glued to the surface and the design painted in watercolour. Sometimes a silver pigment, composed of levigated tin in glue, is also used. The object is then varnished: three coats with no intermediate preparation is the usual practice for common work, but better quality objects are given more coats, with a careful rubbing down between each application. Wood is treated similarly, but the initial dressing is usually a slurry of clay in water, sometimes with a little glue to act as a binder. Mother-of-pearl-inlay, whether on papier mâché or wood, is glued to the substrate after the surface dressing stage. Several coats of varnish or mastic are applied until the shell is covered, and then the surface is abraded until the shell is exposed again, when one or two more coats of clear varnish are applied. Raised work (*munabathi*) is made from baked and ground shell mixed with rice paste. This is applied in layers until the requisite shape and height are achieved. It is then gilded, painted with watercolour and coated with one or two layers of lac. The varnishes are based on lac, copal, rosin or mastic, used singly or in combination.

Some of the finest Indian lacquerware is produced in Kashmir, where laminated-paper boxes, trays and food containers are a speciality. Sheets of paper (occasionally textile, or laminated paper with a final layer of textile) are stuck together with various pastes and glues and 'laid up' in moulds. When the foundation layers are dry, the object is coated with a layer of gesso, which has been specially prepared to retain a degree of plasticity that is not present in the normal plaster/glue-size mixtures. When dry, the gesso layer may be varnished, or it may be covered with tin foil or gold leaf. The decoration is done with watercolour carried in gum arabic or oil colours bound with linseed or sesame oil. Several thin coats of varnish are then applied, the surface being prepared between coats by careful rubbing down with fine abrasives. These products have a particularly fine lustre and seem to resist impact damage better than those of other regions. The varnishes or lacquers employed are based on the finest grades of lac or sandarac resin mixed with sesame or linseed oil after the Iranian tradition.

In Turkey and Iran the grounds and basic technique of lacquerwork are similar to those used in the Indian subcontinent. The best known products of Iran are decorated book covers, mirror-cases and pen-boxes. The book covers are made from tooled leather or cloth-covered laminated paper, and they are often decorated with miniature paintings lacquered and mounted as medallions. Pen-boxes are made from papier mâché or laminated paper with asphodel paste as the adhesive. The paper ground is dried and burnished, then varnished with a mixture of sandarac resin and linseed oil or shellac and linseed oil. The designs are applied in oil colour or watercolour bound with gum arabic and finished with two or three coats of varnish, each carefully rubbed down. The technique that utilises sandarac resin and watercolour is regarded as the best.

J. Chardin: *Sir John Chardin's Travels in Persia* (London, 1686); ed. W. M. Penser, intro. Sir P. Sykes (London, 1927)

J. de Rochechouart: *Souvenirs d'un voyage en Perse* (Paris, 1867)

J. Mukharji: *Art Manufactures of India* (Calcutta, 1888)

Sir G. Watt: *Indian Art at Delhi* (Calcutta, 1903)

Sir G. Watt: *Commercial Products of India* (Calcutta, 1908)

R. M. Riefstahl: 'A Seljuk Koran Stand with Painted Lacquer Decoration', *Parnassus*, iv (1932)

F. N. Howes: 'Vegetable Gums and Resins', *Chronica botanica* (Waltham, MA, 1949)

Jain and Agrawal: *National Handicrafts and Handlooms Museum* (New Delhi, 1964)

H. E. Wulff: *The Traditional Crafts of Persia* (Cambridge, MA, 1966), pp. 236–9

K. Cig: 'Turkish Lacquer Painters and their Works', *Sanat Tarihi Yıllığı*, iii (1969), pp. 243–57

G. Fehérvári: 'A Seventeenth-century Persian Lacquered Door and Some Problems of Safavid Lacquer Painted Doors', *Bulletin of the School of Oriental and African Studies*, xxxii/2 (1969), pp. 268–80

B. W. Robinson: 'Book Covers and Lacquer', *Islamic Painting and the Arts of the Book*, ed. B. W. Robinson (London, 1976), pp. 301–8

O. Aslapana: *The Art of Bookbinding*, iii of *The Arts of the Book in Central Asia*, ed. B. Gray (London, 1979), pp. 59–91

M. Zebrowski: *Decorative Arts of the Mughal Period: The Arts of India* (Oxford, 1981), pp. 180–81

W. Watson, ed.: *Lacquerwork in Asia and Beyond,* Colloquies on. Art and Archaeology in Asia, xi (1982)

J. Bourne and others: *Lacquer: An International History and Collector's Guide* (London, 1984)

X. Fraser-Lu: *Burmese Lacquerware* (Bangkok, 1985)

J. C. Y. Watt and B. B. Ford: *East Asian Lacquer: The Florence and Herbert Irving Collection* (New York, 1991)

M. Shôno-Sládek: *The Splendour of Urushi: The Lacquer Art Collection at the Museum of East Asian Art, Cologne: Inventory Catalogue with Reflexions on Cultural History* (Cologne, 1994)

N. D. Khalili, B. W. Robinson and T. Stanley: *Lacquer of the Islamic Lands* (London, 1996)

J. Earle: *Masterpieces of Japanese Lacquer from the Khalili Collection* (Edinburgh, 1997)

T. Helmert-Corvey, ed.: *Inro: Das Ding am Gürtel* (Bielefeld, 1997)

J. Hutt: *Japanese Inro* (London, 1997)

R. Isaacs and R. Blurton: *Visions from a Golden Land: Burma and the Art of Lacquer* (London, 2000)

M. McArthur: *The Arts of Asia: Materials, Techniques, Styles* (London, 2005)

3. IMITATION.

(i) Introduction. The popularity from the late 16th century of lacquer wares imported from Asia (*see* §II, 1 below) prompted European craftsmen to manufacture imitations (*see* §II, 2 below). None of these ever rivalled *urushi* ware in durability, and it was not until the mid-18th century that at least the depth and brilliance of the genuine article was reproduced. The first to be copied were Iranian and Indian lacquer wares. European craftsmen were already familiar with such Indian resins as lac and sandarac, and it would seem that the imitation wares were made using authentic materials and at least good approximations of the original techniques. When Chinese designs were added to the repertory, they were reproduced in the same fashion, since *urushi* was not even correctly described until the early 18th century. These methods, however, only produced rough approximations of the authentic Chinese and Japanese finishes, so the period from the late 17th century to the end of the 18th was one of constant experimentation to improve and refine technique. Numerous systems were developed, known collectively as japanning, and many descriptions of them were published, but the information in many of these publications was spurious, some of the authors (probably writing from hearsay) failing to understand even the basic principles of the processes involved.

The first accurate description of methodology and 'receipts', the *Treatise of Japanning and Varnishing*, was published in 1688 by John Stalker and George Parker, and in 1730 the Martin brothers of Paris patented a system under the name of VERNIS MARTIN, which, due to the clarity, brilliance and toughness of its finish, became the most famous of the European techniques. At its best it rivals the appearance of good quality East Asian work, but it lacks the hardness and resistance to chemical attack of *urushi* ware.

The japanners originally used wooden substrates, but from the beginning of the 18th century metal and papier mâché grew in popularity, the latter being a favourite base for mother-of-pearl inlay. The substrate was carefully prepared and smoothed and the design painted directly on to the surface, or on to an intermediate layer of gesso, which provided a smooth, white ground. The varnishes were complex blends of resins (*see* RESIN, §1), dissolved in turpentine and other substances. The best English imitation lacquer varnish of the late 17th century, for example, was based on the use of sandarac or seed lac mixed with mastic, Venice turpentine, copal resin, gum elemi, benzoin and colophony dissolved in ethanol, or on similar blends in turpentine. These mixtures were left to mature for up to six weeks before use. The work then had to be carried out in well-heated and dry workshops; special rooms known as 'stoves' were used. Regardless of which of the various techniques was employed, each coating was allowed to dry thoroughly before it was polished and cleaned in preparation for the next coat. Aspects of the japanner's art have continued to the present day in the cabinetmaker's finishing technique known as French polishing, in which numerous coats of an alcoholic solution of pure shellac are applied to a carefully finished surface with a cloth 'rubber' lubricated with linseed oil (*see* WOOD, §III, 5).

(ii) Some 17th-century English techniques. The best quality work was executed on such close-grained hardwoods as pear-wood, while common work was done on deal or oak. To obtain a smooth, uniform surface the panels used for common work were coated with gesso made by mixing whiting with glue size. Nine coats were applied in three stages. Each coat was allowed to dry thoroughly, then rubbed smooth with rushes; a longer drying period was allowed after each third coat. When the gesso was completely dry, it was sealed with two coats of seed lac varnish in alcohol, then allowed to dry and rubbed smooth. The design was drawn or painted in outline, then built up with a paste of finely ground whiting and bole in a strong solution of gum arabic. This was applied with a long, pointed wooden 'pencil'. When dry, the design was outlined and the details painted in with vermilion watercolour. The various levels were carved in and smoothed with a well-worn brush. The raised work was usually painted with gold or silver pigments, although it may have been leaf gilded or silvered, and the details were accentuated with a colour that contrasted with or matched the background. Following burnishing with a dog's tooth or agate, the decoration was coated with two or three coats of seed lac varnish.

For polychrome work it was usual to use watercolour, sealed and prepared for polishing by the application of several coats of seed lac varnish. Such ground colours as red or black were mixed with seed lac varnish. Black japanned work was prepared by applying three coats of varnish mixed with lampblack to the support. Three further coats were applied, each being carefully polished. Six thin coats of seed lac mixed with Venice turpentine and a little lampblack were then applied, followed by twelve coats of pure seed lac tinted with lampblack. This was allowed to dry for six days, then given a preliminary polish with fine tripoli powder and water, rested for two days and further polished using more water than in the first polishing. After washing to remove all traces of the tripoli powder, the work was rested for a further five days before a final polish using lampblack and oil that was cleaned off with a dry cloth.

(iii) Vernis Martin. The Martins' copal varnish was prepared by melting together Cyprus turpentine, amber, copal, oil of turpentine, colophony and a vegetable oil, such as linseed or poppy. The amber varnish was similarly made by blending the same materials in different proportions and excluding the copal resin. The method of application was similar to that described in §(ii) above. The support

was prepared and decorated with watercolour, oil or pigments in varnish. Six coats of varnish were then applied. These were allowed to dry for two or three days, then rubbed down with pumice powder and water. A further ten or twelve coats of varnish were applied and allowed to stand until thoroughly dry, usually about five days, then lightly rubbed down with finely ground pumice. All traces of the pumice were removed by washing with water, and the object was polished again with fine emery in water. The emery was washed off and a final polish given using sifted rottenstone. The object was then cleaned using dry rags and rubbed over with a soft cloth dipped in oil. The oil was removed with fine wheat flour and the finished lustre brought up by gentle rubbing with a soft cloth loaded with more flour.

One of the techniques developed by the Martin brothers was called 'aventurine' after the mineral that it resembles. It was made by inlaying numerous pieces of rectangular-sectioned gilt-brass wire into a green, red or sometimes black ground, then covering them with several layers of transparent 'lacquer' to produce an effect similar to the Japanese *makie* technique (*see* §1(ii)(d) above).

(iv) A 19th-century English technique. This technique utilized a simple alcoholic solution of lemon or bleached shellac (cooked with a caustic decolourant to give an almost water white solution in alcohol) to which a small amount of camphor had been added. The support was sealed with two coats of varnish and coated, if necessary, with a thin paste of gilders' whiting in shellac solution followed by ordinary gilders' gesso. The ground was then built up with several coats of powder pigment in varnish. As many as ten coats were applied, with the last two or three containing no more than a trace of pigment or spirit-soluble stain. When dry, each coat was rubbed down with O-grade glass-paper, and the final layer was further smoothed with medium-grade pumice powder and finished with flour-grade pumice. The decoration was applied with powder pigments (including various metal powders) bound with varnish; black details were picked out with 'China black' ink. Raised work was executed with gilders' gesso. Gold size, to which a little Indian red pigment had been added, was applied to those areas of the design that were to be leaf gilded or painted with metal pigments. Once the decoration was complete, three coats of clear varnish were applied, each coat being lightly rubbed down with fine pumice powder. The final coat was given a further polish using flour-grade pumice and finished with gilder's whiting and linseed oil, all trace of which was removed using dry, soft cloths.

J. Stalker and G. Parker: *A Treatise of Japanning and Varnishing* (Oxford, 1688); facs. with intro. by H. D. Molesworth (London, 1960) Repr., Reading, 1998

S. Crowder: *Genuine Receipt for Making the Famous Vernis Martin* (Paris, 1753)

S. Crowder: *A Treatise on the Copal Oil Varnish, or, What in France is Call'd Vernis Martin* (London, 1753)

G. Koizumi: *Lacquer Work* (London, 1923)

J. P. Parry: *Graining and Marbling* (London, 1949)

H. Honour: *Chinoiserie: The Vision of Cathay* (London, 1961)

H. Huth: *Lacquer of the West: The History of a Craft and Industry, 1550–1950* (Chicago, 1971)

I. O'Neil: *The Art of the Painted Finish for Furniture and Decoration* (New York, 1971)

D. A. Fales: *American Painted Furniture, 1660–1880* (New York, 1972)

O. Impey: *Chinoiserie: The Impact of Oriental Styles on Western Art and Decoration* (London, 1977)

F. Oughton: *The Complete Manual of Wood Finishing* (London, 1982)

E.-C. Wellmer: 'Goldfarbene Lacke in den Quellenschriften zur Maltechnik: Ein Überblick zur Geschichte, Verwendung und Material', *Firnis: Material, Ästhetik, Geschichte*, ed. A. Harmssen (Brunswick, 1999), pp. 43–62

K. Walch and J. Koller: *Lacke des Barock und Rokoko/Baroque and Rococo Lacquers* (Munich, 1997)

4. INDUSTRIAL. There is no universal agreement on the definition of the term 'lacquer' in the paint industry. In industry a varnish is usually considered to be a blend of resin and drying oil that dries by autoxidation; in this article the term 'lacquer' will be used to describe a simple solution of resin, and 'varnish' a product containing resin and oil. This distinction is important in conservation work as most lacquers are soluble in organic solvents and are easily removable, whereas varnishes are insoluble. (For further discussion of the problems of definition of a lacquer *see* introduction above.) Originally applied by brush, lacquer is now conveniently applied by spray, except in French polishing (*see* §3 above), when it is applied by rubbing in with a cloth pad.

The lacquers used in industry are of three main types, consisting of solutions of natural resins, cellulose derivatives or synthetic resins. The natural resins are of two classes—those soluble in solvents and those requiring heat treatment to solubilize them, for example copals. The former are used for lacquers and the latter for varnishes. Those used in lacquers include dammar, which can be used as a solution in turpentine, although it becomes hazy on ageing; shellac, which, in methylated spirits, is used for French polishing; manila, which is a useful resin since it is soluble in alcohol, gives a hard film and is favoured for applying over bituminous products that tend to bleed; and sandarac, which, in solution, was once popular for coating metals. Rosin (colophony) is readily soluble, but the films produced are friable, thus it is useless as a lacquer resin. Dragon's-blood is, unique among natural resins, red in colour; its coloured lacquers were used by Italian violinmakers.

The most widely used cellulose for industrial lacquer is nitrocellulose. It loses solvent rapidly and can produce very fast-drying coatings. It needs to be applied by spray and requires strong (ester or ketone) solvents, which render it unsuitable for application over paintwork. Plasticizers are required to reduce the brittleness of the films. Other cellulose derivatives, suitable for lacquers and requiring

less powerful solvents (e.g. aromatic hydrocarbon-alcohol mixtures), are ethyl cellulose, cellulose acetate and cellulose acetate butyrate.

Since most natural resins are now unavailable, new developments are taking place with the modern synthetic resins, in particular the acrylic and vinyl resins. By synthesizing copolymers of various acrylic and methacrylic esters, products of the required hardness and flexibility can be tailor-made. Solubility varies with the copolymers, but a fairly strong solvent mixture is required. The advantages of the acrylic resins are that they are water-white, very durable and resistant to discoloration. The acrylic polymers used are similar to those forming the basis of the water-borne acrylic artists' paints. Other synthetic resins used in lacquers are those consisting of polymers or copolymers of vinyl acetate, which are used for coating paper and metals.

T. H. Barry: *Natural Varnish Resins* (London, 1932)

C. L. Mantell and others: *The Technology of Natural Resins* (New York and London, 1942)

C. J. A. Taylor and S. Marks, eds: *Paint Technology Manual*, Oil and Colour Chemists' Association, i (London, 1961)

M. Ash and I. Ash: *Resins* (London, 1990)

Glossary of Paint and Related Terms, BS 2015, British Standards Institution (London, 1992)

W. G. Simpson: *Plastics and Resin Compositions* (Cambridge, 1995)

II. History. This article discusses briefly the development of the trade in lacquer, firstly between China and Japan and then between East Asia and the West, and the use and manufacture of lacquer in Europe and the USA.

1. East Asia export. 2. Europe and the USA.

1. EAST ASIA EXPORT. The presence of several pieces of Chinese lacquer in the Shōsōin of Tōdaiji in Nara, Japan, testifies to some trade in lacquer, suitably luxurious, before AD 756, i.e. during the Tang period (AD 618–907) in China and the Nara period (AD 710–94) in Japan. Certain areas of China, notably Zhejiang and Jiangsu, were centres of lacquer production, and finds in excavations demonstrate the presence of good quality lacquer over much of China. Some 14th-century Yuan-period (1279–1368) *sūtra* boxes are owned by Japanese temples, to which they probably came when new, and Ming (1368–1644) incised gold-decorated lacquer was exported to Japan in some quantity in the 15th century. By the 15th century, however, the Japanese were also exporting to China *makie*, the gold-dust-sprinkled lacquers (*see* §I, 1(ii)(d) above), so the trade or exchange was in both directions. During the 16th century Chinese objects were in high fashion in Japan, and Chinese lacquer was both imported into and imitated in Japan. Although by this period carved lacquer and pearl-shell inlaid lacquer were still much practised in China, the Japanese *makie* was becoming so refined and was of such quality and variety that it was regarded as the finest lacquer, even

in China, where it was greatly coveted. Some Chinese craftsmen even went to Japan to learn Japanese lacquer techniques.

This was the situation when the Western world began to trade in lacquer. The earliest-known pieces of East Asian lacquer in the West (Innsbruck, Schloss Ambras) are five small Chinese bowls and a Japanese cabinet all inventoried in 1596 in the collections of Archduke Ferdinand of Austria, Count of Tyrol (*reg* 1564–95). Also, similarly inventoried in the Ambras collection, is a European table painted in a style related to and possibly imitating the lacquer bowls. However, it is not the Chinese lacquers that were to be so important in Europe for the next 100 years, but the Japanese. As items of trade carried first by the Portuguese (until their expulsion from Japan in 1639), then by the Dutch (from 1600) and for a short period by the English (1613–23), Japanese lacquer was important not so much for quantity as for quality. The Dutch East India Company in particular used Japanese lacquer as rich gifts for Asian potentates, as well as for less important trade.

The Japanese lacquer cabinet at Schloss Ambras is in the *Nanban* style: this is a type of pearl-shell inlay into thick, coarse lacquer with gold overpainting. When the Dutch achieved the monopoly of the direct European trade with Japan (shared only with the Chinese), they continued the trade in lacquer. The Dutch continued to use Japanese lacquer as a trading commodity and for diplomatic gifts throughout the 17th century, particularly between 1634–45. The main items made for the European market were cabinets and coffers of various shapes. As the Dutch learnt of the particular wishes of the various countries of Asia in which they traded, so they could adapt their orders to suit these tastes. The different Dutch 'factories' in Asia could order pieces from Japan via Batavia (now Jakarta) and Dejima. The Portuguese had used Japanese lacquer palanquins (*norimono*) in Goa; in 1662 the Dutch sent to the Mughal emperor Aurangzeb 'one man's palanquin, one woman's palanquin, 1 elephant's howdah, 2 saddles, 25 shields'. In 1680 the Greek adventurer Constantin Phaulkon (1647–88), then the *de facto* ruler of Thailand, was able to order Japanese lacquer via the Dutch for presents for Louis XIV, King of France (*reg* 1643–1715), at the time of his 'embassy'. This led to one of the great vogues for chinoiserie that were periodically to sweep Europe.

Just as imitations of *urushi* lacquer had been made in Iran and the Indian subcontinent, so in the early 17th century—or even, as the table at Schloss Ambras testifies, in the late 16th century—Europeans attempted to emulate the lustre and durability of lacquer (*see* §2 below). In 1609 William Kick (active *c.* 1609–30) was making japanned ware 'after the fashion of China'. Some pieces by Kick were even used by the Dutch States General as diplomatic gifts to Turkey in 1612. It was, however, the Chinese who best imitated Japanese lacquer for trade purposes. By the 1660s the Chinese, who had already been trading in Japanese lacquer, had begun to imitate Japanese

styles. Such imitations were mostly of screens decorated in gold lacquer on a black ground, but later red-ground screens became increasingly common, to be exported to Europe. There they were often cut up for use as panelling either for rooms or, later, for furniture. A new style, the so-called Coromandel style, with no Japanese ancestry, often suffered the same fate. This was an incised polychrome style that had a great effect on European taste.

At the end of the 17th century the Dutch stopped buying large pieces of Japanese lacquer—it had become too expensive—and only bought smaller items for grand gifts. The Chinese, having successfully undercut the Japanese, exported lesser quality, but much cheaper, lacquer to Europe, via trading companies other than the Dutch. Occasionally European furniture carcases were sent to Tonkin or Amoy (now Xiamen, Fujian Province) to be lacquered, but this was a rare occurrence. One or two instances are recorded of European cabinetmakers being sent to China to teach the Chinese. Chinese lacquers thereafter were increasingly made in the fashionable shapes of smaller European furniture such as work-tables, gaming-boards, nests of tables and so on.

In the 18th century collectors of lacquer strove to find old pieces, with the Dutch acting as agents. At the end of the 18th century there was a vogue for lacquer made in Japan with designs after European prints, and by the mid-19th century much lacquer of very poor quality was exported from Japan to suit the 'greenery-yallery' taste of the Aesthetic Movement. At the same time high quality lacquers were produced in Japan for international exhibitions (e.g. Philadelphia, 1876; Paris, 1878) and for the connoisseurs' market.

W. Speiser: *Lackkunst in Ostasien* (Baden-Baden, 1965)

B. von Ragué: *Geschichte der japanischen Lackkunst* (Berlin, 1967; Eng. trans., Toronto, 1976)

Y. Lee: *Oriental Lacquer Art* (New York, 1972)

Sir H. Garner: *Chinese Lacquer* (London, 1979)

A. J. Pekarik: *Japanese Lacquer, 1600–1900: Selections from the Charles A. Greenfield Collection* (New York, 1980)

W. Watson, ed.: *Lacquerwork in Asia and Beyond*, Colloquies on the Art and Archaeology in Asia, xi (1982)

P.-F. Schneeberger: *The Baur Collection, Geneva: Japanese Lacquer* (Geneva, 1984)

Wang Shixiang: *Ancient Chinese Lacquerware* (Beijing, 1987)

J. C. Y. Watt and B. B. Ford: *East Asian Lacquer: The Florence and Herbert Irving Collection* (New York, 1991)

S. Fraser-Lu: *Burmese Crafts: Past and Present* (Kuala Lumpur, 1994)

O. R. Impey: *Japanese Export Lacquer, 1580–1850* (Amsterdam, 2005)

2. EUROPE AND THE USA. European lacquerwork was originally developed in imitation of the East Asian and Islamic lacquered articles that were imported into Europe in increasing quantities from the late 16th century (*see* §1 above). The widespread enthusiasm for exotic lacquer finishes and the mystery that shrouded their manufacture encouraged European craftsmen to invent their own 'lacquer' from various imitative substances (*see* §I, 3 above). The first European lacquerwork was made in Venice in the early 17th century by painters and gilders (It. *depentori*) in designs adapted from the decorative objects that arrived in Venice from Islamic countries and the East. Stylized interlace and arabesques derived from lacquered bookbindings, damascened metalwork, textiles and ceramics were freely incorporated with Renaissance ornament and depictions of animals on elaborate caskets, cabinets, musical instruments, frames and so on. Black, vermilion and later dark green were the colours most commonly employed, with details picked out in gold. By the 1660s Venetian lacquer was esteemed throughout Europe and emulated in other parts of Italy.

Netherlandish workers in lacquer established guilds in the early 17th century in Amsterdam and Antwerp. They produced chinoiserie and floral designs copied from Dutch flower paintings, with mother-of-pearl enrichment more typical than gilded effects. The principal lacquer-producing centre was Spa, near Liège in Flanders (now Belgium). Lacquered articles made there, especially a characteristic lacquered walking stick or *bourdon*, were renowned and avidly collected by visitors.

The golden age of European lacquer began in the late 17th century, following a wave of lacquered wares imported into Europe from China and Japan. The hardness, gloss and lustre of Eastern lacquer and the charm of the designs captivated everyone, creating a huge demand for lacquered furniture, wall panels and objects. Entire rooms, most notably at Versailles, were decorated with both East Asian and European lacquered panelling and furniture. Virtually *de rigueur* in these interiors were large, two-door lacquered cabinets in the East Asian style mounted on ornate gilded or silvered stands.

The first accurate description of European lacquering techniques, John Stalker and George Parker's *Treatise of Japanning and Varnishing*, was published in 1688, and the work of English craftsmen—highly coloured furniture and articles dubbed *à la chinoise*—was popular on the Continent, particularly in Portugal and Spain. Such work was known as 'japanning' or 'Japan work', since Japanese lacquer was considered to be the finest of all. Japanning continued to be popular in England throughout the 18th century and was employed by such craftsmen as Thomas Chippendale (1718–79), John Linnell (1729–96) and Thomas Sheraton (*d* 1806).

In France imitation lacquerwork, known as *ouvrages de la Chine*, was produced from 1672 at the Gobelins factory in Paris. It is known from contemporary records that Chinese techniques were studied, but in fact the designs were more typically French. About 1713 the Flemish-born Jacques Dagly (1665–1729), brother of Gerhard Dagly, who was Kammerkünstler to Frederick William, Elector of Brandenburg, arrived in France to direct the workshop at Gobelins, and in 1713 he was granted a patent for a transparent varnish (*vernis de Gobelins*)

for textiles and coloured furniture. Dagly specialized in lacquered panels for carriages and walls, musical instrument covers and furniture, executed in the 'Chinese taste'. High-quality lacquer was also made at Chantilly between 1733 and 1740, but the finest 18th-century French lacquer, *vernis Martin*, was produced by the Martin brothers, Guillaume, Robert, Etienne-Simon and Julien (*see* §I, 3 above and VERNIS MARTIN). Patents were taken out in 1730, 1744 and 1753. The lacquer produced by the Martin brothers was renowned for its pale, clear colours, favoured during the reign of Louis XV (*reg* 1715–74)—who apparently disliked black lacquer, especially a soft green that was frequently employed in room panelling. The brothers decorated a number of *petits appartements* at Versailles but concentrated chiefly on the production of many different kinds of small, domestic articles. In the 18th century commodes, cabinets, desks, tables and so forth were made by the *ébénistes*, but the lacquer decoration was usually executed by anonymous masters. Decorative designs were created by such artists as Antoine Watteau (1684–1721), François Boucher (1703–70), Christophe Huet (1700–59) and Jean Pillement (1728–1808), then engraved and the prints widely circulated in France and beyond.

By the late 17th century Hamburg, Berlin and Dresden were established as important centres for lacquered goods. Gerhard Dagly (1657–1715) introduced Flemish styles to Berlin (e.g. lacquered cabinet on stand, *c.* 1690; Berlin, Schloss Charlottenburg), while in Dresden Martin Schnell (*d* 1740), a pupil of Dagly, was known for his lacquerwork in the Indian, Turkish and Japanese manner.

Scandinavian lacquer relied on Dutch, Flemish and English models. Its production was centred in Stockholm, Copenhagen and, most notably, at Braggernes, Norway, where a London-trained Norwegian, Niels Lochstoer (1714–85), was established. Another well-respected master was Niels Dahlin (*fl* 1761; *d* 1787), who made furniture for the Swedish court (e.g. desk of lacquered and gilded wood, *c.* 1765; Stockholm, Nordiska Museum). Spain and Portugal produced limited amounts of lacquered furniture, and Austria even less.

In Italy, Venice lost some of its dominance in the 18th century to Florence, Genoa and Lucca, where excellent lacquerwork was produced. A popular form of decoration, called *lacca povera* or *contrafatta*, sprang up in Venice *c.* 1750. It used prints, cut and pasted on to armoires, cabinets and chests, then painted, gilded and finished with clear varnish; the Remondini company (*fl* 1751–1817) of Bassano in the Veneto was the chief supplier of the special prints.

A court fashion for lacquerwork developed in Russia when Peter I commissioned local craftsmen to decorate rooms in Monplaisir, his summer residence at Peterhof, with red, black and gold chinoiserie lacquered panels. Four panels of the original work, completed in 1722, survive *in situ*. Fine lacquered furniture and objects continued to be made in Russia throughout the 18th century.

In colonial North America, where a great quantity of East Asian, English and Dutch lacquered furniture was imported from the 1690s, craftsmen were quick to develop their own lacquering techniques. Early American chinoiserie designs were fresh and whimsical, the motifs often enriched with gold, silver and bronze metallic powders or with imitation painted tortoiseshell. During the 18th century Boston became a centre of production for simplified Japan work, executed in paint mixed with lampblack and oil resin and finished with coats of clear varnish. Techniques for lacquering on substrates other than wood had been evolving since the early 18th century. Martin Schnell in Germany, for example, lacquered ceramic wares for the Meissen factory between 1712 and 1714. Japanned, tin-plated ironware was first developed in England at Bilston, Staffs, between 1709 and 1719, and a japanned tinware industry flourished throughout the 18th century at Pontypool and Usk in Wales (e.g. tea urn, *c.* 1770; Cardiff, National Museum of Wales). In France japanned tinware was known as *tôle*, while American-made tinware was called 'tole' or 'toleware'.

In Germany, Georg Siegmund Stobwasser (1740–1829) was famous for fine, japanned papier-mâché snuff-boxes and similar items, painted with portraits, landscapes and genre scenes, made at his factory in Brunswick from 1765 until his death in 1829. In the wake of the Napoleonic wars of the early 19th century, the trade in luxury European lacquerwork largely collapsed, but in Britain new techniques for strengthening papier mâché created a demand for japanned papier-mâché furniture and objects, the best of which were made in Birmingham. Lacquered wood, papier mâché and tinware became a significant folk art, particularly in Russia in the Fedoskino area near Moscow, where small articles were painted with landscapes and scenes from Russian myths or peasant life.

By the end of the 19th century interest in lacquer finishes had largely diminished, although some black-painted, Japanese-style furniture was favoured by designers of the Arts and Crafts and Aesthetic Movements. In the 1920s the popularity of Asian lacquerwork was revived in Europe by the efforts of such designers as Jean Dunand (1877–1947) and Eileen Gray (1879–1976), both of whom worked in Paris and were trained in lacquering techniques by the Japanese master Seizo Sugawara (*d* 1937). They created objects finished in traditional lacquers but with imaginative Art Deco designs.

See also PAPIER MÂCHÉ.

H. Huth: *Europäische Lackarbeiten, 1600–1850* (Darmstadt, 1955)

H. Huth: *Lacquer in the West: The History of a Craft and Industry, 1550–1950* (Chicago, 1971)

I. O'Neil: *The Art of the Painted Finish for Furniture and Decoration* (New York, 1971)

Y. Brunhammer: *Art Deco Style* (London, 1983)

N. Malakhov: *Fedoskino* (Moscow, 1984)

V. Guliayev: *Russian Lacquered Miniatures: Fedoskino, Palekh, Mstiora, Kholui* (Leningrad, 1989)

K. Walch and J. Koller: *Lacke des Barock und Rokoko/Baroque and Rococo Lacquers* (Munich, 1997)

M. Kopplin: *European Lacquer: Selected Works* (Munich, 2001)

III. Conservation.

1. Introduction. 2. *Urushi*. 3. Insect and associated lacquers.

1. INTRODUCTION. Lacquer artefacts are usually physically complex. *Urushi* lacquerware incorporates other materials for strength and stability in the primary layers, while insect and associated lacquers are always applied to a substrate of wood, metal, ceramic, papier mâché and so on; all types may also include other materials for decoration in the surface layers. Since *urushi* lacquers and insect and associated lacquers require different environmental conditions and give rise to different conservation problems, it is convenient to treat them under two separate headings. Before this, however, some points should be made about general conservation principles.

The first aim should be to prevent damage and loss. This is done by maintaining the optimum environmental conditions (*see* §3 below) and by avoiding any mechanical damage during handling, transportation and storage. Lacquer objects should be protected against sudden impact, abrasion and skin contact. Their protection requires constant vigilance, imagination in working out routines that minimize risk and thoroughness in documenting and applying such routines.

When handling lacquer objects, a person should use both hands, remove any jewellery and wear lint-free cotton gloves with a good grip. The floor should be cleared of obstructions and a space made available where the objects are to be placed. Unprotected pieces should never stand close together, and objects should only be moved when properly protected in suitable containers. Most good quality East Asian pieces are supplied with wooden boxes. These should be used as they provide protection against mechanical damage, RH changes and light. However, pieces that have been decorated with pigments containing lead or lead alloys may be damaged by reaction with the organic acid vapours released by some timbers and adhesives, which results in the formation of white powdery spots of lead carbonate. When these are detected, it is essential to act quickly to remove the source of contamination.

Active intervention should be carried out only by professionally trained and qualified conservators. Their guiding principles should be as follows: do no harm; aim for minimum intervention consistent with continued preservation; ensure that the object will go back to a suitable environment after treatment; wherever possible, use techniques that can be reversed and avoid any materials and techniques that may prejudice or prevent re-treatment; and finally, ensure that any restorations are aesthetically acceptable yet detectable by fairly simple means. Thorough examination, using techniques similar to those employed for easel paintings (*see* TECHNICAL EXAMINATION, §VIII, 6), should be carried out before conservation

work begins to determine the nature and condition of the construction and materials.

2. URUSHI. *Urushi* lacquer is very sensitive to light, the damage arising mainly from short wavelength radiation (below 400 nm) and the heat generated by the light source. Overexposure causes discoloration and loss of lustre, where short wavelength radiation in particular causes lacquer surfaces to become hydrophilic and therefore susceptible to finger marking and damage from aqueous cleaning materials. To prevent this, direct exposure to unfiltered daylight should be avoided, and fluorescent lamps should be filtered to reduce the ultraviolet light (especially that of wavelength 365 nm or less) to below 75 µ watts/lumen. The maximum safe total dose of illumination before damage can be detected may be as low as 6 years at 150 lux for cinnabar lacquer and 21 years for black lacquer. In practice, damage at this level is unlikely, but it is clear that lacquer objects should be illuminated only when they are actually being viewed.

Another potentially serious consequence of overexposure to light is a rise in the temperature of lacquer films. Incandescent lamps should be arranged to avoid heating effects, which increase the rate of the chemical reactions that cause deterioration and lower the relative humidity (RH) of the immediate environment, so reducing the moisture content of the lacquer. Temperature should be as low as possible, consistent with the avoidance of condensation problems, and as constant as possible. Much damage to lacquer is caused by changes in RH and the varying shrinkage of wood and lacquer. Also, water is an essential part of the structure of *urushi* lacquer. Loss of bound water leads to deterioration, including reduced flexibility and toughness, accompanied by shrinkage and internal stress. It also changes the barrier properties of the lacquer to water and oxygen. Conversely, excess water over the equilibrium amount may promote degradation by oxygen.

Many East Asian lacquer objects in Western collections have suffered from being stored too long in conditions of low average RH (an average of 55–60% is best). To correct this the RH should be increased gradually, with careful monitoring, preferably at a time of year when it is normally rising. Once established, the new environmental conditions should be maintained with minimum fluctuation.

In the cleaning of *urushi* lacquer careful brushing and vacuuming may be used to remove dust, but solvent or abrasive cleaning may be required to remove accumulated dirt. Soiling may range from water-soluble salts to greasy materials more easily removed with such hydrocarbon solvents as white spirit. The condition of the lacquer surface itself may vary from water repellent (usually shiny) to extremely water sensitive (usually dull, i.e. light damaged). In the frequently encountered situation of a water-sensitive surface with water-soluble dirt attached, water will remove the dirt but will also dissolve or mark the surface. Considerable experience and care are thus

needed in both choosing and using solvents to avoid such damage. Furthermore, reaction to a solvent may not be uniform from one area of an object to another.

Where solvent cleaning is unsafe or ineffective and where the surfaces remain unbroken, abrasive cleaning can be used to remove very fine layers of degraded or discoloured material and dirt. However, this should be kept to a minimum and should be attempted only when subsequent storage and display conditions are such that the same problems will not readily recur. On disrupted surfaces it is advisable to carry out consolidation and repair work first (see below). The principles of abrasive cleaning are: to use the finest and softest abrasive that is effective, to keep the system well lubricated, to check progress often and to stop in good time. W. T. Chase ('Lacquer Examination and Treatment at the Freer Gallery of Art: Some Case Histories', *Urushi*, Los Angeles, 1988) has successfully used finely divided anatase (titanium dioxide) as a substitute for the traditional Japanese polishing powder, *tsunoko*. The success or failure of this operation depends considerably on the operative.

Before or, usually, after cleaning, it may be necessary to consolidate the object. The damage may include fine cracks where the lacquer is loose but the ground relatively inaccessible, or areas where the lacquer is missing and the friable ground revealed. Cupping and flaking are also encountered. For this consolidation and relaying of loose material a number of materials are available. Fish glues (e.g. isinglass) and synthetic thermoplastic polymers (e.g. acrylics and polyvinyl acetate) in solution are used to penetrate fine cracks and consolidate loose or friable material. When the adhesive is dry, a combination of pressure and heat (to reactivate the polymer) can be employed to secure lifting or cupping surface layers. The disadvantages of solvent systems are that deposited solid may remain close to the surface, and that shrinkage may occur. However, such systems are widely used, even, on occasion, in East Asia. Polymer emulsions are also used for relaying accessible flakes, and fillers based on these emulsions can be very useful for infilling missing areas. Waxes and wax–resin mixtures have been used for both consolidation and infilling. Work done with wax is, in principle, reversible, but subsequent treatments with most other materials apart from wax may be difficult. Epoxies and polyesters are not normally considered suitable for use *in situ*, but they are useful for casting in silicone rubber moulds replacements of missing areas, which can then be set in place using thermoplastic materials. Once the object has been consolidated, thermoplastic resins in solution can be used for retouching and occasionally for surface coating. Microcrystalline wax provides a better barrier but may easily be removed.

In Japan, where lacquer objects are normally conserved by lacquer artists or craftsmen rather than by specialist conservators, *urushi* is used for all stages of restoration. This approach is often successful, but it does have disadvantages. The material is toxic and

the process irreversible; the colour and transparency change with time, so the repairs eventually do not match their surroundings; specialist techniques, materials and equipment are required that may damage the rest of the object; and the differences in physical properties of the new and aged films may impose stress. Cashew (prepared from the cashew nut) is an alternative to *urushi* that is sometimes used for both manufacture and restoration of lacquer in Japan, although this practice is not widely publicized.

A. Franke: 'Ostasiatische Lackarbeiten und das Problem ihrer Konservierung', *Arbeitsblätter für Restauratoren*, i (1976), pp. 1–10

T. Araki and T. H. Sato: 'Relationships between Exhibition Lighting and Discolouration of Lacquered Wares', *Scientific Papers on Japanese Antiquities and Art Crafts*, xxiii (1978), pp. 1–24

A. Franke: 'The Use of Beeswax and Resin in the Restoration of East Asian Lacquer Work', *Conservation of Wood in Painting and the Decorative Arts* (London, 1978), pp. 45–7

J. Kumanotani and others: 'Attempts to Understand Japanese Lacquer as a Superdurable Material', *Cultural Property and Analytical Chemistry: International Symposium on Conservation and Restoration of Cultural Property*, ed. J. Kumanotani (Tokyo, 1979), pp. 51–61

N. Umney: 'Oriental Lacquer', *Conservation News*, xxxii (1987), pp. 23–5; xxxiii (1987), pp. 13–15

N. S. Bromelle and P. Smith, eds: *Urushi* (Los Angeles, 1988), esp. pp. 95–112, 243–51 [Proceedings of the 1985 Urushi Study Group, Japan]

D. Heath and G. Martin: 'The Corrosion of Lead and Lead/Tin Alloys Occurring on Japanese Lacquer Objects', *Abstracts of the IIC Conference: Conservation of Far Eastern Art: Kyoto, 1988* (London, 1988), pp. 137–41

M. Webb: *Lacquer: Technology and Conservation: A Comprehensive Guide to the Technology and Conservation of Both Asian and European Lacquer* (Oxford and Boston, 2000)

3. INSECT AND ASSOCIATED LACQUERS. Like *urushi*, these lacquers can be damaged by environmental factors. Long exposures to excessive light levels can make some lacquers darken and, under certain circumstances, can accelerate crazing and flaking by causing localized high temperatures and reduced relative humidities (RH). This damage is cumulative, and the most dangerous wavelength is the ultraviolet, especially that in the region of 365 nm. If the light sources are filtered to reduce the ultraviolet emissions to less than 75 μ watts/lumen, and the level of illumination of objects is kept low, the rate of degradation is reduced. The level for long-term display should not exceed 300 lux, which is about the average level of domestic lighting.

High temperatures can cause some lacquer coatings to soften, and prolonged exposure accelerates deterioration by increasing the rate at which deleterious chemical reactions take place. Long-term exposure to low relative humidities can result in the lacquer coatings becoming brittle and the ground becoming excessively dry, which causes cracking and the separation of the lacquer layers. Similarly, wide-ranging fluctuations in RH, by causing differential

expansion and contraction of the support and coating, cause the lacquer layers to flake. Exposure to high RHs can lead to blooming and fungal growth. Consequently, the RH levels should be maintained at about 50–55% and the rate of fluctuation kept as low as possible.

Physical damage should be avoided by taking the precautions outlined above, and the materials from which storage and display cases are made should be carefully selected. Some of the traditional timbers (e.g. oak) and some modern composition boards produce acidic exudates that can have harmful effects on lacquered surfaces. Similar care should be taken over the selection of paints and textiles used in display areas.

Damage may also be caused by the methods and materials used in earlier restorations and repairs. For example, flaking or crazed surfaces were often overpainted with shellac, which was sometimes applied too thickly or in too strong a solution. While this superficially improved the appearance of the object, it soon discoloured and crazed and, if left unattended, exacerbated the problem that it was supposed to correct. Another technique was the introduction of a solution of animal glue under the flaking areas. If the glue solution is applied with care in the correct concentration, this technique can be successful, but often the glue is allowed to contaminate the surface and the solution is too strong. As a glue solution dries, it shrinks; a strong solution dries faster and shrinks more than a weak one; consequently a strong solution will eventually cause the very problem it was intended to solve.

Interventive conservation should only be undertaken by experienced conservators, since even apparently simple procedures often require a great deal of skill for their safe application. Light soiling can be removed with cotton-wool swabs moistened with distilled water, to which a little non-ionic detergent has been added. This process should be followed by thorough drying and polishing with dry cotton wool. Badly discoloured finishing layers or degraded earlier restorations can be removed using organic solvents. It is often the case that the paint layers are carried in the same material as the finishing coats, so that great care must be taken not to soften the paint layers. Crazed and discoloured surfaces can be consolidated and cleaned by the application of a thin layer of a mixture of organic solvents and a drying oil. This is applied, left to stand for 10 or 15 minutes, then rapidly removed using a cotton 'rubber', which is applied with gradually increasing pressure until the surface is dry and polished. Actively flaking surfaces can be stabilized by introducing thin glue size or a water emulsion polyvinyl acetate adhesive into the lacquer–support interface. The adhesive is applied to the edge of a flake on a fine sable brush or a micropipette and is drawn under the flake by capillary action. It should not be applied directly to the surface.

Postprints Urushi Study Group Conference: Tokyo, 1985
The 17th International Symposium on the Conservation and Restoration of Cultural Property: Conservation of Urushi Objects, 1993

Lacquerwork and Japanning: Postprints UKIC Conference: 1994
M. Webb: *Lacquer: Technology and Conservation: A Comprehensive Guide to the Technology and Conservation of Both Asian and European Lacquer* (Oxford and Boston, 2000)

Lacuna [Lat.: 'gap']. Completely blank area on a painting or painted object or manuscript, resulting from any form of damage. On paintings, the cause may be the gradual decay and loss of adhesion of the paint layers, allowing flakes of paint to become detached. Accidental damage can give rise to larger lacunae.

Lake. Term derived from the early medieval Latin *lacca* to indicate both lake pigment and the products of the lac insect (*Kerria lacca*). The latter was imported into Europe from India, and it yielded both red dyestuff and, as a by-product, shellac (*see* LACQUER, §I, 2). Until the 18th century lake, without further qualification, usually indicated red pigments only.

Lake pigments are prepared by the precipitation of a soluble organic DYE on to an insoluble, inorganic, adsorptive substrate. The pigment is formed by the chemical reaction that occurs when a suitable reagent, such as alum, is added to an aqueous solution containing the dyestuff and, usually, one or more other chemicals, such as sodium or potassium carbonate. These chemicals react with the alum to form the substrate, an insoluble product of the reaction. During the reaction the dyestuff becomes intimately combined with the substrate, in this example hydrated alumina, and the resultant coloured solid material is precipitated from the solution.

Before the mid-19th century dyestuffs were extracted exclusively from animal and vegetable sources, and various species of scale insect were important sources of red dyestuff. Kermes (*Kermes vermilio*, from Mediterranean regions) was one of these until it was supplanted by cochineal (*Dactylopius coccus*), imported into Europe from Mexico from early in the 16th century. Use of the lac insect then also declined. Chemically, these closely related dyestuffs are all derivatives of anthraquinone. The dyestuff extracted from the best known and most widespread plant source, madder (*Rubia tinctorum*), contains a mixture of anthraquinones: the most important, alizarin, was one of the earliest dyestuffs to be prepared synthetically, by Carl Graebe (1841–1927) and Carl Lieberman (1842–1914) in 1868. Dyestuffs were also obtained from brazil-wood (*Caesalpinia* spp., soluble redwoods), used for cheaper pigments, and safflower (*Carthamus tinctorius*), probably only used for pigment preparation in Europe from the 18th century. Yellow dyestuffs, mostly containing flavonoid compounds, can be extracted from a variety of plants: buckthorn berries (from *Rhamnus* spp.) were an important source in Europe and Asia. Quercitron, extracted from the bark of certain American oaks (for example *Quercus velutina*), was of considerable commercial importance and was used in Europe from the early 19th century. In England, until the 18th century, yellow lakes were named 'pinks', as in 'Dutch pink'. Many plants,

including turnsole (*Chrozophora tinctoria*), the American log-wood (*Haematoxylon campechianum*) and some lichens (*Roccella* spp.; *Ochrolechia* spp., orchil and litmus), yield fugitive blue dyestuffs (reverting to red), from which lakes used in watercolour painting were prepared.

Following the synthesis of alizarin, different groups of synthetic dyestuffs and insoluble pigments were discovered. Lake pigments were prepared from certain members of the triphenylmethane group of basic and acid dyestuffs, such as magenta (basic) and eosine (acid), but these impermanent, if brilliantly coloured, lakes were used little after the early 20th century. However, the azo group has contributed important pigments, such as the insoluble Hansa yellows: these (and a tartrazine lake) have largely replaced natural yellow lakes. Lakes prepared from natural dyestuffs had poor light-fastness qualities. The natural red varieties were largely replaced by the rather more permanent synthetic alizarin lakes (and, in the 20th century, by insoluble, permanent quinacridone reds), although natural rose madder lake and cochineal carmine continue to be produced.

The traditional substrate for lakes was hydrated alumina, a form of which is still used. A calcium salt, often added in the form of whiting (calcium carbonate), was sometimes incorporated into the substrate, particularly in the case of yellow lakes and brazilwood pigments. The colour of certain polygenetic dyestuffs, such as alizarin, is affected by the presence of certain metal ions, for example calcium, tin and iron, and as this effect came to be understood, an increasingly wide range of metal salts was used in the preparation of lake pigments from the late 18th century onwards, notably for madder lakes.

Traditional lakes were transparent and therefore particularly appropriate for use in watercolour painting and in thin washes (to colour maps, for instance), despite their tendency to fade. In traditional easel painting, with oil or egg tempera, they could be used as glazing pigments, sometimes painted quite thickly over a lighter colour or over metal leaf. Hydrated alumina has a low refractive index, approaching that of oil medium, and the richest effects of saturated colour and transparency were obtained using oil.

See also PIGMENT, §§VI, 5 and IX, 4.

A. H. Church: *The Chemistry of Paints and Painting* (London, 1890, rev. 3/1901), pp. 160–64, 170–78, 183–7

A. W. C. Harrison: *The Manufacture of Lakes and Precipitated Pigments* (London, 1930)

R. Mayer: *The Artist's Handbook of Materials and Techniques* (New York, 1940, rev. 4/1982/*R* London, 1987), pp. 33, 36–70, 86–8, 98–100, 408–12, 454, 654–8 5th ed., London, 1991

R. D. Harley: *Artists' Pigments, c. 1600–1835: A Study in English Documentary Sources* (London, 1970, rev. 2/1982), pp. 61–6, 86–7, 107–15, 131–47, 183–5 2nd ed., London, 2001

T. C. Patton, ed.: *Pigment Handbook*, 3 vols (New York, 1973), i, pp. 319–21, 429–30, 537–9, 599–616, 629–33, 647–9, 697–8; ii, pp. 423–34 2nd ed., New York, 1988 (ed.by P.A. Lewis)

H. Schweppe: *Handbuch der Naturfarbstoffe: Vorkommen; Verwendung; Nachweis* (Landsberg/Lech, 1992)

J. Kirby and R. White: 'The Identification of Red Lake Pigment Dyestuffs and a Discussion of their Use', *National Gallery Technical Bulletin*, xvii (1996), pp. 56–80

J. Kirby, M. Spring and C. Higgitt: 'The Technology of Red Lake Pigment Manufacture: Study of the Dyestuff Substrate', *National Gallery Technical Bulletin*, xxvi (2005), pp. 71–87

Lantern, magic. See MAGIC LANTERN.

Laser. Device used to amplify light to an intense beam of a very pure single colour by stimulated emission of radiation. The theoretical basis for the technique of the laser was calculated by Albert Einstein (1879–1955) in 1917, but it was not until 1960 that Theodore H. Maiman (1927–2007) created the first active laser, using a synthetic ruby crystal. For practical and economic reasons the pulse ruby lasers were largely replaced by continuous wave gas lasers in their helium-neon, argon ion or krypton argon ion versions. The artistic applications of the laser appeared from 1965 in three main areas: in combined visual and aural productions, in long-distance environmental plastic displays and in holography (*see* HOLOGRAM).

Large-scale productions such as *Video/Laser I, II, III*, which took place in Oakland, CA (1969), Osaka, Japan (1970), and in several European towns in 1971–2, were the collective work of the sculptor and physicist Carson Jeffries (1922–95), the musician Lowell Cross (*b* 1938) and the composer and avant-garde pianist David Tudor (1926–96). Iannis Xenakis (1922–2001), composer, architect and artist, conceived single-handedly such combined displays as the *Polytope II* (Paris, 1972) and the *Diatope* (Paris, 1978), involving programmed electronic flashes, electronic music and reflected laser beams in an artistic attempt to attain 'cosmic harmony' in a large interior space. Another composer and media artist, Paul Earls (*b* 1934), started in the early 1970s to introduce laser systems into his displays before specializing in projections of graphic designs (for example *Laser Chamber*, 1979; Grand Rapids, MI, Art Museum) in collaboration with Otto Piene (*b* 1928). Earls also used laser projections in collaborative works with Piene and other members of the Center for Advanced Visual Studies, Massachusetts Institute of Technology, Cambridge, MA, for example *Centrebeam* (Kassel, 1977; Washington, DC, 1978) and the sky opera *Ikarus* (Linz, 1982), conceived as a pretext for altering artistically the site and scale of a performance and for controlling the duration, intensity and distribution of sensory information.

In all these mixed-media works and displays artists put to good use the characteristics of the laser: a controlled and concentrated monochromatic light beam that was capable, thanks to its coherence, of being directed in a defined space. Its spectacular properties were also exploited in theatrical performance and small-scale works by artists such as Joël Stein (*b* 1926) and Carl Fredrick Reuterswärd (*b* 1934). Stein not only experimented with fixed and moving mirrors on

the stage but also used the laser as an educational tool and in environments at *Sigma*, Bordeaux, in 1969; Reuterswärd combined laser beams and laser video images in theatrical productions (e.g. Stockholm, 1969). From 1962 to 1972 he kept a 'Laser diary' in which he describes the 'magic' and 'unbelievable confusion' that can be created in people's minds if the source of radiation of light is hidden from the spectator and only its reflection is perceived. He also created a number of laser-holographic works and made important projects for long-distance laser projections in urban settings.

Rockne Krebs (*b* 1938) was the first artist to create nocturnal urban laser displays, in Buffalo, NY (1971), New Orleans, LA (1972), and Philadelphia, PA (1973). He had already participated with other artists in laser projects and in the first exhibition devoted to the artistic use of the laser, *Laser Light: A New Visual Art* (1969; Cincinnati, OH, Cincinnati Art Museum), and he had installed a helium and argon laser room at the World Fair in Osaka (1970). Horst H. Baumann (*b* 1934), originally a designer and photographer, in the 1970s staged argon and krypton laser displays above the River Rhine in Düsseldorf (1976) and an elaborate laser work in Kassel (1977), later transformed into a permanent municipal feature. He also elaborated a system containing lasers, which, in conjunction with a scanner and a microcomputer, permit the projection of mobile images, texts and symbols at very long distances.

Dani Karavan (*b* 1930) used the laser beam for a symbolic linkage of representative buildings and town districts. In 1978 he connected the Forte del Belvedere and the cupola of the Duomo in Florence in a work entitled *Environment of Peace*; on the occasion of the *Electra* exhibition in Paris (1983) he used an argon green beam to link the Musée d'Art Moderne de la Ville de Paris, the Eiffel Tower and the new area of La Défense in an attempt to symbolize the close relationship that exists between historic and contemporary artistic, architectural and technological feats. A laser beam was also one of the central features of Karavan's monumental urban intervention at the new town of Cergy-Pontoise, near Paris (1980–89).

Laser Light: A New Visual Art (exh. cat., Cincinnati, OH, Cincinnati Art Museum, 1969)

M. Benyon: 'The Holographic Image', *Art and Artists*, iv/11 (1970), p. 45

J. Stein: 'Expériences artistiques à partir du laser', *Leonardo*, iii/3 (1970), pp. 331–2

M. J. Beesley: *Lasers and their Applications* (London, 1971)

Rockne Krebs (exh. cat. by J. N. Wood; Buffalo, NY, Albright–Knox Art Gallery, 1971)

M. Rossi: *Laser Applications*, 3 vols (London, 1971–7)

C. F. Reuterswärd, Centre National d'Art Contemporain (Paris, 1972)

M. Benyon: 'Holography As an Art Medium', *Leonardo*, vi/1 (1973), pp. 1–9

Light Fantastic (exh. cat. by J. Wolff, N. Phillips and A. Furst; London, Royal Academy of Art, 1977)

M. Benyon: 'On the Second Decade of Holography As Art and My Recent Holograms', *Leonardo*, xv/2 (1982), pp. 89–95

Electra: L'Electricité et l'électronique dans l'art au XXe siècle/Electricity and Electronics in the Art of the 20th Century (exh. cat. by F. Popper; Paris, Musée d'Art Moderne de la Ville de Paris, 1983) [Fr. and Eng.]

Holography in Art: Dieter Jung (exh. cat. by E. Roters; Tokyo, Hara Museum of Contemporary Art, 1983)

J. Claus: *ChippppKunst: Computer, Holographie, Kybernetik, Laser* (Frankfurt am Main and Berlin, 1985)

Die Wirklichkeiten der Bilder (exh. cat., Nuremberg, Kunsthalle, 1986)

P. Restany: *Dani Karavan: L'Axe majeur de Cergy-Pontoise* (Cergy-Pontoise, 1987)

F. Popper: *Art of the Electronic Age* (London, 1993)

Lasers in the Conservation of Artworks (LACONA) I (Vienna, 1997–)

M. Cooper, ed.: *Laser Cleaning in Conservation: An Introduction* ([Boston, 1998])

J. G. Hanhardt: *The Worlds of Nam June Paik* (New York, 2000)

L. Poissant: 'New Media Dictionary: Dictionary Terms, Part VII: Multimedia, Part 1', *Leonardo*, xxxvi/1 (2003), pp. 71–6

Lead. Type of lustrous, silvery metal that tarnishes to a dull bluish grey. It is extracted from galena (lead sulphide).

1. PROPERTIES. Lead is a comparatively soft, malleable metal that can be fabricated, bossed, carved and filed with ease, but its most useful properties are its low melting point, 327°C, and the ease with which it can be cast. The masters and moulds for casting can be much less complex than those used for other metals, bronze for example, because the fine detail can be carved afterwards. The moulds themselves can be made simply and cheaply from readily available plaster and building sand, and need only be fired sufficiently to drive out mechanically combined water. It is also durable and resistant to corrosion.

These properties must have been an important consideration in the use of lead for the mass production of garden ornaments, even though it has disadvantages as a medium for sculpture. It is susceptible to 'creep' (the slow flow of the metal), so large pieces must be supported by an armature. It is also highly toxic, and care must be taken when using the metal or its oxides.

2. HISTORY AND USES. Lead has been used for both functional and artistic purposes by many cultures throughout the world. It was known in Mesopotamia by the 6th millennium BC and was extensively used in the Middle Assyrian period (*c.* 1350–1000 BC), particularly for plaques and medallions. In ancient Egypt it was used for coins, weights, ornaments, utensils, ceramic glazes and solder. Many cast-lead votive offerings, religious tokens and pilgrim badges have been discovered from ancient and medieval times.

The use of lead in roofs was introduced by the Romans, and it reappeared in the medieval period. In the 17th and 18th centuries lead was also used in northern Europe for roof crestings, rainwater heads and cisterns, which were often highly decorated. From the 12th century it provided a flexible,

weatherproof armature for stained-glass windows (*see* STAINED GLASS, §1, vii).

The principal use of lead is in sculpture. There are a number of ornate 12th-century English fonts in relief-cast lead (e.g. at the church of St Mary, Frampton-on-Severn, Glos), and in the 16th century it was used for plaquettes, the small-scale reliefs that contributed so much to the diffusion of Renaissance motifs. However, it did not become a popular medium for larger pieces of sculpture until the end of the 17th century. The alterations to the château of Versailles that took place in the 1660s included ornate lead roofs and formal gardens decorated with statues, fountains and urns, many of them of cast and gilded lead. The innovations at Versailles were instrumental in changing the design of gardens throughout northern Europe and created a growing demand for lead sculpture.

In England the first sculptor to produce cast lead in quantity was John van Nost (*d c.* 1712). The pieces that can be positively attributed to van Nost are generally of high quality. They include the collection at Melbourne Hall, Derbys, which was commissioned by Thomas Coke (1675–1727), Vice-Chamberlain of the court of Queen Anne (*reg* 1702–14) and King George I (*reg* 1714–27) and one of van Nost's earliest patrons. The grandest piece at Melbourne is the spectacular *Vase of the Seasons*, which he made in 1705. Other major producers of lead sculpture were Andrew Carpenter (*c.* 1677–1737), who had been van Nost's principal assistant, and John Cheere (1709–87), who took over van Nost's yard in 1739. In 1723 Charles Howard, the 3rd Earl of Carlisle, ordered from Carpenter a number of lead sculptures, of which the *Hercules* and the *Spartan Boy* still remain at Castle Howard, N. Yorks. Two pieces at Powis Castle, Powys, bear Carpenter's signature: the magnificent *Fame Riding Pegasus*, in the courtyard, and *Hercules Slaying the Hydra* at the end of one of the terraces. Van Nost, Carpenter and Cheere were not the only producers of sculpture in lead: the figure of *Neptune* in the centre of Bristol was made in 1723 by Joseph Rendall, a local man who was a founder by trade.

Much of the lead sculpture produced in the 18th century has disappeared, but a number of pieces remain. They vary greatly in the quality of both modelling and casting. Richard Boyle, 3rd Earl of Burlington (1694–1753), complained that lead sculpture soon fell out of shape, but nevertheless he filled his gardens at Chiswick House, London, with it. The sculptures were intended not as great works of art but as part of the garden. They were either copies of Classical pieces, 16th-century Italian pieces, or Arcadian subjects. All were painted, frequently in imitation of stone or marble and in some cases in garish naturalistic colours.

By the middle of the 18th century the more natural landscape designs of Lancelot 'Capability' Brown (1716–83) were gaining popularity. This further change in fashion meant that the demand for lead sculpture started to decrease, and some pieces were removed when gardens were remodelled. At the end of the century lead was largely replaced by Coade stone and ceramics, since the modelling of pieces produced in these materials was of consistently better quality. At the beginning of the 19th century casting methods for lead changed in order to speed up the production process and to cut costs, and although some lead garden sculptures were produced, they tend to be smaller than their 18th-century counterparts, and the quality of both manufacture and modelling is poor. There is, however, one splendid example of Victorian decorative art in lead: the Albert Memorial, London (1863–76), by George Gilbert Scott I (1811–78). The iron structure of the spire is covered in richly ornamented lead panels inset with coloured glass and hardstones and finished in the funerary colours of black and gold. Later in the 19th century some well-made garden sculptures were produced by the Bromsgrove Guild, which developed from the Arts and Crafts Movement and the Art Workers Guild.

In the 20th century lead was used rarely for sculpture, although it was employed by such artists as Henry Moore (1898–1986), Jacob Epstein (1880–1959) (e.g. the *Virgin and Child* in Cavendish Square, London) and Richard Serra (*b* 1939). An increased awareness of its toxic nature, and subsequently the health and safety procedures that are required for the casting and working processes, may be partly responsible for this decline.

See also PIGMENT, §VIII for lead in paint; CERAMICS, §I, 5 for lead glazes; and METALPOINT, §1.

J. T. Smith: *An Antiquarian Rumble in the Streets of London* (London, 1846)

R. Gunnis: *Dictionary of British Sculptors: 1660–1851* (London, 1951, rev. 2/1968)

F. Souchal, ed.: *French Sculptors of the 17th and 18th Centuries: The Reign of Louis XIV* (Oxford, 1977–)

L. Weaver: *English Leadwork: Its Art and History* (London, 1909/R Shaftesbury, 2002)

G. Jekyll: *Garden Ornament* (London, 1918/R Woodbridge, 1984)

R. Paulson: *Emblem and Expression: Meaning in English Art of the Eighteenth Century* (London, 1975)

W. W. Krysko: *Blei in Geschichte und Kunst/Lead in History and Art* (Stuttgart, 1979) [bilingual text]

S. Bayley: *The Albert Memorial* (London, 1981)

F. Haskell and N. Penny: *Taste and the Antique: The Lure of Classical Sculpture, 1500–1900* (London, 1982)

P. M. Sutton-Goold: *Decorative Leadwork* (Princes Risborough, 1990)

R. F. Homer: 'Tin, Lead, Pewter', *English Medieval Industries*, ed. J. Blain and W. Ramsey (London, 1991), pp. 57–80

S. W. Meier: *Blei in der Antike: Bergbau, Verhüttung, Fernhandel* (thesis, Universität Zürich, 1995)

M. Trusted: *Spanish Sculpture: Catalogue of the Post-medieval Spanish Sculpture in Wood, Terracotta, Alabaster, Marble, Stone, Lead and Jet in the Victoria and Albert Museum* (London, 1996)

A. Cochet: *Le plomb en Gaule romaine: Techniques de fabrication et produits* (Montagnac, 2000)

'Blei', *Lexikon des künstlerischen Materials: Werkstoffe der modernen Kunst von Abfall bis Zinn* (Munich, 2002)

Leaf. See GILDING, §I, 1

Leather. The preserved hide of animals. It can be divided into two main categories: hides, which are taken from the skins of large animals such as horses and buffaloes; and skins, which are taken from small animals such as pigs, goats, sheep, reptiles and birds. Both hides and skins are composed of three layers: the top layer, or epidermis, which has fur or hair growing out of it; the middle layer, or corium; and the bottom layer of fat or flesh (adipose tissue). The top and bottom layers are destroyed before the tanning process, and only the corium is used to make leather. The surface of the corium is marked by a grain, formed by the holes of the hair follicles, from which the origin of the leather can be determined.

Leather is strong yet flexible, and it can be treated to be as firm as board or as soft as woven cloth. Its fibrous structure enables it to be moulded and set, and it will also take many forms of decoration. It is used for clothing and footwear, armour, harness and saddlery, bookbinding, upholstery and various decorative and utilitarian items.

1. Types. 2. Techniques. 3. History and uses. 4. Conservation.

1. TYPES. The main types of hides are: 'sole bends', which are taken from half of the back of a hide and become one of the finest quality leathers; 'harness' or 'strap backs', made from the hide once the belly and shoulder have been removed; 'bag' or 'case' leathers, made from hides that have been split to a thickness of *c.* 1.5 or 2 mm; and 'upholstery hide', a soft leather, of which the surface has been brought up by 'boarding' (i.e. folding the leather grain to grain and rolling it in two directions). The main types of skins are: 'calf', which is soft and fine-grained; 'modelling calf', which has no surface finish or colouring; and 'morocco leather', which is made of goatskin tanned with sumach, its grain worked by boarding to produce a characteristic pattern.

2. TECHNIQUES.

(i) Preparation. Leather is treated to protect it from decay and to develop such properties as strength, pliability and water resistance. The hides or skins are soaked in lime and water and the epidermis and adipose tissue removed. The leather then undergoes one or more of the three basic tanning processes: 'oil tannage' or 'chamoising', where the skin is treated with oil or fat; 'mineral tannage' or 'tawing', in which it is immersed in a mixture of mineral salts, often alum; and 'vegetable tannage', in which it is soaked in astringent liquids, originally obtained from a variety of vegetable sources including oak bark and sumach. The different types of animals produce skins that require different tanning treatments. The leather is dried and then softened by 'staking', which involves stretching the damp skins over a blunt-edged blade of metal or wood. Sometimes there is a final treatment known as 'stuffing', in which the leather is rubbed with such lubricants as egg yolk.

The cutting of leather requires considerable skill. The natural tendency of the skin to stretch in certain directions must be taken into account, as must the type of leather required and the use to which it will be put. The softer leathers are often delicate. Defects and areas of excessive thickness must be avoided, but wastage should be kept to a minimum.

The half-moon cutting knife has been used since at least 1500 BC, but the knife most commonly used has the cutting edge on a curve ground out at one side near the top of the blade. The cut edges of the leather are often bevelled or chamfered; on good-quality leathers they may be treated with mixtures of glue, dye and wax and then rubbed up well. Separate pieces of leather are joined by sticking (usually with animal glue), sewing with waxed thread (the holes being made with an awl) and riveting.

(ii) Decoration. Leather can be decorated in many ways. Cutting, piercing and scoring were used from the earliest times, as was dyeing (fragments of red leather have been found in Predynastic graves in Egypt). Leather is dyed by immersion in a dye bath. The dyes came from vegetable or mineral sources until the mid-19th century, when chemical dyes were gradually introduced, which made more brilliant colours possible.

Another early method of decoration was gilding. The design is traced on to the surface of the leather and then lightly impressed with heated tools. Glair (beaten egg white) or gold size is applied to the design, and the gold leaf laid over it. The gold is gone over with heated tools and the superfluous leaf brushed away. In 'gilt' leather the effect is achieved by facing the skins with silver or tin foil, which is then punched with small patterns that reflect the light. The main pattern is painted on top and the metalled areas that remain unpainted are glazed with a yellow varnish to simulate the appearance of gold. One of the earliest references to gilt hangings is in an inventory of 1380 made for Charles V of France (*reg* 1364–80), but no examples of such leatherwork survive from before the mid-15th century.

Leather can also be embossed. The earliest method for this was probably a Spanish invention developed from the early practice of hand-stamping leather bookbindings. The design is engraved on metal plates that give fine detail but only a low degree of relief. The plates are then heated, the leather placed between them and the embossing carried out through pressure applied by a screw press. This method is not suitable for large areas and was superseded by smaller metal plates from which impressions were punched over the surface. The most important method of embossing uses moulds in a roller press. The first mould is produced by cutting a design into a wooden block composed of dovetailed sections about 10 mm thick, strengthened with battens on the back. A counter-mould is then prepared by pouring on to a sheet of board a special paste made of pieces of soaked leather. A sheet of paper is glued over the

paste and the combination placed face downwards. It is run through the roller press several times and allowed to dry, producing a hard counter-mould of the original mould. Then the damp leather, already silvered and varnished, is put between the mould and counter-mould and passed between rollers to produce an embossed panel.

Leather may also be decorated by tooling, punching, modelling (with a small tool called a 'spade' that depresses the background to leave other areas in relief), other forms of embossing (working the reverse of damp leather with a ball tool) and carving. 'Scorched' leather is a reddish-brown leather on which a pattern has been made by pressing a heated metal plate on the front surface against a mould at the back. The effect is similar to damask, and it is likely that the 'leather damask' referred to in inventories is in fact scorched leather.

(iii) Moulding. Leather has a unique fibrous structure that allows it to be moulded. In the process known as 'cuir-bouilli', vegetable-tanned leather is soaked in cold water until it becomes saturated and highly pliable. It can then be moulded by hand over wooden forms or in a press. The surface may be decorated by punching or incising while it is still soft, after which it is dried in a moderate heat. The term has been used since the medieval period, and it has been suggested that the leather was boiled in order to harden it, but it seems more likely that 'bouilli' merely refers to the application of heat. Cuir-bouilli was used for armour and shields as a cheap alternative to metal.

3. HISTORY AND USES. In the Palaeolithic period untreated skins were used for clothing; the process of making leather was not developed until the Neolithic period. In Predynastic Egypt leather was used for bags, bottles, clothing and sandals. The use of alum for tawing probably originated in East Asia: later it was known throughout the antique world. The Romans called alumed leather *aluta* and its makers *alutarii*.

(i) Decorative objects. (ii) Furniture.

(i) Decorative objects. It is often difficult to attribute the date and provenance of European leather, but parallels can be drawn with other forms of decorative art, particularly textiles. Early Spanish leather, for example, was decorated with geometric patterns similar to those on Moorish tiles, but by the 17th century the designs were based on contemporary textiles. These later hangings were made to imitate costly brocades and damasks: heavy Baroque designs were combined with dense floral ornamentation, and flowers, fruit, foliage, putti and pomegranate patterns became increasingly popular. Vernacular motifs were copied by rival leatherworkers throughout Europe, and, since moulds and plates were expensive to produce, many of the same designs recur over a considerable period of time.

(a) Spain. One of the main centres of leather production was Córdoba, which was famous by the 10th century for its *guadameci*, a type of soft leather. The term was derived from the Libyan town of Ghadames, which produced a similar type of soft goatskin dressed with alum. Córdoba (hence the English term 'cordwainer') produced *guadameci* in its natural white form or dyed red with kermes. The leather was sometimes covered with gold or silver foil, and during the 14th century this metallized surface was punched. During the early 17th century, designs were embossed on silvered leather using moulds in a modified printing press. Other centres of production in Spain were Granada, Seville and Valencia. The leather was used for upholstery, cushions, floor coverings, wall and bed hangings and ecclesiastical purposes (antependiums, kneelers and vestments).

(b) France, Italy, the Low Countries and Portugal. Though developed in Spain, decorated leather was soon copied and adapted throughout Europe. In France a charter was granted in 1594 to the 'doreurs sur cuir, garnisseurs et enjoliveurs', allowing them to make gilt-leather hangings and such leather furnishings as cabinets, coffers and frames; the craftsmen also acquired a special stamp with which they were required to mark their work. After some conflict, the leatherworkers amalgamated with two other guilds, the sheathmakers and the silverers. During this period, however, much of the leather used in France was probably imported, and import duties were imposed on gilt leather in 1664. Leather hangings were often put up in the summer to replace the woollen hangings used in the winter.

Italian craftsmen developed their own techniques for decorating leather with the bold designs and coloured glazes that are characteristic of their work. Surviving examples of Italian leatherware include shields and coffers, often with punched decoration. Few gilt-leather hangings survive in Italy, but they were certainly known during the Renaissance; for example, they are depicted in the *Venus of Urbino* (*c.* 1538; Florence, Galleria degli Uffizi) by Titian (*c.* ?1485/90–1576). Italian leatherworkers used cuir-bouilli for book covers, knife and scissor cases, and even church plate.

By the end of the 16th century the Low Countries had become the most important centre of production, and the majority of surviving leather panels are either Flemish or Dutch. Mechelen in Flanders (now Belgium) was the most important centre, but leather was also produced in Antwerp, Liège and Brussels. The main centre in the northern Netherlands was Amsterdam. A complex and sophisticated style of decoration developed, based on contemporary textiles and using bold pomegranate forms. At a time when tapestries and silk wall hangings were prestigious and expensive, gilt-leather panels became an affordable alternative. Indeed, the Dutch continued to cover the walls of their houses with lavish gilt leather well into the 18th century, by which time it was no longer fashionable in other European countries.

(c) England and Scandinavia. In England the production of cuir-bouilli was widespread from the 15th century. The most popular product was a type of tankard known as a blackjack. A larger tankard was also made, known as a bombard since it resembled a cannon of the same name. The body, complete with handle, was cut in one, but the round bottom was a separate piece. Once the moulded leather had set, molten pitch or resin was poured into the container to prevent liquids soaking into it.

Some form of gilt-leather industry existed in England by 1601 when the inventory for Hardwick Hall, Derbys, listed 50 pieces of 'wrought' gilt leather and 34 pieces of leather 'silvered but not finished'. Further evidence that England was producing leather by the mid-17th century can be found in the diary of Samuel Pepys (1633–1703). On 19 October 1660 he wrote, 'This morning my dining room was finished with green serge and gilt leather which is very handsome.' On 5 November 1668 he selected his first vehicle, 'a little chariot whose body was framed … to be covered with leather.' He watched impatiently while successive coats of yellow varnish were applied and explained that most coaches were then 'done so, and it is very pretty when laid on well, and not too pale, as some are, even to show the silver'. A small but important group of leather gilders were working in London around St Paul's Cathedral between 1714 and 1785.

Gilt leather, whether English or imported, became an increasingly popular form of interior decoration. Perhaps the most important surviving leather hangings are those at Dunster Castle, Somerset, depicting the story of Antony and Cleopatra. Their similarity to mid-17th-century engravings and tapestries suggests that they came from France or Flanders. Comparable sets of narrative leather hangings are extremely rare; there are some from Rouen, now at Ecouen, one in the château at Lunéville and two of 1688 in the royal palace at Drottningholm, Sweden. It is likely that they all originated from the same workshop.

The widespread taste for objects 'à la chinoise' that developed in Europe in the early 18th century influenced contemporary leather production. Chinoiserie screens became particularly fashionable for rooms and closets in this style, and leather was often used in preference to delicate fabrics. Leather was eminently suitable as it was solid, practical and reasonably priced. It could be japanned or varnished in imitation of lacquer (*see* LACQUER, §II, 2), which made it a popular background for objects from East Asia and an appropriate substitute for true lacquer screens, which were then very expensive.

By the end of the 18th century leather gilders' trade cards indicate that paper hangings were among the wares they sold. Gradually, as a result of changing fashion, they channelled their skills into the production of embossed wallpapers. The catalogue of the Great Exhibition of 1851 in London lists only one exhibit of gilt, embossed and painted leather, but leather panels were occasionally produced in the 1890s for rooms decorated in the Art Nouveau style.

(ii) Furniture. In England leather covers for beds and tables are mentioned as early as 1423, in an inventory of the wardrobe of Henry VI (*reg* 1422–61; 1471). By the 17th century gilt leather was sometimes used to cover chairs, but plain leather was more common. Scorched leather was used for protective covers (e.g. the celestial and terrestrial globes at Ham House, Surrey, dated *c.* 1730) and for upholstery on chairs. In 17th-century Italy and Spain there was a fashion for chairs upholstered in heavily tooled gilt leather comparable to bookbindings, and in the early 18th century many chairs in Scandinavia and central Europe were covered with gilt leather, but such covers are rarely found in France and England (see fig.).

Some pieces of leatherwork in revivalist styles were made in the 1920s, for example the leather boxes with polychrome Moresque decoration made by Alex Behrens and painted by Louis Churchill for Studland Art Industries in Dorset. Leather also became a major component in such designer classics as a lounge chair and ottoman (1956) by Charles Eames (1907–78), as well as playing a predominant role in the furniture industry, particularly in Italy, where such designers as Vico Magistretti (1920–2006) consistently used leather in their work.

Moroccan leather upholstery chair *à la Reine* made for Pierre Crozat, gilded walnut, French, 1100×690 mm, *c.* 1710–20 (Paris, Musée du Louvre); photo credit: Réunion des Musées Nationaux/Art Resource, NY

D. Diderot and J. Le Rond d'Alembert: *Encyclopédie*, v/54 (Paris, 1755);

Supplément, ii/735 (Paris, 1762); plates: *Planches*, iii, *Doreur* (Paris, 1763); *Suite de recueil de planches*, 120 (Paris, 1777)

A. D. Fougeroux de Bondaroy: 'Art de travailler les cuirs dorés ou argentés', *Description des arts et métiers* (Paris, 1762)

F. Lenygon: 'Gilt Leather Rooms', *Art Journal* [London] (1911), p. 281

H. Clouzot: *Cuirs décorés*, 2 vols (Paris, 1925)

A. Lucas: *Ancient Egyptian Materials and Industries* (London, 1934)

H. Huth: 'English Chinoiserie Gilt Leather', *Burlington Magazine*, lxxi (1937), pp. 25–35

G. R. Faber: 'Dyeing and Tanning in Classical Antiquity', *Ciba Zeitschrift*, ix (May 1938)

J. W. Waterer: *Leather in Life, Art and Industry* (London, 1946)

C. Singer, E. J. Holmyard and A. R. Hall: *A History of Technology* (Oxford, 1956), i, *passim*; ii, pp. 147–86, 187–90

J. W. Waterer: *Leather Craftsmanship* (London, 1968)

G. A. Bravo and J. Trupke: *10,000 Jahre Leder* (Basle and Stuttgart, 1970)

J. W. Waterer: *Spanish Leather* (London, 1971)

D. Dodd: *Dunster Castle* (London, 1986)

International Glossary of Leather Terms (Northampton, 2/1997)

E. Cameron, ed.: *Leather and Fur: Aspects of Early Medieval Trade and Technology* (London, 1998)

E. R. Lhotka: *ABC of Leather Bookbinding: An Illustrated Manual on Traditional Bookbinding* (New Castle, DE, 2000)

M. Leguilloux: *Le cuir et la pelleterie à l'époque romaine* (Paris, 2004)

4. CONSERVATION. Leather is a complex organic material made up of skin protein, tanning compounds and lubricants (*see* §2(i) above). The character and, to a large extent, the type of deterioration is determined by the nature of the tanning compounds.

The most widely encountered leather is vegetable tanned. This is to be found on saddlery and harness, military accoutrements, upholstery and items that require tooling and embossing, for example screens and panels for wall hangings. Other types of tannage are alum tawing, which produces a white leather used principally for such costume as gloves and furs, and oil tanning, which produces buff leather from which gloves and jerkins were made.

One of the commonest and most damaging forms of deterioration is the chemical breakdown known as 'red rot'. This only occurs with vegetable-tanned leather. The deterioration is characterized by the reddish coloration of the leather, delamination, embrittlement and, in extreme cases, a total loss of strength of the leather fibres, which turn to powder when rubbed. It is caused by the action of acidic gases from the atmosphere (principally sulphur dioxide), which are absorbed and converted into acids within the leather. Once the deterioration has begun, specialist help must be sought to stabilize the leather. Acid-deteriorated leathers may be in a very fragile condition and, if this is the case, consolidation and support treatments will need to be carried out after stabilization. A similar form of deterioration

is caused by contact with iron; it is known as 'black rot', as badly affected leather fibres turn black. It leads to embrittlement, delamination and loss of strength.

Leather objects can be very hard and inflexible. Sometimes this is an intentional property, as in cuir-bouilli, but for objects that have lost flexibility the application of a lubricant may be required. Lubricants should be applied as solutions or emulsions; undiluted salves should be avoided as they tend to lead to over-application of oil. Lubricants should never be applied to the front surface of leathers that have been painted or varnished, but always on the reverse or flesh side. Lubricants may darken light-coloured leathers, and advice should be sought about their suitability.

Breakdown of oils within the leather can lead to a white bloom forming on the leather surface; this is termed 'fatty acid spue'. It is easily removed with organic solvents, but the potential for further spue formation will always be present.

In common with other organic materials, leather is affected by extremes in temperature and relative humidity. Long-term exposure to heat and high/low humidity cycles can lead to a cumulative hardening and loss of flexibility. Surface checks may also occur, and these may eventually develop into cracks and splits especially if the leather also suffers from chemical deterioration.

If leather is stored at too high a relative humidity (above 65% RH), mould growth may occur. When this happens the leather items should be immediately removed from contact with other objects to prevent contamination and placed in a dry environment. The mould can be removed by brush or with a vacuum and the surface swabbed with alcohol or a fungicide solution to destroy the growth.

The best conditions for the storage or display of leather are moderate temperatures and a relative humidity of 55–65% RH, although these longstanding environmental guidelines have been questioned in recent years. Direct sunlight and high light levels should be avoided as these can lead to fading, cracking and embrittlement. For painted leather surfaces (e.g. screens and wall hangings), recommended light levels should be similar to those for oil paintings. Leather should be kept free from dust by being enclosed, if displayed, or by being wrapped in acid-free tissue, if stored. However, enamelled or patent leather objects should not be wrapped as the tissue may with time become attached to the leather surface. Leather is very prone to deformation: if it is not correctly supported it may stretch and distort, and if folded it may develop crease lines. This applies particularly to leather used in clothing, so costume accessories should be padded with acid-free tissue and garments hung on padded hangers or laid flat without folding.

See also BOOKBINDING, §I, 2.

P. E. Guldbeck: *The Care of Historical Collections* (Nashville, TN, 1972)

J. W. Waterer: *A Guide to the Conservation and Restoration of Objects Made Wholly or in Part of Leather* (London, 1972)

H. Kühn: *Erhaltung und Pflege von Kunstwerken und Antiquitäten*, i (Munich, 1974, rev. 2/1981; Eng. trans., London, 1986)

S. Fogel, ed.: *Recent Advances in Leather Conservation* (Washington, DC, 1985)

ICOM International Leather and Parchment Symposium: Leathercraft and Related Objects: Offenbach am Main, 1989

C. N. Calnan, ed.: *Conservation of Leather in Transport Collections* (London, 1991)

C. N. Calnan and B. M. Haines, eds: *Leather: Its Composition and Changes with Time* (Northampton, 1991)

B. C. Middleton, Bernard C.: *The Restoration of Leather Bindings* (New Castle, DE, and London, 3/1998)

M. Kite and R. Thomson: *Conservation of Leather and Related Materials* (London and Boston, 2006)

Leather, imitation [artificial]. The common name for various types of coated fabric, used in place of true leather. Imitation or artificial leather has been commonly used in furniture, as upholstery for seating furniture, writing surfaces for desks, tables and related forms, and for various articles of clothing and other objects.

Early versions of imitation leather were created through the use of a fabric coated with oils, rubber, gums or waxes. For example, in one type, cotton was coated with a layer of boiled linseed oil mixed with dryers and pigments, such as lampblack. This coating was compressed onto the cloth through rollers, and then varnished to achieve its final appearance. Various other coatings were also used, some with decorative finishes in imitation of, for example, Moroccan leather. Developed as early as the 14th century, coated fabrics (generally known as 'leather cloth' or 'oil cloth') continued to be popular into the 19th century, when the material—by then sometimes known as 'American cloth'—became a standard part of the upholsterer's trade. A number of variations were granted patents in the 19th century in the continuing search for improvements in flexibility.

Modern versions of artificial leather are made with a plastic coating (often termed 'pleather') and include many commercial varieties; perhaps the most familiar brand is Naugahyde. Introduced in the 1930s, PVC (polyvinyl chloride) became popular in the 1940s as an alternative coating material, being flexible and less prone to cracking. It could also be applied efficiently though vacuum-forming processes, and vinyl fabrics have remained popular in commercial furniture during the last half-century.

K. C. Grier: *Culture and Comfort: People, Parlors, and Upholstery, 1850–1930* (Rochester, NY, 1988)

M. Brunn: 'Treatment of Cellulose Nitrate Coated Upholstery', in *Upholstery Conference Pre-Prints: Williamsburg, February 2–4 1990*, pp. 449–55

V. Thorp: 'Imitation Leather: Structure, Composition, and Conservation', *Leather Conservation News* (Spring 1990), pp. 7–15

C. Edwards: *Encyclopedia of Furniture Materials, Trades, and Techniques* (Aldershot, 2000)

Lime secco. Wall painting technique that is a variant of Fresco. The painting is executed with fresco pigments that have been mixed into a paste with water and lime. On drying they develop a characteristically pale tonality. In preparation for painting, the wall should be absolutely dry and the surface smoothed with pumice stone. It is then washed with limewater. When the wall has again dried out, it is dampened with plain water, and the design is transferred from a cartoon by pouncing.

The origins of lime secco are ancient, and it was much used in the Romanesque and Gothic periods as well as in 18th-century decorative painting. In the late Roman period and in the 16th century a hybrid technique related to fresco painting was used, particularly for paintings with a white background. The dry *intonaco* was faced with a thick layer of lime, on to which the design was transferred by pouncing. As the lime dried it formed a transparent, vitreous layer of calcium carbonate on its surface, into which the pigments became fixed. If the artist wished to exploit this property, he painted while the lime was still damp, using fresco colours bound in water with a small quantity of adhesive. If a large area had to be painted, the work was carried out on dry lime with pigments bound in limewater and milk.

The conservation of lime secco is problematic, since the thick, inflexible layer of lime on which the painting is executed often becomes detached from the *intonaco* as the masonry of the wall gradually settles. It then forms ridge-like protrusions that may run the length of the painting in an almost geometrical fashion.

G. Ronchetti: *Pittura murale* (Milan, 1983)

M. Koller, H. Leitner and H. Paschinger: 'Reconversion of Altered Lead Pigments in Alpine Mural Paintings', *Studies in Conservation*, xxxv/1 (Feb 1990), pp. 15–20

Linen diaper and damask. Self-patterned, fine white linen that has been used in western Europe since the 15th century for tablecloths, napkins and handtowels. Initially, these figured linens were described in various ways, but in England by the mid-16th century they were classed, notably in probate inventories, as either 'diaper' or 'damask'. This classification was descriptive rather than technical, 'diaper' and 'damask' being differentiated solely on the complexity of the pattern: small repeat patterns, often of a geometrical form, were described as 'diaper' and figurative patterns with longer repeats as 'damasks'.

1. Techniques. 2. Patterns. 3. Centres of production.

1. Techniques. Diaper and damask are both 'float' or 'self-patterned' weaves, and it is the warp or weft threads 'floating' unbound over two or more weft or warp threads that catch the light and reveal the figure. The three basic binding systems, tabby, twill and satin (*see* Textile, §II, 1(ii)), were all used for float weaves. A few figured linens with tabby bindings survive, probably what were described in the 17th century as 'huckaback-diaper'. The diapers with patterns that

match such inventory descriptions as 'losinge', 'cross diamondes' and 'birdes eyes' have twill bindings. Some, particularly those of fine quality woven in the Dutch Republic from the 17th century, have satin bindings.

Unlike diapers, which exhibit all three binding systems, damasks normally have only satin bindings. Of the many possible satin bindings, just three have been used in the weaving of linen damasks: satin of 5, 7 and 8. Before 1700 most damasks were of satin of 5. Nevertheless, there is a small group of very beautiful damasks woven between 1515 and 1530 in satin of 7. They have unbalanced weaves with weft counts often double those of the warp. From the mid-16th century balanced weaves were normally used, with point repeats, in which successive units of pattern are mirror images of each other. Around 1710 Saxon weavers began to use satin of 8, with comber repeats, a practice followed later in the century in several other centres, and in which there is a horizontal repetition of units of pattern without variation.

The production of linen thread from flax and the finishing processes, including bleaching, were similar for all fine linens (see TEXTILE, §I, 1); it was the weaving process that set diapers and damasks apart. Diapers were mostly woven on a shaft loom. Damasks were always woven on the much more complicated draw loom.

For weaving diapers with twill bindings, a loom with four shafts was used for the many small-repeat patterns, but considerably more shafts were required for some of the patterns with longer repeats. Diapers with satin of 5 bindings were woven on a loom with either five shafts or a double harness of ten. Knowledge of weaving practice is sketchy, but in the 19th century diaper patterns with satin of 8 bindings were woven on looms with 16 shafts.

The draw loom was first used to weave linen damask in the Low Countries during the 15th century. Certain modifications were made to the loom in the 18th century, and early in the 19th century Joseph-Marie Jacquard (1752–1834) replaced the leashes and drawboy with a punched-card mechanism. By 1840 Jacquard looms were widely used for weaving linen damasks. Soon afterwards power looms were developed. These technological changes had considerable cost benefits, and damasks, which in the early 16th century were found only in the houses of the great, now graced the tables of the middle classes.

Three types of cloth were woven in diaper and damask: tabling, napkining and towelling. They were made in a series of standard widths based on the local ell. In Kortrijk and Haarlem this was c. 700 mm, while in Silesia and Saxony it was c. 670 mm. In the Low Countries most damask tablecloths were 3 or 4 ells wide, and napkins 1 ell or 5 quarters of an ell wide. Before the widespread use of forks (which in several countries did not occur until c. 1700), towels were used at table for the washing of hands. In the 18th century new beverages and a changed pattern of meals required smaller cloths for supper and napkins for tea.

2. PATTERNS. These can be grouped in three categories: first, those woven for stock for the general market (typically, these were biblical stories, hunting scenes and commemorative and floral designs); second, stock designs personalized by the addition of coats of arms or inscriptions; third, unique designs to fulfil a personal order.

Initially, the patterns were designed by the weavers, who took ideas from a variety of sources. Engravings were fertile ground: in two pieces (London, Victoria and Albert Museum; Amsterdam, Rijksmuseum) a portrait of Elizabeth I was taken from an engraving of 1559, possibly by Frans Huys (c. 1522–62); several early 17th-century biblical scenes were derived from illustrations by Jean de Tournes (1504–64) and Jost Amman (1539–91; for illustration see van Ysselsteyn, 1962, figs vii and viii, cat. nos 92 and 98); and in the 18th century engravings after Antoine Watteau (1684–1721), Daniel Marot I (1661–1752) and P. P. Bacqueville (fl 1720) were used by Saxon weavers (Kortrijk, Museum voor Schone Kunsten). The influence of other woven textiles was also pervasive: several early 16th-century linen damasks have fields of the foliate designs used in the 15th century for silk damasks and velvets; in the third decade of the 18th century bizarre silk designs occurred on German table-linen; a group of finely woven damasks, dating from the 1760s, has patterns of undulating lacy ribbons strewn with posies of flowers similar to those widely produced in silk, typically by L. Galy Gallien & Cie in Lyon. Both these sources can be seen in the engravings by Paul Androuet Du Cerceau (1623–1710), Feuillage et fleures propres aux peintres, brodeurs et ouvriers en soye (Paris, c. 1670); there are Dutch napkins from the 1660s (for illustration see J. D. Hunt, ed.: 'The Anglo-Dutch Garden in the Age of William and Mary', Journal of Garden History, April–Sept 1988) with designs that reflect this work.

It seems that the weavers prepared the point paper plans, from which the loom was set up, from their own preliminary sketches until the mid-18th century, when specialists were commissioned to prepare the designs. In Scotland, for example, the Board of Trustees not only commissioned local artists to design patterns for manufacturers but also sponsored annual design competitions. Between 1818 and 1838 prizes were awarded to 25 designers in these competitions, including the painter Noel Paton (1821–1901), who was to become the most famous Scottish damask designer in the middle of the century. Designs were subsequently produced by such celebrated artists as Walter Crane (1845–1915) in England and Chris Lebeau (1878–1945) in Holland.

Before 1550 three types of composition can be distinguished. The simplest has single motifs with modest horizontal and vertical repeats, often within a decorative lattice, but without any borders; inventory entries seem to describe such designs as 'knotts [with] roses in them', 'roses and Eagles' and 'flower de luces crowned'. A second type has individual scenes treated as elaborately framed 'tables' or pictures. These

occupy the whole of a napkin and for a tablecloth are typically set against a 'pomegranate' ground. They have unbalanced weaves of satin of seven. The third type has up to seven horizontal registers woven in point repeat. These illustrate scenes that tell a story in a complete vertical repeat, which may be as long as 3 m.

This final compositional idea was the most widely used between 1550 and 1750. Initially some pieces were borderless, but after 1600 most tablecloths and napkins had two distinct components, a central field and either two or four borders. The finest work always had four borders, but the cheaper damasks even into the 18th century sported only side borders. As linen damask was woven in a continuous piece c. 33 m long, it was easier to weave it without regular top and bottom borders. Further, there was more flexibility for the merchant and his customer, who could cut the piece into any desired lengths.

As with such similar bordered items as tapestries, the two design elements were initially treated quite separately. Even if similar subjects were used, for example a commemorative design of a siege with military trophies in the borders, the two elements were separated not only by their scale and graphic treatment but also physically by lines between the border and field. For tapestries it was early in the 17th century, but for damasks rather later, that the strict differentiation between the border and the field began to break down, and border motifs began to overflow into the field. By the Rococo period the differentiation had disappeared completely. The Neoclassical revival reinstated the strict hierarchy of the border, but with the difference that the border motifs and the urns and swags of the corner transitions were closely related to those of the field to form a coherent whole.

There were also attempts to break out of the episodic strait-jacket of horizontal registers. An illusion of three dimensions was created by gradations in the vertical scale and by the use of dropped point repeats. One such attempt is the series of patterns of 1680–1740 of an elegant couple by a fountain in a palace garden with the vista closed by a hunting-lodge in the deer-park beyond, most probably woven in Kortrijk (London, Victoria and Albert Museum; Kortrijk, Museum voor Schone Kunsten).

A great number of subjects were depicted on linen damask, but they broadly fall into five groups: armorial, biblical and mythological, floral, commemorative and topographical. Although these were made in all the major production centres, the proportion associated with each type obviously varied with time and place. A significant number of the pieces dominated by coats of arms and heraldic badges were bespoke designs. However, there were stock designs marking the coronations and marriages of princes, often woven for a particular national market.

Biblical subjects from both the Old and New Testaments were made in considerable variety and number in the Low Countries in the 16th and 17th centuries. The early designs included several versions of the Annunciation and the Glorification of the Virgin Mary; later the popular Old Testament stories predominated, although the New Testament was also represented, notably by the parables of the Prodigal Son and the Good Samaritan. This changing emphasis was probably associated with the Reformation, as Haarlem's markets were mostly Protestant and Kortrijk's partly so. Mythological subjects were also made but in much smaller numbers.

Floral designs occurred in profusion and variety, reflecting the current fashion in flowers: gillyflowers and pinecones from Kortrijk in the 16th century; exuberant Baroque tulips and crown-imperials from Haarlem in the 1670s; wide borders of tendrilled passion-flowers from Ireland c. 1800; and Art Nouveau arum lilies from the end of the 19th century. Commemorative patterns were also woven in each period, although the largest number were made during the War of Spanish Succession (1701–13). As most of these were woven in Kortrijk, the particular victories that were celebrated depended on the fortunes of war, for the town changed hands between the Grand Alliance and France several times. The speed of production, as one siege followed hard on the heels of another, meant that many horizontal registers and borders were simply reused with different inscriptions. The topographical patterns were principally views of European cities. There were splendid napkins of London and Venice from the Low Countries, although the majority of pieces in this group were woven in Germany in the early 18th century. In the 19th century, views were woven in Sweden of the factory at Vadstena and in Russia of the elegant panoramas of the city of Yaroslavl'.

It is difficult to establish the numbers that were woven in each group, as it is only the most treasured or fortunate pieces that survive. It seems likely that a higher proportion of stock floral patterns were made than have survived, particularly in view of the comment by the London linen-draper quoted above. This supposition is reinforced by a study of 16th-century English inventories that suggests that more than half the patterns were floral. Most damask patterns made now are still of flowers, but they tend to be pale reflections of their former glory.

3. CENTRES OF PRODUCTION. Diaper, woven on the widely distributed shaft loom, was produced in many places, while linen damasks woven on the rarer draw loom were confined to a few specialized centres. Diaper was made in Italy, Germany and the Low Countries from at least the 14th century and subsequently in many other parts of Europe. Linen damask was first woven in the southern Netherlands during the 15th century and was established at Kortrijk in Flanders by 1496, when the Guild of St Catherine promulgated detailed statues for its production. Although some damask was woven at Caen in Normandy during the 16th century, Kortrijk remained the only important centre until, following the Dutch Revolt, certain weavers moved to Haarlem c. 1585. One of the weavers who moved north was

Passchier Lamertijn (1563–1620). He established a considerable enterprise in Haarlem supplying table-linen to the town council and the States-General of the United Provinces as gifts for foreign princes and visiting dignitaries. In 1607 he moved to Alkmaar and after 1619 to Copenhagen, where until his death he worked for Christian IV (*reg* 1588–1648). Several splendid examples of his work survive (Amsterdam, Rijksmuseum; London, Victoria and Albert Museum; Edinburgh, Royal Museum of Scotland).

Both Kortrijk and Haarlem exported some damask, whereas the Flemish weavers relied heavily on their overseas markets. In the 16th and 17th centuries these were dependent on the political situation: France, for example, was an important market, which at certain periods was closed to Flemish goods.

Around 1600, Flemish weavers also moved to Schleswig-Holstein and Silesia, where the production of damask table-linen was established by the middle of the century. Apart from a few dated pieces from the first half of the 17th century, there are modest entries of 'Sletia' damask in the customs books for the Port of London from 1611. It appears that the first manufacture of linen damask in Saxony was established at Gross Schonau, near Zittau, in 1666 by Friedrich Lange and Christian Lange. Towards the end of the century very large quantities of both diaper and damask were produced in Saxony and Silesia. It was not of such good quality as that from the Low Countries, but it was less expensive. From *c.* 1710 the quality of both design and manufacture improved dramatically, showing a desire for experiment and a rapid response to changing fashion. This reflected the contemporary burgeoning of another Saxon industry, that of porcelain at Meissen. Exports were buoyant, putting pressure on the Low Countries' trade.

In France diaper was produced at several centres from the 15th century, and by the mid-17th century considerable quantities were woven in Normandy. In the 1670s imports to England of French diaper were more than double those from the Low Countries. Damask was produced by the Graindorge family in Caen at the end of the 16th century. It seems that there was a decline from *c.* 1640, although some damask was shipped from Caen in the 1670s. During the ministry of Jean-Baptiste Colbert (1619–83) there were attempts to encourage a native industry, and in the 18th century several manufactures were established in French Flanders, but none of them prospered for very long. In the 19th century several factories were built, including those at Panissières (Loire) and Pau-en-Béarn (Pyrénées-Atlantiques).

In Russia, Sweden and Britain there were also attempts to set up a native industry on the basis of the sort of import-substitution familiar in the case of other commodities. Peter the Great (*reg* 1682–1725) established a large factory at Yaroslavl' in 1722. Although the original factory closed in 1856, other factories continued to weave damask at the end of the 20th century. In Sweden damask was produced briefly in Stockholm at the start of the 18th century and then at the Flors factory in Hälsingland. In 1753

a mill was founded by the state at Vadstena, although it quickly passed into private hands. It closed in 1843.

The British government's first attempt to improve the linen industries was in Ireland, where William III (*reg* 1688–1702) granted a patent in 1698 to a Huguenot, Louis Crommelin (1652–1727), to set up a fine-linen manufacture in Lisburn. As in similar ventures in Saxony, Russia and Sweden, specialists from Holland or Flanders were initially employed. The industry prospered, helped by the establishment in 1711 of the Irish Linen Board, which concentrated on improving the quality of plain linens.

In 1737 Lionel Cranfield Sackville, the 1st Duke of Dorset (1688–1765), who had served as Lord Lieutenant in Ireland, ordered considerable quantities of Irish damask and diaper for the royal household, where he was Lord Steward to George II. From this date the English Crown no longer bought damask and diaper from the Low Countries but switched entirely to Irish production. However, only a few identified examples of Irish damask (London, Victoria and Albert Museum) survive from before the late 18th century; many of these were produced by the I. W. W. Coulson factory established at Lisburn in 1765. Factories were also established in Belfast, and some of these continued to operate into the 20th century.

In Scotland the existing linen industry was similarly encouraged by the Scottish Board of Trustees, formed in 1727. Although both diaper and damask had been woven in the 17th century, the concentration, as in Ireland, was on plain linens. Nevertheless, determined efforts were made in the middle of the century to improve the quality of diaper by 'means of the floreigner some years brought overhere' (Campbell, 1964, p. 82). The only damasks produced in any quantity were bespoke napkins, often woven with the year and the names of husband and wife. It was only from *c.* 1800 that Scottish stock patterns were able to compete with Continental designs. In the 19th century production expanded considerably, and Dunfermline became a major centre of production.

Both Scotland and Ireland not only satisfied the British market but also exported large quantities of table-linen to the USA and to the expanding British empire. In the 20th century all the manufacturing centres in Britain and Continental Europe experienced a severe decline.

J. F.: *The Merchant's Warehouse Laid Open, or The Plain Dealing Linnen-Draper* (London, 1696)

E. Kumsch: *Leinendamastmuster des XVII und XVIII Jahrhunderts* (Dresden, 1891)

A. F. Gryaznov: *Yaroslavskaya bol'shaya manufatture* [The great Yaroslavl' manufactory] (Moscow, 1910)

Linnedamast (Stockholm, 1931)

M. Braun-Ronsdorf: *Alte Tafeldamaste* (Darmstadt, 1955)

C. A. Burgers: *Damast* ('s Hertogenbosch, 1959)

C. A. Burgers: 'De Friese wapens tussen andere wapen inwerikngen in Haarlemse linnen Tafeldamasten mit de 17c aeeuw', *Vrije Fries*, xliv (1960), pp. 123–48 [Frisian armorials]

G. T. van Ysselsteyn: *White Figurated Linen Damask* (The Hague, 1962) [bibliog. incl. pioneering works by J. Six and J. de Bethune]

A. S. Cavallo: 'Joseph Neil Paton: Designer of Damasks', *Connoisseur*, cliii (1963), pp. 59–64

A. S. Cavallo: 'To Set a Smart Board', *Business History Review*, xxxvii (1963), pp. 49–58

C. A. Burgers: *Antiek damast modern gedekt* [Antique damask in modern table settings] (Enschede, 1964)

R. H. Campbell, ed.: *States of the Annual Progress of the Linen Manufacture, 1727–54* (Edinburgh, 1964), p. 82

C. A. Burgers: 'Nogmaals Passchier Lammertijn', *Oud-Holland*, lxxx (1965), pp. 139–68

A. S. Cavallo: 'Continental Sources of Early Damask Patterns in Scotland', *Burlington Magazine*, cvii (1965), pp. 559–63

A. Bugge and S. Haugstoga: *Damaskveving på bondegården* [Damask weaving on farms] (Oslo, 1968)

R. Jacques: *Gebilddamast* (Krefeld, 1968)

C. A. Burgers: 'De verovering van Boeda-Pest' [The capture of Budapest], *Bulletin van het Rijksmuseum*, xvii (1969), pp. 126–34

E. László: 'Gebilddamaste aus Sachsen und Schlesien', *Ars Decorativa*, iv (1976), pp. 69–87

C. A. Burgers: 'Bizarre patronen in linnen damast', *Nederlands kunsthistorisch jaarboek*, xxxi (1980), pp. 289–98

C. A. Burgers: 'Dutch Damasks for Denmark', *Documenta Textilia*, ed. M. Flury-Lemberg and K. Stolleis (1981), pp. 251–60

M. Prinet: *Le Damas de lin historié* (Berne, 1982)

J. Eracle: 'Souvenir du couronnement d'un tsar', *Musées de Genève*, cclii (Feb 1985), pp. 6–12

A.-S. Topelius: *Damastduktyg, och verksamheten vid Vadstena fabrik, 1753–1843* [Damask tablecloths and the products of the Vadstena factory, 1753–1843] (Stockholm, 1985) [bibliog. incl. 19 important works by E. Thorman, 1933–51]

A. G. Pauwels and I. Bauwens-de Jaegere: *Damast* (Kortrijk, 1986)

C. A. Burgers: 'Some Notes on Western European Table Linen', *Upholstery in America and Europe* (New York, 1987), pp. 149–61

D. M. Mitchell: 'By your Leave my Masters', *Textile History*, xx (1989), pp. 49–77

C. Paludan and B. Wieth-Knudsen, eds: *Damask og drejl* [Damask and drill] (Copenhagen, 1989)

R. Strong: 'Folded away for Now', *Country Life*, clxxxvii/19 (13 May 1993), pp. 68–9

E. Lewis and M. Lamb: 'An 18th Century Linen Damask Tablecloth from Ireland', *Textile History*, xv/2 (1994), pp. 235–44

B. J. Backey: 'Centres of Drawloom Damask Linen Weaving in Ireland in the 18th and 19th Centuries', *Leinendamaste: Produktionszentren und Sammlungen*, eds R. Schorta and C. A. Burgers (Riggisberg, 1999), pp. 99–112

D. M. Mitchell: 'Le linge de table dans les cours européennes aux XVIIe et XVIIIe siècles', *Tables royales et festins de cour en Europe 1661–1789*, eds C. Arminjon and B. Saule (Paris, 2005), pp. 127–62

Linocut [linoleum cut, linoleum block print; Fr. *linogravure*, Ger. *Linolschnitt*, It. *linografia*, Sp. *grabado en linóleo*]. Type of relief print in which linoleum is used as the printing surface. Using gouges and knives, the artist cuts the design into linoleum, a man-made sheet flooring composed primarily of oxidized linseed oil and ground cork. Battleship linoleum, a variety *c.* 6 mm thick, is frequently recommended, as is Desk-top, a thinner sheet. With the advent of synthetic floorings, linoleum became less easily available. In the late 20th century it was no longer produced in the USA but was manufactured in Scotland and commonly sold only in artists' shops. For printmaking, linoleum may be mounted on to plywood, to produce a block that can be printed mechanically. The linocut can also be printed in a simple screw or lever press or by hand, by rubbing the paper against the inked block with a spoon, rolling pin or *baren* (a slightly concave disc sheathed in bamboo), or by laying the inked linoleum on to the paper and hammering the back of the block. These hand-printing methods can also be used to print on to textiles, or the inked block can be turned on to fabric stretched on the floor and trodden on by the printer.

Either water- or oil-based inks are used, the former often preferred for their ease of cleaning. Waterfast inks are essential for textile printing. Any paper suitable for relief painting, damp or dry, can be used with linoleum blocks, depending on its texture and on the printing method. Type-high linoleum blocks can easily be printed with type and have been used in book illustration. Because sheet linoleum weighs relatively little and can be printed by hand, it has been used for exceptionally large printed images. Because linocuts are so easily printed by hand, they have been favoured by many artists who personally produce very small editions, although mechanically printed editions of as many as 25,000 are reported (Yeaton, p. 21). Since linoleum lends itself to broad effects, it is particularly adapted to multicolour printing, usually with a separate block for each colour. Linocut manuals commonly prescribe the offsetting of an impression of the key block, which establishes the composition, on to additional blocks in order to guarantee correct registration of colour areas. Likewise, in printing, a jig or other registration device is recommended to locate the paper precisely on each inked block.

Linocuts resemble woodcuts, although the softness and lack of grain of linoleum, which permit the artist to cut fluently in every direction, deprive cuts of the vigour and bias often seen in woodcuts. As fine networks of printing lines tend to crumble in linoleum, broader effects are usually sought. As the surface of linoleum is smooth, unless specially treated, it will not print with a texture that is visible in some woodcuts. The slickness of linoleum can produce a distinctive curdled effect in broadly inked areas, as seen in the *Frog Queen* (1905) by Erich Heckel (1883–1970); in this print linoleum's lack of grain bias is evident in the perpendicular clusters of gouge strokes.

Although linoleum was invented in the early 1860s, it was first used for printing only in 1890 in Germany for the manufacture of wallpaper. By the early 20th century it had been popularized for artists' prints, largely through the efforts of Franz Cižek (1865–1946), an Austrian artist and teacher who recognized the medium's potential to instruct children in colour and design: it was cheap, easily worked with

simple tools, adaptable to water-based inks, and versatile. Cižek toured Europe and North America with examples by his pupils and influenced art education worldwide. The earliest linocut by Heckel, the first major artist to adopt the medium, is dated 1903. He and the other artists of Die Brücke regularly used linocut through the next dozen years.

Such major artists as Henri Matisse (1869–1954) and Pablo Picasso (1881–1973) worked in linoleum. Matisse executed 70 linocuts between 1938 and 1952, in a fluent white-line technique, taking evident advantage of the smooth passage of the knife through the soft material. Picasso, after using linoleum for popular posters in the early 1950s, began a series of innovative colour linocuts in 1959. He developed a method of printing in different colours progressive states cut on a single block, so that the finished print comprises layered impressions of all the states.

Linocut gained particular favour in poorer cultures that were less inhibited by a tradition of fine printing. In revolutionary Russia important linocuts were produced by Lyubov' Popova (1889–1924) c. 1918. In Canada in the 1920s and 1930s the linocut was more common than the woodcut. The most important British advocate of the linocut was Claude Flight (1881–1955), who taught linocut from 1925 at the Grosvenor School of Modern Art in London and emphasized its accessibility to the proletariat. This attitude was later demonstrated by such prints as *Smokers* (1982) by the Australian artist Richard Bosman (*b* 1944), which was printed by the artist and his wife in an edition of two rolls of paper towels. Prejudice grew up against linoleum block printing, as suitable only for children, amateurs and the uncultured. The linocut's popularity also fell with the rise of commercial collaboration between printmaker and publisher, which encouraged more technically complex media.

C. Flight: *Lino-cuts* (London, 1927)

L. B. Yeaton: *Linoleum Block Printing for the Amateur* (New York, 1931)

F. J. Kafka: *Linoleum Block Printing* (New York, 1955)

J. Erickson: *Block Printing on Textiles* (New York, 1961)

M. Rothenstein: *Linocuts and Woodcuts* (New York, c. 1962)

P. Ainslie: *Images of the Land* (Calgary, 1984)

W. S. Liebermann and L. D. McVinney: *Picasso Linoleum Cuts* (New York, 1985)

S. Coppel: *Linocuts of the Machine Age: Claude Flight and the Grosvenor School* (Aldershot, 1995)

A. Griffiths: *Prints and Printmaking: An Introduction to the History and Techniques* (London, 1996)

J. Greenwood: *Omega Cuts: Woodcuts and Linocuts by Artists Associated with the Omega Workshops and the Hogarth Press* (Woodbridge, 1998)

S. Gordon and N. Penny: *The Cutting Edge of Modernity: Linocuts of the Grosvenor Gallery* (Aldershot, 2002)

Lithography [Fr. *Lithographie*, Ger. *Steindruckerei, chemische Druckerei*]. Planographic printmaking technique based on the antipathy of grease and water, and the attraction of these two substances to others of a similar nature and to a prepared surface of porous limestone or grained metal (*see* PRINTS, §III, 3). The term was first used in French on a music cover c. 1803; however, its Prague-born inventor, J. N. F. Alois Senefelder (1771–1834), preferred the term 'chemical printing' for the technique he developed in Munich between 1796 and 1799. In Britain it was called 'polyautography', until H. Bankes entitled the first English treatise: *Lithography; or, The Art of Making Drawings on Stone, for the Purpose of Being Multiplied by Printing* (Bath, 1813). Adaptations of Senefelder's technique are still called 'lithography', although stone has long been commercially superseded. Senefelder himself discussed metal and composition plates in his 1801 patent and 1818 treatise. Recently, microlayered plates with two metals—one receptive to grease, another to water—have been devised, as has waterless litho, where different substances within the plate attract or reject the ink. Manual or photomechanical images generated on translucent film can also be transferred by light to continuous tone alloy plates. The link between traditional and contemporary practice is a surface with ink-accepting and ink-rejecting areas in the same plane.

Artists in the 19th century customarily employed a drawing medium of carbon pigment, binders and fatty substances, including soap, applied to a slab of porous limestone. Although artists have utilized the most recent discoveries, many still value stone for its fidelity to every nuance of the hand. To make a lithograph on stone, the surface is ground with abrasives to prepare a grease-free surface, which can be smooth or coarse, to suit the intended image. The drawing medium comes in solid sticks of various consistencies or as tusche (Ger.: 'ink'), which is diluted with distilled water or more volatile solvents for application by pen or brush. When the drawn stone has been treated with a mixture of acid and gum arabic (called 'the etch' but not related to intaglio printing), adsorption bonds the greasy constituents to the stone, creating insoluble particles so integral to its surface that it can be reused only when they have been ground away. The 'etch' also creates a water-loving barrier to resist grease, thus establishing image and non-image area simultaneously. After a solvent has removed the pigment in the image to leave only the grease, impressions are made by sponging the stone with water, then inking the image with a roller bearing oil-based printing ink. Drawn areas repel water and attract ink, undrawn areas retain water and repel ink. Lithographs from zinc—sometimes called zincographs—are made in a similar way.

To draw a pen lithograph the stone must be polished, whereas for crayon work the stone is roughened. A granular effect imparted by the 'tooth' of a stone or plate is therefore natural to chalk or crayon and can be mistaken for the intaglio 'crayon manner' (see fig.). In the 19th century burin engraving was imitated by needling the image through a water-soluble ground to admit grease selectively to the stone. A mezzotint manner (Fr. *manière noire*), perfected in the 1830s, entailed modifying a coating of drawing medium with tools or abrasives. From c. 1840 lithotint

Lithograph by George Bellows: *Stag at Sharkey's*, 1917; photo credit: Art Resource, NY

simulated watercolour with diluted tusche—a procedure so tricky that wash (Fr. *lavis*) was often imitated by rubbing crayon. For Senefelder's sprinkled manner (Fr. *crachis*), a shower of liquid medium was spattered by passing a knife across a loaded brush and controlling the random half-tone by stencil or gum stop-out; airbrushing is a later variant. Artists have also harnessed the effects of oxidation on zinc, known as *peau-de-crapaud* (Fr.: 'toadskin').

Senefelder devised a way of writing with a special liquid on prepared paper and transferring it to stone by damping it and passing it, face down, through the press. Chalk drawings too can be transferred, as can inked impressions from relief blocks, intaglio plates or 'mother stones' replicated for the speedier delivery of large editions. Whereas a direct drawing reverses when printed and must be conceived back-to-front, transferred images are returned to their original orientation by double reversal. Senefelder believed this 'the principal and most important part' of his discovery.

Lithographs can be crudely printed by placing paper over an inked image and rubbing it from the back, but Senefelder built an upright pole press with a hardwood scraper-bar pulled under pressure across a greased tympan holding the sheet of paper against the inked stone. Professor Hermann Joseph Mitterer (1764–1821) of Munich designed the 'star wheel' or cylinder press *c.* 1805, keeping the scraper-bar stationary and moving the stone; this was forerunner to the French Brisset press, which dominated the Continent by the mid-19th century. In the late 20th century similar presses were still used by some printers and artists continuing the craft of hand-printing.

A separate stone or plate is normally used to print each colour, but small rollers can localize many colours on one surface, and skilful printers can seamlessly blend a number of inks on the roller—a technique called 'rainbow roll' or iris printing. The grey scale in monochrome lithography is unparalleled. Traditional lithographs look soft and flat, with veils of ink rather than palpable deposits. While thousands of impressions can be taken from robust crayon work, delicate washes wear more rapidly. No clue as obvious as an intaglio platemark betrays the process, but as the scraper-bar smooths the paper it may leave a trace of the stone's rounded corners or the metal plate's sharper perimeter.

After 1850 commercial and 'artistic' or fine art lithography began to diverge as a result of mechanical and photochemical developments. Senefelder foresaw automated damping and inking, but the Sigl press, patented in Austria and France in 1851, was the first successful powered machine. It produced up to 1000 sheets an hour—some ten times faster than manual presses. Such speeds could only be attained by using highly polished stones. As the flood of commercial colour printing increased during the second half of the 19th century, armies of chromolithographers, so skilful that they were able to make colour separations by eye, had to render tonal values by pen stippling. In 1879, Benjamin Day (1836–1916) marketed labour-saving 'shading mediums' to facilitate the task, and by 1887 chromolithographic draughtsmen could choose from many different patterns embossed on to flexible sheets to be inked and transferred to the stones. As a result of this increasing mechanization, the word 'chromolithograph'—which simply means a

lithograph in colour—became a pejorative term, particularly as it was usually applied to reproductive rather than to 'original' printmaking (see colour pl. VII, fig. 3).

The first photolithographs were made in France, c. 1852, by the printer Rosé-Joseph Lemercier (1803–87), helped by an optician and two chemists. Stones coated with light-sensitive asphaltum were exposed under paper negatives for a set of architectural subjects called *Lithophotographie; ou, Impressions obtenues sur pierre à l'aide de la photographie* (Paris, 1853). In 1855 Alphonse Louis Poitevin (?1819–82) patented an alternative, using chromates on a mixture of albumen and gelatin. Lemercier bought the rights in 1857, but both methods proved commercially uneconomic. Line photolithographs were developed for cartography in 1859 by Eduard Asser (1809–94) in the Netherlands and J. W. Osborne (1828–1902) in Australia. Osborne transferred images on photosensitized paper to stone. Col. Henry James (1803–77), Director of Ordnance Survey in England, adapted the method to zinc in 1860. Despite many experiments, such as a patent of November 1865 to copy photos on to sensitized transfer paper impressed with an aquatint grain, photolithography lacked commercially viable half-tones. 'Ink photos' from reticulated gelatin provided tonal transfers in the mid-1880s, but half-tone screens were satisfactorily combined with the process only in the early 20th century.

Offset lithography—an extension of the principle of double reversal previously achieved by transfer paper—was first used on tin in 1875. The inked image was transferred to rubberized cloth, thence to metal. By 1904 Ira Rubel of New Jersey had built the first practical offset press for paper. One cylinder carried a curved metal printing plate automatically inked and dampened, the second a rubberized 'blanket' to relay the image, the third a sheet of paper to be printed. By 1910 speeds reached 5000–6000 sheets an hour. When photomechanical and photochemical techniques were combined with web-fed paper, simultaneously printed on both sides, offset outstripped most other mass-production methods.

Transparent plastic plates, used for mapmaking during World War II, were developed for artists after 1945, notably by W. S. Cowell. Photocomposition and electronic scanners able to convert transparencies into trichromatic half-tones appeared in the 1950s. Screenless or continuous tone lithography became viable c. 1960, when hand-drawn or photo positives on translucent film could be transferred by ultra-violet light to sensitized polymer-coated anodized aluminium plates.

Despite the fact that offset plates can also be hand-drawn, the technique's association with photomechanical production and supposed lack of 'originality' rendered it suspect for 'art', especially in the USA c. 1960. By the early 1970s this prejudice had been largely overcome and offset proofing presses increasingly adopted by artists' printers. Offset impressions

are lighter than those from a direct press; the image suffers less wear, and many colours can be superimposed with precision. These characteristics make it an attractive process for the painter.

W. D. Richmond: *The Grammar of Lithography: A Practical Guide for the Artist and Printer in Commercial and Artistic Lithography and Chromo-lithography, Zincography, Photo-lithography and Lithographic Machine Printing* (London, 1878, 2/1880, 12/c. 1901); Ger. trans. by C. A. Franke (Leipzig, 1880)

J. Schnauss: *Der Lichtdruck und die Photolithographie* (Düsseldorf, 1879, 3/1886); Eng. trans. as *Collotype and Photo-lithography Practically Elaborated* ([?London], 1889)

W. T. Wilkinson: *Photo-mechanical Processes: A Practical Guide to Photo-zincography, Photo-lithography and Collotype* (London, 1892, 2/1897)

J. Pennell and E. R. Pennell: *Lithography and Lithographers: Some Chapters in the History of the Art* (London, 1898, 2/1915)

C. Kampmann: *Die Literatur der Lithographie von 1798–1898* (Vienna, 1899)

D. Cumming: *Handbook of Lithography: A Practical Treatise* (London, 1904, 2/1919, 3/1932)

E. de Crauzat: *Handbook of Lithography* (London, 1905/R 1919; rev. 1932)

C. Wagner: *Die Geschichte der Lithographie* (Leipzig, 1914)

M. J. Friedländer: *Die Lithographie* (Berlin, 1922)

B. Brown: *Lithography* (New York, 1923)

O. Kruger: *Die lithographischen Verfahren und der Offsetdruck* (Leipzig, 1929)

B. Brown: *Lithography for Artists* (Chicago, [1930])

C. A. Seward: *Metal Plate Lithography for Artists and Draftsmen* (New York, 1931)

A. S. Hartrick: *Lithography as a Fine Art* (London, 1932)

S. Wengenroth: *Making a Lithograph* (London, 1936)

W. Söderstrom: *The Lithographer's Manual* (New York, 1937)

L. Barrett: *Techniques of Stone Preparation* (Colorado Springs, 1940)

G. Arnold: *Creative Lithography and How to Do it* (New York, 1941)

J. Adhémar: *L'Estampe française: La Lithographie française au XIXe siècle* (Paris, 1944)

T. E. Griffits: *The Technique of Colour Printing by Lithography* (London, [1944])

L. Lang and J. E. Bersier: *La Lithographie en France*, 3 vols (Mulhouse, 1946–52)

One Hundred and Fifty Years of Lithography (exh. cat. by G. von Groschwitz; Cincinnati, OH, Cincinnati Art Museum, 1948)

A. Dehn and L. Barrett: *How to Draw and Print Lithographs* (New York, 1950)

Bild von Stein: Die Entwicklung der Lithographie von Senefelder bis heute (exh. cat., Munich, Staatliche Graphische Sammlung, 1961)

L. E. Lawson: *Offset Lithography* (London, 1963)

W. Weber: *Saxa loquuntur, Steine reden: Geschichte der Lithographie* (Heidelberg and Berlin, 1961); Eng. trans. as *A History of Lithography* (London, 1966; Fr. trans., Paris, 1967)

H. Cliffe: *Lithography* (New York, 1965)

M. Twyman: 'The Tinted Lithograph', *Journal of the Printing Historical Society*, i (1965), pp. 39–56

P. Weaver: *The Technique of Lithography* (New York, 1965)

E. Weddige: *Lithography* (Scranton, PA, 1966)

M. Twyman: 'The Lithographic Hand Press, 1796–1850', *Journal of the Printing Historical Society*, iii (1967), pp. 3–50

F. H. Man: *Artists' Lithographs: A World History from Senefelder to the Present Day* (London and New York, 1970)

M. Twyman: *Lithography, 1800–1850: The Techniques of Drawing on Stone in England and France and their Application in Works of Topography* (London, New York and Toronto, 1970) [the most thorough and reliable account in Eng.]

M. Twyman: 'Lithographic Stone and the Printing Trade in the Nineteenth Century', *Journal of the Printing Historical Society*, viii (1972), pp. 1–41

M. Knigin and M. Zimiles: *The Contemporary Lithographic Workshop around the World* (New York, 1974)

Tamarind Technical Papers (Albuquerque, 1974–8); *Tamarind Papers* (Albuquerque, 1978–) [hist., crit. & tech. articles on prts, esp. lithog.]

R. Vicary: *The Thames & Hudson Manual of Advanced Lithography* (London, 1976)

B. Farwell: *French Popular Lithographic Imagery, 1815–1870*, 12 vols (Chicago, 1981–1997)

La Pierre parle: Lithography in France, 1848–1900 (exh. cat. by D. Druick and P. Zegers; Ottawa, National Gallery of Canada, 1981)

D. Porzio, ed.: *La Litografia: Duecento anni di storia, arte e tecnica* (Milan, 1982, 2/1983; Fr. and Eng. trans., both 1983)

M. Hunter: *The New Lithography: A Complete Guide for Artists and Printers in the Use of Modern Translucent Materials for the Creation of Hand-drawn Original Fine-art Lithographic Prints* (New York, 1984)

La Lithographie en France des origines à nos jours (exh. cat. by B. Bouret and C. Bouret; Paris, Fondation Nationales des Arts Graphiques et Plastiques, [1984])

P. Gilmour, ed.: *Lasting Impressions: Lithography as Art* (London, Philadelphia and Canberra, 1988) [comprehensive bibliography; new research on C. Hullmandel & A. Clot; essays on Ger., Fr., Amer. & Austral. lithog.]

M. Twyman: *Early Lithographed Books: A Study of the Design and Production of Improper Books in the Age of the Hand Press* (London, 1990)

J. Vega: *Origen de la litografía en España: El Real Establecimiento Litográfico* ([Madrid], 1990)

H.-J. Imiela: Geschichte der Druckverfahren: Teil 4, Stein- und Offsetdruck (Stuttgart, 1993)

K. Tritton: *Colour Control in Lithography* (Leatherhead, 1993)

P. Berghaus, ed.: *Graphische Porträts in Büchern des 15. bis 19. Jahrhunderts* (Wiesbaden, 1995)

R. Michler and L. W. Löpsinger, ed.: *Salvador Dalí: Catalogue Raisonné of Prints, II: Lithographs and Wood Engravings, 1956–1980* (Munich, 1995)

C. Adams, ed.: *Second Impressions: Modern Prints & Printmakers Reconsidered* (Albuquerque, 1996)

M. B. Cohn and C. I. Rogan: *Touchstone: 200 Years of Artists' Lithographs* (Cambridge, MA, 1998)

K. S. Howe, ed.: *Intersections: Lithography, Photography, and the Traditions of Printmaking* (Albuquerque, 1998)

H. K. Stratis and M. Tedeschi, eds: *The Lithographs of James McNeill Whistler* (Chicago, 1998)

D. H. J. Schenck: *Directory of the Lithographic Printers of Scotland, 1820–1870: Their Locations, Periods and a Guide to Artistic Lithographic Printers* (Edinburgh, 1999)

P. Croft: *Stone Lithography* (London, 2001)

M. Twyman: *Breaking the Mould: The First Hundred Years of Lithography* (London, 2001)

P. Croft: *Plate Lithography* (London, 2003)

De Géricault à Delacroix: Knecht et l'invention de la lithographie, 1800–1830 (exh. cat. by F. Fossier and others; L'Isle-Adam, Musée d'art et d'histoire Louis Senlecq, 2005)

D. Tatham, ed.: *North American Prints, 1913–1947: An Examination at Century's End* (Syracuse, NY, 2006)

Lost-wax casting [Fr. *cire perdue*]. Method of hollow casting with wax (*see* METAL, §III, 1(iv)).

M

Maculature. Print made by taking a second impression without re-inking the plate or block. The process is usually used to clean the plate, and the resulting image is weak and ghostly.

Magic lantern. Apparatus used to project an image, usually on to a screen, in use from at least the 17th century to the early 20th, the precursor of the modern slide projector. A transparent slide containing the image was placed between a source of illumination and a set of lenses to focus and direct the image. Although Athanasius Kircher (1602–80) is traditionally regarded as the first to outline the principles involved in the magic lantern in his book *Ars magna lucis et umbrae* (Rome, 1646, rev. Amsterdam, 1671), it is known to have been in use much earlier. Kircher's work is regarded as a development of the work of Giovan Battista della Porta (?1535–1615), who popularized the CAMERA OBSCURA and wrote *Magiae naturalis* (Naples, 1558). Although Kircher had apparent success in projecting images painted on strips of glass, improvements to the apparatus came about only following the investigations of such scientists as W. J. 's Gravesande (1688–1742). Early lanterns were crude, and the dependence on oil for illumination meant that most were fitted with a chimney in order to expel heat and fumes. Improvements in the magic lantern and the development of possibilities in the projection of optical effects were closely tied to the search for an illuminant that was stronger and more stable. When oil was finally superseded by limelight (lime ignited in oxy-hydrogen gas) and then by acetylene and the electric arc lamp, the magic lantern show was able to exploit sophisticated images involving effects of colour and movement; having been for a time the preserve of travelling showmen, the magic lantern was able to take its place among the major public optical spectacles of the 18th and 19th centuries.

Slides were hand-painted on glass until well into the 19th century. The ground pigments (occasionally watercolours) were diluted with varnish and blacked in with India ink. The spectacle itself usually demanded the use of strong colours, and sometimes an artist was employed simply to make the outlines of the image, leaving the rest to a colourist. Many 19th-century slides contain skilfully executed images—there was already a tradition of painting on glass (e.g. slides painted by Thomas Gainsborough (1727–88) for his 'show-box', 1780s; London, Victoria and Albert Museum)—while the cruder examples from the 18th and 19th centuries have a direct relation to images in contemporary popular prints. Few of the earlier slide painters' names are known, with the exception of the showman Etienne Gaspard Robertson (1763–1837), inventor of the *Fantasmagorie* spectacle (slides in Paris, Conservatoire National des Arts et Métiers), who also patented in 1799 a method of transferring an impression of a copperplate engraving onto glass. Despite the limitations of hand-painting, sophisticated optical effects were known, especially after the introduction of a method of imparting movement to figures in the early 18th century: this was generally achieved by pulling the slide across by hand, but the image could also be manipulated with the use of levers, and random movement could be created with the use of airstreams, for example. Panoramic slides and processional images (along with chase scenes) were especially popular. During the second half of the 19th century the painting, or at least colouring, of slides became a popular amateur pastime. The slide industry grew, and lantern shows became more popular and more ambitious. Vast spectacles involving sophisticated optical effects and simple narratives were produced, often before large audiences, as at the Royal Polytechnic Institution in London (slides now in London, Science Museum; Oxford, Oxford University, Museum of the History of Science; and elsewhere), where such images as the 'chromatrope' (a revolving kaleidoscopic slide) were used. One of the main developments of this period was the 'dissolving view', introduced *c.* 1837 by the projectionist Henry Langdon Childe (1782–1874); this created a simple but startling transformation scene not unlike the effect of the diorama. This effect itself became so popular that 'dissolving views' became synonymous with 'lantern shows'.

Early magic-lantern spectacles had often consisted of supernatural images, sometimes projected on to smoke or a semi-transparent screen (e.g. Robertson's *Fantasmagorie*), which satisfied a public taste for the ghoulish and macabre. The magic lantern was also used for similar effects in the theatre. Gradually, however, as they became larger and involved more sophisticated optical effects, magic lantern shows

were, by the 1860s at least, well on the way to becoming the most popular of all forms of public entertainment. In addition, around this time the photographic lantern slide (first developed *c.* 1858 by the Langenheim Brothers of Philadelphia) was introduced, although hand-painted slides were still being produced at the end of the 19th century. Photographic slides were still often coloured by hand, but along with the introduction of chromolithographic transfer, they ushered in a period of mass production. The possibility of photographic projection developed with the introduction of the gelatin dry-plate process, the achromatic lens and a powerful illuminant. The successful projection of detail became possible, and immediately the educational possibilities were exploited. The most popular subjects were works of art and topographical views. The teaching of art history, in particular, was transformed. The 'lantern lecture' became more of an instructional occasion. In Britain, for example, what had earlier been an optical spectacle became dominated by the Church and temperance societies for moral instruction. In this context a particularly successful photographic genre developed, the 'life-model series', in which a lengthy narrative illustrating some sternly moral tale or song was represented in a series of photographic scenes. In the USA a more secular context enabled one showman, Alexander Black (1859–1940), to produce narrative dramas lasting a whole evening, containing hundreds of slides. This meant that when the first film was produced in 1895 (the film projector itself being a modified magic lantern), there was already a public arena for cinema, which eventually usurped the magic lantern. It was not until after World War I, however, that the magic lantern ceased to be used for major public entertainments. By the late 20th century its modern equivalent, the slide projector, continued in use in instructional contexts and private settings.

See also MOTION PICTURE FILM.

T. C. Hepworth: *The Book of the Lantern* (London, 1889)

O. Cook: *Movement in Two Dimensions* (London, 1963)

C. W. Ceram: *Archaeology of the Cinema* (London, 1965)

J. Barnes: *Catalogue of the Collection: Barnes Museum of Cinematography, St Ives, Cornwall, England*, i–ii (St Ives, 1967–70)

J. Remise, P. Remise and R. Van de Walle: *Magie lumineuse: Du théâtre d'ombres à la lanterne magique* (Paris, 1979)

W. Hoffmann and A. Junker: *Laterna magica: Lichtbilder aus Menschenwelt und Gotterwelt* (Berlin, 1982)

H. B. Leighton: 'The Lantern Slide and Art History', *History of Photography*, viii/1 (Jan–March 1984), pp. 107–18

J. Barnes: 'The Projected Image: A Short History of Magic Lantern Slides', *New Magic Lantern Journal*, iii/3 (1985), pp. 2–7

L. Mannoni: *Le Grand Art de la lumière et de l'ombre: Archéologie du cinéma* (Paris, 1994)

B. M. Stafford: *Devices of Wonder: From the World in a Box to Images on a Screen* (Los Angeles, 2001)

J. Lyons and J. Plunkett, eds: *Multimedia Histories: From the Magic Lantern to the Internet* (Exeter, 2007)

Magnetic tape. Medium utilizing oxidized metal particles carried on a flexible substrate, in order to record an electronic signal, most commonly in the form of audiotape or videotape. Magnetic tape is also used in computers for the storage of data, but this usage is unlikely to be encountered in an art conservation context.

1. Properties and types. 2. History. 3. Conservation.

1. PROPERTIES AND TYPES. Magnetic recording tape generally is made up of a plastic film base (most tapes, including all videotapes, have a base of polyester terephthalate (PET)), coated on one side with a binder system containing oxidized metal particles. Often, recording tape will also have what is known as a backcoating on the reverse side, which reduces friction, dissipates the buildup of static electricity, and allows for the tape to be more evenly wound. Some early audiotapes had paper backing, while others may also have a backing of acetate plastic, which is subject to the same deterioration factors as acetate photographic film, including so-called 'vinegar syndrome'. The binder layer, the most critical component of the recording tape, usually consists of metal particles suspended in a binder of polyester and polyurethane, although it can contain numerous other chemicals. Different manufacturers have used different binder formulations, and changed them frequently over time. For this reason, some tapes may be more subject to deterioration than others of similar age and format. In the 1980s, manufacturers began to produce tapes with no binder polymer, but instead a very thin layer of metal alloy evaporated onto the tape base, known as 'metal evaporated' or ME tapes. The binder system may also contain lubricants designed to minimize friction as the tape passes through a recording or playback device.

The earliest audiotapes and videotapes were on open reels, with manufacturers introducing cassette and cartridge audio and videotape formats in the 1960s. Cassettes are plastic housings containing two tape reels, which are inserted into devices for playback; cartridges are similar in concept, but instead of having tape that unwinds from one reel onto another as in cassettes, cartridges contain a single continuous loop of tape. There have been numerous variant formats of both audio and videotape, with little or no interoperability.

Format obsolescence is a major issue in the conservation of magnetic tape, especially videotape. Because tape is not human-readable—it requires electronic equipment in order to be viewed or listened to—it is difficult to assess the condition of magnetic tape without it being played back. Equipment to play back tapes, as well as the expertise needed to operate this equipment, can be difficult to find, and generally requires the use of a specialized restoration lab.

2. HISTORY. The concept of recording an electrical signal through magnetic means dates back to the 1880s. In 1888 Oberlin Smith (1840–1926), an American engineer, first wrote about the concept of

fixing an audio signal by storing it as a pattern of magnetic charges on a moving carrier. The audio signal passes through a magnetic coil and creates varying magnetic fields, causing a pattern of magnetization to be created on the recording medium. Smith envisioned the medium as being thread embedded with steel dust, or a type of ribbon. The Danish engineer Vladimir Poulsen (1869–1942) produced the first successful magnetic sound recording device around the turn of the 20th century.

Early applications of this principle employed wire or steel ribbons, but did not gain widespread use. A breakthrough came in the mid-1930s when the German firm AEG developed a device for recording audio signals, known as the Magnetophone. The Magnetophone, first shown publicly in 1935 (Engel 608) used thin acetate plastic tape.

Following the war, the American firm Ampex developed its own audiotape recorder, based in part on Magnetophone machines brought back from Germany by American soldiers. Ampex introduced its recorder to the market in 1948, and audiotape was quickly adopted for professional use by the radio and phonograph industries. These early machines used ¼ inch (6.35 mm) wide reel-to-reel tape. By the mid-1950s, ¼ inch reel-to-reel audiotape had also gained a foothold in the consumer market, as well as being adopted by businesses, governments, anthropologists etc. Eventually, wider audiotape, capable of carrying multiple audio tracks, was developed for professional use in the recording industry.

Also in the 1950s, as the American television industry continued to expand, broadcasters expressed a desire for a device that would record television signals on tape. In 1956, the Ampex Corporation introduced the first practical videotape recorder, which used 2 inch (50.8 mm) wide reel-to-reel tape. Known as 'quad' tape, for the machine's four recording heads, this 2-inch format was the international standard for broadcast television until the late 1970s. The large size and high cost of these machines restricted their use to television broadcasters, government agencies and large institutions. In the mid 1960s, however, smaller, cheaper videotape recorders appeared on the market. The most successful of these recorders used ½ inch (12.7 mm) wide reel-to-reel tape, and saw wide use by artists, activists and experimental video makers, as well as educational and corporate organizations.

Cassette formats, developed for ease of use, began to appear in the late 1960s. Sony's U-matic cassette was the first successful such tape, also known as ¾ inch for the width of the tape used. U-matic tape was widely adopted for corporate and institutional use, and eventually by television broadcasters. (The tape was also used as an audio mastering format.) In 1975, Sony introduced Betamax, a cassette aimed at the consumer market; the following year JVC introduced the competing VHS, which eventually came to dominate the home market. Sony eventually introduced a professional broadcast Beta tape known as Betacam, as well as digital Beta tapes. Nearly all of these

formats were used by video artists over the years, though generally artists worked with less expensive and more portable non-professional formats.

By the early 21st century, videotape was rapidly being superseded in the consumer market by DVDs, which are not magnetic but optical storage devices. In the professional and archival realms, storage and preservation of audio has been almost entirely taken over by digital file formats, and video preservation is likely to follow suit.

C. Bensinger: *The Video Guide* (Santa Barbara, 1981)

R. Mueller: 'Magnetic Tape Development', *The BKSTS Journal* (April 1986), pp. 204–10

F. K. Engel: '1888–1988: A Hundred Years of Magnetic Sound Recording', *Journal of the Audio Engineering Society*, xxxvi/3 (March 1988), pp. 170–78

H. K. Thiele: 'Magnetic Sound Recording in Europe up to 1945', *Journal of the Audio Engineering Society*, xxxvi/5 (May 1988), pp. 396–407

C. D. Mee and E. D. Daniels: *Magnetic Recording Handbook* (New York, 1990)

M. H. Clark: *The Magnetic Recording Industry: 1878–1960: An International Study in Business and Technological History*, University Microfilms International No. 9232638, 1992

E. D. Daniel, C. D. Mee and M. H. Clark, eds: *Magnetic Recording: The First 100 Years* (New York, 1999)

S. B. Luitjens and A. M. A. Ricjckaert: 'The History of Consumer Magnetic Video Tape Recording, from a Rarity to a Mass Product', *Journal of Magnetism and Magnetic Materials* (1999), pp. 17–23

M. Weise and D. Weyland: *How Video Works: From Analog to High Definition* (Burlington, MA and Oxford, 2004)

L. Enticknap: *Moving Image Technology: From Zoetrope to Digital* (London, 2005)

3. CONSERVATION. It is important to remember that magnetic tapes are in a constant process of chemical decay, which by current methods can only be slowed, not fully stopped or permanently reversed. This decay will eventually render the tapes unplayable, and the information on them—the signal that is the actual object of conservation—inaccessible. For this reason, long-term conservation of audio and videotape materials requires migration to new carriers, whether to new tape or to digital files. It also requires careful storage and handling of the tapes to slow decay, and to protect them from a myriad of factors that can cause harm.

The life expectancy of any given magnetic tape is difficult to determine. Some estimates place the maximum life of a magnetic tape at 30 years, but many tapes dating back to the 1940s and 1950s are still in usable form. Factors such as the number of times a tape has been played, how it has been stored, how carefully it is handled, and the specific chemical formulations used in its manufacture all play a role in how long a tape can remain usable.

Tape can suffer chemical deterioration for a number of reasons. The most common deterioration methods involve the binder with which the tape is coated, and which contains the metal oxide particles carrying the recorded signal. Because the exact

chemical formulations of tape binders can vary widely between different manufacturers, different tape formats, and different periods of time, few generalizations can be made about the behaviour of older tapes. Moreover, the companies that have produced videotape historically have resisted giving out any useful information about the chemistry of their binder systems. There are, however, several clear and documented deterioration mechanisms.

Exposure to ambient moisture in the air results in a chemical process called hydrolysis, in which long polyester molecules in the binder are broken apart. This scission, or breaking, causes the binder to become less stable, and to shed oxide particles when the tape is played back. This shedding gives hydrolysis its colloquial name, 'sticky-shed syndrome', and can clog playback heads and jam machines.

This hydrolysis can be reversed temporarily by exposing the tapes for a period of time to dry heat, commonly called 'baking', although the temperatures used are far below those of a conventional oven. Various methods are used—including commercial convection ovens and consumer-model food dehydrators—but there have been no scientific studies examining this process. Those who use it are generally technicians operating on anecdotal evidence and personal experience, and though it is important to be aware of its potential utility, baking of tapes is not advised by anyone but experts. Baking generally results in giving the tapes sufficient stability to be played back at least once and thus migrated to a new format, but the effect is temporary and the tape will eventually return to its deteriorated state.

Another form of tape deterioration is lubricant loss. Tapes are often coated with chemical solutions added to the binder in order to reduce friction as tapes pass through playback devices and over heads. Over time, this lubricant is shed onto various parts of the machine, and can also evaporate while the tape is in storage. Lubricant loss can, like sticky-shed syndrome, result in tapes jamming machines and not playing back. Tapes can be re-lubricated to ameliorate this problem, but again, this is best handled by experts.

It should also be noted that early audiotapes, which used a base of acetate plastic, are subject to the same chemical decomposition as acetate photographic film, including the so-called 'vinegar syndrome', in which acetic acid off-gassing creates an autocatalytic reaction leading to increasingly rapid deterioration. (A quick way of determining if an audiotape has an acetate or polyester base is to hold it up to the light. If light can be seen through the tape on the reel, it has an acetate base.)

Most magnetic tape, however, is made with a polyester base. Polyester is a very stable material and not subject to chemical deterioration. The tape base is, however, subject to physical damage through mishandling or poor storage. Playing tapes on poorly maintained equipment can stretch tapes, resulting in distorted playback, or cause damage to tape edges, where critical synchronization and sound information is carried.

Magnetic tapes should be handled with care—kept away from dirt and dust, which can cause visible or audible defects when a tape is played back. The tape should never be touched, as oils from the skin can also affect playback.

Another danger is magnetic fields. Exposure to a magnetic field can cause a tape to be partially or completely erased. Common sources of magnetic fields include televisions, computer monitors, microphones, speakers, motors, transformers and generators. Care should be taken to keep video and audio tapes away from all of these.

Additionally, all audio and video cassettes have a mechanism by which recording can be prevented—generally a tab or button which can be removed, or slid from one position to another. Whenever handling important cassettes, it is vital to be sure that it is in 'record-protect' mode, in order to prevent accidental erasure.

Storage conditions are critical for magnetic tape. As defined by ISO standard 18923:2000, the ideal situation for the storage of videotapes is cool but not cold: 7–8°C and 25% RH. In particular, higher humidity can result in accelerated deterioration.

Long-term conservation of magnetic tape materials requires that they be migrated to new storage devices, whether tape or digital file. Audio preservation is now generally handled by creating uncompressed digital audio files from tape originals, and Compact Disc copies for access and use.

Videotape preservation still generally uses tape-to-tape remastering. General practice in video preservation is to create an archival master, which is stored and ideally not played back unless absolutely necessary, and a dub master, which is used to make viewing or access copies. Originals should be retained even if deteriorated, in case the new masters fail, or new technology allows for higher-quality remastering. The standard videotape format for remastering is Digital Betacam as it provides a high-quality image, is widely used and has been proven over time to be relatively sturdy. It should always remembered, however, that these new tapes will in turn eventually need to be remastered themselves—new tapes are just as subject to deterioration and decay as old.

J. W. C. Van Bogart: "Magnetic Tape Storage and Handling: A Guide for Libraries and Archives." National Media Laboratory, 1995. Accessed 12/12/2007 at http://www.clir.org/pubs/reports/pub54/.

I. Gilmour: 'Media Testing in Audiovisual Archives', *Image and Sound Archiving and Access: The Challenges of the 3rd Millenium: Proceedings of the Joint Technical Symposium: Paris, 2000*, pp. 79–87

O. Hinterhofer, K. Binder and L. Kranner: 'Minimal-Invasive Approaches to Magnetic Tapes Life Expectancy Testing', *Image and Sound Archiving and Access: The Challenges of the 3rd Millenium: Proceedings of the Joint Technical Symposium: Paris, 2000*, pp. 88–93

M. Jimenez and L. Platt: Videotape Identification and Assessment Guide. Texas Commission on the Arts, 2004. Accessed 12/11/2007 at http://www.arts.state.tx.us/video/pdf/video.pdf.

C. A. Richardson: *Process for Restoring Magnetic Recording Tape Damaged by 'Sticky Shed' Syndrome*, USA, Patent n°6,797,072 B1. 2004-09-28.

Digital Video Preservation Reformatting Project, Dance Heritage Coalition (New York, 2004)

B. Thiébaut, L. B. Vilmont and B. Lavédrine: "Report on Video and Audio Tape Deterioration Mechanisms and Considerations About Implementation of a Collection Condition Assessment Method." Accessed 12/11/2007 at http://prestospace.org/project/deliverables/D6-1.pdf.

Mahlstick. Wooden rod, dowel or length of cane *c.* 1 m long, one end of which is covered by a small, ball-shaped pad of leather, cloth or cork. It is used by painters to steady the hand and keep it clear of the painting's surface. A mahlstick is held in the hand that is not actively painting. It is usually passed through the fingers and held rigid against the underside of the forearm, in a grip that also holds the palette and several spare brushes. The cushioned end is then supported against a convenient resting place, perhaps on the easel or on the edge of the stretcher or panel. Thus held, the mahlstick traverses the space in front of the painting, providing a rigid support for the hand holding the brush.

The mahlstick first appeared in the 16th century, coinciding roughly with the adoption of oil paint, and its use may have been further encouraged by the concurrent development of canvas supports. Neither wet oil paint nor flexible, insubstantial canvases allow the hand or arm to rest on the painting itself. In his *Arte de la pintura* (1649) Francisco Pacheco seemed to confirm this connection, when he remarked that most painters did not use mahlsticks for tempera (Zahira, pp. 146–7). Mahlsticks are shown in use on the title-page of a book of 1549 by Valentin Boltz (*Farbbuch oder Illuminierbuch*; Basle) and in a print of 1577 (the *Unlucky Painter*; Paris, Bibliothèque Nationale) by Marcus Gheerhaerts the elder (*c.* 1520–*c.* 1590). However, they are not shown consistently in painters' self-portraits or studio scenes until the 17th century. From then, they are almost always present. Mahlsticks appear in *St Luke Painting the Virgin and Child* (*c.* 1613), *Las Meninas* (1656; Madrid, Prado) by Diego Velázquez (1599–1660), a *Self-portrait* (*c.* 1664; London, Kenwood House) by Rembrandt van Rijn (1606–69), the *Allegory of Painting* (*c.* 1666–7; Vienna, Kunsthistorisches Museum) by Johannes Vermeer (1632–75) and a *Self-portrait* (1753–4; London, National Portrait Gallery) by Joshua Reynolds (1723–92). They are frequently shown or discussed in 18th-century sources and are the subject of some anecdotes in Antonio Palomino's treatise *El museo pictórico y escala óptica* (1715–24; Zahira, p. 50). A mahlstick in the form of William Hogarth's 'Line of Beauty' appears in the caricature of 1753, the *Author Run Mad* (example in London, British Museum) by Paul Sandby (1731–1809). The use of the mahlstick has declined since the mid-19th century with the introduction of broader painting styles and the more robust use of oil paint.

F. Schmid: *The Practice of Painting* (London, 1948)

V. Zahira, ed. and trans.: *Artists' Techniques in Golden Age Spain* (Cambridge, 1986)

Maiolica. Term used strictly to describe tin-glazed earthenware of Italian origin. The name may be derived from the imported lustrewares sent from Valencia via the Balearic island of Maiolica (now Mallorca) to Italy, or may derive from the Málaga wares known as *opus de Melica.*

Manière criblée [Fr.: 'sieved manner']. Term used for an early tonal DOTTED PRINT, with punched and stamped decoration, made with METALCUT during the second half of the 15th century in Germany and France.

Manuscript [Lat.: 'written by hand']. In its broadest sense, a handwritten book, ROLL, tablet or other form of portable means for storing information. Many different materials have been used for the production of manuscripts, the choice of which depends largely on geographical availability, the stage of technological development and prevailing traditional values. These factors have in turn frequently played an important part in deciding the shape and appearance of the manuscript itself, as well as influencing the script.

1. INTRODUCTION. Clay tablets were used extensively as a writing material between *c.* 3000 BC and the 7th century BC in Mesopotamia and other regions of the ancient Near East; the script impressed on them, with a reed stylus while the clay was still wet, was one of the earliest systematic forms of writing. Inscribed tablets manufactured from water-cleaned clay were sun-dried or baked in a kiln (according to the importance of the text they were meant to store). Their size varied, the most popular formats being the cylinder and the oblong brick with convex sides. As a result of their role in the social and economic life of the ancient city states, clay tablets were stored in special libraries attached to temples and palaces, where they were foliated, indexed (according to the first sentence) and arranged on shelves in the appropriate order.

In ancient China bamboo strips strung together to form rolls were widely used, first for administrative records but later also for literary, philosophical and other compositions. It has been suggested that the shape of the bamboo cane determined the vertical direction of Chinese script. Wood slips, often with notches on one or both ends for binding them together, may have been imitations of earlier bamboo models, a change made necessary when Chinese administration moved to areas where the bamboo cane was rarer. Bamboo manuscripts, their texts incised with a sharp knife, are also found in Indonesia. Wood, freely available in most parts of the world, has always been a popular writing material. Extant wooden writing boards from ancient Egypt date from as far back as the Middle Kingdom (*c.* 2008–*c.* 1630 BC);

wooden tablets in various shapes and sizes, either covered with plaster, mud, brick dust or wax, lacquered and polished or more usually left in their natural state, were used in Mesopotamia, China and the Mediterranean countries of Classical antiquity. Greek and Roman writing tablets, consisting of rectangular boards with a slightly hollowed-out surface filled with wax and laced together not unlike a modern looseleaf binding, were one of the most popular forms of manuscript and were referred to in Latin as a 'codex'.

A material that needs only a moderate amount of processing to make it suitable for writing is tree bark (Lat. *liber*). In India the earliest extant birch-bark folios, cut, polished and oiled, are fragments of Buddhist works written at the beginning of the Christian era, but there is evidence that birch-bark manuscripts existed at the time of Alexander the Great's invasion (326–325 BC). The long, narrow shape of some early examples has provoked speculation about connections with Greek papyrus rolls; however, most extant Indian birch-bark manuscripts clearly copy the shape of the palm leaf (see below), and in Kashmir from the 15th century, even that of the codex. In Sumatra long sheets of coarse bark, folded like a concertina, served until the modern era as notebooks for Batak medicine men. Bark was also used in this form by the Mayas and Aztecs of Pre-Columbian America.

The palm leaf, which has a long tradition of use for manuscripts, had a decisive influence not only on the shape of the manuscript but also on the development of a large number of scripts in India and South-east Asia. Unlike wood and bamboo, palm leaves require a simple manufacturing process of boiling and drying to render them suitable for writing. A pile of leaves (inscribed on both sides), usually between 30 and 50 mm wide and 300–420 mm long, and secured between two wooden covers, was, until the beginning of the 20th century, the most common form of the handwritten book in South and South-east Asia. After the introduction of paper to India by the Muslims in the early 13th century, certain types of manuscripts retained the characteristic oblong shape of palm-leaf manuscripts and even the blank space in the text, originally left by the scribe to provide room for the cord; this became a focal point for decoration.

Skin made into leather (by curing, processing and manipulation; for an explanation of these techniques *see* LEATHER, §2(i)) is impervious to water and is thus durable as a writing material. The earliest extant examples of ancient Egyptian leather manuscripts date from *c.* 2500 BC; leather was also an established writing material in Western and Central Asia. It has also always played an important part in Jewish ritual; for example, the Torah scroll kept in the synagogue is always made of skin. Since only one side is normally suitable for writing, leather promoted the roll format.

Silk, cotton and linen, originally used for clothing, became, during certain periods and in certain circumstances, established forms of writing material.

Perhaps best known are the linen wrappings of Egyptian mummies inscribed with passages from the Book of the Dead. In India pieces of cotton, cut to size and treated with a paste made of rice or wheat flour, were, until the 20th century, used for the writing of texts and, in Karnataka (formerly the State of Mysore), for accounts. In Burma cotton cloth was sometimes cut into palm-leaf shaped pieces, which were stiffened with black lacquer, a slow and painstaking process during which letters were inlaid with mother-of-pearl. Manuscripts manufactured from cloth were not restricted to the East: Livy (59 BC–AD 17) described the *libri lintei*, the linen books used in Rome during his lifetime. Silk, the most expensive textile, was first produced in China, where references to it as a writing material in the 5th and 4th centuries BC imply frequent use. Silk, however, was at all times a costly commodity, and eventually a recycling process, by which old silk rags could be pulped and the resulting mixture spread thinly on to a frame, led to the production of silk 'paper'.

One of the most durable forms of writing material is metal. This quality made it well suited for documents of a legal nature: bronze tablets inscribed with the Roman laws were supposedly kept in the Capitol; in South and South-east Asia it was customary, until the 19th century, to record grants of land on (often palm-leaf shaped) copper-plate charters, which served the recipients as title deeds. The earliest extant, inscribed copper plate comes from the Indus valley (*c.* 2800 BC), although its exact purpose is uncertain. Lead, both pliable and durable, could be beaten into thin sheets and if necessary rolled up for storage; Pliny the elder (AD 23/4–79) and Pausanias (*fl* late 2nd century AD) made reference to this custom. Gold and silver were used, especially in the East, to stress the value of a religious text, to gain special merit by commissioning such an expensive work, to express proper respect for the position of the person to whom a letter was addressed or simply to draw attention to one's own wealth and status. Two beaten-gold sheets, for example, inscribed with a famous Pali verse, were found inside a brick (probably the foundation stone) of a Burmese Buddhist structure dating from the 5th or 6th century AD. In Sri Lanka, according to tradition, the entire Theravada Buddhist canon was written on golden plates in 88 BC, and as late as the 18th and 19th centuries South-east Asian princes sometimes wrote their letters on thin sheets of pure gold.

The plant *Papyrus cyperus*, after which papyrus is named, was extensively cultivated in the ancient Nile Delta. As a writing material it was prominent for over three millennia, first in Egypt, and later also in Greece and Rome (*see* PAPYRUS). Although other materials were used simultaneously, none was as serviceable or as pleasing, and none could be produced as readily in equally large quantities. Once the papyrus had been prepared, several sheets were glued together to form a roll, which was inscribed on one side only. At the beginning of the Christian era papyrus became increasingly scarcer and, in consequence, more

expensive. Traditional Egyptian society and economy, which had fostered its use and production, had disintegrated, and from *c.* AD 400 the parchment manuscript in codex form took precedence over the papyrus roll. After the 10th century the use of papyrus as a writing material rapidly declined, and by the 14th century it was more or less extinct.

Although the invention of PARCHMENT had traditionally been associated with the city of Pergamon in the 2nd century BC, its earlier use elsewhere has been established. The transformation of leather into parchment involves a fairly complex manufacturing process. Early fragments have survived from the 2nd century BC, but it was not before AD 200 that parchment started to rival papyrus in the Roman world, and two more centuries passed before it was used for the highest quality books. At about the same time the codex began to replace the roll format, since there was no longer any need to write on one side only. In Europe, parchment was the most common material for manuscripts until the end of the Middle Ages when it was eventually supplanted by paper.

The invention of paper, which lends itself with equal ease to the roll and the codex form of the manuscript, is traditionally attributed to Cai Lun, a minister at the court of the Eastern Han emperor Hedi, in AD 105. Among the factors that stimulated the process was the ever growing cost of silk, the knowledge of how to produce silk 'paper' and the cumbersome nature of bamboo books. The basic ingredient of paper is macerated vegetable fibre; the manufacturing process is skilful and, like that of papyrus, a triumph of traditional technology (*see* PAPER, §I). Paper reached Europe a millennium after its invention by a tortuous and uncertain route. By the 12th century the Muslims had introduced it via the Middle East and North Africa to Spain and Sicily. When the Muslims lost Spain in 1492, the art of paper-making passed into the hands of less skilled Christian craftsmen. Its quality almost immediately declined, but during the following century paper became firmly established in western Europe. Although paper lacks the 'life' of parchment, it is better suited for taking an impression from type or an engraved plate. In the 15th century its cheapness and availability played an important part in facilitating the explosion of PRINTING, which ultimately heralded the decline of the handwritten book or manuscript.

F. A. Ebert: *Zur Handschriftenkunde* (Leipzig, 1820)

F. Madan: *Books in Manuscript* (London, 1920)

D. Diringer: *The Hand-produced Book* (London, 1953)

D. Diringer: *The Illuminated Book: Its History and Production* (Cambridge, 1958, rev. London, 1967)

T. S. Pattie and E. G. Turner: *The Written Word on Papyrus* (London, 1974)

A. Gaur: *Indian Charters on Copper Plates* (London, 1975)

A. Gaur: *Writing Materials of the East* (London, 1975)

J. I. Whalley: *Writing Implements and Accessories* (New York, 1975, 2/1980)

J. I. Whalley: *The Pen's Excellence: Calligraphy of Western Europe and America* (New York, 1980)

2. ILLUMINATION. Strictly, the embellishment of a manuscript using burnished gold, the term is more usually and widely applied to denote all types of manuscript decoration or illustration, whether or not this involves the use of gold.

(i) Introduction. (ii) Survey. (iii) Materials and techniques. (iv) Conservation.

(i) Introduction. Handwritten texts have been ornamented and illustrated from the earliest times and in diverse parts of the world. In the East, in Arabia, Persia, Turkey, India, China, Japan and South-east Asia, there was a long tradition, paralleling that in the West, but more enduring, lasting even into the 19th century in some regions. In Central America the few surviving Maya and Aztec illustrated texts of the 14th to 16th centuries are evidence of their interest and skill in this form of painting. The tradition in the West is represented by a rich heritage, beginning with the books and papyri of the ancient and Classical Mediterranean (PAPYRUS and ROLL) and continuing unbroken from the 6th to the 15th centuries in Christian medieval Europe up to the final flowering during the Renaissance (*see* §(ii) below), at the same time extending into such areas as the Byzantine and Jewish worlds.

The earliest Western examples of illustrated texts are fragmentary Egyptian papyri of the 20th century BC and the Books of the Dead, which have small drawn or painted vignettes set within the columns of text. Greek papyrus fragments with a similar format of illustration, from the 2nd century BC, have been excavated in Egypt. Survivals from the Roman period are scarce, and those from before the 5th century AD consist almost entirely of papyrus fragments from Egypt. It is not until the 4th century AD that the numbers of surviving manuscript books on parchment gradually increase. From the 8th century on in Europe and the Byzantine world, large quantities of illuminated books are extant, reaching a peak in the first half of the 15th century. The great European tradition of manuscript illumination slowly came to an end in the first half of the 16th century as the printed book supplanted the handwritten one (*see* PRINTING). The only successful, if short-lived, modern revival was that of the Arts and Crafts Movement in the 19th century.

For certain periods and regions our knowledge of painting is derived almost entirely from illuminated manuscripts. Thousands of medieval examples survive, many having hundreds of pages with decoration and illustration (see colour pl. VIII, fig. 1). These far exceed the number of surviving examples of painting on walls, panels, canvas and in stained glass. Thus manuscripts provide vital and abundant material for the study of stylistic developments in painting and of religious and secular iconography. Preserved in the closed pages of books, protected from the effects of wear and damage over the centuries, most manuscript painting has a freshness of colour that is hardly diminished.

J. A. Herbert: *Illuminated Manuscripts* (London, 1911/*R* Bath, 1972)

A. Boeckler: *Abendländische Miniaturen bis zum Ausgang der romanischen Zeit* (Leipzig, 1930)

'Buchmalerei', *Reallexikon zur deutschen Kunstgeschichte*, eds O. Schmitt and others (Stuttgart, Metzler and Munich, 1937–)

K. Weitzmann: *Ancient Book Illumination* (Cambridge, MA, 1959)

'Miniatures and Illumination', *Encyclopedia of World Art* (New York, 1959–68)

D. Formaggio and C. Basso: *La miniatura* (Novara, 1960)

S. Mitchell: *Medieval Manuscript Painting* (London, 1965)

D. Diringer: *The Illuminated Book* (London, 1967)

P. d'Ancona and E. Aeschlimann: *The Art of Illumination* (London, 1969)

B. Narkiss: *Hebrew Illuminated Manuscripts* (New York, 1969)

K. Weitzmann: *Illustrations in Roll and Codex* (Princeton, 1970)

L. Donati: *Bibliografia della miniatura* (Florence, 1972)

H. D. L. L, ed.: *The Book through Five Thousand Years* (London, 1972)

D. M. Robb: *The Art of the Illuminated Manuscript* (London, 1973)

F. Unterkircher: *Die Buchmalerei: Entwicklung, Technik, Eigenart* (Vienna, 1974)

O. Mazal: *Buchkunst der Gotik* (Vienna, 1975)

H. Zotter: *Bibliographie faksimilierte Handschriften* (Graz, 1976)

J. Gutmann: *Hebrew Manuscript Painting* (New York, 1978)

O. Mazal: *Buchkunst der Romanik* (Vienna, 1978)

J. Backhouse: *The Illuminated Manuscript* (Oxford, 1979)

'Buchmalerei', *Lexikon der Mittelalters* (Munich, 1980–)

'Manuscript Illumination', *Dictionary of the Middle Ages*, ed. J. R. Strayer, 13 vols (New York, 1982–9)

D. Diringer: *The Book before Printing: Ancient, Medieval and Oriental* (New York, 1982)

R. G. Calkins: *Illuminated Books of the Middle Ages* (London and New York, 1983)

C. de Hamel: *A History of Illuminated Manuscripts* (Oxford, 1986, rev. 1994)

O. Pächt: *Book Illumination in the Middle Ages* (Oxford, 1986/*R* 1994)

T. Mathews and R. Wieck, eds: *Treasures in Heaven: Armenian Illuminated Manuscripts* (New York, 1994)

W. Cahn: *Romanesque Manuscripts: The Twelfth Century*, 2 vols (London, 1996)

K. L. Scott: *Later Gothic Manuscripts, 1390–1490* (London, 1996)

M. Smeyers: *L'Art de la miniature flamande du VIIIe au XVIe siècle* (Tournai, 1998)

R. Watson: *Illuminated Manuscripts and their Makers* (London, 2003)

(ii) Survey. The illumination of a manuscript may be purely decorative or else illustrative (and often both), rendering the appearance of a text more attractive or communicating in visual form its narrative or ideas. It may also function to emphasize important sections or divisions of a text. The history of the forms of manuscript illumination is thus inevitably linked to the history of the texts that were required to be illustrated, and the needs and tastes of the readers of those texts. For some books it was necessary to mark the beginnings of significant texts. For others, pictorial illustration was required to assist the text description: for example diagrams in scientific works or illustrations of plants, animals and birds in works on natural history. In some cases lavish decorative borders and frontispieces, purple-dyed parchment with writing in gold, and rich displays of heraldic devices were used to signify the wealth of the owner. For books used in the liturgy, richness of decoration and illustration signified an offering worthy of God; many of these would be used only a few times a year on the greatest feast days of the Church.

Various formats were used for the decoration and illustration of a text, using one or a combination of several elements: miniatures, decorated or historiated initials, line-endings and borders (see fig.). These were integrated with the text into a total system of ornamentation. In different periods and regions more or less emphasis was placed on these elements of the decoration; their position in relation to the text block also changed as styles developed. A scribe might either impose certain constraints on the format of the decoration or collaborate closely with the artist to coordinate its design with that of the text. In such cases a choice would be made between single, double or triple columns of text. If the illustrations were to be inserted within the text, the scribe would leave appropriate spaces, or, in the case of historiated or decorative initials, he would indent the text. If heavy, decorative borders were intended as a frame for the text, the size of the text block was reduced accordingly.

A. Schardt: *Das Initial* (Berlin, 1938)

E. A. Van Moé: *Illuminated Initials in Medieval Manuscripts* (London, 1950)

J. Gutbrod: *Die Initiale in Handschriften des achten bis dreizehnten Jahrhunderts* (Stuttgart, 1965)

L. M. C. Randall: *Images in the Margins of Gothic Manuscripts* (Berkeley, 1966)

D. Debes: 'Das Figurenalphabet', *Beiträge zur Geschichte des Buchwesens*, iii (1968), pp. 7–134

C. Nordenfalk: *Die spätantiken Zierbuchstaben* (Stockholm, 1970)

J. J. G. Alexander: *The Decorated Letter* (London, 1978)

M. Camille: *Image on the Edge: The Margins of Medieval Art* (Cambridge, MA, 1992)

J. J. G. Alexander: 'Giovan Pietro da Birago, Illuminator of Milan: Some Initials Cut from Choir Books', *Excavating the Medieval Image: Manuscripts, Artists, Audiences: Essays in Honor of Sandra Hindman, Chicago, IL, 2004*, pp. 225–46

(iii) Materials and techniques. The materials used in the production of Western manuscripts may be divided into the support (*see* §1 above), ink, pigments and the media in which they are mixed, and finally the gold and its ground. The most usual supports for Western medieval manuscripts are PARCHMENT and PAPER. Sheets of these were folded and cut according to the size of the double page required. A number of folded sheets, usually eight or ten, constitute a 'gathering', and several gatherings make up a book. Before the book was assembled, however, the double sheets were ruled with horizontal lines for the text and vertical lines for the columns and borders of the text

Professor Lecturing at the University of Paris; miniature from the *Grandes Chroniques de France*, from France, *c.* 1400 (Paris, Bibliothèque Nationale, MS. Fr. 2608, fol. 295*v*); photo credit: Giraudon/ Art Resource, NY

block, often referred to as the 'ruling pattern'. Ruling was done either in drypoint, with the blunt end of a STYLUS, resulting in an indentation in the parchment, or leadpoint (plummet) or silverpoint, resulting in pale grey lines, or in ink. Once one sheet had been ruled out, this pattern could be transferred to a number of sheets laid beneath it by means of guiding marks pricked through the sheets with a sharp instrument. These 'prickmarks' are visible on many medieval manuscripts at the very edge of the sheet, although frequently they have been cropped during binding.

Carbon-based and metal tannate inks were the most usual media for writing in Western manuscripts (*see* INK, §§I, 1(ii) and II, 2(i)). Red, green,

purple and blue pigments were also used for writing, as well as for the decorative penwork flourishes of line-endings and border ornament; in English manuscripts, especially during the Anglo-Saxon period, such pigments were also used for drawing figures in outline. The substances used for pigments vary considerably, but, unless scientific analysis has been carried out, it is almost impossible to identify them with certainty. Most of the pigments used for manuscript painting occur naturally, either as minerals or as organic compounds derived from plants, but some artificial pigments were also manufactured (for a detailed discussion *see* PIGMENT, §I). As many of the substances exist only in certain parts of Europe or Asia, a trade in pigments developed, with

apothecaries often supplying artists. Some pigments such as lapis lazuli, which is found only in Afghanistan, were understandably costly. The binding medium with which pigments were most commonly mixed was glair, made from the white of an egg, beaten for a long time, and then allowed to settle until it became clear again; this liquid was then mixed with a little water. The instructions for making glair in medieval technical treatises are very precise, even specifying the type and age of the eggs to be used. For some pigments the treatises suggest the addition of egg yolk to glair, while an alternative was a solution of GUM in water.

The survival of several unfinished manuscripts makes it possible to discern the stages involved in their decoration and illustration. In addition, some manuscripts contain small marginal notes, instructing the artist on what to depict or the colours to use, while others have faint trial sketches in silverpoint or leadpoint; such marginal notes or sketches would usually be erased in the final stages.

Once the text had been copied, with appropriate spaces left by the scribe for the illustrations, the first stage in the process of decoration could begin: this was to draw out the design of the frame, ornament and figures in silverpoint or leadpoint. Often the illuminator would then work up these sketches in ink lines. If gold leaf was to be used, this was applied and burnished before the paint was laid on. On rare occasions silver leaf was also used, but its tendency to tarnish quickly made it unsuitable (see §(iv) below). If the gold was to be burnished, it was laid over a smoothed GROUND of raised gesso, sometimes mixed with Armenian bole (a red clay). Once applied, the gold leaf was burnished with a polisher, for which a large animal's tooth is often recommended in the treatises. Gold leaf could alternatively be applied on an adhesive (mordant) rather than on gesso, but in this case it could not be burnished. In many manuscripts punched geometrical or foliage patterns would be made on the burnished gold. Occasionally similar patterns would be painted on to the polished gold in powdered (shell) gold. Such powdered gold, mixed in a gum solution and applied with a brush, could also be used for details and highlights in the painting.

The next stage was the painting, when the pigments were applied with an animal-hair brush (usually squirrel) and possibly also in many cases with a quill pen. In most manuscripts there is only a two-stage application of colour, although three-stage coloration does occur. Some of the unfinished manuscripts show the first stage, the application of a flat ground colour, sometimes slightly varied in tone according to the placing of highlights or shadows. The next stage was the use of a darker shade to paint in the shadow areas. Highlights in early medieval and Romanesque manuscripts are applied with streaks of white or sometimes gold paint, often in patterned forms. From the second half of the 13th century on, after applying the shadow colour, the illuminator

would apply highlights in a lighter tone than the ground colour so as to create fully modelled effects. Streaks of white continued to be used to enhance the highlights, and these, combined with dots in white paint, are frequently found for foliage ornament. In the 14th and 15th centuries more sophisticated modelling was achieved by a variety of techniques, including stippling. Hatched, painted lines in gold on a flat colour ground are frequently used in 15th-century manuscripts to create modelled forms. As a final stage, it was necessary to re-emphasize some of the figure and drapery outlines as well as more detailed areas in black or brown ink, using a quill or fine brush.

Some manuscripts were not illustrated with full-colour painting and gold illumination, but had outline or tinted drawings. In the latter, ink or coloured drawings were given substance and body by the application of light colour washes to indicate shadow areas and the tints of garment and flesh areas. In some cases the colour was applied as a light overall wash with little interest in modelling. These drawing techniques, although used all over Europe, were particularly popular in English manuscripts from the 10th to the 14th centuries. In France and the Netherlands during the 14th and 15th centuries monochrome tinted drawings developed into grisaille painting, in which tones of grey, black or brown were highlighted with white. Grisaille painting was sometimes combined with areas of full colour (see GRISAILLE, §1(iii)).

M. P. Merrifield: *Original Treatises … on the Arts of Painting*, 2 vols (London, 1849/R New York, 1968)

C. J. Benziger: *Valentin Boltz von Ruffach, Illuminierbuch* (1549) (Munich, 1913/R Munich, 1988)

D. V. Thompson: 'Liber de coloribus illuminatorum sive pictorum', *Speculum*, i (1926), pp. 280–307, 448–50

D. S. Blondheim: 'An Old Portuguese Work on Manuscript Illumination', *Jewish Quarterly Review*, xix (1928–9), pp. 97–135

D. V. Thompson: 'The *De Clarea* of the so-called Anonymous Bernensis', *Technical Studies in the Field of Fine Arts*, i (1932), pp. 9–19, 70–81

D. V. Thompson: 'The Art of Limning', *Technical Studies in the Field of Fine Arts*, ii (1933), pp. 35–7

D. V. Thompson: 'The *ricepte daffare piu colori* of Ambrogio de Ser Pietro da Siena', *Archeion*, xv (1933), pp. 339–47

D. V. Thompson and G. H. Hamilton, eds: *An Anonymous Fourteenth-century Treatise, 'De arte illuminandi': The Technique of Manuscript Illumination* (New Haven, 1933)

D. V. Thompson: 'Medieval Color Making', *Isis*, xxii (1935), pp. 456–68

D. V. Thompson: 'Medieval Parchment Making', *The Library*, xvi (1935), pp. 113–17

D. V. Thompson: 'The Liber Magistri Petri de Sancto Audomaro *De coloribus faciendis*', *Technical Studies in the Field of Fine Arts*, iv (1935), pp. 28–33

D. V. Thompson: 'More Medieval Color Making', *Isis*, xxiv (1935–6), pp. 382–96

D. V. Thompson: *The Materials and Techniques of Medieval Painting* (London, 1936/R New York, 1956)

'Farbe, Farbmittel', *Reallexikon zur deutschen Kunstgeschichte*, eds O. Schmitt (Stuttgart, Metzler and Munich, 1937–)

H. Roosen-Runge: 'Die Buchmalerei-Rezepte des Theophilus', *Münchner Jahrbuch der bildenden Kunst*, iii–iv (1952–3), pp. 159–72

S. Waetzoldt: 'Systematisches Verzeichnis der Farbnamen', *Münchner Jahrbuch der bildenden Kunst*, iii–iv (1952–3), pp. 150–58

H. Roosen-Runge and A. E. A. Werner: 'The Pictorial Techniques of the Lindisfarne Gospels', *Evangeliorum Quattuor Codex Lindisfarniensis*, eds T. D. Kendrick, T. J. Brown and R. L. S. Bruce-Mitford, ii (Lausanne, 1960), pp. 263–77

S. M. Alexander: 'Medieval Recipes Describing the Use of Metals in Manuscripts', *Marsyas*, xii (1964–5), pp. 34–51

S. M. Alexander: 'Base and Noble Metals in Illumination', *Natural History*, lxxiv/10 (1965), pp. 31–9

F. Avril: *La Technique de l'enluminure d'après les textes médiévaux: Essai de bibliographie* (Paris, 1967)

H. Roosen-Runge: *Farbgebung und Technik der frühmittelalterlichen Buchmalerei* (Munich, 1967)

C. R. Dodwell: 'Techniques of Manuscript Painting in Anglo-Saxon Manuscripts', *Settimane di studio del Centro italiano di studi sull'alto medioevo*, xviii (1970), pp. 643–62

L. van Acker, ed.: *Petri de Sancto Audomaro: Librum de coloribus faciendis*, Corpus Christianorum continuatio mediaevalis, xxv (Turnhout, 1972), pp. 145–98

J. L. Ross: 'A Note on the Use of Mosaic Gold', *Studies in Conservation*, xviii (1973), pp. 174–6

F. Brunello, ed.: 'De arte illuminandi' e altri trattati sulla tecnica della miniatura medievale (Vicenza, 1975)

M. Frinta: 'On the Punched Decoration in Medieval Panel Painting and Manuscript Illumination', *Conservation and Pictorial Art*, ed. N. Brommelle and P. Smith (London, 1976), pp. 54–60

U. Schiessl: 'Musivgold', *Maltechnik*, 87 (1981), pp. 219–30

H. Kühn and others: *Farbmittel: Buchmalerei, Tafel- und Leinwandmalerei* (Stuttgart, 1984)

V. Trost: *Skriptorium: Die Buchherstellung im Mittelalter* (Heidelberg, 1986)

J. J. G. Alexander: *Medieval Illuminators and their Methods of Work* (New Haven and London, 1992)

C. de Hamel: *Scribes and Illuminators*, Medieval Craftsmen (London, 1992)

N. Turner: 'The Recipe Collection of Johannes Alcherius and the Painting Materials Used in Manuscript Illumination in France and Northern Italy, *c.* 1380–1420', *Painting Techniques History, Materials and Studio Practice*, eds A. Roy and P. Smith (London, 1998), pp. 45–50

J. Gage: 'Colour Words in the High Middle Ages', *Looking through Paintings: The Study of Painting Techniques and Materials in Support of Art Historical Research*, ed. E. Hermens (London, 1998), pp. 35–48

M. Clarke: 'The Analysis of Medieval European Manuscripts', *Reviews in Conservation*, ii (2001), pp. 3–17

M. Barkeshli: 'Historical and Scientific Analysis on Sizing Materials Used in Iranian Manuscripts and Miniature Paintings', *Book and Paper Group Annual*, xxii (2003), pp. 9–16

Y. Egami: 'Materials for "Gold" and "Silver" Tints in Pictorial Ornamentation of Twelfth-century Japanese Manuscripts', *Scientific Research on the Pictorial Arts of Asia: Proceedings of the Second Forbes Symposium at the Freer Gallery of Art, Washington, DC, 2003*, pp. 10–15

M. Clarke: 'Anglo-Saxon Manuscript Pigments', *Studies in Conservation*, xlix/4 (2004), pp. 231–44

Excavating the Medieval Image: Manuscripts, Artists, Audiences: Essays in Honor of Sandra Hindman, Chicago, IL, 2004

(iv) Conservation. Since most manuscript painting remains within a closed book, it is protected from light and atmospheric pollution and buffered by the bulk of pages from rapid changes in humidity; it thus often retains all its original crispness and brilliance. Once the book is opened, progressive and irreversible deterioration starts to take place because of the effects of light (photochemical changes), which fade organic pigments and blacken vermilion. Other pigments are discoloured by atmospheric gases: traces of hydrogen sulphide can convert lead white and red lead to black lead sulphides; oxygen will tarnish silver, turning the shiny metallic foil to a dull grey or black. Of these only blackened lead white can be treated, by oxidizing it to white lead sulphate. The copper-based pigments, malachite, azurite and verdigris, can also become destructive. They undergo a chemical reaction with the cellulose, causing the paint to turn brown and embrittling the parchment, a process probably exacerbated by damp and dirt. It has also been suggested that the application of a solution of magnesium or calcium salts will inhibit the decomposition process.

The parchment is prone to fungal, rodent and insect damage. This may be treated by fumigation and secure, dry storage. Parchment is very sensitive to fluctuations in humidity, shrinking and buckling in dry air. A desiccated and distorted sheet can be made to relax by treatment in a humidifying tank, and much of its flatness is then recovered by placing it in tension and letting it dry slowly. Caution must be exercised, however, when painting is involved, as this treatment can lead to loss of adhesion between paint and page. A relative humidity of 55–60% at temperatures between 15.5°C and 21°C is considered the optimum for most organic materials. In the absence of air-conditioning, manuscripts can be buffered from the effect of rapid moisture change by wrapping them in textiles and storing them in rooms that contain such hygroscopic materials as carpets and curtains, rather than on bare shelves in cold storage vaults.

Tears and holes in parchment are fairly simply repaired using parchment insets and size made from parchment clippings. Crumbling, flaking and blistering paint is much harder to conserve because the unvarnished pigments are so sensitive: their brightness, opacity, texture, even their colour being affected by changes to the medium. Intervention should be avoided wherever possible, but when absolutely necessary, adhesive is carefully injected along the crack lines to secure flaking paint and a diluted form applied by spray or soft brush to consolidate crumbling areas. The adhesives are usually the same as the paint medium (egg white, gum or parchment size), but where persistent flaking occurs, as on the smoothly polished pages of Byzantine manuscripts, traditional materials are simply not strong enough to correct the trouble. Certain acrylic polymers and adhesives based on cellulose have come close to meeting the strict requirements of manuscript conservators. Since manuscript painting is always

unvarnished, the removal of later paint is virtually impossible. For this reason the practice of touching in losses and damages is no longer considered acceptable.

H. Plenderleith and A. Warner: *The Conservation of Antiquities and Works of Art* (Oxford, 1956/R 1974)

I. Bikova and others: 'Conservation Methods for Miniature Paintings on Parchment: Treatment of the Paint Layer', *Conservation and Restoration of Pictorial Art*, ed. N. Brommelle and P. Smith (London, 1976)

I. Mokretsova: 'Treatment of a Greek 13th Century Manuscript', *Reprints of the International Council of Museums Meeting* (Ottowa, 1981)

M. Huxtable and others: 'Improving and Monitoring the Condition of a Collection of Illuminated Parchment Manuscript Fragments—At Home and in Transit', *11th Triennial Meeting, Edinburgh, Scotland, 1–6 September, 1996: Preprints (ICOM Committee for Conservation)*, pp. 523–32

L. Gyles and I. Maver: 'Conserving Eleven Late Mediaeval Manuscripts for Liverpool University', *Works of Art on Paper: Books, Documents and Photographs: Techniques and Conservation*, eds V. Daniels, A. Donnithorne and P. Smith (London, 2002), pp. 88–91

Marble. See under STONE, §I.

Marbling. *See under* PAPER, DECORATIVE.

Marouflage. Technique of fastening a canvas painting on to a solid support, such as a wall or a wooden or synthetic board. White lead in oil is the traditional adhesive for fastening painted canvas to internal walls as decoration. Reversible synthetic adhesives are used for marouflaging damaged or delicate canvases on to rigid supports as an alternative to lining.

Marquetry. Pattern or design assembled from small, shaped pieces of veneer (see fig. 1). With marquetry the entire surface, including the background, is veneered, whereas with inlay, with which marquetry is historically associated, the pattern pieces are laid into a solid ground (*see* WOOD, §III, 5). The term 'intarsia' derives from 15th-century Italian inlay and is commonly used in continental Europe to describe both techniques.

1. Materials and techniques. 2. History.

1. MATERIALS AND TECHNIQUES. The design is drawn on strong paper and transferred by needle-pricking the outlines to create a copy marked with tiny holes. (The master patterns are often kept, so designs may be repeated over a long period.) Powder, usually a carbon or vegetable black, is then used to dust or pounce the design through these holes on to further pieces of paper, which will be used as guides when cutting the veneer.

The veneers, contrasted by colour and grain, are then prepared. The technique basic to marquetry involves cutting bundles of veneer, interleaved with paper and sandwiched together in layers. These bundles, known as parcels, are protected front and back by waste veneers, one of which carries a piece of paper with the design. In the 17th and 18th centuries the veneers were heavy: it is common to find examples up to 4 mm thick in work of that date (compared to the modern 0.5 mm), so most parcels contained only three veneers. In early marquetry the sawing was often crude, but methods were improved in the early 17th century with the development of the fretsaw frame, originally made from a bow of wood, which held a fine blade suitable for cutting intricate designs. Initially the saw was used vertically, but later a horizontal position was found to admit more light. The 'French horse' or 'cutter's donkey', which holds the saw in guides and so guarantees a 90° saw-cut, was invented *c.* 1780. It enables a skilled craftsman to follow complex patterns with ease, aided by a foot strap or pedal, which controls the vice and leaves his hands free to work the parcel of veneers around the saw as it moves.

The sawing is done from the centre outwards, and each piece of veneer is then lightly stuck on paper, vellum or linen. This assembly is then pinned on to the carcass, which has been previously been covered with a layer of glue, and a large, hot wooden panel is clamped on top of it. The underside of this panel, or caul, is slightly convex, which ensures that no glue is trapped under the veneer when the clamps are tightened. The heat of the panel resoftens the glue, and when it has set again, the caul is removed, the paper peeled off and the marquetry panel polished. In the finest work the ground veneer is laid on the furniture carcass first, and the pattern shapes inlaid into the ground veneer, using the technique most inlayers continue to call intarsia.

Marquetry is generally used to describe curvilinear designs, whereas the term parquetry is applied to the creation of veneered geometric patterns, including rhomboid, herringbone, chessboard and *trompe l'oeil* chequered effects. For the last, each element forms a diamond or parallelogram, its widest angle 120°; parcels of three are sawn in a mitre box, then assembled with the grains directed to form visual 'cubes'. Designs can be framed by decorative cross-banding composed of narrow strips or lines (strings) of box, holly, ebony, metal or ivory, or by check or herringbone patterns; the designs are varied and wide.

The woods used in marquetry include such native European timbers as plane, sycamore, walnut, mulberry, laburnum, hawthorn, holly, box, lime, cedar, olive, fruitwoods, thuja, bog yew and bog oak, as well as a variety of exotic, imported woods. Ebony was among the first tropical woods to be employed, beginning in the early 16th century, but by the 17th and 18th centuries satin-wood, purpleheart (amaranth), king-wood, rose-wood, amboyna, tulip-wood and padauk also became available. The dark brown of bog yew and the black of bog oak are the result of chemical changes occurring naturally during the trees' decades of immersion in peat bogs. Both were frequently used in place of ebony, set off against such pale woods as holly and sycamore. Light-coloured woods were often dyed, possibly by soaking or

fuming. Decorative 'leaves' cut from ivory or bone were sometimes stained green, and to brighten the effect of ivory inlay whiting was mixed with clear fish glue. Scorching the wood in shallow trays of heated sand achieved remarkable effects of animation, light and shade. From $c.$ 1760 the wood pieces were sometimes engraved for finer detail; later, the scored lines were inked to emulate penwork. Another practice was to induce colour changes in the wood of living trees; the application of ferrous oxide to the roots of sycamore trees, for example, produced a silvery-grey wood known as hare-wood.

Marquetries of ebony, brass and tortoiseshell are known as boullework. Prior to roller presses, the brass or pewter sheets were cast and beaten by hand to the thickness required, and the design was sometimes engraved in the metal before sawing. The tortoiseshell was, in fact, the shell of marine turtles, generally Hawksbill and Green turtle: the Hawksbills' thin 'blond' shell with random mottle was considered superior. The shells were flattened and thinned by being boiled in salt-water and placed under pressure, though some thick shells were reduced by laborious hand-scraping. The colour was achieved not by dyeing the shell, but by adding coloured pigments to the animal glue adhesive, which then showed through the semi-translucent shell. The favoured hues were vermilion, umber, yellow or white. These were sometimes mixed with gold and silver powders, though on important furniture the finest gold leaf was often used. A similar practice was applied to horn, which was also translucent. Another method of elaboration was to inlay into brass or pewter grounds fine miniature paintings executed in oil or tempera on good rag-paper. Their surfaces were protected by horn, which allowed the picture to show through and so served the role that hardened plastic sheet plays today. Mother-of-pearl is a hard, brittle substance that cracks easily; nonetheless it sometimes appeared in boullework. The pieces of shell were obtained from the abalone and other molluscs and came in a range of shades. They were cut with the finest piercing or jewellers' saws and were polished and engraved.

Until the 20th century hot and cold animal glues, made from bone, skin and hide, provided the adhesives for marquetry work; there were also fish glues. These organic adhesives are neither water nor heat proof, but they form a flexible bond that allows the wood to move in response to changes in temperature and humidity. Modern adhesives include polyvinyl acetate and a variety of synthetic resins. However, many craftsmen still use animal glues because of their easy reversibility, which enables them to rectify any mistakes.

2. HISTORY. Geometric marquetry veneers were used in the ancient world, for example in Egypt where craftsmen decorated low tables and coffers with coloured woods in herringbone and basketweave designs (e.g. the funerary furnishings from the tomb

1. A French craftsman works on a copy of an 18th-century writing table in the collection of the J. Paul Getty Museum (Los Angeles, CA, J. Paul Getty Museum); photo credit: The J. Paul Getty Museum, Los Angeles

of Tutankhamun, 14th century BC; Cairo, Egyptian Museum). The practice fell into disuse prior to the Middle Ages but re-emerged in Germany and the Low Countries in the early 17th century. From there it spread to France and England, where it reached the peak of sophistication in the 18th century. The resurgence of marquetry decoration was stimulated by improved sawing techniques, particularly in Germany where the first water-driven veneer mills were established by the late 1600s. As Europe became increasingly prosperous, there was a demand for more luxurious furniture. A wide range of tropical woods was imported, and with marquetry the craftsman could utilize small pieces of these to advantage and could incorporate other such valuable materials as ivory and tortoiseshell.

The origins of marquetry lay in Italian intarsia work, which had been used since the 14th century to decorate furniture and architectural woodwork (e.g. the *studiolo* of Federigo da Montefeltro, 1476; Urbino, Palazzo Ducale; see fig. 2). Inlay satisfied the Italian love of surface decoration and was thought to be more durable than painted wood. The designs included plant arabesques, geometric mosaic (known as *certosina*) and ingenious architectural perspectives. Many of the pictorial compositions were closely

2. Marquetry panel (detail) attributed to Giuliano and Benedetto da Maiano, Studiolo of Federigo da Montefeltro in the Palazzo Ducale, Urbino, completed *c.* 1476; photo credit: Scala/Art Resource, NY

linked to advanced ideas in early Renaissance painting, and such artists as Piero della Francesca (*c.* 1415–1492) and Lorenzo Lotto (*c.* 1480–1556) were known to have supplied craftsmen with designs (e.g. the choir-screen and stalls designed by Lorenzo Lotto, 1524–30; Bergamo, S Maria Maggiore). Admired throughout Europe, Italian inlay was copied and eventually surpassed by south German craftsmen during the 16th century. Augsburg was particularly known for this type of work, of which the most outstanding example is the *Wrangelschrank* (1566; Münster, Westfälisches Landesmuseum für Kunst und Kulturgeschichte), with its illusionist pictorial panels.

In England 'markatre' furniture is mentioned in Tudor inventories, and a few rare pieces survive from this period. The best known is the so-called 'Aeglantyne' table (Hardwick Hall, Derbys, NT), made in 1567 for Elizabeth Talbot, Countess of Shrewsbury (1527–1608). The top has an elaborate marquetry design of flowers, musical instruments, playing cards and strapwork surrounding the Talbot–Cavendish coat of arms.

Given the German and Elizabethan examples, it is evident that inlay and marquetry were both practised quite early in northern Europe. In the 17th century, however, marquetry became the dominant form in the hands of Dutch and Flemish cabinetmakers. The

extensive trading links of the Low Countries gave them access to an array of tropical woods, and they soon mastered the new techniques of veneering and marquetry. They introduced oyster-work, small, ringed patterns made up of veneer pieces cross-cut from branches of walnut, laburnum and olive trees, and created vivid floral designs, frequently derived from Dutch flower paintings, on cabinets, chests and table-tops. The finest Dutch floral marquetry was executed between 1660 and 1700 and characterized by designs of bouquets or large blossoms overflowing vases or urns (e.g. the cabinet attributed to Jan van Mekeren (1658–1733), *c.* 1700; Amsterdam, Rijksmuseum).

Intarsia work, Italian in influence, had been practised in France throughout the 16th century, and Flemish-style marquetry soon became fashionable in the 17th century. There was close interchange between France and the Low Countries. Jean Macé (*c.* 1602–72), for example, who is said to have introduced the craft to the French, trained in Middelburg, Zeeland, *c.* 1620, and on his return to France became a specialist in the laying of patterned floors. His *parquet marqueté* commissioned by Anne of Austria (1601–66) for the Palais-Royal was the wonder of Paris, and thereafter the term 'parquetry' was associated with floors and furniture embellished with geometric patterning. A Dutch master craftsman, Pierre Gole (*c.* 1620–84), who worked at the Gobelins from *c.* 1653, was probably responsible for introducing the art of floral marquetry and pewter inlay. A specifically French contribution, however, was boullework, the complex marquetry of brass, pewter and tortoiseshell perfected by André Charles Boulle (1642–1732) (e.g. the commode for Louis XIV's bedroom at the Grand Trianon, 1708–9; Versailles, Château). In boullework the veneers were often used in a reciprocal fashion, either within the same piece of furniture or on two complementary pieces: a tortoiseshell ground inlaid with brass formed the 'first part', a brass ground inlaid with shell the 'counter part'. The technique was particularly suited to designs in the style of Jean Berain I (1640–1711), with whom Boulle had collaborated, and was practised widely in France, Germany and England.

Marquetry was introduced to England by Dutch and French Huguenot craftsmen, who settled there in large numbers in the late 17th century. One of these, Gerrit Jensen (*fl c.* 1680–1715), worked for the royal household from *c.* 1680 to 1715 and became the first London cabinetmaker of note. He specialized in metal inlay, similar to boullework, as well as in arabesque and scrolling 'seaweed' marquetry (e.g. the writing-table attributed to Jensen, *c.* 1690; Windsor Castle, Berks, Royal Collection). Arabesque and 'seaweed' marquetry was especially popular in England, as were Dutch- and Flemish-style floral designs (e.g. the Anglo-Dutch side chair, *c.* 1720; London, Victoria and Albert Museum, W. 40–1953) and geometrically patterned figured veneers (e.g. one of a pair of cabinets veneered in 'oyster' lignum vitae,

c. 1660–69; Windsor Castle, Berks, Royal Collection). Similar figured veneers appeared in American colonial furniture.

The celebrated *ébénistes* at work in France during the 18th century produced some of the finest marquetry in the history of the craft. During that period furniture was still largely ranged against the walls of rooms, so surface interest was of paramount importance. The craftsmen mastered the technique of applying marquetry veneers to curved surfaces, and this practice was further developed with the spread of Rococo styles; gilt-bronze mounts protected the thin edges of veneers as furniture forms became more serpentine. The woods included king-wood, satin-wood, purpleheart, rose-wood and amboyna: by the 1770s a total of over 50 exotic varieties and some 40 native ones were recorded.

At the beginning of the 18th century symmetrically patterned veneers of matched, figured burl or with striped grain were the chief form of marquetry (e.g. the commode attributed to Charles Cressent (1685–1768), 1730–35; London, Wallace Collection); these were set off by cross-banding, achieved by running narrow strips of cross-cut veneer at right angles to the grain of the background veneer. Later three-dimensional geometric patterns came into favour, as well as pictorial scenes with architectural views, hunts, trophies, floral and still-life arrangements. Many *ébénistes*, for example Jean-François Oeben (1721–63) and Jean-Henri Riesener (1734–1806), combined geometric and pictorial marquetry in one piece of furniture (e.g. chest-of-drawers by Riesener, 1776; Waddesdon Manor, Bucks, NT). The designs of the panels, which were intended to emulate painting, were sometimes taken directly from engravings; craftsmen dyed, etched, stained and scorched the wood pieces to enhance the detail and create an illusion of depth. The construction of these scenes was highly specialized work, and busy, or less skilled, craftsmen could buy prefabricated panels from other tradesmen. Towards the end of the century there was a move away from such elaborate marquetry. David Roentgen (1743–1807), in particular, whose marquetry work was Neo-classical yet delicately naturalistic, preferred from *c.* 1780 to use figured veneers and geometric forms.

After 1760 classical ornament was increasingly adopted for marquetry furniture in France, Britain, the Netherlands, Germany, Italy and Scandinavia; eventually it reached Spain, Portugal (e.g. Neo-classical commode, *c.* 1785; Lisbon, Museu Nacional de Arte Antiga) and the USA (e.g. gentleman's secretaire, *c.* 1810–20; New York, Metropolitan Museum of Art, 67.203). In Italy the best-known practitioner was Giuseppe Maggiolini (1738–1814) of Milan. His rectilinear furniture featured marquetry veneers with antique ornaments, quivers of arrows, birds, ribbons and trophies (e.g. commode, 1790; Milan, Castello Sforzesco). Georg Haupt (1741–84) was a German-trained Swede whose work for the Swedish crown displayed the popular royal insignia of a vase-shaped sheaf of corn (e.g. commode, 1779; London, Victoria

and Albert Museum, 1108–1882). In England marquetry was revived in the 1760s by John Cobb (*c.* 1715–78), Pierre Langlois (*fl* 1759–81) and, later, John Linnell (1729–96) and Thomas Chippendale (1718–79). Sophisticated marquetry furniture in light-coloured woods was executed according to designs by Robert Adam (1728–92; e.g. the commode attributed to William Ince (*c.* 1738–1804) and John Mayhew (1736–1811), 1773–4; London, Osterley Park House, NT).

In the early 19th century the French Empire style was influential throughout Europe, reaching as far as Russia. Such Napoleonic motifs as trophies, armour, laurel wreaths and eagles were evident in marquetry 'still-lifes' in all lands subject to Napoleon's campaigns. In England marquetry patterns in early Regency furniture were mostly confined to central fan motifs and border designs of bellflowers. There was, however, a revival of boullework, led by George

Bullock (1778 or 1782/3–1818), which employed a system of repetitive inlay as used by Charles Percier (1764–1838). In this, the ground of stained veneer and the metal ornament, usually of pewter or brass, were stamped together and cut out in a single mechanical process (e.g. mixed metal-and-tortoiseshell marquetry writing-table, *c.* 1815; London, Wallace Collection). Throughout the 19th century there was a fashion in England for Tunbridge ware, a type of fine, wood mosaic decoration that had been used for small articles since the late 17th century and was made principally in the area of Tunbridge Wells, Kent.

Elsewhere, there were spasmodic revivals of marquetry (see fig. 3), for example in the USA, where Peter Glass (1824–95), an English-born, European-trained inlayer, created unique, high-quality marquetry designs (e.g. the sewing-table attributed to Peter Glass, 1865–75; New York,

3. Marquetry armchair, ebony aspen, yellow pine, ivory and mother-of-pearl, 984×679×889 mm, *c.* 1875 (New York, Metropolitan Museum of Art, Purchase, Mrs Paul Moore Gift, by exchange, 1981 (1981.206)); image © The Metropolitan Museum of Art

Metropolitan Museum of Art, 1978.284). In France the tradition persisted in luxury furniture right through to the Art Nouveau period, when floral marquetry was revitalized by Emile Gallé (1846–1904) and Louis Majorelle (1859–1926). Art Deco designers continued to use marquetry in floral bouquets (e.g. armoire by Jacques-Emile Ruhlmann (1879–1933); *c.* 1922; Paris, Musée des Arts Décoratifs) and in geometric designs composed of figured or cross-cut woods.

J. A. Roubo: *L'Art du menuisier ébéniste*, III/iii of *L'Art du menuisier* (Paris, 1774/*R* 1977)

P. Macquoid and R. Edwards: *The Dictionary of English Furniture*, 3 vols (London, 1924–7, rev. 1954/*R* Woodbridge, Suffolk, 1983)

P. Verlet: *Le Mobilier royal français*, 2 vols (Paris, 1945–55; Eng. trans., London, 1963)

H. Hayward, ed.: *World Furniture* (London, 1965)

W. A. Lincoln: *The Art and Practice of Marquetry* (London, 1971)

G. de Bellaigue: *Furniture, Clocks and Gilt Bronzes*, i of *The James A. de Rothschild Collection at Waddesdon Manor* (London and Fribourg, 1974)

P. Ramond: *La Marqueterie* (Dourdan, 1978) Eng. trans. (Newtown, CT, 1989/*R* Los Angeles, 2002)

A. Duncan: *Art Deco Furniture: The French Designers* (London, 1984)

F. Collard: *Regency Furniture* (Woodbridge, Suffolk, 1985)

M. A. V. Gill: *Tunbridge Ware* (Aylesbury, Bucks, 1985)

H. Flade: *Intarsia: Europäische Einlegekunst aus sechs Jahrhunderten* (Munich and Dresden, 1986)

D. Hawkins: *The Techniques of Wood Surface Decoration* (London, 1986)

D. DuBon and T. Dell: *Furniture: Italian & French*, v of *The Frick Collection: An Illustrated Catalogue*, ed. J. Foscarino (New York, 1992)

T. Dell: *Furniture and Gilt Bronzes: French*, vi of *The Frick Collection: An Illustrated Catalogue*, ed. J. Foscarino (New York, 1992)

F. Germond: *L'Ebéniste restaurateur* ([Paris, 1992])

G. Beretti: *Giuseppe e Carlo Francesco Maggiolini: L'Officina del Neoclassicismo* (Milan, 1994)

L. Robinson: *The Art of Inlay: Contemporary Design & Technique for Musical Instruments, Fine Woodworking & Objéts d'art* (San Francisco, 1994)

J. Bloom: *The Minbar from the Kutubiyya Mosque* (New York, 1999)

O. Raggio: *The Gubbio Studiolo and its Conservation*, 2 vols (New York, 1999)

P. Ramond: *Masterpieces of Marquetry*, 3 vols (Los Angeles, 2000)

Masonry. Assemblage of stones, bricks or sun-dried mud (adobe), fitted together for construction, with or without mortar.

1. INTRODUCTION. Masonry can be either quarried and artificially shaped (dressed and ashlar; *see* §2 below), or natural (dry-stone and flint walling). Dry-stone walling is an ancient masonry technique, using well-chosen frost-shattered or splintered rocks carefully interlocked. The resulting structures are most frequently used for field walls and crude huts. South Italian trulli, with their beehive domes, are remarkable survivors of this continuous tradition. The dry-stone walling of Great Zimbabwe, however, shows that it could also be used in ceremonial buildings.

The ancient Egyptians first exploited cut stone, using primitive tools to extract and shape rectangular blocks and harder granites to grind and polish smooth surfaces and perfect joints. Their extraordinary skill permitted substantial masonry structures to be erected without any form of bonding or mortar. Aswan granite was quarried using wedges, heat and rapid cooling, whereby the Egyptians created substantial monolithic blocks, such as the obelisk (h. 30 m) now in the Piazza di S Giovanni in Laterano, Rome.

Ancient Greek and Roman masonry shows variants upon Egyptian, including use of rustication (*see* §2 below), concrete and brickwork, the commonest Roman form. The Romans often combined masonry, concrete and brick in complex ways, as in the Pantheon (*c.* AD 120) and the Tomb of Caecilia Metella (late 1st century BC; see fig. 1), both Rome. Ancient Greek and Roman masonry depended on the quality of the stone and the methods of extraction. Medieval European architecture often lacked one or the other, and commonly both, hence the predominance of rubble (*see* §2 below), which consisted of virtually anything to hand. The Byzantine and Islamic civilizations were the true inheritors of the Classical tradition, and Islam reintroduced such Roman refinements as the hardened chisel and the drill into 11th-century Europe. Gothic architecture was heavily dependent upon good masonry technology, although some areas, notably England, persevered with older rubble-based techniques. By the early Renaissance most ancient Roman masonry techniques, with the important exception of concrete, had been re-learnt, and masonry became the mainstay of European architecture until the advent of cast-iron and steel beams in the 18th and 19th centuries. Modern steel construction has reduced masonry to mere cladding, with brick or stone infilling.

Islamic civilizations used many masonry techniques including ashlar, brick and rubble. The buildings of the Ottoman Turks exhibit outstanding cutting and finish. The 16th-century Selimiye Cami at Edirne is one of the greatest structural achievements of world architecture. In Islamic Iran brick was favoured, but in India the climate made sandstone a suitable, desirable and durable building material. Marble cutting achieved a remarkable level of sophistication, with the intricate undercutting in the 11th- and 12th-century temples at Mt Abu approaching the level of filigree. The Taj Mahal at Agra is perhaps the finest example of marble cutting in the world.

Masonry became important to the ceremonial architecture of Mesoamerica from about the 6th century BC, but, although cutting techniques were refined, the post-and-lintel construction precluded much development. The Pueblo Indians of Chaco Canyon, NM, had constructed elaborate masonry buildings by the mid-11th century AD.

1. Masonry construction depicted in Giovanni Battista Piranesi: *An Analysis of the Structure of the Mausoleum of Caecilia Metella*, etching, pl. 49 from *Le Antichità Romane* (1756, vol. III, 1st edition) (New York, Metropolitan Museum of Art, Rogers Fund, transferred from the Library (41.71.1.3.(49)); image © The Metropolitan Museum of Art

Traditional Chinese, Japanese and Korean architecture was almost entirely timber-based, stone being reserved for foundations and platforms. The most significant role for masonry was in fortification and subterranean tombs. The Great Wall of China is the largest masonry structure in the world.

See also STONE, §II.

2. TYPES. There follows an alphabetical listing with descriptions of masonry types.

Ashlar. Fine-jointed, regularly shaped stone blocks, with a smooth, dressed exposed face (see fig. 2). The term generally applies to tight-fitting oblong blocks laid in horizontal courses. Ashlar was introduced (*c.* 2620 BC) by the ancient Egyptians in the step pyramid of Djoser at Saqqara and employed universally thereafter for public or high-quality architecture. English Portland stone is considered one of the finest materials for ashlar. Ashlar is often used as a veneer concealing another material, such as rubble or brick.

Cloisonné. Rectangular stone blocks set within 'frames' of another material, usually brick, for colour contrast. Cloisonné was especially popular in Byzantine architecture (e.g. the church of the Theotokos, Hosios Loukas, Phokis, 946–55, and Hagioi Theodoroi, Athens, mid-11th century).

Cyclopean [polygonal]. Method of using large irregular blocks, seen in several structures of the Greek Late Bronze Age, *c.* 1300–1200 BC. The rocks were smoothed and finished, then interlocked skilfully to accommodate their polygonal shapes. The walls of Mycenae, Greece (*c.* 1250 BC), preserve the best examples. The Etruscans built cyclopean walls from the 6th century BC, and the Romans continued the tradition down to the last centuries BC (e.g. Aletrium [now Alatri], 3rd century BC; Praeneste [now Palestrina], Temple of Fortuna Primigenia, *c.* 80 BC).

Dressed. Term for any stone block with a finished or smoothly worked surface. Normally made for use in ashlar walling, dressed stone may also be used for quoins or long and short work (see below).

Dry-stone. Use of stone blocks or slabs without mortar or cement bonding. Dry masonry may be either ashlar, cyclopean or rubble. The ancient Egyptians were able to lay their ashlar dry, each block resting directly upon the next with exceptionally fine joints. The Greeks also employed dry-stone techniques, although the Romans, with their liking for brick and concrete, favoured mortar and cement. Few later architectural periods had sufficiently good stone-cutting technology to permit dry ashlar walling, although the rusticated façades of the Westgate (1380) of Canterbury, England, were constructed entirely without mortar.

2. Ashlar masonry walls of a temple in Baalbek, Lebanon; photo credit: Adoc-photos/Art Resource, NY

Dry-stone rubble walling, either for boundary walls or for structures, is an ancient tradition still found in much of Europe. The Aran islands off Co. Galway, Ireland, have many miles of dry-stone walling, while in areas of England such as Derbyshire and the Cotswolds dry-stone walls and buildings abound. Other notable areas for dry-rubble masonry are southern Africa, for example Great Zimbabwe (11th–15th centuries), and, in modern times, south Italy and the Canary Islands (Spain). Dry-stone walling is not dressed but cut into slabs that are laid in irregular courses. In buildings, dry-stone walls are thickly plastered inside.

Flushwork. Technique in which knapped flint is contrasted with ashlar to make patterns in the masonry, as at, for example, the gatehouse (*c.* 1320–25) of Butley Priory, Suffolk. The split side of the flint is set flush with the surface.

Galleting. Technique whereby sherds or fragments of a material are inserted into the mortar to fill gaps left by rubble or irregular masonry blocks. It is most common in flint buildings of eastern and southern England, where walls abound with sharp black splinters, and is also found in areas where volcanic debris is employed, such as the Canary Islands.

Herringbone. Pattern of brick or stone courses laid obliquely in alternating rows, creating interlocking zigzags, each pair of rows resembling the backbone of a fish. Occasionally, a horizontal course is inserted between layers, creating a 'spine'. It is very common in Anglo-Saxon buildings, using either re-used Roman brick or slabs of ragstone. Roman rubble cores sometimes approximate herringbone patterns

(e.g. Richborough Castle, Kent; 280s). Anglo-Saxon examples were often plastered over, suggesting that the intent was structural rather than decorative. Perhaps the most extensive use is the west tower of St Margaret, Marton (Lincs), probably built in the 11th century. English herringbone continued after the Norman Conquest of 1066: in brick in the south transept of St Albans Abbey (now Cathedral), and in the rubble repairs to Pevensey Castle (E. Sussex), both 1070–80.

Decorative herringbone reappeared in late medieval English domestic building, employed in the brick nogging infill of timber-framing, as at Ockwells Manor (1450s), Bray (Berks): it is most commonly found in thin brick fire-backs of early chimney-stacks. Decorative brick herringbone was briefly popular in late Byzantine architecture: Hagia Theodora, Arta (Greece), and the south church of Fenarı Isa Cami (church of Constantine Lips), Istanbul (Turkey), both late 13th century.

Long and short. Arrangement of stone blocks that is both structural and decorative, in which individual dressed stones alternate vertically, one lengthwise, the next on end etc. The origin may be Roman, as Ostia exhibits many examples of vertical strips of tufa jigsawed into regular brick masonry. The method is particularly associated with Anglo-Saxon architecture in England, where it is employed for angle quoins, or as stripwork within a wall. The advantage of long and short angles within a rubble structure comes from the greater strength and longevity of cut-stone masonry corners, plus the deep bedding of the rectangular short blocks into the wall, which gives extra support to the rubble structure at every second block. Long and short work often appears as

stripwork decoration within a façade, where it is both decorative and stiffens the fabric. Long and short work seems to have been well established by *c.* 1000: the tower of All Saints, Earls Barton (Northants), is the most famous example.

Although it occurs seldom in continental Europe, one example exists on the west façade of S Simpliciano, Milan (Italy), where a stone narthex (probably 12th century) employing long and short technology has been embedded into the Late Antique brickwork.

Opus Africanum. Type of masonry used in Roman North Africa, in which a framework of dressed stone is infilled with panels of mud brick or rubble.

Opus incertum. Small, irregular blocks inserted into thick mortar to create a crude masonry surface to a rubble or concrete wall. It appears in Roman Republican architecture, certainly by the 3rd or 2nd century BC at Ostia, and perhaps earlier.

Opus mixtum. See OPUS TESTACEUM below.

Opus reticulatum. Roman decorative device using small, square slabs of stone embedded into a regular, tightly knit diamond pattern, used by 55 BC in the Theatre of Pompey, Rome. The Torhalle of Lorsch Abbey (*c.* AD 800) has multi-coloured *opus reticulatum* on its upper façade.

Opus testaceum. Concrete faced with regular courses of brick, used in the Roman period, as in the Theatre of Marcellus, Rome (13 BC). When panels of *opus reticulatum* are combined with vertical strips of *opus testaceum* the technique is known as *opus mixtum.*

Polygonal. See CYCLOPEAN above.

Rubble. The most common masonry technique, incorporating any material found or recovered, such as dressed blocks, broken fragments, brick or flint. The success of rubble depends on the thickness of the wall and the strength of the binding mortar. If either is too thin, the structure will fail. As it is almost impossible to construct a thin rubble wall, owing to the irregularity of the material and the size of the gaps to be filled by the mortar, in areas or building traditions lacking dressed stone and ashlar technology, rubble walls are likely to be very thick, with all the consequent architectural disadvantages.

Rubble was, however, the key to the Roman use of concrete, which was a contained rubble core drenched in a lime mortar mix. Builders in later architectural periods, such as the Romanesque, having no practical knowledge of Roman concrete, enclosed massive rubble walling within two skins of dressed ashlar. English Romanesque and Gothic buildings are notorious for their employment of heavy rubble walling. Rubble has been generally avoided in sophisticated architecture since the 13th century, and modern concrete is made from a different mix. Rubble has,

however, survived as the mainstay of simple vernacular masonry building worldwide.

Rustication. Ancient decorative treatment of ashlar, where the exposed surface is deliberately roughened to suggest the original strength of the natural rock. The rugged texture contrasts strongly with the fine-jointing of the coursing. The Greeks first exploited rustication, commonly on fortified walls or platforms, for example the temple complex at Pergamon (Turkey), since when it has been associated with expressions of power. Although a rusticated wall may be more difficult to scale, the defensive effectiveness is not great. Appearance is all. Almost every Classically based style in architectural history has employed rustication for effect, usually for the basement or lower storeys of important public buildings, for example the Porta Rosa (4th century BC) at Velia and the Palazzo Medici–Riccardi (begun 1444) in Florence, both in Italy, and the 17th-century palace of Versailles, France. Completely rusticated façades are less common but usually express some aggressive intent: the 13th-century walls of Aigues-Mortes, France, the Palazzo Vecchio (begun 1298) in Florence, Newgate Prison (1770–78; destr. 1902) in London and the Marshall Field Wholesale Store (1885–7; destr.) in Chicago, USA. Rustication became almost obligatory in all 18th- and 19th-century public buildings in Europe and the USA. Other forms include smooth blocks raised above wide 'cement' bonding lines, as with the Radcliffe Camera (finished 1749), Oxford, England; individual blocks with sharply bevelled angles; and another form that enjoyed a brief popularity, Diamond Point, which has smooth-sided pyramids projecting from each show-face, as at the 17th-century Czernin Palace (Prague, Czech Republic).

Spolia [Lat.: 'spoils']. Masonry derived from a previous building; a term commonly applied to the re-use of Greek or Roman fragments. The respond bases within the aisles of S Lorenzo Maggiore, Milan (Italy), are up-turned Corinthian capitals. The chancel arch of Escomb Church (7th–9th century), in County Durham, England, is apparently a 4th-century arch dismantled and removed from a Roman fort. Classical and earlier spolia occasionally appear in the foundations of later buildings: the New Kingdom statues (*c.* 1539–*c.* 1075 BC) excavated from beneath the forecourt of the Greco-Roman Temple of Horus at Edfu, and the apse foundation of Notre-Dame-de-Nazareth, the 12th-century former cathedral of Vaison-la-Romaine (Provence), packed with fluted column sections and other Roman fragments.

Vermiculated [Lat. vermiculus: 'little worm']. Variety of rustication, where the exposed surface is carved into intricate, worm-like patterns, sometimes in high relief, which may occupy the entire block or be framed within a plain border. Popular in some Renaissance architecture, for example the house (1538–44) in Mantua, Italy of Giulio Romano (?1499–1546), it was especially liked in England: the

18th-century doorcases of Bedford Square (built 1775–80) and the New Government Offices (1898–c. 1912), both in London.

W. C. Huntington and R. E. Mickadeit: *Building Construction* (New York, 1929, 4/1975)

A. Behringer and F. Rek: *Das Mauerbuch* (Ravensburg, 1953)

F. Rainsford-Hannay: *Dry Stone Walling* (London, 1957/R 1976)

A. Clifton Taylor: *The Pattern of English Building* (Frome, 1962, rev. 4/1987)

J. Bowyer: *A History of Building* (London, 1973)

J. S. Ackerman: 'The Tuscan/Rustic Order: A Study in the Metaphorical Language of Architecture', *Journal of the Society of Architectural Historians*, xlii (1983), pp. 15–34

L. G. Redstone: *Masonry in Architecture* (New York, 1984)

M. London: *Masonry* (Washington, DC, 1988)

A. Shadmon: *Stone: An Introduction* (London, 1989)

U. Meisel: 'Restaurierung historischer Fassaden als Planungsaufgabe', *Deutsches Architektenblatt*, xxx/6 (1 June 1998), pp. 812, 815–16

M. Hislop: *Medieval Masons* (Princes Risborough, 2000)

'Masonry', *Detail* [entire issue], vi (Nov–Dec 2005)

Master printers. Term used to describe a variety of professional people collaborating with artists in the creation of prints and paperworks. Although study and training programmes that led to the designation of 'master printer' existed in the late 20th century, the title was more generally used with reference to printers who achieved a level of critical success and respect based on their collaborations, regardless of their backgrounds. At this time many of the best-known collaborators resisted the label owing to its outdated historical reference to the separation of roles of artist and printer. Other printers felt that their roles as directors of presses, which incorporated a range of responsibilities far beyond the actual collaborative process, did not adequately describe their function. While the term 'master printer' has continued to be used as a title of respect, it is unlikely that universal consensus on its definition will ever be reached. The phenomenon of the master printer is almost exclusively Western.

Mastic. Natural resin widely used as a varnish for paintings, as well as an additive to oil paint or a medium in its own right (*see* RESIN, §1). It has been obtained from the bark of a Mediterranean tree of the genus *Pistacia* since at least the 9th century. For use as varnish, it is dissolved in turpentine or linseed oil but suffers from both the defects of increased yellowness with age and a tendency to BLOOM. It has now been superseded by dammar or synthetic resin varnishes.

Mattoir [macehead]. Printmaking tool with a rounded spiked head, used particularly for STIPPLE engraving.

Medium. Term used to refer to the actual physical material chosen as a vehicle of expression for any work of art. In painting it is used more specifically for the liquid in which the PIGMENT is suspended. By diluting the vehicle (the liquid binding agent in which the pigment particles are dispersed), the paint is made thinner and easier to apply.

Megilp [magilp]. Oil painting medium composed of mastic resin dissolved in turpentine and linseed oil to give a gelatinous consistency. It was used in the 18th and 19th centuries to produce an enamel-like finish, but it becomes brittle and yellow with age and is vulnerable to some cleaning solvents.

Metal. Metals can be defined by their properties: they are malleable, so can be shaped by hammering and bending; tough and fairly elastic, so can sustain considerable stress without breaking; and dense and highly reflective, so capable of taking a good polish. They are also good conductors of heat and electricity. With the exception of iron, most common metals have relatively low melting-points (below 1100°C), so they can be easily melted, and on cooling they retain their molten shape. They can, therefore, be shaped by casting. They are also highly reactive, so although abundant in the earth's crust, they are usually found in combination with other elements.

Many of the distinctive traits of metals, including reactivity, stem from their atomic structures. In any element the electrons move around the atomic nucleus in fixed orbitals or shells, which contain only a certain number of electrons before becoming filled, thus causing the next orbital to be commenced. Metallic elements have just one or two electrons in otherwise unfilled orbitals, and, therefore, these orbitals readily react with other elements, especially those that have an almost filled electron shell. A classic example is sodium chloride: the metal sodium has one spare electron, and it reacts with the non-metal chlorine, which needs just one electron to complete an electron shell. The spare electrons tend to be shared loosely between all the atoms, and they account particularly for the conductivity of metals.

Apart from gold and copper, all metals are called white because of their reflective properties, although zinc is claimed to have a blue tinge. By contrast, metallic salts are often brilliantly coloured, and beautiful effects have been produced through the ages by chemically treating the surfaces of metals (*see* §V, 5 below). Owing to their strength, metals are ideally suited for tools, weapons and machinery; they have also been used throughout history for all kinds of decorative, liturgical and utilitarian objects.

I. Types and properties. II. Extraction and production. III. Shaping. IV. Joining. V. Decorative techniques. VI. Conservation.

I. Types and properties.

1. SINGLE METALS. Like most solids, metals are basically crystalline. When a molten metal sets, the atoms begin to crystallize in regular arrays from the edges and from solid points throughout the melt. These crystals continue to grow until they meet other

growing crystals. Thus any solid metal will consist of these interlocked crystals, known as grains. Their size is determined by the rate of cooling and by the distribution of solid particles in the melt, which act as nuclei for the developing grains and are usually fragments of foreign matter, for example bits of fuel, slag and furnace wall. Small-grained castings tend to be tougher, and thus metalworkers sometimes seed the metal with fine sand to facilitate grain formation. Sometimes the grains are large enough to be visible with the naked eye: the grains of zinc on galvanized items are a familiar example.

Although the chains of atoms in any grain can sustain considerable deformation, at the grain boundaries there is far less cohesion, and these are the points of potential chemical and physical weakness. Corrosion tends to penetrate into the metal along these boundaries, and when metal is worked or bent, cracks tend to develop in these areas. In the 20th century extensive research has gone into this and other areas of potential weakness in basic structure. This, together with new alloys, has resulted in much stronger metals; consequently less metal is now needed in all manner of objects from bridges to typewriters, an important factor behind the light, 'modern' designs of the 20th century.

During working, metals can sustain only a limited amount of deformation before they begin to crack. To overcome this, the metal must be periodically raised to a dull red heat during working in order that the softened grains may rearrange themselves and release the strain that has been generated. This is known as annealing. Under magnification, pairs of parallel lines in the grains indicate that the metal has been extensively worked and annealed. Only pure gold can be worked indefinitely without annealing.

2. ALLOYS. Any mixture of two or more metals is known as an alloy. Some metals, such as gold and silver, dissolve in each other in any proportion to form what are known as solid solutions, but most metals are only partially soluble in each other. Thus, in a typical brass the 30% of zinc will be dissolved in the copper, but if the alloy contained much more zinc, the excess would solidify as a separate phase surrounded by the saturated solid solution. Some metals are virtually insoluble in each other: lead will not dissolve in copper or in its alloys but remains as separate globules of almost pure lead within the copper. In other instances, metals can react together to produce an intermetallic compound with a precise structure and composition. These compounds lose many metallic properties and can be hard and brittle: cast iron is perhaps the most familiar example of a metal made brittle by intermetallics, in this case cementite (Fe_3C), and speculum bronze mirrors contain tin–copper intermetallic compounds and are very fragile.

The properties of alloys are usually intermediate between their constituent metals, thus the colour of gold–silver alloys depends on the relative amounts of gold and silver. There are, however, important exceptions that were discovered and utilized early in the history of metallurgy. The melting-point, in particular, is often depressed so alloys usually melt over a wide temperature range. In casting this allows more time for the metal to fill all extremities of a mould; and with a solder the longer cooling time allows the semi-solidified 'mushy' metal to be worked into the joint (*see* §III below). Alloys are also usually harder and stronger than their constituents; thus BRONZE, a mixture of copper and tin (sometimes known as speculum or bell metal if the tin content is over 20%), is much stronger than either tin or copper. Another common alloy is BRASS, a mixture of copper and zinc. PEWTER was traditionally an alloy of tin with a little lead (and/or other metals, such as copper and antimony), although, due to the enormous difference in price between the two metals, the proportion of lead was often much higher. Modern pewter contains no lead and is an alloy of tin and antimony. SILVER is a rather soft metal, so it is usually alloyed with copper. Sterling silver contains 7.5% copper, and the rather uncommon Britannia standard contains 4.2%. There are many artificial silvers, most based on alloys of brass with about 20% nickel. This is the basis of the traditional Chinese *baitong* alloy and of more recent alloys such as German silver. Steel is an alloy of iron with usually up to about 1% carbon, and more rarely up to 2%. Cast iron contains between 2% and 5% carbon plus a little silicon.

II. *Extraction and production.*

1. NATIVE METALS. Only a few unreactive metals, notably GOLD and the platinum group, regularly occur in their metallic state. A small amount of native COPPER is found in the upper, oxidized levels of many copper deposits and as such was almost certainly the first metal used by man, but it was of little significance after the beginning of the Bronze Age, except in North America, where enormous quantities occur. Meteoric iron (*see* IRON AND STEEL), distinguished by its high nickel content, was also used on a small scale. Terrestrial native iron, known as telluric iron, is very rare but was used, together with meteoric iron, by the Inuit of Greenland. Until the medieval period most gold was obtained from river gravel (placer deposits), brought down from eroding primary deposits. The gold was separated from the waste material (gangue) by agitation in the water, the greater density of the gold making it sink while the lighter gangue was carried off.

2. SMELTED METALS. As most metals are highly reactive, they occur as chemical compounds, notably as oxides or sulphides. They are extracted from these compounds, or ores, by reduction with carbon, traditionally in the form of charcoal, but now usually coke. The furnaces and the principles of smelting changed little over the millennia from the Bronze Age to the Industrial Revolution. The ores were usually roasted or calcined in the presence of air to

dehydrate them and make them more friable and especially to convert the sulphides (more rarely chlorides) into oxides. The smelting furnace was a bowl or a shaft, usually built of clay and sometimes incorporating brick or stone. The furnaces were all small, about 1 m tall with an internal diameter of between 250 and 500 mm. Air was supplied from manually operated bellows through clay tubes (tuyères) near the base of the furnace wall. (The factor that limited the size of the furnace was the amount of air that could be supplied by blowpipe or manually operated bellows.) A small fire was lit in the base of the furnace. Fed with charcoal and supplied with air, it would rapidly reach a temperature of over 1000°C. Then the calcined ore, together with more fuel, was added and the reduction commenced. In the limited air supply, the charcoal burned to produce carbon monoxide, which in turn reduced the metal oxides to metal.

It was then necessary to separate the gangue from the forming metal. Most of the gangue would be either silica (e.g. quartz or sand) or iron minerals, which would react together in the furnace to produce various iron silicates. Melting at about 1200°C, the silicates formed molten slag that could be run out of the furnace. Thus, if the gangue were rich in silica, iron minerals would be added; conversely, if rich in iron then silica would redress the balance. These additions are known as the flux. With high temperatures and the addition of the appropriate flux, all the gangue would be liquefied to form the slag. Periodically the slag would be tapped, allowing the process to continue until a considerable body of metal had built up. The droplets of molten metal drained to the base of the furnace. The metal could also be tapped from the furnace, but it was usually allowed to cool, forming an ingot, and then removed solid from the base of the dismantled furnace. This process was used for all metals except iron, which was usually produced in the solid state in antiquity, and mercury and zinc (see BRASS, §II, 1), which were volatile and had to be condensed from a vapour.

In more advanced processes the cycle of roasting and smelting was repeated several times (matte smelting). The resulting metal was highly impure, containing sulphides and oxides, usually of iron. These were removed by melting the raw metal in an open crucible, burning out the sulphur and other substances and skimming impurities from the surface. Finally green twigs (or latterly whole trees) were plunged into the molten metal to generate gases that reduced any residual oxides. This operation, known as poling, continues to be performed, especially in small foundries where alloys are made up.

As production became industrialized, so manually operated bellows were replaced, first, in the medieval period, by water power and then by other sources. From the 17th century coke began to replace charcoal as fuel. It was cheaper and is also much stronger, thus able to support a greater weight of fuel and ore in the furnace. This enables the furnace gases to circulate freely in the combustion zone at the base of the furnace. With the two constraints of air supply and fuel strength removed, furnaces grew rapidly to their present enormous size: modern blast furnaces are capable of producing over 10,000 tonnes of metal per day.

3. ELECTROLYSIS. Many metals are produced from their fused salts by the process of electrolysis from an aqueous solution. The salts are composed of negatively charged anions (such as oxide, chloride or sulphide) and positively charged metal ions, known as cations. When an electrical current is applied, the anions are attracted to the positive electrode (anode), and the cations go to the negative electrode (cathode), where they are deposited as metal. Some metals, such as magnesium and ALUMINIUM, are produced solely by electrolysis. For others, such as ZINC, electrolysis is only one of the methods employed. Electrolysis is also used to produce high-purity metals and is the usual method of refining such metals as copper.

III. Shaping.

1. Casting. 2. Wrought work.

1. CASTING. Perhaps the most direct method of fabrication is to pour the molten metal into a mould of the required shape. The materials of the mould must be capable of withstanding the molten metal without melting or disintegrating. Traditionally the most popular materials have been clay and sand, though others, such as stone and metal itself, have been successfully used. In antiquity most clay moulds were not especially heat-resistant, except in China, where the abundant loess clays were used (see BRONZE, §II, 3). Now special heat-resistant ceramics, known as refractories, are made of selected clays to which minerals and sometimes charcoal or graphite are added; true refractories were first made in post-medieval Europe.

(i) Open moulding. The shape to be cast is carved in the flat surface of a suitable material, for example stone, and the metal then poured in. This simple method was used in the earliest stages of metallurgy all over the world and continues to be employed for such uncomplicated shapes as ingots. One surface, however, will be flat, thus severely limiting the range of shapes that can be cast. There is also the danger of oxidization and gas porosity from the exposed surface (see §(vii) below), even if a lid is added.

(ii) Two-piece moulding. A better method of casting relatively simple forms is to make a two-piece mould and to shape it by carving or by pressing a pattern into the wet clay. The two close-fitting halves are then tightly bound together and the metal poured in from the top. In any but the most simple shape, it will be necessary to have small channels, known as risers, through the mould to allow the air displaced by the metal to escape. The metal is poured into the mould

through a cup (sprue) at the top. This is kept topped up with metal and acts as a reservoir (or header), which is cut off from the casting afterwards. As the metal cools in the mould, it shrinks, and without replacement from the header cavities will appear in the top of the casting. Solid impurities also tend to float up into the header. The mould can be reused, depending only on the durability of the refractory.

(iii) Piece moulding. For objects of greater complexity, with undercuts and projections that would preclude the use of a simple two-piece mould, a piece mould of many sections can be used. In China this method was employed with great success to cast ritual bronze vessels from the 2nd millennium BC. No matter how closely the sections are held together during casting, some metal will penetrate the joints, and these thin fins or 'flashes' of metal are indicative of piece-moulding.

A hollow casting can be made by suspending a core of refractory material in the mould. If the core is to be completely surrounded by metal it must be held in place, without touching the sides, by metal pins (chaplets) set into the mould. After the casting has been made and the mould broken away, the ends of the chaplets sticking out of the casting are cut off and filed down flush with the surface.

(iv) Direct lost-wax casting. Lost-wax casting (*cire perdue*, also known as investment or precision casting) is used where very accurate reproduction of detail is required. The process was developed in the ancient Near East in the 4th millennium BC: initially it was used only for small objects, but by the 6th century BC it was employed in Greece for large-scale statuary. The shape to be cast is modelled in a material with a low melting-point, such as wax (see fig. 1a), and the sprue and risers are added in wax. In the 'direct' process the model is dipped in a fine clay slip, the consistency of batter mixture, and allowed to dry. This is repeated until a good coating has built up, and then a stronger, but coarser clay (the investment) is fitted around it for strength (1b). The mould is then heated, which bakes the investment and melts the wax, causing it to run out and leave the mould empty (1c) and ready to receive the metal (1d). The mould is often rotated during casting, and the centrifugal force pushes the molten metal into the details of the mould. When the metal is set the mould is broken away to reveal the casting (1e).

(v) Indirect lost-wax casting. In the direct process the wax model is inevitably destroyed. In reality, however, the wax original is rarely used (hence the survival of many wax models) because the 'indirect' process is used instead. In this process a cast is taken of the original, and from this a piece mould is made. Any number of wax models can then be cast, and the original preserved in case the casting should be spoilt.

A better understanding of the indirect process can be obtained by following the various stages in the

1. Direct lost-wax casting sequence: (a) form is modelled in wax; (b) wax model is covered in clay; (c) clay is baked and wax runs out; (d) clay mould is inverted and hot metal poured in; (e) clay is broken off

production of a life-size statue (for variations and alternatives at each stage see Cellini, 1888 trans.; Mills and Gillespie, 1969; and Choate, 1966). First the statue is modelled in wax or clay. If the piece is to be cast in sections, rather than whole, the model is then cut up into pieces of a size suitable for casting (e.g. head, limbs and torso). Casts are taken of the model or the pieces and cut away in sections so the original can be removed. Traditionally plaster was used for casts, but gelatin and latterly rubber have virtually replaced it. These elastic materials can be easily peeled from the model but then resume the shape of the impression; they are usually backed by a hard case, or mother mould, often made of plaster or resin.

The next stage is to make the core by lining the inside of the mould to the required thickness of the metal with strips of wax or a similar material (Benvenuto Cellini (1500–71) recommended pasta). Clay is then poured in and allowed to set, forming the core. The core is removed, fitted with chaplets and replaced in the mould. Wax is run into the space, giving a wax positive around the core. Sprues and risers of wax are added and the whole invested in clay as described for the direct lost-wax process. After the metal casting has been removed from the mould, the chaplets and sprues are cut off and any defects rectified. The statue is then assembled

(if not already whole) and the components welded or soldered together. Finally, cold working with a scraper and chisel adds or sharpens the detail.

For large castings, for example bells, the mould is set in a pit. This makes the pouring of considerable quantities of molten metal much safer, and enables the mould to be supported firmly but evenly by the surrounding soil. Casting pits have survived from antiquity and have been excavated in a number of places, including Olympia and the Athenian Agora. They are usually full of casting debris, including mould fragments, and thus reveal much information on early foundry practice.

(vi) Sand casting. In this process an impression of the original (usually of wood or metal) is taken with a suitable sand–clay mixture in two halves, each contained in a rigid metal frame known as the flask. Air channels and the channel for the sprue are added in the sand. The original is removed and the two halves of the flask brought together to complete the mould. This is a convenient method of producing multiple castings, widely used in industry, but it is not suitable for complex shapes, especially if there are undercuts or fine detail. The method is of uncertain antiquity. Some authors claim it was used in the Classical period, but the earliest certain usage seems to be medieval.

Al-Jazari, writing in northern Mesopotamia in 1206, describes the technique of casting with green sand in connection with the production of lattice work. A particular kind of sand was used for making closed (or open) mould boxes which, unlike the more common clay boxes, contained no surplus moisture and therefore required no heating or drying before the molten metal was poured in. The origin of the technique is somewhat obscure, but it probably came from China, since it is mentioned in Chinese sources slightly earlier than al-Jazari.

(vii) Casting problems. The production of a major casting is a difficult technical operation and is rarely achieved without blemishes. Minor cracks and holes in the mould fill with metal, which then stands proud on the casting. On flat or exposed surfaces these protuberances can be easily filed or chiselled off. When the damage runs over inaccessible areas or complex decoration it can be more difficult to remove. These blemishes, however, provide useful clues as to how the piece was made. If the casting fault runs through a decorated area, the detail must have been part of the mould. Conversely, if a detail runs over and obliterates a casting fault that is otherwise untouched, it suggests that the detail was worked on the metal after casting.

Minor faults can be corrected by judicious working with a scraper and chisel, but more major damage or missing areas can only be repaired by a 'burn in' or by 'casting on'. The damaged area is cut out and replaced by wax. It is then re-cast following the lost-wax procedure. A good repair will fuse or weld perfectly with the rest of the casting. Alternatively the damaged area can be cut out and a patch soldered into place. These are especially prevalent in Classical statuary but due to the excellent workmanship are rarely perceptible.

A common fault is for the metal to set before it has penetrated all the detail or narrow confines of the mould. This is usually because the metal is too cold; a 'cast-on' repair is the only remedy. Sometimes one pour of metal sets before the next joins it, leaving a distinct line where the metals have met but failed to amalgamate: this is known as a 'cold shut'. It weakens the casting and should be welded or soldered.

If the mould contains material, such as limestone, that is easily decomposed by heat, the molten metal will generate gas and create a potentially dangerous situation. The mould must also be perfectly dry, since even a little dampness will generate enough steam to cause turbulence, leading to gas holes in the casting and to metal droplets spraying over the mould walls. These quickly set and fail to amalgamate with the rest of the metal, remaining as recognizable droplets in the surface of the casting.

It is essential to exclude air from contact with the molten metal either in the crucible or in the mould (hence the drawback in using open moulds). It will cause the metal to absorb oxygen and then oxidize, which will create gas holes in the casting (gas porosity) when the metal cools. Thus the metal in a crucible is always covered with a thick layer of charcoal, and some foundries still pole the metal with green twigs to deoxidize it just before pouring. In addition, various deoxidants can be added.

The rate of cooling of the casting is also important, as considerable strain can be set up within the metal as it solidifies and contracts. In extreme cases this can make the casting crack. The problems resulting from the casting of two famous bells are well known. 'Big Ben', the principal bell in the clock-tower of the Palace of Westminster, London, cracked when the clapper was installed in 1857 due to the strains that had arisen during casting. The 'Tsar's Bell', the largest bell in the world, cracked in the mould when it was cast in Moscow in 1733. It was then left in the bell pit for over 100 years before being taken out and installed.

The rate of cooling also affects the homogeneity of the metal. There are three principal types of segregation of the alloy. In the first, gravity segregation, the denser metal sinks to the bottom of the mould. Heavily leaded alloys are especially prone to this fault. Alloys with a wide cooling range, such as bronze, are prone to the second type, which is known as normal segregation. The first metal to set in the mould—usually that at the extremities—will be rich in the higher-melting-point metals. As cooling proceeds, the metal becomes progressively richer in the lower-melting-point components. These become concentrated in the centre of the casting and at the top near the sprue where the last molten metal remains. Finally, if the rate of cooling of an alloy containing a low-melting-point metal is too swift, there is a danger

of 'sweating', the third type of segregation. This is especially prevalent with bronzes. The last metal to remain molten in the casting is that which is rich in the lowest-melting-point metal. As the rest of the metal contracts around it, this is literally squeezed to the surface. In a 'leaded' bronze, in which the metal is rich in tin or lead, this gives a dull grey surface. These segregations can cause noticeable variations in the colour over the surface of a casting, as well as serious internal weaknesses.

2. WROUGHT WORK.

(i) Forging. The simplest, and doubtless the oldest, method of shaping metal is by beating it with a hammer on an anvil. This process both shapes and extends the metal. Iron is normally forged hot while held in tongs, but other metals can be more satisfactorily cold forged. The hammering distorts the grain structure, so the metal has to be annealed at frequent intervals to relieve the strain and prevent cracks appearing. Many special processes and tools are used in the forging of iron, including pairs of blunt chisels (sets; see fig. 2a) to cut it. Rods of various diameters can be produced by hammering and rotating a hot iron bar into tools with concave grooves (swages; 2b). Forging tools are often used in pairs, the lower one set into the anvil, and the upper held over the workpiece and hit by the hammer (2d).

(ii) Silversmithing. The production of sheet-metal and its fabrication into various shapes is known as silversmithing. This term applies to all fine metals except iron, in which case the process is known as blacksmithing. Sheet-metal was originally made by hammering down a plate ingot. The practice of rolling metal between steel rollers was introduced in the 16th century (the earliest reference is in the notebooks of Leonardo da Vinci (1452–1519)), but sheet-metal was regularly produced by this method only from the 19th century. Sheet-metal is usually cut with snips or shears, and it can be shaped in a number of ways.

(a) Raising, sinking and spinning. Raising is a compressive process where the sheet is beaten against a metal bar anvil (stake) with a round-headed hammer,

and periodically annealed. The stake is normally T-shaped, with a projecting shank that is held in a vice or anvil. It has a bar that comes in a wide range of profiles depending on the work to be done (see fig. 3).

Sinking is a stretching process where the disc of metal is hammered into a concave 'former' of leather or wood or into a suitably shaped sandbag. If necessary, the piece can then be raised. If a tall vessel is required, the edges of the workpiece are hammered (after sinking) on to a specially shaped, grooved stake or a wooden form, until the whole sheet has flutes radiating from the centre: this is known as crimping. The workpiece can then be rapidly raised to the required shape by hammering it from outside against the stake on the inside.

Spinning is a very specific process where a disc of metal is spun on a lathe while pressing the metal back against a wooden former with blunt steel tools. The method is useful when a series of identical shapes is required. Soft metals are more suitable, but mild steel can also be shaped by spinning. The history of the technique is obscure. It requires a powerful continuous-action lathe, which was probably not available in the ancient world, and the earliest certain examples of spun ware seem to be some 13th-century Islamic vessels (Craddock and Lang, 1983). It is difficult to recognize any diagnostic features in spun ware,

3. Metalworkers' stakes, anvils and raising hammers, including (top left) a crimping or valley stake and (top right) a range of stakes with their profiles

2. Forging tools: (a) sets to cut metal; (b) swages to shape rods; (c) flatters; (d) swages in use on an anvil to draw down a rod of metal

particularly if the vessel has been carefully finished. Sometimes spun ware can be identified by the broad concentric bands on the inside of vessels that have not been subsequently smoothed out (the presence of concentric marks on the outside of a vessel and of a small pip in the centre, where the vessel was held to the lathe, are not necessarily diagnostic of spinning, but are more likely to indicate that the piece was finished and polished on a lathe).

Once the basic shape has been formed by the methods above, the rim of the vessel is made by hammering down the thin edge of the workpiece. After this the piece is finished by beating it against an anvil with a highly polished, light hammer. This is known as planishing and produces a series of light facets all over the surface. In the past these facets were usually polished out, but they are often visible on the interior or in inaccessible places. On some craft silverwork produced in Europe and North America from the end of the 19th century the planishing marks have been retained, not just as part of the design but also to differentiate the work from machine-made pieces; this can be seen in the work of Omar Ramsden (1873–1939), for example. Finally, the piece can be polished and burnished with a steel or stone burnisher. If the piece is circular it can be turned and polished on a lathe—this seems to have been the practice in the Western world for well over 2000 years.

(b) Presswork. Though now the most common method of commercial production, presswork is relatively recent. It involves the use of 'formers' or dies to produce basic shapes pressed into sheet-metal. Simple designs were stamped on to metal with a metal punch or die from early times (*see also* §V, 1(iv) below), and coins were almost always produced by striking between dies until well into the 19th century. From the 18th century small items, such as buttons, lids or spoon-bowls, began to be made from sheet-metal using the fly press, and slowly the practice spread to larger, more complex shapes. However, until the beginning of the 20th century, large brass buckets and bowls were commercially made in Europe by raising, using power-driven trip-hammers, and in the Indian subcontinent and elsewhere vessels continue to be made by hand.

(c) Repoussé. This is a process of great antiquity where deep-relief designs are hammered on to sheet-metal. The sheet is supported on a bed of firm but soft material, such as pitch mixed with brick dust and linseed oil, and the design is hammered out from behind with tracers, which are like blunt chisels with rounded corners. This pushes the metal into the support. After the main design has been created, the workpiece is removed from the support and annealed. The work is then continued on the front of the piece with smaller tracers and punches, sharpening up the design and adding detail. The punches can carry a variety of designs, ranging from simple grooves for matting the surface to quite intricate patterns.

(d) Wire. For the last 1000 years wire has been made by drawing thin rods through a series of progressively narrowing dies in a steel draw-plate. Now not only wire but a variety of other shapes can be extruded through a suitably-shaped hard steel profile. In earlier times wire was produced by a variety of methods. The two most usual for making gold and silver wires were 'strip twisting' or 'swaging'. In the former process a strip of thin sheet-metal was twisted to give a hollow tube similar to a drinking straw; in the latter a square-section rod was twisted and rolled. The wires produced by both these methods have distinctive helical grooves; these are clearly visible under low magnification and can sometimes be seen with the unaided eye.

IV. Joining. Metal components have been held together by many means. Sometimes they were just stuck together with resin or other glues, as on the Basse-Yutz Celtic flagons now in the British Museum, London, but this does not give a strong joint, and quite early in the history of metalworking other methods were developed. Pegged dowels were used to hold assemblages of metal parts, for example clock movements, that needed to be easily dismantled. These often worked loose, however, and a more satisfactory solution was the screw. Although occasionally used in Roman times to hold metalwork together, screws only became common in Europe at the end of the medieval period on armour and in clocks.

1. RIVETING. In this technique a pre-formed rivet, of which the head is wider than the body, is pushed through holes drilled in the pieces to be joined. It is then hammered down with a special hollowed punch, causing the head to spread out and grip the metal tightly. Pre-formed bronze rivets with conical heads have been found on sites dating from the Bronze Age, and clearly the technique is of great antiquity. Such items as cauldrons and buckets of riveted bronze were common in Europe from the later prehistoric period. Many rivets were necessary to produce a watertight joint in such articles, and a better join could be made by using hot rivets. As the metal cooled the rivet would contract, pulling the join together even more tightly.

2. SOLDERING. In a soldered joint the metal components are held together by a metal of lower melting-point (the solder). Soldering is the most common method of joining non-ferrous metalwork and has been in use from at least Babylonian times. The joint is heated locally, traditionally with a lamp and blowpipe or with a hot iron, now with a blowtorch or soldering-iron. The solder should have a wide cooling range and become slushy as it cools, so that it can be worked into the joint with the soldering-iron. The surfaces to be joined must be completely clean and unoxidized, or the solder will not adhere. To protect the surface and to promote the spread of the solder a flux is used—borax has long been the most common.

There are two main classes of solder: 'soft' and 'hard'. 'Soft' solders, such as plumbers' solder that has one part tin to two parts lead, have low melting-points. There is no fusion with the metals to be secured, and the joint is held by capillary action. 'Hard' solders (also known as silver solders) have a much higher melting-point, and the join must be heated to red heat. In these joins there is actual fusion between the solder and the metals, which creates a much stronger bond. A variety of solders were used with a range of melting temperatures sometimes on the same object, so that the craftsman could start with a high-melting-point solder progressing through lower-melting solders without melting the existing joins. The Romans used copper–silver, silver–tin and even mercury as solders on their silver wares. When a copper–zinc alloy is used for hard soldering the process is known as brazing.

3. WELDING. A welded join consists of components that have fused or melted into each other. Most metals can be welded, and many specific techniques, such as 'casting on' (see §1(vii) above) or Sheffield plating (see §V, 6 below), are technically welding. Welding has always been particularly associated with iron. Traditionally, the iron was heated to white heat and the pieces hammered together to make the weld, but now it is welded with heat alone using an oxy-acetylene torch. The metal has to be clean and free from corrosion, and for this a flux is necessary to protect the surface. Wrought iron traditionally contained a small percentage of slag, which acts as an internal flux and greatly facilitates welding.

V. Decorative techniques. The methods used to decorate metalwork are numerous and varied in their approach. They will be dealt with by method rather than by material. Some techniques, for example GILDING, are discussed in greater detail elsewhere in this dictionary. The principal general sources for this section are Untracht (1968, 1982), Maryon (1971) and Ogden (1982).

1. Worked decoration. 2. Polychromy. 3. Wirework, granulation and filigree. 4. Inlay. 5. Patination. 6. Plating.

1. WORKED DECORATION. This section deals with the execution of a design on the surface of the metal. Repoussé work, though decorative, is a process that actually forms the shape of the metal and thus is discussed in §III, 2(ii)(c) above.

(i) Scribing, engraving and chasing. There are three principal methods of producing an incised design on the surface of metal (Untracht, 1968; Lowery and others, 1976; Formigli, 1985, pp. 83–90; see fig. 4). In scribing a sharp steel point (4a) held like a pencil is used to draw a design on the surface of the metal. This method is widely employed to set out a design, but on some soft metals (e.g. gold) the scribed lines are deep enough to require no further work. In engraving a small gouge, known as the graver (4b), is pushed along to remove a thin sliver of metal. The graver has

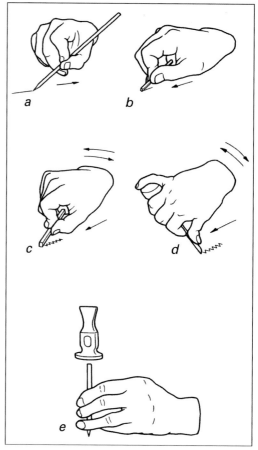

4. Tools and methods used to produce an incised design: (a) scriber; (b) graver; (c) and (d) rocked graver to produce a wriggled line (forward and back); (e) tracer

a 'v' profile and is of hardened steel. In capable hands engraving can give free and flowing lines. By rocking the graver (4c and 4d), usually a broad-bladed type known as a scorper, a wriggled or zigzag line can be produced. This can be used to produce a more decorative line, or with more pronounced rocking, a matted effect over the surface. Wriggled lines were extensively employed on European pewter from the 17th century (1989 exh. cat.), though the technique is much earlier in origin, being found on bronzes of the European Iron Age (Lowery and others, 1976). In the 18th century there was a fashion for deeply engraved designs on silver, with steep-sided, faceted channels that reflected light well, hence the name 'bright-cut' to describe such work. The origins of engraving itself are uncertain, but as the graver needs to be of steel to work all but the softest metals, it seems unlikely that the art of engraving preceded the Iron Age. In chasing a straight-edged chisel, known as a tracer (4e), is hammered into the metal to produce a line made up of a continuous chain of individual indentations.

It might be thought that it would be easy to identify the method by which a line has been made, but in fact it can be difficult. All but the most clumsy of chased lines are flowing and continuous with no obvious irregularities. All three methods produce lines of similar section, with raised sides. Engraving tends to pull up the sides and chasing to push them up, though in practice raised sides standing proud of the surface will have been worn or polished level. The problems are exacerbated on antiquities by corrosion and damage, and often the only certain method of identification is the presence of a specific variation, for example the rocked graver technique.

(ii) Carving. In this method the metal is carved with a chisel or a scorper to create the design or make a bed for an inlay (*see* §4 below). Often the carving has been executed not on the metal itself, but on the mould in which the metal was cast (*see* §III, 1 above). For example, much of the so-called 'chip-carved' decoration on Late Roman and Insular metalwork found in western Europe is in fact cast. The problem of identification is compounded where cast carving was subsequently worked over with a chisel to give it a cleaner, brighter appearance. On some types of heavily inlaid metalwork the channels and beds are always carved, thus Indian bidri vessels are cast, but the areas to be inlaid are carved afterwards with tracer and chisel (*see* §§4 and 5(v) below). Similarly, much of the decoration on Islamic sheet brasswork is carved, but on cast metalwork it was often done on the mould.

(iii) Reserving or matting. To provide contrast or to emphasize a design it is often necessary to reserve or matt an area. Sometimes, if the area to be reserved is quite narrow, this can be achieved simply by creating a depression in the surface: the depressed area will inevitably become duller than the more exposed and polished raised areas, as well as retaining dirt. On broad, flat areas, however, other means have to be adopted. The surface can be stippled with a punch or with multi-pointed matting punches. A broad wriggled line can be produced with a rocked graver (*see* §(i) above). Special gravers with three or five channels, known as liners, can be used to create a series of fine parallel lines or, by fine crosshatching, a variety of textured surfaces, known collectively as 'Florentine finishes'. From the late 17th century this could be performed mechanically, and the process, known as engine-turning, produced complex patterns of straight or curved lines over the surface. This technique was described in manuals, for example that of Charles Plumier (1701). Aside from purely decorative purposes, fine lines have often been scored on to the metal surfaces of scientific and optical instruments where reflections could disrupt measurements (Binnie, 1993).

(iv) Stamping or punching. A design can be built up using decorative punches of varying complexity, from a simple ring to quite elaborate patterns. These reduce repetitive free-hand work and were in use in the Middle East from at least the 3rd millennium BC (Ogden, 1982, p. 36). The punch has to be carefully placed to ensure that the design, when struck, comes out at a uniform depth on the metal. In Pre-Columbian South America sheet-gold was often decorated with quite deep and complex designs, struck with stone dies; in the Classical world metal dies of a hard, high-tin bronze, similar to that used for contemporary coin dies, were preferred. Complete scenes can be struck from an intaglio die on to sheets of soft metal. This technique was used from Hellenistic times, at the latest, for mass-producing small but complex items, for example religious plaques in sheet-metal. It continues to be practised in the Middle East and the Indian subcontinent, where a flat piece of soft metal (gold or silver) is placed over the die with a folded sheet of lead on top. The lead backing is then hammered, forcing the metal into the design. In the 18th century advances in press design, particularly the introduction of the fly press, made it feasible to stamp out complete, decorated pieces from sheet-metal. (See also Untracht, 1968; Ogden, 1982.)

(v) Pierced work. This is done with a punch, a drill or a piercing saw, usually on such soft sheet-metal as gold or silver. The piercing saw is a relatively modern tool, and the superb late Roman and Byzantine *opus interrasile* work, which seems to have begun around the 3rd century AD, was largely executed by setting out the design with a drill and then opening it out with a chisel (Ogden, 1982, p. 43; Deppert-Lippitz, 1993).

2. POLYCHROMY. An obvious and widespread technique for creating polychromy is to juxtapose two metals of a different colour. In parts of Africa bangles have been made by twisting together thin rods of brass and copper to give a pleasing contrast, and in Mexico the *metales casados* (Sp.: 'married metals') are made by soldering silver, copper, brass and other metals (Untracht, 1968, p. 184).

(i) Mokume. This technique was developed and perfected by the Japanese in the late 17th century. Thin plates of various coloured metals, sometimes silver but more usually copper and its alloys, including *shakudō* (*see* §5(iii) below), are soldered together to make a sandwich. This is then drilled or cut with sloping sides to expose the layers beneath. Alternatively, the piece can be deformed with a punch to create raised areas that can then be filed flat, exposing the 'grain' or layers of metal beneath (Maryon, 1971, p. 166; Untracht, 1982, p. 372; see fig. 5). The final appearance depends on the surface treatments, but that of wood grain, from which *mokume* derives its name, or watered effects are especially favoured.

(ii) Pattern welding. Iron and steel can be decoratively contrasted by pattern welding, also known as damascening. (Damascening can also mean inlaid metalwork) In pattern welding (see fig. 6) bundles of iron and steel rods were arranged alternately

5. *Mokume*, in which a sandwich of variously coloured metals is deformed with a punch and then filed flat to expose the 'grain' beneath

6. Pattern welding: (a) an iron rod is (b) carburized, (c) piled and (d) drawn down; the process is repeated (e), (f) and (g); two such iron and steel rods are (h) twisted and (i) welded to form a core; an edge is welded on (j) and the blade polished and etched to bring out the pattern

(or twisted) and welded together. They were then hammered out, twisted and annealed repeatedly to fabricate the basic shape, usually a weapon (Tylecote and Gilmour, 1986; Lang and Ager, 1989), while also building up complex patterns running through the metal. The contrast was revealed by polishing and etching. The technique was probably first used in Late Iron Age Celtic Europe, and became popular in the late Roman period and the early medieval period, when it was used particularly on sword blades but also on spears and knives. There is some debate concerning whether the technique was functional (i.e. to produce a stronger weapon) or decorative; some items were simply inlaid with thin panels of patterned metal, and these must be regarded as purely decorative. The Malayan and Indonesian *kris* blades (Rostoker and Bronson, 1990; Frey, 1990), produced from the medieval period, are made of thin sheets of iron of varying composition forged together and hammered, deformed and filed in a manner similar to *mokume*. They are then welded on to a central plate of steel, and either deep-etched (Malaya and Java) or just patinated (Bali).

The famed damascus blades made by Islamic craftsmen in the Middle East and India relied on the special properties of the *wootz* crucible steel from south India and Sri Lanka. The earliest such blades are medieval, and literary evidence would suggest both damascus swords and the use of *wootz* flourished over 1000 years ago (Bronson, 1986).

3. WIREWORK, GRANULATION AND FILIGREE.

(i) Wirework. Many pieces of gold jewellery are built up of wires soldered either together or to a base plate. The basic techniques of wire production are discussed in §III, 2(ii)(d) above, but the wires could be decorated by a variety of techniques (Meryon, 1971, pp. 135–40). Beading was common: this is now done by swaging, i.e. by hammering lengths of wire between two halves of a steel die with a line of conical depressions. In antiquity the wire was rolled under a hard, rounded edge to produce a groove, which, repeated at regular intervals, gave a beaded effect.

The technique of making wires from a twisted ribbon lent itself to decoration, either by incomplete twisting or by flattening and untwisting to produce wavy ribbons. Wires of various sizes and sections could be used together, either laid parallel or twisted: in the Middle East complex chains were interwoven from the 3rd millennium BC. Short lengths of wire could be coiled to form small cones to be used as decorative components, often in conjunction with granulation. (See also Ogden, 1982; Whitfield, 1987, 1989; Untracht, 1982.)

(ii) Granulation. This technique was widely used in antiquity: Etruscan jewellery, for example, was often heavily granulated (Cristofani and Martelli, 1983). The technique was known at Ur in the 3rd millennium BC and was common by the 2nd millennium BC. In this technique small spheres of gold are bonded to gold sheet, either giving total coverage or arranged in patterns. The beads are minute, and even a small design can incorporate thousands, but they are surprisingly easy to make. Small clippings of gold are dispersed in charcoal and carefully heated until the gold just melts, and surface tension pulls each clipping into a sphere. The best ancient work shows no evidence of solder, which has led to much speculation on 'lost' technologies (see Ogden, 1982). The experiments of Littledale suggested that minute granules were stuck to the surface with glue containing finely powdered copper salts. When heated to just below the melting point of gold, the glue would char, reducing the copper mineral to metal, which in turn would dissolve in the gold forming an *in situ* and invisible gold solder. This technique, known as colloidal soldering, was so ingenious and successful that it was assumed that it was universally used in antiquity. In fact, more detailed study from the 1940s showed that a variety of methods were used: the finest Greek and Etruscan work was probably done by colloidal soldering, but another method possibly used in antiquity was to arrange the granules along thin filaments of solder. (See also Walters, 1983; Ogden, 1982, pp. 64–6.)

(iii) Filigree. In filigree work soldered wires are used not just to produce decorative elements but to form the whole object. This 'technique of captured air' has always been especially popular in silver for jewellery and such small items as plaques, frames and glass-lined boxes. After each flat panel has been soldered the wire is normally flattened out by gentle hammering before the work is finally assembled. It is virtually impossible to polish filigree work, and thus it is normally left unpolished after pickling, therefore looking rather white and granular. The technique was widely used in antiquity and continues to be practised as a traditional craft in China and the Indian subcontinent, where it is centred on Cuttack in Orissa. (See also Meryon, 1971, pp. 41–2; Untracht, 1968, pp. 196–200.)

4. INLAY. The craft of inlaying a metal substrate with another metal or material has a long history, and a great variety of methods have been used. In true inlaying the inlay is let into the metal substrate so that it lies flush with the surface. The beds or channels into which the inlay is set can be made in the original casting or chiselled out. The form of the bed is to some degree dictated by the inlay, but it is common for the bottom to be roughened with a chisel to provide a key, and for the sides to be undercut to hold soft or molten inlays. Sometimes the depression is slight, no more than a surface roughening. On most medieval Islamic sheet brasses, for example, the beds, where they exist at all, were made by shallow chisel cuts and the outlines stippled with a punch to give a key on to which silver, or more rarely gold, was hammered. Thus the inlays, or more correctly overlays, stand proud of the surface, and, inevitably after centuries of use, polishing and pilfering, many of them are missing.

Metal inlays can be hammered into place and secured without the need for adhesive, while other materials can be softened by heat and worked in. Clearly this method was not possible with precious gemstones or inlays of *millefiori* glass, as found on Roman or Insular items. Similarly, the shell and coral so prized as an inlay by Iron Age Celtic craftsmen could not be hammered into place. Instead these inlays were sometimes held by adhesives within a raised bronze openwork frame, as on the Basse-Yutz flagons (*c*. early 4th century BC; London, British Museum). A wide variety of adhesives and putties have been identified, usually consisting of an inorganic filler with a drying oil or wax (Arrhenius, 1985).

Metal inlays can be held by burring over the surface of the substrate. This technique can be seen on the copper and silver inlay of the decorative plates made in Thanjavur in Tamil Nadu, India (Saravanavel, 1985; Untracht, 1968, pp. 134–8). A line is scribed around the inlay on to the base plate and opened up with a chisel. The inlay is then laid in this and the outer edge burred. A simpler method, of course, would be to use solder.

A different approach is to build up cells by soldering wires on to the surface. This technique is used when a considerable area of the surface is to be covered with inlay. If the inlay is enamel the technique is known as *cloisonné*; if there is no supporting plate beneath, but just the framework of wires filled with enamel, it is known as *plique à jour*; if the cells that hold the enamel have been cut into the metal beneath, the technique is known as *champlevé*; and if the surface of the metal has been carved to differing depths and covered with translucent enamel to give a three-dimensional effect, it is known as *basse taille* (*see also* ENAMEL, §3).

A variety of other materials can be used as inlays (La Niece, 1988), including virtually all metals: although gold and silver have been especially favoured, copper, pewter and even iron have all been used, the last being quite common on Etruscan and Roman bronzes. Sometimes the contrast is not just in colour but also in texture. Thus the substrate metal can be patinated and inlaid with shiny metal, as in Indian *kuftkäri* and bidri work (*see* §5(iv) and (v) below), or bright metal can be inlaid with a matt or non-metallic material. The carved and engraved areas on some Islamic brasses were picked out with bitumen, and in Europe the designs on some medieval memorial brasses were filled with black wax or bone black.

Another popular inlay was niello, which is a dense, black material formed from single or, latterly, mixed metal sulphides. When hot it melts, or at least becomes pasty, and can be pressed into the depressions in the substrate. The early history of the material is rather confused. Laffineur (1974) claimed to have identified it in Mycenaean artefacts, but most of these are untested or have been shown not to be niello. The daggers from the Shaft Graves at Mycenae, for example, were inlaid with patinated metal (*see* §5(iii) below). The strongest claim is made for the black inlay on the silver cup of Mycenaean date found at Enkomi, Cyprus, but no scientific identification was ever published by Plenderleith, who carried out the conservation and examination (see his report in Schaeffer, 1952, p. 381). The material was apparently little used by the ancient Greeks or Etruscans but suddenly became popular in Roman times, especially on silver. The niello used was usually the sulphide of the corresponding body metal. Thus, silver pieces were inlaid with silver sulphide and bronzes with copper sulphides. In one instance a Roman gold ring was found to have been inlaid with a gold sulphide niello, which must have been difficult to make (La Niece, 1983). Pliny the elder (AD 23/4–79) described a mixed sulphide niello (*Natural History* XXXIII.xlvi.131), but this did not come into general use until the Byzantine period. By the 12th century AD Theophilus (Hawthorne and Smith, 1963 edn, pp. 104–5) was describing niello made from a mixture of silver, copper and lead sulphides, but this remained a rarity until the Renaissance.

Single sulphide niellos used in the Classical and medieval periods were difficult to use because, when hot enough to be sufficiently soft to work into the inlay bed, they tended to decompose. Mixed sulphide niellos have lower melting-points and are much more

fluid, which makes their application easier. The popularity of niello declined in post-medieval Europe, except in Russia, where fine niello inlay continued to be made in the 19th century. Niello was also utilized in East Asia and on traditional Islamic jewellery until the early 20th century, but by the end of the 20th century its use had almost completely dwindled. (See also Meryon, 1971.)

5. PATINATION. The bright, shiny surfaces of metals have usually been one of their most attractive features (Fishlock, 1962), but sometimes they have been deliberately patinated, either to provide attractive colours in their own right or to form a contrasting background for metallic inlays. The prevalence of patinated alloys in antiquity is rather uncertain. It is difficult, for example, to assess whether the patinated surface of an ancient bronze represents an original treatment or natural corrosion: in general it would seem that in antiquity most artistic metalwork was kept in a bright and shiny state (see Jones, 1990). Some of the more important patination processes will be discussed below in relation to specific metals. (See also Hiorns, 1892; Field and Bonney, 1925; Hughes and Rowe, 1982; La Niece and Craddock, 1993.)

(i) Silver. Vickers (Vickers, Impey and Allan, 1986) has argued that much ancient Greek silver originally had a black 'oxidized' surface. He suggested that the familiar Greek Red-figure ceramics were imitations of silver originals, with the red figures echoing the gilded figures on the silver. While some pieces of part-gilded Greek silver (e.g. Venedikov and Gerasimov, 1975, pl. 169) look attractive when tarnished and certainly similar to the contemporary Red-figure wares, Vickers's ideas on ancient silver have not found general acceptance (see Boardman, 1987). In the 19th century, however, blackened silver became fashionable in both Europe and North America. Although usually known as 'oxidized' silver, the black patina was in fact sulphidic, produced by reaction with various sulphides. An alternative method was to deposit on the surface a thin layer of another metal, usually platinum, that appeared black.

(ii) Gold. Some gold items, notably those from royal burials from New Kingdom Egypt, have a distinctly rosy appearance, which is almost certainly the result of deliberate treatment (Ogden, 1982; Frantz and Schorsch, 1990). The gold contains small amounts of iron, and with the correct heat treatment a red colour was developed. This effect is not to be confused with *or gris* or *or bleu*, alloys of gold with 10–20% iron, which enjoyed a certain popularity in polychrome jewellery in the early 20th century, mainly in Paris.

(iii) Copper and its alloys. Although most bronzes seem to have been kept in a bright, shiny condition (Craddock, 1992), some were of a specific alloy, treated to produce a purple-black patina and with gold or silver inlay. The earliest of these is the *hesmen*

kem or 'black copper' of the Egyptians (Cooney, 1966), shown by surviving inscriptions from the 18th Dynasty (*c.* 1540–*c.* 1292 BC) onwards to be a prestigious material. Analysis of Egyptian statuettes of this distinctive black-patinated, inlaid metal showed that some have a highly unusual composition containing small amounts of gold, silver and arsenic in the alloy, similar to the much later Japanese *shakud* alloys (Craddock and Giumlia-Mair, 1993; see below). The same type of metal was used for the inlaid daggers from Mycenae, in which panels of black bronze were inlaid with gold and silver and let into the sides of the blades. Analysis of a panel from a previously unrecorded dagger of this type showed it to contain small amounts of gold and silver (Ogden, 1993).

There are references to black-patinated copper alloys inlaid with gold and silver in the *Iliad*, especially in the description of the shield of Achilles (XVIII), and in other Classical sources. This alloy has also been linked with the mysterious but prestigious 'Corinthian bronze' of the Roman world. From Plutarch (*c.* AD 50–after 120) (*Moralia* V.395) and Pliny the elder (AD 23/4–79) (*Natural History* XXXIV.i, vi–viii) it can be deduced that 'Corinthian bronze' was a patinated alloy of copper with some gold and silver, though there were many imitations; other authors, for example Petronius, lampooned the connoisseurs who claimed to be able to identify the genuine material (e.g. *Satyricon* L) (Heseltine, 1913). Pausanias, writing in the 2nd century AD, mentioned the production of 'Corinthian bronze' in his description of the city of Corinth (*Guide to Greece*, II.iii.3). Unfortunately the description has not survived intact, but it suggests that the hot bronze was plunged into water from the Peirene fountain in order to dye (Gr. *bapto*) or patinate it. The most complete description of the process for making 'Corinthian bronze' is found in the Syriac text by the Alexandrian alchemist Zosimos (VI.2; Berthelot, 1983); it is similar to the Japanese *irogane* method of making *shakudō*. Several examples of Roman copper alloys containing small amounts of gold or silver, patinated black and inlaid with gold or silver, have been identified in the collections of the British Museum, London, either as complete objects or in decorative inlays in bronzework (Craddock and Giumlia-Mair, 1993).

The evidence for the production of Japanese *irogane* alloys (Roberts-Austen, 1888; Gowland, 1915), which continue to be made in Japan, only begins in the 14th century AD, and the vast majority of surviving pieces were made from the late 18th century. The types of *irogane* include *shibuichi*, an alloy of copper with about 30% silver, and *shirome*, a natural alloy of impure copper with small amounts of arsenic and antimony, but the most well-known is *shakudō*, which is composed of copper with small amounts of gold and silver (La Niece, 1990[B]; Notis, 1988)—in modern practice *c.* 0.5–1% imparts a black colour and 5–10% a purple-black. The piece is made, inlaid and then patinated. As in all surface treatments the initial polishing and cleaning are vitally important: first the alloy is carefully polished with the softest of abrasives,

often charcoal prepared from deer antler; it is then carefully cleaned and degreased by boiling in solutions containing organic acids derived from such fruit as the bitter cherry plum, though radish juice is now preferred (Murakami, 1993). Finally the prepared metal is boiled in weak, aqueous solutions containing some copper salts. *Shakudō*, inlaid with gold and silver, as well as brass, *shibuchi* and *shirome*, was popular for sword guards and other sword fittings throughout the Edo period and represents the peak of achievement in patinated metal. It has been suggested that the 'purple sheen gold' referred to in many ancient Chinese documents should be equated with the Japanese *shakudō* (Needham, 1974, pp. 257–68). Examples of this have not yet been identified, but black-patinated copper containing small amounts of gold and inlaid with silver continue to be produced under the name of *wu tong* in Yunnan and other remote provinces (Wayman and Craddock, 1993).

(iv) Iron and steel. Damascened or pattern-welded iron relies on surface treatment or etching to bring out the pattern (*see* §2(ii) above), but sometimes the whole surface can be uniformly patinated by careful heat treatment and quenching to produce an attractive blue-black surface that is usually inlaid with gold or silver. Obviously the process has to be carefully controlled to ensure that a stable, firmly adhering magnetite layer is formed rather than the usual flaking iron rust. Islamic blacksmiths produced a black-patinated steel inlaid with gold and silver. This is sometimes known as 'false damascening' or Toledo ware, after the city in Spain where the craft was and continues to be practised. The conquistadors introduced the craft to the Americas, and the small town of Amozoc, near Puebla, in Mexico is well known for the production of saddle and bridle fittings. The steel is inlaid with gold and silver, then oiled and plunged into hot nitre and quenched in water. Finally it is placed in boiling water, followed by a dip in oil to impart a peacock-blue colour to the metal (Untracht, 1968, p. 158).

A similar technique is used in the Indian subcontinent to make *kuftkārī* wares, Kerala and Rajasthan being especially celebrated for this work (Untracht, 1968, pp. 153–8; Bisham Pal, 1984, pp. 27–8). A steel plate is first inlaid with fine silver or gold wire and then patinated by holding it over a charcoal fire until the desired purple-black colour is attained. It is then quenched and treated with vegetable oil to preserve the colour. Methods similar to these were widely used in Renaissance Europe to patinate or 'blue' armour and other steelwork.

(v) Zinc. A patinated alloy of zinc, known as bidri, has been made in India from the 15th century. It takes its name from the city of Bidar in central India, where it continues to be made, though production is centred on Hyderabad. Some production takes place in the Ganga valley, with Lucknow the traditional centre. Bidri is made from an alloy containing *c.* 95% zinc and 5% copper. The objects are sand cast (*see* §III,

1(vi) above) (Stronge and Craddock, 1993) and, after cleaning, inlaid with silver sheet or now usually silver wire. The inlaid casting is then carefully polished and cleaned. The patination is achieved by using an aqueous solution or a poultice of ammonium chloride and mud collected from beneath old walls: as anyone who has been to India will testify, the soil beneath old walls is likely to be rich in minerals deriving from urine, and it is the nitre, salt and ammonium compounds that are the active ingredients. The casting may be heated and then coated in a mud poultice, or the solution may be boiled and the casting placed in it. Within seconds the alloy develops a deep matt black patination, which is permanent. No further treatment is used, other than rubbing with a little coconut oil to enhance the black lustre that contrasts superbly with the silver inlay.

6. PLATING. Plating has a history almost as long as that of metallurgy itself (*see also* GILDING, §II, 4), and many ways have been devised to cover one metal with another. The simplest and oldest was to cover the body metal with a foil held in place by adhesive, pins or nails. Several extant Syrian bronze figurines dating from the 2nd millennium BC illustrate this technique well. A thin foil of the precious metal, usually gold or silver, was stretched over the body metal and burnished into place to ensure a close fit. The edges of the foil overlap at the rear and were held by pins hammered into small troughs of lead let into the back of the figure.

Foil plating, particularly with silver, continued in the ancient Roman period, when copper-alloy horse trappings and other decorative fittings were often plated with thin foils of silver held by soft solder, and the technique was still widely used to plate minor items in the 18th century and early 19th, when it was known in England as close plating. A much stronger union could be achieved with a hard solder or by diffusion welding, which can be found on ancient metalwork, especially on counterfeit silver coins. In the former process a layer of copper–silver hard solder was introduced between the silver foil and the copper alloy substrate; in the latter the foil and substrate were held together and strongly heated until they fused. Metallographically the joins are usually indistinguishable. Sheffield plating (*see* SHEFFIELD PLATE) was basically the diffusion welding of silver on to copper. The process is usually thought to date from the 18th century, but claims have been made that it was known in Minoan times (Charles, 1968), though the examples cited to support these arguments could have been hard soldered.

Pure gold can be beaten extremely thin, and the resulting leaves held in place on the carefully cleaned base metal by burnishing (*see* GILDING, §I, 1(i)). Gold of sufficient purity is not found naturally, and thus true leaf gilding was impossible until the technology of purifying the gold had been perfected; this probably took place in the Middle East in the later 2nd millennium BC (Oddy, 1982). Leaf silvering was also practised to a limited extent, mainly in post-medieval

Europe, when it was known in England as French plating and used mainly for clock dials.

Another technique, known as mercury, fire or parcel gilding (see also GILDING, §I, 3), was to make an amalgam with mercury of the metal to be deposited, which was almost invariably gold or silver. This paste was applied to the carefully prepared metal substrate and the mercury driven off by heating. Both mercury gilding and silvering were practised in China by the 4th century BC, but mercury silvering only became popular in Europe in the Middle Ages. Amalgam gilding and silvering were widely used on small fittings, as well as on the dials of scientific instruments and clocks, but were largely replaced by Sheffield plating in the 18th century.

Another technique of plating is to coat the substrate with molten metal. This technique was used to silver copper in Pre-Columbian South America and in early medieval Europe (La Niece, 1990[A]) but is only feasible with low-melting-point plating metals, the two most common being zinc and tin. The process of coating carefully cleaned iron sheet with molten zinc, which is known as galvanizing, was developed in the 19th century. It is used primarily as a method of protecting iron against corrosion, but it was occasionally used decoratively when still novel.

By contrast, the tinning of bronze dates from the Bronze Age, and the Mycenaeans plated some of their ceramic vessels with tin foil. It was not until Roman times, however, that the tinning of bronze became popular (Pliny, Natural History XXXIV.xlviii.161–2). By the late 1990s the earliest evidence of tinned iron so far discovered was on the hilt of an Iron Age dagger from Spain (London, British Museum); the technique remained popular throughout the medieval period (Harrison, 1980). It developed into a considerable industry in Saxony, Bohemia and in Britain at Pontypool. Tin plate was often lacquered or japanned (see LACQUER, §§I, 3 and II, 2), and the trays, teapots and other goods made in Pontypool or nearby Usk were popular throughout Europe in the 18th century and early 19th (Reade, 1968).

Tin melts at a temperature of 232°C, and thus the piece could be coated by dipping the object in molten tin. More usually, however, the piece was heated and a stick of tin wiped across the surface. The tin was then spread evenly with a cloth. These simple techniques continue to be practised across the world by tinkers refurbishing copper cooking pots. Alternatively, if the tinned layer on copper alloy is carefully heated, controlled diffusion takes place, and a high-tin bronze will be formed on the surface (Meeks, 1986, 1993). This will be hard, silvery and corrosion resistant. Perhaps the most familiar examples of this technique are the silvery bronze mirrors of the ancient Romans, though this specialized tinning is common on a wide range of other items, such as the small decorative 'bronzes' that are often described as silvered or silver-plated.

A plating can also be achieved chemically by treating an alloy of base metals and gold or silver to preferentially leach out the base metal, leaving the surface enriched with the precious metal. After treatment the surface appears matt and must be burnished. This technique is of great antiquity, though it continues to be used to enhance the appearance of low-carat gold. Before mineral acids were available, the surface would be heated to oxidize the base metals, which were then removed by the use of certain iron salts or organic acids and vinegars made from fruit juice. The debased Roman silver denarii of the 2nd and 3rd centuries AD are good examples of the technique. In order to make them appear silvery, the base-metal flans were chemically treated to remove copper from the surface. They were then struck, which had the effect of spreading the silver over the surface. In this way coins made of alloys with as little as 10–20% silver could, at least temporarily, have the appearance of silver (Cope, 1972). The technique was also used extensively in Andean and Isthmian South America. An alloy of gold and copper, known as tumbaga, was chemically treated to remove the surface copper and burnished. Sometimes part of the surface was protected with a resist and polychrome patterns created (Bray, 1978 exh. cat. and 1993).

Metals can also be deposited on to the surface of more reactive metals from solution. The familiar experiment of plating copper on to an iron blade placed in a copper sulphate solution is a good example of the technique. A thin layer of silver can be deposited from a paste containing silver in solution with a nitrate or ammonium salt. No heat is required, and various patent cold silvering solutions are still quite widely used to repair worn plating (see §VI, 3 below). There is less evidence for its use in antiquity, but the thin layers of silver on some South American copper objects of the Mochica culture of 100–600 AD have been postulated as examples of chemical silvering. From the 16th century the technique was quite widely used to silver coffin plates and handles and such other items as clock dials, where the silvering would not be subjected to wear or frequent polishing. In the mid-19th century it was replaced by ELECTROPLATING, as were all the other traditional processes of gilding and silvering metal.

Early sources

Theophilus: De diversis artibus (MS.; c. 1123); ed. and trans. by J. G. Hawthorne and C. S. Smith (Chicago, 1963)

V. Biringuccio: De la pirotechnia (Venice, 1540); ed. C. S. Smith, trans. M. T. Gnudi as The Pirotechnia of Vannoccio Biringuccio (New York, 1943, rev. Cambridge, MA, 2/1959)

G. Agricola: De re metallica (Basle, 1556); Eng. trans. by H. C. Hoover and L. Hoover (London, 1912/R 1950) [contains comprehensive account of metal production in Renaissance Europe]

B. Cellini: I trattati dell'oreficeria e della scultura di Benvenuto Cellini; ed. G. Milanesi (Florence, 1857, rev. 2/1893); Eng. trans. of original by C. R. Ashbee as The Treatises of Benvenuto Cellini on Goldsmithing and Sculpture (London, 1888/R New York, 1967)

M. Heseltine: Petronius, Loeb Classical Library (London, 1913)

General

A. R. Bailey: *A Text Book of Metallurgy* (London, 1960)

W. Alexander and A. Street: *Metals in the Service of Man* (London, 1962)

H. Hodges: *Artifacts: An Introduction to Early Materials and Technology* (London, 1964, rev. 2/1989)

O. Untracht: *Metal Techniques for Craftsmen* (New York, 1968)

J. E. Gordon: *The New Science of Strong Materials, or Why you Don't Fall through the Floor* (London, 1976)

J. W. Allan: *Persian Metal Technology, 700–1300 AD* (London, 1979)

J. Ogden: *Jewellery of the Ancient World* (London, 1982)

O. Untracht: *Jewelry: Concepts and Technology* (London, 1982)

E. Formigli: *Tecniche dell'oreficeria etrusca e romana* (Florence, 1985)

R. F. Tylecote: *The Prehistory of Metallurgy* (London, 1986)

R. F. Tylecote: *A History of Metallurgy* (London, 1992)

R. E. Smallman and R. J. Bishop: *Metals and Materials: Science, Processes, Applications* (Oxford and Boston, 1995)

V. M. Liritzis: *The Role and Development of Metallurgy in the Late Neolithic and Early Bronze Age of Greece* (Jonsered, Sweden, 1996)

K. Reiter: *Die Metalle im Alten Orient: Unter besonderer Berücksichtigung altbabylonischer Quellen* (Münster, 1997)

M. Treister: *The Role of Metals in Ancient Greek History* (Leiden, 1998)

R. O. Bork: *De re metallica: The Uses of Metal in the Middle Ages* (Aldershot, and Burlington, VT, 2005)

Native metals

R. Maddin, T. S. Wheeler and J. D. Muhly: 'Distinguishing Artifacts of Nature Copper', *Journal of Archaeological Science*, viii/3 (1980), pp. 211–26

V. F. Buchwald and G. Mosdal: 'Meteoric Iron, Telluric and Wrought Iron in Greenland', *Man and Society*, ix (1985) [whole issue]

K. L. Ehrhardt: *European Metals in Native Hands: Rethinking the Dynamics of Technological Change, 1640–1683* (Tuscaloosa, AL, 2005)

Shaping

J. W. Lilco: *Blacksmith's Manual Illustrated* (Oxford, 1930)

S. Choate: *Creative Casting* (London, 1966)

J. W. Mills and M. Gillespie: *Studio Bronze Casting* (London, 1969)

W. A. Oddy: 'The Production of Gold Wire in Antiquity', *Gold Bulletin*, x/3 (1977), pp. 79–87

P. T. Craddock and J. Lang: 'Spinning, Turning, Polishing', *Journal of the Historical Metallurgy Society*, xvii/2 (1983), pp. 79–81

H. Born, ed.: *Archäologische Bronzen, antike Kunst und moderne Technik* (Berlin, 1985)

J. M. Ogden: 'Casting Doubt: Economic and Technological Considerations Regarding Metal Casting in the Ancient World', *Materials Issues in Art and Archaeology II*, eds P. B. Vandiver, J. Druzik and G. S. Wheeler (Pittsburgh, 1991), pp. 713–17

B. Till and P. Swart: 'Cast Iron Statuary of China', *Orientations*, xxiv/8 (1993), pp. 40–45

R. H. Waggoner and J.-L. Chenot: *Fundamentals of Metal Forming* (New York, 1997)

P. Dillmann and P. Fluzin: 'Analyse des matériaux et histoire de la sidérurgie: Apport de la métallurgie et de l'analyse à l'étude de l'élaboration et de l'utilisation des fers anciens', *Technè*, xviii (2003), pp. 20–25

Decorative techniques

P. T. Craddock: 'Gold in Antique Copper Alloys', *Gold Bulletin*, xv/2 (n.d.), pp. 69–72

C. Plumier: *L'Art de tourner* (Lyon, 1701)

W. C. Roberts-Austen: 'Cantor Lectures on Alloys: Colours of Metals and Alloys Considered in Relation to their Application to Art', *Journal of the Society of Arts*, xxxvi (1888), pp. 1137–46

A. H. Hiorns: *Metal-colouring and Bronzing* (London, 1892)

M. Berthelot: *La Chimie au Moyen Age*, 3 vols (Paris, 1893)

W. Gowland: 'Metals and Metalworking of Old Japan', *Transactions and Proceedings of the Japan Society, London*, xiii (1915), pp. 19–100

S. Field and S. R. Bonney: *The Chemical Coloring of Metals* (London, 1925)

C. F. A. Schaeffer: *Enkomi-Alasia: Nouvelles missions en Chypre, 1946–1950* (Paris, 1952), pp. 379–89, figs 116–22, pl. cxvi [includes a technical report by H. J. Plenderleith]

O. Untracht: *Enameling on Metal* (London, 1958)

W. J. Anstee and L. Biek: 'A Study in Pattern-welding', *Medieval Archaeology*, v (1961), pp. 71–93

D. Fishlock: *Metal Colouring* (Teddington, 1962)

J. D. Cooney: 'On the Meaning of *Hesmen Kem*', *Zeitschrift für ägyptische Sprache und Altertumskunde*, xciii (1966), pp. 43–7

J. A. Charles: 'The First Sheffield Plate', *Antiquity*, xlii (1968), pp. 278–84

B. Reade: *Architectural and Domestic Metalwork*, The *Connoisseur*'s Complete Period Guides (London, 1968), pp. 1163–76

P. R. Lowery, R. D. A. Savage and R. L. Wilkins: 'Scriber, Graver, Scorper, Tracer', *Proceedings of the Prehistoric Society*, xxxvii/1 (1971), pp. 167–82

H. Maryon: *Metalwork and Enamelling* (New York, 1971)

L. H. Cope: 'Surface-silvered Ancient Coins', *Methods of Chemical and Metallurgical Investigation of Ancient Coinage*, ed. E. T. Hall and D. M. Metcalf (London, 1972), pp. 261–79

R. Laffineur: 'L'Incrustation à l'époque mycénienne', *L'Antiquité classique*, xliii (1974), pp. 5–37

J. Needham with the collaboration of Lu Gwei-Djen: *Spagyrical Discovery and Invention: Magisteries of Gold and Immortality* (1974), ii of *Chemistry and Chemical Technology*, v of *Science and Civilisation in China* (Cambridge, 1954–)

I. Venedikov and T. D. Gerasimov: *Trakiĭskoto izkustvo/Thracian Art Treasures* (London and Sofia, 1975) [bilingual text]

P. R. Lowery, R. D. A. Savage and R. L. Wilkins: 'A Technical Study of the Designs on the British Mirror Series', *Archaeologia*, cv (1976), pp. 99–126

H. B. Collier: 'X-ray Fluorescence Analysis of Black Copper from Yunnan', *Naturwissenschaften*, lxiv (1977), p. 484

The Gold of Eldorado (exh. cat. by W. Bray; London, Royal Academy of Arts, 1978)

H. Lechtmann: 'A Precolumbian Technique for Electrochemical Plating of Gold and Silver on Objects of Copper', *Journal of Metals*, xxxi (1979), pp. 154–60

H. Lechtmann: 'New Perspectives on Moche Metallurgy', *American Antiquity*, xlvii/1 (1979), pp. 3–30

R. J. Harrison: 'A Tin-plated Dagger of the Early Iron Age from Spain', *Madrider Mitteilungen*, xxi (1980), pp. 140–46

R. Hughes and M. Rowe: *The Colouring, Bronzing and Patination of Metals* (London, 1982)

W. A. Oddy: 'Gold in Antiquity', *Journal of the Royal Society of Arts*, cxxx (1982), pp. 730–44

M. Cristofani and M. Martelli: *L'oro degli Etruschi* (Novara, 1983)

J. Lang and M. J. Hughes: 'Soldering Roman Silver Plate', *Oxford Journal of Archaeology*, iii (1983), pp. 77–97

S. La Niece: 'Niello', *Antiquaries Journal*, lxiii/2 (1983), pp. 279–97

J. Wolters: *Die Granulation* (Munich, 1983)

H. Bhisham Pal: *Handicrafts of Rajasthan* (New Delhi, 1984)

B. Arrhenius: *Merovingian Garnet Jewellery* (Stockholm, 1985)

P. Saravanavel: *A Study on the Thanjavur Art Plate* (Thanjavur, 1985)

S. Stronge: *Bidri Ware* (London, 1985)

B. Bronson: 'The Making and Selling of Wootz', *Archaeomaterials*, i (1986), pp. 13–51

N. D. Meeks: 'Tin-rich Surfaces on Bronze', *Archaeometry*, xxviii/2 (1986), pp. 133–62

R. F. Tylecote and B. J. J. Gilmour: *The Metallography of Early Ferrous Edge Tools and Edged Weapons*, British Archaeological Reports, British Series, clv (Oxford, 1986)

M. Vickers, O. Impey and J. Allan: *From Silver to Ceramic: The Potter's Debt to Metalwork in the Graeco-Roman, Oriental and Islamic Worlds* (Oxford, 1986)

J. Boardman: 'Silver Is White', *Revue archéologique*, ii (1987), pp. 279–85

N. Whitefield: 'Motifs and Techniques of Celtic Filigree: Are they Original?', *Ireland and Insular Art*, ed. M. Ryan (Dublin, 1987)

E. Frey: *The Kris* (Singapore, 1988)

S. La Niece: 'White Inlays in Anglo-Saxon Jewellery', *Science and Archaeology: Glasgow 1987*, ed. E. A. Slater and J. A. Tate, British Archaeological Reports, British Series cxcvi (Oxford, 1988), pp. 235–45

R. Murakami, S. Niiyama and M. Kitada: 'Characterisation of the Black Surface on a Copper Alloyed by Traditional Japanese Surface Treatment', *Abstracts of the IIC Congress. The Conservation of Far Eastern Art: Kyoto, 1988*, pp. 13–136

M. R. Notis: 'The Japanese Alloy *Shakudo*: Its History and its Patination', *The Beginning of the Use of Metals and Alloys*, ed. R. Maddin (Cambridge, MA, 1988), pp. 315–27

J. Lang and B. Ager: 'Swords of the Anglo-Saxon and Viking Period in the British Museum', *Weapons and Warfare in Anglo-Saxon England*, ed. S. Chadwick Hawkes, Oxford University Committee on Archaeology, xxi (Oxford, 1989), pp. 85–123

Pewter: A Celebration of the Craft, 1200–1700 (exh. cat. by P. R. G. Hornsby, R. Weinstein and R. F. Homer; London, Museum of London, 1989)

J. H. Frantz and D. Schorsch: 'Egyptian Red Gold', *Archaeomaterials*, iv (1990), pp. 133–52

S. La Niece: 'Silver Plating on Copper, Bronze and Brass', *Antiquaries Journal*, lxx/1 (1990), pp. 102–14 [A]

S. La Niece: 'Japanese Polychrome Metalwork', *Archaeometry '90*, ed. A. Hauptmann, E. Pernicka and G. Wagner (Basle, 1990), pp. 87–94 [B]

J. V. S. Megaw and M. R. Megaw: *The Basse-Yutz Find*, Society of Antiquaries of London Research Report, xlvi (London, 1990)

W. Rostoker and B. Bronson: *Pre-industrial Iron*, Archaeomaterials Monograph, 1 (Philadelphia, 1990)

N. Whitefield: 'Round Wire in the Early Middle Ages', *Jewellery Studies*, iv (1990), pp. 13–28

P. T. Craddock: 'A Short History of the Patination of Bronze', *Why Fakes Matter*, ed. M. Jones (London, 1992)

L. Binnie: 'Special Finishes on Non-ferrous Metals at the National Maritime Museum', *Metal Plating and Patination*, ed. S. La Niece and P. T. Craddock (London, 1993), pp. 148–54

W. Bray: 'Techniques of Gilding and Surface Enrichment in Pre-Hispanic America', *Metal Plating and Patination*, ed. S. La Niece and P. T. Craddock (London, 1993), pp. 182–91, pl. 16.1

P. T. Craddock and A. R. Giumlia-Mair: '*Hsmn Km* Corinthian Bronze and *Shakudo*', *Metal Plating and Patination*, ed. S. La Niece and P. T. Craddock (London, 1993), pp. 101–27

B. Deppert-Lippitz: 'L'Opus interrasile des orfèvres romains', *Outils et ateliers d'orfèvres des temps anciens*, ed. C. Elvère, Antiquités Nationales, ii (Paris, 1993), pp. 69–73

S. La Niece and P. T. Craddock, eds: *Metal Plating and Patination* (London, 1993)

N. D. Meeks: 'Surface Characterization of Tinned Bronze', *Metal Plating and Patination*, eds S. La Niece and P. T. Craddock (London, 1993), pp. 247–75

R. Murakami: 'Japanese Traditional Alloys', *Metal Plating and Patination*, ed. S. La Niece and P. T. Craddock (London, 1993), pp. 85–94

J. Ogden: 'Aesthetic and Technical Considerations Regarding the Colour and Texture of Ancient Goldwork', *Metal Plating and Patination*, ed. S. La Niece and P. T. Craddock (London, 1993), pp. 39–49

S. Stronge and P. T. Craddock: '*Bidri* Ware of India', *Metal Plating and Patination*, ed. S. La Niece and P. T. Craddock (London, 1993), pp. 135–47

W. Wayman and P. T. Craddock: '*Wu Tong*, a Neglected Chinese Decorative Technology', *Metal Plating and Patination*, ed. S. La Niece and P. T. Craddock (London, 1993), pp. 128–34

T. Drayman-Weisser, ed.: *Gilded Metals: History, Technology and Conservation* (London, 2000)

M. Y. Treister: *Hammering Techniques in Greek and Roman Jewellery and Toreutics* (Leiden, 2001)

R. O. Bork: *De re metallica: The Uses of Metal in the Middle Ages* (Aldershot, 2005)

VI. Conservation. With metalwork, as with other art objects, the aim of any conservation treatment must be to enhance the appearance of the object and to arrest its physical or chemical decay, while causing as little irreversible change as possible. The purpose of this section is to give a general outline of the more common conservation treatments, so the principles of these methods can be understood, but not to provide specific instructions for the reader to follow. The conservation of metalwork is a specialized field requiring great skill and long training, so professional advice should be sought in most cases.

When considering the appropriate treatment for a metal object the conservator may have to take into account conflicting priorities. If, for example, damaged metalwork has to be reshaped or badly corroded iron conserved, it may be necessary to anneal the embrittled metal by heating to red heat (*see* §I, 1 above). This, however, will erase much, if not all, of the original metallographic structure, which often provides a unique record of how the metal was fashioned. The nature of the corrosion and its penetration into the metal along the grain boundaries

may also provide the only evidence of an object's antiquity, thus its removal will make any future scientific authentication difficult, if not impossible.

There are a number of useful guides for the layman on the care and preservation of antique metalwork, including Plowden and Halahan (1987) and Drayman-Weisser (1992), both books devoted to the general care and maintenance of collectibles and art objects. There are more specific works, such as Browning (1987) on repair, Bradley (1990) on storage and handling and Ashurst and Ashurst (1988) on the conservation and maintenance of architectural metalwork. Some earlier books on the care of antiques that include sections on metalwork should be approached with great caution, as the treatments recommended can be drastic, involving, for example, the total removal of patina by chemical means that is not only irreversible but also potentially ruinous to the whole object. Earlier conservation methods were often intended to restore the original appearance of the object as fully as possible, thus leading to over-restoration. Finally, some of the recommended treatments are dangerous to both the objects and the operators, since they involve procedures and chemicals that should be used only by trained personnel in a fully equipped laboratory. For the specialist the classic textbook on conservation, by Werner and Plenderleith (1971), is now outdated and replaced by more modern texts, such as Cronyn (1990) and articles in *Studies in Conservation*. Archaeological conservation is covered by Dowman (1970) and by Leigh (1972), both of which contain sections on metals.

1. Cleaning. 2. Repair. 3. Replating. 4. Storage and display.

1. CLEANING. There is considerable difference in approach to the treatment of ancient and more recent metalwork. Even a badly damaged and corroded piece of ancient metalwork is of sufficient art-historical and financial value to justify its conservation, whereas a more recent piece in a similar condition would be worthless. Ancient metalwork may also have been buried or exposed to prolonged environmental attack.

It is common knowledge that metal objects tarnish when their surfaces are attacked by air and moisture. Normally, an oxide is formed initially, and, if it is left for long enough, a more stable mineral may follow: a carbonate, chloride or sulphide, depending on the metal and the environment. This is the process of tarnishing, patination or corrosion. The choice of terminology is to some extent a question of degree but also of desirability: if the mineralization is visually enhancing it is likely to be called a patina, but if disfiguring, tarnish or corrosion; chemically they are similar. Although the corrosion on an ancient piece and the tarnish on a more recent piece are essentially part of the same process, they require quite different conservation treatments.

(i) Removal of corrosion. Often the patinated surface is desirable and should be retained, for example on an ancient Chinese bronze or an antique lead garden trough. Sometimes, however, the corrosion is active and unless treated will lead rapidly to the permanent disfigurement and eventual destruction of the object. During a long period in a specific environment (usually underground) the chemical attack on a metal will have reached an equilibrium, and the corrosion will be reasonably stable. When the object is excavated, however, all the conditions of moisture, temperature and oxygen content will change, destroying this equilibrium. Active corrosion may then recommence, attacking fresh metal and causing the old corrosion to flake off. For example, copper and its alloys, when buried in a salty environment, acquire a patina of copper chlorides that are stable, but the patinated or corroded layer also contains more active chloride minerals that can be activated by a change of environment, causing rapid and potentially serious attack on the metal. This is known as bronze disease because at one time it was believed to be caused by micro-organisms.

In general, modern treatments are much less drastic than previous ones. Only the minimum amount of loose and disfiguring corrosion is removed, preferably mechanically rather than chemically, the only exception being low-value coins from archaeological sites. Before the cleaning begins, the possible existence of hidden decoration or inlays buried deeply in heavy corrosion should be checked by careful examination or by X-radiography (see TECHNICAL EXAMINATION, §VIII, 4). Loose corrosion is usually removed manually with a needle mounted in a wooden handle or mechanically with a low-powered vibro tool. This will reveal the smooth, firmly adhering patina beneath. Active corrosion, however, has to be treated chemically.

With copper and its alloys it is almost impossible to remove the active chlorides from the corrosion layer. Formerly, the rather drastic solution to this problem was to electrochemically reduce the corrosion back to copper metal. This usually, but not always, eliminated the chlorides but left a granular, coppery surface that was unsightly and bore little resemblance to the original. Alternative chemical treatments, for example repeated washing with sodium sesquicarbonate or treating the affected areas locally with silver oxide, were not always completely successful, and the presence of carbonate minerals or silver on the surface could be confusing to future study. The most common approach now is to treat the active areas selectively with sodium benzotriasole, an organic chelating or molecular binding agent. The powdery, light green, active corrosion is removed mechanically, and the remainder is treated with the benzotriasole, which surrounds and deactivates the chloride ions, thereby preventing further attack. More recently treatment with other chemicals, such as diethylene triamine penta acetic acid, has been reported.

Corroded iron presents serious problems in both its conservation and its storage. Ironwork from archaeological deposits is often so badly corroded as

to be unrecognizable, and very difficult to treat. In these cases the best course is to X-ray the pieces. The radiograph will often give a good indication of the object's original state and provide a more permanent and scientifically useful record than the badly corroded original object. The usual treatment for less severely corroded iron is to remove the active salts by washing the corroded iron in a sodium sesquicarbonate solution, but active salts may still be present after many weeks. Before storage the treated iron should be fully dried and impregnated with an organic consolidant such as PVA. It should then be kept in dry conditions and inspected regularly.

An alternative treatment is to reduce the corroded iron to metallic iron by heating the object in a stream of hydrogen at red heat (900–1000°C) in a furnace. This is a drastic treatment that largely destroys any remaining original metallographic structure, but at least the metal is saved from further decay. Research by Archer and Barker (1987) has shown that if the temperature is reduced to 350°C (the minimum temperature at which the reaction will take place), the alteration of the metallographic structure is much reduced. Recently success has been reported in treating iron by plasma reduction (Sjøgren and Buchwald, 1991). This novel approach is still under evaluation but is claimed to be permanent, with very few of the side-effects of more drastic methods.

Active corrosion rarely occurs on silver; the principal corrosion product, silver chloride or horn silver, is usually firm, compact and chemically stable. Thus chemical treatment should not be necessary, and mechanical work can be kept to a minimum. The thin, barely perceptible patina that can often be seen on silver recovered from the ground is probably best left untouched, although the object can be polished if necessary (see §(ii) below). Base silver, which has been adulterated with considerable quantities of copper, is often covered with copper corrosion. This can be removed mechanically, though it may be necessary to loosen it with formic acid.

The corrosion products of lead, tin and pewter are generally stable and not unsightly, thus after the removal of any disfiguring loose corrosion, the remainder can be left. Corrosive agents in lead and its alloys can become active, however, especially in the presence of organic acids, such as those found in wood or cardboard (see §4 below), and can be difficult to control. The best treatment for such small items as coins or tokens is often local electrochemical reduction.

(ii) Removal of tarnish. When the metalwork is basically in sound condition (tarnished but not heavily corroded), the cleaning can often be undertaken by the non-specialist. It is good practice to experiment on a small, inconspicuous area before proceeding to the whole object. Traditionally, most metalwork was cleaned with a scouring powder of the appropriate fineness, ranging from fine sand for an iron or brass cooking pot to jewellers' rouge (fine iron oxide) for silverware. Modern proprietary metal polishes usually

contain a fine abrasive, a mild, often ammonia-based, chemical to remove grease and the thin oxidized layer and an organic medium to inhibit further tarnishing. On soft metals, for example silver, copper or gold alloys, a soft cloth should be used: a scouring pad, even if made of plastic, or a scouring agent must not be used, as they will remove the tarnish but will leave permanent scratches on the metal.

Before cleaning, it is advisable to check carefully if the metalwork has been previously lacquered to prevent tarnish. If so, the object should be washed in warm, soapy water and then immediately dried with a soft towel or tissues. If the lacquer is peeling or badly cracked it can be removed with an organic solvent, for example white spirit, methylated spirit or acetone. These solvents, especially acetone, should be used with care since they could penetrate any organic binders holding joints or inlays. Organic solvents should only be used outdoors or in a well-ventilated room, away from any exposed flame.

On heavier, more mundane pieces, for example window or door furniture and fireplace fittings, heavy tarnish can be removed more vigorously. First, however, the metal should be carefully inspected for any signs of surface treatment. During the 19th century, for example, many fittings were chemically treated to give a fine patina. Arsenic and antimony salts were commonly used on copper alloys, and these impart a grey colour to the surface of the metal beneath the dirt and tarnish. A small, inconspicuous part of the metal should be tested, and, if the presence of deliberate plating or patination is suspected, professional advice should be sought. Files or sandpaper should never be used on metalwork, in any condition, since the long parallel scratches that result are unsightly and almost impossible to remove.

Cast or wrought iron can be quickly and effectively cleaned with a wire brush or buffing wheel. After cleaning it can be lacquered or blackleaded with a graphite-based polish to give a pleasing appearance and some protection against further rusting. If the iron is heavily tarnished, the rust can be softened with a proprietary paraffin-based rust remover and then brushed off with an old toothbrush or possibly wire wool. The surface beneath the rust will be pitted, but this is unavoidable and irreversible.

Heavily tarnished pieces of copper or copper alloy, for example cast brass door furniture, can be satisfactorily cleaned with the appropriate grade of wire wool or buffing wheel, followed by proprietary polishes. An abrasive powder, for example jewellers' rouge, can also be used. Alternatively, an acceptable soft abrasive can be produced by rubbing together two old, soft, red bricks. All these methods should be tried on a test area to ensure that the metal is not seriously scratched.

The tarnish on silver can be safely and conveniently removed with any of the proprietary cleaners. Heavy tarnish, often caused by long exposure to salt or such sulphur-rich compounds as egg or vinegar, can be removed with Silver Dip. It was a common practice to emphasise the engraved decoration on silver with

niello (*see* §V, 4 above), which is black. This must not be mistaken for dirt. Lead, tin and pewter are generally too soft for abrasive cleaning, but the patina is usually desirable. Old paint, provided it is not original, should be removed with a chemical stripper.

2. REPAIR. The repair of a damaged or deformed piece should only be undertaken by a professional conservator. Apart from the aesthetic implications, extensive repair can seriously damage or even destroy vital metallographic evidence of how and when the object was made, as well as evidence of authenticity. Badly deformed sheet-metal can be hammered back to shape, but it may be necessary to anneal it first by heating it to red heat. Over long periods of time, sheet-metal gradually becomes more brittle, partly as a result of internal corrosion but sometimes through changes in the metallographic structure. This is especially true of silver. Thus, a thin sheet of ancient silver can be as brittle as eggshell and will certainly have to be annealed before reshaping. This would remove all traces of the original metallographic structure, as well as endangering any plating, inlays or soldered joints.

New repairs or additions can be welded or soldered, but original solders or plating can be damaged in the process. It is often better to use a reversible organic adhesive. If the object is badly broken, the fragments can be attached to a clear plastic support. This might seem an unsatisfactory repair, but it is preferable to a badly executed metallurgical join that could destroy the aesthetic, scientific and commercial value of the object.

A new repair or addition may stand out against the rest of the object but can be disguised by the use of sulphur-rich chemicals on the fresh surface or by infilling with suitably coloured waxes or resins. Patinated surfaces, because of their generally variegated nature, can easily be treated to disguise a join, but this is more difficult on clean, polished surfaces. The disguise of a modern repair is a contentious issue, since the boundary between aesthetic 'tidying up' and deceptive, possibly even criminal, concealment is not always clear. Certainly, any new work that is not visible when the object is on display (e.g. the inside of a vessel) should be left untreated, so that even a cursory inspection will reveal the new work.

3. REPLATING. Replating is another contentious subject in the conservation of metalwork, especially when the technique employed is different from that originally used on the object. The electroplating of old Sheffield plate, for example, restores a silver surface but covers the remaining authentic plating and produces a much whiter surface than the original layer of Sterling silver. Simple gilding and silvering kits are also available: the piece is dipped in a plating solution, and a thin layer of gold or silver is deposited on the surface. These treatments are cheap and fairly harmless, but the results are disappointing, since the plating only approximates to the original colour, and the texture is completely wrong. Moreover, the plated layer is very thin and wears off quickly.

4. STORAGE AND DISPLAY. The conditions under which metalwork should be stored and displayed are not as critical as for many other materials, but some precautions are necessary, especially with patinated metalwork, where active corrosion could recommence. Corrosion is promoted by high humidity, and thus metalwork should be stored in dry conditions. Even if sound, metalwork should not be left for long periods in an atmosphere above 55% relative humidity, but where there is evidence of active corrosion the RH should not exceed 45%. As with all materials, a stable environment is desirable but rarely completely attainable, especially in an enclosed space, for example a closed display case. During the day the case will warm up (especially if exposed to sunlight) and the RH drop, but at night the temperature will drop and the RH rise.

Metals are not affected by light, and thus any illumination can be used. In general metals are not at risk at normal temperatures, though tin can decay if left for prolonged periods at a low temperature. This phenomenon, known as 'tin pest', theoretically occurs at 13.2°C, when the metal begins to turn to a grey powder, but in practice tin can survive much lower temperatures for a considerable time before any disintegration takes place.

Since metals are generally reactive they are susceptible to chemical attack. Thus a vulcanized rubber flooring, which gives off volatile sulphur compounds, should not be used in a room in which silver or copper alloys are kept. Lead is susceptible to attack by organic acids: tannic acid from poorly seasoned wood, particularly oak, can have a ruinous effect, especially if the ventilation is poor; lead or pewter medals, for example, stored in an oak cabinet, could quickly suffer irreparable damage. Other woods are not so dangerous, provided they are fully seasoned and sealed and the cabinet kept well ventilated, but it is probably best not to use wooden storage cabinets for lead. Some adhesives used in the manufacture of cardboard also contain volatile organic acids.

All metalwork should be examined periodically for signs of excessive tarnish or fresh corrosion. This is especially important for small items (e.g. coins) that are likely to be stored out of sight in confined spaces, where local environmental changes could cause serious problems. A protective coating greatly reduces the rate of tarnishing, especially in urban environments, and thereby reduces the damage done by frequent polishing. A clear lacquer or silicone wax can be carefully applied to the surface with either a soft brush or an aerosol to avoid unsightly brushmarks and to ensure as complete a coverage as possible. Inevitably, however, some pinholes will remain, and eventually the layer will harden and crack. It is not recommended that corroded metalwork be lacquered, as the corrosion can proceed beneath the lacquer. The shiny appearance thereby given to the corrosion is also unsightly.

See also CONSERVATION AND RESTORATION, §II.

E. A. Dowman: *Conservation in Field Archaeology* (London, 1970)

H. J. Plenderleith and A. E. A. Werner: *The Conservation of Antiquities and Works of Art* (Oxford, 1971)

D. Leigh and others: *First Aid for Finds: A Practical Guide for Archaeologists* (Southampton, 1972)

R. F. Tylecote and J. W. Black: 'The Effect of Hydrogen Reduction on the Properties of Ferrous Materials', *Studies in Conservation*, xxv (1980), pp. 87–96

B. D. Barker: 'Conservation of Ferrous Archaeological Artefacts', *Industrial Corrosion*, iii/2 (1985), pp. 9–13

P. J. Archer and B. D. Barker: 'Phase Changes Associated with the Hydrogen Reduction Conservation Process for Ferrous Artifacts', *Journal of the Historical Metallurgy Society*, xxi/2 (1987), pp. 86–91

C. Browning: *The Care and Repair of Antique Metalware* (London, 1987)

A. Plowden and F. Halahan: *Looking after Antiques* (London, 1987)

J. Ashurst and N. Ashurst: *Metals*, iv of *Practical Buildings Conservation* (London, 1988)

M. Gilberg: 'History of Bronze Disease and its Treatment', *Early Advances in Conservation*, ed. V. Daniels, British Museum Occasional Papers, lxv (London, 1988), pp. 59–70

S. Bradley, ed.: 'A Guide to the Storage, Exhibition and Handling of Antiquities', *Ethnographia and Pictorial Art*, British Museum Occasional Papers, lxvi (London, 1990)

J. M. Cronyn: *Elements of Archaeological Conservation* (London, 1990)

A. Sjøgren and V. F. Buchwald: 'Hydrogen Plasma Reactions in a DC Mode for the Conservation of Iron Meteorites and Antiquities', *Studies in Conservation*, xxxvi (1991), pp. 161–71

T. Drayman-Weisser: 'Metal Objects', *Caring for your Collections*, ed. A. W. Schultz (New York, 1992), pp. 108–21

D. A. Scott, J. Podany and B. B. Considine, eds: *Ancient & Historic Metals: Conservation and Scientific Research* ([Marina del Rey, CA], 1994)

T. Drayman-Weisser, ed.: *Gilded Metals: History, Technology and Conservation* (London, 2000)

G. M. Radke: *Verrochio's David Restored* (Atlanta, 2003)

L. Selwin: *Metals and Corrosion: A Handbook for the Conservation Professional* (Ottawa, 2004)

M. Jones, ed.: *Conservation Science: Heritage Materials* (Portsmouth, 2006) [chap. on Metals']

Metalcut [Fr. *gravure sur métal*; Ger. *Metallschnitt*]. Type of relief print produced by cutting a metal plate rather than a wooden block; the term is also applied to the printmaking process. The technique was favoured for the metal's durability over wood. Copper, brass or lead plates were engraved in relief with a burin or punch, producing a result that often combined black-line engraving, white-line engraving and stipple. Metalcut was superseded by RELIEF ETCHING, and the technique was more or less abandoned after 1500.

1. MATERIALS AND TECHNIQUES. There are two principal methods employed by the metal-engraver to fix an image on the plate and print it: black line and white line. The former, also known as interrasile, derived from goldsmithing practised in the second half of the 15th century. In a black-line metalcut, as in wood-engraving, the motif to be printed in black is not hollowed out but retained, the areas around it being cut away, so forming a relief, across which the ink passes, rather than the incised lines (*see* PRINTS, §III, 1(ii)). White-line metalcut is the opposite of wood-engraving, which gives a black image on a white ground, the black being the strokes that make up the drawing in relief and the white corresponding to the empty spaces in the intervals between lines. In white-line metalcuts a burin is used to cut away the parts that constitute the image and that are to appear white when printed. The whites are the active element of the drawing. The image itself stands out against a black background (the relief), the only part that is inked, and which, when printed, is sometimes set off by a scattering of white dots. This effect, known as *criblé* or dotted, is obtained with various punches. The technique seems to derive from one described by the monk Theophilus in *De diversis artibus* (12th century), when he discussed the work of chasing metal, *opus interrasile*. Such work, which originated with metal chasing and damascening, was subsequently meant to be inlaid with metal. White-line engraving (white stroke on black background) is easier to obtain than black-line (in relief).

The spectacular effect of black–white contrast, looking more decorative than graphic, would seem to suggest that some plates were intended for decoration rather than for printing, a transparent glaze reducing the contrasts between light and shadow. In addition, inscriptions were sometimes engraved on the copper the right way round, appearing in reverse in the print itself. In the vast majority of cases, however, the engraver attempted to get all the elements of the engraving to appear the right way round in the proof, and it would be reasonable to suppose that the plate was therefore meant to be printed. The delicate method of inking required for metalcuts rapidly led to the process being rejected. They were also very limited in the extent to which they could represent depth and different planes. Moreover, the image lacked the luminous white background (of the paper) so precious for any work of graphic art.

2. HISTORY. The history and development of metalcut techniques are closely related. The term *criblé* is usually applied to the work of all the principal masters and to works combining various methods of engraving. It is practically impossible to distinguish between every individual method and to write a separate history for each. More than 700 metalcuts are extant. Their subject-matter is essentially religious. Their dimensions vary from folio to medium size. Most are duodecimo. Certain series comprise small-scale engravings that have been stuck into prayerbooks as illustrations. Metalcuts are found in the Rhineland, the Netherlands and Basle and around Lake Constance. The first examples appeared in the Upper Rhineland and were stylistically close to contemporary copperplate engravings although distinct from them in their decorative effect. The works may be grouped together (see Schreiber and Hind) by studio, the studio being run by a master distinguished by

his style, technique, monogram or stamp. The Monogrammist D (*fl* 1446–65), claimed by France, the Netherlands and Germany, was perhaps an engraver from the region of Bolcholt or perhaps Bernard Milnet de Donai. He was undoubtedly one of the first to use white line. His signature, a Gothic D in a heart and the whole contained in an escutcheon, appears on two engravings, a *Last Judgement* (s. 2407) and a *Resurrection* (s. 2375). On the proofs the letter and image are reversed, which classes them with several other plates attributed to him as works meant for decoration. The same hand is found in the *Annunciation with the Unicorn* (also called the *Mystery of the Incarnation*, s. 2481) without the monogram, in which the lettering and image appear the right way round.

The Master of the Stoeger Passion, active in the Upper Rhineland *c.* 1455–65, produced a complete series of 20 prints of the *Passion* and seven of the *Joys of the Virgin* (Munich, Königliche Hof- und Staatsbibliothek; s. 2500), also known as the Pfister *Passion*. These fragments illustrate a little book printed in movable type; there is no indication of date or place of printing, but the work may have been printed by Albert Pfister (*fl* 1454–70) in Bamberg *c.* 1460. Several prints from this series exist elsewhere, and there must have been several editions, as well as some copies. The plates must have been fixed on wood, for the engravings all bear the mark of nail holes. They were made with a stamp and burin. The Stoeger *Passion* may well have been the first typographic book to be illustrated, only five years after the 42-line Bible (Mainz, *c.* 1455) of Johann Gutenberg (*c.* 1394/9–1468). These metalcuts are characterized by their backgrounds decorated with arabesques, foliage or tapestry-like motifs. The more prolific Master of the Aix Annunciation, working in the Upper Rhineland *c.* 1460–70, used tapestry backgrounds and secular subject-matter, rare in this type of print, as in the *Battle of the Sexes* (s. 2763). Five engravings have been identified by his stamp, a coat of arms with clubs, but he was undoubtedly the author of several others that do not carry it. The Master of the Reticulated Background, active in the area between Basle and Strasbourg in the last quarter of the 15th century, employed a very decorative fishnet background, with two columns framing its subject and scrolls of foliage ending in an ogival arch.

The Master at Arms (*fl c.* 1470–80) probably worked in Cologne, as indicated by the escutcheon stamped on his work. This city was a major centre for the goldsmith's trade, and numerous books from Cologne are illustrated with *criblé* engravings. Several engravings can be attributed to him. Also active in Cologne, the Master of the Borders Decorated with Fathers of the Church (*fl c.* 1470–80) produced metalcuts surrounded with various types of border, among which are ribboned clouds, stars and medallions with symbols of the Evangelists and the four Fathers of the Church. The Master of Jesus at Bethany (*fl c.* 1465–85), also called the Master of the Anchor, from a stamp interpreted as being from the anchor studio, probably also came from the Cologne region. There is an escutcheon with an anchor, sometimes accompanied by an escutcheon with a compass, on engravings in very different styles and of uneven quality. Several derive their inspiration from the Master of the Berlin Passion. As well as the masters mentioned above, there are the Monogrammist I, the Master of St Catherine (*fl c.* 1460–75), and three copper plates, still preserved, which constitute extremely interesting documents for the study of techniques and the interpretation of metalcuts. One of the plates, of *St John and St Paul* (Paris, Musée du Louvre; see A. Blum: *Les Origines du papier, de l'imprimerie, de la gravure* (Paris, 1935), p. 182), is engraved with a burin in relief and bears inscriptions (articles of the creed in Latin) engraved on two banderoles. A date of 1423 (a later addition) appears at the top, as do two holes from pins with which it had been fixed. From its style, the plate may illustrate the work of the Monogrammist D or come from the studio of the Cologne Master at Arms.

The second plate, depicting the *Annunciation*, *Visitation* and *Nativity* (1466; Paris, Bibliothèque National; s. 2865), is one of the best examples of engraving in relief on metal. It shows the complexity of these techniques, the difficulty of seeing them as a group when studying them individually, and the different interpretations that can be given them. It is copper, engraved mostly in *criblé*, with the burin and the punch, and has been attributed to the Master of the Borders Decorated with Fathers of the Church (Schreiber). The inscription in the banderole appears in reverse on the copper, and the right way round on the proof. The engraver had therefore envisaged an impression on paper, and the plate was not meant mainly for decoration. The plate has been printed in positive and negative, the positive showing the mark of various types of punch used to obtain decorative backgrounds or the effect of clothing in various materials. The punch-work is broken up by strokes cut across it: the white areas are obtained with the burin, and the empty spaces are hollowed out, in the faces particularly. The burin is used in single strokes to trace the folds of the angel's robe or in crosshatching to give half-tones.

The third plate, *St Bathildis* (s. 2564), a French work, has a xylographic text. The copper, with double borderline, is cut like a piece of wood, hollowed out and fixed to a piece of wood of which the lower part bears an inscription of three lines of woodcut; a special technique has been used for the folds, executed by a black line echoed by a white line.

The difficult techniques of metalcut did not last beyond the 15th century, when the punch was laid aside, and metal engraving in relief came close to champlevé. The technique became more simplified, and artists abandoned goldsmiths' techniques for others closer to drawing: copperplate engraving and etching.

Theophilus: *De diversis artibus* (12th century); ed. J. G. Hawthorne and C. S. Smith (1963)

W. L. Schreiber: *Manuel de la gravure sur bois et sur métal au XVe siècle*, 5 vols (Berlin, 1891–1910) [s.]

H. Bouchot: *Les Deux Cents Incunables xylographiques du Département des Estampes* (Paris, 1903)

P. Gusman: *La Gravure sur bois et d'épargne sur métal du XIVe au XXe siècle* (Paris, 1916)

P. Gusman: 'La Gravure en taille d'épargne sur métal', *Byblis*, iii (1922), pp. 118–24

A. Blum: 'Les Débuts de la gravure sur métal', *Gazette des beaux-arts*, n. s. 6, vi (1931), pp. 65–77

A. M. Hind: *An Introduction to a History of Woodcut with a Detailed Survey of Work Done in the Fifteenth Century*, 2 vols (London, 1935/R London and New York, 1963)

Fifteenth-century Woodcuts and Metalcuts from the National Gallery of Art (exh. cat. by R. S. Field; Washington, DC, National Gallery of Art, 1966)

S. Bertalan: 'Medieval Pasteprints in the National Gallery of Art', *Conservation Research*, Studies in the History of Art monography series, II: Studies in the History of Art, 41 National Gallery of Art (1993), pp. 31–61

A. Grffiths: *Prints and Printmaking: An Introduction to the History and Techniques* (London, 1996)

K. Arbour: 'The First North American Mathematical Book and its Metalcut Illustrations: Jacob Taylor's Tenebrae, 1697', *Pennsylvania Magazine of History and Biography*, cxxiii/1–2 (Jan–April 1999), pp. 87–98

Metalpoint. Drawing instrument (the forerunner of the pencil) made from a small, pointed metal tip, usually of lead, silver, copper or gold, encased in a wooden holder. Metalpoint can be used on various supports, including paper, parchment, wood and ivory, but the surface usually requires a special preparation or ground for the metal to leave a mark. Paper, which is most commonly used, is coated with an opaque white or tinted ground composed of lead-white powdered bone, pigment and gum-water. Several layers are applied. The natural tone for the ground is off-white, but it can be coloured with any pigment. The ground has to be slightly granular for the metalpoint stylus to rub off and must have sufficient 'tooth' to retain the metal particles. The preferred metals are lead and silver. Lead produces a dull, flat grey mark, not unlike that of a pencil. Its popularity was probably due to the fact that the paper does not have to be prepared beforehand. If it is not, the leadpoint gives a soft, pleasing line, but on a prepared ground the mark tends to be a little coarse. The soft blue-grey tonality of leadpoint darkens as the lead oxidizes. Another drawback to leadpoint is that the tip blunts quite quickly and needs frequent reshaping. Silver was a more popular medium, perhaps because the point shows no appreciable wear for some time. It produces a delicate silver-grey line, which does not smudge, but this eventually tarnishes, taking on more definition as it gradually oxidizes to a warm brown-black.

1. HISTORY. Although a metal STYLUS had been used to inscribe surfaces since Classical times, metalpoint was employed for drawing only from the medieval period. It was in frequent use from the late 14th century up to the early 17th and was particularly favoured in the Renaissance period in Italy, the Netherlands and Germany, where many highly coloured grounds were used. Until the development of the graphite pencil, most sketches and preliminary drawings for paintings were carried out in metalpoint, brush or charcoal. Occasionally metalpoint was used for the whole drawing, but its value was limited because the tonal and textural values were so restricted; for this reason, white lead was often used to highlight silverpoint drawings. Also, the drawn line could not be greatly varied, nor could it be erased without scraping away the ground. However, metalpoint did allow the artist to prepare a meticulous but faint underdrawing, which would be easily obscured by pen and ink, black chalk, graphite or thin layers of paint. It was also used for working drawings on primed panels, which would be scraped down and recoated as necessary. Metalpoint was especially suitable for pocket sketchbooks. The pages could be prepared in advance with tinted grounds, and the metalpoint stylus was a conveniently portable implement before the invention of the lead pencil. On his journey to the Netherlands in 1520–21 Albrecht Dürer (1471–1528) took a sketchbook (dispersed) in which he drew portraits, town- and landscapes and other subjects in silverpoint. With the developments in oil painting of the 16th century, preparatory drawing with metalpoint became impractical. Paintings became larger and freer, and chalk was more suitable for the preparatory stages since it could be used on a larger scale and allowed for a greater range of tonality and texture. In the late 19th century, however, there was a brief revival of metalpoint drawing, particularly in England by such artists as Frederic Leighton (1830–96) and William Strang (1859–1921). Its appeal then lay in its ability to emulate the effects of photography and etching and in its association with the Renaissance masters. In the 20th century it was rarely used.

2. CONSERVATION. Metalpoint drawings are easily damaged and should be kept in the best possible environment for their preservation. Atmospheric pollution is dangerous if lead white has been used in the highlights or in the ground. Hydrogen sulphide gas, which is always present in traces in the air, will blacken the lead white, causing disfigurement to the drawing. This oxidization can be reversed by treating the drawing with hydrogen peroxide, a gentle bleach that converts the black lead sulphide to a colourless lead sulphate, allowing the white below the surface to show through. The image is therefore restored to some degree of normality. Excessive light is also hazardous. Visible light can fade many pigments and dyes, and ultraviolet radiation can damage the binding agents within the paper and in the prepared ground. Because paper is a moisture-containing material, it will expand and contract with changes in humidity; the prepared ground of a metalpoint drawing is therefore in danger of cracking if the paper is allowed to flex in an uncontrolled and unmonitored environment. Because of the surface fragility of metalpoint drawings, careful handling, mounting and framing are also important.

For further conservation guidelines *see also* PAPER, §VI.

C. Cennini: *Il libro dell'arte* (*c.* 1390); Eng. trans. and notes by D. V. Thompson jr as *The Craftsman's Handbook: 'Il libro dell'arte'* (New Haven, 1933/*R* New York, 1954)

G. Vasari: *Vite* (1550, rev. 2/1568); Eng. trans. of the introduction prefixed to the *Vite* by L. S. Maclehose as *Vasari on Technique* (London, 1907/*R* New York, 1960)

J. Meder: *Die Handzeichnung* (Vienna, 1919); Eng. trans. by W. Ames as *The Mastery of Drawing*, 2 vols (New York, 1978)

J. Watrous: *The Craft of Old-Master Drawings* (Madison, 1957/*R* 1975)

P. Goldman: *Looking at Drawings: A Guide to Technical Terms* (London, 1979)

Drawing: Technique and Purpose (exh. cat. by S. Lambert; London, Victoria and Albert Museum, 1981)

M. J. Ellis: *The Care of Prints and Drawings* (Nashville, TN, 1987, rev. Walnut Creek, CA, 2/1997)

C. James and others: *Manuale per la conservazione e il restauro di disegni e stampe antichi* (Florence, 1991; Eng. trans. Amsterdam, 1997)

Mezzotint. Type of intaglio print or tonal engraving and the technique from which such a print is produced. The plate is grounded (or roughened) so that its surface retains ink according to the degree of burr (or roughness) in any particular area. The earliest mezzotints date from the 17th century.

Grounding involves working across the plate in different directions with a rocker, a chisel-like tool with a broad and sharpened fan-shaped end, which has grooves on one side giving it a series of small points along the edge (see fig. 1). The ground can be rendered 'coarse' or 'close' depending upon the number of points on the rocker and also upon the number of times the tool is passed across the plate, a tedious process usually given in the past to apprentices. In a totally grounded state the plate prints an intense black; where the engraver wants the light to be, he uses a scraper and a burnisher to produce varying degrees of roughness, hence the name of 'scrapers' popularly attached to British mezzotint-engravers.

The aesthetic attraction of mezzotint was a rich tonal range much nearer to that of a painting than a line-engraving's (see fig. 2). The different textures of flesh or fabric could be reproduced in a sympathetic way, and the best mezzotints have a velvety warmth and internal glow unequalled by other media. Mezzotint has the advantage that the plates are more easily worked than those in line. The line-engraver faced an initial problem in deciding how to translate a picture into a pattern of lines, and the process of engraving involved laborious work. The line-engraver William Sharp (1749–1824), perhaps exaggerating to bolster his own calling, estimated in 1810 that line-engraving took 20 times as long as mezzotint. On the other hand a line plate can produce thousands of good impressions where a mezzotint will yield 100. The deterioration of the roughened surface when it was wiped to remove excess ink before printing meant that sometimes only the first handful of prints were truly brilliant. Hence there was a considerable premium on proofs, the first impressions taken before the plate was fully lettered. In practice plates could be reworked, and if this was done skilfully,

1. Photomicrograph of a mezzotint, detail from Vaillant Wallerant and Cornelis Bega: *Woman with a Sleeping Child in a Tavern*, 367×296 mm, *c.* 1658–77 (Boston, Museum of Fine Arts, Stephen Bullard Memorial Fund, 1993); photo credit: Keith Lawrence, Museum of Fine Arts, Boston

2. Mezzotint by John Constable and David Lucas: *Summer Afternoon – After a Shower*, 1831; from the series, *English Landscape Scenery*, 1831 (London, British Museum); photo © British Museum/ Art Resource, NY

preferably by the original engraver, far greater numbers of impressions could be issued than the engravers cared to admit. A great deal depended on the skill of the printing, which was usually done by specialist copperplate printers, who could easily ink the plate wrongly or indeed ruin the plate itself.

Steel plates were first used for mezzotint in the 1820s; these were difficult to work. With steel facing of copper plates (patented in 1857) engravers enjoyed the ease of working on copper with the long life of steel, but this laborious technique, which was by its nature confined largely to the reproduction of paintings, was superseded by the development of photomechanical processes.

A. Browne: *Ars pictoria* (London, 1669)

J. Chaloner Smith: *British Mezzotinto Portraits*, 4 vols (London, 1878–83)

J. E. Wenely: *Verzeichnis seiner Raderungen und Schabkunstblätter* (Hamburg, 1886), pp. 58–82

A. Whitman: *The Masters of Mezzotint* (London, 1898)

A. M. Hind: *A History of Engraving & Etching from the 15th Century to the Year 1914* (London, 1908, rev. 3/1923; R New York, 1963)

M. Salaman: *Old English Mezzotints* (London, 1910)

H. C. Levis: *A Descriptive Bibliography of Books in … English … Relating to … Engraving* (London, 1912–13), pp. 96–9 [incl. letter from W. Sharp]

J. Leisching: *Schabkunst* (Vienna, c. 1913)

A. J. Finberg: *The History of Turner's 'Liber Studiorum', with a New Catalogue Raisonné* (London, 1924)

F. Short: *British Mezzotints: Being a Lecture Delivered to the Print Collectors Club on November 7, 1924* (London, 1925)

C. E. Russell: *English Mezzotint Portraits and their States. A Catalogue of Corrections of and Additions to Chaloner-Smith's 'British Mezzotint Portraits'* (London, 1926)

P. H. Martindale: *Engraving Old and Modern* (London, 1928)

A. Shirley: *Mezzotints by David Lucas after Constable* (London, 1930)

F. W. H. Hollstein: *Dutch and Flemish Etchings, Engravings and Woodcuts, c. 1450–1700* (Amsterdam, 1949–)

F. W. H. Hollstein: *German Engravings, Etchings and Woodcuts, c. 1400–1700* (Amsterdam, 1954–)

O. C. Pisarro: 'Prince Rupert and the Invention of Mezzotint', *Walpole Society*, xxxvi (1956–8), pp. 1–9

W. P. Belknap: *American Colonial Painting* (Cambridge, MA, 1959), pp. 271–329

A. Gross: *Etching, Engraving and Intaglio Printing* (London, 1970), pp. 144–9

Victorian Engravings (exh. cat. by H. Beck; London, Victoria and Albert Museum, 1973)

The Mezzotint Rediscovered (exh. cat., London, Colnaghi's, 1975)

Darkness into Light: The Early Mezzotint (exh. cat. by J. Bayard and E. D'Oench; New Haven, CT, Yale University Art Gallery, 1976)

A. Griffiths: 'Prints after Reynolds and Gainsborough', *Gainsborough and Reynolds in the British Museum* (exh. cat., London, British Museum, 1978)

Painters and Engraving: The Reproductive Print from Hogarth to Wilkie (exh. cat. by D. Alexander and R. T. Godfrey; New Haven, CT, Yale Center for British Art, 1980)

A. Dyson: *Pictures to Print: The Nineteenth-century Engraving Trade* (London, 1984)

Regency to Empire: French Printmaking, 1715–1814 (exh. cat. by V. Carlson and J. W. Ittman; Baltimore, MD, Baltimore Museum of Art, 1984)

C. Wax: *The Mezzotint: History and Technique* (London, 1990)

G. Forrester: *Turner's Drawing Book: The Liber Studiorum* (London, 1996)

C. Joubert: *Ars nigra: La gravure en manière noire aux XVIIe et XVIIIe siècles* (Paris, 2002)

T. Stanley: 'Mezzotint under Glass: A Historical Review of the Glass Print', *Journal of the American Institute for Conservation*, xlv/2 (Summer 2006), pp. 147–54

Micrography. Minute writing arranged in geometric shapes or drawn as outlines of objects, animals or humans. Hebrew micrography is one of the most characteristic of Jewish art forms.

The earliest Hebrew micrographic texts date possibly from the late 9th century AD and the 10th and were written in Tiberias in Palestine (now in Israel) and in Egypt, where the *masorah*, the concordance-like notes that appeared in the margins of Bible codices, was at times written into figural shapes, a form known as internal micrography. Masoretic notes and occasionally psalms or dedications might also be combined with painted ornament to compose full-page finispieces (external micrography). Examples include the Moshe Ben-Asher Codex of the Prophets (dated AD 895–6; Cairo, Karaite Synagogue), the Leningrad Codex (a Bible, St Petersburg, National Library of Russia, MS. B.19a) and a Pentateuch (New York, private collection, see Avrin, pl. 13) from the early 11th century by the same scribe, Samuel ben Jacob. In Egypt *ketubbot* (marriage contracts) were decorated micrographically from the 12th century.

Jewish micrography flourished in western Europe and the Yemen from the 13th to the 15th century. Sephardi Bibles are characterized by Islamic-influenced interlace and vegetal carpet pages and geometric and architectural frames, and very occasionally with painted designs at the beginning and end of the codex and between the individual books. Psalms frequently provided the external micrographic text, but internal micrography, which at times depicted stylized animal forms, continued to be used only for masoretic notes. One scribe from 14th-century Barcelona specialized in full-page frontispieces and marginal decoration in Bibles, prayerbooks and *haggadot*. He is known to have accomplished micrographic illustrations for a Bible (Jerusalem, Jewish National and University Library, Nahum MS., heb. 8o 5147), a machzor—the Catalan Machzor (Jerusalem, Jewish National and University Library, heb. 8o 6527)—and the liturgical poetry (*piyyutim*) in a Haggadah (Manchester, John Rylands University Library of Manchester, MS. heb. 6).

In Ashkenazi Bibles, figured *masorah* was often concentrated in the initial-word panels, which occupied a third of the page at the openings of the books of the Bible. Full-page illustrations and designs were rare. Marginal illustrations were related to the text on the same page more commonly than in the Sephardi Bibles. German micrographers drew on the Romanesque repertory of grotesques for their animals. Typical Ashkenazi micrographed Bibles are found in the Bibliothèque Nationale, Paris (MS. héb. 5 and 8–10), and the Staatsbibliothek zu Berlin Preussischer Kulturbesitz, Berlin (MS. Or. fol. 1212; MSS Or. fols 1–4, 5–7). Few medieval micrographers signed their work; most were anonymous, but a few of these can be recognized in several books by their style of drawing.

Following the introduction of printing, when fewer manuscript Bibles were made, scribes in Italy in the early 17th century began to decorate *ketubbot* with micrography (e.g. London, British Library, Or. MS. 6706; Modena, 1557). The most popular texts were the Song of Solomon and the books of Esther and Ruth, along with other biblical passages appropriate to weddings. In Europe from the 18th century micrographic pictures portraying biblical or symbolic subjects related to holidays or prayers were written on parchment and paper and were intended to be hung in homes. Small books of benedictions for special occasions were also commissioned from scribes. In the 18th century micrographic portraits of royalty began to appear; in the 19th century rabbis, authors and leading Zionists were popular subjects, as were holy sites in Jerusalem. By that time the art had spread back to the Near East and to the USA, and many micrographic illustrations were reproduced by lithography. In the late 20th century Jewish scribes and calligraphers continued to practise the art, introducing new subjects and finding creative applications of this ancient art form.

T. Metzger: 'La Masora ornementale et le décor calligraphique dans les manuscrits hébreux espagnols au moyen âge', *La Paléographie hébraïque médiévale* (Paris, 1974), pp. 87–116

L. Avrin: *Micrography as Art* (Jerusalem and Paris, 1981)

'Hebrew Micrographers Then and Now', *Calligraphy Idea Exchange*, iv/4 (1987), pp. 40–50

T. Metzger: 'Josue ben Abraham ibn Gaon et la *masora* du MS. Iluminado 72 de la Biblioteca Nacional de Lisbonne', *Codices manuscripti*, xv/5 (1990), pp. 1–27

Modello [It.: 'model']. Term used to refer to the comparatively highly finished drawings or three-dimensional models made by an artist before executing the final work. The drawn modelli were most frequently created for paintings but were also employed for sculptures, architectural projects and decorative artworks. Three-dimensional modelli were used almost exclusively for sculptures. Historically, the treatment of the term is complex and varied. The earliest editions (1612, 1623 and 1691) of the dictionaries compiled by the Tuscan Accademia della Crusca invoke its derivation from the Latin *modulus* or *typus*: 'a model, type or example for emulation or imitation'. Modelli fulfilled various functions: within the workshop or studio they enabled an artist to delegate some or most of the final execution to assistants, while outside this they might be presented to a patron to win or confirm a commission. In sculpture the modello was preceded by less finished versions called either models, *bozzetti* or maquettes. For the other preliminary stages in painting see CARTOON; DRAWING, §II and OIL SKETCH.

1. DRAWN. As generally used in the context of draughtsmanship, modello designates a drawing on paper or parchment that demonstrates clearly and in detail the appearance of a composition, figure or motif prior to its execution in another medium. Besides the cognates for 'model', the following less

precise terms are used as equivalents in the literature on non-Italian drawings: 'design' (Eng.); '*étude*' (Fr.); '*Entwurf*' or '*Werkzeichnung*' (Ger.); and '*diseño*', or '*estudio*' (Sp.). Such demonstration drawings are usually relatively highly finished and smaller in scale than the final work. Practices in preparing modelli, however, varied greatly. The use of the term in Italian primary sources from the early 14th century to the late 18th poses substantial problems of interpretation. These sources do, however, establish that such drawings served both a creative, practical function within the artist's workshop or studio and a contractual function between artist and patron. In the latter sense the terms 'presentation drawing' and 'contract drawing' are sometimes used to denote a modello.

A reconstruction of the modello as a drawing type remains problematic for two reasons. First, from the earliest use of the term 'modello' in 14th-century documents the word designated both a preliminary drawing on paper and, more frequently, a preliminary three-dimensional model. The two meanings were, however, closely allied within the Tuscan tradition of design. For example, an important element of 15th- and 16th-century design practice consisted of drawing after sculptural models representing the human figure (modelli), usually fashioned of wax or clay. These drawings after models allowed the artist to study foreshortening, chiaroscuro, disposition of draperies and counterpoints of pose. In his introduction to the *Vite*, Giorgio Vasari (1511–74) included this practice in a sequence of steps leading to the execution of a composition, modelli (models) being the only step that was not a type of drawing: (1) *schizzi* (sketches); (2) *disegni* (drawings); (3) modelli (models); and (4) *cartoni* (cartoons). Second, the term 'modello' was understood and used in its broadest meaning: an object serving as an example, model or type for work to be carried out. In this general sense, a drawing, a three-dimensional representation, or even a painting, could serve as a preliminary model. Andrea Pozzo (1642–1709), for example, referred to the production of a preliminary, painted model (*modello colorito*) before the painting of a full-scale fresco (1693–1700). In Book III of *De pictura* (1435), Leon Battista Alberti (1404–72) recommended the use of modelli drawn on paper, scaled with parallels (e.g. squared proportionally), as a necessary step in designing a figural composition. Yet Vasari, in his introduction to the *Vite*, a seminal text for the formation of a theory and vocabulary of *disegno* (drawing and design), did not give the term 'modello' as denoting a drawing. He used the term '*disegni*' to refer to the carefully rendered compositional drawings that we would designate today as modelli. Other sources follow Vasari in this respect, including Gilio (1564), Borghini (1584), Armenini (1586–7) and Baldinucci (1681), who also did not use the term 'modello' as designating a drawing. This evidence suggests that drawings functioning as modelli, as demonstrations of works to be carried out, whether done for use in the design process or for use by the patron, were not recognized as a specific, formal drawing type. Thus, the creative,

practical and contractual functions of the drawings that are generally called modelli appear ambiguous only if an overly restrictive system of classification is used.

From the 1420s artists in Italy prepared compositions in an increasingly systematic fashion by drawing on paper, rather than directly on the final working surface as in medieval practice, and by following distinct steps. The modello thus began to play a significant role, particularly in the central Italian tradition of design. As defined by this tradition, and as adopted by non-Italian artists well into the period of the Beaux-Arts academy in the 19th century, the modello was a form of summary, rather than an exploratory drawing type: after developing a design in a sequence of rapid figural or compositional sketches, as well as in more elaborate studies after the live model, the artist or his assistants attempted to synthesize this research in a carefully rendered, small-scale drawing—the modello. Although surviving modelli from the 15th to the 19th century exemplify a rich diversity of drawing media and techniques, they are usually characterized by a precise, often emphatic disposition of both outline and CHIAROSCURO and incorporate a reference to the size of the final work in the form of squaring grids, measurements or ruled scales. During the 15th century linear drawing media predominated: METALPOINT on prepared paper, as well as pen and ink. In the 16th and 17th centuries artists favoured more painterly techniques: black or red chalk, sometimes with STUMPING to obtain even transitions of tone; as well as ink, wash, GOUACHE, or, more rarely, watercolour, applied with a brush. From the late 18th century GRAPHITE was also commonly employed.

The modello often served as the final drawing from which the design was enlarged to its full scale on the working surface and subsequently executed. To facilitate this enlargement, the modello was usually overlaid with a grid of squares proportional to a grid of squares constructed on the working surface. Such a grid is visible on the head and body of the Virgin in the fresco of the *Trinity* (*c.* 1425–7; Florence, S Maria Novella) by Masaccio (1401–28). It suggests that Masaccio transferred the design directly on to the fresco surface from a smaller-scale drawing, a modello, of the Virgin. Although the drawing no longer survives, this fresco is recognized as the earliest extant application of the method. The earliest surviving example of such a modello is the coloured drawing (Florence, Uffizi, 31 F) by Paolo Uccello (*c.* 1397–1475) for the fresco commemorating Sir John Hawkwood (1436; Florence Cathedral). Uccello's modello is in metalpoint on green prepared paper, with purple wash and highlights in white gouache. It is indented with a grid of squares, and the few incised lines on the fresco surface itself—notably the vertical centering line—correspond to this grid.

From shortly before the mid-15th century the modello more frequently preceded the elaboration of a cartoon, or full-scale drawing on paper, and often both were squared proportionally. An unusually

complete sequence of preliminary drawings by Raphael (1483–1520) survives for the *Entombment* (1507; Rome, Galleria Borghese), for the Baglione Chapel in S Francesco, Perugia. Raphael's large modello (Florence, Galleria degli Uffizi, 538 E), precisely drawn and crosshatched in pen and brown ink over an UNDERDRAWING in black chalk, exhibits two squaring grids: one in red chalk under the drawing, another in pen and brown ink on top of it. The grid in red chalk helped the artist to correlate the differing scales of the figural and compositional studies that preceded the modello, while that in pen and brown ink served as a more accurate reference in enlarging the scale of the modello to that of the cartoon. From the late 15th century, with the increased use of the oil medium, which permitted a more direct manner of painting, artists often omitted full-scale cartoons. In such cases the modello, squared for proportional enlargement, served to transfer the design directly on to the final working surface.

Detailed modelli were indispensable when the execution of the composition was to be done by an artist other than the designer. In 1502–3 Raphael drew the highly finished, squared modello of the *Departure of Aeneas Silvius Piccolomini to the Council of Basle* (Florence, Galleria degli Uffizi, 520 E) for Bernardino Pinturicchio (*c.* 1452–1513) to fresco in the Piccolomini Library of Siena Cathedral. Drawn in an almost painterly technique with pen and brown ink, brush and brown washes, and white heightening over black chalk, Raphael's large modello also includes detailed, autograph notes regarding the iconography of the scene. The division of labour in the designing and painting of the Piccolomini programme is documented in the contract (1502) and in Vasari's biographies of both artists. For complex sculptural and architectural projects, designers, or professional draughtsmen hired specifically for this purpose, often drafted carefully rendered modelli in addition to fashioning three-dimensional models, also termed modelli (*see* §2 below). A detailed modello often further enabled the delegation of the execution of a project, particularly in the decorative arts. Inscriptions on the modello (London, Victoria and Albert Museum, E.509–1937) by Cristoforo Sorte (1506/10–94) for the ceiling of the Sala del Senato in the Doge's Palace, Venice, confirm the craftsmen's commitment to follow Sorte's designs. The long inscription on the bottom of the modello (1614; Madrid, Biblioteca Nacional, B 365) by the architect Juan Gómez de Mora (1586–1648) for the main retable in the church of the monastery of Our Lady, Guadalupe, indicates that it served a contractual purpose: 'His Majesty therefore commands that nothing herein be altered without his personal sanction'. Elaborately rendered in pen and ink with brush and washes over black chalk, the drawing itself is referred to in the inscription as the '*traça* (design)'. The style of ornamentation for the framing members, as well as the various materials to be employed for the carving, are specified; Vicente Carducho (1570/76–1638) and Eugenio Cajés (1575–1634) are named as the

painters of the altarpiece panel. Three vigorously drawn, squared modelli by Peter Paul Rubens (1577–1640) survive for the marble sculptures for the central portal of the Jesuit church of St Carolus Borromeus in Antwerp (1615–18). The sculptor of Rubens's designs was most likely Hans van Mildert (1588–1638), who is repeatedly mentioned in the account-books of St Carolus Borromeus; members of the de Nole family may also have worked on the commission. Among the modelli by Sir James Thornhill (1675–1734) for the decoration of James Bateman's house in London, that for the stained-glass windows (1719; Providence, RI, Rhode Island School of Design, Museum of Art) bears the name of the patron, whose approval was essential, and also that of the painter, Francis Price (*fl* 1734–7?; *d* 1753), who was to execute the work along with specific instructions. A nearly contemporary modello (Berlin, Kunstbibliothek, 825) attributed to Pierre Legros II (1666–1719) for a tomb of a member of the French royal family provides scales, measurements and iconographic notes in both Italian and French for accurate communication. The squared modello by Edward Burne-Jones (1833–98) for a tile design portrays the *Marriage at Cana* in green chalk over graphite (1886; Birmingham, City of Birmingham Museum and Art Gallery). The instruction he inscribed on the modello, 'all to be richly covered with grass & flowers', was for the ceramicist who would paint the tile.

A division of labour between design and execution was typical of printmaking. Modelli drawn for this purpose are full scale and show the indented outlines left by the stylus used to transfer the image to the plate, with the composition usually in reverse. The highly finished modello of *Mankind Awaiting the Last Judgement* (London, Victoria and Albert Museum, Dyce 442) by Dirck Barendsz. (1534–92) was engraved by Jan Sadeler I (1550–1600). Rubens's *Adoration of the Magi* (New York, Pierpont Morgan Library, I.230) is among a number of extant modelli for the engraved illustrations of the *Breviarium Romanum* (1614; Antwerp), published by Balthasar Moretus (1574–1641). Rubens delegated much of the drawing for reproductive engraving; the modello for the *Flight into Egypt* (London, British Museum, Gg.2–234), based on his painting (1614; Kassel, Schloss Wilhelmshöhe, Gemäldegalerie Alte Meister), was drawn and used expressly for the engraving by Marinus Robyn van der Goes (?1599–1639). The basic drawing in black chalk was done by a pupil; Rubens reworked the drawing with chalk, as well as grey washes.

The drawing of a modello was laborious and required a skill for synthesis rather than invention. Although Raphael produced his own modelli early in his career (e.g. Florence, Galleria degli Uffizi, 538 E), after *c.* 1515 he often delegated this task to his workshop assistants (e.g. Paris, Musée du Louvre, 3884; Oxford, Ashmolean Museum, P II 574; Windsor Castle, Royal Library, RL 12739; London, British Museum, 1900–6–11–2). At times Michelangelo

(?1475–1564) may also have entrusted to assistants the drafting of elaborately constructed and rendered modelli for his sculptural and architectural projects (e.g. Paris, Musée du Louvre, 837, 838; Florence, Casa Buonarroti, 45 A).

Although they were not often used strictly as contractual drawings, modelli enabled the patron to approve, criticize or reject an artist's design. The modello (Basle, Kunstmuseum, 1662.31) by Hans Holbein the younger (1497/8–1543) for the group portrait of the *Family of Sir Thomas More* (*c.* 1527–8; destr.) offers unusual documentation in this respect. Drawn with precise outlines in pen and black ink over black chalk, the large Basle modello also bears inscriptions and sketchily drawn suggestions for changes in the details of the composition. These were added in brown ink, apparently in Holbein's own hand (the sitters' names and ages are a later insertion). For instance, next to the kneeling figure of More's wife a note states *'Dise soll sitze[n]'* ('she must sit'), and a small ape climbing her skirt is sketched. The autograph modifications to the Basle modello are reflected in a copy of Holbein's painting (*c.* 1530; Nostell Priory, W. Yorks) by Rowland Lockey (?1565/7–1616). The modello was sent by the More family to Desiderius Erasmus (?1466–1536), and his two letters of acknowledgement discuss the drawing in great detail.

A book of architectural designs by Nanni di Baccio Bigi (1512/13–68; New York, Pierpont Morgan Library, MA 1346 [32]), Michelangelo's rival, includes plans drawn in pen and brown ink for two storeys of a house. The descriptive inscriptions explicitly designate the plans as 'modelli'. The plans are signed and approved by the two men who had apparently commissioned the house. Similarly, the modello signed by Eugenio Cajés for the decoration of a vault (1621; Madrid, Archivo Histórico Nacional) also bears the signature of the patron and his notes on the subject-matter of the scenes to be painted. A modello by Jacob Jordaens (1593–1678) for an unidentified architectural project (*c.* 1630–35; Amsterdam, Rijksmuseum, A. 1926) offers alternative designs for the pediment: one plainly curved with a sphinx; one scrolled with a *putto*. Such motifs were left to the patron's choice. Finally, a detailed list of modifications dictated by the patron appears on the *verso* of the modello (Berlin, Kupferstichkabinett, KdZ 15845) by Marco Benefial (1684–1764) for an altarpiece portraying the *Assumption of the Virgin with SS Terentius and Mustiola* in Pesaro Cathedral.

Modelli were crucial in the commissioning of works of art, for an attractively finished drawing could help procure a commission from a private patron or a public competition. In his life (1568) of Antonio Pollaiuolo (*c.* 1432–98), Vasari mentioned his design and model (*disegno e modello*) for an equestrian statue of Francesco Sforza, Duke of Milan. He noted that there were two versions of the design: these have been identified with two highly finished drawings in pen and ink with brush and wash over black chalk (New York, Metropolitan Museum of

Art, Robert Lehman Collection; Munich, Staatliche Graphische Sammlung, 1908:168). Detailed inscriptions, written in a semi-literate style, on a 17th-century central Italian (?Roman) design for the frieze of a palace vestibule (Oxford, Christ Church, 0958) make explicit the artist's eagerness to please his patron: 'This is the idea for the entrance hall of the castle, but other [sketches] have been made. Your Excellency, choose which you like best … By taking the trouble, here we will duplicate your plinths in a beautiful manner …'. Some of the modelli by Giulio Romano (?1499–1546) for lavishly ornamented tableware exhibit autograph inscriptions with the names of his Mantuan patrons (London, Victoria and Albert Museum, E.5129–1910, E.5131–1910). Vasari's account of the competition held in 1564 for the decoration of the Scuola Grande di S Rocco, Venice, is also significant. While Giuseppe Salviati (*c.* 1520–*c.* 1575), Federico Zuccaro (1540/42–1609) and Paolo Veronese (1528–88) prepared the standard demonstration drawings, Jacopo Tintoretto (1519–94) won over the judges by producing the completed painting as his demonstration piece. Tintoretto's justification was that 'designs (disegni) and models (modelli) should be such that they do not deceive'.

Early sources

L. B. Alberti: *De pictura* (MS. 1435); ed. C. Grayson, Biblioteca degli scrittori d'Italia degli editori Laterza (Rome and Bari, 1975), pp. 102–3; Eng. trans. by C. Grayson (London, 1972)

G. Vasari: *Vite* (1550, rev. 2/1568); ed. G. Milanesi (1878–85), iii, p. 525; vi/2, pp. 592–4

G. Vasari: *Vite* (1550, rev. 2/1568); ed. R. Bettarini, annotated by P. Barocchi (Florence, 1966–87), i, pp. 117–24; iii, pp. 507, 572–3; iv, p. 159

G. A. Gilio: *Due dialoghi: Degli errori e degli abusi de' pittori circa l'istoria* (Camerino, 1564)

R. Borghini: *Il riposo* (Florence, 1584), pp. 138–49

G. B. Armenini: *De' veri precetti della pittura, libri tre* (Ravenna, 1586–7/R New York, 1971), pp. 89–99; Eng. trans. by E. Olszewski (New York, 1977)

Vocabolario degli accademici della Crusca (Florence, 1612; rev. 5/1910), x, pp. 398–400

F. Baldinucci: *Vocabolario toscano dell'arte del disegno* (Florence, 1681/R Florence, 1975), pp. 99–100

A. Pozzo: 'Breve instruttione per dipingere a fresco', *Perspectiva pictorum et architectorum* (Rome, 1693–1700, rev. 1717), ii, §§5–6

General

N. Tommaseo: *Dizionario della lingua italiana* (Turin, 1915), v, pp. 314–15

E. Borsook: *The Mural Painters of Tuscany* (London, 1960, rev. Oxford, 2/1980), pp. xlvi, 59–63, 77–9

S. Battaglia: *Grande dizionario della lingua italiana* (Turin, 1978), x, pp. 644–8

M. Hollingsworth: 'The Architect in Fifteenth-century Florence', *Art History*, vii (1984), pp. 385–410

Drawings

J. Meder: *Die Handzeichnung* (Vienna, 1919); Eng. trans. and rev. by W. Ames as *The Mastery of Drawing*, 2 vols (New York,

1978), i, pp. 236–57, 286–8, 528 ('contract drawing'), 529 ('modello')

H. Tietze and E. Tietze-Conrat: *The Drawings of the Venetian Painters in the 15th and 16th Centuries*, i (New York, 1944), pp. 12–17

B. Degenhart and A. Schmitt: *Corpus der italienischen Zeichnungen, 1300–1450: Teil I. Süd- und Mittelitalien* (Berlin, 1968), I/i, pp. xiii–li [esp. pp.xxi (note 41), xxii–xl]; I/ii, pp. 383–6 (no. 302), p. 516 [the role of modelli in early It. drawing practice; Paolo Uccello's Uffizi modello; doc. regarding Alesso Baldovinetti's modelli]

E. Berckenhagen: *Die französischen Zeichnungen der Kunstbibliothek Berlin: Kritischer Katalog*, W. Berlin, Kunstbibliothek und Museum (Berlin, 1970), pp. 156–7 (no. 825)

J. Harris: *A Catalogue of British Drawings for Architecture, Decoration, Sculpture and Landscape Gardening, 1550–1900, in American Collections* (Upper Saddle River, NJ, 1971), pp. 232–61

C. Monbeig Goguel: *Vasari et son temps: Inventaire général des dessins italiens. I. Maîtres toscans nés après 1500, morts avant 1600*, Paris, Musée du Louvre, Cabinet des Dessins cat. (Paris, 1972), pp. 162–4 (no. 211)

J. Byam-Shaw: *Drawings by Old Masters at Christ Church, Oxford*, i (Oxford, 1976), pp. 65, 165–6 (nos 119, 594)

D. Angulo and A. Pérez Sánchez: *A Corpus of Spanish Drawings: Madrid, 1600–1650* ii (London, 1977), pp. 27, 34, 50 (nos 107, 156, 274)

P. Dreyer: *Kupferstichkabinett Berlin: Italienische Zeichnungen* (Stuttgart and Zurich, 1979), pp. 34–8

J. Leymarie, G. Monnier and B. Rose: *Drawing: History of an Art* (Geneva and New York, 1979), pp. 102–3

P. Ward-Jackson: *Victoria and Albert Museum Catalogues: Italian Drawings. Volume One: 14th–16th Century* (London, 1979), pp. 30–32, 78–9, 146–8, 153–4 (nos 28, 159–60, 311–12, 321)

M. Roland Michel: *Die französische Zeichnung im 18. Jahrhundert* (Munich, 1987), pp. 129–36

Exhibition catalogues
Ingres (exh. cat. by M. Serullaz and others, Paris, Petit Pal., 1967–8), p. 94 (no. 62)
Drawing: Technique and Purpose (exh. cat. by S. Lambert; London, Victoria and Albert Museum, 1981)
Drawings by Raphael from the Royal Library, the Ashmolean Museum, the British Museum, Chatsworth and other English Collections (exh. cat. by J. A. Gere and N. Turner; London, British Museum, 1983), pp. 239–40, 242 (nos 191–2, 194)
Reading Drawings: An Introduction to Looking at Drawings (exh. cat. by S. Lambert; New York, Drawing Center, 1984)
Hans Holbein d. J.: Zeichnungen aus dem Kupferstichkabinett der Öffentlichen Kunstsammlung Basel (exh. cat. by C. Müller; Basle, Öffentliche Kunstsammlung, 1988), pp. 208–12 (no. 65)
Michelangelo Architect: The Façade of San Lorenzo and the Drum and Dome of St Peter's (exh. cat. by H. Millon and C. Smyth; Washington, DC, National Gallery of Art, 1988), pp. 3–31, 79–83
Pietro Testa, 1612–1650: Prints and Drawings (exh. cat. by E. Cropper; Philadelphia, PA, Museum of Art, 1988), pp. 193–7 (no. 90)
Prag um 1600: Kunst und Kultur am Hofe Kaiser Rudolf II (exh. cat., Vienna, Kunsthistorisches Museum, 1988), p. 154 (no. 619)
Dessins français du XVIIe siècle dans les collections publiques françaises (exh. cat., Paris, Musée du Louvre, 1993), pp. 174–5 (no. 84)

Monographs
W. Friedlaender and A. Blunt, eds: *The Drawings of Nicolas Poussin* (London, 1953), v, p. 27 (no. 198)

J. Held: *Rubens: Selected Drawings, with an Introduction and a Critical Catalogue*, 2 vols (Oxford, 1959, rev. 2/1986), i, pp. 16–41, 100, 117–19 (nos 77, 125–7)

K. Oberhuber: *Raphaels Zeichnungen: Abt. IX. Entwürfe zu Werken Raphaels und seiner Schule im Vatikan 1511/12 bis 1520* (Berlin, 1972), pp. 20–24, 139–40, 162–4, 166–7, 174 (nos 452, 457, 459b, 469)

R. A. d'Hulst: *Jordaens Drawings*, i (Brussels, 1974), pp. 209–10 (no. A 114)

F. Ames-Lewis: *The Draftsman Raphael* (New Haven and London, 1986), pp. 1–11, 39–59, 73–100, 126–36

M. Hirst: *Michelangelo and his Drawings* (New Haven and London, 1988), pp. 79–90; review by C. Bambach Cappel in *Art Bulletin*, lxxii (1990), pp. 493–8; see also M. Hirst in *Art Bulletin*, lxxiv (1992), p. 172 and C. Bambach Cappel in *Art Bulletin*, lxxiv (1992), pp. 172–3

M. Gareau: *Charles Le Brun: Premier Peintre du roi Louis XIV* (Paris, 1992), pp. 122–3

Specialist studies
A. Grote: *Das Dombau-amt in Florenz, 1285–1370: Studien zur Geschichte der Opera di Santa Reparata* (Munich, 1960), pp. 113–19 [doc. mentioning modelli]

K. Oberhuber: 'Vorzeichnungen zu Raffaels *Transfiguration*', *Jahrbuch der Berliner Museen*, iv (1962), pp. 116–49

L. Shelby: 'The Role of the Master Mason in Mediaeval English Building', *Speculum*, xxxix/3 (1964), pp. 387–403

J. Shearman: 'Raphael's Unexecuted Projects for the *Stanze*', *Walter Friedlaender zum 90. Geburtstag* (Berlin, 1965), pp. 158–80

M. Fitzsimmons: 'Purpose and Quality in Architectural Drawings', *Drawing*, iv/3 (1982), pp. 55–9

F. Toker: 'Gothic Architecture by Remote Control: An Illustrated Building Contract of 1340', *Art Bulletin*, lxvii (1985), pp. 67–95

W. Wallace: 'Two Presentation Drawings for Michelangelo's Medici Chapel', *Master Drawings*, xxv (1987), pp. 242–60

B. Barnes: 'A Lost *Modello* for Michelangelo's *Last Judgment*', *Master Drawings*, xxvi (1988), pp. 239–48

2. SCULPTED. The laborious techniques involved in sculpture, in particular when hewing large images out of stone or wood, and the difficulty of visualizing anything in three dimensions has led to the widespread use among sculptors of models in easily worked and cheap materials, on a small scale or at full size, before setting to work on the final block of material. It is, however, far from certain when the practice of making such models began; the relatively simple forms and straightforward poses of Egyptian or Archaic Greek statues may be visualized without great difficulty and were probably achieved by drawing the desired outlines from different viewpoints on the faces of a block. Similar, small-scale figures were modelled in clay or carved out of wood as votive offerings in these civilizations and might have served as reference models, but there is no evidence of the deliberate use of preliminary modelli. It is thought that artists generally carved directly into the block, a

technique revived in the 20th century, as being more truly 'sculptural' and somehow metaphysically superior to copying from a modello.

Wittkower convincingly attributes the introduction of modelli, probably worked in clay, to Athens in the 5th century BC, when much more lifelike figures and poses were being introduced and when the sheer size of the programmes of three-dimensional architectural sculpture would have required the simultaneous participation of many craftsmen in the labour of blocking-out and carving. Sculptures such as those from the Parthenon in Athens (London, British Museum) cannot have been carved directly, for their poses and drapery patterns are far too complex; the uniform style and finish also strongly suggests that the many sculptors involved must have had modelli from which to work. The drill, the tool necessary for transferring the measurements taken from a working modello into the uncarved block, was much in use by this time. The idea of using modelli may have been the catalyst that led to the emergence of Classical from Archaic sculpture. Modelling in clay (*plastica*) was held in high esteem but differentiated as an art from carving (*sculptura*) and casting (*fusoria*) in antiquity, as codified by Pliny the elder in the 1st century AD.

Descriptions of technique are rare until the Renaissance, and even later, for craftsmen may have been barely literate, and some details may also have constituted trade secrets, for example among masons. Secondly, it was not until the High Renaissance, around 1500, that the processes of creation, including an artist's sketchy preparations, whether on paper or in wax or clay, became of general interest. The emergence of interest in the history of art that came with the writings *c.* 1550 of Giorgio Vasari (1511–74) had as a concomitant factor a new regard for the artist as a creator, not just as an artisan, and this in turn promoted a concern for all his creations, be they preliminary ideas or finished works. At this time Neo-Platonic philosophy also revived the belief that things on Earth were imperfect renderings of heavenly 'ideas', and the act of creation by an artist was likened to that of God in the Book of Genesis. Indeed, the creation of Adam out of a handful of earth had clear analogies with the making of copies of human figures in the same basic material by a sculptor. By Vasari's time there was even emerging an aesthetic preference for modelli over their finished counterparts, at least as regards painting. It was yet more applicable to sculpture, where the labour of carving (or casting) involved hours of tedious work, as well as delegation to juniors, whose necessary intervention might tend to stultify the artist's initial spontaneity, achieved in such ductile materials as wax or clay.

The principal materials used for making modelli—beeswax and clay—are easily available; softwood may also be carved into a modello, as was the practice among Late Gothic German silversmiths and bronzefounders. Beeswax, sometimes mixed with tallow for extra malleability, has the advantages of ductility and cleanliness in use (*see* WAX, §II, 1(i)). It is slow to

harden and so permits change over a longer period: 'Wax always waits' was an adage of the Florentine studios, quoted by Ridolfo Sirigatti (*fl* 1594–1601) in his observations on sculpture techniques in Raffaele Borghini's *Il riposo* (Florence, 1584).

The disadvantages of wax are that it is extremely fragile and is prone to melt and thus sag with undue heating. It may also be re-melted and reused, which may explain why more wax modelli have not survived. To preserve the form of a wax modello, it is necessary to take piece-moulds from it, so that a cast in plaster, bronze or another inert and durable material may be made. Some Renaissance bronze statuettes, apparently solid and with unfinished and waxy surfaces, are such 'relict' casts. They also have an iron-wire armature embedded in the bronze; this was necessary to support the original wax figure if it had limbs projecting from the body or was undercut in other ways. Several such examples exist and are believed to come from the workshops of Donatello (1386/7–1466; e.g. the *David with the Head of Goliath*, Berlin, Bodemuseum), Antonio Pollaiuolo (*c.* 1432–98; e.g. *David, c.* 1470; Paris, Musée du Louvre) and Francesco di Giorgio Martini (1439–1501; e.g. *David, c.* 1470; Naples, Museo e Gallerie Nazionali di Capodimonte).

Clay is also ductile but is messy to use and hardens quite quickly, unless it is kept under damp rags; also, its surface does not take quite as fine detail as does wax. It does, however, have the advantage over wax that by drying in the sun or firing in a kiln, it becomes hard and, as terracotta (*see* TERRACOTTA, §I), virtually indestructible. Its use did not therefore necessitate the extra labour of casting to preserve one's efforts. It is probably on account of this durability that the earliest surviving sketch modelli are made in terracotta; dating from the later years of the Florentine Renaissance, they are virtually intact. In at least one case, that of Andrea del Verrocchio's modello (*c.* 1477; London, Victoria and Albert Museum) for the monument to *Cardinal Forteguerri*, preservation, initially at least, may be due to the terracotta having been physically attached to a legal contract for the erection of the monument in Pistoia Cathedral (*in situ*), but also because it was the evidence on which Verrocchio won the competition to execute the commission. Several modelli survive from this period, and their aesthetic appeal may have played a part in their preservation. Examples include the modello for the *Virgin with the Laughing Child* by Antonio Rossellino (1427/8–79) and the series of plaques by Benedetto da Maiano (1442–97) with Franciscan scenes for the pulpit of Santa Croce, Florence (all London, Victoria and Albert Museum).

By the end of the 15th century such modelli were generally regarded as collectable objects: a modello for *St James the Greater* by Jacopo Sansovino (1486–1570) in Florence Cathedral was presented to Bindo Altoviti (1491–1557); now lost, this must have resembled that of his *St Paul* in terracotta (Paris, Musée Jacquemart-André). Another modello, a tableau of the *Deposition* (1510; London, Victoria and

Albert Museum), with figures in wax and real textiles and a wooden cross and ladders, was created by Sansovino as a modello for the painter Perugino (c. 1450–1523) and survived because it was presented after use to Giovanni de' Gaddi (1493–1542), as a work of art in its own right. Sansovino also created modelli for the painter Andrea del Sarto (1486–1530); the use of these is evident in the latter's grisaille frescoes of statuary in the Chiostro dello Scalzo, Florence. A modello of the *Virgin and Child* (c. 1515; Budapest, Museum of Fine Art) is probably Sansovino's entry in a competition for a commission for the Mercato Nuovo, Florence.

Michelangelo (?1475–1564) is famed for his preparatory pen-and-ink or chalk drawings for sculpture, but relatively few of his three-dimensional modelli survive. This was not because of a lack of interest among collectors—indeed the sculptor gave one to Leone Leoni for making a portrait of him—but because he deliberately destroyed his creations from time to time, fearing that other, less gifted artists might steal his ideas without acknowledgement. A wax modello (1516; London, Victoria and Albert Museum) for the *Young Slave* from the tomb of *Pope Julius II* (Rome, St Peter's) is one of the survivors that is generally accepted to be autograph, but Michelangelo's authority and international fame were such that younger artists studied his work by making modelli from them, and this causes great confusion, even to specialists.

After the High Renaissance the making (and occasional preservation) of modelli became common practice, and Vasari in his *Vite* and Benvenuto Cellini (1500–71) in his *Tratatti* set out clearly the successive stages: first thoughts (*pensieri*) were committed to paper and then (or sometimes omitting the drawing stage) to wax or clay modelli on a very small scale, usually with a wire armature. X-ray radiographs of the wax modelli by Giambologna (1529–1608) in the Victoria and Albert Museum, London, show that in one instance the armature is simply a bent nail hammered into an off-cut of wood, while in another it is a more elaborate structure with knitted wire to give bulk to a torso and to prevent the warm wax from slipping down the straighter wire axis of the figure. Similar armatures have been used ever since and are evident in, for example, the wax modelli of horses and ballerinas made by Edgar Degas (1834–1917) in connection with his paintings. Some 20th-century sculptors (e.g. Alberto Giacometti (1901–66)) have raised the minimalist, linear concept of such an armature to the status of a finished sculpture.

After the initial sketch had been approved by the sculptor, and possibly also by his patron, he would 'flesh out' the composition in a clay modello 300–450 mm in height. The torso could be hollowed out, to withstand the eventual firing, and some parts cut off with wires, for separate piece-moulding; studies of heads and hands in greater detail might be made separately. From such a modello (e.g. Giambologna's *Florence Triumphant over Pisa*, terracotta, h. 380 mm; London, Victoria and Albert Museum) assistants could

create a yet larger, final modello, the size of the final sculpture (e.g. Giambologna's *Florence Triumphant over Pisa*, whitewashed clay; Florence, Palazzo Vecchio). The term 'modello' was used specifically to describe this type of modello, which was built up round a wooden armature in a mixture of clay and plaster. Too big to be fired in a kiln, it could only be dried in the sun or by the heat of stoves and would thus be more friable than terracotta and prone to fall apart if exposed to rain. Few of these inconveniently large and relatively immovable modelli have survived, although that for Giambologna's *Rape of a Sabine* (h. 4.10 m) is in the Accademia, Florence. From this modello, stone-carvers would transfer the measurements into the raw block of marble by drilling into it at various depths and from various fixed points. They would then carve down to just short of the bottoms of these holes, leaving enough scope for the sculptor or his foreman to adjust the eventual surfaces exactly as he wished and then to finish the work in every detail.

Gianlorenzo Bernini (1598–1680) did not leave any wax modelli and seems to have worked from sketches on paper directly into clay modelli some 300 mm high: a good number of these, showing various designs for many of his commissions, survive, for example those of the angels for the balustrades of Ponte Sant'Angelo, Rome (1667–8; Cambridge, MA, Fogg Art Museum; Fort Worth, TX, Kimbell Art Museum; St Petersburg, Hermitage Museum; Rome, Palazzo Venezia). His modelli were avidly collected, and some may have been produced to satisfy the demands of collectors, not just as preliminary sketches.

These techniques remained standard until the 19th century; a variation was introduced, however, by such Neo-classical sculptors as Antonio Canova (1757–1822) and Bertel Thorvaldsen (1768/70–1844) and their French contemporaries. Among them it became usual to produce a plaster cast of the initial clay modello and to work with it, rather than with the clay modello fired into terracotta. This cast is known as the 'original plaster' (Fr. *plâtre originale*), thus distinguishing it from copies of the final sculpture cast in plaster. Many of the original plasters by Canova and Lorenzo Bartolini (1777–1850) are easily recognized by the large number of metal points attached to their surfaces, for use in the process of transferring measurements to the marble block. During the same period it became common for an artist to preserve all his original plasters, not only to enable the making of several versions in marble at later dates but also as a record of his artistic achievement: these plasters, points and all, often provided the mainstay for posthumous museums of the sculptors' work (e.g. the Gipsoteca Canoviana, Possagno, and the Thorvaldsens Museum, Copenhagen). Similarly, original modelli often survived due to their being part of the 'studio effects' inherited by or sold on to another artist. In England in the late 18th century such artists as Richard Cosway (1742–1821), Joseph Nollekens (1737–1823) and Thomas

Lawrence (1769–1830) all owned modelli believed to be by Michelangelo (although in fact they were more often by Giambologna) as exemplars of High Renaissance compositions. Nollekens even created a series of small modelli of mythological figure compositions, in imitation of Italian practice, most of which are now in the Victoria and Albert Museum, London.

From the Renaissance, but particularly during the 18th century in France and England, elaborate modelli for façades or tombs were often produced with wax or clay figurines and reliefs mounted on a wooden architectural carcass: these were used, together with scale drawings, to demonstrate a commission to a patron. In the 19th century, with the proliferation of bronze-casting, it was usual to preserve the original wax modello in bronze, and often to label it as such. Several meticulously detailed wax modelli of animals by Antoine-Louis Barye (1796–1875) survive (Paris, Musée du Louvre), as well as those by other sculptors. Some of the most aesthetically exciting modelli are those made by Edgar Degas (1834–1917) in connection with his paintings, for they show immense verve in rendering form and movement spontaneously and were probably executed from life: wire armatures were bent into shape and then red wax was rapidly applied (e.g. Washington, DC, National Gallery of Art; Cambridge, Fitzwilliam Museum).

During the 20th century the admiration for spontaneity and the quest for originality that was initiated by Auguste Rodin (1840–1917) has elevated what would once have been dismissed as working modelli to the status of works of art, leading them to be regarded as satisfactory in themselves, however incomplete their conception. The very lack of completion is seen as a challenge to the spectator, who is thereby encouraged mentally to complete them for himself in whatever way he chooses.

A. E. Brinckmann: *Barock-Bozzetti* (Frankfurt am Main, 1923)

L. Réau: 'Les Maquettes des sculpteurs français du XVIIIe siècle', *Bulletin de la Société de l'histoire de l'art Français* (1936), pp. 7–28

I. Lavin: 'Bozzetti and Modelli', *Stil und Überlieferung in der Kunst des Abendlandes. Akten des 21. internationalen Kongresses für Kunstgeschichte: Bonn, 1964* (Berlin, 1967), pp. 93–104, pl. III

R. Wittkower: *Sculpture: Processes and Principles* (London, 1977)

C. Avery: 'Terracotta: The Fingerprints of the Sculptor', *Fingerprints of the Artist: European Terra-cotta Sculpture from the Arthur M. Sackler Collection* (exh. cat., ed. L. Katz; Washington, DC, National Gallery of Art; New York, Metropolitan Museum of Art; Cambridge, MA, Fogg Museum; 1981), pp. 16–25 [repr. in Avery, 1988]

L. Katz: 'La cera sempre aspetta: Wax Sketch Models for Sculpture', *Apollo*, cxix (1984), pp. 166–76 [repr. in Avery, 1988]

M. Baker: 'Roubiliac's Models and Eighteenth-century English Sculptors' Working Practices', *Entwurf und Ausführung in der europäischen Barockplastik* (Munich, 1986), pp. 59–84

C. Avery: *Studies in European Sculpture*, ii (London, 1988)

M. Baker: 'Roubiliac's Argyll Monument and the Interpretation of Eighteenth-century Sculptors' Designs', *Burlington Magazine*, cxxxiv (1992), pp. 785–97

Monotype. Type of print and the process in which a drawing or painting executed on a flat, unworked printing plate or other surface is transferred through pressure to a sheet of paper. As most of the image is transferred in the printing process, only one strong impression can be taken, hence the term 'monotype' (unique, single impression). Residual ink on the printing surface occasionally permits the printing of fainter second or third impressions; these are called 'ghosts' or 'cognates'. A monotype is distinct from a monoprint, which is a uniquely inked and printed impression from a traditional print matrix.

The often experimental genesis and comparative technical ease of monotype have combined to render very broad parameters for the process. Monotype is, in effect, the simplest printmaking process (a printed transfer of an image), but, combined with its inherent uniqueness, it has fallen between strict definitions of painting, drawing and printmaking. The classical monotype requires only a copper plate, ink, a printing press and paper. The artist may manipulate the ink on the plate with brushes, sticks, rags or fingers to create an image. Traditionally the image can be created either subtractively, from a film of ink previously laid on the plate (dark-field manner), or positively, with direct linear or tonal application of the ink on a clean plate (light-field manner). The printing of the image on to a sheet of paper is accomplished either in a traditional etching press or by manual application of pressure with a spoon or the hand itself. The primary technical variant is the trace monotype, which involves drawing with a stylus on the *verso* of a sheet of paper that has been laid on an inked surface; the local application of the 'printing' process transfers ink to the underside (*recto*) of the sheet being drawn upon.

Further variations on the monotype process are presumably without limit. The image-making media may include watercolour, chalk, crayon, pastel, oil pigment, printing ink or graphite (pencil), to name only the most common. These media may be drawn or painted upon surfaces as varied as metal printing plates, glass, Perspex, cardboard or wood. The essential quality of the printing surface for a strict monotype is that it has no image already fixed on it by etching, lithography, collage or any other traditional printmaking process.

The monotype typically has relied for its appeal on the combination of the freedom and spontaneity of drawing and the interaction of pigment and paper under pressure. The transfer process usually softens hard edges in the drawn image, rendering areas more painterly and textured in the resulting impression. The extraordinary variety of media used in producing monotypes also renders an inclusive definition of their appearance difficult. One characteristic feature usually present on a monotype is the mark embossed in the paper by the edges of the printing plate; the rather 'flattened' appearance of a work which otherwise resembles a drawing is often another indication of a monotype process.

Monotypes have been utilized by artists as foundations for further elaboration with drawing or painting

media over the printed impression (or the fainter cognate or ghost impressions), notably employed by Edgar Degas (1834–1917). The printing plate itself, which usually retains a shadow (ghost) of the original drawing, can also serve as the basis for another application of pigment and be printed again. This process may be repeated a number of times, producing an evolving series of individual, yet closely related monotype impressions. Another recent variation similarly consists of repeated applications of pigment on the printing plate, but on each occasion printing on to the same sheet of paper, thereby building up a single, multilayered monotype image.

The monotype does not present a direct historical development due to its elusive status as neither a true drawing nor a traditionally defined multiple (print) and to its sporadic and experimental use by artists. The impossiblity of duplication has thwarted its widespread use; it is a private medium, more akin to an artist's studio drawings. Indeed, the technique was not described in printmaking manuals until comparatively recently. Artists usually discovered monotype themselves or learnt of it through verbal tradition. While it has been employed most often by artists engaged in traditional printmaking, it has also been utilized by those who have not, particularly contemporary painters.

H. von Herkomer: *Etching and Mezzotint Engraving* (London, 1892), pp. 104–7

E. Ertz: 'Monotyping', *The Studio*, xvii (1902), pp. 172–7

H. Rasmusen: *Printmaking with Monotype* (Philadelphia, 1960)

J. Ross, C. Romano and T. Ross: *The Complete Printmaker* (New York and London, 1972; rev. New York, 1990), pp. 245–58

N. Laliberté and A. Mogelon: *The Art of Monoprint: History and Modern Techniques* (New York, 1974)

J. Ayres: *Monotype* (New York, 1991)

F. Carey: 'The Monotype in Britain', *Tamarind Papers*, xiv (1991–2), pp. 14–20

J. Moser: *Singular Impressions: The Monotype in America* (Washington and London, 1997)

Mordant (i). Term for the acidic solution in which the metal plate or object is immersed in the printing processes of etching and aquatint. The acid bites into the unprotected areas of the plate, creating the hollows that hold the ink during printing.

Mordant (ii). Term for the resin or oil layer used in gilding to stick the gold leaf on to the prepared surface of wood, sealed plaster or paint (*see* GILDING, §I, 1(i)).

Mordant (iii). Term for the substance used to fix the colour in dyeing and printing textiles (*see* TEXTILE, §III, 1(ii)).

Mosaic. Closely spaced polychrome or monochrome particles (tesserae) of near uniform size embedded in a binder, such as mortar or cement. Mosaic has been used as a decorative medium on walls, floors and columns for over 5000 years. A wide range of natural and artificial materials may be used for the tesserae: pebbles, hardstone, shells, vitreous paste, terracotta, mother-of-pearl, enamels and turquoise. The shapes are usually fairly regular: rectangles, squares, triangles or trapezoids. They normally vary in size from a few millimetres to more than 1 cm sq. The terms 'tile mosaic' and 'mosaic faience' are applied to a technique used in the decoration of Islamic buildings from the 11th century onwards, in which tiles of different colours were cut to form a design.

I. Materials and techniques. II. Conservation.

I. Materials and techniques.

1. Western world. 2. Pre-Columbian Americas.

1. WESTERN WORLD.

(i) Classical. (ii) Post-Antique and medieval. (iii) The Renaissance to the 20th century.

(i) Classical. The term 'mosaic' is taken from the Greek: mosaic pieces were called *abakiskoi* by the Greeks and *abaculi, tesserae* or *tessellae* by the Romans. The list of artisans in Diocletian's *Edict on Prices* (AD 301) distinguishes between the *tessellarii*, who laid mosaic pavements, and the *museiarii*, the makers of wall and vault mosaics. The latter term was universally adopted to include both types of artisans in the post-Antique period.

An understanding of how mosaics were produced in antiquity is based almost entirely on the surviving physical evidence (apart from the *Edict on Prices* (AD 301) and some passages in Vitruvius' *On Architecture (late 1st century BC)*) and on the epigraphic evidence from various mosaic projects. It is generally believed that the ancient floor mosaics were produced *in situ*, as suggested, for example, by the archaeological evidence from the 4th-century AD nymphaeum at Neapolis (now Nabeul, Tunisia), where chippings and strips of the polychrome marble used in the pavement were discovered on site. A further proof of this direct method of production is found in the Late Antique relief from Ostia, which may illustrate the *in situ* production of a floor mosaic: it shows the master mosaicist directing two porters who carry sacks of mosaic material, and two mosaicists who cut tesserae on the ground. In fact, it has been suggested that corporations of mosaicists were responsible for the pavements in private buildings, as indicated by inscriptions that include such terms as *ex officina* followed by the name of the artisan (see Balmelle and Damon).

As stone dominated the early history of mosaic production, it is not surprising that its natural colours provided the basic range of hues for the artist (see colour pl. VIII, fig. 3). The practice of using stone or marble for certain parts of a mosaic—faces, hands and feet—continued into the Middle Ages in both the East (i.e. Byzantium) and the West.

For the pebble mosaics at Olynthos (*c.* 5th century BC), fairly uniform stones were selected with diameters from 10 to 20 mm. The pebble mosaics from

1. Mosaic of a hare, pomegranate and grapes, from the floor of the House of the Dolphins in Thysdrus (present-day El Djem), early 3rd century AD; photo © The J. Paul Getty Trust, all rights reserved

Pella (4th century BC) are made of natural pebbles, but in places the mosaicists found it necessary to use strips of lead to outline some of the inner markings and contours. Shaped tesserae from the 3rd century BC are found in the House of Ganymede at Morgantina, Italy, and tessellated mosaic pavements had gradually superseded pebble floors by the end of that century.

While the majority of mosaic pavements in antiquity were laid directly on site, a number of floors display emblemata, which are inset panels of images or ornamental motifs made of fine, precisely set tesserae that could be produced in another location (see fig. 1). Emblemata were normally preset on trays of stone or terracotta, which were then embedded in the setting-bed. They are usually of high quality, as may be seen in the 1st-century BC copy of the mosaic by Sosos of doves drinking (Rome, Museo Capitolino).

The technique known as *opus vermiculatum* is so-called from the wormlike look of the close-set rows of undulating tesserae; it first appears in Alexandrian floor mosaics of the late 3rd–early 2nd century BC. The most famous example of this type of work is the late 2nd-century BC *Alexander* Mosaic depicting the battle of Alexander and Darius at Issus found in the House of the Faun at Pompeii. Mosaics of this sort were undoubtedly luxury items.

Glass tesserae first appeared on floor and wall mosaics between the 3rd and 1st centuries BC. They brought unlimited colour possibilities to this art form, but their brittleness made them unsuitable for floor mosaics.

(ii) Post-Antique and medieval. The character of mosaic was altered irrevocably by the widespread use of gold and silver tesserae, and with these craftsmen developed considerable practical experience in how mosaics could serve the laws of optics. Glass for this kind of tesserae had a piece of metal foil applied on to or, better, embedded in it. Pieces of gold leaf were used, or, in the case of silver tesserae, pieces of silver or tin. Both types of tesserae impart a luminous, reflective quality of high intensity; they were usually used to suggest the idea of light emanating from God (see colour pl. VIII, fig. 2). Gold was first used in floor and vault decoration in late antiquity; one of the earliest instances of the use of gold to depict the light of God is found in the representation of Christ as Helios in a 3rd-century mausoleum under St Peter's.

Coloured glass tesserae were prepared by glassmakers, who employed a mixture of sand, soda or

potash, and lime, with varying amounts of metallic oxides to obtain the different hues of glass. A number of ancient and medieval treatises have survived that discuss how to colour and manufacture glass tesserae. The 12th-century monk Theophilus, for example, described this process in his treatise *De diversis artibus*. He stated that sheets of glass were prepared using the 'muff' technique of glassmaking, and that these were later cut into the appropriate shapes and sizes. The documents for the 14th-century mosaics on the façade of Orvieto Cathedral corroborate his assertion that some medieval glassmakers used the 'muff' technique rather than casting to make sheets of glass. However, two 12th-century *linguae* or tongues of cast glass, intended for the mosaics at S Marco, Venice, have survived to this day, so production methods obviously varied from site to site.

The provision of the other tesserae also varied. The mosaic decoration of AD 965 in the mosque at Córdoba, for example, was probably executed by Greek mosaicists, and the emperor Nikephoros II Phokas (*reg* 963–9) sent a substantial quantity of tesserae with the workers. After the conquest of Constantinople (now Istanbul) in 1204 the Venetians sent tesserae and other pieces of stone and marble back to Venice, presumably for use at S Marco. That mosaic tesserae were in short supply at certain periods, even in Constantinople, may be deduced from sources that inform us that, for the decoration of the Nea Ekklesia (destr.) within the Great Palace there, Basil I (*reg* 867–86) had mosaic tesserae and marble slabs removed from Justinian's mausoleum at the church of the Holy Apostles (destr.). On other occasions, various ad hoc solutions were found. For instance, some of the materials for the 11th-century mosaics in the cathedral of St Sophia in Kiev, such as coloured glass tesserae, may have been produced locally in a workshop that included a glass furnace. However, the gold tesserae at Kiev are cut with such precision that it has been suggested that they were produced elsewhere, perhaps in Constantinople, where the manufacture of such tesserae was a long and established practice (see Lazarev). But tesserae may also have been cut, if not produced, *in situ* for a number of medieval mosaic schemes; new evidence shows that this was the case at Monreale during the late 12th century (see Andaloro).

The evidence from Orvieto indicates that glass tesserae were produced and cut on site there. In fact, between 1321 and 1390, cathedral officials at Orvieto paid for the construction and maintenance of at least one furnace, which was near the bishop's palace across from the cathedral. The officials also sent to Venice for supplies of coloured glass; in addition, tesserae were produced at a small forest glassworks at Monteleone, near Orvieto. By contrast, in Pisa during the early 14th century itinerant merchants supplied cathedral officials with glass and stone for the apse mosaic.

There has been much debate as to how mosaics were produced during the Middle Ages. Until the late 1950s it was thought by some scholars that they were created by the indirect method, in which the tesserae were attached to a cartoon in the studio and then transferred to the wall. While this method was often used for post-medieval mosaics (particularly in the 19th century), a survey carried out in 1957–9 of the unfinished mosaics of the church of the Pammakaristos (now the Fethiye mosque) led Byzantine scholars to revise their opinions in favour of the direct method, in which artists did preliminary drawings on the wall and then set the tesserae directly on to this surface. It is now generally agreed that both Byzantine and Western mosaics were produced in this manner.

A reasonable amount of information about underdrawings and the composition of mosaic setting-beds is provided by analyses of various mosaic projects. The setting-beds were usually built up of two or three layers of mortar, and in the case of walls and vaults the supporting surfaces were reinforced with iron nails. The documentation for the mosaics on the façade of Orvieto Cathedral makes frequent reference to the purchase of materials for the mortar, as well as to reinforcing nails and clamps for the tops of the gabled surfaces. Nails and clamps have been found at the tops of walls and vaults in a number of medieval mosaic projects in both East and West.

To guide the mosaicists in the setting of the tesserae it was a common practice to paint detailed preparatory drawings directly on to the setting-bed. There is, however, extant physical evidence to suggest that sometimes both Byzantine and Western mosaicists executed a preliminary compositional sketch either on the masonry itself or on one of the preliminary coats of plaster (*see* SINOPIA). The Orvietan evidence reveals an interesting and somewhat different approach to this phase of the work, one that may reflect a moment of transition in mosaic production that would lead ultimately to its transformation during the Renaissance. The documents suggest that a CARTOON or auxiliary drawing was used in conjunction with the *sinopia* to establish the main elements of the composition. Regrettably neither the auxiliary drawings nor a preparatory sketch have been preserved at Orvieto. Iconographic guides and motif books were also used in the early planning stages, as evidenced by the use of a manuscript of the Cotton Genesis type to complete some of the atrium mosaics at S Marco in Venice during the early 13th century.

It seems that the development of wall and vault mosaics in antiquity led to experimentation with the spacing and angling of tesserae (see Nordhagen, 1976). Floor mosaics required a close, solid setting, but this was not such a key factor for wall and vault mosaics so the artisans could adopt a much looser approach to the setting. Between the 5th century AD and the 8th, tesserae were placed quite far apart and set at irregular angles to one another, so that the overall effect is one of diverse facets and angles. This may be seen, for example, in the mosaics of the 7th-century chapel of S Venanzio in the Lateran Baptistery, Rome.

The mosaics produced in the Byzantine empire during the Palaiologan period, such as the *Deësis* Mosaic (*c.* 1260–1300) at Hagia Sophia, Constantinople,

illustrate the care and precision used to set the tiny particles of stone and marble for the faces and hands. In general, Palaiologan mosaicists used small tesserae in their work, and they abandoned hard contours and outlines to achieve effects of soft modelling and subtle transitions of colour. They would also touch up the finished result with paint, if they felt it was needed. In the Renaissance, in accordance with Giorgio Vasari's idea that mosaic was painting for eternity, the tesserae were set as closely as possible, to minimize the abrupt transitions in colour and form that had been so highly prized by earlier mosaicists.

Another matter for debate is how mosaic workshops were organized in the Middle Ages. Deichmann has suggested that Diocletian's *Edict on Prices* cannot be used as a guide, and indeed one medieval reference, a Carolingian manuscript in Leiden, describes a different system of production. It distinguishes between the *pictor*, who supervised the laying of the mortar and possibly the initial drawings on the wall, and the *artifex*, who did the laying-out and setting of the tesserae on the plaster bed.

The evidence from 14th-century work at Orvieto confirms Kitzinger's hypothesis (1960) of a hierarchical division of labour, with the master mosaicists and their assistants working together with a team of glass-cutters, as well as collaborating with master glaziers employed by the Orvietan officials. Each gable of mosaic was carried out by one or two highly skilled artisans, who were assisted by several individuals on the more routine tasks, such as the setting of backgrounds, other uniform surfaces, landscape details or ornament. Another group of craftsmen was engaged in the preparation of the setting-bed and in the preparation and cutting of the tesserae. These individuals were paid either a daily or a piece-work rate, and they had little financial security should construction work be discontinued at any time. A third team took charge of the manufacture of the glass tesserae, maintaining the furnaces and ensuring that the master mosaicists were supplied with sufficient material. These master glassmakers produced the glass tesserae at their own expense, although they were also granted certain fringe benefits, such as a house, some bedding and the use of a furnace. At the top of this hierarchy were the master mosaicists, who enjoyed the highest wages and the best conditions of employment, including the luxury of a negotiated contract and a *lodo*, or independent assessment by committee, to determine the final price of their work.

However, the 12th-century inscription on the mosaics in the church of the Nativity in Bethlehem names as executant one Ephraim, painter and mosaicist, thus implying that in some decorative schemes an artist might carry out most of the tasks himself, from the drawing of the images to the setting of the tesserae.

Useful information on the relative costs of producing a mosaic as against those involved in fresco production is provided by the Orvietan evidence. Between 1359 and 1364 comparative costs of production suggest that the mosaics were approximately four times as expensive to manufacture, so that a decision to use mosaic rather than fresco would have had important cost implications for prospective patrons.

(iii) The Renaissance to the 20th century. Mosaic lost its popularity in Italy at the beginning of the Renaissance. Essentially, it became an imitation of painting, and the unique optical possibilities of the medium were not used to best advantage, particularly since the artists, striving for pictorial realism, rebelled against the use of gold. In addition, the distinction between the artist responsible for the project and the setters of the tesserae became more pronounced, and the preparatory work became divorced from the execution. The artist submitted his cartoon and left its transposition to artisans, as occurred in Venice during the 15th and 16th centuries. On-the-spot decisions about setting angles and distances between tesserae were no longer the concern of a master mosaicist.

Many of the great painters of the Renaissance made designs for mosaics—Raphael (1483–1520), for instance, designed decorations representing God the Father, angels and the seven planets (executed in 1516 by the Venetian Luigi di Pace) for the dome of the Chigi Chapel in S Maria del Popolo in Rome. During the late 16th century the dome of St Peter's in Rome was lined with mosaic. This location gradually became an important centre for the manufacture of mosaics, and it remained so in the late 20th century, together with the mosaic studios at Spilimbergo, Ravenna and Venice.

During the 19th century a renewed sense of historicism and an interest in craft techniques led to a demand for mosaic. Tesserae were mass-produced in workshops such as those of Antonio Salviati (1816–90) in Venice or August Wagner in Germany: both used the indirect system of setting tesserae on a prepared base, so that an entire mosaic could be produced in the workshop and then shipped to its final destination. In the 20th century surface texture and mixed materials returned to favour. Antoni Gaudí (1852–1926) at the Park Güell (1900–14), Barcelona, for example, arranged pieces of broken glazed tiles with fragments of glass bottles and china plates as a decorative coating over walls and other structures. Mexican artists, particularly Juan O'Gorman (1905–82) and Diego Rivera (1886–1957), used extensive areas of mosaic, made largely of stone, to cover large, unbroken architectural surfaces. Later in the century, mosaic workshops in Rome and Ravenna promoted the use of mosaic as independent 'panels' or on walls and vaults. The mosaics produced for the 1988 exhibition in the Castello Estense at Mésola were manufactured by artists using the direct method: cubes of glass and stone, shells and pieces of mirrors were combined to exploit the aesthetic possibilities of different materials, shapes, sizes, setting angles and distances.

2. PRE-COLUMBIAN AMERICAS. The workers who produced Pre-Columbian mosaics used obsidian, garnet, quartz, beryl, malachite, jadeite (see JADE,

colour pl. VII, fig. 2), marcasite, gold, mother-of-pearl and shell for their work, but turquoise was preferred above all as a material that conferred prestige and status on the wearer. These various materials were laid on objects made of wood, stone, gold, shell, pottery and leather and were held in place by a vegetal pitch or some kind of cement. In the turquoise-covered mask of Quetzalcóatl (14th–15th centuries; London, British Museum, Museum of Mankind) tiny pieces of the precious stone have been encrusted all over the surface, cabochon turquoises have been laid on the nose and in lines around the eyes and mouth, and shell inlay represents the eyes and teeth. Mosaic was also used for exterior wall-cladding. At Mitla in Oaxaca, for example, striking geometrical and animal patterns were produced on the 14th-century palaces by fitting together small stones of different shapes and sizes: each stone was cut for the spot it occupies, and some are more deeply embedded than others so that the designs stand out in sharp relief.

G. Milanesi: *Dell'arte del vetro per musaico* (Bologna, 1864)

G. B. De Rossi: *Musaici cristiani e saggi dei pavimenti delle chiese di Roma anteriori al secolo XV*, 27 parts (Rome, 1872–99)

E. Gerspach: *La Mosaïque* (Paris, 1881)

M. van Berchem and E. Clouzot: *Mosaïques chrétiennes du IV au X siècle* (Geneva, 1924)

E. Diez and O. Demus: *Byzantine Mosaics in Greece: Hosios Lucas and Daphni* (Cambridge, MA, 1931)

H. Hedfors, ed.: *Compositiones ad tingenda musiva* (Uppsala, 1932)

E. W. Anthony: *A History of Mosaics* (Boston, 1935)

C. R. Morey: *The Mosaics of Antioch* (London and New York, 1938)

J. W. Crowfoot: *Early Churches in Palestine* (London, 1941)

D. Levi: *Antioch Mosaic Pavements*, 2 vols (Princeton, 1947)

F. Forlati: 'La tecnica dei primi mosaici marciani', *Arte veneta*, iii (1949), pp. 85–7

O. Demus: *The Mosaics of Norman Sicily* (London, 1950)

H. Frankworth: *The Art and Architecture of the Ancient Orient* (Harmondsworth, 1954)

O. Demus: *Byzantine Mosaic Decoration* (Boston, 1955)

B. R. Brown: *Ptolemaic Paintings and Mosaics and the Alexandrian Style* (Cambridge, MA, 1957)

H. Stern: *Gallia, Sup. X*, i of *Recueil général des mosaïques de la Gaule* (Paris, 1957)

F. Deichmann: *Ravenna: Hauptstadt des spätantiken Abendlandes*, 4 vols (Wiesbaden, 1958–76)

Theophilus [Rugerus]: *De diversis artibus*; ed. and trans. by C. R. Dodwell as *On Divers Arts* (London, 1961)

Colloque international pour l'étude de la mosaïque antique. La mosaïque greco-romaine: Paris, 1963

J. M. C. Toynbee: *Art in Britain under the Romans* (Oxford, 1964)

V. Lazarev: *Old Russian Murals and Mosaics* (London, 1966)

H. P. L'Orange and P. J. Nordhagen: *Mosaic* (London, 1966)

G. Matthiae: *Mosaici medioevali delle chiese di Roma* (Rome, 1967)

A. Diem: 'Techniken des Mittelalters zur Herstellung von Glas und Mosaik', *Artigianato e tecnica nella società dell'alto medioevo occidentale. Settimane di studio del Centro italiano di studi sull'alto medioevo: Spoleto, 1970*, pp. 609–32

A. Balil: *Mosaicos romanos de Hispania citerior* (Santiago de Compostela, 1971)

I. Fiorentini Roncuzzi: *Arte e tecnologia nel mosaico* (Ravenna, 1971)

E. Kitzinger: 'Mosaic Technique', *Encyclopedia of World Art*, x (New York, Toronto, London, 1972), pp. 325–7

J. Mellentin-Haswell: *Van Nostrand Reinhold Manual of Mosaic* (London, 1973)

2e Colloque international pour l'étude de la mosaïque antique. La mosaïque greco-romaine: Paris, 1975

P. J. Nordhagen: 'Mosaic', *New Encyclopedia Britannica*, xii (Chicago, rev. 15/1976), pp. 462–74

J. Wilpert: *Die römischen Mosaiken der kirchlichen Bauten von IV–XIII Jahrhundert*; rev. ed. W. Schumacher (Vienna, 1976)

K. Dunbabin: *The Mosaics of Roman North Africa* (Oxford, 1978)

J. R. Clarke: *Roman Black and White Figural Mosaics* (New York, 1979)

I. Furlan: *Le icone bizantine a mosaico* (Milan, 1979)

E. Alfoldi-Rosenblum: *Justinian Mosaic Pavements in Cyrenaican Churches* (Rome, 1980)

A. Ovadiah: *Geometric and Floral Patterns in Ancient Mosaics* (Rome, 1980)

D. S. Neal: *Roman Mosaics in Britain* (Sutton, 1981)

D. Salzmann: *Untersuchungen zu den antiken Kieselmosaiken* (Berlin, 1982)

D. von Boeselager: *Antike Mosaiken in Sizilien* (Rome, 1983)

Mosaïque: Recueil d'hommages à Henri Stern (Paris, 1983)

D. Parrish: *Seasons Mosaics of Roman North Africa* (Rome, 1984)

I. Kriseleit: *Antike Mosaiken* (Berlin, 1985)

M. Alfieri and others: *Mosaici minuti romani del '700 e dell'800* (Vatican City, 1986)

C. Balmelle and J. P. Damon: 'L'Artisan-mosaïste dans l'Antiquité Tardive', *Artistes, artisans et production artistique au moyen âge*, ed. X. Barral I Altet, 2 vols (Paris, 1986)

P. C. Claussen: *Magistri doctissimi Romani* (Stuttgart, 1987)

C. Harding: 'The Production of Medieval Mosaics', *Dumbarton Oaks Papers* (1989)

R. Ling: *Ancient Mosaics* (London, 1998)

K. E. Werner: *Die Sammlung antiker Mosaiken in den Vatikanischen Museen* (Vatican City, 1998)

K. M. D. Dunbabin: *Mosaics of the Greek and Roman World* (Cambridge and New York, 1999)

P. Hills: *Venetian Colour: Marble, Mosaic, Painting and Glass, 1250–1550* (New Haven, 1999)

E. Borsook, F. Gioffredi Superbi and G. Pagliarulo, eds: *Medieval Mosaics: Light, Color, Materials* (Milan, 2000)

A. González-Palacios: *Las colecciones reales españolas de mosaicos y piedras duras* (Madrid, 2001)

H. Whitehouse: *Ancient Mosaics and Wallpaintings* (London, 2001)

C. Balmelle and others: *Le décor géométrique de la mosaïque romaine* (Paris, 2/2002)

I. Fiorentini Roncuzzi: *Mosaic: Materials, Techniques and History* (Ravenna, 2002)

B. Andreae: *Antike Bildmosaiken* (Mainz, 2003)

II. Conservation. A summary of the restoration procedures adopted in antiquity and the Middle Ages reveals that whenever earlier mosaics were restored or altered mosaicists usually did not try to disguise the resultant differences in style and technique, although certain signs of restoration, for example the joints in the setting-bed, were concealed if possible. Also, written sources indicate that on occasion mosaics were lifted and transported far afield, as when

Charlemagne removed mosaics from Ravenna to decorate the Palatine Chapel (now the cathedral) at Aachen during the late 8th century. There are a number of instances before the Renaissance when early mosaics were destroyed and the tesserae reused in other locations, particularly in the Byzantine empire.

The normal course of restoration for wall and vault mosaics, until even relatively recently, is exemplified in the practices of Alesso Baldovinetti, who repaired the mosaics of the Baptistery in Florence during the mid-15th century by gouging out decayed mortar, consolidating the setting-bed with iron clamps and nails, and patching the originals; he did not attempt to make his restorations resemble the late medieval originals. At times, however, restorers would try to reproduce the style of the originals as closely as possible, as occurred during the early 16th century in Venice, when certain sections of the S Marco mosaics had to be remade after a fire. The mosaicist, known only as Petrus, sought to reproduce the style of the 12th-century originals. Attitudes there to restoration changed drastically during the course of the century. Instead of restoring the mosaics, workshops began to replace damaged work with compositions that were designed by contemporary artists but followed the iconographic scheme of the originals. The Venetian authorities decided to stop this practice in 1610. Attitudes such as these persisted until relatively recently, however, as in the case of the 13th-century mosaics at S Miniato, Florence, where in the 19th century restorers replaced the originals with faithful copies.

Modern conservators try, wherever possible, to respect the original in its setting, whatever its date, and to provide only a minimal amount of intervention when restoration is required. The conservation of mosaics is always closely related to the supporting architectural framework or foundation. Roofs, walls and vaults must be sound and must not permit water to enter the supporting layers of mortar. If the mortar is badly decayed it may be injected with a consolidating substance, such as a mixture of lime, crushed marble and brick mixed with a little acrylic resin, to fill the gaps between the tesserae and the support plaster and to bind the mortar to the masonry or floor. Clamps and nails are used only rarely to hold in the setting-bed.

The *stacco* technique of detachment, in which whole sections of mosaic are removed and reset, is now used only rarely because of the potential disturbance to the surface texture of the work. If the mosaics have to be detached, impressions are taken beforehand and often painted to obtain faithful copies. The *stacco* method is recommended only when the slight pressure used in the injection of the wall or floor causes extensive areas of tesserae to break away.

Apart from the treatment of the different layers of mortar, the conservation process also includes the cleaning of tesserae and their interstices and the reinsertion of any individual tesserae that have fallen out. Patching may be carried out with reused tesserae or closely matched modern tesserae. New tesserae must be clearly recognizable and not made to

2. Mosaic maintenance technicians working at Jebel Oust, Tunisia (Los Angeles, CA, Getty Conservation Institute); photo © The J. Paul Getty Trust, all rights reserved

look old. If the restorer leaves a gap in the tesserae, this is filled with plaster and the missing portions indicated in paint.

Exterior mosaics pose special conservation problems (see fig. 2). Floor mosaics, for example, must be kept free and clean from algae and mosses, especially in northern Europe, where conservators cannot seal the surface of the floor because of continual rising moisture from the subsoil. Restorers must also prevent dramatic changes in temperature and ensure the circulation of air to maintain a constant level of humidity.

I. Andreescu: 'La Mosaïque murale: Histoire des restaurations, évolutions de ses techniques', and L. Majewski: 'Nettoyage, consolidation et traitement des mosaïques murales', *Mosaïque: Détérioration et conservation* (Rome, 1977), pp. 19–33, 50–56 *Mosaics/Mosaïque/Mosaicos* (Rome, 1978–)

I. Roncuzzi Fiorentini: *Il mosaico: Materiali e tecniche dalle origini a oggi* (Ravenna, 1984)

G. Fumo: 'The Mosaics in the Basilica of Santa Maria Assunta on Torcello', *Twenty Years of Restoration in Venice* (Venice, 1987)

F. Piqué and D. C. Stulik, eds: *Conservation of the Last Judgment Mosaic: St Vitus Cathedral* (Los Angeles, 2004)

A. Ben Abed: *Conserving Mosaics of Roman Africa* (Los Angeles, 2006)

Mother-of-pearl. Type of iridescent substance lining the shell of some molluscs and other marine invertebrates.

1. Material, sources and techniques. 2. Uses.

1. MATERIAL, SOURCES AND TECHNIQUES. Mother-of-pearl is composed of thin, flat calcium-carbonate plates secreted by certain bivalve molluscs (as well as cuttlefish and snails) and arranged in layers around the inside of the shell. The outside of the shell is composed of a brown, horny substance, known as conchiolin. The iridescence of mother-of-pearl is a result of the refraction of light through the many layers. The waters in which the shell is fished determine the colour of mother-of-pearl: in warmer seas near the Equator colours range from pink through amber to black, although white mother-of-pearl has always been the most prized. Pigments that create various markings on the shell are also secreted by the mollusc. The established source of mother-of-pearl, as well as pearls, is the large saltwater pearl oyster (*Auricula margaritifera* or *Meleagrina margaritifera*), found mainly in the Red Sea, Persian Gulf, the Indian Ocean, South China Sea, Celebes Sea and North Pacific Ocean at a depth of between 10 and 70 m. The freshwater pearl oyster (*Unio margaritifera*) is found in rivers and lakes throughout Europe, Asia and North America. Other sources of mother-of-pearl are the shells of the cuttlefish (*Nautilus pompilus*), found in tropical waters, and the red abalone (*Haliotis iris*), found in the Pacific. The shells of turbinate snails also produce mother-of-pearl: these were traditionally fished by divers until the Japanese developed commercial oyster farming in the 1920s.

The hard outer layer of conchiolin must be removed before the mother-of-pearl can be worked. This can be achieved either by the use of acid or by grinding with a stone in a water-filled trough. As a soft material, mother-of-pearl can be carved by hand or dissolved in acid, those areas to remain in relief being protected by wax. The mother-of-pearl can then be polished with abrasives or acid to regain its lustre. Carving and engraving can be carried out with goldsmiths' tools. Mother-of-pearl will lose its iridescence on exposure to sunlight and will effervesce in acid; the outer layers can be damaged by prolonged exposure to heat (over 100°C), humidity and dryness.

2. USES.

(i) Europe. One of the oldest items of secular jewellery to be found in Europe, thought to be Palaeolithic, is made of mussel shells and pearls, with remaining traces of etching. The use of mother-of-pearl as a material for mosaic work may have originated in the East but was employed in the Roman Empire (e.g. mother-of-pearl mosaics, 6th century AD; Ravenna, S Apollinare). There is insufficient evidence to allow attribution of Late Gothic works in mother-of-pearl to a particular artist or workshop, but goldsmiths or gem-cutters may have carved mother-of-pearl, as they would have had the necessary tools and techniques. Most surviving examples of carved mother-of-pearl lamellae are relief carvings; only a few objects carved in the round are known, of which the oldest extant work (1406) is a silver reliquary inset with mother-of-pearl figures carved in the round (Prague, former Benedictine monastery of St Margaret). Mother-of-pearl carving increased after the mid-15th century, and the work is mostly circular or polygonal in form, occasionally pierced or in the *plique à jour* style. Mother-of-pearl, usually set in silver or brass, was used in plaques, reliquaries or family altars, or in rosaries, medallions and secular jewellery; it was not usually painted, but a few examples survive that show traces of paint or gilding (e.g. *Reading Saint*; Graz, Steiermärkisches Landesmuseum Joanneum). The thinness of the material usually only allowed carving on one side, but there are examples of lamellae with carving on both sides in the Österreichisches Museum für Angewandte Kunst, Vienna. The subject-matter of mother-of-pearl carving is usually ecclesiastical, and of the approximately 400 lamellae known by the late 20th century, scenes of the *Annunciation*, *Birth of Christ*, *Crucifixion* and *St George* were well represented.

During the 15th century centres specializing in goldsmiths' work also produced mother-of-pearl carving. Israhel van Meckenem the younger, probably active in Cleve in 1465, is thought to be responsible for a number of mother-of-pearl carvings, among which are a silver-gilt pax with a mother-of-pearl relief of the *Adoration of the Magi* (Cleve, Städtisches Museum Haus Koekkoek) and the *Birth of Christ* (Munich, Bayerisches Nationalmuseum). Mother-of-pearl reliefs carved in Basle are similar in style to silver medallions

produced in the Upper Rhine area, for example the *Annunciation* (London, Victoria and Albert Museum), *Birth of Christ* (Brussels, Musées Royaux d'Art et d'Histoire) and a reliquary with a mother-of-pearl relief depicting the *Man of Sorrows* (Basle, Historisches Museum). The Bistritz pax with a mother-of-pearl relief of *St George* (Budapest, Hungarian National Museum) may have been produced in Nuremberg, and a reliquary (1486; Innsbruck, Premonstratensian Abbey) with a pierced mother-of-pearl relief of the *Crucifixion* is also linked with this city. The Augsburg tax records mention a Claus 'Berlachmuterschneider' in 1484, who may possibly have been responsible for the *Death of the Virgin* on the Rechberg Pax (Augsburg, Maximilianmuseum), although the exact source of this work remains unclear. Salzburg was another centre of production.

Some mother-of-pearl carving is based on 15th-century engravings by Master E.S. (*fl c.* 1450–67) or Martin Schongauer (*c.* 1435/50–91), although the engraving and carving may not have been produced in the same place; for example the engraving by Schongauer (Lehrs, no. 363) and the carving of *Death of the Virgin* (Innsbruck, Tiroler Landesmuseum Ferdinandeum). Other carved lamellae are more loosely based on engravings by Schongauer, for example *Christ Carrying the Cross* and *Christ before St Anne*, which decorate the silver tabernacle triptych made for the monastery of St Peter, Salzburg. There may be a connection between the mother-of-pearl reliefs on an altar and the work of Master E.S. (Berliner, no. 13, pl. 10), as a surviving fragment depicting *St George* (Baltimore, MD, Walters Art Gallery) can be connected to an extant drawing (Berliner, no. 52, pl. 25c). In the wake of humanist thought, ecclesiastical subject-matter gave way to secular themes, the portrait being especially popular. Many more named artists were known. The carving of shell-cameos also became widespread during this period and, as with the shell-cameo, there was an interest in creating a multicoloured surface. Consequently, the dark, outer layer of the shell was occasionally used (e.g. half-length portraits of *Philip II* and *Charles V*, 1556; Hamburg, Museum für Kunst und Gewerbe), although the white, iridescent surface soon regained its popularity (e.g. portrait of *Emperor Matthias of Hungary* by Dionysio Miseroni (*d* 1661), 1613, Vienna, Kunsthistorisches Museum; portrait of *Henry III*, Berlin, Skulpturengalerie mit Frühchristlich-Byzantinischer Sammlung).

During the late Renaissance and Baroque periods, nautilus shells, turbo shells and trochus shells were frequently mounted in goldsmiths' work; examples include a nautilus cup in the form of a snail (*c.* 1630; Hartford, CT, Wadsworth Atheneum), by Jeremias Ritter of Nuremberg, and a turbo shell with silver-gilt mounts (late 16th century; Madrid, Museo Thyssen-Bornemisza), possibly by Claus Harders of Lüneburg. The Jamnitzer workshop in Nuremberg was a specialist centre for curiosities of this type (e.g. trochus shell in silver-gilt mounts, *c.* 1570; Munich, Residenz). The towns of Nuremberg and Augsburg were the main centres of production for mounted shells

during the 16th and 17th centuries, but Antwerp (e.g. nautilus shell, 1555–6; London, British Museum), London (e.g. salt, *c.* 1750; London, Victoria and Albert Museum) and Paris also produced pieces of comparable workmanship and complexity of design. The shell could be polished flat, etched with acid to leave patterns in relief, or engraved, with a pigment comprising coal dust, oil or wax creating additional definition (examples in Vienna, Kunsthistorisches Museum; Munich, Residenz). Mother-of-pearl relief carvings with additional black line-engravings of mythological or genre scenes were produced in the Belkein family workshop in Amsterdam (e.g. shell depicting *Perseus and Andromeda*; Stuttgart, Württembergisches Landesmuseum). Another method of working was to use the prismatic layers of the mother-of-pearl as a contrast to the flat relief.

From the 17th century onwards mother-of-pearl was frequently used in Europe as a material for inlay or marquetry. Known craftsmen included Bernhard Strauss (*fl* 1662–81) in Augsburg and Dirk van Ryswyck (1596–1679), a leading craftsman in Amsterdam working in mother-of-pearl marquetry, signed examples of whose work can be seen in the Grünes Gewölbe, Dresden. Van Ryswyck had immediate access to the material through the Dutch East India Co. trade. Musical instruments, mirror frames and weapons were also inlaid with mother-of-pearl, often in conjunction with such other materials as brass, tortoiseshell and pewter (e.g. wheel lock and stock, early 17th century; Stuttgart, Württembergisches Landesmuseum).

Vessels embellished with mother-of-pearl originated in Paris but were produced throughout Europe. The lamellae could be attached with studs or with more complex metal ornament (e.g. vessel in the form of a partridge; Copenhagen, Nationalmuseum). In 18th-century Paris mother-of-pearl was an extremely fashionable material for snuff boxes, étuis and gold-mounted boxes of all types (examples in Madrid, Museo Thyssen-Bornemisza; Paris, Musée des Arts Décoratifs; Waddesdon Manor, Bucks, NT). In the 19th century mother-of-pearl was used extensively as decoration to simulate inlay in a wide variety of papier-mâché work, ranging from furniture (e.g. papier-mâché settee with mother-of-pearl decoration; London, Victoria and Albert Museum) to boxes and trays (*see* PAPIER-MÂCHÉ, §§1 and 2). Mother-of-pearl was also frequently used as inlay in wood furniture from the late 19th century until the 1930s (*see* MARQUETRY, §§1 and 2). A mother-of-pearl industry had been established in Austria in the 18th century, two notable craftsmen being Veit Pnotsch and Leopold Rauch (both active in 1768). Wood-turned objects, for example buttons and other fashion accessories, were produced, and by the end of the 19th century such items as pipe-bowls and walking-stick handles were popular. The use of the colourful haliotis shell in the 19th century led to new techniques in which the material, in the form of thin lamellae, was placed between layers of white mother-of-pearl (e.g. visiting-card holder; Stuttgart, Württembergisches Landesmuseum). Mother-of-pearl inlay was also used in such religious

souvenirs as Jerusalem crosses (e.g. Freiburg im Breisgau, Augustinermuseum) or models of the Church of the Holy Sepulchre, Jerusalem (examples in London, British Museum; Munich, Bayerisches Nationalmuseum). In the Art Nouveau period mother-of-pearl was used extensively by such craftsmen and designers as Kolo Moser (1868–1918) (e.g. mother-of-pearl letter rack and inkwell, c. 1900; Klein and Bishop, fig. 5) and C. R. Ashbee (1863–1942), and the nautilus shell continued to be mounted in novel settings (e.g. silvered pewter and nautilus shell desk lamp, 1904; Klein and Bishop, fig. 3).

(ii) America, Asia and Islamic lands. In Pre-Columbian Mesoamerica and in Native American art mother-of-pearl was used, among other shells, to make beads for necklaces and other body ornaments. It was also used as inlay in masks and stone sculptures and included in elite tomb offerings. One of the most famous examples is a large pair of artificial pearls from the Temple of Inscriptions at Maya Palenque, each made from two hollow mother-of-pearl pieces, filled and glued with a limestone paste (Mexico City, Museo Nacional de Antropología). In South-east Asia mother-of-pearl inlay is widely used to decorate jewellery, boxes, utensils, weapons, furniture, screens, doors and window shutters. The art of mother-of-pearl inlay has reached a particularly high level of refinement and technical skill in Thailand. In the Philippines mother-of-pearl inlay and other nacreous shells are also used to decorate such diverse objects as boats, weapons, guitars and other musical instruments. In East Asia mother-of-pearl was used in conjunction with lacquer (see colour pl. IX, fig. 1), while in the Ottoman court it was used as an inlay on wooden furniture.

H. Grunn: *Perlmutterkunst in alter und neuer Zeit. 73. Sonderausstellung des Niederösterreichischen Landesmuseums* (Vienna, n.d.)

M. Lehrs: *Geschichte und kritischer Katalog des deutschen, niederländischen und französischen Kupferstichs im XV. Jahrhundert*, v (Vienna, 1925)

P. H. Halm and R. Berliner: *Das Hallesche Heiltum* (Berlin, 1931)

G. E. Pazaurek: *Perlmutter* (Berlin, 1937)

A. Stifft-Gottlieb: 'Linearkeramische Gräber mit Spondylusschmuck aus Eggenburg, Nierdonau', *Mitteilungen der Antropologischen Gesellschaft Wien*, lxix (1939), p. 149f

M. C. Ross: 'A Late XVth-century Mother-of-pearl Carving', *Journal of the Walters Art Gallery*, vii–viii (1944–5), pp. 125–6

L. Ehret: *Seeschwäbische Goldschmiedekunst im 15. und 16. Jahrhundert* (Freiburg im Breisgau, 1954)

H. Muller: 'Augsburger Goldschmiedekunst der Zeit Hans Holbein d. Ä.', *Hans Holbein der Ältere und die Kunst der Spätgotik* (exh. cat., Augsburg, Rathaus, 1965), pp. 194–5

H. Kohlsausen: *Nürnberger Goldschmiedekunst des Mittelalters und der Dürerzeit: 1240–1540* (Berlin, 1968)

G. Smith: 'Reflections of a Pattern Print by Master E.S.: Passion Cycles in Mother-of-pearl', *Pantheon* (Jan–Feb 1968), pp. 430–39

C. I. A. Ritchie: *Carving Shells and Cameos* (London, 1970)

C. I. A. Ritchie: *Shell Carving: History and Techniques* (London, 1974)

F. Wagner: 'Goldschmiedekunst: Spätgotik in Salzburg: Skulptur und Kunstgewerbe', *Jahresschrift des Salzburger Museums Carolino Augusteum*, xxi (1975), pp. 75–92

J. F. Hayward: *Virtuoso Goldsmiths and the Triumph of Mannerism: 1540–1620* (London, 1976)

J. Rasmussen: 'Untersuchungen zum Halleschen Heiltum des Kardinal Albrecht von Brandenburg', *Münchner Jahrbuch der bildenden Kunst*, xvii (1976), pp. 59–118; xviii (1977), pp. 91–132

A. Limpinsky: 'Exotische Meeresschnecken in der europäischen Goldschmiedekunst des 16. und 17. Jahrhunderts', *Alte und moderne Kunst*, xxii (1977), p. 151

J. Schlosser: *Kunst- und Wunderkammern*, 2 vols (Brunswick, 1978)

E. Scheicher: *Die Kunst- und Wunderkammern der Habsburger* (Zurich, 1979)

Die Muschel in der Kunst (exh. cat., Zurich, Museum Bellerive, 1985)

D. Klein and M. Bishop: *Decorative Art: 1880–1980* (Oxford, 1986)

'Dirck van Rijswijck (1596–1679), a Master of Mother-of-pearl', [special issue] *Oud Holland*, cxi/2 (1997), pp. 77–151

D. Kisluk-Grosheide: 'Maison Giroux and its "Oriental" Marquetry Technique', *Furniture History*, xxxv (1999), pp. 147–72

A. Buttner: 'Die kinder des Taus: Spätgotische Perlmuttreliefs in den Museen der Stadt Köln', *Wallraf-Richartz-Jarhbuch*, lxi (2000), pp. 69–98

J. Byachranda: *Thai Mother-of-pearl Inlay* (London, 2001)

S. Sangl: 'Indisch Perlmutt-Raritäten und ihre europäischen Adaptionen', *Jahrbuch des Kunsthistorischen Museums Wien*, iii (2001), pp. 262–87

K. Lee and S. Hu: 'Song Dynasty Mother-of-pearl Inlay Lacquers and a Dish in the British Museum', *Oriental Art*, xlviii/4 (2002), pp. 36–42

M. Bincsik: 'Japanese Maki-e Incense Boxes Exported in the Meiji Period: Kogo and Kobako as "Objets de vitrine" in Europe During the Second Half of the 19th Century', *Arts of Asia*, xxxvi/4 (July–Aug 2006), pp. 72–83

Motion picture film. Medium on which a series of photographic images are recorded on a flexible plastic base in order to produce the illusion of movement when reproduced by projection through a lens or other means. Although 'film' has been used by the general public as a catch-all term for any moving image medium, it actually refers specifically to photochemical reproduction.

1. Properties and types. 2. History. 3. Conservation.

1. PROPERTIES AND TYPES.

(i) Bases. Three different types of film base have been used in motion picture production. The first, cellulose nitrate, was used from the time it was introduced by Eastman Kodak in 1889, through the early 1950s. Cellulose nitrate was durable, withstood repeated projection, and provided a high-quality image. It was also extremely flammable, requiring careful handling in shipping and storage, and the construction of special fireproof projection booths in theatres. It is always identified by the words 'Nitrate film' along

one edge. Cellulose acetate film was first made available commercially in 1909, but was inferior in strength to nitrate film, and was not widely adopted for theatrical use. It was, however, used exclusively in smaller-gauge film for home and amateur use by the 1920s. In 1948, Eastman Kodak introduced a more durable acetate film, which became the standard for both theatrical and home projection; acetate film is generally marked 'Safety film' along one edge. The third base, polyester, is more durable than either nitrate or acetate film. First introduced in 1955, it did not see wide adoption until the 1980s. Not always labelled as such, polyester film can be identified by holding a reel up to the light; if it is translucent, the film is on polyester base, if it is opaque, it is acetate.

(ii) Gauges. Motion picture film has been produced in a relatively small number of standard sizes, or gauges, which are produced according to standards set by the Society of Motion Picture and Television Engineers. The earliest standard gauge, 35mm, is used for the production of feature films, commercials, and television shows, and for theatrical projection. Slightly less than half the size of 35mm, 16mm film has been widely used in experimental, avant-garde, television and educational films. The smallest two gauges, 8mm (or 'regular 8') and Super 8, are both 8 millimetres wide, however, Super 8 has smaller sprocket holes and a larger frame than 8mm.

(iii) Sound. Sound information is carried on film in one of three general ways. Optical sound involves a photochemically created soundtrack down one side of the film. Light is passed through an area with variable levels of image density, onto a photosensitive surface that translates the variations in light into variations in electrical current that control speakers. Magnetic sound involves a thin strip of magnetic oxides down one or both sides of the film, onto which sound is recorded and played back. Digital sound may be recorded as data on the film strip, or as a time code signal that controls audio being played back from a compact disc.

2. HISTORY. The idea of projecting images onto a wall or screen by passing light through a translucent image, focused by a lens, dates back centuries. By the 19th century, the MAGIC LANTERN, which projected still images onto a screen, was in wide use throughout the world for both entertainment and education. At the same time, the concept that a series of still images viewed in rapid motion could create an illusion of movement was also well-understood, and used in mechanical devices such as the zoetrope, or children's toys such as the flipbook. It was not until the development of flexible strip film by the Eastman Kodak Company in the late 1880s, however, that the rapid photographing and eventual projection of photographic images became a practical reality.

In the early days of motion pictures, little about the technology was standardized. The size of the film, the location and shape of perforations, and the projection speed all varied among different producers and inventors. Eventually, the first standardized format was settled on: film 35mm wide, with a frame having a width to height ratio of approximately 4:3, with perforations down each side. Film speed was standardized to 24 frames per second with the coming of sound in the 1920s. Initially, systems involving optical sound on film, and sound on discs synchronized with the projector were in use; the disc system fell out of use by the early 1930s.

The three most common smaller-gauge formats—16mm (introduced 1923), 8mm (introduced 1932) and Super 8 (introduced 1965)—were originally designed for use in the home, and therefore have only ever used non-flammable acetate or polyester film bases. (When shot without a soundtrack, as with most home movies, these smaller gauges may have a slower speed of 18 frames per second.) All three of these gauges were (and continue to be) used widely by artists and experimental film makers. Conversely, larger gauges have been developed for theatrical exhibition in special venues or large-budget films; with 70mm and IMAX dominating the market by the 21st century.

3. CONSERVATION. Motion picture film is subject to the same chemical decay mechanisms that afflict photographic negatives and transparencies. Cellulose nitrate film is highly flammable, and must be stored in properly designed nitrate vaults. Though nitrate can have a long life—there are nitrate films in good condition that date back more than a century—it can also decay rapidly and catastrophically. The film will first discolour, then become sticky, eventually turning into a solid mass and finally a brown powder.

Cellulose acetate film was initially believed to be a more durable alternative to nitrate film. While it is indeed safer in the sense of not being flammable, it has serious longevity issues of its own. Acetate film is subject to what is colloquially known as 'vinegar syndrome', in which the film begins to give off acetic acid gasses (whose pungent odour gives the syndrome its name). Once this decomposition has begun, the rate of decay increases rapidly—the acetic acid itself causes further and faster decay as the chemical reaction becomes autocatalytic. Vinegar syndrome can cause film to buckle, warp, become brittle and eventually unsalvageable. Anecdotal evidence suggests that film with a magnetic soundtrack may be more susceptible to vinegar syndrome, moreover, colour motion picture film, like transparencies, can be subject to colour fading over time. Polyester film is subject to none of these decay mechanisms, and is generally considered to be an extremely stable medium.

Correct storage conditions are absolutely critical for maintaining film's longevity. The Image Permanence Institute recommends that both nitrate and acetate film be stored at cold temperatures (4.4°C) or frozen (0°C) with humidity in the range of 30–50% RH. (It is important to note, however, that films with a magnetic component—i.e. magnetic soundtrack—as

well as videotape or audiotape can be severely damaged by below-freezing temperatures.

The Book of Film Care, Eastman Kodak (Rochester, NY, 1992)

J. M. Reilly: *Storage Guide for Color Photographic Materials: Caring for Color Slides, Prints, Negatives, and Movie Films*, New York State Program for the Conservation and Preservation of Library Research Materials (Albany, NY, 1998)

P. Read and M.-P. Meyer, eds: *Restoration of Motion Picture Film* (Woburn, MA, 2000)

R. Smither, ed: *This Film Is Dangerous: A Celebration of Nitrate Film* (Brussels, 2002)

P. Adelstein: *IPI Media Storage Quick Reference* (Rochester, NY, 2004)

The Film Preservation Guide, National Film Preservation Foundation (San Francisco, 2004)

L. Enticknap: *Moving Image Technology: From Zoetrope to Digital* (London, 2005)

Mounting. Attachment of a work of art to a support or setting, or the application of accessories or decoration as embellishment. In many types of mount, these two distinct concepts may be combined, and the mount serves both a functional and decorative purpose.

Although the term 'mounting' may apply to the support or fixing of three-dimensional art, this article is concerned with the description and history of the mounting of two-dimensional or flat format pictorial and other graphic material. In East and Eastern Central Asia this includes paintings and calligraphy in scroll, screen, fan, album and banner formats, as well as prints of various sorts; in India and the Islamic world, calligraphy, painted decoration, miniatures and various kinds of banner painting; in the West, mainly prints, drawings and watercolours. The chief substances used in the fabrication of these works of art are such materials as paper and woven silk. These form the original, or primary, support for the pigment with which the pictorial image or script is created. The pigment, usually mixed with a binding medium, may be applied directly to the surface of the support, as in an East Asian scroll painting or European engraved print, or the support may first be coated with a preparation or ground as in a Renaissance metalpoint drawing, an Indian or Islamic miniature painting or a Tibetan *tangka*. In their unmounted state, all these works of art are fragile and vulnerable to damage from handling and other environmental effects of unprotected storage or display, and adequate physical support in the form of a mount became necessary once people sought to preserve them. In some civilizations mounting evolved with the art form itself, as in the case of East Asian scrolls; elsewhere methods evolved from the need to organize and display collections, initially in the form of albums and later by fixing into a cut-out cardboard surround or 'window' mount (USA: mat). In the West this practice developed when collections of drawings and prints began to be assembled from the 15th century onwards. Since then, the 'window' mount style of mounting has evolved in conjunction with the increasing practice of framing and displaying graphic art.

The underlying reason, therefore, for mounting works of art is that of conservation, but this may be overshadowed where cultural tradition dictates the format for the presentation of works of art. Additional reasons arise from more abstract, aesthetic considerations. In many forms of mounting, the mount comprises or includes a border area surrounding the art work itself. Like the picture frame, this serves the dual purpose of defining or emphasizing the physical boundary of the image and isolating it from its immediate surroundings, thus allowing the viewer to focus on the work with minimal distraction or confusion from background detail. Equally, a lavishly decorated mount or one made of rare or expensive materials may serve to indicate the high regard of the owner for the piece as a work of art, or its status as an object of veneration.

The forms and methods of construction of mounts are related to the type of object and its use or function in the culture in which it originated. Although a few East Asian hanging scrolls or hand scrolls were displayed in imperial, domestic or religious interiors, most were normally stored rolled and brought out only on special occasions, such as for private viewing or literary gatherings. The same is true of Tibetan *tangka*s, which have a religious function as a focus for Buddhist worship and meditation; even when exhibited, the image is usually concealed with a cover, which is attached to and forms part of the silk mount. The shape, size and materials of painting and mount, together with accessories such as rods and hanging cord, are fixed by traditional rules and religious custom. In Japan a major consideration in the design of fine art forms was that of portability, owing to the conventions of use and to the high risk of earthquake and fire in dwelling houses. Hence a type of painting made of lightweight materials that could be rolled up in a compact, easily transportable form was an obvious advantage when the work needed to be either changed, as scrolls often were according to season or special occasion, or saved in the event of sudden evacuation.

The choice of materials for mounting is also influenced by availability, cost, physical compatibility and aesthetics. For example, luxurious materials such as patterned silk are used to form the 'frame' around East Asian SCROLL paintings and for the two strips that hang from the top of the scroll. This is a product of the same civilization as the painting and is readily available, if costly. Not only does it enhance and embellish the painting by providing a harmonious setting, but it also has an essential structural role because it behaves physically in the same way as the support of the painting, whether paper-backed woven silk or paper. This together with appropriate paper backings and adhesive allow the scroll to be rolled, unrolled and hung without causing distortion. In contrast, cardboard made from mechanical wood-pulp has been used in the West for mounting prints and drawings since the mid-19th century. As a material, it has low chemical stability, but its cheapness and ready availability recommend it to commercial

mounters. In recent decades, with a growing concern for factors affecting the long-term preservation of works of art, the need for high chemical stability and purity in mounting material has assumed a greater priority.

In the West from the late 18th century onwards works of art from all over the world were amassed in private and public collections. Partly from the requirement for display in Western-style picture frames and partly though a tendency in museums and art galleries to impose uniformity of storage format, this has led to the Western-style cardboard mount becoming adopted worldwide as the preferred storage and display format for many types of graphic and pictorial art.

Even at an early date some drawings and prints were pasted to wooden, paperboard or textile supports and framed. Canvas linings were useful for displaying outsize works such as cartoons, and laying down on to calico was a cheaper and simpler means of mounting prints—by stretching them over a wooden strainer—until ready-made mounting board became commonly available in the second quarter of the 19th century. Exhibition watercolours were often mounted on stretched canvas and framed 'close' in an attempt to emulate the appearance of oil paintings (see Bayard). Later, it became common to show watercolours with a gilt 'slip' or 'flat' around the edge, inside the frame. Originally made of wood, these later came to be made of cardboard, the most commonly used type consisting of a core of inferior pulp covered on both sides with thin, good-quality paper.

Cardboard mounts usually consist of two parts: a backing sheet to which the print or drawing is attached and a cover sheet—often referred to as a 'mat'—in which an aperture or 'window' is cut to expose the work. The aperture, usually cut with a bevelled edge, is generally placed so that its geometric centre is higher than the centre of the sheet. Originally, hand-held knives were used, but by the mid-20th century various mount-cutting devices were available. These consist of a straight-edge with a sliding jig that holds the blade, together with some means of clamping the board. Modifications include wall-mounted units and devices for cutting circular and oval apertures. Some mounters also use metal templates for set sizes; these are particularly appropriate for photographs, for which many standard formats exist.

Once mounted, the work is usually fixed in a glazed frame. The mount therefore has two main functions: to provide a 'neutral' gap between the pictorial composition and its display surroundings, and to keep the surface of the work from touching the glass (most important in the case of 'soft' drawing media such as charcoal, pastel and chalks). This method of mounting was endorsed by John Ruskin (1819–1900) in a letter to *The Times* of 28 October 1856, by which time artists' suppliers and stationers were already advertising various grades of 'mounting board'. Towards the end of the 19th century the fashion for gilt mounts gave way to plain cream or white (see Hardie), and in the 20th century there was a revival of wash-line decoration, applied to the surface of the mat itself. There has also been a proliferation in the variety of colours and surface textures of mounting board, including textile coverings. Unfortunately, the commercialization of mounting has had an adverse effect on the quality of the product. Early mounting boards, such as 'Bristol' board (see Krill), were made from good-quality fibre such as rags, but from 1850, following the introduction of mechanically processed woodpulp (an acidic material), the quality rapidly declined. It tended to be only in museums and galleries that finer, acid-free quality boards continued to be used to any great extent.

A slightly different style of cardboard mount is sometimes used in large public collections where the main method of storage of prints and drawings is by boxing rather than framing. This type of mount, called a 'raised', 'sunk' or 'solid' mount, was developed in the 1850s at the British Museum, London (see Willshire). The drawing or print is pasted around its edges to a backboard and the bevelled mat pasted solidly around the edges of the backboard, forming a kind of thin, wide tray with the art work 'sunk' into its centre. This type of mount affords adequate protection from the hazards of handling and protects the surface of the work from abrasion when several mounts are stacked together in their solander boxes.

A variety of methods and materials has been used to attach graphic works of art to their mounts. The traditional adhesive was flour paste, although animal glue and even sealing wax have been used. Some mounters used spots of paste at the corners, with extra spots along the edges for larger works. More careful mounters first adhered small rectangles of paper to the back of a drawing before attaching it to the mount, as is characteristic of Bouverie mounts (see 1991 exh. cat.). A later development was the continuous hinge or 'guard' of thin paper fixed around all four edges (see Plenderleith 1937 and 1952). An alternative method of attachment is by means of a false margin or 'inlay': the drawing is pasted around the edges to a sheet of paper with an aperture slightly smaller than the drawing, thus exposing the *verso* of the work (see Harding). Alternatively, the aperture in the margin may be cut just larger than the drawing and the latter attached to the inlay using narrow strips of thin paper, such as Japanese *kōzo* (mulberry) paper. In the case of double-sided drawings, a window may be cut in the back of the mount, incorporating a sheet of transparent acrylic plastic as glazing (earlier examples made use of hardened gelatin or cellulose acetate).

However, the most commonly recommended method of attachment is by means of paper hinges, Japanese papers being favoured because they are thin, strong and flexible. Hinges are either folded (like a stamp-hinge) or pendant (flat). In the latter case, the part of the hinge attached to the mount is visible, the print appearing to hang from it. Sometimes

PLATE I

1. Alabaster *Cup of Immortality of the Benefactor of Thebes (The Wishing Cup),* from the tomb of Tutankhamun, Egyptian, *c.* 1325 BC (Cairo, Egyptian Museum); photo credit: Erich Lessing/Art Resource, NY; *see* Alabaster

2. Amber samples from the Baltic (Washington, DC, Smithsonian Institution); photo credit: Aldo Tutino/Art Resource, NY; *see* Amber

3. Aquatint by Louis Garneray: *Malmaison: View of the Park Taken from the Château*, 314×381 mm, *c.* 1815–20 (Malmaison, Musées Nationaux des Châteaux de Malmaison et de Bois-Préau); photo credit: Réunion des Musées Nationaux/Art Resource, NY; *see* Aquatint

PLATE II

1. Brick with glazed relief decoration, showing human-headed winged lions (*lamassus*), under a winged disc, from the palace of Darius the Great, Susa, Iran, *c.* 510 BC (Paris, Musée du Louvre); photo credit: Erich Lessing/Art Resource, NY; *see* Brick

2. Blue-and-white ceramic vases, Meissen, h. from left to right 290 mm, 540 mm, 393 mm, early 18th century (Dresden, Porzellansammlung); photo credit: Erich Lessing/Art Resource, NY; *see* Blue-and-white ceramic

3. Beaded necklaces, faience, Canaanite, from Lachish, *c.* 1500–1200 BC (London, British Museum); photo credit: Erich Lessing/Art Resource, NY; *see* Beadwork

PLATE III

1. Porcelain plate and tureen, from the service made for the Schloss auf der Pfaueninsel by the Königliche Porzellan-Manufaktur, 1795 (Berlin, Kunstgewerbemuseum); photo credit: Erich Lessing /Art Resource, NY; *see* Ceramics

2. Coral and silver *Daphne* by Wenzel Jamnitzer, h. 670 mm, from Nuremberg, *c.* 1550 (Ecouen, Musée National de la Renaissance); photo credit: Erich Lessing/Art Resource, NY; *see* Coral

3. Michelangelo: *Study for the Porta Pia*, drawing, mid-16th century (Florence, Casa Buonarroti); photo credit: Scala/Art Resource, NY; *see* Drawing

PLATE IV

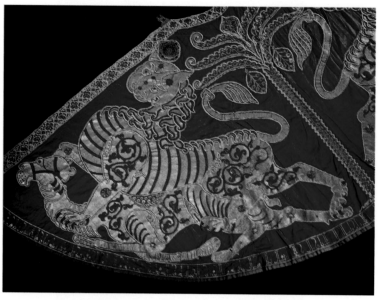

1. Embroidered silk robe with gold and pearls (detail), diam. 3.42 m, made in Palermo for the coronation of Roger II, King of Sicily, 1133–4 (Vienna, Schatzkammer); photo credit: Erich Lessing/Art Resource, NY; *see* Embroidery

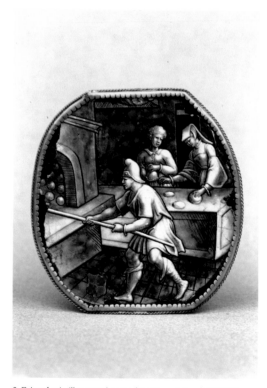

2. Painted grisaille enamel scene depicting a bakery, 105×103 mm, from Limoges, France, 16th century (Ecouen, Musée National de la Renaissance); photo credit: Réunion des Musées Nationaux/Art Resource, NY; *see* Enamel

3. Ed Rossbach: *Early Cross*, cotton knotted netting with wool pile, 330×305mm, 1967 (Boston, MA, Museum of Fine Arts); photograph © 2008 Museum of Fine Arts, Boston; *see* Fibre art

PLATE V

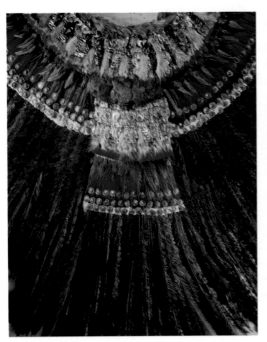

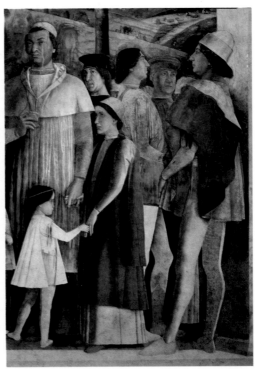

1. Featherwork headdress of an Aztec priest (detail), feathers and gold, h. 1160 mm, early 16th century (Vienna, Museum für Völkerkunde); photo credit: Erich Lessing/Art Resource, NY; *see* Featherwork

2. Fresco of the *Meeting Scene* (1465–74; detail) by Andrea Mantegna, Camera Picta, Palazzo Ducale, Mantua; detail showing range of colour; photo credit: Scala/Art Resource, NY; *see* Fresco

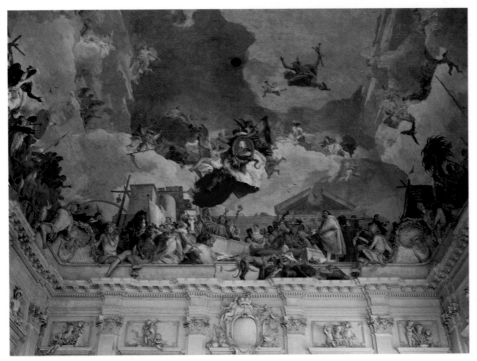

3. Fresco of the *Four Continents* (1752–3) by Giambattista Tiepolo, ceiling of the Residenz, Würzburg; detail showing large scale; photo credit: Scala/Art Resource, NY; *see* Fresco

PLATE VI

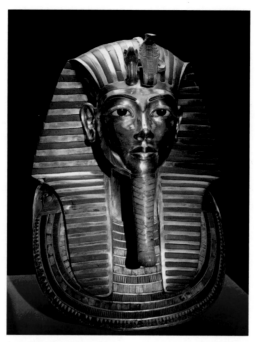

1. Gold mask of Tutankhamun, gold inlaid with lapis lazuli, quartz, cornelian and coloured glass, 18th Dynasty, c. 1332–c. 1323 BC (Cairo, Egyptian Museum); photo credit: Scala/Art Resource, NY; *see* Gold

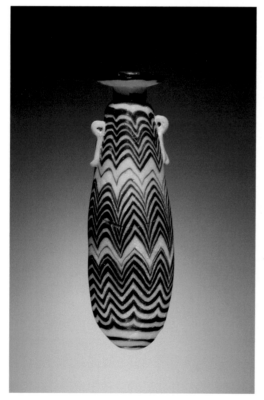

2. Core-formed glass perfume alabastron, h. 132 mm, perhaps Roman, 6th–4th century BC (Malibu, CA, The J. Paul Getty Museum); photo credit: The J. Paul Getty Museum; *see* Glass

3. Glass goblet, with freemason's symbols: compass, trowel, hammer and T-square, 2nd half 19th century (Vienna, Collection of Friedrich Gottschalk); photo credit: Erich Lessing/Art Resource, NY; *see* Glass

PLATE VII

1. Hardstone box by Johann Christian Neuber, gold ground, diam. 47 mm, Dresden, *c.* 1780; inset with later cameo by Nicola Morelli (London, British Museum); photo © British Museum/Art Resource, NY; *see* Hardstones

2. Diopside-jadeite mosaic burial mask, from tomb 160, Tikal, El Peten, Guatemala, shell, mother-of-pearl, h. 345 mm. Maya culture, Classic period, 6th century AD (Guatemala City, Museo Nacional de Arqueologiá y Etnologiá); photo credit: Erich Lessing/Art Resource, NY; *see* Jade

3. Colour lithograph by James Montgomery Flagg: *I Want You for the U.S. Army*, 241×737 mm, 1917 (Washington, DC, Library of Congress); photo credit: Art Resource, NY; *see* Lithography

PLATE VIII

1. *Execution by Hanging*, miniature from the *Roman de Godefroy de Bouillon*, from France, 14th century (Paris, Bibliothèque Nationale, MS. Fr. 22497, fol. 52*v*); photo credit: Snark/Art Resource, NY; *see* Manuscript

2. Mosaics in the dome of Hagia Sophia, Istanbul, AD 532–62; photo credit: Erich Lessing/Art Resource, NY; *see* Mosaic

3. Mosaic with acanthus leaves (detail), from Leptis Magna, Roman, 2nd century AD (Tripoli, Al-Saray Al-Hamra Museum); photo © Gilles Mermet/Art Resource, NY; *see* Mosaic

PLATE IX

1. Mother-of-pearl inlay on a lacquer tray, l. 193 mm, Ming period, 16th century (London, Victoria and Albert Museum); photo credit: Victoria and Albert Museum, London/Art Resource, NY; *see* Mother-of-pearl

2. Edgar Degas: *Laundress*, pastel, white crayon and charcoal, 740×610 mm, 1869 (Paris, Musée d'Orsay); photo credit: Réunion des Musées Nationaux/Art Resource, NY; *see* Pastel

3. Patchwork quilt by Maria Washington Layfield Miller: *Star of LeMoyne Quilt*, cotton, 2.3×2.5 m, 1850–75 (Newark, NJ, Newark Museum); photo credit: Newark Museum/Art Resource, NY; *see* Patchwork

PLATE X

1. Pentimenti around the head, shoulders and right arm, shown in *Drapery Study* by Domenico Ghirlandaio, brush with grey-brown tempera, heightened with white, on grey-brown prepared linen, laid down on paper, 268×178 mm, late 15th century (Berlin, Kupferstichkabinett); photo credit: Bildarchiv Preussischer Kulturbesitz/Art Resource, NY; *see* Pentiment

2. Collage by Juan Gris: *Breakfast*, gouache, oil and crayon on cut-and-pasted printed paper on canvas with oil and crayon, 809×597 mm, 1914 (New York, Museum of Modern Art, acquired through the Lillie P. Bliss Bequest (248.1948)); photo © Museum of Modern Art/Licensed by SCALA/Art Resource, NY; *see* Collage

3. Pentimenti in upper left of *The Miracles of St Francis of Paola*, by Peter Paul Rubens, oil on panel, 975×772 mm, *c.* 1627–8; two columns appear super-imposed on top of an archway; archway was painted over, but it reappeared when layers of oil paint became transparent (Los Angeles, CA, J. Paul Getty Museum); photo credit: The J. Paul Getty Museum; *see* Pentiment

PLATE XI

1. Cabinet inlaid with pietre dure (detail), made in Florence, *c.* 1700 (Potsdam, Neues Palais); photo credit: Erich Lessing/Art Resource, NY; *see* Pietra dura

2. Quilted silk and velvet medallion by Mrs. C. S. Conover, 2.6×2.7 m, 1885 (Newark, NJ, Newark Museum); photo credit: Newark Museum/Art Resource, NY; *see* Quilting

PLATE XII

1. Black marble table-top inlaid with pietre dure, including lapis lazuli, chalcedonies, agates and jaspers, diam. 1.25 m, made by Jacopo Ligozzi and Bernardino Poccetti at the Opficio delle Pietre Dure, Florence, 1633–49 (Florence, Museo dell'Opficio delle Pietre Dure); photo credit: Scala/Art Resource, NY; *see* Pietra dura

2. Stained-glass rose and band windows, in the south transept of Notre-Dame, Paris, begun 1258; photo credit: Giraudon/Art Resource, NY; *see* Stained glass

PLATE XIII

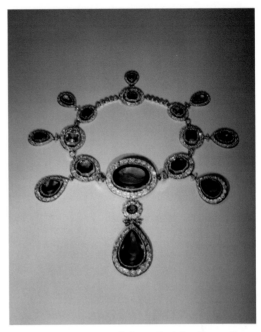

1. Plaque with champlevé enamelled decoration (detail), gold, from Limoges, early 13th century (Limoges, Musée Municipal); photo credit: Erich Lessing/ Art Resource, NY; *see* Enamel

2. Necklace, sapphires and diamonds, belonging to Queen Marie Christine of Spain, probably 19th century (private collection); photo credit: Art Resource, NY; *see* Gems

3. *Three Marys at the Sepulchre*, secco painting transferred to canvas, 1.95×3.87 m, from the Church of San Baudello near Berlanga, Spanish, 12th century (Boston, MA, Museum of Fine Arts, Maria Antoinette Evans Fund, 27.786); photograph © 2008 Museum of Fine Arts, Boston; *see* Secco

PLATE XIV

2. Colour screenprint by Anni Albers: *Do-C*, 483×419mm, 1973 (Bethany, CT, The Josef and Anni Albers Foundation); © 2007 The Josef and Anni Albers Foundation/Artists Rights Society (ARS), New York, photo credit: photo: Albers Foundation/ Art Resource, NY; *see* Screenprinting

1. Stone tesserae mosaic of a tiger (detail), from the House of the Muses, Ostia, *c.* AD 128; photo credit: Vanni/Art Resource, NY; *see* Tessera

3. Sandro Botticelli: *Primavera* (detail showing brushstrokes), tempera on panel, 2.03×3.14 m, *c.* 1478 (Florence, Galleria degli Uffizi); photo credit: Erich Lessing/Art Resource, NY; *see* Tempera

PLATE XV

1. Wall painting depicting *Narcissus*, from Pompeii, probably 1st century AD (Naples, Museo Archeologico Nazionale); photo credit: Scala/Art Resource, NY; *see* Wall painting

2. Tile-panel decoration, Rüstem Pasha Mosque, Istanbul, *c.* 1561–2; photo credit: Vanni/Art Resource, NY; *see* Tile

PLATE XVI

1. Maurice Prendergast: *New England Beach Scene,* watercolour, late 19th century–early 20th century (private collection); photo credit: Art Resource, NY; *see* Watercolour

2. Wax encaustic paint of a young man, limewood, probably from a mummy case, from Faiyum, Egypt, Roman period, 2nd century AD (Dijon, Musée des Beaux-Arts); photo credit: Erich Lessing/Art Resource, NY; *see* Wax

it is advisable to place another strip of Japanese paper at right angles over the pendant hinge, making a T-hinge. Pure starch paste is a recommended adhesive, although several cellulose ether gels, for example methylcellulose, are also archivally durable. Animal glue, rubber and pressure-sensitive tapes should be avoided as these deteriorate, causing eventual staining of the art work. With hinged as well as inlaid material, it is customary to attach the mat to the backboard with a cloth hinge.

G. Vasari: *Vite* (1550, rev. 2/1568); ed. G. Milanesi (1878–85)

F. Nicholson: *The Practice of Drawing and Painting Landscape from Nature in Watercolours* (London, 1820, 2/1823), pp. 96–105 [discussion of the mounting and varnishing of watercolours]

[J. Maberly]: *The Print Collector* (London, 1845, rev. 2/New York, 1880), chap. vi W. H. Willshire: *An Introduction to the Study and Collection of Ancient Prints* (London, 1874)

J. Meder: *Die Handzeichnung: Ihre Technik und Entwicklung* (Vienna, 1919/*R* 1923); Eng. trans., rev. and ed. by W. Ames as *The Mastery of Drawing* (New York, 1978) [chap. 17 gives an account of the history of drawing collectors and collections]

F. Lugt: *Marques* (1921)

A. E. Popham: 'Sebastiano Resta and his Collections', *Old Master Drawings*, xli (1936), pp. 1–19 [18 pls]

O. Kurz: 'Giorgio Vasari's *Libro de' disegni*', *Old Master Drawings*, xlv (1937), pp. 1–15 [16 pls]; xlvii (1937), pp. 32–44 [16 pls]

H. J. Plenderleith: *The Conservation of Prints, Drawings and Manuscripts* (London, 1937), pp. 13–27

H. J. Plenderleith: *The Conservation of Antiquities and Works of Art* (Oxford, 1952); rev. with A. E. A. Werner (Oxford, 1972)

M. Hardie: *Watercolour Painting in Britain*, 2 vols (London, 1956–67), ii, pp. 40–43

F. Lugt: *Marques*, suppl. (1956)

C. Zigrosser and C. Gaehde: *A Guide to the Collecting and Care of Original Prints* (New York, 1965), pp. 99–109

E. G. Harding: *The Mounting of Prints and Drawings*, Museums Association Information Sheet, xii (London, 1972, rev. 2/1980)

A. F. Clapp: *The Curatorial Care of Works of Art on Paper* (Oberlin, 1973, rev. 2/1974, rev. 3/1978, rev. 4/New York, 1987)

L. Ragghianti Collobi: *Il Libro de' disegni del Vasari* (Florence, 1974)

J. Bayard: *Works of Splendour and Imagination: The Exhibition Watercolour, 1770–1870* (New Haven, 1981)

A. Petrioli Tofani: 'I montaggi', *Restauro e conservazione delle opere d'arte su carta* (Florence, 1981), pp. 161–80 [eight illus. of various historical mounting styles]

M. A. Smith: *Matting and Hinging Works of Art on Paper* (Washington, DC, 1981)

L. Keefe and D. Inch: *The Life of a Photograph* (London and New York, 1984/*R* 1990) [incl. long section on techniques of mount-cutting]

D. Le Marois: 'Les Montages de dessins au XVIIIe siècle: L'Exemple de Mariette', *Bulletin de la Société de l'histoire de l'art Français* (1984), pp. 87–96

M. H. Ellis: *The Care of Prints and Drawings* (Nashville, TN, 1987, rev. Walnut Creek, CA, 2/1995), pp. 13–50

J. Krill: *English Artists' Paper* (London, 1987), pp. 139–41

C. Monbeig Goguel: 'Le Dessin encadré', *Revue de l'art* [Paris], lxxvi (1987), pp. 25–31

C. James and others: *Manuale per la conservazione e il restauro di disegni e stampe antichi* (Florence, 1991; Eng. trans. Amsterdam, 1997) [chap. 1 gives well-illustrated descriptions of a great many mounting styles]

Drawings by Guercino from British Collections (exh. cat. by N. Turner and C. Plazzotta; London, British Museum, 1991), pp. 25 ff [history of Bouverie collection mounts, formerly called 'Casa Gennari' mounts]

A. Griffiths and C. Hartley: 'The Print Collection of the duc de Mortemart', *Print Quarterly*, xi (June 1994), pp. 107–16

N. Walker: 'Feature it or File it: Mounting and Framing at the Whitworth Art Gallery', *Historic Framing and Presentation of Watercolours, Drawings and Prints* (Leigh, 1997), pp. 43–50

J. Shulla: 'A Glance at the History of Display and Mounting of British Watercolours', *Paper Conservator*, xxiv (2000), pp. 35–43

J. M. Kosek: *Conservation Mounting for Prints and Drawings: A Manual Based on Current Practice at the British Museum* (London, 2004)

J. Rayner, J. M. Kosek and B. Christensen, eds: *Art on Paper: Mounting and Housing* (London, 2005)

Muller. Stone or glass implement with a flat base, used to grind paints by hand on a hard flat surface or slab. Mullers and slabs of hard stone are first recorded in ancient Egypt. Large glass mullers were used for the commercial preparation of paints until the 19th century. Pigments could be ground on their own for use in fresco or aqueous media or ground in oil for later use.

N

Neon. Term used in its widest meaning to refer to luminous devices containing neon, mercury vapour, argon or other inert gases and their combinations used in electric signs or lamps generally tubular in shape. This extended definition is also applied in an artistic context. In its narrower, more technical sense, neon (from Gr. *neos*: 'new') is a rare inert gas that was discovered in 1898 and that was immediately recognized as a new element by its unique glow when electrically stimulated. The vapour-tube device filled with neon gas was invented by Georges Claude in Boulogne-Billancourt near Paris in 1910. When a high voltage was applied to the two electrodes at either end of the tube, it emitted a deep red light. With other gases, mercury vapour and their mixtures, a small range of colours was obtained in the following years in tubes that could be cut to any length, bent and formed by skilled craftsmen into almost any shape and used for signs that had, however, a very limited lighting capacity. When industrially produced, low-tension fluorescent straight tubing of white (and occasionally coloured) light in standardized sizes came into use in the 1930s, results approaching natural lighting were obtained.

Artists have incorporated both straight and curved 'neon' devices in pieces of sculpture or in interior or exterior environmental statements. Although neon tubes were widely used in the 1930s for decorative and advertising purposes, only very few artists employed them in their works during that period. The first attempt to use neon light as the principal material of a sculpture can be ascribed to Gyula Košice (*b* 1924) in Buenos Aires in 1946. His constructivist, dynamic *Luminous Structures* were conceived in the spirit of *Manifiesto blanco* by Lucio Fontana (1899–1968); Fontana in turn created an elaborate, elegant neon ceiling called *Spatial Concept* for the Triennale in Milan in 1951.

In the works of American artist Stephen Antonakos (*b* 1926), chromatic high-tension neon, available in a large spectrum, takes a prominent part in both his interior and exterior environmental pieces. Of the latter such permanent installations as *Incomplete Neon Circles* (1978) at the Federal Building, Dayton, OH, *Neon for 42nd Street* (1981), New York, or *Neons for the Tacoma Dome* (1984), Tacoma, WA, display a formal language of circles and squares; their fragmented versions, composed of arcs and right angles

are rather different from the preceding Minimalist artistic statements and in particular the works of Dan Flavin (1933–96), whose fluorescent light systems with standardized tubes were put to their most effective use in large-scale interior installations, exploring the phenomenon of coloured perception in space (e.g. *Untitled (To Donna)*, 1971; Paris, Centre Georges Pompidou). The conceptual artists Joseph Kosuth (*b* 1945) and Bruce Nauman (*b* 1941) had introduced neon light both for the purpose of a critical commentary on language mechanisms (e.g. Kosuth's *Five Words in Orange Neon*, 1965; Paris, L. & M. Durand-Dessert) and for a graphic demonstration in deforming real space (e.g. Nauman's *My Name as Written at the Surface of the Moon*, 1968; Bordeaux, Musée d'Art Contemporain). Nauman sometimes also tested the capacities of apprehension of the spectator in such fluorescent lamp installations as *Dream Passage with Four Corridors* (1983–4; Paris, Centre Georges Pompidou). Neon is present in some works by the Arte Povera artist Mario Merz (1925–2003) (e.g. *Giap's Igloo*, 1968; Paris, Centre Georges Pompidou), principally in order to stimulate the perception of materials such as stone, concrete, wax, textiles or paper in their daily usage, or in the works of Keith Sonnier (*b* 1941) in order to test the perception of hardness, colour and light (*Sel VII*, 1978; artist's collection, see 1989 exh. cat.; *Sel Piece*, 1981; Paris, Galerie Fabre).

Martial Raysse (*b* 1936) also attempted to challenge the perceptual capacities of the spectator in pieces in which he outlined human faces, hearts and palm trees with multicoloured neon tubing, thereby alluding simultaneously to the artificiality of modern times, and to the purity and innocence of a new way of life (e.g. *America, America*, 1964; Paris, Centre Georges Pompidou). Brilliantly coloured neon tubing is also the principal building material in sculptures by Chryssa (*b* 1933), which contain mysterious symbols and alphabetical elements in an attempt to bridge the gap between Classical Greek and Byzantine civilization and the modern electrically dominated environment (*Clytemnestra*, 1968; Washington, DC, Corcoran Gallery of Art; *Gates to Times Square*, 1966; Buffalo, NY, Albright–Knox Art Gallery).

Piotr Kowalski (*b* 1927) and François Morellet (*b* 1926) used neon devices in their sculptural works and installations with the intention of implicating the

public in the apperception of basic physical and technological facts. Kowalski's *Manipulator No. 3* (1967; Paris, Centre Georges Pompidou) placed the spectator into an active situation, whereas his *Pyramid* (1973) in Bordeaux tested his architectural awareness. Morellet used neon light conspicuously in his early programmed installations in museums, galleries and in the street, and more subtly in later geometrical works or in outside installations such as *Neons with Two Rhythms of Interference* (1986) at the Grande Halle de la Villette, Paris.

The various uses of neon in art correspond to the need for creating coloured dynamic light effects, for modelling interior and exterior spaces and for modifying existing architecture. Although it can be maintained that neon light, from Las Vegas to Tokyo, symbolizes the energy and vitality of modern life, its presence in works conceived by artists operates rather as an antidote to hectic agitation and invites quiet contemplation and meditation.

Kunst–Licht–Kunst (exh. cat., Eindhoven, Stedelijk Van Abbemuseum, 1966)

W. Ellenbass: *Fluorescent Lamps* (London, 1971)

W. Ellenbass: *Light Sources* (London, 1972)

R. Stern: *Let There Be Neon* (New York, 1979)

Luminous Art for the Urban Landscape (exh. cat. by O. Giorgia; Washington, DC, Washington Project for the Arts, 1981)

M. Webb: *The Magic of Neon* (Salt Lake City, 1983)

Electra: L'Electricité et l'électronique dans l'art au XXe siècle (exh. cat. by F. Popper; Paris, Musée d'Art Moderne de la Ville de Paris, 1983)

A. Bodet: 'Néon: De L'Electricité dans l'art', *Beaux-arts*, viii (1983), pp. 52–7, 96–8

G. Breerette: 'Espace, lumière, repos', *Le Monde* (16 Dec 1983)

Néon, fluor et cie (exh. cat., Brussels, Institut Supérieur pour l'Etude du Langage Plastique, 1984)

Directions: Keith Sonnier: Neon (exh. cat., Washington, DC, Hirshhorn Museum and Sculpture Gallery, 1989)

D. Elger: *Neon Stücke: Joseph Kosuth, Mario Merz, François Morellet, Maurizio Nannucci, Bruce Nauman, Richard Serra, Keith Sonnier* (Stuttgart, 1990)

F. Popper: *Art of the Electronic Age* (London, 1993)

D. Chihuly: *Chihuly Projects* (New York, 1999)

H. Rothman: *Neon Metropolis: How Las Vegas Started the Twenty-first Century* (New York and London, 2002)

M. Lovejoy: *Digital Currents: Art in the Electronic Age* (New York, 3/2004)

Dan Flavin: A Retrospective (exh. cat. by M. Govan and T. Bell; Washington, DC, National Gallery of Art, 2004)

J. D. Ketner: *Elusive Signs: Bruce Nauman Works with Light* (Milwaukee, 2006)

C. Meigh-Andrews: *A History of Video Art: The Development of Form and Function* (Oxford and New York, 2006)

Niello. *See under* METAL, §V.

Niello print [Fr. *nielle estampe*, It. *niello*, Ger. *Niellodruck*]. Type of print made as a proof on paper from a plate of gold or silver (or from a sulphur cast serving as an intermediary), which has been engraved with a view to being inlaid with niello, a black substance composed of metallic alloys. It developed from a type of

goldsmiths' work that was practised widely in northern Italy in the 15th century and that was associated with the development of Italian copperplate engraving (*see* ENGRAVING, §II, 1). The art of niello has been practised since antiquity (*see* METAL, §V). During the Middle Ages the Latin word *nigellum* was applied to the black enamel that was poured into a design or engraved on plates, which were used as paxes or to ornament religious objects (reliquaries, crucifixes, candlesticks) and secular objects (boxes, jewellery, buckles, buttons, book bindings, tableware, sword scabbards, dagger sheaths). In the Renaissance *nigellum* was contracted to *niello*, which by extension was applied to the object thus enamelled and to the proof on paper pulled from the prepared plate, before being nielloed. This proof permitted the goldsmith to check his work, to keep a record of his work and perhaps also to constitute a model book. It was not intended for distribution, which explains the rarity of preserved copies.

The gold or silver plates (usually very small—20–70 mm) were incised using a burin. The outlines of designs were traced with precision and sharpness and then modelled using light, short, thin and close cuts. The background was hatched in a vigorous and irregular manner by large, crossed, deep and dense cuts, of which the numerous burrs were intended to receive the enamel. Before receiving the enamel, the plate was cleaned, boiled in water with oak ashes for 15 minutes, then rinsed in pure water and polished with a small brush. The incisions in the engraved plate were then filled with a thick, black tint. The goldsmith took a cast with a very fine and compact clay; the design then appeared in reverse. (These clay moulds were fragile and easily broken. None survives.) Over this clay mould, the goldsmith poured sulphur. The cast thus obtained had the advantage of facing the same way as the original; it was easier to preserve when a plaster backing consolidated it. The grooves were filled with lampblack, and a coat of oil gave the polished sulphur the appearance of silver plate. The goldsmith thus had an exact vision of his future object.

This cast in blackened sulphur was laid on a sheet of damp paper subjected to the manual pressure of a goldsmith's roller (usually used to give form to objects with the aid of a hammer), being too fragile to withstand a press. The result was a niello print, with the design reversed in relation to the metal plate. The cast sometimes cracked, and these accidents were recorded on the paper proof.

It is possible that the goldsmith made use of this intermediary to obtain a paper proof, in order not to impair the metal plate. It is difficult to ascertain whether a proof on paper was printed from the inked metal plate itself or from the sulphur cast of this plate, or even from an engraved plate not intended to be inlaid with niello but simply to furnish models for niello-working goldsmiths.

Niello prints have characteristic features. The subject is reversed on the print, so inscriptions must be read with the help of a mirror. Often the nail holes

Niello print by Peregrino da Cesena: *Orpheus Charming the Animals*, 52×30 mm, late 15th century (New York, Metropolitan Museum of Art, Harris Brisbane Dick Fund, 1928 (28.97.99)); image © The Metropolitan Museum of Art

made in the metal for fixing it to the object to be decorated appear on the print. Inking is either very light, more grey than black, bluish or greenish for the oldest niellos, or muddy and thick. Most have a black background and light features, but some have a white background. Plates exist of which the engraving was not finished at the time of printing or of which the grooved background was intended to be gilded. Niello prints were generally made in one or two copies, without much care, and the figures sometimes spill over the square outline. The designs include religious, mythological and allegorical scenes, portraits of notable Italians and subjects symbolizing love and marriage.

In 1797 Pietro Zani discovered in the Cabinet des Estampes in Paris a print of a nielloed plate (Paris, Bibliothèque Nationale), a pax representing the *Coronation of the Virgin* (1452; ex-Baptistry, S Giovanni, Florence; now Florence, Museo Nazionale del Bargello). This niello print was acquired in the 17th century, with the Marolles collection, and considered from then as an engraving. Two impressions of it in

sulphur have been discovered (London, British Museum; Paris, Musée du Louvre), probably executed at two different stages of the work. Niello prints became thereafter much sought by enthusiasts, and large collections were formed. Public collections were established, made up from their own material, by identifying engravings as niello prints. The difficulty was in differentiating them from small engravings with black backgrounds that served as models for goldsmiths. This was exacerbated by the spread of forgeries and counterfeits, which proliferated during the 19th century. Cataloguers ran into problems of attribution, no niello being signed, except those of Peregrino da Cesena (*fl c.* 1490–1520; see fig.), which are impressions of engraved plates in the niello manner, with inscriptions the right way round.

Two important centres of activity can be distinguished: Florence, with the goldsmiths Maso Finiguerra (1426–64) and Antonio Pollaiuolo (*c.* 1432–98); and Bologna, with Francesco Francia (*c.* 1450–1517) and Peregrino da Cesena. The technique of the niello print considerably influenced the first 15th-century line engravers in Florence and Ferrara, and it was prolonged in small engravings in the niello manner by minor German masters of the 16th century.

Theophilus: *Diversarum artium schedula* (*c.* 1100; Berlin, 1933), iii

G. Vasari: *Vite* (1550, rev. 2/1568); ed. G. Milanesi (1878–85)

B. Cellini: *Trattado dell'oreficeria* (Florence, 1568/*R* 1857), pp. 15–19

E. Dutuit: *Manuel de l'amateur d'estampes, nielles* (Paris, 1888)

J. Duchesne: *Essai sur les nielles* (Paris, 1926)

A. M. Hind: *Nielli in the British Museum* (London, 1936)

A. Blum: *Musée du Louvre, Cabinet d'estampes d'Edmond de Rothschild, les nielles du quattrocento* (Paris, 1950)

J. van der Stock: *Early Prints: The Print Collection of the Royal Library of Belgium* (London and Turnhout, 2002)

O

Oil painting. Method of painting using pigments dispersed in oil. It is not known how oil painting was first developed, but in Western Europe there are indications of its use from at least the 12th century AD, and it was widely used from the Renaissance. This article discusses the characteristics and development of oil painting in Western Europe.

See under CONSERVATION AND RESTORATION for technical details regarding the deterioration and restoration of oil paintings.

1. MATERIALS. Only some oils have a chemical composition that allows them to dry to a solid film, and even these can take several weeks or even months to dry (*see* OILS, DRYING). Drying time can be speeded up by certain processes, for example heating the freshly pressed oil in air to give boiled or blown oils, or heating the oil in the absence of air to produce stand oils. This viscous material is then usually combined not only with the pigment but also various modifying painting media (*see* PAINTING MEDIUM). For example, the paint can be combined with resins and alkyds to promote drying time and the handling qualities of the medium, and to enhance general appearance (*see also* PAINT, §I, 2). The viscous oil is thinned during the painting process with a volatile liquid, usually turpentine, which will gradually evaporate from the painting (*see* SOLVENT). Oil painting is commonly associated with panel (wood) or canvas supports, although it has been used with a lesser degree of success on other materials, for example stone and paper. As in other types of painting some type of GROUND is usually prepared; in oil painting this is often coloured. A finishing, protective layer of varnish is also usually applied, the composition of which may include the same evaporating solvent used as the oil thinner (*see* VARNISH, §§1 and 2).

The most frequently used oils by painters are linseed (*Linum usitatissimum*), walnut (*Juglans regia*) and poppyseed (*Papaver somniferum*). Linseed dries the fastest but has a yellowish colour, while walnut and poppyseed oil are often used specifically to keep colours cool in tone. The refractive index of such oils is higher than, for example, egg tempera, and this renders many pigments translucent in oil where they would not be so in other binding media. Such translucent qualities make oil paint an ideal medium for techniques of glazing (*see* GLAZE), which results in a

richness and depth to the colour not found with simple mixing. The crimson lakes made from kermes and cochineal beetles, ultramarine from lapis lazuli and copper green from verdigris dissolved in resin produce particularly fine glazes.

The disadvantages of the slow drying time of oil paint are offset by its durability when dry and its ease of handling and versatility on the palette and at the picture surface. Many of the techniques in oil painting that developed over the centuries (*see* §2 below) are simply not possible with paints based on, for example, water or egg: not only can oil paint be applied flatly over large areas without leaving brushmarks, but, by changing its consistency or harnessing its slow-drying properties, it can be applied to give a wide range of textural effects. Furthermore, the quality of oil as a binding medium for pigment is such that whether loaded on to the brush and applied thickly (impasto), or built up in layers of glazes, or even applied as a single, hairline brushstroke, oil paint can produce the finest clarity of colour.

2. HISTORY.

(i) 12th–15th centuries. (ii) 16th–17th centuries. (iii) 18th–20th centuries.

(i) 12th–15th centuries. Egg tempera was the main paint medium of the Middle Ages before the advent of oil paint (*see* TEMPERA). The use of drying oils as a varnish for paintings was described by the medical writer Aetius in the 6th century AD, but the earliest reference to mixing oil with pigment to make paint was not until the 12th century, in the manual *De diversis artibus* (*c.* 1110–40) by Theophilus. A practising craftsman, Theophilus wrote: 'All the kinds of pigments can be ground with this same oil and laid on woodwork, but only on things that can be dried in the sun, because whenever you have laid on one pigment, you cannot lay a second over it until the first has dried out. This process is an excessively long and tedious one in the case of figures.' Certainly, oil paint as it was used before the 16th century was not easy to handle. The time that it took to dry varied according to the pigment used, but with certain colours it could be weeks before it was possible to progress to another layer of paint. Furthermore, much time would be spent, usually by workshop assistants, grinding the

materials between granite surfaces to achieve the right consistency (*see* PAINT, §II, 1).

Technical examinations of paint media in the late 20th century, using such methods as gas chromatography and mass spectrometry, has established the medium of various medieval and early Renaissance works—a distinction that is often not possible with the naked eye. Some of the earliest uses of oil paint were on Norwegian altarpieces and sculptures dating from the mid-13th century. These are sometimes a combination of oil and tempera. Cennino Cennini (*c*. 1370–*c*. 1440) discussed the German practice of oil painting on wall or panel in *Il libro dell'arte* (*c*. 1390). Historians have established a geographical pattern with regard to the introduction of oil to Europe, distinguishing northern trends (e.g. in Scandinavia, England, the Netherlands, Germany and northern France) from southern (e.g. in Italy and southern France). By the 15th century, painters in northern Europe worked entirely in oil for PANEL PAINTING; the preference was for linseed oil, although walnut oil was also popular. The northern painters also used oil on walls (*see* SECCO, §1(ii)), although to a lesser extent. The southern painters did not start experimenting with the medium until the 15th century, and at first they chose walnut oil. There was little enthusiasm in the south for wall painting using oils due to problems of deterioration; fresco painting was to remain predominant in Italy.

In the northern countries, particularly the Netherlands, the transparency of oil paint was fully exploited from the outset, and a technique was developed in which layers of glazes were built up from a detailed underdrawing, like sheets of coloured glass. In some paintings by Dieric Bouts (*c*. 1415–75) as many as five layers have been found. This method of layering, requiring careful planning and meticulous execution, reached such a high quality in the paintings of Jan van Eyck (*c*. 1395–1441) that he was credited wrongly by Giorgio Vasari (1511–74) with having invented the process. Vasari also suggested that the method was introduced to Italy by Antonello da Messina (*c*. 1430–79), which is less disputed. Antonello had adopted many of the techniques of the south Netherlandish schools, and certainly his work was much admired in Venice during a working visit of 1475–6; his use of thin glazed paint and miniaturistic detail was distinctive. The tempera tradition was, however, well established in southern Europe, thus the introduction of oil paint was a gradual process, with many painters continuing to work in egg and animal size during the 15th century.

The paintings of Perugino (*c*. 1450–1523) illustrate the transition stage in Italy very well. In works such as the *Virgin and Child with the Infant St John* (*c*. 1485; London, National Gallery) both mediums are used: the lower layers are painted with the little hatched brushstrokes characteristic of tempera, while the red and blue upper layers of the drapery have the richness, smoothness and transparency of oil glazes. By contrast the altarpiece for the Certosa di Pavia (1499; London, National Gallery) was

worked entirely in oil. The paintings are similar in technique, in that the image was precisely outlined on the white gesso, then carefully coloured in, but the Certosa Altarpiece is strikingly different in effect: the brushstrokes are blended, the colours richer, the modelling softer and more rounded, and the detail finer.

Because the change from egg to oil was gradual in the south, certain conventions were retained at first, for instance most of the modelling and blocking in of colour was carried out with opaque paint, with only the final layers being glazed. On the other hand, the possibilities of the new medium were actively explored in Venice, even in the 15th century, in particular different ways of blending one area of paint into another and producing soft modelling effects. The gradual transition from tempera to oil in Italy also altered the balance of the palette. Since oil had the effect of making pigments more transparent, some of the light, bright pigments that had been popular with tempera painters were found to be unsuitable. Green earth, for example, which had been important as a strong green base for flesh tones, lost its colour when mixed with oil and subsequently ceased to have much use. Such darker pigments as the carbon blacks and the brown earths, which in tempera were dense and opaque and therefore useful only for outlines and details, were used in a new way in oil as transparent shadows and glazes. It was easier for painters to experiment with chiaroscuro shading, and slowly the change was made away from simple colouring (e.g. red shadows on red, blue shadows on blue) to a system of mixed and broken tones.

The use of canvas rather than panel for the painting support burgeoned in the 15th century, particularly in Venice—canvas being well suited to the medium of oil paint. Stiff brushes made of hog hair were developed to suit the rough surface and slight give of the canvas, and to produce an easy, flowing brushstroke. Such brushes could be loaded with paint and, because of the stiffness of the bristles, could leave a distinctive brush pattern not achieved by the soft squirrel-hair brushes used by panel painters. Canvases were not cheaper than panels but were more convenient and could be stitched together to produce large working surfaces. A broader handling of oil paint was the obvious response to this change in scale. Whether using panel or canvas, however, a further change linked to the rise of oil painting in the 15th century was the increasing importance attached to EASEL PAINTING. As artists became used to the freedom of not having to work on location and within the constraints of building regulations (as was the case with fresco painting), so the seeds were laid for painting—and oil painting in particular—to develop with the status of an independent art and noble pursuit.

(ii) 16th–17th centuries. Most 16th-century paintings were executed in linseed oil, and this remained the most popular oil. Throughout the 16th century, painters continued to experiment, and there was a

move away from the dependence on a careful preliminary drawing to a method of painting in which the image evolved as work progressed. X-rays of 16th-century paintings, compared to those of the 15th century, demonstrate the change. Whereas Perugino's Certosa Altarpiece shows the paint carefully blocked into drawn outlines, X-rays of *The Tempest* (*c.* 1505–6 or 1509; Venice, Galleria dell'Accademia) reveal that Giorgione (?1477/8–1510) added or subtracted some important details in the process of painting. The working of the image was even more complex in the *Death of Actaeon* (*c.* 1560; London, National Gallery) by Titian (*c.* ?1485/90–1576). X-rays reveal that such main parts of the painting as Diana's arm and the group of hounds were constantly altered. Titian was carrying out in paint the process that had previously been finalized at the early drawing stage. Palma Giovane (*c.* 1548–1628) watched him at work, and his description corroborates the evidence of the X-ray: 'If he found something which displeased him he went to work like a surgeon … Thus by repeated revisions he brought his pictures to a high state of perfection.'

While it was the slow drying property of the oil that enabled painters to alter, add, scrape off or obliterate as the work progressed, measures were also taken to reduce the overall drying time. Although there are no 16th-century technical descriptions of how painters speeded up the drying of the oil, it is clear from the canvases of such painters as Jacopo Tintoretto (1519–94) and Paolo Veronese (1528–88) that their brushstrokes dried quickly: they were able to create soft highlights by dragging stiff paint across the bumps of the canvas weave or over the ridges of earlier brushstrokes to leave a broken, scumbled line. This was the first time such effects were used. There is no reference to thinners in the literature until the 17th century, when lavender oil is mentioned, but the distillation process was well understood even by the 13th century, and it is possible that natural resins were distilled to produce such solvents as turpentine. These solvents were probably used more often in varnishes and for cleaning brushes than for thinning the paint during this period. A work from the school of Quinten Metsys (1466–1530) depicting *St Luke Painting the Virgin and Child* (*c.* 1513) documents the tools of 16th-century oil painting, including distillation flasks (on the shelf) and a jar of oil or thinner (on the stool). Other interesting details in this picture are the shell containing gold paint (on the stool); the convex mirror behind the artist to produce a small image; and the MAHLSTICK, a device to stop the artist's hand touching the surface of the painting, the origin of which is linked to the growth of oil painting. From 1620 to 1646 the Swiss physician Théodore Turquet de Mayerne (1573–1655) compiled a collection of notes based on experiments and conversations with artist friends, and these included several methods for boiling oil with one of the lead- or copper-based pigments and then filtering it. The metal initiated oxidation, and painting layers could dry in hours rather than days.

Adjustments to the ratio of pigment to oil resulted in substances ranging from liquid washes to gritty pastes, and many 17th-century painters exploited a wide range in single works. For instance in the *Toilet of Venus* (*c.* 1651; London, National Gallery) by Diego Velázquez (1599–1660) the suggestion of texture varies in consistency from feature to feature: the flesh of the nude is a solid paint applied thickly and with the brushstrokes smoothed out, perhaps with a softer brush as the oil started to dry; the paint of the white sheets was wetter and so followed the broad and fluid brush lines; the pink ribbon was painted with a scumble of thick, dry paint creating the effect of broken, reflected light; the paint of the green and the black veils is so diluted and thin that the white of the sheets shows through it, suggesting perfectly the diaphanous quality of the material depicted.

It is interesting to note that the shape of artists' palettes had changed by the 17th century in response to the way in which oil paint was handled. Early illustrations of painters working depict them holding small paddle-shaped palettes just large enough to support the one or two colours needed to work up a single detail (*see* PALETTE). The palette depicted in *St Luke Painting the Virgin and Child* (*c.* 1513; London, National Gallery) by a follower of Quinten Metsys had a thumb hole, and later in the 16th century the palette of Jacopo Bassano (*c.* 1510–92) was the size of a large table-tennis bat. By the 17th century, however, when painters built up the painting as a whole, palettes were often twice that size.

The wide differences in the way in which different 17th-century painters handled paint were compounded by the choice of coloured grounds on which to work. The traditional ground for panels was a dense white layer based on chalk or gypsum, and at first a thin skim of this was also used on canvases. By the end of the 16th century, however, it became increasingly common for painters to prepare canvases with coloured grounds based on oil. Early 17th-century canvases, Spanish and southern Italian in particular, were often extremely dark, but later the tone became lighter. The initial reasons for this colouration were probably practical—brown earth pigments were cheap and speeded up the drying process—but painters subsequently developed particular preferences to suit their technique. El Greco (*c.* 1541–1614), for example, chose near-black grounds. The dark base colour encouraged the painter to block in the illuminated parts of his composition as a first stage, using quite thick, opaque paint, which was known as 'dead colouring'. The unlit areas barely needed any paint at all as the colour of the ground could be left to act as the shadow tone. The painting could then be brought to completion rapidly with coloured glazes and some descriptive brushwork. It was an economic technique, and such painters as Luca Giordano (1634–1705) developed the formula so well that his output of paintings was phenomenal. The price of using brown grounds, however, was a general darkening of tone, and this effect was exacerbated over time as the overlying

paint became more transparent to reveal preparatory layers to a greater extent than was intended.

The grounds of panels by Peter Paul Rubens (1577–1640) are unique: streaky brushstrokes of semi-transparent brown laid over the traditional white preparation. This inventive solution allowed him to exploit the rapid, economic technique of dark ground painting, without losing the luminosity of the traditional chalk ground. Rubens's paintings summarize all the technical achievements of 17th-century European oil painting, pulling together as they do the expressive brushwork and looser handling of the Venetian tradition with the rich and transparent paint of the northern schools.

(iii) 18th–20th centuries. During the 18th century, colour merchants, a new professional group, emerged who processed, packaged and supplied most of the needs of the painter's workshop. This meant a gradual but inevitable change in workshop practices and a reduced emphasis on the craftsmanship aspect of painting. It became increasingly rare for a painter to prepare his own paints. One effect of this development was that the painter no longer had the same understanding of his materials, and some paintings produced in the 18th and 19th centuries are cracked and discoloured simply because the paint was applied incorrectly.

Joshua Reynolds (1723–92) is probably the most notorious example of a painter who abandoned the tried and tested rules of painting. In his determination to emulate the great 16th-century Venetian painters he experimented with the oil medium, adding waxes to make it soft and pliable, or resins to make the colours more transparent. Fast-drying paint, slow-drying paint and paint that would never dry at all were built up layer upon layer, and the result was usually a cracked surface ('*craquelure anglaise*'; *see* CRAQUELURE) and contraction. Sometimes this was so severe that parts of the worst-affected paintings have all but disappeared. Reynolds was aware of the dangers but the glorious short-term effects were felt by him to be worth the future decay. An equally experimental painter was George Stubbs (1724–1806), who used a mixture of beeswax, pine resin and non-drying oils in an attempt to follow the ancient Greek and Roman technique of encaustic painting. Other artists were less innovative, but throughout the 18th century and early 19th it was common to adapt the oil medium to a greater or lesser extent. With regard to grounds on canvas, a common 18th-century practice was the use of a cool grey layer to cover the traditional warm brown tone, although such painters as Giambattista Tiepolo (1696–1770) and Thomas Gainsborough (1727–88) chose mushroom pink. In northern Europe, many wall paintings still continued to be executed in oil, occasionally combined with other techniques and materials, as with French marouflage, in which an oil painting on canvas is pasted on to a wall.

Paints prepared by colour merchants were at first packaged in pieces of animal, usually pig bladder.

This was wasteful of expensive pigment as the paint dried out rapidly, and some painters continued to grind and mix their own. It was the invention of the collapsible aluminium paint tube in 1841 (*see* PAINT, §III) that was decisive in transferring all paint manufacture away from the studio and into the factory. No longer was each pigment ground and mixed as appropriate to its chemical and physical character; instead each was reduced to a uniform powder in the mechanical mills and then mixed to a standard consistency. The shelf life of the paint became one of the most important criteria, therefore such materials as spermaceti, paraffin wax and tallow were included to prevent pigment and oil separating in the tube, followed by more oil to make the mixture workable. The result was often a stiff yet oily mixture that gave rise to many complaints from 19th-century artists. Tube paint, however, was so easy to transport that it became a major factor in the development of outdoor (*plein-air*) rather than studio-based painting. Another major change to paint of all media between *c.* 1800 and 1860 was the invention of a new range of strong, bright and intensely coloured pigments based on the newly discovered elements chromium, cadmium, zinc and cobalt (*see* PAINT, §II, 2). Towards the end of the 19th century, the potential of colours was augmented by the chemical synthesis of organic dyes. Not all the latter were found to be appropriate to oil painting, however, and there were problems with fading. William Holman Hunt (1827–1910), among others, was involved in getting manufacturing standards set, which eventually led to tube paints being coded for their stability.

A small revolution in brushes for oil painting was the development of bristles set in a metal ferrule rather than in the traditional section of quill. This metal could be pressed into any shape and a range of square-ended brushes was produced that allowed paint to be pushed around the canvas in a completely new way. The combination of the standardized, stiff paints and the square-ended brushes made possible the distinctive surface texture of Impressionist and Post-Impressionist paintings. Furthermore, while palette knives had been used by painters since at least the 15th century, it was only in the 19th century that they became really established as painting tools and were marketed as such. J. M. W. Turner (1775–1851) had used a palette knife extensively to spread the thick white underlayers of his later paintings, but it was probably Paul Cézanne (1839–1906) who first completed paintings almost entirely with a knife, for instance *Man with a Cloth Cap (Uncle Dominique)* (*c.* 1866; New York, Metropolitan Museum of Art). *Alla prima* painting, that is, the producing of the finished effect at a single stage, became a common practice by the end of the 19th century. As well as being essential for the Impressionist's *plein-air* painting to record rapidly changing scenes, the technique was also adopted in the studio. The portrait of *Derain* (1905; London, Tate) by Henri Matisse (1869–1954) demonstrates *alla prima* and the technique of blending oil paint wet-in-wet with a square-ended brush.

In the 20th century, while oil paint remained the same, experiments were made with surfaces other than canvas or wood and also the combining of the paint with such extraneous materials as tobacco, sand or newsprint. From the 1950s, research by paint manufacturers concentrated on developing acrylics and alkyds, which were particularly popular in the 1960s and 1970s. Despite being quick drying and convenient, however, acrylic did not replace the position of oil as the pre-eminent paint medium—this is sustained by the working properties, richness and transparency of oil painting.

Unpublished sources

London, British Library, Sloane MS. 2052 [MS of T. Turquet de Mayerne: *Pictoria et quae subalternarum artium* (1620–46)]

Bibliography

C. L. Eastlake: *Materials for a History of Oil Painting* (London, 1847–69); rev. as *Methods and Materials of Painting of the Great Schools and Masters* (New York, 1960)

R. Mayer: The Artist's Handbook of Materials and Techniques (New York, 1940, rev. London, 5/1991)

R. Feller, N. Stolow and E. H. Jones: *On Picture Varnishes and their Solvents* (London, 1971)

R. D. Harley: 'Oil Colour Containers', *Annals of Science*, xxvii/1 (1971), pp. 1–12

J. H. Townsend: 'Whistler's Oil Painting Materials', *Burlington Magazine*, cxxxvi/1099 (1994), pp. 690–95

A. Massing: 'French Painting Technique in the Seventeenth and Early Eighteenth Centuries and De La Fontaine's *Académie de la peinture* (Paris 1679)', *Looking through Paintings: The Study of Painting Techniques and Materials in Support of Art Historical Research*, eds E. Hermens, A. Ouwerkerk and N. Costaras, Leids Kunsthistorisch Jaarboek (Baarn and London, 1998), pp. 319–90

M. P. Merrifield: *Original Treatises Dating from the XIIth to XVIIth Centuries on the Arts of Painting, in Oil, Miniature, Mosaic, and on Glass* (Mineola, NY, 1999)

L. Carlyle: *The Artist's Assistant: Oil Painting Instruction Manuals and Handbooks in Britain, 1800–1900 with Reference to Selected Eighteenth-century Sources* (London, 2001)

J. H. Townsend and others: 'Blake's Only Surviving Palette?', *Blake: An Illustrated Quarterly*, xxxix/2 (Fall 2005), pp. 100–03

A. Fuga: *Artists' Techniques and Materials* (Los Angeles, 2006)

Oil pigment. *See under* PHOTOGRAPHY, §I.

Oil sketch [It. *bozza*; *bozzetto*; *macchia*]. Type of painted work of small dimensions, generally executed as a preliminary or intermediary study for a finished work of larger size. It is generally characterized by its spontaneity; occasionally, however, the study is more refined and very close to the final work, when it is known as a MODELLO. The oil sketch is quite different from an UNDERDRAWING (It. *abbozzo*), which is the first application of a composition directly on to the final support.

Oil sketching first appeared in the 16th century and represented a departure from the working methods described by Giorgio Vasari (1511–74), which involved only preliminary graphic studies and drawings. The earliest known oil sketches are by Polidoro da Caravaggio (*c.* 1499–*c.* 1543). These are three studies (Rome, Palazzo della Cancelleria; Naples, Museo e Gallerie Nazionali di Capodimonte; London, Pouncey private collection) for his altarpiece of the *Ascent to Calvary* (*c.* 1534; Naples, Museo e Gallerie Nazionali di Capodimonte). Shortly afterwards Federico Barocci (*c.* 1535–1612) began to execute oil sketches in mixed oil and tempera as an alternative to drawings. Cristofano Allori (1577–1621) and other Florentine painters made methodical use of this preparatory method and often used oil on paper, a technique that allows the preliminary underdrawing to remain visible, thus ensuring continuity of design. Marcantonio Bassetti (1586–1630), writing to Palma Giovane in 1616, attested to this method: 'Whatever is drawn must be painted'.

Oil sketches were not always produced solely for the artist's benefit, or by his own choice. A patron often requested an oil sketch in order to evaluate a project of particular importance at an early stage. Equally, a patron might ask several artists to submit oil sketches when competing for a commission, as happened with the large painting of *Paradise* intended for the Sala del Maggior Consiglio in the Doge's Palace, Venice. The Senate invited Jacopo Tintoretto (1519–94), Paolo Veronese (1528–88), Francesco Bassano (*c.* 1510–92) and Palma Giovane (*c.* 1548–1628) to submit designs; Tintoretto, who gained the commission, painted two oil sketches (Paris, Musée du Louvre, and Madrid, Museo Thyssen-Bornemisza). Veronese's sketch is in the Musée des Beaux-Arts, Lille, Bassano's in the Hermitage Museum, St Petersburg, and Palma's in the Pinacoteca Ambrosiana, Milan. An oil sketch might also be requested by a patron to ensure that the iconographic content of a commission was correct. For instance Nicolas Poussin (1594–1665) (who never produced any other examples) was required to execute an oil sketch (Ottawa, National Gallery of Canada) in 1627–8 for his altarpiece of the *Martyrdom of St Erasmus* (Rome, Pinacoteca Vaticana) commissioned for St Peter's, Rome. Certain patrons, notably the Medici in Florence and the Barberini in Rome, began collecting oil sketches. Thus oil sketches could sometimes effect a closer cooperation between artists and patrons of the Baroque era.

The most significant example of a Baroque artist's use of the oil sketch is found in the work of Peter Paul Rubens (1577–1640). He began the practice when he was first in Italy from 1600 to 1608. For *St Gregory and the Saints* (1606; Grenoble, Musée de Grenoble), commissioned for the high altar of S Maria in Vallicella, Rome, he executed three oil sketches (versions Berlin, Gemäldegalerie; London, University of London, Courtauld Institute Galleries, and Vienna, Akademie der Bildenden Künste). For the rest of his life, Rubens executed oil sketches for all his major works, religious and secular (e.g. the *Rape of Proserpina*; Bayonne, Musée Bonnat). Some of his oil sketches painted in grisaille (e.g. the *Coup de*

Lance; London, National Gallery) are, like those of the Florentine painters, a half-way stage between the drawing and the painted work. Rubens's oil sketches were frequently used as models for his pupils to work from: Anthony van Dyck (1599–1641), for example, completed many of the paintings in the Jesuitenkirche in Antwerp in this way.

Rubens's example was important, not only for van Dyck, but also for other Flemish painters such as Gaspar de Crayer (1584–1669), Jacob Jordaens (1593–1678), Otto van Veen (*c.* 1556–1629) and Cornelis de Vos (*c.* 1584–1651). The painters of the next generation fully understood the advantages of the oil sketch in large-scale projects such as altarpieces and, above all, in the fresco cycles commissioned to decorate churches, palaces and villas. The use of oil sketches was consequently related to complex religious or historic subjects, but not employed for landscapes or views. Equally, the practice of oil sketching coincided perfectly with the aesthetic tendencies of the Baroque style. Those artists following the classicizing tradition of the Carracci and Poussin hardly ever executed oil sketches; the more habitual producers of preparatory painted studies were artists such as Andrea Sacchi (*c.* 1599–1661) and the pupils of Pietro da Cortona (1596–1669) and, in France, Charles Le Brun (1619–90) (for the ceiling of the Galerie des Glaces at the château of Versailles; Compiègne, Musée Municipal Antoine-Vivinel; Auxerre, Musée d'Art et d'Histoire; Troyes, Musée des Beaux-Arts et d'Archéologie). Outstanding practitioners of the later Baroque included Giovanni Battista Gaulli (1639–1709), Mattia Preti (1613–99) (e.g. in Naples, Museo e Gallerie Nazionali di Capodimonte) and Luca Giordano (1634–1705) (e.g. in London, Sir Denis Mahon private collection). Giordano would sometimes make replicas of his oil sketches as gifts for connoisseurs.

Artists themselves became aware of the intrinsic artistic value of oil sketches: in a letter of 1731 Sebastiano Ricci (1659–1734) declared 'the sketch … is the finished painting … and the altarpiece is the copy'. He, like Giambattista Tiepolo (1696–1770) and all the principal Venetian painters of the 18th century, made systematic use of oil sketches. The use and appreciation of oil sketches was spread throughout Europe by painters travelling from Italy like Giordano, Ricci and Tiepolo: their lesson was ably learnt by Central European artists like Franz Anton Maulbertsch (1724–96), Paul Troger (1698–1762) and Johann Michael Rottmayr (1654–1730), Spaniards such as Francisco Bayeu (1734–95) and Antonio Gonzalez Velázquez (1723–94) and, in England, James Thornhill (1675–1734).

In the 18th century French artists found the oil sketch a means of expressing the bright elegance of the Rococo. François Boucher (1703–70) and Jean-François de Troy (1679–1752) produced their oil sketches mainly as designs for tapestries made in Beauvais and by the Gobelins factory. The oil sketches of Jean-Honoré Fragonard (1732–1806) are, on the other hand, first ideas for paintings of *fêtes galantes* or genre paintings: the final product conserved intact the pictorial immediacy of the preparatory studies. For the Neo-classicists the oil sketch became an academic exercise, very often required of young artists as a test for their admission to the academies.

The major Romantic painters (Francisco de Goya (1746–1828), Eugène Delacroix (1798–1863), John Constable (1776–1837) and J. M. W. Turner (1775–1851)) rediscovered the peculiar value of the oil sketch to record direct from nature and saw it as the means whereby the artist could best express his own personality. The whole Romantic aesthetic in fact exalted the spontaneity of the 'first idea' and its pre-eminent value, as against respect for the observance of technical rules. During the 19th century the oil sketch became a habitual practice, often the first sketch *en plein air*; but eventually the very aspiration of the artists to an expressive immediacy led them to paint *alla prima* and to abandon the oil sketch in its function as preparatory study.

Vasari: *Vite* (1550, rev. 2/1568); ed. G. Milanesi (1878–85) [Intro.]

F. Baldinucci: *Vocabolario toscano dell'arte del disegno* (Florence, 1681)

L. Grassi: 'I concetti di schizzo, abbozzo, macchia, "non finito" e la costruzione dell'opera d'arte', *Studi in onore di Pietro Silva* (Florence, 1957), pp. 97–106

P. Wescher: *'La prima idea': Die Entwicklung der Ölskizze von Tintoretto bis Picasso* (Munich, 1960)

R. Longhi: 'L'inizio dell'abbozzo autonomo', *Paragone*, cxcv (1966), pp. 25–9

Masters of the Loaded Brush: Oil Sketches from Rubens to Tiepolo (exh. cat., ed. R. Wittkower; New York, Knoedler's, 1967)

E. Haverkamp-Begemann: 'The Sketch', *ARTnews Annual*, xxxvii (1971), pp. 57–74

L. Freeman Bauer: "Quanto si disegna si dipinge ancora": Some Observations on the Development of the Oil Sketch', *Storia dell'arte*, xxxii (1978), pp. 45–57

Malerei aus erster Hand: Ölskizze von Tintoretto bis Goya (exh. cat. by R. K. Klessmann and J. Giltray; Rotterdam, Museum Boymans–van Beuningen; Brunswick, Herzog Anton Ulrich-Museum; 1983–4)

L. Freeman Bauer: 'Oil Sketches, Unfinished Paintings and the Inventories of Artists' Estates', *In the Eternal City: Papers of Art History from the Pennsylvania State University*, ii (1987), pp. 93–107

Bozzetti, modelli, grisailles dal XVI al XVIII secolo (exh. cat., Torgiano, Museo del Vino, 1988)

O. Ferrari: *Bozzetti italiani dal manierismo al barocco* (Naples, 1990)

C. S. Rhyne: 'Constable's First Two Six-foot Landscapes', *Studies in the History of Art*, xxiv (1990), pp. 109–29

D. B. Brown: *Oil Sketches from Nature: Turner and his Contemporaries* (London, 1991)

B. L. Brown: *Giambattista Tiepolo: Master of the Oil Sketch* (Milan and New York, 1993)

In the Light of Italy: Corot and Early Open-air Painting (exh. cat. by P. Conisbee; Washington, DC, National Gallery of Art, 1996)

L. Bauer: 'Artists' Inventories and the Language of the Oil Sketch', *Burlington Magazine*, cxli/1158 (Sept 1999), pp. 520–30

C. Riopelle: *A Brush with Nature: The Gere Collection of Landscape Oil Sketches* (London, 1999, rev. 2003)

P. Sutton: *Drawn by the Brush: Oil Sketches of Peter Paul Rubens* (New Haven and London, 2004)

H. Widauer: 'Die Ölskizzen bei Rubens: Bedeutung und Funktion', *Peter Paul Rubens* (Ostfildern-Ruit, 2004), pp. 119–26

Constable: The Great Landscapes (exh. cat., ed. A. Lyles; London, Tate and Washington, DC, National Gallery of Art, 2006)

Oils, drying. Natural vegetable oils expressed from a variety of seeds, of which the most often used in Europe are walnut (*Juglans regia*), linseed (*Linum usitatissimum*), poppyseed (*Papaver somniferum*) and, to a lesser degree, hempseed (*Cannabis sativa*) and possibly pinenut (*Pinus pinea*). Drying oils replaced egg tempera as the predominant medium of European painting from the second half of the 15th century, but they had been in use for at least two centuries before that in both Norway and England. Certain other oils, such as perilla (*Perilla ocymoides*) and tung (*Aleurites fordii*), may have been used as paint media in East Asia. In the 20th century such other drying oils as tobaccoseed (*Nicotiana* spp.) and dehydrated castor oil (*Ricinus communis*) have also been used in paints.

In common with other oils and fats, drying oils are, chemically speaking, mixtures of mixed triglycerides. The triglycerides are formed by esterifying the trihydric alcohol glycerol with a number of fatty acids. These are long chain carboxylic acids, predominantly with 18 carbon atoms in the chain, which may or may not contain double bonds. The properties of oils and fats are largely determined by their fatty acid composition. Animal fats, as is now well known, are largely saturated, that is they contain a high proportion of fatty acids without double bonds including palmitic (C^{16}) and stearic acid (C^{18}). Conversely, most edible oils (for example sunflower seed, olive and corn oils) are rich in the C^{18} mono-unsaturated acid oleic acid; the drying oils contain high proportions of the C^{18} di- and/or triunsaturated acids linoleic and linolenic acid. The presence of these multiple unsaturated centres enables the molecules containing them to react by linking with the oxygen in the air and with one another to form larger molecules and eventually an extended cross-linked network. This process of polymerization is accompanied by a thickening and finally solidification of the oil to form a firm, rubbery solid. When the oil is mixed with pigment in suitable proportions the resulting paint dries to a hard and resistant film.

The chemistry of the free radical reactions involved in the drying process is complicated and variable. Oxygen is essential, light promotes the reaction and different pigments can have an accelerating or, as tends to be the case with carbon black and bituminous pigments, a delaying effect. Pigments that are good driers include those based on (or containing as impurities) such multivalent elements as cobalt, manganese and lead, as these actually participate in the reactions involved. Sometimes compounds of these elements that are soluble in oils are deliberately added as driers or, as in earlier practice, the less soluble compounds may be incorporated by cooking with the oil. The green copper pigments, such as verdigris, behave in ways that are not fully understood. While being good driers, they also seem subsequently to protect the dried oil from oxidative degradation reactions.

Oils obtained by any of these processes contain variable amounts of impurities. The oil-soluble impurities include a small percentage of plant sterols (solid alcohols) but their presence is unimportant. The group of four tocopherols (vitamin E) equally are not removed as they are natural antioxidants. This property is responsible for the initial induction period commonly observed before the onset of drying in drying oils. The presence of some free fatty acids is beneficial, as they can react with basic pigments to form soaps that improve the wetting properties of the pigments and prevent them settling out. Oil-insoluble impurities, so-called mucilages or slimes, may be removed either by allowing them to settle followed by decantation or by water washing. Oils are often bleached to improve their colour. In the case of drying oils this is usually carried out by filtering through a bleaching earth of the fullers' earth type, but it does not affect any subsequent yellowing of the paint or other properties.

Drying oils can be processed so that they are partly prepolymerized before they are used. There are two methods of doing this: heating in the presence of air to give boiled or blown oils and, more importantly, heating in the absence of air to give stand oils. Both result in thick-bodied oils with a viscosity proportionate to the length of time the heating has been carried on. The former process probably involves reactions similar to the usual drying ones, with the formation of oxygen linkages between molecules, but the latter must come about through carbon–carbon linking and since these bonds are the more stable chemically, paints made with stand oils are probably more permanent than those from raw or untreated oils. Linseed stand oils also yellow less on drying than the corresponding raw oil. Yellowing appears to be associated with the presence of a high proportion of the triunsaturated linolenic acid, which is much reduced by polymerization in the stand oils. Walnut and poppyseed oils contain high percentages of linoleic and rather little linolenic acid and are thus intrinsically less yellowing than linseed (though rather poorer driers). This was early recognized by oil painters, who recommended their use for light colours (Mayer, p. 135), and analysis has suggested that this advice was followed to some extent.

The identity of drying oils in paintings can be determined from very small samples using gas chromatography to analyse their fatty acid composition. The unsaturated acids have, of course, largely disappeared since they have been linked together to form polymers but the two saturated acids, palmitic and stearic, survive and the ratios in which they are present give the clue to the identity of the oil.

R. Mayer: *The Artist's Handbook of Materials and Techniques* (New York, 1940, rev. 4/1982/*R* London, 1987), pp. 129–40

Regular articles in *National Gallery Technical Bulletin*, i– (1977–)

D. Swern, ed.: *Bailey's Industrial Oil and Fat Products* (New York, 1979, rev. 2/1987)

J. S. Mills and R. White: *The Organic Chemistry of Museum Objects* (London, 1987), pp. 26–40

D. Erhardt: 'Paints Based on Drying-oil Media', *Painted Wood: History and Conservation*, eds V. Dorge and F. C. Howlett (Los Angeles, 1998), pp. 17–32

M. E. Machado de Araújo: 'Óleos, pintura e química', *Conservar Património*, ii (2005), pp. 3–12

Oleograph. Photographically produced colour lithograph (chromolithograph). Such prints were pressed on to canvas or some other textured surface and then varnished so as to resemble an oil painting.

Openwork. Any form of decoration that is perforated.

Ormolu [Fr. *or moulu*: 'ground gold']. Term used to describe decorative metalwork, including furniture and porcelain mounts, made of fire-gilt bronze. The finest work was executed in France in the 18th century. It should be distinguished from finished objects dipped in acid and lacquered in imitation of gilding.

See also GILDING, §§I, 3 and II, 4.

P

Paint. Substance comprising a pigment in a binding medium, used to apply colour to a surface.

I. Types. II. Manufacture and trade. III. Containers.

I. *Types.* Paint has two essential elements: a solid PIGMENT to provide colour, and a liquid binder or binding medium that acts as a glue and coats, lubricates and surrounds the finely divided pigment particles dispersed within it, allowing them to be applied as paint. As the binding medium dries or sets into a solid film, the colour within it is fixed in a durable way to the GROUND. In general, the same pigments may be employed with different media, so it is the nature of the binding medium and not the pigment that determines the paint type and its characteristic properties. The appearance and behaviour of a pigment can vary considerably according to the binding medium employed—a fact that has determined artists' use of paint as well as the history of its use.

Modern studies in conservation have identified the various binding media, but difficulties over the exact determination of paint types remain. Some are identified by reference to the binding medium (e.g. egg tempera or oil colour), while others (e.g. watercolour or gouache) are really named after the way they are employed. Further confusion is caused by the proliferation of sub-categories of media resulting from advances in chemistry and from the continuing experimentation with paint by artists themselves. To make sense of such anomalies it is simplest to consider individual paints in the context of larger groups, each representing a general type, although some paints clearly belong to more than one group or do not fit comfortably into any.

1. Water-based. 2. Oil-based. 3. Encaustic. 4. Spirit-based. 5. Other.

1. WATER-BASED. This is the largest group of paint types; water features in their composition or manufacture and all can be mixed with it, so water is used as a diluent during painting and to clean brushes and equipment afterwards. The common factors are ease of use, fairly rapid drying and definite colour change (generally lightening) as the paint dries. The materials involved are diverse and may be divided into those that are permanently soluble in water and those that

are not; it makes more sense, however, to discuss water-based paints in their approximate chronological order.

(i) Prehistoric paint. The materials of prehistoric cave painting barely qualify as paint. Red and yellow earth colours occur naturally as iron oxides within hydraulic clays and when these are softened or dissolved with water, the result is effectively a paint. They could also have been applied dry, as were the chalk and charcoal used with them, but if a vehicle was employed with any of these materials, it would most likely have been water, although it is possible that animal and plant oils were also used.

(ii) Tempera. The oldest true paints belong to the tempera family, have been employed since antiquity and until the Renaissance dominated painting. 'Tempera' is actually a reference to the making of paint, and the specific association of the name with egg as a binding medium is relatively modern (*see* TEMPERA, §1). Even as late as the 17th century, painters took a very general view of water-based materials and considered them all types of tempera or distemper. The binders are all natural in origin and produce results that are not dissimilar. In addition to egg, animal glue-size and water-soluble vegetable gums were used (*see* SIZE).

(iii) Distemper and gouache. Neither distemper nor GOUACHE is a true paint type. 'Distemper' was an alternative name for the whole or most of the tempera family and gradually became associated specifically with size-colour. Gouache has similar associations; its origin was probably size-colour, but since its appearance in the 18th century as a new medium it is as likely to have been bound with gum. Gum arabic and sometimes dextrin are used in the modern product.

(iv) Watercolour. Colour bound with gum and egg-white stained with dye were used for the illumination of manuscripts during the Middle Ages and Renaissance; the colour made with white of egg was known as 'glair'. Gum arabic was the most commonly employed binder for pigment. The same materials were used for miniature painting from the 16th century onwards. Their capacity for transparency features very little in

such techniques, but was clearly appreciated for finishing, and other methods of using water-based paints transparently were occasionally alluded to. It was not until the 18th century, however, that transparent watercolours came into being. Watercolour painting is the use of transparent washes of paint substantially thinned with water over white or light coloured paper (see WATERCOLOUR, §1). Its brilliance is derived from the paper itself, which reflects light through the veil-like covering of pigment. White is confined to occasional highlights. It is therefore the complete opposite of the gouache method, although in composition the paints are very similar.

(v) Emulsions. All the binding media so far discussed can be emulsified with oil (see EMULSION). If this is done, the resulting emulsion paint remains water-thinnable and is likely to be fast drying, but it will also possess some of the properties associated with oil colour. Egg-yolk is a natural emulsion and contains lecithin, an emulsifying agent. There is some evidence of the early use of emulsions and they were firmly believed to be an important aspect of tempera painting when this was revived in the 19th century, a view probably coloured by the commercial use of emulsions, but enthusiasm among artists has since waned.

(vi) Acrylic and vinyl paints. Aqueous emulsion acrylics were introduced in the 1950s and were rapidly adopted as an artists' material (see ACRYLIC PAINTING, §1). Since then they have been actively marketed as a universal cure-all for the technical and creative problems faced by artists. However, questions have arisen concerning their suitability, and it seems unlikely that acrylics will eclipse rival media as they originally threatened to do. Acrylic paints and their close relative, vinyl colours, use plastics as binding media (see also POLYMER COLOUR).

2. OIL-BASED. The common factor in the oil-paint family is a drying oil (see OIL PAINTING, §1, and OILS, DRYING). These are vegetable oils that on exposure to air, aided by light and warmth, solidify to form an elastic film. The most important is linseed oil; walnut, poppy and safflower oils have also been used but are less perfect dryers, although they are a lighter colour and discolour less with age. Oil paint is not a single paint type, but the fact that the artists' colour trade has offered oil colour as a more or less standard commodity since the middle of the 19th century has encouraged this view. Oil paint is the most flexible medium available to painters, and exists in many slight but significant variations because drying oil can be conditioned in different ways to produce different results. For example, it may be heated, or cooked with such compatible materials as resins, tree pitches and waxes. Treated and untreated oil may also be thinned with diluents or mixed cold with varnish or a paint medium (see PAINTING MEDIUM). Oil may also be emulsified with several water-based media (see §1(v) above), and if the concentration of oil is sufficiently high, a form of oil colour not watercolour results. Drying oils also feature in some encaustic recipes (see §3 below) with the same wax and resin types that can be used in oil paint itself; only the proportions are different.

(i) Oil colour. Basic oil colour is a mixture of pigment and drying oil and need contain nothing else, although small amounts of thickened or cooked oil may be added, and sometimes the pigment may have been ground directly into such media. When oil painting was first practised, a technique very like that of tempera painting was used, but during the first quarter of the 15th century a new method emerged, which almost certainly made a greater use of prepared oils to gain fluidity and transparency.

Because it is slow drying, oil colour can be manipulated during its application to achieve subtle modelling and blended colours. Because it 'saturates' the pigment and does not evaporate during drying, the colours are richer, shadow is deeper and the painting does not lose any of its intensity of colour or tonal quality on drying. Also, because it is flexible until it becomes very old, oil paint may be used freely on canvas and may be applied in impasto effects.

By the mid-19th century oil paint was largely commercially produced, the stiff, buttery consistency of manufactured oil colour giving a more limited technical range, with quite major adjustments being required to equal the qualities of original, hand mixed oil colours. In the 20th century artists' oil colour in general became even more a product of the paint chemist, not the artist. However, since it can, in theory, still be modified at will by the painter, oil colour continues to exist in many different forms.

(ii) Resin oil. When oil is combined with resin, a richer, more viscous liquid is formed (see RESIN, §1). It will have greater gloss when dry than oil alone, and the natural tendency of such a mixture to flow will have a softening effect on brushstrokes. It is likely to be stickier as well, and will be better able to wet pigments or bond on to such non-absorbent surfaces as lower layers of dry oil colour. The clarity of the medium and its saturation of colours may be heightened too. Perhaps of most importance is the increase in 'body' or 'fatness', meaning roughly that the oil is moved closer to a solid state, is then less prone to defects as it dries and no longer requires a heavy loading of pigment to ensure its stability, hence the suitability of such media for glazing (see GLAZE).

In the 18th and 19th centuries resin oils were much used. Copal oil and megilp medium were used with damaging consequences, and J. M. W. Turner (1775–1851) may have extended glazes with simple additions of spirit varnish. In the 20th century synthetic alternatives have found their way into artists' colours.

(iii) Alkyds. Alkyds are synthetic resins used in combination with oil that have replaced such hard natural

resins as Congo copal in modern gloss paints and varnishes (*see* RESIN, §2). They are now widely used in oil painting media, and some artists' colours are made with alkyds too. They are compatible with oil colour but are much faster drying. Despite their apparent advantages, their long-term suitability for artistic purposes is unproven. Alkyds affect colour values noticeably, and claims that they age better than oil colours require further scrutiny.

3. ENCAUSTIC. Wax is the principle binder of encaustic colours (*see* ENCAUSTIC PAINTING). The name 'encaustic' refers to the use of heat to liquefy or 'burn in' such colours as they are used. The wax stiffens oil colour and gives it a more matt finish. It is primarily a method used in the ancient world, and since its decline in the Byzantine era, there have only been isolated incidences of the use of wax. Wax combined with resin, a combination employed by Jasper Johns (*b* 1930), provides a rare modern example of the encaustic technique. (For other uses of wax in painting, *see* WAX, §II, 2.)

4. SPIRIT-BASED. Resinous solids dissolved in organic solvents form the binding media of some paints. Lacquers are a typical example (*see* LACQUER, §I). Some of these are a form of ethereal varnish coloured by a pigment or dye. Specialized paints for painting on glass or for the restoration of paintings (*see* CONSERVATION AND RESTORATION, §II, 2(i)), may also be based on resins dissolved in solvents. A form of acrylic also depends on its solution in solvent. These solvent acrylics were the acrylics originally experimented with by artists in the 1930s.

5. OTHER. Animation-cell paints use latex or synthetic materials as binding media. These are also popular with airbrush artists, who have a variety of airbrush colours to choose from, mostly types of watercolour or acrylic, but airbrush artists and designers also use dyes as liquid watercolours, and these are also occasionally employed by fine artists. (Dyes are not paints, since they do not contain pigment, and their permanence cannot usually be relied on.) Some experimental use of epoxy resins as paint media has been pursued too, and silicate paints are occasionally used for external murals (*see* SILICATE PAINTING).

The two methods of painting that do not involve paint are FRESCO and PASTEL. In fresco the pigment is mixed only with water, which serves only as a temporary carrier for the pigment, which is then incorporated into the surface of the wet plaster it is painted on to. An early method of painting on cloth may have had similarities, with pigment being fixed to a gum priming by means only of the water that the pigment was mixed with. With pastel the term 'painting' is loosely applied to methods that might be considered closer to drawing; pastel is not fixed to its support by any medium, and the pigment relies on friction and electro-static forces to make it adhere. Frequently a very dilute binder is applied afterwards as a fixative.

C. L. Eastlake: *Methods and Materials of Painting of the Great Schools and Masters*, 2 vols (London, 1847/*R* London and New York, 1960)

A. H. Church: *The Chemistry of Paints and Painting* (London, 1890, rev. 2/1901)

M. Doerner: *Malmaterial und seine Verwendung im Bilde* (Stuttgart, 1933); Eng. trans. by E. Neuhaus as *The Materials of the Artist* (New York, 1934/*R* London, 1979)

R. Mayer: *The Artists' Handbook of Materials and Techniques* (London, 1951, rev. 4/1991)

K. Whelte: *The Materials and Techniques of Painting with a Supplement on Color Theory* (New York, 1975)

W. M. Morgans and J. R. Taylor: *An Introduction to Paint Technology* (London, 1976)

I. Bristow: 'Ready-mixed Paint in the Eighteenth Century', *Architectural Review* [London], cmlxiii (1977), pp. 246–8

National Gallery Technical Bulletin (1977–) [for analysis of media]

G. P. A. Turner: *Introduction to Paint Chemistry and Principles of Paint Technology* (London, 1980)

Completing the Picture (exh. cat., ed. S. Hackney; London, Tate, 1982)

Paint and Painting (exh. cat., London, Tate, 1982)

W. Janaszczak and others: *Techniques of the Great Masters of Art* (New Jersey, 1985)

J. Stephenson: *The Materials and Techniques of Painting* (London, 1989)

S. Arnold: 'The Technology of Poster Paint', *Modern Works, Modern Problems*, ed. A. Richmond (London, 1994)

A. Gair, ed.: *Artist's Manual: A Complete Guide to Painting and Drawing Materials & Techniques* (San Francisco, 1996)

S. Hackney, R. Jones and J. Townsend, eds: *Paint and Purpose: A Study of Technique in British Art* (London, 1999)

A. Callen: *The Art of Impressionism: Painting Technique & the Making of Modernity* (New Haven, 2000)

P. M. Whitmore, ed.: *Contributions to Conservation Science: A Collection of Robert Feller's Published Works on Artists' Paints, Papers, and Varnishes* (Pittsburgh, 2002)

J. H. Townsend, J. Ridge and S. Hackney: *Pre-Raphaelite Painting Techniques, 1848–56* (London, 2004)

II. Manufacture and trade.

1. Before the 19th century. 2. 19th and 20th centuries.

1. BEFORE THE 19TH CENTURY.

(i) *Early sources and marketing.* A remarkably diverse range of pigments was already being traded in antiquity. White, yellow, red, brown and green earths were procured from various parts of the Roman Empire; bright green and blue were prepared by crushing the naturally occurring minerals, malachite from Macedonia (*see* PIGMENT, §V, 1) and azurite from Armenia (*see* PIGMENT, §III, 1), and bright yellow by crushing orpiment (*see* PIGMENT, §IX, 1). Native cinnabar from Spain was processed (by beating, crushing and washing) in Rome to make vermilion (*see* PIGMENT, §VI, 1), and lampblack was prepared by collecting soot from burning resin (*see* PIGMENT, §II). In Rhodes in particular more advanced methods were used to manufacture verdigris, white lead and red lead; and Egyptian blue frit was made in

Alexandria and Pozzuoli (*see* PIGMENT, §III). In addition, natural indigo dye was imported and could be used directly as a pigment, while red and yellow lakes were prepared by dyeing chalk with madder, weld and other dyestuffs (*see* LAKE).

Despite the upheaval following the collapse of Roman civilization, in broad terms this range of pigments survived into the Middle Ages. Writing *c.* 1390, the Italian artist Cennino Cennini (*c.* 1370–*c.* 1440) listed in addition natural ultramarine (prepared by extracting the blue mineral constituents from crushed lapis lazuli from Afghanistan; *see* PIGMENT, §III) and *giallorino* (probably at that date lead-tin yellow rather than Naples yellow; *see* PIGMENT, §IX, 2). From his descriptions, it seems that Cennini expected the artist to purchase a number of pigments in cake, granular or powder form, notably the artificially manufactured white lead, verdigris, orpiment and lake, together with some of the natural earths, such as *terra verde* and the red ochre that he called *sinopia*. He advised that certain minerals (including cinnabar and lapis lazuli) could be bought in lump form and processed by the artist himself. Similarly a white pigment could be prepared domestically from lime, and instructions were given for the preparation of different kinds of charcoal black. Cennini further described how the pigments should be prepared for use by being ground with water using a slab and muller (see below), a procedure that he clearly expected the artist to do as a matter of routine for work in fresco and tempera.

Even when the artist was painting in oil (a medium that had become established in northern Europe by *c.* 1250), Cennini seems to have expected him to grind his own pigment into the medium. Although this practice was continued by many painters until the late 16th century, by the 17th century pigments that were used in large quantities for house-painting (e.g. yellow ochre, red ochre and white lead) could be purchased in England ready ground by the merchant. By the late 17th century many of the finer colours were also available in this form for artists' use from 'colour-grocers'; but even into the 19th century many painters seem to have preferred to grind at least some of their own material, probably as a precaution against fraudulent sophistication of pigments such as white lead and vermilion, since this could be better detected in the dry powder.

The simple grinding process using a marble slab (often *c.* 450 mm square) and muller (shaped like an egg, with the bottom cut off and ground flat) was tedious and time-consuming; but by the 1730s horse-mills (in which horizontal millstone-like wheels were fed with oil and pigment through a cone) had been developed to produce the large quantities of paste required for house-painting. These were sold by retailers in wooden casks, and once a cask had been opened the pigment was prevented from hardening by covering unused paste with water. Smaller quantities for artists were tied up in bladders, which were pricked with a pin and squeezed to release pigment for use (*see* §III).

The paste was diluted by the artist or craftsman with more oil or with a mixture of oil and a thinner. The thinner was generally oil of turpentine, prepared by distilling crude turpentine tapped from various species of pine growing in France and North America. The most commonly used oil was that extracted from linseed, the manufacture of which in the 17th and 18th centuries (often using seed imported from the Baltic) is associated with the east coast of England. The process required the seed to be crushed in an edge-runner mill before being pressed in sacks between iron wedges confined in a strong press-box, which were knocked in by stampers commonly operated by a wind- or water-mill. This method was to continue in use into the 19th century but was superseded following development of the hydraulic press, which allowed a greater yield of oil, at the end of the 18th. The artist generally diluted the paste on the palette, but larger quantities were mixed in a 'gally-pot' or other suitable container. Driers too would be added by the user where necessary (*see* OILS, DRYING).

(ii) Industrialization and commercialization. During the years between 1400 and 1800 there were significant developments in the range of pigments on the market. During the 16th century exploitation of cobalt deposits in central Europe allowed the commercial introduction of smalt, and dyestuffs from the New World, such as cochineal and brazil-wood, led to developments in lake manufacture. By *c.* 1600 blue verditer was being produced in England as a by-product of silver refining, and in the early 18th century Prussian blue was discovered by Ghislain Diesbach (*fl* 1704–7), a Berlin colour-maker. Although this event appears to have been accidental, systematic research by the Swedish chemist Carl Wilhelm Scheele (1742–86) produced patent yellow (*c.* 1770) and the green (1775) that bears his name. Both soon became extensively manufactured in England: a patent covering the yellow was taken out by James Turner (*fl* 1770–87) in 1781, and by the early 19th century large quantities of the green were being made by Lewis Berger (1741–1814) at Homerton in east London. In France in 1782 Guyton de Morveau (1737–1816) suggested that zinc white might provide a non-toxic substitute for white lead, and two patents protecting its manufacture in England were taken out in the 1790s by John Atkinson (*fl* 1794–6), a colour-maker from the Liverpool area.

Thus by the late 18th century most painting materials were commercially produced and sold. By then watercolours for amateur and professional use were available from specialist retailers, and the use of the PAINTBOX was becoming common. Coarser oil-colours and pigments, on the other hand, were often sold by retailers whose trade cards (examples in London, British Museum) show that their wares were not restricted to painting commodities and included lamp and salad oils, besides a range of common groceries and hardware. It appears to have been by the marriage of a similar business with the making of Prussian blue that Lewis Berger founded his long-lived manufacturing firm in the 1760s. During the

late 1770s and 1780s he was selling commodities including pigments, anchovies, capers and emery paper to shops in provincial towns and cities in Britain and Ireland, but he had already added the making of cochineal lakes to his activities. Soon he was specializing in pigment manufacture, and by *c.* 1810 this side of his business was being strenuously developed. By this date he was also supplying material to a number of artists' colourmen, and the records of his firm demonstrate vividly the manner in which he kept pace with technical developments, anticipating the burgeoning paint industry of the mid-19th century.

Unpublished sources
Hackney, Archives [archive of Berger Paints]

Bibliography
Cennino Cennini: *Il libro dell'arte* (MS. *c.* 1390); trans. and notes by D. V. Thompson jr (1933)
R. D. Harley: *Artists' Pigments c. 1600–1835: A Study in English Documentary Sources* (London, 1970, rev. 2/1982)
I. C. Bristow: 'Ready-mixed Paint in the Eighteenth Century', *Architectural Review* [London], cmlxiii (1977), pp. 246–8
R. L. Feller, ed.: *Artists' Pigments: A Handbook of their History and Characteristics*, i (Cambridge, 1986)
I. C. Bristow: *Interior House-painting Colours and Technology, 1615–1840* (New Haven, 1996)

2. 19TH AND 20TH CENTURIES. During the 19th and 20th centuries significant changes in the development of pigments, oils (*see* OILS, DRYING) and synthetic resins (*see* RESIN, §2) as well as changes in the industrial manufacturing processes influenced the range and type of paints and painting materials available to artists. Artists as manufacturers of their own paints had been superseded by artists' colourmen, and they, in turn, were to be dependent upon the development and supply of raw materials from the larger chemical and oil-producing industries. These changes had their origin in the late 18th century and early 19th when the new science of analytical chemistry and the discovery of new elements (e.g. cadmium, chromate and cobalt) provided a range of chemical compounds that were exploited by various industries. However, due to availability and cost of manufacturing, there was often a timelag between the discovery of a new element and the development of a pigment. For example, cobalt green (a compound of cobalt and zinc oxides) was identified in 1780, but its manufacture was delayed until the mid-19th century when zinc oxide was available on a large scale.

Although the discovery of these important inorganic compounds occurred in Europe, the sources of the raw materials were further afield in Russia, eastern Europe, the USA and Canada. In the organic field the discovery of alizarin (1,2 dihydroxyanthraquinone), with its subsequent manufacture as a synthetic dyestuff (alizarin crimson) in 1826, and mauve, the first aniline dyestuff (*see* DYE, §3), discovered by William Henry Perkin in 1856, resulted in the growth of national industries that did not rely so heavily on foreign imports. Germany was the largest producer of pigment dyestuffs until World War I, when the cessation of trade provided the impetus for the development of a large dyestuff industry in Britain. During the two world wars, the cessation of trade also affected the availability of artists' materials, as there were restrictions on the use of available materials for domestic rather than military purposes.

By the 19th century major changes had occurred in industry and society, which influenced the demand for oils and paints and the type of machinery used in their production. A more affluent society required decorative paints, textiles, soaps and other products, which necessitated the large-scale manufacture of pigments, dyestuffs and oils, and in order to meet these demands industry became more mechanized. In 1852 roller grinding mills were introduced in the paint industry to replace the stone and cone mills (*see* §1 above). As the industry developed, ball mills, vertical mixers and triple-roll mills produced pigments of smaller particle size, which were used for the mixing and dispersion of paint, as well as increasing production rates and providing a more uniform product. At the same time a range of additives was incorporated into the paint to increase its shelf-life, prevent separation of pigment and oil in the tube and enhance the working properties of the paint.

An important development in the extraction of linseed oil was a method proposed in 1843 that extracted the oil from the seed by means of solvents. This method was not, however, completely accepted until 1903, when the problem of the removal of residual solvent was solved in the USA by the development of the expeller method, using a steel screw conveyor contained within a cylindrical barrel.

In the 20th century artists began to experiment with various new synthetic resins, either using commercial paints or adding pigments to the different resins. These resins included pyroxlin (a blend of various nitrocelluloses), alkyd resins, polyvinyl acetate resins, acrylic resins and acrylic emulsions. The artists' colourmen eventually provided a range of paints specifically for artists' use: acrylic (Magna, 1949), acrylic emulsion (Liquitex, 1954) and oil-modified alkyd (Winsor & Newton, 1976).

Although the improvement in the manufacturing of pigments and oils increased production and reduced costs, there was concern that the traditional characteristics and appearance of the artists' oil paints had changed. In the late 19th century artists expressed concern about the lightfastness of the organic pigments, and in the 20th century concern about the various constituents of paints and correct nomenclature of artists' paints became an issue. However, the experimental nature of many modern works of art led to a general decline in the understanding of the traditional 'artist's craft'.

P. F. Tingry: *Painter's and Colourman's Complete Guide* (London, 1830)
H. W. Brace: *History of Seed Crushing in Great Britain* (London, 1960)

J. R. Gettens and G. L. Stout: *Painting Materials* (New York, 1966)

R. D. Harley: *Artists' Pigments, c. 1600–1835: A Study in English Documentary Sources* (London, 1970, rev. 2/1982)

Introduction to Paint Technology, Oil and Colour Chemists' Association (London, rev. 4/1976)

Paint and Painting (exh. cat., London, Tate, 1982)

R. L. Feller, ed.: *Artists' Pigments: A Handbook of their History and Characteristics*, i (Cambridge, 1986)

C. Leback Sitwell: *The Dilemma of the Painter and Conservator in the Synthetic Age* (London, 1987)

R. G. Lodge: *A History of Synthetic Painting Media with Special Reference to Commercial Materials* (Washington, DC, 1988)

S. Hackney, R. Jones and J. Townsend: *Paint and Purpose: A Study of Technique in British Art* (London, 1999)

J. Crook and T. Learner: *The Impact of Modern Paints* (New York, 2000)

III. Containers. Paint containers should be airtight to prevent drying, easy to open and use and should not react with any of the pigments or binding media contained in the paint. A bottle or horn with some form of stopper was used for liquid aqueous colours such as inks, and glass bottles; some with dropper stoppers are still in use. For aqueous colours that are sold in paste consistency, pots with either press-on or screw caps are usual, although they are also sold in collapsible tubes.

Traditional watercolours can be prepared in paste consistency, then dried and sold in a form from which they can be reconstituted. The earliest containers for such watercolours were shells: mussel and mother-of-pearl are mentioned by Edward Norgate in *Miniatura; Or, the Art of Limning* … (*c.* 1620; London, British Library, Harley MS. 6000, fol. 2*r*). Such containers were small and sufficiently shallow for the paint to be lifted easily with a moist brush, and they were wrapped to keep the colour clean. Watercolour cakes were developed in the second half of the 18th century. The paint was compressed by means of metal moulds into small oblong cakes embossed with the colour name and the colourman's insignia. Such cakes, available until the second half of the 20th century, were dry to handle and needed no container other than a convenient box. For use they required rubbing down with water on a ground glass slab. In the 1830s moist watercolours containing glycerin, a humectant, were introduced. This enabled the paint to be lifted easily with a moist brush but made it slightly sticky to handle, so a container was necessary. The paint was cut into small pieces and then shaped and pressed by hand into china pans. Since the second half of the 20th century whole pans (oblong) and half pans (square) have been made of plastic with the paint extruded and cut to size by machine.

Traditional containers for oil colours were animal bladders bound tightly at the top after filling. To extract paint the bag was punctured with a tack, colour was squeezed out and the hole stopped by means of the tack or a bone plug. As, however, the bladders sometimes burst when squeezed, and air

could not be completely excluded, the consistency of some colours (e.g. Prussian blue and the red lakes) deteriorated.

In 1822 a tinned brass syringe with a removable cap to the nozzle and a screw piston to push out the paint was introduced. A glass syringe was patented in London in 1840 (specification 8394). Such containers were refillable but expensive. Collapsible metal tubes made by impact extrusion were introduced in 1841. The inventor, John G. Rand (1801–73), an American artist working in London, took out British patents 8863 (1841) and 9480 (1842). The colourman Thomas Brown of High Holborn, London, was initially the sole supplier of oil colours in Rand's patent tubes. Winsor & Newton competed by introducing collapsible tubes made by rolling thin sheets of metal, but the seam with which these were sealed was prone to seepage. By 1842 the use of Rand's patent collapsible tubes was unrestricted; they were universally used by colourmen, and bladder containers became obsolete shortly afterwards. Adoption for watercolours followed *c.* 1850.

Metal for collapsible tubes must be soft enough for impact extrusion and non-reactive with all pigments. Tin was generally used until the mid-20th century when aluminium was used for large tubes and tin-coated lead (less expensive than pure tin) for small to medium sizes. At about the same time metal screw caps with wads to prevent leakage were replaced with plastic screw caps. Tubes, complete with caps, are filled from the open end, which is then folded several times to close it. Plastic tubes were introduced in the second half of the 20th century but were not adopted for artists' quality colours, since early types, although compressible, were not collapsible and thus allowed paint to fall back and air to enter. This problem was overcome with fully collapsible glaminate tubes composed of an impermeable plastic inside, coated with aluminium and with varnished printed paper or thin cardboard on the outside. Small containers, such as tubes or pans, are available in specially designed colour boxes that also hold painting tools. Modern containers for larger quantities of oil and acrylic colours include lever-lid tins and plastic containers with plastic screw tops.

See also PAINTBOX.

R. D. Harley: 'Oil Colour Containers: Development Work by Artists and Colourmen in the Nineteenth Century', *Annals of Science*, xxvii/1 (1971), pp. 1–12

Paintbox. Receptacle used by artists to store and carry paints and to contain them when working (see fig.). The term incorporates several distinct types that vary according to period and purpose, such as the sketchbox, the studio chest, or painter's cabinet, as well as other receptacles for artists' materials that are not literally boxes. The earliest example that qualifies as a paintbox is the ivory palette (*c.* 1350 BC; Cairo, Egyptian Museum) of Princess Merytaten from the tomb of Tutankhamun. Its six colours confirm that it was for painting, as a scribe's palette would have had only two. Other early examples

Paintbox and palette belonging to Auguste Renoir, probably late 19th–20th century (Paris, Musée d'Orsay); photo credit: Réunion des Musées Nationaux/Art Resource, NY

are rare. Watercolour and tempera paints were usually put out individually in shells or small pots (*see* PAINT, §III), and, as the colours could not be kept for long, the need for a box to contain them did not arise, although the pigments used to make them were stored in dry, dust-free containers or as pastes pre-ground with water (*see* PAINT, §II, 1(i)). The organized storage of artists' materials in boxes or chests of some kind is confirmed by a reference in the notebooks of Leonardo da Vinci (1452–1519) (MS. C.A. 247r) to the box of colours *c.* 1499 of Jean Perréal (?1450/60–1530), while Cennino Cennini (*c.* 1370–*c.* 1440) in *Il libro dell'arte* describes dishes of prepared oil paint stored in a small box to keep them clean. In *St Luke Painting the Virgin* (1515; Berne, Kunstmuseum) by Niklaus Manuel Deutsch I (?1484–1530), what may be such a box stands on top of what might be a larger storage chest for the artists' materials shown. A similar shallow wooden box also appears in the *Artist in his Studio* (*c.* 1723; Paris, Musée du Louvre) by François Boucher (1703–70). More significant are the sketch and description in *Secrete intorno la pittura* (London, British Library, Egerton MS. 1636, fol. 37) by Richard Symonds (1617–60) of a portable oil-painting sketchbox with compartments to take an oil glass, paint rags and a rectangular palette on which the colours were presumably laid in anticipation of their use. The metal painting box (London, Tate) belonging to J. M. W. Turner (1775–1851) represents a compromise between the storing of raw materials and prepared paint that was probably quite common before *c.* 1850: it contains both paint bladders and pigment jars and might represent a travelling box rather than just a sketchbox. By *c.* 1850 the shallow wooden case fitted with compartments for paints and brushes, with a slim hinged lid containing a palette and perhaps a

board for sketching on, had become a standard design. The one shown in *A Corner of his Studio* (1845; Paris, Musée du Louvre) by Octave Tassaert (1800–74) hardly differs from a modern oil sketchbox.

The studio chest or painter's cabinet acted as a compact storage unit for raw materials and important equipment. Some were obviously intended to be portable, for example the 17th-century box (Amsterdam, Rijksmuseum) with painted decorations attributed to Anthonie Jansz. van Croos (*b c.* 1606; *d* after 1662) and Jan Martszens II (*b* ?1609; *d* after 1647). During the 18th century comprehensive artists' travelling boxes appeared as a variant form of the studio chest. These were presumably used by itinerant painters and were, in effect, transportable studios. Miniature painters' boxes in particular were self-contained, with fitted compartments for storing material and a top that could be raised to serve as an easel (e.g. *c.* 1800; London, Victoria and Albert Museum). Studio chests, or cabinets, could also be used as more permanent items of studio furniture, such as those of Alfred Stevens (1817–75) (Dorchester, Dorset, County Museum) and Eugène Delacroix (1798–1863) (Paris, Musée Delacroix). In the 19th century the traditional painters' box or studio chest was developed into a luxury item. Queen Victoria's box of colours (*c.* 1840; London, Royal Academy of Arts) of inlaid woods and tortoiseshell and the Winsor & Newton International Exhibition Watercolour Box (1851; Wealdstone, Winsor & Newton Collection) are prime examples, although paintboxes available commercially were hardly less sumptuous. In contrast, an early 19th-century mahogany and brass box containing glass jars of pigment (London, Victoria and Albert Museum) is an example of the essentially functional painter's chest, before its commercial development by the increasingly important trade of the artists' colourman.

Watercolour boxes were usually small and were directly related to the evolution of the medium and its materials (*see* WATERCOLOUR, §2). The earliest description of one, in *The Art of Drawing and Painting in Watercolours* (London, 1732), refers to '…a small case with colours in it, about the bigness of a snuffbox, made of ivory … in which should be scooped several concaves … these may be placed as near one another as possible, and filled with colours of several sorts …'. Watercolour boxes, usually of wood, first became numerous and standardized in form during the late 18th century, when watercolours themselves became available as manufactured items. The scale of watercolour boxes reflects the medium's suitability for outdoor sketching, and the china palette that they contained was a necessary companion to the dry watercolour cakes that were at first used. By *c.* 1800 the watercolour pan, a small porcelain trough, was in use as a container for the paint, and box designs altered to accommodate these. By the 1830s the watercolour box had a central compartment containing the colours and a lid and flap that hinged outwards to provide wells for wash and mixing palette. These sketchboxes were of metal and, when closed, could easily be slipped into a pocket or luggage. At about the same time the softer, semi-moist watercolour was introduced, ensuring the popularity of watercolour pans and eventually leading also to the preparation of watercolour in tubes. In consequence box designs were modified.

The japanned metal watercolour sketchbox designed in the 19th century, white inside and black outside, with a thumb ring, was superbly adapted to watercolour painting in the field. It was also influenced by commercial considerations and was marketed very successfully to amateur painters, often containing far more colours than they needed. The travelling watercolour case (after 1814, probably 1830s; London, Tate) of J. M. W. Turner (1775–1851) was, however, just a simple leather wallet converted from the cover of a book, although it too was capable of carrying about 20 colours.

C. Cennini: *Il libro dell'arte* (MS.; *c.* 1390); Eng. trans. and notes by D. V. Thompson jr (1933)

E. W. Brayley, ed.: *The Works of the Late Edward Dayes* (London, 1805)

A. P. Oppé: 'A Roman Sketchbook by Alexander Cozens', *Walpole Society*, xvi (1927), pp. 81–93

Treasures of Tutankhamun (exh. cat. by I. E. S. Edwards; London, British Museum, 1972)

Paint and Painting (exh. cat., London, Tate, 1982)

M. Beal: *A Study of Richard Symonds: His Italian Notebooks and Their Relevance to Seventeenth-century Painting Techniques* (New York, 1984)

D. Pavey: *The Artists' Colourmen's Story* (Harrow, 1984)

J. Ayres: *The Artist's Craft* (London, 1985)

A. Wilton: *The Turner Collection in the Clore Gallery: An Illustrated Guide* (London, 1987)

J. Stephenson: *Paint with the Impressionists* (London, 1995)

S. Cove: 'Mixing and Mingling: John Constable's Oil Paint Mediums *c.* 1802–37, Including the Analysis of the "Manton" Paint Box', *Painting Techniques, History, Materials and Studio Practice: Contributions to the Dublin Congress, 7–11 September 1998*, pp. 211–16

B. Berrie, Y. Strumfels and C. Tolocka: 'Winslow Homer's Watercolor Pigments', *The Broad Spectrum: Studies in the Materials, Techniques, and Conservation of Color on Paper*, eds H. K. Stratis and B. Salvesen (London, 2002), pp. 101–7

E. Hermens and others: 'A Travel Experience: The Corot Painting Box, Matthijs Maris and some 19th-century Tube Paints Examined', *ArtMatters: Netherlands Technical Studies in Art*, i (2002), pp. 104–21

A. J. Cruz: 'A pintura de Columbano segundo as suas caixas de tintas e pincéis', *Conservar Património*, i (2005), pp. 5–19

Painted effects. Paint applied to interiors and objects to create mock, or *faux* [Fr.: 'false'], decorative effects. This article deals with the various painting techniques used to imitate costly or exotic materials such as marble and other hardstones, tropical woods, grained and burr woods, tortoiseshell and textiles. The earliest manual in England on the subject of decorative painting was *The Art of Painting in Oyl* by John Smith (*fl* 1673–80), first published in London in 1676; subsequent editions were published until 1821. Craftsmen working in *faux bois* employed special brushes and combs, the latter of ivory, bone, wood, leather, rubber, cork or steel, to imitate the graining of more exotic varieties of wood (see WOOD, §III, 3 and 5). The veining and mottling effects of *faux marbre* were achieved using large feathers and sponges against the wet paint; when dry, the surface was varnished to imitate polished marble (see fig.). Sponging and stippling techniques were used for smaller areas and were thought to have originated in Italy in imitation of pietre dure. Stippling, the process of dabbing the wet paint surface with a wide, flat-faced brush, achieved a finer texture that was often used to simulate such hardstones as lapis lazuli, for example. Dragging with a brush and rag-rolling were similar methods employed to add depth and interest to walls and panels.

The techniques of graining and marbling were developed in western Europe during the 17th century to satisfy the demand for fashionable yet less costly interior decoration. Pine and other softwood panelling was painted to imitate such expensive timbers as oak, walnut and cedar. In Ham House, Surrey, NT, rooms are painted in imitation of olive, cedar and walnut wood, and the elaborately carved and gilt staircase (*c.* 1637/8) is painted and veined to imitate walnut. The use of marbling on paintwork to imitate various kinds of marble or other costly hardswwtones can be seen in the Painted Parlour (*c.* 1717) at Canons Ashby, Northants, NT, where the pilasters, architrave and cornice are marbled to imitate the colour of the chimneypiece, and the capitals are marbled in white. A combination of graining and marbling was often used. The pine panelling in the Balcony Room (*c.* 1694) at Dyrham Park, Avon, NT, is grained to imitate walnut, but the pilasters have been painted in imitation of porphyry. The door of the Painted Bedroom (*c.* 1705) at Hill Court, Hereford & Worcs, shows the levels of sophistication possible; the main fields of the panelling imitate various types of figured marble, the mouldings are painted to imitate white marble, and the

Marbling on panelling from Marmion (Fitzhugh House), pine and walnut, 6.4×5.0×3.3, Marmion, VA, *c.* 1735–80 (New York, Metropolitan Museum of Art, Rogers Fund, 1916 (16.112)); photograph © 1991 The Metropolitan Museum of Art

stiles and rails imitate lacquer. The upper panelled room at Swangrove, Badminton House, Glos, was painted in the early 18th century to imitate both marble and lacquer. On the Continent stairwells were often painted in imitation of marble, a technique that was probably diffused by Italian craftsmen. The wainscot and doors are marbled in the Marble Room (1720) in Wasserschloss Anholt, Germany, and the ground-floor of the stairwell (*c.* 1740) at Schloss Augustusburg, Brühl, is painted with a *faux marbre* finish on stucco. In Copenhagen, Frederiksberg Palace has marbled wainscoting dating to the 1680s, and a room (*c.* late 1660s) in Rosenborg Palace was painted in imitation of tortoiseshell. Marbling remained in use throughout the 18th century but became especially fashionable in Britain once more with the Regency taste for colourful interiors. It was often used in conjunction with SCAGLIOLA (e.g. scagliola columns *c.* 1780s, marbled panels, *c.* 1806; Attingham Park, Salop, NT). By the 19th century

British 'painter–stainers' excelled in marbling, and their work was highly fashionable; the outstanding practitioner was Thomas Kershaw (1819–98), whose skill can be judged from his specimen panels (*c.* 1860; London, Victoria and Albert Museum). The practice of graining declined with the advent of Palladianism and the vogue for fully painted interiors, but was revived in the late 18th century and early 19th. The effects were more subtle and lighter in tone, reflecting the taste for such light-coloured woods as fruitwoods, satinwood and maple (e.g. Music Room, *c.* 1830; Pencarrow, Cornwall).

From the late 17th century to the end of the 18th the vogue for chinoiserie encouraged European craftsmen to experiment with different techniques to produce imitation East Asian lacquerware. Japanning, as these techniques were called, was first accurately described in the *Treatise of Japanning and Varnishing* by John Stalker and George Palmer (London, 1688; *see* LACQUER, §I, 3). The 18th-century vogue for

chinoiserie was further stimulated at the beginning of the 19th century by the Prince of Wales (later George IV), reaching its apogee at the Royal Pavilion, Brighton. Imitation bamboo furniture, usually of sandalwood or beech, was carved with imitation joints and grained to resemble bamboo (e.g. chairs, mirrors and tables, 1802; Brighton, Royal Pavilion), and imitation bamboo staircases were also created in cast iron *c.* 1815. Marbling and graining are distinct features of the interior decoration, an additional interest being the chinoiserie dragons appearing in the satinwood graining.

In the late 20th century there was a revival of interest in the techniques of decorative commercial painting, which were used for interior decoration and applied to furniture.

J. P. Parry: *Graining and Marbling* (London, 1949)

A. Chastel: *The Studios and Styles of the Renaissance: Italy, 1460–1500* (London, 1966)

J. Fowler and J. Cornforth: *English Decoration in the 18th Century* (London, 1974, rev. 3/1986), pp. 174–97

G. Beard: *Craftsmen and Interior Decoration in England, 1660–1820* (Edinburgh, 1981), pp. 90–93, 152–63

C. McCorquodale: *The History of Interior Decoration* (Oxford, 1983)

C. Hemming: *Paint Finishes: How to Rag-roll, Sponge, Marble, Stipple, Wood Grain and Create Other Special Paint Effects* (Secaucus, NJ, 1985)

B. Rhodes and J. Windsor: *Parry's Graining and Marbling* (London, 2/1985)

G. Beard: *The National Trust Book of the English House Interior* (London and New York, 1990)

E. Gaynor and K. Haavisto: *Russian Houses* (New York, 1991)

J. Miller and M. Miller: *Period Finishes and Effects* (London, 1992)

Painting medium. Substance added to paint by the artist during use to alter its properties and modify its behaviour to suit the intentions of the painter. The term 'vehicle' is sometimes used as an alternative to painting medium, although technically 'vehicle' also refers to a substance introduced (not necessarily by the painter) before the paint is used. The performance of handmade paint can also be determined by altering the recipe.

1. FUNCTIONS. The basic function of a painting medium is to modify the handling qualities of the paint, usually by increasing its flow, so that the painter can paint more easily or in a more personal manner (*see* SOLVENT). An equally important, and overlapping, objective is to adjust the paint so that it works in a particular technique. Here the modification goes beyond an alteration of the handling qualities and introduces some additional characteristics. For example, the drying time of the paint might be shortened or extended, or the paint might be enriched and made more flowing, enabling application of detail or blending of colour or transparent glazes. When seeking to achieve desired qualities in the completed work, the painter looks beyond the effect of the medium on the physical act of painting (although that usually

remains a partial consideration) and anticipates its effect on the painting itself; so one painting medium might produce a gloss finish or remove brushmarks, while another might create a durable surface and another make the paint film elastic.

There is no way of knowing in hindsight exactly why a painter selected a particular painting medium, especially as some properties are innate characteristics of a medium that may have been employed for some other attribute. Indeed, any identification of the use of a painting medium after the event presents enormous difficulties, as the substances introduced to the paint may not be present in sufficient quantity to be identifiable, or may be easily confused with other materials that were already present. Circumstantial evidence and an extensive practical knowledge of painting are needed to interpret scientific data and are at times more valuable.

2. COMPOSITION. A painting medium is usually composed of one, or a combination of some or all, of the following: a diluent; a further addition of binding medium or of a similar or related substance; substances compatible with, but different from, the paint's original binding medium.

A diluent is a substance that thins the binding medium and therefore the paint, for example turpentine in the case of oil colours, or water in the case of acrylics. An example of a further addition of binding medium might be extra oil added to oil colour, or acrylic medium added to acrylic paint, while an example of the addition of a similar or related medium is the use of different types of oil with oil paint: poppy oil with paint that has linseed oil as a binding medium, or a processed oil that has been altered in character—for example stand oil (polymerized oil). In these cases the behaviour of the paint would be significantly altered because the added medium has different properties. Examples of substances that are compatible with the paint's original binding medium but quite different from it are resins or balsams used with oil paints, or the addition of acrylic medium to ordinary watercolours. In practice, a diluent, in its capacity as a thinner or solvent or both, is usually present in order to prevent the additive substances being used to excess. In some cases it may make their use possible by rendering them liquid or putting them into a state in which they are intermixable; for example, solid resin or wax might be dissolved in turpentine so that they might be added to oil.

There is, arguably, a fourth type of ingredient: an active substance added in small amounts to control or support the behaviour of the other ingredients of the painting medium. A drying agent in an oil-paint medium would, for example, accelerate both its drying rate and that of the paint mixed with it; a matting agent in an acrylic medium would make both it and the paint mixed with it dry without gloss.

3. USE IN WATER-BASED TECHNIQUES. Tempera, gouache and watercolour (*see* PAINT, §I) are all thinned with water during use, and the addition of a paint

medium as such is the exception rather than the rule. Transparent watercolour offers the most scope for the use of a paint medium (*see* WATERCOLOUR, §1). Adding gin to the painting water was an early solution to the problems of cold weather: its alcohol content accelerates the evaporation of the water and permits painting to continue at an acceptable pace. A common addition during the 19th century and until the late 20th century was ox-gall, which acts as a wetting agent and improves the flow of watercolour washes. The addition of gum arabic and gum water to the painting water will deepen and enrich the colours. They are therefore used mostly with dark values to increase the sense of depth; sometimes they are applied over the top as a selective varnish.

The watercolour paintings produced by some 19th-century artists often have features that suggest the use of a medium. Some of the extraordinary effects in a number of Turner's watercolours, where the wash seems to have been scratched into while still wet, may have been produced by the addition of such substances as gelatin or gum tragacanth.

Modern acrylic paints have created new scope for the use of painting media with water-based materials (*see* ACRYLIC PAINTING, §1). Most product ranges offer gloss and matt painting media, gel media, glazing media and additives to retard drying or improve the flow of acrylic colour when used in a dilute state. These correspond roughly to the kind of painting media used with oil paint and are similarly used to extend the range of techniques possible with acrylics in comparable directions. Decorative effect paint additives have also become a feature of acrylic paint ranges. Conventional watercolour and gouache paints can be modified with acrylic media.

4. USE IN OIL TECHNIQUES. The earliest medium used to adjust oil paint seems to have been extra additions of oil, possibly of the same quality as that used to bind the paint but probably of a thicker, richer and more flowing character. Oil thickened in the sun, oil boiled with or without metallic dryers, and oil cooked with resin to make varnish (*see* VARNISH, §1) seem likely media (*see* OIL PAINTING, §1). Very small amounts of these substances have a dramatic effect when added to oil paint: they make it much easier to brush out and encourage a rich, enamel-like finish, brushmarks are automatically softened, and the paint's surface is smoothed by the flowing tendency of the medium. A substantial addition will increase the transparency of the paint. The addition of varnishes of amber, sandarac or pine resin cooked into oil permits glazing, not simply because they are clear but also because they have 'body'. These thick, sticky, substantial materials are capable of forming a stable film on their own. When tinted with particular pigments, they become coloured transparent glazes (*see* GLAZE). Plain oil cannot be used successfully for oil glazing because it either wrinkles or cracks and cannot wet the lower layers of oil colour. Diluents do not produce the desired optical qualities and impair the paint adhesion.

The 'bodied' oils and 'varnishes', however, are described as 'fat' and satisfy the most basic rule of oil painting: to work 'fat over lean'. As scientific analysis cannot determine how an oil has been treated before being painted with and there need only be a minute amount of active ingredients such as dryers or amber, visual examination is the only way to determine if a paint medium has been used. Any conclusion is necessarily speculative: proud edges to glazes, solidified drips or runs in the paint, a smooth but probably not evenly thick surface, softened brush marks, gloss, depth and transparency are all tell-tale signs.

In Europe solvent diluents were not widely used with oil paint until the 17th century. By the 18th century there was less expertise in the use of painting media, and by the 19th century their use with oil colours had become erratic and fanciful. A belief, on the part of increasingly inexpert painters, in apocryphal 'lost secrets' of the Old Masters, and a willingness, in the growing trade of the artists' colourmen, to supply products of dubious authenticity led to the widespread adoption of imaginative concoctions, and oil painters used painting media carelessly and to excess. As a result, their works have often suffered or are in a vulnerable condition. The use of a 'solvent varnish' for glazing, for example, as opposed to the oil varnishes discussed earlier, makes the cleaning of paintings very difficult and sometimes impossible. Some of the oil-painting media and practices of the 19th century were still being used in the late 20th century. The best proprietary media tend to focus on the use of alkyds, stand oil, turpentine (or its modern equivalents) and silica gel. Oil-painting media are still used, but only a minority of painters fully appreciate their purpose and potential.

C. Cennini: *Il libro dell'arte* (MS.; *c.* 1390); Eng. trans. and notes by D. V. Thompson jr (1933)

G. Vasari: *Vite* (1550, rev. 2/1568); ed. G. Milanesi (1878–85); intro. trans. as *Vasari on Technique* by L. S. Maclehose (London, 1907/*R* New York, 1960)

C. L. Eastlake: *Methods and Materials of Painting of the Great Schools and Masters*, 2 vols (London, 1847/*R* London and New York, 1960)

M. K. Talley: *Portrait Painting in England: Studies in the Technical Literature before 1700* (London, 1981)

J. Stephenson: *The Materials and Techniques of Painting* (London, 1989)

S. Foister, S. Jones and D. Cool eds: 'II. Van Eyck's Working Methods', *Investigating Jan van Eyck* (Turnhout, 2000), pp. 79–117

J. H. Townsend, J. Ridge and S. Hackney, eds: *Pre-Raphaelite Painting Techniques, 1848–56* (London, 2004)

Palaeography. Term applied to the study of ancient handwriting but more widely to the study of the manuscript book as a whole, overlapping to some extent with CODICOLOGY. It embraces the investigation of the technical processes by which a manuscript was produced and of the historical circumstances in which it appeared. As such, palaeography is a fundamental tool for those interested in the transmission and preservation of texts, Classical or medieval,

Latin, Greek or vernacular. The contribution of palaeography to understanding the conditions in which a text was copied and disseminated has important implications for students in many disciplines including history of art.

L. D. Reynolds and N. G. Wilson: *Scribes and Scholars: A Guide to the Transmission of Greek and Latin Manuscripts* (Oxford, 1968, rev. 3/1991)

B. Bischoff: *Paläographie des römischen Altertums und des abendländischen Mittelalters*, Grundlagen der Germanistik, xxiv (Berlin, 1979); Eng. trans. by D. O'Cróinín and D. Ganz (Cambridge, 1990)

L. E. Boyle: *Medieval Latin Palaeography: A Bibliographical Introduction*, Toronto Medieval Bibliographies, viii (Toronto, 1984)

P. Canart: *Paleografia e codicologia greca: una rassegna bibliografica* (Vatican City, 1991)

M. Beit-Arié: *The Makings of the Medieval Hebrew Book: Studies in Palaeography and Codicology* (Jerusalem, 1993)

R. Gameson, ed.: *The Early Medieval Bible: Its Production, Decoration, and Use* (Cambridge, 1994)

C. Sirat: *Writing as Handwork: A History of Handwriting in Mediterranean and Western Culture* (Turnhout, 2006)

Palette. Smooth, non-porous, inert, stain-resistant surface on which an artist sets out and mixes colours immediately before painting. For oil painters this is frequently a flat, hand-held wooden board with a thumb-hole; alternatively, it may be a suitable area such as a marble table top. For watercolourists it may be a series of mixing-wells or saucers placed on a worktop close to the easel.

Mixing-well palettes of stone and wood were used in ancient Egypt. Shallow shells or bowls were employed in medieval Europe, as depicted in the illustration of a woman artist painting a mural (London, British Library, Royal MS. 16.G.V, fol. 73*v*). Thin panels of well-prepared hardwood served for paint of a thicker consistency. Representations of early oil painters in the 15th century show them with a small wooden palette, often oblong, sometimes with the corners cut away into concave curves, as in the *St Luke Painting the Virgin and Child* by a follower of Quentin Massys (*c.* 1513; London, National Gallery, 3902), usually with a thumb-hole that in

Palette depicted in Paul Cézanne: *Self-Portrait with Palette*, oil on canvas, 927×730 mm, 1885–7 (Zurich, Foundation E.G. Bührle); photo credit: Erich Lessing/Art Resource, NY

some examples was placed in an elongated area of the palette, showing development towards a handle (*St Luke Painting the Virgin and Child*, London, British Library, Add. MS. 20,694, fol. 14*r*). A rectangular palette with a handle was used by William Hogarth (1697–1764) and by Joshua Reynolds (1723–92) in the 18th century, but oval palettes were also used from the 17th century onwards. In the 20th century rectangular (see fig.), oval and kidney-shaped mahogany palettes have been used with a thumb-hole and an area cut away for gripping the palette and accommodating spare brushes. Kidney-shaped palettes, which are curved to fit the elbow, have been made in sizes up to 36 inches (914 mm) but now 24 inches (609 mm) is the maximum size. Thickness is varied to provide good balance. Stock patterns are for left hand only; a left-handed artist must order a right-hand palette specially.

The brown colour of a varnished mahogany palette was consistent with the middle-tone painting grounds often used up to the 19th century, but the optical appearance of colours on a warm brown ground is different from that on a white ground, and some artists who employ a light painting ground prefer to use a light-coloured palette. Such palettes are available in porcelain and in less expensive melamine-faced material. These, and inexpensive birch plywood palettes, are generally produced in rectangular shape in sizes up to about 13 inches (330 mm) long. Palettes for watercolours and acrylics are usually white. Porcelain palettes with wells or slant well tiles are the most satisfactory to use in that they are inert, accept the watercolour readily and resist staining. Other materials, such as enamelled metal or polystyrene, may not have all these properties but have their uses, as, for example, the enamelled metal mixing palettes incorporated in watercolour sketching boxes; polystyrene is useful in a situation where light weight and strength are important. White, rectangular palettes with a thumb-hole and shallow depressions for colour mixing are also available for watercolour artists.

In order to retain its smooth surface, a palette that has been used for oil, acrylic or alkyd colours must be cleaned by scraping off the surplus paint and applying a suitable solvent immediately after use. A mahogany palette used for oil painting can with advantage be oiled from time to time. For any situation in which cleaning a traditional palette would be difficult, it is possible to use a palette pad, composed of tear-off, white vegetable-parchment leaves, but this is neither as comfortable to hold nor as perfectly flat as a traditional wooden palette.

R. Mayer: *The Artist's Handbook of Materials and Techniques* (New York, 1940, rev. London, 5/1991)

R. J. Gettens and G. L. Stout: *Painting Materials: A Short Encyclopaedia* (New York, 1942, rev. 2/1966), pp. 299–303

N. Usherwood: 'Every Palette Tells a Story', *RA: Royal Academy Magazine*, xviii (1988), p. 29

N. Eastaugh: 'Some Dyes and Dye-based Pigments in Turner's Palette', *Turner's Painting Techniques in Context: UKIC Conference Postprints, 1995*, pp. 45–8

J. H. Townsend And others: 'Blake's Only Surviving Palette?', *Blake: An Illustrated Quarterly*, xxxix/2 (Fall 2005), pp. 100–03

Panel painting. Painting on a wooden support. This article treats the construction and conservation of panel supports from a technical point of view; for the application of the ground and paint layers in a panel painting *see* GROUND, ENCAUSTIC PAINTING, OIL PAINTING and TEMPERA.

1. History. 2. Technique. 3. Conservation.

1. HISTORY. Wood was used in ancient Greece and Rome as a support for encaustic painting, and the first Byzantine icons, of the 6th century, are executed in this technique. In the late 20th century the Greek and Russian Orthodox churches were still using wood for their icons, though encaustic painting has long been replaced by tempera. In western and northern Europe wood was not widely used as a support until the Gothic period. The painted altarpieces and altar frontals of the 13th and 14th centuries are on wood, as are the more complex altarpieces that evolved at this period, for which wood was the only suitable support. Most surviving works from the 15th century are on wooden supports, but during this period canvas became increasingly popular and was employed for paintings intended to have some permanence, including altarpieces, whereas previously its use had been confined to short-term projects (*see* CANVAS, §2).

By the 16th century altarpieces had less gilding, so the support did not need to have an absolutely smooth surface. Also, they were no longer partitioned off into many small compartments, but instead presented a unified picture area, which could be very large. These factors favoured the use of canvas, with its relative cheapness, lightness and portability: in 16th-century Venice, for example, few big paintings were on panel. Canvas also tended to displace panel for portraits and other forms of secular and decorative painting, though wood was still used for small-scale works, even in Italy. In Flanders and Holland panels continued to be widely used, and in the 17th century they were employed for landscapes, portraits and genre scenes, as well as for small devotional works. The introduction in the 17th and 18th centuries of new wood species from the Americas, notably mahogany, encouraged the continued use of wooden supports, especially for such highly finished works as still-lifes and flower-pieces.

In the 19th century, panels were favoured by those artists interested in reviving the techniques of medieval and early Renaissance painting, for instance William Blake (1757–1827) and Samuel Palmer (1805–81) in England. Others, including the Impressionists and Post-Impressionists, barely used them at all, however, the notable exception being Georges Seurat (1859–91), who employed small panels cut from cigar boxes for preparatory studies for his large canvas paintings. In the 20th century artists who wished to have a rigid support tended to use blockboard, plywood and other

forms of manufactured veneered panels, as well as various types of particle board, including millboard and hardboard (*see* BOARD). Millboard had been introduced in the 17th century, but it was not widely used until the 19th century when it was employed, for example, by John Constable (1776–1837) for small-scale studies and oil sketches.

E. S. Skaug: *Punch Marks from Giotto to Fra Angelico: Attribution, Chronology, and Workshop Relationships in Tuscan Panel Painting: With Particular Consideration to Florence, c. 1330–1430* (Oslo, 1994)

D. Rodrigues: *Grão Vasco: Pintura portuguesa del Renacimiento, c. 1500–1540* (Salamanca, 2002)

V. M. Schmidt, ed.: *Italian Panel Painting of the Duecento and Trecento* (Washington, DC, 2002)

A. Simon: *Österreichische Tafelmalerei der Spätgotik: Der niederländische Einfluss im 15. Jahrhundert* (Berlin, 2002)

S. Alcolea Blanch and others: *La pintura gótica hispanoflamenca: Bartolomé Bermejo y su época* (Barcelona, 2003)

J. E. A. Kroesen: *Het middeleeuwse altaarretabel op het Iberisch Schiereiland: Vorm, plaats, boodschap* (Groningen, 2003)

V. M. Schmidt: *Painted Piety: Panel Paintings for Personal Devotion in Tuscany, 1250–1400* (Florence, 2004)

R. van Schoute, T.-H. Borchert, eds: *Restaurateurs ou faussaires des primitives flamands* (Ghent, 2004)

F. Kahsnitz: *Die grossen Schnitzaltäre: Spätgotik in Süddeutschland, Österreich, Südtirol* (Munich, 2005)

J. O. Hand, C. A. Metzger and R. Spronk: *Prayers and Portraits: Unfolding the Netherlandish Diptych* (Washington, DC, 2006)

2. TECHNIQUE.

(i) Wood types and preparation. (ii) Construction. (iii) Manufacture.

(i) Wood types and preparation. Throughout the history of panel painting the choice of wood species has generally been dictated by availability. Thus, in the Netherlands from the 15th century to the 17th, oak was almost invariably used, while in Italy poplar was the standard and most readily available timber. Occasionally, however, Italian panels are made of walnut, lime or cherry and other fruit woods, or even of soft woods, such as pine or spruce. In Spain and parts of Germany painters seem to have been prepared to use a wider range of timbers, including not only those referred to above but also chestnut, beech and several types of soft wood.

The different types of wood vary in their stability and durability: oak is fairly hard, dense and dimensionally stable, whereas poplar is soft, weak and dimensionally unstable because the trees grow so rapidly. To have any strength, a poplar panel has to be several times thicker than an oak panel of equivalent dimensions. The chief advantage of poplar is that planks are obtainable in large widths, which reduces the need for joins. In spite of its defects, painters in Italy seem to have had little choice but to use poplar, since deforestation had resulted in a general shortage of timber in the Mediterranean area. The imported and better quality timber was needed for construction purposes and for shipbuilding.

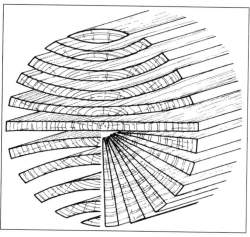

Diagram showing the division of a log into planks; quarter-sawn planks, cut through the diameter or radius of a log (lower right segment) are less likely to warp than plain-sawn planks, cut tangentially

Whatever the wood species, the way the planks are sawn from the logs (see fig.) affects their quality and dimensional stability (*see* WOOD, §III, 1). The best and most stable (that is, the least likely to warp) are the quarter-sawn planks cut through the radius or diameter of the log (also sometimes called radial planks). Those cut tangentially (plain-sawn planks) become increasingly asymmetric in their response to moisture changes—and therefore more prone to warping—the further they are cut from the centre of the log. The importance of a commission may be reflected in the cut of the planks: a painting by Jan van Eyck (*c.* 1395–1441), for instance, is nearly always found to be on a panel constructed from the best quarter-sawn planks. In the case of Italian poplar panels, the planks are generally cut tangentially through the whole width of the log, and the need to avoid the central pith or core means that quarter-sawn planks are less often found.

The timber used to construct a panel should be well seasoned. Dendrochronological analysis (*see* TECHNICAL EXAMINATION, §VII, 3) of early Netherlandish oak panels of known date has indicated intervals of ten or more years between the felling of the trees and the date of the painting. Italian poplar panels, with their irregular and often erratically curved grain, are less suitable subjects for dendrochronology, and Cennino Cennini, whose treatise *Il libro dell'arte* of *c.* 1390 is the main source of information for the techniques of early Italian panel painting, was not specific as to seasoning times. It has been suggested that the problems of shrinkage of the wood and opening of joins that afflict some Italian panel paintings, for example the Rucellai *Madonna* (1285; Florence, Galleria degli Uffizi) by Duccio (*d* before 1319), are the results of poorly seasoned timber.

(ii) Construction. Smaller panels may consist of a single plank (in Italian ones, sometimes of considerable

width), but for a larger work, an altarpiece for example, the planks have to be joined to make a panel. Generally panels are assembled with simple butt joins, that is, with the edges cut perpendicular to the main plane and then glued together. According to Cennini, the adhesive used in Italy was CASEIN, a very tough and durable carpenters' glue made from milk curds and quicklime. Analysis of early Italian panels suggests, however, that adhesives made from animal skin, bone, hooves and other waste were also used; certainly later panels are likely to have been joined with animal-skin glues. Modern panels, which are mainly laminates, use a wide range of synthetic adhesives.

In general, panels are constructed with the grain of all the planks running in the same direction. In some Italian examples care was evidently taken to avoid a join running through an important part of the design, for example the head and face of a figure. In such a case a panel may consist of one wide plank with two narrow ones on either side, instead of two equal-sized planks. It has been observed that Tuscan altarpieces are invariably constructed with the wood grain and the joins running vertically (with the exception of the horizontal predella). Venetian altarpieces, on the other hand, sometimes have horizontal joins. For a large unified altarpiece, or *pala*, this permits the use of shorter (and perhaps more readily obtainable) planks, but the weight of the upper planks can place pressure on the joins causing splitting and bowing of the panel. Some panel paintings by Peter Paul Rubens (1577–1640) and his school are very eccentric in their construction, with a central area consisting of normally joined oak planks, all with the same orientation of the wood grain, but with added—and certainly original—extensions, often with the grain at right angles to that of the main part of the panel. These extensions appear to have been made in the course of painting.

Occasionally the joins on early Italian panels were reinforced with dowels—round wooden pegs inserted into pre-drilled holes at right angles across the join—or with wooden blocks, generally shaped like a bow or butterfly, inset into the back of the panel across the join. Often, however, these are found to be later restorers' additions (*see* §3 below.) In northern Europe dowels seem to have been more commonly used, generally across the join, but sometimes in a complex construction whereby a thin plate of wood was placed across the join, parallel to the face of the panel, and then pegged in place with short dowels hammered in at right angles to the wooden plate. The dowels were then trimmed off level with the front and back faces of the panel. This form of joinery has been noted on several works by Hugo van der Goes (*c.* 1440–82). Later panel paintings may also have complex forms of joint: for example oak panels painted by George Stubbs (1724–1806) sometimes have stepped half-lap joins rather than the simple butt joins of earlier panels.

Until the 16th century the frame was often an integral part of the construction of the panel. In icons and many early altarpieces the recessed picture area was carved out of the thick panel, leaving the frame mouldings proud. This practice has also been found on some early Netherlandish panels, notably small oak pieces from the workshop of the Master of Flémalle (*fl c.* 1420–*c.* 1440). For the frame of the *Man in a Red Chaperon* (traditionally known as '*Man in a Red Turban*', 1433; London, National Gallery) by Jan van Eyck a compromise was used: the side mouldings, which run in the same direction as the grain of the wood and were therefore easy to carve, are integral to the panel, whereas the top and bottom mouldings were carved separately and then pegged in place with wooden dowels. As the 15th century progressed, it seems to have become more common to make the mouldings separately, but still to attach them to the panel before any of the stages preparatory to painting.

In Italy as well, many elements of the frame, or, in the case of small works, the complete frame, were applied to the panel before painting and gilding, but for reasons of size, complex multi-tiered polyptychs were often divided into separate units and fully assembled on the altar only once the painting and gilding of each one was complete. The joins between the units could then be covered with columns, pilasters and pinnacles. North of the Apennines, on the other hand, where frames became extraordinarily complex and ornate, particularly in the first half of the 15th century, it was the usual practice to make the frames and panels of a polyptych separately and to insert the panels into the frame only on completion of the painting and gilding.

In the 16th century, when those altarpieces still painted on panel were less likely to be free-standing and more likely to be incorporated into the architecture of the church, the frame was no longer treated as part of the construction of the panel. Similarly, secular works and smaller panels were made independently of their frames, which in Italy in particular had become increasingly complex and architectural in their design and construction. To assist in fitting paintings into frames, the outer edges of the backs of panels were often chamfered or bevelled, especially in northern Europe. The slope of the chamfer facilitates the driving in of the nails or dowels that secure the panels. The absence of a chamfered edge on, for instance, one side of an otherwise chamfered panel can be an indication that the picture has been cut down.

For panels above a certain size, auxiliary support in the form of battens was needed to reinforce the structure and prevent twisting and warping. Northern European panels constructed from the strong and relatively stable oak generally needed less support. On the rare examples of northern European altarpieces with their original construction and frame, the battens are sometimes attached to the frame only, providing support but no restriction to the panel contained in the frame. Poplar panels needed more reinforcement, especially if the work was free-standing, for example a painted Crucifix to be raised above a rood screen or a complex 14th-century polyptych. Unfortunately, few works survive with their original

carpentry intact. More often it has been wholly or partially replaced, so important evidence concerning the construction and status of the work has been destroyed. Where original carpentry has survived, it can be seen to vary from rough, but flexible, battens made from the trunks of saplings to the carefully finished work seen on the reverses of some paintings by Giotto. From the 15th century onwards the battens are often shaped so that they are narrower at one end than the other, and they are recessed slightly into dovetailed channels cut into the back of the panel. These grooves were probably sufficient to hold the battens. In other cases nails were used (but never, for early panels at least, glue); if the battens have been removed, the broken remnants of the nails will show when the panel is X-rayed.

The heads of iron nails hammered in from the front of the panel may expand as they rust, causing a lump to appear beneath the ground and paint or gilding. Such distortions can occasionally be seen on the surfaces of paintings. To prevent this, Cennini gave instructions (p. 69) to cover the heads of the nails with squares of tinfoil, which gave them some protection from the moisture in the ground. These pieces of tinfoil can also be detected in X-radiographs. Cennini also recommended the cutting out of knots and major flaws in the wood (particularly necessary in the case of poplar, which usually has many such faults) and replacing them with small wooden blocks and inserts. Again, these can be seen on the painting surface or in X-radiographs.

Until the 15th century it was common practice to cover the front faces, and sometimes even the applied frame mouldings, with pieces of linen fabric to even out and conceal flaws in the panel. This also provided a good surface for the application of the ground and perhaps prevented or reduced its subsequent cracking. Even in the 15th century, when this practice became less common, faults and potentially weak areas such as joins were often covered with strips of fabric (or occasionally with parchment). According to Cennini, the fabric was attached with the same animal-skin or parchment glue used to size the wood before the application of the ground.

Some panels, mostly from northern Europe, have ground and paint layers on their reverses. These painted backs are often done in imitation of marble and must have been intended principally for decorative purposes, but they have the added advantage of equalizing the structure of the object. A panel with paint and ground layers on one side but bare wood on the other is more likely to lose or absorb moisture on the side with the exposed wood, resulting in warping. Occasionally panels are found to have had a form of moisture barrier—apparently original—applied to their backs: Spanish panels, in particular, may have a rough but effective coating of dried sparto grass.

(iii) Manufacture. The final stages in the preparation of a panel for painting, including the application of the ground, were the responsibility of the painters' workshop, but there is evidence that the manufacture of panels, especially of those for large or ornate altarpieces, was assigned to specialist carpenters. It was not uncommon for arrangements to be made for the carpentry of an altarpiece before the contract for painting had even been assigned. The carpentry, especially if it included an elaborate frame, could be very expensive, in some instances as much as half the cost of the altarpiece.

The names of carpenters often appear in contracts and records of payment, and their marks or monograms are sometimes found stamped or branded into the backs of panels. In panels originating from Antwerp in the 16th and 17th centuries these are accompanied by an impression of a hand stamped in the wood, the hand of the Giant of Antwerp. This stamp indicated the origin of the panel and a certain approved standard of workmanship. The presence of these marks on quite small pieces suggests that there was a market in ready-made panels for painters. This is likely to have been the case in most major art centres.

L. Marcucci: *Saggio analitico-chimico sopra i colori minerali e mezzi di procurarsi gli arte fatti, gli smalti, e le vernici . . . [e] la pratica del dipingere ad olio tenuta dale scuole Fiorenttina, Veneziana e Fiamminga ne' loro migliori tempi* (Rome, 1813)

N. S. Brommelle and others, eds: *Conservation of Wood in Painting and the Decorative Arts* (London, 1978)

R. Vos and H. van Os, eds: *Aan de Oorsprong van de Schilderkunst: Vroege Italiaanse schilderijen in Nederlands bezit* ('s-Gravenhage, 1989)

M. S. Frinta: *Punched Decoration on Late Medieval Panel and Miniature Painting* (Prague, 1998)

E. Hermens, ed.: *Looking through Paintings: The Study of Painting Techniques and Materials in Support of Art Historical Research*, Leids Kunsthistorisch Jaarboek, xi (Baarn and London, 1998)

A. P. Torresi: *Dizionario biografico di pittori restauratori italiani dal 1750 al 1950* (Ferrara, 1999–2003)

T. T. de Mayerne: *Lost Secrets of Flemish Painting* (Hillsville, 2001)

C. B. Strehlke and C. Frosinini: *The Panel Paintings of Masolino and Masaccio: The Role of Technique* (Milan, 2002)

M. Faries and R. Spronk, eds: *Recent Developments in the Technical Examination of Early Netherlandish Painting* (Cambridge, MA, 2003)

M. Fernandez, ed.: *Retablos: Su restauración, estudio y conservación* (Mexico City, 2003)

A.Massing, ed.: *The Thornham Parva Retable: Technique, Conservation and Content of an English Medieval Painting* (Cambridge, 2003)

M. Ciatti, C. Castelli and A. Santacesaria, eds: *Panel Painting: Technique and Conservation of Wood Supports* (Florence, 2006)

3. CONSERVATION. The main factor in the conservation of panel paintings is the ability of wood cells, no matter how old the wood, to take up or lose moisture, swelling or shrinking as they do so. In theory, if a panel painting has always been kept in the same stable environment with the right degree of moisture, it should remain in good condition. Most panels, however, have been subjected to fluctuating conditions, and in dry atmospheres they have lost moisture, principally through their unpainted backs.

This causes the wood cells to shrink and the reverse of the panel to contract, which results in a warp convex to the picture face. On regaining moisture, the cells swell, and the panel becomes flat again. Repeated fluctuations and movement can eventually place strain on any joins and on the brittle ground and paint layers, causing them to blister and flake off. Little is known about early treatments to panels since, in the absence of records, it is difficult to determine when an intervention may have taken place. Early treatments are likely to have consisted of the regluing and reinforcement of open joins using strips of wood and the inset wooden blocks and butterfly keys also sometimes used in the construction of the panel. Original battens have often been removed and replaced, especially if an altarpiece has been moved from its original position and perhaps cut down and altered in some way. The fixing of replacement battens with glue can lead to problems. If the wood of the original panel is trying to respond to changes in humidity by expanding or contracting but is restrained from doing so by a strong, heavy batten glued across the grain, the tension that results can cause the weaker old wood to crack and split. (Original battens attached at only a few points are more likely to flex to some extent with the panel and therefore generally do not place it under such tension.)

(i) *Support.* With the rise of the professional restorer in the 18th and 19th centuries, conservation treatments became more ambitious and elaborate. Attempts to support panels and keep them flat—but without placing them under the tension caused by battens glued across the grain—led to the development of the cradle. This is a lattice-like construction, in which one set of struts or battens, the fixed members, are glued to the back of the panel but in the same direction as the grain of the wood. The original thickness of the panel was usually planed down, in the belief that this reduced its proneness to warping (the contrary is in fact generally the case). At right angles to the fixed members, a second set of wooden strips was inserted through slots cut in the fixed members. The idea was that because these sliding members were not actually glued to the panel they would hold it flat but without restricting it like a fixed batten. Cradles that have been applied to strong, stable panels (which probably did not need them in the first place) may not have done much harm, but in many cases the panel has tried to warp and the sliding members of the cradle have become jammed. The panel can then be under such tension that it is forced into a warp concave to the picture face, which is dangerous because the paint and ground are compressed and likely to blister, or it may develop splits and cracks, usually at the points where the fixed members have been attached, producing a characteristic corrugated wash-board effect.

Modern conservation practice varies to some extent from country to country, but in general most restorers would consider adapting or removing a cradle that was adversely affecting the panel. Once the cradle has been removed, there are several options.

Now that the dangers of forcing a panel to stay flat are known, some degree of curvature is usually considered acceptable. If the panel is to be kept in a stable environment (which usually means an air-conditioned environment; *see* CONSERVATION AND RESTORATION, §II, 1), it may need only minimal support. This might take the form of a specially cushioned backing panel or panel tray, designed so that if the curvature of the panel alters for any reason, it will be able to do so without restriction.

When, before the application of the cradle, a panel has been planed down to such an extent that it has lost its rigidity and is no longer able to support itself, a new support may have to be built up on the reverse. Relatively weak adhesives and woods are used (e.g. balsawood), and, unlike a cradle, the support is intended to be less strong than the original panel, so that in the event of any movement the built-up backing panel gives way rather than the original wood. In the case of fragile panels that have to return to less closely controlled environments, for example churches, more elaborate measures may be taken. Sometimes the reverses are fitted with wood and metal constructions that are highly complex pieces of engineering designed to support the panel without placing it under the tensions imposed by fixed battens or by the traditional cradle.

(ii) *Consolidation and transfer.* The other major problem affecting the conservation of wooden panels is their susceptibility to insect damage and in particular to the larvae of the wood-boring furniture beetle (*Anobium punctatum*), commonly known as woodworm. The beetle lays its eggs in the wood, and the hatched larvae bore long, winding tunnels as they eat their way through the wood, eventually emerging as winged beetles through the small round holes often seen in old timber. The damage is caused not so much by the exit holes as by the tunnels. A panel that appears to be in reasonably sound condition from an examination of its front and back surfaces may in fact have been reduced internally to a fragile honeycomb, into which the paint and ground are liable to collapse. Worst affected are Italian panels, both because of the soft, open-cell structure of the poplar and because of the greater size—and therefore the larger tunnels—of southern European wood-boring beetles. Less commonly, panels are also attacked in tropical climates by termites and, in especially damp conditions, by fungal growths including dry-rot.

If the insect or fungal infestation is still active, the panel has to be fumigated. The damaged wood can be consolidated by impregnation with adhesives (*see* CONSOLIDANT), but if the structure of the painting is severely weakened, the affected wood may have to be cut out and replaced. If the damage is extreme, or if, for some other reason, the adhesion between the paint and ground and the panel has broken down completely, the process of TRANSFER to a new support may be undertaken.

The transfer of panel paintings became common practice in the 18th century. It was believed that by

removing paintings from their wooden supports and transferring them to canvas the problems of the instability of panels would be avoided. Unfortunately, during this process, the surface properties intrinsic to panel paintings were lost, and the very different texture of the new canvas support imposed itself on the paint surface. In addition, extensive damage was done to the thin paint layers—and often to the ground—and much original paint was lost. In modern conservation practice transfer is undertaken with reluctance, simply as a last resort to save the paint. Panel paintings are transferred not to canvas but to new solid supports, often constructed from lightweight and stable synthetic materials, for example fibreglass or aluminium honeycomb. Care is taken to preserve as much as possible of the original surface texture of the painting. Since the historic importance of the original support and its construction is now fully appreciated, detailed photographic documentation of the panel before transfer (or indeed before any other major treatment) is regarded as essential.

(iii) Reconstruction. With the use of dendrochronology it is sometimes possible to reassemble dismembered fragments of an altarpiece, in particular those from a predella, by matching up the distinctive patterns of the wood grain. Italian poplar panels, with their highly irregular grain, can often be linked in this way. In addition, it is sometimes possible to determine that the planks from a panel, or even a series of panels once associated with one another but now separated, have in fact been cut from the same tree. Providing a panel has retained its original thickness, the marks made by the tools used in its manufacture, for example the saws, chisels and adzes, can also provide evidence for the reconstruction of dismembered works. Such marks are more likely to be seen on the backs of Italian panels, which were often left in a rough, unfinished state, than on Netherlandish panels, which were generally more carefully finished.

C. Cennini: *Il libro dell'arte* (*c.* 1390); Eng. trans. and notes by D. V. Thompson jr as *The Craftsman's Handbook: 'Il libro dell'arte'* (New Haven, 1933/*R* New York, 1954)

U. Forni: Il manuale del pittore restauratore (Florence, 1866/*R* 2004)

G. Secco Suardo: *Manuale ragionato per la parte meccanica dell'arte del ristauratore dei dipinti* (Milan, 1866)

Manuel de la conservation et restauration des tableaux (Paris, 1939); Eng. trans. as *Manual on the Conservation of Paintings* ([London], 1997])

R. J. Gettens and G. L. Stout: *Painting Materials: A Short Encyclopedia* (New York, 1942/*R* 1966)

G. L. Stout. *The Care of Pictures* (New York, 1948/*R* 1975)

'The Care of Wood Panels', *Museum: Revue trimestrielle* [Paris], viii (1955), pp. 139–94

J. Marette: *Connaissance des primitifs par l'étude du bois du XIIe au XVIe siècle* (Paris, 1961)

H. Ruhemann: *The Cleaning of Paintings* (London, 1968/*R* 1982)

J. Bauch, D. Eckstein and M. Meier-Siem: 'Dating the Wood of Panels by a Dendrochronological Analysis of the Tree-rings', *Nederlands kunsthistorisch jaarboek*, xxiii (1972), pp. 485–96

Carta del restauro 1972, Ministry of Education Circular, cxvii (Rome, 6 April 1972)

A. Conti: *Storia del restauro e della conservazione delle opere d'arte* (Milan, 1973; rev. 2/1998)

C. Gilbert: 'Peintres et menuisiers au début de la Renaissance en Italie', *Revue de l'art*, xxxvii (1977), pp. 9–28

Preprints of the Contributions to the Oxford Congress of the International Institute for Conservation of Wood in Painting and the Decorative Arts. Conservation of Wood in Painting and the Decorative Arts: Oxford, 1978

K. Nicolaus: *Du Mont's Handbuch der Gemäldekunde: Material, Technik, Pflege* (Cologne, 1979)

A. Smith, A. Reeve and A. Roy: 'Francesco del Cossa's *St Vincent Ferrer*', *National Gallery Technical Bulletinn*, v (1981), pp. 45–57

C. Brown, A. Reeve and M. Wyld: 'Rubens' *The Watering Place*', *National Gallery Technical Buletin.*, vi (1982), pp. 27–39

A. Conti: *Storia del restauro e della conservazione delle opere d'arte* (Milan, 1983)

P. Klein and J. Bauch: 'Analyses of Wood from Italian Paintings with Special Reference to Raphael', *The Princeton Raphael Symposium. Science in the Service of Art History: Princeton, 1983*, pp. 85–91

D. Bomford: 'Conservation and Storage: Easel Paintings', *Manual of Curatorship: A Guide to Museum Practice*, ed. J. Thompson (London, 1984), pp. 263–76

M. Wyld and J. Dunkerton: 'The Transfer of Cima's *The Incredulity of St Thomas*', *National Gallery Technical Bulletin*, ix (1985), pp. 38–59

K. Dardes and A. Rothe, eds: *The Structural Conservation of Panel Paintings* (Los Angeles, 1998)

Art in the Making: Rembrandt (exh. cat. by D. Bomford, C. Brown and A. Roy; London, National Gallery, 1988)

H. Verougstraete-Marcq and R. Van Schoute: *Cadres et supports dans la peinture flamande aux 15e et 16e siècles* (Heure-le-Romain, 1989)

Art in the Making: Italian Painting before 1400 (exh. cat. by D. Bomford and others; London, National Gallery, 1989–90)

Italian Renaissance Frames (exh. cat. by T. Newbery, G. Bisacca and L. Kanter; New York, Metropolitan Museum of Art, 1990)

S. Cove: 'Constable's Oil Painting Materials and Techniques', *Constable* (exh. cat., ed. L. Parris and I. Fleming-Williams; London, Tate, 1991)

J. Dunkerton and others: *Giotto to Dürer: Early Renaissance Painting in the National Gallery* (New Haven and London, 1991)

K. Nicolaus: Handbuch der Gemälderestaurierung (Cologne, 1998); Eng. trans. as *The Restoration of Paintings* (Cologne, 1999)

G. Perusini: *Il restauro dei dipinti nel secondo Ottocento: Giuseppe Uberto Valentinis e il metodo Pettenkofer* (Udine, 2001)

P. Garland, ed.: *Early Italian Painting: Approaches to Conservation* (New Haven, 2003)

D. Bomford and M. Leonard, eds: *Issues in the Conservation of Paintings* (Los Angeles, 2004)

S. Walden: *The Ravished Image: An Introduction to the Art of Picture Restoration and its Risks* (London, 1984; rev. 2004)

Studying and Conserving Paintings: Occasional Papers on the Samuel H. Kress Collection (London, 2006)

Pantograph. Instrument used by artists, draughtsmen and technical designers to copy an original drawing, diagram or plan on the same, or on an enlarged or

reduced scale; it is sometimes erroneously referred to in commercial and technical use as a pentagraph. The pantograph is made of rods and pins in the form of a parallelogram (the name by which it was first known in the 17th century) and uses the same principle as that found in the geometric figure: that it can easily change its configuration but will always remain a parallelogram. This can perhaps be visualized and understood best by picturing a collapsible gate such as those found at level-crossings. On the artist's pantograph, one corner is fixed, and a pencil or tracing-point is added to the corner diagonally opposite. If a free point is then manipulated over the outlines of the subject to be copied, the pencil or tracing-point duplicates its movements and so produces the copy. The pantograph is supported on castors, and the joints of the rods are very loose, so it moves extremely easily but can be difficult to control. An eidograph is a more complicated, but more stable, version.

The rods of the pantograph are extendable and marked with a ratio of scales to facilitate reduction or enlargement according to the length at which they are set. The basic geometric principle of the pantograph is so simple that it would be difficult to give credit for any one authority realizing its usefulness; however, a number of technical introductions to its use and surveys of its development (and that of the many variations on the basic instrument) have been produced since the 17th century.

C. Scheiner: *Pantographice, seu ars delineandi res qualibet per parallelogrammum lineare mobile* (Rome, 1631)

G. Benvenuti: *Descrizione succinta d'un pantografo verticale* (Florence, 1817)

G. Pellehn: *Der Pantograph* (Berlin, 1903)

H. Hutter: *Die Handzeichnung* (Vienna, 1966); Eng. trans. as *Drawing, History and Technique* (London, 1968), pp. 145–6

B. M. Stafford and F. Terpak: *Devices of Wonder: From the World in a Box to Images on a Screen* (Los Angeles, 2001)

Paper. Random or felted sheet of isolated vegetable fibre produced by sieving the macerated vegetable fibre from a watery slurry. Certain criteria must be met for a substance to be called paper: most importantly, the fibre must be vegetable; it must be processed in some way to break the material into individual fibres; and the sheets must be formed by casting the macerated fibre–water mixture on a sieve, usually a screen that is dipped into the aqueous mixture and allows the excess water to drain away. Paper is the most common support for DRAWING, PRINTING, PRINTS, WATERCOLOUR painting and writing; with parchment, it was also widely used for the medieval MANUSCRIPT, and for the development, from the 15th century onwards, of the printed book.

I. Manufacture. II. Types. III. History. IV. Trade. V. Uses. VI. Conservation.

I. Manufacture. Although papermaking by hand has not changed much since its invention in China in the 2nd or 1st century BC during the Western Han period (206 BC–AD 9), improvements to the process of forming sheets have been necessary to allow indigenous raw materials to be employed, to render the sheets fit for Western graphics and to provide the almost limitless number of sheets needed for modern life. The earliest papers, made from old rags processed entirely by hand in cottage industries, gave way to the centralized mills and modest mechanical processing of the 13th and 14th centuries in Europe. The demand for paper and the industrial development of the following centuries began the mechanization of papermaking and brought it into factories. By the end of the 19th century, wood pulp had replaced rags, and machinery had largely replaced the hand processes in commercial papermaking, providing ever-increasing numbers of sheets of considerably poorer quality.

1. Western. 2. East Asian. 3. Islamic.

1. WESTERN.

(i) Introduction. (ii) Fibre selection. (iii) Fibre preparation. (iv) Sheet formation. (v) Sizing and finishing.

(i) Introduction. Technical illustrations of paper manufacture were included in many texts beginning *c.* 1568, when Jost Amman (1539–91) depicted a *Papermaker* at the vat in a woodblock print for a German-language book of trades, the *Eygentliche Beschreibung aller Stände* (Frankfurt am Main, 1568). His illustration set the format for subsequent artists, although the most complete illustration of traditional papermaking accompanied a detailed description of the craft in the 1761 encyclopedia of arts and occupations published by the French Académie Royale des Sciences. Joseph-Jérôme Le Français de La Lande (1732–1807), an astronomer and member of the Académie, contributed a 150-page description of contemporary papermaking practice, laws and regulations pertinent to the craft (including rag gathering). Importantly, he included 14 engraved illustrations of the industry, which had been executed in 1698. His work was quickly translated into German, Italian, Dutch, Spanish and English. Later, Denis Diderot (1713–84) and Jean Le Rond d'Alembert (1717–83) adopted his format for their illustrated works.

An early illustration in the series contributed by La Lande shows the preliminary steps of fibre preparation, in which rags are sorted, then soaked in water and then beaten to disperse the fibres into pulp. The pulp is suspended in greater quantities of water, making a stock. The stock is placed in a wooden tub or vat, into which the craftsman papermaker or vatman dips a frame (mould), which acts as a sieve, holding the fibre in the shape of a sheet while the excess water drains. The vat is heated by the small oven insert, called a 'pistolet' at the side of the tub. A huge paddle with holes in it, used in the 17th century to keep the pulp in suspension, was laid across the vat. (Later vats had a stirring device built into the tub, which the vatman could operate by a foot-pedal.)

The vatman grasped the mould at its short sides, holding the deckle in place, and dipped the mould

into the vat, scooping up the amount of pulp he needed to make the desired thickness of paper. It took a great skill to make a series of sheets of similar weight. The mould was rocked and shaken to disperse the fibres, while the water drained out of the bottom.

Once the sheet was sufficiently drained, the deckle was removed and the screen passed to the vatman's partner, the coucher (pronounced 'coosher', from Fr.); the print shows him in the act of turning or couching a very wet sheet on to a woollen felt. Another felt was placed on top of the wet sheet, and the coucher returned the empty mould to the vatman, who by then had another sheet to be couched. In papermaking practice, two moulds of the same size or 'sisters' would be used in tandem, requiring only one deckle, which the vatman would hold and replace on the empty mould returned by the coucher. Their rhythm would continue until a stack of perhaps 100 sheets (a post) were formed. These were pressed, along with the felts, in a large press to remove water and compress the sheets. The third member of the papermaking crew, the layer, pulled the post and removed the sheets from the felts, laying them in a stack, for further pressing. The sheets were laid against a wooden board held at an angle on a small easel, which aided in handling the still soft and fragile sheets. The stack was set in the screw press and left overnight. The next morning the sheets were restacked (parted) in the opposite order and returned to the press to reduce the surface texture imparted by the felts. The next day, spurs of sheets (four to ten individual sheets in a stack) were strung over wooden poles of horsehair ropes in a well-ventilated, louvered, drying loft of the papermill and allowed to dry over several days.

The dry, unsized (waterleaf) sheets must be dipped into a solution of water-resistant sizing, usually warm gelatin, to render them suitable for writing, drawing or printing. Finally, finishing with polishing devices, such as pounding with a glazing hammer or pressing the dry sheet against a hot metal plate, lessened small surface irregularities. Individual sheets would be inspected and small inclusions or irregularities removed with a small knife. It was then necessary for the sheets to be allowed to mature for three to twelve months before leaving the mill to avoid later cockling and distortions due to atmospheric changes. In the 17th century, the demand for paper was so great that often the papermaker would ship paper that had not been thoroughly dried and matured: the result of poor procedure can be seen in many folios from this time, as the sheets have rippled in the bindings, creating a diamond pattern bulge in the centre of the book block.

(ii) Fibre selection. A wide range of vegetable fibres have been used in making paper, sometimes chosen for their inherent qualities of strength, softness, flexibility, texture, colour and absorbency, but probably just as often for their easy availability. Fibres can be obtained from the seed hairs of cotton; from the inner bark or bast fibres of linen, hemp, jute and mulberry; from leaf or grass fibres of banana, sparto,

manila, straw and bamboo; from well-worn textiles; or from wood. All these fibres are made of cellulose and are from less than 1 mm to 300 mm in length, and only tenths of 1 mm wide. They are flexible when saturated but on bonding in sheets become rigid. A thin sheet of writing paper may show up to ten layers of fibres in cross section.

When the Muslims began making paper, probably in the early 8th century AD, it was necessary to find a readily available substitute for the mulberry bark fibre most commonly used in East Asian paper. Linen rags and cotton and hemp from old ropes were employed as a substitute. In Europe, rags of cotton and linen cloth, canvas, ropes and towelling provided processed fibre that could be easily broken into a pulp for papermaking. Rag shortages soon plagued papermakers, as competition for the raw stuff of paper became more acute. As early as the 12th century, a diarist reported that the ancient pyramids had been raided for mummy wrappings for paper manufacture in Cairo. In 1666, a proclamation in England forbade the use of cotton or linen fabric for burial shrouds, demanding that woollen fabric (which is not suitable for papermaking) should be used instead. This saved about 100,000 kg of fabric for papermaking per year. A similar regulation was put in place in Germany.

During the 18th century rags could not be found to provide the paper needed for the increasing number of new books, periodicals and novels demanded by the general public. The shortage of good rags for paper was due to the proliferation of paper mills: by *c.* 1800 there were roughly 500-plus mills in both Germany and France; over 200 in Spain; 185 in the USA; 26 in Russia; 24 in Sweden; and 11 large mills in the northern Netherlands. No estimate could be found for England, where in excess of 10 million kg of rags were used to make paper that year. The competition for rags was strong.

Advertisements to purchase rags and appeals to save rags appeared regularly in the popular publications. In 1769 *The Boston News Letter* made its plea in verse:

Rags are as beauties, which concealed lie,
But when in paper how it charms the eye,
Pray save your rags, new beauties to discover,
For paper, truly, everyone's a lover:
By the pen and press such knowledge is displayed,
As wouldn't exist if paper were not made.
Wisdom of things, mysteries divine,
Illustriously doth on paper shine.

Moses Johnson was more direct: in 1792 he enticed his young readers in the Keene, NH, *Journal* with notice that

1½ pounds of rags will buy a primer or a story book, or one yard of ribbon, two thimbles, two rings, twelve good needles, two strings of beads, one penknife, nine rows of pins—4 pounds of rags will buy a pair of handsome buckles, or the famous 'History of Robinson Crusoe', who lived 28 years on an uninhabited island.

In 1799 one papermaker in Massachusetts went so far as to watermark his sheets with the words

'SAVE RAGS'. No bit of cloth was safe; in 1856 the *Syracuse Standard* boasted its issue was printed on paper made from rags from the land of the pharaohs, stripped from mummies. As the laws of supply and demand took hold, serious investigations of other suitable fibres for papermaking were undertaken.

As early as 1719, the sight of papermaking wasps suggested to René-Antoine Ferchault de Réaumur (1683–1757) that wood might be used in papermaking. Naturalists and botanists throughout the 18th century suggested other fibres that might be substituted for the increasingly expensive rags, but the six-volume *Versuche und Muster ohne Lumpen oder doch mit einem gerlingen Zusatze denselben Papier zu machen* (Regensburg, 1765–71) by the Bavarian botanist Dr Jacob Schaffer is a landmark study, documenting his extensive experimentation with papermaking from all types of flora.

A few curious texts were published on specimens of odd-fibred papers during the last part of the 18th century. Mathias Koops's *Historical Account of Substances which have been Used to Describe Events and Convey Ideas* (London, 1800) had its text printed on paper made from straw and the seven-page appendix on paper made from wood pulp. In 1801 Koops published a second edition of the treatise on recycled paper from which he had removed the ink of previous printing. He obtained patents in 1802–3 on his new processes of removing ink from paper and for 'manufacturing paper from straw, hay, thistles, waste and refuse of hemp and flax, and different kinds of wood and bark' and went into production in London. Although he went bankrupt within three years, this enterprise marked the first commercial attempt to manufacture paper in the West from anything other than rags.

In the mid-1800s ground wood fibre became a practical substitute for rags after Friedrich Keller (*fl* 1797–1846), a weaver in Saxony, invented a wood-grinding machine. By *c.* 1870 papers made from groundwood pulp were in common production for use in less permanent printing such as 'pulp' novels or newspapers (whence the nickname). Groundwood paper was markedly inferior to rag sheets from the standpoint of durability and permanence, due to the ageing characteristics of the naturally occurring lignin and resins within the woody fibres. However, developments in the processing of wood fibres have subsequently enabled the removal of the damaging portions so that papers can now be produced from wood pulp that are as permanent and durable as earlier rag papers.

(iii) Fibre preparation. Fibre from the vegetable matter chosen to make paper must be beaten to prepare it for sheet formation. The individual fibres must be released from fibre bundles so that they are able to form a sheet. The individual fibres form strong hydrogen bonds to each other when brought into close contact during the evaporation of moisture from the formed wet sheet: no adhesive is used to hold the macerated fibre together in the felted sheets.

The amount of beating is critical to the proper formation of the finished sheets. If the pulp is beaten too little, the stock will form clumps in the vat, and an even sheet cannot be formed. If the stock is beaten too much, the fibre becomes brittle: it cockles and shrinks on drying and cracks if dried under pressure.

The early Muslims probably disintegrated their linen rags by placing them in heaps and saturating them with water to ferment, then boiling the mass in wood ashes. The boiled rags were rinsed and cleansed by putting them in cloth sacks, suspended in a running stream. These treated rags were then macerated by hand, by pounding with a stone or wooden mortar and pestle in imitation of the Chinese manner. Later they began using the labour-saving device of a foot-operated trip hammer.

Soon after the Muslims introduced papermaking to Spain in the mid-11th century, a water-powered stamping mill was invented to reduce still further the labour of beating the fibre. Early stamping mills consisted of rows of wooden hammers that rose and fell in 'vat-holes' or troughs into which prepared rags were tossed. The hammers, set in series on an axle, were made of great logs or stones, which fitted into wooden cavities lined with metal. This simple method of disintegration of the fibre was almost immediately effective if the rags were fermented beforehand into a tender mass. At this time well-worn cotton and linen rags were piled up, kept wetted and allowed to ferment as long as six or eight weeks. Although this method was quite wasteful of the rags, as about a third rotted beyond use, the ease of beating coupled with the small demand for paper in Europe before the invention of movable type made it perfectly practical. By the end of the 15th century, however, the increased demand for paper made it necessary to husband the fibre available from rags. At the best mills, the fabric was sorted by coarseness, fibre and colour before beating, so the rags could be given the most efficient fermentation and beating. The pulps could then be mixed for sheet formation.

Paper made during the era of the stamping mills is still supple and strong because the old-style machines broke the fibre apart by friction, rubbing the fibre bundles under great pressure. Papers from this period can be identified by inspection of the fibres under the microscope: they show long, uncut and unbroken fibres.

In the northern Netherlands, where machinery was powered by windmills, papermakers could not compete with the water-driven stamping mills of France and Germany. By *c.* 1680 an unknown Dutch citizen invented a cylinder beater, which required less energy and no running water to macerate rags: the 'Hollander' beater consists of an oval wooden tub fitted with a turning wheel made from a cross-section of a log holding *c.* 30 iron knife blades. The blades hit a metal or stone bed in the bottom of the tub. Rags and water were placed in the tub and made to circulate through the system between the blades and bed by the action of the turning wheel and a backfall, macerating the rags by cutting and chopping.

Hollander beaters were more efficient than stampers in preparing fibres: one Hollander was able to prepare the same amount of fibre in five or six hours as could be made in a five-hole stamper in twenty-four. In addition, more time was saved as rags did not need to be wetted, fermented and then washed before beating in a Hollander. However, the fibres were necessarily damaged by this machine, being cut up by the blades rather than pushed apart as they were by the stampers. European papermakers increased their production by adopting the Hollander throughout the 18th century. Today the same Hollander design, with slight modifications, produces almost all the rag pulp used in papermaking.

Wood fibre could not be pulped by stamper or Hollander since the fibres are much shorter than bast fibres and are held together chemically by lignin. The first grinding machines for creating 'mechanical' or groundwood pulp were developed in Germany in the 1840s. This process provided cheap paper in vast quantities but the paper was so impermanent, becoming yellowed and embrittled in a short time, that it could not be recommended for many uses.

Research in the chemical separation of wood fibres and the removal of lignin and resins from wood chips eventually provided two methods of pulping wood fibre, which became known as 'chemical pulp'. Two Englishmen prepared white paper suitable for printing from wood pulp stock in 1851 by use of what became known as the 'soda' process. Charles Watt and Hugh Burgess (1825–92) discovered that by boiling barked wood chips in caustic soda (sodium hydroxide) at a high temperature, the lignin and resins, which constitute about 50% of the weight of the wood, were dissolved without damage to the cellulose fibres. The boiled pulp had to be well washed before use in making printing papers. Faint interest in their discovery in England encouraged Watt and Burgess to seek an American patent in 1854, and in 1863 they established the American Wood Paper Co. in Pennsylvania. Here the pulp was prepared from indigenous hard woods, such as poplar, hemlock and whitewood, at the capacity of 20 tons of pulp a day. The modern 'sulphate' process, by which brown wrapping or Kraft paper is made, is a modification of the soda process, which adds sodium sulphate to the cooking liquor. Although this process is responsible for most of the objectionable odour and sulphurous air pollution associated with paper mills, it is economically attractive since much of the processing solution can be recovered for further use.

An acid process for the production of wood pulp was devised by the American scientist Benjamin Tilghman (1821–1903), who began his experiments in Paris in 1857. His 'sulphite' method dissolves the resins and lignin present among the wood cells by a solution of sulphurous acid held at high temperature and pressure. The addition of an excess of sulphite of lime (calcium bisulphite) in the processing removes the acid from the fibre, which must be washed in great quantities of running water to prepare it for sheet formation. The processed fibre is white and suitable for use to give additional strength to mechanical wood pulp in the manufacturing of cheap printing and writing papers, or for use in combination with rag fibres for bond, ledger and writing papers. Commercial use of this technology began in the 1880s, and by 1887 the International Paper and Fiber Co. had set up a mill in Michigan in partnership with lumbermen, to use their waste to manufacture paper. Production of wood-pulp paper worldwide at the end of the 20th century was in excess of 99% of all paper produced by tonnage. The historical cooperation of the lumbering and papermaking industries has continued in North America, where the big paper companies own and control great tracts of soft and hardwood forest, which they harvest for their pulp mills. Pressures to protect the environment began in the 1990s to affect the industry, as the public continued to demand ever-increasing amounts of cheap paper products while concurrently objecting to deforestation, air pollution and the contamination of rivers traditionally associated with the manufacture of wood pulp.

Before the discovery of chlorine in 1774, paper assumed the colour of the rags from which it was made. Sorted by fibre and colour, the best white rags made the best white paper. The rags could be wetted and laid in full sunlight in fields to lessen their colour, but this process was time-consuming and was used sparingly in production papermaking. Chlorine significantly brightens the rags, but unfortunately it also significantly weakens the fibre: if not thoroughly washed out (in running water for more than ten hours), the residual chemical causes darkening and marked embrittlement of the sheets in short order.

(iv) Sheet formation. The papermaker's mould is the most important tool in hand papermaking. Dipped into the vat to scoop the watery fibre, it governs sheet size and imparts both the surface and internal texture to any sheet formed on it. No extant examples of the earliest moulds exist, but close inspection of the earliest sheets suggests that they were probably only cloth stretched over wooden frames. As papermaking spread across the world, improvements to the mould were effected. In Japan, Korea and the rest of East Asia, bamboo slats replaced the cloth surfaces of earlier moulds.

By the 13th century, a crude 'laid' mould constructed of metal wires was in use in Europe. The wooden frame of a 'laid' mould is reinforced by parallel wooden ribs across which wires are laid. These so-called 'laid' wires are placed quite close to each other; they are secured to the underlying wooden ribs by two interwoven 'chain' wires, so called because in profile their crossing wires approximated the links in a chain. In the early 14th century moulds were constructed from thin pounded strips of metal rather than wires, but as the technology of forming wire developed, the screens became finer, showing from six to twelve laid lines per centimetre. All European papers made from the 13th century to the mid-18th show strong laid and chain lines, easily observable by holding a sheet up to transmitted light. The visible

pattern in papers is due to a thinner deposit of fibre above the wires. The chain lines, which were usually more prominent, ran along the short side of the paper and were spaced about 12 to 50 mm apart above each rib. At first the chains were attached directly to the ribs, which blocked the drainage of pulp somewhat on either side of the chain line, giving a shaded texture where comparatively more pulp had settled. The resulting papers are known as 'antique laid' or 'shadowed laid'.

'Wove' moulds were invented c. 1750, at the request of the English printer John Baskerville (1706–75), who wanted a more finely textured paper for his printing business. Replacing the individual strung wires with a wire mesh screening allowed the formation of an evenly textured sheet, which shows no areas of thinness in transmitted light.

Both types of mould would be fitted with a detachable 'deckle' framing on the top, which ensured that the watery paper pulp could be held in place as it drained. Inevitably, some pulp would flow between the deckle and the mould, creating the thin and irregular 'deckle edge' characteristic of handmade sheets. Either type of mould might also have a papermaker's device or WATERMARK affixed to its surface. The wire form identifying the papermaker or mill was stitched in place on the mould, creating lines of thinness in the formed sheet as laid and chain lines do. The century and country of a sheet of paper's origin can be determined by comparison with records of papermaking and documented use of particular sheets in dated material.

Casting paper by hand on moulds was a laborious task. The three-man team of hand papermakers could make between a quarter and three-quarters of a ton of paper per week. By the mid-18th century this production was far outstripped by the demand for sheets. In 1798 Nicholas-Louis Robert (1761–1828) obtained the first patent for a mechanical papermaker. His invention of the papermaking machine was prompted not so much by demand as by the problems he faced as personnel inspector of the fractious and contentious members of the papermakers' guild in a mill at Essonnes, France. His ingenious machine replaced the rectangular single-sheet mould with a long loop of wire that pulled a continuous sheet of paper from the vat. After some tribulations in France, in 1801–2 he sold his patent to prominent stationers in England, John Fourdrinier (1714–1802) and Sealy Fourdrinier (fl 1791–1847). They perfected the machine, gave it their name and in 1804 built one that was capable of making fairly good paper. It was said to do the daily work of six vats in twelve hours. A flaw in their patent allowed other papermakers to use their design without payment of royalties, and, like so many other pioneers of papermaking, the Fourdriniers went bankrupt. A Fourdrinier machine enabled continuous sheet formation, from the deposition of fibre from the wooden vat or 'head box' (far right) to the uptake of the finished sheet (far left). The continuously moving wire belt receives the pulp by gravity feed from the 'head box', then quickly whisks it away, shedding much of

the water, before 'couching' the sheet on the second belt, which feeds the sheet through the large heated drying drums just before being rolled. (A Fourdrinier machine can nowadays also size the sheet and finish it with a false watermark or laid and chain lines.)

Robert was able to form extraordinary sheets 12 to 15 m in length and 600 m wide on his first machine, five to seven times faster than by the vat-mill system. Modern Fourdrinier machines, which work on the same principle as Robert's, are one of the largest single units of machinery in operation today: newer machines can make sheets up to 9 m wide, on a bed of wire mesh running at 2000 m per minute (about 75 miles per hour). Such a machine could turn out a strip of paper over 110 km long each day. The capacity of this machine, when making standard newsprint 300 days per year, would be about 150 tons per day or 45,000 tons per year. The huge Fourdrinier would require over 60,000 cords of wood or the clear cutting of 6000 acres of Adirondack Spruce per year. The world's appetite for paper seems insatiable.

The quality of machine-made papers is not as high as that of handmade sheets, due to the rapid and consistent alignment of fibres on the continuously moving belt. Papermakers have tried, however, to invest their machine-made papers with many of the outward signs of a handmade sheet, even by simulating laid and chain lines and watermarks by wax impregnation of sheets or by physical impressions imparted to still wet paper supplied by a 'dandy roll'.

In 1809 John Dickinson (1782–c. 1860), a papermaker in Hertfordshire, England, invented another way to form sheets by machine, creating mould-made sheets that stand midway between handmade and rapid machine-made papers. His invention consisted of a large wire-covered cylinder, which was half submerged in a tub of papermaking stock. As the cylinder turned slowly, the fibre was cast on the mesh by means of a vacuum pulled from within the cylinder, and the sheets were couched automatically on another cylinder covered with felt. From this point, the sheets were pressed, dried and sized as in the hand process. This machine was quickly made obsolete by the massive Fourdriniers, but the design was revived in the 20th century to manufacture many art papers of a quality intermediate between machine-made and handmade sheets. Using a slow-turning drum, the so-called 'mould-made' papers are intended to imitate handmade sheets in many respects: watermarks, laid lines and deckles can all be imparted to the sheets, but these deckles and the surface characteristics and grain are subtly different from handmade sheets.

(v) Sizing and finishing. Once dried, the waterleaf paper has to be treated to make it slightly resistant to water and suitable for receiving ink and other media. European papermakers dipped the sheets into tubs of warm animal size made from the parings of hides, bones and hooves obtained from parchment-makers. The sheets were then run through rollers to squeeze the excess sizing from the sheets. Many sheets were torn, crushed or wrinkled during this process, known

as 'tub sizing', and had to be discarded. Improved papermaking machines preserved sheets by applying 'surface size' as the paper passed between sizing rollers. Papers that received a lot of sizing were said to be 'hard sized'; papers with lesser sizing are known as 'slack sized'. In the 19th century chemical sizing by the alum/rosin process replaced the traditional warm gelatinous animal material or starch. Chemical sizing proved to be quite impermanent and detrimental to the longevity of the paper product, but it was economically attractive for several reasons. It could be introduced to the sheets in the pulping and set by chemical reaction later in the papermaking process, and it added bulk to the pulp, increasing the yield. By the end of the 20th century, some synthetic resins were in use in sizing handmade and machine-made papers.

The earliest papers were finished by burnishing with a smooth stone, in the finishing room, where the sheets were inspected one by one and imperfections removed with a sharp knife. In the early 17th century improved finishing was possible using a huge wooden 'glazing hammer' powered by water, by which imperfections and knots in the sheet would be pounded and compressed. About 1720 the Dutch began to pass their sheets between wooden glazing rolls to surface their papers. In the late 20th century, heated metal rollers and hot and cold metal press plates were being used in finishing handmade and mould-made papers in calendering and super-calendering machines, which pass the rolls of paper over and between rollers to impart smoothness and gloss to finish machine-made paper.

2. EAST ASIAN. The method of papermaking invented in China between *c.* 2000 and 2200 years ago is similar to the Western method described above which evolved from it, but the raw materials, tools and resulting paper are quite different. East Asian papers (often referred to as oriental papers and, mistakenly, as rice papers) are fine-weight, translucent, glossy sheets, which show a very faint laid texture in transmitted light. The fibre used is very strong. Single sheets of these papers have been used for windows or screens in homes, while laminates have been used for the breastplates in armour or flooring in traditional Korean houses. This paper is known as *washi* ('hand-moulded paper') in Japan.

Before the 10th century, hemp or *asa* (*Cannabis sativa*) was widely used in Japanese papermaking, but since then the three most common fibres are: *kōzo* or paper mulberry (*Broussonetia kazinoki*), *mitsumata* (*Edgeworthia chrysantha*) and *ganpi* (*Wikstroemia sikokiana*). The first two may be cultivated, but *ganpi* must be gathered from the wild. *Kōzo*, the most commonly used fibre, is about 10 times longer than a wood-pulp fibre and therefore makes a tough sheet. *Mitsumata* makes a less strong sheet than *kōzo*, but its fibres are glossy and flexible. *Mitsumata* papers have soft, smooth surfaces and show an elegant gloss; they are insect-resistant and are commonly used for calligraphy and Japanese printmaking. *Ganpi* paper is fine, smooth surfaced, lustrous and translucent. The

sheets, which have a considerable 'rattle' when shaken and are resistant to insects, have been used for centuries in such wide-ranging applications as tracing fine calligraphy and in dressing wounds.

Japan has in abundance two important resources needed for good *washi* production: clear water and cold weather. Historically, farmers would make paper during the winter months when the low temperature in the workshop discouraged mould growth and tightened the fibres to produce a crisper sheet. The fibre, obtained from the inner bark of the three papermaking plants, would be washed and beaten by hand and foot in the clear running winter streams. After cooking with wood ash and washing, and perhaps bleaching in the sun, final maceration was accomplished by beating with a wooden mallet, when small imperfections and bark bits were removed by hand. The fibre is mixed with water in a wooden vat about 600×1200 mm, called a 'papermaker's boat'; it is held in dispersion with mucilage obtained from the root of the hibiscus plant (Jap. *neri*). This material is critical to the manufacture of *washi*: it allows thin sheets to be made and then to be separated when pressed.

The East Asian papermaking mould is a flexible bamboo screen set on a bamboo and silk thread frame. It is plunged into the vat in a traditional papermakers' scooping motion, picking up some pulp. The mould is rocked and shaken, depositing draining fibre randomly on the screen as in the Western method, but, in a unique characteristic motion, the excess fibre is sloshed over the edge of the screen, looking and sounding like a wave. The sound of this wave indicates whether or not the papermaker is a good craftsman and the solution of the proper temperature and viscosity. It lends its name to the description in Japanese of this type of papermaking, *nagashizuki* ('flowing-over moulding'). (The Western technique of papermaking is known in Japan as *tamezuki* or 'filling and holding papermaking'.)

Sheets of East Asian paper are quite thin but can be built up in laminates by redipping the mould in the vat. Decorative papers can be made by adding coloured fibre to the moulded sheets, either from other vats of coloured fibre or by dripping the coloured pulp from a container or pot on to the screen. After draining, the papermaker couches the sheets in a pile without the interleaving felts used in Western papermaking. The post of papers is pressed, then the sheets are carefully separated and brushed on to wooden planks or heated metal drums to dry. The hibiscus root mucilage, *neri*, allows the sheets to be separated after pressing. The sheets need no sizing or finishing.

3. ISLAMIC. Little is known in the West about papermaking in the Islamic world until late in the 19th century, when Joseph Karabacek published his study based on an early 11th-century manuscript entitled *Umdat al-Kuttāb* ('Staff of the scribes') by the Zirid prince al-Mu'izz ibn Badis (*d* 1062), who described papermaking from hemp found in the fine white ropes made in Syria and Jerusalem. The ropes were

loosened by hand, combed and soaked in a water and lime solution overnight, then dried in the sun for a few days. After repeated washings, the pulp was beaten with a stone mortar, diluted with water, stirred in a large vat and sieved through a fine reed screen, which would be evened off by a stick. The sheet was transferred to a board or expanse of fabric, then dried in the open air. To prepare the sheets for traditional writing and painting, they would be coated front and back, in two steps, with a purified starch solution and allowed to dry. This procedure both filled and sized the sheet, which, after polishing with a stone, provided a smooth surface for writing. Some papers were given additional 'antiquing' effects by the addition of saffron or fig juice to the starch solution.

Papermaking in the Islamic world obviously varied from place to place and over time. At first, Chinese methods doubtless played a great role, but soon Islamic paper was made of hemp and rags. Reliance on beating the rag stuff by methods other than machine continued in the Islamic world long after they were discarded by Westerners, so Islamic papers are soft, long fibred and bulky by comparison. Some show small bits of woven fabrics still intact within the sheets. The sheets were sometimes glazed and sized better on one side and pasted together to make a two-sided sheet suitable for writing or painting.

II. Types. Papers may be described by at least three different bases, which in practice tend to merge and overlap. The first is the paper's main use (*see* §V below); second, its manufacturing history (which would help in describing characteristics of the sheet and predicting its suitability for a particular use); and third, a brief description of its most important physical properties, including weight and thickness (expressed as the number of pounds per ream (516 sheets) cut to 24 × 40 ins or the number of grams per sheet cut to a square metre).

Describing paper by use is fraught with imprecision, since idiosyncratic use and historical changes make definitions impossible, whereas specific data about a sheet's manufacturing history and physical properties offer much better descriptions. For example, an art supply catalogue might describe a sheet as '100% rag, mould-made, cold-pressed paper showing four deckles, which is tub-sized and available in 140 and 300 lb weights' and another sheet as 'handmade, 100% rag, waterleaf sheet developed for screenprinting, 300 gm/m²'. Yet even with these precise descriptions, it is not easy to imagine the paper, and in informal descriptions it is even more difficult—the first paper is generically known as 'watercolour paper', the second as 'printing paper'. Contemporary art supply catalogues contain scores of descriptions such as these, and it is only through practice and handling of many sheets that appropriate choices can be made for particular applications.

Only two main types of papers were manufactured in Europe in the 16th and 17th centuries: white paper and brown paper. 'White' paper was made from good-quality fibres that were clean and often quite fine. The resulting papers, actually cream coloured, were made in several grades, 'superfine', 'fine' or 'coarse'. These papers were designed for use in printing and writing. 'Brown' papers were made from soiled or coarser papermaking fibres or using poorer papermaking techniques, such as those that involved less beating. These papers were cheaper and could be put to any use. Other coloured papers, in blue, fawn or grey, made from coloured rags, were first produced in Venice near the end of the 15th century. By the 16th century all these papers were part of the stock of an artist's studio. Later coloured papers were made from dyed fibre or by the inclusion of ground pigment in the pulp.

During the 16th and 17th centuries the expanding world trade of papers gave artists the freedom to choose a particular type of paper deliberately for its characteristics of colour or receptivity to inking. The market for art supplies grew with the leisure time of an educated middle class until the great manufacturing innovations of the late 18th century and the 19th finally allowed papermakers to respond directly to the demand for various types and textures of papers for commercial printing and the arts. Indeed, wove paper is thought to have been invented in 1750 by the Whatman Turkey Mill in Maidstone, Kent, to suit the specifications of John Baskerville, the English printer and typographer, who first used the new fine-textured paper in his 1757 edition of Virgil.

Throughout the 18th century, amateurs and professional artists, as well as their art societies, used their influence to effect the manufacturing of art papers. Copperplate paper was manufactured from 1773, in response to the call for a suitable paper issued by Britain's Society of Antiquaries. The Society of Arts also offered a competition for a copperplate paper in 1756 but did not award the first prize until 1787. About this same time, drawing papers, especially a paper for watercolour painting, became commercially viable as the medium developed into a popular amateur pastime and also a means for serious artistic expression. A stout paper, well sized and showing an evenly mottled texture allowed artists to exploit new techniques in watercolour. English papermakers also responded to innovations in printmaking techniques at this time, which included more tonal processes of lithography, aquatint, mezzotint, stipple engraving and soft-ground etching. By the end of the 18th century, fashionable stationers' stores in London and on the Continent offered a wide range of papers (in several surfaces, colours and weights), which were offered specifically for watercolour, charcoal drawing, pencil sketching, copperplate engraving, etching, lithography, woodblock etc. Decorated papers were available for papier-mâché, as were decorative paper objects in general.

Commercial machine processes have been adapted to provide better quality sheets with aesthetic appeal at advantageous prices, while fine-quality handmade sheets have continued to be available, often at

considerable cost. In fact, hand papermaking underwent something of a renaissance in the late 20th century, with the reopening of several very old mills in England and on the Continent. These and new small operations worldwide produce traditional-type handmade sheets for limited speciality markets, and some accept commissions from fine printers and artists. A few art schools have begun to teach papermaking, and the collaborative printmaking studio-workshops, which have published some of the most important original prints since 1960, have encouraged artists to use handmade paper and coloured paper pulp as media for multiples and sculptural objects. Handmade sheets of rag or raw vegetable fibre are desirable for their aesthetic appeal and for their longevity. They may remain supple and strong for several hundred years, while the generally inferior machine-made wood-pulp sheets often discolour and became embrittled in a short time (*see* §VI below).

Mu'izz ibn Badis al-: *Umdat al-Kuttāb* [Staff of the scribes] (MS., before 1062); Eng. trans. and ed. by M. Levey as 'Mediaeval Arabic Bookmaking and its Relation to Early Chemistry and Pharmacology', *Transactions of the American Philosophical Society*, n. s., lii/4 (1962) [entire issue]

J. J. Le Français Le Lande: 'Art de faire le papier', *Descriptions des arts et métiers*, iv (Paris, 1761; Ger. trans., 1762; Eng. trans., 1762–3/*R* Kilmurry, Ireland, 1976; Sp. trans., 1778; Dut. trans., 1792)

J. Kunisaki: *Kamisuki chōhōki* (Tokyo, 1798); Eng. trans. and ed. by C. E. Hamilton as *Kamisuki chōhōki: A Handy Guide to Papermaking* (Berkeley, CA, 1948)

M. Koops: *Historical Account of the Substances which Have Been Used to Describe Events and Convey Ideas* (London, 1800, rev. 1801)

J. Munsell: *Chronology of the Origins and Progress of Papers and Papermaking* (Albany, NY, 5/1876)

J. Karabacek: 'Das arabische Papier: Eine historisch-antiquarische Untersuchung', *Mitteilungen aus der Sammlung Papyrus Erzherzog Rainer*, ii (Vienna, 1887); Eng. trans. as *Arab Paper* (London, 2001)

D. Hunter: *Handmade Paper and its Watermarks: A Bibliography* (New York, 1916)

D. Hunter: *Papermaking through 18 Centuries* (New York, 1930)

D. Hunter: *A Papermaking Pilgrimage to Japan, Korea and China* (New York, 1936)

The Dictionary of Paper, American Paper & Pulp Association (New York, 1940, rev. 1951)

D. Hunter: *Papermaking: The History and Technique of an Ancient Craft* (New York, 1943, rev. 2/1947/*R* 1978)

Paper and Paperboard: Characteristics, Nomenclature and Significance of Tests, American Society for Testing and Materials (Philadelphia, 1944, 3/1963)

D. Hunter: *Papermaking by Hand in America* (Chillicothe, OH, 1950)

T. Tindale and H. Ramsey: *The Handmade Papers of Japan* (Tokyo, 1952) [incl. paper samples]

E. Sutermeister: *The Story of Papermaking* (Boston, 1954)

J. B. Green: *One Hundred and Fifty Years of Papermaking by Hand* (Maidstone, 1960)

J. P. Casey: *Pulp and Paper*, 3 vols (New York, 1961)

J. Grant: *A Laboratory Handbook of Pulp and Paper Manufacture* (London, 1961)

R. H. Clapperton: *The Papermaking Machine: Its Invention, Evolution and Development* (London, 1967/*R* 1995)

T. Barrett and A. Shimura: *Nagashizuki & Tamezuki: Oriental and Western Methods of Papermaking* (Tokyo, 1977)

A. Shimura: *Papermaking in Korea* (Tokyo, 1977)

E. Haylock: 'Paper', *A History of Technology*, ed. T. Williams (Oxford, 1978), vi, pp. 607–21

S. Hughes: *Washi: The World of Japanese Paper* (Tokyo, 1978) [de luxe edition with paper samples]

T. Barrett: *Nagashizuki: The Japanese Craft of Hand Papermaking* (North Hills, PA, 1979)

P. Long, ed.: *Paper: Art and Technology* (San Francisco, 1979)

S. Turner and B. Skiold: *Handmade Paper Today: A Worldwide Survey of Mills, Papers, Techniques and Uses* (London, 1983)

Pan Jixing: *Zhongguo zaozhi jishu shigoa* [Draft history of the techniques of Chinese papermaking] (Beijing, 1987)

J. Krill: *English Artists Paper: Renaissance to Regency* (London, 1987, rev. New Castle, DE, 2/2001)

E. Lunning: 'Characteristics of Italian Paper of the 17th Century', *Italian Etchers of the Renaissance and Baroque* (exh. cat., ed. S. W. Reed and R. Wallace; Boston, MA, Museum of Fine Arts, 1989), pp. xxxii–xliii

J. Green: *The Rittenhouse Mill and the Beginnings of Papermaking in America* (Philadelphia, 1990)

D. Baker: 'Arab Papermaking', *Paper Conservator*, xv (1991), pp. 28–35

J. N. Balston: *The Elder James Whatman, England's Greatest Paper Maker (1702–1759): A Study of Eighteenth Century Papermaking Technology*, 2 vols (West Farleigh, 1992)

D. Buisson: *The Art of Japanese Paper* (Paris, 1992)

T. Barrett: 'Fifteenth Century Papermaking', *Printing History*, xxx (1993), pp. 33–41

J. N. Balston: *The Whatmans and Wove Paper* (West Farleigh, 1998)

M. Z. Bat-Yehouda: *Le papier au moyen âge: Histoire et techniques* (Turnhout, 1999)

D. W. Mosser, ed.: *Puzzles in Paper: Concepts in Historical Watermarks* (New Castle, DE, and London, 2000)

J. M. Bloom: *Paper before Print: The History and Impact of Paper in the Islamic World* (New Haven and London, 2001)

H. Loveday: *Islamic Paper: A Study of the Ancient Craft* (London, 2001)

T. Barrett: *Japanese Papermaking: Traditions, Tools, Techniques* (Warren, CT, 2005)

S. E. Berger: *Edward Seymour & the Fancy Paper Company: The Story of a British Marbled Paper Manufacturer* (New Castle, DE, 2006)

A. Helman-Wazny: 'Asian Paper in Works of Art: A Comparative Fiber Analysis', *Hand Papermaking*, xxi/2 (Winter 2006), pp. 3–9

III. History.

1. Invention in China. 2. Spread to Korea and Japan. 3. Islamic lands. 4. Europe and the New World.

1. INVENTION IN CHINA. According to tradition, paper was invented in China in AD 105 by Cai Lun (*fl* AD 97–117), chief eunuch in the court of the Chinese Eastern Han emperor Hedi (*reg* AD 89–106); this is based on records of Cai Lun's claim for patents on the material. However, paper was certainly developed in China much earlier than that, probably during the Western Han period (206 BC–AD 9).

Fragments (including one large piece 10 cm sq.) of paper made from hemp bast fibres, looking much like contemporary paper tissue, were found in a tomb in Xi'an, Shaanxi Province, in 1957 (Beijing, Historical Museum); they have been dated to *c.* 200 BC. Believed to have been made from silk dross, the paper was called *zhi* ('silk') in Chinese records of the following centuries, the same character that later referred to true paper. Only microscopic study in the years subsequent to the discovery this century established the fragments in fact to be of hemp. Likewise, written documents from the 2nd century BC found at Karakhoto (Chin. Juyan), in Inner Mongolia, and Lopnor in Xinjiang record the existence of papers made of vegetable fibre from old fish nets, hemp ropes, rags and mulberry bark (later to become the staple fibre of East Asian papermaking). The use of these early papers, whether for wrapping and padding (e.g. of bronze mirrors in the 1957 find) alone, or whether also for writing, is uncertain; their coarseness and surface unnevenness point to the former.

In the 3rd century BC, however, China began to standardize written language, causing a revolution in the materials of writing, and by the 4th century AD paper had almost completely replaced earlier writing surfaces of silk and bamboo strips and had spread as far as Turfan. By the Tang period (AD 618–907) papermaking had spread and developed into a major industry, in use almost everywhere in Central Asia. Judging by the sheets found in a group of 5th- to 12th-century manuscripts at Dunhuang in extreme north-west China, a wide variety of papers was available: fine grey sheets from hemp for copying the Buddhist sutras, papers made from mulberry bark for official documents and other stationery, and coarser papers made locally for wrapping and heavier uses.

2. SPREAD TO KOREA AND JAPAN. Papermaking probably first made its way from China to Japan in the 4th century AD, via Korea, which was then a tributary vassal of China and an active trading partner with Japan. No doubt knowledge of the craft later became closely linked with the introduction of Buddhism and religious manuscripts on paper, which were brought to Japan by Korean monks in the 6th century AD. The *Nihon shoki* ('Chronicle of Japan'; AD 720) specifically mentions that paper was made in Japan in AD 610, under the direction of a Korean monk, Donchō [Tam Chi]. (There is reason to believe that paper was available for records and censuses before then, though it is not known whether it was imported or of local manufacture.) Donchō was a learned man who became an adviser to the imperial household, which encouraged the making of paper and ordered the planting of paper mulberry in many areas of the empire. From then onwards papermaking in Japan grew rapidly, practised in an estimated 20 provinces by 770 AD. By *c.* 806–10 a government paper mill had been established in Kyoto, and all provinces were required to pay a tribute in papermaking fibres.

Washi, the handmade paper of Japan, was soon incorporated into every part of Japanese life and culture. Paper was used as offerings at Shinto shrines, in the devotional copying of Buddhist texts, as holiday decorations, in making toys and for simple woven clothing. It was made into the standing and dividing screens so important in Japanese architecture. By the Heian period (794–1185) the great skill of Japanese papermakers had developed the traditional *nagashizuki* ('flowing over moulding') method, in which the papermaker created the desired thickness of a sheet by repeated lamination of very thin sheets, each formed by dipping into the slurry of fibre. The repeated dippings made the overlaying of different colours or pulps possible and produced papers reminiscent of swirling water or white clouds on blue backgrounds. Flowers and leaves were included in some sheets, as were gold- and silver-coloured flecks, mica and other bits of decoration. The flowering of literature and poetry at court during the Heian period fed the demand for decorated papers, and each province became known for its own speciality papers. Papers were collected and traded for poetry writing in this period, sometimes presented as gifts among the wealthy. Using the first 'recycled' paper, pious but sentimental Heian-period Buddhists would copy sutras on repulped and reformed sheets once used for poetry by deceased loved ones. Repulping made a sheet that was softer and denser than the originals, with a soft grey tone that resulted from the residues of ink. Examples of very beautifully coloured, decorated and swirling dyed papers can be found in the calligraphy of this period. In the provinces, paper was as negotiable as any product in the official barter system, acceptable as a tax payment along with rice, cloth or metal currency. Western papermakers have never made papers to equal these in fineness and beauty.

Papermaking followed the feudal patterns of Japanese life in the following centuries, protected as a trade under the great lords. During the Kamakura period (1185–1333), when the Samurai military aristocracy presided over a religious awakening of Zen Buddhism that stressed duty and asceticism, the decorative glory of Heian paper gave way to sheets that were stylishly plain and humble in spirit, very much like modern Japanese papers. Guilds for papermakers helped the craft flourish throughout the Muramachi period (1333–1568). Nobles set up trade monopolies for certain papers, although families were known to smuggle papermakers from one province to another to obtain their secrets. By the Edo period (1600–1868) paper was the second largest source of tax income for the government; only rice contributed more to the treasury. Paper was made in all the provinces and traded widely, and for the first time in history paper was readily available to all classes of people.

As early as 1643 Japanese papers were exported to Europe through the Dutch controlled port of Nagasaki. Western interest in East Asian papermaking appears to have been keen: in 1788 Benjamin Franklin (1706–90) described the oriental manner of manufacturing sheets as large as '4½ ells by 1½ ells'

(approximately 3.00 × 1.00 m) to the American Philosophical Society in Philadelphia, which included several members of the Rittenhouse paper-making family. Japan kept its papermaking industry strong until pressure from the outside world during the Meiji Restoration (1868) opened the country to Western thought and technology. By the end of the first quarter of the 20th century, European methods of machine papermaking, introduced to meet modern demands for paper, had pushed Japan's once proud *washi* industry into small enclaves of cottage or craft production, where it is still practised today. In 1975, only about 4000 craftsmen were engaged in making traditional Japanese *washi*, in every part of the country, but especially in the prefectures of Ehime, Fukui, Tottori, Kochi and Gifu. Specific papers from Izumo, Shimane, Fukui and Gifu have been officially designated as Important Intangible Cultural Assets to encourage continued production, and a few remarkable papermakers have been deemed Living National Treasures in appreciation of their skill. But the number of craftsmen seems to be dwindling, and it has become increasingly difficult to obtain high-quality Japanese *washi* that does not include bleached or wood fibre in the sheet.

3. ISLAMIC LANDS. Sheets of paper were traded westward from China through Central Asia and Sasanian Iran with the silk caravans. An example of East Asian paper from the 1st century AD was found in Samarkand in Uzbekistan, and paper documents were also discovered at Khocho in Chinese Turkestan. The actual technology for making paper appears to have been guarded, however, and, according to an 11th-century account, it was not divulged outside East Asia until Chinese papermakers were captured by the Muslims in a battle fought in AD 751 on the banks of the Talas River near Samarkand in western Central Asia. This may have been the genesis of the first papermaking centre at Samarkand, which had ample vegetation and abundant clear water. That papermaking skills may have been introduced even a bit earlier is suggested by an important cache of paper documents, dating from the early 8th century, which was found at Kala-i Mug in Uzbekistan. Paper quickly replaced papyrus and parchment as the usual writing material for official documents because it could not easily be erased. In AD 794–5 the Abbasid caliph Harun al-Raschid (*reg* AD 786–809) established the first paper mill at Baghdad, and 'Baghdadi' paper was highly prized well into the 14th century. The craft spread throughout the Islamic lands, from India to Spain. By the 10th century Damascus in Syria had also become a well-known papermaking centre, which sold its product in Europe under the name *charta damascena*. Although rare in most parts of the world, paper must have been quite common in Egypt, as the Persian traveller Nasir-i Khusraw, who was in Egypt in the 1040s, was astonished to see merchants use paper to wrap their goods in the bazaars. It was nevertheless expensive, and small sheets of paper were reused many times, as shown by the Geniza

documents, a huge cache of medieval papers discovered in a Cairo synagogue in the 19th century. By the 11th century, papermaking had reached the coast of North Africa with centres in Fez, Tripoli and Tunis, as well as Sicily and Spain. From here papermaking was finally introduced into Europe over a thousand years after its invention in China.

Particular sizes and kinds of paper were appropriate for specific purposes in the Islamic world. The largest sheets (1100 × 750 mm), known as 'full Baghdadi', were used for the largest manuscripts of the Koran, such as a 30-volume copy transcribed at Baghdad between 1306 and 1313 for the Mongol ruler Uljayta and bequeathed to his mausoleum (dispersed, e.g. Istanbul, Topkapı Palace Library, E.H. 245). Small sheets of extremely fine paper (e.g. 61 × 91 mm) were used for pigeon airmail. Fine paper was often coloured, flecked with gold or marbled.

4. EUROPE AND THE NEW WORLD. The Muslims brought paper with them to the Iberian Peninsula, establishing the first European paper mill in Játiva, Spain, in the 11th century. But papermaking in Europe made slow gains, taking almost another 500 years to spread throughout the continent. According to paper historian Dard Hunter (1947), early examples of paper in Europe were regarded with scepticism, not only because they were more expensive and more fragile than parchment but also because a fanaticism drove the Christian world to condemn, and even destroy, everything that suggested Muslim civilization. Nevertheless, papermaking was established in Italy in 1276 at Fabriano, which in the late 20th century still boasted papermaking facilities. A mill was recorded in operation in France by *c.* 1348 and in Germany by 1390. The invention of movable type by Johann Gutenberg (*c.* 1394/9–1468) *c.* 1440 eventually increased the demand for paper and loosened European prejudice against the material, although the most important documents continued to be inscribed on parchment in the medieval craft tradition. The spread across the continent was slow but continuous as the secrets of the guarded craft were passed on from master to apprentice. Mills were founded in 1491 in Kraków; in 1576 in Moscow; in 1586 in Holland; and in 1635 in Denmark. Although the first mill in England was noted in 1494, papermaking was not established there until *c.* 1588, when a sustained mill was founded.

Papermaking in the New World was first established in Mexico in 1575, and finally in Philadelphia, PA, by William Rittenhouse (1644–1708) in 1690. The industry was discouraged in these American colonies by legislation by the mother countries to protect their captive markets abroad for light-manufactured goods. As early as 1732, for example, there was a clamour in the English Parliament to investigate the establishment of competitive mills in Massachusetts.

IV. Trade. Until papermaking was established in the mill system throughout Europe, it was traded in small bundles from the Middle East and over the

established European trade routes. (In fact, the Arabic word for 'bundle', *rizma*, is the derivation, via Spanish and Middle French, of the word 'ream'—the standard unit of measuring paper in quantity.) Although the industrial revolution of the 13th century centralized and increased production in Europe, papers were still used locally, until specialization finally expanded the trade in the 16th century. Even though artists of the 14th to the 16th century travelled from one European country to another, their prints were usually issued on the local paper. By the beginning of the 17th century, however, there was a brisk trade in paper throughout Europe, centred in Cologne and Antwerp. The Dutch, for example, imported writing and printing papers from Germany, France, Switzerland and Genoa, because no fine white paper was then manufactured in the northern Netherlands. In the early 17th century prices for sheets became so high that the Dutch sent factors or middlemen directly to the paper manufacturing sources in Angoumois, France, to commission paper for the Dutch market, some even showing Dutch watermarks. As Amsterdam, through the work of the factors, grew into the world marketplace for paper the French began to resent Dutch economic control of their product, and the French government moved awkwardly to protect the industry.

When the Edict of Nantes was revoked in 1685, many Huguenot papermakers, and all the Dutch factors, removed to the Protestant lands of the northern Netherlands and England to avoid religious persecution. This immigration coincided with major technological advances in fibre preparation and bolstered both countries' papermaking industries, turning the Dutch merchants and English consumers into producers. James II of England (*reg* 1685–8) went so far as to prohibit the repatriation of valued Huguenot papermakers by proclamation in 1687, in order to protect the 'White Paper Company' they had established in his country. Even before these changes, the strong world trade position of the Dutch had supplied native artists with an exhilarating choice of papers for drawing and printmaking: in the mid-17th century, for instance, Rembrandt van Rijn (1606–69) was able to purchase small bundles of exotic papers from any of several paper merchants in Amsterdam, then the centre of the world trade. He used some of these papers for his prints but is also known to have 'collected' papers: an inventory of his possessions in 1656 includes several portfolios of old and various blank papers among albums of prints and drawings. A survey of the papers used in Rembrandt's etchings found that Dutch papers of the early and mid-century were apparently not fine enough for his purposes, so Rembrandt exploited Holland's trade position by using Swiss, German and French 'writing' papers for his prints. He also used parchment and commercial papers made specifically for other purposes, for example oatmeal or cartridge paper, apparently chosen for the pleasing tonal effects it made possible in his prints. The Dutch East India Company, which had exclusive trading rights with Japan at Nagasaki, introduced Japanese papers to the Netherlands in

two small shipments in 1643 and 1644. By *c.* 1647 Rembrandt had used these fine-weight, glossy *ganpi*-fibred papers to beautiful effect in his etchings. He also used an off-white paper that was probably manufactured in India. The experimental use of a variety of papers for printing was not really possible until Rembrandt's day, but it has since become the standard for graphic artists as both world trade and production have expanded.

Following the introduction of cheap wood-pulp fibre, papers were manufactured for all types of commercial and ephemeral uses, and artists soon availed themselves of these in idiosyncratic ways. The list of papers found in Cubist collages, for example, reads like the catalogue of a 19th-century paper manufacturer: newsprint, book paper, drawing and printing paper, wallpaper, wrapping tissue, wrapping paper, cigarette package wrappers, labels, writing paper, coloured sheets etc. The historian of 20th-century art needs a good general knowledge of the types of paper manufactured for industrial and domestic uses worldwide in addition to traditional 'artist's' papers to write clear descriptions of works of art on paper.

B. Franklin: 'Description of the Process of Making Large Sheets of Paper in the Chinese Manner, with One Smooth Surface', *Transactions of the American Philosophical Society*, iii (1793), pp. 8–10

T. Hansard: *Typographia: Origin and Progress of Printing* (London, 1825)

J. Munsell: *Chronology of the Origins and Progress of Papers and Papermaking* (Albany, NY, 1870/*R* 1876)

C. M. Briquet: 'Recherches sur les premiers papiers employés en Occident et en Orient du Xe au XIVe siècle', *Mémoires de la Société nationale des antiquaires de France*, xlvi (1886)

A. Blanchet: *Essais sur l'histoire du papier et sa fabrication* (Paris, 1900)

D. Hunter: *Handmade Paper and its Watermarks: A Bibliography* (New York, 1916)

H. Alibaux: *Les Premières Papeteries françaises* (Paris, 1926)

D. Hunter: *Papermaking through 18 Centuries* (New York, 1930)

D. Hunter: *Papermaking: The History and Technique of an Ancient Craft* (New York, 1947/*R* Dover, 1978)

D. C. Coleman: *The British Paper Industry, 1495–1860* (Oxford, 1958)

C. White: *Rembrandt as an Etcher* (London, 1969)

Rembrandt: Experimental Etcher (exh. cat., Boston, MA, Museum of Fine Arts; New York, Pierpont Morgan Library; 1969)

D. C. Smith: *History of Papermaking in the United States, 1691–1969* (New York, 1970)

Papers by Eishiro Abe: Living National Treasure of Japan (exh. cat. by Shin Yagahashi; New York, Museum of Contemporary Art, 1977) [samples of papers]

S. Hughes: *Washi: The World of Japanese Paper* (Tokyo, 1978) [de luxe edn with paper samples]

T. Barrett: *Japanese Papermaking: Traditions, Tools & Techniques* (New York and Tokyo, 1983)

D. Twitchett: *Printing and Publishing in Medieval China* (New York, 1983)

Tsien Tsuen-Hsuin: *Paper and Printing* (1985), V/i of *Science and Civilization in China*, ed. J. Needham (Cambridge, 1954–98)

J. Krill: *English Artists Paper: Renaissance to Regency* (London, 1987)

J. M. Bloom: *Paper before Print: The History and Impact of Paper in the Islamic World* (New Haven and London, 2001)

F. Schmidt and E. Sobek: *Internationale Bibliographie zur papierge-schichte*, 4 vols (Munich, 2003)

V. Uses. In addition to the traditional artistic uses of paper for drawing, painting, books and printmaking, the explosion of technological developments of the last two centuries has broadened paper production so that paper has now been used for everything from building roofing to coach parts, furniture, clothing and containers. Printed materials range from ephemeral sheets, such as newspapers, pulp books, calendars, magazines, packaging, sponges and towelling, to more permanent printed documents, treaties, books and diplomas.

1. Drawing and painting. 2. Printing. 3. Bookbinding. 4. Building. 5. Packaging.

1. DRAWING AND PAINTING. Paper was used for writing as early as the 11th century in Europe, but the earliest extant Western drawing on paper dates from the 14th century. Early draughtsmen used the so-called 'writing' papers for their drawings in all media; these papers were available in only a few creamy colours, derived from the colour of the rags from which they were manufactured. Their textures were determined during the pressing process, and early sheets were referred to as 'smooth' or 'coarse'. Generally speaking, artists chose the finer surfaced sheets for pen-and-ink drawings and the coarser sheets for friable media such as chalk and graphite. Sometimes sheets were manipulated by the artist before use, either roughed up by abrasion with pumice or smoothed by burnishing or preparation with a pigmented ground for metalpoint or other drawings.

By the 16th century, papers in a range of blues, greys and warm browns, intended for other commercial uses, were available for artists. These were recommended to artists in drawing manuals from the late 17th century onwards, but papers specifically designed for drawing were not made until the mid-18th century, when popular interest in art created a speciality market for papermakers. Until *c.* 1820, all paper was made by hand on screens. Size and texture of the sheet were limited by the strength of the vatman and the design of the paper mould. With the invention of the papermaking machine, large sheets of paper, cast in a continuous roll, could be made, and all manner of textures and grids could be imparted to papers. Soon papers were developed that suited specific drawing techniques, such as pastel paper, which is a thin drawing paper with an even, moderate texture that provides some tooth for holding the unbound pastel pigment from the stick. Pastel papers differ from charcoal papers by virtue of being coloured by the addition of a minor percentage of coloured fibre, perhaps in a range of tones, to the cream-coloured pulp. The resulting 'flecked fibre' makes a lively surface for the draughtsman.

Drawings in brush and wash on paper grew out of the medieval tradition of manuscript illumination and miniature portrait painting on parchment. Early artists' manuals, such as the one by Cennino Cennini (*c.* 1370–*c.* 1440), instructed artists to prepare papers with a gum-based coloured ground before drawing. Coloured washes were commonly added to pen-and-ink and chalk studies by the 16th century, and there are also instances of drawings on paper from that period in brush and wash alone. As an art form in its own right, watercolour painting on paper was well established as a legitimate means for serious artistic expression by the early 18th century. Two major schools of practice developed: transparent watercolour washes became associated with the English tradition, while on the Continent opaque water-based paint, known as GOUACHE, was more highly favoured. Different papers were necessary for these techniques. Transparent watercolourists used thick sheets, with much sizing (i.e. hand-sized), to allow wetting and rewetting without damage to the sheet. The papers were quite white in tone, providing maximum reflection of light through the transparent washes of colour. The play of light over the paper's surface was exceedingly important in the transparent technique, and sheets were available in various surfaces described by the terms of their manufacture. From least to most textured they were known as 'hot-pressed', 'not hot' or 'cold-pressed' or 'unpressed'.

Gouache could be used in a drier manner, its body more akin to oil paint. Smoother papers, many used for all sorts of drawing, were used in the opaque watercolour technique. Bitter controversies flared up over the use of opaque white versus completely transparent technique, and the relative value of works in the water-based media compared to traditional easel painting in oil. In an illogical extension of this argument, 19th-century Pre-Raphaelite artists used watercolours on paper to imitate oil paintings.

The convenience and economy of painting on paper led a few artists to experiment with oil-based paint on paper. Notable, but isolated examples of artists using dilute oil paint on paper are found from the 17th century onwards, for example Peter Paul Rubens (1577–1640), Giovanni Benedetto Castiglione (1609–64) and Edgar Degas (1834–1917). These paintings remain in a good state of preservation, despite the inherent incompatibility of the acidic ageing properties of oil with paper, because the artist prepared both the paper and the medium, sizing the paper with glutinous material and thinning the oil paint with turpentine or blotting the oil from the colour. Some 19th-century studio artists and commercial colourmen prepared heavy papers with an oil-based ground to be used for oil sketches rendered *en plein air*. But artists who wanted to make traditional paintings on paper were still plagued by the problems of long drying times and the incompatibility of the materials over time. The development of synthetic acrylic- and later vinyl-based paints, which handle something like oils but dilute with water and dry

quickly without damaging the paper with ageing, allowed 'painting on paper' to be fully realized in the mid-20th century.

J. Meder: *Die Zeichnung* (Vienna, 1919); trans and rev. by W. Ames as *The Mastery of Drawing* (New York, 1978)

M. Cohn: *Wash and Gouache* (Cambridge, MA, 1977)

P. Bower: *Turner's Papers: A Study of the Manufacture, Selection, and Use of his Drawing Papers, 1787–1820* (London, 1990)

T. Fairbanks: *Papermaking and the Art of Watercolor in Eighteenth-century Britain: Paul Sandby and the Whatman Paper Mill* (New Haven, 2006)

2. PRINTING. Through the invention of the movable type printing press *c.* 1450, paper became the common carrier for information in modern civilization. Movable type required a sturdy paper that would absorb thick ink under pressure yet easily release from the printing matrix; traditional handmade rag papers with a soft-surface size met this need. Printing papers from the 15th to the 17th centuries are found in several weights, in a limited range of cream to white colours, with some novelty papers in blue, green and beige. All sheets were laid, and their surface textures were also limited: some sheets show moderate texture, others are reasonably smooth. Comparisons of watermarks show the same papers used in books and in individual prints from the same period.

By the mid-17th century, when Dutch shipping fuelled the worldwide trade of papers, artists for the first time in history had the possibility of wide paper choice. Rembrandt's experimentation in his etchings with Japanese, Indian and various European papers for their inherent aesthetic effects marks the beginning of the 'modern attitude' of the artist, which considers the relationship of the paper substrate to the final effect of the artistic print. About 1750 wove paper was invented in response to a request for a smoother paper for printing, and by 1773 James Whatman (1741–98) was manufacturing 'antiquarian' plate paper for the newer tonal printing processes of mezzotint and stipple engraving, according to the specifications put forth by James Basire (1730–1802), an engraver, on behalf of the Royal Society of Antiquaries. Basire specified all the important factors in the printing paper: colour, thickness, opacity, sizing and finish.

In planographic or offset printing, which applies pressure evenly over the sheet and transfers the ink by slight suction, the paper must be of sufficient internal strength so as not to 'pick' or delaminate as the inked roll or plate is removed from the sheet. Intaglio printmaking also relies on an overall pressure, and the moist sheet must lie flat so that it does not crease as it absorbs ink from the deep etched or engraved lines in the printing plate. Relief and embossed printing techniques require a paper of sufficient substance that it will not break or crack at the deepest areas of impression. Printing papers differ from writing and drawing papers only by being relatively soft-sized to absorb and hold ink. Permanence and durability of the sheet have also become concerns of collectors and professional art printers;

archival qualities, such as colourfastness and neutral pH, are a recent additional consideration for papers used in many costly studio edition prints.

W. B. Wheelwright: *Printing Papers* (Chicago, 1936)

J. Krill: *English Artists' Paper: Renaissance to Regency* (London, 1987, rev. New Castle, DE, 2/2001)

3. BOOKBINDING. The use of paper as a covering material for books is associated with temporary wrappers or publishers' bindings, usually intended to be discarded in favour of something more permanent once the book was sold. Surviving examples are consequently rare. Woodblock-printed wrappers were used by various printers in Augsburg from 1482, Ferrara from the 1490s and Venice from *c.* 1520; until the end of the 18th century, particularly in Venice, they were more common for certain types of book (e.g. *gratulatorie*, opera librettos etc) and were often blocked in gold on to coloured paper. All of these books used woodcuts that were designed to fit them, some having printed titles.

These woodblock-printed wrappers are different in kind to the wrappers cut from plain, coloured or decorated papers commonly used to protect pamphlets and other small publications since the 16th century. Such pamphlets were normally very simply stitched with thread through the side of the inner margin. Their plain paper wrappers (typically grey or blue in all European countries) were not considered as bindings. Copies intended for presentation or for a more elegant market used marbled, block-printed, paste or gilt papers. Special copies might also have gilt edges. Larger books were sewn through the folds of the gatherings, with the paper wrapper pasted to the spine. From the mid-18th century these wrappers might also be printed with the title of the book and some advertising material, as well as having decorative borders and woodcuts. Such wrappers were commonly used for journals and magazines, as well as for part issues of books, especially in the 19th century. The ubiquitous modern paperback derives from these earlier examples, the only difference being that the binding is no longer seen as temporary.

More substantial bindings or covers in thick paper (cartonnage), either laced on to conventional sewing structures in the manner of limp parchment bindings or using a long-stitch technique (in which the leaves were sewn directly to the cover itself), were common in Italy from the 17th century to the 19th, and proved both durable and convenient to handle (*see* BOOKBINDING). Examples of similar laced-on cartonnage covers are also found in France and the Netherlands in the 18th century. All are likely to have been intended as temporary publishers' or booksellers' retail bindings, and the edges of the leaves were left uncut. The cartonnage is usually left plain, with perhaps a manuscript title on the spine, but some examples have decorated papers wrapped around them. The English publishers' binding of the later 18th century and the early 19th century consists of paper over a book bound in boards. Typically, these books have a cream paper on the spine and grey or

blue paper on the boards, though other colours are also found. The edges were usually left uncut or roughly trimmed, and the bindings again were seen as temporary.

The German paper-covered case bindings dating from the second quarter of the 18th century seem to have been considered more permanent, often having cut and coloured edges, with various decorated papers. In the 19th century, paper-covered case bindings, using a variety of printed, glazed or embossed papers, became common throughout Europe, especially on books intended for children or the coffee table. Papers of all sorts, both decorated and undecorated, were used on the boards of books with leather, vellum or cloth on the spines and/or corners. Such half- or quarter-bindings were found first in Germany from the mid-16th century and from the end of the 17th century were increasingly common throughout Europe.

E. P. Goldschmidt: *Gothic and Renaissance Bookbindings*, 2 vols (London, 1928, 2/Amsterdam, 1967)

D. Miners: *The History of Bookbinding, 525–1950 AD* (Baltimore, 1957)

B. Middleton: *A History of English Craft Binding Technique* (London, 1963/R 1978)

G. Barber: 'Continental Paper Wrappers and Publishers' Bindings in the 18th Century', *Book Collector*, xxiv (1975), pp. 37–49

D. Foxon: 'Stitched Books', *Book Collector*, xxiv (1975), pp. 111–24

A. Haemmerle: *Buntpapier: Herkommen, Geschichte, Techniken, Beziehungen zur Kunst* (Munich, 1977)

P. Needham: *Twelve Centuries of Bookbindings, 400–1600* (New York, 1979)

R. McLean: *Victorian Publishers' Book-bindings in Paper* (London, 1983)

S. Malavieille: *Reliures et cartonnages d'éditeur au XIXe siècle, 1815–1865* (Paris, 1985)

J. Bidwell: 'French Paper in English Books', *The Cambridge History of the Book in Britian, vol. 4: 1557–1695*, eds J. Barnard and D. F. McKenzie (Cambridge, 2002)

4. BUILDING. Except for WALLPAPER and decorative laminates, as in some kitchen work surfaces and furniture, most paper applications in building and construction are highly functional. A wide range of physical characteristics can be engineered into paper to meet the special requirements of each building application through the judicious choice of raw materials, method of manufacture, additives and finishing techniques. The Chinese and Japanese have used paper in their homes as a translucent and decorative room-dividing medium for many hundreds of years. Western civilization had to wait until the 19th century before paper was used in any substantial quantities in its buildings.

Underlay for carpets made from felt paper, an innovation derived from the general use of newspapers for that purpose, became increasingly popular in the West in the 1880s. In its most sophisticated form, the manufacturing process incorporated a cedar dust that over a long period filled the room with a resinous aroma, a phenomenon much appreciated by Queen Mary (1866–1953), wife of the British king George V. Although felt paper underlays are still made, they have been largely superseded by foamed rubber equivalents, some of which have a crêped Kraft paper backing. Felt paper also featured in experimental work undertaken in the USA in the late 19th century, which led to the development of plasterboard, a substitute for the traditional internal wall construction of lath and plaster. Augustine Sackett (1841–1914) of New York was granted a patent in 1894, and the first small plasterboard factory was set up at Pamropo, NJ. This versatile construction material is a sandwich of gypsum between two sheets of multi-ply paperboard and is used predominantly in the construction of walls and ceilings and associated coving. The manufacture of plasterboard, available in a wide range of variants, has now evolved into a profitable industry covering most of the world's industrialized nations.

Predating man's use of paper in the construction industry by millions of years is the practice of those insects, such as wasps, that construct their nests from a form of paper made by the mastication of slivers of wood. The principles exhibited by these natural masterpieces of design and engineering based on the hexagonal cell and protective 'paper' envelope have been adapted in the industrial world. One example is the honeycomb structure found between the face panels of doors and between wall sections made from two sheets of plasterboard. An alternative method of door construction uses moulded pulp profiles similar to egg boxes. Specially formulated papers and boards are used as 'breathable' barrier membranes in the walls of timber-framed buildings, as underslating and as roof sarking. Traditional roofing felts and some shingles are also made from bitumen-impregnated papers. New uses for paper in building will continue to be developed, either as products in their own right or more particularly in combination with other materials, such innovations frequently being stimulated by the increasing need to recycle and reuse short-life consumer products made from paper. Already many current building products made from or incorporating paper have as their source of raw material specially selected grades of recycled waste paper.

D. Jenkins and others: *The History of BPB Industries* (Chatham, 1973)

5. PACKAGING. Before the great expansion in production of paper that took place during the Industrial Revolution in the 19th century, products that required protection by packaging were transported in relatively large, rigid structures, such as wooden barrels or chests. With the increase in population, migration to cities and new types of social organization, the need arose for more convenient forms of packaging. Paper proved to be a highly suitable material for wrapping goods, because it gave good protection from dust and dirt and had the important property of 'dead folding', that is folds could easily be formed that did not spring back but retained the folded

configuration. With the increase in general standards of living and the expansion of both trade and the range and variety of goods requiring packaging and protection, together with developments in paper technology, many new types of packaging structure were brought into being to meet specific needs. With supermarket trading now dominating the retail grocery market, and given the sophistication of product marketing and distribution in general, packaging has become a highly advanced technology.

Some of the key developments have been associated with progress in manufacturing heavier weights of paper, which are generally known as 'cardboard' but referred to in the paper trade simply as 'board' (a contraction of 'paperboard'). These may be manufactured either by laminating two or more layers of paper ('pasteboard') or by forming and combining several layers of paper in one continuous operation on large special board machines. These layers can have different compositions to suit the eventual use. Typical applications are in all kinds of rigid cartons, and the product is sometimes known as 'cartonboard'. The outer layer, called the liner, is often coated with a mineral such as china clay or chalk to enable the carton to carry a high-quality printed image in full colour. Cartonboards can be specially treated and combined with other materials, such as waxes or synthetic polymer films, for specialized packaging applications, such as containers for liquids, milk in particular. A specialized derivative of pasteboard is the formation of tubular structures by helically winding and laminating a narrow continuous strip of paper. These tubes can then be closed at their ends in various ways and can carry multicoloured printed labels made from coated paper.

A particularly important development in paper-based packaging was the introduction of the corrugated case, its rigidity and light weight obtained by affixing a corrugated sheet of paper (known as the fluting medium) between two flat sheets, the liner and the back. This corrugated cartonboard can be used to produce a wide range of multi-purpose rigid packaging structures. Very strong cases can be made by using multilayer corrugated boards.

Paper itself, however, continues to find many applications in packaging, an example of particular importance being the multi-wall paper sack for packaging a wide variety of granular and powder products such as fertilizers and chemicals generally. Smaller packages for many products are also based on paper, which may be of special kinds, such as glassine or greaseproof, or, commonly nowadays, as part of a multilayer structure involving various types of polymer film or metallic foil.

R. Opie: *The Package* (London, 1976)
R. Opie: *Packaging Source Book* (London, 1989)

VI. Conservation. The preservation of works on paper involves attempting to stabilize their condition by arresting active deterioration, achieved through chemical or physical intervention, including the modification of display and storage environments to reduce harmful factors. The emphasis across the field is on preservation, although remedial treatment amounting to restoration is often carried out by paper conservators specializing in prints, drawings and watercolours.

1. Causes of deterioration. 2. Preservation. 3. Treatment.

1. CAUSES OF DETERIORATION. The materials and processes used in the manufacture of the paper often bring about its deterioration. Innovations in the industry (*see* §I above), beginning in the 17th century with the 'Hollander' beater machine and the introduction of alum–rosin sizes to the pulp, followed by chlorine bleaches in the 18th century, led to much European and American paper that was inherently weaker than earlier types. Now the main cause of paper deterioration is the industry's dependence on mechanical wood pulp, in use since the mid-19th century. When chemically treated, wood pulp can make a paper almost as stable as rag paper, which is made from cotton or linen fibres. But in its crude, mechanically pulped form (as used for newsprint) wood pulp contains lignin, which, like the acid products of chlorine bleaches and alum (aluminium potassium sulphate), leads to the breakdown of the cellulose that gives paper its strength. The paper consequently becomes brittle, more vulnerable to mechanical damage and often discoloured. Other additives that can contribute to this deterioration include vegetable oils (traditionally used to make translucent tracing paper), some coloured dyes and metallic particles.

External factors can also contribute to the deterioration of even the best-quality papers: the environment, modifications made by the artist or collector, handling and use are the main considerations in this category. Paper responds naturally to changing levels of atmospheric moisture. If kept in too dry an environment (below about 40% relative humidity (RH)), the material becomes brittle; if too wet (above about 60% RH), it may weaken and become vulnerable to the growth of moulds and bacteria, which break down the cellulose and cause severe staining. The particular bacteria and fungi that cause the brown spots sometimes known as 'foxing' are pH dependent and may grow more readily on acid paper. Furthermore, the hygroscopic nature of paper means that it is dimensionally unstable. So-called cockling (the buckling of paper supports caused by changes in RH) results in unsightly distortion and may dislodge fragile pigment layers. Biological factors generally contribute most to attacks on paper when environmental conditions (especially humidity) are poorly controlled. In tropical countries insects and mould cause enormous damage to paper collections; even in temperate climates they are a problem. Temperature also affects paper, partly because fluctuating RH is related to temperature changes and partly because elevated temperatures increase chemical activity. This factor is particularly relevant to photographs, because photographic emulsions and supports

deteriorate most rapidly in conditions of high humidity and temperature.

Light, especially the high-energy short wavelengths such as ultraviolet, is damaging both to paper (particularly that containing mechanical wood pulp) and to certain dyes, pigments and media. Many inks and paints made with organic dyes fade permanently on prolonged exposure to light. Some watercolours are an obvious example, while Japanese woodblock *ukiyoe* prints of the 17th to 19th centuries, coloured with vegetable extracts, are as vulnerable to photo-degradation as some modern works of art executed in felt-tip pen, artists' drawing inks or coloured crayons, which may all contain fugitive organic dyes.

Further environmental factors affecting paper permanence include sulphur compounds, oil and grease, particulate dirt and fine dusts. Gaseous sulphur compounds in the atmosphere form sulphuric acid in paper. Other gases, for example ozone and peroxides, are also harmful to works of art on paper, but, in addition, sulphur leads to what is probably one of the most dramatic instances of deterioration: the oxidization or conversion of white lead in the image to black lead sulphide, a process that is at least reversible. White lead, the basic carbonate of lead, was the most commonly used white pigment until the development of titanium dioxide in the early 19th century. It was frequently employed for highlights or 'heightening' in Old Master drawings, though many of them have already been treated to change the blackened pigment to a stable white one.

Media, adhesives and mounting or display materials are also common causes of damage to paper. Historically, the ink known as iron-gall (in widespread use until the end of the 19th century) is a source of localized acid deterioration in paper. Copper compounds, known as verdigris and frequently found on Asian paintings, also decompose to produce acids that discolour and weaken a paper support. The tradition of adding alum to water-based media as a mordant or to paper as a size is a further source of acidity.

The synthetic polymer adhesives invented during the 20th century present difficult problems for paper conservators. The traditional adhesives for paper (starch paste, animal glue, gelatin, gum arabic and fish glues) generally remain removable with water, even after many years; but the newer adhesive products, particularly rubber solutions (e.g. Cow gum) and pressure-sensitive tapes (e.g. Sellotape, Scotch tape, masking tape), rapidly deteriorate to leave a permanent stain and are extremely difficult to remove from paper. These materials are usually added to the work of art by a framer or as an amateur repair, but sometimes they are part of the original. Paper conservators are aware in this case, as in others, that the artist may have deliberately selected materials subject to inbuilt degradation in order to achieve a specific effect. The use of mechanical wood-pulp board for mounting is most damaging. Its acid content is transferred to the support (i.e. the paper on which the work of art is executed), weakening it and causing

discoloration. A notable effect of an acid mount is 'mat burn' or 'mount burn', a pronounced brown line where the overmount bevel is in contact with the support. 'Light staining' is a similar discoloration of the mount backboard, and usually of the paper support too, caused by light passing through the work of art as through a photographic negative. Large 19th-century watercolours and prints are also often stained and torn because they have been mounted on a wooden backboard or stretcher.

The function of a work on paper can also clearly determine its rate of degradation to some extent. Mechanical damage such as tears, creases and abrasion is usually caused by handling, which may also deposit grease, acid and dirt. Some drawings on paper, for instance a CARTOON or a preparatory study for a print that has been traced with a STYLUS for transfer on to a copperplate, survive only in fragile states of preservation as a result.

While large amounts of paper (especially in 19th- and 20th-century library collections) are becoming unusable gradually because of acid deterioration, immediate and wholesale destruction of a collection is usually the result of fire or flood. Such events as the floods in Florence in 1966 or the fire in 1988 in the library of the Leningrad Academy of Sciences have led to the development of conservation procedures and techniques that can be employed on a large-scale in response to such disasters. For example, wet paper can sometimes be freeze-dried to eliminate mould growth and insect pests as well as excess moisture. Vandalism is another danger, one notorious example being the severe damage caused to the cartoon by Leonardo da Vinci (1452–1519) of the *Virgin and Child with St Anne and St John* (London, National Gallery) when a madman took a shotgun to it in 1987. Months of painstaking work were needed to repair it.

2. PRESERVATION. With modern air-conditioning technology, it is theoretically possible to maintain ideal environmental conditions for the preservation of paper. However, these conditions have to be reconciled with the needs of curators and the public. A compromise set of standards is now internationally accepted: museums and galleries aim to keep storage and display areas for paper at a constant 50% RH and 20°C, with light levels for display of 50 lux, ultraviolet light at less than 75 μw/lumen and air filtration to 95% of outside levels of pollutants (see CONSERVATION AND RESTORATION, §II). In practice, however, these levels are rarely consistently achieved and realistic alternatives are often chosen, such as the creation of micro-climate frames and conditioned showcases for vulnerable items.

Careful handling is also important. As far as possible, the paper should not be touched, and contact between individual items should be avoided. In the past, collectors pasted valuable drawings and prints into albums; in most museum collections today individual items are usually mounted and placed in solander boxes, or even permanently framed, to avoid

direct handling. Extremely fragile or rare works on paper are sometimes viewed and handled in facsimile. It is equally important that prints and drawings, manuscripts and other valuable paper artefacts should be mounted, displayed and stored only in contact with conservation-quality or acid-free materials. These materials should be as permanent, inert and pure as possible, for example polyester transparent film (Melinex or Mylar), and the mounting board should be free from mechanical woodpulp. Suitable types of mounting board are known as acid-free board, conservation board, museum board and wood-free board. A wide range of conservation-quality boxes, folders and albums is commercially available.

The paper conservation profession aims to make artists and the printing and publishing industry more aware of the self-destructive qualities of much modern paper. Alkaline papers are now available for the production of permanent printed material, and good quality artists' papers continue to be obtainable. Unless these are more widely used in preference to potentially acidic papers, the problem of paper preservation will continue to grow. The new electronic data-storage systems will present further problems, for they may have an even shorter life.

3. TREATMENT. When control of the immediate environment is not enough to preserve paper, and when aesthetic considerations call for intervention from the conservator, suitable treatments must be selected with the aim of stabilizing the condition of the item. Before any conservation processes are applied, tests are carried out where applicable (*see* TECHNICAL EXAMINATION, §VIII, 6). These help both in the choice of treatment and in investigating historical or technical aspects of the work. They range from examination of the physical properties of the support and image by microscopy and β radiography, to chemical tests such as measuring the pH of the paper or identifying its sizing method. Any additions or modifications made to the item should be discussed with the curator or owner and, as far as possible, should be reversible.

Often, the first stage is dry cleaning, or surface cleaning, which is intended to remove particulate dirt and superficial staining. Brushes, erasers and low-suction vacuum cleaners are among the tools used. Ingrained or grease-bound dirt and staining, such as foxing, that has penetrated the paper can usually only be reduced by the use of solvents, including water. Provided that only the stain—and not the paper and image—is affected by the solvents (which are carefully tested first), various methods are available to remove these blemishes, ranging from pH adjusted aqueous treatments to remove general discoloration, through organic solvents or enzyme solutions to break down adhesive residues, to the use of oxidizing and reducing agents to lessen the disfiguring effects of mould staining. Stain reduction is one of the most difficult procedures in paper conservation and is carried out only when essential. It requires controlled

conditions and such specialist equipment as the low-pressure vacuum-suction table and ultrasonic humidifier. It may also be necessary to remove acidic mounting boards, lining papers and old repairs with the aid of tools, controlled moistening with various solvents etc. These materials may be attached with discoloured or damaging adhesives, which must be removed by specialized cleaning methods. Backing removal can reveal hidden drawings or inscriptions.

Aqueous treatments intended to clean the paper often assist in deacidification, that is to say the neutralizing or removal of acidic substances soluble in water. This important process is intended to stabilize the paper by arresting acid breakdown of the cellulose. To ensure that this breakdown does not continue over time (because of atmospheric pollution, adjacent materials or the deterioration caused by lignin in mechanical wood pulp), it is preferable to add an alkaline reserve or buffer to the paper after deacidification. However, not all works on paper can be deacidified easily. Some papers, dyes and pigments are pH sensitive and change colour if they become alkaline; some images and papers are affected by water, or by the organic solvents that can be used as an alternative. The biggest difficulty in deacidification and also in strengthening brittle paper is the processing of those library and archive materials that, for reasons of economy and scale, must be treated in bulk. Various methods of mass preservation treatment are in use or being investigated, and some processes are intended to combine deacidification with consolidation of brittle paper.

When paper has been weakened, for example by acids or handling, physical reinforcement may also be needed. One of the simplest techniques available, often used on archival documents, is encapsulation, where the item is enclosed in an envelope of transparent polyester film. For further reinforcement, the tears and losses in a paper sheet can be supported and filled individually. Lining or the complete backing of the support sheet is sometimes carried out on fragile artefacts. A variety of repair materials and adhesives, both natural and synthetic, is used for lining or infilling; the main requirements are that these materials will not deteriorate, will look sympathetic and will remain reversible, and it is a case of choosing the most appropriate from a range of manual or mechanical techniques, of which leaf-casting, lamination and paper splitting are well established means of reinforcing damaged paper when many similar sheets have to be treated. Traditional Japanese scroll-mounting methods and materials are increasingly used for repairing and lining individual Western works on paper. Japanese brushes, paper and drying boards help to give a light, flexible lining, which preserves the quality of the original paper. When Western papers are used on Western works of art, a so-called facsimile repair is often carried out. In this case, the repair paper (perhaps antique) is chosen to match the original paper as closely as possible. The most commonly used adhesives in the lining and repair of works on paper are starch paste and methyl

cellulose, but many other polymers are also used. Various adhesives can be applied to consolidate or fix flaking and powdery media, but as most polymers change the refractive index of the media, few consolidation treatments in paper conservation are truly satisfactory (*see also* CONSOLIDANT).

In contrast to established practice in the restoration of oil paintings, very little retouching is carried out by paper conservators. This is partly because most retouching, or inpainting, on paper would violate the principle of reversibility, since it is rarely possible to place an isolating layer between the original and the new. Paper is a very absorbent material, so retouching media and pigments would be permanently fixed. However, when missing parts of a design can be identified, for example in the case of a print where other impressions exist, then it may be possible to reconstruct the losses on inserted repairs.

W. J. Barrow: *Manuscripts and Documents: Their Deterioration and Restoration* (Charlottesville, VA, 1955)

G. M. Cunha: *Conservation of Library Materials: A Manual and Bibliography on the Care, Repair and Restoration of Library Materials* (Metuchen, NJ, 1971)

Paper Conservator (1976–)

Paper Conservation News (1976–)

A. F. Clapp: *Curatorial Care of Works of Art on Paper* (Oberlin, OH, 1978)

G. Thomson: *The Museum Environment* (London, 1978, rev. 1986)

Book and Paper Group Annual (1982–)

O. P. Agrawal: *Conservation of Manuscripts and Paintings of South East Asia* (London, 1984)

M. H. Ellis: *The Care of Prints and Drawings* (Nashville, TN, 1987)

The Conservation of Library and Archive Materials and the Graphic Arts: Cambridge, 1980, Society of Archivists and Institute of Paper Conservation (London, 1987)

Modern Works, Modern Problems?: London, 1994, Institute of Paper Conservation (1994)

Paper, decorative. Paper decorated by marbling, block-printing, embossing, stencilling and other means. In the West these papers have been used for the end-papers and covers of books (see BOOKBINDING, §I), for lining drawers, cupboards and boxes, for wrapping presents and for stationery; and in the East for scrolls and sacred screens, and as a background for fine calligraphy.

Perhaps the most commonly known form of decoration is the marbling of paper. This entails the dropping of inks or colours on to the surface of a liquid bath, or tray, on which a sheet of paper is gently laid. The colours adhere to the paper (leaving the bath clear), which gives a marbled or veined effect. The ancient Japanese form of the art is known as *suminagashi* ('ink dropped on water'); inks mixed with a solution of pine resin were dropped on a bath of clear water and gently manipulated by drawing a lightly greased human hair through the spots of ink, or by fanning or blowing on them to disperse them, before transferring the design to a sheet of handmade paper. Sometimes only black ink was used and

the marbling done on the margins of quite small sheets of paper, on which poems were then written. The earliest known example of this is the *Sanjurokunin kashu* ('Collection of 36 poets'), an anthology dating from 1118 (Kyoto, Nishi Honganji). Marbling was also used as a background for other forms of decoration, such as gilding and blocking. Until 1582 it was the preserve of the Imperial Household and the nobility in Japan. It is still practised there by a few craftsmen.

Documentary evidence suggests that marbling was done by the Chinese in the 10th century (Wolfe, pp. 5–6), but there are no known examples. A different method seems to have originated in Iran in the 15th century, and soon reached Turkey, where it is called *ebru*. According to Athanasius Kircher (*Ars magna lucis et umbrae*; Rome, 1646) the Turks sprinkled the size with solutions of egg white, ox-gall and oil, and then sprinkled on the colours. Marbling was widely used in the Ottoman empire, in books, as a background for calligraphy and for official documents to deter forgery.

During the 16th century the art moved through Turkey into Europe. Persian and Turkish decorated papers appeared in German albums (e.g. album of Antoneim Duits, *c.* 1580; The Hague, Koninklijke Bibliotheek), and marbling was practised in Western Europe by *c.* 1630. There is evidence of the use of marbled end-papers in an English calf binding of 1655. The marblers were secretive about the craft, and the process remained arcane until the publication in 1853 of C. W. Woolnough's *Art of Marbling* (London). The craft was revitalized in 1880 by Joseph Halfer, a bookbinder of Budapest, who perfected the use of carragheen moss in place of the previously used gum tragacanth, linseed or fleaseed. Carragheen has been used almost exclusively in the West ever since. Sydney Cockerell (1906–87) was a famous practitioner in England. Traditional marbled papers with such names as Antique Dutch, French Shell, Stormont, Gloster, Peacock Curl and combed marbled are still made today. Another form of marbling is done by using oil colours thinned with turpentine, dropped on to a thin gelatinous size; the drops are then combed, or manipulated with a stylus or piece of card.

The use of printing as a means of decorating paper arose *c.* 1570 and was closely related to the book- and textile-printing industries centred on Augsburg. The blocks were made in wood and metal. Initially the designs were in black printers' ink on white paper, but they became more varied and colourful. The craft spread to other cities in Germany (e.g. Nuremberg and Leipzig) and reached its peak in the later part of the 18th century. It also flourished in France, particularly in Orléans, where the makers were known as *dominotiers*. In Italy the most important manufacturers were the Remondini family of Bassano (*fl* 1649–1861), followed by Rizzi of Varese. Hand block-printing was revived in England in the 1920s by the Curwen Press, which employed such artists as Enid Marx (1902–98) and Eric Ravilious (1903–42) to design their papers.

In the late 17th century and early 18th gilded and embossed papers were popular. Although made largely in Germany, they were known as 'Dutch gilt' papers (probably a corruption of 'deutsch'). Many of the papers simulated rich brocades, others had alphabets for children, images of saints, chinoiseries or decorative patterns with foliage, animals and birds. These papers were embossed by means of an engraved and heated copperplate, to which pressure were applied, and gilded using an alloy of copper, tin and zinc to simulate gold. They were also made by preparing blocks with size before pressing them on to the paper; when the size was nearly dry, gold powder was dusted on. If the gold were to be raised, the size was thickened with yellow ochre and red lead.

Paste papers were another German invention, first appearing in the early 17th century. Later they were made throughout Europe and then in the USA. A starch paste made of flour, rice flour or cornflour, to which watercolours (not oil) are added, is applied to the paper with a wide brush and can then be combed with a piece of stiff card, or splattered with a brush, or sponged on, or dabbed off. An 18th-century favourite was pulled paste, when two sheets of pasted paper were laid face to face and then pulled apart. Another method was to use a fine object, such as a thin stick, to draw through the paste, dividing it into sections or trellis, which were then decorated with tiny flowers or emblems. There is also a less well-known form of this art, sometimes used by American settlers to decorate their houses, whereby sugar is dissolved in vinegar, making a grainy paste that yielded a very durable wallpaper, similar in appearance to a Lincrusta.

In the 16th and 17th centuries Turkish silhouette papers were prized in Europe. The technique, which originated in Iran, involved cutting thin pieces of leather into patterns with a knife, soaking them in dye and sandwiching them, under pressure, between leaves of damp paper soaked in alum water; the resulting foliate and latticework patterns were quite faint. A variation was stencilling, which was often combined with marbling (e.g. the *album amicorum* of I. Pfinzing von Helenfeld of Nuremberg, 1618; London, British Library): a cut-out was pasted on to the sheet of paper before the marbling process and removed after, leaving a silhouetted image. In the 1930s airbrushed stencil papers were made in Germany. Batik papers were made in Germany at the same period by applying a pattern in melted wax, painting the exposed paper and then removing the wax with heat.

A wide range of decorative papers is still made by hand in Japan. In *orizomegami*, for example, rice-paper or other handmade, absorbent paper is folded and pleated into small squares or fans. The corners and edges are then dipped into bowls of vegetable dye, and the wet paper carefully unfolded to reveal the colour that it has picked up.

See also PAPER, §III, 4 and WALLPAPER.

M. Fichtenberg: *Papiers de fantaisie* (Paris, 1852)

J. Halfer: *Die Fortschritte der Marmorierkunst* (Stuttgart, 1891; Eng. trans., Buffalo, 1893/R London, 1990)

S. M. Cockerell: *Marbling Paper* (Hitchin, 1934)

R. B. Loring: *Decorated Book Papers, Being an Account of their Designs and Fashions* (Cambridge, MA, 1942)

A. Haemmerle: *Buntpapier: Herkommen, Geschichte, Techniken, Beziehungen zur Kunst* (Munich, 1971)

M. M. Foot: 'The Olga Hirsch Collection of Decorated Papers', *British Library Journal*, vii (1981), pp. 12–38

A. Chambers: *Guide to Making Decorated Papers* (London, 1986)

A. Chambers: *The Practical Guide to Marbling Paper* (London, 1986)

A. Herring: *The World of Chiyogami: Hand-printed Patterned Papers of Japan* (New York, 1987)

D. McKitterick and others: *A New Specimen Book of Curwen Pattern Papers* (Andoversford, 1987)

R. J. Wolfe: *Marbled Paper: Its History, Techniques and Patterns* (Philadelphia, 1990)

Papercut. Technique and form of cutting and pricking pictures and designs in paper by hand. The tools employed in papercutting were simply a pair of sharp scissors, razor-edged, quill-shaped knives or penknives with a hone and oil for sharpening, and good-quality paper. For pin-pricking, steel needles of different sizes were fixed to short wooden handles or mounted on a roulette wheel. The paper was worked from the back as well as the front for various effects. Handcut and pricked papers were largely outmoded by machine production in the mid-19th century.

In China papercutting has probably been practised since the invention of papermaking (*c.* AD 105). Waxed-paper stencils were made in Japan from *c.* AD 600. Cut and sewn doll-like figures of bark paper were made in the 16th century in Mexico by the Otami Indians as votive offerings to the gods.

Papercut work appeared in Europe in the 16th century. In England heraldic devices and simple, narrative pictures were cut in parchment, and in Germany, the Netherlands and Switzerland the exchange of cut-paper greeting cards was established by the 17th century. In the USA 'heart-in-hand' and *fraktur* (Gothic script) home-made, cut-paper valentines were a tradition among Dutch and German Pennsylvanians in the 18th century. Most papercut work (*scherenschnitte*) was done by amateurs and preserved as keepsakes in scrap-books, although by the 18th century pin-pricked and lace-cut papers were produced by professional papercutters for use in early valentines, New Year cards and similar items (e.g. papercut *Virgin and Child* by Joanna Koerten (1650–1715), 1703; London, Victoria and Albert Museum).

In the 18th century papercut work embraced a wide variety of styles and methods. In Europe and the USA the most popular form was the silhouette. Paper mosaics, scissor-cut from watercolour-stained papers, and reliefs or shadow pictures, built up from pieces cut from contemporary prints of flowers and plants, were made by such enthusiasts as Mary Delany (1700–88; examples in London, British Museum), Princess Elizabeth (1770–1840), daughter of George III, and Amelia Blackburn, who gave her name to cut-paper pictures assembled from

minute fragments of coloured paper (e.g. Amelia paper mosaic, 18th century; London, British Museum). The *mizrah*, a decorated plaque used by Ashkenazi Jews, is another variant of the papercut popular from the 18th century. In the American colonies, especially in Boston, young girls were taught to make so-called quillwork pictures, often fitted with candle arms to form wall sconces. These quillwork sconces were especially popular in the 1720s and 1730s. They comprised sections of rolled and gilded or coloured paper arranged in decorative and heraldic designs, in combination with wax fruit and figures, mica flowers, shells, prints, wire, glass and other materials, all arranged in a wooden shadow box-type frame (see fig.).

The practice of papercutting continued in China and Japan throughout the 19th century (e.g. Japanese stencil of chrysanthemums, Edo period, 1600–1868; New York, Metropolitan Museum of Art) and into the 20th. In China itinerant papercutters travelled from town to town to make 'wind-flowers' for festivals:

brightly coloured, delicately cut sheets in designs of animals, fish, lotus buds, pomegranates and dragons (e.g. Chinese cut-paper stencil, 20th century; London, British Museum). They were hung in windows or from balconies and were decorative ephemera meant to last for a week or two. In Japan paperfolding (origami) and papercutting are studied as an art.

See also COLLAGE.

R. W. Lee: *A History of Valentines* (London, 1953)

E. Gaines: 'Quillwork: American Paper Filigree', *Antiques*, lxxviii/6 (Dec 1960), pp. 562–5

J. Hejzlar: *Chinese Paper Cut-outs* (London, 1960)

T. R. Newman, J. H. Newman and L. S. Newman: *Paper as Art and Craft* (London, 1973)

A. Oliver: *Auguste Edouart's Silhouettes of Eminent Americans, 1839–1844* (Charlottesville, VA, 1977)

M. Kreisel: *Papercutting: An International Bibliography and Selected Guide to U.S. Collections* (Metuchen, NJ, 1984)

J. Shadur and others: *Traditional Jewish Papercuts: An Inner World of Art and Symbol* (Hanover, NH, 2002)

C. Hopf: *Papercutting* (Mechanicsburg, PA, 2007)

Quillwork shadow box, by Myra Bates Willcutt, paper, mica, silk, maple, pine and glass, 356×305×76 mm, from Cohasset, MA, *c.* 1817 (New York, Metropolitan Museum of Art, Purchase, Jan and Warren Adelson, Theodore J. Slavin, Fern Hurst and Mrs. George Kaufman Gifts, 2006 (2006.45)); image © The Metropolitan Museum of Art

Papier mâché. [Fr.: 'chewed paper'] Material consisting of pulped or pasted paper, resinous binders and other fibrous materials or plaster. It was invented in East Asia *c.* AD 200 and was in use throughout Europe by the 18th century. Its early use was predominantly for small household and ceremonial objects, and by the late 20th century it was not only employed for home crafts, theatrical props and toys but also for an increasing array of objects, including sculpture.

1. MATERIALS AND TECHNIQUES. Wares made from shredded, beaten and mashed paper mixed with copal varnishes (resins obtained from certain tropical trees) or vegetable gum have been produced in East Asia since *c.* AD 200. Resins provide a smooth hard surface, while in hot countries potash was frequently added to deter rodents and insects. Rags and other fibrous materials are often mixed with the paper pulp for strength. The paper waste and fibres are usually softened by boiling in water, then squeezed dry to obtain a workable mixture and the fillers and binders added. The material is then either air-dried or baked into flat sheets or cast in shaped moulds made from wood or hard clay.

In Europe during the 18th century plaster was mixed with various compositions of paper pulp to produce imitation plaster and stucco ornaments, which were cast in oiled box-wood moulds and lightly stove-dried (baked). The term 'papier mâché' probably evolved during the 18th century from French émigrés employed in the trade in England. Manufacturers' recipes were jealously guarded, but analyses prove that the pulp was frequently mixed with flour, chalk, sawdust, sand and plaster and bound with wax, resin, animal glues or gum arabic. In Paris papier mâché was often made from paper stripped from billboards. Carton-pierre was a similar product, imitating stone, derived from waste cardboard, and 'composition' is a material with a greater ratio of plaster to paper.

The basic technique of mashing, softening and mixing paper pulp with fillers and binders before heat drying was gradually improved for the sophisticated, japanned furniture and domestic objects made in the 18th and 19th centuries. In 1772 a japanner, Henry Clay (*d* 1812) of Birmingham, patented a heat-resistant, laminated paper panel, which could be worked like wood. Papier-mâché panels were die-pressed from *c.* 1780, and in 1847 Jennens & Bettridge (active 1816–64) of Birmingham introduced steam pressure for moulding laminated paper board. Die machines enabled manufacturers to stamp out sheets of buttons and trays in one operation.

John Baskerville (1706–75) invented *c.* 1740 a method of decorating papier mâché to resemble oriental lacquered wood. Thus japanning, as it was called (*see* LACQUER, §§I, 3, and II, 2), became the exclusive finish for papier mâché, executed mainly in black but also in vermilion, green and yellow. The imitation lacquer used was a compound of coal tar, amber resin, linseed oil, rosin and asphaltum thinned with turpentine. After the 1830s the lacquer finish of heat- and moisture-resistant papier mâché was stove-dried in special japanning ovens at around 106°C. Decorative techniques included painting in oils on the black ground and/or bronzing with metallic powders made from finely ground copper, zinc or an alloy of both called 'Dutch metal', which was a popular substitute for gold leaf. The metallic powders were mixed with clear enamel or varnish and applied with small cotton-waste swabs wrapped around brush handles. For the best pieces, ornamenters used gold leaf.

Mother-of-pearl decoration, popular in the mid-19th century, was not inlaid but applied. Thin laminae from a flat, oyster-like shell found mainly around Bombay and the Isthmus of Panama and, later, from Australian shells were used. The shell pieces were thinned by grinding, handcut into shape and attached to the prepared surface with adhesive varnish or copal. The article was then stove-dried, and repeated layers of black lacquer, stove-dried between coats, were built up to cover the pearl and level the surface. The superfluous lacquer was then removed with pumice-stone to reveal the pearl decoration. After *c.* 1840 japanners also used ground pearl. Transfer-printed decoration eventually replaced hand decoration after *c.* 1850.

P. Rush: *Papier Mâché* (Edinburgh, 1980)

J. Bawden: *The Art and Craft of Papier Mâché* (New York, 1990)

2. USES. Toughened and rendered waterproof with layers of lacquer, papier mâché was favoured in China from *c.* AD 200 for its low cost, durability and lightness. It was cut and shaped in a similar manner to wood and used for ceremonial armour, trays, boxes and small objects. The craft spread to other centres of paper production; in Japan from the 7th century AD the paper pulp was sometimes mixed with sawdust to make lacquered bowls, plates, ewers, low tables, actors' masks and small sculptures.

Beautiful papier-mâché wares were produced in India from about the 17th century, particularly in Kashmir. Items included caskets, bowls, fan holders, knife-cases and pencil-boxes for fine camel's-hair brushes (e.g. London, Victoria and Albert Museum). The surfaces are often thickly painted in egg tempera with myriad tiny flowers against light or dark grounds, a feature characteristic of Italian design that probably reached India in the mid-17th century. In the 18th and 19th centuries Persian craftsmen fashioned mirror-cases, platters, toys and boxes from papier mâché, painted with flowers or miniature scenes of Persian life (e.g. Persian mirror-back; London, Victoria and Albert Museum).

Papier mâché first appeared in Europe in Italy, where paper was milled from the 13th century. Papier-mâché techniques were probably assimilated by trade with China and Japan, although no early Italian examples are known. During the 17th and 18th centuries papier-mâché snuff-boxes made in France, often decorated with *vernis Martin* in green or red-gold, were widely emulated. Small, painted and black-lacquered snuff-boxes called *boîtes à portrait* were also produced in France. They were introduced

because Louis XIV disapproved of snuff-taking; hence courtiers carried their snuff in shallow boxes disguised as portrait-keepsakes. A prominent German maker of French-style, papier-mâché snuff- and tobacco-boxes was Georg Siegmund Stobwasser (1717–76), who established a workshop in Brunswick in 1763 (examples in Brunswick, Städtisches Museum).

Papier mâché was introduced into England by French craftsmen in the late 17th century and was used to make small mirror and picture frames, wall-brackets and sconces. In the 18th century and the early 19th Clay & Co. (active 1770–1860) was renowned for its superbly decorated papier-mâché trays, but the firm also produced panels for coaches, ships' cabins and screens. Its wares were usually japanned in red, green or black, then gilded with metallic pigments and painted (e.g. Gothic-style tray, c. 1810; London, Victoria and Albert Museum). Henry Clay presented Queen Charlotte (1744–1818) with a wood and papier-mâché sedan-chair (destr.), lighter in weight than an all-wood version.

A variety of papier mâché, known as 'fibrous slab', made from rags, hay, straw and pulped woodbark mixed with plaster, was also developed during the 18th century. It was cast in moulds and proved an effective substitute for plaster in pilasters, cornice mouldings and ceiling roses. Two London manufacturers that specialized in papier-mâché mouldings were George Jackson & Sons (from 1780) and Charles Frederick Bielefeld (fl 1840s–50s).

In the mid-19th century Birmingham and Wolverhampton, followed by London and Oxford, were the chief centres of papier-mâché production in England, and vast quantities of furniture and household items were produced. English Georgian and Victorian wares were renowned in Europe and the USA for their quality and lustrous finish. Papier-mâché furniture, introduced in the second quarter of the 19th century, was strengthened with wood or iron frames. The most popular form was the black lacquered and gilded or pearlized balloon-back chair with cabriole legs and often a cane or upholstered seat (e.g. London, Victoria and Albert Museum). A set of bedroom furniture of c. 1851 (Lotherton Hall, W. Yorks) is decorated with crushed pearl shell, coloured enamels and gold leaf. Papier-mâché furniture and other articles followed the prevailing styles, with an emphasis on curved forms. Domestic items included letter racks, inkstands, caddies, coasters, small boxes (e.g. English Louis XV-style games-box, 19th century; Windsor, Guildhall Exhibition) and the parlour-maid's tray, popular from c. 1840 to 1850 (e.g. London, Victoria and Albert Museum), which often has mother-of-pearl and gilt decoration. Among the artists who decorated papier-mâché wares were the portrait painter Samuel Raven (1775–1847) and the flower-painter George Neville (1810–87), both from Birmingham.

Papier-mâché wares in Russia, modelled on imported French and English examples, were first made c. 1830 at Fedoskino, near Moscow, and were painted with folk-art motifs on black lacquer with the insides generally lacquered cinnabar red. Small chests of drawers, cupboards, caskets, mirror frames, snuff-boxes and cigarette-cases were particularly popular. Later painted decoration included portraits and land-scape scenery. Between 1830 and 1890 papier-mâché products were made at the Lukutin family's factory in Fedoskino and were marked with a double eagle.

Dolls were moulded from papier mâché in the 19th century; in Britain the substance used was known as 'composition' and often included crushed eggshells, whereas in the USA the paper pulp was reinforced with linen rags. American papier mâché was first produced at several small factories established in Connecticut from c. 1850, notably the Litchfield Manufacturing Co., which specialized in papier-mâché clock faces. American products paralleled those made in England: table-top writing desks, spill-boxes, yarn holders, portfolios, spectacle- and daguerreotype-cases, as well as furniture, were all popular. In the late 19th century interest in papier mâché waned. In the late 20th century it was used mainly for toys, home crafts and theatrical props, although it was revived in the 1980s for a wide variety of objects, including sculpture.

Collection of Detached Enrichments … Executed in Composition Ornament and Improved Papier Mâché, G. Jackson & Sons cat. (London, 1836)

B. Hughes: *English Papier Mâché: Origin and Decline* (London, 1925)

J. Toller: *Papier Mâché in Great Britain and America* (London, 1962)

S. S. DeVoe: *English Papier Mâché of the Georgian and Victorian Periods* (London, 1971)

G. Walkling: 'Papier maché', *Connoisseur*, cciv/821 (July 1980), pp. 222–7

T. Carpentieri: 'Barocchi leccesi. Der Stein von Lecce: Barocchi leccesi oder die Lust am Leben', *Du*, xii (1987), pp. 18–71

W. Gabler: 'Surrogate. Material- und Technikimitation des 19. Jahrhunderts', *Werkbund-Archiv*, xvi (1987), pp. 114–26

C. Grafnitz: *Deutsche Papiermaché-Puppen: 1760–1860* (Duisburg, 1994)

D. Griffin: 'Eighteenth Century Papier-maché Ceiling Decoration in Ireland', *Irish Arts Review Yearbook*, xi (1995), pp. 108–11

C. Horbas: 'Von kunstvollen Werkstoffen und ihren Rezepturen: Teil III: Papiermaché', *Weltkunst*, lxvii/8 (1997), pp. 841–8

H. Dagnall: *The Taxation of Paper in Great Britain, 1643–1861: A History and Documentation* (London, 1998)

F. Fersini: *La scultura sacra cartacea nel Capo di Leuca, secc. XVII–XX* (Nardo, 2001)

V. Maksymowicz: 'High, Low, and in-between', *Sculpture*, xx/2 (March 2001), pp. 24–9

J. Bardt: *Kunst aus Papier: Zur Ikonographie eines plastischen Werkmaterials der zeitgenössischen Kunst* (Hildesheim, 2006)

Papyrus [Lat. *Papyrus cyperus*]. Plant of the sedge family. It was widespread in the uncultivated, swampy areas of the ancient Nile Valley and was exploited for many practical purposes including the making of baskets and boats. As a material for the use of scribes

and artists, it has a history going back to at least the 3rd millennium BC. This article focuses on the manufacture and history of papyrus as a material used in writing and painting.

Little direct evidence has survived from the dynastic period regarding methods of manufacture and the organization of the papyrus trade, and caution is necessary when applying to earlier periods the relatively copious evidence from Greco-Roman Egypt. Ancient Egyptian tomb reliefs, illustrating scenes of daily life, show only the gathering of bundles of papyrus stalks. Papyrus was probably manufactured at all periods by numerous small workshops, close to sources of supply. These workshops must always have been most abundant in the Delta and Faiyum, but papyrus may also have been made elsewhere. The cost of papyrus has been much discussed, some writers being more impressed by, for example, the vast amounts of new papyrus used by the bureaucracies of the New Kingdom and later, others by the frequent reuse of papyrus scraps and the employment of ostraca as substitutes. Until the Greco-Roman period there is very little direct evidence, apart from a few prices from the Ramesside period. In pharaonic times, as in the Greco-Roman period, papyrus was no doubt too expensive for the very poorest (who would hardly need it) but involved what would have seemed merely trivial expenditure to the wealthy.

In favourable conditions the triangular stems of the papyrus plant grow to a height of 3–4 m and can be 50 mm or more thick. To manufacture the writing material, the outer rind was removed and very thin strips prepared from the pith, with a width of anything from 10 to 30 mm. Their lengths were cut to correspond roughly to the dimensions of the sheets to be made; as they thus measured only a fraction of the full height of the plant, all but the best portions of the stalks could be discarded. Individual sheets of papyrus were made by arranging first one layer of parallel strips, laid down just touching one another or very slightly overlapping, and then a second, similar layer on top, with its strips running at right angles to those of the first layer. In freshly-cut papyrus strips, the three-armed cells that form the bulk of the pith readily interlock, so that no paste needed to be added. Some hammering or pressing seems to have been all that was required for the strips to cohere as they dried out to form a strong, supple sheet. The sheet's thickness varied according to that of the constituent strips, while the colour and flexibility depended on the quality of the papyrus stalks used. In pharaonic Egypt, a very thin and nearly white sheet was considered ideal, although already in antiquity it was noted that papyrus yellowed with age. The surface was well sized by the plant's juices, so the carbon ink of the pharaonic period, which was also the commonest ink of Greco-Roman Egypt, hardly penetrated the surface. The same was true of the various pigments used by artists, although some have subsequently had a destructive effect on the papyrus. Erasures could be made by wiping or washing away the ink, wet or dry; or, once dried, an eraser, such as a piece

of sandstone, could be used. The surface of papyrus sheets is also naturally smooth: the 'fibres', which, to modern eyes, are such a conspicuous feature of ancient papyrus (they are actually the fibro-vascular bundles running through the pith of the plant), do not seem to have greatly concerned the Egyptians, and they did not provide any marked obstacle to painting or writing. It is uncertain whether or not the manufacturer needed to smooth the surface mechanically; more likely burnishing was applied only to local irregularities, chiefly by the user. Papyrus was evidently never supplied to scribes and artists in sheet form. The manufacturer made up rolls by pasting together overlapping sheets; about 20 sheets was the standard size (*see* ROLL).

Papyrus paper was essentially an Egyptian product. The plant yields only modest stalks in less than ideal conditions, and reports of its production elsewhere in the ancient world are either dubious or of minor significance. Manufactured papyrus rolls formed an Egyptian export of growing importance through the course of the 1st millennium BC. Papyrus was clearly for the Egyptians the writing ground *par excellence* and basic to much scribal practice; its use in Egypt seems to date back as far as writing itself. The earliest surviving papyrus is a blank roll found in a 1st Dynasty tomb (*c.* 2925–*c.* 2775 BC) and the earliest substantial body of inscribed papyri consists of temple accounts of the 5th Dynasty (*c.* 2465–*c.* 2325 BC). From these it is clear that already in the Old Kingdom administrative business involved the regular consumption of considerable quantities of papyrus. In the mid-18th Dynasty (*c.* 1450 BC) the Egyptians began to produce large numbers of illustrated funerary texts on papyri. These painted funerary papyri, forming part of the tomb equipment, usually bore smaller versions of the scenes in contemporary tomb paintings.

Various minor changes in papyrus manufacture can be discerned throughout its history. For example, the shape of sheets changed many times, a clear preference in the Middle Kingdom for sheets broader than they were tall (e.g. 300 × 400 mm) being replaced by the various narrower formats of the New Kingdom and later. An apparent steady decline in the fineness and quality of papyrus from the Old Kingdom onwards may be deceptive, at most indicating that a wider range of qualities was in production or happens to have survived. It is tempting, however, to associate this with the spread of agricultural land and the reduction in the natural habitat of the plant, a process completed in the 19th century AD, when papyrus finally disappeared from the wild in Egyptian Nile Valley. The introduction into Egypt, shortly before the Ptolemaic period, of the stiff Greek style of pen, which was liable to puncture the writing surface, seems to have led to the deliberate adoption of a thicker style of papyrus. Exports to all parts of the Classical world, quite apart from the increase in the Egyptian population, must have meant that production in the Greco-Roman period was on a far greater scale than, for instance, in the Old Kingdom. In the Roman period, papyrus for

writing material was apparently specially cultivated, but it is not clear at how early a date this may have begun to be necessary.

Although several alternative, quite different, writing grounds were used in Egypt—usually for particular purposes—papyrus had no rival as a general writing material until parchment became widely used in the 4th century AD. Papyrus was only finally, but gradually, superseded by this and by true paper (made from linen) after the Arab conquest. The first evidence of the use of the codex form of book in Egypt is from the 2nd century AD. For perhaps two centuries the pages were predominantly of papyrus, even though the codex particularly exposed two of the weaknesses of papyrus: the fact that it is damaged by creasing, and the ease with which it frays at unprotected edges. The inconvenience of cutting codex leaves from the raw material of a pasted-up roll with its frequent joins seems to have led to a final, exceptional development in papyrus manufacture: the making of extremely broad sheets for this particular purpose.

L. Borchardt: 'Bemerkungen zu den ägyptischen Handschriften des Berliner Museums', *Zeitschrift für ägyptische Sprache et Altertumskunde*, xxvii (1889), pp. 118–22

F. Woenig: *Die Pflanzen in alten Aegypten* (Leipzig, 1897), pp. 74–129

A. Lucas: *Ancient Egyptian Materials and Industries* (London, 1926, rev. 4/1962)

V. Täckholm and M. Drar: *Flora of Egypt*, ii (Cairo, 1950)

J. Černý: *Paper and Books in Ancient Egypt* (London, 1952/R Chicago, 1977)

E. G. Turner: *Greek Papyri: An Introduction* (Oxford, 1968, rev. 2/1980)

N. Lewis: *Papyrus in Classical Antiquity* (Oxford, 1974)

W. Helck, E. Otto and W. Westerndorff, eds: *Lexikon der Ägyptologie* (Wiesbaden, 1975–)

M. Weber: *Beiträge zur Kenntnis des Schrift- und Buchwesens der alten Ägypter* (diss., Universität zu Köln, 1979)

H. Ragab: *Le Papyrus* (Cairo, 1980)

W. E. H. Cockle: 'Restoring and Conserving Papyri', *Bulletin of the Institute of Classical Studies of the University of London*, xxx (1983), pp. 147–65

C. H. Roberts and T. C. Skeat: *The Birth of the Codex* (London, 1983)

J. M. Robinson: 'The Kollemata', *The Facsimile Edition of the Nag Hammadi Codices* (Leiden, 1984), pp. 61–70

M. L. Bierbrier, ed.: *Papyrus: Structure and Usage* (London, 1986)

R. Parkinson and S. Quirke: *Papyrus* (London, 1995)

Y. Ibish, ed.: *The Conservation and Preservation of Islamic Manuscripts* (London, 1996)

F. Flieder and others: 'Papyrus: The Need for Analysis', *Restaurator*, xxii/2 (2001), pp. 84 –106

Parchment [Lat. *pergamena*, from the city of Pergamon]. Animal skin dried and treated to provide a flat sheet for writing, painting, bookbinding and other purposes (see fig.). The terms 'parchment' and 'vellum' have long been used indiscriminately, but strictly speaking 'vellum' should refer only to skins made from calves. 'Parchment' is often used of skins made from sheepskin, thus distinguishing it from vellum, but is better employed to define all skins treated in a certain way, together with the name of the animal from which it is taken: thus goatskin parchment, sheepskin parchment etc.

1. MANUFACTURE. Parchment can be made from the skins of different animals, but those of calves, sheep and goats are the most commonly used. Its appearance will be affected not only by the individual animal from which it is taken but also by the exact processes used in its manufacture. The finest skins, in terms of both weight and strength, are those made from foetal animals; these are known as uterine skins. The colour of the hair of the animal affects the colour of the parchment: the whitest skins, suitable for manuscript work, come from animals with white hair. Animals with black, brown or variegated hair tend to produce darker parchments, more suitable as a binding material, and the presence of blood in the skin will also affect its colour. Animals with low fat levels tend to make better parchments.

Parchment is prepared from pelt, that is, wet, unhaired and limed skins, simply by drying at ordinary temperatures under tension. This process reorganizes the fibre network in alignment with the grain and flesh surfaces of the pelt by stretching it and then fixes it in the stretched form as the pelt fluid dries to a hard gluelike consistency. The result is a sheet that is taut, highly stressed, relatively inelastic and has a stiff handle. The inclusion of oils, fats, aluminium salts and vegetable tannins in the pelt structure, the rate at which the pelt is allowed to dry and the working carried out on the surface of the sheet all affect the water-absorption properties, softness and surface quality of the skin, making it suitable for different uses.

The first stage of the processing consists of softening the epidermal layer of the skin prior to its removal. This is achieved either through the natural agents of decay ('sweating'), or through the introduction of bacterial agents ('bating'), or by soaking the skin in a lime liquor and keeping it agitated with a paddle or in a drum. In the Middle Ages this process might have lasted up to ten days, but modern processing, using sharpened liquors containing sodium sulphide, is much faster, though with a noticeable loss of quality in the finished parchment. After sweating, bating or liming, the pelt is thrown over a beam (a curved wooden board) and the hair removed with a knife. A fleshing machine may now be used to clean the flesh-side of the pelt, after which heavier skins may be split. The skin is then washed in water and tightly stretched on a wooden frame to dry. While drying, the grain surface is 'slicked' with a round-edged knife or scraper, which frees residual hairs and pigment from the hairside and removes weak tissue and fat from the flesh side, exposing the smooth boundary surface of the corium layer. By smoothing and stretching the skin, the process also helps to establish its optical and physical qualities. The thickness can also be reduced after drying by working the skin with sharp, semi-lunar knives. Further

Parchment cover of a chrysobull, Byzantine, early 14th century (Athens, Byzantine Museum); photo credit: Werner Forman/Art Resource, NY

smoothness can be obtained by working over the surface with a flat piece of pumice stone, which gives a fine nap to the surface of the skin. The conditions under which the skins are allowed to dry, together with the degree of tension used to stretch them while drying, will determine the opacity of the skins.

2. HISTORY AND USE. The strength and durability of parchment have resulted in its being used for many purposes, from drumskins (as early as *c.* 1900 BC in Egypt) to, in its transparent form, windows and even spectacle lenses. It is, however, best known for its use as a writing surface (*see* MANUSCRIPT, §§1 and 2(iii)) and later as a bookbinding material (*see* BOOKBINDING, §I). It derives its name from the city of Pergamon (Lat. *pergamena*: 'parchment') and was long thought to have been invented to provide a writing material for the library of Eumenes II Soter (*reg* 197–160 BC), when supplies of papyrus from Egypt were supposed to have been suspended by the Ptolemies, jealous of the growing library in Pergamon. Its earlier use elsewhere is now established, but Pergamene scholars are credited with taking the material to Rome, where it seems to have been regarded as an inferior material to papyrus, suitable for notebooks rather than rolls. However, the Dead Sea Scrolls (2nd century BC–1st century AD)

were written on parchment (Vermes, 1987), and the material is also associated with the early use of the book in codex form. In the Middle Ages it established itself as the ubiquitous writing material in Europe, replacing papyrus and tablets, and was used for books and documents of all sorts until gradually superseded by paper. The skins of different animals were treated in different ways according to date and location, and a vast range of entirely distinct parchments of varying quality was produced during the period of its use. Subsequently its use has been largely restricted to important documents where extra permanence is required, for special copies of both manuscript and printed books and for paintings, especially those containing fine detail.

Parchment was used as a binding material in the Middle Ages, most typically in the form of a limp wrapper attached to the sewing structure, either directly or by means of tackets, though it is also found as a covering material on books with stiff boards. Limp parchment bindings are commonly found on printed books from the 15th and 16th centuries, usually in the form of cheap retail bindings, though gold-tooled examples are also found. Parchment bindings over stiff boards became increasingly common in the second half of the 16th century,

surviving in common use in the Netherlands, Italy and Spain until the 19th century. Limp vellum bindings were also still found in Spain at that date, long after they had ceased to be in common use elsewhere in Europe. Similar vellum bindings were revived in England by both the Kelmscott and Doves presses. In the late 20th century, following the floods in Florence in 1966, the use of limp vellum bindings based on late medieval types became a significant feature of book conservation.

3. CONSERVATION. As surviving material shows, parchment is strong and durable if stored in suitably cool and slightly humid conditions (not above 20°C and at 50–60% RH; *see* MANUSCRIPT, §2(iv)). It is, however, extremely hygroscopic, expanding and contracting rapidly with changes of humidity, and it becomes brittle at low levels of humidity. It needs therefore to be kept at even temperature and humidity levels, and under restraint to control the tendency to cockle. The thick wooden boards of the typical medieval binding, held shut with clasps, were designed to control this tendency as well as to offer protection. In addition, medieval binders seldom used any adhesive on the spine of parchment-leaved books, relying solely on the sewing to hold them together and control their opening characteristics. It is the application of animal glues in the course of later repairs or rebinding that has caused many of the problems found today: the severe cockling of the leaves, the stiffness of the spine and the embrittlement of the vellum on the spine folds.

R. R. Johnson: *The Role of Parchment in Graeco-Roman Antiquity* (diss., Los Angeles, UCLA; microfilm, Ann Arbor, 1968)

R. Reed: *Ancient Skins, Parchments and Leathers* (London and New York, 1972)

G. Vermes: *The Dead Sea Scrolls* (London, 1977, rev. Sheffield, 3/1987)

C. Clarkson: *Limp Vellum Binding and its Potential as a Conservation Type Structure for the Rebinding of Early Printed Books* (Hitchin, 1982)

C. H. Roberts and T. C. Skeat: *The Birth of the Codex* (London, 1983/R 1987)

B. Vorst: 'Parchment Making—Ancient and Modern', *Fine Print*, xii (1986), pp. 209–11, 220

A. Cains: 'The Vellum', *The Book of Kells: MS 58, Trinity College Library Dublin*, ed. P. Fox (Lucerne, 1990)

Y. Ibish, ed.: *The Conservation and Preservation of Islamic Manuscripts* (London, 1995)

R. Cavasin: 'Parchment vs Vellum: What's the Difference?', *Newsletter: Canadian Bookbinders and Book Artists Guild*, xiv/2 (1996), pp. 11–13

V. Kireyeva: 'Examination of Parchment in Byzantine Manuscripts', *Restaurator*, xx/1 (1999), pp. 39–47

P. Werner: *Vellum Preparation: History and Technique* (New York, 1999)

N. L. Ralston: *Parchment/Vellum Conservation Survey and Bibliography* (Edinburgh, 2000)

D. J. Donahue, J. S. Olin and G. Harbottle: 'Determination of the Radiocarbon Age of Parchment of the Vinland Map', *Radiocarbon*, xliv/1 (2002), pp. 45–52

R. Larsen: *Microanalysis of Parchment* (London, 2002)

Parquetry. See MARQUETRY.

Passementerie. Fringes, tassels and trimmings applied to UPHOLSTERY, especially to window curtains and bed-hangings. Also used to decorate textiles for clothing and other purposes, passementerie covers seams and outlines edges and contours. It greatly enhances the finished appearance of furnishing textiles, and in the 17th and 18th centuries it often represented considerable extra expense.

The finest passementerie was produced in France by master trimming-makers (*passementiers*), who followed an apprenticeship of up to five years: the *Encyclopédie* by Denis Diderot (1713–84) shows *passementiers* at work on specially constructed looms. Simple trimmings were often made at home, for example the white linen knotted fringes popular in England in the late 17th century and early 18th.

Passementerie is made from silk, linen, wool, cotton and metal thread (gold and silver). The flat, narrow trims take various forms. Gimp is made from very stiff, wrapped or overspun silk cord, which holds its shape when bent into loops or points. Braid, which is softer and straight-edged, is usually made from wool, but sometimes from cotton or silk. Galloon, which was used to make strapwork patterns on curtains and pelmets, is a ribbon-like tape made from gold, silver or silk thread. Orrice is a metal-thread lace, made on a loom but sometimes finished off on a pillow. Fringes and tassels are often enriched with bows, 'flies' and bobbles.

Passementerie first became a feature of fine upholstery in the 17th century, when it was used to create sumptuous three-dimensional effects (e.g. the Melville bed, *c.* 1690; London, Victoria and Albert Museum). In the 18th century it was employed in a more restrained manner, simply to outline forms or to emphasize the architectural character of a design, particularly a bed. By the end of the century it was confined to deep bullion, trellis or tasselled fringes, which remained popular into the early decades of the 19th century. In the Victorian period passementerie again became highly ornate, and there was a further revival in the 1980s, stimulated by the interest in interior decoration of earlier periods.

D. Diderot and J. d'Alembert: *Encyclopédie*, ii (1764), pp. pls 3 and 5

R. Edwards: 'Upholstery', *A Dictionary of English Furniture*, iii (London, 1954), pp. 355–62

R. Heutte: *Le Livre de la passementerie* (Paris, 1972)

The Golden Age of English Furniture Upholstery, 1660–1840 (exh. cat. by K.-M. Walton; Leeds, Temple Newsam House, 1973)

J. Fowler and J. Cornforth: *English Decoration in the 18th Century* (London, 1974)

E. S. Cooke jr, ed.: *Upholstery in America and Europe from the Seventeenth Century to World War I* (New York, 1987), pp. 131–46

C. Donzel and S. Marchal: *L'art de la passementerie et sa contribution à l'histoire de la mode et de la decoration* ([Paris], 1992)

Pastel [It. *pastello*, from Lat. *pasta*: 'paste']. Chalky coloured powder (pigment), which is modelled into a stick or CRAYON for use as a drawing material. It can

be variegated into more than 1650 different hues and shades. The term is also applied to works of art produced in this medium.

1. Materials and techniques. 2. History and use.

1. MATERIALS AND TECHNIQUES. The techniques of pastel manufacture date back to the 15th and 16th centuries, as is known, for instance, from the description by Petrus Gregorius in his *Syntaxeon artis mirabilis* (Cologne, 1583): 'Painters fashion crayons in cylindrical form and roll them with a mixture of fish glue, gum arabic, fig juice or, what is better to my mind, whey.' One of the principal challenges posed by the very nature of pastel powder has always been that of fixing it (for the conservation of pastel drawings *see* CHALK, §2): the problem was addressed in the anonymous treatise on pastel painting published in Paris in 1788 (chap. VI):

> The means of fixing pastel: it is readily realized that if one could penetrate into a pastel painting some transparent substance of a concrete nature dissolved into a liqueur, the pastel would remain bound to the picture until the pastel had dried. No doubt this would be a great advantage, for the ease of painting with pastel & the freedom that it has to polish, finish, retouch a picture as much as is wanted, surely gives it advantages over fresco & tempera. But how to apply a liqueur over colours which come away as soon as they are touched.

Pastel is extremely fragile, and the balance between surface resistance and ease of application depends on the correct proportions of the three raw materials that go into its manufacture: pigments, fillers and a binding medium, usually gum arabic. The mineral fillers constitute the physical support, while the pigments produce the intense coloration of the substrate. Both these ingredients are introduced in a more or less finely pulverulent form. In the first phase of manufacture the three components are weighed out according to a basic formula; the pigments and fillers, together with the binding medium diluted with water, are then ground in a colour grinder (consisting of a hopper and two porcelain discs) to produce a finely ground paste. On removal from the grinder, this more or less viscous paste is collected in a sturdy cloth. The cloth is then folded up so as to form an envelope, with the paste inside, and then put through a wringer or press to extract the water. Following this operation, a 'moist cake' is obtained, which, after pounding, is introduced into a die to create a thin cylinder about 1 m long. This cylinder is then put on a wooden rack and cut to size. About 15 days are allowed for the pastel crayons to dry before they are packaged.

Although pastel was originally a technique of dry colouring, in the 19th century artists modified its use by adding water to it. After having sketched out a subject in pastel, Edgar Degas (1834–1917), for instance, sprayed boiling water over his sketch, thus restoring the coloured powder to its paste state so that it could be worked with a stiff brush. Even if the original pastel layer was not thick enough to make a paste, it created a coloured wash, which he then manipulated with a brush.

As a medium, pastel has considerable advantages: it allows an artist to work quickly, to transcribe an emotion or idea immediately; it is easily erased and reworked, permitting second thoughts and superimposition. Pastel is line and colour at the same time. It can be smudged and used in networks of well-blended lines or in a multicoloured series of individual dashes that create a dense and vivid texture. It can convey the velvetiness or matt texture of a soft and silky material, as well as a sense of luminosity. Some artists have used it for its qualities of softness and vaporousness (e.g. Joseph Vivien (1657–1734), Maurice-Quentin de La Tour (1704–88) and Jean-Etienne Liotard (1702–89)); others for its vigorous drawing potential and boldly hatched lines (e.g. Jean-Siméon Chardin (1699–1779) and Pablo Picasso (1881–1973)). Many draughtsmen have exploited the ambivalence of its possibilities: Jean-Baptiste Perronneau (1715–83) streaking with green shadows a well-blended area of modelling already worked over with the stump and Henri Michaux (1899–1980) superimposing multiple layers and scraping. The composition of pastel offers a sumptuous diversity of means. It is animated, varied and variegated. Strokes can be applied in straight lines, zigzags, stippled dots, curved, short dashes or long meandering lines; they can be hatched in fine parallel lines or thickly smudged, overlaid from top to bottom or side to side, or obliterated by blotting, scraping, scratching or crossing out.

2. HISTORY AND USE. The etymology of the word 'pastel' indicates an Italian origin. However, according to Leonardo da Vinci (1452–1519), the technique, which he called 'the manner of dry colouring', was revealed to him by a French artist, Jean Perréal (?1450/60–1530), who had come to Milan in 1499 with Louis XII. It was shortly thereafter in Mantua that Leonardo executed his famous portrait *Isabella d'Este* (Paris, Musée du Louvre), a preparatory study in black and red chalk, with highlights in pastel, which was used to emphasize the neckline of her gown in yellow and to shade off the mass of her hair in browns. The drawing was then pricked for transfer along the outlines in preparation for a painted portrait that was never realized. This rare work was probably the prototype for the countless bust-length drawn portraits that appeared in the following century, when pastel was used to enhance the images with a few deft coloured strokes.

In the 17th century likeness was the primary aim of all pastel portraits. The sumptuous costume, the pompous setting and haughty pose were the main elements of official commissions. The format of the picture gradually increased to full-length representations in which the figure leans on the pommel of a sword or a cane. Afterwards there was a revival of the bust-length format, with the subject now seated, resting his or her elbow on the edge of a table or on a

book. The trend was also towards more familiar, intimate and casual attitudes. The prototype of the solemn and majestic life-size, bust-length portrait so common in the 18th century was created by Joseph Vivien, who in 1698 was received (*reçu*) into the Académie Royale de Peinture et de Sculpture in Paris as a 'peintre en pastel' for his pastel portraits of the sculptor *François Girardon* and the architect *Robert de Cotte* (both Paris, Musée du Louvre). Vivien's pastels are characterized by well-blended and stumped strokes, which render perfectly the reflections on armour and iridescent fabrics. His is an art of surfaces rather than volume. For Vivien, the pastel was no longer simply a preparatory study (as it had been for Leonardo): it was a finished work in its own right, of dimensions as imposing as those of an oil painting, all the effects of which it copied. An enormous output of pastel portraits developed from his examples, in which the sitters are generally presented half-length, accompanied by attributes that identify them socially or professionally; looking out towards the spectator, they are as if transfixed in an attitude of pomp.

The pastel portrait grew in popularity throughout the 18th century, especially in France, although there were also splendid examples produced in Switzerland by Liotard and in Italy by Rosalba Carriera (1675–1757), who was truly innovative in according pastel a leading role in the creation of society portraits. Her work contributed many new elements: a superb mastery of technique and a slightly more amiable conception of the sitter, as can be seen in her *Portrait of Antoine Watteau* (1720; Treviso, Museo Civico Luigi Bailo). Also novel were the lighter range of colours (pink, blue and white) and the rendering of large pieces of diaphanous material. Yet the underlying structure of the drawing is precise, and the contours are skilfully shaded. Carriera always used pastels dry, with much stumping, which made retouching easy. Her interest in technical research was recorded in the journal she kept during her stay in Paris (1720–21). Carriera's influence is also evident in the evolution of female portraits, a much appreciated theme throughout the 18th century. Indeed, towards the middle of the century, the introduction of mythological and allegorical subjects became a pretext to present the sitter slightly undressed. Nearly all the pastellists of the mid-18th century made use of a more playful style, full of grace and seduction.

There was also a greater sense of spontaneity, as, for example, François Boucher (1703–70) or Jean-Baptiste Perronneau sketching portraits of smiling and mischievous children or adolescents from life. Perronneau was an exceptional colourist, who sought rare harmonies in most of his pastels (notably garnets and violets set off by yellow grounds). He was also one of the first before Chardin to use green strokes to suggest shadows, a completely new method in the mid-18th century. With Maurice-Quentin de La Tour, pastel attained the summit of its technical virtuosity in his many sumptuous and stately portraits. The texture is so diversified that it expresses

perfectly the nature of each of the various materials— silks, velvet, brocades, carpets, lace, woodwork etc— without detracting from the serene breadth of the composition.

In the second half of the 18th century Chardin introduced more realism, character and sincerity into his portraits, which suffer less affectation and fewer accessories. A certain picturesque and more intimate quality is evident for the first time, as can be seen from the casual studio attire in which he depicted himself in his *Self-portrait with Spectacles* (1771; Paris, Musée du Louvre). Chardin also made important technical innovations: one was the use of individual parallel strokes of pure colour to model the figures and to convey form, light and shade. He also introduced thicker textures by superimposing layers of pastel in the same manner in which he worked in oils; each successive layer was meant to refine the structure, tonality and texture of the forms. He made no attempt to blend his broad hatchings, but left the surface dabs of colour visible, knowing that the individual strokes would harmonize when viewed at a distance. This divisionist technique was revolutionary at that time, prefiguring the approach of the Impressionists by more than a century.

In the early decades of the 19th century pastel declined in popularity. Until then it had been used mostly—though not exclusively—for portraiture. Exceptions include preparatory figure studies for paintings (e.g. by Jacopo Bassano (*c.* 1510–92) and Federico Barocci (*c.* 1535–1612) in the late 16th century), conversation pieces and even landscapes (e.g. by Simon-Mathurin Lantara (1729–78)). With the decline of portraiture by the early 19th century, there was a shift in usage. It was employed for narrative scenes, such as the *Descent from the Cross* (1827; Lisbon, Palmela private collection) by Domingos Antonio de Sequeira (1768–1836). In the Romantic era pastel reappeared with vigour: the intensity of its colours and the dramatic facial emotions and gestures it was capable of conveying were vividly exploited. For Eugène Delacroix (1798–1863), pastel was well suited to preparatory studies for large paintings. Since it was versatile and quick, he used it for colour notations and to outline forms and contours and to block in intense passages of light. Pastel summarized movement, volume and luminosity at the same time. It was a favourite medium for his landscape studies, especially twilight and nocturnal scenes.

In the second half of the 19th century, pastel drawings reflected innovations in composition as well as technique. Most novel was the use of pastel for underdrawings in densely hatched strokes of pure colour, a bold approach that influenced several artists of the following generation, such as Vincent van Gogh (1853–90) and, later, Pablo Picasso. Degas, in his numerous pastels, emphasized cut-off compositions and close-up views, and pastel provided a most suitable medium for his dramatic low-angle lighting and modelling of faces from below (see colour pl. IX, fig. 2). Degas also sought a greater stridency of colours, punctuated by a few blacks. No less

important was his use of mixed techniques. He blended pastel, gouache, tempera and oil paints diluted with turpentine. Used dry or mixed with water, pastel permitted him to correct endlessly the details of his compositions. There were no longer any boundaries between the application of 'dry' coloured powders and 'wet' brushwork, between the craft of the draughtsman and that of the painter.

Pastel corresponded perfectly to the aims of the Impressionists, who sought to record the rapid notation of sensations, nature's vivid palette and the fluctuating effects of light. The transience of its substance matched the evanescence of fleeting perceptions. Manet employed pastel to create finished portraits, very often on canvas or board, with the support showing through in places. The backgrounds are rarely elaborated, usually just a simple plain colour, mainly pinkish-grey or beige. The specificity of the pastel medium created a double possibility: precise contours, defined by lines or hatchings, could be created, but these underdrawings might disappear under one or more layers of pastel, with the forms blended by stumping. Edouard Manet (1832–83) knew perfectly well how to harmonize this duality, while accentuating the contrast.

For Symbolist artists, pastel was no longer a means of rendering reality but of expressing dreams or the imagination. The themes and titles changed: Silence, Meditation, Solitude, Melancholy etc. Portraits remained important but were treated rather like slightly disquieting evocations or apparitions. Often a single colour predominated: it became almost the main subject. Odilon Redon (1840–1916) made pastel one of his favourite techniques. He started with portraits, in which the schematic presentation of the profile heralded the theme of *profils de lumière*. From *c.* 1900 Redon produced numerous pastels of bouquets of flowers and underwater fantasies. He used scintillating colours in which the decorative signification became predominant. In the midst of an avalanche of flowers or seashells, a figure or a face would be integrated or submerged.

While pastel portraits continued to be produced in the early years of the 20th century, at the same time colour was becoming increasingly liberated from all descriptive function. There followed an explosion of the imagination and a breaking down of all barriers in the use of the technique. František Kupka (1871–1957), one of the first to use colour as a vector leading directly to abstraction, juxtaposed bands of pastel colour according to a rhythmic and linear schema. In his pastels of the years 1901–4 Picasso attained great power with very intense colours in a series of large works representing figures occupying the whole of the picture space. In those of a few years later (1906–7) he worked towards the simplification of forms, the deformation of bodies and the abstraction and geometrization of faces. He used parallel hatched strokes of different coloured pastels to create triangular and asymmetrical zones of space, a process that prefigured the disintegration of volumes into Cubist facets during the years 1910–11. The alternation

between narrative, imaginary and totally abstract images, for example in the work of Paul Klee (1879–1940), which co-existed in parallel, continued throughout the 20th century. There has been an infinite growth in textural possibilities, but certain characteristics of pastel remain unchanged: the intensity of its colour and the mattness of the texture.

General

[P. R. de C.]: *Traité de la peinture au pastel* (Paris, 1788)

C. Bazin: *Petit traité ou méthode de peinture, pastel* (Paris, 1849)

A. Sensier, ed. and trans.: *Journal de Rosalba Carriera pendant son séjour à Paris en 1720 et 1721* (Paris, 1865)

K. Robert: *Le Pastel: Traité pratique et complet comprenant la figure et le portrait, le paysage et la nature morte* (Paris, 1884/*R* 1950)

J. Robert: *Nouvelle méthode à la portée de tous: Le Pastel* (Paris, 1908)

L. Roger-Miles: *Maîtres du XVIIIe siècle: Cent pastels* (Paris, 1908)

H. MacFali: *The French Pastellists of the XVIIIth Century* (London, 1909)

R. M. See: *English Pastels* (London, 1911)

W. Ostwald: *Monumentales und dekoratives Pastell* (Leipzig, 1912)

J. Meder: *Die Handzeichnung: Ihre Technik und Entwicklung* (Vienna, 1919–23); Eng. trans. by W. Ames, 2 vols (New York, 1978)

L. Brieger: *Das Pastell: Seine Geschichte und seine Meister* (Berlin, 1921)

P. Ratouis de Limay: *Les Pastels du XVIIe et XVIIIe siècles au Musée du Louvre* (Paris, 1925)

J. Bouchot-Saupique: *Catalogue des pastels au Musée National du Louvre* (Paris, 1930)

J. Robert: *Le Pastel* (Paris, 1933)

R. Hahn: *Pastellmalerei: Eine Einführung in die Technik* (Ravensburg, 1940)

R. Breteau: *Pastels* (Paris, 1946)

P. Ratouis de Limay: *Le Pastel en France au XVIIIe siècle* (Paris, 1946)

G. Caster: *Le Commerce du pastel et de l'épicerie à Toulouse de 1450 env. à 1561* (Toulouse, 1962)

J. Watrous: *The Craft of Old-Master Drawings* (Madison, WI, 1967)

E. L. Sears: *Pastel Painting Step by Step* (New York, 1968)

V. L. Adair: *Eighteenth-century Pastel Portraits* (London, 1971)

G. Caster: *Catalogue des pastels, gouaches, miniatures au Musée des beaux-arts, Dijon* (Dijon, 1972)

G. Monnier: *Inventaire des collections publiques françaises, Musée du Louvre, Cabinet des Dessins: Pastels XVIIe et XVIIIe siècles* (Paris, 1972)

L. Norman, A. Mogelon and B. Thompson: *Pastel, Charcoal and Chalk Drawing: History, Classical and Contemporary Techniques* (London, 1973)

D. E. Greene: *Pastel* (New York and London, 1974)

F. Goupil: *Initiation au pastel* (Paris, 1976)

G. Monnier: *Petits guides des grands musées: Le Pastel* (Paris, 1979)

J. Clair: 'Eloge du pastel', *Considérations sur l'état des beaux-arts, critique de la modernité* (Paris, 1983)

G. Monnier: *Le Pastel* (Geneva, 1983)

G. Monnier: *Inventaire des collections publiques françaises, Musée du Louvre et Musée d'Orsay: Pastels du XIXe siècle* (Paris, 1986)

J. Martin: *The Encyclopedia of Pastel Techniques* (London, 1992, rev. Tunbridge Wells, 2/2002)

R. Loche: *Catalogue raisonné des peintures et pastels de l'école française XVIe, XVIIe et XVIIIe siècles* (Geneva, 1996)

X. Salmon and J. Babelon: *Les pastels* (Paris, 1997)

C. Stoullig and others: *Jean-Etienne Liotard 1702–1789 dans les collections des Musées d'art et d'histoire de Genève* (Paris, 2002)

X. Salmon: *Le voleur d'âmes: Maurice Quentin de La Tour* (Versailles, 2004)

R. M. Hoisington: *Maurice-Quentin de la Tour and the Triumph of Pastel Painting in Eighteenth-century France* (PhD thesis, New York, New York University, Institute of Fine Arts, 2006)

N. Jeffares: *Dictionary of Pastellistes before 1800* (London, 2006)

Exhibition catalogues

Rétrospective des pastellistes français (exh. cat., Paris, Galerie Georges Petit, 1885)

Works in Oil and Pastel by the Impressionists (exh. cat., New York, American Art Galleries and National Academy Design, 1886)

Société de pastellistes français (exh. cat., Paris, Galerie Georges Petit, 1888, 1889 and 1897)

Pastels français des XVIIe et XVIIIe siècles (exh. cat. by E. Dacier and P. Ratouis de Limay; Paris, Galerie Charpentier, 1927)

Pastels de La Tour (exh. cat., Paris, Orangerie des Tuileries, 1930)

Pastels français du XVIIe siècle à nos jours (exh. cat., Paris, Galerie A. J. Seligmann, 1933)

Pastels français des collections nationales et du Musée La Tour de Saint-Quentin (exh. cat., Paris, Orangerie des Tuileries, 1949)

Pastels et miniatures du XIXe siècle (exh. cat., Paris, Musée du Louvre, 1966)

Emailleurs et pastellistes du XVIIe au XIXe siècle (exh. cat., Paris, Musée du Louvre, 1978)

French Pastels (exh. cat., New York, Wildenstein's, 1979)

Pastels et miniatures du XIXe siècle: Acquisitions récentes du Cabinet des Dessins (exh. cat., Paris, Musée du Louvre, 1980–81)

Degas Pastels (exh. cat. by A. F. Maheux; Ottawa, National Gallery of Canada, 1988) [with essay on history of pastel painting before Degas]

Pasteprints [Ger. *Teigdrucke*; Fr. *empreintes en pâte*]. Rare category of small low relief images produced by covering a sheet of paper with one or more layers of material (referred to as the 'paste') and impressing it with a printing plate. Pasteprints were made mainly in southern Germany from the mid-15th century to the early 16th and usually depict saints, the Virgin and scenes of the life of Christ. Only *c.* 200 examples survive, many as unique impressions.

The simplest type of pasteprint has only a single layer of gum or resin varnish applied to a paper support and embossed with a metal plate. The design is picked out in black ink, applied during printing or later by hand. It may be decorated with hand-applied pigments, in details such as faces and drapery. More typically the pasteprint consists of alternating layers of varnish and tin leaf. The tin leaf above the varnish was often made to simulate gold by glazing with an organic pigment, then embossed and inked, sometimes with additional hand-colouring.

The original effect of the completed pasteprint would have been that of a glittering silvery or golden low-relief image with contrasting raised black lines and background and, sometimes, additional touches of colour. These qualities have led to pasteprints being considered as ingenious, mass-produced facsimiles

of luxurious goldsmiths' work, but also make use of the medieval workshop practice of decorating sculpture and other items with embossed, coloured foil. Since the varnish-tin-leaf complex was of sufficient depth and plasticity to take an impression of great fidelity with very little pressure, the resulting pasteprint must also have appeared as an inked imitation of the original metal plate.

Most of the surviving pasteprints, however, are generally in such a state of deterioration that the original sumptuous effect is diminished or lost and the images may be hard to decipher. The tin leaf has often oxidized to a drab grey, brown or, occasionally, white powder relieved by remnants of black ink. The whole matrix tends to have become brittle, so that there is widespread loss of the different layers, particularly the raised black lines, which would have received the least pressure in printing. For example in the late 15th century pasteprint of the *Crucifixion* (London, Guildhall Library) the black background is largely intact (the area to the left of the Magdalene's left hand and inside her halo in the detail reproduced), but the lightest areas where the underlying paper support is exposed were once raised black lines, which are now lost. The topography and tonal value of the print is thus reversed. Ironically, since the overall paste surface has darkened to brown, the losses are an aid to legibility.

No plates known to have produced pasteprints survive, so the nature of the plate and the printing process may be surmised only through careful examination of the objects themselves. Some pasteprints were printed directly from metalcut plates variably incised and punched or inked in relief in a manner analogous to woodblock-printing (*see* PRINTS, §III, 1). Others, perhaps the majority, were printed from casts of metalcut or dotted print plates (*see* PRINTS, §III, 2). The latter process would explain some 15 pasteprints that are exact mirror-images of known METALCUTS and DOTTED PRINTS. In cases of corresponding pairs of pasteprints and metalcuts where the image contains an inscription, it reads correctly in the pasteprint but is reversed in the metalcut, suggesting that the pasteprint was the intended end product of the process. For example in the *Crucifixion* described above, the Good Thief and Christ's wound are on the correct side, and the *INRI* above Christ's head reads the right way round, unlike the corresponding metalcut image (Munich, Staatliche Graphische Sammlung; Schreiber, 1928, no. 2344).

While some pasteprints are as small as postage stamps, they average 110 × 75 mm. At 175 mm high, the *Crucifixion* is one of the largest known. They are always finely detailed and densely textured with cross-hatching, stippling and striations, like the metalcuts and dotted prints with which they are associated.

Pasteprints are invariably anonymous, and there are no contemporary accounts of their manufacture. Some pairs of pasteprints and metalcuts have been assigned to the workshop of the Master of the Housemark ✠, located *c.* 1475 in Nuremberg, and a couple of others are associated with dotted prints by

the Master Ⓓ. Based on the dates and places of origin both of associated metalcuts and of manuscripts into which the pasteprints were inserted, it is known that they were produced between 1455 and 1525, primarily in southern Germany.

W. Molsdorf: *Beiträge zur Geschichte und Technik des ältesten Bilddrucks* (Strasbourg, 1921) [esp. chs 5, 7]

W. L. Schreiber: *Handbuch der Holz- und Metallschnitte des XV. Jahrhunderts*, vi (Leipzig, 1928), nos 2768–998

A. M. Hind: *An Introduction to a History of Woodcut with a Detailed Survey of Work Done in the Fifteenth Century*, i (London, 1935), pp. 197–206

E. Kistner: 'Studien an Teigdrucken aus dem Besitz des Germanischen Nationalmuseums in Nürnberg', *Festschrift Eugen Stollreither* (Erlangen, 1950), pp. 65–97

C. Wehmer: 'Gutenbergs Typographie und die Teigdrucke des Monogrammisten d', *Essays in Honor of Victor Scholderer*, ed. D. E. Rhodes and K. Pressler (Munich, 1970), pp. 442–9

C. Bowman: 'Pasteprints: A New Hypothesis about their Production', *Print Quarterly*, ii (1985), pp. 4–11

E. Coombs, E. Farrell and R. S. Field: *Pasteprints: A Technical and Art Historical Investigation* (Cambridge, MA, 1986)

S. Bertalan: 'Medieval Pasteprints in the National Gallery of Art', *Conservation Research*, Studies in the History of Art, xli/2 (Washington, DC, 1993)

R. S. Field, ed.: *A Census of Fifteenth-century Prints in Public Collections of the United States and Canada* (New Haven, 1995)

Pastiglia [*pasta di muschio*]. Italian term used to describe a form of decoration applied to furniture and, in particular, small caskets (see fig.). Pastiglia decoration was made from white powder formed when ground lead was exposed to vinegar vapour in a sealed jar (Pliny: *Natural History* IX.vi.6). It was then mixed with egg white to make a malleable paste; and lead matrices (moulds) were used to stamp out relief figures or decorative motifs, which were applied with rabbit-skin glue to the gilding. There are at least two examples (*c.* 1500, London, Victoria and Albert Museum; *c.* 1500, Venice, Fondazione Giorgio Cini, Istituto di Storia dell'Arte) where pastiglia was applied to a casket surface of coloured-glass fragments. The gilt surface of the casket was built up from a layer of *gesso sottile* (*see* GESSO), then Armenian bole, and finally gold leaf; it was punched with either palmette or lozenge-shaped patterns (imitating *opus reticulatum*), which possibly gave the pastiglia a better grip. The pastiglia was left in white or highlighted with gilding or paint. A matrix was made for each element of the composition: figures, buildings, trees, and the decorative motifs applied to the mouldings and lids. The matrices were reused and recognizable figures reappear on various caskets.

There is documentary evidence of pastiglia or *pasta di muschio* (the contemporary term) in the mid- and late 15th century in Ferrara, where Carlo di Monlione, a craftsman originally from Brittany, is recorded in the 1450s as a specialist of this type of decoration. Pastiglia decoration also appears to have flourished in the Veneto in the early 16th century: the inventory of Bianca Maria di Challant (1522) refers to 'five little caskets gilt in the Venetian style'; this is possibly a description of pastiglia boxes. Other factors that make this likely are that the Venetians controlled the monopoly of lead and had a taste for luxurious gilt furniture and objects, and that the wood used for the carcass of the caskets was mainly alder, commonly found in the Veneto. One surviving casket (*c.* 1535; London, Victoria and Albert Museum), which can be dated from the coat of arms on the lid, was made for Cardinal Bernhard von Cles of Trent.

There were several popular decorative themes used on pastiglia caskets: Greek myths from Ovid's *Metamorphoses* or early Roman legends from Livy such

Pastiglia decoration on boxes showing narrative scenes, Italian, 15th–16th century (Florence, Palazzo Davanzati); photo credit: Scala/Art Resource, NY

as the torture of Regulus or the story of Marcus Curtius. The casket designs may have been taken from engravings by Andrea Mantegna (1430/31–1506) (e.g. casket, *c.* 1500; London, Victoria and Albert Museum), his plagiarist Zoan Andrea (*fl c.* 1475–?1519), or Benedetto Montagna (*c.* 1480–1556/8). Illustrations to Classical texts such as Giovanni Rosso's edition of the *Metamorphoses* (1497) and the 1509 edition of Livy (Venice, Fondazione Giorgio Cini, Istituto di Storia dell'Arte) were also available. Biblical stories of a heroic nature, such as Judith and Holofernes, and David and Goliath (e.g. casket, *c.* 1500; London, Victoria and Albert Museum), were also used, as were the scenes from bronze medallions or plaquettes. Six pastiglia workshops have been identified (de Winter); of these, the workshops of the Moral and Love themes, possibly Ferrarese (Manni), were the most prolific.

The term 'pastiglia' has also been used to describe a technique employed in the Gothic painter's workshop in which *gesso sottile* was used as a form of surface decoration (*see* WALL PAINTING, §I), but late 20th-century research (de Winter and Manni) has shown that gesso and pastiglia are two different things in contemporary accounts. *Cassone* decoration, described in books from the late 19th century onwards as pastiglia, is in fact gilt gesso. Pastiglia would be too small and fragile for a large *cassone*.

W. L. Hildburgh: 'On Some Italian Renaissance Caskets', *Antiquaries Journal*, xxvi (1946), pp. 118–22

A. M. Marien-Dugardin: 'Un Coffret italien', *Bulletin des Musées royaux d'art et d'histoire*, n.s. 4, xxv (1953), pp. 37–41

P. M. de Winter: 'A Little-known Creation of Renaissance Decorative Arts: The White Lead Pastiglia Box', *Saggi e memorie di storia dell'arte*, xiv (1984), pp. 7–42

G. Manni: *Il mobile emiliano* (Modena, 1986)

Hamsík, Mojmír. 'The Relief Decoration of Medieval Painting—Pastiglia: Origin and Technique', *Umění: Časopis Kabinetu theorie a dejin umeni Československe akademie ved 40*, ii (1992), pp. 100–07

M. Koller: 'Zur Technologie der Pastiglia vom 13. bis 20. Jahrhundert', *Zum Thema Mirabilia und Curiosa: Porträtminiaturen, Elfenbein, Wachs, Pastiglia, Scagliola, Eglomise, Keramik, Steinätzung, Leder, Klosterarbeiten, Eisenschnitt. Restauratorenblätter*, xxi (Vienna, 2000), pp. 121–5

L. Martini and L. Fox, eds: *Cofanetti in pastiglia del Rinascimento italiano* (Brescia, 2005)

Patchwork. Method of producing a decorative effect by piecing together or applying small pieces of fabric. Applied patchwork is closely related to the more elaborate technique of shaped appliqué, and both techniques overlap with pieced patchwork, in which a new fabric is created by joining patches together edge-to-edge (see fig.). These different

Patchwork Buddhist altar cloth (*uchishiki*), silk damask, silk twill with supplementary silk and gilt paper patterning wefts, hemp plain weave, ink painting, 520×530 mm, from Japan, 19th century (Boston, MA, Museum of Fine Arts); photograph © 2008 Museum of Fine Arts, Boston

techniques are often combined, for example in a felt saddle-cloth from the Altay region of southern Siberia (5th–4th century BC; St Petersburg, Hermitage Museum), which is decorated with griffins worked in inlaid appliqué (intarsia) and applied patches. They were also used to create objects as diverse as the large hangings made at Rasht in Persia (now Iran) during the 18th century, European printed cotton coverlets of c. 1800 and the coats worn by the women of Galilee in the 19th century.

Inlaid appliqué was also used on its own in some late medieval Swedish hangings (Stockholm, Statens Historiska Museum), which are decorated with inset foliate roundels containing animals. These still depended on a woven ground, unlike the counter-charged panels made in Spain and Italy during the 16th and 17th centuries, in which shaped pieces were cut from two contrasting fabrics and one inset in the other to make two identically patterned but differently coloured objects. This technique really differs from pieced patchwork only in the size and complexity of the pattern pieces.

The pieced fabrics of Europe and North America, to which the term 'patchwork' is now largely confined, possibly originated in, for example, medieval banners and surcoats, which were made from fairly large, geometric pieces joined edge-to-edge. This bold technique seems to have been reduced to a domestic scale by c. 1700, when the first references to it occur; for example, in the novel *Gulliver's Travels* (1726) by Jonathan Swift, the Lilliputians make clothes for Gulliver that 'looked like the patch-work made by the ladies in England'. A patchwork cover of about this date (London, Victoria and Albert Museum) is made of rectangular patches of silk, some of which date from the late 17th century. Silk patchwork, pieced together without any attempt to create an overall design, continued to be made throughout the 18th century, but it was superseded by cotton fabrics and new designs.

The earliest surviving use of cotton for patchwork seems to be in the set of hangings (1720s; Vienna, Österreichisches Museum für Angewandte Kunst) made for Eugene, Prince of Savoy (1663–1736), and decorated with applied chinoiserie motifs cut from imported Indian chintz. Indian painted cottons are combined with European block-printed cottons in a set of hangings (London, Victoria and Albert Museum) of the third quarter of the 18th century, which are pieced in a shell pattern based on contemporary quilting. The growth of the European printed cotton industries seems to have created an explosion of patchwork in the late 18th century, when hangings and covers were made from new as well as old fabric. In 1789 Parson Woodford recorded the purchase of '1 yard of different kinds of cotton for patchwork for my Niece', and by 1800 the English manufacturers were printing centrepieces and borders specifically for patchwork covers. The large-scale birds and flowers that decorated furnishing cottons from the 1790s to 1810s were often cut out and applied to covers, sometimes alone and sometimes in combination with pieced patchwork.

By c. 1830 patchwork was less fashionable, and new fabric was used less often than scraps saved from dressmaking. Small-patterned cottons were skilfully cut so that tiny motifs were centred in the small hexagons, octagons, squares and diamonds of which most patchwork was composed; the patches were arranged by motif or colour value to create an overall design (see colour pl. IX, fig. 3). Although small-scale patchwork was highly regarded and continued to be made in Britain into the 20th century, other forms reappeared in the mid–19th century. Silk was again used and also wool; one group of pieced and inlaid covers with pictorial designs employed tailors' scraps from military uniforms. Among the new patterns were those with such three-dimensional effects as 'tumbling blocks' and, from the late 1870s, 'log-cabin', in which ribbons or strips of cloth were built up around a small, central square to form square or rectangular blocks, which were then sewn together. Crazy patchwork was very popular in the late 19th century and consisted of irregularly shaped, overlapping patches of silk and velvet, the edges of which were covered with embroidery.

Many of the fancy patchwork techniques of the late 19th century originated in North America, where patchwork had developed differently. The large, simpler patches of the 18th century and the appliqué techniques of c. 1800 both remained in use but were transformed into a variety of new patterns with such names as 'Dutchman's puzzle', 'Indian trail', 'pineapple' and 'hovering hawks'. Peculiar to the Amish communities was the use of plain, mostly dark fabrics and simple shapes to create beautiful, strong, abstract patterns. Patchwork was also taken up by some Native American communities: the Seminole of Florida transformed it into a new technique, piecing fabrics with the aid of a sewing machine and then cutting them into strips and rejoining them to form completely different patterns.

In the 20th century patchwork dwindled in popularity until the needlework revival of the 1970s, since which time it flourished worldwide. It continued to be made in a great variety of materials and styles for use in dress and furnishings and as an art form for gallery display.

A. Miall: *Patchwork Old and New* (London, 1937)

L. Baker Carlisle: *Pieced Work and Appliqué Quilts at the Shelburne Museum* (Shelburne, 1957)

A. Colby: *Patchwork* (London, 1958)

A. Colby: *Patchwork Quilts* (London, 1965)

J. Holstein: *The American Pieced Quilt: An American Design Tradition* (Boston, 1975)

Irish Patchwork, Kilkenny Design Workshop (Kilkenny, 1979)

V. Churchill Bath: *Needlework in America* (London, 1979)

Baltimore Album Quilts (exh. cat. by D. S. Katzenberg; Baltimore, MD, Baltimore Museum of Art, 1981)

S. Betterton: *Quilts and Coverlets* (Bath, 1982)

S. Betterton: *More Quilts and Coverlets* (Bath, c. 1983)

P. Clabburn: *Patchwork* (Princes Risborough, 1983)

M. Rolfe: Patchwork Quilts in Australia (Ringwood, 1987/*R* 1990)

J. Kimball: *Red and Green : An Appliqué Tradition* (Bothell, WA, 1990)

J. Bullen: *Patchwork: From Beginner to Expert* (London, 1992)

B. Brackman: *Encyclopedia of Pieced Quilt Patterns* (Paducah, KY, 1993)

M. Innes: *Rags to Rainbows: Traditional Quilting, Patchwork and Appliqué from Around the World* (Vancouver, 1993)

C. Hordé: *Artistes français du patchwork contemporain* (Paris, 1999)

D. Wood: *Patchwork Skills & Techniques* (London, 2000)

C. Napoleone: 'Aristocratic Patches', *F.M.R. Magazine*, cxv (April–May 2002), pp. 103–20

C. Eddy: *Quilted Planet: A Sourcebook of Quilts from Around the World* (New York, 2005)

Patina. Surface appearance of materials, in particular metals, that results naturally from many years of use or corrosion. Patina may also be imparted artificially by the application of various substances or by chemical treatment. The chemical mechanisms by which materials develop a patina and the appropriate conservation treatments are covered in the articles on specific materials (e.g. SILVER, COPPER); similarly, some of the more specialized patination techniques applied to metals are described in METAL, §V. Hence, only the aesthetic and historical aspects of the subject will be discussed here.

Some metals, notably copper alloys that have been buried for long periods, acquire a distinctive patina that is often admired in its own right. Also most materials, including wood, ivory and many stones, gradually develop a patina brought about by years of use, cleaning and polishing, together with the slow action of the air. Thus patina is partly a manifestation of the age of the piece, and as such it is valued for the aura of history that it endows. Although patina is a prized symbol of authenticity, it is not the original surface, nor does it represent the original appearance; therein lies a contradiction that has long vexed curators, collectors and restorers. How can something that is clearly so intrinsic to the object not be 'genuine'?

Wooden furniture may have been varnished or painted originally, but repeated wax polishing over the years, coupled with fine and sometimes not so fine scratches, will have worn through the original varnish causing some polish and dirt to become ingrained in the wood. This will give the smooth, rounded, rather dark and variegated surface characteristic of antique furniture. The patination on stone will primarily be the result of weathering, which can, for example, give a warm, honey-coloured patina to marble that originally may have been white. In the case of ancient Classical sculpture, the problem of its original appearance, and to what extent it would have been painted, has been much debated. This is even more true of bronze sculpture. Collectors came to associate ancient bronzes with the fine green patinas that developed over the centuries and therefore assumed that this was how they originally appeared. Ancient bronzes were collected in China from *c.* AD 1000, and in the Song (960–1279), Ming

(1368–1644) and Qing (1644–1911) periods bronzes dug from the ground were copied and given an artificial patina of ground-up malachite to satisfy the whims of collectors.

The bronzes of Classical antiquity, on the other hand, were probably left unpatinated (Hill). The few surviving contemporary wall paintings that depict bronze statues in landscapes or streetscenes show them as bronze-coloured, never green or black. Also, many of the surviving bronzes have details (e.g. lips or nipples) made of copper to show red against the gold of the bronze. This could only have been apparent if the metal was kept untarnished. There are some Classical references to treating bronzes with oil, and practical experiment as well as contemporary comments suggest this would probably impart a dark hue to the otherwise unpatinated metal. However, collectors from the Renaissance onwards believed that the ancient bronzes originally had a black patina, and sometimes the natural green patina on a genuine antiquity was repatinated to give the black patina the collector felt it should have had. Thus, for example, the bronzes (London, British Museum) that belonged to the 18th-century collector Richard Payne Knight (1751–1824) were repatinated to fit his perception of the past.

In the Renaissance, bronze sculptures were normally given a simple patina with coloured varnishes or oils, followed by careful polishing to create the desired finish. Chemical patination was rarely used, except to imitate genuine patinas on forgeries, until the 19th century. This was probably the great age of surface treatments with splendid polychrome effects produced by a variety of methods including oils and varnishes, electrochemical processes, smoking and a plethora of chemical treatments. The recipes used by craftsmen were often closely guarded secrets, but some were published by such teachers as Arthur Hiorns. At the end of the 19th century the arrival in Europe of Japanese metalwork with sophisticated patination prompted further innovation, and some exciting and elaborate treatments were applied to Art Nouveau metalwork around the turn of the century. In the 20th century the regular application of complex surface treatments ceased, along with many other craft techniques, although from the 1970s attempts were made, mainly in art schools and by artist-craftsmen, to continue some of the surface treatments.

A. H. Hiorns: *Metal-colouring and Bronzing* (London, 1892)

D. K. Hill: 'Bronzeworking', *The Muses at Work*, ed. C. Roebuck (Cambridge, MA, 1969), pp. 60–95

R. Hughes and M. Rowe: *The Colouring, Bronzing and Patination of Metals* (London, 1982/R 1991)

P. T. Craddock: 'The Art and Craft of Faking', *Fake?: The Art of Deception* (exh. cat., ed. M. Jones; London, British Museum, 1990), pp. 247–75

R. Kerr: *Later Chinese Bronzes* (London, 1990)

R. Hughes and M. Rowe: *The Colouring, Bronzing and Patination of Metals* (London, 1991)

S. La Niece: *Metal Plating and Patination: Cultural, Technical and Historical Developments* (Oxford, 1993)

Pen. Instrument made from a reed, quill or metal-tipped equivalent, generally used with INK for writing or drawing (*see* DRAWING, §III, 2(i)). In East Asia brush pens are used.

1. REED. The earliest pens were made from reeds, dried, cut short and shaped to a blunt point. These were used by the Egyptians and subsequently by the Romans. Isidore, Bishop of Seville, writing in the early 7th century AD, referred to the quill as a substitute, and by the Middle Ages the reed was employed only for very large scripts. It was, however, used by Erasmus in the mid-16th century in deference to its Classical associations. In the Islamic world the reed pen has always been the preferred writing instrument.

The reed pen is stiff and not as adaptable as the quill: it produces short, blunt, angular lines, often with uneven edges, and is suited only to vigorous, sketchy drawings. Its qualities were not appreciated by the earlier masters, with the exception of Rembrandt van Rijn (1606–69), and it was not until the late 19th century that it came into its own again. Vincent van Gogh (1853–90), Henri Matisse (1869–1954), Albert Marquet (1875–1947) and George Grosz (1893–1959) are artists who used it with success.

2. QUILL. Quill pens were known from at least the 6th century AD, but until the 12th century they were used for writing and manuscript illustration, not for drawing. Goose, swan and, later, turkey feathers were generally used for writing, but crow feathers were considered best for drawing. The feathers, large and stiff, were taken from the wing or tail of the bird. They were dipped in hot ashes to remove the outer membrane and make them hard and transparent. The angled heads were then cut and sharpened with a knife to form a tip, which was split to enable the ink, held in the central cavity, to flow more readily. Cennino Cennini (*c.* 1370–*c.* 1440), writing in the late 14th century, gave detailed and practical instructions for pen cutting (p. 8):

> If you need to learn how this goose quill should be cut, get a good, firm quill, and take it, upside down, straight across the two fingers of your left hand; and get a very nice sharp penknife, and make a horizontal cut one finger along the quill; and cut it by drawing the knife toward you, taking care that the cut runs even and through the middle of the quill. And then put the knife back on one of the edges of this quill, say on the left side, which faces you, and pare it, and taper it off toward the point. And cut the other side to the same curve, and bring it down to the same point. Then turn the pen around the other side up, and lay it over your left thumb nail; and carefully, bit by bit, pare and cut that little tip, and make the shape broad or fine, whichever you want, either for drawing or for writing.

In the 18th and 19th centuries quills were commercially prepared in quantity.

The advantage of the quill pen, apart from its availability and the fact that it can be cut to the preference of the user, lies in its peculiarly attractive action, gliding over the surface of the paper, even irregular handmade paper. The lines are lively, on account of their slightly uneven edges, and can be varied in width depending on the cut of the quill and the pressure applied by the artist. These qualities mean it is easily adapted to current drawing styles, and it is hardly surprising that the quill pen, often used in combination with other media, has been so popular as a drawing instrument. Its disadvantages, however, are that it wears down quickly and carries only a small supply of ink. Despite this, it is still used, especially by calligraphers.

3. METAL. The metal nib eventually replaced the quill due to the convenience of its tip remaining sharp. Experiments had been made with metal pens since the Roman period (one was found at Pompeii), and from the 16th century gold and silver pens were prestigious gifts. However, most metal nibs were hardly practical: the tip was uncomfortably stiff and made rusty by the ink. These problems were not surmounted until the 1820s, when steel nibs, which had been used since the late 18th century, were produced industrially. The first successful metal pen was patented in 1831 by Joseph Gillott (1799–1872) of Birmingham, who improved its flexibility by making three slits in the nib. By 1849 steel nibs, stamped out of sheet metal and bent, were an important manufacture in Birmingham. A vast number of different nibs became available, the gauge ranging from the fine crow quills to the blunt points. Dip pens, the nibs inserted in a holder, continue to be convenient because they can be used with any type of ink or even with paint. They do not clog unless the paper breaks up and sticks to the tip. The pens are made in a variety of sizes and styles, the finest being known as mapping pens.

The problem of the ink supply was solved by the introduction of fountain and reservoir pens. Fountain pens, which draw up ink by suction through the nib, had been known since the 17th century but became fully operative only after L. E. Waterman's improvements in the 1880s. The nib range is very limited compared to the dip pen, showing its purpose as a writing rather than drawing tool. Reservoir pens hold the ink above the nib in the penholder. Ink made for these pens is very smooth-flowing and waterproof, and the nibs can be changed quickly to produce a variety of lines. These pens, which are popular with graphic artists and illustrators, can be used for bold or stylized drawing and sketching. A further development was the biro (Amer. ballpoint), invented in Argentina in the 1930s by László József Biró (1900–85), a Hungarian; the ink is held in the pen and delivered by a revolving ball at the tip. Fibre-tip pens, in which felt or nylon fibre serves as a nib, were invented in Japan in the 1970s.

All pens can be used for preliminary drawings and for underdrawing, sketching and illustration. Once the pen is combined with a brush, drawings

can record tone and may even be used in finished paintings, along with watercolour and gouache. These are often described as pen and wash drawings or pen and mixed media.

C. Cennini: *Il libro dell'arte* (*c.* 1390); Eng. trans. and notes by D. V. Thompson jr as *The Craftsman's Handbook: 'Il libro dell'arte'* (New Haven, 1933/*R* New York, 1954)

A. P. Laurie: *The Painter's Methods and Materials* (Philadelphia, 1926/*R* New York, 1967)

J. Watrous: *The Craft of Old-Master Drawings* (Madison, 1957)

J. I. Whalley: *Writing Implements and Accessories* (Newton Abbot, 1975)

M. H. Ellis: 'The Fiber-tipped Pen as a Drawing Tool', *Drawing*, xvi/6 (March–April 1995), pp. 126–9

Pencil. Originally the name of a small brush (and still occasionally used as such, as in the description 'sable pencil'), the term was subsequently transferred to a wooden-cased graphite strip, presumably because of its analogous function. The latter was described as a 'dry pencil' in an early account (1683) by Sir John Pettus, Deputy Governor of the Royal Mines, England. The term 'pencil' derives from the use of a feather quill to mount the hair of the original brush and therefore has the same origin as pen. 'Pencil' is now most commonly understood to mean a writing or drawing instrument containing a graphite 'lead', but usage of the term has evolved to include identically presented items containing a colour strip in place of the traditional GRAPHITE.

The dry pencil was first manufactured in England, probably around Borrowdale, Cumberland (now in Cumbria), where graphite was found for the first time in 1504, and, for a while, it was known as a *crayon d'Angleterre*. The first distinct allusion to the pencil occurs in a treatise on fossils of 1565 by Konrad Gesner (1516–65) of Zurich. He described an article for writing, formed of wood and a piece of 'lead' or, as he believed, an artificial composition called *Stimmi Anglicanum* (or English antimony). By the end of the 17th century pencils were also being made in Germany, as is confirmed by a reference (1662) to the carpenter Friedrich Staedtler as a 'pencil-maker'. These consisted of a sawn strip of graphite, protected and supported by a slim wooden case, a recognizable form that continues in use with only minor modifications.

In 1760 the Faber pencil factory was established in Nuremberg. Their pencils were made from pulverized graphite cemented into solid blocks by means of gums, resins, glues, sulphur and other such substances. They were not initially very successful. The most significant development was the replacement of the pure graphite strip with a manufactured lead made of milled graphite and china clay, extruded, fired in a kiln and then dipped in wax to facilitate a smooth lay down when applied. This resulted from the Napoleonic Wars, when the interruption of supplies of graphite to France encouraged Nicolas-Jacques Conté (1755–1805) to develop an alternative way of using it, for which a patent was granted in 1795 (*see* CRAYON). It consequently became possible

to offer pencils in various degrees, dependent on the relative proportions of graphite or clay. These are classified with the letters 'H' or 'B', said to mean 'Hard' and 'Black' respectively, and with a number indicating the comparative strength of the property exhibited. The 'H' degrees (those with the least amount of graphite) are favoured by professional draughtsmen and the softer 'B' degrees by artists.

The more widespread adoption of the graphite pencil for drawing largely follows on from these developments in the early 19th century, with Jean-Auguste-Dominique Ingres (1780–1867) being a notable exponent of the medium, but 'black lead' (as graphite was also known) is certainly in evidence in artists' work from much earlier in the 18th century and is referred to on occasion in the 17th century.

The clutch pencil or lead holder is a modern alternative to the traditional wooden implement. Its most up-to-date manifestation is the technical pencil, which holds a fine, flexible lead delivering a line of precise dimensions. Some versions are automatic or semi-automatic, feeding out more lead as it is used.

The continuing development of coloured pencils offers yet more artistic potential. These are made with pigment in place of graphite, and the colour strip or 'lead' is not fired. Originally educational products, these have been upgraded and marketed for artists, illustrators and designers since at least the 1970s. David Hockney (*b* 1937) showed an early interest in the medium (e.g. his drawing *Pink, Red and Green Pencils in a Glass Jar*, 1968; J. Kirkman private collection, see Hockney, p. 184), and his experiment with pencil crayons may have been influential on their ensuring popularity. Oskar Kokoschka (1886–1980) also adopted coloured pencils for sketching and drawing. In fact, the diversity of what is meant by pencil has expanded considerably as manufacturers have employed the form of the wooden-cased pencil for a variety of media. There are now pastel pencils, charcoal pencils, sanguine and carbon black pencils, as well as watercolour pencils, both in colour and water-soluble versions of graphite (for which the term 'aquarelle pencil' is commonly used). Since none of these is identical in performance to the media they represent or imitate—and, in some cases, they are an entirely new material—all may be regarded as additional facets of the artistic use of pencils.

E. H. Voice: 'History of the Manufacture of Pencils', *Transactions of the Newcomen Society*, xxvii (1949–51), pp. 131–41

D. Hockney: *Hockney by Hockney* (London, 1985)

J. Stephenson: *Graphic Design Materials and Equipment* (London, 1987)

H. Petroski: *The Pencil* (London, 1990/*R* New York, 2003)

R. Mayer: *The Artist's Handbook of Materials and Techniques* (New York, 5/1991)

J. Martin: *The Encyclopedia of Coloured Pencil Techniques: A Unique A-Z Directory of Coloured Pencil Drawing Techniques with a Step-by-step Guide to their Use* (London, 1992)

B. Borgeson: *The Colored Pencil* (New York, 1993)

K. Christensen and R. Burningham: *Turning Pens and Pencils* (Lewes, 1999)

L. Dube: 'The Copying Pencil', *AIC News*, xxiv/3 (1999)

C. Massey: *Water Soluble Pencils* (Tunbridge Wells, 2001)

M. Wagner, D. Rübel and S. Hackenschmidt: *Lexikon des künstlerischen Materials: Werkstoffe der modernen Kunst von Abfall bis Zinn* (Munich, 2002)

Pentiment [*pentimento*; It.: 'repentance']. Visible evidence of an alteration to a painting or drawing that suggests a change of mind on the part of the artist (see colour pl. X, fig. 1). In particular, it refers to previous workings (*see also* UNDERDRAWING) revealed by the change in the refractive index of oil paint that occurs as it ages: thin layers of paint that were originally opaque may become semi-transparent (see colour pl. X, fig. 3). In the group portrait of the *Vendramin Family* (*c.* 1543–7; London, National Gallery) by Titian (*c.* ?1485/90–1576), for example, the figure of a young, bearded man on the far left was moved inwards. The head of the figure in the original position is now evident as a ghostly image on a patch of sky. The term is also used to refer to such effects where they do not necessarily imply a deviation from the original intention. In *Interior* (*c.* 1658; London, National Gallery) by Pieter de Hooch (1629–84), for example, the chequered floor is visible beneath a maid's dress, confirming that the figure was added after the floor was painted. This may have been necessary given the precise geometric pattern of the floor and the perspective involved. Pentimenti suggest that painters refined and altered compositions as they worked, and, for this reason, they are often cited as evidence of authenticity; similarly, they are less likely to appear in copies. The term is also used to describe the hesitant preliminary workings that show beneath some drawings.

Perspex [Amer. Plexiglass]. Patented name for a transparent colourless thermoplastic RESIN, employed as a substitute for glass, especially in framed works of art and for curved architectural elements such as barrel vaults (*see* PLASTIC).

Pewter. Alloy of tin with small amounts of other metals, usually lead, copper or antimony. Only in the English language has a special word been invented for it; elsewhere the word for tin is applied to pewter.

 1. Introduction. 2. Techniques and decoration.

1. INTRODUCTION. Tin is a relatively soft metal, but, with small amounts of other metals added, it becomes adequately durable for domestic use, although because of its low melting-point (170°–230°C) it will not withstand the heat of an ordinary domestic fire. This vulnerability restricts its use in household wares. Tin was mined in Cornwall, England, certainly from ancient Roman times and in the Middle Ages in Saxony and Bohemia. In 1650 England was the major source of tin. In the late 17th century tin was imported from East Asia, and less reliance was placed thereafter on European sources.

The metals added to pewter have varied at different periods and with the purpose of the object. Ancient Roman pewter tended to have a higher proportion of lead (up to 60%) than later wares, but from the 15th century the proportion of lead is seldom above 25% and most commonly below 10%. The other ingredient was copper, which was added from the 15th century to *c.* 1720. A copper content of above 10% is rare, and usually only about 3% of copper was used. Antimony was used in Europe from the 16th century, but it does not appear in British pewter until the late 17th century. Small amounts of bismuth were also added. The amount of lead in pewter tended to be related to the purpose and construction of the object. Flatware, which had to withstand knife cuts, needed to be as resistant as possible, but such complex vessels as measures contained more lead to make casting easier and to keep down the cost of commercial items.

The composition and standard of pewter in many countries was controlled by the guilds. The highest-quality pewter, used for flatware, contained 90–95% tin with small additions of lead and/or copper. In France, for example, pewter of the highest standard contained at least 90% tin, the Antwerp standard of 1603 required 97.5% tin and that from Zutphen in the Netherlands 95% tin. In Britain the standard was based on the amount of copper used, but in practice it was similar to those adopted by other European guilds. The second and lower standard of pewter permitted the use of 16% lead; a third standard, incorporating old pewter, was used for making small objects and toys. A separate standard was also established for the solder used in assembling objects cast in several parts.

An alloy that excluded lead but contained antimony, known as 'hard metal' or 'French pewter', was introduced in the 17th century by Huguenot pewterers. A similar lead-free alloy of tin with small amounts of antimony and copper was used after 1780 for the manufacture of Britannia metal, a cheap alternative to pewter. Modern pewter contains only tin and antimony. Unlike items in pewter, which were made by casting, objects in the harder Britannia metal were produced by spinning or by die-stamping. Similar alloys were made in the USA and Europe in the 19th century.

2. TECHNIQUES AND DECORATION. Most pewter is made by casting in a mould. Early moulds were made of soft stone, wood or clay, but only one or two items could be cast before a new mould was needed. Bronze moulds became dominant by the 15th century. Iron moulds were introduced in the early 18th century. Moulds were expensive and were often shared by members of a guild.

A plate is cast in a simple two-part mould, but more complex hollow-ware shapes, for example tankards and flagons, require several moulds. A tankard was cast using several moulds for the thumbpiece, hinge, handle and lid, while the body was cast in two sections. The mould was treated with an agent, for

example ochre or pumice, to facilitate the removal of the casting. When the casting had been made, the mould was opened and the part or section cast removed. It was found that by hammering flatware, for example plates and dishes, pewter attained added strength. These hammermarks can often be seen clearly on plates around the booge—the section between the bottom of the plate and the rim. Surplus metal was removed with shears, iron pincers or rasps. The rough surfaces were then planished and the separate parts soldered together. The finished product was finally turned on a lathe to create a burnished appearance.

Most pewter is plain, but many items have decorative features. Engraving is used to decorate the surface with attractive shapes, patterns, emblems or armorials. One form of engraving, known as wrigglework because of its uneven nature (e.g. flat-lidded tankard, *c.* 1670–80), was popular in England *c.* 1680–1720. Cast decoration, that is the addition of cast features to lids, thumbpieces and handles, is also common. A few items in pewter are also inlaid with brass (e.g. German guild flagons; London, Victoria and Albert Museum). Cutting and fretwork were also used.

In the 16th century decorative pewter objects, known as *Edelzinn*, were made in Europe with elaborate cast Mannerist designs. This type of decoration originated in France and Germany and also appears to a lesser extent on pewter from the Netherlands, Britain and Sweden. The technique was used in particular by François Briot (*c.* 1550–*c.* 1612) of Montbéliard and Caspar Enderlein (1560–1633) of Nuremberg and by many other pewterers in Augsburg and Nuremberg. Briot is best known for his Temperantia dish (*c.* 1585; Dresden, Museum für Kunsthandwerk), the design of which is similar to contemporary French goldsmiths' work. These elaborate objects were probably used as substitutes for more expensive silver items. In Britain fewer cast decorated items were made.

L. Laughlin: *Pewter in America: Its Makers and their Marks* (Barre, 1972)

J. Hatcher and T. Barker: *A History of British Pewter* (London, 1974)

P. Boucaud and C. Fregnac: *Les Étains* (Fribourg, 1978)

V. Brett: *Phaidon Guide to Pewter* (Oxford, 1981)

P. R. G. Hornsby: *Pewter of the Western World* (Exton, 1983)

Pewter: A Celebration of the Craft, 1200–1700 (exh. cat. by P. R. G. Hornsby, R. Weinstein and R. F. Homer; London, Museum of London, 1988)

D. Thormann: *Zunftzinn und Zunftsilber* (Nuremberg, 1991)

G. Reinheckel: 'Zinn', *Lexikon des Mittelalters*, ix (Munich, 1998), p. 620 ff

A. North and A. Spira: *Pewter at the Victoria and Albert Museum* (London, 1999)

C. Rickets: *Pewterers of London, 1600–1900* (London, 2001)

Photogenic drawing. Process invented by William Henry Fox Talbot (1800–77) in the mid- to late 1830s, in which a 'natural and artistic' object, such as a feather or leaf, was placed on paper sensitized with common salt and a silver nitrate solution and then exposed to sunlight. The resulting negative could then be contacted to another sheet of sensitized paper to obtain a positive print. Among the processes that developed from this invention were the calotype and the CLICHÉ-VERRE.

Photogenic etching. *See* CLICHÉ-VERRE.

Photography. Term used to describe the technique of producing an image by the action of light on a chemically prepared material. Although used privately as early as 1833, it was not until the public discussion of the first processes in 1839 that the term popularly attributed to Sir John Herschel (1792–1871) came to be used in its present general sense.

I. Processes and materials. II. Conservation.

I. Processes and materials.

1. Introduction. 2. Glossary.

1. INTRODUCTION. All photographic processes derive ultimately from the knowledge that certain substances can be physically changed by the action of light. It was known as early as the 16th century that salts of silver would darken when exposed to light, a phenomenon that was exploited by the pioneers of photography, and almost all the major photographic processes to the present day have been silver halide based. Photomechanical prints, however, are usually derived from processes based on the hardening action of light on bichromated gelatin. From the introduction of the calotype the basic photographic process has remained one of producing a negative in the camera and using this negative to make a positive print. In terms of the progress of photographic technique, the various processes and materials are in general related to the broad areas of concern outlined here.

(i) The first photographic processes. Apart from a direct positive process on paper devised by Hippolyte Bayard (1801–87), which enjoyed brief popularity in France, the two first fully practicable methods of producing photographic images were the daguerreotype and photogenic drawing. The discovery of the daguerreotype process (see §2 below), partly based on earlier experiments by Nicéphore Niépce (1765–1833), was announced in France on 7 January 1839. Daguerreotypes (named after the inventor Louis Daguerre (1787–1851)) were direct positive images on copper plates coated with a thin layer of silver. The announcement of the French discovery prompted the Englishman William Henry Fox Talbot (1800–77) to publish details of a process he had devised that involved the production of a negative from which an unlimited number of positive images could be produced, a technique that formed the basis of the major subsequent photographic processes. Initially both of the early processes required long exposures in the camera, but during 1840 a series of

improvements to the daguerreotype process reduced exposure times to the point where portrait photography became feasible (*see* §II below). In September of the same year Talbot discovered that a brief exposure in the camera produced a latent invisible negative image on paper that could be made visible by chemical treatment. This improved process, calotype (see §2 below), also reduced exposure times sufficiently to allow the photography of living subjects. These two pioneering photographic processes were favoured by the vast majority of photographers for the next decade. With some notable exceptions, the daguerreotype process was favoured by the professional photographic portraitist, while the calotype process, which produced images on paper, was largely practised by amateurs, especially in Britain.

(*ii*) *Negative materials*. A variant of the calotype process, the waxed paper negative process (see §2 below) was announced in 1851. It offered several advantages over Talbot's process, although exposure times were rather long. However, because it was convenient to use out of doors, it found favour for a time with many landscape and architectural photographers, particularly in England and France. Much more important was the announcement in the same year of the wet collodion process (see COLLODION NEGATIVE below). This involved the production of a negative on glass. It combined the relative advantages of the two pioneering processes, and, requiring a shorter exposure time than either, it soon displaced them from favour.

The great disadvantage of wet collodion photography was the need to coat and sensitize the glass plate with collodion, make the exposure and develop the latent image to produce a negative, all before the collodion had dried. This meant that the photographer was always encumbered with camera, dark tent, processing equipment, chemicals and water. For the next 20 years much energy was expended in the search for a dry pre-prepared plate with a sensitivity comparable to wet collodion. In 1871 Dr Richard Leach Maddox (1816–1902) published details of a method of preparing gelatin emulsion dry plates. The process was improved during the 1870s, and by the end of the decade gelatin dry plates (see §2 below), even more sensitive than wet collodion plates, were being mass-produced and widely marketed. A new age for photography had begun. With dry-plate photography the photographer was at last freed from the encumbrance of large quantities of equipment and much of the chemical manipulations that had hitherto been essential. Dry gelatin emulsions soon made possible hand-held cameras and roll film, heralding the snapshot era and true popular photography. From the 1880s onwards the bulk of photographic negative materials manufactured have been silver gelatin based.

(*iii*) *Positive prints*. The negative is essential for most photographic processes, but the finished product is a positive print, usually produced by a separate and distinct operation. The earliest photographic prints were produced by what are known as printing-out processes. By this technique sensitized paper was exposed to daylight beneath a negative and allowed to darken until an image appeared without further chemical treatment. In contrast, developing-out processes, produced by chemically treating briefly exposed sensitized paper, were well known to the pioneers but not widely favoured until the end of the 19th century. The natural tint of a photographic image is dependent on the number and size of the silver particles that make up the image. Printing out produces a comparatively low number of very small silver particles that appear red-brown to the human eye. The image formed by chemical development is made up of a greater number of larger silver particles that appear more neutral in colour and denser in tone.

Talbot's prints using paper treated with a common salt solution and sensitized with silver nitrate were always produced by printing out, although the calotype process used a development technique for making negatives. Similar or identical processes for producing prints were favoured by many photographers even after the introduction of wet collodion negatives, although salted paper prints (see §2 below) were generally abandoned in the 1860s. From 1850 to 1890 the vast majority of photographs were produced as albumen prints (see §2 below). Albumen printing, based on a paper made from salted egg white and sensitized with silver nitrate, was also a printing-out process. During the 1880s gelatin papers derived from the new gelatin dry plates began to be introduced. They were based on gelatin, in which were suspended silver salts, and were initially produced as both printing-out and development papers. They soon displaced albumen paper and remained the common means of producing photographic prints. During the 20th century the photographic industry produced a variety of papers that gave the photographer great latitude in the choice of textures, tones and surface finishes to enhance the image (see PRINTING PAPER below).

(*iv*) *Toning*. Chemical toning to intensify the tones of the image and also to reduce the risk of fading was a common practice in the 19th century. The most widely used agent was gold, and the majority of surviving daguerreotypes and albumen prints are gold toned. Sulphur was quite frequently used to tone salt prints and albumen prints in the 1840s and 1850s, before it was realized that these faded much more rapidly than untoned prints. Platinum was also used as early as the 1850s but was only in widespread use in combination with gold in the 1890s. In the 20th century toning was less universally practised, but the technique was not uncommon in specific circumstances. Sulphide, a variety of metal toners and mordant dyes have all been used by photographers.

(*v*) *Permanent prints*. One of the greatest problems of 19th-century photography was the fading of prints. Many experimenters made attempts to devise a

'permanent print', the most important perhaps being the process using carbon pigment, announced in 1864. Carbon prints (see §2 below) are extremely stable and were produced in large numbers in both the 19th and 20th centuries. Another solution was platinum printing, which derived from a process patented in 1873. Platinum prints (see §2 below) became popular until the rise in price of the metal during World War I caused it to be discontinued.

It was the problem of fading as much as the desire to reproduce photographs alongside text on a printed page that led to the invention of satisfactory photomechanical processes. Almost all photomechanical processes depend on the fact that bichromated gelatin is hardened by the action of light. The first person to make use of this was Talbot, and the foundations of the successful photogravure processes (see §2 below) were laid in his patent of 1852. Both photolithography and half-tone printing (see §2 below) also depend on the same action of light on bichromated gelatin.

(vi) Colour photography. From the earliest days of photography attempts were made to produce images showing natural colour. The most simple way was to colour by hand, and many early photographs were hand coloured using powders, watercolours or thinned oil paints. True colour photography depends on the principle that any colour is represented to the human eye by mixtures of the three primary colours blue, green and red light, and also that colours can be reproduced either by adding portions of the primary colours together (additive processes) or by subtracting them using filters of the complementary colours yellow, magenta and cyan (subtractive processes). The first true colour photograph was produced by the physicist James Clerk Maxwell (1831–79) in 1861, but it was not until 1907 that a satisfactory commercial colour process, Autochrome (see §2 below), became widely available. This process was based on starch grains dyed in the three primary colours randomly distributed across a tacky glass plate. Other such 'screen plate' processes were marketed and quite widely used up to the 1930s. A 'screen film' process working on similar principles, Dufaycolor, was marketed in England until the 1950s. Orthochromatic plates (sensitive to all colours except red and oversensitive to blue) were in use from the 1870s, and in the 1910s film sensitive to all colours (panchromatic film) was introduced.

From around the first decade of the century until the end of the 1930s most commercial colour photographers produced colour prints from three separate negatives taken through red, green and blue filters. For static subjects, it was possible to make three consecutive exposures, most conveniently by using a repeating back on the camera. For subjects requiring short exposures, specially constructed beam-splitting cameras were used to make the separation negatives. Prints from these negatives were made by a variety of methods. In all these processes the final print or transparency was built up by superimposition

from three separate negatives. Considerable care was required to ensure that they came together in accurate register. In most modern photographic processes the colour record is produced on a single film or printing base coated with three layers of emulsion sensitive to blue, green and red light respectively. The coloured image is produced by building up coloured dyes released during the development process. There are a number of variants of these 'integral tripack processes', but almost all work on the principles described above. This is even true of the instant picture systems marketed by both Polaroid (see §2 below) and Kodak, although here the film is multi-layered and the sequence of chemical events much more complicated. The first successful tripack processes were introduced in the mid-1930s but were not widely marketed until after World War II (see CIBACHROME, Ektachrome and Kodachrome below).

Since 1839 a bewildering variety of photographic processes have been devised, perhaps hundreds in the 19th century alone. An outline of the more widely used processes and materials follows.

2. GLOSSARY.

Albertype. See COLLOTYPE below.

Albumen print. The process for producing these was introduced by Louis-Désiré Blanquart-Evrard (1802–72) in 1851. It soon became the most widely used means of producing photographic prints in the 19th-century, until *c.* 1895. Paper was coated with salted albumen derived from egg white and sensitized with silver nitrate before use. The print was made by placing this sensitized paper in a printing frame beneath a negative and exposing it to daylight until an image appeared. When fixed, the image was a red-brown colour with yellow highlights. From the mid-1860s lightly tinted albumen paper became popular as a means of masking or disguising the yellow highlights, which many photographers found objectionable. Most albumen prints were gold toned to the rich purple-brown image colour often described as sepia and accepted by many observers as typical of the 19th-century photograph. Most of the vast numbers of *cartes-de-visite* and stereoscopic images (see below) that were so popular in the 19th century were produced as albumen prints, and the process was favoured at one time or another by almost all the distinguished photographers of the period .

Ambrotype. See COLLODION POSITIVE below.

Autochrome. The first commercially successful colour process. It was announced by the brothers Auguste Lumière (1862–1954) and Louis Lumière (1864–1948) in 1904, first marketed in 1907 and in use until *c.* 1935. Autochrome plates were prepared by scattering starch grains dyed in the three primary colours across a sticky glass plate. The screen plate was coated with a silver gelatin emulsion and sold to the public in this form. When the plates were exposed in the camera, the starch grains acted as a three-colour

screen. The exposed plates were then subjected to a reversal development process, which produced a positive image. The finished photograph was in the form of a dense but richly coloured glass transparency made up of microscopic colour filters. Because of the dense nature of the plates they were viewed in front of a strong light source. The Autochrome process was the most practicable and popular of the early colour processes, even though the plates were expensive and required comparatively long exposures. Several distinguished photographers experimented with the process, one of the most notable being Edward J. Steichen (1879–1973), but the majority of specimens that survive were made by enthusiastic and sometimes highly competent amateurs.

Blueprint. See CYANOTYPE below.

Bromide print. Term applied to the first type of gelatin silver bromide development paper, which was introduced *c*. 1880. By the turn of the century bromide prints were in widespread use and remained the standard means of producing monochrome prints. The term 'bromide print' was commonly used until the 1920s, but with the decline of rival processes, the description gradually fell into disuse. (See also GELATIN SILVER PAPER, Printing paper below.)

Bromoil print. Technique devised by E. J. Wall (*d* 1928) and C. Wellbourne Piper (1866–1919) in 1907 as a variant of the oil pigment process (see below). A standard gelatin silver bromide print (see above) was treated with a potassium bichromate solution, which bleached the image and selectively hardened the gelatin. After washing and fixing, greasy inks were applied by brush, the ink being absorbed by the softer areas of the gelatin in proportion to the amount of silver in the original bromide print. The inked prints were sometimes transferred to a second sheet of paper by means of a printing press.

Cabinet card. A fall in demand for the *carte-de-visite* (see below) in the 1860s and the lack of opportunity for retouching (see below) provided by the smallness of the *carte* image prompted F. R. Window's introduction in 1867 of the 'cabinet card' for portraits (cabinet portraits). About four times the size of the *carte* and of a size more suitable for display (hence 'cabinet'), the cabinet card allowed photographs of groups and women in large dresses to be taken, and remained popular until World War I (see fig. 1).

Calotype. Paper negative process discovered by William Henry Fox Talbot (1800–77) in September 1840 and patented by him in 1841. Good-quality writing paper was treated with a silver nitrate and potassium iodide solution. After drying, the paper could be stored indefinitely in the dark or used immediately. Prior to exposure in the camera the paper was usually sensitized using a freshly prepared solution of silver nitrate, gallic acid and acetic acid. After exposure a similar gallo-nitrate of silver solution was used to develop the image, which was fixed using a solution of potassium bromide or more commonly 'hypo' (hyposulphite of Soda or sodium thiosulphate). The final negative was usually waxed to make it translucent (see WAXED PAPER NEGATIVE below). The positive prints made from these negatives were printed on to salted paper as described by Talbot for his 'photogenic drawing' process. Nevertheless, the term calotype (or Talbotype) has also been more or less indiscriminately used to describe the salted paper positive prints (see SALTED PAPER PRINT below) produced from calotype negatives. The calotype process was the dominant negative-positive process practised between 1841 and 1851. It was popular with amateur landscape and architectural photographers, particularly in Britain and France. The inexact chemical knowledge of the time affected the stability of the calotype so that it had a tendency to fade, while the irregular paper grain produced a less finely detailed representation of visible reality.

Cameraless image. See PHOTOGRAM below.

Carbon print. A means of producing permanent pigment prints that was perfected by Sir Joseph Wilson Swan (1828–1914) in 1864 and based ultimately on the work of Alphonse Louis Poitevin (?1819–82). It is a process that depends on the hardening action of light on bichromated gelatin. Swan prepared his 'carbon tissue' by spreading a layer of gelatin impregnated with a coloured pigment (typically carbon black) on to a sheet of paper and sensitizing it with potassium bichromate. The tissue was then placed beneath a negative and exposed to light. The areas beneath the dense parts of the negative remained more or less unaffected, but areas unprotected from light were hardened. In theory the tissue could then be washed with warm water, which removed only the soft soluble gelatin thus 'developing' the image. In practice Swan found that the entire surface of the original tissue became hardened during exposure, although this was no more than a very thin coat in the areas least exposed to light. It was therefore found necessary to cement a fresh sheet of paper to the face of the exposed gelatin before the warm, water wash. The soaking action removed the original support tissue exposing the soft unchanged gelatin, which was also washed away leaving an image of hardened gelatin impregnated with pigment. This final print was laterally reversed but could be corrected by a further transfer process. Carbon prints show a very slight relief and rarely exhibit signs of ageing or image deterioration. During the last quarter of the 19th century they were widely used for book illustrations and the commercial reproduction of conventionally made photographs and prints. The process was actively exploited in England by the Autotype Company, who acquired Swan's patent rights in 1868.

Carte-de-visite. Art form that was first popularized by the Parisian photographer André Adolphe-Eugène-Disdéri

1. A few examples from the study collection of photographs and photographic material from the Getty Conservation Institute, Los Angeles, CA, 1869 to the present (Los Angeles, CA, Getty Conservation Institute); photo © The J. Paul Getty Trust, all rights reserved

(1819–89) in the later 1850s. Typically a *carte-de-visite* was a full-length portrait in the form of an albumen print pasted on to a mount the size of a visiting card. During the 1860s they became immensely popular, and a craze developed for collecting *cartes* of celebrities of the day as well as of family and friends. *Cartes* of fashionable personalities such as the British Royal family sold in thousands. The portraits were usually made using multiple-lens cameras taking several pictures simultaneously or with single lens cameras taking successive images on a single plate. Cheap viewers containing a single magnifying lens were popular for viewing *cartes*. The fashion also created a demand for albums, often elaborately decorated, which contained

pages of stiff cards cut with appropriate apertures to hold *cartes*. Many such Victorian albums survive in public and private collections. Although they remained popular until World War I, waning demand in the later 1860s prompted the introduction of the cabinet card (see above).

Chlorobromide paper. See PRINTING PAPER below.

Chronophotography. A technique devised by Etienne-Jules Marey (1830–1904) in the 1880s for producing a photographic record of a chronological sequence of movements at short regular intervals as multiple exposures (see below) on a single negative. The term

is also sometimes applied to a series of separate images exposed by multiple cameras, a technique first used by Eadweard Muybridge (1830–1904) from the 1870s. (See also HIGH-SPEED PHOTOGRAPHY below.)

Cibachrome. A colour print process introduced in 1963 and marketed in England by Ilford Ltd. It is an integral tripack process (see §1(vi) above), but instead of producing a coloured image by building up dyes, the final print is produced by bleaching out the dyes not required. This silver dye-bleach process results in a very stable colour print, which is particularly suitable for exhibition work.

Collodion negative. A method for producing negatives on glass devised by Frederick Scott Archer (1813–57) in 1851 and in use until *c.* 1885. Collodion was made by dissolving gun-cotton in alcoholic ether. It was treated with a solution of potassium iodide and coated on to a glass plate that was then sensitized with silver nitrate and exposed in the camera while still wet. Immediately following exposure, the plate was developed and fixed. It was possible to capture extremely fine detail on collodion negatives, and under good conditions exposure times could be as short as a few seconds. The great drawback of the process was that the plate had to be exposed while still wet. A series of chemical manipulations and a great quantity of paraphernalia were an essential adjunct to the taking of every photograph. Despite these problems the wet collodion (or wet-plate) process was the most widely used technique for making negatives for *c.* 25 years, and the process was practised by almost every mid-19th-century photographer of note. However, the problems of fading in the print, which used silver salts in an albumen emulsion, had not disappeared, and efforts to make positives using other light-sensitive chemicals occupied a number of practitioners.

Collodion positive. A technique that involved placing an underexposed, bleached glass collodion negative in front of a dark ground, which gave it the appearance of a positive image. In England these were known as collodion positives and in the USA as ambrotypes. They were produced almost exclusively by commercial portrait photographers and were typically sold in a cased form as cheap imitations of the daguerreotypes they partially superseded. Although they were widely popular for only *c.* 15 years after their introduction in 1852, they continued to be favoured by a small number of portrait photographers at the lower end of the market almost until the end of the 19th century.

Collotype. A photolithographic process that was based on a patent by Alphonse Louis Poitevin (?1819–82) in 1855 and developed by various experimenters in the 1860s; it was not fully practicable until the 1870s. The basic process consisted of bichromated gelatin on a printing plate exposed to light under a negative and then moistened with water. A greasy ink was applied and was taken up in proportion to the hardening produced by the light falling on the gelatin.

As the gelatin dried, it produced a characteristic wrinkling or reticulation on the surface of the plate. The inked image was then transferred from plate to paper using a printing press. Until *c.* 1900 collotypes and a number of variations of the process (Albertotype, Heliotype, papyrotype etc) were used quite widely, particularly to illustrate books. The process was occasionally used later as a method of good-quality printing (*see* COLLOTYPE).

Colour photography. See §1(vi) above.

Combination print. Prints made from two or more different negatives or prints. Combination prints can be produced by printing negatives placed together in the negative carrier of an enlarger. Alternatively, one negative image may be printed over another on the same sheet of paper. A specialized form of combination printing is the PHOTOMONTAGE, where parts of several prints are cut out and fixed to a support to make a composite image. Combination printing was first widely practised in the 1850s when it became commonplace to add clouds to photographic landscapes by printing in separate cloud negatives. The Victorian art photographers made extensive use of the technique. O. G. Rejlander (1813–75), Henry Peach Robinson (1830–1901) and William L. Price (1861–1916) were particularly notable exponents, using up to 30 negatives to produce compositions that never existed in reality. The technique became familiar to professional photographers and came to be widely applied in the advertising industry. (See also MULTIPLE EXPOSURE below.)

Cyanotype. A process invented by Sir John Herschel (1792–1871) in 1842 but not much used until the 1880s. It depended on the light-sensitivity of certain iron salts. Paper coated with a ferric salt and potassium ferricyanide was exposed to light producing an image in the insoluble pigment Prussian blue. The image was fixed simply by washing in water. From the 1880s until the second half of the 20th century the process was used irregularly by amateurs as a quick, cheap means of producing sample prints from negatives. Its principal use, however, was for copying plans and drawings, from which arose the popular name 'blueprint'. One notable early practitioner was Anna Atkins (1799–1871). (See also PHOTOCOPY.)

Daguerreotype. The first practicable photographic process to be announced to the public in 1839 by Louis Daguerre (1787–1851) and originally discovered by his compatriot and partner Joseph Nicéphore Niépce (1765–1833). A copper plate thinly coated with silver was carefully cleaned and polished and then sensitized with iodine vapour. After exposure in the camera, the image was developed with mercury vapour and fixed by washing in a common salt solution. The image was a direct positive; no negative was involved. The original process required exposure times of several minutes, but a series of small improvements in 1840 soon reduced this to seconds and thus made

possible portrait photography. Throughout its life the daguerreotype process remained largely the preserve of the professional portrait photographer. The cold, mirror-like appearance of the daguerreotype image was not entirely to contemporary taste, and many daguerreotypes were delicately hand coloured. The surface of a finished plate was easily marked, and it was therefore necessary to protect it with glass. The professional photographer's usual procedure was to fit the plates into cases of red morocco leather or a black ornately moulded thermoplastic material. Daguerreotype photography was widely practised in England from the early 1840s until *c.* 1855, when it began to be displaced by other processes based primarily on the calotype (see above). Particularly fine daguerreotypes were made in the USA, where the process remained popular for rather longer .

Diazo printing. See PHOTOCOPY below.

Dry plate. See GELATIN DRY PLATE below.

Dufaycolor. See §1(vi) above.

Ektachrome. An improved integral tripack colour process (see §1(vi) above) introduced by Eastman Kodak in 1946. In this process the colour couplers forming the different dyes are dispersed in the form of oily globules in the emulsion layers.

Electrostatic printing. See PHOTOCOPY below.

Enlarging. Until the introduction of fast gelatin halide developing papers towards the end of the 19th century, large photographs were commonly made by contact printing large negatives made in a large camera. With the widespread adoption of small format and miniature cameras in the 20th century, enlarging (producing the print by shining light through the negative held away from the paper in an enlarger) became one of the most important elements of modern photographic practice. As well as simply enlarging (or reducing) the size of camera negatives, the creative photographer is able to manipulate an image in an almost endless variety of different ways. The techniques of shading and spot printing by use of masks or even hands are widely practised. These are methods of enhancing or holding back the tones of parts of an image. Vignetting by masks or by optical methods is also common. Bizarre, elongated, compressed or otherwise distorted images can be produced by flexing the printing paper on the enlarger baseboard. Novel effects can also be produced by inserting ornamental glass or texture screens made up from muslin, tissue, gauze or similar in the light path of an enlarger. (See also PRINTING PAPER below.)

Ferrotype. Name given to a collodion positive (see above) on a black metal plate (tintype in the USA). The process was introduced in the 1850s and was practised until *c.* 1940. A ferrotype photograph could be taken and processed very quickly, especially after

the introduction of dry ferrotype plates in 1891. For this reason it was much favoured by cheap itinerant photographers, and the images produced are generally of poor quality.

Film. Thin sheet of flexible material covered with a light-sensitive emulsion and used to make photographic negatives. *See* EXPERIMENTAL FILM; Motion picture film.

Flash photography. A process of photographing otherwise dimly lit scenes by providing 'instantaneous' illumination. The freezing of movement using sudden illumination had been demonstrated by Sir Charles Wheatstone (1802–75) as early as 1834, and William Henry Fox Talbot (1800–77) took photographs using flash from a battery of Leyden jars in 1851. Magnesium wire was used as an illuminant in photography from the 1860s, and magnesium flash powder was in use from the 1880s until the flash bulb was introduced in 1925. (See also HIGH-SPEED PHOTOGRAPHY below).

Gaslight paper. Gelatin silver paper (see below) incorporating silver chloride rather than silver bromide. Because gaslight papers were rather slow, they offered certain advantages to amateurs working in less than ideal conditions. Contact prints could be made in artificial light, but the papers were not suitable for enlargements. The image colour was generally colder than that of contemporary bromide prints.

Gelatin dry plate. Details of the first gelatin dry plates were published by Dr Richard Leach Maddox (1816–1902) in 1871. The gelatin silver bromide emulsion he proposed was improved throughout the 1870s and soon became so superior and more convenient to use than other contemporary negative materials that they were almost completely abandoned within a few years. Gelatin silver bromide plates continued to be mass-produced until the mid-1970s. Similar gelatin silver emulsions are used on modern sheet and roll film.

Gelatin silver paper. The gelatin silver halide emulsion used to make gelatin dry plates (see above) soon proved equally suitable when applied to paper for making prints. Such papers were introduced in the 1880s and remained the primary means of making monochrome photographic prints. When introduced, the new papers immediately made contact printing by artificial light a practical proposition, even for amateurs. Within a few years the same was true of enlarging (see above), previously an inconvenient process involving cumbersome apparatus. (See also GASLIGHT PAPER above and PRINTING-OUT PAPER below.)

Glass positive and slide. The fine detail and range of tone that can be reproduced on glass have always attracted photographers. The earliest practicable glass process was introduced by Claude Abel Félix Niépce de Saint-Victor (1805–70) in 1847. His albumen-coated plates

were very insensitive, even by the standards of the time, but capable of reproducing extremely fine details. Similar plates were later used for making positive transparencies for stereoscopes (see below) and lantern slides (see fig. 2; see also MAGIC LANTERN), and there were many distinguished 19th-century photographers who produced fine work in these media. A popular form of portrait photograph during the 1850s and 1860s was the glass collodion positive or ambrotype (see above). This was a bleached wet collodion negative (see COLLODION NEGATIVE) mounted on a dark ground. Gelatin halide plates for lantern slides were widely available by the end of the 19th century. These were specifically formulated to reproduce the finest detail with absolute clarity. Modern slides are produced from plates with similar characteristics, for any fault in the photograph will be grossly emphasized when enlarged by projection. Transparencies for projection are usually made denser than equivalent prints as the powerful illuminant is capable of resolving a wider graduation of tones.

Gum bichromate. A printing process based on a patent by Alphonse Louis Poitevin (?1819–82) of 1855. Gum printing was developed by John Pouncy (*c.* 1820–1894) who took out a further patent in 1858

and later exhibited several specimens. Paper coated with gum arabic was sensitized with a bichromate solution containing vegetable carbon pigment. The paper was exposed to light under a negative and then washed with water. By removing the soft gum that had not been hardened by light the water acted as a developer. The remaining hand-pigmented gum remained to give a positive picture. The washing stage gave the operator considerable scope to manipulate the results, and there was a great choice of pigment colours. The finished picture often resembled an artist's charcoal drawing more than a photograph. The process was revived and improved in the 1890s. For a few years the process enjoyed a great deal of popularity, especially in Pictorial photography, perhaps the most notable exponent being Robert Demachy (1859–1936), and it was used until *c.* 1930.

Half-tone printing. A photomechanical means of reproducing photographs using very small dots of variable size to reproduce tone. The principle was first suggested by William Henry Fox Talbot (1800–77) in 1852 but was not developed commercially until the 1880s. The process involves rephotographing a photograph through a ruled screen, which gives a negative image made of dots of variable size. This negative

2. Edward S. Curtis: *In a Piegan Lodge*, 1910; from *The North American Indian* (1907–30), vol. 6, pl. 188, glass lantern slide (New York, Pierpont Morgan Library); photo credit: Pierpont Morgan Library/Art Resource, NY

is then used to produce a print on a metal plate coated with bichromated gelatin. The print is developed with water yielding a plate bearing an image made up of dots of gelatin. The plate is heated and etched before being used in a printing press. From the end of the 19th century onwards half-tone has been the principal means of reproducing photographs in printer's ink where long print runs are required and quality is not of paramount importance.

Heliogravure. See PHOTOGRAVURE below.

Heliotype. See COLLOTYPE above.

High-speed photography. Photography involving exposures of usually less than 1/1000 second. The techniques are highly specialized, generally using sophisticated shutter systems or very short duration flash. They are almost exclusively practised for scientific purposes, notably for weapons research, but the images have fascinated and influenced the artistic community. The first high-speed photographs were taken by William Henry Fox Talbot (1800–77) in 1851 using flash derived from a battery of Leyden jars. Between 1878 and 1885 Eadweard Muybridge (1830–1904) produced his celebrated studies of animal motion using electromagnetic shutters. His sequential photographs enabled artists to understand and accurately depict human and animal movement for the first time. Muybridge's contemporary, the French scientist Etienne-Jules Marey (1830–1904), designed a revolving shutter camera that produced superimposed multiple images on a single plate (see CHRONOPHOTOGRAPHY above), an effect much admired by modern artistic photographers. The most influential 20th-century high-speed photographs are the striking images produced by Harold E. Edgerton (1903–90) using electronic flash and stroboscopic techniques. In 1964 Edgerton was able to photograph a bullet travelling at 900 m per second as it pierced an apple, with an exposure of 1/3 of a microsecond.

Infra-red photography. Photography by means of invisible rays beyond the red end of the visible spectrum that makes it possible, using an orthodox camera with specially sensitized film, to record objects obscured by distance, fog or darkness. The possibility that photographs could be taken using 'invisible rays' was postulated by William Henry Fox Talbot (1800–77), and infra-red photographs were made in the 19th century. It was not until the 1930s that suitable film became generally available, and the technique was greatly developed during World War II as an aid to aerial reconnaissance. Infra-red photography later had many applications in science and industry. It has been widely used by galleries and art historians to examine brushwork and alterations hidden beneath dirt, varnish and paint (*see* TECHNICAL EXAMINATION, §II, 2). The normal tones and colours of scenes are transformed by infra-red film, giving effects that range from the mildly curious to the bizarre, qualities that have been exploited by several photographers for aesthetic effect.

Kodachrome. The first commercially successful integral tripack colour process (see §1(vi) above) introduced by Eastman Kodak in 1935. The process was developed by two musicians, Leopold Mannes (1899–1964) and Leopold Godowsky (1900–83), who began their photographic investigations as amateurs but later joined the staff of the Kodak Research Laboratory. Although the original Kodachromes compared favourably with the other colour materials of the period, they suffered from dye instability and were difficult to process. These problems were partially overcome in 1938 with the introduction of an improved film. In 1941 a Kodachrome paper for making prints from Kodachrome transparencies was introduced. The paper was coated with a three-layered emulsion, which paralleled the arrangement on the tripack film. Kodachrome always used a method of processing where the dye-forming colour couplers are carried in the developing solution. Such a system requires complex processing arrangements, and Kodachrome was not completely compatible with other modern colour systems.

Magnetic tape. Flexible tape used to record an electronic signal. See MAGNETIC TAPE; Video art.

Multiple exposure. Multiple exposure photographs are composed from several exposures made on a single plate or film frame. The most notable historical exponent was the French scientist Etienne-Jules Marey (1830–1904), who around 1883 published a chronological series of overlapping motion studies on a single plate (see CHRONOPHOTOGRAPHY above). Some modern photographers have adapted his methods to produce composite serial images. More commonly several similar or different exposures are made on the same negative, yielding an image that can appear surreal.

Oil pigment. A printing process based on the same principles as photolithography (see below). The essentials of the process were practised by John Pouncy (c. 1820–1894) in the 1860s, but it became only briefly popular following a publication by G. E. H. Rawlins in 1905, and it was in use only until c. 1914. Bichromated gelatin on paper was exposed under negative and then treated with oily ink applied with a roller or brush. The ink was taken up selectively and could be either pressed on to another sheet of paper while still wet (oil transfer) or left to dry on the original base. The appearance of the final print was dependent to a great extent on the manipulation of the roller or brush. Broad tonal effects were possible, and it was one of the methods much favoured in Pictorial photography.

Orthochromatic plates. See §1(vi) above.

Panchromatic film. See §1(vi) above.

Panoramic photography. Photographic panoramas have been made from the earliest days of photography. In the 1840s William Henry Fox Talbot (1800–77) and

Calvert Jones (*fl* 1840s) made panoramas from a succession of calotype views (see CALOTYPE above) by shifting the camera after each exposure so that one picture overlapped with the next. When trimmed and mounted, pictures with an angle of view much wider than the usual 40°–50° were produced. Similar methods, occasionally also employed by daguerreotypists (see DAGUERREOTYPE above) are still in use. No special equipment other than a tripod is required, but the technique is only generally suitable for static subjects such as landscapes or architecture. Special panoramic cameras designed to scan a wide arc on a single plate or film length in one operation were made from the earliest days of photography. The first was probably the daguerreotype plate camera designed in Paris in 1845 by Friedrich von Martens (1809–75). Other notable 19th-century cameras include Sutton's Panoramic camera of 1859, which employed a revolutionary wide-angle globe lens, and Johnson's Pantascopic camera of 1862, where the camera body was moved by a clock-work motor. Similar mechanisms were used in the popular Al Vista and Panoram Kodak roll-film cameras marketed *c.* 1900. Perhaps the best-known clockwork-driven panoramic camera was the Cirkut, patented in 1904 and still being sold in 1941. The widespread availability of interchangeable lens systems, which include wide-angle and fish-eye lenses, diminished the role of panoramic cameras, but the simple panoramic photograph was only ever sparingly employed for aesthetic ends. Panoramic montages using techniques similar to those employed by Talbot and his associates have, however, found much more favour.

Papyrotype. See COLLOTYPE above.

Photocopy. A term commonly applied to techniques used to copy plans and documents. Earliest forms employed photographic processes, including cyanotype (blueprint), diazo printing and photolithography as well as conventional silver photography. Most modern copying systems are based on electrostatic processes, where an image is formed by a change in the electrical properties of sensitive materials when exposed to light. The first practicable electrostatic system, xerography, was devised by the American Chester F. Carlson (1906–68) in 1938. Early photographic copying techniques were rarely employed by artists except to make crude reference copies of images. Electrostatic copiers underwent tremendous improvement in later years but tend to produce images with limited tonal range. However, they have been used, where a particular effect is required, to make photograms (see below), or to make copy images to incorporate into montages or collages.

Photogenic drawing. See SALTED PAPER PRINT below.

Photogram. A term once used to describe many forms of art photograph but now the accepted term for all photographic images made without a camera. Many of the earliest photographs made by pioneers such as William Henry Fox Talbot (1800–77), Sir John Herschel (1792–1871) and Anna Atkins (1799–1871) were made by placing objects such as leaves and lace on to sensitive paper and exposing them to sunlight. The resulting simple outline image would today be called a photogram. Similar techniques were practised intermittently throughout the 19th century. It was not until the 1920s that the process was widely exploited artistically by such photographers as Christian Schad (1894–1982; Schadographs), Man Ray (1890–1976; Rayographs) and László Moholy-Nagy (1895–1946). Modern photographers have combined photograms with a variety of other techniques to produce complex abstract images. (See also CYANOTYPE above.) The transference of a drawing on a transparent or translucent (negative) medium on to photographic paper is known as CLICHÉ-VERRE.

Photogravure. A photomechanical printing process based on patents taken out by William Henry Fox Talbot (1800–77) in the 1850s. The process was improved by Karel Klíč (1841–1926) in 1878 and only then developed commercially. In Klíč's process a copper plate was coated with a fine bitumen dust to provide grain and then heated to cause it to adhere. A carbon print (see above) was transferred on to the plate and developed in warm water to give a negative relief image. Etching solutions of ferric chloride were applied successively so that the plate was etched to different depths. The plate was then inked and the image transferred to paper in a press. There were many improvements to the process from the 1880s, but the essentials remained the same. Around 1900 photogravure was used to reproduce the work of some of the most distinguished photographers of the age. The process has always been favoured where high-quality reproductions at a reasonable cost are required. 'Heliogravure' is applied to a type of photogravure developed in France in the 1850s from the 'heliography' of Nicéphore Niépce (1765–1833), which used bitumen made light-sensitive as a resist in etching the plate, and it is also an alternative name for photogravure widely used in Europe.

Photolithography. A generic term for a wide range of processes in general use that depend on the principle that bichromated gelatin when exposed under a negative and then treated with water will take up greasy inks selectively. The first photolithographic processes were practised in the 1850s. (See also BROMOIL PRINT, CARBON PRINT, COLLOTYPE, GUM BICHROMATE, HALF-TONE PRINTING, OIL PIGMENT and WOODBURYTYPE).

Photomicrography. The technique of making photographs of minute objects using a camera and a microscope, photomicrography is one of the oldest branches of photography. The first photographs produced with an optical instrument by William Henry Fox Talbot (1800–77) were made with a solar microscope, not a camera. Several early daguerreotypists made photomicrographs, particularly notable being the scientific specimens of Alfred Donné (1801–78) and Léon Foucault (1819–68). Before the invention

of photography, it was the task of a skilled artist to record painstakingly the view down a microscope. Photomicrography became one of the most important tools of science, medicine and industry, and artists have found inspiration in images of the delicate structures of micro-organisms and the complex matrix of mineral specimens and crystal patterns.

Platinum print [platinotype]. A printing process for producing platinum prints was patented by William Willis (1841–1923) in 1873. Paper coated with iron and platinum salts was exposed to light under a negative. When the paper was washed with a potassium oxalate solution, an image was formed of finely divided platinum metal. Few photographers attempted to make up their own platinotype paper, and in 1879 the Platinotype Company was set up to market the process. A platinum print was typically a rich black with extremely fine detail. Warmer prints with the same detail could be produced using a hot developing solution or by toning. Platinum printing was favoured by many photographers up until the time of World War I, when the rise in price of the metal made it prohibitively expensive.

Polaroid. A method of instant photography that entails the production of a negative and positive in the camera, devised in the USA by Edwin H. Land (1909–82). As originally marketed in 1948, it required the use of a purpose-designed camera taking a roll of negative sensitized paper combined with a roll of positive non-sensitized paper that contained pods of viscous developer. It produced a brown picture in about a minute. The process was rapidly improved, and by 1960 black-and-white pictures could be produced in 10–15 seconds. In 1963 the first Polaroid colour film was marketed, and film-packs rather than picture-rolls were offered. Film-packs in appropriate adaptors led to the widespread use of Polaroid materials with traditionally designed cameras. The SX-70 Polaroid Land camera, introduced in 1972, was a landmark in camera design. In its infancy Polaroid photography was seen by serious photographers as an amusing gimmick or, at best, useful for quick record shots. As the quality of film and equipment improved, professionals began to discover the advantages of the process. Polaroid photography was championed by Ansel Adams (1902–84), who wrote a technical handbook containing a portfolio of Polaroid images by himself and other distinguished photographers. Other notable photographers who have made use of Polaroid materials include Yousuf Karsh (1908–2002), Sam Haskins (*b* 1926) and Helmut Newton (1920–2004).

Printing-out paper [POP]. Term coined by Ilford Ltd in 1891 to describe a specific range of gelatin silver printing-out papers introduced to replace albumen papers. By popular usage the term was widened to include all similar papers that were exposed beneath a negative in daylight until an image appeared. The red-brown POP image was usually toned with gold

before fixing, which changed the colour to a rich purple. Although printing-out papers were discarded by most photographers in the 1920s and 1930s, they continued to be favoured by a minority, generally for portrait proofing, until *c.* 1950.

Printing paper. The characteristics of modern printing papers vary according to their physical quality, the chemistry of the emulsion coatings and their contrast range. Physical characteristics include texture, surface coating, colour and thickness. The tone of a finished print is largely governed by the emulsion chemistry of the paper. Silver chloride papers will give hard blue-black prints. Silver bromide papers give dense black prints. Chloro-bromide papers containing a mixture of the two halides tend to give warmer black prints, but tones will vary according to the balance of components. With appropriate manipulation of the development process, however, they may yield sepia or red-brown tones. Papers are also manufactured in contrasting grades on a scale ranging from extra-soft to ultra-hard. Soft papers tend to give flat prints with grey uniform tones. With the same negative a hard paper would give an overcontrasted print with the light tones white and the dark tones completely black. Variable contrast papers usually contain two emulsions, one rather soft, the other contrasty. The emulsions are sensitive to different coloured lights, and by the use of appropriate colour filters in the enlarger the skilled photographer can exert exceedingly fine control of contrast, even over different areas of a single image if desired.

Retouching. Term describing manipulations and alterations of the negative and/or positive image after development. As photographic portraits of the size of the cabinet card (see above) became popular in the late 1860s, opportunities were sought to hide defects and blemishes in the image (photographic or not) by altering either the negative or the print with pencil, paint etc; evidence of it can be seen in the paper negatives of Fox Talbot and his circle. Although controversial from its inception, retouching remains in common practice (often employing the airbrush), especially in portrait photography and photojournalism.

Sabattier effect. See SOLARIZATION below.

Salted paper print. In his earliest photographic experiments in 1834 William Henry Fox Talbot (1800–77) discovered that writing paper dipped into a weak solution of common salt and then treated with silver nitrate would darken when exposed to light. In the 1830s Talbot used this simple reaction to make outline pictures using leaves or lace placed directly on the sensitive paper and later to make camera negatives. He went on to make positive prints by placing a second sheet of the same sensitive paper under a negative and exposing it to light. The images were fixed at first with a saturated salt solution. Later Talbot used potassium bromide or sodium thiosulphate ('hypo'). In 1839 Talbot published details of

this process, which he called 'photogenic drawing'. Talbot's improved process, the calotype process (see above), involved the production of a negative made visible by development, but he continued to make the positive images by printing out on the same salted paper he used to make photogenic drawings. The process was employed by most photographers to produce prints on paper until it was superseded by albumen printing in the 1850s.

Shading. See ENLARGING above.

Silver chloride paper. See PRINTING PAPER above.

Silver gelatin paper. See GELATIN SILVER PAPER above.

Slide. See GLASS POSITIVE AND SLIDE above.

Snapshot. A term coined by Herschel in 1860 to describe a method of taking photographs quickly and easily using simple apparatus introduced mainly as a result of advances in magazine cameras and the roll-film cameras made by George Eastman (1854–1932) *c.* 1890.

Solarization. Term originally used to describe the effect whereby the image on a plate or film was reversed from negative to positive when exposed to strong light during the development process. Examples of such positives were exhibited in France by Armand Sabattier (1834–1910) as early as 1860 (the 'Sabattier effect'), but most solarized images produced during the 19th century were simply the results of faulty processing. In the 20th century the term was more widely used to describe a range of techniques for producing partly reversed images by exposing negatives to calculated amounts of light during developing and printing. Man Ray (1890–1976) and Lee Miller (1907–77) were the first photographers to employ these techniques for artistic effect *c.* 1930. Solarization can be a difficult technique to master but the results are often striking. Images showing qualities of negative and positive combined can be produced. Often they are eerie ghost-like pictures with dark areas outlined by contrasting light. The technique was used by many distinguished photographers including Erwin Blumenfeld (1897–1969) and László Moholy-Nagy (1895–1946).

Spot printing. See ENLARGING above.

Stereoscopic photography. The principles of binocular vision and depth perception were explained by Euclid. In 1832 Sir Charles Wheatstone (1802–75) applied Euclid's principles to devise an instrument he called a stereoscope, which used a pair of mirrors to reflect two slightly different flat drawings to each eye; they were perceived as a single solid object. The stereoscope was of limited interest until the announcement of a practicable photographic process in 1839 allowed the possibility of stereoscopic pictures from life. Around 1849 Sir David Brewster (1781–1868)

designed a stereoscope in the form of a box fitted with two lenses, eye distance apart. Using this device to view a pair of small photographs taken at a separation of two to three inches, a single image of startling depth could be seen. Brewster's stereoscope became an immediate success when displayed at the Great Exhibition, London, in 1851. Throughout the 1850s and 1860s thousands of stereoscopes and hundreds of thousands of stereoscopic photographs (stereographs) were sold.

Initially, stereoscopic photographs were made by successive exposures of a single camera or by using two cameras side by side. In the mid-1850s twin-lens cameras were introduced, a pattern that continued. Most stereoscopes marketed followed Brewster's basic pattern, although there were many variants, including elaborate cabinet forms. A cheap open form of the viewer designed by the American Oliver Wendell Holmes (1809–94) in 1861 was particularly popular and sold in vast numbers. Many eminent Victorian photographers produced stereoscopic photographs, including Francis Bedford (1816–94), Francis Frith (1822–98) and George Washington Wilson (1823–93). Their work was marketed by concerns such as The London Stereoscopic Company who had outlets all over the world. In the 20th century stereoscopic photography found many applications in science and technology. Exploitation by the artist was limited because the pictures can be appreciated only with the aid of a viewer. The future for photographic imagery with the illusion of three-dimensionality probably lies in holography (*see* HOLOGRAM).

Talbotype. See CALOTYPE above.

Texture screen. See ENLARGING above.

Tintype. See FERROTYPE above.

Toning. See §1(iv) above.

Transparency. See GLASS POSITIVE AND SLIDE above.

Variable contrast paper. See PRINTING PAPER above.

Vignetting. See ENLARGING above.

Waxed paper negative. A modified form of the calotype process (see above), announced by Gustave Le Gray (1820–84) in 1851. In the calotype process the negative was usually waxed immediately before printing to make it more translucent. In Le Gray's process the paper was waxed before sensitizing, primarily to improve its keeping properties and enhance its capacity to record fine detail. Exposure times were longer than for the calotype process or the contemporary wet collodion process (see COLLODION NEGATIVE above), but it was convenient for the travelling photographer to use for landscape and architectural photography. The process was practised most widely in Britain and France; it never became popular in the USA.

Wet collodion process [wet-plate process]. See COLLODION NEGATIVE above.

Woodburytype. A photomechanical process patented by Walter Bentley Woodbury (1834–85) in 1865. An image in relief made in bichromated gelatin, as in the carbon process (see CARBON PRINT above), was placed on a soft lead sheet in a hydraulic press. When compressed, a shallow mould was formed in the lead following the contours of the original image. Warm pigmented gelatin was then poured into this mould, a sheet of paper placed over it and, again using a press, the image transferred to the paper. Woodburytypes have no grain and could be produced in any colour. The image is of high quality and in appearance almost indistinguishable from a carbon print. They were widely used for book illustrations during the last quarter of the 19th century.

Xerography. See PHOTOCOPY above.

T. F. Hardwich: *A Manual of Photographic Chemistry* (London, 1855); rev. 7, ed. G. Dawson, as *A Manual of Photography* (London, 1873)

W. K. Burton: *Practical Guide to Photographic and Photo-mechanical Printing* (London, 1887)

A. Brothers: *A Manual of Photography* (London, 1892)

J. M. Eder: *Geschichte der Photographie* (Vienna, 1905, rev. Halle, 4/1932; Eng. trans., New York, 1945/*R* 1978)

B. E. Jones, ed.: *Cassell's Cyclopaedia of Photography* (London, 1911)

L. Moholy: *100 Years of Photography, 1839–1939* (Harmondsworth, 1939)

The Focal Encyclopaedia of Photography, 2 vols (London and New York, 1956, rev. 1965)

A. Adams: *Polaroid Land Photography Manual* (New York, 1963, rev. 1978)

H. Gernsheim and A. Gernsheim: *The History of Photography from the Camera Obscura to the Beginning of the Modern Era* (Oxford, 1965, rev. London and New York, 2/1969); rev. 3 as H. Gernsheim: i: *The Origins of Photography* (New York and London, 1982), ii: *The Rise of Photography: The Age of Collodion* (London and New York, 1987) [other volumes in preparation]

D. B. Thomas: *The Science Museum Photography Collection* (London, 1969)

The Print, Time-Life Library of Photography (New York, 1970, 1972)

The Art of Photography, Time-Life Library of Photography (New York, 1971, 1973)

G. Wakeman: *Victorian Book Illustration* (Newton Abbot, 1973)

B. Coe: *The Birth of Photography: The Story of the Formative Years, 1800–1900* (London and New York, 1976)

O. R. Croy: *The Complete Art of Printing and Enlarging* (London and New York, 1976)

W. Johnson, ed.: *An Index to Articles on Photography* (Rochester, 1977, 1978); cont. as *International Photography Index* (Boston, 1979, 1980, 1981)

B. Coe: *Colour Photography: The First Hundred Years, 1840–1940* (London, 1978)

N. Hall Duncan: *The History of Fashion Photography* (New York, 1979)

G. Gilbert: *Photography, the Early Years: An Historical Guide for Collectors* (New York, 1980)

B. Newhall: *The History of Photography from 1839 to the Present* (New York, 1982)

G. Walsh, H. Michel and C. Naylor, eds: *Contemporary Photographers* (London and New York, 1982, rev. Chicago, 1988)

T. Browne and E. Partnow: *Macmillan Biographical Encylopedia of Photographic Artists and Innovators* (New York and London, 1983)

B. Coe and M. Haworth-Booth: *A Guide to Early Photographic Processes* (London, 1983)

W. L. Broecker, ed.: *Encyclopedia of Photography* (New York, 1984)

N. Rosenblum: *A World History of Photography* (New York, 1984, rev. 2/1989)

M. Auer and M. Auer, eds: *Photographic Encyclopedia International: 1839 to the Present* (Hermance, 1985)

J. M. Reilly: *Care and Identification of 19th-century Photographic Prints* (Rochester, NY, 1986)

W. Johnson: *Nineteenth-century Photography: An Annotated Bibliography, 1839–1879* (Boston, 1990)

F. M. Neusüss and others: *Das Fotogramm in der Kunst des 20. Jahrhunderts: die andere Seite der Bilder: Fotografie ohne Kamera* (Cologne, 1990)

R. F. Smith: *Microscopy and Photomicrography: A Working Manual* (Boca Raton and London, 1990)

S. M. Barger and W. B. White: *The Daguerreotype: Nineteenth-century Technology and Modern Science* (Washington, DC [1991])

M. M. Evans, ed.: *Looking at Photographs: A Guide to Technical Terms* ([Malibu, CA, 1991])

S. Stevenson: *Hill and Adamson's The Fishermen and Women of the Firth of the Forth* (Edinburgh, 1991)

W. J. Mitchell: *The Reconfigured Eye: Visual Truth in the Post-photographic Era* (Cambridge, MA, 1992)

J. H. Coote: *The Illustrated History of Colour Photography* ([Surbiton, 1993])

J. Wood: *The Art of the Autochrome: The Birth of Color Photography* (Iowa City, 1993)

J. S. Craig, ed.: *Craig's Daguerreian Registry*, 3 vols (Torrington, CT, 1994–5)

D. Breuger: *Journeys in Microspace: The Art of the Scanning Electron Microscope* (New York, 1995)

M. M. Evans: *Contemporary Photographers* (New York, [3/1995])

K. S. Howe, ed.: *Intersections: Lithography, Photography and the Traditions of Printmaking* (Albuquerque, 1998)

M. Ware: *Cyanotype: The History, Science and Art of Photographic Printing in Blue* (London, 1999)

D. Arentz: *Platinum and Palladium Printing* (Boston, MA, and Oxford, 2000)

F. W. D. Rost and R. Jowett: *Photography with a Microscope* (Cambridge, 2000)

D. Morrish and M. MacCallum: *Copper Plate Photogravure: Demystifying the Process* (Amsterdam and Oxford, 2003)

P. Prodger and T. Gunning: *Time Stands Still: Muybridge and the Instantaneous Photography Movement* (Stanford, CA, 2003)

II. Conservation. The conservation of photographic materials relates to the passive and interventive techniques used to clean, stabilize, consolidate, repair and restore original photographic positive and negative images. In so doing, account must be taken of the characteristics and properties that denote the photograph as an artefact, rather than just a visual image, and historic and technological information

must be preserved to ensure the continuation of the provenance of the photograph. Regarding the photograph as an image will include all the visual, social, historic, artistic and aesthetic information that is represented within the picture created by the photographer. This concept also relates to the individuality of style, interpretation and presentation of the photographer in respect of that which he purposefully or accidentally captured in his work. Regarding the photograph as an artefact will include the visual and material characteristics that make up and form the essence of the photograph. These physical properties include the light-sensitive coatings found in non-colloidal images such as calotypes, salted paper prints, cyanotypes and platinum prints or in the image-carrying colloid or colloidal emulsions, whether silver or pigmented, and their supporting bases, mountants and presentation materials. These properties are relatively easy to recognize (see §I above). Less easy to identify are the visual and material characteristics that are products of the individual photographic process and photographic technology, the photographer's skill, and the manipulations and adaptations that are personal to him. Condition is also an inseparable part of the intrinsic make-up of a photograph, as all photographic images exist in an altered, imperfect state. The one factor affecting image condition is image permanence. Of all human artefacts the photograph is possibly one of the most sensitive and vulnerable to physical and chemical degradation, on all levels of its existence.

Photographs are prone to degradation by both external and internal factors. External factors affecting image permanence in photographic materials are, firstly, environmental, including light, temperature, humidity and air quality. Other factors include poor storage environments and support materials, poor, unprotected handling (patron use) and benign neglect. Internal factors affecting degradation are mainly: residual processing chemistries, migratory contaminants and physical incompatibilities. In addition, the inherent qualities of the component materials being affected must also be considered. First, the base or support material: this can be either paper, glass, metal, leather, wood, fabric, ceramic, bone or a transparent synthetic support. These materials will react independently to the image-bearing emulsion, inducing physical incompatibilities. Emulsions also vary. Second, the colloid emulsion: if present this can be albumen, collodion, gelatin or gum arabic and all of these materials are degradable as a direct result of their inherent qualities. For example, albumen has a natural free sulphur element in its composition; collodion, a nitrated cellulose, is susceptible to both chemical and physical degradation; gelatin and gum arabic are susceptible to high humidity, mould attack and acid and alkaline conditions. These materials will react independently to their support. Third, the photographic image: for all intents and purposes the photograph is classified as a work of art, but unlike its counterpart the painting or drawing it cannot effectively be restored using the same media, photographic chemistries, related

processes and techniques that produced it. Lastly, the inherent chemical characteristics: the deliberate degradation of known sensitive materials such as silver nitrate, iron III compounds and bichromated colloids, by light and chemical oxidizing agents, gives rise to the phenomenon known as a photograph, and yet these very same agents must be controlled in order to prevent the photograph from being degraded to the point of destruction. Contemporary colour photographs present an additional problem in the inherent instability of the dye chemistries in chromogenic materials, positives and negatives.

All photographs clearly exist in a vulnerable state. It is of vital importance to understand fully the nature of the materials used in the original process, for it not only allows an appreciation of the physical subtleties inherent in individual photographic processes, enhancing still further the reputation of the photographer, but it also enables ethically sound preservation, conservation and restoration techniques to be formulated. Examining more closely the phenomena of colour in the monochrome processes, for example, will help us to understand and recognize these often intangible physical characteristics, while clearly showing the interrelationship between all of the component aspects. Image colour in photographs is dependent upon several factors, including the relative size, formation, density and concentration of the visible image-forming silver particles and their respective spectral reflectance values; the singular or combined use of light-sensitive salts; the actinic quality of light during exposure; and the influence of temperature and humidity upon the image production processes. In addition, the surface texture of the image support, coated or uncoated, alters its spectral reflectance value depending upon the amount of light refraction. Other factors concern the addition of pigments to bichromated colloids and the presence of additives to paper bases or other porous supports in the form of loadings and sizes that interact with the various halides or combinations of halides during the initial reaction. Also important is the influence of pH upon the image production processes. The majority of photographic processes are based upon the effects of acids or alkalis upon organic or inorganic compounds where changes in material state are brought about by the reaction between acid and alkaline substances. In all cases the resulting photograph is either acid or alkaline stabilized. Lastly, attention must be paid to aftertreatments, tones and intensifiers used in the original production of the image. In addition to the physical characteristics of a process and its materials, it is equally important to preserve all original modes of presentation and containment, including decorative or accredited mounts, album forms and printed photographic ephemera.

With so many variables, alteration of any one of these integral characteristics as a result of any photographic or conservation treatment changes the intrinsic nature of the original and is therefore ethically unacceptable. How then is it possible to reconcile preservation and conservation requirements with the

need to preserve the intrinsic characteristics of the image and artefact? Every conservation and restoration discipline has very rigid standards, ethics and principles, designed to protect the artefact from misuse and malpractice detrimental to its continued longevity and to preserve all intrinsic and integral characteristics (*see* CONSERVATION AND RESTORATION, §I). A clear distinction must be made between what was acceptable for the photographer to do in the initial production of his work and what is acceptable for the conservator, whose job it is to preserve all the essential characteristics and the integrity of the photographer's work, without changing or trying to improve upon them. All repair, mounting and storage materials must conform to the highest conservation standards and purity, in that they should not contain materials detrimental to the artefact's continued longevity. No treatment should be carried out that will in any way alter or remove information or change the intrinsic and integral characteristics of the artefact. All treatments must be reversible and should not preclude future treatments or research. All applied techniques should not in any way affect the long-term stability of the artefact. Since all photographs have a natural life span, there will be an inevitable change in their visual and material characteristics. To place degraded material in good storage conditions will not in itself ensure its long-term preservation. It is necessary, therefore, as part of any preservation and conservation policy, first to stabilize the photograph and its mode of presentation by the removal of particulate and, where possible, material contaminants. The purpose of preservation and conservation is to slow down, and hopefully to arrest, the processes of degradation, many of which are very subtle, thereby preserving the integrity of the artefact.

R. Hunt: *Researches on Light* (London, 1844)

T. F. Hardwich: *A Manual of Photographic Chemistry* (London, 1855); rev. 7, ed. G. Dawson, as *A Manual of Photography* (London, 1873)

J. M. Eder: *Geschichte der Photographie* (Vienna, 1905, rev. Halle, 4/1932; Eng. trans., New York, 1945 *R*/1978)

B. E. Jones: *The Cyclopaedia of Photography* (London, 1912, *R*/1982)

L. P. Clerc: *Photography Theory and Practice* (London, 1971, rev. 2/1972)

J. M. Reilly: *The Albumen and Salted Paper Book: The History and Practice of Photographic Printing* (Rochester, NY, 1980)

J. M. Reilly: *Care and Identification of 19th-century Photographic Prints* (Rochester, NY, 1986)

E. Martin: *Collecting and Preserving Old Photographs* (London, 1988)

K. B. Hendricks and others: *Fundamentals of Photograph Conservation: A Study Guide* (Toronto, 1992)

The Imperfect Image: Photographs, their Past, Present and Future: Papers Presented at the Centre for Photographic Conservation's First International Conference: Windermere, 6–10 April 1992

H. Wilhelm and C. Brower: *The Permanence and Care of Color Photographs: Traditional and Digital Color Prints, Color Negatives, Slides and Motion Pictures* (Grinnell, IA, 1993)

K. Eismann: *Photoshop Restoration & Retouching* (Berkeley, CA, 3/2006)

H. Stratis and B. Salvesen, eds: *The Broad Spectrum: Studies in the Materials, Techniques, and Conservation of Color on Paper* (London, 2002)

Photomontage. Technique by which a composite photographic image is formed by combining images from separate photographic sources. The term was coined by Berlin Dadaists *c.* 1918 and was employed by artists such as George Grosz (1893–1959), John Heartfield (1891–1968), Raoul Hausmann (1886–1971) and Hannah Höch (1889–1978) for images often composed from mass-produced sources such as newspapers and magazines.

Photomontages are made using photographic negatives or positives. Negative montages are produced in the darkroom by, for example, sandwiching negatives in an enlarger or masking sections of photographic paper. Positive montages are usually made by combining photographic prints or reproductions. Both approaches and endless variants, such as photographing constructed objects, were used by a specialist such as John Heartfield.

A wide range of photomontage-type work was produced in the 19th century. This can be categorized according to its naturalist or formalist orientation. Famous examples of the first type are *Two Ways of Life* (1857; Bath, Royal Photographic Society of Great Britain) by O. G. Rejlander (1813–75) and *Fading Away* (1858; Rochester, NY, International Museum of Photography) by Henry Peach Robinson (1830–1901). Rejlander composed his work with over thirty negatives (a combination print), and Robinson pasted together five separate photographs, both producing composite images that tried to achieve the naturalism of a single shot. Formalist work such as fantasy postcards from the turn of the century made no attempt to disguise spatial disharmonies or incongruities of scale (see fig.). This second tendency, playing with impossibilities and rooted in popular art, was to be developed by avant-garde artists in the 20th century.

Dadaist photomontage was related to, but distinct from, earlier Cubist, Futurist and Suprematist collage. The latter occasionally included photographs, but never as a dominant element, unlike many Dada works. There is also frequent use of a third term, photocollage, to describe a work such as Grosz's and John Heartfield's *Universal City* (1919; Berlin, Akademie der Künste), which combined photographs with a wide range of typography and non-photographic imagery.

The invention of photomontage cannot be attributed to one person, although Raoul Hausmann described how he was inspired to invent it during a vacation on the Baltic coast in 1918 (see R. Hausmann: *Courrier Dada*, Paris, 1958, p. 42):

> In nearly all the homes was found, hung on the wall, a coloured lithograph representing the image of a grenadier in front of barracks. In order to make this military memento more personal, a photographic portrait of the soldier was glued on the head. It was like a flash; I saw instantly that one could make *pictures* composed entirely of cut-up photos.

André Adolphe Eugène Disdéri: *Imperial Family*, photomontage, 19th century (Paris, Musée d'Orsay); photo credit: Réunion des Musées Nationaux/Art Resource, NY

The novelty of the work of the Berlin Dadaists lay in their motives rather than their techniques. They were particularly interested in photomontage as a product of, and a comment on, the chaos of World War I. More specifically, they saw it as a mechanical, impersonal alternative to what was considered the excessive subjectivism of German Expressionist art and attitudes. This movement had greatly affected many of the Dadaists, but they felt it had been discredited by the war and made redundant by the Russian Revolution of 1917. Photomontage began as an anti-art provocation, but became a respected medium in Germany and elsewhere by the mid-1920s. As well as becoming a subdivision of fine art, it was also rapidly assimilated by the applied arts of advertising and political propaganda.

Among the exponents of photomontage in advertising were Paul Schuitema (1897–1973) and Piet Zwart (1885–1977) in Holland; Herbert Bayer (1900–85), Max Burchartz (1887–1961) and László

Moholy-Nagy (1895–1946) in Germany. Bayer regularly used photomontage as a Bauhaus master in typography and advertising, and in the advertising agency that he ran in Berlin from 1928 to 1938. Reflecting on his life's work in 1969, he noted that 'the photomontage has shown itself to be particularly suitable for advertising in which psychological suggestion or allusion are desired' (Eng. trans. in A. A. Cohen: *Herbert Bayer: The Complete Work*, Cambridge, MA, 1984, pp. 358–60).

Photomontage was used for political propaganda from an early date in the former Soviet Union, notably by Gustav Klucis (1895–1944), El Lissitzky (1890–1941), Aleksandr Rodchenko (1891–1956) and Sergey Senkin (1894–1963). Their work tended to emphasize and encourage commitment to Communist aims and achievements. In Germany, by contrast, Heartfield pioneered the use of photomontage for political satire. His most famous works appeared in Communist magazines between 1930 and 1938, using a variety of techniques to ridicule the pretensions of Nazism.

The first photomontage retrospective was held at the Kunstgewerbemuseum, Berlin, in 1931. It was organized by César Domela (1900–92) and included a section on historical precedents, but the bulk of the exhibition lay in the work of around 50 contemporary artists, mainly from Germany and the former Soviet Union. Their work defines the parameters of photomontage.

J.-A. Keim: 'Photomontage after World War I', *One Hundred Years of Photographic History: Essays in Honor of Beaumont Newhall*, ed. V. D. Coke (Albuquerque, 1975), pp. 84–90

D. Ades: *Photomontage: Photography as Propaganda* (London, 1976); rev. as *Photomontage* (London, 1986)

J. Heartfield: *Photomontages of the Nazi Period* (London, 1977)

D. Evans and S. Gohl: *Photomontage: A Political Weapon* (London, 1986)

D. Evans: *John Heartfield: AIZ/VI, 1930–1938* (New York, 1992)

P. Pachnicke and K. Honnef, eds: *John Heartfield* (New York, 1992)

M. Teitelbaum, ed.: *Montage and Modern Life, 1919–1942* (Cambridge, MA, and London, 1992)

M. Lavin: *Cut with the Kitchen Knife: The Weimar Photomontages of Hannah Höch* (New Haven and London, 1993)

E. Dluhosch and R. Švácha, eds: *Karel Teige, 1900–1951: L'Enfant Terrible of the Czech Modernist Avant-garde* (Cambridge, MA, 1999)

H. Möbius: *Montage und Collage: Literatur, bildende Künste, Film, Fotografie, Musik, Theater bis 1933* (Munich, 2000)

G. Lista: *Futurism and Photography* (London, 2001)

M. Jolly: 'Composite Propaganda Photographs during the First World War', *History of Photography*, xxvii/2 (Summer 2003), pp. 154–65

M.-H. Joyeux: 'Le photomontage politique à travers les couvertures de Vu (1928–1936)', *Cahiers du Musée national d'art moderne*, lxxxiv (Summer 2003), pp. 48–65

L. Becker and R. Hollis: *Avant-garde Graphics, 1918–1934: From the Merrill C. Berman Collection* (London, 2004)

D. Hopkins: *Dada and Surrealism* (Oxford, 2004)

Dada: Zurich, Berlin, Hannover, Cologne, New York, Paris (exh. cat. by L. Dickerman and others; Washington, DC, National Gallery of Art, 2005)

L. Bailey and L. Thynne: 'Beyond Representation: Claude Cahun's Monstrous Mischief-making', *History of Photography*, xxix/2 (Summer 2005), pp. 135–48

J. Fiedler and H. Moholy-Nagy, eds: *László Moholy-Nagy: Color in Transparency: Photographic Experiments in Color 1934–1946/ Fotografische Experimente in Farbe 1934–1946* (Göttingen, 2006)

Photosculpture. Mechanical technique for producing miniature portrait figures and busts. It was the invention of François Willème (1830–1905) and was promoted with success in France, England and America in the mid-19th century. A registered patent of the invention was issued to Willème on 14 August 1860 by the Department of Commerce, Paris, allowing 15 years sole operation by the owner. The general public was introduced to the medium at the Société Générale de Photosculpture, Boulevard des Capucines, Paris, which operated from 1863 to 1868.

Subjects were posed in the centre of a large rotunda in the building, a circular room 10 m in diameter. The point of focus was indicated by a silver ball, suspended above the person to be portrayed. Twenty-four cameras set at equal distance in the walls of the rotunda made synchronized photographs of the subject at 15-degree intervals; a lamposcope then projected negative images on to a screen. In the next stage, a PANTOGRAPH was employed to automatically transcribe and hollow the profiles in a block of clay, achieving an accurate composite mould of the figure. From this, highly accurate sculptures were produced on a miniature scale. Willème lodged moulds of the originals with the Paris factory of Gilles the younger for extended production. Models were usually made in biscuit (unglazed porcelain).

The invention proved to be an immediate success. In 1863 Willème presented his sculptures in an exhibition of photography at the Palais de l'Industrie, Champs Elysées, Paris, and the statuettes (in wood, terracotta and bronze) quickly became a centre of attraction. Willème next exhibited 23 sculptures in the Universal Exhibition of 1864 in Vienna. These included figures of leading personalities of the day, such as the Duc de la Rochefauld-Doudeauville, J. P. L. E. Vandal (1813–89), Director of the Paris postal service, and the writer Théophile Gautier (1811–72).

Willème expanded his operation to England in 1866, where the Society of Photosculpture in London paid him £7500 for an operating licence. A similar society was also set up in 1866 by Huston and Kurtz in New York. These ventures, however, were short-lived and did not approach the popularity of the Parisian scheme. The Exposition Universelle of 1867 in Paris was Willème's last triumph. He then retired from active involvement with the Society of Photosculpture, which was dissolved in 1868.

A long-lasting debate ensued on the relative merits of industrially produced art for general markets as

opposed to *l'art pour l'art*, the creation of art exclusively for private patronage. Willème wanted an art for the people rather than for professional collectors, believing that art was not the exclusive privilege of the owning class but should be accessible to all. He also recognized the emergence of a mass market for artefacts and accordingly fixed pricing levels for reproductions at one-tenth of the original. Among the examples of photosculpture that survive is a *Self-portrait* by Willème (1863; Rochester, NY, International Museum of Photography).

T. Gautier: *Photosculpture* (Paris, 1864)

R. A. Sobieszek: 'Sculpture as the Sum of its Profiles: François Willème and Photosculpture in France, 1859–68', *Art Bulletin*, lxii/4 (1980), pp. 617–30

W. Drost: 'La Photosculpture: Entre art industriel et artisanat', *Gazette des beaux-arts*, n. s. 6, cvi (1985), pp. 113–29

A. Beckmann: 'Fotoskulptur: Überlegungen zu einem Bildmedium des 19. Jahrhunderts', *Fotogeschichte*, xxxix (1991), pp. 3–16

Pietra dura [It.: 'hard stone'; pl. pietre dure]. Decorative form of mosaic made of hardstones and used on table tops, altar panels and so on (see colour pl. XI, fig. 1). The singular form of the term, 'pietra dura', is used in Italy to denote work incorporating a single type of stone but is widely used outside Italy to denote combinations of more than one type of stone. The hardstones used are semi-precious stones, typically agate, chalcedony, jasper and lapis lazuli, but do not include marble or precious stones. Pietre dure had been carved in Classical Rome, and the techniques for cutting such hard stones were revived in 16th-century Florence, where a workshop established under the patronage of Grand Duke Cosimo I de' Medici (*reg* 1569–74) produced the decorative panels known in English as Florentine mosaics; the workshop was refounded in 1588 as the Opificio delle Pietre Dure, which still manufactures mosaics (see colour pl. XII, fig. 1). Pietra dura was also produced in the Real Laboratorio delle Pietre Dure in Naples, the Laboratorio de Piedras y Mosaico at Buen Retiro and by Italian craftsmen elsewhere in Europe (e.g. the Miseroni family in Prague).

A. M. Giusti: *Masterpieces in Pietre Dure: Palazzo Pitti, the Uffizi and Other Museums and Monuments in Florence* (Florence, 1989)

F. Rossi: *La pittura di pietra: Dall'arte del mosaico allo splendore delle pietre dure* (Florence, 2002)

A. M. Giusti: *Pietre Dure: Hardstone in Furniture and Decorations* (London, 2003)

Pigment. Finely powdered colouring matter that is suspended in a binding medium to form paint; for pastel (*see* PASTEL, §1) the pigment is moulded into sticks with the aid of a binding medium. In most forms of painting the binding medium, which may be oil, egg yolk, water or a variety of other substances, holds the pigment particles together and attaches them to a surface. In FRESCO painting, however, the pigments are mixed with water for application, but when dry they form an integral part of the surface of the plaster.

I. Introduction. II. Black. III. Blue. IV. Brown. V. Green. VI. Red. VII. Violet. VIII. White. IX. Yellow and orange.

I. Introduction. Pigments can be black, white or coloured. To understand how they appear to the viewer, it is necessary to consider the nature of light. White light is made up of different coloured lights, from blue in the short-wavelength end (*c.* 400 nm) of the visible spectrum, via green, yellow and orange to red at the long-wavelength end at *c.* 700 nm. On account of their molecular structure, pigments, like all coloured materials, absorb part of the visible spectrum, while reflecting or transmitting other parts. The absorption or removal of one or more of the colours results in the white light being coloured and the material appearing coloured to the eye. White pigments reflect most of the visible light falling on them, and black pigments absorb most of it. For this reason, dark paint layers have better hiding power than white or light coloured ones.

When light enters a paint film, the tiny, transparent pigment particles reflect and transmit it until it hits another pigment particle where the same thing happens. Eventually the light will be reflected back to the eye of the viewer. The nature of the area immediately surrounding the pigment particles is important to their appearance. Colourless powdered glass looks white when surrounded by air, but when dispersed in water it is colourless and hardly visible. This is due to refraction, that is to say the change of direction of the light rays as they pass from one medium to another. This change is determined by the change in the velocity of propagation of the radiation, the speed of light being dependent on the optical density of the medium through which it travels. The phenomenon is expressed in figures as the refractive index, n, which is the ratio of the speed of light in a vacuum to that in a given medium. The powdered glass appears colourless in water because its refractive index is close to that of the water.

The refractive index of most pigments lies between 1.5 and 2.8. That of the aqueous binders, for example gum arabic (*see* GUM) or egg tempera, is around 1.35 (water is 1.33) and that of oils around 1.48. Hiding power is greatest when the difference in refractive indices is greatest, so titanium dioxide ($n = 2.72$) suspended in oil will have very good hiding power, while aluminium hydroxide ($n = 1.54$) will appear transparent in the same binding medium. This makes organic dyes on a substrate of aluminium hydroxide suitable for the translucent paint required for glazing. A pigment suspended in an aqueous medium will have better hiding power than the same pigment suspended in oil because there is a greater difference in the refractive indices. For instance, for ultramarine in gum arabic the difference is 0.16, while for ultramarine in oil it is 0.02. A paint layer of ultramarine in oil will therefore appear rather transparent.

In aqueous media the evaporation of the water will make the pigment appear lighter, since the water in the space between the particles is replaced by air, and

a greater proportion of the light is reflected. Oil films become darker and more transparent with time because the refractive index of the oil increases.

Materials can have more than one refractive index. This property is not of much consequence for the appearance of paint films, but it can be used for the identification of pigments (see TECHNICAL EXAMINA-TION, §§IV, 2 and VIII, 6). Isotropic pigments have one refractive index, while those that are optically anisotropic have more than one. This results in bire-fringence, which can be studied under the micro-scope in plane-polarized light (light in which there is only one vibration direction). Azurite, for instance, shows birefringence, while the blue particles of ultra-marine do not.

Pigments can be further distinguished by chemical methods and by their behaviour when treated with acids and alkalis. Those that are susceptible to attack by acids and alkalis in the laboratory are sensitive to the same agents in their natural surroundings.

Pigments may be of natural origin, or they may be artificially produced. Natural pigments include the inorganic earths, the inorganic minerals and organic compounds derived from animals and plants. Artificial pigments, for example Egyptian blue and lead white (see §§III, 1 and VIII, 1 below), were made from an early date. Sometimes a natural and an artificial vari-ety, with the same chemical composition, were in use at the same period. This is the case with the natural azurite and the artificial blue bice, both chemically basic copper carbonate (see §III, 1 below).

A prerequisite for a compound to be a pigment is that it is insoluble in water and in the binding medium. In this way, pigments can be distinguished from dyes, but dyes can be made into pigments by precipitation on to an inert substrate (see LAKE). True lake pigments always contain aluminium hydroxide as the substrate, because their manufac-ture involves a reaction between alum and an alkali. The precondition of insolubility is the reason for finding many oxides and hydroxides among the inorganic pigments.

The accidental discovery of Prussian blue (see §III, 5 below) at the beginning of the 18th century can be regarded as a forerunner of the manufacture of new pigments that developed rapidly in the fol-lowing century. The newly prepared 19th-century pigments comprised both inorganic ones, com-pounds from CHROMIUM and cadmium for example, and the synthetic organics. Sometimes they replaced ancient pigments that were poisonous, unsatisfac-tory in use or too expensive, although several of the early pigments continue to be used. After the discovery in 1845 of what could be regarded as the first synthetic dye (see DYE, §3), the yellow picric acid, numerous dyes of different colours were made. Many of these could be converted into pigments, and others (e.g. azo compounds) did not need con-version as they could be used as both dyes and pig-ments. A well-known example of the early synthetic organic pigments is Perkin's mauve, first made by William Perkin in 1856.

II. Black.

1. CARBON BLACKS. In many black pigments the colouring matter is carbon. GRAPHITE is a crystalline form of carbon, widely distributed in nature as a mineral and used for writing and drawing, but the black pigments most often used in painting are veg-etable and ivory blacks. The colouring matter in these is finely divided elementary carbon. Both were known by the ancients: Pliny the elder (AD 23/4–79) reported that Greek painters in the 5th century BC used a black made from the husks of grapes; Apelles (fl late 4th century BC–early 3rd century BC) probably used a black obtained from burnt ivory.

Vegetable blacks are obtained from such burnt plant material as vine twigs or vine wood (which give vine black), wine lees, peach stones and cork. Another vegetable black is CHARCOAL (also called blue black), which is used mainly for drawing. Bone black (animal black, drop black) is obtained by charring bones in closed retorts. It has a brownish to bluish-black colour and contains about 10–20% carbon. The rest is mainly calcium phosphate, and although the cal-cium compounds that compose the ash do not add to the colour, they do improve the working qualities. It is a stable pigment. For making ivory black, the waste cuttings of ivory were charred. It is the most intense of all the black pigments, and 'ivory black' is still popular with artists, although it is now made from animal bones and often sold with Prussian blue (see §III, 5 below) added.

Another carbon black is lampblack. This is nearly pure amorphous carbon with a small proportion of mineral impurities and hydrocarbons that are tarry in nature. It is in fact soot, formed by the incomplete burning of such carbon-rich sources as mineral oil, tar, pitch or resin. The incomplete burning is done by flames with the aid of burners or lamps. The flames can either burn openly so the soot escapes as smoke that is collected later, or the flames are played against cool surfaces on to which the carbon precipitates. The pigment does not wet well with water because of the small amount of unburnt oil or tar it contains. The finely divided pigment is slightly bluish in colour and very stable (it can only be destroyed by burning at very high temperatures). Microscopically it is extremely fine and homogeneous, but it can form lumps when mixed with other pigments. It was known as a slow-drying pigment from early on, so sometimes other pigments are added for drying.

In the 2nd century BC, manufacturing processes for the use of lampblack in ink were already well established in China (see INK, §I). In the 1st century BC the Roman writer Vitruvius described the use of special furnaces for the preparation of smoke from resin. In the 19th century the animal and vegetable sources for lampblack were replaced by coal tar; the pigment is sold under the name 'carbon black'.

2. OTHER SOURCES. Black chalk (see CHALK, §1), which derives from a natural slaty deposit rich in car-bon, is usually used for drawing. A comment by the

author Théodore Turquet de Mayerne (1573–1655) about its drying properties when used as a pigment suggests that it contained iron or manganese. Magnetite, the natural form of the black mineral ferro-ferric oxide (Fe_3O_4), does not appear to have been much used as a pigment. Black iron oxide is sometimes found in paintings of the late 19th century, when it was probably artificially prepared like the Mars colours (yellow, red, violet and brown iron oxides; see §VI, 2 below). Manganese black (brownish black manganese oxide), which occurs naturally, does not appear to have been much used either. Since the 19th century it has been prepared artificially and is mainly used in cheap paint.

III. Blue. The number of blue pigments used in European painting is small, the main examples being natural ultramarine, azurite, smalt and, less frequently, indigo. An artificial blue pigment known as Prussian blue, which was first prepared at the beginning of the 18th century, is the earliest synthetic pigment of which the date of manufacture is more or less accurately known.

1. Azurite and artificial copper derivatives. 2. Ultramarine. 3. Smalt. 4. Organic sources. 5. Other sources.

1. AZURITE AND ARTIFICIAL COPPER DERIVATIVES. Azurite is a natural blue pigment derived from the mineral azurite ($Cu_3(OH)_2(CO_3)_2$), a basic carbonate of copper. Azurite mineral is found in the zone of weathering of copper lodes and also in deposits associated with other oxidized copper minerals, particularly malachite, the green basic carbonate of copper. Obsolete names and synonyms include mountain blue, *Bergblau*, *bleu d'Allemagne* and *az(z)ur(r)o dell'Allemagna*, also known as *az(z)ur(r)o della magna*. In southern Europe these names were used to distinguish azurite from natural ultramarine.

Azurite as a pigment was known to the Ancients. In Europe it was the blue pigment most frequently used in painting from the 15th century until the middle of the 17th, possibly because the sources, which were mainly in Hungary and were not extensive, were becoming exhausted. The pigment was hardly used for paintings in the 19th century. Azurite was also the most important blue pigment in East Asia, and in Japan it was being used in the late 20th century.

Coarsely ground azurite produces dark blue, while the finely ground pigment is pale and weak. In contrast to ultramarine, which has a purplish undertone, azurite has a greenish undertone. The pigment particles have a fractured surface. The crystals are moderately highly refracting and strongly birefracting. Azurite is a stable pigment under normal light and atmospheric conditions, but it is readily decomposed by dilute mineral acids. Areas originally painted blue with azurite have often turned greenish, but this is not due to the transformation of azurite to malachite: it results from the yellowing or darkening of the oil medium and varnish films.

Blue verditer or blue bice are artificially prepared basic carbonates of copper. Sources on painting technique contain many recipes for the preparation of blue pigments from copper salts. The particles of these artificially prepared copper pigments are often rounded and more regular than azurite; the colour is similar to that of finely ground azurite. Bremen blue is copper hydroxide ($Cu(OH)_2$). It was manufactured in the 19th century but was not widely used in painting. The Ancients used a blue pigment, called frit or Egyptian blue, that contained copper in the form of a calcium coppersilicate. This pigment was prepared by burning a mixture of lime, quartz sand and copper ore. It was used in Egypt and in other early cultures, but knowledge of the process was later lost. At the beginning of the 20th century the process was rediscovered, and the pigment became available under the name Pompeian blue.

2. ULTRAMARINE. Natural ultramarine is a complex, sulphur-containing sodium aluminium silicate with the approximate formula $Na_{9-10}Al_6Si_6O_{24}S_{2-4}$. It is made from the hardstone lapis lazuli, which contains the blue mineral lazurite. Natural ultramarine can be prepared from high-quality lapis lazuli by just washing and grinding; for minerals of low quality, laborious methods of extraction of the lazurite were required.

The mineral was probably mainly imported into Europe via Venice, and the name ultramarine derives from such obsolete names as *azzurro oltramarino*, meaning the blue that was imported from overseas. In this way it was distinguished from azurite. The main source of lapis lazuli in the past was Badakhshan (now divided between Afghanistan and Tajikistan). Marco Polo, who visited the mines in 1271, described the quarries and said that the mineral was used for making a blue pigment.

Among the earliest known examples of the use of lapis lazuli as a pigment are the 6th- and 7th-century AD wall paintings in Bamiyan, Afghanistan. It is possible, however, that it was used even earlier in the paintings at Ajanta, which date from the 1st century BC to the 5th century AD. The pigment has definitely been identified in Chinese paintings from the 10th and 11th centuries and in Indian wall paintings from the 11th and 12th centuries. In Europe it was most extensively used in the 14th century to the mid-15th. However, the high cost of the imported raw material and the long process of extraction resulted in the pigment being as expensive as gold. The patron sometimes supplied or paid for the amount of ultramarine necessary, and the highest quality was often reserved for the robe of the Virgin.

The deep blue, translucent particles are isotropic and have a low refractive index ($n = 1.50$). Unless highly purified, ultramarine contains colourless, birefracting particles of calcite and iron pyrites. The pigment is very sensitive to acids, and exposure to even dilute acids results in a complete loss of colour. The refractive index is low, so ultramarine served better and was brighter in oil. The yellowing of the oil

medium, however, tends to turn the blue areas green. Another form of discoloration, known as ultramarine sickness, is due to the degradation of an aqueous medium, which gives the ultramarine a greyish appearance. This is merely an optical effect since the pigment, as in oil paintings, remains blue.

Artificial ultramarine is closely similar in composition, colour and chemical properties to the natural variety. It was first prepared in 1828 by Jean-Baptiste Guimet in Toulouse, after the Société d'Encouragement pour l'Industrie Nationale had offered a prize of 6000 francs for the discovery of a process for making ultramarine.

3. SMALT. Smalt is pulverized blue potassium glass. The blue colour is due to small amounts of cobalt, added as cobalt oxide during manufacture. Smalt has been on the market under many different names, some of them related to coarseness and therefore quality, for instance starch blue (in 17th- and 18th-century sources), *émail*, *Streublau*, *couleur*, *Eschel* and *Zafferblau*. For the manufacture of smalt, cobalt oxide or zaffer, obtained from roasted cobalt ores, was added to quartz sand with potassium as flux. This hot, molten mass was then poured into water, which made it break up into tiny splinters. Smalt can be recognized under the microscope by the sharp edges of glass splinters. Although cobalt ores were used for colouring glass in Egyptian and Classical times, the earliest find of smalt as a pigment in European paintings dates from the 15th century, thus coinciding with the manufacture of cobalt glass in Venice. Smalt was extensively used as a pigment from the 16th century until the mid-18th. It was then rapidly replaced by Prussian blue, and in the 19th century it was seldom used.

Smalt can have a deep blue colour when coarse, but it is pale when the particles are fine. It has a low refractive index ($n = c.$ 1.46–1.52 depending on the composition) and therefore low covering power. It is not affected by light, acids and alkalis, but it does sometimes discolour in an oil medium. This is due to an interaction between the pigment particles and the surrounding oil, a process that starts with cobalt acting as a catalyst in the drying of the oil. Unless it has been mixed with lead white, as was common in the 17th century for painting skies, the original blue colour of areas painted in smalt is sometimes unrecognizable.

4. ORGANIC SOURCES. Two blue pigments, woad and indigo, are organic in origin. They both have a similar chemical composition, but woad is obtained from the leaves of *Isatis tinctoria* while the source of the indigo used in European painting was the genus *Indigofera*. Different *Indigofera* plants were cultivated in India and China from early on, mainly for dyeing textiles. Woad was grown in Europe and used as a pigment up to the early 17th century, when it was replaced with indigo, which had become more plentiful since the opening of sea routes to the East. (For further information on woad and indigo, *see* DYE, §2.)

The colouring matter in both is indigotin ($C_{16}H_{10}N_2O_2$), which is obtained from the plants as a colourless glycoside, an indican, which turns blue on oxidation. In contrast to most organic colouring materials, indigotin is already insoluble in water and in oil, so it does not have to be precipitated on to an inert substrate to make it suitable for use as as a lake pigment. The pigment particles are dark and very fine, so indigo has good tinting strength. In an oil medium it appears nearly black, and under high magnification it seems to stain the medium. To give an opaque blue paint it has to be mixed with white. Although indigo may fade when exposed to strong sunlight, it is fairly stable when locked in a paint medium. It is stable chemically, except to nitric acid, which decomposes it. In 1880 Professor Adolf von Baeyer discovered the process for making synthetic indigo, which was manufactured from about 1900. The synthetic variety is identical in colour and chemical composition to the natural one.

5. OTHER SOURCES. From the second quarter of the 18th century natural indigo was largely replaced by Prussian blue. This pigment, also known as Berlin blue, Antwerp blue, Paris blue or Chinese blue, is a complex iron compound, the formula of which on analysis has been shown to be $KFe(II)Fe(III)(CN)_6$. It was first made between 1704 and 1707 by Diesbach, a colour maker in Berlin, who discovered it by chance. Details of the manufacturing process were kept secret, but the pigment was mentioned in a source of 1722 in the Netherlands, and in 1724 Woodward, in England, was allowed to publish the process in *Philosophical Transactions*. Prussian blue may occasionally be found in paintings from the first quarter of the 18th century. In the second quarter it was widely distributed, and it was extensively used in late 18th- and 19th-century works. Prussian blue is a very fine, dark blue powder with extraordinary tinting strength. It is usually found mixed with white. Its colour and pigment properties are very similar to those of indigo. It is fairly stable to light and air, but is readily attacked by alkalis, which turn it into brown iron hydroxide. Sometimes paint films appear green because of yellowing of the oil.

Cobalt blue (Thénard's blue) is an important cobalt pigment. It is a double oxide of cobalt and aluminium ($CoO.Al_2O_3$) obtained by calcining a mixture of cobalt oxide and aluminium hydroxide. The pure blue colour varies slightly with different impurities and methods of manufacture. In the second half of the 18th century a cobalt blue pigment known as Leithner's blue was made in Vienna by Leithner, but it was only after the discovery by Thénard in 1802 of a manufacturing process that it was used on a large scale. Cobalt blue is stable towards light, heat, acids and alkalis, so it can even be used for ceramic glazes. The pigment particles are relatively coarse, rounded and isotropic. The refractive index is medium, about 1.74.

By the beginning of the 19th century double oxides of cobalt and tin were being manufactured, but it was only in 1860 that this blue was introduced

as a pigment under the name 'caeruleum'; later it was known as cerulean blue. Like cobalt blue, it is stable and inert. It is more finely divided, with homogeneous, rounded, isotropic particles, which have a high refractive index and are green–blue by transmitted light.

Manganese blue was first made in 1907 but was hardly available before 1935. The double salt $BaSO_4$.$BaMnO_4$ has a greenish blue colour and is chemically inert; the particles are fairly coarse and moderately birefracting. Phthalocyanine blue, or monastral blue, is a later introduction. It is an organic blue, first synthesized by R. P. Linstead in 1934 and introduced as a pigment under the name 'monastral blue' in 1935, becoming available commercially soon after. It is lightfast, has very high tinting strength and is unaffected by alkalis and acids except concentrated sulphuric and phosphoric acids. Because of its stability, its strong and brilliant colour and its reasonable price, it became increasingly important from the 1930s.

IV. Brown. Brown pigments did not play a large role in painting before the 16th century. Even in the 17th century, browns were sometimes made from mixtures of other pigments.

1. EARTH BROWNS. Brown ochre is, like yellow, golden and red ochre, a natural earth consisting of silica and clay minerals. It owes its colour to iron oxide. A typical brown ochre is the rock limonite, also called brown haematite, which is not a pure mineral but consists of a variety of hydrous ferric oxides, mainly goethite ($Fe_2O_3.H_2O$). Ochres occur all over the world, and since they are natural, not chemically pure compounds, they can be found in different shades. Some ochres have good hiding power, but sienna (a yellow ochre that owes its name to the city of Siena) is valued for its transparency. A warm reddish brown, known as burnt sienna, is obtained by calcining raw sienna, by which process it loses its hydrated water. Good sienna should contain at least 50% iron oxide. It generally contains a small amount of manganese dioxide as well. Raw and burnt umber are similar earth pigments, but in umbers the manganese dioxide content is higher.

Microscopically, the ochreous pigments are heterogeneous. Goethite shows strong birefringent spherulites of about 1 μ, together with colourless silica and more opaque particles. The colour of the particles in burnt sienna is more homogeneous than in the raw variety. In analysis, however, usually no attempt is made to distinguish the different ochres and siennas since there is no clear distinction between them.

2. ORGANIC AND OTHER SOURCES. Other browns and blackish browns used in painting include asphalt and bitumen. The terms are used rather loosely and are not clearly distinguishable: they derive from the Greek and Roman names for the same material. Bitumen was known by the ancient Egyptians, who used it for gluing and consolidation. In spite of the

problems these substances caused in drying, they were also used for painting. In Europe references to their use as a pigment appear in the 17th century, for example in Théodore Turquet de Mayerne (1573–1655), but from the latter part of the 19th century synthetic coal-tar dyestuffs were developed in their place.

In composition asphalt and bitumen are geologically modified organic matter. They represent the waxy residue from crude petroleum and are a soft, but occasionally solid, substance depending on the amount of mineral matter present. The earliest known outcrops are probably those along the Dead Sea. Chemically these materials are very complex and variable. They contain hydrocarbons, both aliphatic and polycyclic aromatic, together with nitrogen compounds. These components are the fossilized products of the cell membranes of marine plankton and bacteria that have accumulated at the bottom of the sea or lakes. Debris from terrestrial plants may have added to the final composition. When green marine algae were originally present, chlorophyll can be identified. The complex composition of asphalt and bitumen makes their positive identification very difficult. The presence of hopanes, derived from bacteriohopanoids, is an indication of the asphaltic nature of a sample, since these are restricted to bacteria. In what is termed asphalt, the nitrogen content is higher and the amount of hopanes lower than in bitumen. Hopanes, indicating bituminous material, have been identified in pictures by Anthony van Dyck (1599–1641) and Gerrit Dou (1613–75).

Van Dyck brown (also known as Cologne earth or Cassel earth) consists mainly of organic material from lignitic or peat deposits. Most of the raw material has come from brown coal deposits near Cologne and Kassel in Germany. Although it was known earlier, it seems to have become much more popular in the 17th century. Like asphalt, it was used for glazing in oil paint and is a bad dryer.

Another pigment used for brown glazes was mummy. This was made from ground-up parts of Egyptian mummies, the fleshiest areas being most highly recommended. In 16th-century Europe it was prized as a medicine, but in the late 18th century it was mentioned as a pigment. It contains a variety of compounds, depending on the process of mummification.

Bistre is the name given to a pigment from wood soot. It was known by the medieval period and was used mainly for watercolour and wash drawings. Sepia, which was also used as a watercolour, seems to have been introduced in the last quarter of the 18th century by Professor Jacob C. Seydelmann in Dresden. It is a brownish-black secretion from the ink-bag of the common cuttlefish or squid. It has very high tinctorial power. For the preparation of sepia, the ink-bags were removed and quickly dried. In the 19th century some use was made of brown pigments chemically related to and made from Prussian blue. Manganese oxides were used as well.

V. Green. The main green pigments are green earth and the copper pigments: malachite, verdigris and copper resinate. Painters had difficulty in obtaining a bright green as the green copper pigments tend towards blue and the colour of green earth was often found to be dull. Greens, especially in 17th-century Dutch painting, were therefore frequently made from mixtures of blue (usually azurite) and yellow. In the 19th century green pigments containing chromium, zinc, cobalt and barium were added to the palette, and by the late 20th century a series of stable, synthetic organic green pigments was available.

1. Green earth. 2. Copper greens. 3. Chromium greens. 4. Organic and other sources.

1. GREEN EARTH. Known in Italian as *terra verde*, this is a silicate originating as a marine sediment. It is rich in the greenish coloured minerals glauconite or celadonite, which contain iron II (ferrous), formed as a result of diagenetic reactions under reducing conditions. Glauconite and celadonite are sheet silicates related to micas. Besides iron II and silicon, there is iron III (ferric), potassium, magnesium and aluminium. Good quantities of green earth are found near Verona, in the Tyrol and in Cyprus; it is sometimes called Veronese green after the source. Since green earth varies in composition, there is a range of shades, from yellowish green to greyish green depending on its origin. Green earth has a low hiding power, especially in oil. It is a very stable pigment, changing only when it is strongly heated and becomes red brown. This burnt green earth is used as a pigment as well. Although true green earth is still obtainable, it is subject to substitution by mixtures of other pigments, especially viridian.

Green earth is one of the earliest known pigments. In early sources it was called *creta viridis*, and it was used in all periods of European easel and mural painting. Typical examples are the greenish underpainting used for flesh in early Italian panel painting and the green in the landscapes by Claude Lorrain (?1604/5–82) and Gaspar Dughet (1615–75).

2. COPPER GREENS. The only naturally occurring copper green is malachite ($Cu_2CO_3(OH)_2$), a basic carbonate of copper. It is found in large masses in many parts of the world, usually in association with azurite, the blue basic copper carbonate (*see* §III, 1 above). Obsolete terms and synonyms for the pigment are mountain green, *Berggrun*, *verdetto della Magna*, Hungarian green and mineral green among others. In Classical and medieval writing it is referred to as chrysocolla, a word derived from the Greek words for gold and glue, since it was used by the Ancients for soldering gold. The term chrysocolla was later given by mineralogists to a blue–green hydrous silicate of copper. This mineral has been identified in wall paintings in Sino-Central Asia and in Egyptian tombs of the 12th dynasty.

Malachite was used in wall painting in all periods, both in Europe and elsewhere. Although in nature it occurs in far greater abundance than azurite, it has not been used as extensively in European easel painting and it is also mentioned less frequently in written sources. It has been suggested that the reason for this is that malachite, to be useful as a bright green, must be ground coarse. If ground finely it becomes too pale. Like azurite, it is stable to light and normal atmosphere. In transmitted light a fibrous structure can be seen in the larger particles of malachite under the microscope. Being chemically identical to azurite, it behaves in the same way towards acids, alkalis and heating.

Recipes for the preparation of artificial copper greens appear from the 17th century. Green verditer (*vert de terre* or *green bice*) is an artificial basic copper carbonate, which can be distinguished from the natural variety, malachite, by its regular, rounded particles. It was identified, for instance, in the *Hunt in the Forest* (Oxford, Ashmolean Museum) by Paolo Uccello (*c.* 1397–1475) and, mixed with black, in paintings by Frans Hals (1581/5–1666). It too is stable to light and normal atmosphere.

Besides copper carbonate, other green basic copper salts have been identified. Paratacamite, basic copper chloride, was found in Sino-Central Asia in wall paintings from the 5th century to the 8th, in Persian Islamic miniatures and in European painting. Basic copper sulphate (brochantite) has been identified as well, and a few examples of copper nitrates have been reported. In at least some instances these pigments must have been artificially prepared.

Verdigris is the best known of the early artificially prepared green copper pigments. It is a copper acetate. According to its colour and chemical composition, a distinction can be made between the bluish-green neutral verdigris ($Cu(CH_3COO)_2.H_2O$) and the blue to blue–green basic verdigris of variable composition ($Cu(CH_3COO)_2.nCu(OH)_2.mH_2O$). Basic verdigris is formed when acetic acid vapour, water vapour and air act on copper and copper alloys. It originated in wine-growing areas, for instance from the surroundings of Montpellier in the south of France, where grape husks and copper sheets were stacked alternately. Verdigris would form as a crust on the surface of the copper sheets and could be scraped off. The lumps of pigment, which, when pulverized, produced a light-blue powder, were sold as verdigris 'from Montpellier', 'from Grenoble', or as 'French', 'English', 'German', 'Swedish', 'ordinary' or 'crude' verdigris. These names are neither a guarantee of their origin nor of their method of preparation.

Neutral verdigris, also called crystallized or distilled verdigris, was made by dissolving basic verdigris in acetic acid and letting it recrystallize, or by grinding basic verdigris in strong acetic acid. Recipes for the manufacture of verdigris can be found in numerous sources from ancient times through the medieval period until the 19th century.

Verdigris reacts with binding media; with resins it forms copper resinates (see below), with oils copper

oleates. In these media its effect is that of a glaze. When mixed with white, it gives a bright, opaque, green paint. Verdigris was recommended by Cennino Cennini (*c.* 1370–*c.* 1440) as a drying agent for paint films. Although in early literature on painting its incompatibility with other pigments is often pointed out, areas in paintings containing verdigris together with lead or sulphur pigments have usually remained unchanged. Only in aqueous media and together with sulphur-containing pigments can a darkening sometimes be seen. The strong brown discoloration often seen in the green landscape in early oil paintings is usually caused by the darkening of the medium and/or a yellow glaze, rather than by the darkening of the pigment. Tests have shown that verdigris changes from blue–green to green in the first months after its preparation. After this period, specimens show good light-fastness. Verdigris occurs most often in paintings from 15th- and 16th-century Europe. In later work it occurs less often, although its identification in paintings from the last quarter of the 19th century shows that it was still available then.

Copper resinate is the name commonly given to the transparent copper green whose colouring matter is the copper salts of resin acids. It was used for glazing and was also mixed with other colours such as white and yellow. The earliest known recipe for the preparation of copper resinate is that of Théodore Turquet de Mayerne (1573–1655) and dates from the 1620s to 1646. According to this recipe, transparent copper green can be made by heating together verdigris and Venice turpentine, by which process a viscous, transparent mass is obtained. When dry, this green mass can be pulverized. The pigment particles appear under the microscope as irregular, sometimes glassy, green fragments without a crystalline structure. The refractive index is low, *c.* 1.52. Tests have shown that copper resinate turns brown when exposed to high intensity, short-wave ultraviolet radiation, while it shows different degrees of fading when exposed to daylight and other light sources. Brown discoloration of copper resinate glazes can sometimes be observed at the surface of a painting. In these cases the brown discoloration is often less pronounced where the green is hidden from the light by the frame. Since the short-wave ultraviolet radiation indoors would not be sufficient to cause this discoloration, it is not clear what causes this phenomenon.

In 1775 the Swedish chemist Carl Wilhelm Scheele, while investigating the nature of arsenic, discovered another copper green. This pigment, an acid copper arsenite ($CuHAsO_3$), was named Scheele's green after him. Scheele did not publish detailed instructions for the manufacture of the pigment until 1778 (see Harley), because he felt that potential users should first be aware of the poisonous nature of the pigment. Scheele's green does not seem to have been much used in easel painting, but another pigment that contains both copper and arsenic, Schweinfurt or emerald green (copper aceto arsenite, $Cu(CH_3COO)_2.3(Cu(AsO_2)_2)$, can often be found in paintings dating from the 19th century and early 20th.

It was first made in Vienna around 1800 and was manufactured commercially from 1814 by Sattler in Schweinfurt. It became available under such names as Paris, Munich and Vienna green and other fancy names (Brunswick green seems to have been a basic copper chloride). Emerald green, as it is generally called, has a bright, bluish-green colour and is one of the most brilliant of the inorganic colours. Some specimens are very characteristic when viewed under the microscope: they have small, uniform, rounded grains that can be seen to exhibit a radial structure, giving the appearance of a pit or dark spot in the middle. Like the other copper pigments (except for the transparent copper greens) the particles show birefringence. Although it is readily decomposed by acids and alkalis and is blackened by heat, emerald green is a fairly stable pigment in an oil medium. Sulphur-bearing pigments and air pollutants can blacken it when in an aqueous medium. On account of its poisonous nature, which makes it difficult to handle, it is no longer used.

3. CHROMIUM GREENS. Green pigments that owe their colour to chromium have been used widely since the 19th century. Chromium was first isolated as an element by Louis Nicolas Vauquelin in 1797. It owes its name to the different coloured precipitates that could be obtained from it. The chromium pigments include not only green but also red and yellow compounds (*see* §§VI, 4 and IX, 3 below). There are two varieties of chromium oxide green, namely chromium oxide green opaque and chromium oxide green transparent. The opaque variety is the anhydrous oxide of chromium (Cr_2O_3) first made by Vauquelin in 1809. Vauquelin mentioned that the pigment was already in use for colouring ceramic glazes. Although its introduction as an artist's pigment could have been delayed because of its dull colour, there is evidence that artists could get hold of the pigment in the first half of the 19th century.

Also in the first half of the 19th century, Pannetier, a French colour maker, developed the transparent variety of chromium oxide, a hydrous oxide ($Cr_2O_3.2H_2O$), now known as viridian. From 1860, after Guignet patented a new method for the production of transparent chromium oxide, it was manufactured in much larger quantities, replacing Schweinfurt green. The new pigment was called *vert émeraude* in France, not to be confused with emerald green, the English name for Schweinfurt green. When it is mixed with other pigments or with fillers it is marketed under the names permanent green or Victoria green. Viridian is a deep, very pure green with excellent tinting strength, working as a glaze in an oil medium. It is stable in all media and not affected by acids, alkalis or light. Microscopically it shows characteristic, bright green, birefringent particles.

The pigment with the name chrome green, also called cinnabar green, has come into common use as a green pigment made by mixing Prussian blue and chrome yellow (lead chromate, *see* §IX, 3 below). The availability of chrome green must have coincided

with that of chrome yellow, which was first made in 1809 and became available on a larger scale around 1820. The homogeneous mixture of Prussian blue and chrome yellow is sensitive to acids and to alkalis (the latter preventing its use in fresco painting), while the chromium component can darken in strong light. In spite of this, the pigment was used extensively in the 19th century.

Mixtures of Prussian blue and zinc chromate were used for making zinc green, but this pigment was not used as extensively as chrome green. Several other green chromium pigments were manufactured in the second half of the 19th century, for instance those containing chromium phosphate, but these were not much used in easel painting. The manufacture of cobalt green (Rinmann's green) was first published by the Swedish chemist Rinmann in 1780. It is a double oxide of cobalt and zinc, or a combination of the oxides of cobalt, zinc and aluminium in varying amounts. It probably became available in the early 1820s, but perhaps owing to its high price it was not used as much as chrome green.

4. ORGANIC AND OTHER SOURCES. The variety of organic green pigments is not as great as that of red and yellow ones, owing to the fact that chlorophyll is almost the only green colouring matter in nature and it is very fugitive. In the 17th century mention was occasionally made of pansy green and Lely green; the dye, extracted from flower petals, was precipitated on to alum to form a lake. Since these dyes are fugitive it is not possible easily to identify the organic greens in small paint samples. Sap green, a green colour made from ripe buckthorn (*Rhamnus*) berries, is mentioned more frequently, along with its fugitiveness. In the 18th century it became more popular for use in watercolour.

In the second half of the 19th century the first synthetic organic green pigments were made, and eventually a variety of stable synthetic organic pigments became available. Unfortunately one of these synthetics (a triphenylmethane dye) was called malachite green, which can cause confusion with the copper compound of the same name.

VI. Red.

1. Vermilion. 2. Red ochre and iron oxides. 3. Red lead. 4. Other artificial reds. 5. Organic sources.

1. VERMILION. Together with red ochres and iron oxides, the most widely used red pigment is vermilion. It has been identified in numerous paintings, ranging from Roman murals and medieval miniatures to 20th-century easel paintings. Only in the 20th century was vermilion largely replaced by the more durable cadmium red.

Vermilion is mercuric sulphide (HgS). Three different kinds have been used: the natural variety, which is finely ground cinnabar, the common red crystalline form of the natural mineral; synthetically produced mercuric sulphide, made by a dry process and called vermilion; and the synthetic variety made

by a wet process, also called vermilion. The synthetic products are derived indirectly from native cinnabar and have been manufactured since the early medieval period. Apart from names related to vermilion and cinnabar (*vermiculus*, *cinnabaris* and *cenobrium*), vermilion has also been known from the medieval period onwards as minium, the name used for red lead (*see* §3 below). Pliny the elder (AD 23/4–79) reported that minium (in this case, true vermilion) was imported mainly from Sisapu (or Sisopo) in Spain and that it was often adulterated. Vermilion and *vermiculus* are supposed to derive from the Latin *vermes*, the original name of the kermes insect from which a red dye was extracted (*see* DYE, §2); *cinnabaris* was used by the Ancients to designate both vermilion and dragon's-blood, another red dye (*see also* DYE, §2).

According to Vitruvius (*fl* late 1st century BC), ground cinnabar was made by crushing lumps of the ore in iron mortars, then washing and heating it repeatedly until the impurities had gone. Dry-process vermilion may have been invented in China and the knowledge of it carried to Europe by the Arabs. There are numerous recipes for the manufacture of vermilion in medieval sources, including the *Compositiones variae* of the late 8th century to early 9th, where vermilion is prepared by uniting mercury and sulphur. By the beginning of the 17th century the principal European centre for the manufacture of dry-process vermilion was Amsterdam. In the Dutch method, about 100 parts by weight of mercury are combined with 20 parts of molten sulphur to form black, amorphous mercuric sulphide, also called ethiops. The black mass is heated to above 580°C, when it sublimes and converts to the red crystalline modification α–HgS. It was treated with strong alkali to remove free sulphur, then washed and ground. In the last quarter of the 17th century it was discovered that ethiops could be converted into vermilion by heating it in a solution of ammonium or potassium sulphide, an easier and less costly method than the dry sublimation process. This method overtook the dry process and found favour with English, German and American producers.

Natural and artificially prepared vermilion do not differ chemically or physically. The sublimed product is usually more coarsely crystalline and has a bluish colour when compared to the orange of wet-process vermilion, which is fine and uniform in particle size. It is not easy to distinguish natural and dry-process vermilion under the optical microscope, but scanning electron microscopy does reveal different particle characteristics between ground natural cinnabar and wet-process vermilion.

Vermilion is a heavy pigment with a brilliant red colour and good hiding power. It is insoluble in alkalis and in concentrated acids but soluble in aqua regia. Vermilion has proved to be essentially a stable pigment, although this is not always the case. In an aqueous medium and exposed to strong light it can change to the metastable black modification of mercuric sulphide, metacinnabar (α'–HgS).

2. RED OCHRE AND IRON OXIDES. Red ochre is an important natural earth pigment. As with brown ochre (see §IV, 1 above), the different varieties contain more or less clay and quartz, along with iron oxides. The best sorts of red ochre contain as much as 95% red, anhydrous ferric oxide or haematite (Fe_2O_3). Burnt red ochre was made by heating yellow or brown ochre, thereby driving off the hydrated water of the goethite. Deposits of iron oxide vary in hue, depending on the degree of hydration, and red ochres are named after their place of origin (Pozzuoli red, Indian red) or after their colour (light red). Pozzuoli red is of volcanic origin from Pozzuoli, near Naples. Indian red was formerly exported from India and varied in colour from light to deep purple red; later the name became used for an artificially prepared iron oxide, which has also been called caput mortuum. The name 'light red' was sometimes used for calcined yellow ochre, but then came to mean a processed blend of iron oxide and calcium sulphate, brick red in colour. This was almost identical to Venetian red, which was originally a natural, partially hydrated ferric oxide but by the late 20th century included up to 90% calcium carbonate and calcium sulphate. Other artificial iron oxides are in common use, including English red, *Morellensalz* and Paris red.

The so-called Mars colours (Mars yellow, Mars orange, Mars red and Mars violet) are made by mixing a soluble iron salt (ferrous sulphate) with alum and precipitating it with an alkali. A yellow product results, its depth of colour depending on the proportion of alum used. Heating this primary product over various timespans gives orange, red, brown and violet shades. The preparation of iron oxides of this nature was first described in the mid-19th century.

Ochres are stable pigments and have been used from ancient times in Egypt, Rome and Asia, and in all periods of European painting.

See also SINOPIA.

3. RED LEAD. Also known as minium or orange mineral, this red tetroxide of lead (Pb_3O_4) is made by heating litharge or lead white for some hours at a temperature of around 480°C. It is also produced by direct oxidation of lead to form the yellow monoxide and then reheating the cooled product at a lower temperature. Red lead has a bright scarlet colour and good hiding power. It is finely divided and not very characteristic under the microscope. It turns white in hydrochloric acid and forms $PbCl_2$; nitric acid can cause it to turn brown; sulphides blacken it. Like all the other lead pigments, it is poisonous. It is permanent in oil, but on exposure to light it can darken by the partial or complete transformation to brown–black lead dioxide (PbO_2). The precise mechanism of this black discoloration is not fully understood. It occurs particularly when the pigment is dispersed in an aqueous medium and can often be seen in mural paintings, less often in watercolours. The unsuitability of red lead for wall painting was noted by Cennino Cennini (*c.* 1370–*c.* 1440).

Red lead was known to the Ancients. Pliny called it *minium secondarium*, a term that distinguished it from natural vermilion, which he called *minium*. Other names, such as false sandarach, *sandyx* and *syricum* have been in use for the pigment and mixtures containing it from the time of Pliny to the medieval period, when minium became the generally accepted name for red lead. In later centuries the terms Paris red and Saturn red were sometimes used.

The manufactured pigment was known in China in the 2nd century BC. Further evidence of its early use was obtained from objects at the Greco-Roman site of Hawara in Egypt and on Roman Faiyum portraits from the 2nd century to the 4th. Red lead was used extensively in medieval manuscripts, on its own and with vermilion, in the paint used for the miniatures as well as in the red initials and borders. Indeed, the word 'miniature' seems to derive from the Latin verb *miniare*, to paint red. Otherwise the pigment was used relatively little in European painting. It has been found on polychromed Romanesque and Early Gothic sculpture and occasionally on paintings executed between 1300 and 1900. It was popular for decorative painting and was still used for this purpose in the late 20th century. Now, however, its commercial importance lies in its extensive use as an anti-corrosive paint for iron.

4. OTHER ARTIFICIAL REDS. Cadmium red is a sulphoselenide (CdS(Se)), a stable and lightfast pigment first mentioned and patented in Germany in 1892 and therefore more recent than the straight cadmium sulphides (*see* CADMIUM YELLOW AND ORANGE in §IX, 3 below). The commercial preparation of cadmium red did not begin until around 1910, and by the late 20th century it had largely replaced vermilion. Cadmium red lithopone is cadmium sulphoselenide co-precipitated with barium sulphate. It was first made in 1926 and was then mainly available in the USA. A shortage of selenium around 1948 gave rise to a pigment in which cadmium was partially replaced by mercury, the resulting pigment containing crystals of cadmium sulphide and mercury sulphide. This and cadmium red lithopone have the same stability as cadmium red.

Other artificially prepared red pigments include a red antimonyoxide sulphide ($2Sb_2S_3.Sb_2O_3$), first made in 1842, and chrome red and chrome orange (lead chromate, $PbCrO_4.PbO$), first made in 1809. These pigments, and also mercury iodide (HgI), which was recommended as a pigment in the 19th century, were rarely used by artists. The same is true of molybdate red, which came on the market around 1935 (*see* MOLYBDATE ORANGE in §IX, 3 below).

5. ORGANIC SOURCES. Red organic colouring matter, extracted from plants and animals (*see* DYE, §2), was made into pigment by precipitating a soluble dye on to an inert inorganic base, such as aluminium hydrate or calcium sulphate. The precipitated dye is called a LAKE or lake pigment. Dyes, which are soluble, are used for colouring fabrics, while the insoluble

lakes can be mixed with a binding medium and used for painting. Since the manufacture of synthetic dyes in the 19th century, lakes have been prepared in enormous quantities from synthetic dyestuffs, the coal-tar colours.

One of the most commonly used lakes is madder. The colouring matter is found in the roots of the madder plant *Rubia tinctorum* as a glucoside which is hydrolyzed when the dead roots ferment under damp conditions; it is chiefly alizarin (1,2-dihydroxyanthraquinone, $C_{14}H_8O_4$), with purpurin as the next main component. The dye was extracted from the root and treated with alum and sodium or potassium carbonate, which precipitated as aluminium hydroxide on to which the dye was adsorbed. In 1869 the German chemists C. Graebe and C. Liebermann succeeded in synthesizing alizarin, and from that date synthetic alizarin replaced natural madder. It differs from madder by the absence of other components such as purpurin. Besides red, purple–red and pink alizarin, brown–red to bluish-black varieties are made by using tin, chromium and iron substrates.

Madder can be found in European paintings and polychromed sculpture of all periods. It is often applied as a translucent paint layer or glaze over an opaque red paint to give an optically deeper red.

Red lakes were also made with dye extracted from brazil-wood. Known in the Middle Ages, these lakes were sometimes called *Verzino* and *Bresilwood*. The main colouring matter is brazilein ($C_{16}H_{12}O_5$), which is a deep red to brown colour extracted by boiling chips of wood in water. The lake is prepared in the same way as for madder.

A further source of red lakes comprised the insect dyes, kermes, carmine and lac. Carmine (or crimson) dye is obtained from the dried female bodies of the cochineal shield-louse *Dactylopius coccus*; it was imported into Europe after the conquest of Mexico in 1523. The colouring matter in cochineal is carminic acid ($C_{22}H_{20}O_{13}$), an anthraquinone dye. Carmine is an aluminium or calcium salt of carminic acid and in this form is not a lake. The lake is prepared by adding additional alum and sodium carbonate to a solution of carmine; the addition of lime gives a deep purple tone. Cochineal lakes, which are known as crimson or carmine lakes, are not permanent to light, although in oil they are fairly stable.

Kermes is an ancient dye, similar in colour and chemical composition to cochineal. The colouring matter is kermesic acid ($C_{18}H_{12}O_9$), an anthraquinone derivative, obtained from the dried bodies of the female insect *Kermes vermilio*, which is found on the kermes oak indigenous to southern Europe. Kermes lost its importance when cochineal, which contains about ten times as much colouring matter, began to be imported into Europe. Scientific analysis has suggested that the use of kermes or grain lake was continued longer in Italy than in northern Europe.

Lac (lac lake; Indian lake) is prepared from the resinous secretion of the larvae of the lac insect *Kerria lacca*, which lives on fig trees in India and East Asia

(*see* LACQUER, §I, 2). The substance was exported on sticks (stick lac), in cake form or thin pieces as shellac. The dye was extracted with a dilute solution of sodium carbonate during the purification of the shellac or seed lac. The lake is made by precipitation with alum. The colouring matter of the dye, laccaic acid ($C_{20}H_{14}O_{10}$), is similar in colour and in chemical composition to the carmine dyes from cochineal. Complications in the nomenclature of lake pigments in history and the dearth of analytical examination of its use in paintings make it impossible to draw conclusions about the use of lac in paintings.

Tyrian purple was prepared from several molluscs, including *Murex brandaris* and *Purpura lapillus* found on the shores of the Mediterranean and on the Atlantic as far as the British and Irish coasts. The molluscs secrete a pale yellow liquid that becomes purplish red or crimson when exposed to strong sunlight. At the beginning of the 20th century the identity of the dye was established as 6, 6′ dibromoindigo. The production of lake from the dye was described by Pliny the elder (AD 23/4–79), but it is not clear to what extent Tyrian purple was indeed used by the Ancients.

A dye known as dragon's-blood is obtained from a dark red resinous exudation from such trees as the rattan palm (*Daemonorops* spp.) indigenous to East Asia and *Dracaena* spp. in the Middle East. The resin, collected from the fruit and from wounds in the bark, was heated, moulded into sticks and wrapped in palm leaves. Its appearance when dry must have been responsible for its name. It was used for colouring resin and oil-resin varnishes and for glazing on gold and silver leaf. It was not much used in painting.

VII. Violet. That new pigments developed in the 19th century consisted of inorganic pigments as well as organic is illustrated by the violets. The exact chemical composition is not always known and could vary, depending on the process used.

Ultramarine violet and reds were developed in Germany around 1875. They are chemically similar to ultramarine blue and are readily available. Cobalt violet has been made in various ways. The violet cobalt pigment on the market in the late 20th century appears to be anhydrous cobalt phosphate or arsenate, or a mixture of the two. The preparation of cobalt phosphate as a pigment was first described in 1859. Manganese (or permanent) violet is said to be a manganese ammonium phosphate. It was first prepared in 1868.

VIII. White.

1. LEAD DERIVATIVES. White was sometimes used in easel paintings to represent light. For modelling it was mixed with other pigments, and an addition of white can be found in most of the paint layers. Until the 19th century, lead white was the only white pigment used in easel painting. Lead, being a heavy element, absorbs X-rays, so X-radiographs of easel paintings can be generated to show different aspects of the artist's working method (*see* TECHNICAL EXAMINATION, §VIII, 6).

Lead white (white lead, flake white, Cremnitz white, silver white, ceruse) is chemically the basic carbonate of lead $(2PbCO_3.Pb(OH)_2)$. Although this compound occurs naturally as the rare mineral hydrocerusite, the pigment has been prepared artificially since early times. It is one of the oldest synthetically produced pigments. Until recently lead white was made by the Dutch or stack process, the principle of which was described by Theophrastus (c. 370–c. 288/5 BC) and Pliny the elder. Clay pots containing strips of metallic lead, with vinegar in a separate compartment in the bottom, were stacked in a shed with fermenting horse manure. The resulting heat and carbon dioxide, together with the acetic acid vapours, led to the formation of white basic lead carbonate on the surface of the metal. This flaky product was scraped off, dried and washed. Lead white made in this way can be recognized under the microscope by its lumpy nature. Variations on this manufacturing process were used, and by the late 19th century more rapid chemical methods had been developed.

Admixtures of lead white with other whites may be encountered in paintings. In the 16th and 17th centuries Dutch painters could obtain a pure lead white called *schelpwit* (shell white) and a cheaper white, which was a mixture of lead white and chalk, referred to as *lootwit*. This cheaper white has been identified in the priming and undermodelling in paintings by Peter Paul Rubens (1577–1640), Johannes Vermeer (1632–75) and Rembrandt van Rijn (1606–69). Since the 19th century barium sulphate has often been added to lead white as a filler.

When ground in oil, lead white forms a quick-drying, durable film with good covering qualities. The film becomes more transparent with time, so the underdrawing, originally invisible, may eventually show through the paint layers. When used in aqueous media lead white often turns black. This is due to the formation of lead sulphide (PbS) by the presence of sulphur in polluted air or in the paint mixture. Brownish-black lead dioxide (PbO_2) has been identified in mural paintings. Other white lead pigments were first manufactured in the 19th century. These include a basic lead chloride and basic and neutral lead sulphate.

2. ZINC DERIVATIVES. Zinc white or Chinese white is zinc oxide (ZnO), a very fine, cold-white powder. It has less hiding power than lead white, so in oil paint it is often mixed with lead white. The advantages of zinc white over lead white in watercolour are that it is not poisonous and it does not turn black: the zinc sulphide (ZnS) that forms in the presence of sulphur is a white compound so there is no visible change. Zinc white can be made either by burning metallic zinc (the French process) or with a zinc ore as the starting material (the direct or American process). Since zinc oxide is photochemically active, the paint films containing it are prone to chalking. This property is used to advantage in outdoor paint, where rainwater washes away the crumbled surface together with collected dirt.

Although zinc was not described as an element until 1746, zinc oxide was known and used as a medicine in the Middle Ages under such names as *nihil album* and *nix album*. Small amounts of zinc white for use in painting were first made in 1780 by Courtois in Dijon. In 1834 Winsor & Newton introduced zinc white as a watercolour, calling it Chinese white, but it was only from around 1840 that zinc white was used extensively in painting in both water and oil. The early knowledge of zinc oxide explains the occasional use of zinc in paintings dating before the 18th century.

Lithopone, an intimate mixture of zinc sulphide (ZnS) and barium sulphate $(BaSO_44)$, was first prepared around 1847. It came into use as an artists' pigment towards the end of the 19th century.

3. TITANIUM AND OTHER SOURCES. Titanium white (Titanox in the USA) is titanium dioxide (TiO_2), the whitest pigment and also the white with the greatest hiding power. It is a slower drier than lead white but does not blacken in watercolour. Although the titanium ore, ilmenite (iron titanium oxide), was described earlier, the element was first named titanium in 1795. Titanium dioxide was first prepared as a pigment in 1870 from the mineral rutile; later reports suggest that it was intended for painting ships rather than as an artists' material. It was only around 1916–18, after several attempts, that production of the pigment was started in the USA. The first commercial product was a composition consisting of 25% titanium dioxide in the crystal form anatase and 75% barium sulphate—titanium dioxide occurs in nature in three different crystal forms, anatase, rutile and brookite—but a major drawback of the anatase pigment was its poor chalking resistance. The development of the rutile form, which was less prone to chalking, started in 1938, and the first commercial rutile titanium pigment, containing 30% rutile, appeared on the market in 1941. A pure rutile pigment followed soon after and came on the market after World War II.

The earliest known use of titanium white in painting dates from the 1920s. However, a slightly earlier use cannot be ruled out; analyses of securely dated paintings from around 1900 should establish the date of its introduction.

Oxides of antimony and bismuth were prepared for use as pigments in the 19th century, but they were hardly used. Chalk was used as a GROUND for panel paintings in northern Europe, gypsum in Italy; these substances were also used as cheap fillers in grounds and paint layers. A white chalk pigment known as *bianco sangiovanni* was used in frescoes. It was made by exposing little cakes of slaked lime to the air to convert it back to chalk.

IX. Yellow and orange.

1. Yellow ochre and orpiment. 2. Lead derivatives. 3. Chromium, cadmium and cobalt derivatives. 4. Organic sources.

1. YELLOW OCHRE AND ORPIMENT. Yellow ochre was used as a pigment from early on and in all types of painting. It owes its colour to various hydrated

forms of iron oxide, mainly the mineral goethite ($Fe_2O_3.H_2O$). The preparation of artificial yellow iron oxide, Mars yellow, was first described in the middle of the 19th century. The properties of yellow ochre are similar to those of brown and red iron oxides (*see* §§IV, 1 and VI, 2 above).

Orpiment or King's yellow is a bright yellow pigment, chemically arsenic sulphide (As_2S_3). It occurs naturally, often together with the orange–red sulphide, realgar (As_2S_2). Both orpiment and realgar were known in ancient times, orpiment as *auripigmentum* and realgar probably as the *sandarack* to which Pliny the elder (AD 23/4–79) referred. Orpiment is reported to have been used in paintings of the 18th dynasty in Tell el-Amarna in Egypt. Artificial arsenic sulphide came on the market in the 19th century under the name of King's yellow. It is not used any more because of its poisonous nature. Orpiment has been identified in many paintings, for instance those of Paolo Veronese (1528–88), who used it together with realgar in draperies, and in 17th-century Dutch landscapes, where it is mixed with blue to make green. In 18th-century portraits it was used for the highlight on gold. Orpiment and realgar are stable pigments, but they can darken in aqueous media in the presence of lead and copper pigments.

2. LEAD DERIVATIVES. Lead-tin yellow is a lead-tin oxide, Pb_2SnO_4, a light yellow pigment. It has been identified in many paintings from the 15th, 16th and 17th centuries. Before and after this period it was found less often, and so far it has not been identified in paintings from the 19th century or indeed before 1941, after which date it can be found in modern fakes. Until 1941 lead-tin yellow was not mentioned in the literature, and reference to a pigment made from tin and lead occurs in only one source, the 15th-century Bolognese manuscript (see Merrifield, ii, pp. 528–9). In 1940 R. Jacobi, in the Doerner–Institut, Munich, found through emission spectralanalysis that tin often accompanied lead in the yellow paint samples—previous methods of analysis had not been able to reveal this—and from 1941 lead-tin oxide pigments were made in the laboratory. It is now generally accepted that lead-tin yellow is the pigment called *giallolino* or *giallorino* in the treatise by Cennino Cennini (*c.* 1370–*c.* 1440) and other Italian sources, *masticot* or *massicot* in northern ones.

There are two types of lead-tin yellow, the composition depending on the method of preparation. The type referred to as lead-tin yellow I is the lead-tin oxide (Pb_2SnO_4); lead-tin yellow II contains free tin oxide and additional silicon. It has been found that most lead-tin yellow is of type I. Type II has been occasionally identified in Venetian and Bohemian paintings. This and the manufacturing process of type II, which involves a yellow lead glass, suggest a possible connection with the manufacture of coloured glass.

Lead-tin yellow I is obtained by heating a mixture of red lead (Pb_3O_4) and tin (IV) oxide (SnO_2) at temperatures of between 650°C and 800°C, whereby warm hues appear at the lower temperatures and

lemon-coloured hues at the high temperatures. The pigment is a finely divided powder with no characteristic particles microscopically.

Lead-tin yellow is a stable pigment in all media. It is not affected by light (in contrast to yellow lead oxide, PbO) and has high hiding power. It has been found unchanged in its frequently occurring mixtures with azurite, verdigris and lead white.

Massicot and litharge are names used for the yellow and the orange–red variety respectively of lead monoxide (PbO). Massicot is obtained by heating lead white for some time at 300°C, avoiding temperatures above 400°C. Litharge is the fused oxide, formed from the direct oxidation of the molten metallic lead. Until 1941 it was assumed erroneously that massicot had been used extensively in painting, because of the mention of *masticot* and *massicot* in sources (see lead-tin yellow above). Although yellow and orange–red lead monoxide must have been known as early as metallic lead, modern analytical techniques have shown that they were rarely used as pigments. The reason for this could be that they darken readily when exposed to light. By the end of the 18th century lead-tin yellow seems to have gone out of use, and lead antimonate (see below) was called Naples yellow. So the assumption that references to massicot from the end of the 18th century are to lead monoxide seems reasonable. Both with the naked eye and under the microscope, massicot looks very similar to lead–tin yellow.

Naples yellow is lead antimonate (lead antimonyoxide), its stoichiometry depending on the ratios of the starting materials used and the time and temperature of calcination. The artificial pigment has been manufactured at various periods, although early on, for instance in ancient Egypt, it was used for coloured glass and glazes rather than for painting. Its first use as a pigment probably dates from the 17th century (it was identified for instance in a few paintings by Claude Lorrain (?1604/5–82)), although it was still relatively rare; in the 18th century it was used much more extensively. In the late 20th century it was still on the market as an artists' pigment. Its hue, yellow to orange, depends on the proportions of lead and antimony used in its production. Originally the starting materials were usually the oxides, but later they were replaced by nitrate of lead. The particles are finely divided. Naples yellow is a lightfast pigment with good hiding power. Like lead white, when used in an aqueous medium it can turn black in the presence of sulphur.

Patent yellow, a lead oxychloride ($PbCl_2.6PbO$), was discovered by Scheele in 1770 as a by-product in a process for preparing soda. The discovery was made public about five years later and patented in England by James Turner in 1781. Little is known about its use by artists.

3. CHROMIUM, CADMIUM AND COBALT DERIVATIVES. Chrome yellow (lead chromate, $PbCrO_4$ and $PbCrO_4.PbSO_4$) is one of the most important yellow pigments. It has been on the market under many fancy

names, some of them misrepresentative. Lead chromate occurs in nature as the rare mineral crocoite, also called Siberian red lead after its original place of discovery. It was not used in this form as a pigment. Louis Nicolas Vauquelin, in 1797, reported the discovery of the element chromium in the mineral. Lead chromate was recognized as a possible pigment by 1804, but it was not until ores in sufficient quantities for production of chromium were discovered around 1820 that chrome yellow came on the market on a large scale. However, an earlier reference to the pigment and the identification of it on a painting by Thomas Lawrence (1769–1830) dated before 1810 indicate that it must have been introduced shortly after 1804. It appeared also as the yellow component in chrome green soon after that date.

The early varieties of chrome yellow are not permanent when exposed to light, tending to turn brown or greenish. Modern varieties have been made lightfast by the addition of photochemical stabilizers.

Other yellow chromium pigments include: zinc yellow, a complex zinc potassium chromate; strontium chromate ($SrCrO_4$); barium chromate ($BaCrO_4$) and calcium chromate ($CaCrO_4$). Chrome orange has the same chemical composition as chrome red, $PbCrO_4 \cdot PbO$. All these, together with basic cadmium chromate, bismuth chromate and basic iron chromate, were available from the beginning of the 19th century but were not used on a large scale until around 1850; only zinc yellow became significant. Molybdate orange, a mixed crystal pigment of lead chromate and lead molybdate, was first described in 1930 and went into production soon after 1935.

Cadmium yellow is cadmium sulphide (CdS). Its hue alters through orange to red by the inclusion of more and more selenium. The cadmium pigments can also be extended with barium sulphate to give the lithopone varieties, called cadmium lithopone or cadmopone.

Cadmium was discovered as an element in 1817, and cadmium sulphide came into use as a pigment soon after this date. Little information is available on the early history of the pigment, but it seems to have come on the market shortly before 1850. In the last quarter of the 19th century cadmium yellow was very expensive compared to chrome yellow, for example. The high price was probably the reason why the use of cadmium yellow by artists remained limited until around 1917, when the amount consumed by industry began to increase rapidly. By 1920 cadmium yellow had become a trustworthy pigment, available in a variety of shades, and later in the decade the price went down further with the introduction of the cadmium lithopones. Cadmium yellow has a lemon to orange–yellow colour and good hiding power; it is one of the most stable pigments in all types of medium.

Cobalt yellow or aureolin is potassium cobaltnitrite, first prepared in Breslau (now Wrocław) in 1848 and in 1861 introduced as a pigment by Winsor & Newton. Lacking in hiding power, it is used more for glazing and for watercolour.

4. ORGANIC SOURCES. It is known that yellow dyes were extracted from several species of plants (*see* DYE, §2) and made into pigments. The dyes were often fugitive and are difficult to identify with certainty in paint samples. It is not possible, therefore, to say how extensively organic yellow pigments were used at different periods and in different kinds of painting.

A yellow dye was extracted from the unripe buckthorn berries of the genus *Rhamnus* and precipitated on to alum or chalk. The principal colouring matter of the yellow to olive-green lakes (ripe berries give green) is rhamnetin ($C_{16}H_{12}O_7$), the methyl ester of a tri-hydroxyflavonol.

Weld originated from the leaves and stems of *Reseda luteola*, which is found in many parts of Central Europe. The colouring matter is luteolin, again a flavone. It was used mainly for dyeing silk and according to sources it was used in miniature painting. Quercitron was extracted from the inner bark of various species of American oak tree. Little is known about its use in Europe until 1775, when it was imported into England for the preparation of the dye. The colouring matter is quercetin, a tetra-hydroxyflavonol, and quercitrin, a glucoside of quercetin. A yellow made from the broom plant *Genista tinctoria*, in England called dyer's broom, was used for dyeing fabric. Other yellows, fustic and saffron for example, were little used in watercolour painting and probably not at all in oil until the early 19th century.

Indian yellow was a pigment imported into Britain from India, where it was known as *piuri* or *peori*. It was not until the late 19th century that a systematic inquiry led to the discovery that it was an extract from the urine of cows that had been fed on the leaves of mangoes. The colouring matter is principally the calcium or magnesium salt of euxanthic acid, which is insoluble and so does not have to be made into a lake. It was used in Britain from the late 18th century, and there is some evidence that it was used in 17th-century Dutch painting. The practice for obtaining the product is now prohibited by law.

Gamboge is the gum resin from varieties of *Garcinia* trees growing in India, Sri Lanka and Thailand. It was used in watercolour and in oil for glazing. It is not known when it was first used in Europe. Mixed with Prussian blue, it was known as Hooker's green and used for watercolour.

For metallic pigments *see* GILDING, §I, 2.

Vitruvius: *On Architecture*

Pliny: *Natural History*

C. Cennini: *Il libro dell'arte* (*c.* 1390); Eng. trans. and notes by D. V. Thompson jr as *The Craftsman's Handbook: 'Il libro dell'arte'* (New Haven, 1933/*R* New York, 1954)

T. Turquet de Mayerne: *Pictoria, sculptoria, tinctoria …* (1620–46; London, British Library, MS. Sloane 2052); Dut. trans. and notes by J. A. van de Graaf as *Het de Mayerne manuscript als bron voor de schildertechniek van de barok* [The de Mayerne manuscript as a source for Baroque painting technique] (Utrecht, 1958); Fr. trans. as *Le manuscrit de Turquet de Mayerne* (Lyon, n.d.)

Mrs M. P. Merrifield: *Original Treatises Dating from the XIIth to the XVIIIth Centuries on the Arts of Painting*, 2 vols (London, 1849/*R* London and New York, 1967)

R. Mayer: *The Artist's Handbook of Materials and Techniques* (New York, 1940, rev. London, 5/1991)

R. J. Gettens and G. L. Stout: *Painting Materials: A Short Encyclopedia* (New York, 1942/*R* 1966)

E. H. Schafer: 'The Early History of Lead Pigments and Cosmetics in China', *T'oung Pao*, xliv (1955), pp. 413–38

H. Kittel: *Pigmente* (Stuttgart, 1960)

R. J. Gettens and E. West Fitzhugh: 'Azurite and Blue Verditer', *Studies in Conservation*, xi (1966), pp. 54–61

J. Plesters: 'Ultramarine Blue, Natural and Artificial', *Studies in Conservation*, xi (1966), pp. 62–91

R. J. Gettens, H. Kühn and W. T. Chase: 'Lead White', *Studies in Conservation*, xii (1967), pp. 125–39

H. Kühn: 'Lead-tin Yellow', *Studies in Conservation*, xiii (1968), pp. 7–33

B. Mühlethaler and J. Thissen: 'Smalt', *Studies in Conservation*, xiv (1969), pp. 47–61

R. D. Harley: *Artists' Pigments, c. 1600–1835: A Study in English Documentary Sources* (London, 1970, rev. 2/2001)

H. Kühn: 'Verdigris and Copper Resinate', *Studies in Conservation*, xv (1970), pp. 12–36

E. H. Van't Hul-Ehrnreich and P. B. Hallebeek: 'A New Kind of Old Green Copper Pigments Found', *ICOM Conference: Madrid, 1972*

T. C. Patton, ed.: *Pigment Handbook*, 3 vols (New York, 1973)

R. J. Gettens and E. West Fitzhugh: 'Malachite and Green Verditer', *Studies in Conservation*, xix (1974), pp. 2–23

K. McLaren: *The Colour Science of Dyes and Pigments* (Bristol, 1983)

K. Nassau: The Physics and Chemistry of Color (New York, 1983, rev. 2/2001)

H. Kühn and others: *Farbmittel, Buchmalerei, Tafel- und Leinwandmalerei* (Stuttgart, 1984)

R. L. Feller, ed.: *Artists' Pigments, 3 vols.* (Cambridge, 1986)

R. White: 'Brown and Black Organic Glazes, Pigments and Paints', *National Gallery Technical Bulletin*, x (1986), pp. 58–71

H. Kühn and others: *Reclams Handbuch der künstlerischen Techniken*, i (Stuttgart, 1988)

Pigments et colorants de l'Antiquité et du Moyen Age: Teinture, peinture, enluminure: Etudes historiques et physico-chimiques (Paris, 1990)

J. Balfour-Paul: *Indigo in the Arab World* (London, 1997)

E.-C. Wellmer: 'Goldfarbene Lacke in den Quellenschriften aur Maltechnik: Ein Überblick zur Geschichte, Verwendung und Material', *Firnis: Material, Ästhetik, Geschichte*, ed. A. Harmssen (Brunswick, 1999), pp. 43–62

N. J. Koch: *Techne und Erfindung in der klassischen Malerei: Eine terminologische Untersuchung* (Munich, 2000)

M. Clarke: *The Art of all Colours: Mediaeval Recipe Books for Painters and Illuminators* (London, 2001)

W. V. Davies: *Colour and Painting in Ancient Egypt* (London, 2001)

H. K. Stratis and B. Salvesen: *The Broad Spectrum: Studies in the Materials, Techniques, and Conservation of Color on Paper* (London, 2002)

P. M. Whitmore, ed.: *Contributions to Conservation Science: A Collection of Robert Feller's Published Works on Artists' Paints, Papers, and Varnishes* (Pittsburgh, 2002)

D. Verret and D. Stevaert, eds: *La couleur et la pirre: Polychromie des portails gothiques* (Paris, 2002)

E. W. FitzHugh, J. Winter and M. Leona: *Studies Using Scientific Methods: Pigments in Later Japanese Paintings* (Washington, DC, 2003)

H. Howard: *Pigments of English Medieval Wall Painting* (London, 2003)

V. Brinkmann and R. Wünsche: *Bunte Götter: Die Farbigkeit antiker Skulptur* (Munich, 2004)

N. Eastaugh and others: *The Pigment Compendium: A Dictionary of Historical Pigments* (Amsterdam and London, 2004)

M. van Eikema Hommes: *Changing Pictures: Discoloration in 15th—17th Century Oil Paintings* (London, 2004)

B. Guineau: *Glossaire des matériaux de la couleru et des teres techniques empolyés dans les recettes de coleurs anciennes* (Turnhout, 2005)

P. Jett, J. Winter and B. McCarthy, eds: *Scientific Research on the Pictorial Arts of Asia* (Washington, DC, 2005)

J. Albers: *Interaction of Color* (New Haven and London, 2006)

A. Fuga: *Artists' Techniques and Materials* (Los Angeles, 2006)

C. Saccaroni: *Giallorino: Storia dei pigmenti gialli di natura sintetica* (Rome, 2006)

Planographic. Term applied to printmaking processes, most notably LITHOGRAPHY, in which the image is printed from a flat surface (*see* PRINTS, §III, 3).

Plastic. Term applied to many natural and synthetic materials with different forms, properties and appearances. They are all composed of large, usually carbon-based, molecules called polymers. The chemical composition of the polymers and the size and arrangement of their molecules determine the key properties of the plastic material. In addition to the base polymer most plastics have substances added to give colour, improve performance and facilitate manufacture.

1. Types. 2. Uses. 3. Conservation.

1. TYPES. Most commercially useful plastics are derived from oil, natural gas and coal; they are referred to as synthetic polymers. Natural polymers that have been used as plastics include gutta-percha, horn, beeswax, tortoiseshell and shellac. These and later synthesized polymers share the potential to be shaped into new forms as solids, fibres or coatings. Natural and synthetic rubbers are organic polymers called elastomers but they are normally grouped apart from plastics. Some semi-synthetic polymers are made by treating a natural material, such as cotton (almost pure cellulose), with chemicals to produce a modified plastic substance. CASEIN, a semi-synthetic material derived from milk, is still used as a binder in some paints and as a decorative material in fashion accessories and buttons, although it was more widely used between 1900 and 1930. All polymeric types are still being altered by the introduction of different additives so that the formulation of well-known paints and other products containing plastic rarely continues unchanged for more than a few years.

Plastic materials are conveniently grouped into two classes: thermoplastic and thermosetting. Thermoplastic polymers can be shaped by heating and pressure after

their molecules have polymerized into long chain-like structures. As materials they are suitable for mass production of containers and flexible sheeting but can also be dissolved in solvents to make coating and binding materials (*see* RESIN, §2). The plastic properties of shellac (*see* RESIN, §1) were apparent in its use as a principal constituent of sealing wax and heat-sensitive, pre-1960s phonograph records. It is still used by sculptors as a water and oil resistant coating to seal plaster moulds and casts. Thermoplastics include all the cellulose-based semi-synthetic polymers, such as cellulose nitrate (celluloid) and cellulose acetate—the support for most 20th-century photographic images, early manmade fibres and some industrial coatings. Common synthetic thermoplastics include: polyethylene (polythene), structurally the simplest and commercially the most common plastic; polystyrene, which can be formed as a brittle transparent plastic or expanded to make a lightweight insulating foam; acrylic plastics, including polymethyl methacrylate (Perspex, Lucite, Oroglas), a useful glazing substitute that is used by some artists as a structural component in paintings and sculptures (*see* §2(ii) and (iii) below); polyvinyl chloride (PVC), which when unplasticized is an important piping material but when plasticized for flexibility is widely used for electrical insulation and waterproof fabrics; and polycarbonates, which as both castings and sheet material combine strength with transparency or colour depending on the additives.

Thermosetting polymers usually go through a liquid stage during manufacture, permitting very complex shapes to be cast. They solidify by polymerizing their molecules into long chains and cross-linking between those chains, which usually makes them more rigid and heat resistant than thermoplastics. (As thermoplastics age, however, they too tend to cross-link and become more brittle.) Thermosets include: epoxy resins used as chemical resistant coatings and structural adhesives in buildings, furniture, sculptures, stained glass etc; phenolic and urea-formaldehyde plastics used for casings of electrical goods and fittings, and decorative laminate sheeting (Formica); and polyesters, a large group of polymers with a common chemical component. Glass reinforced plastic (GRP) is polyester resin reinforced with glass fibres and is used as a structural material by artists (*see* FIBREGLASS). Polyester-based resins are found in most domestic gloss paints.

The development of plastics has often been driven by a commercial wish to replace such existing natural polymers as ivory or wood with polymeric materials that perform as well if not better (*see* §2(iv) below). Although new plastics are synthesized for specific purposes, they may eventually be used in other contexts; for example, to make repeated casts sculptors now employ moulds made from flexible polyurethane or silicone rubber instead of time-consuming plaster or short-lived gelatin (a natural polymer). Polymer technology has expanded during the latter half of the 20th century and many designed objects are a combination of different types of plastic: a domestic food-processor produced in the 1970s, for example, contains at least ten plastic materials, while a motor car manufactured in the 1990s contains over 50. More complex and ingenious combinations of polymers with other polymers, fibres, ceramics and metals are producing materials with novel properties that designers, architects, engineers and artists can exploit in new designs and applications.

V. E. Yarsley and E. G. Couzens: *Plastics* (London, 1941)

M. Kaufman: *The First Century of Plastics* (London, [1963])

J. A. Brydson: *Plastics Materials* (Princeton, 1966, rev. London, 5/1989)

J. M. G. Cowie: *Polymers: Chemistry and Physics of Modern Materials* (Aylesbury, 1973)

D. Braun: *Simple Methods for Identification of Plastics* (Munich, 1982)

S. Katz: *Classic Plastics: From Bakelite to High Tech* (London, 1984)

S. Blank: 'An Introduction to Plastics and Rubbers in Collections', *Studies in Conservation*, xxxv/2 (May 1990), pp. 53–63

M. Barker: 'Defining Plastics', *Plastics: Collecting and Conserving*, eds A. Quye and C. Williamson (Cambridge, 1999)

T. van Oosten, Y. Shashoua and F. Waentig, eds: *Plastics in Art: History, Technology, Preservation* (Munich, 2002)

'Kunststoff', *Lexikon des künstlerischen Materials: Werkstoffe der modernen Kunst von Abfall bis Zinn*, eds M. Wagner, D. Rübel and S. Hackenschmidt (Munich, 2002)

T. J. S. Learner: *Analysis of Modern Paintings* (Los Angeles, 2005)

R. Tauchid: *The New Acrylics: Complete Guide to the New Generation of Acrylic Paints* (New York, 2005)

2. USES.

(i) Architecture. (ii) Painting. (iii) Sculpture. (iv) Decorative arts.

(i) Architecture. Plastics were adopted relatively slowly in architecture, partly because of an early misconception that they are ersatz materials primarily used for cheap products, partly because of a lack of experience in their use in the building industry and partly because their chemical composition made architects and clients suspicious of their longevity. They are now extensively used as an adjunct to traditional building materials, for example for improving protective coatings such as paints, providing lightweight and flexible fittings for electrical and plumbing systems, as insulation for masonry and as more effective weather-proofing sealants, gaskets and damp-proof membranes for floors and roofs. As the costs of traditional building materials increased, coinciding with a greater demand after World War II for more efficient construction, plastics began to be used in place of traditional materials in fencing, wall and ceiling claddings, joinery mouldings and gutters, frequently made to imitate metal or timber models; extrusion techniques used to make flat sheets, rods and tubes, for example, can also produce planks to replace timber weatherboard cladding. Plastics are widely used in the construction of laminated sandwich panels, often with foam plastic cores, providing strength,

insulation and lightness. High-strength moulded panels of plastic reinforced with glass fibre (GRP) are used for larger wall and roof components, both structural (e.g. modular 'capsules') and non-loadbearing (e.g. cladding); they can be easily shaped to provide rigidity and sculptural forms, for example rounded window inserts, and can also be given highly shined or coloured finishes.

More expressive architectural uses emerged with transparent acrylic or scratch-resistant polycarbonate sheeting, which can be heat-formed to curves and other shapes to increase rigidity. It is widely used as an alternative to glass in roof glazing, its lightness and resistance to breakage offering considerable design opportunities; examples include the external escalator tubes at the Centre Georges Pompidou (1971–7), Paris, which are formed from clear plastic panels shaped into curves, and the travelling IBM Pavilion (1983) designed by the Building Workshop of Renzo Piano (b 1937), in which the strength of formed polycarbonate is cleverly exploited. Curved, balloon shapes made from acrylic panels were used within the geodesic dome structure designed by R. Buckminster Fuller (1895–1983) for the US Pavilion at Expo 67, Montreal. Synthetic fabrics made from nylon, polyester or glass fibre coated with PVC or neoprene have been used to create dramatic tension structures, seen particularly in the work of Frei Otto (b 1925), as well as inflatable (pneumatic) ones; the latter comprise either single-layer, air-supported membranes that require a constant input of air to maintain internal pressure, or tubular, ribbed air-inflated structures (e.g. Fuji Pavilion, Expo 70, Osaka). A more radical use of plastics in architecture is their potential to construct entire buildings from foam sprayed on to a mould. Significant disadvantages remain, however, including the flammability and degradation of plastics and such environmental concerns as energy use and pollution in the manufacturing process. Nevertheless, materials science is rapidly expanding, and in view of the scarcity and cost of traditional building materials plastics will continue to be studied as a viable alternative capable of a unique freedom of expression.

I. Skeist: *Plastics in Building* (New York, 1966)

M. Foster, ed.: *Architecture: Style, Structure and Design* (New York, 1982), pp. 166–81

R. Montella, Ralph: *Plastics in Architecture: A Guide to Acrylic and Polycarbonate* (New York, 1985)

Detail, xlii/12 (Dec 2002) [entire issue]

(ii) Painting. The successful adoption of modern plastics into artists' paints has been comparatively slow as only a limited number of synthetic resins have been found that can be used in fine art painting. In the 1920s the Mexican muralists experimented with pyroxylin automobile lacquers, which David Alfaro Siqueiros (1896–1975) used for *Echo of a Scream* (1937; New York, Museum of Modern Art), and which Jackson Pollock (1912–56) used, in the form of Duco, for such works as *Number 2, 1949* (Utica, NY, Munson–Williams–Proctor Institute). In 1921

synthetic alkyd resins were combined with drying oils to make oil-modified alkyd resins, which are widely used in house paints and were also employed by such artists as Mark Rothko (1903–70) during the 1950s and 1960s, although the lasting qualities of these paintings is uncertain. Alkyd artists' paints have been developed subsequently. They most resemble oil paints, are compatible with the same media and thinners and with oil paint itself, and are employed in essentially the same techniques (*see* PAINT, §I). Although the pigment loading, colour quality and handling characteristics are inferior to that of good oil colour, alkyds dry much more quickly and are therefore very practical.

Solid acrylic resin dissolved in an organic solvent (*see* ACRYLIC PAINTING, §1) was introduced commercially in 1946 as Magna and was used by, among others, Morris Louis (1912–62), Helen Frankenthaler (b 1928) and Roy Lichtenstein (1923–97) (e.g. *Whaam!*, 1963; London, Tate). In the 1950s acrylic resin in the form of an aqueous emulsion superseded solvent acrylics as an artists' paint and was used extensively in colour field painting and by Abstract Expressionist painters (e.g. *Cape (Provincetown)* by Helen Frankenthaler, 1964; Melbourne, National Gallery of Victoria). It was also used extensively in Pop art by, for example, Peter Blake (b 1932) and Andy Warhol (1928–87; e.g. *129 Die in Jet (Plane Crash)*, 1964; Cologne, Museum Ludwig). David Hockney (b 1937; e.g. *Peter Getting out of Nick's Pool*, 1966; Liverpool, Walker Art Gallery) and later Patrick Caulfield (1936–2005; e.g. *After Lunch*, 1975; London, Tate) exploited the medium's potential for large, flat areas of colour, and Paula Rego (b 1935) adopted the medium in the late 1970s because of its quick drying properties and her aversion to the smell of turpentine. Artists' acrylic colours form a permanent elastic film on drying and seem to age well. Their biggest advantages are their speed and convenience, and in the late 20th century they have become an established medium.

Vinyl resins such as PVA have also been prepared as emulsions and used to make water-based artists' paints (*see* POLYMER COLOUR). They are generally lower-grade formulations used for large-scale cost-effective painting and for educational use; they have limited use as artists' paint. Household emulsion paints based on vinyl or acrylic emulsions are widely but inadvisably used as primers. Acrylic primed canvases, however, properly prepared by art materials manufacturers, have largely displaced oil primed canvases. Polyester resins and epoxy resins (*see* RESIN, §2) have been experimented with as painting materials but have proved both hazardous (because of toxic fumes) and impractical. Such artists as Peter Blake and Richard Hamilton (b 1922) have incorporated plastic in their paintings; in the *Masked Zebra Kid* (1965; London, Tate), a painted assemblage, Blake includes a piece of transparent acrylic sheet (ICI Perspex) as an integral component, and Hamilton made extensive use of different types of plastic in such works as *Towards a Definitive Statement of the Coming Trends in Men's Wear and Accessories (d)* (1963; Cologne, Museum Ludwig).

Other less immediate applications of plastic include manmade fibre canvases, which were gradually adopted in the late 20th century as the predominance of acrylic primings made them more practical, and acetate film (cellulose acetate), which is used as an overlay for photocopy art.

R. Mayer: *The Artists' Handbook of Materials and Techniques* (New York, 1940, rev. 5/1991)

S. Katz: *Plastics, Designs and Materials* (London, 1978)

S. Hackney, ed.: *Completing the Picture: Materials and Techniques of 26 Paintings in The Tate Gallery* (London, 1982)

J. A. Brydson: *Plastics Materials* (London, 5/1989)

J. Stephenson: *The Materials and Techniques of Painting* (London, 1989)

M. Wagner: *Das Material der Kunst: eine andere Geschichte der Moderne* (Munich, 2001)

T. Hoppe: *Acrylmalerei: Die kunstlerischen Techniken* (Leipzig, 2/2002)

M. Wagner, D. Rübel, S. Hackenschmidt, eds: *Lexikon des künstlerischen Materials: Werkstoffe der modernen Kunst von Abfall bis Zinn* (Munich, 2002)

(iii) Sculpture. In 1862 at the International Exhibition in London, Alexander Parkes (1813–90) exhibited a number of objects, including plaques (e.g. circular plaque with low relief Classical figures, 1862–8; London, Science Museum) and medallions, moulded in Parkesine, the first manmade plastic (*see also* RESIN, §2). In 1869, the American John W. Hyatt (1837–1920) introduced celluloid, which, in sheet form, was first used by the sculptor Naum Gabo (1890–1977) for the preliminary model of *Woman's Head* (*c.* 1916–17; New York, Museum of Modern Art) and subsequently for many other models, including that for *Column* (1920–21; London, Tate). In 1920 Gabo and his elder brother Antoine Pevsner (1886–1962) published *Realistic Manifesto*, which formally established the concept of abstract art dedicated to the modern age and its materials (such as plastics) and espoused construction and kineticism. Pevsner combined sheet with sheet copper in *Torso* (1924–6; New York, Museum of Modern Art), a construction of intersecting planes and formalized abstract shapes. Gabo used other plastic materials as they became available, including hardened casein, cellulose acetate and acrylic sheet, and László Moholy-Nagy (1895–1946) used Perspex (Plexiglass) for his 'space modulators'.

As the commercial exploitation of plastic increased during the 20th century it was increasingly used for modernist design projects, several of which straddled the applied/fine art divide, for example the inflatable chair designed by William H. Miller (*c.* 1944; New York, Museum of Modern Art) and the red latex and steel Djinn chaise longue designed by Olivier Morgue (*b* 1939). By the 1960s various types of plastic were being used in the emerging Pop art. Claes Oldenburg (*b* 1929) began using flexible polyvinyl chloride (PVC) materials to make sculptures filled with kapok as he began to explore the ideas of soft art. He also used plastic in such pieces as *Bedroom Ensemble I* (1963; Darmstadt, Hessisches Landesmuseum). In 1966 Andy Warhol (1928–87) created *Clouds*, 'floating

paintings' consisting of helium-filled pillows of aluminium coated with Mylar polyester film that were to be released at an exhibition at the Leo Castelli Gallery, New York. The ability of plastic to transmit light was exploited in such kinetic constructions as *Sculptures Spatiodynamiques* (n.d.; Paris, Centre Georges Pompidou) by Nicolas Schöffer (1912–92).

Polyurethane foam was used in sculpture on its own, or as a foundation, or as filling in such pieces as *Floor Cone* by Claes Oldenburg (1963) and *Armchair* (1964) by Gunnar Aargaard Andersen (1919–82; both New York, Museum of Modern Art). Foamed plastics were cut to make lightweight structures either for temporary display or as a rough core for a work to be built around it in some other material. FIBREGLASS (glass reinforced plastic), probably the most workable plastic for sculptural purposes, was used by such artists as John McCracken (*b* 1934; e.g. *Red Plant*, 1967; Los Angeles, L. M. Asher private collection), Allen Jones (*b* 1937; e.g. *Chair*, 1969; London, Tate), Phillip King (*b* 1934; e.g. *Call*, 1967; London, Juda Rowan Gallery) and Mark Boyle (1934–2005). Although McCracken's minimalist shapes are in sharp contrast to Jones's fetish figures, both exploit the structural qualities of fibreglass, while Mark Boyle uses cast fibreglass as an integral part of his records of urban terrain (e.g. *Holland Park Avenue Study*, 1967; London, Tate). The original bronze of *Two Piece Reclining Figure No. 1* (1959) by Henry Moore (1898–1986) at Glenkiln, Dumfriesshire, was subsequently replaced by one cast in fibreglass with bronze dust. Crystic polyester and epoxy resin have both been used with fibreglass to make solid castings. Vacuum forming, a technique for moulding thin plastic sheet, has been employed for three-dimensional plastic surfaces and is used where the same motif needs to be reproduced in multiples for repetition within a sculptural structure, for example in Oldenburg's *Profile Airflow* (1969; New York, Museum of Modern Art); Richard Hamilton also used this technique to make plastic replicas of the Guggenheim Museum in New York. In the mid- and late 20th century, plastic 'found objects' have been incorporated into various forms of sculpture, collage, montage and assemblage.

C. Smale: *Creative Plastics Techniques* (New York, 1973)

E. Lucie-Smith: *Arte oggi: Dall'espressionismo astratto all'iperrealismo* (Milan, 1976; Eng. trans., Oxford, 1983)

S. Katz: *Plastics, Designs and Materials* (London, 1978)

N. Roukes: *Sculpture in Plastics* (London and New York, 1978)

J. A. Brydson: *Plastics Materials* (London, 5/1989)

N. Penny: *The Materials of Sculpture* (New Haven and London, 1993)

A. Williams: *Sculpture: Technique, Form, Content* (Worcester, MA, 1995)

G. Rivet, ed.: *Charles Worthen: Silicone* (Ostfildern, 2000)

(iv) Decorative arts. The first semi-synthetic plastics were developed in the second half of the 19th century in response to the increasing expense and rarity of natural plastic materials such as horn and tortoiseshell, as well as other decorative materials such as jet, ivory (*see* IVORY, §1) and amber. As substitute

materials, early semi-synthetic plastics followed the form and the use of the material they were emulating and were used almost exclusively for decorative purposes.

The earliest plastics were vulcanite, Parkesine and shellac. Vulcanite (also known as ebonite) and shellac were naturally dark in colour and were often used in jewellery as a substitute for jet. Parkesine was more colourful and was used, often with painted appliqué or with inlaid precious metals or mother-of-pearl, primarily for such objects as jewellery, buttons, fountain-pens and handles. Shellac was also used in the manufacture of union cases—frames for carrying the heavy glass 19th-century photographs—and was particularly noted for its ability to reproduce the fine detail of the intricately moulded pictorial scenes pressed on to such cases. Celluloid (cellulose nitrate) was developed in the late 1860s as a direct response to the search for a substitute for ivory (see RESIN, §2). Although it was used in the manufacture of relatively utilitarian objects such as billiard balls and detachable collars and cuffs, its versatility was such that it could also simulate horn, bone, tortoiseshell, coral and mother-of-pearl; it was therefore often used to make highly decorative objects such as boxes, jewellery and combs. Many of the simulated effects were achieved by hand-painted decoration on celluloid, and precious metals were sometimes used to enhance the value of an object. The quality of workmanship was often of such a high standard that by the 1920s a hand-cut celluloid comb could be more valuable than a comb made from any other material.

Synthetic plastics such as phenol-formaldehyde (Bakelite) and urea-formaldehyde (Beetle) were introduced during the 1920s and 1930s. Their unique structural strength and electrical insulating properties meant that their use was initially confined to electrical and engineering industries. The naturally dark colour of Bakelite and the woodgrain effects achieved by the use of fillers, however, led to its use in a decorative capacity, mainly as a substitute for wood in radio cabinets; without fillers Bakelite produced a more colourful and glossy, though brittle, plastic which was used in jewellery and American radio cabinets. Bakelite was used for the Phonola radio set (1938) designed by Livio Castiglioni (1911–71) and Pier Giacomo Castiglioni (1913–68) and exhibited at the VII Triennale in Milan in 1940, which was later considered to be a significant example of Italian product design. Beetle's lighter colours and its chemical stability resulted in its extensive use in kitchen- and tableware. Another more decorative plastic was urea-thiourea formaldehyde (Bandalasta or Linga Longa), the precursor of Beetle, which was moulded with a sprinkling of coloured powder to produce a mottled effect that was used to imitate marble, alabaster and stone in the design of tableware.

During World War II, the increase in research into plastics technology resulted in many more sophisticated types. These were aimed primarily at technological, electrical and engineering industries, so their decorative uses were limited. The best-known plastics

used in a decorative capacity were melamine (or Formica), used for tableware and laminates, and nylon and polyethylene or polythene (trading under Tupperware). In the 1960s designers began to use the recent advances in plastics technology to develop new shapes in product design and furniture, in particular chairs (see fig.). More importantly, plastics began to be used for their own intrinsic qualities rather than as substitutes for other materials. Polyurethane, ABS (acrylonitrile butadiene styrene), acrylic and polyvinyl chloride (PVC) were used in the design of foam shapes, glossy 'wet look' products, including clothes and jewellery by such designers as Caroline Broadhead (b 1950), Peter Chang (b 1944) and David Watkins (b 1940; e.g. tiara and cloak clasp, 1975; London, Victoria and Albert Museum), and inflatable furniture. The Italian company Kartell, in particular, was noted for its exemplary use of plastics in furniture design, while Memphis—another Italian design group founded in 1981 in Milan by Ettore Sottsass (b 1917)—came to the fore in the 1980s for their use of surface colour and pattern in decorative laminates in such pieces as Sottsass's 'Casablanca' cupboard (1981).

J. Gloag: *Plastics and Industrial Design* (London, 1945)

Landmarks of the Plastics Industry, ICI (London, 1962)

M. Kaufman: *The First Century of Plastics: Celluloid and its Sequel* (London, 1963)

A. Morello and A. Castelli Ferrieri: *Plastic Design: Material Culture and the Culture of Materials Planning and Reality at Kartell* (Milan, 1988)

P. Sparke, ed.: *The Plastics Age: From Modernity to Post-modernity* (London, 1989)

P. Ball: *Made to Measure: New Materials for the 21st Century* (Princeton, 1997)

M. Wagner: *Das Material der Kunst: Eine andere Geschichte der Moderne* (Munich, 2001)

M. Wagner: *Lexicon des künstlerischen Materials: Werkstoffe der modernen Kunst von Abfall bis Zinn* (Munich, 2002)

3. CONSERVATION. Plastics conservation is a developing area, and few practices have as yet been firmly established. The chemical structure of the base polymer and the influence of the additives determine the chemical and mechanical properties of the many types of plastics. Because of this great variety, almost any environmental or chemical factor is a potential agent of deterioration to some class of plastics. Reaction with oxygen in the atmosphere is the major cause of the degradation of all types, but they may also react with water, gaseous atmospheric pollutants, liquid acids and alkalis. Deterioration may also be initiated or accelerated by mechanical damage, possibly due to use. In order to select the most appropriate conservation treatment, it is very important to identify first the plastics present in a particular artefact. The appearance of a piece, however, does not always provide reliable information, as plastics were originally developed to replicate expensive natural materials (see §§1 and 2(iv) above); in addition, the appearance of many plastics alters with time. Conservation may require intervention and involve

Rodney Kinsman: *OMK Stack SI* (*Omkstack Chair*), tubular steel, with epoxy resined perforated sheet steel, 750×577 mm, 1970 (London, Victoria and Albert Museum); photo credit: Victoria and Albert Museum, London/Art Resource, NY

the cleaning and repair of artefacts, or it may be preventive, where the aim is to control the environment in order to inhibit the degradation process.

(i) Cellulose nitrate. Light, heat and moisture are the main factors that accelerate deterioration of cellulose nitrate (also known as celluloid and Parkesine). Slow, spontaneous degradation reactions result in the production of gaseous oxides of nitrogen and sulphur. These gases subsequently react with water and oxygen to form highly corrosive nitric and sulphuric acids that accelerate further degradation. Deterioration manifests itself as discoloration, embrittlement, warping of cast sheets and crazing of the surface. The odour of evaporating camphor, used as a plasticizer until the 1950s, or of nitrogen dioxide may be detected in the early stages of degradation. Environmental control is critical to the stability of cellulose nitrate: relative humidity (RH) and temperature should be kept as low as is practical, exposure to light should be minimized and the

storage area kept well ventilated. The rapid deterioration of a 20th-century shadow puppet constructed from sheets of cellulose nitrate has been successfully slowed by the use of charcoal cloth, which absorbs gaseous degradation products in the vicinity of the puppet.

(ii) Cellulose acetate. Deterioration is accelerated by the presence of moisture, acids and alkalis. Degrading cellulose acetate produces acetic acid, detectable by its vinegar-like odour, which corrodes metals. The presence of beads of liquid plasticizer on the surface, discoloration, shrinkage and cracking are further indicators of deterioration. Adding sachets of zeolite pellets (a form of aluminosilicate) to a sealed container of cellulose acetate greatly slows the rate of decomposition, as zeolites absorb acetic acid and moisture from the atmosphere. Recommended environmental conditions for storage of cellulose acetate are a maximum of 15°C and 30–35% RH. Polyvinyl acetate adhesives may be used to repair tears.

(iii) Casein. CASEIN (known commercially as Erinoid, Galalith and Lactoid) is plasticized by water, the loss of which is the major cause of deterioration. Artefacts should be stored in an environment that has a stable RH and temperature. Contact with aqueous solutions of acids and alkalis may cause surface crazing and staining, so artefacts containing casein should only be handled wearing gloves. Wax coatings can protect vulnerable surfaces. Since casein is manufactured from proteinaceous materials, it is susceptible to attack by fungi and insects.

(iv) Acrylics. Acrylics (Perspex, Oroglas, Plexiglass) are generally resistant to heat and ultraviolet light. Cast acrylics are susceptible to stress cracking. Exposure to alcohols can cause acrylics to crack when subjected to minimal stress. Although acrylics are very prone to scratching, shallow scratches can be buffed out using mild abrasives. Solutions of polyvinyl acetate adhesives and acrylic emulsions may be used for repair work.

(v) Formaldehyde plastics. Formaldehyde plastics (e.g. Bakelite, Catalin and Formica) are affected by water, acids and alkalis. Cellulosic filling agents tend to swell when in prolonged contact with water, causing mechanical damage to plastics. Any conservation treatments involving aqueous solutions should be avoided. When heated, formaldehyde plastics tend to darken and blister, but disrupted surfaces should not be abraded since this will tend to accelerate the rate of degradation. Plastics cast in pale colours discolour and lose their gloss when exposed to ultraviolet light. Since the products of degradation include formaldehyde and ammonia, which may corrode metals, formaldehyde plastics should be stored separately from artefacts containing lead and zinc. Polyvinyl acetate adhesives can be used for repairs.

(vi) Fibreglass (GRP). Glassfibre reinforced polyester (GRP; also known as FIBREGLASS) tends to yellow and lose strength on exposure to light. Oils, alcohols and hydrocarbons may cause swelling and aggravate stress cracking, and such materials should not be used for intrusive conservation treatments. Degradation products include various organic acids depending on the catalyst used to accelerate curing of the plastic. GRP should not be stored close to pieces containing metal. Acrylic adhesives, water-based methyl celluloses, epoxies and cyanoacrylates have successfully been used for repairs.

(vii) Polyethylene. Polyethylene yellows when exposed to light for prolonged periods. It is prone to stress cracking, especially when in contact with chlorinated solvents, oils and detergents, so these should not be used as cleaning agents. Polyethylene is notoriously difficult to bond, although some success using hot-melt glues has been recorded.

(viii) Polyvinyl chloride (PVC). This is a basically unstable polymer and owes its widespread use to the actions of plasticizers and stabilizers. Oxidation is accelerated by heat and light. The first indication of deterioration is the appearance of a brown coloration, often tinged with purple or black. Loss of plasticizer is characterized by embrittlement and tackiness of the surface. Since beads of migrating plasticizer may be absorbed by other materials, PVC should not be allowed to come into contact with textiles or works of art on paper. Hydrochloric acid is the major product of degradation and attacks most types of metals. Since PVC is dissolved by all common solvents with the exception of alcohols, suitable materials for conservation are limited.

W. J. Roff and J. R. Scott: *Fibres, Films, Plastics and Rubbers* (London, 1971)

S. Blank: 'Practical Answers to Plastic Problems', *Preprints of Modern Organic Materials: Edinburgh, 1988*, pp. 115–21

J. A. Brydson: *Plastics Materials* (London, 5/1989)

S. Blank: 'An Introduction to Plastics and Rubbers in Collections', *Studies in Conservation*, xxxv (1990), pp. 53–63

M. Derrik, D. Stulik and G. Ordonez: 'Deterioration of Cellulose Nitrate Sculptures by Gabo and Pevsner', *Postprints of Saving the 20th Century: The Conservation of Modern Materials: Ottawa, 1991*, pp. 169–82

J. Morgan: *Conservation of Plastics* (London, 1991)

D. Sale: 'An Evaluation of Eleven Adhesives for Repairing Poly(methyl methacrylate) Objects', *Postprints of Saving the 20th Century: The Conservation of Modern Materials: Ottawa, 1991*, pp. 325–39

N. S. Allen, M. Edge and C. V. Horie: *Polymers in Conservation* (Cambridge, 1992)

Y. Shashoua, S. M. Bradley and V. D. Daniels: 'Degradation of Cellulose Nitrate Adhesive', *Studies in Conservation*, xxxvii (1992), pp. 113–19

J. Morgan: *Conservation of Plastics: An Introduction to their History, Manufacture, Deterioration, Identification and Care* ([London, 1991])

D. Kaplan, ed.: *Silk Polymers: Materials, Science and Biotechnology* (Washington, DC, 1994)

J. Heuman, ed.: *From Marble to Chocolate: The Conservation of Modern Sculpture* (London, 1995)

J. Heuman, ed.: *Material Matters: The Conservation of Modern Sculpture* (London, 1999)

T. van Oosten, Y. Shashoua and F. Waentig, eds: *Plastics in Art: History, Technology, Preservation* (Munich, 2002)

M. Jones, ed.: *Conservation Science: Heritage Materials* (Portsmouth, 2006) [chap. on Plastics]

Plate. Generic term for any flat or flattish sheet, slab or lamina of metal or other hard material. It has several applications in the field of art. It is used generally for objects wrought in gold or silver (*see* GOLD, §2, and SILVER, §3). It also refers to articles in base metal that have been combined with precious metal through heat and pressure, for example SHEFFIELD PLATE (or fused plate). ELECTROPLATING is the process of depositing a metal layer, often gold or silver, on to a metal by electrolysis. The term is also used for a broad piece of armour; a piece of metal employed in printmaking (*see* PRINTS, §III), as well as an impression printed from it, especially a whole-pagebook illustration; a film-coated sheet of glass or other

material used in photo (*see* PHOTOGRAPHY, §I, 1); a horizontal supporting timber in building construction. Finally, it applies to table utensils generally, as well as a shallow dish and a prize cup or trophy.

Platemark. In intaglio printmaking, an indented line surrounding the image, which results from the edges of the printing plate being pressed against the support (usually paper).

Pointillism. Technique of employing a point, or small dot, of colour to create the maximum colour intensity in a Neo-Impressionist canvas. While Neo-Impressionism suggests both the style created by Georges Seurat (1859–91) and the ensuing movement that flourished between 1886 and 1906, Pointillism denotes only the technique. Seurat favoured the term 'chromo-luminarism', which conveys his dual interest in intensifying the effect of colour and light. Seurat's chief disciple, Paul Signac (1863–1935), in his book *D'Eugène Delacroix au Néo-Impressionnisme* (Paris, 1899), offered an alternative term to Pointillism or chromo-luminarism: Divisionism. Divisionism refers to the separation of colour into individual strokes of pigment, in accord with colour theories, rather than to the points themselves.

Pointing. In stone-carving, the process used to copy and enlarge a small three-dimensional model into a full-sized sculpture by measuring off points from the original (*see* STONE, §II, 2).

Pokerwork. Term applied to ornamental patterns created in wood with a hot poker or brand. The burnt incised marks can be scrubbed out and smoothed.

Polychromy. Decoration of architecture, both internally and externally, and of sculpture by using differently coloured materials or by the addition of colour by painting or other means.

 1. Architecture. 2. Sculpture.

1. ARCHITECTURE.

(i) Before c. 1800. The application of colour, which often provided a protective cover as well as improving a building's aesthetic appearance, and the selection of coloured building materials may be traced back to the earliest civilizations (see BRICK, colour pl. II, fig. 1). As early as the 4th millennium BC, for example, walls at Uruk, Mesopotamia, were decorated with geometric patterns created by cones of coloured limestone or clay dipped in paint. Egyptian temples and the portals of royal tombs were brightly coloured and gilded, the limestone casing of the pyramids at Giza was probably painted in three colours, and private premises may have had painted decoration. At Khorsabad (founded late 8th century BC) the Assyrian palace temples were decorated with glazed bricks painted with symbolic images, and the four stages of the ziggurat were painted in different colours. At Babylon designs on the Ishtar Gate (reconstructed in Berlin, Pergamonmuseum)

and the throne-room façade of the 'Southern Palace', built by Nebuchadnezzar (*reg* 604–562 BC) were moulded in relief and glazed (see BRICK, fig. 1). Decoration at the Achaemenid city of Persepolis (founded *c.* 515 BC) included painted doorframes and stone reliefs on the staircase façades, exterior brickwork glazed in bright colours and elaborate patterns painted on the plaster that covered wooden columns. Colour could also be used on a monumental scale: Herodotus, for example, writing in the 5th century BC, states that the crenellation of the central wall around the Achaemenid royal palace (destr.) of Ecbatana (now Hamadan, Iran) was plated with gold, the next with silver, and the further five concentric walls were painted orange, blue, crimson, black and white.

Architectural mouldings and sculpture on Greek buildings were decorated with elaborate, brightly painted designs in tempera, encaustic and fresco. Although the wall surfaces of monumental stone buildings were usually left uncoloured, except when decorated with wall paintings, domestic architecture was commonly painted. Polychrome effects could be achieved using different coloured limestones and terracotta. This practice was followed by the Romans, who used coloured column shafts to contrast with white marble capitals, bases and entablatures. Their technique of concrete construction faced with brickwork or stone encouraged geometric designs in different coloured materials, including tile. The Early Christian traditions of polychromatic stone cladding and mosaic decoration, which developed from Roman practices, survived in Italy into the Middle Ages, for example at Siena Cathedral, where the interior (completed early 1270s) has alternating bands of white, pink and dark green marble. Striking geometric patterns are also characteristic of many buildings in Florence.

Although in medieval Europe buildings were often whitewashed, on great churches and princely residences the exterior architectural features and sculpture were commonly painted and gilded, while interiors might be covered in extensive painted cycles. Various effects could also be achieved by diapering and other means of arranging coloured or glazed bricks (*see* BRICK, §I, 3(iii)). In the Renaissance bold colouristic effects of dark stone structural elements against white walls were developed by Filippo Brunelleschi (1377–1446; e.g. Pazzi Chapel, Florence) and later by Michelangelo (1475–1564). A similar but reverse effect was adopted by architects in later, Neoclassical buildings in St Petersburg, where strongly coloured surfaces were contrasted with structural features.

Colours have sometimes been chosen for their symbolic value: the glazed roof tiles, for example, on the Hall of Supreme Harmony (1420) in the Forbidden City, Beijing, are yellow, the imperial colour. Chinese domestic buildings were decorated in distinct regional colour combinations. The lavishly coloured decoration of Islamic architecture, using carved, inlaid, painted and gilded stone, wood and plaster, as well as carved and glazed brick, terracotta

and tile, is intended to make the building prominent and to enliven the surfaces. The designs are often independent of the underlying structure.

Use of tin-glazed ceramic tiles (*azulejos*), derived from Moorish traditions, became a characteristic feature of Spanish and Portuguese architecture from the late 15th century (*see* TILE), and they were arranged to form elaborate decorative friezes and figurative panels on interior and exterior walls. This practice was also exported to the colonies of the New World.

African architecture is often enhanced by bold, highly coloured designs. Although there are few examples from before the 20th century, owing to the impermanent quality of the mud commonly used, the widespread adoption of painted geometric (and less commonly figurative) decoration throughout much of sub-Saharan Africa indicates a long tradition that has continued to evolve.

(ii) After c. 1800. Since 1800, at moments of artistic crisis and renewal, Western architects and writers have advocated the adoption of a brilliant polychromy. These experimenters included Henri Labrouste (1801–75), Gottfried Semper (1803–75) and Karl Friedrich Schinkel (1781–1841) in the 1830s; John Ruskin (1819–1900) and William Butterfield (1814–1900) in the 1850s; Victor Horta (1861–1947), Frantz Jourdain (1847–1935) and Antoni Gaudí (1852–1926) in the 1890s; Bruno Taut (1880–1938) and Le Corbusier (1887–1965) in the 1920s; and Robert Venturi (*b* 1925), Michael Graves (*b* 1934) and Peter Eisenman (*b* 1932) in the 1980s. It should be noted that until 1800 colour was not an issue in itself, being used quite readily before the stern whiteness of Neo-classicism. Even after that time polychromy was admissible in informal or interior designs: it was questioned only when applied to formal façades. Significantly, when it did appear on the public face of architecture, it often assumed a bright, over-scaled aspect, implying that it was to be noticed and carried meaning.

Sources

F. C. Gau: *Antiquités de la Nubie* (Stuttgart, 1822–7)

J. I. Hittorff and L. Zanth: *Architecture antique de la Sicile* (Paris, [1827])

G. Semper: *Die Anwendung der Farben in der Architektur und Plastik* (Dresden, 1834–6)

G. Semper: *Vorläufige Bemerkungen über bemalte Architektur und Plastik bei den Alten* (Altona, 1834)

F. T. Kugler: *Über die Polychromie der griechischen Architektur und Plastik und ihre Grenzen* (Berlin, 1835)

O. Jones and J. Goury: *Plans, Elevations, Sections and Details of the Alhambra*, 3 vols (London, 1836–45)

A. Paccard: *Restauration polychrome du Parthénon* (Paris, 1847)

J. Ruskin: *The Seven Lamps of Architecture* (London, 1849)

J. I. Hittorff: *Restitution du temple d'Empodocle à Sélinonte ou l'Architecture polychrome chez les Grecs* (Paris, 1851)

J. Ruskin: *The Stones of Venice*, 3 vols (London, 1851–3)

G. Semper: *Vier Elemente der Baukunst* (Brunswick, 1851)

C.-E. Beulé: *L'Acropole d'Athènes*, 2 vols (Paris, 1853–4)

P. Coste and E. Flandin: *Voyage en Perse* (Paris, 1853)

O. Jones: *Grammar of Ornament* (London, 1856)

G. Semper: *Der Stil in den technischen und tektonischen Künste, oder praktische Aesthetik*, 2 vols (Frankfurt am Main and Munich, 1860–63, rev. 2/1878–9)

V. Place and F. Thomas: *Ninive et l'Assyrie* (Paris, 1867–70)

C. Garnier: *Le Temple de Jupiter panhellenien à Egine* (Paris, 1881)

P. Scheerbart: *Das Paradies: Die Heimat der Kunst* (Berlin, 1889)

P. Scheerbart: *Glasarchitektur* (Berlin, 1914/R Munich, 1971; Eng. trans., ed. D. Sharp, London, 1972)

B. Taut: *Alpinearchitektur* (Hagen, 1919; Eng. trans., ed. D. Sharp, London, 1972)

B. Taut: *Die Auflösung die Städte* (Hagen, 1920)

Studies

U. Conrads and H. Sperlich: *Phantastische Architektur*; Eng. trans. and ed. C. C. Collins and G. R. Collins as *The Architecture of Fantasy* (New York, 1962)

K. Hammer: *Jakob Ignaz Hittorff: Ein Pariser Baumeister, 1792–1867* (Stuttgart, 1968)

P. Thompson: *William Butterfield* (London, 1971)

E. Börsch-Suppan: *Berliner Baukunst nach Schinkel, 1840–1870* (Munich, 1977)

D. Van Zanten: *The Architectural Polychromy of the 1830s* (New York, 1977)

R. H. Bletter: 'Interpretations of the Glass Dream: Expressionist Architecture and the History of the Crystal Metaphor', *Journal of the Society of Architectural Historians*, xl (1981), pp. 20–43

I. B. White: *Bruno Taut: Baumeister einer neuer Welt* (Stuttgart, 1981); Eng. trans. as *Bruno Taut and the Architecture of Activism* (Cambridge, 1982)

Paris/Rome/Athènes: Le Voyage en Grèce des architectes français aux XIXe et XXe siècles (exh. cat. by M. C. Hellmann and others; Paris, Ecole Nationale Supérieure des Beaux-Arts, 1982)

J. Baines: 'Color Terminology and Color Classification: Ancient Egyptian Color Terminology and Polychromy', *American Anthropologist*, lxxxvii (1985), pp 282–96

R. Middleton: 'Perfezione e colore: La polichromia nell'architettura del XVIII e XIX secolo', *Rassegna* (1986), pp. 55–67

M. L. Clausen: *Frantz Jourdain and the Samaritaine* (Leiden, 1987)

C.C. Connor: *The Color of Ivory: Polychromy on Byzantine Ivories* (Princeton, 1998)

D. Nadler: *China to Order: Focusing on the XIXth Century and Surveying Polychrome Export Porcelain Produced during the Qing Dynasty (1644–1908)* (Paris, 2001)

P. Pajares-Ayuela: *Cosmatesque Ornament: Flat Polychrome Geometric Patterns in Architecture* (London, 2002)

L. de Margerie and E. Papet: *Facing the Other: Charles Cordier (1827–1905), Ethnographic Sculptor* (New York, 2004)

E. Rossetti Brezzi, ed.: *La scultura dipinta: Arredi sacri negli antichi stati di Savoia: 1200–1500* (Quart, 2004)

A. M. Giusti: *Pietre Dure: The Art of Semiprecious Stonework* (Los Angeles, 2006)

2. SCULPTURE. It is impossible to be certain when the first polychrome sculpture was produced, due to the fragility of the material, but one may assume that a significant proportion of the earliest forms of three-dimensional representation was coloured at the time of production. In the West a taste for showing the

qualities of the material itself seems to have come to prominence in Europe during the Renaissance, enhanced by the appreciation of form and its rendition. Works showing traces of coloured matter date back to Palaeolithic times. In the ancient world the Egyptians are believed to have used colour decoratively (rather than naturalistically), as did the Greeks. The importance of colour seems to have declined in ancient Rome, however. During the medieval period more naturalistic colour began to be favoured. The major centre of polychrome sculpture was Spain, and the country's influence and taste for this type of sculpture spread to the New World from about the early 16th century by means of colonization. Colour continued to be used during the Baroque era, when it was sometimes employed as a way of uniting the painting and architecture that it complemented. By modern times, however, the importance of form once again predominated, and in the 20th century its use was a conscious characteristic of some three-dimensional work, though rarely realistic, except perhaps when featuring in works in such modern materials as fibreglass.

Paint of various colours is generally employed to render sculpture partially or wholly polychrome. It is applied usually in three stages: a sealant layer, a ground and a paint layer. A varnish is sometimes used to protect the paint layer. Decorative elements, such as hardstones, wax paper and plaster motifs, may also be applied to the sculptured surfaces.

(i) Sealants. (ii) Grounds. (iii) Paint. (iv) Other decorative elements.

(i) Sealants. Porous sculptural materials can be painted with a sealant to prevent the binding media of the ground and the paint layer from being absorbed into the sculpture. If depleted of the binding media, the ground and paint would become unstable and turn to powder. Sealants are always rich in binding media. These include drying oils, egg, with or without drying oil, caseins, resins, gums, waxes, lacquers and hot glue size, of fish, animal or plant origin; for example, a proteinaceous sealant, probably animal glue, was applied to the lunettes (1196–1216) of the baptistery in Parma, before the application of colour. Occasionally a small amount of pigment, sometimes acting as a drying agent or filler, may be mixed with the sealant, enabling the painter to see which areas have been sealed. Sealants are difficult and sometimes impossible to sample, so that their existence must sometimes be presumed.

(ii) Grounds. These are mixtures of binding medium or media and one or several fillers, usually with a preponderance of filler material; they are applied to a sculpture to smooth or texture its surface, or to provide a base for relief or incised decoration. The binding media used are the same as those for sealants, but the binding medium used for a ground need not necessarily be compatible with that used for the sealant or the paint layer. Common fillers are clays, calcium carbonate (lime, chalk), calcium sulphate and red and white lead. Other additions to the filling material include sand, iron oxide, charcoal, dolomite, powdered mica, shell and sawdust. Plant fibres have sometimes been added to strengthen the ground. Grounds have sometimes been composed of immiscible constituents, such as a drying oil with a water-based glue, made to mix by the bulk of the filler. They have sometimes been omitted altogether, the paint layer being applied directly to the sealant.

Another ground that has been used for painting is papier mâché, or *cartapesta*, made by laying a thick mixture of hot glue size and paper into a mould. The resulting image, when removed from the mould, provides a suitable surface for paint, as in the polychrome relief by Jacopo Sansovino (1486–1570) of the *Virgin and Child* (Fort Worth, TX, Kimbell Art Museum).

Grounds have sometimes been built up to form relief decoration; this was achieved by painting warm gesso (a glue size with a calcium carbonate/calcium sulphide filler) in the required pattern on a previously applied smooth gesso ground; the pattern could be refined by carving the hardened painted gesso, and the carved edges of the relief could be softened by wiping them with a damp sponge. An example of this method is a 14th-century polychrome oak relief portraying a bishop, which has free-hand relief decoration encrusted with glass fragments (Namur, Musée des Arts Anciens du Namurois).

An early group of sculptures from Jerico (e.g. Toronto, Royal Ontario Museum), dated to the Pre-Pottery Neolithic B, around 6000 BC, are rare examples of sculptures made of lime plaster, formed by the reaction of slaked lime and carbon dioxide, and having grounds of the same material. Such grounds sometimes had a high quartz content, giving a rough-textured surface, and sometimes a nearly pure lime content, giving a smooth surface, which might be burnished. The pigments used to colour the sculptures, haematite and manganese dioxide, were applied by a fresco technique, being encapsulated in the hardening lime plaster.

(iii) Paint. When used on sculpture, paint usually consists of a binding medium or a mixture of binding media (the same as those used for sealants and grounds) and a pigment or a mixture of pigments. This colouring system allows a greater variety of painterly effects than the fresco technique, and the application is not limited by time (as it is with fresco), an important consideration in colouring complex three-dimensional objects. Paint layers based on different media might be used on different component parts of a sculpture, as in the polychrome limestone effigy of *Joan Nevill, Countess of Arundel* (d 1462) in the Fitzalan Chapel, St Nicholas, Arundel, W. Sussex. There the mantle, coloured with burnished gold leaf, laid on to a water-based mordant, had a painted white lining of lead white in linseed oil.

Pigment in a medium was applied in a number of ways. It could be a flat colour with a single pigment; or a mixture of pigments; or a layered structure, with the colour of the underpaint being used to enhance

the final coloured layer; thus in the Tyrolean *Virgin and Child* (*c.* 1400–25; London, Victoria and Albert Museum) the Virgin's blue mantle lining is painted in azurite over a black ground. The pigment could be applied by the *sgraffito* technique, as a matt paint layer over gold, the uppermost layer being scraped away in a design to reveal the gold beneath; or applied in layers, with a translucent glaze representing the final paint layer. This could be, for instance, a crimson lake over an opaque red, a crimson lake or green copper resinate glaze over gold (as in the *Joan Nevill* effigy), or a resinous gold-coloured glaze over very pure silver leaf (e.g. the gold-coloured robe and mantle of the Heddal *Madonna*, 1250–1300; Oslo, Universitets Oldsaksamlingen).

Glass fragments were sometimes incorporated into the glazes to produce a sparkling effect. A glaze might be painted directly on to an unsealed or sealed surface, as in the case of Alfred Gilbert's glazed and coloured bronze figures (1893–1928) for the tomb of *Prince Albert Victor, Duke of Clarence* (Windsor Castle, Berks, Albert Memorial Chapel); or of the pink-tinted marble cheeks of the *Tinted Venus* (1851–6; Liverpool, Walker Art Gallery) by John Gibson (1790–1866). A gradation of colours might be achieved by the use of 'wet on wet' techniques, as in the flesh areas of the polychrome terracotta portrait bust by an unknown sculptor of *Cardinal Giovanni de' Medici*, later Leo X (1512–13, London, Victoria and Albert Museum). Shading could be produced by gradating paint layers: the throne of the seated figure of *St Olaf* from Fresvik shows lead white shaded into a deepening copper green or organic yellow glaze, while the robe lining of the figure of *St Paul* from Gausdal has gradated vermilion shading over red lead (both 1250–1300; Oslo, Universitets Oldsaksamlingen). Chinese Tang-dynasty sculptures and Japanese Buddhist sculptures of the 7th–8th centuries have Ungen colouring (bands of the same colour overlaid one on top of another). A thin paint film might be laid over a dark underdrawing; thus an underdrawing of dark-blue arm veins would show pale blue beneath the pink flesh paint.

Terracotta sculptures were sometimes coloured with fired coloured glazes, as in the case of the sculptures of Luca della Robbia (1399/1400–82), for example *Crucifixion with Three Mourners and SS Francis and Girolamo*. On some terracottas both fired glazes and painting and gilding were used, as in the *Lamentation* group by the school of della Robbia (*c.* 1500–25; London, Victoria and Albert Museum). Many large terracotta groups were merely painted and gilded, for example the polychrome terracotta *Lamentation* group (16th century; Bologna, S Petronio) by Vicenzo Onofri (*fl c.* 1503–24). In northern Europe towards the end of the 16th century paint on sculpture became more subdued in colour. Some sculptures were painted so as to give a homogeneous monochrome surface colouring. Some more recent sculptures have been only partly polychromed, the colour, together with the texture of the sculpture material, being incorporated into the overall design and colour scheme; thus in Gibson's *Tinted Venus*

only the cheeks of the goddess were tinted pink, the rest of the flesh being left unpainted.

(iv) Other decorative elements. Materials other than paint that were also applied to polychromed sculptural surfaces include thin sheets of precast patterned relief motifs, which could be bent and applied to curved surfaces. The limestone effigies of *Joan Nevill* and her husband *William Fitzalan, 9th Earl of Arundel* (Arundel, W. Sussex, St Nicholas, Fitzalan Chapel) are decorated with tin-reinforced, cast, gilded and glazed wax relief sheets. The lime plaster reliefs on the painted limestone effigy of *Sir Bartholomew Bacon* (14th century; Erwarton, Suffolk, St Mary) were either stamped *in situ* or, more probably, applied subsequently. A Reigate-stone effigy of a knight of the De Lucy family (1340–50; London, Victoria and Albert Museum) was given applied or stamped chain mail decoration. Other materials included embossed, painted or gilded paper, as in the bodice of the Virgin's robe in the Tyrolean *Virgin and Child* mentioned above. Gilded cast relief motifs made of colophony (resin) were applied to the robes of the figures (1216–20) on the south porch of Lausanne Cathedral. Semi-precious stones were used, and also glass in the form of diamond-shaped glass insets with painted decoration on the back, as in the maniple worn by the stone effigy of *John de Northwoode, Bishop of Sheppey* (*d* 1360) in Rochester Cathedral. In Japanese Kamakura sculpture, glass or crystal was used for eyes; pieces of shaped crystal were inserted into the open eye sockets from behind and fixed in place with bamboo pins. The pupils were painted black, and the whites of the eyes were simulated by stretching silk or paper across the back of the crystal eyeball.

In European medieval sculpture metal was used for crowns, nails, etc, or as relief decoration; as in the oil-gilded lead–tin alloy decoration on the loincloth borders in a Crucifix (1478) from Melk Abbey. Cloth was sometimes draped around sculptures and then stiffened with size; the wooden figure of *Lucretia* (*c.* 1522; London, Victoria and Albert Museum) attributed to Jacopo Sansovino (1486–1570) has tinfoil on draped, gathered and sized cloth. Other additions include cord, string and leather, as in the Crucifix (1477) by Bernt Notke (*c.* 1440–1509) in Lübeck Cathedral.

M. Quatremère de Quincy: *Le Jupiter olympien, ou l'art de la sculpture antique considéré sous un nouveau point de vue* (Paris, 1815)

D. V. Thompson, ed.: *The Craftsman's Handbook* (New Haven, 1933/R London, 1960) [Eng. trans. of unpublished MS. *Il libro dell'arte* by C. Cennini]

P. Philpott: 'La Restauration des sculptures polychromes', *Studies in Conservation*, xv (1970), pp. 248–52

F. Rieber and R. E. Straub: 'The Herlin Altarpiece at Bopfingen (1474): Technique and Condition of the Painted Wings', *Studies in Conservation*, xxii (1977), pp. 129–45

T. Verdun: *The Art of Guido Mazzoni* (New York, 1978)

Preprints of the IIC Congress: Conservation of Wood in Painting and the Decorative Arts: Oxford, 1978 [incl. articles by M. Serck-Dewaide and B. Rabin and C. A. Grissom]

R. F. McGiffin: 'A Method for Overpaint Retention', *Studies in Conservation*, xxiv (1979), pp. 47–53

U. Plahter and S. A. Wiik: 'St Olav fra Fresvik og St Paulus fra Gausdal: To polychrome treskulpturer fra middelaleren', *Universitets oldsaksamling årbok* (1979), pp. 213–27

M. Baxandall: *The Limewood Sculptors of Renaissance Germany* (New Haven, 1980, 4/1990)

T. A. Hermanès and E. Deuber-Pauli: 'Le Couleur gothique', *Connaissance des arts*, 367 (1982), pp. 36–45 [Study of the figures on the south porch of Lausanne Cathedral]

A. Leroi-Gourham: 'The Archaeology of Lascaux Cave', *Scientific American* (1982)

'Restauro di una terracotta del quattrocento: Il compianto di Giacomo Cozzarelli', *Opificio delle Pietre Dure e Laboratori di Restauro* (Florence, 1984)

J. Larson and R. Kerr: *Guanyin: A Masterpiece Revealed* (London, 1985)

Preprints of the 13th Annual Meeting of the AIC: Washington, DC, 1985 [incl. article by J. Thornton]

A. Brodrick and J. Darrah: 'The Fifteenth-century Polychromed Limestone Effigies of William Fitzalan, 9th Earl of Arundel, and his Wife, Joan Nevill, in the Fitzalan Chapel, Arundel', *Journal of the Church Monumets Society*, i/2 (1986), pp. 65–94

Preprints of the IIC Congress: Case Studies in the Conservation of Stone and Wall Paintings: Bologna, 1986

C. Galvin and P. Lindley: 'Pietro Torrigiano's Tomb for Dr Yonge', *Journal of the Church Monumets Society*, iii (1988), pp. 42–60

Preprints of the Contributions to the IIC Congress: The Conservation of Far Eastern Art: Kyoto, 1988 [incl. article by J. Larson]

A. Brodrick and J. Darrah: 'A Description of the Polychromy on the Fragments of Limestone Figure Sculpture from the Great Screen at Winchester Cathedral', *Burlington Magazine*, cxxxi (1989), pp. 615–17

J. Larson: 'A Polychrome Bust of a Laughing Child at Windsor Castle', *Burlington Magazine*, cxxxi (1989), pp. 618–24

Preprints of the Contributions to the IIC Congress: Cleaning, Retouching and Coatings: Technology and Practice for Easel Paintings and Polychrome Sculpture: Brussels, 1990

V. Harris and K. Matsushima: *Kamakura: The Renaissance of Japanese Sculpture, 1185–1333*, British Museum handlist (London, 1991)

S. L. Stratton, ed.: *Spanish Polychrome Sculpture 1500–1800 in United States Collections* ([New York, 1993])

A. Blühm and others: *The Colour of Sculpture, 1840–1910* (Zwolle, 1996)

Y. Luke: *Quatremère de Quincy's Role in the Revival of Polychromy in Sculpture* (Leeds, 1996)

Wu Yongqi and others, eds: *The Polychromy of Antique Sculptures and the Terracotta Army of the First Chinese Emperor*, ICOMOS Monuments and Sites, iii (Munich, 2001)

S. Boldrick, D. Park and P. Williamson: *Wonder: Painted Sculpture from Medieval England* (Leeds, 2003)

V. Brinkmann and O. Primavesi: *Die Polychromie der archaischen und frühklassischen Skulptur* (Munich, 2003)

V. Brinkmann and R. Wünsche: *Bunte Götter: Die Farbigkeit antiker Skulptur* (Munich, 2004)

M. Kühlenthal and S. Miura: *Historische Polychromie: Skulpturenfassung in Deutschland und Japan* (Munich, 2004)

R. Kahshnitz and A. Bunz: *Die grossen Schnitzaltäre: Spätgotik in Süddeutschland, Österreich, Südtirol* (Munich, 2005; Eng. trans. Los Angeles, 2006)

J. Portal: *The First Emperor: China's Terracotta Army* (London, 2007)

Polymer colour. Alternative name for acrylic paint, or any similar paint based on plastic polymers. Methyl methacrylate emulsions are employed for acrylic, polyvinyl acetate emulsions for PVA or vinyl colours. Artists' polymer colours have been available since the early 1950s and are usually encountered as aqueous emulsions, although some solvent acrylics were employed in the 1960s. They have many advantages over oil: plasticity, permanence and stability; freedom from acidity and complete colourlessness; fast drying and ease of use. However, they have not proved to be the panacea that artists hoped for. Despite the claims made for them, they are not always free from degradation, and problems of cracking, discoloration and the accumulation of dirt have arisen as the use of polymer colour grows.

See also ACRYLIC PAINTING.

R. Mayer: *The Artist's Handbook of Materials and Techniques* (New York, 1940, rev. 5/1991)

F. Gettings: *Polymer Painting Manual* (London, 1971)

L. Fairbairn: *Paint and Painting* (London, 1982)

S. Hackney: *Completing the Picture: Materials and Techniques of Twenty-six Paintings in the Tate Gallery* (London, 1982)

J. Stephenson: *The Materials and Techniques of Painting* (London, 1989)

T. van Oosten, Y. Shashoua and F. Waentig, eds: *Plastics in Art: History, Technology, Preservation* (Munich, 2002)

M. Wagner, D. Rübel and S. Hackenschmidt, eds: *Lexikon des künstlerischen Materials: Werkstoffe der modernen Kunst von Abfall bis Zinn* (Munich, 2002)

T. J. S. Learner: *Analysis of Modern Paintings* (Los Angeles, 2005)

R. Tauchid: *The New Acrylics: Complete Guide to the New Generation of Acrylic Paints* (New York, 2005)

Pontata. Term for the section of a fresco painted in a single day. Unlike giornate (see GIORNATA), which follow the outlines of the composition and are thus irregular in shape, pontate correspond to the arrangement of the scaffolding (*ponteggio*) and are rectangular in form (see FRESCO, §4).

Porcelain. See CERAMICS, §§I, 2(iii) and (iv).

Port crayon [Fr.: 'chalk holder']. Instrument for holding a piece of pastel, chalk or crayon.

Poster. Art form usually comprising a design of images and lettering printed on paper and generally mass produced for display in public places such as on walls and hoardings. The early development of the form in the 19th century was closely linked to the introduction of lithography, since when its evolution has been bound up with subsequent advances in printmaking techniques. The access to a large public has attracted many artists to the poster and allowed it to be harnessed for a number of social purposes, such as the dissemination of information and propaganda; it has also made it one of the most significant forms of commercial art.

Printing with movable type was invented by Johann Gutenberg (*c.* 1394/9–1468) between 1439

and 1444; however, William Caxton (?1427–92) printed the first notices in 1477. The invention of LITHOGRAPHY by J. N. F. Alois Senefelder (1771–1834) in 1798–9 and the introduction in 1827 of chromolithography made printing with colour a reality with a consequent impact on poster design. During the 19th century the process of lithography was used to create original works of art by such artists as Francisco de Goya (1746–1828) and Honoré Daumier (1808–79), but the method was also used to reproduce the art of others. There were also well-known illustrators who created work of quality. However, it was not until Jules Chéret (1836–1932) started his own colour lithographic press in Paris in 1866, using Senefelder's patent but on improved machinery imported from England, that the first large-scale lithographed posters appeared. By the end of the 19th century standard poster sizes in France were listed by Ernest Maindron in *Les Affiches illustrées* (1886 and 1896) in a range from '1/4-Colombier' (410 × 300 mm) to 'Quadruple Grand Aigle' (2.2 × 1.4 m). In poster-printing, the lithographed image was frequently combined with letterpress type, which could be added afterwards (see LITHOGRAPHY, colour pl. VII, fig. 3). Alternative methods of printing were introduced later (*see* PRINTS, §III), including serigraphy or silk-screen printing and various photo-mechanical processes, such as COLLOTYPE, and later still photogravure (based on the intaglio process, in which the image area is etched below the surface of the printing plate), as in the photographic posters introduced in the 1920s. In the 1950s improved colour printing, particularly the use of photolithography (a planographic process allowing image and text to be printed together), made high-quality reproduction possible. In the 1970s the introduction of laser scanners, together with such developments as electronic retouching and image generation, marked a break from former photolithographic methods. Additions and corrections to the original were easier to implement, while 4-colour-process printing and the improvement in the quality of paper also made sharper definition possible.

Techniques of display have always been important to the poster's success in attracting attention. The haphazard siting of a variety of messages in competition with each other encouraged an aggressiveness of image and design. Exhibiting identical images in rows encouraged consumer interest through repetition; alternatively, sequential series of posters relayed their message over a period of time by arousing viewers' expectations. Because the normal run of mass-produced posters was made on cheap, perishable paper, collectors always sought high-quality issues. Examples exist of editions of posters designed by Alphonse Mucha (1860–1939) and printed on silk for the theatre productions of Sarah Bernhardt (1844–1933). In the 20th century large-scale public displays included single and multi-sheet posters in competition with multi-media signs and hand-painted hoardings that can measure 14.0 × 3.5 m. Because such posters were meant to be viewed quickly by passing motorists there was a simplification of the design and an ever increasing sophistication in both concept and response.

E. Maindron: *Les Affiches illustrées*, 2 vols (Paris, 1886/R 1896)

M. Bauwens, ed.: *Les Affiches étrangères illustrées* (Paris, 1897)

E. McKnight Kauffer: *The Art of the Poster* (London, 1924)

A. Cooper: *Making a Poster* (London, 1938)

P. Wember: *Die Jugend der Plakate, 1887–1917* (Krefeld, 1961)

H. Hutchinson: *Art for All: London Transport Posters* (London, 1963)

H. Rademacher: *Deutsche Plakat* (Dresden, 1965)

D. Dooijes and P. Brattinga: *A History of the Dutch Poster, 1880–1960* (Amsterdam, 1968)

B. Hillier: *Posters* (London, 1968)

H. Hutchinson: *The Poster* (London, 1968)

J. Abdy: *The French Poster from Chéret to Capiello* (New York, 1969)

A. Fern and M. Constantine: *Word and Image* (New York, 1970)

D. Stermer: *The Art of Revolution* (London, 1970)

J. Müller-Brockmann: *A History of Visual Communication* (Teufen am Rhein, 1971)

J. Müller-Brockmann and S. Müller-Brockmann: *History of the Poster* (Zurich, 1971)

J. Barnicoat: *A Concise History of Posters* (London, 1972)

V. Lyakhov: *Soviet Advertising Posters* (Moscow, 1972)

M. Gallo: *The Poster in History* (Feltham, 1974/R New York and London, 2001)

J. Delhaye: *Art Deco Posters and Graphics* (New York, 1977)

R. Sainton: *Art Nouveau Posters and Graphics* (New York, 1977)

P. Bourget: *Sur les murs de Paris et de France* (Paris, 1980)

The 20th-century Poster: Design of the Avant-garde (exh. cat. by D. Ades and others; Minneapolis, MN, Walker Art Center; Syracuse, NY, Everson Museum of Art; St Louis, MO, Art Museum; and elsewhere; 1984–5)

H. Mouron: *Cassandre* (London, 1985)

A. Weill: *Affiches et art publicitaire* (Paris, 1987)

S. Wrede: *The Modern Poster* (New York, 1988)

Plakat Kunst von Toulouse Lautrec bis Benetton (exh. cat. by J. Döring; Hamburg, Museum für Kunst und Gewerbe, 1994)

S. Landsberger: *Chinese Propaganda Posters: From Revolution to Modernization* (Armonk, NY, 1995)

L. Dickerman, ed.: *Building the Collective: Soviet Graphic Design, 1917–1937* (New York, 1996)

M. Timmers, ed.: *The Power of the Poster* (London, 1998)

A. Rosenfeld, ed.: *Defining Russian Graphic Arts: From Diaghilev to Stalin, 1898–1934* (New Brunswick, NJ, 1999)

A. Weill: *Graphics: A Century of Poster and Advertising Design* (London, 2004)

J. Schnapp: *Revolutionary Tides: The Art of the Political Poster, 1914–1989* (Milan, 2005)

Pouncing [Fr.: *poncer*; It.: *spolvero*]. Transfer process in which powder or dust is rubbed through a pricked design, creating a dotted underdrawing on the surface beneath. Though primarily known as an Italian Renaissance technique for translating designs from a CARTOON to the moist plaster in FRESCO painting, pouncing had a wide application in the work of artists, craftsmen and amateurs. Draughtsmen, easel painters, illuminators, embroiderers, lacemakers, ceramicists, printmakers and writing-masters used pouncing to duplicate their

designs. The drawing to be reproduced was placed over the working surface (paper, cloth, wall or panel), and the outlines of the design were pricked with a pointed implement such as a needle or stylus and rubbed with pounce (powder or dust of black chalk, charcoal or pumice if the support was light; of white chalk, gesso or light pumice powder if the support was dark) contained in a pouncing bag (a small cloth pouch with its end tied). The advantages of pouncing compensated for the laboriousness of the task: precise correspondence between drawing and final work was assured; a painter could delegate the task to an assistant; and once a drawing was pricked it could be reused to repeat designs or, by pouncing the *verso*, to create symmetrical patterns and complementary figures. Giovan Battista Armenini described in his *De' veri precetti della pittura* (1586) how artists also used pouncing to reduce the effort of drawing the chiaroscuro in a cartoon. The areas representing shadows were tapped with the pouncing bag, so that the settled pounce gave the impression of shaded preliminary drawing.

The earliest written references to pouncing occur in the *Libro dell'arte* (*c.* 1390) by Cennino Cennini (*c.* 1370–*c.* 1440), which includes instructions on how to replicate complex gold brocade patterns in panel paintings by means of pounced patterns. Between 1450 and 1520 the pouncing of drawings became routine practice in painters' workshops, but the technique is relatively undocumented in 15th- and 16th-century primary sources. Notes by Leonardo da Vinci (1452–1519) *c.* 1490 for his treatise on painting contain a passing recommendation to use a pricked drawing (cartoon) to pounce designs for panel paintings. For frescoes Armenini described the process of laying a second cartoon ('sub-cartoon' or 'substitute cartoon') underneath the drawn cartoon, pricking both with the needle and using pieces of the substitute cartoon to pounce the design onto the wall. This refinement of the technique spared valuable fresco cartoons from damage or possible destruction. Although both Giorgio Vasari (1511–74) and Vincenzo Borghini (1515–80) possessed pounced drawings in their collections, neither commented on pouncing figural fresco cartoons, probably because the advantages of the technique were mainly those of replication, and it was considered assistants' work, too laborious to be described. Fortunately 16th-century Venetian pattern-books on embroidery and treatises by Alessandro Paganino, Giovanni Tagliente, Giovanni Ostaus and Cesare Vecellio document aspects of the practice that would otherwise be lost. A few 17th-century, non-Italian writers on painting, such as Claude Boutet, Vicente Carducho and Francisco Pacheco, described pouncing in their treatises, probably because it was not well known to their readers. With the rising interest in encyclopedias and dictionaries during the 18th century, definitions of pouncing proliferated.

The technique of pouncing appears to have been known by the the mid-10th century in China. This is suggested by the existence of three pricked, heavily pounced patterns (London, British Museum, OA 1919.1–1.072 (Ch. 00159); OA 1919.1–1.073 (1) (Ch. xli.002); OA 1919.1–1.073 (2) (Ch. xli.004)). The patterns were among the materials discovered by Sir Aurel Stein (1862–1943) in 1907 in the Caves of the Thousand Buddhas at Dunhuang. Their designs relate closely to the painted murals found in the cave shrines. That the pricking on the sheets is original seems relatively certain, on account of both the patterns' provenance and the ample physical evidence of their utilization. The argument concerning the use of pouncing as a technique in producing manuscripts in medieval workshops, from as early as the mid-11th century onward, is not persuasive (Miner; Bambach Cappel, 1988). First, such medieval manuscripts could have been pricked long after they were produced; they also do not usually show rubbed pouncing dust. Second, the internal measurements of the allegedly repeated motifs do not coincide (e.g., Paris, Bibliothèque Nationale, MS. lat. 12610, fol. 40*v*, and MS. lat. 11751, fol. 59*r*). Third, no pounce marks as underdrawing have been found on early manuscripts to document the procedure. And last, the examples of manuscripts usually cited show only selectively pricked motifs (e.g. the Paris manuscripts; New York, Pierpont Morgan Library, MS. 736; London, British Museum, MS. 12283; New Haven, CT, Yale University, Beinecke Library, Marston MS. 157; Cambridge, MA, Harvard University, Harvard Collection Library, MS. Typ 101 H; Brussels, Bibliothèque Royale Albert 1er, MS. 8340; Bergamo, Biblioteca Civica A. Mai, Cod. D VII, 14). Yet the technique emerged in the West during the late Middle Ages, probably making its way along the Silk Route during the period of trade established between Europe and the Orient, after Marco Polo's return to Venice in 1295. A dissemination of the technique through the Silk Route might especially explain Cennino's allusion to pouncing in connection with painting gold brocade patterns.

Pounce marks first appear in the ornamental parts of mid-14th-century Central Italian frescoes and panels. Examples are the decorative borders by Andrea di Cione (1315/20–68) and his workshop framing the series of prophets detatched from the Cappella Maggiore frescoes in S Maria Novella, Florence (*c.* 1340–1348; now Florence, Museo di S Maria Novella), and framing the fragments of scenes from the *Triumph of Death*, the *Last Judgement* and *Hell* formerly in Santa Croce, Florence (*c.* 1348–1368/69; now Florence, Museo dell'Opera di Santa Croce). The earliest function of pouncing in European art was exclusively replicative, to enable the multiple repetition of ornamental motifs. Gradually artists began applying the technique selectively within figural compositions as a means of preparing their design. By the 1430s and 1440s, the practice of pouncing figural cartoons for fresco compositions (often combined with a *sinopia* underdrawing) became common in the workshops of Italian painters. Among the pioneers of pounced figural cartoons were Paolo Uccello (*c.* 1397–1475), Domenico Veneziano (*fl* 1438; *d* 1461), Andrea del Castagno (before 1419–57) and Piero della Francesca (*c.* 1415–92).

Between 1475 and 1520 pouncing enjoyed its highest popularity among painters and draughtsmen in Italy, especially in Tuscany and Umbria. Nearly all Central Italian painters working in this period seem to have produced pricked and/or pounced drawings. Leonardo da Vinci was probably one of the first artists to exploit pouncing creatively in drawing symmetrical or nearly symmetrical designs (e.g. *Study of the Organs of a Woman*, Windsor Castle, Berks, Royal Library, 12281*r*; *Perspective Study of a Mazzocchio*, Milan, Biblioteca Ambrosiana, Cod. Atlanticus, VIII, fol. 710b). The exceptional number of pricked and/or pounced drawings by Raphael (1483–1520) bears witness to his systematic use of pouncing in many phases of the artistic process (e.g. Paris, Musée du Louvre, 3860; Oxford, Ashmolean Museum, KTP 530*r*, 530*v* and 568*r*; and Chatsworth, Derbys, 67). Even Armenini's description of how a pounced substitute cartoon was produced seems to stem from knowledge of Raphael's workshop practice through his acquaintance with Raphael's assistant Giulio Romano (?1499–1546). Between 1520 and 1550 pouncing suffered virtual extinction among painters and draughtsmen, though some artists of the older generation and from provincial outposts stubbornly clung to the technique. Pounced cartoons were introduced to northern Europe probably during the 1480s and 1490s but by the early 17th century they were obsolete there too.

Early sources

C. Cennino: *Il libro dell'arte* (*c.* 1390); Eng. trans. and notes by D. V. Thompson jr as *The Craftsman's Handbook: 'Il libro dell'arte'* (New Haven, 1933/*R* New York, 1954), pp. 3, 6–7, 86–7, 89

A. Paganino: *De rechami pelquale se impara in diversi modi l'ordine e il modo de recamare …* (Venice, 1527/*R* 1875–91) [see 'Allessandro Paganino al lettore', r and *v*]

G. Tagliente: *Esemplario nuovo che insegna a le donne a cuscire, a reccamare, et a disegnare a ciascuno …* (Venice, [?1527], 1531/*R* 1875–91) [see last two pages]

G. Ostaus: *La vera perfettione del disegno di varie sorti di ricami et di cucire punti a fogliami punti tagliati* (Venice, 1567/*R* 1875–91) [see 'Alli saggi et giuditiosi lettori', r]

G. B. Armenini: *De' veri precetti della pittura* (Ravenna, 1586/*R* New York, 1971; Eng. trans., New York, 1977), pp. 172–4

C. Vecellio: *Corona delle nobili et virtuose donne …* (Venice, 1591/*R* 1875–91)

V. Carducho: *Diálogos de la pintura, su defensa, origen, esencia, definición, modos y diferencias* (Madrid, 1633); ed. F. Calvo Serraller (Madrid, 1979), pp. 385–6

F. Pacheco: *Arte de la pintura, su antigüedad, y grandezas* (MS., 1638; Seville, 1649); ed. F. J. Sánchez Cantón (Madrid, 1956), ii, pp. 2–3, 26–7, 52–3, 76–7

C. Boutet: *Traité de mignature, pour apprendre aisément à peindre sans maître* (Paris, 1676, Eng. trans., 1752), pp. 6–7

F. Baldinucci: *Vocabolario toscano dell'arte del disegno* (Florence, 1681); rev. in *Opere di Filippo Baldinucci*, ed. D. M. Manni (Milan, 1809), ii, pp. 114–15; iii, p. 157

A. Pozzo: 'Breve instruttione per dipingere a fresco', *Perspectiva pictorum et architectorum*, ii (Rome, 1700) [see 'Settione settima: ricalcare']

A. Palomino de Castro y Velasco: *El museo pictórico y escala óptica* (Madrid, 1715–24); ed. M. Aguilar, intro. J. A. Ceán y Bermúdez (Madrid, 1947), pp. 78, 518, 545–6, 579–81, 1152, 1159

F. Milizia: *Dizionario delle belle arti del disegno* (Bassano, 1771; rev. in *Opere complete di Francesco Milizia*, ii, Bologna, 1827), p. 231 [see 'cartoni']

J. P. Richter, ed.: *The Literary Works of Leonardo da Vinci*, i (London, 1888, rev. 1970), p. 319

General

O. Fischel: 'Raphael's Auxiliary Cartoons', *Burlington Magazine*, lxxi (1937), pp. 167–8

R. Oertel: 'Wandmalerei und Zeichnung in Italien', *Mitteilungen Kunsthistorischen Instituts in Florenz*, v (1940), pp. 217–314

S. A. Ives and H. Lehmann-Haupt: *An English 13th-century Bestiary: A New Discovery in the Technique of Medieval Illumination* (New York, 1942)

E. Borsook: *The Mural Painters of Tuscany* (London, 1960, rev. Oxford, 2/1980), pp. xxxiv–xxxvi, xliv–xlvi, 72–3, 91, 95–7, 107–8, 114–15, 119–20

D. Miner: 'More about Medieval Pouncing', *Homage to a Bookman: Essays … for Hans P. Kraus on his 60th Birthday* (Berlin, 1967), pp. 87–107

B. Degenhart and A. Schmitt: *Süd- und Mittelitalien* (1968), i of *Corpus der italienischen Zeichnungen, 1300–1450* (Berlin, 1968–90), pp. xxxvii–xxxix

J. Taubert: 'Pauspunkte in Tafelbildern des 15. und 16. Jahrhunderts', *Bulletin de l'Institut royal du patrimoine artistique*, xv (1975), pp. 387–401

J. Meder and W. Ames: *The Mastery of Drawing*, i (New York, 1978), pp. 391–9

B. Degenhart and A. Schmitt: *Venedig: Addenda zu Süd- und Mittelitalien* (1980), ii of *Corpus der italienischen Zeichnungen, 1300–1450* (Berlin, 1968–90), pp. 136–72

M. Koller: 'Die technische Entwicklung und künstlerische Funktion der Unterzeichnung in der europäische Malerei vom 16. bis zum 18. Jahrhundert', *Colloque IV pour l'étude du dessin sous-jacent dans la peinture: Louvain, 1981*, pp. 173–89

R. Whitfield: *The Art of Central Asia: The Stein Collection in the British Museum*, 3 vols (Tokyo, 1983), figs 138a/b, 139, pl. 78 [see commentary]

C. Bambach Cappel: 'Michelangelo's Cartoon for the *Crucifixion of St Peter* Reconsidered', *Master Drawings*, xxv (1987), pp. 131–42

C. Bambach Cappel: *The Tradition of Pouncing Drawings in the Italian Renaissance Workshop: Innovation and Derivation* (diss., New Haven, CT, Yale University, 1988)

C. Bambach Cappel: 'Pounced Drawings in Leonardo's *Codex Atlanticus*', *Achademia Leonardi Vinci: Journal of Leonardo Studies and Bibliography of Vinciana*, iii (1990), pp. 129–31

J. C. Wilson: 'Workshop Patterns and the Production of Paintings in Sixteenth-century Bruges', *Burlington Magazine*, cxxxii/1049 (Aug 1990), pp. 523–7

Caves of the Thousand Buddhas: Chinese Art from the Silk Route (exh. cat. by R. Whitfield and A. Farrar; London, British Museum, 1990), pp. 16–17, 88–9, nos 70–71

C. Bambach Cappel: 'Leonardo, Tagliente, and Dürer: 'La scienza del far di groppi', *Achademia Leonardi Vinci: Journal of Leonardo Studies and Bibliography of Vinciana*, iv (1991), pp. 72–98

C. Bambach Cappel: 'A Substitute Cartoon for Raphael's *Disputa*', *Master Drawings*, xxx (1992), pp. 9–30

L. Arbace: 'Nella bottega dei Gentili: Spolveri e disegni per le maioliche di Castelli', *Ceramic Antica*, viii/10 (Nov 1998), pp. 18–26

C. Bambach: *Drawing and Painting in the Italian Renaissance Workshop: Theory and Practice, 1300–1600* (Cambridge, 1999)

Poupée, à la [Fr.: 'with a dolly']. Method of colour printing from a single intaglio plate. Different coloured inks are applied to the plate using often no more than improvised stumps of rag or a dabbing tool ('dolly'), taking care that the colours do not smudge. It is used especially with tonal processes, such as stipple.

See also PRINTS, §III, 6(ii).

Priming. Term for the white preparatory paint layer applied to a support of wood, canvas or metal before painting. The GROUND is the normal term used for the priming of an oil or tempera painting, which may form an intrinsic part of the picture. Commercially available canvases prepared with one or two uniform coats of white paint are sold 'ready-primed' or 'double-primed'.

Printing. Term used to embrace three distinct but related concepts. First, it denotes the multiplication of documents or similar items consisting of words, pictures or other signs by means of some controlling surface, image or set of codes; the assumption is that all the resulting copies of such documents are identical to one another, although there may sometimes be appreciable differences between them. Secondly, it means the transfer of ink or some other substance by the impressing of one surface against another; such an action may lead to the above but does not necessarily lead to multiplication. Thirdly, an essential stage in some, but by no means all, printing is the assembly of prefabricated or otherwise predetermined characters (letters, numerals, and other signs) that relate to a particular written language or set of languages. Many printed items involve multiplication, impression and the assembly of prefabricated characters, but none of the three is essential to printing.

This article discusses the history and development of printing as a technical process. For a discussion of printmaking techniques *see* PRINTS. *See also* individual entries on specific kinds of printing.

1. Invention. 2. Origination of the image. 3. The printing surface. 4. Multiplication of copies. 5. Electronic publishing.

1. INVENTION. If printing is taken to mean either the multiplication of more or less identical images or the transfer of ink by impressing one surface against another, it is well over 1000 years old. Textiles were printed in Europe as early as the 6th century AD and religious documents in Japan and Korea by the 8th century AD. These items were printed from woodblocks, which had their non-printing parts cut away, so that they were lower than the parts that printed. Large numbers of documents, mainly Buddhist texts, were printed by such means in East Asia before the end of the 9th century. The earliest datable printed text is held to be the *Dhāraṇīsūtra* (London, British Museum), which was printed in Korea between AD 704 and 751.

In the West the technique of printing from woodblocks on paper probably dates from the late 14th century, although the first such WOODCUT that it is possible to date is from the early 15th century. Prints of this kind that have survived include religious images and playing cards. In both the East and the West the multiplication of large numbers of documents depended on the availability of a cheap substrate, and it was no accident that printing was developed after the invention of paper and, in the case of printing in the West, after paper began to be manufactured in Europe (*see* PAPER, §III, 4).

If printing is taken to mean the assembly of prefabricated or otherwise predetermined characters for use in written documents, it was again an invention of East Asia. The Chinese were responsible for the assembly of prefabricated characters made of clay as early as the mid-11th century and of wood from the beginning of the 14th. Metal types, made by sandcasting, were produced in Korea in the early 13th century and were in wide use there by the first half of the 15th century, when the Korean alphabet *han'gŭl* was devised and introduced. The common belief that printing was a European invention of the mid-15th century results not just from Western parochialism, nor from the fact that the invention of movable type in the East encountered difficulties posed by languages with thousands of different characters: it lies partly in the methods used for the production of the prefabricated characters.

Johann Gutenberg (*c.* 1394/9–1468), working in Strasbourg and Mainz in the mid-15th century and now generally credited with the invention of printing with prefabricated characters (usually called printing from movable type) was a goldsmith by trade: his main contribution was to discover a way of casting letters from an adjustable mould. Although it is not known precisely what his mould was like, it is clear that it allowed the dimensions of type to be controlled so that they could be fitted together physically and impressions taken from them; it undoubtedly accommodated letter-forms of varying width and ensured that all letters lined perfectly with one another visually. Gutenberg's method of manufacturing type allowed him to imitate with remarkable success the shapes and proportions of letters and the ways in which they were combined by scribes. Despite the limited knowledge of the precise methods he employed, it is supposed that he initiated the techniques used by later manufacturers of type, called type-founders. These techniques involved the following stages. A letter was cut in relief and in reverse on the end of a steel shaft, called a punch. The end of the punch was struck into soft copper, thereby producing an indented letter the right way round. This piece of copper was tidied up, in which form it is known as a matrix, and was placed in an adjustable mould. Molten metal, composed mainly of lead, was then poured into the mould with a ladle, and, within

seconds, a single piece of type was produced, with its character standing in relief and in reverse. Such pieces of type were subsequently brought together and prepared so that they aligned and fitted together perfectly. Once smoothed and planed, they could be kept in a way that allowed them to be brought together to form lines of words.

Credit for the invention of printing is given to Gutenberg rather than to anonymous craftsmen in East Asia or a rival European claimant, such as Coster of Haarlem (c. 1439–c. 1514), who was long regarded as a serious contender, since Gutenberg devised a convenient and accurate way of replica-casting that allowed him to bring together letters to form an infinite number of different written messages. His invention proved to be good enough to compete with the work of the scribe in terms of appearance, and it had the added advantage that it made the editing and correction of texts relatively easy. It ousted writing in certain fields, particularly book production, only because it was competitive economically. The apparatus and materials needed for type manufacture were expensive, and both type-casting and composition were slow. These initial costs could be recovered only if multiple impressions were printed from the type. The discovery of a way of multiplying documents was therefore central to Gutenberg's invention, and the manufacture of a printing press must be seen as a second and important part of it. Presses were not new: they had been used in the Rhineland for wine-making from ancient Roman times. Nothing is known about the first printing presses, but Gutenberg must have made substantial adaptations to existing forms of press to have devised something that could be used to take impressions on paper (see fig.). He would also have needed to develop an ink that took to metal types more easily than the ink used to print woodcuts (see INK, §I, 2), and it is supposed that he took advantage of the improvements made by painters in the Netherlands in the use of oil as a medium for binding pigments.

Gutenberg's invention was a synthesis of many elements, none of which was absolutely new. Although he failed to make the most of it commercially, he set standards of craftsmanship that ensured its exploitation by others and established the value of the use of interchangeable characters in the composition of text. The production for which he is best known is a 42-line Bible (Mainz, c. 1452–6), which remains one of the greatest achievements of both printing and book production.

2. ORIGINATION OF THE IMAGE. The word 'origination', used here to describe the stage at which the marks that appear in a printed item are determined, is intended to cover, on the one hand, words and pictures and, on the other, physical materials and electronically coded data; it also has to cater for methods that involve the production of the actual printing surface, besides others that do not. The origination of verbal messages in printing is known as typesetting, composition or character assembly and involves

the use of prefabricated or other predetermined characters and units of spacing. Both the composition of characters into words and lines and their subsequent organization into larger groupings belong to the origination stage of printing.

All type continued to be set by hand, in much the same way as it must have been in Gutenberg's time, until the mid-19th century. Although numerous experiments were made in the 19th century to develop typesetting machines that made use of pre-existing type, some of which were used commercially, it was not until the end of the century that typesetting machines were widely taken up (Linotype, 1886; Monotype, 1897). These machines made use of a keyboard, an essential ingredient in making composition faster; they also manufactured types or lines of type as part of the typesetting function. Linotype and Monotype machines were still in use in the late 20th century, but in the commercial world of printing they were almost entirely replaced by different kinds of composition systems. The most important of these is photocomposition, which had its roots in the late 19th century but which was not taken up seriously until after World War II. With the growth of offset lithography, photocomposition quickly supplanted metal typesetting, particularly from the early 1970s. The first generation of photocomposition machines made use of photographic negatives of characters through which light passed to form images on paper or film. In the last decades of the 20th century photocomposition machines were storing the shapes of the characters as binary electronic codes, the characters given a material form by the defining of thousands of minute dots with a laser beam. All methods of photocomposition involve the exposure of characters on photosensitized paper or film, which can then be used to produce a printing surface.

The typewriter, which was first marketed successfully by E. Remington & Sons in 1874, can also be considered a means of composition. It appears to have been used in connection with printing from the late 19th century in the USA and from the 1940s in the UK. With the introduction of electric typewriters, and particularly the IBM 72 Selectric composer in the mid-1960s, it was rapidly taken up as an alternative to metal composition and photocomposition.

In the mid-1980s laser printing began to challenge photocomposition. As in most advanced photocomposition systems, laser-printed characters are defined digitally by electronic codes, but they are made visible by xerography. The process of laser printing involves the deposit of very fine black powder on paper in response to electrical charges determined by digital codes. The major conceptual difference between photocomposition and laser printing is that the first involves the origination of a controlling image, which is then used to produce a printing surface from which copies can be multiplied, whereas the second was designed to produce a series of separately generated documents and therefore combines origination, production of the printing surface and multiplication. However, the

Selecting letters, inking and preparing paper for printing shown in Jost Amman: *Printer's Workshop*, woodcut, 79×60 mm, from *The Book of Trades*, 1568 (London, British Museum, PD, Book 159.D.11); photo © British Museum/Art Resource, NY

images of the most advanced photocomposition machines have resolutions of over 2000 lines to the inch/750 lines to the centimetre, whereas existing laser printers have resolutions of only 300–600 lines to the inch/112–224 lines to the centimetre.

A disadvantage of all composition systems is that the user is normally limited to the particular characters available with the system. This ranges from 88 on a standard typewriter to many thousands on the most flexible systems. The only composition method that copes with all known characters in all languages is handwriting; this is one reason why it has been used for the origination of printed texts. Some books, particularly lithographically printed ones of the 19th and early 20th centuries, were written out entirely by hand.

The origination of printed pictures was closely linked with the production of printing surfaces until the development of photography (see PRINTS, §III). Consequently printed images have reflected the limitations and possibilities of the various methods of production. One limitation that such images had in common for many centuries was that they were usually printed monochrome, although many were coloured by hand afterwards. The earliest printed pictures were simple outline images, designed with hand-colouring in mind; but by the end of the 15th century, and principally through the innovations of Albrecht Dürer (1471–1528), methods of making marks were developed that allowed images to be printed in monochrome that did not need hand-colouring. These methods, which involved crosshatching and the use of swelling and tapering lines, became an essential part of the printmaker's repertory for representing tone, form and texture for almost four centuries. They were developed with the processes of woodcut and line-engraving in mind but were later employed in etching, wood-engraving and even lithography. What began as a necessary means of producing particular effects in monochrome eventually became almost a stylistic end in itself.

In the early 16th century some woodcuts were printed in imitation of sepia drawings or of drawings on tinted paper touched up with white. It was not until the 18th century that images were printed in a full range of colours. Jacob Christoph Le Blon (1667–1741) and Jacques Fabian Gautier-Dagoty (1710–81) used intaglio plates, and John Baptist Jackson (c. 1701–c. 1780) printed from relief blocks. Colour printing was taken a stage further in Britain by William Savage (1770–1843), whose Practical Hints on Decorative Printing (1818–22) stands as a landmark in the history of making prints in colour. It was not until the late 1830s, however, that colour printing was developed commercially across a range of processes. In this period Godefroy Engelmann (1788–1839) in France and Charles Joseph Hullmandel (1789–1850) in Britain explored the use of successive workings in different colours by means of lithography; Charles Knight (1743–after 1826) perfected a process of colour printing in Britain using relief blocks in 1838, and George Baxter (1804–67) took out a British patent for a colour printing process in 1835 that involved printing a master plate (usually intaglio) and applying successive workings from relief blocks.

The other main limitation on the production of printing surfaces before the 19th century was that images had to be produced in reverse, so that they appeared the right way round when printed. The methods used to get around this problem involved tracing through an image that had been placed in reverse on the printing surface, drawing from an original by looking at it through a mirror, and (in the case of woodcuts only) pasting down on the surface of the block, and, in reverse, an image drawn boldly in ink on thin paper. The problems of reversal were resolved by the transfer branch of lithography (1798), which made it possible to transfer on to stone images

that had been drawn or written with greasy lithographic materials on specially prepared paper; the work was done the right way round so that the image could be transferred to a stone in reverse (see LITHOGRAPHY). However, although this process worked reasonably well when using lithographic ink, it was much less successful when lithographic crayons were used. The daguerreotype process of photography also suffered initially because it produced images in reverse, but the negative–positive process of photography invented by William Henry Fox Talbot (1800–77) gave right-reading images from its discovery in 1839. The exposure of photographic images on to printing surfaces coated with light-sensitive chemicals, particularly on to woodblocks from 1860, also helped to remove this traditional difficulty in the making of prints.

With the successful use of the photomechanical processes in the second half of the 19th century, the artist was freed from the restrictions of print-production methods almost entirely: thereafter any image produced by an artist could be reproduced tolerably well using such processes. The path to this achievement was opened up by the development of the half-tone screen in the early 1880s and by three- and four-colour process printing at the end of the 19th century. By the 1990s such methods had been replaced by electronic techniques of scanning and digitally storing images, which allow pictures to be modified in innumerable ways without manual intervention. In the 1980s techniques used for character assembly and picture origination converged. Electronic methods reduce all marks, however they are made, to a series of minute dots. The advantage of this technique is that, almost for the first time since the days of the block-book, words and pictures can be originated and multiplied by exactly the same means. The bringing together of words and pictures in common technologies has led to the use of the term 'marking engine' to describe the means used for originating marks, whatever form they may take.

3. THE PRINTING SURFACE. Until the end of the 18th century there were two essentially different kinds of printing surfaces: relief and intaglio (see PRINTS, §III, 1 and 2). Both depend on physical differences in relief between the printing and non-printing areas and on the application of pressure. In relief printing, ink is deposited on those parts of the printing surface that are higher than others. In intaglio printing, ink is forced into the hollows of a plate by the inking of its whole surface; the surface is then wiped clean, leaving the ink in the hollows. Relief and intaglio techniques tended to be used for different kinds of work. Relief printing was undertaken mainly by the letterpress printing trade and therefore often included type matter. Intaglio printing related more to the work of the artist and was widely used for pictorial prints, illustration and decorative work of a refined kind; except in the case of trade cards, bookplates and similar material, such work rarely included verbal material.

The simple dual division of printing into relief and intaglio branches was shattered in the closing years of the 18th century, when J. N. F. Alois Senefelder (1771–1834) invented LITHOGRAPHY. Lithography differs from other earlier processes in that it depends not on physical differences between printing and non-printing areas but on chemical (strictly speaking, electrical) differences. The process rests on the antipathy of grease and water and the attraction of these two substances to their like and to a common porous ground. The ground that was initially found most appropriate was limestone. From the middle of the 19th century, however, metal plates (principally of zinc) were increasingly used instead of stone. In most branches of lithography the printing area is, to all intents and purposes, on the same level as the non-printing area. For this reason lithography is regarded as belonging to the third main branch of printing, known as planographic.

The invention of lithography did more than introduce a new printing process: it was so versatile that it could imitate most of the existing processes very convincingly. What is more, it had as one of its major branches the technique of transfer lithography; henceforth pictures and writing done on a specially prepared paper could be transferred to stone, as could prints produced by most of the other printing processes. This not only gave the process considerable advantages commercially but also meant that it took time for it to develop its own graphic identity.

The ways in which printing surfaces could be made proliferated in the mid-19th century; one contemporary writer, William John Stannard, went as far as to describe and illustrate over 150 different ways of producing prints. In order to give longer runs in intaglio printing, steel began to be used from around 1822 and steel facing of copperplates from around 1840 (see ENGRAVING, §II, 5). WOOD-ENGRAVING became more refined and emerged as the standard method for producing pictures that needed to be printed along with type, although usually copies were made by stereotyping (taking casts in lead), so that the original could be preserved and more than one press used at a time.

The greatest change in the manufacture of printing surfaces came with the harnessing of photography, a process that, in the negative–positive version developed by William Henry Fox Talbot (1800–77), can also be regarded as a kind of printing since it allowed for the multiplication of identical copies of an image. Photography was applied to all the major printing processes before the end of the 19th century, and photolithographic methods were being used on a limited basis as early as 1850. The most important commercial application of photography to printing came with the manufacture of relief blocks, both line and half-tone, by means of a combination of photography and chemical etching. Such photomechanically produced blocks could be printed along with type, and they effectively replaced woodengraving for illustrating books and journals by the end of the 19th century.

The main consequence of such changes in printing technology for artists was that it became increasingly difficult for them to be closely involved with production processes. At the beginning of the 19th century it was common enough for artists to make their own printing surfaces, almost regardless of the process. For example, artists as varied in their use of processes as Thomas Bewick (1753–1828), William Blake (1757–1827), J. D. Harding (1798–1863) and William Westall (1781–1850) all made original images for printing and on occasion also produced the printing surface themselves; they were following a tradition begun by such early artist-printmakers as Andrea Mantegna (1430/31–1506) and Albrecht Dürer (1471–1528; although the latter did not do all his own woodcutting). With increasing specialization in the 19th century this became less common in all processes, but particularly in wood-engraving and steelengraving. The introduction of photomechanical processes in the closing decades of the 19th century effectively completed the separation of the artist from the making of printed images for commercial production. From this time onwards artists began to return to 'craft' forms of printing, particularly woodengraving, etching and lithography, in order to retain a close relationship between the origination of an image and the manufacture of the printing surface.

In the 20th century the most significant developments were the commercial growth of SCREENPRINTING, a stencil process that had its origins in the 19th century, and the extraordinary impact of xerography after World War II (see PHOTOGRAPHY, §I). Although these processes were originally developed for commercial purposes and have continued to be used in this way, both have been taken up by artists. Xerography, invented in the USA by Chester Carlson (1906–68) in 1938, involves transferring a very fine black powder from an electrically charged surface to paper and was used initially for office copying. It has developed rapidly in quality, and machines usually enlarge and reduce images and some produce prints in full colour. Like photography and screen printing, xerography differs fundamentally from the traditional printing processes discussed above in that it does not depend on the pressure of one surface against another. Other printing methods have been developed in recent years, such as ink-jet printing, that likewise do not depend on pressure. They are described by the generic term 'non-impact printing'.

4. MULTIPLICATION OF COPIES. Although the multiplication of copies is not an essential feature of printing, the economic, social and intellectual consequences of printing derive from its ability to produce identical or near-identical copies of a document in large numbers. The ways in which printing can multiply copies may be considered in three categories: printing without presses, printing with the handpress and printing with machines. Artists' prints have rarely been produced in large editions, partly because the market for them is usually small and partly because limiting the size of an edition is a means of making the prints more desirable. Conventionally, therefore,

artists' prints have been made on handpresses or occasionally without the use of a press. Printing undertaken for commercial production involves the use of presses, and powered machines were introduced in relation to all the major printing processes in the course of the 19th century.

It seems likely that the earliest woodcuts were printed by one of two methods: by striking or pressing the block against the material on which it was to be printed or by placing it with the inked surface face up, laying the material on top and rubbing its back. The invention of the printing press in the mid-15th century effectively removed the need for such methods, although the second of them continues to be used for proofing purposes in some crafts. The oldest surviving printing presses probably date from no earlier than the 17th century. What is known about very early presses derives mainly from woodcut illustrations of the late 15th century. Such presses, known as common presses, were made of wood and were used mainly for printing pages of metal type, sometimes along with woodcut blocks. Pages of metal type, with or without blocks, were locked up in a rectangular chase to produce a forme. This forme was then placed on the bed of the press and inked up with leather-covered inking balls. The paper to be printed was held in place with a tympan and frisket and was brought down on the printing forme. By turning a handle, the bed of the press was positioned beneath a flat surface (the platen), which applied pressure to the forme and paper by means of a worm screw and lever.

Common presses continued to be used into the middle of the 19th century, although by this time most had been replaced by iron presses. The first successful iron press, invented by Charles, 3rd Earl Stanhope (1753–1816), was in use in Britain by the early 19th century. It was modelled on the common press in most respects, but it allowed for larger areas to be printed with less effort with the help of a system of compound levers. Such presses represented the advanced technology of the day and were used, for example, to print *The Times* newspaper in the early 19th century. The Stanhope press was followed by many other kinds of iron presses, the most popular being the Columbian (1817) and Albion (*c.* 1822).

Platen presses (which applied pressure across a broad area by forcing one flat surface against another) were appropriate for relief printing but not for intaglio or planographic printing, which required greater pressure; the simplest way of achieving this was to reduce the area over which pressure was applied at a given time. Intaglio printing solved the problem by laying the inked-up copperplate and paper on a plank and forcing them between two cylinders or rollers. The pressure was applied successively along a line and had to be great enough to force the ink out of the sunken lines on to the paper. Such presses are known as rolling presses. The first rolling presses were made of wood, but from *c.* 1830 they began to be made of iron. Presses of considerable size were made to print maps and other large-format work,

and such presses were normally geared to make them easier to operate.

The first successful lithographic presses also applied pressure successively but by means of a wooden scraper. This was less rigid than a cylinder and was therefore less likely to break stones; it could also be changed according to the size of the image to be printed. Numerous kinds of scraper presses were manufactured in the first half of the 19th century, from very small ones designed for printing stationery to others that were capable of printing the largest sheets of paper available at the time. Those that achieved greatest success placed the lithographic stone on a bed, which was then pulled under pressure beneath a scraper. Most lithographic presses of this kind incorporated a tympan to protect the paper from the friction of the scraper; they therefore owed something to both the platen press and the rolling press. The earliest lithographic presses were made of wood, but iron ones were introduced in the 1820s and became increasingly common, particularly in Britain and America.

All the 19th-century handpresses discussed above were still being used for craft purposes in the late 20th century. Iron platen presses, many of them from the 19th century, were being used by printmakers and private-press printers and had not been improved on for certain kinds of work. Nineteenth-century intaglio and lithographic presses are also used by some printmakers. All kinds of presses continued to be used industrially for proofing purposes into the 20th century, although long before this they had been replaced by powered machines when large runs were needed.

Steam power was first used in printing in 1810, when the German engineer Friedrich König (1774–1833) applied it to a platen press. Koenig's claim to fame as the inventor of the powered printing machine rests, however, on his cylinder machine, which was first used to print *The Times* on 29 November 1814. This machine had a moving bed on which the printing surface travelled successively under inking rollers and an impression cylinder; this principle of working formed the basis of a wide range of cylinder presses manufactured since. Successful powered machines were not developed for lithographic printing until Georg Sigl (1811–87) patented such a machine in 1851, both in his native Austria and in France; they were not introduced for intaglio printing until almost the end of the century.

In the complicated history of powered machines two significant developments need to be highlighted. One is the rotary printing press, in which the printing surface is cylindrical, as is the surface that applies the pressure. This means that it is possible to feed a continuous sheet of paper between the two cylinders, thereby doing away with the slow business of feeding individual sheets by hand. The rotary principle was first applied to calico-printing in the late 18th century. The first successful rotary machine for printing on paper was a vertical rotary machine, which was used for printing parts of *The Times* in 1848 and relied

on hand-feeding. In the 1860s, however, William Bullock (1813–67) in the USA and John Walter III (1818–94) in the UK introduced horizontal reel-fed rotary machines. Presses of this kind printed *c.* 10,000 copies of a paper an hour, compared with the *c.* 200 sheets an hour, printed on one side of the sheet only, that could be taken from letterpress handpresses of the early 19th century and with the output of *c.* 1000 sheets an hour claimed for the first powered letterpress cylinder machines.

The second major development was offset printing, which was first explored industrially in connection with lithography. In offset printing an image is transferred from the printing surface to an intermediary cylinder (coated with a rubber-like composition) and from there to the material that has to receive it. The method was originally developed as a means of getting over the problem of printing on the insensitive surface of metal and was first practised by the firm of Barclay & Fry in London in 1875. By *c.* 1880 it was being used successfully for the printing of biscuit tins. Tin printers of this period used flat lithographic stones; however, the real significance of the offset principle of printing was not felt until it was adapted to rotary printing and used for printing on paper. This was first proposed in 1903 by the American Ira W. Rubel, who seems to have stumbled on the offset idea quite independently as a result of accidentally offsetting a print from a rubber impression cylinder. Rubel developed his idea commercially and within a few years offset presses were being manufactured in the USA and UK. Although a latecomer in the history of printing, offset lithography accounts for most of the world's printing.

Apart from xerography, there were no fundamental changes in the ways in which documents were multiplied in the 20th century. Substantial improvements were, however, made in such areas as the printing of two, four or many more colours at one pass through the press, in methods of drying and in the computer control of inking, drying and pressure.

5. Electronic publishing. In the last quarter of the 20th century all advanced printing involved computing at the composition stage, and most computing needed a printer or other marking engine to produce marks on paper. Printing and computing were, however, beginning to converge in a more coherent way in an area referred to as 'electronic publishing'. The term has not been used very precisely and is almost impossible to define. It is used to describe the electronic capture, storage, handling and dissemination of information from credited sources, such as publishers, and also the much less formal electronic communication between individuals and groups of people. It is used when a large part of the communication is electronic, whether the material is presented on screen, on paper or in both forms. Only such communication on paper would normally be called printing, but it is becoming increasingly difficult to consider printing separately from other methods of presenting information. In its fully developed form, electronic publishing may include the electronic capture, storage, handling, transmission, production and dissemination of information and even the involvement of the user in selecting what information is presented. The activity might also still be called electronic publishing even if some of these stages were omitted, for example when the production is done by printing (photocomposition and offset lithography).

The origination of verbal messages is increasingly being done on microcomputers equipped with word-processing or desktop publishing software. Such devices have simple keyboards and are both widely available and relatively easy to use; this means that authors can do their own keyboarding should they wish to do so. This approach to text origination means, however, that keyboard operators need typographic design skills if their documents are to resemble conventional printing. An alternative approach to capturing data, if the material has already been cleanly typed or printed, involves the use of an optical character recognition (OCR) machine. Such 'reading' machines began to be developed shortly after World War II but by the end of the century had not been taken up for text composition as quickly as had been predicted. Speech-input devices of a fairly rudimentary kind had also been developed, and it is possible that improved versions will provide yet another means of capturing some kinds of straightforward verbal data. Pictorial images used in electronic publishing are usually scanned electronically so that they can be stored and, if necessary, manipulated in many ways. Since both pictorial and verbal images are reduced to binary codes, they can be brought together and handled in precisely the same way. This facility allows for the visual arrangement of pictures and words on computer-controlled page make-up terminals.

The real advantages of electronic publishing lie not so much at the data-capture stage but in what can be done with the data afterwards. The storage and handling of data are now all part of computing; they are referred to here, since—like Gutenberg's method of manufacturing type in relation to printing—they lie at the heart of electronic publishing. They will probably determine the economic success of electronic publishing, and it seems likely that the latter will flourish increasingly as the data, once captured, are able to be used for a greater variety of purposes. For example, different selections of data might be made available for different readerships, or users may themselves choose the information they want through an interactive terminal. Additionally, however, electronic publishing offers the advantage of storing vast quantities of data in a compact and relatively cheap form, such as a compact disc.

Developments in satellite communications have made it possible for information to be transmitted around the world in coded form in a matter of seconds. Such data can be reconstructed as readable information where this is required. Techniques of this kind are regularly used for newspaper production, and similar 'facsimile' (fax) methods of transmitting graphic messages are also available for office and

private communication through public telephone networks. A transmission stage, which is foreign to traditional printing, is central to much electronic publishing, and some publishers provide users with a choice between reading information on-line from a computer screen or in a paper version. An equally important development is 'on-demand' printing and publishing; this is the production of a document when the client wants it and possibly in the form that suits the client best.

Developments in electronic publishing since *c.* 1975 have led to changes in communication far greater than those that came about with Gutenberg's invention of movable type in the mid-15th century. They have brought pictures and words together and have opened the way for multimedia communication involving a combination of audio and visual messages. In the late 20th century electronic publishing was still too young for predictions to be made as to the medium's development, but it was already clear that it had complicated the relatively simple interpretations of printing outlined above. The use of predetermined characters is as central to most electronic publishing as it was to Gutenberg's invention, but printing has become part of a larger world of communication systems and just one of several means of making available messages that are stored as binary codes.

J. Moxon: *Mechanick Exercises: Or, the Doctrine of Handyworks, Applied to the Art of Printing* (London, 1683–4); ed. H. Davis and H. Carter (London, 1958)

P. S. Fournier: *Manuel typographique, utile aux gens de lettres*, 2 vols (Paris, 1764–6)

C. Stower: *The Printers' Grammar: Or, an Introduction to the Whole Art of Printing* (London, 1808)

W. Savage: *Practical Hints on Decorative Printing* (London, 1818–22)

T. C. Hansard: *Typographia* (London, 1825)

J. L. Ringwalt: *American Encyclopaedia of Printing* (Philadelphia, 1871)

E. C. Bigmore and C. W. H. Wyman: *A Bibliography of Printing* (London, 1880/R 1969)

R. M. Burch: *Colour Printing and Colour Printers* (London, 1910/R New York, 1981)

L. A. Legros and J. C. Grant: *Typographical Printing-surfaces* (London, 1916)

T. F. Carter: *The Invention of Printing in China and its Spread Westwards* (New York, 1925, 2/rev. by L. C. Goodrich, New York, 1955)

G. A. Kubler: *A New History of Stereotyping* (New York, 1941)

D. C. McMurtrie: *The Gutenberg Documents* (New York, 1941)

E. P. Goldschmidt: *The Printed Book of the Renaissance* (Cambridge, 1950)

Printing 'The Times' since 1785, The Times (London, 1953)

W. M. Ivins: *Prints and Visual Communication* (London, 1953/R Cambridge, MA, 1969)

S. H. Steinberg: *Five Hundred Years of Printing* (London, 1955/R 1974)

C. F. Bühler: *The Fifteenth-century Book* (Philadelphia, 1960)

G. A. Glaister: *Glaister's Glossary of the Book* (London, 1960, 2/1979)

P. M. Handover: *Printing in London from 1476 to Modern Times* (London, 1960)

J. Moran: *The Composition of Reading Matter* (London, 1965)

Journal of the Printing Historical Society (London, 1965–)

W. T. Berry and E. H. Poole: *Annals of Printing: A Chronological Encyclopedia from the Earliest Times to 1950* (London, 1966)

C. H. Bloy: *A History of Printing Ink, Balls and Rollers, 1440–1850* (London, 1967)

R. H. Clapperton: *The Paper-making Machine: Its Evolution and Development* (Oxford, 1967)

R. Hirsch: *Printing, Selling and Reading, 1450–1550* (Wiesbaden, 1967)

H. Carter: *A View of Early Typography up to about 1600* (Oxford, 1969)

Printing Patents: Abridgements of Patent Specifications Relating to Printing, 1617–1857, Printing Historical Society (London, 1969)

M. Twyman: *Printing, 1770–1970: An Illustrated History of its Development and Uses in England* (London, 1970)

H. Carter, ed.: *Fournier on Typefounding: The Text of the 'Manuel typographique' (1764–1766)* (Eng. trans., New York, 1972)

P. Gaskell: *A New Introduction to Bibliography* (London, 1972)

W. G. Hellinga: *Copy and Print in the Netherlands: An Atlas of Historical Bibliography* (Amsterdam, 1972)

O. M. Lilien: *History of Industrial Gravure Printing up to 1920* (London, 1972)

R. McLean: *Victorian Book Design and Colour Printing* (2/London, 1972)

J. Moran: *Printing Presses: History and Development from the Fifteenth Century to Modern Times* (London, 1973)

A. I. Doyle, E. Rainey and D. B. Wilson: *Manuscript to Print: Tradition and Innovation in the Renaissance Book*, Durham University Library Guides Special Series, 1 (Durham, 1975)

G. Wakeman and G. D. R. Bridson: *A Guide to Nineteenth-century Colour Printers* (Loughborough, 1975)

L. Febvre and H.-J. Martin: *The Coming of the Book: The Impact of Printing, 1450–1800* (London, 1976)

C. Franklin: *A Catalogue of Early Colour Printing from Chiaroscuro to Aquatint* (Culham, 1977)

A. Griffiths: *Prints and Printmaking* (London, 1980)

E. Eisenstein: *The Printing Revolution in Early Modern Europe* (Cambridge, 1983)

P. B. Meggs: *A History of Graphic Design* (London, 1983, rev. Hoboken, 4/2006)

G. Bridson and G. Wakeman: *Printmaking & Picture Printing: A Bibliographical Guide to Artistic & Industrial Techniques in Britain, 1750–1900* (Oxford and Williamsburg, PA, 1984)

A. Dyson: *Pictures to Print* (London, 1984)

J. W. Seybold: *The World of Digital Typesetting* (Media, PA, 1984)

L. W. Wallis: *Electronic Typesetting: A Quarter Century of Technological Upheaval* (Gateshead, 1984)

Early Korean Printing (exh. cat., ed. Sohn Pow-key; London, Victoria and Albert Museum, 1984)

Tsien Tsuen-hsin: *Paper and printing*, i of *Science and Civilization in China* (Cambridge, 1985)

R. L. Hills: *Papermaking in Britain, 1488–1988: A Short History* (London, 1988)

J. Ing: *Johann Gutenberg and his Bible: A Historical Study* (New York, 1988)

M. Twyman: *Early Lithographed Books* (London, 1990)

S. Sabin: 'The Great Age of Anhui Printing', *Shadows of Mt Huang: Chinese Painting and Printing of the Anhui School*, ed. J. Cahill (Berkeley, CA, 1991)

P. T. Daniels and W. Bright: *The World's Writing Systems, Pt 13: Imprinting and Printing: Analog and Digital Writing* (Oxford and New York, 1996)

A. Kapr: *Johann Gutenberg: The Man and his Invention* (Aldershot and Brookfield, VT, 1996)

S. H. Steinberg: *Five Hundred Years of Printing* (London and New Castle, DE, 1996)

M. Rowell: *The Russian Avant-garde Book, 1910–1934* (New York, 2002)

D. Daniell: *The Bible in English: Its History and Influence* (New Haven, 2003)

L. Blackwell: *20th-century Type* (New Haven, 2004)

L. Pon: *Raphael, Dürer, and Marcantonio Raimondi: Copying and the Italian Renaissance Print* (New Haven, 2004)

For further bibliography *see* ENGRAVING; ETCHING; PHOTOGRAPHY; PRINTS.

Prints. Images or designs impressed or stamped on a support (e.g. paper or fabric). The term encompasses a wide variety of techniques used to produce multiple versions of an original design. Long traditions of printmaking exist both in the West and in East Asia (where the basic techniques were first developed); in general, this article focuses mainly on the technical aspects of the Western tradition from the early 15th century to the present day.

I. Introduction. II. Subject-matter. III. Technical processes. IV. Workshops. V. Conservation.

I. Introduction.

1. Terminology. 2. Function. 3. Development. 4. Practice.

1. TERMINOLOGY. In Western art the term 'engraving' is commonly but misleadingly used for any print pulled from a metal plate—and sometimes as a general term for printmaking—although strictly it refers only to prints engraved with a burin and printed in intaglio (*see* §III, 2 below). The word 'print' is employed to refer to a number of different printed objects. Before the invention of photomechanical methods of reproduction (*see* §III, 4 below), all prints were produced and printed by hand and were either 'original' or 'reproductive'. Since then, however, most printed images have been mechanical reproductions, and prints made as individual art objects are almost the only ones now made by hand. The distinction made between 'original' and 'reproductive' prints is controversial. From the aesthetic point of view, it matters if the artist's personal touch adds an important quality to the 'original' print—especially if exploration of graphic media affects the artist's style. With geometric, hard-edged prints, originality is of less importance because of the impersonal finish, but it does still affect the price.

(i) 'Original' prints. These are printed by hand from designs actually handmade by the artist on blocks, plates or stones. Since the later 19th century such prints have usually been produced in numbered editions and signed by the artist. An artist who makes his own prints is called a painter–engraver, painter–etcher or painter–lithographer. Among the painters deeply interested in original printmaking were Albrecht Dürer (1471–1528), Rembrandt van Rijn (1606–69), Francisco de Goya (1746–1828), Edgar Degas (1834–1917), Edvard Munch (1863–1944) and Pablo Picasso (1881–1973).

(ii) 'Reproductive' prints. These are printed by hand from blocks etc on which the design is handmade by a professional printmaker, who translates the artist's work into a print medium. Much East Asian printmaking is the result of organized teamwork between designer, block copy draughtsman and blockcutter. Painters such as Raphael (1483–1520), Pieter Bruegel the elder (*c.* 1525/30–69), Peter Paul Rubens (1577–1640), Joshua Reynolds (1723–92), John Constable (1776–1837) and Dante Gabriel Rossetti (1828–82) all worked closely with professional printmakers.

(iii) Collaborative prints. These result from a collaboration between a busy artist, or one who has a limited knowledge of printmaking techniques, and a professional printmaker, who adds or assists with the more complicated processes. European guild rules (*see* §IV, 1 below) ensured that until the 20th century woodcuts (even those by trained engravers such as Dürer) were cut by professional woodcutters following designs drawn on the block by the artist. Anthony van Dyck (1599–1641), Thomas Girtin (1775–1802) and J. M. W. Turner (1775–1851) were among those who produced intaglio prints together with professional printmakers, and technicians often added the tint or colour stones to lithographs.

(iv) Photomechanical reproductions. These are made and printed by machine and have largely replaced handmade reproductive prints because of their accuracy and cheapness (*see* §III, 4 below). In the 20th century artists such as Robert Rauschenberg (1925–2008), Allen Jones (*b* 1937) and Richard Hamilton (*b* 1922) have combined photomechanical processes with autograph printmaking media to produce original prints. The term 'artist's print' should signify the same as 'original' print but is often wrongly employed for signed photomechanical reproductions of artists' drawings.

(v) Photographic prints. These are printed from photographic negatives (*see* PHOTOGRAPHY).

2. FUNCTION. The primary function of prints is to multiply images accurately. Some prints are intended to be individual art objects, but most have been produced for practical purposes—devotional, recreational and educational, or to record and multiply existing designs or objects. Another function of an original print is to make an artist's work available in a large edition and at a modest price. This function, however, often comes into conflict with the wish of

artists to limit editions in order to increase the value of individual prints. Many collectors like to own prints published in small editions as objects that will appreciate in value. An important aspect of print-making used to be the imitation of paintings, drawings and other works of art so that the compositions and designs could be widely disseminated. At best, these were interpretations of the original designs, not facsimile reproductions. It is only with the invention of accurate methods of mechanical reproduction in the later 19th century and the development of colour reproduction in the 20th that the concept of reproduction has been transformed. The advent of such improved means of reproduction has, for instance, radically changed the way art history is studied by permitting the comparative examination of an artist's entire oeuvre.

Printmaking made book illustration possible, and the requirements of book publishers led to developments such as colour printing (see §III, 6(ii) below) for rubrication and decorative initial letters. The provision of editions of identical plates for scientific and educational books was especially valuable because of the need for accuracy. Book covers were sometimes printed (see BOOKBINDING), and endpapers and bookplates form significant categories of prints. Printmaking techniques were also adapted for industrial uses, including the production of patterned and textured wallpaper (see WALLPAPER), fabrics, toys and the transfer of images on to ceramics (see CERAMICS); similar transfers were employed in the production of enamelled copper objects.

3. DEVELOPMENT. The development of printmaking before the mid-15th century was not the result of closely related inventions; instead it came about through the combination of various elements that evolved as part of other crafts and technologies, often in different parts of the world. These included the various types of master or design bearer (stencils, cut or engraved woodblocks, metal plates and stones), the image supports themselves (paper, parchment, fabric) and the inks and the transfer methods (stamping, rubbing, printing with presses).

(i) Design bearers. The early printmaking media (design bearers) were originally developed for other purposes—stencil (see STENCILLING) to apply resists and dye to textiles, for labelling and for decorating cave and house walls; seal stones to impress personal marks on clay or wax ; engraving for making niellos (see NIELLO PRINT) and chasing gold, silver and bronze (see METAL, §V, 1(i)); metalcut for decorating metalwork (see METAL, §V, 1(i)) and producing matrices for enamels (see ENAMEL, §3); etching for ornamenting armour; and woodcut blocks for printing textiles. The latter process was known in China during the Eastern Han period (AD 25–220), and by the late 7th century AD woodblock images were being printed on paper.

Woodcut and stencil, in particular, were the media employed for printmaking in China and Japan, and woodcut was developed to a high degree of perfection in later centuries. In China rubbings or 'squeezes' were also taken from lapidary inscriptions. In East Asia printmakers remained faithful to relief printing, creating ever more sophisticated woodblock techniques and superb colour woodcuts. In Europe in the 15th century and early 16th WOODCUT as well as several techniques created to decorate metal—ENGRAVING, niello, METALCUT and ETCHING—were adapted to paper, and new printmaking media—DRYPOINT and RELIEF ETCHING—were also invented at that period. Tonal effects were achieved by the use of complex hatched and crosshatched lines printed in black and white more often than by flat areas of colour printed from woodblocks. In the 17th and 18th centuries new tonal media were developed employing metal plates—MEZZOTINT, SOFT-GROUND ETCHING, AQUATINT, CRAYON MANNER and pastel manner. It was only in the 19th century, with the development of LITHOGRAPHY, that stone emerged to challenge European printmakers' preference for metal plates.

(ii) Supports. Crucial to the development of printmaking was the invention of PAPER and the spread of papermaking technology. It was only after paper became more widely available that existing stamping and stencilling techniques were employed to print images on it, and printmaking emerged as a distinct art form. Paper was a Chinese invention, so printmaking developed at least 700 years earlier in East Asia than it did in Europe. It was first produced during the Western Han period (206 BC–AD 9), and writing paper was being manufactured by AD 105 during the Eastern Han period (AD 25–220); by the end of that period the quality had improved greatly.

Early extant examples of East Asian paper (commonly known as oriental paper) were composed of hemp, paper-mulberry or mulberry fibres and those of the wikstroemia canescans plant used to make gampi ('bird-skin') paper. East Asian papers varied in thickness, but high-quality ones were soft and pliant and made from long plant fibres that meshed closely together; they were not absorbent. As a result they did not need to be sized with animal glue or gelatin for added strength and body, and to prevent the ink from spreading. They were used by Western printmakers, including Rembrandt and Whistler.

The reasons for the delay in the transfer of paper and printmaking techniques from China to the West are obscure. They may relate to the spread of Islam and decrees against the production and worship of images, to iconoclasm in the Byzantine empire and to suspicion in Christian Europe of inventions imported via Muslim countries, especially ones bearing Islamic texts. At first, papermaking technology seems to have been kept secret by the Chinese. However, according to legend, it was divulged by Chinese prisoners captured by the Arabs and was known in Baghdad by AD 795, in Syria and Egypt in the 10th century and in Fez, Tripoli and Tunis by the 11th. Papermaking was introduced into Spain and Sicily after they were conquered

by the Arabs, but it was treated with suspicion in the rest of Europe. Islamic paper was made from plant material with short fibres, as was the paper produced in Europe from the 13th century onwards (from 1276 at Fabriano in the Marches, central Italy), which was made from macerated linen cloth. Because it was not sized, it was soft, fragile and far less durable than parchment. From 1337 at the Fabriano factory the sheets of paper were dipped in size (animal glue or gelatin) to strengthen them and to reduce absorbency. Mills were set up in France and Germany in the 14th century, but paper remained a rare commodity until the invention of printed books increased the demand. It seems to have taken a century or more between the introduction of paper to Europe and its use for printing woodcuts.

Writing and drawing papers contain more size than those suitable for printing, which should be 'soft-sized'. If they are used, the paper must be soaked both to make it soft and pliable and to reduce the amount of size so that the paper can readily pick up the thicker, oily printing ink. The paper is therefore soaked before use for between 30 minutes and 12 hours, depending on the amount of size present. It is then stacked and weighted down for 6 to 24 hours. Before printing it is lightly dampened. High-quality rag paper is advisable for all printing; the surface used (hot- or cold-pressed or rough) will vary according to the effects required by the printmaker. Generally, a finely worked plate or block probably responds better to lighter paper.

Paper remains the commonest support for printed designs; however, printers occasionally employ such textiles as linen, cotton, silk and satin as alternatives. Printmaking techniques (including photomechanical ones) are also employed to transfer or print designs on to other less receptive surfaces, such as ceramics, metal and plastic. These techniques have not been much used to produce original artists' prints but may increase in importance. They are also likely to play an ever larger role in creating three-dimensional multiples.

(iii) Inks. It seems likely that the earliest Chinese printers (*c.* AD 175) used thin, fluid inks to produce embossed or stamped images. This type of ink is not, however, suitable for use with a printing press, which requires a thicker, oil-based medium to spread evenly. Oleo-resinous paints seem to have been known to Pliny the elder, while the use of oil-based colours to print on fabric was recommended by Cennino Cennini in his *Libro dell'arte* (*c.* 1390). The standard ingredients for black ink seem to have been known at an early date: linseed oil (sometimes walnut), lamp-black (burnt pitch resin) and turpentine to prevent the ink from spreading. In his *Traité des manières de graver* (Paris, 1645), Abraham Bosse (1602–76) provided a detailed and clear recipe for the preparation of ink: nut oil is boiled to ignition; it is burnt away for 30 minutes and cooled; meticulously ground Frankfurt black pigment is then gradually blended on a slab. Bosse warned that the resultant liquid must not be too thin or it would stick to the plate (or block)

rather than the paper. Various methods for printing in gold were in use from an early date. Bronze powders to imitate gold were developed in Bavaria *c.* 1750, but a successful bronze-based fluid ink was a much later development. The development of the mechanized newspaper industry in the 19th century also resulted in a search for cheap inks. These were frequently based on resin with soap and yellowed quickly.

4. PRACTICE.

(i) Design transfer. (ii) Reversal. (iii) States. (iv) Lettering and inscriptions. (v) Editions. (vi) Copyright and censorship.

(i) Design transfer. Designs may be transferred to the block or plate in a variety of ways. In East Asia designs on thin paper were pasted face down on to the block and the paper abraded using a *baren* (a circular pad made of layers of paper and twisted cord covered with a ribbed bamboo leaf); the remaining very thin layer of paper was oiled to make it transparent so that the cutter could see the design, which was then in reverse so that it would be the right way round when printed. In Europe blockcutters could produce quite accurate replicas of worn blocks for devotional woodcuts by pasting impressions on to a new block and cutting from this pattern. However, artists usually drew directly on to the prepared wooden blocks; they were already accustomed to doing so, for drawing paper was expensive. A few drawings on uncut blocks survive, for example for woodcuts by Albrecht Dürer (1471–1528; for illustration see WOODCUT), Albrecht Altdorfer (*c.* 1480–1538) and Pieter Bruegel the elder (*c.* 1525/30–69) and for wood-engravings by Thomas Bewick (1753–1828), G. J. Pinwell (1842–75), Fred Walker (1840–75) and Arthur Boyd Houghton (1836–75).

Before starting to use the burin, engravers scratch outlines lightly on to the copper as guides, perhaps over more fugitive indications in chalk or charcoal. Alternatively they prick the design on to the metal through a cartoon. Etching grounds are soft enough to receive the imprint of a stylus or hard pencil, so designs may be transferred by drawing over them through the paper. The *verso* of drawn designs may be blackened to create a form of carbon paper so that the outlines may be drawn over to leave traces on the etching ground. Lithographers draw directly on to the stone or plate or employ easily portable lithographic transfer paper for the initial design, which can be transferred to the stone by moistening the paper.

(ii) Reversal. Designs are reversed during printing unless steps are taken to transfer them on to the plate in reverse. Drawings on thin paper, oiled to make them transparent, can be inverted on to the plate and the (reversed) designs gone over with a stylus. The use of lithographic transfer paper also ensures the reversal of the image on the stone. Artists who regularly provided designs for printmakers learnt to reverse them as a matter of course.

In Japan draughtsmen copied the designers' drawings and produced *hanshitae* (block copies) to be pasted on to the blocks. In Europe there were draughtsmen who specialized in copying famous images in reverse and to scale for the use of engravers. Some of the 19th-century casting and duplicating processes were invented in order to produce an image in the same direction as the original design. Photomechanical processes may also be employed to ensure the accurate transfer, in reverse, of a design to the block, plate or stone. For example in the later 19th century this was done with designs for wood-engravings, allowing the artist to retain the drawing for sale. The publisher Ambroise Vollard (*c.* 1867–1939) had designs by Georges Rouault (1871–1958) for the *Miserere* aquatints photo-etched on to plates to speed production; however, the artist covered virtually the whole surface with new work.

(iii) States. Printmakers need to pull progress proofs of their work to check whether alterations are necessary. These proofs constitute changes of STATE. Rembrandt van Rijn (1606–69), Edgar Degas (1834–1917), James McNeill Whistler (1834–1903), Pablo Picasso (1881–1973) and Rolf Nesch (1893–1975) are among the artists who made the most dramatic alterations to plates and took them through a large number of states. In the case of mixed-method prints, such as etchings with engraving, mezzotint or aquatint, the etched state was normally proofed before the tonal work was added. Colour prints require proofing to discover the best combination of tones. Prints with inscriptions (*see* §(iv) below) were often proofed before being sent to the lettering expert, producing 'proofs before letters' and 'scratched letter proofs'. A change of publisher often meant a change of the publisher's name in the margin. Other typical state changes relate to patronage, political or prudish censorship, the reworking of a worn plate or the reattribution of the print to a more famous artist to make it more saleable. These changes of state are the result of practical requirements.

The growth of a print-collecting public, who were aware of the gradual deterioration of the plate during printing and the rarity of the finest, earliest impressions and who were interested in the way the composition evolved, led to the creation of proof states and variant printings to satisfy the market for them. These range from the addition of the word 'proof' or the placing of *remarques* (scratched sketches) in the margins of early impressions, to the printing of small editions of proofs of the various states that preceded the finished one. Another practice involves collaging of pieces of coloured paper on to prints (e.g. those of Picasso, Joan Miró (1893–1983) and R. B. Kitaj (1932–2007)) to make each image different.

The existence of numerous different states of a particular print creates special problems for scholars who catalogue graphic work, and different conventions are applied. Some start listing states with the first published state and call all impressions printed before that proofs; others include the proofs in the list of the states of the plate—especially when there is no clear distinction to be made between the published and unpublished states. Catalogues of prints published in sets, such as those of Giovanni Battista Piranesi (1720–78) and Francisco de Goya (1746–1828), are more complex because the state changes do not always correspond to the changes in edition, and details of both have to be given. Print catalogues facilitate making distinctions between fine-quality, early impressions and later reprints printed from plates that may be worn or reworked, and thus no longer give a true idea of the artist's intention.

(iv) Lettering and inscriptions. The expansion of the print trade in the 16th century led to the development of a number of terms, first used from *c.* 1520, which, when inscribed on the plate or block, indicated where the print was made, by whom, after which artist's design and for which publisher. Printed terms and letters are referred to as lettering, while manuscript annotations are called inscriptions. The most commonly found lettering includes the following words and abbreviations: *Invenit* (Lat.: 'invented'; follows the name of the designer of the original painting or drawing that the print reproduces); *pinxit, pingebat, pinx* or *ping.* ('painted'; for the painter of the original composition); *delineavit, delin.* or *del.* ('drew'; for the draughtsman who made the original drawing); *fecit, faciebat, fec.,* fe., ft or f. ('made'; for the name of the printmaker); *incidit, incidebat* or *inc.* ('engraved'; for the name of the engraver); *excudit, excud.* or *ex.* ('published'; for the name of the publisher); *ex typis* and *ex formis* ('from the press of'; implies that the printer and publisher are the same); *chez* ('printed and issued from the press of'). Such lettering could be found either within the image itself, often in quite a prominent part of the design, or in a blank space reserved for lettering below the image. The sale of plates between publishers and the subsequent production of a new edition is evident on many prints by the erasure of the former publisher's name and/or address (often badly done and therefore visible as a smudged patch on an impression) and the addition of the new publisher's name, either on top of the previous one or elsewhere on the plate.

The inclusion of a blank space below the image allowed for other types of lettering. These included poems, particularly moralizing verses, illustrated by the image above, sometimes in two or more languages including Latin; lengthy dedications from the artist or publisher to a patron (sometimes with his coat of arms); a key to the image above, particularly for geographical views, sometimes for allegorical subjects.

The addition of inscriptions, annotations and corrections to impressions has a long history. In the 18th century Daniel Nikolaus Chodowiecki (1726–1801) annotated his prints with details of their states, while the working proofs by David Lucas (1802–81) of

prints after John Constable (1776–1837) have always been in demand. The personalizing of a print by the addition of a signature is the culmination of this trend, becoming widespread in the second half of the 19th century. James McNeill Whistler (1834–1903) encouraged this practice: his pencil signature took the form of a stylized butterfly placed just below the platemark and cut round to form a delicate 'tab', which contributed to the aesthetic effect of the print. Particularly fine impressions of Whistler's later prints were also inscribed with two tiny circles on the *verso* to indicate their quality. Other, less frequent annotations include the signatures of the publisher, for example Abbé Paul-Antoine Naudet (*fl* 1893–1908) of Paris, or the printer, for example Otto Felsing (*b* 1853). The artist may also mark a print '*b.à t.*' (*bon à tirer*) to confirm to the printer that an edition conforming to this impression may be pulled. It is, of course, common for print dealers and collectors to mark the state of a print or to note some indication of its quality on the mount or back of the frame.

The increased codification of edition sizes allied to the ever-widening division between reproductive and original printmaking by the late 19th century resulted in the practice of numbering prints or inscribing them with standard annotations, such as 'h.c.' (*hors commerce*; outside the numbered edition), 'A.P.' (artist's proof) or 'P.P.' (printer's proof). Some publishers instituted stamps or blindstamps to indicate whether an impression was an early proof, a standard impression or a posthumous impression (e.g. editions by Edmond Frapier of prints by Pierre Bonnard (1867–1947)). In other cases artists added their own stamps, possibly to indicate fine impressions (e.g. Henri de Toulouse-Lautrec (1864–1901), James Tissot (1836–1902)). In the 20th century the use of a stamped signature, although acceptable, is generally seen as a lesser substitute for a hand-signed impression. The power of a signature to authenticate a print is evident in the application of a signature on behalf of a deceased artist, for example prints by Otto Mueller (1874–1930), which were signed by Erich Heckel (1883–1970) or by Maschka Mueller (*fl* 1899–1930), and prints by Ernst Ludwig Kirchner (1880–1938), which were signed by Erna Schilling (1884–1945). Some artists, however, have been prepared to add their signatures to impressions from large unsigned editions.

(*v*) *Editions.* The size of an edition is directly related to the type of print involved. It is well known that a pure drypoint will yield only a few impressions before the burr on the plate is flattened by the pressure of printing; hence the high premium set on early impressions of drypoint prints. It is notoriously difficult to assess the number of prints produced for any edition without access to publishers' or printers' records, and the hazards of survival can distort the view. The earliest devotional woodcuts were probably produced in large numbers to be sold at shrines, fairs and churches; very few have survived, due to their lowly status. Conversely

the prints of Andrea Mantegna (1430/31–1506) and Rembrandt van Rijn (1606–69), for example, were treasured by collectors from the time of their production and have therefore survived in greater numbers, even though the original editions were probably quite small. The reworking of many of Rembrandt's plates by later publishers and their subsequent reprinting, even into the 20th century in some cases, attests to both the continuing demand for his works and the robustness of the copperplates, many of which suffered at the hands of later publishers.

The increased mechanization of the printing industry in the first half of the 19th century led to the invention of several processes that could yield greater print runs. The process of steel-facing plates meant that editions of thousands were possible, while the electrotype process extended the life of a plate by the production of an exact duplicate. While processes such as these had a significant impact on the production of commercial and reproductive prints, they had little impact on the development of original intaglio and relief printmaking. In the case of lithography, a much later and technically more complex process, the alliance between the skills of the professional lithographer and the artist is evident in the posters of Henri di Toulouse-Lautrec (1864–1901), Jules Chéret (1836–1932) and others, many of which were issued in editions of several thousands. One of the safeguards introduced to ensure the limited size of an edition is the cancellation of plates, blocks or stones, usually by scoring through (more drastically, by destroying the matrix). In the case of some highly regarded plates, impressions have been taken after cancellation (e.g. prints by Edgar Degas (1834–1917), Pablo Picasso (1881–1973)), usually with rather depressing results. Light cancellations can be erased, although rarely completely.

(*vi*) *Copyright and censorship.* The power of prints to politicize, amuse or offend their public is evident in the practice of censorship. The later erasure from the plate of the more explicit areas of many 16th-century Italian mythological–erotic prints is common, while the freedom of artists and publishers to produce satirical or uncomplimentary comments on an event or regime has rarely been unfettered. Laws governing the limits of artistic expression were enforced by fine, confiscation of property and imprisonment of the artist, printer or publisher.

A publisher could protect his design from unauthorized reissue or straightforward copying by a privilege, first used on individual prints (as opposed to books) from *c.* 1500 in Venice. By applying to the royal or state-invested authority through the correct channel (e.g. the Keeper of Seals via the Official Censor to Louis XIV), the design could be protected for a period of years. This is often indicated on the plate itself with lettering such as '*cum privilegio*'. In Britain prints were first copyrighted in 1735 after lobbying by William Hogarth (1697–1764).

Bibliographies

L. Mason and J. Ludman: *Print Reference Sources: A Selected Bibliography of Print-related Literature* (Millwood, NY, 1975, 2/1979)

J. Ludman and L. Mason: *Fine Print References: A Selected Bibliography of Print-related Literature* (Millwood, NY, and London, 1982)

T. A. Riggs: *The Print Council Index of Oeuvre-catalogues of Prints by European and American Artists* (Millwood, NY, and London, 1983)

C. Karpinski: *Italian Printmaking: Fifteenth and Sixteenth Centuries. An Annotated Bibliography* (Boston, MA, 1987)

N. Grammacini: *Théorie der französischen Druckgrafik im 18. Jahrhunderts: Eine Quellenanthologie* (Berne, 1997)

Periodicals

Print Collector's Quarterly (1911–17; 1923–50)
Nouvelles de l'estampe (1963–)
Print Collector's Newsletter (1970–)
Print Collector/Il conoscitore di stampe (1973–83)
Print Quarterly (1984–)

General: 15th–19th centuries

A. von Bartsch: *Le Peintre-graveur*, 21 vols (Vienna, 1803–21, 2/1818–76); suppl. by R. Weigel (Leipzig, 1843); suppl. by J. Heller (Nuremberg, 1854)

C. Le Blanc: *Manuel de l'amateur d'estampes*, 4 vols (Paris, 1854–89)

J. D. Passavant: *Le Peintre-graveur*, 6 vols (Leipzig, 1860–64/R New York, 1966)

H. Beraldi: *Les Graveurs du dix-neuvième siècle*, 12 vols (Paris, 1885–92)

P. Kristeller: *Kupferstich und Holzschnitt in vier Jahrhunderten* (Berlin, 1905, 4/Berlin, 1922)

H. W. Singer: *Die moderne Graphik* (Leipzig, 1914, 2/1920)

C. Glaser: *Die Graphik der Neuzeit vom Anfang des 19. Jahrhunderts bis zur Gegenwart* (Berlin, 1922)

E. Bock: *Geschichte der graphischen Künste von ihren Anfängen bis zur Gegenwart* (Berlin, 1930)

C. Zigrosser: *Six Centuries of Fine Prints* (New York, 1937); rev. as *The Book of Fine Prints: An Anthology of Printed Pictures and Introduction to the Study of Graphic Art in the West and East* (London, 1956)

C. Roger-Marx: *La Gravure originale au XIXe siècle* (Paris, 1939); Eng. trans. as *Graphic Art of the 19th Century* (New York, Toronto and London, 1962)

The First Century of Printmaking, 1400–1500 (exh. cat. by E. Mongan and C. O. Schniewind; Chicago, IL, Art Institute of Chicago, 1941)

W. M. Ivins jr: *How Prints Look* (New York, 1943, 2/1958)

W. M. Ivins jr: *Prints and Visual Communication* (London, 1953/R Cambridge, MA, 1969)

Prints, 1400–1800: A Loan Exhibition from Museums and Private Collections (exh. cat., ed. H. Joachim; Minneapolis, MN, Minneapolis Institute of Arts; Cleveland, OH, Cleveland Museum of Art; Chicago, IL, Art Institute of Chicago; 1956–7)

J. Laran: *L'Estampe* (Paris, 1959)

J. Adhémar: *La Gravure originale au XVIIIe siècle* (Paris 1963; Eng. trans., New York, Toronto and London, 1964)

Die Kunst der Graphik: Werke aus dem Besitz der Albertina, I: Das 15. Jahrhundert (exh. cat., ed. E. Mitsch; Vienna, Graphische Sammlung Albertina, 1963)

Die Kunst der Graphik: Werke aus dem Besitz der Albertina, II: Das Zeitalter Albrecht Dürers (exh. cat., ed. A. Strobl; Vienna, Graphische Sammlung Albertina, 1964)

K. Sotriffer: *Die Druckgraphik: Entwicklung, Technik, Eigenart* (Vienna and Munich, 1966/R 1977)

Fünf Jahrhunderte europäischer Graphik (exh. cat., ed. W. Wegner; Munich, Haus der Kunst, 1966)

Die Kunst der Graphik: Werke aus dem Besitz der Albertina, III: Renaissance in Italien, 16. Jahrhundert (exh. cat., ed. K. Oberhuber; Vienna, Graphische Sammlung Albertina, 1966)

De meesterwerken van de Europeese prentkunst, 1410–1914 (exh. cat., ed. D. de Hoop Scheffer and J. Verbeek; Amsterdam, Rijksmuseum, 1966) [Dut. ed. of Munich cat.]

Les Plus Belles Gravures du monde occidental, 1410–1914 (exh. cat., Paris, Bibliothèque Nationale, 1966) [Fr. ed. of Munich cat.]

Die Kunst der Graphik: Werke aus dem Besitz der Albertina, IV: Zwischen Renaissance und Barock: Das Zeitalter von Bruegel und Bellange (exh. cat., ed. K. Oberhuber; Vienna, Graphische Sammlung Albertina, 1968)

L'incisione europea dal XV al XX secolo (exh. cat., ed. F. Salamon; Turin, Galleria Civica d'Arte Moderna e Contemporanea, 1968)

F. Wilder: *How to Identify Old Prints* (London, 1969)

Die Kunst der Graphik: Werke aus dem Besitz der Albertina und Leihgabe aus den Uffizien, V: Jacques Callot und sein Kreis (exh. cat., ed. E. Knab; Vienna, Graphische Sammlung Albertina, 1969)

Die Kunst der Graphik: Werke aus dem Besitz der Albertina, VI: Rembrandt (exh. cat., ed. E. Mitsch; Vienna, Graphische Sammlung Albertina, 1970–71)

A. Hyatt Mayor: *Prints and People: A Social History of Printed Pictures* (New York, 1971)

Meisterwerke europäischer Graphik 15.–18. Jh. aus dem Besitz des Kupferstichkabinetts, 1775–1975 (exh. cat., ed. H. Maedebach and M. Maedebach; Coburg, Kupferstichkabinett der Kunstsammlungen der Veste Coburg, 1976)

A. Robison: *Paper in Prints* (Washington, DC, 1977)

The Illustrated Bartsch (New York, 1978–)

A. Griffiths: *Prints and Printmaking: An Introduction to the History and Techniques* (London, 1980, rev. Berkeley, CA, 2/1996)

Circa 1800: The Beginnings of Modern Printmaking, 1775–1835 (exh. cat., ed. P. D. Cate; New Brunswick, NJ, Rutgers University, Jane Voorhees Zimmerli Art Museum, 1981)

M. Hébert: *Inventaire des gravures des écoles du nord, 1440–1550*, Paris, Bib. N., Dépt Est. cat., 2 vols (Paris, 1983)

S. Lambert: *Printmaking* (London, 1983)

Printmaking: The Evolving Image (exh. cat. by C. S. Ackley; Boston, MA, Museum of Fine Arts, 1987)

Mannerist Prints: International Style in the Sixteenth Century (exh. cat., ed. B. Davis; Los Angeles, CA, County Museum of Art; Toledo, OH, Museum of Art; Sarasota, FL, John and Mable Ringling Museum of Art; Baltimore, MD, Baltimore Museum of Art; and elsewhere; 1988–9)

A. Griffiths and F. Carey: *German Printmaking in the Age of Goethe* (London, 1994)

K. Jacobson, ed.: *The French Renaissance in Prints from the Bibliothèque Nationale de France* ([Los Angeles], 1994)

D. Landau and P. Parshall: *The Renaissance Print, 1470–1550* (New Haven and London, 1994)

G. Bartrum: *German Renaissance Prints, 1490–1550* (London, 1995)

L. C. Hults: *The Print in the Western World: An Introductory History* (Madison, 1996)

M. Melot: *L'Estampe impressioniste* (Paris, 1994; Eng. trans. New Haven, 1996)

A. Staley and others: *The Post-Pre-Raphaelite Print: Etching, Illustration, Reproductive Engraving, and Photography in England in and around the 1860s* (New York, 1995)

T. Clayton: *The English Print, 1688–1802* (New Haven, 1997)

P. J. Mariette: *Catalogues de la collection d'estampes de Jean V., roi de Portugal*, 3 vols (Paris and Lisbon, 2003)

M. W. Driver: *The Image in Print: Book Illustration in Late Medieval England and its Sources* (London, 2004)

A. Griffiths: *Prints for Books: Book Illustration in France, 1760–1800* (London, 2004)

L. Pon: *Raphael, Dürer, and Marcantonio Raimondi: Copying and the Italian Renaissance Print* (New Haven, 2004)

P. Parshall and R. Schoch: *Origins of European Printmaking: Fifteenth-century Woodcuts and their Public* (Washington and Nuremberg, 2005)

General: 20th and 21st century

S. W. Hayter: *About Prints* (London, 1960)

W. Stubbe: *Die Graphik des 20. Jahrhunderts* (Berlin, 1962)

M. Rothenstein: *Frontiers of Printmaking: New Aspects of Relief Printmaking* (London, 1966)

J. Adhémar: *La Gravure originale au XXe siècle* (Paris, 1967; Eng. trans., London, 1971)

P. Gilmour: *Modern Prints* (London, 1970)

R. Castleman: *Modern Prints since 1945* (London and Munich, 1973)

R. Castleman: *Prints of the Twentieth Century: A History* (London, 1976)

P. Gilmour: *The Mechanised Image: An Historical Perspective on 20th-century Prints* (London, 1978)

P. Gilmour: *Understanding Prints: A Contemporary Guide* (London, 1979)

Printed Art: A View of Two Decades (exh. cat. by R. Castleman; New York, Museum of Modern Art, 1980)

R. Castleman: *Prints from Blocks* (New York, 1983)

70s into 80s: Printmaking Now (exh. cat., ed. C. S. Ackley; Boston, MA, Museum of Fine Arts, 1986–7)

Contemporary Prints from the Lilja Collection (exh. cat., ed. T. Lilja; Vaduz, Sammlungen der Fürsten von Liechtenstein, 1995)

F. Carey and A. Griffiths: *Avant-garde British Printmaking, 1914–1960* (London, 1990)

R. Michler and L. W. Löpsinger, eds: *Salvador Dalí: Catalogue raisonné of Prints*, 2 vols (Munich, 1995)

C. Adams, ed.: *Second Impressions: Modern Prints & Printmakers Reconsidered* (Albuquerque, 1996)

J. Lust: *Chinese Popular Prints* (New York, 1996)

G. Kaplan, ed.: *Surrealist Prints* (Los Angeles, 1997)

R. Heller and A. Chávez: *Two and One: Printmaking in Germany, 1945–1990* (Wellesley, MA, 2003)

D. Wye: *Artists & Prints: Masterworks from the Museum of Modern Art* (New York, 2004)

D. Barker: *Traditional Techniques in Contemporary Chinese Printmaking* (London, 2005)

J. Ittmann, ed.: *Mexico and Modern Printmaking: Revolution in the Graphic Arts, 1920 to 1950* (New Haven and London, 2006)

B. Walker: *Singular Multiples: The Peter Blum Edition Archive, 1980–1994* (Houston and New Haven, 2006)

D. Wye and W. Weitman: *Eye on Europe: Prints, Books & Multiples: 1960 to Now* (New York, 2006)

II. Subject-matter. The history of printmaking includes versions of almost every conceivable subject, ranging from well-established themes of figural art to hermetic symbols or abstract images. Within particular periods or traditions, however, certain subjects or genres are often especially closely identified with the art of the print, for instance landscapes in the Netherlands in the 17th century. As the serious collecting and connoisseurship of prints became established in Europe in the 17th and 18th centuries, the first print catalogues were produced, and these imposed various classifications on the material available to collectors. The system of categories adopted by Adam von Bartsch (1757–1821) and other scholars, treating the oeuvre of individual artists in iconographical order, has to a large extent defined the discussion of European printmaking since then. It focuses, however, exclusively on the original 'art' print and excludes the huge category of prints produced for the popular market (e.g. broadsheets, caricatures, sporting prints etc) and for practical purposes (e.g. banknotes, postage stamps, wallpaper). In the early 20th century, methods of photomechanical reproduction brought about a change in the market for traditionally produced prints, to the extent that specific genres of original printmaking (i.e. popular categories of subject-matter chosen for prints by numerous artists) no longer exist. Indeed, classification of prints according to subject-matter loses its significance with prints after 1700, when original prints came to be regarded increasingly as artistic products in their own right, like paintings, and the choice of subject-matter was no longer limited to the traditional classifications.

A. von Bartsch: *Le Peintre-graveur* (1803–21) [B.]

A.-P.-F. Robert-Dumesnil: *Le Peintre-graveur français* (1835–71)

C. Le Blanc: *Manuel de l'amateur d'estampes 1550–1820*, 4 vols (Paris, 1854–89)

P. de Baudicour: *Le Peintre-graveur français continué*, 2 vols (Paris, 1859–71)

J. D. Passavant: *Le Peintre-graveur*, 6 vols (Leipzig, 1860–64)

A. Andresen: *Der deutsche Peintre-graveur von dem letzten Drittel des 16. Jahrhunderts bis zum Schluss des 18. Jahrhunderts*, 5 vols (Leipzig, 1864–78)

J. P. van der Kellen: *Le Peintre-graveur hollandais et flamand* (Utrecht, 1866)

A. Andresen: *Die deutschen Maler-Radierer des 19. Jahrhunderts*, 5 vols (Leipzig, 1878)

H. Beraldi: *Les Graveurs du dix-neuvième siècle*, 3 vols (Paris, 1880–82)

H. Beraldi: *Les Graveurs du dix-huitième siècle*, 12 vols (Paris, 1885–92)

L. Delteil: *Le Peintre-graveur illustré*, 31 vols (Paris, 1902–26)

A. de Vesme: *Le Peintre-graveur italien* (Milan, 1906)

A. J. J. Delen: *Histoire de la gravure dans les anciens Pays-Bas et dans les provinces belges, des origines jusqu'à la fin du XVIIIe siècle*, 3 vols (Paris and Brussels, 1924–35)

A. M. Hind: *Early Italian Engravings*, 7 vols (London, 1938–48)

F. W. H. Hollstein: *Dutch and Flemish Etchings, Engravings and Woodcuts, c. 1450–1700* (Amsterdam, 1949–)

F. W. H. Hollstein: *German Engravings, Etchings and Woodcuts, c. 1400–1700* (Amsterdam, 1954–)

R. Castleman: *Prints of the Twentieth Century: A History* (London, 1976)

W. L. Strauss, ed.: *The Illustrated Bartsch* (New York, 1978–)

The New Hollstein 'Dutch and Flemish' (Roosendaal, 1993)

III. Technical processes. The traditional technical processes of printmaking can be broken down into three main categories: relief, intaglio and planographic (*see* §§1–3 below). In relief processes the inked surface is raised above the areas that are to remain blank on the print. This is achieved by cutting away the surrounding areas. The oldest form of relief is the woodcut, which was used to produce the earliest surviving European pictorial prints, dating from *c.* 1400. Intaglio prints are produced by the reverse of this method: lines or areas are cut into the surface of the plate (traditionally a copperplate) and these hold the ink that is wiped over the plate before printing. The pressure of the intaglio press forces the sheet of paper into the incised lines to pick up the ink. Planographic processes, of which the two main types are lithography and screenprinting, utilize the surface of the matrix rather than cutting into or away from it.

In the 19th and 20th centuries these three standard processes were adapted to produce new processes, frequently combining elements from two or all of the principal methods. The introduction of photography and photomechanical techniques (*see* §4 below) led to further innovation, particularly in the field of reproductive printmaking. All printmaking techniques have developed as a result of experimentation on the part of the printmaker. From an early date artists strove to introduce variety and individuality into their prints by exploring the use of different types and colours of paper and inks, and experimenting with varied printing surfaces, such as textiles and parchment. Great printmakers, in general, frequently push the materials and techniques at their disposal to an extreme in order to achieve new or more dramatic effects, with the finished results often not falling within the conventional categories (*see* §5 below).

G. Peterdi: *Printmaking Methods Old and New* (New York, 1959)

F. Brunner: *A Handbook of Graphic Reproduction Processes/Handbuch der Druckgraphik/Manuel de la gravure* (Teufen, 1962)

E. Rhein: *The Art of Printmaking: A Comprehensive Guide to Graphic Techniques* (1976)

The Processes of Printmaking (exh. cat., ed. J. Atkinson; British Council, 1976)

J. Dawson, ed.: *The Complete Guide to Prints and Printmaking Techniques and Materials* (Oxford, 1981)

P. Goldman: *Looking at Prints: A Guide to Technical Terms* (London, *c.* 1981)

B. Gascoigne: *How to Identify Prints: A Complete Guide to Manual & Mechanical Processes from Woodcit to Ink Jet* (London, *c.* 1986, rev. 2/2004)

S. Turner: *A Printmaker's Handbook* (London, 1989)

R. Simmons and J. Stobart: *Dictionary of Printmaking Terms* (London, 2002)

D. Barker: *Traditional Techniques in Contemporary Chinese Printmaking* (London, 2005)

G. Saunders and R. Miles: *Prints Now: Directions and Definitions* (London, 2006)

1. Relief. 2. Intaglio. 3. Planographic. 4. Photomechanical. 5. Mixed and experimental. 6. Colour.

1. RELIEF. Term for processes in which the design to be inked stands up in raised lines from the surface of the matrix (a wooden block, metal plate or other flat surface), which has been either cut away or removed by various means. The most common forms of relief prints, both of which use wood as the matrix, are the WOODCUT and the WOOD-ENGRAVING (the latter so-called because of the method of cutting the block with a tool similar to an engraver's burin, though the impression itself is printed in relief). Other relief techniques employ metal plates (*see* METALCUT), stone blocks, rubber slabs, household linoleum (*see* LINOCUT), potatoes and other vegetables. Relief prints have been printed on a number of supports other than paper, including parchment, leather and fabric.

(i) Wooden matrices. The standard tool used to make woodcuts is a simple knife similar to a penknife, with an obliquely cut blade that cuts away the block surrounding the lines of the intended design. The block is a plank of polished softwood, such as beech, sycamore, apple or pear. Unlike intaglio plates, mistakes are difficult to rectify in woodcuts: the faulty area is drilled out and a plug is inserted, often visible on the printed impression. The skill required to cut out a complex linear design on a woodblock meant that from an early date the task was assigned to a specialist cutter, who worked from the artist's drawing, made either directly on the block or on a separate sheet of paper that was then laid over the block.

The tool used in wood-engraving is known as a graver and resembles a copperplate engraver's burin but with the handle fitted at an angle to the blade. The graver is held with the thumb laid along the length of the rod, guiding it forwards. Other tools include a scorper, a tint tool for series of fine lines, the spitstick, which has a curved, triangular face for curved lines, and various multiple tools to facilitate the production of large areas of parallel lines. Much greater detail is possible in a wood-engraving since the wood-engraver is incising lines rather than cutting away wood to leave lines exposed. Before cutting the planed surface, the block may be rubbed with slightly dampened, powdered bath-brick to give the pencil a better grip. The surface is sometimes painted white for greater visibility. During cutting, the block is supported on a sand-filled leather cushion. The matrix is hardwood (usually box) cut along the endgrain. This limits the maximum size of each block, and the large wood-engravings produced for 19th-century periodicals were made by bolting together numerous smaller blocks, often cut by different hands. It is now rare to find a single piece of box as large as 200×150 mm.

From the earliest stage of typographical printing, woodcuts were printed in conjunction with the text

on a wooden-framed printing press, the design of which possibly derived from the grape press, the papermaker's press or (more likely) a domestic press such as the linen press (see WOODCUT). The block, with or without accompanying type, was laid on the chase, where it was inked with a fairly stiff ink using a mushroom-shaped dabber made of a ball of animal skin (dog or sheep) stuffed with wool or hair and attached to a wooden handle. The skin was traditionally soaked in human urine and trampled underfoot to achieve the necessary softness. In the 1820s the dabber was superseded by the composition roller, made from glue and molasses, probably derived from rollers used in the pottery industry.

The paper that was to receive the woodcut impression was placed on an attached frame called the tympan, which was, in turn, hinged to a frame known as the frisket, which held a further sheet of paper designed to protect the paper on the tympan. The tympan and frisket were then folded over the block and pushed under the metal platen, which was manually screwed down by means of a bar to produce the necessary pressure to obtain an impression. The amount of pressure required to produce a relief print is considerably less than that for an intaglio print; consequently, relief prints show little or no sign of platemark. A number of improvements, such as a sprint system to return the bar and a metal rather than wooden screw, were gradually adopted, but the basic formula of the traditional wooden press altered very little and did not become obsolete until the mid-19th century. Probably the two best-known types of iron-framed manual press of the early 19th century were the Columbian (1813) and the Albion (c. 1822), both still highly valued for the production of relief prints.

With the development of mechanical presses in the early 19th century, the durability of woodcuts and particularly wood-engravings and their suitability for printing with type were fully exploited. The steam-powered press invented by Friedrich König (1774–1833) and used to print *The Times* in 1814 was calculated to produce four times more sheets per hour than the hand press. The development of methods to reproduce plates, such as stereotyping and electrotyping, meant that wood-engravings could also be printed by rotary presses. The mechanical platen press developed in the 1820s was also used.

Among the processes most closely allied to the traditional woodcut and wood-engraving are the white-line woodcut (or negative woodcut), in which the design is carried by the lines incised into the block, and the similarly reversed white-line wood-engraving. White-line woodcuts were produced in the 1520s by Urs Graf (c. 1485–1527/9) in Switzerland, while white-line wood-engravings were used for English 18th-century book illustrations.

A special category of woodcut is formed by FLOCK AND TINSEL PRINTS, of which only a few, rare impressions survive. These 15th-century prints depict figurative scenes but are textured to imitate textiles. They are produced by gluing a piece of textile on to a sheet of paper and then pressing it against a woodblock covered with glue instead of ink. The design image in glue is transferred to the textile, which is then sprinkled with powdered wool while still wet; the sheet is then shaken to dislodge the excess wool.

Another variation is the CHIAROSCURO WOODCUT, an early 16th-century development in which several woodblocks are superimposed when printed. The woodblocks were usually cut to exploit the white of the paper as highlights and often printed in shades of the same colour (with black used for the key-block to print the main outlines of the design). The general appellation for all the various types of colour woodcuts is chromoxylography (see also §6 below).

(ii) Other matrices. The use of a longer-lasting metal plate instead of a woodblock to produce a metalcut may have occurred from an early date. From the 15th to the 19th century metalcuts were used in particular for frequently repeated ornamental details, such as vignettes and initial letters in books, for which the durability of the matrix was important. A particular type of metalcut, the DOTTED PRINT, was made in the late 15th century in France, Germany and the Netherlands. Dotted prints were probably created by goldsmiths rather than printers, using punches and stamps with variously decorated heads to form ornamental patterns.

The main exponent of the use of the relief metal plate, however, was the late 18th-century English artist–poet William Blake (1757–1827), who developed the process to produce book illustrations together with text. He probably drew his images on paper with an etching ground, then transferred them to a metal plate which was etched, leaving the design and letters in relief. The precise details of his method remain unclear.

The practice of relief etching on stone, although known by the 16th century, was not commonly used until the 19th century for French book illustration. Two other processes that were developed in the 19th century, stereotyping and electrotyping, greatly increased the number of impressions that could be taken from a wood-engraving. A stereotype could be produced by two methods: a plaster cast was taken of the woodblock and used as a mould into which type metal was poured to form a cast or, alternatively, the block was dropped face down on to slightly molten metal and a relief cast made from this impression *(clichage)*. Stereotyping was largely outmoded by the electrotype process developed in 1839 for commercial printing. A mould made of wax or gutta-percha, taken from the original block, was covered with graphite to form an electrical conductor and placed in a galvanic bath. Copper was precipitated in to the mould, producing an exact replica of the original.

A number of processes relied on stereotyping or electrotyping to produce the printing matrix. In glyphography (used in Britain from 1842) an opaque white fluid was spread over a metal plate previously stained black. The artist drew through the white ground to produce the design. The plate was then electrotyped to form a relief printing block. The result

imitated wood-engraving. A chemically produced variant of the stereotype, known as CHEMITYPE, was invented in 1846 by Christian Actonius Theodorus Piil (1804–84). The artist drew the design on a zinc plate prepared with a normal etching ground. Filings of metal were then spread over the plate and heated to melting-point. The metal ran into the incised lines and, on cooling, was planed down to the level of the original zinc plate, which was etched with hydrochloric acid. The acid bit away only the zinc, leaving the fusible metal in relief. Both stereotyping and electrotyping were also used in the production of nature prints, a particularly unusual category of relief print made in the 19th century. A plant or leaf (or even a piece of lace) was pressed between a soft lead plate and a harder plate, and the lead impression was then stereotyped or electrotyped to form a relief plate. The method was invented in 1852 by Alois Auer in Vienna and patented in Great Britain in 1853.

In the early 1860s an American artist, De Witt Clinton Hitchcock (1832–1901), experimented with the use of chalk blocks as a matrix, developing a process known as graphotype. The compressed chalk block was polished and sized. The artist drew his design on it in reverse and filled in the lines with an ink composed of glue and lampblack. The untouched chalk was then brushed away to leave the design in relief and the whole surface covered in silicate. As the chalk blocks could not stand the pressure of the press, they too were replicated by stereotyping or electrotyping. In gypsography, invented in 1837, a drawing made through plaster mounted on a metal base was used as a mould in which to cast a stereotype. Little is known about kerography, invented by William James Linton (1812–98). Probably the drawing was made through wax and electrotyped to make the block. A lithographic stone or glass was used as the matrix in acrography. It was coated with a white compound, the design was scratched through, and an electrotype was made.

See also EMBOSSING.

J. B. Jackson: *An Essay on the Invention of Engraving and Painting in Chiaroscuro: And the Application of it to the Making of Paper Hangings of Taste, Duration and of Elegance* (London, 1754)

J.-M. Papillon: *Traité historique et pratique de la gravure en bois* (Paris, 1762)

J. Jackson and W. A. Chatto: *A Treatise on Wood-engraving* (London, 1839, 2/1861)

P. Heitz, ed.: *Einblattdrucke des fünfzehnten Jahrhunderts* (Strasbourg, 1899–1942)

H. Furst: *The Modern Woodcut* (London, 1924/R Vaduz, 1979)

R. Avermaete: *La Gravure sur bois moderne de l'occident* (?Paris, 1928/R Vaduz, 1977)

D. P. Bliss: *A History of Wood-engraving* (London, 1928)

A. M. Hind: *An Introduction to a History of the Woodcut* (London, 1935/R New York, 1963)

J. R. Biggs: *Woodcuts, Wood-engravings, Linocuts and Prints by Related Methods of Printmaking* (London, 1958)

J. Kairien: *John Baptist Jackson: Eighteenth-century Master of the Color Woodcut* (Washington, DC, 1962)

C. H. Boyle: *A History of Printing Inks, Balls and Rollers, 1440–1850* (London, 1967)

K. Lindley: *The Woodblock Engravers* (Newton Abbot, 1970)

M. Rothenstein: *Relief Printing: Basic Methods, New Directions* (London, 1970)

J. O'Connor: *The Technique of Wood-engraving* (London, 1971)

J. Moran: *Printing Presses: History and Development from the Fifteenth Century to Modern Times* (London, 1973)

G. Wakeman: *Victorian Book Illustration: The Technical Revolution* (Newton Abbot, 1973)

W. L. Strauss: *The German Single-leaf Woodcut, 1550–1600* (New York, 1975)

G. Wakeman: *Printing Relief Illustrations: Kirkall to the Lineblock* (Loughborough, 1977)

W. Chamberlain: *The Thames and Hudson Manual of Woodcut Printmaking and Related Techniques* (London, 1978)

H. Körner: *Der früheste deutsche Einblattholzschnitt* (Itzelberg, 1979)

A. Garrett: *British Wood-engraving of the 20th Century: A Personal View* (London, 1980)

2. INTAGLIO. Term (from It. *intagliare*: 'to cut into') for processes in which the design is produced by lines and areas cut into the surface of the plate, which is then inked and printed under pressure so that the paper is forced into the sunken areas and draws out the ink. Historically, the earliest forms of intaglio probably lie in the engraving of metal, bone, horn and rock with tools such as blades or flints. The ornamentation of precious metals in the Near East, Greece, Italy and other areas of the ancient world and by medieval goldsmiths is the direct antecedent to its use in printmaking in the 15th century and later. The earliest intaglio prints on paper were probably produced in goldsmiths' workshops in southern Germany in the 1430s. The most common processes used to make intaglio prints are ENGRAVING and ETCHING (see fig.). While the printing method is basically the same for all types of intaglio processes, the tools and materials vary from process to process.

The standard material for intaglio plates is the copperplate, which was hand-beaten until the 19th century, then cold rolled; hand-beaten plates were harder and of a more even and consistent structure. Zinc, steel, iron, pewter (for music printing) and, more recently, alloys (e.g. micro-metal) and non-metals (e.g. Perspex) have also been employed. The plate is generally supplied to the printmaker in a highly polished state and is bevelled at the edges for ease in printing. The traditional copperplate lends itself well to reuse after grinding down and repolishing and to correction by 'knocking out' from the back unwanted lines or areas with a small hammer, a technique known as *repoussage*.

The type of tool used to work on the plate varies according to the intaglio process used. The basic engraving tool is the burin (or graver), a straight steel rod, usually square in cross-section, with the cutting end sharpened to an angle of 45°. For short cutting and dotting, a second burin cut to 60° is often used. The burin is fitted into a rounded wooden handle, and the blade is held between the thumb and first or second finger. The point of the graver is pressed into the surface of the plate, which is supported on a pad

Etcher and Engraver in a Studio by Abraham Bosse, engraving, 266 × 341 mm, 1634 (London, Victoria and Albert Museum) photo credit: Victoria and Albert Museum, London/Art Resource, NY

to enable it to be turned, facilitating the movement of the tool. A variant shape of the burin, the scorper (or gouge), is used for cutting broader lines. A scraper is used to remove the curl of copper produced by the cutting movement of the burin through the plate. The standard etching tool is the etching needle, a point or needle of varying thickness and pointedness, held in a straight holder. Cut to an oblique oval, it is termed an *échoppe* and is used to create swelling lines. Drypoint is executed with a tool of that name, frequently a piece of steel sharpened at each end. Tools used for later intaglio processes include the mezzotint rocker, which employs a curved serrated edge to break up the surface of the plate before producing the design with a scraper and burnisher. A spiked wheel, or roulette, used in early mezzotint, was adapted in the 18th century for use on crayon manner prints in combination with the mattoir, a tool with a rounded spiked head.

The basic formula for intaglio printing ink remains oil and pigment. Some of the pigments recommended in older recipes, however, are no longer available (e.g. Frankfurt black) and have been replaced by modern substitutes. There are three copperplate oils—light, medium and heavy—made from burning linseed oils

to various temperatures depending on the required texture. Raw linseed oil can also be added to ink to enrich it. Pigments can be ground by hand on a stone slab, mixed with oil and pounded with a marble or glass muller, but ink is nowadays available ready made from dealers. One of the most widely used ink mixtures consists of two-thirds imitation Frankfurt with one third heavy French.

The ink is applied to a plate, which has been warmed to ease application, with a felt or cloth dabber (made of tied, rolled felt) or with a wooden, felt-covered roller, so that the entire surface is well covered. It is then wiped clean with a series of muslin rags or simply with the hand, leaving the ink only in the areas or lines that are to print positive. An effect known as 'surface tone' is achieved by leaving a film of ink on the wiped plate, and lines can be softened by a process known as *retroussage* in which muslin is lightly wiped across the plate, catching up some of the ink and spreading it across the edges of the grooves. The plate is inked between each impression. The number of impressions (print run) that a plate is capable of yielding varies greatly between processes: the delicate surface of a drypoint or a mezzotint will not withstand a long print run without signs of wear.

The skill of the printer is crucial and can help to prolong the lifespan of a worn plate. The introduction of steel facing in 1857 greatly extended the print run of copperplates.

The printing process is vital in the production of a good impression and includes factors such as evenness of wipe, correct dampness of paper and accurate pressure of the press. A print produced by an intaglio press can generally be distinguished by the indentation known as the platemark around the image and by the fact that the ink stands out in relief on the paper, both effects due to the considerable amount of pressure exerted in printing. The standard dual cylinder press used in workshops and art schools today has developed little since its invention c. 1500 (iron or steel frames replaced wooden ones in the late 18th century). It comprises a base plate (the plank) between two rollers: the lower one is a hollow cylinder that turns on bearings; the upper is of solid steel, capable of exerting the necessary pressure and adjustable by a screw system. Larger presses may be geared. The standard modern roller lengths are 19, 23 and 28 ins, corresponding to paper widths. To ensure even printing, three to five blankets or felts are laid over the plate and paper during printing. Engraved plates require greater press pressure than etched ones, which, in turn, can be printed at greater pressure than delicate drypoint plates.

Paper used for intaglio printing must be able to pick up and retain oily ink. Generally, finely worked prints may be more suited to light papers, and Japanese papers have been exploited for their delicacy. Before printing, all size in the paper must be removed by soaking. The paper is then stacked, weighted down and left to dry, and individual sheets are redampened for printing. Fragile papers, such as Japanese, are sometimes backed with another sheet during printing to protect them. Printing on surfaces other than paper has a long history; parchment in particular was used at an early stage, both for its permanence and for its delicate surface. While intaglio printing on textiles for costumes and furnishing was not developed until 1752, individual 'art' prints were produced on cloth in the 17th century (e.g. by Hercules Segers (1589/90–1633/8)). For earthenware and plastic, transfer methods are used.

Intaglio techniques can be divided into two general categories: engraving and its variants, in which the design is cut out of the plate by means of various tools, and etching, in which acid or other corrosive liquids 'bite' the plate to create the image. Engraving has refinements, including the use of a ruling machine, invented in 1790 and widely used on steel and steel-faced copperplates in the 19th century to engrave large areas rapidly, such as skies. NIELLO PRINTS originated in the goldsmith's practice of decorating metalwork by filling the lines of an engraved design with a black amalgam called *nigellum*. Impressions of these objects were sometimes taken on paper, particularly in Florence and Bologna in the late 15th century. DRYPOINT is probably the simplest intaglio technique: the tool is held like a pencil, and

shallow lines are scratched on to the plate; the curl of rough metal thrown up by the point is known as the 'burr' and if left on the plate during inking will retain ink to create a blurred line. Unlike the above processes, MEZZOTINT works from dark to light, that is the design is scraped and burnished from a plate 'grounded' or roughened with a rocker to produce an all-over burr. In the late 19th century mezzotint was frequently combined with other processes.

In the etching process, the plate is covered with an acid-resistant waxy 'ground' applied with a dabber or in liquid form. It may then be blackened by smoking with tapers to enable the printmaker to see his design more clearly as he works. The image is produced by drawing through the ground with a needle; the plate itself is not scratched. The back and edges of the plate are then protected with varnish, and it is immersed in a bath of acid diluted with water; the type of acid used varies according to the metal of the plate. The acid 'bites' into the plate where it is no longer protected by the ground. A plate can be repeatedly immersed in the acid solution to deepen the biting of some lines. Those lines that are not to be strengthened are covered with varnish before immersion, a process known as 'stopping-out'. An etched line is recognizable by its rounded, blunt end, distinguishing it from the sharp, pointed end of a drypoint line or engraved line. Refinements of etching include SOFT-GROUND ETCHING, in which a sheet of paper is laid over the wax ground and the design made by gently pressing the point of a pencil on to the paper. The ground under the indented lines adheres to the paper and is pulled away when the paper is removed, leaving the copper exposed. As an alternative to paper, materials such as silk and nylon have been used to give a background texture. CRAYON MANNER uses the roulette and mattoir over an etched ground to imitate chalk drawing. An English variant, STIPPLE, uses roulettes and a curved, pointed burin to build up areas of dots over an etching ground.

A special type of etching ground consisting of minute particles of resin is used for AQUATINT. The resin is applied to the plate in powder form with a dust box or dissolved in alcohol. The acid bites into the plate in pools around each particle of resin; ink is retained in these pools and when printed gives a soft, grainy tone. Further effects are achieved by stopping-out or varying the size of the resin particles. This is purely a tonal process, often used in conjunction with etching. A variant of aquatint known as sugar-lift or LIFT-GROUND ETCHING involves painting the design on to the plate with a sugar solution. The whole plate is then covered with stopping-out varnish and immersed in water. The sugar swells, pushing off the varnish in the areas above the design. The exposed design is then covered with an aquatint ground and bitten in the normal way. Other tonal processes include acid tint (*lavis*), sulphur tint and electrotint.

V. Zonca: *Nuovo teatro di machine et edificii* (Padua, 1607)

A. Bosse: *Traicté des manières de graver* (Paris, 1645, rev. 2/1701, 3/1745, 4/'1758' [*c*. 1770]

A. Browne: *Whole Art of Drawing … and Etching* (London, 1660, 2/1675)

J. Evelyn: *Sculptura: Or the History and Art of Chalcography and Engraving in Copper … to which Is Annexed a New Manner of Engraving or Mezzotinto* (London, 1662)

W. Faithorne: *The Art of Graving and Etching* (London, 1662/R New York, 1970)

P. G. Hamerton: *Etching and Etchers* (London, 1880)

A. Delâtre: *Eauforte, pointe-sèche et vernis mou* (Paris, 1887)

S. T. Prideaux: *Aquatint Engraving* (London, 1909)

A. M. Hind: *A Short History of Engraving and Etching* (London, 1908); rev. 3 as *A History of Engraving and Etching from the 15th Century to the Year 1914* (London, 1923/R New York, 1963)

E. S. Lumsden: *The Art of Etching: A Complete and Fully Illustrated Description of Etching, Drypoint, Soft-ground Etching, Aquatint and their Allied Arts* (London, 1924/R 1962)

S. W. Hayter: *New Ways of Gravure* (London and New York, 1949, 2/1966)

J. Buckland-Wright: *Etching and Engraving: Techniques and the Modern Trend* (London, 1953/R New York, 1973)

J. Trevelyan: *Etching: Modern Methods of Intaglio Printmaking* (London, 1963)

A. Gross: *Etching, Engraving and Intaglio Printing* (Oxford, 1970)

W. Chamberlain: *The Thames and Hudson Manual of Etching and Engraving* (London, 1972/R 1977)

J. Ross: *The Complete Intaglio Print: The Art and Technique* (New York, 1974)

F. Maggio: *La stampa d'arte: Incisione* (Milan, 1979)

A. Stijnman: *Bibliografie van de techniek van de manuele diepdruk: Een inventarisatie van het bezit van de 21 collecties in Nederland, met aanvullingen en met toevegingen* [Bibliography of the technique of hand engraving: an inventory of the holdings of the 21 collections in the Netherlands, with supplements] (The Hague, 1986) [with Eng. summary]

C. Wax: *The Mezzotint: History and Technique* (London and New York, 1990)

3. PLANOGRAPHIC. Term for processes in which the design is made on the actual surface of the matrix (stone, paper or screen) rather than by cutting into or away from it. There are three principal planographic processes: STENCILLING, LITHOGRAPHY and SCREENPRINTING (often termed silkscreen). Of these, lithography is technically the most complex, while screenprinting is basically a more sophisticated development of the ancient stencil process. The MONOTYPE, an unusual hybrid technique that bridges the line between drawing and printmaking, is also discussed here, since in that process too the image is applied to the surface of the printing matrix. As with other printmaking techniques, several of these processes can be combined in one print.

(i) Stencilling. (ii) Lithography and related processes. (iii) Screenprinting. (iv) Monotype.

(i) Stencilling. Of the three types of planographic process, stencilling is both the simplest and the oldest. Stencils were used to decorate walls, pottery and fabrics by a number of ancient civilizations, including the Egyptians, Romans and Chinese. The technique simply involves cutting out shapes or letters, generally of card or metal, and placing them over the required printing surface (paper, textile etc). Pigment is then painted or sprayed over them. The problem of connecting the elements of a design with isolated parts was overcome by the Japanese, who used human hair, then silk, to tie the stencils together. In the West, stencils were used from an early date to apply colour to prints and continued in widespread use for cheap, popular prints. The term *pochoir* is applied to 20th-century French commercial coloured stencils.

(ii) Lithography and related processes. Compared with relief and intaglio printing, lithography (from Gr. *lithos*: 'stone') is a recent process, invented by the Bavarian J. N. F. Alois Senefelder (1771–1834) in 1797–8. Known in England in its earliest stages as 'polyautography', the fundamental principle lies in the non-compatibility of grease and water. When applied to a specially treated lithographic surface (termed a 'stone', since it was originally limestone; later a zinc or aluminium plate or, since the 1940s, paper), grease accepts the greasy lithographic ink rolled on to the surface and water repels it. The process depends on the readiness of Bavarian Kelheim limestone (available in three grades, blue, yellow and grey, corresponding to their relative hardness) to 'adsorb' grease, which fuses with the surface of the slab. (If plates are used, their surface must be treated by graining to receive grease.) A solution of nitric acid and gum arabic is used to 'etch' the design (drawn in greasy crayon, or usually chalk, or lithographic ink called tusche) on to the stone and creates a grease-resistant surface round the design. The surface of the stone is not itself affected by this. The stone is then washed, and the crayon or ink pigment dissolved with turpentine, being no longer required as the grease has fused with the stone and provides the necessary basis for inking. The layer of gum arabic is then washed away and with it the dissolved pigment. The stone is dampened again and ready for inking with a roller and greasy lithographic ink, which adheres only to the greasy areas of the design and is repelled by the wet areas around the design.

A wide range of papers provides suitable printing surfaces for lithographs. As a general rule, smoother papers are used with more heavily grained plates or stones and vice versa. Paper designed for lithographic use is normally slightly waterproofed by the addition of resins in order to withstand the dampening process. On the whole, very heavy, rough, handmade papers are not considered suitable. Paper is prepared for printing by stacking between damp blotters, wrapping in oilcloth and placing between boards overnight. Colour lithographs usually use dry paper to ensure accurate registration.

Printing is carried out with a press operated on a 'scraper' principle. A sheet of paper dampened for 15–20 minutes is laid over the stone and above this a layer of fibre greased at the edges to facilitate the forward progress of the stone on the press bed, which is raised by means of a hand screw to meet the 'scraper', a greased, leather-edged wooden bar mounted in a

box. A crank operates gears, which move the press bed forward, passing the stone and paper under the scraper. The first powered lithopress was introduced in Paris in 1833. The size of the print run varies according to the materials: the 19th-century printer and publisher Godefroy Engelmann (1788–1839) estimated a print run of 30,000–40,000 impressions for an ink (tusche) lithograph, longer than that possible with chalk. Chalk was, however, considered easier to use. The stick of chalk was sharpened to a thin, fine point and held in a holder.

Within 20 years of the invention of the process, the need to develop a fast and efficient method of creating tone resulted in the invention of several new techniques. These include *lavis lithographique*, invented in 1819: sticky ink is applied across the stone with circular wooden dabbers stuffed with cotton and covered with kid skin. In place of ink, stopping-out gum arabic can be used to preserve the white areas of the design. Charles Joseph Hullmandel (1789–1850)—who had previously used a laborious system of parallel crosshatching with chalk to achieve tone—started to use flat rubbers coated with chalk rather than ink. This was known as 'stump style' and was probably faster than ink ground. The French printer R.-J. Lemercier used powdered crayon spread on to a stone that had been slightly warmed; the crayon could then be worked in to create a tint. Other methods developed in the mid-19th century worked in a negative direction: part or all of the stone was covered with lithographic ink or chalk, and highlights were produced by revealing the stone in various ways. One such method was the *manière noire* invented by the French artist Edmond Tudot (1805–61) in 1831. He covered the entire stone in chalk hatchings, then removed them with a combination of tools, including pieces of flannel, box-wood and ivory points, mezzotint scrapers and specially designed steel brushes called *égranoirs*. A slightly different technique, the 'sprinkled manner', was developed by Senefelder but achieved widespread acclaim only under Henri de Toulouse-Lautrec (1864–1901) and Jules Chéret (1836–1932), who exploited its artistic possibilities to great effect, especially in posters. A toothbrush is charged with lithographic ink and a knife passed across, spattering the stone (hence its more common name, 'spatter technique'). Additional tones can be produced with the use of stencils. The brush can be charged with gum instead of ink; when dried, writing ink diluted with turpentine is painted over it, a process known as 'gumming out'.

A major development in 1840 was Hullmandel's invention of lithotint. This apparently involved the use of successive applications of graduated washes of lithographic ink applied with a brush. The stone was prepared with resin, then washed with nitric acid and a gum–water mixture. It was then washed off with turpentine and printed. The technique was particularly well suited to the reproduction of watercolours, as the marks of the brush with which the ink was applied remained visible on the stone. The use of lithotint should not be confused with the use of a second tintstone, popular from the late 1830s although invented a decade earlier. Tintstones were used to achieve pure whites on the final image by stopping-out with gum or by scraping with a knife. Tintstones were frequently printed in a warm buff colour. The use of a second tint of grey-blue to indicate sky became popular from the 1840s. (For the relationship of tinted lithography to colour lithography *see* §6 below.)

There are numerous refinements of the lithographic process. In transfer lithography the artist draws in a greasy medium on a sheet of paper covered with a soluble layer of gum arabic, which dissolves when laid face down on the stone and moistened, leaving the drawing attached to the stone. This process enables him to draw in the same direction as the final print and is thus useful for such features as lettering. In offset lithography, which has widespread commercial use, the design is transferred on to a rubber roller that is applied to the paper. It produces an image in the original direction.

(iii) Screenprinting. The third major process, screenprinting, has a much more recent history, although the misconception persists that it originated in China. A form of screenprinting process was patented in Britain in 1907, but the earliest known examples are all American and date to *c.* 1916. The earliest screenprints were produced for commercial use (calendars, interior decoration), and it was not until the early 1930s in North America that artists began to explore the artistic possibilities of the medium. The technique is a fast and inexpensive development of the stencil process. The stencil is attached to a screen of silk, nylon or fine mesh, which is stretched across a frame. The frame itself is hinged to a baseboard, usually of formica-covered plywood. Ink is pushed across the screen with a blade of flexible rubber or synthetic composite known as a squeegee, which forces it through the areas of the screen not masked by the stencil on to the paper (or textile etc) below.

The cheapest material to use as a screen is cotton organdie, but this is not sufficiently elastic to allow for frequent reuse. Before the development of synthetic meshes, silk was the most commonly used fabric. Three grades of silk are available, corresponding to the weave fineness and thread thickness. More recently, nylon and polyester mesh have been adopted. Of these, polyester is the more successful, being less elastic than nylon, with a high resistance to moisture. Metallic meshes continue to be used with abrasive and crystalline inks and with thermoplastic inks that require heating during printing. The screen can be attached to the frame manually, if the frame is wooden, or by a number of mechanical methods.

Manual (i.e. not photomechanical) stencils can be divided into two types: direct stencils, which are made (sprayed, painted or dripped) on the screen, and indirect stencils, which are applied to it just before printing. A wide range of substances can be used to make

direct stencils; the most traditional are gum arabic and water-based glues. Others include nail-varnish, cellulose filler, oil crayon and lithographic tusche (Ger.: 'ink'). The original indirect stencil is paper. Suitable papers include newsprint, greaseproof paper and crystal parchment. A more sophisticated version of the paper stencil is knife-cut film. This is made of two layers: the stencil coat layer is cut away to create the stencil, while the lower backing sheet creates a support that is removed when the stencil is attached to the screen. Other types include iron-on, shellac-based stencil, water-based knife-cut film, lacquer-type knife-cut film and French chalk stencil. Readymade objects such as paper doilies, computer tape and plastic netting can form 'found' stencils.

A wide range of papers can be used in screenprinting, including a form of plastic-coated paper, which has proved suitable for this medium. The textile industry has always relied heavily on screenprinting; another innovation is the rotary screen, which obviates the need for laying out long lengths of material on tables before printing. Screenprints are also widely used on plastics, metal, ceramics and glass. The term 'serigraphy' was invented in the USA in the 1940s in order to draw an arbitrary distinction between commercial screenprinting and fine art screenprints. It is doubtful whether any real distinction can be made between the two on technical grounds, as screenprint artists have always been willing to exploit commercial innovations.

(iv) Monotype. In this technique, the design is painted on to a variety of surfaces (originally copperplate, later card, paper or glass) with brushes (both ends), fingers or rags. The painted matrix is then printed on paper, normally yielding one unique impression. Two main types have been distinguished: the 'additive', in which the artist paints on the lines of the design to form the positive parts of the image, and the 'subtractive', in which he scrapes or wipes the design away from a previously laid-in layer of paint. A second impression, sometimes called the 'cognate', can be obtained by retouching the surface, often producing an impression startlingly different from the first.

The monotype was invented in the 1640s by Giovanni Benedetto Castiglione (1609–64) and further developed by many other artists, including Edgar Degas (1834–1917), who took fresh impressions of lightly brushed monotypes and, while the ink was still wet, placed the sheets face down on to a lithographic stone, transferring under pressure the inked images to its surface (e.g. *Nude Woman Standing, Drying herself*, 1891–92; Delteil, no. 65). By this monotype–lithograph process he thus created a multiple from a one-off image. The development of the traced monotype by Paul Gauguin (1848–1903) represents another form of the technique, while in the 20th century Robert Colquhoun (1914–62) experimented with a form of traced offset monotype, which had much the appearance of a line drawing.

G. E. Engelmann: *Rapport sur la lithographie introduite en France par G. E. Engelmann* (Mulhouse, 1815)

A. Senefelder: *Vollständiges Lehrbuch der Steindruckerey* (Munich, 1818)

C. Hullmandel: *The Art of Drawing on Stone* (London, 1824)

G. Engelmann: *Rapport sur la chromolithographie* (Mulhouse, 1837)

A. Mellerio: *La Lithographie originale en couleurs* (Paris, 1898)

J. Pennell and E. R. Pennell: *Lithography and Lithographers: Some Chapters in the History of Art* (London, 1898, 2/1915)

L. Delteil: *Le Peintre-graveur illustré*, 21 vols (Paris, 1906–26)

L. Ozzola: *La litografia italiana dal 1805 al 1870* (Rome, 1923)

S. Wengeroth: *Making a Lithograph* (London, 1936)

F. H. Man: *150 Years of Artists' Lithographs, 1803–1953* (London, Melbourne and Toronto, 1953)

T. E. Griffiths: *The Rudiments of Lithography* (London, 1956)

W. Weber: *Saxa loquuntur (Steine reden): Geschichte der Lithographie*, 2 vols (Munich, 1964)

S. Jones: *Lithography for Artists* (London, 1967)

F. H. Man: *Artists' Lithographs: A World History from Senefelder to the Present Day* (London, 1970)

M. Twyman: *Lithography, 1800–1850: The Techniques of Drawing on Stone in England and France and their Application in Works of Topography* (London, New York and Toronto, 1970)

Homage to Senefelder (exh. cat., London, Victoria and Albert Museum, 1972)

M. Caza: *Silkscreen Printing* (New York, 1973)

Die Lithographie von den Anfängen bis zur Gegenwart (exh. cat., Bremen, Kunsthalle, 1976)

W. McAllister Johnson: *French Lithography: The Restoration Salons, 1817–1824* (Toronto, 1977)

R. Vicary: *The Thames and Hudson Manual of Advanced Lithography* (London, 1977)

F. Eichenberg: *Lithography and Silkscreen* (London, 1978)

T. Mara: *The Thames and Hudson Manual of Screenprinting* (London, 1979)

The Painterly Print: Monotypes from the Seventeenth to the Twentieth Centuries (exh. cat., ed. C. Ives; New York, Metropolitan Museum of Art; Boston, MA, Museum of Fine Arts; 1980)

D. Porzio, ed.: *La litografia: Duecento anni di storia, arte e tecnica* (Milan, 1982; Eng. and Fr. trans., 1983)

W. M. Mathes: *Mexico on Stone: Lithography in Mexico, 1826–1900* (San Francisco, 1984)

Die Kunst vom Stein: Künstlerlithographien von ihren Anfängen bis zur Gegenwart (exh. cat., ed. W. Koschatzky and K. Sotriffer; Vienna, Graphische Sammlung Albertina; Munich, Villa Stuck; 1985)

P. Gilmour, ed.: *Lasting Impressions: Lithography as Art* (London, 1988)

K. S. Howe, ed.: *Intersections: Lithography, Photography and the Traditions of Printmaking* (Albuquerque, 1998)

4. PHOTOMECHANICAL. Term for processes in which the printing matrix is produced by methods based on photographic technologies rather than mechanical work carried out by the printmaker. The invention and development of photography in the 1820s and 1830s revolutionized the technical processes of printmaking, though it was some time before its impact was fully realized. Many photomechanical processes are based on the discovery made by Alphonse Louis Poitevin (?1819–82) in 1855 that bichromated gelatin is sensitive to light: it hardens when exposed to light and remains soft where shielded from light. Most photomechanical

methods can be classified according to the three main traditional printing processes.

(i) Relief.

(a) Phototype. This photomechanical method, developed by Fruwirth and Hawkins in the 1860s, was used to produce a relief printing block before the invention of the line block (*see* §(c) below). A plate was coated with bichromated gelatin and exposed under a photographic negative of the image. The unexposed gelatin remained soft and could be washed away, leaving a relief of the hardened gelatin on the printing plate. The plate is similar to but less durable than a line block.

(b) Woodburytype. In this photo-relief method, patented by Walter Bentley Woodbury (1834–85) in 1866–7, pigmented light-sensitive gelatin is spread on to a glass plate and exposed under a negative. The gelatin film is separated and left to contract; the dark areas forming the image remain proportionally thicker than the light ones. Using a hydraulic press, a mould is formed by pressing the film into sheet-lead. A mixture of gelatin, water and pigment is poured into the mould, paper is laid on top and pressure is applied in a special press. The resultant print, treated with alum to become insoluble, looks superficially like a conventional photograph but does not fade.

(c) Line block. The process was developed in the 1870s, and by the 1890s it had become the traditional method of producing printing blocks photomechanically. To make a line block (also sometimes called a linecut), a zinc plate is covered with bichromated albumen or some other light-sensitive material and then exposed under a negative. A layer of tacky ink is then rolled over the plate and the soft, unexposed albumen is washed away. Next, the plate is dusted with powder, which sticks only to the inked areas. It is then heated so that the powder forms a resist protecting the dark areas of the image. The plate is then immersed in acid four times, eventually leaving the protected lines of the design standing in relief. The resist is cleaned off and the plate printed using any relief printing press. The disadvantage of the process is that it can reproduce only linear designs.

(d) Half-tone blocks. To overcome the inherent limitations of the line block process, the half-tone method was developed so that areas of tone could be reproduced. A special negative is made by photographing the original image through a screen, which breaks it up into dots of varying sizes depending on the intensity of the original tones. This negative is then used to make a printing plate in the same way as a line block. The dots, although clear under magnification, are invisible to the human eye, which instead perceives them as areas of grey. The first commercially successful use of the half-tone was patented in Germany and Britain in 1882 by Georg Meisenbach (1841–1912).

(ii) Intaglio.

(a) Heliograph. In 1827 the Frenchman Nicéphore Niépce (1765–1833) took a traditional print and waxed it in order to make it translucent; he then applied it to a glass, metal or stone plate coated with bitumen of Judea, which was then exposed to bright light over a prolonged period. Where the light filtered through the blank areas of the design, the bitumen hardened, but those areas protected by the lines of the print remained soft and could be washed away. The plate, if metal, was then etched in the usual manner. (Such images could also be printed lithographically.) Niépce's process utilized some of the principles of photography before the developments of Louis Daguerre (1787–1851) and William Henry Fox Talbot (1800–77).

(b) Photogalvanography. An early version of hand photogravure patented in 1854 by Paul Pretsch (1803–73); the process combines collotype (*see* §(iii) (b) below) and electrotype (*see* §1 above). A plate was coated with light-sensitive bichromated gelatin and exposed through a negative. A surface of varying relief is produced by wetting the gelatin, which swells most where not exposed to light. This film is electrotyped, and this copy is electrotyped again to produce an intaglio plate, which is inked and printed in the usual way. The development of the standard hand photogravure process (*see* §(d) below) made this process obsolete by the late 1870s.

(c) Goupilgravure [photomezzotint]. A method combining elements of the Woodburytype to produce an intaglio plate, developed by Adolphe Goupil (1806/9–93) in 1867; it was called photomezzotint in Britain. A mixture of bichromate gum and glucose was spread over a metal plate to give a sensitized surface. This was exposed under a negative. After exposure the mixture remained tacky according to tone—the dark areas were wettest, the highlights dry. The plate was sprinkled with ground glass or emery powder; the coarse particles adhered to the darker areas, finer ones to the lighter patches, creating a granular surface. A Woodburytype mould was taken and a relief electrotype was made from this. Finally an intaglio electrotype was produced.

(d) Photogravure. The principal photomechanical intaglio process is photogravure, which can be subdivided into hand and machine photogravure. By the 1880s photogravure techniques had attained levels of *technical* mastery such that the skill of the traditional reproductive engraver became largely obsolete.

Hand. To make a hand photogravure, a sheet of bichromated gelatin is exposed to light through a negative, then transferred on to a copperplate covered with an aquatint ground; it is this aquatint ground that supplies the areas of tone. The soft gelatin is washed away and the plate is etched in acid, cleaned, inked by hand and printed in the same way as an ordinary intaglio plate. The process, developed

by Karel Klíč (1841–1926) in 1879, is known as Heliogravure in France; the term photoaquatint has also been used. Its applications were limited because the plates could not be printed mechanically.

Machine. Although essentially the same process as a hand photogravure, a machine photogravure uses a cross-line screen printed on to the gelatin (rather than an aquatint ground) to create areas of tone. When the gelatin is etched away, the screen stands in relief, which allows the plate to be inked and printed mechanically. The use of a rotary printer for photogravure is estimated to have increased production from 400 to 5000 prints a day. The process was developed by Klíč, who substituted a screen for the aquatint ground in 1890; however, it was not widely available commercially until after 1900, when his secret process was rediscovered by others. It offers a greater range of tone than any other photomechanical process except collotype.

(iii) Planographic.

(a) Photolithograph. A lithograph made from a photographic impression on a sensitized stone or plate. It was first attempted in France in the 1830s when Nicéphore Niépce (1765–1833) sensitized a lithographic stone with bitumen and oil of lavender. In 1852–3 Lerebours, Lemercier, Charles-Louis Barreswil (1817–70) and Louis-Alphonse Davanne (1824–1912) published *Lithographie, ou impressions obtenues sur pierre à l'aide de la photographie* (Paris) using an improved variant of Niépce's method. In 1855 Alphonse Louis Poitevin (?1819–82) used bichromated gelatin in place of bitumen and oil.

(b) Collotype. Light-sensitized gelatin is poured over a sheet of heavy glass, which is exposed under a negative; the gelatin dries and hardens in proportion to the amount of light received. It can then be printed lithographically. When inked, the dry areas absorb the most ink, thus printing darkest. This process produces very fine tonal gradations, but the surface is too delicate to produce a large number of impressions (2000 as compared to machine photogravures, which are not usually economic unless produced in print runs of more than 100,000). The collotype process was patented in 1855 in France, where it is called phototype, though the first commercial collotypes were produced in Germany in 1868 by Josef Albert (1825–86) and in England the following year by Ernest Edwards (1837–1903).

(c) Collograph. Term applied to the autographic use of collotype by Henry Moore (1898–1986) *c.* 1950. He drew on transparent plastic sheets of film (one for each colour) in the same direction as the final print. The image was then transferred photographically through the film on to a collotype plate.

H. Gernsheim and A. Gernsheim: *The History of Photography* (London, 1969)

G. Wakeman: *Victorian Book Illustration: The Technical Revolution* (Newton Abbot, 1973)

Photography in Printmaking (exh. cat. by C. Newton; London, Victoria and Albert Museum, 1979)

T. Fawcett: 'Graphic versus Photographic in the 19th Century Reproduction', *Art History*, ix/2 (1986), pp. 185–212

5. MIXED AND EXPERIMENTAL. It is common to find a combination of two or more printmaking processes on one matrix, either to increase the range of effects or, in the case of reproductive prints, to speed up the process of production. Sometimes, especially in the late 17th century and throughout the 18th, such prints were produced by two or more craftsmen, one etching the basic design and the other(s) engraving or adding the tonal effects.

One of the most frequent combinations is engraving with etching, a mixed method used by Lucas van Leyden (*c.* 1494–1533) for his *Emperor Maximilian I* (1520; B. 172) and by Marcantonio Raimondi (*c.* 1470/82–1527/34) for *c.* 40 prints of about the same date. The relative speed of etching meant that it was often chosen by reproductive engravers to lay in the outlines of their plates before adding engraved hatching. The quality of lightness and freedom characteristic of an etched line was also exploited for its own sake, for example in the *Destruction of the Children of Niobe* (1761) by William Woollett (1735–85) after Richard Wilson (1713/14–82), where etching predominates over other techniques. Some printmakers, before completing a work in engraving, used drypoint instead of etching to lay in the outlines, though it is rare to find it alone, without any further work in etching. Etching and drypoint were often employed together, especially by Rembrandt van Rijn (1606–69), as in his print of *Christ Preaching* ('*La Petite Tombe*', *c.* 1652; B. 67), in which the amount of drypoint 'burr' evident on Christ's sleeve is used to categorize impressions of this print into 'black sleeve' and 'white sleeve' by dealers and collectors.

The use of flicks and dots to provide tone in combination with intaglio techniques was developed by Giulio Campagnola (*c.* 1482–after 1515), who used stipple over an engraved outline for his *Child with Three Cats* (*c.* 1510; B. 15). The combination of stipple with etching, rather than engraving, was practised with great skill by such artists as Federico Barocci (*c.* 1535–1612) and Jacques Bellange (*c.* 1575–1616). The true stipple technique, as developed in Britain in the second half of the 18th century (*see* STIPPLE, §1), was also combined with etching where a more pronounced outline was required, an effect seen in the print of *Mrs Siddons as the Tragic Muse* (1787) by Francis Haward (1759–97) after Joshua Reynolds (1723–92).

Tonal effects were achieved by other combinations, such as etching with sulphur tint, a technique in which sulphur is used to create an atmospheric smoky background, as in Rembrandt's *The Windmill* (1641; B. 233). The purely tonal nature of aquatint means that it has also been frequently used with etched lines: in the print of *Vauxhall Gardens* (1785) after Thomas Rowlandson (1756/7–1827), the etching was done by Robert Pollard (*c.* 1755/7–1838), while the aquatint was carried out by Francis Jukes

(1745–1812). Aquatint was also frequently used by Francisco de Goya (1746–1828) with etching and drypoint, as in prints from the series of *Los Caprichos* (1797–8). It was particularly well suited to the reproduction of Old Master drawings, such as those prints by Adam von Bartsch (1757–1821) after Rembrandt, and topographical watercolours of the late 18th century and the early 19th. In the 20th century the combination of aquatint and etching has been employed with great expressive force by many artists, including Paul Klee (1879–1940), Emil Nolde (1867–1956), Pablo Picasso (1881–1973), Joan Miró (1893–1983), David Hockney (*b* 1937) and Richard Hamilton (*b* 1922). Miró produced dramatic effects by combining these two techniques with carborundum, an unusual method in which the surface of the intaglio plate is bitten with sand. He and Picasso also used etching together with collage in the 1930s.

Mezzotint, being essentially a tonal process like aquatint, is also receptive to combination with other, more linear techniques. The basic outlines of the composition are often etched before the addition of rocker work, sometimes in considerable detail, as in the fruit- and flower-pieces by Richard Earlom (1743–1822) after Jan van Huysum (1682–1749), produced for the *Houghton Gallery* series (1787–8) of John Boydell (1719–1804). In other cases, the etched work was intended as an integral part of the finished plate, for example Earlom's two-volume *Liber veritatis* (London, 1777) after Claude Lorrain (?1604/5–82). Three decades later, J. M. W. Turner (1775–1851), working in collaboration with a team of professional printmakers, used a combination of etching and mezzotint for his *Liber studiorum* (London, 1807–19), a set of landscape prints reminiscent of Earlom's earlier project. Elisha Kirkall (*c.* 1682–1742) combined both these techniques with relief printing from pewter plates in a series of 12 prints (1722–4) after Italian drawings in the collection of the Duke of Devonshire. There was even less emphasis on 'pure' techniques in France: thus such artists as Jean-Baptiste Chapuy (1760–1802), Philibert-Louis Debucourt (1755–1832) and Jean-François Janinet (1752–1814) combined mezzotint with etching, aquatint and a wide variety of rocker work. As a substitute for etching, Samuel Cousins (1801–87) used a stipple base for his mezzotint prints after Thomas Lawrence (1769–1830) and others. In the course of the 19th century the pure mezzotint was gradually superseded by the 'mixed-method mezzotint', in which the etched and engraved lines often outweigh the amount of mezzotint work on the plate, as in the prints of Charles George Lewis (1808–80) and Thomas Landseer (1795–1880). Mezzotint rocker work can also be added to delicate soft-ground etchings, adding depth to the background (e.g. *Fox-hound*, 1788 by George Stubbs (1724–1806); Lenox-Boyd, no. 80).

The effects of line and wash drawings can also be reproduced by combining intaglio methods with the technique of the chiaroscuro woodcut. An etched line was used with a chiaroscuro woodcut already in the 16th century, as can be seen from the *Wedding Feast at Cana* by Crispin van den Broeck (1523–91; Hollstein: *Dut. & Flem.*, no. 44). In the next generation fine examples were produced after compositions by Abraham Bloemaert (1566–1651), including some by his son Frederick Bloemaert (*c.* 1616–90), for example *Three Women Lamenting* (Strauss, no. 168). The combined technique was used in the 1720s for the first edition of the unfinished *Recueil Crozat* by Nicolas Le Sueur (1691–1764) and others, and a decade later by Arthur Pond (1701–1758) for his similar project, *Prints in Imitation of Drawings* (1734–6). In 1835 George Baxter (1804–67) patented a technique of combining woodblocks printed in bright oil colours over a monochrome key impression from an etched or engraved plate or occasionally a lithographic stone (instead of a woodcut key-block). The popular success of these resulted in a prolific body of work by Baxter and his licensees.

Other 19th- and 20th-century mixed-media developments involve the combination of lithography with other printing techniques, including intaglio and screenprinting, as well as sculpture and collage (e.g. Robert Motherwell (1915–91) and Christo (*b* 1935)). In lithographic engraving, a fast and economical 19th-century process widely used for labels and letterheads, the stone is coated with an acid and gum layer, then blackened with lampblack to show up the design, which is engraved as for a metal plate; the entire surface is then coated with linseed oil, which sinks into the engraved lines and attracts the printing ink (applied with a dabber). Impressions are characterized by lines with blunted ends.

Technical innovation played an important part in the expressive power of woodcuts by Edvard Munch (1863–1944) and lithographs by Ernst Ludwig Kirchner (1880–1938). Munch combined both woodcut and lithography in one image, and he also explored different effects by allowing the texture of his pine woodblocks to show through the brightly printed grounds and by cutting up his blocks and inking the elements separately before printing them. Kirchner's home-printed lithographs have a distinctive texture and surface tone that are the result of his having washed the stone with water mixed with a few drops of turpentine. In the continuing search for unusual effects, the physical properties of lithographic stones were exploited by Kirchner and by Erich Heckel (1883–1970), who drew up to the edge of it or occasionally used a damaged stone. These two artists also experimented with hand printing by rubbing on the backs of the sheets.

Among the many other experiments with lithography were the use of the spatter technique (flicking lithographic wash at the stone with a brush) and gold dust by Henri de Toulouse-Lautrec (1864–1901) to create a rich exotic effect on some of his lithographic prints, for example *Miss Loïe Fuller* (1893). Other 19th-century experiments explored ways of transferring an image from one matrix to another, for instance the transference of an etching to a lithographic stone by Rodolphe Bresdin (1822–85); adapting a method described by Alois Senefelder, he pulled

an impression of an etching using a greasy ink consisting of soot, soap, lampblack and oily varnish and then placed it face down on the lithographic stone and ran it through the press.

In the 20th century the combination of two or more techniques on one plate or stone has been as common as the use of a single technique. Screenprinting has been mixed with aquatint (e.g. by Fernand Léger (1881–1955)), as well as with woodcut and collage (Roy Lichtenstein (1923–97)); embossing with etching, aquatint and carborundum (Antoni Clavé (1913–2005)) and with various other mixed methods (S. W. Hayter (1901–88)); and collotype with lithography (Keith Haring (1958–90)). But 20th-century technical innovations have not stopped with the mere combination of standard techniques. Rolf Nesch (1893–1975), using a technique described as metal printing, attached pieces of metal and wire mesh to the plate before printing images such as *Elevated Bridge, Rodingsmarket*, plate 10 from the series *Hamburg Bridges* (1932). Hayter experimented with a new method of colour intaglio printing involving inks of differing viscosities. Among the more amusing of late 20th-century experiments are David Hockney's use of fax prints; prints dusted with diamond dust by Andy Warhol (1928–87; e.g. *Mickey Mouse*; Feldman and Schellmann, no. 265); and prints made from pulverized foodstuffs such as baked beans and chocolate by Ed Ruscha (*b* 1937). The use of computers represents perhaps the most radical trend in current experimentation.

A. von Bartsch: *Le Peintre-graveur* (1803–21) [B.]

F. W. H. Hollstein: *Dutch and Flemish Etchings, Engravings and Woodcuts, c. 1450–1700* (Amsterdam, 1949–)

Rembrandt: Experimental Etcher (exh. cat. by C. S. Ackley and others; Boston, MA, Museum of Fine Arts, 1969)

E. M. Harris: 'Experimental Graphic Processes in England, 1800–1859', *Journal of the Printing Historical Society*, vi (1970), pp. 53–89

W. Strauss: *Chiaroscuro: The Clair Obscur Woodcuts by the German and Netherlandish Masters of the XVI and XVII Centuries* (New York, 1973)

D. van Gelder: *Rodolphe Bresdin*, 2 vols (The Hague, 1976)

David Hockney: Prints, 1954–77 (exh. cat., Scottish Arts Council, 1979)

E. Prelinger: *Edvard Munch: Master Printmaker* (New York, 1983)

S. Terenzio: *The Prints of Robert Motherwell: A Catalogue Raisonné, 1943–84* (New York, 1984)

G. Adriani: *Toulouse-Lautrec: Das gesamte graphische Werk* (Cologne, 1986)

P. M. S. Hacker, ed.: *The Renaissance of Gravure: The Art of S. W. Hayter* (Oxford, 1988)

J. Schellmann and J. Benecke: *Christo: Prints and Objects, 1963–87: A Catalogue Raisonné* (Munich and New York, 1988)

J. Dupin: *Joan Miró: Engraver* (New York, 1989)

F. Feldman and J. Schellmann: *Andy Warhol Prints* (Munich and New York, 1989)

C. Lennox-Boyd and others: *George Stubbs: The Complete Engraved Works* (London, 1989)

Avant-garde British Printmaking, 1914–1960 (exh. cat. by F. Carey and A. Griffiths; London, British Museum, 1990)

6. COLOUR. A hand-coloured or hand-tinted print is one that has been drawn or painted over *after* it was printed (*see* §(i) below). It is sometimes also known simply as a 'coloured print'. By contrast, a 'colour print' is one that is printed with different coloured inks (*see* §(ii) below).

(i) Hand-tinted. Hand-colouring can be done either freehand or through a stencil. The latter method, though quicker, is appropriate only to the application of areas of flat colour and so has not generally been used in artists' original prints but been confined chiefly to the production of such things as playing cards, wallpaper and toy theatres. Hand-colouring done freehand reveals the individual colourist's touch in a manner absent in even the most autographic of printmaking techniques. It was used as a means of producing coloured images before the development of a satisfactory, cheap colour-printing method in the form of colour lithography in the mid-19th century (*see* §(ii) below). Hand-colouring is found on woodcuts, outline etchings, aquatints and lithographs more often than on more highly prized engravings or mezzotints. It was also used to enhance images partly printed in colour.

A print may be hand-coloured simply to make it more decorative, or to convey essential information about the colour of objects represented, such as costumes, flora and fauna, interiors and historical artefacts. These two types of colouring were usually done by anonymous colourists employed by print publishers. Artist–printmakers, among them William Blake (1757–1827), Edgar Degas (1834–1917) and James Ensor (1860–1949), also sometimes applied colour to their own prints.

The illumination of texts was already a well-established art at the time at which images were first printed on paper in Europe in the early 15th century. Many 15th-century woodcuts, mostly either playing cards or devotional images, were hand-coloured at the time of their production. The range of colours present on anonymous early woodcuts and metalcuts has been used to suggest their place of origin. Since most such works were aimed at a mass audience and are unrecorded in the contemporary literature, however, this method is not always conclusive. Only a tiny fraction of 16th- and 17th-century prints were published hand-coloured, for example early 16th-century woodcuts by Sebald Beham (1500–50), Erhard Schön (*c.* 1491–1542), Niclas Stör (*fl c.* 1520; d 1562/3) and Cornelis Anthonisz. (*c.* 1505–53), and special illuminated examples of books printed in black and white (e.g. that produced for Holy Roman Emperor Maximilian I). Other examples include woodcuts by Jost Amman (1539–91), and it is known that Georg Mack (*fl* 1569–1623) was colouring and illuminating engravings in Nuremberg in the 1570s, including coloured maps and views, and botanical and zoological works. Hercules Segers (1589/90–1633/8) produced extraordinary prints either hand-coloured or on coloured grounds, while on a more mundane level cheap popular prints continued to have colour added to them.

In England references to the hand-colouring ('washing') of maps and prints first appear in *The Compleat Gentleman* (London, 1622) by Henry Peacham (1578–?1644) and recur in most artists' manuals at least until the second edition (1764) of *The Handmaid to the Arts* (London, 1758) by Robert Dossie. The hand-tinting of prints began to decline as a recreational activity in the 1770s with the growing popularity of watercolour painting, although instructional watercolour manuals often included 'progressive examples' consisting of etchings and aquatints coloured by hand. The hand-colouring of maps and prints shares a common history in the development of watercolour pigments, but the legal implications of colour on maps, indicating boundaries and rights of possession, placed special constraints on the colourists.

The heyday of hand-tinting was the period 1750–1840 (see AQUATINT, colour pl. I, fig. 3), when the diverse classes of hand-coloured print included perspective prints produced throughout Europe, Swiss landscapes in etched outline and prints depicting the frescoes in recently excavated ancient Roman buildings, as well as those by Raphael (1483–1520) in the Vatican loggie, caricatures (e.g. ex-British Royal Collection; Washington, DC, Library of Congress) and British sporting prints (Upperville, VA, Paul Mellon private collection). In the same period publishers in Britain, in particular, produced a formidable number of colourplate books (e.g. London, British Library; New Haven, CT, Yale Center for British Art, including J. R. Abbey collection). In the 1830s and 1840s several sets of lithographs partly printed in colour from tintstones and further coloured by hand were published. Many colour-printed works had minor details added by hand.

By the 18th century hand-coloured prints were often on sale at twice the price of plain impressions of the same image, but the expression 'A Penny Plain and Twopence Coloured' used by the writer Robert Louis Stevenson as the title for an essay in *The Magazine of Art* (1884) applies only to a type of print that was used to make up a toy theatre. These first appeared in England *c.* 1811 and were the work of journeyman printmakers.

In the 20th century the advent of colour photography and efficient colour-printing methods has meant an increase in the popular taste for coloured prints. This has led to the colouring-up of many prints that were never intended by the artist or publisher to be hand-coloured, often ruining their effect. The recognition of genuinely old colouring is a question of connoisseurship, relying on comparison with prints of impeccable provenance. Scientific analysis, such as energy dispersive X-ray fluorescence spectroscopy, can help to determine the pigments present, but, as many pigments of ancient origin remain in use, this will pinpoint only anachronistic modern pigments. In the 1980s hand-colouring enjoyed a revival in the works of some notable artist–printmakers, such as Jim Dine (*b* 1935) and Howard Hodgkin (*b* 1932), an example of the way in which the old hierarchy of printmaking techniques has broken down.

J. C. Le Blon: *Coloritto: or the Harmony of Colouring in Painting Reduced to Mechanical Practice under Easy Precepts and Infalible Rules* (London, [?*c.* 1723–6])

W. Schreiber: *Handbuch der Holz- und Metallschnitte des XV. Jahrhunderts*, 8 vols (Leipzig, 1926–30)

A. M. Hind: *An Introduction to a History of the Woodcut*, 2 vols (London, 1935)

J. R. Abbey: *Travel in Aquatint and Lithography, 1770–1860: From the Library of J. R. Abbey*, 2 vols (London, 1956–7)

R. A. Skelton: 'Colour in Mapmaking', *Geography Magazine*, xxxii (1960), pp. 544–53

F. L. Wilder: *How to Identify Old Prints* (London, 1969)

H. Körner: *Der früheste deutsche Einblattholzschnitt* (Itzelberg, 1979)

Hand-coloured British Prints (exh. cat. by E. Miller; London, Victoria and Albert Museum, 1987)

(ii) Printed. Most of the traditional relief, intaglio and planographic techniques have been adapted to colour printing. In addition, the following less common processes have been used: nature printing, collograph, relief etching (e.g. by William Blake (1757–1827)), relief metalcuts (e.g. by Charles Knight (1743–after 1826)), engraving and coloured woodcut (e.g. by George Baxter (1804–67)), lineblock and photogravure, dye transfer and photocopy.

(a) 15th–18th centuries. (b) 19th–20th centuries.

(a) 15th–18th centuries. The earliest European colour printing appeared in the form of coloured woodcut initials in the Mainz Psalter (1457; Mainz, Gutenberg-Museum) of Johannes Fust (*c.* 1400–66) and Peter Schöffer (*c.* 1425–1502). Red and blue are used for the initials, which were probably removed from the forme (body of type set in the chase) before printing, individually coloured and replaced, to be printed with the main body of the text. The use of red for printing the 'rubric' (headings etc originally written in red) appears in the Mazarin Bible of about this date. In the mid-1460s Master E.S. (*fl c.* 1450–67) attempted to achieve a new colouristic balance between black and white in a *Virgin on a Grassy Bank* (Lehrs, no. 70), which seems to have been printed in relief to produce a white image on a black ground, probably the only 15th-century white-line engraving. A more complex method, involving successive applications of coloured blocks, was developed in Venice by Erhard Ratdolt (1447–1528) in 1482 for the printing of diagrams for the 13th-century astronomical treatise *Sphaera mundi* (Venice, 1482) by Joannes de Sacrobosco. A black-outline block was used in conjunction with red and yellow. A similar method was employed in England by the 'Schoolmaster Printer' in the *Book of Hawking, Hunting and Heraldry* (St Albans, 1486), in which three colours are used to ornament coats of arms. Ratdolt continued to experiment with new techniques on his return to Augsburg in 1486. The *Obsequiale Augustense* (Augsburg, 1487) contains a woodcut of *St Augustine* in which two blocks, inked

with two shades of the same colour, are printed over each other, a precursor of the CHIAROSCURO WOODCUT technique. Ratdolt was similarly innovative in the use of printing with gold (probably sprayed over a prepared ground), a technique also employed by Lucas Cranach the elder (1472–1553) in Wittenberg.

Competition between Hans Burgkmair the elder (1473–1531) in Augsburg and Lucas Cranach the elder in Wittenberg led to the development of the chiaroscuro woodcut. The first print of this type was Hans Burgkmair's *St George* (1508; Burkhard, p. 92). Cranach's claim to the invention, on the basis of a *Venus and Cupid* and a *St Christopher* (Bock, nos 38, 20), both dated 1506, can be dismissed, as it is known that he deliberately antedated these prints by two years. The technique was taken up and developed in Italy by Ugo da Carpi (*fl c.* 1502–32), who applied for a copyright in Venice in 1516. The greater part of the work of John Baptist Jackson (*c.* 1701–*c.* 1780) represents a late development of the chiaroscuro technique. From the late 1730s he used a copperplate press to print his chiaroscuros, creating a richly embossed effect. From 1739 to 1745 he produced 17 prints after paintings by Titian (*c.* ?1485/90–1576), Paolo Veronese (1528–88), Jacopo Tintoretto (1519–94) and Jacopo Bassano (*c.* 1510–92), a departure from the normal function of the chiaroscuro, which was to reproduce drawings. His six landscapes after gouache paintings by Marco Ricci (1676–1730) used between seven and ten distinct colours. Jackson's illustrations to his *Essay on the Invention of Engraving and Printing in chiaro oscuro* (London, 1754) were the first coloured book illustrations printed in Britain since those by the 'Schoolmaster Printer'. His experiments were made in the course of his search for improved techniques of manufacturing wallpaper. William Savage (1770–1843) improved on Jackson's colour chiaroscuro by extensive research to replace the oil base in ink with resin. He published *Practical Hints on Decorative Printing* (London, 1818–23) using his new ink.

The first use of etched line with chiaroscuro was probably made by Parmigianino (1503–40). It was used by Hubertus Goltzius (1558–1617) in his illustrations to *Le vive imagini di tutti quasi gl'imperatore* (Antwerp, 1557) and by Nicolas Le Sueur (1691–1764) with the Comte de Caylus (1692–1765) and Paul-Ponce-Antoine Robert (1686–1733) from 1729 to reproduce Old Master drawings for the *Cabinet Crozat* (1729, 1742). Arthur Pond (1701–58) employed a similar technique in England to publish a series of imitations of Italian drawings, *Prints in Imitation of Drawings* (London, 1734–6). Also working in the 1720s, Elisha Kirkall (?1682–1742) reproduced the tapestry cartoons of Raphael (1483–1520) and paintings by Willem van de Velde II (1633–1707), using a mixture of etching and mezzotint with a chiaroscuro block.

In intaglio printmaking, two methods of producing coloured prints were developed, both achieving widespread use in the 18th century. These are the techniques known as '*à la poupée*' and multiple-plate printing. The former derives its name from the resemblance of the dabber (used to apply areas of different-coloured inks to a single plate before a single pull) to a rag doll. The latter relies on the careful superimposition of a succession of plates, each inked with a single colour. While '*à la poupée*' probably received most attention in Britain, multiple printing was much favoured in France.

An early exponent of '*à la poupée*' was the Haarlem printmaker Johannes Teyler (1648–1709), who produced a variety of delicately coloured, now rare prints from *c.* 1688, some with the addition of hand-colouring. '*A la poupée*' was probably most suited to tonal techniques, particularly stipple. The market for decorative stipple prints was exploited in Britain by the Florentine Francesco Bartolozzi (1727–1815) and his school. Mezzotint was less widely used for colouring '*à la poupée*', as the delicate burr forming the surface was damaged by repeated dabbing. In the last decade of the 18th century '*à la poupée*' was taken up by a number of French printmakers to produce lavishly illustrated botanical and ornithological volumes. Foremost among these were Philibert-Louis Debucourt (1755–1832) and Pierre-Joseph Redouté (1759–1840). A remarkable, but isolated, practitioner of colour printing in the Netherlands was the collector and amateur engraver Cornelis Ploos van Amstel (1726–98). Between 1765 and 1787 he issued a series of 46 plates after Netherlandish works of art, the earliest of which is dated 1758. His exact techniques remain unclear, but he may have used emery powder to reproduce chalk drawings. His colour prints seem to have involved '*à la poupée*' inking and hand-colouring. In England from 1764 Captain William Baillie (1723–1810) produced reproductions of drawings in a technique similar to that used by Ploos.

Some of the most outstanding results in the field of multiple-plate intaglio printing were achieved by Jacob Christoph Le Blon (1667–1741), whose mezzotints, specifically designed to imitate paintings, were produced by superimposing several plates (*see also* MEZZOTINT). It has been suggested that his method relied on the theory of light devised by Isaac Newton (1642–1727). He first produced colour prints in Amsterdam *c.* 1704 before moving to England, where he published *Coloritto, or the Harmony of Colours in Painting* (London, [?*c.* 1723–6]). Le Blon's chief successor in France (he returned there in 1732) was Jacques Fabian Gautier-Dagoty (1716–85), who obtained a privilege to use Le Blon's patent. Gautier-Dagoty produced a number of scientific publications including the serialized *Observations sur l'histoire naturelle, sur la physique et sur la peinture* (Paris, 1752–5). Some of his sons produced similar prints, including Edouard Gautier-Dagoty (1745–83), who seems to have passed on the technique to the Florentine Carlo Lasinio (1759–1838). Joanne L'Admiral (1745–83) worked in this technique in the Netherlands. In 1769 Louis-Marin Bonnet (1736–1793) announced the invention of pastel manner, an adaptation of crayon manner designed to imitate three-colour drawings. He used an exceptional eight plates for his virtuoso

Head of Flora (1769; Herold, p. 126) after François Boucher (1703–70). He also invented the method of using pins to ensure accurate registration of the various plates.

(b) 19th–20th centuries. The relatively low cost of woodblocks and relief processes compared to colour intaglio printing undoubtedly encouraged the development of new techniques in the early 19th century. Chief among these were Baxter prints, patented in 1835 by George Baxter (1804–67). Coloured woodblocks were superimposed over a monochrome key impression from an engraved plate or lithographic stone. The process was basically a refinement of that used by Goltzius, Kirkall and Pond. Between 1849 and 1851 Baxter sold licences of his method to six firms. The high quality of his own prints was not always maintained by these followers. In 1838 Charles Knight (1743–after 1826) patented 'illuminated printing', which differed from Baxter's method in using relief metal plates alone or to colour a wood-engraving. Knight used a modified 'Ruthven' type press, enabling colours to be applied in quick succession to a sheet of paper.

In France the Royal Printing Office experimented with colour woodblocks from the 1820s, producing an *Album typographique* in 1830, using two colours and gold. A more elaborate volume with the same title was published by Gustav Sibermann in Strasbourg in 1840 using four colours with the text in brown; he produced an expanded version of this work in 1872. In Vienna Heinrich Knofler I (1824–86) printed fine-quality ecclesiastical texts. His sons, Heinrich Knofler II and Rudolf Knofler, took over the firm, later publishing reproductions of Old Masters to be sold either separately or as text illustrations.

The inventor of lithography, J. N. F. Alois Senefelder (1771–1834), made numerous refinements to the process from 1801 to 1818, including the introduction of colour. He provided general information on colour lithography in his *Vollständiges Lehrbuch der Steindruckerey* (Munich, 1818), which had colour lithograph illustrations. His methods were introduced into Britain by the publisher Rudolph Ackermann (1764–1834) and the artist Charles Joseph Hullmandel (1789–1850). One of the earliest uses of colour lithography in England was Ackermann's edition (London, 1817) of Senefelder's facsimile of the marginal designs by Albrecht Dürer (1471–1528) for a prayerbook of the Holy Roman Emperor Maximilian I. Most early lithographs were, however, monochrome or hand-tinted. Hullmandel exploited the suitability of lithography for landscape prints, introducing various technical refinements such as 'stump' and the use of a resin to create the effect of washes, known as 'lithotint' (patented 1840). One of the finest achievements of English lithotint is *The Holy Land, Syria, Idumea, Arabia, Egypt and Nubia* (London, 1842–5) by David Roberts (1796–1864), with lithographs after his original watercolours by Louis Haghe (1806–85), issued plain (i.e. with tint-stones alone) or hand-coloured. Tinted topographical

lithographs were not as widely produced in France as in Britain; the English tradition of topographical watercolours accounts for their popularity and suitability as a reproductive medium.

The first appearance of true chromolithography (i.e. the use of numerous colour blocks printed in succession) is probably in the second edition of the collection of poems entitled *Pacis monumentum* (Breslau, 1818) by Johann August Barth (1765–1818), which includes borders of up to six colours. A major contributor to this form of the technique in Britain was Thomas Shotter Boys (1803–74), whose *Picturesque Architecture in Paris, Ghent, Antwerp* (London, 1839) was printed by Hullmandel with a 'Descriptive Notice' pointing out the novelty of the technique. The suitability of chromolithography for reproducing ornamental motifs is evident in *Plans, Elevations, Sections and Details of the Alhambra* (London, 1836–45) by Owen Jones (1809–74) and Jules Goury (1776–1853), in which six or seven colours, including gold, are used. Jones's *The Grammar of Ornament* (London, 1856) marks the peak of his achievement. In Germany early experiments produced *Ornamente und merkwürdigste Gemälde aus Pompeji, Herkulaneum und Stabiae* (Berlin, 1828–59) by Wilhelm Zahn (1800–71). Gold and silver were used by C. H. von Gelbke for a heraldic work (Berlin, 1832). In France early colour lithographs were produced *c.* 1820 by Charles-Philibert, Comte de Lasteyrie du Saillant (1759–1849), but it was not until 1837 that Godefroy Engelmann (1788–1839) patented the chromolithograph process, which was given its present name for the first time. Technically French colour lithography was not comparable to the earlier English productions. In the 1850s Lemercier, Engelmann and Graf produced important work.

The major revival of colour printing, particularly lithography, in France from the late 1880s was encouraged by several factors, including the influence of Japanese prints, the entrepreneurial efforts of such figures as Ambroise Vollard (*c.* 1867–1939) and André Marty, and the rise of new specialized magazines, such as *L'Estampe et l'affiche*. The role of Henri de Toulouse-Lautrec (1864–1901) in the history of poster-making is well known. His major technical contribution was probably the increased range of six or seven colours in contrast to the limited use of primary colours by Jules Chéret (1836–1932), the 'father of modern posters'. The cult of the poster spread across Europe in the mid-1890s. Important work was produced by Manuel Orazi (1860–1934) and Alphonse Mucha (1860–1939) in France, Aubrey Beardsley (1872–98) in Britain and the Secessionists in Austria. Vollard and Marty's portfolios were dominated by the work of Toulouse-Lautrec and the Nabis, all of whom were profoundly influenced by the work of the Japanese printmakers Kitagawa Utamaro (1753–1806) and Katsushika Hokusai (1760–1849). The 12 lithographs *Some Aspects of Life in Paris* (1899; Bouvet, pp. 76–101) by Pierre Bonnard (1867–1947) and the colour lithographs *Landscapes and Interiors* (1899; Roger-Marx, pp. 91–122) by Edouard Vuillard (1868–1940) are representative of

the new work. Much of the impetus behind the revival of colour lithography may lie with Toulouse-Lautrec, whose *Miss Loïe Fuller* (1893) represents his first colour lithograph that was not a poster. Impressions of this remarkable print were heightened with gold or silver powder in imitation of the Japanese use of mica and brass dust. Other painters who produced notable works in colour lithography include James McNeill Whistler (1834–1903), Paul Signac (1863–1935) and Odilon Redon (1840–1916).

The stylistic lessons of Japanese prints are equally evident in the woodcuts of Paul Gauguin (1848–1903) and Edvard Munch (1863–1944). In 1893 Gauguin illustrated his Tahitian journal *Noa Noa* (Paris, 1924) with hand-printed woodcuts cut with a carpenter's chisel, generally on 'end-grain' box-wood blocks intended for wood-engraving. Munch's similarly innovative technique involved the division of the pine-wood plank into separate pieces corresponding to each colour. A second block with the design in black outline was then superimposed. Munch also combined coloured woodcuts and lithography in one image (e.g. *Vampire*, 1895; Prelinger, pp. 142–3; six colours). In Germany Vasily Kandinsky (1866–1944) was using wood or linoblock inked with stencilled-on watercolour pigments, over which a linoblock carrying the design in black was printed (e.g. *The Mirror*, 1907; Derouet and Boissel, p. 60). The chief exponents of the linocut before Pablo Picasso (1881–1973; who developed the 'reduce block' method) were Horace Brodsky (1885–1969) and Claude Flight (1881–1955) and his pupils in Britain from *c.* 1919.

In the field of colour aquatint Mary Cassatt (1844–1926) produced ten beautiful interiors in 1891, strongly influenced by Utamaro. Georges Rouault (1871–1958) executed prints from 1910, combining a number of intaglio techniques such as roulette and etching, brushed acid and drypoint and colour aquatint. Of the many artists experimenting with colour monotype (*see* §3 above), Edgar Degas (1834–1917) used pastel over oil in 1890, Camille Pissarro (1830–1903) worked in coloured ink and Gauguin in watercolour in 1894 and gouache in 1902. Picasso's output of monotypes was characteristically large, both monochrome and colour. In the second half of the 20th century additions to the colour printing field include the colour etching of S. W. Hayter (1901–88), in which inks of different viscosities are deposited at different levels of the plate by the use of a variety of rollers, the dye transfer of Richard Hamilton (*b* 1922), colour Xerox and the latest lithographic technology applied to newspaper colour printing.

R. M. Burch: *Colour Printing and Colour Printers* (London, 1910)

A. Burkhard: *Hans Burgkmair der Ältere* (Leipzig, 1934)

M. Lehrs: *Geschichte und kritische-Katalog des deutschen, niederländischen und französischen Kupferstiches im XV Jahrhundert*, 9 vols (Vienna, 1934/*R* Nendeln, 1969)

J. Herold: *Louis-Marin Bonnet* (Paris, 1935)

S. W. Hayter: *New Ways of Gravure* (London, 1949, 2/1966)

C. E. Russell: *French Colour Prints of the 18th Century: The Art of Debucourt, Janinet and Descourtis* (New York and London, 1949)

Colour in Prints (exh. cat., ed. E. Haverkamp-Begemann; New Haven, CT, Yale University Art Gallery, 1962)

R. McLean: *Victorian Book Design and Colour Printing* (London, 1963)

R. S. Field: 'Gauguin's *Noa Noa* Suite', *Burlington Magazine*, cx (1968), pp. 500–11

M. Twyman: *Lithography, 1800–1850: The Techniques of Drawing on Stone in England and France and their Application in the Works of Topography* (London, 1970)

H. Bock: *Lucas Cranach* (Berlin, 1973)

W. L. Strauss: *Chiaroscuro: The Clair-obscur Woodcuts by the German and Netherlandish Masters of the XVI and XVII Centuries* (Greenwich, 1973)

G. Wakeman: *Victorian Book Illustration: The Technical Revolution* (Newton Abbot, 1973)

C. F. Ives: *The Great Wave: The Influence of Japanese Woodcuts on French Prints* (New York, 1974)

C. Franklin: *A Catalogue of Early Colour Printing: From Chiaroscuro to Aquatint* (Oxford, 1977)

A. Griffiths and F. Carey: *From Manet to Toulouse-Lautrec* (London, 1978)

Colour Printing in England, 1486–1870 (exh. cat., ed. J. M. Friedman; New Haven, CT, Yale Center for British Art, 1978)

The Color Revolution: Color Lithography in France, 1890–1900 (exh. cat., ed. P. D. Cate and S. H. Hitchings; New Brunswick, NJ, Rutgers University, Jane Voorhees Zimmerli Art Museum; Baltimore, MD, Baltimore Museum of Art; Boston, MA, Museum of Fine Arts; 1978–9)

P. Gilmour: *Understanding Prints: A Contemporary Guide* (London, 1979)

A. Griffiths: *Prints and Printmaking: An Introduction to the History and Techniques* (London, 1980), pp. 114–21

The Painterly Print: Monotypes from the 17th to the 20th Century (exh. cat., New York, Metropolitan Museum of Art, 1980)

F. Bouvet: *Bonnard* (London, 1981)

C. Derouet and J. Boissel: *Kandinsky* (Paris, 1984)

E. Prelinger: *Edvard Munch* (London and New York, 1984)

Regency to Empire: French Printmaking, 1715–1814 (exh. cat. by V. I. Carlson and J. W. Ittmann; Baltimore, MD, Baltimore Museum of Art; Minneapolis, MN, Minneapolis Institute of Arts; Boston, MA, Museum of Fine Arts; 1984–5)

G. Adriani: *Toulouse-Lautrec* (Cologne, 1986)

A. Griffiths: 'Notes on Early Aquatint in England and France', *Print Quarterly*, iv (1987), pp. 255–70

Hand-coloured British Prints (exh. cat. by E. Miller; London, Victoria and Albert Museum, 1987)

C. Roger-Marx: *The Graphic Work of Edouard Vuillard* (San Francisco, 1990)

Anatomie de la couleur: L'invention de l'estampe en couleurs (exh. cat., Paris, Bibliothèque Nationale, 1996)

IV. Workshops. Before the 20th century, workshops catering exclusively for reproductive prints of artists' images were practically unknown, and, with a few distinguished exceptions, workshops where artists could produce autographic prints with the assistance of master printers did not proliferate until the 1950s.

1. INTAGLIO. In the field of intaglio printing, one of the earliest workshops of which there is a full account is that of Abraham Bosse (1602–76), the

17th-century Paris engraver and plate-printer. The fundamental techniques of plate-printing have hardly altered since then, and both their persistence and their use internationally are borne out by the account of the equipping in 1714 of a small workshop for intaglio printing by the Antwerp printer Balthasar Moretus (1574–1641). The equipment is precisely similar to that used by Bosse and his predecessors in various parts of Europe. Later manuals, such as that of 1836 by the Paris plate-printers Berthiau and Boitard and, in England, that of 1841 by Theodore Henry Adolphus Fielding (1781–1851), right down to such 20th-century accounts as those by Martin Hardie (1910), David Strang (1930) and Anthony Gross (1970, 1973), describe processes and procedures that have remained virtually unaltered for 500 years.

Early 19th-century London workshops, such as Ackermann's, McQueen's, Dixon & Ross's and Holdgate's, produced work ranging from trade-cards and bill-heads to hunting and racing prints and engraved reproductions of the work of celebrated artists. In response to the burgeoning demand for prints in the first half of the century, all these firms moved into larger workshop premises. The McQueen workshop of 1832 in Tottenham Court Road was among the first to be specially constructed to meet the greater demands of the time. Plans show that the buildings were arranged around an open square and that a separate drying house was placed in the centre. The workshop accommodated 25 to 30 rolling-presses. Dixon & Ross's premises, a little further north in Hampstead Road, were in converted stables. The firm remained there from 1833 until 1966, when it moved to Putney, and it still preserves, at new offices in Binfield, Berks, a practically unbroken record of its transactions. Such eminent engravers as Samuel Cousins (1801–87), Thomas Landseer (1795–1880) and David Lucas (1802–81) were associated with the firm.

Auguste Delâtre (1822–1907) was among the first plate-printers to work exclusively for artists, James McNeill Whistler (1834–1903) being among his clients. Operating in France and (during and after the Franco-Prussian War) in England, he built a high reputation in both countries. In 1862 he helped found the French Société des Aquafortistes, becoming its official printer and basing himself in a workshop in the Rue Saint-Jacques, Paris. Delâtre's English counterpart was Frederick Goulding (1842–1909), apprenticed in 1857 to Day & Son, the well-known lithographers, who also undertook intaglio printing. There Goulding, like Delâtre, collaborated with Whistler.

A good idea of a traditional French plate-printer's workshop may be gained from the largely unaltered 19th-century premises of the Atelier Georges Leblanc at 187, Rue Saint-Jacques, Paris. There, printing was still being carried out in the 1990s on 19th-century presses, with some 18th-century equipment. Like the now-vanished McQueen workshop in Tottenham Court Road, London, the buildings are arranged in an open square, with a separate drying house placed in the centre. A more recently established Paris workshop is that of Jacques and Robert Frélaut in the Rue Foyatier, Montmartre. Established in 1929 by Roger Lacourière, it contains a great deal of early equipment and machinery, including a 17th-century wooden rolling-press. The firm concentrates exclusively on the reproduction of the work of 20th-century artists and has been associated with Marc Chagall (1887–1985), Georges Rouault (1871–1958), Pablo Picasso (1881–1973) and Henry Moore (1898–1986).

The workshop of S. W. Hayter (1901–88) is perhaps the best known among those open to artists. Hayter, who abandoned chemistry to devote himself entirely to art, moved to Paris in 1926. The printmaking workshop that he opened in his Paris studio in 1927 developed into the celebrated Atelier 17. At the outbreak of World War II, Hayter went to London and thence, in 1940, to New York, where he re-established the Atelier. In 1950 Atelier 17 was reopened in Paris, where it still flourishes.

2. LITHOGRAPHY. D. J. Redman was the first native English exponent of lithography, which originated in Munich in 1798 and arrived in England at the beginning of the 19th century (see LITHOGRAPHY). Having learnt the craft from German practitioners in the first decade of the century, Redman established a lithographic press at the Quartermaster-General's Office in Whitehall, London. In 1812 or 1813 he set up the first lithographic press outside London, in Bath, where he printed for both professional and amateur artists. For the next hundred years such artists as Richard Parkes Bonington (1802–28), Théodore Gericault (1791–1824), Eugène Delacroix (1798–1863), James McNeill Whistler (1834–1903), Edgar Degas (1834–1917), Henri de Toulouse-Lautrec (1864–1901) and many others—mainly, though by no means exclusively, in Paris—availed themselves in various ways of the proliferation of lithographic workshops. In 1917 George Miller opened the first lithographic workshop in New York. This was followed by Lynton Kistler's in Los Angeles in the 1940s, and by the 1950s American artists such as Robert Rauschenberg (1925–2008) and Jasper Johns (b 1930) were having their lithographs editioned by Robert Blackburn (1920–2003), who had opened a workshop modelled on Hayter's Atelier 17 and had refined his skills through study in the Desjobert workshop, Paris. In Britain such firms as the Curwen Press and the Baynard Press had by the 1930s developed as excellent printers of colour lithographs, and these and other workshops collaborated with such artists as John Piper (1903–92), Edward Bawden (1903–89), Eric Ravilious (1903–42), Graham Sutherland (1903–80) and many others to bring about a new surge of interest in the technique as a medium of artistic expression. After the war, photomechanical methods revolutionized commercial lithography, and this resulted in an even closer collaboration

between artists and the newly redundant hand-lithographers, many of whom took their skills into the printmaking departments of the Royal College of Art and similar institutions, to which artists were attracted both to teach and to carry out their own work. The most celebrated postwar lithography studio for artists has been the Curwen Studio (now Curwen Chilford Prints), set up in 1959 by Stanley Jones (*b* 1933).

3. SCREENPRINTING. About 1960, after a couple of decades of American domination of the medium, screenprinting became adopted by a number of prominent British artists. Sophisticated technical help had become available with the establishment in London, in 1957, of the Kelpra Studio of Chris and Rose Prater. Alan Davie (*b* 1920), William Turnbull (*b* 1922) and Patrick Heron (1920–99) were prominent among artists exploiting the medium, and, when photographic processes extended its possibilities, Eduardo Paolozzi (1924–2005) and Richard Hamilton (*b* 1922) were among the foremost experimenters.

4. RELIEF. The most important heir to the long European tradition of relief printing was the late 18th-century Newcastle printmaker Thomas Bewick (1753–1828), whose seminal achievement was the development of wood-engraving. After a long association with Ralph Beilby (1743–1817), also of Newcastle, Bewick ran his own workshop, in which he trained many apprentices in both wood- and copper-engraving. Today, relief prints (mainly woodcuts, linocuts and wood-engravings) are frequently editioned by craftsman–typographers. Among those undertaking this work in Britain are Ian Mortimer (of I. M. Imprimit, London), Jonathan Stephenson (of the Rocket Press, Oxon) and Simon Lawrence (of the Fleece Press, Yorks).

A. Bosse: *Traicté des manières de graver en taille-douce* (Paris, 1645)

Henry Bankes's' Treatise on Lithography (Bath, 1813/*R* London, 1816); ed. M. Twyman (London, 1976)

Berthiau and Boitard: *Nouveau manuel complet de l'imprimeur en taille-douce* (Paris, 1836)

T. H. Fielding: *The Art of Engraving* (London, 1841)

M. Hardie: *Frederick Goulding: Master Printer of Copperplates* (London, 1910)

D. Strang: *The Printing of Etchings and Engravings* (London, 1930)

I. Bain: 'Thomas Ross & Son', *Journal of the Printingg Historical Society*, ii (1966), pp. 3–22

L. Voet: 'Een aantekenboek van Franciscus Joannes Moretus', *Gulden Passer*, xliv (1966), p. 234

L. Voet: *The Golden Compasses: A History and Evaluation of the Printing and Publishing Activities of the Officina Pantiniana at Antwerp*, 2 vols (Amsterdam, 1969–72)

A. Gross: *Etching, Engraving and Intaglio Printing* (Oxford, 1970, 2/1973)

Artists at Curwen (exh. cat. by P. Gilmour; London, Tate, 1977)

Thomas Bewick (exh. cat. by I. Bain; Newcastle upon Tyne, Laing Art Gallery, 1979)

A. Dyson: *Pictures to Print* (London, 1984)

Avant-garde British Printmaking, 1914–1960 (exh. cat. by A. Griffiths and F. Carey; London, British Museum, 1990)

S. Turner: *British Printmaking Studios* (London, 1992)

V. Conservation. In many respects the problems encountered in the care and conservation of prints are similar to those of drawings and watercolours: all share the use of paper as a support, and it is here that the major work of the print conservator is centred (*see* PAPER, §VI). The relative stability of the print medium, however, allows for the use of methods of restoration that are not always feasible for drawn or painted works. Black printing inks are generally stable not only in water but also in many of the chemicals used in paper conservation treatments. Hand-coloured prints, however, need to be treated with greater circumspection, especially if the pigments contain white lead or have a varnish applied to the surface.

The quality and condition of the paper support depend on both the history and physical treatment of the work and on the materials used in its manufacture. Paper produced before the mid-19th century is often stronger than later papers, due to the fact that the common fibre type, generally cotton or linen, has a high cellulose content. Few fillers were added, and no chemicals were used in its manufacture. In the later production of paper, wood pulp became increasingly popular as raw material for the paperstock. Wood pulp has much shorter fibres and a lower percentage of cellulose in its makeup. It also has a high content of lignin, an acidic, non-cellulose bonding material. Acids may also be present in the form of residual chemicals that were used in the pulping and bleaching of the paperstock and from some of the sizes, coatings and fillers that were used increasingly from the 19th century. When combined with moisture (present in the humidity of the atmosphere and readily absorbed by the hygroscopic cellulose), acidity in paper leads to the breakdown of the cellulose structure. This process, known as 'acid hydrolysis', is catalysed by heat, provided, for example, by sunlight. Acidic paper becomes discoloured (in severe cases to a biscuit brown) and brittle. The resulting friable condition of the paper means that works are vulnerable to damage when handled. Chemical treatments are not always sufficient to reduce acidity and restore strength; in this instance prints may be backed with a stronger, sympathetic paper, often Japanese paper, which is strong, light and flexible and gives good support without greatly changing the character of the work. Paper should be ideally of a neutral pH (i.e. pH 7). When the pH is low (i.e. the paper is acidic), 'foxing' in the form of small brown spots is commonly found. Foxing may also be associated with the oxidization of iron impurities in the paper. Mould growth, possible in an atmosphere with a relative humidity above 65%, is also encouraged by acidic conditions.

Damage to the paper may result from exposure to a polluted atmosphere, in the form of dust (which becomes embedded in the paper fibres) and chemical attack, for example from sulphur dioxide, which can lead to the presence of sulphuric acid in the paper. Damage may also be sustained from insect attack: bookworms and termites may eat through the paper, leaving numerous small holes and channels.

In practice, most damage sustained by prints is the result of poor handling, framing and misguided attempts at conservation. Careless handling may result in tears, losses and abrasions, marking and staining. Works that are mounted on board other than 100% rag 'conservation' (or 'museum') board or placed in contact with other acidic materials, such as hardboard or other frame backings, will become acidic and discoloured themselves. The material used for hingeing prints and for attaching the glass to the mount can also create problems. White, acid-free paper tape and Japanese paper hinges used with conservation paste are recommended. Metal rings should never be screwed into the backing board, as these will become rusty and penetrate the mount; instead, brass hooks screwed into the edges of the frame should be used. Many attempts at restoring damaged works in the past have resulted in further disfigurement: chemicals have not been completely washed from the paper, causing degradation; sticky mending tapes, such as Sellotape, cause severe brown stains and brittleness of the paper.

The print conservator's job is to prevent damage, as well as to repair it. Prevention entails maintaining a stable environment and filtering out ultraviolet rays from daylight and artificial light. Ultraviolet-absorbing Perspex and polycarbonate (Lexan) can be used to make exhibition cases. Fluorescent tubes should be used with ultraviolet-absorbing sleeves. The amount of sunlight to which prints are exposed should also be stringently controlled, as it can give up to 800 times the level of light recommended for works of art on paper (i.e. 50 lux). Simple measures to prevent over-exposure of prints can include hanging them away from windows on a north wall and covering them with a curtain or cloth when not on view.

Where serious damage has occurred, a wide variety of treatments may be employed to restore the work to its former condition, but such damage is often better left untouched. Standard measures include the use of draft clean powder, backing removal, washing the print, deacidifying, patching, repair (often with Japanese paper) and retouching. One especially pernicious form of restoration that used to be done involved cutting around the design of a damaged print and replacing the whole of the background. When expertly done, it is very hard to detect, because the restoration follows the line of the design. Even expert restoration work, which aims to make an impression appear in perfect condition, tends to deteriorate with time. The paper looks flat and flabby, and the restored areas change colour, while narrow brown strips at the edges of the *verso* show where the impression was taped down during

the work. If retouching is considered necessary, the modern conservator aims to use materials that will make the process reversible.

J. McAusland: *Causes of Damage to Art on Paper* (London, n.d.)

M. Schweidler: *Die Instandsetzung von Kupferstichen, Zeichnungen, Büchern usw.: Alte Fehler und neue Methoden bei der Beseitigung von Alterschäden am graphischen Kulturgut* (Stuttgart, 1950)

How to Care for Works of Art on Paper (exh. cat., ed. F. W. Dolloff and R. L. Perkinson; Boston, MA, Museum of Fine Arts, 1971)

On Mounting of Prints and Drawings, Museums' Association Information Sheet, xii (London, 1972, rev. 1980)

K. Colleran: *The Collector's Guide to Conservation: The Care and Preservation of Prints and Watercolours* (London, 1981)

M. H. Ellis: The Care of Prints and Drawings (Nashville, TN, 1987, rev. Walnut Creek, CA, 2/1995)

C. James and others: *Manuale per la conservazione e il restauro di disegni e stampe antichi* (Florence, 1991)

C. James and others: *Manuale per la conservazione e il restauro di disegni e stampe antichi* (Florence, 1991); Eng. trans. as *Old Master Prints and Drawings: A Guide to Preservation and Conservation* ([Amsterdam, 1997])

Projector. See under MAGIC LANTERN.

Proof. Impression of a print taken from a plate or block, usually before the production of the regular edition. Traditionally, it was often done (as a 'trial') in order to see how the work was progressing. Sometimes the proof is corrected ('touched') by hand by the artist. Printed 'proof' editions of the finished state of the print, but before the addition of lettering or other details, are common from the 18th century.

See also COUNTERPROOF and REMARQUE.

Punch. Small metal tool, usually of iron or steel, tapering to a point at one end, which, when it is struck firmly from the other end, produces an indentation (circular or intricately shaped) used to create decorative patterning. Punches were employed in late medieval painting, and the following account relates principally to that function. However, similar tools are used in leatherwork (*see* LEATHER, §2(ii)) and bookbinding (*see* BOOKBINDING, §I and GILDING, §II, 5). A punch in the form of an iron or steel spike with a small tip is also a type of stonemason's chisel, used to rough out the stone (*see* STONE, §II, 2). Since a punch or puncheon occurs in die-sinking, the term may also relate to the making of coins and medals.

In painting the use of punches is connected to the use of gold, particularly on the backgrounds of panels and manuscript miniatures (*see* GILDING, §§I, 1(ii) and II, 1). Punching, often combined with tooled, incised or painted decoration, introduces surface texture to the burnished gold background. This allows a greater play of light, as well as the differentiation of such elements as haloes. These techniques are described in the late 14th-century treatise *Il libro dell'arte*, by Cennino Cennini (*c.* 1370–*c.* 1440). He also recommended the use of a pointed or multi-pointed (rosette) punch to create stippled effects when combined with SGRAFFITO. Punching on gold

backgrounds may be traced back to 13th-century Italian panel painting, but the development of the technique appears to be closely associated with Duccio and his Sienese workshop; the elaboration and perfection of punching was achieved by the following generation of Sienese artists, including Simone Martini and Ugolino di Nerio. During the 15th century the use of punches in Italian painting declined, being replaced for some purposes with incised lines applied to the ground before gilding.

The quality and extent of punching varied from artist to artist: as many as 11 different punches have been identified on a single painting, although elaborate designs could also be achieved with quite simple tools. The study of punch marks may help identify a certain artist's work, while the recurrence of certain punch patterns on the works of different masters suggests that some punches may have been transported from one workshop to another. For example, punches were apparently imported from Siena to Florence in 1363 by Giovanni da Milano (*fl c.* 1346–69).

C. Cennini: *Il libro dell'arte* (*c.* 1390); Eng. trans. and notes by D. V. Thompson jr (1933)

E. Skang: 'Punch Marks—What Are They Worth? Problems of Tuscan Workshop Interrelationships in the Mid-fourteenth Century: The Ovile Master and Giovanni da Milano', *La pittura nel XIV e XV secolo: Atti del XXIV congresso internazionale di storia dell'arte: Bologna, 1979*, pp. 253–82

Art in the Making: Italian Painting before 1400 (exh. cat. by D. Bomford and others; London, National Gallery, 1989–90) [with bibliog].

J. Dunkerton and others: *Giotto to Dürer: Early Renaissance Painting in the National Gallery* (London, 1991)

E. S. Skaug: *Punch Marks from Giotto to Fra Angelico: Attribution, Chronology, and Workshop Relationships in Tuscan Panel Painting with Particular Consideration to Florence, c.1330–1430*, 2 vols (Oslo, 1994)

M. S. Frinta: *Punched Decoration on Late Medieval Panel and Miniature Painting* (Prague, 1998)

C. B. Strehlke: *Italian Paintings 1250–1450 in the John G. Johnson Collection and the Philadelphia Museum of Art: Appendix II: Punch Marks* (Philadelphia, 2004), pp. 470–82

Punched print. Type of print for which marks are impressed by hammering punches, small metal tools, into the surface of a metal plate, which is then printed by either a relief or intaglio process. The techniques of punch printing evolved in the second half of the 15th century from those used at least since the 12th century in Europe by metalsmiths and leather bookbinders for decorating their products, using small metal punches to impress repetitive design elements into a surface. The ends of the printing punches varied from simple points and dots to more elaborate carved motifs, such as stars, diamonds, fleurs-de-lis and simplified flower or cloud designs. By the 20th century, tools included the dotting punch, matting punch and ring punch.

The first prints using the above techniques appeared in Germany and the Netherlands, a large number emanating from the Cologne region. Many of these have historically been referred to as dotted prints, from the overwhelming use of round dots as decorative elements in the composition (*see* DOTTED PRINT). Only one such print, a *Raising of Lazarus* (*c.* 1470), bears a signature (reading 'Bartholmeus'; Schreiber, no. 2218), and a minimum of others have initials; they have been classified by style and occasionally by indications of place. Only one print is dated (1454; Schreiber, no. 2567): *St Bernard of Siena* (Paris, Bibliothèque Nationale). Virtually all punched prints of this period include standard line-engraving techniques in addition to the strict use of hammered punches. Punched prints also appear in several later 15th-century illustrated books from Germany, the Netherlands and France. Fifteenth-century punched prints were printed in a relief manner, inking the unworked surface of a plate, leaving the impressed design elements to appear as white accents on a black ground. They often have the marks of nailholes at their corners, perhaps indicating attachment to a woodblock for printing on a press used for woodcuts and letterpress type. Several surviving 15th-century plates are made of copper, but some scholars have also argued for the use of a softer metal, perhaps lead or a pewter alloy.

In later centuries, the design elements of punched prints were usually impressed positively, and the plates were printed in an intaglio manner. In Germany *c.* 1580, prints produced by punching very fine points into a plate appeared, often as linear compositions with a minimum of shading, producing black-line designs when inked and printed. Goldsmith-engravers such as Franz Aspruck (*b c.* 1570/80), Hieronymus Bang (1558–1629/33), Paul Flindt II (1567–1631 or later), Jonas Silber (*fl* 1572–89), Mathias Strobel (*d* 1570), Bernhard Zan (*fl* 1580s) and the Kellerthaller family used them as patterns for decorative objects such as goblets and beakers. At least two 17th-century Dutch goldsmiths executed more elaborately shaded punched prints. One landscape is attributed to Paulus van Vianen (*c.* 1570–1613), and a number of portrait prints are signed by Johannes Lutma II (1624–89) and inscribed '*opus mallei*' (hammer work). Lutma's portraits are carefully built-up densities of varied marks in the plate, which when printed resemble wash drawings.

On occasion, letter punches were used to impress place-names and captions on engraved maps of the 15th and 16th centuries. As late as the 19th century, punches were at times used to produce areas of texture in combination with stipple or crayon-manner techniques, but punched prints do not occur as a specific class. Similarly prints made in the late 20th century by artists who use hammers or electric drills on their printing plates cannot be included in the proper definition of punched prints.

Theophilus: *De diversis artibus* (*c.* 1100); Eng. trans. by C. R. Dodwell as *The Various Arts* (London, 1961), pp. 130–31

S. R. Koehler: 'White-line Engraving for Relief-printing in the XV and XVI Centuries', *Report of the National Museum: 1890* (Washington, 1892), pp. 385–94

C. Dodgson: *Catalogue of Early German and Flemish Woodcuts Preserved in the … British Museum*, 2 vols (London, 1903–11), pp. 152–66

P. Gusman: *La Gravure sur bois et d'épargne sur métal du XIVe au XXe siècle* (Paris, 1916), pp. 34–52

P. Jessen: *Der Ornamentstich* (Berlin, 1920), pp. 115–21

A. M. Hind: *A History of Engraving and Etching* (London and New York, 1923/R 1963), pp. 10–11, 290–91

W. L. Schreiber: *Die Meister der Metallschneidekunst nebst einem nach Schulen geordneten Katalog ihrer Arbeiten* (Strasbourg, 1926)

W. L. Schreiber: *Handbuch der Holz- und Metallschnitte des XV. Jahrhunderts*, 8 vols (Leipzig, 1926–30); as 10 vols (3/Stuttgart, 1969) [Schreiber]

A. M. Hind: *An Introduction to a History of Woodcut with a Detailed Survey of Work Done in the Fifteenth Century*, 2 vols (London and New York, 1935/R 1963), pp. 175–97, 679–80

C. Dodgson: *Prints in the Dotted Manner and Other Metal-cuts of the XV Century in the … British Museum* (London, 1937)

C. S. Ackley: *Printmaking in the Age of Rembrandt* (Boston, 1981), pp. 31–2, 280–81

T. Campbell: 'Letter Punches: A Little-known Feature of Early Engraved Maps', *Print Quarterly*, iv (1987), pp. 151–4

F. Koreny: 'Notes on Martin Schongauer', *Print Quarterly*, x/4 (Dec 1993), pp. 385–91

Q

Quillwork. Collective term for artefacts made of or decorated with porcupine quills. The art of quillwork is distinctively North American. Quills from the porcupine were most often used (*Erethizon dorsatum* in the east and *E. epixanthum* in the west), although bird quills were also worked, and moose hair, coloured grasses and dyed cornhusks were employed in a similar way. Real quill embroidery was practised throughout most of the habitat of the porcupine, from eastern Alaska across the northern forest to Nova Scotia, and south in the Rocky Mountains, on the Plains and in the Great Lakes region. After European contact, through the second half of the 19th century, imported Venetian trade beads replaced the use of quills in embroidery, but more recently, in the 20th century, Native American cultural pride has brought the return of interest in traditional quillwork techniques.

The quills differed in size, the largest ones coming from the tail of the animal and then decreasing in size across the back to the neck, to slim and delicate quills from the belly. The quills were plucked out of the skin of the animal, and then, after the barb at the tip had been cut off, they were washed and dyed. Dyeing was done simply by boiling the quills and dyeing material together in water until the required colour was obtained. Native materials for dye-making were plentiful and varied from region to region. The inner bark of trees and dried or shredded roots were most often used, frequently mixed with such minerals as black earth, ochre and grindstone dust, all of which contain iron to act as a setting agent (mordant); berries, plants and flowers were also used. Among the Slavey indigo was used for blue, indigo and turmeric for green, turmeric for yellow and cochineal for red. During the second half of the 19th century a wider variety of bright aniline dyes was traded from Europe.

After being washed, dyed and sorted, quills were stored in containers of animal bladder or rawhide. Before the quills were applied to soft tanned leather, they were softened to make them more workable, either in warm water or in the quillworker's mouth. As she needed quills, she drew them out and flattened them between her teeth, with her fingernails or with a bone or wood quill-flattener. The most important techniques for applying the quills to the leather were wrapping, a great variety of sewing, plaiting and, in northern Canada, a type of loom-woven method.

Feder (1987) has shown that the use of bird quills was much more important than Orchard (1916) had originally suggested. Bird quills were often combined with porcupine quills, and on the Plains among the Hidatsa, at least, bird quills were preferred. There were three important centres for bird-quill embroidery: the upper Missouri River area, the upper Mississippi River area and among the Northern Athapaskan, Cree and Eskimo.

Archaeological evidence suggests that porcupine quillwork has long been practised in North America. The earliest and main evidence comes from Nevada and Utah, where specimens preserved in caves suggest the use of quills as a bonding element as early as 530 BC and as decoration on moccasins from the 13th and 14th centuries AD (Loud and Harrington, p. 24; Libby, no. 276; and Martin, Quimby and Collier). Ling Roth has suggested that quillwork possibly had its beginnings in Asia, citing examples of woven mats and baskets from Asia that show the same basic weaving and sewing techniques as employed in quillwork in North America (Roth, pp. 1–4).

Some of the earliest extant examples of quillwork are to be found in European museums, for example: an elaborate quill-embellished shirt, probably from the region just north of Lake Huron and collected prior to 1683 (Oxford, Ashmolean); the Sloane and Christy material in the Museum of Mankind, London (Braunholtz, p. 25 and King, pp. 51, 65); and the collection of early moccasins and headdresses in the Musée de l'Homme, Paris (Fardoulis). Porcupine-quill decorated bags, pouches and robes, dating before 1800 and in the collections of the Museum of the American Indian, Heye Foundation, New York, are described in Orchard (1926, pp. 59–68). While most of these specimens are from a region east of the Great Plains, they exhibit wrapped, woven, and sewn techniques virtually identical to those found on later Plains specimens.

W. C. Orchard: *The Technique of Porcupine Quill Decoration among the Indians of North America*, Contributions from the Museum of the American Indian, Heye Foundation, iv/1 (New York, 1916/*R* 1971)

H. L. Roth: 'American Quillwork: A Possible Clue to its Origins', *Man* (1923)

W. C. Orchard: *Porcupine-quill Ornamentation*, Indian Notes of the Museum of the American Indian, Heye Foundation, iii/2 (New York, 1926)

L. L. Loud and M. R. Harrington: *Lovelock Cave*, University of California Publications in American Archaeology and Ethnology, xxv/1 (Berkeley, 1929)

C. Lyford: *Quill and Beadwork of the Western Sioux* (Lawrence, KS, 1940)

P. S. Martin, G. I. Quimby and D. Collier: *Indians before Columbus* (Chicago, 1947)

W. F. Libby: 'Radiocarbon Dates, II', *Science*, cxiv (1951), pp. 291–6

G. Turner: *Hair Embroidery in Siberia and North America*, Pitt Rivers Museum Occasional Papers on Technology, vii (Oxford, 1955/R 1976)

F. Fenenga: 'An Early Nineteenth-century Account of Assiniboine Quillwork', *Plains Anthropologist*, iv (1959), pp. 19–22

C. Taylor: 'Early Plains Indian Quill Techniques in European Museum Collections', *Plains Anthropologist*, vii (1962), pp. 58–69

H. Dempsey: 'Religious Significance of Blackfoot Quillwork', *Plains Anthropologist*, viii (1963), pp. 52–3

H. Benndorf and A. Speyer: *Indianer Nordamerikas, 1760–1860* (Offenbach, 1968)

H. J. Braunholtz: *Sir Hans Sloane and Ethnography* (London, 1970)

N. Feder: *American Indian Art* (New York, 1971)

A. Best and A. McClelland: *Quillwork by Native Peoples in Canada* (Ontario, 1977)

A. Fardoulis: *Le Cabinet du Roi, et les anciens cabinets de curiosités dans les collections du Musée de l'Homme* (Paris, 1979)

C. Taylor: 'Costume with Quill-wrapped Hair: Nez Perce or Crow?', *American Indian Art*, vi/3 (1981), pp. 42–53

J. M. Bebbington: *Quillwork of the Plains* (Calgary, 1982)

J. C. H. King: *Thunderbird and Lightning* (London, 1982)

R. H. Whitehead: *Micmac Quillwork* (Halifax, 1982)

G. Turner: *Tradescant's Rarities* (Oxford, 1983)

Ottawa Quillwork on Birchbark, Harbor Springs Historical Commission (Harbor Springs, MI, 1983)

N. Feder: 'Bird Quillwork', *American Indian Art*, xii/3 (1987), pp. 46–57

C. Taylor: 'Early Nineteenth Century Crow Warrior Costume', *Jahrbuch des Museums für Völkerkunde zu Leipzig*, xxxvii (1987), pp. 302–19

J. Thompson: '"No Little Variety of Ornament": Northern Athapaskan Artistic Traditions', *The Spirit Sings: Artistic Traditions of Canada's First Peoples* (Toronto, 1987), pp. 133–68

K. C. Duncan: *Northern Athapaskan Art: A Beadwork Tradition* (Seattle and London, 1989)

B. Hail and K. C. Duncan: *Out of the North: The Subarctic Collection of the Haffenreffer Museum of Anthropology* (Providence, RI, 1989)

D. W. Penney: *Art of the American Indian Frontier: The Chandler-Pohrt Collection* ([Detroit] and Seattle, 1992)

L. S. Dubin: *North American Indian Jewelry and Adornment: From Prehistory to the Present* (New York, 1999)

J. Thompson and others: *Fascinating Challenges: Studying Material Culture with Dorothy Burnham* (Quebec, 2001)

C. McLaughlin: *Arts of Diplomacy: Lewis and Clark's Indian Collection* (Cambridge, MA, 2003)

Quilting. Method of securing wadding between two layers of fabric with lines of stitching, or a decorative technique employing various forms of padding. From the earliest times simple wadded quilting was used to make furnishings and warm and protective garments and it survives in this form throughout the world. Decorative quilting, worked usually in running or back stitches, also has a long history. Some of the earliest examples come from sites dating from the 1st century AD in the Noin Ula Mountains of northern Mongolia; they include a wadded carpet (St Petersburg, Institute of Archaeology) that has a centre quilted in an all-over pattern of spirals and a border of diamond quilting and applied animal shapes with contour-quilted fillings. Both patterns and techniques remain part of the quilter's repertory.

European references to protective quilted garments first occurred in the 12th century, and such furnishings as bed quilts are recorded with increasing frequency from *c.* 1300. The most spectacular example of early European quilting is a large cover of *c.* 1400, now in two pieces (London, Victoria and Albert Museum; Florence, Palazzo Davanzati), which is decorated with scenes from the story of Tristan, floral motifs and inscriptions in a Sicilian dialect. It is worked in back stitch, not on a wadded base but through a double layer of heavy linen. The motifs were raised by being stuffed with pieces of cotton pushed through the more loosely woven backing. This technique, now known as stuffed quilting or *trapunto*, is related to that of cord quilting, in which cords or thick twisted threads are inserted from the back between narrow parallel lines stitched through two layers of fabric. The two techniques are combined in a 15th-century coverlet (London, Victoria and Albert Museum; New York, Cooper-Hewitt Museum), in which stuffed leaf and animal motifs are contained within octagonal and diamond-shaped compartments outlined in cord quilting.

These techniques and variants on them were also practised outside Europe, notably in Persia (now Iran) and India. In the 16th and 17th centuries, as trade between India and Europe increased, the interchange of goods and ideas had a marked effect on European quilting. Among the imported goods were Indo-Portuguese covers and hangings of cotton backed with cotton or jute and thinly wadded, produced mainly in the area around Satgoan, near Calcutta. The patterns of these textiles, a combination of Indian and European motifs, were embroidered with yellow or red silk in chain stitch on a quilted ground. Of the surviving examples, several bear European coats of arms, such as those of the Portuguese family of Lima da Villa Norvada Cerveira on a cover in the Victoria and Albert Museum, London. By the late 17th century the thinly wadded quilts and other chain-stitch embroideries were being copied in Europe, and the colourful chain-stitch patterns were often set against grounds flat-quilted in back stitch. Flat or false quilting was increasingly used during the first half of the 18th century to decorate the backgrounds of silk as well as linen and cotton embroideries.

Another group of early 17th-century, Indo-Portuguese quilts was decorated with a form of quilting worked between two layers of thin silk in a

double-sided technique not found in Europe. Thin rolls of soft cotton were used as in cord quilting, but without forming the hard outlines of European work; they were doubled or trebled to fill out small figurative motifs in an effect that was closer to European stuffed quilting. To make the quilts double-sided, however, the shaped padding had to be put in as the outlines were stitched.

Wadded quilting was popular during the 17th and 18th centuries for furnishings and for such garments as informal jackets, night-caps and women's petticoats. When made of silk, petticoats were acceptable for formal wear, particularly in the period c. 1735 to 1765. Quilted dresses were also worn. It is possible that some of the finest pieces, which combined corded and stuffed effects but which were double-sided, were made in India for the European market. Under the impetus of imports, European cord quilting grew in popularity during the late 17th century; it was used for a variety of objects from baby caps to bed-hangings and was worked both densely and in the form of isolated motifs on a plain ground. During the period c. 1720 to 1760 it was often combined with whitework on such items as men's linen waistcoats. From as early as 1703 Marseille is known to have been an important centre for cord quilting, worked initially on Indian cotton, and in 1783 the English Society for the Encouragement of Arts, Manufactures and Commerce offered a premium for the successful imitation of Marseille quilting on the loom. This was achieved by weaving a cotton double-cloth with a heavy cording weft enclosed between the two layers. Imitation Marseille quilts became an important branch of the Lancashire cotton industry from the late 18th century to the early 20th.

The use of decorative quilting declined in the late 18th century, although simple quilting survived into the 19th as a practical means of making such garments as dressing-gowns and a variety of household furnishings. PATCHWORK was a more popular method of producing decorative covers, although the two techniques were often combined, notably in North America (see colour pl. XI, fig. 2). There bed quilts served both a practical and a decorative purpose, and quilting bees were held to help friends in quilting together the patchwork top and wadded base.

Quilting clubs served a similar purpose in the north of England, where, as in Wales, the plain quilted face of a cover was valued more highly than the patchwork side.

In the 20th century interest in quilting declined sharply in Europe and North America, although there were enough practitioners to keep the craft alive. Sometimes there was active encouragement, as in the 1960s, when the Rural Industries Bureau sought to revive quilting in Durham on a semi-commercial basis, but it was not until the 1970s that it was rediscovered by embroiderers. Since then it has enjoyed a remarkable revival both for practical use, in garments as well as furnishings, and as a decorative method to be used alone or in combination with other textile techniques to create art objects for gallery display.

B. Scott: *Quilting in the North Country* (Leicester, 1928)

M. Symons and L. Preece: *Needlework through the Ages* (London, 1928)

B. Scott: *The Craft of Quilting with a Note on Patchwork* (Leicester, 1932)

E. Hake: *English Quilting Old and New* (London, 1937)

M. Fitzrandolph: *Quilting* (London, 1954, 4/1972)

M. Fitzrandolph: *Traditional Quilting: Its Story and Practice* (London, 1954)

A. Colby: *Quilting* (London, 1965, 2/1972)

V. Churchill Bath: *Needlework in America* (London, 1979)

S. Betterton: *Quilts and Coverlets* (Bath, 1982)

S. Betterton: *More Quilts and Coverlets* (Bath, c. 1983)

D. Osler: *Traditional British Quilts* (London, 1987)

E. V. Warren and S. L. Eisenstat: *Glorious American Quilts: The Quilt Collection of the Museum of American Folk Art* (New York, 1996)

D. Cameron: *Dancing at the Louvre: Faith Ringgold's French Collection and Other Story Quilts* (New York, 1998)

Quilt Studies: The Journal of the British Quilt Study Group (Halifax, 1999–)

S. S. Takeda and L. S. Roberts: *Japanese Fishermen's Coats from Awaji Island* (Los Angeles, 2001)

J. Beardsley and others: *Gee's Bend: The Women and their Quilts* (Atlanta, 2002)

S. Queen and V. L. Berger, eds: *Clothing and Textile Collections in the United States: A CSA Guide* (Lubbock, 2006)

L. Eaton: *Quilts in a Material World: Selections from the Henry Francis du Pont Collection* (New York, 2007)

R

Réchampi [Fr.: 'set off']. Carved ornament picked out in gold-leaf or in a strong contrasting colour.

Reducing glass. Small hand lens with a double concave shape, which reduces the image of the object viewed. It is used to gauge the effect of reproducing a work in a smaller size.

Redware. See CERAMICS, §I, 2(i) Earthenware.

Registration. Term used in multi-plate printing for the correct alignment of the paper with each plate or block. It is especially important in colour printing. Register marks, such as crosses, triangles or some other device, are frequently employed to ensure accuracy.

Relief sculpture. Form of sculpture in which the ornaments or figures are attached to a background, from which they stand out to a greater or lesser degree, being accordingly known as high relief or low relief (bas relief). It is commonly used for architectural decoration, and also for pictorial narration. This is because sculpture in the round is usually limited to not more than three figures in a group, constraining the amount of incident that can be depicted; furthermore, it excludes all but the most elementary references to a setting. The capacity of relief sculpture for narration has often led artists, including Leonardo da Vinci (1452–1519) and Michelangelo (1475–1564), to associate it with the art of painting, rather than with sculpture in the round.

A natural, elementary form of relief is produced by scratching a design on the surface of a material and then enhancing the linear effect by chiselling off matter to one side. This gives a slight convexity to the contours of the figures depicted, as in ancient Egyptian sunk reliefs, in which the surrounding surface was used not only to depict graphically the natural surroundings or attributes of the figures, but also as a field for writing, with hieroglyphs incised into the original face of the slab in a way that negated any illusion of real appearances. Colour and gilding were normally applied to improve legibility and to give a decorative effect.

True relief carving consists of cutting away the material all round the figures, down into the thickness of the slab, to a more or less uniform or flat background plane. This approach was normally used in antiquity by the Egyptians, the Assyrians, and notably by the Greeks (see fig. 1), as in the frieze and metopes of the Parthenon (London, British Museum). The Romans used it, not only on buildings (particularly triumphal arches; see fig. 2), but also on sarcophagi, and, uniquely, on triumphal columns, such as Trajan's Column (Rome, Trajan's Forum; plaster cast, London, Victoria and Albert Museum). The technique was especially effective when applied in miniature to a stone with different coloured layers, such as onyx, agate or chalcedony, or to a sea shell; there the figures could be left reserved in a white layer, relieved against the diverse, naturally coloured background of the layer below. On occasion three such layers might be utilized to still more dazzling effect: for example a brown or black layer used in the top plane for a Negro face, set off against a white garment cut from the layer below, and then a background of diverse hue from the lowest layer. This technique, called cameo carving, should be distinguished from intaglio carving, which is relief carving in reverse, with figures being excavated out of a material, such as a gemstone. A translucent stone or piece of crystal or glass was often used, so that when the intaglio was held up against the light, the figure showed up paler than the surrounding plane, as there was less thickness of material behind it. Intaglios were frequently used as moulds, to be pressed into a pliable material, such as warm sealing-wax, for use as seal matrices and signet rings.

It is also possible to model reliefs on a board, starting with a flat bed of clay or wax, and building up figures or ornament on top. Reliefs made in this way could be easily cast in metal for greater durability or value. Gold, silver and bronze were normally used; the last was often in turn gilded, to resemble gold, while having greater tensile strength. Simple reliefs, with the figures modelled so that they project no more than halfway out of the background, and thus with no undercutting, are easy to cast in a mould and therefore to replicate: typical examples are medals and plaquettes of the Renaissance

1. Relief sculpture of *Demeter and Kore Exalting the Flower,* relief from Pharsalos, 470–460 BC (Paris, Musée du Louvre); photo credit: Erich Lessing/Art Resource, NY

(see fig. 3), Baroque and Romantic periods, by artists ranging from Pisanello (1395–*c.* 1455) and Andrea Riccio (1470–1532) to David d'Angers (1788–1856) and Thomas Woolner (1825–92).

In much relief carving there is a tendency to 'respect' the original front plane of the material, by keeping the foremost protrusions of the figures level with it, and frequently also leaving a surrounding frame, which may be plain or decorated. The action of the figures thus takes place in a tranche or sandwich of space between an actual rear plane cut into the block and a notional but easily apprehended front plane, the remains of the original surface of the slab. How the sculptor disposes his figures to fit within this space gives the carving its character. In Egyptian art, Romanesque art and also in the mid-20th century (e.g. the work of Eric Gill (1882–1940)) frequent use was made of clever and charming stylization, in which, for example, the head and legs of a figure are seen in profile, but the torso from in front (the 'characteristic' views). Typical examples are the figure of *Eve* by Giselbertus (*fl c.* 1120–40) on the portal of Autun Cathedral, and the sequence by Henri Matisse (1869–1954) of a progressively more abstracted nude woman with a tress of hair, seen from behind (*Backs* I–IV, 1955–6; London, Tate). A further refinement is that the various tranches of space receding towards the furthest plane or background may be substantially reduced in comparison with what should be their real proportionate depth: a great distance may be represented in a physical

depth of just a few millimetres, as in the special technique practised by Donatello (1386/7–1466) of shallow relief or *rilievo schiacciato.*

The tympana of Romanesque churches, such as the basilica of Ste Madeleine, Vézelay (Yonne), display a vibrant range of reliefs of various depths and intricate shapes, with figures on radically diverse scales, bound together by the encompassing remnants of the front plane of the blocks of stone from which they are hewn. The implicitly continued physical existence of much of the original front plane emphasizes the architectural function of the relief, by relating it to the unadorned surface of the surrounding wall that it physically helps to support.

The same materials may be used for relief sculpture as for sculpture in the round, although organic materials with grains, such as wood, bone and ivory, are often turned horizontally, to accommodate a frieze of figures; this may affect the sculptor's style, as the figures are then cut across the grain.

Relief sculpture has been used in every period and place. Its character has normally reflected that of contemporaneous sculpture in the round, but with differences imposed by the nature of the medium: principally the problems of suggesting depth greater than that possessed by the piece of material being carved. Although relief sculpture has played a continuous role from its use as one of the earliest forms of art to the present day, by the end of the 20th century it had waned in importance. Owing to the permanence of its materials it has served admirably as a vehicle for creating a visual

2. Relief sculpture of the *Spoils of Jerusalem*, marble, AD 8, detail of a photograph of the Arch of Titus, Rome, by Robert MacPherson, albumen silver, 408×310 mm, 1850 (Los Angeles, CA, J. Paul Getty Museum); photo credit: The J. Paul Getty Museum, Los Angeles

record of historical events and religious beliefs; indeed, carved reliefs constitute the principal record of many of the great civilizations of the past.

B. Myers: *Sculpture: Form and Method* (London, 1965)

R. Butler: *Western Sculpture: Definitions of Man* (New York, 1975)
Sculpture, Newsweek Books (New York, 1975)
R. Wittkower: *Sculpture* (London, 1977)
G. Bazin: *A Concise History of World Sculpture* (London, 1981)

3. Medal by Matteo de' Pasti: *Leon Battista Alberti* (obverse), bronze, 1454–6 (Florence, Museo Nazionale del Bargello); photo credit: Scala/Art Resource, NY

Relining. The addition of a new canvas to the back of an existing one that has deteriorated, in order to extend the life of the ageing support and possibly repair and renovate the paint and ground layers. There are three basic methods of relining. Relining with glue, probably dating from the 17th century, uses a paste of vegetable starch made from wheat or rye flour and animal glue, with various additions. The advantages of this method are that it has little or no effect on the quality and appearance of the paint and ground layers, acts partially to rejuvenate them and is fully reversible. Possible disadvantages are that the substantial presence of moisture during the process makes skill and experience essential, as the canvas may contract and the paint and ground layers may be loosened, and glue relining also needs to be redone periodically. The second method, the use of wax combined with resin, often with minor additions, may have originated in the 18th century and has been in common use since the 19th century. In this method beeswax and dammar resin (and, in the late 20th century, microcrystalline wax and various synthetic resins) are made to penetrate and adhere by means of heat. The advantages of this method are the absence of moisture and any risk of mould growth, and the stability of the wax medium and the permanence of its bonding. Although this method overcomes defects in the paint layer, it only arrests the ageing process and does not restore the original physical qualities of the painting. It is not suitable for works in lean media, such as egg tempera or glue size, as it may alter their appearance; there is a slight risk even with oil paintings,

as the optical properties of the ground may be altered once penetrated by wax. While it is easy to repeat a wax-based relining treatment, the process is not fully reversible, nor can all trace of the adhesive be removed.

The third method, using synthetic resins, has been in general use since the 1950s. There are two approaches. The first involves a light bonding of synthetic adhesive with the fabric being relined; in the second the canvas and ground are deeply impregnated with synthetic resin. Thermoplastic adhesives are employed, usually forms of acrylic. The advantages of this method are the permanence, stability and colourlessness of the resins; the disadvantages are the limited improvement of the painting's surface and, in the case of impregnation, the irreversibility of the process. Current practice is to consolidate the degraded painting with a resin prior to a separate relining operation. Fibreglass lining fabric may be used instead of canvas.

With the modern trend towards minimal conservation procedures, full relining is no longer an automatic choice; strip lining damaged canvas margins, for example, leaves most of the canvas in an authentic state. Commercially a form of dry mounting may be employed for relining. 'Loose lining' protects a canvas with another, unattached, piece of cloth put over the same stretcher; for works on paper, Japanese tissue may be used to back the deteriorating sheet.

See also CANVAS, §3 and OIL PAINTING, §2.

B. Soldenhoff: 'Colouristic Changes in Oil Paintings after a Wax Resin Reline', *Konserwacja Malarstwa* [The conservation of painting], *Warszawa Seria B.27* [Warsaw, Series B.27] (Warsaw, 1970)

V. R. Mehra: 'Comparative Study of Conventional Relining Methods and Materials and Research towards their Improvement', *International Council of Museums Conference: Madrid, 1972*

W. Percival-Prescott: 'The Lining Cycle', *Conference on Comparative Lining Techniques: National Maritime Museum: Greenwich, 1974*

V. R. Mehra: 'Cold Lining and its Scope', *International Council of Museums Conference: Copenhagen, 1984*

W. Percival-Prescott and P. Boissonnas: 'Alternatives to Lining', *International Council of Museums Conference: Copenhagen, 1984*

Remarque [Fr.: 'remark, notice, observation']. Scribble, sketch or doodle on a print made by the artist outside his main design. The practice started as a way of testing the strength of the acid on a plate about to be etched before risking the biting of the image. *Remarques* were usually burnished away before printing, though occasionally some marginal marks were deliberately left in some printed editions to exploit the collector's desire for rarities; such prints are known as 'remarque proofs'.

Repoussage [from Fr. *repousser*: 'to push back']. Term applied to the process of hammering the back of a metal printmaking plate to remove an engraved or etched mistake or to flatten the plate for reuse.

Repoussé. Term applied to embossed decoration on metal, which is hammered from the back to create a design in relief (see fig.; *see also* METAL, §III, 2(ii)(c)).

Resin. Material of either natural or synthetic origin, used by artists and conservators for ADHESIVES, binding media (*see* VEHICLE) and VARNISH. All resins are insoluble in water, but wholly or partly soluble in other liquids such as drying oils, alcohol or turpentine.

1. NATURAL. With the exception of shellac, natural resins are of vegetable origin and the more readily available of them have been used by artists since the earliest times. In the temperate latitudes of the northern hemisphere the main source of resins are the conifers (Coniferae family), particularly those of the Pinaceae and Cupressaceae subfamilies. The former includes the most abundant source, the pines (yielding common turpentine which, by distillation, yields oil of turpentine and residual rosin or colophony), along with the larches (the source of Venice turpentine) and the firs (Strasbourg turpentine and Canada balsam); while the latter includes the source of the North African sandarac resin. In the southern hemisphere the genus *Agathis* (Araucariaceae) is the principal source of coniferous resins, including *kauri* from New Zealand.

All the above are 'soft', solvent-soluble resins, the solid components of which are largely diterpenoid (C_{20} compounds) and low molecular weight polymers formed from them. They are therefore common ingredients of spirit varnishes made with oil of turpentine or alcohol. Another group of resins consisting mainly of insoluble and more highly polymerized diterpenoids (the so-called 'hard' resins) comes from several genera of leguminaceous tropical trees and includes the African and South American copals. These can only be brought into solution by fusing or 'running', being then mixed with hot drying oil to yield thick oil varnishes. Such varnishes can also be made with such 'soft' resins as colophony. They must have been those in use before solvents became available.

A further group of resins contains triterpenoids (C_{30} compounds) rather than diterpenoids. These come mainly from tropical trees of the Dipterocarpaceae family (the dammars, important as varnishes, from South-east Asia) or the Burseraceae (elemis and others; South-east Asia and tropical America), but one small group from Pistacia species originates in the Near East and Mediterranean countries. This includes the varnish resin mastic, which comes from a variety of *P. lentiscus* growing on the Aegean island of Chios, and terebinth resin or Chios turpentine from *P. atlantica*, a large tree that was once common in the Near East. This soft, balsam-like material was probably much used in Antiquity until felling of the trees reduced the supply. Natural rubber is also drawn from trees (*Hevea braziliensis*), though very similar materials are produced synthetically. Rubbers in solid form are used occasionally for collages. A wider use

Repoussé buckle end, gold, from Norway, 9th century (Oslo, Universitetets Oldsaksamling); photo credit: Werner Forman/Art Resource, NY

is as pressure sensitive tapes. Both forms are extremely unstable and frequently cause damage to works of art.

Shellac is produced by an insect, *Laccifer lacca* (*Kerria lacca*), which infests a number of possible host trees (*see* LACQUER, §I, 2). It is cultivated in India, the main source of supply, and is a low molecular weight polymer formed by interesterification of several different hydroxy acids. It is usually used as a varnish in alcohol solution (so-called French polish, *see* WOOD, §III). Baltic AMBER or succinite is a fossil material many millions of years old. Highly polymerized, amber is consequently very incompletely soluble. However, in addition to its use in the decorative arts, it has been used to make oil resin varnishes in the same way as the copals.

2. SYNTHETIC. Synthetic resins can be divided into two main categories: thermoplastics and cross-linking resins. All are polymers made by reacting monomers together chemically. Thermoplastics can be melted and moulded while hot and most can be dissolved in solvents. The molecules in cross-linking resins

combine once the polymer has been formed and cannot subsequently be melted or dissolved. Polymers can be soft and flabby like polyethylene bags, or stiff and rigid like glazing sheet. Most polymers are modified for use by blending with other resins, fillers, colorants or stabilizers. They became ubiquitous in the 20th century, either forming complete objects, or used for components, adhesives and coatings. All these resins, whether used as a minor component, for example as picture varnish, or more extensively in an art work, degrade more or less rapidly. This process is speeded up by light, oxygen and contamination with metals and is frequently accompanied by oozing out of oils (plasticizers), cracking, warping and discoloration. The conservation of degraded synthetic resins was only addressed from the 1980s (Allen and others).

Polymer technology began in the 1850s with the invention of cellulose nitrate, produced by reacting cotton (cellulose) with nitric and sulphuric acids. Alexander Parkes (1813–90), a prolific English inventor, compounded the resulting gun-cotton with camphor and fillers to make Parkesine, a mouldable plastic.

In the USA John W. Hyatt (1837–1920) improved the material, creating the commercially successful celluloid. For over 100 years this was used for decorative and utilitarian objects, and cellulose nitrate lacquers became standard. Cellulose nitrate solutions were also widely used as consolidants and adhesives in the conservation of objects. Unfortunately, cellulose nitrate is highly unstable and will self-destruct. Many cinema films, for example, have been lost because of the deterioration of the polymer base. Cellulose acetate was produced as a safer, though less tractable, alternative to the nitrate by reacting cellulose with acetic and sulphuric acids. It displaced the nitrate from many of its uses and remains the normal base material for photographic film. It was also used for some decades in the lamination of fragile paper, but can degrade catastrophically, leading to the loss of the object.

The first totally synthetic polymers were the Bakelite resins, widely used from 1910 for rigid, moulded objects such as radio cabinets. Phenol and formaldehyde react together to form a prepolymer that is mixed with fillers and reacted under great pressure and heat to cure the resin. Later developments included urea-formaldehyde (UF) and melamine-formaldehyde (MF) resins used for light-coloured objects, adhesives for plywood and particle boards (UF) and decorative laminates (MF). Bakelite polymers were used in the 1920s for consolidating objects while MF resins were used for consolidating water-logged wood in the 1970s. Formaldehyde resins are archetypal thermosetting resins; they are infusible, insoluble and irremovable.

Many thermoplastics were introduced in the 1920s and 1930s. Polystyrene is a brittle, transparent polymer widely used in light fittings, toys and containers, either coloured or clear. It can yellow severely, especially when exposed to light. Polyvinyl chloride (PVC), a major commercial polymer, is a rigid material but is often softened or plasticized, for example for plastic raincoats. However, the plasticizer can leach out, allowing the plastic to revert to its rigid state. PVC is one of the most unstable polymers in widespread use, but fortunately it has only rarely been used in conservation, for example as an adhesive during the lifting of mosaic pavements.

Acrylic polymers form a versatile family of which the best-known member is acrylic sheet, for example Perspex (Amer. Plexiglass) or Oroglas, made from polymethyl methacrylate, or PMMA. Water-white or coloured, the sheet has been used for 'stained-glass' windows, and the material may also be moulded or carved. PMMA is quite stable to light and will not yellow but, like all plastics, is easily scratched. A less rigid acrylic polymer, Paraloid B-72, is the standard for high-stability picture varnishes and has been adapted for other purposes in conservation. Dispersions of similar acrylic polymers in water have been used as adhesives for paper and canvas and also as media for artists' paints. By creating the polymer *in situ* from liquid monomers, fragile wood and stone objects can be consolidated and strengthened. Cyanoacrylate adhesives have been used for temporary fixing during the reconstruction of glass panels and objects. Polyvinyl acetate, PVAC (PVA), is widely used in emulsion paints and as white glues for wood and other craft work. These are used as adhesives in the conservation of paper and textiles and for consolidation in archaeological conservation. PVAC resin is a stable medium for inpainting during the restoration of pictures. Polyethylene is another major commercial plastic that has found a small use in the lamination of fragile paper. Soluble nylon has also been used as a consolidant for pigments and delicate surfaces but has proved in some cases to cause significant harm and to be impossible to remove. Ketone resins are the nearest synthetic counterparts to the natural resins used for picture varnishes such as dammar and mastic. Specially stabilized ketone resins show considerable improvement over natural resins though the acrylic polymers are much better in this respect. Efforts are being made to devise a polymer for picture varnishes that will combine all the desirable properties. Ethylene-vinyl acetate copolymers (EVA) have found a firm role in formulations for relining adhesives for canvas paintings.

Of the cross-linked polymers, polyester resins have been used as binding media in glass-fibre laminate constructions, for example, in sculpture. Many grades are available but most are unstable to light and can deteriorate badly on weathering. Polyester casts are frequently used for reproducing works of art, with silicone rubbers now being the preferred material for taking moulds from objects, despite their expense. The stability of silicone compounds to weathering has led to their use as adhesives in the reconstruction of stained-glass panels. Considerable improvements have been achieved in the treatment of degraded stone by consolidation with silicon-based monomers (silanes) that harden inside the stone. Polyurethane foams are widely employed as padding in clothes and furniture. However, these flexible foams are unstable, degrade rapidly and can cause damage to adjacent materials, so presenting severe problems in their conservation. Epoxy resins are widely used as adhesives. Most yellow badly over time, though a few are sufficiently stable to find applications in the conservation of glass objects. Unfortunately, the bond between glass and epoxy is not stable to weathering, leading to the breaking-up of windows on which it has been used.

See also PLASTIC.

T. H. Barry: *Natural Varnish Resins* (London, 1932)

A. Tschirch and E. Stock: *Die Harze*, 4 vols (Berlin, 1933–6)

M. Kaufman: *The First Century of Plastics* (London, [1963])

J. A. Brydson: *Plastics Materials* (London, 1982)

S. Katz: *Classic Plastics* (London, 1984)

P. K. T. Oldring, ed.: *Resins for Surface Coatings* (Edinburgh, 1986, rev. Chichester, 2/2000)

C. V. Horie: *Materials for Conservation: Organic Consolidants, Adhesives and Coatings* (London, 1987)

J. S. Mills and R. White: *The Organic Chemistry of Museum Objects* (London, 1987), pp. 83–110

N. S. Allen and others: 'Degradation and Stabilisation of Historic Cellulose Acetate/Nitrate Base Cinematograph Film', *Journal of Photographic Science*, xxxvi (1988), pp. 103–6

Scottish Society for Conservation and Restoration. Modern Organic Materials: Edinburgh, 1988

M. Ash and I. Ash: *Handbook of Plastic Compounds, Elastomers, and Resins* (New York, 1992)

K. B. Anderson and J. C. Crelling, eds: *Amber, Resinite, and Fossil Resins* (Washington, DC, 1995)

W. G. Simpson: *Plastics and Resin Compositions* (Cambridge, 1995)

Resist. Material such as wax or varnish used to cover those parts of a surface (e.g. cloth, pottery or a metal printmaking plate) that are not meant to be exposed to dye, lustre or acid (*see* TEXTILE, §III, 1(ii)(b)). In printmaking, the term refers to both the ground and the stopping-out varnish; in watercolour it is often called 'masking medium'.

Restoration. See CONSERVATION AND RESTORATION.

Reticle [Lat. *reticulum*: 'net']. Apparatus consisting of a viewing grid made up of a frame with a set of precisely placed wires stretched across or set into it, vertically and horizontally. It is used by artists to facilitate the transfer or enlargement of an image from an object or original to a copy. The reticle is set up between the subject and the artist who then draws, square by square, the image he sees through the grid on to a sheet of similarly squared-up paper. Glass, set in a frame and etched with lines, can also be used as a reticle.

Like the camera obscura, with which it could be used, it seems at least possible that the reticle was taken over and adapted by artists for their own use from the equipment used by astronomers, who placed reticles, far smaller than those used by artists but working on the same principle, over the glass of a telescope in order to make accurate observations. In 1731 Bailey defined the reticle as 'a contrivance for the exact measuring of the quantity of eclipses'; it must have been known and used by artists long before then, however, since Albrecht Dürer (1471–1528) made what is probably a uniquely erotic record of its use in the woodcut known as the *Screen Draughtsman* (*c.* 1525). The draughtsman here depicted appears to be using the apex of the model obelisk placed on his drawing-table as a sighting rod, although this may also be a visual sexual pun. The reticle was also used in the 19th century in photography: its image, ruled on the negative, would immediately show, when developed, if any shrinkage or distortion of the film had occurred.

N. Bailey: *Dictionarium Britannicum*, ii (London, 1730)

H. Hutter: *Die Handzeichnung* (Vienna, 1966); Eng. trans. as *Drawing, History and Technique* (London, 1968), p. 145

C. Ashwin: *The Encyclopedia of Drawing* (London, 1982), pp. 16–20

Retroussage [Fr.: 'dragging up']. Term applied to the technique of wiping an intaglio printmaking plate by flicking or gently dragging a soft rag or fine muslin cloth over it to draw out some of the ink, so that when printed the line is softer and in areas smudged.

Rock crystal. Naturally occuring transparent, colourless stone. Rock crystal consists of pure quartz formed in large, hexagonal crystals of uniform texture, with no metallic impurities. Small bubbles of gas are often trapped within the stone. When few in number, these produce small, reflective areas, creating a glittering effect. When numerous, particularly when aligned in sheetlike flaws, they cause the material to become translucent or cloudy. Rock crystal is found throughout the world, and because of its chemical purity it cannot be traced to specific natural deposits. Rock crystal is extremely hard, registering seven on the Mohs scale. The techniques used to work rock crystal are the same as those used on gem- and hardstones (*see* HARDSTONES, §2): it may be sawn by using metal or a cord charged with abrasive grit, carved or drilled with abrasives and rotating metal discs and balls, polished with fine-grained abrasive material on thicker sheets of metal and wood and engraved with hardstone chips. Engraved areas are often left matt to contrast with highly reflective and colourless surfaces.

Rock crystal has been used in almost every culture with a tradition of glyptics. The majority of rock crystal objects are sculptural forms: vessels (see fig.), stones carved in relief or engraved and free-standing figures. It has also acted as a base for painting: the Minoans painted the backs of polished rock crystal panels, and in the 20th century in China snuff bottles (Cambridge, Fitzwilliam Museum) were painted on the inside, so that figures could be seen through the transparent stone. The physical properties of rock crystal have also influenced the choice of decoration: the lack of grain allows a high polish, giving reliefs a reflective surface and contrasting with the matt finish of engraving. Its hardness and consequent durability have led to its widespread use for seal-matrices. These parallel the forms of seals in other gems and hardstones: cylindrical, scaraboid, conical, cabochon and ring bezels. Rock crystal was also often credited with special powers, ranging from protection to the attraction of divine attention.

See also GEM-ENGRAVING.

E. Kris: *Meister und Meisterwerke der Steinschneidekunst in der italianischen Renaissance* (Vienna, 1929/*R* 1979)

C. J. Lamm: *Mittelalterliche Gläser und Steinschnittarbeiten aus dem nahen Osten*, 2 vols (Berlin, 1929–30)

J. Lee: 'The Crozier Collection, I: Rock Crystals', *Bulletin: Philadelphia Museum of Art*, xl/203 (1944) [whole issue]

H. Goldman: 'A Crystal Statuette from Tarsus', *Archaeologica Orientalia in Memoriam Ernst Herzfeld* (New York, 1952), pp. 129–33

R. Ghirshman: *Iran: Parthes et Sassanides* (Paris, 1962), pp. 203–54

A. B. Griswold: 'A Glass Image and its Associations', *Journal of Glass Studies*, v (1963), pp. 75–104

H. Härtel, ed.: *Indien und Südostasien*, Propyläen-Kunstgeschichte (Berlin, 1971), pp. 238–44

H.-P. Bühler: *Antike Gefässe aus Edelsteinen* (Mainz, 1973)

K.-H. Meyer: *Studien zum Steinschnitt des 17. und der ersten Hälfte des 18. Jahrhunderts* (diss., Universität Hamburg, 1973)

Rock crystal tazza and cover, mounted with gold, enamel and precious stones, attributed to the Saracchi brothers, h. 315 mm, *c.* 1589 (Florence, Palazzo Pitti, Museo degli Argenti); photo credit: Erich Lessing/Art Resource, NY

F. Fremersdorf: *Antikes, islamisches und mittelalterliches Glas sowie kleinere Arbeiten aus Stein, Gagat und verwandten Stoffen in den Vatikanischen Sammlungen Roms* (Rome, 1975)

A. El-Khouly: *Egyptian Stone Vessels*, 3 vols (Mainz, 1978)

A. Krug: 'Die "kauernde Aphrodite" in Kristall', *J. Paul Getty Museum Journal*, x (1982), pp. 145–52

Y. Hackenbroch: 'Reinhold Vasters: Goldsmith', *Metropolitan Museum Journal*, xix/xx (1984/85), pp. 163–268

H. Hahnloser and S. Brugger-Koch: *Corpus der Hartsteinschliffe des 12.–15. Jahrhunderts* (Berlin, 1985)

R. Ettinghausen and O. Grabar: *The Art and Architecture of Islam, 650–1250*, Pelican History of Art (Harmondsworth, 1987), pp. 186–208

R. H. Pinder-Wilson: 'Rock Crystals', *Islamic Art in the Keir Collection*, ed. B. W. Robinson (London, 1988), pp. 287–309

G. Kornbluth: 'The Susanna Crystal of Lothar II: Chastity, the Church, and Royal Justice', *Gesta*, xxxi/1 (1992), pp. 25–39

G. Kornbluth: 'Early Byzantine Crystals: An Assessment', Journal of the Walters Art Gallery, lii–liii (1994–1995), pp. 23–32

T. Schroder: 'A Royal Tudor *Rock-crystal* and Silver-gilt Vase', *Burlington Magazine*, cxxxvii (June 1995), pp. 356–66

M. Vickers: 'Rock Crystal: The Key to Cut Glass and Diatreta in Persia and Rome', *Journal of Roman Archaeology*, ix (1996), pp. 48–65

E. M. Stern: 'Glass and *Rock Crystal*: A Multifaceted Relationship', *Journal of Roman Archaeology*, x (1997), pp. 192–206

A. Contadini: 'The Cutting Edge: Problems of History, Identification and Technique of Fatimid Rock Crystals', *L'Egypte fatimide: Son art et son histoire*, ed. M. Barrucand (Paris, 1999), pp. 319–29

Topkapı à Versailles: Trésors de la Cour ottomane (exh. cat., Versailles, Musées Nationaux, 1999)

Rocker. Serrated tool used in Mezzotint to prepare the metal printmaking plate. It is moved backwards and forwards in a variety of directions so that the surface is roughened evenly with numerous tiny pits and scratches.

Roll. In its art-historical context, a cylinder formed of papyrus, parchment, paper, cloth or other material used to store information (see fig.). The papyrus roll dominated Greek and Roman literary culture for almost a millennium (c. 500 BC–c. AD 400), when it was superseded by the codex. The earliest extant example (uninscribed) was discovered in a grave at Saqqara and dates from the 1st Dynasty (c. 2925–c. 2775 BC); there are stone inscriptions of the same date that depict scribes with rolls. Although the papyrus roll is, therefore, of about the same antiquity as the Mesopotamian clay tablet, it is more directly the ancestor of the modern book. This article is concerned with the history and development of the roll in the Western tradition; for the Eastern tradition see SCROLL.

The manufacture of a papyrus roll involved much technical skill. The thin, fibrous wafers from the pith of the plant were made into sheets by pressing a layer of parallel strips on to another layer of strips at right angles. Individual sheets were pasted together to form rolls of various lengths (for further discussion of the techniques involved *see* PAPYRUS). Such rolls as the Great Harris Papyrus (c. 1166 BC; London, British Museum, EA 9999), measuring c. 41 m, are exceptionally long, and rolls of about 20 sheets were more usual.

From the earliest times a royal monopoly, papyrus was never a cheap material, and rolls have survived with inscriptions (sometimes in different hands, perhaps even dating from different periods) written on both sides, or with the original text washed off to allow for a second text to be written over it. Papyrus rolls that have been reused in this fashion are referred to as palimpsests (Gr. *palin*: 'again'; *psestos*: 'scraped', 'rubbed'). Papyrus sheets were occasionally inscribed before being glued together into rolls, but usually this occurred once in roll format, when they were inscribed on one side only. The natural grain of the plant tissues made the ruling of papyrus largely unnecessary. Various alternatives for the arrangement of the text were employed: from top to bottom across the width of the roll; parallel to its length; or in a succession of columns following each other from left to right across the length. The number of lines per column varied according to subject and period. Writing in columns was especially popular in Republican Rome and reappeared, almost unchanged, in early parchment codices. Once the text was complete, the papyrus was rolled up into a volume with the inscribed side on the inside, and a rod or *umbilicus* was sometimes inserted into the central hollow for added stability. Rolls could further be secured with string and a seal (as depicted in the Egyptian hieroglyph denoting the determinative for 'abstract') and placed into brightly coloured leather or pottery containers; specially constructed cupboards provided

Handscroll of the *Scroll of Esther*, from Italy, mid-18th century (Jerusalem, Sir Issac and Lady Edith Wolfson Museum); photo credit: Erich Lessing/Art Resource, NY

further protection. An indication of the subject of the text was usually written either on the outside of the roll itself, or on a piece of papyrus affixed to its container. Manuscripts in the great library of Alexandria (founded *c.* 284 BC) were thus catalogued according to incipits (the first word of the text). Much of our knowledge about the actual process of reading and writing, and the way rolls were handled, is derived from ancient and Classical wall painting, book illustration and sculpture. Rolls were, indeed, a favourite attribute in Greek and Roman art, denoting status, mood or intention.

The Egyptians also developed methods of illustrating rolls. The earliest extant example of an illustrated papyrus roll, the Ramesseum Papyrus (London, British Museum, 10610), which dates from the 20th century BC, shows some 30 line-drawn figures along the bottom of the roll. Later examples generally use a cyclical method of simple text-related illustrations with more elaborate compositions reserved for key issues. This method was adopted by the Greeks, probably in the 4th century BC in Alexandria, and from there it passed into the Greek and Roman world. Few illustrated papyri have survived, and much of the history of early book illustration has to be reconstructed from medieval imitations in parchment codices of earlier pictorial archetypes.

Papyrus was not the only material from which rolls were fashioned, nor was the format itself restricted to ancient Egypt and the Classical Mediterranean world. Though never a serious rival, leather served the same purpose, and the earliest fragment of an Egyptian leather roll dates from the 24th century BC. Leather rolls were also used in western Asia, Iran, Iraq and later Turkestan. They have always played an important part in Jewish ritual, the most famous leather rolls (or scrolls) being without doubt the Dead Sea Scrolls discovered in 1947 at Qumran. Leather rolls had certain drawbacks, however: they were thicker, heavier and more cumbersome than papyrus, and badly tanned leather decays easily. Those shortcomings do not apply to parchment, which, due to its more sophisticated manufacturing process, is a far more durable material, finer in both texture and quality. Most importantly, unlike papyrus and leather, it can be inscribed on both sides. According to Martial (*c.* AD 40–104) and Pliny the elder (AD 23/4–79), parchment was commonly used in Rome during the 1st century AD. To fashion a leather or parchment roll, individual sheets of skin were stitched together, forming a bond much stronger than the pasted joins of a papyrus roll. Other materials such as gold, silver, lead, tin, palm leaves and specially prepared strips of cloth have also been used for rolls.

Although the parchment codex superseded the papyrus roll in western Europe *c.* AD 400, the roll format did not disappear. It retained a place in the Eastern Orthodox Church where the liturgy continued to be written on parchment rolls for some time. During the Middle Ages and later, in some instances up to the late 20th century, both term and format

continued to serve for such official records or registers as diplomas, heraldic and genealogical lists, Pontifical Bulls, rolls of arms, mortuary rolls, court rolls, or records of manorial courts. The building where the records of the English Chancery Court were kept was long referred to as 'The Rolls', and its keeper was known as the 'Master of the Rolls', a title still in use for the third member of the English High Court. Moreover, there are still references to 'roll calls' and 'rolls of honour'. In the British House of Lords, new peers are required to sign a parchment roll called the Test Roll. Begun in 1675, this document now measures some 36 m. In May 1981 it was proposed that it should be replaced with a register in codex form, but the proposal was rejected without a vote. Finally, the term continues to be used in architecture to denote a moulding resembling a section of a parchment roll with the ends overlapping.

T. Birt: *Die Buchrolle in der Kunst: Archäologische und antiquarische Untersuchungen zum antiken Buchwesen* (Leipzig, 1907)

W. Schubart: *Das Buch bei den Griechen und Römern* (Berlin, 2/1921, rev. E. Paul, Heidelberg, 3/1961)

E. Bethe: *Buch und Bild im Altertum* (Leipzig, 1945)

K. Weitzmann: *Illustration in Roll and Codex: A Study of the Origin and Method of Text Illustration* (Princeton, 1947)

K. Weitzmann: *Ancient Book Illumination* (London, 1959)

R. R. Johnson: *The Roll of Parchment in Graeco-Roman Antiquity* (Los Angeles, 1968)

R. Reed: *Ancient Skins, Parchment and Leather* (London, 1972)

N. Lewis: *Papyrus in Classical Antiquity* (Oxford, 1974)

R. Reed: *The Nature and Making of Parchment* (Leeds, 1975)

E. G. Turner: *The Terms Recto and Verso: The Anatomy of the Papyrus Roll*, Papyrological Bruxellensia, xvi (Brussels, 1978)

Roulette. Tool used in engraving. It has a toothed wheel that makes a series of small indentations on the metal printmaking plate and was used together with a mattoir to make prints in the various dot and tonal processes of the 18th century (*see* CRAYON MANNER and STIPPLE).

Rubber. The term 'rubber' has come to define both natural and manmade substances sharing a similar characteristic of elasticity. Joseph Priestley (1733–1804), an English chemist, is said to have given the material its common modern name in 1770 when he discovered that it could be used to erase pencil marks through rubbing.

Natural rubber is a hydrocarbon polymer derived from the latex (a viscous, milky sap) of one or more trees from the Euphorbiaceae family. The latex is obtained from the tree (through tapping a cut in the bark), precipitated with acid and then washed and dried. The resulting material is very elastic and has been used for a variety of utilitarian purposes, including ADHESIVES.

In 1839, Charles Goodyear (1800–60), an American inventor, discovered that natural rubber, which is very soft, could be hardened with the addition of sulphur, in a process known as vulcanization. Vulcanized rubber found a wide variety of applications for small decorative objects, musical instruments,

foams (often used in upholstery) and fabric coatings. Over time, vulcanized rubber will emit sulphur when exposed to heat or light, causing it to degrade and become brittle; small amounts of wax added in the vulcanization process can slow this process.

Synthetic rubber, derived from petroleum and alcohol, can take the form of many manmade elastomers (synthetic polymers with properties similar to those of natural rubber). Like natural rubber, synthetic rubbers must also be vulcanized. The development of synthetic rubbers, begun in the 19th century, was accelerated during World War II, when, starting in 1941, the importation of natural rubber from Asia to the United States was halted by the Japanese. Synthetic rubbers include neoprene, polyethylene, polysulphide, silicone, styrene and many other varieties.

While most applications of rubber are industrial or utilitarian (as in car tyres or rubber bands), it has also been used over time in many decorative and artistic capacities, such as in the creation of footwear, clothing (especially swimwear and foundation garments), handbags, toys, balls (dating back to the ancient Mesoamerican ballgame), the grips of modern firearms and many other types of small articles. Rubber moulds are frequently used in the casting of ceramics and sculptures, foam rubber (polyurethane) has been used extensively in the upholstery of modern commercial and designer furniture, and rubber mounts were often used by 20th-century chair designers, such as Charles (1907–78) and Ray Eames (1916–88). Among the many architectural applications of rubber are its use in flooring and tiles. In the 1940s, a water-based paint with a rubber binder, known as latex, was introduced and often used as house paint. The term 'latex paint' has continued in use even though aqueous emulsions of other resins have long since replaced the natural rubber.

By the late 20th century, several artists had made use of both natural and synthetic rubber for sculptures and installations. One artist, Chakaia Booker (b 1953), consistently used recycled rubber tyres in her conceptual sculptures from the mid-1990s, leading to her nickname the 'Rubber Queen'. Some printmakers, such as Jim Dine (b 1935), made use of rubber stamps in their work, and the material also has been used extensively by contemporary studio jewellers.

P. Schidrowitz and T. R. Dawson, eds: *History of the Rubber Industry* (Cambridge, 1952)

M. Morton: *Rubber Technology* (New York, 1987)

R. Korman: *The Goodyear Story: An Inventor's Obsession and the Struggle for a Rubber Monopoly* (San Francisco, 2002)

J. Bloor: *Rubber! Fun, Fashion, Fetish* (London and New York, 2004)

J. Loadman: *Tears of the Tree: The Story of Rubber: A Modern Marvel* (New York, 2005)

Rug. Floor-mat, especially for the hearth. Floor coverings have been made in societies throughout the world from a variety of woven and non-woven materials, including plaited reeds, FELT and bark

fibre. There is no direct link between European and North American rugs and the knotted carpets of the Near East (*see* CARPET, §I, 1). The term probably comes from the Norwegian *regga* or *rugga*, meaning a soft, coarse cover used as an alternative to animal fleeces or skins. In Scandinavia long-piled *ryijy* were knotted, but elsewhere in Europe such covers were made of coarse woollen fabric with a raised nap. In the 16th and 17th centuries this yardage fabric was used by the poor for clothing and later for bedding. By the end of the 18th century the term was also applied to small mats and covers produced, mainly domestically, for tables, beds and increasingly floors. These rugs were mostly made by such needlework techniques as canvaswork embroidery (*see* CARPET, §1, iv), appliqué and patchwork, and by hooking and progging. Early European settlers took these traditions with them to North America. The Mexicans learnt the technique of weaving heavy, narrow carpet strips, called *jergas*, from the Spanish, and the Navajo began to make lightweight blankets, which later evolved into distinctive tapestry-woven rugs.

1. Hooked. 2. Other.

1. HOOKED. This kind of rug is worked from the right side. A long strip of fabric is held under the foundation material, usually burlap or sacking, and a hook rather like a crochet hook is used to pierce the material in order to catch the strip and pull a loop to the top. The strips of fabric can be as wide as 12 mm or as fine as 2 mm.

Hooked rugs, or mats, were once made in most parts of the British Isles, but the craft lasted longest in the north of England and the valleys of South Wales. After the Industrial Revolution textiles were mass-produced, and rags in the form of cast-off clothes and mill remnants were converted into practical and economical floor coverings for working-class and country homes. Rug-hooking was a working-class craft, seldom adopted by middle-class women as were patchwork and quilting.

Patterns were created to suit the materials available. Templates were cut out of brown paper or cardboard, or designs were drawn freehand in chalk or indelible pencil. Sometimes quilting templates were used, and patterns could also be bought from the local co-operative store. Scottish rugs usually had a black or dark-grey ground with a pattern of diamonds or squares in a contrasting colour, often red.

Mat-making was often a social activity. Families spent time together, the men making the frames and hooks as well as working on the frame. There were mat-making 'bees' (*see* QUILTING), and groups hooked mats to sell to raise money for church funds. Hooks were often home-made from bent nails or skewers, or perhaps custom-made with a wooden handle by the local blacksmith. Different styles of rug were made to suit different rooms in the house.

By the 1920s hooked rug-making had almost died out in Britain, but in Cumbria, Winifred Nicholson (1893–1981), seeing hooked rugs in her neighbours'

homes, began to design patterns for local mat-makers. Apart from some utilitarian mats made during World War II, few mats were then made until the 1960s, when Nicholson was approached to revitalize mat-making. With the help of other artists and craftsmen, she started a successful revival.

In the USA rug-hooking was first practised on the eastern seaboard. The earliest rugs were hooked on a linen foundation, but after *c.* 1850 burlap made from jute was used. During the 19th century more hooked rugs were made in the USA than any other kind. The patterns for these early rugs were home-drawn, and the most common designs were made up of a repeat that was easy to follow if more than one person were involved in the making. An American housewife might make two rugs each winter.

After the Civil War, it was possible to buy rug patterns. Edward Sands Frost of Biddeford, ME, became a pedlar after being invalided out of the army. He added rug patterns, designed by himself, to the usual pedlar's stock and developed a series of stencils, which he used to mark them out. Others copied his ideas, and mail-order firms began to produce patterns commercially, often derived from those of Frost. A distinctive style of rug with a high-sculptured pile was made in Waldoboro, ME, and in time 'Waldoboro' became the name for any rug so made.

In the early 20th century rug-hooking became a cottage industry in parts of New England. One of the earliest, Abnakee, founded in 1902, specialized in rugs with Native American motifs. Many small rug-hooking groups were founded in the Appalachian Mountains of Tennessee, Kentucky, North Carolina and Virginia.

Sometimes more than one technique was used in a rug, for example the centre panel hooked and the border braided.

In Canada mat-making began in Newfoundland, the Maritime provinces and Ontario. Cloth, too precious to waste, was reused in quilts or rugs, and Canadian mats always had a frugal mixture of materials. Women designed the mats themselves, portraying familiar scenes, flowers, animals and landscapes. Floral designs introduced by Ursuline and other nuns in 17th-century embroidery were used by country people in their own domestic crafts. Many Canadian rugs were sold in New York sale-rooms, but there was no trade in the opposite direction.

Floors in Newfoundland homes would have been completely covered with mats and, as in Britain, the place where the mat was to be used influenced the design, with geometric patterns in kitchens and florals in the best rooms. In 1913 William Grenfell, an English doctor who dedicated his life to the poor living in isolated villages along the Newfoundland coast, organized a cottage industry to sell mats, which the women had previously made for domestic use. Grenfell mats, still made at the end of the 20th century, are always worked with narrow strips of fabric hooked in parallel rows. Many of the patterns have some connection with the sea. The Newfoundland poked mat, with a shaggy pile, is made in the same way as the British proggy (*see* §2) and was used primarily as a doormat. In Nova Scotia, too, there has always been a rug-making tradition, and there is a rug-hooking school at Cheticamp. Rug-making is still carried on in many parts of Canada.

2. OTHER. There are a number of other rug-making techniques used in North America and Britain. Proggy rugs, in contrast to hooked rugs, are worked with the underside uppermost. The ends of a strip of cloth 50×12 mm are poked through the foundation fabric, giving a shaggy top and a smooth underside. Because of the shaggy surface, the patterns are not as sharply delineated as those of hooked rugs. Almost anything that could be sharpened to a point was used as a progger, mostly home-made but sometimes fashioned by the village blacksmith. These mats were very heavy but were an economical way of covering stone or uneven floors in country or working-class homes. In the British Isles the proggy mat was more popular than the hooked variety. It is also called 'cloutie' (in Scotland), 'clippy' or 'pegged'.

The first braided rugs were made between 1830 and 1850, and traditionally they were round or oval. Strips of fabric 50 mm wide had both edges turned in to make a 25 mm strand. The strands were grouped in threes, fives or sevens and plaited to make a braid, the end of which was turned in on itself and firmly stitched. The braid was then wound round this core until it was the required shape and size. Stitching with strong carpet thread at regular intervals, keeping the work perfectly flat, held the braids together. More braided rugs were made in North America than in the British Isles.

Shirred rugs, often called 'chenille' rugs after the French word for caterpillar, were popular during the first half of the 19th century. A running stitch was taken lengthwise down the middle of a strip of fabric and the thread pulled up, so that the gathered strip looked rather like a caterpillar. Each 'caterpillar' was then sewn to a foundation fabric. Another method was to stitch strips of woollen fabric across their width to the backing, then to loop and stitch them down again, each loop being very close to the preceding one, forming a series of pleats. On a shirred rug all the cloth is on the top surface, and only the stitches used to attach the strips to the foundation show on the underside.

Tongue rugs were utilitarian and showed another use of thick and heavy material that could not be employed for any other purpose. Pieces of fabric, cut with one end rounded, were sewn to a heavy foundation. Starting at the outside edge, each row of 'tongues' slightly overlapped the previous one, like tiles on a roof, until the centre was reached. Sometimes the 'tongues' were decorated with button-hole stitches. Tongue rugs were usually only doormat size.

List rugs were woven, with a cotton or linen warp; the weft was list (selvedge) cut from lengths of fabric. Strips cut from worn-out clothing or household textiles were also used.

Knitted and crochet rugs were also made from worn-out textiles. Strips of cloth were wound into balls and used in the same way as yarn. Knitted mats usually consisted of squares that were then joined together. Another method was to knit or crochet a foundation from string or strong yarn and to insert a small piece of cloth into a stitch at intervals, resulting in a shaggy surface.

American bed rugs (often spelled "ruggs") were made mainly in New England, between c. 1720 and 1830. They were treasured possessions, rarely mentioned in wills or inventories as they were usually passed down in the family from one woman to another. They were the top cover of the bed, and unlike many other rugs they were always made of new materials. The foundation was woollen fabric or a fine blanket, and the embroidery was worked in polychrome wools over a stick or reed to give a looped pile, which was sometimes cut. As many as six strands of wool might be threaded into a large needle for working the embroidery.

Yarn-sewn rugs, also made mainly in New England, used homespun linen or a grain bag for the foundation. Two-ply yarn was sewn with a needle through the base in a continuous running stitch. In the 18th century these rugs were rectangular and were used to cover tables or chests, but c. 1800 they began to be made in a longer shape to cover the hearth-stone in the summer months.

American dollar or button rugs were made for use on tables or chests and would not have been put on the floor. Circular patches of three different sizes were cut from felt or discarded clothing, the largest being the size of a silver dollar. These were placed on top of each other, the smallest at the top, to form a 'button', which was then sewn down firmly to a strong foundation fabric. Sometimes the 'buttons' were embellished with embroidery.

A. Macbeth: *The Countrywoman's Rug Book* (Leicester, 1929)

W. W. Kent: *The Hooked Rug* (New York, 1937)

W. W. Kent: *Rare Hooked Rugs* (Springfield, MA, 1941)

H. H. Feeley: *The Complete Book of Rug Braiding* (New York, 1957)

P. Collingwood: *The Techniques of Rug Weaving* (London, 1968, rev. 1993)

N. F. Little: *Floor Coverings in New England before 1850* (Sturbridge, MA, 1967)

J. Kopp and K. Kopp: *American Hooked and Sewn Rugs* (New York, 1974)

J. Kopp and K. Kopp: *Hooked Rugs in the Folk Art Tradition* (New York, 1974)

J. Moshimer: *The Complete Rug Hooker* (New York, 1975)

H. von Rosenstiel: *American Rugs and Carpets* (London, 1978)

The Fabric of their Lives: Hooked and Poked Mats of Newfoundland and Labrador (exh. cat. by C. Lynch; St John's, Memorial University of Newfoundland, Art Gallery, 1980)

K. Pyman, ed.: *Rag Rugs* (London, 1980)

S. Betterton: *Rugs from the American Museum in Britain* (Bath, 1981)

D. M. Grayson: *Rugs and Wallhangings* (London, 1984)

L. Garrard: 'The Making and Use of Rag Rugs in the Isle of Man', *Folk Life*, xxvii (1988), pp. 71–9

Ragtime (exh. cat., Gateshead, Shipley Art Gallery, 1988)

P. Collingwood: *Rug Weaving Techniques: Beyond the Basics* (London, 1990)

E. Tennant: *Rag Rugs of England and America* (London, 1992)

J. Kopp and K. Kopp: *American Hooked and Sewn Rugs: Folk Art Underfoot* (Albuquerque, NM, 1995)

S. B. Sherrill: *Carpets and Rugs of Europe and America* (New York, 1996)

I. Bennet: *Rugs & Carpets of the World* (London, 1997)

Rustication. Term applied to stonework that resembles large, deeply chamfered blocks, often with a deliberately rough surface effect. It was employed especially on Italian Renaissance palazzi (*see* MASONRY, §2).

S

Saggar [sagger; seggar]. Clay casing used to protect objects, especially pottery, during firing.

Sandbag. In printmaking, a leather cushion packed with sand that is used as a rest for a plate or block while being worked.

Scagliola. Imitation marble or pietra dura made from a fine plaster of powdered selenite (a crystalline variety of gypsum), mixed with glue and coloured. It was either applied like paint to a wet gesso ground, fixed under heat and polished, or formed into coloured chips and inlaid as a mosaic, sometimes combined with brecciated marble. The technique, known in ancient Rome, was revived in Italy during the 16th century and spread to other countries in Europe. In comparison with inlays of hardstones, scagliola is susceptible to damage, and relatively few early examples survive. An English gilded pine table (*c.* 1675; London, Victoria and Albert Museum) has a scagliola top in an elaborate design of cornucopias overflowing with fruit. In the Queen's Closet at Ham House, Surrey, 17th-century scagliola work in the fireplace and window-sill is thought to have been executed by an itinerant Dutch craftsman. The highest quality scagliola was produced in the 18th century in Florence, where Florentine mosaics in pietra dura and *pietra tenera* (coloured marbles) were a flourishing tradition. The Italian preference for furniture enhanced with surface pattern provided the scagliola workshops with a rich market, particularly among tourists to Florence, who collected scagliola table-tops by the score. Italian designers who specialized in scagliola were Don Enrico Hugford (1695–1771), Lamberto Cristiano Gori (1730–1801) and Pietro Antonio Paolini (*fl* 1730s; e.g. scagliola table, 1732; Florence, Palazzo Pitti). Scagliola was also applied to walls, overmantels and door panels in designs that featured landscapes, ships at harbour, floral sprays and garlands, acanthus-leaf scrolls and geometric patterns. As a fluid medium, painted scagliola was suited to Rococo designs; later in the 18th century Neoclassical styles in scagliola, imitating slab marble, replaced pictorial and abstract designs.

See also STUCCO AND PLASTERWORK, §2.

W. M. Odom: *A History of Italian Furniture: From the Fourteenth to the Early Nineteenth Centuries* (New York, 1967)

F. Rossi: *Mosaics: A Survey of their History and Techniques* (London, 1970)

F. Watson and others: *The History of Furniture* (London, 1976)

A. M. Massinelli: *Scagliola: L'Arte della pietra di luna* (Rome, 1997)

N. Manni: *I maestri della scagliola in Emilia Romagna e Marche* (Modena, 1997)

Scraper. Versatile tool with a three-sided tapered blade, used in printmaking to remove the unwanted BURR that can be thrown up in engraving or drypoint. It is also employed to make corrections by smoothing the surface of a metal plate.

Scraperboard. Prepared surface of gesso covered with ink. It can be scratched and incised with a sharp point to give a white line.

Screenprinting [Fr. *sérigraphie*; Ger. *Siebdruck*; screen process printing; silk screen printing]. Twentieth-century printmaking technique developed from STENCILLING (*see* PRINTS, §III, 3). It is commercially known as screen process printing or silkscreen; a group of American artists renamed it serigraphy in 1940 to denote its use for fine art. A gauze textile—originally of organdie or silk, more recently of synthetic fabric or wire—is stretched on a frame. The stencil is made by selectively blocking parts of the mesh. A thick ink is wiped across the mesh with a blade called a squeegee, so that it passes through the unblocked areas on to the surface to be printed (see colour pl. XIV, fig. 2).

1. Materials and techniques. 2. History.

1. MATERIALS AND TECHNIQUES. Screenprinting requires the 'block-out' forming the negative areas of the design to be resistant to the solvents in the ink. Ordinary paper stencils, adhered by ink to the mesh, can be used for short runs; for larger editions there are proprietary stencils comprising a thin lacquer or shellac layer, temporarily bonded to a backing sheet coated with a release agent. The parts coinciding with the intended image are cut and peeled away, while the remaining stencil, destined to block unwanted colour, is fused to the screen by heat or solvent, at which point its backing sheet is removed.

A stencil-making method known as 'wash-out', in principle similar to sugar aquatint, was developed in the 1940s to permit grease-based marks painted or drawn directly on to the mesh to be printed. A drawing was made with solid wax or liquid lithographic tusche (Ger.: 'ink') and the whole screen then covered with a water-soluble filler. This water-based 'block-out' was repelled by the drawn grease, but effectively filled the remainder of the mesh. When it had dried, the grease was dissolved by a solvent, which opened the drawn areas to the passage of ink.

Photo-stencils can be made either by filling the mesh with a light-sensitive coating or by adhering a film to the screen after processing. The light-sensitive surface is exposed under a negative or diapositive in the form of a transparent sheet on which opaque image areas have been hand-drawn or photographically produced. Those parts of the stencil exposed to light harden, so blocking the screen, while those protected from light by the opaque areas remain soluble and wash away, opening the mesh to ink. Many different manipulative photographic procedures can be used, but when the half-tone process common to other forms of photomechanical printing is employed, the dot size must be larger than the space between the mesh threads.

The precise nature of a screenprinted impression is determined by the tension and number of threads per centimetre of the mesh, the liquidity of the ink and whether the stencil is integral with or superimposed on the mesh. With the increasing sophistication of materials, it can be difficult to distinguish a photo-screenprint from a photolithograph. In the early days of the process, when inks were adapted from paint and there were clogging and drying problems, the colour deposit was thicker than that of any other process and the silk weave sometimes left a permanent impression in the ink, as well as a characteristic saw-toothed edge.

Contemporary applications of screenprinting are extremely varied. Anything capable of receiving ink can be printed, and 'ink' is anything that can be passed through a mesh. Pastes that can conduct electricity, for example, can be set down on mica, pyrex or porcelain, an important development for computer circuitry. Cylindrical objects such as bottles are printed by rotating them beneath a laterally moving screen. Although hand processes are still used to make artists' prints, industrial screenprinting machines have been developed with continuous feed mechanisms, electrically operated screen-lowering devices, mechanized squeegees, suction printing beds and drying belts.

2. HISTORY. Many of the accoutrements associated with screenprinting were pioneered for office duplicating. The waxed paper handwriting stencils, patented in 1877, were fixed in a holding frame after they had been incised so that fluid ink could be forced through them by rubber squeegee. By the late 1880s, the 'Cyclostyle' of David Gestetner (1854–1939) in the UK and the 'Mimeograph' of

A. B. Dick (1856–1934) in the USA had adapted handwriting stencils to the typewriter, using a fine and porous waxed Yoshino paper, patented in February 1888 (US.377706) by John Brodrick. Typewriting stencils proved so delicate that they were at first sandwiched between a sheet of muslin and a gauze 'perforating silk', which helped to displace the wax. By the early 1890s Gestetner's 'Neo-Cyclostyle' duplicating apparatus was supplied with a hinged frame covered by a silk diaphragm on which the stencil could be supported while ink was roller-printed through it. Although the early history of screenprinting has yet to be documented, this apparatus, together with the influx into the West of Japanese *itoire* stencils, in which individual threads were replaced by silk gauze, must have made an important contribution to its development.

Signwriters on the American West Coast are said to have used screenprinting around 1900, although nothing dating from before *c.* 1916 has yet been identified. The first patent (UK.756) was issued on 11 July 1907 to Samuel Simon of Manchester. He stated that 'stencils of gauze or netting by which patterns not broken by ties are reproduced have been previously proposed' but claimed as his innovation the stretching of 'chiffon' on a frame, blocked out with painted 'knotting' (shellac), the design then being brushed or sprayed on to cloth or paper through the open part of the mesh. Another commercial process, Selectasine ('Select-a-sign'), patented in the USA in 1918, involved printing all the colours from the same screen, progressing from pale to dark by systematically blocking out more and more of the mesh. The rights to the process, which had already been used by the American commercial artist John Pilsworth from 1911, were secured for Britain in 1919 by Lt-Col. Mark Mayhew, member of a milling family. He became involved because the silk bolting cloth used in screenprinting was also used for sifting flour.

Materials for cut stencils—notably 'Profilm' patented by Louis F. d'Autremont—were improved between the wars. After 1915, when photo-screenprinting became a possibility, the process became popular for textile printing, because, unlike block or roller printing, it allowed a repeat of almost any height. Artists such as Vanessa Bell (1879–1961), Duncan Grant (1885–1978) and Frank Dobson (1886–1963) were commissioned by Allan Walton (1891–1948) to design screenprinted fabrics. After World War II individual wall hangings, by Ascher in England and Katzenbach and Warren in the USA, were screenprinted from designs by Joan Miró (1893–1983), Henri Matisse (1869–1954), Alexander Calder (1898–1976), Roberto Matta (1911–2002) and Henry Moore (1898–1986).

The credit for making the first artist's screenprint is usually given to the American Guy Maccoy (1904–81), who experimented with original rather than reproductive work in two prints of 1932 and had a one-man show in New York in 1938. It was Anthony Velonis (1911–97), however, who, after screenprinting with the Works Progress Administration's Federal

Art Project Poster Division from 1935, suggested a silkscreen unit for fine art prints, which he headed from late 1938. That same year he wrote the first screenprinting manual for artists. In 1940 American artists renamed the technique serigraphy ('silk drawing'); more than 200 artists made about 1700 serigraphs during the period 1932–49 (see Williams and Williams, 1986). After World War II the National Serigraphic Society toured exhibitions of American screenprints internationally. Poldi Domberger (*b* 1912) of Stuttgart, who became one of Germany's foremost screenprinters, was introduced to the process by such an exhibition, and in 1949–50 he made his first original print, *Komische Geste*, for his artist neighbour Willi Baumeister (1889–1955). From 1952, the Cuban Wilfredo Arcay (*b* 1925) was commissioned to make screenprints for André Bloc, publisher of *Art d'aujourd'hui*. Arcay later printed extensively for many of the hard-edge optical and Constructivist painters associated with the Galerie Denise René, Paris. Alan Sumner (1911–94) experimented with the process in Australia from 1943 and held the first screenprint exhibition in the country in 1946. Francis Carr (*b* 1919), who helped Eduardo Paolozzi (1925–2005) to screenprint wallpaper at the London College of Printing, claimed that in 1949 he was the first Briton to make an artist's screenprint. He was closely followed by a group of artists in St Ives, including Peter Lanyon (1918–64), who in 1951 learnt the process from the American Warren MacKenzie (*b* 1924). Among those to use the process in the 1950s were the American Jackson Pollock (1912–56), who translated some paintings of 1951 into photo-screenprints, Alex Colville (*b* 1920) of Canada and a group of British artists, including Alan Davie (*b* 1920) and William Turnbull (*b* 1922), who worked at a London studio started by John Coplans (1920–2003). Ironically, the American National Serigraphic Society closed through lack of support in 1962, just as Robert Rauschenberg (1925–2008) and Andy Warhol (1928–87) began to incorporate screenprinted images from the mass media into their paintings.

Screenprinting's ability to combine a dense and colourful ink layer with photomechanical elements endeared it to the generation of artists who matured in the 1960s, particularly those interested in interpreting collage. Since original prints were traditionally hand-drawn by the artist, the photographic applications of the process and the tendency for artists to rely on the printer to make their stencils aroused considerable controversy. Chris Prater (1924–96) of Kelpra Studio, London, was one of the printers on whom public attention focused at the time. He had started a commercial screenprinting business in 1957 but showed such sensitivity in collaboration that he was soon invited to work with many of the most talented artists of the decade. Richard Hamilton (*b* 1922) made his famous proto-Pop art collage *'Just what is it that makes today's homes so different, so appealing?'* as a maquette for his own screenprinted half-tone poster for the 1956 *This Is Tomorrow* exhibition at the Whitechapel Art Gallery, London. Subsequently he used Prater's studio for both posters and prints, including *Adonis in Y-fronts* (1963) and *My Marilyn* (1965). In 1963 Hamilton suggested that the Institute of Contemporary Arts in London commission Prater to work with 24 British-based artists of every aesthetic persuasion. Several of the artists then introduced to screenprinting—notably Joe Tilson (*b* 1928), Bridget Riley (*b* 1931), R. B. Kitaj (1932–2007) and Patrick Caulfield (1936–2005)—made brilliant use of the technique. Eduardo Paolozzi, who began working at Kelpra in 1962, published the 12-print suite *As Is When* in 1965. This demonstrated not only Prater's dazzling ability as a stencil-cutter but also the outstanding skill of his cameraman Dennis Francis (1935–82). In 1970 the Arts Council of Great Britain featured the work of Kelpra Studio in a major exhibition. Two years later the American curator Richard Field drew a third of the contemporary exhibits from Kelpra Studio in his attempt to trace the history of screenprinting for the first time, at an exhibition in Philadelphia. Later Field wrote that Prater had 'almost singlehandedly … metamorphosed screenprinting into a fine art'. In 1980, after Prater and his wife, Rose, had presented the Tate Gallery, London, with a complete set of printer's proofs, Kelpra Studio was honoured there in a second major exhibition.

Common assumptions about prints were challenged in *Déjeuner sur l'herbe* (1964) by the French artist Alain Jacquet (*b* 1939), an immense screenprint on two panels that used an enlarged trichromatic half-tone dot, measured 1.75×2.00 m and was distributed in an edition of 90. The German artist Gerd Winner (*b* 1936) also made both large-scale screenprints on canvas and more conventional editions on paper. In 1970–71 the art dealer Dorothea Leonhart of Munich, interested in widening the audience for art, commissioned several artists to make inexpensive screenprints in unusually large editions; one of these—*Good Morning City* by Friedensreich Hundertwasser (1928–2000)—was issued in 10,000 individualized impressions. In a different spirit entirely, students of the Atelier Populaire in Paris used screenprinting to communicate with the public during the uprisings of 1968.

In the first half of the 1960s there was a major revival of screenprinting in the USA. The portfolio *Ten Prints by Ten Painters* was published by the Wadsworth Atheneum in 1964 and brought together works by Josef Albers (1888–1976), Andy Warhol, Ellsworth Kelly (*b* 1923), Roy Lichtenstein (1923–97) and Robert Indiana (*b* 1928), all of whom continued to use the process. Lichtenstein debunked Abstract Expressionism wittily with *Brushstrokes* (1967); Warhol went on to make annual suites, each of ten images, among them *Marilyn* (1967), *Campbell's Soup* (1968 and 1969), *Flowers* (1970), *Electric Chair* (1971) and *Mao Tse-Tung* (1972). Two years before his death, Albers, working with the printer Kenneth Tyler (*b* 1931), produced the exquisite suite *Gray Instrumentation* (1974), a prodigious feat of registration in which the abutting colours of his concentric squares were fitted without overlap. In the same decade Photorealists

Photomicrograph of a screenprint, detail from Richard Estes: *Chock Full O' Nuts*, from the portfolio *Urban Landscapes No. 2*, screenprint in colour on white wove (Fabriano Cottone) paper, 506×354 mm, 1979 (Boston, Museum of Fine Arts, Gift of Paul Grand, 1986, 1986.968); photo credit: Keith Lawrence, Museum of Fine Arts, Boston

such as Richard Estes (*b* 1932; see fig.) also found the technique appropriate to their needs. In 1972 Jasper Johns (*b* 1930) began collaborating with the Japanese screenprinter Hiroshi Kawanishi, who, by rekindling interest in direct drawing on the mesh, returned screenprinting in New York to its serigraphic origins.

H. L. Hiett: *Hiett's Manual on Stencil Screen Process Work: Formulas, Working Instructions and General Up-to-date Information* (Indianapolis, 1926)

F. A. Baker: *Silk Screen Practice and the Roller Process* (London, 1934)

A. Velonis: 'Making Prints for the US Government', *Prints*, vi (1936), pp. 135–42

A. Velonis: *Technical Problems of the Artist: Techniques of the Silk Screen Process* (New York, 1938, 2/1941)

C. Zigrosser: 'The Serigraph, a New Medium', *Print Collector's Quarterly*, xxviii (1941), pp. 442–77

J. Biegeleisen and M. A. Cohn: *Silk Screen Stencilling as a Fine Art* (New York, 1942); rev. as *Silk Screen Techniques* (New York, 1958)

H. Sternberg: *Silk Screen Color Printing* (New York, 1942)

A. Kosloff: *Photographic Screen Process Printing* (Cincinnati, 1955, rev. 1977)

P. Gilmour: 'The Artists' Artisan', *Sunday Times Colour Supplement* (7 June 1970), pp. 28–31

Kelpra Prints (exh. cat., intro. R. Alley; London, Arts Council of Great Britain, 1970)

Silkscreen: History of a Medium (exh. cat., intro. R. S. Field; Philadelphia, PA, Museum of Art, 1971–2)

C. Bouyer: 'Arcay et la sérigraphie', *Cimaise*, cxiv (1973), pp. 108–9

M. Caza: *La Sérigraphie* (Geneva, 1973)

W. Hainke: *Siebdruck: Technik, Praxis, Geschichte* (Cologne, 1979)

T. Mara: *The Thames and Hudson Manual of Screenprinting* (London, 1979)

Kelpra Studio: The Rose and Chris Prater Gift, Artists' Prints, 1961–1980 (exh. cat., intro. P. Gilmour; London, Tate, 1980)

S. Bacot: 'La Sérigraphie d'art en France', *Nouvelles de l'estampe*, lxxii (1983), pp. 9–30 [incl. list of workshops]

M. Lovejoy: 'The Kelpra Contribution: Silkscreen Joins the Mainstream', *Print News*, v (1983), pp. 8–12

Harry Gottlieb: The Silk Screen and Social Concern in the WPA Era (exh. cat., intro. G. Gilbert and S. Conkelton; New Brunswick, NJ, Rutgers University, Jane Voorhees Zimmerli Art Museum, 1983)

R. Butler: 'Stencil and Screenprint in Australia', *Imprint* (1985), pp. 4–11

R. Williams and D. Williams: 'The Early History of the Screenprint', *Print Quarterly*, iii (1986), pp. 286–321 [incl. checklist of serigraphs made 1932–49]

C. De Noon: *Posters of the W.P.A., 1935–1943* (Seattle, 1987)

R. Williams and D. Williams: 'The Later History of the Screenprint', *Print Quarterly*, iv (1987), pp. 379–403

Illustrated Catalogue of Acquisitions 1984–86, London, Tate cat. (London, 1988) [esp. entries on Patrick Hayman, Peter Lanyon, Warren and Alix MacKenzie, and John Wells]

P. Gilmour: 'R. B. Kitaj and Chris Prater', *Print Quarterly*, xi (1994), pp. 117–50

R. Adam and C. Robertson: *Screenprinting: The Complete Water-based System* (London, 2003)

F. Feldman and J. Schellmann: *Andy Warhol Prints: A Catalogue Raisonné: 1962–1987* (New York, 4/2003)

R. Henning: *Water-based Screenprinting Today: From Hands-on Techniques to Digital Technology* (New York, 2006)

Scrimshaw. Art form that was developed as a pastime by people in the whaling industry; a folk art, but not one based on regional peasant traditions. Scrimshaw includes a wide variety of objects made from sperm-whale teeth (whale ivory), walrus and other tusks, whale bones and baleen. These may be whole or cut up and are identifiable by shape, colour, texture and by the structure and deposition of the growth layers (the grain). Sperm-whale teeth are roughly conical, and decorated examples are usually 80–160 mm long. Walrus tusks resemble angular elephant tusks, but their core is marbled. Narwhal tusks have spiral grain. The lower jawbone (pan bone) of the great whales, of very dense, even texture, was carved, turned or sawn into thin sheets, then polished and engraved. Baleen is a brown, horny, flexible material growing in thin plates with bristle fringes from the upper jaw of baleen whales. Small pieces resemble wood. It takes a high polish and a fine engraving (sometimes heightened with chalk), as seen on plaques and busks; alternatively, it could be heated and moulded to make boxes, canes, riding-whips and life-preservers. Other materials include wood, horn, tropical nuts, shell and tortoiseshell.

Scrimshaw includes such objects as plaques, walking-sticks, pastry-cutters, busks, winders for wool, birdcages, toys, games, jewellery, tools and ship's fittings. Some scrimshaw has inlays and relief carving (see fig.), but the commonest decorations are pictures and designs, referred to as engravings. These were scratched, picked or cut into polished surfaces (especially of sperm-whale teeth) with a sharp point or blade. The grooves were heightened with colour, usually black, but red, blue, green and brown were also used.

The motifs were diverse: animals, plants, children, romantic or topographical scenes, actors, dancers, political or literary figures, even tombstones, but the commonest were ships and pretty women in fashionable clothes. Many pictures were original, especially the ships and whaling scenes, but some were copied or pricked through a template. Some artists and sources have been identified. A whaling scene (Hull,

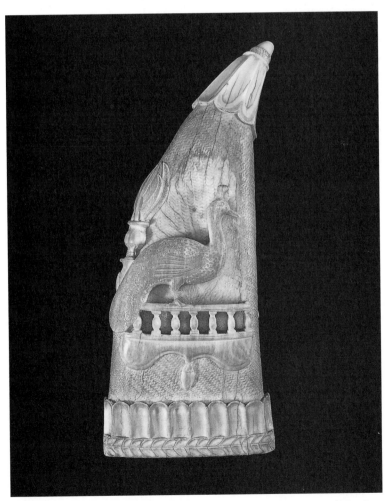

Scrimshaw, ivory, one of a pair, 203×85 mm, *c.* 1850 (Boston, MA, Museum of Fine Arts, Harriet Otis Cruft Fund, 64.2175); photograph © 2008 Museum of Fine Arts, Boston

Town Docks Museum) has been ascribed to Edward Burdett of Nantucket (*fl c.* 1823–33), the earliest documented American engraver of sperm-whale teeth. It is inscribed *Phoenix of London*; one side shows two boats from the vessel attacking sperm-whales, and the other is engraved with a starboard profile view of the vessel cutting-in a whale alongside. It should be noted, however, that dates and the names of ships, people and localities are rare on old scrimshaw but common on forgeries.

The tools were simple: saws, files, chisels and gouges for shaping; sharkskin, pumice, ashes, oil and whiting for polishing. Lathes were uncommon. According to Herman Melville in *Moby-Dick* (1851), some men used only a knife. Line decoration scribed into bone or ivory with a sharp point often has fractured edges. Knife-cut lines and marks are generally asymmetrical and undercut. Broken sail needles make triangular stipples. Broad, shallow, U-shaped grooves may indicate a dentist's drill or a plastic casting, and therefore a recent origin. A good hand-lens helps to identify the materials and techniques.

The first special word for the art appeared in 1821 in the log of the New England brig *Orion*, but the earliest datable scrimshaw is a baleen and wood box (*c.* 1630; Sharon, MA, Kendall Whaling Museum) engraved with Dutch vessels whaling in the Arctic. Much British scrimshaw also originated in the Arctic, where the main materials were baleen, whale bones, walrus and narwhal tusks. However, most scrimshaw was done between 1830 and 1870 and is associated with the hunting of sperm whales, which frequent the warmer deep oceans of the world. Voyages often lasted for several years and gave more opportunity for pastimes. As New Englanders dominated this industry, most scrimshaw has American associations (e.g. national flags and patriotic motifs), but much British scrimshaw exists, as does work from Australia and New Zealand.

Scrimshaw survived the change to modern whaling methods, but 20th-century whalemen preferred sculpted forms. From the 1950s scrimshaw became collectable and expensive. Traditional scrimshaw materials and pictorial decoration are increasingly used by artists and craftsmen; the best is signed, but much of this scrimshaw imitates the old styles and can pass as 19th-century. There are also many mass-produced plastic fakes and reproductions with names and dates, most of which are catalogued.

E. N. Flayderman: *Scrimshaw and Scrimshanders, Whales and Whalemen* (New Milford, CT, 1972)

J. West: 'Scrimshaw: Facts and Forgeries', *Antique Collecting*, xvi/10 (1982), pp. 17–21

R. C. Malley: *Graven by the Fishermen Themselves: Scrimshaw in Mystic Seaport Museum* (Mystic, CT, 1983)

J. West: 'Scrimshaw in Australia with Special Reference to the 19th Century', *Great Circle*, viii/2 (1986), pp. 82–95; ix/1 (1987), pp. 26–39

S. M. Frank: *Fakeshaw: A Checklist of Plastic 'Scrimshaw'*, Kendall Whaling Museum Monograph, i (Sharon, MA, 1988)

S. M. Frank: *A Dictionary of Scrimshaw Artists* (Mystic, CT, 1991)

J. West: 'Scrimshaw and the Identification of Sea Mammal Products', *Journal of Museum Ethnography*, ii (1991), pp. 39–79

N. Hellman and N. Brouwer: *A Mariner's Fancy: The Whaleman's Art of Scrimshaw* (South Street Seaport, NY, 1992)

M. Lawrence: *Scrimshaw: The Whaler's Legacy* (Schiffer, PA, 1993)

J. West and A. C. Credland: *Scrimshaw: The Art of the Whaler* (Hull, 1995)

N. Redman: *Whales' Bones of the British Isles* ([Teddington], 1995)

Scroll. Roll of cloth or paper with written text and/or decoration. This article discusses the scroll in Asia; for Western scrolls, *see* ROLL. The scroll format developed independently in several regions of Asia. Its advantages over other pictorial formats, such as screens and murals, are portability, durability and ease of storage. Scrolls were first made in China *c.* the 1st–2nd century AD. The form was transmitted to Korea and Japan with Buddhism in the 4th and 6th century. Scrolls exist in two forms: the handscroll or horizontal scroll (Chin. *shoujuan*; Jap. *emakimono*) and the hanging or vertical scroll (Chin. *lizhou*; Jap. *kakemono*). The handscroll is read from right to left, being unrolled to the left one arm's length at a time, while the right-hand portion is loosely re-rolled inwards. When finished it is carefully rolled back to the right. The hanging scroll is completely unrolled when on display. Similar in design to East Asian hanging scrolls are *tangkas*, the painted or embroidered Buddhist icons of Tibet, Nepal, Sikkim, Bhutan and Ladakh. Painted cloth scrolls (Skt *paṭas*) are known from 8th-century India, and paper scrolls were made there after the introduction of paper by the Arabs in the 12th century. The tradition of using painted scrolls to illustrate the narration of Hindu epics is found in many areas of India and, until recently, in East Java, where the form is known as *wayang beber*.

1. Materials and techniques. 2. Conservation.

1. MATERIALS AND TECHNIQUES. Handscrolls are generally between 230 mm and 320 mm in height and can reach 10 m or more in length (see fig.). A cylindrical roller (a) of pine or sandalwood is attached to the left end, followed by a length of blank paper (b) that both protects the work or works of art (c) and provides space for later connoisseurs and collectors to write colophons. Paper-backed patterned silk, wider at the sides than at the top and bottom, frames the painting or calligraphy. To the right of the silk border, at the beginning of the scroll, is another length of paper on which the title or heading is inscribed (d) and to which is attached a semicircular wooden stave (e). The stave and roller maintain the shape of the scroll. The entire piece is backed by one or more layers of heavy paper and bonded together with rice paste. A ribbon (f) attached to the stave is wound around the rolled scroll and secured by a toggle. A title label (g) is pasted vertically on to the outer surface. Luxury mountings have protective end-flaps of patterned silk and roller knobs, usually in lacquered or polished

wood, but sometimes in porcelain, coral, gold, jade, crystal, amber, ivory or rhinoceros horn. Although scrolls are generally stored on shelves, they may be kept in embroidered silk wrappers or cushioned wooden boxes.

Hanging scrolls are of much the same construction as handscrolls, except for the absence of the sheets of paper at the top or bottom for colophons. They range in height from 500 mm to 3.5 m. The work of art is edged by two narrow bands of contrasting patterned silk at the top and bottom, known as 'teeth'. A wider paper-backed silk border surrounds the work on all four sides, the upper and lower portions of which are known as 'heaven' and 'earth'. Two vertical strips of silk are sometimes attached to 'heaven', a vestige of the handscroll tie. A suspension loop is affixed to the semicircular stave at the top, and the roller at the bottom serves to keep the scroll flush to the wall.

Himalayan *tangka*s have a central work of art and are always vertical in format. They are embroidered or painted in natural pigments on cloth (usually cotton sized with yak-hide glue mixed with chalk, kaolin or lime) and stitched to a flared silk border that often combines brightly coloured silks and gold and silver brocades. A veil of fine silk attached to the top border protects the painting and conceals it when it is not intended for viewing. The production of a *tangka* is overseen by a monk who approves and consecrates the icon. Inscriptions sometimes appear on the front of the *tangka*, identifying the deities or historical figures depicted, or frequently on the back as *mantra*s (sacred sounds) and dedicatory inscriptions.

A. K. Coomaraswamy: 'Picture Showmen', *Indian Historical Quarterly*, v/2 (June 1929), pp. 182–7

R. H. van Gulik: *Chinese Pictorial Art as Viewed by the Connoisseur* (Rome, 1958)

T. Akiyama: *Japanese Painting* (Geneva, 1961)

Tsien Tsue-hsuin: *Written on Bamboo and Silk: The Beginnings of Chinese Books and Inscriptions* (Chicago, 1962)

M. Sullivan: 'Notes on Early Chinese Screen Painting', *Artibus Asiae*, xxvii (1966), pp. 239–54

J. Mittal: *Andhra Paintings of the Ramayana* (Hyderabad, 1969)

H. Okudaira: *Narrative Picture Scrolls* (Tokyo and New York, 1973)

J. Jain-Neubauer: 'The Chitrakathi Paintings of Maharashtra', *Marg* (Nov 1978), pp. 109–21

A. L. Dallapiccola: *Die 'Paithan' Malerei: Studie zu ihrer stilistischen Entwicklung und Ikonographie*, Heidelberg Universität Sudasien-Institut, xxviii (Wiesbaden, 1980)

J. Jain: 'The Painted Scrolls of the Garoda Picture-showmen of Gujarat', *Quarterly Journal of the National Centre for the Performing Arts*, xi/3 (Sept 1980), pp. 3–23

Xu Bangda: *Gu shu hua jianding gailun* [Connoisseurship of ancient calligraphy and painting] (Beijing, 1981)

Traditional Korean Painting, Korean National Commission for UNESCO (Seoul and Arch Cape, OR, 1983)

D. P. Jackson and J. A. Jackson: *Tibetan Thangka Painting: Methods and Materials* (Boulder and London, 1984)

V. H. Mair: *Painting and Performance* (Honolulu, 1988)

W. Fong: *Beyond Representation: Chinese Painting and Calligraphy, 8th–14th Century* (New York, 1992)

Handscroll constituent elements: a. roller, b. blank paper, c. artwork, d. blank paper for title, e. wooden stave, f. securing ribbon, g. label

S. K. Sharma: *The Indian Painted Scroll* (Varanasi, 1993)

J. Cahill: *The Painter's Practice: How Artists Lived and Worked in Traditional China* (New York, 1994)

P. Ghosh: 'The Story of a Storyteller's Scroll', *Res*, xxxvii (Spring 2000), pp. 166–85

S. McAusland: *Gu Kaizhi and the Admonitions Scroll* (London, 2003)

R. Linrothe and J. Watt: *Demonic Divine: Himalayan Art and Beyond*, New York, Rubin Museum of Art (New York, 2004)

Z. Hongxing: 'Re-reading Inscriptions in Chinese Scroll Painting: The Eleventh to the Fourteenth Centuries', *Art History*, xxviii/5 (Nov 2005), pp. 606–25

2. CONSERVATION. In addition to the conservation problems associated with all painting formats, scrolls are particularly prone to cracks caused by the action of rolling and unrolling. These are often located at the joins between different materials; however, some paintings develop cracks over their entire surface, leading to the loss of painted material and then of the backing. Other agents causing deterioration are insects and humidity, and on religious paintings displayed above temple altars, smoke from incense may cause serious blackening.

The restorer begins by separating the painting from its mounting, normally by cutting the silk surround with a special knife. It is unusual for silk mountings to be reused, although certain exceptional brocades are carefully detached, repaired and remounted. Once the painting has been separated from its mounting, the next step is to treat the coloured areas that are considered unstable. As the glue (Chin. *jiao*; Jap. *nikawa*) in the pigments, which was made from animal skin, loses its strength with age, a fresh solution is applied with a brush. During the drying process, the restorer prepares the main operations: the removal of the old backings and the treatment of the painting. In China the backing paper is generally *Xuan zhi* (bamboo and sandalwood bark fibres; in Japan, *minogami* (*Broussonetia papyrifera*, or paper mulberry, fibres) or *misugami* (the same fibres with kaolin) are the most common. One or two thicknesses of protective paper (in China oiled paper, *shui you zhi*; in Japan ridged paper, *rayonshi*) are stretched over a work-bench to absorb any excess ink or colour. After having been well wetted from the back, the painting is laid out face down so that the backings can be peeled off. Once the first backing has been removed, it is often necessary to proceed fibre by fibre, in order not to pull away any

part of the support. The exposed reverse side of the painting is now rebacked. Wheatstarch paste (Chin. *jianghu*; Jap. *nori*) is carefully filtered and diluted, and the backing paper is applied to the reverse of the painting with an even coat of paste. It is usually after the second backing that the cracks in the painting are treated by covering each with a thin strip of pasted paper. The painting is then remoistened and placed on a drying-board. Once the work is stretched the restorer fills the gaps of the paintings; in China this is done from behind, prior to the placing of the new backing, while the reverse of the painting is exposed. In Japan, where the work of the painter and mounter are separate, the reintegrations are carried out by a professional painter.

Once cleaned, backed and retouched, its cracks and missing parts treated, the stretched painting is ready to be remounted. In Japanese vertical scroll mountings, paintings are often surrounded by three different kinds of silk, often brightly coloured. In China, where the sober vertical mounting of the Qing period (1644–1911) is still in fashion, it is rare to assemble more than two kinds of silk. These are usually of the *lingzi* ('shadow silk') type (very fine damask with flower and bird patterns). On occasion, a fine band of rich brocade is used to highlight the sides of the painting (*see also* MOUNTING). It is the work of two people to lower the final backings and then brush the painting. In China, the laying of the work on the drying-table comes immediately after backing, because *lingzi* silks are liable to shrinkage. For vertical scrolls, pockets (Jap. *jikubukuro*) are constructed, with two strips of strong paper to receive the stave and roller. In China this final backing is made of a thick paper saturated with liquid paste; the adhesive used in mounting is wheatstarch paste. In the finishing process the scroll is detached from the table, and the stave and roller are fixed. In the case of handscrolls, these are much finer and are fixed without pockets. Finally, a container is made for the scroll. Chinese collectors, for whom handscrolls have always been the most valuable, often keep them wrapped in a silk square inside a pocket made of expensive brocade, closed by a jade or ivory pin. In Japan, where vertical scrolls are the most highly considered, a box in Japanese cedar (*sugi*; *Cryptomeria japonica*) is often made to measure. A particularly valuable scroll may be provided with a second box around the first.

Shuhua de zhuangbiao yu xiufu [The mounting and restoration of calligraphy and paintings] (Beijing, 1981)

C. Illouz: *Les Sept Trésors du lettre; Matériaux de la peinture chinoise et japonaise* (Paris, 1985)

P. Wills and N. Pickwoad: '*Hyogu*: The Japanese Tradition in Picture Conservation', *Paper Conservator*, ix (1985)

J. S. Mills, P. Smith and K. Yamasaki: *The Conservation of Far Eastern Art* (London, 1988)

H. Lin: 'La restauration des peintures et calligraphies chinoises anciennes', *Conservation restauration des biens culturels*, xii (1998), pp. 35–9

K. Robinson: 'An Edo Masterwork Restored: The Chogonka Scrolls in the Chester Beatty Library, Dublin', *Irish Arts Review Yearbook*, xvi (2000), pp. 73–80

V. Lee, X. Gu and Y.-L. Hou: 'The Treatment of Chinese Ancestor Portraits: An Introduction to Chinese Painting Conservaion Techniques', *Journal of the American Institute for Conservation*, xlii/3 (Fall–Winter 2003), pp 452–56, 463–77

Scumble. Term for a thin layer of opaque or semi-transparent oil paint, applied on top of another layer without completely hiding it. It is effectively the opposite of a glaze and gives a broken and hazy effect, toning down the brilliance of the underlying colour.

Secco. Generic term given to any method of wall painting carried out on dry plaster, as opposed to FRESCO, which is executed on wet plaster. When the pigments are oil-based, it is more correct to call the technique 'oil mural painting'; when the colours are suspended in limewater, the term LIME SECCO is used.

Although secco is easier to execute than fresco, it is far less durable. For this reason it was not highly regarded by fresco painters, or by the authors of treatises. It cannot withstand exposure to the elements and is thus suitable only for the decoration of interiors, where it is used to paint scenes (see colour pl. XIII, fig. 3) or to add finishing touches to a fresco.

1. Materials and techniques. 2. Conservation.

1. MATERIALS AND TECHNIQUES. The techniques of secco painting are many and varied, as are the methods of preparing the dry plaster. Often a number of techniques were used in different layers of the same painting, and sometimes tempera and oil paint cannot be readily distinguished, for example when egg and oil are combined in the same emulsion.

(i) Tempera. Secco painting was frequently carried out in TEMPERA and among the most common media were egg beaten with fig-tree latex, casein, dilute glues obtained from animal skins and parchment, and stronger animal glues, such as rabbit-skin glue, to which milk could be added.

There were many ways of preparing the plaster for tempera painting. Usually the *intonaco* was carefully smoothed, then smeared with *gesso spresato* (a non-setting plaster made of calcium sulphate heated to 400–600°C) and glue. Then it was treated with layers of dilute animal glue, or with gesso bound in a light glue. Sometimes minium (red lead) was added to obtain a thicker mixture. Once this preparatory layer was thoroughly dry, a further coat of *bianco di Spagna* (a white chalk consisting of calcium carbonate from seashell deposits) and glue could be applied, mixed with a coloured pigment if a white background was not required. The preparatory process was now complete and painting could begin: the colours were ground with a little water, and to this mixture a dilute animal glue, previously warmed, was added at intervals. A similar technique,

widespread from the mid-18th century to the early 20th, was used for decorative painting in the antique style. The surface of the plaster was prepared with *gesso spresato* and rabbit-skin glue, then treated with a coat of milk. The pigments were mixed with milk or animal glue to which white lead and a little gypsum were added.

For mural painting in egg tempera, Cennino Cennini (*c.* 1370–*c.* 1440) recommended that the pigments be bound in whole egg mixed with fig-tree latex. He warned that 'too much tempera [medium] will break up the colour and cause it to come away from the wall'. The areas to which the paint was to be applied were prepared by sponging with a mixture of whole egg beaten in water. If an entire scene was to be painted in secco, Cennino recommended that the surface of the wall be carefully smoothed. A drawing in charcoal (which is correctable) could be made on the plaster before the definitive design was fixed in ink or *verdaccio* (one part black to two parts ochre). Over this drawing, and indeed over the whole surface, a layer of very dilute glue, or egg tempera with fig-tree latex, was applied.

In the 14th century any colours that could not be painted in fresco technique were left until last and completed in tempera when the plaster had dried, and in the 16th century less able painters sometimes shaded their nudes with thin layers of watercolour composed of lampblack bound with gum arabic. In the Baroque period, however, finishing touches in tempera were not confined to specific areas but were applied freely over the whole surface of the painting, at the end of the fresco process, wherever the tonal range needed modifying. Andrea Pozzo (1642–1709) described this method in his treatise of 1692: 'Lime always alters in some measure, especially in the shadows, and consequently one can—indeed one must—retouch, using short strokes to apply pastels made from eggshells, or simply by going over the work with a slightly damp brush'.

(ii) Oil. In northern Europe oil became the preferred medium for mural painting, partly because it was more durable in damper climates. Sources dating from the 12th century suggest that certain pigments were even then applied in oil, and by the 14th century oil was used extensively. In important, costly commissions the paint was often applied in layers in a technique similar to that of panel painting: first, a glue- or oil-based primer to prevent the absorption of the paint, then a tinted base coat highlighted with white, and finally glazes. In more popular work oil was combined with other techniques based on the fresco or lime secco process. Oil continued to be used in northern Europe and in England; for example, virtually all the mural schemes of the 17th and 18th centuries were executed in oil.

In Italy, however, wall painting in oil was experimented with on a large scale only in the 16th century. The gradations of tone and rich modelling that were then desirable could not be achieved in fresco or tempera, so such artists as Leonardo da Vinci (1452–1519), Giorgio Vasari (1511–74), Sebastiano del Piombo (1485/6–1547) and Francesco Salviati (1510–63) sought methods of painting murals in oil. Their attempts were generally unsuccessful and the technique was soon abandoned on account of its poor durability in the climate.

Sometimes the oil was put directly on to stone or slate in emulation of panel painting. For painting on walls, Vasari advised the application of two coats of boiled linseed oil (or as many as it took for the wall to become saturated); then the surface was to be primed or coated with a mixture of gesso and glue, followed by a layer of hot animal glue put on with a sponge. If the wall suffered from damp, a stucco of marble or brick dust could be applied first, followed by a layer of linseed oil and, finally, a mixture of mastic, Greek pitch and coarse varnish applied with a hot trowel to smooth over any irregularities. Another method of preparing a newly erected wall was to prime it, after an initial swabbing down, with boiling linseed oil and lead acetate over which a layer of white lead, mixed with the selected colour, could be applied. When finished, the painting could be protected with a light coating of wax varnish. (*See also* OIL PAINTING, §1.)

(iii) Hybrid techniques. In the 19th century, after the great age of fresco painting had waned, mural painting was usually carried out in secco using various hybrid techniques. These generally consisted of painting a sketch in fresco, smearing it with glue and then completing the composition in tempera. Another technique was to plaster large sections (bigger than the *giornate* found in fresco painting) and then to work on these in fresco, starting with the pounced design and subsequently sketching in the half-tones and dark colours in raw umber, Venetian red and black, but omitting the light colours. When the plaster was dry, this sketch was smeared with two or three coats of milk or another such medium, on top of which the painting was completed.

In the 20th century new methods of secco painting, using acrylic and vinyl resins and industrial enamels, were adopted by such mural painters as David Alfaro Siqueiros (1896–1975).

2. CONSERVATION.

(i) Tempera. The cleaning of tempera requires care and skill, since the solvents that remove grease, protein, soot and other extraneous substances from the paint surface also act on the medium. Organic solvents can be used, but the results are often unsatisfactory. It is dangerous to dampen the painting with water because tempera stains extremely easily and the marks are irreversible. It is advisable, therefore, to carry out the cleaning process dry, using very soft putties, similar in consistency to soft bread. (In the past bread itself was used.) Good results can also be obtained by using

packs of damp wood-pulp and Japanese paper: the humidity of the pack causes the film of dirt to swell and soften and thus to be readily absorbed into the pack as it dries. The paint layer is protected by the sheet of Japanese paper and is not submitted to any mechanical cleaning process other than the delicate operation just described. The adhesion of the paint is weakened by this treatment and it has to be restored with very dilute acrylic resins. These must be used with great care as an excess of resin will heighten the tone of the colour. As an alternative to resin, a weak solution of barium hydroxide can be applied.

Tempera painting that has been executed on a preparatory layer of gesso and glue does not always adhere properly to its support, particularly when the glue is too strong and dry, and the mortar of the *intonaco* not sufficiently compact. Again, adhesion is achieved with injections of acrylic resins. As a further conservation measure the humidity of the surrounding atmosphere may be raised to prevent the glue from drying out further.

Tempera painting can be retouched in watercolour. It is more common, however, for the retouching media to be egg and wine vinegar, or Primal AC33 and water.

(ii) Oil. Paint flaking may also be a problem with oil murals. As the plaster ages it becomes friable and powdery, so dislodging the film of paint and the preparatory layer. When this happens the crumbling plaster can be consolidated with barium hydroxide or a 2–4% solution of Paraloid B-72. The flakes of paint are then stuck back with a solution of Primal AC33 in a concentration of about 15%. Oil mural paintings are cleaned and retouched in watercolour using the same methods as are used for oil on panel and canvas (*see* OIL PAINTING).

See also WALL PAINTING.

Early sources
C. Cennini: *Il libro dell'arte* (*c.* 1390); Eng. trans. and notes by D. V. Thompson jr as *The Craftsman's Handbook: 'Il libro dell'arte'* (New Haven, 1933/R New York, 1954)
G. Vasari: *Vite* (1550; rev. 2/1568); ed. G. Milanesi (1878–85)
A. Pozzo: 'Breve istruttione per dipingere a fresco', *Prospettiva de' pittori ed architetti* (Rome, 1692)

Specialist studies
R. Mayer: *The Artist's Handbook* (New York, 1940, rev. 5/1991)
G. Ronchetti: *Pittura murale* (Milan, 1983)
P. Mora, L. Mora and P. Philippot: *Conservation of Wall Paintings* (London, 1984)
G. Colalucci, A. Ballantyne and A. Hulbert: '19th and Early 20th Century Restorations of English Mediaeval Wall Paintings: Problems and Solutions', *Les anciennes restaurations en peinture murale* (Paris, 1993), pp. 143–51
F. Fernetti: 'Considerazioni sulla tipologia delle stessure a secco/Notes on the Types of *a secco*', *Bollettino d'arte*, special volume (2005), pp. 109–20

Serigraphy [from Gr.: 'silk' and 'drawing']. Name applied by a group of American artists in the 1940s

to the silk screen process, now generally known as SCREENPRINTING. They coined the term to differentiate the technique developed for fine art prints from its cruder commercial applications. The artist Anthony Velonis (1911–97) and the historian and curator Carl Zigrosser (1891–1975) tentatively advanced the new name in the catalogue of the second group exhibition of screenprints, which opened in 1940 at the Weyhe Gallery, New York. The use of 'pseudo-learned' Classical roots for the etymology of the term was immediately attacked by the reviewer Elizabeth McCausland, but it was successfully defended by Zigrosser and institutionalized in the name of the National Serigraphic Society (1940–62). This American neologism, which survives in both French (*sérigraphie*) and Italian (*serigrafia*), became a misnomer when silk was gradually replaced by synthetic gauzes as the mesh used in the process.

E. McCausland: 'Gallery Exhibits Silk Screen Color Prints', *Springfield Sunday Union and Republican* (24 March 1940)
C. Zigrosser: 'As to "Serigraph" for Silk Screen Prints', letter to the editor in *Springfield Sunday Union and Republican* (21 April 1940)
C. Zigrosser: 'The Serigraph: A New Medium', *Print Collector's Quarterly*, xxviii (1941), pp. 442–77

Sfregazzi [It.: 'light rubbing']. Term used in oil painting to refer to shadows applied as a glaze with the fingers over flesh tones.

Sgraffito [It.: 'scratched']. Term applied to ceramics, fresco decoration and painting to describe the use of a sharpened tool to score or scrape designs through an opaque coating, to reveal either the base fabric or a secondary colour beneath. *Sgraffito* has been mainly used in ceramics, where the cut channels were sometimes inlaid with slip or glaze of different colours for contrast. The effect of *sgraffito* is to emphasize decorative motifs or to outline forms.

Sheffield plate. Type of silver-plated wares produced from the mid-18th century in Sheffield and later in Birmingham and elsewhere (see fig.). Sheffield plate was manufactured by a technique known as fused plating, which involved fusing thin sheets of silver onto ingots of copper in a furnace; these ingots were then rolled into sheets, which could then be worked by methods similar to those used for solid silver (*see* SILVER, §3 and METAL, §III). The marketing of 'copper rolled plate' is first attributed to the cutler Thomas Boulsover (1704–88), who is said to have produced buttons, buckles and small boxes from 1745. Production of Sheffield plate on a commercial scale was established by Joseph Hancock (1711–91), who developed industrial processes to manufacture a wide range of solid and hollow wares during the 1760s.

By the 1770s most forms of silverware were also available in Sheffield plate. The danger of exposing the copper base, however, presented problems to the manufacturer and gave rise to techniques of decoration unique to Sheffield plate. Emphasis was given to

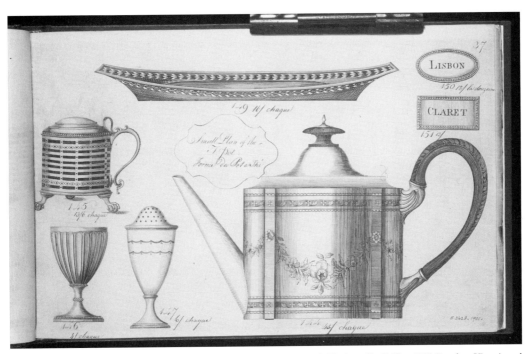

Sheffield plate designs, engraving from a commercial traveller's catalogue, probably from Sheffield, c. 1785 (London, Victoria and Albert Museum); photo credit: Victoria and Albert Museum, London/Art Resource, NY

the elaboration of form, and fluting and reeding were commonly used. Wire of silvered copper or solid silver, which could be plain, threaded or beaded, was also often soldered along edges and rims. A special type of fly punch, which drew the silver through the opening to conceal the copper core, was developed for pierced decoration; this could be employed only on double-plated articles, which appeared after 1760. Flat-chasing and die-stamping were used as alternatives to engraving, although panels of solid silver were often incorporated into plate wares to permit monograms, crests and deep-cut decoration, so popular on glass and silver, to be engraved. The characteristic brilliance of Sheffield plate was obtained by burnishing and polishing with wet rouge, a task often carried out by women.

The industry was quick to adapt to mechanization, and production also started in Edinburgh and Birmingham. The latter overtook Sheffield as a centre of production during the 1830s. Among the early manufacturers of Sheffield plate wasMatthew Boulton (1728–1809), who installed water-powered machinery at his factory in Soho, Birmingham, where he produced objects of the highest quality in the fashionable Neo-classical style. Other important manufacturers in Sheffield were Roberts, Cadman & Co., Winter, Parsons & Hall, Wilkinson & Co., and Thomas Bradbury & Sons. The last, together with Dixons & Sons of Birmingham, displayed Sheffield plate at the Great Exhibition in London in 1851.

The composition of Sheffield plate was never standardized, and its commercial success, together with frequent abuses of the use of silver hallmarks by Sheffield plate manufacturers, led to the establishment of assay offices in Sheffield and Birmingham. After 1784 plate could be stamped with the manufacturer's name and mark in a single punch, if this was registered with the Sheffield Assay Office. After 1815, a crown, the Sheffield town mark, was unofficially used to distinguish high quality pieces from continental plated wares. Sheffield plate continued to be manufactured in Britain on a large scale until the mid-19th century, when the less expensive method of ELECTROPLATING, using a variety of base metals, supplanted it.

F. Bradbury: *History of Old Sheffield Plate* (London, 1912, 2/Sheffield, 1968)

E. Wenham: *Old Sheffield Plate* (London, 1955)

G. B. Hughes: *Antique Sheffield Plate* (London, 1970)

A. Bambery: *Old Sheffield Plate* (Aylesbury, 1988)

J. Bly: *Miller's Silver and Sheffield Plate Marks: Including a Guide to Makers and Styles* (London, 1993)

Shell. Hard, protective outer covering of calcium carbonate secreted by animals of the worldwide invertebrate phylum Mollusca.

1. MATERIALS AND TECHNIQUES. Almost all species of shell used for artefacts are of the marine variety. The most important genera are *Haliotis* (abalone), found in the waters off New Zealand, California and western Europe; *Conus*, found in the Indo-Pacific area and East Africa; *Dentalium*, found on the Pacific rim, particularly off the west coast of Canada; *Melo*,

found off Papua New Guinea; *Nassa, Nautilus, Nerita, Pinctada* (pearl oyster), *Triton* and *Tridacna* (clam), all found in Indo-Pacific waters; *Spondylus* (thorny oyster) of the Pacific; *Cassis* (helmet) found in the Caribbean; and *Monetaria* (cowrie), found in the Indo-Pacific area. Species of the *Mytilidae* (mussel) family occur worldwide. The continuously exuded skeleton of colonies of polyps found in the Mediterranean, the Red Sea and the Pacific forms coral, a calcareous substance similar to shell and used in the same way for inlaying and to make beads (*see* CORAL, §2).

Shell can be cut or engraved, pierced, and polished (see fig. 1). In Western art shells have been carved or engraved whole or in sections for use as inlay. Whole shells have also been widely used, especially for the walls of grottoes. A greater variety of decorative techniques have been employed in other cultures; bow-saws, pump-drills and such abrasives as pumice or sand in water have been widely used to shape and polish sections of shell, for use in jewellery and inlay on carved wood. Shell was also made into beads, for example in the Solomon Islands, the hole being bored using a pump-drill tipped with flint, before European-made tools became available in the 17th century.

See also TORTOISESHELL and MOTHER-OF-PEARL.

C. Ritchie: *Shell Carving: History and Techniques* (London, 1974)

R. Novella: *Classification and Interpretation of Marine Shell Artifacts from Western Mexico* (Oxford, 1995)

2. USES. Shell has been used principally in decoration, both of objects and architecture, but it is also used extensively in jewellery and as a work of art in itself. In Egypt in the Predynastic period shells were strung together for necklaces; this also occurred in prehistoric Europe, when shells were obtained from the Mediterranean and must have been traded over considerable distances. Shells were also polished and smoothed as discs or other simple, decorative forms.

In Western art, shell carved in low relief has been widely used for jewellery and for inlay, particularly on furniture and musical instruments. During the 16th and 17th centuries, however, an entire shell, usually that of the nautilus, sometimes engraved, was often mounted in precious metal (see fig. 2). Bullmouth helmet shells were the species generally used for carving shell cameos during the same period. From the Renaissance, but particularly in the 17th and 18th centuries, the use of shell in grottoes and shell-houses or shell-rooms was extremely popular. In the shell-house (1740s) at Goodwood House, W. Sussex,

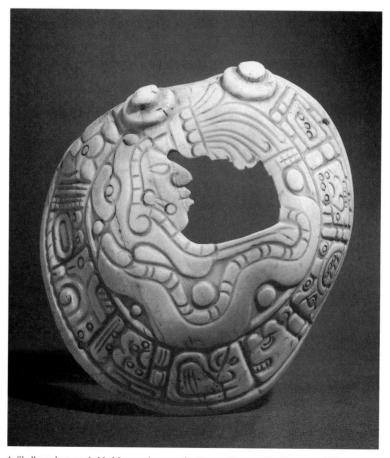

1. Shell pendant, probably Mayan; photo credit: Werner Forman/Art Resource, NY

2. Nautilus shell ewer (detail) with gilt mounts, pearls, rubies and turquoise, Italian, *c.* 1570. (Florence, Palazzo Pitti, Museo degli Argenti); photo credit: Erich Lessing/Art Resource, NY

and in the Shell Gallery at A la Ronde, Devon, a variety of shell species was used to emphasize the architectural forms. Shells were used with greater abandon in the grotto (1739) in Goldney House, Bristol, and Oatlands Park (destr.), Surrey. This skill of working with shells, which included the decoration of such smaller items as boxes and mirror-frames, was one of many amusements practised by ladies. Tourist souvenirs composed of shell and using shell as applied ornament were mass produced from the mid-19th century but consisted mostly of shell-encrusted boxes or pictures that did not emphasize the inherent qualities of the material.

In other cultures shell has also been incorporated in items of personal adornment as well as for inlay. Although use of specific shells has been described in ethnographic literature, it is often difficult to detect exactly which species has been employed in the making of an artefact.

The most extensive use of marine shell has occurred in the islands of the Pacific. Discs of the *Tridacna gigas* (giant clam) were used in Melanesia in conjunction with turtle-shell, with which it contrasted in colour and texture, for example in the spectacular forehead ornaments known as *kap-kap* (examples in Maidstone, Museum and Art Gallery). Belts and arm-bands of shell in three colours—black (mussel), red (*Spondylus*) and white (*Arca*)—in chevron and other geometric designs were made in the Solomon Islands, where inlay incorporating *Pinctada margaritifera*, the black-lipped pearl-shell, or pearl-shell from the nautilus, was used extensively on canoes, carved figures, dance batons, shields, spears, axes and clubs in geometric designs. *Haliotis (Haliotis*

australis) was favoured for inlay by the Maori of New Zealand, for highlighting eyes in carvings on figures, canoes and other objects (e.g. in Wellington, Museum of New Zealand, Te Papa Tongarewa).

Conus shells were highly valued in Melanesia and were used as inlay to decorate ancestors' skulls in the Sepik region of Papua New Guinea. A *Conus*-shell armband was one of the essential elements in the long-distance trading partnerships of southeast New Guinea. In New Caledonia armlets were made of a thick cross-section of the shell. Hawaiian shell necklaces were made of cowries, *Nerita* and *Conus* shells, of which the *Nerita* were especially valued; imitations of them were even made in sperm whale ivory. Some images of gods from the Hawaiian Islands incorporated shell decoration (*see* FEATHERWORK).

In Africa shells have been most commonly used polished and pierced as necklaces: cowries throughout the continent, mussel-shell particularly in West and Central Africa, ostrich egg-shell by San women in the Kalahari desert. Money cowries (*Monetaria moneta*) from the Indian Ocean have been traded extensively throughout Africa from the 11th century AD. Strings of cowries decorate carved figures, for example Yoruba *ere ibeji* (wooden figures that commemorate departed twins) from south-west Nigeria, baskets from northern Nigeria and Ghana, and leather bags and calabash milk containers from Kenya. In all African cultures the cowrie represents wealth. The *Conus* shell was also highly valued in East and Central Africa and was traded from the east coast far inland. The flattened spiral disc at the base of the shell was worn as a head or neck ornament in Zambia, Tanzania

and the Democratic Republic of Congo (formerly Zaïre).

Spondylus has been used in South America since the second millennium BC in personal adornment. The Pacific form of this shell (*Spondylus princeps*: the prince thorny oyster) was traded from the Ecuadorian coast into Peru. The whole shell, roughly prepared, was used as a ground for a figured inlay of bone, shell and stone in the first half of the first millennium. It was also made into beads and woven into elaborate collars (examples in London, British Museum).

The use of long, thin, white tubes of *Dentalium* (tusk-shell) was widespread in western North America: it was regarded as a sign of wealth. It originates on the Pacific coast of Canada but is used from northern California to the Arctic. Necklaces and chest ornaments of *Dentalium* laced in parallel were worn by Plains Indian groups from the early period until the late 19th century. After European contact, longer, straighter sections of bone or non-specific shell known as 'hair pipes', a European-made copy, were more widely used than *Dentalium*. *Haliotis* (abalone) was used as inlay by North-west Coast groups on masks, smoking pipes, clubs, dagger-handles and rattles to represent teeth or eyes. *Haliotis*-shell necklaces were used by Californian Indians in offerings to the dead (see Mack, p. 165). *Wampum* was made of cylindrical white and purple beads, the white from various species of whelk (Busycon), the purple from *quahog* (*Mercenaria mercenaria*). It was highly prized by the Iroquois and used to authenticate transactions. Strung on animal sinews in particular combinations of colour and pattern, a *wampum* 'belt' (e.g. London, British Museum; Oxford, Oxford University, Pitt Rivers Museum) could convey messages. Shell was often used in conjunction with beadwork on such items as clothing, sculpture, furniture, jewellery and baskets.

Although the use of shell was less widespread in Asia than in other continents, the conch shell (*Turbinella pyrum*) is one of the eight sacred Buddhist symbols, symbolizing the voice of the Buddha. The use of conch-shell trumpets was imported into East Asia from southern India, where they were originally employed in Hindu religious ceremonies. In Tibetan Buddhism, conch-shell trumpets comprise one of the monotonal musical instruments used in worship; some are decorated with textile streamers, while others are fitted with stylized metal pennants. Bracelets made from sections of the conch shell are used in Bengali marriage ceremonies.

A. Pitt-Rivers: *Antique Works of Art from Benin* (London, 1900/R New York, 1975)

W. G. Ivens: *Melanesians of the South-east Solomon Islands* (London, 1927)

B. Jones: *Follies and Grottoes* (London, 1953, rev. 1974)

B. Danielsson and others, ed.: *La Découverte de la Polynésie* (Paris, 1972)

T. J. Brasser: *"Bo'jou, Neejee!"* (Ottawa, 1974)

S. Phelps: *Art and Artefacts of the Pacific, Africa and the Americas* (London, 1976)

D. B. White: *Artefacts from the Solomon Islands in the Julius L. Brenchley Collection* (London, 1987)

J. Mack, ed.: *Ethnic Jewellery* (London, 1988)

P. J. C. Dark and R. G. Rose, eds: *Artistic Heritage in a Changing Pacific* (Honolulu, 1993)

H. Stewart: *Stone, Bone, Antler and Shell: Artifacts of the Northwest* (Vancouver and Seattle, 1996)

R. L. Zettler and L. Horne, eds: *Treasures from the Royal Tombs of Ur* (Philadelphia, 1998)

L. S. Dubin: *North American Indian Jewelry and Adornment: From Prehistory to the Present* (New York, 1999)

S. Kleinert and M. Neale: *The Oxford Companion to Aboriginal Art and Culture* (Melbourne and New York, 2000)

H. Jackson: Shell Houses and Grottoes (Princes Risborough, 2001)

A. P. Bautista: *Shell Ornamentation of La Purisima Concepción Church, Guiana, Eastern Samar* (Manila, 2003)

M. C. Pedersen: *Gem and Ornamental Materials of Organic Origin* (Oxford and Burlington, MA, 2004)

Shuttering [formwork]. Term applied to the liners or forms, made of steel, wood or plastics, into which liquid concrete is poured or pumped, and which determine its final shape. In the USA the term 'formwork' is used to describe these. The shuttering is removed or 'struck' after the concrete has hardened sufficiently to bear at least its own weight. Shuttering may require design and layout as complex as that for the finished structure, especially for a large project; in addition, the shuttering must be easily assembled, have no re-entrant angles that would make it difficult to remove, and must usually be reusable. It must also take the weight of wet, liquid concrete, be reasonably watertight to prevent leakage of the water and cement slurry and must keep the intended shape of the member that is being cast within it without bulging or distortion. Steel, wood or plastics can all be used although building codes in most countries prohibit the use of aluminium in shuttering unless it is effectively coated or covered to prevent interaction with the cement. In waffle slab construction, plastic pans or 'domes' are favoured for ease of removal and repositioning.

In pre-tensioned pre-stressed concrete construction the shuttering must be of steel: pre-stressing wires are threaded through the end plates of the forms and are then highly pre-stressed, which causes the forms to be under considerable compression. The concrete is then poured round the pre-stressed wires and sets round them, thereby gripping them, after which the wires are cut, thereby pre-stressing the beam. In post-tensioned pre-stressed concrete, however, used for very heavy structures, pre-stressing is carried out after the concrete has hardened, and so the shuttering has to take only the weight of the liquid concrete, although by this method such loads can themselves be very high.

Another consideration in the design of shuttering is providing adequate support for the entire assembly of forms. In multi-storey, high-rise construction the shuttering for each floor can be supported by the floor directly beneath it. In some structures, such as

towers and the cores of high-rise buildings, a later method called slip-forming may be used. This involves the use of forms that are moved upwards as the concrete sets. After World War II much attention was devoted to ways of dispensing with traditional shuttering: air balloons were used with sprayed concrete, for example, and deflated after the concrete set. There are many methods in which the shuttering remains part of the completed structure; even the site itself may be used as shuttering. Paolo Soleri (*b* 1919) and others have experimented with casting over earth that is dug out after setting. The 'tilt-slab' technique is more common, in which concrete wall panels are poured horizontally into forms on the ground and then raised into their vertical position.

T. Dinescu: *Slip Form Techniques* (Bucharest, 1970, rev. Tunbridge Wells, 1984)

D. L. Hightower: *Fibreglass Reinforced Polyester Wall Forming System* (Lawrence, KS, 1974)

C. E. Moore: *Concrete Form Construction* (New York, 1977)

J. G. Richardson: *Formwork Construction and Practice* (Slough, 1977)

J. M. Fehlhaber: 'Concrete: A Constructive History', *Baumeister*, xcviii/12 (Dec 2001), pp. 63–5, 67

A. Moravanszky: 'Verlorene Schalung?', *Werk, Bauen + Wohnen*, i–ii (2005), pp. 4–9

Siccative. Substance, usually a metallic salt or solution, added to linseed oil or other painting oils to accelerate the rate of drying (*see* OILS, DRYING). Some pigments, such as lead white, have siccative properties.

Silicate painting. Comparatively modern method of painting in which the pigment is bonded with an extremely durable film of glassy silicates or silica. The end result can resemble either *buon fresco* or fresco *a secco* (*see* WALL PAINTING, §I), depending on the exact method and choice of materials, although a greater range of effects is possible with the latest generation of silicate paints. The original method of silicate painting is more difficult to employ even than true fresco, but is longer lasting, with the potential to endure in unfavourable conditions, such as on external walls in northern climates, for up to 100 years.

The alchemist Basilius Valentinus first made 'liquor silicum' in the 15th century, and water glass—sodium or potassium silicate in liquid form—was rediscovered in 1818; silicate painting was first proposed as 'stereochemistry' *c.* 1850. In the 19th century it was also known as 'mineral painting' or 'stereochromy'. Adolf Wilhelm Keim (1851–1913) eventually succeeded in making the medium workable, but, because of its complexity, it was not widely adopted. Keim's mineral painting was used in Switzerland and Germany, where the largest example of a silicate work was executed in 1934 by Hans Bürck. Silicon esters, in particular ethyl silicate, have replaced water glass in modern silicate paints.

In the most complex system of silicate painting, Keim's Mineral Colours Type A, the silicates are formed by the reaction of the pre-treated colour, the complex binding materials and the support. In systems intended for decorative use, Keim's Mineral Colours Types B and C for example, and the most up-to-date organo-silicate systems, the method of handling the colours is much simpler. Silicate painting is, in theory, the most suitable method of working on concrete and therefore has considerable artistic potential in the modern environment; however, its technicalities, the limited availability of the materials and a general lack of artistic awareness of the technique mean that it is little used. Silicate paints are not, in fact, extensively used either artistically or decoratively and are mostly employed for their non-flammable or anti-corrosive properties. Keim's Mineral Colours were, however, apparently still available in Germany in the 1960s.

M. Doerner: *Malmaterial und seine Verwendung im Bilde* (Stuttgart, 1933); Eng. trans. by E. Neuhaus as *The Materials of the Artist* (New York, 1934/R London, 1979)

R. Mayer: *A Dictionary of Art Terms and Techniques* (London, 1969)

K. Welhte: *The Materials and Techniques of Painting, with a Supplement on Colour Theory* (New York, 1975)

Silk. Strong, soft and lustrous fibre produced by the larvae of certain moths. The most widely exploited variety for the manufacture of textiles is derived from the cocoons of the *Bombyx mori* moth, which is fed on mulberry leaves. Although its economic significance is relatively minor, as it has always been an expensive and rare commodity and used only for the clothing and furnishings of the wealthy, silk has been very significant to the arts. Its ability to take dyestuffs (see fig. 1) results in fabrics of rich, dazzling colours, and it has been used for the manufacture of a wide variety of textiles, from heavy, rich velvets to the most delicate gauze. Due to its wide dispersal through international trade, it has also been an important means of disseminating ornament and pattern.

The cultivation of silk originated in China in the late 4th millennium BC and spread slowly westwards via the Silk Route, which became one of the main arteries of trade. Western Central Asia and the area of modern Syria, Iran and Iraq were extremely important in the spread of silks, the craft of silk-weaving and sericulture, as trade routes linking China and the West traversed this region. The history of the introduction of silk-weaving (and sericulture) into this region is obscure, although it is likely that the craft became established in Iran under the Parthians and Sasanians (3rd century BC–7th century AD). Trade in silk was conducted between China and the Roman Empire from the 1st century BC through Persian and Egyptian merchants, and silk was cultivated within the Empire probably by the 2nd and 3rd centuries AD. This industry was continued under the Byzantine emperors, who, from the 4th century AD, had their own court workshops in Constantinople (now Istanbul), which produced silks of a dazzling quality and sophistication.

In the early medieval period both Near Eastern and Byzantine silks were prized diplomatic gifts and

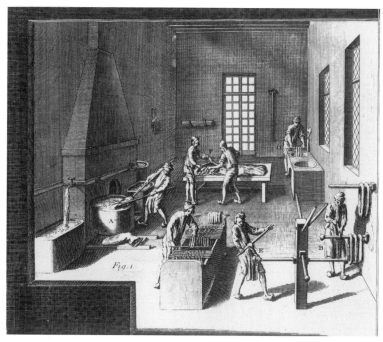

1. Dyeing silk threads; from Denis Diderot: *Encyclopédie, ou Dictionnaire raisonné des sciences, des arts et des métiers* (Paris, 1751–65); photo © Visual Arts Library (London)/Alamy

were widely dispersed. Their patterns, which reflected the highest artistic achievements of the lands from which they came, were a major means of transporting both Asian and Islamic designs to the West. In turn, the silks worn by the clergy or aristocracy in the West were the source material for much decoration in other media. Near Eastern and Byzantine silks have been found in European tombs dating from the 9th century onwards, for example the *Earth and Ocean* silk from the tomb of St Cuthbert at Durham Cathedral (first half of the 9th century AD; Durham, Cathedral Treasury). A Western Asian silk decorated with a Semourv (10th century; London, Victoria and Albert Museum) from the tomb of St Rémi (Reims, St Rémi), dating from AD 852, is another important example. Near Eastern silks also survive in the collections of the Vatican, Rome, and the church of St Mary, Gdańsk, although many have been transferred to other collections (London, Victoria and Albert Museum; Vienna, Kunsthistorisches Museum; Paris, Musées des Arts Décoratifs). Some of the earliest silks from the Near East were also copied in China and exported to Japan; many are preserved in the collection of mid-8th century artefacts in the Shōsōin repository of the Nara temple at Tōdaiji.

During the late 1st millennium AD silks and the craft of silk-weaving were carried across the Mediterranean to North Africa and Islamic Spain. The presence of compound twills in Egyptian graves is evidence of demand among the richest Egyptians from the 7th century AD. Under the patronage of the Abbasid caliphs (*reg* 750–1258) and the Fatimid caliphs (*reg* 969–1171), Tiraz—royal factories producing

patterned silks, fabrics embroidered with silks or decorated with silk tapestry-woven inscriptions—flourished in this part of the Islamic world. Silk cultivation and weaving were also introduced into Spain by the Umayyads (*reg* 756–1031), where, from the early medieval period, the celebrated Hispano-Moresque silks were produced, a number of which have survived (e.g. London, Victoria and Albert Museum). Their geometric style of decoration contrasts with that of silks produced later in Christian Spain. From the 15th century the Mamluk sultans of Egypt and Syria (*reg* 1250–1517) had carpets woven for them with geometric designs in silk pile. This tradition, albeit in a different style, was taken by the Ottomans (*reg* 1281–1924) to Constantinople, after their conquest of the region in 1516–17. Eventually, in the late medieval period, silk-weaving was introduced into Christian Europe, primarily through trade between the Venetian Empire and the Ottomans (see fig. 2).

For the properties of silk, the manufacture of silk fabrics and their conservation *see* TEXTILE.

E. Kühnel: *Catalogue of Dated Tirāz Fabrics: Umayyad, Abbasid, Fatimid*, Washington, DC, Textile Museum cat. (Washington, DC, 1952)

C. F. Battiscombe: *Relics of St Cuthbert* (Oxford, 1956)

F. L. May: *Silk Textiles of Spain, 8th–15th Century* (New York, 1957)

D. Shepherd and W. B. Henning: 'Zandaniji Identified', *Festschrift Presented to Ernst Kühnel: Aus der Welt der islamischen Kunst* (Berlin, 1959), pp. 15–40

Iris, Marchioness Origo: *The Merchant of Prato* (London, 1960)

P. Thornton: *Baroque and Rococo Silks* (London, 1965)

2. Silk fabric, laceria design, Venetian, 15th century (London, Victoria and Albert Museum);
photo credit: Victoria and Albert Museum, London/Art Resource, NY

D. C. Coleman: *Courtaulds: An Economic and Social History*, 2 vols (Oxford, 1969)

Arts of Islam (exh. cat., London, Hayward Gallery, 1976)

L. Parry: *William Morris Textiles* (London, 1983)

J. Arnold, ed.: *Queen Elizabeth's Wardrobe Unlock'd* (Leeds, 1988)

M. Turner and L. Hoskins: *Silver Studio of Design* (London, 1988)

M. King and D. King: *European Textiles in the Keir Collection* (London, 1990)

N. Rothstein: *Silk Designs of the Eighteenth Century in the Collection of the Victoria and Albert Museum* (London, 1990)

400 Years of Fashion, London, Victoria and Albert Museum cat. (London, 1992)

P. Scott: *The Book of Silk* (London, 1993)

A. Ertug and others: *Silks for the Sultans: Ottoman Imperial Garments from Topkapi Palace* ([Istanbul], 1996)

A. Muthesius: *Byzantine Silk Weaving: AD 400 to AD 1200* (Vienna, 1997)

N. Atasoy and others: *Ipek, the Crescent & the Rose: Imperial Ottoman Silks and Velvets* (London, 2001)

D. Jenkins, ed.: *The Cambridge History of Western Textiles* (Cambridge, 2003)

D. De Jonghe and others: *The Ottoman Silk Textiles of the Royal Museums of Art and History in Brussels* (Turnhout, 2004)

S. Vainker: *Chinese Silk: A Cultural History* (London, 2004)

M. Schoeser: *Silk* (New Haven, 2007)

Silver. White, chalcophile metallic element, with an atomic weight of 107.87 and a specific gravity of 10.7. It is one of the 'noble' metal group and is usually found in ores combined with gold and/or copper, as well as with lead and zinc sulphides. In earliest times it was scarcer than gold and was used sparingly for jewellery and smaller objects, often of a mystical nature. Hence it was likened to the moon, given the name Luna by alchemists, and became the symbol of the goddess Diana. As 'a Mineral of that excellent Nature' (William Badcock: *A New Touchstone for Gold and Silver Wares*, 1679), silver has been most valued for its lustre and non-reactivity. It is traditionally valued at approximately 6.6% of the equivalent weight of gold. Silver used to be in heavy demand for most of the world's coinage and particularly for the photographic industry, while the space industry is still reliant on it.

1. Introduction. 2. Properties. 3. Techniques.

1. INTRODUCTION. The traditional sources of silver in Europe, for example Goslar in Germany, were

supplemented by the discovery in the 16th century of deposits in Mexico, Central America (particularly Potosí in Bolivia), and later in Nevada, USA, Canada, Australia and Russia. Native silver, which contains 80–90% pure metal and frequently proportions of gold, copper and other metals, can be found in some areas in nuggets, but usually the richest deposits are veins found in such lesser minerals as quartz.

Cupellation was one of the earliest traditional refining methods, as described, for example, in Georgius Agricola's *De re metallica* (Basle, 1556); it involves heating the silver ore in air to above its melting point (960.8°C) when the impurities oxidize. Lead, mixed with the ore to absorb the impurities, is then absorbed into the cupella, or cupel (porous bowl), in which the heating takes place. Another early method was the parting of gold and silver from combined alloys by dissolution in nitric acid. Silver, being the more reactive of the two noble metals, dissolves, and is subsequently recovered from a filmy dust to leave the metallic gold intact. Amalgamation was used from its inception in Mexico in the 16th century until the end of the 19th. After the silver ore is crushed, it is mixed with a solution of mercury, salt and copper sulphate. Steam and then pressure are applied, and the mixture is heated to a cherry-red intensity in retorts. The mercury is fully expelled, leaving the pure gold–silver metals intact.

Refining techniques that successfully separate silver from other elements, in particular gold, were not perfected until the late 19th century, since when silver has been recovered from copper and lead ores by electrolysis. An electrolytic bath with two electrodes is employed; the positive electrode (anode) comprises partially refined silver, and the negative electrode (cathode) is a thin sheet of almost pure silver. When the current is turned on the positive electrode is dissolved in the acid solution and the cations that are forced through the solution deposit themselves as pure silver on the negative electrode. Any gold present does not dissolve and is thus recovered, and the silver is simultaneously refined.

In the late 20th century silver was extremely cheap in relative terms, but this did not prevent a serious decline in demand for the metal for domestic purposes. A lack of patrons and of good contemporary designers, together with heavy overheads, maintained high prices for a restricted choice of silverware. The demand moved substantially to jewellery and so did much of the young talent in the craft. The craft was divided between the craftsman silversmith, who often specialized in a particular technique and engaged in small-scale production, and the manufacturing silversmith, who often catered for the reproduction market.

2. PROPERTIES. Silver is highly malleable and ductile and is an outstanding conductor of electricity. The relatively low melting point, strength and fluidity of silver facilitate alloying, working and annealing. Silver is usually alloyed with copper to make it harder. Its high reflectivity led to its use in the production of mirrors from 1835, and later in the coating of reflectors. Because it lubricates at high temperatures, it has been used to coat engine parts.

The use of silver has contributed to several important advances in the history of science. Assaying methods fed into the evolution of modern chemistry and quantitative analytical methods, and the introduction of industrial electroplating in the second quarter of the 19th century led to the development of large electric generators. Units of electric charge, current and power are still defined in terms of the amount of silver deposited by a current passing through an electrolytic cell. Silver is used for photography, which depends on the presence of light-sensitive silver halide crystals; exposure to light converts these into minute grains and clusters of metallic silver, which are frozen by developing (*see* PHOTOGRAPHY, §I, 1).

Above all, it is the whiteness of silver, which is warmer than that of platinum, steel or any other metal, that constitutes its aesthetic appeal (see fig.). Its scarcity from antiquity until the end of the Middle Ages sustained its nobility. Contrary to traditional beliefs, it does react to air; tarnish occurs in reaction to sulphur in the atmosphere and permanently etches the surface of the metal unless removed. Likewise, chlorine or chlorides corrode the metal to leave unsightly black stains. Silver is otherwise non-reactive; the copper alloy that is added to it oxidizes during annealing to cause discolouration, or firestain.

3. TECHNIQUES. Many of the techniques employed in the manufacture and decoration of gold, copper and other metals are also applicable to silver (*see* GOLD, §2 and METAL, §§III and IV). Individual craftsmen and workshops may specialize in certain techniques.

(i) Forming. (ii) Joining. (iii) Decorating.

(i) Forming. Most objects are fashioned from sheet, which was formerly obtained by hammering a precast ingot on a steel block; a master and two journeymen simultaneously wielded hammers to flatten and extend the ingot to the required, even gauge. This method gives a radial grain to the metal, instead of the longitudinal striations, only clear under magnification, which are imparted by later steam or electrically powered milling methods. Objects of even, cylindrical shape (e.g. beakers, tankards, flagons or coffeepots) are then seamed up with solder and the bases of fitted discs of sheet of the same gauge affixed.

Vessels of a baluster or bowl shape are normally raised from a circular disc of silver. This is first sunk with a round-headed hammer on to a concave former. The resulting elliptical saucer-like bowl is then ready to take to the stake or anvil. A raising hammer, with a distinctive wedge-shaped head, is then applied concentrically from the outer centre of the vessel to the rim. The hammer blows must be angled to move the silver over the stake, and the shape of the stake determines that of the vessel. After just one rotation,

Silver tureen, partially gilded, by Georg Wilhelm Marggraff and Müller, diam. 410 mm, Berlin, *c.* 1765 (Berlin, Kunstgewerbemuseum); photo credit: Bildarchiv Preussischer Kulturbesitz/ Art Resource, NY

the silver hardens considerably, especially towards the rim, and must then be annealed; a charcoal furnace or gas torch heats the metal to *c.* 700°C to soften it and realign the atoms of silver and copper alloy after the damage inflicted by the raising hammer. The object is then quenched in a weak acid solution to eradicate some of the firestain. This grey–purple discolouration is found in all silver objects except on the face of salvers and trays and in objects that have been mechanically polished, usually in the late 19th century or the 20th.

The rims of most vessels and other types of silverware, such as salvers or trays, are strengthened by the application of wires. These take the form of rectangular or shaped-section strips, which are made by drawing small ingots through swages (steel plates drilled with apertures of diminishing diameter or width. The wire is progressively pulled on a windlass-like bench until it reaches the correct dimensions. It is then cut to the required length and soldered to the parent object. The rim or edge of a beaker, for example, that is left after raising is often irregular and fairly thin in gauge. Even if a wire is to be added, the edge has first to be caulked, which involves the application of a raising hammer transversely along the edge in several rotations to even up the edge and simultaneously thicken and strengthen it.

Raising objects is labour-intensive and time-consuming, and so, with the development of the power-driven lathe during the Industrial Revolution, the spinning or forming of objects by machine became popular. Spinning is appropriate only in the manufacture of concentric hollowware or vessels, although such parts as the bases of candlesticks,

when round, are also commonly made by this time-consuming technique. The operation of a spinning lathe is highly specialized. First, an elliptical disc is prepared. A chuck (or turned hardwood model that corresponds to the inner profile of the work to be prepared) is clamped to one pin of the lathe. The disc is positioned between the rotating pin and the chuck, and the operator turns the lathe and, using a burnishing tool with a smooth head, levers the disc over the chuck with a rowing motion. Fairly thick gauges are possible with this technique, although a mechanical evenness can be detected.

Once the object has attained the required shape, a planishing hammer is then applied in exactly the same way as the raising hammer, but using lighter blows. The hammer's well-polished, slightly convex head leaves facets on the surface of the silver that overlap and remove the sharper ridges left by the raising hammer. This finish is normally removed by later polishing processes now mechanically applied by the lathe, although the Arts and Crafts Movement valued the hand-wrought appearance of planished surfaces, which continued to be favoured by many silversmiths and jewellers in the late 20th century.

Objects or parts of objects that cannot be wrought from sheet on account of their dimensions, weight and gauge, have to be cast. Lost-wax casting involves the creation of a mould from a wax model; molten metal is then poured into the mould. Sand casting is commonly used for such components as the stems of candlesticks, the spouts of tea- and coffeepots or the bracket feet of salvers. A brass or pewter pattern is first made and embedded in a certain type of fine sand. It acts as a mould, and molten silver is poured

into it. In the similar technique of investment casting, impressions of objects are made in a plaster case within an electrically driven centrifuge. Molten silver is then poured through sprues into a network of chancels, or risers, that lead to each mould, and the force of the rotation ensures that the silver reaches every crevice. After casting, much filing and finishing are necessary to achieve a precise replica of the pattern or model.

Concurrent with the evolution of SHEFFIELD PLATE was the introduction of stamping machinery, eventually driven by steam power and later electricity. Matthew Boulton (1728–1809) and James Watt (1736–1819) developed machinery to stamp out whole objects in several blows, a process that assisted the new fashion for flatware of more elaborate form and heavier gauge than had been fashionable in the 18th century. The Birmingham smallware industry and the Sheffield cutlery industry, where, in particular, handles were stamped out for knives, took to machinery with alacrity, employing as thin a gauge as possible. Electricity made possible the new techniques of ELECTROPLATING, electrogilding and electroforming (or electrotyping) from the 1840s; the latter method used the plating process to form whole objects, using specially prepared moulds coated with zinc or a silver-based shellac to conduct the current. The anode in this process could be gold, silver or copper, and frequently all three metals were used, particularly by G. R. Elkington & Co. of Birmingham, Christofle et Cie of Paris and Tiffany & Co. of New York. Electric power was also harnessed to drive the lathes used in the spinning and polishing processes, which drastically reduced the labour and time involved. In the late 20th century mechanization and new techniques using lasers allowed a greater variety of silversmithing than at any time in the past.

(ii) Joining. Solder is the adhesive in all metalworking. It is usually applied with a flux of borax, which aids the flow of the molten solder. Solder in silversmithing consists of a silver–brass alloy, with a pure silver content acceptable to the Goldsmiths' Company. In an object that requires applied work as well as, for example, a hinge, or in the case of a lid, a finial, more than one type of solder will be required with varying melting points. That with the highest must be used first to enable later additions to be soldered on at lower temperatures without undoing previous work. Soldering is very exacting and the gas torch has to be carefully controlled. For delicate work, the flame can be directed by a blowtorch controlled by the breath of the silversmith or jeweller.

(iii) Decorating. Relief work, or embossing, can be achieved using a variety of techniques. Repoussé, is literally the 'pushing out' of relief decoration; it can be executed only on thin- or medium-gauge silver sheet. The required design is lightly engraved as a guide, and the object is set in a bed of Swedish pitch before it sets. The pitch takes the blows from the variety of embossing hammers that are used to force

the silver downwards. When the object is extricated, the side that faced down has mounds ready to be shaped further into flowers, foliage, animals, scrolls etc. The process is then reversed, and the opposite side, which will be seen, faces upwards, so that the pitch fills the design from below. This is the stage at which chasing begins. The point of each tool consists of a carefully engraved design or motif, or a matted (rough) surface. Chasing indents the surface; no metal is removed, it is simply punched in a manner similar to the tooling of leather in bookbinding. To achieve this, special hammers are used, but some freedom is allowed; a hyphen-shaped punch can be used to draw into the surface, moving the chasing tool in the direction of the linear ornament required. Cast chasing is used to sharpen up cast forms and can be used on thick-gauge silver, although it leaves a negative pattern on the reverse or underside; this is sometimes eradicated afterwards, for example on the rim of a boat-shaped sauceboat, where the unwanted ghost image would be too apparent. If no relief work is present, this type of decoration is called 'flat chasing'.

Engraving is one of the most demanding techniques used to inscribe and decorate silver. The tool used is a graver, or burin, fitted with a turned handle shaped to fit into the palm of the hand; its blade is honed into a sharp wedgelike shape and is tilted so that only a V-shaped section cuts into the silver. The graver is then pushed gently into and along the surface of the metal, removing part of the surface. The technique is very similar to that of steel- or copper-plate engraving used in the preparation of prints. William Hogarth (1697–1764) was originally apprenticed as a silver-plate engraver before he became a painter and printmaker. Engraving is used for armorials, monograms, crests, inscriptions and initials. As a decorative technique it is most favoured for high-quality detail but is more prone to wear than chasing. Re-engraving is practised on worn silver; for example, bright cutting achieves decoration by faceting the surface and burnishing the cut rather than by engraving it, and is subject to greater softening. When re-engraving occurs, it is necessary to ensure that the condition of the whole object is not incompatible with the new ornamenting or inscribing. Another hazard is the filing off of the armorials of a former owner after a change of ownership. If this happens more than twice in the same spot, the silver will become dangerously thin. In flatware unsightly concavities and ridges appear on the handles of spoons and forks where initials have been removed altogether or replaced. On some vessels silver plates are found where re-engraving has threatened to penetrate the wall of the item.

Techniques associated with engraving include niello, usually a Russian and East Asian practice, in which engraved (often pictorial) designs are filled with a compound of silver, lead, copper and sulphur, which is applied in a fluid state may be used to add colour and translucent surfaces. Underlying worked silver, or *basse taille*, surfaces add texture and lustre to

such wares. Engine-turning has been in use since the 18th century for boxes, buttons, watchcases and other smallware; surfaces are engraved, *en guilloche*, for example, with interlacing lines and hatchings by applying the surface against carefully turned batteries of fixed gravers using a series of hand-operated mechanisms. Engine-turning enjoyed a sumptuous revival in the Fabergé, Cartier, Tiffany and Boucheron workshops during the late 19th century and the 20th.

Stamping machinery allowed openwork ornament, normally achieved with a piercing saw, to be stamped out from carefully prepared steel dies in the shape of mask-heads, borders, urns and other motifs, according to fashion. One grain of silver (0.05 of a Troy ounce) can be drawn out into 122 m of wire. Like gold, silver can be beaten into thin leaf for application to frames and furniture, but this has never been as popular as gold leaf (*see* GILDING, §I, 1). Silver can also be used in textiles (*see* TEXTILE, §I, 2).

An object may be decorated by soldering on other pieces of silver. Beading is a simple type of such ornamentation; it is often used along the edges of pieces. Filigree decoration involves the creation of designs using fine wire. Alternatively, thin plates of silver, cut into a shape and possibly decorated with engraving or beading or by casting, may be soldered on to a piece to form relief decoration; this technique is known as cut cardwork and is characteristic of Huguenot silverware. Silver inlays may be applied to objects made of other materials, or inlays in other materials applied to silver.

Theophilus: *De diversis artibus* (MS.; 12th century); ed. and trans. J. G. Hawthorne and C. S. Smith (Chicago, 1963/*R* 1979)

C. Cennini: *Il libro dell'arte* (MS.; *c.* 1390); trans. and notes by D. V. Thompson jr (1933)

B. Cellini: *Vita* (MS.; *c.* 1558–67); trans. by J. A. Symonds as *The Life of Benvenuto Cellini*, 2 vols (London, 1887; *R*); abridged C. Hope and A. Nova as *The Autobiography of Benvenuto Cellini* (Oxford, 1983) [with notes and illus.]

B. Cellini: *I trattati dell'oreficeria e della scultura di Benvenuto Cellini* (MS.; begun 1565); trans. by C. R. Ashbee as *The Treatises of Benvenuto Cellini on Goldsmithing and Sculpture* (London, 1888/*R* New York, 1967)

H. Wilson: *Silverwork and Jewellery* (London, 1902/*R* New York, 1972)

S. Grandjean: *L'Orfèvrerie du XIXe siècle en Europe* (Paris, 1962)

H. Brunner: *Altes Tafelsilber* (Munich, 1964); Eng. trans. by J. Seligman as *Old Table Silver: A Handbook for Collectors and Amateurs* (London, 1967)

G. Hughes: *Modern Silver throughout the World, 1880–1967* (London, 1967)

G. Taylor: *Continental Gold and Silver* (London, 1967)

H. Honour: *Goldsmiths and Silversmiths* (London, 1971)

H. Maryon: *Metalwork and Enamelling* (New York, 1971)

P. Goodden and P. Popham: *Silversmithing* (Oxford, 1976)

J. Hayward: *Virtuoso Goldsmiths and the Triumph of Mannerism* (London, 1976)

R. F. Tylecote: *A History of Metallurgy* (London, 1976)

K. Hernmarck: *The Art of the European Silversmith, 1430–1830*, 2 vols (London, 1977)

B. McLean Ward and G. W. R. Ward: *Silver in American Life* (New Haven, 1979–82)

D. Brand Inglis: *Guide to British Silver* (London, 1980)

J. M. Ridgway: *Silver*, Mineral Dossier, XXV (London, 1983)

C. Blair and others: *The History of Silver* (London, 1987)

P. Glanville: *Silver in England* (London, 1987)

J. Culme: *The Directory of Gold and Silversmiths, Jewellers and Allied Traders, 1838–1914* (Woodbridge, 1988)

T. Schroder: *The National Trust Book of Silver* (London, 1988)

P. Glanville and J. Fauld Goldsborough: *Women Silversmiths, 1685–1845: Works from the Collection of the National Museum of Women in the Arts* (Washington, DC, and London, 1990)

J. P. Fallon: *Marks of London Goldsmiths and Silversmiths, 1837–1914* (London, 1992)

P. G. Guzzo: *Oreficerie dalla Magna Grecia: Ornamenti in oro e argento dall'Italia meridionale tra l'VIII ed il I secolo* (Taranto, 1993)

S. Helliwell: *Understanding Antique Silver Plate* (Woodbridge, Suffolk, 1996)

G. Kürkman: *Ottoman Silver Marks* (Istanbul, 1996)

K. A. Citroen: *Dutch Goldsmiths' and Silversmiths' Marks and Names Prior to 1812* (Leiden, 1993)

P. Kane and others: *Colonial Massachusetts Silversmiths and Jewelers* (New Haven, 1998)

L. H. White: *The History of Gold and Silver*, 3 vols (London, 2000)

K. Annhauser and P. France: 'Silver Plating Technology of the Late 3rd Century Roman Coinage', *Historical Metallurgy*, xxxvi/2 (2002), pp. 17–23

R.-A. Schütte: *Die Silberkammer der Landgrafen von Hessen-Kassel* (Kassel, 2003)

F. Téreygeol: 'Technique de production et diffusion de l'argent au haut Moyen Age: L'Exemple de Melle', *Technè*, xviii (2003), pp. 66–73

H. Clifford: *Silver in London: The Parker and Wakelin Partnership, 1760–1776* (New Haven and London, 2004)

Y. Egami: 'Materials for "Gold" and "Silver" Tints in Pictorial Ornamentation of Twelfth-century Japanese Manuscripts', *Scientific Research on the Pictorial Arts of Asia*, eds P. Jett, J. Winter and B. McCarthy (London, 2005)

Sinopia. Red earth pigment, also known as porphyry or *terra di Sinope*. The term is more commonly used for a preparatory underdrawing in FRESCO painting in which the whole pictorial composition is drawn, usually in *sinopia*, directly on to the wall or on to the rough plaster (*arriccio*).

The red earth (sinopite) from which *sinopia* was obtained is found in Egypt, in the Balearic Islands and in Cappodocia (Turkey). After purification, it was taken to Sinop, a town on the Turkish coast of the Black Sea, where it was sold. According to Pliny the elder (AD 23/4–79), *sinopia* was one of only four colours used by the Greeks. It was certainly highly prized by the ancient Greeks and Romans since they took care to maintain the quality of the product, but by the medieval period the term was applied to other, inferior red earth colours. Cennino Cennini (*c.* 1370–*c.* 1440), in his treatise of *c.* 1390, described *sinopia* as a 'natural colour … lean [i.e. greaseless] and dry in character', and said it could be ground very fine to form an excellent pigment for painting on panels or plaster, either fresco or *a secco*. In the medieval period this pigment was widely employed not only by painters but also by builders and carpenters, who used

it to coat the cords (*fili di sinopia*) that served to trace straight lines when stretched and sprung against walls or wooden beams.

Originally mural compositions had been sketched directly on to the plaster that was to be painted. The use of a *sinopia*, which was common from the mid-13th century to the 1430s (when it was largely replaced by the CARTOON), may have been adopted from the practice of mosaicists of making a preparatory drawing on the setting-bed (*see* MOSAIC, §I). Cennini recommended that *sinopia* be used to draw figures on the *arriccio*; he advised painters not to add glue to the pigment and to make a preliminary charcoal sketch to be brushed off afterwards.

Fresco painting was carried out in sections known as *giornate* that were freshly plastered every day (*see* FRESCO, §1). The use of a *sinopia* underdrawing enabled the painter to refer to the whole composition as he painted the *giornate*. In establishing the *sinopia*, the artist would use a stylus to trace the perimeter of the composition and any internal lines; he would then work up the drawing with a brush. During this process he could keep an eye on the overall balance of the composition and make any changes in the original plan that might occur to him on seeing the full-size composition on the wall. The work was then completed with a final coat of plaster (the *intonaco*), on to which the main features of the composition were again sketched before the application of the paint.

In the Renaissance period the *sinopia* pigment was no longer used for drawing on the *arriccio*. It was replaced by other colours such as black, cinnabar or vermilion, red earth and yellow ochre. Sixteenth-century writers do not therefore speak of *sinopia* when referring to this type of underdrawing, and it is only since the mid-20th century that the term *sinopia* has been widely used for underdrawings made with other pigments.

During the 1950s and 1960s frescoes were frequently detached from the wall using the *strappo* method, in which only the thin layer of plaster that carried the paint was lifted off, leaving the underlying plaster intact (*see* FRESCO, §2). This process brought to light a great number of *sinopie*, some of which are particularly interesting for the study of early drawing. The *sinopie* may be quite schematic, and even differ considerably from the final fresco; or finely drawn and corresponding closely to the finished work. By the later 20th century the practice of detaching frescoes, especially by the *strappo* method, was considered undesirable, so the discovery of *sinopie* became increasingly rare.

Pliny: *Natural History* IX, xxxiii, 117, xxxv, 30–32, 36, 40, 50

C. Cennini: *Il libro dell'arte* (*c.* 1390); Eng. trans. and notes by D. V. Thompson jr as *The Craftsman's Handbook: 'Il libro dell'arte'* (New Haven, 1933/R New York, 1954)

G. Vasari: *Vite* (1550, rev. 2/1568); ed. G. Milanesi (1878–85)

Frescoes from Florence (exh. cat. by U. Procacci and others; London, Hayward Gallery, 1969)

P. Mora, L. Mora and P. Philippot: *Conservation of Wall Paintings* (London, 1984)

L. Tintori: 'Note sulla tecnica, I restauri, la conservazione del *Trionfo della morte* e di altri affreschi dello stesso ciclo nel Camposanto Monumentale di Pisa', *Critica d'arte*, lviii/2 (1995), pp. 41–52

M. Ceriana and C. Quattrini: 'Per Vincenzo Foppa e Bernardino Luini in Santa Maria di Brera', *Bollettino d'arte*, vi/126 (2003), pp. 27–46

Size. Dilute glue used as a binding medium and as a sealant or stabilizer. The term generally refers to a low concentration of animal glue in water, sometimes referred to as 'glue-size', although it is also used to describe the employment of other materials in a similar manner. It can also simply mean glue (*see* ADHESIVES, §2).

Animal glue is a gelatinous protein extracted from skin, bone or cartilage. For artistic purposes, hide glue and gelatins serve best. They may be stored dry and are reconstituted by first soaking and then warming in water. A typical glue-size contains only 5%–10% of glue solids but still retains significant adhesive properties. Cennino Cennini (*c.* 1370–*c.* 1440) described equivalent products made from goatskin and cartilage and from parchment clippings.

Size has been widely used in the preparation of supports and grounds for painting. Animal glue is used to size, or coat, wooden panels and canvases; it stabilizes the surface, particularly in the case of canvas, which is thereby made much less flexible, and prepares it for the ground layers. In oil painting size additionally prevents or reduces the penetration of oil into the support; this is especially important for canvas, which eventually may become embrittled and degraded by the acids in the oils (*see* OIL PAINTING, §1).

Glue-size is the binding medium of the traditional gesso ground and an ingredient of emulsion grounds derived from it. It may also be applied on top of gesso or any similarly absorbent surface as a priming to reduce absorbency and allow for the easier manipulation of paint. Cennini stated that panels should first be sized when being painted in oils (by implication on top of the gesso), and later Giorgio Vasari (1511–74) appeared to recommend the same use of size on top of gesso before priming with oil. Cennini also described the use of size as an isolating layer to prevent varnish sinking into tempera and altering its effect. Oil sketches on paper also ideally require a preliminary size layer, again to reduce absorbency but also to prevent the potential destruction of the paper by acids in the oil.

Several factors affect the quality and strength of glue-size and determine its colour, flexibility and adhesive properties. Incorrect preparation and use may give rise to technical problems, brittleness being a common defect. The addition of honey, mentioned in 17th-century writings, or glycerin improves flexibility by retaining moisture, but unless a preservative is also added mould growth can result. Vinegar has been used as a preservative, as has alum, which also acts as a fixative, although formalin is more effective. Modern additives and standard qualities of glue can produce high performance formulations of size but

are generally restricted to commercial applications. The best artistic practice is to use only suitable qualities of glue, diluted approximately 1:15 in water for canvas and 1:10 for panels. Even weaker concentrations should be used if there is doubt.

The extent to which size-colour has been employed for painting continues to emerge as water-based media are scientifically investigated (*see* TECHNICAL EXAMINATION, §VIII, 6), as it is almost impossible to differentiate by sight between colours bound with glue-size, egg or gum. It is probable that much has perished, as painting in glue-size is susceptible to cold and damp; it is also assumed that it was used for works of lesser importance.

It is possible that the use of size in painting has a parallel history to that of egg tempera or that it even pre-dates it. Cennini mentioned the use of glue-size with blue pigments, and size for painting is listed in an account of 1353 from the Westminster Records. Works in glue-size were executed by such painters as Dieric Bouts (*c.* 1415–75; e.g. *Entombment*; London, National Gallery) and Andrea Mantegna (1430/31–1506) during the 15th century. Distemper was said to be widely used in the late 16th century, though by implication in a decorative context, and it was mentioned with some frequency during the 17th century. From the 18th century, however, it became confused with GOUACHE. Size-colour remained in use for decorative painting at least until the 19th century; Edgar Degas (1834–1917) and Paul Cézanne (1839–1906) may have experimented with it, and it continued to be used by scene-painters in the late 20th century.

Animal glue-size also features in traditional paper-making: it is applied to the surface of each sheet to strengthen the paper and make it more receptive to the chosen medium. Artists' papers are produced in a similar fashion, usually employing near colourless gelatin as a surface size. Many pulps also incorporate a starch-based or synthetic size, a treatment that is used alone in many standard papers. The trend towards a combined use of internal and external sizing in paper allows for rough handling. It is clear that in the past artists modified the sizing of papers: it is possible that early tinted papers, for example those coloured with the blue pigment smalt, were so treated in order to disguise the discolouring of inferior animal glue.

The term 'size' also refers to a glue used as a mordant for gold leaf in gilding (*see* GILDING, §I, 1(i)). Gold size may refer to thick, sticky, oil-based preparations, as well as to the more usual water-based glues and gums.

C. Cennini: *Il libro dell' arte* (MS.; *c.* 1390); trans. and notes by D. V. Thompson jr (1933)

D. Bomford, A. Roy and A. Smith: 'The Techniques of Dieric Bouts: Two Paintings Contrasted', *National Gallery Technical Bulletin*, x (1986), pp. 39–57

A. Roy: 'The Technique of a "Tüchlein" by Quenten Massys', *National Gallery Technical Bulletin*, xii (1988), pp. 36–43

Yu Feian: *Chinese Painting Colors: Studies on their Preparation and Application in Traditional and Modern Times* (Hong Kong, 1988)

J. Stephenson: *The Materials and Techniques of Painting* (London, 1989)

D. Wolfthal: *The Beginnings of Netherlandish Canvas Painting, 1400–1530* (Cambridge, 1989)

J. Ridge and J. H. Townsend: 'G.F. Watts in Context: His Choice of Materials and Techniques', *Painting Techniques, History, Materials and Studio Practice*, ed. A. Roy and P. Smith (London, 1998), pp. 223–8

M. Barkeshli: 'Historical and Scientific Analysis on Sizing Materials Used in Iranian Manuscripts and Miniature Paintings', *Book and Paper Group Annual*, xxii (2003), pp. 9–16

M. A. Hubbe: 'Acidic and Alkaline Sizings for Printing, Writing, and Drawing Papers', *Book and Paper Group Annual*, xxiii (2004), pp. 139–51

M. Witlox and L. Carlyle: '"A Perfect Ground Is the Very Soul of the Art" (Kingston 1835): Ground Recipes for Oil Painting, 1600–1900', *ICOM Committee for Conservation: 14th Triennial Meeting: Preprints* (London, 2005), pp. 519–28

E. Pasnak, Season Tse and A. Murray: 'An Investigation of Alum in the Gelatin Sizing of Far Eastern Paintings on Silk', *Scientific Research on the Pictorial Arts of Asia*, eds P. Jett, J. Winter and B. McCarthy (London, 2005), pp. 81–91

Sketch. Rough, preliminary version of a composition. The term can be used for preparatory drawings, paintings or sculptural modelli (*see* DRAWING, MODELLO and OIL SKETCH). By the late 18th century it was also applied to small, rapidly executed drawings made for pleasure and practice, with no other final work in mind.

Slide, lantern. See MAGIC LANTERN.

Slip. Diluted pottery clay used in ceramics. It is usually a different colour to the clay of the main body of the pottery form and is employed as decoration, but it can also be used as a coating to make it waterproof or as a glue to join parts together.

Solvent. Liquid able to dissolve or dilute a solid or more viscose substance. The substance may be recovered from the solution by evaporation of the solvent. Different solvents are active in varying degrees, and some are specific to certain substances.

Solvents have numerous applications in painting, printmaking and conservation procedures. They are primarily used to thin the consistency of painting media and for cleaning purposes. In the first of these applications, the solvent acts as a diluent or thinner, a function that differs technically from that of a solvent. Watercolour paint, for example, consists of pigment bound in a water-soluble gum; in use it is further thinned with water to create a wash. The water acts both as a solvent for the gum and the diluent for the paint. Some substances can be diluted but not dissolved by certain solvents. Acrylic paint may also be thinned with water, but the acrylic resin in the dried paint film is insoluble in it. 'Spirit varnishes' and oleoresinous substances, made from hard resins melted into oil, can be diluted with turpentine, but only the soluble resin film deposited by a 'spirit varnish' can be removed with it later. A solvent acting as a diluent

need not therefore be a solvent for the material it thins.

Many substances, as they age, become less soluble in their original solvents, and different ones may be needed to re-activate or dissolve them. This is a matter for careful consideration in conservation, where the choice of solvents frequently presents difficulty. The use of varnish as a painting medium or the ageing of a varnish layer, for example, may make both paint and varnish susceptible to the same solvents.

A wide variety of solvents have been used in painting. Turpentine, distilled from a resinous tree pitch, was known to the Romans. Although there is no firm evidence of the use of solvents for oil paint and varnishes before the 16th century, a reference to Leonardo da Vinci (1452–1519) distilling herbs, probably in connection with varnish-making, has been interpreted as an account of solvent extraction. This may have been oil of spike lavender or lavender oil, which was also recorded by Paul van Somer (1576–1621). Turpentine was discussed by Peter Paul Rubens (1577–1640), although the use of solvents in painting in the early 17th century was probably not widespread and was mainly confined to varnish-making and brush cleaning. The use of petrol as a solvent is also mentioned in 17th-century Spanish sources, and it may also have been employed in Italy.

From the mid-17th century white spirit and various petroleum distillates, as well as lavender oil and turpentine, were increasingly used in oil painting. Ethyl alcohol, known as 'spirit of wine' and 'aqua vitae', perhaps because it was redistilled from brandy, was one of the most powerful solvents available before the development of modern chemistry. Its use in painting was limited to cleansing oil, but its ability to dissolve amber was known to alchemists by the 16th century. It was mainly employed for varnish removal from the mid-17th century, as recorded by Jerome Lanier, brother of the English composer, dealer and painter Nicholas Lanier (1588–1666), c. 1644, and Robert Dossie in *The Handmaid to the Arts* (London, 1758). Various types of alcohol, including ethyl (ethanol), isopropyl (isopropanol), butyl (butanol), acetone (diacetone alcohol), xylene, toluene and polypropylene glycolether and such proprietary brands as the mild 'Genklene' continued to be used as solvents in the conservation practices of the late 20th century, not only for cleaning purposes but also for the solution of materials used to impregnate and stabilize deteriorating works of art.

C. L. Eastlake: *Materials for a History of Oil Painting* (London, 1847–69); rev. as *Methods and Materials of Painting of the Great Schools and Masters* (New York, 1960)

P. L. Jones: *The Leaching of Linseed Oil Films in Iso-propyl Alcohol*, Studies in Conservation, 10 (London, 1965)

R. Feller, N. Stolow and E. H. Jones: *On Picture Varnishes and their Solvents* (rev. London, 1971)

K. Talley Mansfield: *Portrait Painting in England: Studies in the Technical Literature before 1700* (New Haven, 1981)

J. Stephenson: *The Materials & Techniques of Painting* (London, 1989)

G. Torraca: *Solubility and Solvents for Conservation Problems* (Rome, 4/1990)

M. Ash and Irene Ash: *The Index of Solvents: An International Guide to More than 1700 Products by Trade Name, Chemical, Application, and Manufacturer* (Brookfield, 1996)

D. Stove and W. Freitag, eds: *Paints, Coatings, and Solvents* (Weinheim and New York, 2/1998)

Spolvero [It.: 'dust']. Term for a secondary cartoon used to transfer the design to the support, leaving the original cartoon intact (*see* CARTOON, §1). The word *spolvero* also describes the dotted outline produced by POUNCING, a method of transfer in which finely ground chalk is forced through perforations in the cartoon.

Squaring up. System of transferring a drawing or repeating the composition of an existing painting that also allows for its enlargement or reduction. An image is divided up into a number of squares by overlaying on it a grid of regularly spaced intersected lines. It may then be repeated by copying the image within each division on to the corresponding square of another grid pattern containing the same number of segments. The same principle may be applied when drawing from life by means of a device called a drawing-frame (see below), although squaring up is now mostly considered to be no more than a technical stage in the creative process rather than a contribution to the design (*see* DRAWING, §I).

Squaring up is usually employed for altering the size of the design as it is repeated; tracing or pouncing can be more suitable methods of transferring a design in the same size. Variations of the squaring up method can also be used deliberately to distort an image. In *De pictura* (1435), Leon Battista Alberti (1404–72) was the first to describe the method involving the division of a circle into 'quadrangles' so that its appearance in perspective could be drawn. Anamorphic paintings may also be calculated in a similar fashion. The skull in *Jean de Dinteville and Georges de Selve* ('The Ambassadors', 1533; London, National Gallery) by Hans Holbein the younger (1497/8–1543) is a well known, though not complex, example of such visual trickery.

The principles of squaring up have been understood and employed over a long period. In what appears to be a working drawing for an ancient Egyptian wall painting from Thebes on a gesso panel (1400–1000 BC; London, British Museum), the black outline drawing of the seated figure is completely covered over with a carefully drawn grid in red. It is evident that during the Renaissance Leon Battista Alberti (1404–72), Leonardo da Vinci (1452–1519) and Albrecht Dürer (1471–1528) were familiar with the principles involved, either from their direct references to the use of square divisions or from their descriptions or depictions of drawing-frames. The process of squaring up to enlarge a drawing is specifically illustrated in the edition of 1701 of William Salmon's *Polygraphice*, and a print from the *Encyclopédie* (Paris, 1751–65) of Denis Diderot (1713–84) and

Jean Le Rond d'Alembert (1717–83) also suggests enlargement by this method. Richard Symonds gives an account in *Secrete intorno la pittura* (London, British Library, Egerton MS. 1636) of the transfer and enlargement of a drawing to a support said to be 12 ft in height × 24 ft long (*c.* 3.66×7.32 m). The support was divided into 13 equal divisions of its depth and 26 equal squares along its length. These were marked on the drawing with black lead (graphite) and on the support by snapping chalked strings against it, a method described much earlier by Cennino Cennini (*c.* 1370–*c.* 1440) in *Il libro dell'arte* (*c.* 1390) for placing guidelines when painting (*see also* FRESCO, §§1 and 2). The outside edges of the support were then numbered to give each square a grid reference, and the original drawing being copied was mounted in a cane and hung from a thread with a counterbalancing weight, so that it could be moved along the top of the support to the area being copied on to as required.

A drawing-frame is simply a rectangular frame pierced at regular intervals around its perimeter so that threads strung from side to side and top to bottom create a network of squares through which the subject may be viewed. It is placed in a fixed position between the artist and the subject, and a corresponding grid is used over the surface being copied into. Although they are usually shown in prints to be of quite modest proportions, there were almost certainly much larger copying-frames in use in major studios.

In the 20th century squaring up assumed a degree of stylistic importance due to the possible implications of its use. In the 1960s Malcolm Morley (*b* 1931) employed a variation of the method to enlarge and copy printed versions of photographs of ships from travel brochures and similar promotional material. The image was covered, and then copied by Morley from one revealed square at a time, sometimes upside down, to impart the same mechanical quality to the painting as was possessed by the original printed matter.

Squaring up is commonly employed by portrait painters working from photographs or carefully executed preparatory drawings. A grid pattern can clearly be seen beneath the paint layers of the face, for example, in the portrait of *Charles, Prince of Wales* (1980; London, National Portrait Gallery) by Bryan Organ (*b* 1935).

C. Cennini: *Il libro dell'arte* (MS.; *c.* 1390); trans. and notes by D. V. Thompson jr (1933)

L. B. Alberti: *De pictura* (MS., 1435; Basle, 1540); It. trans. as *Della pittura* (MS.; 1436); ed. in H. Janitschek: *L. B. Alberti's kleinere kunsttheoretische Schriften* (Vienna, 1877); ed. L. Mallè (Florence, 1950)

M. P. Merrifield: *Original Treatises Dating from the XIIth Centuries on the Arts of Painting*, 2 vols (London, 1849/R New York, 1967)

E. Lucie-Smith: *Art Today* (Oxford, 1977, rev. 1983)

M. Kirby Talley: *Portrait Painting in England: Studies in the Technical Literature before 1700* (London, 1981)

M. Beal: *A Study of Richard Symonds: His Italian Notebooks and their Relevance to Seventeenth-century Painting Techniques* (New York

and London, 1984) [incl. transcription (pp. 214–313) of *Secrete intorno la pittura*]

J. Ayres: *The Artist's Craft: A History of Tools, Techniques and Materials* (London, 1985)

Z. Veliz, ed. and trans.: *Artists' Techniques in Golden Age Spain* (Cambridge, 1986)

J. Stephenson: *The Materials and Techniques of Painting* (London, 1989)

Squeegee. Tool used in SCREENPRINTING. It has a rubber blade and is used to draw the ink across the screen.

Stained glass. Artistic medium, generally found in the form of windows or autonomous panels composed of coloured glass. It is the only such medium to be observed through refracted and not reflected light. The variety and quality of light passing through the translucent panels depends on the time of day and season; it is also affected by the texture of the glass. The highest achievements in the art of stained glass were those of the Gothic era in Europe (see colour pl. XII, fig. 2) and those of the Gothic Revival during the 19th century.

1. Materials and techniques. 2. Conservation.

1. MATERIALS AND TECHNIQUES. Stained glass should properly be called 'coloured, stained and painted glass', since staining is only one of the processes involved in the production of decorated windows. The main techniques of the craft have hardly changed since medieval times; apart from improved tools and more scientifically controlled methods, the stages of manufacture in the late 20th century were broadly those described in the manual *De diversis artibus* (?1110–40), by Theophilus, the monk and practising craftsman, who gave guidelines for making coloured glass; the process he described involved cutting out glass from a full-size design (cartoon); painting details on its surface and firing it in a kiln; holding the pieces together by strips of lead; weatherproofing; and finally fixing the window in an aperture. A significant development introduced in the late 15th century was the use of various coloured enamel paints instead of one monochrome outline; this meant that windows were no longer composed of pieces of different coloured glass supported by lead strips that contributed to the design but were made of rectangular panes of clear glass treated as a painter's canvas. In the mid-19th century the Gothic Revival inspired the rediscovery of medieval glazing techniques together with the manufacture of coloured glass. Developments in the 20th century included thick slabs of glass set in concrete (*dalle de verre*) and panels held together by epoxy resin.

In the Middle Ages stained glass was produced by workshops, originally monastic and later controlled by guilds, which made windows primarily for ecclesiastical buildings. After the 17th- and 18th-century period of decline, when glass painting was practised by a few individuals or families, during the 19th century large studios were formed, which employed as

many as 200 workmen, each specializing in a particular process. Stained glass in the late 20th century was made both by studios and by individual craftsmen; products ranged from glass roofs and wall-sized windows to lampshades and jewel-boxes. The various processes involved can all be carried out by one artist, but in a large studio there is normally some specialization of labour.

The range of necessary techniques and the fact that they can be carried out by different workers means that stained glass has been regarded as a 'craft' rather than a 'fine' art; in medieval times, however, such distinctions were unknown. The art is also closely integrated with architecture, since the location and dimension of windows are determined by the structure of the building and should not be regarded merely as applied ornament. Christopher Whall (1849–1924), who inspired the stained glass of the Arts and Crafts Movement, wrote 'Keep your pictures for the walls and your windows for the holes in them'.

(i) Types of glass. (ii) Preparation of the design. (iii) Cutting. (iv) Painting. (v) Firing. (vi) Glazing. (vii) Methods of fixing.

(i) Types of glass. Glass is a viscous liquid that solidifies during cooling. Its main component in the natural form is silica (*see* GLASS, §§I and II), normally in the form of sand; this is combined with alkali (potash or soda) as a flux, which lowers the melting point of silica, and lime, which stabilizes the mixture. These ingredients become molten by heating in a furnace and can then be shaped by various methods. In medieval times window glass was blown from the gather (ball) of molten glass through a blowing-iron either into an oval bubble, which was turned into a cylinder and then cut and flattened into a rectangular sheet (muff glass), or into a circular disc by spinning the gather on the end of a rod (crown glass); the latter produces a thick, central boss (bull's eye) sometimes used for decorative effects. Glass still made by these methods is known as 'antique' glass; the textural irregularities refract light in a particularly attractive way. The mass-produced glass of modern times is known as 'float glass' because it is formed by floating glass on molten tin.

'Norman slab' glass is made by blowing the molten mixture into a rectangular mould; the technique was devised in the late 19th century to produce deliberately uneven sheets, which inspired the manufacture of the richly textured but minimally painted panels of the Arts and Crafts Movement. Modern commercial or 'cathedral' glass is machine-made by rollers; variety in texture can be achieved by the use of patterned rollers to make reeded glass. The extremely thick slabs known as *dalles de verre* are cast by pouring the molten glass into a mould.

The combination of silica, potash and lime produces a colourless or white glass. It is the addition of metal oxides at the molten stage that adds colour to glass. Such glass, in which the colour is consistent throughout, is known as pot-metal glass, because the compound is melted in a clay pot in the furnace. In medieval times there was greater variety in colour owing to the natural impurities in the oxide-bearing earths; it is possible that colours were originally produced from oxides already present in the potash, and that separate workshops tended to produce particular colours. The traditional method of making a stained-glass window is by arranging separate pieces of pot-metal glass into a mosaic-like pattern of contrasting colours. Variant forms include 'streaky' glass, blown from two colours combined in the molten state, and 'reamy' glass, which blends white with coloured glass. On its own, red glass, normally known as ruby, is too dense to transmit light and is therefore diluted by being combined with a layer of white glass at the molten stage. This is known as flashed glass; the technique can also be applied to other colour combinations. In the late 19th century other types of coloured glass were created by the designer Louis Comfort Tiffany (1848–1933); his opalescent and iridescent glass was made by the combination of various colours and the fusing together of several layers.

(ii) Preparation of the design. When a window is commissioned, the artist makes a preliminary small coloured design, known in medieval times as the *vidimus* (an early 16th-century example, probably for a window in the chapel of Hampton Court Palace, near London, is in Brussels, Musée d'Art Ancien). This should relate both to the patron's requirements and to the building in which the window is to be installed. When this has been approved, the window aperture is precisely measured, and the full-size drawing, known as the cartoon, is prepared (*see* CARTOON, §1). Theophilus described how cartoons were made by painting in black on to a whitened board or table on which the glass was directly cut. Modern cartoons are copied, either on to cartridge paper by scaling-up on a grid or by photographic enlargement. The cartoon should also show the location of the horizontal or vertical iron bars already in the opening, which will support the completed window. When the cartoon is complete, the lines where the leads are to go (cut-lines) are drawn in ink on tracing paper or tracing cloth over the cartoon to indicate the exact width of the lead. This determines the correct dimensions for the separate pieces of glass, which can also be numbered and marked for colour choice. The cut-line is placed underneath a sheet of plate glass, and the lines are repainted on to the surface of the glass (lead-lining). In France and Germany, however, it is more common to make templates from the cartoon for the separate pieces of glass.

(iii) Cutting. Pieces of glass are cut from larger panels into the shape required by placing them over the cut-line or under the template. Theophilus described how the line to be cut was chalked on to the glass and the surface then initially cracked by the tip of a red-hot iron; the crack was extended by dragging the

iron along the design, and the glass could then be separated. Any rough or uneven edges were smoothed ('knocked off') with a notched tool known as a grozing iron. In the late 20th century glaziers normally used a steel-wheeled or diamond-tipped cutter that scores a fine line on the surface of the glass, creating a vertical fracture underneath; the two pieces can be easily separated by tapping on the underside of the glass with the end of the cutter. Curved incisions may also require some trimming of the edges by the grozing iron. When all the pieces are cut, they are assembled on the sheet of plate glass painted with lead-lines from the cut-line diagram. The pieces are held temporarily in place by melted beeswax or Plasticine so that the whole assemblage may be placed on a vertical easel and examined against the light. If the overall effect of the colour tones is not successful, any necessary changes can be made before the more irreversible stages of painting and leading together are begun.

(iv) Painting. The reproduction of different colours on one piece of pot-metal glass eliminates unnecessary leadwork and therefore simplifies the design; there are various ways of achieving this. The top layer of flashed glass can be removed to reveal the second colour underneath; in medieval times this was done by abrading the surface, but in the late 20th century it was usually carried out by painting hydrofluoric acid on the areas to be removed. The technique of silver-stain or yellow-stain, developed at the end of the 13th century or in the early 14th, also enables the craftsman to obtain varied effects on one panel. Silver nitrate is painted on to the surface of a piece of white glass; a molecular change is created so that the yellow portion of the glass transmits a yellow light. It is then stabilized by firing in a kiln. The stain produced is in a controlled range of yellow tones, which vary from a pale lemon to a deep orange. It was originally used to add fair hair, a golden halo or a crown, but it can also be used for example on blue glass to produce green tones.

As the use of paint (a dark-brown or black mixture of iron oxide, ground glass and a borax flux) on glass blocks out the light, it is generally confined to outlines and internal details. Areas of light wash can also provide some variety of texture and modelled effects.

From the 16th century to the 18th a range of coloured enamels was used to paint pictures on white glass. Although this was a successful way of decorating small, ornate panels, large painted windows tended to obscure the buildings they were set in, since light could not penetrate the enamelled surfaces. It also resulted in the use of uniformly rectangular panes of glass, since the leads holding the separate pieces of pot-metal glass together were no longer needed to form the main outlines of the design. During the Gothic Revival, however, monochrome painting on pot-metal glass was resumed.

Monochrome paint is applied with a variety of brushes in order to obtain different effects: long, thin, flexible-haired brushes are used to draw outlines, the badger-hair brush produces a matt wash or stipple that maximizes the light transmitted, while broader, hog-hair brushes can be used for most textures. More light can be obtained by removing areas of paint with a sharp implement. Paint is normally applied to the front (inside) of the panel but can occasionally also be applied to the back (outside) in order to obtain a more three-dimensional effect. Silver-stain is always applied to the back of the panel.

Other modern methods of obtaining varied surface patterns include sand-blasting, plating together two layers of differently coloured or painted glass within one broad lead frame and the fusing together of two differently coloured pieces in the kiln.

(v) Firing. After the separate pieces of glass have been painted, they have to be heated in a kiln so that the applied paint melts and fuses with the surface of the glass. Medieval kilns were heated by wood and took a long time to reach the required temperature; modern kilns are more easily controlled by gas or electricity. There are two main types, a one-chamber kiln (closed), in which the glass is placed cold, heated to the right temperature and then annealed; and a three-chamber kiln (open), with separate sections for pre-heating, firing and annealing.

The pieces of glass are placed flat on an iron tray, resting on powdered plaster of Paris to prevent movement and to absorb any surplus moisture; the tray is then placed on a rack in the kiln. The temperature depends on the type of glass and the amount of paint used; around 650°C is required for a short period in an open kiln and 450°C for a longer period in a closed kiln. Many separate firings may be required in the production of a large window, and some pieces may need to be fired several times, with subsequent stages of repainting in between. Silver-stain requires a lower firing temperature than paint; when both techniques are used on the same panel, the staining will be done after the paint has been fired. Correct temperatures and the necessary time for the heating and cooling processes are essential, and there must be no draughts, otherwise the firing will be uneven or the glass may crack or melt.

(vi) Glazing. This process has hardly changed since medieval times. After the final firing, the pieces of glass are assembled for glazing; this stage is often carried out by a skilled lead-glazier rather than the designer. The separate pieces of glass in a window are held in place by strips of lead, known as calmes (Lat. calamus: 'reed'). These have an H-shaped cross section into which two adjacent panels can be slotted. Lead is used because it is weatherproof and durable yet sufficiently flexible to be moulded into place around the glass; it has to be stretched to even out any twists and to strengthen it before use.

For assemblage a right-angled wooden frame is placed on the glazing bench with the cut-line diagram underneath. Two wider strips of lead, which will form the outer border of the panel, are placed within

the frame and cut diagonally to join in a mitred corner; lead is easily cut with a wide-edged cutting knife. The first piece of glass is slotted into the corner and framed by another strip of lead, which is then temporarily held in place by farriers' nails. The adjacent panels are added consecutively by being slotted into the grooves in the lead and in turn framed by lead. When the whole panel has been assembled and edged by the wider calmes, the lead joints are rubbed with tallow and soldered together by a gas-fired or electric soldering-iron; in medieval times the iron was simply heated in the furnace. After one side has been soldered the same process is repeated on the reverse. In order to stabilize and weatherproof the completed panel, it is rubbed with a cement mixture made of linseed oil, plaster of Paris, powdered red lead and lampblack, which fills any gaps between the glass and lead. When this has dried, the surplus is brushed off. The glazier's final job is to solder ties of lead or copper wire to the outer lead frame, which will be used to attach it to the supporting glazing bar in the prepared aperture.

(vii) Methods of fixing. A window is normally made up of several individual panels, which are installed by inserting them in the aperture from the bottom to the top; the flexibility of the lead facilitates the process. The panels are slotted into grooves in the surrounding stonework of the aperture; this opening is also usually divided vertically by iron saddle bars, to which the panels are tied by their lead or copper wires. During the 12th and 13th centuries panels were supported by the armature (see fig.), a complex iron frame that filled the whole window and determined the shape of each panel. In the late 20th century a simpler vertical support system was used. When one panel rests directly on another the lead frame of the upper one is fitted over that of the one below, to assist drainage. When all the panels are in place, any gaps between the lead and stonework are filled with mortar or mastic for additional weatherproofing, and the window is again cleaned. Fixing may be done by a specialist firm, depending on the scale of the commission and the location of the window.

Theophilus: *De diversis artibus* (12th century); ed. and trans. J. G. Hawthorne and C. S. Smith (Chicago, 1963/*R* 1979)

C. Winston: *Memoirs Illustrative of the Art of Glass Painting* (London, 1865)

C. Whall: *Stained Glass Work* (London, 1905)

E. L. Armitage: *Stained Glass: History, Technique and Practice* (Cambridge, MA, 1959)

P. Reyntiens: *The Technique of Stained Glass* (London, 1967; rev. 2/1977)

A. Isenberg and S. Isenberg: *How to Work in Stained Glass* (Radnor, 1972)

A. Duncan: *The Technique of Leaded Glass* (London, 1975)

L. Lee, G. Sedden and F. Stephens: *Stained Glass* (London, 1982)

A. Becattini: 'Per una storia tecnica dell'arte vetraria', *Kermes*, ii/6 (1989), pp. 30–35

Stained-glass window representing the *Tree of Jesse*, Freiburg im Breisgau Cathedral, Germany, before 1218 (shaded areas show modern restorations); the round metal armatures follow the patterns of the medallions; reconstruction drawing

N. Blondel: *Le vitrail: Vocabulaire typologique et technique* (Paris, 1993)

G. Hartmann: 'Late-medieval Glass Manufacture in the Eichsfeld Region (Thuringia, Germany)', *Chemie der Erde*, liv/2 (1994), pp. 103–28

D. Royce-Roll: 'The Colors of Romanesque Stained Glass', *Journal of Glass Studies*, xxxvi (1994), pp. 71–80

V. C. Raguin: *Stained Glass: From its Origins to the Present* (New York, 2003)

2. CONSERVATION. Stained glass is a fragile and sensitive medium unable to withstand extremes of

stress. Also, in addition to natural deterioration over several hundred years, it has suffered at times from a loss of prestige and from clumsy methods of restoration. A high percentage of medieval glass has been totally lost.

(i) Deterioration. (ii) Physical damage. (iii) Examination. (iv) Cleaning. (v) Bonding. (vi) Restoration. (vii) Protection.

(i) Deterioration. The glasses used in the manufacture of stained glass are subject to organic damage to a degree dependent on their chemical composition and environment. The damage is as varied as its causes. For instance, sometimes a pigment line prolongs the life of the glass, but on other occasions the pigment line has itself corroded to the point of forming a negative image. The differing degrees of corrosion found on a mosaic of coloured and tinted glasses display their relative durability. In the west windows of Chartres Cathedral, for example, the translucency of the durable blue glass is greater than that of the other corroded and less durable coloured glasses, so the blue tone has become dominant. In medieval glasses the greater potash content renders them more vulnerable to weathering than modern soda glasses as potash is highly soluble in water. Their durability is further affected by impurities, air bubbles inherent in the crude manufacture and scratching or etching sustained in subsequent restorations.

The process of decay begins from the time a window is installed and subjected to moisture. This may take the form of rain, dew, condensation and relative humidity of 30–40%: constant wetting and drying of alkali glasses, hydrating the surface molecules and leaching soluble components from the glass, initiates the disintegration. In modern times the most significant element in the acceleration of glass corrosion has been atmospheric pollution (*see* CONSERVATION AND RESTORATION, §II, 1). This is widespread, and remote country locations are as endangered as industrial areas. Other factors that add to the decay include soot from candles and old coke boilers, cobwebs, dust, paint and mortar splashes, bird droppings and lichen growths on the areas of corrosion.

Types of glass corrosion are varied. A common problem in English and French glass is cratering of the surface, which begins as pinhole pitting and gradually enlarges until the craters meet. Sometimes a layered type of corrosion covers the whole surface. A crystallized form can become iridescent, even opaque, and form a crusty deposit. Glasses with a manganese content are often found with oxidization within the softer gel layer of the glass, which in extreme cases causes opaqueness. The external surface inevitably weathers to a greater extent than the inner, and the corrosion on the inner surface is often progressively worse towards the centre of a piece, the retracting point of evaporating condensation. Greater deterioration is also evident where the water held on the window's armature meets the glass, and a

leaking window will leave patterns of deterioration from the points of water penetration.

The pigments should be fired at a temperature above the melting point of the glass if they are to fuse successfully into the surface (*see* §1(v) above). Pigment loss is generally the result of underfiring, but it may also be caused by borax, added to the pigment to reduce the temperature necessary for fusion or by insufficient flux. Past chemical or abrasive cleaning and unsuitable storage conditions can shorten the life of the pigments. Coloured enamels applied to glass often crack, flake off and leave a crazed surface.

(ii) Physical damage. The armature and support systems for stained glass are important to its stability. In size and strength they must be designed to withstand wind pressure and sustain the weight of the window, and they must be adequately tied to the stained glass. Insufficient support allows the panels to buckle and so cracks the glass. A rusting iron armature stains the glass and can even split the stone window frames, causing fractures to the glass. Poor-quality or fatigued lead calmes, too frail or brittle for their purpose, will fail in storm conditions, with consequential loss of glass.

Fracture damage to stained glass resulting from technical failure, neglect, vandalism, branches of trees, birds, stones from grass cutting and fire cracks has left an inheritance of problems. Until recently repairs to fractures were made by inserting a lead calme. These mending leads visually impair the work of art, especially when set across human faces. They also slightly increase the dimensions of the original panels, and to reduce the increased size glaziers often removed glass from the fractured edge rather than the original perimeter. Edge bonding of these damaged fractures is then impractical. Other early bonding techniques included the use of wood resins, applied to the fractured edges or to a sheet of backing glass, but these can later fail, and water can penetrate the poorly sealed plating. The first epoxy resins used for bonding have in some instances discoloured. The temporary repairs undertaken by non-professionals, using adhesive tape and an array of inappropriate materials, are another serious cause of damage, as are the expedients reached by jobbing glaziers when they have undertaken a restoration scheme: to repair lost pieces in a panel they would destroy another damaged section. The transference of complete panels from other windows was not uncommon, and panels would be refixed inside out and without regard to their original locations. Complete compositions and iconographic glazing schemes have been destroyed by such restorations, which have caused more harm than centuries of neglect. In the 19th century some restorers used copies to fill in missing areas only, but others made copies of all the corroded glass and scrapped the originals.

(iii) Examination. Before treatment the conservator, aided by a scientist, will evaluate the composition of

the glasses and deposits and the nature of the deterioration. Microscopes are widely used for the inspection of the glass and lead, and when complex problems are encountered various analytical techniques can be employed (*see* TECHNICAL EXAMINATION, §VIII, 3). The art historian will research into past records, make comparisons with similar work and possibly establish lost heraldry, inscriptions and iconographic schemes. The conservator will record the state of the window before conservation and determine what is original and what are later insertions. From inspection of the grozed edges on original glass, misplaced pieces can be identified and the original lead design lines redrawn. The lead calmes are inspected: there may be original medieval cast leads that must be retained in the panel for their artistic and historic importance. The lead may also provide clues to past repair or restoration, since the milling marks on the heart of the calmes from the 16th century onwards may be pressed with the date and glazier's or vice-maker's name or initials. Past fixings, revealed when a window is removed, provide clues to earlier glazing arrangements.

(iv) Cleaning. Glass is cleaned to restore its transparency and arguably to remove the deposits of corrosion that would otherwise retain moisture and accelerate deterioration. However, the process is irreversible, and past mistakes have led to a more cautious approach. The stability of the paint pigment and the nature of the deposits should be established before cleaning begins. Methods of cleaning arouse controversy. For severe problems chemical solvents and mechanical devices including air abrasives, ultrasonic baths and dental descalers have been used. The safest method is to use soft fibreglass brushes after a light dusting with soft hair brushes: this method is controllable, especially with the aid of the microscope. Surgical scalpels are employed for the removal of old putty from the perimeters of pieces and for shaving down thick deposits to a safe degree before final cleaning. Lichen growth and mortar splashes may be damp swabbed with deionized water to remove the heaviest deposits. If the glass remains *in situ* the cleaning should be restricted to a light dusting only. Full cleaning must be entrusted to a specialist conservator in a workshop.

(v) Bonding. Fractures may be bonded physically or chemically, depending on the nature of the break and the environment in which the window is to remain. Self-curing silicone is successful in most situations, since the flexible bond, reversible mechanically, allows for thermal expansion. Epoxy resin is suitable for museum conditions. It is good for bonding very thin glass and aesthetically pleasing when the refractive index matches that of the glass. Coloured dyes may be added to the resin to in-fill lost fragments. The edges are degreased with solvent before the adhesive is applied and the joints held in position with adhesive tape, clips and props while the adhesive cures. This process may be done in stages

depending on the complexity of the break. Bonding is best undertaken before cleaning as it is safer to remove the excess adhesive from the surface dirt than from cleaned, newly exposed pigments. If multi-fractured pieces have portions that will not fit under the lead calmes, a backing plate may be added for support. The thin sheet of glass is moulded in a kiln to fit the undulations of the bonded glass, and the final assembly is edge-sealed to exclude moisture. Fire-crazed glass is sandwiched between a front and back plate after bonding. On star-fractured pieces plating can be avoided by the insertion of a rivet through the point of impact. The pieces are then held physically by the lead calmes and the rivet. As the long-term durability of adhesives is unknown, additional physical precautions are sometimes taken. Copper foil tape can be wrapped around the fractured edges and soldered together, or fine string lead calmes can be used when the edges of the fractures are damaged.

(vi) Restoration. The insertion of new painted repairs in pre-19th-century windows is usually confined to heraldry and significant subject-matter. These insertions should be undertaken only when there is adequate historical evidence for the lost design, and when stylistic comparisons can be found. Each insertion is dated on the piece and recorded. Repairs to post-19th-century glass may include the renewal of all severely fractured pieces. Missing pigment can be restored by painting the lost detail on a thin sheet backing plate, which is then double-glazed with the original piece. The lost pigment is detectable from the etched or corroded surface of the glass. A flashed glass of red or blue on white, which has lost its colour through corrosion, may be doubled with a new coloured backing plate, the original colours having been identified from the perimeter edges that were protected by the lead calme flanges. Generally, no rearrangement of glass is made without overwhelming proof of the original location. Past repair and restoration, even of a mediocre standard, may often be retained as part of the history of the window.

(vii) Protection. Protection is necessary against mechanical and environmental damage. For mechanical protection, wire guards fixed externally within the framework of the window opening are commonly used; stainless steel wire is preferable to steel or copper as it does not stain stonework. If vandalism is a problem, exterior protective glazing using polycarbonate sheet or toughened or laminated glass may be erected. These solutions, however, often mar the architectural appearance.

Environmental protection can be afforded by external sheet glazing provided the fixing allows adequate ventilation between the glazings. Synthetic coatings have been applied to the external surface of corroded glass to prolong its life, but these coatings must be reversible, flawlessly applied to prevent moisture penetration and not prone to discoloration. The coating offers protection only to the exterior,

and the painted internal surface is still exposed to condensation. To be protected these monumental works of art should be isolated from all forms of moisture, which is difficult to achieve considering their technical function and the architectural settings for which they were designed. The most effective system has proved to be isothermal glazing, a form of double-glazing with ventilated space that maintains an almost equal air temperature over both faces of the endangered glass. This reduces condensation and keeps the glass dry, especially on its vulnerable painted inner surface.

The new protective window is usually sited in the original glazing groove, and the stained glass is framed and suspended inside the new glazing. Internal ventilation is provided at the base and top of the openings, and air inside the building is drawn up the interspace by the chimney effect, keeping the painted glass dry. In extreme climatic conditions, double-glazed units may be installed as protective glazing, and the flow of air through the interspace aided by a heating system. The ideal gap between the glazings has not yet been established, but the minimum distance is normally restricted by the profile of the window mullions or frame: a distance of no less than 20 mm will allow the free circulation of air.

This system can change the aesthetic appearance of the architecture, but solutions to the problem have been found. Non-reflective coatings on the protective glazing, or matted glass, kiln-distorted to reflect light randomly, will eliminate the mirror effect. Leaded glazing that copies the main design lines of the stained glass can be used. The frames are made of materials that are strong, light in appearance, able to be formed to the most complex of tracery shapes and compatible with the related fabric. Disturbing side light around the edges of the frames is eliminated by the addition of leaf lead strips attached to the frames and folded back to accommodate undulations in the window openings. The parallax problem of having two saddle-bar support systems is calculated for and the bars sited to align at the average viewing position.

E. Bacher: 'Medieval Stained Glass: Restoration and Conservation', *Conservation of Stained Glass Symposium: York, 1977*

J. Ashurst: *Wood, Glass and Resins and Technical Bibliography*, v of: *Practical Building Conservation*, English Heritage Technical Handbook (Aldershot, 1988)

R. Newton and S. Davison: *Conservation of Glass* (London, 1989)

A. J. Femenella: 'Restoring Stained Glass Paint', *Stained Glass Quarterly*, lxxxix/1 (Spring 1994), pp. 42–7, 54–8

J. L. Sloan: *Conservation of Stained Glass in America: A Manual for Studios and Caretakers* (Wilmington, DE, 1995)

S. Brown and S. Strobl: *A Fragile Inheritance: The Care of Stained Glass and Historic Glazing* (London, 2002)

State. Term used to describe a printing surface in a given condition at a particular stage and used to classify impressions printed from the surface in this particular condition. Printmaking is a technique of multiple impressions from a single matrix, or, generically, plate.

Changes to the plate produce differences among impressions. Surviving impressions that reflect such changes are classified by state, referring both to the state of the plate and to the print. States are distinct from differences among impressions resulting from variations in printing, paper quality, plate wear, or condition (*see* PRINTS, §III).

Working, or proof, states are produced by printing from an unfinished plate. Impressions of the first two states of the engraving *Adam and Eve* (1504) by Albrecht Dürer (1471–1528) show unengraved areas, which in the third state were completed. After completion of the design, the artist may make additions (e.g. a signature), which constitute a separate state, or corrections: the reversed numeral '5' of the first three states of *Adam and Eve* is corrected in the fourth. The artist may reconsider passages: in the fifth and final state of *Adam and Eve*, Dürer shaded a tree trunk to enhance its recession. Reconsiderations can become obsessive: an intaglio plate by Edgar Degas (1834–1917), *Leaving the Bath* (1879–80; Reed and Shapiro, no. 42), compositionally complete in the first state, passed through 22 surviving states. As a physical object, the plate offers the artist the opportunity for radical alteration, by cutting either to reduce its size or to make separate compositions of fragments. Thus two etchings by Canaletto (1697–1768), *The House with the Inscription* and *The House with the Peristyle*, in reality comprise the second state of *Imaginary View of Venice* (1741; Bromberg, nos 13, 14 and 12), which was cut in half. Artists in the 20th century have viewed the metamorphosis of states as a conceptual entity: the seven successive states of the woodcut *Standing* (1985; Bardon, p. 157) by the German artist Matthias Mansen (*b* 1958) are mounted side by side to form a single image. Physical amalgamation of states is exploited, as in linocuts by Pablo Picasso (1881–1973) in which successive states of a single block are printed in different colours, each over the last, so that impressions of all states comprise the finished print; and in wood-engravings by Paul Gauguin (1848–1903) in which a later state, printed on translucent paper, is pasted on to an impression of the earlier state.

States may proceed from alterations not by the artist but by others. Some of these may be desired by the artist: historically, titles were conventionally added by specialists. As an example of collaboration in the design itself, Anthony van Dyck (1599–1641), in the portrait series *The Iconography* (*c.* 1632–44; Mauquoy-Hendrickx, nos. 1, 4, 6, 9, 11, 14–17), etched the heads of sitters and then turned his plates over to professional engravers, who completed the figures in later states. Additional states may reflect the continuing use of a plate by a publisher, who might add his name and address, correct outdated publisher's information or even rework a worn plate. Expedients taken to conceal wear may result in additional states: the woodcut portrait by Dürer of *Ulrich Varnbühler* (1522; Talbot, nos 203, 204), originally a single block, was complemented by two chiaroscuro blocks in the 17th century, apparently to conceal damage in the original block. Publishers have also altered plates in

order to maintain their topical value: the first state of engravings by Michael Vandergucht (1660–1725) and Romeyn de Hooghe (1645–1708) portray Queen Anne (*c.* 1702–14), their second, King George I (*c.* 1714–27; Layard, nos 1, 2). The reverse motive, to limit the number of impressions, may also inspire a new state in which the plate is defaced so that it no longer fairly represents the artist's work or at least is manifestly a last state. The Degas print cited above exists in a twenty-third, cancelled state.

The collecting of multiple states, and especially of earlier states, which by definition exist in a limited number, developed as soon as prints themselves became objects of value. As early as the 16th century an engraving by Marcantonio Raimondi (*c.* 1470/82–1527/34; *Mars, Venus and Eros*, 1508; B. 345–I, 345–II) was fraudulently printed to simulate an otherwise-unknown first state. By the later 18th century artificial proofs created by arbitrary reworkings and additions and printed in limited editions transformed states from practical expedients into a commercial system, referred to by a contemporary publisher as 'the gold mine of engraving' (Couboin, p. 123). Abuses proliferated during the 19th century, so that in the 20th century Joseph Pennell wrote, 'States, if not an invention of the Devil, certainly are the spawn of the Dealers' (p. 293).

A parallel debate developed among print cataloguers about what a state was or should be. In the 18th century the usual term for state was 'impression', indicating a vagueness in dissociating the class from the individual example, but by the 19th century the concept was well established. Cataloguers conditioned by contemporary mores attributed commercial motives to the proliferation of states by Rembrandt van Rijn (1606–69) himself and maintained that for financial reasons states should be counted only when the plate was completed, that is, only artificial proofs rather than working proofs, would be ranked. By the end of the 19th century, when the concoction of states had been discredited through commercial abuse (and when the print publication industry had been transformed by photography), dictionaries adopted an exactly opposite attitude and defined 'state' through the description of working proofs only.

C. H. von Heinecken: *Dictionnaire des artistes, dont nous avons des estampes avec une notice detaillée de leurs ouvrages gravés*, 4 vols (Leipzig, 1778–90)

J. Strutt: *A Biographical Dictionary: Containing an Historical Account of the Engraver, from the Earliest Period of the Art of Engraving to the Present Time*, 2 vols (London, 1785)

A. von Bartsch: *Catalogue raisonné de toutes les estampes qui forment l'oeuvre de Rembrandt et ceux de ses principaux imitateurs* (Vienna, 1797)

A. von Bartsch: *Le Peintre-graveur* (1803–21)

A. von Bartsch: *Anleitung zur Kupferstichkunde* (Vienna, 1821)

S. R. Koehler: *Etching* (New York, 1885)

J. Adeline: *Lexique des termes d'art* (Paris, 1884); Eng. trans. as *The Adeline Art Dictionary* (London, 1891/R New York, 1966)

A. Whitman: *Charles Turner* (London, 1907)

F. Couboin: *L'Estampe français* (Brussels, 1914)

J. Pennell: *Etchers and Etching* (London, 1920, rev. 4/New York, 1941)

A. J. Finberg: *The History of Turner's 'Liber Studiorum'* (London, 1924)

G. S. Layard: *Catalogue Raisonné of Engraved British Portraits from Altered Plates* (London, 1927)

H. Zerner: 'A propos de faux marcantoine: Notes sur les amateurs d'estampes à la renaissance', *Bibliothèque d'humanisme et renaissance*, xxiii (1961), pp. 477–81

R. Mayer: *A Dictionary of Art Terms and Techniques* (New York, 1965, rev. 5/1991)

C. Talbot, ed.: *Dürer in America: His Graphic Work* (Washington, 1971)

K. Oberhuber: *The Works of Marcantonio Raimondi and of his School* (1978), 27 (XIV/ii) of *The Illustrated Bartsch*, ed. W. Strauss (New York, 1978–)

J. Baas and R. S. Field: *The Artistic Revival of the Woodcut in France, 1850–1900* (Ann Arbor, 1984)

S. W. Reed and B. S. Shapiro: *Edgar Degas: The Painter as Printmaker* (Boston, 1984)

W. S. Liebermann and L. D. McVinney: *Picasso Linoleum Cuts* (New York, 1985)

A. Bardon: 'New Paths in Germany: The Woodcuts of Droese, Kluge and Mansen', *Print Collector's Newsletter*, xvii (1986), pp. 157–63

M. Mauquoy-Hendrickx: *L'Iconographie d'Antoine van Dyck*, 2 vols (Brussels, 2/1991)

R. Bromberg: *Canaletto's Etchings* (San Francisco, rev. 1993)

Steel. *See* IRON AND STEEL.

Stencilling [Fr. *pochoir*; Ger. *Schablone*]. Printmaking technique that allows a design to be repeated on almost any surface by rubbing, brushing or spraying ink, dye or paint through holes cut in a thin sheet of semi-rigid, moisture-proof material (*see also* PRINTS, §III, 3). A negative stencil design can be made by placing any object against a surface and depositing colour around it.

1. TECHNIQUES. The process has been used most frequently to accelerate the hand colouring of line drawings printed on paper by other means. In some cases it is possible to distinguish stencilled colour from that applied freehand. The stencil, of toughened paper, metal shim or celluloid, forms a 'well' in which the liquid colour collects, drying with a heavier concentration at the perimeter; yet it does not display any sign of the pressure typical of relief blocks. While freehand colouring may overshoot an outline at random, the entire area of a misregistered stencil will tend to be displaced.

'Stencil' is said to derive from the Old French *estanceler* or the Latin *scintillare* ('to glitter'), but the word *patron* (Fr.: 'pattern') was also used for the technique, which has had very wide applications. People in prehistoric times blew earth colours on to cave walls, using parts of their bodies as masking devices. Fiji islanders pattern their bark cloth by applying earth colours mixed with tree sap through holes cut in dried banana leaves. One of the simpler uses of stencilling, found both in Asia and in medieval Europe, was to apply adhesive through a stencil to which foil, flocking, ground quartz or tinsel was then

glued (see FLOCK AND TINSEL PRINTS). In a process related to stencilling called POUNCING, powder is rubbed through tiny perforations pricked along the lines of a cartoon, thus transferring the image to another surface in order to aid, for instance, the embroiderer on cloth or the fresco painter working on the day's fresh plaster.

The Chinese and especially the Japanese achieved great sophistication in their stencil-dyed textiles (see TEXTILE, §III, 1(ii)(e);. In an early Japanese technique (*kyōtechi*) folded cloth was clamped between two identically pierced boards through which dye was introduced. Later, intricate pattern-dyeing in indigo (called *komon* or *chūgata* depending on the size of the pattern) required accurate stencilling of a rice-paste resist on both sides of the fabric. On the Ise Peninsula, notably in the towns of Shiroko and Jike, stencils (*katagami*) are still cut with a variety of awls, punches and small knives. Patterns with larger areas of colour have always presented problems, since stencils cannot reserve 'islands' within an open area unless bridges or ties hold these elements in place; the Japanese solved the problem by devising *itoire* techniques, in which a network of filaments was glued between two identical stencils cut from mulberry paper toughened with persimmon juice (*shibugami*). This made possible the most complex tracery patterns. The later substitution of a piece of silk gauze for individual strands of human hair or silk undoubtedly led to the development of the silk screen process, now known as SCREENPRINTING. By *c.* 1900 stencilling in the West had been partially mechanized. At Epinal, France, where images had been stencil-coloured since the 18th century, jigsaws were introduced for cutting stencils in quantity, and conveyor belts moved them past the piece-workers. In the same period waxed paper stencils for office duplicating enabled typewritten texts to be mass-produced by a rotary version of the process. In 1907–8 the title of *Penrose's Pictorial Annual* was printed by aerograph through a stencil, a process described as 'spray printing' (see also AIRBRUSH).

2. HISTORY. Stencilling was used in cave painting during the Upper Palaeolithic period in the Franco-Cantabrian region, and Aboriginal examples of negative stencilling, especially of the left hand, abound throughout Australia. A complete stencilled human figure and a frieze of 600 red ochre designs, for example, have been found in Queensland's Carnarvon Ranges. While such work may be relatively recent, radiocarbon dating suggests that appropriate ochre pigments existed 25,000 years ago. Stencils were recommended by Quintilian (*c.* AD 35–*c.* 100) as a teaching aid for school children, and unlettered kings and emperors—Theodoric, King of the Ostrogoths (reg *c.* AD 455–526), Justinian I (reg 483–565) and Charlemagne, King of the Franks (reg *c.* 742–814)—used them to sign documents.

Other notable historical examples come from East Asia. Pounces of the Chinese Tang dynasty (AD 618–907), used to repeat Buddhist images on walls and cloth, were found in 1907 in the Caves of a Thousand Buddhas at Dunhuang on the Central Asian silk route. A Japanese figured silk stencilled with a Buddhist sacred wheel (London, Victoria and Albert Museum) survives from the Nara period (AD 710–94), and there are examples of armour decorated with stencils of leather from the Kamakura period (1185–1333). The summer kimono that belonged to the Japanese warlord Uesugi Kenshin (1530–78; Yamagata Prefecture, Uesugi shrine) is one of the oldest extant examples of *surihaku* ('printed foil'), in which gold- and silver-leaf decorations are laid on top of adhesive applied through a stencil. A form of stencilled dye-resist known as *chayazome*, after a Kyoto draper, reached its peak during the Edo period (1600–1868), as did the related method of *chūgata*.

After paper had spread from Asia to Europe in the early 12th century, decorative textile techniques such as stencilling were adapted to religious prints and to playing cards. The term *Kartenmaler* (card painter) is apparently first found on a document of 1402 from Ulm, although stencilled cards themselves were certainly made earlier. In 1568 a stenciller was depicted by Jost Amman (1539–91) in his woodcut illustrations of the *Ständebuch*, and in 1735 Martin Engelbrecht (*c.* 1684–1756) engraved male and female card painters as composite figures formed from the tools of the stenciller's trade. Because of the practice of recycling waste into cardboard for binding books, a few card stencils have been preserved, as have some used by *dominotiers* (a word that may stem from *domino*, Lat.: 'Lord') to colour woodcut religious images. The *dominotiers* also stencilled banners, ballad sheets, broadsides and pattern papers. The latter evolved into sophisticated stencilled wallpaper, especially in the hands of Jean-Michel Papillon (1661–1723), whose first stencil-coloured woodcut design, *Poppies* (1707), survives (Paris, Bibliothèque National), together with an informative series of drawings showing how his sheets of stencilled woodcuts were printed and hung. In the 18th century stencils were used for music; the service book of the Gregorian chant produced by U. Boddaert in 1755 (New Haven, CT, Yale University Library) is prefaced by a letter about the process to the stenciller's abbot. The stencilled letters IHS and small decorative motifs were common on the walls, rafters and rood screens, and stencilled fragments have also been preserved from European houses, notably in parts of France and East Anglia. Stencilling directly on the wall, however, is a craft particularly associated with colonial America in the years preceding the mass production of wallpaper, and examples in the eastern states date from the late 18th century. Itinerant workmen, among them the famous Moses Eaton (1753–1833), whose stencilling equipment is preserved (Boston, MA, Society for the Preservation of New England Antiquities), would mix dry colour with sour milk and apply it through stencils of oiled card. At about this time Poonah or Theorem painting—stencilling on velvet—became a genteel pastime for

middle-class ladies, 'French stencil painting plates' to assist them being advertised as early as 1788.

By the end of the 19th century stencilling was used as an economical way of colouring artists' drawings converted into line blocks for such periodicals as *Le Mirliton*. Known in France as *pochoir* and used extensively on picture postcards, stencilling developed into a luxury trade associated with interior design and high fashion and was used in such magazines as the *Gazette du bon ton* (7 vols from 1912). An enormous output was issued from such Parisian publishing houses as André Marty, Vérel, Barré Dayez, Gréningaire and Jacomet for illustrators such as Georges Barbier (1882–1932) and Umberto Brunelleschi (1879–1949); the Trianon Press reproduced all of the illuminated books by William Blake (1757–1827). It has been estimated that between the wars there were some 30 such houses in Paris and its suburbs, employing perhaps 600 workers. In 1925, at the height of this activity, Jean Saudé published an exquisitely illustrated treatise on stencilling, which inspired the English printer Harold Curwen (1885–?1965) to emulate the French example. Between 1926 and 1932 at his press in London, Curwen produced some beautiful books embellished by Paul Nash (1889–1946) and E. McKnight Kauffer (1890–1954), among others. After World War II a serious recession affected Parisian production, although one of the loveliest books ever stencilled, *Jazz* by Henri Matisse (1869–1954), appeared in 1947. Other artists have made intermittent use of the technique. Pablo Picasso (1881–1973) and the painter Cecil Collins (1908–89) made wartime print editions from office stencils. Between 1959 and 1964 the American sculptor David Smith (1906–65) stencilled around scrap-metal and other objects placed on paper to create the series *Sprays from Bolton Landing*. In New York, where contemporary painters have combined stencilling with other techniques, the process became the speciality of the printer Chip Elwell (1940–86). In the 1980s there was a revival of stencilling for fashionable domestic interiors, with patterns applied to ceilings, floors, fabric and furniture as well as walls. One of the most intriguing uses of the technique at roughly the same time was by anonymous Parisians wielding cans of spray paint who stencilled pictures or small symbols all over the city walls, a practice recorded in the book *Serigraffitis* (1986).

G. Fischer von Waldheim: ' Über ein in der Mainzer Universitäts-Bibliothek befindliches durch Blech geschriebenes Buch', *Beschreibung einiger typographischen Seltenheiten nebst Beyträgen zur Erfindungsgeschichte der Buchdruckerkunst* (Mainz, 1800–04), pp. 139–60

W. H. Willshire: *Descriptive Catalogue of Playing and Other Cards in the British Museum* (London, 1876)

A. W. Tuer: *The Book of Delightful and Strange Designs Being 100 Facsimiles Illustrating the Art of the Japanese Stencil-cutter* (London, 1892); repr. as *Japanese Stencil Designs: 100 Outstanding Examples* (New York, 1967)

H. R. d'Allemagne: *Les Cartes à jouer du XIVe au XXe siècle*, 2 vols (Paris, 1906)

H. Balfour: 'The Origin of Stencilling in the Fiji Islands', *Journal of the Royal Anthropological Institute of Great Britain and Ireland*, liv (1924), pp. 347–52

J. Saudé: *Traité d'enluminure d'art au pochoir* (Paris, 1925)

L. Karr: 'Paintings on Velvet', *Antiques*, xx (1931), pp. 162–5

P. Nash: 'The Stencil', *Curwen Press Miscellany* (London, 1931)

E. J. O'Meara: 'Notes on Stencilled Choirbooks', *Gutenberg Jahrbuch* (1933)

A. M. Hind: *An Introduction to the History of Woodcut, with a Detailed Survey of Work Done in the 15th Century*, 2 vols (London, 1935/R New York, 1963)

J. Waring: *Early American Stencils on Walls and Furniture* (New York, 1937/R New York, 1968)

H. Meier: 'Woodcut Stencils of 400 Years Ago', *Print Collector's Quarterly*, xxv (1938), pp. 8–31

F. W. Reader: 'The Use of the Stencil in Mural Decoration', *Archaeological Journal*, xcv (1938–9), pp. 112–26

M. B. Cary, jr: 'A Stencil Sheet of Playing Cards of the Late 15th Century with Two Related Uncut Sheets of Cards', *Print Collector's Quarterly*, xxvi (1939), pp. 393–410

J.-M. Dumont: *La Vie et l'oeuvre de Jean-Charles Pellerin* (Epinal, 1956)

F. D. McCarthy: *Australian Aboriginal Rock Art* (Sydney, 1958)

W. B. Proudfoot: *The Origin of Stencil Duplicating* (London, 1972)

'L'Enluminure au pochoir: Un Art méconnu', *Nouvelles de l'estampe*, xxi (1975), pp. 9–16

A. Bishop and C. Lord: *The Art of Decorative Stencilling* (London, 1976)

Artists at Curwen (exh. cat. by P. Gilmour; London, Tate, 1977)

Pochoir (exh. cat., intro. by E. M. Harris; Washington, DC, National Museum of History and Technology, 1977)

Diderot Encyclopaedia: The Complete Illustrations, 1762–1777 (New York, 1978) [esp. pls 409–14]

Pochoir: Flowering of the Hand-color Process in Prints and Illustrated Books, 1910–1935 (exh. cat., intro. B. Wallen; Santa Barbara, CA, University of California, University Art Museum, 1978)

P. Larson: 'Glasgow and Chicago: Stencils and Other Prints', *Print Collector's Newsletter*, x/1 (1979), pp. 1–7

B. Wallen: 'Sonia Delaunay and Pochoir', *Arts Magazine*, liv (1979), pp. 96–101

Katagami: Japanese Stencils in the Collection of the Cooper-Hewitt Museum (Washington, DC, 1979)

N. Gisha with B. B. Stephan: *Japanese Stencil Dyeing: Paste Resist Techniques* (New York, 1982)

David Smith: Sprays from Bolton Landing (exh. cat., London, Anthony d'Offay Gallery, 1985)

L. Le Grice: *The Art of Stencilling* (London, 1986)

Serigraffitis: Photographies de Joerg Huber (Paris, 1986)

G. Ercoli: *Il pochoir: Art Déco* (Florence, 1987)

G. Ercoli: *Art Deco Prints* (Oxford, 1989)

T. Baum and others, eds: *Surrealist Prints* (New York, 1997)

S. S. Tai and others, eds: *Carved Paper: The Art of the Japanese Stencil* (Santa Barbara and New York, 1998)

I. Finch: 'Printing and Resist Methods on Japanese Porcelains', *Arts of Asia*, xxxi/2 (March–April 2001), pp. 66–78

J. Gillow: *Printed and Dyed Textiles from Africa* (London, 2001)

S. Lambert: *Prints: Art and Techniques* (London, 2001)

Stereotomy. Art and science of cutting solids precisely so that their parts fit together tightly. Stereotomic problems arise in all masonry or wood construction in which a whole must be made of various parts. Cutting simple rectangular blocks is conceptually simple, but

precise compound-angle or curved cuts require special methods. For lack of documentation, ancient and medieval stereotomy can be studied only in executed works. After the 15th century, stereotomic developments can be studied more profitably through technical treatises.

The intersection of cylinders (i.e. a groin vault) was first analysed precisely by Piero della Francesca (*c.* 1415–92) in his worked example for Problem X in *De quinque corporibus regularibus*, and their perspectival representation in *De prospectiva pingendi* (II and XI). Albrecht Dürer (1471–1528) introduced Euclidean geometry to northern artists in *Vnderweysung der Messung mit den Zirkel un Richtscheyt* (1525), which became more accessible outside Germany in a Latin translation, *Institutiones Geometricae* (Paris, 1538).

In the 16th century French and Spanish architects learned in Classical geometry applied exact geometric procedures to stereotomy. According to Philibert de L'Orme (1514–70), for example, important new techniques were developed in Paris at the workshop of the Château de Madrid (1528; destr. 1793–1847). He states that in his youth every *trompe* (a cantilevered trumpet squinch) had its own idiosyncratic analysis and that the art of *traits* (stereotomic cuts) was very difficult to learn. In 1536 he built two *trompes* at the Hôtel Bullioud in Lyon, for which he invented an exact computational procedure applicable to other *trompes*. Earlier, from *c.* 1528, Diego de Siloé (*c.* 1490–1563) had developed stereotomic calculations for trumpet arches and three-dimensional arches at Granada Cathedral, where many Andalusian stereotomists were trained. He also trained the most skilled of these, Andrés de Vandelvira (1509–75), at El Salvador, Ubeda, in 1540. The *Libro de arquitectura* by Hernán Ruiz II (*c.* 1500–69), which was compiled in Seville using texts by Vitruvius (1st century BC) and Sebastiano Serlio (1475–?1553/5), includes a few simple stereotomic diagrams.

The earliest extant texts on exact stereotomy date from the second half of the 16th century. They supported an aesthetic appreciation of complex displays of technical virtuosity, such as de L'Orme's *trompe* at the château of Anet (1547–55; destr. after 1798) and his staircase (1564–72; destr. 1871) at the Tuileries, Paris. Books III and IV of de L'Orme's *Premier tome de l'architecture* (Paris, 1567) are practical geometry texts on complex vaults. A larger and more systematic work, however, was written by Alonso de Vandelvira (1544–*c.* 1625), Andrés's son. It was the first book that focused strictly on stereotomy. Although it remained unpublished, it was widely read and copied: Lorenzo de San Nicoláse (1595–1679) published selected problems and Pedro de la Peña (*d* 1650) adapted the manuscript for publication. Juan de Torija (1624–66) has been accused of plagiarizing this revision, although his book advocates simpler mathematical procedures. A major stereotomic treatise written *c.* 1590–1600 by Ginés Martínez de Aranda (*d* before 1636) also remained unpublished.

During the 17th century many specialized books on stereotomy were produced. Diego López de Arenas (?1579/80–?1638/40), for example, wrote an unusual text on traditional Islamic carpentry interlaces, while *Le Secret d'architecture* by Mathurin Jousse (1607–before 1692) and the more luxurious folio by François Derand (1588 or 1591–1644) were addressed to both apprentices and master masons. Other technical treatises, some intended for painters and engravers, dealt with Euclidean geometry and perspective, discussing conic sections and complex curves resulting from the intersection of various solids. Examples include *La Perspective positive de Viator* (1635) by Jousse, *Euclides adauctus* (1671) by Guarino Guarini (1624–83) and the three-volume work (1674) by Claude François Milliet Dechales (1621–78). Only the architectural treatises of Augustin-Charles d'Aviler (1653–1701) and Guarini dealt with the subject, although Müller has suggested that the chapter on stereotomy in the latter's *Architettura civile*, as edited by Bernardo Antonio Vittone in 1737, may have been taken from *Euclides adauctus*. The brilliant mathematical analysis of the subject by Gérard Desargues (1591–1661), which anticipated the study of descriptive geometry by Gaspard Monge (1746–1818) at the end of the 18th century (see below), was rejected by workers owing to its generality and abstraction. Stone-cutting remained a practical skill rather than a theoretical art. Every Parisian master mason, for example, had to be able to cut stones for vaults, relying on his ability to analyse spatial structure without mathematical aids.

The tradition established in France during the 17th century continued in stereotomic treatises published during the 18th, of which the most important were by Jean-Baptiste de La Rue (*d* 1750), Amédée-François Frézier (1682–1773), Christian Rieger and Benito Bails (1730–97). The earlier taste for spectacular skewed arches, *trompes* and cantilevered stairs was tempered by Neo-classical decorum, and the study of stereotomy became more purely technical, increasingly divorced from design.

Monge's theory of descriptive geometry was influential in the 19th century and projective techniques of greater generality were widely adopted in the many stereotomic textbooks. While it was not unusual for works to be produced that were stereotomically complex, their aesthetic expression tended to be restrained, although remarkable exceptions may be found in the portico for the Palacio Episcopal (1887–93) at Astorga (León) and the sinuous arched façade for the Casa Milà (1906–10) in Barcelona, both by Antoni Gaudí (1852–1926).

Treatises

Piero della Francesca: *De prospectiva pingendi* (*c.* 1480; Parma, Bib. Palatina, MS. 1576); ed. G. Nicco Fasola (Florence, 1942/*R* 1984)

Piero della Francesca: *Libellus de quinque corporibus regularibus* (*c.* 1490; Rome, Vatican, Bib. Apostolica, Cod. Urb. 273); ed. G. Mancini (Rome, 1916)

A. Dürer: *Vnderweysung der Messung mit den Zirckel un Richtscheyt* (Nuremberg, 1525/*R* London, 1970) [foreword by A. Wagner]; Eng. trans., commentary by W. L. Strauss, as *The Painter's Manual* (New York, 1977)

H. Ruiz el Joven: *Libro de arquitectura* (*c.* 1560; Madrid, Universidad Complutense, Escuela Técnica Superior de Arquitectura, MS. R16); ed. P. Navascues Palacio (Madrid, 1974)

P. de L'Orme: *Nouvelles inventions pour bien bastir et à petis fraiz* (Paris, 1561); also as suppl. to *Le Premier Tome de l'architecture,* 2/1568/*R* 1988)

A. de Vandelvira: *Libro de traças de cortes de piedra* (*c.* 1575–91; Madrid, Biblioteca Nacional, MS. 12719); ed. G. Barbé-Coquelin de Lisle, 2 vols (Albacete, 1977)

G. Martínez de Aranda: *Cerramientos y trazas de montea* (MS. *c.* 1590–1600; Madrid, Servicio Histórico Militar, Biblioteca) (Madrid, 1986) [photographic copy with intro. by A. Bonet Correa]

D. López de Arenas: *Breve compendio de la carpintería de lo blanco, y tratado de alarifes* (Seville, 1633; rev. 2/1727); original MS., ed. M. Gómez-Moreno, also in *Primera y segunda parte de las reglas de la carpintería de Diego Lopez de Arenas* (Madrid, 1966)

M. Jousse: *La Perspective positive de Viator* (La Flèche, 1635)

G. Desargues: *Brouillon Projet d'exemple d'une manière du S.G.D. touchant la pratique du trait à preuves pour la coupe des pierres en l'architecture* (Paris, 1639/40; ed. A. Brosse as *La Pratique du trait à preuves* (Paris, 1643)

L. de San Nicolás: *Arte y uso de arquitectura,* 2 vols (Madrid, 1639–63)

M. Jousse: *Le Secret d'architecture découvrant fidèlement les traits géométriques, coupes, et derobemens nécessaires dans les bastiments* (La Flèche, 1642)

F. Derand, SJ: *L'Architecture des voûtes, ou l'art de trait et coupe des voûtes* (Paris, 1643)

J. de Torija: *Breve tratado de todo género de bobedas* (Madrid, 1661)

G. Guarini: *Euclides adauctus et methodicus mathematicaque universalis* (Turin, 1671)

C. F. M. Dechales: *Cursus seu mundus mathematicus,* 3 vols (Lyon, 1674)

A.-C. D'Aviler: *Cours complet d'architecture* (Paris, 1691)

J.-B. de La Rue: *Traité de la coupe des pierres, où par une méthode facile et abrégée, l'on peut aisément se perfectionner en cette science* (Paris, 1728)

G. Guarini: *Architettura civile,* ed. B. Vittone (Turin, 1737); ed. B. T. La Greca (Milan, 1968)

A.–F. Frézier: *La Théorie et la pratique de la coupe des pierres et des bois pour la construction des voûtes et autres parties des bâtiments civils et militaires: Ou traité de stéréotomie à l'usage de l'architecture,* 3 vols (Strasbourg and Paris, 1737–9)

C. Rieger: *Universae architecturae civilis elementa* (Vienna, Prague and Trieste, 1756)

B. Bails: *Elementos de matemática,* ix/1 (Madrid, 1783)

G. Monge: *Géométrie descriptive* (Paris, 1799)

J. Chaix: *Traité de coupe des pierres: Stéréotomie* (Paris, 1890/*R* 1997)

Studies

N. G. Poudra and M. Chasles: *Œuvres de Desargues: Réunies et analysées par M. Poudra,* 2 vols (Paris, 1864)

N. Pevsner: 'The Three-dimensional Arch from the Sixteenth to the Eighteenth Century', *Journal of the Society of Architectural Historians,* xvii (1958), pp. 22–4

W. Müller: 'The Authenticity of Guarini's Stereotomy in his *Architettura civile', Journal of the Society of Architectural Historians,* xxvii (1968), pp. 202–8

W. Müller: 'Guarini e la stereotomia', *Atti del convegno internazionale promosso dall'Accademia delle scienze di Torino: Guarino Guarini e l'internazionalità del Barocco: Torino, 1968,* i, pp. 531–56

M. Daly Davis: *Piero della Francesca's Mathematical Treatises* (Ravenna, 1977)

M. L. Rokiski Lázaro: *La cabecera de la iglesia de Priego (Cuenca): Dibujos y tasación* (Cuenca, 1980)

J.-M. Pérouse de Montclos: *L'Architecture à la française* (Paris, 1982)

E. Nuere: *La carpintería de lo Blanco* (Madrid, 1985)

C. Lalbat, M. Gilbert and J. Martin: 'De la stéréotomie médiévale: La coupe des pierres chez Villard de Honnecourt', *Bulletin monumental,* cxlv/4 (1987), pp. 387–406; cxlvii/1 (1989), pp. 11–34

P. Rockwell: *The Art of Stoneworking: A Reference Guide* (Cambridge, 1993)

S. L. Sanabria: 'From Gothic to Renaissance Stereotomy: The Design Methods of Philibert de l'Orme and Alonso de Vandelvira', *Technology and Culture,* xxx (1989), pp. 266–99

J. C. Palacios: *Trazas y cortes de cantería en el renacimiento Español* (Madrid, 1990)

J. Sakarovitch: 'La taille des pierres et la géométrie descriptive', *La figure et l'espace* (Lyon, 1993), pp. 117–38

R. Evans: *The Projective Cast: Architecture and its Three Geometries* (Cambridge, MA, 1995)

J. Sakarovitch: 'The Teaching of Stereotomy in Engineering Schools in France in the XVIIIth and XIXth Centuries: An Application of Geometry, an Applied Geometry or a Construction Technique?', *Entre mécanique et architecture/Between Mechanics and Architecture,* eds P Radelet-de Grave and E. Benvenuto (Basle, 1995), pp. 205–18

J. Sakarovitch: *Epures d'architecture: De la coupe des pierres à la géométrie descriptive* (Basle, 1998)

B. Cache: 'Gottfried Semper: Stereotomy, Biology, and Geometry', *Perspecta,* xxxiii (2002), pp. 80–87 (also in *Architectural Design,* lxxii/1 (2002), pp. 28–33)

Stipple. Type of intaglio engraving in which groups of dots rather than lines are used to build up tonal effects. It evolved from the CRAYON MANNER and became a technique in its own right in the late 18th century.

1. MATERIALS AND TECHNIQUE. Stipple dots are initially produced by working through an etching ground with a needle, or with a roulette, the principal tool used for the crayon manner. After biting one or more times, the engraver worked directly on the plate with a needle or a stippling graver, which was curved in order to obtain short strokes where these were preferred to dots. In practice stipple engravers used the conventional graver or burin as well, and many prints called stipples should more accurately be described as mixed method.

The appearance of a stipple can be closer to the effect of pencil drawing than any other intaglio technique. The plates also have the advantage that they are less subject to wear than those of mezzotint, the other major tonal technique. The latter rely for their strength on the roughness built up by grounding the plate, which is reduced each time ink is wiped from the plate prior to printing. Stipple plates are similar to those in line engraving: wiping was carried out in order to remove the excess ink from the smooth surface of the plate, and it did not wear down the plate

in the same way. Stipple plates were also easier to print in colours than other techniques; this was usually done *à la poupée*, by dabbing the colours on to the plate. This was a lengthy process requiring great skill, and colour-printed impressions were usually double the price of monochrome ones. Their richness of colour made such stipples greatly superior to those coloured by hand, although a certain amount of hand colouring was often used in finishing them.

2. HISTORY. Dots were used in the earliest engravings, for example by Giulio Campagnola (*c.* 1482–after 1515), to build up areas of tone. Stipple as a technique in its own right, however, did not develop until the late 18th century. Having emerged from the crayon manner developed in France by Jean-Charles François (1717–69), it was popularized by Gilles Demarteau (1722–76), whose prints, often in sanguine, of drawings by François Boucher (1703–70) and others, became well known.

William Wynne Ryland (1732–83), the first British engraver to work in the crayon manner, first used stipple in 1774, and during the next decade he engraved and published a number of stipples after Angelica Kauffman (1741–1807), which sold very well. The majority were circles or ovals and designed to be framed as 'furniture' prints, used as part of a scheme of interior decoration. Other early publisher–engravers in London included the Frenchman Victor Marie Picot (1744–1802), who may also have learnt the technique in Paris. The success of Ryland and his followers had an immediate effect on the print market. Such established publishers as John Boydell (1719–1804) and Robert Sayer (*fl* 1751–94) had to add stipples to their stock, and many engravers learnt the new technique, notably the line engraver Francesco Bartolozzi (1727–1815), who was soon employing many assistants and pupils to execute much of the preliminary work on plates, which he finished and signed. Among the mezzotint engravers who learnt the method, some, such as Thomas Burke (1749–1815), devoted themselves entirely to stipple; others, including William Dickinson (1747–1823), Richard Earlom (1743–1822), Thomas Watson (1748–81) and John Jones (1799–1882), worked in both methods.

Before the development of stipple, the demand for decorative and sentimental prints was growing. During the late 1780s, when there were fewer prints after Kauffman, the work of such English genre painters as William Redmore Bigg (1755–1828), Francis Wheatley (1747–1801), Thomas Stothard (1755–1834) and George Morland (?1763–1804) became known through prints; other painters, such as the portrait painter Matthew William Peters (1742–1814) and the pastellist John Russell (1745–1806), turned their hands to genre. The print publishers obtained permission to engrave exhibited pictures from painters or purchasers; on occasion they commissioned or bought pictures to be engraved. Many stipples were in fact based not on pictures but on specially executed drawings, such as the allegorical drawings of Giovanni Battista Cipriani (1727–85) engraved by his friend Bartolozzi,

many of which were tickets for public and private events and were much collected. Other drawings made into popular prints were those of playing children produced by William Hamilton (1751–1801), better known as a Neo-classical decorative painter. All of this affected the art market as a whole.

Several painters themselves published stipples of their work. In 1781 Robert Edge Pine (?1720/30–88) launched a series based on his paintings of Shakespearian scenes, engraved by Caroline Watson (*c.* 1760–1814). Richard Cosway (1742–1821) published stipples of some of his delicate portrait drawings of the leading figures of society and of the stage. Indeed, many stipples were made from portrait drawings, for example after John Downman (1750–1824), and many prints of little-known people were executed as private plates for which a family or sitter paid the engraver directly. Because of the small scale in which it was possible to work, stipple was also admirably suited to the reproduction of miniatures. Although most illustration was executed in line, stipple was often used, in particular, for portraits in books or such periodicals as the *European Magazine*, which employed some first-rate engravers, for example Jean Condé (1767–94). The outstanding British book illustrated with stipple plates was the ninth edition (London, 1797) of the *Seasons* (London, 1730) by James Thomson (1700–48), with charming small plates by Bartolozzi and Peltro William Tomkins (1760–1840), one of his best pupils, which the latter issued.

London became and remained the centre for stipple engraving. The fashion for furniture prints in Britain also reflected the strength of the consumer revolution that was taking place. An important ingredient in the success of the stipple was its appeal to the fashionable world. Many of the prints were aimed specifically at aristocratic ladies and those who aped their taste. Indeed, even Charlotte of Mecklenburg-Strelitz (1744–1818), wife of George III, King of England, began to collect prints, and in 1793 she appointed Tomkins as her Historical Engraver. The prints were sometimes sold by subscription, aimed at gentry, in the hope that subscribers would feel that some cachet was attached to lending their names to the list. The visiting Swedish painter Elias Martin (1739–1818) engraved and published a series of small prints of domestic genre, which he sought to sell to ladies by subscription in 1778. Many amateur artists, men and women, themselves provided drawings to be engraved in stipple; during the 1780s stipples of the humorous drawings of Henry William Bunbury (1750–1811), who was well known in fashionable society, were immensely popular. Other links with this included the use of stipple for fansheets and designs printed on to satin in needlework. British stipples were widely exported and also copied, especially in Paris. Many foreigners went to Britain to study stipple engraving.

The years before the French Revolution (1789–95) were the most prosperous for the London stipple engravers, and many found it more profitable to set up as print publishers rather than to work for fixed

fees for others. William Dickinson and Mariano Bovi (1758–1813) were among those who built up large businesses in fashionable locations. The outstanding engraver–publisher was John Raphael Smith (1752–1812); he remained primarily a mezzotint engraver but began in 1781 to publish stipples by himself, his pupil William Ward (1766–1826) and others.

The loss of export markets and the reduction of home demand when Britain and France went to war in 1793 led to the bankruptcy of several print publishers, such as Dickinson. The major businesses that had embarked on ambitious long-term schemes were also affected: the Boydells had launched an edition of Shakespeare (London, 1787), to be illustrated with 100 large prints after paintings that they commissioned; the project, which took over 15 years, was primarily carried out in stipple and employed over 20 of the leading engravers. The other principal employer of stipple engravers was Thomas Macklin (fl 1787; d before 1800), who is said to have paid Bartolozzi nearly £3500 for 11 plates, mostly for his *English Poets* in *Machlin's British Poets* (London, 1788–99). A third venture, born of the confidence of the late 1780s, was the Turf Gallery of George Stubbs (1724–1806), for which his son George Townly Stubbs (1756–1815) engraved about sixteen racehorses in two sizes of stipple plate before the gallery closed in the mid-1790s.

Despite the troubled times, some publishing projects were successful, especially the 13 plates that P. & D. Colnaghi published after the *Cries of London* (1793–7) by Francis Wheatley (1747–1801); most of these were engraved either by or under the direction of the brothers Luigi Schiavonetti (1765–1810) and Niccolo Schiavonetti (1771–1813). Other projects relying on stipple continued to be launched, such as the *Imitations of Original Drawings by Hans Holbein* (London, 1792–1800) of John Chamberlayne (1666–1723). However, many publishers found that patriotic subjects sold better than decorative subjects, and several, notably Edward Orme (fl 1800–19), founded businesses that sold many stipples of this kind.

In 1802 Bartolozzi left London for the security of an official post in Portugal. Much distinguished work was done in the following few years, for example by Anthony Cardon (1772–1813). As well as decorative subjects there were fine prints of cattle and horses, including about nine plates of horses by John Whessell (1760–*c*. 1824) after his own paintings, and stipple engravers still found employment on book illustrations. Stipple was, however, being replaced by aquatint as the preferred medium for decorative prints. One of the last major projects using stipple was the set of the *British Gallery of Contemporary Portraits* (London, 1809–22), issued by Cadell & Davies; by its completion, there were few notable stipple engravers, and the advantages of the new process of lithography were already apparent.

A. W. Tuer: *Bartolozzi and his Works*, 2 vols (London, 1882, 2/1885)

F. B. Daniell: *The Engraved Works of Richard Conroy RA* (London, 1890)

J. Frankau: *Eighteenth-century Colour Prints* (London, 1900, 2/1906)

J. Herbert Baily: *Francesco Bartolozzi* (London, 1907)

A. M. Hind: *A History of Engraving and Etching* (London, 1908, 3/1923/R 1963)

C. Salaman: *Old English Colour-Prints* (London, 1909)

R. M. Burch: *Colour Printing and Colour Printers* (London, 1910)

A. M. Hind: *Great Engravers: Bartolozzi* (London, 1912)

F. Siltzer: *The Story of British Sporting Prints* (London, 1925, 2/1929/R 1979)

A. de Vesme and A. Calabi: *Francesco Bartolozzi: Catalogue des estampes et notice biographique* (Milan, 1928)

F. Harvey: 'Stipple Engraving as Practised in England, 1760–1810', *Print Collector's Quarterly.*, xvii (1930), pp. 48–71

G. E. Beddington Collection of Colour-Prints (exh. cat., Cambridge, Fitzwilliam Museum, 1959)

M. Webster: *Francis Wheatley* (London, 1970)

C. Helbok: *Angelika Kauffmann und ihre Zeit*, Neue Lagerliste, xx (Düsseldorf, 1979)

Angelika Kauffmann und ihre Zeit. Graphik und Zeichnungen von 1760 bis 1810 (exh. cat. by C. Helbok and R.-M. Muthmann; Düsseldorf, Galerie Boerner, 1979)

A. Dyson: 'The Engraving and Printing of the Holbein Heads', *The Library*, n. s. 5, v (1983), pp. 223–36

Regency to Empire: French Printmaking, 1715–1814 (exh. cat. by W. Ittmann and V. I. Carsen; Minneapolis, MN, Minneapolis Institute of Arts, 1984)

A. Griffiths: *Prints and Printmaking: An Introduction to the History and Techniques* (London, 1996)

D. Pankow: *Tempting the Palette: A Survey of Color Printing Processes* (Rochester, NY, 2/2005)

Stone. Stone has been one of the world's most predominantly used materials for building and sculpture. It has been worked since the Palaeolithic period, when man learnt how to cut flint and related hard stones to produce tools and weapons. Soon after, stone began to be used for carving small sculptures, and it was used in the construction of the earliest domestic dwellings.

The identification of stones (*see* TECHNICAL EXAMINATION, §VIII, 1) and the determination of their provenance is of great importance. This information not only characterizes the single objects, but also allows archaeologists, art historians and architects to confirm or strengthen their attributions of the works to a certain workshop; to understand how physical properties of stones affected techniques and styles; and to reconstruct the patterns of import, use and commercial trade routes. To know the provenance of stone is also important for the supply of new materials for restorations, substitutions and copies. The following survey defines the major types of stone and describes their properties and distribution, the general techniques of stone-working and the conservation of stone buildings and objects.

I. Types and properties. II. Techniques. III. Conservation.

I. Types and properties. The following survey is arranged alphabetically by type.

Alabaster. See ALABASTER.

Anhydrite. Naturally occurring crystalline form of calcium sulphate, usually found as fine-grained nodular masses. Anhydrite is commonly associated with gypsum, dolomite and rock salt as the saline residue deposited after the evaporation of sea water in enclosed sedimentary basins. It is nearly always a natural dehydration product of gypsum; in its fine-grained form it occurs as a constituent of alabaster. Crystals of anhydrite are of the orthorhombic system and, when perfect, take a thick, tabular form. Perfect cleavage planes in three directions make these crystals brittle and difficult to work. They are transparent or white when perfect, but impurities of iron oxides and clay give yellow, brown, red or grey colours.

Anhydrite also commonly occurs as amorphous masses of small, granular crystals. In this form it has the same use as alabaster in the production of decorative objects, although it is a little harder than alabaster and may be polished to a more brilliant finish (*see* ALABASTER). It is rare, however, for anhydrite to occur in sufficiently pure masses to warrant separation as a distinct material. An exception is the deposit at Volpino in Lombardy, Italy, where massive anhydrite of scaly and granular structure and bluish tint has been quarried and used for the production of small, decorative objects. This type has been given the name of volpinite, from the source.

W. A. Deer, R. A. Howie and J. Zussman: *Non-silicates* (1962), v of *Rock-forming Minerals* (London, 1962–3)

R. Webster: *Gems: Their Sources, Descriptions and Identifications* (London, 1962, 4/1983)

W. L. Roberts, T. J. Campbell and G. R. Rapp: *Encyclopedia of Minerals* (New York, 1974, 2/1990)

Basalt. Term used to describe dark-coloured, fine-grained igneous rocks resulting from the crystallization of magma at or near the earth's surface and often associated with volcanic activity. Basalt is commonly regarded as being synonymous with lava (magma that has been extruded on to the surface of a planet). The terms used to describe basalts in ancient Greece and Rome encompassed all fine-grained, black rocks, including some that have proved not to be of magmatic origin.

Basalts may be massive, tough rocks of intergrown crystals. Lavas often have a rough texture, due to the presence of numerous gas bubbles. Both types are widely dispersed in ancient and modern volcanic areas of the world. The durability and effectiveness of these stones have made them important trade goods from prehistoric times. Massive types of basalt have also been used for the manufacture of such tools as pestles, axes, weapons and pounders for sculpting. Rougher, porous varieties, which tend to be of finer grain and glassy, make admirable mill and quern stones, because use constantly renews the cutting edges of the pores of the stone. Basalts may also be the source of such gemstones as peridot, spinel and sapphire.

I. S. E. Carmichael, F. J. Turner and J. Verhoogen: *Igneous Petrology* (New York, 1974)

W. S. MacKenzie, C. H. Donaldson and C. Guilford: *Atlas of Igneous Rocks and their Textures* (Harlow, 1982)

D. R. C. Kempe and A. P. Harvey, eds: *The Petrology of Archaeological Artefacts* (Oxford, 1983)

R. B. Pasqua: *Sculture di età romana in 'basalto'* (Rome, 1995)

Bath stone. See under LIMESTONE below.

Chalk. White, pure, amorphous limestone (see LIMESTONE below), formed during the Upper Cretaceous Period in north-western Europe. In its typical form it occurs at the Earth's surface in southern and eastern England and northern France. It is essentially composed of micron-sized elements of coccospheres—microscopic planktonic algae—with variable amounts of sand, clay and fossil shell. Much chalk is virtually pure calcium carbonate. It is this purity, combined with uniform fine grain size, that gives it importance as a graphic art material (*see* CHALK). Unprocessed, it can be used as a white sketching pigment; by simply crushing and washing, the finest slurry gives whiting. When burnt, it provides lime for building and agriculture. In England and France chalk has been used as a building stone, although of inferior quality, as it generally has poor weather resistance. It is suitable for interior work and was often used for sculpted memorials. English chalk for building is generally termed 'clunch', the low density of which makes it a suitable material for vaulting, but better quality material, gritty with much fragmented shell, occurs in Bedfordshire and Cambridgeshire, for example Totternhoe stone, and in Dorset, for example Beer stone. In England these types, which are no longer employed for new work but are quarried for restoration of existing buildings, were used as alternatives to Caen stone, a limestone from Normandy, France, which was a favourite building stone during the Middle Ages. French chalk tends to be denser than the English varieties and continues to be quarried in the lower Seine valley in the region of Rouen for building purposes.

A. J. Jukes-Brown: *The Cretaceous Rocks of Britain*, Memoirs of the Geological Survey of Great Britain, iii (London, 1900–04)

J. Allen Howe: *The Geology of Building Stones* (London, 1910)

C. Mégnien: *Synthèse géologique du bassin de Paris*, Mémoires du Bureau de Recherche Géologiques et Minières, ci–iii (Orléans, 1980)

Chert. See under FLINT below.

Diorite. See under GRANITE below.

Flint. Pure form of chemically precipitated cryptocrystalline quartz. It occurs as spherical, plate-like or irregularly shaped nodules or as the hollow cylindrical bodies known in Britain either as paramoudras or as pot stones from their shape. Larger nodules may be 1 m or more in width. When unweathered, the nodules have a dark grey or black centre of glassy

appearance and a white porous cortex. The former is hard and brittle, breaking like glass with a conchoidal fracture to a razor-sharp edge. When weathered, the material becomes paler, tougher and almost indestructible by natural means. The term 'flint' (derived from Old English) originally referred to the fire-lighting artefact rather than the stone, but it came to be applied to the stone used to provide the spark. Modern usage, however, distinguishes chert as the generic name for this type of stone and flint as the term for an especially pure, fine and even-grained variety, although the terms are in part interchangeable. Geologists' restrictive use of the word 'flint' to describe nodules of chert occurring within the limestone of the Upper Chalk Formation of the Cretaceous Period in north-western Europe is falling into disuse.

Flint is found in association with limestones in many parts of the world. Early human cultures exploited its hardness and the ease with which it provides a cutting edge. Broken shards provided an abundant source of efficient cutting implements, from minute knives to axes and arrow- and spearheads. In western Europe it was also a trade item. During the mid-19th century it was used to make silicate cements for the fabrication of such artificial stones as Ransome's Stone. Several industrial processes require flint as a raw material, notably as aggregate for the building industry and as an ingredient for porcelain manufacture. It also continued in use into the 20th century as a simply processed material for strike-a-lights and gun-flints and as pulverisers in ball mills.

S. B. J. Skertchley: *On the Manufacture of Gun-flints, the Methods of Excavating for Flint, the Age of Palaeolithic Man, and the Connexion between Neolithic Art and the Gun-flint Trade*, Memoirs of the Geological Survey of England and Wales (London, 1879) [the flints and items described in this pubn are held by the Mineralogy Dept, Natural History Museum, London]

W. Shepherd: *Flint: Its Origin, Properties and Uses* (London, 1972)

The Human Uses of Flint and Chert: 4th International Flint Symposium: Brighton, 1983

I. Longworth and others: *Shaft X: Bronze Age Flint, Chalk and Metal Working*, iii/1 of *Excavations at Grimes Graves, Norfolk, 19721976*, ed. J. Clutton-Brock (London, 1984–1996).

B. E Luedtke: *An Archaeologist's Guide to Chert and Flint* (Los Angeles, 1992)

J. Conolly: *The Çatalhöyük Flint and Obsidian Industry: Technology and Typology in Context* (Oxford, 1999)

S. Hart: *Flint Architecture of East Anglia* (London, 2000)

Granite. Intrusive igneous rock of various geological dates, essentially made of the minerals quartz, sodium-calcium plagioclase, potassium feldspar and micas, and generally light in colour. The word 'granite' is also used to refer to such other rocks as granodiorites (far more common than granites and slightly differing mineralogically), diorites (sometimes named black granite), monzonites etc. Granite is widely distributed on the earth's crust, most often in connection with the great mountainous chains (Alps, Himalayas, Andes), as well as in stable geological shields, such as those in Scandinavia and Canada. Being extremely hard stones, granites are very difficult to quarry and work, but have been widely used since antiquity and appreciated for their great durability, both in the West and in China, Japan, Sri Lanka and India. Granites have been used to construct obelisks, columns and pillars; for statuary, fountain basins and sarcophagi; in blocks for buildings; and in slabs for exterior cladding, pavements and floors.

Granite was first quarried in the Eastern Desert of Egypt, from the beginning of the dynastic period. The Egyptians used a type called syenite, as well as diorite, in slabs for facing the interior of funerary chambers or the exterior of buildings. Syenite was employed in many ancient Mediterranean cities. The Eastern Desert is rich with other types of granites used in antiquity, notably black-and-white granite, 'Granite of the Column', *marmor claudianus*, the granite of Wadi Fawakhir and green-grey granite. Black-and-white granite is a beautiful diorite with a large grain size characterized by prismatic inclusions of hornblende (a green to black mineral) in a white mass. It was quarried in small blocks and much used for the manufacture of canopic jars. This stone was rediscovered in Roman times, when its use extended to the production of small columns (e.g. at S Marco, Venice), tesserae for *opus sectile* and slabs for cladding. 'Granite of the Column', a pegmatoid rock quarried near Umm Shegilat, derives its name from a small column at S Prassede, Rome. Almost as important and diffuse as syenite was *marmor claudianus*, used in numerous columns found in Trajan's Forum. Little is known of the pinkish granite quarried in the Wadi Fawakhir, a true granite, probably already carved in ancient Egypt for statuary and certainly used for the manufacture of columns by the Romans. Green-grey granite is a quartz–diorite extracted in small quantity in Egyptian and Roman times and used for vases and small columns, tesserae and slabs respectively. Two beautiful columns of this stone can be seen in an altar in S Cecilia, Rome.

Among granites from Asia Minor, *marmor troadense*, also called violet granite for its violet-grey colour, is a quartz–monzonite still quarried to a small extent on the slopes of the Cigri Dag, a mountain near the ancient city of Troad (mod. Dalyan, Turkey). This stone was used locally from the 6th century BC, but it was largely exploited and exported throughout the Mediterranean from the 2nd century AD. Several ancient quarries can be seen in the area that show clear traces of Roman exploitation, for example the quarry in Ezine, where seven columns of $c.$ 12×1.5 m lie abandoned since antiquity. Also diffuse was Mysian granite, quarried at Kozak, some 30 km from Pergamon. It is a granodiorite with a light grey colour and a very fine and homogeneous grain, used for columns and other architectural elements.

From Roman times Italian, Spanish and German granites were used. Among Italian varieties there are grey granites from Nicotera and the island of Giglio, pink granite from Capo Testa and other localities in

northern Sardinia (also found in southern Corsica) and light grey granite from the island of Elba. The Elba type is a granodiorite with a fine grain, still quarried in small quantities on Mt Capanne. In Spain granite was quarried in the Segovia area in the north and around Seville in the south. These granites (mostly granodiorites) seem not to have been exported. The Segovian one was largely used in medieval and Renaissance times, for example for building the Escorial, Madrid. The German granite from Felsburg, although quarried in Roman times, became more widely used locally in the late Middle Ages.

Granites were never considered stones of great value by the Romans, possibly because of their limited decorative capacity. This attitude did not change in medieval times nor during the Renaissance, but today granites are highly valued. This renewed recognition is due in part to the great beauty of certain types quarried in such countries as Scotland, the USA and Brazil.

Granodiorite. See under GRANITE above.

Limestone. Sedimentary rock often largely of biological origin or less commonly chemical precipitations of lime. Limestones have a worldwide distribution and cover approximately 19% of the land surface of the earth. They are essentially composed of the minerals calcite and/or dolomite, which must compose at least 50% of the rock. Most limestones are essentially monomineralic calcite rocks, but dolomite-rich stones, for example Magnesian Limestones, are characteristic of eastern-central England. The remainder may be admixed sand, clay or volcanic ash, which greatly modify the characteristics of the rock. Limestones form as accumulations of calcareous shells and skeletal remains of such organisms as shell-fish, corals, sea-urchins, microscopic foraminifera and algae, together with impalpable calcareous mud, predominantly in tropical, shallow water. Their structure reflects their origins and shows patterning due to accumulations of shell, as in the types known as lumachelle, or of rounded grains, known as ooliths, produced by deposition of concentric layers of lime around a nucleus of sand or shell, for example in such oolitic limestones as Bath stone or Portland stone; such lime mudstones as the Lithographic limestones of Bavaria have a fine porcellanous appearance. Spongy tufa or travertine, notably from Italy, is the product of lime precipitation associated with algal growths.

Pure limestone, such as chalk or Portland stone, is white, due to reflection of light from internal surfaces between the clear calcite grains. The varying tints of yellow, ochre, brown and red seen in Bath and Lincolnshire limestones are due to the presence of disseminated iron oxides or hydroxides. An appreciable amount of clay may give shades of grey or green, and iron sulphide or bitumen, dark bluish grey or black.

The variations of weather resistance, toughness and appearance in limestones are the result of minute local variations in the combination and reorganization of the carbonate mineral grains during diagenesis (the changes produced by natural processes affecting sedimentary rocks after their deposition and burial). The essential carbonate minerals of limestone are readily dissolved by percolating water and redistributed as a crystalline cement between the remaining fragments. Ultimately a wholly crystalline rock may be formed that is distinguishable with difficulty from marble. The denser and harder limestones, such as the Derbyshire Fossil 'marbles', many of the French and all the Belgian 'marbles', which can be polished and are used mainly for decorative objects and veneers, are regarded as 'marble', although the use to which the stone is to be put will bias the terminological preference. A stone employed for building will be considered a limestone, even if it can be used for polished decoration. There is no English equivalent to the French term *pierres marbrières* for these polishable limestones.

Limestones have been a favourite material for building and sculpture from the earliest times. The combination of uniform fine texture, ease of working and pale colour in many types make them admirably suited to the preparation of finely finished and detailed sculpted work, and they may form a base for polychromy without the need for a ground coat. In addition to its use for block work, limestone is crushed to give construction aggregate and calcined to produce lime for the preparation of lime mortar, lime-wash and, with the addition of clay, Portland cement. Some impure limestones are of the correct composition to produce hydraulic cement on calcining, and the dolomitic varieties are used in fluxes for iron smelting and other industrial processes.

E. Hull: *On Building and Ornamental Stones of Great Britain and Foreign Countries* (London, 1872)

J. Allen Howe: *The Geology of Building Stones* (London, 1910)

J. Watson: *British and Foreign Building Stones* (Cambridge, 1911)

R. J. Schaffer: *The Weathering of Natural Building Stones*, Building Research Special Report, xviii (Garston, 1972)

J. Lee Wilson: *Carbonate Facies in Geologic History* (Berlin, Heidelberg and New York, 1975)

A. E. Adams, W. S. MacKenzie and C. Guilford: *Atlas of Sedimentary Rocks under the Microscope* (Harlow, 1984)

J. A. H. Oates: *Lime and Limestone: Chemistry and Technology, Production and Uses* (Chichester, 1998)

S. Holmes: *Evaluation of Limestone and Building Limes in Scotland* (Edinburgh, 2003)

Marble. Metamorphosed carbonatic limestone recrystallized by heat or pressure; the term is also loosely applied to any hard limestone (see LIMESTONE above). Marble is commonly composed of calcite or dolomite and is widely distributed in mountain chains and continental shields. It comes in a large variety of colours—from pure white to pinks, greens, greys and black—and its patterns result from the presence of impurities. Because of its appearance and strength, it has been used since ancient times for a wide range of purposes, including exterior and interior architecture, sculpture and furniture.

It was in the Cycladic islands of Greece in the 3rd millennium BC that true marbles were first carved. Cycladic marbles, extracted in the islands of Paros, Naxos, Ios, Amorgos, Sifnos, Tinos etc, are composed of almost pure crystalline calcite and are mostly of a pure white colour with an average to large grain size. When polished, their surface is translucent and shiny; some of them are semitransparent in thin slabs. Parian marble in particular became one of the most famous of classical antiquity, prized for the purity of its colour and easy workability. Initially the marble was removed in more or less large fragments with levers from fractured outcrops and then carved in the form of stylized idols, small vases and male and female figurines, which were traded throughout the Mediterranean.

Cycladic marbles continued to be exploited by the Greeks, from the archaic period on, for the production of kouroi and korai and of acroliths. The Greeks also used marble for temples (e.g. the Parthenon, Athens, 447–432 BC) and public buildings; they opened new important quarries of white and grey marbles in Attica on Mt Pentelikon and Mt Hymettos, in the Peloponnese at Vrestena, Doliana and Mani, in central Greece near Larissa and Volos, in Macedonia at Drama and Veria, in Thrace at Neapolis and Philippi and on the island of Thasos. Among many sites in Asia Minor, important quarries included those at Ephesos, Mylassa and their provinces and on the island of Prokonnesos (mod. Marmara, Turkey), which became by far the most important white marble quarry in Roman and Byzantine times.

The Romans added to this list the white and grey marbles of Luna (Carrara, Italy), Dokimeion (Iscehisar, Turkey) and Aphrodisias (Geyre, Turkey). They also exploited new areas in Africa (Filfila), the Iberian Peninsula (Estremos, Macael, Badajoz) and the Pyrenees (Saint Béat). From the 1st century BC marble became a symbol of luxury, and the more difficult and expensive it was to obtain a certain material, the more it was sought after. Thus, Asia Minor and Egypt were exploited more than Italy, in spite of the fact that Italy does not lack for beautiful ornamental stones. Marble was imported to Rome from all the provinces of the Empire and the amount of materials used was so great that many quarries, some of them imperial property, were already exhausted in the 2nd century AD. The production of marble sarcophagi, statues and columns was enormous, and the diffusion of these objects, even in the most remote provinces of the Empire, is astonishing.

Coloured marbles, not much appreciated by the Greeks except in the late Hellenistic period, began to appear in Rome in the 2nd century BC, but reached their maximum in terms of species and quantity in the 1st and 2nd centuries AD. It was in fact with the conquest of Greece, Asia Minor and especially of Egypt that the Romans developed a special taste for coloured stones, to many of which they assigned special meanings. For example, they quarried huge amounts of red porphyry on Mons Porphyrites in the Eastern Desert of Egypt, because its purplish-red colour symbolizes nobility and richness. Purple was also the colour of emperors, many of whom were buried in porphyry sarcophagi, initiating a tradition that continued in the Byzantine period (Byzantine emperors were also usually born on a slab of porphyry), in the Middle Ages (e.g. the Norman tombs in Palermo Cathedral) and more recently with the tomb of Napoleon (reg 1804–14) at Les Invalides, Paris, and of Umberto I (reg 1878–1900) in the Pantheon of Rome. Other important coloured marbles include giallo antico, quarried at Chemtou, Tunisia, and 'pavonazzetto' from Dokimeion. Rosso antico (quarried at ancient Tainaron in the Peloponnese), being the red colour of wine, was used for statues of Dionysos, god of wine, and related humans/animals (satyrs, fauns, goats etc). Marmor luculleum (africano) from Teos (now Sigacik, Turkey), Aquitanian marble (bianco e nero antico) from Aubert, France, and verde antico from Larissa, Greece, are wonderful breccias of pink-greenish, black and white, green and red colours respectively, which were widely used in Roman monuments.

After the collapse of the Roman Empire, marbles were frequently removed from their original places and reused in later buildings, so continuing to be much favoured building materials during the Middle Ages, the Renaissance, the Baroque and later. The Italian Carrara marble, a pure white, has been popular with sculptors, from Michelangelo (1475–1564) to Antonio Canova (1757–1822). Other sources of marble that have been exploited include quarries in Connemara, Ireland, in the Scottish islands of Skye, Iona and Tiree and in Tournai, Belgium. The 'Belgian black' of Tournai was used for medieval fonts and remains a choice material for modern sculptors.

Y. Maniatis, N. Herz and Y. Basiakos, eds: *The Study of Marble and Other Stones Used in Antiquity* (London, 1995)

S. B. Butters: *The Triumph of Vulcan: Sculptors' Tools, Porphyry, and the Prince in Ducal Florence* (Florence, 1996)

M. De Nuccio and L. Ungaro: *I marmi colorati della Roma imperiale* (Venice, [2002])

D. Attanasio: *Ancient White Marbles: Analysis and Identification* (Rome, 2003)

P. Malgouyres: *Porphyre: La pierre pourpre des Ptolémées aux Bonaparte* (Paris, 2003)

Brice Marden: Paintings on Marble (exh. cat. New York, Matthew Marks Gallery, 2004)

Obsidian. Naturally occurring volcanic rock resulting from the rapid cooling of highly siliceous rhyolitic lava. It is normally dark-coloured, with a conchoidal fracture and vitreous lustre. Colour banding, due to chemical variation or the presence of trains of incipient crystals, is often present, and thin slivers of the stone are translucent. Pliny the elder (AD 23/4–79) recorded a dark rock from Ethiopia that he called obsiana, later altered to obsidiana, from which the modern name derives. At various times such names as Iceland agate, hyalopsite and Mountain mahogany have also been applied to the stone. Pitchstone is a variety of obsidian with a higher proportion of crystalline material, which may be visible to the naked

eye, and a duller lustre. Pumice is highly vesicular obsidian produced during explosive volcanic eruption of the lava.

Volcanic glasses are not common rocks and are unstable at the earth's surface. They are most often found at sites of geologically recent volcanic activity. Silica-rich magmas are viscous and mostly ejected as volcanic ash during explosive eruptions; only a minor portion of the magma solidifies to form obsidian. Obsidian fractures easily to give thin, sharp-edged flakes that make good cutting and piercing instruments, for example knives, arrowheads and blades of sickles. It is a soft material, so quickly loses its cutting edge, but can be easily flaked to new razor sharpness. It was traded by the ancient cultures of the Mediterranean and Near East and also by the Maori of New Zealand and was highly valued in Pre-Columbian Mesoamerica. Major Mediterranean sources of obsidian have been the islands of Melos and Lipari, in the latter of which it is associated with considerable quantities of friable pumice, also important as an abrasive material. Pitchstone was less favoured than obsidian, as the more crystalline structure gave a rougher edge to the flakes; however, sources on the Isle of Arran, Scotland, were exploited.

W. S. MacKenzie, C. H. Donaldson and C. Guilford: *Atlas of Igneous Rocks and their Textures* (Harlow, 1982)

D. R. C. Kempe and A. P. Harvey, eds: *The Petrology of Archaeological Artefacts* (Oxford, 1983)

J. Conolly: *The Çatalhöyük Flint and Obsidian industry: Technology and Typology in Context* (Oxford, 1999)

Pitchstone. See under OBSIDIAN above.

Porphyry. See under MARBLE above.

Portland stone. See under LIMESTONE above.

Pumice. See under OBSIDIAN above.

Sandstone. Coherent, sedimentary rock composed predominantly of small grains. Any naturally occurring coherent aggregate of small, detrital mineral grains might be generally regarded as a sandstone, although in practice the majority are composed of the tougher silicate minerals. Such rocks cover approximately 23% of the continental surfaces of the earth and are of great economic and practical importance. Natural sandstones are water- or wind-concentrated materials that have accumulated in seas, lakes, rivers or on dry land. Sandstones are composed of sediment produced by the mechanical and chemical breakdown of pre-existing rocks, with the exception of volcanic ashes or tuff (of igneous origin) and those rocks composed dominantly of comminuted shell, coral or limestone, which are regarded as limestones (see above).

The three components of sandstones are detrital sand grains, a fine-grained detrital matrix and secondarily introduced mineral cements. The essential sand grains must compose more than 50% of the rock and measure between 0.0625 mm and 2 mm in diameter, coarser rocks being termed conglomerates or breccias, and finer ones siltstones. As the result of prolonged exposure to weathering at the earth's surface, chemically unstable or mechanically weak mineral grains are quickly destroyed, and usually only the tougher, stable types remain to form sandstones. The relative proportions and variety of mineral grains in the stone reflects the rapidity with which the material has accumulated. In the vast majority of sandstones the predominant mineral is quartz, with minor proportions of feldspar and possibly fragments of rock, together with a little of such rarer minerals as zircon and tourmaline. A variable amount of fine clay may be present as a matrix. The change from incoherent sand to sandstone is effected by the deposition of a pore-filling mineral cement from percolating ground water or by welding of the mineral grains at their contacts due to pressure-induced local reorganization. The naming of sandstones derives in part from the type of cementing matter: such carbonate minerals as calcite or dolomite cements give calcareous sandstones, quartzites are cemented by silica and ferruginous sandstones by iron oxides or hydrates. Secondary deposits of clay, such as kaolinite or illite, are also important cementing materials.

The strength and weather resistance of sandstones is dependent upon the minerals of the cement. Calcareous cemented sandstones tend to have poor weather resistance because this type of mineral cement is soluble in rain water; a disproportionately large volume of stone is lost by solution of a small amount of the cement. Silica and iron cemented stones can be almost indestructible because of the toughness of the cement, although this also causes them to be intractable to work.

Sandstones are abundant in many parts of the world and in consequence have been employed for many purposes. The durability of quartz has resulted in the accumulation in many areas of extensive layers of relatively pure sandstone, often of uniform thickness. Exploitation of this feature enables stone to be obtained with a minimum of effort. The hardness of the quartz grains has led to the use of sandstones for good grinding and milling stones, for example the Millstone Grits of northern England, but the most common use of sandstone is in construction and for sculpture. Vast quantities are now used for aggregate, but formerly sandstone was more important as dimension stone for building. Most of the ancient temples of Egypt dating from the New Kingdom period attest to the durability of good-quality sandstone, their ruined state being the result of human depredation rather than natural decay. The thinly bedded varieties provide tilestones for roofing and flagstone, for example Yorkstone, for paving; in northern Britain they were, until the mass production of brick, the main material for prestigious buildings.

A. Clifton-Taylor: *The Pattern of English Building*, (London, 1962, 4/1987)

F. J. Pettijohn, P. E. Potter and R. Siever: *Sand and Sandstone* (Berlin, 1973)

R. L. Folk: *Petrology of Sedimentary Rocks* (Austin, 1974)

A. E. Adams, W. S. MacKenzie and C. Guilford: *Atlas of Sedimentary Rocks under the Microscope* (Harlow, 1984)

R. Shaffrey: *Grinding and Milling: A Study of Romano-British Rotary Querns and Millstones Made from Old Red Sandstone* (Oxford, 2006)

Travertine. See under LIMESTONE above.

Volpinite. See under ANHYDRITE above.

II. Techniques.

1. Splitting. 2. Carving. 3. Drilling. 4. Abrasion. 5. Polishing. 6. Pointing.

1. SPLITTING. Splitting or coping stones may occur along bedding planes; these are sedimentary stones that have weaknesses along certain planes because of a change in depositional regime during formations. Other stones, particularly metamorphic ones, for example slates, split easily along areas of certain mineral alignments: it is often only necessary to place a broad chisel along the plane of intended fracture and tap it gently with a hammer. Stones that do not have a determined direction of splitting are known as free stones, which are most suitable for architecture or sculpture. Techniques for splitting free stones depend on their hardness.

A basic method of splitting soft stones is to insert steel wedges into the stone and tap them with a hammer to force a split. Soft stones can also be split by first cutting or sawing a groove along the required direction of split. An iron bar is then placed underneath and along the cut. Heavy pressure is applied to force the split. The technique for splitting harder stones has been developed from these two methods. The stone should rest on an iron bar along the required direction of split. Wedges should be used at one end to level the top surface of the block, leaving the other end free. A V-shaped groove or furrow is cut along the line of split, and holes are cut or drilled into the stone at regular intervals along the groove. Short steel punches or wedges, sometimes known as gads, are tapped into the holes. The punches must be kept parallel in the direction of split or the surface will be highly irregular. These punches are struck gently and rotated; sometimes water is also poured into the holes. The force of the blows is gradually increased until the stone splits.

The most sophisticated technique, used for the hardest stones, is a further development of this method. Instead of using punches, a wedge-shaped plug is specially made to fit in between two 'feathers', curved and tapering semicylindrical steel casements. Long pilot holes are drilled into the outermost area to fit the plugs and feathers. Two feathers are inserted into each hole and aligned so that any forcing action by the plug will act on the stone perpendicular to the plane of intended fracture. The plugs are then inserted and again tapped in sequence until the stone splits. The success of the split depends on the accurate drilling of the deep pilot holes and the noting of any bedding planes or natural faults within the stone.

2. CARVING. During the Stone Age such tools as the flint axe can have been effective only on softer, less brittle stones. Bronze Age tools, made of relatively soft material, would have quickly lost their cutting edge. The ancient Egyptians were skilled stone-carvers, and many of the tools they used remained similar for centuries. Chisels would have been applied at right angles to the stone, producing indentations rather than furrows, as oblique strokes would glide off the surface. Some extant unfinished carvings dating from before 500 BC are clearly pockmarked with indentations, caused by heavy blows at right angles, which prevent undercutting and freeing of shapes. The introduction of iron tools after 500 BC, tempered to a high degree of hardness, enabled the use of the oblique stroke, producing furrows and leading to advances in sculptural techniques. Axes, though still in use, developed from a single item into hammer and chisel, which perform the same function but are more easily transported.

In carving a durable stone a series of tools (see fig.) are used—generally larger first, through to smaller, more intricate tools for the final surface. The first tool used for the initial roughing out of the carved shape is the pitcher, a broad, flat-ended chisel with a cutting edge of approximately 85°. This is placed on the stone and struck with a heavy hammer weighing 1 kg or more, causing large chunks of the stone to split off the block. Careful and intelligent use of the pitcher can produce remarkably quick results. The punch, or point, is next used in the carving sequence for more accurate roughing out of the required shape. This type of chisel is, as its name implies, sharpened to a point, the angle of which depends on the hardness of the stone. For carving granite, a very hard stone, a point with a less acute cutting edge than that used for a soft stone, such as chalk, would be needed. The point is used to make furrows in the stone, often parallel to and within about 20 mm of the required final surface of the carving. The claw chisel is used after the punch or point; this is essentially a flat chisel with the cutting edge formed into a series of teeth, performing the same function as a row of smaller points. Surface undulations and final shapes can be formed with this tool, which is generally used in conjunction with a mallet instead of a hammer. Work with the claw tool can be to within a few millimetres of the required surface. Finally, the flat chisel is used to remove the last few millimetres of stone and to carve the detail, including any delicate undercutting. At this stage larger areas may be undercut using drills or abrasives. Such specially shaped chisels as gouges or bull-noses are used for concave surfaces, while awkward areas can be drilled or filed away. Generally, the angle at which the chisel is held and the force with which it is struck will affect how much 'bite' it will have on the stone.

Tungsten tips can be braized onto chisels to form harder and more durable cutting edges that are more

effective on harder and more abrasive stones. Such tools as kivels, a pitcher and point in the form of an axe, can also be used. Very hard stones can be worked with a bouchard, a hammer-shaped tool with a number of sharp points in the head, which is used to strike the stone and wear down the surface. Soft stones are often sawn either by hand or with an electrical cutting disc. This technique can be used to cut a series of parallel ledges in the stone that can be knocked off with a sharp blow, producing a quick method of removing stone. Pneumatic hammers, known as air tools, can be employed with interchangeable bits, such as points, claw chisels or flat chisels. These tools are, however, noisy, dusty and sometimes dangerous, and their use may result in a permanent numbness in the hands, known as 'white finger'.

Before carving in stone, a sculptor often produces a model in clay, wax or plaster, a quick and cheap method of simulating the final carving. By taking measurements from the model, a series of points that defines the final sculpture can be fixed on the block of stone. A pointing machine has a number of metal pointers that can be adjusted to fix angles and depth relative to other points. The number of points taken can vary, depending on the complexity of the carving; for example, up to 50 may be necessary for an eye. Profile gauges can be useful in transferring the profile between two points on the model to the carving. Lasers can also fix points extremely accurately; the information is analysed by computer and fed into cutting machines programmed to operate on the data.

3. DRILLING. Drilling is used as a preparation for splitting such harder stones as granite and for quarry work with large blocks. As a sculptural technique, in conjunction with carving, however, it has not been used continuously. Extensive use of the drill in sculpture produces distinctive results, chiefly widespread undercutting with the remains of numerous drill holes still visible. Several different types of hand drill have been used but have been largely superseded by electric drills.

The earliest and simplest method of drilling was to rub a long drill between the hands to produce a rapid rotary motion. The bow or running drill, sometimes portrayed in Greek vase paintings, works by quick movement of the bow, with a string wrapped around the drill held by a handle in the other hand, producing a rotary motion. This was especially useful for holes of a small diameter. The auger or brace and bit is held on the handle and is pressed into the shoulder to provide a great force, while the other hand is used to turn the drill. This was more commonly used for larger holes.

A jumper drill, used on harder stones, is a long chisel with a cutting edge in the shape of a cross, which is struck and rotated between blows. This is an early version of the modern percussion tool. Electric drills with variable speeds and hammer action are most often used for modern drilling. A slow rotary motion combined with a rapid blow is often found to be most effective. Percussion drills must be used with

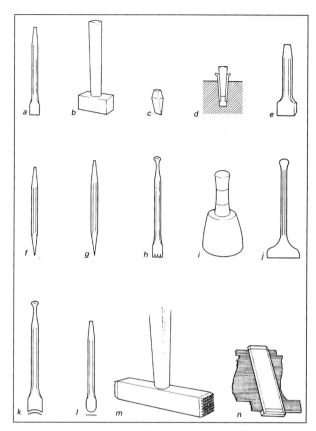

Stoneworking tools, c. 1860: (a) broad chisel; (b) hammer; (c) gad; (d) wedge and feather; (e) pitcher; (f) punch; (g) point; (h) claw; (i) mallet; (j) flat chisel; (k) gouge; (l) bull-nose; (m) bouchard; (n) profile gauge

percussion bits, the tips of which are normally reinforced with tungsten.

The primacy of the electric drill has also resulted in the invention of the core drill, which incises a circle in the stone down to the required depth, leaving a solid core of stone in the centre. The core drill is used not only for holes of a large diameter but also for obtaining samples of stone in the form of a solid column. Owing to the brittle nature of stone, the technique developed for working large-diameter holes normally consists of drilling a small pilot hole first, then gradually increasing it to the required size.

4. ABRASION. Stone is abraded primarily with rasps, files and rifflers; these are made from steel tempered to a high degree of hardness. Such abrasive materials as carborundum and emery are used as a secondary process to wear down the surface of the stone, removing chisel or saw marks. Emery is found on the island of Naxos and was used, together with sand and pumice, in ancient Greece. Carborundum, diamonds and tungsten for abrasive purposes are industrially produced and glued on to discs or files or impregnated into pads. A wide variety of shapes of slips suitable for subtle modulations of stone are also used. Electric

grinders commonly have an adjustable head that can be fitted with a variety of discs, grinding wheels and pads. Water is continually applied to the surface of the stone to reduce the dust to a minimum, and to ensure the abrasive material does not get clogged up. Stones may be pre-softened by soaking in water; others may be suitable for etching with acids.

Some stones are abraded more successfully than others; this depends not only on hardness but also on silica content. A soft sandstone containing much silica, for example, will wear out abrasive tools more quickly than an equally soft limestone. Carborundum slips that are more resistant to silica are, however, also produced: the grains in the slip are stuck together with a weaker than normal glue, so that fresh angular grains are constantly exposed on the surface of the abrasive.

5. Polishing. Only certain types of stone can be polished; these are hard stones in which not only the grains or crystals are sufficiently hard to reflect light but also in which there is strong interstitial or bonding cement. Hard and firmly held grains will allow a smooth enough surface to be produced to give a glossy polish. Weakly cemented grains in softer stones tend to pluck out when the friction required to produce a smooth surface is applied. This leaves a surface too rough to reflect uninterfered light, although some softer stones, for example alabaster, will take a polish. There is also an intermediary group of stones that can be polished only to a velvety sheen, such as some slates.

The friction required to make a smooth surface is produced by abrasion. A grinding machine may be used for both grinding or abrasion and polishing but should be run at different speeds for maximum effect. Mechanical polishing is used for basic shapes and flat areas, whereas more complicated shapes are done by hand, although dentistry drills fitted with soft pads can be useful for the latter.

Various grades of abrasive material that have successively finer grains are used. The stone is rubbed down methodically with each grade of material, removing scratch marks caused by the previous grade, with water being used to prevent any clogging up. The interval between the fineness of grades will vary depending on the type of stone, but typically six or seven different sized grades are used from removing fine chisel marks to producing a dull polish. If the interval chosen is too large, the abrasive material will have worn out before the marks from the previous grade have been removed. Final polishing is carried out using very fine abrasive powders, for example putty powder, zinc or tin oxide, oxalic acid or salts of sorrel rubbed in with a soft cloth and washed off. These are intended to give the surface a high lustre but will work only on certain stones. Waxing produces only a temporary polish that fades as the wax wears off the surface.

6. Pointing. Pointing is the outermost layer of mortar separating courses and individual stones within a structure. Pointing not only shares the function of the mortar, that is either to separate the blocks of stone in a building or to join them together, but also prevents excess water entering into the structure between the stones. Generally, a cement-rich pointing is to be avoided, as it is hard and impermeable, whereas soft, permeable lime pointing is compatible for use with stone. The joints should be carefully raked out and brushed down to remove loose material. The stone and mortar must be dampened but not saturated to ensure that the pointing does not dry out too quickly. The mix should be applied carefully with a pointing trowel, pressing firmly to fill completely any voids. Excess material should be brushed off, and these areas scrupulously cleaned to ensure the surrounding stonework is not stained. The pointing should be renewed every few decades as part of regular building maintenance.

The softness and permeability of pointing are crucial factors in determining the longevity of the stonework. Structures expand, contract and settle in fluctuating atmospheric conditions, causing movement between individual stones; good-quality pointing and mortar will allow this to happen with few ill effects. A pointing that is softer than the stone can absorb small movements by microfractures, which, under certain circumstances, can be self-healing, particularly if the mortar and pointing are composed of lime. Microfractures act as channels for water movement in which dissolved lime may be deposited, especially at the outermost surfaces of the stone where water evaporates. Larger movements in the structure may cause the pointing to fail, but a soft mix may save the stones from damage. If the pointing is too hard the stones develop conchoidal or scoop-like fractures around the arrises, or edges of the stones. Fractures that run through the stones, rather than the pointing, of a building are further indications of the use of a pointing mixture that is too hard.

As well as being relatively soft compared to the stone, pointing must be sufficiently permeable to allow for water migration. Water absorbed by the structure must be allowed to evaporate, and in most circumstances it is better for this to occur through the expendable pointing rather than through the valuable stone. This is generally perfectly harmless, but frost action may cause premature failure. One important exception to the use of permeable pointing is in the use of sandstones with a clay content and weak intergranular bonding. In this case, a highly permeable pointing will concentrate waters in these areas, causing persistent wetting of the edges of the sandstone. This will cause the clay content of the stone to expand significantly, producing strong enough forces to break the intergranular bonding, resulting in failure, which is evident as a band of deterioration around the stone. The use of an impermeable pointing, however, will also result in water migration into the sandstone, in particular just above the pointing. The only solution in this case appears to be the use of a pointing of equal permeability to the sandstone.

Another factor affecting the pointing is the degree of exposure. Hostile environmental conditions may necessitate the use of a less permeable pointing than normally desired to prevent the ingress of water. Very narrow horizontal beds or vertical joints may require a pointing with very little or no aggregate in order to allow sufficient depth of water penetration. In this case, the pointing trowel or spatula, normally used to apply pointing, may be too cumbersome; dentistry tools or even syringes may be used to inject the mix into the joints.

The aesthetics of colour and texture should be explored only after the technical factors of hardness and permeability have been considered. The most direct way of effecting this would be to use lime and sand in a ratio of 1:3, but it can be 1:10 or even higher. The preferred aggregate is a 'sharp' sand, in which the individual grains are roughly polygonal with sharp angles, as opposed to rounded. The 'sharp' sand grains will interlock when the mix contracts on setting, which helps to reduce shrinkage. Rounded grains tend to compact well and will facilitate shrinkage. Often a compromise has to be made in which a proportion of round-grained sand of the desired colour is used in conjunction with 'sharp' grained aggregate of an unsuitable colour. Stone dust or mixtures of different coloured sands and stone dusts, are also used as aggregates. The texture of the mix is varied by the inclusion of larger-sized aggregates. Care must be taken to ensure the aggregate is washed free from salts, commonly a problem with beach sand, and that fines are sieved out to combat shrinkage. Decorative effects can be obtained, for example, by pressing rows of flint pebbles into the soft pointing, or adding charcoal for texture and colour. Generally, pigments are avoided as better permanence can be achieved from naturally coloured sands.

III. Conservation.

1. Introduction. 2. Mechanisms of deterioration. 3. Conservation.

1. INTRODUCTION. All stone weathers and eventually decays. Conservation methods never reverse or stop this process; they can only delay its progress. Materials and methods used by conservators and restorers of stone over the centuries have been numerous and not always successful.

There is evidence for measures having been taken for the preservation of statuary and building stones in ancient Egypt. Ancient Greek stone sarcophagi (c. 1500 BC; London, British Museum) from Thebes have adhesive mortar repairs in natural stone faults and cavities. It is known that the Romans restored broken and damaged sculpture. Statuary excavated in 1978 in the Sculptors Studio (c. AD 180) in the Roman provincial city of Aphrodisias, Asia Minor, was found in the process of repair: ferrous dowels were set in lead to reunite broken limbs, and some sculpture appeared to be in the process of being repolished.

Most preservative methods used before the modern period, however, have been for the weatherproofing of stone. Full colour schemes in a lime medium assisted in the preservation of Gandharan statuary of the 1st to 4th centuries AD carved in schist. The applications of coloured lime wash in the 3rd and 4th centuries on Trajan's Column, Rome, prevented organic growths from becoming too firmly attached and reduced the ingress of rainwater and atmospheric pollutants that were present even in Roman times. It is arguable that many of the decorative paint schemes on medieval façades and statuary both enhanced and preserved their appearance. The statuary on the west front of Wells Cathedral (c. 1360) and both statuary and masonry of the Market Cross, Bristol (c. 1390; now at Stourhead, Wilts), were repeatedly fully covered with layers of oil paint and gilding.

Post-Industrial Revolution advances in material and geological science have led to the development of preservation methods that attempt to arrest the course of stone decay by consolidation or alteration of the mineralogy of the stone. The degree of replacement of original stone that is made to preserve the work varies in different cultures. In the Indian subcontinent and Bali, for example, schools of modern sculptors continue the tradition of freely replacing eroded and decayed stone of temples. In the West, however, emphasis is placed on the need to repair rather than restore. Guidance on the ethics of stone conservation has emanated from numerous conferences, the most notable being that of 1980 at Venice.

By far the most effective preservation method is to ensure that the correct choice of stone is made for the work. The more durable local stones are usually chosen for buildings and exterior sculpture. Harder and more robust stone is used for undecorated work, and, if protected by architectural features, softer and thus possibly less durable stone is used for intricate carved work.

2. MECHANISMS OF DETERIORATION. Stone decay varies according to the type of stone and is influenced by its position and by local and global environmental factors. To ensure that money is not wasted and that irreversible mistakes are not made, the type of stone decay should be fully identified before any preservative method is applied. Decay may be caused by numerous factors, the most notable being chemical reactions initiated by atmospheric agents. With every category of stone—igneous, sedimentary or metamorphic—there are minerals that, if present in significant amounts, will greatly accelerate decay by weathering. Such stones of this type as argillaceous sandstones and limestones and ferruginous sandstones, together with stone with many fault lines or of inferior quality, were generally avoided by the mason or sculptor. Lack of alternative stones may have necessitated their use, predisposing their decay.

(i) Chemical and physio-chemical. (ii) Physical and mechanical. (iii) Defective craftsmanship.

(i) Chemical and physio-chemical.

(a) Atmospheric pollution. Fossil fuel combustion produces gases of sulphur dioxide, nitric oxide, nitrogen dioxide and hydrocarbons. These, together with secondary gases of naturally occurring ozone and sulphuric and nitric acids, form the basis of airborne pollutants that harm stone. Sources of pollutants can be both near and far. In Venice, for example, gases emitted by domestic central heating rise and amalgamate with the passing industrial gases from nearby Mestre. Local climate conditions produce air turbulence that causes the deposition of both pollutant clouds on to the buildings below. Deposition of these pollutants is in dry or wet particle form; when precipitated in rain or snow the deposition is known as 'acid rain'. All types of stone have a degree of porosity allowing acid deposition to be absorbed. It is estimated that 'acid rain' has caused more decay on stone buildings in the last 100 years than in the last 2000 years.

Effects of the deposition will in part depend on the geology of the stone: such stones as limestones and marble with a high content of calcium carbonate are readily affected by dissolution. Since 1780 as much as 50 mm of the Portland limestone coping stone of St Paul's Cathedral, London, has been dissolved. Where the carbonate forms a bonding structure, for example in sandstone, the effect is more pronounced: removal by dissolution of the calcium carbonate matrix causes severe stone decay, as the stone is shaled away in layers. A similar effect is achieved by acid deposition on dolomitic stones; the constituent minerals of magnesium and calcium carbonates are converted into more soluble calcium and magnesium sulphates.

When pollutant action on calcareous stone is not washed by rainfall, dampness will cause an impermeable layer of increasing thickness to be formed. The crust, composed of converted calcium sulphate, will take the contours of the stone beneath and will turn black due to the accumulation of atmospheric soot particles. The crust will gradually peel, assisting the dissolution of the stone surface beneath by the continued presence of salt ions.

(b) Salts. Damaging salts enter stone from the atmosphere, adjacent materials or from burial, although some salts are inherent in the stone. Many surviving Egyptian stelae that were originally quarried in the Nile delta region of Akydos have a high concentration of sodium and sulphate salts, frequently causing decay. Ground salts of sodium, potassium and nitrate are common in stone buildings, rising up the walls by capillary action or osmotic pressure. Sea salt is also detectable on the buildings of London, blown from 70 km away. Salts damage stone mainly by crystallization that exerts pressure within the stone, but decay can also be caused by chemical means: the migration of some external salts may activate inherent salts that lie dormant within the stone, converting them into other, more soluble compounds.

(c) Biological and microbiological action. Biological growths on stone are both visible and invisible to the naked eye. Such higher forms of plant life as creepers, shrubs and trees send disruptive roots into cavities of the stone that absorb moisture and minerals. Lichen algaes and mosses lie on the surface, producing, among others, chelators of carbonic, nitric, sulphuric and oxalic acid to assist in the digestion of minerals. Limestones and siliceous sandstones in the less toxic atmosphere of rural areas are prey to such cultures. By water retention such cultures maintain a damaging, moist stone surface. Bacterial cultures within the stone require little moisture but retain water. Such cultures are hidden, and are considered to be the more deleterious. As many as 16 million bacteria per gramme of rock have been recorded in tropical Java. Microbiological activity appears above ground in areas of dampness and decay. Bacteria will fix harmful nitrates, oxidize sulphurs to sulphates and combine with the sooty crust on stone, the last to such an extent that such disfiguring blemishes are considered to be predominantly composed of bacteria.

(d) Animal activity. Decay by some animal activity is by physical removal of stone. Birds, for example, peck at limestone to procure grit. Submerged stone in seawater will be eroded more by boring molluscs or sea urchins than by water action. Rocks with a high content of carbonates, for example limestones, are vulnerable to acid-secreting clams and digesting worms to such an extent that they are not recommended for sea defences or submerged supports. Bird droppings and dog urine produce secondary chemical reactions on stone surfaces, etching exterior ledges and shelves and plinth courses near pavements.

(e) Staining and discolouring agents. Staining is a sudden and unwanted coloration considered a detraction or a deterioration of the appearance of stone, as opposed to the slow, natural discoloration of weathered stone, which is often considered a pleasing patination of age. Stone discoloration begins immediately when a stone is quarried. Sap of soluble minerals will rise to the surface and darken the freshly cut stone. When the stone is exposed to weathering, further mineral migration occurs. This, together with the action of organic growths and atmospheric pollution, gives a building the distinctive appearance of its time and place. Strong alkali mortars and coloured surface washes and finishes, the use of which may result in the efflorescence of salts, are all potential staining agents, but it is the addition of surface etching by the staining, for example the burial marks left by acidic soil on antique stonework or the surface pitting by sooty atmospheric pollution, that makes the staining more indelible.

(ii) Physical and mechanical.

(a) Wind and water attrition. Wind abrasion normally accompanies erosion by salt action (*see* §(d) below).

Erosion by windborne grits, however, is most evident in desert regions and is one of the main causes of the deterioration of the surviving stone on the great pyramids of Egypt. Although it is difficult to discern erosion that is solely by wind, research has shown that short bursts of strong velocity wind will erode stone more quickly than constant winds of low velocity, with or without grit particles. Soft areas of stone are removed first, dislodging adjacent hard areas.

Even if the atmosphere is relatively unpolluted, rainwater is weakly acidic; dissolved carbon dioxide in rain forms weak carbonic acid, and repeated washing of stone by rainwater causes dissolution of the stone surface. Some stones, for example alabaster, are soluble and should not be placed on the exterior of a building.

(b) Frost action. Freezing water trapped in the pores and micropores of stone will exert great pressure if cavities are blocked by trapped vapour or moisture, and expanding ice crystals may cause cracking of the stone. Damaging frost action does not readily occur in stone with large pore structures.

(c) Salt crystallization. The dehydration and rehydration of salts as water vapour is emitted or absorbed will, in fluctuating relative humidity, cause their crystallization, which, like frost action, exerts great pressure. As most evaporation of water occurs at the surface of stone, erosion by salt action occurs at the line of fine carving and surface patination.

(d) Alveolar erosion. The strong pattern of erosion that results from combined wind and salt action on the surface of stone is termed alveolar erosion. This form of erosion is particularly evident on the more exposed façades of buildings on coastlines, where there is a regular atmospheric combination of strong winds, airborne sea salt and sand or grit. Strong winds are directed into natural cavities formed in the surface of the stone. Moisture within the stone will migrate to dry, windswept cavities, in which rapid evaporation occurs. Inevitable increases of salt efflorescence, together with rapid wetting and drying of the stone, cause this dramatic form of erosion.

(e) Temperature changes. Thermal expansion and contraction occurs in all types of stone in normal temperature changes between day and night. Such movement rarely affects stone unless it is decayed. A hardened, decayed surface will expand and contract more than the sounder stone beneath, causing loss of adhesion of the surface. Dimensional change in the structure occurs in proportion to the size of the individual stones—larger surfaces will move more than smaller ones. If the movement is restricted by rigid metal fixings or hard mortars then decay by compression will occur: bulging stone cladding is common on buildings without expansion-receiving joints. A slab of marble 5 m in length will expand by approximately 20 mm in a temperature change of 10°C, and individual crystals will expand and contract according to their orientation. Thus, weathered marble has an irregular crystalline appearance, as the marble crystals lose their bond. This effect is particularly notable if the sugary appearance of the surviving marble sculptures on the Parthenon, Athens, is compared with that of those in the British Museum, London.

The thermal expansion and contraction of stone is made complex by the variations in coefficient of expansion or contraction between composite minerals and other materials in the structure. In some sandstones wet clay deposits will expand more than the siliceous elements at the same temperature, assisting in the break-up of the stone. Metal has a higher coefficient of expansion than stone, and consequently a buffer between metal fixings and stone is required if they are not to cause damage by expansion. Similarly, thermoplastics have a relatively high coefficient of expansion; these are nevertheless widely used as adhesives and grouts in building repair.

Thermal 'shock' can result if stone is removed from its original environment. Cleopatra's Needle in London, for example, deteriorated rapidly after its arrival from Egypt to the cold, wet English climate.

(f) Load. As a material of heterogeneous composition, stone has a variable response to load and traditionally has been used to take load only by compression, hence the construction of stone arches. Where stone lintels have been used the stones are generally large and well supported at either end. It is essential that stone structures are kept static; strong foundations, adequate fixings and sound jointing materials are necessary, as failure of any one of these puts stone under strain.

(g) Vibrations. Traffic noise, sonic booms and pedestrian feet will all produce vibration harmful to stone structures. Resonance on the stone structure caused by the emitted vibration is by far the most damaging, and, if the amplitude of the vibration increases, the stone structure will shake to a similar frequency.

(iii) Defective craftsmanship. Traditional quarrying techniques relying on little or no mechanical power extracted stone from the rock face by exploiting natural fault lines or bedlines. The architect or sculptor often visited the rock face to choose the block and witness its extraction. The mark of Christopher Wren (1632–1723) can be seen on some uncollected blocks on the Isle of Portland, Dorset, England. The development of mechanical means of blasting for extraction, however, has led to the possible introduction of hidden, secondary fault lines into the stone that do not cause immediate damage but may appear during weathering.

Lack of care during transportation can also produce problems; bruising damage on sculpture is common. Suitable storage measures are also necessary: care must be taken to keep the blocks away from potentially damaging earth salts by placing stretchers of wood underneath or by storing on hard

ground. Vigilance is also necessary in the working of the stone. Sharp blows by tools held at right angles to the surface will cause undetectable bruising. The use of the bouchard, which produces a roughened granular texture, or the pneumatic hammer, to remove stone prior to fine tooling, is known to cause hidden microfissure.

3. CONSERVATION.

(i) Introduction. (ii) Diagnosis and analysis. (iii) Treatments.

(i) Introduction. The success of any conservation project is the result of the drawing up of clearly defined objectives; from this a measured programme can be developed. Aesthetic considerations of the final appearance of the stone require judgement on levels of cleaning, the removal of previous unsightly or irrelevant restorations and, of course, visual changes by the intervention of treatments. When embarking on any treatment for the conservation of stone, essential procedures for the preparation, carrying out and recording of the work should be followed.

The choice of repair materials is of great importance, for most conservation work involves replacing or putting right former repairs. As conservation treatments should be reversible, conservation materials should not fundamentally alter the material or the appearance of the object; they should be stable and, when removed, not cause harm to either stone or conservator. Repair materials should be compatible with the stone in both chemical and physical aspects, having similar properties of porosity and permeability and not being liable to sharp increases in expansion that result in stress on the stone. For external stone and sculpture the repair material should allow free passage of gases and moisture. All repair materials will display differing physical and chemical characteristics in a varying environment, particularly such synthetic materials as resins and curing polymer consolidants. It may be necessary to undertake trials in situ to test curing times and performance changes. More synthetic products are being made available for the lucrative market of stone preservation. Such materials require special care and attention, and the conservator needs to be particularly vigilant when assessing their long-term benefits.

(ii) Diagnosis and analysis. No diagnosis of stone decay is possible without an understanding of the effects of such environmental factors as humidity and temperature, as well as identification and assessment of the evidence of external pollutants and contaminates. Although two works in stone may show similar decay, the causes may be different, particularly if the works are set in differing environments. A 6th-century Buddha in Gueisses stone at Galvihere, Sri Lanka, was found to have delaminated badly through exposure to continuous daytime temperatures in excess of 30°C; heavy rains and frequent condensation exacerbated the problem. Two 19th-century red sandstone sculptures of a sea god and Ceres in the

gardens of the Treasurer's House, York, England, have delaminated in a similar manner. Although protected from bad weather by a walled and shady garden, the stone decayed through a combination of general weathering by rain and frost and the effects of airborne pollutants of sulphur and nitric acid from the urban atmosphere. More detailed analysis of stone decay can be by non-destructive means or by the testing of samples.

(a) Radiography. Stone that is both soft and thin in section can be exposed to X-rays that will produce accurate images of natural flaws, changes in densities and the size and position of reinforcing. Stones of a thickness greater than c. 220 mm will require more powerful radiation. Gamma radiation was required for the survey of a fountain (London, Victoria and Albert Museum) by Gianlorenzo Bernini (1598–1680), revealing structural cracks, as well as plumbing, within the sculpture. The location and condition of fixings, reinforcements and cavities within a building can also be found by sending waves of pulsed radar at low frequencies and higher ultrasound frequencies through the structure, revealing variations of density and construction in the stones of the wall.

(b) Microscopy and chemical analysis. The mineralogical composition of a stone can be revealed by the observation of a thin section of the stone taken from samples under a microscope, illuminated by polarized light. The pore structure can also be observed and the porosity and permeability calculated by the measured absorption of heavy liquids. Crushing and tensile strengths can also be tested. X-ray diffraction (see §(a) above) will reveal elements not easily noted under thin section. Chemical analysis identifies the presence and quantities of compounds, for example salts, in the stone.

(iii) Treatments.

(a) Non-intervention.

Passive conservation and maintenance. The natural durability of stone is aided by protection from excesses of temperature and water. Sound and proven maintenance procedures for stone buildings and exterior sculpture reduce ingress of ground- and rainwater. Builders in all climates have placed great importance on protecting masonry and sculpture from the effects of rainwater. The design of classical buildings, in particular, makes due provision for the protection of the entablature and ashlar: cornices project outwards to throw rainwater clear of the walls beneath, and, where the building is particularly tall, string courses protect lower stonework in a similar manner. Devices for channelling water assist in the protection of stone: upper surfaces of entablature slope downwards, causing rainwater to drain away from blocking courses, cills and tympana; 'drip lines' set underneath cornices, string courses and cills prevent rainwater running down ashlar; and joint lines are generally thin, well compacted and of durable mortars and positioned so as not to coincide

from course to course. At ground level, water is drained away by gulleys and the earth banked away to dry the foundations. Niches provide shelter for façade statuary.

It follows that for buildings preservation of stone rests in maintaining the façade, joints being well pointed, projecting entablatures kept in good order and drains cleared. Plants should be weeded out of crevices and a consistent damp-proof course above ground level maintained.

Arguably, where individual stones fail, they should be replaced to maintain the whole structure; a decayed stone column, for example, should have replacement parts if it supports a portico but not if it is a free-standing monument. In many cases the objectives of conservation do not allow for stone replacement, particularly if the original type is no longer available. For sculpture, replacement of the stone is generally not possible, as replacement parts are inevitably detectable and, of course, irreversible. It requires particular skill in surface distressing and stylistic interpretation to disguise new stonework.

Winter protection. Where winter temperatures can drop below freezing, statuary should be protected from frost and damp by winter covers, for example waterproof tents or boxes, which should be ventilated, firmly held and free from the sculpture. Very low winter temperatures require the sculpture to be further protected by insulation, traditionally of hessian or straw within the boxes. Statuary hidden in winter by sentry-like boxes is an accepted and integral part of the garden landscape at the château of Versailles.

Replacement of sculpture by copies. As fine exterior sculpture is increasingly threatened by vandalism, theft and atmospheric pollution, it is desirable to remove it from its original environment to be replaced by copies in a more durable natural or artificial stone, the originals being housed in a museum. The fine original medieval statuary of Strasbourg Cathedral, for example, can now be viewed only in a museum; passable copies have taken its place on the façade. It is debatable whether the prototype laser machines that have been used to make three-dimensional facsimiles in plaster of objects depicted in photographs will make passable stone copies of sculpture. It is prudent, therefore, to record decaying stonework, for example with casts, holograms and photogrammetry, for future replacement by copies produced by improved technology.

Resiting and reburial. The resiting or reburial of a stone structure may be an option to preserve it. Modern technology, together with vast amounts of international finance, made possible the resiting of two Nubian temples on the Island of Philae in the River Nile, when the building of the Aswan High Dam further down river threatened to engulf them in rising flood water. In 1965 both temples, originally carved out of a sandstone rockface and including statuary of Ramesses II and Nefertiti 30 m high,

were moved to a safe site 50 m higher. As many as 1072 stone blocks, some weighing 30 tonnes each, were cut into transportable sizes by use of chain and hand saws set on rigs to ensure exactly measured stones. Those stones considered in a parlous state were backed with concrete and reinforced with epoxy resin. Lifting anchors were set in with resin-grouted cables. The stones were resited in a false hill made of a concrete dome with rubble topsoil to simulate the original setting of the temples.

A simpler method of preservation for ancient buildings, particularly those that have been excavated, is to rebury them. For financial reasons, exposed, weakened and insecure stonework on many archaeological sites cannot be conserved. A solution to this problem is to backfill and bury such structures, having first recorded and protected the stonework with dividing membranes. Stretches of the Roman Wall in the City of London, exposed by bombing in 1941–2, were recorded and reburied in the 1950s, to be re-excavated in the 1960s and 1970s.

(b) Intervention.

Surface coatings. The history of applied treatments begins with coatings. Surface protection provides an impermeable barrier against atmospheric pollutants and rainwater. Surface coatings should not, however, be penetrative nor seal the surface of the stone. There are two categories of surface treatments, inorganic and organic.

Inorganic. The use of lime-based coatings is common for the protection of limestone buildings in the USA and Europe, although there is some debate concerning the reliability and reversibility of this method. The treatment came to prominence in the 1970s as part of the repairs of the 14th-century west front of Wells Cathedral. All the statuary of local Doulting limestone was treated systematically: lime was applied both as a cleaning agent and as a protective coating. The statuary was first saturated by water sprays before being covered in a layer of freshly slaked lime bound in hessian. Over a period of days the caustic properties of the alkaline lime softened the hardened surface layers of dirt and sulphation. Washing with water and use of wooden tools removed the lime poultice and loosened surface dirt. The surface of the statuary, softened by both weathering and cleaning, was then sprayed with saturated lime water (calcium hydroxide) that, on carbonating, lightly hardened the surface. Cavities were filled with mortars of limestone dust aggregate and pozzolana. Eroded limbs and features were not replaced but capped over with mortars before the final treatment—an application of stone-coloured lime and stone dust, hardened by casein. This 'shelter' coat, as it is known, was applied as a paint, rubbed in and allowed to harden to form a protective shield. Regular maintenance requires the 'shelter' coat to be reapplied every five years.

Organic. Organic surface treatments are generally invisible to the naked eye. They are chosen for their

rapid absorption into the surface, due mainly to their low viscosity. Their durability is, however, suspect, giving rise to concern about complications of decay if the surface treatment itself decays within the pores of the stone. Organic surface treatments are thus generally chosen with a view to ease of removal. The protective qualities of oils and wax on stone were recorded in 15th- and 16th-century England: the mason of Henry V (reg 1413–22), for example, recommended the use of linseed oil to protect stone buildings. In the 19th century and the early 20th beeswax and paraffin wax were commonly used to protect sculpture, with damaging results. Waxes generally have a low melting-point, attract dirt and will seal the surface of stone. Two Egyptian granite obelisks, one by the River Thames in London and the other in Central Park, New York, both erected in the mid-19th century, were treated in a similar manner to protect them from urban atmospheres. In each case the stone was pre-heated with blow lamps before the application of paraffin wax; although this treatment provided protection more surface dirt than had been wished has accumulated. The removal of the protective bronze cap on the obelisk in New York revealed stone untreated but with a far cleaner surface. Stones with greater porosity than granite that received similar treatment have fared far worse. Egyptian limestone stelae in the British Museum, London, that were treated with paraffin wax in the early 20th century have lost much of their original surface; salts within the limestone have crystallized behind the wax barrier, forcing off the surface. More successful hydrophobic coatings that do not alter the porosity and permeability of stone were perfected in the late 20th century. Silicone polymers that rest lightly on the surface are preferred to deep penetrative waxes for both exterior and interior sculpture, and coatings of fluorinated hydrocarbons have also been developed.

Consolidation. Consolidation of weathered or decayed stone by the impregnation of liquids that harden through curing or chemical reaction provides a stable structure for further surface and internal treatments. It is often the case that dirt can be removed or supportive fixings inserted only by a preliminary consolidation of the stone. The liquid consolidant sets or cures within the stone to form a supportive lining or latticework within the pore structure, allowing moisture to pass freely through the stone. Through the ages waxes, resins, fats and, more recently, synthetic polymers have all been used for this purpose. Success has been gauged by the lack of disturbance to the appearance of the stone and the longevity of the treatment. During the Industrial Revolution the increasing value that was accorded to historic buildings and sculpture resulted in the development of a plethora of consolidants for stone, for example Churches' recipe based on the application of buffered barium hydroxide, which forms an insoluble compound of barium sulphate within weathered stonework. The application of various silicate treatments, the most common being buffered sodium silicate and ethyl silicate, proved popular across Europe. Silicate treatments on buildings of siliceous stone have generally proved durable, as silicate compounds bond well with siliceous stone. Advances in the use of silicon compounds, most notably silane treatments, have proved extremely useful for emergency, but irreversible, treatment of decayed sculpture. Additives of methacrylics and epoxy resins assist in providing strength to the cured polymer within the stone. A notable case of the use of such treatments is the Porta della Carte, Venice.

(c) Cleaning. Cleaning is undertaken generally for aesthetic reasons, although a soiled, discoloured stone surface can be regarded as having both a pleasing patina of age and an appearance of neglect. A discoloured surface often detracts, however, from the original appearance of the carving or tooling. Stone should be cleaned if the surface soiling is proven to be harmful: deposition of atmospheric pollutants will etch stone by chemical means or by clogging the pore structure of the stone. Routine light and careful cleaning that prevents surface accretions is traditionally a sound maintenance procedure.

Unless otherwise needed, only the lightest cleaning should take place. Often a surface accretion or discoloration is indelibly inscribed in the stone surface; cleaning methods must leave the original stone surface intact. Water used without pressure or as a light spray is the simplest and best method, removing soluble accretions and insoluble matter that can be easily washed or brushed off. If too much water is used, dissolution of the stone surface, the oxidation of metal fixings and the movement of soluble minerals within the stone may result. Abrasion and chemicals may also be used for cleaning. Although, in theory, only unwanted accretions are removed by targeted abrasive dust or granules, in practice the stone surface is rarely unharmed by this method. Surface bruising and discoloration often result from abrasive methods of cleaning. Stains and dirt deposits are often removed by washing with or applying a poultice of chemicals. It is essential that all traces of chemical cleaning agents are removed from the stone and that the stone itself is not harmed.

W. R. Purchase: *Practical Masonry* (London, 1895/*R* 1987)

R. J. Schaffer: *The Weathering of Natural Building Stones* (London, 1932/*R* 1972)

E. G. Warland: *Modern Practical Masonry* (London, 1932)

International Institute of Conservation Conference on the Conservation of Stone and Wooden Objects: New York, 1970

E. M. Winckler: 'Decay of Stone', *Conservation of Stone*, ed. G. Thomson (London, 1971), pp. 1–14

G. Torraca: *Porous Building Materials: Materials Science for Architectural Conservation* (Rome, 1981)

International Council of Museums Symposium on the Conservation of Stone: Bologna, 1981

International Institute of Conservation Conference on Adhesives and Consolidants: Paris, 1984

Cinquième congrès international sur l'alteration et la conservation de la pierre: Lausanne, 1985

N. S. Bromelle and P. Smith, eds: *Case Studies in the Conservation of Stone and Wallpaintings* (Bologna and London, 1986)

J. Ashurst and N. Ashurst: *Practical Building Conservation*, i (Aldershot, 1988)

Sixth International Congress on Deterioration and Conservation of Stone: Torun, 1988

E. Corbella: *The Architect's Handbook of Marble, Granite, and Stone*, 3 vols (New York, 1989)

D. Arnold: *Building in Egypt: Pharaonic Stone* Masonry (New York and Oxford, 1991)

G. T. Pearson: *Conservation of Clay and Chalk Buildings* (London, 1992)

J. Philippon, ed.: *La conservation de la Pierre monumentale en France* ([Paris, 1992])

R. Fisher: *Buddhist Art and Architecture* (London and New York, 1993)

P. Rockwell: *The Art of Stoneworking: A Reference Guide* (Cambridge and New York, 1993)

F. Menotti: *The Inkas: Last Stage of Stone Masonry Development in the Andes* (Oxford, 1998)

G. Henderson and I. Henderson: *The Art of the Picts: Sculpture and Metalwork in Early Medieval Scotland* (London, 2004)

G. Wheeler: *Alkoxysilanes and the Consolidation of Stone* (Los Angeles, 2005)

A. Acocella: *Stone Architecture: Ancient and Modern Construction Skills* (Milan, 2006)

A. M. Giusti: *Pietre Dure: The Art of Semiprecious Stonework* (Los Angeles, 2006)

A. Henry: *Stone Conservation: Principles and Practice* (Shaftesbury, 2006)

Stoneware. See CERAMICS, §2(ii).

Stopping-out. Technique used in ETCHING to make the acid bite to different depths so that parts of the design appear in different tones. After the lightest lines or areas are bitten, the plate is removed from the acid bath and varnish is applied to these areas as a resist; the plate is then put back for further bitings, and the process is repeated as often as is necessary.

Straw. Dried stalks of cereals and other grasses. The generic name for agricultural and domestic articles made of straw is 'lipwork'. Unthreshed winter-sown wheat or rye straw was considered best for making rolls, which were coiled and bound with strips of bramble, split withy or twine. This ancient craft was practised throughout western Europe and by African tribes. Owing to the perishable nature of the material, few straw chairs predating 1800 survive; one of the earliest, which belonged to Edward Jenner (1749–1823), is at the Museum of the History of Science, Oxford University. References in inventories and paintings, however, show that straw furniture was used at an early date. Straw chairs with spectacular canopied hoods were made in Wales and the English counties bordering the River Severn (e.g. St Fagans, Welsh Folk Museum; Brecon, Brecknock Museum); they were customarily used by nursing mothers and by the old or infirm. Low-backed versions, broadly following the pattern of WICKER seat furniture, were sometimes reinforced by an inner structure of rods,

but rigidity was often achieved entirely by means of the stiffness of the tightly coiled straw ropes (e.g. Dublin, National Museum of Ireland; Gressenhall, Norfolk Rural Life Museum). In the Orkney Islands, off the coast of Scotland, 'beehive' chairs made of marram grass were constructed with a wooden lower frame (e.g. Kirkwall, Orkney, Tankerness House Museum). Drum-shaped straw or rush hassocks (e.g. Norwich, Castle Museum), cradles (e.g. Barnard Castle, Bowes Museum) and beds for harvest labourers or shepherds were also produced. Straw furniture was used mainly in cottages and farmhouses but, during the period *c.* 1825–50, it became briefly fashionable in country houses (e.g. Leeds, Temple Newsam House), where the chairs might be covered in fabric. Straw chairs have become the focus of a craft revival in Orkney, and in the Netherlands capacious canopied straw chairs are popular on beaches.

C. G. Gilbert: 'Straw and Wicker Furniture', *English Vernacular Furniture, 1750–1900* (New Haven and London, 1991)

E. Borsook, ed.: *L'Oro dei poveri: La paglia nell'arredo liturgico e nelle immagini devozionali fra il 1670 e il 1870* (Florence, 2000)

Stretcher. Wooden framework that serves as a support for a painting on stretched canvas. Large stretchers usually have several cross-members to keep them rigid. Since the 18th century, stretchers have been designed with triangular keys or wedges at each corner. These allow the stretcher to be expanded to increase the tension on the canvas, which may become slack with age.

Striation. Pattern of hatched, parallel lines, used especially to represent drapery in Byzantine and Romanesque painting and sculpture.

Striking. Process of hammering a heated blank piece of metal between two dies, especially as in the creation of coins and medals.

Stucco and plasterwork. General terms for a decorative art that, at its simplest, is a render of mortar designed to decorate a smooth wall or ceiling and, in its more sophisticated form, is a combination of high-relief, sculptural and surface decoration. The words 'stucco' and 'plaster' are used virtually interchangeably and, most flexibly, can be applied to mixtures of mud or clay; more precisely, however, 'stucco' usually means a hard, slow-setting substance based on lime as opposed to quick-setting plaster based on gypsum. The following survey discusses the technical aspects of stucco and plasterwork and their conservation, and supplies a brief overview of their history and uses.

1. Introduction. 2. Properties and techniques. 3. Conservation.

1. INTRODUCTION. Stucco is a soft, plastic material comprising mortar and various additives. In Italy, the word is a general term for a soft material that can be shaped and used for repairs or for covering architectural surfaces; elsewhere, it refers mainly to finished

modelled, drawn or cast decorative plasterwork. Because it is pliable while it cures and hardens, stucco requires some kind of support or reinforcement, which may simply be the wall itself or an armature set within it. Stucco can be applied directly to a masonry wall or ceiling or on to a wooden frame. Where the modelling is in high relief, the separate modelled or cast elements are held in place with adhesives or wood and metal fixings. Ingredients of stucco and plaster vary substantially according to the period and country of origin. Giorgio Vasari (1511–74), for example, described a *stucco bianco* made with marble powder for use in modelling and casting. The lightness of the base compounds of lime and gypsum, combined with the firm support and strength of the armatures and added ingredients, allow stucco and plaster to have an enormous variety of uses, ranging from large-scale wall covering to fine modelling and, of course, extensive sculptural relief. Gypsum plaster, light white in colour and long-lasting, gels rapidly following hydration and is eminently suitable for the casting of mouldings and statuary (*see* CAST, §1). It is also used as an accelerator for the carbonation process of lime stucco, and because it is inert it is a suitable material for the construction of protective, fire-resistant barriers.

2. PROPERTIES AND TECHNIQUES. All stucco and plaster has as its basis the raw material of lime or gypsum. Lime is produced either from burning limestone at a temperature of 880°C or from burning marble at 1000°C. The dry, brittle stone that results becomes a fluid, creamy substance when mixed with water, which then hardens to an almost stonelike density. The lime used for stucco is calcium hydroxide in a pure, putty form, generally used as aged as possible. Roman laws prohibited the use of slaked (hydrated) and prepared lime that was less than three years old. Vitruvius (*On Architecture* VII) and Leon Battista Alberti (1404–72) both wrote of the importance of well-worked and sieved lime, demanding that, from the firing (calcining) process to the slaking period and the final setting (carbonation), the lime should be carefully monitored. Gypsum is a hydrated form of calcium sulphate occurring as alabaster, rock gypsum and selenite. The large deposits of gypsum found under Montmartre in Paris are well known and gave rise to the name 'plaster of Paris'. When heated at moderate temperatures, the water is driven off, and the opaque heated rock can be ground to a powder (hemihydrate); this can be stored until needed. When mixed with water, plaster sets rapidly. Too much water, however, and the plaster will not set; too little and the set will be weak. The needle-like crystals of the powder elongate as they absorb water, interlock and form a hard, brittle set. For a good and pure plaster, 95% calcium sulphate needs a setting time of between 15 and 35 minutes. It is not necessary to add an aggregate to prevent shrinkage because of the speed with which the plaster hardens. To achieve a stronger plaster, the hemihydrate state can be advanced to an anhydrite by further heating. Grinding to a finer flour will accelerate the setting of

the slow anhydrite mix. This, and the soaking of plaster in alum prior to baking, was patented as Keenes cement in 1836.

Washed and graded sands of differing particle shapes and dampness are used as aggregates for various layers of stucco and plaster. The purity of the sand is essential for durability. South of the Alps, marble has traditionally been used as an aggregate in what is known as *stucco duro* to assist in the hardness of the material and the polishing. In northern Europe plasterers have employed hair to add strength; coarse cattle hair is used for the ground layers and fine goat hair for the final, top-most layers. Additives are arguably ingredients of equal importance to lime and gypsum, as small amounts of organic and pozzolanic materials assist the setting qualities and strength of the finished product. Although difficult to distinguish in hardened mixes, additives include such accelerators as gypsum (when added to stucco), such binders as casein, dung or reeds, such plasticizers as gelatin, curd and sugars and such air enhancers as beer and urine. The setting time of plaster can be accelerated by the addition of such crystalline materials as salt, alum and potassium sulphate. The addition of such organic materials as animal glue, milk and blood retards the setting time, with a proportionate degenerative effect on the plaster. The strength of plaster can be improved with mineral additives, for example cement, magnesium and flurosilicate, or with organic additives such as gum arabic or dextrin.

The recipes unique to each journeyman plasterer are unfortunately not documented, and the precise proportions and methods of mixing remain secret. Methods of production are, however, inextricably linked with the style of the period. The flat, polished and painted stucco used by the ancient Greeks and Romans (see fig. 1) comprised various plaster mixes that were built up in a different way from the more ornate relief work of later periods. By the 20th century stucco ingredients could incorporate high proportions of cement and gypsum as a fast-setting substitute for lime.

Where the plaster surface was to be painted or decorated with relief stuccowork, the design was plotted out directly on the flat plastered wall or ceiling, ensuring that the design carefully fitted within the architectural framework. The method of transferring the design on to the wall varies. In the Ancient Near East designs were scratched on to the top layer of plaster before the application of paint (see fig. 2). During the Middle Ages charcoal drawings indicated the outline of the stucco to follow. North Italian stuccowork incorporated the techniques of *sgraffito* in the design, selectively cutting out areas of plaster to expose an underlying layer of grey-black plaster. The pricking-out and pouncing of full-scale drawings on to the ceiling surface was common practice in England in the 18th century.

The durability of stucco and plasterwork derives from the reinforcing and building up of successive layers. Greater freedom of modelling may be achieved in plaster than can be produced in carving, and the

1. Stuccowork decoration, detail from a house, excavated beneath the Villa Farnesina, Rome, late 1st century BC (Rome, Museo Nazionale Romano); photo credit: Werner Forman/Art Resource, NY

surface can be finished to a smooth effect by applying unifying coats of lime skim. The description by Vitruvius (1st century BC) of the application of stucco to a vault is an important informative account: care was taken to describe the importance of a firm wooden construction of horizontal 'furring' strips (laths), on which the various layers of flat work were applied, each layer varying in ingredients and thickness. For large, flat areas of plaster, the backing should be of porous wood, laths, bricks and mortar. For damp walls, a hydraulic quality can be obtained in the stucco mixture by the addition of pottery sherds. In the 17th century gypsum was added to stucco to provide a hard surface for painting *a secco* in oils. Long runs of ornament, such as cornices, ribs or coffering, are made by pushing a rigid profile 'horse' along and through quantities of plaster set up on the wall or ceiling until the correct profile is achieved. Again the stucco would be built up in layers. Relief work shaped *in situ* or created by moulds is always executed in the lightest of materials. Armatures of wood, leather, string and metal wire have been used to create deep and extended projections, and charcoal cores were also used in mouldings to reduce their weight. Large quantities of repeated ornament are made of lime or gypsum plaster turned out of solid moulds. The finding of the moulds used in 1750 at Audley End, Essex, confirms the supposition that lime plaster was pressed into solid box or lead moulds and taken out while still pliable to be tooled to provide subtle variations in the ornament. The reinforcement of plaster with textiles for architectural mouldings was widespread following a patent method of 1856. Known as fibrous plaster, this technique was to the detriment of stuccoists, as it proved more economic to produce

small shallow mouldings and decoration in repeated cast form than to handcraft lime stucco mixes.

Decorative finishes seal the porous surface of plasterwork and disguise it; it is rare not to have an applied surface layer. Plaster often requires waterproofing, and this is best achieved with barium oxide. The surface can be sealed with applications of white shellac, dextrin, beeswax and glycerin, skimmed milk or linseed oil to prevent the ingress of dirt. Alberti suggested heating the stucco to enable the absorption of oil. Other, more tried and tested methods of pigmenting stucco or applying a select group of lime-fast earth colours to wet plaster survive from antiquity (*see* FRESCO and WALL PAINTING). In the SCAGLIOLA technique marble and alabaster powder is added to the final layers; glue additives and polishing ensure a glossy, glasslike finish. Bound paint is never applied directly to freshly executed stuccowork; the migration of efflorescence of calcium salts during the curing process ensures that the surface will not readily take paint other than a pigmented lime wash or pigments mixed only with water. Oil, egg-bound or other tempera paints should be applied only after a period of one to two years. Because gypsum plaster is strongly alkaline, surfaces to be oil-painted or gilded require a buffer coat of chalk and size, which also provides a fine, smooth surface. Oil paints fail to give the depth of finish required to simulate bronze or marble; to achieve this, it is necessary to apply a layer of bronze powder in shellac or layers of pigment alone in shellac.

3. CONSERVATION.

(i) *Causes of deterioration.* The degradation of stucco is often due either to the method of fabrication of the

2. Stucco and plasterwork patterns from ancient Iran: (a) complex motifs derived from a single element; (b) patterns created by the repetition of a single motif; (c) and (d) complex patterns created by the alteration of different motifs

base materials or the methods by which the plaster has been created. There is considerable opportunity for error in the production of the materials and in the forming of the stucco. The making of good-quality lime is a skilled, time-consuming job, and the successful, thorough completion of all stages of the lime-making process is of primary importance to the longevity of stucco. It is critical that all the quicklime in the slaking pit is thoroughly slaked. Particles left unslaked because of impurities in the raw lime, or through compaction of the lime when water was added, will slake in time in the stucco, and the subsequent sudden dimensional and chemical changes will inevitably disrupt the stucco.

Although the raw materials of stucco are individually stable, some combinations may prove incompatible. Iron nails in unseasoned oak laths and joists will inevitably tarnish and corrode, and likewise metal armatures that rust will cause physical disruption and staining in the plaster. It has been noted that the high proportions of sand grains in ancient mortars have coincided with surface deterioration. Badly applied plasters will deteriorate more rapidly; it is therefore important to allow layers of plaster to dry between

applications and to soak the underlying layer before applying a new one, as failure to do so results in weaker stucco. The most immediate area of decay is at the surface, with surface finishes peeling and flaking away.

It is generally assumed that the degenerative weathering process affecting stucco will be of the same nature as those affecting limestone. If the stuccowork is placed externally, wind and rain abrasion will mechanically wear the surfaces. Infiltration of stucco by water through cracks and pores will cause migration of the soluble salts from unslaked lime and additives. The force of salt crystallization will cause deterioration by the delamination of layers and the break-up of surfaces. If damp is allowed to freeze within the stucco, the freeze/thaw action of water crystals will cause acute damage. Water is doubly harmful if there is gypsum in the plaster, because gypsum remains slightly soluble and absorbent; slats will be produced, as well as a general weakening of the stucco. The variety of materials in stucco, with their differing coefficients of expansion, will, in fluctuating temperatures, move and break up the stuccowork.

Atmospheric pollutants of acid rain and noxious gases will settle on and attack mortars. Damp stucco will be converted by acid deposition to soluble calcium sulphate, resulting in a reduction of the binding material and a softening of the stucco. Stucco made from Dolomitic lime, which has a high proportion of magnesium carbonate, will be particularly affected by atmospheric pollution. Metal armatures in stucco will oxidize and expand, splitting and expanding the plaster. Fabrics (e.g. hessian or cotton) used for reinforcement in plasterwork will deteriorate, becoming mouldy and brittle and thus weakening the structure of the stucco. The growth of micro-organisms in damp conditions will affect all the organic elements of stucco. Wooden reinforcements and backings and the framework can all be severely affected by bacterial decay. Staining caused by the ingress of dirt and organic growths will disfigure and break the visual effect of a decorative finish and will reverse the surface modelling. There can also be decay caused by pests, notably woodworm and death-watch beetle, and by the acidic action of bird and animal faeces. Fatigue is probably the least-documented cause of decay. Gradual delamination of stuccowork on ceilings can be an inevitable consequence of gravity on the many layers of stucco.

(ii) Analysis and conservation techniques. Stucco, as an illusive and imitative medium, cannot be easily analysed. Observations of surface decoration, detail and pigments can generally be made by eye and low magnification. The use of cross-lighting, to throw tool marks and polishing techniques into shadow, assists the recognition of the plasterer's methods. Greater magnification and polarized light will aid specific identification of pigments and minerals within and on stucco. To discern the presence of lime as either a binding agent or filler and of gypsum as either an accelerator of filler (the latter in the form of alabaster), more sophisticated analysis is required, usually in the form of scanning electron microscopes and X-ray defraction. The use of an acid test will immediately distinguish gypsum from lime plaster, as lime is soluble in dilute acid. Analysis by thermoluminescence will determine the presence and proportion of hydraulic components in the plaster, and X-rays and gamma radiography are used to locate the presence and position of structural supports (*see* TECHNICAL EXAMINATION). For the conservation and maintenance of stucco *in situ*, it is imperative that an evaluation of the climatic conditions above and below the stucco is made. The relative humidity and moisture content in adjacent masonry, together with the ambient temperature, will all greatly influence the condition of the stucco, a porous material often attached to wood. Increasingly, plaster conservators assess the pollution levels of the local atmosphere before diagnosing decay.

Before conservation, cleaning should be undertaken to improve the aesthetic appearance and to re-establish lost modelling and surface decoration. Cleaning will remove harmful and disfiguring chemical deposits, either inside or on the surface of the stucco. Superficial cleaning by brushing is necessary on a regular basis to prevent dirt becoming ingrained. More purposeful brushing with the use of detergents and solvents will improve the light removal of staining. Deeper cleaning of surfaces is made possible by poultices of ammonia, ammonia carbonate and liniment of soap. Light abrasion with talcum and chalk in air pressure is also recommended.

Replacement of losses using the same working techniques as used originally is essential to maintain the aesthetic appearance of the decoration. It is also sensible to use similar materials. Stucco, used as a multimedia decoration, has within it a complicated arrangement of joints and interfaces of different materials. Generally the varying thermal movements and adhesive forces within the stucco will balance, with no one material alone causing decay. The insertion of a new and alien repair medium could prove problematic in the long term.

A firm frame of external and internal support is essential for all high-relief work. Low-relief and flat wall and ceiling stucco must be well-provided with a stable background support. For large areas, the support must be flexible. Stucco is generally not a rigid material and will move with vibration and climatic changes; the support must move in conjunction with the stucco. Small rigid repairs to a background frame are sometimes both economical and necessary, but these must be limited. Repairs should not add damaging weight to the stucco. The adhesion of lime plaster to wooden laths is through surface bonding of the cured lime on the rough surfaces of the cleaved or sawn wooden laths and by the 'key' of the lime plaster of the backing (or pricking-up) coat, which has been forced through the laths to set on the other side. Decay of the wood or insufficient key of the plaster will require either part replacement of the lath or repair of the lime key. Increasingly, repair of such failures is in the form of the provision of a structural by-pass. Metal or wooden ties are passed through from the underside of the lime plaster to bearers behind the laths. Support of the plaster is thus made on a flexible and independent basis. The use of thick coats of adhesive gypsum plaster or resin behind the laths is to be discouraged on the grounds of rigidity and excessive weight.

Plaster of similar strength and make-up to the original is generally used for replacement and fills. To assist adhesion of the old stucco with new filling material, priming of the bare faces of the plaster is made with strengthening coats of lime water or bonding coats of a colloidal acrylic wash. Inorganic adhesives are mortars of plaster refined by the fine sifting of aggregates and lime with additions of pozzolana and hardening agents such as HTI (High Temperature Insulation), brick dust and casein. Organic adhesives are chosen for their lightness and quick-setting abilities. Resins of polyester, epoxy and acrylics will hold broken and ragged plaster in a hard, increasingly flexible bond. For repairing the lost key with laths behind plasters, a technique has been perfected that

combines the high-expanding and adhesive capabilities of epoxy resin and fluid coke with acrylic microballoons, a light-weight filler. Consolidants should ideally be reversible, non-toxic, flexible and resistant to atmospheric pollutants and biological degradation. They should not change the colour of the stucco. Dilute adhesives were used in the 20th century but increasingly conservators turned to the repeated application of saturated lime-rich water to harden a carbonation-weak, soft plaster.

W. Miller: *Plastering: Plain and Decorative* (London, 1897)

G. Beard: *Decorative Plasterwork in Great Britain* (London, 1975)

M. Koller: 'The Abbey Church of Melk: Examination and Conservation', *IIC Conference: Vienna, 1980*

P. J. Drury: 'Joseph Rose Senior's Site Workshop', *Antiquaries Journal*, cxiv/1 (1984)

M. Koller: 'Historic Stuccowork in Austria: Technique, Colour and Preservation', *IIC Conference: Bologna, 1986*

S. Healey: *Stucco as a Vehicle for Architecture and Ornament: Its Development, Constitution and its Associated Conservation Techniques* (diss., 1989)

A. Grimmer: *The Preservation and Repair of Historic Stucco* (Washington, DC, 1990)

R. Ling: *Stuccowork and Painting in Roman Italy* (Aldershot, 1999)

C. Gapper: 'What Is "Stucco"? English Interpretations of an Italian Term', *Architectural History*, xlii (1999), pp. 333–43

G. Biscontin and G. Driussi, eds: *Lo stucco: Cultura, tecnologia, conoscenza* (Marghera-Venezia, [2001])

C. Paolini: *Glossario delle malte e degli intonaci da rivestimento, decorazione plastica e supporto pittorico* (Florence, 2001)

A. Northedge: 'Abbasid Earth Architecture and Decoration at Samarra, Iraq', *Conservation of Decorated Surfaces on Earthen Architecture*, eds L. Rainer and A. B. Rivera (Los Angeles, 2006), pp. 5–14

Stumping. Technique of blending or rubbing in deposits of dry colour from chalk, charcoal or pastel, using a roll of leather or paper known as a stump. Approximately a finger's length and diameter, with a stubby conical or domed point at either end, the stump duplicates the action of a fingertip but allows more control.

Stumps were initially made of tightly rolled and bound leather, probably chamois; later versions were made from blotting paper or felted paper and possibly *amadou*, a prepared dried fungus. The name 'tortillon' is an alternative to stump, most often applied to a thinner implement of rolled paper with one elongated and more acute point.

The stump appeared from the second half of the 18th century onwards; it is illustrated by Denis Diderot (1713–84) in his *Encyclopédie* (Paris, 1754–63), and John Russell (1745–1806) in his *Elements of Painting with Crayons* (London, 1772) refers to 'a leather stump' and its use. The delicately modelled and highly finished pastel paintings of this period by Maurice-Quentin de La Tour (1704–88), Jean-Etienne Liotard (1702–89) and Jean-Baptiste Perronneau (1715–83) imply the use of a stump. A more graphic and textural use of the same drawing materials has predominated since the 19th century, as illustrated by the works of Edgar Degas (1834–1917), so the stump has been less frequently used. However, there is little visual difference between blending done with the fingers and the use of a stump or tortillon, so the technique is by no means obsolete.

J. Russell: *Elements of Painting with Crayons* (London, 1772, rev. and enlarged 1777)

M. Shelley: 'An Aesthetic Overview of the Pastel Palette: 1500–1900', *The Broad Spectrum: Studies in the Materials, Techniques, and Conservation of Color on Paper*, eds H. K. Stratis and B. Salvesen (London, 2002), pp. 2–11

Stylus [style]. Pointed instrument, typically of bone or metal, used to impress or score a soft or receptive surface. It has a variety of uses. In writing a stylus, perhaps of stick or reed, was used to mark tablets of clay or wax throughout ancient times. The cuneiform writing of the Sumerians is the earliest example, dating from the late 4th millennium BC or early 3rd. The wedge-shaped marks must have resulted from an angular stylus impressed downwards into the clay; any attempt at a more flowing script would have been hampered by ridges of wet clay building up around the stylus point or the letter forms themselves. With the development of the pen, the stylus ceased to be a writing instrument and became instead an implement for making guiding marks. In many early manuscripts the point of a hard stylus was used by the scribe to lay out the ruling by scoring the parchment between pricked-out measurements (*see* MANUSCRIPT, §2(iii)). This indentation shows as a faint raised line on the other side and guided the layout of the page discreetly. Such marks can be seen, for example, on pages of the 7th-century Cathach of St Columba (Dublin, Royal Irish Academy, s.n.), and appear on documents throughout the Middle Ages. Up to and during the Renaissance the stylus was used in a similar fashion to score perspective guiding lines for drawings and paintings, particularly those with an architectural content, where unobtrusive construction lines were necessary. Alvise Vivarini's pen, ink and wash *Design for an Altarpiece* (Windsor Castle, Berks, Royal Library) provides an example.

The accounts of the use of a stylus by Cennino Cennini (*c.* 1370–*c.* 1440) are probably mostly to be interpreted as references to metalpoints. He specifically mentioned points of silver, even in connection with styles of copper or brass, and also referred to the leadpoint that could mark unprepared paper; this implement was used as an alternative to the plain stylus for laying out manuscripts in the manner already described. However, his remarks are occasionally ambiguous, and drawing with an impressed mark is sometimes implied. For the depiction of gold and silver brocades, he mentioned a stylus of birch, a similar hard wood or bone, pointed at one end and with an apparently chisel-shaped scraper at the other. This was used to remove colour laid in egg tempera over gold- or silver-leaf, so as to reveal a pattern—a form of *sgraffito* seen in the background of *St John the Baptist with SS John the Evangelist and James* (*c.* 1365; London, National Gallery) by Nardo di Cione (*c.* 1320–65/6).

Giorgio Vasari (1511–74) also mentioned the stylus in connection with *sgraffito* work, although in his case with reference to plaster. He also described the use of a stylus for tracing a cartoon on to soft, wet plaster, a feature particularly apparent in frescoes of his time. He also explained how a stylus could be used to trace a drawing on to a new sheet by going over it, a practice often used by Raphael (1483–1520). Sometimes a sheet of paper coated with black (probably chalk) is interleaved between the original drawing and the new support, a method roughly equivalent to using carbon paper. The drawing of *A Greyhound* (Windsor Castle, Royal Library) by Albrecht Dürer (1471–1528) is coated on the *verso* with black chalk, implying that it may have been transferred in a similar way. Vasari also recorded the use of the stylus in connection with niello work (*see* NIELLO PRINT). With the adoption of the metalpoint and subsequently the graphite pencil, the stylus ceased to be used. However, a tradition of incising outlines on to the gesso ground before painting continues in contemporary icon painting.

C. Cennini: *Il libro dell'arte* (MS.; *c.* 1390); trans. and notes by D. V. Thompson jr (1933)

G. Vasari: *Vasari on Technique*, Eng. trans. by L. S. Maclehose, ed. G. B. Brown (London, 1907/*R* New York, 1960)

J. Roberts: *Master Drawings in the Royal Collection* (London, 1986)

L. Montalbano: 'Il disegno a punta metallica: Storia di una tecnica ormai dimenticata', *OPD Restauro*, viii (1996), pp. 241–54

Support. Surface object or substance that carries a two-dimensional work of art, in particular a painting, drawing or print. Thus, in the case of a painting on canvas, the cloth and the frame over which it is stretched are together considered the support.

1. Introduction. 2. Types.

1. INTRODUCTION. To be technically correct, a support should be carefully differentiated from its GROUND, that is any preparatory layer that renders the surface of the support suitable for receiving paint or other media. However, it is not always practical or necessary to prepare the surface; in some cases, the same substance may both act as a support and provide the ground. Paper is a good example: the type of fibre in it, the sizing and introduced colouring, if any, all affect the performance of the paper as a ground, but they are also part of its structure and therefore its role as a support. This is most obvious with transparent watercolour, where the brilliance of the colour washes depends on the lightness of the underlying paper acting as a ground, but it applies equally to other media, where paper is the support and no separate ground is applied. Niceties of definition occur with fresco too, where the support is a wall. The preparatory layers of plaster are so integral a part of it that the fact that the final *intonaco* (It.: 'plaster') is to all intents and purposes a ground becomes irrelevant. In true fresco, the painting itself is incorporated into the surface of the wall and so becomes quite literally part of the support.

The ideal support for a two-dimensional work of art should be durable, stable and suitable. That includes being receptive to the materials applied to it. The life expectancy and state of preservation of a painting greatly depend on and may often be wholly determined by the qualities of its support. Transfer from or the consolidation of deteriorated supports is possible, but the cost and expertise involved limit such action to accepted masterpieces or, at least, major works. Even so, this would only lessen or slow the consequences of any fundamental defects. The artist's choice of support and the care exercised over its selection and preparation are therefore critical. Unfortunately, no support material fulfills the ideals in all respects and its suitability in different applications varies. The decision is often a compromise affected by practical considerations, many of which may be non-technical, for example cost and availability or habit and tradition, as much as by the pursuit of good craftsmanship. A background of sound technical knowledge in relation to supports can only be assumed before the 18th century. For example, there is evidence that Albrecht Dürer (1471–1528) took an interest in the potential life expectancy of his panels, and the choice by Peter Paul Rubens (1577–1640) of canvas for large-scale works but clear preference for panels when working on a modest scale implies his appreciation of their relative merits. Since the 18th century painters have relied increasingly on readymade supports, and the deliberate selection of specific types for good reason has been a comparatively isolated occurrence. An emphasis on experimental creativity in the 20th century led to some errors of judgement in the choice of support, but the number of possible support materials has also increased dramatically, with some advantages. A growing awareness of the need for permanence is also having an effect, with a life expectancy for a work of art of between 500 and 1000 years being increasingly accepted. Such durability is a potential feature of several types of support, although the assistance of conservation procedures will often be required. This has led to the argument that ease of conservation should also be taken into account when an artist chooses a support.

2. TYPES. Supports may be categorized as fixed or portable, although this relates as much to size as to substance; a better distinction is between a rigid and a flexible support. Walls and solid objects provide rigid supports, as do wooden panels, metal sheets, slabs of stone, slivers of ivory and the various sheet materials that can be loosely classified as board. While thin pieces of some of these substances are no more than semi-rigid, they are not prone to movement to the extent that those classified as flexible supports may be. The latter are textile supports, most of which are collectively known as canvas, and various types of paper. In general, flexible supports tend to be less durable, partly because they are also fragile, although the actual materials concerned can, in theory, have a long life expectancy. More important

is their relative suitability for different media or styles of working. Because of its inherent stability, for example, a suitably prepared rigid support could, in theory, accommodate anything, but flexible supports cope well only with flexible media or with thinly applied materials. Composite supports involving more than one of the materials described below are not unusual, for example wooden panels covered in cloth and paper mounted on canvas.

(i) Fixed. The oldest surviving pictorial art is WALL PAINTING on bare rock surfaces, usually the walls of caves. Later the surfaces of buildings took on the same role and the smoothly plastered wall would have been quickly recognized as a suitable surface for painted decoration. Throughout antiquity walls were the principal support, and this trend continued until the Middle Ages. In the early Renaissance, walls continued to be important, but mural painting has since declined to a minor activity. Durability has always been a problem, not of the walls themselves, but of the paintings on them; these are easily affected by dampness or chemical action from within the wall, and only wall paintings in dry climates or works in FRESCO have survived in any quantity.

Small, free-standing pieces of stone have been experimented with successfully as supports for encaustic and oil painting, as shown by such examples as the *Virgin and Child with St John* (*c.* 1600) in oil on quartz by Hans Rottenhammer I (1564/5–1625) and the *Infant Christ Asleep Adored by Two Angels* (*c.* 1730) in wax on slate by Agostino Cornacchini (1686–1754; both London, Victoria and Albert Museum). However, it was other more practical portable supports that took over from the static wall. There is every possibility that both panels and canvases were employed by the Greeks and the Romans, but nothing has survived to confirm this, other than the late Egyptian funeral portraits from Faiyum on small panels in Hellenistic style from a period of Roman domination. The earliest of these date from the 1st century BC and by their quality suggest a more widespread art of painting on portable supports.

Although cloth was definitely painted on at an early date, it was the wooden panel, technically better suited to tempera paint and encaustic colours, that emerged during the 6th century as an important small-scale alternative to architectural surfaces. With the gradual refinement of painting techniques during the 13th and 14th centuries, panels assumed greater importance and, at the beginning of the Renaissance period, wooden supports became associated with painting at its highest level. As EASEL PAINTING rose to supremacy, the panel dominated briefly, but by the end of the Renaissance it had been largely replaced by canvas. As wooden panels are inherently more stable and long lasting, they have enjoyed a continued, if sporadic, use and in the 20th century the popularity of the panel, albeit in a modified form, has been revived by the adoption of various modern BOARD products for use as painting supports. Some

of these offer the qualities of traditional panels with significantly increased stability. Historically, locally available woods were selected, typically oak in northern regions and poplar in Italy and the construction of the panels, from the way that the wood was sawn onwards, had to be carefully attended to, if maximum stability were to be achieved (*see* PANEL PAINTING). Sheets of metal, in particular copper, have also served as fixed supports for oil paintings and for paintings in enamel, as have ceramic, glass, ivory, plastics and resin-coated honeycomb aluminium.

(ii) Portable. Textile supports have a vague early history, but what is not in doubt is the dramatic effect on their use of combining oil paint with them during the 15th century. As oil paint is flexible, at least for the early part of its life, and is less susceptible to damp and micro-organisms, it is able to overcome the inherent deficiencies of a canvas support. That means that the advantages of low cost, light weight and potentially massive scale can be exploited. This was first done in Venice at the height of the Renaissance, and Titian (*c.* ?1485/90–1576) was among the earliest artists to explore the full potential of combining the two. Stretched CANVAS has been the most important support for major paintings since then, and the oil medium has occupied a primary position too. Canvas is also a popular support for acrylic paint and is likely to retain a position of some significance into the foreseeable future. The use of increasingly inferior grades of cloth and poor standards of preparation have become features of both commercially prepared and studio-made canvases in the 20th century. Technically ignorant or careless artists have also made inappropriate use of canvas supports in various ways since the 19th century but mostly during the 20th. Textile supports cannot be expected to carry weight, are easily distorted by the differential contraction of various materials applied to them and are easily degraded by substances that are allowed to penetrate into them during the course of painting.

Prepared animal skins in the form of PARCHMENT and vellum have acted as supports for small-scale paintings, often in fact illustrations or decorations to text, in both Eastern and Western civilizations. In the West, the art of manuscript illumination (*see* MANUSCRIPT, §2(iii)) almost completely disappeared with the introduction of printed books and, except for the English miniature, which reached perfection during the reign of Elizabeth I (*reg* 1558–1603), there was no continuation of the materials and techniques involved. In Indian and Islamic art, however, a form of miniature painting evolved on parchment, as well as on cotton, paper and ivory, for which there is no exact parallel in the West. The exquisite style of these miniatures and the opaque watercolour media employed in them are well suited to supports of this nature, as indeed is the limited scale. Perhaps through contact with India, ivory was also adopted for English portrait miniatures during the 18th and 19th centuries.

Compared to vellum, which was preferred to parchment for the purposes of painting, PAPER was a cheap commodity. Its introduction therefore made possible an expansion of artistic activity by allowing artists to sketch more freely (*see* DRAWING, §III) and making widescale printmaking a practical possibility (*see* PRINTS, §I, 3(ii)). Paper as a painting support is chiefly associated with WATERCOLOUR. The heavy, high-quality papers that 20th-century artists have used with that medium are a development of papermaking in direct response to the growth of watercolour painting during the 18th century. They were pioneered by papermakers such as James Whatman, who commenced manufacturing in 1740, and have, over the years, come to offer a range of surface textures and weights suited to the diverse needs of the watercolour artist. 'Rough' papers retain the impression of the woollen felts used to express water from the newly formed sheet. 'Hot' or 'cold-pressed' papers have a definite but less pronounced texture and 'hot-pressed' or 'satin' finished papers have been pressed smooth to remove all trace of the felts. Paper can offer a considerable life expectancy when made of cotton or linen fibre or of special types of wood pulps, for example photographic wood pulp or alpha-cellulose, and if carefully manufactured. Its fragility can be compensated for by a high standard of framing beneath glass or Perspex, and this, coupled with the availability of large sheet sizes and substantial lengths of the modern machine-made artists' papers, have stimulated its use as a support. Works of art on paper are thus once again in the process of gaining a higher status. The development of paper conservation as a distinct field (*see* PAPER, §VI) may also have contributed to this.

M. Doerner: *Malmaterial und seine Verwendung im Bilde* (Stuttgart, 1933); Eng. trans. by E. Neuhaus as *The Materials of the Artist* (New York, 1934/*R* London, 1979)

R. Mayer: *Artist's Handbook* (New York, 1940, rev., ed. S. Sheehan, London, 5/1991)

J. Marette: *Connaissance des primitifs par l'étude du bois du XIIe au XVIe siècle* (Paris, 1961)

E. Mâle: *The Restorers' Handbook of Easel Painting* (New York and London, 1976)

C. Gilbert: 'Peintres et menuisiers au début de la Renaissance en Italie', *Revue de l'art*, xxxvii (1977)

National Gallery Technical Bulletin (1977 onwards)

Completing the Picture (exh. cat., London, Tate, 1982)

Paint and Painting (exh. cat., ed. L. Fairburn; London, Tate, 1982)

J. Stephenson: *The Materials and Techniques of Painting* (London, 1989)

D. Wolfthal: *The Beginnings of Netherlandish Canvas Painting, 1400–1530* (Cambridge, 1989)

M. Mattioli: 'Restauro di due dipinti su cuoio dorato', *Progetto restauro*, xxvi (March 2003), pp. 6–16

T

Tambour. Circular embroidery frame. Also used in reference to a decorative feature of furniture, consisting of narrow strips of wood glued to a textile backing, and used as sliding doors or rolling tops in various types of desks (often called tambour desks). Thomas Sheraton (*d* 1806) noted, for example, in his Cabinet Dictionary (London, 1803) that tambour is "glued up in narrow strips of mahogany, and laid upon canvas, which binds them together, and suffers them, at the same time, to yield to the motion their ends make in the curved groove in which they run."

Tapestry. Technique of weaving discontinuous weft threads into an undyed warp thread to form a pictorial or decorative design. The term also denotes wall hangings made by this technique, most notably the pictorial wall hangings popular in Europe from the 14th century.

1. Materials and techniques. 2. Conservation.

1. MATERIALS AND TECHNIQUES.

(i) Weaving techniques and fibres. Tapestry-weaving differs from cloth-weaving in that the weft does not travel from edge to edge in one pass. Each part of the design is built up independently, with the weft travelling in each pass only to the warp at the edge of a particular colour area before returning in the next pass. Each colour is built up from a base of the previous colour woven. The weft follows the same path as a plain weave (*see* TEXTILE, §II, 1). Two sheds are required; the weft is first placed behind one set of alternate warps and returns behind the remaining alternate warps. Each colour of the weft is contained on a bobbin with a pointed end. The weaver opens a shed, and the bobbin is passed by hand in short lengths behind a group of warps; the shed is then released, and the weft is knocked down with the bobbin, so that it lies weaving around straight warps. After several passes, the wefts are pressed down with a hand-held beater, until the warps are covered. Areas of plain colour are built up in this way. If they are large, they are built up in diagonal blocks (see fig. 1a). Where colours change along the line of a warp and the weft turns more than once on that warp, a space in the weaving, called a slit, is formed (1b). Slits are sometimes used as an effect to create a shape, such as facial lines, within one colour area. Usually they are

not required and are sewn together, either during the weaving or after the tapestry has been removed from the loom. Too many slits weaken the structure, so joins can be made by weaving the two adjoining colour areas at the same time and interlocking the two wefts (1c). It is not, however, always technically possible to interlock all joins, so a mixture of the two methods is found in most tapestries. A more decorative zigzag join can be created by dovetailing, that is, having wefts turn on alternate warps at the juncture.

Various techniques are used in mixing colours to create shading and patterns. Shading from one tone to another is created by hatching and hachures (1d). Two different colours woven together create an intermediate shade by mottling. Stripes and checks can be made by changing colours for each pass in various combinations. Colour refraction can be altered by varying the thickness of weft thread to give different surface textures. To create a smooth curved line, such as a defining outline, the weft can be passed at an angle over previously woven shapes (1e). The angle between weft and warp can be varied to some extent from 45°, in order to make a smooth angled shape.

Materials for tapestry-weaving are chosen for characteristics appropriate for the technique and for their visual quality when woven. The warp is held under high tension, so that each thread remains straight while the weft bends around it; this tension must be maintained for the usually long duration of the weaving process, and the warp sustains a certain amount of abrasion as weft threads are introduced. Consequently a strong thread with good elasticity is required. The thread most commonly used in historic tapestries, being both suitable and easily obtainable in Europe, was a tightly spun and plyed worsted wool. However, other fibres were occasionally used, for example linen in 15th- and 16th-century Swiss and German tapestries. From the 19th century cotton warps became common. Silk warps were very rarely used in European tapestries.

In early tapestries wool was the most commonly used fibre for weft threads. There, too, worsted wool was the most suitable, since the longer, aligned fibres gave a smooth and strong thread with a lustrous appearance. Colours were obtained with natural dyes, and wool, which has a good affinity for dyes, gave a range of strong shades. Silk was used for highlights in shading and to create such effects as rich fabrics.

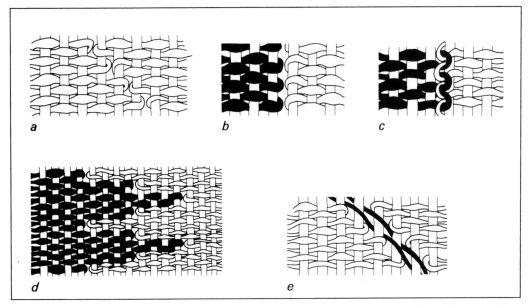

1. Tapestry-weave structures: (a) diagonal join between two sections of weave; (b) formation of a slit; (c) join formed by double interlocking; (d) shading created by hachures (e) angled weft creating smooth outline

Linen was used sparingly for highlights in early Swiss and German tapestries. In later centuries silk was used extensively; sometimes the silk content exceeded the wool content. In the finest tapestries gold, silver or silver-gilt-wrapped silk threads were woven in for a sumptuous effect. In the second half of the 19th century chemical dyes came into common use, gradually replacing natural dyes. In the 20th century man-made fibres became available and can provide some interesting surface effects.

(ii) Looms. Large tapestries are woven on looms, but small pieces can be woven on a simple frame. One of the two most commonly used looms is called high warp, because the warp is tensioned in a vertical position between two horizontal rollers, supported one above the other in a frame. Each roller has a tensioning device and a lengthwise groove, into which a rod holding the ends of the warp is secured by clamps. The bulk of the warp is rolled on to the upper roller, and the ends are attached to the lower roller. As the weaving progresses, the warp is periodically released from the upper roller, and the completed work is rolled on to the lower roller. To create a shed, a combination of a flat rod and heddles is used. The rod is inserted through the width of the warp, picking up alternate threads; the threads lying behind the rod are then encircled individually with string heddles, which are held on a heddle bar attached to the frame, above the weaving level. The weaver, working entirely by hand, alternately lowers and turns the rod for one shed and pulls on a group of heddles for the second shed. The high-warp loom was traditionally made from wood, but in modern times tubular-metal frames have become popular.

The other commonly used loom is known as the low warp (see fig. 2). It has the same basic components as the high-warp loom, but the warp is held in a horizontal position, with the rollers placed at the front and back of the frame. The warp is stored on the back roller, and the weaver works seated at the front roller, which stores the tapestry as it is completed. To form the sheds, short heddle bars, arranged in pairs, one behind the other, are suspended below the warp and attached to pedals operated by the weaver. Starting from one side of the warp width, threads are passed alternately through the string heddles of the front and the back bars before being secured to the front roller. To create a shed, one or other of the pedals is depressed. Because both hands and both feet are used, the low-warp loom is faster than the high-warp loom.

(iii) Making a tapestry. The process of creating a tapestry wall hanging starts with the choice of a design by a client, who may wish to commission an original subject or choose from a stock of previously woven designs. From an initial sketch, a painted cartoon is produced to the scale of the tapestry, with details of colours and shading; in the late 20th century the design can be enlarged by photographic techniques to the intended size of the tapestry. Both the cost of the tapestry and its detail are determined by the spacing of the warp threads. A closely spaced warp of 8–9 threads per 10 mm requires a fine weft thread and allows a great deal of detail in the use of colour and shading. A widely spaced warp of 4–5 threads per 10 mm requires a coarser weft and is suitable for a bolder design with less detail. Once the size and quality of the tapestry have been decided, sometimes following the weaving of a sample piece, the warp is

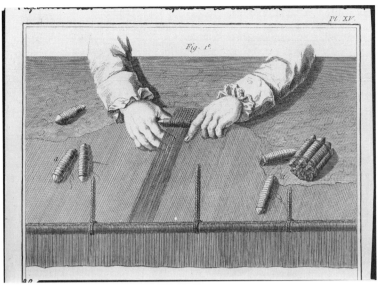

2. Low warp technique at the Gobelins Tapestry Manufactory; from Denis Diderot: *Encyclopédie, ou Dictionnaire raisonné des sciences, des arts et des métiers* (Paris, 1751–65); photo © Visual Arts Library (London)/Alamy

prepared and mounted on the loom, with great attention paid to maintaining even tension overall.

The weaver begins by spacing the warps evenly. To maintain this spacing, a firm thread is woven in a plain weave for three or four passes across the width. A strip of selvage, approximately 100 mm wide, is woven in plain tapestry weave, usually in one colour, across the width of the warp, to act as an edge for the tapestry; it is continued up each side of the weaving and finally across, to form the other edge. Selvages often contain marks identifying the weaver and workshop. The design for the tapestry is now incorporated; either an outline drawing, taken from the cartoon, is pinned under the warp threads and can be seen through the spaces or the painted cartoon is placed behind the warp threads and each warp is marked with ink, so as to transfer the outlines of the design on to the warps. The painted cartoon is then hung beside the weaver, who can refer to it for colour and shading.

Most tapestries are woven so that, when they are hung, the warp direction runs horizontally. One reason for this is that the height of a tapestry is often restricted by ceiling height, but considerable width is possible; it is therefore practical to choose as the smallest dimension the warp width, which is limited by the loom width. Technically, it is easiest to interpret the design with smooth, crisp lines if the weft runs in the direction of most elongated shapes (see fig. 3), such as human figures, trees and buildings; thus, when the tapestry is hung, the weft runs vertically. The designs for modern tapestries, particularly abstract ones, often lend themselves to being woven with vertical warps if most of the shapes run horizontally; the warps must also run vertically in the occasional instances where the height of the tapestry is much larger than the loom width.

When the warps run horizontally, the tapestry has to be woven with the design sideways to the weaver. Traditionally, the weaver works facing the reverse of the weaving, which protects the face of the tapestry from abrasion and dust and makes easier the working of such techniques as interlocking. Therefore the design is worked both back to front and sideways. Weavers using a high-warp loom are able to see a section of the front of the weaving and can also prop a mirror behind the warps to reflect the front as it is woven. The low-warp loom does not allow the front to be seen; the first glimpse the weaver has of the tapestry is when it is removed from the loom on completion. In order to avoid this difficulty, some contemporary weavers prefer to weave with the front of the tapestry towards them.

When the weaving is completed, the warps are cut, releasing the tapestry from the loom. It can be blocked by dampening it and pinning it out flat under tension, to remove minor distortions. The side selvages are turned and sewn down to secure the warp ends. A lining and a means of hanging are then attached.

D. Diderot and J. Le Rond d'Alembert: *L'Encyclopédie Diderot et d'Alembert: Tapissier* (Paris, 1786)

W. G. Thomson: *A History of Tapestry from the Earliest Times until the Present Day* (London, 1906, rev. Wakefield, 3/1973)

R.-A. Weigert: *La Tapisserie française* (Paris, 1956; Eng. trans., London, 1962)

C. C. Gillespie, ed.: *A Diderot Pictorial Encyclopedia of Trades and Industry*, 2 vols (New York, 1959/R 1993)

J. Jobé, ed.: *The Art of Tapestry* (London, 1965)

W. S. Sevensma: *Tapestries* (London, 1965)

I. Emery: *The Primary Structures of Fabrics* (Washington, DC, 1966)

T. Beutlich: *The Technique of Woven Tapestry* (London, 1967)

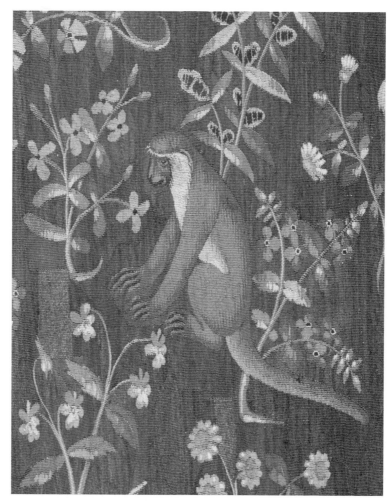

3. Tapestry depicting a monkey, wool and silk, detail from *Taste,* from the series of the *Lady and the Unicorn*, woven in the Low Countries based on cartoons made in Paris, 1484–1500 (Paris, Musée de Cluny); photo credit: Réunion des Musées Nationaux/Art Resource, NY

M. Jarry: *World Tapestry from its Origins to the Present* (New York, 1969)

M. Rhodes: *Small Woven Tapestries* (London, 1973)

M. Pianzola and J. Coffinet: *Tapestry* (New York, 1974)

A. G. Bennet: *Five Centuries of Tapestry* (San Francisco, 1976, rev. 2/1992)

A. Geijer: *A History of Textile Art* (London, 1979)

K. Wilson: *A History of Textiles* (Boulder, CO, 1979)

D. K. Burnham: *Warp and Weft: A Textile Terminology* (Toronto, 1980)

F. P. Thomson: *Tapestry: A Mirror of History* (Newton Abbot, 1980)

Master Weavers: Tapestry from the Dovecot Studios, 1912–1980 (exh. cat., Edinburgh, Scottish Arts Council, 1980)

A. Garrould and V. Power: *Henry Moore Tapestries* (London, 1988)

C. K. Russell: *The Tapestry Handbook: An Illustrated Manual of Traditional Techniques* (Asheville, 1990/R London, 1991)

N. Harvey: *Tapestry Weaving: A Comprehensive Study Guide* (Loveland, 1991)

T. Campbell: 'Tapestry', *Textiles: 5,000 Years*, ed. J. Harris (New York, 1993), pp. 188–99

A. Seiler-Baldinger: *Systematik der textilen Techniken* (Basle, 1991; Eng. trans. Washington, DC, 1994)

2. CONSERVATION.

(i) Introduction. For the purposes of conservation it is necessary to place tapestries in a category of their own. There are several reasons for this. Tapestries have always been expensive and highly valued, especially since they often incorporate fine silk and metal threads. The skill of manufacture and pictorial subject-matter, together with the fact that they were designed by such well-known artists as David Teniers II (1610–90) and William Morris (1834–96), have given them a cultural significance and monetary value more commonly associated with paintings than with textiles. From a practical point of view certain characteristics of the tapestry-weaving technique, along

with the great size and weight of many hangings, give rise to specific problems that need to be dealt with by specialist conservators. In addition, the space, equipment and skill required in handling a delicate object that can measure as much as 4–5 m high and 8 m long, and the difficulties of maintaining a consistent standard of workmanship throughout a single treatment that might last many months or even years, mean that tapestry conservation has to some extent evolved as a separate discipline.

Until the second half of the 20th century tapestries that showed signs of deterioration were restored rather than conserved. This generally entailed the removal of all weak fibres, such as friable silk weft, and the replacement of damaged areas by reweaving. In this way, the appearance of the tapestry was renewed, and the repaired areas became an integral part of the structure. This approach was acceptable when the materials and weaving skills matched those of the original, or when the work was carried out by the workshop that made the tapestry originally. However, much damage has been caused by unskilled restorers using substandard materials, especially in the 19th and 20th centuries. The reweaving often ignores the finer details and even the colouring of the original, producing results that dramatically change the aesthetic quality of the weaving. Conservation, on the other hand, seeks a compromise that enables the viewer to perceive the original intentions of the designer and weaver without being distracted by the areas that have been damaged. The solution is usually a sewing technique that reduces the visual discrepancy between the damaged and intact areas but cannot be mistaken for the original weaving; nor does it require the removal of any of the original yarn.

The deterioration of tapestries is the result of both weaknesses inherent in their structure and external factors. Twentieth-century tapestries are likely to be woven with a vertical warp, but nearly all earlier ones are woven so that the warp lies horizontally as the tapestry hangs. This means that the weight of the hanging is borne by the weft threads, and in tapestry-weaving the weft is not continuous from one side to the other but is joined together in various ways (see §1 above). These joins are potential weaknesses on which the weight of the tapestry, combined with its movement in relation to environmental changes (see CONSERVATION AND RESTORATION, §II, 1), can put a considerable strain. Certain areas are especially vulnerable. The slits that were left open by the weaver, to emphasize a line or exaggerate a form, can gape and become distorted, as can those where the sewing thread has broken. The line between two blocks of weft, where one yarn is locked around another, is also vulnerable, especially when one area is in wool and the other in silk. Any warps that have been exposed by the disappearance of the weft will hang in swags and eventually break. As dust and dirt collect on them, they will discolour quickly.

Tapestries that are hung within an ornate framework often fare better than those that hang free from the top edge. This is probably because the warp is pulled taut, and all four sides of the tapestry are attached to a stretcher beneath the frame. Thus the weight of the textile is more evenly distributed and is not taken entirely by the weft. However, once areas have been weakened, the tapestry can drop or stretch even within a frame. It will then bulge outwards across the bottom edge and appear to be held up too tightly at the sides.

Other damage, often less immediately visible, may be caused by external factors. The photochemical action of light will break down the silk fibres, and large areas of weft, notably in the sky or in highlighted details, may fall out. Light will also fade dyes, and this may only become apparent when the face of the tapestry is compared with the reverse. Some dyes—the dark browns, blues and reds that were applied with an iron mordant—may themselves embrittle the wool fibre (see DYE, §2). Insect attack may remain undetected for years, and, especially in tapestries of a fine warp count, the tiny moth holes may only be discovered when detailed examination takes place during conservation. If two or more warps have been eaten through, the dirt collects around the ends of the wool yarn, and the tapestry becomes spotted with black marks.

(ii) Treatment. Tapestries must be protected like any other textiles by preventive conservation. When conservation treatment becomes necessary, a thorough initial examination must take place. This will establish why, where and to what extent damage has occurred, how much original weaving remains and whether the tapestry requires only remedial repair or full conservation.

Remedial conservation may involve surface vacuuming, checking and sewing of slits, and relining. If no further treatment is required, surface vacuuming can be carried out while the tapestry is hanging. The vacuum-cleaner nozzle is drawn slowly over the surface of the weave in the direction of the weft. The appearance and safety of the tapestry will be improved by the attachment of a suitable hanging mechanism. It is important that the weight of the tapestry be distributed evenly along the top edge to avoid specific points of strain.

Full conservation will first require the removal of all such extraneous material as linings, old repairs or patches. Extensive restorations are not necessarily removed, unless they are causing distortion or are visually disturbing. Many old tapestries are very dirty and can be much improved by washing. Wet cleaning, however, is irreversible and can be destructive, so it should only be used after the dyes have been colour-tested and the condition of the tapestry has been carefully assessed. If large areas of the silk weft are friable, they may be lost when the tapestry is immersed in water. Wool yarn, too, may be so damaged that it will break up during the cleaning process. The amount of loss that may occur cannot be precisely determined, but some at least must be expected. This may result in the

removal of valuable evidence about a colour or yarn used in a given area, so detailed documentation, including photographs, is essential at this stage.

Before wet cleaning the tapestry must be vacuumed and weak areas protected by a temporary covering of fine net. Sometimes the whole tapestry, back and front, will be sandwiched in net. For ease of handling during this stage, the tapestry will need to be rolled. Large tapestries are best washed in a flat bath so that the whole textile can be viewed at once. Depending on the nature of the soiling, long periods of soaking may be required. As a general guide, two or three applications of non-ionic detergent are made on the front and then again on the back. Between each wash the tapestry is thoroughly rinsed with purified water to flush away the released dirt. The final rinse may take as much as three hours, and the entire wash can occupy a whole day. The tapestry is blotted with white sheeting and laid out flat to dry. Drying should not take more than two days. If the warp yarn is cotton or linen, the drying period may be longer. Discoloration and shrinkage can occur if drying is not controlled, and wet cleaning may in fact be inadvisable.

Conservation requires the addition of a lightweight fabric sewn on the reverse of the tapestry to support the sewing repairs. If the weak areas are few and isolated from each other, small patches of fabric may suffice. Often, however, a full support is required. This should be a strong, undyed, lightweight fabric stripped of all impurities and dressings; traditionally the choice has been linen scrim. When the fabric is measured and prepared, allowances are made for a certain amount of fullness, which will be taken up by the stitching. This extra fullness also enables movement in both the tapestry and support after conservation.

During the treatment, the tapestry and its support are sewn together section by section. Work is carried out on a frame with three rollers (see fig. 4). The scrim occupies the front and middle rollers, while the tapestry is attached to the front and back ones, the warp lying at right angles to the rollers. As work proceeds, the tapestry and scrim are sewn together by detailed conservation stitching, and each completed section is rolled on to the front roller. The slits are sewn up and the bare warps and weak weft held with couching, a spaced darning technique in which lines

of stitching are worked over and under alternate warps. Parallel lines are worked $c.$ 2–3 mm apart, the stitches being taken over warps that were not covered in the previous row.

The yarns are chosen to blend into the original weaving both in colour and texture, but when no evidence of the original colour exists a neutral tone is used. Where whole areas are missing, couching in the appropriate colours is worked to suggest the original design. Certain schools of thought believe that this practice is unethical and that what remains must be accepted as it is without embellishment. This may be reasonable for small fragments, but the appearance of larger pieces may be seriously impaired if there are extensive areas of missing weft.

Following the supporting treatment, the linen scrim and the warp ends of the tapestry are turned under. If the galloon (the very outer edge of the tapestry, generally woven in one colour) is missing, a replacement may be added. A lining is attached (similar to a curtain lining but again with extra fabric for movement), together with a hanging mechanism. When a tapestry is rehung after conservation, the natural drop or stretch of the weave must be taken into account. The tapestry should be left to hang freely for a short period to allow it to find its own level before the linings are turned up or the edges are attached to a stretcher. Even if this precaution is taken, adjustments may be necessary later.

See also TEXTILE, §IV.

W. Hefford: '"Bread, Brushes and Brooms": Aspects of Tapestry Restoration in England, 1660–1760', *Acts of the Tapestry Symposium: San Francisco, 1976*, pp. 67–75

M. Lemberg: 'The Problem of Brown Wool in Mediaeval Tapestries: The Restoration of the Fourth Caesar Tapestry', *Studies in Textile History in Memory of Harold B. Burnham*, ed. V. Gervers (Toronto, 1977), pp. 178–83

K. Marko, V. Blyth and J. Kendall: 'Three Methods of Handling and Washing Large Tapestry Hangings', *The Conservator*, v (1981), pp. 1–8

F. Hartog: 'An Away Day to Belgium—Washing Tapestries', *Victoria and Albert Museum Conservation Journal*, xlviii (Autumn 2004), pp. 6–7

F. Lennard: 'Preserving Image and Structure: Tapestry Conservation in Europe and the United States', *Reviews in Conservation*, vi (2006)

F. Lennard and M. Hayward, eds: *Tapestry Conservation: Principles and Practice* (Amsterdam, 2006)

Technical examination. Examination of a work of art by technical means; its aims are, first, to identify the raw materials used and, where appropriate, their geographic source or provenance; second, to investigate the techniques used in production; third, to establish the age and authenticity; and finally, to provide a full record of the surface appearance.

I. Introduction. II. Surface appearance and macrostruture. III. Recording techniques. IV. Microscropy. V. Inorganic analysis. VI. Organic analysis. VII. Age determination. VIII. Raw materials, production techniques and authenticity.

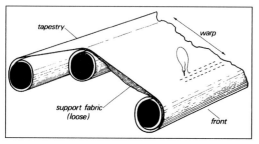

4. Tapestry conservation frame and support stitching technique

I. Introduction. Clearly, the relative importance of these four aspects of technical examination, as well as the most appropriate scientific techniques to use, depends critically on the specific work of art under consideration, be it a building, a sculpture, a ceramic, a piece of decorative metalwork, a painting or a textile. Aspects of a work of art that are relevant in this context include its physical size, whether it is three-dimensional or two-dimensional and whether it is made predominantly from inorganic or organic material.

The first stage is to examine the work of art and provide a record of its surface appearance and macrostructure using entirely non-destructive methods (*see* §§II and III below). This approach starts with simple visual examination and photographic recording. The examination can then be extended to the use of low-power microscopy, to observation under ultra-violet and infra-red light and to X-ray radiography in order to investigate the underlying structure. The recording can be further extended to the use of a variety of specialized and ever-evolving techniques.

The second stage involves the extension of visual examination to higher magnification (*see* §IV below) in order to obtain information on the microstructure of the materials from which the work of art was made. Such an examination normally involves the removal of a small sample. It starts with optical microscopy of polished cross-sections through the materials in reflected light, or of thin cross-sections in transmitted light. The former are normally used in the case of metals and the latter in the case of stone, ceramics and structural biological materials, for example wood and bone. The examination can then be extended to higher magnification, using either scanning electron microscopy of polished sections or transmission electron microscopy of ultra-thin sections. X-ray spectrometers can be attached to both types of electron microscope in order to provide compositional analysis of small areas of interest within the microstructure.

The third stage is concerned with determining all aspects of the composition of the materials from which the work of art was made. The range of techniques employed depends very much on whether the investigator is concerned with such inorganic materials as stone, metal, ceramics and glass (*see* §V below) or such organic materials as resins, waxes, glues and dyes (*see* §VI below).

In the case of inorganic materials, the investigation starts with the determination of the bulk elemental composition of the material. Classical wet chemical methods of analysis have now been superseded by a very wide range of physical methods. These involve the measurement of characteristic electromagnetic radiation (visible light, X-rays and γ–rays) associated with the excitation of the outer electrons (e.g. by optical emission, atomic absorption and inductively coupled plasma spectrometry), the inner electrons (e.g. by X-ray fluorescence and particle-induced X-ray emission spectrometry) and the nuclei (e.g. by neutron activation analysis and particle-induced γ-ray emission spectrometry) of the constituent atoms. Specialized extensions to bulk elemental analysis include the analysis of extremely thin surface layers using such techniques as secondary ion mass spectroscopy and X-ray photoelectron spectroscopy; the analysis of the pigment distribution over a painting using neutron-induced autoradiography; and the analysis of particular phases within a material using electron-probe microanalysis. Having determined the elemental composition of a material, it is sometimes also appropriate to determine the relative abundance of the different stable isotopes for specific elements (in particular lead, carbon and oxygen) using mass spectrometry.

As well as determining the elemental and isotopic composition of inorganic materials, it is frequently also necessary to identify the different mineral and metal phases present. Apart from optical and electron microscopy, the most generally applicable method is X-ray powder diffraction analysis. However, in addition, infra-red spectrometry is useful for the identification of poorly crystalline inorganic phases; thermal analysis is useful in the study of pottery; and Mossbauer spectroscopy is useful for the identification of iron-bearing phases.

In the case of organic materials, separation or chromatography methods (i.e. paper, thin-layer, gas-liquid and high-performance liquid chromatography) are of primary importance in the identification of the different organic compounds present. In addition, mass spectrometry is often used in conjunction with gas-liquid chromatography, and both infra-red spectrometry and nuclear magnetic resonance can provide valuable supplementary data.

The fourth stage in the technical examination is concerned with determining the age, and hence the authenticity, of the work of art (*see* §§VII and VIII below). The most important scientific methods for absolute age determination are radiocarbon dating, which is applicable to all materials that once formed part of the biosphere; thermoluminescence dating, which is applicable to ceramics and, where present, to the heated clay cores of metal objects; and dendrochronology, which is applicable to wood, for example building timbers and in panel paintings. In the case of works of art made from materials that cannot be dated by these methods (e.g. stone, metal, glass) authentication must instead be based either on whether the materials and methods of fabrication are appropriate to the ascribed age or on the extent of surface weathering and patination.

Archaeometry (1958–)

H. Hodges: *Artifacts: An Introduction to Early Materials and Technology* (London, 1964, rev. 2/1989)

H. Hodges: *Technology in the Ancient World* (London, 1970)

M. S. Tite: *Methods of Physical Examination in Archaeology* (London, 1972)

S. J. Fleming: *Authenticity in Art* (London, 1975)

National Gallery Technical Bulletin (1977–)

D. R. C. Kempe and A. P. Harvey, eds: *Petrology of Archaeological Artefacts* (Oxford, 1983)

J. S. Mills and R. White: *The Organic Chemistry of Museum Objects* (London, 1987)

J. Henderson, ed.: *Scientific Analysis in Archaeology*, Oxford University Committee for Archaeology, Monograph 19 (Oxford, 1989)

Fake? The Art of Deception (exh. cat., ed. M. Jones; London, British Museum, 1990)

S. G. E. E, ed.: *Science and the Past* (London, 1991)

I. N. M. Wainwright: 'Physics and the Scientific Examination of Works of Art', *Physics in Canada*, lviii/5 (Sept–Oct 2002), pp. 225–32

Conservation Science 2002: Papers from the Conference Held in Edinburgh, Scotland, 22–23 May 2002

K. Janssens and R. Van Grieken: *Non-destructive Microanalysis of Cultural Heritage Materials* (Amsterdam, 2004)

R. Van Grieken and K. H. A. Janssens, eds: *Cultural Heritage Conservation and Environmental Impact Assessment by Non-destructive Testing and Microanalysis* (Lisse, 2005)

II. Surface appearance and macrostructure. The technical examination of a work of art starts with the investigation of its surface appearance and macrostructure using a combination of visual examination, low power microscopy, observation under ultra-violet and infra-red light and X-ray radiography.

1. LOW POWER MICROSCOPY. Examination of the surface of an object with a binocular microscope at magnifications in the range 10× to 80× is the essential supplement to visual examination (see fig. 1). Together these two methods provide a very powerful tool for obtaining information on the raw materials and technology used in the production of a wide range of objects. Thus, with the necessary experience, it is frequently possible to identify the rock type or mineral used for stone objects, the temper added to pottery and the species of plant or animal from which such materials as wood, fibres and skins were obtained. Tool marks produced by working stone, metals , wood and bone can be similarly studied. The detailed construction of complex metal objects can often be successfully elucidated. Also, the different methods used in forming ceramics and glass vessels can be distinguished, and craquelure and areas of damage on paintings can be studied. In areas of paint loss, a preliminary assessment of any layer structure can be made, and thus information can be obtained on overpainting and paint film defects.

A recent development in low power microscopy has been the introduction of video microscopy, consisting of an optical fibre plus camera probe that provides video output. With this system it is possible very easily to examine bulky objects and to look into orifices. A significant increase in the depth of field, as compared to that of conventional optical microscopy, is also achieved.

2. ULTRA-VIOLET AND INFRA-RED LIGHT. Examination of an object under either ultra-violet or infra-red light can sometimes reveal information on its construction not apparent under visible light.

Under ultra-violet light certain organic chemicals fluoresce and give out visible light. Many glues and binding agents have this property, so that if a false patina made from ground-up minerals has been stuck in place on a metal object with such a glue, the patina will fluoresce. On paintings, relatively recent retouchings and overpaints can sometimes be detected, since such areas tend to fluoresce less strongly than the well aged surrounding media. Also, examination of paintings by ultra-violet light during varnish removal will often help in determining the progress made in cleaning.

Infra-red light has the ability to pass through certain materials opaque to visible light. Thus the denser surface of a solid object below a layer of dirt can sometimes be recorded using either infra-red photography or an infra-red vidicon camera. Similarly, the carbon black or metalpoint lines of underdrawings on paintings can be revealed, the examination of early Netherlandish paintings by this method being particularly successful because of their generally thinner paint layers.

L. Olivier and others: 'The Evolution of Rubens's Judgement of Paris (NG 194)', *National Gallery Technical Bulletin*, xxvi (2005), pp. 4–22

3. X-RAY RADIOGRAPHY. X-rays penetrate solid materials that are opaque to light and can thus reveal details of construction deep within an object. The object to be examined is placed in the X-ray beam, and the penetrating X-rays impinge on an X-ray sensitive film beneath the object. Variations in density within the object result in differential absorption of the X-rays and thus appear as variations in contrast on the film, dark areas on the film corresponding to low density and vice-versa. Using X-ray radiography, it is possible, therefore, to detect repairs within ceramic and metal objects concealed respectively by glaze and a fake patina. Similarly, within an unrestored metal object, components made from different materials and soldered joints can be revealed.

On paintings, areas of retouching and overpainting can sometimes be detected because of variations in the thickness and density of the different pigments used, lead-based pigments being especially opaque to X-rays. In favourable cases, the 'fingerprinting' of a particular artist's handling of paints and brushwork may be revealed, as may the work-up of such details as anatomical and architectural elements in relation to the background and overall composition. Also, detailed examination of the structural elements of the painting support is possible, and information on the texture of the canvas or on the wooden panel and stretcher construction can thus be obtained.

A. Gilardoni, R. A. Orsini and S. Taccani: *X-rays in Art* (Mandello Lario, 1977)

III. Recording techniques.

1. PHOTOGRAPHY. The examination of works of art by photographic methods falls into two main categories: the first uses the visible portion of the

1. Getty Conservation Institute scientist examining a 19th-century photograph (Los Angeles, CA, Getty Conservation Institute); photo © The J. Paul Getty Trust, all rights reserved

electromagnetic spectrum, the second either ultra-violet or infra-red radiation. In the former, objects can be photographed under white light through primary colour filters; this enhances definition by increasing the contrast between colours. Raking or tangent light photography under a parallel beam light source positioned across the surface of an artwork will throw the surface into relief and so demonstrate the impasto, surface irregularities and any warping. A polarizing filter placed in front of the camera lens reduces surface reflection, and if at the same time the light source is transmitted through polarizing screens, the reflections will be eliminated entirely. This technique of cross polarization will also increase the contrast. Finally, the light can be transmitted through the support medium to show the structure of a canvas (if it is translucent enough) or the watermarks in a paper.

If an artwork is illuminated with an ultra-violet light source and photographed through an ultra-violet passing filter, hidden detail may be revealed. Ultra-violet light may also produce fluorescence, which can be photographed through an ultra-violet absorbing filter that records only this fluorescence. At the other end of the spectrum, infra-red radiation can be photographed through an infra-red passing filter. In infra-red reflectography the light source is reflected from the surface, while in infra-red transmitography it is transmitted through the artwork.

J. Coddington and S. Siano: 'Infrared Imaging of 20th Century Works of Art', *Tradition and Innovation: Advances in Conservation: Contributions to the Melbourne Congress, 10–14 October 2000*, pp. 39–44

P. Swallow and others: *Measurement and Recording of Historic Buildings* (Shaftesbury, 2004)

2. PHOTOGRAMMETRY. Photogrammetry is the method of taking measurements through the medium of photography. Strictly speaking, any measurement made through the use of a photograph might be classed as photogrammetric. In practice, however, the term is usually reserved for accurate measurement achieved through taking stereoscopic photographs of the object with a 'metric' or calibrated camera and then measuring the photographs in a specialized photogrammetric instrument. The accuracy of the process is very high.

The traditional area of application of this form of photogrammetry has been in aerial survey for the preparation of maps. Since the 1970s its widespread application in the field of architecture has also developed, with similar principles; the most common products are elevation drawings of façades at scales of 1:20 or 1:50. 'Stereo' photography, which can be viewed in three dimensions, is also an excellent form of record.

Photogrammetric techniques can, however, be used for the measurement of any object. Being a non-contact method, photogrammetry might, for example, be valuably employed to obtain measurements of a very fragile object. On the other hand, if a simple measurement of a robust object (e.g. a stone moulding profile) is needed, the technique will usually be too complicated and expensive.

A related technique is rectified photography. This involves taking a photograph parallel to an essentially flat surface and printing the photograph to a precise scale. This method is extensively used for architectural recording but may be adapted for other areas, for example in recording wallpaper.

K. B. Atkinson. ed.: *Developments in Close-range Photogrammetry*, i (London, 1980)

H. M. Karara, ed.: *Non-topographic Photogrammetry* (Falls Church, VA, 1989)

K. Pavelka and T. Dolansky: 'Using of Non-expensive 3D Scanning Instruments for Cultural Heritage Documentation',

Proceedings of the XIXth International Symposium, CIPA 2003: New Perspectives to Save Cultural Heritage: Anatalya (Turkey), 30 September –04 October 2003, pp. 534–6

3. HOLOGRAPHY. A hologram is a photographic record of the pattern produced by the interference of two coherent light beams derived from the same source. One, the 'object' beam, is reflected from the object on to the plate; the other beam, the 'reference' beam, falls directly on the plate. When the processed hologram is placed back in the reference beam, a three-dimensional image appears in the position of the original object. Lasers are the only suitable light sources for making holograms.

If two holographic exposures are made of an object on the same plate, and the object is slightly deformed between the exposures (by applying stress or by changing temperature, humidity etc.), the two interference patterns will generate large moiré fringes on the image surface, contouring the deformation at intervals of one half-wavelength (*c.* 0.0003 mm). This technique is known as holographic interferometry. Its main application in art is in the preliminary examination of art works that require restoration or preservation treatment. It can be used, for example, to detect areas of poor adhesion between paint and substrate, internal cracks in wood-carvings and structural weaknesses in statuary, all non-invasively. A related technique, speckle interferometry, uses a television camera and laser illumination to produce lower-resolution fringe patterns in real time.

Another useful technique is holographic contouring. Two exposures of the object are made using slightly different wavelengths. The resulting moiré pattern is a contour map of the object with intervals that depend on the difference between the wavelengths, the available intervals ranging from about one wavelength (*c.* 0006 mm) to several millimetres. Apart from its uses in the three-dimensional mapping of art works, the technique can show up areas of erosion that would not otherwise be detectable.

F. Gori: 'Applications of Holography to the Restoration of Works of Art', *Coherent Optical Engineering*, ed. F. T. Arecchi and V. Degiorgio (Amsterdam, 1977), pp. 225–36

N. Abramson: *The Making and Evaluation of Holograms* (New York, 1981)

S. Amadesi and others: 'Sandwich Holography for Painting Diagnostics', *Applied Optics*, xxi (1982)

S. Amadesi and others: 'Real-time Holography for Microcrack Detection in Ancient Golden Paintings', *Optical Engineering*, xxii (1983), pp. 660–62

P. Carelli and others: 'Holographic Contouring Method: Application to Automatic Measurements of Surface Defects in Artwork', *Optical Engineering*, xxx (1991), pp. 1294–8

G. Saxby: *Manual of Practical Holography* (Oxford, 1991); rev. as *Practical Holography* (Hemel Hempstead, 1994)

J. M. Dulieu-Barton and others: 'Deformation and Strain Measurement Techniques for the Inspection of Damage in Works of Art', *Reviews in Conservation*, vi (2005), pp. 63–73

IV. Microscopy.

1. OPTICAL. The examination of a cross-section through a material under an optical microscope provides information on its microstructure. The limit of resolution for an optical microscope is typically about 0.5 μm, so that the maximum usable magnification is about 1000×. If significantly higher resolution is required, electron microscopy, in which high energy electrons replace visible light as the source of 'illumination', must be used.

The examination of microstructure normally involves the removal of a small sample from which either a polished cross-section for use in reflected light or a thin cross-section for use in transmitted light is prepared. However, it is sometimes possible to prepare a cross-section for examination in reflected light by merely polishing the surface of an object without the need to remove a sample.

For metals, polished, etched cross-sections are examined in reflected light using a metallurgical microscope. These examinations reveal the internal structure of the metals, which in turn provides information on the thermal and mechanical treatments to which they have been subjected. For example, after casting, a non-ferrous alloy (e.g. gold, silver, copper) exhibits a 'cored' dendritic structure. With subsequent cold working, the dendrites become distorted; if the object is then annealed, the dendrites disappear, and polyhedral twinned grains are formed. Similarly, the processes (e.g. carburization, quenching, tempering) used in the manufacture of iron and steel can be inferred from the various iron-carbon phases observed.

For stone and ceramics, thin cross-sections, typically about 30 μm thick, are examined in transmitted light using a petrological (i.e. polarizing) microscope. In this way it is possible to determine the rocks used to make stone objects and the rock and mineral fragments present in the ceramic bodies. The minerals are identified by means of the observed crystal shape, cleavage planes and, most importantly, optical properties (e.g. isotropy, pleochroism, twinning) in plane polarized light. The rock or the rock fragments can then be classified as one of the different types of igneous, metamorphic or sedimentary rocks on the basis of the relative proportions, size, shape and arrangement of the minerals identified.

Structural biological material (e.g. wood, bone, ivory, vegetable and animal fibres, skin) are again normally examined in thin section using transmitted light, although reflected light is employed in the case of materials exhibiting heavy pigmentation. The thin sections are typically stained with appropriate organic dyes in order to reveal details of cell structure that is otherwise frequently transparent and colourless. Alternatively, phase contrast microscopy can be employed. With this technique, cell structure is revealed as a result of the differential modification of the phase of the light, rather than through the differential absorption achieved after staining. The details of the cell structure revealed by either of

these microscopic techniques is invaluable for the identification of the plant or animal species from which the material is derived.

For paintings, polished cross-sections through the layers of paint down to the ground are examined in reflected light. The technique is used primarily for the investigation of the pigment layers present. The different pigments are identified on the basis of their optical properties in plane polarized light supplemented by microchemical tests. In addition, some information on the nature of the binding medium can be obtained by staining the section with an appropriate dyestuff and observing which layers take up the stain.

2. ELECTRON. For the examination of material at magnifications greater than the 1000× possible with optical microscopy (see §1 above), it is necessary to resort to electron microscopy. Electron microscopes are of two basic types, scanning and transmission, which are more or less analogous to reflected and transmitted light microscopy respectively. With both types of electron microscope, a very narrow beam of electrons is focused on to the specimen using electromagnetic lenses.

In the case of the scanning electron microscope (SEM), the electron beam is scanned back and forth across the surface of the specimen. As the electrons hit the sample, some are backscattered from the surface and some generate secondary electrons, a proportion of which escape from the surface. These backscattered and secondary electrons are converted into electronic signals that give rise to images of the scanned area on a television screen. Magnifications up to at least 50,000× can thus be obtained. A further major advantage of an SEM, as compared to an optical microscope, is its much greater depth of focus: it is possible to examine a rough surface at high magnification with both the 'hills' and 'valleys' fully in focus. This technique is therefore valuable for examining tool or wear marks on stone, metals and bone, either directly on the surface of the object or on a cast taken from the surface. Alternatively, using polished cross-sections, the internal microstructures of materials can be investigated at magnifications far higher than those possible with optical microscopy. When an X-ray spectrometer (see §V, 4 below) is attached to the SEM, the elemental composition of the phases present in the microstructure can be determined. This approach has proved to be useful in the study of a wide range of materials, in particular, for such high-fired ceramics as porcelain, the microstructure of which tends to be too finely textured for resolution under an optical microscope.

In the case of transmission electron microscopy (TEM), the electron beam passes through the sample. Because electrons are rapidly absorbed, the sample must be very finely crushed or prepared as extremely thin sections. The magnification range of the TEM overlaps that of the SEM but also extends to considerably higher magnifications, allowing very fine inclusions to be imaged. In addition, electron diffraction patterns can be formed and used to provide information on the structure and identity of these minute particles. For example TEM examination of a sample taken from the Lycurgus Cup (London, British Museum), an outstanding late Roman cut-glass cage-cup, which appears wine-red in transmitted light and pea-green in reflected light, has confirmed that its dichroism is due to light scattering by silver-gold-copper particles as small as 50 nm in diameter.

M. Schreiner, M. Melcher and K. Uhlir: 'Scanning Electron Microscopy and Energy Dispersive Analysis: Applications in the Field of Cultural History', *Analytical and Bioanalytical Chemistry*, ccclxxxvii/3 (2007), pp. 737–47

V. Inorganic analysis.

1. BULK ELEMENTAL ANALYSIS. Bulk elemental analysis involves the determination of selected major elements (100–2%), minor elements (2–0.01%) and trace elements (0.01% to 0.1 parts per million). In choosing a technique for the analysis of works of art, a primary consideration is the need to minimize the damage to the object. Although a completely non-destructive method of analysis represents the ideal, this is very rarely possible. Instead, one looks to a method that requires less than some 50–100 mg of sample that can be removed, typically by drilling, from an unobtrusive position on the object. Other factors determining the choice of technique include the elements for which the sample is analysed, their concentrations (trace, minor, major) and the accuracy required.

In view of the need to minimize damage and analyse for a wide range of elements down to trace concentrations, classical wet chemical methods have been largely superseded by a range of physical methods of analysis. These involve the measurement of electromagnetic radiation (visible light, X-rays, γ-rays) associated with the excitation of the electrons and nuclei of the constituent atoms. In each case, the wavelengths of the electromagnetic radiation are characteristic of the elements present and can be used to identify them, while the intensity of the radiation at these wavelengths provides an estimate of the concentrations of the corresponding elements.

With optical emission spectrometry (OES) the sample, either in solution or in powder form, is subjected to an electric discharge between two electrodes. The sample is thus volatilized, the outer electrons of the constituent atoms are excited, and when they return to their unexcited ground state, near ultra-violet or visible light characteristic of the particular element excited is emitted. This light is separated into its constituent wavelengths using a prism or diffraction grating. It is then detected and its intensity determined using either a photographic plate or a series of photomultipliers. A major advantage of OES when used with a photographic plate is its ability to detect simultaneously a large number of elements down to trace concentration. However, fully quantitative analysis, particularly for major elements, is extremely difficult, and therefore the

method has been largely replaced by either inductively coupled plasma spectrometry (ICPS) or atomic absorption spectrometry (AAS).

With ICPS the electrical discharge used in OES to volatilize and excite the sample is replaced with an inductively coupled plasma, the sample, which is in solution, being aspirated into the plasma. Because the plasma operates at a much higher temperature than the electrical discharge, this system, when used with a series of photomultipliers to detect the emitted light, is fully capable of the simultaneous quantitative analyses of a large number of elements over a wide range of concentrations.

With AAS the sample, which again is in solution, is aspirated into an acetylene flame, where it is atomized. A hollow cathode lamp, the cathode of which is lined with the particular element chosen for analysis, provides light of the required characteristic wavelength. This light is focused on to the atomized sample, where it excites the outer electrons of atoms of the chosen element. The extent to which the light is absorbed depends on the concentration of the chosen element in the sample. This concentration is therefore determined by measuring the intensity of the emergent light beam, after absorption by the sample, using a photomultiplier. AAS is thus capable of providing fully quantitative analyses over a wide range of concentrations. However, as separate measurements are required for each element to be analysed, the method is somewhat time-consuming when a large number of elements are being studied.

In X-ray fluorescence spectrometry (XRF), the specimen is irradiated with primary X-rays from a high voltage X-ray tube. Inner electrons of the constituent atoms are thus displaced; when the vacant energy levels are refilled by outer electrons, secondary X-rays, the energies or wavelengths of which are characteristic of the particular element irradiated, are emitted. The secondary X-rays are detected either using a semiconductor counter (energy dispersive spectrometer), which determines both the energies and the intensities, or they are separated into their constituent wavelengths using a diffracting crystal and their intensities determined with a proportional counter (wavelength dispersive spectrometer). A major advantage of XRF is that the direct analysis of a work of art is possible, without prior removal of a small sample. However, because of the short range of X-rays, the analysis relates to only a thin surface layer of the specimen, which may not be representative of the bulk. Furthermore, unless the specimen is small enough to be accommodated in a vacuum chamber, only those elements with an atomic number above about 19 (i.e. potassium) can be analysed. In spite of these limitations, XRF is undoubtedly the most generally useful method for the qualitative analysis of works of art. Moreover, if a sample is removed and measurements are made in a vacuum, using a wavelength dispersive spectrometer, XRF is comparable to ICPS and AAS in regard to the number of elements that can be analysed and the accuracy achieved.

The minimum element concentration that can be determined, however, is somewhat higher for XRF.

In particle-induced X-ray emission spectrometry (PIXE), the specimen is irradiated with high-energy particles (typically protons; see fig. 2) from an accelerator, instead of with primary X-rays. Otherwise, the principles and procedures are similar to those for XRF. A major advantage of PIXE is that, because there are no Compton scattered X-rays, the minimum element concentrations that can be determined are significantly lower.

In neutron activation analysis (NAA) the specimen is irradiated with slow neutrons in a nuclear reactor. The neutrons interact with the nuclei of the constituent atoms, transforming them into unstable radioactive isotopes. These unstable isotopes subsequently decay to form stable isotopes with the emission of γ-rays, of which the wavelengths or energies are effectively characteristic of the elements originally irradiated with neutrons. After irradiation in the nuclear reactor, the γ-rays are detected using a semiconductor counter, which determines both their energy and intensity. As with XRF, completely non-destructive analysis is possible with NAA if the specimens are sufficiently small (coin-size) to be irradiated in the reactor. Furthermore, because of the long range of γ-rays, the composition of the entire specimen, rather than that of a thin surface layer, is determined. However, NAA cannot be used for all elements, since some do not form radioactive isotopes, and for others the decay time is too short for convenient measurement. Therefore, NAA is not as widely used for the analysis of works of art as XRF.

In particle-induced γ-ray emission spectrometry (PIGME) the specimen is irradiated with high-energy particles from an accelerator instead of with slow neutrons in a reactor. Otherwise, the principles and procedures are essentially similar to those for NAA. However, with PIGME it is possible to extend the range of elements to be analysed by varying both the type and energy of the particle radiation and the length of time between irradiation and measurements of the emitted γ-rays.

E. Angelini and others: 'Potentialities of XRF and EIS Portable Instruments for the Characterization of Ancient Artifacts', *Applied Physics A: Materials Science and Processing*, lxxxiii/4 (2006), pp. 643–9

2. SURFACE ANALYSIS. Surface analysis involves the determination of the elemental composition of a very thin surface layer of a specimen, typically 2–5 nm in thickness. Such a surface analysis is achieved either by the use of incident exciting radiation, which has a very low penetration depth, or by detecting emitted radiation, which has a very small escape depth.

In the case of secondary ion mass spectrometry (SIMS), the surface of the specimen is bombarded with an incident beam of, for example, argon ions. The resulting secondary ions emitted from the surface, which can be either atomic or molecular species, are analysed with a mass spectrometer. A depth profile of composition can be achieved by repeatedly

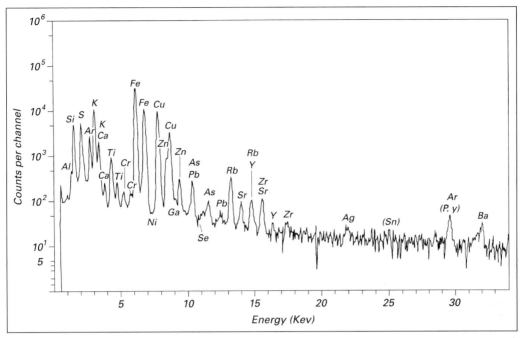

2. X-ray spectrum from particle-induced X-ray emission spectrometry (PIXE) analysis of rock sample irradiated with high energy protons

analysing the secondary ions emitted as the argon ion beam progressively sputters away the surface atoms. With X-ray photoelectron spectroscopy (XPS) low-energy X-rays provide the exciting radiation. The resulting photoelectrons emitted from the surface are analysed using a photoelectron spectrometer, the energies of these electrons being characteristic of the elements from which they were emitted. A depth profile of composition can again be obtained by progressively sputtering away the surface atoms using a beam of argon ions. Although providing only semi-quantitative elemental analyses, both these techniques can be used for the analysis of such low atomic number elements as carbon, as well as for providing some information on the oxidation states and chemical environments of particular elements.

The application of surface analysis techniques to the examination of works of art has been somewhat limited, in part because such works will most probably have suffered from weathering since being made. The present composition of the surface is therefore unlikely to be fully representative of its original composition. Indeed, in undertaking the analysis of such objects, it is normally regarded as essential first to remove the weathered surface layer, before using SIMS and XPS to analyse the newly exposed surface of the object. However, these techniques have some potential in the investigation of surface layers on, for example, ceramics and metals.

P. Gaspar and others: 'SIMS Analysis in Conservation Surface Studies', *Victoria and Albert Museum Conservation Journal*, xxxviii (Summer 2001), pp. 13–15

3. AUTORADIOGRAPHY. Autoradiography, otherwise known as neutron activation autoradiography (NAAR), involves the artificial induction of radioactivity among the mineral pigments of a painting by exposure to a thermal neutron flux emanating from a nuclear reactor. The induced radioactivity changes over a period of time, both in intensity and characteristics. This decay of different radionuclides produced in the differently pigmented paint layers may be monitored by bringing the picture into intimate contact with a succession of fresh photographic emulsions over a period of time following irradiation. By virtue of the different decay half-lives of individual radionuclides, these contact autoradiographs can provide useful information on the stratigraphical and topological distribution of various pigments within the painting, as well as an indication of the inorganic elements of the pigment molecules themselves.

P. Meyers and others: *Art and Autoradiography: Insights into the Genesis of Paintings by Rembrandt, Van Dijck and Vermeer* (New York, 1982)
C. Laurenze-Landsberg: 'Neutron Activation Autoradiography of Paintings by Rembrandt at the Berlin Picture Gallery', *Conservation Science 2002: Papers from the Confeence Held in Edinburgh, Scotland 22–24 May 2002*, pp. 254–8

4. ELECTRON-PROBE MICROANALYSIS. Electron-probe microanalysis (EPM) involves the determination of the elemental composition of particular phases within a material. As with scanning electron microscopy (*see* §IV, 2 above), a very narrow beam

of electrons is focused on to the specimen using electromagnetic lenses. The electron beam generates characteristic X-rays, which are then analysed using wavelength dispersive spectrometry (*see* §1 above). The elemental composition of the area irradiated by the electron beam is thus determined. The smallest area that can be analysed is about 1 micron, the specimen being in the form of a well-polished cross-section through a small sample taken from the object.

An electron-probe microanalyser is therefore more or less equivalent to an SEM with an attached X-ray spectrometer. It is thus similarly used to determine the elemental composition of both individual phases within a microstructure and different components of a specimen (e.g. separate layers of pigment on a painting or the glaze layer on a ceramic). The technique is used increasingly now also for the bulk elemental analysis of an object when only a very small sample can be removed, the analysis of glass being of particular importance in this context.

J.-C. Dran and others: 'Ion Beam Analysis of Art Works', *Nuclear Instruments & Methods in Physics Research Section B, Beam Interactions with Materials and Atoms* (2004), pp. 7–15

K. Janssens: 'A Survey of the Recent Use of X-ray Beam Methods for Non-destructive Investigations in the Cultural Heritage Sector', *Cultural Heritage Conservation and Environmental Impact Assessment by Non-Destructive Testing and Micro-Analysis* (Leiden, 2005), pp. 265–308

5. ISOTOPE ANALYSIS. Isotope analysis involves the determination of the relative abundance of the different stable isotopes (i.e. stable isotope ratios) of selected elements within a material using mass spectrometry. With this technique, atoms of the element under investigation are ionized, accelerated by an electric field, separated into the different isotopes (i.e. different masses) in a magnetic field and counted. For the majority of chemical elements the stable isotope ratios are the same, regardless of where the elements are found in the earth's crust. However, for certain elements the isotopic ratios vary significantly, depending on the origin of the material in which they are found. In the context of works of art, the relevant elements are lead, carbon and oxygen.

The ratios for the four stable isotopes of lead (lead-204, lead-206, lead-207, lead-208) depend on the geological age of the ores from which the lead was obtained and thus serve to characterize the different ore sources used in the past. Lead isotope analysis is therefore used in the investigation of the ore sources from which the lead used in lead objects, as well as in leaded glasses and glazes, derives. The method can also be used to investigate sources of silver produced from galena and of copper that contains small concentrations of indigenous, as opposed to deliberately added, lead.

The ratios of the stable carbon and oxygen isotopes (carbon-12 and carbon-13, and oxygen-16 and oxygen-18 respectively) in marble can similarly be used to characterize and identify the different quarries from which the marble for sculpture and buildings was obtained (see fig. 4 below). In this case, the isotopic ratios are determined by the geological conditions prevailing, in particular temperature and pressure, when the marble was formed.

6. MINERAL AND METAL PHASE IDENTIFICATION. As well as determining the bulk elemental composition of inorganic materials, it is also frequently important to establish which specific mineral and metal phases are present. In addition to optical and electron microscopy (*see* §IV above), X-ray powder diffraction analysis is the most widely used technique. Other techniques, which are only applicable to particular types of material, include infra-red spectrometry, thermal analysis and Mössbauer spectroscopy.

With X-ray powder diffraction analysis a beam of monochromatic X-rays is diffracted from the specimen on to a photographic film in a cylindrical camera. The resulting pattern of lines on the film is specific to the mineral and metal phases present, which can thus be identified. A particular advantage of X-ray powder diffraction analysis in the examination of works of art is that only very small samples are required (less than the size of a pinhead), so the technique can be regarded as virtually non-destructive. It has therefore been extensively used in the identification of, for example, pigments, opacifiers in glasses and glazes, gemstones and metal corrosion products.

With infra-red spectrometry the extent of absorption of infra-red radiation in the specimen is measured at different wavelengths. The resulting infra-red absorption spectrum is determined by the vibration frequencies of the interatomic bonds of the phases present. In principle, therefore, the phases present can be identified, although identification is often less precise than that by X-ray diffraction. The technique is mainly used for the identification of poorly crystalline inorganic materials, as well as organic compounds (*see* §VI, 2 below).

Thermal analysis involves the measurement of various physical and chemical changes that occur when a specimen is heated from room temperature to approximately 1000°C. Differential thermal analysis (DTA) provides information on the endothermic and exothermic reactions that occur when the sample is heated, thermogravimetric analysis involves measuring the loss in weight when heated and thermal expansion analysis the corresponding change in length. These techniques, although not establishing the precise identity, do provide some information on the mineral phases present in the specimen. They are used principally in the study of pottery, to obtain information both on the types of clay used and the firing temperatures employed in its production.

In the context of the analysis of works of art, Mössbauer spectroscopy has been used to identify the different iron phases present. The technique involves measuring the extent of the absorption of a specific range of γ–rays by the iron nuclei in the specimen. Mössbauer spectroscopy has again been

used principally in the study of pottery to obtain information on the firing temperatures and atmospheres employed in its production.

VI. Organic analysis.

1. CHROMATOGRAPHY. Chromatography in its various forms is designed for separating mixtures into their components, either in order to produce a characteristic pattern or as a first step to their further study individually.

Column chromatography was first used in 1906 by Mikhail Semenovich Tswett (1872–1919) to separate coloured plant pigments adsorbed on a column of powdered chalk (stationary phase) packed into a glass tube. A solvent petroleum (moving phase) was allowed to percolate through under the action of gravity. Revived and developed in the 1930s, it became one of the standard methods for separating mixtures of organic compounds on a preparative scale by collecting the various components at the column outlet as they were eluted. A number of adsorbents can be used (e.g. alumina powders, silica and silica modified with silicone coatings), according to compound classes. As the polarity of the solvent mixture flowing through the column increases (hydrocarbons would be non-polar, while methanol or water would be polar solvents), so—broadly speaking—the adsorbed components are selectively displaced in order of ascending polarity. However, the conventional column technique is limited in its ability to resolve compounds of similar structure and is poorly adapted for analysis of very small amounts of material.

High-performance liquid chromatography (HPLC) is a recent development of the above method; it has come about only as a result of recent advances in high-pressure pumping and fluid-handling technology. Here, extremely finely divided and uniform stationary-phase particles are packed into steel tubes, and high-pressure, pulseless pumps supply a uniform flow of eluent. The eluted components at the outlet end of the column are fed to a detector. Typically this will be an ultra-violet absorbance detector (sensitivity limited to uv-absorbing compounds) or a diode array detector for coloured compounds (also providing the profile of the visible light absorbance at various wavebands). Fluorescence detectors are available for components that fluoresce naturally, or can be made to do so, as are refractive index detectors suited for detection of polymers. Conventional HPLC uses columns of 150–300 mm in length and eluent flow rates of 0.5–2 ml/min. By the late 1990s HPLC had found limited application in the analysis of art objects, despite its potential, particularly for the more polar and higher molecular weight compounds in natural products.

Paper chromatography was developed in the 1940s and employs a stationary phase of paper or water absorbed on to paper. The strip of paper is suspended vertically in a glass tank fitted with a lid. Its lower end is immersed in the eluent, which consists of an organic solvent or mixture of solvents that flow upwards through the paper by virtue of capillary action. The mixture under investigation is dissolved in a volatile solvent, spotted and dried near the lower edge of the paper, just above the eluent level. Depending on the differing solubilities of components in the moving eluent and their various affinities for the stationary phase, so they will progress upwards at differing rates and become separated into a series of individual spots. Colourless components may be revealed by spraying with a chromogenic reagent. Once again, this technique suffers from poor sensitivity (in terms of the demands of easel painting samples), limited resolution of complex mixtures and poor reproducibility. The technique has been used, however, to separate the components of natural resins and for the analysis of glue in grounds.

Gas-liquid chromatography (GC) was found to have the widest application in the late 1990s in the analysis of organic components from easel paintings and museum objects. Though developed in the early 1950s, it figured minimally as a routine method of investigating art objects until reliable and affordable systems became commercially available during the 1970s. Here, the moving phase is an inert gas, such as helium, nitrogen or hydrogen. The stationary phase is usually some form of modified, thermally inert and very high boiling-point silicone grease, thinly coating a powdered, inert mineral support. This is packed into a coiled glass column through which the inert gas flows at a uniform rate. At the inlet end of the column a septum injection unit is fitted. The whole is contained within a temperature-programmable oven capable of accurately maintaining a temperature of up to 450°C. Typically, a sample such as a paint fragment less than 0.5 mm × 0.5 mm is removed from under the frame rebate, a canvas turnover, a paint crack or from the edge of a paint loss, following local removal of varnish. The sample is chemically derivatized and worked up on the micro-scale to remove mineral pigments, thus producing a relatively volatile and thermally stable mixture of the remaining organic components of the paint binder or adhesive. Following concentration, a small aliquot (c.a. 1 ml) is taken up in a micro-syringe and injected through the inlet septum into the heated gas stream of the column. The mixture is immediately vaporized, and the 'plug' of gaseous components is swept through the packing. According to the relative volatility of each component at the temperature of analysis and its individual strength of interaction with the silicone stationary phase, so some components move readily through the column, and others are selectively retarded in their progress. Conditions are arranged to cause each component to emerge separately from the column exit as a series of pure gaseous plugs. These progress sequentially to a detector, such as a flame ionization detector, where the effluent is burnt in an oxy-hydrogen flame. As a gaseous organic component enters this flame, its molecular structure is broken up into charged molecular debris, and the increased conductivity can be

monitored by passage between two electrodes. The detector response is usually displayed on a moving chart recorder as a series of peaks, known as a chromatogram. The technique is very sensitive to a wide spectrum of the organic components in art objects and possesses high resolution. This is especially so in the case of capillary gas-liquid chromatography, where the packed column is replaced by a thin, modified silicone coating, chemically bonded on to the inside of a quartz capillary column (typically 25 m length × 0.53 mm internal diam.). Although GC tells the investigator nothing about the intrinsic molecular construction of the isolated components, it is a quantitative technique, and compounds can be identified by running pure standards under identical conditions to the unknown. To a considerable extent this deficiency can be made good by connecting the column outlet to a mass spectrometer (see §V, 5 above), so presenting the purified components sequentially for molecular mass determination and fragmentometry to elucidate their structure at the molecular level. The mass spectrometer may also be successfully employed as a mass-specific detector for the gas chromatograph to resolve out from the chromatographic background minor natural resin components in paint media.

E. Stahl: *Thin-layer Chromatography: A Laboratory Handbook* (London, 1969)
A. B. Littlewood: *Gas Chromatography: Principles, Techniques and Applications* (New York and London, 1970)
W. H. McFadden: *Techniques of Combined Gas-chromatography/Mass-spectrometry: Applications in Organic Analysis* (New York, 1973)
J. G. Kirchner: *Thin-layer Chromatography* (New York, 1978)
L. R. Snyder and J. J. Kirkland: *Introduction to Modern Liquid Chromatography* (New York, 1979)
F. J. Yang, ed.: *Microbore Column Chromatography: A Unified Approach to Chromatography* (New York and Basle, 1989)
M. Striegel and J. Hill: *Thin-Layer Chromatography for Binding Media Analysis* (Los Angeles, 1996)

2. INFRA-RED SPECTROMETRY. This is based upon the irradiation of a material by infra-red radiation in the wavelength band 2.5–25 μm. Such radiation is able to induce vibration of the chemical bonds between atoms within the molecular structure of organic materials. Different bond types (i.e. linking different atoms or with one or several bonds between and in differing environments) will absorb at a specific wavelength, which corresponds to the various fundamental vibrational modes and overtones. The absorption spectrum that results does not give a complete molecular picture, but the various absorption bands will indicate the nature of the functional groups that are present. Dispersive infra-red spectrometers employ prisms or diffraction gratings to split up 'white' infra-red radiation into wavelength bands. These are scanned across the specimen in succession, behind which a detector monitors the relative intensity of the transmitted infra-red radiation. Such spectrometers are limited in sensitivity and resolution. Non-dispersive Fourier transform

infra-red (FTIR) spectrometers, based on an interferometric principle, with mathematical de-convolution of absorbance/wavelength information, have to some degree replaced the dispersive kind. This technique is most effective when coupled with a separation technique, for example chromatography.

L. J. Bellamy: *The Infra-red Spectra of Complex Molecules*, 2 vols (London, 1975–80)
R. G. Messerschmidt and M. A. Harthcock: *Infrared Microspectroscopy: Theory and Applications* (New York and Basle, 1988)
M. R. Derrick, D. Stulik and J. M. Landry: *Infrared Spectroscopy in Conservation Science* (Los Angeles, 1999)
J. R. Mansfield and others: 'Near Infrared Spectroscopic Reflectance Imaging: A New Tool in Art Conservation', *Vibrational Spectroscopy*, xxviii/1 (2002), pp. 59–66

3. NUCLEAR MAGNETIC RESONANCE SPECTROMETRY. This technique (NMR) is based on the propensity for certain nuclei, such as hydrogen and the carbon-13 isotope, to generate a magnetic dipole by virtue of the charge that spins about the axis of their nuclei. When under the influence of a strong magnetic field, this dipole will be aligned in a parallel orientation to it. However, this state can be 'flipped' into an antiparallel state as a result of absorption by the spinning nucleus of electromagnetic energy. This is of a characteristic resonance frequency, which is determined by the degree of shielding of the nucleus by surrounding groups of atoms. Radio frequencies in the range of 60–220 MHz are used to excite this transition. In practice it is easier to fix the excitation energy and scan the 'splitting' magnetic field to obtain a spectrum of resonances that characterize the types of hydrogen nuclei or carbon-13 nuclei present within the molecular structure of the material examined. As with infra-red spectrometry (see §2 above), the investigator does not see the whole molecular structure but catches just a glimpse of certain parts of the molecule. The technique has not found application where samples from easel paintings are concerned because of the strict limits placed on sample size.

A. Spyros and D. Anglos: 'Studies of Organic Paint Binders by NMR Spectroscopy', *Applied Physics A: Materials Science & Processing*, lxxxiii/4 (2006), pp. 705–8

VII. Age determination. The determination of an absolute age normally involves either a radioactive decay process or some natural, annual, rhythmic process. In the context of dating works of art, the relevant techniques are radiocarbon dating, thermoluminescence dating and dendrochronology.

M. J. Aitken: *Science-based Dating in Archaeology* (London, 1990)

1. RADIOCARBON DATING. Radiocarbon dating is possible because of the continuous formation of the radioactive isotope of carbon (carbon-14) that occurs in the upper atmosphere when neutrons produced by cosmic rays interact with atmospheric nitrogen atoms. Carbon-14 combines with oxygen to form

radioactive carbon dioxide, which then mixes throughout the atmosphere, dissolves in the oceans and, via the photosynthesis process and the food chain, enters all plant and animal life. Since carbon-14 is produced by cosmic ray neutrons at a more or less constant rate and, at the same time, is lost by radioactive decay, an equilibrium concentration of carbon-14 is established: the ratio of carbon-14 to carbon-12 atoms being approximately 1 to a million million. All living plants and animals therefore contain this equilibrium concentration of carbon-14. However, once dead, the plant or animal no longer takes in carbon dioxide from the atmosphere, so that the carbon-14 lost by radioactive decay is not replaced, and therefore its concentration slowly decreases—by half in 5730 years. Consequently, by measuring the carbon-14 concentration in, for example, dead wood and comparing it with the concentration in living wood, the age of the dead wood can be determined.

Radiocarbon dating is applied to materials that once formed part of the biosphere. In the context of works of art, this includes wood, bone, ivory, all types of textile, leather, parchment and paper. Until recently the carbon-14 content of such material could be determined only by counting the number of beta particles emitted by those carbon-14 atoms undergoing radioactive decay. This measurement technique requires comparatively large samples (at least 1 g of carbon, which is equivalent to some 10 g of wood or 50 g of bone), and the resultant damage to works of art was generally unacceptable. However, in the late 1970s the technique of accelerator mass spectrometry was developed. With this technique the total number of carbon-14 atoms present in a sample are counted, and as a result only 1 mg of carbon is required. Consequently, radiocarbon dating now has a significant role to play in the dating of works of art, in particular textiles and ivories. A much publicized application in the 1980s was the dating of the Shroud of Turin (Turin Cathedral) to the 13th–14th century AD rather than to the period of Christ.

The basic assumption on which radiocarbon dating depends is that the carbon-14 concentration in living plants and animals has always been the same as it is now. Unfortunately, for a number of reasons, this assumption is not strictly valid. Therefore, in order to obtain true calendar dates the radiocarbon dates must first be calibrated. A calibration curve extending back some 8000 years (see fig. 3) has now been established using long sequences of tree-rings dated by dendrochronology (see §3 below). The correction necessary to convert radiocarbon dates into calendar dates varies from less than one hundred to several hundred years, depending on the period under consideration. Typically, the corrected radiocarbon dates are accurate to within ±50–100 years.

S. G. E. Bowman: *Radiocarbon Dating* (London, 1990)

R. E. Taylor: 'Fifty Years of Radiocarbon Dating', *American Scientist*, lxxxviii/1 (2000), pp. 60–67

2. THERMOLUMINESCENCE DATING. Thermoluminescence (TL) dating depends on the fact that

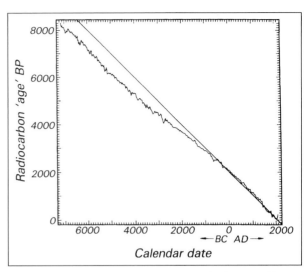

3. High-precision radiocarbon calibration curve for the past 8000 years based on the dendrochronological dating of Irish oak; the straight line represents the ideal 1:1 correspondence between radiocarbon age and dendrochronological (calendar) age

when crystalline materials, for example quartz and feldspars, are subjected to ionizing radiation (e.g. alpha particles, beta particles and gamma rays) a proportion of the free electrons thus produced are trapped at defects in the crystalline lattice. When the material is subsequently heated the electrons escape from the traps, and if they then combine with another type of defect, referred to as a luminescence centre, the energy associated with recombination is released in the form of light or thermoluminescence. The intensity of this light provides a measure of the number of trapped electrons and hence a measure of the ionizing radiation dose that the material received.

In the production of pottery, clay is fired at temperatures in the range of 500°–1000°C, and the TL acquired due to the action of ionizing radiation during geological times is removed. The TL clock is thus reset to zero. Subsequently, the stored TL or number of trapped electrons builds up again, due to the action of ionizing radiation from radioactive impurities (i.e. a few parts per million of uranium and thorium and a few per cent of potassium), both in the pottery itself and associated with its burial or storage environment.

Assuming that the firing associated with its production was the last heating to which the pottery was subjected, then in principle the age of the pottery can be determined from three measurements: (1) the natural TL stored at the present day; (2) the TL sensitivity (i.e. the amount of TL produced per unit dose of radiation); and (3) the radiation dose received per year. In practice the situation is not quite so simple, and many measurements and checks involving several grams of sample are required in order to obtain an accurate date for a piece of pottery. Further, for an accurate date a knowledge of

the burial or storage environment of the pottery is essential, since this contributes significantly to the overall annual radiation dose. Therefore, as a method of accurate dating, thermoluminescence can normally be applied only to pottery sherds obtained from archaeological sites during controlled excavations. Even so, the resulting age determination is still typically accurate only to ±5–10%.

In the case of fine art ceramics, the limitation on sample size and the lack of information on storage history means that the date obtained by TL is even less accurate. However, the method is normally adequate to distinguish between recently made objects—fakes—and those manufactured in antiquity. Typically for such authenticity testing, some 30 mg of sample is drilled from an inconspicuous area of the ceramic, usually the base. In estimating the age a range of values are assumed for the environmental contribution to the annual radiation dose. In addition to pottery and porcelain, the core material from bronzes that have been cast using a clay core can also be tested by TL, since this material has again normally been fired to a sufficiently high temperature to reset its TL clock to zero.

M. J. Aitken: *Thermoluminescence Dating* (London, 1985)

A. Zink, J. Castaing, and E. Porto: 'Terres cuites de la Renaissance et datation par luminescence: Défi et réalité, *Technè: La science au service de l'histoire de l'art et des civilizations*, xx (2004), pp. 111–17

3. DENDROCHRONOLOGY. The basis of dendrochronology lies in the fact that in temperate climates, where there is a contrast between the seasons, trees grow by the addition of a well-defined annual ring formed between the bark and the sapwood. The width of each ring depends on the prevailing climatic conditions, principally rainfall and temperature. Therefore, trees of a single species growing in similar localities should have a similar pattern of ring widths, uniquely defined by their common climatic history. This similarity in ring pattern provides the basis for cross-dating by which a tree-ring sequence of unknown age is matched with one of known age.

Long chronologies, sometimes referred to as master curves, are established, starting with living trees. The timescale is then extended by using large timbers from felled trees or from buildings, with ring patterns that sufficiently overlap the existing chronology to be certain of an exact match. In this way master chronologies have been built up that extend over several thousands of years and are accurate to within one year.

In order to be able to use dendrochronology for dating works of art a number of conditions must be fulfilled. First, the wood needs to be of a species for which there is a master chronology, and there must normally be at least 100 rings in the sample to be dated to ensure an exact match with the master pattern. Then, if the date is to be precise to the year of felling, either the bark must be present or an estimate must be made of the number of rings lost during the preparation of the timber. Finally, to determine the

date of actual use, allowance must be made for seasoning the timber. If these conditions are adequately fulfilled, then dendrochronology provides a valuable technique for dating panel paintings and building timbers.

M. G. L. Baillie: *Tree-ring Dating and Archaeology* (London, 1982)

S. E. Nash: 'Archaeological Tree-ring Dating at the Millennium', *Journal of Archaeological Research*, x/3 (Sept 2002), pp. 243–75

P. Klein: 'Unfolding the Netherlandish Diptych: Dendrochronological Analyses', *Essays in Context: Unfolding the Netherlandish Diptych*, eds J. O. Hand and R. Spronk (Cambridge, MA, 2006)

VIII. *Raw materials, production techniques and authenticity.*

1. Stone. 2. Ceramics. 3. Glass and enamel. 4. Metals. 5. Building materials. 6. Paintings. 7. Resins, waxes and glues. 8. Structural plant and animal materials. 9. Textiles.

See also PAPER.

1. STONE. In the technical examination of the STONE used in building, sculpture, small objects and jewellery, the investigator is concerned with identifying the type of rock or mineral used, together with its provenance or source; with discovering how the stone was worked and its surface decorated; and, in the case of stone objects, with establishing authenticity.

The common types of rock and mineral can often be identified by visual examination. However, for the full identification of rocks, examination in thin section using a petrological microscope (*see* §IV, 1 above) is necessary. In addition, with this technique, the location of the actual source or outcrop from which the rock was obtained can sometimes be determined. Thus, it has been shown that the bluestones used at Stonehenge, Wilts, originated in the Presceli Mountains in south Wales, although whether they were transported to the region by man or by glacial action remains unproven. When the damage caused by removing a section for petrological examination is not permissible, then X-ray powder diffraction (*see* §V, 6 above) provides an alternative method of examination. With this technique the wide range of minerals or rocks used for gemstones and Near Eastern cylinder seals has been readily identified.

For locating the source from which the rock was obtained, minor and trace element analysis, using for example AAS or NAA (*see* §V, 1 above), provides an alternative to petrological examination. The concentration patterns of minor and trace impurities in the object are compared with those for outcrops or quarries that might have been used. Trace element analysis has helped in provenancing Classical marble sculpture. However, for marble, measurement of the stable isotope ratios for carbon and oxygen (*see* §V, 5 above) is of prime importance. Although there is some overlap between the isotopic ratios for the different quarries used in the Classical world, some quarries can often be eliminated as sources of the

marble for particular sculpture on the basis of other information, such as style and date. Thus, using isotope analysis, the different quarries providing the marble for building the Mausoleum of Halikarnassos in Anatolia have been identified (see fig. 4). Fine-quality marble from the Pentelic quarries was used for the monumental sculpture, with Paros marble being used for the heads of selected figure sculpture. In contrast, more local Anatolian marble quarries were used for the main architectural building blocks of the monument.

The way in which stone has been worked is best studied by careful visual examination, supplemented as necessary by examination under a binocular microscope or with an SEM (see §§II, 1 and IV, 2 above). Any surviving painted decoration or overall coating applied to the surface of the stone can also be located by visual examination, the materials used then being identified by X-ray diffraction. In this way, it has been possible to show that the Parthenon in Athens was probably coated with some form of varnish in order to protect the surface and perhaps tone down its brightness.

No method of absolute dating exists for stone. Therefore, for authentication one has to decide whether the material used and the methods of working are appropriate for the ascribed age and provenance. For example, the probable use of a jeweller's wheel to cut the teeth of a rock crystal skull in the British Museum, London, casts considerable doubt on its supposedly Aztec origins. In addition, the weathering or patination on the surface of stone can, in theory, provide a clue as to whether or not an object is ancient, although the results tend to be more ambiguous than those obtained for corrosion on metals.

J. C. Fant, ed.: *Ancient Marble Quarrying and Trade*, British Archaeological Reports, International Series no. 453 (Oxford, 1988)

D. Parsons, ed.: *Stone: Quarrying and Building in England AD 43–1525* (Chichester, 1990)

Marble. Art Historical and Scientific Perspectives on Ancient Sculpture (Malibu, CA, 1990)

2. CERAMICS. In the present context, the term CERAMICS is taken to include not just vessels and figurines of earthenware, stoneware and porcelain but also TERRACOTTA sculpture as well as bricks and tiles used in buildings (see BRICK and TILE). In all cases, technical examination is concerned with determining the raw materials used to make the ceramics, together with their provenance or source; the methods used to form the ceramics; the types of surface decoration; the firing temperatures and atmospheres employed in their production; and authenticity.

In studying the raw materials used to make ceramics, examination in thin section using a petrological microscope (see §IV, 1 above) is of primary importance for earthenwares, terracottas, bricks and tiles. With this technique, the rock and mineral fragments that were present in the clay or were added as temper

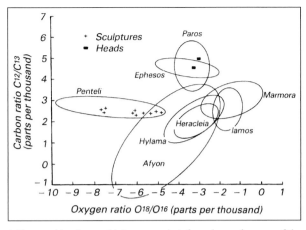

4. Data resulting from stable isotope analysis for carbon and oxygen of the marble sculptures from the Mausoleum of Halikarnassos, superimposed on the data for samples from Classical marble quarries; the ellipses represent 90% confidence limits for samples from the named quarries

to improve its drying and firing properties can be identified. For such high-fired ceramics as porcelain an SEM with attached X-ray spectrometer (see §IV, 2 above) and X-ray powder diffraction analysis (see §V, 6 above) can be used to identify the phases formed during firing. From these data the nature of the original raw materials can often be inferred. Thus it is possible to distinguish the three principal types of soft-paste porcelain (i.e. glassy, bone-ash and soapstone) both from one another and from hard-paste porcelain.

Petrological examination can also assist in establishing the distribution and trade of the ceramics away from their production centres. This is possible because some rock and mineral fragments, particularly those from igneous and metamorphic rocks, are characteristic of a particular provenance or source of the clay or temper and hence of a particular production centre. An alternative approach to the investigation of distribution and trade is minor and trace element analysis using, for example, ICPS, XRF and NAA (see §V, 1 above): the concentration pattern of minor and trace impurities in a clay can be characteristic of a particular source and hence can provide a 'fingerprint' for a particular production centre. For example, it has thus been possible to distinguish Hispano-Moresque lustreware produced at Málaga from that produced at Valencia during the late-14th century and early 15th (see fig. 5).

The methods used to form ceramics, in particular bodies, include modelling, building up from coils or slabs, forming in a mould, throwing on a wheel and slip casting. These different forming methods can often be distinguished on the basis of visual examination of surface markings as well as from variations in the wall thickness. However, X-ray radiography (see §II, 3 above) can provide valuable supplementary information.

In order fully to investigate the surface decoration of ceramics, an SEM with attached X-ray spectrometer or electron-probe microanalysis (see §V, 4 above)

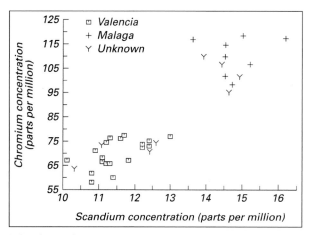

5. Scandium and chromium concentrations determined by neutron activation analysis for Hispano-Moresque lustreware produced at Málaga and Valencia; lustreware of unknown provenance can be assigned to one or the other of these two centres on the basis of analytical data

is again necessary. In this way, surface burnishing, the application of a clay slip or the use of mineral pigments can be distinguished. Similarly, the different types of glaze (alkali-lime, lead, salt) can be identified, together with the colourants and opacifiers used. However, if only completely non-destructive examination is possible, then some information on the glaze can be obtained with XRF analysis of the surface.

The firing temperatures employed in the production of ceramics range from as low as 700–800°C for some earthenwares up to as much as 1300°C for porcelains. One approach to the estimation of firing temperatures is to identify the mineral phases surviving or formed as a result of firing, using such techniques as thin-section petrology, X-ray diffraction, thermal analysis or Mössbauer spectroscopy (see §V, 6 above). An alternative approach is the examination of the microstructure and, in particular, the extent to which a glassy phase has formed, using scanning electron microscopy. Whether an oxidizing or reducing atmosphere predominated during firing can usually be inferred from the colour of the ceramics (i.e. red or grey respectively). However, examination of both the mineralogy and microstructure can provide supplementary data regarding the firing atmosphere.

The primary technique for establishing whether or not a ceramic is authentic is thermoluminescence dating (see §VII, 2 above). However, elemental analysis of the glaze and body can provide supplementary information by establishing whether the compositions are appropriate for the ascribed age and provenance. For example the identification of titanium oxide as the opacifier in a glaze means that ceramic cannot be more than some 50 years old.

W. D. Kingery and P. B. Vandiver: *Ceramic Masterpieces: Art, Structure and Technology* (New York, 1986)

A. Wallert: 'Questions and Answers: The Technical Examination of Polychrome Terra-cotta Sculptures by Johan Georg van der Schardt', *ArtMatters: Netherlands Technical Studies in Art*, i (2002), pp. 32–45

3. GLASS AND ENAMEL. GLASS and ENAMEL, as well as glaze, are each typically produced by melting finely ground quartz sand with an alkali (soda or potash), which significantly reduces the melting point of quartz. The technical examination of these materials is concerned with determining the raw materials used in their production; the methods of forming and embellishment; and authenticity.

In studying the raw materials used, bulk elemental analysis is of primary importance. Provided that a very small sample can be removed from, for example, an already damaged edge, any technique providing data on major and minor element concentrations (ICPS, AAS, PIXE, EPM) can be used (see §V, 1 and 4 above). XRF analysis of the surface, although avoiding the need to remove a sample, is of limited value because of the changes in composition due to surface weathering. The identity of any opacifiers (i.e. the dispersion of particles within the glass that scatter rather than transmit light) can be confirmed by X-ray powder diffraction (see §V, 6 above).

As glass is a multicomponent material, it is rarely possible to identify the geographic sources of the various raw materials used. However, different glass-making traditions, and sometimes even different workshops, can be distinguished on the basis of elemental composition. The majority of ancient glass is of the alkali–lime–silica type, with lead-glass also being used from the Roman period onwards. The principal alkali used was soda, added either in the form of ash obtained from burning saline coastal plants or as the high-quality mineral soda known as natron. In medieval Europe, potash in the form of ash, obtained from burning inland plants, was used instead of soda. The lime, which helps to stabilize the glass, was most probably initially added as an impurity with the silica or alkali.

A number of additives were used to impart colour to glass. For transparent glass, these included copper for turquoise to green, cobalt for deep blue, and manganese for violet. For opaque glasses, it is found that during the Roman period the opacifiers used were based on compounds of antimony (calcium antimonate for white and lead antimonate for yellow). In contrast, from the 4th century AD opacifiers based on compounds of tin (tin oxide for white and lead stannate for yellow) became increasingly common. The use in medieval Mosan enamels of opacifiers based on compounds of antimony therefore suggests that the enamellers were obtaining their glass from tesserae surviving in Roman mosaics. The ways in which glass was formed (e.g. on a core, by moulding or blowing) and embellished (e.g. cutting or engraving) are best studied by visual examination in combination with examination under a binocular microscope (see §II, 1 above).

No absolute method of dating exists for glass. The authenticity of a glass object has to be assessed either on the basis of whether the materials and methods of fabrication are appropriate to the ascribed age and provenance or from the extent of surface weathering. For example, the high lead content of a set of blue

glass canopic jars, supposedly from New Kingdom Egypt, suggests strongly that they are in fact modern. Conversely, the presence of an iridescent patina on a glass suggests that it dates from antiquity, since such patination is difficult to induce artificially.

S. Frank: *Glass and Archaeology* (London, 1982)

M. Bimson and I. C. Freestone, eds: *Early Vitreous Materials*, British Museum, Occasional Papers, lvi (London, 1987)

I. C. Freestone: 'The Provenance of Ancient Glass through Compositional Analysis', *Materials Issues in Art and Archaeology VII: Proceedings of the MRS Fall Meeting 2004*, pp. 195–208

4. METALS. The technical examination of the metals (*see* METAL) used for sculpture, fine metalwork (e.g. vessels, statuettes) and jewellery is concerned with investigating the alloy composition, the provenance or source of the metals, the methods of fabrication, the types of decoration and the authenticity. The techniques employed and the type of information obtained differ according to whether non-ferrous (e.g. GOLD, SILVER, COPPER) or ferrous (e.g. iron, steel; *see* IRON AND STEEL) metal is being considered.

For non-ferrous metals XRF analysis is of primary importance because it provides a direct analysis of a metal object without the need to remove a small sample. The method is used primarily to determine the alloy composition. Thus, the extent to which gold has been debased by the addition of silver and copper, or silver by the addition of copper, can be established. Similarly, BRONZE (copper–tin) can be distinguished from BRASS (copper–zinc), and the amount of lead added in either case can be determined. Because of surface corrosion, it is sometimes preferable to analyse copper-based alloys by means of ICPS and AAS on a sample drilled from the body of the object. In any case, these methods have to be used if the concentrations of the full range of minor and trace impurities are to be determined. (For information on all these methods *see* §V, 1 above.)

Unfortunately, the concentration pattern for minor and trace impurities is not normally characteristic of the ore source used to produce non-ferrous metals, since varying proportions of these impurities are lost during the smelting process. A more rewarding approach for the investigation of the distribution and trade of metal away from its ore source and production centre is the measurement of the stable isotope ratios for the LEAD that is present in small amounts in both silver and copper (*see* §V, 5 above). This is because the isotopic ratios for the lead will have been unchanged by the smelting process. However, the problems associated with the use or re-use of metal from more than one ore source still remain.

The methods of fabrication and decoration of non-ferrous metal objects are studied by a combination of visual examination, microscopy and analysis. For example examination of the surface of wire under a binocular microscope (*see* §II, 1 above) can reveal either the longitudinal striations characteristic of drawn wire or the helical joins characteristic of wire produced from a spirally wound strip of foil. Additionally, examination of the internal microstructure of the metal in polished cross-sections using a metallurgical microscope (*see* §IV, 1 above) can provide evidence for the casting, cold-working and annealing employed in its fabrication.

The type of solder used for joining the different components of a metal object can be established by semi-quantitative analysis using XRF. Similarly, the general nature of any surface plating (e.g. GILDING, silvering, tinning) can be determined non-destructively using the same method. Further, the detection of a trace of mercury in a gilded layer indicates that fire-gilding, rather than leaf-gilding or ELECTROPLATING, has been used. However, in order to establish the exact plating technique used it is often necessary to examine a section through the surface layer using an SEM with attached X-ray spectrometer (*see* §VI, 2 above). In this way it is possible to distinguish, for example, deliberate tinning of a bronze by wiping with or dipping in molten tin (*see* METAL, §V, 6) from 'tin sweat', in which tin has concentrated at the surface of the bronze during casting (*see* METAL, §III, 1(vii)). The materials used for inlaid decoration can be identified by a combination of XRF and X-ray powder diffraction analysis (*see* §V, 6 above). Thus the different metal sulphides used to produce niello, a dense black material inlaid into silver and gold from at least Roman times, can be distinguished.

For ferrous metals the examination of the microstructure in polished section using both metallurgical and scanning electron microscopy provides the primary method for investigating both the type of iron and the processes used in its manufacture. Thus cast iron, wrought iron and steel can be distinguished from each other. Similarly, it is possible to establish the extent to which wrought iron was carburized to produce steel by heating in glowing charcoal; the degree to which the steel was hardened by heating in a reducing atmosphere and then quenching rapidly in cold water; and finally, whether the hardened steel was tempered by reheating at a lower temperature. When iron is heavily corroded, then X-ray radiography (*see* §II, 3 above) can be used to establish both the shape of the object surviving under the corrosion and the presence of non-ferrous metal inlays in the iron.

When a clay casting core survives, then, as for ceramics, metal objects can be authenticated using thermoluminescence dating (*see* §VII, 2 above). Otherwise, for the authentication of metals the investigator has to rely first on whether the alloy and methods of fabrication and decoration are appropriate to the ascribed age and provenance. For example, the copper–zinc alloy, brass, was not used until the Roman period, and wire drawing has been known only since the early medieval period. Second, the patination or corrosion on a metal object can provide a valuable clue as to whether it is ancient or modern, with well-bonded corrosion that penetrates into the surface of the metal being a good indication of antiquity.

R. F. Tylecote: *A History of Metallurgy* (London, 1976)

R. F. Tylecote: *The Early History of Metallurgy in Europe* (London, 1987)

R. Maddin, ed.: *The Beginning of the Use of Metals and Alloys* (Cambridge, MA, 1988)

M. F. Guerra and T. Calligaro: 'Gold Traces to Gold', *Journal of Archaeological Science*, xxxi/9 (Sept 2004), pp. 1199–1208

5. BUILDING MATERIALS. In the present context, the term 'building materials' is taken to include the main constructional materials (e.g. stone, brick, tile, wood, concrete, mortar, plaster) as well as the decorative elements of a building (e.g. wall paintings, mosaics). The aims of the technical examination of these materials, a number of which are further discussed in other sections, depend very much on the particular material under consideration.

For stone, the primary aims are to identify the type of rock used and, where possible, the outcrop or quarry from which it was obtained (*see* §1 above). In the case of bricks and clay tiles (i.e. roof, floor and flue), the examination is similarly concerned with establishing where they were produced, as well as obtaining information on how they were formed and fired (*see* §2 above). With wood, the primary aim is to identify the species of tree from which the wood originated (*see* §8 below). In addition, thermoluminescence dating of brick and tile together with radiocarbon and dendrochronological dating of timbers provides an estimate of the age of the building (*see* §VII above), or rather the age of that phase of construction or restoration into which the bricks, tiles or timbers are incorporated.

For plaster, cement, mortar and CONCRETE the main aim is to identify the raw materials used in their production. Because of the very fine texture of these materials, examination in thin section with a petrological microscope (*see* §IV, 1 above) usually needs to be supplemented with scanning electron microscopy (*see* §IV, 2 above). X-ray powder diffraction (*see* §V, 6 above) is also valuable in identifying the mineral phases present. The term 'cement', which includes lime and gypsum plasters as well as Portland cement, refers to the fine textured binding matrix material. Mortars are produced by adding a sand or crushed-rock filler to the cement. During the Roman period a particularly durable mortar was produced by using volcanic ash or pozzolana as the filler. Concrete is produced by the addition of a coarser textured filler to mortar.

The investigation of WALL PAINTING in buildings involves principally the identification of the pigment and binding media used (*see* §6 below), as well as establishing the type of plaster (i.e. lime or gypsum) to which the painting was applied. The pigments can be most readily identified by X-ray powder diffraction, supplemented where necessary by analysis in the SEM. Typical pigments used in antiquity include various iron-oxide minerals (yellow to red), malachite (green) and azurite (blue), as well as the artificial blue pigment known as Egyptian blue, which was produced by firing a mixture of quartz sand, lime and a copper compound. For the identification of the binding media, a range of techniques of organic analysis (*see* §VI above) are available.

In the case of MOSAIC, the primary interest is the investigation of the nature of the rock and glass tesserae used (*see* §§1 and 3 above), together with establishing the type of mortar in which they are embedded.

N. Davey: *A History of Building Materials* (London, 1961)

S. Perkins: 'New Database Describes All the Marbles', *Science News*, clviii/21 (2000), p. 324

6. PAINTINGS. The technical examination of paintings is concerned with investigating the SUPPORT, the GROUND, the paint layers (pigments and binding medium) and any VARNISH or glaze-paints (*see* GLAZE) applied to the surface, as well as the date or authenticity of the painting. In the case of wooden panel supports, the type of wood used (e.g. poplar or oak, *see* PANEL PAINTING, §§2 and 3) can be identified by microscopic examination of its ray and vessel pattern and its cell structure (*see* §IV, 1 above). The mode of construction and jointing of the planks forming the completed panel can be assessed by visual examination supplemented by X-ray radiography (*see* §II, 3 above). In the case of canvas supports, the origin of the fibre (e.g. flax) can be established by optical microscopy (*see* §IV, 1 above), and the weave structure can be analysed by visual examination. The natural minerals used as ground and as pigments, together with manufactured pigments such as smalt and Prussian blue (*see* PIGMENT), can be identified by a combination of optical petrology, elemental analysis and X-ray diffraction analysis (*see* §V above). Natural organic dyes from plant and insect species (e.g. madder and cochineal) and artificial dyes are difficult to characterize when made up into LAKE pigments. Typically, various chromatographic methods are used to separate and identify the constituent organic compounds associated with such lake pigments. The binding media in which the pigments are applied and worked up may be either proteinaceous, and thus compatible with water (e.g. animal- or fish-glue distemper and egg tempera), or oil-based (e.g. linseed, walnut and poppyseed oils; *see* PAINTING MEDIUM). Sometimes the drying oils are subjected to pre-polymerization and sometimes terpenoid resins are also added. Although there are a number of approaches to the problem of binding media identification, the most satisfactory and informative method tends to be gas chromatography (GC) supplemented by mass spectrometry (*see* §V, 1 above). Other techniques that have been used include amino-acid analysis, Fourier transform infra-red (FTIR, *see* §VI, 2 above) spectrometry, thin layer chromatography and high-performance liquid chromatography (HPLC, *see* §VI, 1 above). This same overall range of techniques is also used to identify the varnishes and glaze-paints applied to the surface.

There is often more than one layer of ground, paint or varnish, and a complete investigation must therefore involve the examination of a cross-section through the painting, typically taken using a hypodermic needle. Such a cross-section is then examined using an optical microscope or a scanning electron microscope (SEM) to identify the pigments and a

FTIR microscope to analyse the binding media and varnishes (*see* §IV, 1 and 2 above). For dating wooden panel paintings, dendrochronology (*see* §VII, 3 above) provides a powerful technique provided that allowance can be made for any tree-rings lost during preparation of the timber and for the length of time for which the wood was seasoned. Radiocarbon dating of either the canvas support or the organic binding medium is in principle feasible, but due to the peculiarities of the radiocarbon calibration curve, the method is not applicable to material post *c.* 1650 AD. In such cases, authentication of a painting must be based on whether the ground, pigments and binding medium used are appropriate to the ascribed age of the painting. For example, the use of Prussian blue or other 18th- or 19th-century manufactured pigments on a supposedly 16th-century painting suggests that the ascribed date is wrong or that the painting has been subjected, at least, to partial repainting.

Art in the Making: Rembrandt (exh. cat. by D. Bomford, C. Brown and A. Roy; London, National Gallery, 1988)

Art in the Making: Italian Painting before 1400 (exh. cat. by D. Bomford and others; London, National Gallery, 1989)

Art in the Making: Impressionism (exh. cat. by D. Bomford and others; London, National Gallery, 1990)

J. Padfield and others: 'Improvements in the Acquisition and Processing of X-ray Images of Paintings', *National Gallery Technical Bulletin*, xxiii (2002), pp. 62–75

J. Dik: *Scientific Analysis of Historical Paint and the Implications for Art History and Art Conservation: The Case Studies of Naples Yellow and Discoloured Smalt* (2003)

T. J. S. Learner: *Analysis of Modern Paints* (Los Angeles, 2004)

7. RESINS, WAXES AND GLUES. The various chemical reagent tests that may be used to attempt to classify resins, waxes and glues are quite crude, and on aged and heavily oxidized material they may give misleading results (e.g. the Liebermann–Storch test for pine resin, or biological stains for drying oils, egg proteins and resins). Small samples from paintings and objects are best analysed by gas chromatography (GC, *see* §VI, 1 above), preferably coupled with mass spectrometry (MS, *see* §V, 2 above), following chemical derivatization to render the material volatile and stable to heat. Using these techniques, resins, waxes and glues may be characterized at the molecular level and to some extent quantified. Such analysis may be preceded by a preliminary use of infra-red absorption spectrometry (*see* §V, 6 above), a technique that does not destroy the sample, which may be subsequently passed on for GC-MS examination. For very small samples with complex layer structure, a Fourier transform infra-red (FTIR, *see* §VI, 2 above) spectrometer coupled with an infra-red microscope (FTIR-IR microscopy) is most suitable. Another technique that has found some application is high-performance liquid chromatography (HPLC, *see* §VI, 1 above).

M. Andreotti and others: 'Combined GC/MS Analytical Procedure for the Characterization of Glycerolipid, Waxy, Resinous and Proteinaceous Materials in a Unique Paint Microsample', *Analytical Chemistry*, lxxviii/13 (2006), pp. 4490–4500.

8. STRUCTURAL PLANT AND ANIMAL MATERIALS. In the present context, the term 'structural plant and animal materials' is taken to include wood, bone, ivory, fibres and skins. The technical examination of these materials is concerned with, first, identifying the plant and animal species used and, second, investigating the way in which the material was worked, prepared or treated.

Species identification is achieved by means of informed examination that progresses as necessary from visual, to low-power binocular microscopy (*see* §II, 1 above), to high-power optical microscopy in transmitted light (*see* §IV, 1 above) and, finally, to scanning electron microscopy (*see* §IV, 2 above). Wood can be identified from the gross pattern of rays and vessels seen in transverse section under the binocular microscope, often together with the cell structure as seen in thin section in transmitted light (*see* WOOD, §I). BONE can be distinguished from ivory on the basis of its canal structure, and the different types of ivory (e.g. elephant or walrus) can normally be identified, again from their microstructures (*see* IVORY, §1); the identification of bone to species is difficult unless gross surface morphological detail survives. The different types of fibre (e.g. wool, linen, cotton, silk, *see* TEXTILE, §I) can be identified either in transmitted light or in the SEM on the basis of characteristic features, such as the scale pattern of animal fibres and the cell structure of plant fibres. Similarly, the animal from which LEATHER was prepared can normally be determined from the arrangement of hair follicles and the epidermal tissue structure.

The way in which wood, bone and ivory was worked can again best be studied by a combination of visual examination, binocular microscopy and scanning electron microscopy. The use of fibres in the production of textiles is considered separately (*see* §9 below). Information on the treatment of skins can sometimes be obtained from the analysis of organic residues surviving from the dressing and tanning.

9. TEXTILES. The technical examination of textiles is concerned with identifying the materials from which the object is made, investigating the surface and structural condition of the object, analysing the dyes used, and authentication. In such studies low-power optical microscopy is a primary tool. At 180× magnification and over, it is possible to identify the nature of an organic fibre and the species of plant or animal from which the fibre came. Synthetic and artificial fibres may also be identified, but often cross-sections of fibre samples must be prepared for examination. Cross-sections may also be needed to identify accurately natural fibres. When metal fibres are incorporated into a textile, the metal used (e.g. gold, silver or copper) can be identified by elemental analysis with an X-ray spectrometer. At 10× magnification the weave structure of a textile may be easily analysed and the weave counted; at 30× to 40× magnification the condition of the fibre bundles that make up the weave structure may be clearly seen. To the naked eye, areas of wear-damage and areas of

fading can appear similar, but with low-power magnification it is easy to distinguish between these two conditions. Holes caused by insect damage may also be identified, and dirt and dust particles on the surface of the textile can be distinguished from those trapped in the interstices of the weave.

The identification of the vegetable, animal and synthetic dyes used on textiles first involves the extraction of the dye into solution. The dye can then sometimes be identified by comparing the optical absorption spectrum of the solution with those for solutions of known dyes (e.g. indigotin, madder, kermes; see DYE, §2). If this simple approach is unsuccessful, the standard methods of organic analysis such as infra-red spectrometry (see §VI, 2 above) or gas chromatography with mass spectrometry (see §VI, 1 above) could be used. Dating and authentication of textiles can be based on whether or not the fibres, the weave structure and the dyes used are appropriate to the ascribed age and provenance of the textile. For example a viscose-rayon lining in a 19th-century costume must be a replacement as viscose rayon was not in general use until the early 20th century. Similarly, if what appears to be a piece of 17th-century Italian lace is made of cotton, not linen, it is likely to be a 19th-century copy as cotton was not used to make lace in the 17th century.

A. Geijer: *A History of Textile Art* (London, 1979)

I. B. Wingate: *Fairchild's Dictionary of Textiles* (New York, 6/1979)

M. M Brooks and S. O'Connor: 'Revealing the Hidden: The X-radiography of Textiles', *NPO e-Journal*, ii (Nov 2004)

W. A. Mohamed: 'Analysis, Identification and Deterioration Aspects of Metallic Threads', *Scientific Analysis of Ancient and Historic Textiles: Informing Preservation, Display and Interpretation: Postprints* (London, 2005), pp. 241–5

Tempera [Lat. *temperare*: 'to mix or regulate']. Type of painting medium used to bind pigments. Strictly, and as used by Cennino Cennini in his *Libro dell'arte*, the term may be applied to any combination of pigment and medium. By the 16th century, however, Vasari used the term specifically to mean egg tempera, a paint made using egg yolk as the binding medium, and this is the meaning now generally understood.

1. Materials and techniques. 2. Conservation.

1. MATERIALS AND TECHNIQUES.

(i) Early use, to c. 1400. Egg has probably been used as a binder for pigments since antiquity: it is mentioned by Pliny the elder (AD 23/4–79), its use has been identified on some Roman Faiyum portraits and it was, and remains, the principal paint medium for the icons of the Greek and Russian Orthodox churches. In Western painting the technique is particularly associated with Italian panel paintings from the 13th to the 15th centuries, although the medium was widely used throughout Europe. The techniques of Italian tempera painting are unusually well documented in a late 14th-century treatise, *Il libro dell'arte*,

by the Tuscan painter Cennino Cennini (*c.* 1370–*c.* 1440). Modern methods of photographic and scientific examination and analysis applied to Italian panel paintings of this period have confirmed that the techniques Cennino described were indeed used by painters of the time. His treatise remains the single most important source of information on the techniques of tempera painting, describing them in such precise and practical detail that his manual is still consulted by painters and gilders.

Cennino, and later Giorgio Vasari (1511–74), stated that only the yolk of the egg was used for panel painting, the whole egg being employed more often for painting *a secco* on walls (see SECCO, §1). Analytical results, however, suggest that occasionally painters may have used the white as well as the yolk in panel painting. The yolk of an egg is an emulsion consisting of fatty material suspended in egg proteins in water, while the white contains only the proteins (principally albumen) in water. A paint film bound with the white as well as the yolk will include a higher proportion of protein and therefore will dry to a harder, more brittle finish since it contains relatively less egg fat to plasticize the paint film. When using the yolk alone, Cennino recommended (and practice bears this out) the addition of approximately equal volumes of egg yolk to pigment, which had been ground to a wet paste with water. The exact proportions vary slightly depending on the pigment employed, the correct amount being determined by trial and experience. As the paste contains a certain amount of water, this makes a paint that is easily handled and, when built up in the prescribed way, that dries to the desired semi-matt sheen.

Egg tempera dries first by the evaporation of the water, followed by the setting of the egg proteins to a hard and eventually waterproof film. This determines the handling properties of the medium. Since the evaporation of the water leads to the loss of a considerable part of the volume of the paint film, the paint cannot be applied thickly or with brushmarked impasto as in oil paint (which sets with little loss of bulk). Too thick an application of tempera, contracting as it dries, may result in the cracking of the paint film and surface flaking. The paint film, therefore, has to be built up gradually by repeated thin applications. This method allows the water to evaporate rapidly and the egg medium to harden sufficiently to allow further layers, providing the brushstrokes are made with a light and rapid touch. If attempts are made to manipulate the paint and to blend the colours when wet, as in oil painting, the previously applied layers, still only partially set, will tend to redissolve and peel away from the ground.

Egg tempera paint must, therefore, be applied with care, employing soft, pointed brushes (Cennino described the manufacture of brushes of miniver—the modern equivalent are those made from sable) and usually some form of hatched or stippled brushwork. The extent to which the hatched application of paint is allowed to show when painting is finished depends on the painter. In a few instances it is barely

detectable, but generally it appears to have been an accepted convention of the technique to allow the brushstrokes to remain distinct and visible on close inspection. In many of the works of the 20th-century tempera painter Edward Wadsworth (1889–1949), this is exaggerated so that the white ground is often glimpsed between gaps in the interlaced hatching or pointillist stippling.

Since the colours cannot be blended on the surface of the painting when using tempera, all the hues and tones of colour needed to achieve modelling and relief must be mixed and combined with the medium in advance. Cennino described a method of preparing pre-mixed shades of colour for drapery painting, which appears to have been in widespread use among painters in tempera: the chosen pigment is used at its purest and most saturated for the shadows (i.e. mixed with little or no lead white), while for the highlights a high proportion of lead white is used. To make a mid-tone the two are combined, and further intermediate tones are obtained by combining the mid-tone again with one of the two original preparations. These pre-mixed tones are then applied in sequence, beginning with the deepest shadows of the folds and working through to the highlights, repeating the process until sufficient coverage of the ground has been achieved and the transitions between the tones have been blended and softened to the desired extent by the intermeshing of the hatched brushstokes. An area painted in this way tends to have a light, bright tonality since many pigments when used pure and unmixed, as for the shadows, remain relatively light in tone. To deepen the tone and achieve a more naturalistic effect it would be necessary to mix darker pigments, such as black, making the colours appear dull and muddy, or to superimpose glazes, a technique more suited to the different properties of oil painting. However, an advantage of the relatively light tonality of a tempera painting executed in this way is its greater visibility and clarity in a dimly lit setting, especially in the churches for which many of these works were intended.

The smooth and not too absorbent surface of Gesso (or in the case of northern European painting, chalk) grounds, whether on panel or on canvas, has always been considered the most suitable preparation for tempera painting, even when there are no areas of gilding. The reflective properties of white grounds also contribute to the bright tonality of tempera paintings since the paint layers are seldom built up so thickly as to obscure completely the brilliance of the ground. The need to retain the reflective properties of the ground is one reason why major alterations are inadvisable in tempera painting: careful planning of the design and usually some form of preliminary underdrawing on the ground are necessary before beginning to paint. The optical properties of the egg medium are such that the pigments will appear brighter and closer to their appearance in the dry state than they do when in an oil medium. Since the refractive index of egg tempera is lower than that of any pigment, it cannot be used to make truly transparent glazes, even when combined with

such pigments as the red lakes, which are transparent when used in oil. Effects of optical complexity resulting from superimposed colours are obtained more by the thinness of application necessary to the technique than through any inherent properties of the medium.

The most complex optical effects to be seen in early Italian tempera painting occur in areas of flesh painting. Until the end of the 15th century it was common practice to underpaint any area of flesh with a thin and unmodulated layer of green earth mixed with lead white or, alternatively, with a combination of black, white and yellow pigments, which produces a greenish brown colour, called *verdaccio* by Cennino. The flesh tones are then applied over this underlayer. In the highlights, painted with opaque pigments with good covering power, for example lead white and vermilion, the green underpaint is obscured, but in the more thinly painted mid-tones and in the shadows, modelled with less opaque brown and black pigments or with the *verdaccio* mixture, the green underpaint is allowed to show through to some extent, giving a cool opalescent effect in the mid-tones and a warmer olive tinge to the shadows.

The properties of egg tempera make it well suited to use in combination with various forms of gilded decoration. The brilliant tonality characteristic of the medium complements the gleam and sparkle of burnished and tooled water gilding, while the decorative qualities of the painted draperies can be enhanced with patterns of mordant gilding or the more delicate effects of shell gold. The fact that tempera will adhere to gold is exploited to spectacular decorative effect in the technique of *sgraffito*, generally used to represent cloth-of-gold textiles: the paint is applied over gold leaf, and, when it is dry, but not yet fully hardened, it is scraped away to expose the gold part of the design.

(ii) *Later use, after c. 1400.* Many of the techniques and principles of tempera painting described by Cennino continued to be used in Italy in the 15th century, but towards the middle of the century techniques began to change radically with the introduction of novel oil painting methods from northern Europe. In these transitional years the egg medium was often used in combination with separate layers of oil-based paints, either for lighter coloured areas or more particularly as a quick-drying underpaint for subsequent oil-based glazes. Technical examination suggests that it was also sometimes used for this purpose in the Netherlands. Furthermore, scientific analysis has shown that some Italian painters, among them Pesellino (*c.* 1422–57), Sandro Botticelli (1444/5–1510; (see colour pl. XIV, fig. 3) and Carlo Crivelli (?1430/35–95), occasionally added small amounts of drying oil to their egg tempera, creating an enriched tempera, appropriately described in Italian as *tempera grassa* (fatty tempera). With *tempera grassa* it is possible to produce slightly more blended effects and a deeper tonality closer to that of oil-based media. These emulsions, however, still start their drying process with the evaporation of water, so their

handling properties remain closer to those of pure tempera than of oil.

By the 16th century egg tempera was being rapidly displaced by oil, but Vasari gave brief instructions for its use, and it was selected by some painters for specific works where a light, bright tonality was needed: for example, analysis has shown that whereas the main panel of the *Madonna and Child with SS John the Baptist and Nicholas of Bari*, the Ansidei *Madonna* (1505; London, National Gallery) by Raphael (1483–1520) appears to be a deep-toned and richly glazed oil painting, the *St John the Baptist Preaching* from its predella is mainly in egg tempera. According to Vasari, Domenico Beccafumi (1484–1551) was also in the habit of using egg tempera to enhance the legibility of small-scale narrative predella panels while using oil for the main panel where the larger, broader forms would remain visible in a dark church.

In subsequent centuries egg tempera seems to have almost completely died out as a medium, except, perhaps, in some forms of decorative painting. It was revived, however, in the 19th century when, stimulated by the rediscovery and publication of Cennino's treatise, painters, restorers, copyists and forgers began to experiment with its use. In late 19th-century Britain tempera techniques had a particular appeal to followers of William Morris (1834–96) and John Ruskin (1819–1900), among them the Birmingham painter Joseph Southall (1861–1944) who adopted Cennino's methods with considerable success. Some early 20th-century writers on painting techniques published recipes for tempera consisting of complex mixtures of egg, oils, varnishes and other materials, probably in an attempt to make the technique more amenable to modern approaches to painting. Similar complex mixtures with egg as a relatively minor component have been sold ready-made in tubes as tempera colours. Scientific analysis shows that these recipes have no basis in the simple but strict disciplines of traditional tempera technique.

2. CONSERVATION. Tempera paintings share with works in other media many problems of condition and conservation, for example the changes brought about by unstable and fugitive pigments. The condition of any paint film, whatever its medium, is affected by the ageing of its support and ground; thus, for example, cracks that appear in a gesso ground as a result of its embrittlement and of movement in the support, will be visible in the paint film. An egg tempera paint film also develops its own much finer network of cracks, generally a fine crazing, often only just visible to the naked eye. If the paint is too thickly applied or if a later varnish or some other coating layer is tending to shrink and contract, this crazing can lead to fine flaking. Another cause of fine flaking can be air bubbles, resulting from foaming paint, that are trapped in the paint film as it dries, forming small voids. Egg-bound paints foam readily, especially if applied with a loaded brush or if sponged on to imitate marbled patterns, as

in some 15th-century paintings. Although tempera adheres initially to burnished gold (as in *sgraffito*), flaking may occur when it becomes embrittled with age. Losses can often be seen where a painted form overlaps a gilded background. If the paint film has been carefully built up with the correct proportion of medium to pigment, the surface of a tempera painting can be hard and durable. It is often said that tempera paintings are more resistant to materials traditionally used in picture cleaning than most oil paintings. Nevertheless, the paint surfaces of many tempera paintings have become abraded, most probably by routine dusting and perhaps washing (the washing of paintings with alkaline solutions of lye is described in many manuals and treatises), and by the removal of old varnish layers.

It is not clear to what extent tempera paintings were varnished originally. The identification of possible original varnish layers is problematic, both because of the need for very sensitive methods of scientific analysis and because of the difficulty in proving that the layer is original as opposed to merely old. There is, however, some documentary evidence—including a Venetian guild regulation of 1278 that forbids the sale of any unvarnished painted article, including altarpieces—to suggest that tempera paintings were varnished more often than has sometimes been thought. Varnishing protects the surface against dust and dirt but also against mould and mildew. Modern tempera paintings, which are almost always left unvarnished, are very prone to mould attack. The varnishes used until at least the 16th century were based on so-called 'hard' resins, heated until liquid and then incorporated with drying oils. They may sometimes have been applied over egg-white varnishes of the type described by Cennino as being suitable for making the surface appear glossy and more saturated while waiting for the tempera to harden sufficiently to be ready for the application of the oil and resin varnish; he recommended a delay of at least a year. With time these oil and resin varnishes must have become discoloured and opaque, leading to their eventual removal. The cleaning agents and methods for their removal are likely to have been responsible for some of the damage to the surfaces of tempera paintings. This abrasion, together with the tendency for tempera paint films to become slightly more transparent as they age, accounts for the most familiar effect of time and damage on early Italian tempera paintings: the increased visibility of the green earth underpainting in areas of flesh paint.

See also TECHNICAL EXAMINATION, §VIII, 6.

C. Cennini: *Il libro dell'arte* (MS.; *c.* 1390); Eng. trans. and notes by D. V. Thompson jr (1933)

G. B. Brown, ed.: *Vasari on Technique* (London, 1907/*R* New York, 1960) [Eng. trans. by L. S. Maclehose]

D. V. Thompson: *The Materials of Medieval Painting* (London, 1936/*R* New York and London, 1956)

D. V. Thompson: *The Practice of Tempera Painting* (New Haven, 1936/*R* New York and London, 1962)

R. J. Gettens and G. L. Stout: *Painting Materials: A Short Encyclopedia* (New York, 1942/*R* 1966)

J. Dunkerton: 'Joseph Southall's Tempera Paintings', *Joseph Southall, 1861–1944: Artist Craftsman* (exh. cat., Birmingham, City of Birmingham Museum and Art Gallery, 1980), pp. 18–24

A. del Serra: 'A Conversation on Painting Techniques', *Burlington Magazine*, cxxvii (1985), pp. 4–16

D. Gordon and others: 'Nardo di Cione's *Altarpiece: Three Saints*', *National Gallery Technical Bulletin*, ix (1985), pp. 21–37

Art in the Making: Italian Painting before 1400 (exh. cat. by D. Bomford and others; London, National Gallery, 1989–90)

J. Dunkerton, J. Kirby and R. White: 'Varnish and Early Italian Tempera Paintings', *Preprints of the Contributions to the Brussels Congress of the International Institute for Conservation: Brussels, 1990*, pp. 63–9

J. Dunkerton and others: *Giotto to Dürer: Early Renaissance Painting in the National Gallery* (New Haven and London, 1991)

A. Fuga: *Artists' Techniques and Materials* (Los Angeles, 2006)

Terracotta [It.: 'cooked earth']. The commonly used term for a type of natural plastic clay that hardens when dried.

1. Properties and techniques. 2. Uses. 3. Conservation.

1. PROPERTIES AND TECHNIQUES. When exposed to firing temperatures in excess of 600°C, terracotta increases in mechanical strength and, though porous, will not revert to its plastic state when saturated by water. In ceramic terms, the composition of terracotta can be compared to that of earthenware. Earthenware clays are formed from sedimentary clays, which contain many organic and mineral impurities. It is these that determine the characteristic colour of the clay. The colour most commonly associated with terracotta is a rich red-brown, which is due to the presence of iron oxide in the clay that, when fired in an oxygen-rich atmosphere, produces the distinctive red colour. The presence of other minerals, the firing temperature and the atmosphere in the kiln all contribute to the final colour of terracotta, which can range from dark brown to pink, buff, tan, orange or even green.

For further discussion of clays, forming techniques, kilns, firing and decoration *see* CERAMICS, §I. For terracotta bricks *see* BRICK, §I, 1(iii).

A. Toft: *Modelling and Sculpture* (London, 1911)

J. Rich: *The Materials and Methods of Sculpture* (New York, 1947)

N. Penny: *The Materials of Sculpture* (New Haven and London, 1993)

2. USES. The plastic property of terracotta clays has resulted in their use globally since Neolithic times in the production of vessels, votive objects, sculpture and architectural decoration. The following essay touches briefly on the use of terracotta in the Western tradition, especially with regard to its use in sculpture and architecture.

(i) Sculpture. Throughout the history of European sculpture terracotta has always been a popular medium, although there are certain periods and regions, for example the 15th and 16th centuries in Tuscany and Emilia and the 18th and 19th centuries in France, where the use of terracotta was comparable with marble and bronze, the so-called 'nobler' materials.

Sculptors were, and are, attracted to terracotta as a medium for several reasons, not least because ideas can be realized in clay with great speed, often resulting in a spontaneity and verve that can be lost in the more laborious processes involved in bronze casting or carving stone. Clay also permits an extraordinarily fine degree of detail. The ability to model directly from life in clay, its malleability and the possible addition of polychromy for heightened realism also meant that terracotta was used widely for portrait busts, especially in Italy from the 15th century.

The relatively low cost of clay compared to materials such as bronze and marble was another important factor affecting a patron's choice. This was particularly so in areas lacking in stone quarries, such as Emilia-Romagna, the Marches and even the Veneto where the cost of transporting the stone from quarries such as Carrara in Tuscany made marble prohibitively expensive for most commissions. The inexpensiveness of clay and its ease of handling also meant that it was often employed to make small-scale copies or versions of famous bronzes or marbles for collectors. This practice of copying famous works in terracotta continued into the 19th century when copies after works by such Quattrocento masters as Donatello (1386/7–1466) and Desiderio da Settignano (1429/32–64) were mass-produced. The low cost of clay also meant that it was used for ephemeral works intended for celebratory occasions.

One of the most important uses of clay for sculptors was for making models (*see* MODELLO, §2), which fulfilled a variety of functions. As clay studies they were considered an important part of a sculptor's academic training and were often passed on by masters to their workshops or to a favoured pupil. They also acted as presentation models, which often formed part of the contract between an artist and his patron and were used as a guide to the artist, such as the relief model (1476; London, Victoria and Albert Museum) by Andrea del Verrocchio (1435–88) for the Forteguerri Monument for Pisa Cathedral. Sometimes financial or other difficulties meant that full-scale highly worked models were substitutions for the intended finished works in marble or bronze. The fine line between modelli and finished works of art becomes increasingly difficult to define in the late 17th century and 18th when sculptors began to sign and date their models. The signed and dated *Bacchante Riding a Goat* (h. 900 mm; New York, Metropolitan Museum of Art) by Philippe-Laurent Roland (1746–1816), for example, is a highly finished piece that was undoubtedly intended to be replicated in bronze, but also represented a finished work of art that was exhibited in the Salon of 1798 and subsequently sold. Models were considered collectable items by the beginning of the 16th century when models by Jacopo Sansovino (1486–1570) were sought after by Florentine *cognoscenti*. By simply

gilding or painting models with a patina to look like bronze, they could be turned into finished works of art for collectors. Although some of this 'finishing' of models was carried out after an artist's death, it was certainly also a practice used by sculptors themselves. Ultimately it was the popularity of terracotta models that led to the small-scale highly finished groups by such artists as Clodion (1738–1814) and Albert-Ernest Carrier-Belleuse (1824–87) in the 18th and 19th centuries.

Before the 18th century fired terracotta was never left bare. The most widespread technique for finishing terracotta sculpture has always been polychromy. Colour was applied, usually over an initial gesso layer, by the modeller himself or often by a specialized painter. Sometimes gilding would be combined with elaborate polychromy resulting in a richly extravagant effect that appealed to princely taste (e.g. *Lamentation*, 1492, commissioned by Alfonso, Duke of Calabria, for S Anna dei Lombardi, Naples) by Guido Mazzoni (?1450–1518). Polychromy continued to be used on both small- and large-scale works in the 18th and 19th centuries, such as the over life-size *Pietà* (Bologna, S Maria Maddalena) by Giuseppe Mazza (1653–1741) or the numerous small-scale polychrome groups produced in Naples. Terracotta finishes also frequently simulated precious materials such as bronze, marble or gold. The glazed terracotta technique, first applied to sculpture by Luca della Robbia (1399/1400–82) in the 1440s has been widely imitated up until the present day. By the 18th century terracotta's natural colour was becoming acceptable. Michael Rysbrack (1694–1770) merely covered his figures in a thin layer of red paint, and Clodion and his contemporaries applied light watercolour washes, often in a pinkish buff or pinkish grey colour, to disguise any flaws resulting from firing and to give the surface a smooth matt finish.

Few tools were employed for the actual modelling of figures. A toothed *ébauchoir* (a tool that cuts clay into ridges) was used regularly in the 18th century for helping create lights and shadows (e.g. anonymous Roman low relief of *Clement XI*, early 18th century, h. 603 mm; Cambridge, MA, Fogg Art Museum), but the greatest practitioners used their fingers more than tools.

L. Ghiberti: *Commentarii* (1912)

J. Pope-Hennessy: *Catalogue of the Italian Sculpture in the Victoria and Albert Museum*, 3 vols (London, 1964)

La civiltà del cotto: Arte della terracotta nell' area fiorentina dal XV al XX secolo (exh. cat., ed. A. Paolucci; Impruneta, 1980)

C. Avery: *The Fingerprints of the Sculptor: European Terra-cotta Sculpture from the Arthur M. Sackler Collection* (Washington, DC, 1981)

J. D. Draper: *French Terracottas* (New York, 1992)

N. Penny: *The Materials of Sculpture* (New Haven, 1993), pp. 176–8, 201–14

M. Trusted: *Spanish Sculpture: Catalogue of the Post-medieval Spanish Sculpture in Wood, Terracotta, Alabaster, Marble, Stone, Lead and Jet in the Victoria and Albert Museum* (London, 1996)

B. Boucher: *Earth and Fire: Italian Terracotta Sculpture from Donatello to Canova* (New Haven and London, 2001)

J. Draper and G. Scherf: *Playing with Fire: European Terracotta Models* (New York, 2004)

(ii) Architecture. Versatile terracotta has been a channel for the transmission of style; its propensity for intricate ornament has made it the jewel of design, as terracotta artistry has fused architecture and ornament. Just as Islamic tile sheathing was transposed from the Alhambra at Granada to the polychrome façades of 18th-century Mexico, tiles, portable decorative arts and books of measured drawings, such as the chromolithographic, two-volume *Alhambra* (London, 1842–5) by Owen Jones (1809–74), made Moorish design available in the English-speaking world. Meanwhile Italian 15th-century terracotta became the clay model, as it were, for the carved stone decoration of 16th-century Spain and for 19th- and 20th-century architecture. From *c.* 1750 a sweeping terracotta revival developed, as artificial stone until 1850, as mosaic and ornament in masonry construction until 1892, then as sheathing and fireproofing for the skyscraper, making terracotta the most abiding manmade building material. Yet following 1930 reinforced concrete and Modernism, with its dicta for ornament-free structures of metal and glass, virtually destroyed the terracotta industry.

Two technical developments redirected the history of architectural terracotta *c.* 1890. First, an expanding supply of steel supported the proliferation of commercial buildings, especially skyscrapers. Savings in weight, ease of firing, drying and anchoring made hollow clay blocks with inside webbing for strength suitable adjuncts to steel-frame construction. In the 1870s, following the Boston and Chicago fires, terracotta was recognized as the ideal insulator, cladding and fireproofing material. Pioneering work in this area had been done by the Chicago architect Peter B. Wight (1838–1925) since 1869, and the use of terracotta lumber became ubiquitous after Sanford Loring developed a more porous and lighter fireproof material at the Chicago Terra Cotta Company in 1871. With the advent of steel-frame construction in the USA, terracotta lumber and protective arches began to be exploited to create firebreaks isolating the horizontal 'T'-beams of the skyscraper and to protect the steel frame from heat. At the same time elaborate systems for anchoring industrial blocks in steel-frame construction were developed. Often these stretched the limits of the material with projecting cornices and other three-dimensional components. Skill in terracotta specification (as opposed to stone construction) was requisite for urban architects, especially in the USA where standards were established by the National Terra Cotta Society in 1914.

The second major technical development in the 1890s was the perfection of coloured glazes for terracotta, increasing its appeal as ornament. As an adjunct to brick in natural colour, dark red, yellow, buff and slate blue terracotta was used until *c.* 1892. With rising interest in the Renaissance, single-coloured and then polychromatic glazes were introduced into industrial production between 1894 and 1930.

A misconception that added (coloured) glazes would protect the argillaceous body of terracotta led to a reduction in the silicate level and consequent quality of the clay by some manufacturers. Because of over-confidence in the permanence and impermeable nature of glazed, baked-clay cladding, which was envisioned as a miracle material, architects often failed to design appropriately (using it in highly exposed locations), and owners failed to maintain mortar joints with ongoing tuckpointing. Glazed sculptured terracotta (faience) has not matched natural slip-glazed clay in longevity for exterior use, because shrinkage and expansion of the glaze and the clay body occurring at different rates can cause blocks to crack, allowing water to enter the masonry and to rust the anchoring systems that attach the terracotta cladding to the frame. Nonetheless, where properly designed, manufactured and maintained, terracotta remains more impervious to deterioration than stone.

19th-century sources

J. Britton and A. C. Pugin: *Illustrations of the Public Buildings of London*, 2 vols (London, 1825–8)

L. Runge: *Beiträge zur Kenntniss der Backsteinarchitektur Italiens, nach Reiseskizzen*, 2nd series (Berlin, 1846–53)

E. Dobson: *A Rudimentary Treatise on the Manufacture of Bricks and Tiles* (London, 1850, 2/1868)

M. D. Wyatt: 'Observations on Polychromatic Decoration in Italy from the 12th to the 16th Centuries', *Session Papers RIBA* (Dec 1850)

J. M. Blashfield: *An Account of the History and Manufacture of Ancient and Modern Terra Cotta* (London, 1855)

G. E. Street: 'On Colour as Applied to Architecture', *Associated Architectural Socities Reports and Papers*, iii (1855), pp. 348–66

M. D. Wyatt: *On the Influence on Ceramic Manufacture by the Late Mr Herbert Minton* (London, 1858)

L. Gruner, ed.: *The Terra Cotta Architecture of North Italy (XIIth–XVth Centuries), Portrayed as Examples for Imitation in Other Countries from Careful Drawings by Frederick Lose* (London, 1867)

E. Locke: 'On the Application of Moulded and Shaped Bricks to Architectural Purposes', *Building News*, xv (1868)

G. Redgrave: 'Terra Cotta and its Employment as a London Building Material', *Building News*, xv (1868), p. 91

J. H. Sturgis: 'Terra Cotta and its Uses', *AIA Proceedings, 5th Annual Convention: Boston, 1871*

J. Taylor: 'Terracotta Manufacture in Chicago', *American Architect and Building News*, i (1876), p. 420

Clayworker (Indianapolis, 1884–1933)

J. Taylor: 'Terra Cotta in New York', *Architectural Record*, ii (1892), pp. 137–48

Brick and Clay Record (Chicago, 1892–1910)

Brickbuilder (Boston, 1892–1916)

A. Prentice: *Renaissance Architecture and Ornament in Spain* (London, 1893)

20th-century sources

A. Penafiel: *Ceramica mexicana y loza de talavera de Puebla* (Mexico, 1910)

H. Strack: *Brick and Terra Cotta Work during the Middle Ages and the Renaissance in Italy* (New York, c. 1910)

Architectural Terra Cotta, Standard Construction, Draughtsman's Edition, National Terra Cotta Society (New York, 1914)

Terra Cotta of the Italian Renaissance, National Terra Cotta Society (Derby, 1928)

W. S. Lowndes: *Plastering and Architectural Terra Cotta* (Scranton, PA, 1931)

F. A. Randall: *History of the Development of Building Construction in Chicago* (Urbana, IL, 1949, 2/New York, 1972)

M. H. Floyd: 'A Terra-cotta Cornerstone for Copley Square: Museum of Fine Arts, Boston, by Sturgis and Brigham (1870–1876)', *Journal for the Society of Architectural Historians*, xxxii (1973), pp. 83–102

S. Gilfillen, ed.: *American Terra Cotta Index* (Chicago, 1973)

Marble Halls: Drawings and Models for Victorian Secular Buildings (exh. cat., ed. J. Physick and M. Darby; London, Victoria and Albert Museum, 1973)

T. H. M. Prudon: 'Terra Cotta as a Building Material: A Bibliography', *Association for Preservation Technology Supplement Communiqué*, v/3 (1976)

D. Hamilton: *The Thames and Hudson Manual of Architectural Ceramics* (London, 1978)

S. Darling: *Chicago Ceramics and Glass: An Illustrated History from 1871–1933* (Chicago, 1979)

M. Girouard: *Sweetness and Light: The 'Queen Anne' Movement, 1860–1900* (London, 1979)

S. Tindall and J. Hamrick: *American Architectural Terra Cotta: A Bibliography* (Montecito, IL, 1981)

M. Stratton: 'The Terracotta Revival', *Victorian Society Annual* (1982–3), pp. 9–31

N. D. Berryman and S. M. Tindall: *Terra Cotta: Preservation of an Historic Building Material* (Chicago, 1984)

A. Kelly: 'Coadestone in Georgian Architecture', *Architectural History*, xxviii (1985), pp. 71–95

M. Stokroos: *Terracotta in Nederland het gebruik van terracotta en kunststeen in de 19e eeuw* (Amsterdam, 1985)

Impressions of Imagination: Terra-cotta Seattle (Seattle, WA, 1986)

M. H. Floyd: 'Architectural Terra Cotta to 1900', *Studio Potter*, xvii (1989), pp. 32–9

S. Tunick: 'Architectural Terra Cotta, 1900–1990', *Studio Potter*, xvii (1989), pp. 40–48

A. Kelly: *Mrs Coade's Stone* (London, 1990)

M. Stratton: *The Terracotta Revival: Building Innovation and the Image of the Industrial City in Britain and North America* (London, 1993)

J. M. Teutonico, ed.: *Architectural Ceramics: Their History, Manufacture and Conservation* (London, 1996)

21st-century sources

C. Cunningham: *The Terracotta Designs of Alfred Waterhouse* (London, 2001)

S. Tunick: 'The Evolution of Terra Cotta: "Glazing New Trails"', *APT Bulletin*, xxxii/4 (2001), pp. 3–8

K. R. Hoigard, G. R. Mulholland and R. C. Haukohl: 'Terra Cotta Facades', *Building Facade Maintenance, Repair, and Inspection*, eds. J. L. Erdly and T. A. Schwartz (Washington, DC, 2004), pp. 75–90

3. CONSERVATION. Most terracotta objects are porous, with low mechanical strength, and can be structurally weakened by firing damage. When fired at low temperatures they can remain soluble in water and may contain soluble salts. The use of inappropriate restoration and mounting materials can accelerate deterioration, and exposure to outdoor conditions can cause frost damage, algae growth and salt contamination.

Terracottas should be kept in a dust-free environment with moderate and constant humidity and temperature levels. Light levels should be low if fugitive pigments are present in the surface decoration. Wooden frames around reliefs should be avoided, as dimensional changes in the wood can cause compression damage. Direct contact with bedding or mounting materials such as plaster or cement should be avoided as they are potential sources of salts.

The unsuitable cleaning of a terracotta can cause irreversible damage. Dry methods are more controllable but will often only remove surface dirt, while wet cleaning methods involve the use of solvents. Deteriorated terracotta objects can be consolidated but this often results in the darkening of the clay body. Repairs to damaged terracotta can be made using thixotropic or fast-curing adhesives and acrylic resins that avoid bleeding into the porous clay. Ideally, the process chosen should be reversible. Noncorroding dowels can be used to strengthen joints; filling materials should be reversible and salt free.

For further discussion of conservation techniques *see* Ceramics, §II.

J. Larson: 'The Conservation of Terracotta Sculpture', *The Conservator*, iv (1980), pp. 38–45

N. Stolow: *Conservation and Exhibitions* (London, 1987)

J. Warren: *Conservation of Brick* (Oxford, 1999)

Wu Yongqi and others, eds: *The Polychromy of Antique Sculptures and the Terracotta Army of the First Chinese Emperor: Studies on Materials, Painting Techniques and Conservation* (Munich, 2001)

Terrazzo. Polished floor surface made from marble chippings mixed with white or coloured cement mortar.

Tessera. Term applied to a small piece of glass or stone used in Mosaic (see colour pl. XIV, fig. 1).

Textile. Fabric composed of any form of pliable fibre held together by such techniques as weaving, felting, plaiting, looping etc. The following survey describes the technical aspects of textile production.

D. Burnham: *Weft and Warp: A Textile Terminology* (Toronto, 1980)

A. Seiler-Baldinger: *Systematik der Textilen Techniken* (Basle, 1991; Eng. trans. Washington, DC, 1994)

J. Harris, ed.: *5000 Years of Textiles* (London, 1993)

E. Hardouin-Fugier, B. Berthod and M. Chavent-Fusaro: *Les étoffes: Dictionnaire historique* ([Paris, 1994])

M. C. Tubbs: *Textile Terms and Definitions: Compiled by the Textile Institute Textile Terms and Definitions Committee* (Manchester, 10/1995)

P. Tortora, ed.: *Fairchild's Dictionary of Textiles* (New York, 1996)

J. Gillow and B. Sentence: *World Textiles: A Visual Guide to Traditional Techniques* (London, 1999)

I. Threads and preparation. II. Fabric manufacture. III. Patterns. IV. Conservation.

I. Threads and preparation. A thread (or yarn) is a continuous strand made from either natural fibres of vegetable or animal origin, metal or man-made fibres, by the processes of spinning, twisting, reeling or throwing. It is the basic unit used in the construction of textiles, and its primary requirements are flexibility and length.

1. Vegetable and animal fibres. 2. Metal threads. 3. Manmade fibres.

1. Vegetable and animal fibres. Some fibrous plant materials, such as raffia, can be used in their natural state by splitting apart thick sections and knotting ends together for length. Natural fibres with the exception of silk have a limited length and must undergo extensive preparation before they become a thread. Short lengths of fibre can be manipulated and laid parallel, drawn out and spun into a yarn of desired length, diameter, strength and texture. Silk, by contrast, is a continuous filament.

(i) Types. (ii) Spinning.

(i) Types.

(a) Bast fibres. (b) Seed hairs. (c) Animal fibres.

(a) Bast fibres. Bast is the fibrous cellulose found in the stalks of certain plants.

Linen. Linen is obtained from the flax plant. The distribution of wild varieties of flax occurs from the Mediterranean region eastward to Iran and Iraq and is also found along the Atlantic coast of Europe. The cultivation of flax was even more widespread, and Belgium, the Netherlands, England and Ireland still cultivate flax commercially. Evidence of a cultivated flax (*Linum usitatissimum*) dates from before 5000 BC in the Middle East. The plant is a herbaceous flowering annual that adapts easily to its environment. It is not known whether the earliest use of flax was for its valuable oil-bearing seeds (linseed) or its woody stems for textile production.

The physical and chemical properties of flax make it a valuable fibre for textile production. The plant grows tall and straight, up to 1.3 m, thereby producing a relatively long length of fibre for spinning, which is actually composed of short segments, 20 mm to 40 mm, placed end to end. The diameter of the fibre ranges from 12 to 25 microns. Linen threads are strong and lustrous and feel cool to the touch. In its natural state, linen ranges in colour from tones of grey to brown (see fig. 1). It can be bleached, traditionally by placing the cloth on wet grass where the daylight and air gradually lighten the colour. The fibres do not accept dyes readily.

The plant is harvested young to obtain a fine fibre. It is pulled from its roots and dried, and the stalks are separated from the leaves by rippling, a process of drawing them through a comb. They are then submerged in water and allowed to rot, a process known as retting. The fibrous cellulose, the bast, is then separated from the outer tissue. Alternatively, flax can be spread in a field and slowly left to rot. Boiling the stems in dilute oxalic acid will also cause separation of the tissues. The retting process must be carefully controlled as over-retting will produce a weak

1. Linen sheet, 1050×1370 mm, from the tomb of Sebekhetepi at Beni Hasan, Egypt, *c.* 2125–*c.* 1795 BC (London, British Museum); photo © British Museum/Art Resource, NY

fibre and under-retting will make the fibre difficult to separate from the outer woody elements. After retting, the flax is dried, and the stems are broken up to reduce them into finer pieces. These broken pieces are removed by beating, known as scutching, which gradually frees the fibrous material. The final processing step involves pulling the scutched flax through a sharp-toothed comb known as a hackle, or heckle, to remove the last woody pieces and align the fibres in parallel for spinning. Some of the tow, or waste, fibre is usable for lower grades of thread and ropes.

Flax processing is labour intensive. The use of linen in Europe declined as cotton cloth became readily and cheaply available due to mechanization. Only in the 20th century did flax processing become mechanized.

Hemp. Another bast fibre used by ancient cultures is hemp, from the plant *Cannabis sativa*. It has a wide geographical distribution and is adaptable to all but the harshest climates. The plant is an annual with a straight stalk growing between 2 and 5 m tall. The fibres are processed in a similar manner to flax. The retting, breaking and hackling processes result in a thread that is coarser than flax and less desirable for use in clothing. Hemp fibres are very durable and resistant to rot and are therefore used extensively in the making of ropes and sails. The natural colour of the fibre is dark brown. Bleaching weakens the fibre, and it is also difficult to dye.

Rami. Rami (*Boehmeria nivea*) grows in such tropical and sub-tropical climates as India and China. The shrubby plant grows to 2 m high and is easily cultivated. Fibre separation is done either by hand or by machine. The outer bark of the stem is scraped away once the plant has been soaked in water. A gummy substance that holds the fibres together remains; this must be removed, usually through the use of an alkali. Rami produces very fine threads that are lustrous, strong and durable but lack elasticity. For this reason, rami is often compared to silk. It will accept dyes easily, although the colorant will not completely penetrate the fibres.

Other. Several other bast fibres have been processed into threads for use in textiles and have had regional, historic or economic importance. These include jute (*Corchorus capsularis*), nettle (*Urtica dioica*) and sparto grass (*Stipa*).

(b) Seed hairs. Seed hairs differ from bast fibres in that they have a short staple (length of fibre) that derives from the downy hairs that cover the seed. Seed hairs provide another important source of plant fibres for spinning threads, of which cotton is the best known.

Cotton. Cotton fibres come from the seed hairs of a variety of plants of the *Gossypium* genus, native to Asia, Africa, the Middle East and the Americas.

The plant is a shrubby perennial that grows wild or is cultivated in warm and humid regions. The fibres develop inside a seed pod, or boll, that bursts open and exposes the seeds and hairs to the light. The long fibres are used for spinning, and the short fibres, or lintres, are used in papermaking. Cotton fibres are white or various shades of brown. Growing, harvesting and processing of cotton is labour intensive. Susceptible to damage from insects or severe weather conditions, cotton crops must be carefully tended. When mature, the cotton bolls are harvested, either by hand or by machine.

The fibres are separated into components by beating, or ginning. The staple of cotton fibres varies according to type and quality, the types known as Sea Island ranging from 12 mm to as long as 50 mm. The longer the fibre, the easier the spinning and the finer the thread that results. The fibres can be bleached white, and they accept dyes easily. Under the microscope, an unprocessed cotton fibre resembles a ribbon with bends and twists. It is relatively flat but can be made more cylindrical by immersion in a solution of sodium hydroxide. The fibres then swell, untwist and acquire some lustre, and, although the length decreases, a negative factor for production purposes, the tensile strength increases, as does the ability to receive dye. This process is known as mercerization and was developed in 1844 (patented 1950). By keeping the threads under tension during mercerization, the length of the fibre remains stable.

See also COTTON.

Kapok. The only other seed hair that has any economic importance is kapok (*Eridendron anfractuosum*), grown in South-east Asia. The fibres are not used for threads but as a stuffing material for upholstery. An unusual property of kapok is its low specific gravity. Life jackets and cushions stuffed with kapok are buoyant.

(c) Animal fibres. Animals provide a variety of fibres that may be spun into threads. Wool from the fleece of sheep and hairs from camel, llama, alpaca and goat are used in textile production. While silk also belongs to this group of animal fibres, its physiology is different as it originates as a glandular secretion.

Wool. The unique structure of wool makes it highly suitable for spinning. Grown in locks, the fibres have an outer epidermis consisting of minute, flattened scales that overlap at the edges and can be seen only through a microscope. The scales cling and adhere to each other, facilitating spinning. Along the length of the fibre are tiny undulations known as the crimp, which can be either fine or coarse. The wool of early sheep would have resembled the coarse hairs of goat, making identification of fibres in ancient fabrics difficult. Before domestication, the animal was covered with brown kemp, coarse hairs that were shed, and a finer, wool-like undercoat that moulted. Rare breeds of sheep that possess some of these characteristics still exist, for example the Mouflon on the islands of

Corsica and Sardinia and the Soay on St Kilda. Accurate identification of woollen textiles is possible for those produced after 3000 BC in the Near East and westward to Europe. Selective breeding for colour and quality of coat resulted in sheep with a soft, white fleece that could produce fine threads that could be dyed. Modern fleece seems to date to Roman times. During the Middle Ages the Merino sheep, a fine-wool breed, was developed in Spain. In the late 20th century this breed dominated the wool market.

Wool is obtained by shearing the fleece from the sheep. The fleece of some breeds, the Shetland for example, is, however, plucked during moulting, a term known as rooing, the same technique used with early sheep. Fibre quality depends on the location of the fleece on the body; the back, exposed to sun and rain, produces among the poorest fibres. The fleece is sorted into grades, and the raw wool is washed to remove dirt and some of the natural lanolin oils to make the spinning easier. If the fibres have a long staple, they can be pulled through a comb with long, sharp spikes. This process separates the staple and aligns the strands in parallel. This is the preparation method for a worsted yarn, known for its high quality and warmth. If the staple is relatively short, however, it is carded. Locks of fleece are spread along the back of a carder, a paddle covered with fine wire teeth. Worked in pairs, one carder is passed over the other to separate and straighten the fibres. They are rolled off the carder in a tube-shape mass known as a rolag, ready to spin. This preparation method results in a woollen yarn where the fibres are orientated randomly. Since ancient times, hand cards have been made from thistles or other prickly seed pods held together with cords or in a wooden frame. The mechanical process consists of a rotating drum covered with wire teeth, which cards the fleece and deposits it in sheets ready for spinning.

Mohair. Mohair is another important hair for textile production and comes from the Angora goat. It is believed to have its origins in Anatolia. The long staple, as much as 250 mm in length, is fine and has a high lustre. The dominant colour is white, which accepts dyes readily, but black and brown coloured goats also exist. The goats are clipped twice a year, yielding 2 kg of fleece.

Cashmere, other goat hair and camel hair. The Himalayan mountain goat, *Capra hircus*, native to Tibet and Kashmir, produces the luxury fibre cashmere. Known as pashmina in the West (Pers. *pashm*: 'wool') and *tus* in India, the fibres come from the undercoat of the goat. The fibres are gathered during the spring moulting season from domesticated goats, and each goat yields only 100 g of fibre a year. The fibres are spun into threads that produce the renowned Kashmir shawls. Hair from the common goat is also used in spinning threads. The coarseness of the yarn and its subsequent use depend on the species and environment of the animal. Yarns spun from goat

hair are commonly used in carpets, while camel hair, which is of varying fineness, is used in the making of garments.

Alpaca, llama and vicuña hair. In South America the hair of the alpaca, llama and vicuña provides fibres for spinning. The animals are native to the mountainous regions of the Andes. Alpaca hairs are long and fine and are coloured in shades ranging from brown to black; white also exists. Llamas are sheared every few years. The fibres obtained are coarse, and in order to obtain a softer thread, llama hair is often combined with alpaca for spinning. Vicuña fleece is reddish brown in colour and has a very fine, soft texture. The fibres are highly prized and difficult to obtain as the animal is not domesticated.

Silk. Silk is prized for its long filament, lustrous appearance, high tensile strength and facility to accept dyes. It is derived from the cocoon of the silkworm or caterpillar. The larvae of more than 200 species of caterpillars secrete a silk filament, which forms a cocoon. However, only the *Lepidoptera* class secretes enough fibre to make its cultivation an economically viable process, and, specifically, the *Bombyx mori* silkworm is responsible for the largest proportion of silk used in textiles (see fig. 2). This silkworm is bred commercially and feeds on cultivated mulberry leaves. It produces the highest quality silk. Of the other species that produce sufficient silk for use in textiles, none can be cultivated, and therefore the silk obtained from them is known generically as wild silk. Varieties of these silkworms grow wild and have a global distribution. Both the colour and quality of the fibre of wild silk vary.

The silkworm has two glands supplying one spinneret, which produces a fibre with two continuous filaments known as brins, often up to 1500 m in length. These are composed of the protein fibroin and are coated and glued together by a second protein, sericin. Sericin is a sticky, gumlike substance that solidifies on exposure to air and may be coloured yellow or green without staining the filaments it covers. Silk that retains its gum is known as raw silk, which is strong but lacks lustre. The gum, however, makes dye penetration difficult, and it is usually fully or partially removed by immersion in an alkali bath or through fermentation. There are two basic types of silk threads, those composed of groups of filament bundles and spun silk. These types correspond to how the fibre is obtained from the cocoon. Unbroken cocoons with the larvae still inside, are reeled. These cocoons are placed in a basin of warm water until the gum softens. When stirred with a stick, the filaments start to unravel into a continuous length, often between 500 and 800 m, that may be reeled off on to a bobbin. Routinely, between five to eight or ten cocoons are reeled simultaneously. The filament bundles are used in this state, or a slight amount of twist, known as throwing, can be introduced to the thread. Threads processed in this manner are of the highest quality and are used to produce luxury fabrics. Only the filament at the centre of the cocoon can be used for a reeled yarn. The beginning and end of the filament has poor conformity, and silk from these sections is spun. Cocoons of the breeding stock, which have become broken and stained during the exiting of the moth, are also used to produce a spun yarn. Wild silk is usually gathered after the moth has broken free, and it, too, is spun. Once woven, spun silk will create a heavyweight fabric in comparison to fabric woven from reeled silk.

See also Silk.

(ii) Spinning. A natural fibre is most commonly made into a thread by spinning. Short fibres are processed so that they are aligned in parallel. They are then drawn out and twisted together to form a continuous thread, usually with the assistance of a spindle or spinning wheel. The spinning process imparts a twist to the thread, and the features of this twist are delineated when describing a thread. The letters S or Z are used to designate the direction of twist of the yarn axis as it corresponds to the slant, \ or /, of the centre of these two letters (see fig. 3a and b). A thread composed of one strand is called a single. When two or more singles are twisted together, the thread is called plied. The number of singles joined together in the thread is designated as 2-ply, 3-ply etc. Generally, the direction of the twist in the plying process is opposite to that of the singles units. The tightness of the twist is recorded as the number of twists per linear unit of measurement or can be described by the angle of twist, or helix angle (3c). What visually appears as a loosely spun thread may have a 10° angle, a medium-spun thread up to a 25° angle and a tightly spun thread up to a 45° angle (3d). An overspun thread will twist back on itself if not held under tension, and it is this property that creates a crêpe effect in a woven cloth. The diameter of a thread also affects the texture and appearance of a fabric.

The earliest threads were probably formed by the drawing-out of a fibrous mass and the twisting of it by hand. With the assistance of a weight on a stick to provide momentum, the fibres can be twisted together with greater ease and rapidity, with the resulting threads stored on the stick. There is a measure of control in both the diameter and evenness of the thread achieved with this weighted drop-spindle. A variety of stone and clay whorls (weights) survive from most yarn-spinning cultures. They range from very light weights appropriate for spinning short cotton fibres to heavier whorls used for spinning wool and goat hair. The ancient Egyptians spun extremely fine linen threads. The flax was processed with great skill, and the lengths of fibres were virtually preformed as a thread and rolled into balls ready for twisting. Rather than continuously drawing from fibre bundles, the spinner would splice together already parallel fibres. Three of these lengths would be twisted together so that the splices did not overlap, thickening the diameter of the thread. The ancient Egyptians are depicted in paintings using a spindle with the whorl at the top. Spindle design reflects the requirements of the fibres to be spun.

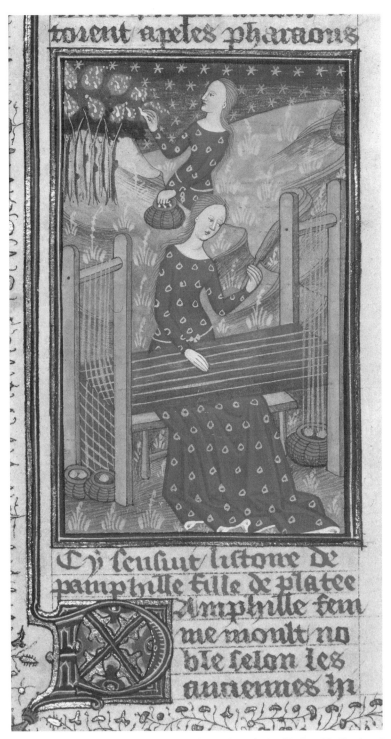

2. Silk worm cocoon collecting and spinning silk on a loom depicted in *Pamphila, Daughter of Plates*, miniature from Giovanni Boccaccio's *De claris mulieribus*, French, *c.* 1400–*c.* 1425 (London, British Library, MS. roy.16.g.v, folio 54*v*); photo credit: HIP/Art Resource, NY

Weights can be located at the top or the bottom of the stick. Cotton, with its short staple, cannot be spun with a heavy whorl, but needs a light weight. Most cotton-spinning cultures developed a system in which the whorl is oriented at the bottom and spins in a dish. The limitations to the spindle method of spinning thread is readily apparent. Skill is needed to twist the spindle with consistent force with one hand,

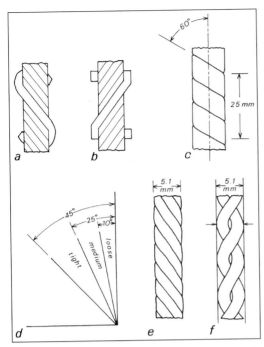

3. Description and measurement of a thread: (a) S-twist; (b) Z-twist; (c) angle of twist and number of twists per unit of linear measurement; (d) designation of angle of twist; (e) diameter of a tightly twisted thread; (f) diameter of a loosely twisted thread

while the other hand draws out the fibres. The spinner must stop frequently to wind the newly spun thread on to the stick. A storage system, the distaff, is needed to keep prepared fibres close at hand and ready for use.

The development of the spinning-wheel radically changed the manner in which yarns are spun (see fig. 4). From a technological point of view, the spinning-wheel is important as one of the earliest machines to use continuous rotary motion. Early wheel design orientated the spindle horizontally, pointing toward the spinner. A nearby wheel was fitted with a drive band connecting it to what would be the whorl of a spindle. By turning the large wheel, the spindle shaft turned, allowing the fibres to twist as they were drawn out. Reversing the direction of rotation of the large wheel allowed the spun thread to wind around the spindle shaft. The next development was the invention of the treadle drive and fly assembly. Increased demand for cloth created a need for faster production, and to accomplish this a winding-storage function needed to occur simultaneously with the spinning. A flyer, with hooks that turn around a bobbin, mounted on the spindle shaft successfully achieved continuous winding. A foot treadle provided consistent power, leaving both hands free to manipulate the fibres. The weaving process underwent mechanization in the 18th century, and thus demand for thread increased dramatically. In 1767 James Hargreaves (1720–78) invented

the Spinning Jenny, a machine that could turn a number of spindles at one time. Threads produced on the jenny did not have a tight twist nor much strength and were useful only as wefts. In 1771 Richard Arkwright (1732–92) improved the jenny, developing an auxiliary spinner powered by water or horse to create a stronger yarn suitable for warp threads. In 1779 Samuel Crompton (1753–1827) combined aspects of both machines to develop the mule-spinning frame, which provided weaving mills with the appropriate yarns for looms in the quantities desired.

J. M. Mathews: *Textile Fibers: Their Physical, Microscopic and Chemical Properties* (New York, 1904, rev. 4/1924)

J. Chittick: *Silk Manufacture and its Problems* (New York, 1913)

L. Bellinger: 'Basic Habits of Textile Fibers', *Recent Advances in Conservation: Contributions to the IIC Conference: Rome, 1961*, pp. 192–4

L. Bellinger: 'The Romance of Fibers, Natural and Man Made, and the Art of their Use in Decorative Textiles', *Threads of History: Catalog of the American Federation of Fine Arts* (New York, 1963), pp. 20–43

I. Emery: *The Primary Structure of Fabrics: An Illustrated Classification* (Washington, DC, 1966; rev. New York, 1994)

E. Mikosch: 'The Scent of Flowers', *Textile Museum Journal*, xxiv (1985), pp. 7–22

E. J. W. Barber: *Prehistoric Textiles* (Princeton, 1990)

E.W. Barber: *The Mummies of Ürümchi* (London, 2000)

B. J. Collier and P. G. Tortora: *Understanding Textiles* (Upper Saddle River, NJ, 6/2001)

2. METAL THREADS. A desire for luxury led man to embellish garments with precious metals. Gold and silver, soft, pliable materials, are used in the production of metal threads. Their expense, however, led to the use of non-precious substitutes, primarily copper, that could be coated with gold or silver leaf or dust. Metallic threads made partially or entirely of metal were used in weaving from a very early date to produce luxurious, expensive cloths. Metallic threads were used extensively in embroidery, lace and braiding. Early reference to gold threads is found in the Bible. A religious garment is described as including gold, and the passage continues 'they beat the gold into thin plates and cut it into wires, to work it in the blue, and in the purple, and in the scarlet, and in the fine linen with cunning work' (Exodus 39:2–3).

Two different production techniques are used to make metallic threads. Beating and cutting is the simplest method, whereby the metal is beaten flat and cut into strips as narrow as 5 mm in width, known as a lamella. These strips may be used for wefts in weaving, but are usually wrapped around a core yarn or couched down on the foundation cloth. Metal leaf can also be applied to a membrane substrate, comprising parchment, from a variety of animal gut, or paper. These strips present the same appearance as the solid metal strip but are less costly. However, when this cheaper substitute wears, the substrate becomes visible. Paper substrate is used extensively in Asia. In Japan particularly, modern computerized looms feed pre-cut lengths of metallic-coated paper

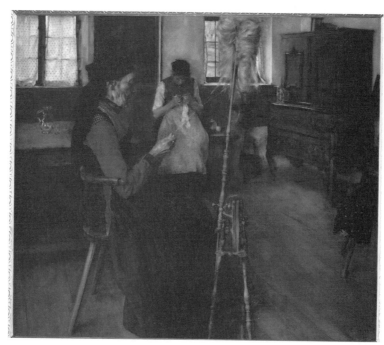

4. *Women Spinning Yarn and Knitting* by Wilhelm Leibl, oil on canvas, 650×740 mm, 1892 (Leipzig, Museum der Bildenden Künste); photo credit: Erich Lessing/Art Resource, NY

strips that serve as wefts into luxurious cloths. Gilt thread is now produced by electroplating, typically over a cupro-nickel base. The second method of producing metallic thread is the cast and draw technique. A thin rod of gold or silver is cast in a mould, turned and burnished. It is passed through reducing plates until a thin, continuous length of wire results. The wire can be burnished to a fine finish, or gold leaf can be applied and fused to a silver wire. To produce flat metal strips, the wire is placed between rollers and flattened. This technology significantly increased the amount of metallic threads that could be produced. The French-born traveller Sir John Chardin described metal thread-workers in Iran in the 17th century:

The gold wire drawers and thread twisters are very dextrous workmen. They draw an ingot, weighing a mescal, or drachm, nine hundred guezes, or Persian ells long, each gueze being five and thirty inches long. Their tools of several sizes are like our wire-drawing irons: they wind on bobbins and drums and buy at the mint, the small wire of the bigness of a pin: their thread is the best and the smoothest that can be imagined. All the art they use to give it that lively and lasting colour is to guild the wire very fine and very thick.

In many historic textiles flat metal strips are wrapped around a core yarn of silk, cotton or linen threads. The density of the wrapping is controlled to cover greater or lesser areas of the core yarn. This affects the reflection of light and is a factor in production costs. Often the core threads are dyed a colour that complements the wrapping metal; typically, a gold strip is wrapped around a yellow core, and a silver strip is wrapped over a white core. Luxury cloths were often unpicked for the content of their metal threads, although the foundation cloth is usually kept intact for its intrinsic value. In Europe metallic threads were used extensively in ecclesiastical textiles. English embroideries, *opus anglicanum*, were renowned for the lavish use of gold and silver threads. A particularly fine example is the 14th-century Syon Cope (London, Victoria and Albert Museum). Sumptuary laws were enacted in many countries to reduce the use of precious metals, because of its drain on the economy. The popularity of metallic threads found its way into lacemaking. During the 17th, 18th and 19th centuries gold and silver threads enhanced most types of lace and were also used to make braids, a particularly popular embellishment for uniforms.

Metallic threads created an opulence that could not be matched, so cost-effective alternatives were sought. In the 19th century a core was bored out of the silver rod and replaced with a copper filler. During the 1930s metallic laminated filaments were developed in Germany and later improved in the USA. Lurex is a well-known example of this type of material. These imitations of metallic threads comprise a metallicized plastic film sandwiched between two layers of clear plastic and come in a sheet form. Narrow threads are then cut from the sheet. The production of metallic thread in the late 20th century was limited, although France remained a major producer.

A. D. Barker: *Gold Lace and Embroidery* (Altrincham, 1980)

M. Járó: 'The Technological and Analytical Examination of Metal Threads on Old Textiles', *Proceedings from the Fourth International Restorer Seminar: Veszprém, 1983*, ii, pp. 253–64

N. Indictor and R. J. Koestler: 'The Identification and Characterization of Metal Wrappings in Historic Textiles Using Microscopy and Energy Dispersive X-ray Spectrometry: Problems Associated with Identification and Characterization', *Scanning Electron Microscopy*, ii (1986), pp. 491–7

C. Bier, ed.: *Woven from the Soul, Spun from the Heart* (Washington, DC, 1987)

J. P. P. Higgins: *Cloth of Gold: A History of Metallised Textiles* (London, [1993])

Botticelli e il ricamo del Museo Poldi Pezzoli: Storia di un restauro (Milan, n.d.)

3. MANMADE FIBRES. These are continuous filaments produced in imitation of natural silk by forcing a prepared viscous substance through a fine hole and solidifying it by cooling, evaporation and/or chemical action. Manmade fibres include threads with amazing performance characteristics and have expanded the repertory of textile manufacturers greatly.

(i) Natural polymers. A natural polymer fibre is one derived from cellulose. Scientists have long looked at silk as a model of an almost ideal fibre, due to its long filament, high tensile strength and lustrous appearance. During the 19th century scientists began to produce artificial fibres in imitation of silk, thereby beginning the manmade fibre industry. To make a fibre similar to silk, a fibre-forming material must be prepared to form a viscous solution. The raw material can be melted or dissolved in an aqueous or organic solvent. The liquid is then stored until the viscosity increases, a process known as ripening or ageing. The aged liquid is pumped through openings in the spinning jet, or spinneret. The resultant thread solidifies either by cooling or by reaction with another fluid medium that causes it to coagulate. Evaporation is used to remove the solvent and complete the solidification process. The shape of the thread is determined by the size of the openings and the design of the spinneret itself, which can be circular, oval or triangular in form. The shape of the spinneret is designed to convey particular physical properties to the threads so they become smooth and lustrous, reflect light and adhere to other fibres as desired.

The first manmade fibres were derivatives of cellulose. In the 1830s experiments were made with such materials as cotton, wood and paper, which were treated with nitric acid to produce cellulose nitrate. It took nearly 20 years of experimentation before crudely formed threads were pulled out from the cellulose nitrate solution, and another 20 years before Joseph Swann (1828–1914) succeeded in extruding filaments. By 1885 Comte Hilaire de Chardonnet (1839–1924) was producing cellulose nitrate threads, or 'artificial silk', on a commercial scale in France. Chardonnet used cellulose nitrate and a mixture of alcohol and ether to produce the necessary viscous solution, which was then spun in warm air to encourage and complete the hardening process. When the solvents evaporated, solidifed cellulose nitrate fibres, rayon, were created (see fig. 5). The yarns were highly flammable, and alternative processes were soon developed. This first production of rayon was significant, however, in proving that an artificial silk could be manufactured commercially.

The technology to synthesize fibres improved and developed rapidly from this point. Two British chemists, C. F. Cross and E. J. Bevan, conducted research into converting cellulose into soluble derivatives. By 1891 they had developed the viscose rayon process, which treated cellulose (lintres or wood pulp) with a strong alkali such as caustic soda to obtain an alkali cellulose. After converting the alkali cellulose into several intermediate derivatives, the viscous solution could be extruded through spinnerets and passed through an acid solution to regenerate the cellulose, producing a viscose rayon thread. Cross and Bevan also developed cellulose acetate during their experiments. While it is a cellulose derivative, it is not a true regenerated cellulose. In this process the cellulose is chemically combined with acetic acid to produce acetate fibres. Di- and tri-acetate fibres were used for clothing in the 20th century.

(ii) Synthetic fibres. Synthetic fibres are those derived from a synthetic raw material. The production of synthetic fibres began in the 1930s.

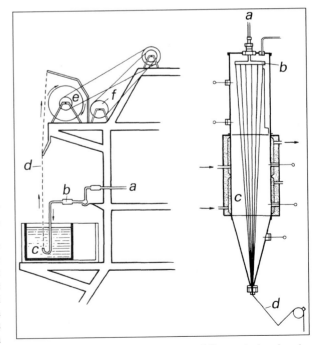

5. Wet and dry spinning techniques for rayon: (left) wet spinning: the spinning solution enters (a), travels through the glass tube (b), coagulates in the bath of water (c) and is wound (d), on to bobbins (e) and (f); (right) dry spinning: the spinning solution (a) is extruded through the spinneret (b), into a chamber of hot air (c) that evaporates the solvent, leaving a solid thread (d)

(a) Polyamides. Fundamental to the development of synthetic fibres is an understanding of polymer chemistry and the construction of molecular chains. These chains are formed when short chain molecules, called monomer units, are bonded together to form polymer chains or macromolecules. The understanding of this process and how it can be controlled enabled scientists to synthesize polymers.

In 1929 W. H. Carothers (1896–1937), a chemist at the Du Pont Co. in the USA, began research into the synthesis of polymeric materials, which resulted in the production of nylon in 1938. Nylon, a synthetic polymeric amide characterized by extreme durability, elasticity and strength, is formed by the reaction of adipic acid and hexamethylene diamine, in varying proportions and under different reaction conditions, to yield specific polymer formulations, producing, for example, nylon-6, nylon-6,6, nylon-4 etc. Nylon is a thermoplastic polymer, the physical properties of which vary depending on composition and structure. Melt-spinning is the simplest technique used to produce synthetic fibres from organic polymers. A thermoplastic polymer is melted, the molten material extruded through spinnerets, and the resulting filaments solidify when cooled. This spinning technology can be used for any fibre-forming polymer that melts before significant decomposition begins. Many polymers will decompose at or below their melting point and cannot be melt-spun. For these polymers two alternative spinning techniques have been developed known as wet and dry spinning, techniques that are similar in principle to those used by Chardonnet. In wet spinning, the polymer is dissolved in a solvent and the solution passed through spinnerets into a bath of liquid that must have special properties. The liquid need not be a solvent for the polymer, but must be miscible with the solution in which the polymer is dissolved. A separation reaction then occurs, in which the polymer coagulates and forms filaments that thicken and harden. The dry-spinning process uses hot gas to evaporate the solvent and effect the drying of the extruded polymer solution. Dry spinning is the principal method in use for continuous filament production, while wet spinning is used for both filament and staple fibre production.

Both these spinning technologies produce a continuous filament, but the filament is often processed further before it can become thread. As with natural fibres, twisting may be introduced to give cohesion or to combine two different polymers, although it is a cumbersome process. A speedier alternative is to pass the filaments through a jet of air that causes them to oscillate and combine into a thread without actually twisting. Further processing may have to take place to lock the filaments together. Filament bundles aligned in parallel, known as tow, can be fed through a rotary cutter and cut into short lengths to form a staple for spinning. Fibres prepared in this manner go through the same steps of carding or combing as a natural fibre before being made into a thread.

(b) Polyesters. During his early experiments Carothers produced polyester, but concentrated his work on the polyamides. It was, therefore, not until the 1950s that the commercial production of polyester was begun by Du Pont using the trademark 'Dacron' and at I.C.I. in the United Kingdom under the trade name 'Terylene'. Polyester, polyethylene terephalate, is produced from ethylene glycol and terephthalic acid. It is produced in large quantities and has extensive applications in the clothing and furnishing industries, especially when combined with cotton or rayon. It is chemically inert, which increases its possible uses; polyester threads are used by the medical profession, and museum professionals and archivists employ polyester products extensively in the preservation of artefacts.

(c) Acrylics. Acrylic fibres are composed of acrylonitrile, made from such materials as coal, water, petroleum and limestone. The fibres are often used in their short staple form and are crimped before cutting to produce a textured thread that was used extensively in the late 20th century as a wool substitute. Commercial production of these threads began in the late 1940s. Modacrylic, a related fibre that has less acrylonitrile by weight than acrylic, is used extensively for simulated fur fabrics.

(d) Polyalkenes. Ethane and propylene are both byproducts of mineral oil and can be converted to polymer polyethylene, also known as polythene. Polyethylene fibres for use in furnishing fabrics are melt-spun from the high-density form of this polymer. Their application is limited because the material has a relatively low melting point. Polypropylene or polypropene fibres have a higher melting point than polyethylene but their use in textiles is limited to carpeting.

(e) Elastomerics. Du Pont was the first company to produce commercially a synthetic textile material with rubber-like properties, which was marketed from 1958 as 'Lycra'. From the late 20th century the term 'spandex' was applied to elastomers that can have elongation properties up to 500% and withstand repeated flexing. Fabrics made from spandex are used extensively for sports and exercise wear.

E. R. Trotman: *Dyeing and Chemical Technology of Textile Fibres* (London, 1924, rev. 5/1975)

A. J. Hall: *The Standard Handbook of Textiles* (London, 1946, rev. 8/1975)

M. E. Carter: *Essential Fiber Chemistry* (New York, 1971)

C. B. Chapman: *Fibres* (London, 1974)

R. W. Moncrieff: *Man-made Fibers* (New York, 1975)

R. R. King: *Textile Identification, Conservation and Preservation* (Bellingham, WA, 1985)

M. L. Joseph and others: *Joseph's Introductory Textile Science.* (New York, 1993)

M. Lewin and E. M. Pearce: Handbook of Fiber Chemistry (New York, 2/1998)

A. Seiler-Baldinger and others: *Textil: Technik, Design, Funktion: Eine systematiche Auswahl* (Basle, 2000)

D. Reneker and H. Fong: *Polymeric Nanofibers* (Washington, DC, 2006)

II. Fabric manufacture.

1. Woven. 2. Non-woven.

1. WOVEN. Woven fabric is produced on a loom. A loom can consist of a frame or be frameless, but its basic function is to keep the warp threads continually taut and to provide some means of allowing the weft to pass through them. The evolution from the simple looms of ancient times to the high-speed, fully automated power looms of the late 20th century is a transformation of great magnitude.

(i) Manual patterning. (ii) Mechanical patterning.

(i) Manual patterning. Many variations of primitive looms have been and still are used throughout the world; all serve the same basic process. In a piece of woven fabric the threads cross at right angles; one set of threads is known as the warp (ends) and the other as the weft (picks). In plain weave the odd-numbered ends are lifted to form an opening (shed) with the even-numbered ends remaining level. It is through this shed that the weft, usually a single, continuous thread wound on a stick or spool, is inserted. For the following pick the odd-numbered ends are pushed down below the even-numbered ends to create the counter-shed. This concludes the weaving cycle (see fig. 6(i)). After each insertion of the weft and before the next shed is formed, the last pick is beaten against the already woven fabric. Plain weave is the most basic weave structure and forms the foundation of many more complex weaves (*see* §III, 1(i) below).

Various developments to improve the loom and speed up weaving have, from time to time, taken place. It is often extremely difficult to pinpoint the origins of these changes. One, the invention of the heddle rod, speeded up shed formation. The heddle rod is placed across the warps, and the odd-numbered ends are attached to it by a series of loops. All odd-numbered ends can thus be lifted simultaneously above the even-numbered ends to form the shed. The counter-shed is formed when the heddle rod is lowered and a shed stick is inserted between the odd- and even-numbered ends and then turned on its side, pushing down the odd-numbered ends. When the weft has been inserted the stick is laid flat but left in position for the following pick. The even ends thus remain almost in their original position throughout the cycle.

The ancient Egyptians used a warp-spacer, or raddle, to keep the width of the warp and the fabric constant. This looked like a large rake or comb, and one or more ends passed through the spaces between the teeth, depending on the density of the warp required. A raddle is still used to space out the warp when setting up a hand loom, but in weaving, from 1100 BC, it was gradually replaced by the reed. The reed was, as its name suggests, originally made of reeds and was

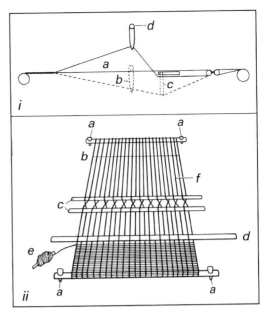

6. Manual weaving methods: (i) basic weave cycle: (a) shed; (b) loop; (c) shed stick; (d) heddle rod; (ii) horizontal ground loom: (a) peg; (b) lease band; (c) lease rods; (d) beater; (e) weft; (f) warp

contained in a frame to prevent the ends slipping out. The reed was at first only used as a spacer but later also served as a beater.

(a) Horizontal ground loom. Here the warp beam is secured with pegs into the ground. The warp, which is prepared separately, is fastened on to the warp beam. Lease bands, which consist of pieces of string, space the warp ends to the required width and density and are secured to the pegs. The lease bands also separate the odd from the even threads and stop the warp from becoming entangled. The warp is then attached to the cloth beam. Lease rods, consisting of either round or flat sticks, are inserted nearer to the weaver's end of the loom, where they separate the odd and even ends and aid the insertion of the weft stick or spool. The weft is pushed into position with a beater. The earliest illustration of a horizontal ground loom is found on a Predynastic (*c.* 4500–4000 BC) painted pottery bowl from Egypt, and these looms also feature on wall paintings in Egyptian tombs of *c.* 2000–1200 BC. Such looms are still in use among the Bedouin and in North Africa and are also known in Guatemala and Peru.

(b) Backstrap loom. This is another form of the horizontal loom. Here one end of the warp is tied to a tree, pole or hook in the ground. The other end is tied round the weaver's waist; it is the weaver who provides the tension for the warp. The woven fabric is wound on to a roller, and the heddle rod is supported on stones or a heddle jack and is fixed or can be removed for the counter-shed.

(c) Box loom. Here a rectangular box is fitted with a warp roller at one end and a cloth roller at the other. Due to the size of the box the warp is of limited length. Shedding can be manipulated by means of a rigid heddle rod or string heddles fixed to a frame. Using a rigid heddle, which is a flat board with vertical bars, ends are drawn alternately through a hole in one bar and the space between two bars. The ends in the hole are kept level while the ends in the space are lowered and raised, when weaving plain weave, by moving the board up or down. For the beating-up of the weft, either a comb is employed or a reed, if one is used to space the warp. Box looms can be seen in medieval paintings and were still in use in the late 20th century.

(d) Band loom. Many of the looms already discussed are used to weave narrow fabrics or bands. Most simply, however, the warp, which can be very long is tied between two stumps or trees and a tripod frame supports the heddle and the treadles, or the heddle frame is suspended from the branch of a tree; the warp can be rolled up when transported. Narrow band looms were still in use in West Africa in the late 20th century. The ornate and colourful bands produced are used to decorate plain garments but are often sewn together to make larger pieces of fabric, which are in turn made into garments, blankets and shawls among other things. The inkle loom, a form of band loom, can be either floor-standing or small enough to go on a table and was used to make narrow, plain-weave bands. The basic inkle loom consists of a base board and three (now sometimes only two) uprights, into which pegs or dowels are fixed horizontally. Of the three or four pegs in the lowest row, a central one acts as the heddle peg on which simple string leashes can be slipped. The continuous warp is taken round a varying number of pegs (according to the length required): the first (uneven-numbered) end from peg 1, under peg 2 (see fig. 7(i)) and over every following peg back to the beginning; the second (even-numbered) end from peg 1, through the first heddle, over peg 2 and over every following peg. This continues until all the required ends are warped, finishing with an uneven-numbered end. The warp, being continuous, carries the colours, rather than the weft, which is covered by the warp, and is rotated on the pegs. The shed is formed by pulling all uneven-numbered ends down and the counter-shed is formed by pushing the uneven-numbered ends up. The weft is wound on to a bobbin or card. Warp-faced plain weave (more ends than picks) is preferred. When weaving a weft-faced plain weave, the tension of the warp needs more frequent adjusting.

(e) Tablet weaving. This is an ancient and widespread method of weaving narrow, patterned bands and braids with detailed designs without a loom. The only equipment needed is a set of square (less commonly triangular) tablets that were traditionally made of horn, wood or bone, but today are made of card or plastic (see fig. 7(ii)). A hole in the centre of each

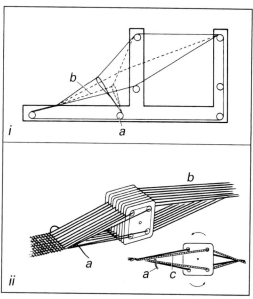

7. Manual weaving methods: (i) inkle loom: (a) heddle peg; (b) space for shed and counter-shed; (ii) tablet weaving: (a) weft; (b) warp; (c) shed

card, through which a string is threaded, allows them to be tied together in the correct sequence. The string is removed during weaving but re-applied when the weaving is left unattended. There is also a hole in each corner of each tablet through which the warp ends are drawn. The number of tablets depends on the number of ends required for the width of the band. The warp ends are tied to a support to give them the necessary tension, which can be either two fixed points or one fixed point and the weaver's waist. The shed is formed automatically between the ends threaded through the upper and lower pairs of holes. Different sheds are opened by giving a quarter turn to the pack of tablets held in the weaver's hand. The weft, which is wound on a bobbin or piece of card, is completely hidden by the warp. Designs are achieved by using different coloured ends and by turning the tablets clockwise and anti-clockwise. The use of this alternating sequence is also needed to stop the build-up of twists along the unwoven warp, although a special device is now available to prevent this. Extremely complex patterns have been worked in the past by turning individual or small groups of tablets instead of the whole pack. This weaving technique, being cheap and effective, was still widely used in the late 20th century.

(f) Vertical loom. This loom, too, is depicted in the wall paintings of ancient Egypt. At its simplest, a rigid, rectangular frame is supported on stones, and the warp is stretched between the warp beam at the top and the cloth beam at the bottom. The size of the frame and the reach of the weaver dictates the size of the woven object as, for example, the tapestry-woven rugs of the Navajo Indians. From the Dynastic

period in Egypt, however, an improved version has existed in which warp and cloth beams are attached to the top and bottom of fixed bars, enabling the use of a longer warp. The European high-warp tapestry loom (*see* TAPESTRY, §1(ii)) belongs to this group. The insertion of the weft starts at the bottom and is worked upwards, allowing the weaver to sit down. The shed is opened by pulling the warps forward, and, in the tapestry loom, where discontinuous wefts travel short distances through the warp ends, loose half-heddles, collected in bunches, are pulled forward by hand as the design demands. The looms are equipped, like horizontal looms, with a warp spacer, lease rods and beater.

(*g*) *Warp-weighted loom.* In this form of vertical loom each separate warp end was taken over the top beam of a rigid, vertical frame. The warp ends were then bunched together, with each end of the warp tied to heavy stones or specially made loom weights to provide the necessary tension (see fig. 8). The thickness of the top beam automatically separated uneven- and even-numbered ends, which were separated by a lease rod; a heddle rod was attached to the even-numbered ends. Another method of warping was used in Scandinavia, where the ends were first woven, either with tablets or a fixed-heddle band loom, into a narrow border with an enormously long fringe. Turned on its side, this formed a starting band that was then fixed to the top beam of the loom, leaving the warp ends hanging down. The warp ends were grouped in pairs and weighted as in the first method. Whatever the method, weaving started at the top and proceeded downwards. The weaver, therefore, had to stand and beat the last pick upwards. Such materials as wool were advantageous as they did not slip as easily as linen or silk. To keep the heddle rod at a comfortable height, the woven fabric was rolled on to the

top beam. The use of this type of loom in ancient times is attested to by the presence of warp weights in archaeological sites dating from the 7th–6th century BC in Syria, Anatolia, Greece and Europe. It was still in use in Scandinavia in the early 20th century. Another warp-weighted loom, the tubular warp loom, produced tubular fabric using two warps, hanging from two warp beams, and one weft. Later, structures for tubular weaves removed the need for special looms.

(*h*) *Treadle loom.* Treadles can be attached only to a loom equipped with either a heddle rod or a heddle frame. A primitive Korean loom had a pivoted bar on top, to which was attached an arm with a piece of string at one end, fastened to the top of the heddle rod; on the other end the string was tied to the weaver's foot. A shed was made with the lease rod being lifted to a jack stick and the counter-shed by the weaver tugging the string tied to the foot. The warp beam was flat, not round, and it was therefore advantageous that the tension could be adjusted by the weaver with a backstrap. In India, an early pit loom was in operation. It was worked in the open air to accommodate the long warp, which was stretched along the ground and fastened to a roller on either end. Two heddle frames were suspended from the branches of trees, with a pit dug out to provide room for the treadles and the legs of the weaver. The treadles were made out of looped string and tied to the bottom of the heddle frames. On some looms hollow bamboo sticks replaced the string. This type of loom was still used in the last decade of the 20th century in some countries. The treadle loom did not develop fully until the creation of rigid looms strong enough to support a warp beam and the breast, or cloth beam, against which the weaver works. There may also be a knee beam that enables the woven cloth to be carried back under the horizontal warp, out of the way of the weaver's knees and down to a cloth beam. The upper structure of such a loom can also support rows of heddles stretched between heddle bars, which can be grouped side by side to form a shaft. Banks of shafts together form the figure harness. Up to 20 shafts can be mounted on a hand loom. They are attached by cords to hinged bars, called lams, that link them to the foot treadles. A reed is suspended between the heddles and the weaver and serves also as a beater. Complex patterns can be woven on such looms, but they are all basically geometric; freely drawn designs require a more elaborate mechanism (*see* §(ii) below).

H. L. Roth: *Ancient Egyptian and Greek Looms* (Halifax, 1913/R Bedford, 1978)

H. L. Roth: *Studies in Primitive Looms* (Halifax, 1918/R Bedford, 1977)

C. Singer: *History of Technology*, i (Oxford, 1955)

M. Halsey and L. Youngmark: *Foundations of Weaving* (London and Vancouver, 1975)

A. Sutton and P. Holton: *Tablet Weaving* (London, 1975)

L. E. Simpson and M. Weir: *The Weavers Craft* (Leicester, 1978)

E. Broudy: *The Book of Looms* (London, 1979)

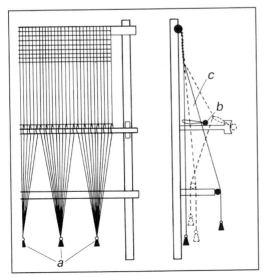

8. Warp-weighted loom: (a) warp weights; (b) heddle rod; (c) space for shed and counter-shed

R. Brown: *The Weaving, Spinning and Dyeing Book* (London, 1979)

J. Picton and J. Mack: *African Textile Looms, Weaving and Design* (London, 1979)

L. Bradley: *Inkle Weaving: A Comprehensive Manual* (London and New York, 1987)

A. Hecht: *The Art of the Loom* (London, 1989/R 2001)

A. Ormerod and W. Sondheim: *Weaving: Technology and Operations* (Manchester, 1995)

N. Spies: 'A Thousand Years of Brocaded Tablet Woven Bands', *Archaeological Textiles Newsletter*, xxi (1995), pp. 17–22

V. Lamb: *Looms Past and Present: Around the Mediterranean and Elsewhere* (Hertingfordbury, 2005)

(ii) Mechanical patterning. This is the creation of a woven pattern with the aid of repetitive mechanisms.

(a) Draw loom. In Europe until the early 19th century and in some parts of the world even in the late 20th century the essential method of making a free-woven pattern on a textile was by means of the draw loom. In this type of loom the warp threads are controlled both by shafts and in individual groups of three to ten or twelve threads by the figure harness. Two people are required to operate a draw loom: the weaver opens the shed using treadles, and an assistant, known as the drawboy, lifts the group of threads required for each line of the pattern. A notable characteristic of the draw loom is that the pattern is prepared in advance and entered on the loom prior to weaving. A frequently stated modern comparison is the programming of a computer. Once the pattern has been entered and the weaver and the drawboy start weaving, any mistakes that have been entered will be reproduced in the weave.

The draw loom probably originated in ancient China, and its use spread gradually throughout the Near East and the Mediterranean, following the same route as silk and silk-weaving. This is not coincidental. The draw-loom mechanism was slow to set up and slow to operate, the costs of labour were considerable, and great skill was needed; it was, however, a viable economic proposition for the weaving of silk, as silk has always been an extremely expensive fibre, and the labour costs, however much they exceeded those for other textiles, were very small compared with the intrinsic cost of the silk, to say nothing of the gold and silver thread also used in many patterned textiles.

The loom itself was constructed of wood and string, which would be easy to assemble. In Europe and possibly also in China the string would have been made from durable flax. In India indigenous cotton was used, but it is far less satisfactory because cotton frays badly. The warp threads were wound on the warp beam and then threaded through the eyes of the cords of the figure harness. Because of the inevitable friction, the warp threads had to be grouped together, which gives a draw-loom-woven design its characteristic stepped outline. The threads were then entered through the eyes of the heddles on the shafts, through the reed and finally wound on to the cloth beam.

The reed determined the spread of the textile and its fineness, and the width and the number of dents in the reed had to be exact. The cords of the figure harness were taken through a comber board, over a pulley and then out to the side to be fixed firmly to the wall of the workshop. Before going over the pulley they might be tied into two or more groups and that would determine the number of repeats across the width of the fabric. These could be straight repeats of two or more motifs or a point repeat in which the motifs were woven in mirror image by tying the last cord to the first and so on. Once set up the loom would not be altered as to do so would be uneconomical.

To prepare the pattern a sketch was made, followed by a careful watercolour drawing that was squared up. This was transferred to a type of graph paper (in England, 'rule' paper and later 'point' paper) that was set out in different scales according to the type of fabric to be woven. It was very important to put the pattern on the correct count of paper, as a satin-weave ground had more warp threads than wefts, for example, in comparison to a tabby-weave ground. The draughtsman transferred the pattern to the graph paper, painting each square or small oblong in the correct colour. He could paint several colours in one line, provided that they were for brocaded wefts spread out across the textile, since the weaver would know from the original design which brocading shuttle to use. Even so, painting the draft took a long time and was a skilled task.

The vital part for making the pattern was the simple. This consisted of a series of threads, each one of which was tied to one of the pulley cords stretched out between the loom and the wall. They hung down by the side of the loom, and a series of lashes was tied to a selection of them to control each line of the design. For example, if the first, third and tenth to fifteenth cords had to be lifted for a particular line, the lashes controlling those simple threads would be tied together in a bunch. Even when the loom was already prepared for a particular kind of repeat and the warp threads in place, entering the pattern alone could take up to three weeks or more, and more time would be spent adjusting the tension, correcting mistakes in reading the pattern, mending broken threads and weaving trial pieces.

The weaver opened the shed, using treadles to operate the shafts. He might use as many as five wefts in one pass for one line of the design, one or more wefts for the ground, operated by the treadles, and then several other wefts for the pattern, either pattern wefts going right across the loom or brocaded wefts. To create the pattern, the drawboy pulled the group of lashes, which lifted the warp ends for the weaver. Textiles were usually woven face down, partly to keep them clean and partly because there were then generally fewer threads to lift. Different features of the loom occur in different countries. A 17th-century Chinese drawing (London, Victoria and Albert Museum) shows the drawboy sitting on top of the loom, and in India the drawboy is a fully grown man sitting on a platform facing the weaver and using a rather heavy wooden implement to twist each group

of lashes and thus raise the warp threads. In Europe the drawboy, or girl, stood at the side of the loom. There could be several thousand lashes to pull for a long and multicoloured pattern. Progress might vary from a few centimetres to a metre per day, depending on the fineness of the material and the complexity of the pattern. A complicated pattern might be divided into several simples, either occurring one after the other or used for different parts of the design, for example the borders and central field.

The draw loom had significant advantages: a line could be repeated twice if necessary, the use of brocading economized on expensive silk and metal threads, and quite subtle textures could be achieved by contrasting weaves, the latter depending on the number of shafts. The draw loom, however, had two major disadvantages: the slow rate of weaving required a minimum of two operations for each line of the design, and for the most elaborate textiles, a second, binding, warp was needed.

(b) Jacquard loom. Throughout the 18th century attempts were made, especially in France, to find an alternative mechanism to the draw loom. Some had a limited use for small patterns, but none was truly successful until Joseph-Marie Jacquard (1752–1834) combined several processes to produce the device that has been known by his name ever since. He replaced the figure harness and the drawboy by attaching needles to the cords. The needles were lifted automatically each time the weaver opened the shed, and at the top of the loom they met a perforated card that replaced the bunch of lashes controlling the pattern. Where there was a perforation in the card the needles went through it, lifting the warp threads as they did so. The weaver passed the shuttle across the loom, closed the shed and re-opened it for the next weft. As he did so, a ratchet turned the card and brought the next card into use. The cards were tied together and the pattern could be repeated indefinitely.

Although the main details of the Jacquard device were worked out before the end of the 18th century, it took between 10 and 30 years before the Jacquard loom was in commercial use. The method of drafting patterns for draw looms had to be changed, since every single effect needed its own card and two colours could not be combined in one line. The first Jacquard draughtsman had to incorporate the weaves he required on to his drafts, which made the preparation of the draft an even longer operation than it had been previously, and mistakes could still be made. The card had to be of a very good quality and was expensive, even before duty was paid to import the card into England, for instance. Many minor adjustments had still to be made to ensure that the ratchet mechanism worked infallibly, and, above all, old wooden looms were gradually replaced by metal ones. The normal movement of wood meant that it was very difficult to ensure that the metal needles always entered their respective holes, and even metal was subject to wear and tear. Initially the holes for

each card had to be punched by hand, and this took the same length of time as it had done to tie the lashes, while at the same time a second operator had to tie the cards together. Later, a kind of typewriter was developed for punching the holes, as well as a small machine for tying the cards. The Jacquard device was at least twice as expensive as the draw loom, even without any refinements.

Other than the grand furnishing fabrics designed by Philippe de Lasalle (1723–1804/5), the period when Jacquard was working on his device was one when large woven patterns for dress were completely out of fashion. Only when the demand for patterns revived after the Napoleonic Wars did it become worthwhile to develop the Jacquard loom commercially. Even so, for a long time dress fabrics could be woven without either the draw loom or the Jacquard loom. The Jacquard loom's advantages were first appreciated for the weaving of shawls. The patterns were large, and more fabric could be woven to offset the initial cost of the loom. Perhaps most crucially, the newly prosperous middle class began to demand patterned furnishings by the 1830s, so the market increased significantly. This demand coincided with the increasing refinement of the power loom and of the spinning of cotton and worsted thread. The Jacquard device could be attached to a power loom, although once again refinements were necessary, but once the technical problems were overcome the draw loom became totally obsolete.

Speed and simplicity of production signalled the end of brocaded effects. Almost immediately the Jacquard replaced the shafts as well as the old figure harness. Once the passage of the needles through the cards was automatic and accurate control of each individual warp thread was achieved, it was possible to attain subtle shading and the imitation of any type of weave. The second, binding, warp became redundant and so did the skilled weaver and the drawboy. Nineteenth-century pride in technology, as true in France as in England, encouraged designers to show just how complicated a woven design could be. While French good taste prevented the worst excesses in silks for the wealthy, the same cannot be said of middle-class furnishing fabrics. Mechanization and the application of power ensured the production of Jacquard-woven cotton and worsted furnishing fabrics, Jacquard-woven lace curtains and Jacquard-woven carpets, all with many different patterns, as can be seen in many 19th-century paintings and early photographs.

A. Barlow: *History and Principles of Weaving* (1879)

C. Singer, E. J. Holmyard and A. R. Hall, eds: *A History of Technology* (Oxford, 1954–8)

N. Rothstein: 'The Introduction of the Jacquard Loom to Great Britain', *Studies in Textile History*, ed. V. Gervers (Toronto, 1977), pp. 281–304

C. S. Anderson and S. M. Spivak: 'Re-examination of American Antebellum Handloom Technology for Weaving Fancy Coverlets and Carpets', *Textile History*, xxi/2 (Fall 1990), pp. 181–201

N. A. Hoskins: *Weft-faced Pattern Weaves: Tabby to Taqueté* (Seattle, 1992)

S. Colenbrander: 'Met de simpel of met de klosjes: Weefgetouwen in Amsterdam en Haarlem in de zeventiende eeuw', *Jaarboek 2002: Jacquard in erfgoed en in industrie*, ed. J. Mosk (Amsterdam, 2003), pp. 27–36

2. NON-WOVEN. Various techniques other than weaving can be employed to create a piece of fabric. FELT, for example, depends on the tendency of the hairy fibres of unspun wool to mat together, especially when wet and under pressure. Felt almost certainly pre-dated weaving in many parts of the world.

(i) Single thread techniques. Such techniques are of great antiquity, and the earliest forms are probably those made with a short length of thread, to which new lengths have to be plied as work progresses.

(a) Linking. This technique can be worked in the hand with a needle and thread to produce a very solid fabric, but it is more widely employed to make stretchy net bags. For these, one end of the thread is attached to the top of an upright stick; it is stretched across and round a second stick, and on the return journey is loosely passed over and under the stretched line. All subsequent rows are linked by the same over-and-under action. In an alternative method, two parallel lines are stretched between the sticks before the thread is taken under one and over the other to link them together. The thread then alternately passes straight across and over and under the two last rows.

(b) Looping. Looping forms the basis of a very large group of techniques. It requires a starting thread to which a series of simple loops is attached with a needle and thread or small shuttle. The starting thread is usually pulled into a tight circle and the subsequent rows of loops are worked in a spiral formation that produces either a flat circle or a three-dimensional cylindrical bag. The looping may be solid or widely spaced, but the fabric is unstable until the final row of loops is secured.

(c) Crossed looping. In this slightly more complex form, also known as single-needle netting, knotless netting or naalbinding, the needle is taken, not into the lag between the loops of the row above, but behind the cross at the base of each loop. This aligns the loops both vertically and horizontally and the fabric looks and behaves like knitting, except that it does not ladder if a thread is broken. It is worked in the round and has been used throughout the world to make socks and mittens. It is slow to work, but it can be used to make very fine as well as solid objects.

(d) Inter-connected looping. In this even more complex form, the loops are linked both into the row above and sideways through several loops (see fig. 9) to produce a very solid fabric with a distinctive ridged surface. Used to make socks and mittens in many parts of the world, it is worked in a spiral using the thumb as a gauge.

(e) Needle lace. Although a complex fabric, needle lace is basically a looped structure built up with needle and thread on a base of couched outlining threads (*see* LACE, §1(i)).

(f) Netting. This form of looping, also known as lacis or filet, is made under tension and produces a stable fabric. It is worked with a large needle or shuttle, and a gauge is used to maintain a uniform size of mesh. As the thread is looped round the gauge it is passed through a secondary loop to form a non-slipping knot. The net can vary in shape, size and weight and has a range of uses from fishing nets to trimmings and hairnets. From an early date decorative patterns have been darned into the net.

(g) Tatting. In this technique a small, oval shuttle is used to work rows of knotted loops over a foundation thread, which is then pulled into a circular or semicircular shape. A series of motifs is joined together to form an openwork trimming.

(h) Looping with a continuous thread. Commonly called crochet, this is often built up on a starting cord, and a small hooked needle is used to pull loops of the continuous thread through the existing loops. When a loop is taken both into the row above and sideways through a second loop, it produces a dense, stable fabric. In Afghanistan, for example, it is worked in a very tight spiral to make the so-called Afghan socks. In Europe in the 19th century it was developed to make more complex structures by combining solid and open work and by elaborating the loops with twists and knots.

(i) Hairpin crochet. An implement like a large hairpin is used to support loops extending out from a line of crochet to produce an open-edged braid, which can be used as a trimming or joined to make a netlike fabric. A braiding fork, which has a pair of lyre-shaped prongs attached to a vertical handle, is similarly used for working a double crochet loop to make a solid cord.

(j) Knitting. This is one of the best-known forms of looping. It is worked with two or more long needles, which, like the hooked needle of crochet, make possible the use of a single continuous thread (*see* KNITTING).

(k) Peg knitting. In this method, a vertical line of fine pegs is mounted on a wooden base, and a row of starting loops is attached to the pegs. The thread is returned in front of the loops, which one by one are lifted with a needle from under the thread, and slipped off the pegs, pulling the thread into a new series of loops. With two parallel rows of pegs a piece of circular knitting can be worked, and if the pins are placed in a close circle tubular cords can be made, as in French knitting worked on a cotton reel.

(l) Machine knitting. The knitting frame (invented in 1589) was the first complex piece of textile machinery.

It combined the principles of hand and peg-frame knitting by working pieces of plain knitting row by row, instead of stitch by stitch.

(ii) Multiple thread techniques. In these, the threads all lie in one direction.

(a) Braiding. A large variety of fabrics and braids (solid and hollow cords) can be made by the diagonal interlacing of a number of vertical threads. Some are worked with doubled threads looped round the fingers, others are simply manipulated with the hands. In some techniques bobbins are used to facilitate the movement of the threads. The end result may be open or solid, plain or decorated.

(b) Split-ply twining. This variant of braiding is made with thin cords, the ply of which is split to enable other cords to be passed through. Each cord alternately splits and is split on its diagonal passage across the braid.

(c) Bobbin lace. In its earliest form this had a braided structure, and diagonal interlacing remains a basic feature of later, more complex versions (*see* LACE, §1(ii)).

(d) Knotting. Knots can be worked along a single thread to make a decorative braid or combined with looped structures, as in crochet. They can also be worked into groups of threads, such as the loose ends of a warp, for both practical and decorative purposes.

(e) Macramé. This decorative trimming (no doubt a development from knotted warp ends) is formed by working combinations of half hitches and square knots into a series of threads attached to a horizontal starting cord.

(iii) Other techniques. There are many variations and combinations of the above techniques and others that relate to weaving.

(a) Sprang. Although made with a single continuous thread, this is wound between the top and bottom bars of a fixed frame, like a tubular continuous warp. Starting in the centre, the worker crosses or twists selected threads, holding them in place with inserted rods. The rods are pushed to the top and bottom of the frame, where the fabric builds up in mirror image. Where the two halves meet, a line of stitching is worked to prevent the whole fabric unravelling when the rods are removed. Depending on the thread and the closeness of the work, the result varies from a delicate net to a solid, but pliable, fabric. Sprang is a very old technique that has been used throughout the world.

(b) Weft twining. This can be worked on a simple loom without a shedding device. Two weft threads are taken by hand through the warp, crossing one another as they enclose each end. There are decorative variations of the technique, and it is also used as a warp-spacer on some simple looms.

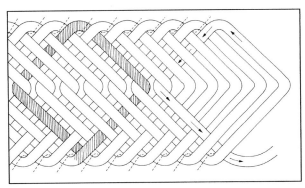

9. Inter-connected looping: the arrowed thread at the working point goes over one, under four, over four and under two previous loops, as well as through a loop of the row above; the dotted lines show how this row of loops is joined to the row above and below, and the shaded loop shows one fully complete loop

A. Geijer: *Birka III: Die Textilfunde aus den Gräbern* (Uppsala, 1938)

G. M. Crowfoot: 'Handicrafts in Palestine: Primitive Weaving, Plaiting and Finger Weaving', *Palestine Exploration Quarterly* (1943), pp. 75–89

M. Hald: 'Ancient Textile Techniques in Egypt and Scandinavia', *Acta archaeologica*, xvii (1946)

G. M. Crowfoot and E. Crowfoot: 'Textiles and Basketry', *Discoveries in the Judean Desert II: Les Grottes de Murabba'â* (Oxford, 1961)

R. d'Harcourt: *Textiles of Ancient Peru and their Techniques* (Seattle, 1962)

I. Emery: *The Primary Structure of Fabrics* (Washington, DC, 1966, rev. New York, 1994)

P. Collingwood: *The Techniques of Sprang* (London, 1974)

M. Hald: *Ancient Danish Textiles from Bogs and Burials* (Copenhagen, 1980)

K. P. Kent: *Prehistoric Textiles of the Southwest* (Santa Fe, 1983)

N. Speiser: *Manual of Braiding* (Basle, 1983)

M. Grayson: *Encyclopedia of Textiles, Fibers and Nonwoven Fabrics* (New York, 1984)

P. Collingwood: *Textile and Weaving Structures* (London, 1987)

P. Collingwood: *The Maker's Hand: A Close Look at Textile Structures* (Ashville, NC, 1987, rev. London, 1998)

III. Patterns.

1. Woven. 2. Sewn and other techniques.

1. WOVEN.

(i) Loom-made. (ii) Dyed.

(i) Loom-made.

(a) Self-coloured patterned weaves. (b) Compound weaves.

(a) Self-coloured patterned weaves. The simplest method of patterning a textile is to enter warp threads of different colours in the loom, thereby producing stripes even in a plain tabby weave (*see* §II, 1 above); if the wefts are also alternated in the same colours, a chequered effect can be achieved

without altering the set up of the loom. Such methods have been used for centuries and are capable of many variations. An even simpler, though more subtle method is to alternate the spin of warp or weft threads to give a self-coloured textured effect; also the thickness of the wefts can be alternated to give a ribbed effect. A more elaborate self-coloured textured effect can be created by an extra warp that floats on the surface of the textile and is bound at intervals. This warp can be in regular floats over three or more wefts or it can be stepped to form a brick effect. This method of patterning is called *cannellé* in France (or *cannetillé* for the brick effect) and tobine in England. While quite often used for the ground of more elaborate silks, it could also be controlled by the figure harness of the draw loom (*see* §II, 1(ii)(a) above). A self-coloured effect in the weft can be obtained by an interruption of the ground weave to give, for example, a simple spot or dash, or by introducing an extra weft that can be controlled by the draw loom and form part of the complete design of the textile. Without an extra weft, motifs had to be limited in size or the whole fabric would have been distorted. By the late 18th century such vestigial patterns as remained in dress fabrics were produced by this simple 'flush' technique.

Twill. By using three or more shafts the weaver can make a twill weave. This forms a supple fabric much used for linings, but the twill itself can be used to form a pattern. The warp is divided, with the first thread on the first shaft, the second on the second and so on. If the weaver proceeds in numerical order 1, 2, 3 etc the weave is plain; if 1, 2, 3 and then 3, 2, 1 a zigzag effect is created up the textile. If, in addition, the threads are entered into the loom in a lozenge shape more complicated effects can be produced, such as the bird's-eye twill found in surviving medieval linens and still in use. Very complicated diapered patterns can be produced using this quite simple technique, which was an important way of patterning table linen. Twill weaves were also used for the grounds of more elaborately patterned fabrics and, in particular, as the binding for the pattern wefts in compound weaves and the lampas/tissue structure (*see* §(b) below). The technique was used in Japanese textiles as early as the 3rd century AD and is still used in contemporary Japan.

Satin. In satin weave the points of binding are set over so that they do not touch, thus forming a very smooth surface. Satin is an important weave for silk and linen, but less popular for cotton, which was inherently fluffy until the invention of mercerized cotton (*see* §I, 1(i)(b) above). It was also used for certain highly glazed worsteds in the 18th century. The patterning of a satin does, however, depend on other elements and requires a minimum of five shafts. It was frequently used for voided velvets (*see* §(b) below) to create a contrast between the pile and an open shiny ground.

Damask. The effect of the damask pattern is created by a contrast of light reflected from the warp and weft of the same weave (or a weave using an equal number of shafts). The light reflects differently from the vertical and horizontal planes, thus creating the pattern without necessarily using any colour contrasts. Although other weaves can be used, the most common damasks, whether of silk or linen, are based on satin weave, in which the shining warp face contrasts with the matt weft face of the same weave or, for extra emphasis, of some other weave (see fig. 10). If the warp and weft of the same weave are used and no other effects are introduced then the damask is reversible—a useful quality for table linen, for example (*see* LINEN DIAPER AND DAMASK).

The loom to make a damask has shafts that go down as well as up. Obviously, the same warp thread cannot go up and down at the same time (it would break), but the trained weaver knew the different combinations of satin weave and made sure that this did not happen. When the shed was opened and the shuttle passed across the loom, certain portions of the design appeared in the warp face of the weave and others in the matt weft surface, because some shafts rose and others descended. The pattern itself was controlled by the figure harness of the draw loom and later by the cards of the Jacquard loom (*see* §II, 1(ii)(b) above). Because no extra colour was needed for the design it was much quicker to weave than other patterned materials; it was also a little cheaper. A damask ground could, however, also form part of a much more complicated structure such as lampas (*see* §(b) below).

The earliest Ancient Near Eastern silk damasks seem to date from the 6th to the 7th century AD. Chinese silk damasks were imported into Europe in the early Middle Ages, and it can only be deduced that skilled weavers in the West analysed such materials to work out how their effects were created. Damask became a very important weave, and by extension cloth, in the 15th century; from the 16th century onwards a heavier, furnishing weight was used for bed curtains and accessories in wealthy households, while linen damask began to appear in the inventories of their table-linen.

Gauze. Gauze was used in China as early as the 2nd century BC and in Japan in the 7th and 8th centuries. It is a sophisticated weave and was probably in use in the Near East in the 15th and 16th centuries and in Europe by the end of the 16th century, although little has survived. It was used for veils, oversleeves, fichus and, by the 18th century, imitation lace lappets and aprons. The basic principle of manufacture depends on two different kinds of warp: the first is controlled by a normal shaft, while the second, called the doup warp, is controlled by a shaft that can move from side to side in the loom. Its threads can thus cross those of the regular warp and are fixed in place by the passage of the weft. Quite complicated effects can be achieved as well as a simple, yet strong, open fabric. It was used primarily to form a diaphanous fabric

that did not fall apart, and when a pattern was required it was usually brocaded (*see* §(b) below) or embroidered. Until the 20th century gauzes were usually made from silk and used for fashionable dress, but many 20th-century hand-weavers have used gauzes made of other fibres as well as silk to create what are primarily works of art.

(b) Compound weaves. 'Compound weaves' is a modern term devised to cover some of the earliest draw-loom-woven fabrics that required two warp systems. One warp was controlled by the figure harness and the other only by shafts; thus the first made the pattern, while the second was used to bind it in place.

Compound tabby. The first draw-loom-woven fabrics found in Egypt (dating from the 7th century onwards and possibly even earlier) are compound tabby woollens with quite small repeating patterns. In a compound tabby the surface of the textile appears to be an ordinary tabby but set so that the weft is much more in evidence than the rather thin warp threads, and the textile is weft-faced in effect. Between the binding warp threads other warp threads can be seen if the textile is at all worn. It is these threads that form the main warp controlled by the figure harness, but they never appear on the surface of the textile. Such very early textiles are generally restricted to two colours, which was enough to create a pattern. The main warp threads were raised by the weaver, the weft passed across, and they were then bound by one of the two shafts controlling the binding. When restricted to two colours compound tabbies are reversible, with one colour appearing on the face and the other on the back. The main warp threads remain hidden. Although compound tabbies were superseded in most weaving communities, they remained in use for some specialized fabrics such as the sashes woven in Poland for the aristocracy between the 17th and 19th centuries. The earliest draw-loom-woven fabrics from ancient China are warp-patterned, but the method used is still a matter for discussion.

Compound twill. The same principle of a main and a binding warp with the former not used for visible effect was applied to a twill weave. Silks woven in compound twill from the Ancient Near East and the eastern Mediterranean are also found in the burying grounds of Egypt. They are weft-faced and generally bound in a 2/1 or 2\1 twill (*see* §(a) above), that is the direction of the twill is immaterial. Some silks with this structure have such patterns as charioteers, lions and griffinlike beasts derived from ancient Roman decoration and mythology and even earlier Sasanian art. The surface of the textile is smooth with no contrast except colour, which could be eliminated. An etched effect is created by using two wefts of the same colour; a number of silks patterned in this way have survived and are thought to have come from Byzantium. Fragments of compound weft twill fabric

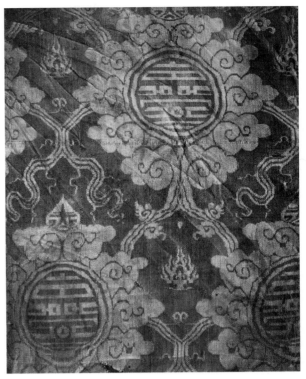

10. Silk-damask robe with Chinese influenced decoration (detail), from Al A'Azam, near Asyut, Egypt, 14th century (London, Victoria and Albert Museum); photo credit: Erich Lessing/Art Resource, NY

have been found in 7th-century Chinese tombs. Compound twills woven in the Ancient Near East have been found wrapped round relics in many western European tombs dating from the early Middle Ages onwards (e.g. *Earth and Ocean* silk from the tomb of St Cuthbert, first half of the 9th century AD; Durham, Cathedral Treasury; *Elephant* silk, probably placed in the tomb of Charlemagne by Otto III, *c.* AD 1000). However, although the scribes who recorded the inventories of the major churches and cathedrals used various terms to describe the textiles in their care, it has proved difficult to equate these descriptions firmly with the surviving textiles.

Lampas. Although the main warp in a compound weave actually made the pattern, it remained out of sight. The next stage in the development of the draw loom was to combine the main or ground warp with a ground weft so that it could be bound in a visible weave to make a contrast with that of the pattern. This added the element of texture to that of colour. There was an almost infinite choice: tabby on tabby (but one in a different proportion to the other), twill on tabby, twill on satin, twill or tabby on a damask ground etc. This structure can be found in textiles (especially silks) dating from the 12th to 13th centuries until the last days of the draw loom in the early 19th century. As long as elaborately patterned textiles were required, whether for furnishing or dress, this

structure was dominant. Again, like the simpler compound weaves, the medieval name for this technique is uncertain. By the 18th century textiles made with two warp systems and two weft systems were known as 'lampas' in France and 'tissue' in England, and there are sufficient extant, documented examples to confirm that these were the correct terms. (Owing to the strict control over language by the Académie Française, French terms have remained unaltered since the 18th century, thus the 20th-century use of 'lampas' corresponds to the 18th-century use. French has therefore been adopted as the source for textile definitions, and a vocabulary of technical terms has been drawn up by the Centre International d'Etude des Textiles Anciens, Lyon.)

The silks woven in the lampas technique in the late 13th century and throughout the 14th are patterned with such Gothic motifs as foliage and heraldic beasts, religious themes and exotic animals, and lampas silks are depicted in such contemporary paintings as the Wilton Diptych (1394; London, National Gallery). In addition to their contrasting weaves, many early lampas textiles are also brocaded, often to introduce an area of gold or silver thread (see below). In the Middle Ages this thread was made by applying a very fine layer of precious metal to a membrane, which was then cut into fine lengths and, in Europe and the Near East, then wound on a linen or silk core. The richest silks might have their entire pattern in gold and silver thread, but few pre-18th-century examples have survived, because, as they went out of fashion, many were burnt to reclaim the precious metal. ('Tissue paper' protected such silks from rubbing unnecessarily, although only a few tissues were woven with metal thread.) Many medieval examples have survived in church treasuries, passing ultimately to museums. As with other compound weaves, the threads of the main warp were distributed between those of the binding warp, with far more ground or main warp threads than binding warp threads. The lampas textiles were patterned by the weft, so it was desirable to have the longest possible floats of weft with the least conspicuous points of binding.

Until the late 17th century the structures of a lampas were reasonably simple, but when fashions in elaborate dress textiles began to change by year and then by season, the silk designer had to create not only new patterns and styles but also new textured effects. A good designer did so with the minimum of expense, using a gold-coloured silk rather than pure gold thread to support a silver or silver-gilt thread, for example. Chenille was used, made from a pre-woven textile that was cut up to produce a fluffy thread to use as a decorative weft, but since it was expensive it was brocaded. Although the labour of a skilled draw-loom weaver was much more expensive than, for example, that of a weaver of coarse woollens or linens, it was still a much smaller proportion of the total cost of the cloth than was the metal thread or the high-quality silk needed for a draw-loom-woven textile. The lampas textiles of the 18th century and the early 19th are some of the most beautiful and characteristic cloths of their time and have survived both as lengths of fabric and as dresses and waistcoats. Its contrasting textures made lampas unsuitable for furnishings, although some 19th- and 20th-century restorers have, anachronistically, re-covered chairs and sofas in such fabrics.

Velvet. A true velvet is made by a warp that is additional to the ground warp. This second warp is raised in loops by inserting a rod instead of a weft. The rod is either round in cross-section if the pile is to be left uncut, or wedge-shaped with a groove in the top if the pile is to be cut. Rods of different diameters can be used successively to create several heights of pile. The pile warp threads are bound at regular intervals and, after a few shoots, the weaver cuts the pile with a special sharp knife. Velvets were among the most expensive silk fabrics. Each pile warp thread was wound on its own separate bobbin instead of the normal warp beam and could be controlled by the figure harness of the draw loom. A combination of cut and uncut pile (known as *ciselé*) was often used for decorative effects. In the second half of the 18th century men's suits were usually made of cut and uncut silk pile (although portraits also show men wearing plain cut velvet), while the waistcoat might be a much more elaborate lampas with gold and silver thread. A kind of looped silk pile was also woven and used for sumptuous linings for the loose informal coats worn indoors by men in the 17th century. This kind of pile—later called shag and not always silk—was woven rather differently.

As a further refinement to a draw-loom-woven velvet the motifs could be surrounded by plain areas, which, in the 15th century, might be woven with gold thread or, in the 16th century and later, with a satin ground. Both made a pleasing contrast with the pile. In addition, some of the richest late medieval velvets are embellished with gold loops that sparkle above the surface. These can be seen in Italian and Flemish paintings, very often as a panel behind the throne on which sit the Virgin and Child. Together with damask, velvet was a very important decorative weave in the 15th and 16th centuries. Velvet palls from this period have survived because they were used only rarely and kept carefully.

Velvet was also an important furnishing fabric for prestigious interiors, as shown by the English royal accounts from the 17th century onwards, which are full of orders for enormous quantities of '3 pile Genoa velvet'. (The velvet was, initially, exported from Genoa, though not necessarily made there; the '3' refers to the number of threads working as one unit in the pile rather than its height.) When skilfully woven from the best silk, velvet was hard-wearing, so although it was expensive, it was not completely impractical. It could also be combined with other weaves; there are, for example, late 18th-century silks with alternating velvet and satin stripes. During the 19th century there were experiments to weave velvet as a weft fabric (similar experiments in the 18th century had produced corduroy and velveteen with a cotton pile). Although this proved feasible it was

impossible to obtain the same density of pile and, therefore, the same quality.

Brocading. Any textile can be brocaded since it is an effect that is additional to the main structure. A brocaded weft is one that is introduced only for the width of its motif; for example, if a daisy has a yellow centre, a yellow thread is carried on a small brocading shuttle from side to side of this centre and no further. Before the use of the Jacquard loom a brocade was a draw-loom-woven textile, the entire pattern of which depended on brocaded wefts. These might float on the surface or be bound by a binding warp to give the designer greater freedom to use larger areas of colour. Because the weft travels only the width of its motif, the textile is very light. The favourite English dress-silk of the mid-18th century was a brocaded lutestring, which had a ground of lightweight taffeta specially treated to produce an extra gloss, with a brocaded pattern of naturalistic flowers on the front and very little wasted silk on the back. As the weaver had to insert the appropriate shuttle individually for each motif in every line, weaving a brocade was very slow work. Brocades were best suited to patterns composed entirely of metal thread, which was intrinsically expensive and therefore not to be wasted on the back of the textile. The term became meaningless after the introduction of the Jacquard loom, when brocading became not impossible but uneconomic as the speed of the Jacquard would have been lost had the weaver stopped to brocade instead of passing the shuttle from selvage to selvage. Although modern hand-weavers use brocading they would seldom call the results 'brocades'.

Tapestry. Some confusion has arisen over the meaning of tapestry-weaving because of definitions that cite the Bayeux Tapestry as an example. The Bayeux Tapestry is embroidered, that is the pattern is applied to an existing textile, whereas the essence of a tapestry is that the weaver in creating the pattern also creates the textile. Tapestry-weaving is thus the most important technique for making large painterly scenes.

Other techniques. There are several important techniques that are difficult to place in any one category. From the late 16th century onwards some textiles were 'watered' to give a wavy effect, also known as moiré. The textile, whether a silk or a worsted, was woven with a pronounced rib, folded down the centre and then passed through two rollers with engraved surfaces. The rollers crushed the ribbed surface, giving the characteristic shimmering patterns. This was an important technique for some silks, even those woven with silver thread in the ground, and 'Tabbies watered and unwatered' appear on many 18th-century trade cards. Dress silks with this effect have survived, and others can be seen in portraits. The technique was also used for certain worsted furnishings from the 17th century to the 19th and has proved to be surprisingly durable. These furnishings might also be 'stamped' with a simple pattern, probably

made by a heated metal dyestamp. Some early 17th-century costume materials were also stamped with patterns that form slightly raised areas. The 'slashing' of expensive silks was another early 17th-century form of conspicuous consumption. Although it enabled the underlying fabric in a contrasting colour and material to show through, it greatly weakened the outer fabric. It can be seen in the portraits produced by such artists as William Larkin (*c.* 1585–1619), and there are a few surviving fragments of slashed fabrics. Rather similar in its results was the technique of decorative 'pinking' of fabrics with pinking shears.

C. Singer, E. J. Holmyard and A. R. Hall, eds: *A History of Technology* (Oxford, 1954–8)

C. F. Battiscombe: *The Relics of St Cuthbert* (Oxford, 1956)

J. Jobé, ed.: *The Art of Tapestry* (London, 1965)

M. Hoffman and H. B. Burnham: 'Prehistory of Textiles in the Old World', *Viking*, xxxvii (1973), pp. 49–76

J. E. Vollmer: 'Chinese Tapestry Weaving: K'o-ssu', *Hali*, v/1 (1982), pp. 36–48

L. Adelson and A. Tracht: *Aymara Weavings: Ceremonial Textiles of Colonial and Nineteenth-century Bolivia* (Washington, DC, 1983)

F. Montgomery: *Textiles in America, 1650–1870* (New York, 1984)

U. Cyrus-Zetterström: 'Fabric Structures of the Woven Textiles', *18th Century Textiles: The Anders Berch Collection at the Nordiska Museet*, ed. E. Hidemark (Stockholm), pp. 45–63

A. Seiler-Baldinger: *Systematik der Textilen Techniken* (Basle, 1991; Eng. trans. Washington, DC, 1994)

E. Phipps: *The Colonial Andes: Tapestries and Silverwork 1530–1830* (New York, 2004)

(ii) Dyed.

(a) Tie and dye. (b) Resist. (c) Discharge. (d) Painted. (e) Stencilled. (f) Printed.

(a) Tie and dye. Patterns are made by tying or binding yarn or cloth so tightly that dye cannot penetrate the protected areas. The term commonly used for patterning yarn is 'ikat' (from Indon. *mengikat*: 'tie' or 'bind'), while for cloth the general term is 'tie and dye'.

Ikat. In the ikat technique groups of threads are bound in a pattern sequence (see fig. 11(i)a), dyed (11(i)b) and untied again (11(i)c) before weaving. The warp only may be bound, the weft only, or, in certain cloths, both warp and weft. The basic effect when woven is a light pattern with a characteristic blurred edge on a darker ground (11(i)d). Ikats are normally woven in tabby weave so both sides of the cloth are identically patterned. The setting of the yarn in weaving can help clarify the pattern, with a preponderance of warp threads over weft threads for warp ikat, and vice versa for weft ikat. When both warp and weft threads are patterned the cloth is woven in a more balanced tabby weave. Fibres range from cotton and various bast fibres to silk, but wool is rarely used because of its elasticity. Any dyes appropriate to the fibre are suitable, but indigo is very important, either

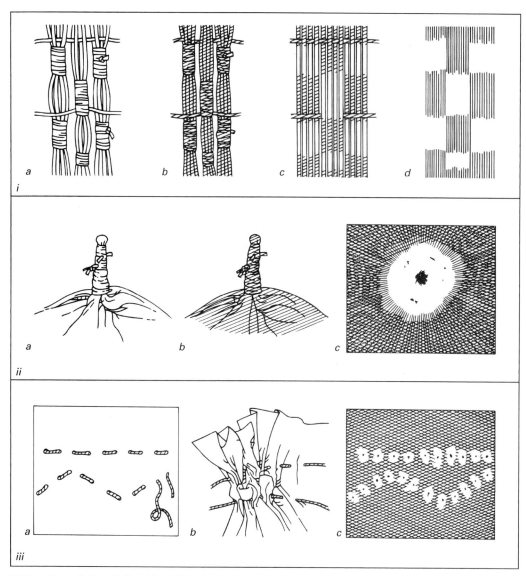

11. Tie and dye techniques: (i) ikat: (a) bound threads; (b) dyed threads; (c) untied threads; (d) woven threads; (ii) tie-dyeing: (a) bound cloth; (b) dyed cloth; (c) characteristic pattern; (iii) stitching: (a) running stitches; (b) gathered stitches; (c) resulting effect

on its own or with other dyes (see DYE, §2). Bound and dyed threads can be just a section of the warp or weft or set among uniformly dyed yarn stripes, or the whole cloth can be formed from them.

Warp ikats are traditional in the East, especially in the Middle East, Central Asia (see fig. 12), India, Indonesia, Japan and in parts of Africa and Central America. Designs range from the flicks of light in a dark ground (e.g. the Batak cloths of Sumatra) to large-scale figurative images, as in the Dyak cloths of Kalimantan (e.g. cotton blanket, c. 1904; London, British Museum), or patterns with a repeat of over two metres on some of the silk ikats of Turkestan and Afghanistan. The last, like many of the Persian, Turkish, Syrian and Greek warp ikats, are woven in a satin weave (see §(i)(a) above), which gives a

smooth warp-faced surface with patterns that are very clear on the right side only. The procedures for binding vary according to region but the warp is always made, measured and stretched taut on a temporary frame or other structure so that it can be bound exactly to the required pattern. Groups of warp threads, ranging from three to nine threads to a larger skein, are tightly bound at intervals and covered completely in defined areas with a thread (now often of plastic) of suitable thickness. After dyeing the bound area of the warp will remain the original colour of the yarn. For multicoloured ikats areas to be dyed different colours are bound separately and then undone before a subsequent dyeing, while any areas of colour to be protected from a subsequent dyeing are also bound. The Japanese, among

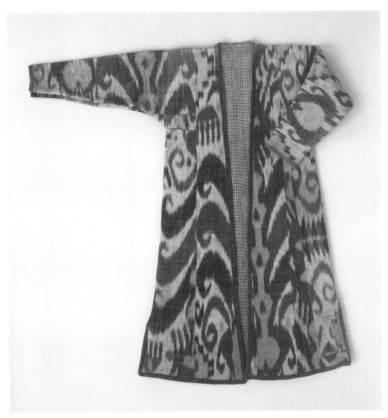

12. Mantle, cotton ikat and woven braid, from Uzbekistan, 20th century (Paris, Musée d'art et d'histoire du Judaïsme); photo credit: Réunion des Musées Nationaux/Art Resource, NY

others, use a special slip knot for ending each area of binding to hasten the slow process of untying after dyeing and to avoid the danger of warps being cut accidentally. Patterns formed by warp binding are made up of small vertical strips parallel to the warp so greater clarity is achieved by keeping the number of threads in a group as few as possible, especially for curved shapes. Many designs include mirror images, which usually means that the warps have been doubled or quadrupled for binding. The figurative cloths of Sumba, in Indonesia (*see* DYE), are examples, and some cloths from central Asia and parts of Indonesia have telltale light horizontal stripes across the cloth where the design reverses in mirror image, implying the warp has been folded before binding. Another method for complex designs is to tie threads for two cloths at the same time. Cloths from some Indonesian islands are made from two identical lengths sewn together. The binding, untying and dyeing of warp ikat is very time consuming, and the warp must be set exactly on the loom; the weaving, however, is comparatively quick and simple. Some warp ikats have pattern variations that are made by shifting the warp threads in groups when the warp is put on the loom, thus producing a diagonal or an arrow shape instead of a horizontal bar. The Japanese have developed three different methods, including the use of a special shifting box

with adjustable bars for different designs, which is placed on the loom when the warp is put on. The *maśrū* cloths of north-west India, made of silk warps and cotton wefts, woven in a satin weave, often have ikat patterns created by warp shifting.

Weft ikats are traditional in India and South-east Asia, especially in Thailand, Burma, Indonesia and Malaysia, and in Japan and Guatemala. In weft ikat the weft is stretched taut before binding, but its width must be calculated accurately by measuring how much yarn will be taken up in the weaving. Usually a section of cloth is woven and then undone and the weft measured. Binding and dyeing follow as for warp ikat. The designs are built up from small light strips running parallel to the weft, and patterns usually have smaller repeats than warp ikats. The Japanese have developed many styles of weft *kasuri* (ikat), including the shifting of the threads before weaving and 'picture' *kasuri* (weft ikat with pictorial imagery). A guide thread is stretched from side to side of a board set with nails the width of the weft and then marked with the design to be followed by binding the weft. The guide thread is taken off the board and laid parallel to the stretched weft for binding. The weaving of weft ikat is more difficult than that of warp ikat, as the weft thread must be precisely positioned. The weaver often allows an area of small loops of yarn near the selvages for adjustments. In the 20th

century short cuts were developed for use in weft ikat especially, but also sometimes in warp ikats: instead of a succession of dyeings for multicolour designs, some dyes are brushed on the stretched yarn between areas of binding and later fixed by steaming.

Some cloths have both areas of warp ikat and areas of weft ikat. Known as combined ikat, the technique is particularly effective in Indian saris, especially those woven in Orissa, where warp ikat may be used in the narrow side borders and weft ikat for the deeper end borders. Double ikat refers to cloths where warp and weft ikat threads are designed to cross when woven, thus creating areas of pure, undyed yarn or areas of pure colour, helped by the use of a balanced tabby weave. In Japan many designs exploit the contrasts, in cloths dyed indigo or black, of areas of speckle (where the bound areas of warp or weft threads are affected in the weaving by the dyed warp or weft) and areas of bright white where the bound threads cross. Because of the balanced weave the white areas can be made to form squares, and such motifs are often found in Japanese double ikats and are traditional in the *saktapar* cloths of Orissa, which are woven in single and double ikat and have a chequerboard design in the central field. Textiles that rely completely on the patterns built up from squares made from the crossing of undyed or dyed warp and weft threads are the silk *paṭoḷā* of Gujarat in India and the cotton *geringsing* cloth woven in the Tenganan Pegeringsingan village in Eastern Bali. Both cloths take months to complete and demand great accuracy of the binder and the weaver. The *paṭoḷā* colours are traditionally natural cream, red and yellow, with green and black achieved by over-dyeing. The weaving is very slow, the fairly loose weave allowing the weavers to adjust the weft threads with a pointed metal tool. Two weavers work to one loom, which is tipped so that one side is higher than the other to make the process easier. The *geringsing* cloths have patterns of natural cotton dyed in red *mengkudu* (*morinda citrifolia*) dye and are then bound in certain areas before being overdyed in indigo to make a purplish black.

Tie-dyeing. Tie-dyeing of cloth involves binding (or otherwise physically protecting) areas of cloth to prevent dye penetrating them. Any fibre or dye can be used, but the effects depend on the thickness and pliancy of the cloth and the characteristics of different dyes. Some of the most beautiful tie-dyed textiles are of very fine tabby-woven cotton or silk. The technique, popular in the West since the 1960s, is long established in Asia, especially in the Indian sub-continent, Japan (where it is known as *shibori*) and China; it is also found in West Africa. The simplest technique is to lift a small portion of cloth that is then bound tightly with thread below the tip. When dyed and untied this produces a light spot or ring, which, at its most characteristic, is roughly square with a spot of the dyed colour in the centre. Spots may be set singly or in small clusters in an area of

plain dyed ground, or set very closely in a line to 'draw' patterns or figurative images or to create an area of tone when the lines are set closely side by side. The *chunari* cloths from Gujarat and Rajasthan in India are made of cotton muslin or silk fine enough to be folded in two, four or even eight layers before binding). (Fine cloth gives fine definition, and several layers give extra protection against the dye as well as shortening the time taken to bind.) A metal finger ring with a spike is sometimes used to poke up the cloth for binding, or the folded cloth is damped and laid over a board set with nails in the pattern to be bound. Untying is made easier by using a continuous thread and slip knots that can be pulled off after dyeing. The Japanese have developed many variations of this *kanoko* spot technique, often exploiting the folding of cloth on the bias, and have invented gadgets to help in the binding, such as a vertical wooden stand with a hooked metal spike at right angles to keep the cloth taut. Some *kanoko* cloths are left in the puckered state after untying. In West Africa guinea-corn seed is put inside the cloth before binding. Spot tie-dyeing is a very slow process and has often been imitated by block-printed resists (*see* §(b) below) or, in the 20th century, by screen printing (*see* §(f) below).

Other binding techniques give stripe designs. In India narrow-width turban cloths are patterned using the *lahariyā* (wavy) method, which depends on very thin but absorbent cotton. At its simplest the turban length is rolled tightly and diagonally from one corner, then bound at intervals along the length while being kept taut. After dyeing and untying, the cloth will be striped diagonally. Zigzag patterns are made by pleating the cloth in four before rolling. Diagonal checks occur if the cloth is rolled from the other corner of the same end when it has been untied after the first dyeing. A succession of dyeings preceded by binding and untying creates multicolour effects. Bright colours are highly prized and are usually achieved with fugitive dyes, whether vegetable or chemical. In Japan many kinds of stripes, usually dyed in indigo, are made by binding the traditional narrow weave cloth round bamboo poles in different techniques.

Stitching. A third basic method is stitching, the most common being hand running stitches (see fig. 11(iii)a, a technique often referred to by the Indonesian word *tritik*. Threads are pulled up to create tight gathers, then tied off (11 (iii)b) and, when dyed, give the effect of tiny wavy lines (11 (iii)c). Areas can be outlined by single or double rows of stitching or solid areas and bands of texture made with repeated rows. The Japanese *tsujigahana* textiles of the Momoyama period (1568–1615) display stitching techniques at their most sophisticated on very fine plain-weave silk. Shapes were outlined by running stitches, and often, after pulling up, the area inside was 'capped' with a protective layer of bamboo bark, secured by binding. Alternatively the puckered area was dip-dyed before being covered

and dyed in the main background colour. Undyed areas were later decorated with painted designs (*see* §(d) below). In western China indigo-dyed cotton cloths have linear designs of animals, fish, butterflies, flowers etc, drawn with either pulled running stitches or overstitching on a small pleat of cloth. Associated with these pictorial images are tiny butterfly motifs made by folding a small part of the cloth in a special sequence and then securing this with one stitch. Hand-stitching followed by indigo dyeing is an established technique in parts of West Africa, but in the late 20th century machine sewing was commonly used to make bold designs by stitching down pleats and folds without pulling up the threads.

C. Schuster: 'Stitch-resist Dyed Fabrics of Western China', *Bulletin of the Needle and Bobbin Club*, xxxii (1948), pp. 11–28

T. Tanaka and R. Tanaka: *A Study of Okinawan Textile Fabrics* (Tokyo, 1952)

L. Langewis and F. Wagner: *Decorative Art in Indonesian Textiles* (Leigh-on-Sea, 1964)

J. Barbour, ed.: *Adire Cloth in Nigeria* (Ibadan, 1971)

A. Bühler: *Ikat, Batik, Plangi*, 3 vols (Basle, 1972)

A. Bühler, U. Ramseyer and N. Ramseyer-Gygi: *Patola und Geringsing* (Basle, 1975)

J. L. Larsen: *The Dyer's Art* (New York, 1976)

Splendid Symbols: Textiles and Tradition in Indonesia (exh. cat. by R. M. Gittinger; Washington, DC, Textile Museum; New York, Asia House Galleries; 1979)

A. Bühler, E. Fischer and M. L. Nabholz: *Indian Tie-dyed Fabrics* (1980), iv of *Historic Textiles of India at the Calico Museum, Ahmedabad* (Ahmadabad, 1971–)

T. Ito: *Tsujigahana* (Tokyo, 1981)

W. Warming and M. Gaworski: *The World of Indonesian Textiles* (Tokyo, 1981)

J. Tomita and N. Tomita: *Japanese Ikat Weaving* (London, 1982)

Y. Wada, M. K. Rice and J. Barton: *Shibori* (Tokyo, 1983)

S. Fraser-Lu: *Handwoven Textiles of South-east Asia* (Singapore, 1988)

A. Hale and K. Fitzgibbon: 'Ikats', *Woven Silks from Central Asia* (Oxford, 1988)

M. Sarabhai: *Patolas and Resist-dyed Fabrics of India* (Middleton, 1988)

R. Barnes: *The Ikat Textiles of Lamalera: A Study of an Eastern Indonesian Weaving Tradition* (Leiden, 1989)

V. Murphy and R. Crill: *Tie-dyed Textiles of India* (London, 1991)

N. Bhagat: *Batik and Tie-dye: The Art of the Resist Dye* (Howrah, 1996)

K. F. Gibbon: *Ikat: Splendid Silks of Central Asia* (London, 1997)

R. Crill: *Indian Ikat Textiles* (London, 1998)

(b) Resist. The resist technique, often referred to by the Malay word 'batik', involves the application of a substance to a cloth to prevent dye penetrating it. There are two kinds of resist: paste and wax. In the East, and also in Europe, resists have primarily been associated with indigo dye (*see* DYE, §2(i)), which is extremely difficult to print directly and yet is the major traditional blue dye for such cellulosic fibres as cotton, linen and hemp.

Paste. Paste resists may be printed by block, roller or stencils or be drawn free-hand with a suitable tool. The composition of the paste is of prime importance: it must print and keep a clear image, adhere firmly to the cloth and be sufficiently resilient to survive liquid dyes and, in the case of the indigo vat, a succession of dippings. Traditionally, pastes are based on starches, gums, clay and water, but chemicals can be added to resist particular dye types. The paste is applied to the cloth (see fig. 13(i)a), left to dry before dyeing (13(i)b) and is removed from the cloth after dyeing by soaking in water and/or scraping (13(i)c). In north-west India, chiefly in Rajasthan, cloth that has been mordant-printed and dyed, usually to give black and red, is then block-printed with a mud resist made from clay, gum and water, before being dyed in indigo. This gives only ill-defined areas of resist, and the clarification of the pattern is given by the printed mordants. In the Gujarati *ajrakh* cloths, however, the *kariyanu* resist, which produces clear linear block-printed patterns, is made from gum from the *babul* tree (*Acacia nilotica indica*) and lime and water. This resist is printed first on one side of the cloth and then usually on the other side as well, while the first side is still damp. Before dyeing in indigo, however, another resist of different composition is printed to cover larger areas of cloth. This paste is made from sorghum, of a particularly sticky quality, ground to a paste and then boiled with clay and water, to which powdered alum is added. The inclusion of alum is very significant because it means the paste has two functions: to resist the indigo dye and to print the mordant, which will later give a red colour. After printing this resist is sprinkled with powdered dung. The cloth is dipped in indigo, washed very gently to avoid smearing the resists, then dyed in alizarin.

The inclusion of a colouring agent in a resist gives an effect similar to a coloured discharge (*see* §(c) below). Procedures similar to those of the *ajrakh* process were used in Europe and referred to as 'red resist', but in both India and Europe resists including azoic dyes are now often preferred to give very fast and bright reds, oranges and pinks under indigo. In Europe indigo-resist pastes have been developed to give great clarity of image, based on mixtures of wheat starch, powdered clay (often china clay), zinc oxide, lead sulphate, gum and water. To these are added soluble salts with oxidizing properties, such as the sulphates and nitrates of copper and zinc, which chemically resist the indigo, thus enabling the cloth to be printed on one side only. In Austria and Slovakia what are misleadingly referred to as 'blue prints' are still printed using techniques that were previously widespread across Europe. These block-printed resists give white patterns on a blue ground, or both white and blue patterns, by printing a second layer of resist after the cloth has been dyed to a pale blue. The addition of lead nitrate to the paste produces a yellow instead of a white resist. Other resists using chemicals are those termed chemical resists in the madder style (*see* §(c) below). Modern chemicals are used in the comparatively new reactive

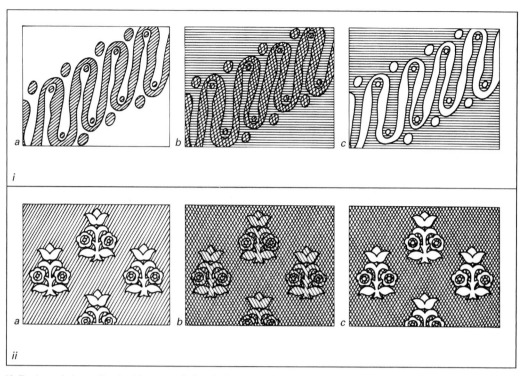

13. Dyeing techniques: (i) resist: (a) paste applied to cloth; (b) dyed cloth; (c) paste removed from cloth; (ii) discharge: (a) printing paste applied to cloth; (b) dyed cloth; (c) resulting pattern

resist style to create multicolour patterns using reactive dyes (see DYE, §1).

Some paste resists are based on common foods. In Nigeria, for example, copper sulphate is included in a paste resist based on cassava root flour, which is cooked in water and then applied through a stencil or free-hand with a chicken feather or palm-leaf rib. The paste is applied to one surface only of the cloth, which is then dyed in indigo. In eastern China in particular a resist of bean flour and slaked lime is pushed through stencils, while the Japanese have developed the most sophisticated resist, which is based on the use of glutinous rice flour (mochiko) and gives a very adhesive paste that can be used for designs with very fine lines (see §§(d) and (e) below).

Wax. Hot melted wax resist (often referred to as 'batik') prevents the penetration of any dye that can be used cold or lukewarm. Traditionally this meant indigo, with the use of some wood dyes, but any colour is possible with modern azoic and reactive dyes. Techniques depend on the tools used to apply the wax, the kind of wax and the quality of cloth. Free-hand drawing can be done with a stick, as in traditional cloths from Sulawesi in Indonesia, or with a brush, but metal tools that keep the wax molten and have some kind of reservoir have been developed to give a fine flowing line. (The traditional Indian tool is described in §(d) below.) In south-west China two or more small triangular pieces of sheet copper are bound by wire to a bamboo handle, and

a variation of this is found in Thailand. The Javanese canting consists of a small copper cup with a rolled spout at one corner and at the other a spike, which is pushed into a bamboo handle. This drawing tool is extremely efficient and can have spouts of different diameters or several spouts for parallel lines or grouped spots. The preparation of the finely woven cloth, usually cotton, involves first washing (to shrink it), then beating (to make it supple and uniform) and finally starching (to prevent the wax running too far). The cloth is then decorated by women, who sit on the ground with the cloth hung over a frame; with wax in a bowl over a charcoal heater, they make the tulis or hand-drawn batik cloths (e.g. cotton skirt cloth, late 19th century; London, Victoria and Albert Museum).

Although beeswax is the traditional resist, it can be mixed with paraffin wax, resins or fat, which alter the melting point, the flow and adherence to the cloth. Skilled practitioners alter the ratios for different designs, tools and effects. After dyeing, the wax is best removed by immersing the fabric in boiling water. There may be several waxings and dyeings before all the wax is removed. In the famous black, brown, blue and white Javanese cloths, for example, two different waxes are used on the white cloth, which is then dyed in indigo. The softer wax is scraped off, and the cloth is waxed again and then dyed in brown bark dyes, mainly soga (Peltophorum ferrugineum). The remaining wax is then removed by boiling. Although waxing is primarily suited to cotton and cellulose fibres, silk was

used in early batiks in China and Japan and is traditional for certain Javanese cloths.

In order to speed up the wax resist process various methods have been developed of printing wax for repeat patterns. The consistency of the wax medium must be carefully judged, or the hot mixture will spread and destroy the definition. Wooden blocks were probably used for early wax resists from India, but metal holds the heat better. The indigo resist cloths found in the USA (but probably printed in England in the 18th century) were printed by blocks with metal pinning and what was possibly a hybrid resist paste made of wax, flour and gum and used hot. The most sophisticated wax printing is produced in Java using metal *cap*s. These are made from thin copper strips (approx. 20 mm wide), which are slashed like a frilled piece of paper, then rolled for printing spots or folded into shapes. This printing surface is then set by a tongue and groove method into a back grid structure of thicker metal, to which a metal handle is attached. The men who print with *cap*s need great skill and stamina; they pick up the wax from a shallow receptacle, flicking away any excess before pressing the *cap* down on the cloth. They print both sides of the fabric, using a second *cap* giving a reverse image (e.g. silk shoulder-cloth, *c.* 1920; London, Victoria and Albert Museum). In England and the Netherlands 'wax' printed cloth for the African market is produced using hot resin rather than wax and passing the cloth between two heated engraved copper rollers. The design is engraved more deeply than in normal roller printing and on leaving the rollers the cloth passes through a bath of water to cool the resin. Before dyeing in indigo, the cloth is deliberately crushed in various ways to give 'crackle' effects where the dye penetrates the wax. In the past crackle was deliberately avoided in the East, but it now tends to be more popular, especially in Malaysia and the West.

P. Mijer: *Batiks and How to Make Them* (New York, 1924)

J. Vydra: *Indigo Blue Print in Slovak Folk Art* (Prague, 1954)

N. Krevitsky: *Batik* (New York, 1964)

J. Irwin and V. Murphy: *Batiks* (London, 1969)

K. Tetsuro: 'Yuzenzome' [The *yūzen* rice-starch-resist textile dyeing method], *Nihon no Bijutsu*, cvi (1975)

N. Katsumi, ed.: *Tsutsugakizome* [Hand-drawn, paste-resist dyeing] (Tokyo, 1977)

J. Storey: *Dyes and Fabrics* (London, 1978)

L. Oei: *Indigo* (Amsterdam, 1985)

R. M. Brandon: *Country Textiles of Japan: The Art of Tsutsugaki* (New York, 1986)

L. Brassington: *Indigo Country Cloths and Artefacts from Czechoslovakia* (Farnham, 1987)

B. S. Benjamin: *The World of Rozome: Wax-resist Textiles of Japan* (Tokyo and New York, 1996/R 2002)

R. Heringa and H. Veldhuisen: *Fabric of Enchantment: Batik from the North Coast of Java* (Los Angeles, 1996)

J. Balfour-Paul: *Indigo in the Arab World* (Richmond, 1997)

J. Balfour-Paul: *Indigo* (London, 1998)

I. C. van Hout: *Batik Drawn in Wax: 200 Years of Batik Art from Indonesia in the Tropenmuseum Collection* (Amsterdam, 2001)

(c) Discharge. Discharge is the process of using appropriate chemicals to remove the colour from dyed cloth. Patterns are made by mixing the chemicals with gum and water to form a printing paste, which is applied by any of the printing methods (e.g. block, roller or screen; *see* §(f) below) to the cloth (see fig. 13(ii)a above), which is then steamed. Fabrics dyed with selected direct, azoic, reactive or acid dyes (*see* DYE, §1) are usually discharged with a reducing agent—sodium sulphoxylate formaldehyde—manufactured under such brand names as Decrolin, Formosul and Redusol. Dyestuffs within a dye family have different dischargeability properties, and only certain ones discharge to a good white. If dyestuffs that withstand the action of the reducing chemical, such as vat dyes and basic dyes, are included in the discharge paste, coloured discharges can be achieved; for example, instead of a white pattern in a green ground, there could be a red pattern in a green ground, thereby avoiding the problems of registration posed by direct printing.

More traditional dyestuffs have to be treated in other ways. Mordants used in the madder style, such as alum or iron, are dischargeable with citric and tartaric acid and citrates and tartrates. It is slightly confusing that they are described as resists or discharges depending on whether they are applied to the cloth before or after the mordants. The final effect after dyeing (see fig. 13(ii)b) is the same: a light pattern in a dyed ground, the mordant having been rendered ineffective by the acid (13(ii)c). There are many variations, one being the cover style, where after the first printing of the acid the mordant is applied in a fine all-over pattern rather than a solid area. It should be emphasized that it is always the mordant, not the dye, which is discharged.

The faster Turkey red cloths dyed in madder or alizarin are discharged by the acid or chloride of lime process. The dyed cloth is printed with strongly acid solutions, the real discharging agent being the bleaching powder, through a solution of which the cloth is passed after printing. For a white discharge, citric, tartaric or arsenic acids are used. For coloured discharges yellow is obtained by printing a paste containing citric acid and lead salts; blue from a solution of Prussian blue in oxalic or tartaric acid; and green from a mixture of blue and yellow. A black is often printed alongside using logwood and iron black. Indigo, whether natural or synthetic, being a vat dye is unsuitable for normal discharge by reduction but is more readily discharged by oxidation. The most important method is the chromate discharge. Indigo-dyed cloth, printed with a pattern in a chromate, is passed through a hot bath of sulphuric and oxalic acid. If a pale blue as well as a white discharge is required (as, for example, in the two-tone discharges of William Morris (1834–96)) then the bichromate of soda is printed at a weaker strength. Discharge by oxidation may easily tender the fabric. Research to avoid this led to the successful introduction in 1910 of Leucotrope, a patented compound that makes indigo discharge by reduction

viable using sodium sulphoxylate formaldehyde. This continues to be the main process.

C. O'Neill: *A Dictionary of Calico Printing and Dyeing* (London, 1862)

W. Clarke: *An Introduction to Textile Printing* (London, 1924, 4/1974)

E. Knecht and J. B. Fothergill: *The Principles and Practice of Textile Printing* (London, 1924, 4/1974)

N. Tarrant: 'The Turkey Red Industry in the Vale of Leven', *Scottish Textiles*, ed. J. Butt and K. Ponting (Aberdeen, 1987), pp. 37–47

J. Storey: *The Thames and Hudson Manual of Dyes and Fabrics* (London, 1992)

J. Gillow: *Printed and Dyed Textiles from Africa* (London, 2001)

(d) Painted. The technique of decorating cloth with a free-hand application of colour or resist, using a tool which does not of itself produce a repeat image, has been practised mainly in the East. An important distinction must be made between the use of colour from pigments (*see* PIGMENT, §I) or dyes (*see* DYE, §1). China has an ancient tradition of using pigments to paint silk. In Japan the resist paste used with stencils (*see* §(e) below) is also used for free-hand drawing using a *tsutsu*, a cone-shaped tube of stencil paper with a brass tip. Colour is then applied by brush. The *yūzen* silk-dyeing process involves drawing the pattern free-hand on the cloth using a *tsutsu* with a fine tip, covering the pattern with a paste resist, painting the uncovered inner areas with dyes and then covering them with paste, brushing on the background colour, steaming the painted fabric to fix the dye, and finally washing off the paste in water. For the cotton or hemp country textiles called *tsutsugaki* (lit. 'tube drawing'), pigment colours mixed with soya-bean liquid (*gojiru*) are brushed on before being covered by another layer of protective paste on both sides of the cloth, which is then dyed in indigo. The bingata cotton or banana-fibre cloths from Okinawa are first stencilled using a resist paste, then colour is applied by brushing on pigments, mixed with soya-bean liquid. The depth of colour is built up by layers, which has led to a characteristic shading where, in an area bounded or crossed by a resist line, there is a tonal change from light to dark or from colour to colour. In contrast *sumi* (black ink) was used for hand-painting the *tsujigahana* silks in some of the areas defined by stitching and binding. Fine-lined brush drawing of leaves, flowers etc is accentuated by shading at the tips of petals and corners of other areas. Among the well-known textile-painting traditions of India are the hangings (*picchavai*) created for the shrines of Sri Nathji and the temple cloths made at such centres as Kalahasti. One of the most important techniques of painting cotton cloth that was developed in India was kalamkani, known (by Europeans) as 'chintz', which influenced both the technique and design of printed cloths in the West. The technique used mordants and resist-dyeing processes to produce a cotton fabric with brilliant fast colours that was washable because the colouring was produced by dyes. The colour palette encompassed black, reds, purples, browns, blue,

green and yellow, although not all cloths have the full range, and in old examples the yellows have often faded. Limited colour ranges may be red and black, as for some Hindu temple cloths. The chintzes made for the Mughal courts and the European market usually have large areas of white ground (e.g. chintz overdress, painted and dyed cotton; Toronto, Royal Ontario Museum), and may be just in several tones of red on white. A large complex cloth could take months to decorate and would involve at least ten stages of production, the main reason being the difficulty, before the advent of suitable synthetic dyes, of dyeing cotton and other cellulose fibres. The best cloths also depend on finely spun cotton.

The traditional process for producing these painted cloths known as *kalamkāri*s involves several stages. After a preliminary bleaching, the cloth is soaked in a mixture of buffalo milk and ground myrobalan (a dried plum that contains a high proportion of tannin). Oils or fats, provided here by the milk, help the successful bonding of alum with cotton. The design is transferred by pouncing with charcoal, and the outlines are drawn in with iron acetate (made from soaking rusty iron in molasses or acids) using a *kalam* or pen. This is made from a short piece of bamboo, shaped at the end to form a nib, above which a compact ball of hair is bound on to form a reservoir for the iron acetate, which turns the cloth black on contact. Further outlines, later to be red, are drawn with a colourless alum mordant dissolved in water and tinted red with a fugitive dye, sappan. The cloth is then dyed in a dye containing alizarin, often from the *chay* plant (*Oldenlandia umbellata*), which makes the lines drawn with alum a permanent red but also colours or 'dirties' the ground of the cloth, which then has to be cleared by immersion in a cow-dung bath and bleaching in the sun. Blue is the next colour, given by indigo, but, because in India indigo is a vat dye, the cloth must be waxed, first with fine lines to define areas such as leaves and to give detail, and then all over to protect the majority of the cloth from being dyed blue. The waxing tool, which is similar in shape to the bamboo *kalam*, is made of iron moulded as a bulb, above which is bound a layer of hair. After successive dips in the indigo vat to build up the colour, the wax is removed in boiling water, leaving the cloth blue only in areas, but with an occasional blue hairline in the white ground to show that the cloth has been waxed. A second painting with an alum solution follows, often in several different strengths to make different depths of red, and in the best cloths this is preceded by further fine waxing to give fine white details under areas of colour. Weak iron mordants are mixed with the alum mordant to produce violet, purple and browns after a further dyeing in *chay* tap-root. After a final de-waxing and clearing of the background, the cloth is painted with a decoction of yellow dye to give yellow, orange and green areas.

Textile Designs of Japan, Japan Textile Color Design Center, 3 vols (Osaka, 1959–61, rev. Tokyo and New York, 1980)

J. Irwin and P. R. Schwartz: *Studies in Indo-European Textile History* (Ahmadabad, 1966)

J. Irwin and K. B. Brett: *Origins of Chintz with a Catalogue of Indo-European Cotton-paintings in the Victoria and Albert Museum, London, and the Royal Ontario Museum, Toronto* (London, 1970)

J. Irwin and M. Hall: *Indian Painted and Printed Fabrics* (1971), i of *Historic Textiles of India at the Calico Museum, Ahmedabad* (Ahmadabad, 1971–)

B. Adachi: *The Living Treasures of Japan* (Tokyo and New York, 1973)

M. R. Anand and others: *Homage to Kalamkari* (Bombay, 1979)

K. Talwar and K. Krishna: *Indian Pigment Paintings on Cloth* (1979), iii of *Historic Textiles of India at the Calico Museum, Ahmadabad* (Ahmadabad, 1971–)

M. Gittinger: *Master Dyers to the World* (Washington, DC, 1982)

R. M. Brandon: *Country Textiles of Japan: The Art of Tsutsugaki* (Tokyo, 1986)

R. E. Hartkamp-Jonxis: *Sits* [Painted cotton] (Zwolle, 1987)

N. Hirai, ed.: *Tsutsugaki Textiles of Japan: Traditional Freehand Paste Resist Indigo Dyeing Technique of Auspicious Motifs* (Kyoto, 1987)

S. Yang and R. M. Narasin: *Textile Art of Japan* (Tokyo, 1989)

C. Villers: *The Fabric of Images: European Paintings on Textile Supports in the Fourteenth and Fifteenth Centuries* (London, 2000)

J. Gillow: *Printed and Dyed Textiles from Africa* (London, 2001)

(e) Stencilled. A stencil is a piece of paper or thin sheet of metal perforated with a pattern. The stencil is placed flat on the cloth, and a paste is pushed through the perforations to transfer the pattern. Stencils are used to repeat patterns on a length of cloth or to reproduce unit designs. Stencilling on cloth developed in China and Japan, where the paste used is traditionally a resist, the cloth being coloured when the resist has dried. In its simplest form the cut-out areas of the stencil appear as uncoloured patterns on a coloured cloth, but in the most sophisticated designs the ground may be so covered with resist that the pattern looks like a positive print on a white ground. After the introduction of chemical dyes, a paste containing dyes was sometimes pushed through the stencil; this was the precursor of screen-printing (*see* §(f) below).

In China and Japan stencils are cut from paper made from the inner bark of the paper mulberry (*Broussonetia papyrifera*). Two or more thin sheets are laminated together through impregnation with the juice of the persimmon fruit, which changes the colour to a rich brown, toughens the paper and prevents it from warping, although the paper remains flexible and easy to cut. The paper should be kept for some months or years before being cut. The most skilled stencil makers are found in Japan, where the specialist stencil-cutter has a range of steel knives and augers appropriate for different types of patterns. The craftsman cuts through a pile of eight or nine laminated sheets of paper, which have been laced together at the edges to prevent slippage. Thin bars of paper may be left to attach areas that might otherwise fall out, but the Japanese usually reinforce stencils with a fine silk mesh, using one of two methods. In the most skilled process the laminated stencil sheets are split apart before cutting. One half of the cut stencil is laid on a board and a frame laid on top, across which 21-denier silk threads are interlaced in a configuration suitable to the design. The second identical stencil is laid on top of the silk, and the sandwich is then laminated with persimmon juice. On thicker stencils an open gauze-weave silk cloth is lacquered on the back. In both methods the silk rolls slightly in use and is completely invisible on the cloth. If possible the stencils are aged for some time to make them sturdy enough to last for 80 bolts of cloth. Stencils with very small patterns are called *komon*, and those with medium-size patterns *chūgata*.

The traditional resist paste in China is made from bean flour and lime. The Japanese paste depends for its success on finely ground ingredients and skilful mixing; for example, the consistency has to be adapted to the prevailing weather conditions, especially the humidity level. It should be made fresh each day. Finely ground glutinous rice flour (*mochiko*) is mixed with finely ground rice bran (*nuka*) to make the sticky rice easier to handle, add bulk, give greater volume to the layer of paste on the fabric and increase the solubility of the paste, making it easier to wash off. The dry ingredients are mixed into a pliable dough with salt and water, formed into 'doughnuts' with holes in the centre and steamed. When cooked these are pounded together with water and slaked lime (calcium hydroxide). The cloth is laid flat on long wooden boards, and the stenciller lays down the stencil and spreads across it a dollop of paste with a wide curved wooden spatula. The stencil is then lifted off to leave the paste lying slightly raised on the surface of the cloth. If the paste is well made it dries with very little shrinking or cracking, thus keeping the crisp outlines of the stencil pattern. For a kimono length the stenciller may lay and lift the stencil 80 to 100 times. The stencil is just over the width of the traditional narrow weave cloth, but the length varies with the pattern and great attention has to be paid to correct registration. When dried the paste is brushed with soya-bean juice to increase its adhesion and water resistance.

The stencilled cloth is coloured either by immersing the cloth in a dye or by brushing on pigments or dyes. In China and Japan the main dye used is indigo to produce blue and white patterned textiles, usually of cotton or bast fibres (see fig. 14). The Japanese paste has to be stencilled on both sides of the cloth to resist the indigo dye. For patterns with a large amount of white in the final design two stencils have to be used, one giving the finer details, the second the larger blank areas, so the cloth must be stencilled four times. The multicoloured Japanese *yūzen* cloths are produced by brushing one side of resist-stencilled silk with vegetable or chemical dyes, which are steamed for fixation. The cotton or banana-fibre *bingata* textiles from Okinawa are painted with pigments mixed with soya-bean juice. The resist paste is removed by soaking the cloth in water. In Nigeria comparatively crude stencils cut from thin metal are used by women stencillers who push through a resist paste made with cassava flour cooked with water, to

which is added copper sulphate to help resist the indigo dye chemically, so the cloths are stencilled only on one side.

An earlier stencil-like technique (no longer in current use) has been deduced from some early patterned cloths from China and Japan, which are characterized by repeat patterns with uncoloured outlines defining coloured areas. The Japanese term for this technique is *kyōkechi*, the German term is *Pressschablonen* and the English clamp-resist dyeing. Two wooden boards are carved with an identical pattern in mirror image. These boards are then pressed together on a flat surface with a thin cloth, usually silk, folded between them. The areas between the raised walls of the pattern have been drilled with holes right through the boards to allow dye to be poured in to colour the cloth. These types of boards have been found in India.

Chai Fei, Hsu Chen Peng and others: *Indigo Prints of China* (Beijing, 1956)

Textile Designs of Japan, Japan Textile Color Design Center, 3 vols (Osaka, 1959–61, rev. Tokyo and New York, 1980)

A. Bühler: *Ikat, Batik, Plangi*, 3 vols (Basle, 1972)

B. Adachi: *The Living Treasures of Japan* (Tokyo and New York, 1973)

E. Fischer and A. Bühler: *Clamp-resist Dyeing of Fabric* (Ahmadabad, 1976)

F. Blakemore: *Japanese Design through Textile Patterns* (Tokyo, 1978)

Craft Treasures of Okinawa (exh. cat., Kyoto, National Museum of Modern Art, 1978)

E. Nakano and B. B. Stephan: *Japanese Stencil Dyeing: Paste-Resist Techniques* (New York, 1982)

K. Matsumoto: *Jōdaigire: 7th and 8th Century Textiles in Japan from the Shōsō-in and Hōryū-ji* (Kyoto, 1984)

G. Sandberg: *Indigo Textiles: Technique and History* (London, 1989)

S. Yang and R. M. Naasrin: *Textile Art of Japan* (Tokyo, 1989)

N. Sato: 'Patterns from Paper', *Asia–Pacific Perspectives, Japan*, ii/8 (Dec 2004), pp. 40–45

(f) Printed. In the West, textile printing using woodblocks carved to leave the pattern in relief and imitating the designs of contemporary velvets and damasks can be traced back to the 15th century. However, because these linens were printed with ink and not fast dyes, they could not be washed, and their use was therefore restricted. By the 17th century similar methods were used for printing silk handkerchiefs and the grounds for certain embroideries. During this period the import of painted and printed cottons from the Near East and from India stimulated European manufacturers to experiment with techniques that could compete with the dazzling range of imported goods. Although woodblocks could be cut successfully in the West, European production was delayed until the nature of dyestuffs and mordants began to be fully understood. By the late 17th century both the Dutch and the English were printing successfully in a range of madder colours. By using different mordants, such as alum, printers achieved a wide range of colours from a deep purplish brown to pale pink. The patterns were sometimes

figurative—a tea-party with people in contemporary clothes sitting among stylized trees and flowers was very popular, for example—but the majority of patterns imitated those imported from India. Indigo blue was a particularly difficult colour which, because it quickly oxidized on exposure to air, had to be 'pencilled' by hand until the English discovered a method of printing it in a paste form. All the dyestuffs for yellow were fugitive, and green was achieved only by printing yellow on blue. Since the yellow faded more quickly many surviving textiles have blue leaves. Cotton took dyes much better than linen, but as the European woollen and silk industries succeeded in obtaining the prohibition of printed cottons early in the 18th century, many printed textiles were either linens or fustians—a mixture with a linen warp and a cotton weft—that produced a characteristically speckled pattern. Similar patterns were also printed on worsted wool, examples of which, dating from 1763, survive in Barbara Johnson's *Album* (London, Victoria and Albert Museum).

By the mid-18th century English printers were able to achieve a 'full chintz' with five or more colours. By this time they had also broken away from their dependence on Indian patterns and were producing graceful patterns inspired by contemporary brocaded silks with sharp outlines formed by a metal strip set into the block. Fine nails were also hammered into the blocks to achieve stippled effects. These fustians could be washed and offered serious competition to their rivals. A new development that was first used in Ireland in 1752 and was especially relevant to furnishing textiles was the large engraved copper plate, similar to those used for books or maps, which was used to print exquisite monochrome designs in either madder or indigo. Other colours were added by hand by pencillers using small blocks or brushes. Pure cottons became legal in France in 1759, and large numbers of often short-lived factories were established in both France and England. The factory established by Christophe-Philippe Oberkampf (1738–1815) in 1759 at Jouy-en-Josas, near Versailles, produced both superb plate-printed and colourful block-printed cottons. Other factories at Nantes and Rouen were producing Neo-classical and Romantic designs, while printers in Mulhouse concentrated on block-printed floral cottons. From the 1770s until the end of the century printing was the dominant method of creating patterns for both dress and furnishing textiles. Textile printing outside England and France remained comparatively primitive, although Swiss and Bohemian manufacturers rapidly developed expertise, with the latter specializing in blue-resist printing (*see* §(b) above).

Plate-printing produced beautiful results but was slow and expensive. It continued to be the favoured method for printing handkerchiefs, often with highly topical subjects (*see* COTTON), but the manufacturers looked for cheaper alternatives, especially for less discriminating markets. Engraved rollers appeared the best option, even though the first ones employed in England and France printed cramped, foreshortened

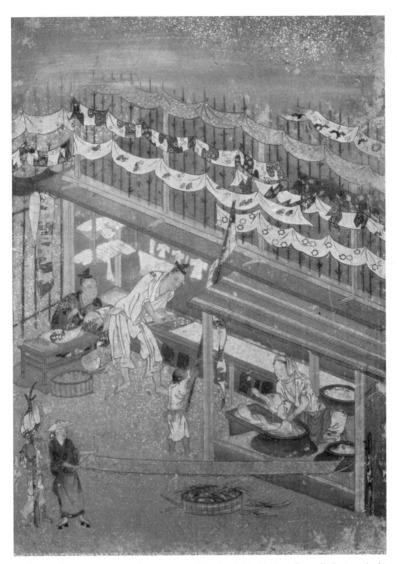

14. Dyers shown on a painted screen panel by Kanō Yoshinobu, from *Shokunin zukushie* ('Depictions of trades') showing: (centre) man dressed in a small-patterned robe stencilling gold leaf over a stretched robe (*kosode*); (left) seated man checking quality of dyed cloth; (right) woman kneeling at an indigo vat immersing a portion of cloth in indigo dye *(tsumamizome* dyeing technique); (foreground) children stretching dyed cloth out to dry (other dyed bolts are laid out on latticework above shop, and finished fabrics lie ready for sale on racks); (back, left) piece of bound-resist and gold-leaf stencilled cloth hanging from the eaves of the shop; 577×421 mm, early 17th century; Important Cultural Property (Saitama, Kita-In Temple); photo credit: Werner Forman/Art Resource, NY

designs. Roller-printing could, however, be fully mechanized, thus producing cheaper goods. In the 1820s and 1830s metal rollers were often engraved with fancy 'machine-grounds' instead of the ground being white or plain coloured. Meanwhile, block-printing continued to be used by such designers as William Morris (1834–96) and later members of the Arts and Crafts Movement. Other alternatives explored in the 19th century included LITHOGRAPHY; various methods of resist-printing, some of which

were especially relevant for such overseas markets as West Africa (*see* COTTON and §(b) above); warp-printing; and patterns that were partly woven and partly printed. By the 1860s the desire for cheap novelties led to many short-lived experiments, as well as imitations of techniques used elsewhere in the world. Even stencilling, normally used in the West for wallpaper borders, was occasionally applied to dress fabrics. The typical cheap fabrics of the mid-19th century were, however, often printed in lurid colours as, from the

late 18th century onwards, chemists discovered new sources of dyestuffs, including chrome colours and the dangerous but pretty arsenical green. W. H. Perkin's discovery in 1856 of the colours that could be extracted from coal tar transformed the palette of popular printed textiles. A plentiful supply of cheap raw cotton from India meant that consumers did not mind if the vivid mauves, purples, greens and pinks did not last beyond a season, as dresses or curtains could be easily replaced. Lifelike floral patterns in unlimited and often clashing colours remained popular well into the 20th century. Aniline colours from coal tar faded quickly but were very easy to use, hence their rapid spread and consequent detrimental effect on textiles hand-produced outside Europe.

In the 20th century SCREENPRINTING superseded nearly all other techniques. In this technique the pattern is broken down into component areas of colour, which are outlined on a large silk screen, while the rest of the screen is obscured by an impervious substance. Photography is a popular method of colour separation for each screen and ensures an exact match. Preparing the screens is much quicker than cutting blocks, and with modern, quick-drying dyestuffs the screens can be operated mechanically one after the other (see SCREENPRINTING, §1). They can, moreover, be printed with much greater accuracy than is possible with block-printing, and complicated designs can be produced on virtually any fabric, given an understanding of the affinity of particular dyestuffs for both natural and manmade fibres. From the late 1960s rotary screen printing largely replaced flat-bed printing in commercial production. One of the greatest technical advances was the ability of dye chemists to produce dyestuffs that were accurate and consistent in every batch. This very success, however, resulted in a preference among many sophisticated Western consumers for the irregularity of the less than perfect fabrics produced in East Asia and developing countries.

S. D. Chapman and S. Chassagne: *European Textile Printers in the Eighteenth Century: A Study of Peel and Oberkampf* (London, 1981)

F. Montgomery: *Textiles in America, 1650–1870* (New York, 1984)

J. Brédif: *Toiles de Jouy: Classic Printed Textiles from France, 1760–1843* (London, 1989)

L.W.C. Miles, ed.: *Textile Printing* (Bradford, 2/1994)

H. Clark: *Textile Printing* (Princes Risborough, 1997)

J. Gillow: *Printed and Dyed Textiles from Africa* (London, 2001)

S. Meller and J. Elffers: *Textile Designs: 200 Years of Patterns for Printed Fabrics Arranged by Motif, Colour, Period and Design* (London, 2002)

J. Kinnersly-Taylor: *Dyeing and Screen-printing on Textiles* (London, 2003)

M. Riffel and S. Rouart: *Toile de Jouy: Printed Textiles in the French Classic Style* (London, 2003)

2. SEWN AND OTHER TECHNIQUES. Sewing is one of the oldest and most widespread means of decorating a wide variety of pre-existing ground fabrics and, as a portmanteau term, covers a vast range of techniques that employ a needle and thread.

The threads, which include all those that can be used to make a textile (see §I above), may match the fibre and colour of the ground fabric, be in sharp contrast to it or combine a range of colours and textures. They are often combined with other materials, including such unusual ones as seeds and grasses, feathers, porcupine quills, beetle wings, spangles, metal ornaments, pearls, beads, gemstones and hardstones. In a sewn textile, the stitching may entirely cover the ground fabric or may merely be a means of combining pieces of material. Cut strips of different coloured cloth can simply be sewn together, or more elaborate effects can be achieved by the use of patterned strips, as in African cloths composed of joined woven bands. Patchwork and appliqué are more sophisticated forms of joining. Simple lines of stitching are a means of producing a variety of geometric patterns on a ground fabric, but they are also basic to such complex techniques as QUILTING. Similarly, when the structure of the ground fabric is used to guide the stitches, very different effects are achieved, as in darned net, canvas work, counted-stitch embroidery and the openwork techniques of cutwork, drawn-thread and pulled-fabric work. The use of different threads, whether monochrome or multicoloured, can also affect the appearance of a stitch or technique, and much depends on whether a stitch is worked as a line or solidly. Thus straight stitches have been used to work monochrome linear designs and to create subtly shaded needle-painting effects.

Stitches can be grouped according to their form—straight, looped, knotted, interlaced or composite—or whether they are worked into the ground fabric, are secured to it only at certain points or are held down by a second thread. It is possible to create exceedingly elaborate effects by combining different threads, stitches and techniques, but some of the most beautiful embroideries have been achieved by using just a single stitch and a limited range of colours. The first embroidery machine was invented by Josué Heilmann (1796–1848) in 1828 and employed multiple needles controlled by a pantograph. These were combined with the double-thread, lock-stitch mechanism used in the domestic sewing machine by Isaac Groebli in his Schiffli machine of 1863. By 1885 it was being used in combination with the chemical or burnt-out technique to produce excellent copies of lace. Another 19th-century invention was the Cornely machine (patented in 1865), which consisted of a universal feed system and a single hooked needle that was moved to any position by a rotary handle mounted below the machine. It initially produced a chain stitch, but later versions could be used for a wide range of embroidery techniques. In the late 20th century embroidery had been part of the FIBRE ART movement, and traditional techniques have been combined with machine stitching, painting, felting, photography and the chemical removal of areas of cloth.

Most non-woven textiles such as sprang, knitting, crochet, needle lace etc (see §II, 2 above), can be decorated by missing out or combining loops in a

regular sequence to produce an openwork pattern (*see* KNITTING and LACE, §1). Such openwork patterns could also be worked on the knitting frame; at first the loops had to be laboriously lifted from one needle to another but, from the 1760s, the process was mechanized. Simple striped patterns can be worked in many twining and looping techniques by joining on lengths of different coloured yarn. In knitting it is possible to work with multiple coloured threads, which are simply stranded or knitted into the back until needed for the pattern. In the late 20th century the domestic knitting-machine had been increasingly used for multicoloured knitting.

In the late 20th century there had begun an increasing use of the computer in various textile processes. It is particularly successful as a manipulation device for re-colouring and colour separation in SCREENPRINTING, and it is used by many handloom weavers both as a design tool and in combination with, or as an alternative to, the Jacquard loom. The complex images that can be achieved are strikingly illustrated by such pieces as *Nuno Me Gara* or *Fabric Patterned Fabric* (*c.* 1980; Providence, RI, Rhode Island School of Design, Museum of Art) woven by Junichi Arai (*b* 1932) using 3600 computer-generated punch cards. Commercially, the computer has been applied most successfully in the carpet industry, where it has largely replaced the Jacquard loom.

See also EMBROIDERY.

M. de Saint-Aubin: *L'Art du brodeur* (Paris, 1770; Eng. trans., Los Angeles, 1983)

S. F. A. Caulfeild and B. C. Saward: *The Dictionary of Needlework* (London, 1882/*R* in 2 vols, New York and London, 1972)

T. de Dillmont: *Encyclopedia of Needlework* (Paris, 1924)

A. H. Christie: *Samplers and Stitches* (London, 1934)

M. Thomas: *Mary Thomas's Dictionary of Embroidery Stitches* (London, 1934, rev. 1989)

M. Thomas: *Mary Thomas's Dictionary of Embroidery* (London, 1936)

C. Risley: *Machine Embroidery* (London, 1973)

P. Clabburn: *The Needleworker's Dictionary* (London, 1976)

A. Butler: *The Batsford Encyclopaedia of Embroidery Stitches* (London, 1979)

L. Synge: *Art of Embroidery: History of Style and Technique* (Woodbridge, 2001)

Y. Y. Chung: *Silken Threads: A History of Embroidery in China, Korea, Japan, and Vietnam* ([New York], 2005)

S. M. Levey: *An Elizabethan Inheritance: The Hardwick Hall Textiles* (London, 2006)

IV. Conservation.

1. Introduction. 2. Preventive. 3. Remedial.

1. INTRODUCTION. The fragments of ancient textiles recovered from bogs and burial grounds around the world are among the first signs of the technological ability that has brought about modern civilization. However, they have not always been treated with the respect they deserve, and much information has been lost through indifference on the part of early archaeologists and dealers, and some museum curators who were blind to the cultural

significance of textiles. On the other hand, on a domestic level and in religious foundations, textiles have been seen as valuables to be repaired, cleaned and continued in use for as long as possible.

As a professional activity, textile conservation had its beginnings in the 1930s when a few curators began to think seriously about textiles as works of decorative art and to introduce a more systematic approach to the problems of repair and cleaning. Such developments were made more necessary as attitudes brought into being by a consumerist society put at risk objects that had previously been cherished. Before then, broadly speaking, only tapestries and banners had been considered important enough to be conserved, although some of the practices followed in the early years of the 20th century have proved more of a hindrance than a help. The original structure was often obscured or distorted and unsuitable materials were introduced for purposes of repair that quickly faded and weakened along with the object. Many tapestries now show a speckled effect as wool, originally dyed to match the dark blues and greens of foliage and the ground have faded to a pale fawn colour. The profession became fully established in the second half of the 20th century, when countries throughout the world became anxious to preserve their textile past from the ravages of climate and environmental pollution. Institutions in London and Amsterdam were in the forefront of the search for new methods and materials, while the Abegg-Stiftung in Riggisberg, Switzerland, became the symbol of traditional attitudes towards the support of fragile textiles. In the USA the emphasis had been more on preventive conservation than on remedial intervention on individual objects. Alongside the development of methodology there also grew a set of ethical considerations that steadily imposed restraints on the more radical interventions of the early years.

The aim of the textile conservator is that of the profession in general: to preserve the object for as long as possible, at the same time gathering as much information as possible about the technology and purpose of its construction. This job is complicated by the essentially transitory nature of textile fibres, made from organic compounds that are bound to degrade, despite any measures that are taken to slow down the process. The results of such degradation are manifested in loss of tensile strength, loss of surface texture, the fading of dyes and yellowing of white fabric. Atmospheric pollution and display in high light levels have accelerated this process in many cases, and now only the very best preventive conservation can preserve our most valuable heritage. Unfortunately, most museums are short of space and money, and provision for textiles is often particularly poorly as attitudes have been slow to change. Poor storage conditions, after the wear and tear of ordinary use exposes the objects to further damage: (1) from mould encouraged by high humidities and fluctuating temperatures; (2) from heat, which dries and embrittles the fibres; (3) insects, which eat them; (4) dust, which harbours micro-organisms and

encourages the absorption of acidity in the atmosphere; and (5) dirt and grease, which become ingrained in the fibres, causing unsightly stains if objects are put away before being cleaned. Furthermore, textiles are particularly vulnerable to careless handling by human beings.

It is clear that there are two sides to conservation, which can perhaps be regarded as the passive and active voices of the verb 'to conserve', that is preventive and remedial. Preventive conservation comprises storage, display and control of the environment. Its aim is to recognize the agents and mechanisms of decay and to slow down the process by introducing optimum conditions into any area designated for textiles. Remedial conservation means active intervention in the physical state of the object by cleaning, consolidation, repair and support.

2. PREVENTIVE.

(i) Storage. Ideally, storage areas should be fully air-conditioned, with stringent specifications for the filtration of dust particles and the removal of such harmful gases as sulphur dioxide. In any case, such areas should be kept as dust-proof as possible. They should also be in the dark with all the objects protected from light except during examination. They should be free from damp, with the relative humidity between 45% and 55%, and free from atmospheric pollution. There are now many specialist firms providing storage containers and display cabinets made with the most suitable materials to prevent further contamination, and it is generally agreed that all packing materials should be acid-free.

Shelving, drawers and boxes should, if possible, be large enough to contain the objects without folding, as the sharp creases produced during long periods in one position are irreversible. Flat textiles should, therefore, be kept either flat or rolled, with roller storage systems for the larger objects devised to take up a minimum of space. Rollers can be cardboard or plastic, but they must be wrapped in an acid-free material before use. The textile should be rolled with the right side outwards and the roller at right-angles to the run of the warp. (Certain types of weave structure, including that of tapestries and most carpets, are particularly weak in the weft direction.) In the case of a piled textile, for example a carpet or velvet, rolling should be with the direction of the pile to avoid crushing it. The rolled object should be wrapped in a protective covering of clean fabric that is kept in position with flat straps, not string. Fabric or acid-free tissue paper can be used to interleave with the object if long-term storage is likely. Polythene should be avoided for any of these purposes as it develops static that attracts dust, degrades and becomes brittle in the course of time and can trap moisture that encourages mould growth.

Three-dimensional objects, costume for example, can be laid flat or hung according to the condition and structure of the fabric. Small items can easily be lost, so it is better to place them in a transparent envelope than to wrap them in tissue paper. Accessories should be padded or otherwise supported in their proper shape to prevent collapse and permanent distortion. Damage by abrasion and by surface decoration becoming entangled can result from moving unprotected objects in close proximity to each other. The temptation to push in just one more object into a space should be resisted.

(ii) Display. Environmental conditions inside frames, showcases and galleries should be governed by the same criteria as those for storage. In particular, light levels should be maintained at 50 lux, and any concentration of light on small areas should be avoided, as this can produce differential fading and weakening. Each object has a finite life in terms of lux hours of exposure to light (see CONSERVATION AND RESTORATION, §II, 1(i)), damage being accumulative from all parts of the waveband but greatest from the UV region. Thus, the intensity and content of the light source can be regulated in accordance with the role played by the textile, whether, for instance, it is on permanent display or in a temporary exhibition.

The longevity of textiles on display can be greatly increased by proper support. For this purpose, textiles can be divided into three groups: large, flat items that can be suspended freely from the top; smaller ones that are unsuitable or too fragile to be hung; and free-standing objects, three-dimensional in nature, that need support to maintain their individual shape.

There are various methods of hanging textiles. The hooks or studs used in the past for tapestries tend to introduce points of stress that eventually bring about a permanent deformation of the weave. It is better to sew a strip of strong material along a straight line at the top of the hanging, making a sleeve into which a bar can be introduced. Alternatively Velcro can be used, one half of which is stitched to the object and the other fixed to the wall or to a batten. Both methods ensure total support of the weave structure.

Small or fragile textiles require rigid display on a solid board. This is preferable to the open stretchers used for pictures as the board protects the textile against mechanical damage, provides a buffer against changes in relative humidity and impedes the passage of airborne dust particles. The board, which may be lightly padded, should be covered with a strong fabric to which the textile can be stitched. The object should be pinned out under slight tension before stitching to prevent it from dropping under its own weight in the course of time. For large and heavy objects it is advisable to lay lines of stitches through the centre as well as around the edges. Only the most chemically stable materials should be chosen both for the board and the padding. Many composition boards, for example, give off formaldehyde in enclosed conditions.

Three-dimensional textiles consist mainly of costume, and the achievement of a good costume dummy is no easy matter. The human body has been distorted into preconceived notions of fashionable beauty by corsets of extreme rigidity, and these now provide valuable clues to the correct silhouette for each

period. The most obvious difference between the female figure of the 18th and 19th centuries and the present day is the position of the bust, which in the past was pushed up to sit on top of the thorax, hence modern dress dummies are unsuitable without drastic surgery. The type of display, whether the costume is presented as social history with other period objects, or in isolation, more or less as sculpture, determines the pose, but extremes of posture should always be avoided in order to prevent creases of distortion being formed in the costume. For other three-dimensional textiles the basic principle is always to prevent distortion. The designer of an exhibition is usually responsible for supplying fittings, but the conservator must brief him on the needs of individual items.

3. REMEDIAL. The aim of remedial conservation is to reveal the structure of the object by removing any dirt or old repairs that obscure its true nature and then to give the fabric sufficient support to withstand the stresses of display and study. The method of support must be aesthetically acceptable in terms of the colour and texture of the original. Conservation ethics demand that the original must be preserved at almost any cost, and no responsible textile conservator will make decisions involving the removal of original stitching, nor indeed alterations or repairs that may have historical interest, without consulting an art historian. In private practice such consultation may not be possible, putting even more responsibility on the conservator to act with caution.

Many textiles are flat with a very straightforward structure, and with these there is no particular problem, except perhaps in regard to an original lining. Three-dimensional objects, for example costume, church vestments and upholstery, present a greater dilemma since the way they were made is often as interesting as the fabric that was used .

Worn and weakened textiles are usually supported by applying new material to the reverse, not always easy when three-dimensional objects are concerned. The alternative of covering the front with a semi-transparent fabric is to be avoided, except as a last resort, since so much detail of surface texture can be lost. These are difficult choices, and at times it may be necessary to accept defeat and leave the object as it is, storing it for study purposes only.

In conservation the choice of techniques and materials must respect the nature of the textile and be identifiable on close examination. It is no longer acceptable to reweave missing areas in a tapestry, nor to replace embroidery that has worn away, nor to cut out and remount embroidery on new material. It is better instead to stabilize what remains, giving great consideration to the aesthetics of the final result. While traditional methods, using sewing techniques, still dominate textile conservation, it is clear that some conditions, produced by the chemical breakdown of textile fibres, cannot be treated in this way, but can only be treated by using an adhesive. Both sewing and adhesive methods may be used on the same object, the choice being governed by the type of fabric, its condition, the degree of flexibility required and the ultimate situation of the object after conservation. Consolidation, in the sense of impregnation with a thin film of resin has mostly been abandoned after a number of experiments proved to be unsuccessful in the aim of giving greater flexibility to brittle fibres.

(i) Examination. A thorough examination to ascertain the content and condition is the basis for all decisions about the future of an object. With the cooperation of the art historian, the type, age and geographical origin of the object is noted, as are the materials used in its manufacture.

Broadly, the fibres that are most commonly found in decorative arts textiles (as opposed to those from ethnic collections) are cotton and linen, which come from plants, (cellulose) and wool, which is produced by such animals as sheep, goats and camels (protein) (see §I, 1(i) above). The most luxurious of all is silk, drawn from the cocoons of the silkworm (protein). The importance of identification lies in the chemical basis of the different classes of fibre, those from plants being based on cellulose and those from animals being based on protein. These compounds respond in different ways to conservation treatments involving the use of acids and alkalis. If mishandled, permanent damage the molecular structure of the fibres can result.

If metal thread (*see* §I, 2 above) has been used in the weave or as surface decoration, the identity of the metal and of any fibre core should be established, as well as any corrosion products present, especially if chemical cleaning is envisaged. Other decorative materials, for example paint, embroidery thread, surface decoration of feathers, ivory, parchment etc, and any concealed materials, for example stiffenings of canvas, metal or whalebone, and cotton or woollen padding in embroidery, should all at least be noted, even if full identification is not necessary.

Examination must also clarify the precise state of the weave structure and of the stitching holding together the different parts of a composite object, also the degree and type of soiling and any additions or alterations that may have been made to the original. It may be appropriate to photograph the object before and after any conservation treatment.

(ii) Cleaning. This is the most irreversible of all conservation procedures and thus should be undertaken only if absolutely necessary, when colours and textures are obscured by ingrained dirt, when deposits are actively attacking the fibre structure, or when gritty dust is cutting through the fibres. Agitation of some kind is essential to the process. This may be achieved by the use of brushes or suction or by fluid being passed through the textile fibres, but normal commercial methods are far too violent for all but the most robust of items.

Loose particles of dust and fluff can be removed by brushing or by suction. If the object is strong

enough the latter method is the most common. The surface of the object should be protected from direct contact with the nozzle of the vacuum cleaner by a layer of net. Screens of monofilament nylon netting should be used for carpets, tapestries and similar objects. The preferred type of machine provides for different degrees of suction power.

Wet cleaning, using purified water with the addition of detergents, acids, alkalis and bleaches, is the most efficient way to remove more deeply seated dirt, discoloration and grease. Tests must be carried out first to ensure that dyes and finishes will not be adversely affected. Most wet cleaning takes place in a shallow tank, called a washing-table, made of stainless steel or aluminium, with a surface that can be tilted to aid drainage. It should be as large as possible in order to keep the objects flat, but the width of the table should be such that the conservator can reach across to the middle of the surface. Purified water, preferably de-ionized, otherwise softened, is often supplied through overhead sprays. During washing, the textile is supported on a sheet of plastic film, usually Melinex, but if the object is too large to be laid flat, the surplus can be rolled, with its flexible support, on to a plastic roller and treated sectionally. The cleaned textile is laid out flat on the plastic film to dry. If the fabric is thick, a piled carpet for example, it can be transferred to an open mesh frame to allow free circulation of air.

Not all textiles are suitable for washing. If the dyes are fugitive in water, if the finish or surface decoration would be disturbed, or if the type of soiling will not respond to water, organic solvents are sometimes used. The best results can be obtained only in a proper dry-cleaning machine, but most objects are not strong enough to withstand the violent mechanical action of commercial machines. An added complication is the steady withdrawal from general use of many of the common solvents used in dry cleaning. Industrials methylated spirit has proved useful as a replacement for perchloroethylene or 1.1. try-chloroethane and white spirit or Stoddards solvent can also be used where soiling is greasy in character. The disposal of the dirty solvent can also be a problem. Thus, this is not a method easily employed on a large scale. Small items can, however, be cleaned by the conservator. All apparatus should be made of stainless steel, glass or enamel. Plastics are unsuitable as they may be attacked by the solvent. Polyvinyl chloride (PVC) gloves should always be worn and work carried out in a fume chamber. The object can be gently shaken in the container, or a brush can be used to agitate the solvent.

Metal components can be brightened by washing or by solvent cleaning, but corrosion can only be removed by the use of an acid or alkali. Since the removal of corrosion products can be regarded as more cosmetic than necessary to the continued existence of the object, and since the application of chemical cleaners is likely to adversely affect the surrounding textile fibres, treatment of silver-gilt has become increasingly restricted by ethical considerations.

Often it is only local spots and stains that spoil the appearance of an otherwise clean textile. Techniques for local cleaning use suction to remove loosened dirt and to prevent the formation of darker rings around the area being treated. (The rings are caused by the movement of soluble substances in the fibres.) Spotting-tables with built-in extraction and a steam-gun can be bought from the dry-cleaning trade, but it is perfectly possible to construct instead a small box with a perforated top. The box is connected to a vacuum pump, which must be of the fan-driven type to avoid the possibility of solvents passing through the motor and causing an explosion. The method is to cover the perforations with absorbent material, then to place the soiled area of the textile on top, apply a suitable solvent and allow the suction to draw away the loosened stain. On white, cellulosic material that has become brown or foxed, a bleach may be used in controlled conditions, but protein fibres would be severely damaged by the alkaline action of bleaching. When the fibres of stained and discoloured areas are also very weak, it is better to leave them alone.

(iii) Repair and support. After an object has been cleaned, any structural weakness can be repaired and strengthened, either by traditional sewing methods or with the use of adhesives. Frequently both methods will be used on the same object for different purposes.

Repair implies a process of tidying up rather than full-scale conservation; the replacement of broken stitching in seams, for example, sewing or sticking back loose decorative features, or applying local support by darning or couching in an otherwise strong object. Darning is less common than in the past, when it was used for domestic repairs, but it can still find a place in conservation in repairing local mechanical damage in fabric that is basically sound or when the object is double-sided.

The stitch most commonly used in conservation is couching (see fig. 15). A support fabric is chosen, of similar colour and texture to the original, but slightly lighter in weight, and stretched on a frame. The damaged area of the object is placed over it, with the warp and weft arranged in line with that of the support. Starting at one side of the area, a long thread is laid parallel to the weave, across the damaged area. Small stab stitches are made over the laid thread at equidistant points along its length. A second thread is laid alongside the first, at a distance suitable to the type of damage (an average distance would be 500mm), and the process repeated, staggering the stab stitches in a brick pattern. Provided the area is fully covered, this system provides an excellent way of supporting a weakened textile, while any areas actually missing will be filled in by the backing fabric.

Embroidery frames of the beam type, with slats and pegs for tensioning, are frequently employed, but for small areas a padded frame is preferable. This is made by cutting a hole of suitable size in a board, which is then padded and tightly covered

with cloth. The object can be placed over the space, to be worked on directly, or a new support can be pinned or tacked out under tension before the object is placed over it. The frame can be supported over the edge of a table or on trestles to enable the worker to use one hand above and one below in the usual way. The round frame, which encloses only part of the fabric, should never be used.

Animal glues and wheat or starch pastes have been used in the manufacture of composite textile objects for many centuries. They have also been used for purposes of repair, though not always with the happiest of results. Modern glues based on rubber have been even more disastrous in their effects, becoming black and insoluble in a comparatively short space of time. Wheat starch can be used in some circumstances, but the fact that it attracts insects as a source of food must be a disadvantage. Also, with wheat starch, it is essential that the dyes in the object are fast to water.

Thus, alternatives have been sought. Flexibility is the prime quality required, with long-term stability to retain the possibility of reversal, together with a method of application that avoids total penetration of the weave structure. Choice has fallen on the class of thermoplastics based on polyvinyl acetate (PVA) or on acrylic resins, which can be applied to a separate fabric, allowed to dry and then attached to the reverse of the object by means of heat and pressure. A limiting factor is the melting temperature, which must be low enough not to damage the object, but not so low that unprotected adhesive remains tacky in normal, warm, ambient temperatures. The safe range lies between 60.007° and 75.007°C.

A flat work surface is needed, slightly softened with a sheet and covered with a material (e.g. Melinex) that is resistant to heat and adhesives. A domestic iron can be used, set at a controlled temperature suitable for the particular adhesive, with silicone paper as a release between the iron and the adhesive. Alternatively, a vacuum hot-table may be used to provide, in one action, both the heat and pressure required over the whole surface.

With age, textile fibres may become either stiff and brittle or soft and powdery, eventually reaching a stage when support by another fabric ceases to be sufficient, so a consolidant is needed. The consolidating substance must not alter the colour of the original, nor stiffen with age. Also, to meet ethical requirements, it must remain soluble so it can be removed if necessary. Unfortunately, no product has yet become available that entirely meets these criteria, and as one of the problems with such treatment seems to be an increase in brittleness, even when tensile strength has been improved, it remains a last resort.

15. Couching technique as used in textile conservation: (a) view from the front; dotted lines represent the thread on the reverse; (b) section through a line of stitching

A. H. A. Poot: 'Chemical Bleaching of Ancient Textiles', *Collected Preprints from the IIC Delft Conference on the Conservation of Textiles: Delft, 1964* (London, 2/1965), pp. 53–64

T. Padfield and S. Landi: 'The Light-fastness of the Natural Dyes', *Studies in Conservation*, iv (1966), pp. 181–96

H. Plenderleith and A. E. Werner: *The Conservation of Antiquities and Works of Art* (London, 2/1972)

S. Landi: 'Notes on the Use of a Vacuum Hot-Table for Textiles', *Studies in Conservation*, xviii (1973), pp. 167–71

K. J. Harris: *Costume Display Techniques* (Nashville, TN, 1977)

'The Costume Issue', *Museum News Technical Bulletin*, lvi/2 (1977)

Z. K. Annis and B. M. Reagan: 'Evaluation of Selected Bleaching Treatments for Historical White Cottons', *Studies in Conservation*, xxiv (1979), pp. 171–8

A. Geijer: *A History of Textile Art* (London, 1979)

S. Landi and R. M. Hall: 'The Discovery and Conservation of an Ancient Egyptian Linen Tunic', *Studies in Conservation*, xxiv (1979), pp. 141–52

S. R. Edwards, B. M. Bell and M. E. King: *Pest Control in Museums* (Lawrence, KS, 1980)

J. Hofenk de Graaff: 'Some Recent Developments in the Cleaning of Ancient Textiles', *Collected Preprints, IIC Conference: Washington, DC, 1982*

R. L. Feller and M. Wilt: 'Adhesives and Consolidants', *Preprints of the IIC Conference: Paris, 1984*

S. Sandwith and S. Stainton: *The National Trust Manual of Housekeeping* (London, 1984)

S. Landi: *The Textile Conservator's Manual* (Boston, 1985, rev. Oxford and Boston, 2/1997)

D. Allsop and K. J. Seal: *Introduction to Biodeterioration* (London, 1986)

E. S. Cooke, ed.: *Upholstery in America and Europe* (New York, 1987)

J. A. Darrah: 'Metal Threads and Filaments', *Collected Preprints, Recent Advances in the Conservation and Analysis of Artifacts. Institute of Archaeology Jubilee Conference: London, 1987*

A. V. Horie: *The Materials of Conservation* (London, 1987)

S. Michalski: 'Damage to Museum Objects by Visible Radiation (Light) and Ultraviolet Radiation (UV)', *Collected Preprints, Lighting: Conference Organized by the Museums Association, United Kingdom Institute for Conservation et al.: Bristol, 1987*

M. Flury-Lemberg: *Textile Conservation and Research*, Abegg-Stiftung (Riggisberg, 1988)

D. Howell: 'Metal Cleaning at Hampton Court Palace', *Preprints of the UKIC 30th Anniversary Conference: 1988*, pp. 36–7

J. Hunnisett: *Period Costume for Stage and Screen* (London, 1988)

Upholstery Conservation: Collected Preprints of the American Conservation Consortium Conference: Williamsburg, 1990

V. Davies: *State Beds and Throne Canopies: Care and Conservation* (London, 2003)

F. Boersma: *Unravelling Textiles: A Handbook for the Preservation of Textile Collections* (London, 2007)

Tile. Thin slab of fired clay used for covering roofs, floors, walls, stoves and chimney-pieces; they can be either square, rectangular, hexagonal, cruciform or star-shaped, so that they can be fitted together to form a mosaic or tile-panel. The most commonly used material for decorative tiles is glazed earthenware.

1. UNGLAZED. These tiles are distinguished from glazed tiles by the lack of a glaze on their surface. Their colour depends on the colour of the clay used. Most clays when fired become either red or yellow because of the minerals or oxides they contain, but some white clays remain white during firing or can be stained with oxides to achieve a certain colour. The strength of an unglazed tile depends on the temperature to which it has been fired and the thickness and quality of the body. Unglazed tiles that have been fired up to 1100–1150°C are known as 'earthenware tiles' and are highly porous. When unglazed tiles are fired to a temperature of 1350–1400°C, they are known as 'vitreous tiles' and are hard and dense with a low porosity. Very hard, unglazed vitreous tiles are made by the dust-pressing process, in which dust clay with a low moisture content is compacted in a tile press and fired to a high temperature, which results in a dense, hard, fine-grained body, impervious to water. They make good floor-tiles and can be made thinner than earthenware tiles without losing any of their strength and durability. Unglazed tiles can be decorated by indenting or embossing the surface with patterns or figurative scenes, by painting with coloured slips or by the *sgraffito* technique, in which a layer of different-coloured clay is laid over the tile surface and cut or scored through to reveal the contrasting colour of the clay body beneath. It is also possible to inlay the tile body with different coloured clays (*see* §2(iii) below).

2. GLAZED. The surface of a glazed tile has a thin glaze on a clay body fired on to it in the kiln; this makes the surface of the tile impervious to water and can also be used as a form of decoration (see fig.). There are many different kinds of glazes and techniques for applying them. Transparent and coloured lead glazes are among the most common and have been used in Europe since the Middle Ages, although

Historic tile-glazed wall, Salvador, Museu de Arte Sacra da Universidade Federal da Bahia; damage to the tiles is the result of salt coming up from ground-water through the building structure and out between the seams in the tiles; loss to the tile glazing is caused by salt crystallization pressures; environmental management strategies were developed that integrated the conservation needs of both the historic structure and the collection (Los Angeles, CA, Getty Conservation Institute); photo © The J. Paul Getty Trust, all rights reserved

at the beginning of the 20th century leadless glazes began to be used to reduce the high level of lead-poisoning in the ceramics industry.

Many decoration techniques have been developed for glazed tiles. In the case of painted tiles, colours are applied under, in or over the glaze. Underglaze decoration consists of painting on the unglazed, biscuit-fired tile. A coating of transparent glaze is then applied both to protect the decoration and to make the tile surface more hygienic and functional. In the case of in-glaze decoration, the design is painted on to the unfired glaze and sinks into it during the second firing when both glaze and decoration are fixed to the tile. This is a particular feature of maiolica, faience and Delftware (*see* §(ii) below). The overglaze technique uses enamel colours, which are painted on to the fired, glazed surface of the tile and are then fixed in a muffle (enclosed) kiln at a low temperature (700–900°C). Printed decoration has been used on tiles from the mid-18th century and can be applied on or under the glaze using transfer paper.

Glaze can also be used on a tile surface that has been indented or embossed by hand or with the aid of wooden, metal or plaster moulds when the clay is still soft. Transparent or coloured glazes are applied over the surface creating effects of light and dark as the glaze settles on either sunken or raised areas. In Spain two techniques were developed to decorate the whole tile surface with a number of differently coloured glazes in close proximity to each other (*see* §(i) below). Salt-glazed tiles can only be produced in such kilns fuelled by real fires as bottle kilns. Salt is thrown into the kiln when a temperature of 1100–1200°C has been reached. The salt volatilizes, and the vapours react with the clay to form a sodium aluminosilicate glaze, which is strong and acid resistant. Salt glaze is the only glazing process that takes place in the kiln during firing.

(i) Cuerda seca and cuenca [Sp.: 'dry cord'; 'hollow']. If a number of differently coloured glazes are used close together on a flat tile, they tend to 'run' during firing. In Spain, where the tradition of Islamic pottery had been influential since the Moorish occupation, the *cuerda seca* technique provided an effective solution to this problem. The technique consists of drawing lines using a mixture of dark ceramic pigments and a greasy substance that keeps the water-based coloured glazes separate from each other. The grease burns away during firing and leaves a thin, sunken, unglazed line between the slightly raised glazed surfaces. This technique was much used in Spain during the 15th and 16th centuries.

A modified form of the *cuerda seca* technique consists of imprinting a design in the soft clay with a mould. When the tile has been fired once, the incised lines of the design are filled with the greasy substance. This is a particularly labour-saving device as *cuerda seca* tiles have complex geometrical Moorish patterns that would be difficult to draw free-hand. A further simplification of this is known as the *cuenca* technique: moulds of individual parts of the design are sunk into the clay leaving a thin, raised line around each one. The hollows are then filled with coloured glazes. Both *cuerda seca* and *cuenca* tiles need to be stacked horizontally for firing to prevent the glazes from running out of their delineated areas.

(ii) Tin glaze. Technically, tin glaze is a lead glaze to which tin oxide has been added, making the glaze opaque white and thus an ideal ground for painting. The technique of tin glaze was introduced into southern Europe by Islamic potters and became widely used on tiles from the 15th century (see colour pl. XV, fig. 2). Its three main forms are maiolica, faience and Delftware. The name 'maiolica' comes from 'Majorca', the island between Spain and Italy that was a major trading centre for tin-glazed pottery, while 'faience' may be derived from the town of Faenza in northern Italy or Fayence in France, where much tin-glazed ware was produced. The term 'Delftware' is likewise derived from the Dutch

town of Delft where tin-glazed pottery was made during the 17th and 18th centuries. The technique was also used in such other European countries as Spain, Portugal, France, Britain and Germany. There was considerable interaction between tin-glaze tile-makers and decorators and a wide dissemination of knowledge during the 16th and 17th centuries, when Italian maiolica painters began to work in southern Spain and Flanders, while Dutch potters set up businesses in Portugal and England. Although many inexpensive plain, white tin-glazed tiles were made, they were also often decorated to add colour, pattern and pictorial designs to the interior and exterior of buildings. Tin-glazed tiles were decorated with small individual designs or with larger motifs as tile-panels. Such high-temperature colours as orange, green, purple and blue were painted on the unfired, white tin glaze as inglaze decoration. Such overglaze enamels as red, pink or delicate green were added to extend the range of colours.

(iii) Encaustic. In relation to tiles, encaustic (Gr.: 'burnt in') essentially means inlaying clay of one colour with clay of a contrasting colour; this technique probably spread to England from France at the beginning of the 13th century. Encaustic tiles were usually made from red-firing clay, and while the tile was still soft, a design was pressed into it with the aid of a wooden stamp. The indentations were then filled with white clay. When finished, the inlaid white design would clearly stand out against the red ground. The medieval practice was to dip the unfired tile in a transparent lead glaze, so that the firing of the tile body, the inlaid pattern and the glaze all took place at the same time. The glaze gave the white clay a slightly yellow tinge and the red ground a deeper red-brown tint. Encaustic tiles were extensively used in the Middle Ages to pave cathedral and church floors and are characterized by such designs as heraldic emblems, knights on horseback, lions and such stylized floral patterns as the fleur-de-lis.

With the dissolution of the monasteries (1536–40), the encaustic technique fell into disuse, but was revived again during the mid-19th century with the building of Gothic-Revival churches by such English architects as A. W. N. Pugin (1812–52) and such French architects as Eugène-Emmanuel Viollet-le-Duc (1814–79). Encaustic tiles were used for the restoration of medieval cathedrals and churches. Such tile manufacturers as Minton in Stoke-on-Trent and Maw & Co. in Broseley, Salop, made thousands of encaustic tiles to satisfy the burgeoning demand from 1860 until the end of the century. The tiles were also used for public and domestic buildings, and to meet the needs of taste and fashion, some were produced in an unglazed form.

Tiles are among the most varied and widely found ceramic products; they have been produced in Europe on a large scale since the 13th century and many countries have made various contributions to their technical development and architectural

applications. Many examples have survived throughout Europe and show how they have been used both functionally and decoratively. From the 13th to the 16th century they were for the greater part used for floors, but since the 16th century wall tiles have also played an important role. They add colour and decoration to the façades of buildings, while inside they have been used on floors, stoves, in fireplaces, kitchens, bathrooms and dairies.

E. A. Barber: *Spanish Maiolica* (New York, 1915)

A. Lane: *Guide to the Collection of Tiles* (London, 1939), pp. 57–65

A. Berendsen: *Tiles: A General History* (London, 1967)

R. J. Charleston, ed.: *World Ceramics* (London, 1968/R 1990), pp. 146–76

E. Eames: *Medieval Tiles: A Handbook* (London, 1968)

B. C. Southwell: *Making and Decorating Pottery Tiles* (London, 1972), pp. 64–82

A. Caiger-Smith: *Tin-glaze Pottery* (London, 1973), pp. 127–40

J. Wight: *Medieval Floor Tiles* (London, 1975)

D. S. Skinner and H. van Lemmen, eds: *Minton Tiles, 1835–1935* (Stoke-on-Trent, 1984)

G. K. Beaulah: *Church Tiles of the 19th Century* (Aylesbury, 1987)

N. Riley: *Tile Art* (London, 1987)

V. Porter: *Islamic Tiles* (London, 1995)

M. Barry: *Colour and Symbolism in Islamic Architecture: Eight Centuries of the Tile-maker's Art* (London, 1996)

W. Denny: *Gardens of Paradise: 16th Century Turkish Ceramic Tile Decoration* ([Istanbul], 1998)

E. de Balanda and A. Uribe Echeverria: *Les Métamorphoses de l'azur: L'Art de l'azulejo dans le monde latin* (Paris, 2/2002)

A. Ben Amara and others: 'Recherche d'indices sur les techniques de fabrication de zelliges du XIVe siècle (Chellah, Maroc)', *Revue d'archéométrie*, xxvii (2003), pp. 103–13

L. Pearson: *Tile Gazetteer: A Guide to British Tile and Architectural Ceramics Locations* ([Shepton Beauchamp], 2005)

T. De Lillo, A. Monte and G. Quarta: 'Storia e tecniche di produzione di mattonelle policrome in pasta cementizia', *Pavimentazioni storiche: Uso e conservazione*, eds G. Biscontin and G. Driussi (Marghera, 2006), pp. 423–4, 432

Timber structure. Timber has played a unique role in both high-style and vernacular historic buildings. Its combination of strength in compression and especially in tension was unmatched by any other material until the development of wrought iron, steel and reinforced concrete. As a result timber is the principal structural material for roofs, which have been designed in a wide variety of techniques and forms. The only significant exceptions are the roofs of corbelled or rock-cut buildings. Although timber might be thought unnecessary for stone vaults and domes (apart from its use for centering during construction), in wet climates a roof over such structures is essential to prevent water penetration.

The most suitable material for the construction of walls is masonry (stone or brick), because the principal stresses involve compression. The nearest equivalent in timber is log construction, in which logs are laid horizontally one above another and their ends are interlocked at the corners of the building. This construction was particularly common in the vernacular architecture of Scandinavia, Eastern Europe and North America.

The dominant north-west European construction was timber-framing, whereby members were connected principally with mortise-and-tenon or lap joints (*see* §1 below). This form of construction was also common in North America, where in the mid-19th century it was superseded by the balloon frame, a prefabricated type of construction utilizing light timber sections, joined together principally with nails (*see* §2 below).

1. Traditional jointed frames. In the northern European tradition of timber framing, a building was prefabricated as a series of two-dimensional frames. As each frame was completed the members were numbered, disassembled and stored, until finally the full frame could be erected. The 'making' or 'framing' took several months, while the 'raising' or 'rearing' took a matter of days. The frame was finished by infilling the panels with wattle and daub, lath and plaster, or bricks, while weatherboard became common in the 18th and 19th centuries. Several distinctive techniques can be recognized, although there are significant regional variations. It is known, for example, that frames were prefabricated in a particular order. In some English traditions the horizontal frame composed of wall plates and tie-beams was constructed first, and in most traditions there was a close relationship between rafter spacing, bay spacing and plan dimensions. Most, perhaps all, European carpentry seems to have been 'scribe rule' carpentry: that is, joints were scribed to fit. This contrasts with the American system of 'square rule' carpentry, in which the joints were cut to precise, predetermined dimensions, so that the timbers were, in theory, interchangeable. The French carpentry tradition, still practised today by the *Compagnonnage*, used a centreline layout system, while most British carpentry seems to have used the face of the frame as its setting-out plane. In the Middle Ages timbers were predominantly used as 'boxed heart' (the whole tree was squared up for use in a frame), but in some areas the use of sawn timber started quite early and became predominant. Crucks, for instance, were usually made by sawing a tree in half.

J. Moxon: *Mechanick Exercises, or the Doctrine of Handy-works* (London, 1703/R 1970)

F. H. Crossley: *Timber Building in England* (London, 1951)

J. T. Smith: 'Timber-framed Building in England: Its Development and Regional Differences', *Archaeol. J.*, cxxii (1966), pp. 133–58

J. I. Rempel: *Building with Wood, and Other Aspects of Nineteenth Century Building in Central Canada* (Toronto, 1967)

R. T. Mason: *Framed Buildings of England* (Horsham, 1973)

E. Mercer: *English Vernacular Houses* (London, 1975)

P. Smith: *Houses of the Welsh Countryside* (London, 1975)

R. Harris: *Discovering Timber-framed Buildings* (Princes Risborough, 1978)

A. L. Cummings: *The Framed Houses of Massachusetts Bay, 1625–1725* (Cambridge, MA, 1979)

K. Bedal: *Fachwerk in Franken* (Hof an der Saale, 1980)

C. A. Hewett: *English Historic Carpentry* (Chichester, 1980)

J. Sobon and R. Schroeder: *Timber Frame Construction* (Pownal, VT, 1984)

R. W. Brunskill: *Timber Building in Britain* (London, 1985, rev. 2/1994)

U. Grossmann: *Der Fachwerkbau* (Cologne, 1986)

D. Martin and B. Martin: *Wall Construction: Domestic Building in the Eastern High Weald, 1300–1750*, i (Robertsbridge, 1989)

R. W. Brunskill: *Traditional Buildings of Britain* (London, 1992, rev. 3/2004)

D. Yeomans: *The Trussed Roof* (Aldershot, 1992)

E. Roberts and K. Clark: 'The Rediscovery of Two Major Monastic Buildings at Wherwell', *Proceedings of the Hampshire Field Club and Archaeological Society*, liii, (1998), pp. 137–53

Qinghua Guo: *The Structure of Chinese Timber Architecture* (London, 1999)

Proceedings of the First International Congress on Construction History: Madrid, 20–24 Jan 2003, 3 vols

2. BALLOON FRAME. Originally known as 'Chicago construction' until the 1870s, the balloon frame was a derisive term for this unusually light form of construction that went up quickly. The structural principle that differentiates the balloon frame from other forms of timber frame construction centres on the way the loads are distributed on the frame. In a balloon frame there is an equal distribution of vertical compressive loads over a series of 2×4 or 2×6 in. (50×100 or 50×150 mm) studs. The studs are spaced approximately every 16 ins (400 mm) on centre to allow for the overlapping of the standard length of 4-ft-l (1.2 m) long lath for the plasterer, but this often varies between 12 and 24 ins (300 and 600 mm). Unlike the self-supporting bay system of the traditional jointed frame, the one- or two-storey continuous stud system of the balloon frame does not utilize the girdling support of connecting horizontal beams (girts) tied into stout corner posts; hence, the frame requires lateral support from the wrapping (diaphragm) action of the sheathing to make it rigid. Later in the development of the balloon frame (by 1911) the sub-sheathing was nailed diagonally to further counter the racking of the frame.

The balloon frame is clearly a product of the American Industrial Revolution. Thinner, standardized framing members prompted standardized construction methods that were generally optimized more for cost and ease of construction than for structural economy. Dimensioned lumber was made possible by improvements in sawing and planing. The circular saw was introduced in 1814, but it was not perfected until the 1840s; the band saw was introduced in the 1860s. By the 1850s numerous planing machines for smoothing large timbers were also available. Daniel's traverse planing machine was the most popular for heavy work; it mimicked the manual adzing technique by placing two cutters in a rotating horizontal arm driven at high speeds by water power and line shafting. Even so, good hewn or planed sills (used in early balloon frames to carry the loads of the studs and joists) were difficult to find; William E. Bell proposed placing two 2×6 in. (50×150 mm) boards on edge and leaving a 2 in. (150 mm) space between for stud tenons. The tenons were fitted into what, in effect, was one long, open mortise reminiscent of traditional jointed-frame construction. Hence, while the idea of equal load distribution was new to timber framing, the conceptualization of carpentry methods was still based on old traditional jointed-frame practices until later in the evolution of the balloon frame. The development of the balloon frame was aided, too, by the availability and affordability of nails. Expensive hand-wrought nails were being replaced in the 1790s by machine-cut nails, and by 1850 malleable wire nails were both abundant and inexpensive; they were used to hold structural members together and replaced time-consuming intricate joinery and wooden pegs. The 'all-nail' balloon frame was outlined in Solon Robinson's 1846 article.

The principal advantages that the balloon frame had over the traditional jointed frame were that it used one third the volume of lumber, involved less construction time and required less skilled labour. As a result, the balloon frame cost *c.* 40% less to construct. George Washington Snow (1797–1870) produced the first balloon frame in the form of a warehouse in Chicago (destr.) in 1832. While the new construction was rapidly adopted in the developing West, sometimes even being transported there ready-made, with the various pieces numbered, it was resisted in the craft-based East until the 1860s and 1870s. Interestingly, carpenters' guides continued to refer to the balloon frame as a cheap and—as usually put together—a more or less objectionable form of construction. Because of fire danger, caused by air circulation between the walls and siding, the 'combination frame' was developed as a compromise solution. It used 'budging' between the studs for fire safety and replaced the heavy timbers and mortice-and-tenon of the traditional jointed frame with more substantial planks and nails than were found in the conventional balloon frame. By the 1920s 'Western' or 'platform' construction began to replace balloon construction as the preferred timber-framing method, because long framing members were difficult to find. It also offered a stable platform to workers as the walls were raised one storey at a time and so could be lifted more easily than the balloon frame. These methods were more in accordance with the industrial standardization of building practice, which, following World War I, had adopted such principles as the 8-ft building module.

S. Robinson: 'A Cheap Farm-house', *American Agriculturalist*, v (1846), pp. 57–8

G. Wheeler: *Homes for the People* (New York, 1855), pp. 409–14

W. E. Bell: *Carpentry Made Easy or the Science and Art of Framing on a New and Improved System, with Specific Instructions for Building Balloon Frames* (Philadelphia, 1858)

G. E. Woodward: *Woodward's Country Homes* (New York, 1865)

A. T. Andreas: *History of Chicago*, i (Chicago, 1884), pp. 145, 290

S. Giedion: *Space, Time and Architecture* (Cambridge, 1941), pp. 281–8

W. Field: 'A Re-examination into the Invention of the Balloon Frame', *Journal of the Society of Architectural Historians*, ii (1942), pp. 3–29

L. H. Nelson: 'Nail Chronology as an Aid to Dating Old Buildings', *History News*, xxiv (1968)

R. Jensen: 'Board and Batten Siding and the Balloon Frame: Their Incompatibility in the Nineteenth Century', *Journal of the Society of Architectural Historians*, xxx (March 1971), pp. 40–50

B. Hindle, ed.: *America's Wooden Age: Aspects of its Early Technology* (Tarrytown, NY, 1975)

P. E. Sprague: 'The Origin of Balloon Framing', *Journal of the Society of Architectural Historians*, xl (Dec 1981), pp. 311–19

P. E. Sprague: 'Chicago Balloon Frame: The Evolution during the Nineteenth Century of George W. Snow's System for Erecting Light Frame Buildings from Dimension Lumber to Machine-made Nails', *The Technology of Historic American Buildings: Studies of the Materials, Craft Processes and the Mechanization of Building Construction*, ed. H. W. Jandl (Washington, DC, 1983), pp. 35–62

F. Peterson: *Homes in the Heartland: Balloon Frame Farmhouses of the Upper Midwest, 1850–1920* (Lawrence, KS, 1992)

M. Pizzi: 'The Invention of the Balloon Frame: How it Affected Architecture in the New World: The Case of Chile', *Proceedings of the First International Congress on Construction History: Madrid, 20–24 Jan 2003*, iii

A. L. Cummings: 'Recent Tree-ring Studies of Early New England Buildings: An Evaluation', *Vernacular Architecture*, xxxv (2004), pp. 66–71

Tin. *See under* PEWTER.

Titanium. A lustrous silvery-grey metallic element (Ti), known for its light weight, exceptional strength, ductility, and malleability. Discovered in England in 1791 by William Gregor, the noble metal is named for the Titans of Greek mythology. It is widely distributed in nature in compound forms, such as rutile and ilmenite. Titanium's special characteristics have led to its use in recent years for a wide variety of applications such as a coating and in alloys in the aerospace industry, the military, in sporting goods, medicine, dentistry, the automotive industry, and many other industrial applications. On occasion, titanium panels have been used to sheath new buildings, including the Guggenheim Museum, Bilbao, designed by Frank O. Gehry (*b* 1929) and opened in 1997, and its durability has led to its selective use for large-scale outdoor sculptures.

A number of studio artists use titanium, often anodized, in the creation of furniture, jewellery, and other works of art. Because of its durability and non-reactivity, titanium is also used for commercial, mass-produced jewellery. Titanium rings, including engagement rings and wedding bands, are one of the fastest growing segments of the titanium jewellery market. Some titanium jewellery also incorporates gemstones. Its hypoallergenic qualities have made titanium a frequent selection for objects used as body piercings.

Titanium dioxide is used as a gemstone (titania) and also extensively for both house paint and artist's paint. Titanium white is a brilliant white, lead-free pigment consisting of titanium dioxide together with barium sulphate and zinc oxide (see also PIGMENT, §VIII, 3).

N. N. Greenwood and A. Earnshaw: *Chemistry of the Elements* (Amsterdam and Boston, 2/1997)

M. J. Donachie: *Titanium: A Technical Guide* (Materials Park, OH, 2000)

Tooling. Any work or ornamentation carried out with tools. The term is widely used, from the process of smoothing and finishing a stone block with a chisel (*see* STONE, §II) to removing the roughness and blemishes on metalwork after casting. When employed in the sense of decorating metalwork with punches and gravers, the process is also called chasing (*see* METAL, §V). Tooling also describes the process of using heated tools to impress decoration and lettering on to the covers of books or leather (*see* LEATHER, §2(ii)).

Tortoiseshell. Semi-transparent or translucent material of mottled patterns of brown pigmentation, obtained from the enlarged scales or plates that form the protective outer shell of certain species of tropical and sub-tropical marine turtles (see fig. 1). These scales are joined to form the carapace or back and the plastron or belly of the turtle. The plates from the carapace are heavily pigmented in shades of dark brown, amber and red, whereas those of the plastron are usually clear and yellow in colour and provide 'blonde' plates. The three species of turtle associated with providing tortoiseshell for decorative art objects are the Hawksbill turtle (*Chelone imbricata*), which provides the finest scales, the Loggerhead (*Thalassochelys caretta*) and the Green turtle (*Chelone mydas*). The plates from these turtles vary considerably in colour, size and working characteristics. The shell of some land tortoises has also been used to make objects, but 'tortoiseshell' refers almost exclusively to the scales from marine turtles.

1. PROPERTIES AND TECHNIQUES. Tortoiseshell's colour, transparency and brilliant shine when polished have made it a highly prized material for both making and decorating objects. Its principal chemical constituent is keratin, a protein complex secreted by the epidermis of the skin of vertebrates. In marine turtles this keratinous outer layer has developed to a great thickness acting as a protective armour. The protein chains that make up keratin have a high proportion of the amino acid cysteine, which can form disulphide bonds between parallel protein chains.

These disulphide bonds account for the major working characteristics of tortoiseshell. It can be easily sawn and worked with basic hand tools. Due to its chemical make-up it also possesses thermoplastic properties, which means that the normally hard and rigid tortoiseshell can be softened and made pliable by either boiling in salted water or applying direct heat. In this softened state it can be bent, shaped or impressed, and when it cools back

1. Photomacrograph of pieces of tortoiseshell; photo credit: Keith Lawrence, Museum of Fine Arts, Boston

to room temperature it will retain its new shape or form. The softening process breaks some of the chemical bonds between the protein chains and allows a rearrangement of them. When the tortoiseshell cools, the bonds re-form to make it rigid again. Sheets of tortoiseshell can be welded together to form larger sheets or bent into a circular shape and welded together on itself, such as for circular boxes. Heat and moisture are used, and pressure is applied over the area to be welded, so that the two pieces become fused together. The tortoiseshell is heated in water until it is pliable, and the two edges to be joined together are overlapped or scarf-jointed, then clamped between heated tongs.

2. Uses. Tortoiseshell has been employed for a wide range of decorative effects. Due to the thinness of the scales, one of its major uses is as an inlay or veneer (see fig. 2). The shell of the Loggerhead turtle was used, for instance, for furniture inlay in China, and it was imported for the same purpose by the Romans and later the Ottomans. Since the 16th century softened tortoiseshell veneer has been used to decorate European furniture and picture frames by bending it to the desired curve before gluing it in place on a wood groundwork. Tortoiseshell veneer was also used in conjunction with exotic woods and ivory to decorate musical instruments. One of its most celebrated uses as a veneer was in combination with brass veneers in decorative patterns, a technique refined and brought to a high degree of perfection by André-Charles Boulle (1642–1732). This type of work, a special form of marquetry, has since

been termed boullework. From the 17th century onwards it was used on a variety of furniture types, such as cabinets, commodes and bracket clocks.

In its slightly thicker form, tortoiseshell has been used to make smaller objects such as combs, hairbrush backs, snuff and tobacco boxes, spectacle frames and pieces of jewellery (e.g. in ancient Egypt). The surface of these objects is often decorated by pressing the softened tortoiseshell with a decorated relief mould or by pressing metal pins or wire into it. Occasionally thicker sheets of tortoiseshell have also been carved, for example into netsuke in Japan and in low relief for decorated boxes and other objects made in China in the 19th century, principally for export to the European market. Tortoiseshell has been imitated by stained horn and since the late 19th century by celluloid (cellulose nitrate).

C. Ritchie: *Carving Shells and Cameos* (London, 1970)

C. Ritchie: *Shell Carving: History and Techniques* (London, 1974)

S. O'Connor: *The Identification of Osseous and Keratinaceous Materials at York*, United Kingdom Institute for Conservation (UKIC), Occasional Papers, v (1987)

M. C. Pedersen: *Gem and Ornamental Materials of Organic Origin* (Oxford, 2004)

Trabeated construction [post and lintel]. Structural system based on the use of columns or posts and beams. It contrasts with arcuated construction, involving the use of arches and vaults. Trabeated construction is an inherent characteristic of framed structures, from the traditional timber-framed architecture of China and Japan to steel-framed buildings of the 20th century. It played a particularly important role in the architecture of ancient Greece, where it

2. Tortoiseshell tea caddy, with inner velvet lining, ivory knobs and borders, supported on wooden ball feet, probably from Europe, 203×127×152 mm, *c.* 19th century (private collection); artwork and photo in the public domain, photo provided by Ruth W. Lieber

was directly related to the development of the architectural orders, a system in which the columns surrounding temples and other public buildings were surmounted by an entablature formed by rectangular architrave blocks, a frieze and cornice. The Temple of Hephaistos in Athens, the best preserved of all Doric temples, illustrates its principles. It was also the usual type of structure in the architecture of both ancient Egypt and southern Arabia, where columns or piers were crowned by rectangular blocks; in ancient Roman architecture, however, extensive use was made of arches and vaults, and in such buildings as the Colosseum, Rome, the trabeated system of the architectural orders was used only as a means of articulation for an essentially arcuated structure.

In Greek architecture the use of the trabeated system was appropriate to the local limestone, as in the temples of Hera and Zeus at Olympia, or later to marble, as in the Parthenon and Erechtheion on the Acropolis at Athens. It also reflected an approach to architecture in which there was no break between structure and appearance: loads were clearly carried by carefully proportioned columns and rectangular entablature blocks, while non-structural and other architectural elements, including pilasters, were rarely introduced. The plans of buildings were usually rectangular to fit the principles of trabeated construction, and the use of arches in Greek architecture above ground was rare, although examples exist in the entrance to the stadium at Olympia and the entrance to the agora at Priene. Roman architecture was liberated from this essentially rectangular style by its use of arches and vaulting.

The Classical style of trabeated construction was revived in the Renaissance and after, for example in such colonnaded buildings as the circular Tempietto di S Pietro in Montorio (after 1502) by Donato Bramante

(?1443/4–1514), Rome, and in Neo-classical and Greek Revival architecture, and it was echoed in the innumerable buildings that were articulated by the architectural orders in the Roman manner.

J. Summerson: *The Classical Language of Architecture* (London, 1963, rev. 1980)

D. S. Robertson: *A Handbook of Greek and Roman Architecture* (Cambridge, 1929, rev. 2/1943); repr. as *Greek and Roman Architecture* (London, 1969)

R. Middleton: 'Architects as Engineers: The Iron Reinforcement of Entablatures in Eighteenth-century France', *AA Files*, ix (Summer 1985), pp. 54–64

A. Boëthius: *Etruscan and Early Roman Architecture*, Pelican History of Art (Harmondsworth, 1978/*R* New Haven, 1994)

J. B. Ward-Perkins: *Roman Imperial Architecture*, Pelican History of Art (Harmondsworth, 1981, rev. New Haven, 2/1994)

A. W. Lawrence: *Greek Architecture*, Pelican History of Art (Harmondsworth, 1957, rev. New Haven, 5/1996)

Tracing. Practice of transferring an image from a drawing on to a support (canvas, wood, board, metal etc) or from a finished image to a copy by working over the outlines with a pen, pencil or stylus. One method of tracing is to rub the *verso* or back of the drawing with a soft-leaded pencil or coloured chalk. The drawing is then placed against the support, face up, and the contours of the original drawing are traced using a pencil or stylus. If required, the traced image on the new support can be reinforced by drawing over it again, though a faint outline is often sufficient.

If the artist wishes to preserve the original drawing from the damage caused by this direct method of tracing, a second drawing may be made using 'tracing paper' to record the main outlines of the original work. The tracing paper version is then lightly rubbed on the back with a soft pencil or coloured chalk and its outlines are then transferred to the new support.

A tracing taken from an original drawing can also be used to enlarge or reduce the design by SQUARING UP or to reverse the image by turning it over and redrawing it from behind. This is usually done by holding the sheet up to the light and laying it flat against a transparent surface, such as a pane of glass.

Before the 1820s tracing papers were usually made from gelatin (e.g. fish size brushed and peeled off a marble slab once it dried) or by impregnating a fine, smooth white rag paper with various oils (e.g. linseed) and resins until it became transparent, but the result was not entirely satisfactory. Good tracing paper must be semi-transparent, smooth and free from knots, patterns or irregularities and this was possible only after the introduction of machine-made paper. In the 19th century tracing paper became an increasingly useful material for artists, designers, architects and engineers, since it was the most straightforward and accurate technique available for reproducing drawings and designs until photographic copying processes came into use. Moreover, with the development of these photographic reproductive methods, tracing became even more important. A full-sized copy of a drawing could be made quickly by sandwiching a layer of sensitized paper below a tracing and exposing it to light, thus allowing many copies to be made from one master copy.

A wide range of materials can be used on tracing paper, including pencil, crayon, coloured inks, watercolour, gouache and various stamp forms (e.g. oil- and water-based red, blue and black ink stamps and those produced by embossing and sealing wax). Because of their utilitarian purpose, tracings are usually subjected to considerable wear and tear, and this, combined with the effects of the impregnation materials and the methods of giving the paper its translucency, makes them discolour and become brittle on ageing.

C. Cennini: *Il libro dell'arte* (*c.* 1390); Eng. trans. and notes by D. V. Thompson jr as *The Craftsman's Handbook: 'Il libro dell'arte'* (New Haven, 1933/*R* New York, 1954), pp. 13 and 14

J. Watrous: *The Craft of Old Master Drawings* (Madison, WI, 1957)

The Art of the Engineer: Two Hundred Years in the Development of Drawings for Design of Transport on Land, Sea and Air (exh. cat. by K. Baynes and F. Pugh; Cardiff, Welsh Arts Council, 1978)

J. Stephenson: *The Materials and Techniques of Painting* (London, 1989)

R. Kendall: *Degas: Beyond Impressionism* (London, 1996)

Transfer. Process of conveying an image from one surface to another. Preparatory drawings or designs can be transferred to another support by several methods: *see* CARTOON, COUNTERPROOF, POUNCING, SQUARING UP, STYLUS and TRACING. For the history of transfer printing in the decoration of ceramics (a process in which an engraved copperplate is printed on to paper, which is then pressed while still wet against the ceramic surface to be decorated) *see* CERAMICS, §I, 4. The article below discusses the conservation technique of transferring paint layers on to a new backing following the complete removal of an irretrievably deteriorated support. It concentrates on the use of transfer for panel and canvas supports; for information on the detachment of frescoes *see* FRESCO, §2.

1. HISTORY AND USES. The process of transfer was developed in France in the mid-18th century by Robert Picault (1705–*c.* 1777), a restorer who worked on many of the large altarpieces brought to Paris from Italy. Since then, it has been a regular part of conservation practice, though it is now used only in extreme circumstances, when all other courses of treatment have been tried and found to fail. The transfer of a painting is a long and laborious task, but a relatively straightforward one. The reluctance to carry it out is partly due to the fact that it goes against the conservation principle that all treatment should be reversible. A transfer is clearly not reversible: the panel, board, paper or canvas is removed in little pieces, and an important part of the historical record of the painting is lost. Another reason for caution is that the appearance of the painting is inevitably slightly altered, however carefully the process is carried out. Paintings transferred from wooden supports are worst affected. Old panel paintings are rarely completely flat, as they usually acquire a slightly convex warp; if more than one panel has been used in the construction, the surface can even have an undulating shape. This has the effect of making the painting reflect light in an irregular and characteristic way. A transferred painting, on the other hand, is uniformly flat and reflects light with an even sheen. The difference is subtle, but can be disturbing if the painting has a smooth and therefore shiny surface finish.

The process was undertaken more frequently in the past, particularly with badly warped or worm-damaged panels. In modern conservation practice alternative solutions are preferred, either consolidating and building up the fragile part of the painting, or placing the work in a sealed display case with a controlled microclimate. However, when the paint and ground layers are as weak as the support, the removal of the damaged support and its replacement with a strong new backing can be a prerequisite of saving the painting.

It is still usually panels that are transferred, especially those that have been destroyed by dry-rot or wood-worm infestation. Pine and poplar, in particular, are soft and easy to tunnel, and within a few years the wood can be reduced to a spongy pulp. Occasionally transfer is necessary because the adhesion between the wood and gesso ground fails, which leads to flaking and paint loss.

Canvas paintings are transferred when the fabric ceases to be of any structural use. This may be brought about by mould, which flourishes in damp conditions, particularly if the canvas has been heavily sized. It breaks down the cellulose in the fibres, and the process is accelerated by acidic conditions brought about by atmospheric pollutants. A more common cause of the destruction of a canvas support is past

conservation treatment. When an old lining canvas is removed in preparation for relining, the thick glue layer has to be scraped off. If this is done dry and the glue picked carefully off the strands, then not too much damage occurs, but if the glue is wetted to speed up the process, it sinks further into the original canvas, and as it is scraped off fibres come away with it. Canvas paintings are sometimes relined as often as every 80 or 100 years, and treatment like this can soon make the original canvas too fragile to be of structural use. When this happens, a transfer has to be considered.

2. TECHNIQUES. The technical innovations that have taken place since the 1960s have all been concerned with the reconstruction stage. The processes involved in removing the old support remain unchanged, relying for their success on good craftsmanship, careful handling and a systematic procedure.

In transfer the backing is removed from the paint, not the other way around. This means that there is never any stage at which the paint layer is unsupported: in fact, throughout most of the operation it remains taped face down on to a smooth working surface. To ensure that the paint is not disturbed by the removal of the support, which in the case of panels involves fairly vigorous carpentry, sheets of thin tissue-paper are stuck on to the paint with a readily soluble adhesive. Mulberry tissue is often chosen for this 'facing' because it is strong yet very thin and therefore forms a perfect contact with the paint. Subsequent layers of paper and fine fabric are then built up until the facing has the rigidity needed to hold the paint together and the thickness to act as a cushion for any raised brushwork. The facing is made to extend beyond the sides of the painting, so that when the work is placed upside down on a lightly padded surface, the paper edges of the facing can be taped down all round. This prevents the painting from moving and keeps dirt from reaching the front.

The back is removed piecemeal. If it is paper or canvas, this can be done quite simply using a sharp scalpel; if it is wood, then the procedure has to be carried out in stages. Shallow grooves about 20 mm apart are cut across the grain of the wood and the ridges between them chiselled away. This is repeated until only a thin layer of wood remains. Some Italian panels made of poplar are as much as 70 mm thick and are reinforced with broad batons. With these it is necessary to use mechanical tools for the first stages, but the final 10 mm are always removed by hand, using first chisels and then a scalpel.

With all the wood (or canvas) taken off, the back of the ground is left exposed. If this is in such poor condition that it cannot be saved by consolidation, then it too can be cautiously scraped away until only the paint layers remain, still firmly stuck to the facing. This stage can provide an interesting insight into the painter's technique, as it reveals the preparatory layers: the drawing and the first blocking in of colour. For example the removal in 1991 of an old backing from the portrait of *Eugène Manet Reclining on the Grass*

(private collection, see *L'opera completa di Degas* (Milan, 1970), no. 371) by Edgar Degas (1834–1917) showed that it had been painted over a life study of a standing male nude.

The painting then has to be rebuilt. The first stage is to ensure that the back of the paint (or ground, if this has been left on) is strong. Very fragile paint or a crumbling ground is consolidated by brushing on several coats of dilute adhesive. A perfectly level surface must then be prepared before the backing can be glued on, otherwise any lumps or depressions will be transmitted through to the paint. This is done with fillers and judicious scraping.

From this point onwards, modern methods vary from traditional transfer techniques. Previously, the painting remained face down on the flat surface while the new support—usually canvas—was glued to the back. Then the whole assembly was placed under pressure to dry. One of two types of adhesive was used. The first was rabbit-skin glue bulked out with flour paste. This mixture has a long history as a conservation adhesive, but if used in transfer its effect can be disastrous. Being aqueous, it causes the chalk or gesso grounds of panels to swell and soften, and as the painting was always kept under weights while it dried, the expanded paint layers were squashed hard against the working surface. When this happened, the paint was irreversibly disfigured by wrinkling, crushed impasto and an unnaturally flattened look. The second common adhesive was red lead or lead white oil paint. This avoided some of the more damaging effects of the glue paste, but had the problem that it was virtually irreversible. A thick layer of lead-based paint is much stronger than the old paint layers to which it is stuck; it is therefore extremely difficult to remove.

The wide range of synthetic polymers that became available from the 1960s enabled conservators to experiment with new materials. Indeed, some of these adhesives were designed to meet conservation specifications: the ideal adhesive is one that can be softened or made soluble for easy removal should a different treatment be found advisable in the future.

There have also been improvements in the type of support used in transfer. Until the 1960s panel paintings were generally transferred to canvas, which would later impress its weave pattern on the paint surface. Also, the painting would gradually but inevitably acquire the kind of craquelure associated with a fabric support. Since then, however, a number of new materials, including Perspex, fibreboard, marine ply, chipboard and aluminium, have been experimented with in an attempt to find a replacement support that is satisfactory from both the structural and the aesthetic point of view. The criteria are that it should be strong, rigid, flat and, above all, that it should not expand and contract in response to moisture or temperature change.

The transfer in the 1970s of the *Incredulity of St Thomas* (1502–4; London, National Gallery) by Cima da Conegliano (?1459/60–1517/18) by the

conservation department of the National Gallery in London was the occasion of an exhaustive study into the most appropriate and acceptable materials to be used. It represents, therefore, one of the most carefully researched examples of modern transfer technique. The transfer was made necessary by the complete failure of adhesion between the wood and the gesso ground. Conservation records on the painting, dating back to the 18th century, document repeated and unsuccessful attempts to keep paint and panel together by the traditional method of introducing glue under the paint. Glue does not travel far when fed in through the craquelure, and restorers in the past resorted to puncturing the paint in the worst affected areas and introducing the adhesive by hypodermic syringe. When the painting was cleaned, the little holes could be seen all over the surface. Despite such drastic intervention, the paint continued to lift, and it was decided that the only way to get at the ground and solve the problem once and for all was to remove the wooden panel.

The method can be summarized as follows. After removal of the wood, the exposed paint and ground layers were consolidated with an acrylic sealant, then made level with a vinyl-based filler. The painting, which had been faced, was turned over and laid face up on a linen canvas previously coated with a thermoplastic adhesive. Painting and canvas were then bonded on a lining table, which supplies regulated heat and light vacuum pressure. The painting, now backed by linen, was heat-sealed again, using the same adhesive, on to a composite panel consisting of two sheets of aluminium around a honeycomb core. This structure had itself been previously built up with layers of fibreglass fabric and fillers to ensure a perfectly flawless surface that would not impose its own texture on the early 16th-century paint layers. Nine surface contacts were involved in this elaborate sandwich, the effect of which was to ensure that the paint remained undamaged by the operation and retained the same surface texture it had when resting on the original poplar panel. After a history of at least three centuries of cracking, flaking and loss, it is possible that the paint on the Cima altarpiece was finally made secure. The pattern of the wood grain and the surface texture of the paint have been left unaltered by the treatment, and it would be impossible to tell that a transfer had been carried out were it not for the fact that the painting no longer

has the slight curvature developed by all large panels. Instead it is perfectly flat.

P. Marot: 'Recherches sur les origines de la transposition de la peinture en France', *Annales de l'est*, i (1950), pp. 241–83

A. W. Lucas: 'The Transfer of Easel Paintings', *Contributions to the IIC Conference: Recent Advances in Conservation: Rome, 1961*, ed. G. Thomson (London, 1963), pp. 165–8

B. Marconi: 'The Transfer of Panel Paintings on Linen by Sidorov (Hermitage Museum, St Petersburg) in the Nineteenth Century', *Applications of Science in Examination of Works of Art: Proceedings of the Seminar 7–16 May 1965, Boston, MA, Boston Museum of Fine Arts*, pp. 246–54

G. Urbani and G. Torraca: 'Nuovi supporti per affreschi staccati', *Bollettino dell'Istituto centrale del restauro* (1965), pp. 23–36

U. Procacci: 'Introduction: The Technique of Mural Paintings and their Detachment', *The Great Age of Fresco—Giotto to Pontormo* (New York, 1968), pp. 18–44

G. A. Berger: 'Formulating Adhesives for the Conservation of Paintings', *Conservation and Restoration of Pictorial Art*, IIC, ed. N. Brommelle and P. Smith (London, 1972), pp. 161–81

R. Buck and R. Merrill: 'Honeycomb Core Construction for Supporting Panels', *Bulletin of the American Institute for Conservation of Historic and Artistic Works*, xii/2 (1972), pp. 62–7

A. Conti: *Storia del restauro* (Milan, 1973, 2/1988/R 2002)

C. Brandi: *Teoria del restauro* (Turin, 1977, Eng. trans. Rome 2005)

M. Mecklenburg and J. Webster: 'Aluminium Honeycomb Supports: Their Fabrication and Use in Painting Conservation', *Studies in Conservation*, xxii (1977), pp. 177–89

Preprints of the IIC Congress: Conservation of Wood in Paintings and the Decorative Arts: Oxford, 1978 [incl. articles by T. Lennon and M. Viana]

M. Wyld and J. Dunkerton: 'The Transfer of Cima's *The Incredulity of S Thomas*', *National Gallery Technical Bulletin*, ix (1985), pp. 38–59

I. Brajer: *The Transfer of Wall Paintings: Based on Danish Experience* (London, 2002)

Turning. Technique of shaping wood in a lathe with a sharp tool as it rotates. It is used to make chair legs, vessels, etc (*see* WOOD, §III).

Turpentine. Colourless, volatile SOLVENT commonly used as a thinner for oil paints and as a solvent for varnish. It is derived from distilling balsam, a resin obtained by tapping pine trees, and has been known since at least the 1st century AD. Balsams are occasionally referred to as turpentines, and the distillate is known as oil or spirits of turpentine. Turpentine has been used in oil painting since the 15th century but has now largely been replaced by solvents derived from petroleum. It has slight toxic and irritant properties.

U

Underdrawing. Preliminary drawing made before the application of an overlying layer. Although most commonly understood as the preliminary sketch on a panel, canvas or parchment, the term is also applicable to works on paper that have multiple layers of drawing in different media, such as a black chalk underdrawing for a metalpoint or pen-and-ink sketch. Underdrawings are discussed as a working stage of a finished drawing or painting in early artist's manuals and technical treatises by Cennino Cennini (c. 1370–c. 1440), Karel van Mander I (1548–1606), Giorgio Vasari (1511–74), Paolo Pino (fl 1534–65) and Albrecht Dürer (1471–1528), among others. Some underdrawings have always been visible to the naked eye, especially in drawings and in thinly painted or unfinished pictures. However, the actual detection and documentation of many only became possible through the use of infra-red techniques, specifically infra-red reflectography (see TECHNICAL EXAMINATION, §II, 2), which was developed for application to paintings by J. R. J. van Asperen de Boer in the early 1970s. In this method, portions of the underdrawing may be documented by photography from a monitor screen or recorded and assembled by computer. The most substantial body of published information on underdrawing is associated with paintings of the Renaissance period. This is because the underdrawing on an early panel painting is more easily detected due to the painting technique, typically a carbon black drawing on a white-ground preparation, superimposed by thin overlying paint layers. By the 16th century certain artists, including Jan Gossart (c. 1478–1532), began to use a grey undermodelling that obscures the underdrawing; paint layers became more opaque and the colour of the ground preparation began to change. Moreover, the purpose and function of the underdrawing was considerably altered by the introduction of the independent oil sketch, which originated in Venice after 1550 and came into common usage in northern Europe in the 17th century. Underdrawings have nonetheless been discovered beneath the paintings of later artists: for example in works by such 17th-century artists as Peter Paul Rubens (1577–1640), Anthony van Dyck (1599–1641), Michelangelo Merisi da Caravaggio (1571–1610), Jan van Goyen (1596–1656) and Jan Saenredam (c. 1565–1607), in 18th-century works by Antoine Watteau (1684–1721) and in the 19th

century in those by Jean-Auguste-Dominique Ingres (1780–1867). Such American painters as Winslow Homer (1836–1910) or William Michael Harnett (1848–92) and such 20th-century artists as Pablo Picasso (1881–1973) and Paul Klee (1879–1940) also made underdrawings on their chosen painting support. In fact most artists presumably made some kind of preliminary sketch on their panels or canvases; it is simply that the detection of them by current techniques is not always possible and thus warrants further investigation. Equally fruitful would be the study of underdrawings in manuscript illumination.

Underdrawings vary in their state of finish and complexity as well as in their medium. They range from the most summary sketch roughly laying out the composition to fully worked-up drawings that include hatching and crosshatching for the description of volumes and the tonal modelling of forms (Dürer and Giovanni Bellini (?1431/6–1516), for example, share this latter feature in their underdrawings). The form of some underdrawings indicates that they were transferred from a pre-existing design, or cartoon, by means of tracing, pouncing or squaring. Since these cartoons rarely survive due to repeated use, the underdrawing gives the only evidence of their previous existence and appearance.

Artists of the 15th century generally followed the instructions of Cennini, making use of a preliminary black chalk or charcoal underdrawing, which was gone over and 'fixed' in its details in brush or pen and an aqueous black pigment. As this first sketch in charcoal or black chalk was then brushed away, it is far more difficult to detect than is the much more prevalent brush or pen underdrawing. Metalpoint lines may also have been employed for preliminary designs of early 15th-century paintings. Incised stylus lines used to indicate the perspective system of a composition occasionally appear in northern Renaissance paintings but are more commonly used for the contours of the entire design on Italian panels of the same period. Other materials, such as red chalk or brown ink, cannot be detected by infra-red reflectography but are sometimes visible to the naked eye or through the microscope. In the 16th century both liquid and dry media underdrawings are found, but after c. 1520 black chalk became the favoured medium and the character of the underdrawing became less finished and more sketchy. With the introduction of

coloured ground preparations on canvases in the 17th century, the traditional underdrawing media also changed, to white chalk (as is found in the *Allegory of Painting*, *c*. 1666–7 by Johannes Vermeer (1632–75); Vienna, Kunsthistorisches Museum) or brown paint, or simply to palette scrapings, as in Rembrandt's underpainted sketches. Underdrawings of the 18th and 19th centuries were executed using a variety of materials, among them pencil or graphite.

The function of the underdrawing can be self-evident but is further discerned by its relationship both to the overlying painted layers and to other existing preparatory drawings on paper. The underdrawing may show reworking in certain forms or that the alterations occurred in the paint layers alone. For many northern Renaissance artists, underdrawings are the only indication of their drawing style, for relatively few drawings on paper by them survive, and of these the preparatory nature of the drawings is questionable. The case is different for Italian Renaissance artists, as the opportunity exists more often to compare drawings with underdrawings. That some underdrawings were meant to be seen or approved by others may be deduced by the discovery of colour notations (combinations of letters found mostly on northern Netherlandish and German paintings) and other identifying words (as of characters or locations) in the underdrawing. Such annotations would also have been useful if part or all of the final painting was to be carried out by a workshop assistant. Furthermore, in the first quarter of the 16th century tonal washes were sometimes added to already very finished-looking underdrawings, and it has been suggested that these chiaroscuro underdrawings (as in works by Lucas van Leyden (*c*. 1494–1533), Bernard van Orley (*c*. 1488–1541), Hans Schäufelein (*c*. 1482–1539/40) and Jacopo da Pontormo (1494–1556), among others) may have served as a kind of *vidimus* for the patron to approve.

J. R. J. van Asperen de Boer: *Infrared Reflectography: A Contribution to the Examination of Earlier European Paintings* (diss., Universiteit van Amsterdam, 1970)

J. R. J. van Asperen de Boer: 'The Study of Underdrawing: An Assessment', *Le Dessin sous-jacent dans la peinture, colloque V: Louvain-la-Neuve, 1983*, pp. 12–24

M. Ainsworth and M. Faries: 'Northern Renaissance Paintings: The Discovery of Invention', *Bulletin of St Louis Art Museum*, xviii/1 (1986) [whole issue]

J. R. J. van Asperen de Boer, M. Faries and J. P. Filedt Kok: 'Painting Technique and Workshop Practice in Northern Netherlandish Art of the Sixteenth Century', *Kunst voor de Beeldenstorm: Noordnederlandse kunst, 1525–50* [Art before the iconoclasm: northern Netherlandish art, 1525–50] (exh. cat., Amsterdam, Rijksmuseum, 1986), ii, pp. 106–16

M. Ainsworth: 'Northern Renaissance Drawings and Underdrawings: A Proposed Method of Study', *Master Drawings*, xxvii/1 (1989), pp. 5–38

J. R. J. van Asperen de Boer: *Underdrawing in Paintings of the Rogier van der Weyden and Master of Flémalle Groups* (Zwolle, 1992)

D. Bomford and R. Billinge: *Underdrawings in Renaissance Paintings* (London, 2002)

H. Verougstraete-Marcq and R. van Schoute: *Jérôme Bosch et son entrourage et autre études* (Louvain, 2003)

Upholstery. Application of textiles to the decoration and furniture of a room. This has traditionally included the provision of all those components of a room that rely principally on textiles or leather for their visual effect. In the 20th century it has come to mean more specifically the stuffing of seat furniture and its covering with textiles. In the ancient world, upholstery appears to have been confined to loose but often highly decorated mattresses, coverlets, cushions and curtains, usually of textiles but sometimes of leather. This article deals with Western aspects of upholstery, from the Middle Ages onwards.

I. Introduction. II. History and development. III. Conservation.

I. Introduction. The heyday of the upholsterer lasted roughly from 1670 to 1890. As his work could transform completely the appearance of a room, the upholsterer gradually also undertook to provide all the furnishings that a room could require, even those that were not primarily textile-based. He played an important role in the dissemination of fashionable styles and eventually came to occupy the position enjoyed by the modern interior decorator, although his social station was undoubtedly less exalted. His work also impinged on that of the architect, who required the upholsterer's services to 'dress' a new room. Here the upholsterer could enhance the architect's spatial creation, or he could spoil it if he were not working in sympathy with the latter's intentions. Moreover, while architects might be called on to extend or alter the fabric of an important residential building perhaps two or three times in a century at most, an upholsterer might be brought in to change the décor of a room much more frequently and, in doing so, could make the basic structure of the room unrecognizable.

The upholsterer's ability to work this miracle—and the creations of the best upholsterers could possess real artistic merit—meant that the leading practitioners acquired such a reputation that clients were prepared to pay enormous sums for the sometimes impressive, often delightful and not infrequently glamorous confections that these craftsmen–entrepreneurs were able to provide. Although it was far more ephemeral, the work of the leading upholsterers of the 17th and 18th centuries deserves similar attention to that of contemporary cabinetmakers. Indeed, it made a far greater impact visually because it was in greater evidence. Their work occupied much more space, it was invariably colourful, and the materials of which it was composed were often of great beauty and very costly. Unfortunately, however, upholstery suffers too readily from fading, wear and grime, and unless carefully protected it soon becomes shabby and is then removed. Until the early 20th century it would be replaced with something of equal richness but in the current fashion. More recently, however, replacements, if any, have generally been meaner, chiefly as a consequence of a change in taste away from rich effects in the mid-20th century.

The ephemeral nature of upholstery has resulted in its having been largely ignored by historians of the decorative arts, who have tended to concentrate on what can be acquired in good condition by collectors, rather than on the range of what was created in the past. Only in the second half of the 20th century has the growing interest in the details of interior decoration of the past led to a reappraisal of the importance of the upholsterer and his achievements. All too often the only surviving evidence for his work is contemporary visual material and descriptions and the documentary evidence of the enormous bills.

II. History and development.

1. Before 1670. 2. 1670–1800. 3. After 1800.

1. BEFORE 1670. In important households, from early medieval times, it must have fallen on certain servants to be responsible for contriving comfortable domestic arrangements using textiles. Eventually, a senior officer of such households was put in charge of these arrangements, with staff below him. In Giovanni Boccaccio's *Decameron* (written *c.* 1350), a household official called a *siniscalco* was required to rig up a pleasant ambience in which the storytellers could relate their tales. The title of the official changed over the centuries, but his duties remained much the same.

Until modern times upholstery was rarely left hanging or otherwise exposed day after day. It was either protected with loose covers or removed entirely and stored in a 'wardrobe'. (It. *guardaroba*; Fr. *gardemeuble*), which could be a large room with presses or cupboards for storage and tables at which the specialist wardrobe staff could brush or repair existing items or make up new ones. Such establishments, which became important in the 16th and 17th centuries, were to be found in most households of standing. Later some upholsterers set up as independent suppliers in the principal cities, and it became common, by the second half of the 17th century, even for monarchs to order upholstery work from such tradesmen. In 1660, for example, Charles II (*reg* 1660–85) appointed to the office of King's Upholsterer the London tradesman Robert Morris, who supplied the court with over £10,000 worth of carpets, chairs, couches and beds over a period of 21 months.

If not working to the dictates of an architect, an upholsterer would call on his customers to measure up the site, might advise on matters of style and taste, and was then prepared to provide whatever was needed to furnish the room concerned.

The furnishings used by the seigneurial classes during the Middle Ages were of necessity portable, as an entire household and most of its possessions would often move from one residence to another, sometimes at short notice. Chairs that folded were useful under such a regime, as was tapestry (*see* TAPESTRY, §1), which was a decorative and very robust material that could withstand much putting up and taking down. These two types of furnishings later came to symbolize seigneurial or princely status in the 16th century, to the extent that updated versions of folding chairs, such as the X-frame chair, and of tapestries were retained in use long after the practical need for such things had ceased, as the upper classes came increasingly to lead a more static life. Once wall hangings remained in position for months on end, the practical characteristics of tapestry no longer mattered, and there were many other materials, such as velvet, silk damask, brocatelle and several sorts of fine woollen cloth, that were at least as pleasing and did not need to be as robust, as they were not removed once hung in place.

During the late medieval period attention began to be paid to the padding of important pieces of seat furniture, to make them more comfortable for the most exalted ranks of society. Primitive stuffed upholstery was very simple. A heap of some yielding material, such as carded wool or wool flock, was placed on a stout canvas base stretched across the seat-frame; the heap was then kept in place by a second piece of material laid over it and nailed as tightly as possible to the four outer edges of the frame. This produced a domed seat, but the stuffing, being unsecured except by such pressure as the top cover exerted, tended to shift around and lose its shape and resilience. The challenge for makers of upholstered seat furniture lay in getting the stuffing to remain in place and retain its shape, and it is not surprising, therefore, to find indications that early seat upholstery was often made by saddlers who knew how to fix padding so that it stayed in place. A saddler (calling himself *selaro* in his bill) was involved in the making of a chair at Ferrara in 1531, according to the ducal accounts, and a court saddler provided Charles X, King of Sweden (*reg* 1654–60), with some stuffed chairs in 1654. Gradually upholsterers learnt to secure padding more effectively, first with quilting, a type of regular stitching in parallel lines right across the seat or back (backs began to be padded on a few extremely comfortable chairs in the late 16th century) and, later, by introducing 'brides', which were bold stitches inserted where needed, executed with strong twine that linked tightly the base canvas and the cover, thus locking the padding in place. An invalid-chair made in the 1590s for Philip II of Spain, known from a contemporary drawing, was padded with quilted horsehair. During this early phase the wooden members of seat furniture (the arms, their supports and sometimes their legs) were often close-covered with the same material as that covering the padded seat. This close-covering was apparently secured with nails for decorative reasons, but was actually glued to the wooden surface. Because coffermakers also commonly covered the chests they produced with leather (*see* LEATHER, §3(ii)), velvet and other textile materials, these craftsmen dressed chairs in this manner in the late 16th century, certainly in England but probably elsewhere as well. However,

by the time of James I, King of England (*reg* 1603–25), purveyors of stuffed seat furniture were often calling themselves 'upholsterers' or 'upholders'.

The Renaissance expectation that the decorative elements of a room should present a unified appearance could be achieved architecturally, but that unity was then easily spoilt if the furnishings that were subsequently introduced did not in themselves match in colour, style and ornament. The upholsterer could play an exceedingly important role in imparting a sense of unity to a room. Although decorative wooden furniture had been made in matching suites already in the 1460s, it was not until about 1570 that unified suites of upholstery became a familiar sight in Italy, then still the leading country in terms of interior decoration. An inventory of Ingatestone Hall, Essex, taken in 1600, indicates that even where chairs were not actually made to match each other, they were at least upholstered *en suite*. Unified schemes achieved by the use of textiles became the norm during the Baroque period all over Europe, as can be seen in the Queen's Closet (*c.* 1670) at Ham House, Surrey, where the crimson and gold upholstery of the seat furniture matches the wall hangings.

2. 1670–1800.

(i) Beds. (ii) Curtains. (iii) Seat furniture.

(i) Beds. The most important piece of furniture in a great 17th-century house was the formal bed, which stood in the main bedchamber. Monarchs and great lords felt obliged to place a splendid state bed in the principal bedchamber of the house, as a symbol of their authority. Lesser mortals had beds that were correspondingly less imposing, but were still intended to remind visitors that their hosts too were people of standing. In this connection, it is of course important to note that, in former times, visitors of a respectable social standing were commonly shown the rooms in a principal apartment, including the main bedchamber, which therefore acquired an almost public character. Even the most modest of these huge beds was an extremely costly item. They were tall structures requiring a vast yardage of expensive material for the curtains, valances (or pelmets), tester, headboard and coverlet. Every component had to be lined (again, with an expensive material, as the lining was often displayed), and many of the components required stiffening. Every component, moreover, was embellished with trimmings (*see* Passementerie) of various kinds (silk or gold lace, for example, as well as fringe, tassels, cords and braid), all of which were made of costly materials. Indeed, the greatest talents of the upholsterer went into making these enormous edifices, which, during the Baroque period, appeared to be made entirely of textiles and heavy trimmings: no part of the wooden structure was visible once the bed had been dressed. Contemporary bills show that the difference in value between the upholstery and the bed frame was considerable. A bill submitted to the Great

Wardrobe in London by Francis Lapiere (1653–1714) in 1699 for two beds indicates that, with similar frames, one bed cost £134 7s. 6d., while the other, with extremely lavish hangings and six matching walnut chairs, came to £630 5s. 9d. One of the finest complete Baroque beds still in existence is the Melville state bed (London, Victoria and Albert Museum), which dates from *c.* 1690 and is over 5 m high.

Increasingly in the 17th century the curtains of beds and canopies (which were rather like beds without the sleeping surface and were suspended over thrones and other seats of honour) might be hitched up, tied back, draped or decorated with bunched or gathered pieces of material to produce wildly flamboyant effects, which were then often echoed in the decoration of the wall hangings of the room and, from the 1680s, of window-curtains, after these had become common from about 1670. The valances of bed-testers were frequently cut with fancy profiles (tongues, lappets, scrolling shapes) to their lower edges and were particularly richly ornamented, since they occupied the most eye-catching position when viewed by a visitor advancing into the bedchamber. The most elaborate confections of this type were produced during the last quarter of the 17th century; two beds made in the early 1670s for Louis XIV and his mistress to stand in the Trianon de Porcelaine (destr.) at Versailles were among the earliest manifestations of this riotous form of decoration, which required prodigious amounts of very costly material.

The state bed was almost invariably the most expensive piece of furniture in the house, and there might be two or even three important beds in the building, one for each principal apartment. It is not surprising, therefore, that the makers of such costly and impressive objects, which were designed to occupy a focal point in an important building, should themselves have acquired a high standing among the purveyors of luxury goods during the time when the state bed was an essential adjunct to courtly life or life among the rich, from the mid-16th century until about 1770. The lack of interest in the history of upholstery until the late 20th century explains why the names of such masters of their craft as Delobel (who served Louis XIV) and Francis Lapiere (who served William III) are unfamiliar compared with those of such cabinetmakers as André-Charles Boulle (1642–1732), John Cobb (*c.* 1715–78), Jean-Henri Riesener (1734–1806) and George Bullock (1778 or 1782/3–1818), whose furniture is today so highly regarded and valuable. It should be added that, in 18th- and 19th-century England, many cabinetmakers, such as Thomas Chippendale (1718–79) and Gillow, could also undertake upholstery work in all its branches. One of the best-known English upholsterers during the 18th century was Thomas K. Bromwich (*d* 1787), whose trade card of 1748 indicates how wide the definition of upholsterer had become by that date.

(ii) Curtains. Curtains were very rarely fitted to windows before 1600 and were at first purely utilitarian

fittings, installed to exclude strong sunlight. Draughts were excluded by wooden shutters or, in bedrooms, by furnishing the bed itself with warm curtains. Indeed, so utilitarian were early window-curtains that no attempt seems to have been made to make them look attractive until after the middle of the 17th century, when the divided form—a pair of curtains to each window—was introduced for the sake of symmetry and balance. But even when the main curtains were divided, it was long common to fit a single subsidiary sun-curtain within, leaving this to be pulled to one side when open, thus destroying the symmetry.

The heavily draped style of late 17th-century state beds was echoed in the pelmets of window-curtains, perhaps as early as the 1680s, and the draped character was compounded when a new form of curtain was introduced that could be pulled up towards the pelmet-board by means of cords, instead of being suspended from rings running on horizontal rods and pulled to the sides. Several variants were devised, but the general impression of such curtains, when pulled up, was of billowing festoons. Apart from suiting the taste of the times, the pull-up or festoon curtain served a practical purpose. It was the habit to place candlestands on either side of pier-tables standing between the windows of grand rooms at this period. It would have been easy to knock over such a stand, and particularly dangerous if it was bearing a lighted candelabrum, when pulling a curtain sideways. Pull-up curtains obviated this particular risk, but they had the disadvantage that they somewhat obscured the upper part of the window. Houses built in the expectation that such curtains would be fitted therefore tend to have taller windows than those designed with divided curtains pulling sideways in mind.

(iii) Seat furniture. In the late 17th century there were great advances in the stuffing of seat furniture, especially in France. For rather more than a century until about 1785, two traditions, the French and the English, ran in parallel, using different upholstery techniques on chair-frames of quite different shapes and producing chairs of very different appearance. After that the two traditions merged, and seat furniture in the two countries came to look very much alike. Other nations followed one or other of the two traditions right through the period of schism.

Materials of many kinds have been used for stuffing the seats and backs of chairs, the requirements being that they should offer a soft or springy seat that remained in position and retained its shape under constant use. Particularly useful in this respect is curled horsehair, which is springy and readily available. While yielding to pressure it springs back into shape once the pressure is removed. Saddlers had known of its properties for a long while.

It was probably in the construction of invalid-chairs that most of the advances in contriving comfortable seating were first made. It is unlikely that there were standard models of such chairs. They were made for wealthy people who became invalids and could afford to buy the comforts that such a piece of furniture offered. Accommodating seats and backs were the first requirement. Adjustable backs and leg-supports came second. Casters, so that the chair could be moved, came third: they were an option about which few people then knew. In some places the less affluent had invalid-chairs of wicker with a large hooded back. Such seats tended to be used in the bedchamber in front of the fire, and this was where 'easy-chairs', which derived from the invalid-chair, were also originally placed. Related to these are sleeping-chairs, of which a pair of English examples of the 1670s survives at Ham House, Surrey. By using down for the top layer of the stuffing, especially for the seat (which often took the form of a fat cushion resting in a padded well between the arms), a supremely comfortable piece of seat furniture was evolved, but it was intended for informal relaxation, not for show in presentation rooms. Thus the Ham House sleeping-chairs were placed in a private room, the Queen's Closet, rather than in one of the more public rooms.

The Parisian easy-chair (*fauteuil de commodité*) of the late 17th century has probably never been bettered as a seat in terms of bodily comfort. A painting by Jean-François de Troy (1679–1752) shows a particularly low-slung variant of the French *fauteuil*, showing the domed effect of French stuffing. The characteristics of the easy chair were later extended sideways, as it were, to form the sofa or *canapé*, which sometimes actually had two backs, set side by side, recalling its origins in the single-back conformation (see fig.). Sofas, too, must have formed part of private and informal rooms, where one could take advantage of such relaxed comfort. Lolling about in the manner depicted by de Troy would never have been considered polite in rooms of parade.

Chairs for rooms of this more formal type had quite a different character at the end of the 17th century. They were members of the main line of development where the seat was upholstered and there was a back-support that was padded; there was no fully upholstered back, as on the invalid-chair and its voluptuous derivatives. These more formal chairs were much more sparsely treated. Until about 1670 arms were often close-covered along with the rest of the woodwork, but later armchairs had bare, polished wooden arms. Much use was made of trimming or passementerie on grand chairs of this class. One could alter the proportions of a chair very considerably by attaching a deep fringe around the edges of the stuffed seat, or by continuing down a flap of the seat-covering to produce a similar effect. Such chairs usually came in sets, which included armless versions that were *en suite* in every way except that they were usually slightly narrower.

French chairs of this principal class became increasingly comfortable, both in the armed and armless versions, and the mid-18th century form, with its sinuously carved frame and its, by then, well-padded seat and back-support (the two elements were still

Embroidered upholstered settee, wool, silk, walnut, beech, kid skin cushion lining, from Hampton Court, Herefordshire, 1575×950×1378 mm, *c.* 1695 (London, Victoria and Albert Museum); photo credit: Victoria and Albert Museum, London/Art Resource, NY

not united at this stage in France), was one of the most comfortable types of chair ever devised for general use. The English equivalent was far less comfortable: it had a harder seat and often no padding at all in the back, which was commonly decorated with openwork carving. A technique that seems to have been developed in England concerned the production of a rigid and square vertical edge to seats and backs by means of tightly stitching a roll of horsehair running along an edge so as to compact it into rigidity. This was needed on English chairs, which, already in the 1740s, had squared forms—at a time when French seats were all domed and yieldingly round without any vertical border. A design by John Linnell (1729–96) shows the characteristic English square-edged seat with shallow tufting. Later, after the introduction of Neo-classical forms, French chairs also needed squared edges, and the French quickly adopted the same technique. The silhouette of chairs was largely formed by the outline of their upholstery, which is why it became a matter of importance to get the lineaments right. The elegance of a chair could depend very much on the skill of the upholsterer.

The 18th century was more a period of general refining of known techniques than a time when totally new methods were introduced. There was a certain amount of experimenting with springs and even with inflatable cushions, but this met with little success. One of the daughters of Louis XV insisted that she would certainly not want to retire to a convent, as her sister had just done, because it would mean giving up her sprung easy chair. It is not

known what this chair was like, and it was presumably a one-off production by the royal upholsterer in Paris.

3. AFTER 1800. Upholstery reached the height of perfection in the 19th century, in terms of technique and what could be achieved. Never had such ambitious schemes been undertaken and never was the precision of the work so great. The apogee was reached between about 1860 and 1880. Although the upholsterer's creations of that period now seem unattractive or worse, the brilliance of the workmanship must be acknowledged. It is worth noting this because it is widely believed that 17th- and 18th-century upholstery was of far higher quality than that of the 19th century. The opposite is true. Indeed, 17th-century upholstery was technically really very crude, and the same is also true of upholstery produced in the 18th century, at least before about 1770. This refers, of course, to high-class upholstery, for upholstery of poor quality has been carried out at all periods, and a great deal of shoddy work was produced in the 19th century because furniture production overall was so much less exclusive than in earlier centuries. What is true, on the other hand, about 17th- and 18th-century upholstery is that the quality of the textiles was generally far more sumptuous and expensive than it has been more recently, if only because upholstery was then a trade serving almost exclusively the rich. The equivalent level of expenditure in the 19th century could produce comfortable arrangements of the utmost opulence, all executed with

finesse and imbued with an assurance that by then rested on a long and substantial tradition. This tradition has been maintained, and a modern skilled craftsman, steeped in the Victorian tradition, is inclined when faced with a specimen of high-class 17th-century upholstery, to believe it must be the work of an amateur.

(i) Hangings and draperies. Upholsterers in the mid-19th century invented even more items that required their skills than their predecessors in the 18th century had done. Mantel-shelves might sport a heavily trimmed cover with a pelmet all round, and the fire-opening might in addition be furnished with curtains. Mirrors could have drapery borders, the chains of chandeliers and gasoliers had elaborate sleeves, and some lamps had flounced shades. Doors were fitted with *portières*, again heavily draped, which echoed the no less heavy arrangement of the window-curtains, which were, however, additionally complemented by inner curtains of net or lace. Walls in richly appointed rooms were not merely hung with textiles (more opulent than wallpaper, which was also provided by upholsterers) but might even be quilted. An infinite variety of seat furniture was evolved, much of it deeply stuffed and heavily trimmed with fringe and sometimes with added drapery as well. Never before had there been an age when textile embellishment could totally dominate a room. The architecture was often swamped by all this ornament, which, in skilled hands, could be delightful, magnificent or extremely elegant, but which, in the hands of the average upholsterer, all too often presented a confused clutter, where good judgement had not been brought into play and an understanding of the principles of integrated decoration was all too evidently absent. This was to bring about a reaction, which began to manifest itself in the late 1860s, particularly in England, although it was not really until the 1890s that the reformers' recommendations came to be widely adopted. Then the load of ornament, the fussiness of pattern, the heavily draped curtains and the generally suffocating atmosphere of the characteristic High Victorian room yielded to arrangements where the bones were still in place but much of the flesh, or perhaps fat, had been pared away. New and lighter forms of curtain were devised, lighter colours were adopted, and upholstered seating assumed slimmer lines.

(ii) Seat furniture. The highest achievements of the upholsterer in the mid-19th century lay in the stuffing and covering of seat furniture. Stuffing in the 16th century and the early 17th had been so shallow that a quilting technique sufficed to hold it in place (*see* §1 above). As stuffing became deeper in the 18th century, a technique used in mattress-making was adopted. This involved stitching through the padding with a long needle, using strong twine pulled fairly tight, with tufts of twine at each end that prevented the thread under tension pulling through the covering material. This method of securing the padding could be organized to produce a calculated disposition of tufts in patterns that enhanced the appearance of chair-seats and chair-backs. As the strain put on the thread was not great, the resulting depressions in which the tufts nestled were shallow, and no additional yardage of covering material was needed to accommodate the distortion. When the stuffing grew thicker from the 1830s and the strain on the thread became greater, however, the depression in consequence became deeper, and much ingenuity, and some mathematics, had to be devoted to cutting the cover with ample spare material to take into the folds that were thus generated (these were commonly organized to form a diamond pattern). As the strain on the tufts increased, moreover, it was found necessary to replace them with rigid buttons. Stuffing that is buttoned is nevertheless still called *capitonné* in French, a reminder that this technique had formerly involved the use of a tuft (or *capiton*) of material.

The depth of the padding and the strain on the buttoning increased greatly when effective upholstery springs were introduced. This occurred in the second quarter of the 19th century even though successful experiments were carried out around 1820. The breakthrough occurred when the double-cone form of spiral spring was adopted, but it took time to devise ways of lashing the cones with twine to anchor them and control their movement. All this was perfected by about 1850.

Spiral springs work in compression. Tension springs, adopted in the 1930s from metal-framed bed-springing, work horizontally (deflected slightly downwards when a sitter's weight presses down on the seat). Rubber webbing, laminated with rayon that limited the stretch, was introduced in the 1940s and worked on the same principle. These methods ushered in a new phase in the history of seat-upholstery. Perhaps of even greater significance was the introduction of rubber latex foam in the 1930s and polyurethane foam in the 1950s, both produced in moulds. As these moulds were in themselves expensive, so moulded latex or polyurethane cushions and seats were most economically manufactured in long production runs. This made the method too costly for small batches and custom-built furniture; its greatest successes were to be seen in contract seating, for cinemas, railways, aircraft and motor cars. It should be noted that some of the greatest advances in comfortable seating technology have been made by the motor industry.

Traditional methods, however, continued to be used everywhere, especially for domestic seating of high quality. Sometimes, especially in the late 20th century, old techniques have been combined with modern materials, notably with foam fillings that can be of different qualities, some possessing more resilience than others. While these developments in technology were taking place, the traditional upholsterer frequently rose to the occasion when new styles demanded new lineaments. For instance, much Parisian Art Deco seat furniture

of the 1920s and 1930s required a slimmer line than furniture of the pre-World War I period had possessed; this was achieved by traditional methods skilfully adapted to the trim elegance of the new style.

III. Conservation. The study of upholstery is still in its infancy, not having kept pace with the study of other aspects of furniture history. Great advances, however, have been made since the early 1980s. In many quarters the same amount of care is now being taken over the restoration or replacement of old upholstery as over a fine piece of veneered furniture, and much has been learnt about traditional practices and techniques in recent years. The methods of the archaeologist have been applied to the dismantling of surviving old upholstery on chairs and beds, the process often taking as long as its restoration or its replacement. This is in stark contrast to the 'stripping out' of old upholstery by commercial upholsterers, which is usually accomplished in a matter of minutes.

Much has been learnt from this patient dismantling. It has also come to be recognized that some widely accepted methods of repair to old furniture should no longer be used where ancient upholstery is also involved. For example, it is now rather frowned on to fill old nail-holes with glue or similar filling substances, so as to provide a fresh set of nails with a secure ground into which they can be hammered. Conservators have developed a range of what they call 'minimally intrusive' restoration processes, the most striking of which is the fitting of a rigid foam-plastic 'cap' to old seat furniture. Instead of nailing new replacement layers of upholstery on to the old frame, using traditional techniques, the loose 'cap' carefully shaped to the supposed original conformation, is dropped into position on the old seat-frame. The cap is covered with appropriate material so as to present precisely the same contours as the traditionally stuffed seat would have possessed; it can even be given a certain amount of resilient surface-stuffing to make the effect seem less solid and unyielding. Decorative nailing is simulated by affixing nail-heads to the covered surface of the cap. Thus no changes are made to the surviving frame, and all its tell-tale blemishes are retained. Such capped furniture cannot be used, and the method can be applied only to museum objects.

J.-F. Bimont: *Principes de l'art du tapissier* (Paris, 1770)

H. Havard: *Dictionnaire de l'ameublement et de la décoration*, 4 vols (Paris, 1887–90)

R. Edwards, ed.: *The Dictionary of English Furniture* (London, 1954)

P. Verlet: *Les Meubles français du XVIIe siècle*, i (Paris, 1956, rev. 1982)

H. Lassen: *Sadler og draperier og polstermöblets historie* (Copenhagen, 1960)

E. Stavenow: *Siden, sammet, läder, larft, klädsel på gamla stolar* (Stockholm, 1961, rev. 1993)

The Golden Age of English Furniture Upholstery, 1660–1840 (exh. cat., Leeds, Temple Newsam House, 1973)

J. Fowler and J. Cornforth: *English Decoration in the Eighteenth Century* (London, 1974), pp. 82–173

P. Eames: 'Furniture in England, France and the Netherlands from the Twelfth to the Fifteenth Century', *Furniture History*, viii (1977) [whole issue; see especially sections B and D]

P. Thornton: *Seventeenth Century Interior Decoration in England, France and Holland* (New Haven and London, 1978), chaps IV–VIII

L. White: 'Two English State Beds in the Metropolitan Museum of Art', *Apollo*, cxvi (1982), pp. 84–8

F. Montgomery: *Textiles in America, 1650–1870* (New York, 1984)

P. Thornton: *Authentic Decor: The Domestic Interior, 1620–1920* (London, 1984)

P. Verlet: 'Notes sur quelques tapissiers parisiens du XVIIIe siècle', *Furniture History*, xxi (1985), pp. 19–31

E. Cooke, ed.: *Upholstery in America & Europe from the Seventeenth Century to World War I* (New York, 1987)

A. Westman: 'English Window Curtains in the Eighteenth Century', *Antiques* (June 1990), pp. 1407–17

Upholstery Conservation: Preprints of a Symposium: Colonial Williamsburg, 1990

P. Thornton: *The Italian Renaissance Interior, 1400–1600* (London, 1991)

G. Beard: *Upholsterers & Interior Furnishing in England, 1530-1840* (New Haven and London, 1997)

L. Graves and F. Carey Howlett: 'Leather Bottoms, Satin Haircloth, and Spanish Beard: Conserving Virginia Upholstered Seating Furniture' *American Furniture*, ed. L. Beckerdite, Chipstone Foundation (Milwaukee, 1997), pp. 197–266

Textiles in Trust: Proceedings of the Symposium Held at Blickling Hall, Norfolk, September 1995

K. Gill and D. Eastop, eds: *Upholstery Conservation: Principles and Practice* (2000), pp. 90–99

K. Gill: 'The Development of Upholstery Conservation as a Practice of Investigation, Interpretation and Preservation', *Reviews in Conservation, IIC*, v, (2004), pp. 3–22

V

Varnish. Coating material consisting of resin dissolved in a liquid, which dries to form a transparent film. Drying may result from the evaporation of a SOLVENT vehicle to leave a glassy residue of resin, or from a combination of solvent evaporation and chemical reaction between resin molecules to form larger molecular units (polymerization). Traditionally, varnish films have a high gloss, but, by varying the varnish constituents and the method of application, it is possible to vary the degree of gloss as well as the hardness, toughness and flexibility of the film. Varnishes may be colourless or tinted by the addition of dyes or pigments. The word 'varnish' is derived from the medieval (*c.* 8th century) Latin *veronix* or *vernix*, itself related to the Greek *berenice*, then apparently used for amber. By extension, *vernix* came to be used for sandarac resin, sometimes confused with amber and a common ingredient in medieval varnish recipes. By the 15th or 16th centuries *vernix* also denoted juniper resin. The word 'varnish' only acquired its modern meaning around the late 16th century; before this time the liquid coating material was known by such names as the Italian *vernice liquida*.

See also LACQUER, §I, 3 and 4 and RESIN, §1.

1. Materials and techniques. 2. Uses. 3. Conservation.

1. MATERIALS AND TECHNIQUES.

(i) Natural resin varnishes.

(a) Oil-based. In Europe the earliest varnishes consisted of natural resins (*see* RESIN, §1) dissolved in hot linseed oil, and oil varnishes of this type remained the standard coating material for a wide range of applications until well into the 20th century. Some very early recipes are extremely complicated: one cited in the early 9th-century collection known as the *Compositiones variae* (Lucca, Biblioteca Capitolare, MS. 490) includes eight different resins, two of which are the gum-resins myrrh and frankincense. Other ingredients can probably be identified as Chios turpentine, galbanum, larch turpentine (i.e. Venice turpentine), mastic, sandarac and pine resin (colophony). Later varnish recipes, such as those described by Theophilus in *De diversis artibus* (*c.* 1140), are essentially very similar to 19th- or 20th-century recipes. The ingredients consisted typically of one or more insoluble or 'hard' resins such as sandarac (*see* RESIN, §1) and a 'boiled' oil, generally linseed. For the resin to dissolve in the oil it was necessary to melt or 'run' it by heating it to about 300°C; the oil was heated separately to about 240–260°C and added gradually to the liquid resin. The mixture was then 'boiled' until the varnish could be drawn out to form a string, at which point it was allowed to cool. After the time of Theophilus, driers (e.g. lead salts) were frequently incorporated during the heating process. In the 19th and 20th centuries a varnish thus prepared was diluted with oil of turpentine (in earlier recipes there is frequently no indication that the mixture was diluted) and it would probably have been necessary to warm the varnish for use.

Apart from sandarac, juniper resin and the highly insoluble fossil resin amber, pine resin (rosin or colophony), the solid residue left after the distillation of turpentine oil, was probably also used. It is more readily soluble in hot oil than the generally recommended 'hard' resins, although the resultant varnish is rather less hard wearing. It is still in use, either directly or in a modified form. Venice turpentine, from the European larch, mentioned in 17th-century varnish recipes, for example, makes a less satisfactory varnish, although it has been used as an ingredient in paint media. 'Hard' resins used have included the African and South American copals and mastic; as well as being widely used as a varnish, the latter was an ingredient in oil-varnish paint media such as megilp (*see* PAINT, §I, 2(ii)). The use of such media is documented from the late 17th century, but they appear to have been used increasingly from the latter part of the 18th (*see* PAINTING MEDIUM). Before the invention of synthetic resin varnishes copal-oil varnishes were widely used in the 19th century and early 20th as a varnish not only for paintings but also for, for example, woodwork (*see* LACQUER, §I, 3). The 'semi-fossil' kauri resin was also imported into Europe from New Zealand in the 19th century for varnish preparation.

Varnishes prepared from oil and natural resins tend to be rather dark in colour in bulk; the more they are heated, the darker they become, although their drying properties are improved. After the initial evaporation of any volatile diluent, they harden and dry principally by the formation of cross-linkages between the triglyceride molecules of the drying oil and become increasingly insoluble, producing very tough, quite hard-wearing films. An aged varnish of this type may be difficult to remove (*see* §3 below). Although a

thin film of the fresh varnish may have little perceptible colour, it will darken with age. An oil varnish used as a medium for easel painting may cause such defects as cracking and wrinkling of the paint film.

(b) Spirit-based. Spirit, or solvent-type, varnishes consist of a natural resin dissolved in a rapidly evaporating solvent such as alcohol or oil of turpentine; they were unknown in Europe much before the early 16th century and are still used today. Materials used have included the balsamic resin benzoin, from the Styracaceae family (from Sumatra and Thailand), dissolved in alcohol, but in the 19th and 20th centuries mastic or dammar resins dissolved in turpentine were generally used. Dammars appear in varnish preparation in Europe *c.* 1830, although they would have been widely used for many purposes in the areas around the Indian Ocean (e.g. Malaysia, Indonesia and the Indian subcontinent) where the species of tree producing them occurs. Solvent-type varnishes dry by evaporation of the solvent, leaving a film of the resin; they may be brushed or sprayed on to the object. As natural resins oxidize and yellow with age, the films discolour; they also become brittle and fragile and are usually only suitable for use on objects that do not receive much wear and tear.

(c) Other organically based varnishes. A variety of other naturally occurring materials may be used as varnishes. Beaten egg white (glair) gives a sheen to the surface of paintings to which it is applied, and it was sometimes used as a temporary varnish before the final varnish could be applied. An aqueous solution of gum arabic, which gives a fairly glossy surface, can be used similarly, particularly in manuscript illumination; also known as gum acacia, it was used in ancient Egypt. Frescoes and marble sculptures were sometimes given a thin protective coating of wax in the early Middle Ages. Shellac, which is secreted by insects of the family Tachardiidae found throughout the Indian subcontinent and in parts of Burma and Thailand (*see* LACQUER, §I, 2), has been used as a coating on furniture—so-called French polish (*see* WOOD, §III, 5)—small decorative objects, metal items and scientific instruments. It can be applied either in alcoholic solution or as the melted material. Japanese lacquer (*urushi*) is a thick, milky, water-in-oil emulsion produced by the sumach tree *Rhus vernicifera*, which grows in Japan and China, and it has been used from very early times (*see* LACQUER, §I, 1).

(ii) Synthetic resin varnishes. In the 20th century synthetic resin varnishes largely superseded those prepared from natural resins (*see* RESIN, §2). Some, such as rosin derivatives, alkyds and certain phenolic and epoxy resins, can be modified with unsaturated oils; others, such as polyvinyl acetate and the polyacrylate and cyclohexanone resins widely used in conservation (*see* §3 below), may be applied in solvents in the same way as dammar and mastic. For any particular class of polymer, by varying the starting materials and conditions it is possible to obtain a product with the desired physical properties of hardness, flexibility and solubility. The glass transition temperature, the temperature at which a polymer changes from a glassy to a flaccid state, determines the mechanical properties of the polymer. Other properties, such as refractive index, may also alter around this temperature. It indicates the softness of a resin: if a varnish resin is too soft, the varnish may pick up dirt; if too hard, it may lack flexibility and crack. The molecular weight of the resin (natural or synthetic) has an influence on such properties as the viscosity of the varnish. The refractive index of the resin to some extent influences the effect the varnish film has on the appearance of the object. Polyvinyl acetate (formed from vinyl acetate), first available in the 1930s, is very stable but little used as a varnish for conservation purposes as it is only soluble in relatively polar solvents. Far more important from the point of view of conservation are certain polyacrylate resins—Paraloid B-72 and Paraloid B-67—which have slightly different physical properties and are both widely used. Alkyds are perhaps the most widely used group of synthetic coating materials. Alkyd resins closely resemble drying oils, which may indeed be incorporated into the resin molecule; varying the ingredients and careful control of the reaction give products with a range of properties (such as gloss and flexibility) suitable for many different purposes, including varnishes for wood. Polyurethane resins are extremely tough, hard, inert varnishes used, for example, for floors. Similarly durable products may be obtained from certain formulations of epoxy resins, although these tend to darken. Cyclohexanone or ketone resins have properties rather similar to dammar and mastic and are widely used in the conservation of paintings.

C. L. Eastlake: *Materials for a History of Oil Painting* (London, 1847/R New York and London, 1960), i, pp. 229–54

R. Mayer: *Artist's Handbook* (1941, rev. 4/1982), pp. 180–213, 715–17

R. L. Feller, N. Stolow and E. H. Jones: *On Picture Varnishes and their Solvents* (Oberlin, 1959, rev. Cleveland, OH, 1971/R Washington, DC, 1985), pp. 119–45

Surface Coatings, i: *Raw Materials and their Usage*, Oil and Colour Chemists' Association (Kensington, New South Wales, 1974, rev. London, 1983), pp. 45–56, 65–74, 77–9, 84, 88–90, 96, 99–115, 144–52

C. V. Horie: *Materials for Conservation: Organic Consolidants, Adhesives and Coatings* (London, 1987), pp. 92–6, 103–12, 116–17, 145–53, 165–70

J. S. Mills and R. White: *The Organic Chemistry of Museum Objects* (London, 1987, 2/1994), pp. 35–6, 42–3, 95–128, 132–40, 179–84

Cleaning, Retouching and Coatings: Technology and Practice for Easel Paintings and Polychrome Sculpture: Preprints of the Contributions to the IIC Congress: Brussels, 1990, esp. pp. 63–80, 131–3

J. Petit: *Glossaire des peintures et vernis: Des substances naturelles et des matériaux synthetiques* (Champs sur Marne, 1991)

L. Masschelein-Kleiner: *Ancient Binding Media, Varnishes and Adhesives*, International Centre for the Study of the Preservation and Restoration of Cultural Property, Rome (ICCROM), Technical Notes Series (Rome, 1985, 2/1995)

A. Harmssen, ed.: *Firnis: Material, Ästhetik, Geschichte* (Brunswick, 1999)

2. Uses. Varnishes are used as protective or decorative coatings. The choice of varnish depends on the hardness, inertness, flexibility, durability, resistance to darkening and solubility required. The highly durable but insoluble coatings such as polyurethane and epoxy-resin varnishes are particularly suitable where the coating is intended to be both permanent and hard-wearing (e.g. on furniture or wood floors); they are not appropriate for temporary use. Some varnish formulations, such as those of certain alkyd resins, can be baked to form a durable coating with high gloss; these are suitable for enamels, for example.

The varnishes used as protective coatings on easel paintings do not need to be so resilient, and solvent-based types are used. The colours of a painting will appear more saturated if the varnish resin has a high refractive index, but other factors should also be taken into account, for example the surface gloss, how well the varnish wets the paint surface and the extent to which it penetrates the paint. A varnish gives visual unity to a painted surface, providing depth as well as the desired degree of gloss. A matt surface, often considered more appropriate for paintings in tempera, may be obtained by using a resin constituent of high viscosity, by adjusting the spraying conditions, or by incorporating a matting agent such as microcrystalline wax or beeswax. Varnishes may penetrate the paint film to some extent; in the case of a freshly painted picture this is not desirable, and many authorities, including Cennino Cennini (c. 1370–c. 1440), writing in the 1390s and referring to paintings in tempera, have advised against varnishing a painting too soon after it has been finished. In the past, temporary egg-white varnishes (glair), which did not penetrate vulnerable fresh paint and which could be removed by washing a short while later, were often suggested as an interim measure.

Tinted varnishes were widely used as a decorative coating over metal leaf in interior decoration and for furniture, picture frames, mirrors and sculpture. They also appear in easel painting, wall painting and on other painted surfaces. Tinted red, green or yellow, they are used over gold leaf to simulate jewels. Yellow-tinted varnishes have a long history of use over silver or tin leaf in imitation of the more expensive gold leaf, or to intensify the colour of gold leaf (see GILDING, §I). Varnishes have also been used as a paint medium, such as the unctuous gelled megilp medium of the late 18th century and the 19th (see PAINT, §I). The proportion of varnish in these mixtures was quite high, as much as 1:1 mastic varnish to linseed oil; as a result the paint medium retained a degree of solubility even when aged. The paint was also liable to crack or discolour. However, in slightly earlier times a very little varnish might be added to oil paint to give desired properties of flow, gloss or richness to particular colours or passages of paint (see GLAZE and OIL PAINTING, §1). The addition of a proportion of pine-resin varnish to oil paint was suggested in late 17th-century painters' and decorators' manuals to give increased gloss and improved weather resistance to the final coating. Retouching varnishes are used during oil painting to bring out the full colour of passages that have sunk or dried matt and to lessen the absorbency of an area where painting is to be continued, allowing subsequent layers of paint to flow on easily. The use of isolating varnishes over a recently dried painted area allows work to be continued or corrected without affecting the paint beneath. Various types of varnish materials are used to protect untouched, or lightly etched areas on copper or zinc plates during additional etching bites; such varnishes are generally based on wax and asphaltum and are known as 'stopping-out' varnishes (see ETCHING, §I). They may also be used to paint the design on to a prepared, grounded aquatint plate before etching. The fixatives used on pastel or charcoal drawings to prevent the pigment being brushed away, for example dilute aqueous gum arabic and alcoholic solutions of cellulose nitrate, are in effect very dilute varnish solutions. Mastic or shellac solutions are often used for charcoal drawings but are unsuitable for pastel drawings as they affect the colour.

C. Cennini: *Il libro dell'arte* (MS.; *c.* 1390); trans. and notes by D. V. Thompson jr (1933), pp. 99–100

R. Mayer: *Artist's Handbook* (1941, rev. 4/1982), pp. 174–5, 184–6, 217–27, 325–7, 427, 533–7

Surface Coatings, Oil and Colour Chemists' Association, Australia, i: *Raw Materials and their Usage* (Kensington, New South Wales, 1974, rev. London, 1983); ii: *Paints and their Applications* (Kensington, New South Wales, 1974, rev. London, 1984)

J. Harten: 'When Artists Were Still Heroes', *Siqueiros–Pollock, Pollock–Siqueiros* (Düsseldorf, 1995)

M. D. Gottsegen: *The Painter's Handbook* (New York, 2006)

P. Steenhorst: 'Schellak vernissen op messing: Een praktische handleiding', *CR: Interdisciplinair vakblad voor conservering en restauratie*, vii/1 (2006), pp. 38–41

3. CONSERVATION. Varnishes that serve a decorative purpose rather than, or as well as, a protective function and those used as painting media are examples of varnish for which conservation treatment may be considered appropriate. In these circumstances, the varnish is considered and treated in a manner comparable with that accorded to a paint. The criteria taken into account before, or during, treatment to paint are similar in the case of varnishes, bearing in mind the fact that some varnishes may be rather more soluble than a normal oil paint film of equivalent age and so require a careful choice of cleaning method. A varnish that acts solely as a protective coating is less likely to be conserved, unless there is some particular reason: for example, the varnish is of considerable age and therefore of historical interest. In other cases when a protective varnish deteriorates it is usually removed, if possible, and replaced. Removal of dark yellowish varnish from the *Toilet of Venus* ('Rokeby *Venus*', c. 1651; London, National Gallery) by Diego Velázquez (1599–1660) revealed delicate luminous colour and bold brushwork. Since

the 19th century, attempts have been made to 'reform' deteriorated varnish or paint films, essentially by exposing the painting to vapours of a suitable solvent; the effects are often only temporary. One of the earliest reforming procedures was the Pettenkofer process, patented by its inventor Max von Pettenkofer in Bavaria in 1863, whereby paintings were exposed to alcohol vapour and copaiba balsam.

The role of varnishes in conservation is of fundamental importance. For conservation purposes the ideal varnish should be colourless, transparent and without physical or chemical effect on any property (such as colour of paint) of the artefact, either initially or as the result of any alteration in its own physical or chemical properties. It should not discolour and should retain sufficient flexibility to accommodate any normal movement in the varnished surface caused by fluctuations in atmospheric conditions. The composition of the varnish ingredients should be known and should not include ingredients such as plasticizers, which might migrate into paint or the fabric of the object. It should remain easily removable (even after deterioration) without damage to the object, as reversibility is one of the most important attributes of any conservation treatment. It should not have any deleterious effect on the health of the conservator (many solvents in common use have vapours that are toxic or flammable). The resin component should preferably dissolve in relatively mild, non-polar solvents such as white spirit, reducing the risk that the artefact will be adversely affected by the solvent. The varnishes used in conservation are usually based on thermoplastic synthetic resins (e.g. polyacrylates and cyclohexanones) and also, to some extent, natural resins (e.g. dammar); certain hydrogenated hydrocarbon resins have also been suggested for use.

However closely varnishes may meet the required specifications when first applied, changes may take place with time. The materials used may be subject to deterioration, often caused by the reaction of a varnish component with oxygen, frequently catalysed by light or heat. As a result the polymer chains may break down, causing the varnish film to weaken or become brittle; or they may cross-link, rendering it less soluble. Yellowing of the varnish film and an increased polarity of the resin used also result from chemical reactions of this type. The increased polarity necessitates the use of a more polar solvent to remove the varnish than that in which it was applied, thus increasing the risk of damage to the artefact itself.

It is often felt that dammar varnish gives a more satisfactory result when used on a picture surface than many synthetic resin varnishes: the relatively low molecular weight and high refractive index of the resin give a varnish that makes the pigments appear saturated in colour. However, it has certain disadvantages: it tends to wrinkle and to 'bloom' under certain circumstances. ('Bloom' gives the surface of the varnish a white or misty appearance; mastic and other varnishes are also affected. There are a number of possible causes.) It also becomes brittle and yellows in a relatively short time (*c*. 20 years),

although the addition of an antioxidant to the varnish reduces yellowing. Partial removal of varnish from the *Virgin and Child Embracing* by Sassoferrato (1609–85) revealed the freshness of its colours. However, research has shown that the addition of light stabilizing chemicals to the varnish film and the elimination of ultraviolet radiation result in an increase in the useful life of dammar varnish; it may thus be made more suitable for conservation purposes. Varnishes prepared from mastic, which deteriorates in a rather similar manner to dammar, and certain cyclohexanone resin varnishes commonly used in conservation, which tend to become brittle, have similarly been stabilized by these means under laboratory conditions.

R. L. Feller, N. Stolow and E. H. Jones: *On Picture Varnishes and their Solvents* (Oberlin, 1959, rev. Cleveland, OH, 1971/*R* Washington, DC, 1985)

H. Ruhemann: *The Cleaning of Paintings: Problems and Potentialities* (London, 1968), pp. 269–79

C. Brandi: *Teoria del restauro* (Turin, 1977, Eng. trans. Rome, 2005)

C. V. Horie: *Materials for Conservation: Organic Consolidants, Adhesives and Coatings* (London, 1987)

E. R. de la Rie and A. M. Shedrinsky: 'The Chemistry of Ketone Resins and the Synthesis of a Derivative with Increased Stability and Flexibility', *Studies in Conservation*, xxxiv/1 (1989), pp. 9–19 [with bibliog. refs]

E. R. de la Rie and C. W. McGlinchey: 'Stabilized Dammar Picture Varnish', *Studies in Conservation*, xxxiv/3 (1989), pp. 137–46 [with bibliog.]

Cleaning, Retouching and Coatings: Technology and Practice for Easel Paintings and Polychrome Sculpture: Preprints of the Contributions to the IIC Congress: Brussels, 1990, pp. 81–4, 158–76, 160–64, 168–73

V. Massa: *Le vernici per il restauro: I leganti* (Florence, 1991)

P. M. Whitmore, ed.: *Contributions to Conservation Science: A Collection of Robert Feller's Published Works on Artists' Paints, Papers, and Varnishes* (Pittsburgh, 2002)

Vehicle [binding medium]. Liquid in which dry pigments are dispersed to make paint. The vehicle may modify the appearance of the pigments, as in oil acrylic and encaustic paints. In watercolour and casein paints, the vehicle has little visual effect and serves only to bind the pigments into a film and to adhere them to the support.

Vellum. Skin of a calf, which is treated for use as a fine quality writing or drawing support. Vellum is sometimes used incorrectly as a substitute for the generic term PARCHMENT, which refers to any animal skin, including also that of kids and lambs.

P. Werner: *Vellum Preparation: History and Technique* (New York, 1999)

Veneer. Thin sheets of decorative material, usually wood, but also occasionally ivory, tortoiseshell or brass, used to cover the surface of furniture constructed of coarser and cheaper wood (*see* MARQUETRY, §1 and WOOD, §III, 1).

Vernis Martin. Generic term used for all types of japanning produced in France in the 18th century. It takes its name from the production of the brothers Guillaume Martin (*d* 1749) and Etienne-Simon Martin (*d* 1770), from a Parisian family of tailors, who perfected a form of japanning based on copal resin (*see* LACQUER, §I, 3(iii)). The brothers were granted letters of patent on 27 November 1730, renewed on 18 February 1744, for an exclusive monopoly lasting 20 years to make 'all sorts of works in relief in the manner of Japan and China'. On 15 April 1753 a further renewal of the monopoly stated that the Martin brothers had 'brought the technique to the highest possible level of perfection'. Two younger brothers, Julien Martin (*d* 1782, and known as Martin le Jeune) and Robert Martin (1706–65), joined the business after 1748, when the factory, operating three separate workshops in Paris, was described as 'Manufacture Royale des Vernis Martin'. Guillaume Martin's son, Guillaume-Jean Martin (*b* 1743), and Etienne-Simon Martin's son, Etienne-François Martin (*d* 1771), also joined the family business. All the Martin brothers and sons, with the exception of Martin le Jeune, held the title 'Vernisseur de Roy'. Robert Martin's son, Jean-Alexandre (1739–after 1791), worked for Frederick the Great (*reg* 1740–86) at Sanssouci and was appointed Vernisseur du Roi there in 1760. Voltaire was a client, and mentioned the elder brothers Martin twice: in *De l'Egalité des conditions* he referred to 'the gilt and varnished panels by the brothers Martin', made for Mme de Chatelet's Château de Cirey in 1738, and in *Les Tu and les vous*, he praised 'these Cabinets where the Martin have surpassed the art of China'. The technique developed by the elder brothers was so successful that it was quickly imitated by numerous makers; these imitations became generically known as *vernis Martin*. The Martin family remained active until the last decades of the 18th century.

Vernis Martin is applied in a similar manner to true lacquer. It was produced in many different colours ranging from black, red and a deep, Prussian blue (e.g. *secrétaire en pente, c.* 1750–60; Paris, Musée des Arts Décoratifs) to paler or clear shades of green, lilac and yellow fashionable in the Rococo style. White *vernis Martin* often underwent a chemical reaction and could turn bright yellow (e.g. *table en chiffonnière, c.* 1765; Paris, Musée Nissim de Camondo). An imitation aventurine lacquer, powdered with gold, brass or copper, was also produced (*see* LACQUER, §I, 3(iii)).

The Martin brothers not only reproduced and repaired East-Asian lacquer, but adapted the technique to the current styles in France, creating japanned panelling in the apartments of the Dauphine at Versailles (1748–9), and in the Château de Bellevue and the Hôtel d'Ormesson for Mme de Pompadour (1721–64). They also lacquered such European forms as carriages, sedan chairs, furniture, and smaller items such as fans, toilet accessories, *étuis* and snuff-boxes. The *marchand-mercier* Lazare Duvaux (?1703–58) commissioned many items of furniture from Etienne-Simon Martin between 1755 and 1759, among them a mirror frame with gold and aventurine lacquer.

Unpublished sources
Paris, Archives Nationale [inventory of crown furniture (1760)]

Bibliography
L. Courajod, ed.: *Livre journal de Lazare Duvaux*, 2 vols (Paris, 1873)
G. Brière: *Le Château de Versailles* (Paris, 1910)
H. Vial, A. Marcel and A. Girodie: *Les Artistes décorateurs du bois*, 2 vols (Paris, 1922)
A. Czarnocka: 'Vernis Martin: The Lacquerwork of the Martin Family in Eighteenth-century France', *Studies in the Decorative Arts*, ii/1, (Fall 1994), pp. 56–74
T. Wolvesperges and D. Alcouffe: *Le meuble français en laque au XVIIIe siècle* (Paris, 2000)
T. Wolvesperges: 'A propos d'une pendule aux magots en vernis Martin du musée du Louvre provenant de la collection Grog-Carven', *Revue du Louvre et des musées de France*, li/4 (2001), pp. 66–78

Video art. Term used to describe art that uses both the apparatus and processes of television and video (*see also* MAGNETIC TAPE). It can take many forms: recordings that are broadcast, viewed in galleries or other venues, or distributed as tapes or discs; sculptural installations, which may incorporate one or more television receivers or monitors, displaying 'live' or recorded images and sound; and performances in which video representations are included. Occasionally, artists have devised events to be broadcast 'live' by cable, terrestrial or satellite transmission. Before video production facilities were available, some artists used television receivers and programmes as raw material, which they modified or placed in unexpected contexts. In 1959 the German artist Wolf Vostell (1932–98) included working television sets in three-dimensional collage works. In the same year Nam June Paik (1932–2006) began to experiment with broadcast pictures distorted by magnets. He acquired video recording equipment in 1965, after moving to New York, and began to produce tapes, performances and multi-monitor installations (e.g. Moon is the Oldest TV, 1965, reworked 1976 and 1985; Paris, Centre Georges Pompidou). Paik is generally acknowledged to be the single most important figure in the emergence of video art, but he was not alone in grasping the artistic potential of electronic media. Several American independent film makers, including Stan Vanderbeek (1927–84) and Scott Bartlett (1943–90), made use of video processes to develop new kinds of imagery, although the end result was usually a projected film. Others, such as Steina (*b* 1940) and Woody Vasulka (*b* 1937), used electronic skills to produce elaborate transformations of television camera images on videotape.

By 1969, when the Howard Wise Gallery, New York, presented the landmark exhibition *TV as a Creative Medium*, a fascination with electronic effects and complex imagery had been joined by other concerns. With the rise of conceptual art, many artists who explored relationships between themselves, the physical world and other people used video as a

convenient medium for recording events. Bruce Nauman (*b* 1941) employed both film and video for his explorations of the relationship between the body and the spaces of the room and screen, while William Wegman (*b* 1943) brought the form of the television comedy sketch into the service of his own distinctive sensibility. Terry Fox (*b* 1943) used household objects in close-up in *Children's Tapes* (1974) in order to enact tiny melodramas demonstrating the laws of physics. Some artists engaged themselves with the specific qualities of video and the equipment involved, such as the camera, microphone and monitor. Joan Jonas (*b* 1936) made performance tapes in which the properties of video were made to interact with her own activity in front of the camera. *Organic Honey's Vertical Roll* (1972) features the insistent rhythmic jump of her image on a 'wrongly' adjusted monitor.

In Europe, until *c.* 1970, when video recorders became available outside commercial and scientific institutions, artists' concern with video was largely either theoretical and speculative or dependent on broadcast television as a foil and means of production. In the former Federal Republic of Germany, Gerry Schum (*d* 1974) developed the notion of a 'Gallery on TV', in which avant-garde artists could present their work in purely televisual terms, free from the distractions of physical artefacts or of programme narration or interpretation. The artists performed or directed activity for the camera, keeping in mind the eventual context of the television screen, creating not a film about the artist but a work by him or her. Schum produced two 'TV Gallery' compilations, *Land Art* (1968) and *Identifications* (1969). In 1970 he established the Videogalerie Schum in Düsseldorf, where he made and sold video-art tapes. In 1971 *Seven TV Pieces* by David Hall (*b* 1937) appeared on Scottish Television, interrupting regular programmes without announcement or explanation. In each, the filmed event emphasized the physical presence of the television set with which it was viewed, as when the set appeared to fill with water, which then drained away at a totally unexpected angle. In subsequent video installations and tapes, Hall drew attention to the illusory nature of television images, placing video art in confrontation with broadcast television.

In the 1970s a number of artists in Europe and the USA shared a commitment to video art as an autonomous form, rather than as documentation or a source of abstract imagery. An aesthetic evolved associated with conceptual art, which was concerned with ideas as well as images: it was characterized by real rather than edited timescales and by the use of closed-circuit, multi-monitor installations. This tendency, typified by the installation of Dan Graham (*b* 1942), was prominent in the exhibitions *Projekt '74* at Cologne; *The Video Show* (1975) at the Serpentine Gallery, London; a show at the Tate Gallery, London (1976); and at the Kassel *Documenta* of 1977.

In the late 1970s work by Bill Viola (*b* 1951), Kit Fitzgerald and John Sanborn suggested a reaction against the self-referential tendency, accompanied by an advance in video production techniques. Their tapes often deployed broadcast facilities provided by television companies and demonstrated a sophistication in the montage of image and sound that would become standard during the next decade. Dara Birnbaum (*b* 1946), with her use of edited fragments of 'found' television material combined with rock music soundtracks, influenced the later British genre of 'Scratch Video', a style made popular by George Barber and the Duvet Brothers and quickly appropriated by directors of television programmes and popular music videos.

During the 1980s video art established its own context of production, exhibition and criticism, with organizations emerging in North America and western Europe to support and promote 'video culture'. Television producers began to buy and commission work from artists, and specialist venues, festivals, courses and workshops for video proliferated. Many artists made work addressing social, sexual and racial issues, renewing links with what survived of the 'community video' movement of the 1970s. By 1990 video installations had featured in several large international exhibitions and were a familiar presence in galleries and museums, assuming fresh authority through the work of such artists as Gary Hill (*b* 1951) and Marie-Jo Lafontaine (*b* 1945). Artists making single-screen work exhibited increasingly on television, and the medium of video was merging with that of the computer (see COMPUTER ART). Video art, no longer novel nor wholly dependent on a gallery context, had become part of an increasingly elaborate network of electronic communication.

See also EXPERIMENTAL FILM; MOTION PICTURE FILM.

Video Art (exh. cat. by D. Antin and others, Philadelphia, PA, University of Pennsylvania, Institute of Contemporary of Art, and elsewhere; 1975)

D. Hall, ed.: *Studio International* (May–June 1976) [special issue on video art]

I. Schneider and B. Korot, eds: *Video Art: An Anthology* (New York and London, 1976)

Het lumineuze beeld: The Luminous Image (exh. cat. by D. Mignot; Amsterdam, Stedelijk Museum, 1984)

J. G. Hanhardt, ed.: *Video Culture: A Critical Investigation* (New York, 1986)

R. Payant, ed.: *Vidéo*, Artextes (Montreal, 1986)

W. Herzogenrath and E. Decker, eds: *Video-Skulptur: Retrospektiv und aktuell, 1963–1989* (Cologne, 1989)

D. Hall and S. J. Fifer, eds: *Illuminating Video: An Essential Guide to Video Art* (New York, 1990)

C. Meighs-Andrews: *A History of Video Art: The Development of Form and Function* (New York, 2006)

A. Clarke and G. Mitchell, eds: *Videogames and Art* (Chicago, 2007)

M. Rush: *Video Art* (New York, 2007)

Videotape. See MAGNETIC TAPE.

W

Wall painting. Painting applied to a prepared wall surface.

I. Techniques. II. Conservation.

I. Techniques.

1. Introduction. 2. Antiquity. 3. Asia. 4. Western.

1. INTRODUCTION. At the outset, it is necessary to outline the various stages of a wall painting, the variations of which distinguish one technique from another. Of primary importance are the composition of the rendering or plaster ground and the method in which it is applied. Renderings may be clay-based or composed of lime plaster, to name the two most common types. They are often applied in several coats: in the Western tradition the first, rough coat of plaster is known as the *arriccio* and the final, smooth layer(s) on which the mural is executed as the *intonaco*. When lime plaster is used, the condition of the *intonaco* layer is a factor in determining whether the work is painted *a fresco* or *a secco*: FRESCO painting is executed on a damp *intonaco*, so that the pigments are fused to the wall by the carbonation of the calcium hydroxide from the wet plaster; SECCO painting is carried out on a dry rendering with the pigments fixed by binders. Also in the case of lime plaster, a basic distinction is drawn between two different ways of applying the *intonaco* layer. In the *pontate* system, the *intonaco* is applied in broad horizontal bands that correspond roughly in height to the levels of scaffolding (It. *ponteggio*). This method is used when large surface areas are to be painted quickly *a fresco*, or when a lot of secco work is envisioned. For a fresco painting, however, the *intonaco* can also be applied in smaller patches of varying sizes known as *giornate*. These represent the amount of work that can be painted in one day (It. *giorno*) while the plaster is fresh. The medium in which the pigments are applied is one further feature that characterizes the overall technique of the wall painting. In *buon fresco* (or true fresco) the pigments are ground in pure water and applied to a wet *intonaco* of lime plaster. For secco painting a variety of binders, including egg, glue, casein and drying oils, can be used to secure the pigments to the dry ground. Two important intermediate techniques are 'lime fresco', a fresco technique in which the pigments are ground in lime water or milk of lime to increase their opacity, and LIME SECCO, in which the pigments, similarly mixed with lime water or milk of lime, are applied to dry lime plaster that has been wetted down. The preparatory underdrawing of a wall painting, applied before the pigments, is called a SINOPIA.

2. ANTIQUITY.

(i) Prehistoric. The earliest surviving wall paintings, which date from the Upper Paleolithic period (40,000–10,000 BC), were generally produced with a limited range of earth pigments and black, usually manganese dioxide, applied by hand or brush on to the bare rock interior of caves. Alternatively, dry pigment was blown through a tube on to a wall surface coated with mixtures of grease, blood and urine. In the limestone cave at Lascaux in south-western France the pigments may have become fused to the wall by the natural presence of calcium carbonate in a process of crystallization. Some Australian Aborigines continue to use similar techniques. During the Neolithic period (8000–3000 BC) wall paintings began to be applied to architectural structures, and clay renderings were used for the first time, sometimes covered by a thin whitewash of plaster. In the secco paintings (*c.* 6500–5700 BC) discovered at Çatal Hüyük in Turkey, the pigments were found to include not only earth, clay and carbon colours but also haematite and azurite. Whether a binder was employed could not be ascertained.

(ii) Egypt and the Ancient Near East. In Egypt the Neolithic secco techniques were elaborated and refined. The rendering was composed of fine-grained silt from the banks of the Nile, containing sand, clay and a little calcium carbonate, mixed with straw or other fibrous materials. The final coats were made of gypsum plaster prepared from heated raw gypsum (calcium sulphate) and usually applied in two layers, the second finer and smoother than the first. Painting was carried out after the plaster had dried using a water-soluble binder with a gum or gelatin base. A set working procedure can be reconstructed from the tomb paintings. First the wall was divided with grid lines by snapping a cord coated with red pigment. Preliminary drawings were made in red, and then the

contours were reinforced in black. The outlines were filled in with areas of flat colour and the details added on top. The Neolithic palette was enhanced by the addition of Egyptian blue, which is a copper-based frit and the earliest known artificial pigment.

The cultures of Mesopotamia practised a secco technique similar to that of the Egyptians, with a rendering composed of clay and chopped straw covered by a lime plaster final coat. There is some evidence, however, that fresco techniques were also employed. The paintings that decorated the palace of Yarim-Lim at Tell Atchana (*c.* 1800 BC) were executed on brick wall sometimes prepared first with clay and then covered with two coats of lime plaster, the first layer measuring 4–8 mm, the second (of pure lime) no more than 1 mm. The murals may have been painted largely *a fresco* with secco highlights. If this is so, they constitute the earliest known fresco paintings.

(iii) Pre-Columbian Americas. The painters of ancient Mesoamerica knew of and developed two basic techniques, namely tempera and fresco. Tempera, as used in some murals at Teotihuacán, Chichén Itzá and Tizatlán, was applied over dry, levelled mud; the pigments were mixed with a binder made from native gums such as *tzautli* or secretions from the prickly pear cactus or from orchids. The fresco technique was used at Monte Albán, Bonampak, Cacaxtla and Teotihuacán: the wall was first rendered with a thick coat of fine mud mixed with crushed *tezantle* (a red volcanic rock), then a thin layer of plaster made of lime and pumice sand or obsidian dust was spread in sections and the design was then traced on to this surface in a dilute red paint. The pigments were mixed with lime and water and applied to the wet plaster without shadowing; later the figures were outlined in red or black. Finally, when both the coat of clay and the paint were dry, the surface was thoroughly polished in order to make it more durable.

The pigments used were mainly of mineral origin: orange and red from iron oxide; ochre or yellow from iron hydroxide; green from copper bicarbonate (blue malachite); and blue from sodium silicate and aluminium silicate. The colour known as 'Maya blue'—found at Bonampak and Cacaxtla—was, however, made up of *atalpujita* and indigo. The pigments were placed in earthenware pots and applied with animal-hair brushes of different thicknesses. Their use was so common that they are known to have been on sale in the large city markets.

The technology of Central Andean wall painting was relatively simple and changed little through time or between cultures. Two basic techniques were employed. In one technique the walls were first plastered, then covered with a layer of thick paint on which the designs to be painted were marked out by incisions. In most cases the designs were made after the surface had dried, but this was also sometimes done when the undercoat was still wet. The designs thus marked out were filled with colour. In the second technique the plastered walls were either painted

on directly, or the painting was done on a dense, white undercoat, without incising and filling.

There has been a great deal of speculation about the pigments used, but few actual chemical analyses have been done. It is thought that basic pigments were obtained from cochineal, from several molluscs and from minerals. All pigments so far analysed, however, have proved to be exclusively of mineral origin. There is little doubt that a fixative material was used, but it has not been possible to determine the exact origin of this organic substance. Historical and ethnographic data indicate that it was of plant origin, and some chroniclers of the 16th century and beginning of the 17th state that the indigenous peoples used the sap of the cactus *Trichocereus* Riccob—of which 12 species are known in Peru—as a fixative when they painted their houses. More recent ethnographic data shows that on the north coast of Peru the gum of the sapota, or zapote, tree (*Capparis angulata*) is used for the same purpose. In Mediterranean cultures gum arabic, obtained from several varieties of the acacia tree, was used as a colour fixative, and in Peru a member of this plant family, the *huarango* (*Acacia macracantha*), is common and could also have been used.

There has also been much speculation on the technical category to which these paintings belonged. Most wall paintings have been claimed to be frescoes, but this is technically incorrect. The technique of fresco painting was known only in Mesoamerica and was not known in the Central Andean region before European contact. All Andean wall paintings were water-based with some glutinous substance added as a fixative and are therefore technically matt distemper paintings.

(iv) Greece and Rome. The wall paintings surviving from Crete and Mycenae seem to represent a tradition intermediary to those of the Ancient Near East and Greece. The exact nature of the techniques used has aroused controversy, but recent evidence indicates that fresco techniques were known in Crete by the 2nd millennium BC and that the use of an unusually thick *intonaco*, which dried very slowly, enabled fresco painting to continue over a period of days without the necessity of a *giornate* technique. There is abundant evidence that preliminary sketches were carried out on the *intonaco* in *sinopie*. The range of pigments corresponds to the palette used in the Ancient Near East, generally comprising earth minerals with the exception of Egyptian blue.

Although little evidence of mural painting survives *in situ* from ancient Greece, the Greek traditions are reflected in Etruscan painted tombs in Italy dating from the 7th century BC to the 1st. Etruscan wall paintings exhibit a range of techniques, but the dominant method was fresco on a natural tufa wall prepared with a rough lime plaster rendering and finished by a thin lime whitewash. Preparatory sketches were engraved with a stylus in the fresh rendering and then gone over with chalk. Colours were applied in flat tones circumscribed by emphatic black contour lines.

In ancient Rome, the wall was prepared with a rough *arriccio* of lime and sand on which *sinopia* sketches were often carried out. Several *intonaco* layers composed of lime and powdered marble were then applied using the *pontate* system and polished with a hard instrument to achieve shiny, transparent effects, often in imitation of marble veneers. The *pontate* were sometimes also subdivided into *giornate* following the outlines of architecture or figures. Alternatively, as in the late Fourth Style murals at the House of the Vettii in Pompeii, more complex inserted pictures could be executed after the remainder had been completed by cutting out and replacing the *intonaco* for the circumscribed areas with fresh plaster (see colour pl. XV, fig. 1). Roman murals of this type were painted *a fresco*, but the pigments were probably mixed with lime water or milk of lime with a clay such as kaolin added. As a finishing touch, wax was applied to the surface for protection and to enhance the rich, shiny appearance. Pliny the elder (AD 23/4–79) also mentioned a form of wall painting (*cretula*) carried out on dry, clay-based renderings (*Natural History* XXXV, xxxi), which suggests that more traditional secco techniques were also current.

3. ASIA. As in the Ancient Near East, the techniques used in Asia have evolved on the whole from the secco methods of the Neolithic period. In Iran, little is known of the wall paintings from early times, although a few examples have survived of frescoes painted on polished lime-based renderings in a technique reminiscent of Classical Roman works. By contrast, the large body of paintings from the Safavid period (1501–1732) seem to reflect traditional secco methods. A clay-based rendering would be completed by a gypsum plaster final coat and painted when dry using tempera binders, perhaps egg. Lavish gilding was applied with gum arabic.

The similar secco wall-painting tradition of India is described in a series of Sanskrit texts dating from the 4th century AD to the 16th. According to these writings, the wall was prepared with a thick rendering composed of clay, straw or other fibrous materials and sometimes also granular matter. Then the finishing coats, made from white clay and gypsum or lime, were applied in one or more thin, smooth layers. The binders recorded include gums, resins, wax, sugars, saps and oil. Study of the surviving murals suggests, however, a technical development: from secco painting on a thin clay rendering, as found in the earliest preserved murals in Buddhist rock temples (e.g. the Jogimara Caves of the Ramgarh Hill, probably 2nd century BC), to an intermediary secco method resembling the textual descriptions, as found in Buddhist murals up until the 6th century AD (e.g. the 5th-century examples from the Gupta period in the Ajanta caves), and culminating in what may be an early form of fresco painting, involving the use of renderings composed of lime and sand. For the murals (8th–9th centuries) in the Jaina temple at Sittannavasal, near Madras, a rendering of lime and sand was covered with a thin wash of pure lime that

may have been painted while wet. This method was employed for temple wall paintings as late as the 18th century. An extensive range of pigments has been identified in Indian works, including lapis lazuli from Afghanistan. However, the binding media for the secco paintings are unknown.

Another Indian fresco technique is the so-called *fresco lustro*, still practised in Rajasthan and represented earlier by the 18th-century murals of the Amer Fort, near Jaipur. The rendering, composed of slaked lime, sand, limestone and marble powder, is beaten on to the wall using a flat stick. The finishing coat, made of very fine slaked lime and casein, is then brushed on to a small area, polished and painted while wet, using a gum or glue binder. The polishing before and after painting helps to incorporate the pigments and lends a special shine to the surface.

In Central Asia and China there are many examples of Buddhist wall paintings in the major temples along the pilgrim route. They date from the 3rd century AD to the 10th and were executed in a limited variety of secco techniques similar to those found in the early Buddhist wall paintings in India (see fig.). Generally a clay and straw rendering was covered by a thin final coat of lime, gypsum or kaolin (a pure clay) applied with gum or starch, which were probably also used to bind the pigments.

Nearly all the surviving wall paintings from Thailand date from the 17th century onwards. These are typically painted using gum made from tamarind seeds on dry lime-based renderings. Similar techniques were employed in Burma.

Two associated wall painting sites from Korea and Japan also merit consideration, as they may represent early examples of the fresco technique and possibly relate to contemporary work in India. These are the murals in the tombs near P'yŏngyang in Korea (5th–7th centuries AD) and the paintings in the tomb of Takamatsuzuka (late 7th century) in Japan. At Takamatsuzuka the colours, applied to a very smooth lime plaster, are fused to the surface through carbonation. However, the murals of the nearby temple of Hōryūji (*c.* AD 700; destr.) include secco work in mineral pigments on renderings of mud and sand.

4. WESTERN.

(i) Early Christian and Byzantine. During the Early Christian period the methods used in Roman times were continued in a much simplified form. In the catacombs, for example, fresco paintings were executed rapidly on thinner, two-layer renderings in large *pontate*. By the 5th century, however, more elaborate methods had developed. The mural techniques characteristic of the Byzantine world were recorded in a series of texts known as the *Ermeneia* ('Interpretation'). These survived in later recensions, the best known being the 'Mt Athos Painters' Guide' by Dionysios of Furna (*c.* 1670–after 1744), which was probably composed between 1730 and 1734. Examination of remaining murals affirms the reliability of Dionysios's account. The work was carried

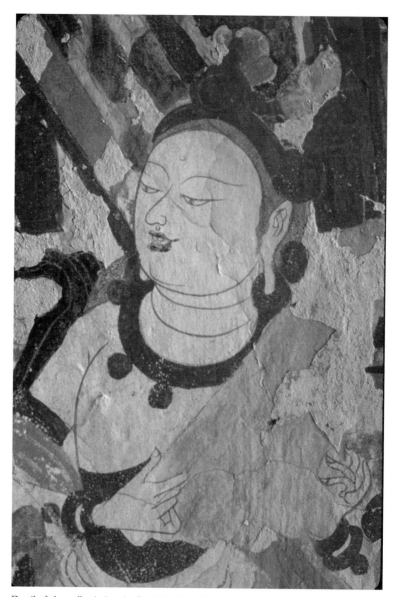

Detail of the wall paintings in Cave 85 of the Mogao grottoes, Dunhuang, where the Getty Conservation Institute is collaborating with the Dunhuang Academy on a wall paintings conservation project; the rock temples of Mogao were created by carving into the soft conglomerate rock cliff face and plastering the walls with a mixture of local clay, sand and hemp fibres; to prepare the surface for painting, a second layer of finer clay plaster was applied, and over this, a thin white coloured ground was added; line drawings were made over the ground to outline the figures; mineral and organic colours were added later (Los Angeles, CA, Getty Conservation Institute); photo © The J. Paul Getty Trust, all rights reserved

out *a fresco* on lime-based renderings to which fibrous materials had been added, following the Asian clay-based tradition. The *intonaco* was applied using the *pontate* system, and the area to be painted was then polished to draw the calcium hydroxide to the surface and ensure carbonation. Deep, lustrous tones resulted. Working within a relatively formulaic iconographic system, Byzantine artists seem usually to have omitted the *sinopia* stage and outlined their

compositions on the *intonaco* layer. Colours were modelled in a series of overlays, with a unified ground tone applied first to each part of the composition, middle tones painted on top, highlights and darker shadow tones added as a third step and, finally, the contours of the picture reinforced. Although the Byzantine fresco tradition continued in the Balkans up until the 19th century, in Russia from the 15th century the desire to imitate icon

painting led to an increased use of decorative secco effects.

(ii) Medieval. Romanesque wall painting seems to be a version of the Byzantine method, with regional variations due to the influence of local techniques that survived from the late Roman era. Lime plaster was used and the *intonaco* applied according to the *pontate* system, but the Byzantine technique of polishing was abandoned. The tradition of modelling through successive overlays continued in a simplified form, and the final layers of colour, now largely lost, seem to have been applied once the *intonaco* had dried using binders or by dampening the plaster and applying pigments in a lime medium (i.e. lime secco; see SECCO, colour pl. XIII, fig. 3). In northern Europe decorative relief techniques, especially gilded stucco, became popular, and the *Zackenstil* artists of 13th-century Germany used gilding extensively.

Decorative and translucent effects achieved through secco techniques, including the use of oil as a binder, reached a peak of popularity, however, during the Gothic period. Although in Italy fresco painting remained the standard method, northern European artists strove to reproduce some of the aesthetic effects of stained glass and the decorative arts in their murals. In such projects as the Sainte-Chapelle (1239–43), Paris, artists experimented with transferring the rich techniques of panel painting to the wall. The wall surface was plastered and then treated with a white priming to enhance the luminosity of the paint layers. Painting was carried out *a secco*, and binders capable of creating translucent effects, particularly oils and varnishes, were selected. Glazing was used over opaque ground tones and metal leaf. The surfaces were also extensively gilded and encrusted with glass pieces and gemstones to maximize the decorative effect.

(iii) Renaissance. In the late 13th century and the 14th, the methods that were to be perfected during the Italian Renaissance were introduced and developed, particularly in the work of the Isaac Master (*fl c.* 1290s) and Giotto (1267/75–1337) and his followers. These methods are described in greater detail in FRESCO.

The most widespread early Italian technique involved painting in true fresco on *giornate* with some areas completed *a secco*. The procedure is described in detail in *Libro dell'arte* (*c.* 1390) of Cennino Cennini (*c.* 1370–*c.* 1440). An *arriccio* composed of one part lime to two parts sand was applied to the entire wall space and left rough to provide a tooth for the *intonaco*. Compositional drawings were sketched in charcoal on the *arriccio* and then gone over in *sinopia* with a brush. This enabled the exploration of increasingly complex pictorial conceptions including perspectival settings. The process of execution could then be mapped out and the *giornate* divisions determined. After an area had been covered by *intonaco*, the drawing would be retraced, perhaps from memory. Sketches on parchment or paper may have been used, though none survives from the 14th century.

The amount of secco work varied considerably from artist to artist and even between compositions by the same artist. For instance, Giotto and his workshop painted the Arena Chapel in Padua (*c.* 1303–6) using the true fresco technique with only small additions *a secco*, but for the Peruzzi Chapel at Santa Croce in Florence (probably 1320s) the *intonaco* was applied using the *pontate* system and painted *a secco*. Secco techniques were used most extensively in Siena, as in the *Maestà* (1315–16; Siena, Palazzo Pubblico) by Simone Martini (*c.* 1284–1344), painted largely in a decorative secco method reminiscent of northern European Gothic works with large amounts of glazing, gilding and distinctive haloes moulded in relief.

During the 15th century the *sinopia* was gradually replaced by other forms of transfer more suitable for the increasingly complex designs. Squared grids, described by Leon Battista Alberti (1404–72), were used to enlarge and transfer small-scale studies (e.g. the face of the Virgin in the *Trinity* (*c.* 1428) by Masaccio (1401–28); Florence, S Maria Novella). POUNCING came into use for detailed passages by the mid-15th century, and by the late 15th century the technique of incising into the *intonaco* layer through the contours of a CARTOON was being employed in Florence.

In the High Renaissance period some Florentine artists experimented with the more subtle colouristic and modelling effects possible in secco work. Leonardo da Vinci (1452–1519), in particular, painted the *Last Supper* (1495–8) at S Maria delle Grazie in Milan on a dry ground with a lead white priming layer and tempera binders, probably egg with a little drying oil. Michelangelo (1475–1564), in contrast, held *buon fresco* to be the most elevated technique and for the Sistine Chapel Ceiling (1508–12; Rome, Vatican) employed the fresco methods developed during the 15th century. The wall paintings by Raphael (1483–1520) and his school in the Stanza della Segnatura (e.g. *School of Athens* and *Disputa*), the Stanza dell'Incendio and the Stanza d'Eliodoro at the Vatican (1509–11, 1511–14) reflect his concern to enrich the mural painting repertory with methods drawn from contemporary easel painting. The flat, linear characteristics of fresco are replaced by more textured brushwork and surface finishes. In the Sala di Costantino (1519–20), carried out by Raphael's school, the aesthetic potential of oil painting is juxtaposed with that of fresco: allegorical figures of Justice and Comity in oil frame and contrast with fictive tapestries of Christian narratives painted *a fresco*. Such technical effects were picked up by several of the Mannerists and used in simulating different levels of reality within an image. In Venice canvas was the preferred support, and such artists as Paolo Veronese (1528–88) strove to imitate the textural qualities of a coarse canvas weave by working in fresco on a rougher plaster ground with more emphatic brushwork (e.g. *c.* 1561; Maser, Villa Barbaro).

(iv) Baroque and after. Although some Italian Baroque artists, including Michelangelo Merisi da Caravaggio

(1571–1610), worked in oil on canvases that were then fixed to the wall, in general the fresco method continued to be used with adaptations. On account of the extreme complexity of architectural settings and compositions, the stages of preparatory drawing evolved to include detailed coloured sketches and oil studies. Coloured grounds were sometimes used, and to allow for the textural effects favoured during the period the *intonaco* layer was roughened. The pigments were applied more thickly and unevenly, perhaps sometimes with the addition of lime to increase the opacity of the colours. In France a type of secco work known as marouflage was preferred. It involved painting in oil on canvas that was glued to the wall using an adhesive cement made of resin and wax or white lead in oil.

In the late 18th century the monumental style and complex perspectives of Baroque mural painting fell out of favour. Some Neo-classical artists became absorbed with discovering the technique of ancient Roman mural painting, which led to experiments with ENCAUSTIC PAINTING, while others explored various methods of secco painting. In the early 19th century, however, the Nazarenes' nostalgia for the styles and methods of the Italian Renaissance led to a somewhat rigid revival of *buon fresco* techniques. This was followed by an increasing scholarly interest in historic techniques (e.g. in the work of Mary Philadelphia Merrifield (?1804/5–89)) and some imitation of them. Despite this, wall painting was usually carried out *a secco* using glue, casein or oil as binders (e.g. by Thomas Gambier-Parry (1816–88)) or done in marouflage: the underlying trend, which continued into the early 20th century, was to borrow the techniques of canvas painting in an effort to reproduce textural effects on the wall.

In the 1920s a revival of fresco painting took place in several countries, especially Mexico, where Diego Rivera (1886–1957) adapted the *giornate* technique for his epic compositions. On the whole, however, fresco painting has been abandoned. More and more synthetic commercial products have been introduced for secco painting, including resins, acrylic and vinyl on a variety of supports.

II. Conservation. Conservation treatments are geared so specifically to the unique features of each site that only certain facets of the subject permit generalizations of the kind necessary in a survey article. The basic causes of deterioration can be enumerated, however, as well as the general approaches that have been adopted to stabilize and restore wall paintings.

1. Causes of deterioration. 2. Treatment.

1. CAUSES OF DETERIORATION. Three general categories of deterioration, which often operate together, can be distinguished: they relate to environmental factors, the method in which the painting was executed and earlier conservation treatments.

(i) Environmental factors. Among the environmental factors detrimental to wall paintings moisture is the most critical, both because it is so frequently present and because it initiates several types of deterioration. The sources of moisture comprise the infiltration of water from leaking roofs and walls (or from rain and wind when the wall occupies an exposed location), moisture rising in the walls from the ground due to capillary action, the condensation of moisture from the air on cold walls and the absorption of moisture by hygroscopic materials in the mural layers.

The principal type of alteration due to moisture is caused by soluble inorganic salts, which migrate through the wall and recrystallize. These salts can originate within the components of the wall, in the soil or in the atmosphere. They can be deposited by pests, or they can result from later conservation treatments. The most damaging are the sulphates of sodium, potassium, magnesium and calcium. Such salts often crystallize on the wall painting and disfigure the surface, but they can also recrystallize within the rendering and cause disintegration by expanding.

If harmful compounds are present in the air, damage takes place when water passing through the paint layer initiates chemical reactions between gases in the atmosphere and the materials of the painting. Among the natural gases, carbon dioxide, a component of the air and one of the by-products of human respiration, can cause serious damage to paintings on lime-based renderings. In the presence of water, carbon dioxide is transformed into carbonic acid, which acts on lime plaster to produce white incrustations of insoluble calcium carbonate on the surface. The detrimental effects on fresco paintings of sulphur dioxide, found in polluted urban environments, have been recognized only recently. In moist air the gas is transformed to sulphuric acid, which reacts on the lime renderings to change surface areas into calcium sulphate, a white efflorescence, with an increase in volume that results in surface disintegration.

Biological organisms, for example bacteria and moulds, flourish in damp areas on the surface of wall paintings. They appear as spots or stains, spread quickly and may cause large areas of disfigurement or colour loss. Extremes of temperature, which lead to the expansion and contraction of moisture within the mural layers, can also cause disintegration. In addition, in the presence of moisture the hues of some pigments undergo changes caused by chemical transformations. In northern European and Italian Gothic wall paintings, for example, azurite blue used for areas of sky or to depict the vault of heaven has often been transformed into its green relative, malachite.

Other environmental factors responsible for damage include wind exposure, which can lead to surface erosion, and exposure to strong light, which causes some colours to fade. The heat from isolated sources, for example candles, may damage limited areas of a painting's surface. Intermittent overall heating of churches and monuments, which alters the temperature and relative humidity, can cause damage by destroying the equilibrium between the masonry and

the interior, inducing moisture exchange. In addition, surface deposits of dust can be problematic, clouding the surface and providing a site for bacterial growth.

(ii) Painting methods. Deterioration can result from the composition and method of application of any one of the layers of the painting: support, rendering or pigment layer. The support may not be strong enough to resist weathering over an extended period of time, as in the case of unbaked brick walls when the bricks are of poor quality and contain salts. Moreover, walls made of heterogeneous substances that differ in porosity and thermal conductivity, such as brick combined with stone, can cause condensation in areas of the paint surface, which leads to staining due to salts or biological organisms. Clay-based renderings tend to be very friable and extremely sensitive to moisture; they have usually been employed only in regions with very dry climates. Lime-based renderings can also be delicate, because they often absorb moisture from the air. If one component of the lime plaster is gypsum, the calcium carbonate will have a more marked tendency to be transformed into calcium sulphate when sulphur dioxide is present in polluted air. When walls are prepared for fresco painting, particular care must be taken in the choice and mixing of the lime and filler ingredients. Straw and other vegetable fibres, which are often added to ensure cohesion, also absorb moisture. The moisture provides conditions favourable to biological attack and in freezing temperatures can expand in volume, which leads to problems within the rendering and paint layers. In secco painting, on the other hand, a rendering that is too powdery may adhere poorly and cause the paint layer to flake, particularly if the binding medium used was too concentrated and contracted too much on drying.

The way in which the paint layers were applied can also in part determine the extent of deterioration. Whereas skilfully executed *buon fresco* paintings tend to be relatively resistant to deterioration because the pigment layer is fused to the lime plaster ground, secco wall paintings are often more fragile. The traditional binders, which include egg, oil, glue, casein and lime, often lose their adhesive power over time, and this leads to the flaking of the paint layer. For instance, in Romanesque wall paintings that were painted in superimposed layers, typically little remains of the final modelling layers of the compositions. With the advent in the 20th century of modern secco techniques, which employ newly manufactured synthetic products in highly personal and eclectic ways, numerous conservation problems have arisen due to as yet poorly understood defects in the materials and methods.

(iii) Previous conservation treatments. Until early in the 20th century it was common to apply substances to the surface of wall paintings to heighten the colours or to improve adhesion, including varnish, oils, waxes, fats and glue. These often cause distortions in the colour balance of works. Wax, for instance, deepens the colours and creates a shine. Such substances as glue can induce cracking of the paint layers due to contraction during the drying process. Alkaline silicates have been used liberally as fixatives, but they form a cloudy veil on the surface that is very hard to remove.

2. TREATMENT. Unlike an easel painting, a wall painting is by its physical nature part of its contextual environment. Conservation is extremely complex, because the environment in which the painting is fixed is usually the principal cause of its deterioration. This fundamental problem can be approached in two contrasting ways, either by removing the wall painting from its environment through a process of detachment or by regulating the environment and then proceeding to repair the work *in situ*.

(i) Detachment. The three standard techniques of detachment developed in Italy are the *stacco, stacco a massello* and *strappo* methods. Of these, the *stacco* method is generally preferred as the least damaging. A soluble adhesive is applied to the surface of the mural, and pieces of gauze and hemp are laid on top. The *intonaco* is pounded to free it from the *arriccio*, and then a knife is used to separate the two plaster layers. The paint layer and *intonaco* are pulled away together from the *arriccio* and mounted on a new, inert support. The *stacco a massello* method is more radical as it involves the removal of the *arriccio* as well as the *intonaco*. To achieve this, the wall is hollowed out behind the painting to a depth of 100–200 mm. In the *strappo* technique only the thin paint layer is removed. A cloth, fixed with a soluble adhesive to the surface of the painting, is securely attached to an overhead beam, and when the adhesive has dried the paint layer is detached by slowly peeling the cloth away from the wall.

The detachment methods that were popular in the past salvaged wall paintings, but often at the expense of damage to the site or to the painting itself. *Stacco a massello*, entailing destruction of the wall behind the painting, was clearly a very hazardous approach. The *strappo* technique could be equally damaging, as the peeling process resulted in the pulverization of the enamel surface of the painting, which caused paint loss and impaired the original surface qualities of the work. The surface characteristics of the painting could also be substantially altered by the texture of the new support, particularly when a canvas layer was included.

Improvements are being made in detachment procedures to reduce the degree of resulting damage. For instance, wet adhesives, which sometimes caused staining on fragile works, have been replaced by dry paper foils, and suction plates pressed up against the surface are used to ease the painting gently from its site. Detachment has fallen out of favour and is resorted to only when less radical approaches have proved unviable.

(ii) Regulating the environment. With the aim of preserving the wall painting within its original context, most

modern conservation teams strive first to alleviate, in non-destructive ways, the detrimental environmental factors acting on it. This can offer a sometimes insurmountable challenge, as the sites that wall paintings occupy were typically not designed to maintain a stable environment. The initial project is generally to identify the origin of moisture through diagnostic testing of relative humidity, temperature and moisture levels and then to eliminate its cause. A wide spectrum of solutions are in practice, geared to the specific nature of the moisture problem. Obvious remedies involve repairing leaks and covering exposed walls with overhangs or inserting protective screens. To eliminate rising damp, walls can be isolated at the bottom and sides from the source of moisture by cutting through the entire thickness of the wall low down and by inserting isolating layers. Walls may be heated to avoid condensation. For underground archaeological sites, where, over the ages, the wall paintings have reached an equilibrium with the site, sophisticated systems have been designed by engineering specialists to isolate the site climatically by controlling the temperature and humidity.

(iii) Restoration. Once the environmental causes of deterioration have been alleviated or, as a last resort, the painting has been detached from its site, restoration typically proceeds in a sequence of three stages: consolidation, cleaning and inpainting. Consolidation is carried out through the application of fixatives (*see* CONSOLIDANT). The appropriate fixative must be carefully selected after the specific problem has been diagnosed, that is to say, after it has been ascertained whether the paint layer is flaking or powdering or has lost its surface qualities, or whether the rendering has lost its cohesive strength. The conservator chooses between a wide range of traditional organic or inorganic fixatives and fixatives based on synthetic resins. One important organic fixative is barium hydroxide, which has been used successfully together with ammonium carbonate solution to correct the deterioration caused by the crystallization of calcium sulphate on the surface of frescoes.

The consolidated painting is then cleaned to remove layers of dirt and other accretions. However, the extent to which these additions, whether natural or applied by man, should be removed is a subject of continuing debate. Wall paintings, although generally free from varnish, acquire a patina naturally with age as dirt particles are incorporated into the substance of the surface. Similarly, wall paintings have often acquired layers of coatings or repaintings over the centuries for reasons of taste or cult. There is a growing understanding that cleaning cannot restore a wall painting to its original state but only to the present state of the original materials, and also that every act of preservation involves subjective interpretations and judgements. After the degree of cleaning necessary has been decided, the cleaning materials and methods are selected depending on the nature of the substances to be removed and the condition and stability of the painted surfaces. The conservator makes

his choice from a range of solvents, chemical agents, detergents and biological agents and begins the cleaning process on less important areas of the work, leaving the most significant and delicate regions to the end. If the painting has been the site of biological attack, disinfection and cleaning are usually carried out by washing the surface with water containing a fungicide.

The final stage in the restoration of wall paintings is the treatment of losses through inpainting. Although in the past deceptive techniques were adopted in the attempt to return wall paintings to their original glory, a number of inpainting methods are now in use that help to consolidate and unify the composition while still preserving the distinction between the original and the restorer's hand. One widely adopted technique is *tratteggio*, in which the loss is filled with thin parallel lines of a pure hue, resolving at a distance into a neutral colour or a colour that blends in with the original. Only easily soluble paints are used. Such sensitive approaches reflect the increasing awareness among conservators of the ethical implications of their treatments, as well as a great respect for the authenticity and the historical dimensions of the paintings under repair.

See also SECCO, §2 and TECHNICAL EXAMINATION, §VIII, 6.

C. Cennini: *Il libro dell'arte* (*c.* 1390); Eng. trans. and notes by D. V. Thompson jr as *The Craftsman's Handbook: 'Il libro dell'arte'* (New Haven, 1933/R New York, 1954)

N. Heaton: 'The Mural Paintings of Knossos: An Investigation into the Method of their Production', *Journal of the Royal Society of the Arts*, lviii (1910), pp. 206–12

R. J. Gettens: 'The Materials in the Wall Paintings from Kizil in Chinese Turkestan', *Technical Studies in the Field of Fine Arts*, vi (1937–8), pp. 281–94

R. Oertel: 'Wandmalerei und Zeichnung in Italien', *Mitteilungen des Kunsthistorischen Instituts in Florenz*, v (1940), pp. 217–314

P. Duell and R. J. Gettens: 'A Review of the Problem of Aegean Wall Painting', *Technical Studies in the Field of Fine Arts*, x (1941–2), pp. 178–223

L. Woolley and others: *Alalakh: An Account of the Excavations at Tell Atchana in the Hatay, 1937–1949* (Oxford, 1955), pp. 228–34

C. Wales: 'The Treatment of Wall Paintings at the Kariye Çamii', *Studies in Conservation*, iii (1958), pp. 120–24

E. Borsook: *The Mural Painters of Tuscany from Cimabue to Andrea del Sarto* (London, 1960, rev. Oxford, 1980)

J. Mellaart: 'Excavations at Catal Hüyük', *Anatolian Studies*, xi (1961), pp. 159–95; xii (1962), pp. 41–65

U. Procacci: *Sinopie e affreschi* (Milan, 1961)

L. Tintori: 'Methods Used in Italy for Detaching Murals', *Recent Advances in Conservation: Contributions to the IIC Conference: Rome, 1961*, pp. 118–22

A. Lucas: *Ancient Egyptian Materials and Industries* (London, 1962)

C. Brandi: *Teoria del restauro* (Rome, 1963/R Turin, 1977)

L. Tintori, E. V. Sayre and L. J. Majewski: 'Studies for the Preservation of the Frescoes by Giotto in the Scrovegni Chapel at Padua', *Studies in Conservation*, viii (1963), pp. 37–54

S. Augusti: 'Analysis of the Material and Technique of Ancient Mural Paintings', *Application of Science in Examination of Works of Art: Boston, 1965*, pp. 67–70

The Great Age of Fresco: Giotto to Pontormo (exh. cat. by M. Meiss, U. Procacci and others; New York, Metropolian Museum of Art, 1968)

D. C. Winfield: 'Middle and Later Byzantine Wall Painting Methods: A Comparative Study', *Dumbarton Oaks Papers*, xxii (1968), pp. 61–139

O. P. Agrawal: 'A Study on the Techniques of Indian Wall Paintings', *Journal of the Indian Museums*, xxv–xxvi (1969–70), pp. 99–118

H. Lehmann: 'Dry Conservation of Mural Paintings', *Studies in Conservation*, xv (1970), pp. 231–2

A. Reith: 'Maltechnik von Lascaux', *Maltechnik, Restauro*, lxxvi/2 (1970), pp. 33–4

W. J. Young, ed.: *Application of Science in Examination of Works of Art, 1970* (Boston, 1973)

M. Lefèvre: 'La "Maladie verte" de Lascaux', *Studies in Conservation*, xix (1974), pp. 126–56

C. Brandi: Teoria del restauro (Turin, 1977, Eng. trans. Rome, 2005)

M. A. S. Cameron, R. E. Jones and S. E. Philippakis: 'Analyses of Fresco Samples from Knossos', *Annual of the British School of Athens*, lxxii (1977), pp. 121–84

P. Mora, L. Mora and P. Philippot: *La Conservation des peintures murales* (Bologna, 1977; Eng. trans., London and Boston, 1984) [best survey of subject]

M. Matteini and A. Moles: 'A Preliminary Investigation of the Unusual Technique of Leonardo's Mural *The Last Supper*', *Studies in Conservation*, xxiv (1979), pp. 125–33

Atti de XXIV congresso internationale di storia dell'arte. La pittura nel XIV e XV secolo: Il contributo dell'analisi tecnica alla storia dell'arte: Bologna, 1979

F. Mancinelli: 'Raphael's *Coronation of Charlemagne* and its Cleaning', *Burlington Magazine*, cxxvi (1984), pp. 404–10

P. Mora, L. Mora and P. Philippot: *Conservation of Wall Paintings* (Boston, MA, 1984)

P. Burman, ed.: *Conservation of Wallpaintings: The International Scene* (London, 1986)

Case Studies in the Conservation of Stone and Wall Painting: Preprints of the Contributors to the Bologna Congress, 1986 (London, 1986)

S. Cather, ed.: 'The Conservation of Wall Paintings', *Proceedings of a Symposium Organized by the Courtauld Institute of Art and the Getty Conservation Institute: London, 1987*

K. M. Wilson-Yang and G. Burns: 'The Stability of the Tomb of Nefertari, 1904–1987', *Studies in Conservation*, xxxiv (1989), pp. 153–70

C. Danti, M. Matteini and A. Moles: *Le pitture murali: Tecniche, problemi, conservazione* (Florence, 1990) [extensive bibliog.]

C. E. Rouse: *Medieval Wall Paintings* (Princes Risborough, 4/1991)

M. A. Corzo and M. Afshar, eds: *Art and Eternity: The Nefertari Wall Paintings Conservation Project, 1986–1992* (Santa Monica, 1993)

H. Béarat and others, eds: *Roman Wall Painting: Materials, Techniques, Analysis and Conservation* (Fribourg, 1997)

O. Prakash Agrawal and R. Pathak: *Examination and Conservation of Wall Paintings: A Manual* (New Delhi, 2001)

P. Brambilla Barcilon and P. C. Marani: *Leonardo: The Last Supper* (Chicago, 2001)

I. Brajer: *The Transfer of Wall Paintings: Based on Danish Experience* (London, 2002)

G. Basile: *Il restauro della Cappella degli Scrovegni* (Milan, 2003)

H. Howard: *Pigments of English Medieval Wall Painting* (London, 2003)

Wallpaper. Paper, usually coloured or decorated with a hand- or machine-printed design, applied to the walls of a room.

I. Types. II. Conservation.

I. Types.

1. Painted. 2. Printed. 3. Flock.

1. PAINTED. Hand-painting as a technique in wallpaper production has been mainly used in the Western world in combination with printing processes. In the early to mid-18th century in England, France and Germany imitation Chinese wallpaper was produced by hand-colouring printed outlines, usually with gouache or tempera, or, rarely, an entire design might be hand-painted. Some engraved wallpapers printed from copper plates were also hand-coloured, either with watercolour or oil-based inks, although the latter produced flat, lustreless results compared with distemper printing. Sets of hand-painted wallpaper, in colours and grisaille, were produced as special orders in England in the 1760s for export to America, such as those ordered by Jeremiah Lee (1721–75) of Marblehead, MA, in the late 1760s (see Nylander, Redmond and Sander, figs 1–5, p. 7).

The lengths of paper imported into Europe from China from the late 17th century to the 19th were made up of pasted sheets up to 1.2 m wide joined together with an overlap to form lengths of over 3 m. Each sheet was a laminate of thin papers held together with starch pastes topped by a layer of white mulberry fibre paper (*mien lien*) and was probably painted with a white lead ground. Powdered mica was either mixed with the ground or dusted on to the surface, both to smooth it and to give a lustrous sheen. The outline of the design was drawn—or in some later examples printed—in black carbon ink, and inscriptions identifying individual motifs were added to aid colouring in. The outlines were then filled in using ground pigments mixed with animal glue used as gouache or tempera. Details were applied last, and coloured glazes were sometimes added to highlight such motifs as flowers or fruit. After lining with a thin bamboo paper and then a mulberry paper, the sheets were probably stretched over a drying board and then trimmed. Each length in a set of paper was numbered to show its sequence in the design. Additional sheets were supplied so that individual motifs could be cut out and used to hide joins or to enhance the design.

2. PRINTED.

(i) Hand-printing.

(a) Woodblock. Woodblock-printing is the commonest method of hand-printing wallpaper. Block cutters made up the block from a laminate of three or four woods, generally two white woods, such as pine or poplar, topped by a fine-grained fruitwood, for example apple or pear, that was more suitable

both for carving and use as a printing surface. The design was carved in relief, and thin wooden wedges could be inserted to print delicate lines or dots. Small brass pitch pins were fitted into the sides of the block to help register the design on the paper.

In the 16th and 17th centuries the technique involved inking the block, which was positioned face up on the printing table, carefully placing the paper to be printed over the block and pushing a weighted roller across: the paper was then peeled off and hung up to dry. Colour was usually added, if required, using a stencil (see §(b) below). With the introduction of multicolour distemper printing in the mid-18th century, designs were divided up according to colour (usually by the blockmaker), and a new block was carved to print each shade. A very large repeat design that was to be printed in several colours might require two or more blocks for each colour if the repeat exceeded the width of the block (a standard 21 ins (525 mm) in Britain by the 19th century but smaller in France).

With the introduction of the wallpaper piece—a roll made up of pasted sheets—at the end of the 17th century, sizing and grounding could be done along the entire roll. First size and then a coloured ground were spread across the length and width of the roll using elongated rectangular brushes; finally, a round brush was used to give uniform coverage. Different finishes could be added: passing the paper face down through a rounded copper roller produced a very smooth finish; brushing the surface of the paper with a hand brush produced a striated effect; adding powdered mica to the ground colour gave a lustrous finish; or varnish could be applied to brighten the coloured ground. Later innovations included the *irisé*, or blended colour grounds, developed by the French firm of Zuber & Cie from 1819.

Once sizing and grounding were completed, the roll to be printed was fixed to an iron rod at the side of the printing table. Beside this stood the colour tray, a square trough with a layer of paper scraps covered with water in the bottom, then a tight-fitting wooden frame covered with calfskin and finally another felt- or cloth-covered frame. An apprentice spread the colour to be printed on to the cloth or felt, and the block was pressed into it lightly by hand. The 'water-bed' principle of the colour tray ensured an even take-up of colour. The block was then positioned on the paper using the pitch pins and tapped with a rounded hammer to print the image clearly. Any areas of insufficient colour were touched up by hand. In the 19th century a foot-operated leverage system was introduced using a weighted wooden cross lever fixed on to the back of the printing table. When the block was positioned on the paper, the lever was swung on to the batten on the back of the block and pressure applied by weights. After the paper had been printed, a system of rods and ropes carried it away to dry in festoons before another colour could be printed. Gilding could be added by printing the design in a slow-drying adhesive over which the silver leaf or bronze powder was spread.

Woodblock-printing became increasingly rare in the 20th century but continued to be used mainly for luxury wallpapers produced by such companies as Arthur Sanderson and Sons Ltd, which used the original Morris & Co. blocks acquired in 1925 after the takeover of Jeffrey & Co. by the Wall Paper Manufacturers Ltd.

(b) Stencilling. In the late 17th century stencils, probably of leather or oilcloth, were used to add watercolour to woodblock-printed outlines on paper hangings (see STENCILLING). Registration was often poor as large brushes were used, and colours were limited. Stencils continued to be used until *c.* 1760, most notably by the French firm of Papillon, which refined the technique using watercolour washes and inks. Stencils were also used for large-scale flock designs, which would have required more than one woodblock to print the adhesive.

In the late 19th century stencilling was employed as a technique in its own right, principally to print friezes, most notably by Shand Kydd Ltd. Stencils were used both for background and motifs, although woodblocks were generally used to print the outlines, thereby concealing the stencil ties and hiding any poor registration or colour seepage from beneath the stencil plates. These were made of copper, brass or zinc (from the mid-1920s), although varnished cartridge paper was thought to produce the best results. Different types of brushes and sponges were used to produce a range of print effects, usually with water- rather than oil-based paint. By 1912 the aerograph spray painter had largely replaced these more labour-intensive techniques.

(ii) Machine-printing. The first wallpaper-printing processes to be mechanized were sizing and grounding, and by the beginning of the 19th century power-driven cylindrical brushes were replacing hand techniques. In the 1820s French manufacturers, using cylindrical rollers and the newly available continuous paper rolls, attempted to apply textile-printing techniques to wallpaper. By *c.* 1830 Zuber & Cie had succeeded in printing stripes by steam power, using brass cylinders into which parallel grooves had been cut.

In 1839 Potter & Ross of Darwen, Lancs, developed a steam-driven wallpaper-printing machine that used engraved copper rollers. By 1840 Potter & Co. had replaced the copper rollers with wooden ones that produced much better results using distemper colours. In this 'surface-printing machine' the paper was fed around a large rotating drum. Rollers were arranged horizontally around the base of the drum, and the paper was printed as it passed over each roller in turn. As in block-printing, each roller carried a different part of the design and printed in one colour, although different shades could be produced by overprinting. Potters also perfected a method of using a belt system to fill the colour tray for each roller, thus ensuring an even supply of colour.

In the early 1870s British manufacturers revived the use of copper cylinders. Etched with an intaglio

design, the cylinders printed in spirit- and oil-based colours, which were resistant to water and gave a semi-washable finish to what became known as sanitary wallpaper. Intaglio printing produced delicate and detailed effects and a very smooth finish, which was often varnished for added protection. In 1884 Lightbown, Aspinall & Co., Lancs, introduced multicoloured sanitaries.

In the 1870s embossing techniques developed from the simple use of two heated metal rollers to print an imitation of silk moiré—patented in France by Isidore Leroy in 1842—to the production of much more elaborate raised designs, often incorporating gold or silver, by such companies as Paul Balin in France and Jeffrey & Co. and Woollams & Co. in England.

In 1877 a new type of wall covering, Lincrusta Walton, was invented by a British engineer, Frederick Walton. It was made from a semi-liquid linoleum-like mixture, which was forced between two metal rollers, one of which carried the design to be produced as a raised pattern. Once dry, the material hardened and could either be used plain, decorated (often once hung on the wall) or varnished. The wide range of designs that were produced included imitations of tiles, architectural ornaments and leather. The disadvantage of Lincrusta Walton was its weight, and in 1887 Thomas J. Palmer took out a patent on a similar but lighter-weight material, Anaglypta, which was launched in 1887.

In the 20th century new printing techniques applied to the mass production of wallpaper included silkscreen-printing, first used in Britain by John Line & Sons Ltd, machine photogravure and flexographic printing, in which rubber rollers replace the surface-printing rollers.

3. FLOCK. The art of flocking on cloth and canvas in order to make them resemble more expensive wall coverings was known in the Middle Ages, and flocked hangings were in use in Holland in the late 16th century. By the mid- to late 17th century paper-manufacturing techniques had improved sufficiently to produce paper that was strong enough to be covered either wholly or partially with cloth clippings to imitate cut velvet or tapestries, and methods of adhering the flock to painted paper were also developed.

In the technique developed in England in the 18th century, and subsequently copied in France, the paper piece was first grounded with a watercolour wash and allowed to dry. From c. 1750 the ground was often block-printed in distemper colours in a diaper or other simple design prior to flocking. The design to be flocked was then stencilled or block-printed in a slow-drying adhesive, such as linseed oil mixed with litharge ground with white lead, on to which the flock—wool clippings, bleached, dyed and ground to powder—was scattered by hand. The flocked paper could be compressed under a board to improve adhesion. After drying, any excess flock was brushed off. In the 1750s two-stage grounding was perfected; after the ground had dried a varnish, made of oil of turpentine, resin and gums, and sometimes pigmented, was brushed over the piece, both to improve the adhesion of the flock and to brighten the ground. Experiments were also carried out using cotton and silk flock.

In the 19th century the process was modified. After the paper roll had been printed with adhesive, about two metres of paper at a time were laid in a flocking box—an elongated drum with a hinged lid and a base of stretched canvas. The flock was sifted over the paper, then, with the lid closed, the base was beaten by hand from below with two sticks to align the flock fibres and ensure they settled into the adhesive. After the entire piece had been flocked, often several times to build up a raised surface, the paper was hung up to dry vertically, thereby also removing any excess flock. Additional colours were added by block-printing over the fibres. In c. 1877 Woollams & Co. of London introduced raised flocks, a process that combined embossing and flocking by moulding the paper under pressure with a heated die after printing. Machine techniques have involved spraying powdered flock on to paper prepared with adhesive and, in the 20th century, the electrostatic application of synthetic flock.

R. Dossie: 'On the Manufacture of Paper Hangings', *The Handmaid to the Arts, Teaching: I. A Perfect Knowledge of the Materia Pictoria*, ii (London, 1758, 3/1796), pp. 304–16

A. V. Sugden and J. L. Edmundson: *A History of English Wallpaper, 1509–1914* (London, 1925)

H. Clouzot and C. Follot: *Histoire du papier peint en France* (Paris, 1935)

E. A. Entwisle: *The Book of Wallpaper* (London, 1954)

E. A. Entwisle: *A Literary History of Wallpaper* (London, 1960)

B. Greysmith: *Wallpaper* (London, 1976)

C. Lynn: *Wallpaper in America* (New York, 1980)

O. Nouvel: *Wallpapers of France, 1800–1850* (London, 1981)

E. W. Mick: *Hauptwerke des Deutschen Tapetenmuseum in Kassel*, 2 vols (Tokyo, 1981)

C. C. Oman and J. Hamilton: *Wallpapers: A History and Illustrated Catalogue of the Collection of the Victoria and Albert Museum* (London, 1982)

F. Teynac, P. Nolot and J. D. Vivien: *Wallpaper: A History* (London, 1982)

Historic Paper Hangings from Temple Newsam and Other English Houses (exh. cat. by A. Wells-Cole; Leeds, Temple Newsam House, 1983)

J. Hamilton: *An Introduction to Wallpaper* (London, 1983)

A Decorative Art: 19th-Century Wallpapers from the Whitworth Art Gallery (exh. cat. by J. Banham; Manchester, University of Manchester, Whitworth Art Gallery, 1985)

R. C. Nylander, E. Redmond and P. J. Sander: *Wallpaper in New England* (Boston, 1986)

M. Schoeser: *Fabrics and Wallpapers: Twentieth Century* (London, 1986)

B. Jacque and O. Nouvel-Kammerer: *Le Papier peint décor d'illusion* (Barenbach, 1987)

Papiers peints panoramiques (exh. cat., ed. O. Nouvel-Kammerer; Paris, Musées des Arts Décoratifs, 1990)

E. F. Koldeweij, M. J. F. Knuijt and E. G. M. Adriaansz: *Achter het behang: 400 jaar wanddecoratie in het Nederlandse binnenhuis* (Amsterdam, 1991)

R. C. Nylander: *Wallpapers for Historic Buildings* (Washington, DC, 1992)

London Wallpapers: Their Manufacture and Use, 1690–1840 (exh. cat. by T. Rosaman; London, Royal Institute of British Architects, 1992)

L. Hoskins, ed.: *The Papered Wall: History, Pattern, Technique* ([New York, 1994], rev. London, 2005)

II. Conservation. The deterioration of wallpaper is caused by the inherent and external dangers common to all works of art on paper: acidity (from the paper, support, media and environment); accumulated dirt and accidental damage; extremes of temperature and humidity; biological attack; and damage caused by overexposure to light. But wallpaper is also subject to damage resulting from defects in the fabric of the building that acts as its ultimate support.

Many of the earliest surviving European wallpapers have been discovered on wooden beams and panels or inside cupboards and boxes. Wood acids, insects and the natural movement of the wood itself usually result in the paper becoming extremely discoloured, brittle and fragmented. Papers hung on a plaster wall have often fared better, but dampness in the wall may cause moisture staining and mould growth and contribute to insect activity, especially attack by silver-fish. Also, settlement cracks will tear the paper. Wallpaper mounted on canvas and attached to the wall with wooden battens is protected to some extent from these problems, but the acidity of the ageing canvas and adhesives, combined with the continual expansion and contraction of the support (related to changes in relative humidity), can themselves cause discoloration, weakening and splitting of the paper while crumbling plaster and dust accumulates in the space behind.

Although many standard paper-conservation techniques can be applied to the preservation and restoration of wallpaper, especially in the case of unused samples and archival material, paper on the wall does call for a unique approach from the conservator. The treatment is complicated by vertical orientation and scale, interaction with the building and the difficulty of maintaining ideal environmental conditions in the historic interior. Each case has to be separately assessed, and the extent of conservation or restoration treatment required will further modify the conservator's approach. For example, in the hypothetical case of fragments, perhaps in multiple layers, of 19th-century machine-printed wallpaper, found behind panelling in a house undergoing renovation or demolition, the conservation treatment will simply involve surface-cleaning one or more repeats of the pattern and removing these from the wall for preservation in an archive. In contrast, a stateroom in a great house hung with 18th-century hand-painted Chinese wallpaper or with French *papiers peints* of the 19th century will demand much more extensive work. Treatment might then include the following stages: survey, documentation and photography; surface cleaning; consolidation of media; separation from the supports and removal of the paper from

the wall; removal of such secondary supports as paper, canvas and plaster; removal of discoloration; repair and relining with compatible conservation paper and perhaps a textile; remounting and/or rehanging; and finally retouching. Meanwhile, building defects would have to be remedied and, if necessary, modifications to other decorative features of the interior carried out.

In practice, the conservator will try to preserve papers *in situ* and choose appropriate options from the following treatment stages. The initial stage is surface cleaning, which involves removing dust, soot and accretions of dirt with soft brushes, low-suction vacuum-cleaners, erasers and sponge rubbers; solvents, mainly water, can sometimes be used locally. The next stage is to consolidate flaking, powdery or fugitive pigments and media (especially common on 19th-century block-printed wallpapers), using a variety of natural and synthetic polymers applied by spray, brush or syringe. If wallpaper that is mounted or hung on plaster has to be removed (perhaps to be rehung in another room, to facilitate repairs to the building or simply for thorough conservation treatment), then removal is often effected by scalpels and spatulas inserted between the paper and the wall. This process may be carried out while the paper is dry, or after varying degrees of moistening by spray, humidification or direct wetting intended to soften the original adhesive. The use of steam will soften less easily soluble adhesives, and if enzyme solutions are applied at the same time the structure of the adhesive can be broken down. If moisture or steam is used the paper must be surface cleaned first, otherwise any stains may become permanently fixed in the paper. Very fragmented or fragile wallpapers may have to be temporarily faced with thin tissue-paper and a reversible adhesive before removal from the wall. Wallpaper mounted on canvas can often be de-backed by removing the linings by standard methods, after releasing fixings around the edge of battens. In extreme cases, where none of the above methods is effective, the wall behind the paper may have to be dismantled. Once the wallpaper is off the wall, further conservation treatment can proceed: cleaning, the removal of old backings and supports, chemical stabilization, repair, relining and, if required, retouching. For this, standard paper-conservation techniques can be used, albeit on a larger scale than usual and with the important exception of treatment by immersion, which is rarely possible.

When the treated paper is rehung, various techniques are again possible. A choice is made according to the condition and structure of the walls and surrounding features. The conservation principle of reversibility precludes pasting the treated wallpaper directly on to a wall. Instead, the same effect can be achieved by first lining the prepared wall with a polyester fabric release layer between two layers of acid-free paper; if it is necessary at a later date to remove the wallpaper, in theory the paper support can be separated from this release layer.

Alternatively the paper can be relined with a final support of a natural or synthetic textile and attached by its borders to the wall by means of wooden stretchers. An expensive but more desirable variation is to mount the conserved wallpaper on panels of acid-free honeycomb board faced with acid-free paper, or on screens constructed according to the oriental pattern, like the Japanese *karibari* board. Panels can be screwed to the wall or even secured with magnets.

Inpainting, or retouching to restore missing areas of the design, though not often practised in other fields of paper conservation, can represent a major proportion of the cost of wallpaper conservation. Various techniques of reproducing historic papers, for infills or even whole rooms, are increasingly the province of the conservator, working with artists and printers.

After conservation and restoration, wallpaper that is displayed *in situ* in a historic interior should be protected from future damage by careful building maintenance and environmental controls. Barriers and glass or Perspex panels may be necessary to protect the paper from passing visitors.

IIC Congress: Conservation within Historic Buildings: Vienna, 1980 [incl. articles by J. Hamm and P. D. Hamm, K. Jahoda and H. Rosenberger, and A. Fiedler]

M. Phillips: 'Conservation of Historic Wallpaper', *Journal of the American Institute for Conservation*, xx/2 (1981) [issue also contains other related articles]

C. Rickman: 'Wallpaper Conservation', *UKIC Conference: Conservation Today: London, 1988*, pp. 64–70

IIC Conference: The Conservation of Far Eastern Art: Kyoto, 1988 [incl. articles by P. Webber, M. Huxtable and C. Rickman]

P. J. Kipp: 'Wallpaper Conservation', *IADA Preprints, 7th International Congress of Restorers of Graphic Art: Uppsala, 1991*

Wash. Broad area of dilute INK or transparent WATERCOLOUR applied by brush. Gradations of tone and colour can be achieved through successive applications of washes. The technique developed from medieval manuscript illumination and was used from the 14th century to give tone to pen-and-ink drawings (*see* DRAWING). In watercolour painting the technique was most fully developed by the English watercolourists of the late 18th century. Washes have also been used by miniature painters on parchment or ivory since the 16th century.

Wash manner [Fr. *manière de lavis*]. Term applied to a broad range of printmaking processes that attempt to imitate the effect of ink-and-wash or watercolour drawings. The printmaking plate (or plates) may be delicately worked in either AQUATINT, GOUACHE MANNER or *lavis* (and sometimes in combination) so that it has a finely textured surface that catches just enough ink to print in transparent layers of colour. Wash manner prints were produced mainly by French engravers working in the last quarter of the 18th century (e.g. Jean-François Janinet (1752–1814)). The tools used directly on to the plate, or through an etching ground, are generally the roulettes and mattoirs

developed for crayon manner (*see* ENGRAVING) and modifications of these (e.g. mushrooms). It is often difficult to tell precisely whether a chemical or mechanical process has been employed, though aquatint, when viewed with a magnifying glass, tends to have a more granular patterning.

Regency to Empire: French Printmaking, 1715–1814 (exh. cat. by V. I. Carlson and J. W. Ittmann; Baltimore, MD, Baltimore Museum of Art; Minneapolis, MN, Minneapolis Institute of Arts; 1984)

A. Griffiths: 'Notes on Early Aquatint in England and France', *Print Quarterly*, iv (1987), pp. 255–70

Watercolour [Fr. *aquarelle*; Ger. *aquarellfarbe*; It. *acquerello*; Sp. *acuarela*]. Pigment dissolved in water and bound by a colloid agent so that it adheres to the working surface when applied with the brush. The same name is used for a work of art in that medium. Watercolour may be transparent or opaque and is usually applied to paper, but sometimes also to such materials as silk or vellum. The term arises because, in varying degrees, water is always used in the largest proportion and, in the purest application of the medium, twice—both to mix pigments and to dilute the colours.

1. Materials and techniques. 2. History.

1. MATERIALS AND TECHNIQUES. The colloid matter is usually combined with the pigment, which may be made up in dry cakes or moist in tubes. More rarely, it is dissolved in water, and the brush is dipped in the solution before taking up the colour. Varieties of gum are the most common colloids, the usual being gum arabic, derived from the acacia. Pastes of flour or rice, egg yolk or white, animal size or the casein of cheese have also been used. The binding medium may also include a wetting agent such as ox-gall or a thickener such as gum tragacanth, starch or dextrin, and, nowadays, a fungicide and bacteriacide. Further agents may be added while painting; glycerin to retard the drying of the pigment, alcohol to accelerate it.

The first proper list of watercolour pigments was given in *Miniatura or the Art of Limning* (c. 1630), written by Edward Norgate (1580s–1650) for Sir Théodore Turquet de Mayerne and later widely circulated. Norgate listed the varieties of white, yellow, red, green, blue, brown and black—24 in all—that could be bought in apothecaries' shops for artists to grind themselves. These pigments were derived from natural materials and were to be combined with gum arabic and 'sugar candy' to ensure that they dried 'smooth and even'. Subsequent writers have refined Norgate's recipes and enlarged his range of pigments without altering the basic principles, and the process remains essentially the same today. The establishment of artists' colourmen in the large European cities and the rapid expansion of pigment choice during the 18th century did little to change working practices. Artists long preferred to grind their own colours and even now often choose to work with a

basic set of about 15 pigments rather than use all the hundreds available.

The production of colours in small hard cakes, begun in England by the Reeves firm *c.* 1780, was, however, a crucial development. Portable watercolour boxes, available from the early 18th century, were readily adapted to these and developed into the boxes with pans or cakes of colour used from the 19th century onwards (see fig.) *see also* Paintbox). Tube colours, containing additional glycerin as a plasticizer, are currently preferred by most professionals. Modern pigments are generally synthetic and, being very fine-ground, produce smooth and regular washes rather than the granular effects so vigorously exploited by earlier artists; however, they are also exceptionally pure and lend themselves to a wide range of colour mixes. Colours are mixed on watercolour palettes or on china plates or saucers.

So that washes flow steadily over the paper without running out of control of the brush, the studio watercolourist generally works on an easel or drawing board inclined at an angle of 5° to 10°. The paper, first moistened and stretched, is mounted over a frame or board and held tight and smooth. If working outdoors on a large scale, the artist may use a folding easel. Brushes must be strong but pliant and should not abrade the damp paper. They should readily twist to a fine point when required (traditionally this was done in the mouth). Early Chinese painters turned to deer, fox, rabbit and even to rats' whiskers or kingfishers' beaks for appropriately fine hairs. More recently, expensive brushes have been made from red sable, more economical ones from camel-hair. Artists in the 18th and 19th centuries used broader brushes than those now preferred.

Early brushes were set into quill handles; from the mid-19th century onwards these were replaced by wooden handles with nickel or aluminium fixings (*see* Brush).

In its pure form a watercolour is made with pigment and colloid, with water as the only vehicle, so that it is transparent. The colour sinks into the paper without completely hiding its tone. Watercolourists have always exploited their papers, sometimes choosing textured or granulous papers to retain pockets of colour, or toned papers to modify the colour values, sometimes leaving patches of paper bare to act as highlights. Pure watercolour is therefore applied over white or pale buff paper. Artists continue to prefer fine, handmade rag papers rather than machine–made varieties.

Watercolour may be applied in a broad wash, laid down with a full and well-soaked brush, or in separate brushstrokes or stipples with relatively little water (see colour pl. XVI, fig. 1). The swift application of a flat or tonally gradated wash is a fundamental skill. Additional washes may be laid over the initial one, sometimes while it is still wet. When using transparent washes, pale ones are applied first and the darker ones laid over them; each preceding wash, and the paper beneath, will contribute to the final effect. A wash may be smooth or broken. The latter effect is achieved by dragging a lightly damped brush, charged with dry or almost dry colour, on its side across the paper so that patches of pigment remain trapped in the surface recesses. To develop or alter effects, damp colour may be lifted, 'stopped' or blended by a variety of methods. Rags, blotting paper, india-rubber, bread pellets, a brush handle, penknife or finger nail have served widely to remove colour and to expose

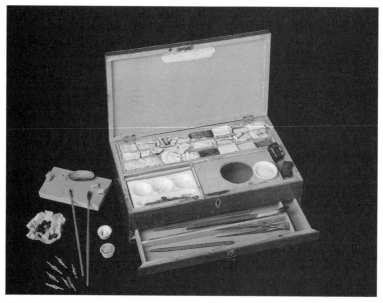

Watercolour paint box, wood, watercolour cakes and artists' tools, English, *c.* 1780–1800 (Los Angeles, CA, Getty Research Institute); photo credit: Research Library, The Getty Research Institute, Los Angeles, California

the paper. Since the medium is resoluble when dry, more radical transformations may be achieved by wiping over the entire watercolour or even holding it under a tap; other washes may then be floated over it or dabs of stronger colours run in.

Watercolour may be made opaque by the addition of a further agent. In this form it is called GOUACHE or, traditionally, bodycolour. The extra 'body' is usually Chinese white, an opaque white originally based on lead and later on oxide of zinc, which is added to all the colours. Barium sulphate or precipitated chalk may also be added to the pigments as opaque extenders. To obtain the greater opacity and flexibility required of gouache, both pigment and glycerin are used in larger proportions than for transparent watercolour. The medium is favoured by designers and illustrators, who need to achieve flat, even fields of colour, and also by miniature-painters, who appreciate its possibilities for a jewel-like texture. Although it will not leave the paper visible, gouache is often applied to toned papers. Whereas in pure watercolour, tonal gradations must be anticipated, and a dark one can only be reduced by thinning down or washing out with water, with gouache a pale colour may be laid over a dark. Gouache can be used exclusively or combined as a heightening agent with transparent watercolour; the latter requires great skill and is rarely entirely satisfactory. Some artists prepared their paper with white gouache and then painted over it in transparent watercolour, thus producing great brilliance of tone, a result similar to that achieved by oil painters—for example the Pre-Raphaelites—when painting over a pale ground.

2. HISTORY. Painting with pigment and water goes back to antiquity and occurs throughout the world. The ancient Egyptians dipped brushes made from rush stems in water and rubbed them on cakes of ink and gum to decorate papyrus rolls. The Chinese were beginning to paint on paper by about the 9th century (although they were using other supports, e.g. silk, before this). In the West, early manuscripts were illuminated with transparent washes adorning ink outlines or more elaborate applications of bodycolour or mixed media heightened with gold; the first manner led to 'stained' or 'tinted' drawing and ultimately to the modern watercolour, the second to gouache. Medieval manuscripts were also the ancestors of Turkish and Mughal miniatures, or those made in England by Nicholas Hilliard (?1547–1619). Technically, inks are watercolours, so that the early calligraphers may be said to have practised the art, as can brush draughtsmen from East and West who have worked in monochrome or ink-based washes—the classical Chinese and Koreans or Japanese artists such as Tōyō Sesshū (1420–1506) and his school, whose economy of line went far beyond anything achieved in Europe for at least a century; or, later, Rembrandt van Rijn (1606–69) and Claude Lorrain (?1604/5–82). A complete history of watercolour defined in purely technical terms would need to embrace these and many other elements, but, in practice, the term has usually been

understood to apply to particular Western manifestations and mainly to the classical transparent watercolour as evolved in Europe—and especially in Britain—in the 18th century and afterwards.

(i) 16th century–mid-18th. The beginnings of a coherent and autonomous tradition are generally traced to the 16th and 17th centuries in northern Europe. The alpine studies made by Albrecht Dürer (1471–1528) in 1490 and his later watercolours of animals or birds employed the medium with unprecedented richness and breadth; his landscapes were unequalled in Europe. More typically, watercolour was being used as a tint for line drawings of places, people or natural history made by the growing number of itinerant draughtsmen.

Norgate's *Miniatura* discusses watercolour's use for portraiture, subject painting and 'history', as practised, for example, by Isaac Oliver (1558/68–1617) and his son Peter (?1594–1647), and landscape, recognizing the increasing recourse to the medium in the Low Countries and England. Dutch and Flemish artists of the 17th century used watercolour in their chalk, ink or bistre drawings, usually in a restrained and delicately atmospheric manner to tint outlines and imitate the colours of nature. Exceptions are the richer and denser effects achieved by Peter Paul Rubens (1577–1640) and his school, especially Jacob Jordaens (1593–1678), who applied strong local colours over their initial washes, or the vivid monochrome wash drawings of Claude or Rembrandt with their tonal abstraction or emphasis on chiaroscuro. Perhaps most advanced in their handling of pure watercolour and liberation from outline were the landscapes of Anthony van Dyck (1599–1641).

Van Dyck might stand at the head of the European tradition of landscape watercolour, Wenceslaus Hollar (1607–77) at that of the tinted topographical drawing. Hollar's drawings in pen, lightly washed with a limited range of descriptive colours, made in England, continental Europe or Morocco, correspond closely to techniques of printmaking, which he also practised. They set a pattern widely followed in England during the first half of the 18th century, though sometimes modified, as in certain works by Francis Place (1647–1728), by a sensitive appreciation of effects of light and shade. Such artists as William Taverner (1703–72) and Jonathan Skelton (*d* 1759) perfected the 'stained' drawing, in which local colour is applied over shading in India ink and sometimes also worked in a range of fresh colours without monochrome under painting. By the second half of the century the method of the English topographical watercolour—often made for engraving—had become firmly established; foundations of mass and shade were laid in blue or grey washes over pencil indications, and when these were dry, local colour and appropriate heightenings in pen and ink were added to contribute a dense and intricately descriptive effect. This discipline, perfected by artists such as Edward Dayes (1763–1804), was the springboard that enabled J. M. W. Turner (1775–1851) and

Thomas Girtin (1775–1802) to develop their own highly expressive styles.

(ii) Mid-18th century–19th. It was also in England, however, that artists had striven hardest to explore the possibilities of watercolour as a medium uniquely adapted to render light, atmosphere and the fleeting movement of nature. With greater appreciation of the qualities of the medium came also its maturity as an art in its own right. From the middle of the century Paul Sandby (1731–1809) united a sensitive eye for pure landscape and a corresponding freedom and delicacy of technique, closest to Netherlandish prototypes, to the business of military and architectural topography, thus earning Thomas Gainsborough's accolade of 'genius'. Alexander Cozens (1717–86) rendered the essence of ideal landscape or climatic effect in monochrome washes with the abstract grandeur and simplicity of East Asian artists, while his son John Robert Cozens (1752–98) broke away from topographical constraints to discover a lyrical style based on a limited range of tones applied directly, without underpainting. Meanwhile Francis Towne (1739/40–1816) produced no less remarkable effects through clear washes of jewel-like brilliance laid over taut and economical outlines in ink.

The bold exploration of watercolour's possibilities in 18th-century England was unmatched elsewhere, giving rise to the understandable, if misleading, image of watercolour as a 'British' art form. Watercolour was widely used in continental Europe, and some artists, for instance the Frenchman Charles-Joseph Natoire (1700–77), even came to prefer it to oils. Generally, however, it remained an essentially decorative medium, one that was subordinate to ink or chalk. Touches of local colour rather than broad washes remained the continental norm, and while Eugène Delacroix (1798–1863) and Théodore Gericault (1791–1824) produced some vivid studies, many artists in France or Germany continued well into the 19th century to practise habits that seem archaic compared to those of their British counterparts.

Gouache, on the other hand—though regarded by purists as the vulgar cousin of watercolour—reached its own perfection in continental Europe during the 18th century. Marco Ricci (1676–1730) and later Francesco Zuccarelli (1702–88) mastered a type of classical landscape with ruins that became fashionable throughout Europe and found ready followers in London. French draughtsmen were also fond of gouache, and in London it was taken up by Sandby in some large landscapes with heroic trees that were sent to exhibitions to compete with oil paintings. Painting in gouache reached its nadir in the following century in the thousands of quick and shoddy views of continental scenery—above all of the Bay of Naples—peddled to tourists, but not before it had enjoyed a splendid apotheosis (though often combined with oil or varnish) in the huge views of antiquities or beauty spots by Louis Ducros (1748–1810).

By the end of the 18th century, and chiefly in England, watercolours had broken out of their long-standing place in the cabinet or portfolio and assumed space on the exhibition wall. Grudgingly admitted to the Royal Academy in London, they came into their own with the foundation in 1804 of the Society of Painters in Water-colours. Their shows encouraged the development of the large and highly finished 'exhibition watercolours', exploiting new pigments and techniques to the full, that dominated the Victorian exhibitions. At the same time, however, British watercolourists could benefit from the broad, modulated effects achieved during a brief life by, from the vast range of technical refinements and quirks developed by J. M. W. Turner (1775–1851) during his many years of devotion to the medium, from the subtle colour harmonies of Peter De Wint (1784–1849), the lyrical economy of John Sell Cotman (1782–1842) or the dynamic vigour of David Cox (1783–1859). If Samuel Palmer (1805–81), whose early work expressed his visionary imagination through unique combinations of watercolour, gouache and other media, was later obliged to adapt to convention and to propagate consensual wisdom through his activities as a drawing master—inevitable for many artists as a means of financing their careers—it is also true that invention and individuality remained abundant in English watercolour throughout the century. In continental Europe watercolour continued to be associated with popular topography, although the gradual erosion of academic principles and hierarchies in France encouraged artists to work in a variety of media regardless of subject-matter. Richard Parkes Bonington (1802–28) and Delacroix painted brilliant figure subjects in watercolour, while Henri-Joseph Harpignies (1819–1916), Johan Barthold Jongkind (1819–91) and Jules Jacquemart (1837–80) anticipated the Impressionists in developing a fluent, expressive brushwork to convey sensations and to record fugitive effects. The establishment of the Société d'Aquarellistes Français in 1879 acknowledged a growing middle-class market for works in a medium more affordable than oil, and while the Impressionists were to capitalize on this demand, watercolour was clearly highly relevant to their artistic objectives. For Paul Cézanne (1839–1906), it was central to his investigation of the structure of landscape and still-life, used not only for preparatory work but also, by the 1880s, for exhibition subjects, while Camille Pissarro (1830–1903) showed a particular commitment to watercolour and gouache and advised younger artists such as his own son Lucien (1863–1944) and Paul Signac (1863–1935) to specialize in them. Meanwhile, high prices were paid for highly finished watercolours by Pierre Puvis de Chavannes (1824–98) or Gustave Moreau (1826–98).

(iii) 20th century. Even if the century from 1750 to 1850 was perhaps the great age of the 'amateur' watercolourist, the medium has retained its broad appeal in the 20th century and indeed has never been

more popular. Unfortunately, the sheer abundance of stylistic examples from the past has tended to depress the imaginative zeal of many later practitioners, and a sense of *déja vu* is likely to be communicated by many mainstream exhibitions.

Watercolour has nonetheless continued to find fresh interpreters in the 20th century. Gustave Moreau's studies had already suggested its abstract possibilities, while the sensual works of Auguste Rodin (1840–1917) and Gustav Klimt (1862–1918) opened up other avenues. Vestiges of its topographical function survived, for instance in Fauvism, and for such artists as Raoul Dufy (1877–1953) the medium's immediacy and intensity were paramount. In Germany the painters associated with the Blaue Reiter used this saturation differently. While Vasily Kandinsky (1866–1944) made large numbers of abstract watercolours in preparation for his oils, Paul Klee (1879–1940) was one of the few modernists whose work was dominated by the medium, using its strong colour and intimate scale to capture a quixotic personal vision.

For artists emerging after World War I, watercolour took on different possibilities. It served utopian ends in the sketches of many abstract artists (e.g. El Lissitzky (1890–1941), Johannes Itten (1888–1967) and Theo van Doesburg (1883–1931)), but had a different function in the satirical works of George Grosz (1893–1959), Jules Pascin (1885–1930) and others. In England the tradition for topographical watercolour was renewed in the visionary landscapes of Paul Nash (1889–1946), John Piper (1903–92), David Jones (1895–1974) and others; while Henry Moore (1898–1986) developed an original combination of wax, ink and watercolour in his wartime *Shelter* drawings. Having been forbidden to paint by the Nazis, Emil Nolde (1867–1956) produced secret watercolours (preferred to oil, which could be smelt) that have a strong emotional and chromatic dependence on his native landscape. By contrast, Wols (1913–51), a late associate of Surrealism, produced minute gestural abstractions, the jewel-like intensity of which was comparable to works by Klee, whom he admired. Watercolour was taken up both by Pop artists R. B. Kitaj (1932–2007), David Hockney (*b* 1937) and others, and by those in the 1970s who looked back to the Abstract Expressionists, such as Brice Marden (*b* 1938) and Sean Scully (*b* 1945). The subsequent return of neo-Expressionistic figuration also favoured the fluency of watercolour, and its use by Francesco Clemente (*b* 1952) unites it with still potent non-Western (especially Indian) traditions of watercolour painting.

For information on the conservation of watercolours *see* DRAWING, §V.

N. Hilliard: *The Arte of Limning* (MS.; *c.* 1600); ed. R. K. H. Thornton and T. G. S. Cain (Manchester, 1981)

T. H. Fielding: *On Painting in Oil and Watercolours for Landscape and Portraits* (London, 1839)

G. Bernard: *The Theory and Practice of Landscape Painting in Water-Colours* (London, 1858)

J. L. Roget: *A History of the Old Water-Colour Society, now the Royal Society of Painters in Water-Colours* (London, 1891)

I. A. Williams: *Early English Watercolours* (London, 1952/*R* Bath, 1970)

M. Hardie: *Watercolour Painting in Britain*, 3 vols (London, 1967–8)

R. D. Harley: *Artists' Pigments, 1600–1835* (London, 1970)

W. Koschatzky: *Watercolour History and Technique*, trans. M. Whittall (London, 1970)

G. Reynolds: *A Concise History of Watercolours* (London, 1971)

W. Haltmann: *Meisteraquarelle des 20. Jahrhunderts* (Cologne, 1973)

T. E. Stebbins: *American Master Drawings and Watercolours: A History of Works on Paper from Colonial Times to the Present* (London and New York, 1976)

Wash and Gouache: A Study of the Development of the Materials of Watercolors (exh. cat. by M. Cohn; Cambridge, MA, Fogg Art Museum, 1977)

A. Wilton: *British Watercolours, 1750–1850* (London, 1980)

M. Clarke: *The Tempting Prospect: A Social History of English Watercolours* (London, 1981)

The Art of Watercolour (exh. cat. by J. Spalding; Manchester, City Art Gallery, 1987)

R. Mayer: The Artist's Handbook of Materials and Techniques (London, 5/1991)

Nature into Art: English Landscape Watercolours from the British Museum (exh. cat. by L. Stainton; London, British Museum; Cleveland, OH, Cleveland Museum of Art; Raleigh, NC, North Carolina Museum of Art; 1991)

Original Eyes: Progressive Vision in English Watercolour, 1750–1850 (exh. cat. by D. B. Brown; Liverpool, Tate, 1991)

C. Newall: *Victorian Watercolours* (London, 1992)

The Great Age of British Watercolours, 1750–1850 (exh. cat. by A. Wilton and A. Lyles; London, Royal Academy of Arts; Washington, DC, National Gallery of Arts; 1993)

D. Cordingly: *Ships and Seascapes: An Introduction to Maritime Prints, Drawings and Watercolours* (London, 1997)

G. Reynolds: *Watercolours: A Concise History* (London, 1998)

M. Royalton-Kisch: *The Light of Nature: Landscape Drawings and Watercolours by Van Dyck and his Contemporaries* (London, 1999)

E. Shanes and others: *Turner, the Great Watercolours* (London, 2000)

M. H. Ellis: 'Watercolors Today: Dr. Ph. Martin's Synchromatic Transparent Watercolors, Magic Markers and Day-glo Colors', *Gekleurd of Verkleurd: Symposium 11–12 October 2001, Den Haag*

K. J. Avery: *American Drawings and Watercolors in the Metropolitan Museum of Art* (New York, 2002)

G. Smith: *Thomas Girtin: The Art of Watercolour* (London, 2002)

B. A. Ormsby, J. H. Townsend and B. W. Singer: 'British Watercolour Cakes from the Eighteenth to the Early Twentieth Century', *Studies in Conservation*, l (2005), pp. 45–80

E. N. Petrova: *Drawing and Watercolours in Russian Culture: First Half of the 19th Century* (St Petersburg, 2005)

Watermark. Distinguishing mark incorporated into paper and visible only through transmitted light. Watermarks may include names, symbols, initials, seals and dates. They are used as a mill or papermaker's trademark, with a given mill using several different watermarks to distinguish papers of differing qualities. Before *c.* 1790 they were usually referred to as 'papermarks'.

A watermark appears as a pale pattern in the sheet when a piece of paper is held up to the light or placed over a lightbox. In handmade paper the watermark is produced during the manufacture of the sheet by the screen and by the vatman's handling of the mould (see PAPER, §I). The design is made of wire and set into the screen in the mould on which the sheet of paper is to be formed. The vatman dips the mould into the prepared paper pulp and then lifts it out horizontally. The screen retains the fibred pulp while allowing the water to drain away. The vatman then shakes the mould in two directions, from left to right and then from back to front, matting the fibres together. The wet pulp settles out more thinly over the wires that form the watermark design than it does over the rest of the screen, so the mark is more translucent than the sheet around it. The mould is then passed to a second workman, who turns it over and quickly releases the paper on to a piece of felt.

East Asian papers have no watermarks, nor have those of Islamic and European manufacture before the end of the 13th century. They were first used in Italy, either in Bologna in 1285 or in Fabriano in 1293. Since then they have been in common use. In the 14th century watermarks were characterized by simple designs and large wires. By 1545 the date of manufacture began to be added to the full name of the maker. When John Baskerville (1706–75) introduced the wove mould (c. 1750), the laid and chain lines of the earlier laid-paper mould were replaced by a fine brass screen. The only prominent wires on the face of a wove mould are therefore the wires of the watermark.

Watermarks can be helpful in determining the age and origin of a piece of paper, and thus to some extent of a drawing or print on it. However, they are not an infallible guide, because if a paper was popular its mark was soon imitated by other mills. Moreover, artists have frequently had access to old paper. This makes the identification and dating of papers and works of art through watermarks extremely difficult. An additional problem is the difficulty of documenting watermarks, especially when layers of media or print on the paper surface may obscure the detail. Accuracy is necessary for specific identifications, and the most widely used method of recording a watermark is to trace the design over a lightbox. As well as the design, the chain and laid line spacing and the sewing dots where the watermark wire was attached to the mould should be noted. Other methods include transmitted light photography, low-voltage X-ray radiography and beta radiography (see TECHNICAL EXAMINATION, §§II, 3, and III, 1).

C. M. Briquet: *Les Filigranes: Dictionnaire historique des marques du papier dès leur apparition vers 1282 jusqu'en 1600*, 4 vols (Geneva, 1907)

C. F. Cross and E. J. Bevan: *A Textbook of Paper-making* (London, 1907)

D. Hunter: *Paper-making through Eighteen Centuries* (New York, 1930)

W. A. Churchill: *Watermarks in Paper in Holland, England, France etc in the Sixteenth and Seventeenth Centuries and their Interconnections* (Amsterdam, 1935)

E. Heawood: *Watermarks Mainly of the Seventeenth and Eighteenth Centuries* (Hilversum, 1950)

G. Piccard: *Die Wasserzeichenkartei … im Hauptstaatsarchiv Stuttgart* (Stuttgart, 1961–) [numerous vols]

T. L. Gravell and G. Miller: *A Catalogue of American Watermarks, 1690–1835* (New York, 1979, rev. New Castle, DE, 2/2002)

T. L. Gravell and G. Miller: *A Catalogue of Foreign Watermarks Found on Paper Used in America, 1700–1835* (New York, 1983)

J. Roberts: *A Dictionary of Michelangelo's Watermarks* (Milan, 1988)

P. Bower: *Turner's Papers: A Study of the Manufacture, Selection and Use of his Drawing Papers, 1787–1820* (London, 1990)

N. J. Lindberg: *Paper Comes to the North: Sources and Trade Routes of Paper in the Baltic Sea Region, 1350–1700: A Study Based on Watermark Research* (Marburg, 1998)

D. W. Mosser, M. Saffle and E. W. Sullivan, eds: *Puzzles in Paper: Concepts in Historical Watermarks* (New Castle, DE, and London, 2000)

E. Hinterding: *Rembrandt as an Etcher*, vols ii and iii (Ouderkerk aan den Ijssel, c. 2006)

Wax. Substance composed of varying proportions of esters, acids, alcohols and hydrocarbons and similar in composition to fats. Waxes are relatively stable compounds and have a low toxicity and mild odour. Most natural waxes are solid at room temperature but soften or liquefy at higher temperatures. They are insoluble but emulsify easily in water and are soluble in some organic solvents (e.g. turpentine). Waxes range in colour from white through yellow to brown and black, although they can discolour when exposed to natural light or due to the action of additives or solvents.

I. Types and properties. II. Techniques and uses. III. Conservation.

I. Types and properties. Natural waxes are obtained from animal, vegetable and mineral sources. Beeswax is the most common of natural waxes. It is a secretion of the glands on the abdomen of the 'worker' bee, primarily of the domestic species (*Apis mellifica*), and is made ductile through chewing and impregnation of saliva by the insect. The colour of beeswax can vary, depending on the original source of the pollen. Heather, which has white pollen, produces a wax that has little colour, but sainfoin pollen, being yellow, produces an ochre-yellow wax. African beeswax is dark in colour, and Turkish beeswax is bright red.

Beeswax is refined by immersing canvas bags filled with the honeycomb in boiling water, although it is also possible to use organic solvents to extract the wax from the honeycomb. Beeswax that has been refined in this way retains some colour but can be bleached by exposure to ultraviolet light or by the use of chemical agents, for example chlorine, potassium bichromate, potassium permanganate or hydrogen peroxide. Bleached and refined beeswax is usually more dense and brittle than unrefined wax. Beeswax melts at 63–66°C and is used for many different purposes, for

example the making of candles and sculpture, pharmaceutical products and in the food industry. Beeswax is also the major component of the wax used in encaustic painting.

Chinese insect wax or cochineal wax is produced from the secretion of the *Coccus ceriferus*, deposited on ash trees. The wax is relatively hard, melting between 79 and 83°C, and is white and odourless. It is used for making candles and polishes and as a protective layer on paper and textiles.

Suint, first produced in the 19th century, is extracted from water in which sheep's fleece has been washed. When dried it is pale yellow in colour, with a faint but agreeable odour. When added to water it creates stable emulsions. As lanolin (with the addition of 25% water) it is used in the pharmaceutical industry and in the production of paint.

Spermaceti wax comes from the oil on the head of the sperm-whale. It is a white, translucent powder with a crystalline structure and contains some glycerides. It melts between 41 and 44°C. It was first used in the 18th century and is employed in pharmaceutical products and to soften beeswax and occasionally in the restoration of works of art.

Carnauba wax is derived from the exudate of the leaves of the *Copernicia cerifera*, the Brazilian carnauba palm. After it has been extracted through beating the leaves, it changes in colour from light yellow to dark grey. It is the hardest of natural waxes, melting between 83 and 86°C, and is used for making candles, polishes, as a protective layer on rope, and for glazing paper. It is also one of the components of printers' ink, lubricants, varnishes, lacquers and enamels. Phonograph cylinders were formerly made out of this type of wax, and it can be combined with other components to make precision moulds. It can also be used in the restoration of works of art.

Candelilla wax is made from the *Euphorbia cerifera* plant that grows mainly in northern Mexico and Texas. It is yellow–brown in colour and is hard and brittle. It is used in the manufacture of plasters, polishes, ebonite varnishes, gummed paper and sealing wax, and as a water and insect repellant and to harden softer waxes.

Japan wax is a by-product of lacquer from the *Rhus succedanea*, originally from China and Japan. It contains 10% glycerin and is rather soft, melting between 50 and 52°C. It is used for polishes, cosmetics, in the production of pastels and crayon and in treating leather.

Mineral waxes are obtained from fossil sources; ozokerite is the most common and is extracted from bituminous deposits. It is dark yellow, with a greenish tone, and has a characteristic aromatic odour. Refined ozokerite is known as ceresin, which is white. Both ozokerite and ceresin are used in the production of cosmetics, paints, varnishes and printers' ink. They can occasionally be found in the composition of wax overlaid on sculpture. Montan wax, brown or blackish in colour, is obtained from coal or lignite and is used as a substitute for carnauba wax when sufficiently pale in colour. Waxes extracted from petroleum, which are not true waxes, have been widely used since 1830. Paraffin wax is produced in a number of grades of purity and melts between 50 and 60°C. Microcrystalline waxes are often used as a plasticiser, as they contain more residual oil.

Synthetic waxes are produced by chemical processes. Stearine is the commercial name given to the ester of glycerin. It is an opaque, white substance produced by the hydrolysis of fat. It has been used as a substitute for beeswax since 1821 to make candles and subsequently for sculpture, bonded with such pigments as zinc white.

T. W. Cowan: *La Cire: Histoire, production, fabrication* (Paris, 1911)

N. Margival: *Cires et encaustiques* (Paris, 1937)

H. Kuhn: 'Detection and Identification of Waxes, Including Punic Waxes, by Infra-red Spectrography', *Studies in Conservation*, ii (1960), pp. 71–80

H. Bennet: *Industrial Waxes* (New York, 1975)

P. E. Kdattukudy, ed.: *Chemistry and Biochemistry of Natural Waxes* (Amsterdam, 1976)

J. S. Mills and R. White: 'Natural Resins of Art and Archaeology: Their Sources, Chemistry and Identification', *Studies in Conservation*, xxiii (1977), pp. 12–31

R. White: 'The Application of Gas Chromatography to the Identification of Waxes', *Studies in Conservation*, xxiii (1978), pp. 57–68

D. Besnainou: *Cire et cires: Etude sur la composition, l'altération, la restauration, la conservation des oeuvres céroplastiques* (diss., Paris, Institut Francais de Restauration des Oeuvres d'Art, 1984)

'Wachs', *Lexikon des kübstkeruscgen Materials: Werkstoffe der modernen Kunst von Abfall bis Zinn* (Munich 2002), pp. 231–8

II. Techniques and uses.

1. Sculpture. 2. Painting. 3. Seals.

1. SCULPTURE.

(i) Techniques. There are two main techniques for producing wax sculpture: modelling and casting. The plasticity of wax for modelling can be improved by the addition of grease and oils; animal fat, Venice turpentine, turpentine and pitch also act as solvents or plasticizers. It can be made harder by the addition of resins. In time, these additives darken the composition, because of the processes of oxidation and polymerization on drying. By lowering the melting point, some compositions can remain adhesive for a long time. As the volatile elements evaporate, however, shrinkage can occur, and cracks form (*see also* §III below).

The composition of wax used for cast objects differs only slightly from that of wax used in modelling. The composition is made harder, and consequently has a higher melting point, by the addition of natural resins, for example rosin or dammar. Cast wax pieces are also more durable, although the colour also tends to darken. Synthetic resins are used in preference to wax for the hyper-realism of modern waxworks (*see* §1(ii)(b) below).

Bleached wax can be coloured by the addition of pigments, either mixed directly with molten wax or in

a dilute turpentine solution. Care must be taken to ensure that the grains of pigment are fine and evenly sized, otherwise the largest will colour the wax in proportion to their density. This will alter the appearance of the surface by darkening the areas in relief. Flesh tints should be lightly coloured in order to appear translucent. The appearance of clothing on wax figures can be achieved with the addition of kaolin, aluminium or plaster, which produces more opaque areas. Some wax is also coloured by applying liquid coloured wax or oil paint to the surface.

Modelling in wax involves the same technique as modelling in clay. The model is built up by the addition of small balls of wax, sometimes on to an armature, depending on the desired form, then worked with a cold or warmed spatula. This technique is particularly suitable for making studies and models.

Casting is the most common technique of producing wax sculpture. A rough model in clay, wax or plastilina is made, and a plaster mould is taken of it. Molten wax is then poured into the mould and can be coloured with pigments at this stage if necessary. Once the wax has solidified the mould is removed and the piece finished by hand with a spatula.

Certain precautions are necessary with this technique. The plaster mould should be made of several, well-oiled layers of between 10 and 30 mm thick, in order to avoid damaging the wax on its removal. It is important that the plaster mould be saturated with water at a temperature of 80°C, in order that, when pouring, the wax remains molten and thus avoids trapping air bubbles. The wet mould also prevents the wax from sticking to the plaster, making the object easier to remove.

Cast wax objects can be strengthened by placing cloth or fibre that has been impregnated with wax inside the mould. For larger models and those that might have areas of weakness, it is advisable to use a framework or armature made out of metal, wood, bone or plaster.

The molten wax must be poured at a temperature just above its melting point. If the temperature is too high there is a risk of changing the properties of the wax and a darkening in colour. When the molten wax begins to harden, any excess must be removed to ensure an even distribution and to avoid cracking once the wax has solidified completely.

Low-relief wax sculpture is always attached to a base, made of slate, glass (with a coat of coloured wax on the reverse), marble or wood covered with fabric, paper or paint. The wax is attached to the base by metal strips or with adhesives, for example hide glue with or without litharge, natural resin or a mixture of wax and resin.

For information on the lost-wax casting process see METAL, §III.

(ii) History.

(a) Small-scale works. Wax has been widely used for sculptures on a small scale, due to its malleability, ease of preparation and ability to harden without cracking. The use of wax for artificial flowers, as well

as figurines for funeral ceremonies, from which the tradition of naturalistic life-size figures developed (*see* §(b) below), was known in the ancient world. Wax was most widely employed, however, for the production of sketches or modelli (*see* MODELLO, §2) that were often built up on wire armatures and used for casting works in metal by the lost-wax method; many wax objects of this type have therefore not survived. In the 15th and 16th centuries wax modelling and casting emerged as an art in its own right, particularly in Italy. In the second half of the 16th century such medallists as Antonio Abondio (1538–91) began to make portrait medallions in coloured wax, often embellished with textiles, gems and pearls. In the 17th century Gaetano Zumbo (1656–1701) exploited the realism afforded by the use of coloured waxes to produce illusionistic, macabre tableaux, as well as anatomical models.

Small wax sculptures continued to be produced in the 18th century and early 19th by such sculptors as John Flaxman (1755–1826) in England and Edme Bouchardon (1698–1762) and Clodion (1738–1814) in France. Classicizing profile heads or busts in light-coloured wax against a background of darker wax also came into fashion. The malleability of wax, and consequently its ability to convey movement, also made the material widely popular among late 19th-century French sculptors, such as Antoine-Louis Barye (1796–1875) and Pierre-Jules Mène (1810–79), known for their figurative sculpture, particularly of animal subjects. This quality was also exploited by the sculptor Medardo Rosso (1858–1928) in his impressionistic works. With the development in the 20th century of patent modelling materials, such as Plasticine, and more durable synthetic resins, the use of wax for small sculptures declined.

E. Dubois: *La Statuaire: Modelage-moulage et terre cuite* (Paris, n.d.)

S. Blondel: 'Les modeleurs en cire', *Gazette des beaux-arts* (1882)

G. Le Breton: 'Histoire de la sculpture en cire', *Les Amis des monuments et des arts*, vii (1893), pp. 269–78

G. Le Breton: *Essai historique sur la sculpture en cire* (Rouen, 1894)

J. von Schlosser: 'Geschichte der Porträtbildnerei in Wachs: Ein Versuch', *Jahrbuch der kunsthistorischen Sammlungen des allerhöchsten Kaiserhauses*, xxix/3 (1911; repr. Berlin, 1993; French trans. Paris, 1993)

F. A. A. Goupil: *Manuel général du modelage en bas relief et ronde-bosse, du moulage et de la sculpture* (Paris, 1949)

R. Reilly: *Portrait Waxes* (London, 1953)

J. K. W. Badien: *Technique du moulage* (Paris, 1967)

E. J. Pyke: *A Biographical Dictionary of Wax Modellers* (Oxford, 1973)

E. Bolton Stanwood: *Wax Portraits and Silhouettes* (Boston, 1974, Detroit, 2/1974)

C. D. Clarke: 'Modelling and Casting for Wax Reproductions', *Technical Studies*, iv (1975)

La ceroplastica nella scienza e nell'arte: Atti del I congresso internazionale della biblioteca della rivista di storia delle scienze mediche e naturali: Firenze, 1977, xx

B. Lanza and others: *Le cere anatomiche della Specola* (Florence, 1979)

A. Parenti: *La ceroplastica* (Florence, 1980)

N. Penny: *The Materials of Sculpture* (New Haven and London, 1993)

M. J. Esparsa Liberal: *La cera en Mexico: Arte e historia* (Mexico City, 1994)

R. Kendall: 'Striking a Blow for Sculpture: Degas' Waxes and Bronzes', *Apollo*, cxlii/402 (Aug 1995), pp. 2–5

G. Lista: *Medardo Rosso: Scultura e fotografia* (Milan, 2003)

M. Regert and others: 'Elucidation of Molecular and Elementary Composition of Organic and Inorganic Substances Involved in 19th century Wax Sculptures Using an Integrated Analytical Approach', *Analytica chimica acta*, dlxxvii/1 (2006), pp. 140–52

(b) Life-size figures. Displays of life-size wax figures, usually known as waxworks, derive from the tradition in antiquity of bearing funeral effigies of deceased leaders. This practice was revived at the English and French courts in the 14th century and was maintained by some English nobles into the 18th century. In France, Michel Bourdin (*c*. 1580–*c*. 1650) modelled a life-size wax funerary portrait bust of *Henry IV* in 1611; illicit wax replicas of this work toured provincial fairs, and one was exhibited in Amsterdam in the 1630s at one of the first recorded commercial displays of life-size wax portraits. In 1668 Louis XIV granted the sculptor Antoine Benoist (1632–1717) a monopoly to show effigies (untraced) of the French royal family and court, which were often dressed in clothes provided by the subject. Benoist also modelled figures (untraced) at the English court in 1684, and in 1688, at the renewal of his privilege, toured his wax 'puppets' around fairs in France.

Waxworks were recorded in England at the Bartholomew Fair in 1647, and a tableau of the *Last Supper* was noted by John Evelyn (1620–1706) at the French Ambassador's lodgings in 1672. The figures in Westminster Abbey, London, are the most important surviving group of early English waxworks, dating from 1686 to 1806. In the late 17th century the German Johann Schalch (1623–*c*. 1704) travelled throughout northern Europe with his wax models of court figures, visiting London in 1685. A rival modeller was Mrs Goldsmith (*fl* 1695–1703), who made the effigies in Westminster Abbey, London, of *Frances, Duchess of Richmond*, which cost £260 in 1703, *William III* and *Mary II*. The most celebrated English waxworks of the late 17th century and early 18th was that of Mrs Salmon (1650–1740), established in 1693, whose 140 figures included diverse tableaux and a booby-trapped mechanical figure of *Old Mother Shipton*. Her closest rival was Benjamin Rackstrow (*d* 1772), whose 'Museum of Anatomy and Curiosities' contained similar subject groups and a large number of anatomical pieces verging on the titillating. Serious anatomical waxwork collections had appeared in Europe in the late 17th century, of which the most renowned was 'La Specola' in Florence, founded in 1675 on the Medici collections.

Popular late 18th-century waxworks included Sylvester's 'Cabinet of Royal Figures', and that of Patience Wright (1725–86), who had come to London in 1772 after the destruction of her waxworks in New York, the first in America. More celebrated are the waxworks of Dr Philippe Curtius (1737–94). As a physician in Berne, he had made wax anatomical models, and portraits for friends; these so impressed Louis-François de Bourbon, Prince de Conti, that he brought Curtius to Paris in 1761. In 1767 he was joined by his niece, Marie Grosholtz (1761–1850), later Mme Tussaud, whom he taught wax modelling. Curtius moved his 'Salon de Cire', with tableaux of the French royal family, to the Palais Royal in 1770 and in 1783 opened on the Boulevard du Temple the infamous 'Caverne des Grands Voleurs', the basis of the later 'Chamber of Horrors', which, during the Revolution, was filled with wax casts of the heads of guillotined nobility. After Curtius's death, Mme Tussaud brought most of the collection to England, touring Britain between 1802 and 1835 before settling in London. Other celebrated waxworks collections are in the Panoptikum in Hamburg (1879) and the Musée Grévin, Paris (1882).

By 1900 waxworks, often featuring tableaux reminiscent of Victorian genre painting, were to be found in some 190 British and 200 American towns and resorts, but they rapidly became unfashionable after 1918. With the arrival of Pop art in the 1960s, however, the super-realism of waxworks again became acceptable. Their enduring popularity can be explained by the potential for verisimilitude offered by the medium and the popular fascination with the appearance of the famous and infamous. While Curtius and Mme Tussaud ensured accuracy by taking life or death masks of their subjects, present likenesses are established by modelled clay portrait heads, achieved with the assistance of photographs and measurements; from these, the casting moulds are created. Synthetic resins are often used instead of wax. The illusion is enhanced by the use of human hair and original or closely copied clothes.

E. J. Pyke: *A Biographical Dictionary of Wax Modellers* (Oxford, 1973)

E. V. Gatacre and L. Dru: 'Portraiture in the Cabinet de Cire de Curtius and its Successor, Madame Tussaud's Exhibition', *La ceroplastica nella scienza e nell'arte: Atti del I congresso internazionale della biblioteca della rivista di storia delle scienze mediche e naturali: Firenze, 1977*, xx, pp. 639–48

J. Adhémar: 'Les Musées de cire en France, Curtius, le "Banquet Royal", les têtes coupées', *Gazette des beaux-arts*, xcii (1978), pp. 203–14

R. D. Altick: *The Shows of London* (Cambridge, MA, and London, 1978)

N. Hopwood: *Embryos in Wax: Models from the Ziegler Studio* (Berne, 2002)

U. Kornmeier: 'Madame Tussaud's as a Popular Pantheon', *Pantheons: Transformations of a Monumental Idea*, eds R. Wrigley and M. Casket (Aldershot, 2004), pp. 147–66

C. Undine: 'Tussaud [*née* Grosholtz], Anna Maria [Marie; *known as* Madame Tussaud]', *Dictionary of National Biography* (Oxford, 2005)

2. PAINTING. Wax has been widely used as a binder in the manufacture of paint and as a stabilizer in commercially produced oil paints (*see* PAINT, §I), as

well as a matting agent in varnishes and oil paint. A warmed mixture of beeswax and resin has traditionally been employed in fresco painting to provide decorative areas in relief to which metal leaf is applied. In the late 19th century Thomas Gambier-Parry (1816–88) developed the technique of 'spirit fresco painting', involving heating a mixture of resin, wax, oil of spike lavender and copal, with pigments; this was applied to plaster that had been coated with whiting and lead white mixed with turpentine.

The main use of wax in painting, however, has been in the technique of ENCAUSTIC PAINTING (see colour pl. XVI, fig. 2), in which dry pigments are mixed with molten wax on a heated metal palette, then applied to a support; a heat source is then passed close to the surface to 'burn in' the colours by fusing them to the support. Encaustic painting was widely used in the ancient world and described by Pliny the elder (AD 23/4–79), Vitruvius (1st century BC) and Plutarch (c. AD 50–after 120); attempts were made to revive the technique in Europe in the 18th century. There is, however, considerable debate concerning the media and processes originally used and whether a number of painting methods involving wax can be described as encaustic: wax can be dissolved in turpentine and is made water-soluble by the addition of alkali and thus can be combined with a wide variety of paints; several emulsions of waxes, oils and resins have also been patented as artists' media (see also PAINTING MEDIUM).

F. Pratt and B. Fizel: *Encaustic Materials and Methods* (New York, 1949)

J. Ayres: *The Artist's Craft: A History of Tools, Techniques and Materials* (Oxford, 1985)

L. Masschelein-Kleiner: *Ancient Binding Media, Varnishes and Adhesives* (Rome, 1985)

For further bibliography *see* Encaustic painting.

3. SEALS. Small pieces of wax stamped with a device or emblem have been widely used for the purposes of authentication, most commonly of letters or documents; the word 'seal' applies both to the matrix or die that stamps the impression and to the impressed material. Although wax seals were occasionally employed in the Islamic world, their use was mainly confined to the Byzantine empire and Western Europe, where their importance greatly increased during the Middle Ages (see fig.).

The substance employed for medieval wax seals was a mixture of beeswax, Venice turpentine and pigment, usually vermilion, although yellow, off-white and green seals are also extant. Shellac (*see* LACQUER) was introduced in the 17th century and eventually replaced beeswax.

A stick of sealing wax was held under a flame in order to melt a drop of wax, which was then impressed with a seal matrix. These usually took the form of a stamp or signet ring and were commonly made from brass, occasionally silver or carved hardstones or marble. In Byzantium sealing cones were also used. These are small cones of hardstone or bronze (used from the 10th century) with an intaglio

sealing device carved into the bezel-like base, with a tiny loop at the apex for suspension. Until the early 11th century in Western Europe a wax seal was affixed *en placard* (directly to the parchment) and pressed partially through a slit to prevent it falling off. In the late 11th century and throughout the 12th a second, counter seal was usually added and appended to fastenings of silk cord, hemp, leather or parchment.

In Western Europe wax seals were initially used only by royalty, nobility or by high-ranking ecclesiastics, and as they were the only means of validating official documents or private correspondence constituted a symbol of power and legality. By the late 12th century, however, seals had been adopted to represent towns, guilds, colleges, marine companies and similar bodies, and objects as varied as caskets of relics and bundles of wool were sealed. Medieval wax seals could be up to 100 mm in diameter and were typically either round or in pointed ovals; they are linked iconographically to medals and coins, usually with a central device surrounded by an abbreviated inscription within plain or beaded borders. Many seals are among the finest expressions of the art of miniature relief work. Between the 13th and 17th centuries English seal cutters were renowned for their skill and the rich complexity of their designs. From the 17th century to the early 20th wax seals remained an emblem of authority for documents of state and law. Personal seals, which constituted the largest group, became simply an adornment and gradually went out of use.

A. B. Tonnochy: *Catalogue of British Seal-dies in the British Museum* (London, 1952)

J. Favier: *La Vie au moyen âge illustrée par les sceaux* (Paris, 1985)

R. H. Ellis: *Catalogue of Seals in the Public Record Office* (London, 1986)

T. A. Heslop: 'English Seals in the Thirteenth and Fourteenth Centuries', *Age of Chivalry: Art in Plantagenet England, 1200–1400* (exh. cat., ed. J. Alexander and P. Binski; London, Royal Academy of Arts, 1987)

E. Parra, M. D. Gayo and A. Serrano: 'The Creation of a Database for Wax Seals from Parchment Documents Using the Results of Chemical Analysis', *ICOM Committee for Conservation 10th Triennial Meeting: Preprints* (London, 1993), pp. 37–41

III. Conservation. The type of wax, additives and colorants can contribute to the state of preservation of a wax artefact; most forms of deterioration, however, result from environmental factors. A temperature of just 30°C can cause slumping, while excessive cold can lead to embrittlement and cracking. Shrinkage and eventual cracking may also occur when important plasticizers are leached out of some waxes as a result of fluctuations in temperature; these plasticizers may be seen as white crystals on the surface. In relative humidities over 65%, wax may grow mould, which also attacks important structural elements. Oxidation, catalyzed by light, causes darkening in wax and can lead to structural changes and hardening.

7. Henry II. 2nd seal, obv. [1176-77.] *Add. Ch.* 5719.

Wax second seal of Henry II, showing *Henry II Enthroned* (obverse), 1176–7 (London, British Library); photo credit: HIP/Art Resource, NY

Such additives as fats can migrate out of the wax to form sticky droplets on the surface. Pigments may discolour or even move around in the wax. Discolouration can also result from solvent cleaning: turpentine appears to leave brown residues on the surface, while ammonia causes blanching. Methods of manufacture can also contribute to poor preservation. For example, wax built around an armature may crack due to restricted movement, and a wax artefact built up in layers can delaminate due to different drying rates in the layers.

Wax has a tendency to attract and embed dust, which can only be effectively removed using solvents. Solvent cleaning, however, partially removes the surface and may affect surface paint or pigmentation. If the risk to the artefact is too great, it is advisable not to clean. Coating the artefact is also not recommended, as varnish often yellows with time and becomes difficult to remove without damaging the surface. Regular dusting should overcome the need for either coating or solvent cleaning.

If solvent cleaning is necessary, water containing a small amount of detergent should be used initially. Heavily embedded dirt may require such a solvent as alcohol, iso-propyl alcohol or petroleum spirit to soften the surface enough to lift the dirt. Cleaning should be carried out over a small area at a time, applying the solvent with a brush and then drawing it off the surface with a dry brush. Rinsing in water is essential to remove residual solvent or detergent. White crystals on the surface may be removed effectively by using iso-propyl alcohol.

Dowelling a broken wax artefact is generally not recommended, as it involves too much structural interference. Instead, wax can be joined with adhesive, although it is difficult to achieve a strong bond. The most effective adhesives for this purpose are epoxy resins, PVA emulsion, acrylic emulsions, and acrylic dispersions. Filling losses in a wax artefact is necessary only for structural and, sometimes, aesthetic reasons. The wax used for filling should be softer than that of the artefact to facilitate removal if

necessary. Wax fills can be pigmented and can be cast or built up and carved back.

Despite the relative chemical stability of wax, its sensitivity to temperature fluctuations means that, ideally, wax artefacts should be stored in stable conditions with a temperature of around 20–22°C and with a relative humidity of 50±5%. Covered display is recommended to prevent dust accumulation. Alternatively, artefacts should be dusted daily with a soft brush. Lighting is also an important consideration, due to potential oxidation, discolouring and slumping. Wax objects should be stored covered in a box and not left in contact with such materials as tissue that may fuse with the surface. Most basic conservation treatments are in fact quite delicate operations that should best be undertaken by a qualified conservator in order to prevent damage to the object.

V. J. Murrell: *The Care of Wax Objects* (London, 1970)

D. Reid of Robertland and A. Ross: 'The Conservation of Non-metallic Seals', *Studies in Conservation*, xv/1 (1970), pp. 51–62

V. J. Murrell: 'Some Aspects of the Conservation of Wax Models', *Studies in Conservation*, xvi/3 (1971), pp. 95–109

V. J. Murrell: 'A Discussion of Some Methods of Wax Conservation and their Application to Recent Conservation Problems', *Papers of the First International Congress on Wax Modelling: Florence, 1975*

H. Kuhn: *Conservation and Restoration of Works of Art and Antiquities*, i (London, 1986)

E. Pearlstein: 'Fatty Bloom on Wood Sculpture from Mali', *Studies in Conservation*, xxxi/2 (1986), pp. 83–91

J. S. Mills and R. White: *The Organic Chemistry of Museum Objects* (London, 1987)

V. Kaufmann: 'Restoration of an 18th Century Half Life-size Anatomical Figure Modelled in Beeswax', *The Conservator*, xii (1988), pp. 25–30

J. Koller and U. Baumer: 'Organische Überzüge auf Metallen. Teil 2: Wachse und Emulsionen', *Arbeitsblätter für Restauratoren*, xxxiii/2 (2000), pp. 227–41

M. te Marvelde: 'How Dutch Is "the Dutch method"? A History of Wax-resin Lining in its International Context', *Past Practice, Future Prospects*, eds W. A. Oddy and S. Smith (London, 2001), pp. 143–9

R. Lapkin and others: 'Waxing Scientific: Exploring New Options for Wax Seal Consolidation', *Book and Paper Group Annual*, xxi (2002), pp. 95–8

Wicker. Term that describes both natural and man-made materials used for BASKETWORK; in the late 20th century it became almost exclusively associated with furniture. The natural materials, which are still worked mainly by hand, are obtained from the willow family (*Salix*) and from the trailing, vinelike rattan palm (*Calamus* and *Daemonorops*); the hard outer skin of the rattan provides 'cane', which is split and used for weaving, while the hard inner core is properly known as 'reed', but also called cane. The artificial fibres are made mainly from machine-woven, twisted paper, often stiffened with glue sizing and reinforced with fine metal wire.

Wickerwork is as old as basketmaking, itself one of the oldest known crafts. The materials are inexpensive,

pliant and easy to work when wet, and robust structures can be made by interweaving a stout framework of rods or stakes with cane or fresh osier withies. Evidence from Mesopotamia, Egypt, Greece and Rome suggests that in ancient times a wide range of products was made, including seat furniture, footstools, headrests, cradles, coffins, mats, hats, shoes and tea-strainers, as well as an enormous variety of boxes and baskets. In fact, until the 19th century the vast majority of wicker items produced all over the world were non-furniture objects. These have been mainly appreciated by anthropologists and ethnographers: art and design historians, generally speaking, have considered them unworthy of attention because of their humble materials and association with everyday utilities and work. By contrast, the study of wicker furniture is validated because, at the very end of the 19th century and at the beginning of the 20th, it became a central concern of avant-garde architects and designers. At that period European design reformers became fascinated by what they considered ethnic craftwork, uncorrupted by the effects of industrialization and supposedly offering pure examples of function determining form. Through their efforts, exhibitions of such work, including a great deal of basketry, regularly toured around art and design institutions in Britain, Austria and Germany in order that designers and manufacturers might better understand the relationship of function and material to form and decoration.

1. BEFORE 1900. The earliest surviving wicker furniture was made in ancient Egypt, where it was preserved by the extremely dry atmosphere of the tombs. The pieces indicate a similarity of construction, particularly in the wrapping of the joints, to techniques used in the late 20th century, as do those illustrated in ancient Greek and Roman stone carvings. The making of wicker furniture was an extension of basketmaking and therefore took place in willow-growing/basketmaking areas. Little is known about it during the Middle Ages, but it appears to have been a relatively cheap product used by the poorer classes right up to the 19th century. By the 16th century references to 'twiggen', 'wanded', wicker, willow, 'rodd', withy and osier chairs (to name the commoner regional terms) abound in household inventories from all levels of society. Wicker was also widely used to make cradles and birdcages, sometimes for firescreens, and occasionally for the side panels of food cupboards. Where timber was scarce, it was used for beds, hanging shelves, window shutters and coffins. Basketwork chairs were used by nursing mothers, the old and the infirm; they were also considered particularly suitable for infants.

Cane was introduced into European furniture-making in the second half of the 17th century, when it was imported from the Malay Peninsula by the East India Company. It became fashionable in England and France for weaving the backs and seats of chairs. These caned chairs, as they are known to distinguish them from later cane ones, were light and pleasantly exotic, and they remained in favour with the upper

classes throughout the 18th century. It was only in the second half of the 19th century, when the tough, fibrous core of Malaysian and Indonesian rattan palm began to be used in China, Europe and the USA, that cane furniture and wickerwork became widespread, the peak of their popularity lasting from c. 1870 to 1920.

Wickerwork appealed to the general mood of Orientalism, and its handcrafted nature attracted adherents of the Arts and Crafts Movement, as did its aesthetic qualities, which also found admirers in the Aesthetic Movement. 'Artistic, Odd and Inexpensive', it was the perfect way for the newly rich middle classes of the USA and Europe to add touches of beauty and exoticism to their homes and gardens without financial ruination. The large-scale production and mail-order distribution of the larger American companies of the second half of the 19th century made this furniture more widely available to the American domestic market and to foreign consumers than ever before.

Wicker furniture had been made in the USA in colonial times, but not a great deal was produced. In the early 19th century, however, caned seat furniture became popular, and in the 1870s the machine-weaving of sheets of cane was introduced, together with machines for boring holes in seat furniture in order to accelerate the production of caned seats. Imported wicker furniture, mainly from East Asia, was gaining in popularity around the middle of the century, but a dramatic development in wicker furniture production within the USA meant that by 1860 the vast bulk of it was manufactured internally. This was due, in part, to the entrepreneurial activities of Cyrus Wakefield, who in 1844 began experimenting with the rattan ballast discarded on the dockside after it had been used to protect cargoes from the East. By 1855 he had founded what was to become a highly successful business importing rattan and producing furniture. At first, he combined cane (usually wrapped around a wooden frame) with locally grown willow; later, he utilized the strong inner core of the cane. In 1897 the Wakefield Rattan Co. merged with Heywood Bros of Gardner, MA (the largest chair manufacturer in the USA), to become the world's largest producer of wicker furniture.

The pieces, which became increasingly ornate as the century progressed, were enormously popular as porch and garden furniture and also began to be accepted as indoor furniture. The range of products was vast. The use of lacquer introduced colour into the furniture from 1883. Although some pieces continued to be imported from East Asia, notably the well-known 'Peacock throne' and 'Hour-glass' chair popularized at the Philadelphia Centennial Exhibition of 1876, the American wicker industry grew from strength to strength until, at the beginning of the 20th century, it met with unexpected competition from abroad. This time the threat of imports came not from Asia but from well-designed and well-made cane furniture from Austria, Germany and Britain.

2. 1900 AND AFTER. Willow work had been carried out in parts of the Austro-Hungarian empire since the late 1820s, when the government sponsored basketmaking as a winter occupation in agricultural areas. State subsidies assisted the development of new and better types of willow, and the craft was taught by teachers trained at the Imperial School, Vienna. By c. 1900 the curriculum of the school reflected the new ideas about art and design prevalent in the Austrian capital. The outburst of creative activity in Vienna in the late 1890s gave birth to cooperative ventures between artists, architects and designers and local crafts or trades in order to produce relatively cheap items of everyday use. Leading members of the Vienna Secession, in a desire to democratize art and design, concerned themselves with designing furniture in willow, cane and bentwood (e.g. chairs designed by Hans Vollmer, 1904).

In Germany the number of firms producing cane and willow furniture in the years before World War I was extensive. Just as in Austro-Hungary, avant-garde architects and designers believed design should be applied to everyday items produced in bulk, and not simply to expensive one-off products. Many of them, most notably Henry Van de Velde (1863–1957), Peter Behrens (1868–1940) and Richard Riemerschmid (1868–1957), believed that there should be closer links between educational institutions and the manufacturing sector, and all three men produced designs for cane or willow furniture. Many German firms decided to employ a professional designer, often an architect or academic, in order to raise the design standards of their goods so that the German economy might better compete in international markets. The most notable partnership in Germany was that between the firm of Theodor Reimann of Dresden and Richard Riemerschmid.

Cane and willow furniture was produced in other European countries, including the Netherlands (where the leading architect P. J. H. Cuypers (1827–1921) designed cane furniture), Switzerland, Belgium and France, but it was England that was to provide the strongest competition to the German and Austrian firms that were exporting well-designed and soundly made goods all over the world, including Britain itself.

When *The Studio* published an article on Austrian wicker furniture in 1904, the British market was swamped with imports while the native trade languished. Determined to redress the situation, Benjamin Fletcher, headmaster of Leicester School of Art, decided to emulate the Continental initiatives and to make links between his institution and local crafts and trades (Leicester was situated near a traditional willow-growing area and already had an established labour force). He visited Austria and Germany in 1906 and brought back some cane furniture to Leicester, where, with the assistance of Charles Crampton, one of the most skilled basketmakers in the area, he began to experiment in the design and construction of cane furniture.

In 1907 the firm of Dryad was founded in Leicester by Fletcher's close friend Harry Hardy

Peach (1874–1936), with Fletcher as designer and Crampton one of the four workers. Dryad aimed at producing well-made, well-designed furniture that was light, comfortable and appropriate to modern living. Both Fletcher and Peach considered the rigid geometric shapes favoured by the Vienna Secession inappropriate to such a pliant material as cane. In the manner of certain German designs, Dryad pieces show a greater sensitivity to the material and reflect Arts and Crafts notions of honesty in materials. Furthermore, the originators of Dryad considered that harsh geometric forms did not 'commend themselves to British notions of comfort or fit the homely reserve of English houses'. In Dryad furniture the comfort came mainly from the shaping of the basic form, which, when woven with the slightly springy cane, rendered virtually unnecessary the use of upholstery or cushions. In general, Fletcher's designs adapted the sense of movement found in Art Nouveau to the malleability of the cane, restricting the stylistic vocabulary of the Vienna Secession to detailing and an emphasis on the linear. Dryad was immensely successful, employing nearly 200 people by 1914, by which date it was exporting its goods all over the world, including the British colonies and South America. It even broke into the massive American market, obtaining retail outlets in New York and Chicago.

Other new firms were established in the area, but after World War I the trade became increasingly competitive. The war seriously affected production, and some firms never fully recovered; those that did found that they faced even stiffer competition as firms sought to keep down costs. Some did it by using less skilled labour, but this showed in loose and uneven weaving, some by adopting more openweave styles, which took less labour and materials. Others abandoned willow and cane in favour of the new 'artificial fibers' marketed in the USA from 1904, but it was not until Marshall B. Lloyd (1858–1927), of Menominee, MI, invented a machine in 1917 to weave wicker from twisted paper that the price of wicker furniture was dramatically reduced. The machine-woven wicker (reinforced by thin wire) offered a close weave at cheap costs and soon put many cane and willow furniture-makers out of business. No firm recognized the new threat more than Heywood-Wakefield, which took over the Lloyd Manufacturing Co. in 1921. A franchise was established in Britain in 1922, and W. Lusty & Sons Ltd of London produced its famous 'Lloyd Loom' pieces from 1922 to 1962. In 1912 fibre furniture had accounted for only 15% of wicker furniture production in the USA, but by 1920 it had risen to almost 50% and by the end of the decade to 80%. The situation was similar in Britain, as wicker firms either abandoned cane and willow or produced artificial fibres in an effort to stay in business.

The rapid demise of the wicker furniture trade in the 1930s should not obscure its immense popularity in the early 1920s, when wicker graced some of the world's finest ocean liners, hotels, restaurants and cinemas, as well as country clubs, sports clubs and vehicles, from aeroplanes to motor-buses. It has been argued that once wicker furniture was made by machine it lost some of its charm, but this can hardly account for its downfall in the 1930s in the face of Modernism. Customers who wanted light and modern-looking furniture appropriate for the new machine age then chose tubular steel instead of wicker. There was some copying in cane of the popular styles in tubular steel, particularly in Britain, Germany and the USA, but the days of wicker were numbered. Both natural and artificial wicker seemed quaint by comparison with the hard, shiny steel. Some use was made of cane in the 1950s, when sculptural forms were sought after, but by then there were a whole new range of plastics available, which were just as light, colourful and malleable but spoke more of a machine age. In the 1980s, however, wicker returned to favour, precisely because of its nostalgic references to a pre-machine age.

See also BAMBOO.

A Completed Century: The Story of the Heywood-Wakefield Company, 1826–1926 (Boston, 1926)

R. Saunders: *Collecting and Restoring Wicker Furniture* (New York, 1976)

P. Corbin: *All About Wicker* (New York, 1978)

F. Thompson: *The Complete Wicker Book* (New York, 1979)

Cane Furniture Hand Made by the Angraves [cat. pubd by Angraves Invincible Registered Cane Furniture Ltd] (Leicester, [1980])

G. Dale: 'Lloyd Loom Furniture', *Antique Collector*, li/2 (1980), pp. 52–4

A. Heseltine: *Baskets and Basket Making* (Aylesbury, 1982)

Heywood Brothers and Wakefield Company: *Classic Wicker Furniture: The Complete 1898–1899 Illustrated Catalog*, intro. R. Saunders (London, 1982)

R. Saunders: *Collectors Guide to American Wicker Furniture* (New York, 1983)

P. Kirkham: 'Willow and Cane Furniture in Austria, Germany and England, c. 1900–14', *Furniture History*, xxi (1985), pp. 128–31

P. Kirkham: 'Dryad Cane Furniture', *Antique Collecting*, xix/9 (1985), pp. 11–15

P. Kirkham: *Harry Peach, Dryad and the DIA* (London, 1986)

E. B. Ottilinger: *Korbmöbel* (Salzburg, 1990)

C. G. Gilbert: *English Vernacular Furniture, 1750–1900* (London, 1991)

J. Lee Curtis: *Lloyd Loom: Woven Fibre Furniture* (London, 1991, rev. 1997)

J. E. Adamson: *American Wicker: Woven Furniture from 1850 to 1930* (New York, c1993)

D. Knell: *English Country Furniture: The Vernacular Tradition* (Princes Risborough, 1993)

H. Teiwes: *Hopi Basket Weaving: Artistry in Natural Fibers* (Tucson, c1996.)

C. Edwards: '"Wicker" Furniture', *Antique Collecting*, xxxi/9 (1997), pp. 18–21

Wood. Material derived from the trunks, boughs and other hard parts of trees and shrubs and serving a wide range of artistic purposes. It has been used as a raw material for millennia, first to construct houses and make tools and weapons, and later to build temples,

palaces and boats and to carve sculptures and furniture. As an organic raw material, wood is subject to destruction by fire, insects, fungi and bacteria, and even by light and water: thus the preservation and study of the relatively few wooden artefacts that have survived from early civilizations are of crucial importance.

I. Introduction. II. Varieties and uses. III. Techniques. IV. Conservation.

I. Introduction.

1. BIOLOGY. Wood represents the secondary permanent tissue of ligneous plants (trees and shrubs) that consist of trunks, branches and roots. It is produced from a formative layer known as cambium (see fig. 1a), which is between the bark and the wood. As it constantly increases in girth, cambium sheds wood cells (xylem; 1b) inwardly and bark cells (phloem; 1c) outwardly. In this process the growth of bark is much less than the growth of wood. In older trees bark represents 10–15% of the whole and wood 85–90%. On the cross-section of a trunk with bark the following can be seen, varying according to the type of wood: the bark composed of a combination of inner bark (bast) and outer bark (1d); the wood part with sapwood (1e) and heartwood (1f), the annual or growth rings (1g) and various complexes of cell and tissue; and the central pith (1h). As wood ages, it is separated into sapwood and heartwood by processes aimed at producing a heart or core. The sapwood that lies on the outside as the living part of the trunk serves to conduct water and to hold nutrients. The heartwood—the inner core of the wood—is formed when the living cells die off; this process begins sooner or later in different species, but generally between the 20th and 40th year of a tree's life. In Europe the species of trees are divided according to the way in which the heartwood is formed. Trees that invariably form coloured heartwood are known as heartwood trees; examples include pine, larch, Douglas fir, oak, elm, walnut and cherry. Trees that may form coloured heartwood are not true heartwoods but are known as false heartwoods. These form heartwood only in certain conditions. False heartwood typically is of irregular shape in cross-section with cloud-like curving projections; examples include red heart in beech, brown heart in ash. Some trees form light-coloured heartwood; here the heartwood differs from the surrounding sapwood only in containing less water, but not in colour, for example spruce, fir, red beech, lime and pear. Such trees as birch, alder, aspen, sycamore, Norway maple and hornbeam (previously known as sapwood trees) have delayed heartwood formation. There are no differences between the sapwood and the heartwood as regards colour or moisture. The signs indicating heartwood formation can only be detected microscopically.

The tissue of wood is constructed of cells of various kinds, most of which extend lengthwise in the direction of the trunk (along the 'grain'; 1i and 1j). In the living tree these lignified cells take over the

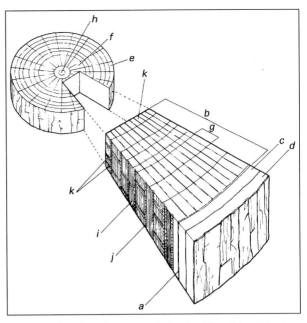

1. Cross-section through a tree trunk showing (a) cambium; (b) xylem; (c) phloem or inner bark (bast); (d) outer bark; (e) sapwood; (f) heartwood; (g) annual rings; (h) pith; (i) fibre or tracheids; (j) vessels or tracheids; (k) wood rays

functions of conducting water and nutrients from the root to the crown and of supporting the trunk. Accordingly when the wood comes to be worked, it is fairly penetrable in the direction of the grain as well as being very rigid and strong. Across the grain—thus in a horizontal direction in relation to the standing tree—there are several ribbon-like bundles of cells that, because of their radiating pattern running from the centre of the trunk to the outer edge, are known as wood rays (1k). They take care of the transport and storage of nutrients. As a result of a secondary form of growth involving the thickening of the trunk, the tree periodically forms growth layers, known in temperate climates as annual rings. Thus the body of the wood shows three vertically superimposed main axes: the direction of the grain, the radial direction (in line with the wood rays) and the tangential direction (in line with the growth rings).

Just as coniferous and broad-leaf trees are very different in their outward structure, there are also clear distinctions in the anatomical structure of their woods (softwoods and hardwoods). In evolutionary terms conifers are very much older than broad-leaf trees. The origins of the modern coniferous families can be traced back to the Jurassic/Cretaceous period (starting 185 or 140 million years ago), and woods with a typically coniferous structure are known from as early as the period of the mineral coal forest (Carboniferous), starting 330 million years ago. Broad-leaf trees, on the other hand, evolved mainly in the Tertiary period (65 million years ago). The wood of conifers is made up principally of tracheids, which take over both the functions of support and

conduction; within an annual ring, which consists of porous early wood and denser late wood, the tracheids differ in the size of their cell cavities and the wall thickness. Wood rays represent a relatively small proportion of the volume of coniferous wood. The wood of broad-leaf trees is more evolved in terms of phylogenesis and is composed of cells that are more varied than those in coniferous wood, each being specially adapted to its particular function. This can be clearly seen in beech-wood with the division into vessels for providing water and wood fibres for support. Tracheids capable of taking over both functions and storage cells running parallel to the fibres and along the rays complete the structure.

In the different varieties of wood the substance of the wood is generally very similar in composition. Of the weight, 40 to 50% consists of cellulose, which is present in long chain molecules with a high degree of orientation. The cellulose, which is crystalline in structure, is embedded in amorphous lignin (25–30%) and hemicellulose (20–25%), which is in short chains. Thus within the individual cells wood displays a compound system in which the cellulose accounts for its great tensile strength and the lignin for its high resistance to pressure.

2. PROPERTIES. The great range of varieties of wood available means that it is always possible to choose one that meets the special requirements for any given use. On the other hand, this diversity makes it difficult to give a comprehensive review of the varieties and their specific properties. The first guide to selecting woods is the basic density, that is the relationship of the mass of a body of wood to its volume, including any cavities. Theoretically this can range from 0 (consisting only of cavities and pores) to 1.5 g/cm^3 (consisting only of cell walls); in practice the basic densities of woods lie between the very light balsa (Ochroma lacopus; 0.16 g/cm^3) and the very heavy lignum vitae (Guaiacum officinale; 1.2 g/cm^3). When basic density is used as a measure, the range found among tropical woods is much wider than among native European wood varieties. Although the density of the substance forming the cell walls of all varieties of wood is the same, the differences in basic density are explained by the fact that the number of lignified cells and the thickness of their walls vary widely in test pieces of wood of the same size. Thus the basic density provides indications about the properties of the wood on which the specific amount of space occupied by the cell wall substance has a determining effect. As the basic density increases, the following also tend to increase: elasticity, hardness and resistance to wear, heat conductivity, degrees of swelling and shrinkage and the consumption of energy when machining.

Many types of wood contain extractable substances; these are highly varied in their chemical composition and have a considerable effect in determining the particular character of each variety of wood. Such substances are responsible for the colour, smell, resistance to pest infestation and chemical reactivity of the variety of wood in question. Tropical varieties of wood in particular have a countless number of these extracts and come in every colour of the palette, from the pale antiaris (Antiaris africana), through the lemon-yellow movingui (Distemonanthus benthamianus), the greenish greenheart (Ocotea rodiei), the brilliant red padauk (Pterocarpus macrocarpus), the purple amaranth or purpleheart (Peltogyne venosa) to black ebony (Diospyros crassiflora). There are also many other varieties that are popular because of decorative veins, differentiated areas of colour or marked colour contrasts, such as Indian rose-wood (Dalbergia latifolia), wenge (Milettia laurentii) and zebrano (Microberlinia brazzavillensis). The gamut of scents ranges from the highly aromatic sandalwood (Santalum album) to some varieties of Ocotea that are aptly named 'stinkwood'. However, the reactivity of the substances contained within the wood can also be a disadvantage when the timber is being used. Among possible consequences are the corrosion of metals in contact with damp wood, interference with the setting of cement and the failure of lacquers and glues to harden. When machining some varieties of woods, workers may even experience allergic reactions.

II. Varieties and uses. There is a vast number of types of wood throughout the world, with well over 10,000 varieties of tree having been identified and described. There are, for example, more than 500 varieties of conifer worldwide and more than 3000 different varieties of broadleaved trees in the Amazon tropical forest alone. About 80% of the earth's forest cover is located in two large areas, one in the north of the northern hemisphere and the other in the Tropics. As regards their importance, the various types of forest tree must be judged on different criteria. Not only the properties of the wood but also the speed at which the tree grows and its size are important considerations. Thus in Germany oaks and even the yew grow slowly, while in Italy the trunks of poplars can reach a diameter of 300 mm in just six years. Different genera of tree vary markedly in their size. While in Europe conifers reach a maximum height of 50 m, some species of eucalyptus in the Australian savannah (e.g. Eucalyptus regnans) can grow as tall as 120 m. The tallest recorded tree, however, was a conifer (Sequoia sempervirens) that grew in North America.

The diversity of trees is reflected in the variety of woods, as can be seen in the way their names are listed for commercial use. These are not the botanical names of the species but those used in the timber trade and among users of wood. False names are often used particularly for imported timbers and result in confusion and the use of the wrong timber. Thus, for example, African walnut (Masonia altissima) is not walnut (Juglans regia), parana pine, or Brazilian pine, is not pine but a type of araucaria (Araucaria angustifolia), Western red cedar is not cedar but wood from the Cupressaceae family (Thuja plicata), and Philippine mahogany is not mahogany.

Moreover, one false name can be used to cover several types of timber: for example, African walnut is also used for dibétou (*Lovoa klaineana*). These false names developed when settlers applied the names of familiar woods from their native countries to different woods in the countries where they settled. They used such familiar-sounding names as oak, elm, ash, walnut, cherry and pear, as well as mahogany, cypress, cedar and teak. Besides false names there are also a large number of fanciful names, such as zebra-wood, red-wood, tiger-wood, violet-wood, rose-wood, coral-wood, iron-wood and satin-wood; while they do not suggest a different variety of wood, they can be misleading when applied to several varieties of timber.

Throughout history wood has been used in a wide variety of art forms, including architecture, sculpture, PANEL PAINTING, altarpieces, musical instruments, WOODCUTS and WOOD-ENGRAVING, to name but a few examples. For wood sculpture and wood-carving it is the general practice to use indigenous woods as the basic material. In Japan wood was a popular medium for sculptors and artist craftsmen. The main variety of wood used in the 7th century AD was camphor-wood or kusu (*Laurus camphora*). In the 8th century mainly hinoki, Japanese cypress (*Chamaecyparis obtusa*), was used alongside several other indigenous varieties. In India, too, different varieties of wood were available for sculpting and carving, and a rigorous selection was made according to the quality of the wood. Among the most important woods for carving were teak (*Tectona grandis*), shisham (*Dalbergia sissoo*), Indian rose-wood (*Dalbergia latifolia*), cedar-wood or deodar (*Cedrus deodara*), sandalwood (*Santalum album*) and Himalayan ash (*Fraxinus floribunda*).

Wood sculpting was enormously important in Oceania. Early carved works of art in wood were made using stone and shell tools, scrapers made out of teeth and various finishing implements (including skate bones and blades). The load-bearing posts of the houses of ancestors were often carved and painted. Identification of the wood has been carried out in a very few cases. In Africa indigenous varieties of wood were always worked. These ranged from not very resistant woods that were easy to work to very durable species that were hard to work. The wood was mainly worked with adzes and knives made of iron. In the various countries of Africa it was mainly ancestral or cult figures that were worked in wood, but only very few pieces of carving more than 100 years old have survived. In Central America very few works in wood have been preserved. These include the carved wooden door supports of the Maya, which were made from sapotilla (*Achras zapota* or *Manilkara zapota*). In North America, on the other hand, there are huge totem poles mainly made from Western red cedar-wood (*Thuja plicata*), or the various masks of the different native peoples mostly made from alder-wood, maple and birch.

In Europe, wood sculpture particularly flourished during the Middle Ages. Until the end of the 18th century lime-wood was preferred to other varieties of wood for carving in almost every region of Europe, though on the Upper Rhine poplar and willow-wood were also used in the 14th century, and artists from Lower Germany, Flanders, Brabant and the Rhine region worked mainly in oak and walnut. In south Germany the Siberian yellow pine also occurred more frequently. Hard, dense box-wood (*Buxus sempervirens*) was mainly used for plaquettes and small sculptures. In Italy and Spain the most popular woods were poplar, parasol pine and walnut; in France, lime, poplar and walnut. Thus altogether about 20 European woods were used for wood-carving. Towards the end of the Middle Ages cedar and such imported woods as ebony were added to the list. In the 20th century a wide range of tropical and indigenous woods were used according to the preference of the craftsman, although from the 1980s rain-forest timbers were increasingly avoided for ecological reasons.

A. Seidensticker: *Waldgeschichte des Altertums* (Frankfurt an der Oder, 1886)

W. M. Harlow and E. S. Harrar: *Textbook of Dendrology* (New York, 1937, rev. 6/1979)

H. E. Desch: *Timber: Its Structure and Properties* (London, 1938, rev. 4/1968)

A. J. Panshin, H. P. Brown and C. C. Forsaith: *Textbook of Wood Technology* (New York, 1949); 4th edn by A. J. Panshin and C. de Zeeuw (New York, 1980)

C. P. Metcalfe, C. R. Chalk and L. Chalk: *Anatomy of the Dicotyledons*, 2 vols (Oxford, 1950)

H. Gottwald: *Handelshölzer* (Hamburg, 1958)

J. Marette: *Connaissance des primitifs par l'étude du bois du XII au XVI siècle* (Paris, 1961)

W. Sandermann: 'Holzfunde aus alten Kulturen', *Bild der Wissenschaft* (1967), pp. 207–17

B. J. Rendle: *World Timbers*, 3 vols (London, 1969–70)

M. Bramwell, ed.: *The International Book of Wood* (London, 1976)

D. Grosser: *Die Hölzer Mitteleuropas* (Berlin, 1977)

R. B. Hoadley: *Understanding Wood: A Craftsman's Guide to Wood Technology* (Newton, CT, 1980)

'Natural Variations of Wood Properties', *Proceedings of IUFRO Working Party: Oxford, 1980*

H. Willeitner and E. Schwab: *Holz: Aussenverwendung im Hochbau* (Stuttgart, 1981)

Nomenclature générale des bois tropicaux, Association Technique Internationale des Bois Tropicaux (Nogent-sur-Marne, 1982)

R. Wagenführ and G. Schreiber: *Holzatlas* (Leipzig, 1985)

H. J. Richter: *Holz als Rohstoff für den Musikinstrumentenbau* (Celle, 1988)

Holz-Lexikon (Stuttgart, 1988)

N. Penny: *The Materials of Sculpture* (New Haven, 1993)

S. Fraser-Lu: *Burmese Crafts: Past and Present* (Kuala Lumpur, 1994)

A. Goldsworthy: *Wood* (London, 1996)

J. G. Hather: The identification of the Northern European woods (London, 2000)

'Holz', *Lexikon des künstlerischen materials: Werkstoffe der modernen Kunst von Abfall bis Zinn* (Munich, 2002), pp. 145–52

H. Green: *Wood: Craft, Culture, History* (New York, 2006)

III. Techniques.

1. Preparation. 2. Construction. 3. Decorative techniques. 4. Carving. 5. Surface finish.

1. PREPARATION. Wood requires controlled drying, called seasoning, before use to minimize shrinkage and distortion caused by loss of water. Because shrinkage is unequal in the three structural dimensions, timber tends to distort or warp as it dries. Normally, the outside of the wood, in intimate contact with the air, begins to dry before the inside; if this occurs too quickly, surface rupture, splitting and distortion will occur. Shrinkage cannot be avoided, but careful regulation of the extent and rate of drying helps to ensure that shrinkage will take place without undue distortion or damage before the wood is put to use. Before seasoning, logs are converted into square-edged pieces of timber suitable for use. Timber cut so that growth rings meet the surface at right angles (described as quarter sawn, radially or rift cut) reveals figure due to rays and tends to season slowly but retain its shape well. Timber cut so that the width of the boards is tangential to the growth rings exhibits growth ring figure. This is produced by back sawing (also described as tangential, flat or slash cutting). It seasons quickly but does not retain its shape well.

Seasoning may be carried out by the traditional method of natural air drying or by accelerated drying in kilns. Air drying is achieved by stacking boards with strips between them to allow circulation of air. The stack is raised clear of the ground and covered to keep out rain and sun. The timber dries according to the prevailing weather conditions at a rate determined by the gaps between boards and by the species and method of conversion of the timber in the stack. A rule of thumb is to allow a year for each inch of thickness. Using this method, moisture contents of 15–20% are achieved. Further drying takes place indoors in the environment where the wood is to be used. In kiln drying the timber is stacked as for air drying and placed in special kilns where the temperature, relative humidity and circulation of air can be controlled (see fig. 2). Starting with low temperature and high relative humidity, the temperature is gradually raised and the relative humidity lowered until the moisture content of the timber has been brought down to the desired level. Kiln drying is much quicker than air drying (5–30 days per inch of board thickness) and can result in moisture contents as low as 6–8% to suit applications in centrally heated environments. Kiln drying also kills eggs, larvae and adult stages of wood-boring insects.

It is difficult to season large baulks of wood (over 4 inches) without defects. Several different chemical treatments have therefore been developed to stabilize wood and prevent moisture-induced dimensional changes. Using polyethylene glycol (PEG), up to 90% reduction in shrinkage of green wood can be achieved. This is particularly appropriate for large pieces required for turning or carving where pieces of green timber can be worked close to the required size and shape before treatment. Chemical treatments are also used to increase resistance to fungi, wood-boring insects and fire. Several types of manmade timber products are available, including blockboard and laminboard, plywood, particle boards and fibreboards; these have the advantages of uniform strength and dimensional stability achieved by cancelling the effect of the pronounced grain direction of solid timber.

Newly converted and seasoned solid timber must be further prepared for most construction uses. The face side is selected and planed perfectly flat. One edge is selected to be the face edge and planed perfectly straight, flat and at right angles to the face side. The board is cut and planed to the correct width with edges parallel. The required thickness is then prepared by cutting and planing to gauge lines previously marked around both edges using a gauge held against the face side. One end is then marked, sawn and planed square to the face edge. The required length is measured from the prepared end and the remaining end cut and planed square to the face and edge. The process of planing an edge or end straight and square is called 'shooting'. When shaped members are required, only a modified form of preparation may be required.

Solid wood required for bending is carefully selected to be free of defects and with straight grain. Tangentially cut, air-dried timbers of species with good bending properties are most likely to be successful. Timbers with poor bending properties may be first glued to a good compressible bending wood that is later removed. Before bending solid wood it is plasticized, normally with heat and steam, to enable it to yield to compressive forces during bending.

It is not always practicable to use wood in solid form. Logs may be converted into thin sheets, called veneers, which are subsequently fixed to a stable support. Veneers are cut by one of three basic methods: sawing, slicing or rotary peeling. Wood to be veneered is prepared as for use in contruction. If a liquid glue is to be used in laying veneer, planing diagonally across the grain with a toothing plane will promote a uniform, thin glue line. A 'cross-band' veneer may be applied under the face veneer at right angles to the grain of the ground. Face veneers are cut to size and jointed for matching into patterns if required (see MARQUETRY). When cauls or presses are to be used, the pieces for built-up patterns are marked, cut and taped together before laying.

Wood surfaces should be smooth and perfectly clean before any form of finishing material is applied. Nails and pins are punched below the surface. Bruises may be removed by local application of steam. Small defects, setting-out marks and excess adhesive are removed using a smoothing plane followed by cabinet-scrapers and abrasive papers. The grain may then be raised by damping with water followed by light sanding and thorough dusting off when dry. Small holes, cracks and minor imperfections may be filled with a

2. Timber-drying kiln, diagram: (a) automatic ventilators; (b) heating coils; (c) fan; (d) steam sprayline; (e) controller dry bulb; (f) false ceiling; (g) wet bulb; (h) control room; (i) door

suitable stopping compound. Where a transparent finish is to be used, bleaching and/or staining followed by grain filling may be carried out beforehand.

A. J. Panshin, H. P. Brown and C. C. Forsaith: *Textbook of Wood Technology* (New York, 1949, rev. 4/1980)

E. Joyce: *The Technique of Furniture Making* (London, 1970)

J. A. Walton: *Woodwork in Theory and Practice* (Sydney, 1979)

R. B. Hoadley: *Understanding Wood: A Craftsman's Guide to Wood Technology* (Newtown, CT, 1980)

R. Rowell: *The Chemistry of Solid Wood* (1984)

R. A. Salaman: *Dictionary of Woodworking Tools c. 1700–1970 and Tools of Allied Trades*, rev. by P. Walker (London, 1989)

A. P. Schniewind: *Concise Encyclopaedia of Wood and Wood-based Materials* (Oxford, 1989)

M. Cross: *Wood: Materials Technology* (Dublin, 1992, rev. 2/1998)

C. Edwards: *Encyclopedia of Furniture Materials, Trades and Techniques* ([Brookfield, VT, 2000])

J. Broun: *The Encyclopedia of Woodworking Techniques* (London, 1993, rev. Newton Abbot, 2/2002)

Wood Chemistry: Fundamentals and Applications (San Diego and London, 2003)

2. CONSTRUCTION. For centuries wood has been an important material in architectural construction. However, this section will concentrate on furniture construction.

Woodworking construction techniques are primarily determined by two major factors: the anatomical nature of wood and the availability of necessary tools. The nature of wood establishes the requirements for processing, preparation and joining, and tools were developed to satisfy those requirements in an efficient manner. The greatest strength of wood, in compression, tension and bending, lies in the direction of the grain; the weakest orientation is across the grain. Therefore, techniques of construction must overcome the unidirectional character of wood in order to make three-dimensional objects. This is accomplished either by carving the desired object from the solid or by joining smaller pieces of wood into a larger whole, with each piece orientated in the most advantageous way.

The full range of woodworking tools had appeared by the time of transition from the Stone Age to the Bronze Age: axe, adze, chisel, saw, piercer (drill), hammer and various scraping tools. For the most part, subsequent historical developments were less invention than refinement, as in the case of iron and steel replacing copper or bronze for cutting tools. The rotary motion lathe apparently first appeared c. 700 BC on the island of Samos. However, turned Celtic articles indicate that independent development also took place in other parts of the world. Although anticipated by the Egyptian scraper-adze, the plane was probably introduced by the Greeks and in wide use by the time of the Romans. Iron planes from the Roman period have been found at Pompeii and throughout Europe. The tools, the related woodworking techniques and all of the basic construction techniques were developed or at least anticipated by c. 500 BC. It is therefore misleading to suggest a chronological development of wood construction.

In the 19th and 20th centuries improved ADHESIVES and power tools began to influence construction, as a result of individual craftsmen experimenting with new technologies in order to create inventive designs. This was most apparent in such design movements as Art Nouveau and Art Deco, as well as in the work of the Austrian Secessionists and part of the American Prairie School.

The simplest wood forms are those that are carved from the solid. This would include a felled tree trunk, perhaps crudely worked on one side with stone tools, as well as 20th-century machine-sculpted examples. Hollowing can also be accomplished with adze and scraper, in some cases assisted by fire, as in the dug-out canoe. There has been periodic use of this technique in the 20th century by such craftsmen as the Americans Wharton Esherick (1887–1970) and Wendell Castle (b 1932). Wood that has been processed into large flat planks, either by sawing or riving (splitting), may be stacked, lashed, nailed or otherwise assembled together in what is termed 'plank' construction. Prehistorical lashing techniques survived in the earliest Egyptian furniture, for which fibre or skin thongs were used to join boards together and even to fasten legs to some pieces. Owing to the unidirectional strength of wood, it is difficult to design an adequate joint for fastening two boards together with the grain of one parallel to the other, as when fastening the bottom board of a chest to the sides. This was usually accomplished by driving a metal nail or trunnel (literally, 'tree-nail') through one board into the other. Often the wood was pre-pierced with a drill or awl to minimize the possibility of splitting. Even when the orientation of the boards allowed for the cutting of structural joints, as in the case where the ends of two boards meet at right angles, butting together and nailing persisted throughout history. Examples range from simple ancient objects to the elaborately carved and decorated Italian Renaissance *cassoni* and modern, inexpensive production furniture.

In the ancient world the slip-tenon developed as an alternative to some nailed plank construction (see fig. 3a). Where two boards were to be edge-fastened to create a wider panel, a number of slots (mortices), a few centimetres deep and long, were chiselled into the edges of each. When assembled, a small matching slip of wood (tenon) was inserted (3b), bridging the interface between the boards. Each mortice and enclosed tenon was then pierced and a wooden peg driven through to lock the assembly together. Although pegs have been replaced by modern adhesives, this type of construction enjoys a widespread revival in the form of 'biscuit' joinery. Here, mass-produced wafers of wood are glued into uniform, machine-produced mortices to effect the quick joining up of pieces of wood. The simplest form of construction that relies on integral joinery consists of a primary slab or slab-type element in which squared or rounded mortices are cut or bored. Into these mortices are fastened secondary elements on which corresponding tenons have been cut. Most slab-type

furniture is made with either round or square mortice-and-tenon joinery, reflecting a natural distinction between joint types that are cut with processes based on axial rotation on the one hand, and 'square' or linear woodworking processes on the other. The former utilizes drill and lathe, and the latter chisel and saw. This division was institutionalized by the separate medieval guilds for craftsmen who made 'turned' objects and for those who made 'joined' objects.

The simplest example of slab construction is the split log bench into which three or four legs are socketed. A more complex slab construction is the Windsor chair, in which legs and back elements are joined to a plank seat with round mortice-and-tenon joints (3c). A less well-known example is the typical chair of ancient Egypt, in which legs and back were attached to the seat with square or rectangular mortice-and-tenon joints. Enormous bending stress can be applied to individual mortice-and-tenon joints, and chairs, benches and tables constructed in this fashion usually require the added support of back braces or stretchers, which are socketed into the legs. If mortices are cut completely through the slab, structural integrity can be increased by driving a wedge into the end grain of a tenon where it emerges from the opposite side. If the mortices are 'blind' (i.e. not completely penetrating the slab but close enough to an edge), small pegs can be driven sideways through the joint to prevent the tenon from being withdrawn from the mortice (3d).

Square mortice-and-tenon joints, also pinned, are used to join up boards into a square, structural frame. Tenons are cut on the ends of one pair of 'rails', and corresponding mortices are cut into the perpendicularly orientated 'stiles'. A pair of these frames hinged in the middle of the rails to move in scissor-like fashion with fabric mounted between corresponding stiles is one of the earliest types of seating furniture: a 'camp'-type folding stool. Virtually identical examples of this construction appeared in ancient Nordic, Chinese and Egyptian cultures; the seat and legs of the modern 'director's' chair constitute another example. Open mortice-and-tenon frames may also be incorporated into other construction designs. Egyptian craftsmen often used this type of frame covered with fabric instead of a solid board in the slab construction of beds and chairs. Other examples can be seen throughout history in caned seating furniture or as applied doorframes to the open face of cupboards or other box-type objects.

In frame-and-panel construction (3e), a thinner solid board or panel is housed in a groove cut around the inside edge of the frame. With the longitudinal axis of the individual frame elements orientated around the perimeter of the assembly and the engaged board 'floating' freely within the groove, the problems of environmentally induced dimensional change in a solid piece of wood are avoided. Constructed with multiple stiles (as in a raised-panel door), rails and panels greatly expand the area that can be covered or filled with a thin, stable slab of wood. Frame-and-panel slabs (sometimes referred to as made-up panels) can also be used in plank

construction, where they are simply edge joined to each other with wooden pegs or metal nails to form a box. Frame-and-panel elements were used in the plank construction of an Egyptian coffin from Tarkhan (c. 2850–c. 2600 BC; New York, Metropolitan Museum of Art).

Morticed frame or frame-and-panel assemblies can be incorporated into more complex, three-dimensional box-frames. For example, four vertical stiles can be joined together with eight rails into a square or rectangular structure. If five of the openings are filled with panels, an open box is the result. Box-frame construction is also used in chair-making (3f), where the top of the box is covered with an applied wood or fabric seat and two of the vertical stiles extend above the seat to become part of the back-frame. The front stiles may also extend to become supports for arms. Solid wood panels may be fitted to some of the frame openings, but only the seat and back need be filled and even these not necessarily with wood. This method differs fundamentally from slab construction and is most recognizable in European joined chairs where many, and in some examples all, frame openings are filled with panels. The use of panels and the position of rails varied, but this type of box-frame construction has been in widespread use throughout history. Demonstrating a fundamental break with slab-type Egyptian chair construction, the Greeks used a minimalist form of box-frame construction to create the klismos chair. In this case there are no panels and only one set of horizontal seat rails that mortice into the front and rear legs. The back, formed by continuous rear legs and a horizontal top or crest rail, no longer required cumbersome additional support where it meets the seat.

An alternative to the mortice-and-tenon socket-type joint is the interlocking dovetail (see 3g). A series of dovetails is generally used to join full-width boards end to end, into a box-type structure. To this box additional elements can be added to produce various primary and secondary furniture forms. Examples of dovetail construction include drawers and the chest in which they reside.

Construction techniques that involve lamination can also be used to overcome the transverse weakness of wood, to produce curved shapes, or both. Medieval slab-built doors were constructed by bolting or riveting together multiple layers of boards with the grain of each layer orientated perpendicularly to the next. Banded together with iron straps, chests and coffers made of composite slabs of this type are very strong. With improvements in adhesive technology, glue-laminated furniture parts were introduced in the 19th century. Curved elements were made from multiple layers of thin wood, bent to shape and glued together. Thin but rigid curved shells were also produced by laminating many layers of thin veneer, usually with alternating grain direction, over a curved mould. This shell could be part of an otherwise traditionally constructed piece of furniture, or, as in the 20th century, it could become the primary structural element. Laminated and carved chair backs constructed by this

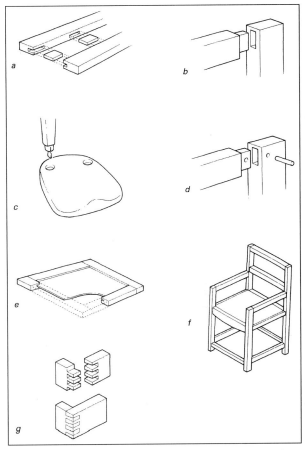

3. Types of wood joint: (a) slip-tenon; (b) mortice-and-tenon; (c) slab construction, as used in a Windsor chair; (d) pinned mortice-and-tenon; (e) frame and panel; (f) box-frame construction, as used in a chair; (g) dovetail

method were introduced by John Henry Belter (1804–63) in his New York factory in the mid-19th century. Such craftsmen as Charles Eames (1907–78) and Alvar Aalto (1898–1976) further refined this technology in the 20th century.

W. L. Goodman: *The History of Woodworking Tools* (London, 1964)

H. S. Baker: *Furniture in the Ancient World: Origins and Evolution, 3100–475 BC* (London, 1966)

L. Feduchi: *A History of World Furniture* (Barcelona, 1975)

K. Seike: *The Art of Japanese Joinery* (New York, 1977)

V. Chinnery: *Oak Furniture: The British Tradition* (Woodbridge, 1979)

W. L. Goodman: 'Classical Greek Joinery', *Working Wood*, i/3 (Autumn 1979), pp. 20–24

C. A. Hewett: *English Historic Carpentry* (London, 1980)

R. B. Hoadley: *Understanding Wood: A Craftsman's Guide to Wood Technology* (Newtown, CT, 1980)

E. Klatt: *Die Konstruktion alter Möbel* (Stuttgart, 1982)

L. Chanson: *Traité d'ébénisterie* (Dourdan, 1986)

B. Forman: *American Seating Furniture, 1630–1730* (New York, 1988)

G. Rogowski: *The Complete Illustrated Guide to Joinery* (Newton, CT, 2002)

P. Pugsley: 'The Origins of Medieval Vessel Turning', *Antiquaries Journal*, lxxxv (2005), pp. 1–22

3. DECORATIVE TECHNIQUES. Many techniques used to decorate furniture and woodwork throughout history have their roots in ancient Egypt. Several hundred pieces of furniture, often of great elaboration, survive from tombs as early as 3000 BC. In Mesopotamia, as later in Classical Greece and Rome and the Byzantine empire, very little survives apart from fragments, and decorative techniques are difficult to ascertain from such secondary sources as contemporary paintings and sculpture. As the design of much early furniture, whether fixed or movable, grew from architectural form, decorative motifs and techniques evolved in a similar manner. It is therefore important to consider the subject in relation to the surroundings for which pieces were conceived. Sometimes the same craftsmen would have worked on both. Until the 17th century almost all surviving furniture and interiors in the Western world were those of the Church and the wealthiest classes; fashion was generally driven by the desire of rulers and their courts to find sumptuous and innovative styles to rival their neighbours. Thus many techniques became widespread, with different countries developing their own specializations depending on particular traditions and influences, or the woods and other materials that were available.

Paint has been used on furniture and woodwork in a variety of ways: to represent images in the tradition of painting on canvas or panel; to create decorative coloured or patterned surfaces; or to simulate a more valuable wood or some other material such as marble or ivory (*see* §5 below). Each of these techniques executed in tempera paint can be found on ancient Egyptian furniture as well as on Greek and Roman examples. Pictorial decoration was common at various periods, sometimes with commemorative or symbolic significance. Examples include elaborately painted scenes on Florentine 16th-century marriage chests, mythological or biblical scenes painted on copper panels on drawer fronts of 17th-century Flemish cabinets, portraits of deities in the decorative borders of Neo-classical painted furniture at the end of the 18th century and scenes from medieval legends painted on furniture by William Morris (1834–96) at the end of the 19th century. There is also a widespread tradition of simpler regional furniture in which paint generally covered the entire surface, often with vigorous and uninhibited colours and patterns. In southern Germany and France, northern Italy, Russia and Scandinavia, where even the wealthiest homes had painted furniture and painted floors, this tradition is particularly notable. In these areas most of the available wood was inferior softwood. By contrast, very few vernacular chairs in Britain were painted, apart from those used outdoors and painted, generally in green, for protection. The USA has a strong folk tradition of painted furniture,

and most early pieces seem to have been painted or stained. Pennsylvania Germans carried on the European custom of painted dower chests, taking decorative motifs from Bible stories and medieval myths and legends. American Windsor chairs were generally painted, and in the early 19th century the Hitchcock factory in Connecticut popularized stencilled gilt decoration on painted chairs of inexpensive birch or maple. Many techniques use wood merely as a carcase to be covered up with decoration (*see* GILDING and LACQUER). Where they were readily available or could be acquired through trade or conquest, fine hardwoods were also used for their own qualities, whether in the solid or veneer. These might include a striking colour or grain pattern or a burr that could be enhanced by the way it was cut and polished. Varnishes and oils were used for this purpose from Egyptian times onwards. Different woods were juxtaposed to create an effective contrast or laid, particularly in veneer, so that dramatic figuring might be matched in reverse or in quarters. The practice of veneering an inferior wood with a more valuable or attractive wood cut into thin sheets has been known since the Egyptian 1st Dynasty. Bandings with the grain running in different directions were also used to frame panels of figured wood and applied mouldings; these could be of great complexity or textured, such as the rippled ebony mouldings made in the Netherlands in the 17th century. At the same time in northern Italy there was a fashion for pyrographic decoration or pokerwork. In the 18th century oriental influence in the West is shown in applied or pierced fretwork, while at all periods, except those of particular restraint, richness and texture were added with carving (*see* §4 below).

Inlay is the decoration of wood with a pattern or motif composed of pieces of wood or other materials in contrasting colours cut out and set into the solid. In MARQUETRY the carcase is completely covered with veneers of different colours, cut into a design and fitted together. Pictorial marquetry was a comparatively late development, but geometric inlay (parquetry) is known from early Egyptian times, when thin pieces of glazed faience, such stones as lapis lazuli, painted glass and stained ivory were sometimes used. Complex inlaid furniture of the 1st century AD has been reconstructed from fragments found at Pompeii. In the 15th century walnut panels in Italian churches and palazzi were decorated with inlay of various coloured woods, known as intarsia (a term widely used on the Continent to denote both inlay and marquetry). Architectural perspectives and still-life groups of great skill survive. In the 16th and 17th centuries the German states were famous for their exuberant inlay, and Nuremberg and Augsburg had long traditions of making fine ebony cabinets inlaid with ivory, tortoiseshell, amber, metals and hardstones; these were exported all over Europe.

In 16th-century Spain and Portugal, another type of decoration with small-scale geometric patterns inlaid in precious woods, ivory and even metal derived from the long Islamic tradition of exquisite

woodwork in the region. It is linked to similar *certosina* work carried out in Italy, particularly around Lombardy and Venice. The intricate interlaced foliage patterns known as arabesques were also derived from Islamic art, probably by way of Syrian and Egyptian metalwork of the 15th century. Silver and gold from South American colonies as well as exotic woods, mother-of-pearl and tortoiseshell were much used throughout the colonial period, especially on prestigious Spanish *vargueños* and cabinets. In Italy ebony cabinets were also inlaid with iron damascened with silver and gold, while in the Germanic countries and northern Italy engraved ivory, arabesque and figured (grotesque) inlay was fashionable on cabinets. The boxes and larger pieces inlaid and veneered in ivory that were imported from India in the 18th century were similarly popular.

The idea of marquetry of contrasting brass, pewter and tortoiseshell is thought to have been an Italian one, but it gained popularity in 17th-century France at the hands of a Dutch master craftsman, Pierre Gole. The technique was perfected, however, by the Frenchman André-Charles Boulle (1642–1732), from whom it took its name of boullework. Each material was cut into patterns and glued together to form fanciful scenes with elaborate foliate or grotesque borders. Boulle used these panels in reversed pairs, known as *premier partie* and *contre partie*, to decorate either the same or matching pieces of furniture. Often the brass would be finely engraved and set in ebony with splendid gilded mounts. Further refinements were made with the addition of pewter, mother-of-pearl or stained horn. Boulle marquetry was also produced in southern Germany and continued in France through the 18th century. During the first half of the 18th century some English or Germanic furniture featured inlay of finely engraved brass panels or mother-of-pearl with decorative stringing of brass, sometimes in padauk or other hardwoods. The collecting of earlier French furniture by the English in the post-Revolutionary dispersals led to a revival of boullework and brass inlay in the early 19th century.

R. Dossie: *Handmaid to the Arts* (London, 1758)

T. Sheraton: *The Cabinet Dictionary* (London, 1803)

R. Bitmead: *The London Cabinetmaker's Guide to … the Art of Laying Veneers of All Kinds … and Marqueterie, Buhl-work, Mosaic, Inlaying etc.* (London, 1873)

J. M. Ritz: *Alte bemalte Bauernmöbeln* (Munich, 1938)

F. Arcangeli: *Tarsie* (Rome, 1943)

H. S. Baker: *Furniture in the Ancient World* (London, 1966)

E. Mercer: *Furniture, 700–1700* (London, 1969)

H. Huth: *Lacquer in the West* (Chicago and London, 1971)

W. A. Lincoln: *The Art and Practice of Marquetry* (London, 1971)

I. O'Neil: *The Art of Painted Finish for Furniture and Decoration* (New York, 1971)

D. A. Fales jr: *American Painted Furniture, 1668–1880* (New York, 1972)

P. Eames: *Furniture in England, France and the Netherlands from the 12th to 15th Century* (Leeds, 1977)

D. Hawkins: *The Technique of Wood Surface Decoration* (London, 1986)

G. Manni: *Mobili in Emilia, con una indagine sulla civiltà dell'arredo alla corte degli estense* (Modena, 1986)

F. de Dampierre: *The Best of Painted Furniture* (London, 1987)

S. Digby: *The Mother-of-pearl Overlay Furniture of Gujarat* (Oxford, 1987)

D. Bigelow, ed.: *Gilded Wood: Conservation and History* (Madison, CT, 1991)

V. Dorge and F. C. Howlett: *Painted Wood: History and Conservation* (Los Angeles, 1998)

A. Erlande-Brandenberg, K. Simmoneau and C. Benoît: *Les cassoni peints* (Paris, 2004)

4. Carving. Besides the knife, the basic tools of wood-carving—the technique of cutting ornament and sculpture in wood—are those used by any woodworker (see fig. 4). The type and size of tool affect the size and intricacy of the work achieved. Wood makes particular demands on the carver: as it is mainly composed of long, parallel fibres, most of its strength lies along the grain. A sharp edge running between the fibres prizes them apart, causing various degrees of tearing or splitting; a blunt or rough edge will tear the fibres. This peculiarity of wood has caused the development of most shapes

4. Woodcarving tools: (a) straight-edged chisel; (b) straight-edged skew or corner chisel; (c) straight carving gouge (shallow); (d) adze; (e) whittling knife; (f) straight gouge, showing position of hand; (g) U-shaped gouge or veiner; (h) V-shaped chisel or parting tool, showing typical tang for fixing into a handle; (i) long or salmon bent gouge; (j) short bent (spoon bit) gouge; (k) short bent (grounder) 'flat' gouge; (l) backbent gouge

of tool, especially the many types of chisel, known as gouges, that have a hollow or 'flute' on one side. Tools run from a straight-edged chisel (4a) and a straight-edged 'skew' or corner chisel (4b), acutely angled at one corner and obtuse at the other, to the deepest gouge. The depth of the flute, known as the sweep, progresses from nearly flat (4c) in narrow gouges to a 'U' shape. If a gouge enters the wood with its corners above the surface, the risk of splitting when carving straight or diagonally across the grain is reduced. The flatter the gouge the more even the surface produced. Superior quality steel is essential to maintain sharpness.

Chip-carving, the simplest form of carving, involves two or more short cuts aimed at the same place in the wood from different angles and is generally used for surface decoration. Much totem pole-carving, for example, is chip-carved with an adze (4d) or axe. Many types of cut are variations of chip carving, even in such sophisticated work as the curling ringlets of hair on the head of a late 15th-century German lime-wood figure. To create this, a shallow gouge is driven into the wood, usually perpendicular to the surface, and is then pushed in from a steep angle at the side until a crescent-shaped piece of wood chips out. By repeatedly reversing the direction of the chisel for succeeding pairs of cuts, a wavy pattern will develop. When forming an eyeball, a berry or a small boss in the centre of a flower, for example, the same technique is used, but with the flute facing downwards. The other main type of cut, made with a knife or a chisel, is a long stroke that creates a groove on the surface of the wood or slices off an edge. Whittling is a form of carving carried out with a knife (4e). The object to be carved is usually held in one hand, and the knife is used to chip pieces out and create patterns, or to pare away larger pieces and create small sculptures. The knife can be moved with a sawing or a slicing action. As considerable pressure is needed in this process, the knife has to be used with care. Larger items can be reduced by sawing or by hewing with an axe or adze before whittling. Carving with a chisel is a faster method, as more power can be used. A particular shape of chisel can be selected to create a distinct impression in the wood that may be impossible or extremely difficult to make using only a knife. A chisel needs to be held and guided by one hand while the other hand wields a mallet to strike the end of the handle of the chisel, strikes the chisel with the base of the palm, or grips the handle of the chisel to push it. Right-handed people would usually hold the chisel in the left hand, the hand normally gripping part of the blade and handle, but experienced carvers, especially those carving decorative mouldings, work ambidextrously. As both hands are thus occupied, the object to be carved has to be held firmly. Large objects are held steady by their own weight. In some cultures, the object to be carved is held between the legs, and in the Western tradition is held by mechanical means.

Relief-carving may involve simply creating an outline of the design (see fig. 5) with shallow cuts made with a U-shaped gouge (4f), which in widths of approximately less than 5 mm is known as a 'veiner' (4g). Many carving chisels are sold unhandled. The V-shaped chisel or parting tool (4h) has a tang, which is used to ream a conical hole in the handle before being driven in the last few millimetres. Extremely sharp tools are essential when carving relief work, as cuts that are diagonal to the grain are inevitably rough on one side. On one side of the cut the fibres are stroked together and cut cleanly, but on the other side are pulled apart and torn. The solution to this problem is to make a preliminary cut all around, then achieve the required depth and width by using the same or a smaller tool to cut along the rough side of the channel in the direction of the grain. At corners, where the angle of grain changes sharply, a cut in from the side across the grain is usually necessary. The surface may then be finely carved using various gouges. Deeper relief-carving involves setting down around the object using the above method or using stabbing cuts made all around and at least 2 mm outside the outline of the design. A deep gouge can then carve away the waste wood across the grain. As the required depth is reached, flatter gouges can level off the ground. The outline of the design is then cleared until it appears to have been fretted out and fastened down. Experienced carvers, however, may establish high and low reliefs prior to cutting in the details of the design. To reach those areas of the ground that are inaccessible to straight gouges, bent gouges have been developed. These are bent in a long curve from the handle and are known as long, or 'salmon', bent gouges (4i), or are short bent and known as 'spoon bit' gouges (4j). The flatter types, known as 'grounders' (4k), are used to smooth the ground in difficult areas. Deeper spoon bit gouges are used to hollow out inside curves. To create convex inside curves, a backbent gouge (4l) is used. Once the ground is established, high- and low-relief features are roughed (bosted) out and the fine detail carved.

Work in the round is first roughed out with an axe or saw. Some carvers tend to start by cutting closely to profiles, but sculptors usually work in from further away, carving around the forms with deep gouges across the grain, or chopping, sawing or rasping the planes before attempting any detailed carving. Machines, for example the chainsaw and various rotary cutters, save time and can create unique textures.

Cutting letters is a specialized form of carving, achieved by a mixture of stabbing and chasing. V-shaped tools and veiners do not usually produce good letters. Carving decoy ducks and other animal forms can combine whittling and burning in the details with a pyrograph. Wire, adhesives and resins are also used in creating these types of object, as they are overpainted later.

Particularly fine stones and strops are used to sharpen chisels. Specially shaped slip stones can grind a short bevel on the inside surface of gouges. This makes a lower cutting angle on the under bevel possible, which is essential for long, sweeping cuts, and enables gouges to be used with the hollow face

5. Oak chest, 1270×597×660 mm, from Guilford, CT, 1650–80 (Newark, NJ, Newark Museum) photo credit: Newark Museum/ Art Resource, NY

downwards. A steep under-bevel without another bevel inside is best for the short, scooping cuts that are used in Japanese and other traditions of carving.

Any type of wood can be carved. The ideal timber for carving is even-textured and hard enough to take fine detail (see fig. 6). Lime is a good timber, but lacks figure, while walnut can be too dark or have too much pattern in the figure for detailing to show. The liveliest carving is created by finishing with only a chisel, then waxed or oiled. Sandpapering wood to a very fine finish can blur detail. Gilded or polychromed sculpture can be smoothed with abrasives, as detail can later be recut in the gesso.

G. Jack: *Woodcarving: Design and Workmanship* (London, 1903/R 1978)

P. N. Hasluck, ed.: *Manual of Traditional Woodcarving* (London, 1911/R New York, 1978)

E. J. Tangerman: *Whittling and Woodcarving* (New York, 1936); rev. as *Big Book of Whittling and Woodcarving* (New York, 1990)

W. Wheeler and C. Hayward: *Practical Woodcarving and Gilding* (London, 1963/R 1973) [the most authoritative modern work]

J. C. Rich: *Sculpture in Wood* (New York, 1970/R 1992)

F. Oughton: *The History and Practice of Woodcarving* (London, 1976)

M. Baxandall: *The Limewood Sculptors of Renaissance Germany* (New Haven, CT, 1980/R 1985)

A. Bridgewater and G. Bridgewater: *The Craft of Woodcarving* (Newton Abbot, 1981)

I. Norbury: *The Technique of Creative Woodcarving* (London, 1984/R 1990)

J. Ayers: *The Artist's Craft* (Oxford, 1985)

A. T. Jackson: *Collins Complete Woodworker's Manual* (London, 1989/R 1990), pp. 272–82

Woodcarving (Lewes, 1992–)

V. Harris and K. Matsushima: *Kamakura: The Renaissance of Japanese Sculpture, 1185–1333* (London, 1991)

G. Michel: *Living Wood: Sculptural Traditions of Southern India* (London, 1992)

J. Broun: *The Encyclopedia of Woodworking Techniques* (London, 1993, rev. Newton Abbot, 2/2002)

N. Penny: *The Materials of Sculpture* (New Haven, 1993)

J. M. Gaynor and N. L. Hagedorn: *Tools: Working Wood in Eighteenth-century America* (Charlottesville, 1994)

C. Pye: *Woodcarving: Tools, Materials and Equipment* (Lewes, 1994, rev. as 2 vols, Lewes 2/2002)

J. Williams: *Decorative Woodcarving* (Lewes, 1994, rev. 2/2002)

M. Trusted: *Spanish Sculpture: Catalogue of the Post-medieval Spanish Sculpture in Wood, Terracotta, Alabaster, Marble, Stone, Lead and Jet in the Victoria and Albert Museum* (London, 1996)

D Onians: *Essential Woodcarving Techniques* (London, 1997)

C. A. Morris: *Craft, Industry and Everyday Life: Wood and Woodworking in Anglo-Scandinavian and Medieval York* (York, 2000)

6. Wood-carving showing burgher and mascaron, detail from a spiral staircase leading to the great hall of the townhall, Bremen, 1620; photo credit: Erich Lessing/Art Resource, NY

R. Neich: *Carved Histories: Rotorua Ngati Tarawhai Woodcarving* (Auckland, 2001)

A. Bailey: *Woodworking Techniques and Projects* (Lewes, 2003)

G. Romano and C. Salsi: *Maestri della scultura in legno nel Ducato degli Sforza* (Cinisello Balsamo, Milan, 2005)

C. van de Velde and others, eds: *Constructing Wooden Images* [late Gothic carved altarpieces in the Low Countries] (Brussels, 2005)

R. B. Ulrich: *Roman Woodworking* (New Haven and London, 2007)

Knight of Glin and J. Peill: *Irish Furniture: Woodwork and Carving in Ireland from the Earliest Times to the Act of Union* (New Haven and London, 2007)

5. SURFACE FINISH. Surface coatings on wood have been found on objects dating from as early as the 1st millennium BC. Microscopic analysis of samples taken from furniture of the 8th century BC found in Gordion, Turkey, has revealed the presence of a resinous coating. Theophilus, a German monk, wrote of oil-resin varnishes in the 12th century, and similar Italian recipes are known from the 15th century. In the 20th century coatings have been manufactured from a wide range of materials to achieve many appearances, from high gloss transparent natural resin finishes to opaque, synthetic painted or lacquered surfaces. Coatings on wood serve two important functions: they protect the wooden substrate from damage due to abrasion and exposure to excessive moisture, and manipulation of the finished surface can achieve a wide range of visual effects. Colour, texture and the gloss level can all be adjusted through various finishing procedures.

The surface treatment of wooden objects falls into the two general categories: transparent coatings and such decorative opaque coverings as PAINT, GILDING or LACQUER. In addition, painted surfaces were sometimes coated with a protective transparent coating. The category of decorative surfaces also includes those to which DYE or stain has been

applied. Dyes and stains are used selectively to exaggerate the grain of the wood, to diminish variations in the wood and to provide contrast between various parts of an object. Before 1850 the dyes used in wood finishing were generally naturally occurring organic materials that could be dissolved in alcohol or water. Alkanet root, cochineal, madder and logwood were among the most frequently used dye materials during the 18th century. After this date, aniline dyes began to be more commonly used. Stains, which are thinly dispersed pigments suspended in a medium such as a drying oil, have also been used extensively to colour wood. Ebonizing is a method of dyeing such light woods as maple to imitate the more expensive ebony. Fuming is a method of colouring wood with chemicals in the place of dyes or stains. Woods with a high tannin content will darken when exposed to ammonia gas. This technique was used to colour much of the oak furniture of the Arts and Crafts Movement.

Pigments in an oil binder have been the preferred paint for decorating furniture; among the most notable exceptions are the tempera found on Italian *cassoni* of the 15th and 16th centuries and the use of resinous binders by japanners to imitate Eastern lacquerwork in the 18th century. The methods for preparing the surface for painting are as varied as the decorative schemes. Often the wood was coated with a GESSO layer to fill the grain and provide a smooth opaque surface on which to paint, although on vernacular objects painting was frequently done directly on bare wood. Beginning as early as the 17th century, a technique known as graining was used to decorate common woods to look like the more prized varieties; marble was often imitated as well (*see* PAINTED EFFECTS). Both graining and marbling were carried out in a similar manner: the application of a base coat, a transparent glaze coat to simulate the grain, followed by a protective varnish layer.

While painted surfaces were not always coated with additional transparent protective varnish layers, those that had been dyed, stained or left uncoloured almost always were. Drying oils, waxes and varnishes made from natural resins were the most common materials used to coat wooden objects prior to the 20th century. Natural resins, including such soft resins as the sap of living trees and insect exudate, as well as the harder fossilized tree resins, have all been used in traditional varnish-making. There are three general types of VARNISH made from natural resins: spirit varnish, essential oil varnish and fixed oil varnish. Each is applied in liquid form and dries to a hard transparent surface.

Spirit varnishes are made by dissolving one of the soft resins, such as shellac or sandarac, in alcohol. Recipes for spirit varnishes exist from as early as the 16th century, and they were the most frequently mentioned varnishes in the European cabinet making guidebooks of the 17th and 18th centuries. These varnishes were usually applied with a brush, although the French developed a technique for wiping on thin layers with a cloth around the turn of the 19th century (French polish). Essential oil varnishes consist of a RESIN dissolved in a petroleum distillate or a SOLVENT derived from the distillation of a plant sap, such as spirits of turpentine. Petroleum distillates (often referred to as naphtha in early documents) were probably in most common use until the 16th century, when the distillation of turpentine became better known. Mastic varnish was a familiar essential oil varnish, although it tended to be soft and was more appropriate as a picture varnish. An essential oil varnish made of colophony (pine sap) dissolved in spirits of turpentine was frequently used as an inexpensive furniture varnish in 18th- and 19th-century America. The most durable of the varnishes, fixed oil varnish, is made from one of the harder fossil resins such as copal or amber. As these resins are not easily dissolved in alcohol or other distillates, they can be incorporated into a varnish, needing only to be heated and ground before combination with a drying oil such as linseed oil. Fixed oil varnishes are also referred to as 'rubbing varnishes' because on hardening they can be polished with such fine abrasives as pumice and rottenstone to produce a brilliant shine.

While varnish-making has a lengthy history, it was not until the late 17th century that varnishes became the primary material for finishing furniture and other wood surfaces. Oak, which had been the predominant cabinet wood to this point, was not well suited for a varnished surface because of its coarse texture. As such fine-grained woods as walnut and mahogany became more prevalent in cabinetmaking, the use of varnish became more common. Before this time, the two most common treatments for wooden surfaces were DRYING OILS and WAX. Linseed oil was the most frequently used drying oil, but others such as poppy, nut and hempseed oil were also popular. Techniques involving the use of oil vary from simply soaking the wood to more elaborate polishing steps, often with the addition of PIGMENT to the oil. Wax was particularly favoured for turned work as it could simply be held against the work while it was turned on the lathe. Beeswax was also combined with spirits of turpentine to form a paste that could easily be applied to furniture. Both oil and wax continued to be used, primarily on more common goods, throughout the 18th century despite the increased use of spirit varnishes.

Towards the end of the 18th century varnish-making became more of a commercial endeavour with the large-scale production of fixed oil varnishes. While high-gloss spirit varnishes continued to be used for the Neo-classical and Empire furniture of the early 19th century, fixed oil varnish eventually supplanted it as the most common finish treatment; it maintained this position until well into the 20th century. In the 20th century many synthetic resins and sophisticated application techniques such as pressurized spray guns were introduced. Nitrocellulose lacquer, polyurethane and alkyd resins have been widely used in furniture finishing. These new synthetic materials vastly expand the variety of visual

surface effects that can be achieved and greatly reduce application time.

J. Stalker and G. Parker: *A Treatise of Japanning and Varnishing* (Oxford, 1688/*R* London, 1960)

J. Moxon: *Mechanick Exercises or the Doctrine of Handy-works* (London, 1703/*R* Morristown, NJ, 1989)

R. Dossie: *The Handmaid to the Arts* (London, 1758)

A. J. Roubo: *L'Art du menuisier* (Paris, 1774)

J. F. Watin: *L'Art du peintre, doreur, vernisseur* (Paris, 3/1776)

E. Middleton: *The New Complete Dictionary of Arts and Sciences* (London, 1778)

The Golden Cabinet: Being the Laboratory, or Handmaid of the Arts (Philadelphia, PA, 1793)

T. Sheraton: *The Cabinet Dictionary*, 2 vols (London, 1803/*R* New York, 1970)

P. F. Tingry: *The Painter and Varnisher's Guide* (London, 2/1816)

The Cabinet-makers Guide (Concord, MA, 1827/*R* New York, 1987)

The Painter, Gilder and Varnisher's Companion (Philadelphia, PA, 2/1854)

P. N. Hasluck: *Wood Finishing* (New York, 1906)

R. J. Gettens and G. L. Stout: *Painting Materials* (New York, 1942/*R* New York, 1966)

T. Brachert: 'Historische Klarlacke und Möbelpolituren', *Maltechnik, Restauro* (1978–9), pp. 1–5

T. Z. Penn: 'Decorative and Protective Finishes, 1750–1850', *Bulletin of the Association for Preservation Technology*, xiv/1 (1984), pp. 3–46

L. Masschelein-Kleiner: *Ancient Binding Media* (Rome, 1985)

R. Mussey: 'Transparent Furniture Finishes in New England, 1700–1825', *Old-Time New England*, lxxii (1987), pp. 287–311

P. Hatchfield: *Ancient Egyptian Gilding Methods* (Madison, 1991)

I. Hosker: *Complete Woodfinishing* (Lewes, 1995, rev. 2003)

J. Sanders: *Colouring Techniques for Woodturners* (Lewes, 1996)

E. B. Rossetti, ed.: *La scultura dipinta: Arredi sacri negli antichi stati di Savoia, 1200–1500* (Quart, 2004)

IV. Conservation. The goal of conservation is to minimize future deterioration, to stabilize current deterioration and to repair or replace past deterioration.

1. Causes of deterioration. 2. Repair. 3. Treatment for infestation and decay. 4. Cleaning.

1. CAUSES OF DETERIORATION. Although wood is a durable material its deterioration can be brought about by agents present in the environment, by chemical decomposition and through mechanical wear in use. Outdoors, above ground, a complex combination of light, energy, and chemical and mechanical factors contribute to discoloration and disintegration, a phenomenon known as weathering. Wood kept in permanently wet conditions is susceptible to fungal decay or rot and can deteriorate rapidly. Indoors, wood is susceptible to the factors that cause weathering, but the effects are less severe.

Wood absorbs sufficient ultraviolet (UV) and visible light to undergo photochemical reactions leading to discoloration and degradation of surfaces. The initial colour change is yellowing or browning due to photo-oxidation. Woods rich in extractives (non-structural organic materials that influence colour,

odour and other non-mechanical properties) may become bleached before the browning becomes observable. Wherever possible, light sources should be filtered to remove UV. The duration and intensity of exposure to visible light should be kept to the minimum. The change in dimensions of wood due to change in temperature alone is slight. However, heating is associated with drying and corresponding dimensional changes.

Changes in the moisture content of wood below the fibre saturation point (about 30%) are associated with dimensional changes. Moisture contents above about 20% are associated with fungal decay. A principal cause of weathering is frequent changes in moisture content. Stresses are set up in the wood as it swells and shrinks due to moisture gradients between the surface and the interior. Stresses are greater near the surface of the wood and may result in warping and surface rupture along the grain. Movement (the dimensional changes of wood after seasoning) is unequal in the three structural dimensions, and if not allowed for in construction damage will result (*see* §1 above). Differences in response times and grain directions between components of wooden structures lead to movement in different directions and at different rates, resulting in warping, dislocation of parts, splitting and breaking of fibres. Similar problems exist in the interaction of different materials in mixed-media objects containing wood. If wood is prevented from moving in response to changes in relative humidity, plastic compression can take place leading to permanent reduction in the maximum dimensions of the piece. Relative humidity should be kept as near constant as possible. A level of 50% (+ or −10%) is suggested for internal woodwork and often requires control of heating.

Wood-destroying fungi and soft rots cause decay in wood by disintegrating cell walls to obtain food for growth and reproduction. Based on physical and chemical changes and the resulting alterations in colour of decaying wood, wood-destroying fungi are classified as brown rots, white rots and soft rots. Fungi require temperatures in the range 24° to 38°C, oxygen, a suitable food source and adequate moisture. The critical average moisture content is 20%, below which fungi will not grow. Since absence of any of these requirements will prevent or greatly inhibit growth, methods for control are based on eliminating or modifying one or more of these conditions. Alternatively, poisoning wood with preservatives offers an effective and reliable means of protecting wood against attack by fungi.

Various insects also attack wood, and those that attack seasoned timber present the greatest hazard. Some of the most destructive pests are beetles (*Coleoptera*), damage being caused by the larvae feeding in the wood. Infestation by wood-boring insects may be distinguished by the presence of tunnels containing bore-dust (frass) within the wood and by circular flight holes on the surface. Fresh dust and clean holes with sharp edges are signs of active workings, though the larval stage may last up to five

years before adults emerge. Common furniture beetle or woodworm (*Anobium punctatum*) is widespread in most temperate countries and is often present in buildings and furniture. In countries with warm temperate or tropical climates the most destructive pests of structural timber are termites (*Isoptera*). Low levels of moisture and temperature and clean, secure environments reduce the likelihood of insect damage.

2. REPAIR. Wood conservation cannot be reduced to a formula, but certain processes and procedures are in common use. Initial examination and documentation provide reference for materials, geometry, methods of construction, age and condition. Methods of examination that minimize disruption and loss are preferred (*see* TECHNICAL EXAMINATION). These include visual examination with low-power magnifiers and photography. Surface fluorescence seen under ultraviolet illumination can indicate the nature of coatings and retouches. Wood identification usually requires removal of a small sample from an inconspicuous or broken area. Samples are prepared as thin sections and examined microscopically under transmitted light. Suitably prepared cross-sections of samples of surface decoration may also be microscopically examined to establish a history of decoration and materials used. Other specialized microscopy techniques may supplement and extend these techniques. The presence of nails and screws may be detected using small hand-held metal detectors. For more complex or difficult objects X-radiography may be required to determine the nature of construction and reveal concealed metal parts. Soft X-rays can reveal the presence of live wood-boring beetle larvae. Moisture content can be measured using a variety of commercially available meters of various types. Dendrochronology or radiocarbon dating can sometimes be used to establish the age of a piece of wood and may help to confirm authenticity. Wood defects have also been detected using ultrasonic techniques. A range of specialized instrumental techniques is used for identification and examination of media adhesives and coatings.

Disassembly should only be carried out when necessary and then with the utmost care and patience. The materials and nature of construction should first be determined. All dimensions and angles should be carefully recorded and photographs taken. All parts of the object should be protected and labelled and registration marks applied to aid reassembly. Such fastenings as nails, wooden pegs and screws should be identified, labelled and removed before attempting to separate components. Animal glues can be softened by prolonged contact with water or steam, and old glue joints can sometimes be broken with pure alcohol. Wedges and cramps are used to apply force in a progressive and controlled manner to ease joints apart. Structures must be carefully supported as their centre of gravity is likely to change suddenly as they come apart. Regluing loose joints without disassembly is less satisfactory but can be done by infiltrating or injecting such a slow curing

adhesive as cold-setting animal glue and 'working' the joint. Very loose joints can sometimes be stiffened by thin fillets of wood inserted into the joint, by replacing loose pegs or by attention to external reinforcements, where these already exist. False tenons are used to repair broken or badly damaged mortice-and-tenon joints, and the principle can be extended to other joint types. A mortice is cut in the end of the member from which the tenon has broken and a piece of new wood inserted to act as a new tenon.

The first stage in repairing existing components or replacing structural losses is to select material having appropriate strength, appearance, dimensional stability and working properties. Replacements are normally made in the original material unless this would cause damage or distortion or the original material is unavailable or unidentifiable. Wood is matched according to species, density, pattern and direction of growth rings, and direction of rays. Creating a surface to which replacements or detached pieces can be securely attached may involve building up or slightly cutting down original material to provide the best possible mechanical and aesthetic integration of the old and new. Consolidation of friable and degraded objects may also be required beforehand.

Repairs must provide accurately prepared shapes and sound, clean gluing surfaces. For damaged corners and carvings, a freshly prepared plane surface is adhesive bonded to an excess of suitable repair material and the excess later shaped and finished as required. Where new wood has to be inlaid into the surface of the solid, tracings or measurements of the outline of the damage are first transferred on to a suitable piece of repair material. The repair material is then cut out very slightly larger than the area of damage before being fitted in one of two ways. Where the shape of the replacement is defined by an area of flat design it can be shaped to fit precisely into the space available. Alternatively, the repair can be laid over the damage and marked round so that a very small amount of original material is then removed for a perfect fit. In this case, the shape of the repair is chosen to give the best possible aesthetic integration while restricting removal of extra original material to the minimum.

Surfaces to be bonded should be thoroughly cleaned and modified to a suitable condition before joining. Surface preparation is most important and is best done immediately before gluing. Planed surfaces on wood are preferred to sawn surfaces and finely sanded ones to those coarsely sanded. Intentionally roughening a surface does not directly improve adhesive bond quality, though it may help to create channels for the removal of excess glue and thereby promote a more nearly ideal glue line thickness. Solvent cleaning of oily or resinous timbers is beneficial. Surface preparation is critical for the durability of adhesive bonds even though initial joint strengths with untreated surfaces appear satisfactory.

Assembly of components into a complete structure follows the pattern of the original. This is normally accomplished with adhesive bonding (*see* ADHESIVES),

though some structures are assembled without adhesive. These rely on mechanically interlocking components, either joints or such fastenings as wooden pegs, nails or screws. Repairs to part of a component are normally attached with adhesive. Animal glues are still widely used for furniture. Although they have limited resistance to moisture and are readily biodegradable, animal glues have some significant advantages for inside use. They have stood the test of time and are compatible with old material. They possess adequate strength, yet joints made with them remain reversible throughout their effective life. They are non-staining, non-toxic and non-flammable. Excess glue is easily removed, and reactivation of glue under veneers is possible. Polyvinyl acetate emulsions and epoxy resins are among other materials used for special purposes. Where setting involves loss of solvent, joints must be held together under pressure while the adhesive sets. When adhesive has been applied, assembly of components must be completed within the 'open' working time limit imposed by the adhesive. The right amount of pressure must be applied in the right places to bring all parts of the assembly into correct alignment without damage or distortion. This is normally done using various kinds of cramp. 'Softening' of wood or card is used to prevent cramps causing surface damage. Also a glue-resistant layer of silicone paper or similar material must be interposed between the softening and the object to prevent the softening sticking to the surface. Excess adhesive should be removed before it sets. Cramping must be complete within the time limit imposed by the adhesive and must be left undisturbed while the adhesive sets. If required, shaping of repairs after attachment is done in a way that reduces the risk of damaging original material. Wood must be dry before shaping begins. When replacing substantial losses, evidence beyond reasonable doubt is required. This may include recent photographs of the object, symmetry, interpolation or evidence from other members of a set.

Careful selection of repair material makes the integration and finishing of old and new work much easier, though some colouring is usually needed. Retouching should take account of the natural colour changes that occur on ageing. The light source and viewing angle can profoundly affect appearance and should be carefully chosen. Daylight is preferred because retouches made under it are less likely to show up under other light sources. Each stage of the finishing process should be tested on waste repair material before being applied to the object. The first stage of finishing is surface preparation. The general tone of the area to be coloured must not be darker than the area to be matched. If necessary a bleach such as hydrogen peroxide may be used to lighten some or all new wood before staining to the correct hue. Once the hue of the new wood is correct, a toning stain can be applied to get the desired final effect. This will be modified by surface coatings.

Several types of stain are available, each with advantages and disadvantages regarding quality of effect, permanence, grain raising, penetration and ease of use. Such chemical stains as potassium bichromate and ammonia cause colour changes by reacting with chemical components of wood. Other stains are classified according to the solubility of the dyes used. Coatings provide protection against dirt, atmospheric gases, water vapour, wear and light. They also enhance appearance by bringing out surface colours. Where a coating exists this should be matched in repairs. Where there is no coating the intended effect must be balanced against the risk to the object of leaving it uncoated. Coatings must wet the surface, be sufficiently tough to resist movement of the wood and dry at an appropriate rate. A variety of traditional materials is available including paint, VARNISH, shellac (French polish), oils and waxes. The range is extended by modern conservation materials that attempt to combine superior protection and appearance with ease of removal.

3. TREATMENT FOR INFESTATION AND DECAY. Treatment for structures damaged by wood-boring insects includes isolation of affected objects, killing all insect life present, strengthening and repairing structural damage, disguising disfigurement caused by flight holes and reducing the likelihood of reinfestation. Objects with signs of active infestation should be treated immediately. Methods vary according to their efficacy, hazards, toxicity, equipment required, cost and likelihood of damage to the object itself. Such gases as methyl bromide, ethylene oxide and hydrogen cyanide are highly effective, act quickly and have good penetration but are highly toxic to other organisms and require special apparatus to apply. The risk of staining or damage to the object is low if the correct procedures are adopted. However, the effect is not persistent, and prevention of future reinfestation is not guaranteed. Long-term protection is afforded by applying insecticides in solution in organic solvents, and various formulations are available commercially. Permethrin is a frequently used insecticide that has replaced pentachlorophenol. Insecticidal fluids are initially slower than gas, and penetration is comparatively poor by normal means of application. Their persistence prevents reinfestation, but their continued presence in and on the object could be hazardous to those handling and working with treated surfaces. Other methods include freezing, prolonged exposure to low-oxygen environments (usually of nitrogen) and vapour phase deposition of inorganic boron.

Consolidation of seriously weakened or damaged wooden objects is used to impart strength sufficient for handling, load bearing and further conservation treatments. This ranges from consolidation of friable surface decoration to the restoration of structural strength in load-bearing members of buildings. Consolidation (see CONSOLIDANT) is accomplished by introducing a liquid (or vapour) that is converted *in situ* to the solid state. Consolidants should possess good adhesion, impart strength to the surface and to the structure if required and be flexible but hard. Solutions should combine high concentration with

low viscosity, solvents used should be non-toxic and non-damaging to the object, and application should be simple. Ideally, conversion to the solid state should occur at a controlled rate, at room temperature and without shrinkage. Treatments should maintain their mechanical and optical characteristics for long periods but should also be reversible at least in the short term. Classes of material that have been used include epoxies, acrylics, wax and resin mixtures, poly(vinyl butyral) and Parylene. Reinforcement with new wood or other material is sometimes required to provide adequate strength while preserving original surfaces. This is normally incorporated into the structure so that it is not visible. The extent of disguise of flight holes depends on the extent to which damage interferes with normal viewing of the object. This in turn depends on the age and nature of the object and, to some extent, personal taste. A small amount of damage in old furniture may be expected and therefore acceptable. Major damage to a modern wood sculpture with smooth surfaces and flowing curves would probably require attention. Consolidant can be allowed to act as filler, but more usually surface damage is filled independently, for example with pigmented wax and resin mixtures or proprietary fillers based on synthetic thermoplastic resins.

For simple shrinkage without splitting or warping, there are three treatment options. The shrinkage may be left uncompensated, the more shrunken part may be enlarged or the less shrunken part reduced. The course of action that results in least damage to original material and provides the most easily reversible change is considered the most acceptable. Shrinkage, in the width of drawer fronts for example, may leave vertically aligned moulding extending beyond the margin of the drawer and at constant risk of being broken off during use. In such cases it is generally advisable to slightly reduce the length of the moulding to prevent further damage. Gaps may be aesthetically unacceptable or a potential source of further damage. Where separation of components without breakage has occurred it may be possible to close the gap and make up the shrinkage loss by adding an extra piece of wood. However, the symmetry of any overlying design must be preserved.

More serious failure may occur internally—within the width and thickness of the timber itself—leaving an irregularly shaped crack that may be difficult to close. Treatment depends on the nature of construction, on the nature and position of the gap or split, on the physical resistance of the components to be brought back together and on the type of surface decoration. An important step is to remedy, so far as is practicable, the causes of the problem so that a repetition does not occur. Treatment options include closing the crack and making up loss of thickness on one side or filling the gap with a fillet of wood or a softer type of adhesive-based filler. Dovetail keys may be used to hold parts together and prevent further splitting. Warping can be difficult to remedy, because most of the methods used to correct it involve serious disruption and none is entirely satisfactory.

Sometimes the construction of a piece may allow the support or restraint of thin weak members by stronger ones. Soaking of the piece in water followed by drying in a position directly opposing the warp can sometimes produce the desired result. Often, however, the piece reverts to its warped state, and the application of this technique is restricted to plain wooden objects. Another alternative is to groove out the back of a solid board or the core of a veneered construction and insert strips of wood to help keep the panel flat. This, however, is a last resort, scarcely less disruptive than complete removal and remounting of a thin section of the surface on a more stable support.

4. CLEANING. Although wood may be encountered in its raw or unfinished state it has usually been coated. Cleaning may be required to prevent or reduce deterioration, to remove an aesthetic obstruction or to allow essential conservation. The ideal of cleaning is to remove all the dirt without removing or damaging any part of the object and without leaving behind any of the cleaning materials. In practice even the mildest cleaning treatments cause some damage. The need for cleaning can be reduced by proper storage and handling. The decision to clean is based on the state of the object, the estimated rate of deterioration with and without dirt, the available cleaning methods, the presence of historical or other evidence associated with the dirt, the estimated extent of damage likely to be caused by cleaning and the likelihood of the need to repeat the treatment in future. Loose dirt can be removed using a vacuum cleaner with the aid of cloths and soft brushes. Harder, more brittle dirt that is more strongly attached to the surface may, with care, be chipped off. Where dirt is more resistant it may be necessary to use abrasive methods. Mechanical cleaning methods are more suited to flat or evenly curved surfaces with no sharp re-entrants or three-dimensional decoration. For removal of more elastic, rubbery or greasy kinds of dirt and for the treatment of intricate surfaces with a thin and fragile decoration SOLVENT cleaning is used.

Wax, especially the softer sorts such as beeswax, which is commonly applied at intervals to furniture, may have been allowed to build up, incorporating layers of dirt, until a rather ugly semi-hard black grease covers much of the surface. A mixture frequently used to remove this accumulated grime is known as furniture reviver. Such materials are commercially available or may be prepared by shaking thoroughly together two parts pure gum turpentine, two parts industrial methylated spirits, two parts malt vinegar and one part raw linseed oil. After application the mixture is left to act for a short time before removing loosened wax and dirt on cotton wool or cloth, followed by vigorous burnishing to remove excess oil. It is preferable, where further finishing is anticipated, to clean with white spirit to remove excess oil. A light coat of a paste wax based on carnauba wax is often applied to provide some protection and to enhance the surface.

Wood surfaces that have been decorated with paint, gilding, japanning or lacquer are cleaned using methods appropriate to the form of decoration present.

A. J. Panshin, H. P. Brown and C. C. Forsaith: *Textbook of Wood Technology* (New York, 1949); 4th edn by A. J. Panshin and C. de Zeeuw (New York, 1980)

C. H. Hayward: *Furniture Repairs* (London, 1969)

F. Oughton: *The Finishing and Re-finishing of Wood* (London, 1969)

E. Joyce: *The Technique of Furniture Making* (London, 1970)

N.-S. Bromelle, J. A. D. Darrah and A. J. Moncrieff: *Papers on the Conservation and Technology of Wood*, International Council of Museums: Sub-committee–Furniture (Madrid, 1972)

R. M. Rowell: 'Non-conventional Wood Preservation Methods', *Wood Technology: Chemical Aspects*, American Chemical Society, xxxxiii (1977), pp. 47–56

C. H. Hayward: *Staining and Polishing* (London, 1978)

Conservation of Wood in Painting and the Decorative Arts: Proceedings of the International Institute for the Conservation of Historic and Artistic Works: Oxford, 1978

D. W. Grattan: 'Consolidants for Degraded and Damaged Wood', *Proceedings of Furniture and Wooden Objects Symposium: Ottawa, 1980*

R. B. Hoadley: *Understanding Woods: A Craftsman's Guide to Wood Technology* (Newton, CT, 1980)

A. Barefoot and F. Hawkins: *Identification of Modern and Tertiary Wood* (Oxford, 1982)

B. M. Fielden: *The Conservation of Historic Buildings* (London, 1982)

P. Cunnington: *Care for Old Houses* (London, 1984, 2/1991)

D. Eckstein, M. G. L. Baillie and H. Egger: *Dendrochronological Dating*, Handbooks for Archaeologists, ii (Strasbourg, 1984)

I. A. Melville and I. A. Gordon: *The Repair and Maintenance of Houses* (London, 1984)

R. Rowell: *The Chemistry of Solid Wood*, American Chemical Society (1984)

Proceedings of the Symposium: Adhesives and Consolidants: Paris, 1984

Proceedings of the Symposium of the Scottish Society for Conservation and Restoration: Decorative Wood: Glasgow, 1984

G. Buchanan: *The Illustrated Handbook of Furniture Restoration* (London, 1985)

Y. Wang and A. P. Schniewind: 'Consolidation of Deteriorated Wood with Soluble Resins', *Journal of the American Institute for Conservation*, xxiv/2 (1985), pp. 77–91

Proceedings of CETBGE and the International Council of Museums: Waterlogged Wood: Study and Conservation: Grenoble, 1985

D. Hawkins: *The Technique of Wood Surface Decoration* (London, 1986)

A. F. Bravery and others: *Recognizing Wood Rot and Insect Damage in Buildings* (London, 1987)

C. V. Horie: *Materials for Conservation* (London, 1987)

D. W. Grattan and R. L. Barclay: 'A Study of Gap Fillers for Wooden Objects', *Studies for Conservation*, xxxiii/2 (1988), pp. 71–86

M. A. Williams: *Keeping it All Together: The Preservation and Care of Historic Furniture* (Worthington, 1988)

D. Pinniger: *Insect Pests in Museums* (London, 1989)

A. P. Schniewind: *Concise Encyclopaedia of Wood and Wood-based Materials* (Oxford, 1989)

S. Bowman: *Radiocarbon Dating* (London, 1990)

R. M. Rowell: *Archaeological Wood* (Washington, 1990)

H. Munn: *Joinery for Repair and Restoration Contracts* (Builth Wells, 3/1991)

K. Dardes, ed.: *Structural Conservation of Panel Paintings* (Los Angeles, 1998)

V. Dorge and F. C. Howlett: *Painted Wood: History and Conservation* (Los Angeles, 1998)

O. Raggio: *The Gubbio Studiolo and its Conservation* (New York, 1999)

A. Unger, A. P. Schniewind and W. Unger: *Conservation of Wood Artefacts: A Handbook* (Berlin and London, 2001)

S. Rivers: *Conservation of Furniture* (Oxford and Boston, 2003)

Woodcut [Fr. *gravure en bois, gravure sur bois*; Ger. *Holzschnitt*; It. *silografia, xilografia*; Sp. *grabado en madera, xilografía*]. Type of relief print and the process by which it is made. The term 'woodcut' is often used loosely for any printmaking technique that employs a wooden block. Strictly speaking, however, the term applies only to cuts made on planks of wood. The precise term for the method that involves cutting the design on the end-grain of the block is WOOD-ENGRAVING. The term 'xylography' is sometimes used to refer to both processes. CHIAROSCURO WOODCUTS are printed from at least two blocks using dark ink and white highlights on a coloured background. This article discusses the materials and techniques of Western woodcuts, including those coloured freehand or by stencil or printed from one or more blocks.

Woodcut is a relief-printing technique (*see* PRINTS, §III, 1), in which the printing surface is raised above other portions of the block, which are cut away so that they remain blank (see fig.). The blocks are made from well-seasoned planks *c.* 25 mm thick, cut from the length of the tree and usually of fairly soft wood, such as pear; alder, beech, cherry, sycamore and walnut are also used. Because the image is reversed by printing, the design on the block must be in reverse of the intended direction. It can be drawn with pen, pencil or brush directly on the block, which may be prepared with a white ground. Alternatively, pigments brushed on to the back of a design may be transferred using a stylus. Drawings are sometimes pasted on to the surface of the block either face upwards or face down in order to reverse the design (having been oiled to make them transparent). Photographic methods of transfer became available in the 1860s, but these have been used more commonly for commercial wood-engraving than for woodcut.

Using a sharp knife, the design is cut by making two incisions along each side of the drawn lines to remove a fine shaving of wood. One incision is inclined away from the line and the other towards it, to leave a line with a conical section between two v-shaped grooves. Once the design is established, the surplus wood is removed with scoops, gouges and chisels, leaving a network of 'lines' or 'hatching' at surface level. In fact the cutter often creates graphic signs that give the impression of a cross-hatched pen drawing. During printing the summits of the lines are gradually worn down, and the blocks also often

Woodcut by Albrecht Dürer: *Four Horsemen of the Apocalypse*, from the *Apocalypse* series, 394×281 mm, 1498 (London, British Museum); photo © British Museum/Art Resource, NY

develop splits, breaks and wormholes, so that later impressions are coarser. A worn block may be copied by pasting an impression from it on to a new one and cutting a second version.

In order to withstand pressure during printing, the lines cannot be cut too thin, so woodcuts can never be as precise as engravings. Broader effects can be achieved by using gouges and chisels on their own and by exploiting the textures produced by the grain of the wood. Mistakes may be corrected by removing part of the block and inserting a plug, but the joins often open up during printing. State changes therefore usually involve removal of part of the work, not additions to the design. White-line woodcuts are created by cutting the design directly into the block, leaving large areas untouched to print as solid colour. Until the late 19th century the cutting was normally done by separate craftsmen, usually members of the

carpenters' guild. Black-line woodcutting required expert training and was too laborious and time-consuming to appeal to the creative artist.

The ink used must be stiff enough to remain on the raised parts of the block and not run down into the hollows. It is applied with a dabber or, since the 19th century, with a roller. The support for the image is normally paper, preferably an absorbent type, which has been dampened before printing. Sometimes vellum or fabric is used. The first European woodcuts seem to have been stamped by hand or mallet, without a press, like early textiles. Alternatively, the back of the paper was rubbed using a burnisher, pebble or smooth wooden rubber to transfer the ink. Following the invention of movable type, known in China as early as the mid-11th century and in the West from the mid-15th century, simple screw presses came into use (*see* PRINTING); these are still used. The pressure is

applied vertically and uniformly and does not need to be heavy. In the 19th century burnishing was revived as a method of taking proofs of woodcuts.

Most early woodcuts were printed in black or brownish ink, a practice that has continued; they were often coloured, either free-hand or using a stencil. Blocks may also be printed blind (without ink) to create 'seal prints' or embossed paper reliefs (*see* EMBOSSING). A single block can be printed in colours, either by selective inking of different areas of the image, or by sawing the block into sections, inking these separately and slotting them together again for printing. Colour woodcuts may also be printed from several blocks with the colours either separate or superimposed to create new shades. In Japan and, to a lesser extent, China, where woodcut has been the dominant graphic medium, complex methods of colour printing have been developed to achieve very subtle effects. A number of European artists have adopted these techniques.

G. Petardi: *Printmaking Methods Old and New* (New York, 1959)

F. Brunner: *Handbook of Graphik Reproduction Processes/Handbuch der Druckgraphik/Manuel de la gravure* (Teufen, 1962)

K. Sotriffer: *Die Druckgraphik: Entwicklung, Technik, Eigenart* (Vienna, 1966)

P. Gilmore: *Modern Prints* (London, 1970)

F. Eichenberg: *The Art of the Print: Masterpieces, History, Techniques* (London, 1976)

E. Rhein: *The Art of Printmaking: A Comprehensive Guide to Graphic Techniques* (1976)

The Processes of Printmaking (exh. cat., ed. J. Atkinson; British Council, 1976)

W. Chamberlain: *The Thames and Hudson Manual of Woodcut Printmaking and Related Techniques* (London, 1978)

P. Gilmore: *Understanding Prints: A Contemporary Guide* (London, 1979)

A. Griffiths: *Prints and Printmaking: An Introduction to the History and Techniques* (London, 1980)

J. Dawson, ed.: *The Complete Guide to Prints and Printmaking Techniques and Materials* (London, 1981)

S. Lambert: *Printmaking* (London, 1983)

B. Gascoigne: *How to Identify Prints: A Complete Guide to Manual and Mechanical Processes from Woodcut to Ink Jet* (London and New York, 1986, rev. 2/2004)

N. A. Bialler: *Chiaroscuro Woodcuts: Hendrick Goltzius (1558–1617) and his Time* (Amsterdam and Ghent, 1992)

H. Merritt: *Modern Japanese Woodblock Prints: The Early Years* (Honolulu, [1992])

H. Merritt and N. Yamada: *Guide to Modern Japanese Woodblock Prints: 1900–1975* (Honolulu, [1992])

M. W. Driver: *The Image in Print: Book Illustration in Late Medieval England and its Sources* (London, 2004)

Woodcut, chiaroscuro [Fr. *clair obscur, camaïeu*; Ger. *Helldunkelschnitt*]. Early form of colour print, in which two or more woodblocks were printed one on top of the other, usually consisting of flat tonal blocks with limited chromatic range and a line block printed last. The Italian word 'chiaroscuro', which refers to contrasts of light and dark in a work of art, came to be applied from the early 16th century to drawings and woodcuts in which figures were delineated in a dark

ink on a coloured background, with white strokes modelling the volumes.

A chiaroscuro woodcut could be made with only two blocks: a key-block (or line-block) conveying the primary details of the design and suggesting through its hatching intermediate shading; and a tone-block of identical size creating a coloured ground interrupted by highlights, wherever cut-out lines or areas permitted the white of the paper to show through. The key-block would be cut first and printed on the tone-block itself to assist the planning of the highlights but was applied last in printing the impression. If more than two blocks were used (generally three or four but occasionally as many as ten), the key-block could be restricted to printing intermittent outlines, or dark accents, and the intermediate blocks could convey the shading and much more of the design information, with the background block still describing the highlights. For this more complex form of chiaroscuro, careful planning of the colour separations and meticulous registration in the printing were required. Early scholars distinguished the two-block from the multi-block method by calling it *camaïeu*, that is, the 'monochrome method'.

Relatively soft fruit-wood blocks were employed, cut along the grain, not usually exceeding *c.* 500×350 mm. If a large design was planned, it could be extended on to adjacent blocks, and, after printing, the various sheets could be pasted together to compose the whole. Andrea Andreani (1558/9–1629) made several prints calling for over 40 blocks. Cutting of the design was done with knives and gouges. Inks, pounded on the surface with balls or dabbers, were oil-based and incorporated a wide range of pigments, by all appearances pure mineral colours rather than blended pigments. While neutral and closely related hues were predominant, bright colours and striking combinations also occurred. A screw-and-lever press, identical or similar to a type-press, would have been used. The pressure could be varied from one block to another to create embossed areas. A complex press especially designed for the printing of chiaroscuro woodcuts was constructed by the 17th-century Parisian painter Georges Lallemant (*c.* 1580–1636), but it proved too expensive to operate.

Several 16th-century artists recognized that colour blocks could be combined effectively with intaglio plates. Parmigianino (1503–40) and Domenico Beccafumi (1484–1551) printed tone-blocks together with etched and engraved plates respectively as early as the 1520s; Erhard Altdorfer (*c.* 1480/85–1561/2), Crispin van den Broeck (1523–89/91), Hendrick Goltzius (1558–1617) and Abraham Bloemaert (1566–1651) followed later in the century. In the 18th century the English artist Elisha Kirkall (1685–1742) also combined woodcut with mezzotint; the most impressive revival, however, was the two-volume *Cabinet Crozat* (1729–42), which included reproductions of important French paintings and drawings in mixed-method chiaroscuros by the Le Sueur family in collaboration with the Comte de Caylus (1692–1765) and others.

J. M. Papillon: *Traité historique et practique de la gravure sur bois* (Paris, 1766)

A. von Bartsch: *Le Peintre-graveur* (Vienna, 1803–21), xii [B.]

J. D. Passavant: *Le Peintre-graveur … catalogue supplémentaire … de Bartsch*, 6 vols (Leipzig, 1860–64)

G. K. W. Seibt: 'Helldunkel iii: Chiaroscuro, Camaieu, Holzschnitte in Helldunkel', *Studien zur Kunst und Kulturgeschichte*, v (Frankfurt am Main, 1891)

A. Reichel: *Die Clair-obscur-Schnitte des XVI, XVII, und XVIII Jahrhunderts* (Zurich, 1926)

L. Servolini: *La xilografia a chiaroscuro italiana nei secoli XVI, XVII, XVIII* (Lecco, 1930)

P. Gusman: *Gravure sur bois et taille d'épargne: Historique et technique* (Paris, 1938)

F. W. H. Hollstein: *Dutch and Flemish Etchings, Engravings and Woodcuts, c. 1450–1700* (Amsterdam, 1949–)

Mostra di chiaroscuri italiani dei secoli XVI, XVII, XVIII (exh. cat., ed. M. Fossi; Florence, Galleria degli Uffizi, 1956)

Parmigianino und sein Kreis (exh. cat. by K. Oberhuber; Vienna, Graphische Sammlung Albertina, 1963)

Gravures sur bois clairs-obscurs de 1500 à 1800 (exh. cat., ed. C. van Hasselt; Paris, Fondation Custodia, Institut Néerlandais; Rotterdam, Museum Boymans–van Beuningen; 1965–6)

Renaissance in Italien 16 Jahrhundert: Die Kunst der Graphik III (exh. cat., ed. K. Oberhuber; Vienna, Graphische Sammlung Albertina, 1966)

A. E. Popham: 'Observations on Parmigianino's Designs for Chiaroscuro Woodcuts', *Miscellanea, I. Q. van Regteren Altena* (Amsterdam, 1969)

W. Strauss: *Chiaroscuro: The Clair-obscur Woodcuts by the German and Netherlandish Masters of the XVIIth Centuries* (New York, 1973)

Hans Burgkmair: Das graphische Werk (exh. cat., ed. T. Falk; Augsburg, Schaezlerpalais, 1973)

Tiziano e la silografia veneziana del cinquecento (exh. cat., ed. M. Muraro and D. Rosand; Venice, Fondazione Giorgio Cini, Istituto di Storia dell'Arte, Biblioteca, 1976)

Chiaroscuro Woodcuts: Hendrick Goltzius and his Time (exh. cat., ed. N. Bialler; Amsterdam, Rijksmuseum; Cleveland, OH, Cleveland Museum of Art, 1993)

D. Landau and P. Parshall: *The Renaissance Print, 1470–1550* (New Haven and London, 1994)

German Renaissance Prints (exh. cat., ed. G. Bartrum; London, British Museum, 1995)

Wood-engraving [Fr. *gravure sur bois debout*; Ger. *Holzstich*]. Type of relief print related to the WOODCUT, and the process by which it is made. The two processes are, however, quite distinct, despite the terms 'woodcut' and 'wood-engraving' having been used synonymously to refer to any image printed from a wooden surface. Although it was probably used first in the 17th century, it was not until the 18th that wood-engraving could be identified confidently as a distinct engraving process.

The wood-engraver's block is made from a hardwood, preferably box-wood (*Buxus sempervirens*). The box-wood block is made from roundels cut across the grain, so that the closely formed growth rings of the tree are clearly apparent on the surface of the prepared block. By working against this grain the wood-engraver is able to execute very fine work. The disadvantage of box-wood is its generally small girth; for a print or illustration bigger than 150–200 mm, several separate pieces of box-wood have to be joined together. Tongue-and-grooved blocks, glued and/or screwed together, were used before the invention in the mid-19th century of the bolted block, a multiple box-wood block held together by nuts and bolts located in grooves cut into the back of the individual blocks. In the late 20th century multiple blocks were once again of the glued kind. Blocks are conventionally supplied 'type high', that is at a thickness that allows them to be locked in a printing press ready for printing.

The wood-engraver uses a variety of tools closely related to those used by metal-engravers (*see* ENGRAVING, §I). These fall into two groups: those for engraving lines and textures (gravers or burins, spitstickers and tint tools); and those for clearing areas of the block (scorpers and chisels). To clear large areas, a routing machine may be employed. The design to be engraved can be committed to the surface of the block in several ways: by drawing directly on to the block; by tracing a drawing; or by photographing on to the engraving surface. For much of the 19th century there was a professional divide between the designer of wood-engraved illustration and the engraver, the latter being seen as an interpreter or translator. When artist–engravers became interested in the process, conception and execution came to be the sole responsibility of the artist.

During engraving the sides of the block are gripped by hand on a leather sandbag. Coordinating with the tool held in the other hand, the engraver is then able to manipulate the block more easily and to execute curved lines. Unlike in woodcutting, where the knife is drawn towards the body, all work is done away from the body. During most of the period of its employment as a commercial reproductive process, apprentice engravers were schooled in the correct manner of working, which tended towards a standardized 'finish'. The modern artist–engraver is constrained only by the degree of experimentation he wishes to try and by the scope of his imagination.

If an inked but unengraved block is passed through the press, it produces a rectangle of unbroken black. As the engraver works on the block, lines, textures and spaces are created by the removal of wood by the tools. These appear as white on the print itself. It is argued not only that this 'white line' is the most natural way of creating a wood-engraved image but also that as a matter of principle a design should be conceived from the start in terms of white marks on a black surface. The commercial wood-engravers were required to make facsimiles of illustrators' pen-and-ink and wash drawings and worked largely in 'black line', where the engraver imitates the pen drawing by removing all the wood from around drawn lines, thus leaving them cleanly in relief. Pure use of the 'white line' is seen by some artist–engravers as a commitment to the true principles of the process, and the use of 'black line' as a failure to understand these principles. In practice it is not uncommon to see both 'white' and 'black' line in use in any one wood-engraved image.

To secure a perfect print from the wood-engraved block demands the best inks, paper and printing technique. In general a fairly stiff, high-quality printer's ink is used, and Indian and Japanese papers are preferred. Papers that are either too hard or too soft will not take a good impression. It is possible to print from a wood-engraved block by hand and produce a reasonable print, but it is usual to pull proofs in a printing press. Both hand and machine presses are used. If carefully printed, the box-wood block can deliver thousands of good impressions before wear becomes a factor. The surface, however, is always vulnerable to accidental damage, and in the 19th century electrotype casts were made from the blocks and used in the actual printing, the blocks themselves being kept as masters from which further 'electros' could be made.

Alongside the dominant tradition of black-and-white wood-engraving runs the colour print pulled from a number of wood blocks, usually one for each colour, printed in fine register over a 'key' or outline block. Both commercial engravers and artist–engravers have used the process.

The invention of wood-engraving cannot be ascribed to any one person nor to a specific date. It was probably one of several processes developed by the general engraver from the 17th century onwards. Occasionally white-line engraving showing evidence of graver rather than knife work can be found in 17th-century printed ephemera. It is, however, only in the work of Thomas Bewick (1753–1828) in Britain in the latter half of the 18th century that it is seen as a specific technique. Bewick combined the skills of drawing and engraving. His use of the white line is considered exemplary by modern artist–engravers, and its legitimacy as *the* principle of engraving on wood was expressed in his own writing. Bewick's technical brilliance combined with the novelty of his work has secured for him the misleading sobriquet of 'the father of wood-engraving'.

Another contemporary, William Blake (1757–1827), executed only a handful of wood-engravings, but his influence has been as great as Bewick's. The romantic spirituality of Blake's illustrations to *The Pastorals of Virgil* (London, 1821) are in direct contrast to the closely observed detail of Bewick's natural history illustrations and the anecdotal realism of his celebrated vignettes. It is, however, precisely the pastoral sublimity of Blake, together with an unrestrained use of white line, that has endeared him to later generations of artist–engravers.

The apprentices of Bewick, Robert Branston (1778–1827) and their contemporaries were the first generation of engravers able to make a livelihood solely from wood-engraving, and for a while Britain was a centre of excellence to which foreign publishers turned for their wood-engravings. British engravers began working abroad, and Charles Thompson (1791–1843) is widely credited with introducing the new technique into France, although native engravers were at work there. During the first three decades of the 19th century wood-engraving was only slowly adopted commercially as a process for the illustration of books.

With the advent of a popular illustrated press in the 1830s and 1840s, however, the advantages of engraving on wood as a relatively cheap reproductive process secured its general use. For half a century, from the 1830s, wood-engraving was the dominant reproductive process used by publishers in Europe and North America, and not until the successful introduction of the photomechanical line-block and half-tone plate was it made obsolete. During this period much of the best illustration was reproduced by wood-engraving.

At the point in the 1890s at which wood-engraving as a viable commercial process was virtually obsolete, artist–engravers adopted it as a means of original expression. In Europe generally original wood-engraving became an established part of the graphic arts. During the first two decades of the 20th century the teaching of wood-engraving became centred in the art schools. Between 1918 and 1939 wood-engraved prints and illustrations, for both private press and commercially produced books, enjoyed something of a vogue in Britain and Europe. The commitment of artist-engravers to the process can be followed through the number of societies and publications embracing wood-engraving. In the latter half of the 20th century wood-engraving, if less favoured than earlier, was still being practised by artist-engravers and enjoying short, recurrent bouts of fashion for book and advertising illustration.

J. Jackson and W. A. Chatto: *A Treatise on Wood Engraving: Historical and Practical* (London, 1839/R Detroit, 1969)

W. J. Linton: *Wood Engraving: A Manual of Instruction* (London, 1884)

W. J. Linton: *The Masters of Wood Engraving* (London, 1889)

P. Kristeller: *Kupferstich and Holzschnitt in vier Jahrhunderten* (Berlin, 1905/R 1922)

H. Furst: *The Modern Woodcut* (London, 1924)

N. Rooke: *Woodcuts and Wood Engravings* (London, 1926)

D. P. Bliss: *A History of Wood-engraving* (London, 1928/R 1964)

P. Gusman: *La Gravure sur bois en France au XIXe siècle* (Paris, 1929)

C. Leighton: *Wood Engraving and Wood Cuts* (London, 1932)

B. Sleigh: *Wood Engraving since 1890* (London, 1932)

G. E. Mackley: *Wood Engraving* (London, 1948)

K. Lindley: *The Woodblock Engravers* (Newton Abbot, 1970)

G. Wakeman: *Victorian Book Illustration: The Technical Revolution* (Newton Abbot, 1973)

A. Garrett: *A History of British Wood Engraving* (Tunbridge Wells, 1978)

E. de Mare: *The Victorian Woodblock Illustrators* (London, 1980)

R. K. Engen: *Dictionary of Victorian Wood Engravers* (Cambridge, 1985) [useful bibliographies]

Victorian Illustrated Books, 1850–1870: The Heyday of Wood-engraving (exh. cat., London, British Museum, 1994)

B. Gascoigne: *How to Identify Prints: A Complete Guide to Manual and Mechanical Processes from Woodcut to Ink Jet* (London and New York, 1986, rev. 2/2004)

R. Micheler and L. W. Löpsinger, eds: *Salvador Dali: Catalogue Raisonné of Prints II, Lithographs and Wood Engravings 1956–1980* (Munich, 1995)

S. Brett: *An Engraver's Globe: Wood Engraving World-wide in the Twenty-first Century* (London, 2002)

R. Salter: *Japanese Woodblock Printing* (Honolulu, 2002)

X

Xerography. *See* ELECTROGRAPHY.

Z

Zinc. Hard, bluish-white metal. Its ores frequently occur with those of lead. Metallic zinc was produced in antiquity but was not isolated as a metal in modern Europe (which imported it from the East) until *c.* 1740. Zinc is a major constituent of brass. Objects cast from pure zinc are generally known as spelter. The metal is also used as an inexpensive alternative to copper in printmaking.

Contributors

The Grove Encyclopedia of Materials and Techniques in Art includes fully updated and revised articles from *The Dictionary of Art* and Grove Art Online. These original articles were contributed by the international scholars listed below and have been edited by Gerald W. R. Ward for this publication. New material has been provided by Jeffrey Martin (Computer art; Magnetic tape; Motion picture film).

Abse, Bathsheba
Ainsworth, Maryan Wynn
Akers, Robert C.
Alcock, N. W.
Alexander, David
Allardyce, Fiona
Ashcan, Marit Guinness
Attwood, Philip
Avery, Charles
Avrin, Leila
Barley, K. C.
Barnicoat, John
Barringer, D. A.
Baxter, Ronald
Becker, David P.
Bell, Janis Callen
Benjamin, B. S.
Besnainou, Didier
Betterton, Shiela
Black, Emily
Block, Jane
Bonavia, Duccio
Bosomworth, Dorothy
Bria, Carmen
Brian, Anthea
Brisby, Claire
Bristow, Ian C.
Broderick, A.
Brown, David Blayney
Brown, Hilton
Burkett, M. E.
Burns, Thea
Buys, Susan
Calnan, Christopher
Cappel, Carmen Bambach
Carey, Margret
Catterall, Claire
Charola, A. Elena
Cheetham, Francis

Clack, Valerie A.
Clark, Caroline
Cohn, M. B.
Colalucci, Gianluigi
Collon, Dominique
Condit, Carl W.
Constantine, Mildred
Coombs, Elizabeth T.
Cooper, John K. D.
Cottle, Simon
Craddock, P. T.
Cummings, K.
Dallas, R. W. A.
De Freitas, Leo John
De Witte, Eddy
Donnithorne, Alan
Duffet, Michael
Dunkerton, Jill
Dunsmore, Susi
Dyson, Anthony
Eimer, Christopher
Eswarn, Rudy
Evans, David
Featherstone, David
Ferrari, Oreste
Firth, Mark
FitzHugh, Elisabeth West
Floyd, Margaret Henderson
Foot, Mirjam M.
Fuente, Beatriz de la
Galvin, C. A.
Gaur, Albertine
Gibson, Jennifer
Gilbert, Christopher
Gilmour, Pat
Godla, Joseph J.
Goerner, Doris
Green, Malcolm
Grigsby, Leslie B.

Groen, Karin
Gullick, Michael
Halliwell, Kevin
Hammond, Martin D. P.
Hansen, Trudy V.
Harding, Catherine
Harley, Cate
Harley, R. D.
Harris, Richard
Hartley, Craig
Hartney, Mick
Harvey, Jacqueline Colliss
Hassall, Catherine
Haunton, Katharina Mayer
Heath, Kingston W.
Heyman, Jacques
Hicks, Carola
Hoeniger, Cathleen
Hooley, A. D.
Horie, C. V.
Hornsby, Peter
Horrocks, Roger
Howard, Peter Wren
Hughes, Quentin
Ilouz, Claire
Impey, Oliver
Ivey, Paul Eli
Jacoby, Beverley
Jirat-Wasiutyński, Vojtěch
Johnson, Jan
Kachur, Lewis
Kirby, Jo
Kirkham, Pat
Kirkpatrick, Diane
Kite, Marion
Klein, Peter
Kombluth, Genevra
Krieger, Michaela
Lambert, Gisèle
Landi, Sheila
Lazzarini, Lorenzo
Lees, Tim
Leigh, David
Levey, Santina M.
Lister, Raymond
Lyttleton, Margaret
McNair, Amy
McNally, Rika Smith
Marcus, Stanley E.
Marko, Ksynia
Mata, Angela Franco

Martin Jeffrey
Meek, H. A.
Meek, Marion
Merrit, Jane L.
Michel, Christian
Miller, Elizabeth
Millidge, Shirley
Mills, John S.
Minney, Frank
Mitchell, D. M.
Monnier, Geneviève
Moor, Angela H.
Moor, Ian L.
Moore, Nicholas J.
Morgan, Nigel J.
Mowat, Linda
Nagy, Imre
Naylor, Janet
O'Connor, Deryn
Oddy, Andrew
O'Neill, L. A.
Onians, Dick
Pickwoad, Nicholas
Pinder, Michael
Podmaniczky, Michael Sándor von
Pole, Len
Popper, Frank
Priest, D. J.
Proudfoot, Trevor
Pullen, D.
Rabinovitch, Celia
Rae, Allyson
Riccardi-Cubitt, Monique
Rice, Danielle
Rickman, Catherine
Rigal, Christian
Roberts, Margaret
Robinson, P. R.
Rothstein, Natalie
Rutt, Richard
Sanabria, Sergio L.
Sanderson, R. W.
Sargent, William R.
Saxby, Graham
Scaratt, Ken
Scheicher, Elisabeth
Semowich, Charles J.
Serck-Dewaide, Myriam
Shashoua, Yvonne
Shelley, Marjorie
Sickler, Michael

Singer, Jane Casey
Skoler, Louis
Slatner-Prückl, Michaela
Smare, Tim
Smith, Perry
Staniforth, Sarah
Stephenson, Jonathan
Stevens, Christopher Claxton
Stijnman, Ad
Suffield, Laura
Summers, David
Sutherland, R. J. M.
Symmes, Marilyn F.
Tait, W. J.
Taylor, Clare
Taylor, Colin
Thornton, Peter
Tite, M. S.
Turner, S. J.

Twyman, Michael
Umney, N. D.
Van Zanten, David
Veldman, Ilja M.
Walsh, Judith
Ward, J. P.
Wardle, Patricia
Wegner, Nicholas
Wenley, Robert
West, Janet
White, Raymond
Whiting, M. C.
Wigginton, Michael
Wilckens, Leonie von
Winter, John
Woodman, Francis
Worthen, Amy Namowitz
Yorke, James

Index

Numbers in **bold** refer to the main entry on that subject. Page numbers in *italics* refer to illustrations. Colour plates are introduced by the abbreviation pl.

Alphabetization is letter by letter up to the first comma (ignoring spaces, hyphens and any parenthesized matter). Abbreviations of 'Saint' and its foreign equivalents are alphabetized as if spelt out; the same principle applies to abbreviations of 'Mount'. Headings with the prefix 'Mc' appear under 'Mac'.

Index entries containing *see* or *see also* are directions to other index entries; references to the text are always indicated by page numbers.

Etching Revival 172, **206–7**
ether 489
Ethiopia
 beadwork 32
 ceramics 34
ethiops 508
ethyl alcohol *see* alcohol
ethyl cellulose 329
ethylene oxide 776
ethylene-vinyl acetate copoly-
 mers (EVA) 575
ethyl silicate 1, 634
Eton College 63
Etruscan
 ivory 298
 jewellery 255, 257, 380
 masonry 368
 wall painting 736
Etty, William 39
Euclid 495
Eugene, Prince of Savoy 479
Eumenes II Soter, King of
 Pergamon
 (*reg* 197–160 BC) 471
European Confederation of
 Conservator–Restorer's
 Organizations *see*
 ECCO
European Magazine 619
eutectic soldering 257
Evelyn, John 755
experimental film 213–15
Ewelme Almshouses 17
Eyck, Hubert van 238, 264
Eyck, Jan van
 gesso 229, 269
 Ghent Altarpiece 238, 264
 glazes 253, 422
 grisaille paintings 264
 grounds 267
 panel paintings 442, 443
 Turin–Milan Hours 164
Eyzies, Les *see* Les Eyzies
Ezine 622
Fabergé 603
Fabergé, Carl 189, 255, 306
Faber pencil factory 482
Fabriano 196, 456, 539, 752
'Façadism' 20
facsimiles *see* reproduction of
 works of art
Fagolino, Marcello 211
faience (i) 30, 32, **217**, pl. II.3
faience (ii) 38, **217**, 711
 see also Delftware; maiolica
Faiyum
 papyrus 469
 portraits 191, 642, 668, pl.
 XVI.2
false sandarach *see* red lead
famille rose 36
Fantin-Latour, Henri 179
Fantuzzi, Antonio 202
fatty acid spue 341
fauteuil de commodité 725
faux bois 436
faux marbre 436
fax art 181
Fazola, Henrik 293
feathers 217, *218*
 quill pens 73, 159, 161, 481
 quillwork 565
 upholstery 725
featherwork 217–18, pl. V.1
Fedoskino 468
feicui 305
Feixian 35

Felbrigge Psalter 46
feldspar 22, 61, 92, 94, 96
Félibien, André 105
Felsburg 623
Felsing, Otto 541
felt 103, **219**, 688
felt paper 460
Ferchault de Réaumur,
 René-Antoine 449
Ferdinand of Austria, Archduke,
 Count of Tyrol 329
Fernbach, Franz Xavier 192
Ferrara 196, 459, 477
ferric-chlorate 200
ferric salts 489
ferro-cimento 124
ferro-concrete *see* reinforced
 concrete
ferrotype 490
ferrous oxide *see* iron oxide
ferrules 73
fertility talismans 32
Fez 456
fibre art **220–21**, pl. IV.3
fibreboard 39, 718
fibreglass (GRP) 90, 91, 117,
 221, 515, 516, 517, 520
fibre pens 481
fibroin 677
fibrous plaster 637
fibrous slab 468
Field, Richard 585
Fielding, Theodore Henry
 Adolphus 209, 560
fig juice 150, 453, 473
fig-tree latex 590
figura serpentinata 142
figurines 67, 70
Fiji
 bone 41
 stencils 614
Filarete 269
Filareto, Apollonio 47
filbert brushes 73
filet 688
Filfila 624
fili di sinopia 604
filigrana glass 246
filigree **222**, 257, 381
filled-in *urushi* 321
film 490
 see also experimental film;
 motion picture film;
 photography
Finiguerra, Maso 195, 420
Finland
 rugs 84
fir 761
fire-clay 96
fire gilding 143, **233–4**
fireplace furnishings 294
fireproof architecture 118, 288,
 290, 672
firestain 600
Firth, Mark 10
Firth of Forth Bridge 290
Fischer, Jürgen Lit 115
Fischinger, Oskar W. 213
fish glue 3, 150, 280, 332, 363,
 473, 717
 see also isinglass
Fishpool 237
Fitzgerald, Kit 734
'Fitzhugh' pattern 36
fixatives 103, 141, **222**, 731
 see also adhesives; consolidants
Flack, Audrey 2

flake white *see* white lead
Flanders *see* Belgium
Flandrin, Hippolyte 192
flashed glass 608
flash photography 490
Flavin, Dan 417
flax (*Linum usitatissimum*) 42, 78,
 79, 674
 see also linen
Flaxman, John 167, 754
Fleece Press 561
Fleischmann, C. W. 278
Flémalle, Master of 264, 443
Flemish bond 62
flesh, depictions of 506, 669,
 670
Fletcher, Benjamin 759
Fletton bricks 60
Flight, Claude 347, 559
Flindt, Paul, II 563
flint **621–2**
 artificial stone 22
 ceramics 92, 96
 enamel 187
 masonry 369
Flint, William Russell 116
flipbooks 412
Flitcroft, Henry 21
flock prints 222, 545
flock wallpaper 745
Flocon, Albert 199
Floding, Per Gustaf 12
Florence
 Cathedral
 dome 118
 monument to *Niccolò da
 Tolentino on Horseback*
 265
 monument to *Sir John
 Hawkwood* 265, 396
 vestments 185
 Chiostro dello Scalzo 401
 embroidery 185
 engravings 196
 flooding in 1966 17
 hardstones 273, 274, 275, 501
 lacquer 331
 La Specola 755
 niello prints 419, 548
 painting restoration 137
 Palazzo Medici–Riccardi 370,
 582
 Palazzo Vecchio 370
 Sala della Signoria 89
 pietra dura 501, pl. XI.1,
 pl. XII.1
 porcelain 37
 Santa Croce
 Baroncelli Chapel 263
 Pazzi Chapel 521
 Peruzzi Chapel 739
 pulpit 400
 S Lorenzo 111
 S Maria Novella
 Trinity fresco 110, 396, 739
 S Miniato 408
 scagliola 583
Florentine finishes 379
Florentine mosaic 273, 274
Flors factory 345
flour
 adhesives 415
 lacquer 328
 painting 187, 224, 572
 paper (decorative) 465
 papier mâché 467
'Flow blue' 38

flowered jasper 274
fluorescent light 417
fluorine 241
flurosilicate 636
flushwork 369
flux 96, 240, 373
foam rubber *see* polyurethane
Fogolino, Marcello 171
foil **223**, 383
 see also gilding
Fontaine, Cécile 215
Fontainebleau Château 293
Fontana, Lucio 417
Forbes, Elizabeth Stanhope 172
forgery 237
forging 8
formalin 604
Formica 515, 518, 520
Formosul 699
formwork *see* shuttering
Foster, Sir Norman 291
Foucault, Léon 493
foul-biting 200, 223
Fountain Brush Co. 6
fountain pens 481
Fountains Abbey 17
Fouquet, Georges 258
Fouquet, Jean 159, 164
Fourdrinier, John 451
Fourdrinier, Sealy 451
Fourier transform infra-red
 (FTIR) spectrometers
Fowke, Francis 289
Fowler, Charles 19
Fowler, John 290
Fox, Terry 734
fox hair 72, 748
foxing **223**, 561
fractals 115
Fragonard, Jean-Honoré 205,
 426
frames 40, 414, 443
Frampton, Hollis 214
Frampton-on-Severn
 St Mary's font 337
France
 alabaster 7
 architectural conservation 15,
 16, 19
 bauxite 8
 beadwork 32
 bookbinding 42, 43, 44, 45,
 46, 47, 48, 238
 ceramics 38
 chairs 725–6
 chalk 621
 chalk (black) 101
 cliché-verre 109
 concrete 119, 120
 cotton 148
 drawings 166
 enamel 189, pl. IV.2, pl. XIII.1
 encaustic painting 192
 experimental film 213–15
 furniture *340*
 iron and steel 289
 lace 316, 317
 lacquer 330–31
 leather 339
 linen 345
 manuscripts pl. VIII.1
 marquetry 365
 papier mâché 467–8
 photosculpture 500
 prints
 aquatints 12, 13
 crayon manner 152–3